Guide to Art

Guide to Art

General Editor
Shearer West

BLOOMSBURY

First published 1996 by Bloomsbury Publishing Plc, 2 Soho Square, London W1V 6HB

The publishers would like to thank the following for their help in the preparation of this volume: Sara Al-Bader; Kate Bouverie; Jeanne Brady; Katherine Cooley; Margaret Cornell; Angela Cran; Maya Derrington; Josie Henley; Huw Jones; Miren Lopategui; Katy Lord; Noel Lyons; Erika Mellina; Philip Parr; Jenny Parrott; Jane Parsons; Sarah Polden; Sarah Prest; Kate Quarry; Dermot Ryan; Kathryn Seabrook; Véronique Sérafinowicz; Colette Shannon; Anne Simpson; James Spackman; Gareth Wakeham; Dominic Wright.

Editorial Team
Commissioning and Project Editor: Tracey Smith
Chief Copy Editor: Mike Hirst
Editorial Assistant: Barnaby Harsent
Production Controller: Polly Napper
Text Design: Hugh Adams, AB3
Picture Layout: Leonard Gale, Artbar
Picture Research: Vivien Adelman
Picture Research Assistant: Amanda Hill

A copy of the CIP record for this book is available on request from the British Library

ISBN 0 7475 25625
10 9 8 7 6 5 4 3 2 1
Text design by Hugh Adams, AB3
Typeset by Selwood Systems, Midsomer Norton
Printed in Britain by Clays Ltd, St Ives plc

The publishers would like to thank the Bridgeman Art Library for their help and co-operation in producing this book.

Contents

Preface vi
Contributor Biographies & Acknowledgements vii
Introduction ix

Essay Section

1. Art in the Classical World 1
 Richard Brilliant

2. Penetrating Ecclesia: Interpretations of Gothic Architecture 13
 Phillip Lindley

3. Art and the Renaissance in Italy 29
 N. S. Davidson

4. Court Art in Seventeenth-Century Europe 43
 Joan Crossley

5. Everyday Life 54
 Paul Barlow

6. Portraiture: Likeness and Identity 71
 Shearer West

7. Art Institutions: Academies, Exhibitions, Art Training and Museums 84
 Paul Duro

8. The Politics of the Landscape in European Art 96
 Stephen Daniels

9. 'Other' Art: Approaching Non-European Cultures 109
 Shaun Hides

10. Art in North America: The United States and Mexico, 1820s–1920s 129
 Lucretia Hoover Giese

11. Women as Artists and Subjects 147
 Marsha Meskimmon

12. Modernism and Modernity 159
 Catriona Miller

13. Grounding Postmodernism 175
 Jonathan Harris

Reference Section: A–Z entries 187

Picture Credits & Acknowledgements 912

Preface

Cross references

A liberal use of cross references has been made. Throughout the essays and the dictionary entries, names, titles, works and topics are frequently marked with an arrow head (\triangleright) to guide the reader to the appropriate entry in the A-Z section for a more detailed or related explanation.

Dates

Dates after names of people indicate their life spans. The abbreviation fl. (*floruit*) has been used, in the absence of more detailed information, to indicate the period in which the person was active.

Bibliographies

Many entries in the A–Z section include a bibliography, indicated by **Bib.**. These listings are by no means comprehensive and are simply a starting point for the interested reader.

Contributor Biographies and Acknowledgements

General Editor

SHEARER WEST is Senior Lecturer and Head of Art History at the University of Birmingham. She is the author of *Chagall* (1990), *The Image of the Actor: Verbal and Visual Representation in the Age of Garrick and Kemble* (1991), *Fin de Siècle: Art and Society in an Age of Uncertainty* (1993) and co-editor (with Marsha Meskimmon) of *Visions of the 'neue Frau': Women and the Visual Arts in Weimar Germany* (1995). She is currently editing *The Victorians and Race* and completing a survey of German art 1870–1940. She has also written a number of articles on 18th-, 19th- and 20th-century art, including a prize-winning essay on representations of Jewishness in late 19th-century drama and art.

Editorial Assistant

CATRIONA MILLER is completing her Ph.D. at the University of Leicester on late 19th-century British landscape painting. She is the author of over 500 entries in the *Bloomsbury Guide*, in addition to the essay on Modern Art and Modernism.

Additional Essay Contributors

PAUL BARLOW is Lecturer in History of Art at the University of Northumbria.

RICHARD BRILLIANT is Professor of Art History and Archaeology and Anna S. Garbedian Professor in the Humanities at Columbia University in New York. He is the author of many books and articles on Greek and especially Roman art and has recently published *Commentaries on Roman Art* (1994) and is completing a book on interpreting art works, entitled *My Laocoon*.

JOAN CROSSLEY lectures part-time at the University of Leicester. She is the author of a major study on Victorian attitudes to art and war, *Images of the Army* (1988) (writing as J. Hichberger). She co-selected the Arts Council exhibition on childhood in art, *Innocence and Experience* (1992). She now lectures on 17th-century English painting and is researching a book on portraits of women. Her latest book, *Velázquez, Master Painter* will be published shortly.

STEPHEN DANIELS is Reader in Landscape and Cultural Geography at the University of Nottingham. He is the author of *Fields of Vision: Landscape Imagery and National Identity in England and the United States* (1993). He is currently writing a book on the landscape gardener Humphrey Repton.

N. S. DAVIDSON is Lecturer in History at the University of Leicester. He is the author of a book on the Counter-Reformation and many articles on the social and cultural history of Renaissance Italy. He is currently completing a study of the Inquisition in 16th-century Venice and has been commissioned by Oxford University Press to write a new history of Italy 1500–1800.

PAUL DURO is Senior Lecturer in Art History at the Australian National University, Canberra. He has published articles on art history and theory, and on the history of art institutions, in such journals as the *Bulletin de la Société de l'Art français*, *Oxford Art Journal*, *Gazette des Beaux-Arts* and *Women's Art Journal*. He is also, with Michael Greenhalgh, the author of *Essential Art History* (1992), and editor of *The Rhetoric of the Frame: Essays on the Boundaries of the Artwork* (forthcoming).

JONATHAN HARRIS is Lecturer in Art History and Critical Theory at Keele University. He is the co-editor of *Art in Modern Culture: An Anthology of Critical Texts* (1992) and co-author of *Modernism in Dispute: Art Since the Forties* (1993). His most recent book is *Federal Art and National Culture: The Politics of Identity in New Deal America* (1995). Dr. Harris contributes an annual review of art history and theory publications to *The Year's Work in Cultural and Critical Theory*. He is currently working on a history of the American Artists Congress Against Racism and Fascism.

LUCRETIA HOOVER GIESE is Assistant Professor of Art History at the Rhode Island School of Design, where she concentrates on U.S. and Mexican art of the 19th and early 20th centuries. She is the co-editor of *Redefining American History Painting* (1995) and has authored numerous articles on Winslow Homer and other North American painters. Homer's activity as a painter of the 1860s is the focus of her current work.

SHAUN HIDES is Senior Lecturer in Cultural Studies at Leeds Metropolitan University, having taught and studied Archaeology at the University of Leicester. He is the author of many articles and essays on theories of material culture, and ethnicity in anthropology and archaeology. He has developed research and teaching interests in the relationships between material culture and cultural identity, as well as European responses to non-western art.

PHILLIP LINDLEY is a Lecturer in the History of Art at Leicester University. He has published articles on medieval and Tudor artists, sculpture and architecture, and has edited books on *Gainsborough Old Hall* (1991) and *Cardinal Wolsey: Church, State and Art* (with S.J. Gunn, 1991). His book *From Gothic to Renaissance: Essays on Sculpture in England* was published in 1995, and he edited *The Black Death* (with W.M. Ormrod, 1996) and *Sculpture Conservation: Preservation or Interference?*

MARSHA MESKIMMON is Lecturer in the History of Art and Design at Staffordshire University. She is co-author (with Martin Davies) of the exhibition catalogue *Domesticity and Dissent: The Role of Women Artists in Germany 1918–1938* (1992) and co-editor (with Shearer West) of the book *Visions of the 'neue Frau': Women and the Visual Arts in Weimar Germany* (1995). She has just completed a book on women artists' self-portraiture entitled *The Art of Reflection: Women Artists' Self-Portraiture in the Twentieth Century* (1996).

Additional Dictionary Contributors

Listed below are the principal contributors of dictionary entries. The publishers would also like to thank the numerous additional people who helped in the checking and compilation of this dictionary section.

SIMON BOLITHO is a freelance writer and documentary film-maker.

TERRY CAVANAGH is a Ph.D. student at the University of Leicester. He is the author of the PMSA *Guide to Public Sculpture in Liverpool*. He is currently researching the influence of Italian Renaissance sculpture on British sculpture of the late 19th century. He contributed over 1000 entries to the *Bloomsbury Guide to Art*.

HILARY CLARKE was educated at Cambridge University and the Courtauld Institute of Art. She is currently Curator of the Stirling Foundation, London.

SIMON GROOM was a Lecturer in English at Florence University and is currently researching a Ph.D on 'Informel' art at the Courtauld Institute of Art.

DAVID HAYCOCK read Modern History at Saint John's College, Oxford, and Art History at the University of Sussex. He is currently a doctoral student at Birkbeck College, London, researching landscape, topography and printmaking in early 18th-century England.

A number of the dictionary entries are based on material taken from Paul Duro and Michael Greenhalgh's *Essential Art History*. The Publishers would like to thank Paul and Michael for their assistance.

Introduction

Since the Second World War, a larger cross-section of the public has been exposed to works of art either through museums and exhibitions or vicariously through the media. At the same time, art and design history courses have multiplied, and other disciplines have begun looking to art history for materials and inspiration. The history of art is not a monolithic discipline with one strategy, methodology and taxonomy. It is multivalent and defies easy categorization and limitation. On one level, the study of art history involves the interpretation of objects, whether they may be paintings, sculptures, architecture or such ephemera as album covers. The identification and classification of aesthetic artefacts has always been one of the main functions of the art historian, who has also been concerned with an assessment of an artist's style and technique and the placement of a work of art within a particular cultural context. The complexity of the study of art has intensified in recent years with the introduction of new methodologies into art-historical research. These are drawn from cognate areas of literary studies, sociology, anthropology and psychology, and they have served to open out the discipline, increase its complexity and contribute to the fluctuating nature of its studies.

While students have been confused, thrilled or irritated by the eclecticism of art history, members of the general public have more and more frequently been exposed to art through its higher profile within middle-class leisure experience. A larger proportion of the populations of Europe, the Americas and Japan now attend blockbuster exhibitions, and are responsible for purchasing the plethora of consumer goods and art publications which accompany such shows. Art features regularly on television, not only in documentaries, but through advertising, which exploits the familiarity of old master paintings and sculptures. Art has been demystified through its familiarity, but the need to understand art, its history and methods for interpreting it has become even more essential.

Given the complexities of the subject, it has become increasingly necessary to provide reference books which explain or define the many different ways in which art can be approached and provide a handbook for the student or general reader who feels confused by the multitude of terms and ideas that the discipline engenders. The *Bloomsbury Guide to Art* fulfils this need as it takes into account the fact that the study of art is constantly changing, and that a student may be confronted simultaneously with both old and new terminologies and approaches. There are many levels on which the study of art needs the prop of a reference book. First of all, the artist or art student, as well as the art historian, requires a detailed knowledge of the materials and techniques of art. Secondly, the amateur or connoisseur, as well as the regular gallery visitor, needs to know something about the formal properties of works of art, as well as some detail about the lives of the artists represented. Thirdly, students of art history need to understand new terminologies and methodologies which represent changing patterns within the discipline. Fourthly, anyone who is interested in art needs to acquire some familiarity with basic art-historical terms and techniques, such as 'chiaroscuro' and 'mezzotint' in order to appreciate the work he or she is viewing. Finally, no matter what level of knowledge one has, a discursive analysis of art within its social, cultural, political and historical contexts is necessary to aid the interpretation of art objects.

It is perhaps dangerous to attempt to produce a reference book which fulfills all these needs, but it is important to make the attempt nevertheless. The *Bloomsbury Guide to Art* combines an essay section with a comprehensive Dictionary to provide the student of art or art history, as well as the general reader, with a corpus of technical terms as well as an insight into the ongoing debates that surround the discipline, and a perspective on important artists, works, themes and periods in the history of art.

The essay section offers a selective survey of the history of art which is distinct from conventional

survey books on the subject. Books which attempt to give a comprehensive overview of the history of art are rare, and those that do exist, whatever their strengths, quickly become canonic and contribute to the entrenchment of certain diachronic views of art history. Although the essays in the *Bloomsbury Guide* are based roughly on a chronological framework, each of the authors has focused his or her subject in a thematic, rather than chronological, way, in order to give the reader material for thought, rather than a self-contained answer to the riddles of art history. The essays open up the subject and suggest new possibilities, rather than provide a dogmatic view.

I have chosen the essay contributors to represent as wide a range of approaches to the subject as possible. Given that art history has become increasingly interdisciplinary in its methods, I have also included authors from other disciplines whose research has an art-historical component, but whose methods are very different from those of traditional art historians. The purpose of the essays is not to be comprehensive, and the reader will undoubtedly spot many gaps in the coverage provided. Instead, each essay gives a snapshot of a key theme or period in the history of art and considers a series of ideas intended to stimulate and challenge the reader. Full cross-references to the Dictionary section are provided in each essay for the reader who may wish to follow up unfamiliar terms and names, and each essay contains a select bibliography to assist the reader who wishes to study the subject in greater depth and detail.

The Dictionary complements the essays in that it provides information on the many areas which cannot be covered in the essays and which need factual or discursive explication. Art history has always required more of this sort of apparatus than many other disciplines: the study of both art and architecture has always been heavily laden with terminology, and this has been enhanced by recent theoretical changes in the discipline. Equally, the subject-matter of art, relying as it often does on classical or Biblical themes which are no longer part of contemporary culture, is often totally inexplicable to the modern viewer without some sort of written or verbal explanation.

Although there are many art dictionaries available in bookshops, there are certain limitations with the current market. Art dictionaries tend to be specialized. There are dictionaries of art and artists; art terms; architecture; subjects and symbols in art; women artists; and artists of particular periods or countries. There is, as yet, no easily affordable dictionary of art which provides all of these functions. The *Bloomsbury Guide to Art* seeks to redress this balance by fulfilling a number of different needs at once. First of all, it provides biographies of individual artists, patrons, art historians, art theorists, and art critics. Obviously, the task of selecting those names that should be included and excluded was a difficult one, but I have tried to base my choices on my own experience of what is taught at both school and university level and what teachers and students feel they most need to know. The length and detail of each biography varies according to the amount of information available, but I have inevitably been somewhat restricted by the canon of art history which privileges certain 'great' artists over others. For example, although I have attempted to include many more women artists than many other dictionaries, I have not artificially expanded these entries while artificially reducing the word length for such 'old masters' as Michelangelo. Although art history now rightly questions these canons, it is clear that the student of art history still requires extensive information about 'canonic' artists.

The second function fulfilled by the Dictionary is a list of art and architectural terms. Again, I have tried to be as comprehensive as possible here, and I have included terms relating to art techniques (e.g. lithography, photomontage), materials (e.g. pencil, chalk), as well as those general terms used by art historians in discussing and describing works of art (e.g. contrapposto, repoussoir). Architectural terms have been included because it is impossible to study painting and sculpture in isolation, and many important works of art in the past have been inextricably linked with buildings or building programmes. Architectural terms are daunting for most students new to art history, but easy access to them puts their function into perspective.

Thirdly, the Dictionary provides an overview of subjects and symbols in art, including classical gods, goddesses and heroes (e.g. Venus, Hercules), as well as Biblical figures and themes (e.g. Virgin Mary, Matthew, Passion). These entries are especially important for the reader who may lack a classical or Biblical background and who wishes to understand the subject-matter of works of art more fully.

These entries explain both the significance of the subject and its importance to the history of art, with several key examples given in each case.

Fourthly, the Dictionary offers entries on areas which are not covered in most conventional art dictionaries. These include general summaries of art in particular countries (e.g. Germany, art in), as well as detailed analyses of important buildings (e.g. Tempietto), programmes (e.g. Arena Chapel) and individual works of art (e.g. *Primavera*). The Dictionary also comprises a number of terms which will assist the student confused by the pluralism of the so-called 'new art history'. These include general movements (e.g. feminism, Marxist art history, poststructuralism), biographies of theorists (e.g. Foucault, Barthes) and concepts used frequently and all too often without explanation by art historians (e.g. discourse, metonymy). Finally, many entries end with a short bibliography which will aid the student who wishes to follow up his or her study with more detail. These bibliographies were selected to include: (1) recent works on the subject, whether articles or books; (2) key works on the subject which may not be recent but which have not been superseded by subsequent literature; (3) primary sources on the subject. Ideally, bibliographies need to be updated constantly, but given that the *Bloomsbury Guide* is in print and not on the Internet, it is hoped that the entries will be recent enough to assist any student who wishes to pursue a subject in greater depth.

In attempting to satisfy so many different needs, I have undoubtedly left gaps, many of which I am all too aware of myself. For example, I have not made any systematic attempt to incorporate non-Western art terms into the Dictionary. In part, this is because the discipline of art history as it stands is orientated strongly towards the West and towards Europe. The Eurocentric nature of much art history has been rightly criticized in recent years, and my inclusion of an essay on 'Approaches to Non-European Art' attempts to address hermeneutic issues such as the ways in which Western artists and art historians have misunderstood and misinterpreted non-European artefacts. However, it is problematic to include dictionary entries on non-Western art, when the usual narrative and stylistic analyses of Western art are inappropriate tools of explanation for works which have such a different purpose and meaning. In future revisions of this book, I hope to work on ways around this problem with the assistance of experts in the field of non-Western material culture and traditions.

Apart from the relative dearth of non-Western art terms, the reader may also find that a number of important contemporary artists are omitted from the Dictionary (although many of these are mentioned in the essays). Given the fluctuating nature of taste and the contemporary art world, I felt it would be dangerous to include too many artists who were very young, or whose reputations were just beginning to be formed. Dictionaries have a way of encasing knowledge in stone, and this seems particularly inappropriate for artists who are at the beginning of their careers and whose work is undergoing constant evolution towards unpredictable goals. When the Dictionary includes living artists, it normally concentrates on those living artists who have many years of notoriety and experience behind them and who have already, to an extent, become part of art *history*, even though their work continues to develop, possibly in quite new directions.

Putting together the *Bloomsbury Guide to Art* was obviously a mammoth undertaking, and I have no illusion about the deficiencies which naturally result from any major collaborative project. I take full responsibility for these deficiencies, but the positive qualities of the book were due in no small part to the excellent team of authors who assisted me from the beginning. The essay contributors all approached their task with vigour and enthusiasm, and none of them was daunted by my desire that their essays be accessible, challenging and original in their approach. I learned a great deal from their imagination and intellectual rigour.

However, I perhaps owe my biggest debt to the Dictionary contributors – a group of Ph.D. students and freelancers who showed remarkable efficiency and professionalism in their dealings with me. Special thanks are due to Terry Cavanagh, who wrote over 1000 entries – all of which were of a very high standard – and who was a perfectionist in every detail. I must especially thank Catriona Miller, who acted as my editorial assistant as well as producing Dictionary entries and an essay. She never once complained about the tedious jobs I passed on to her, and she did not miss a beat with my often unrealistic deadlines.

I also wish to thank some people whose names do not appear in this volume, but without whose patience it would never have been completed. These are the secretaries, full-time, part-time and temporary, who worked in the Leicester University History of Art department during the compilation of this book: Krys Wysocki, Joy Fox, Mich Bingham, Gemma Jackson and Carol Charles. They assisted me at every stage of this endeavour with typing, photocopying, faxing, good humour and endless cups of coffee. Finally, without the encouragement of Tracey Smith at Bloomsbury, the faith of my husband Nick Davidson, and the tolerance of our daughter Eleanor, the book would never have been started, much less completed. I hope the reader will learn as much from it as I have done.

<div style="text-align: right">

Shearer West
Department of Fine Art
University of Birmingham

</div>

Essay Section

Art in the Classical World

Richard Brilliant

The history of Greek and Roman art: Classical art and its divisions

Monuments of Greek and Roman art withstood the ravages of time all through the Middle Ages and ▷Renaissance in Western Europe and along the shores of the Mediterranean. Often visible above ground, if in a ruinous state, or sporadically uncovered by casual excavation, these works of art and architecture maintained the physical presence of Classical art long after the collapse of Graeco-Roman culture. Ancient texts, preserving the literary and intellectual heritage of Classical antiquity, received much greater attention during the Middle Ages than the monuments with the exception, perhaps, of the ▷Colosseum, the ▷triumphal arches and the columns of Rome, marvellous symbols of the ancient city, now the capital of Catholic Christendom. Roman coins, engraved ▷gems and ▷cameos, and gold and silver medallions were often preserved in church treasuries as precious objects, frequently inserted into medieval mountings symbolizing Christianity's succession to pagan antiquity; as in the Campo Santo at Pisa, Roman ▷sarcophagi were reused as coffins for medieval dignitaries, and fragments of Roman architecture – decorated ▷entablatures, column shafts, capitals and veneers of coloured marbles – reappeared as *spolia* in Christian churches, especially in Italy.

The monuments of Greece and the Eastern Mediterranean were largely unknown in the West but not to the ▷Byzantines, who usually ignored or abused works of architecture but did collect ancient statuary for display at Constantinople, only to lose much of it to the Crusaders in the 13th and 14th centuries. However, the Byzantines considered themselves to be the only legitimate continuers of Hellenic civilization, and their collections of antiquities, even the idea of making such a collection, brought attention to these works as being worthy of study and esteem in their own right, not merely as tokens of past glories nor of displaced paganism. When Constantinople fell to the Turks in 1453, Byzantine Classical scholars fled to Italy, especially to Venice which had previously received and put on display many of the works of Graeco-Roman sculpture brought to the West by the rapacious Crusaders. Fifteenth-century Italy was most hospitable to these cultured Byzantine refugees, because Renaissance ▷humanism which sought to reinvigorate the creative powers of Classical antiquity was in full tide. Italian humanists and their patrons were already eagerly looking for and collecting ancient manuscripts, coins, gems and sculptures in marble and bronze. Among the sculptures, bronze statuettes representing the ancient gods and mythological personages were highly prized, as were the portraits of the great philosophers, authors and rulers of the Graeco-Roman world, although like the 'Pseudo-Seneca' (Naples) they were frequently misidentified.

If, at first, these Italian humanists poorly comprehended the meaning, origin and chronology of these ancient art works, their eagerness to collect and publish their collections was limitless. Their enthusiastic activity combined with the spread of humanist learning in Europe and led, eventually, to the creation of large private and semi-private collections in Italy, Spain, France and England from the 16th to the 18th century. Antiquarian lore, some of it still valuable, contributed significantly to the large, illustrated volumes by means of which these collections became known and, in turn, inspired further collections. Aristocratic travellers on the ▷Grand Tour in Italy visited these collections and had recourse to the burgeoning art market which provided would-be collectors with opportunities to

acquire objects of ancient (or not-so-ancient) art and to bring them home for others to see and admire. Portraits in the round might be identified on the basis of inscriptions, textual descriptions, comparisons with numismatic busts or wishful thinking; the differentiation between 'Greek' and 'Roman' depended almost exclusively on subject matter rather than on distinctions of style because accepted criteria for making such critical judgements were lacking. Still, ▷Raphael in the early 16th century had recognized that elements in the Arch of Constantine in Rome came from different periods of Roman art; and the more venturesome travellers of the 18th century visited the Greek temples at Paestum or in Sicily and even reached Athens where they found the character and appearance of Greek masonry very different from that of Roman vaulted architecture such as the Pantheon in Rome. Slowly, these perceptions began to erode the seamless continuity of Classical art and architecture, to break up their development into earlier or later stages, and to separate Greek from Roman.

In addition to the evolution of the collector into a connoisseur, two important events in the mid-18th century changed the perception of Classical art for ever. The first was the publication of ▷J.J. Winckelmann's *History of Greek Art* in 1754, which not only initiated the history of art itself as a separate discipline in the humanities but, also, laid the groundwork for the study of Classical art as a history of successive styles. He distinguished those styles through the closest visual analysis of the formal characteristics of the works themselves in Italian museums and collections without ever going to Greece. Nevertheless, he created a structure of stylistic evolution, covering more than a thousand years, beginning at the time of Homer in an ▷Archaic phase, culminating in the ▷High Classical of the 5th century BC, and undergoing a slow decline through the ▷Hellenistic period and early Roman empire until reaching the nadir of Classical art in the 4th century AD after Constantine. His conception of stylistic evolution, of early and late stages, and of greater and lesser phases, qualitatively speaking, provides the still-operative framework of the 'history' of Greek and Roman art. Winckelmann combined extraordinary ▷connoisseurship, a thorough command of ancient, especially Greek literature and a sure sense of the relationship between image and text in the creation of his historical scheme, but not as an end in itself. Rather, he sought to elevate the level of artistic creation in his own time by presenting the works of High Classical Greek art as models of an idealized imagery of man and nature to be emulated, but not copied, by contemporary artists. Thus, he never lost sight of the intimate connection between the work and its maker, while simultaneously propounding an elitist ideology of aesthetically gratifying achievement.

Winckelmann's legacy for the 19th and 20th centuries is thoroughly elitist, not only in its exhortation but also in its strong emphasis on the notion of the 'great artist' and his 'masterworks'. By relying on the testimony of ancient texts, especially Pliny The Elder's *Natural History* (Books 34–36) and Pausanias's *Itinerary of Greece* – the former written in Latin in the 1st century AD, the latter in Greek in the early 2nd century AD – Winckelmann began the patient reconstruction of the lost *oeuvres* of Greek sculptors and painters, finding traces of their noble existence and subsequent influence on the development of art in later Roman copies. Indeed, when the statue of the ▷*Laocoön*, now in the Vatican Museum, came to light in Rome in 1506 to be admired by many Renaissance artists including ▷Michelangelo, one reason for the excited response to its discovery was their knowledge of the passage in Pliny's text that referred to the work explicitly and to the three Rhodian sculptors whose virtuosity had made such an extraordinary sculpture possible. That the statue itself has been variously dated from the 2nd century BC to the 1st century AD is only symptomatic of the difficulty in establishing even now acceptable stylistic criteria as chronological markers.

Of course, Winckelmann first had to identify the extant copy as a 'copy' of a lost Greek original, whose very existence and appearance he had to posit and reconstruct. Generations of German scholars before and after Adolf Furtwangler, well into the 20th century, have adopted this strategy in their effort to reconstruct the lost masterworks of 5th- and 4th-century Greece, now buttressed by recourse to contemporary Greek works, uncovered by excavation but not necessarily attributable to the great masters themselves. Masters, or lesser masters, so constituted by reconstructive connoisseurship, then came to punctuate the history of Greek art as nodal personalities, reinforcing the existing tendency to valorize high art, especially of the 5th and 4th centuries. This restrictive, aestheticized attitude was detrimental to the study of other periods, other levels of patronage and artistic production and, also, served to demonstrate the inferiority of Roman art which lacked textual evidence for its own 'great masters'. Furthermore, while the attributions of so many masterpieces of Greek art rest on a foundation of value-laden, tendentious supposition, the Roman copies, on which they primarily depend, became

transparent vehicles for the construction of these anterior models with little regard for their own intrinsic properties and meaning, at least until fairly recently. Histories of ancient art which ignore the *realia* of art works and the contexts of their making and use are both problematic and seriously misleading for the reader.

An even more important event in the historiography and reception of Classical art was the rediscovery of the buried cities of Herculaneum and ▷Pompeii in the 1730s and 40s, and with it the beginning of true archaeological excavation. Although excavation would later become more methodical, less of a treasure-hunting enterprise and more a means of developing the social history of Classical civilization, the excavations of Pompeii and elsewhere proved to be a veritable mine of worthy, and not so worthy, monuments, found in the physical context of their ancient placement and use in the daily lives of the ancients. Archaeology made possible the history of specific buildings and their sites as well as the history of Greek and Roman cities, their urban structures and services, and of ancient city-planning; archaeology revealed how sculptures were displayed and mounted, how schemes of interior decoration comprised paintings, mosaics, stone veneers and moulded ▷stucco to create rich ensembles; archaeology extended our knowledge of ancient religious practices and patterns of belief from the smallest shrines to the temples of the great gods and beyond them to the often secret centres of cults and the great sanctuaries such as Delphi, Olympia, Samothrace and Palestrina; archaeology led to the systematic study of Greek and Roman architecture, to the history of building types and spatial organization, and to a penetrating analysis of domestic structures from humble rural and urban dwellings to luxurious villas, urban palaces, and the great tenements of Rome and Ostia; archaeology helped situate the remnants of ancient ▷material culture, preserved in museums and collections, if not in the original environments, at least in reasonable facsimiles thereof. In sum, archaeology restored the rich visual texture of ancient culture, the messy life of Classical antiquity as it was lived with objects of various kinds, and in so doing confronted the traditional art historian and connoisseur with the potential devaluation of the art work so long prized. An instance of the latter is the acknowledgement that Greek painted vases, despite their evident beauty and great repertory of images and themes – subjects of acute connoisseurship and inspired iconographic interpretation – were only pots, priced very low in antiquity, if not at present, and never mentioned by the ancient sources in the context of art works.

Revisionist views of Classical art, whether stimulated by the new archaeology, by negative ▷postmodernist attitudes toward 'authorship', or by current art-historical practice that emphasizes the social context of art production, have not completely displaced connoisseurship's role in the agenda of legitimate historical research. J.D. Beazley, for example, has organized the corpus of Greek ▷black-figure and ▷red-figure vases, while A.B. Trendall has done the same for the Greek vases of South Italy, tracing the distribution of these objects among artists, artisans and workshops. The work of these scholars in establishing a relative, but narrow, chronology retains its fundamental value for anyone interested in Greek painted pottery. Their example informs the *Corpus Vasorum Antiquorum* in which, eventually, all the ancient vases in all the world's public collections will be published. Other scholars have pursued their leads in following up the economic and ethnic character of pottery workshops in Athens as well as the relationship between the proprietor and the potters and painters working for him. Still others investigate the lines of trade, seeking the patterns of distribution, locally and abroad, and uncovering the evidence for the Greek workshops' adjustment of shapes and designs to suit the taste of their foreign markets. Thinking about the vases as pots has brought greater attention to their function as ordinary table utensils, as participants in parties and other social or religious rituals, and as containers of the goods – especially grain, wine, oil and perfumes – shipped in them.

From painted pots, qualified in modern times as objects of art, one passes easily to the consideration of unpainted pots, common ware for the table or large ▷amphora for commercial storage and shipment. These 'ordinary' objects were produced at an industrial level of enterprise, and it is possible to follow the rise and fall of the producers in Greece, Italy, North Africa, Gaul and the Rhineland over the centuries, as well as tracing the scope of their distributional networks. In addition, many of the amphora bear stamped handles, which makes tracking them from their source to their destination much simpler, thereby constituting a very important chapter in the economic history of antiquity. A good sense of the volume of this trade can be had from the great hill of broken amphora on the southern edge of Rome near the Tiber and the great warehouses that received goods from all over the ancient world. The Roman brick trade was similarly organized on an industrial scale, and here, too, many bricks bear the stamps of the maker, permitting a close examination of the economics of the

Roman building industry, the fluctuating fortunes of the brick-makers, and the dates of their provision of building materials. Ancient glass, although rarely marked by makers' names, followed a comparable course of development, manufacture and distribution, and like pottery ranges from the ordinary to the extraordinary, the latter evidently qualifying in antiquity as especially precious. ▷Ceramic and glass products may range from the common to the fine, but now the scope of their treatment is no longer circumscribed by their aesthetic status, even if 'beautiful' objects still receive special attention. Conversely, the questions raised about the utility and function of ordinary objects, their value in antiquity, and their production now can be applied to extraordinary objects as well.

Most of the best preserved and renowned Greek vases, such as the François Vase in Florence, have been found in ▷Etruscan tombs, indicating that these vases were prized by the Etruscans. Their presence in such large numbers demonstrates the volume of trade between Greece and Etruria, but it also raises a question: why were Greek vases so esteemed by the Etruscans that they placed them in their tombs? The painted decorations, usually drawn from Greek mythology, which adorned these vessels may not have always been intelligible to the Etruscans but this ornamentation did provide the Etruscans with an extensive repertory of images and themes which Etruscan artists then borrowed and adapted in their own painted pottery, tomb paintings and cinerary urns. This absorption of Greek imagery and form into an indigenous Etruscan art set the pattern for the subsequent assimilation of the Greek artistic repertory by the Romans, and through them to the provinces of the western empire.

The diffusion of Greek Classical art throughout the ancient world is a significant topic in itself, a demonstration of its attraction to non-Greeks and of the difficulties they had in moving their own artistic culture closer to the Greek. Their borrowing often concentrated on the externals of imagery and composition, as if the intrinsic meaning of the Greek images were inaccessible to those who did not fully share the normative assumptions of Greek culture. Even modern analysts of Greek mythological representations have only recently begun to move beneath the mythographic surface to discover in Greek vase paintings, for example, subtle, yet recognizable responses to contemporary political and social pressures: the chauvinistically inspired change from representing the labours of ▷Hercules, the universal Greek hero, to the exploits of Theseus, the heroic Athenian, in the late 6th century BC; the increasingly frequent appearance of barbarians, especially Persians, and of conflict motifs featuring the Amazons during and immediately following the Persian Wars; the presentation of women in dependent or submissive roles, only occasionally challenged by powerful females such as ▷Medea, reflecting their repression in times of social unrest in the 5th and 4th centuries BC; the evident transformation of power relationships between men, as the dominant aristocratic culture of the 6th and 5th centuries was progressively modified, or redirected, by democratic or anti-aristocratic tendencies; and the rise in importance of motifs drawn from the incidents of daily life, the theatre in its more melodramatic or comic aspects, and erotic situations, especially in 4th-century vases from the Greek communities in South Italy, all indicative of the greater value placed on secular pursuits and individual activities in the post-Classic age.

In some respects the current study of Classical art is preoccupied with the extension of boundaries, not just in broadening the range of materials that fall under its purview, but also in the greater attention given to identifying and characterizing the audience to the programmes and monuments of art and architecture, created for an ever more varied public. The transition from the small Greek city state, or *polis*, to the vastness of the Roman empire was accompanied by the fragmentation of the population into a multitude of semi-discrete communities. Distinctions of class, civil status and occupation, of ethnic and religious affiliation, of language and local culture, of rural or urban experience, of degrees of political power and of acculturation to the norms of Graeco-Roman civilization – especially significant in the Roman provinces – all contributed to the development of differentiated audiences, sometimes brought together by political necessity, by force, by economics, by law and by a desire to be entertained. Greek and Roman artists and architects, artisan-producers, and purveyors of luxury goods sought favour with these communities as sources of patronage and custom; the nature of their address to them and, conversely, the interests so addressed have come under increasing scrutiny. Thus, the apparent homogeneity of 'Classical art', once seen as an embodiment of Athenian 5th-century values or its subsequent derogation, has slowly given way to a more complex, changeable definition of the norms of Graeco-Roman visual culture, especially in its Hellenistic and Imperial phases.

High art/low art distinctions still obtain, as do attempts to (dis)qualify works of 'provincial' art from metropolitan examples or to discriminate, chronologically, among styles. However, there is a new

interest in the richness of ancient visual culture and its recipients, a greater appreciation of the fundamental importance of visual communication in antique society. Much of this new scholarly-critical activity has concentrated on topics perceived to be instrumental in the creation, expression, and satisfaction of social demands: in particular, the imagery of the human condition, its depiction and portrayal, and its contextualized narrativization; the expression of belief in the (im)permanence of life and death; manifestations of political power and authority through consciousness-raising programmes of art and public building; and the exploitation of spectacle, of visual splendour, as a means of conditioning behaviour.

Of course, demand stimulated the production of works of architecture and art, which, in turn, intensified demand when they were successful. Thus, the repetition of types and motifs, reflected more or less accurately in comparable rates of survival, provides markers of relative success and of fluctuations in popular reception. One can, therefore, plot the occurrence of similarly designed bath-buildings, theatres, circuses and arenas in the Roman world and their central role in ancient urban culture, given the expense of such projects. As fixtures of the urban scene, the popularity of these grand buildings proves their political value as a means of diverting the populace from other, potentially disruptive concerns, while also demonstrating that such a large-scale allocation of resources to the serious business of entertainment bespeaks a society that has disposable leisure time. Similarly, the extraordinary rise in the number of carved stone sarcophagi, beginning in the late 1st century AD and extending well into Early Christian times, marks the preference for inhumation over cremation at least for those who could afford such monuments. In addition, the themes and motifs presented by the sculptural decoration of the sides and lid of the sarcophagi reveal the aspirations of living patrons for themselves and their loved ones after death. These aspirations might have an individual cast or a particular religious dependency on some deity for salvation in some instances, but in general they were programmatically served by sculptors' workshops located efficiently near marble quarries, perhaps in Asia Minor, in traditional centres of sculptural production, such as Athens, or in 'show-rooms' close to large markets like Rome.

An incidental benefit of the traceable commerce in Roman sarcophagi has been the exposure of workshop practices, including the separation of various stages in production – quarrying, roughing-out, finishing, and, where called for, using a 'specialist' to complete the portraits of the deceased. If on one hand the physical labour of carving the sarcophagus was parcelled out, not all of it to be performed in one place, the overall design of the coffin and of the motifs employed in its decoration should be considered the intellectual property or stock-in-trade of individual or regional workshops. Knowledge of this fact leads to a better understanding of the workshop's particular appeal and of the flexible relationship between the sculptor, or entrepreneurial artisan, and the patron, whether an originating commissioner of the work or a purchaser out of stock.

The movement of these heavy objects from the point of manufacture along the shipping lines to the ultimate user, often hundreds of miles away, surely required a functioning art market, so that the workshops had a reasonable expectation that their products could be sold. How the larger sarcophagi, weighing several tons, arrived at their destination safely, given the ancient means of transport, is unclear, nor is it known whether individual pieces were shipped on order – in which case the patron could have played a more active role in determining the imagery, carved in ▷relief – or on speculation. Similar observations, with similar uncertainties, have been made with respect to the production of architectural ornament during the Roman empire – capitals, elaborately carved entablatures, fine stone veneers, coloured marble, granite, or ▷porphyry ▷columns – as well as in the production, design, distribution and laying-out of floor mosaics in lands bordering the Mediterranean. Pattern books, whose existence is presumed, works of art in various materials, some of them recovered from sunken ships, and trained personnel who occasionally left identifying marks on their work, all seem to have been in active circulation for centuries, comprising, in effect, an art industry operating at a high level of intensity and dependent on private as well as public patronage. The scale of this activity is both a marker of the high degree of resource allocation to the arts and, also, an indication of the ancients' great interest in the visual enrichment of their environment.

Sarcophagi, architectural members and laid mosaics are large and heavy; once in place they rarely move. But there was an equally intense commerce in smaller, portable objects, such as small ▷bronzes and ▷terracotta sculptures, usually in the form of figurines made in large numbers and for a more modest clientele. Many of these objects have been found in tombs, in votive deposits, in shrines dedicated to local or foreign deities or in domestic contexts. Their repertories are derived from

conventional representations of the gods or other well-known images, often as miniature versions of famous art works, otherwise lost to us. Frequently, these figurines portray the distinctive elements of the human condition in exacting detail, an image-making response to the almost anthropologically sophisticated definition of human types that came to the fore in the Hellenistic art of Alexandria and soon became an endemic feature of metropolitan taste. Noble philosophers and heroic leaders, modest matrons, gossiping women fashionably dressed, handsome youths and maidens, teachers and their pupils, the elderly, Africans and Asiatics, the poor, country bumpkins, erotic couples, drunks and the diseased and deformed altogether constitute a veritable panoply of urban culture. The very specificity of their representation seems responsive to and supportive of the sense of familiarity that comes from a deliberate engagement in the stuff of daily life. The parallel introduction of landscape imagery, peopled with such human types or conceived as an environment for mythological scene-setting in Roman wall-painting strengthens the temporal-spatial association of characters and the locales of action. It also sets the stage for the effective narration of historical events, most completely achieved by the Romans in the triumphal columns of Trajan and Marcus Aurelius in Rome.

Narrativization also served to ennoble the lives of 'ordinary people', especially in sepulchral or funerary contexts. Romans of the republic and early empire often represented their business activities, in effect publicizing how they gained the means to embellish their tombs for the benefit of their own reputations in the eyes of their contemporaries. Portrait statues, busts and reliefs of the well-to-do and of the not-so-high-and-mighty, placed in, on or beside Roman tombs, preserve the often unflattering likenesses of these people, depict their family and social relationships and proclaim the *realia* of their existence as something worthy of respect. These images are not so much about death and the fallibility of memory as they are about life before death, at least up to the 2nd century AD when, slowly, the quality of life began to change.

How the ancients dealt with death, of course, informs the sepulchral art of antiquity; it manifests the changing estimation of the quality of life here, in the world, and in the hereafter (if any). Roman sarcophagi of the 2nd and 3rd centuries often used stories drawn from Greek mythology in their relief decoration as metaphors, expressing through them the desire to attain some degree of immortality. The intensity of this aspiration was especially poignant when portraits of the deceased were substituted for the faces of gods and heroes, a theatrical mode of assimilating them to the immortals that brought the hope of an everlasting life. This transcendental, allegorizing approach to sepulchral imagery, with its enhancement of the prospect of life in the hereafter, was fulfilled in the paintings in the Early Christian ▷catacombs of Rome and in 4th-century sarcophagi, where scenes taken from the Old and New Testaments offered redemptive hope to the faithful. Conversely, Etruscan tomb-paintings and cinerary urns, which exploited the Greek mythological repertory for centuries, stressed the awful presence of death in the world, witness the bloody nature of their combat motifs, the merciless killing of prisoners – perhaps the precedent for Roman gladiatorial contests – and the terrifying aspect of the dire beings who transport the spirits of the dead to the underworld. Intense violence, so often represented in Etruscan and Roman art, may have been a useful response to a hostile world.

Greeks seemed to think otherwise. Carefully composed combat motifs and the heroic associations implicated in their usage figure in the grave monuments of people on the periphery of the Greek world in Asia Minor and the Levant, especially in the late 5th and 4th centuries BC – on the Mausoleum at Halicarnassus in Caria, on the Lycian tombs, and on the famous Alexander Sarcophagus from Sidon, this last monument carefully balancing historical and idealized images of battle and hunt with actual personages depicted in action. Yet Athenian grave ▷stele from the same period continuously offer an idealized, ahistorical, often domestic and only occasionally heroic repertory of motifs in mitigation of the loss of a family member in death, as if separation between the two states were less complete. Perhaps the reduction of tension, visible in these grave stele, reflects Athenian confidence in the permanence of group memories befitting the communality of individuals in the Classical *polis*.

If sepulchral monuments reflect the world view of a culture and focus the belief system on a central episode in the human experience, they may also respond to political considerations, not the politics of death, but the politics of life in organized societies. Demetrius of Phaleron, the philosopher king, dictatorial ruler of Athens in the late 4th century BC, terminated the two-century-old tradition of Athenian grave stele because too much money was being lavished on such private monuments to the detriment of the state's moral posture and the stability of its social structure, threatened by disparities in wealth among its citizenry.

Such strictures had not kept earlier Athenian politicians from the active, public patronage of major architectural projects both in Athens and elsewhere. Nor did they keep Pericles from expropriating the funds of the Delian League, entrusted to Athens, in order to embellish the Athenian Acropolis with great monuments, including the ▷Parthenon; his activity and its splendid result were understood from the beginning as an overt, political statement of Athenians' pride in themselves and in their city for all other Greeks to see. Similar impulses generated the competing monuments – temples, porticoes, sculptural dedications – commissioned by different Greek cities and their leaders to represent them at the great sanctuaries of Delphi and Olympia. Certainly, no sense of moral impropriety inhibited the extraordinary campaign of building and monumental commissions undertaken by the kings of Pergamon in the 3rd and 2nd centuries BC to advertise the dedication of their energies and wealth to maintaining Greek culture itself against the Gallic barbarians who invaded their territories in Asia Minor. And the Romans, who inherited Pergamon in 133 BC, knew, perhaps instinctively, how great public monuments reflected politics, and vice versa.

The great leaders of republican Rome, Sulla, Pompey and Caesar, looked to the Hellenistic kings for artistic modes, but the notion of using art in the service of the state and of their own political ambition was something they grasped for themselves. This was especially true for someone so powerful and so subtle a manipulator of public opinion as the first emperor, Augustus, who boasted that he had found Rome a (rude) city of brick and left it a (glorious) city of marble. His recognition of the power and authority of images had no limit: it extended from his control of the motifs and themes on the coinage to the sponsorship of exquisite luxury objects, then to the cultivation of an imperial mode of portraiture, dependent on Greek 5th-century types, and on to the ostensible commissioning of large-scale building projects.

Augustus's success in establishing the political dimension of art in the Roman world capitalized on two important perceptions: that Rome, much more than Greece, was a class-conscious society at all levels with Romans accustomed to reading the signs or codes necessary to the definition of operative social/political distinctions; and that in a world of limited literacy, but of large numbers of people spread over a wide area, the persuasive force of visual images constituted an unrivalled means of mass communication, so the repetition of images and the well-advertised patronage of large-scale architectural enterprises made effective public statements that reached wide audiences. As a result of these factors, the manifest equivalence of power and visual splendour became an ever-stronger desideratum of imperial policy and of the Roman ruling classes.

In the late 20th century a notable shift occurred in the study of Greek and Roman art. This shift can be described as the transfer of primary attention from questions of value, attribution and dating to the analysis of the contexts of making art, the political and social implications of its use, and the character of its ancient reception by diverse audiences. These last considerations involve a heightened sensitivity to issues and agendas of representation that reflect notions of ▷gender and sexuality, civil status, provinciality, personal religion and, in general, alienation from the norms of Graeco-Roman civilization. The move from the art work to the circumstances surrounding it – some might say from pleasure to pain – is hardly peculiar to the history of Classical art, as the denigration and subordination of the individual art work are commonplaces of contemporary art theory. Yet the works of ancient art survive into the present against many obstacles. They possess a rich pedigree of profound study and appreciation, going back several centuries, and inseparable from them. And if there is an ongoing, revisionist history of their history, the former is surely secondary to their own.

Greek art

In any historical account, beginnings have a particular importance. Preliminary, or preformative, aspects of Greek art may be said to have begun in the Bronze Age, the 2nd millennium BC, the age of Homer's *Iliad* and *Odyssey*, and of the Mycenaeans, when the personae of the Olympian gods and of the legendary heroes of the Trojan War came into being. Stories of the gods and the heroes, and of the mortals associated with them for good and for ill, provided the mythological framework for the representation of human action in the world that stimulated the search for the formal solutions to render that action visible in art. During the ▷Geometric and Archaic periods, from the 8th century to shortly after 500 BC, the Greeks invented much of the visual repertory of their art: figure types – including men, women, animals (especially horses) and imaginary, composite creatures, such as ▷centaurs; a recognizable ▷iconography for representing the gods and heroes; vegetal ornament; and

a compositional principle that emphasized structure, order and an organic relationship among the constituent elements of each form.

The rapid pace of invention and experimentation in the 7th and 6th centuries encompassed the evolution of the ▷kouros (the youth) and the ▷kore (the maiden) in more or less life-size stone sculpture, originally inspired, perhaps, by Egyptian statues and their proportional schemes. But the Greek statues quickly changed from rigid, highly articulated bodies towards ones with greater flexibility, suggesting their potential for motion as the figures became ever more infused with natural, closely-observed features of anatomy.

Figures which are seemingly capable of motion, at least in the viewer's imagination, can also appear to act, and human action bespeaks will and responsibility, tantalizingly evident in the gradual movement of the body away from frontality with its emphatic bilateral symmetry and in the curve of the ▷'Archaic smile', so prominent on the faces of kouroi and korai in the 6th century. A figure like the *Anavyssos kouros* invites the viewer not just to be cognizant of the sculpted image but also to view it as the embodiment of a living being. Greek sculpture never loses this connection between the organic treatment of the human form and the world of nature, however refined and complicated that relationship might become.

Greek vase-painting exploited many of these same qualities in a medium which permitted a greater range of expressive possibilities. The François Vase is a great ▷krater, originally intended for aristocratic drinking parties; it was made by ▷Kleitias and Ergotimos, who signed the vase as painter and potter in Athens c570 BC, but was recovered, intact, in an Etruscan tomb. This masterpiece of figural composition in miniature, a triumph of virtuosity in the black-figure technique, presents a nearly encyclopaedic repertory of mythological subjects, carefully identified by inscription – thus presuming some degree of shared literacy – and equally carefully staged, even in architectural settings. Its seriousness is leavened with humour. If the François Vase displays a wide range of subjects, ▷Exekias, perhaps the greatest of all Greek vase-painters, concentrated all eyes upon the scene of Achilles and Ajax playing a board game, while, as any Greek would know, the Trojans 'outside' were winning the battle and only when Achilles got over his sulk and returned to fight – and die – would the situation change. Indeed, the noble, often fatal consequences of action, dominant themes of 5th-century Athenian drama, if implied in the Exekias vase, are clearly laid out in ▷Euphronios's late 6th-century red-figure ▷krater, representing the *Death of Sarpedon*, the once powerful body of the Trojan hero sagging in death. Both Exekias and Euphronios modified the pose of the body to express, or elicit, profound states of feeling or thought, both for the participants represented within their works and for the viewer. In subsequent centuries, Greek artists would continue to employ the body as an expressive vehicle, even if the particular stylistic mode would change and the artists' address to the viewer become more direct.

Greek architecture in the 6th and 5th centuries underwent a development comparable to that of monumental sculpture. Principles of clarified design, subsumed in the formal languages of the ▷'Doric' and ▷'Ionic' orders, effected the transition from massive to lighter, more supple structures in the temples at Paestum and Aegina; they lead in turn to the Classic monuments of 5th-century Athens, the Parthenon and Propylaia, which incorporate elements of both orders harmoniously into their fabric. Just as the shape of form in the figural arts retained its clarity in the visual field, so too were Greek temples sited so as to provide the viewer with a coherent sense of the whole as a distinct spatial entity. Oblique views revealed the three-dimensional character of rectangular buildings; and a superb masonry technique allowed master masons to make columns tilt and horizontals rise in the centre, just enough to correct the distortions of human vision so that both horizontals and verticals appeared in orderly, regular, perpendicular relationships.

This highly conceptualized rationalization of experience reached beyond the design of individual buildings or groups of buildings to the regular organization of cities, especially the new towns planted in Sicily, southern Italy and Asia Minor. Greeks invented city planning as a conscious enterprise, based on practical experience in town foundation and on theories of political organization of the kind described by Aristotle in his *Politics*. City planners like Hippodamus of Miletus relied on the grid to establish a regular street system of parallel and perpendicular streets and avenues, allocating accessible space to sites of religious, political and commercial activities, and paying attention to securing reliable sources of wind and water and to the requirements of defence, all in order to create healthy, beneficial environments for successful communal living.

Confidence in the exercise of human reason expressed itself in the physical organization of urban

life and, fundamentally, supports the advocacy of a moral and physical balance in the ideal citizen, so often identified in Greek art of the 5th and 4th century. ▷Phidias is said to have created the ideal imagery of the Olympian gods, ▷Polykleitos that of the ideal male nude, the ▷*Doryphorus* who incorporates rest and motion in one harmonious form. Later, ▷Praxiteles will represent grace in the human form and put forward images of the nude ▷Aphrodite as its most complete, and desirable, embodiment ▷Lysippos opens up Greek statuary to the physical space of its environment and exalts the extraordinary nature of Alexander the Great while the painters, ▷Zeuxis and ▷Apelles explore the relationship between perception and illusion in their pictorial fantasies. Works of these great sculptors and painters survive, if at all, in textual descriptions or in copies of uncertain reliability, but their reputations and the tradition of their works resonated throughout the subsequent history of Graeco-Roman art.

Of course, the Greeks knew something of the irrational, not only because of their involvement in popular mystery and nature cults, particularly that of Dionysus (▷Bacchus) with his welcome offer of ecstatic release, but also because of their growing sensitivity to the effect of that element in human affairs, so trenchantly observed in the plays of Euripides and by the Greek historians. However, the full exploitation of demonstrably irrational behaviour, of divine or drunken possession, of the defencelessness of sleep, of the power of strong emotion and the experience of pain, and of the trivialization of such feelings in sentimentality, occurred in Hellenistic art. This proliferation of the visual repertory departed from the noble standards of High Classical art; its scope was more encyclopaedic, extending to ▷genre and the depiction of the extremes of the human condition, to the increasing specificity of portraits and ethnic designation, and to the floral and faunal components of nature, now more closely observed. If the Greeks' gaze was less elevated than before, it was more focused on the mundane details of the everyday.

The increase in personal wealth, following Alexander's conquest of the Persian empire, brought about the private patronage of art and the creation of a more intimate repertory of images. Disposable personal wealth made possible the embellishment of the domestic environment, leading to the creation of luxurious interior spaces, punctuated by gardens and porticoes, and enriched by wall-paintings and floor mosaics, by elaborate furnishings, by utensils of silver and gold, by decorative hangings or floor coverings and by a large number of art objects – clearly recognized as such – hung on the walls, standing on small podia or adorning the gardens and fountain pools of the larger houses. To each according to his means; but if the grander houses of Cyrene, Delos and Pompeii reveal the delectable pleasures of wealth and the private nature of their enjoyment, the more modest houses show how these pleasures were no less an objective for their inhabitants. Hellenistic architecture demonstrated similar tendencies in the rapid evolution of secular building types, more and more elaborately adorned: theatres, council houses, the various meeting places associated with the market and gymnasiums, all points of connection between the citizens' private and public selves.

Despite these creative impulses, Hellenistic artists and their patrons exhibited a degree of cultural fatigue, partly revealed in their retrospective endeavour to consolidate the 'Classical tradition' in some canonical way, especially around the central figure of Homer. The late 2nd and 1st century is the time of the eclectic revival of past styles, often given an elegant, even mannered cast, and occasionally taking refuge in an allegorical imagery as refined as it is abstruse, thus meant to appeal to a very limited audience of cognoscenti. And yet, there was sufficient vitality left in Hellenistic art to attract the attention of foreigners, especially at Rome, where uncultivated would-be patrons of the arts with money to spend and a great desire to do so employed Greek artists, purchased Greek works of art, often at high prices, and engaged Greeks, knowledgeable in the arts and possessors of 'good taste', to instruct them. The Romans learned quickly.

Roman art

Roman art is difficult to characterize, in part because it consists of so many diverse elements, poorly integrated, and in part because the term covers, inadequately, the art works produced over a very wide area and for a long period of time. Romans continued many of the traditions of Hellenistic art and architecture, and even became significant patrons in the East, well into the 2nd century AD. At the same time, the Romans were not Greeks and were never wholly assimilated to Greek cultural norms, although occasionally they tried very hard to transform themselves. Roman art originated in a small city on the Tiber under Etruscan control and depended for several centuries on an Etrusco-Italic

foundation which adopted the ductile forms of ▷ terracotta and bronze as its sculptural medium rather than stone, with the result that surface rather than structure dominated. Figural imagery relied heavily on a codified system of signs – costume, insignia, gesture – rather than on the integrated human body, and was principally conceived as an instrument of communication and commemoration, especially in portraiture. Still, prolonged exposure to Greek art, particularly in southern Italy and Sicily, conquered by Rome in the Punic Wars, led to the slow infiltration of Greek images and forms, so that Roman republican art from the 3rd to the 1st century BC was progressively hellenized. Roman gods began to look more like their Greek counterparts – Jupiter/Zeus, ▷ Mercury/Hermes – Roman dignitaries took off some of their clothes to become more heroic, but seemed uncomfortable in doing so, and Roman portraits adopted an idealizing plasticity unless there were good ideological or political reasons for preserving the dry wrinkles, the bald pate and grim expression of ageing men, as a sign of old Roman virtue.

Roman republican architecture, like Roman sculpture, incorporated many of the externals of prestigious Greek models (gabled temples with columnar orders, for instance), but its principal building materials were not marble but soft, volcanic tufa and porous limestone, wrapped around a rubble concrete core; the ▷ arch and its extension into the ▷ vault were its identifying markers. Roman concrete, coupled with the arch and the vault, brought into being the great architectural complexes of the late republic, such as the Sanctuary of Fortuna at Palestrina, probably built around 125 BC. This vast structure, and others like it in Italy, established a precedent for the reconfiguration of landscape through large-scale building as a setting for centralized, axial compositions that would continue for generations. The new formal language set in motion the extraordinary development of the Roman urban infrastructure: bridges, aqueducts, theatres and amphitheatres, employing the arch and the vault, individually and in combination, in straight or in curving lines, the rhythm of solid and void, and of dark and light a paraphrase of the Roman architect's concern for scale, symmetry and space.

Roman architecture achieved its greatest triumphs in large-scale projects, where inventive spatial solutions, dependent on the masterful use of concrete, usually clad in brick, stucco or stone veneer, produced such varied buildings as the warehouses and tenements of Ostia, Trajan's market-mall in Rome the baths and basilicas found in Italy and the western provinces, and, perhaps most completely, Hadrian's Pantheon in Rome. The Pantheon combines a monumental, rectangular 'Greek' façade, functioning as a porch, and a marble- and brick-clad cylinder, containing wholly within itself a perfect sphere of open space, penetrated by the shafts of light, or rain, entering that space through the ▷ oculus (or 'eye') at the top of the ribbed dome capping the interior. The geometrical clarity of that interior volume, uncluttered yet at once bounded by a richly decorated surface, manifests the fundamentally abstract character of Roman architectural thought. Similarly, the far-flung symmetry of the great imperial bath buildings, the dominance of the central axis in Roman enclosures, whether roofed or not, and the strong emphasis upon the rhythmic play of arcuated structures, all indicate a sensibility that is peculiarly Roman: a preference, not for the solidity of architectural forms typical of Greek masonry buildings, but for the treatment of the load-bearing wall, the columnar screen, the dome-cum-oculus as a penetrable spatial boundary, defining, yet never fully limiting space itself.

Hadrian's ▷ villa at Tivoli, a few miles east of Rome, comprises a veritable compendium of Graeco-Roman architecture and art, in his attempt to incorporate the full range of the Classical tradition in one place. Hadrian, philhellene and Roman architect, collected, recreated and displayed the treasures of the Classical, Mediterranean world for his own delectation while in retreat from the affairs of government. Roman magnates, beginning in the late republic, built lavish suburban, rural, or seaside villas, where they could refresh themselves in cultivated leisure (otium), removed from the world of public affairs (negotium). Here they could collect paintings and sculptures, discuss them with their friends, enjoy their library and stroll along shaded porticoes, looking out at the peaceful landscape of their properties. However, as the Roman world in the 3rd and 4th centuries became less and less secure, such open country retreats – still being built in Gaul, Germany and Britain – often required fortifications and, thus, consolidation. Nothing more clearly demonstrates this change than the contrast between Hadrian's Tivoli villa, stretching out irregularly for more than a mile, and Diocletian's seaside palace at Split on the Adriatic, built almost two centuries later. More fortified town than private villa, the Split palace resembles the schematic layout of a Roman military encampment or of a Roman provincial town, such as Timgad in Algeria; it also symbolizes the increasingly repressive organization of the Roman state in late antiquity under the domination of absolute rulers.

And yet, even at the height of the Roman empire in the 2nd century, Hadrian's compulsive activity at Tivoli suggests that he had become aware of the fragility of Graeco-Roman culture and was desperately trying to preserve and enjoy it while that was still possible. Certainly, Romans had derived great profit from their intense exposure to Greek artistic culture: their houses combined the Roman ▷atrium plan with the Greek ▷peristyle at Pompeii and the walls were decorated with paintings, often derived from Greek models, if extensively adapted to their new settings; Augustus conceived of a ▷Neoclassical imperial style as suitable for the art of an empire, based on Athenian 5th-century models, evident in the appearance of marble architecture in Rome and in the idealizing mode of his dynastic portraits, exemplified by the statue of himself from Primaporta based on the Polykleitan *Doryphorus*; Greek motifs informed Roman sarcophagi; and Roman public places, especially libraries, continued to honour the Greek intellectual heritage with statues of philosophers and authors. Yet very often that employment of Greek models took the form of partial quotation, as if the essence of the example were increasingly estranged from the value system of contemporary Romans, who were, themselves, more and more diverse.

It has been said that the Romans, even the very wealthy, never gave their full allegiance to Greek culture, never fully recognized the authority of Greek art. The majority of the Roman population lacked the means, the education, and the inclination to adopt the veneer of Hellenic culture, and they continued to admire and adopt the straightforward traditions of republican Rome in making images of themselves for posterity. In the provinces, despite the extensive romanization of the ruling class, the veneer of Graeco-Roman culture remained relatively thin, especially when it came to the continued observance of local cult, as exemplified by the shrine of Minerva Sulis at Bath. The rise of private religion, such as Mithraism, or of religions deemed adversarial to the state, such as Judaism and Christianity, contributed to the fragmentation of Roman society and to growing alienation from its norms. For the exploited poor, refuge from the harshness of life was sought either in actual flight from authority, from the cities and towns into the lawless countryside – often to join barbarian invaders – or in some form of spiritual withdrawal that vaunted an afterlife.

Roman triumphal monuments, arches and columns had been the most visible proof of Roman power and of the violence whereby it was enforced. Under the closest imperial control, they display the ferocity of the Roman onslaught on their enemies in the columns of Trajan and Marcus Aurelius, and in the arches of Septimius Severus and of Constantine in Rome. Yet, they too reveal how the pressure of events, of changing times, has robbed the human actor of his humanity, replacing the organic creations of Graeco-Roman art with anonymous, depersonalized subjects or the superhuman, awesome figures of their absolute masters. Just as Roman architecture was essentially abstract in nature, just as there was a perceptible retreat from the physical presence of the body in late Roman figural arts, so too did late antique artists show a marked preference for the incorporeal. In the oscillations of colour and light, late Roman art celebrated the glories of the spirit, but lost the world.

Bibliography

Adam, J.-P., *Roman Building Materials and Techniques*, Bloomington, 1994
Beazley, J.D., *The Development of Attic Black-Figure*, Berkeley, 1951
Becatti, G., *The Art of Ancient Greece and Rome*, New York, 1967
Bianchi Bandinelli, R., *Rome: The Center of Power*, New York, 1970
Bianchi Bandinelli, R., *Rome: The Late Empire*, New York, 1971
Boardman, J. (ed.), *The Oxford History of Classical Art*, Oxford, 1993
Boardman, J. (ed.), *The Diffusion of Classical Art in Antiquity*, Princeton, 1994
Brendel, O.J., *Etruscan Art*, Harmondsworth, 1978
Brilliant, R., *Visual Narratives*, Ithaca, 1984
Carpenter, T.H., *Art and Myth in Ancient Greece*, New York, 1990
Coulton, J.J., *Ancient Greek Architects at Work*, Ithaca, 1977
Doxiadis, C.A., *Architectural Space in Ancient Greece*, Cambridge MA, 1972
Hannestad, N., *Roman Art and Imperial Policy*, Aarhus, 1986

Hurwit, J., *The Art and Culture of Early Greece, 1100–480 B.C.*, Ithaca, 1985

Kondoleon, C., *Domestic and Divine. Roman Mosaics in the House of Dionysos*, Ithaca, 1994

Lawrence, A.W., *Greek Architecture*, rev. edn., Harmondsworth, 1962

Macdonald, W.L., *The Architecture of the Roman Empire* I, New Haven, 1965

Macdonald, W.L., *The Architecture of the Roman Empire* II, New Haven, 1986

MacKay, A.G., *Houses, Villas, and Palaces in the Roman World*, Ithaca, 1975

Pollitt, J.J., *Art in the Hellenistic Age*, Cambridge, 1986

Rasmussen, T. and Spivey, N., *Looking at Greek Vases*, Cambridge, 1991

Robertson, M., *A History of Greek Art*, Cambridge, 1975

Stewart, A.F., *Greek Sculpture*, New Haven, 1990

Wallace-Hadrill, A., *Houses and Society in Pompeii and Herculaneum*, Princeton, 1994

Penetrating Ecclesia: Interpretations of Gothic Architecture

Phillip Lindley

Medieval buildings include some of the most important monuments of Western Art. Aesthetically and intellectually they can be enormously rewarding to study and they provide a unique insight into cultures whose attitude towards the world, and to God, was radically different from our own. Yet, medieval architectural history often seems a forbidding subject. There are four initial obstacles. First, the student must learn a complicated architectural terminology before he or she can make any sense of the vast literature on the subject. Second, there is a problem which is common to all architectural history, but which is particularly acute when dealing with medieval architecture: it is extremely difficult to comprehend the connections of various architectural components to one another, or to understand relative scale or spatial relationships without a first-hand experience of each building in question. As yet, neither analogue nor digital media have been really exploited to aid the student. Third, iconoclasm and the loss or replacement of medieval liturgical fittings such as the *pulpita* or choir-screens and the religious changes of the post-medieval period have fundamentally affected the way medieval churches function and look. Finally, much of the literature on medieval architecture seems to be obsessively concerned with the sequencing or typology of buildings: this is particularly true of the buildings which we term ▷Gothic in style, those of the 'High' and Late Middle Ages with which I shall here be almost exclusively concerned. In other words, a great deal of effort has been expended on arranging buildings in sequence, to isolate the 'progress' of medieval architecture, a process which inevitably privileges some canonical buildings at the expense of others. There has been a massive concentration of scholarly attention on the most 'progressive' buildings which even the charge into the ▷canons of art history has failed to change.

In the following essay, although I do not intend to provide a brief history of the stylistic development of Gothic architecture, neither do I wish to disparage this form of architectural history – which is as essential to the architectural historian as ▷connoisseurship is to the historian of paintings or sculpture – and which will be of great importance in the largely uncharted territory of parochial architecture. Some of the undesirable consequences of its methodology are self-evident: buildings which are stylistically 'old-fashioned' tend to be neglected. One such example is the presbytery of Ely Cathedral, funded by Bishop Hugh Northwold and completed in 1252, which is conventionally contrasted with the strongly French-influenced work of Henry III's contemporary Westminster Abbey. Crucially for its critical assessment, Northwold's presbytery does not feature the ▷bar tracery developed in French buildings and used at Westminster. Yet many fascinating questions could be posed about the Ely Presbytery none the less: how architectural forms were transmitted in 13th-century England; what the building's functions and liturgical significance were; its cost and the sources of funding; the building's context in terms of regional or national rivalries, or of a common architectural ideal formed by a specific patron class; the relationship between the bishop and the monastery (for he had no obligation to pay for the cathedral church); the structural systems employed by the builders; the size and nature of the workforce; the proportional systems used by the designer; the new presbytery's response to the norms of buildings already on the site; its ▷polychromy and glazing; the design sources and detailing, and the materials and their usage.

Another problem with the classificatory model of architectural history is the implicit belief that resemblances are always due to direct evolutionary descent, rather than convergent, i.e. deriving from

similar conditions, but without a common ancestry. So the first building which exhibits a feature is often viewed as the 'source' for all later ones, whether or not such a relationship can be demonstrated. In order to arrive at a wider understanding of any building's cultural meaning, it is not adequate to concentrate on its stylistic place viewed from the perspective of an obsession with 'progress', to classify it as provincial or conservative solely in terms of its response to French norms. Moreover, as our estimation of Ely's presbytery conflicts with that of Hugh's contemporaries, even those who knew Henry III's Westminster, it is possible that our whole scheme of appraisal is too narrowly focussed. The science of classification is important but we must also consider alternative or additional methods of analysing medieval buildings.

The Gothic

The term 'Gothic' originates in the pejorative judgements of the ▷Renaissance. The Italian artist, architect and art historian, ▷Giorgio Vasari – the man who introduced the idea of innovation as the chief measure of artistic worth – characterized medieval buildings as the antithesis of ▷Classical architecture. In his introduction to the three arts of design – architecture, sculpture and painting – Vasari writes:

> There are works of another sort [of architecture] called German, which differ greatly in ornament and proportion from the antique and the modern [Renaissance]. Today they are not employed by distinguished architects but are avoided by them as monstrous and barbarous since they ignore every familiar idea of order ... above all their façades and their other decorative parts, they built one cursed tabernacle on top of the other, with so many [pinnacles] and points ... and they have more the quality of seeming to have been made of paper than of marble. And in these works they made so many projections, openings, little consoles and twining vines, that they threw the works they built out of proportion, and often they reached such a height, by placing one thing on top of another that the end of a door touched its roof. This manner was invented by the Goths who, after the destruction of the wars, built edifices in this manner; these men fashioned the vaults with pointed arches of quarter circles and filled all Italy with these damnable buildings ...

If we set aside, for the moment, Vasari's vituperative polarity between the 'true principles' of Classical architecture and the 'monstrous and barbarous' Gothic, there is much in this passage which betrays a real understanding of the aesthetic qualities of the later Gothic architecture with which he was familiar (it should be noted that he did not recognize any succession of styles in medieval architecture). The ornamental complexity, the concentration on the ▷portals, the pointed ▷arches and ▷vaults, the attempt to keep walls thin and yet to attain great height, the lavish embellishment with niche sculpture, all these are real features of the style, though characterized by him in entirely negative terms. Vasari knew, too, that Gothic architecture was an alien importation into Italy – though its true origins lay in 12th-century France, not in Germany – and that Gothic buildings dominated the whole of northern Europe. His assumption that Gothic was German may perhaps have been influenced by early printed texts such as Mathes Roriczer's *Büchlein von der Fialen Gerechtigkeit* (Booklet concerning the correct design of pinnacles) of 1486 or the same author's *Die Geometria deutsch* (Geometry [in] German) as well as the commonly-held belief that German invaders had precipitated the collapse of Rome in antiquity, just as Charles V's Habsburg forces had humiliated Rome in 1527.

Vasari never visited northern Europe and the buildings he had in mind when he described medieval architecture were churches such as Siena or Milan cathedrals, two of the relatively few Italian medieval churches to attain the scale and architectural complexity of those in the north. The reasons for the poverty of Gothic architecture in Italy (if we omit secular buildings from our discussion) may also help us to understand why the Renaissance was Italian in origin, for the peninsula possessed a unique Classical inheritance which dominated all subsequent building. Italian dioceses were generally smaller and less wealthy than their northern counterparts, so that the largest and most important medieval churches in Italy tended to be those of the mendicant orders, the Franciscans and Dominicans. Their function as preaching churches tended to preclude the ostentatious architectural complexity of northern cathedrals. Crucially, architects enjoyed a much less elevated status in medieval Italy than they did in France, Germany or England (Wilson, 1990, p. 258). It would have been inconceivable in the north for sculptors such as ▷Giovanni Pisano and ▷Arnolfo di Cambio or painters such as ▷Giotto to have designed major buildings as they did in Italy. Although there had been major structural failures in

the north – at Beauvais for instance – the particular problems encountered in the building programmes at Siena or Milan cathedrals seem to have resulted from failures peculiar to Italian procedures. At Milan, built from 1386 onwards with funds and materials supplied by the Visconti, there were a number of consultations of foreigners to solve the structural and design problems. In 1400 the Parisian architect Jean Mignot criticized the Milanese proposals as wilful and contrary to good rules. To the Milanese response that knowledge of geometry was irrelevant and that a practical solution could be arrived at simply by the application of practical skill, Mignot uttered the famous retort, '*ars sine scientia nihil est*': practical skill is nothing without theoretical knowledge. It is clear that Gothic architecture was conceived by its French builders as being based on rules formulated by reference to general design principles (even if these rules had not been codified in a medieval counterpart to the Classical architect Vitruvius's *De Architectura*) Paradoxically, in the medieval age, it was the Italians whose theoretical knowledge was deficient.

French architects of this date were working with design principles which had, very largely, been formulated by the mid-13th century. We have surprising evidence of this dependence on previous models in the accounts of Troyes Cathedral from 1455–56. Master Bleuet, the master mason (whom we would now term the 'architect') of ▷Reims Cathedral, was called to Troyes to design the cathedral's western façade. Bleuet's suggestion that a tour of some of the key monuments of 13th-century Gothic would provide ideas was accepted and two of his clerical patrons accompanied him to ▷Reims, ▷Amiens and Notre-Dame in Paris. Bleuet's façade design was produced after this tour, in which we must imagine the mason and clerics in frequent discussion. Although his façade plans were never realised, Bleuet's surviving pier mouldings reveal a search for uniformity in visual effects, and a taste for linear and brittle forms characteristic of the mid-15th century. Thus, his work simultaneously combines a respect for canonical solutions to the problem of façade design with a confident revision of detailing in favour of a more co-ordinated, luxurious and up-to-date architectural vocabulary.

Romanesque Architecture and its Replacement

From the perspective of Bleuet and his contemporaries, the architecture of the 13th century embodied definitive solutions to problems such as the relationship of flanking towers to the main façade and the integration of a rose widow and triple portal scheme into the composition. The façades of buildings such as Amiens Cathedral, no less than the elevation of the ▷nave or the handling of details, were the products of a phase of intensive experimentation which had begun less than a century before. Before the development of Gothic, the dominant architectural language of continental church architecture was what we call ▷Romanesque. In England, after 1066, the Romanesque of the Norman conquerors replaced the indigenous ▷Anglo-Saxon style in the huge phase of building which succeeded and – in the case of military architecture – accompanied the Conquest. Edward the Confessor's church at Westminster, begun c1050, had already been built in the Romanesque style before the Conquest – a fact commented on by William of Malmesbury in the 12th century, when he described it as the first in England 'of that style of design' ('*illo compositionis genere*').

The contrast between Anglo-Saxon and Romanesque architecture in England conveniently enables the identification of some of the latter style's defining characteristics. One of the most striking features of the new buildings was their great size: the nave alone of Winchester's Romanesque cathedral, at 318' was greater than the total length of the Anglo-Saxon minster at the end of its centuries-long enlargements. Nor was it just in church building that the Normans thought that size mattered: the Conqueror's White Tower in London was amongst the largest stone keeps in Christendom, and William II's new hall at Westminster was the largest in northern Europe at the time of its completion. In England, Romanesque buildings generally relied on massively thick walls to bear the loading necessary for the desired height to be safely attained. ▷Buttresses were simply narrow strips, although quadrant arches were employed at Durham, for instance, over the aisle vaults. Quadrant arches and the flying buttresses which later superseded them were conceived as a kind of strut for transmitting lateral thrusts to the aisle walls, where massive wall buttresses could be incorporated far more conveniently than on ▷clerestoreys. In Normandy and England, however, the structural device generally employed to ensure that the walls stood up was massive construction. Although the walls were thick, they were not entirely made of ashlar, but were merely faced in squared stone, the interiors being filled with rubble and mortar. There was a dramatic improvement in the dressing of ashlar and in laying techniques in the 100 years from the mid-11th century, which must have been made possible by the use of new,

more durable and more accurate tools. The huge scale of ▷Norman building in England must also have greatly accelerated the organization and management of masons.

Unlike early Christian ▷basilicas – which were essentially rectangular buildings with closely-spaced columnar arcades opening into the flanking aisles – or Anglo-Saxon churches, Romanesque buildings used a bay system to articulate the main elements of the design, often stressed by a tall shaft rising to the top of the elevation. Characteristically, the distance between the piers was half that across the nave. Sometimes a rhythm between bays was introduced by alternating the compound piers with ones of columnar form. Major churches were of three storeys, the middle one articulated by openings, often into the dark spaces beneath the aisle roofs. Although flat wooden roofs were usually employed over the main spaces, groin vaults – essentially composed of two intersecting tunnel vaults – were deployed over the aisles. The upper walls were often reinforced against the lateral thrusts of the masonry vaults by the partial filling with rubble of the pockets above their springing. Groin vaults were first replaced by rib vaults (which had the advantage of increased strength, regularity and continuity of detailing) at Durham Cathedral, in the choir aisles (1093–6). The ribs were made of specially-shaped ashlar blocks and must have required detailed initial drawings and the provision for the masons of accurate templates. The employment and development of ribbed vaults at Durham may have been innovatory but they do not seem to have been the direct source of inspiration for the Île de France designers who produced the first Gothic churches.

It is perhaps an oversimplification to argue that Gothic architecture is the result of combining features derived from the Romanesque churches of Normandy with those of Burgundy, but it is evident that Gothic builders inherited many features from these areas. From Normandy came the bay division of the lateral walls into vertical compartments using half columns or shafts, linked together by arches as a coherently organized system throughout the whole building. The employment of twin-tower façades, which enabled the side of the towers facing into the nave to be treated as if they were a regular bay, may also derive from this source. The consistent application of a three-storey elevation and the use of ribbed stone vaulting were also derived from Norman precedent. However, the most important distinction between Norman Romanesque buildings and their French Gothic successors was Gothic architecture's adoption of a thin-wall construction technique, derived from ▷Burgundy. In Burgundian Romanesque architecture it was necessary to reinforce the thin upper walls against the lateral thrusts exerted by masonry vaults, and to give more depth and projection to the piers. The tall proportions of Burgundian Romanesque buildings were therefore combined with sharply pointed arches, because the lateral thrusts exerted by a pointed arch are more steeply inclined than those from a semicircular one. The high tunnel vaults of ▷Cluny, for example, had a pointed profile and the clerestorey walls also extended far above the windows to provide a massive load to withstand the lateral thrusts from the vaults, though this technique was to be rejected by later Gothic designers for aesthetic reasons. In order to reinforce the upper walls against the lateral thrusts of the vaults, the key to the future would actually be the development of the flying buttress. Whether such buttresses were found in the first great Gothic church, at St-Denis, is a matter of continuing scholarly debate.

Saint-Denis: prototypical Gothic

Histories of Gothic architecture conventionally begin with the choir added between 1140 and 1144 to the abbey church of ▷St-Denis, a few kilometres north of Paris. In order to understand the building's importance, a few preliminary comments are necessary. The abbey church had special links with the French Capetian monarchy: it was an important burial church, which housed tombs of the Capetians' predecessors, and the building as it stood in the early 12th century seems to have been essentially that completed in 775 by King Pepin, father of Charlemagne. It also housed the shrine of St-Denis, the patron saint of the French, then mistakenly identified with Dionysius the Pseudo-Areopagite whose writings were very influential in the early 12th century. St-Denis also housed the royal banner of France – the oriflamme – and in 1120 Louis VI instituted the custom of keeping the crown and coronation regalia in the church; four years later he gave the monastery the rights to a profitable fair. There was, moreover, a close personal relationship between the ambitious abbot of St-Denis, ▷Abbot Suger (from 1122), and Kings Louis VI and VII (the latter coming to the throne in 1137). Not only was there considerable royal support for St-Denis but, reciprocally, there was powerful royal propaganda amongst the imagery commissioned by Suger.

While there were many reasons why the abbey church of St-Denis was significant for the aggressively

expansionist French monarchy, the cause of its seminal position in the history of medieval architecture is the rebuilding work begun by Suger. His building programme was on a grand scale, a model suitable for cathedrals. No fewer than thirteen bishops attended the dedication ceremony of 1144, so there was ample opportunity for potential patrons to see Suger's achievements. Moreover, Suger, very unusually for a medieval patron, has left copious writings about his intentions and ambitions for the church, writings which demonstrate the abbot's involvement in work, although they also make it clear that his main interests were in the expensive metalwork and in the ▷iconography of the ▷stained glass he commissioned, and in justifying his huge expenditure by reference to theological ideas derived, probably via Hugh of St-Victor, from the Pseudo-Dionysius's writings.

The first part of the building to be reconstructed by Suger was the west front, probably started around 1135 and completed by 1140. It is the prototype of a long tradition of French Gothic twin-tower façades, and also housed the first Gothic triple portal, with a sculpture programme of major importance articulated on columns on the jambs, in the ▷voussoirs, ▷trumeau, ▷lintels and ▷tympana (but for the northern one which featured a ▷mosaic). The systematic arrangement of the sculpture on the portals, at the entrance to the church, and the fundamental innovation of life-sized column-figures had an immediate impact, but the round window in the upper area of the church – relatively unimportant in itself – was lent new significance after Laon Cathedral's example at the end of the century, from which time rose windows were seen as an essential component of the great façade. After 1200, the integration of portals, towers and rose windows in façades at Paris, Amiens and Reims provided models which were to be of importance for centuries. Thus Suger's west façade combined disparate elements from a variety of sources into a newly significant whole. The interior of the western ▷narthex at St-Denis is notable for its cross-ribbed vaults and multiple shafts. The tall proportions and numerous shafts emphasize the building's height and help to alleviate the massiveness of the piers which support the tower (it must be borne in mind that the floor of the narthex was 104 cm lower in Suger's time than it is today). It is one of the key features of Gothic architecture that there is an insistence on height, an impression of verticality.

The second part of the building reconstructed by Suger was the ▷choir. He left intact the nave and is very defensive in his writings about his demolition of the earlier building which was believed at St-Denis to have been dedicated by Christ himself (in reality it was an 8th-century structure). Work started in 1140. It is difficult to study the choir now because its upper parts were replaced in the 1230s, ironically a victim of the stylistic revolution it had itself initiated. Suger claimed his reason for the rebuilding was the purely functional one of making more space for the pilgrims coming to venerate the relics stored behind the high altar. The plan is for a continuous ▷chevet of radiating chapels housed in very shallow apses, and borrows from experiments in churches such as the Parisian Saint-Martin-des-Champs c1130–45. This blurred the space between the ▷ambulatory and the chapels. Light penetrated the area through the large stained-glass windows, which read as a continuous ring; Suger we know, was particularly proud of the stained glass, for he expatiates on the iconography which he had himself devised.

Suger's choice of columns in the ambulatory exerted an enormous impact on the development of early Gothic architecture up to the time of Chartres Cathedral. The choice of columns rather than structurally more logical compound piers may have been deliberately intended by Suger to evoke the 8th-century east end which his work replaced, and which he thought dated to the time of Christ. His new east end has a self-consciously classicizing air which would have been reinforced had he been able – as he intended – to obtain the great marble columns from Diocletian's palace in Rome. The deployment of such *spolia* would be analogous with Suger's provision of precious mountings for ▷antique and ▷Carolingian objects in the treasury of St-Denis. However, the use of columns had fundamental structural implications since it necessitated the adoption of a skeletal structure in the upper parts of the building. There is considerable debate in the scholarly literature not only whether the east end featured flying buttresses but also whether it was two or three storeys high. The destruction of the upper parts of the building in the 13th century has made a definitive resolution of these arguments unlikely, but what is not in doubt is that much of the initial structural development in Gothic came from Suger's desire to combine columnar supports, and therefore a relatively thin-wall construction, with masonry vaults. Ribbed masonry vaults necessitate either a thick-wall construction – as at Durham – or a structural system to cope with the thrusts the vaults exert. Of course the use of pointed arches and thin vault webs, eschewing rubble for ashlar, could also reduce the thrust of the

vaults, but if Suger's design was to be followed in large new buildings, architects would have to concentrate on engineering the structural loading away from the high walls and providing a system of abutment to deal with the thrusts. That these innovations were taken up, and developed with astounding precocity, is partly the result of the expansion of the Capetian monarchy's power, which accompanied and accelerated the forced appropriation of English possessions, generating vast new wealth and close links between the bishops and those of the feudal aristocracy who sided with the French king. The second half of the 12th and beginning of the 13th century witnessed an unparalleled explosion of church building throughout much of France. The massive new financial resources were accompanied by developments in technology and by a drive to rebuild churches, not just the great cathedrals but also at parochial level.

Funding the Gothic cathedral

On 10–11 June 1194, a large fire destroyed the cathedral of Chartres – but for the crypt and the west façade – together with a substantial part of the town. Yet within about thirty years a splendid new Gothic cathedral had been erected. How was this financially possible? The terrible disaster of the fire was much commented on at the time, for Chartres was one of the most revered shrines of medieval France. The cathedral's chief relic was the tunic claimed to have been worn by the Virgin Mary at the birth of Christ, and which had been presented to the cathedral by King Charles the Bald in 876. The sanctuary of Chartres itself was said to have been built more than a century before the birth of Christ in response to the oracles of prophets and sibyls about the Virgin Birth. Naturally, successive bishops of Chartres enthusiastically endorsed such beliefs which made of their church the chief sanctuary of the Virgin in the country. Around 1210, a cleric of Chartres wrote *The Miracles of the Blessed Virgin Mary in the Church of Chartres*, a treatise which opens with a vivid description of the damage done by the fire. The author of the *Miracles* claimed that the Virgin had permitted the fire because she wanted a new and more beautiful church to be built in her honour. Confirmation of this belief was the discovery of the miraculous survival in the crypt of the Sacred Tunic, a discovery which coincided with an appeal by Cardinal Melior of Pisa to the citizens of Chartres for funds to rebuild the church. This 'coincidence' helps emphasize the point that a celebrated relic was valuable financially as well as in terms of prestige. There could be huge revenues from the donations of those seeking cures at the shrine as well as revenues from the pilgrims whilst they were in the town. Relics were often sent on fund-raising tours: clerics from Chartres came to England and received donations even though the two kingdoms were at war. The donation of Stephen Langton, Archbishop of Canterbury, was commemorated in a stained glass window.

The economic prosperity of the town of Chartres was indissolubly linked to the prestige of the cathedral. The life of the town focused on four fairs which coincided with the feasts of the Virgin: the Purification, ▷Annunciation, ▷Assumption and the ▷Nativity. The right to hold fairs was jealously guarded by medieval towns, because they generated such substantial income. At Chartres, huge sales of devotional items and the consumption of drink and food by pilgrims brought benefits like those of the tourist trade today. The entwining of what we would now differentiate as secular and religious concerns can be highlighted by the fact that the fairs were held in the *cloître* of the cathedral, the streets and squares next to the church which were the property of the chapter: vegetables, meat and fuel were on sale by the southern portal, textiles near the northern one. Food could be sold in the nave and wine was on sale in the crypt, whilst masons, carpenters and craftsmen gathered in the church, waiting for employers to hire them. The townspeople depended upon the support of the dean and chapter for their freedom from the Count of Chartres' taxation. They thus had every reason to support the rebuilding enterprise, and this explains why the ▷guilds figure very conspicuously among the donors of the stained-glass windows of the cathedral: the five great chevet windows were given by merchants such as the butchers and bakers (Von Simson, 1962, 166–7).

The major source of revenue for building most Gothic cathedrals derived from the income of the bishop and of the dean and chapter (from their estates, from urban properties and from their ability to benefit directly – through legal rights for instance – or indirectly from the commercial expansion of the late 12th and early 13th century). Renaud of Mouçon, Bishop of Chartres from 1182 to 1217, and the canons agreed to divert all their disposable revenues for three years towards the rebuilding of the church. Bishop Renaud was the nephew of the queen of France and his mother was the daughter of Count Thibault the Great, so he himself was directly related to the two most important secular

authorities. The diocese over which he ruled was the largest and richest in France, and generated massive revenues. Additionally, the feudal nobility and royalty made large donations: the stained glass of the north transept, celebrating Mary and her Biblical ancestors, was donated by Queen Blanche, whilst the south transept windows were the gift of Peter of Dreux, Duke of Brittany. The astonishing rapidity with which Chartres Cathedral was reconstructed was dependent, as much as anything, on a congruity of interests between the bishop and canons, crown and magnates, and the town and guilds. It was this harmony of interests which enabled the new church to be completed by 1220.

At Amiens in Picardy, the destruction of the power of the counts in 1185 under Philip Augustus, and the subsequent annexation of the county to the crown, was the prelude to a long-lasting alliance between the monarchy and a town made wealthy by its dye and wine trades. The bishop of Amiens had common economic interests with the town such as their joint ownership of the new Great Quay on the Somme from the middle of the 12th century. In 1218 a massive fire destroyed the Romanesque Cathedral of Amiens. Stained glass in the upper windows of the cathedral's new nave commemorated twenty-five donors, of whom eleven were burghers whose wealth depended on the trade in dye. One rich dye merchant, André Malherbe, helped pay for no fewer than six windows. At Amiens, mercantile assistance to the cathedral's construction, dependent on the town's economic well-being and on the merchants' cordial relations with the clerics, helped ensure that the nave was completed and glazed in a quarter century even though there were no major relics, as there were at Chartres, to generate substantial donations. However, we should be wary of overstressing the *direct* contribution of the townspeople to the architectural fabric of Amiens: they were more likely to contribute *indirectly* through the revenues their prosperity made available to the bishop and clerics from rents and sales of urban properties, through their ability to benefit from trade and legal rights, and from the agricultural produce of their estates in the surrounding countryside. Bishop Geoffroy d'Eu (1226–36) sustained the building campaign by selling episcopal properties, whilst the canons appear to have made generous donations. As almost everywhere in northern Europe, it was the ecclesiastical hierarchy who directly paid for the building of the Gothic cathedrals. Only in Strasbourg from the late 13th century did town authorities exercise a control of building comparable to that in Italian city states where guild organizations or the communes could manage the fabric. The donation of expensive stained glass windows by specific donors at Amiens may well have helped complete work, but such contributions, which enabled the donor to see exactly what he had paid for, should be differentiated from the ordinary costs of architectural construction.

We should, however, beware of assuming that the relationship between clerical and lay communities was invariably cordial. At Beauvais Cathedral the bishop combined secular with spiritual power as he was simultaneously count of Beauvais, one of the richest and most powerful magnates in France. Work on a huge new Gothic cathedral began in 1225 under Bishop Miles of Nanteuil (1217–34). He provided both the initiative for the new building programme and a substantial portion of the direct funding. Gathering the canons round him after the old cathedral (the *Basse Oeuvre*) was damaged by a fire, Miles conceded a tenth of all his revenues, spiritual and secular, to the new work for ten years, and ordered the chapter to concede a tenth of its annual income for the same period. After seven years, however, there was a violent urban uprising, tension having been exacerbated by the bishop's exactions to provide funding for his new cathedral. Whereas his predecessor, Philip of Dreux, had been a cousin of Philip II of France and his ally in the successful struggle to seize Normandy from the English crown, Miles opposed Capetian power during the years when the French monarchy was consolidating its control over magnate and ecclesiastical opposition. In 1232-3 the king intervened in a power struggle between different bourgeois groups, one of which was supported by the bishop, and there began a conflict which did not end with the bishop's death in 1234 *en route* to Rome to present his case to the Pope. For a period of nearly six years, the king seems to have enjoyed the temporalities of the bishopric. Thus, whereas the crown might aid building campaigns – as at Chartres – royal opposition could also have a powerfully negative effect on building, as happened at Beauvais.

Work on the building came to a virtual halt for six years, and was resumed on a streamlined, simplified and reduced form, reflecting both the stylistic changes of contemporary architecture and the reduced funds now available to the bishop. When the work on the upper part of the choir was completed under Bishop William of Grez (1249–67), major stylistic and structural changes deviated from the plans of the builders of the lower parts of the building. The most important change was the decision to increase the height of the building by about five metres, making it the tallest elevation of

medieval Gothic. Unfortunately, this decision led directly to the collapse of the choir in 1284 owing to the fact that the lower parts of the building were structurally inadequate to counter the thrust of the high vault. The collapse can be rooted in changes in stylistic norms during the period of construction, an ambition to build high which was not matched by an adequate understanding of the structural consequences of such a decision, and in problems already existing in the lower parts of the building. As Stephen Murray has shown, the disaster was not caused by faulty detailing but by the grafting of irreconcilably different artistic visions onto one another. He concludes: 'The collapse may be seen as the result of the funding crisis of the 1230s, which in turn resulted from the struggle between Miles of Nanteuil, the bishop who was "as proud as Nebuchadnezzar" and the king and his mother [Blanche of Castile, the regent during Louis IX's minority]' (Murray, 1989, p. 119).

In the later Middle Ages, it was frequently the dean and chapter who took over responsibility for building programmes, often allocating specific estates or income directly to the office of the fabric. In the peculiarly English phenomenon, the monastic cathedral, major campaigns might be co-operatively funded by the bishop and the monks: the most remarkable instance of such a venture is at Ely Cathedral, where during the second quarter of the 14th century, Bishop Hotham (d 1337) paid for the new three bay choir, the sacrist, ▷Alan of Walsingham, funded the construction of the new octagonal crossing-tower from the revenues available to him, whilst a separate obedientiary, John of Wisbech (d 1349), oversaw the construction of the Lady Chapel, and the prior, John of Crauden, built himself a new domestic chapel and study. At Gloucester Abbey in the same period, possession of the body of the murdered Edward II, who was ironically (like the opposition leader whom he had murdered, Thomas of Lancaster) popularly reputed to have been a saint, led to donations of such importance that they funded the rebuilding of the church's south transept between 1331–7.

No cathedral ever received royal largesse on the scale of St. Louis' finance for the Cistercian Abbey of Royaumont, or of Henry III's funding which paid for the rebuilding, on the most lavish scale, of Westminster Abbey. Building campaigns of this magnitude were enormously expensive: Sir Howard Colvin has calculated that Henry III paid over £41,000 (around $75,000) on the fabric alone of the Abbey between 1245 and 1272, a sum which represented nearly the king's *total* annual income for two years. The functions of the Abbey – which was the coronation church, shrine of St. Edward and was to become a royal mausoleum – and its proximity to the most important royal palace, help explain why the king was prepared to underwrite the building to such an extent. With his death, in 1272, work ceased abruptly, on the fifth bay of the nave. No later king shared Henry's commitment to the building (although Richard II and Henry V were benefactors), and completion of the nave was dependent on the monks themselves: the west end was still unfinished at the monastery's dissolution in 1540. For more effective building campaigns, a large regular income, guaranteed for a period of years, was required.

Similarly, cathedral chapters might devote specific fines to augment the fabric during building campaigns, but the only way to sustain a major campaign was for them to agree to donate a specified portion of their annual income, for a carefully defined period towards construction. The possession of important relics, the granting of indulgences to those who contributed to the fabric, collection campaigns in the dioceses and elsewhere, the appropriation of parishes towards the cathedral fabric, direct and indirect taxes and the gifts of the faithful, all played a part in funding the creation of the Gothic cathedral, but ultimate responsibility was that of the ecclesiastical hierarchy.

Meanings: Metaphysics and Gothic form

The Chancellor of Chartres Cathedral's school during the rebuilding period, and a contributor to the building programme, was Peter of Roissy. He also wrote a manual on *The Mysteries of the Church* of which the first part is devoted to an allegorical interpretation of the Christian basilica. He mentions the elevation, major and minor pillars and gives an allegorical interpretation of church windows. The symbolic meanings of churches had, of course, always been explored by Christian writers. St. Augustine asserted that all things in creation teach us about their author, they are signs of the Trinity and – as ▷Emile Mâle showed – there was a long medieval tradition of understanding the world in terms of allegory and symbol. Thus, the conventional cross plan of the church was the symbol of Christ's triumph on the cross, and the sign which he predicted would appear at the end of the world. The early 12th-century writer Rupert of Deutz specifically mentions the three-storey elevation found in almost all major Gothic churches as a symbol of the Trinity and Abbot Suger of St-Denis interpreted

the twelve pillars of his new church as symbolic of the apostles and prophets. At Milan Cathedral four towers at the corners of the crossing tower were proposed 'after the model' of the apocalyptic vision of the four ▷Evangelists, an idea expressed by the architects.

For modern architectural historians, the task of going beyond the merely conventional or frustratingly inexact symbolical exegesis of medieval ecclesiatics is a complicated one. The enterprise of decoding the symbolism intended by the builders has led, inevitably, into a larger project, that of positioning medieval architecture within its cultural and intellectual nexus, of establishing the historical context and significance of the symbols in the first place.

Richard Krautheimer, in an influential paper published in 1942, mapped out certain 'genres' of architecture on the analogy of genres of painting (Crossley, 1988, p. 116). These architectural genres were usually determined by liturgical function or dedication. Krautheimer noted that certain ancient structures venerated for their religious or political importance were frequently copied in early medieval architecture. The vagueness – to modern eyes – of the formal relationship between prototype and copy exemplified for Krautheimer how in the Middle Ages it was only necessary to reproduce *some* of the essential features of the prototype in order to evoke its meaning. The relationship between form and meaning in the Middle Ages was, he showed, vague and inexact. This is an insight which continues to be profitable: Richard Gem, in an examination of Bishop Robert of Lorraine's chapel at Hereford Cathedral, showed in what sense it could be understood – as a medieval chronicler actually described the building – as a copy of the basilica of Aachen. The bishop's chapel, a two-storeyed building, square in plan with a projecting rectangular sanctuary to the east and a portal to the west, had a lower floor with four freestanding cruciform piers, the central compartment leaving an octagonal opening into the upper storey. Gem was able to demonstrate that the building was indeed conceived by the patron as a copy of the Aachen chapel, not directly but mediated by reference to later German buildings which had already transposed certain features from Aachen into a two-storey rectangular chapel format. He convincingly hypothesized that Bishop Robert had specified that the building should be a two-storey square structure with an eastern sanctuary, with an octagonal well opening between the two storeys of the chapel, and with a western portal flanked by spiral stairs leading to a tribune. These features were then interpreted by a late 11th-century English mason who can never himself have seen the prototypes which the bishop had in mind. What resulted was a strange hybrid building in which the relationship between the bishop's chapel and imperial prototype is extremely complex, yet which was evidently understood at the time as a 'copy'.

A totally different interpretative methodology is advanced in Erwin Panofsky's *Gothic Architecture and Scholasticism* (first published in 1951), where it is argued that the design and construction of Gothic cathedrals reflected the same habits of mind as contemporary scholasticism: 'There exists between Gothic architecture and Scholasticism a palpable and hardly accidental concurrence in the purely factual domain of time and place'. The High Scholastic *Summa* differed, he argued, from the less comprehensive, less strictly organized and much less uniform encyclopaedias and *Libri Sententiarum* of the 11th and 12th centuries in much the same way as does the High Gothic style from its ancestry. The controlling principles of Scholasticism were, first, *manifestatio* (elucidation or clarification) and second, *concordantia*, the reconciliation of contradictory possibilities. The *Summa's* first requirements were totality, sufficient articulation and sufficient interrelation. 'Like the ... *Summa*, the High Gothic cathedral aimed, first of all, at "totality" and therefore tended to approximate, by synthesis as well as elimination, one perfect and final solution.' The second requirement – sufficient articulation – necessitated the uniform division and subdivision of the whole structure. 'It may be mentioned that the very principle of homology that controls the whole process implies and accounts for the relative uniformity which distinguishes the High Gothic vocabulary from the Romanesque.' The third requirement, distinctness and deductive cogency, was revealed in the manner whereby every part was linked and expressed in High Gothic. Finally, the reconciliation of contradictory possibilities in the *Summa* was expressed by the architects' attempts to reconcile apparently contradictory motifs each with impeccable 'authority', such as the use of the rose window in the western façade.

Panofsky was explicitly concerned not to examine parallels but to establish a causative link between scholastic theology and Gothic architecture, although the method he deploys relies on the concept of causation by 'diffusion rather than direct impact'. For him, the architect 'assimilated and conveyed' the substance of contemporary thought. Panofsky explained how this process of assimilation and dispersal took place in his introduction to *Studies in Iconology*. He articulates the belief that there is a unifying

principle – he terms it 'intrinsic meaning' – which underlies and explains both the visible event and its intelligible significance and which determines even the forms in which the visible event takes shape. Intrinsic meaning is revealed by ascertaining those underlying principles which reveal the basic attitude of a nation, a period, a class, a religion or a philosophical persuasion – qualified by one personality and condensed into one whole. Since it is the historian who determines what the underlying principles of the work of art actually are, there is no need for him to demonstrate a causality between the mental habits of scholastic theologians and the High Gothic cathedral; it can be, and is, inferred. Ultimately, indeed, Panofsky assigns the interpreter to a position outside history, a supposedly objective viewpoint from which to interpret meaning. Paradoxically, of course, it is this attempt to stand outside the interpretative process which reveals the critical hermeneutical weakness of his whole theory.

A much subtler interpretation of Gothic architecture is put forward by Otto von Simson in his 1956 book *The Gothic Cathedral: Origins of Gothic Architecture and the Medieval Concept of Order*. The first part of this remarkable work is focused on a discussion of the intellectual and theological background to the birth of Gothic, whilst the second part attempts to relate this background to the two greatest monuments of the period: St-Denis and Chartres. Von Simson hoped thus to illuminate both the meaning of Gothic and its origin and sought to understand Gothic architecture as an image, as 'the representation of supernatural reality'. Taking as a starting point the changed definition of the symbol for us and for the 13th century, von Simson argued that today a symbol is 'an image that invests physical reality with poetical meaning', whereas to medieval man the physical world was itself a symbol of that invisible reality which lay behind it. Indeed, Hugh of St-Victor defined the symbol as 'a gathering together of visible forms' in order to 'demonstrate' invisible ones. Architecture, then, was designed and experienced as a symbolic representation of divine reality.

For von Simson, the decisive feature of Gothic is not the cross-ribbed vault, the flying buttress or the pointed arch. All these are constructive means not artistic ends. 'Two aspects of Gothic architecture are,' he argued, 'without precedent: the use of light and the unique relationship between structure and appearance.' Gothic architecture is, for von Simson, transparent architecture. 'No segment of inner space was allowed to remain in darkness undefined by light.' The second striking feature of Gothic was the new relationship between function and form, structure and appearance. Whereas to many 19th-century architectural historians structural clarity marked the triumph of functionalism, to von Simson it was the aesthetic values which were dominant and these values were, he claimed, 'to a surprising extent, linear values'.

Von Simson's theory has the merit of explaining how a concentration on liturgical issues to explain change has a strictly limited usefulness. The unchanging texts of the liturgy might determine the limits within which the builder's imagination must move, he argued, but these texts could not explain the changes in architectural style. If the supernatural truth that the liturgy conveyed was immutable, the artistic means of representing this truth were not. In other words, what differentiated the Gothic cathedral from its Romanesque predecessor was 'not the eschatological theme but the different mode of its evocation'. For von Simson, Gothic architectural drawings provided an insight into the medieval architect's obsession with the geometrical principles of his work. The drawings contained no indication of volume, but were linear, based on geometrically determined ratios and without any indication of volume. The Gothic architect developed all magnitudes of his groundplan and elevation by strictly geometrical means, using as modules certain regular polygons, above all the square.

St. Augustine assigned geometry a place among the ▷Liberal Arts because it had an anagogical function, an ability to lead the mind from the world of appearances to the contemplation of divine order. True beauty was anchored in metaphysical reality. For von Simson, the crucial connection between Augustine's philosophy of beauty and the architecture of Chartres cathedral was provided by the existence of a 'School of Chartres' – a group of eminent theologians assembled at the cathedral school. Indeed, he goes so far – absurdly too far – as to claim that 'Gothic art would not have come into existence without the Platonic cosmology cultivated at Chartres'. For the theologians of Chartres, Plato's work (which they knew only through fragmentary sources and commentaries) was in substantial agreement with the Book of Genesis in what it revealed about the creation of the universe. The notion of the cosmos as a work of architecture and of God as its architect had a special significance. Perfect proportional systems chained and knitted together the different elements of the cosmos. Perfect proportion accounted for the beauty and stability of the cosmic edifice. For Alan of Lille, writing towards the end of the century, God was the artful architect (*elegans architectus*) who built the cosmos

as his regal palace. Alexander of Hales (d 1245) actually used the example of the master mason or architect who 'measures and numbers and weighs' in composing his building, to illustrate the harmonious composition of everything beautiful.

The critical question, though, is how much effect these intellectual and spiritual movements had upon the creation of Gothic architecture. Von Simson certainly overstated his case when arguing that 'the geometrical knowledge displayed by a Gothic architect such as ▷Villard de Honnecourt was substantially that of the cathedral and monastic schools and was acquired in them.' Not only is it now a matter for debate whether Villard was even an architect, but it seems most unlikely that architects learned their geometrical skills in such 'schools'. On the other hand, there can be no doubt that Gothic architecture, particularly of the great churches, demanded a quite sophisticated ability to design according to geometrical ratios. Perhaps von Simson may not have taken sufficient account of the distinction between the simple practice and speculative knowledge of geometry but at least one recent commentator has argued that the very difficulty of the discipline of stereotomy, of generating the section from the groundplan, 'suggests that many craftsmen speculated about the meanings of their operations: their moral, philosophical or even theological implications'. It would be most surprising if medieval architects – who were in constant contact with patrons for whom geometry was intimately connected with ▷neo-Platonic theology – failed to see any connection whatsoever between metaphysics and architecture.

After dealing with geometry, von Simson next turns to the issue of light. According to the metaphysics of the middle ages, light is the most noble of natural phenomena, the least material, the closest approximation to pure form. All things have been created according to the law of analogy, in virtue of which they are, in various degrees, manifestations of God, images, vestiges or shadows of the Creator. Light is conceived as the form that all things have in common. In the physical light that illuminated the sanctuary, the mystical reality seemed to become palpable to the senses. 'The distinction between physical nature and theological significance was bridged by the notion of corporeal light as an "analogy" to the divine light'. Abbot Suger had been profoundly influenced by the theological ideas of Dionysius, the so-called Pseudo-Areopagite. Things of the material world could lead minds upwards to the True Light where Christ is the True Door, by an anagogical method. Suger would have known these works through the translations and commentary by John Scotus Eriugena and Hugh of St-Victor's famous commentary on the pseudo-Dionysius's *Celestial Hierarchy*. For von Simson, 'the transformation of Norman and Burgundian models in the design of St-Denis can really be explained as the artistic realization of ideas actually taken over from the Pseudo-Areopagite.' Here von Simson completely obliterates all notion of how the relationship between patron and architect – so subtly explored by Gem – may result in a building which melds the ideas of both in a new and quite unpredictable manner.

The territory so stimulatingly explored by von Simson and Panofsky is still of importance today. One recent work, whilst arguing that 'builders and masters probably had only minimal direct effect on each other's work,' and rejecting Panofsky's notion of 'mental habits' as characteristic of entire cultures, nevertheless suggests that 12th-century architecture and scholarship had in common the foundation of increasingly specialized disciplines and cognitive processes which enabled them to shape several variables into a whole and to take account of potential differences in viewpoint (Radding and Clark, 1992). A slightly earlier essay, by Paul Crossley, illuminatingly explores the whole field of medieval architectural iconography and suggests that 'iconographic methods might *rescue* [my emphasis] the present-day study of medieval architecture from its formal and archaeological preoccupations' and from 'the myopic examination of the fabric of single buildings'.

Excavating upwards

Crossley's rather damning indictment of a whole methodology is perhaps surprising since the examination of individual buildings using techniques derived from archaeological excavation has, arguably, achieved more than any other single methodology in furthering our understanding of medieval churches. These techniques are not solely used below floor or ground level: anything which comprises a series of superimposed layers can be examined. Standing buildings are therefore susceptible to the archaeological technique of stratigraphical interpretation. Building archaeologists often refer to 'vertical stratigraphy', in diagnosing sequential relationships in standing structures. The basic principles of archaeological investigation of English ecclesiastical architecture go back to the work of Robert Willis,

one of the very few 19th-century architectural historians whose research is still of importance today. Archaeological methodology is essential to differentiate styles and construction periods in buildings and can provide unique insights into the history, development and function of churches. Even ostensibly simple buildings, such as King's College Chapel, Cambridge, can be revealed to be complex multi-period structures with important design changes (see RCHM, *City of Cambridge* and Francis Woodman, *The Architectural History of King's College Chapel* London, 1986). Archaeological methodology pre-supposes an initial investigation of all existing visual records, which may range from original working documents of medieval architects to antiquarian records or restoration drawings. This should accompany a thorough scrutiny of documentary sources. The archaeologist requires a clear sense of typology in order to differentiate styles but also a stratigraphical approach to the study of the fabric in order to distinguish different phases: most medieval buildings are multiperiod.

The earliest systematic expositions of Gothic resulted from attempts to understand and analyse medieval architecture. (These attempts were themselves rooted in a romanticist appreciation of medieval architecture, which opposed it to a severely rational classicism. 'One must have taste', Horace Walpole claimed, 'to be sensible to the beauties of Grecian architecture: one only wants passion to feel Gothic.') The first steps in the classification of medieval architecture took place in 17th-century England. Works such as Sir William Dugdale and Roger Dodsworth's *Monasticon Anglicanum*, with engravings by Daniel King and Wenzel Hollar – the latter also illustrating Dugdale's monograph on St. Paul's Cathedral published in 1658 (eight years before the Great Fire destroyed the building) – helped provide the visual material necessary for the systematic comparison of buildings. The *Chronologia Architectonica* written in the 1670s by John Aubrey, attempted to establish a chronology for medieval architecture for the first time. This treatise, illustrated with chronologically arranged drawings of architectural features, remained unpublished as did the treatise on the history of Gothic by the 18th-century architect James Essex. The first published classification of English medieval architecture is contained in a few pages of commentary in Thomas Warton's 1762 *Observations on the Faerie Queene of Spenser* (vol 2). Henry Malden's *An Account of King's College-Chapel in Cambridge*, 1769, makes a serious attempt to identify the various building phases by close attention to the documentary evidence and to that of the fabric. With James Bentham's *History and Antiquities of the Conventical and Cathedral Church of Ely*, published in 1771, engravings became useful as expository aids, and this tradition developed in John Britton's *Architectural Antiquities of Great Britain* (5 vols., 1807–26). Britton (in the fascicle dealing with Mal-mesbury Abbey) set forth a five phase chronology of English medieval architecture.

By the early 19th century Thomas Rickman's *An Attempt to Discriminate the Styles of Architecture in England from the Conquest to the Reformation* (first published in 1817) already provided a systematic exposition of the forms of Gothic architecture. For Rickman, all architecture could be divided into two principal modes: first, the Antique, Grecian or Roman and, secondly, the English or Gothic. This is the reason that Rickman's treatise on Gothic architecture opens – bizarrely for modern readers – with a disquisition on the five orders and an enumeration of examples of each. Exactly the same method is adopted by him in discussing medieval architecture, although Gothic buildings, unlike Classical ones, are not assembled from elements whose form is relatively constant and therefore easy to distinguish. Rickman, however, provided a systematic treatise on the style and components of medieval architecture, aligned in chronological sequence, and a huge appendix, county by county, giving examples of buildings and the styles they exhibit. Fine engravings also illustrated his work, to provide visual examples. For all the numerous errors in his book, Rickman provided the essential foundations on which attempts to arrange medieval architecture in England would thenceforth be based and constitutes a great improvement on the unillustrated and rather confused account in J. Dallaway's 1806 *Observations on English Architecture, Military, Ecclesiastical and Civil*. It needs to be stressed that Rickman's view of medieval architecture is excessively nationalistic: he calls Gothic architecture 'English' because he believed that the finest buildings in the style with their 'pure simplicity and boldness of composition' were English. In fact, he had never visited France and his knowledge of continental Gothic was entirely derived from secondary sources. George Downing Whittington's 1809 *An Historical Survey of the Ecclesiastical Antiquities of France with a view to illustrating the rise and progress of Gothic architecture in Europe*, had already demonstrated the French origins of Gothic at St-Denis. Whittington drew heavily on Jean-François Félibien's *Recueil historique de la vie et des ouvrages des plus célèbres architectes* of 1687 (including chapters on great Gothic architects such as Robert de Luzarches and Pierre de Montreuil) and on Dom Michel Felibien's *Histoire de l'abbaye royale de Saint-Denys en France* of 1706.

The rest of the 19th century, the great century of classification, saw increasingly precise typologies of Gothic architecture, in which even the Germans were finally forced to acknowledge that the '*alt deutsch*' architecture was, in fact, of French origin. The methodologies established in this period for systematic comparison and evaluation are still of fundamental importance to understanding Gothic architecture. It is for this reason that the work of architectural historians such as Robert Willis or Eugene Viollet le Duc's *Dictionnaire raisonné de l'architecture française du XIe au XVIe siècle* (10 vols., 1854–68) can still be read profitably today.

Anglo-Saxon architecture perhaps owes most to the typological and archaeological methodologies developed in the 19th century. H.M. Taylor, the great historian of Anglo-Saxon architecture, listed the features which distinguish pre-conquest churches from those of the Norman invaders: irregular stone size; arches of a single square order and of through-stone construction both in the arch and in its jambs; outlining of arches by plain square section or stripwork; doorways of a single square order, cut straight through the wall and often built wholly of rubble; double splayed windows; unrecessed double openings in belfries; generally thinner walls; distinctive types of quoins (e.g. long-and-short); the division of the wall-surface by pilaster strips; and the cellular plan. In order to understand Anglo-Saxon buildings at all, it is first necessary to recognize their characteristic features and to try to differentiate architecture of this period from later building phases.

The simplest method for differentiating sequences is to draw a series of sketch plans, one for each architectural phase, for in general medieval churches tended to grow piecemeal (a fact particularly true of parochial church architecture). Another important diagnostic tool is the examination of stratification. It is not, though, always true in walls that the upper parts are the latest as is generally the case with geological layers: the earliest fabric in an aisled church may survive only above the arcades. In the vast majority of cases, dating cannot be absolute but has to be argued on the basis of analytical sequencing. In the archaeology of walls, the date of the wall must be that of the earliest *original* feature in it. If the windows and doorways in a component part of a church are all architecturally similar and there is no evidence for earlier works, then there is a fairly high probability that that part is of one build. If on the other hand, the windows and doorways appear to be a jumble of varying styles and dates, there is a strong probability that the walls of that component part are older than most, or all, of the features.

Mouldings and the 'individual hand'

The study of architectural details as a diagnostic guide to relative date, coupled with a wide-ranging attempt to recover the biographies of medieval master masons led, particularly in England, to the analytical study of architectural mouldings. They can also provide information about individual master masons, the architects of the medieval period. During the 12th and 13th centuries, there were considerable innovations not just in the technical side of building (in crane technology, the manufacture of tools and so on) but also in architectural practice. Although the whole issue has been the subject of intense debate by specialists, it now seems clear that drawings were widely used by architects by the mid-13th century. Indeed it seems very likely that drawings would have been used much before this, for as soon as accurate templates were required for individual stones – as for instance in the stereotomy (geometrical cutting of stones) of rib-vaulting – careful preparatory designs would have been required, and these must have been worked out on a small scale before 1:1 designs were drawn out.

From the end of the Middle Ages, there exist numerous architectural designs, some of which were used by architects to communicate their ideas to their patrons. The prestigious nature of architectural drawing was indicated by the now destroyed labyrinth laid into the nave pavement at Reims Cathedral in c1290. This contained images of the four architects in charge of work on the cathedral since its inception. Three of the architects were represented holding drawing instruments. This emphasizes that in order to build a Gothic church a mastery of a precise linear geometry was necessary, and the importance of this knowledge was recognized not only by the master masons themselves but also by their clients. Throughout northern Europe, architects achieved a high status: indeed, in England, they were probably the only artists other than goldsmiths consistently to attain such status.

About 1260 an inscription to the master mason Jean de Chelles was actually cut into the base of the south transept façade of Notre Dame in Paris. Such inscriptions are very rare and it is more common to find portrait heads carved on master masons' work. This type of commemoration indicates a status which is also attested by documentary evidence: during construction of New College, Oxford in 1389, the master masons Henry Yeveley and William Wynford sat together with the master carpenter Hugh

Herland at High Table. Architectural expertise was recognized and highly valued. The French poet Christine de Pisan referred to Raymond du Temple, the master mason of Charles V, as 'a learned artist who very well understood geometry and showed his knowledge in the designing of buildings'. A little later, the 15th-century English poet Lydgate, in his *Troy Book*, describes how King Priam sent out to find:

> Such workemen as were curious
> Of wit inventive, of casting [arithmetic] marvellous
> Or such as could craft of geometry
> Or were subtle in their fantasy;
> And for everyone that was good deviser
> Mason, hewer or craft quarrier
> For every wight and passing [able] carpenter
> That may be found.

The medieval architect not only used drawings to transmit his ideas to his workmen, but also to delegate responsibility, as happened at Westminster in the 1250s, where the designer Henry of Reyns worked simultaneously on other projects, one of which was a castle at York. In 1261, the Dominican preacher Nicholas de Biard complained how: 'Masters of the masons carrying a yard-stick and with gloves on their hands, say to others: "Cut it for me this way" and do no work, yet they receive higher pay.' (Harvey, 1972 p. 78)

Although few working drawings survive in England, larger numbers remain from continental Europe. Initial designs would be made on trestle tables: often on parchment and later on large sheets of paper. For full-scale designs, boards or plastered floors were employed. Once the drawing had served its purpose, the floor could be painted over with a thin wash and made ready for use again. Drawing floors of this type are extant at Wells and York in England. Joiners would then cut wooden moulds or templates to the correct size and these would be handed over to the working masons. Today, by comparing architectural details (often using a template former, which takes a negative imprint of the moulding, which can then be drawn out) it becomes possible to recognize the repetition of particular design details. Very occasionally the same template was used on different sites; more generally, the same groups of forms are employed and this means that 'sets' of mouldings taken from various architectural details provide the architectural historian with a set of comparative data which can be applied to determine the region from which the designer originated or even – on occasion – the identity of the particular designer. In applying this methodology to analyse individual hands, the historian has also to remember that the same designer might not only develop throughout his career, but might also have different 'manners' depending on the cost, size and function of the building he was designing, just as a scribe could use different 'styles' to write different types of book. Finally, the control over all aspects of the design could vary dramatically: the master mason might not design all the templates, especially if he was essentially a consultant. So applying this method demands the same sorts of intellectual skills as are required by the connoisseur.

Liturgical strictures and mnemonic structures

The stylistic and archaeological analysis of Gothic architecture is time consuming, difficult, and demands first-hand knowledge both of individual buildings and of their predecessors, contemporaries and successors. This is undoubtedly one of the reasons why stylistic analysis is increasingly decried. Functional approaches, on the other hand, suffer from some quite specific problems of their own: beyond very general points about the suitability of bare and simple hall churches for the mendicant orders – because a concentration on surface complexity and cost would ill accord with the symbolic poverty of the mendicants – there often seems remarkably little direct interaction between form and function in great church architecture. It is mainly in the ground plan, claustral layout and placing and design of domestic architecture that functional considerations are most evident. Once such major provisions as a sanctuary area round the high altar and a liturgical choir near the presbytery (to provide a private area for the staff of the church), or spaces for access to subordinate altars and an accessible area behind the high altar for a shrine, had been satisfied, there was considerable liberty from purely functional requirements in ecclesiastical buildings. Christopher Wilson has rightly emphasized that

different functions could be fulfilled by identically shaped areas: this is shown by the T-shaped plans of the Nine Altars chapels at Durham Cathedral and Fountains Abbey, the former housing an important shrine, the latter not. Conversely the same kind of activity could take place in totally different architectural settings.

Major architectural undertakings were certainly often prompted by a desire for new liturgically significant spaces, such as Abbot Suger's choir or Bishop Northwold's presbytery at Ely Cathedral, both of which housed important shrines. In the rebuilding of Wells Cathedral in the Decorated Style, the dependence on Salisbury's liturgical observances may have affected some aspects of the new building's layout. Wells, like Salisbury, was a cathedral of secular canons: the clergy were not monks, nor were they under a common rule as were regular canons (e.g. Augustinians). Secular canons were permitted to live within their own households, usually in the cathedral close, but they often did not remain in residence. Those canons who were in residence had to appear in their choir stalls at least once during the day if they were to receive their stipend. The Wells calendar included 24 major feast days and 13 minor ones, on each of which, as well as on every Sunday, processions at high mass and vespers were required. Processions were thus required on at least 80 days of the year. Three liturgical observances have been identified as having important architectural consequences. First, the processions in columns of two abreast encouraged a logical arrangement of altars around one continuous processional route. Secondly, all the altars of the eastern arm of the church had to be censed during canticles on major festivals and this tended towards the grouping of these round the high altar: there were twelve altars at Wells, all but two of which were east of the choir screen. Thirdly, the cult of the Virgin required a major chapel space to accommodate the daily Lady Mass and vespers. The new east end at Wells, it could be argued, was constructed above all to provide an environment which fully accommodated the observances of the liturgical year.

There is no doubt that much interesting research is taking place into the functions of great churches and their ancillary buildings: much too, remains to be done to extend the analysis into parochial architecture, where the functional requirements and the relationship between cleric and laity was of a different nature. Such research may lead up unexpected paths and draw on unusual sources. One such source is a 16th-century self-help treatise. In his *Ars memorativa* of 1523, Laurent Fries aimed to help the reader enrich his natural memory (*memoria naturalis*) and to develop his artificial memory (*memoria artifitiosa*). Artificial memory consisted of visualizing a group of locations and mentally placing words or images (*imagines*) there: this method had been used in Greece by the pre-Socratic philosophers and was transmitted to Christendom via Cicero. Fries counselled his reader to choose locations in a church or other large building, and used the example of Strasbourg Cathedral to demonstrate his method. In a fascinating paper Jean Michel Massing has showed how Fries's *Ars memorativa* can now be used to reconstruct aspects of Strasbourg Cathedral's layout before the Reformation and the subsequent effacement of many of the church's medieval furnishings. There is a pleasing irony in the fact that a wonderfully complex treatise on memory has, in deploying the church as a mnemonic theatre, itself preserved the memory of the lost topography of a great medieval cathedral.

Bibliography

Bony, J., *French Gothic Architecture of the 12th and 13th Centuries*, Berkeley, 1983

du Colombier, P., *Les Chantiers des cathédrales*, Paris, 1953

Crossley, P., 'Medieval Architecture and Meaning: The Limits of Iconography', *Burlington Magazine*, 130 (1988), pp. 116–121

Draper, P., and N. Coldstream (eds.), *Medieval Art & Architecture at Ely Cathedral*, Leeds, 1979

Fernie, E., and P. Crossley (eds.), *Medieval Architecture and its Intellectual Context*, London, 1990

R. Gem, 'The Bishop's Chapel at Hereford: the roles of patron and craftsman,' in S. Macready and F. H. Thompson (eds.), *Art and Patronage in the English Romanesque*, London, 1986, pp. 87–96

Gerson, P.L. (ed.), *Abbot Suger & Saint-Denis*, New York, 1986

Harvey, J.H., *The Mediæval Architect*, London, 1972

Kraus, H., *Gold was the Mortar: The Economics of Cathedral Building*, London, 1979

Massing, J.M., 'Laurent Fries et son "Ars Memorativa": la cathédrale de Strasbourg comme espace mnémonique', *Bulletin de la cathédrale de Strasbourg*, 16 (1984), pp. 69–78

Morris, R.K., 'The Development of Later Gothic Mouldings in England, c1250–1400, Part I', *Architectural History*, 20 (1977), pp. 18–57 and Part II, in *ibid.*, 22 (1979), pp. 1–48

Murray, S., *Building Troyes Cathedral: the Late Gothic Campaigns*, Bloomington, 1987

Murray, S., *Beauvais Cathedral: Architecture of Transcendence*, Princeton, 1989

Panofsky, E., *Gothic Architecture and Scholasticism*, Latrobe, 1951

Radding, C.M., and Clark, W.W. *Medieval Architecture, Medieval Learning*, Yale, 1992

Rodwell, W., *Church Archaeology*, London, 1989

Shelby, L.R., *Gothic Design Techniques: the fifteenth-century design booklets of Mathes Roriczer and Hanns Schmuttermayer*, Carbondale and Edwardsville, 1977

von Simson, O., *The Gothic Cathedral: Origins of Gothic Architecture and the Medieval Concept of Order*, Princeton, 1962

Taylor, H.M., *Anglo-Saxon Architecture, III*, Cambridge, 1978

Vroom, W.H., *De financiering van de kathedralbouw in de middeleeuwen*, Maarssen, 1981

Watkin, D., *The Rise of Architectural History*, London, 1980

Wilson, C., *The Gothic Cathedral*, London, 1990

Art and the Renaissance in Italy

N. S. Davidson

The impact of the ▷Renaissance on the history of Western art is easy to demonstrate. If we were to take two paintings of the ▷Virgin and Child – one attributed to ▷Guido da Siena (c1275, Siena, Palazzo Pubblico) and the other by ▷Fra Angelico (1438–40, Florence, S. Marco) – and then place them side by side, few people seeing them would hesitate to label the first as 'medieval' and the second as 'Renaissance'. The formal differences between the two pictures seem to be obvious. Guido's panel is not easy to read: it seems like a two-dimensional pattern on a painted background. The bodies are stiff and angular, the drapery falls unnaturally, and the design of the throne is entirely unconvincing. Fra Angelico's altarpiece, on the other hand, can be apprehended immediately because there is a clear spatial relationship between the figures and the furnishings. The bodies and draperies look entirely natural, and the whole scene is placed before a realistic landscape background.

Formal changes of this kind – changes in design and methods of composition – can also be traced in the other visual arts of the period, and in the past it has sometimes been assumed that such stylistic changes marked an advance in the quality of the works produced. That assumption was certainly prevalent in parts of Italy by the 15th century, and in 1550 it was formalized in the first edition of ▷Giorgio Vasari's *Lives of the Artists*, which presented the history of recent art in three steadily improving ages, each one lasting roughly a century, from the rebirth of the arts at the time of ▷Cimabue and ▷Giotto around 1300 to the incomparable achievements of ▷Michelangelo, teacher and friend of Vasari himself, in the early 16th century.

Few historians now would accept Vasari's argument that Renaissance art was objectively 'better' than medieval art; but there is no doubt that our views of Renaissance art – and indeed our model of European art history, which tends to give a special significance to Italian art after 1300 – are still deeply (and sometimes unconsciously) influenced by Vasari's assumption of stylistic progress in the previous two and a half centuries. Yet Vasari was a writer and a historian, as well as a painter and architect, and his interpretation of the art of his own time owed at least as much to intellectual changes outside the visual arts as to stylistic changes within them. For the notion of a 'Renaissance' or 'rebirth' predated Vasari, and referred initially not to any advance in the visual arts, but to a much broader cultural movement in Italy, whose origins can be traced to the 14th century. We must therefore begin our study of Italian Renaissance art with an investigation of this broader Renaissance movement outside the visual arts.

The Renaissance and the Antique

The cultural renewal that we now call 'the Renaissance' had begun in Italy around 1300 among scholars committed to the revival of learning about the ancient world. In the 19th century, such scholars were labelled ▷'humanists', because they had defined their own purpose as the inculcation through a training in the Greek and Roman classics of those personal qualities that they believed to be characteristic of the most developed and civilized human beings. This aspiration was itself derived from the ancient world. The 2nd-century Latin author, Aulus Gellius, recorded, for example, that 'the pursuit of that kind of knowledge, and the training given by it, have been granted to man alone of all the animals, and for that reason it is termed *humanitas*, or humanity.' The humanists' aim was therefore educational above all: to encourage the study of the culture of ancient Greece and Rome, and by that means to improve both the moral character of their pupils and their ability to lead an active life in a civilized community. A humanist education thus began with a rigorous training in the ancient languages

of Greece and Rome, and then moved on to a close study of significant Classical texts – not just works of literature, but also of history, philosophy, ethics and political theory. As the 16th-century English humanist, Sir Thomas Elyot, put it, the ancients provide us with 'precepts, exhortations, counsels, and good persuasions, comprehended in quick sentences and eloquent orations'. Ancient wisdom would encourage contemporary virtue.

It was therefore believed that a good humanist education could produce moral individuals, conscientious citizens and a good society. But it was inevitably restricted to a small group. Social, economic and political realities prohibited the provision of a Classical education to the vast majority of young people even after the invention of the printing press in the 1450s. The significance of the humanists' educational programme lies therefore not in its direct impact on society at large, but in its influence on the cultural élite of the time, who gradually adopted its message and techniques, and extended them even to intellectual disciplines such as mathematics and natural science that were apparently remote from its original concerns.

Among such wide-ranging interests, a passion for collecting the material remains of the ancient world was often prominent. Sometimes, these artefacts were incorporated into the ornamentation of gardens and houses, and some collections were opened to public view. In 1474, for example, Pope Sixtus IV established a museum of antiquities in Rome on the Capitoline Hill. But humanists and their supporters were not interested in the art of the ancient world alone. The mid-15th-century Duke of Urbino, ▷ Federico da Montefeltro, for instance, employed a number of humanists in his household service, and collected a huge library containing virtually all known Classical texts; but in the 1470s he also commissioned some of the most celebrated painters of the day to decorate his private study with portraits not just of ancient poets, philosophers and scientists, but also contemporary humanists and Christian theologians. ▷ Isabella d'Este, the wife of Gian Francesco II Gonzaga, Marquis of Mantua in the early 16th century, was an equally erudite woman, who read Latin easily, and had a wide knowledge of the ancient world; but she too became a noted expert in contemporary painting and poetry, and at her court in Mantua, she fostered the work of a glittering circle of writers and artists, including the Venetian painter ▷ Titian.

Individuals involved in this Renaissance did not therefore restrict their energies to one field only, but tried to foster both scholarship and the arts. Such eclectic and wide-ranging cultural interests were especially common in the cities and courts of northern and central Italy, where artists, scholars and writers gathered together in search of employment from powerful patrons who were themselves actively committed to the humanist programme, and who were often, indeed, trained within it. The contemporary visual arts were thus seen by contemporaries as playing a significant part in the broader cultural Renaissance of late medieval and early modern Italy. In 1463, for example, the Florentine bookseller Vespasiano da Bisticci praised the cultural activity of his native city in a letter to a Spanish friend: 'Now more than ever before Florence is flourishing, not only in its study of literature ... but also in its painting, sculpture and many other arts.'

In line with this combination of interests in both scholarship and the arts, many humanists discussed the arts in their own writings, so that from the 15th century onwards, a separate literary genre of art criticism was gradually developed. The problem faced by such humanist critics, however, was that they initially had no separate vocabulary with which to discuss works of art. They therefore turned instinctively – as with all their intellectual pursuits – to the Classics, from where they appropriated the terms and methods used by ancient writers to describe and analyse works of literature.

This trait is especially evident in ▷ Leon Battista Alberti's *Della pittura* (*On Painting*), the first Latin version of which was completed in 1435. This book drew extensively on the works of Cicero, the Roman orator who died in 43 BC, and of the 1st-century rhetorician Quintillian, whose *De institutione oratoriae* had been recovered in its entirety in 1416. Alberti's text analysed paintings using the same methods as the ancients when they had explained the construction of the most effective prose, and he advocated a method of training painters that was derived explicitly from the step-by-step method of teaching writing: 'I should like youths who first come to painting to do as those who are taught to write. We teach the latter by first separating all the forms of the letters which the ancients called elements. Then we teach the syllables, next we teach how to put together the words. Our pupils ought to follow this rule in painting.'

The ancient preoccupation with literature also influenced the humanists' approach to the history of art. Vasari's *Lives of the Artists* thus follows Classical precedents in presenting the past through a series

of individual biographies, and in linking the production of the greatest art with the innate moral virtues and courage of the greatest artists. His celebrated three ages of art since about 1300 similarly corresponds to the three-part structure for the development of oratory provided by Quintillian. And the achievements of ancient art, as reported by ancient authors, were used by humanist writers as a measure of the work of contemporary artists, who were often judged by their faithfulness to the subjects and styles of their ancient predecessors. Cristoforo Landino, for instance, writing in about 1480, characterized ▷Donatello as 'a great imitator of the ancients'. (It is interesting to note here, however, that the main text of Alberti's *On Painting*, a treatise which explicitly praised recent Florentine art, managed to mention only one recent Italian painter by name – though ancient artists such as ▷Apelles were discussed frequently.) Imitation of the ancients was therefore regularly advanced as the best method of training a modern artist could adopt, and Vasari attributed the revival of the arts since 1300 explicitly to the insight of those artists who 'were able to distinguish the good from the bad', abandoning 'the old style and reverting to the imitation of classical art'.

It could be argued that this reliance on ancient writings and artists was nothing more than a rhetorical device that tells us little about the real attitudes of contemporaries to art and art history. But writers like Alberti and Vasari were not mere copyists, slavishly applying the judgement of the ancients to the artists of their own time. Vasari's celebrated reference to Michelangelo's 'seeing' his statues imprisoned in the rock at the quarry at ▷Carrara certainly echoes Cicero's praise for the ancient sculptor ▷Praxiteles, who reportedly also saw his carved heads in the unhewn blocks of stone on Chios. But Vasari does not apply this Classical literary figure to any other sculptor apart from Michelangelo. Ancient models and themes were thus employed selectively. Moreover, the humanists' enormous respect for the achievements of antiquity meant that they genuinely believed that the language and thinking of the Classics were still applicable in later times. They had so absorbed the ancients' world view that it had significantly transformed their own.

Artists were not ignorant of this prevailing intellectual climate. They met scholars regularly, in the service of rulers and nobles and also in the vigorous intellectual and cultural circles of Italy's cities and universities. In the 13th century, the humanist Petrarch had commissioned ▷Simone Martini to paint a portrait of his lover, Laura. In the following century, ▷Filippo Brunelleschi, ▷Lorenzo Ghiberti and Donatello were all friends of the humanist Niccolò de'Niccoli in Florence, who died in 1437. Niccoli was knowledgeable about all the fine arts, and spent virtually his entire inheritance on collecting ancient books and manuscripts, ▷medals, bronzes, busts, vases and ▷inscriptions, as well as contemporary paintings. In the 16th century, the celebrated writer Aretino knew ▷Raphael in Rome before 1520, and he later befriended Titian in Venice. A few artists were themselves the product of a humanist education, and some contributed to contemporary intellectual debates by their own research and writings. Alberti received a humanist education in Padua before entering the University of Bologna in 1421. His treatise *De re aedificatoria* (*On Architecture*), which was completed in 1452 and printed in 1486, was the first major study of Classical architectural style, based on a close examination of the surviving archaeological evidence as well as of the ancient literary texts. The Umbrian painter ▷Piero della Francesca wrote a learned geometrical treatise in Latin entitled *De quinque corporibus regularibus* (*On the Five Regular Solids*).

In such circumstances, it is not surprising that Classical themes and subjects should in time appear in the work of painters, sculptors and architects. The first modern example of the ▷equestrian statue of a prince, derived from the statue of the philosopher-emperor Marcus Aurelius (which Pope Paul III was later to place on the Capitoline Hill in Rome) was designed in 1443 by Antonio Baroncelli and Antonio di Cristoforo for Nicolo III d'Este in Ferrara. Before its completion, the design was appraised by Alberti, who also designed the pedestal in 1451. The planning of large-scale decorative schemes was also often entrusted to humanists. One of the earliest documented examples is a detailed programme devised for Leonello d'Este's study at Belfiore in 1447 by his former tutor, ▷Guarino Guarini. Guarino was a humanist who had studied in Padua and Constantinople, and who subsequently taught in Florence, Venice and his home town of Verona before joining the household of the Este family at Ferrara, where he died in 1460. His proposal for the Belfiore study led to the first visual representation of the ▷muses in the Renaissance: in Greek myth, the nine muses were the goddesses of literature, music, dance and intellectual activities, and they therefore formed a fitting subject for this room. Guarino's programme provided a brief description for the representation of each muse. Clio, the muse of history, for instance, should 'hold a trumpet in one hand and a book in the other; varied

colours and patterns will be woven into her garments in the manner of silken drapery in the ancient style'. The scheme was painted by Angelo da Siena and ▷Cosimo Tura, and they probably worked closely with Guarino to develop his suggestions. Sadly, the cycle was destroyed in 1483.

Such detailed programmes have not always survived, but the frequent appearance in Renaissance art of subjects from ancient literature and history, as well as Classical symbols and ▷allegories, can often be attributed to this sort of intellectual influence, particularly in the relatively closed world of governing courts and households. Rulers and courtiers were sometimes depicted in such works in the guise of Classical gods themselves: ▷Giulio Romano's ▷frescos at the Palazzo del Tè in Mantua include one showing his patron, Federico Gonzaga, as the ancient god ▷Jupiter in the form of a Triton about to embrace Olympia, who has the face of Federico's own mistress, Isabella Boschetti.

The influence of the humanists has thus often been proposed as the source for the Classical subjects which appear in Renaissance art. Some historians even argue that it was this interest in, and reliance on, ancient precedents which produced a different artistic style in the Renaissance – a style that distinguished it sharply from the art of the Middle Ages. In architecture, for example, ▷Gothic pointed ▷arches were replaced with the round arches of ancient Rome; Classical columns, porticoes and ▷pediments appeared again. The façade of the church of San Francesco, Rimini, built in the 1450s, was adopted from the characteristic form of the Roman ▷triumphal arch – an example of which, the Arch of Augustus (c27 BC) still survives in the city nearby. Ancient architecture and statuary influenced the Paduan painter ▷Andrea Mantegna, who frequently attempted to reproduce the appearance of the ancient world in his paintings. In his *Condemnation of St. James*, for example, a fresco completed at the Eremitani Chapel in Padua in 1455, the background is dominated by a fine Roman triumphal arch. The supply of such ancient artistic sources was constantly augmented by new finds – many made as Rome and other cities expanded beyond their medieval walls. Artists flocked to see the latest excavations, such as Nero's Golden House in Rome, from where the ▷*Laocoön*, now in the Vatican, was probably unearthed in 1506. By the turn of the 16th century, aspiring artists would deliberately travel to Rome in their early careers to study and sketch the city's Classical remains, and they frequently used Classical models in their own later work. ▷Raphael moved in 1509 from Florence to Rome, where he read the ancient authors and visited the ancient sites. He was subsequently commissioned by Pope Leo X to survey and record the remains of the ancient buildings in the city. Much of his own work shows the influence of this exposure to the art of the ancient world. He made use, for example, of the celebrated ▷grotesques in Nero's Golden House in his decoration of the Long Gallery of the Vatican Palace, now known as the Loggia of Raphael.

But not all artists could travel to such sites in person, nor visit the great collections of antiquities that were built up. They were reliant instead on manuscript drawings or printed reproductions of antique survivals. Artists and archaeologists often collaborated on projects of this kind, and published attempts to recreate the image of Classical art and architecture became increasingly frequent. Flavio Biondo's *Roma instaurata* was the first systematic guide to Rome's ruins: compiled in the mid-15th century, it was subsequently translated and printed in many published editions, and reached an audience well beyond those able to visit the city whose past appearance it sought to depict.

Florence and Tuscany

Although the broad cultural interest in the ancient world had an undoubted influence on the development of the visual arts in the Renaissance, artists were not trying merely to imitate the achievements of Classical art. In the first place, the evidence of ancient art which had actually survived the Middle Ages was, at best, fragmentary; very little ancient painting had survived at all. Moreover – as the ample provision of published reproductions of Classical art might suggest – many artists acquired their knowledge of the ancient world only indirectly and at second hand. Just as the humanists such as Alberti were selective in their use of ancient precedents, so were the artists. At times, Renaissance artists and writers were positively critical of some Classical practices, and encouraged contemporary artists to move beyond the models of the ancients. Vasari, for example, praised Michelangelo, who 'wanted to break away' from the rules of ancient architecture. While there was therefore a recognition that modern artists could learn and benefit from the example of the ancient world, there was also a desire to improve on the culture of the ancients, and to develop it for use in the contemporary world. Imitation of the ancients was thus a spur to a new creativity.

In any case the earliest examples of 'Renaissance' art, which all appear in Florence, do not seem to

have been consciously influenced to any great extent by examples from the ancient world, or by the humanists' extensive praise of them. ▷Lorenzo Ghiberti's *Commentarii* (*Commentaries*), written in the middle of the 15th century, credited the Tuscan painter Giotto, who died in 1336, with the 'discovery' of 'the doctrine of art which had lain buried for 600 years'. Vasari also pointed to Giotto as the reviver of 'the true art of painting'. Yet Giotto's work shows no obvious Classical tendencies at all, and there is no evidence that he looked to the ancients for inspiration.

Similarly, when we move forward to the 15th century to examine the new architecture of ▷Brunelleschi, it is hard to discover any predominantly Classical precedents for his innovative style. A later story (reported by Vasari) tells how Brunelleschi travelled from Florence to Rome early in the 15th century to measure and draw the ruins of the city's ancient buildings; but this account may not be true, and there is no firm evidence from his early years that Brunelleschi had any conscious desire to revive ancient architecture. There is nothing overtly Classical about his celebrated dome for Florence's 13th-century cathedral, which was begun in 1420 and is constructed on a pyramid of pointed arches. He never identified himself publicly with the humanists, and it seems as if he found his inspiration chiefly in local ▷Romanesque buildings, such as the ▷baptistery or the church of San Miniato al Monte in Florence itself, the cathedral of Pisa, or the church of S. Frediano in Lucca, which all date from the 11th or 12th century.

The apparently precocious development of Florentine art by the early 15th century, therefore, owed less to intellectual humanists than to conscious localism. This sort of civic or regional patriotism is apparent throughout the work of contemporary Florentine writers. They were happy to credit the Florentine Dante with restoring Italian poetry, and as early as the 1380s the historian Filippo Villani had credited Florentine artists – and especially Giotto – with reviving the visual arts after their decline in the Middle Ages. By the 1430s, the humanist Matteo Palmieri asserted that the array of talents in all cultural fields then present in Florence was greater than any seen in the world for 1,000 years. In a sense of course, the 'Classical tradition' had never entirely perished in Italy, even though the north European Gothic style had been widely adopted. Many cities contained prominent Roman monuments, medieval buildings in a Romanesque style remained in regular use, and the language of the ancient Romans, Latin, was still the language of scholarship and the church. Long before the later Middle Ages, Italian artists, such as the 13th century ▷Nicola Pisano, had already made regular use of Roman models in their own work. To revive the culture of the Romans was therefore seen as an act of homage to the Italians' own past. For example, Alberti refers in his treatise on painting specifically to 'our ancient Tuscan ancestors'.

What we see in early Renaissance Florence, then, is a continuation and refinement of what was perceived as a specifically Tuscan tradition. It is true that Classical details or decorations appeared occasionally in Brunelleschi's early work; but they were used primarily as decoration and embellishment, and were often placed beside forcefully non-Classical elements such as the winged cherubs' heads that adorned the ▷entablature he designed in the early 1420s at the reconstructed church of San Lorenzo in Florence. Brunelleschi's early architectural innovations had a rapid influence on the work of his contemporaries in Florence and elsewhere. ▷Donatello made use of the Classical ▷orders when designing the ▷tabernacle for his free-standing statue of St. Louis at Or San Michele in the mid-1420s, and ▷Masaccio similarly used novel architectural details in the background to his *Trinità* at Sta Maria Novella, painted at about the same date. But again it is hard to find any direct Classical precedent for any of these compositions. Indeed, for many years explicitly 'Classical' art was viewed with suspicion by some Christians. The ancient Greeks and Romans had, after all, been pagans, and it was not always easy to adapt non-Christian subjects and styles to pious Christian uses. Many early Renaissance churches, such as Alberti's San Francesco in Rimini, thus retained their more overtly Christian Gothic windows alongside their Classical forms, and ▷Sandro Botticelli's *Adoration of the Magi* (c1472, Florence, Uffizi) takes place before a ruined Classical building – Christ's coming has destroyed paganism.

If this interpretation is correct, what we find in the early Renaissance is thus a revival of a conscious Tuscan or Italian artistic tradition, particularly in architecture, that was seen as a continuation of the ancient Roman past and as a contrast to the imported north European Gothic tradition. It began without much reference to the intellectual Renaissance of the humanists – but it was very quickly adopted by them. Alberti, although a member of an old Florentine family, was born in exile in Genoa and subsequently studied with humanists in Padua and Bologna; he settled in Florence only in 1434 (though he may have visited the city briefly in 1428). Brunelleschi's dome on the cathedral was almost

completed by the time Alberti arrived, and San Lorenzo was already under construction. Donatello had finished his work at Or San Michele. Masaccio had died some six years earlier. The prologue to the Italian edition of Alberti's treatise *On Painting*, which was completed in 1436, makes clear his astonishment on returning to Florence to encounter the recent work of these men and their contemporaries for the first time: 'I used to marvel and at the same time to grieve that so many excellent and superior arts and sciences from our most vigorous antique past could now seem lacking ... Since then, I have been brought back here to Florence ... [and] I have come to understand that in many men ... there is a genius for accomplishing every praiseworthy thing. For they should not be slighted in favour of anyone famous in antiquity in these arts.'

What Alberti and other humanist commentators therefore tried to do was to provide a Classical structure and justification for artistic innovations that had already been created without them. It was the repeated insistence of these humanist writers on the need to learn from the ancients that was later to persuade practising artists to look more seriously at genuinely ancient models. They also persuaded the contemporary cultural élite to value and judge the art of their own time in the light of those models. In time then, the 'Tuscan' revival of Brunelleschi and his contemporaries became 'Romanized' under humanist pressure.

Patronage

The influence of the ancient world was thus more apparent in the course of the artistic Renaissance than in its origins. The visual arts may have played a role in the broad cultural Renaissance of the time, but we cannot attribute the extraordinary efflorescence in Italian art and architecture after 1300 simply to a contemporary admiration for the achievements of Classical civilization. In order to discover what provoked the formal developments of the Renaissance, historians have turned to the social context in which art was produced, and in particular to the role of patronage. Why did anyone consider it worthwhile to pay artists or architects to work in the way they did? What did the patrons of art seek to gain by their investment?

At its simplest, we can explain artistic patronage by saying that individuals liked to live in well-designed houses and to decorate their homes and churches with suitable pictures and statues. Obviously, such pragmatic considerations cannot be ignored. ▷Palladio's rural ▷villas had to serve a practical purpose in the management of large country estates; they were not just aesthetic statements. But clearly there was much more to patronage in the Renaissance than personal taste or conspicuous consumption. Throughout the Renaissance, there was a widespread feeling that support for the arts was a duty of the rich and powerful, and that commissioning a celebrated work of art would enhance the fame and reputation of the individuals or institutions that had paid for it. Artistic patronage thus became the activity that marked off the élite from their subordinates, and financial support for the arts became a matter of social policy. As Filippo Brunelleschi reportedly put it, 'The walls of our buildings ... commemorate those who put them up for hundreds and thousands of years.'

Much of the patronage for new art in Renaissance Italy came from rulers. Throughout the Middle Ages, most towns in northern Italy had largely governed themselves, but from the 14th century, they were increasingly subordinated to the rule of a few dominant cities, including Florence, although some smaller states based on a single city and its region, such as Mantua or Ferrara, survived as well. Central Italy, meanwhile, was dominated by the Papal State; the South was incorporated into the Kingdom of Naples. At no point, though, did any single ruler control the whole peninsula – a contrast to the achievement of a single monarchy in countries such as France or England. Autonomous, republican constitutions did survive in a few of the northern cities, including Lucca and Venice, but many came to be ruled by a single dominant family, who often took hereditary titles for themselves. These new rulers were conscious that they lacked the legitimacy bestowed by a long constitutional history, and that their hold on power was by no means secure. They were therefore keen to establish a dignified image for their office and their family that could help to sustain their claim to government. As part of this policy, they turned to the arts, which were often used not just to reinforce the stature of individual rulers, but also to link their new regimes explicitly with the past. The ▷Medici's financial support for Brunelleschi's new Tuscan art in 15th-century Florence, for example, conveyed a clear ideological message to the community. The efflorescence of the arts in Renaissance Italy can therefore be in part at least explained by the desire of contemporary governments to create a sense of legitimacy through art that they would otherwise have lacked. The purpose of much of the art commissioned by rulers

was frequently a political one. And the propaganda value of their artistic patronage can be traced not just in commissions paid for from public funds, but also in the works commissioned for their own private use. It is difficult to separate a ruler's public from his private patronage – or even his secular from his ecclesiastical commissions.

The most public expression of a ruler's power and prestige was perhaps made by his architectural patronage. Some rulers continued to commission, and then live in, awesome buildings with a medieval military appearance. The Castello Sforzesco in Milan, for instance, designed for ▷Francesco Sforza in part by the Florentine architect ▷Filarete and begun in 1451, retains the huge walls and high ▷crenellated towers characteristic of a medieval fortress; but inside, it contains the typical ▷loggias, courtyards, fountains, gardens, and decorated residential rooms more characteristic of the Renaissance. Other rulers reconstructed the earlier communal government buildings and used them as a private residence, thus identifying themselves and their family with a supposed continuity of local government history. Increasingly, though, this residential policy tended to separate the rulers from their people. This was a process evident especially clearly in Florence in the 16th century, when Vasari created a private covered passage which enabled the Medici rulers to travel in seclusion across the river Arno between their private residence at the Palazzo Pitti and their government offices at the Palazzo Vecchio.

Orders to rebuild or reinforce city fortifications and defences could also be used to demonstrate a ruler's authority, as were large-scale plans to develop their cities' physical appearance. The first example of major new town planning by a ruler was Ercole I d'Este's extension of Ferrara to the north of the old town. This is usually known as the 'Herculean Addition', and it was designed by the local architect Biagio Rossetti and begun in 1492. Rossetti's plan envisaged a mostly rectangular street system focused on the ducal court, and within ten years, some 20 palaces and 12 churches had been built in this area. Ercole did not lay down any rigid design specifications for individual buildings in the Addition; but later rulers often did, and some even created almost entirely new model cities: Pienza was virtually rebuilt by Pope Pius II from 1462; Sabbioneta was planned by Vespasiano Gonzaga in the second half of the 16th century.

Rural palaces could serve to assert dynastic power outside the city, and rulers could obviously also use sculpture and sometimes paintings to enhance their public image. Within their private residences, however, the propaganda campaign continued. Palaces were decorated with portraits of members of the ruling family and with representations of their public activities and achievements. Mantegna's celebrated Camera degli Sposi, completed in 1471 in the ducal palace at Mantua, is a good example. Such works might seem superfluous in what were officially private apartments, but we must remember that buildings of this sort had to accommodate the ruler's court and household as well as his family. Employees and dependants of the governing prince needed to be persuaded of their master's power and authority at least as much as his subjects.

All rulers exploit art, of course; but the peculiar circumstances of the many governments in Renaissance Italy – insecure and often almost illegitimate – meant that they made unusually extensive use of their opportunities for patronage, and so encouraged an extraordinary increase in the volume of art produced. This is the case even with the most ancient ruling power of all, the papacy. For most of the 14th century, the popes resided at Avignon in the south of France. Thereafter they were preoccupied first with the Great Schism (1378–1417), when western Christendom was divided by the election of a number of competing candidates for the papal throne, and then by repeated attempts to re-establish their power in Rome. It was not until 1443 that the papacy settled permanently in Rome, and even after that date, papal government was not always secure. Pope Nicholas V (reigned 1447–55) therefore began a major campaign of art patronage to put his stamp on the city. He reconstructed the Capitol, the ancient seat of urban government, and he began restoration work on significant buildings from the early history of the Church, such as S. Stefano Rotondo, in order to emphasize the link between the contemporary papacy and Rome's ancient and apostolic pasts. He initiated the first plans to rebuild St. Peter's, and he also began to reorder the urban topography to make the papal palace at the ▷Vatican into the proper focus of the city. Old buildings were demolished, new streets and squares constructed. Nicholas V's campaign was continued by his successors, so that by the 17th century, Rome was perhaps the grandest city in Europe. The popes' own residence was decorated with works of art that also proclaimed a clear ideological message: their private chapel, the ▷Sistine, was decorated in the 1480s with frescos evoking papal primacy, a theme also picked up by Raphael in his celebrated ▷tapestries, first exhibited in the Sistine Chapel in 1519.

But not all art was commissioned by rulers. Members of lesser noble or patrician families, successful merchants and professional men were all equally keen to establish their social status by artistic patronage. Their houses, too, were designed to impress visitors and passers-by with their design and decoration. Such upper and middle-class patrons often followed the lead of their governing superiors when selecting artists or styles to support; but many were genuinely knowledgeable about art and art history. Giangiorgio Trissino, for instance, a member of an ancient Vicentine family, was a humanist and poet, who had known many scholars and artists when resident in Rome; after his return to Vicenza in 1527, he wrote a treatise on architecture, supported the young Palladio, and became actively involved in designing his own rural villa just outside the city. In cities without a dominant ruling court – such as Florence before the Medici established their power, and especially perhaps the cities subject to republican Venetian rule – a serious fragmentation of artistic patronage could prove beneficial, as it encouraged a diversity of approach and allowed for the development of a much larger number of small-scale architectural and decorative schemes.

It might seem at first sight, then, as if Renaissance Italy was, in artistic terms, a seller's market: that the vast increase in patronage available would make an artist's life relatively easy and profitable. But the rapid increase in the number of patrons seeking skilled artists and architects, and especially the fragmentation of patronage in cities without a dominant governing court, meant that artists had to devote enormous efforts to gaining recognition and securing even small commissions. And it is this very competitiveness of the contemporary artistic world that some historians have identified as the source of the major stylistic innovations of Renaissance Italy.

Some artists did acquire regular employment, but many had to earn their income from an endless series of separate works commissioned by different individuals or institutions. To secure a new patron, artists had first to attract his attention. One tactic was to display dazzling technical skills, in order to demonstrate their superiority to other artists. Vasari recorded, for example, how Sandro Botticelli painted a fresco of St. Augustine in the Florentine church of Ognissanti, 'over which he took very great pains in an attempt to surpass all his contemporaries'. When discussing Michelangelo's *Doni Tondo* (c1504–5, Florence, Uffizi), a ▷panel painting with the ▷Holy Family in the foreground, Vasari explained that 'to show his superb mastery of painting, Michelangelo depicted in the background several nude figures, some leaning, others standing and seated'. Another tactic was to compose a painting or sculpture, or design a building in a completely novel and unexpected way. This is not to deny the role of tradition or even of fashion in art history: some patrons clearly preferred less innovative work. But it does help to explain the willingness of some artists in the Renaissance to break away from traditional forms in order to produce an original solution to a patron's requirement. The formal innovation so evident in Renaissance art can therefore sometimes be explained by the artist's desire for patronage.

But however impressive such displays of skill and originality might be, no patrons were likely to commission an artist unless they were sure that he could produce what they wanted. And not all art was commissioned for primarily selfish purposes. To some extent, the credit a patron gained from his expenditure on art was increased if it was seen to be above mere personal interest. In a manuscript left by the rich Florentine merchant Giovanni Rucellai, who was responsible (among many other commissions) for funding the completion of the façade of the church of Sta Maria Novella in Florence, we find the following note: 'The said Giovanni Rucellai was highly commended for having known in his business life how to acquire and increase his wealth and credit . . . he was even more highly commended for having known how to pay from his wealth for the works of art recorded here.' Rulers and nobles thus continued to pay for building and decorating public works, such as hospitals and churches, sometimes even after they had run into financial difficulties, seeing these as 'pious causes' through which God and the saints were honoured as well as themselves.

The same thinking animated support for religious art by both clerical and lay organizations, including guilds and city governments, who often played an active role in the construction and maintenance of sacred buildings. Pope Nicholas V reportedly explained the religious function of art in a speech given to his Cardinals on his deathbed in 1455. The majority of the laity cannot apprehend the teaching of the Church, he said, unless they 'are moved by certain extraordinary sights', such as buildings, paintings or sculptures. 'Think of them as perpetual monuments or eternal testaments, as if made by God himself . . . In this way belief is preserved and increased.' In 1506, therefore, the recent frenzy of confraternal building and decoration in Venice could be justified by the local Scuola Grande (confraternity) of the

Carità in the following terms: 'All the confraternities of our noble city try by all means possible to exalt and glorify themselves in different ways, and have begun major adornments and furnishings of necessary things; these efforts one can only praise greatly, everything being done for the praise and glory of Almighty God.' The whole community would benefit from the permanent expression of piety established by such patronage, and artists and architects once again benefited from the multitude of new employment opportunities created.

Patrons therefore often expected to gain some personal or political benefit from their commissions, but many works of art were intended to honour God and the saints or the local community. And the credit a patron received would be greater the more his commission seemed to benefit others. As Giovanni Rucellai explained, 'All these [commissions] have given and still give me great contentment and satisfaction, because they will bring honour to God and the city as well as to my memory.' So we must now ask how contemporaries thought that art could serve the interests of those who did not pay for it – its viewers and users.

The Purpose and the techniques of art

It is of course very difficult for historians now to recover the exact intentions of any artist in the past. Contemporary expectations about the purpose of art were not always made explicit, and the works of art themselves have often decayed or been altered during the intervening centuries. It may be impossible now to reconstruct in our minds the surroundings for which buildings were first designed, or the original locations of paintings and sculptures, which have often been moved to museums and galleries. And it is surely too simplistic to assume that any one work of art had a single purpose or message which we can now easily explain or translate from the visual language of the time to the written language of the modern world.

But in Renaissance Italy, an explicit debate about the purpose of the visual arts did take place, provoked in part by the humanists, who discussed the status and value of all cultural activities and their works at great length. As we have seen, the humanists tended to analyse the visual arts in the same way as literature, and they therefore judged the effectiveness of any work of art by its success as a means of communication. Some early humanists believed that painting and sculpture were inferior to literature as means of communication. This argument was made forcibly in 1447 by Guarino Guarini, who suggested that paintings should be accompanied by inscriptions, so that viewers could understand their creators' intentions more easily. In 1456, another humanist, Aeneas Silvius Piccolomini, claimed that an artist's reputation was established more by those who wrote about him than by his works: 'The power of art responds to that of literature.' This humanist debate undoubtedly influenced practising artists. The link between the intellectual and the visual was stated explicitly, for example, by the Portuguese painter and architect, ▷ Francisco de Holanda, who lived in Italy between 1538 and 1541, and who defined painting as 'a declaration of thought in visible form and a demonstration of man's mind and spirit'.

Painters and sculptors, like writers, were thus expected to communicate to the viewer the experience and inner feelings of their subjects. ▷ Leonardo da Vinci insisted, for instance, that, 'If the poet claims that he can inflame men to love ... the painter has the power to do the same, and indeed more so.' This humanist aspiration for the arts is clearly indicated by Vasari in his description of a statue of an old man carved by Donatello for the façade of Florence Cathedral: 'This shows more similarities to the ancient style than any other work left by Donatello; the man's head expresses the thoughts of one bowed down over the years by time and toil'. A similar intention is evident in the inscription added by ▷ Domenico Ghirlandaio to his portrait of Giovanna Tornabuoni (1488, Thyssen Collection, Lugano). The quotation is taken (slightly altered) from a description of an ancient portrait by the 1st-century Latin poet Martial: 'Art, would that you could represent character and mind!'

There was thus, by the later 15th century at least, a clear humanist programme for artists (and patrons) to follow. But this desire to communicate experience and emotion through art did not originate solely with the humanists. Quite independently of the 14th-century intellectual Renaissance, a similar purpose had already been developed for religious art in the 13th century. Late medieval devotional practice – influenced by the teaching of the new mendicant orders, and especially by the Franciscans – encouraged the laity to a personal engagement with the sacred story, to imagine what it was like to have been present at the events retold in the Bible or the lives of the saints. Art could assist this process of spiritual involvement, first by clearly representing scenes so that they could be easily

understood, and then by conveying the experience of the individuals involved in such a way that the viewer could identify with it. The church built above St. Francis' own grave at Assisi, decorated at the turn of the 14th century by ▷Cimabue and Giotto among others, was perhaps the first large-scale example of how art could serve religion and personal devotion in these ways by conveying simple doctrine and encouraging individual commitment. And despite the representation in Renaissance art of many new subjects – including stories from Classical literature and myth – the majority of works by artists (at least until the 16th century) remained predominantly religious. The ideas developed for religious art were thus carried over, with the encouragement of the humanists, into secular settings, and artists attempted to design all their works in such a way that anyone seeing them would feel an engagement with the figures or story depicted. To this end, for example, painters came to pay more attention (in both religious and secular works) to the mundane surroundings in which the events depicted took place, often presenting them in contemporary settings which viewers would immediately recognize and appreciate.

The artist's desire to engage his viewers in this way with the experience and feelings of the individuals he had represented could also be assisted by incorporating new technical devices that seemed to draw the spectator imaginatively into the action portrayed: by including within the composition a figure who looked out of the picture directly at the viewer, for example, turning, perhaps, as if reacting to the viewers' approach; or alternatively by presenting the scene as if the figures within it were about to move bodily towards the spectator. 'I like to see someone (in a picture) who admonishes and points out to us what is happening there', said Alberti; 'or beckons with his hand to see; or menaces with an angry face and with flashing eyes, so that no one should come near; or shows some danger or marvellous thing there; or invites us to weep or to laugh together with them. Thus whatever the painted persons do among themselves or with the beholder, all is pointed towards ornament or teaching.' In all these cases the aim was to turn the viewer into an active participant in the scene, in line with the requirements of late medieval devotional practice and also with the aspirations of the humanists.

If such effects were to be successful, however, the artist had to manipulate the viewers' perception of space with some skill – to persuade them, for example, that a painting attached to a wall was not just a decorated canvas but a view on to another space, behind the wall, in which the action depicted was actually taking place. Similar skills were required to engage the spectator with works of sculpture or architecture, which also rely on the manipulation of the spectator's sense of space. One of the most important technical innovations of the Renaissance that helped artists to create a new awareness of space was the development of arithmetical rules of ▷linear perspective. These are traditionally attributed to Brunelleschi, but they were then formalized by Alberti and later refined by ▷Piero della Francesca and others. These rules enabled painters to create a more effective illusion of three-dimensional space on a two-dimensional surface. They were particularly useful when painters prepared the backgrounds for their compositions – the buildings or landscape behind the figures, the ground on which they stand – as they made it possible to locate the principal action more firmly in the apparent space of the picture, and so enabled the spectator to relate that pictorial space more convincingly to his own. Actual and represented space could thus be perceived as continuous, and the viewer could therefore enter into and engage with the scene depicted more effectively. As Alberti himself explained when discussing the viewing and appreciation of works, 'A painted thing can never appear truthful where there is not a definite distance for seeing it.'

The application of the rules of linear perspective certainly led to a dramatic change in the appearance and form of Renaissance painting, but their appeal to many contemporary artists was that they enabled works of art to engage the spectators far more effectively than before – a very traditional purpose, in other words, which could now be achieved by a novel method. In paintings for religious sites, such as ▷Giovanni Bellini's San Giobbe altarpiece (c1487, Venice, Accademia), the illusion of reality created by these methods could be heightened still further by continuing the architectural setting which framed the painting into the pictorial space itself. In secular settings, such as Mantegna's Camera degli Sposi mentioned earlier, the same techniques could be used inside a closed room, to create the illusion that the spectator was standing within a larger courtyard or landscape, peopled with recognizable portraits and adorned with familiar objects. Again, what was achieved was an apparent continuum between the real and the painted scene.

The same rules could also be used by sculptors working on ▷relief panels, or by architects hoping to create a ▷*trompe l'oeil* illusion of greater space than a three-dimensional construction could actually

contain. The interest in arithmetical rules was particularly marked among Renaissance architects, who developed and used some highly complex arithmetical calculations to determine the proportions of rooms in their buildings and the relationships of each element in their plans and elevations. The importance of this approach to architecture was made clear in the 1468 contract between Federigo da Montefeltro and Luciano da Laurana, the Dalmatian architect who directed building works at the ducal palace in Urbino; the contract states that architecture is 'founded upon the arts of arithmetic and geometry'. A similar sense of arithmetical order was applied to many plans for new towns and town developments. The assumption that lay behind this interest was that a harmoniously ordered residential, devotional or urban environment would help to create ordered human beings. Again, we see new artistic styles being developed to improve the impact of works of art on their spectators – in this case, the people who use the buildings.

The attempt in painting to create a more convincing illusion of space has often been explained by historians as the result of a desire to produce a more 'realistic' art. A number of artists devoted themselves to the study of the human body, and many were credited with great skill in reproducing the appearance of things: Cristoforo Landino, whom we have already noticed praising Donatello as an imitator of the ancients, called Masaccio 'an excellent imitator of nature'. A number of technical innovations, such as the adoption of oil-based paints, may have helped painters to create a more convincing illusion of reality in the Renaissance, and the ability to represent living things convincingly was generally believed to be one of the great achievements of ancient art. According to Vasari, the *Laocoön* and other great Classical sculptures possessed 'the appeal and vigour of living flesh'.

Yet the reliance on carefully formulated rules of composition, as well as the concern for an arithmetical basis for architecture, should make us pause before accepting uncritically the idea that Renaissance artists were interested merely in 'realism'. All works of art are constructions, and the construction process involves both selection and arrangement. Vasari frequently praised artists for their successful depiction of realistic detail; but in his description of Michelangelo's last frescos, in the Cappella Paolina in the Vatican Palace (painted 1542–50), he emphasized that 'Michelangelo concentrated his energies on what he could do best, so there are no landscapes to be seen in these scenes, nor any trees, buildings or other embellishments'. Yet both frescos depict outdoor scenes where such 'embellishments' might seem natural – the conversion of ▷St. Paul and the crucifixion of ▷St. Peter. To secure the viewer's attention effectively, artists had to avoid distracting detail, and compose images that were orderly, uncluttered and clearly readable. Complete 'realism', spontaneous and usually lacking structure and balance, could therefore never be attained.

This was true even of individual portraits, a genre that became much more popular after the 14th century, and whose most celebrated practitioners were often praised for almost seeming to bring their subjects to life. Francis I of France praised Titian's portrait of the Cardinal of Lorraine in these terms, saying that it needed only movement and speech to be the real man. But many painters produced portraits of individuals already dead, and often they depicted scenes which could never have taken place, as when the living were shown as present at events in the distant past. The details of these pictures may be naturalistic, but the compositions are anything but realistic. Sometimes, we even find artists who deliberately seek to alert the viewer to the fact that the work of art is really no more than an illusion. In the Camera degli Sposi at Mantua, for instance, Mantegna depicted the ruler's chair as standing on a carpet whose edge appears to fall over the top of a real fireplace in the wall. Such a composition deliberately subverts the spectator's sense of a continuum between real and depicted space. The technical innovations and skills of Renaissance art were therefore adopted to increase the impact of art on its viewers, but not to persuade them that the art they were viewing was anything other than a consciously created fiction.

Renaissance artists never forgot the viewer. But they also knew that different viewers would bring different levels of appreciation to any work of art: educated viewers might interpret what they saw differently to the uneducated. Art produced for a privileged home, or for a court, which only the élite would regularly see, could therefore use different means to engage its spectators than an image for a parish church, which would be viewed by everyone in the community. Learned or Classical allusions, symbols and emblems, could be appropriate in the first, but might well be wasted in the second. And it is possible, by the end of the 15th century, to see an ever greater awareness of the distance between different audiences, not least as a result of the development of private galleries and museums from which the majority of the population were normally excluded.

Workshop practices

We are thus led back to the inescapable artificiality of artistic production – and to the artist as a creator possessed of significant technical skills. As Alberti insisted, 'The power of acquiring wide fame in any art or science lies in our industry and diligence more than in the times or in the gifts of nature.' So how were these techniques learned, and how were works of art actually produced?

Many artists were born into the profession. Raphael's father, for example, was a painter; Vasari himself was related through his grandfather to ▷Luca Signorelli. Sometimes, workshops were organized on a family basis: this was especially common in north-eastern Italy, where Venetian families such as the ▷Bellini, the ▷Bassano and the ▷Tintoretto ran the same business over several generations. Others, though, came from a more literary or privileged background. Brunelleschi's father was a notary, and Brunelleschi himself owned property in rural Tuscany. But all artists trained for many years with one or more recognized masters in a workshop: Leonardo entered ▷Verrocchio's studio while still a boy, for example. Clearly, for many artists, the profession provided not just a working environment but a social world as well, and artists therefore worked within an established profession with a self-conscious tradition and ethos of its own.

Within the workshop, they learned many skills. Some artists became involved in painting, sculpture or architecture only after an earlier training in another related profession – Ghiberti, Brunelleschi, Botticelli and Verrocchio all began work as goldsmiths, ▷Giuliano da Sangallo as a woodworker. Contemporaries did not necessarily see these as alternative professions, nor did they expect artists to concentrate their attention on one single art form. Giotto, Leonardo and Michelangelo received commissions in painting and sculpture as well as architecture. Giovanni Battista Rosso, a Florentine artist generally known as ▷Rosso Florentino, worked on paintings, sculpture and architecture while employed by King Francis I of France in the 1530s; he also designed costumes, tapestries, tableware and stage spectacles.

But we must beware of assuming that even the most talented artists worked alone. Obviously no one man could build a church or palace single-handed, and we know that commissions for buildings were often given to teams of construction workers headed by a named contractor. Beltrame da Varese's team was already working on the fortifications of the Leonine city in Rome in 1452 when he received the contract to begin the new east end and ▷crossing of St. Peter's. But individual works of sculpture and painting were often put together by teams as well. When the Venetians first agreed to put up an ▷equestrian statue in honour of Bartolomeo ▷Colleoni, a former mercenary captain, they asked Verrocchio to make the horse and Vallano da Padova the figure. The statue was left unfinished at Verrocchio's death in 1488, but now stands in front of the church of SS Giovanni e Paolo. Large-scale decorative schemes were also sometimes entrusted to several artists rather than to just one; but even when a single work was commissioned from a named artist, it was often completed not by the master acting alone, but with the assistance of other members of his workshop. As part of their training, young artists were often required to assist the master in this way. Vasari records, for example, how Leonardo contributed one of the angels to a panel picture of the Baptism of Christ (c1470, Florence, Uffizi) on which Verrocchio had previously been working.

It is difficult now to ascertain how the responsibilities were allocated for any one picture, but members of the team might take on certain specific tasks such as painting the buildings in the background or the drapery on the figures, while the master himself completed the faces and acted as 'director' of the whole project. Moreover, the results of this method of producing pictures could sometimes be unfortunate, as the separate contributions did not always coordinate convincingly with each other; floors and landscapes might be constructed from different viewpoints, and figures occasionally seem disconnected from their backgrounds.

Buildings, sculptures and paintings were therefore all often constructed piecemeal, and many artists made their careers as specialist members of a more celebrated artist's team. In 1529, a Veronese artist called Girolamo de Arlati was described by his colleagues as a skilful painter of ornaments, ▷friezes and ▷cornices – but 'in things where figures come in, he is not adequate'. In fact, for many of the background elements that were necessary in any painting, but which could safely be entrusted to assistants, models were frequently collected together into manuscript sketchbooks, such as the one owned by the mid-16th-century Ferrarese painter Girolamo da Carpi. This manuscript contains an enormous number of figural studies, some apparently copies of antique examples, others copies of

work by earlier Renaissance artists. Girolamo seems to have used this 'copybook' as a source for his own work, constructing different motifs – a head from here, a foot from there – into a single new combination of his own. Similar exemplars were published in books and ▷engravings designed to assist the training of young artists who (rather along the lines recommended by Alberti) were first taught how to design different parts of the human body, animals, trees and so on, and then learnt how to combine these separate elements into a coherent whole.

We must therefore be careful not to be misled by humanist writers who present art history as a procession of heroic great masters. As we have seen, humanists took their model of art criticism from Classical texts on literature, and they tended as a result to discuss what was necessarily a collaborative activity in terms of individual biographies. The master's practice of signing the finished article (a practice which became more common from the 14th century) was a guarantee of its originality, but it should not be taken as evidence that he alone had done the work. On the other hand, the humanist image of the artist in time had an influence on the way both artists and patrons saw themselves. In the 14th and 15th century, the workshop environment ensured that artists were viewed as craftsmen and tradesmen, practitioners of a respected profession and members of a ▷guild, but manual workers nonetheless. The nature of the relationship between patron and artist at this time is indicated clearly by the wording of many contracts for artistic commissions. Ghiberti's contract for his first door at the Florence Baptistery, dated 1407, states that he 'must on every day when work is done, work with his [own] hands the entire day, like any wage worker and, refraining from work, the lost time must be entered on his account'.

By the end of the 15th century, however, some artists were granted a much more elevated status, and they tended consequently to handle their patrons with a much greater sense of their own worth than would have normally been the case 200 or even 100 years before. Leonardo, for example, was a notoriously unreliable producer. In 1483, he signed a contract to paint a panel for a Milanese confraternity dedicated to the Immaculate Conception; but he delivered the finished article only in 1508, some 25 years later. (The painting, a near copy of the artist's celebrated *Virgin on the Rocks*, is now in the National Gallery, London.) It is interesting in this context to note Vasari's claim that Michelangelo destroyed many of his sketches and drawings, so that nobody should realize how much sheer physical labour he had had to put into his work.

This apparently deliberate policy of presenting oneself as an inspired and supremely gifted individual owed much to humanist rhetoric, which had discussed artists in the same terms as orators and poets – as intellectuals, and not as craftsmen. As Michelangelo said, 'one paints not with the hand but with the brain'. The works of each artist were therefore increasingly seen as expressions of a unique personality: in Leonardo's famous words, 'every painter paints himself'. Patrons thus started to concentrate their patronage on selected favourites only, and they were increasingly prepared to allow those artists much greater freedom in carrying out their commissions. Isabella d'Este occasionally stated that she wanted any painting by a named artist, regardless of its theme or subject, and when Giovanni Bellini expressed reluctance to do an allegorical painting for her, the humanist and poet Pietro Bembo explained, 'He does not like to be given many written details which cramp his style; his way of working, as he says, is always to wander at will in his pictures.' Although the patron still paid, it was the artist who now largely called the tune.

Bibliography

Baxandall, M., *Giotto and the Orators: Humanist Observers of Painting in Italy and the Discovery of Pictorial Composition 1350–1450*, Oxford, 1971

Fortini Brown, P., *Venetian Narrative Painting in the Age of Carpaccio*, New Haven, 1988

Chastel, A., 'The Artist' in E. Garin (ed.), *Renaissance Characters*, Chicago, 1988

Freedberg, S.J., *Painting in Italy, 1500–1600*, Harmondsworth, 1975

Goldthwaite, R., *Wealth and the Demand for Art in Renaissance Italy, 1300–1600*, Baltimore, 1993

Heydenreich, L.H., *Architecture in Italy, 1400–1500*, New Haven, 1996

Nauert, C., *Humanism and the Culture of Renaissance Europe*, Cambridge, 1995

Onians, J., *Bearers of Meaning: The Classical Orders in Antiquity, the Middle Ages and the Renaissance*, Cambridge, 1988

Seymour, C., *Sculpture in Italy, 1400–1500*, Harmondsworth, 1966

Shearman, J., *Only Connect: Art and the Spectator in the Italian Renaissance*, Princeton, 1992

Stephens, J., *The Italian Renaissance: The Origins of Intellectual and Artistic Change before the Reformation*, London, 1990

Stumpel, J., *The Province of Painting: Theories of Italian Renaissance Art*, Utrecht, 1990

Thompson, D., *Renaissance Architecture: Critics, Patrons, Luxury*, Manchester, 1993

White, J., *Art and Architecture in Italy, 1250–1400*, Harmondsworth, 1966

Wittkower, R., *Architectural Principles in the Age of Humanism*, London, 1973

Court Art in Seventeenth-Century Europe

Joan Crossley

n the 17th century painting became increasingly significant as an expression of political authority. Portraits and allegorical paintings were used by monarchs as instruments of propaganda. Although some important artists such as ▷Rembrandt and ▷Vermeer were unaffected by court patronage, for the most part, the wealth of princes generated the characteristic works of the era.

This essay will begin by considering paintings and sculpture commissioned by the Papal court in Rome. Although the Pope was not royal, he fulfilled the function of head of state as well as being leader of the Roman Catholic Church. It was in Rome that the term 'propaganda' was first used to describe the process of propagating the faith. The word might also be used to describe the use of art to aggrandize a royal family or monarch.

Europe in the 17th century was divided by religious differences. The Roman Catholic empire of Spain dominated the Low Countries, some Italian city states and stretched to the New World. All the Catholic countries in Europe met together at the first Council of Trent (1545) to decide on a concerted response to the success of Protestantism in Northern Europe. They decided to abolish much of the superstition and abuses which had accrued over the centuries, and decreed that the Church should concentrate on teaching the fundamental truths of the faith. The ▷Counter-Reformation movement recognized the potential of art to depict biblical stories and episodes from the lives of the saints to the largely illiterate masses. The art of the 17th century in general is sometimes termed ▷Baroque. In fact, this term should only be used to describe the style of intense, emotional, dramatic art which was developed in Rome to clearly state the beliefs of the Counter-Reformation Church.

This essay concentrates on the patronage of four courts, those of France, England, Spain and Rome. The career of ▷Rubens, the greatest Baroque painter, is considered in some detail. He moved from court to court, painting portraits and history pictures, but also acting as a diplomat, cementing political alliances and negotiating peace treaties. The need of 17th-century rulers to impress and dominate through the medium of art produced a handful of painters – Rubens, ▷Bernini, ▷Velázquez and ▷Van Dyck – who received unheard-of rewards and high social status. For the most part, artists remained in their traditional ▷guilds and craft organizations. In every country, the claim of painting to be considered as a ▷Liberal Art rather than as a trade was being argued. States varied in their willingness to support the claim of artists to higher intellectual importance. In France, the Académie was founded in 1648, while the English ▷Royal Academy was not founded until over a century later.

The outstanding trend in court art in this period was towards a greater concentration on the person and personality of the ruler. The political philosophy of the Divine Right of Kings, which argued that as God's deputies, kings had the right to absolute power, was reinforced in art. Painting was used to proclaim the authority, uniqueness and glamour of the princes of Europe. The way kingship was defined varied. In England, Charles I favoured a view of himself as a wise father, ruling over his happy prosperous country in the same way he ruled his perfect family. In France, Marie de'Medici and later Louis XIV compared themselves to the gods of antiquity, elevating kingship to the level of divinity. Philip IV of Spain, who enjoyed unquestioned power, chose to present himself as a country gentleman with exquisite good manners and self-restraint. The art produced for the European courts of the 17th century was diverse, yet linked by this sense that it was to be placed at the service of royal authority.

Court art in Rome

Rome was the centre of the art world at the beginning of the century. A succession of art-loving Popes had created rich patronage and an atmosphere of artistic innovation. Each Pope, upon his election, created a new court, made up of friends, supporters and family members. An incoming Pope would often adorn his favourite church in Rome or make alterations to the Vatican as a way of leaving his mark upon the See. The cultured, pleasure-loving cardinals and princes of the Church were also enthusiastic collectors and patrons. Patrons such as Cardinal Scipione Borghese and Cardinal Francesco del Monte were rich and powerful enough to buy works of startling originality and worldliness. The pictures of ▷Caravaggio, with their noticeably homoerotic content and the pagan erotic sculptures of Bernini's early period, were outside the canons of ecclesiastical taste, although the Church indirectly financed them. Art was increasingly valued for its aesthetic rather than its spiritual content.

Michaelangelo Merisi, called Caravaggio, worked as a hack still-life painter before winning the patronage of Cardinal Francesco del Monte. Del Monte bought Caravaggio's pictures and allowed him to become part of his household. His early works for del Monte include a *Bacchus* (c1595, Florence, Uffizi) which may be a self-portrait. A young man is shown in a reclining pose, with his torso half revealed by a toga-like garment. The unidealized quality of the figure is striking – the boy's hands are dirty and work-worn, his skin pale and podgy. The still life of rotting fruits undoubtedly carries a warning about self-indulgence and the price of the fulfilment of desire.

Caravaggio's dramatic ▷tenebrism and exciting realism were developed in his first ecclesiastical commission, obtained for him by del Monte, to decorate a chapel with three scenes from the life of St. Matthew. The chapel was in the French church in Rome, S. Luigi dei Francesi. The commission was only fulfilled after two paintings, depicting the calling and the martyrdom of the saint were radically repainted. The ▷altarpiece, showing the saint being inspired to write his gospel, was refused outright by the French monks on the grounds that it was indecorous. The original picture, which showed the saint with a workman's face, muscular hands and huge, knotted feet, was bought by another outstanding Roman patron, Marchese Vincenzo Giustiniani (1564–1637). The altarpiece finally showed a more noble, idealized St. Matthew, being inspired, rather than being taught, how to write by an angel. Similar problems stemming from Caravaggio's unconventional style and his volatile personality dogged his other commissions. These included the *Conversion of St. Paul* and the *Martyrdom of St. Peter*, both in the Cerasi Chapel in S. Maria del Popolo (1600–1). His style attracted followers within a short space of time. Rubens recommended that his current master, the Duke of Mantua, buy the *Death of the Virgin* which had been rejected by the monks of S. Maria della Scala. Before it left Rome, Caravaggio exhibited the work publicly, attracting large crowds of admiring visitors. Caravaggio's admirers included artists, aristocratic patrons and the working people of Rome. His detractors included middle-ranking clergy who were concerned with propagating dignified images of the saints.

The Classicizing realism of the ▷Carracci family of painters was the other strand of the art which rejuvenated painting in the early 17th century. The Carracci were also patronized by Roman Church princes. Annibale Carracci came from Bologna, where he and his brother Agostino and cousin Ludovico had run a thriving academy of art. In 1595 he embarked on the decoration of the Farnese palace for Cardinal Farnese. He first decorated a relatively small room with scenes from stories of ▷Hercules and ▷Ulysses, before embarking on the huge space of the great hall. The subject was taken from Ovid's *Metamorphoses*, love stories of pagan gods and goddesses. The complex decorative scheme was probably devised by Farnese's librarian, Fulvio Orsini, and was to portray the triumph of love. The taste of the Roman court élite is exemplified by the Farnese ceiling with its emphasis on love in its carnal aspects and its sophisticated classical packaging.

The adventurous patronage of the Church courtiers extended to new genres such as landscape. ▷Claude Gellée, known as Lorraine, was a Frenchman who, by the end of the 1630s, had established a considerable practice as a specialist in seascapes and landscapes. Claude produced poetic landscapes of the Roman *campagna*, filled with historical and literary echoes of the district's Classical past. These landscapes, which often celebrated Virgillian simplicity, were sold to sophisticated collectors such as Béthune, the French Ambassador, Cardinals Crescenzio and Bentivoglio and Pope Urban VIII.

The landscape and religious painter ▷Nicolas Poussin drew his patrons not from the Roman aristocracy or from the princes of the Church, but from their librarians and secretaries. His first patron was Cassiano dal Pozzo (1588–1657), secretary to Cardinal Francesco ▷Barberini, nephew of Pope

Urban VIII. Dal Pozzo, as well as collecting contemporary art was also interested in the natural sciences, Classical literature and the history and art of antiquity. Poussin painted a number of works for dal Pozzo including a monumental series of the Seven Sacraments c1638–42.

It was through Barberini and possibly through the recommendation of Bernini, that Poussin received his only commission to paint an altarpiece for St. Peter's itself. His *Martyrdom of St. Erasmus* (1628–9, Rome, Vatican Museum) was a strikingly unusual work, with the elegant composition and cool light at odds with the subject, the gruesome disembowelling of the saint. The work received a mixed reception and Poussin was not asked to do any further public commissions for his adopted city. The international nature of Rome in the 17th century meant that French visitors heard of Poussin's art and joined the ranks of his patrons. Among the most famous of these were Cardinal de Richelieu, his nephew, the Duc de Richelieu, and various self-made men, merchants and bankers such as Jean Poitel from Lyons. Poussin's art, with its cerebral interest in love and its intellectual exploration of ecclesiastical ritual, appealed more to the gentlemen historians and thinkers at the Roman court than to its leading patrons of the fashionable arts.

The outstanding artist Gianlorenzo Bernini was showered with commissions by a succession of Popes and cardinals. A child prodigy, born in Naples, Bernini was trained by his father in his own trade as a sculptor in marble. Bernini was also the leading architect for the papacy and an accomplished painter. There was, seemingly, no art of which Bernini was not a master. The contemporary English writer John Evelyn recorded in his *Diary* that Bernini had presented an opera for which he painted the scenes, cut the statues, invented the engines, composed the music, wrote the comedy and even built the theatre.

It is not possible here to describe every commission Bernini executed for the Papal court in a career that spanned 60 years and the reigns of eight Popes. His great opportunity arrived with the start of the long pontificate of his friend and patron Maffeo ▷Barberini, Urban VIII (1623–44). Urban VIII entrusted the young Bernini with ambitious projects which stretched his imaginative and organizational powers to the full. Of these one of the earliest and most significant was the construction of a canopy or ▷baldachin over the grave of St. Peter himself, under the great dome of St. Peter's. The spiritual importance of the place and the huge scale of the building demanded a monumental construction. Four huge, twisted, vine-covered columns are surmounted by a decorative dome. Each corner, where the dome lightly rests on the top of a column, is adorned by a beautiful angel. Bernini was simultaneously commissioned to produce four great statues to commemorate four early Christian relics in the possession of St. Peter's. The statues, portraying St. Veronica, St. Helena, St. Longinus and St. Andrew, decorate the four great piers that support the dome.

While able to design on a vast scale, Bernini also excelled as a portrait sculptor, producing speaking likenesses of papal courtiers. One of the finest examples is of Cardinal Scipione Borghese, Bernini's first great patron. The man is shown speaking and moving, the whole figure is animated and reflects Bernini's unique working method. Bernini is reputed to have watched and sketched his subject as he carried out everyday activities, trying to catch the essence of the sitter as well as a likeness of his features. The sculptor later explained that rather than using the sketches when carving, he used them as a way of completely absorbing the features of his sitter. He evolved the general composition using a clay model, before starting work on the marble. This approach explains the success of his portrait busts – they are lifelike, individual and apparently spontaneous.

Bernini's prodigious ability as a portrait sculptor could have occupied the whole of his working life. Among the princes and lords who sat for him were Louis XIV of France, the Duke of Bracciano, Francesco I d'Este and the Popes Gregory XV, Innocent X, Paul V and Urban VIII. Charles I of England commissioned a portrait bust from Bernini and instructed his court painter Van Dyck to furnish the Italian artist with a memorable triple portrait to enable him to carve the bust. This work is an example of the way art was used in diplomacy. The bust was commissioned by the Pope as a gift for the English queen, Henrietta Maria. The queen was a devout Catholic, and it was hoped that she would win her husband over to the Church of Rome. The gift of a work of art was a way of signalling friendly intentions and cementing relationships.

Bernini's powers of organization and invention were stretched by Urban VIII's ambitious plans to develop St. Peter's. Soon after his election to the pontificate Urban began to plan his own tomb. With typical determination, Urban ordered the tomb of a 16th-century Pope to be moved to make room for his own memorial in a prominent position in St. Peter's. The composition, designed and executed

by Bernini, was pyramidal in shape, with a huge bronze statue of the Pope at the apex. The more than life-size statue is placed upon a throne, on a vast marble plinth. In front, a bronze ▷sarcophagus supports two mourning marble figures. These female statues represent love (*caritas*), the greatest of the Christian virtues, and Justice, greatest of the Cardinal ▷Virtues. This device proclaims the Pope's pre-eminence as a Christian leader and a temporal prince. The Pope's name is being written on a bronze plaque by a skeletal figure of Death. The sculptor used the different materials, white marble, coloured marble and dark bronze, to dazzling effect. The dark central areas are connected with the Pope and his sad demise, the light parts are the qualities he leaves for posterity – his charity and justice. The ▷polychromy was thus integral to the meaning or ▷*concetto* of the monument, rather than being merely decorative.

The scale and intellectual brilliance of the Bernini tomb made it the inspiration for many later Baroque tombs. In the years preceding the death of Urban VIII, Bernini enjoyed unrivalled power over the artistic life of Rome. Such was his master's ambition and Bernini's powers that great projects were planned and accomplished. This inevitably created enemies for the sculptor. For example, the bronze required to cast the twisted columns for the baldachin was taken from the portico of the Pantheon itself. Bernini was said to be highly aggressive in defending his remarkably privileged position as art director of Rome. Urban's successor, Innocent X (1644–55), inherited an impoverished pontificate and cut back on the building programme inaugurated by his predecessor. The new Pope, head of the Pamphili family, forced the Barberini family into exile and passed over Bernini where possible. When one of the ▷campanili Bernini designed for St. Peter's began to subside owing to weak foundations, Bernini was in disgrace. Despite this prejudice against the favourite of his dead rival, Innocent X perceived that Bernini's abilities were too great to waste and employed him on his own clan's prestige projects. The Pamphili family had built a great family palace in the Piazza Navona, close to their newly-erected church, Sant'Agnese. The whole piazza then was a manifestation of the power and piety of the Pamphili dynasty. The fountain destined to dominate the centre of the square was to incorporate an ancient Egyptian ▷obelisk that had been discovered on the Appian Way. The project is typical of the grand imaginative scale of mid-17th-century Rome. The centre of the fountain is a great rock, from which the four great rivers of the world spring. Each river symbolizes the continent in which it flows: the Danube for Europe, the Nile for Africa, the Plate for the Americas and the Ganges for Asia. This world-wide vision reminds us of the contemporary zeal for spiritual colonization. Innocent X was sending out missionaries to the four known continents to propagate the Gospel. The statues reminded Romans and visiting Christians of the global power of the Papacy and that this power was in the control of a Pamphili. This family pride is symbolized by the family emblem, the dove, which is placed in a dominant position right at the top of the obelisk.

Bernini's greatest church commission combined genuine religious reverence with a desire to aggrandize the patron's family. Religion was, after all, the route to worldly prosperity and power in Rome. Cardinal Federigo Cornaro, the Patriarch of Venice, commissioned Bernini to create an altarpiece for the Carmelite church in Rome where he intended to be buried. If only one work had to be chosen to exemplify the spirit and style of Roman Baroque it could well be this one. The central space of the altar has a marble figure of St. Theresa in ecstasy with an angel, apparently floating upon a cloud (▷ *Ecstasy of St. Theresa*). This group is in a deep ▷niche which forces the viewer into the place from which Bernini wanted the sculpture to be viewed – directly in front of the altar. The theatricality of this device is echoed in the heavenly spotlight from above, cast down painted wooden rays from a concealed window. Most theatrical of all, members of the Cornaro family watch the miracle from opera boxes on the side walls of the narrow chapel. The viewers are the most prestigious members of the family, providing a subtle means of recalling their fame and influence; they are the donor, his father, a Venetian Doge and six Cornaro cardinals.

Rubens

The figure of Peter Paul Rubens dominated religious and court art throughout almost the whole of the 17th century. In part this was because of his own constant travels and prodigiously high level of productivity. His influence was also extended through his training of such great painters as Van Dyck, and his influence upon such foreign painters as Velázquez.

Rubens was educated by his father who was both a scholar and a successful courtier. Rubens set high value on Classical and philosophical learning, and acquired the ability to discourse on these

subjects with the aristocrats, princes and cardinals who were his patrons. A devout Catholic, Rubens placed his talents at the disposal of the increasingly powerful Jesuit order and worked incessantly for the cause of peace in Europe.

Rubens's first experience as a court painter was at the court of Vincenzo I Gonzaga, Duke of Mantua in 1600. He painted a number of glamorous portraits of the Gonzaga family and their courtiers, already displaying his facility for painting fabric and textures.

One of his tasks in Mantua was to produce a series of portraits of female courtiers. The idea of a series of pictures of court beauties was taken up across Europe over the next few decades. Rubens himself refused a commission to paint a similar series for the French court. In the late 1660s ▷Peter Lely, the Dutch painter to court of Charles II, produced a glamorous series depicting ladies from the aristocracy in semi-mythic guises. It has been argued that the fashionable ▷Neoplatonic ideas of the time equated female beauty with spiritual enlightenment and virtue (Stewart). Whatever the symbolism of the paintings, it is clear that the women at Charles's court are presented as his possessions, giving him added lustre.

The high value accorded to accomplished artists, particularly portrait painters, is demonstrated by Rubens's relations with his second main patrons. The Archduke Albert and the Infanta Isabella, rulers over the United Provinces, welcomed his appointment as their court painter by rewarding him with a gold chain and medallion. They accorded him the extraordinary privilege of living away from the court in Brussels. He took up residence in his native Antwerp, rejoining a lively circle of philosophers and scholars. Rubens built himself a magnificent house and set up a complex, highly efficient studio. This independence and freedom to refuse unwelcome commissions marks a new phase in the status of the artist. A self-portrait with his second wife, Isabella Brandt, in a bower of honeysuckle, presents Rubens in an atmosphere of courtly love. The fine fabrics and rich textures convey the material luxury he had earned. It is noticeable that there is no allusion to the art which had given him such wealth and leisure.

While Rubens was undoubtedly the most important artist at the court of the archdukes, and indeed in Europe, he was not the only painter retained by them. ▷Jan Bruegel, younger son of the famous ▷Pieter Bruegel the Elder, ▷Otto van Veen and Wenzel Coebergher were all constant companions of the archduke, who was said to enjoy relaxing with them after dinner and enjoying their conversation.

When Archduke Albert died in 1621, he recommended that his wife, the Infanta, rely on Rubens's advice in her international affairs. This was because Rubens shared the Archduke's political aims, but also because of the nature of his calling. Rubens was able to travel around the courts of Europe on an informal basis, sure of his welcome because of his skill as a portrait painter. His mastery of his art gave him access to the rulers of Europe, to whom he could argue the cause of peace in the Netherlands and in all Europe. Between 1621 and 1633, the Infanta sent Rubens on three secret missions to Holland and one to Germany, and in 1628, Spinola, commander of the Spanish armies in the Netherlands, persuaded Philip IV to summon Rubens to Spain and to send him as Ambassador Extraordinary to England. During these visits, Rubens not only negotiated with princes and politicians but inspired native artists with his style and ideas.

Rubens was a devout Catholic and formed close relationships with leading Jesuit thinkers in Antwerp and other parts of Europe. His intellectual brilliance and his ability to paint on a grand scale ensured that he and his studio received many commissions for altarpieces. Rubens remained rooted in Antwerp and was able to work closely with prominent community members as well as princes and international diplomats. For example the president of the Antwerp Arquebusiers Guild ordered a large ▷triptych for the guild's chapel in Antwerp Cathedral in 1611. Rubens invented an elaborate scheme showing three very different bearers of Christ (Christophoros) in honour of the guild's patron, ▷St. Christopher. The central panel, Christ being taken down from the cross, shows Rubens's dramatic composition, his use of rich colours and dramatic lighting. It also demonstrates his ability to give his protagonists individuality and dramatic impact.

Although Rubens's abilities as a portrait and religious painter were highly prized, it was his large-scale mythological pictures which made him the most sought-after artist in Europe. Rubens perfected the integration of living characters into scenes containing Classical gods and mythic creatures, harmonizing these disparate elements with exuberant flattery. His work for the courts of England, France and Spain will be discussed below. It is enough to note here that he was only able to handle the large volume of commissions by delegating a high proportion of the work to assistants and apprentices. He

was paid a higher fee for the proportion of his own hand in the completed canvas. Rubens always designed the picture and finished at least some of the canvas. He would also employ specialist artists such as Jan Bruegel to do the birds and animals in certain works. The well-organized studio established by the artist allowed him to accept such huge undertakings as the completion of the ▷Marie de'Medici cycle of 21 canvases in three years. He was commissioned to produce a vast decorative scheme for the Jesuit Church in Antwerp, comprising 39 ceiling paintings and three altarpieces. His work on this and other large projects such as the Banqueting House ceiling in London show his facility for uniting disparate ideas around a central unifying theme and his encyclopaedic knowledge of religious symbolism and Classical mythology.

Painting at the British court

In the early 17th century British court art was stylistically old-fashioned compared with that of its European neighbours. Like his predecessor, Elizabeth I, the first Stuart monarch, James I (1603–25), had shown little interest in painting, apart from essential court portraits for which he employed the Netherlandish artists ▷Paul van Somer and ▷Daniel Mytens. His sons, Henry, Prince of Wales (d 1612) and Charles, later Charles I, recognized the potential of painting to construct a national and monarchical identity.

The short adult life of Henry, Prince of Wales, was devoted to the cultivation and patronage of Italian and Flemish painters. He was one of a growing number of English aristocrats to collect Classical and ▷Renaissance art. Other early art collectors included the royal favourite, the Duke of Buckingham, and the diplomat Earl of ▷Arundel. James I's desire to keep the peace in Europe led him to initiate marriage negotiations for his children with the courts of Orange, Spain and France. The proposed elevation of Britain to the international stage through a union of his second son to the Infanta of Spain spurred James to commission ▷Inigo Jones to build one of the earliest ▷Palladian buildings in England. The Banqueting House in Whitehall was to be the setting for royal masques and official receptions. After James's death in 1625, his son Charles I commissioned Rubens to decorate the ceiling of the Banqueting House.

Rubens was famous in England long before his first visit in 1629. He had painted the portraits of the Earl of Arundel and the Duke of Buckingham and was well known to the Stuart dynasty through his work for their relatives in France. During his ten-month stay from June 1629, he was treated with great honour and made a knight by Charles I. Working at a characteristically intense pace, he painted a picture of St. George vanquishing the dragon, with the English king as the patron saint and the new queen, Henrietta Maria, as a flatteringly beautiful princess.

Rubens's principal commission in England, the Banqueting House ceiling, was executed in the studio in Antwerp, and the canvases were installed in March 1636. The imagery celebrated the achievements of the reign of King James. It was chosen by Charles I to propound his shared belief in the divinely ordained right of kings to absolute authority. This policy, which was to lead to the temporary downfall of the Stuart dynasty and to Charles's own execution, was clearly laid out by Rubens for the court to behold. James, portrayed as a Solomonic figure accompanied by the goddess of wisdom, ▷Minerva, peacefully unites the kingdoms of England and Scotland. The late King's reign is shown to have brought peace and plenty to the kingdom, with Minerva keeping the god of war at bay. The central panel of the ceiling shows the apotheosis of James, being spirited up to heaven to keep eternal company with the saints and God. The conceit of an ▷apotheosis was borrowed from Catholic imagery, recently used to 'deify' the dead monarch Henri IV of France and the murdered Duke of Buckingham. Charles I was taking a grave risk in commissioning such an overtly Catholic celebration of his father's spiritual future, since his political actions were continually being scrutinized for Romish tendencies. The absence of a Protestant ▷iconograpy of equal grandeur must have prompted his choice, along with a desire to have a public room to rival any in Europe.

The collection of paintings amassed by Charles I was at its height the finest in Europe, reflecting the king's good taste, his willingness to spend and his determination to acquire. Before his accession he bought the famous ▷Raphael ▷cartoons of the Acts of the Apostles, both for their artistic value and for use as templates at the royal tapestry factory at Mortlake. The king employed a number of agents to be constantly on the watch for works to augment the royal collection. His greatest acquisition was the collection of the Dukes of Mantua in 1627, which included pictures by ▷Raphael, ▷Titian, ▷Correggio, ▷Guido Reni, ▷Mantegna and ▷Giorgione. The exchange of paintings and the

lending of artists formed an important part of the rituals of international diplomacy in the 17th century, as we have seen. Charles Stuart's well-known love of painting inspired the Pope to try and win concessions for Catholics in England by sending him paintings by ▷Guilio Romano, ▷Andrea del Sarto and ▷Leonardo. He was presented with two ▷Dürers by the city of Nuremberg. Many private courtiers attempted to gain royal favour with the gift of choice works of art.

Rubens's pupil Anthony Van Dyck settled in England in 1632 after training in his master's studio in Antwerp and studying in Italy. Careful study of ▷Titian gave Van Dyck's painting a delicacy and refinement which, combined with Rubens's robust modelling, produced the perfect style for Charles I's court. Van Dyck's portraits of his royal master are superbly elegant and soulful. The life-size portraits contrive to make the five-foot king look unrealistically tall and powerful. Van Dyck may also have allowed the desire to please to influence his representations of the queen. A contemporary, Princess Sophia of Bavaria, said of her meeting with the queen in 1641: 'Van Dyck's handsome portraits had given me so fine an idea of the beauty of all English Ladies, that I was surprised to find that the Queen, who looked so fine in painting, was a small woman rasied up on her chair, with long skinny arms and teeth like defence works projecting from her mouth.'

Van Dyck's portraits of the Stuart family mark a new phase in the depiction of the English monarchy. The political theory of the kingdom as a happy family ruled over by a wise, benevolent patriarch had been expounded by James I. Charles developed this idea, describing himself as the loving father of all his people. To present his domestic life as fruitful, well-ordered and happy was a political, rather than a personal, statement. Van Dyck painted a number of pictures of the royal children, with all his facility in the rendering of lustrous hair, shining eyes and rich fabrics. The children are presented as a family unit, each happily in their given places. The heir to the throne, the future Charles II, is in the central position flanked by his brothers and sisters. Copies of all the royal portraits were sent to family members and allies among the ruling families of Europe. As well as functioning as the political manifesto of the fruitfulness and order of the Stuart court, they also provided valuable physical likenesses of the little princes and princesses who were available for diplomatic marriages.

Charles Stuart's extravagance in collecting Italian religious paintings and the toleration of Roman Catholicism this implied were instrumental in making him unpopular with the austere Protestant factions in the country. After the bloody Civil War, Charles was executed by parliament in 1649.

His successor, Oliver Cromwell, was appointed Lord Protector of England, having refused to be made king. Cromwell was quick to recognize the importance of portraiture in establishing an image of a ruler. He employed the miniaturist ▷Samuel Cooper and a Dutch painter Peter Lely to make a large number of portraits of him to be distributed in Europe and to foreign courts. Cromwell disapproved of flattering portraits and instructed Lely to make a likeness that showed him 'warts and all'. As might be expected from a Puritan ruler, Cromwell believed that a portrait's value resided in the honesty with which it revealed a man's character. The late King's pictures were sold, along with other goods, to pay his debts, and many important works of art went to other royal collections. The republican period came to an end shortly after Cromwell's death. The divergent factions in the country could only be held together by a strong leader, and it was decided to invite Charles II to resume his father's throne in 1660. Recognizing Lely as the natural successor to Van Dyck, who had died in 1641, Charles appointed him as court painter. Lely painted the middle-aged monarch, his queen, Catherine of Braganza, and many other people at the extravagant, pleasure-loving court. Chief among these portraits are images of Charles's many mistresses, often shown in the guise of shepherdesses or goddesses.

Painting at the French court

In the early years of the century, French court art was dominated by a weak ▷Mannerist style. The first major patronage of the century was bestowed on Rubens by the Italian-born Marie de'Medici, who had become regent of France after the assassination of her husband Henri IV. Her family's association with Rubens was of long standing, and the painter may have first met her when he attended her proxy marriage to the king of France in Florence. Marie's precarious political situation demanded the services of the finest apologist for monarchs in Europe, and she commissioned from him a series on her own history and another on her late husband's. Due to the regent's exile from France, only the series on her own life was finished and paid for. The queen's life, as depicted by Rubens, was marked out from her very birth by the special blessings of the gods. Rubens's iconography skilfully blends Classical references with Christian imagery. The paintings depicting the birth and education of Marie

have strong echoes of depictions of the early life of the Virgin. The ludicrous flattery of a picture such as the education of Marie, where Minerva guides her learning and the ▷ Graces adorn her with their own attributes, is somehow reconciled by Rubens's brilliance of design and execution. He moves effortlessly between the earthly and the supernatural, giving the whole vivacity, glamour and conviction. Rubens completed the 21 large canvases, with their myriad figures and complex iconography, in less than three years. They were painted in Antwerp and sent over to France to hang in the ante-chamber of the queen regent's throne room in the Luxembourg Palace. There the visitor awaiting an audience with the queen would be bombarded with her highly-coloured version of France's recent history.

Despite the undoubted success of Rubens's work for Marie de'Medici, the Netherlandish School did not have a lasting impact on French painting. This may have been because Rubens's art was so completely identified with Spanish/Habsburg patronage that it seemed an inappropriate style for their French enemies. Louis XIII chose to favour the modern Italian school of painting when he appointed the Italian-trained ▷ Simon Vouet to be his First Painter in 1627. Vouet's work combined a little of the Carravaggio-like movement with the sweetness and delicacy of the Carracci and their followers, especially Guido Reni. Although Vouet influenced the leading artists of the next generation, it was the expatriate Poussin whose cool, rational Classicism laid the foundation for the distinctive style of the French school.

Louis XIII and his First Minister Richelieu recognized that Poussin's great abilities could be applied to the glorification of the French court and monarchy. After relentless pressure from the French government, Poussin visited his native country in 1640. His work in Rome had been small, easel-pictures with subjects taken from the Bible, Classical history and mythology. In Paris he was asked to execute vast projects such as the decoration of the long gallery of the Louvre. Poussin returned to Rome after only two years, having failed to satisfy the king. Poussin had, however, gained the patronage of a group of intellectuals close to the court: bankers, civil servants and merchants, who were interested in the revival of Stoic philosophy and Classical history. From the 1640s most of Poussin's paintings were destined for French patrons and the new seriousness of his style and subjects were of great importance in the emerging French school.

Art and the court of Louis XIV

When Louis XIV acceded to the throne in 1643, he began to evolve a political policy which centred attention upon himself as monarch. His person would be semi-divine, uniting all France behind his unquestioned authority. After the death of Cardinal Mazarin in 1661, he announced that he would not appoint another first minister, but instead take upon himself the government of the country. He was supported in this undertaking by his highly able minister Jean-Baptiste Colbert, who advised the king on every aspect of political, economic or cultural life. The new administration was particularly successful in encouraging industry and the development of France's rich natural resources. The King's belief in himself as the greatest monarch in Europe, a Sun or an Apollo around which the whole of France revolved, required the development of the arts to illuminate his iconography.

It is in France that we find most fully developed the trends discernible in other 17th-century courts: the belief that the arts should be placed at the disposal of the state; that the state should control nearly all artistic output, and that the visual arts should reflect, indeed project the glory of the monarch. The reign saw prodigious expansion and redecoration of the Louvre, followed by the establishment of a vast and lavish setting for Louis's highly-formalized court at Versailles.

Large amounts of money were poured into developing the visual arts. The ▷ Gobelins factory was founded for the weaving of tapestry and the production of all other furnishings for the Crown. The Savonnerie was likewise founded for the weaving of immense carpets for the Louvre and Versailles. ▷ Charles Lebrun, a talented designer and painter, administered the king's grandiose projects – complex operations involving furniture-makers, goldsmiths, sculptors, painters, engravers, weavers, embroiderers and other skilled craftspersons.

Colbert and Lebrun showed great interest in training artists and craftspersons, improving the teaching of apprentices at Gobelins as well as remodelling the Academies of Painting and Sculpture. The result of their efforts was a sharp rise in the status of French art, and the development of the Louis XIV style. The 'Court Style' of Louis XIV was achieved by marrying the refined principles of Poussin to a restrained form of theatrical Baroque.

The palace of Versailles, decorated in this new style by Lebrun's skilled team, must have been even

more startlingly rich when it was first built than it is today. Much of the silver ornament had to be melted down in a financial crisis in the 1680s and the marble floors proved impractical. The iconography of these rooms was based on the planets – each of the seven rooms of the king's apartments being named after a planet and decorated with the fabled attributes or legends with which it was associated. The stories were all linked with other great monarchs, legendary or historical. The king associated himself with Apollo, or the Sun, the greatest of the planets, the culminating room in the progression.

However, the style of portraiture which evolved at the court of Louis XIV was, perhaps surprisingly, lacking in originality and glamour. Portraits such as ▷Hyacinthe Rigaud's depiction of the King made in 1701 are interesting for the ways in which they unconsciously reveal the restrictions imposed on the court by its own rigid rituals of manners and hierarchies. The king, as befitting the cynosure of the world, is cocooned in a mound of rich fabrics, a silk curtain above him, velvets and furs weighting him down and cushioning his progress. The man at the centre of this luxury – although his pose is mincingly light and graceful – looks tired and watchful. In sculpture, portraits of the French king and his family also take the form of a highly-controlled, almost static Baroque. ▷François Girardon spent some time in Rome absorbing the example of Bernini and the ▷antique before returning to work with Lebrun on the king's architectural projects. Girardon's monumental ▷equestrian portrait of Louis XIV, made to dominate the Place Vendôme in Paris (destroyed in the ▷French Revolution), is an elaborate, detailed and heavy reworking of the famous Marcus Aurelius statue on the Capitoline Hill in Rome. Girardon's most successful commission for the king was for a decorative group sculpture. *Apollo and the Nymphs* was commissioned in 1666 for the Grotto of Thetis in the Park of Versailles. It gave the sculptor an opportunity to build upon his knowledge of Bernini's early work and the antique. The group is graceful, elegant yet without the sensuality that the Italian master would have brought to the representation of six nude female figures.

Another sculptor influenced by Bernini's portrait busts did much to breathe life into this genre in France. ▷Antoine Coysevox was highly skilled and a penetrative recorder of character. His bust of the Grand Dauphin (c1680) is a clever compromise between the formal grandeur necessary for the depiction of such an august personage and a telling delineation of the subject's fat and sulky features.

Bernini himself was lured to Louis XIV's court. The French King saw winning the sculptor's services as a political triumph over the Pope and offered Bernini flattering and lucrative inducements to leave Rome. Bernini was invited to submit designs for the completion of the Louvre. His designs were typically inventive, with a bold concave curve on a façade ornamented with rhythmically-spaced ▷pilasters. The magnificence of Bernini's design was unquestioned but it failed to understand the practical needs of the busy court, and even before Bernini left Paris it was obvious that they would never be realized. Bernini did produce a magnificent portrait bust of Louis XIV. Courtiers remarked that the Italian had freely adapted the monarch's features, ennobling his low brow and enlarging his small eyes. It is a portrait of imperial leadership rather than of a real person, of monarchy rather than the monarch.

Art at the Spanish court

From the mid-16th century, Spain had been the most powerful country in Europe, with influence extending across Germany, the Low Countries, some Italian states and to the Americas. The silver of the Americas had substantially increased Spanish wealth and power. Yet by the mid-17th century the irresolution of the Spanish kings and the growing ambition of France was threatening the Spanish empire, as one region after another challenged central control.

Despite Spain's wealth and undoubted power, it was artistically isolated even in the early 17th century. Visiting the court in 1628 to make portraits of the Habsburg family, Rubens remarked on the generally low standard of contemporary Spanish painting. The exception, to his mind, was Velázquez. Diego Rodriguez de Silva y Velázquez was born and trained in Seville. His master, ▷Pacheco, was a famous religious painter who was also art adviser to the Inquisition. Despite this role as enforcer of artistic conformity, Pacheco was an unusually liberal and cultured man. His studio attracted the leading writers, philosophers and artists of the day.

Velázquez trained as a painter of religious subjects, but displayed an early interest in depicting street people and still life. His first productions were ▷*bodegóns*, or tavern scenes with still lifes, a genre fashionable with rich middle-class patrons. Some of these pictures adapted a Dutch convention of a domestic scene in the foreground, relating to a religious narrative, glimpsed through an archway. *Christ*

in the House of Martha and Mary (1618, London, National Gallery) shows two women working in a kitchen. In the room beyond, Christ preaches to Martha and Mary about the practical versus the contemplative life.

Velázquez displayed considerable ability as a portrait painter and through the Sevillian network in Madrid was called to the court. At the age of only 22 Velázquez began a career of service to Philip IV and he was appointed Painter to the King in 1623. Velázquez's first portrait of the king, *Philip IV in Black* (1626, Madrid, Prado), established him as the King's preferred painter. He gave Philip a gravity and austerity which completely fulfilled the new monarch's public image of himself as an earnest, Christian ruler.

The art collection of the Spanish monarchs had been enriched by the king's grandfather Charles V. It was rich in Netherlandish pictures, and in Italian works by Titian and the Venetian school. Shortly after Rubens's stay in Madrid, Velázquez obtained permission to absent himself from Spain and travelled to Italy. There he visited the great art cities, Venice, Florence and finally spent months in Rome. On his return to Spain in 1631, Velázquez worked on his royal master's schemes to build a new palace, the Buen Retiro on the edge of Madrid. Velázquez painted a series of large equestrian portraits, of the King and Queen and the heir to the throne Baltasar Carlos. These portraits, along with pictures of the King's parents, were hung in a great reception room, the Hall of Realms. The ceiling of this huge room was decorated with the arms of all the countries, principalities and colonies under Spanish control. Twelve battle scenes were commissioned to impress the visitor with Spain's recent military prowess. The second series of pictures celebrated the labours of ▷Hercules, whom the Bourbons claimed as their direct ancestor. Apart from the equestrian portraits, Velázquez contributed a battle picture. This showed *The Surrender of Breda* (1634–5) when the forces of the House of Orange surrendered the town of Breda to the Spanish forces led by General Spinola. The Spanish subjugation of the Low Countries had been violent and brutal, and it is significant that Velázquez chose to represent a time when a Spanish leader had behaved with chivalry, and when conflict was resolved without bloody reprisals.

Velázquez was constantly busy with portraits of the royal family and the prime minister, the Conde-Duque Olivares. He established a thriving studio whose assistants were employed making copies of the royal portraits and finishing the master's works. Velázquez also acted as censor of portraits of the king, ensuring that all royal works were in keeping with the king's desired image. He was also employed to paint the dwarfs and jesters who were kept at court to amuse and serve the royal family. These portraits of physically handicapped people were among his most searching and moving pictures.

The Spanish artist excelled in painting children, producing images of the royal princes and princesses which were both regal and lovable. The portrait of *Prince Baltasar Carlos on Horseback* (1634–5, Madrid, Prado) shows the child emulating his father's equestrian achievements with a dignity which is touching and impressive. However, Velázquez's portraits of children seem formal and cold when compared with Van Dyck's endearing images of the British royal children.

Velázquez was also allowed to work for members of the court and ecclesiastical patrons. The King's constant financial problems meant that he always owed his artist money and so extra commissions were necessary for Velázquez's survival. He painted a number of religious scenes for convents and churches around Madrid. *Christ on the Cross* (1631), painted for the Benedictine Convent of San Placido, is an image which through Christ's downward gaze encourages the viewer to feel personally involved with his suffering.

Velázquez did not produce pictures as prolifically as his friend Rubens, but like him, he excelled in all genres of painting. Only one female nude painting by Velázquez survives, but *Venus and Cupid* (c1649–51) is a masterly treatment of skin and anatomy. Although painting the nude was not specifically forbidden, the severe moral climate enforced by the Inquisition made it an unusual subject at this period. Only the sophisticated court élite would have been able to commission or own such paintings without incurring suspicion.

Velázquez received rapid promotion at court, being appointed Gentleman Usher in 1627 and achieving the great honour of being made Gentleman of the Bedchamber in 1643. This title brought him into daily contact with the king, who was an amateur painter as well as an obsessive collector of art. Velázquez's ambition to be granted aristocratic status led him to seek preferment relentlessly, losing valuable painting time.

Velázquez accompanied the King and his huge retinue to war against the French in Aragon in 1644.

A special studio was converted in a house so that Velázquez could take the King's portrait after the latter's triumphant ride into the newly-retaken stronghold of Fraga. The portrait was sent back to the capital and publicly displayed outside a church.

In late 1648, Velázquez again visited Italy. This time he was treated as an honoured guest and was granted permission to paint the portrait of the Pope himself. This picture of Urban VIII, which reveals the character of the subtle, energetic pontiff, was regarded by ▷Joshua Reynolds as 'one of the first portraits in the world'. As well as painting this portrait as a gift from his royal master to the Pope, Velázquez acted as Philip's art agent. He bought large numbers of Italian pictures on the king's behalf, found collections whose owners were pressured into giving pictures to the king of Spain and sought out suitable painters for his master to employ.

On his return to Spain, Velázquez's role changed. He was made Palace Chamberlain, with responsibility not only for all the contents of the royal houses, but also for the King's journeys. In the last decade of his life Velázquez developed a painting technique of astonishing freedom and looseness. There is a strange contrast between the dazzling ▷bravura technique of these late royal portraits and the formal poses of the sitters.

The work regarded Velázquez's masterpiece, ▷ *Las Meninas* (*The Maids of Honour*) was painted in 1656. It is a complex, illusionistic work, showing the artist in his richly-appointed studio in the royal palace, painting the portraits of the King and Queen. The royal sitters appear only as reflections in a mirror, the foreground of the picture being filled with a lively group of the Infanta (Princess) Margarita with her maids, dwarfs and dogs. The strange spatial relationships and the ambigious figures perching on stairs and appearing in reflections make this a compelling work. It later fascinated such diverse artists as ▷Courbet, ▷Manet and ▷Picasso.

Velázquez's lifelong campaign for noble status was successful in 1658, when he was made a Knight of the Order of Santiago. Ironically he could only be granted this honour if witnesses swore that he had never demeaned himself by accepting money for his art. He died in 1660 and was buried with the full honours of his knightly rank.

Velázquez was influenced by Rubens in his determination to be elevated to the rank of gentleman. As we have seen, there were other isolated cases of artists who made themselves so valuable as royal propagandists that they were able to rise to high social status. However, it must be emphasized that Van Dyck, Rubens and Velázquez were the exceptions and that most artists in 17th-century Europe retained the stigma of being identified as craftsmen. Nonetheless the debate as to whether painters were practitioners of a liberal art or mere mechanics was gathering strength. The French Royal Academy of Painting and Sculpture was founded in 1648 to educate artists in the theory of Classical painting and to free these arts from guild restrictions. The aim behind the founding of the Academy was to produce great artists to serve the king and the state. Art was becoming identified as a matter of national pride.

Bibliography

Blunt, A., *Art and Architecture in France 1500–1700*, 4th edn., Harmondsworth, 1980

Downes, K., *Rubens*, London, 1980

Fletcher, J., *Rubens*, London, 1968

Harris, E., *Velázquez*, Oxford, 1982

Haskell, F., *Patrons and Painters: A Study in the Relations between Italian Art and Society in the Age of the Baroque*, London, 1963

Hibbard, H., *Bernini*, Harmondsworth, 1965

Millar, O., *Van Dyck in England*, London, 1982

Stewart, D., ' "Pin-ups" or Virtues? The Concept of the Beauties in Late Stewart Portraiture', in *English Portraits of the Seventeenth and Eighteenth Centuries*, London, 1974

Trevor Roper, H., *Princes and Artists: Patronage and Ideology at Four Habsburg Courts, 1517–1633*, New York, 1976

Waterhouse, E.K., *Painting in Britain, 1530–1790*, London, 1953

Whinney, M., and Miller, O., *English Art 1625–1714*, Oxford, 1957

Wittkower, R., *Art and Architecture in Italy, 1600–1750*, New Haven and London, 1958

Wittkower, R., *Studies in the Italian Baroque*, London, 1975

Everyday Life

Paul Barlow

Introduction: inventing and suppressing everyday life

Everyday life is difficult to pin down. To define a particular subject as 'everyday' would seem to imply that it has no obvious significance, that it is ordinary or even banal. Ordinary experiences are those which are both accessible and overlooked. So what does this paradoxical concept of ordinariness mean in art? How is this realm of ordinary life depicted? In Western art there has been a long tradition of scenes of people engaged in their daily work, in leisure pursuits or in moments of domestic intimacy. Such scenes are normally labelled ▷'genre'. This word, like 'generic' and 'general', implies something that is everywhere and is shared by everyone. Thus genre painting could be said to concern aspects of *common* experience. In modern English the word common has a double meaning; not only does it refer to that which is shared, it also suggests negative aspects of experience: those associated with crudity, ignorance and tastelessness.

This ambiguity points to a consistent paradox in the history of genre painting. Shared experience has been a repeated theme, whether in images of community activity or domestic intimacy. However, genre has also centred on aspects of human behaviour which have been identified as coarse or unsophisticated: images of peasant life, of popular entertainment and of physical indulgence. While some genre painting has sought to characterize certain social classes or forms of behaviour in these terms, it has itself been identified with them. Throughout much of the history of Western art since the ▷Renaissance distinctions between the 'higher' and the 'lower' branches of painting have been organized as a static hierarchy, understood in terms of gradations between spirit and matter. Genre has been closely associated with the material, the trivial and the unmeaning. Critical opinion has regularly identified it with the subjects it depicts.

Attempting a comprehensive account of the depiction of everyday life in Western art would be a near impossible task. This essay will indicate some of the ways in which the painting of everyday life has been implicated in the critical categories just described. The interconnections between the range of subjects that have been labelled as genre are intricate and shifting, but one thing is clear; everyday life has been a problem. Two instances will serve to indicate the ways in which a complex of ideas and practices have identified genre painting in relation to other forms of art. One example is from the mid-18th century, when hierarchies in the arts were most fully defined. The other is from the early Renaissance, when such assumptions were only beginning to be formulated.

In 1759, towards the end of his career, ▷William Hogarth painted *Sigismunda Mourning over the Heart of Giuscardo* (London, Tate Gallery); a young woman, leaning over a table, gazes out at the viewer. On the table is a goblet containing a human heart. The woman, Sigismunda, is supposed to be lamenting the death of her husband, murdered by her father. Hogarth was not known for such subjects; his career had been built up with paintings and ▷engravings of scenes of contemporary London life. Though popular, the critical consensus was that such scenes constituted a 'low' form of art. By painting *Sigismunda* Hogarth sought to demonstrate his abilities as a ▷history painter, narrating scenes of elevated moral and emotional import. The response of critics was not, however, as Hogarth might have wished. The politician John Wilkes dismissed *Sigismunda* as 'a portrait of Mrs Hogarth in an agony of passion'. Wilkes's quip is revealing. He describes the picture as an amalgam of the ordinary and the outlandish. Hogarth's art had always documented the life around him. This picture is no different. It purports to depict the imaginary Sigismunda, but instead reveals the prosaic features of Hogarth's wife.

What is implied by this criticism? Wilkes's attack reinserts Hogarth's would-be history painting into the category of everyday life. In doing so he implies that Hogarth's position as a painter of the everyday is not simply a matter of his choice of *subject*, but is bound up with the *process* of representation itself.

In *Sigismunda* the everyday is an intrusion: a sign of Hogarth's failure. Hogarth's model, his wife, stubbornly refuses to become 'Sigismunda'. In other words, the relationship between artist and his source material is visible. The painting reveals its origins in Hogarth's home and studio.

This judgement indicates the way in which the depiction of everyday life has been associated with inadequacy. For *Sigismunda* to have been successful Hogarth should have repressed all evidence of the conditions in which the image had been made. For Wilkes, Hogarth is trapped by circumstances. He cannot abstract from his own experience.

Wilkes identifies a problematic relationship between the subject of a painting and the mechanics of making it. This problem has been of particular importance in the history of genre painting and has often acquired a political significance. Like Hogarth, artists as diverse as ▷Rembrandt, ▷Courbet and ▷Manet have been criticized for failing to respect proper boundaries between the studio and the completed painting. The everyday has again been claimed to intrude itself, disrupting the hierarchical relationship that should obtain between the materials used and the use to which they are put. Like Wilkes, such critics have tended to assume that such confusions are signs of inadequacy. The intrusion of everyday life disturbs the hierarchies.

These notions can be seen to emerge during the Renaissance. The concern with the rational ordering of pictorial space in relation to both narration and representation generated this situation. A second instance of the use of everyday life illustrates some of these problems. The 15th-century Flemish artist ▷Robert Campin (who has been related to the ▷Master of Flémalle) documents aspects of everyday life in his religious paintings. His approach arises from developments in late medieval devotional culture. However, his work signals the origin of those paradoxes which were later to exercise the critics of Hogarth's *Sigismunda*. Like other Flemish artists of the time Campin includes within his compositions an apparent excess of circumstantial detail. This identifies a domestic space within which the action takes place. The detail is partly of objects, partly of spatial relationships and the effects of light. Such features have been labelled ▷'naturalistic'. This is because Campin does not seem to depict a thing in order for it to perform a role in a narrative, but rather to mark out an environment in which action takes place.

This approach is evident in his *Madonna and Child with Firescreen* (c1428, London, National Gallery), a depiction of a mother and child in a bourgeois domestic interior, surrounded by everyday objects. Behind the Madonna's head is a circular wickerwork screen; a few flames peep up from behind. In one respect the screen connects the space occupied by the figures with contemporary social experience. It links it with ordinary life. Details emphasize this connection; as the mother prepares to breast-feed the child, her hands are seen to press into her flesh. Campin's ▷modelling signals the physicality of the figures. But the firescreen also occupies a space which would normally be held by the Madonna's halo. If the figures are read as the Madonna and Child, rather than as an ordinary family, then the firescreen carries the sign of sanctity itself. But its capacity to signify depends on the knowledge of convention; it is 'superimposed' over the material conditions of life. The sacred is seen to exist in a different order from the secular: in the realm of interpretation rather than of visible fact.

In this painting Campin identifies a particular kind of relationship between the everyday and the sacred: a distinction between documentation and signification. Reading the concept 'halo' from the depicted firescreen contradicts the recognition of the object as part of a documentation of the environment occupied by the figures. The image as a whole changes from the *depiction* of a woman and child in an interior to the *concept* of 'the Madonna and child'. The relationship between the two defines the meaning of motherhood in general. It is both a material fact of experience and the living embodiment of a sacred idea.

Thus Campin's visual pun with the firescreen identifies the relationship between signification and documentation which marks the condition of the 'everyday'. He sets up a complex of interconnections between objects, the act of documentation, the recognition of ideas and the creation of meaning from fact. Campin's paintings initiate such correlations in a way which persists in North European culture until the end of the 17th century.

This double aspect has been labelled 'hidden symbolism'. The symbolism is said to be hidden because the depicted objects appear to be irrelevant to the action depicted: plausible naturalistic detail that just 'happens' to be there. The viewer can choose to see the everyday or the sacred as the subject of the painting. It is a characteristic of other works by Campin, such as the ▷*Merode Altarpiece* (c1425, New York, Metropolitan Museum) a ▷triptych in which the Madonna at home is surrounded by

▷donors on one side who peer through a door into the central scene and by Joseph in his carpentry workshop on the other side. The everyday figures of the donors look in at the sacred space. The sacred figure of Joseph looks away at his apparently everyday work making mousetraps.

The complex play with sacred and secular vision is found in other artists, such as ▷Jan van Eyck and ▷Rogier van der Weyden. It provides the basis for the development of genre painting in the 16th and 17th century. By the High Renaissance Italian commentators identified problems with Netherlandish art. In Italian painting the 'rebirth' of art has been closely tied to the concepts of rhetoric, the ideal body, the rational ordering of pictorial space and clarity in narrative (on the model of Classical ▷ekphrasis). ▷Michelangelo expressed a common view when he claimed that northern painting appealed to uneducated people; such people would be impressed by the detail devoted to circumstantial features and by the familiarity of the scenes portrayed. Art ought to subordinate representation to controlling values derived from antiquity and from study of the body.

This attitude is the beginning of the argument that had become fully institutionalized by the time that Hogarth painted *Sigismunda*. It contains the same implication that such images indicate intellectual inadequacy: a failure by both artist and viewer to think rather than simply to look. It is no coincidence that such views have been echoed by 20th-century commentators on ▷mass culture.

This is the beginning of the idea that there is a relationship between the subjects of paintings which represent aspects of everyday life and the style in which such images are painted. Up to the end of the 19th century Campin and other northern artists were considered to be ▷naive in comparison with the masters of the Italian Renaissance. This idea extended to other representations of everyday life, especially as they began to emerge independently of religious narratives. Such naiveté pertained to the subjects represented, the untutored 'vulgar' classes, to the style adopted and to their supposed audience.

The idea that there was a particular category of painting which represented everyday life emerged in the 16th century. As Michelangelo had implied, everyday life was seen as vulgar in both the social and cultural sense. It was literally insignificant; it did not signify, or articulate, ideas but merely recorded things that happened.

The range of activities grouped together as everyday experience thus has no meaningful place within an ordered scheme of subjects. They were the equivalent of 'any other business' at the bottom of an agenda. All the many and various activities depicted in paintings which could not be defined in relation to intellectual or theological values thus formed a 'generic' or common category. This elision of categories with subjects is revealing. Everyday life is identified as a variety of images depicting activity of such specificity that they cannot be categorized; it is a category of the uncategorizable: both a jumble of subjects and also the endless multiplicity of experience in all its kinds and contexts. It is also paradoxical in another sense. Everyday life implies common experience: those activities everyone holds in common. But it is also highly specific, potentially including any action, gesture or situation.

Genre painting in this sense emerges in the 16th century. A variety of secular topics develop with the spread of easel-painting. Portable images, unlike murals, are saleable commodities, incorporated into the realm of commerce. Already in 1533 ▷Hans Holbein's ▷ *The Ambassadors* (London, National Gallery) had combined images of rich fabric, trade, science and leisure in the form of an accumulation of crafted commodities. Observation, accumulation and calculation were skills required in bourgeois commercial cultures. These were the conditions which produced Campin's strong emphasis on craft and commodities.

▷'Merry company' subjects, nominally warning against the dangers of sensual indulgence, also emerged at this time. Like other secular topics these develop in relation to ethical maxims and proverbs, a theme which dates back to the 15th century. The merry company topic was often allied to the theme of deception, the unreliability of the surface of experience. This theme also extends into the 19th century, notably in the work of ▷William Powell Frith.

The artist most closely identified with the use of popular proverbs is ▷Pieter Bruegel the Elder. One of his most famous works dramatized a number of *Flemish Proverbs* (1559, Berlin) set in a local village. Bruegel also developed the tradition of illustrating the seasons and the Gothic interest in the ▷grotesque as a sign of the fallen condition of humanity. *The Fall of Icarus* (1558, Brussels, Musée des Beaux Arts) represents a peasant farmer ploughing a field. The figure of ▷Icarus himself appears as a pair of flailing legs pushed to one side of the image. The narrative technique is the antithesis of the methods recommended by Italian theorists. The nominal subject is subordinated to the circumstances in which it is enacted. The ploughman, in this sense, exists outside narrative itself. He is presented as

an unchanging fact of experience, uninvolved in events which aspire to significance. Furthermore, his unthinking concentration on his task is stressed.

In this respect Bruegel's contrast of the ploughman with Icarus confirms Michelangelo's judgement on Netherlandish art; circumstantial detail predominates over narration and unthinking interest in the contingent and the banal is encouraged. But with Bruegel this inversion is a deliberate principle. The ploughman and his horse are equally unthinking, heads looking down to earth. In this respect Bruegel is constructing an ethic of the everyday in his work which entails a specific ▷compositional and ▷iconographical logic. Such features suggest that Bruegel is developing a style in which common experience is identified with a particular set of visual devices. Such an approach helps constitute an aesthetic of everyday life. Bruegel's paintings on peasant themes indicate the ways in which he sustains an imagery of the 'vulgar'. Bruegel's own style develops to accommodate the theme of the crudity of the peasantry. In this respect Bruegel institutes an element of deliberate naiveté. The eschewing of the ordering principles of perspective, of compositional clarity and bodily restraint in such images as the *Peasant Dance* (Vienna, Kunsthistorisches Museum) creates a dynamic of popular experience which can be set against the controlling tendency of Renaissance Classicism. The *Peasant Dance* is ambiguous. It could be said to be placing peasant experience within a realm of crudity and incoherence, continuing the traditional themes of human folly, gluttony and vice. Indeed, by identifying such characteristics of fallen humanity with the peasant class, Bruegel could be said to have helped to bring about a merging of moral, cultural and social status. But because Bruegel's own art is *identified* by this very 'crudity', it tends to validate popular experience and traditions. At times Bruegel draws on sources which would sustain the reading of his images as critical and satirical, at other times the stoicism, humour and vitality of the peasants he portrays appear to be celebrated. This paradoxical feature of Bruegel's imagery of the everyday continues through into 17th-century Dutch art and on to the work of Hogarth himself.

Bruegel was working at a time of increased political and religious conflict in the Netherlands. The region's ruler, the Spanish monarchy, was moving to establish direct control over the area and to root out Protestantism. The threat to local rights and freedoms, set against the background of the increasing economic strength of the Low Countries; produced counter-moves of resistance by the local population. In the 1560s, when Bruegel was painting his peasant scenes, Calvinist preachers were making significant numbers of conversions in the region. In 1566 ▷iconoclastic riots broke out in several places across the Netherlands, precipitating a war between the Spanish monarchy and various local alliances. The latter part of the 16th century was one of fluctuating conflict between the contending parties. The changes brought about by these events produced a new form of genre in which the local, the specific and the domestic were often celebrated.

Being ordinary: Dutch genre painting

The ▷Reformation and ▷Counter-Reformation were fought out in a sea of printed texts and images. Luther had claimed that print had been divinely sent to spread reform. The proliferation of texts published in ways that could not be easily controlled by centralized authority certainly produced a market in ideas and images which thrived particularly in those areas of Europe in which independent, devolved forms of political power were strongest. Such conditions existed in the United Provinces, the Dutch Protestant lands which had broken free from Spanish rule. This country proved central in the development of the painting of everyday life, or genre. Indeed Dutch painting of the 17th century became almost talismanic for future artists and critics who sought to align themselves to traditions of the representation of everyday experience.

The spread of genre in the Netherlands is closely related to a general proliferation of images, particularly printed illustrations. This proliferation in itself undermined the control of rigid structures of narrative and iconography, producing conditions in which visual motifs could develop in unpredictable configurations. This process is the consequence of visual transactions uncontrolled by the stabilizing mechanisms of authority. Elsewhere in Europe a strong central state, a dominant ▷academy of art or the prescriptive role of the Church restrained such transactions. In the United Provinces there was a comparatively 'free market' of visual motifs. It is no coincidence, therefore, that it was in the United Provinces, which rejoiced in the most advanced mercantile-capitalist economy of the 17th century, that genre painting came to be most fully developed. The academic confusion that has arisen about genre is related to the fact that visual transactions occurred in the complex, shifting and uncontrollable form of the marketplace.

Even before the Reformation everyday life subjects (children playing, bathhouses, soldiers) had appeared in the prints of ▷Albrecht Dürer among others. These were an extension of the Gothic tradition of marginal illumination; indeed engraving and etching were closely tied to the book trade, which flourished in the Low Countries. When the English diarist John Evelyn visited Rotterdam in 1641 he noted the popularity of 'drolleries': humorous genre scenes. The Dutch so delighted in these 'clownish representations' that they were sold openly at 'marts or fairs'. Ordinary farmers bought and dealt in them to their profit. The United Provinces was notable for the relative absence of an aristocratic landed class and for its dynamic social structure, deriving its strength from the diversity of economic activity and aggressive naval trade. Dutch painting mirrors this social structure in a number of respects. From the early merry company subjects of the 16th century on to the bourgeois interiors of the 1660s there is an emphasis on the representation of commodities, their textures and the conditions of their consumption or display. The relation of private to public spaces is also a recurrent theme. The paintings of several artists make use of maps and globes, often depicting the process of marking and articulating spaces and boundaries.

Much ink has been spilt on the question of whether the imagery of Dutch painting can be described as dominantly documentary or symbolic. It has been claimed that the mercantile interest in the properties of materials and commodities combined with new empiricist theories of knowledge and the emergent technology of the lens led to an art concerned with the act of visual description. Holland was the centre for the production of optical equipment and of other devices for measuring and observing. Nevertheless, Dutch art still ties the idea of everyday experience to proverbial and emblematic literature. Emblem literature, in which allegorical prints were juxtaposed with moral maxims, enjoyed much popularity at this time. Some artists such as ▷Jan Steen used emblematic devices. The idea that all life is infused with significance goes back to Campin, but the distinction between description and symbolization in Dutch art is more complex and difficult to define. In some instances scenes of everyday life do function as extended moral emblems, in other cases meaning seems to be deliberately occluded or withheld. Emblem literature does not necessarily explain 'hidden meanings' in Dutch genre, rather it provides a network of orientation points by which an increasingly complex range of objects and events can be related to one another. The image of the map is apposite when trying to understand the significance and perceived meaning of emblematic objects and devices in paintings. Maps describe a real space as fully as possible, but they also require a system of symbols for that space to be intelligible.

The most famous artist to incorporate everyday life into a framework of ethical maxims was Jan Steen, in whose paintings the ethical basis for the image is sometimes written into the scene depicted, an approach that recalls both emblem literature and also the tradition of appending verses to engravings. Steen's figures are commonly posed in interiors, adopting rhetorical gestures in relation to the position of the viewer. In this respect they also draw upon forms of theatre, a method which was to be important for the representation of everyday life into the 18th century. The implication that the characters in the painting are performing a tableau for the benefit of the viewer allies them to other forms of secular entertainment. Steen depicted riotous and disorderly domestic spaces as in his *Beware of Luxury* (1663, Vienna, Kunsthistorisches Museum), in which each figure is related to textual sources in the manner of Bruegel's *Flemish Proverbs*. Steen also presented the interior as a space of piety, as in *Prayer Before a Meal* (1660, Sudeley Castle, Gloucestershire) in which the nuclear family of mother, father and child sit at a table before a simple meal. A text from Proverbs, written on a document hanging on the wall, confronts the viewer.

Such prayer scenes were not uncommon. Both the peasant interior and the middle-class home could be represented as a site of piety or of disorder. Thus Dutch genre painting offered the possibility of a variety of responses to class differences. While the work of ▷Adriaen Brouwer and ▷Adriaen van Ostade continued to associate peasant and 'low-life' figures with moral laxity, brutality and uncontrolled desire, an imagery of simplicity and conviviality existed alongside it, particularly evident in Ostade's cottage scenes.

Brouwer could be said to represent one extreme of Dutch genre, ▷Jan Vermeer representing the other. Brouwer was probably a pupil of ▷Franz Hals, whose portraits had sometimes taken on the character of genre, depicting figures such as *Malle Babbe* (c1633, Berlin), a local woman notorious for her drunken rowdiness. Hals's style incorporates marks of energy and movement into his brushwork. This interest links him with both Bruegel and with later artists like Hogarth. Brouwer adopts a similar

energetic style for tavern scenes and isolated figures associated with forms of sensual indulgence. Both subject and style emphasize violence and crudity as dominant values.

Vermeer's paintings are the antithesis of Brouwer's. Though human action is central to each scene, narrative is reduced to a minimal point so that it is apparently almost reaching a condition of absolute stasis. Admirers of Vermeer have described this feature as a magical or even spiritual calm. It may be related to the growth of religious Pietism, a movement which played down doctrine in favour of mental passivity, an openness to divine grace. Vermeer tends to remove cues which would have identified a legible narrative or iconography. This ambiguity is an extension of the work of artists like ▷Gerard Terborch and ▷Nicholas Maes who had depicted rich interiors with figures engaged in ambiguous negotiations, often implicitly sexual in content. In the work of such artists, figures are usually surrounded by imagery of wealth and pleasure. Ter Borch was famous for his sensuous portrayal of silken costumes. These paintings, like the objects they depicted, were to be lingered over. The reading and writing of letters is a common motif. Texts are illegible, access to knowledge possessed by the characters denied to the viewer. Reality is identified as something in excess of the image itself, only partially encompassed by it. Detailed observation, the desire to see more fully, is encouraged by subject and style. At the same time such paintings move towards a kind of inarticulacy. By suggesting thoughts without communicating them and by drawing the viewer into an imagined engagement with the surfaces and shapes of depicted objects, they create an experience of intimacy, a theme which was to be central to the future history of genre painting.

Vermeer's *Seated Woman Playing the Virginals* (c1673, London, National Gallery) illustrates this device. The woman glances towards the viewer. Behind her on the wall is a brothel scene, a copy by Vermeer of a painting by ▷Dirck van Baburen. The blatant meaning of the latter contrasts with the ambiguity of the main scene. The image moves from the explicit to the implicit. Indeed the brothel painting is copied in an abstracted form; the laughing face of the prostitute has become a blank, flat plane; its explanatory role is negated. Her gesture, playing the lute, is mirrored by that of the woman playing the virginals: a simple instrument replaced by a more complex (and expensive) one. The painting has gone 'up-market'. Its meaning is derived from the van Baburen, but distanced, complicated, insecure. Meaning has become possible rather than certain. The viewer's interaction with the woman cannot be reduced to the crudely commercial exchange depicted by van Baburen.

This stretching of the bounds of legibility extends to Vermeer's use of objects, space and light. It is generally believed that Vermeer used a ▷camera obscura to construct his images; some paintings contain objects which are apparently in blurred focus. Thus his concern with the everyday is connected to a general concern with the nature of the material world and the conditions of vision. Vermeer is not alone in this. Earlier in the century Rembrandt had explored the analysis of light. However, Rembrandt had largely confined scenes of everyday life to the medium of etchings. Vermeer's contemporary in Delft, ▷Pieter de Hooch, was also marking ordered spatial relationships in relation to the imagery of the home, a process which reached its height in the 1660s. Intricate patterns of light interact with the receding spaces of rooms within buildings, or mark the transition from interior to exterior. These devices in de Hooch's paintings are related to an imagery of domesticity, a fact which made him very popular in the 19th century.

Dutch art offered a range of imagery allied to working-class and middle-class experience, in which both could be identified as riotous or pious. Most importantly, the studied inarticulacy of the paintings of de Hooch, Vermeer and Terborch offered a model for the visual language of intimacy, a concern of artists associated with images of the home which continued into the 20th century. The everyday in this sense was emphatically set against the public and the rhetorical.

Though Holland was the country in which genre painting became most fully developed, the style also emerged in Catholic Europe at much the same time, though there it continued to be closely allied to the realist traditions emerging from the work of ▷Caravaggio in the 16th century. In Spain ▷Velázquez and ▷Murillo depicted tavern scenes (▷*bodegón*) and street urchins. While these bear some similarity to the work of Brouwer, they remain more closely tied to Catholic piety. Velázquez's *Christ in the House of Martha and Mary* (1618, Madrid, Prado) depicts a kitchen scene. In the background an image can be seen of Christ with his followers. It is unclear whether the image is a view through a window or a picture on a wall. Martha, at work in the kitchen, confronts the viewer with her presence. This confrontational gaze recurs in the work of other Spanish artists. However, Velázquez's most famous work ▷*Las Meninas* (1656, Madrid, Prado) shares some features with Vermeer's carefully

spaced interiors. The emphasis on the integration of the contingent aspects of life with the stability of social hierarchy indicates the different political context in which Velázquez worked.

The French family ▷Le Nain adopted a similar confrontational realist style to the Spanish. Louis Le Nain's *Peasant Family* (c1640) stare out at the viewer from a virtually monochrome pictorial space. Both the Spanish and French artists were working in countries with authoritarian regimes. In Dutch art, ethical and social status, like the commodities which fill the images, are capable of migration: moving from one configuration of motifs to another. In French and Spanish art the poor are always with us. Le Nain's paintings place the viewer as a figure alien to the world of the peasant, observing it and being visually challenged in return.

Le Nain's works are comparable to the paintings of ▷Jean-Baptiste-Siméon Chardin of over a century later. Chardin was a contemporary of Hogarth, but can most usefully be compared with the traditions of Le Nain and Vermeer. Like Vermeer, Chardin relates the formal and iconographical elements of his paintings in such a way that the ordering of composition is connected to a relationship between stasis and action in the scenes he depicts.

Chardin's genre paintings are mostly of middle-class homes, families and servants. Objects play an important role in his compositions, but their status as desirable commodities is underplayed. Instead they form part of an imagery of laboured control, similar to the basic objects in the peasant home laid out before the viewer in Le Nain's *Peasant Family*. Images of labour are often tied in with the depiction of its instruments. In *The Kitchen Maid* (1738, Washington DC, National Gallery) a servant pauses while peeling turnips. Her knife rests on her arm, intruding from the space of her body. On a chopping block nearby a hatchet can be seen angled towards the viewer. These visual intrusions, characteristic of Chardin, mark out objects as things to be used rather than consumed. The process of labouring is identified with the tension between two-dimensional and three-dimensional space.

The laboured spaces and surfaces of Chardin's paintings set his work against the tendency towards theatricality in 18th-century art. Chardin's older contemporary ▷Jean-Antoine Watteau is important for reviving the imagery of leisure associated with masquerades. This had been a feature of some Dutch art, connected with ambiguous amorous transactions. Watteau's ▷*fêtes galantes* elaborated this theme. The events depicted were of leisured parties in semi-theatrical costume. ▷Jean-Baptiste-Joseph Pater, ▷Nicolas Lancret and others continued this theatrical imagery.

The distinction between labour and leisure in images of everyday life had been present in the 17th century, but became increasingly important during the 18th century, especially as realism acquired increasingly political implications. Seventeenth-century genre had been fundamentally static in character, despite the complexity and ambiguity of Dutch art. Moral and social conditions were seen as states of being, observed and structured in tandem with objects in stable spaces. The tradition initiated by Watteau was developed in radically different form by Hogarth who reasserts the relevance of public rhetoric to the depiction of everyday life.

Multiplicity and irony: the theatre of the commercial world

As the economic importance of Holland fell towards the end of the 17th century, that of its rival, Britain, rose. William Hogarth was the first significant British artist born after the constitutional settlement following the Glorious Revolution of 1688. For many later commentators Hogarth epitomized the values of national commercial society which the revolution had secured and would be later consolidated by the Industrial Revolution and the expansion of empire. The conditions in which Hogarth produced and circulated his images were therefore comparable to those in which the Dutch genre painters of the 17th century had worked. Hogarth, however, was distinctive in a number of ways. He extends the elision of documentation and signification which characterizes the Dutch tradition of genre but he organizes it differently. It is no longer based on emblematic thinking or tied to an ahistorical ethic epitomized by proverbs and epigrams. A Dutch genre painter might have commented on the vice of gluttony by exemplifying it in a scene of everyday life. Hogarth, in contrast, ties ethical values to unfolding narratives in which vice is defined in relation to changing social conditions. This is an important departure. In Hogarth's work social and ethical values exist in relation to one another, as a *process*. Events and their meaning are seen as dynamic, a proliferation of possibilities rather than static facts observed by the artist.

The importance of Hogarth's departures from Dutch precedent is apparent in his early works. Hogarth does not stress the physical presence of objects, as many Dutch artists had done. In this respect

his work does not play on the analogy of paintings with other materials and commodities. Hogarth's style is characteristically ▷Rococo. In this respect he can be compared with Watteau. Like Watteau, Hogarth creates an ambiguous space between theatrical performance and social documentation. In a sense Hogarth's works deal with the *enactment* of representation: the point at which hitherto indeterminate facts of experience are co-opted for a particular purpose. In doing so they turn on moments of pictorial and narrative ambiguity in which the motivations of the characters and the drift of the image's ethical claims are destabilized.

In a straightforward sense, Hogarth's works are peopled with characters who are 'on the make', aware of the possibility of exploiting positions and transforming meaning to suit their purposes. By requiring of the viewer a similar co-option of knowledge from the social scene, Hogarth's works implicate us in this process. In doing so he complicates the relationship between the realm of narrative painting and of popular print. Journalistic illustrations of recent events and of people in the news which were characteristic of the latter drawn into his pictures. Ephemeral public 'gossip' is incorporated into dramas which also address general emotional states or moral absolutes.

This process is most evident in what Hogarth called his 'modern moral' sequences. The first of these was ▷*A Harlot's Progress* (1732, paintings destroyed), a series of paintings and prints depicting the career of a young woman from the country who comes to town and is drawn into prostitution. The idea of a sequence was not new. In part it derived from illustrations to literature, in part from history paintings which told stories from mythology in sequential form. But Hogarth's narratives were specifically about modernity. They were not illustrations of pre-existing plots, rather, the events were unfolded by the pictures themselves in the manner of a staged play or a novel.

This new approach to genre allowed Hogarth to develop paradoxes and ironies that are at their clearest in ▷*Marriage à la Mode* (c1743, London, National Gallery), the most complex of his modern moral sequences. The story concerns the arranged marriage of the son of an impoverished earl to the daughter of a wealthy merchant. Hogarth uses his pictorial theatricality to portray events as a conflict between everyday life and failed attempts to suppress it.

In the first scene the marriage is being arranged; the couple's fathers negotiate the deal, while the bride and groom pointedly ignore one another. This is clearly not an everyday subject in either the sense of an aspect of lower-class, 'vulgar' life, or in the sense of day-to-day activity. It is an event of special significance which is also seen to be emblematic of the condition of national culture as a whole. It epitomizes a society caught between the institutionalized status of landed aristocracy and the increasing power of an aggressive commercial class. Thus Hogarth is extrapolating from the emblematic tradition by exemplifying a general truth. But this is not the simple moral truth of proverbs, it is a complex and unresolved problem. Modern life has become an issue which the image addresses. It does so by depicting the confrontations that exist within both social and artistic conventions with irrepressible and disruptive force.

The earl and the merchant are caught in a relationship of dependence. In order to maintain his status the earl is forced to move out of the static conventions that define his aristocratic persona. He sits grandly in his chair adopting pompous theatrical poses, attempting to live up to his own portrait, visible on the wall nearby. As depicted by Hogarth the portrait is a parody of ▷Baroque conventions, a compendium of rhetorical clichés in the manner of ▷Hyacinthe Rigaud. Thus the earl's pose is life aspiring to sustain the conventions of art, doing so most insistently when its status is in question. But the earl's forced engagement with common experience sets in play an opposition between 'convention' and 'reality'. The earl's status becomes nothing more than a set of signs. The portrait loses its claim to depict the truth about the earl and instead becomes an absurd and hysterical token of grandiosity. The real earl is alienated from his own status, forced to step out of convention and into commonness, as it invades his domain, undermining his attempt to suppress his own ordinary nature: his shared identity with commoners. The presence of the merchant transforms status itself into a commodity. He is in effect buying the earl's capacity to signify social authority. The fact that status is a matter of visual rhetoric is revealed in the direct confrontation with the reality of commercial power seeking to buy into it.

This conflict of convention and reality is most clear in Hogarth's use of apparently circumstantial objects. On the wall behind the figures are a number of paintings with mythological subjects, supposed to form part of the earl's collection. These comment on the action in a variety of ways, providing emblematic equivalents of the events depicted. Hogarth thus relates everyday experience with the

conventions of high art. The iconography of the paintings (martyrdoms and images of bondage) becomes referable to the scene existing in 'reality', occurring beneath it.

The first scene of *Marriage à la Mode* is a summation of Hogarth's art: rhetoric continually set to play against forces turning it against itself. Hogarth's work spread across the continent through his engravings. Trained as an engraver, Hogarth marketed his works effectively through reproductions. Thus Hogarth engaged with the commercial conditions of life in the very way in which his images circulated. This close relationship between selling paintings and their reproductions was to acquire special significance in the next century.

By circulating so widely Hogarth's prints provided an image-bank for the depiction of modern urban life. The Dutch painter ▷Cornelis Troost used Hogarth's prints as a source in this way, as did others. But perhaps more important was the fact that Hogarth had developed a form of art which sought to represent everyday life in such a way that the same technique of critical and satirical documentation could be applied to all social classes. His works depicted the complex social dynamic of urban modernity. This was a concern that was to be central to genre painting of the 19th century.

The future in everyday life: modernity and genre

Throughout the 19th century, the art of 17th-century Holland continued to provide models for scenes of everyday life. Imitators of de Hooch portrayed the bourgeois home. Likewise, Ostade and Brouwer formed the basis for many depictions of the rural poor. Such borrowings were often associated with social values that affirmed continuity and stability. Cottage interiors in particular came to signal forms of traditional rural life increasingly forced to the margins by the spread of urban modernity. By the mid-century cottage subjects are often used to epitomize the 'eternal' verities of security, domestic intimacy and proximity to nature. Such values were set in opposition to the disruptive consequences of urban modernity identified by Hogarth and his successors.

The political and economic developments of the 19th century led to a concept of social 'progress' which undermined the old static hierarchy structured in terms of the opposition of spirit to matter. Ordinary life was now no longer simply equated with insignificant circumstances of existence. Genre painters had dealt with activities which came to be of increasing relevance with the spread of industrial society. Forms of popular recreation, manufactured commodities in the home, the character of the new working class: all of these subjects were no longer 'drolleries'. They were the stuff of urgent political debate, government investigations and expanding commercial interest. The theories that had led Hogarth to prove his worth as an artist by painting *Sigismunda* persisted, but the new problem, the investigation of the social process itself, required the documentation of the changing face of everyday life. The growth of cities and the changes in patterns of work, leisure and domesticity were accompanied by increasingly populist politics and agitations for extensions of the franchise.

In France such conflicts tended to be organized around debates over the role of the ▷Academy. Differing forms of realism were set up in opposition to approved history painting constructed around the repression of signs of everyday experience. Academic valuation of the beautiful was contested by disruptions of pictorial etiquette. The rural and peasant subjects of Gustave Courbet drew on the pictorial methods of Caravaggio and Le Nain in such a way that apparent compositional 'clumsiness' functioned to place the viewer in uncomfortable proximity to the subjects, forcing confrontation with jagged fragments of reality which resisted full incorporation into a coherent image. In Catholic countries such confrontational compositions had a long history, but in *Burial at Ornans* (Paris, Musée d'Orsay) Courbet pushed the distortion of space so far that the viewer encounters figures which seem to tip into reality, spilling into the space of the gallery. This is social reality as a threat: an insubordinate incursion into a realm of control and decorum.

The aggressive use of genre as an implicitly revolutionary intrusion of social reality into sanitized arena is also characteristic of the early work of Manet, most notably in ▷*Déjeuner sur l'herbe* (1862, Paris, Louvre). In *Déjeuner* the traditions of genre and of history painting are forced into an irresolvable collision. Men and women picnic in a vaguely 'natural' environment, but poses are forced and formal. The nakedness of the principal female figure is neither coherently allegorical nor naturalistic. The painting draws on genre to the extent that it appears to represent both recreational activity and a moment of intimacy, but the academic formality of the composition undermines any suggestion of relaxation. Like *Burial at Ornans*, *Déjeuner* identifies the intrusion of the everyday into a set of conventions which are unable to contain it. In this respect it is a kind of visual parable of the new and

troubled attempts of intellectual and institutional traditions to make sense of new forms of 'ordinary' life and to express and reflect these new forms.

Manet's later work adopted the pictorial techniques of ▷Impressionism as a new mode of painting appropriate to modernity. Everyday life was approached by a pictorial method comparable to experimentation. The traditional themes of genre – leisure, labour, intimacy, entertainment – were documented by ▷Degas, ▷Monet, ▷Renoir and ▷Toulouse-Lautrec. Like Vermeer, whom they admired, they sought to relate such themes to the analysis of light and space, but their characteristically restless, fluid paint-surface marks their engagement with the mobility of modern life. Impressionism tended to locate the everyday and the intimate in the realm of 'bohemia', the semi-imaginary site of human interaction which is not constrained by social or aesthetic convention. Their style stresses the gestures of painting itself, involving the viewer in the activity of observing and recording, placed alongside the artist at the moment of engagement with experience. In the work of Degas and Toulouse-Lautrec in particular the ambiguities that had always been evident in genre took on a new significance. Paintings of people in bars, or behind the scenes at the ballet and the variety theatre incorporate the viewer into a space between public and private, observation and participation. This is especially apparent in images of women dressing or washing. Often the women could be either intimates of the artist or prostitutes. Thus hidden and dubious aspects of urban 'leisure' are conflated with moments of private tenderness. Such subjects place the viewer in an ambivalent condition: both voyeurism and personal devotion. They are simultaneously images of human commodities and of the opposite: moments of unselfconscious relaxation, when people act without inhibitions. Dutch genre had also oscillated between the brothel and the home, but Impressionism created a radically ambivalent form of image that played on this bohemian realm, equally possessed of the positive values of community, conviviality and intimacy, and of the negative values ▷alienation, degradation and decay.

Such ambivalence had also been evident in Hogarth's work, but in a very different form. For British critics Hogarth had visualized the character of modern liberal-mercantile society. His commercial methods, populism and nationalistic subject matter suited the new conditions. His subjects were drawn from modern urban life and so represented a rejection of the authority and hierarchies associated with the use of academic conventions, but his approach was also 'libertarian' in a more complex way. The very concern with the ordinary was seen to encompass a range of experience which was not contained by either moral or social norms. This tendency towards excess was seen to be the sign that Hogarth was a progressive, forward-looking artist, whose work generated an active rather than affirmed a static condition of experience.

The Scottish artist ▷David Wilkie tempered the anarchic implications of Hogarth's work by integrating it with Dutch traditions. Wilkie achieved success in 1804 with *Pitlessie Fair*, a depiction of a village fair which was derived in style from Dutch models, though it also drew on Hogarth's *Southwark Fair* (1733, London, National Gallery). Wilkie went on to paint a number of subjects derived from modern life in a manner which combined the stylistic influence of Dutch models with the work of Hogarth. He painted cottage interiors in the manner of Ostade, but began the process of presenting these country dwellings as sites of intimacy and social communion. The depiction of peasantry as venal and crude was still in evidence in some paintings, but in general Wilkie developed that aspect of the Dutch tradition which associated interiors with an intimacy set in opposition to the crowd and the dubious transactions of the brothel or gaming table.

Some of Wilkie's works, such as *The Letter of Introduction* (1813), are related to those aspects of Dutch art which set up uncertain and unresolved transactions between the depicted figures. Wilkie's painting is, however, explicitly illustrative of the problematic moments created by complex and uncertain social alliances. The subject depicted is a young man standing before an older man who reads the letter of the title. The two figures are presented in an unresolved tension. The personality of the youth, whom the letter presumably recommends, is left unclear. His slightly hunched pose and unfocused expression could be read as signs of an unreliable character or merely of his embarrassment.

This topic is derived from the many Dutch paintings of figures reading letters, but the Dutch images functioned to block the prospect of legibility; Wilkie sets up the scene to encourage speculation about the motives of the characters and the likely outcome of events. This tendency to suggest possible readings to the viewer was to become a central concern of 19th-century genre painting, as was the process of reading character in the conditions of modern life.

Like Hogarth, Wilkie proved influential outside Britain. More than one of his subjects was repeated

by artists working in ▷Biedermeier Germany. The forms of bourgeois culture which were powerful in Britain had similar status in Germany during the first half of the century. The subjects of Wilkie's paintings *Distraining for Rent* (1815, Edinburgh, National Gallery of Scotland) and *The Reading of the Will* (1820) were both repeated by German artists. These subjects are clearly indicative of middle-class concerns regarding family, finance and the unstable relationship between the two. Such themes recur consistently in Biedermeier and Victorian art.

While Biedermeier art followed Wilkie with images of the ups and downs of modern life, it also drew on some of the formal features of the Dutch legacy. De Hooch in particular was widely admired in both Germany and Britain. Artists such as ▷Georg Frederick Kersting took their cue from Pieter Elinga's *Woman Reading* (c1669, Munich, Alte Pinakothek), believed at the time to have been painted by de Hooch, constructing interiors of restrained colours and isolated figures. De Hooch's interest in light and in the points of transition between interior and exterior space allowed some Biedermeier painters to combine his domestic interiors with the concerns of ▷Romanticism while also referring back to the recurrent theme of the sacred in the secular, marked by the portrayal of signs of intimacy in the space of the home.

In the Netherlands itself the motifs deployed by 17th-century artists had never entirely disappeared. But by the beginning of the 19th century they came to be used to signify local traditions of Puritan virtue, stoicism and honesty. In this respect the Dutch tradition acquired a particular function: to identify national cultural values. Since the academic conventions of history painting had claimed access to universal values that operated independently of local custom, the specific, the local and the everyday increasingly functioned as signs of cultural nationhood.

By the 1840s Victorian artists were combining motifs derived from the Dutch with borrowings from Hogarth. Dutch emphasis on domestic imagery, in particular, took on special significance in mid-Victorian culture. The very ordinariness of domestic experience is commonly seen as a source of value. In such images domestic life is construed as the site of the influence of femininity. Thus the ordinariness and intimacy associated with genre painting become the basis for the presentation of the home as a realm aestheticized by female influence. In many Victorian paintings, the viewer is placed in the position of a figure who is being invited into the domestic realm, as if directly into the space of the work of art itself.

The combination of Dutch domestic imagery with the legacy of Hogarth is most evident in the work of 'The Clique'. Originally led by ▷Richard Dadd this group emerged at the beginning of Victoria's reign. Its members were W.P. Frith, ▷Augustus Egg, ▷John Phillip, Henry O'Neil, Alfred Elmore and E.M. Ward (husband to ▷Henrietta Ward). Alfred Elmore's *The Invention of the Stocking Loom* (1847, Nottingham, Castle Museum) exemplifies this use of Dutch modes to redefine the significance of everyday life in the home. Its subject is a nationalistic reworking of a common subject of Dutch art, textiles. Both richly-woven cloth and working weavers, spinners and lacemakers appear in many 17th-century paintings.

Elmore depicts the 16th-century inventor William Lee with his wife and child in a modest room. He is watching his wife's fingers as she knits. Studying her movements, he conceives the idea for a machine to replace her labour. The subject is a celebration of the achievements of British industry, identifying the origin of mechanized textile manufacture. In this respect it is an affirmation of modernity as embodied by technology. However, what Elmore actually depicts is an archaic and picturesque domestic interior with a woman bent over her needlework, as if creating a pastiche of Dutch art. Her husband, like the viewer, gazes on this 'traditional' scene of devotion to domestic duty, resolving that her labours should henceforth belong only to the domestic realm. The machine will ensure that she is no longer required to earn extra money for the family, but can confine herself to rearing their child.

The Invention of the Stocking Loom is a depiction of everyday life, but it identifies ordinary domesticity with an event of historical importance. With its theme of national pride in technological innovation brought about in the ideal space of the home *The Invention of the Stocking Loom* is an attempt to sum up the qualities of modern Britain. In this respect it is as much of a history painting as any which narrates a tale from Classical literature. By merging the everyday with the historically significant a form of 'historical genre' is being created.

Elmore was by no means the first to domesticate history painting. In 1822 Wilkie had exhibited *The Chelsea Pensioners Reading the Gazette of the Battle of Waterloo* (London, Apsley House). In turn he had drawn on Hogarth's *The March of the Guards towards Finchley* (1750, London, Thomas Coram

Foundation), an unheroic treatment of the Jacobite rebellion of 1745. Wilkie's painting was a scene outside a tavern at which a group of veterans and local families are gathered; one reads out Wellington's dispatch from the battle. The scene drew on the visual language of the ▷picturesque to create an image of a community united in celebration of national victory. *The Chelsea Pensioners* was an enormous success. In representing a body of 'ordinary' people participating in the significance of national events it signalled a changing relationship between the idea of popular experience and national culture. Throughout the early 19th century the urban population of Britain was expanding. Illustrated newspapers fed the better-off sections of the population with a mixture of news and engraved images which regularly included reproductions of recently exhibited art alongside hastily produced prints of recent events or portraits of figures of the day. The continuing relationship between print-making and the spread of scenes of everyday life developed to incorporate a far greater expansion of texts and images than had been known before. The importance of print extended to the market for paintings themselves. *The Invention of the Stocking Loom* was a popular success in engraved reproduction. As the century progressed some artists would be able to make lucrative deals on the strength of projected print sales. The art market was thus developing to incorporate a mass audience for images, as methods of mechanical reproduction allowed images to penetrate further into the fabric of everyday life itself.

An artist who successfully exploited these new market conditions was William Powell Frith. Frith sought to follow the example of Hogarth in painting panoramic views of modern urban life. In this respect Frith sees in the depiction of everyday life the basis for an understanding of society as a whole. Unlike Hogarth, Frith saw himself as an anthropologist, describing the range of social types and their interaction. His panoramas of modern life, such as *Life at the Seaside (Ramsgate Sands)* (1854, Royal Collection) and *Derby Day* (1856–8, London, Tate Gallery), depict crowds participating in the beginnings of the modern leisure industry. A complex variety of social types and classes interact in these images. As in Hogarth's paintings, this interaction is too varied to be fully controlled by the composition. The viewer is unable to 'take it all in' at once.

For Hogarth this was the visual form by which the indeterminacy of modern life could be characterized. For Frith this is also true, but his paintings are constructed in a way which attempts to signal processes of control operating within the crowd. Groupings of figures and the management of light and shade draw on academic methods of compositional integration. His crowds are generally in the process of surveillance by guardians of social order. Frith's panoramas are caught in precarious balance of orderliness and uncontrolled vitality, offering a visual equivalent to the wider social and intellectual concern with the scientific, journalistic and governmental documentation and analysis of the urban crowd. Frith's work involves a paradoxical celebration of diversity and desire for control.

Frith's colleague Augustus Egg developed Hogarth's modern moral paintings in a different way, one which looked back to Flemish painting and forward to the cinema. Egg's ▷triptych *Past and Present* (1858, London, Tate Gallery) depicts a family in crisis. It was originally exhibited as three separately-framed paintings. In the painting to the left a woman holding a baby shelters under the arch of a bridge; she looks up at the moon as a cloud flits across it. In the central painting, placed slightly higher than the flanking images, a middle-class couple with two children are seen at home. The husband crushes a letter in his hand, the wife lies in a faint on the floor; in the background one of their two girls looks round in surprise. In the painting to the right two teenage girls are seen in a dingy room; one looks out at the moon as a cloud flits across it.

The viewer is required to construct from this series of isolated moments a story of the collapse of a family. In the central painting a husband has discovered evidence of his wife's adultery. The two flanking paintings represent the mother and the daughters a few years after the fateful day. The mother has been abandoned by her lover and wanders the streets with her illegitimate child. The two children are now alone (their father having died) living in poverty. The cloud crossing the moon indicates that both these later moments are occurring simultaneously.

The viewer is expected to recognize that both are remembering the event depicted in the central scene. This central painting is raised up above the others to indicate that the characters' gaze up at the moon is a cue for their recollection of this moment. They both look back at the ideal they have lost. Hence they gaze up 'through' the moon to the remembered vision of the family home. Ordinary life, the norm of the Victorian household, is precisely what has been lost. In this respect the meaning of the everyday has undergone a dramatic transformation. It has acquired some of the status of the ideal; it becomes an object of day-dreams for the characters as a consequence of its loss, simultaneously a

vision of heaven and a perpetual torture: the knowledge of eternal separation from happiness. This is another reason for the central painting being raised above the others. The characters literally look up to the ideal home of their memories and aspirations.

In this respect Egg looks back to the northern Renaissance ▷ altarpieces from which the tradition of genre had developed. Unlike Hogarth's *Progresses*, this is not a story which unfolds in sequence. It is a depiction of fallen individuals looking up to a secular vision of heaven, just as the supplicant donors in the *Merode Altarpiece* gaze through the door showing them the Angel and Madonna in her well-appointed modern home. Like the donors they are engaged in continual meditation on a single event which encapsulates both a vision of felicity and the signs of the ▷ Fall. As in Flemish and Dutch art the room in the central scene contains both implicit and explicit references to the moral implications of the events (a rotten apple, a print of the Expulsion near a portrait of the mother). Egg thus revives the emblematic implications of genre painting while also affirming the Victorian conception of the absolute sanctity of the home.

Past and Present, however, also indicates new features in the representation of everyday life which look forward to the 20th century. The viewer is expected to read the central image as both a memory and also as an event happening as we watch. In this respect it is the equivalent of a flashback in cinema. The moon provides a visual link which allows the viewer to identify two events occurring simultaneously; this looks forward to the cinematic device of cross-cutting. These 'cinematic' aspects of *Past and Present* derive from the fact that Victorian narrative painting was beginning to develop techniques for incorporating the viewer into the psychology of characters by a series of cues correlated to narratives. This derived from Wilkie's tendency to encourage the viewer to create imagined narratives concerning the thoughts of characters or the events that had led to the current situation. Dutch painting had been much more ambiguous in its suggestion of intimacy. Victorian pastiches of de Hooch, as in the work of J.C. Horsley, tend to structure narratives so as to encourage speculation about motives and past and future events. Such an approach was related to the expansion of popular and journalistic use of images. By the mid-century artists like Egg could create new narratives which drew on a range of cues which audiences could be expected to identify. However, other artists drew on the ambiguities in Dutch painting. Female artists such as Edith and Jessica Hayllar drew on de Hooch's intricate internal spaces and Vermeer's dramatic foregrounding of carefully placed objects. The 'sanctified' female space of the home is made potentially momentous, a realm of complexity and undefined significance.

Similar concerns are evident in the use of genre painting in the expanding United States of America. Scenes of everyday life were bound up with the development of populist politics during the 1830s. They emerged alongside the growth of the mythology of the West, which increased in importance as the century progressed. As in Britain, the hybrid form of historical genre signalled the increasingly complex relationship between day-to-day activity and the formation of a new society. Wilkie and Hogarth provided models for many scenes centring on sites of public activity. The former also influenced rural and frontier imagery which affirmed 'cottage' values similar to those found in European art. But genre in the USA was inflected by the position of the United States as a nation in the making. The formation of communities at the edge of the wilderness as the nation expanded westwards meant that 'progress' could be associated with small-scale human activity. Whereas European images of rural life in the 19th century were associated with a threatened tradition, the western community could be construed as the vanguard of national future.

By the mid-century genre images were often directly related to contemporary political debates, appropriating slogans or referring to specific platforms. In this respect they could be said to have fully integrated emblematic thinking with the documentation of modernity. Pictorial engagement with popular politics defined the point of interaction between social observation and the generation of meaning. As in Campin's work, such meaning makes sense of the experience observed, but here meaning is publicly contested. Ordinary life is no longer a phenomenon to be observed, but an activity in which to participate.

▷ George Caleb Bingham is the best-known exponent of this populist form of genre. Like other American genre painters his works are specific affirmations of popular participation in politics. The *County Election* (1852, St. Louis, Boatman's National Bank) is derived from Hogarth's scathingly satirical *Election* series, but where Hogarth's image stresses deranged confusion and instability, in Bingham's painting the populace construct a solid block at the polling station, the voters and the

building giving structural priority to a banner proclaiming the sovereignty of the people. In one of Bingham's most famous paintings, *The Jolly Flatboatmen* (1846, Manoogian Collection), a group of bargees dance on the wooden roof of their boat. The central figure leaps up, arms raised, forming the apex of a triangle. Bingham draws on the legacy of Bruegel and Hogarth. Like his predecessors, his style avoids tonal modelling, adopts a graphic emphasis on outline and eschews smooth transitions between forms and spaces. But *The Jolly Flatboatmen* involves a complete inversion of the values connoted by Bruegel's *Peasant's Dance*. Bruegel's painting may have suggested positive 'peasant' values of energy and spontaneity, but its primary function was satirical. Bingham, in contrast, presents his bargees as the apotheosis of popular experience. Documentation of leisure is transformed into an affirmation of centrality of the energetic pursuit of happiness.

Bingham's graphic style was suited to engraved reproduction. Later in the century the relationship between artists and illustrated newspapers became more immediate. British painters like Frank Holl (1845–88) and ▷Hubert Herkomer documented the plight of the urban poor in images specifically intended for reproduction in the periodical, the *Graphic*. Such works took their place in a complex of developments across Europe as the century moved to its end. In some cases this involved the explicit use of genre painting as a political weapon, as in the case of the Russian group known as ▷The Wanderers. Their concentration on scenes of everyday life was connected with anti-authoritarian politics. Documentation of the circumstances of the modern world was a gesture against the Tsarist state's claim to timelessness and an affirmation of the value of working-class experience. Such concerns led directly to the promotion of socially-engaged genre painting within ▷Marxist theory. In Stalinist Russia such images constituted ▷Socialist Realism. The history of genre was seen to mirror the progress of the working class, despised as lowly and unimportant but finally triumphant and dominant.

In the West, 20th-century genre painting often functioned as resistance to international ▷Modernism. The ▷Regionalist movement in the USA drew on the work of Bingham, continuing the imagery of the small town. ▷Thomas Hart Benton, ▷Grant Wood and others placed themselves as defenders of popular and semi-naive traditions epitomized by the traditional concentration of genre on local detail. In Wood's talismanic image ▷*American Gothic* (1930, Chicago, Art Institute) a severe middle-aged couple glare unrelentingly at the viewer, blocking access to the space they occupy. The composition looks back to Le Nain, but these people do not represent peasantry, but independent farmers whose way of life is to be protected from intrusion, not opened up to the gaze of outsiders.

The technological reproduction of everyday life

The Victorian system of painting had increasingly related scenes of everyday life to the development of the urban world as it was tied to the spread of illustrated newspapers. Everyday life shaded into current affairs. The artist who exhibited at the Royal Academy might find that his or her painting was reproduced in the *Illustrated London News* next to an image of a recent public event. By the beginning of the 20th century the situation had changed radically. The development of the technology of photography had begun to have effects on the appearance of magazines and newspapers. The artists who had produced images for the *Graphic* had worked in a situation in which the mechanisms of reproduction were still largely unchanged from the period in which genre painting emerged. From its origins in the 16th century, genre proper had developed alongside the spread of printed imagery.

When Hubert Herkomer documented the plight of the unemployed for the *Graphic* he did so in a way which required the same skills that had characterized art since the Renaissance. He relied on his pictorial skill to observe, record and build up the image. An engraving appeared in the *Graphic*, an easel-painted version appeared at the Royal Academy exhibition. By the turn of the century this network of connections was breaking down. The representation of everyday life was no longer tied to the system of practices which sustained fine art. The same motivation which had led Herkomer into the back streets of London drew photographers, whose use of the medium with connotations of science and objectivity gave them greater claim on the status of anthropologists than was ever possible for painters.

Attempts to record the complexity of human experience using photography had been developed from the mid-19th century as the incipient sciences of psychology and sociology had emerged. As cameras became more flexible and mobile, photographers such as Jacob Riis and Lewis Hine moved into the streets and workplaces to record the problems of the slums and the sweatshops. The idea that aspects of everyday life might be a 'dark' realm hidden from the light of social observation was given

real presence by the mechanics of the camera, its shutter literally bringing such truths to light.

At the end of the 19th century Oscar Wilde had slighted Frith's work by claiming that the painter had done much to 'elevate painting to the dignity of photography'. It was certainly true that Frith's attempt to visually survey and codify the modern crowd was most fully developed by a complex of social agencies in the new century. They continued to expand and penetrate into new areas as the technology of lens-based media improved. By the 1930s such documentary images were used to both reform and to control social experience. Photographic magazines such as *Picture Post* in Britain and *Life* in the USA sought to capture the range of human social action and the character of its agents. In doing so they called on the traditions for the representation of everyday life which stemmed back to the 16th century, captured close-ups of people at moments of fleeting expression like Hals's *Malle Babbe*, or in community festivities, the interiors of the home and in typical incidents of daily life. Such photo-essays organized these disparate moments into a discursive totality, commonly allied to a rhetoric of progress. Thus the Victorian conception of genre painting as engaged in a quest to encompass the totality of the modern world continues in the elaboration and circulation of images documenting, surveying and epitomizing social activity and its development.

Another aspect of the imagery of everyday life which continues into the 20th century is the uncertain cultural status it is accorded. In the 17th century John Evelyn had described Dutch painting as 'clownish representations'. As the means for making such representations moved from the paint box to the camera its problematic status moved with it. In the 20th century the old academic categories that had identified genre as vulgar entertainment in contrast to serious art were reconstituted as a distinction between commercial culture (or ▷'kitsch') and high culture (both traditional and ▷avant-garde). Modernist critics such as ▷Greenberg and ▷Bell castigated Victorian artists like Frith for involvement in commercial culture by appealing to popular taste.

Mechanized means for producing images of everyday life were seen as a threat to authentically valuable culture. Evelyn had seen his Dutch drolleries at a public market and complained that ordinary farmers were participating in their cultural and commercial exchange. Such images had been most closely associated with assertive market economies and broadly liberal political conditions, a fact which had not been lost on the Victorians. Twentieth-century consumer capitalism may be said to constitute the consummation of such trends. In this respect the technology of image-projection pioneered by Dutch artists such as Vermeer may in retrospect be seen as primal moves towards techniques which were only fully realized with the development of cinema.

The mixture of dismissal and disturbance which characterizes Evelyn's account of Dutch art (and Michelangelo's response to the Flemish) certainly finds echoes in 20th-century commentary on the cinema. Critics were right to see a connection with Victorian art. Both cinema and the more explicitly commercial medium of advertising drew on Victorian genre. Already in 1889 Frith's *The New Frock* (Port Sunlight, Lady Lever Art Gallery), which depicted a young girl showing off her latest acquisition, had been retitled *It's So Clean!* and used to advertise Sunlight soap. In the new century such redeployment and adaptations of genre pieces expanded. Everyday life was increasingly incorporated into the culture of commerce.

Likewise, the magic lantern slide shows which preceded the invention of cinema often drew directly on exhibited paintings and engravings, elaborating them into full narratives. Early film is closely dependent for its visual devices on the conventions developed in Victorian art. Viewers' participation in narratives constructed from a series of separate shots was facilitated by the methods developed in the Victorian art system. The mixture between the everyday and the historical which defined Victorian historical genre painting also fed into the cinema. The continuum between Victorian representations of everyday life and cinema is most apparent in the work of D.W. Griffith (1875–1948). His most ambitious film *Intolerance* (1916) draws the viewer into the narrative and defines its meaning in a way which might be seen as microcosm of the history of genre painting.

Intolerance moves between four narratives set at different periods of history. The main story is derived from modern life. Continuing the tradition of Frith, Egg and Herkomer, it tells of problems in the modern city, centring on the lives of working-class characters. This story is told in parallel to one set in ancient Babylon, presented as an opulent, pleasure-loving city devoted to love. Running in tandem with these are two shorter stories, one centring on the massacre of St. Bartholomew's Day in the 16th century, the other on episodes from the life of Christ. Several scenes in the Babylon and massacre sequences are almost directly derived from Victorian historical genre paintings; at one point Griffith

has his actors act out ▷Edwin Long's popular picture *The Babylonian Marriage Market* (1875, London, Royal Holloway College).

Just as Victorian painting sought to suggest parallels between modern and historical experience by using the idea of everyday life to break the conventions by which the past was identified, so Griffith draws the viewer in by creating psychological links between the centuries which are made coherent by the idea of ordinariness: common human desires and behaviour which persist across the centuries. The central working-class character in the modern story is linked to a peasant girl in the Babylon scenes by cross-cutting of a kind which derives from the devices exploited by Egg in *Past and Present*. Scenes cut from one figure to the other in ways which indicate to the viewer that the thoughts of the modern character counterpoint those of the historical one.

The aspiration towards intimacy which had been one of the recurrent themes of genre painting is thus further articulated by the mechanics of cinematic narrative. But the increasing tendency of modern genre to be concerned with surveillance is also apparent. Not only are the thoughts of the characters more fully visualized by cinema, the camera potentially moves across all spaces of action, surveying the entirety of possible experience. Indeed the narrative of the modern sequence is initiated by the attempts of a factory boss to control every aspect of the life of his employees, using social agencies to oversee their leisure hours and to enter their homes in order to police their morals.

This mechanism of control over everyday life is set in opposition to psychological and cinematic processes which set up parallels with historical experience. Like early forms of genre painting such as Velázquez's *Martha and Mary*, everyday experience is identified in relation to ethical maxims and biblical examples. Just as many Spanish and Dutch genre paintings include biblical stories juxtaposed with the apparently purely documentary aspects of the everyday, so Griffith cuts between the modern sequence and the story of Christ in order to set up ethical propositions in relation to the action. The technique is an extrapolation from the emblematic tradition deployed by the Dutch. Cutting is used instead of juxtaposition within the image, but the relation of the everyday to the biblical is identical and marks a striking link between the art forms across the centuries.

If *Intolerance* can be said to encompass the history of genre painting in its form and narrative technique, modernist artists took their cue from different aspects of the tradition which worked to contrary effect. For the French avant-garde of the 19th century the painter of modern life should be a realist, but not of the kind envisaged by Frith or Griffith. Manet's images of fleeting unexplained moments such as his *Two Women Drinking Beer* (1880, Glasgow, Burrell Collection) are not susceptible of invasion by cinema and advertising, as were the devices adopted by Frith. The figures are depicted at a moment which is caught between definable positions, the smudged surface and semi-defined figures identify modern life as something which escapes control and in which the motives for transactions are mysterious. Such images of alienation were developed into the 20th century by artists such as ▷Edward Hopper, in whose paintings the surface patterns and transactions which form everyday experience in the city are visions of moments, objects, spaces and events whose meaning is unattainable to view.

A different set of concerns is evident in the work of ▷Pierre Bonnard and ▷Eduard Vuillard, ▷Post-Impressionist painters whose style is sometimes labelled ▷Intimisme. As in Vermeer and Chardin the relationship between action and stasis identifies personal intimacy with aesthetic experience. Intimacy is a product of the fusion of subject matter with pictorial method. Scenes of private relaxation are painted in such a way that the whole space is equated with the interaction of surface patterns of colour into which figures, objects and spaces are integrated.

Such manipulations also characterize the appropriation of the values of intimacy and the use of signs of everyday experience in ▷Cubism. The paintings produced by ▷Georges Braque and ▷Pablo Picasso from around 1910 to 1914 combined elements of genre and still life. The fragmented depiction of objects in space has sometimes been compared with cinema, but the implications of Cubist technique work against those of Griffith and emergent commercial popular culture. Like Manet and the Intimistes, Cubist distortion and fragmentation incorporates the viewer into the process of constructing the image. Picasso's adoption of ▷collage from 1912 identifies aspects of the everyday which resist translation into a controlled space. In doing so, Picasso reaffirms the discontinuities and paradoxes of experience which date back to Campin's use of unintegrated perspective and apparently irrelevant and intrusive objects: co-opting the everyday to generate unstable conditions for the reading of significance. Unlike Campin or Griffith, Picasso does not have a framework of ethics or theology to provide the possibility

of a countering process of stabilization. Instead, the immediacy and problematic condition of our ordinary experience is identified.

It has been suggested that Picasso's style at this period is related to the politics of anarchism, which would set it in opposition to those commercial and liberal tendencies of the genre tradition which found their modern articulation in popular cinema. His Cubism is anarchistic in that it offers a direct and unstable immediacy in its representation of the mediated, distanced experience of social life provided by modern communications. The paper is the conveyer of news, but the circumstances in which it is read are palpable in ways that news is not. The Victorian and modern illustrated newspaper, seeking to sustain an intelligible transaction between image and text, is countered. Understanding, control and the surveying gaze are confronted by the ironic and playful physicality of objects and processes, the combination of matter in new forms.

This anarchic deployment of the everyday emerges in other forms of modernist art. Both ▷Dada and ▷Surrealism appropriated and disordered ordinary objects in more systematic ways than Picasso. ▷Kurt Schwitters transformed the detritus of modern culture into images which further emptied communications and commodities of their power to signify. Appropriately, the name he chose for this endeavour was ▷Merz, a meaningless fragment of the German word for commerce.

Schwitters, however, was instrumental in the development of ▷Pop art, the imagery of which identified a new form of everyday life which was increasingly encompassed by commodities and the imagined lifestyles by which they were rendered desirable. Spaces containing objects proliferated within a shifting aura of connoted values. In the 1520s Robert Campin had identified complexes of possible meaning by which all aspects of everyday life could participate of the sacred; contemporary consumer culture generates an endlessly elaborate network of connotations which penetrates everyday experience in the attempt to redefine all aspects of life in terms of commodities.

Bibliography

Alpers, S., *The Art of Describing: Dutch Art in the Seventeenth Century*, 2nd edn, London, 1989

Brown, C., *Scenes of Everyday Life: Dutch Genre Painting of the Seventeenth Century*, London, 1984

Cowley, R., *Marriage à la Mode: A Re-view of Hogarth's Narrative Art*, Manchester, 1983

Hook, P., *Popular Nineteenth-Century Painting: A Dictionary of European Genre Painters*, Woodbridge, 1986

Johns, E., *American Genre Painting: The Politics of Everyday Life*, New Haven, 1991

Johnson, E.D.H., *Paintings of the British Social Scene from Hogarth to Sickert*, London, 1986

Lambourne, L., *An Introduction to Victorian Genre Painting: From Wilkie to Frith*, London, 1982

Legrand, F.C., *Les peintures flamands de genre au XVIIe siècle*, Brussels, 1963

Masters of Seventeenth-Century Dutch Genre Painting, exhibition catalogue, Philadelphia, 1984

Norman, G., *Biedermeier Painting: Reality Observed in Genre, Portrait and Landscape*, London, 1987

Renger, K., *Adrien Brouwer und das niederländische Bauerngenre, 1600–1660*, Munich, 1986

Schama, S., *The Embarrassment of Riches*, Berkeley, 1988

Sir David Wilkie of Scotland, exhibition catalogue, Raleigh, 1987

Stammen, P., *Pietro Longhi und die Tradition der italienischen Genremalerei*, Frankfurt, 1993

Portraiture: Likeness and Identity

Shearer West

With more accuracy than is usually acknowledged, the novelist William Thackeray made one of the most pithy statements ever made about portraiture. 'When speaking of portraits', Thackeray wrote, 'there is never much to say.' It is easy to sympathize with Thackeray's statement, as portraiture is one of the most difficult and complex subjects in art history. The problems with interpreting portraits, or even talking about them intelligently, are manifold, and our response to them is coloured by a number of factors. To begin with, unlike ▷genre paintings or history paintings or even, to an extent, landscape paintings, portraits have no story; we cannot apply to them the sort of narrative descriptions that allow us to discuss other genres of art at such profound length. Secondly, our approach to portraits is more obviously subjective than our approach to any other kind of art. We tend to respond to the individual depicted, rather than the work of art itself; indeed, it is often very difficult to think of portraits as works of art at all. Finally, our response to portraiture is complicated by our own preconceptions: if we know anything at all about the individual depicted, our prior knowledge will inform our understanding of the portrait.

Our understanding of portraiture is further regulated by the particular problems that accompany the creation of a portrait. Most types of art require an artist, a subject and, in some cases, a patron. Among the principal concerns of art historians are the ways in which an artist chooses to represent his or her subject, and to what extent the patron interferes with that representation. However, portraiture requires an artist, a *sitter* and usually a patron who is the same person as the sitter. By replacing the subject with the sitter a further complication appears: the subject of the painting in this case can protest, direct, cajole or otherwise impose his or her expectations on the artist.

This concatenation of factors indeed makes it very difficult to talk or write intelligently about portraiture, and certainly art historians are prone either to dismiss portraiture altogether, or to subject it to a particularly impenetrable array of gnomic utterances. Writing about portraiture tends to be an uneasy mix of art, philosophy and psychology, while portrait painters vacillate wildly between revealing and disguising what they perceive to be the character of their sitters. In order to untangle some of these problems that accompany the study of portraiture it is necessary to focus on issues which inform the whole of portrait practice and interpretation. This essay seeks first to consider the nature and history of portraiture and then to deal with those themes that concern all portraits. These include: the question of how identity interacts with likeness; the issue of individuality in portraits; the ways in which the sitter's unique character is balanced against the iconic, social and gender functions of a portrait; how portraits of famous people contribute to the creation of a public identity; and finally the role of self-portraiture, where the artist and sitter are the same but where the interface between the revelation of individual identity and the socially constructed image is blurred, rather than resolved.

The limits of portraiture

In order to examine portraiture in any depth, it is necessary to define from the beginning what a portrait is, what it is not, and what its functions and purposes have been throughout history. This is not as easy as it may at first seem. Generally, portraits are works of art which depict a known or a named individual, and are intended to represent that individual in a way which is faithful to his or her appearance and reveals something about his or her character, status, profession or social role. However, a simple glance at the history of portraiture will reveal a number of works which do not fulfil some of these criteria. Many ▷Renaissance portraits, including examples by both ▷Titian and ▷Lorenzo

Lotto, represent individuals whose names have been lost. We can discern from their clothes and gestures that they are of a noble class, and we can reconstruct aspects of their character or interests from other clues in the painting. But they are neither named nor known individuals. Conversely, many of the genre scenes painted by ▷Impressionist artists at the end of the 19th century use models whose names have come down to posterity. Although the likenesses of these individuals may be faithful, a genre scene such as Degas' *Absinthe Drinker* (1876–7, Paris, Musée d'Orsay) cannot really be considered a portrait, as its role is not, first and foremost, representational. Determining when a represented individual is merely a model, and when that representation could be called a portrait, is often problematic. Although sometimes a representation of a person may appear strikingly lifelike, it is necessary to determine what that individual's role is within the work of art and whether or not that work was intended to be a portrait.

Part of the difficulty in distinguishing portraits from other forms of art can be related to the changing functions of portraiture throughout history. Until the Renaissance, and in some cases beyond, portraits were seen as substitutes for the real individual, and they carried with them a talismanic aura. The importance of tomb effigies in the late Middle Ages – some of which exhibited likenesses of the dead – can be related to this supernatural air that seemed to reside in a likeness. During the 15th century, when portraiture became more commonly practised, it also assumed more practical functions. Portraits were used as marriage lures or as documents of particular events; they were frequently exchanged by monarchs or commemorated the power and authority of individuals. By the 19th and 20th centuries, an expansion in the portrait market and changes in the art world meant that the previous limitations on the status of the sitter, the poses and accoutrements included, as well as the very nature of the portrait itself, all underwent enormous transformations. Portraits became ubiquitous and consequently, works which were not strictly portraits could take on some of the qualities of portraiture. Some of ▷Gros's romanticized images of Napoleon on the battlefield, for example, could be seen as ▷history paintings, but they contained faithful likenesses of Napoleon himself. ▷Gauguin deliberately rep-resented himself as Christ in some of his 'primitivist' religious scenes, but here the portraiture is used symbolically and is not perhaps as important as the wider implications of the artist's role signalled by Gauguin's work.

If portraits share anything, it is a representational quality and an illusion, if not a reality, of likeness. In the 20th century, there are a handful of 'abstract' portraits, such as ▷Charles Demuth's series of poster portraits, including *I Saw the Figure 5 in Gold* (1928, New York, Museum of Modern Art), a ▷Precisionist rendering of the poet William Carlos Williams. But these are exceptions, rather than the rule. Throughout the history of portraiture, most portraits contain representational qualities that allow the observer to discern the physical features of the sitter.

If we accept these ambiguities in defining a portrait, it is next necessary to understand what a portrait can and cannot reveal about the subject, the artist and the history of art. Roughly speaking, portraits give both external and internal signals about their subjects – the former are easy to isolate and define; the latter are more elusive. External qualities of portraiture may appear unproblematic. Historians often use portraits to illustrate their narratives of history, accepting as given the idea that a particular portrait faithfully represents a given individual. However, taking each external signal of a portrait separately, it is clear that these elements contain clues about more subtle aspects of history and the history of art. Expression, gesture, costume, background, props, lettering, as well as the size, media and original location of a work all reveal something important about the portrait and its function, in addition to information they give about the sitter.

Costume is one of the most important aspects of a portrait. Historians of fashion frequently use portraits as a means of identifying a chronology of costume, but art historians can equally read the costume as a sign of the status of the sitter. The extent to which a sitter's costume is formal or informal, professional dress or robes of state, as well as the question of whether the sitter is masquerading or wearing some other form of fancy dress, are all important in understanding a portrait. If a sitter is wearing antiquated costume, this may be either a satirical slur or evidence of that sitter's penchant for masquerade dress. The former is the case in ▷Quentin Massys's caricatural 'portrait' of *An Old Woman* (c1513, London, National Gallery) whose distorted features are underscored by the unfashionable and unflattering costume she wears; the latter is exemplified by ▷Johan Zoffany's painting of *John, Lord Mountstuart* (c1763–4, private collection) wearing 17th-century attire which was a popular form of masquerade dress with the English aristocracy in the mid-18th century.

Gesture and expression are even more revealing, but perhaps more elusive for the student of art history in the 20th century. Like dress, gesture has a history, and conventions of gesture and deportment have changed through the centuries. Many of these conventions have been lost to us, but in portraiture, they are important signals of the images sitters wished to convey. The way the body is held, the positioning of the hands and feet, and the direction of the gaze are all indicators of gentility or its opposite. Although facial expression has never been associated with social status to the same extent, art academies, such as the French ▷Académie Royale codified facial expression for artists. The Academician ▷Charles Lebrun and his followers conceived of expressions such as anger, fear and joy as being part of the business of the history painter, but the portraitist was concerned with facial expression as well, albeit in a more negative way. Until the 19th century, portraits were frequently devoid of expression, or expression was confined to lower classes of sitters, while in the 20th century, expression became an important tool for artists in conveying their sitter's state of mind. More important than expression to all portrait painters is ▷physiognomy, or the stable, permanent features of the human face. The ways in which these stable features are conveyed, idealized or possibly misrepresented can suggest interesting things about portrait practice and public expectations. Unfortunately, it is not always possible to recognize the level of idealization in a portrait, given that many of the represented individuals are no longer alive. We must, therefore, rely to a certain extent on more tenuous clues, including the level of 'realism' in a work, when it is compared with other contemporary types of art.

As we move away from costume, gesture and expression to the other external features of a portrait, we often find clues which are easier to interpret. Some portraits are painted without any background or accessories, but many portraits contain objects, landscapes, animals or other symbolic elements which have been chosen to convey something about the sitter. Some of these props are purely decorative. Seventeenth-century portraits frequently contain a column and a swatch of curtain which frame the sitter and add an air of grandeur to the work, but do little to characterize the individual depicted. However, other portraits rely on these additional props to carry a message about the sitter. This is the case in ▷Bronzino's portrait of the humanist *Ugolino Martelli* (1537/9, Berlin) who is holding a copy of Homer's *Iliad* in one hand and a book by fellow Italian humanist Bembo in the other. In the background of the work is a statue of ▷David, representative of the city of Florence to which Martelli owed his allegiance. The work is replete with signals of Martelli's personal interests. Another example can be seen in many colonial American portraits which contain items such as chairs, tables and teapots – seemingly gratuitous features which were, in fact, important signals of status in a youthful society which earned its power and influence through trade and sumptuary ownership.

Some Renaissance and ▷Baroque portraits contain an additional feature of lettering, which can either be placed on a painted scroll or on an illusionistic shelf positioned in front of the sitter. These words were frequently mottoes associated with the individual or his family. The ambiguity of many phrases included on portraits sometimes obscures, rather than aids, our understanding of the works.

All of these external features are contained within the portrait, but it is also necessary to look at some wider issues, including the ▷medium of the portrait, its size and its previous and current location. Sculpted portraits can take the form of tomb effigies or commemorative portrait busts, but their purpose is significantly different than that of painted portraits meant to be hung in the family home or ▷engraved portraits intended to be distributed on an open market. Portrait drawings are frequently intimate views of an individual who was close to the artist: ▷Watteau's drawings of his friend Nicolas Vleughels fall into this category, although Watteau later used his friend's features in some of his fantasy ▷*fête galante* scenes. Like media, size can also indicate something about a portrait. A vast state portrait of a monarch would have hung in a different kind of room than a ▷cabinet size ▷conversation piece, and would have thus served a different purpose than, say, a ▷miniature portrait. Finally, the original location of a portrait can reveal much about the way in which it was understood, although frequently such evidence of positioning is not available to us. If a portrait hung in a country house it would have had a different significance than one that was intended for a town hall. Today, the issue of location is further complicated by the existence of National Portrait Galleries, in which portraits now stand for certain values of a given nation or culture. Generally, the location of a portrait – whether it is private home or public museum – is an important piece of evidence in our understanding both of its function in the past and its function for observers today.

All of these aspects of portraiture are external features, those that can be identified and described, as well as interpreted. It is much less straightforward to try to read into a portrait any evidence of

psychology, personality or state of mind, although these are the most common subjective responses to portraiture. It is very difficult to avoid describing the subject of a portrait in terms of his or her character, just as it is impossible not to form such judgements of real-life individuals. Before the 16th century, such elusive qualities as 'character' were not the primary concerns of portraitists, whose principal purpose was to capture a likeness. ▷Leonardo da Vinci was one of the first to become interested in the idea that portraits should and could convey states of mind, although his own portraits, such as his mysterious ▷ *Mona Lisa* (1503/5, Paris, Louvre), elude any sort of reductive characterization. Such a concern with character was given new impetus from the late 19th century, when the new science of psychology inspired a greater attention to the inner life. German and Austrian ▷Expressionist artists in the early years of the 20th century were among the most important group to explore the possibilities of self-examination through portraiture.

However, any such reading of portraiture is dictated by external features, such as the skill of the artist, the choices made about how to represent the sitter's face and body, as well as what we already know about the sitter. If we look at any of ▷ van Gogh's many self-portraits, we immediately interpret them in the light of what we know about his incipient madness. But van Gogh saw his own self-exploration as a way of 'keeping an eye on himself', and the role playing in which he indulged in some of these works is indicative of careful artistic deliberation, rather than the uneasy workings of a disturbed and unpredictable mind.

The history of portraiture

Having determined the limits of portraiture, it is important to establish a chronological framework for its history. This is a mammoth task which taxes the limitations of even the best art historian, and it would be impossible to do full justice to a history that encompasses everything from ancient coins to modern photo-journalism. However, it is crucial to set up the framework of a history of portraiture in order to understand the ways in which portraits have changed through time and the different functions they have had in history. Perhaps more than any other form of art, portraits have played a public and utilitarian role that often obscures or even overrides their purely aesthetic qualities.

Portraits have an ancient origin. They were used in ancient Greece, and they appeared in ▷Etruscan art. However, they were most prominent during the Roman empire, when they became an important part of patrician family rituals as well as imperialist propaganda. Sculpted portraits of Roman emperors, including ▷equestrian statues, were placed in outposts of the empire as a way of reminding inhabitants of the ruler's existence. Given the breadth of the empire and the likelihood that an emperor would never visit certain parts of it, the image of the emperor became a genuine substitute for his presence. Coins and ▷medals distributed throughout the empire served a similar function, making the emperor's face familiar to anyone who purchased goods. On a smaller scale, the worship of ancestors amongst the upper echelons of society led to the importance of ▷death masks and seemingly realistic sculpted images of dead family members. Some of these images were carried in religious processions, and again they served as substitutes for the real individuals they represented. A realistic form of portraiture also existed in the Egyptian civilization from the 1st century AD. ▷Fayum portraits on mummy cases were startling representations of the dead, again serving as part of a funerary tradition.

The importance of portraiture to the pagan Romans and Egyptians was partly responsible for its decline during the Christian Middle Ages. Certainly portraits did not disappear entirely. Idealized representations of the Byzantine Emperor and Empress, Justinian and Theodora, appear in the ▷mosaics at the Mausoleum of Galla Placidia in S. Vitale, Ravenna, and tomb effigies in the later Middle Ages were sometimes modelled on death masks. But generally speaking, the idea of a portrait as a 'likeness' of an individual was undermined in favour of iconic representations or those which served a legitimate purpose as part of a religious ritual. The power of the Church in Europe limited the possibilities of representing individual human beings, and ▷Iconoclastic controversies halted the development of portraiture as well as other arts.

However, it was through a form of religious art that portraiture began to take on a new life from the 15th century onwards. In the Burgundian Netherlands, portraits began to be incorporated more frequently into ▷altarpieces. These took the form of ▷donor portraits, or portraits of the individuals who were responsible for commissioning the altarpiece and donating it to a church or chapel. From the ▷Master of Flémalle's famous representation of the Inglebrechts family on the left wing of his ▷ *Merode Altarpiece* (New York, Metropolitan Museum), donor portraits became more and more

realistic in the Netherlands, and they became an increasingly important part of altarpieces. What is perhaps more significant is that freestanding portraiture also became more common. The most famous early example of this, ▷Jan van Eyck's *Giovanni Arnolfini and His Wife* (1434, London, National Gallery), still contains religious undercurrents in its symbolic representation of the Sacrament of marriage. However, later portraits by van Eyck, and his followers ▷Rogier van der Weyden and ▷Petrus Christus, are stripped of any religious references and focus on the likeness of the individuals, many of whose names are lost to us.

While realistic portraiture gained a new prominence in northern Europe, Italy was experiencing its Renaissance. As in the North, Christianity did not simply disappear, but it was incorporated into new philosophies and new power structures. In Italy, the importance of ▷humanism allowed a cult of man to flourish within a Christian context, and it also gave rise to a reassessment of the importance of the Classical world. Portraiture gained a new place in the changing art world of 15th-century Italy, and an idealized form of portraiture flourished with enthusiastic patronage from the Florentine aristocracy. Artists like ▷Antonello da Messina, Pisanello and ▷Piero della Francesca all produced portraits based sometimes on Flemish models and more often on ancient coins and medals. Idealism continued to dominate Italian portraiture into the 16th century, when a more subtle approach to the character, class and attributes of the sitter was taken. Artists such as Titian were skilled at varying the poses of their sitters and endowing their figures with a startling verisimilitude, while painters like Bronzino added a new elegance to portraits of the nobility.

Throughout Europe, the 16th century brought about interesting changes in both the function and the aesthetics of portraiture. During this period, artists such as ▷Dürer in Germany and ▷Parmigianino in Italy introduced self-portraiture as a new mode of representation. In addition, the subjects of portraiture became somewhat more diverse, as ▷Holbein painted a series of realistic individual portraits of German steelyard merchants during his visit to London in the 1520s and 1530s. Finally, the introduction of the new technique of engraving into visual representation meant that it was now possible for portraits to be engraved and widely disseminated. Martin Luther exploited engraved portraits of himself based on paintings by his friend ▷Cranach as a way of familiarizing European citizens with the initiator of the Protestant ▷Reformation.

If the 16th century was an expansive and experimental period for portraits, the 17th century was much more a period of extremes. The absolutist ambitions of a handful of European monarchs meant that portraiture was dominated by a court ethos and a limited number of powerful patrons. Ironically perhaps, the 17th century is also the period of some of the most masterful portrait painters, such as ▷Van Dyck, and ▷Velázquez. Although much court portraiture was little more than propaganda for the power, learning and wealth of its subjects, Velázquez could also produce sensitive portrayals of court dwarves and ▷Bernini could sculpt a sensuous bust of his mistress Costanza Buonarelli (1630s, Florence, Bargello) with her lips parted and her dress in disarray. In complete contrast, the United Provinces (later the Dutch Republic), with its notionally more republican social structure, could boast a number of portraitists, such as ▷Hals and ▷Rembrandt, whose skill was representing groups of citizens. The many portraits of civic guards and governors of charitable associations that were painted by these artists gave a new credibility to a very important middle class. In many significant ways, 17th-century Dutch portraiture presaged the changes that would dominate portraiture throughout the next two centuries.

These changes consisted primarily of an expanding market for portraiture that coincided with the rise of middle-class power in Europe. By the end of the 18th century, some English artists could complain that the ubiquity of portraiture meant that having one's portrait painted could no longer be considered a signal of gentility. Anyone with a reasonable income could afford to commission a small portrait, and the expansion of the print market meant that more and more portraits were engraved and were thus publicly available. The ▷pastel portrait became common, especially in France and Italy, where it was put behind glass to form part of the decor in ▷Rococo interior design. Furthermore, portraits became more varied. The realism of ▷Wright of Derby's portrait of the industrialist Richard Arkwright (1789–90, private collection) was in striking contrast to the fantasy of Joshua Reynolds, *Mrs. Siddons as the Tragic Muse* (1789, London, Dulwich Picture Gallery). Children became a more frequent subject of portraiture, and groups became more varied and unusual.

From 1790 to the defeat of Napoleon in 1815, these changes in portraiture coincided with what has been labelled the ▷Romantic movement in European art. In the portraits of ▷Goya, ▷Lawrence

and ▷Runge, these Romantic qualities can be detected. First of all, portraits began to veer towards greater extremes of heroism (Gros's portraits of Napoleon) and intimacy (Runge's portraits of children). Secondly, portraiture began to be a less defined art, as it took on the qualities of history or genre painting. Likeness was no longer the primary concern of the portraitist.

To an extent, these changes characterized 19th-century portraits as a whole, but there were other important factors that changed portraits beyond recognition by the 1890s. First of all, photography, especially in the form of the ▷carte-de-visite, rendered the practice of miniature painting obsolete. People who wished to have small images of their loved ones or friends could now have photographs of them, which served the same purpose. Another consequence of photography was that the need for a straight 'realistic' representation of an individual was now fulfilled, at least in theory, by the camera, so that painters could find new ways to approach their subjects. Portraiture came to be used more frequently as a means of formal experiment in the work of the Impressionists and the ▷Post-Impressionists, who employed a new variety of poses, colourism, situations and roles in their portraiture. Furthermore, although public portraiture of a grandiose kind continued to exist, private portraits of friends or acquaintances became more common, and the 'lower' classes – previously beyond the scope of painted portraiture – gained a new importance in representation.

All of these factors remained in the portraiture of the 20th century, but other aspects were highlighted by different individual artists and movements. For example, ugliness was exploited by ▷Egon Schiele in his ▷Expressionist self-portraits, in which he deliberately employed awkward poses and extreme facial expressions as a means of testing the limits of his media. The psychological penetration advocated by Expressionist artists was in contrast to the more formalist or seemingly 'objective' renderings of artists such as ▷Picasso and ▷Matisse, for instance in Matisse's portrait of his wife with a green stripe painted on her nose (1905, Copenhagen Museum). Later in the 20th century, the expansion of new technologies meant that photography took on a new prominence in portrait production, with artists such as ▷Cindy Sherman and Richard Avelon, while the possibilities of ▷mass media were investigated by ▷Pop artists in their images of famous faces.

Generally, the 20th century has witnessed another watershed in the history of portraiture. Artists began representing individuals not necessarily because they were important, but because they were interesting in some way. Public portraiture, such as the sort of portraits that exist in almost every boardroom or university in the country, did not cease, but there has been a general shift from portraiture representing public individuals to the representation of private persons or the private aspects of famous people. Likeness, although still important, is often avoided in favour of deliberate attempts to capture something essential about the individual. The self-portrait has gained a new prominence, and nudity has been regularly introduced into portraiture – thus confusing the categories of portrait and model still further. Finally, the mass media have had a powerful impact on portraiture, particularly of well-known individuals.

This brief survey highlights the complexities, diversity and problems of the history of portraiture, but it is necessary to look closely at particular aspects of portraiture to deal more directly with its importance to the history of art.

Likeness and identity

When speaking of portraits, we are prone to polarize the concepts of 'identity' and 'likeness': likeness is seen to be concerned with the external physical features of the portrait's subject, but identity is seen to be something more essential about the sitter's character. However, this dichotomy is not as unambiguous as it first appears, because our understanding of the sitter's identity relies greatly on the likeness presented to us, and that likeness itself is riddled with problems. This issue can be put into context by comparing two portraits of the same person painted at different times by different artists. Jan van Eyck's *Madonna with Chancellor Rolin* (1436, Paris, Louvre) and Rogier van der Weyden's *Last Judgement* altarpiece (1450s, Beaune, Hôtel Dieu) both contain portraits of Chancellor Rolin – an important and powerful official in the Burgundian court of Philip the Good. In comparing these two depictions, we can see a similarity in the images, and we can tentatively concede that both artists have fulfilled the first requirement of portrait-painting – that is, capturing a likeness. However, the likenesses presented are different in approach: van Eyck shows us a confident, well-dressed and well-fed Chancellor Rolin, who is given a virtually equal status to the Virgin herself in this devotional altarpiece. Van der Weyden's Rolin is humbler in both dress and demeanour, and the ravages of age are beginning to tell

on him. In these two images, we are looking at two different views of the same person – *identities*, rather than identity. Van Eyck shows Rolin at the height of his powers; Rogier shows him near his deathbed. Furthermore, the context of each work must be taken into account: van Eyck's altarpiece was painted for Rolin's private chapel, but van der Weyden's portrait was part of an altarpiece of the Last Judgement which was to be placed in the hospital at Beaune. Rolin's role – and hence his identity – in these two contrasting visions was not consistent, and the depiction of him was tailored as appropriate to the larger works which contained them.

Indeed, we can too often be fooled into accepting what appears to be a good likeness as a stamp of identity. ▷ Ghirlandaio's portrait of an *Old Man and his Grandson* (Paris, Louvre) shows a distinctive individual with a deformed nose – the result of elephantiasis; in contrast, ▷ Godfrey Kneller's portraits of members of the ▷ Kit-Cat Club of c1702–21 (London, National Portrait Gallery) represent each individual with a neat wig and bland expression. This does not mean the former image is a more faithful likeness than the latter, although it was Kneller's ostensibly samey portraits of the club members that led the French writer, the Abbé le Blanc, to claim that British portraits seemed to be merely so many copies of the same original. Certainly the Kit-Cat Club portraits look alike to us, and we can not only question whether they uncover the identity of the sitters, but we can even wonder whether they are, in fact, faithful likenesses. If we stand back a bit, we will realize that what makes them seem so much alike are very superficial things: the fact that they are all in the same half-length format and the fact that most of the sitters wear wigs. In truth, we have lost the referents that would allow 18th-century British observers to read the signs of gentility and professional status in the gesture and costume of these portraits: they mean nothing to us, but they would have done to a contemporary observer. Conversely, the Ghirlandaio portrait – allegedly painted from a death mask – seems more faithful because so much artistic energy has been invested in the sitter's bulbous nose. A 20th-century audience can relate better to a nose than to a wig. However, accepting this unusual facial characteristic as a sign of identity is also rather dangerous: it is just as possible that this could be an exaggeration and thus no more revealing in actuality than some of the idealized profile portraits of women painted by Ghirlandaio's contemporaries ▷ Botticelli and ▷ Baldovinetti.

At this point, we begin to enter the realms of ▷ caricature. Caricature focuses on a single physical feature and exaggerates it, but it also indicates that this feature somehow stands for the character of its possessor. A caricature can hardly be called a likeness, but it is thought to be as much a stamp of identity as a passport photograph is today. ▷ Hogarth's caricature of the radical politician John Wilkes (1763) focused on Wilkes's well-known squint, while ▷ Gillray's *Smelling out a Rat* (1790) isolated the famous pointed nose of another politician and writer Edmund Burke. The squint and the nose are, to an extent, embodiments of the identity of these respective public figures, but they also distort that identity by couching it in a single feature, rather than in the whole character of the individual.

Like identity, likeness is also subject to distortion and misrepresentation. Until the 19th century, 'likeness' was a common synonym for portraiture, and this idea reached back to the ancient world, where the aim of art was felt to rest in ▷ mimesis, or the imitation of reality. Even the Italian word for portrait, '*ritratto*' means, literally, 'to reproduce', and until the 20th century, few artists questioned that this was the ideal of portraiture – whatever they may have done in practice. However, likeness is such a fragile concept that many sitters in the past were not able to accept images of themselves as true likenesses. The most notorious and well-documented of these fussy sitters was Isabella d'Este, who, in 1493, complained of the difficulty of finding 'painters who can perfectly counterfeit the natural face'. She dismissed portraits of herself as not being true likenesses, and accepted only the effort of ▷ Francesco Francia, which was done without a single sitting. Indeed, when Titian painted Isabella in 1534, she refused to sit for him, and urged him instead to copy Francia's image, which had been painted 25 years earlier. In this instance, the representation of the individual had little to do with the true human likeness.

When considering likeness, it is necessary to take into account why the portrait was produced and what it was used for at the time. Holbein's portraits of Anne of Cleves (Paris, Louvre) and Christina of Denmark (1538, London, National Gallery) were intended to be likenesses, but they were used as marriage lures for Henry VIII, who was unable to meet the women themselves before he made a decision about his fourth wife. He rejected Holbein's depiction of Christina, but was attracted by Anne of Cleves. However, when he met Anne, he was disappointed that she failed to live up to Holbein's image of her. Holbein's conception of a likeness did not match Henry VIII's perceptions,

but we can assume that Holbein at least attempted to reproduce what he thought he saw when he painted Anne of Cleves.

The layers of difficulty which emerge when we try to extract likeness from identity are further complicated when we consider more generally the issue of individuality in portraiture. A portrait is intended to be a likeness of an individual, but most portraits contain a blending of individuality with some opposing quality. Portraits construct identity not only from the individuality of the sitter, but from their iconic, social and ▷gender status. In each case, identity in portraiture is made to encompass a whole range of seemingly contradictory elements.

The individual and the icon: royal and presidential portraiture

We could say that the individuality of each portrait rests in the face, but most portraits are not simply discrete images of faces. In fact, the face often takes up the smallest amount of space in a portrait and portraits usually contain much more than simply the face. The balance between the representation of the face and all the other elements in a portrait is very important, and sometimes the face can seem the least significant aspect. Indeed, the face can become so codified as to be treated almost like another inanimate object, and in these cases, the portrait becomes more of an icon than a representation of an individual. This idea can be illustrated most concretely by looking at European royal portraits.

Royal portraiture has always had a very specific role to play: it is rarely private, and the public function it needs to fulfil constrains the modes of representation allowed to the artist. The many portraits of Queen Elizabeth painted during her reign are an obvious example of this (R. Strong, *The Cult of Elizabeth*). The earliest portrait of Elizabeth – painted before it was clear that she would be queen – shows her at age 14. In this case, the anonymous artist sought to individualize the representation: he attempted to depict her character by stressing her serious countenance, and the setting in which she is placed is as much a domestic space as a symbol of her status or abilities. However, after Elizabeth became queen, the issue of representation was complicated by her powerful position as head of Church and State, as well as the problematic fact that she was a woman. Subsequent portraits of her began as marriage lures, and, when it became clear that she would never marry, these portraits congealed into icons of her virginity. The importance of her image was confirmed by a draft decree of 1563 which sought to establish control over the publication of her engraved image. The decree called for a 'perfect pattern' on which all portraits of the queen should be based. Although the decree was ultimately ineffectual, later portraits of Elizabeth played down her personality and concentrated on her symbolic virtues and authority.

Among the many iconic portraits of Elizabeth are the so-called *Sieve Portrait* and the *Armada Portrait*. These are both prototypes for a series of portraits in which the imagery and the Queen's own frozen stance contributed to a contrived representation. The Sieve portraits show Elizabeth holding an implement that she would probably never have cause to use in everyday life. But the sieve was the attribute of the Roman vestal virgin Tucca, who filled a sieve and carried it to a temple without spilling a drop as a way of proving her virginity. Here, the Queen's virgin status is stressed in tandem with her imperialist ambitions – represented by the globe in the background. Although there is no reason to suppose any real relationship between her virginity and her desire for conquest, the two are deliberately linked here by the artist. Conquest is equally exemplified by the *Armada Portrait* of 1588, which also features the globe and includes the defeat of the Spanish fleet in the background. By the time this portrait was painted, there was very little character remaining in the queen's face; she had become an icon, a symbol, and the real facts of age and decay were erased.

The portraits of Elizabeth are the most obvious examples of the ways in which individuality can be transposed into icon, but other royal portraits show similar factors at work – albeit more subtly. The portraits of Henry VIII by Holbein on the surface appear to be more 'realistic' and perhaps 'individualistic' than those of his daughter Elizabeth, but in these works too we are subjected to a frozen image which is imbued with symbolic representation. Indeed, Henry's codpiece, which many observers today avoid with embarrassment, was a very important symbol of his potency as a man and as a king. It was essential, in fact, that the king had the biggest codpiece in the court. Here is another example of costume and attribute detracting from the importance of the face, the individual, the likeness.

Portraits of monarchs in the 17th century show similar sorts of iconic tendencies. Van Dyck's various portraits of Charles I are laden with symbolic trappings which emphasize Charles's absolute authority, whereas the face of the King – however well represented – is frozen into a tight, lifeless mask. One

could argue, perhaps, that Velázquez's portraits of Philip IV of Spain offer a contrast to those of Van Dyck, as they are bereft of such elaborate trappings, and they do not idealize the king. But care must be taken not to accept an unidealized image as somehow more correct than an idealized one. Velázquez's Philip IV may lack the perfection and nobility of Van Dyck's Charles I, but he is given the unmistakable nose and lips of the Habsburg family – a definite indication not only of his own power as king of Spain, but of the imperial power of a whole dynasty. In this case the physical features themselves become iconic.

The iconic aspects of Velázquez's and Van Dyck's portraits were, to an extent, echoed in America, when early presidents of the United States had their portraits painted. The numerous representations of George Washington by ▷Gilbert Stuart are in some ways lifeless masks, but they were intended to embody the moral superiority of the new nation's leader. Washington came to stand for the United States, and the proliferation of Stuart's images led them to be classified into a series of types – the so-called Athenian, Lansdowne and Vaughan portraits. Each of these portraits contains the same calm, expressionless face and powdered wig. The ability of this group of portraits to become iconic embodiments of national character continues today through the presence of Stuart's image of Washington on the American one dollar bill.

Individuality and the social construct

It is not surprising that images of monarchs and presidents had an iconic purpose, particularly given their commemorative and propagandist functions. However, when attempting to identify the iconic aspects of the great majority of portraiture, we are faced with a more complex social and political problem. Specifically, we need to be able to define what that individual's role is within his or her society and the ways in which the portrait represents, or perhaps disguises, that role.

Again, one can initially be deceived by the 'realism' of a portrait. Hogarth's portrait of *Captain Coram* (1740, London, Thomas Coram Foundation) is acclaimed as a faithful likeness of the sea-captain and philanthropist, largely because it shows him wigless, fat enough to burst out of his waistcoat, and sitting rather ungracefully with his feet not quite reaching the floor. But the work is also a symbol of Coram's accomplishments, and contains those Baroque trappings which characterized royal portraiture of the 17th century. The globe and the sea behind indicate Coram's career as a sailor, while the medal he holds in his hand alludes to his role as creator of the Foundling Hospital – a much-needed haven for abandoned children in 18th-century England. The identity of Coram is thus constructed as a mix of character and social position.

The art historian ▷Bernard Berenson drew a neat distinction between what he called 'portrait' and what he called 'effigy': the former intending to individualize character, and the latter reflecting only the sitter's social mask. According to Berenson, 'The effigy aims at the social aspects of the subject, emphasises the soldierliness of the soldier, the judiciousness of the judge, the clericality of the clergy.' But what Berenson did not really acknowledge is that most, if not all, portraits take on this quality of effigy. However seemingly individual the identity represented, it is strongly affected by a whole series of social factors which influence both the representation itself and our reading of it. Even facial configuration and expression are not without their social dimension. Before the 20th century, any portraitist who was determined to individualize his sitters was to an extent hampered by an academic system of facial expression and facial type that was difficult to avoid. From the Renaissance, the idea that facial expression could be codified was a commonplace, and it was frozen into academic theory in the 17th century by the French artist ▷Charles Lebrun. By the end of the 18th century, the Swiss theologian ▷Johann Caspar Lavater had gone even further. He claimed that each human physiognomy revealed specific character traits, and with a mix of religious moralizing and scientific taxonomy, he set forth a series of types of faces which had a strong impact on art for the next 100 years. Similar sorts of taxonomic experiments were carried out by the 18th-century Austrian sculptor ▷Franz Xavier Messerschmidt, who used his own head as a means of testing different facial expressions. Messerschmidt's expressive heads have subsequently been interpreted as signs of his impending madness, but in truth, they reveal an approach to portraiture as a form of signification that had much in common with the physiognomic theories of his time.

The notion of type strongly underlies many portraits, however 'individual' the sitter appears to be. For example, when ▷Géricault painted his series of ten 'portraits' of mad men and women in the mental hospital at Bicêtre, he seems to have responded to the particular facial features and manifestations

of illness characteristic of the individuals he depicted. The kleptomaniac and the envious woman, for example, could not be more strongly characterized and differentiated, despite the fact that they were painted in the same half-length format, without a background. But some art historians believe that these portraits were painted to illustrate a new taxonomy of madness devised by Dr. Étienne-Jean Georget at Bicêtre (S. Bann in G. Clarke (ed.) *The Portrait in Photograpy*). If so, they are not so much individuals, as individual manifestations of a type, and it is the type, rather than the individual, that Géricault sought to represent.

The whole problem of individual character versus typology was thrown into context after the invention of photography problematized the practice of portraiture. Early photographers were fond of referring to their sitters as 'human documents' – thus stressing not only the scientific aspects of their apparatus, but their scientific approach to their human subjects. The most famous example of this is the Weimar photographer August Sander, whose series of types, *Face of Our Time* and *People of the Twentieth Century*, were published in Germany in the 1920s and 1930s. Sander claimed, 'The photographer with his camera can grasp the physiognomic image of his time.' To Sander's mind, it was possible to find individuals who embodied entire professions and social classes. His *People of the Twentieth Century* included such categories as 'The Farmer', 'The Craftsman', 'The Artist'. It also comprised a special category, 'The Last People', which embraced such sub-categories as 'Disabled Man', 'Man Selling Matches', 'Recipient of Welfare Assistance', 'Beggar' and 'Unemployed Man'. Each of these carefully contrived images was intended to represent a particular type, but the individuality of each face cannot be denied.

Gender in the portrait

Individuality in portraiture is constantly competing with iconic and social signs, but the role ▷gender plays in the creation and understanding of a portrait is even more problematic. There is no reason to suppose that any significant difference should exist between portraits of men and portraits of women, but a close study of the history of portraiture indicates that such a distinction does exist. Although certainly there are exceptions, as a general rule, before the 20th century, portraits of women tended to be much more idealized, allegorized, historicized or otherwise falsified than portraits of men. When searching for signs of individuality in portraiture (as opposed to signs of typology), it is more difficult to find this in portraits of women than in those of men. The most blaring example of this is ▷Sir Peter Lely's series of so-called 'beauties' for Windsor Castle which depicted the notable women of King Charles II's court in England. Lely's beauties have been referred to as 'pin-ups' because they represent the women in déshabillé, casting luscious glances out of the canvas (D. Stewart in *English Portraits of the Seventeenth and Eighteenth Centuries*). However, the use of the anachronistic term 'pin-up' reveals as much about the prejudices of art historians as it does about the effect of the works. When Pepys said of these portraits that they were 'good, but not like', he isolated the fact that they did not really represent the women themselves, but some kind of ideal woman. A close analysis of the Windsor beauties reveals that most of the paintings are laden with imagery which alludes to the relationship between ideal love and beauty. The women are thus allegorized and become symbols of beauty, rather than individuals in their own right.

A similar sort of idealizing can be see in the various portraits ▷Dante Gabriel Rossetti painted of his wife ▷Elizabeth Siddal in the mid-19th century. Rossetti's drawings of Siddal in various poses show her to be melancholy, listless and languid – although contemporaries attest to the fact that her real character was more commonly vivacious and mischievous. But not content merely to draw portraits of Siddal acting out of character, Rossetti, and others of the ▷Pre-Raphaelite circle, placed her in historical or allegorical paintings. ▷John Everett Millais, for example, used her as a model for his *Ophelia* (1851–2, London, Tate Gallery), in which she was required to lie in a bathtub to mimic the watery death of Shakespeare's heroine. In such works as these, the real Siddal collapsed into the fictional being, and her subsequent bout of illness – caused by the chill bath water – gave rise to a series of legends about her and her relationship with the Pre-Raphaelite circle. In paintings like *Ophelia*, Siddal's face was recognizably her own, but it was crystallized into an unreal mask which bore very little relationship to her true character or indeed likeness. Rossetti and others of the Pre-Raphaelite circle idealized Siddal through their art.

It would be convenient if such constructions of womanhood were solely confined to male strategies of portraiture, but, in fact, they were not. Rossetti's own contemporary, the photographer ▷Julia

Margaret Cameron, worked a similar magic on her photographic portraits of women. When Cameron photographed men such as Tennyson, Carlyle and Darwin, she entitled these works 'Tennyson', 'Carlyle' or 'Darwin' – even though she certainly attempted to invest poetic associations into her representations of them. But when she photographed her acquaintances Maria Spartali, May Prinsep and Alice Liddell, she gave the works titles such as 'Pomona', 'Circe' or 'Christabel'. Thus although these works were also a form of portrait, the portraiture was subordinated to the allegorical function. Indeed, one of the most famous women artists in history – Artemisia Gentileschi – painted herself as *Pittura* (Royal Collection), or the allegory of painting, borrowing the allegorical trappings from ▷Cesare Ripa's famous emblem book, *Iconologia*.

This analysis of the opposition between individuality and gender does not really account for the reasons behind it. It is possible to argue that before the 20th century, women had less social prominence and less of a public function than men, and therefore their public or social roles were subordinated to their 'womanhood'. But this only goes a short way to providing an explanation, and in truth, the sort of 'role playing' characteristic of portraits of women was not simply confined to them.

The issue of gender in portraiture should not be ignored when examining portraits of men as well. For a start, the very fact that their social status or profession often takes prominence over their more abstract qualities indicates the roles they were expected to play in their societies. Masculinity and all its attributes were not stable entities, but ever-changing manifestations of social expectation and prejudice. For example, the standing cross-legged pose characteristic of so many male portraits of the late 18th century was a signal of status and gentility that was important to both middle- and upper-class male sitters. When Joseph Wright of Derby painted the poet Brook Boothby lying on the ground in a seductive, feminized posture (1781, London, Tate Gallery), he was deliberately undermining a tradition of genteel masculinity and alluding to the new 'man of feeling' advocated by followers of the Enlightenment philosopher Jean-Jacques Rousseau. This is only one example, but it is important to remember that in portraits of men, as well as those of women, the issue of gender should not be disregarded when evaluating the image.

Portraits of the famous

As with portraits of women, role playing is one of the most important aspects of portraits of famous people, especially in the 20th century, when music and film stars replace monarchs as national icons. When considering the issue of fame in portraiture, the subject of identity takes on additional, sometimes disturbing, implications. Some of the portraits discussed so far represent individuals who were famous in their own time and, in some cases, continue to be so today. In many cases – particularly representations of monarchs – the portraits went some way to reinforcing public perception of these famous people, as well as helping to shape that perception.

From a very early point in the history of portraiture, people realized the extent to which portraits could contribute to the image of a public figure. In the ancient world, public sculpture was meant to have an edifying function, by showing common people the visages of great men through sculpture and coinage. But it also had imperial implications, and emperors such as Augustus ensured that their likenesses graced every major town within their empire. The same sort of imperial ambitions were expressed by the English Queen Victoria, and it is no surprise that statues of the queen were legion in India during her reign. Where the monarch was unable to appear, the image was sent instead. With the advent of engraving in the 15th century, this idea of disseminating an image was consolidated, and Martin Luther was one of the first public figures to ensure that his image was frequently painted and, more effectively, engraved. In attempting to battle with the Roman Catholic Church and impose his reformed version of Christianity, Luther realized the importance of making himself into a familiar figure throughout Europe. Art thus contributed to the spreading of fame and the creation of an image.

The use of portraiture as a way of disseminating images of famous people was satirized in the 20th century by ▷Andy Warhol, whose various images of Marilyn Monroe, Elvis Presley and others in the 1960s and 1970s are as much ironic as serious. On one level, Warhol pointed to the tendency of popular culture to inundate daily life with depictions of the famous: the sheer tedium of some of his ▷silk-screen images with their slick, mass-produced lifelessness reminds us just how influenced we are by repetition and familiarity. There is something vacuous in this imagery; we learn little about Elvis or Marilyn from photographs of them, despite the fact that they are as familiar to us as our own faces. In

this respect, we accept familiarity as a knowledge of individuals which we, as strangers, cannot really pretend to have.

Such shaping of public perception still dominates portrait photographs of the famous, and is exploited by professional photographers who reinforce the images being constructed. Robert Mapplethorpe's numerous photographs of the famous and the fashionable reinforced, rather than tempered, the cosmetic aspects of his subjects. His famous sitters played roles, showing a full awareness of being photographed and projecting images which Mapplethorpe had helped to construct. The intentional falseness in these public projections is part of their allure and reveals a perhaps cynical awareness that none of us have a single, definable identity, but that we are all composed of fragments which embody themselves in a plethora of contrasting roles.

Self-portraiture

In trying to discover any single identity in portraits, we are constantly forced back to this idea that the sitters are playing roles or otherwise projecting aspects of character or social position which may or may not be faithful embodiments of their own identity. But the final resting place in the search for identity in portraits must be in self-portraiture, where the artist and subject are the same. Self-portraits may seem at first glance to be the most honest and accessible types of portraits, given that they are fully in the artist's control. But given the complexities of any individual psychology, self-portraits more often reveal, conceal or falsify the character of the artist. When exploring self-portraits, we need to ask ourselves a series of questions: are self-portraits really more revealing than any other form of portraiture? Why did the artist choose to paint self-portraits? Is the artist using self-portraiture to glorify his or her own role? To what extent is the artist experimenting or role playing?

The latter is a particularly important question, as role playing was characteristic of self-portraiture from the start. This can be seen in some of the earliest painted self-portraits by Dürer. Dürer's self-portrait of 1498 shows him as an aristocratic man about town, wearing affected Venetian dress and projecting an image of confidence and security. More significantly, in 1500 he painted himself fully frontal in the pose of the *Salvator Mundi* – Christ as the Saviour of the World – an arrogant role for any human being to assume in the early 16th century. But these roles are neither pure falsifications nor are they merely games. It could be argued that this role playing was a genuine attempt to examine his own identity and to come to terms with himself. This is one theory that is often applied to Rembrandt's many self-portraits. Like Dürer, Rembrandt is undoubtedly playing roles in these portraits, and attempts to link them up with various moments and crises in his life are bound to seem like amateur psychology. But despite the massive amount written about Rembrandt's self-portraits, they still remain something of a puzzle. On one level, the very skill in which they are painted seems to reveal something of a real character, a real identity that is perhaps rather difficult to define; however, we cannot escape the obvious deliberation behind some of these works – the archness, the dressing up – that gives them a playful, rather than a serious, quality. Given the fact that some of these putative self-portraits may have been painted in part by studio assistants complicates the matter further.

Certainly, self-portraits do not resolve the issue of identity, but problematize it. In the early 20th century, German and Austrian Expressionist artists concentrated a great deal of their attention on the self-portrait, seeing in it a means of plumbing the depths of their own souls. But even in these works we see much that is contrived. Egon Schiele's many watercolour self-portraits were partly based on photographs of himself. Although Schiele, like other Expressionists, was ostensibly revealing the soul, he was actually much more interested in the body. His photographs and watercolours reveal that he was fascinated by the visual possibilities of his own body – particularly the idea of distorted limbs and anything else normally branded as 'ugliness'. His fascination with the body constructs his own body into a sort of abstraction which disguises, rather than reveals, anything about his character.

Indeed, at the close of the 20th century, the body has replaced the face as an object of attention in self-portrait photographs. Contemporary artist/photographers such as ▷Bruce Naumann frequently avoid any attempt to convey or reveal character or status, and they show themselves as distant figures – fragmented or separated in other ways from the main focus of their art. In photographs such as these, the self-portrait does not reveal identity, nor is it another form of role playing. In these works, the individuals become a sort of raw material for what could be described as a form of still life.

In portraiture today, the problem of identity is even more vexing than it has been in the past. Today, we know more and more about what people look like, but less and less about what they really are.

Roles are assumed and then cast aside at will; identities are subject to fashion; falseness or artificiality is praised and eagerly sought. We are constantly forced to question whether or not there is such a thing as identity, and individuality is no longer seen as something desirable. Perhaps today more than ever, portraiture has an important role to play in exposing and expressing the problem of identity.

Bibliography

Billeter, E. (ed.), *Self-Portrait in the Age of Photography*, exh. cat., Lausanne, 1985

Brilliant, R., *Portraiture*, London, 1991

Campbell, L., *Renaissance Portraits*, New Haven and London, 1990

Clarke, G. (ed.), *The Portrait in Photography*, London, 1992

Comini, A., *Egon Schiele's Portraits*, 1974

Craven, W., *Colonial American Portraiture*, Cambridge, 1986

Garrard, M.D., 'Artemisia Gentileschi's Self-Portrait as the Allegory of Painting', *Art Bulletin* (no. 62, 1980), pp. 97–112

Koerner, J., *The Moment of Self-Portraiture in German Renaissance Art*, Chicago, 1993

McQuillan, M., *Impressionist Portraits*, London, 1986

Miles, E. (ed.), *The Portrait in Eighteenth-Century America*, Newark, 1993

Perry Chapman, H., *Rembrandt's Self-Portraits: A Study in Seventeenth-Century Identity*, Princeton, 1990

Piper, D., *The English Face*, London, 1992

Pointon, M., *Hanging the Head: Portraiture and Social Formation in Eighteenth-Century England*, New Haven and London, 1993

Pope-Hennessy, J., *The Portrait in the Renaissance*, Oxford, 1966

Schneider, N., *The Art of the Portrait*, Cologne, 1994

Shawe-Taylor, D., *The Georgians: Eighteenth-Century Portraiture and Society*, London, 1990

Simon, R., *The Portrait in Britain and America*, Oxford, 1987

Simons, P., 'Women in Frames: The Eye, the Gaze, the Profile in Renaissance Portraiture', *History Workshop* (1988), pp. 4–20

Stewart, D., ' "Pin-ups" or Virtues?: The Concept of the "Beauties" in Late Stuart Portraiture', in *English Portraits of the Seventeenth and Eighteenth Centuries*, London, 1974

Strong, R., *The Cult of Elizabeth*, London, 1977

West, S., *The Image of the Actor: Verbal and Visual Representation in the Age of Garrick and Kemble*, London, 1990

Whitford, F., *Expressionist Portraits*, London, 1987

Art Institutions: Academies, Exhibitions, Art Training and Museums

Paul Duro

While forms of collective co-operation in the making of art have existed at least since ▷antiquity, and in all probability even earlier, the institutions, associations and exhibitions discussed in this essay may properly be thought of as creating the conditions for the production of art in the modern period; for while institutions of learning date back to the ancient world (the title ▷'academy' derives from the school in Athens where Plato taught philosophy), academies of art, art schools, public exhibitions and fine-art societies form, like their counterparts in science, music and letters, an essentially modern form of cultural production.

The view that painting and sculpture were in some way related to music and letters, and, like science, were open to verifiable and unchanging laws, was a powerful incentive for the creation of the first academies in the 16th century. It was also a fundamental shift in emphasis for the arts. Whereas previously art making had been essentially a question of practice, with the emphasis firmly on knowledge of materials – on the ▷craft aspects of art making – the advent of the academies heralded a shift of focus to theory, that is, towards the role and purpose of visual art within a larger and all-inclusive arena of 'the arts'.

The reasons for this change are many and various. Certainly of great importance to the development of academies was the necessity to respond to new forms of government, especially those of the emergent nation states which required a correspondingly national, public and institutional art to answer the aspirations of their royal patrons. Likewise, a shift in art making away from religious imagery towards ▷Classical themes promoted the need for greater literary skills as well as reducing the artists' dependence on traditional forms of knowledge, thereby creating the conditions for a more reasoned (or academic) form of production. Most important, however, was the belief among artists that painting and sculpture had outgrown the medieval craft associations (the ▷guilds) and were ready to take their place alongside the ▷Liberal Arts. This shift, which had been in preparation for some time, saw the status of artists rise to embrace a new and above all institutional form of association – the academy.

The academies of the 16th and 17th centuries

Before the 16th century, painters and sculptors worked for the most part within the corporate structure of a guild – such as the Communauté des Maîtres Peintres et Sculpteurs, founded in Paris in 1391. They were subject to its traditions, laws and discipline unless – and such artists were relatively few in number – they were attached to a prince of the Church, royalty or the retinue of a powerful courtier and thus escaped guild law.

The procedures, structure and purpose of guild association reflect the social structure of the period in which they were founded. Essentially medieval, guilds upheld the trade secrecy, familial structure and routines of an earlier age. Placed under the patronage of Saint Luke (hence many guilds of painting are known as 'academies' of Saint Luke), the guilds oversaw the execution of commissions, verified the quality of the work and the materials used, imposed fines, arbitrated in disputes and provided welfare for destitute members.

The workshop was a place of tradition, not innovation, and knowledge of materials provided the basis for artistic production. Once initiated into the community, the artist was sworn to protect the guild's trade secrets against all comers. Each member knew his role, from the apprentice who ground

colours and ran errands to the ▷journeyman assistant who lacked none of the skills of the studio head but who had yet to establish a workshop of his own, to the master who co-ordinated those he employed. In short the guilds stood accused of failing to develop a practice commensurate with the aspirations of an ambitious minority and culpably out of touch with new forms of art making demanded by the Church, state and wealthy individuals.

The guilds continued to pursue their traditional role with success well into the modern period. For some artists, however, the guilds had failed to develop beyond their traditional role. By the late 16th century they seemed old-fashioned in their (supposed) lack of interest in the distinction between art and craft, their reliance on tried and tested formulas and their resistance to innovation. Equally, their traditional values were unlikely to impress those ambitious for recognition of their as-yet-unproved status as practitioners of a profession worthy of the title 'liberal' art. Towards the end of the 16th century these artists, first in Italy and later in France, broke away from the guilds and, grouping themselves around a powerful protector, were determined to shake off what they regarded as the shackles of guild association to promote the intellectual and creative aspects of art making over the artisanal practices of their craft-based cousins.

The private gatherings of dilettanti, antiquarians and amateurs were sometimes referred to as academies, but the first artists' academy was established in 1563 in Florence by the artist and historiographer ▷Giorgio Vasari under the patronage of ▷Grand Duke Cosimo I de'Medici and with the aged ▷Michelangelo at its head. The new academy, the Accademia del Disegno, distinguished between fine art and craft, and opened its doors to ambitious artists who preferred to see themselves as the equal of the poets and quickly subsumed the moribund corporation, the Compagnia di S. Luca. Instead of the specalization of the guild, the Accademia welcomed artists (and amateurs) whose practice depended on an understanding of ▷*disegno*, that is, in ▷drawing in its broader meaning of design and intellectual understanding, allowing for the inclusion of not just painters but also sculptors, engravers, architects, art theorists and ▷connoisseurs. The new organization worked. By 1571 painters and sculptors no longer needed to belong to the narrow specialization of the guilds to practise their artistic craft.

The Accademia del Disegno set the pattern for all later academies. Its principal functions included the teaching of drawing, anatomy and perspective with an emphasis on a wider culture than the guilds had hitherto provided. Its structure permitted dilettanti and men of letters to become members, thereby ensuring the centrality of theoretical discussion and a literary bias. In place of the guild's familial structure, the Accademia would be free to choose its members on merit, and not obliged, like the guild, to base acceptance on family ties. Other cities soon followed Florence's example. The ▷Accademia di San Luca was founded in Rome in 1593 with ▷Federico Zuccaro as its first president, although as with its predecessor, more attention was paid to questions of status than the practical matters of art and its making.

As far as practical instruction was concerned, students were expected to draw from the antique, progressing from fragments to an understanding of the whole figure, and from single figures to figure groups which offered the raw material for the principal form of artistic endeavour, and the main, one might almost say unique, justification of academic association – ▷history painting. In this the early academies showed themselves to be not only aware of the kind of painting sought by most patrons, but also cognizant of the kind of training most likely to produce able practitioners in the genre. From an early date these academies instituted the regular study of the nude in life classes to complement the classes in anatomy and perspective.

Unsurprisingly the academies of Florence and Rome impressed the many foreign artists who came to Rome to study. ▷Karel van Mander returned to Haarlem to found, with ▷Cornelius van Haarlem and ▷Hendrik Goltzius, a Dutch academy from which students could draw from life. But in countries such as the Netherlands, Germany and England, where drawing from the nude and the painting of history were not firmly entrenched, the principles of academic association were not likely to change the overall complexion of artistic activity. The Haarlem academy remained a private, if flourishing, institution which operated along with, but did not supplant, the native guild.

Not so in France, where the foundation of the ▷Académie Royale de Peinture et Sculpture in 1648 inaugurated a period of bitter rivalry between the Academy and the guild which was not finally to be quelled until the ▷French Revolution. By 1648 the situation had already been tense for some time, with the guild attempting to make inroads into the privileges of artists who held a *brevet* which

offered them royal protection from guild laws. Those who wished to humble the guild grouped themselves around the ambitious and politically astute ▷Charles Lebrun, who enlisted aristocratic help to win royal approval for the new institution.

The creation of the Paris Academy has frequently been portrayed as a cynical exercise by Louis XIV to inculcate French artists in the Italian manner and provide Lebrun with assistants able to second him in the decorative cycles planned for ▷Versailles. In this scenario, the Academy would institutionalize young artists, and by keeping a tight control on their development, turn them into disciplined workers whose technical ability and familiarity with antiquity would meet the needs of a monarchy seeking to associate itself with the ▷Grand Manner. But an equally compelling reason is to be found in the gap between the ambitions of the young Paris Academy and its achievements.

Lebrun was quick to realize that the Academy's first task was to articulate theoretical and procedural differences from the guild, which it claimed to be a corrupt and degenerate corporation. But here there was a certain difficulty – far from being the 'colour grinders and polishers of marble' which the Academy claimed them to be, many members of the Académie de Saint-Luc were artists of the highest rank; both ▷Simon Vouet and ▷Pierre Mignard were members against whom the Academy could offer little more than the overblown pretensions of the 29-year-old Lebrun, the glacial compositions of ▷Le Sueur or the stilted academicism of ▷Laurent de La Hyre. Lacking proven accomplishment, the Academy opted for claims to future greatness, quickly promising programmes of instruction, a series of conferences on art theory and an annual public exhibition of the best of their work. In reality only the first – the teaching programme – got under way at this time, with the conferences beginning only in the later 1660s, while the annual exhibitions, or ▷Salons, were not a regular feature until the year 1737.

The purpose of this programme was to weaken the importance of craft practices in the work of the fine artist and promote the values of the intellect and of the creative (as opposed to mechanical) parts of painting. In this history painting, the representation of episodes drawn from the Bible or Classical antiquity and executed in a highly-finished technique, often called *le grand goût*, was central to academic practice, for in history painting the Academy could claim that all other genres – landscape, portrait and still life – were subsumed within an all-embracing genre which demonstrated the artists' competence in the representation of the human figure in dramatic action. Not surprisingly the Academy took immediate steps to ensure that it alone could teach from the model, persuading the monarchy to ban the guild from holding life classes. In this way the Academy began to strengthen its grip over fine-art practice, forcing aspiring history painters to join the academy schools and disenfranchising the guild from a traditional area of competence.

To further this emphasis on figure painting and the importance of the antique the government opened a branch academy, the Académie de France, in Rome in 1666. The location was not chosen lightly, as from the end of the 16th century French artists had travelled to Rome as to a finishing school, to round off their studies and acquire the gloss and sophistication of the school they regarded as pre-eminent in Europe. Before the foundation of the Academy in Paris, most ambitious artists had studied for a greater or lesser time in Rome: if Lebrun had sojourned only four years, Vouet had spent the years 1613–27 there and been made the head of the Accademia di San Luca, while both ▷Poussin and ▷Claude parleyed their visits into lengthy careers.

The journey was undertaken by very many artists, most often after completing their apprenticeship, when a period spent in Rome could be expected to give their work an Italianate flavour and stand them in good stead with patrons. By the mid-17th century it was common for artists to journey to Rome: indeed, a stay in Italy was often the only professional qualification necessary to obtain work on royal building projects on their return to Paris. With the institutionalization of the French experience in the Académie de France in Rome, certain examples, practices and attitudes became canonical, while other forms of experience and influences such as ▷Caravaggio (arguably the greatest single influence outside academic circles in the first half of the 17th century) were excluded.

The founding of the French Academy in Rome is evidence of the importance of Italian art to the perceived shortcomings of the French national style. In financial terms, the commitment of royal funds was very much greater than the token grants which had been provided for the parent institution, the Paris Academy itself – an indication of just how necessary a Roman training was seen to be. Louis XIV's chief minister Jean-Baptiste Colbert (1619–83) had first thought of offering the directorship of the Academy to Poussin, but news of the latter's death late in 1665 meant it was offered to an Academy

functionary, Charles Errard. It is in any case unlikely that Poussin would have welcomed the news that he had been chosen as the 'excellent master' to front the Academy. The artist, old and perhaps recalling his brief and unhappy visit to Paris in 1640 when he had been a pawn in the court's hands, continued to keep his distance from royal command. But in the end it mattered little who was a head of the Rome Academy – the system was bigger than any one individual. Very soon traditions, fondly recalled in the memoirs of many winners of the ▷Prix de Rome (the competition for history painters which took the laureate to Rome), added a note of ritual.

Students were expected to spend the majority of their time in making copies, the better to imbue their work with the Italian manner. The programme was strict, with students tightly controlled and unable to mix freely with Roman artists or leave the city. In this way the examples before them – ▷Raphael in strong preference to ▷Michelangelo and always line in preference to colour – affected, one might say inflicted, a perspective on students which ultimately robbed them of individuality and reduced their work to stereotypical formulas not far removed from the routine and pattern books of their despised guild rivals.

These advances of academic organization were hard won and not always definitive. The guild hit back on many occasions with decrees and statutes of its own. But in general the Academy went on abrogating to itself increased institutional power through the support of its patrons and friends at court. Yet on occasions it needed government to prompt innovation. Its new protector Colbert had to force the Academy to begin its long-delayed programme of conferences as the membership, with the exceptions of ▷Sébastien Bourdon, Lebrun and the erudite and religious-minded ▷Philippe de Champaigne, showed itself unenthusiastic about the idea of discussing art.

When lectures – known as the *conférences* – finally did begin in 1667 the tone of the debate remained resolutely abstract. Pictures were borrowed from the royal collection, and an academician presented a paper on the work of art, then the whole assembly discussed the points raised, with the intention of arriving at a 'precept' which could be recorded for the benefit of students and succeeding generations. The problem with the approach, of course, is that a complex work of art does not lend itself to such a reductive analysis as easily as the academicians believed. To avoid this trap, the Academy most often chose work which fell within the Classical tradition and depended on line for pictorial articulation. In the first year of the series (1667), principally Raphael and Poussin were discussed, although works by ▷Veronese and ▷Titian – both colourists – were presented and predictably attacked as a bad influence.

In general the *conférences* failed to meet their objective of elucidating the complexities of art to either members or students. For the most part the meetings were obliged to be content with generalities and platitudes which hedged round, but did not confront, the issues of picture making. However, on one level the *conférences* succeeded admirably. They served to isolate the guild from royal favour, showing up the guild artists as unwilling or unable to engage with the theory of art. In this alone, if nothing else, the *conférences* were worth the effort.

A similar problem of promise tardily fulfilled occurred with the annual exhibitions. Whereas the statutes of the Academy had early promised these public displays of production, in reality artists who were employed for the most part on large public works such as Versailles, or for wealthy individuals like Séguier, saw little advantage in offering up for public consumption or critical comment works which needed no such support and could only be damaged by negative criticism. As a result only six exhibitions were held before 1737.

What then were the advances these academies made towards a new form of artistic association – one free of family ties and a craft tradition? The answer is probably that not all their good intentions bore fruit. For example, while it seems reasonable for the academies to have sought out excellence, there lies in this thinking the seed of a difficulty which was to dog them throughout the centuries. Avoiding a familial structure (which in any case the academies in part failed to do) was not the same as guaranteeing excellence. What did happen is that a bureaucratic structure simply replaced a corporate and familial one. Furthermore, we may question whether an essentially skills-based profession (as painting certainly was at that time) was best served by a structure which laid weight on the intellectual side of the craft while playing down the mechanical parts of painting. In line with this last point, the Accademia del Disegno, and all the academies which followed, placed the weight of picture making on the intellectual parts of painting (its name *disegno* implies both drawing and conception), rather than the application of paint. The credence given to intellectual skills (which all too often translated into the rhetorical and bureaucratic arts of the academic painter) were adopted as an ideological

imperative, without any real evidence being presented that, as a means of realizing the art work, they were superior to the alternatives on offer, or the methods of the institutions which preceded them.

Academies of the 18th and 19th centuries

In the 18th century academies were established in many other cities – both capitals and large provincial centres – principal among them being Berlin in 1696, Bologna in 1709, Dresden in 1750 and, tardily, London in 1768; while in the United States academies organized along European lines were founded in Boston in 1780, New York in 1802 and Philadelphia in 1805. For the most part these academies adopted the ideals and aspirations of the French Royal Academy, that is to say, the ideals and aspirations originating with the academies of Florence and Rome, still held to be the benchmark for academic organization. Yet the French Academy and those which followed the Italian model overlooked the fact that Italian art had been in relative decline in relation to French, Spanish, Dutch and English art since the late 17th century.

The most glittering, when it finally became a regular biannual event in 1737, was that of the French Royal Academy, named the Salon after the Salon Carré in the ▷Louvre where the exhibition was held from the latter part of the century. Previously, in Paris as elsewhere throughout Europe, art works had been displayed ('exhibition' is a rather too ambitious term for what were treated as shop goods) in the windows and doorways of artists' workshops or in the semi-permanent fairs held in most major cities. Among these was the Foire Saint-Germain in Paris which showed the works of many artists, especially those of foreign birth who found their entry into the Paris guild blocked by distinctly xenophobic prohibitions.

Once again conforming to the desire to articulate opposition to traditional artisanal practices, the Academy sought the prestige of royal patronage and an aristocratic setting for its exhibitions. Although early venues had included the open-air colonnades of the Palais Royal, the risk of inclement weather and the certainty of an uncouth and perhaps unruly crowd soon drove the Salon into the Louvre. The Salon emphasized the importance of the ▷hierarchy of genres for exhibiting artists. Although numerically portraits, landscapes and genre paintings massively outnumbered the elevated genres of religious and Classical painting, academicians were careful to emphasize the importance of history painting, giving these large paintings the best position (hung 'on the line', that is, at eye level) and promoting them as significant artistic statements.

But their position was irrelevant to the issue of the value of exhibiting in the first place. As the Academy only exhibited work by members, many artists felt that little was to be gained by exposing their works to criticism. The idea that artists needed the mediation of critics to present their works to the public was itself a new development, accustomed as they were to enjoying, as members of the Academy, a close relationship with official sponsorship and government patronage. Such paintings, however, were not always what the public wanted, and it is this contradiction between public preference and what academic critics believed should be looked at that was responsible for the separation between academic art and Salon painting that grew to dominate art criticism of the 19th century.

In England, the reality of an academy had to await the latter half of the 18th century. In part this was due to the lack of official support for the arts, in part, perhaps, English artists' aversion to state-sponsored forms of association. However, the ▷Royal Academy of Arts was founded in December 1768 when George III signed its Instrument of Foundation. Like its Gallic counterpart, the Academy obtained a royal seal of approval, and like the French Academy, its professed purpose was to raise the status of the arts and form the institutional hub of a national school of painting through instruction, exhibitions and the codification of objective criteria for the judgement of taste.

However, there were differences between the Royal Academy in London and its continental counterparts. Principally, the relation between the institution and the state in England was, by mutual consent, far more tenuous than elsewhere. No one expected the Academy to act like a government body, and England offered few public commissions on the scale found in France (such as Versailles) where art and the state could collaborate. Likewise the advent of ▷Romanticism, with its emphasis on individualism, idiosyncrasy, originality, novelty and rejection of the art of the past, did not provide a sustaining environment for institutional art.

Yet the London Academy was generally successful, perhaps because it did not set out to do too much, and it was notably successful in one field of endeavour – theoretical art instruction. This success was almost entirely due to one man, the Academy's first president, ▷Sir Joshua Reynolds, whose

Discourses, 15 lectures on traditional aspects of painting such as originality, imitation and invention, professed the dignity of the arts, the importance of Classical learning, the belief that art was a reasoned activity (open to the application of rules) and therefore best learned through hard work and study. In practice this meant avoiding the mean and the ugly. The ninth discourse puts this idealist philosophy succinctly:

> *The Art which we profess has beauty for its object; this it is our business to discover and to express; but the beauty of which we are in quest is general and intellectual; it is an idea that subsists only in the mind … which, if it does not lead directly to purity of manners, obviates at least their greatest depravation, by disentangling the mind from appetite, and conducting the thoughts through successive stages of excellence, till that contemplation of universal rectitude and harmony which began by Taste, may, so it is exalted and refined, conclude in Virtue.*
> (Lines 71–86)

Taken together, Reynolds's precepts offer a lucid, if late, defence of institutional learning and the importance of the Classical tradition to the furtherance of ambitious painting.

Overall, academies in the 18th century were successful professional institutions, for the most part fully emancipated from the guilds and offering a reasoned and liberal environment for painters of every kind, for while history painting remained the visible justification of their existence, every academy welcomed artists from other genres. Thus in France ▷Antoine Watteau, ▷Jean-Baptiste-Siméon Chardin and ▷Jean-Baptiste Greuze were members of the Academy, while in England, where in any case history painters were difficult to find, Reynolds himself owed his fame to portrait painting. Moreover, the academies of the 18th century, unlike those of the preceding and subsequent centuries, embraced a quasi-totality of the leading painters of the day.

By the beginning of the 19th century the academies were seemingly in a position of invulnerability, too powerful to be threatened by any opposition. But they had no answer to the challenge of a Romanticism which held that an artist had nothing to learn from rules. In the face of this heresy, the academies reacted by using whatever influence they had to oppose innovation. In part this was because they continued, despite some concessions to contemporary art practice, to profess essentially the same artistic doctrine as their 17th-century forebears. Thus while some academicians acknowledged the importance of imaginative freedom, others insisted on the emulation of the art of the past and set their students to the copying of plaster casts and the use of line, not colour, as the means by which a pictorial composition should be executed (the ▷École des Beaux-Arts in Paris, the principal art school of France, did not teach painting until 1863).

The reason for this increasing conservatism was due to the waning, in the first decades of the 19th century, of the importance of history painting as the central justification of having an academy in the first place (those nations where academies were less important to the pursuit of painting were also the countries where the lower genres of landscape and still life thrived). The importance of history painting to the academies of France and Italy, however, rested on the structural relationship of the genre to the academic hierarchy. As history painting stood at the apex of the hierarchy of genres, so the academies saw themselves as standing at the apex of artistic production, protected less by government (although most were) than by an unbreachable attachment to the Grand Manner.

The problem with this perspective, however, is that by the 19th century, history painting was itself under attack from within. For while the genre seemed untouched by the political and social upheavals of revolution, in fact its *raison d'être* was crumbling. With the rise in importance of exhibitions, and a concomitant rise in importance of public opinion, artists no longer felt the need to demonstrate intimacy with the more recondite episodes of the Classical past, but attempted to meet the needs of a broader and less discriminating public by maintaining the outward appearance of history painting while quietly abandoning its intellectual endeavour. The result was the rise of ▷narrative painting, epitomized in the work of ▷Paul Delaroche, ▷Jean-Léon Gérôme in France, or ▷Sir David Wilkie in Britain.

The result was that academic practice, and the system which underpinned it, lost its dynamic agenda (progress in the arts and an improvement in the status of the artist) to adopt a conservative stance suspicious of change and antagonistic to the ▷avant-garde. Furthermore, the academies' power, which had always found expression in art itself, fell back on institutional and political might to maintain its dominant position. Increasingly, as the 19th century unfolded, the academies were obliged to adopt more and more measures of control to keep at a distance the tide of change. In the case of exhibitions,

juries were most often composed of academy nominees. It is from this period that a split between 'official' and 'academic' art developed in some countries, notably France, where the composition of the Salon jury after the 1830 Revolution moved from an elected mix of artists, amateurs and academicians to a jury of members of the Academy, a move guaranteed to prejudice progressive painters such as ▷Delacroix, ▷Daumier, ▷Courbet and ▷Théodore Rousseau. While the Salon of the Second Empire (1852–70) mixed a jury of government-nominated members with academicians, those who had won medals at previous Salons were exempted. In 1863 a particularly unjust jury prompted artists to petition the head of state, Napoleon III, who responded by authorizing a ▷Salon des Refusés to allow the public to judge the refused artworks for themselves, including ▷Manet's ▷*Déjeuner sur l'herbe*. While the exhibition did not turn out quite as the artists had intended – the public confirmed the taste of the jury – the Salon des Refusés broke the hitherto absolute monopoly of the official Salon.

In 1881 the French republican government, in a rejection of the authoritarian and interventionist policies of the previous regime, declared that now artists must form a 'Republic of the Arts' and shift for themselves. This was the signal for the dissolution of the Salon system. Henceforth the jury would be elected by all artists, while the Salon itself split into four different associations, the Salon des artistes français (1881), the ▷Salon des Indépendants (1884), the Société nationale des Beaux-Arts (1890) and the ▷Salon d'Automne (1903), to be followed in the 20th century by the Salon des Réalités Nouvelles and the Salon de Mai (1945). The works in these exhibitions reflected the taste of the public which flocked to see them, and the government confined its involvement to the purchase of those art works which most pleased the public.

In terms of art education, the 19th century saw substantial, if slow and much-resisted changes (at least before mid-century), in the direction and content of instruction. Until mid-century the typical art student in France progressed from local notoriety towards the national school, the École des Beaux-Arts in Paris. Entry was not automatic, and students had to succeed at a *concours de places*. Training for the competition took place outside the school, in private ▷ateliers such as those run in Paris by ▷J.-A.-D. Ingres or ▷Charles Gleyre. Once within the school, progress was dependent upon winning the monthly and termly competition (which was held in a variety of disciplines such as expression, perspective or composition).

The function of the École des Beaux-Arts was to provide drawing classes to inculcate the basis of art practice in the student; painting was not taught. As a result of this skewed programme, students learned to draw to a very high (if academic) standard while remaining ignorant of the practical side of their craft. In principle, the manual aspects of painting were taught in the ateliers, but in reality teachers like Ingres reinforced the École's preference for line with endlessly reiterated aphorisms on the importance of drawing from the antique. While such a programme made success in the École's own competitions more likely, it did nothing to counter the imbalance between the theoretical (or worse, rhetorical) support teachers gave to drawing and study after the antique and the need to offer the student a wide-ranging and technical education in all aspects of fine art.

After the mid-century the most notable development was the teaching reforms of 1863 to the programme of the École des Beaux-Arts in Paris. Sundering the intimate connection between École and Academy, the government instituted a programme of practical instruction and appointed new studio heads from the ranks of practising (and publicly successful) painters – the first professors being ▷Cabanel, Gérôme and ▷Pils. These changes were a response to the need to make art instruction more relevant to the needs of industry and were echoed elsewhere. A notable example is London, where from 1837 the School of Design, later renamed the Central School of Practical Art, taught a vocationally-oriented programme in industrial design.

In part these changes had been prompted by the world fairs of London (1851), Paris (1855, 1867 and 1889), Vienna (1873), Philadelphia (1876) and Chicago (1893), which had highlighted the differences in technical and art education between competing capitalist economies. But such national strategies for education were paradoxically complemented by the anti-industrialist ideas of ▷John Ruskin and ▷William Morris, whose craft-based approach dreamt impossibly of a return to pre-industrialized production – although as we shall see, their ideas influenced art instruction in the 20th century, particularly in Germany.

As with art training, and indeed the formation of academies as such, the 16th and 17th centuries had seen the development of art collecting on a massive scale. From princes of the Church to royalty and princes of commerce, the acquisition and display of fine art lent an air of culture to the conspicuous

wealth of some individuals and the gloss of high-minded decoration to others. While ▷cabinets of curiosities and royal collections were essentially *private* acquisitions based on the taste of individuals, the institutionalization of collecting and the unification of collections into *national* galleries of art had to await the end of the 18th century. In part this was because the principal collections of the previous centuries had been in the hands of monarchs such as Francis I or Louis XIV of France, or Charles I of England, who had very clear ideas about their status and position.

These royal patrons amassed vast collections of paintings and sculptures which they displayed in galleries within their palaces. However, these works remained essentially decoration within their palatial setting; they were not in themselves thought of as separate from the patrons' other possessions. This state of affairs changed in the 18th century with the rise of national consciousness and the waning of autocratic and monarchical authority. In Italy, the most powerful family from the time of the ▷Renaissance, the Medici, bequeathed their private collection to the Tuscan state in 1737, thereby laying the foundations for the unparalleled collection of Florentine painting now housed in the ▷Uffizi, the palace in Florence designed in 1560 by Vasari for the Medici Prince Cosimo I, Grand Duke of Tuscany.

In France the origins of the national collection are to be found in the great picture galleries of its princes who regarded the acquisition of art as a minor part of a cultural strategy. The building of palaces such as Fontainebleau, Versailles and the Louvre/Tuileries absorbed a great deal more money and effort than purchasing works of art. Even so, Louis XIV massively increased the collection, buying works from Italy (usually though the agency of the Académie de Rome) and commissioning many more. From 1681 the collection was open at certain times to the public in the Louvre and was complemented by the Academy's own exhibitions or Salons discussed above. However, it was the Revolution of 1789 which caused the fundamental shift in display policy. Whereas the collection had hitherto been a royal (and thus to some extent private) collection, the new Louvre housed the national collection. The Louvre's holdings – after the Revolution called the Musée Napoléon – were massively increased as a result of Napoleonic plunder in the Franco-Italian wars, although this booty was happily returned to former owners on Napoleon's fall.

In England the foundation of a National Gallery may be traced to 1824 when an exhibition of 28 paintings from the collection of ▷John Julius Angerstein, soon to be joined by a bequest from ▷Sir George Beaumont, opened at 100 Pall Mall in London. In 1838 the present ▷National Gallery in Trafalgar Square opened. Unlike many continental collections, the London gallery was not based on a royal collection (the Queen's Pictures) but on the bequests of private individuals and a government purchasing programme.

Taken together, national galleries from the beginning of the 19th century have served several functions. First and foremost they are major fine-art institutions which reflect the cultural policies of their respective governments. From this point of view few countries feel they are able, or willing, to dispense with such a significant artistic statement, and national galleries are, for this reason, most often situated in the national capital. Added to this is the belief that it is an enlightened government's responsibility to acquire, conserve and exhibit fine art, whether it is the art of the country concerned or simply the best of what is available irrespective of origin or ideology. From this perspective the museum of art may be said to stand in the same structural relation to its public that the academy stands in relationship to its membership – as an extraordinary framework within which excellence may be nurtured and a platform from which to appraise the fine-art economy of the moment. There are significant national galleries, all of which fulfil at least some of the above criteria, in Edinburgh (1859), Dublin (1864), Ottawa (1880), Washington (1937) and Canberra (1976).

Art institutions of the 20th century

Although the rise of ▷Modernism signalled an end to the academies' relatively brief period of unquestioned supremacy – from their struggle with the guilds in the 17th century to their eventual demotion to the status of honorific bodies with little or no real influence over the direction of the arts in the 20th century – the idea of the art institution was transmuted rather than obliterated. Whereas in the 19th century institutions such as art schools and exhibitions tended to depend on the academies, in the 20th century they were for the most part independent of academic influence.

Many of these new associations, such as the ▷Deutscher Werkbund founded in Munich in 1907, were expressly designed to raise the standard of industrial production and narrow the gap between fine and applied or industrial art. These initiatives developed the use of the machine in manufacture rather

than, as ▷William Morris had done, opposing it, and advocated the principles of mass production. In England the ▷Omega Workshops, founded in London by the art critic ▷Roger Fry in 1913, were more directly inspired by Morris, although free of his medieval ▷antiquarianism.

The philosophy of the Werkbund was carried into the ▷Bauhaus, the design school founded in Weimar in 1919 by the architect ▷Walter Gropius. The art school attracted a talented team of avant-garde artists and designers including the artists ▷Wassily Kandinsky and ▷Paul Klee. The school taught from first principles, instituting an introductory course on form, colour, material and techniques without any reference to the study of antiquity still taught in the Beaux-Arts tradition or the figurative traditions of English art education. The school maintained strong contacts with industry, and much of its efforts were put into finding elegant and practical solutions to the design problems of the day. Seeing in modern industry the chance to manufacture cheaply and well, Bauhaus designers came up with an astonishing range of simple yet stylish furniture which remains to this day a high point of modernist industrial design.

The school, after enduring political pressure from the Nazis for several years, necessitating moves first to Dessau then Berlin, was forced to close in 1933 as its philosophy ran directly counter to the degraded ▷Neoclassical tastes of Hitler's Ministry of Propaganda. The subsequent diaspora of its members, principally to the United States and Canada, gave renewed impetus to developments already under way in North America, notably at Harvard, where Gropius became Professor of Architecture, and in Chicago, where ▷Moholy-Nagy founded a New Bauhaus.

Elsewhere art education took on the form of a progressive practice. The breakdown of the hierarchy of genres, the use of new and unusual materials, the assumption of artistic freedom of expression, while maintaining many of the precepts of the academies, all challenged the norms on which the academies had staked their claim to importance. In some centres, however, these progressive tendencies were reconciled with the tradition of figure painting. In England in particular, where the push for abstraction was seen by many as a development foreign to British naturalism, figurative painting remained pre-eminent. The ▷Royal College of Art (whose graduates include ▷Barbara Hepworth, ▷Henry Moore and ▷David Hockney) and the ▷Slade School of Fine Art (opened in 1871 and boasting among its students ▷Augustus John, ▷Wyndham Lewis and ▷Stanley Spencer) both in the earlier part of the century emphasized drawing and the study of the figure. Likewise in France, where an institutionalized Beaux-Arts tradition of history painting was near-unshakeable, study from the nude continued, although a significant difference from England was that ▷avant-garde artists tended to work away from the stilted mediocrity of its studio teaching.

Since the 1960s (and especially after May 1968 in France when changes to teaching methods were but a small part of larger demands made by students and intellectuals on the government of the day), art education has developed considerably, although not without contradictions on the ideological level. Principal among these difficulties has been the issue of native genius (a post-Romantic notion) versus the importance of vocational training. Thus in France, as in England, recent developments have tended to re-emphasize the artistic training of the student as fundamental to the profession of the artist. This is in opposition to an education based on the liberal arts, even if this shift has been most notably expressed not in a return to the idea of craft but in terms of how artists present their work and themselves, the better to maximize their potential to attract corporate and state sponsorship. These developments echo the guilds' emphasis on the specificity of the artist's work while building on the rhetorical and academic skills introduced by the academies of the 17th century.

Today the teaching of art is at a crossroads. On the one hand there remains the impoverished post-Romanticism of heroic individualism which successive institutions have found impossible to dislodge (when they are not actively promoting it). On the other hand, art education, like the practice of fine art itself, is being challenged by significant 20th-century art forms such as the cinema; while developments in ▷cybernetics offer the artist the opportunity to transcend the norms of the discipline in favour of a virtual practice which may yet see the disappearance of more traditional forms of artistic expression in the future.

If art education in the 20th century has enjoyed only partial success at reconciling contradictions inherent in its ideology with the needs of the present, it may fairly be argued that the display of fine art, both permanent and temporary, has enjoyed widespread public and critical support (although this is not always apparent at the time of the exhibition, when both review notices and journalistic reporting tend to dramatize the novelty and, if possible, degeneracy, of the display). Significantly, much of the

early emphasis on exhibitions in this century came from the United States, where the effects of European ▷Modernism were felt early in the century. In 1913 the ▷Armory Show, officially known as the International Exhibition of Modern Art, opened in the 69th Regiment Armory, New York, with the aim of bringing before the American public a cross-section of modern art. The reaction of critics and public was predictably hostile. Most saw in the exhibition an unwelcome invasion of difficult-to-understand European painting – ▷Duchamp's *Nude Descending a Staircase* (1912) was singled out for particular abuse. After New York the exhibition toured to Chicago and Boston, and was seen by a total of some 300,000 people.

In Europe the idea of exhibitions to promote a particular doctrine or ideology was likewise in evidence. In England Roger Fry promoted a taste for ▷Post-Impressionism with exhibitions he organized at the Grafton Galleries in 1910 and 1912. Other exhibiting societies and artists' groups originated to promote a collective endeavour or point of view. The Vienna ▷Secession of 1897 was organized by ▷Klimt in protest at the conservative exhibition policies of the Viennese Artists Association. In 1906 ▷die Brücke ('The Bridge'), formed around the artists ▷Kirchner, ▷Schmidt-Rottluff and ▷Nolde, exhibited ▷Expressionist works in Dresden. In Munich in 1911 the group ▷der Blaue Reiter ('The Blue Rider') including ▷Kandinsky, ▷Franz Marc and ▷August Macke, also exhibited strongly Expressionist work and produced a manifesto, *Der Blaue Reiter Almanach*, to promote them. The ▷Futurists held exhibitions in Milan in 1911, and in France, Germany, the Netherlands and England in 1912. After the First World War the ▷Dadaists (who had learned the value of exhibitions from the Futurists) organized the First International Dada Fair in Berlin in 1920 and followed it up with exhibitions in Paris (1922) and New York.

But in some ways these short-lived exhibiting societies were but a preparation for the major institutional advances in the presentation and promotion of modern art in the 20th century. In this respect, few galleries can equal the ▷Museum of Modern Art (MOMA), founded in 1929 in New York. Its first director (1929–67), ▷Alfred H. Barr Jr. (1902–81), quickly established the museum as the pre-eminent collection of modern art in the world, with exhibitions, particularly *Cubism and Modern Art* (1936), setting the agenda for the development and presentation of the history of modernism through to the 1960s.

While MOMA was perhaps the first museum of art to narrow the gap between contemporary art production and contemporary approaches to the study of fine art, it is no longer alone. In France the ▷Centre Georges Pompidou is among the most notable examples of contemporary politico-cultural intervention in the arts. Named after the French president who initiated the scheme, the Centre is at once a permanent gallery (it houses the state's collection of modern art), a gallery space (for temporary exhibitions ranging from photography and urban planning to computer art and cyberspace) and an open-access library. The intention of its proposers was to offer Parisians a public space into which they could enter as into a railway station or department store, but pressure of numbers has tended to make this ambition difficult to realize and impossible to police. Furthermore critics have been quick to note that the building, by Renzo Piano and ▷Richard Rogers (1971–7), necessitated the destruction of Les Halles, the central markets of cast iron and glass and a monument to 19th-century industrial design. These critics argue that far from being an architectural bridge between culture and society, the building – with its High-Tech mannerism of displaying air vents, pipes, escalators and walkways on the outside – in fact remains an insensitive monument to a paternalistic state which makes gestures towards artistic freedom while keeping the majority of the population at arm's length.

Museums such as MOMA and the Pompidou Centre have taken on in the 20th century a role which is both curatorial and ideological. They no longer wait for artistic developments to manifest themselves, but actively participate in the construction of taste through the commissioning and presentation of contemporary art, rivalling the commercial galleries and contemporary exhibiting societies in the shaping of art movements. However, another manifestation of contemporary art exhibitions, the blockbuster or 'monograph' exhibition, is of necessity more sensitive to public opinion. These shows, which have tended to grow in size and importance with the reduction in government sponsorship, seek to attract the largest number of visitors and to persuade them to spend the maximum amount of money through the sale of entry tickets, catalogues and souvenirs.

These shows, among which the Treasures of ▷Tutankhamun (1976), ▷Turner (1975), ▷Chardin (1979), ▷Manet (1983) and ▷Renoir (1987) stand out in popularity, offer the public a reassuring view of past greatness, apparently free of an ideological slant and packaged to conceal inconsistencies

in style or quality, for it is not only the public but also the new corporate sponsors (oil companies and banks at the fore) which require the art works exhibited to present their companies in a flattering light. Echoing their multinational sponsorship the blockbuster exhibitions may tour three or four major centres (often on two or more continents), keeping art works away from their home galleries for anything up to two years.

Yet the logistics of organizing such prestigious exhibitions may yet prove to be their downfall. Increasingly galleries are weighing up the advantages of world-wide publicity against the short-term loss of seeing a major art work from their collection absent for so long. Furthermore, many of the world's most celebrated art works are becoming impossible to insure, making their transport in the future less likely. In the face of these difficulties, and yet more compellingly, with the exponential pace of the development of the Information Superhighway, traditional exhibitions may be superseded by 'virtual exhibitions' which can be mounted at a fraction of the cost and with incredible rapidity. Such developments mean that the gallery 'visitor' may in the future browse the galleries of the world without leaving home, interactively assembling and reassembling materials to suit his or her own taste and within the foreseeable future entering the 'virtual reality' of the electronic museum.

Electronic dissemination of images is of course but the latest chapter in the mechanical reproduction of images of art works which towards the end of the 19th century provided the impetus for the study of art to develop from the realm of the connoisseur to that of the art historian. The latter profession relies on the wide availability of reproductions to pursue its arguments, and while few art historians or visual theorists would dispute that viewing art works first hand remains indispensable, art history's various methodologies almost always rely on the reproduced image to state its case.

Whether the public will, in the future, perceive the virtual exhibition as a legitimate alternative to viewing the original remains to be seen. But historical evidence suggests that rather than replacing the museum, virtual exhibitions will complement them. In the 19th century a 'Musée des Copies' in Paris was perceived as just that – a museum of copies. Likewise it is unclear whether the museum will continue as an institution. Most probably it will develop expertise in the new media, if only to preserve its fragile collections from erosion by an over-enthusiastic public, rather in the way that the caves at ▷Lascaux are today permanently closed, the visitor being obliged to accept their adjacent replication. As for the Information Superhighway itself, it seems highly likely that it will engender a visual culture of its own, and not one which merely enlarges our knowledge of existing cultural institutions.

Where does this leave those institutions founded in the 17th and 18th centuries to further the aspirations of ambitious artists for a share in the benefits of academic association? If the institutions created – academies, exhibitions, national art schools and museums – served a purpose in the decades after their foundation, it is less sure that they have a role to play today. It is hard not to conclude that, with the exception of exhibitions, they are now an irrelevance to the successful prosecution of an artistic career and have been out of touch with the evolution of art and artists at least since the advent of ▷Impressionism in the 1860s.

This may seem a harsh judgement, yet there is little evidence to suggest otherwise. To witness the meetings of the fifty members of the French Académie des Beaux-Arts – whose ceremonial attire was designed by the painter ▷Jacques-Louis David during the Revolution, and whose average age in 1986 was 74 years – is to witness an institution which functions almost entirely as a honorific body. And unlike the names recorded as members of the 17th-, 18th- and 19th-century academies, there are few today who would be recognized outside the narrow confines of the art world and none whose work might be termed progressive.

In the face of this decline, the continuing questioning of the role and purpose of traditional art practice, and the development of the new electronic media, there is little to suggest that art institutions will be able to maintain the status quo much beyond the advent of the 21st century. As the academies came into being at the beginning of the modern period, perhaps it is reasonable to expect their decline to match that of the modernism which they have done so much to engender.

Bibliography

Alberti R., *Origine et progresso dell'Academia del Disegno, de' pittori, scultori e architetti di Roma* [1604], reissued Bologna, 1978

Barocchi, P., 'Storiografia e collezionismo dal Vasari al Lanzi', *Storia dell'arte italiana* (vol. 2), Turin, 1979

Blunt, A., *Artistic Theory in Italy 1450–1600*, Oxford, 1962

Boime, A., *The Academy and French Painting in the Nineteenth Century*, New York, 1971

Boime, A., 'The Teaching Reforms of 1863 and the Origins of Modernism in France', *Art Quarterly* (1977–8), pp. 1–39

Crow, T.E., *Painters and Public Life in Eighteenth-Century Paris*, New Haven and London, 1985

Dempsey, C., 'Some Observations on the Education of Artists in Florence and Bologna during the later Sixteenth Century', *Art Bulletin* (no. 62, 1980), pp. 552–69

Dunlop, I., *The Shock of the New: Seven Historic Exhibitions of Modern Art*, London, 1972

Duro, P., "Un Livre Ouvert à l'Instruction": Study Museums in Paris in the NineteenthCentury', *Oxford Art Journal* (vol. 10, no. 1, 1987), pp. 44–58

Duro, P., *The Academy and the Limits of Painting in Seventeenth-Century France*, New York, 1996

Frayling, C., *The Royal College of Art: One Hundred and Fifty Years of Art and Design*, London, 1987

Goldstein, C., *Visual Fact Over Verbal Theory: A Study of the Carracci and the Criticism, Theory, and Practice of Art in Renaissance and Baroque Italy*, New York, 1988

Gordon, E., *The Royal Scottish Academy of Painting, Sculpture and Architecture: 1826–1976*, Edinburgh, 1976

Grunchec, P., *Le grand prix de peinture: les concours des Prix de Rome de 1797–1863*, Paris, 1983

Hargrove, J. (ed.), *The French Academy: Classicism and its Antagonists*, Newark, 1984

Haskell, F., *Patrons and Painters: Art and Society in Baroque Italy*, New Haven and London, 1980

Heinich, N., *Du peintre à l'artiste*, Paris, 1993

Holt, E., *The Triumph of Art for the Public, 1785–1848: The Emerging Role of Exhibitions and Critics*, New York, 1979

Hughes, A., ' "An Academy for Doing" I: The Accademia del Disegno, the Guilds and the Principate in Sixteenth-Century Florence' *Oxford Art Journal* (vol. 9, no. 1, 1986), pp. 3–10

Hughes, A., ' "An Academy for Doing" II: Academies, Status and Power in Early Modern Europe', *Oxford Art Journal* (vol. 9, no. 2, 1986), pp. 50–62

Hutchison, S.C., *The History of the Royal Academy 1768–1986*, London, 1986

Laurent, J., *A Propos de l'Ecole des Beaux-Arts*, Paris, 1987

Mahon, D., *Studies in Seicento Art and Theory*, Westport, 1975

Mainardi, P., *Art and Politics of the Second Empire*, New Haven and London, 1987

Mainardi, P., *The End of the Salon: Art and the State in the Early Third Republic*, New York, 1993

O'Doherty, B., *Inside the White Cube: The Ideology of the Gallery Space*, Santa Monica, 1986

Pearce, S. (ed.), *Art in Museums*, London, 1995

Pevsner, N., *Academies of Art, Past and Present*, Cambridge, 1940; reprint New York, 1973

Reynolds, Sir J., *Discourses on Art*, ed. Robert R. Wark, New Haven and London, 1975

Vergo, P., *The New Museology*, London, 1989

Yates, F., *The French Academies of the Sixteenth Century*, London, 1968

The Politics of Landscape in European Art

Stephen Daniels

From the 18th to the 19th centuries landscape became a powerful, arguably dominant, genre in the visual arts of Europe. Landscape became central to a variety of art forms – painting, drawing, print making, photography, architecture and garden design – and to literary forms too, notably poetry and the novel. As this range might suggest, landscape was not just an artistic category but a cultural sensibility. The period witnessed a broad interest in observing the shape, structure and working of the material world, from wild country to long-civilized regions; landscape was a key concept in a variety of texts from geological treatises to tourist guides.

The rise of landscape art as a genre was not, however, a smooth progression. In European ▷academies of art in the 18th century, landscape occupied a lowly position in the cultural hierarchy, below ▷genre, ▷portraiture, and especially ▷history painting, the depiction of heroic, figure-dominated scenes from the Bible, literature or Classical antiquity. The fight to raise the status of landscape was often conducted by making the genre more than a matter of ▷topographical record, and by attempting to have landscape imagery carry the burden of moral associations, sometimes even narrative content, which characterized history painting. This process could involve a mutation of history painting, infusing the setting with some of the significance which attached to the figures. At the same time pressure was exerted on academic standards from without, from a polite society which placed increasing cultural value on observing and appreciating the real world, familiar places of work and commercial progress. The esteem of topography was raised by enhancing its range. Through a series of scenes, say as part of a tour or itinerary, a particular location might be situated within a wider human and natural world, of climate, geology, work or trade. Such a topographical perspective was more than a superficial view; it was a manifold description and analysis of a place that reflected acute and searching observation on the part of the artist. These enhanced historical and topographical dimensions of landscape combined to make landscape art a force field of vision and knowledge.

Once fought for, landscape in art was constantly fought over; it was a highly-contested terrain of theory and practice. Moreover, the development of landscape art happened in different ways in different places. In 18th-century Britain some experimental advances in topographical art took place outside London, in provincial centres of watercolour art, and within the metropolis there were rival sites of organization, exhibition and sale to the ▷Royal Academy. In 19th-century Paris, fluctuating state policy, from periods of liberalism to reaction, dictated whether landscape was represented at all in the ▷Salon, and if so the degree to which it deviated away from strict realism towards the work of the ▷Impressionists.

Landscape in art was constantly reshaped to address new demands and challenges, both of the dynamic culture which sponsored it and the rapidly changing environment it was called to depict. ▷Old Masters were reclaimed for new subject matter: ▷Claude Lorrain for emparked countryside; ▷Hobbema for farmland and canals; ▷Canaletto for commercial cities; ▷Rembrandt for smoky industrial scenes. Codes of European landscape art were taken overseas and rephrased to represent unfamiliar land forms, climates and cultures. This rephrasing was not just a matter of accommodating new kinds of factual material, but of taking on other, perhaps more factual, forms of knowledge. A variety of discourses, from archaeology to zoology, informed landscape art, enhancing its capacity to represent the grand themes of development and destiny in the natural and social world. There were

exchanges between landscape art and a variety of visual practices, from map-making to stage design. If maps offered the landscape painter a model for displaying a great deal of factual information across the picture surface, stage sets offered a model for representing recessional space and scenic spectacle in a lucid, effective manner.

By the 19th century the term landscape in many European languages – *Landschaft* (German), *landskip* (Dutch), *paysage* (French), *paesaggio* (Italian) – denoted both a material domain and the way that domain was depicted or envisioned. Landscape was in a double sense a social construction. The material landscape of Europe and its overseas dominions was made over by human use, laid out with fields, farms, roads, towns and cities, organized according to various economic and political systems. In many regions the landscape underwent great, sometimes revolutionary, transformations in use, work, ownership and government. The political map of Europe was redrawn in the 19th century, with new nation states like Italy and Germany being created and older ones like Britain and France redefining their identities. A sense of national landscape, of homeland, with hallowed sites and scenery, was integral to the nationalist movement of the period.

The perceptual landscape was no less social a construction. To envisage the material landscape, to see and express it as a coherent picture, was often assumed to be a polite accomplishment, beyond the capacity of those who actually worked the land, and those in a subordinate social position, such as artisans, servants, children and most women. But through the 19th century we witness a broadening of the constituency for landscape, to the point that by the end of the era, it is a mark of public citizenship to be able to recognize and appreciate landscapes exhibited in national galleries or mass produced in magazines.

There was an enormous range of ways of envisioning landscape – as landowner, merchant, farmer, hunter, tourist, connoisseur, military man, suburbanite or lady of leisure – which landscape artists articulated in their work. Moreover sharp social conflicts might be expressed in landscape tastes. Landscapes might be valued as repositories of local tradition or commodities for passing tourists, as promising prospects for commercial development or as ▷sublime nature, resistant to human exploitation, as scenes whose attraction was centred in their material shape and lived culture or in the superior visual sensibilities of the spectator. To look upon one kind of landscape rather than another, and to look upon them in particular ways, raised complex political issues.

The relationship of landscape art to the material landscape was varied and complex. On the one hand landscape art was envisaged as a world apart, an idyllic world uncorrupted by modern developments, located in scenes from Classical mythology or in oases of untouched nature. On the other, landscape art was envisaged as a way of observing and engaging with the modern world, of comprehending what the eye could see. It is not easy to separate idealism and realism, arcadian reverie and actual life. Idyllic landscapes were actualized in the form of aristocratic pleasure grounds or national parks, and even as painted images in exhibitions or private homes they had a material role in the formation of modern culture. Depicting the real world, however, was never just a matter of factual transcription either. Even the most empirically-minded landscape artists envisioned their worlds according to a variety of speculative theories and most incorporated other cultural concerns in their pictures, from allusions to literature to signs of God's handiwork.

Of any landscape painting we may enquire about the worlds it represents, both in and around the picture. There are the places represented, from the conservative world of country house portraiture to the libertarian world of street life and cafés; the spaces of representation, from Classically-ordained compositions to shifting perspectives derived from travel; the vantage points of the pictures, from imaginary God's-eye views through private balconies to public roadsides; the places the pictures were painted, from the easel in the open air to the city studio; the spaces in which the pictures were exhibited, from crowded exhibition halls to dealers' shop windows; and the locations where they were displayed, from the drawing rooms of country mansions to the parlours of suburban villas. These worlds were not beyond the frame; they determined such basic issues as the subject, size, medium and finish of a work.

This essay is organized in terms of the subject-matter of painting, but, as will become evident, the chosen categories, historical agrarian, urban and industrial landscape art, are not stable or exclusive. In almost every picture there is evidence – visible, entailed or implied – to other kinds of subject matter. No less than landscapes on the ground in the 18th and 19th centuries, landscape in art was fluent, not fixed.

Historical landscape

Much European landscape art represents or alludes to worlds of the past, to scenes of medieval history, Classical antiquity, primitive prehistory and beyond to periods of time before human habitation. The growing interest in archaeology and geology, both through fieldwork as well as theory, brought the past down to earth and prompted speculation into its characteristic sites and scenery. Excursion to lands on the Mediterranean periphery of educated Europe, to Greece, the Levant, Egypt and the Holy Land, had travellers searching for scenic evidence of the heritage they claimed. They journeyed north too, to a chiller, more twilight zone of ▷ Gothic lands and heroes. In overseas domains of the European imperium, from North America to the South Seas, they also found scenes which led them to speculate on their own cultural ancestry. The past was rarely regarded as an entirely foreign country; it was seen to shape and inform landscapes of the present and possible future. Educated Europeans thought historically about landscape, especially when reflecting on the political lessons to be learned from its scenic and social order.

Wealthy citizens from northern Europe, many of them aristocratic young men, took the so-called ▷ Grand Tour to the sites of Classical antiquity in Italy. Here they polished their Classical education, acquiring the cultural credentials which equipped them to rule at home. Accompanying Grand Tourists and catering to them were a succession of professional landscape painters, some of whom formed, along with sculptors and architects, resident colonies in Rome. The guidebooks of Grand Tourists were the works of Classical authors like Virgil and Horace, but their notions of what Classical landscape looked like were shaped by the works of 17th-century painters of Classical scenes, Claude Lorrain and ▷ Gaspard Dughet. Professional artists from the North were careful to imitate these painters' style in reconstructions of scenes from literature or in depictions of sites associated with history or mythology. Villas, temples, aqueducts, amphitheatres, tombs, grottoes, terraces and groves accentuated calmly composed, luminous landscapes.

Rome was the main attraction. Here were the material remains of a civilization and its code of civic virtue with which many modern aristocrats identified. Observing Roman ruins on the ground or in art, they reflected on the possible disorders, from luxurious decadence to mob rule, which threatened any patrician culture, not least their own. Of course, it was not all cultural education and moral reflection on the Grand Tour. Venice was renowned for its more gaudy attractions and most tourist cities had flourishing quarters for gambling, drinking and whoring. Yet each side of the Grand Tourists' Italy tended to reinforce the other. In contrast to its former grandeur, modern Italy was seen as decadent and barbarous, less worthy of the custody of its Classical heritage than the visiting English milords or German princes.

Grand Tourists found the landscape and culture of their northern homelands conspicuously lacking in Classical virtues. So they had it refracted through scenic images of Classical antiquity. Artists painted native countryside in the style of Claude. Tinted mirrors called ▷ Claude glasses were available to transform a promising stretch of landscape into an image of the Roman *campagna*. Landscaped parks and gardens were laid out with Claudian vistas, Classical statuary and inscriptions from Horace and Virgil. An ideal past framed the actual present. This may seem to us now like so much drapery, a cover-up of rural reality (and to contemporary critics it did too), but for apologists of the ▷ Grand Manner it was an ideal model, even a divine order latent in the landscape which might be realized under the right political conditions of benign patrician authority.

▷ Richard Wilson made his reputation as a British artist by rendering a variety of scenes in the Grand Manner. His paintings of the classic ground of Italy are history lessons for his British patrons. They evoke an arcadian golden age, the timeless worlds typified by Claude's sunlit scenes, but with a topographical awareness and sense of passing time that made Classical landscape so compelling for his clients. When he turned to Britain Wilson represented scenes by the Thames or on rural estates which had already been given a patrician polish, punctuated with Classical villas and mansions and landscaped into pleasing prospects. When he moved on to the landscape of his native Wales, its mountains and castles, he encountered raw material. Mountainous districts of Britain had been conventionally shunned by polite society, dismissed as dreary wastes full of uncouth monuments. Wilson composed these places into a Classical format, rearranging peaks and lakes to look like Italian scenery and enveloping them in a warm Mediterranean atmosphere. Here was a way of reclaiming native, historic landscape, and in the process raising the cultural register of British landscape art.

A Classical grand style was one of number of scenic codes for depicting and designing the historical landscape of northern Europe. Others were seen to be more representative of these lands and their peoples, to more credibly picture local topography, climate and culture, and to do so for less aristocratic interests. Seventeenth-century Dutch landscape painting, in the style of Hobbema and ▷Ruisdael, offered a model for depicting the development of a vernacular countryside, although there were also attempts to reclaim Claude, not so much for his oils as for his empirical-looking drawings of fields and forests. These styles were incorporated in the development of the ▷picturesque. An incremental, deeply-layered history was seen to be inscribed in hollowed lanes, pollarded trees and mossy cottages. Connoisseurs of the picturesque revered such homely scenes, with their ecological intimacy of land and livelihood. It was conventional to look at such landscapes close up, to focus on foregrounds where the detailed texture of local nature and culture was most evident. Native trees and woodland management serve to root the gaze, in contrast with those schematic specimens of Classical landscape imagery which serve only to frame otherworldly vistas. For the middling gentry of Britain the picturesque offered a model for designing their estates and grounds, a form of landscaping rooted in local conditions and a landowner's careful respect for them. It was, moreover, a reproach to those aristocratic owners who arrogantly swept away copses and cottages to make way for an exclusive, Classical parkland with temples and vistas.

A grander, more dramatic code of native historical landscape focused on medieval monuments like castles and abbeys, or rather the many ruins of them. These were sometimes incorporated in landscape parks along with fabricated Gothic structures as a counterpoint to structures and scenes evoking Classical antiquity, a way of patriotically evoking a native and Christian heritage. Ruined castles and abbeys achieved a wider currency for accentuating wilder landscapes, sublime scenes of precipitous mountains and wintry forests. Here was a native culture which seemed so close to nature as to model its very architecture on organic forms.

Reflections on native history reached back into a more primitive, aboriginal past in the depiction and investigation of earthworks and ▷megaliths and speculations on tribal rites and organization. Stone circles like Stonehenge on Salisbury Plain were major centres of attraction; smaller ▷cromlechs were sought out too. Some antiquarian landowners had them fabricated for their parks. This primordial landscape was imaginatively populated with warriors, bards and druidic priests. Some labourers made a living playing hoary hermits in parkland grottoes. The reputations of Ancient Britons, Gauls and Teutons were transformed from bloodthirsty barbarians to primitive patriots, noble heroes who resisted foreign invasion from Rome. Such cultures were often ascribed a liberty and independence, even a kind of primitive democracy, which somehow sprung from their contact with nature in its more elemental forms. As such they often appealed to radical social interests who were opposed to patrician politics and the Classical imagery which informed it. The inspiration for modern nation states like Britain, France, Germany and Denmark might be found in their less cultivated regions: in the Welsh mountains, Brittany coast, Prussian forests or Jutland heath.

When ▷Caspar David Friedrich exhibited *The 'Chasseur' in the Forest* (1813, private collection) at an exhibition of patriotic art in Dresden in 1814 after the defeat of invading Napoleonic armies, his audience would have immediately understood the message. A French soldier with a Classical-style helmet is engulfed in a dark, wintry forest, dwarfed by the massed ranks of trees. The spirit of the Goths who repelled the invaders of imperial Rome seems alive in the very trees. Friedrich went on to articulate the cult of a Gothic homeland in visionary pictures of old abbeys, oak groves and mountain shrines in pine forests. British artists enlisted Gothic landscapes in the war effort too. Especially at times when the continent was closed to British tourists it was a patriotic duty to admire the picturesque qualities of 'Old English' abbeys and oaks. After the defeat of Napoleon, French tourists and artists consoled themselves by seeking out ruined abbeys and deep forests, recovering signs of a noble, native past, antique material for a period of national renewal.

Rocky, mountainous landscapes were prime sites for geological observation and speculation, a science which was becoming increasingly visual, with the proliferation of maps and diagrams contributing to its growing popularity, as tourists joined scientists in the search for striking rock specimens and natural formations.

Caverns were marketed as tourist sites, with theatrical displays of lighting. New grottoes of fossils, crystal and coral were constructed in landscape gardens. The rocks revealed a historical landscape as profound and dramatic as anything recorded in written history. On the Grand Tour artists like ▷Joseph

Wright joined the trail to the caverns, craters and grottoes around Naples, and was rewarded by the highlight of Vesuvius erupting. Such landscapes activated Classical underworld narratives, of gods and heroes, but also the new narratives of earth science, 'subterraneous geography', with speculations on an underground sea of fire as the basis of present landforms.

Wright drew geological parallels between Italian scenery and that of his native Derbyshire. Here in the English Midlands was a primordial power in the land, now exploited by local industrialists sinking mine shafts, smelting minerals and cutting canals.

As with all historical studies, no matter how universal their scope, geology was a matter of chauvinistic pride. Friedrich's pictures of the Harz mountains are patriotically informed by the geological culture of Saxony with its mines, mining schools and mineral museums. In alpine scenes like *Der Watzmann* (1825, Berlin) – which he never in fact visited – Friedrich deployed Germanic theories of mountain building to articulate the soaring shape and structure of the mountains. British Victorian painters like ▷John Brett and ▷William Dyce deployed a more empirical, field-work tradition, focusing on the fine details of stones and strata, in charting the historical depths beneath the modern scenes of labour or leisure. For influential observers like ▷Goethe or ▷Ruskin the mineral world was not inert, but an energetic, almost organic force, with which societies worked, well or ill, to produce cultural landscapes. Much Romantic landscape art searches out pleasing harmonies of form and material between nature and culture, between the cottage and the hillside, the bridge and the crag. Such landscapes epitomized a stable, secure way of life, all the more so for seeming so isolated from the main currents of modern life.

Agrarian landscapes

In polite circles of the 18th century farming became a fashionable concern. The moral image of good husbandry celebrated in Classical literature was revived. Poets wrote Virgilian odes to the cultivation of various crops: wheat and cider apples in England, rice and hemp in Italy, sugar cane in the Caribbean. There was an outpouring of practical writing on agriculture, not just for farmers managing the fields, but to give polite society an informed pleasure in a well-cultivated countryside. Artists represented a variety of agricultural scenes, from the pastoral fantasies of ▷Boucher and ▷Fragonard, with their aristocratic ladies dressed up as milkmaids and shepherdesses, to down-to-earth depictions of men hedging, ditching and muck spreading in the work of ▷Constable and ▷Turner.

Campaigns for agricultural reform – for new technologies, crops, animal breeding, land redistribution and labour relations – were waged throughout Europe but were successfully realized in only a few places. Some lowland regions of northern Europe – Denmark, the Netherlands and southern England – provided favourable physical and cultural conditions for a modern agrarian landscape to develop. English agricultural landscape was seen both at home and abroad as exemplary: neat, productive, almost garden-like. It was seen to be more than just a matter of fertile soils and gentle terrain but the encapsulation of an entire rural society, an enviable alliance of enlightened landlords, enterprising farmers and sturdy labourers mobilized by trade and urban demand. Landscape painters found a market for farming scenes among both urban consumers and enlightened landowners who, from the early 18th century, commissioned portraits of their acres of agricultural prosperity.

More than pedigree or military prowess, property defined the English ruling class. It was the basis of wealth, status and political authority. High-angled bird's-eye views mapped out the extent of landed property and the details of its prudent management. Parkland, farmland, plantations, roads and waterways are seen radiating from the country house. The scene is often animated by tiny figures of shepherds, milkmaids, hunters and haymakers. It is often the gardens, brilliantly laid out with parterres, fountains, avenues and statuary which establish the order for the landscape at large. Such pictures present an ideal of spatial order, social concord and economic prosperity under landed authority. Many of the earliest of these prospects were produced by Dutch *émigrés*, an indication of how much the English imagery and ideology of landscape improvement owed to the strong Protestant culture of the Low Countries.

Such bird's-eye views were displayed in their owner's country houses, or perhaps in the London mansions of a landed class which held strong financial and cultural interests in the capital. They also appeared as ▷engravings in albums of views from throughout the country, giving the impression to wealthy subscribers that the nation was defined by the seats of the gentry. It is scarcely surprising that such views offered a metaphor for the nation state and its governance. The landed gentry considered

themselves natural statesmen, able to grasp, as from a height, the nation as a whole, in contrast to the partial views of those of low status and specialized occupations.

Conventions of estate portraiture multiplied through the 18th century. As landscape parks were designed in a more informal, naturalistic style, opening up to the surrounding countryside, so painters took various views in and around the property. They portrayed hunting scenes in the deer park, ancient oaks and new plantations in the woodlands, haymaking and stock grazing on the home farm and family portraits in the gardens.

Hunting offered a model of aristocratic manliness. Here was a country pursuit with a long tradition and iconography of courtly conduct, a field for the display of military-style ardour, an antidote to the debilitating attractions for rich men in the metropolis. Large tracts of land were appropriated and managed for hunting, taken into the domain of gentlemen's parks. Styles of landscaping accommodated different modes of hunting, straight rides through woodland for stag shooting, large expanses of grassland with tree clumps and hedges for hunting with hounds. Bloodsports were central to the exercise of aristocratic patronage, both the ritual of the hunt and the disposal of the spoils. The gentry were proud to have themselves portrayed in their parks with their social circle, with their horses, dogs, and guns, in virile pursuit of the kill or gloating over the carcasses. So central was hunting to the definition of aristocratic authority, that deer parks were jealously guarded and the penalties for poaching severe. Hunting grounds extended well beyond the park. Large tracts of farmland were used for fox hunting. Hundreds of sporting prints show hordes of men in scarlet leaping the hedged fields of Midland England in pursuit of their quarry. During the 19th century the mountains and moorlands of upland Britain, many part of huge estates, were also increasingly and intensively managed for armies of hunters arriving by train. Highland landscape tastes at this time reflected hunting sensibilities, sometimes to convey a more solitary, wilderness experience. Some of ▷Landseer's highland scenes project the experience of stalking, the hours spent crouching and crawling in pursuit of the noble stag.

If hunting grounds provided scenes for the display of virility, flower gardens were seen and designed as a feminine domain. This reflected an ▷ideology of women as properly confined in their views and conduct, focused on a small and detailed arena, unable to comprehend or act in the great spaces of public life. Scores of floral scenes, many in the more private medium of watercolour, but also in the form of needlework samplers, were produced, often by genteel women themselves. These same women took a prominent role in designing and supervising flower gardens in the house.

Gardens and horticulture did however also assume a wider constituency, and indeed became part of a new model of more middle-class manliness. Landscape gardeners like ▷Humphry Repton designed grounds for promoting domestic virtues of comfort and convenience; rural writers like William Cowper championed a more serious regard for plants and flowers in the countryside as a whole, moreover for the calm minutiae of everyday life in homes, gardens, fields and woods. The country walk offered a more careful, observant view of landscape than the broadly scenic, rural ride.

A popular style of estate painting was the outdoor ▷conversation piece, of family groups posed in the grounds. Here the landscape provides a setting to amplify the social message of events such as marriage, birth or coming of age. In one of the most famous, ▷Gainsborough's wedding portrait of *Mr. and Mrs. Andrews* on their Suffolk estate (London, National Gallery), a range of features signify the promising prospects of this alliance. The couple are shown under an oak tree, the conventional symbol of landed ▷patriarchy; to their right is a field stacked with regular rows of wheat, signifying the modern practice of using a seed drill as well as female fertility. In the distance are a paddock of sheep on improved pasture, another of cattle, and bounding the whole are trim, well-managed woodland plantations. Mr. Andrews is shown in his shooting jacket, with flintlock and pointer; Mrs. Andrews has a cap under her straw hat rolled in imitation of a milkmaid's. These are not backwoods gentry or idle grandees, but a modern-minded couple, in the latest London fashions, showing off their neatly-managed, productive property.

Larger estates were not confined to a single place in the country. Some included overseas outliers. Thomas Hearne (1744–1806) was commissioned by absentee owners of Caribbean plantations to depict African slaves in their fields of sugar cane, working as harmoniously and contentedly as English labourers were shown to be in scenes of wheat harvest and haymaking closer to home. Nor were the visible interests of the more lucrative estates always restricted to agricultural property and hence easily accommodated in conventional estate views. For Lord Egremont, Turner depicted a portfolio of his patron's investments, from his improved pastures in Petworth Park to the Chichester Canal and the

Chain Pier at Brighton. Landed power did not keep politely to the countryside; it was everywhere.

If English agrarian art could not entirely escape landed authority, it could be organized in alternative ways, to emphasize the expertise of farmers, even the skills of labourers, and to situate the fields in worlds beyond the scope of estate owners, from regions such as river valleys and urban hinterlands controlled by a variety of interests, to those fantasy lands populated by idyllic rustics and entertained by urban and suburban sensibilities.

In the early 19th century a number of English rural painters keenly observed agricultural scenes with detailed attention to local topography, land use and practice. The fields of Lincolnshire were represented by ▷Peter de Wint; of Warwickshire by ▷David Cox; of Herefordshire by G. Lewis; of Surrey by ▷Linnell; of Norfolk by ▷John Cotman; of the Thames valley by Turner; and of the Stour valley on the Suffolk–Essex border by Constable. Literary associations still clung to such scenes, occasionally an echo of Virgil or of modern poets like James Thomson who wrote in a Classical idiom; but the most powerful literary associations are those which were current in the working country culture of the time, those of the Bible. Scenes of sowing, gleaning, shepherding and harvesting readily evoked Christian piety.

This art of agriculture worked against another genre of rural landscape, the portrayal of picturesquely unkempt scenery like heathlands and commons. These were not unproductive places – they were a valuable resource to the woodgatherers and grazers who are sometimes shown in common-land scenes – but it was a landscape independent of the gentry and wealthy farmers and increasingly in danger of being enclosed and put to the plough. Picturesque artists could however explore the limits of polite tolerance by showing more marginal places and figures, such as gypsies camped under hedges or poachers by wayside taverns. The portrayal of such scenes as pleasingly picturesque might at times appear dangerously indulgent towards unregulated land and life, but their main function was to give polite society some relief from the places and responsibilities of work, and to confirm landscape as a leisurely image.

Constable on the other hand worked hard to counter picturesque views of the rural landscape and to portray a well-kept working countryside. He broadened the scope of agricultural landscape to celebrate the enterprise of those who actively managed the land and marketed its produce, the farmers, millers and merchants: the rural bourgeoisie. Constable himself was born into such a family, running corn mills in the Stour valley and an export business along the waterways to London. His art charts many scenes of farming and barge traffic in this his region. Labourers figure too, but not prominently and often merely as functional components of a well-managed scene, dutifully and anonymously working to keep the crops growing and trade flowing. Constable was concerned not merely to project the vision of his local circle, many of whom (like his father) would have been happier to have him managing the actual landscape rather than painting pictures of it. Constable also had ambitions to be a leading figure in the London art world, a Royal Academician. He was intent to raise the status of landscape, both in the size of his exhibition pieces (his 'six-footers') and in the compositional echoes of Old Masters and his allusions to literature and poetry in the most naturalistic looking scenes. Like his contemporary Turner, he was intent to intersect the epic with the everyday.

Not that many of Constable's contemporary audience of urban critics understood his vision. The naturalistic freshness appealed to them, as did the paintings' Englishness, but their local and personal meanings were not apparent until after Constable's death, with the publication of his memoirs. Constable's public reputation as the quintessential painter of the English countryside was not achieved until the end of the 19th century. His most famous six-footer, *The Haywain* (1821, London, National Gallery) remained unsold upon exhibition in England in 1821, yet caused a sensation when it was exhibited in Paris and was nearly purchased for the French nation. Only after it was presented to the British National Gallery in 1886, and reproduced in cheap prints and postcards, did the painting achieve the iconic status that it retains in Britain today.

If Constable and his contemporaries had represented current developments in the English country-side, many of their Victorian successors fell back on portraying the countryside as a timeless, traditional place, a refuge from modern life, rustic not rural. This was in part a matter of their own knowledge, or lack of it, as urban excursionists, but also an index of how cities had come to epitomize modern life. In landscape art the countryside once again lost much of its meaning as a working environment to become a screen for the projection of mystical or moral symbolism. Only towards the end of the century, in the dreary rural landscapes of Frederick Walker (1840–75) and ▷George Clausen, showing

wintry scenes of social hardship, did a note of realism return. This tendency was influenced by campaigning journalism in illustrated news magazines, intended to dismantle images of happy rusticity, as well as by the rural art of continental Europe focusing on the toils of the peasantry.

Much of the actuality of agrarian life in continental Europe remained stubbornly traditional, and even where agriculture was modernized, pictorial imagery was slow to follow. When the most modern painters in later 19th-century Europe, ▷Impressionists and ▷Post-Impressionists, represented agrarian scenes, they showed few of the signs of modern development (such as mechanization) that they seized upon in cities and suburbs. Their blooming orchards and golden haystacks evoke a mythic quality of *la belle France*, a nation peculiarly blessed with fertile fields. Wooden shoes, rough implements and manual labour affirm the idea of a rural culture rooted in the land. The theme of peasant labours, familiar from medieval Books of Hours, persisted powerfully, even if it took on new, more secular meanings for the viewer.

In France, where the very term for landscape (*paysage*) remained implicated with the figure of the peasant (*paysan*), there was in the mid-19th century a resurgence of interest in peasant culture, in music, literature and the visual arts. This was in some measure a response to dramatic changes in rural life: to the depopulation of the countryside, and with it familiar fears of a corrupted citizenry, and also to the rustication of peasant life, the appropriation of artisanal tasks by industrial production and the creation of a purely agricultural labour force. ▷Jean-François Millet's monumental images of peasantry like *The Sower* (1850; Boston Museum of Fine Arts), *The Gleaners* (1851, Paris, Louvre) and *The Angelus* rework epic Classical and biblical themes and figures in contemporary life, and were variously interpreted as both radical, democratic images of an oppressed people and as pious, conservative images of rural fate. On any reading, they disrupt that complacent pleasure in idyllic rural scenery which had characterized much French rural painting from ▷Corot's Classically-composed countryside to ▷Théodore Rousseau's more naturalistic scenes of forested interiors or marshy plains. Indeed, by placing the figure at work so prominently in front of the spectator, they come close to disrupting a scenic notion of landscape altogether. This is even true of Millet's later, less figure-dominated pictures of his native Normandy and adopted ▷Barbizon where what we see tilted towards us is land, or rather earth, heavily inscribed with or worked by peasant labour.

Millet's pictures became canonical images for a variety of interests. After his death his paintings commanded high prices among the railroad magnates and industrial barons who were transforming France, undergoing that process of sentimentalization that seems in time to affect even the most searching and realistic pictures of rural life. When *The Angelus* was finally acquired in 1890 by a French collector in the face of American competition, it was treated as an act of patriotism, one confirmed when it was presented to the Louvre in 1909. Here was an authentic image of France and its people. Millet's images were influential on a variety of nationalist painters in Europe, roaming their native countryside to find scenes of authentic peasant life. They also informed a later 19th-century artistic search for pre-national, virtuously primitive, subsistence cultures on the periphery of all advanced industrial nations. The rootedness of Millet's rural imagery in a real, recognizable countryside loosens in ▷van Gogh's Provence or ▷Gauguin's Brittany; here are highly abstracted figures in a mythological nature, a pure and permanent world of value outside the complexities of modern life.

Urban landscape

The landscapes of large towns and cities offered dramatic evidence of economic and social development. Older capital cities like London, Paris and Vienna expanded enormously and underwent large-scale internal restructuring. Newer commercial and industrially-based cities like Manchester, Lyonss and Hamburg grew rapidly. Contemporaries registered their astonishment at the dynamism and upheaval of cities. Some cities offered convenient vantage points and vistas, indeed were planned or replanned to do so, but the bustle and sprawl of many cities presented a challenge for artists to depict them in ways which articulated their energy and modernity.

A powerful model of urban depiction which persisted from the 16th century was the elevated view or prospect. These were produced, sometimes as paintings but often as engravings, for many large European towns and cities. They might be commissioned by landowners (aristocrats were large urban as well as rural property holders) or offered on subscription to wealthier citizenry; they were also used to illustrate topographical guides or atlases. These prospect views highlighted civic structures like palaces and cathedrals (always big tourist attractions) and also picked out commercial activities which

characterized the place, sometimes as foreground vignettes, cloth bleaching here, fish curing there. In a culture in which cities exercised enormous power, sometimes as the centre of states, these prospects emphasized links between a city and its hinterland. If early 18th-century urban prospects, especially continental ones, present towns as securely bounded enclaves, later views through the 19th century chart urban expansion, including the spilling out of housing and industry into the countryside. In some cities the prospect format was extended into vast, sometimes 360° panoramas, in purpose-built observatories. What, on the ground, may have seemed a confused sprawl of a city was here presented as an orderly enterprise.

Turner deployed prospect conventions in his watercolours of English provincial towns and cities. Often viewed over a main thoroughfare, a road or canal, the impression is of energy and enterprise, a new order or urban power which liberal interests of the time were fighting to have represented in parliament. These were patriotic images too. Here, in these cities, were gathered and processed the resources of the country, from far and wide, from wool regions to coal fields, and from here they were exported, fuelling the nation's imperial power. Like many of his contemporaries raised on cyclical ideas of history, Turner was familiar with cautionary tales of former empires and in his art he also showed once great imperial cities ruined by luxury and corruption. Across Turner's watercolour views of bright and bustling Leeds or Coventry is the shadow of his exhibition oils of ruined ancient Carthage or Rome.

The city which for long offered a model or urban representation to painters was one which was well past it prime as a world power: Venice, or more precisely Venice as depicted by its 18th-century view painter Canaletto.

Canaletto's early training in scenography equipped him to depict the squares, waterways and pageantry of that most theatrical of cities. It was not all a façade for, or of, decadence and decline; Canaletto had a keen eye for signs of commerce, trade and building, and offered glimpses behind the scenes, as it were, of a more workaday city. But in large part Canaletto did portray Venice for foreign consumption, a souvenir city, especially for English Grand Tourists who formed his most important clientele. The British consul Joseph Smith acted as a dealer for most of Canaletto's output. Among the artist's aristocratic patrons was the Duke of Bedford who commissioned a series of 22 views of Venice for his London mansion.

Canaletto, along with his rivals and copyists, deployed Venetian-style view painting for courtly circles of other European cities, including Dresden, Warsaw and Madrid. But, through the British connection, it was London which received the most faithful treatment, at the hand of Canaletto and his compatriot Antonio Joli. As the capital of a great maritime empire, London was assumed to have taken on Venice's mantle and in their paintings of the Thames and its riverside architecture the painters presented the very image of flourishing, patrician city state. Under sparklingly Venetian sky, the Thames recalls the Grand Canal, thronged by boats working from warehouses and by pleasure craft, state barges and even gondolas. This is no city of the past, but one in the making, with bright new churches, palaces and bridges, some still with scaffolding. There is perhaps more than one Italian prototype here; as an image of order and enlightenment this London recalls the reputation of Classical Rome.

Canaletto and Joli produced definitive images of London and most subsequent painters of the capital's cityscape, especially that along the river between the City of London and Westminster, had to reckon with them in some way, rephrasing their conventions to represent new subject matter. Later painters, from Turner to ▷Monet, acknowledged London's smoky atmosphere, indeed made it a definitive part of the city's power and character, and incorporated up-to-date developments along the river, from state buildings to factories, bridges and boats, in the civic theatre of a world city.

The Thames provided the thread for London's scenic coherence and state grandeur. Elsewhere it seemed a more fragmented city. Civic improvements in London were always piecemeal, sponsored by private commercial interests, never part of a comprehensive, official plan. London's artists could find occasional scenic set pieces, especially in the polite squares of the West End, but the modern life of this metropolis was more appropriately charted along its thoroughfares, in the movements of people and commodities, in excavations for streets and railways, sewers and gas mains, and in the urban art of George Scharf and John Cooke Bourne (1841–96).

In contrast to London many capital cities on the continent – Berlin, Paris, Rome and Vienna – were redesigned according to a state-sponsored plan. The replanning of 19th-century Paris under Napoleon III with new parks, boulevards and public buildings turned a patchwork of neighbourhoods

into a coherent cityscape, a brilliant setting for the spectacle and circulation of city life. It almost invited a modern form of urban landscape painting. ▷Manet, ▷Morisot, ▷Caillebotte and ▷Pissarro charted the spaces and circulation of the new metropolis, for work and pleasure, for buying, selling, riding and walking or simply observing. Not that they reproduced the official view. They tended to ignore sites like Place de la Concorde, the Arc de Triomphe or the Opéra to focus on the structures and signs of a more informal bourgeois modernity, close-up pedestrian views of smoky railway stations and bridges like Gare St. Lazare and Pont de l'Europe, busy traffic intersections along the boulevards observed from high from the balconies of new apartments. These landscapes exhibit the interplay of middle-class city spaces, private and public, male and female. The informality of subject and vantage point was amplified by the sketchy execution and the modest size of the canvases. These paintings were not designed for the official Salon, for state approval or purchase, but for display in dealers' windows on those shop-lined boulevards and to decorate the private sphere of bourgeois life.

Urban landscape art was not all civic grandeur or metropolitan pleasure. There was a darker side to the urban landscape, the world of the poor. Slum images depict not just the antithesis of civilized urban life, dirty and dilapidated, but often what appears as a foreign, tribal country, as savage and mysterious as colonial territories abroad. Conventionally slums were seen as subterranean places, an underworld of low life. They were filled with the underground fantasies of polite society. Here horrific, half-human worlds might be discovered, but also fundamental truths of exploitation submerged beneath the brilliant but illusory superstructure of elegant city life. Illustrators and photographers collaborated with writers, journalists, missionaries and reformers in probing the precincts of the urban poor. These explorations were often conducted in a consciously empirical, even scientific way, as surveys itemizing material structures and classifying social types, but there was abundant scope for a literary imagining. Polite Londoners poring over ▷Gustave Doré's engravings of a labyrinthine East End of their city, all grime, menace and imminent collapse, would have been reminded of his apocalyptic paintings of scenes from the Bible, *Paradise Lost* and Dante's *Inferno* exhibited in Piccadilly. Most exhibition oil paintings tended to steer clear of slum subjects, other than as settings for ▷genre pieces, moral narratives of hard times in hard places.

Suburbs offered more scope for the landscape painter; indeed, they served as a testing ground of space and subject matter to stretch and reformulate the genre. A number of the more experimental landscape artists – Turner and Linnell, van Gogh and Manet – explored the outskirts of cities, territories being rapidly and scruffily developed with an assortment of uses, from elegant villas and gardens to brickfields and allotments. Moving to hilltop Hampstead from central London, Constable delighted in panoramic views of the capital, 'a view unequalled in Europe', he thought. He was no less taken with the vast expanse of sky which he set about sketching with meteorological method. Here was a suburban observatory for the study of nature, underscoring Constable's claim that painting shared the investigative power of science. Constable's views of Hampstead Heath show an urban park for promenading Londoners, but they have an eye too for a working landscape, the gravel digging providing material for the city's building. Monet's paintings around his home in Argenteuil, just fifteen minutes from Paris by train, explore a similar suburban world, of bourgeois pleasures like regattas and flower gardens, alongside signs of a more workaday world, the factory chimneys and iron bridges of an increasingly industrialized town.

Industrial landscapes

The image of an industrial landscape is dominated by developments associated with coal, of smoke-billowing factories, sulphurous iron smelters, blackened pit stocks and flaming furnaces. The coalfields of Europe, in northern France, Belgium, Germany's Ruhr Valley, South Wales and the so-called Black Country of the English Midlands, offered scenes of a comprehensively industrialized landscape, one in which most traces of agriculture, even organic nature, were obliterated.

A region early renowned for such developments was Coalbrookdale, in and around England's Severn Gorge. From its inception it was consciously marketed as an industrial landscape, to attract wealthy visitors, the potential consumers of its products as well as its scenery. Here spectacular and revolutionary processes of iron smelting might be observed by tourists on their way to the mountainous country of North Wales. As much as the sublime horrors of the place, redolent of infernal scenes from literature, descriptions and illustrations focused on the details and data of processing; indeed the very statistics of volume, discharge and production had a sublime power. Visitors were told of the sheer range of

ironware produced, from ship's cannon to domestic pipes and railings, giving the impression of a new framework for the country, a nation structured on iron. This was symbolized by the centrepiece of Coalbrookdale, the world's first single-span Iron Bridge. Upon its completion in 1780, the bridge's proprietors commissioned the London stage designer ▷Michael Angelo Rooker to paint a picture of the bridge (Ironbridge Gorge Trust Museum) and had the engraving dedicated to King George III. The bridge frames the river, showing between its arches a smoking smelter on the banks. This became the standard view, used on a variety of souvenirs, and a logo for a large number and wide range of companies in the region.

For much of the period industrialization in Europe took more varied, scattered and subtle forms. The presence of industry in landscape art may now be scarcely recognized because it is an ingredient of a much broader field of vision and concern: the quarry in the mountainside, the bleaching ground by the river, the weaver's cottage on the hillside pasture, the marl pit in the corn field, the rope walk down a city street, the tenter field outside the city, the improved ship, the straightened road. The very category of industrial landscape is perhaps a difficult one to sustain across such a variety of development. On the one hand there are derelict quarries or mines, or ones which seemed so, in wildly mountainous regions, pet subjects of artists in search of a visibly unproductive landscape vision, an extreme version of the ▷picturesque. On the other there are the large corn mills and canalized waterways of visibly productive lowland regions, which are conventionally assimilated into notions of agrarian landscape.

It is useful to remember that for much of the period the term 'industrial', at least in English usage, carried strong ethical as well as technical connotations, of hard work or 'industriousness'. The conjunction of 'industry' with 'idleness' is a stock theme of the visual arts of this period and was carried forward into the representation of scenes of large-scale, comprehensive production. So as a companion picture to his 1835 view of Venice for the Manchester cotton spinner Henry McConnel, which showed luxurious citizens lounging in gondolas, Turner painted a view of Shields on the river Tyne showing men shovelling coal into ships bound for London. While Venice and its citizens stagnate in the sun, the keelmen of Tyneside, working by night, fuel Britain's power.

It was transportation improvements which unlocked the resources of regions, integrated once isolated places into a commercial and political unity, put goods, services people and money into circulation, and in every way mobilized the modernization of nations. Transport and communication are a defining theme of landscape art. Spectators are taken into the scene along a variety of routeways, by road, waterway and railway, and presented with a variety of infrastructures, from bridges to piers. The languor of some landscapes – the meandering river and crumbling aqueduct in Classical scenery or the rutted lane and babbling brook of picturesque scenery – precisely acquired their significance by contrast with the energy of consciously modern landscapes, scenery articulated by turnpike roads, railway bridges and sea lanes, stage coaches, locomotives and ships.

For much of the period marine painting offered the most impressive images of commercial and state power. Drawing on 17th-century Dutch models, artists of all major European powers, and notably the two leading ones, Britain and France, celebrated scenes of shipping, from harbours to the high seas. A variety of vessels from coasters to clippers were delineated in fine detail, amounting to a genre of ship portraiture. Scenes in major ports showed the traffic of import and export, loading and unloading. Shipbuilding, the largest-scale industry of all, is a familiar subject, as is the opening of new docks, like those servicing Britain's colonial expansion, which were the largest commercial sites in the country. The sail and steam ships of the merchant marine are shown plying sea lanes. Warships are shown defending each nation's rights to the waves. Sea battles were popular subjects, with cannon blazing men-of-war pounding the enemy's decks and rigging, shredding their ensigns.

Large-scale industrial development sometimes put pressure on established codes of scenic and social order. Spokesmen for rural, especially landed interests sometimes registered their alarm at the spectacle of large-scale, steam-driven textile mills and railways, not just for any disruption to familiar countryside but because of the subversive social energies they were thought to unleash. A country of benevolent squires and submissive peasants might be transformed into one of upstart industrialists and surly factory hands. Conversely, industrial entrepreneurs and supporters took as much pride and pleasure in the landscape of mills and railways as did landed aristocrats in that of country houses, landscaped gardens and well farmed fields.

If paintings of large factories were exceptional in metropolitan exhibitions of landscape art, they were frequently commissioned by the factory owners themselves. A number of famous names in

European landscape art, including Corot and Friedrich, were commissioned to portray freshly built factories. It did not take much to adapt the conventions of country house portraiture to show a well proportioned, water-powered textile mill sitting prettily in water meadows. Some mill owners had their grounds landscaped to show them as such. Successive generations commissioned subsequent views of factories, detailing the expansion of the enterprise, in the process switching scenic codes from picturesque vignette to panoramic view. Such views were frequently engraved to advertise the firm on company stationery and invoices.

Some industrial landscape paintings resonated with more than local, company pride. Joseph Wright's exhibition-size oil of Richard Arkwright's cotton mills illuminated at night (1782–3, private collection) is the site of number of cultural cross-currents. In their experimental combination of architecture, machinery and management these mills were a model for factories anywhere. The site at Cromford in Derbyshire was the centre of an extensive cotton-spinning empire which extended to London and Scotland and exported world-wide. In their sheer bulk and ranks of luminous windows, the factory buildings reminded more than one observer of a great warship with guns blazing. Arkwright's mills were a national monument worthy of display, and Wright deploys the scenographic conventions which he used to represent other spectacular landscapes, from the eruption of Vesuvius to fireworks in Rome. Wright's painting is more than an industrial scene, it is part of a landscape genre which represented a voluminous, potentially volcanic power in the land.

The same can be said of ▷Loutherbourg's *Coalbrookdale by Night* (London, Science Museum), exhibited at the Royal Academy in 1801. An ironworks blazes in a crater-like hollow under a full moon. Here is the centre of another industrial empire which was fuelling Britain's might at the height of the Napoleonic Wars. Spectators at the Royal Academy would have recognized the compositional parallels with another of Loutherbourg's depictions of British fire power the previous year, the French flagship being blown up during the Battle of the Nile. Loutherbourg's style in both these pictures is informed by his design of stage spectacles, some of which carried an obscure apocalyptic symbolism. At a somewhat frenzied period of millennial prophecying Loutherbourg's painting is more than simply a powerful image of iron making; it is an intimation of the world to come, dominated by the energy and undeniable face of industrialization.

Of all industrial developments it was the railway which most dramatically transformed the 19th-century world and ways of perceiving it. The railway did not so much run on the landscape as through it, creating new perspectives and senses of space. Railway promoters upheld a new, more imaginative order of civil engineers and company shareholders, in contrast to the reactionary ways of peasants and aristocrats. Promotional prints celebrated the new scenic order of great cuttings and embankments, tunnels and viaducts, monumental stations and speeding locomotives, often contrasting them with slower rhythmed landscapes like country lanes and gentleman's parks.

For many well-known British landscape painters the railway offered only a means of getting rapidly far out into an unspoiled countryside and back again. Few represented the railway as even a distant trace in the landscape. The exceptional painting is Turner's *Rain, Steam and Speed* (1851, London, National Gallery). This shows a locomotive of the Great Western Railway racing head-on over the Thames along Maidenhead Bridge. The line from London to the west country was esteemed a great national achievement and the bridge, designed by Isambard Kingdom Brunel (1805–59), a daring piece of civil engineering. The Great Western was more than a railway company. Embarking from Bristol, its revolutionary steamship, also designed by Brunel, plied the Atlantic to New York. The implications of *Rain, Steam and Speed* extend well beyond the picture. Turner's train, while an emblem of modernity, is also a vehicle of a long tradition of heroic landscape, traced along the waterways of Britain, from the Thames to the high seas.

In contrast with British art, the railway is one of the defining motifs of French Impressionist landscape, especially that in and around Paris. Monet's paintings of Gare St. Lazare, shrouded in the steam and noise of locomotives, are not just scenes of the station but look out through the cast iron arches of the engine shed to the boulevards beyond. This was the station which serviced Monet's home town of Argenteuil, and a streaking train on the town's iron-clad railway bridge over the Seine is a recurring subject of his art. The railway served to energize the suburban landscape. As Benjamin Gastineau, a contemporary promoter of the railway put it: 'Before the creation of the railroad nature … was a Sleeping Beauty; even the sky was immobile. The railroad animated everything, mobilized everything … nature became an energized beauty.'

Bibliography

Baetjer, K. (ed.), *Glorious Nature: British Landscape Painting 1750–1850*, New York, 1993

Barrell, J., *The Dark Side of the Landscape: The Rural Poor in English Painting 1730–1840*, Cambridge, 1980

Bermingham, A., *Landscape and Ideology: The English Rustic Tradition 1740–1860*, Berkeley and Los Angeles, 1986

Boime, A., *Art in an Age of Bonapartism 1800–1815*, Chicago, 1990

Clark, T.J., *The Painting of Modern Life: Paris in the Art of Manet and his Followers*, London, 1985

Copley, S. and Garside, P. (eds.), *The Politics of the Picturesque*, Cambridge, 1994

Cosgrove, D. and Daniels, S. (eds.), *The Iconography of Landscape*, Cambridge, 1988

Daniels, S., *Field of Vision: Landscape Imagery and National Identity in England and the United States*, Cambridge, 1993

A Day in the Country: Impressionism and the French Landscape, exh. cat., Los Angeles, 1984

Deuchar, S., *Sporting Art in Eighteenth Century England*, New Haven and London, 1993

Gage, J., *J.M.W. Turner: 'a wonderful range of mind'*, New Haven and London, 1987

Green, N., *The Spectacle of Nature: Landscape and Bourgeois Culture in Nineteenth-Century France*, Manchester, 1990

Hemingway, A., *Landscape Imagery and Urban Culture in Early Nineteenth-Century Britain*, Cambridge, 1992

Herbert, R.L., *J.F. Millet*, exh. cat., London, 1976

Holloway, J. and L. Errington, *The Discovery of Scotland: The Appreciation of Scottish Scenery through Two Centuries of Painting*, exh. cat., Edinburgh, 1978

House, J., *Landscapes of France: Impressionism and its Rivals*, exh. cat., London, 1995

Hugget, F.E., *The Land Question and European Society*, London, 1975

The Image of London: Views by Travellers and Emigrés, exh. cat., London, 1987

Klingender, F.D., *Art and the Industrial Revolution*, London, 1968

Mitchell, T.F., *Art and Science in German Landscape Painting 1770–1840*, Oxford, 1993

Mitchell, W.J.T. (ed.), *Landscape and Power*, Chicago, 1994

Payne, C., *Toil and Plenty: Images of Agricultural Landscape in England 1780–1890*, New Haven and London, 1993

Rosenthal, M., *British Landscape Painting* Oxford, 1982

Rosenthal, M., *Constable: The Painter and his Landscape*, New Haven and London, 1983

Solkin, D.H., *Richard Wilson: the Landscape of Reaction*, exh. cat., London, 1982

Tucker, P.H., *Monet at Argenteuil*, New Haven and London, 1982

'Other' Art: Approaching Non-European Cultures

Shaun Hides

Discussing non-European art

The art and artefacts of other cultures have been a significant presence in European life since the ▷Renaissance. However, that presence has always been characterized by incongruity and ambiguity. Western European culture has been continuously redefined throughout this period, and important aspects of these cultural definitions have been constructed in relation to other cultures. That is, Europeans came to identify what they were by distinguishing themselves from what they most definitely were not.

The inter-relation between Europe and non-European cultures has often been disturbing: for example, artefacts from Africa and ▷Oceania were central to the development of modern art, but these objects also confront ▷modernist theory, highlighting its insecure assumptions and limitations. Throughout modern European history, heterogeneous and often contradictory images of other cultures have coexisted within each field of representation, and these have been linked to the contradictions inherent in European culture. 'Primitive' peoples have been viewed as both naive innocents and cannibalistic savages depending on the political and religious affiliations of their European discoverers. Although formal academic discourses, overtly political agendas and 'popular' representations exhibited certain common characteristics, they also differed considerably in terms of their particular constructions of ▷'the Other'.

This essay is an attempt to come to terms with the challenges posed to European audiences – academics, artists, collectors and curators – by the 'art' of other cultures. It eschews traditional regional or geographical and formal categorizations, the favoured means of organizing and interpreting such material. Numerous general accounts of the artefacts of other cultures exist; many claim their field to be that of 'Tribal Art', or 'Primitive Art' in general. Even more common are those which deal with an ethno-geographically defined corpus of art ('▷African art', or '▷Australian Aboriginal art') or a formally identified category, such as 'primitive sculpture'. Such categories imply a coherence or identity to the art of a whole continent, or the relevance of abstract formal classifications not recognized by the producers of the work. Many of these accounts begin with a rehearsal of the arguments about the appropriate taxonomy for the objects under discussion. Terms such as 'tribal', 'ethnic', 'primitive' and 'art' are often found inadequate, but ultimately retained in the absence of adequate alternatives. Because of this limitation, most of these terms appear here under the qualification of speech marks. The term 'non-European', used in the title, is another flawed generalization, but one which attempts to indicate that the objects of study have been defined by their difference and divergence from an assumed European norm.

This essay is premised upon the recognition that there is no essential, formal, cultural, historical or geographical unity intrinsic to the field of enquiry defined by the objects themselves. The artefacts, material culture and artistic traditions which are assembled within 'ethnographic' collections, in private collections and academic texts, in fact represent an astonishing diversity of cultural traditions. Their coherence is produced by the practices specific to Western European culture and its development: those which caused these objects to leave their original contexts; those which organized, interpreted and represented the artefacts; and those through which the identification between Europe and its

imagined 'other' operated. For this reason, a properly historical account of these artefacts must be organized around an examination of the emergence of the practices, meanings and the institutions in which they have been located.

The essay will examine a number of themes through which the incorporation of the artefacts of other cultures into European modern culture can be understood: the notion of the exotic or monstrous; the early emergence of European materialism; modernity, identity and the search for the primitive; the distinction between art and artefact; 'globalization' and ▷postmodernism. These themes emerged through the transformations, shifts and developments which characterize modernity.

▷Michel Foucault's (1970) influential description of the ▷epistemes (modes of knowledge) which operated in the late Renaissance (c1550–1650), the Classical age (c1650–1790) and the modern age (c1790–1900) constitutes a basic framework around which the re-examination of the interpretation the artefacts of other cultures can be constructed. Foucault's analysis is not unproblematic, and cannot be simply applied to any field of knowledge, power or ▷discourse, but being an 'order(ing) of things', it clearly addresses, if not directly, the material relevant to this essay.

Strange beginnings: Renaissance voyages of discovery

Throughout the medieval period, Europeans constructed complex images of the world beyond Christendom. Medieval encyclopaedists, such as Vincent of Beauvais and Sir John Mandeville, deployed ethnological information formulaically, following contemporary literary conventions and unconsciously incorporating relics of archaic conceptions of monstrosity first articulated by ▷Pliny (AD 23/4–79). Evidence of other cultures was available through missionary and trade contact. However, the actual details of the lives of other peoples were subsumed by the question of their susceptibility to conversion, or debates about their place within biblical accounts of creation and the flood. These debates were also highly abstract and literary, making reference to the so-called 'epitomizations' of peoples rather than literal accounts. Thus when Europeans like Christopher Columbus set out in search of a westerly route to the Orient they took with them an elaborate, if to us fantastical, conception of the monstrous peoples they were likely to encounter.

As a result of the voyages of discovery, artefacts and first-hand accounts of aboriginal cultures were, for the first time, incorporated into European interpretations of man's place within the material world. In conjunction with other categories of 'curiosity' such as antiquities, minerals and strange animal species, exotic material culture was incorporated into Renaissance knowledge through practices of collecting. Exotic objects were displayed in ▷cabinets of curiosity. Other cultures, their material circumstances, customs and mores were also described in written collections – inventories and accounts of voyages and later in cosmographies (encyclopaedic descriptions of the world, its peoples and their place in the universe). A complex web of meanings existed in relation to such collections, organized by a philosophy based on the visible resemblances between all material objects. The philosophy through which Renaissance images of other cultures were constructed was based on the concept of similitude: the idea that specific forms of visual similarity or spatial proximity were signs of shared properties, or qualities. This philosophy of resemblance reached its most developed form in the late 16th century.

Michel Foucault describes in *The Order of Things* the way in which the world was interpreted during the late Renaissance (c1550–1650). Scholars read the visible signs evident in all things (signatures), which revealed their invisible and innate resemblances to others. Thus the face of man was like the sky – the face of heaven – because each had seven points in it: the seven orifices of the head and the seven (then) known planets. Fire rose because of the similarity between the flame and the celestial ether which it was drawn towards. Resemblance united and structured the Renaissance universe, linking every object, word and being, and making their interpretation possible. Its ability to link apparently disparate objects is demonstrated by Foucault using this passage of Renaissance philosophy:

> *It is the same with the affinity of the walnut and the human head: what cures 'wounds of the pericranium' is the thick green rind covering the bones – the shell – of the fruit; but internal head ailments may be prevented by use of the nut itself which is exactly like the brain in appearance*

> (Crollius, *Traité des signatures*)

The material world was the word of God in concrete form, and could therefore be read like a text (or more especially the Bible) by those with the skill to recognize its signatures. Given that signatures

were visible in every object, it is to be expected that the ability to read signs and similitudes was central to the accounts of the early voyages. The narratives chronicling the voyages were assemblages of diverse sorts of information, interweaving navigational observation and accounts of customs together with mythological and biblical quotations. Occasionally, these narratives were separated into an inventory and a chronology, but all the observations were interpreted through similitude. Thus resemblance enabled the incorporation of radically new types of information – images and accounts of novel customs, practices and artefacts – into the established European cosmology.

However, this mode of interpretation always produced the same kind of knowledge about every object, i.e. what resemblances characterized it. This system also implied that certainty, with respect to the resemblances of one object, could only be attained through the infinite collation of resemblances across the entire world; each resemblance pointed immediately to the next before confirming the first. This potentially endless project of accumulation was, Foucault argues, limited by the concept of microcosm, the notion that the whole can be represented by a limited exemplar. Thus the prime microcosm (the visible, concrete world) constituted a finite instance of the greater, divine macrocosm (God's universe). Two particular forms of the microcosm – the book and the collection – are important for this discussion.

The book itself constituted a means of collecting and containing the written form of the resemblances evident in the world. The words of language were implicitly enmeshed in the same similitudes and signatures which ordered objects:

> *The great metaphor of the book that one opens and pores over and reads in order to know nature, is merely the reverse and visible side of another transference, and a much deeper one, which forces language to reside in the world, among the plants, the herbs, the stones and the animals.*
> (M. Foucault, *The Order of Things: An Archaeology of the Human Sciences*, 1970)

Words were seen as being ordered by the same principles of resemblance which linked other signs; letters were drawn together through sympathy. The book as a general concept was always viewed in relation to the Bible and therefore authorized literary collection (*historia*) by re-presenting the writing (signs manifest in nature) that are the words of God. It also offered a figure of containment, a microcosm, in which knowledge could literally be controlled and fixed.

The fundamental socio-cultural impact of the development of printing during the 15th and 16th centuries is also now widely accepted. Printing recovered Classical texts, including early works such as Pliny's *Historia naturalis* (c AD 77), but also induced the dissemination of texts. Whilst initially many scholars were clerics, the rapid proliferation of printing presses through most major European towns consolidated an emergent literati. Thus printing changed the nature of the written matter available, but also radically altered the institutional structure of academic culture, breaking the virtual monopoly over knowledge enjoyed by medieval clerics.

During the 16th century numerous collections of 'ethnographic' information, customs, mores and manners like the early *Omnium gentium mores* of 1520 by Johann Boemus (republished in English in 1555 as *The Fardle of Facions*) were published. This book was widely read and deeply influential, becoming something of a prototype for later works like Sebastian Muenster's *Cosmographia* (1544), and Samuel Purchas's *Purchas his pilgrimage* (1613). Each of these was an encyclopaedic project, an attempt to describe the whole known social, cultural and religious world. Each was also written using the accounts of other people's voyages and integrated with mythological and monstrous representations familiar from medieval and recently recovered Classical texts. Purchas based his 'pilgrimage' on the voyages of Richard Hakluyt and others, interpreting other cultures through similitudes which indicated foreign cultures' common ancestry with Europe, counterpoised with the signs of their monstrous otherness. Thus his account of the Patagonians – giants with bull-like voices – comes from Pigafetta's chronicle of Magellan's voyage to Tierra del Fuego.

The second form of microcosm – the collection of objects – was a crucial feature of late Renaissance culture which emerged from the medieval clerical practice of saving relics, the hoarding of wealth, and early Renaissance 'princely' collections. Several socio-cultural changes of this time are relevant to the proliferation of collecting. In the Italian city states, formal discourses concerned with the aesthetic valuation of art objects were founded upon the practical mathematical education enjoyed by many, and also affected by the contractual valuations of paintings emerging in the artist–patron relationship.

The partial dissipation of clerical authority in the face of expanding mercantile power, and the secular interests of the burgeoning class of editor-scholars also helped to establish a newly materialist view of the world. This view is evident in the distinction made between the natural world and the artificial, man-made world which reproduced (or mirrored) nature. An example is Robert Fludd's cosmography, *Integrae Naturea Speculum Artis que imago.*

The collections of objects in 'cabinets of curiosity' may appear disorganized and heterogeneous. However, the radical diversity of objects found in cabinets and museums like those of Francesco Calceolari and Ulisse Aldrovandi in Italy, Ole Worm in Denmark and the Tradescants in England are in fact ordered through the forms of similitude, visible or innate, as well as through the mirroring of nature in art. Collections were often organized into 'natural' and 'artificial' objects. What appears to be incongruous juxtaposition of natural curiosities, mineral and animal rarities, with exotic artefacts and antiquities, is in fact an encyclopaedic attempt to represent the whole world. The web of resemblances between the diverse, exotic objects – Inuit kayaks and crocodiles – could be read in this microcosm in much the same way as in the literary collections or the signatures inherent in nature. These collections, whilst clearly constituting an expression of status, also acted as a means by which newly discovered and heterodox peoples could be integrated into the Renaissance world view, in all their variety, through the wealth of their possessions and creations.

All such collections emphasized rarity, curiosity and the exotic. Collections manifested this interest in a number of ways. The letter from John Tradescant 'To the marchants of the Ginne Company & the Gouldcost Mr. Humphrie Slainy Captain Crispe & Mr. Clobery & Mr. John Wood Cape marchant' (1625) gives an excellent illustration of this theme. It requests that they find amongst other things:

> on Ellophants head with the teeth In it very larg. . .
> of ther Ivory Long fluts. . .
> of the habits weapons & Instruments. . .
> Of All sorts of Shining Stones or of Any Strang Shapes
> Any thing that Is Strang

<div align="right">(Quoted in A. MacGregor, Tradescant's Rarities)</div>

Rarity itself conferred value on these objects; they were collected less avidly when more commonplace. However, the taste for exotic objects was widespread enough to generate both an academic and commercial exchange. This interest can be directly linked with the rapid expansion of knowledge of the world beyond Europe. Not only did the limits of the known world recede dramatically after the discovery of America in 1492, but the number and diversity of 'voyages of discovery' increased exponentially. In 1532 William Hawkins presented a Brazilian king to the court of Henry VIII; in 1550 a whole Brazilian village was returned to France. As Defert has indicated (D. Defert, *The Collection of the World: Accounts of Voyages from the Sixteenth to the Eighteenth Centuries*) the voyages themselves, as well as the itineraries and chronologies which recorded them, can be seen as a practice of collection. As knowledge of the New World increased, so the categories of the strange were modified.

The microcosm – the limited but perfect set of similitudes – provided the concrete dimensions which made encyclopaedic collection possible. Both in the book or in the cabinet of curiosities, the microcosm had to be able to represent the entire world. This explains the emphasis which Renaissance culture placed on the strange and curious. The cabinet of the world (▷ *Kunstkammer*), had to include similitudes which crossed the entire known world. This could best be achieved by assimilating, and therefore controlling, the most diverse and strange objects. The strangeness within these collections was itself a signature of their sources, at the extremities of the world.

Initially other cultures were construed as physically monstrous, an overt sign of their inhumanity. However, as knowledge of these cultures (Patagonians, Feugians, Virginian Native Americans, etc.) accrued, their congruity with, or divergence from, European culture was interpreted through signs inherent in their behaviour, customs and beliefs. These cultures were assimilated into Renaissance understanding by linking them to ancient European peoples, through similitudes. For example: circumcision signified the resemblance between Native American tribes and Old Testament Jews. Such interpretations also integrated exotic peoples into the realm of European political identities, Protestant-Catholic conflicts, and disputes between sovereigns. Thus for Samuel Purchas and Theodori de Bry (a Huguenot), natives in South America and the East Indies were corrupted by the Spanish and Dutch

emissaries of the Pope (the Antichrist) into fallen practices. This was evident in the presence of the practice of sodomy, which was seen to be a similitude of devil-worship. In contrast, the relative industry of the Virginians indicated their susceptibility to conversion and the fact that they had been discovered by the English.

Actual images of other peoples were relatively rare until the late 16th century. Hans Staden published the account of his time with the Tupinamba of Brazil, illustrated by rough ▷woodcuts in 1557. In England Edmund Harman's monument erected c1569 depicted Brazilian Indians and in 1588 John White's paintings of the expedition led by Thomas Hariot to Virginia were published by Raleigh. These and other accounts were collected and elaborately illustrated by Theodori de Bry in his series *Historia Americae* published from 1590. De Bry's images, though Classical in form, clearly also articulate Renaissance concerns with the signs of strangeness, monstrous practices and potential civilization.

During the late Renaissance, Europeans conceived of, interpreted and represented other cultures in relation to a complex cosmology founded on resemblance, the microcosm and strangeness. From this interpretation, two features emerged which, though subject to transformations, influenced European responses to other cultures throughout the modern era: the development of a secular, materialist view of the artefactual world, expressed in the collection of artefacts; and the identification of exotic cultures in relation to Europeans through notions of strangeness and difference.

The table of order and identity: 17th- and 18th-century natural philosophy

Whilst certain practices characteristic of the Renaissance, such as collecting, continued into the 18th century and later, it is clear that in the mid-17th century the way in which knowledge was accumulated changed dramatically and abruptly. Language was removed from the world of similitude to become the transparent medium of representation.

For Foucault this episteme was typified by attempts to define a general grammar, or ideal language such as those of Etienne Bonnot de Condillac and Adam Smith, by the development of classificatory systems in natural history by Carl Linnaeus and George-Luis de Buffon and by the analyses of economic exchange in terms of wealth by Thomas Hobbes, John Locke and Condillac. The attempts to derive a universal grammar implied that ultimately language should reflect objects in as direct a way as possible, and therefore understanding consisted of pure, well-ordered representation. Foucault argues that the restriction of the scholar's gaze to the observation of each species' external physical form – its morphology – made natural history possible. The *Systems* of Linnaeus, John Ray and Nehemiah Grew then provided a language, based on the idea of a universal grammar or ideal language, through which each species could be represented in a table of identities. Each acquired its place (or name) through observable features, and was thereby simultaneously differentiated from other species approximating to it but which actually exhibited subtle differences:

> *The essential problem of classical thought lay in the relations between* name *and* order: *how to discover a* nomenclature *that would be a taxonomy, or again, how to establish a system of signs that would be transparent to the continuity of being.*
>
> (M. Foucault, op. cit.)

The analysis of other cultures similarly proceeded through the measurement of their customs as deviations from the natural norm. De Buffon defined a series of human kinds and examined 'traditionally sensational cross-cultural topics – eunuchs, harems, human sacrifice – by charting them as innocuous, physiological correlations between sexual forces and vocal range' (J.A. Boon, *Other Tribes, Other Scribes*). Helvetius also analysed human diversity 'from Hottentots and Caribs to Fakirs and Brahmins' in terms of gradeable divergences from natural moral laws. These proto-ethnographies displayed a clear concern to identify (or name) groups, and an attempt to differentiate (or order) them in terms of the material conditions which each displayed. In England, the institutional centre for such projects was the Royal Society, founded in 1660. One of the Society's aims was to replace the *ad hoc* collection of curiosities with the systematic acquisition and cataloguing of objects representing the whole natural order. The establishment of this collection, the Repository, was articulated through the 'scientific' natural history and universal language schemes with which several of the society's fellows

(e.g. John Wilkins and the curator Robert Hooke) were involved. Hooke made explicit the link between the collection of objects, the universal languages and taxonomic tables in his *General Scheme or Idea of the present state of Natural Philosophy.*

However, the Repository remained an eclectic assemblage of objects, founded, and later added to, from private collections of curiosities. It was reorganized *post hoc* by Nehemiah Grew who catalogued the Repository's artefacts in 1681 following the Society's ideas on rational language and classificatory schemes. Only the parochial questionnaires, sent out in the 1670s by Ogilby, Machell and Lhywd, offered a possible model for such a collection. Collection continued, primarily as a private concern related to the aesthetics of mercantilism. However, it was no longer central to the understanding of the material world. This was the age of the catalogue, the written expression and version of the Classical table of order.

In general the acquisition of knowledge of other cultures came to be framed by visual and literary representations of order and identity. John Locke compiled an annotated 'ethnographic' bibliography and Robert Hooke collected a series of programmes of enquiry for travellers in 1692 as *General heads for the natural history of a country, great or small; drawn out for the use of travellers and navigators.* But the discussion of other cultures was usually raised only in relation to other topics such as antiquity. Thomas Hobbes presented a model of the state of nature, an ancient time in which pre-social men lived. This state is defined, like exotic cultures, in terms of those aspects of rational society that it was seen quite clearly to lack:

> In such condition, there is no place for industry . . . no culture of the earth; no navigation . . . no arts; no letters; no society; and which is worst of all, continual fear, and danger of violent death; and the life of man, solitary, poor, nasty, brutish and short . . . The savage people in many places of America . . . live at this day in that brutish manner.
>
> (T. Hobbes, *Leviathan*, 1651)

John Aubrey, following Hobbes, explicitly compares ancient Britons and 'primitive' cultures: 'They knew the use of Iron. They were 2 or 3 degrees, I suppose, less savage than the Americans' (J. Aubrey, *Essay Towards the Description of the North Division of Wiltshire*, 1659).

Aubrey's description shares Hobbes's low estimation of ancient Britons' lives, and assesses their circumstances in the same terms: their difference from the Native Americans (the state of nature), and its representation in material conditions. Unlike the Renaissance form, which integrated exotic artefacts with other objects through similitude, 17th- and 18th-century 'ethnography' classified, differentiated and represented identities through the concrete criteria of the natural sciences, and their graduated divergence from a natural-moral order.

Thus Voltaire describes '*l'Ingénu*' as a native *naif* amenable to ▷Enlightenment reason; Buffon characterizes human types; Condillac orders linguistic diversity; and Helvetius distinguishes between man and the animals according to physical characteristics. Medieval-Renaissance monsters – the giant Patagonians – even survive empirical disproof to be recast by Byron in his letter to Lord Egmont (1765) in ▷Enlightenment terms, i.e. through scientific generalization and measured comparison: 'People, who in size come nearest to Giants of any people I believe in the world . . . nine feet high'.

During the 17th and 18th centuries other cultures were understood in relation to a generalizing project which made sense of the world as an expression of the natural order. This constituted a substantial transformation and extension of the materialism and conception of 'otherness' evident in Renaissance cosmologies. Materiality, both in terms of natural and artificial objects, together with the identity of species, objects and other societies, were all represented through abstract taxonomies and ordered tables.

Modern man and cultural institutions

In the period from the second half of the 19th century to the mid-20th century a series of highly important new practices, institutions and meanings emerged, which helped to define modernity. These new features included the development of evolutionary social theory, the establishment of public museums, and grand spectacles such as the ▷Great Exhibition. These institutional and cultural forms were correlated to the apogee of colonial expansion, and were the main vehicles and venues for the development of the numerous, and sometimes conflicting, responses to other cultures.

During the late 18th and 19th centuries socio-political and economic transformations were numerous and far-reaching. However, Foucault does not directly link the emergence of his modern episteme to such social shifts. Instead he describes it as a consequence of the exhaustion of the Classical episteme's reliance on the representation of the natural order, and the simultaneous development of the new empirical fields – 'labour', 'life' and 'language' (M. Foucault, op. cit.). For David Ricardo and later ▷Karl Marx 'labour' was no longer an abstract equivalence, but a productive process, 'the source of all value' (M. Foucault, op. cit.). After Georges Cuvier, biology became the investigation of the processes of life, organic structure and functions, rather than the form of organisms. Philologists like Frederick Schlegel examined language in its practical and philosophical operation, but no longer presumed that it could be a transparent medium of expression. These new empirical domains became the foundations of the academic and intellectual disciplines with which we are now familiar, for instance economics, biology and linguistics.

Two important orienting principles shaped a diversity of fields of enquiry. First, according to Foucault the generalized figure 'Man' emerged in the 'analytic of finitude' and acted as both the focus of intellectual enquiry and simultaneously, the source of all interpretations within the domains of 'life', 'labour' and 'language'. Man was seen to be constituted as 'a living being, an instrument of production, a vehicle for words which exist before him'. That is to say, man's concrete existence is expressed through the empirical fields of his biological being, his productive capacity and the language he uses. Simultaneously, this existence can only be approached, analysed and represented through language, the products of labour and by living beings. Put simply, finite man (as opposed to infinite God) does not examine the world itself, but instead examines his own understanding of it. Secondly, history occupied a similar place in the modern episteme to that which natural order had held in the Classical mode of thought. Scholars saw history as the fundamental mode of being viewing all phenomena in terms of their points of origin and their development over time, they even acknowledged that thought itself had a history. New academic disciplines, the human sciences (philology, economics, and biology, anthropology, psychoanalysis and others) articulated man's relation to the material world. The task within the Human Sciences was always to examine the origin, 'evolution' and operation of features of its particular province, together with their analogous relations to other structures.

The publication of On the Origin of Species (1859), Darwin's account of the origin and development of man in biological terms, quickly influenced thinking on social development. Progressivism, or the notion of generalized social progress, had been familiar since the Enlightenment, but Darwin's theory of natural selection offered an entirely new (biological) basis through which the differential levels of civilization evident in the world could be explained. The idea of social progress was described in explicitly evolutionary terms by Jean-Baptiste Lamarck and Herbert Spencer. Thomas Huxley, amongst others, established theories of social evolution based on racial differences. Huxley suggested in 1863 that there was a similarity between Australian Aboriginal and Neanderthal skulls, equating contemporary tribal peoples with Europeans' prehistoric ancestors. These theories relied on correlations between physical characteristics, supposedly innate mental qualities and generalized racial traits.

The human sciences were mirrored practically in a series of new institutions: asylums, hospitals, prisons and schools. Each institution, whilst articulating a specific social function, simultaneously promulgated new modes of existence, actively determining the lives they sought to improve. The early 19th century saw the emergence of the concept of society as a totality: 'the people', or nation. Foucault argues that this social body was an effect 'not of a consensus (shared bourgeois values, democratic participation, etc.) but of the materiality of power operating on the very bodies of individuals' (M. Foucault, Body/Power). The new institutions thus produced complicit citizens – 'docile bodies' (M. Foucault, Discipline and Punish). Foucault's exemplary instance is Bentham's Panopticon, an ideal prison in which docility is achieved by continuous surveillance and relentless routine. The subject (prisoner) ultimately subjectifies him or herself, the constant possibility of observation inducing self-surveillance.

An early context for the emergence of such institutions was revolutionary France. The establishment of the Musée Français in the Louvre in 1793 explicitly integrated artefacts within a disciplinary framework. Conflict and military-bureaucratic organization enabled the post-revolutionary commissions to acquire new collections of artefacts and to establish a hierarchical system of central and regional museums. Moreover, the principles of surveillance were extended to the administration, conservation and exhibition of artefacts within the museum.

Art works in museum collections were reordered and exhibited according to the artist's country of origin, and in order to represent the historical development of that country's art. The educative function of such displays was an explicit discursive mode of the constitution of the nation's historical identity. The history of France was identified with history *per se*; as Hudson (1987, p. 42) points out, the Musée Central des Arts recognized no 'English School' of painting because England was not part of the empire.

In England, from the early 19th century onwards, numerous local philosophical societies were established. These often included museums, founded with donations from colonial administrators, which were also intended for 'public education'. The 1845 Museums Bill empowered local authorities to establish public museums, but it was in the period after 1851 that it had significant effects. The Great Exhibition of 1851 was a prime impetus for the establishment of the South Kensington Museum in London (now the Victoria and Albert Museum), which was itself a fulcrum of the implementation of the principles of the modern museum. This new public mode of exhibition 'opened up' the ▷British Museum and set the agenda for the rapid establishment of museums in numerous provincial cities. Similar institutions formalizing cultural practices were founded throughout Europe at this time.

Museum exhibits of the mid-19th century increasingly characterized the history of humanity in racial terms and evidenced differential social evolution through the display of artefacts. In the displays of the Pitt-Rivers Museum the biological analogue of history – evolution – was equated with the production of cultural objects. Pitt-Rivers arranged Australian Aboriginal, Oceanic and other artefacts into 'genetic' or typological series, believing that:

Human ideas, as represented by the various products of human industry, are capable of classification into genera, species and varieties in the same manner as the products of the vegetable and animal kingdoms, and in their development from homogeneous to the heterogeneous they obey the same laws.
(A.H. Lane Fox [Pitt-Rivers], *Catalogue of the Anthropological Collection lent by Colonel Lane Fox ...*, 1874).

A similar approach, if less systematically deployed, representing the evolution of the objects and possessions of other cultures, could be found in the Horniman Museum with its countless artefacts drawn from cultures across the world (along with an intriguing natural history collection).

Conversely in his curation of the collections of the Smithsonian Institute in New York, Boaz arranged the artefacts to represent the specific tribes of North America and their 'culture-history'. These displays acknowledged the regional context and particular historical development of each group, eschewing the attempt to make generalized historical statements about humanity. However, this framework was still clearly historical although oriented around the identity of specific cultures. Ethnographic exhibits are often, even today, organized through the complementary and contradictory principles of these two broad schemas.

Museums constituted one important institutional site for the interpretation of other cultures, but in the mid-19th century other forms of representation came to have as much significance. Bennett argues that the viewpoint of power implicit in institutional surveillance has its counterpart in the way of looking at objects invited by the 'exhibitionary complex' (T. Bennett, *The Exhibitionary Complex*). The large-scale, public exhibition of artefacts – the spectacular mode of consumption of the exhibitions and arcades of the mid-19th century – was exemplified by the Great Exhibition at the Crystal Palace in 1851, and the Paris Exhibition of 1855. In these exhibitions the visitor responded to the artefacts only by looking at them, by consuming the spectacle which they formed. The exhibition articulated power by uniting the viewer's gaze with the gaze that controlled and shaped the exhibits. The visitor, simply by looking at the displays, experienced the white, male, bourgeois, colonialist viewpoint which had caused those particular artefacts to be acquired, curated and displayed. Exhibitions put visitors in a position of authority over the artefact and thus the culture which it represented, by offering them up for interpretation. This located the viewer at the highest point within the overall history of man – civilization itself.

Furthermore, artefacts were themselves only one aspect of the exhibitionary spectacle; the other was society assembled as a group visible to itself. The power of the exhibitionary complex is not a reversal of the principles of surveillance; its effect...

lies in its incorporation of aspects of those principles together with those of the panorama, forming a technology of vision which served not to atomise and disperse the crowd but to regulate it, and to do so by rendering it visible to itself, by making the crowd itself the ultimate spectacle.

(T. Bennett, *The Exhibitionary Complex*)

In such spectacles the social body – the people' or a nation as a whole – could be seen to be constituted from individual beings through three domains. The discourses which articulated objects within knowledge (exhibition narratives), the governmental practices placing objects in relation to power (the administration and control of the exhibition) and the ethical practices ordering the formation of the self (the constrained but 'free' choices offered by commodity consumption and moderated by 'proper' public behaviour) all operated together to produce a convincing sense of collective identity. They enabled individuals to come to 'understand' their place in the world as a member of a European culture, and to recognize their position in the social hierarchies within that culture. The arcades and department stores, like the great exhibitions, with their emphasis on spectacle, offered, 'the spatial and visual means for a self-education from the point of view of capital' (M. Tafuri, *Architecture and Utopia: Design and Capitalist Development*).

The exhibition was a pivotal form through which the dramatic expansion in the number and diversity of commodities available to large urban populations changed the way in which people constructed their lives. Mass-produced goods became integrated into a series of practices through which middle- and working-class identities were articulated. Artefacts – technologies – were treated as a direct index of the level of civilization present within a culture, a concrete manifestation of a people's productive capacity. Analysts of 19th-century capitalist culture took a similar view. Labour, for Marx, constituted the activity which transformed inert matter into value. This value was both economic and cultural. The Great Exhibition represented national identities, and the hierarchy of those identities, through displays of the artefacts produced in each country. Thus the subjected peoples of Africa and the Americas, represented by 'primitive' handicrafts, occupied the lowest levels of civilization (technological, social and physical evolution). Naturally, European metropolitan cultures were the most spectacularly displayed.

The Paris Exposition of 1889 included a colonial city where the whole ambit of social evolution was displayed, the primitive 'other' present in simulated villages populated by Africans and Asians. Similar model villages became a regular feature of exhibitions in European cities around the turn of the century; the Franco-British Exhibition, White City, London 1908 included 'The Senegalese Village'; The Orient in London exhibition of 1908 also had an 'African Village'.

Colonial government, race and representation

As Thomas rightly indicates, a central feature of colonial administration was the acquisition and organization of knowledge of the colonized cultures (N. Thomas, *Colonialism's Culture*). He cites Cohn's examination of the British officials' use of the census as a means of understanding the complexity of the caste system to facilitate efficient rule as a typical example (B. Cohn, *The Census, Social Structure and Objectification in South Asia*). But Thomas also suggests that the social categories derived in this way were not directly based on the realities of the cultures encountered by colonialists. Instead they operated as a series of 'intellectual technologies', abstractions understandable to Europeans, through which the things and people to be governed were rendered into information. These 'technologies' – written reports, illustrations, charts, graphs and statistics – utilized generalized racial and social types, to make colonized cultures intelligible in European contexts. Indigenous Africans and other 'primitive' peoples were often equated with the prehistoric ancestors of Europeans, construed as social-evolutionary fossils incapable of development and represented as superstitious, lazy, lascivious and untrustworthy. Together with their evident lack of (European) morality this 'backwardness' was taken as implicit confirmation of the legitimacy of colonial administration.

However, these formal, governmental and academic discourses existed alongside other heterogeneous forms, such as novels, Christian missionary and political tracts, and illustrated newspapers. These unofficial discourses shared many themes with those through which colonial governments categorized the 'other'. They denigrated 'primitive' peoples for lacking Christian morality, idealized their innocence and demonized them as cannibals, but they also expressed idiosyncratic and often contradictory agendas peculiar to their partisan concerns.

Events like the Stanley and Africa exhibition of 1890, which claimed some level of scientific status, were also unashamedly vehicles for popular entertainment. The dominant narrative of this exhibition, which displayed the artefacts and illustrations brought back from Henry Morgan Stanley's expedition to rescue Emin Pasha, was that of the heroic European explorer, trekking through the dense and dangerous wilderness, and simultaneously bringing to it the benefits of European civilization. The artefacts deployed in illustration of this heroic narrative primarily celebrated and elevated the personality of the explorer himself.

However, as a heroic individual, Stanley represented an archetypal emissary of European civilization, opening the wilderness to the products of commerce and the moral standards of European bourgeois society. This morality found expression in the anti-slavery theme of the exhibition which simultaneously represented the interests of his patrons, the Anti-Slavery Society, and acted as an anti-German tract. In this respect English moral superiority was enlisted in the cause of securing trade routes in East Africa against 'German Adventuring' (A. Coombes, *Reinventing Africa*). Exhibitions, following the 1851 pattern, self-consciously promoted partisan national interest, the development of national interest being represented as equivalent to the progress of mankind in general.

Such views, expressed academically in anthropology and archaeology, constituted the kernel of the so-called 'imperial synthesis' (B. Trigger, *A History of Archaeological Thought*). But the various (and often contradictory) mythologies characterizing 'primitive' cultures as inferior (sexual promiscuity, cannibalism, witchcraft, superstition, moral laxity, treachery, indolence and degeneracy) were most virulently presented in populist forms. These existed in diverse formats: titillating postcards produced for museums, societies and exhibitions, photographic collections such as those of Thomas Andrews and J.W. Lindt, popular novels and travel writing, and in illustrated newspapers.

The ways in which other cultures were interpreted academically, for example in the establishment and exhibition of museum collections, can only be understood within the wider and heterogeneous contexts of 19th-century European culture. Even in the second half of the 19th century, major ethnographic collections such as the Pitt-Rivers, the Horniman and the British Museum all depended heavily on private donations from former colonial administrators, missionaries, soldiers, collectors and dealers. This was also the case in continental museums like the Trocadéro in Paris and in English provincial cities like Birmingham, Leeds, Sheffield and Liverpool where, after 1845, public museums were established, based on the collections of local philosophical societies. These new cultural institutions, together with the practices and discourses which they articulated, formed new relationships between the material world and the conceptions of identity and otherness which characterized the modern era. Materialism and identity, both in general terms and with specific reference to other cultures, were approached through the fields of 'life', 'language' and 'labour', and interpreted with reference to 'man' and his history.

The 20th century: in search of the primitive

Around the turn of the century a distinction that had been evident before, between categorizations of the material culture of other cultures as ethnographic artefacts (in the domain of anthropology) and those which viewed such objects as works of art, became further consolidated. Two developments, each pivotal to the emergence of ▷modernism, marked the formalization of this distinction: the first was the assimilation of the style of African, Oceanic and other exotic artefacts through ▷primitivism into modernist art practice and theory; the second was the foundation of 'scientific' anthropology. What resulted were two distinctive and often conflicting sets of notions about other cultures which were nevertheless bound by a common core of assumptions. The institutions, practices and discourses of modern art and scientific anthropology each produced images of the 'other' cultures, against which their constructions of modern culture could be defined. In both arenas notions of 'primitive culture' as coherent, undivided and symbiotic were opposed to the fractured and divided culture of modernity.

The interest of artists of the late 19th and early 20th centuries in 'primitive' art, and the place of this primitivism in the development of modernism has recently become much better documented. One of the few academic accounts of primitivism which was contemporary with the events themselves is Robert Goldwater's *Primitivism in Modern Art* (originally published in 1938). Goldwater's account is useful in that it is analytically rigorous, for the most part avoiding questions of appreciation or taste. Importantly, it typifies modernist interpretations and concerns, framing the discussion of primitivism in terms of origins, influences and the primitivist trajectories of named artists, movements and schools.

Thus a major concern is to trace the earliest primitivist traits in European art, which he identifies with the ▷Orientalism of ▷Ingres and ▷Delacroix. Orientalism (a European taste for objects and art works which incorporated references to Asian or Middle-Eastern styles, symbols and images) became increasingly popular in the late 19th century, and has been convincingly analysed by Edward Said in *Orientalism* as a counter-identity produced by colonial culture. Out of this context a series of more directly primitivist artistic practices is seen to emerge.

It is with the artists working in the 1890s and early 1900s (including ▷Derain, ▷Gauguin, ▷Matisse, ▷Nolde, ▷Picasso and ▷Vlaminck) that the most significant artistic response to the artefacts of other cultures is associated. For these and other modern artists, the artefacts from Africa and Oceania which they saw in the Trocadéro and other European museums, and which they could even collect for themselves from the flea markets of Paris for example, were an intrinsic element in the formulation of their aesthetic. Goldwater (1986) argues that several distinctive orientations to such artefacts were present in the responses of artists at this time. Each of these different 'primitivisms' imbued non-European artefacts and cultures with a specific set of properties, which traits were then emphasized by the European artists in their own work.

Gauguin's primitivism can be understood in terms of a modified form of the colonialist hierarchy of cultural types: occidental, oriental, primitive. In such a hierarchy the oriental and the primitive are of interest in direct proportion to the extent to which they are exotic, archaic, dangerous, magical and strange. For Gauguin, Breton peasants and later Tahitians and ▷Melanesians were literally primitive – closer to the primal mode of human existence – and therefore offered the possibility of access to forms of representation which were also more primal.

Understood as a series of generalized types and characteristics, the 'primitive', particularly the exotic primitive, enabled Gauguin to produce an art practice which offered a radical critique of the conventions of established European art. Gauguin's romanticized view was manifested in the themes, subjects and symbolism of his work. Only occasionally, for example in sculptures and ▷woodcuts, did he draw directly from specific indigenous artefacts; usually such objects were little more than props, adding authentic detail to the ambience of a scene combining traditional European elements with exotic locations and figures.

Thus Goldwater characterized Gauguin's response to the exotic, together with that of the ▷Fauves like Matisse, Derain and Vlaminck who followed Gauguin, as essentially ▷Romantic. In their works 'Romantic Primitivism', as Goldwater termed it, was represented through a generalized symbolism attached to the notion of the idealized 'other' – the pure and unspoilt savage. This was recognizable in themes of arcadian innocence, benign nature and a nebulous emotional spritituality; it was visually evident in their naive or crude styles of representation, which used simplified pictorial spaces, broad, flat areas of colour and simple, non-naturalistic outlines. These visual and thematic features were never the result of the specific influence of particular objects or cultures but rather emblematic of a generalized view of other cultures. This idealized conception of the simplicity and purity of the life of 'tribal' cultures can be linked to Jean-Jacques Rousseau's notion of the 'noble savage', and even earlier Renaissance antecedents.

For the ▷Brücke group, and ▷Emil Nolde in particular, direct knowledge of ethnographic sources was important but its influence was as diffuse as it had been on the Fauves. For the Brücke and also the ▷Blaue Reiter artists (notably ▷Franz Marc and ▷Auguste Macke) important primitive sources were to be found not only in exotic artefacts from the tribal cultures of Africa and Oceania, but equally in European peasant art and northern European woodcuts. What defined the 'Emotional Primitivism' of these two groups was the belief in the emotive power of the objects which influenced them. Ethnographic objects appeared to these artists to offer a more direct expression of the essential human emotions which they sought to convey in their own work. Similarly, in the work of ▷Paul Klee, and of the ▷Dadaists and ▷Surrealists, a 'Primitivism of the Subconscious' operated which was based on the artists' belief that certain intrinsic human qualities (basically those derived from their subconscious) are more readily apparent in the art of 'primitive' cultures than that of the established European traditions. For Klee the symbolism of both children's art and that of primitive cultures, together with images produced by the insane, all possessed an uncontrived authenticity which he sought to emulate.

But it was with Picasso's response to African sculpture that we see the most obvious influence of non-European artefacts on a European artist. Picasso's primitivism, characterized as 'Intellectual' by

Goldwater, emerged between 1906 and 1907, firstly reflecting his appreciation of Gauguin, and then his interest in archaic and Iberian sculpture. His painting ▷ *Les Demoiselles d'Avignon* (1907) has come to be viewed as one of the key works in the development of primitivism and modern art in general. The painting in its original form showed a primitive Iberian influence, but was still relatively representational, deploying its narrative of feminine sexuality and danger fairly directly. However, in the course of 1907 the painting was reworked to incorporate the effects of what Picasso later termed the 'shock' and 'revelation' which he experienced on his visit to the Musée d'Ethnographie du Trocadéro in 1907 (Quoted in W. Rubin, *'Primitivism' in 20th Century Art*). This influence is particularly clear in the stylized, almost abstract heads of the two right-hand figures and that on the extreme left of the picture.

The expansion of Picasso's interest in African sculpture and its influence on his work is evident in the studies undertaken for *Les Demoiselles d'Avignon*, in studies of tribal objects and paintings like *Bust of a Woman* (1907), and *Dancer* (1907/8). Goldwater was concerned to locate the specific kinds of artefact, or at least the tribal groupings (Dan masks and Senufu sculptures, Ivory Coast; Bakota reliquary figures and Fang heads, Gabon) whose objects were an influence on Picasso's work at this time. Although he was writing much later, Rubin argued at great length for a somewhat different set of objects. In a generalized way Picasso continued to be influenced by *'l'art nègre'*, particularly with respect to his ▷ collage and sculptural works of 1912–13, and also in his sculpture of the early 1930s. Moreover, Picasso quickly established a collection of 'tribal' objects, and they remained a presence in his studio throughout his life.

It is usually assumed that Picasso intended to respond to the plastic properties of tribal sculptural traditions; like his contemporaries, he was unaware of the ethnographic details, or the cultural context from which such artefacts came. ▷ Roger Fry, who set up the influential and notorious 1910 exhibition 'Manet and the Post-Impressionists' (which included the 'primitivist' artists Gauguin, Matisse and Picasso), later eloquently theorized this position in his article of 1920, 'Negro Sculpture'. Fry argued that unencumbered by the Classical burden of illusionistic representation, tribal art was free to be unselfconsciously three-dimensional and expressive. Therefore, 'tribal' sculptors possessed 'the power to create expressive plastic form … not only in higher degree than we at this moment, but than we as a nation have ever possessed it'. Goldwater also presumed that Picasso held exactly this view of the merits of African sculpture and that together, the plastic and formal qualities and the tendency for reductive ▷ abstraction in African artefacts were his main inspirations. Primitivism was thereby seen as an important point of origin for analytical ▷ Cubism. The ▷ iconography and ritualistic associations of African 'fetishes' were only secondary and unintended influences.

W. Rubin, in contrast, rejects the linkage of primitivism and Cubism in *Les Demoiselles d'Avignon*, even arguing that formal devices like ▷ hatching and geometric pattern were present in Picasso's work before the picture was begun (W. Rubin, op. cit.). Rubin does however acknowledge that Picasso was influenced by the formal elements of African artefacts, suggesting he saw 'tribal' works as reductive and ideographic – *'raisonnable'*, that is, conceptual rather than representational. Nevertheless Rubin emphasizes that Picasso simultaneously thought of these works as *'magicaux'*, augmenting his own belief in the artist as magician, and revealing his tacit assumptions about the ritualistic, magical and sinister significance of the objects in their original contexts.

At a formal level, exotic artefacts helped European artists to generate a material critique of established artistic traditions by inspiring and legitimizing their innovations. However, these stylistic innovations were accompanied and shaped by profound, though unstated, beliefs about primitive cultures. To artists like Gauguin, Matisse, Nolde and Picasso other cultures represented an attractive, if threatening, alien counterpoint to their own urban culture. For them 'tribal' objects connoted innocence, magic, death, sexuality and vitality, not because of any ethnographically documented information, but rather because they believed these objects expressed in material form those fundamental conditions of humanity.

In the later 20th century numerous artists followed trajectories of influence similar to that of Picasso, and the role of primitivism within modernist art theory and practice became increasingly established. Surrealists like ▷ Max Ernst fostered close links with ethnographers, as well as seeking connections between ▷ psychoanalytical concepts and the traditions of primitive cultures. ▷ Giacometti collaborated closely with the ethnographers and ▷ Surrealists (Antoine Artaud, ▷ Georges Bataille, and Michel Lieris among them) who were associated with the journal *Documents*. ▷ Henry Moore made extensive use of the British Museum's collections of Sumerian, ▷ Egyptian, ▷ Etruscan, Indian,

▷Pre-Colombian, ▷Gothic, Inuit and African and Oceanic sculpture and artefacts. Furthermore, the artefacts of other cultures increasingly came to be examined within the traditional frameworks of art criticism, ▷connoisseurship and collecting. Objects were displayed as works of art to be assessed aesthetically and some categorized as masterpieces.

However, when in the 1940s American artists such as ▷Adolph Gottlieb, ▷Mark Rothko and ▷Jackson Pollock incorporated primitivism into their emergent ▷Abstract Expressionism, they did so through generalized concepts of expressivity, nobility and natural harmony (qualities associated with the rehabilitated image of ▷Native Americans), rather than through formal borrowings. In what K. Varnedoe views as contemporary primitivism, the notions of exactly what the term constitutes become even more attenuated (K. Varnedoe, *Abstract Expressionism*). Primitivism within recent modern art is represented by the earth-works of ▷Robert Smithson, Michael Heizer and ▷Richard Long which are superficially similar to prehistoric monuments, diverse utilizations of 'natural' (presumably therefore primitive) materials (e.g. Jackie Winsor's *Bound Square*), and the use of these materials in ▷performance art or outdoor contexts (e.g. Richard Singer's *First Gate Ritual*, and ▷Joseph Beuys's *I Like America and America Likes Me*). Thus primitivism appears to have come to indicate the most generalized notions of ritualized practice, nature, natural materials and the production of artefacts which display simplicity or crudity thought to connote primitive cultures. Beyond the dissipation of the 'original' concept of primitivism as attaching to 'tribal' cultures, what this situation indicates is that primitivism has a generalized and intrinsic place in the practice of all modern art.

As D. Miller has argued, modern art always presumes an ideal form of human subjectivity, a primal 'state of grace', upon which all creativity is premised (D. Miller, *Primitive Art and the Necessity of Primitivism to Art*). Primitivism within modern art has 'identified' this ideal in the artefacts of other cultures. Moreover, the 'recognition' of this ideal across cultural boundaries is taken as proof of its general validity, whichever version is implied: primitive innocence, emotional expressivity, subconscious drives and desires or magical and superstitious practice. Rubin's notion of the 'affinity' between the works of 'tribal' sculptures and modern artists constitutes a typical instance, wherein superficial similarities between the objects supposedly reveal a deep-seated commonality.

The establishment of scientific anthropology is roughly contemporary with the emergence of primitivism in art. Just as the emerging artistic themes, concerns and practices of the 19th century came to be incorporated into the institutions of the 20th century, so too in anthropology, the features which define the emergence of the modern era became institutionalized after the turn of the century. Although the development of modern scientific anthropology could be characterized by its attempts to differentiate itself from other approaches to exotic cultures (such as those approaches adopted by artists), it was nevertheless founded upon similar notions to those which defined primitivism. Modern anthropology also sought 'the primitive', but by means of first-hand, extended encounters with 'tribal' peoples living traditional lives.

Anthropologists were concerned to establish the scientific status of their discipline, which required the adoption of appropriate forms of investigation. Their 'Science of Man' was also premised upon the search for the fundamental elements of human social and cultural existence. Furthermore, by directly observing human behaviour (acquiring empirical evidence) and producing generalizable theories or laws, anthropology sought to mirror the physical sciences. For example, Emile Durkheim in *The Elementary Forms of the Religious Life* (1912) attempted to describe the most fundamental aspects of religion, through the comparative analysis of the practices of the Arunta and other Australian Aboriginal peoples. Durkheim's interpretation of culture presumed that societies exist as integrated wholes in which institutions such as religion function (hence the term 'functionalism') to integrate the elements of the society into an organic totality. It is possible to understand the emergence of scientific anthropology as another form of the production of primitive 'other-ness' definitive of modern culture.

Given the place of anthropology within modernity, the two broad approaches to the artefacts of other cultures characteristic of the modern discipline can be seen to have a kind of coherence. Despite the decline of evolutionary theory the artefacts of other cultures continued to be important to anthropologists but not as indexes of social development. Instead, 'tribal' artefacts were treated either as evidence which could elucidate the workings of social institutions, or they were integrated within universalizing theories of ▷aesthetics through anthropologies of art.

The French anthropologist Marcel Mauss perfectly described the status of artefacts which are framed by their display in ethnographic collections and by the interpretations of functionalist anthropology:

Nearly all phenomena of collective life are capable of expression in given objects. A collection of objects systematically acquired is thus a rich gathering of admissible evidence. Their collection creates archives more revealing and sure than written archives, since these are authentic, autonomous objects that cannot have been fabricated for the needs of the case and that thus characterise types of civilisations better than anything else.
(M. Mauss, *Instructions sommaires pour les collecteurs d'objets ethnographiques*, 1931)

Similarly, Bronislaw Malinowski in 1922 in *Argonauts of the Western Pacific* interpreted the Kula exchange system in the Trobriand Islands of the Western Pacific in terms of the functions in economic activity, ritual practice and marriage, which the exchange of these ritual objects served. Many major anthropological monographs of this era follow a similar pattern (e.g. Evans-Pritchard's *Witchcraft, Oracles and Magic Among the Azande*, 1937 and Bateson's *Naven*, 1936). Within this mode of anthropological interpretation the objects themselves, particularly their material and formal features, are effaced by the emphasis on the first-hand observation of the object in use and the efforts to interpret them as evidence of the operation of social institutions.

Functionalist modes of interpretation and the museum display of artefacts as evidence for socio-cultural institutions continued, in various forms, to be dominant in anthropology in Britain until at least the 1950s, but on the continent the notion that cultures were intrinsically orderly found a different expression. Following Durkheim and Mauss, the French anthropologist ▷Claude Lévi-Strauss attempted to devise a theoretical basis for cross-cultural generalization based on the structures inherent in language, social organization and cultural features such as myth and material culture. Lévi-Strauss's conception was derived from the linguistic theory of ▷Ferdinand de Saussure and the belief that the material social and cultural worlds were expressions of the fundamental structures of the human mind. Beginning with analyses of systems of myth and their associated forms of ritual and practice, and then examining other cultural forms such as kinship arrangements and traditions of art, Lévi-Strauss avoided the interpretation of particular features or symbols, but instead resolved such systems into sets of structured opposition (▷Structuralism). For example, Lévi-Strauss suggested that the presence of bi-lateral, mirror symmetry in both North West Coast Native American art and the art of ancient China indicated the fundamental importance for both cultures of this structuring principle, and that this principle also informed other of their social and cultural features.

Lévi-Strauss argues that the contrasting features: protruding/receding eyes, open mouth and pro-truding tongue, and black and white colouring of the *Kwakiutl Dzonokwa* and *Xwexwe* masks relate to their opposed associations of wealth distribution and avarice respectively, and also to the inverted relationships which they have with similar masks in other tribes. Lévi-Strauss's work had a dramatic influence on anthropological theory and in the humanities and social sciences more generally. Struc-turalist analyses of artistic traditions, music and artefacts became much more common, and the reading of these formal structures as symbolic codes and communicative languages appeared to be successful validations of Structuralist interpretation.

Notwithstanding the influence and apparent efficacy of Structuralist interpretations, they share with functionalist analyses the general trait that these positions privilege the principle over the object. In the effort to describe the functioning of social institutions or to elaborate the kinds of structuring principles which organize the system, the artefacts themselves are more or less effaced, merely becoming particular instances of the principle itself. This leads to the specific question of the status of such fundamental principles themselves. For example, are the structuring principles which order the production of artefacts such as masks the actual mental structures of the producers or an abstraction only identified by the anthropologist? This tension (not resolved by Lévi-Strauss) is most apparent in the monographs which deal with one specific 'tribal' culture and its use of artefacts, particularly the more detailed and theoretically sophisticated examples. In general, it can be argued that anthropological analyses of artefacts have sought to treat them as evidence with which to illuminate the search for the fundamentals of human cultural existence, i.e. in search of anthropology's version of the primitive, 'primal man'.

The anthropological discourses on the artefacts of other cultures which presuppose 'Art' to be a universal, cross-cultural category must also be considered. Numerous studies of 'Primitive Art', 'Tribal Art', the 'Art' of particular regions or continents, and aesthetic theories make this assumption. Many of these accounts, like Carl Einstein's *Negerplastik (Negro Sculpture)* of 1920, have made positive evaluations of the art and artefacts of other cultures. However, the difficulties of defining what

'primitive art' might be, and of sustaining a rigorous mode of analysis have proved considerable. Herta Haselberger's article, 'Methods of Studying Ethnological Art' (1961), only serves to highlight the problems it seeks to address, defining its object, 'ethnological art', as:

> the tribal and tourist art of those peoples in Africa, America, Asia, Australia, and Oceania who are the objects of ethnological (or as it is called in the Anglo-American tradition, anthropological) study. As such it corresponds to the area of art that has often and unsatisfactorily been termed primitive, tribal, native, indigenous, folk, or popular. [Author's emphasis]

This was clearly a genuine attempt to clarify theoretical issues, and to make detailed suggestions towards the methodological consistency which might elevate the discipline to the status of art history and general ethnography. However, the presumption is made that ethnography's object of study – non-European, 'tribal' culture – is secure and unquestionable, and therefore that 'ethnographic art' is an objective and unified field. A similar definition which naively suggested that art is defined as that which art historians study would be unlikely to achieve much success.

Most surveys of this 'field' attempt some definition of its scope though they are more usually hedged around with qualifications. Thus Douglas Fraser suggests that 'primitive art may be defined most succinctly as the high art of low cultures', and goes on to distinguish it from: '(1) the lesser arts, usually called crafts; (2) the subordinate art of high cultures, called folk art; and (3) the products of advanced civilizations such as our own' (D. Fraser, *Primitive Art*).

Frank Willett, in reviewing the development of the study of African art, approvingly cites a classification of art types into ' "spirit-regarding", "man-regarding" and the "art of ritual display" ' and continues: 'it has the great merit of emphasising the function of the art in the society which produced it' (F. Willett, *African Art*). Thus traditional theoretical frameworks such as functionalism could be incorporated into descriptive surveys organized through regional or geographical classifications or abstract divisions such as 'sculpture', 'architecture' and 'crafts'. However, from the 1960s onwards several attempts to move beyond such surveys emerged.

Structuralism had emphasized the symbolic and meaningful qualities of all artefacts, and numerous analyses of the communicative capacities of 'art' were undertaken on the premise that communication was a universal cultural trait which therefore underpinned all artistic traditions. A related series of definitions of the universal basis of creativity and aesthetics was founded on the supposed psychological determinants of 'artistic' activity. Following the work of psychologists like D.E. Berlyne, attempts were made to generalize, cross-culturally, about the psychological affects of certain specific forms and design elements, and thereby to examine the creative process at its most fundamental level. However, the kinds of 'objective' criteria upon which these studies were based were of dubious general value, and examples included: the linkage of the attention time given to certain design elements with their subsequent 'success'; categorizations such as 'representativeness of design', or 'complexity of design'; and the definition of behavioural systems as 'oral, anal, and sexual'. These studies often merely served to emphasize the parochial nature of European thinking about the creative process.

Within this field, even as late as the 1980s, analysis reached its most generalizing level of all. Robert Layton in *The Anthropology of Art* (1981) first reviews many of the theoretical and methodological problems and positions referred to above, concluding that the term 'primitive art' is to be rejected in favour of 'the recent art of small-scale societies around the world'. He then goes on to analyse such traditions in terms of 'art and social life', 'art and visual communication', 'style' and 'creativity and the artist'. A series of categorizations which is at once expansively general (a response to the diversity of the material), and yet also narrowly European. For example, Layton acknowledges the tensions within the generalization of the term 'artist'. The problem here is not the details of the particular case studies or how they are employed, nor the inclusion or absence of particular interpretative frameworks, all of which are addressed effectively and clearly. The difficulty with this and all such 'anthropologies of art' is their evident inability to acknowledge the historical origins of the field of study. They try by increasingly complex means to find a unity in the disparate artefacts of diverse cultures. In fact, these objects are only recognized as having a unity when they 'arrive' in western contexts. The real sources of affinity between an Alaskan Aleut hat, a Maori carved door lintel and a Gabon spirit mask lie in the beliefs, values and practices of the Europeans who have come into contact with such objects in the course of colonial, commercial, anthropological and artistic endeavours.

During the 20th century, modernity sought to define itself against the primitive in a number of ways. In each case the notion of the authentic 'primitive other' was based upon presumed abstract universal properties of human existence and sought in the most exotic and distant of places and cultures. Modern artists believed that African and Oceanic sculptures communicated the expressive, ritualistic and instinctual essence of humanity directly through material form. The anthropological accounts of the primitive incorporated exotic artefacts into their grand theories of human society and culture which framed their quest for the authentic and unspoilt primal human, 'primitive man'. Lastly in the anthropologies of art we see the search for the primitive aesthetic, the belief in the universal origins of creativity. It is clear that these projects are differentiated by the institutional locations, the practices specific to those institutions, and the academic or intellectual conceptions which articulate those practices. What they share is the fundamental belief in the search for the origins of the human condition, and its expression in 'authentically' primitive cultures.

Conclusions: late 20th-century post(?)modernism

The fact that this chapter deals with the western responses to the artefacts of other cultures rather than with those objects directly is indicative of a recent and important cultural and academic shift. Increasingly the accepted frameworks, conceptions and practices within anthropology, art history and indeed most of the disciplines in the arts, humanities and social sciences have undergone a radical questioning. In all these conventional disciplines the foundational certainties, such as the idea of truth, the search for methodological and analytical objectivity, basic theoretical premises and grand theoretical models (e.g. Marxism, functionalism, Phenomenology) have all been reappraised and found to be partial, value-laden and historically and culturally determined.

Anthropology for example, underwent the beginnings of this critical scrutiny during the 1970s and early 1980s when it was analysed as an ideologically-loaded practice, implicated in colonialism and intrinsically patriarchal. In more general terms, critics have recently explored the literary constructions and devices which frame anthropological texts so as to create the 'effect' of authenticity and cultural distance and difference. This mode of critique relates the study of 'exotic' artefacts to the wider domain of 'post-colonial' criticism, wherein scholars from formerly colonized and oppressed countries and cultures produce their own accounts of colonial history, and critiques of the dominant western discourses which produced the traditional accounts.

There is a direct connection between work like Said's *Orientalism*, which recasts the Orient as a negative European construct against which the West has defined itself, and the recent reappraisals of primitivism. Indeed, the recent emergence of a substantial literature re-examining the practices of galleries, museums, dealers, artists and anthropologists constitutes a significant dimension of the expanding field of post-colonial criticism. In particular, they represent a consistent attempt to examine the ways in which the ideas of primitivism, the primitive and primitive art have been constructed by the practices within those European institutional contexts, and how artefacts have been framed as art and/or authentic, objective evidence. Moreover, such modes of analysis enable a broader field of relevant cultural practices to be considered. They acknowledge that from the earliest times of contact with other cultures, exotic artefacts have circulated in a number of different contexts, those associated with formal responses and those linked with non-academic practices such as commercial collections, curio and flea-markets and art dealers. James Clifford rightly correlates the activities of modern artists in the 1920s with the *négrophilie* through which Parisians encountered their 'essential' African: 'the Jazzman, the boxer (Al Brown) and the *Sauvage* Josephine Baker' (Clifford 1988, p. 197). In a similar vein, Torgovnic 'takes Tarzan seriously' alongside her examination of Picasso, Roger Fry and Joseph Conrad (M. Torgovnic, *Gone Primitive*).

In part then, this postmodern shift is an analytical one, an acknowledgement that the established notions of cultural difference, identity, authenticity, primitivism and the primitive have really always been produced through the practices and discourses of our culture. This indicates that familiar strategies within modern culture (e.g. the search for the most remote 'unspoilt' – un-westernized – tribes, the privileging of 'authentic' ritual objects over 'tourist art', the collection of masterpieces of tribal art and the quests for the essences of art, expression and culture) have not been wrong, but rather that they have been effects of that culture, not answers to its origins.

At the same time there is also the sense in much recent writing that some qualitative change in the relationship between Western European and other cultures has taken place. D. Harvey's seminal *The

Condition of Postmodernity (1989) sets out many of the salient economic and social features of this new circumstance. These would include the globalization of capitalism, the shift from mass production to flexible accumulation, the use of labour across national boundaries, and, most importantly, continuous innovation. In this context many of the certainties of modernity, like the clear difference between industrialized, capitalist economics and non-industrialized, pre-capitalist ones, have ceased to be meaningful and the two can no longer be seen in simple opposition.

The continued expansion of migration, global travel and particularly tourism has had a profound effect on attitudes towards other cultures. There have been for some time thriving industries in many countries catering for the tourists' desire for the packaged 'authenticity' of souvenirs from their visit. This industry now extends to domestic retailers such as Oxfam, Shared Earth and Tradecraft, which sell tourist-type artefacts (masks, textiles, ceramics) produced in India, Bolivia and Thailand amongst countless others.

At an institutional level, the museums, galleries and academies which played definitive roles in the constitution of the primitive and primitivism have experienced similar shifts and upheavals. Numerous museums in Europe and the United States of America are being subjected to legal and political pressure to repatriate the cultural heritage of so-called 'indigenous peoples' and tribal groups. Diverse groups, including indigenous North Americans, the Maori of New Zealand and the Ashante of Africa, have all intervened to alter the staging, display and narratives of major exhibitions in the West. In many cases minority groups like the Hispanic communities in the USA are for the first time gaining recognition in such spaces and influencing modes of exhibition and representation. In Britain, the Gallery 33 project in Birmingham involved representatives of local ethnic communities in the development of new modes of display which addressed the colonial history of the museum's ethnographic collection. Many contemporary artists identify with a cultural heritage rooted in another culture but with an artistic training derived from the modern tradition. Not surprisingly, this tension has often produced radically innovative outcomes, which constitute a material version of the post-colonial critique. It seems clear that in the late 20th and early 21st centuries the primary characteristics of postmodernity – constant innovation, the disruption of established orders, boundaries and identities, and the interplay between the global and the local – will only become more evident in the cultural interactions surrounding art and artefacts.

I believe that two broad conclusions can be drawn from this historicized account of 'other art'. First, it should be clear that throughout more than 500 years of contact, other cultures have held the attention of Europeans in ways which were crucial to their understanding of their own culture. From at least the Renaissance onwards, non-European cultures have been constituted as a series of identities against which Europeans could define themselves. This set of inter-related identities, which has often been articulated most significantly through artefacts, has undergone a number of radical shifts which indicated the pivotal moments in the emergence of contemporary culture. There have also been significant continuities over this period. Throughout, some form of materialism has been employed to interpret the objects of other cultures. In particular, from the 15th century onwards artefacts have been collected in an effort to interpret the world and the peoples within it. Since the 17th century, classificatory schemas have been employed to order such collections, and since the 19th century, public institutions with bureaucratic systems of administration have controlled such collections, and analysed them in terms of their histories. It is ironic, if inevitable, that we recognize the full role of such institutions at the very moment at which they are challenged.

Secondly, within a historicizing framework, the definition of the category of 'other art' becomes more realizable. 'Primitivism', 'Indigenous Art', 'Ethnographic Art', 'Tribal Art' and 'Primitive Art' were classifications which came to exist at specific moments and through the emergence of particular institutions of modern culture. These notions were often elaborate, highly influential and supported by sophisticated theoretical and practical structures. However, a consistent flaw in all was the inability to acknowledge that their object of concern was defined through the history of modern culture. What this essay has sought to show is exactly that history – the history of modern, western cultures' approaches to the 'other'. The forms that these approaches have taken in the modern era are what has defined 'other art'.

Bibliography

Asad, T. (ed.), *Anthropology and the Colonial Encounter*, London, 1973

Barry, B.H., 'Relationships Between Child-training and the Pictorial Arts' in C.F. Jopling (ed.), *Art and Aesthetics in Primitive Societies*, New York, 1971

Bateson, G., *Naven*, Cambridge, 1936

Baudrillard, J., *Symbolic Exchange and Death*, London, 1994

Baxandall, M., *Painting and Experience in Fifteenth Century Italy*, Oxford, 1972

Bazin, G., *The Museum Age*, Brussels, 1967

Bennett, T., 'The Exhibitionary Complex' in Dirks, Eley and Ortner (eds.), *Culture Power History*, Princeton, 1994

Berlyne, D.E., *Aesthetics and Psychobiology*, New York, 1971

Boon, J.A., *Other Tribes, Other Scribes*, Cambridge, 1982

Braudel, F., *Civilization and Capitalism*, New York, 1967

Briggs, R., *Victorian Things*, Harmondsworth, 1988

Buffon, G.-L. de, *Histoire naturelle de l'homme* (1749), Paris, 1971

Bunn, J.H., 'The Aesthetics of British Mercantilism', *New Literary History* (no. 11, 1980), pp. 303–21

Burke, P., *Tradition and Innovation in Renaissance Italy*, London, 1974

Clifford, J., *The Predicament of Culture*, Cambridge, MA, 1989

Clifford, J. and Marcus, G., *Writing Culture*, Berkeley, 1986

Cohn, B., 'The Census, Social Structure and Objectification in South Asia', in *An Anthropologist among the Historians and Other Essays*, Delhi, 1987

Coombes, A., *Reinventing Africa*, New Haven, 1994

Dean, M., *Critical and Effective Histories: Foucault's Methods and Historical Sociology*, London, 1994

Defert, D., 'The Collection of the World: Accounts of Voyages from the Sixteenth to the Eighteenth Centuries', *Dialectical Anthropology*, (no. 7, 1982), pp. 11–20

Diamond, S., *In Search of the Primitive*, New York, 1974

Einstein, C., *Negerplastik*, Munich, 1920

Einstein, E.L., *The Printing Press as an Agent of Change*, Cambridge, 1979

Evans-Pritchard, E.E., *Witchcraft, Oracles and Magic, Among the Azande*, Oxford, 1937

Fabian, J., *Time and The Other*, New York, 1983

Findlen, P., 'The Economy of Scientific Exchange in Early Modern Italy', in B. Moran (ed.), *Patronage and Institutions*, Woodbridge, 1991

Foucault, M., *Madness and Civilization: A History of Insanity in the Age of Reason*, London, 1965

Foucault, M., *The Order of Things: An Archaeology of the Human Sciences*, London, 1970

Foucault, M., *The Archaeology of Knowledge*, London, 1972

Foucault, M., *The Birth of the Clinic*, London, 1973

Foucault, M., *Discipline and Punish*, London, 1977

Foucault, M., 'Body/Power', in C. Gordon (ed.), *Power/Knowledge: Selected Interviews and Other Writings 1972–1977*, Brighton, 1980

Fraser, D., *Primitive Art*, London, 1962

Fraser, D. and Cole, H., *African Art and Leadership*, Wisconsin, 1972

Faris, J., *Nuba Personal Art*, London, 1972

Foster, H., *Postmodern Culture*, London, 1985

Gathercole, P. and Lowenthal, D. (eds.), *The Politics of the Past*, London, 1990

Gidley, M., *Representing Others*, Exeter, 1990

Glaze, A., *Art and Death in a Senufu Village*, Bloomington, 1981

Goldwater, R., *Primitivism in Modern Art* (1938), Cambridge, MA, 1986

Graburn, N.H., *Ethnic and Tourist Art*, Berkeley, 1976

Grew, N., *Musaeum Regalis Societatis*, London, 1651

Harvey, D., *The Condition of Postmodernity*, Oxford, 1989

Haselberger, H., 'Method of Studying Ethnological art', *Current Anthropology*, (vol. 2, no. 4, 1961), pp. 341–82

Hillier, S., *The Myth of Primitivism*, London, 1993

Hobbes, T., *Leviathan* (first published 1651), London, 1969

Hobsbawm, E., *Nations and Nationalism Since 1780*, Cambridge, 1990

Hobsbawm, E. and Ranger, T., *The Invention of Tradition*, Cambridge, 1983

Hogden, M., *Early Anthropology in the Sixteenth and Seventeenth Centuries*, Philadelphia, 1964

Hooper-Greenhill, E., *Museums and the Shaping of Knowledge*, London, 1992

Hudson, K., *Museums of Influence*, Cambridge, 1987

Hunter, M., 'The Royal Society and the Origins of British Archaeology', *Antiquity*, (no. 65, 1971), pp. 113–21, 187–92

Hunter, M., 'The Cabinet Institutionalised: The Royal Society's "Repository" and its Background', in Impey and MacGregor (eds.), *The Origins of Museums*, Oxford, 1985

Impey, O. and MacGregor, A., *The Origins of Museums*, Oxford, 1985

Jopling, C.F. (ed.), *Art and Aesthetics in Primitive Societies*, New York

Kuper, A., *The Invention of Primitive Society*, Cambridge, 1988

Lane Fox, A.H., *Catalogue of the Anthropological Collection lent by Colonel Lane Fox*, London, 1874

Layton, R., *The Anthropology of Art*, Cambridge, 1981

Layton, R., *Conflict in the Archaeology of Living Traditions*, London, 1989

Leach, E., *Rethinking Anthropology*, London, 1961

Leach, E., *Culture and Communication*, Cambridge, 1976

Lévi-Strauss, C., *Structural Anthropology*, New York, 1963

Lévi-Strauss, C., *The Savage Mind*, London, 1966

Lévi-Strauss, C., *The Raw and the Cooked*, London, 1969

Lévi-Strauss, C., *The Naked Man*, London, 1981

Lévi-Strauss, C., *The Way of the Masks*, London, 1983

Locke, J., *Two Treatises of Government* (first published 1690), Cambridge, 1960

MacCormack, C. and Starthern, M., *Nature, Culture and Gender*, Cambridge, 1980

MacGregor, A., *Tradescant's Rarities*, Oxford, 1983

MacPherson, C.B., *The Political Theory of Possessive Individualism*, Oxford, 1962

Makonde, exh. cat., Oxford 1989

Malinowski, B., *Argonauts of the Western Pacific* (first published 1922), London, 1953

Mandrou, R., *From Humanism to Science 1480–1700*, Harmondsworth, 1978

Mason, P., *Deconstructing America*, London, 1990

Mauss, M., *Instructions sommaires pour les collecteurs d'objets ethnographiques*, Paris, 1931

McLellan, D., *Marx's Grundrisse*, London, 1980

Miller, D., 'Primitive Art and the Necessity of Primitivism to Art', in S. Hillier (ed.), *The Myth of Primitivism*, London, 1991

Mukerji, C., *From Graven Images*, New York, 1983

Mullaney, S., 'Strange Things, Gross Terms, Curious Customs: The Rehearsal of Cultures in the Late Renaissance', *Representations* (no. 3, 1983), pp. 40–67

Munn, N., *Walpiri Iconography*, Ithaca, 1973

Murray, D., *Museums Their History and Their Use*, Glasgow, 1904

Paolozzi, E., *Lost Magic Kingdoms*, London, 1985

Piggott, S., *Ruins in a Landscape*, Edinburgh, 1976

Price, S., *Primitive Art in Civilised Places*, Chicago, 1990

Richards, T., *The Commodity Culture of Victorian England*, London, 1991

Rosaldo, M., *Woman, Culture and Society*, Stanford, 1974

Rosaldo, M., 'The Use and Abuse of Anthropology: Reflections on Feminism and Cross-Cultural Understanding', *Signs*, (vol. 5, no. 3, 1980), pp. 389–417

Rubin, W., *'Primitivism' in 20th Century Art*, New York, 1984

Ryan, M., *Marxism and Deconstruction*, Baltimore, 1982

Said, E., *Orientalism*, New York, 1978

Spivak, G.C., *In Other Worlds*, London, 1988

Steiner, C., *African Art in Transit*, Cambridge, 1994

Sutton, P., *Dreamings*, Cambridge, MA, 1989

Tafuri, M., *Architecture and Utopia: Design and Capitalist Development*, 1976

Thomas, N., *Colonialism's Culture*, Cambridge, 1994

Torgovnic, M., *Gone Primitive*, Chicago, 1990

Trigger, B., *A History of Archaeological Thought*, Cambridge, 1989

Turner, V., *The Forest of Symbols*, Ithaca, 1967

Urry, J., *The Tourist Gaze*, London, 1990

Varnedoe, K., 'Abstract Expressionism', in W. Rubin (ed.), *'Primitivism' in 20th Century Art*, New York, 1984

Varnedoe, K., 'Contemporary Explorations', in W. Rubin (ed.), *'Primitivism' in 20th Century Art*, New York, 1984

Walsh, K., *The Representation of the Past*, London, 1992

Wilkinson, A.G., 'Henry Moore', in W. Rubin (ed.), *'Primitivism' in 20th Century Art*, New York, 1984

Willett, F., *African Art*, London, 1971

Williams, E., 'Art and Artefact at the Trocadero', in G. Stocking (ed.), *Objects and Others*, Wisconsin, 1985

Ybarra-Frausto, T., 'The Chicano Movement/The Movement of Chicano Art', in I. Karp and S. Lavine (eds), *Exhibiting Cultures*, Washington, 1991

Art in North America: The United States and Mexico, 1820s–1920s

Lucretia Hoover Giese

> *Mexico is the most Spanish country in Latin America; at the same time it is the most Indian . . .*
> *Though the language and religion, the political institutions and the culture of the country are*
> *Western, there is one aspect of Mexico that faces in another direction – the Indian direction . . . In*
> *the United States, the Indian element does not appear . . . The historical memory of Americans is*
> *European, not American. For this reason, one of the most powerful and persistent themes in*
> *American literature [and art] . . . has been the search for (or invention of) American roots.*
>
> (From O. Paz, 'Mexico and the United States')

Over the course of the 19th and early 20th centuries, art in North America reflected and influenced a protracted search by Mexico and the United States for national identity. The two countries present wide contrasts, as Octavio Paz has demonstrated, but at the same time they share pronounced correspondences. Mexico has two roots, Indian and Spanish. While Spain exerted the dominant influence from the 15th to the 19th century, Mexico's awareness of its Pre-Columbian past never entirely disappeared. For artists, it provided subject matter and later typology and the basis for expressions of national identity. In the United States, on the other hand, artists looked principally to Britain and France for inspiration and, to a lesser extent, to Italy and Germany. The influence of the indigenous Native American culture was negligible, except as a source of subject matter which was little understood. From the 1820s to the 1920s both Mexico and the United States looked primarily to Europe, even as place and circumstances fostered change and the construction (not necessarily in linear fashion) of a national identity. Yet in cultural terms, 'Americanness' and *Mexicanidad* were manifested in various ways.

Both Mexico and the United States were defining themselves politically, geographically and socio-economically as nations during this period. The process began in Mexico in 1810 with its struggle for independence, which it achieved twelve years later. The Mexican-American War of the 1840s settled its northern borders. Bentio Juarez's reforms of the 1850s led to a constitution and in 1867 the execution of Maximilian, whom Napoleon III had used in his thinly veiled effort to regain a foothold in the western hemisphere, granted Mexico an added measure of independence from European incursions. The dictatorship of Porfirio Diaz in the last quarter of the 19th century provided political stability, though little social or economic equality. In 1910 Mexico experienced its second revolution and, with the conclusion of military government in 1920, the process of national cohesion began.

The United States had already attained its independence before the 19th century, but the period under discussion encompassed its adolescent development and coming-of-age as a nation. Starting with the Louisiana Purchase of 1803, the United States completed its geographic 'manifest destiny' with acquisitions of territories still remaining in European hands (Florida and Oregon), territories wrested from Mexico (Texas, New Mexico and California) and lands appropriated from the Native Americans. Through the Mexican-American War, the Civil War, the Spanish-American War and the First World War, the United States gained in confidence and by the end of the 19th century, had developed and refined its infrastructures and institutions.

A new beginning of sorts occurred after the opening of the 20th century as Mexico and the United

States 'resolved' their relationships with Europe. The Old World no longer had the same hold politically or culturally, and a self-conscious assertion of national identity emerged in the North American nations.

Reliance upon Europe as cultural model

From the beginning and throughout much of the 19th century, the hegemonic artistic model for both Mexico and the United States was European. Europe provided the measuring stick for art in the New World, a base for training and a place of opportunity where a reputation could be established. Within the host countries, Europe maintained its importance by means of immigrating artists and transplanted conventions disseminated largely through ▷academies. The purpose of an academy was to train artists through a regimented programme of study relying upon conventions. The essential character of 19th-century European academies was fashioned after that of the French Academy founded in 1648 under the patronage of Louis XIV.

The English ▷Royal Academy established in 1768 also exerted considerable influence through the writings of its first president, ▷Sir Joshua Reynolds. The positions and precepts articulated in his widely disseminated *Discourses on Art*, itself derived from 17th-century French theoreticians, informed much of the Western world's notions about art and the role of an academy. They directed a student's lessons as well as offering more philosophical commentary. Above all, Reynolds stressed the appropriateness of the general over the particular, the perfected over the natural and universal truth above the incidental.

Academies offered a sense of purpose, status and professionalism, as well as a platform for dissent within the system. They had a broader function as well, at least in the opinion of Reynolds. He considered them appropriate for 'a great, a learned, a polite, and a commercial nation' (J. Reynolds, *Discourses on Art*). Thus academies might stimulate national pride as well as a nation's economic well-being, although they were certainly not the sole determinants of a sense of national identity nor was their hold absolute. After all, the very term 'national identity' is multivalent, making the expression of national identity through art problematic. Nevertheless, academies can be seen as significant agents in this enterprise.

The Academy of San Carlos

The first official academy in the western hemisphere was the Academy of San Carlos of Mexico founded in 1781 by Carlos III of Spain. The Academy's connections with Spain were pronounced and remained so with some fluctuation throughout the 19th century. European art provided its model, and its director and principal instructors were Europeans. Even so, the Academy's royal charter acknowledged particular complexities of New Spain. Race and class were not to inhibit student opportunity, and indeed the German naturalist Alexander von Humboldt observed Indians in the Academy's classrooms while he was in Mexico City in 1803. (His appreciative study of three pieces of Aztec sculpture unearthed within the decade was instrumental in altering European views, at least, on ancient Mexico.) The appointment of the Academy of San Carlos's first Indian director Pedro Patiño Ixtolinqu (1774–1835), however, did not occur until after the establishment of Mexico's First Republic in 1824.

With Mexico's political separation from Spain in 1821, the Academy was formally severed from its sister Academy in Madrid and lost its funding. It also lost its institutional footing and closed for a time. What did not essentially change was its academic pattern: a European-oriented curriculum, despite Patiño's fostering of national themes, and a reliance on foreign personnel. Reorganization of the Academy in 1843 only reinforced this position. One requirement was that the director be drawn from 'among the best artists to be found in Europe' (J. Charlot, *Mexican Art and the Academy of San Carlos, 1785–1915*). The appointment of the Catalan painter Pelegrín Clavé (1810–80) as director occurred mid-century, and his particular preference for the Rome-based German ▷Nazarene painters influenced the Academy long after his return to Spain in 1868. Clavé's European bias is apparent in his use of European artists' work to describe the Mexican School. According to Clavé, there were two styles, 'the first Raphaelesque, and Murilloesque the second'. (Presumably he meant a refined, rational style which followed ▷Renaissance tradition and an expressive, emotional style along ▷Baroque lines.) Clavé's own work and that of his principal rival within the Academy, Juan Cordero (1824–84), each reflected the two styles respectively.

Their feud, as Jean Charlot has called it, was based on more than matters of style. It also had to do

with nationality. Cordero, a Mexican, had trained at the Academy of San Carlos and studied abroad where he achieved some success. However, his *Columbus Before the Catholic Sovereigns* of 1850, painted in Italy and acclaimed there, was criticized when shown in Mexico City 'for no other reason than that he is a Mexican', one reviewer explained. The painting was well within the bounds of academic convention, albeit in 'Murilloesque' rather than 'Raphaelesque' manner, but the Spanish director preferred the latter European model, the Mexican academician the other. The accomplished Cordero, feeling unjustly treated, refused to serve as sub-director under Clavé, a Catalan.

In any case, Cordero undertook what have been interpreted as steps toward a national art, despite or perhaps because of political turmoil. His mural *The Triumph of Science and Labor over Ignorance and Sloth* is said to have been the first non-religious mural in which 'cheap local pigments' rather than imported materials were used. According to a friend's comments in 1874, Cordero even foresaw that 'the administration [might consider] the convenient beautification of public buildings with mural paintings . . . the palaces of the Government, of justice, city halls and others that house the administrative sovereignty, all need distinctive marks and wait for the brush and chisel of Mexican artists, dedicated to the study of the fine arts to the end that such places be spared the trite appearance of private dwellings' (quoted in J. Charlot, 'Juan Cordero: A Nineteenth-Century Mexican Muralist'). These comments of the artist himself proved to be remarkably prescient.

Other signs within the Academy of a growing sense of Mexican national identity can be found from mid-century on. The Academy itself fostered the exploration of subjects from Mexico's past in history paintings. Critics too argued for indigenous subjects. *The Discovery of Pulque*, 1869, by José María Obregón (1832–1902) depicts the introduction of the fermented beverage made from the maguey to a pre-Hispanic ruler and *The Senate of Tlaxcala*, 1875, by Rodrigo Gutiérrez (1848–1909), a similarly hypothetical pre-Hispanic episode. Yet neither artist attempted to cast the scenes with archaeological accuracy or anything resembling an indigenous style. 'History' was presented through a European artistic lens albeit with Mexican subjects as the focus.

Other academically-trained artists modified conventions learned at the Academy. José María Estrada (fl. 1830–65), for example, adapted his portraiture to suit the 'tastes of his provincial clients'. Working outside the reach of Mexico City in Guadalajara, Estrada tailored his style to local patrons presumably preferring a non-academic, more 'naive', indigenous manner. The effect of local middle-class taste is here in evidence.

Swings between an incipient Mexicanness and a reliance upon Europe marked the affairs of the Academy throughout the 1860s. As president of Mexico, Benito Juárez, a full-blooded Indian, installed the Mexican-born Santiago Rebull (1829–1902) over Clavé. In the face of the invading French, who shortly afterwards imposed Maximilian upon Mexico, Juárez also required government employees (including instructors at the Academy) to sign a loyalty oath. Mexican art, however, did not suffer under Maximilian, emperor of Mexico from 1864 to 1867. He retained Rebull as director and gave Mexicans various commissions. Paradoxically, however, with Maximilian's fall the conservative influence of Clavé resurfaced with the appointment of one of his protégés as director.

During Porfirio Diaz's presidency from 1876 until 1910, the seeds of national identity in art withered. Once again the state's pronounced preference for European culture showed itself, and, as controller of the Academy's purse-strings, the state's position was significant. A review of an Academy exhibition of 1898 appearing in the opposition periodical *El Hijo del Ahuizote* ('Son of the Ahuizote' – Ahuizote means a 'serpent' although the word may also have a double sense by referring to the Aztec ruler Ahuítzotl's son Moctezuma II, who confronted Cortés) identified the problem: 'We hear talk of what a difference there is between the Mexican works and the Spanish ones. Only too common among us is the impulse to praise what is foreign and to deprecate what is national, and this regardless of quality' (quoted in J. Charlot, *Mexican Art and the Academy of San Carlos*). Although the Academy nurtured some expressions of creative independence, European art and culture remained its and the state's identifying measurement. History painting on Mexican historical subjects persisted but they remained couched in European manner.

Exhibitions had been instituted by the Academy of San Carlos after its restructuring in 1843, but they served to support the work of the Academy's progeny, to engage and direct the attention of an élite public, and to encourage the emergence of criticism on art. The middle class largely bought the art of local artists. Material exhibited through the Academy neither addressed nor was made accessible to the masses. And *The Torture of Cuauhtémoc* by Leandro Izaguirre (1867–1941), for instance, was

painted expressly for the World's Columbian Exposition in Chicago in 1893. The decision of Diaz to mark the 100th anniversary of the beginning of Mexico's fight for independence in 1910 with an exhibition of contemporary Spanish art epitomizes the Porfiriatos' anti-nationalist position. Although Diaz's action prompted a revolt by some students within the Academy and a counter-exhibition, a conservative Europeanized position on art remained largely intact on the eve of the 1910 Revolution.

The National Academy of Design

More than a decade after the start of the first Mexican Revolution, the Academy of San Carlos's counterpart was established in the United States. The ▷National Academy of Design in New York developed in 1826 out of quite different circumstances. Before that time, the practice of painting in the United States had comparatively shallow professional roots in contrast to the situation in Mexico which had a longer artistic history. And, unlike the Mexican Academy, the National Academy was not instituted by royal decree and had no presidential or state backing. Despite its name, it had no national affiliation. It grew out of artists' dissatisfaction with existing opportunities for study and their longing for an institution which would raise their status as artists while giving them control over their professional lives. Directors were not culled from Europe, and volunteer academicians provided instruction for a good part of the 19th century, giving the National Academy of Design a very different structure from the Academy of San Carlos.

Even so, the curriculum and theoretical base were European, specifically modelled on that of the Royal Academy of London. As in the case of the Academy of San Carlos, drawing from antique casts was the staple fare – though a Life School was opened in the 1830s – and conventional history painting maintained a hold, although without the same official or public support that it enjoyed in Mexico. Even so, many Americans continued to find European training more attractive than that which the Academy offered, and many artists went abroad to study. Disaffection was especially prevalent after the American Civil War of 1861–5.

In addition to being unable to stem an exodus to Europe in the 1870s, the National Academy of Design suffered dissent from within. Complaints about instruction not being comparable to that of European academies resulted in the appointment of the Academy's first salaried professional artist (trained in Europe) in 1870. Disagreement over the suitability of student fees to keep the Academy financially stable and over the dismissal of a professor for economic reasons resulted in a break-away organization, the ▷Art Students' League, in 1875. Another fracture took place in 1877. Some artists, disgruntled by what they interpreted as rigid and conservative standards, formed what became the Society of American Artists. These artists had for the most part been trained abroad rather than at the Academy and had absorbed different standards, making their work suspect to its jurors. Individuality of expression, painterliness rather than solid draughtsmanship, and lack of sentiment and narrative appealed to the Society's members. Even so, while promoting greater flexibility and diversity, they, too, viewed Europe as their ultimate model, and eventually in 1904 the Society of American Artists rejoined the National Academy of Design.

Recognition of European culture and declarations of nationalism came together powerfully in 1893 at the World's Columbian Exposition in Chicago. The Exposition marked the 400th anniversary of Christopher Columbus's voyage to the New World and was intended to demonstrate that 'America was taking a leading place among nations' and 'therefore, [had] the right to obtain art wherever she could'. So claimed architect Stanford White (quoted by R.G. Wilson in *The American Renaissance: 1876–1917*), who had contributed to the design of myriad structures covering hundreds of acres of land. The pavilions themselves contained evidence of America's accomplishments in all spheres of endeavour, including technology, commerce and art. With an Italian Renaissance ▷Beaux-Arts template for the gleaming Great White City, the United States confidently designated itself the worthy inheritor of Old World civilization and the source of the new. This statement of nationalism set aside any previous 'attitudes of cultural inferiority' (W. de Wit in *Grand Illusions: Chicago's World's Fair of 1893*). While Europe remained the underlying source and authority for the spirit and visible forms of the 'American Renaissance' showcased at the Exposition, a truly national American art – so it was thought – was the result.

The Exposition became a 'monument', in Joshua Taylor's words, to those convinced that Parisian training and being 'true to American art' were synonymous (J.C. Taylor, *The Fine Arts in America*). Certainly, artists who had trained abroad numbered heavily among the organizers. Virtually all of the

participating painters had done so also or had travelled to Europe, and most were connected with the National Academy of Design. George de Forest Brush (1855–1941) and Charles Ulrich (1858–1908), for example, had received training at the National Academy of Design as well as abroad. Among the several paintings they each exhibited, *The Indian and the Lily* (1887) and *In the Land of Promise, Castle Garden, New York* (1884), respectively, were of distinct American subjects. Other painters had looser ties to the Academy and Europe; these included Winslow Homer (1836–1910), who became an academician of the National Academy in 1865, although neither a formal student there nor abroad, and George Inness (1825–94), who trained with a French painter in New York and was later influenced by the ▷Barbizon painters during trips abroad. The underlying consistency of artistic background reinforced a strong sense of cohesive nationalism – false though it was in actuality – at the turn of the 20th century.

In what comparative ways did the Academy of San Carlos and the National Academy of Design affect their respective countries' development of a national identity? The Academy of San Carlos's alliance with the state gave it a weightiness on a national level. Could, then, the strictness of the Academy's regimen have 'helped the young, by contrast, to realize the meaning of freedom'? And could the insensitivity of the Academy's leadership to native culture and its allegiance to European art have encouraged more than 'artistic revolution' (J. Charlot, op. cit.)? Breaking with academic tradition is in itself a revolutionary act, opening the way for the development of a national art. Stanton Catlin has taken this position in another direction, believing that the Academy's insistence on a ▷Neoclassical discipline 'put a brake on, if by no means a stop to, individual Romantic tendencies until the end of the century' (S.L. Catlin in *Art in Latin America: The Modern Era, 1820–1980*). Either way, or perhaps more accurately whichever way, the Academy of San Carlos (or the National School of Art as it became known) had an impact on Mexico's art and national identity.

The National Academy of Design exerted less national influence. It spoke without a monolithic voice and had to acknowledge other institutions and a somewhat more artistically enfranchised public. Entrenchment by conservative members in the latter part of the 19th century had, however, stimulated opposition from within, and in that respect the National Academy of Design, too, fostered 'artistic revolution'. More importantly, its early acceptance of work for the annual exhibitions in painting categories not traditionally esteemed both affected and reflected public preference. The National Academy was helped by the fact that it was located in New York City, the artistic hub of the 19th-century United States. This circumstance of geography gave substance to the National Academy's positions and pronouncements. It was more than a bit player, as was the Academy of San Carlos, in the encouragement of art and the development of national identity.

Landscape and a 'nationalization' of identity

By the 1820s, a path toward nationalization gained momentum. After independence from Spain, Mexico began to uncover, sometimes quite literally, its pre-Hispanic past. In the United States, it was more a matter of constructing a culture, as Octavio Paz has pointed out. The means employed in both countries were, however, remarkably similar. Artists turned to their country's unique characteristics, focusing on the land and its indigenous population and customs in an attempt to 'get at' a national identity. However nebulous the concept of a single national identity may be, artists did manage to say something *of* and often *about* Mexico and the United States through both their landscapes and their genre paintings.

Landscape is a nation's physical fabric. Its topography and resources affect a nation's thinking and destiny. As pictorial material, landscape serves aesthetic but also informational or ideological purposes. Small wonder landscape became a national signifier in the hands of Mexican and US artists. Landscape was also sanctioned, and indeed sponsored, by the academies and other national institutions. Painters in turn responded to this encouragement, sensing also the potential national impact of such a subject on a clientele of wealth and position as well as on a broader public.

Convention, however, ranked 'pure' landscape below history painting. Only when invested with literary, historical or allegorical content carried by small-scale figures did landscape acquire higher status. ▷Staffage, as this figuration is called, was the signifier of meaning rather than nature itself. ▷Claude Lorrain, ▷Nicolas Poussin and ▷Salvator Rosa were the principal proponents of this approach to landscape painting in the 17th century. Although certain northern painters of the same century such as ▷Jacob van Ruisdael and ▷Rembrandt particularized 'native' landscapes populated

with contemporary figures, academies advocated the Lorrain/Poussin/Rosa direction. They expected artists to modify their observations of and occasional studies made in nature. Nature was to be represented not as it was but as it ought to be, embellished, as it were, according to established conventions. These conventions provided artists with a compositional formula for landscapes: a high foreground bracketed to either side by trees or other such elements leading to an expansive space in the middle distance extended further through the centre into the background. Figures enlivened either the foreground or middle distance.

By the late 18th century, landscape had become increasingly important as a subject of ▷ aesthetic theory as well as artistic practice. A language of modes developed in England identified the ▷ sublime landscape (vast, wild, majestic nature), the beautiful (regular, artfully arranged, ideally beautiful nature) and the ▷ picturesque (irregular, varied, particularized nature). Although the picturesque did not meet conventional standards for beauty, it was still considered aesthetically attractive and a stimulant to the mind, 'fit' for a picture. These terms employed at first to describe nature eventually became attached to the painted landscape.

▷ Topographical renderings preceded more expressive landscape modes to the New World. Exploratory expeditions had often engaged a cartographer/artist to transcribe the particulars of the land itself and its inhabitants. These images carried useful information, however inaccurately presented, for investors and potential settlers; they were intended to serve a practical rather than aesthetic purpose. Only later did painters set about recording the specifics of towns, patrons' country seats or regional natural wonders, and begin to employ landscape as the vehicle for ideas or commentary.

In Mexico, preference for the traditional categories of history painting and portraiture and the dominance of patronage by the Church delayed the development of landscape as a distinct genre. The Academy of San Carlos did initiate a professorship in landscape after its restructuring of 1843, but that post was not filled until the appointment in 1855 of an Italian-born and trained painter Eugenio Landesio (1810–79). By the end of the 1870s, his protégé José María Velasco (1840–1912), a Mexican who had not studied in Europe, was appointed the Academy's director, indicating landscape's gain in popularity, to say nothing of Velasco's own. The two distinct manners of landscape painting Landesio categorized in his *Clasificación de la Pintura General o de Paisaje (Classification of General Painting or of Landscape)* of 1866 were practised by his own pupils. Luis Coto (1830–91), for example, allied himself with *episodio* (landscape containing a narrative episode) and Velasco with *localidad* (landscape focusing on a particular locality).

In fact, Velasco combined a Landesio picturesque manner derived from European landscape convention with what Stanton Catlin has called 'the empirical legacy of the traveller-reporter' (S.L. Catlin). Drawings indicate the preciseness of Velasco's observation of actual nature for his paintings. Their subjects include the landscape setting of a newly constructed railroad line linking Mexico City and Veracruz in *El Citlaltépetl*, 1879. He also painted the castle of Chapultepec in Mexico City and the city of Tlaxecala, but above all took as his subject the Valley of Mexico. On at least one occasion, however, as Dawn Ades has noted, Velasco may have embellished landscape with national symbols (D. Ades in *Art in Latin America: The Modern Era, 1820–1980*). In a version of his often-repeated *View of the Valley of Mexico from the Hill of Santa Isabel* of 1877, an eagle shares the foreground with a prominent cactus plant. The landing of an eagle on the prickly pear cactus determined, according to Aztec legend, the site of the last Aztec capital Tenochtitlán which lies beneath present-day Mexico City. These elements with national significance are featured on the flag of Mexico. Even without such accoutrements, Velasco's landscapes were seen by his contemporaries to have national content. One reviewer of an Academy exhibition enthusiastically described a painting by Velasco of the Valley of Mexico as a 'most remarkable landscape, lovely as Nature herself, splendid as *our* sky, vigorous as *our* trees, pure as the placid waters of *our* majestic Lake Texacoco ... this craggy ground is covered with plants native to *our* Valley' (J. Marti, *On Art and Literature: Critical Writings*, italics mine).

Outside the perimeters of the Academy, interest in the Mexican landscape took place earlier than mid-century in the hands of the traveller-reporter artist. Humboldt can be said to have 'initiated' this activity in Mexico. Included in the published accounts of his Latin American travels authorized by the Spanish Crown were illustrations of the topography and flora and fauna of New Spain (Velasco would likewise later become involved in botanical, ornithological and zoological illustrative work). Such material excited the interest of other travellers whose entry into Mexico had been facilitated by Mexico's independence. The English artist Daniel Thomas Edgerton (c1800–42) arrived in 1829.

His landscapes display the finesse expected from a member of the Society of British Artists. In subject they range, for example, from the specific *The Valley of Mexico* (1827), and *Gust of Wind at the Summit, Iztaccihuatl* (date unknown), to the general *Travellers Crossing the Brook* (date unknown), enlivened with small-scale figures providing local colour (in the style of Velasco and the traveller-reporter tradition). Edgerton's colour lithographs appeared in his *View of Mexico* which was published in 1839–40.

Perhaps the best-known artist and traveller-reporter to record the Mexican landscape was another English artist Frederick Catherwood (1799–1854), who had trained as an architect and accompanied John Lloyd Stephens from the United States to the Yucatán. Catherwood's transcriptions of ancient ruins illustrated Stephens's accounts, *Incidents of Travel in Central America, Chiapas and Yucatán* (1841) and *Incidents of Travel in Yucatán* (1843) in the form of engravings; Catherwood later published his own *Views of Ancient Monuments in Central America, Chiapas and Yucatán* (1844). In the plates for this volume, Catherwood embellished his transcriptions of the sculptural remains and structural ruins with picturesque local figures, suggesting continuity with the present indigenous population. Stephens had in fact assumed that the Maya whose ruined complexes he and Catherwood examined were 'an indigenous development', an unusual conclusion for the time (B. Braun). Certainly the precision and extent of their records indicate Stephens's and Catherwood's appreciation of Mexican culture, which, however, Stephens did not shy away from trying to exploit.

Artists such as Catherwood and Edgerton departed from the academic Reynoldsian dictum by particularizing. They both responded to the environment at hand and to the nature of their task. It was, as they probably defined it, to render the landscape with care and authenticity. In this they succeeded. Unlike Velasco's later depictions of Mexico, theirs had a more pragmatic, practical business in hand than the aesthetic and expressive pictorialization of national identity. Their work effected a greater awareness and appreciation of Mexico inside the country as well as without, but it was Velasco's landscapes shown abroad and at the Philadelphia Centennial of 1876 and the World's Columbian Exposition of 1893 which came to signify Mexico. Today, a version of Velasco's enormously popular *Valley of Mexico*, which he endlessly repeated until very late in his career, can be seen in the guest house of ▷ Frank Lloyd Wright's 'Falling Water' outside Pittsburgh.

In the 1820s, nearly coincidental with the start of traveller-reporter artists' involvement with landscape in Mexico, landscape painting in the United States became a category of importance. The move from prosaic topographical 'views' of particular sites and scenic wonders to romantic 'visions' occurred earlier than in Mexico (E. Nygren in *Views and Visions*). Although described in terms of European landscape theories, in practice the American landscape was 'unsung and undescribed', as a contemporary writer proclaimed (quoted in A. Wallach, *Thomas Cole: Landscape into History*). English-born ▷ Thomas Cole similarly declared that, 'The painter of American scenery has indeed privileges superior to any other; all nature here is new to Art.' American scenery provided the artist with material not only unburdened by European artistic baggage but nature essentially untainted and free of excessive civilization. For these reasons, American landscape was perceived as aesthetically and morally superior to its European counterpart, as a repository of national pride as well as commercial potential. Rising prosperity and tourist exploration of the countryside by the middle class stimulated a search for aesthetic views. A taste for such scenery and its representation in painting reinforced each other with the result that landscape became a national art form.

Cole, the founder of America's national landscape school of painting, urged the cultivation of a taste for landscape which he felt would improve the mind and spirit. He believed that undefiled 'wilderness ... [was] a fitting place in which to speak of God'. It therefore followed that the 'most distinctive ... most impressive characteristic of American scenery is its wildness' (quoted in J.W. McCoubrey, *American Art 1700–1960*). Cole thus elevated American scenery to a subject of great significance, if not national import. Landscape became the protagonist, the bearer of content, taking on the role of figuration in history painting, whether imagined as in *The Course of Empire* (1833–6), or particularized and regional as in *View from Mount Holyoke, Northampton, Massachusetts, after a Thunderstorm (The Oxbow)* (1836). In his five-part *The Course of Empire*, Cole charted the decline and fall of civilization by recording changes made by man upon a landscape comprised elementally of mountain, water and land. Landscape in arcadian state becomes pastoral, followed by its 'consummation' and decline, and ending in ruination. Essentially through nature itself, Cole expressed his fears that the nation continuing on a materialistic path would repeat Europe's mistakes and risk desolation. These sentiments about America's progress

were not merely parochial, however. Cole placed them in the larger context of universal truths across history and across time.

With *The Oxbow,* Cole explored similar views concerning the condition of America. In this panorama of the already much-frequented spot of Mount Holyoke overlooking a bend in the Connecticut River, Cole juxtaposed 'wilderness' against the 'pastoral': uncultivated nature atop Mount Holyoke against settled land across the river below. The latter is what Leo Marx has termed the middle landscape. '[N]either wild nor urban ... the setting of man's best hope' lies somewhere between 'the *savage* and the *refined*' (L. Marx, *The Machine in the Garden: Technology and the Pastoral Ideal in America*). There man lives harmoniously with nature undefiled by industry and commerce. But in Cole's painting storm clouds develop (or recede) overhead. Because the painting is full of contrasts – 'storm and sunshine, wilderness and pastoral' – the physical landscape appears conflicted, its message ambiguous (A. Wallach, op. cit.). As does *The Course of Empire, The Oxbow* tells a cautionary tale. Even while extolling the American landscape's beauties in his *Essay on American Scenery* published in 1836 (the same year as *The Oxbow*), Cole expressed in paint his fears of unbridled progress and social change occurring in America under Andrew Jackson.

Cole's successors in the ▷Hudson River School of American landscape painting both reflected his influence and were distinct from it. They, like Cole, himself a founder of the National Academy of Design, were largely academicians and exhibited their work in its annuals, although many had also travelled abroad. They, too, painted in the Catskills in upper New York State near the Hudson (the region in which Cole had often, though not exclusively, painted) as well as at numerous other sites. And they, like Cole, acknowledged the inevitable, and not wholly unwanted, displacement of the wilderness by civilization.

They differed, however, from Cole in their confidence in America's direction which they expressed in a nationalistic exaltation of American landscape. Asher B. Durand (1796–1886), described as the first American-born 'painter to view himself a disciple of Cole', followed this course (O.R. Roque in *American Paradise: The World of the Hudson River School*). In his series of *Letters on Landscape Painting* published in 1855, Durand wrote that American nature, being 'fraught with lessons of high and holy meaning', was a suitable subject for study and depiction (quoted in McCoubrey, op. cit.). Durand's agreement with Cole on this matter is clearly stated in his tribute *Kindred Spirits* of 1849, painted the year after Cole's premature death. Cole and the poet William Cullen Bryant stand on a ledge looking out over the American scenery which both painter and poet admired while they ponder its distinctive qualities. In his poem *Thanatopsis* of 1817 Bryant himself had 'admonished' Americans to:

'Go forth, under the open sky, and list to Nature's teachings...'

Durand's somewhat later *Progress (The Advance of Civilization)* of 1853 tells a more overt nationalist tale. From a remnant of wilderness, a Native American looks out across the developing countryside. Its effective harnessing and appropriation by wagon and steamboat go on under the Native American's curious and powerless scrutiny. Settlers' progress appears to be sanctioned by the distant prospect bathed in golden light emanating from the west, the locus of America's final destiny.

Most Hudson River School paintings after Cole concerned the settled landscape and pastoral ideal, and clearly articulated a belief in American exceptionalism. Martin Johnson Heade (1819–1904), Sanford Gifford (1823–80), and John F. Kensett (1816–72), for example, did so subtly, Jasper Cropsey (1823–1900), ▷Frederic Church, and ▷Albert Bierstadt more declaratively. Church, Cole's sole pupil and an academician, and Bierstadt, Church's fellow member of the Academy and sometime rival after Bierstadt's return from Germany where he had trained, made landscape their speciality. Through depictions of North and South American scenery, Church expressed confidence (though not unalloyed) in the nation's future. In his *New England Scenery* of 1851, New England's many natural resources wisely used by man form the background for the distinctive Conestoga wagon being driven across a bridge, presumably westward. Church's view, a composite of various parts of New England, enfolds the regional northeast into the national. Church's two changes from study to final version reinforce such a reading. He transformed the farm wagon into a pioneer 'ship' and removed the ocean view leading perhaps back to the Old World (F. Kelly, *Frederic Church and the National Landscape*). That the American ▷Art-Union chose the painting for distribution to its sizeable membership provides further confirmation. The institution promoted national themes in work it acquired for lottery or subscription. *New England Scenery* seemed to assuage at least one reviewer's dismay that 'no adequate record' of the

'ideas of our own time and country' had figured in the National Academy of Design exhibition that was held in 1850.

Church's *Niagara* of 1857 crystallizes such 'ideas'. Niagara had long been a symbol of America. In this expansive view, Niagara alone tells the story without the aid of allegorical figures or emblems. Water catapults across the foreground, leaving no ledge for the viewer's perch, and tumbles over the cataract into the spray-filled abyss below. Overhead a rainbow connects falls and sky. Although Church had scrupulously studied and realistically rendered the site, he chose to accentuate its sublimity. The painting's unusually elongated format (the height–width ratio is one to three) serves both artistic and ideological purposes. Church's contemporaries believed the falls' relentless, forward propulsion combined with the natural phenomenon of the rainbow signified the nation's unstoppable destiny sanctioned by God. Church's *Niagara* captured the 'national fever' (O.R. Roque).

National sentiment had been readily satisfied by eastern landscape. However, with increased indus-trialization and denser settlement following the American Civil War, the pastoral formula of the Hudson River School seemed anachronistic, if not hackneyed. Artists increasingly saw the West as the landscape of national inflection. Bierstadt, for one, successfully claimed the western United States from the Rocky Mountains to the Pacific Ocean as his 'territory'. *The Rocky Mountains, Lander's Peak* (1863) first brought Bierstadt and his 'Great Pictures' of the American west popular acclaim. (The period term 'Great Picture' was applied to an exceedingly large, publicly exhibited painting, the subject of which was calculated to attract a wide audience.) When Bierstadt exhibited *Looking Down Yosemite Valley, California* (1865) at the National Academy the year the Civil War ended, a San Francisco critic described it 'as if it was painted in an Eldorado, in a distant land of gold; heard of in song and story; dreamed of, but never seen. Yet it is real' (a disbelieving New York reviewer criticized the same painting for its lack of truthfulness) (quoted in N.K. Anderson and L.S. Ferber, *Albert Bierstadt: Art and Enterprise*). By mid-century, thousands of pioneers had surged across the country to find their Eldorado, believing that it was their 'manifest destiny to overspread and possess the whole of the continent which Providence has given us for the development of . . . a noble young empire'. So proclaimed a New York newspaper editor in 1845, who may have coined the term 'manifest destiny' (quoted in J.G. Sweeney, *The Columbus of the Woods: Daniel Boone and the Typology of Manifest Destiny*). The West in 'the whole of the continent' became America's promised land.

Bierstadt's *The Oregon Trail* of 1869 repeats that message once again. Pioneers surge toward their providential birthright aglow in the distance, unimpeded by either Native Americans or the hardships that Francis Parkman wrote about in his accounts of overland travel along that route. (*The California and Oregon Trail* was first serialized in the *Knickerbocker Magazine* in 1849.) Although completion of a transcontinental railroad line in 1866 had undermined the trail's practicality, its potency as a symbol of expansion remained. Its grandiose treatment by Bierstadt seems to legitimize the territorial gains the Oregon Trail made possible. A consummate self-promoter of his own talents, Bierstadt had many patrons who were themselves businessmen involved in entrepreneurial activities, largely land-related.

The so-called Great Surveys of the West undertaken after the Civil War for scientific and strategic purposes by federal agencies provided artists with other means of access to national lands. Government-sponsored treks had occurred as early as 1819, and Bierstadt for one had availed himself of a privately-led expedition westward in 1863. The Great Surveys were more thorough undertakings. Thomas Moran (1837–1926) participated in several, the first being the US Geological and Geographical Survey of the Territories led by Ferdinand Hayden in 1871. Moran was eager to see the Yellowstone for himself, having earlier that year illustrated a *Scribner's Monthly* article on the area using someone else's sketches. The massive *The Grand Cañon of the Yellowstone* of 1872, intended for and purchased by the government for the Capitol, was the result.

Although a result of seeing the landscape itself, *The Grand Cañon*, together with *The Chasm of the Colorado* (1873–4), and *Mountain of the Holy Cross* (1875), was not a scientific transcription of nature. Moran had admitted that literal truth was less important to him than overall impression; each painting was actually a composite of views taken from more than one vantage point. Something else mattered. This group forms a 'natural triptych', to use Joni Kinsey's phrase (J.K. Kinsey, *Thomas Moran and the Surveying of the American West*). Understanding the significance of the American west 'as a microcosm of American culture and of universal ideas', Moran warned (in Colean fashion) of the deleterious effects of mismanagement of western lands and the need to preserve remaining pieces of American wilderness. In fact, Moran's painting of the Yellowstone and his depictions in *Scribner's*, as well as

William Jackson's photographs, helped convince Congress to establish Yellowstone as a National Park in 1872, the first in the United States. Because of the image's continuing power and appeal, Moran repeated *The Grand Cañon* more than once well into the 20th century.

Not all landscape paintings were, of course, as plain speaking of national identity. By the last decade of the 19th century, for example, ▷ Winslow Homer's late marines and his paintings of the Adirondacks, (a forest preserve in upper New York State by 1885) were critically discussed as distinctly American. Homer was given the label 'national artist' by the critic, W.H. Downes. His background as an essentially self-taught artist uninfluenced by Europe (or so Downes thought) contributed to this perception. More important, Homer's work addressed a nostalgia for an American wilderness which had all but disappeared by the 1890s, and his work was believed to express notions of 'individualism, independence, and confidence in the common man that encouraged self-government' which were perceived to have been fostered by wilderness conditions (R. Nash, *Wilderness and the American Mind*). These 'American' characteristics help explain the appreciation of Homer's work interpreted (by some) as expressive of national identity near the end of the century. On the other hand, however, Homer's work – as well as that of some of his contemporaries around the turn of the century – tends to be concerned as much with the act of painting itself as with content.

Paintings of indigenous people, their life and customs

A nation's peoples and their activities narrate its story. They also constitute the stuff of ▷ genre painting. This category of painting includes scenes of everyday life and work showing largely rural activities and often containing examples of *costumbrista*, or local colour. Yet although these images may appear to be realistic, genre paintings, like landscapes, are actually constructs. They are not about life as it really is but articulate, as Patricia Hills has reminded us, the 'cultural ideals and social myths of the picture producers and picture consumers' (P. Hills, *The Painter's America: Rural and Urban Life, 1810–1910*). In this way they, too, indicate regional and national concerns.

Precisely when such work was taken up in Mexico is not easily established, although it was certainly after independence. In the United States, the beginning of Jacksonian democracy provides a possible benchmark. According to Elizabeth Johns, during Jackson's presidency, there occurred 'intense change' and the 'differentiation of the citizenry ... by people seeking or in positions of dominance' that fosters genre painting. The invention of types was a mechanism enabling certain elements of society to distinguish or sort themselves out from others (E. Johns, *American Genre Painting: The Politics of Everyday Life*). Much the same situation existed in Mexico with its highly stratified, heterogeneous population and political upheavals. Rural inhabitants and their activities – the United States remained largely agrarian until the 1870s and Mexico for much longer – provided the stuff of most genre paintings whether ideological or reportorial in tone.

These conditions gave life to a category of painting traditionally held in low esteem. In the United States, genre painting came out of Dutch 17th-century and English 18th-century examples accessible in prints and paintings in the young republic, and in Mexico from the traveller-reporter artists already mentioned and late 18th- and early 19th-century *castas* (breeds) paintings. This distinctive category of painting catalogued racial types, the result of *mestizaje* (miscegenation), set within regional settings. Humboldt had produced sketches of local peoples encountered on his travels, itemizing what he had observed. So, too, did the French artist Carlos Nebel (1800–65), whose plates for his *Voyage pittoresque et archéologique dans la partie la plus intéressante du Mexique (A Picturesque and Archaeological Trip Through the Most Interesting Part of Mexico)* of 1836 contain regional figures of various ethnic groups casually yet artfully arranged in vague regional settings. These images appear to be straightforward renderings, without ideological or social message, produced for simple appeal or information.

Mexicans of course depicted their own people and countryside. Some painters were presumably academically trained but, because the Academy did not sanction genre painting, they were forced to find commissions and support from private patrons. One such painter was Felipe S. Gutiérrez (1824–1904) whose *The Farewell* is said to have been the direct commission of the protagonist depicted taking leave of his family. Another was José Agustín Arrieta (1802–74). His speciality consisted of interior views, market scenes and people in indigenous costume. In *El Chinaco y la China (Indian Man and Woman)* (date unknown) a woman sits cross-legged on the floor before a man on a small stool who holds a black bird with one hand, while resting the other on the woman's shoulder. Their colourfully decorative dress is as much on display as are the fruits and vegetables, glass of liquid and plate of food

laid out before them on a piece of cloth folded on the floor. Their centralized position against an unspecified background gives them the aspect of specimen figures, which tell of local customs. The bird and woman, both 'captured' by the woman's companion, appear in this instance also to comment on social conditions.

Genre painting's appearance in the United States coincided with that of landscape painting in the 1830s. Like landscape, genre painting had clear European roots. Of the many practitioners ▷David Teniers in 17th-century Holland and ▷George Morland and ▷David Wilkie in 18th- and 19th-century England were most often cited. Their work influenced that of many Americans to the extent that an artist was sometimes labelled 'an American Teniers' or 'an American Wilkie'. Genre painting suffered at first in comparison to landscape's moralizing or didactic potential (at least as promoted by Cole). These properties caused landscape to appear the more important and interesting category in the 1830s. If, however, genre painting is a 'phenomenon' which comes out of particular circumstances and 'meets the social needs peculiar to a specific audience' (as was the potential in regional America), it too can be message-bearing, with comic and ideological import (E. Johns, op. cit.). Certainly genre painting in the United States, unlike Mexican *costumbrista* work, contained both narrative and commentary. Particular subjects were addressed and sought after by both institutions and individuals from varying backgrounds.

Cole's counterpart in the rising field of genre painting was William Sidney Mount (1807–68), born in New York and an early member of the National Academy of Design. His *Bargaining for a Horse* of 1835 is representative of his concentration on eastern types. Two men in a farmyard stand bracketed by a barn opening and a horse. As they whittle sticks of wood, they size up each other and attempt to make the best bargain for themselves. These shrewd Yankee farmers are engaged in 'horse trading', an activity described by that vernacular expression as having both economic and political significance. The colloquialism's currency and popular appeal of Mount's pictorialization of the eastern farmer 'type' presumably explain the painting's selection as an engraving for the *Gift*, an annual with virtually nationwide circulation. Eastern capitalism and the politics of the westerner Andrew Jackson, a strong promoter of 'manifest destiny' and opponent of the Bank of America, a self-professed admirer of 'the humble members of society – the farmers, mechanics and laborers', all appear to be alluded to by the painting (C. Stansell and S. Wilentz in A. Wallach, op. cit.). In *Cider Making* (1841), Mount's political signals were more overt; the wooden structure and beverage in the painting allude to the Whig party's 'log cabin and cider' presidential campaign slogan of 1840.

By mid-century, technology and settlement had intruded into America's 'garden', slavery had become a matter of national debate, and 'selling the west', as William Truettner has put it, was well under way (W.H. Truettner in *The West as America: Reinterpreting Images of the Frontier, 1820–1920*). These distinctively American events and concerns spawned artistic treatment. So, too, did the lot of Americans who were living out west. They were literally and figuratively on the 'outer verge of civilization', just as easterners had been perceived from Europe.

Among the earlier depictions of Native Americans are those by ▷George Catlin (1796–1872). Sensing that the 'vanishing' Native American was in fact doomed, Catlin travelled west in the 1830s four times to witness their way of life. His intention, he said, was to portray faithfully 'native looks and history; thus snatching from a hasty oblivion what could be saved for the benefit of posterity, and perpetuating it, as a fair and just monument, to the memory of a truly lofty and noble race'. Paintings such as *Buffalo Hunt under the Wolf-skin Mask* (1832–3), dating from his first expedition, convey an uncommon empathy and interest in the Native American. Two Native Americans concealed beneath white wolf skins crawl stealthily, bow and arrow in hand, toward the herd which shows no apparent apprehension of what lies ahead. Catlin plays up the hunters' skill. In some respects, 'Catlin's Indian Gallery' of over 400 paintings of indigenous people and their customs and his voluminous travel accounts are the equivalents of traveller-reporter artists' work in Mexico. Like these Mexican art works, Catlin's depictions of Indian life hint of an outsider's fascination with the 'other'. However, Catlin's material was also collected for his own purposes and advantage.

Besides being rendered as exotic creatures or 'noble savages', Native Americans served a more obvious ideological purpose which corresponded with the mood and events of the country. They were shown as inevitably doomed by encroaching civilization, as in Tompkin H. Matteson's (1813–84) *The Last of the Race* of 1847. Other paintings presented them more as threatening but disposable obstacles which stood temporarily in the way of the unalterable progress of western expansionism, as in Carl

Wimar's (1828–62) *The Attack on an Emigrant Train* of 1856. Yet another variation on the theme had Native Americans as nostalgic remnants of America's past; towards the conclusion of the Plains Wars, in 1881 Henry Farney (1847–1912) painted *End of the Race*. At a time when immigration from other shores engulfed the United States and it asserted its imperialism in the world, Native Americans also appeared as clearly racially distinct, as in ▷Frederic Remington's *Captured* of 1899. Artists pictorially 'Inventing "the Indian"' over the course of United States expansion mirrored and helped shape attitudes of national identity (J. Schimmel in W.H. Truettner, op. cit.).

Much the same can be said of depictions of the African-American. Approaches differed depending on a painter's attitudes and changes in the market. Representations range from, in Mount's own work, the ambiguously comic *Farmers Nooning* (1836) to *The Power of Music* of 1847. In the first, the image of a sleeping black tickled by a white boy in a worked field takes on racial and political overtones; in the second, the portrayal of a black listening from outside to music performed by whites inside a barn contextualizes the African-American with compassion and empathy. ▷Eastman Johnson's *ante-bellum Old Kentucky Home/Negro Life in the South* of 1859 shows African-Americans in a dishevelled yard surrounded by emblems not of hard work but of leisurely domestic life (children, sweethearts, banjo and dog) while a white 'mistress' observes from the side. This image satisfied varying views on the African-American, as evidenced by difference in pre- and post-Civil War critical responses to it. Winslow Homer's Reconstruction Era depiction of the African-American in *The Cotton Pickers* of 1879 seems less clouded. Two women in a cotton field pause in their picking, unbent by that gruelling task. Foregrounded in heroic scale, they appear confident and able 'to chart their own destinies' (P.H. Wood and K.C.C. Dalton, *Winslow Homer's Images of Blacks: The Civil War and Reconstruction Years*).

Images of the westerner or the frontiersman spoke perhaps more inclusively about national identity. Whether explorer, trapper, hunter, trader, river boatman, squatter or western citizen exercising the right to vote, the frontiersman was the stand-in for those most engaged in what Americans considered 'the major accomplishment of the era', western expansion (W.H. Truettner, op. cit.). Painters such as Charles Deas (1818–67), William Ranney (1813–57), and especially ▷George Caleb Bingham, himself a westerner raised in Missouri, encompass in their paintings a number of these types.

Bingham's depictions of river boatmen plying the rivers taking goods and materials east with them became his signature work. These frontiersmen are given reputable appearance and orderly placement in such works as *The Jolly Boatmen* of 1846. Through judicious compositional arrangement and what he did with physical appearance, Bingham's westerners appear more jolly than unruly or vulgar. To easterners who were curious, perhaps even concerned about those populating the outposts of American civilization, Bingham's 'definition of a national class, or at least a national subject' was reassuring (E. Johns, op. cit.). His depictions of river types and their environment succeeded in the east, which after all sought the resources of the west, because he emphasized westerners' industry and commercial success and thus supported 'the expansionist argument' that so-called 'Yankee virtues' could grow in western regions (G.E. Husch, ' "Poor White Folks" and "Western Squatters": James Henry Beard's Images of Emigration'). (Bingham's Election Series conveys a similar message about the democratic process in the west.) Like Church's quintessential eastern image *New England Scenery* of 1851, the western image *The Jolly Boatmen* in 1847 was taken up by the American Art-Union for distribution as an engraving to its national membership.

By the 1870s, scenes of life in America continued but they were less connected to cultural and political practice than their *ante-bellum* counterparts in which 'national' themes had been readily apparent. They lack the pronounced narrative content (comic or satirical) and sometimes ideological base that had accompanied genre painting earlier. Instead, realist depictions of activities appear – working the land, carrying on other outdoor pursuits, congregating for social or religious purposes – or they are of new social and racial 'types' which had immigrated to the United States in the last quarter of the 19th century. By this time, both the eastern agrarian ideal and the western frontier (and their 'types') were places of the past, the official end of the American frontier have been proclaimed by historian Frederick Jackson Turner at the World's Columbian Exposition in 1893.

More significantly, renewed interest in what Europe offered to artists and patrons jeopardized the health of genre painting. Having encountered different artistic emphases abroad, painters became involved in a more self-reflexive, emotive manner. Individual expressiveness through subject matter and handling of medium became more important than the articulation of a narrative with national or regional resonance. In general, personal rather than national sentiment carried the day.

The assertion of 'Americanness' and Mexicanidad

In the early decades of the 20th century, there was a definite attempt, especially pronounced after the First World War and the Mexican Revolution, to formulate a national identity through a generally ▷avant-garde pictorial language. Up to this point, it had been the art of Europe's past which artists had appreciatively studied and used or weighed themselves against. They now found stimulus in the latest 'revolutionary' counter-academic movements developing in Europe. These modes were not slavishly copied but remoulded for home consumption and meaning.

However, around the turn of the century, before the development of the European avant-garde, both Mexico and the United States felt the influence of French ▷Impressionism's ▷*plein air* method of painting and bright palette. The Academy of San Carlos established an open-air school in the village of Santa Anita on the outskirts of Mexico City in 1913. The move to Santa Anita formalized an earlier break with convention from within. In 1910 after the fall of Diaz, students at the Academy striking for political as well as artistic reasons had been locked out and forced to paint out of doors. On the other hand, the school at Santa Anita was more than a simple expediency. The statements of the Academy's director suggest other more far-reaching goals. Students at 'the Direction of the Academy' were to work 'in locations where the foliage and perspective effects are true to the character of our *patria*. The aim is to awaken the enthusiasm of the students for the beauty of our own land, and to give birth to an art worthy of being truthfully called a national art' (quoted in J. Charlot, op. cit.).

In the United States, French Impressionism had gained popularity by the 1880s through exhibitions of Impressionist work in, among other cities, New York and Boston, and from some Americans' direct contact with ▷Claude Monet at Giverny. Two of them, Theodore Robinson (1852–96) and Lila Cabot Perry (1848–1933), later published their recollections of Monet and his artistic theories and practices. In 1898 several Americans, who had attended academically-run studios in Paris but had taken up an Impressionist manner, formed a group called the ▷Ten American Painters. The Impressionism they practised, although grounded on principles borrowed from French Impressionism, was distinctively American in its genteel content, depiction of native sites, and hesitancy to render the full effects of atmosphere and light on form.

Avant-garde tendencies from Europe also influenced Mexican and American artists. Many American painters were in Europe for periods of time, some falling in with Gertrude and Leo Stein's circle in Paris, where the current art they collected could be seen. In the United States radical work first appeared en masse with the ▷Armory Show of 1913. This assemblage of over three hundred works (many finished that year) by European painters such as ▷Marcel Duchamp, ▷Pablo Picasso, ▷Henri Matisse and ▷Wassily Kandinsky, in the company of comparatively conservative Americans, shocked many, puzzled others, and educated almost everyone. Most American artists reported being greatly excited and were made sharply aware of European art's distinctiveness from their own. In that sense the Armory Show clarified what was American and fostered a sense of Americanness.

The ground for expressions of *Mexicanidad* had been prepared earlier. Grants from Diaz's government had enabled artists to study abroad. There they, too, found themselves surrounded by radical artistic tendencies which they used to inform their own art. Adolfo Best Maugard (1891–1964), having seen in Paris the work of Russians which incorporated aspects of their popular native art, did the same in his abstractions. In this respect Maugard joined in the promotion of Mexican indigenous crafts as 'evidence of *mestizaje*' and a 'symbol of the essence of Mexicanness' which was especially strong around 1910 (K.C. Reiman, 'Constructing a Modern Mexican Art, 1910–1940'). Dr. Atl (1875–1964), who adopted the Aztec (*nahuatl*) word for water for his given name Gerardo Murillo Comadó, nevertheless applied a Post-Impressionist manner to his speciality, the landscapes of Mexico. Atl also conceived of mural programmes for public buildings which, however, never materialized because of the revolution.

Saturnino Herrán (1887–1918) is another painter who, like Dr. Atl, participated in the nationalistic artistic ferment around the 1910 Centennial celebration and shared an interest in muralism. His work shows both his knowledge of European art, notably ▷Symbolism, as well as that of his indigenous Mexico. In his projected mural triptych, *Our Gods* (1914–18), he depicts Aztec and Spanish worshippers paying homage to a central idol serving their two different religions. An image of Christ crucified is superimposed upon an adaptation of the massive stone figure of the Aztec mother-goddess Coatlicue in the National Museum of Anthropology in Mexico City. On the right, the Spanish bear their own venerated piece of sculpture, the Virgin of the Remedies, which came with Hernán Cortés in the

16th century. The volcanic mountains of Ixtaccíhuatl and Popocatépetl form the mural's background; a pass between them facilitated Cortés's entry into present-day Mexico City.

The story of *Mexicanidad*, however, really begins with the so-called Mexican Mural Renaissance after the conclusion of the military phase of the decade-long Mexican Revolution in 1920. ▷Diego Rivera, ▷José Clemente Orozco, ▷David Alfaro Siqueiros, Jean Charlot (1898–1979) and others revitalized the true ▷fresco technique of Europe and ▷Pre-Columbian meso-America to create large-scale, didactic imagery on public walls. Mexico's new minister of education, José Vasconcelos, recognizing the usefulness of art in developing and promoting national consciousness and cultural pride, had initiated the government-supported programme. Governmental structures, including the Ministry of Education and the National Palace, as well as the National Preparatory School in the centre of Mexico City, provided the necessary platform.

To carry out this enterprise, Vasconcelos enlisted many artists, Diego Rivera among them. Rivera had been in Europe since 1906, having received a government-sponsored scholarship through the Academy. Although he brought back to Mexico a familiarity with European avant-garde styles, specifically those of Cézanne and Picasso, he also (re)discovered the indigenous and Pre-Columbian art of his own country. Rivera and others in the mural movement drew upon these ingredients for their art. Initially, however, there was no unified expression stylistically or in terms of content. The first murals in the National Preparatory School, for example, reveal a wide range: from Charlot's visualization of the *Conquest of Tenochtitlán* in Italianate 15th-century manner through Orozco's trenchant, expressionistic commentary on the revolution and the country's social fabric to Rivera's symbolic ▷Art Deco mural on the theme of *Creation*.

Rivera's later legible, decoratively narrative style coloured by indigenous art came to dominate the field in the 1920s. It was especially well suited to communicating a national cultural and political agenda. This mode, representing a shift from what Karen Reiman has called the 'spiritual nationalism' proposed by Vasconcelos, appeared for the first time with Rivera's Ministry of Education mural programme of 1923–8 (K.C. Reiman, op. cit.). On the walls of the two three-storied courtyards, Rivera celebrated the regional resources (Court of Labor) and activities of the people (Court of Fiestas), as in *Day of the Dead – The Offering*, ending with overt political references to the revolution. Rivera essentially pre-empted his colleagues by his skilful self-promotion, the acclaim he received from certain circles in the United States, and, above all, government commissions. Before 1930, especially with murals at the Autonomous University of Chapingo and the National Palace, Rivera fabricated unabashed statements (though not without some historical and archaeological inaccuracies) of clear and emphatic *Mexicanidad*.

In the United States in the early decades of the 19th century, there is no history of government support of the arts apart from the Capitol Rotunda commissions in Washington, DC. These mural-sized history paintings illuminated episodes of America's past and its heroes: Columbus's arrival in the New World; the American Revolution and George Washington; the Pilgrims in New England and Pocahontas at Jamestown, Virginia; DeSoto and his 'discovery' of the Mississippi River. The placement of the paintings also suggested a national forum. Due to the selection of historical events and their manner of presentation, the nation's aggressive appropriation of lands in the fulfilment of its destiny appears condoned. But these mural painters, unlike the later Mexican artists, did not attempt to draw upon perceived vernacular or indigenous languages and their messages did not celebrate the masses' role in the nation's present and future. Between the Capitol Rotunda and the early 20th century, no further collective attempt was made by the United States government, and direct government patronage of the fine arts did not recommence until the Franklin Roosevelt Administration's New Deal programmes of the 1930s.

Nevertheless, a decade earlier in the 1920s, what Michael Kammen has called 'a national obsession with "Americanism"' was under way (M. Kammen, 'The Problem of American Exceptionalism: A Reconsideration'). While this obsession took many forms, clear expression can be found in the words and activities of critics Waldo Frank and Paul Rosenfeld and photographer ▷Alfred Stieglitz. Frank in his *Our America* of 1919 urged painters to represent the essence of America which he considered damaged by the onslaught of modern technology, materialism and foreign cultural influences. He urged American artists to find a 'usable past' for the development of a non-Europeanized art. Rosenfeld, too, and Van Wyck Brooks saw the need for painters to turn to their native soil for aesthetic stimulus. This taking up of the American 'place' started about 1917 (S.W. Peters, *Becoming O'Keeffe: The Early*

Years). Although Stieglitz had exhibited European avant-garde art at his gallery ▷'291' and had previously taken a laissez-faire attitude towards all expressions in art, Stieglitz assumed essentially another position after the First World War. With his 1925 exhibition 'Seven Americans', Stieglitz chose Americans above all: ▷Georgia O'Keeffe, ▷John Marin, ▷Marsden Hartley, ▷Arthur Dove, ▷Charles Demuth, Paul Strand (1890–1976) and himself. He promoted this group not as artists infused with European avant-garde currents (which they were) but as painters and photographers of what Stieglitz called 'America without that damned French flavor'.

Artists went 'in search of "roots"' in their soil and history, as Van Wyck Brooks put it, in 'an affirmation as well as a reaction against the international focus which had characterized American culture before the war' (S. Cohn, *Arthur Dove: Nature as Symbol*). Themes included American technology (the ▷'machine aesthetic' and the 'technological sublime') and America's vernacular tradition as well as that of Native America. Paintings such as Marin's *Red Sun, Brooklyn Bridge* (c1922) and O'Keeffe's *Radiator Building – Night, New York* (1927) convey the city's technological achievements. Marin contrasted 'modern' engineering signified by the Brooklyn Bridge (completed in 1883) with signs of Manhattan's past (a horse-drawn cart on the bridge) all set within a Walt Whitmanesque natural world (an enormous red sun high above the river). O'Keeffe used the Radiator Building skyscraper of 1924, seemingly reaching to unscalable heights, its ornamental, almost organic cupola lit up, to suggest a city pulsating with life.

Other paintings also convey America, as in Demuth's *Aucassin and Nicolette* (1921), in which a paired watertower and smokestack stand as emblems of Demuth's simple home town of Lancaster, Pennsylvania. ▷Charles Sheeler's *Staircase, Doylestown* (1925) features the interior of a 1768 Pennsylvania farmhouse and *Interior* (1926), items from Sheeler's own collection of early American furnishings. Or there are 'American' landscapes of nature's processes and forces, such as Dove's *Waterfall* (1925), and O'Keeffe's *Flower Abstraction* (1924), as well as of aspects of Native American life and traditions, such as Hartley's *Indian Fantasy* (1914), which plays on geometric motifs and colours which Hartley considered redolent of Native American culture, Marin's *Taos Indian Rabbit Hunt* (1929), and O'Keeffe's *Hopi Kachina Doll* (c1930).

A different tack was taken by the so-called regionalist triumvirate of ▷Thomas Hart Benton, ▷Grant Wood and ▷John Steuart Curry, who celebrated America's regional distinctiveness and heritage, and consciously turned their backs on 'foreign' avant-garde art in favour of midwestern subjects and a realist style. Nevertheless, their concern with Americanness equalled that of their 'eastern establishment' brethren. Benton told his colleagues: if you 'let your American environment ... be your source of inspiration, American public meaning your purpose ... an art will come which will represent America' (S. Polcari, *Abstract Expressionism and the Modern Experience*). Wood's depiction in ▷*American Gothic* of 1930 is the paradigmatic example. A couple in farm dress stand pitchfork in hand before their simple house ornamented with a gothic-arched window above the door. Through skilful references to American's pictorial and historical past, to the home-grown values which many had come to associate with the middle west, and through the use of a decidedly anti-avant-garde (hence 'American') style which the regionalist painters promoted, Wood established his own icon of 'Americanness'.

From national identity to universalism

National identity is an elusive and complex concept which, to return to Octavio Paz's observation, involves some invention. The questions are, who speaks for whom, with what means, and for what purpose? The phrase used by Michael Kammen, 'national consciousness', may be helpful here because it is less restrictive and suggests a more fluid concept (M. Kammen, op. cit.). But whatever words or phrases are employed, the ideas of 'Americanness' and *Mexicanidad* are readily understood through pictorial expression. Rivera's gigantic mural *Pan-American Unity* of 1940 offers a climactic metaphoric statement. Out of the distinctive background and achievements of Mexico and the United States, as represented by pre-Hispanic 'antiques' and America's modern technologically-driven 'futures', Rivera stated that a civilization comparable to 'what Greece was to the Old World' would materialize in the New (quoted in T. Smith, *Making the Modern: Industry, Art and Design in America*). Workers from both mental and physical spheres and artists past and present would collaborate in this effort, as the mural shows. Naive or not, the implication is that of Mexico's and the United States' sense of national identity. Pan-Americanism paradoxically presupposes two entities, separate but equal, each bringing a 'national consciousness' to the table. Pan-Americanism also signifies independence from Europe. With

his mural *Pan-American Unity*, Rivera pictorialized a New World 'inter-American solidarity', a combined national identity, so to speak (S.L. Catlin, 'Mural Census').

It is interesting to note that shortly thereafter, in the late 1940s and early 1950s, a non-representational art form, ▷Abstract Expressionism, transfixed the art world and came to epitomize 'Americanness'. This happened even though the painters themselves emphasized the universality of their private yet publicly-oriented (so they asserted) work. To them, the standard imagery of American art – landscape or its peoples, indeed the visible world – seemed inadequate in the post-Second World War world. They used instead archetypal motifs drawn from the ancient and primordial worlds to stress continuum and renewal across time and cultures.

It was the procedure of Abstract Expressionism which took on national connotations. Extremely large formats and unconventional materials vigorously, if not aggressively, handled appeared to signify 'Americanness', and the artistic risk-taking and individuality, American freedom. The style's originality, distinct from the academic and European art, positioned New York as the centre of the art world, and its power was interpreted as matching America's Cold War global assertiveness. Although viewed as American in style (even though later internationalized), Abstract Expressionism was not American in content; it had little to do with narration on national identity. In that sense, Abstract Expressionism no more spoke about 'Americanness' than it did about *Mexicanidad*. Its effect and concerns were larger. The internationalism and universalism of this independent American abstract art displaced the nationalism which had influenced and had been reflected in the representational painting of Mexico and the United States in the century before.

Bibliography

Acevedo, E., 'Mexico: A Landscape Revisited', in *Mexico: Una Vision du su Paisaje (A Landscape Revisited)*, exh. cat., Washington, DC and New York, 1994

Adamson, J.E. et al., *Niagara: Two Centuries of Changing Attitudes, 1697–1901*, exh. cat., Washington, DC, 1985

Ades, D., 'Nature, Science and the Picturesque', and 'José María Velasco', in D. Ades et. al., *Art in Latin America: The Modern Era, 1820–1980*, exh. cat., London, 1989, pp. 63–99, 101–9

Altamirano Piolle, M.E., *José María Velasco: Paisajes de Luz, Horizontes de Modernidad*, exh. cat., Mexico, 1993

Anderson, N.K. and L.S. Ferber, *Albert Bierstadt: Art and Enterprise*, New York, 1990

Boime, A., *The Magisterial Gaze: Manifest Destiny and American Landscape Painting c. 1830–1865*, Washington, DC and London, 1991

Braun, B., *Pre-Columbian Art and the Post-Columbian World: Ancient American Sources of Modern Art*, New York, 1993

Burns, S., *Pastoral Inventions: Rural Life in Nineteenth-Century American Life and Culture*, Philadelphia, 1989

Catlin, G., *Illustrations of the Manners, Customs, and Condition of the North American Indians with Letters and Notes* (vol. 1), 10th edn., London, 1866

Catlin, S.L., 'Mural Census', in *Diego Rivera: A Retrospective*, New York and London, 1986, pp. 237–335

Catlin, S.L., 'Traveller-Reporter Artists and the Empirical Tradition in Post-Independence Latin America', in D. Ades et. al., *Art in Latin America: The Modern Era, 1820–1980*, exh. cat., London, 1989, pp. 41–61

Charlot, J., 'Juan Cordero: A Nineteenth-Century Mexican Muralist', *Art Bulletin* (28, no.4, December 1946), pp. 248–65

Charlot, J., *Mexican Art and the Academy of San Carlos, 1785–1915*, Austin, 1962

Charlot, J., *The Mexican Mural Renaissance, 1920–1925*, New Haven and London, 1983

Cohn, S., *Arthur Dove: Nature as Symbol*, Ann Arbor, 1985

Corn, W.M., *Grant Wood: The Regionalist Vision*, exh. cat., New Haven and London, 1983

de Wit, W., 'Building an Illusion: The Design of the World's Columbian Exposition', in N. Harris et. al., *Grand Illusions: Chicago's World's Fair of 1893*, Chicago, 1994

Downes, W.H., *Twelve Great Artists*, Boston, 1900

Fine, R.E., *John Marin*, New York and London, 1990

Fink, L.M. and J.C. Taylor, *Academy: The Academic Tradition in American Art*, exh. cat., Washington, DC, 1975

Fortune, B.B. and M. Mead, 'Catalogue of American Paintings and Sculptures Exhibited at the World's Columbian Exposition', in *Revisiting the White City: American Art at the 1893 World's Fair*, exh. cat., Hanover, NH and London, 1993, pp. 193–383

Fryd, V.G., *Art and Empire: The Politics of Ethnicity in the U.S. Capitol, 1915–1960*, New Haven and London, 1992

Garcia Sáiz, M.C., *Las Castas Mexicanas: Un Género Pictórico Americano/The Castas: A Genre of Mexican Painting*, trans. J. Escovar, 1989

Guilbaut, S., *How New York Stole the Idea of Modern Art: Abstract Expressionism, Freedom, and the Cold War*, trans. Arthur Goldhammer, Chicago, 1983

Harris, N., *The Artist in American Society: The Formative Years, 1790–1860*, New York, 1970

Hight, K.S., ' "Doomed to Perish": George Catlin's Depictions of the Mandan', *Art Journal* (49, no. 2, Summer 1990), pp. 119–24

Hills, P., *The Painter's America: Rural and Urban Life, 1810–1910*, exh. cat., New York, 1974, pp. 63–81

Hills, P., 'Images of Rural America in the Works of Eastman Johnson, Winslow Homer, and Their Contemporaries', in H. Sturges (ed.), *The Rural Vision: France and America in the Late Nineteenth Century*, Omaha, 1987, pp. 63–82

Husch, G.E., ' "Poor White Folks" and "Western Squatters": James Henry Beard's Images of Emigration', *American Art* (Summer 1998), pp. 15–39

Images of Mexico: The Contribution of Mexico to 20th Century Art, ed. E. Billeter, exh. cat., Dallas, 1987

Johns, E., *American Genre Painting: The Politics of Everyday Life*, New Haven, 1991

Kammen, M., 'The Problem of American Exceptionalism: A Reconsideration', *American Quarterly* (45, no. 1, March 1993), pp. 1–43.

Kelly, F., *Frederic Church and the National Landscape*, Washington, DC, 1988

Kinsey, J.K., *Thomas Moran and the Surveying of the American West*, Washington, DC and London, 1992

Leja, M., *Reframing Abstract Expressionism*, New Haven and London, 1993

Marti, J., *On Art and Literature: Critical Writings*, trans. E. Randall, New York, c1982

Marx, L., *The Machine in the Garden: Technology and the Pastoral Ideal in America*, New York and London, 1964

McCoubrey, J.W., *American Art, 1700–1960*, Sources and Documents in the History of Art Series, H.W. Janson, ed., Englewood Cliffs, 1965

Mexico: Splendors of Thirty Centuries, exh. cat., New York, 1990

Miller, A., *The Empire of the Eye: Landscape Representation and American Cultural Politics, 1825–1875*, Ithaca and London, 1993

Miller, A., 'The Mechanisms of the Market and the Invention of Western Regionalism: The Example of George Caleb Bingham', in D.C. Miller (ed.), *American Iconology: New Approaches to Nineteenth-Century Art and Literature*, New Haven and London, 1993, pp. 112–34

Myers, K.J., 'On the Cultural Construction of Landscape Experience: Contact to 1830', in D.C. Miller (ed.), *American Iconology: New Approaches to Nineteenth-Century Art and Literature*, New Haven and London, 1993, pp. 58–79

Nash, R., *Wilderness and the American Mind*, New Haven and London, 1973

Nygren, E., 'From View to Vision', in E. Nygren and B. Robertson, *Views and Visions*, exh. cat., Washington, DC, 1968, pp. 3–81

O'Connor, F.V. (ed.), *Art for the Millions: Essays from the 1930s by Artists and Administrators of the WPA Federal Art Project*, Boston, 1973

Pasztory, E., *Aztec Art*, New York, 1983

Paz, O., 'Mexico and the United States' (1979), in *The Labyrinth of Solitude*, New York, 1985 (originally published 1972), pp. 357–76

Paz, O., *Essays on Mexican Art*, trans. H. Lane, New York and London, 1987

Peters, S.W., *Becoming O'Keeffe: The Early Years*, New York and London, 1991

Polcari, S., *Abstract Expressionism and the Modern Experience*, Cambridge and New York, 1991

Reiman, K.C., 'Constructing a Modern Mexican Art, 1910–1940', in *South of the Border: Mexico in the American Imagination, 1914–1947*, exh. cat., Washington, DC and London, 1993, pp. 11–47

Reynolds, J., *Discourses on Art*, ed. P. Rogers, London, 1992

Rodgers, T.R., 'False Memories: Alfred Stieglitz and the Development of the Nationalist Aesthetic', in *Over Here! Modernism, The First exile, 1914–1919*, exh. cat., Providence, 1989

Rochfort, D., *Mexican Muralists: Orozco, Rivera, Siqueiros*, London, 1993

Rodríguez, A., *A History of Mexican Mural Painting*, London, 1969

Roque, O.R., 'The Exaltation of American Landscape Painting', in J. Howat, intro. *American Paradise: The World of the Hudson River School*, exh. cat., New York, 1988, pp. 21–48

Rushing, W.J., *Native American Art and the New York Avant-Garde*, Austin, 1995

Schimmel, J., 'Inventing "the Indian" ', in W.H. Truettner (ed.), *The West as America: Reinterpreting Images of the Frontier, 1820–1920*, exh. cat., Washington, DC and London, pp. 149–89

Scott, G.R., *Marsden Hartley*, New York, 1988

Slotkin, R., *The Fatal Environment: The Myth of the Frontier in the Age of Industrialization, 1800–1890*, Middletown, 1986

Smith, T., *Making the Modern: Industry, Art and Design in America*, Chicago and London, 1993

Stansell, C. and S. Wilentz, 'Cole's America', in W.H. Truettner and A. Wallach (eds.), *Thomas Cole: Landscape into History*, New Haven and London, 1994, pp. 3–21

Stavitsky, G., et al., *Precisionism in America 1915–1941: Reordering Reality*, exh. cat., New York, 1994

Sweeney, J.G., *The Columbus of the Woods: Daniel Boone and the Typology of Manifest Destiny*, St Louis, 1992

Taylor, J.C., *America as Art*, Washington, DC, 1976

Taylor, J.C., *The Fine Arts in America*, Chicago, 1979

Troyen, C. and Hirschler, E.E., *Charles Sheeler: Paintings and Drawings*, exh. cat., Boston, 1988

Truettner, W.H., *The Natural Man Observed: A Study of Catlin's Indian Gallery*, Fort Worth and Washington, DC, 1979

Truettner, W.H., 'Ideology and Image: Justifying Western Expansion', in W.H. Truettner (ed.), *The West as America: Reinterpreting Images of the Frontier, 1820–1920*, exh. cat., Washington, DC and London, pp. 27–53

Wallach, A., 'Making a Picture of the View from Mount Holyoke', in D.C. Miller (ed.), *American Iconology: New Approaches to Nineteenth-Century Art and Literature*, New Haven and London, 1993, pp. 80–91

Wallach, A., 'Thomas Cole: Landscape and the Course of American Empire', in W.H. Truettner and A. Wallach (eds.), *Thomas Cole: Landscape into History*, New Haven and London, 1994, pp. 23–111

Widdifield, S.G., 'Dispossession, Assimilation, and the Image of the Indian in Late-Nineteenth-Century Mexican Painting', *Art Journal* (49, no. 2, Summer 1990), pp. 125–32

Wilson, R.G., 'Expressions of Identity', in *The American Renaissance: 1876–1917*, exh. cat., New York, 1979, pp. 11–25

Wood, P.H. and Dalton, K.C.C., *Winslow Homer's Images of Blacks: The Civil War and Reconstruction Years*, exh. cat., Austin, 1988

Women as Artists and Subjects

Marsha Meskimmon

Since the rise of second generation feminism in the late 1960s, questions have been asked regarding the role of women in the arts. These questions are not without precedent; for example, in 1876, Ellen Creathorne Clayton wrote *English Female Artists*, Hans Hildebrandt published *Die Frau als Künstlerin* (*The Woman as Artist*) in 1928 and Simone de Beauvoir wrote eloquently on issues relating to women's creativity in *The Second Sex* of 1949. However, the systematic recovery of women's history and the establishment of ▷ feminist theory in the academic arena have meant that the last two decades have witnessed the production of a much broader and more various array of material on the subject. It is, in fact, nearly impossible in the current climate to approach the subject of women in the arts without having first to understand feminist methodologies and art-historical practices.

Generally, this material is concerned with three inter-related topics which form the basis of arguments concerning women and art. First, the histories of women artists have been researched and recovered by scholars seeking to redress the gender balance in art history and criticism. Similarly, research has been undertaken about women as both art critics and patrons of the arts. This recovery of the lost or forgotten history of women in the arts, typified by the early work by Germaine Greer, *The Obstacle Race: The Fortunes of Women Painters and Their Work* (1979), has been invaluable in terms of providing documentary evidence. More recently, however, the straightforward recovery of information has been criticized as simply adding the names of women artists to a pre-existent male ▷ canon rather than seeking to change the terms under which such information is assessed. Current work on women artists tends less towards the lexicon or monograph source and more towards critical revision.

A second concern of feminist interventions into art history is the reinterpretation of the production and meaning of art works themselves. Such work shifts the emphasis from the artist/producer to the art object and frequently concentrates on rereading works 'against the grain' in order to expose the gender biases of representation in society. For example, canonical works such as ▷ Edouard Manet's ▷ *Olympia* (1863–5) have been reinterpreted by feminist critics who have demonstrated the ways in which this representation is embedded in 19th-century discourses about women, modernity and morality. Such rereading has stimulated debate about the relationship between visual representation and gender construction and has permitted both fruitful revisions of past production as well as new strategies from contemporary practitioners eager to engage in alternative forms of representing women and gender difference.

Research concerning both women as artists and the representation of gender difference has caused the discipline of art history itself to come under scrutiny. A third strand of critical feminist scholarship focuses on the ways in which art history as a discipline has been structured in our ▷ patriarchal society. The language used in art criticism, the value judgements made about art works and the very definitions of 'art' have been produced in systems which privilege men's work in the arts over that of women. For example, the maleness of the artist is a primary assumption in traditional art history, and certain forms of gendered representation (e.g. the female nude) are made to seem natural rather than socially-determined. In this way, the field of art history is itself implicated in constructing gender-exclusive definitions of 'art'.

This essay takes as its starting point the inter-relationships between those three main areas of scholarship and will contend with women as both the subjects and objects of art and the feminist

interventions into art history as an academic discipline. What must be noted from the outset, however is the fact that there is no single, monolithic response to the subject of women and art; women have played a variety of roles in the arts, owing to differences between them in terms of class, race, nationality, sexuality and chronology. To suggest otherwise tends to erode the significant differences between women and posit a universal feminine subject who transcends historical and social specificity.

In order to consider the variety of women's links with the arts, this essay is broken down into themed sub-sections, each of which represents a category that has conditioned critically the practice and the representation of women. They are: ▷media and ▷genre hierarchies; class and politics; race and ethnicity; the body and sexuality; and motherhood and domesticity. Confronting such issues, rather than attempting merely to present a general chronological survey, challenges traditional modes of writing art history which privilege the canonical listing of great artists and masterpieces. Though there will be issues and examples culled from earlier periods, for the sake of brevity and clarity, this essay focuses on the 19th and 20th centuries.

Media and genre hierarchies

The division between the ▷fine arts and the ▷applied or ▷decorative arts has traditionally acted against the artistic practice of women. While male artists dominated the sphere of the fine arts, women more frequently worked within the 'domestic' arts of embroidery, quilting, pottery and interior decoration. This separation can be traced back as far as the medieval period and the arrangement of craft ▷guilds and apprenticeships for men and women. As these arts rarely received the attention given to the fine arts and their producers were often anonymous, much of women's traditional art work has been made marginal by the very definitions of 'art'.

Within craft production itself, particularly in the post-industrial period when home industries were superseded by factory production, there have also been marked gender divisions of labour which have placed women into the areas with the lowest status. For example, within the textile trade until the late 19th century, women were more likely to be spinners than weavers; weavers were considered the more important and paid considerably more for their work. Again, in the pottery industry of the 19th century, similar sexual divisions of labour affected women. Men were employed to throw the pots, while numerous women became 'paintresses', amateur painters of male-designed decorations onto whiteware. Many of these gender distinctions arose through the process of professionalization in craft production during the industrial period, where men tended to be treated as professionals and primary household earners, while women were thought of as amateurs only working for extra money. These distinctions, of course, obscured the hard realities of working-class women's significant contributions to household budgets and maintained sex-based discrimination in wages well into the 20th century.

Class issues are embedded into the distinctions between the fine and the applied arts throughout the 19th century. The concept of a fine art education for women was really only on the agenda for middle- or upper-class women; working-class women, when trained at all, were given vocational training in craft skills. In this way, working-class women were more akin to working-class men than to their middle-class sisters, and their access to the fine arts was strictly limited.

Within the sphere of the fine arts, media hierarchies were still an issue throughout the 19th century, with, for example, ▷watercolour painting perceived to be of lesser significance than painting in oils. Within the category of watercolour painting, women achieved marked successes; the predominance of women watercolourists was one of the reasons it was difficult for male watercolour painters to be accepted as 'serious' artists. Yet the most significant hierarchy in the fine arts was the ordering not of media, but of the genres.

With the establishment of art ▷academies in Europe and the post-Renaissance canon of masterpieces and great artists, certain genres became privileged as the pinnacle of fine art production. The French Academy of the 17th century and the English ▷Royal Academy of the 18th codified these hierarchies. High art ▷history painting was the genre which carried the most status as it was argued to be the most intellectually challenging work to produce, and the most edifying to see. It was marked by large-scale figural works which followed academic rules regarding appropriate subject matter and style. It presupposed a knowledge of the Bible, Classical history and mythology and certain canonical literary texts. Knowledge of these was, in many ways, the exclusive domain of the male middle and upper classes who received a Classical education. The production of history painting also tended to presuppose a particular type of academic art education, with a knowledge of Classical art, the canonical masterpieces

of the post-Renaissance Western tradition and the nude (male) figure. This sort of education was limited to men until the late 19th century, with women being barred from access to the study of the male nude figure.

Other genres were less privileged institutionally, as their production was deemed to be less challenging; portraiture, low-life or local ▷genre scenes, ▷landscapes and ▷still-life painting could be produced without such privileged access to education. Women artists most frequently worked in these lesser genres for just this reason, and certain types of fine art subject matter, such as children's portraits and flower-painting, became associated with women. Clearly, these subjects were more likely to be available to women artists, but also, they were argued to be more naturally akin to the sensibilities of women. The very language of art criticism tended to reinforce such associations by referring to women's production as 'feminine' or 'delicate' whilst men's art work was called 'heroic'.

Women artists who wished to achieve the professional status of their male counterparts began to argue for access to academic art education. The arguments surrounding women's entry into the English ▷Royal Academy schools are paradigmatic of the complex social, moral and educational dilemmas facing women who sought professional careers in the 19th century. Women art students were consistently separated from male art students in terms of the types of instruction they received and even the duration of their academic training. From 1859, a number of women artists including ▷Henrietta Ward, ▷Barbara Bodichon and Anna Mary Howitt protested about the exclusion of women from the Royal Academy schools and particularly, the sacrosanct domain of the life class. Clearly, the issues surrounding this exclusion were complex, but at the heart of it were fears for women's moral welfare and the assumption that women students would and could only aspire to amateur status. The significance of the amateur/professional debates in the fine arts was akin to those arguments which assigned women to the unpaid, domestic craft sphere. Wherever the issue of professionalization in the arts cropped up, women tended to be excluded.

In a work of 1857, *Nameless and Friendless*, ▷Emily Mary Osborn took up the theme of the woman fine artist and confronted just these issues. A young female artist has gone into a gallery to sell her work. She is attempting to cross the boundaries into professional practice. By entering this public space, she has made herself a spectacle and she is leered at by men in the shop. Furthermore, her work is examined as though unsuitable, somehow inappropriate in professional terms. As the title suggests, a woman artist is indeed nameless and friendless in the male-dominated art world of the period.

By the first few decades of the 20th century, women had gained the right to academic art training; paradoxically, this was at the very moment when challenges from the so-called ▷avant-garde had made academies and their strict hierarchies less important. At the turn of the century, there were a number of significant secessions from the academic exhibition structures across Europe (in, for example, Vienna, Munich, Berlin and Paris) and various attempts made to subvert genre and media hierarchies. The ▷Arts and Crafts Movement, ▷Art Nouveau and the so-called ▷Aesthetic Movement all privileged the intermingling of the fine arts, architecture and design as well as crossing the boundaries between the visual arts and music and literature. Furthermore, in the early years of the 20th century, the appropriation of non-western art sources, such as ▷African and ▷Oceanic tribal art, across a spectrum of early modernist art movements challenged strict academic art standards. Additionally, the subject matter of early ▷modernism was frequently that which, by academic standards, could be termed 'low-life': urban scenes, cafés, brothels and prostitutes.

However, this blurring of the sharp divisions between fine and applied art and high and low genres on the part of the early 20th-century avant-garde was not necessarily beneficial for women artists. For example, ▷Robert and ▷Sonia Delaunay were both involved with theories of ▷simultaneity and what came to be known as ▷Orphism or Orphic ▷Cubism during the first few decades of the 20th century in Paris. These theories about the simultaneous contrasts of colours and their abstract potential for producing a sense of movement and depth were demonstrated equally well in painting and applied art. Yet, because of traditional media biases, Robert's work in the fine arts has tended to be seen as the intellectually superior, theorized production, while Sonia's use of simultaneity in clothing design, graphics and costume design has been considered the derivative use of the high theory. It matters little that Sonia Delaunay's work in fashion was far better known than her husband's painting, nor that she too produced large-scale works of fine art in the period, such as *Electric Prisms* (1914); her role as the wife of a male artist and stereotypical assumptions about the significance of media have meant that she has not received adequate attention in retrospective assessments of the movement.

Similar prejudices operated within the ▷Bauhaus in Germany during the 1920s and early 1930s. While ostensibly offering women artists equality in training, in practice, most women ended up in workshops traditionally associated with female craft production (i.e. the weaving workshop) and in designing objects for domestic use (such as teapots and children's toys). Furthermore, the most important commissions of the Bauhaus in terms of both theory and financial remuneration were the architectural projects. These remained almost exclusively the work of the men in the school. Similar patterns of gendered labour division even arose in Revolutionary Russian circles, where women artists did have a powerful role in the avant-garde. Whilst women artists such as Olga Rozanova (1886–1918), ▷Liubov Popova and ▷Varvara Stepanova produced work typically defined as fine art and engaged in the written theoretical debates of the Russian avant-garde, they soon became most closely associated with the textile and fashion spheres. This has tended to maintain their marginality in histories of Russian avant-garde art to this day.

We must be careful, however, not to overplay the negative side of women's unequal status *vis-à-vis* media and genre hierarchies. It would be unfair to simply say, for example, that Sonia Delaunay has been excluded from the critical status granted to Robert Delaunay because of his theoretical engagement and thus to ignore the fact that she has long held a significant place in design history or that she made a considerable amount of money with her work. In the late 19th century too, there were interesting political implications surrounding women's craft production. For example, the suffragettes used their needlework skills to produce highly subversive political banners and flags. Quilting bees in the United States during the period were frequently used as meeting points for the early feminists, such as Susan B. Anthony, to discuss their objectives. Even the sampler, that cliché of female suppression within the home, sometimes contained radical messages.

Certainly since the feminist movement of the 1960s, women artists have been active in reviving traditionally 'feminine' media for the purposes both of parody and subversion. Faith Ringgold used the quilt in her work *Who's Afraid of Aunt Jemima?* (1983) to revise dominant stereotypes of black women's history. Sylvia Sleigh parodied the high art tradition of the female nude in a number of her works, such as *Philip Golub Reclining* (1971) and *The Turkish Bath* (1973), by reversing the sex of the nude. Art and design historians continue to research the history of women in the applied arts and challenge the masculine-normative biases of traditional definitions of art.

Finally, it remains to be mentioned that women have always played a significant role in photography, that medium which fell outside the traditional hierarchies and which has held an uncertain status in the realm of art since its invention. To use Caren Kaplan's phrase, photography is an 'outlaw genre' which was, therefore, more accessible to women artists (C. Kaplan, 'Resisting Autobiography: Outlaw Genres and Transnational Feminist Subjects'). Women have been integral to photographic history; they participated in early developments (▷Julia Margaret Cameron), avant-garde circles (Florence Henri, ▷Hannah Höch), documentary photography (Dorothea Lange, Tina Modotti, Lee Miller), feminist photographic revisions (Jo Spence, Tee Corinne) and ▷postmodern interventions (▷Cindy Sherman, ▷Barbara Kruger, Sherri Levine). Such significant participation is no doubt linked to the relative newness of the medium and the fact that there were fewer restrictions on training and access to the processes of photography for women. Even this accessibility must be qualified, however. There were still problematics related to gender issues which restricted women as photographers, such as the concept of amateur practice rather than professional and the traditions of 'appropriate' subject matter which reinforced women's roles as photographers of family and children particularly.

Class and politics

There are a number of ways in which issues surrounding class and politics are of primary significance to the subject of women and art. Approaches to art history more or less distinctly derived from ▷Marxist theories of history as class struggle (the so-called 'social histories of art') were the earliest paradigms for feminists concerned with interrogating the ways in which the inequalities of patriarchal social systems were inscribed in art and its histories. Methodologies derived from Marxism which enabled art historians to draw out specific links between the production of art in a given period and the socio-economic determinants of that moment were critical tools for feminist scholars; the operations and functions of ▷ideology provided a model for understanding visual culture in terms of its production of meaning in society.

If most art production, sponsored and consumed by the dominant class in a capitalist society, supports

the ideologies of that class, then a similar state of affairs can be inferred about the art of a dominant sex in a patriarchal society. Art produced mainly by and for men within a system which sustains their privilege over women will rarely tend to challenge this privilege. Yet one of the critical insights of Marxism is that economics, the cultural sphere and the ideological structures which link these are socially constructed and thus susceptible to change. Hence, art does not merely reflect a static social condition, it enters into the production of meanings and, possibly, competing ideas, during any given moment. Thus art can be seen to be part of the complex negotiations of power in patriarchy; sometimes underlining the status quo, sometimes subverting it. Marxist interpretations of art were challenged by some feminists who argued against their inherent gender blindness, but the insights into art's relationship to society derived from the Marxist perspective were crucial to the development of feminist theories which challenged the more limited scope offered by feminist approaches which sought to maintain both the canon and the discipline as they stood.

In addition to approaches to art history, issues of class and economic power are critical in any attempt to understand women's art practice. As discussed in the preceding section, for example, women's access to art education was not only determined by gender debates, but by issues concerning class. Working-class women were trained vocationally in the arts; middle-class women were privately educated with the idea that amateur fine art production was an appropriate 'feminine' accomplishment. The very notion of femininity was thus class-determined. It was the middle-class woman who was the Victorians' 'angel in the house', not the supposedly hearty working-class woman whose domestic labour supported the relative inactivity of these 'angels'.

If access to education and professional activities were class-determined for women in the arts, so too were women's positions within the fine art tradition. Powerful patrons and critics such as Rose Schapire, Gertrude Stein, Kate Steinitz and Peggy Guggenheim were mostly wealthy, well-educated women from the upper middle classes. Because of the relative independence their wealth brought, they could both obtain an education and act as patrons of the arts. While these women were able to affect the art world with their purchases and their criticism, this was in no way a certain advance for other women in the arts. Generally, wealthy female patrons did not particularly choose to support women artists; the women above, for example, were all known for assisting male avant-garde practitioners with financial support and encouragement.

Class differences have also been critical in the representation of women. Clearly, most of the women who acted as professional models during the course of the last few hundred years have been from the working classes. Moreover, they were generally exploited, financially and often sexually, by the artists who represented them. The dominant class and economic status of the male artist over his female model is inscribed in the domination of her identity so characteristic of much late 19th- and 20th-century fine art. For example, the portrait of the patron and critic Rose Schapire produced by ▷Karl Schmidt-Rottluff in 1919 shows an individualized female figure, clothed and reading. By contrast, Schmidt-Rottluff's ▷Expressionism was most particularly delineated by his numerous representations of nude female models in landscape settings which effaced their specificity as individuals in a myth of 'woman-as-nature'. For many of the Expressionists, and indeed a number of other avant-garde modernist groups, formal, stylistic developments were dependent upon using the nude female figure as raw material, to be displayed and deformed according to the male artist's genius. The fact that Rose Schapire, as Schmidt-Rottluff's patron, was in a position of power over him meant that he simply could not have represented her as an object in the way that he could manipulate his dominated female models who were at the mercy of their interpretation and vision.

The situation of independent women artists active in the early part of the 20th century makes the exploitative relationship between male artist and female model even more clear. Both ▷Gwen John and ▷Nina Hamnett, Britons who went to Paris in the early years of the century to be at the centre of the art world, found themselves in the position of having to act as models to male artists in order to support themselves. This was detrimental to their status as professional practitioners in the period and, in the case of Hamnett, has caused subsequent criticism to focus far more on her infamous reputation as a 'bohemian' than on her art work.

A few women who were originally artists' models actually became artists themselves, including ▷Suzanne Valadon and ▷Elizabeth Siddal, associated with ▷Edgar Degas and ▷Dante Gabriel Rossetti respectively. Although Valadon never acted as Degas's model, she came to meet him through modelling for such artists as ▷Puvis de Chavannes and ▷Henri Toulouse-Lautrec. Both of these

women were working-class and exploited in various ways by the male artists who employed them. Unusually, they managed to gain an art education through their contacts with male artists and went on to produce work in their own right. However, later criticism has tended to suggest that their art is derivative and their closeness to well-known male artists has often made it difficult to distinguish their individual achievements.

If class affected women's access to a professional career as an artist and the representation of women by male artists, there were also ways in which women's own class-determined power over other women has been characteristic of their role in the arts. For example, two women artists associated with ▷Impressionism, ▷Berthe Morisot and ▷Mary Cassatt, depicted the private, domestic interiors of late 19th-century Paris; these spaces were not, however, universally 'feminine', but rather, those spaces typical of middle-class women's experience. A working-class woman of the period lived much less securely on the margins of the public spaces of the city and was seen as more dangerous and endangered by this. Furthermore, the women represented in these interiors by Cassatt and Morisot were frequently their own relatives, but in the studies which both artists made of semi-clad female figures engaged in personal activities like bathing, they used their servants as models. Thus, even women's approaches to other women in representation can be marked by class differences.

Lest we think that class issues have vanished over the course of the last few decades, it is worth remembering the early work of Jo Spence and the Hackney Flashers, the women's photography collective with whom she worked early in her career. Though Spence is mainly remembered for her moving phototherapy works, her early collaborations with the Hackney Flashers concentrated on the theme of class differentials in women's domestic and working lives. The media stereotypes of middle-class family life were parodied by Spence's images of beleaguered working-class wives and mothers, trapped in the home.

Concepts of 'politics' and the political have often acted within the arts to consign women to the margins as political agents and 'woman' to the centre as a political symbol. For example, the representation of 'Liberty' as a female figure in ▷Eugène Delacroix's *Liberty Leading the People* (1830) and in such a well-known monument as the *Statue of Liberty* by Bartholdy, would seem to fix a central role for women in political struggles. However, the allegorical use of woman in this way acts in the same manner as representations of the 'muse' of painting; the symbol 'woman' is shown to be the inspiration for male action, while women remain inactive and at the margins of significant political change. This, of course, occludes the historical facts of women's participation in political movements from peasant revolts to the French and Russian Revolutions.

In order to understand adequately the nature of women's political engagement in and through the arts, one needs to rethink definitions of the 'political' itself. Many of the struggles with which women engaged over the course of the last century have been described as 'moral' or 'social' struggles rather than as 'political'; such definitions tend to place women's activities on the margins of masculine political activity rather than granting them the central role which they deserve. For example, the suffragettes and early feminists who campaigned for women's rights within marriage were not merely working within a framework of 'women's issues', they were challenging for representation in the public, political arena. So too, the many campaigners in different countries who sought educational opportunities for women; within the arts, organizations such as the The Society of Female Artists, the *Union des Femmes Peintres et Sculpteurs* (The Union of Women Painters and Sculptors), and the Gemeinschaft Deutscher und Österreichischer Künstlerinnen – GEDOK (The Association of German and Austrian Women Artists) – were clearly 'political' in their intentions.

Furthermore, women artists have put political campaigns for women's rights firmly at the centre of their production throughout the century. The campaign to overturn the anti-abortion law (Paragraph 218) in the Weimar Republic was accompanied by a host of works by women artists, including ▷Käthe Kollwitz, Hanna Nagel and Alice Lex-Nerlinger, which illustrated the damage this legislation did to working-class women. In contemporary American practice, this so-called 'women's issue' is still firmly on the political agenda and women artists are still engaging with it. Barbara Kruger produced *Your Body is a Battleground* in 1989, as a poster for a march on Washington of that same year; this march was in support of the Roe v. Wade legislation which ensures abortion rights for women in the United States. Other feminist artists of the post-1968 generation have also echoed in their work the famous cry that for women, 'the personal is political'. Thus, class and politics are critical factors which determine the nature of women's participation in the arts and their practice. However, it is sometimes

only through subtle negotiations of these concepts that we can reach an understanding of their significance for women in art.

Race and ethnicity

If the feminist approaches to art history over the last few decades have enabled both revisions of the canon through the recovery of women artists of the past and criticism of the definitions of 'art' and the practice of art history, there are acute omissions in much of the work. Many of these stem from the fact that the feminisms applied to art history are themselves products of white, Western, middle-class traditions. Recently, the voices of women who have felt excluded from the dominant lines in Western feminisms, namely women of colour and lesbians, have begun to be heard. Writers and artists such as Audre Lorde, Gayatri Spivak, Maud Sulter, Lubaina Himid, Chandra Mohanty and Pratibha Parmar have all pointed to the colour blindness of white Western feminism and the fact that it does not usually find an adequate way to represent the interests or experiences of women of other races. If class marks significant differences between women and will not permit a universal 'woman' to be found, so too do racial and ethnic differences require specificity of approach.

Two main areas are of concern in terms of art and its histories with reference to the experience of women of colour: the privileging of white women artists in the 'alternative' feminist canon and the lack of discussion of the representation of black women in art. Quite simply, most feminists who had the institutional support necessary to produce research on women artists concerned themselves first with white women artists. In the earliest, pivotal lexicon sources, such as those by Ann Sutherland Harris and Linda Nochlin (*Women Artists 1550–1950*, 1976), Karen Petersen and J.J. Wilson (*Women Artists: Recognition and Reappraisal from the Early Middle Ages to the Twentieth Century*, 1978) and Elsa Honig Fine (*Women and Art*, 1978), the very few women of colour mentioned are vastly outnumbered by white women artists. Even the 1990 source by Whitney Chadwick, *Women, Art and Society*, discusses women artists of colour only in the last few pages. The beginnings of the alternative canon of women artists focused on white women artists who produced work in a Western fine art tradition. Though this criticism does not undermine the pioneering work done by those volumes, the occlusions are telling and the research is in need of further refinement.

With reference to the representation of black women, it is the history of Western imperialism from the 19th to the middle of the 20th centuries, and Western artistic appropriations, which are at stake. It is clear that representations of black figures in Western art have been determined by the relationship of white Western missionaries and colonizers to their black subjects. The black figures have represented the myths of the colonizers, from the myths of these 'others' as 'noble savages' to the idea that they and their cultures were ▷'primitive'. Black figures have represented difference, the lack of civilization and a base sexuality in Western art. Further, as imperial nations began to 'import' tribal art itself into its ethnographic museums and markets, appropriations of the formal qualities of 'primitivism' along with attendant notions of 'primitive' origins and uncivilized sexual potency, became a source for Western modernism.

More than simply indicating an 'other' to white Western society, it has been shown that the 'primitive' had distinct gendered implications; the 'primitive' were to the 'civilized' as women were to men. Scientific and pseudo-scientific notions derived from sources such as Charles Darwin and ▷Sigmund Freud emphasized the belief that women, particularly young, uneducated women, were less rational, more intuitive or natural beings than their male counterparts. This plays a role in the arts from Paul Poiret's fabric designs to the work of the German Expressionists and the French ▷Surrealists with their concept of the *femme-enfant* or 'child-woman'. The work ▷*Les Demoiselles d'Avignon* (1907) by ▷Pablo Picasso, often cited as a pivotal work of modernism, makes this abundantly clear. In this work, Picasso linked the seduction and fear of the uncivilized sexuality of prostitutes with the concept of the 'primitive' signified by the use of tribal masks. The powerful ramifications of this work derive in part from the links between female sexuality and the imperialist notions of the 'dark continent'.

Such associations of gender with the 'primitive' has produced a double bind for representations of women of colour, whose bodies have often been displayed in order to contrast with the purity of white female figures, or to indicate their unbridled sexuality. Two 19th-century works make this use of the black and white contrast as an 'exotic', sexual reference abundantly clear: Jules-Robert Auguste's *Les Amies* (c1848) and Fernand Le Quesne's *Les Deux Perles* (1889). In these works, the coupling of the black and white female nudes permits an erotic rendering of the white woman which would have

been out of place without the reference to people and places outside the West. By making the scene 'exotic' and using the black female figure as a foil, the whole work becomes titillating rather than something obscene.

As doubly marginalized, women of colour have, in some ways, lacked representation completely. The inability to bring oneself, one's family or community to representation is an issue taken up in the works of many black artists. Black women photographers in the United States, for example, were commonly employed to produce portraits of local black families throughout the early part of the 20th century. Furthermore, they often took their own local communities as their subjects, documenting the lives of black people which would have been unrepresented in mainstream imagery. Contemporary women artists of colour sometimes continue this trend; Claudette Johnson's large paintings, for example, present monumental portraits of contemporary black women in order to redress this lack of representation.

Other issues at stake for black women artists include their relationship to two contrasting cultures, that from which their ancestors were often brutally torn and that in which they have been raised. The work of Lubaina Himid explicitly takes up this theme, as in, for example, 'Zenobia', *Treatise on the Sublime* (1990). Both Sutapa Biswas and Jagjit Chuhan also explore the dynamics of alternative cultural roots, in their case those of Anglo-Asian women.

Hence, issues of race and ethnicity cast feminist dialogues with art practice and art history in a different light and seek to explore the multiple identifications women can have. The experiences of women of colour cannot simply be merged with those of middle-class white women, nor should we forget that within the black community itself there are class differentials between women. There are variations in the themes of representation of which alternative feminist practices must be mindful.

The body and sexuality

Representations of the body and issues concerning women's sexuality and the construction of sexual difference through visual material have been critical concerns of feminist art history and art practice for decades. Whilst interest in this area has remained constant, the actual treatment of the topic has changed radically over the period. At the risk of oversimplification, the 1970s saw feminist critiques of the 'representation of women' based on liberalism, which were principally concerned with the ways in which images of women in art either accurately represented women's historical experiences or were used, ideologically, to promote sexual discrimination. So, for example, a host of representations of prostitution from the late 19th century were 'reread' in terms of demographic information about prostitutes at the time; certain patterns of representation emerged which did not tally with the 'real' history and these were then discussed in terms of their symbolic significance at the time.

The English artist ▷Augustus Leopold Egg's triptych *Past and Present* (1858, London, Tate), exemplifies this. The work clearly illustrated popular notions about the concept of the 'fallen woman' (once fallen, the only route was a decline into prostitution and untimely death) but had little 'historical' evidence to support its assumptions. That is to say, like most other representations of prostitution from the period, it assumed a melodramatic worst-case scenario which did not represent the variety of experiences of sex workers, from those engaged in casual prostitution to wealthy 'kept women'. Hence, this work was not about women's experiences, but masculine fears of female sexuality and emancipation.

Throughout the last decade, issues concerning gender and the body have still had a central place in feminist theory, but it has not been so straightforwardly addressed as in the previous example. Rather than judging 'representations of women' against an assumed historical 'reality' for women, scholars and artists have attempted to criticize the subtle ways in which these representations actually construct or define our reality. Art, in this model, is not an innocent mirror or even simply mimetic, but part of the interrelated systems of knowledge and belief (such as medical technology, science, religion and law) which define our bodies and ourselves. Images of women in the arts and ▷mass media construct definitions of femininity and gender difference in our culture.

It has been through such theoretical understandings that the use of the female body in art practice and its discussion in the discipline of art history have been most thoroughly challenged. It is clear, for example, that the traditions of fine art have privileged the display of the female body, produced through the 'genius' of the male artist, as the paradigm of art itself. One need only think of the vast array of nude females on display in any European museum to verify this simple point. Furthermore, the ubiquitous representation of the woman as 'object' has led to the creation of a sphere of representation

in the arts in which the concept of the male as artist ('subject') and the female as model ('object') is very difficult to overcome. Women have been marginalized from practice while being vastly over-present as 'inspiration' (the ▷muse) or as the presumed 'natural' material waiting to be transformed by the hand of the artist into 'culture'. Because we have become accustomed to viewing images of passive women as readily available, there have been major repercussions in terms of our social definitions of sexual difference.

The way in which the female nude has been defined and limited in Western art practice is a paradigm for these debates. Besides having produced a non-naturalistic (i.e. hairless, poreless and wrinkleless), controlled female body as a standard, the works have placed the viewer into a position of dominance over these figures. The use of this model implies an ordering of femininity with passivity, display and beauty as the mark of sexual difference from men, who are defined thus as active, dominant viewers and producers of these icons. It also, for the most part, reinforces a dominant heterosexual viewpoint, and prescribes versions of femininity and masculinity.

Particularly in the post-1968 generation, feminist theorists and artists have attempted to interrogate and challenge this tradition and the values which underpin it. These challenges have taken the form of rereading canonical ▷iconography, as described above, as well as exploring the ways in which women artists of the past have developed the theme of the body in their works against the grain of the traditions within which they were producing art. For example, the women artists variously associated with the Surrealist movement frequently used the female body (often their own bodies) as a source for their works. In this way, they were very much in keeping with the Surrealism practised by their male contemporaries, but their use of the body was very different. Where Surrealism proposed the *femme-enfant* ('child-woman') as the source of masculine inspiration and produced images of women's bodies as symbols of raw, intuitive nature which stimulated male sexual and creative energy, the women artists associated with the movement were obliged to negotiate these definitions and produced powerful symbols of female creativity, in such works as *Celestial Pablum* (1958) by Remedios Varo (1913–63). Within a very different aesthetic context, women artists associated with the ▷Neue Sachlichkeit (the 'New Objectivity') in the Weimar Republic also produced art which challenged the male-dominant definitions of the movement. In contrast with the blatant oversimplification of women's roles in the art of the male realists of the Weimar period (mainly representing women as good proletarian mothers or decadent prostitutes), women artists used this realism to show the vast variety of new roles which women had begun to play in the republic. ▷Grethe Jürgens, for example, showed women (including mothers with their children) in the dole queue in *Labour Exchange* (1929) and as workers in *The Flower Seller* (1931).

Women artists, drawing on feminist theory, have also striven to challenge dominant traditions in their representations of the gendered body. ▷Mary Kelly, for example, has sought to show in her installations the way in which the body is a site for a variety of competing ▷discourses; there is, in Kelly's work, no 'natural' body, but a series of texts and images which seek to define or produce it. The absence of the represented body in her work is also significant as it challenges the traditional modes of objectification in art. Jo Spence and Mary Duffy have also contested the traditional views of the female body in fine art and mass media by dealing with the ageing and diseased body. Jo Spence's phototherapy works, which deal directly with her own experiences of cancer and mastectomy, challenge clichés about the nude female form as a symbol of 'beauty' in our culture. Performance artists have displayed their own bodies as 'art' and have made their appearances excessive and uncomprising in order to make audiences aware of their own, sometimes uncomfortable, positions as viewers of displayed figures. Hannah Wilke, in such works as *I, Object* (1977), dealt with the contrast between artist as subject and displayed female nude as object, by placing herself into the context of 'pin-up'. Finally, artists such as Cindy Sherman explore the ways in which multiple media images and stereotypes actually construct contemporary notions of femininity and female identity. These works, again, challenge the traditional ideas of natural female bodies and reveal the social side of the concept 'woman'.

Motherhood and domesticity

Just as the body and sexuality were key themes in feminist theory and art practice, issues surrounding motherhood and domesticity hold a critical place within the history of women and art. Women's experiences of motherhood and their social assignment to the private, domestic sphere have had significant implications for their artistic practice. Motherhood and domesticity have reinforced the

difficulties which women experienced when attempting to enter the male-dominated sphere of professional practice and have placed certain representational themes as central to women's practice.

Clearly, women who conformed to the domestic paradigm which placed them at the centre of the home and hearth and gave them the primary responsibilities for childcare had little time and energy left for any public, professional activity. It is only natural that women art students, after marrying and having children, rarely went on to professional art careers. But the assignment of women to the domestic sphere has more subtle ramifications. For example, women artists who did continue their careers in addition to their domestic responsibilities tended to have non-standard career patterns. Unlike male artists, whose careers tended to follow a traditional chronology of student/apprenticeship, mature years of professional practice and then declining production, women artists were more likely to have fallow periods in the middle of their lives, when they were most actively involved with childcare. Hence, their career patterns could not conform to the usual assumptions of criticism and they were often penalized for their unorthodoxy. Furthermore, it was difficult for women artists who were married (especially to male artists) and/or had children, to be taken seriously as professionals. There have been associations of amateurishness attached to women's art practice for centuries, many of which are derived from the fact that women are not able to be concerned exclusively with their professional lives. It is not surprising to find that middle- and upper-class women who were able to pay other women to look after their domestic chores more frequently gained access to art education and practice than their working-class sisters.

The types of media and patterns of iconography most often associated with women's practice also bear out women's presumed relationship with the domestic sphere. In craft production, for example, spinning, needlework, knitting, crocheting, lacemaking, quilting and painting pottery all have 'feminine' overtones and are all 'domestic' practices. Such things as woodwork and metalwork, and aspects of the textile and pottery industries which became professionalized, such as weaving and throwing pots, were distinguished as more masculine pursuits. In the fine arts, women were most frequently assumed to produce drawings, small-scale paintings (usually watercolour) or, occasionally, small sculpted figurines. All of these conformed not only to the 'feminine' characteristics of delicacy and lightness of touch, but, significantly, could be produced in a corner of the drawing room and left when, periodically, domestic duties interfered. If certain materials were perceived to be more appropriate to women's practice, then certain subjects were equally determined by gender definitions. Flower-painting and domestic portraiture (particularly portraits of children) were the stock-in-trade of women artists and, obviously, derive from the domestic situations of their producers.

Motherhood and domesticity have thus, historically, curtailed the professional practice of women artists in a number of ways. However, despite these difficulties, many women have produced art over the last centuries and the themes of motherhood and domesticity have often held important places in their *oeuvres*. What is most fascinating is the way in which women artists subverted or negotiated these roles and their meanings for their lives as artists and their works. Both ▷Käthe Kollwitz and the British artist ▷Joan Eardley used themes of working-class mothers and children in their works to make social statements. Kollwitz, in graphics such as *Bread* (1924), made the singular experience of one impoverished mother having to choose to feed only one of her two children into a universal metaphor for the capitalist economic exploitation which was destroying Germany in the early 1920s. Eardley was less particularly associated with any political faction than Kollwitz, but still used the poor mothers and children of Glasgow's slums in the 1930s and 40s to express her social critiques. Hence, whilst the subject matter of both of these women artists may be seen as 'traditionally feminine', their treatment of these themes transcends such simplistic interpretation.

The German artist Hanna Nagel, in a series of self-portrait graphics produced between 1928 and 1930, pointedly criticized the situation of professional women bound by domestic commitments and particularly the circumstances of the woman artist faced by these constraints. Her works, such as *Rosy Future: Ideal Marriage* (1930), *Imperfect Marriage* (1928) and *Early Self-Portrait* (1930), consistently show her struggling against her role as an artist's wife and, potentially, as a mother in order to pursue her career. The image of her husband, Hans Fischer, as at best unsupportive and at worst, shown as a weight she must carry, speaks eloquently of her fears of being subsumed by domestic work. Furthermore, her consistent use of the demanding infant figure (she was not actually a mother when these works were produced) as another millstone around the neck of the woman artist reinforces the message that motherhood and domesticity are perilous projects for the serious woman artist.

The experiences of pregnancy and mothering have been used by women artists in more positive ways in their works, but again, the variety of uses to which this theme has been put belies any sense of a universal woman artist, or any 'natural' associations between this theme and women's practice. For example, both ▷Paula Modersohn-Becker and ▷Gerta Overbeck produced representations of themselves pregnant. While both of these works consider the theme of the procreative/creative woman artist, they address these issues in very different ways. Modersohn-Becker's *Self-Portrait on my Sixth Wedding Day* (1906) shows the artist imagining herself as pregnant. The fact that she is nude to the waist and in no identifiable location marks this work as less a document of the experience of a contemporary woman than as an attempt to grasp the subtle interrelationships between women as creators of life and as producers of art. By contrast, Gerta Overbeck's *Self-Portrait at an Easel* of 1936 documents the artist's actual pregnancy of that year. She shows herself in contemporary dress, with the city of Mannheim as a backdrop and, most significantly, working at an easel. This work, therefore, engages with the dynamics of professional contemporary women artists who combined motherhood and careers in the period.

Since 1970, such artists as Susan Hiller and Mary Kelly each took up the theme of maternity in their respective works, *Ten Months* (1977–8) and *Post-Partum Document* (1973–8). In keeping with developments in feminist theory, these artists attempted to show motherhood and the mother-child relationship as themselves products of social discourse. *Ten Months* charts the progress of a pregnancy, through all the various positions in which the pregnant woman may try to reconceive herself. *Post-Partum Document* drew on ▷psychoanalytic theory to comment on the psychic formations of maternity and the separation of the child from the mother as an independent, and gendered, subject. These works show the extent to which motherhood and domesticity are still highly significant themes for women artists, but also that these themes can no longer be taken as in some way naturally feminine subjects. Contemporary women artists problematize the presumptions which link women uncritically to such roles and show the way society creates definitions of women as domestic.

Conclusion

Although the discussion above only touches on a small portion of the issues at stake when one looks at the role of women in the arts, it does show clearly that the subject cannot be divorced from the approach to it. That is, feminist theoretical interventions into the discipline of art history require us to think differently about the subject of women artists and the representations of women. Conversely, to attempt to come to terms with women as subjects and objects in art, it is imperative to have some understanding of feminist methodologies. The purpose of this chapter was precisely to link the three areas (women artists, representations of women and feminist approaches to art history) and to explore new models for their discussion. In so doing, we are introduced to the vast variety of production by women and are forced to acknowledge their critical difference.

Bibliography

Chadwick, W., *Women, Art and Society*, London, 1990

Chadwick, W., *Women Artists and the Surrealist Movement*, London, 1985

Cherry, D., *Painting Women: Victorian Women Artists*, London, 1993

Fine, E.H., *Women and Art: A History of Women Painters and Sculptors from the Renaissance to the 20th Century*, Montclair, 1978

Garb, T., *Sisters of the Brush: Women's Artistic Culture in Late Nineteenth Century Paris*, New Haven and London, 1994

Greer, G., *The Obstacle Race: The Fortunes of Women Painters and their Work*, London, 1979

Harris, A.S. and Nochlin, L., *Women Artists 1550–1950*, exh. cat., Los Angeles, 1976

Kaplan, C., 'Resisting Autobiography: Outlaw Genres and Transnational Feminist Subjects', in S. Smith and J. Watson (eds), *De/Colonizing the Subject: The Politics of Gender in Women's Autobiography*, Minneapolis, 1992, pp. 115–38

Meskimmon, M., 'Domesticity and Dissent: The Dynamics of Women Realists in the Weimar Republic', in *Domesticity and Dissent: The Role of Women Artists in Germany, 1918–1938*, exh. cat., Leicester, 1992, pp. 21–43

Meskimmon, M. and West, S., (eds.), *Visions of the Neue Frau: Women and the Visual Arts in Weimar Germany*, Aldershot, 1995

Moutoussamy-Ashe, J., *Viewfinders: Black Women Photographers*, New York, 1986

Nead, L., *The Female Nude: Art, Obscenity and Sexuality*, London, 1992

Nochlin, L., 'Lost and Found: Once More the Fallen Woman', in N. Broude and M. Garrard (eds), *Feminism and Art History: Questioning the Litany*, New York, 1982, pp. 221–46

Petersen, K. and Wilson, J.J., (eds.), *Women Artists: Recognition and Reappraisal from the Early Middle Ages to the Twentieth Century*, London, 1978

Pollock, G., 'Modernity and the Spaces of Femininity', in *Vision and Difference: Femininity, Feminism and the Histories of Art*, London, 1988, pp. 50–90

Sulter, M. (ed.), *Passion: Discourses on Blackwomen's Creativity*, Hebden Bridge, 1990

Modernism and Modernity

Catriona Miller

t was the mechanized murder of the Western Front which consigned the old 19th-century order to oblivion. The dawning of 1900 itself had relatively little impact on the society and politics of Europe and for the first decade of the new era the old elites enjoyed an Indian summer before the physical and psychological storm of the First World War. But the artistic death knell had been sounded some ten years earlier. In Paris in 1905 and 1907, two separate and very different events ensured that the cultural traditions and certainties of the previous centuries were swept away for good.

▷Fauvism in 1905, and ▷Cubism, in the years after 1907, provided two vital sparks which kick-started ▷modernism into existence. The artists of both these movements were all concerned, to a greater or lesser extent, with the discovery and exploration of a new aesthetic language which would carry art into the 20th century. Equally, they found themselves reacting to the rapidly changing environment in which they worked and thus, consciously or otherwise, their canvases came to reflect modernity. Ultimately, it was the modern world itself which aided the dissemination of the new art: the liberalization of artistic institutions, the commercialization of the art market and the increased ease of international communications all helped to ensure that movements which originated in France could spread to influence the whole of Europe.

The new era also gave artists a new independence. Many of them gloried in their freedom, proclaiming it in manifestoes, magazines and exhibition catalogues. Others wore their ▷avant-garde hearts on their sleeves with overtly anti-establishment political statements and revolutionary programmes. As the rate of change accelerated, artists increasingly expressed their opposition to the work of their immediate predecessors or competitors. Yesterday's innovations had no place in the cult of the new.

By 1940 modernism had spread from its Parisian roots throughout Europe and North America. The early leaders, like ▷Henri Matisse and ▷Pablo Picasso had themselves become members of the establishment and Fascist and Stalinist opposition to the modernist aesthetic and given the old avant-garde a place on the moral high ground. In the post-1945 Cold War, artists like ▷Jackson Pollock even became part of a CIA-sponsored cultural defence of democracy and the American way. But in the space of those 40 years, a collection of diverse, multi-national artists had succeeded in producing irrevocable change.

Modernism was no monolith. It produced no coherent aims or ideals. Its history cannot be told as a simple linear progression or even as a neat patchwork of connected groups and individuals. Instead it spreads as a complex web across time and space, interweaving artists, groups, countries, ideas, events and philosophies. Modernism might well be visually represented by a Pollock drip painting (e.g. *The Cathedral*, 1947, Dallas, Museum of Fine Art): a tangle of lines of varying colour, texture and thickness, some continuing beyond the canvas, others drying up half way across it. The aim of this chapter is to follow some of those lines: the artistic development of Cubism; the influence of the modern world in the shape of the city and war; and the personal search for spiritual expression and psychological understanding. The journey begins, if not on the edge of the canvas, then near it, with a bright splash of paint, in Paris, in 1905.

The ▷Salon d'Automne was one product of the 19th-century liberalization of the art market. Instituted in 1903 by, amongst others, ▷Georges Rouault and ▷Edouard Vuillard, it was one of the many recently established exhibitions which had, since the impact of the eight ▷Impressionist shows during the 1870s and 1880s, ended the monopoly of the Salon. In previous years the show had

established its credentials with a ▷Gauguin retrospective in 1903, and an exhibition dedicated to ▷Cézanne the following year, but the Salon d'Automne of 1905 was to prove far more significant. Thanks to the exaggerated language of the critic, ▷Louis Vauxcelles, the exhibition saw the inauguration of a new artistic 'group' – the *Fauves*, the wild beasts.

The exhibition had brought together the work of several disparate young artists, among them Matisse, ▷André Derain and ▷Maurice Vlaminck, in a single room, in the centre of which was a rather more conventional sculpture by ▷Albert Marquet. This juxtaposition, together with the sheer impact of the canvases themselves was enough to shock even an experienced critic like Vauxcelles. He likened the canvases to wild beasts encroaching on artistic tradition, surrounding the helpless sculpture, ready to move in for the kill.

The young artists were not the first to reject implicitly the lessons of the past in their work, but the effectiveness of Vauxcelles' metaphor, together with the visual strength of the paintings, ensured that their 'rebellion' was perceived to have reached new heights. They took peaceful landscape and rural subjects, not unlike those chosen by the Impressionists – Vlaminck and Derain both worked at Chatou and Bougival on the Seine, for example – and transformed them through a use of pure, striking colour and vigorous, visible, sometimes even crude brushwork into something which, if not actually violent, was frighteningly intense.

Purely in these terms, however, there is little to distinguish the work of the Fauves from that of their *fin-de-siècle* predecessors: both ▷Claude Monet and ▷Vincent van Gogh had, in very different ways, reinterpreted nature with exaggerated colour and brushwork. What Derain and Matisse did at Collioure in the summer of 1905, and what the Fauves as a whole were to do, was to go much further. Their work was not a reinterpretation of the visual world but the creation of an entirely new reality. Their landscapes existed only on the picture surface. They were explicit products of colour and brushwork applied to a two-dimensional plane.

Derain's *Collioure Village and Ocean* (1905, Edinburgh, National Gallery of Modern Art) can be read in a number of ways. It appears, certainly with hindsight, as an evocative, celebratory image of traditional rural life. The colours glow with Mediterranean light, the chunky houses and simplified shapes reinforce the artist's apparent enthusiasm for rusticity: it is the ultimate escapist painting. And viewed like this it is very much a product of the 19th century. The intensification of colour is reminiscent of Monet's serial work of the 1890s, the primitive vision of rural life recalls Gauguin's Brittany paintings of the 1880s. The emotional strength of the painting seems like a neo-▷Romantic paean to nature.

At the same time, however, Derain's *Harbour* denies the whole tradition of 19th-century naturalism. In the work he is not trying to find a new way of representing nature; in his own words he is seeking 'increasingly to purify the transposition of nature' (Harrison, 1992, p. 65), with the ultimate aim of finding a new nature itself. Assisted by both ▷divisionism and ▷Synthetist colour blocks, and armed with ▷Symbolist theory culled from the ▷Nabis, he uses the visual landscape as a springboard towards what Matisse described as: 'insisting on the essentials, to discover its [landscape's] more enduring character and content' (Chipp, 1968, p. 133).

The landmark of 1905 was, in many ways, an accidental one. The Fauves in general, and Matisse in particular, were producing experimental work which was soon to change. And although some of the artists worked together some of the time, they were not in any sense a coherent group. What they did may have been significant, but what they were *seen* to do was more important. The exhibition and, more especially, the press reaction to it are the things which are now remembered.

The 1905 Salon d'Automne was not the first time that publicity had impacted on artists but it was one of the last occasions when it did so coincidently. The following year at the Salon d'Automne the Fauves acknowledged their group identity by exhibiting together again and in later life Matisse looked back on his 'Fauve period' as fact. Vauxcelles' words had created the reality. And the power of the press, the organized exhibition, the group manifesto were all to be increasingly exploited by the new generation of artists.

The second great blow to artistic tradition was, however, an unpublicized affair, the work not of a group but of an individual. Throughout the period of 1906–7 Picasso struggled to realize a large figure composition. It was an experimental piece but clearly an important one, as the size and the careful preparation of the canvas testify. By the time he abandoned it, ▷ *Les Demoiselles d'Avignon* (1907, New York, Museum of Modern Art) had gone through a change of subject as well as numerous stylistic

revisions. It was seen by only a few of the artist's close friends. André Salmon described the impact in words reminiscent of the shock which Vauxcelles had experienced two years earlier:

> Nudes came into being whose deformation caused little surprise . . . [but] It was the ugliness of the faces which froze with horror the half-converted (Fry, 1966, p. 84)

Les Demoiselles seemed to attack systematically the aesthetic canons of the past. The original subject, a brothel scene containing two male figures, was reworked to concentrate the viewer less on narrative than on a shocking confrontation with five staring and distorted female nudes. In them, the epitome of beauty within the Western artistic tradition is reduced not merely to the realist level of prostitution, something which had already been done by ▷Edouard Manet in his Olympia (1863, Paris, Musée d'Orsay). More significantly, Picasso deconstructs the female figures: the bodies are carved up into flattened segments, with the dissection most acute in the squatting figure of the right whose head is twisted over her back. He commits a further assault by replacing the heads with the stylized features of Iberian sculpture and heavily carved African-style masks.

These hybrid figures are placed in space which is visually realized, folded into facets that appear as solid as the flesh and which, through the manipulation of tonality and the incisive use of white, ultimately emphasize the two-dimensionality of the picture surface. The chill blue in the centre of the canvas is like fragments of glass: Picasso has effectively shattered the mirror of reality which painting was traditionally perceived to be.

Revolutionary as Les Demoiselles seems, Picasso produced it by exploiting the ideas of earlier artists. The standing figure on the left is almost a tribute to Gauguin with her sharp, primitively realized profile and darkened figure. The foreground still life and the nude figures themselves are reminders of the debt owed to Cézanne's use of multiple viewpoints and block-like treatment of space. And in his enthusiasm for non-European art, Picasso was following an established trend. All these influences came together in Les Demoiselles to prove that there were other ways of seeing; that the ▷perspective and modelling traditions of European art could, and indeed should, be challenged.

Convenient starting points always have their difficulties. It is crude and rather unnecessary to pronounce the birth of modernism either at the Fauve exhibition of 1905 or, as is more popularly the case, with the production of Les Demoiselles d'Avignon two years later. For much of the 19th century artists had undermined the traditions of their predecessors and explored new methods of representation. To this extent there had long been an avant-garde that chipped away at the foundations of the establishment art world and consciously sought alternatives to it. ▷Gustave Courbet's one-man show Le Réalisme, a defiant though ultimately unsuccessful stand against the Universal Exhibition of 1855, was thus a precursor of the eight ▷Impressionist Exhibitions of the 1870s and 1880s, just as his Burial at Ornans (1849–50, Paris, Musée d'Orsay) foreshadowed Manet's paintings of the mid-1860s in its denial of accepted taste, subject and style.

Alongside such obvious rebellions, the history of 19th-century art traces the development of alternative aesthetic philosophies. On the one hand the Impressionists and ▷Neo-Impressionists adopted the language of optical science to reinvigorate naturalism. On the other ▷art for art's sake led ultimately to ▷Maurice Denis's famous definition of a painting as 'a surface covered with colours arranged in a certain order' (Stangos, 1981, p. 25).

For all this, however, modernism was not a 19th-century phenomenon. The tentative steps of a few artists away from the academies and the official exhibitions were significant but not revolutionary. Denis's dramatic words, must be tempered by the fact that his art rarely rose about trite religious symbolism. The past remained so potent an influence that even Cézanne sought to emulate the ▷Old Masters whilst at the same time abandoning the single viewpoint and unified perspective which characterized their art.

It took 1905 and 1907 to finally break the old artistic order and achieve 'a fundamental liberation . . . the abandonment of the burdensome inheritance of dogma' (Fry, 1966, p. 60). Les Demoiselles d'Avignon swept away the old assumptions so effectively that there could be no going back. For Picasso the painting was a decisive moment, as it was for those who saw it: out of the destruction of the old came the opportunity for rebuilding. The painting began a process of reconstruction which created Cubism and which ultimately influenced art and architecture throughout Europe. It proved what Cézanne had hinted at: there were indeed other ways of seeing. For the next 40 years, modernist artists throughout Europe set about exploring those ways.

The Shape of Things to Come: Cubism

After the shock of *Les Demoiselles*, Cubism developed quietly as a velvet revolution. The clashing colour was rapidly replaced by soft monochromes; the controversial subject matter by innocuous still life and studio scenes. In the first phase of the movement, during 1907–9, the legacy of Picasso's canvas can be clearly seen in the work of ▷Georges Braque, one of the first viewers of *Les Demoiselles* and Picasso's closest collaborator in the years leading up to 1914. His *Nude* (1907–8, Paris, Galerie Alex Manguy) repeats the segmented arcs, the heavily-lined features and even the crumpled blue background of Picasso's painting.

Other influences are apparent, however: the striking blue highlight under the figure's arm and the visible, hatched brushstrokes testify to Braque's awareness of Fauvism. The ▷primitivism of the figure is exaggerated, as in works by Picasso of the same period (e.g. *Seated Woman with Fan*, 1908, St. Petersburg, Hermitage). And both artists experimented with landscape in these early years, creating a synthesis of Cézanne's rich tonality and a new jagged, crisp-edged geometry (e.g. Braque, *Houses at l'Estaque*, 1908, Basel, Kunstmuseum).

By 1909–11 all this experimentation had come together. In Braque's *Still Life with Violin and Pitcher* (1909–10, Basel, Kunstmuseum) the components of the title are explicit, but both these objects and the space surrounding them is fractured by complex, confusing and ultimately ambiguous shaded facets. The clear outlines and large geometric shapes of the earlier paintings have been broken down; distinct lines fade into nothing; light and shade dance in front of the viewer's eyes; terms like solidity and form become meaningless.

Yet amidst all this apparent chaos, the painting is, as the whole of this period of Cubism is often described, 'analytical'. The faceting works with almost centrifugal force towards the heart of the canvas; the dark tones draw the viewer in; the strings of the violin and the illusionist top of the pitcher create reassuring points of certainty. The objects become universalized. Every aspect, every position is accounted for by the artist; the viewer can move through time and space as the eye flicks across the canvas. Thus Braque achieves two things: a comprehensible alternative to traditional perspective which allowed 'a means of getting closer to the objects' (Leymarie, 1988, p. 11) and an intense new two-dimensional reality.

It would be wrong to see the analytical Cubist works as intellectual or scientific conceits, although much of the early writing on the movement emphasized these aspects. Despite their rejection of colour and their general lack of interest in subject, both Picasso and Braque retained a strong emotional element in their work. The paintings were ultimately the products of intuition, not science, and many of the figurative images produced were highly evocative. Picasso's *Portrait of Ambrose Vollard* (1909–10, Moscow, Puskin Museum) presents the character and physical appearance of the man as effectively as any traditional portrait.

By 1911 Cubist paintings had pulverized reality almost to the point of abstraction, certainly of unrecognisability (e.g. Picasso, *Accordion Player* 1911, New York, Guggenheim). But Cubism did not stop there: even as they reached the point of ultimate deconstruction, Picasso and Braque found a new avenue to pursue. In *The Portuguese* (Basel, Kunstmuseum) of the same year, Braque introduced typography. By 1912 Picasso had gone a stage further and incorporated a piece of printed oil cloth into his *Still Life with Chair Caning* (Paris, Musée Picasso). The relationship between painting and reality had taken on a new twist.

At one level these devices were no more than the guitar strings or human features of earlier Cubist works – they helped the viewer to 'read' the image. Equally, however, the introduction of real objects – and what was more, commercially produced or everyday objects – into the world of the painting was a challenge to the viewer. The canvas itself became an 'object', in effect a low ▷relief sculpture. The painter simultaneously analysed – fragmented – and 'synthesized' – rebuilt – the still life, but he did so in unexpected, sometimes even humorous ways: bottles were made of newspaper and guitars of patterned wallpaper in the new reality of the picture.

By the time Picasso and Braque were creating the visual puns of synthetic Cubism, their earlier works had become widely disseminated. ▷Daniel-Henry Kahnweiler's Gallery had supported them since 1908, ▷Guillaume Apollinaire had written articles on the movement since 1911 and the following year ▷Albert Gleizes and ▷Jean Metzinger published *Du Cubisme*. Internationally Cubist work had been exhibited as far afield as Munich and Moscow and many individual artists had made a

pilgrimage to the French capital to see the works first hand. Both there and throughout Europe, artists were using Cubism as a starting point for their own experimentation.

In Paris itself, ▷Robert Delaunay and ▷Fernand Léger were adding colour and light to the basic Cubist formula and exploring the possibilities of abstraction in works which Apollinaire labelled as ▷Orphism:

> *[the artist] must simultaneously give a pure aesthetic pleasure; a structure which is self-evident; and a sublime meaning* (Harrison, 1992, p. 182).

Meanwhile ▷Juan Gris had returned to Cézanne's strictures, working with classical proportion and recognizable geometry to construct objects out of abstract shapes and patterns (e.g. *The Chessboard*, 1914, Chicago, Art Institute). By the end of the War, the increasingly decorative use of Cubism had resulted in the ▷Purist reaction of ▷Amédée Ozenfant who promoted objective representations of everyday objects.

Throughout Europe the same process of development was evident. ▷Futurism in Italy, ▷Vorticism in England and ▷Rayonism and ▷Constructivism in Russia all made use of the language of Cubism to a greater or lesser extent. The association between Picasso and Braque was on the verge of being broken up by the First World War (in which Braque fought), but the revolutionary impact of Cubism was only just beginning.

Metropolis: Delaunay, Expressionism, Futurism, Urban Architecture

For many artists throughout Europe, Picasso and Braque's studio experiments seemed to provide the ideal way of representing the increasing complexity and fractiousness of the modern world. It was not mere coincidence that Cubism developed alongside the new theories of relativity (published by Einstein in 1905 and 1915) and of the nuclear atom (by Lord Rutherford of Nelson in 1911), the 'stream of consciousness' philosophy of ▷Henri Bergson or the popular interest in moving pictures and new methods of rapid transportation. The desire of Picasso and Braque to find an alternative to the fixed certainty of one-point perspective was very much a product of its time.

To a considerable extent, art had failed to keep pace with modernization throughout the 19th century. The growth of the city and with it the fears, hopes and horrors of the urban populations had been catalogued not by painters but in the literature of Charles Dickens and ▷Emile Zola. The Impressionists may have used the backdrop of Paris, Rouen and London but they did so with detachment, recording architecture and street life from the safe distance of apartment blocks, and softening the man-made angularity of buildings with parks, trees or the diffusing qualities of light and water (e.g. ▷Camille Pissarro, *Pont Neuf, Paris, Afternoon Sun*, 1901, Philadelphia, Museum of Art).

Equally, many artists of the new century were inclined to give the modern city a place in the sun. When ▷Robert Delaunay wished to express his enthusiasm for contemporary Paris, he did so using a well-established and celebratory symbol of modernity. In a whole series of images of the Eiffel Tower, he dissolves the solidity of the iron structure into a toppling pinnacle, dazzling in refracted sunlight, utilizing, as the Futurists were to do, Cubist fragmentation to engage the viewer in a vision of modern utopia (e.g. *The Eiffel Tower*, 1910, New York, Guggenheim). Delaunay's interest in the modern city was brief, however: his later series of townscapes, views through the safety of a window, are Orphic abstractions of light and colour in which the city beyond is incidental (e.g. *Window*, 1912–13, Paris, Pompidou Centre).

Delaunay's work was familiar to the Munich artists of the ▷Neue Künstlervereinigung (New Artists' Association, NKV) and ▷Der Blaue Reiter (Blue Rider). His view of the modern city coloured that of ▷Auguste Macke whose elegant figures stroll through Munich's parks and zoos, or survey shop windows impassively, with all the tranquillity of a walk in the country (e.g. *The Hat Shop*, 1914, Essen, Folkwang Museum). The warmth of colour and the flattened, geometric application betoken a sanitized elitism in which capitalism is reduced to the choice of a hat in a milliners. Macke successfully smoothes out the Frenchman's style, replacing dynamism with dreaminess and engagement with observation to produce works which, despite their Cubist-influenced technique, betray the clear legacy of Impressionism.

The need for art to tackle modernity head on was addressed in a manifesto published in *Le Figaro* in 1909 by the Italian poet, ▷ Filippo Marinetti:

we will sing the multicoloured and polyphonic surf of revolutions in modern capitals; the nocturnal vibration of arsenals and docks beneath their glaring electric moons; greedy stations devouring smoking serpents, factories hanging from the clouds by the threads of their smoke (Apollonio, 1973, p. 22).

By the following year the 'Futurist Painters', including ▷ Umberto Boccioni, ▷ Giacomo Balla and ▷ Gino Severini, had produced their own manifesto in answer to Marinetti's. In both cases excitement about the new was combined with a deliberately controversial call for the destruction of the old: 'We will destroy museums, libraries and fight against moralism' (Apollonio, 1973, p. 22). Futurism was the first movement to be overtly enthusiastic about modernity and it was one of the first to court publicity.

It took time for the painters to find a valid means of expressing their views on canvas, and for the early years of the movement they were forced to rely on some of the discredited 'old' by using divisionism to depict light and movement (e.g. Balla, *Girl Running on a Balcony*, 1912, Milan, Galleria d'Arte Moderna). Gradually, however, the Cubist revolution filtered through. Boccioni's *Noises of the Street Penetrate the House* (1911, Hanover, Niedersächsische Landesgalerie) jangles the city in the face of the viewer, its buildings concertina inwards, the whole image disjointed with the movement and noise of the building site, a woman precariously leaning over a balcony in wonder. The artist conjoins the vibrant colour and dashed brushwork on Neo-Impressionism with Cubist faceting and spatial distortion. As in other Futurist works, the city literally rises in front of us, brand new, exciting, modern.

By the time of the first Futurist exhibition in Paris in 1912 – one of a series of international shows which publicized the movement throughout Europe – the group had crystallized their reworking of Cubism: force lines on the canvas could be used to create 'a synthesis of what one remembers and of what one sees' and a 'simultaneity' of noise, light and motion (Apollonio, 1973, p. 47). The emphasis had shifted from Braque's multiple views of static objects, to a visualization of experience through space, time and memory. And this Futurist interest extended beyond the painted canvas: ▷ Luigi Russolo created a noise-machine, Marinetti's poetry was written 'freely' over the entire page and Boccioni attempted to express movement in sculpture (e.g. ▷ *Unique Forms of Continuity in Space*, 1913, bronze, 109 cm high, New York, Museum of Modern Art).

The Futurists glamorized modernity but other artists held a more jaundiced view. Arriving in Berlin in 1910 ▷ Ernst Kirchner turned Macke's images upside down: in *Street Scene in Berlin* (1913, Berlin, Brücke Museum) ladies of the day become women of the night, fashion becomes tarty excess, rich colour becomes unnaturally-lit garishness. The viewer cannot stroll easily amongst these figures; instead, they stride out, blocking the way, forcing a confrontation. Using the pictorial language of ▷ Expressionism rather than Cubism, Kirchner succeeds in encapsulating the thrust of urban modernity. His elongated women are distorted fashion plates, their features reduced to slashes of red lipstick and black kohl. They people a place where the crowd becomes alienating and everything is for sale – there are no need for buildings, this has to be a city.

By the 1920s in Germany, Kirchner's recipe for the modern city was being reused by everyone. ▷ Otto Dix gave an even more explicit response to Macke's window shoppers with his image of decaying prostitutes in front of a world for sale (*Three Prostitutes*, 1925, private collection). ▷ George Grosz had earlier plundered ▷ Cubo-Futurism for his own hellish, red-tinged version of *Metropolis* (1917, New York, Museum of Modern Art). The venom of these representations was ultimately a product of the First World War and its aftermath of economic collapse, but for both artists, the city was an apt symbol of the failings of their generation. Boccioni's city is being erected proudly, that of Grosz is falling down around its miserable inhabitants.

It is symptomatic of the centrality of the city to the culture of this period, that artistic solutions to social problems lay in the rebuilding of the metropolis. ▷ Lyonsel Feininger's image of soaring, spired buildings (e.g. *Cathedral of Socialism*, 1919, woodcut, cover to the *Bauhaus Manifesto*) expressed the hopes of the ▷ Novembergruppe, a broad cultural union established in Berlin in 1918 with the aim of reinvigorating society. They reach for the sky in the same way as ▷ Mies van der Rohe's delicate glass and steel skeletal designs of the same period (e.g. Friedrichstrasse Skyscraper Competition design, 1921). In 1919 ▷ Walter Gropius took over the old ▷ Art Nouveau school at Weimar, reinstituting it as the ▷ Bauhaus and pledging to:

conceive, consider and create together the new building of the future that will bring all into one single integrated creation . . . rising to heaven out of the hands of a million craftsmen, the crystal symbol of the new faith in the future (Curtis, 1987, p. 119).

The old cities had been designed by the ruling elites, as expressions of political power; the new city would be like a machine working for the people – streamlined, efficient, orderly and physically and morally cleansed.

Just as it had taken artists a considerable time to come to terms with the demands, and the experience, of the modern city, so architects had lingered in the habits and styles of the 19th century. In the years up to the 1914 Art Nouveau, with its organic flourishes, its craftsmanship and its inherent luxury had held sway. It was urban architecture, certainly but it was not the architecture of the modern masses. Instead, as ▷Antoni Gaudí proved in Barcelona, the style could be slotted neatly into the sleek façades of bourgeois apartment blocks, bringing a veneer of organic nature and individualism into the anonymity and conformity of city life (e.g. Case Batlló, Barcelona, 1905–7).

However, by the time that the Bauhaus moved to its new purpose-built site at Dessau in 1922, reinforced concrete, flat-roofed blocks, prefabrication and open-plan interiors were the new ▷International Style architectural language and the building blocks for the new city. In Stuttgart, the Weissenhofsiedlung housing project of 1927, organized by the ▷Deutscher Werkbund, brought together some of the leading architects of Europe to design for the urban worker. Three years earlier ▷J.-P. Oud had produced similar integrated, modernist schemes at the Hook of Holland and Rotterdam. In France ▷Le Corbusier was making the ▷International Style chic with a series of Purist villas, which raised their inhabitants above the ground on ▷*pilotis* (stilts) and gave them roof-top gardens so that they could experience clean air and clean living more easily (e.g. Villa Savoye, Poissy, 1928–9). Whilst ▷Theo van Doesberg and ▷Gerrit Rietveld were ensuring the interiors of the new architecture were as efficiently designed as the exteriors (e.g. Schroeder House, Utrecht, 1923–4).

The architects of the 1920s managed to combine a 19th-century belief in the unity and equality of art and craft – an idea which had been exploited to very different effect by Art Nouveau – with a faith in modern materials and mass production. But they balanced practical emphasis on the 'strength of new materials . . . the new audacity of engineering' with a strong spiritual motivation, a belief in 'a universality in which all opposing forces exist in a state of absolute balance' (Curtis, 1987, p. 126). The modern metropolis was to be egalitarian and collective, distanced from both the styles and the attitudes of the past. And that ideal changed the appearance of the city for good.

It is perhaps fitting, therefore, that artists who sought to represent the urban environment in the years after the First World War, turned to abstraction. For ▷Fernand Léger the townscape was a bewildering geometric forest, full of colour and life, almost playful but ultimately mechanistic (e.g. *The City*, 1919, Philadelphia, Museum of Art). Whilst ▷Piet Mondrian responded to New York with a pulsating, jazzy, neon grid (e.g. *Broadway Boogie Woogie*, 1942–3, New York, Museum of Modern Art). Both works are tense with excitement and optimism. Both artists have come to terms with the city and both put their faith in an ideal, modern and modernist metropolis.

The Waste Land: Dada, Neue Sachlichkeit, Vorticism, Rayonism

As the architects of the decade proved, by the 1920s it was possible to look back on the First World War as a *tabula rasa*, a necessary cleansing of old Europe. Internationalism rose out of the rubble and looked only forwards. But for many, the mud and blood of 1914–18 was an indelible memory. Artists from all over Europe went off to fight: some, including Boccioni, ▷Franz Marc and ▷Henri Gaudier-Brzeska, did not come back; others, like Kirchner and ▷Max Beckmann, were psychologically scarred by their experiences and many more found themselves displaced or in voluntary exile.

In Zurich in 1916, the immediate reaction to the War was to match destruction with iconoclasm. For the members of the ▷Cabaret Voltaire, led by ▷Tristan Tzara and ▷Hugo Ball, art was a product of the corrupt, bourgeois society which had instigated the War and as a consequence it deserved to be at the very least questioned, if not openly attacked:

The Dadaist fights against the death-throes and death-drunkenness of his time ... He knows that this world of systems has gone to pieces, and the age which demanded cash has organised a bargain sale of godless philosophies (Harrison, 1992, p. 247).

The performances in Zurich fuelled this 'disgust' in a literal way – inviting the audience to destroy works with sledgehammers – but ▷Dada, as the movement named itself, was not just about nihilism. The artists who sought to destroy also managed to create.

In Hanover, ▷Kurt Schwitters created Dada ▷collages from rubbish, thus producing, in a highly symbolic act, something out of the debris of contemporary society (e.g. *Merz 19*, 1920, collage, New Haven, Yale University Art Gallery). His ▷Merz – the name created in a typical Dada manner from fragments of typography found on one construction – reworked synthetic Cubism, but it was the choice of materials rather than an investigation of spatial problems which interested Schwitters – he eventually moved on to produce room-sized Merzbau. The Merz were, however, not simply ▷anti-art statements: Schwitters combined paint and careful placement of collage to create an aesthetically valid image.

The same artistic priorities can be seen in the work of ▷Hans Arp, one of the early members of Zurich Dada who moved to Cologne in 1919. Although he did work on reliefs created from pieces of driftwood, his main interest lay not so much in ▷'found objects' as in automatic art. His famous *Collage Produced According to the Laws of Chance* (1916–7, pasted coloured paper, New York, Museum of Modern Art) was an obvious development from the Cabaret Voltaire's free poetry and 'music', in which the role of the creator-artist was negated, allowing accident to play the major part. Arp then went on to replace accident with nature, creating brightly-coloured paintings and wood reliefs which underplayed the input of the artist by seeming to flow independently, ameoba-like across the wall (e.g. *Forest*, 1916, painted wood, private collection).

Meanwhile, in the United States, ▷Marcel Duchamp was challenging the whole definition of an artist. Having worked within a Cubist idiom in Paris during 1911–12, he turned, in 1913, to a series of ▷'ready-mades': 'chosen' everyday objects which were exhibited as art (e.g. *Bicycle Wheel*, 1913, wood and metal, New York, Sidney Janis Gallery), claiming that it was not practical skill and training which defined the artist but intellectual decision-making. His major project of the period, *The Bride Stripped Bare by her Bachelors, Even* (1915–23, mixed media on glass, Philadelphia, Museum of Art) utilized illusionist detail and elements of chance to create a mechanistic interpretation of thwarted sexual relations on a piece of glass. It was an art work one could literally see through, yet one which defied understanding.

Under the umbrella of Dada, independent artists working throughout Europe and America, thus channelled their opposition to conventional, 'bourgeois' art forms into works which managed to undermine and reinvent the very concept of art itself. Other members of the movement had an even more wide ranging agenda: in Berlin in the 1920s, Dada became highly politicized. In the hands of ▷John Heartfield and ▷Hannah Höch, found objects – typography and press illustrations – were reworked into ▷photomontages which attached the consumerism and corruption in contemporary society (e.g. Höch, *Cut with a Kitchen Knife*, 1919, Berlin, National Gallery).

Their work dovetailed with the explicit political caricatures of the ▷Neue Sachlichkeit (New Objectivity) artists like Dix, Beckmann and Grosz, which sought to de-personalize artistic expression and create instead a universally comprehensible artistic language. Grosz himself was a founding member of the Berlin Dada group and a major contributor to the First International Dada Fair held in Berlin in 1920, co-producing the infamous 'Art is Dead' placard with Heartfield. In his paintings, however, he succeeded in creating bitingly effective satires which went far beyond the clumsy publicity stunts of the Dada group, (e.g. *The Pillars of Society*, 1926, oil on canvas, Berlin, National Gallery).

For many of the German artists of the early 1920s, political and aesthetic anarchism went hand in hand with personal crisis. Pre-War Expressionism had created the means of putting one's emotions on canvas by using distortions of colour and line and surface-painted hieroglyphs. And throughout the War itself, Expressionism was utilised to deal with the trauma. Having been invalided out of service on mental health grounds, Beckmann produced a self-portrait of bewilderment and shell-shock in which the artist, fearfully looking over his shoulder, seems almost crumpled under the weight of his experience (*Self-Portrait with Red Scarf*, 1917, Stuttgart, Staatsgalerie).

The political and personal later came together in Picasso's ▷*Guernica* (1937, Madrid), an expatriate's

response to the atrocity of aerial bombing during the Spanish Civil War. The painting uses a deceptive monochrome to 'report' the screams and mutilations of the victims; women, children and animals stampede chaotically across the canvas; a jagged light-bulb in the centre seems to symbolize the explosion itself. It was a public condemnation, the centrepiece of the Spanish Pavilion at the Paris Exhibition in 1937, but the impact comes from the artist's personal outrage and the means – the dehumanized figures and the use of mock-collage and newsprint – were influenced by Expressionist and Dadaist responses to the earlier waste land of the First World War.

In *Guernica* humanity is physically distorted by the experience of war, just as it was seen to have been literally corrupted by events in post-War German art. Dehumanization could, however, take on other forms. For many artists the modern world and the destruction which it seemed to have wrought, could only adequately be expressed through images of mechanization. Having created the machine, man was increasingly becoming dependent on, and dominated by, the machine. It was only fitting that he should die by the machine. Even the artists who had embraced technological advance during the first years of the century found it increasingly difficult to do so after 1914.

The geometric dissection of Cubism inevitably led some artists to treat the human figure in terms of 'the cylinder, the sphere and the cone' (Chipp, 1968, p. 19). In France, Léger created chunky tin men who somehow manage to retain their character and humanity despite their robotic appearance (e.g. *Game of Cards*, 1917, Otterlo, Kröller-Müller Museum). Léger was unusual in having his faith in people reinvigorated by the experience of war:

> I was thrust into a reality which was both blinding and new . . . I found myself on a level with the whole of the French people (de Francia, 1983, p. 31).

And his paintings of the 1920s and 30s continued to represent the automaton-worker with an almost classical heroism, using bright colour and simplification (e.g. *The Mechanic*, 1920; Ottawa, National Gallery of Canada).

There were few artists who could share Léger's enthusiasm. The language, and particularly the cold, analytical monochrome, of Cubism was also apparent in Duchamp's *Nude Descending a Staircase No. 2* (1912; Philadelphia, Museum of Art), but here the artist simplified the human figure to a mechanized skeleton in order to trace the path of movement around a central, visually realized axis The tangled lines are a world away from Léger's comfortably solid figures and the *Nude* foreshadows Duchamp's later works, like the ▷ *Bride Stripped Bare by her Bachelors, Even*, in which sinister machines take over all human functions.

Duchamp's fellow New York Dadaist, ▷ Francis Picabia injected an element of humour into his works which is absent from Duchamp's. Yet his emphasis on precise, bland drawing with ruled lines, compass-drawn circles and typography, downplayed the human, as much as the artistic, content of his work. Equally, the images he chose were mechanized: he reduced his photographer friend, ▷ Alfred Stieglitz, to a camera, successfully personifying the man as a machine in *Ici, c'est ici Stieglitz* (1915, pen and ink, New York, Metropolitan Museum of Art).

Dada's attempt to reduce the role of the artist-individual inevitably led to an exploration of the artist-machine – Duchamp used a toy cannon to fire painted-tipped matchsticks at the *Bride Stripped Bare*, for instance, as part of his exploration of automatic art. But mechanization could not provide the answer. 1914–18 provided ample evidence of the destructive, rather than the creative, power of the machine. They were, in the final analysis, a product of the contemporary society which Dada sought to demolish.

Futurism might be considered the one movement likely to promote an image of man and machine in harmony but in fact relatively few works attempted such a balance. In Russia, where Futurism became the inspiration behind the Rayonists, ▷ Kasimir Malevich's *Knife Grinder* (1912, New Haven, Yale University Art Gallery) appears a notable exception. Using brightly coloured, Légeresque facets, Malevich creates an involving image of mechanized activity in which the man is subordinated to, and yet engrossed in, his task. His treadle-operated whetstone is hardly, however, the height of modern technology and figure belongs as much to the world of Malevich's earlier, reassuringly solid peasants (e.g. *Taking in the Harvest*, 1911, Amsterdam, Stedelijk Gallery), as to that of the Rayonist manifesto:

we declare the genius of our day to be: trousers, jackets, shoes, tramways, buses, aeroplanes, railways, magnificent ships (Gray, 1962, p. 124).

In the end, both in Russia and in Italy, that expression of modernity could only be adequately achieved through abstraction.

In England the Vorticists, organised by ▷Wyndham Lewis at least partly in response to the 1912 Sackville Gallery exhibition of Italian Futurism, epitomized the ambiguity of response of early modernist artists to the machine. ▷Jacob Epstein's *Rock Drill* (1912–13, bronze, New York, Museum of Modern Art) simplified the human body in a series of sleek curves and smooth surfaces, topped by an almost reptilian head, and physically attached this creature to a real drill – part man, part machine, part beast. The effect was powerful, sexually potent, but Epstein later dismantled the sculpture, describing it in negative terms:

> *Here is the armed sinister figure of today and tomorrow. No humanity, only the terrible Frankenstein's monster we have made ourselves into* (Cork, 1976, p. 481).

When Lewis came face to face with the realities of war, he reused Epstein's imagery to depict fighting figures, stick men whose limbs are permanently fused with weapons they carry (e.g. *A Battery Shelled*, 1919, London, Imperial War Museum). He, like the other Vorticists, ▷C. R. Nevinson and ▷William Roberts, became an official portrayer of the War, using the group's Cubo-Futurist aesthetic to produce acceptably sanitized images from the Western Front. Works like Nevinson's *Return to the Trenches* (1914, Ottawa, National Gallery of Canada) fulfilled the criteria for modern art expressed in ▷*Blast*, the group's magazine: the figures were indeed 'hard, clean and plastic' – but there was no escaping the fact that they were being made to do a dirty job.

Nevinson's tight-faced, unemotional figures can be seen to represent one way of coping with the horror of war but they are an equally effective metaphor for the general spiritual dearth of the period. In them humanity is reduced to the level of the automaton for the sake of self-preservation but for many, the dehumanization was involuntary and far more fundamental. The physical desert of the Western Front simply mirrored a moral desert caused by the speed of change, the uncertainty, the mechanization of the modern age. What the Dada artists, and many others, sought to express was a waste land of the soul.

The Rainbow: Expressionism, Abstraction, Constructivism

It was perhaps inevitable that during the years 1914–18, artists should seek out spiritual reassurance in their work. Arp certainly believed this was one of the fundamental interests of the Zurich Dadaists:

> *We sang with all our soul. We searched for an elementary art which would, we thought, save mankind from the madness of these times* (Stangos, 1981, p. 114).

But for the pre-War Expressionists also, art had been part of a spiritual quest. Like their 19th-century ▷Romantic predecessors, many early modernist artists sought out nature and primitive culture in the hope of finding peace or fulfilment. Naturism, theosophy, mysticism and conventional religion were all well-trodden paths during the early years of the century, as individuals tried to find human and spiritual direction to their modern, mechanistic, material lives. In the end, however, as the angst-ridden canvases testify, for many peace was not forthcoming. In this sense, ▷Edvard Munch's *The Scream* (1893, Oslo, National Gallery) with its swaying, insubstantial figure and barren, unsympathetic landscape is a true precursor of Expressionism.

The German Expressionist group Die Brücke (The Bridge), based in Dresden from 1905, published a programme full of optimism:

> *Believing as we do in growth, and in a new generation . . . we want to wrest freedom for our actions and our lives from the older, established forces* (Harrison, 1992, p. 67).

But their search for 'freedom' led them to explore medieval art, peasant woodcuts and landscape rather than the world of the 20th century. In a series of collective trips to the Moritzburg Lakes, the group,

including Kirchner, ▷Erich Heckel and ▷Max Pechstein, produced canvases of nude figures immersed in nature (e.g. Pechstein, *Open Air (Bathers in Moritzburg)*, 1910, Duisburg, Lehmbruck Museum), in which the rich, warm colours, reminiscent of Fauvist work, shimmer against heavy delineating contours, soaking up the sensations of nature and exploring the artists' naturist experience of landscape, rather than its visible reality.

The implicit spirituality of these works becomes apparent in the paintings of ▷Emil Nolde, who was invited to join Die Brücke in 1906, after an exhibition of his work in Dresden had proved him to be a kindred spirit. In a series of religious subjects in 1909, Nolde used intense illumination, rich purples and oranges and heavily encrusted impasto to reinterpret New Testament scenes. Figures with crude, mask-like faces loom out of the canvas, claustrophobically constrained by its dimensions (e.g. *Mocking of Christ*, 1909, Berlin, Brücke Museum). His later landscapes retain that intensity: a series of 21 images of the *Autumn Sea* approach abstraction in their exploration of autonomous colour and free-flowing application of paint.

Yet Nolde's autobiography reveals that his apparently celebratory paintings hid a deeper malaise:

> *I could not go on. Had I lost my feeling for religion? Was I spiritually tired? I think I was both. I had had enough* (Chipp, 1968, p. 148).

His work, like that of many of his generation, was an escape from, as much as a search for; it went hand in hand with the artist's distrust of contemporary civilization:

> *The effect of my paintings on unsophisticated people always gratified me . . . Difficulties only arose with people spoiled by the surface glitter of city life* (Chipp, 1968, p. 150).

In the end, like Gauguin before him, Nolde literally escaped modernity by travelling to the Pacific.

The desperation of Nolde's words becomes visually apparent in the later paintings of the other Die Brücke artists. In Kirchner's *Stepping into the Sea* (1912, Stuttgart, Staatsgalerie) the exuberance of the previous landscapes is missing: colours have been thinned down, the line is more tentative, the whole image is edgy. The artist seems less involved with nature, less sure of its recuperative powers; it is as if somehow the earlier ideals of the group have proved unsustainable.

Ultimately, it was modern city life which led to the downfall of Die Brücke. After their move to Berlin in 1910, which brought with it exposure to new influences, the earlier cohesiveness was lost and personality clashes, particularly between Kirchner and ▷Karl Schmidt-Rottluff, intensified. Equally, the group found itself embroiled in the institutional conflicts between the Berlin ▷Secession under ▷Max Liebermann and its off-shoot, ▷Neue Sezession.

In the final analysis, however, it was perhaps the dream which had failed: Die Brücke had sought a purity of expression 'uninfluenced by contemporary movements of Cubism, Futurism, etc . . . [which] fights for a human culture, the soil of all real art' (Chipp, 1968, p. 178). But the 'soil' had been ploughed up too often. It would take a more radical solution than Die Brücke artists could provide – that of abstraction – to catapult art beyond the corrupting influence of the contemporary, and find the end of the spiritual rainbow.

By the time Die Brücke was fragmenting in Berlin, a new artistic focus had emerged in Germany, this time centred in Munich, around the figure of the expatriate Russian, ▷Wassily Kandinsky. The ▷Neue Künstlervereinigung (NKV), was a loose association of artists, writers and musicians which organized exhibitions in 1909 and 1910. By the following year, its more radical members, Kandinsky and Marc, had set up a rival organization, Der Blaue Reiter, issued an *Almanac* and had held their own exhibition.

Der Blaue Reiter was everything which Die Brücke was not. It retained the broad interests and international stance of the NKV: the *Almanac* included an essay by Arnold Schoenberg, a play by Kandinsky (*The Yellow Sound*) and illustrations of ▷folk art, Polynesian artefacts and Japanese prints, as well as reproductions of works by ▷Henri Rousseau, ▷Paul Klee and Cézanne. It had none of the Dresden group's scepticism about Cubism – Marc visited Paris in 1912 to see the work first-hand. Perhaps most importantly, it had, in the presence of Kandinsky, a painter and theorist who was already breaking down the boundaries between representation and abstraction.

During the early years of the century, Kandinsky had explored landscape, creating folk art-influenced rural idylls in and around the village of Murnau. Works like *Grüngrasse in Murnau* (1909, Munich,

Städtische Galerie im Lenbachhaus) employ exuberant yellows, reminiscent of van Gogh's early Arles' work and chunky, rounded Fauvist brushwork. They are the exotic landscapes of childhood escapism, with Hansel and Gretel houses and fairy tale colours. By 1909, however, Kandinsky was taking the essentials of these landscapes and abstracting them into canvases which, although obviously inspired by nature, represented a highly personalized system of symbolism and association. Working through rapid 'improvisations' and long-considered 'compositions' Kandinsky used loose colour patches and free-flowing black line to suggest dream-like castles, horsemen, mountains and rainbows – allegories of his own spiritual quest (e.g. *Study for Composition II*, 1910, New York, Guggenheim).

The ideas behind this development were expressed in his essay *On the Spiritual in Art*, written in 1910 and published two years later. Central to his work was a belief in the power of colour to produce not only an immediate physical impact but also a long lasting psychological effect, which he described as the sound of colour:

> *Colour is the keyboard, the eyes are the hammers, the soul is the piano with many strings . . . It is evident therefore that colour harmony must rest ultimately on the purposeful playing upon the human soul* (Lindsay, 1982, p. 220).

By rejecting the distraction of representational art, Kandinsky sought to achieve paintings which, like music, appealed directly to the emotions. Equally the shift away from representation was part of a broader belief, influenced by his interest in mysticism, concerning 'the breaking-up of the soulless-material life of the 19th-century' (Lindsay, 1982, p. 341).

For Kandinsky's fellow member of Der Blaue Reiter, Marc, the rejection of soulless-materialism was a rejection less of representation, than of the human content of his work. Marc's world was viewed through the eyes of animals and intensified by colour symbolism: his *Large Blue Horses* (1911; Minneapolis, Walker Art Centre) form a series of elegant arcs against the rich reds, greens and yellows of the landscape, as an ultimate expression of the masculinity, austerity and spirituality which the colour blue represented. By the outbreak of the First World War, Marc, like Kandinsky, was producing pure abstractions. In the end neither of them found what they were looking for in nature:

> *Another instinct led me from animals to abstractions . . . suddenly, I have become fully conscious of nature's ugliness and impurity* (Chipp, 1968, p. 182).

For both, colour and form alone could provide a spiritual answer.

A similar path, through nature towards abstraction, can be traced in the work of Mondrian. Having stayed in Paris 1911–14, the Dutch artist produced a series of Cubist-influenced reductions of still life and nature, using muted colours within a loose geometry of verticals and horizontals (e.g. *The Flowering Apple Tree*, 1912, The Hague, Gemeentemuseum). However, by the time he had returned to Holland and established ▷ de Stijl with ▷ Bart van der Leck and van Doesburg in 1916, Mondrian was already critical of the Cubists for not following their ideas to a logical conclusion – abstraction. In *Pier and Ocean No. 10* (1915, Otterlo, Kröller Müller Museum), he represented the movement and sound of water by means of rhythmic, intersecting plus and minus signs.

Like Kandinsky, Mondrian had absorbed the ideas of the Theosophical Society, of which he became a member in 1909. More specifically, from 1916, he was aware of the teachings of M. H. Schoenmaekers, whose book, *The New Image of the World*, appeared in that year. Schoenmaekers' view that nature was fundamentally regular and reducible to the essentials of the cross – verticals and horizontals – and the primary colours provided the impetus for Mondrian's jump to what he called real, 'pure plastic art' (Herbert, 1964, p. 114). By the 1920s he was producing canvases which went beyond the mere abstraction of nature to express the underlying reality and truth of the universe (e.g. *Composition with Red, Yellow and Blue*, 1921, The Hague, Gemeentemuseum).

Like Kandinsky's compositions, these grid canvases of the 1920s were carefully conceived, each a variation on an infinite theme, but Mondrian went beyond the Russian in his desire to find universal, rather than merely personal, spiritual peace. Each canvas expressed, in the purest possible form, balance and stability achieved out of asymmetry and tension. There was no place for dynamism in his work and he objected to van Doesburg's use of diagonal 'counter-compositions' (e.g. *Counter-composition in Dissonances XVI*, 1925, The Hague, Gemeentemuseum):

Disequilibrium means conflict, disorder. Conflict is also part of life and of art, but it is not the whole of life or universal beauty (Herbert, 1964, p. 120).

As an alternative, Mondrian produced whole canvases tilted to 45 degrees (*Fox Trot A*, 1927; New Haven, Yale University Art Gallery) which retained the stability and permanence of his conventionally hung works, whilst emphasizing the universality: the diamonds seem simply a small part of infinite space which extends beyond the boundaries of the canvas.

As a member of de Stijl, Mondrian was part of a group dedicated to social regeneration through art: the group's magazines promoted international cooperation and a programme of reform and rebuilding which echoes that of Gropius at the Bauhaus. He certainly viewed his spiritual abstractions as a product of the changing modern world:

the art of the past is superfluous to the new spirit and harmful to its progress . . . The new art is, however, still very necessary to life (Herbert, 1964, p. 128).

But he remained essentially isolated from de Stijl's practical work. Whilst van Doesburg travelled to the Bauhaus in 1921, Mondrian set himself up in Paris, working in almost ascetic isolation to achieve spiritual enlightenment.

A similar duality can be seen in the development of geometric abstraction in Russia. Here too, the personal quest coexisted uneasily with the desire for social reform. In the early years of the 20th century the Russian avant-garde had sought to absorb the new trends of European art whilst at the same time reasserting their national identity. Artists like Malevich, ▷Mikhail Larionov, ▷Natalia Goncharova and ▷Vladimir Tatlin adapted Cubism and Futurism to their primitivist images of peasants, soldiers and religious icons. At the same time, a frantic progression of exhibitions and manifestoes publicized the new art and, in the case of the ▷Rayonists, explicitly linked it to a programme of social reform.

By the time Malevich showed his first group of ▷Suprematist canvases at the 0.10 exhibition in Petrograd in 1915, however, there was so clear a split between his own views and those of Tatlin, that their works actually had to be hung in separate rooms. Malevich distanced his work from 'necessary practical things':

Every social idea, however great and important it may be, stems from the sensation of hunger; every art work, regardless of how small and insignificant it may seem, originates in pictorial and plastic feeling. It is high time for us to realise that the problems of art lie far apart from those of the stomach or the intellect (Herbert, 1964, p. 101).

From his ▷non-objective art, although a necessary development of the modern world – he likened Suprematism to the flight of an aeroplane – was more importantly, a personal search for 'feeling' using pure shapes against the spatial infinity of the canvas (e.g. *Suprematist Composition: Red Square, Black Square*, 1915, New York, Museum of Modern Art). Suprematism passed through several stages as Malevich sought to express different levels and complexities of feeling, from the initial black square on white canvas, to the use of first red, then multicolours and varied shapes, and the ultimate purity of the white on white series (e.g. *White on White*, 1918, New York, Museum of Modern Art).

Unlike Mondrian, the Russian's art was dynamic with overlapping planes, diagonals and shapes which appeared to float in infinity. But he shared with the other abstractionists an interest in the spiritual, in his case Christian mysticism. His Suprematist work, and his emotional quest, effectively ended with the finality of *White on White*, and having reached that goal his art changed direction, first to architectonic models and then back to figurative canvases.

Although the visual appearance of Suprematism had an impact on Malevich's contemporaries, few of them shared his spiritual views. For most Russian artists, revolutionary fervour demanded politicized and utilitarian artistic production and in the years immediately after the Revolution they were encouraged in this by the new regime which instituted the ▷Vkhutemas workshops and ▷INKHUK (the Institute of Artistic Culture). In such a climate, it was perhaps inevitable that the abstract dynamism of Malevich's canvases was reworked to produce propaganda. ▷El Lissitzky's 'Proun' paintings created three-dimensional forms out of Malevich's coloured planes (e.g. *Construction, Proun 2*, 1920,

Philadelphia, Museum of Art) and in posters like *Beat the Whites with the Red Wedge* (1919) he created allegories of Bolshevik triumph out of Suprematist-influenced geometry.

Tatlin was perhaps the most enthusiastic of these Constructivist artists, even for a time working in a factory to design mass-produced clothes and furniture for the proletariat. He was also responsible for the ▷*Monument to the Third International*, a slanting spiral tower of steel and glass, planned as a Communist rival to the Eiffel Tower at over 1300 feet high. Although never built, the thrusting dynamism and scale of the scheme is a fitting symbol of the grandiose but ultimately impossible ambitions of Soviet art during the early 1920s.

In the long term, it was not the socially-aware, but the anti-materialistic art which survived. By the mid-1920s Soviet sympathy for abstraction had been exhausted and most of the Russians had become refugees, settling among the like-minded artists of the Bauhaus. The future of Constructivism lay in the work of ▷Naum Gabo, who along with his brother, ▷Antoine Pevsner, had issued the *Realistic Manifesto* in Moscow, in 1920, in a direct challenge to the ideas of Tatlin.

Gabo's elegant abstract constructions of perspex, glass and metal (e.g. *Construction in space with Balance on Two Points*, 1925, New Haven, Yale University Art Gallery) were, like Mondrian's canvases, autonomous, 'real' expressions of 'the world without and within [man] ... the very essence of the world which we are searching for' (Chipp, 1968, p. 333). By using the physical materials of the modern world, Gabo had constructed a formal expression of the metaphysical. He had, like the abstract painters, achieved a balance of the modern and the spiritual through art.

The End Game: Surrealism, Abstract Expressionism

By the 1930s, European art had lost much of its earlier certainty, direction and dynamism. Modernism was being actively challenged in both Germany, where official opposition was apparent long before the Entartete Kunst (▷Degenerate Art Exhibition) of 1937, and the Soviet Union, where state promotion of ▷Socialist Realism had excluded the old avant-garde. The 1920s had seen a 'return to order' in the work of Picasso, Matisse and others who appeared to deliberately step back from their earlier radicalism (e.g. Picasso, *Mother and Child*, 1921, Chicago, Art Institute). Equally, the work of, on the one hand, Dada and on the other, the geometric abstractionists, seemed increasingly like a definitive artistic statement, after which there was nothing more to be said.

The ▷Surrealist movement exemplified this dilemma. Built on the rubble of Dada's anti-art in Paris in the 1920s, the movement aimed not at challenging the world or even at expressing its inner truths, but at examining the individual human mind. Despite the political awareness of some of its members, the movement was essentially introspective, turning its back on reality by elevating the status of the unreal and the dream. This was explicit in ▷André Breton's 1924 manifesto:

> *Pure, psychic, automatism ... The dictation of thought in the absence of any control exercised by reason and outside any aesthetic or moral preoccupations* (Harrison, 1992, p. 438).

In the hands of at least some of its artists, Surrealism was to become little more than artistic navel-gazing. ▷André Masson's 'automatic' drawings were self-conscious doodles, doctored to emphasize the ▷Freudian credentials of their creator. Equally, ▷Salvador Dali's minutely detailed canvases were deliberately manipulated pieces of self-analysis in which, in direct contradiction to conventional psychiatry, 'the reality of the external world ... comes to serve the reality of our mind' (Harrison, 1992, p. 479) (e.g. *Giraffe in Flames*, 1935, Basel, Kunstmuseum).

For other artists Surrealism was a logical extension of Dada: a means of redirecting the vehemence of the earlier movement towards a more constructive end. ▷Max Ernst had been a member of the Dada group in Cologne and much of his later work was a development of the chance art, found objects and collage experiments of those years. His discovery and use of ▷'frottage' (a technique of taking rubbings from floor boards) in 1925 could have been nothing more than a Dadaist method of playing down the role of the individual creator. Instead Ernst explored the technique as a means of his own mental liberation:

> *In order to aid my meditative and hallucinatory capacities I made from the [floor] board a series of drawings ... I was surprised by the sudden intensification of my visionary capacities* (Stangos, 1981, p. 128).

A similar reworking of the Dada techniques was achieved in the collage series, *La Femme Cent Têtes* (*The Woman with 100 Heads* or, actually, *The Woman without [sans] Heads*, 1929), in which Ernst used images culled from 19th-century illustrations to produce a bizarre, sexually-tense and ultimately baffling narrative.

Earlier, in *Two Children threatened by a Nightingale* (1924, New York, Museum of Modern Art), the artist combined real objects and crisp painting to reveal an eerie image of death and abduction, based on one of his own poems. Both the varied techniques and the manipulation of scale create a dream-like quality which is reminiscent of ▷Giorgio de Chirico's ▷'metaphysical' canvases of shadowy streets and incongruously presented objects (e.g. *Conquest of the Philosopher*, 1912, Chicago, Art Institute). The unconscious 'surrealism' which these works achieve is a world away from the concrete precision of Dali's canvases and comes much closer to suggesting the workings of the human mind.

For ▷Joan Miró it was the colourful, organic forms of Arp's Dada collages which formed the basis of his Surrealist art. His first works were brightly painted images of the family farm in Catalonia which both precisely catalogued and playfully exaggerated the remembered features of that life (e.g. *The Farm*, 1921–2, private collection). By the mid-1920s he was increasingly abstracting such details into ▷biomorphic extravaganzas, full of wit, colour and finely draughted ▷calligraphy (e.g. *Harlequinade*, 1924–5, Buffalo, Albright Art Gallery). In each case, he used a combination of hallucination (which he achieved by half starving himself) and conscious interpretation, to try and re-enter the imaginative mind of the child.

By the end of the 1920s, however, Miró was using organic, semi-automatic abstractions (e.g. *Painting*, 1933, Hartford, Wadsworth Atheneum) to both explore his own subconscious, and allow the viewer to explore theirs also:

Rather than set out to paint something, I begin painting and as I paint the picture begins to assert itself, or suggest itself under my brush (Chipp, 1968, p. 435).

Just as Ernst was doing with his rubbings, Miró relinquished control over aspects of his production in order to achieve an insight into himself. It seems hardly surprising that his work attracted Kandinsky, who settled in Paris after the closure of the Bauhaus in 1933: the spontaneous, free-flowing forms of Miró's canvases create a psychological insight in the same way that Kandinsky's carefully-conceived canvases had earlier allowed the artist emotional expression.

▷René Magritte also borrowed from Dada, albeit less consciously than either Ernst or Miró. His deliberately deadpan canvases of everyday objects convey all the banality and contradictions of Duchamp's ▷ready-mades and make some of the same challenges to the meaning and definition of art (e.g. *This is not a Pipe*, 1928, private collection). The majority of Magritte's canvases are concerned not with an exploration of the artist's subconscious but with the observation of reality itself. By emphasizing the absurdity of life, he allows the viewer to question their assumptions about the world. His canvases, like those of Ernst and Miró, create a bridge between the mind of the artist and the spectator and thus avoid the internalizing tendencies of some Surrealist work.

By the start of the Second World War, Surrealism had reworked abstraction, ▷automatism and ready-mades, to prove that they were not simply formalist challenges to artistic convention but a necessary part of the individual's creative, expressive vocabulary. For the next generation of artists these devices would become an accepted part of their aesthetic language. Most of the ▷Abstract Expression-ists served an apprenticeship with Surrealism: ▷Ashile Gorky and ▷Mark Rothko, for instance, both produced Miróesque biomorphic abstractions during their early careers (e.g. Gorky *The Betrothal II*, 1947, New York, Whitney Museum of American Art), before moving on, dissatisfied with the limitations of the movement. And by the mid-1950s, ▷Neo-Dadaists like ▷Robert Rauschenberg, were to look again at the work of Ernst, Duchamp and Magritte.

The American artists, however, belonged to a very different world. For the Abstract Expressionists, the influences and experiences which had inspired modernist artists from the beginning were present in an intensified form. They were working in the face of a war more destructive even than that of 1914–18; they experienced in New York, a modern metropolis which Europe could only begin to contemplate; they had to cope with an Existentialist 'nausea' eased only by activity and introspection; and they did so without the hope and faith in the future which had characterized much of the art of the early century.

Works like Pollock's *Cathedral* (1947, Dallas, Museum of Fine Art) make use of 50 years of artistic experience to express not only the painter's mind, emotion and attitude to life but his very existence. Without the aesthetic assault of the Dadaists, the spiritual journey of Kandinsky or the subconscious meanderings of Miró, Pollock's ▷action paintings would not exist. They were, literally in terms of their scale, monuments to half a century of modernism; products of a generation who took modernist art for granted. For them, as ▷Robert Motherwell explained, it had become 'classic':

> *The function of the modern artist is by definition the felt expression of modern reality . . . the capacity of the artist [is] to absorb the shocks of reality . . . and reassert himself in the face of those shocks . . . The 20th century has been one of tremendous crisis in the external world, yet, artistically speaking, it has been a predominantly classic age* (Harrison, 1992, p. 636).

All the divergent avant-gardes and ideas of the early 20th century had, with hindsight, been amalgamated; they had, in the end, created a monolith. Modernism was indeed like a Pollock canvas: the complex paint marks, which had, in the hands of the artist, been a living, interactive entity, were to be hung in a gallery as a 'classic'. Modernism had been reinstituted as a masterpiece. It was time for art to move on.

Bibliography

Ades, D., *Dada and Surrealism Reviewed*, exh. cat., London, 1978

Apollonio, V. (ed.), *The Futurist Manifestoes*, London, 1987

Chipp, H. (ed.), *Theories of Modern Art*, Berkeley, Los Angeles and London, 1968

Cork, R., *Vorticism and Abstract Art in the First Machine Age*, 2 vols, London, 1976

Curtis, W., *Modern Architecture Since 1900*, London, 1987

de Francia, P., *Fernand Léger*, New Haven, 1983

Freemen, J. (ed.) *The Fauve Landscape*, exh. cat., London, 1991

Fry, E., *Cubism*, London, 1966

Golding, J., *Cubism: A History and an Analysis 1907–14*, London, 1968

Gray, C., *The Great Experiment: Russian Art 1863–1922*, London, 1962

Harrison, C. and Wood, P., (eds.), *Art in Theory 1900–1990: An Anthology of Changing Ideas*, Oxford, 1993

Herbert, R. (ed.), *Modern Artists on Art*, New Jersey, 1964

Jaffe, H., *De Stijl, 1917–31: Vision of Utopia*, London, 1986

Leymarie, J. (ed.), *Georges Braque*, exh. cat., New York, 1988

Lindsay, K. and Vergo, P. (eds.), *Kandinsky: The Complete Writings on Art*, vol. 1, London, 1982

Lloyd, J., *German Expressionism: Primitivism and Modernity*, London, 1991

Milner, J., *Russian Revolutionary Art*, London, 1979

Russell, J., *The Meanings of Modern Art*, London, 1981

Stangos, N., *Concepts of Modern Art*, London, 1981

Grounding Postmodernism

Jonathan Harris

Introduction

The most viable sections of the Fontana [steel] plant were . . . sold off . . . to a consortium that included a Long Beach businessman, Japan's giant Kawasaki Steel, and Brazil's Campanhia Vale Rio Doce Ltd. In a mindbending demonstration of how the new globalized economy works, California Steel Industries (as the consortium calls itself) employs a deunionized remnant of the Kaiser workforce under Japanese and British supervision to roll and fabricate steel slabs imported from Brazil to compete in the local market against Korean imports. Derelict Eagle Mountain, whose iron ores are five thousand miles closer to Fontana than Brazil's, has meanwhile been proposed as a giant dump for the nondegradable solid waste being produced by the burgeoning suburbia of the Inland Empire.

(M. Davis, in 'Junkyard of Dreams', City of Quartz: Excavating the Future in Los Angeles)

[Cindy Sherman's] . . . photographs depict seemingly different women drawn from many walks of life. It takes a little while to realize, with a certain shock, that these are portraits of the same woman in different guises. Only the catalogue tells you that it is the artist herself who is that woman. The . . . insistence upon the plasticity of human personality through the malleability of appearances and surfaces is striking, as is the self-referential positioning of the author . . . as subject . . . Cindy Sherman is considered a major figure in the postmodern movement.

(D. Harvey, The Condition of Postmodernity: An Enquiry into the Origins of Cultural Change)

Over the last fifteen years, since the term ▷'postmodernism' achieved a relatively wide currency (mainly inside academic debate and publishing), the word has been used rather more to refer to cultural and artistic artefacts, events or developments than it has been used to explain the character of contemporary economic and social structures or transformations. On the whole, changes in cultural forms and practices deemed to be 'postmodernist' have been welcomed and celebrated as evidence of release from previously constraining 'modern' codes and conventions, and held to be demonstrative of continuing innovation and creativity in the cultural sphere. Conventionally understood, then, postmodernism is a form of expression or representation in culture – literary, visual and philosophical – which draws its resources from contemporary popular culture, using narrative and ▷allegorical forms, and mobilizing motifs extracted from *any* pre-existing artistic or ▷discursive form. For instance, photographs such as those produced by ▷Cindy Sherman have been taken, as by Harvey in the above quotation, as exemplary of this artistic rule-breaking. Sherman photographs herself made up into types reminiscent of women characters portrayed in (mainly) Hollywood films of the 1940s and 1960s, and recreates the narrative settings and 'sets' in which these characters had their filmic life. Sherman's types, however, are always generic and allusive, rather than specific and directly referential. The imaginative power of Sherman's photographs may well lie within this disjunction between reference and meaning.

Yet it is arguable that conceiving postmodernism mainly in cultural or artistic terms, within a broadly sanguine perspective on perceived transformations or reorientations, has gone hand in hand with an ignorance of or a failure to acknowledge important reorganizations in economic, social and political life which have taken place locally, but which are, ultimately, part of a global process. M. Davis's account of the 'plasticity' and 'malleability' of Fontana Steel in California in the 1980s may serve as an

indication of a recasting of basic economic (and, as I will argue, social and political) conditions of life in contemporary western society. Whether the term 'postmodernism' has any explanatory value in this broader context of analysis remains an open question. This essay aims to offer some preliminary definitions and criticisms of postmodernism as a concept or field of ideas and values, and then goes on to consider ways of linking the usually isolated categories of 'socio-economic' and 'cultural' phenomena to revealing ends.

To make progress with the idea of the postmodern we need to understand an equally complex term – the 'modern'. The postmodern, like the preceding modern, it should become clear, has both a utopic and a dystopic face: a side to embrace and celebrate, and a side to reject and mourn. Both concepts have had their advocates and their detractors, and both have sometimes found individuals or groups with very different positions and values united in supporting or attacking them. On the face of it, only a 'post' separates the modern from the *after*-modern. Both terms also have the same modifying suffixes: modern*ism*/postmodern*ism*, modern*ist*/postmodern*ist*, modern*ity*/postmodern*ity*, modern-*ization*/postmodern*ization*. 'After' or 'post' implies, it is important to emphasize, both a difference from that which came before *and yet* a continuance of traits previously present. To describe a painting, for instance, as 'after ▷ Velázquez' means exactly these two things – consider ▷ Robert Rauschenberg's 1964 silk-screen on canvas *Persimmon*. Although Rauschenberg clearly includes an image of Velázquez's *Venus* in his work, it is equally clear that this is a 'processed' reference (or 'quotation'), using photographic sources within a print medium which situates the *Venus* in a very different aesthetic and semantic configuration.

'Modern' society is dated usually from the mid-19th century and seen as synonymous with the development of urban, industrial and capitalist social life. Sometimes the date is pushed further back to include both the ▷ French Revolution of 1789 and a more opaque historical event called the ▷ Enlightenment. The intention here is to bring secular philosophical rationalism into the definition of the 'modern' and, together with the (as it turned out, temporary) abolition of the monarchy in France, to indicate that the state of modernity characteristically is urban, industrial, capitalist and democratic. It is highly significant that, as the great nation states of western and central Europe acquired empires through military and economic colonialization in the 19th century, modernity became synonymous also with *western* and *northern* power in the world, although conquered peoples and territories came to occupy a specific subordinate place within this geography and political economy of modernization.

▷ Modern*ism* in the production of visual art, from the mid-19th century onwards, came to comprise an intense concern with, and desire to represent, these new components of social life. This centrally included representations of urban – and, with the growth of Paris, Berlin and then New York – metropolitan society, in paintings by, for example, ▷ Gustave Courbet, ▷ Edouard Manet, ▷ Claude Monet, ▷ Ludwig Kirchner and ▷ John Sloan. The depiction of modern economic and social relations between town and country became an important theme in works by ▷ Camille Pissarro, ▷ Georges Seurat and ▷ Paul Cézanne. The increasing presence of items of industrial and mechanized 'mass' culture became evident in early 20th-century ▷ Cubist works by ▷ Pablo Picasso, ▷ Georges Braque and paintings and sculptures by the ▷ Futurists. Finally, a kind of imagined 'antidote' to the actual modernity of the urban West began to appear in depictions of idealized 'primitive' or 'tribal' societies, increasingly accessible to artists because of Western colonial economic and political domination. These 'exotic' cultures and social orders, believed by Westerners to be *without history*, and therefore to have been spared the crises of modernization, were represented in paintings and drawings by, for instance, ▷ Paul Gauguin and ▷ Paula Modersohn-Becker.

As this synopsis indicates, artists chose to represent developments at the very heart of modern life, changes which were propelling the development and transformation of human relations and consciousness. Early modern*ist* artists and ▷ avant-gardes (that is, groupings variously organizing to manifest themselves to the world, sometimes identifying programmatic aims and intentions) also opposed the forms, conventions and institutions of ▷ academic art derived from ▷ Renaissance theories of pictorial rhetoric and ▷ naturalism. Avant-garde artists attempted to develop modes of representation able to convey something of the characteristic rapidity and 'fleetingness' of modern vision: 'the impression'. Later groupings would attempt to formulate what were offered or taken to be ▷ 'realist' modes of representation, bound up with political and ideological allegiances.

A flight from social engagement, however, was also an integral component of modernism. One kind

of avant-gardism, then, culminated with ▷Dada and ▷Surrealist activities during the period between about 1914 and 1935. ▷Hannah Höch's ▷collage *Cut with the Kitchen Knife* (1919) satirized the moribund codes and conventions of life in Germany after the Armistice. The central quotation at the bottom of the image reads 'Cut with the kitchen knife of Dada through the last beer-swilling cultural epoch of the Weimar Republic'. ▷Meret Oppenheim's 'sculptures' or arrangements of found objects, such as *My Nurse* (1936), indicate a strand in Surrealist art concerned with a critique of sexual relations and gender identities. A pair of women's heeled shoes is presented on a platter, trussed up, like a joint of meat. Another sector of the avant-garde invented forms of pictorial abstraction, that were mobilized in a variety of ways as extended metaphors for themes of nature, the human body and the psychological essence.

This notion of modernist development has been traced in and between works by Cézanne, Monet, ▷Henri Matisse, ▷Joan Miró and the ▷Abstract Expressionists, active in the USA after the Second World War. During the Cold War period up to about 1970 the account became an institutionally-sanctioned historical orthodoxy. For the influential post-war critics ▷Clement Greenberg and Michael Fried, however, painting had become an intrinsically modernist form, a means solely for investigating the characteristics of the activity understood as a specific material practice. The history of modernist painting was, as far as they were concerned, the history of an internal development in formal means (line, colour, pattern), traceable from Manet to ▷Jackson Pollock, and more or less synonymous with the rise of abstraction. This view (stated most cogently in Greenberg's essay 'Modernist Painting', first published in 1961) signalled a rejection of art understood as a vehicle for social and political engagement, a rejection of concern with art as a record of human intention, agency and nature. Greenberg and Fried linked modernism to the philosopher ▷Immanuel Kant and Enlightenment thought, but they refused the long tradition of social radicalism in the visual arts initiated during the French Revolution and symbolized by a figure like ▷Jacques-Louis David.

Modernism in visual art and criticism, therefore, has a divided and complex history. It is split at least three major ways, between: (i) avant-garde social and political engagement; (ii) forms of psychological ▷humanism; and (iii) a claimed modernist ▷'aesthetic autonomy', what Greenberg called the purity of 'modern specialization'. The tradition of social and political engagement is associated with modernism understood as avant-garde activism. Gustave Courbet's involvement with the uprisings in France in 1848 and 1870–71, the activities of the Dadaists and the Surrealists in the inter-war period, and ▷Constructivist support for the Bolshevik Revolution in Russia in 1917 are all instances of such direct avant-garde involvement in social and political struggle. Artistic practice, within such engagement, necessarily exhibited both technical and social radicalism.

Modernism understood as a form of psychological humanism was the search – usually instigated by individual artists, not groups – to find novel ways to express or represent personal and individual crises thought to have been engendered by modern life. Generally uninterested in class and politics, artists as diverse as ▷Edvard Munch, Henri Matisse, and ▷Mark Rothko attempted to develop formal means in art through which to picture subjective psychological and somatic states.

The notion of modernism as aesthetic autonomy is particularly associated with the criticism of Clement Greenberg produced in the post-1945 period. While *Modernist Painting* encapsulated this view in a powerful and influential formulation, Greenberg had drawn on the work of earlier critics – specifically ▷Clive Bell and ▷Roger Fry – whose disinterest in the intentions of artists, and in the social circumstances within which they produced art, prefigured aspects of Greenberg's later theorization. Although Greenberg's ideas did influence artists working in the 1960s (the so-called ▷Post-Painterly Abstractionists), the understanding of modernism as aesthetic autonomy – of 'art about art' – was predominantly a critical invention often used to make sense of art produced long before Greenberg's views became influential. This is not to underestimate some of the historical and theoretical problems entailed with notions of modernism understood as either avant-garde engagement or psychological humanism. In both these cases, for instance, some sense is implied of modern art being *relatively* autonomous – that is, distanced – from previous, academic (and politically conservative) forms, procedures and institutions. This recognition is far away, though, from the Greenbergian understanding of modernist painting as a practice and set of forms *entirely* autonomous from social and political life.

Given the difficult – not to say contested – history to the concept of modernism, it is not surprising that the concept of postmodernism has brought with it an equally tangled set of positions, values and interests. Just as vast an array of artefacts, texts and visual representations have been designated

postmodernist as those previously called modernist: along with Sherman's photographs would stand buildings such as John Portman's Westin Bonaventure Hotel in Los Angeles (1977) and Mario Botta's office building in Lugano, Switzerland (1981–85); paintings by ▷ Andy Warhol and David Salle; videos produced by Nam June Paik and films such as David Lynch's *Blue Velvet* (1986); and phototext pieces by ▷ Barbara Kruger and Martha Rosler. From observation of these artefacts and images we can identify a number of features usually associated with postmodern ways of using materials and representing the real world.

Botta's building façade has been cited as 'appropriating conventions' from ▷ Renaissance architectural theory and practice, specifically a form of Platonic ornamental pattern, built in brick, which, nevertheless, is cut away to reveal a high-tech interior (C. Jencks, *The Postmodern Reader*). Eclectically juxtaposing round and square forms, old and modern materials (brick, glass and steel), and quoting Renaissance and modernist building conventions, Botta's structure may be seen like a compendium of postmodernist devices. Portman's Bonaventure Hotel has been deemed to contain many allegorical devices, including escalators and elevators ('gigantic kinetic sculptures') and a greenhouse on the sixth floor. This is related to a claim that the hotel offers a 'postmodern hyperspace', not part of the city, 'but rather its equivalent and replacement or substitute' (F. Jameson, *Postmodernism, or the Cultural Logic of Late Capitalism*).

Warhol's painting and silkscreen *Marilyn Monroe Diptych* (1962) contains references to mass or popular culture and uses devices of multiple representation drawn from commercial art and design practices. Along with David Salle, whose allegorical *Wild Locusts Ride* juxtaposes three different forms of figurative art representing a Santa Claus, a girl sitting in a chair and a ▷ 'Socialist Realist' crowd, Warhol has been credited with a return to figuration, to naturalist conventions, which yet contain within the picture frame a 'practice of fragmentation . . . diptych framing, sequential collage, scissored images . . . screen segmentation' (F. Jameson, op. cit.).

Nam June Paik's video presentation of objects of electronic technology (such as television sets) interspersed with vegetation in *TV Garden* (1982) promotes, it is claimed, concepts of difference and striking association. According to commentators, a film such as Lynch's thriller *Blue Velvet*, set in 1950s USA, both works the theme of the sado-masochistic body and invokes nostalgia for a lost (or perhaps imagined) America.

Barbara Kruger's phototext work, in pieces such as *Your Gaze Hits the Side of My Face* (1981) and Martha Rosler's *The Bowery in Two Inadequate Descriptive Systems* (1974–5) have both been claimed to place the practice of representation in the foreground and to reintroduce politically interventionist art.

Kruger's ▷ photomontage shows the profile of a sculptured bust of a woman. Down the side of the photograph the words 'Your gaze hits the side of my face' are printed in modern type. Kruger uses a bust of a face, rather than simply a photograph of a woman, to emphasize further the issue of representation in relation to meaning. Themes of spectatorship, power and pleasure are invoked.

Rosler's work consists of two panels. One is a photograph of the edge of a building in the financial district of Manhattan. Below a sign reading 'First National City Bank' two beer bottles sit on a stone ledge. On the second panel Rosler has simply typed the words 'plastered – stuccoed – rosined – shellacked – vulcanized – inebriated – polluted'. The terms could be said to refer both to literal drunkenness and to the façade of the bank, implying a critique of financial institutions and a social order devoted to seeking profit. The use of image and text by both artists is a characteristic postmodern convention. Kruger and Rosler have been associated with anti-militarist and anti-capitalist art, along with a commitment to feminist politics.

Drawing general features out of these specific examples of postmodernist culture (understood as a collection of individuals or groups working in diverse media and locations) it is possible to identify: (1) an appropriation and/or ▷ pastiche of historical conventions; (2) the making of allegories (stories); (3) reference to, or use of, mass or popular culture; (4) a return to figurative or naturalist conventions, though in forms that sometimes include fragmentation of imagery; (5) a promotion of differences and the creation of striking associations; (6) an invocation of nostalgia; (7) depiction of the human body as a site of, or agent in, sexual and/or violent actions; (8) a foregrounding of representation ('self-referentiality'); and (9) a return to politically interventionist art.

How might it be possible or valuable to relate this postmodern*ism* to a state of postmodern*ity*, to a world or set of conditions in social life that might usefully be called postmodern? In the light of the examples set out by Davis and Harvey above, how might the 'malleability' and 'plasticity' of represented

appearances identified in Sherman's photographs be mapped onto the 'malleability' and 'plasticity' of human economic and social relations of work at Fontana Steel? Once again, to proceed to examine the postmodern requires an examination of the 'modern' before it.

Postmodernisms: utopian and dystopian

The 19th-century 'modern' western world was one of rapid urbanization, fuelled by the predominance of capitalist economic and social relationships, bound up with industrial work practices exemplified by the factory system and the slow shift towards electoral politics based on increasing suffrage. All the great philosophers and commentators of that century were, in equal measure, exhilarated and repulsed by the scale and degree of transformation occurring in the organization of social life. Good and bad, or the utopic and the dystopic, existed bound up together in a state of basic, intrinsic contradiction. Karl Marx wrote:

> On the one hand, there have started into life industrial and scientific forces which no epoch of human history has ever suspected. On the other hand, there exist symptoms of decay, far surpassing the horrors of the latter times of the Roman Empire. In our day everything seems pregnant with its contrary ... All our invention and progress seems to result in endowing forces with intellectual life, and stultifying human life into a material force.
> (K. Marx, 'Speech at the Anniversary of the People's Paper')

Modern life was not a choice that could be accepted or rejected. The forces of economic and geographical transformation released within capitalist development, however, exerted relative degrees of influence over how, where, when and why people lived and worked, as well as over the organization of their family life and prospects for wider social interactions of all kinds. A small but gradually increasing sector of the population, those with control over capital through either ownership of units of production or through investment or inheritance – the bourgeosie – could become extremely wealthy and powerful in a society in which social mobility was still a highly marginal factor. On the other hand, for those without private or commercial income – the masses, or 'proletariat', as Marx called them – any ability significantly to determine such basic yet critical features of their lives was minimal.

It is not surprising then that the modern social order developing in western and central European countries in the 19th century provoked many individuals and groups to invent images of, and plans for creating, alternative and better ways of life: utopias. These constituted visions of a different, new world, magically freed from the realities of urban industrial capitalism. That actual world itself was seen to constitute the opposite: a dystopia – that which should be avoided. As Marx understood it, the modern world which promised so much at the same time rendered itself unlivable; society had become a hideous composite of vertiginous innovations and social debasements.

Modernist art in the 19th century depicted this simultaneously ascending and disintegrating social order. In the latter part of the period many artists also came to identify themselves with opposition to capitalism – for example, ▷Courbet became involved with socialist politics and took part in the Paris Commune of 1870–71, while Pissarro aligned himself with anarchist organizations. Alternatively some artists and groups, such as ▷William Blake and ▷Samuel Palmer in England in the first half of the century, and the ▷Pre-Raphaelites towards the end, combined repulsion at actual society with religious faith or idealistic belief in a prior Golden Age.

If the twinning of utopian and dystopian elements may be said to be characteristic of the visual art of modernity, and modernism itself seen to constitute a precarious balance of such dreams and nightmares, then might it be the case that a similar state of affairs exists within the forms of so-called postmodern culture and social life, forming not a break, but rather an extension of this longer history?

It is often claimed that postmodernist culture is constituted out of a pluralism (or 'radical heterogeneity') of activities, values and interests. ▷Jean Baudrillard's writings on the mass media have often been associated with the extremities of this position, although it is also a theme running through ▷Jean-François Lyotard's account of 'postmodern knowledge' and Ihab Hassan's literary 'para-criticism' (Jean Baudrillard, 'The Ecstasy of Communication', in H. Foster (ed.), Postmodern Culture; J.-F. Lyotard, The Postmodern Condition: A Report on Knowledge; Ihab Hassan, 'Pluralism in Postmodern Perspective', in C. Jencks (ed.), The Postmodern Reader). Sometimes it is claimed that such pluralism in postmodernism has replaced, or displaced, a prior, unitary modernism. The brief characterization of

modernist art outlined above should indicate, however, that, although a particular historical account might claim to identify a mainstream or centre to modernist development (for instance, the Greenbergian account of 'formal development' in particular arts), the actual history always included at least three or four different (even opposing) impetuses. The identification of one postmodernism may be subject to the same criticism: different critics, artists and commentators have selected one feature in preference to another, and contrasted it (favourably or not) with one feature selected from one kind of history of modernism.

Charles Jencks's account of postmodernism in architecture is a good example of such a selective process. For him, the modernism of architects such as ▷Mies van der Rohe was based on what Jencks called 'univalence': the 'use of few materials [e.g. glass, steel, concrete] and a single, right-angled geometry ... this reduced style was justified as rational ... and universal ... The glass and steel box has become the single most used form in modern architecture, and it signifies throughout the world "office building"' (C. Jencks, *The Language of Postmodern Architecture*).

Linking van der Rohe's building preferences (and their associated functionalist justifications) to his view of architecture as an essentially private and élitist activity masquerading as a public profession, Jencks goes on to celebrate forms of architectural theory and building practices which, he claims, reject the doctrine of 'form-follows-function'. Jencks believes this mid-20th-century ideology – which claimed that modernist buildings looked the way they did solely because of the functions they were to fullfil – denied the active role of convention and style in building. He praises Botta's building in Lugano because its stylistic eclecticism foregrounds the place of building conventions drawn from the past, and thereby denies 'form-follows-function' doctrine. In an argument similar to that presented by Kenneth Frampton in his article 'Towards a Critical Regionalism' (in H. Foster (ed.), op. cit.), Jencks defends and defines postmodernism in architecture as a renewed respect for constructing buildings which show formal sympathy for their place amongst other pre-existing structures. Jencks cites as an example of this Van den Bout's and De Ley's Bickerseiland Housing in Amsterdam (1972–6) where two new cheaply-built houses echo the curved gables of the 17th-century house adjacent to it, in what Jencks calls a form of socially responsible 'neo-vernacular'.

The art critic Rosalind Krauss makes a congruent judgement on the enlarged range of choice opened to artists working in what she calls 'the expanded field' of postmodernist sculpture (R. Krauss, 'Sculpture in the Expanded Field', in H. Foster (ed.), op. cit.). By this she meant that the previous received understanding of 'sculpture' as 'universal category', used to authenticate a group of particular ... [objects]' had collapsed; the 'logic' of sculptural form could now be separated from that of the construction of monuments. The resulting 'expanded field' now enabled artists to work with a wide range of materials never used before in traditional sculptural practices. For example, ▷Robert Smithson's *Spiral Jetty* (1970) was constructed out of salt crystals, rocks and mud arranged in a coil shape in a lake in Utah, and has been interpreted as a work with ecological significance. Alice Aycock's *Maze* (1972), a wooden structure resembling a fort, according to Krauss, confused the usual understanding of sculpture as a medium which is *not* architecture and thereby fractured the received frames of reference for interpretation and evaluation. This enlargement and reorientation of the concept of sculpture made it possible for them to situate their works in sites not previously designated for sculpture, and to use this new, heterogeneous array of objects now inadequately called 'sculpture' for an equally expanded range of aesthetic and intellectual purposes. These transformations and expansions she clearly welcomed.

Yet 'pluralism' celebrated in architectural and sculptural postmodernism may be recast as a deadening fragmentation in other contexts of criticism. For example, the art critic Peter Fuller attacked the 'new figurative' painting of artists such as Anselm Kiefer (b 1945), Julian Schnabel and Bruce McLean (associated with the show 'The New Spirit in Painting', held at the Royal Academy in London in 1981) as evidence of what happened to art in what he called the 'absence of a shared symbolic order', by which he meant belief in God and in humanist ideas (P. Fuller, *Images of God: The Consolations of Lost Illusions*). Although Kiefer and Schnabel construct images in paint and other materials of people and nature, thereby rejecting 1960s ▷Minimalist and Post-Painterly Abstract styles, for Fuller – no friend of Greenbergian modernist tenets either – this return to allegories, to the use of naturalist conventions and to concern with the human body did not signal a cultural renovation. Unlike Harvey's admiring description of the attention to surfaces and malleability of appearances in Sherman's photographs, which he takes as an index of creativity and what could be called a

'critical self-authorship', Fuller sees in new figuration only an emptiness and flatness in the use of these conventions – 'pastiche' understood as a dead language of quotations.

Rather, these artists' incapacity to use paint skilfully and to understand properly what Fuller calls the 'imaginative tradition' of post-Renaissance art, indicated that 'the "new expressionism's" inability to articulate, even within the illusory world of the picture, any coherent symbolic order . . . is much closer to the "Late Modernist" problematic than its protagonists like to pretend. For the new tendencies make sense only in terms of *reaction* to the modernist art that went before.' For Fuller, then, the 'new figuration' is simply a crass and opportunistic reaction against Minimalist and Post-Painterly art which had suppressed narrative and evacuated iconic references to the human body. All three forms of art exist in a rootless culture and society, unconnected to any radical and collective belief systems.

Assessing, then, Jencks's and Fuller's specific descriptions of postmodernism, along with their evaluation of the works cited, it should be clear from just two examples that there is a wide stratification of definitions and analyses falling within the rubric of the postmodern. Different senses of the 'modern' and 'modernist' are also implied, although in both cases here the critics may be shown to be occupying anti-modernist positions (one in relation to architecture, the other in relation to painting and sculpture). This, however, guarantees nothing in terms of what critics conclude on the merits of items of postmodernist art: for Jencks postmodern architecture may be a glimpse of an emergent social good; for Fuller 'new expressionism' in painting merely continues and reflects the dismal dystopian reality of conflict-ridden social and cultural modernity. How might the value and meaning of these contrasting judgements be explained? The introduction of a broader analytic framework at this point may enable us to provide an answer.

In the realms of both intellectual and political life in the last quarter of the 20th century (the 'postmodern era' in most accounts) 'fragmentation' has been perceived to be a pervading characteristic of contemporary existence. Within sociological thinking, traceable back, for example, to Ferdinand Tönnies's influential study *Community and Association* (1887), social division or 'anomie' has been identified as a central and persistent feature of modernity and modernization. It invades all chronologies of the 'modern' and the 'postmodern' and crosses all divides used to separate the former concept from the latter.

Consider the following statement. Its author is an art historian closely identified with the tradition of 'social history of art' and the comment draws specifically on Marxist accounts of class, culture and political struggle:

> *I'm not interested in the social history of art as part of a cheerful diversification of the subject, taking its place alongside the other varieties – formalist, 'modernist', sub-Freudian, filmic, feminist, 'radical', all of them hotfoot in pursuit of the New. For diversification, read disintegration.*
>
> (T.J. Clark, 'The Conditions of Artistic Creation')

Now consider a second passage. The author this time is a British feminist and socialist attempting to think through the implications of the emergence of so-called 'new social movements' in Europe and the USA in the 1970s, eroding the power of the traditional male-dominated Left:

> *. . . we are now faced with creating a socialist organization not primarily through debates, struggles and splits within existing parties . . . but through the coming together of socialists based in the various 'sectoral' movements [feminist, green, anti-militarist, etc.], the majority of whom are not members of any political party . . . the possibilities in the localities, of going beyond the fragments, of creating the foundations of a revolutionary movement, will for a time be far greater than on a national level.*
>
> (H. Wainwright, in *Beyond the Fragments: Feminism and the Making of Socialism*)

The continuities which could be identified between postmodernist visual art and the organization of intellectual and political life characterized above are striking. The terms 'fragmentation', 'integration' and 'disintegration' take on lives that may be, in different contexts, (i) artistic, (ii) broadly cultural, (iii) intellectual and (iv) directly political. In artistic terms we have seen that Jencks and Fuller, for instance, both see conventions in architecture and painting as analogous – in complex ways, certainly – to norms and values in social life. For Fuller, on the one hand, a breakdown in the 'shared symbolic order' has brought the disintegration of conventions and meanings in western art. For Jencks, on the other hand,

the breakdown of modernist architectural convention ('form follows function') has enabled a rich diversity of stylistic elements to be integrated into contemporary architectural practice.

For culture broadly defined, processes of fragmentation in postmodern society have created ghettoized communities intent on excluding threatening groups. The Bonaventure Hotel in Los Angeles, for example, according to Jameson, creates a world of 'postmodern hyperspace', protecting itself from the life outside. The hotel creates a controlled internal ambience and physical environment premised on the segregated development (or 'zoning') now practised widely in US cities.

In intellectual terms, for Clark, 'fragmentation' is a destructive and debilitating process. While 'pluralism' has become something of an official and administrative ideology, for Clark the ideology works to redirect and segment attention away from central questions and issues, disintegrating focus and concentrated scrutiny. In sharp contrast, Wainwright and the other authors of *Beyond the Fragments* see the disintegration of traditional party politics (and the monopoly of the Left by the Labour party in Britain) as a positive development, brought about by the rise of a heterogeneity of single-issue pressure groups which could potentially become aligned as part of a new and creative political bloc.

Once again we have here a fusing and *con*fusing of utopic and dystopic elements, depending on which feature is selected and evaluated from a specific perspective. We can conclude, then, that phenomena called postmodernist – be they artistic, social, intellectual or political – may be identified as both good *and* bad, utopic *and* dystopic, according to the particular frame of reference and evaluative system within which they are included. In this fundamental sense the modern and the postmodern exist within a historical and social continuum. Distinctions made between the modern and the postmodern, once this identification has been made, may then appear to be relatively incidental and unimportant.

Postmodernism reconsidered

As the Clark and Wainwright examples above suggest, during the late 1970s and 1980s it became common for postmodernism to be understood as virtually synonymous with other terms held to indicate fundamental changes in the organization of human affairs. In intellectual and academic culture the notion of ▷poststructuralism entered wide usage. This was associated particularly with writings on language, psychology, sexuality and social institutions by ▷Roland Barthes, ▷Jacques Lacan, ▷Michel Foucault and ▷Jacques Derrida. In political life – though with a related academic manifestation – the decline and fall of Soviet Communism ushered in the idea of 'post-Marxism' and the prospect of what, famously, became known as 'the end of history' thesis. This held that, with the disintegration of the Soviet Union in 1990 and the ending of the epochal struggle between democracy and communism, US democratic capitalism was triumphant, and what lay ahead was the creation of a global advanced capitalist society no longer riven by any serious ideological conflicts.

Together, these 'posts' pointed at what was asserted to be a whole new world, and a whole new 'world order', claimed by President George Bush to have been brought into being with the end of Soviet Communism and the US-led defeat of Iraq in the Gulf War of 1991. What connections can be made, then, between 'artistic postmodernism' and such global military and political events? Whatever the complexities of analysis implied by this question, the refusal of an attempt to link postmodernism in the arts with other changes said to have taken place in economic, social and political relations – at both micro and macro levels – leads to the term remaining impoverished as an explanatory tool. Denied connection to any broader picture of the world – be it the world of Fontana Steel, or Middle East relations, or a world in which no ideology competes with capitalist democracy – postmodernism simply exists as a style label, a buzz-word for advertisers and media commentators. How might these connections be made? Social theory may serve as a useful bridge.

Many analysts have attempted to characterize contemporary life in western societies (the worlds of work, of family life, of sexual relations, of social and political institutions) as experiences of fragmentation and division. Anthony Giddens has remarked that such a view may be convincing, but it is simplistic:

> It has become commonplace to claim that modernity fragments, dissociates. Some have even presumed that such fragmentations mark the emergence of a novel phase of social development beyond modernity – a postmodern era. Yet the unifying features of modern institutions are just as central to modernity – especially in the phase of high modernity – as the disaggregating ones ... Taken overall, the many diverse modes of culture and consciousness characteristic of pre-modern 'world systems' formed a genuinely fragmented array of human social

communities. By contrast, late modernity produces a situation in which humankind in some respects becomes a
'we', facing problems and opportunities where there are no 'others'.

(A. Giddens, *Modernity and Self-identity: Self and Society in the Late Modern Age*)

Giddens argues for two important recognitions in his study: firstly, that patterns of fragmentation in society have gone hand in hand with patterns of unification – for instance, through the growth of multi-national capitalist corporations, or through global ecological crises such as the depletion of the ozone layer. The terms 'fragmentation' and 'unification', used in this sense, are not necessarily value-laden – 'good' or 'bad' – although clearly, as we have seen, within cultural criticism, from Fuller's or Jencks's points of view, they may become intrinsically evaluative. Secondly, Giddens argues that these patterns have evolved over the long and continuing period of modern development in western cultures (up to the present, or what he calls the 'late modern' period), which he contrasts with forms of life in traditional societies.

David Harvey, Immanuel Wallerstein and others have claimed that within reorganization of economic activity and relations at local, national, regional and global level such patterns of fragmentation and unification have developed in parallel (D. Harvey, op. cit.; I. Wallerstein, *The Capitalist World Academy*). Broadly speaking, a fragmenting shift has occurred in work-practices from inter-war 'Fordist' principles (based on a high division of labour, mass-production techniques and 'speed-up' technologies) to 'flexible manufacturing' (based on short orders, 'niche' selling and a highly specialized, differentiated rather than homogeneous, market for commodities and services). In terms of corporate ownership, however, 'unifying' forces have created what is often called a 'multinational' or 'paranational' capitalism, with companies owning units of production in many countries and selling in many markets.

This parallel 'fragmentation' and 'unification' is usually dated from the post-Second World War period, although niche marketing is particularly associated with Japanese (and general Pacific basin) economic predominance achieved in the early 1980s. At the same time, a claimed 'softening' of the world economy has taken place, with a shift from corporate capital expenditure on materials such as heavy machinery and raw materials, to a growing percentage spent on software, data servicing, planning and research (L. Forsyth, 'Settling Accounts with Softechnica').

Given the return to relative growth in global capitalism during the 1980s, centred mainly on US and Pacific rim economies, along with the fall of eastern bloc socialist societies and the USSR itself, it was not surprising that a claim would be made that there had occurred an end to a history of global conflict. In such a 'post-Marxist' world, after all, with no ideology or power (Iraqi or otherwise) able to compete with US-brokered 'democratic capitalism', another preferred utopia appeared:

The world's real business in the future will be those economic issues that were pushed to the back of the agenda by the [Iraq-Kuwait] war: issues like competitiveness, deficits, protectionism, education, and the like. And any 'New World Order' will not be built upon abstract principles of international law, but upon the common principles of liberal democracy and market economics . . . with the exception of the Gulf, few regions will have an impact – for good or ill – on the growing part of the world that is democratic and capitalist.

(F. Fukuyama, 'Changed Days for Ruritania's Dictator')

Some of the features identified earlier as characteristic of cultural postmodernism – appropriation of sources, fragmentation of forms, relativizing of codes and conventions, the limitless promotion of differences – might be said to be congruent with Fukuyama's 'end of history' thesis. Capitalist dynamics unleashed, opposed by no critical ideology or morality (state-sponsored or not), could plunder all resources, human and natural, with no respect for the social consequences. This was, as 19th-century writers including Nietzsche, ▷Goethe, Marx and Pushkin saw, the dystopian reality of modernization. Fukuyama invokes and implicitly welcomes this unpredictable dynamic of social change rooted in world capitalist modernization. For while the dynamics are located, overwhelmingly, in specific geo-political regions – the USA, Pacific basin, western European economies – the whole world necessarily is enveloped, or 'unified', within this uneven development.

The postmodern, however, like the modern, has its utopic face as well. The acts of using historical references, promoting differences, foregrounding representation, addressing political issues (based on feminist, ethnic, ecological, anti-capitalist struggles) and invoking ideals of lost community, *may* point

the way to a sense and set of values outside the profit-based dynamics of capitalist modernization and its concomitant cultural imperialisms.

Poststructuralist philosophy, like postmodernism in art and criticism, also has both utopic and dystopic faces. Poststructuralists have attacked traditional notions of 'authorship', 'individuality', 'creativity' and 'expression', casting into radical doubt belief in human nature and human subjectivity. The literary theorist Terry Eagleton has commented that poststructuralists find Enlightenment concepts such as 'justice', 'freedom' and 'emancipation' embarrassing, based as they are on notions of natural and inalienable human rights (T. Eagleton, 'Goodbye to the Enlightenment'). Like forms of analysis usually placed under the rubric of poststructuralism or ▷deconstruction, Eagleton's criticism of Homi Bhabha's study *The Location of Culture* (1994) is an attack on those who, Eagleton claimed, 'resist holistic explanations' in favour of stressing differences and disjunctions.

It is true that the poststructuralist or deconstructionist work of Derrida and Foucault, for example, certainly has stressed such features in social and cultural phenomena. For example, Foucault, in his *History of Sexuality* series, attempted to explore the complex history and character of sexual practices and relationships understood as a set of mutating autonomous forms which are *not* seen as determined by class or state forces and discourses. This was clearly an attempt to counter Marxist accounts of cultural history which saw all such phenomena (including sexual behaviour) as 'determined' by developments in economic structures and relationships. However, such an acknowledgement of difference and disjunction need not result in a form of philosophical relativism bereft of concepts of right and wrong, or, indeed, 'justice' and 'freedom'.

Derrida, usually regarded as the leading poststructuralist, has stated specifically, in fact, that the radical impulse within the movement of deconstruction was, and is:

> . . . *impossible without vigilant and systematic reference to a Marxist problematic, if not to the Marxist conclusions regarding the state, the power of the state, and the state apparatus, the illusions of its legal autonomy as concerns socio-economic forces, but also regarding new forms of a withering or rather a reinscription, a re-delimitation of the state in a space that it no longer dominates and that moreover it never dominated without division.*
>
> (J. Derrida, 'Spectres of Marx').

Postmodernism, then (understood here as an umbrella term including theory and politics termed poststructuralist or deconstructive) may be viewed from this perspective as critical and utopic, turned against the capitalist dynamics of global social modernization.

Conclusion

Three conclusions clearly follow from the above discussion. Firstly, no matter how attractive or convincing an analogy might appear between the identification of a phenomenon like 'fragmentation' in postmodernist art (for instance, in a Salles painting) and 'fragmentation' understood as a feature of economic or social relations in the postmodern world, the connection is merely provisional or suggestive, based on formal or terminological grounds. Neither can the postmodern world (understood as 'social being') be said to determine in any simplistic way the form or content of postmodernist art (understood as a kind of 'social consciousness'). In any case, the analogy itself is only possible when *one* feature is selected from *one* kind of postmodernist art and then mapped on to another selected feature said to be characteristic of postmodernity. As suggested above, a counter-pattern of 'unification' might also be identified in both postmodernist art (e.g. a return to naturalism and narrative) and in postmodern 'multinational' capitalism. The same strictures on the counter-analogy apply.

Secondly, to invest in postmodernist art as a kind of 'critical consciousness' or set of representations able to 'resist' continuing capitalist modernization (along with concomitant forces of imperialism, militarism, racism, etc.) may be to risk illicitly giving priority to one kind of activity or production over others. This is a postmodernist equivalent to what used to be known as the belief in 'socialism in one art work' – the notion that a form of cultural production or style (like Realism) could *in itself* constitute a viable mode of struggle against forces of commodification and social decay. On the other hand, the role of films, posters, videos, paintings, etc. should not be underrated either: they can form an important part of organization against entrenched power.

Thirdly, there is nothing to be gained from minimizing differences in judgements made by radical and conservative critics of artistic postmodernism. Although it is the case that different critics are

always highly selective in their choice of works, because such tactical choices allow them to propound preferred theses about decay or innovation, these traditions of criticism can, in most cases, be traced back to much earlier positions developed in relation to modern, not postmodern, art and society. Peter Fuller, for example, was quite open in his affiliation to what he thought ▷John Ruskin and ▷William Morris stood for at the end of the 19th century. Once again, the continuum between modern and postmodern seems much more important than the claimed differences. The range of features said to constitute postmodern society and culture is also as diverse, as opaque semantically, and as subject to reconceptualization as the range said to define the modern.

Should the terms postmodernism, postmodernity, and the postmodern be shelved, then, or do they have some specific value in understanding contemporary culture and society? If used with the qualification given at the beginning of this essay, which emphasized the senses of both 'difference from' and 'continuity with' an earlier moment or concept, the cluster of terms may sometimes function to allow greater specificity of historical and social analysis, if deployed within rigorous analytic parameters (though this is not typical of most writing on postmodernism). Different historical notions of both 'modern' and 'postmodern' have always existed within the wide rage of academic disciplines and critical frameworks which have tried to understand western culture since the 19th century. If, on the other hand, postmodernism is used as a concept to attempt to signal some fundamental or final break with modernity, that is, with the past history of human social and cultural organization during the 19th and 20th centuries, then this usage, and claim, when examined, is nonsensical and cannot reflect a serious intellectual intent.

Finally, getting 'beyond the fragments' of traditional socialist politics (encumbered as it certainly was by sexist and racist values and practices) and trying to form alliances between groups concerned with gender relations, ethnicity, regional identity, ecology or whatever, may constitute a form of 'postmodern politics' able to operate in parallel with *some* forms of critical postmodernist art. Barbara Kruger's and Martha Rosler's image-text work during the 1980s and 90s reintroduced political issues and questions, and further buried the Greenbergian formalist doctrine of 'aesthetic autonomy' and apolitical 'modern specialization' in the arts. But neither political activism not artistic photomontage on their own add up to an oppositional culture. The culture of 19th- and 20th-century modernism *itself* offers much, now on the historical and cultural margins, in the way of critiques of actual society and views of projected kinds of society radically different from that within industrial capitalism. In this sense, once again, the 'modern' and 'postmodern' are inseparable, despite arguments to the contrary.

Raymond Williams has suggested:

> If we are to break out of the nonhistorical fixity of post modernism, then we must search out and counterpose an alternative tradition taken from the neglected works left in the wide margin of the century, a tradition which may address itself not to this by now exploitable because quite inhuman rewriting of the past but, for all our sakes, to a modern future in which community may be imagined again.
>
> (R. Williams, 'When was Modernism?')

That tradition of social radicalism in the visual arts, stretching from Courbet in the 1840s to the 1960s ▷Situationists and beyond, is a reservoir of images, ideas and values in need of reassessment and reappropriation.

Bibliography

Berman, M., *All That Is Solid Melts into Air: The Experience of Modernity,* London, 1991
Bhabha, H., *The Location of Culture,* London, 1994
Chomsky, N., *Language and Politics,* Montreal, 1988
Clark, T.J., 'The Conditions of Artistic Creation', *Times Literary Supplement,* 24 May 1974, pp. 561–2
Davis, M., 'Junkyard of Dreams', in *City of Quartz: Excavating the Future in Los Angeles,* New York, 1992, p. 417
Derrida, J., 'Spectres of Marx', *New Left Review* (no. 205, May–June 1994), pp. 31–58
Eagleton, T., *Literary Theory: An Introduction,* Oxford, 1983

Eagleton, T., 'Goodbye to the Enlightenment', *The Guardian*, 9 February 1994, p. 17

Forsyth, L., 'Settling Accounts with Softechnica', *Here and Now* (no. 11, 1991), pp. 26–8

Foster, H. (ed.), *Postmodern Culture*, London, 1985

Foucault M., *The History of Sexuality*, London, 1979

Frascina, F., 'A Sign of Appropriation', *Art Monthly* (no. 181, November 1994), pp. 40–41

Frascina, F. and Harris, J., (eds.), *Art in Modern Culture*, London, 1992

Fried, M., *Three American Painters: Kenneth Noland, Jules Olitski, Frank Stella*, exh. cat., Cambridge, MA, 1965

Fukuyama, F., 'Changed Days for Ruritania's Dictator', *The Guardian*, 8 April 1991, p. 19

Fuller, P., *Images of God: The Consolations of Lost Illusions*, London, 1985

Giddens, A., *Modernity and Self-identity: Self and Society in the Late Modern Age*, Cambridge, 1991

Gunn, S., *Revolution of the Right: Europe's New Conservatives*, London, 1989

Hall, S., Held, D. and McLennan, G. (eds.), *The Idea of the Modern State*, Milton Keynes, 1984

Harvey, D., *The Condition of Postmodernity: An Enquiry into the Origins of Cultural Change*, Oxford, 1990

Hebdige, D., 'A Report on the Western Front: Postmodernism and the "Politics" of Style', *Block* (no. 12, 1986/7), pp. 4–26

Hoesterey, I. (ed.), *Zeitgeist in Babel: The Post-modernist Controversy*, Bloomington, 1991

Jameson, F., *Postmodernism, or the Cultural Logic of Late Capitalism*, London, 1991

Jencks, C., *The Language of Postmodern Architecture*, London, 1987

Jencks, C. (ed.), *The Postmodern Reader*, London, 1992

Krauss, R., (with an essay by N. Bryson), *Cindy Sherman 1975–1993*, New York, 1993

Laclau, E. and Mouffe, C., *Hegemony and Socialist Strategy: Towards a Radical Democratic Politics*, London, 1985

Lyotard, J.-F., *The Postmodern Condition: A Report on Knowledge*, Manchester, 1984

Marx, K., 'Speech at the Anniversary of the *People's Paper*', in R.C. Tucker (ed.), *The Marx–Engels Reader*, New York, 1978

Norris, C., *Uncritical Theory: Postmodernism, Intellectuals and the Gulf War*, London, 1992

Rowbotham, S., Segal, L. and Wainwright, H., *Beyond the Fragments: Feminism and the Making of Socialism*, London, 1980

Said, E., *Culture and Imperialism*, London, 1993

Sturrock, J., *Structuralism and Since*, London, 1979

Tönnies, F., *Community and Association* (first published 1887), trans. C. Loomis, London, 1955

Wallerstein, I., *The Capitalist World Academy*, Cambridge, 1979

Williams, R., *The Year Two Thousand*, New York, 1983

Williams, R., 'When was Modernism?', in R. Williams, *The Politics of Modernism: Against the New Conformists*, ed. T. Pinkney, London, 1989

Reference Section

Aalto, (Hugo) Alvar (Henrik) (1898–1976)

Finnish architect. He was a leading and highly influential architect of the 20th century, working mostly in his native Finland. His earliest buildings were in a typically Scandinavian form of ▷Neoclassicism (e.g. Workers' Club, Jyväskylä, 1923–5), but in the late 1920s he began designing buildings in the ▷International Style, the most important being the Municipal Library at Viipuri (1927, 1930–35), the Sanatorium at Paimio (1928, 1929–33) and Cellulose Works and residential complex at Sunila (1936–9, 1951–7). Aalto had a strong feeling for materials and in his buildings sought to bring out their basic characters. Finland being heavily forested, Aalto had a special affinity with timber – an element used to great expressive effect in his Finnish Pavilion for the Paris *Exposition Universelle* of 1937 and in many of his buildings (e.g. the Villa Mairea at Noormarkku, 1937–8). He also invented a totally original type of furniture in bent plywood, marketed as Artek Wooden Furniture, in collaboration with his first wife, the architect, Aino Marsio (married 1925; d 1949). His most important buildings date from after the Second World War, during which time he played a leading part in the reconstruction of Finland. Mostly in brick and timber, they are characterized by the use of curving walls and single-pitched roofs, and include a Hall of Residence at the Massachusetts Institute of Technology (1947–9); the Town Hall at Säynätsalo (1949, 1950–52); the Vuoksenniska Church at Imatra (1952–8); and, his most celebrated building, the Finlandia Concert Hall, Helsinki (1970, 1973–5).
Bib.: Pearson, P.D., *Alvar Aalto*, New York, 1978, 1980; Quantill, M., *Alvar Aalto: A Critical Study*, London, 1983

Aaltonen, Wäino (1894–1966)

Finnish sculptor. Aaltonen came to prominence after the Finnish liberation from Russia in 1918. His public and monumental sculptures were produced in a Realist mode and responded to Finnish nationalist sentiment in the wake of liberation. Aaltonen also produced sculpture busts of distinguished Finnish cultural figures, including Sibelius (1928).

abacus

In Classical architecture, the flat square slab of masonry between the top of the ▷capital of a column and the superincumbent ▷architrave. The edge varies according to the type of capital: Greek ▷Doric has straight unembellished edges; the profile of Greek ▷Ionic, ▷Tuscan, ▷Roman Doric and Roman Ionic is straight but the lower edges are moulded; and ▷Corinthian and Composite have inward-curving edges with truncated corners.

Abbate, Niccolò dell' (c1512–71)

Italian painter. He was a ▷Mannerist, whose early influences include ▷Parmigianino, ▷Correggio (particularly in his use of ▷sfumato) and ▷Dosso Dossi (landscapes). He was trained and began his career in Modena, painting a ▷fresco cycle of the *Aeneid* at Rocca di Scandiano, near Modena (1540) and frescos in Sala dei Conservatori of the Palazzo Pubblico in Modena (1546). By the time he moved to Bologna he had developed his mature manner, consisting mostly of fantastic landscapes with mythological or secular themes. This can be seen in the frescos in the Palazzo Pozzi, Bologna (1547), now the library of Bologna University; and the decorations of the Palazzo Torfanini, which include episodes from *Orlando Furioso* (now Bologna, Pinacoteca). In 1552 Niccolò was invited to ▷Fontainebleau by Henry II to assist ▷Primaticcio in the decoration of the Royal chateau. He remained in France for the rest of his life, much of the time working in collaboration with Primaticcio, with whom he represents the end of the first school of Fontainebleau. Niccolò's essentially decorative landscapes are typically Mannerist fantasies with high viewpoints and panoramic vistas in which human action fulfils only a subordinate role.

Abbey, Edwin Austin (1852–1911)

American painter and illustrator. He worked primarily in England. Abbey began his career as an illustrator for publishing houses in Philadelphia and New York, where he worked for *Harper's Weekly*. He was sent on an assignment to London in 1878. This visit stimulated his interest in subjects from English literature, and he subsequently produced a number of illustrations to Shakespeare's plays and other English classics. His large frieze-like compositions were admired or abjured for their flatness and intense colourism. He drew inspiration from the tableaux and sets of the contemporary English stage, especially the historical productions of Henry Irving. He was elected an ▷RA in 1898. On his return to the United States, he transferred his skills to ▷mural painting, and among other works, he

Edwin Austin Abbey, from 'Vanity Fair', 1898

produced scenes of Arthurian legend for the walls of the Boston Public Library (1902).

Bib.: *Edwin Austin Abbey (1852–1911)*, exh. cat., New Haven, 1973; Simpson, M., 'Windows on the Past: Edwin Austin Abbey and Francis Davis Millet in England', *American Art Journal*, 22/3 (1990), pp. 64–89

Abbott, John White (1763–1857)

English artist. He was an amateur landscape painter, born in Exeter where he trained with ▷ Francis Towne, whose style his work closely resembles. Through the patronage of his uncle he met ▷ Reynolds, ▷ West and ▷ Beaumont. Although he exhibited regularly at the ▷ Royal Academy from 1793 (yearly until 1805, then 1810 and 1822), he continued to practise medicine and rose from being an apothecary to a surgeon. Throughout his life he made a series of sketching tours in Scotland (1791) and Wales (1797). He exploited a range of media, exhibiting oils and watercolours in a conventional pastoral style (e.g. *Canonteign Devo*, 1803, Birmingham gallery; *Helm Crag and Grassmere Lake*, 1791, private collection). Today his drawings are more highly prized. He died in Exeter, a respected member of the local gentry.

Bib.: *Francis Towne and John White Abbot*, exh. cat., Exeter, 1973

Abbott, Lemuel Francis (c1760–1802/3)

English painter. He was the son of a Leicestershire clergyman. He moved to London in 1784 and exhibited at the ▷ Royal Academy, although he never became an ▷ RA. He specialized in portraits and produced famous likenesses of Nelson and literary figures, such as the poet Cowper. In 1798, he was declared insane.

Bib.: Sewter, A.C., 'Lemuel Francis Abbott', *Connoisseur* (April 1955), pp. 178–83

abbozzo

(Italian, 'sketch', 'outline') Term applied (i) in painting to the outline sketch of the composition drawn onto the support, and (ii) in sculpture to the block rough-hewn to an approximation of the form of the finished piece.

Abercrombie, Sir Patrick (1879–1957)

English town planner. Abercrombie trained under Patrick Geddes, and he was one of a number of individuals who helped restore decimated towns after the Second World War. He worked in areas as diverse as London and Plymouth. His plans were based on the topographical layouts of cities, rather than architectural factors.

Bib.: Manno, A., *Patrick Abercrombie: A Chronological Bibliography*, Leeds, 1980

Abildgaard, Nicolai Abraham (1743–1809)

Danish painter, draughtsman and designer. He lived in Italy in 1772–9 and became part of a circle of artists and intellectuals, including the Swiss painter ▷ Henry Fuseli, ▷ Winckelmann and ▷ Mengs. Influenced there by the advent of ▷ Neoclassicism, he returned to Copenhagen to perpetuate the Neoclassical idiom in Denmark. Among his works are a series of ▷ allegorical paintings in the Copenhagen Royal Palace. He also designed severe furniture decorated with Neoclassical motifs. His skill and success led to his election as Director of the Copenhagen Academy in 1789, and he held the post until 1791 and again 1801–9.

Bib.: *Fire danske klassikere: Nicolai Abildgaard, Jens Juel, Christoffer Wilhelm Eckersberg og Bertel Thorvaldsen*, exh. cat., Oslo, 1992

Aboriginal art

This is the art produced by native Australians from prehistory to the present day. The Aboriginal peoples produced different sorts of work, depending upon the geographical limitations of their regions. These cultures have traditionally used the body, rock surfaces, bark, stone and wood as the support for ▷ pigments of natural ochre dyes, along with charcoal and kaolin, although much recent Aboriginal art has adopted ▷ acrylic paint on canvas. There is a great variety of this art, which ranges from the naturalistic to the stylized, and encompasses both the decoration of useful objects and ritualistic or ceremonial symbolism. Both humans and animals are represented. Some of the distinctive features of aboriginal artefacts are the *wondjina* – representations of skull-like human forms without mouths which may have been used in ceremonies of ancestor

him. At Salem Abraham met the king and high priest of Sodom, Melchizedek. The king offered bread and wine and Abraham, in return, gave up a tenth of his spoils of victory. The meeting prefigures the ▷Last Supper and Abraham's donation represents the tithe. Melchizedek is usually represented in priest's robes with a crown or mitre. Abraham is sometimes shown in military garb (S. Maria Maggiore, Rome, mosaic, c440; Chartres north portal, c1194; ▷Rubens, 1625, Washington, National Gallery).

(ii) The meeting with the three angels. Three strangers arrived at Abraham's tent. Having recognized them as angels, Abraham offered food and hospitality. They prophesied that his wife, Sarah, would conceive a son (Isaac), despite her old age. The scene came to symbolize many things: the three angels represent the ▷Trinity; their news prefigures the New Testament ▷Annunciation; and, especially in the ▷Counter Reformation, Abraham's conduct was held up as the epitome of hospitality. Abraham is often shown washing the feet of the angels, an association with Christ's washing of Peter's feet at the Last Supper. The angels are usually made identifiable with wings and haloes. The scene is represented in mosaic at S. Vitale, Ravenna. (e.g. ▷Murillo, *Abraham and the Three Angels*, Ottawa, National Gallery of Canada; ▷Tiepolo, 1725, Udine)

(iii) The Sacrifice of Isaac. The most famous episode in Abraham's life. As a test of faith God told Abraham to sacrifice his only son. Travelling to the place of execution, Abraham is usually shown on an ass and Isaac walks at this side carrying wood to make an altar. At the last moment, Isaac was saved by the intervention of an angel. They found a ram in a nearby thorny thicket and sacrificed that instead. The scene was popular for symbolic and dramatic reasons. It prefigures the sacrifice of Christ in the New Testament; the ass recalls his arrival in Jerusalem on Palm Sunday; the wood carried by Isaac, the cross itself; the thicket, the crown of thorns. Traditionally the scene was supposed to have taken place in Jerusalem, on the site of the Dome of the Rock. Equally, however, artists were attracted to the suspense and the most common depiction was of the arrival of the angel seconds before Isaac's death. Most famously, this was the scene of ▷Ghiberti's prize-winning entry in the Florence Baptistry doors competition in 1401. The scene is recorded from the 3rd-century Duras Europos synagogue, Syria; Chartres north portal c1194; ▷Donatello, 1421, Florence; ▷Rembrandt, 1635, St. Petersburg, Hermitage; ▷Titian, 1542, Sta Maria Della Salute, Venice.

Another common subject in painting, connected with Abraham, is the depiction of Hagar in the desert. Hagar was his first wife, abandoned with her son, Ishmael, but rescued from starvation by an angel (e.g. ▷Lucas van Leyden, *Hagar in the Wilderness*, c1508; Rembrandt, 1640, London, Victoria and Albert Museum).

Aboriginal art: Nym Bunduk, *Snakes and Elms*, Musée des Arts d'Afrique et d'Océanie, Paris

worship – and the 'X-ray' art of the Oenpelli area, which depicts the internal organs of humans and animals. Although the notion of 'art' with its connotations of Western non-functionalism is inappropriate, Aboriginal production, always bearing in mind the cultural and linguistic diversity of the different Aboriginal peoples, may be roughly divided into work on artefacts; on rock walls (which often indicate identification of the artist with a site of cultural significance); and imagery that functions with patterns of ritual, such as the ▷iconography recording the 'Dreaming', the account of Aboriginal social and cultural relations and the history of their land. Aboriginal peoples have also practised ▷body art. In recent years, native Australian peoples have adopted western techniques of using paint on canvas, and the original religious resonances of their earlier art have been diluted or lost.

▷Australian art

Bib.: Berndt, R.M., *Aboriginal Australian Art: A Visual Perspective*, 2nd edn, Port Melbourne, 1992; Morphy, H., *Ancestral Connections: Art and an Aboriginal System of Knowledge*, Chicago, 1991; Sutton, P. (ed.), *Dreamings: the Art of Aboriginal Australia*, New York, 1991

Abraham

The first of the Great Hebrew patriarchs, father of ▷Isaac and Ishmael, uncle of Lot. Three episodes of this life have commonly been represented by artists:

(i) The meeting with Melchizedek. Lot left Canaan to settle in Sodom but was captured there along with his possessions. Abraham, with an army of 300, rescued

Abramtsevo Colony

The name given to a group of Russian artists working in the 1870s and 1880s. With the patronage of the wealthy railway magnate ▷Savva Mamontov and his wife Elizaveta, this group (including the ▷Wanderers ▷Repin and Serov) congregated in the country estate of Abramtsevo, 30 miles outside Moscow, and cultivated the revival of Russian ▷folk-art traditions. They not only painted scenes from Russian history, but ▷Vasnetsov designed and decorated a church for the estate which was based on medieval Russian models. The group's concern with maintaining Russian folk art led them to found a museum at Abramtsevo, as well as a ceramics workshop. The group was also interested in the interrelationship between the arts, and they perpetuated a Russian version of the ▷Arts and Crafts movement.

Bib.: Harris, D., 'A Russian Bloomsbury: visiting the Pre-revolutionary Idyll of Abramtsevo', *Architectural Digest*, 47 (March 1990), pp. 86–93

Abstract Expressionism

A term first used in connection with ▷Kandinsky in 1919, but more commonly associated with post-war American art. Robert Coates, an American critic, coined it in 1946, referring to ▷Gorky, ▷Pollock and ▷de Kooning. By the 1951 ▷Museum of Modern Art exhibition 'Abstract Painting and Sculpture in America', the term was used to refer to all types of non-geometric ▷abstraction. There are two distinct groups within the movement: ▷Colour Field artists (▷Rothko, ▷Newman, ▷Still) worked with simple, unified blocks of colour; and gestural painters like ▷Pollock, ▷De Kooning and ▷Hofmann who made use of ▷Surrealist techniques of automatic art. Not all the artists associated with the term produced either purely abstract, or purely ▷Expressionist work: Harold Rosenburg preferred the phrase ▷Action Painting, whilst ▷Greenberg used the less specific 'American Type Painting', and because of the concentration of artists in New York, they are also known as the ▷New York School. The only real connection between Abstract Expressionists was in their artistic philosophy, and publications like *Tiger's Eye*, an ▷avant-garde magazine that helped spread their ideas. All were influenced by Existentialist ideas, which emphasized the importance of the act of creating, not of the finished object. Most had a Surrealist background, inspired by the presence of ▷Breton, ▷Masson and ▷Matta in New York in the 1940s and by retrospectives on ▷Miró (1941) and Kandinsky (1945), and the Abstract Expressionists sought to express their subconscious through their art. They also shared an interest in Jung's ideas on myth, ritual and memory (inspired by exhibitions of African and American Indian art in 1935 and 1941 respectively) and conceived an almost ▷Romantic view of the artist, seeing their painting as a way of life and themselves as disillusioned commentators on contemporary society after the Depression and the Second World War. Other American artists associated with the movement were ▷Motherwell, ▷Tobey, ▷Kline and ▷Philip Guston.

Post-War European painting has also witnessed forms of Abstract Expressionism (▷Tachisme).

Bib.: *Abstract Expressionism*, exh. cat., Liverpool, 1993; Anfam, D., *Abstract Expressionism*, London, 1990; Auping, M., *Abstract Expressionism*, London, 1987; Sandler, I., *Abstract Expressionism: The Triumph of American Painting*, New York, 1970; Shapiro, D. and C., *Abstract Expressionism*, Cambridge, 1990

abstraction

This is a confusing and misleading term, frequently used incorrectly. Strictly speaking, abstraction involves an art form which simplifies or schematizes the object of imitation, but still regards the basic form of that object. Much non-western and tribal art is abstract, as representations of human bodies and animal forms, for example, are still recognizable as such, although no attempt has been made to imitate those forms faithfully. In the early 20th century, the ▷Cubists developed an abstract art form which was particularly effective for still-life painting. Abstraction of form and colour was used differently by the ▷Fauves, the ▷Orphists and ▷Léger, among others. ▷Kandinsky moved abstract art away from the purely optical sphere, when he developed a theory of the relationship between forms, colours and spirituality. By 1911 his works were no longer based on representation. It is here art entered the realms of the purely non-representational or ▷non-objective. Movements such as ▷De Stijl in Holland, ▷Constructivism in Russia and ▷Abstract Expressionism in the United States advocated art forms which bore no relationship to observable reality. This type of artistic production is also called abstract, although the term has become an umbrella phrase for any art based on colour and form, rather than the imitation of reality.

▷non-objective

Bib.: *Abstraction: Towards a New Art: Painting, 1910–20*, exh. cat., London, 1980; Harrison, C., *Primitivism, Cubism, Abstraction: The Early Twentieth Century*, New Haven, 1993; Osborne, H., *Abstraction and Artifice in Twentieth-Century Art*, Oxford, 1975; Worringer, W., *Abstraktion und Einfühlung*, (1907), Eng. trans. as *Abstraction and Empathy*, London, 1953

Abstraction-Création

A loosely connected group of artists, based in Paris from 1931. The founders of the group, August Herbin, Jean Hélion and ▷Georges Vantongerloo formed the group as a means of fostering various forms of abstract art in the wake of a return to representation in the 1920s. They founded a journal *Abstraction-création: Art non-figuratif*, which was published from 1932 to 1936, and they held annual exhibitions, drawing together

Paul Klee, *Abstract Composition of Houses*, Nordiska Museum, Stockholm

abstract works from all over Europe. However, the group was not prescriptive, and it included painters and sculptors whose practices and artistic ideals were radically diverse. ▷Mondrian, ▷Arp, ▷Gabo and ▷Pevsner were all connected with the group.
Bib.: 'Abstraction-Création 1931–1936', exh. cat., Münster, 1978

abutment

The solid masonry of a wall or ▷pier which resists and supports the lateral pressure exerted by an ▷arch or ▷vault.

academic (art)

A descriptive phrase, often used pejoratively, to refer to painting or sculpture created within an ▷academy system. Academic art tended to be idealistic and concerned mainly with grand historical themes. ▷Avant-garde artists made a point of rejecting it.
▷Grand Manner

Académie Julian

A Parisian art school founded in 1860 by Rodolphe Julian. It was one of several académies in Paris that flourished as training institutions because of the rigid entry standards of the ▷École des Beaux-Arts. Artists who hoped to gain entry to the École often began here and at similar académies with the hope that they could eventually gain entrance to the official art schools. However, the Académie Julian also became a particular focal point for artists who were later associated with the ▷avant-garde, such as ▷Matisse, ▷Léger and ▷Derain.

Bib.: Fehrer, C., *The Julian Academy, Paris 1868–1939*, New York, 1989

Académie Royale de Peinture et Sculpture

The French ▷academy of art. It was founded in 1648 by a group of artists under the auspices of King Louis XIV and his minister Colbert. It served to break the hegemony of the ▷guild system in France and give artists control of their own professional life. Its first director was ▷Charles Lebrun, and from the beginning it promoted a serious and severe form of ▷history painting, based on rigid rules of ▷composition and design.

academies

These were élite institutions which formed a basis for professional artistic activity in both Europe and America from the 16th century onwards. The growth of academies contributed to the demise of the ▷guild system and established systems of training and exhibition that dominated artistic production in the 17th, 18th and early 19th centuries. During the Italian ▷Renaissance, academies took a number of different forms, and they sometimes served as informal forums to allow discussion among intellectuals about philosophy and literature. By the late 16th century, academies became larger and more formal and were patronized by wealthy and powerful individuals who wished to be involved in the cultivation of the arts. It was at this point that the first academy of art was founded by Cosimo ▷de' Medici in Florence. The Accademia del Disegno was opened in 1562, and ▷Michelangelo was involved in its founding. In 1593, the Accademia di S. Luca was opened in Rome, and in 1598 the ▷Carracci founded an academy in Bologna. Each of these regional institutions was designed to provide an informal training establishment for artists, but they also conferred status on the artist through membership.

The academy system was formalized in France during the 17th century, when the ▷Académie Royale was founded in 1648. It was the first national academy in Europe, and it was manipulated by the vice-protector Colbert as an agency of Louis XIV's absolutist aspirations. The French academy centralized teaching and sponsored a series of ▷Salon exhibitions which were at first held sporadically, and then regularly during the 18th century. The French academy also opened a training branch in Rome, and its artists, such as the director, ▷Charles Lebrun, produced a body of theoretical writing which set the standard for academic aspirations for nearly 200 years.

Other academies were founded in the 18th century, including regional academies in Spain and Germany, and the English ▷Royal Academy (1768). The English Royal Academy perpetuated French academic values through the Discourses of its president, ▷Sir Joshua Reynolds, but the academic ideal of the educated artist producing ▷history paintings was undercut by the

reality of the marketplace which, in England, demanded portrait and landscape painting. While in England and France, academies maintained a stranglehold on the art world, in other countries, academic membership was as much an honour conferred on distinguished artists as a tightly-organized and well-established professional body.

The power and authority of the academies were challenged as early as the 1780s, when ▷David and a group of young French painters began questioning the hegemony of the French academy and the exclusivity of the Salon. After the ▷French Revolution, the academy was abolished in 1793, but fully reinstated, with a different structure, in 1816. As art gained a wider bourgeois patronage during the 19th century, the power of the academies was undermined by rival exhibition societies, private training schools and the power of the art dealer.

While academic values were being questioned and challenged in Europe, the United States began opening its first academies. In 1802 the New York Academy of Fine Arts (later the American Academy of Fine Arts) sponsored exhibitions. The ▷National Academy of Design (founded 1825) in New York had both an antique school and a life class, and the Pennsylvania Academy of the Fine Arts (founded 1805) arranged for paintings and sculptures to be accessible for artists to copy.

Academies still exist today, but their power and influence has been diluted in the last century by a ▷Romantic admiration for individualist artists and the greater power of an artistic free market. Academies were notorious for their exclusion of women and their 'closed shop' system of promoting their own members, but they did contribute to a professionalization and liberalization of the art profession until the 20th century when they have become honours, rather than necessities, for artists.

Bib.: Boime, A., *The Academy and French Painting in the Nineteenth Century*, London, 1971; Fink, L.M., *Academy: The Academic Tradition in American Art*, Chicago, 1978; Hutchison, S., *The History of the Royal Academy, 1768–1986*, 2nd edn, London, 1986; Pevsner, N., *Academies of Art, Past and Present*, Ann Arbor, 1967; Yates, F., *The French Academies of the Sixteenth Century*, 2nd edn, London, 1988

academy board

A type of pasteboard commonly used by amateur and professional artists in the 19th century. An academy board is composed of pieces of paper pressed together and treated with a rough ▷ground. Its most common use was for sketching, and it was most appropriate for small pictures.

▷canvas board

academy figure

A life drawing of a nude male or female. Academy figures were produced as part of the academic training of artists. They were not intended as studies for finished paintings but as practices in the art of drawing the nude. The nudes were usually formally posed.

acanthus

A common Mediterranean plant whose large scalloped-edged leaves are used in conventionalized form as the distinctive decoration of ▷Corinthian and ▷Composite ▷capitals, and also on ▷friezes and mouldings.

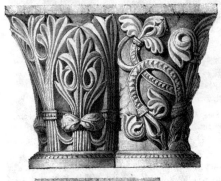

Acanthus

Accademia di Belli Arti, Venice

The municipal picture collection of the city of Venice, opened to the general public on 10 August 1817. It was founded in 1807 by decree of Napoleon, amalgamating the collection of the old academy (hence the name, 'Accademia'), with collections from suppressed monasteries and churches. The building complex taken over and restructured (1807–10) to accommodate the collection includes the former Scuola Grande and Church of Santa Maria della Carità, and ▷Palladio's Convento dei Canonici Lateranensi. Though the interiors of the convent and the church were radically altered, that of the Scuola was not and two works of major importance, painted for the Scuola, are still in their original settings: *The Madonna with Four Saints*, 1446, by ▷Antonio Vivarini and Giovanni d'Alemagna, and *The Presentation of the Virgin*, 1534–9, by ▷Titian. Solely devoted to paintings of the Venetian School, the collection has been continually added to over the succeeding years and represents the most

comprehensive collection of Venetian paintings in the world.

Bib.: Sciré, G.N. and Francesco Valcanover, *Accademia Galleries of Venice*, Milan, 1985

Acis

▷Galatea

Ackermann, Rudolf (1764–1834)

German art publisher and bookseller. He was born in Stolberg, Saxony, the son of a coach builder. After working for his father, he travelled widely, eventually establishing himself as a designer of coaches in London. In 1795 he opened a shop on the Strand and became famous for producing topographical and travel books, like the *History of the University of Oxford* (2 vols., 1814) and *Microcosm of London* (3 vols., 1808–11). He also published a number of popular magazines (*The Repository of the Arts, Literature and Fashion . . .*, 1809–28), and illustrated annuals, a form he introduced to Britain (e.g. *Forget-me-not*, 1825–47). He introduced ▷lithography to England in 1817 and employed a number of famous illustrators of the day, like ▷Rowlandson and ▷Pugin. He also patented a method of waterproofing paper. From 1796–1806 he ran a successful drawing school.

Bib.: Ford, J., *Ackermann: The Business of Art*, London, 1983

Acropolis

An acropolis was the fortified citadel of an ancient Greek city, the most famous being that at Athens, which is now simply referred to as the Acropolis.

An acropolis contained the chief civic buildings and principal temples of a city, although by the 6th century BC the Acropolis at Athens had largely been given over to religious usage. In 480 BC the Persians overran Athens and destroyed all the buildings on the Acropolis, including the beginnings of a temple celebrating the Athenian victory at Marathon and dedicated to Athena. Following the Greek naval victory that same year at Salamis, the Athenians returned to Athens and set fragments of the columns from the ruined beginnings of the temple to Athena into the walls of the north side of the Acropolis overlooking the ▷agora (the main commercial centre of the city) as a kind of war memorial. In c449 BC peace was finally established with Persia and Athens (which, under its leader Pericles, was by now the dominant force in the Greek league of states against Persia), decided to appropriate all surplus war funds for the purpose of building a new temple to Athena (i.e. the Parthenon, 447–32 BC). ▷Ictinus and ▷Callicrates were selected as architects, and ▷Phidias as sculptor – Phidias was to make the colossal gold and ivory statue of Athena to be housed in the Parthenon, and to supervise the many sculptors hired to carve the architectural sculpture on the exterior. The Parthenon is generally regarded as the supreme example of ▷Doric architecture. The next important building to be erected on the Acropolis was the Propylaea (437–32 BC) – the monumental gateway to the mound. It is a mixture of Doric (for the exterior columns of the flanking porticoes) and ▷Ionic (for the columns lining the road passing through the gateway). The Ionic Temple of Athena Nike (427–24 BC) by Callicrates, and the Erectheum (421–5 BC) by

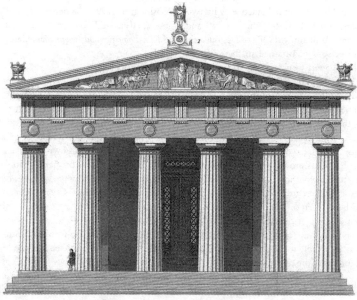

Acropolis, Athens

an unknown architect complete the list of the surviving buildings that make up the temple complex of the Athenian Acropolis.

acrosilium

▷catacomb

acroterion (pl. acroteria)

Properly, the blocks or pedestals supporting statues or ornaments, placed on the apex and at the lower angles of a ▷Classical ▷pediment. More loosely, both the pedestals and the statues of ornaments they support.

acrylic

A type of paint which dries more quickly than oil. Its ▷medium is acrylic resin, hence the name.

Actaeon

▷Diana

Adam, François Gaspard (1710–61) and Lambert Sigisbert (1700–59)

Family of French sculptors. Lambert spent time in Rome (1722–33) and returned to France to produce fountains in the style of ▷Bernini. Bernini's Neptune Fountain was the prototype for Lambert's Neptune Fountain in Versailles (1740). François also travelled and won the patronage of Frederick the Great.

Adam, Robert (1728–92)

Scottish architect, interior decorator and furniture designer. He was the most influential designer of his generation, whose style of interior decoration spread beyond Britain to Russia and the USA making him even today a household name. The second of the four sons of the Scottish architect, William Adam, Robert was later assisted in his architectural practice by his two younger brothers, James (1732–94; chief of staff and draughtsman) and William (c1738–1822; business manager): all three sons had trained in their father's office. In 1754–8 Robert went on his ▷Grand Tour. In Rome he studied Roman Imperial architecture, particularly the public baths, and from Rome he travelled to Spalato (Split) in Dalmatia to study the Palace of Diocletian, the results of which he published in 1764 in his *Ruins of the Palace of the Emperor Diocletian at Spalato*, with a preface outlining his views on architectural design. This proved to be a key work in Adam's architectural revolution: all previous ▷Neoclassical domestic architecture, taking the lead from ▷Palladio, had been based on temple and civic building designs, but Adam was the first architect to base his classical designs on those of a private dwelling. His belief that it was acceptable to alter and modify details of the Classical orders in the pursuit of a ▷picturesque elegance (he aimed to 'transfuse the beautiful spirit of antiquity with novelty and variety') led to considerable opposition from the architectural establishment, and

he was never elected to the ▷Royal Academy.

In 1758 Adam settled in London (followed in due course by his brothers), one of his first important commissions being the columned Admiralty Screen (1759–60). His most ambitious commission, the creation of the Adelphi Terrace along the north bank of the Thames was, however, abandoned owing to the exorbitant cost of the scheme which almost bankrupted him. It is perhaps for his interiors that he is best remembered today, the most important being at Harewood House (1758–71), Kedleston Hall (1760–61), Syon House (1760–69), Osterly Park (1761–80), Luton Hoo (1766–70), Newby Hall (1767–85) and Kenwood (1767–9). In these, the range of Classical decorative motifs is enriched with ▷grotesque designs in ▷stucco derived as much from ▷Raphael's workshop, and ▷Giovanni da Udine in particular, as from original antique sources.

From 1778, Robert and James published three volumes, *The Works in Architecture* (vol. 1, 1778; vol. 2, 1779; vol. 3, posthumously, 1822), in the prefaces of which their theories are set out even more explicitly: they had introduced 'a greater movement and variety in the outside composition and in the decoration of the inside an almost total change', 'movement' being defined as 'the rise and fall, the advance and recess with other diversity of form, in the different parts of a building, so as to add greatly to the Picturesque of the composition'. Adam's elegantly delicate Neoclassical style stands between the solemnity of the Palladians whom he superseded and the severity of the ▷Greek Revivalists by whom his style was in turn superseded (but not eclipsed).

Bib.: Beard, G., *The Work of Robert Adam*, London, 1992; King, D.N., *The Complete Works of Robert and James Adam*, Boston, 1991; Parissien, S., *Adam Style*, Washington, 1992; Sanderson, M.H.B., *Robert Adam and Scotland*, Edinburgh, 1992; Tait, A.A., *Robert Adam: Drawings and Imagination*, Cambridge, 1993

Adam and Eve

Adam and Eve were considered by the medieval Church as ▷typological prefigurations of ▷Christ and the ▷Virgin Mary. As Adam was the first man of the old dispensation or age, so Christ was the first man of the new dispensation, in that he redeemed Adam's original sin through his own sacrifice on the cross and founded the age of Christianity. Similarly, Eve, as the first mother, was seen as prefigurative type of the Virgin Mary, the mother of Christ. The most frequently depicted episodes relating to Adam and Eve are:

(i) The Creation of Adam (Genesis 2: 4–7). The Bible relates how God formed Adam out of the dust of the ground and breathed life into his nostrils. Early representations sometimes show a ray of life-giving breath passing between God's mouth and Adam's nostrils, although a more readable and ultimately more popular form shows God blessing Adam, whilst helping

James Tassie, *Robert Adam*, 1792, Scottish National Portrait Gallery, Edinburgh

treatment of this theme is that by ▷Hugo van der Goes (diptych with the Fall of Man, c1470, Vienna, Kunsthistorisches Museum) in which the serpent still has its legs at the time of the temptation (Genesis 3: 14–15). The bronze door panel of the Church of St Michael, Hildesheim, 1015, shows the moment when Adam blames Eve.

(iv) The Expulsion (Genesis 3: 22–24). After God discovered the sin of Adam and Eve, he clothed them in skins and expelled them both from Eden, placing cherubims and a flaming sword at the gate to prevent their return. Generally, a single angel is depicted expelling Adam and Eve at swordpoint, whilst Adam and Eve are usually shown not in animal skins, but either with leaves or their hands covering their pudenda (e.g. ▷Masaccio, 1423–7, Florence, Brancacci Chapel).

Adams, Herbert (1858–1945)

American sculptor. He went to Paris 1885–90 and studied at the ▷École des Beaux-Arts. There he followed a tendency to reject the smooth surfaces of classical statuary in favour of a more textured and colourful type of sculpture based on the work of Italian ▷Renaissance sculptors. His style was particularly suitable to low ▷relief sculpture and when he returned to the United States, he was hired to produce a series of fountains, architectural sculpture and public portrait sculpture.

Adamson, Robert

▷Hill, David Octavius

Ada School

A term which is no longer widely used to describe a group of anonymous artists working on manuscripts and ivory carving during the reign of Charlemagne. The Ada Gospels in Trier gave the group its name, but they are now felt to be only part of a wider movement in ▷Carolingian art.

Addison, Joseph (1672–1719)

English essayist and critic. He was born in Wiltshire and attended Queen's College, Oxford (1687), where he gained a reputation as a Classical scholar. He spent 1699–1704 on a ▷Grand Tour of Europe, later the subject of several publications. He established the *Tatler* (1709–11) and the *Spectator* (1711–12) with Steele and was the creator of the archetypal country squire, Sir Roger de Coverley. His essay in the *Spectator* in 1712, 'On the Pleasures of the Imagination' formed the basis of discussion on ▷aesthetics for most of the 18th century. He distinguished between the pleasure derived from visible objects and that obtained mentally through art, and postulated the idea of sensibility (▷picturesque). His ideas were developed by Hume and Hutcheson. He believed in promoting education and discussion through his writings, which were circulated in the coffee shops. He was also a Whig politician.

him to his feet (e.g. ▷Lorenzo Ghiberti, Gates of Paradise, 1425–52, Florence, Baptistery). The most famous representation is undoubtedly that by ▷Michelangelo for the ▷Sistine Chapel ceiling (1511) in which God animates Adam by passing the power of life from his to Adam's finger tips.

(ii) The Creation of Eve (Genesis 2: 18–25). God caused Adam to fall into a deep sleep and, whilst he slept, created Eve from his rib. The most common form is to show Eve being drawn out from the side of the sleeping Adam by God, who blesses her (e.g. ▷Jacopo della Quercia, portal relief, 1425–38, Bologna, S. Petronia). This episode was seen by the medieval Church as a typological prefiguration of the Church (through the symbolic connection of the Church/ Virgin Mary/Eve) emerging from the wound of Christ on the cross.

(iii) The Temptation and Fall (Genesis 3: 1–13). God told Adam that he could eat the fruit of any of the trees in Eden, except for the fruit of the tree of the knowledge of good and evil. A serpent tricked Eve, however, into sampling the fruit and sharing it with Adam. God rebuked Adam, who blamed Eve who, in turn, blamed the serpent. From this moment onwards mankind would be mortal, man would toil in the fields, and woman would suffer the pains of childbirth. This important episode has retained a remarkably constant form since the earliest days of the Church: the serpent coils around the tree whilst Adam and Eve stand to each side trying the fruit (cf., Sarcophagus of Adelfia, c340, Syracuse, Museo Archeologico Nazionale and ▷Albrecht Dürer, Fall of Man, 1504, engraving). An unusual, but biblically more accurate,

Joseph Addison

Bib.: Knight, C.A., *Joseph Addison and Richard Steele: A Reference Guide*, New York, 1994; Smithes, P., *Life of Joseph Addison*, London, 1968

Adoration of the Magi

(Matthew 2: 1–12) Matthew's brief account is the only source for this important subject in Christian art. The magi (wise men) had seen a star in the east which portended the birth of the king of the Jews, so they travelled to the court of King Herod in Jerusalem, hoping to see the child. Herod knew nothing about the birth and, fearing usurpation, sought the advice of his chief priests and scribes. On hearing that the birth had been prophesied for Bethlehem he sent the magi on their way with instructions to bring word back to him. The star then led the magi to Bethlehem where they found ▷Christ and fell down and worshipped him, presenting him with gifts. On their way home they were warned in a dream not to inform Herod.

The number of magi is not mentioned, but their three gifts – gold, frankincense and myrrh – suggested to early writers that the donors also numbered three. The symbolism of the gifts gave the subject added importance in that the gold signified Christ's kingship, frankincense his divinity, and myrrh – used in embalming – his humanity. Once the number of the magi was established, the traditional names – Melchior, Balthazar and Caspar – soon followed. The tradition that they were kings dates back to Tertullian (early 3rd century), but the magi do not seem to be portrayed as kings much before the 10th century. The theme came to have great importance for the Church as a symbol of the subjection of temporal power to ecclesiastical

authority and thus from the Middle Ages onwards the magi are frequently represented as crowned. By the later Middle Ages they were sometimes portrayed as representatives of the whole (known) world – Europe, Asia, and Africa – with Balthazar invariably a moor or black African (e.g. Jan Gossaert, c1507, London, National Gallery), the others perhaps less clearly portrayed. They are also frequently shown as representing the three ▷Ages of Man, with the eldest kneeling at Christ's feet, whilst the other two, with the youngest at the back, await their turn.

Although Matthew makes no explicit reference to the domestic arrangements of the Holy Family, the scene is generally set among ruined Classical architecture, symbolizing Christ's overthrow of the pagan world (e.g. Botticelli, early 1470s, Florence, Uffizi). Botticelli's picture also illustrates a convention which became extremely popular with princely patrons (in this case the ▷Medici) – the portrayal of family members as the magi in order to, by association, partake of the magi's piety – the most remarkable example being ▷Benozzo Gozzoli's fresco decorations for the Medici chapel (1459, Florence, Palazzo Medici), where the Medici family and their entourage completely encircle the walls.

Adoration of the Shepherds

(Luke 2: 8–20.) This episode is found only in Luke. One night, some shepherds were tending their flocks in the hills around Bethlehem when an archangel (traditionally ▷Gabriel) descended and announced to them the birth of ▷Christ. The shepherds were told that Christ, their saviour, had been born in Bethlehem and was to be found lying in a manger, wrapped in swaddling clothes. At the archangel's words a whole host of angels appeared, praising God. The shepherds went down into the city and found the Holy Family just as the archangel had said.

The earliest visual treatments emphasize the part of the story that was more important to the early Church: the archangel's announcement that Christ, whom the shepherds are to find lying in a manger, is humanity's saviour. The annunciation to the shepherds is therefore usually represented as one of the supporting incidents of a Nativity scene (e.g. the *Nativity* mosaic, 1143–51, Church of the Martorana, Palermo). ▷Giotto, in his *Nativity* scene in the ▷Arena Chapel, Padua (c1305–6), brings his shepherds into the foreground, but still has them looking over the roof of the stable to listen to the annunciating archangel, rather than into the stable to adore the Christ child. Giovanni del Biondo (▷predella panel, Rinuccini Polyptych, 1379, Sta Croce, Florence) on the other hand, shows only one shepherd standing on the hillside receiving the annunciation, whilst two others kneel in adoration before the manger. This conflation of both parts of the story into one scene achieved widespread popularity, especially in post-Tridentine painting. Where Giotto

shows only two shepherds, Giovanni del Biondo shows three. Three shepherds became the norm, although by no means the rule presumably to make a neat balance with the three magi. Frequently, the adoring shepherds are shown in the foreground with the journeying magi in the background (e.g. ▷Domenico del Ghirlandaio, Sassetti Chapel altarpiece, 1485, Sta Trinita, Florence). Ghirlandaio's altarpiece illustrates another popular treatment, the non-scriptural gifts brought by the shepherds – rustic gifts of a sheep and some eggs which, like the bread and fruit which appear in other treatments, often are intended to allude to Christ's ▷Passion). The increasing emphasis on the adoration of the shepherds and the corresponding shift into the background of the annunciation to them perhaps reflects the emphasis on Christ's humanity which, from the time of the papal approval of the Franciscan order (1210) onwards, became increasingly important. Whereas the magi kneel before an enthroned Virgin, the shepherds and Virgin frequently join together to kneel on the ground in humble adoration of God made man – a theme especially popular in northern Europe (e.g. ▷Hugo van der Goes, c1480, Berlin, Staatliche Museen Preussischer Kulturbesitz, Gemäldegalerie). The stable is frequently depicted amongst Classical ruins to symbolize the overthrow by the birth of Christ of the old pagan order.

Adorno, Theodor (1903–69)

German critic and philosopher. He was one of the members of the ▷Frankfurt School, and he contributed to their ideas especially after 1938 when the school was forced out of Germany and reopened in New York. With fellow philosopher Max Horkheimer, he published *Dialectic of Enlightenment* in 1972. He saw ▷modernist art as an important and progressive critique with political possibilities, as he was appalled by the ways in which both left- and right-wing governments had manipulated ▷Realist art for propaganda purposes.

Bib.: Adorno, T., *Ästhetische Theorie*, Eng. trans. as *Aesthetic Theory*, London, 1984; van den Bergh, G., *Adornos philosphisches Deuten von Dichtung: Ästhetische Theorie und Praxis der Interpretation*, Bonn, 1989; Menke-Eggers, C., *Die Souveränität der Kunst: Ästhetische Erfahrung nach Adorno und Derrida*, Frankfurt, 1988; Zuidervaart, L., *Adorno's Aesthetic Theory: The Redemption of Illusion*, Cambridge, MA, 1993

aedicula (pl. aedicule)

(From the Latin *aediculum*, 'miniature house.') Originally a shrine in the form of a canopied niche flanked by two columns, set in a temple, and intended to contain a statue. More loosely, a door, window or ▷niche framed by ▷columns and crowned with an ▷entablature and ▷pediment or another form of cover or canopy.

Aeneas

Legendary Trojan prince who escaped with his family and followers at the fall of Troy and after many adventures reached the shores of Latium where he founded the community that became the Roman people. His story was told in Virgil's epic poem, *The Aeneid*. Aeneas' main protector in the hardships of his journey was ▷Jupiter, the ruler of the gods. Thus, it was

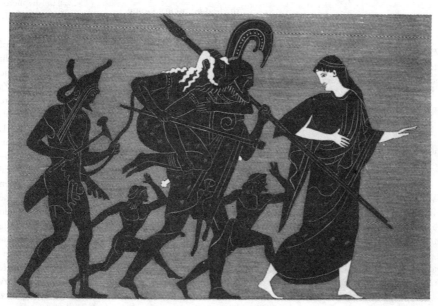

Aeneas' flight from Troy

divinely ordained that the Roman people should prosper, and Aeneas has enjoyed great popularity in Italian art. The most frequently depicted scene is that of Aeneas escaping from the burning city carrying his aged father, Anchises, on his back or shoulder, with his young son, Ascanius, at his side (e.g. ▷Bernini, *Aeneas, Anchises and Ascanius leaving Troy*, c1619, Rome, Galleria Borghese).

aerial perspective

A means of producing an illusion of space in a painting by modulating colour so that fainter colours represent distant landscapes. The theory seems to have been first perpetuated by ▷Leonardo, who was interested in the means of representing atmosphere. Aerial perspective was most famously practised by ▷Claude and the ▷Impressionists, although the technique was also used in ▷Chinese art from an early date. A synonym is 'atmospheric perspective'.

aeropittura

(Italian, 'aeropainting'.) A name given to the art of second generation Italian ▷Futurists (▷Second Futurists), who represented their admiration for machines through themes of flight in painting, sculpture, literature and architecture. The beginning of this phase of Futurism came in 1929, when the *Manifesto dell'aeropittura futurista* (*Manifesto of Futurist Aeropainting*) was published and signed by a group of artists, including ▷Marinetti, ▷Benedetta and Prampolini. The themes of flight were often used metaphorically, referring to higher spiritual or mental levels. Styles of *aeropittura* varied from pure ▷abstraction to a literal rendering of the giddy effects of flight.

Aertsen (Aartsen, Aertszen, Aertsz), Pieter (1508/9–75)

Dutch painter. He began his training in Antwerp but practised mostly in Amsterdam from 1556. Aertsen specialized in interior scenes, often with religious subject matter, but set in a domestic environment. He produced several ▷altarpieces which were destroyed in 1556.
Bib.: special edition of *Nederlands Kunsthistorisch Jaarboek*, 40 (1989) on Aertsen

aestheticism

A term used primarily to refer to ▷Symbolist art of the late 19th century. Aestheticism derives its meaning from ▷Kant's vision of aesthetics as a realm separated from all religious, political and social spheres. The idea that art could only be judged on its own terms inspired a generation of writers and artists who were weary of ▷narrative and ▷academic art that concentrated on content to the exclusion of style and form. Artists such

as ▷Whistler, who advocated an ▷'art for art's sake' idea, carried this separation of spheres to its logical conclusion. The social irresponsibility of such 'decadent' artists was one of the targets of ▷Tolstoy's *What is Art* (1898), which argued that art must be meaningful and political to serve the needs of a mass population. Aestheticism thus became more of a pejorative classification of a group of artists and writers who were considered to be socially irresponsible.
Bib.: Dowling, L., *Aestheticism and Decadence: A Selective Annotated Bibliography*, New York, 1977

Aesthetic Movement

An artistic and literary movement of the 1880s and 1890s which believed in ▷art for art's sake. It developed in opposition to contemporary ideas on the utility of art (▷Ruskin, ▷Morris), as well as to the perceived philistinism of the day. ▷Pater was a leading advocate – the conclusion to his book *Studies in the History of the Renaissance* (1873) used the phrase 'art for art's sake', as was Oscar Wilde (*The Picture of Dorian Gray*, 1891) and artists like ▷Burne Jones, ▷Whistler, ▷Moore, ▷Leighton, ▷Alma-Tadema and ▷Beardsley. It was associated with the ▷Symbolist movement in both art and literature and with the ▷fin-de-siècle publications like the ▷*Yellow Book*. Inevitably the movement concentrated on the beauty of the female form, although artists like Whistler tried to divorce subject matter from their work entirely. Many of the artists sought idealism in the Classical world and through representations of literature. The movement was pilloried in *Punch* and in Gilbert and Sullivan's opera *Patience*, but it did have some lingering impact on British art. ▷Fry's ideas of significant form emphasize the autonomy of art and were influential among the ▷Bloomsbury Group.
Bib.: Aslin, E., *The Aesthetic Movement: A Prelude to Art Nouveau*, London, 1969; Dowling, L.C., *The Vulgarisation of Art: The Victorians and Aesthetic Democracy*, Charlottesville, 1996; Gaunt, W., *The Aesthetic Adventure*, London, 1945; Newall, C., *The Grosvenor Gallery Exhibition*, Cambridge, 1995; Small, I., *The Aesthetes: A Sourcebook*, London, 1979; Spencer, R., *Aesthetic Movement Theory and Practice*, London, 1972

aesthetics

A branch of philosophy concerned with principles of beauty and taste. The term *Ästhetik* was coined in the 18th century by the philosopher Alexander Baumgarten (1714–62), and it was used by ▷Kant in his *Critique of Judgement* (1790). At that time and subsequently, aesthetic theory has concerned itself with the question of how people respond to beauty and whether or not taste is relative or universal. Kant's argument that the human response to art was disinterested opened up a debate about the nature of our relationship with visual culture. By the end of the 19th century, a greater

interest in form and colour led artists to reject an emphasis on subject matter and naturalistic representation in art. This resulted in a resurgence of aesthetic theories, such as those of ▷Clive Bell, which tried to argue that there was a distinct 'aesthetic emotion' that allowed people to respond to the beauty of pure colour and form. This idea was discredited by left-wing groups in Germany and Russia during the 1920s, who felt that political meaning was essential for art, although ▷Theodor Adorno overturned the emphasis on realism, by claiming that realistic representation sanitized horrific events. Adorno's appreciation of the distinctiveness of the aesthetic emotion was politically motivated, but such an emphasis has been challenged since the Second World War by a number of theorists who claim that all aesthetic response is socially conditioned. To a certain extent, aesthetics has been replaced since 1970 by art theory which seeks to contextualize art and deny that it has any intrinsic meaning. Twentieth-century philosophers have also questioned the validity of a standard of taste, particularly in the wake of anthropological research about the aesthetics of non-western cultures. Cross-cultural studies have shown that taste and beauty are relative concepts, and this understanding further undermines any attempts to construct a philosophy of beauty.

▷aestheticism

Bib.: Berenson, B., *Aesthetics and History*, Garden City, 1948; Charlton, W., *Aesthetics, an Introduction*, London, 1970; Duncan, C., *The Aesthetics of Power: Essays in Critical Art History*, Cambridge, 1993; Eagleton, T., *The Ideology of the Aesthetic*, Oxford, 1990; Osborne, H., *Aesthetics and Art Theory*, 2nd edn, New York, 1970; Regan, S., *The Politics of Pleasure: Aesthetics and Cultural Theory*, Buckingham, 1992; Sheppard, A., *Aesthetics: An Introduction to the Philosophy of Art*, Oxford, 1987; Sim, S., *Beyond Aesthetics: Confrontations with Poststructuralism and Postmodernism*, New York, 1992; Wolff, J., *Aesthetics and the Sociology of Art*, London, 1983

African art

The African continent has produced a great diversity of art from prehistoric times to the present day. In many instances, art production has been related to ritual or tribal ceremonies, as well as serving more secular decorative functions, but it is not always easy to determine the function of a particular work. It is also problematic to label as 'art' the productions of African craftspeople who frequently considered their work as an essential part of secular or religious life. In many tribes, the artist had a high status, but the artist would not necessarily have been the equivalent of the western fine artist who relied on patronage or the marketplace to regulate his or her production. With these strictures in mind, it is possible to isolate different areas and different practices of African art. From c7000 BC rock drawings include representations of animals and hunters. From the beginning of tribal differentiations, tribal art has become a way of isolating one tribe from another, and tribal art can take the form of scarification, body painting or sculptural masks used in religious ceremonies.

Such diversity also appears in separate geographical regions, where natural resources dictated the materials used, while tribal power, wealth or sophistication was responsible for the type of objects produced. The Ashanti of Ghana used gold and bronze which were readily accessible in their territory, whereas the Baluba − a tribal people in the Congo, specialized in carved images of women holding bowls. The Fang group of tribes produced high-quality funerary sculptures which were dominated by geometric patterns. The Bambara of west Africa were known for their elaborate head-dresses, which were used during ceremonies, in contrast to the simple wooden masks of the Dogon people of west Africa. The art of Ife and Benin − both cities in western Nigeria − was lavish and naturalistic during the 12th–17th centuries when those areas were infiltrated by European influences, and the Bakuba tribe was known for its royal portrait carvings. The dark wood of the Ivory Coast was the basis for sculptural figurines of the Baule people, who produced classically naturalistic masks, and ▷terracotta was the material used for heads produced by the Nok peoples of central and north Nigeria. Nigeria was also the home of the Yoruba, one of the most prolific tribes in African art.

In the 19th and 20th centuries, African art was 'discovered' by Western colonizers and embraced by ▷modernist artists for its lack of pretension and exciting formal qualities. With the Westernization of much African society, 'traditional' art has become commercialized and sold as souvenirs, while from the 1920s, the growth of African art colleges in more modernized sections of Africa has led a number of African artists to adopt western influences in their work.

Bib.: Brain, R., *Art and Society in Africa*, London, 1980; Carroll, K., *Yoruba Religious Carving: Pagan and Christian Sculpture in Nigeria and Dahomey*, London, 1967; Gillon, W., *A Short History of African Art*, Harmondsworth, 1984; Steiner, C., *African Art in Transit*, Cambridge, 1994; Vansina, J., *Art History in Africa: An Introduction to Method*, London, 1984; Willett, F., *African Art: An Introduction*, London, 1971

Afro-Cubanism

An early 20th-century movement in Cuban music, literature and art. Afro-cubanism looked to both ▷avant-garde art and ▷primitivism as its sources, and it relied for its inspiration on the theories of Fernando Ortiz.

Agar, Eileen (born 1904)

British artist of South American birth. She was born in Buenos Aires, but moved to England in 1906. During the 1920s she studied at the ▷Slade School of Art and went to Paris from 1928 to 1930 where she came across works by ▷Cubist and ▷Surrealist artists.

Eileen Agar, *Edith Sitwell, the Sorceress*

From 1933 she was a member of the ▷London Group, and she exhibited at the Surrealists International Exhibition in London in 1936. Her work shows a precise attention to realism of detail, while its subject matter is inevitably unsettling or bizarre.

Bib.: Agar, E., *A Look at my Life*, London, 1988

Ages of Man

An antique theme revived in the late Middle Ages illustrating the transience of human life and thus a type of ▷vanitas. The number of ages varies (Shakespeare mentions seven in *As You Like It*, II: vii), but three is perhaps the most frequently illustrated. The three ages are generally represented by two babies at play, a young man courting a young girl, and an old man occasionally counting his money, but more usually contemplating a skull (e.g. ▷Titian, *The Three Ages of Man*, Edinburgh, National Gallery of Scotland, c1510–15). The maximum number of ages depicted is twelve, in which case an analogy with the months of the year is intended, although it is more usual, taking the course of a year as an analogy, to make the number four, thus establishing a symbolic link with the four seasons. When represented as four, the ages are childhood, youth, maturity and old age. In another painting by Titian (*An Allegory of Prudence*, London, National Gallery) the age of childhood is omitted and youth, maturity and old age are taken to symbolize past, present and future.

agitprop

(From the Russian: *agitatsaya propaganda*, 'agitation propaganda'.) A term taken from Plekanov and used by Lenin in his 1902 pamphlet *What is to be done?* to suggest a means of combining agitation and propaganda for the achievement of political ends. The idea came into its own in the years following 1917, when the state sponsored a wide range of intensive propaganda projects, including trains fitted with printing presses and Living Newspapers – actors who performed propaganda plays and tableaux for the benefit of Russia's huge illiterate population. The combination of agitation – crude slogans and stunts for the masses – and propaganda – a more subtle exploitation of history and argument for the educated – meant that agitprop affected all aspects of art and life. State control of education extended to the art schools and many artists voluntarily put themselves at the service of the State (▷Productivism), or took part in the promotion of propagandist theatre. Professional artists were involved with the production of agitprop work, which was considered a 'useful' form of art in the contemporary debate about art's purpose in a communist society.

Aglaia

▷Three Graces

Agnes

A virgin saint, martyred at Rome c350 whose story is related by Jacobus de Voragine in *The Golden Legend*. Agnes rejected the love of the son of a Roman prefect as she considered herself a bride of Christ. The prefect, seeing his son almost dying from unrequited love, threatened to consign Agnes to a brothel unless she made a sacrifice to Vesta and gave herself to his son. She refused and was led naked through the streets to the brothel, covered only by her miraculously grown hair. When the prefect's son came to take Agnes by force, he was struck dead by an angel sent to protect her. Agnes was sentenced to death by fire, but the flames miraculously leapt back and consumed her executioners. Agnes finally received her martyrdom when another executioner was ordered to stab her through the throat.

Agnes' identifying attributes are a lamb – the Latin *agnus* being a pun upon her name (e.g. Master of the Bartholomew Altarpiece, central panel, c1500, Munich, Alte Pinakothek) – and a sword or dagger (referring to her martyrdom). As a martyr she will also generally carry a palm. Depictions of her martyrdom, popular in 17th-century Italy and Spain, may show Agnes kneeling on the extinguished pyre, the bodies of her executioners lying around her, whilst another raises a sword or dagger to kill her.

The sky above opens up to reveal a glimpse of Heaven with ▷Christ and an angel who has Agnes' martyr's palm ready.

Agony in the Garden

(Matthew 26: 36–46; Mark 14: 32–42; Luke 22: 39–46). One of the scenes of ▷Christ's ▷Passion, coming between the ▷Last Supper and Judas' ▷betrayal. Judas has already gone to betray Christ to the High Priest and Christ retires to the Garden of Gethsemane with his disciples. He takes the three closest to him – Peter, James and John – and walks some way with them before asking them to keep watch while he prays for strength in the coming struggle between his human wish to avoid a painful death and his divine will to achieve his mission of redemption. The elements of the three slightly differing gospel accounts that are usually represented are Christ praying on his knees (Matthew and Mark say that Christ prayed flat on his face, but this rather awkward visual image appears only in early depictions); Peter, James and John neglecting their watch and falling asleep; and the angel appearing to Christ (mentioned by Luke only). In all three accounts Christ asks that God take away his (metaphorical) cup, if it should be his will. This reference was conflated with Luke's reference to the angel to produce an image of intensified significance with the angel offering Christ the Eucharistic chalice. Christ is usually shown praying on a promontory and although this may allude to Gethsemane's location on the Mount of Olives, it is also a very convenient compositional device for separating Christ from his sleeping disciples. The three disciples are individually identifiable in most pictures: Peter has short grey hair and beard, James long dark hair and beard, and John is clean-shaven with long dark hair. It is either night-time or just before dawn and in the background can be seen the approach of Judas and the High Priest's men (e.g. ▷Giovanni Bellini, 1460, London, National Gallery and ▷El Greco, Budapest).

agora

The principal meeting place or market place in an ancient Greek or Roman town, usually surrounded by ▷porticoes.

Agoracritus

Greek sculptor of the second half of the 5th century BC. He was a pupil of ▷Phidias.

Agostino di Duccio (1418–81)

Italian sculptor and occasional architect. He was from Florence. His highly original relief style with its extremely graceful linearity and predilection for swirling draperies owes virtually nothing to ▷Donatello and ▷Ghiberti, the two main influences in later 15th-century Florentine sculpture. Indeed, by 1433 Agostino had left Florence to earn his living as a mer-cenary soldier and his earliest surviving work as an independent sculptor is the series of ▷reliefs of scenes from the life of S. Gimignano for the ▷antependium at Modena Cathedral (1442; now built into the façade) which are perhaps closer to the manner of the Sienese sculptor, ▷Jacopo della Quercia. In 1446 Agostino fled from Florence to Venice accused of the theft of some silver from SS Annunziata. His absorption of Venetian influences can henceforth be seen in his sculpture. In c1450–57 he was working on the sculptural reliefs in the Tempio Malatestiano at Rimini and in c1457–62 as architect and sculptor on the façade of the Oratory of S.Bernardino, Perugia. He returned to Florence in 1463 and entered the ▷guild. In 1464 he was commissioned by the cathedral workshops to execute a large marble figure for one of the ▷buttresses. Before the end of the year he had abandoned the block for some unknown reason although, according to ▷Vasari and ▷Condivi, it was because he had spoiled it. (It was later used by ▷Michelangelo for his masterpiece of 1501–4, *David*.) Agostino also executed a number of charming marble reliefs on the theme of the Madonna and Child (e.g. Florence, Bargello; London, Victoria and Albert Museum; Paris, Louvre; Washington, National Gallery).

Bib.: Cuccini, G., *Agostino di Duccio: itinerari di un esilio*, Perugia, 1990; Montequin, F.-A. de, *The Oratory of San Bernardino in Perugia*, Albuquerque, 1970

Agrippine Sibyl

▷Sibyl

air brush

A large tube consisting of a paint container and a hose. It is used like a spray gun, but the consistency of the paint is thinner, and it is easier to control. Air brushes are used most frequently by commercial artists.

ajimez

An ▷Islamic architectural motif consisting of a window composed of two ▷arches separated by a ▷column.

AKhRR (Association of Artists of Revolutionary Russia)

A Russian organization of artists formed after 1922 to perpetuate a ▷Realist style of art. Looking back to the ▷Wanderers of the 19th century, this association advocated a form of art that was both legible and tendentious, and they opposed abstract tendencies such as ▷Constructivism as inappropriate for post-Revolutionary Russian culture. They prided themselves on a documentary approach to art which involved researching their subjects thoroughly. Their subject matter consisted primarily of proletarian life and portraits of revolutionary heroes. Members of the organization included Aleksander Grigorev (1886–1939)

AKhRR: Alexander Korolyov, *Land to the Peasants* (detail)

and Isaak Brodsky (1883–1939). Their well-intentioned ideals formed the basis for the cultural policies of State communism. Even when the Soviet government dissolved them in 1932, the ▷Socialist Realist style they had perpetuated remained the state-approved mode.

Bib.: Taylor, B., 'On AKhRR', in M.C. Bown and B. Taylor (eds.), *Art of the Soviets: Painting, Sculpture and Architecture in a One-Party State, 1917–1992*, Manchester, 1993

alabaster

A soft, translucent, fine-grained stone, a form of ▷gypsum (hydrous calcium sulphate), most commonly white, pink or yellowish in colour. It is easily carved, its softness permitting a more delicate style of carving than marble. However, if inexpertly carved it is susceptible to bruising which shows up in the form of white opaque blemishes. Its softness also renders it inappropriate for external carving. Alabaster was cut into slabs and used for the lion reliefs in the palace of King Ashurbanipal in Nineveh (c645 BC, London, British Museum). It was widely used in the Middle Ages and ▷Renaissance, and although naturally available all over Europe, the chief mines were in the Midlands of England, with Nottingham achieving a European reputation as a centre for the production of alabaster ▷retables (consequently the Castle Museum, Nottingham has a collection second only to the Victoria and Albert Museum, London). English alabaster is often characterized by its reddish-brown streaks, caused by iron oxide deposits, although the most highly prized pieces were always those with a minimum of

streaking. The English production of retables was brought to a halt by the ▷Reformation; however, alabaster tombs continued to be produced into the 18th century. Modern sculptors, especially ▷Henry Moore and ▷Jacob Epstein (e.g. *Jacob and the Angel*, 1940–41, Liverpool, Tate Gallery) have revived its use for independent sculptures.

Bib.: Penny, N. *The Materials of Sculpture*, New Haven and London, 1993

Alan of Walsingham

Sacrist of Ely Cathedral in the 1320s who has been credited with the design of the octagonal lantern tower, built after the collapse of the original tower in 1323. The idea may have been his, but the execution was probably the work of William Hurley, the king's Master Carpenter.

Álava, Juan de (d1537)

Spanish architect. He was involved in the design and construction of Salamanca cathedral from 1512 and was master mason there from 1526. He was also a consultant for Seville Cathedral and designed the ▷cloister of Santiago Cathedral.

Albani, Cardinal Alessandro (1692–1779)

Nephew of Pope Clement XI and the leading collector and patron of the arts in Rome in his day. Albani's Roman villa, built by the architect Carlo Marchionni, originally housed Albani's important collection of antique sculpture (now largely in the Munich Glyptothek), assembled with the help of his librarian and great friend ▷Heinrich Winckelmann. The main room is still decorated with the once famous quintessential Neoclassical ceiling painting *Parnassus* (1761) by ▷Anton Raffael Mengs.

Bib.: Debenedetti, E., *Alessandro Albani: patrono delle arti*, Rome, 1993; Howard, S., 'Albani, Winckelmann and Cavaceppi: The Transition from Amateur to Professional Antiquarianism'. *Journal of Historical Collections*, vol. 4 no. 1 (1992), pp. 27–38

Albani (Albano), Francesco (1578–1660)

Italian painter. He was from Bologna. He was one of the earliest pupils at the Bolognese ▷academy run by the ▷Carracci. In 1601–2 he travelled to Rome with ▷Guido Reni. He contributed landscape to decorative designs of Annibale Carracci, and he was known for his arcadian landscape images. In 1616 he returned to Bologna and continued to paint in a style similar to that of ▷Reni and ▷Domenichino, producing landscapes and allegorical scenes. He also took on commissions for ▷altarpieces.

Bib.: Puglisi, C.R., *A Study of the Bolognese-Roman Painter Francesco Albani*, Ann Arbor, 1987

Albers, Josef (1888–1976)

German designer and teacher. He began studying painting under ▷Franz von Stuck, and he trained in Berlin from 1913 to 1915 and at Essen from 1916 to 1919. He abandoned his early ▷Expressionist style when he studied at the ▷Bauhaus during the 1920s and moved to a geometrical style of ▷collage which incorporated glass elements. He contributed to the decorations of the Haus am Horn – the ideal house produced for the Bauhaus exhibition in 1923. His proficiency as a student led to his appointment as one of the first student 'masters' when the Bauhaus moved to Weimar in 1925, and he took charge of the preliminary course. At the Bauhaus he specialized in ▷typography and ▷stained glass, but he was more generally concerned with the possibilities of modern materials. When the Nazis suppressed the Bauhaus he went to the United States in 1933, and began teaching Bauhaus theories at ▷Black Mountain College, at Harvard in 1936–41 and at Yale from 1950 to 1960. He was made an American citizen in 1939. He continued the traditions of the Bauhaus in his later art and theory. In his book *Interaction of Color* (1963), he stressed the importance of colour as the primary component in art, and he carried his colour and form experiments in a series *The Homage to the Square*.
Bib.: Gomringer, E., *Josef Albers*, New York, 1968; *Josef Albers*, exh. cat., London, 1994; *Josef Albers: A Retrospective*, exh. cat., New York, 1988

Alberti, Leon Baptista (1404–72)

Italian humanist and art theorist, as well as practising architect, painter and sculptor. His parents were exiled Florentines living in Genoa when Alberti was born. Educated at Padua and Bologna, he first saw Florence in c1428 following the lifting of the ban on his family and soon formed friendships with the leading lights of the ▷Renaissance movement, ▷Brunelleschi, ▷Donatello, ▷Ghiberti, ▷Luca della Robbia, and ▷Masaccio, to whom the Italian edition of his chief literary work, *Della Pittura* (*On Painting*, 1436), is jointly dedicated (this had originally been published in Latin as *De Pictura*). *Della Pittura* was the first treatise in modern times to treat painting as a liberal art as opposed to a craft. Unlike ▷Cennini's *Libro dell'Arte* (c1390) it is not a recipe book for craftsmen, but a theoretical study for the modern artist, and covers the need for the artist to be educated in mathematics, history and poetry, as well as including the first description of single point ▷perspective as the rational means by which the painter should construct his pictorial world. Alberti did not so much devise these new theories, as popularize them for the sake of patrons (the Latin edition) and artists (the Italian edition) who wished to follow the example of the dedicatees of the book. *Della pittura* was extraordinarily successful, being translated into several languages, influencing the later treatises of ▷Filarete, ▷Piero della Francesca and ▷Leonardo da Vinci and forming the basis for the practice of the academies of the 17th and 18th centuries. Alberti also published treatises on sculpture (*De Statua*, published in the 1460s) and architecture (*De re aedificatura*, published posthumously in 1485): in both of these works it is again the rational basis of the art that is emphasized.

Although nothing of his work as a practising painter or sculptor survives (apart from a plaque supposed to be a self-portrait in Washington, National Gallery), he has left several important and influential ▷Renaissance buildings, including in Florence the classicizing façades of the Palazzo Rucellai (begun 1446) and S. Maria Novella (completed 1470), in Mantua the churches of S. Andrea and S. Sebastiano (begun 1460), and in Rimini the façade of the Tempio Malatestiana (c1450).
Bib.: *Leon Baptista Alberti*, exh. cat. Milan, 1994; Alberti, L.B., *On Painting*, London, 1991; Borsi, F., *Leon Baptista Alberti: The Complete Works*, New York, 1989; Morolli, G., *Leon Baptista Alberti: i nomi e le figure*, Florence, 1994; Jarzombeck, M., *On Leon Baptista Alberti: His Literary and Aesthetic Theories*, Cambridge, MA, 1989

Albertina

Collection of drawings based in Vienna. ▷Old Master drawings by artists from ▷Dürer onwards were collected by Archduke Albert of Sachsen-Teschen (1738–1822) who augmented his possessions when the imminent ▷French Revolution forced a number of European aristocrats to sell their valuables. The state took charge of the collection in 1918. The drawings were housed in the Archducal palace where they can be viewed today.

Albertinelli, Mariotto (1474–1515)

Italian painter. He was from Florence, where he trained in the workshop of ▷Cosimo Rosselli, and he met ▷Fra Bartolommeo with whom he collaborated from about 1508 to 1511. According to Vasari, he was a man easily bored, 'a follower of Venus' who enjoyed good living and resented critics. Thus, for a while, he abandoned painting with its difficult 'foreshortening' and 'perspectives', and took up innkeeping. After a while he apparently missed his former trade and returned to work as an artist. He was an able painter whose style, like that of Fra Bartolommeo, aims at a simplified, balanced monumentality but which lacks his partner's rigour. His most famous work is the *Visitation* (1503, Florence, Uffizi).
Bib.: Borgo, L., *The Works of Mariotto Albertinelli*, New York, 1976; Hugede, N., *Le Peintre des Medicis: memoirs de Mariotto Albertinelli*, Paris, 1985

Albi, Cathedral of St. Cecilia

This huge fortress-like brick structure dominates the city of Albi in south-west France and is part of the distinctive southern ▷Gothic style. Although the

design takes elements from northern French ▷Rayonnant architecture, it is unusual and owes far more to regional idiosyncrasies, like local friar's churches. Begun in 1281, just after the Albigensian Crusades, the cathedral is severe and aisleless, with a flat roof and a series of ▷turrets with high, narrow windows, reminiscent of fortifications. It was intended to be an austere symbol of the power of Christianity in the face of heresy. The only entrance to the church is via an external staircase and a door in the southern wall. This entrance was embellished in 1535 with a ▷baldacchino. The vaulted ▷nave (the widest in France) is without ▷transepts and was complete by 1380. The interior was lavishly decorated in succeeding centuries, with Italianate ▷frescos, including a depiction of the Last Judgement (1480). The ▷choir enclosure, one of the best preserved of the late Middle Ages, was built c1500, as was the magnificent limestone carved ▷rood screen. Restorations by César Daly in the mid-19th century raised the walls, destroying some of the turrets and creating drainage channels.

Albright, Ivan le Lorraine (1897–1983)

American painter. He began his studies in architecture at Northwestern University and the University of Illinois, but the First World War interrupted his progress. After the war he studied art in Chicago and Philadelphia and developed works in which the canvas surface was completely, almost obsessively, covered. He was interested in gloomy themes, and death dominated his compositions, which were painted in a ▷Magic Realist style. He carefully observed every detail of his paintings and painstakingly developed his compositions over a long period of time. The claustrophobic treatment of space and depressing thematic undercurrent continued in the work he produced up to his death.

Bib.: Croydon, M., *Ivan Albright*, New York, 1978

Alcamenes

Athenian sculptor of the 2nd century BC. He was a pupil of ▷Phidias.

alcázar

(Arabic, 'palace'.) The name given to Moorish palaces, some of which were redesigned by Christians after the 14th century. They contain fortifications. Toledo, Madrid and Seville all possess examples.

Aldegrever, Heinrich (1502–c1555)

German engraver. He was strongly under the influence of ▷Dürer and produced small-scale ▷engravings. These primarily represented religious subjects.

Bib.: Plassmann, O., *Die Zeichnungen Heinrich Aldegrevers*, Marburg, 1994

Aldine Press

Venetian printing press. It was founded by Aldus Manutius (1449–1515) in 1494, soon after the discovery of printing. The press became known for its contribution to the spread of learning throughout Europe and for the high quality of its productions. However, its most significant contribution to the history of the book is the invention of the smaller and more portable octavo format, as well as the use of italic type.

Aldobrandini Wedding, The

A large fragment of a Roman ▷mural painting dating from the age of Augustus (1st century BC) perhaps originally part of the interior decorations of a small room in a wealthy Roman house and thought to be derived from a ▷Hellenistic model. Now in the Vatican Library, Rome, it was discovered in 1606 and is so called after its first modern owner, Cardinal Cintio Aldobrandini. It achieved almost immediate celebrity (more for rarity than quality) and was copied by some of the leading artists of the day including ▷Rubens, ▷Van Dyck, ▷Pietro da Cortona and ▷Poussin. The over-zealous restorations and retouchings executed in the 17th century have now been removed. The mural is in the form of a figurative ▷frieze showing the final preparations for a wedding and depicts a mixture of mortals and deities, the latter differentiated by their semi-nude state. The composition is divided vertically into three fictive spaces: in the centre is a bridal chamber, on the left a smaller room, and on the right a ▷vestibule. Following pictorial convention, the near walls of the rooms have been removed to allow the spectator to see in. In the centre a nervous-looking, veiled bride sits on a couch and is advised and reassured by the semi-nude goddess of marriage (Peitho) seated next to her. On the left of the room a young woman pours scented oil into a vessel. In front of the end of the left-hand wall of this room stands a woman in a mantle, generally assumed to be the mother of the bride, while before the end of the right-hand wall reclines the semi-nude god of marriage (Hymenaeus), looking back at the bride and goddess. Occupying the vestibule on the right is a group of three women: one pours aromatic incense, a second plays a lyre and sings, while a third, crowned woman stands, presumably waiting to officiate at the imminent nuptial rites.

Alexander Mosaic

A work of art discovered in ▷Pompeii, dated to the 3rd century BC. It represents the confrontation between Alexander the Great and Darius at the Battle of Issus. It was one of the earliest examples of ▷battle painting.

Alexander Sarcophagus

Ancient marble chest (▷sarcophagus) of Greek workmanship. It was found in a tomb complex in Sidon,

Lebanon, in 1887, and is now in the Archaeological Museum in Istanbul, Turkey. Dating from c325–300 BC, the richly carved sarcophagus is decorated with remarkably naturalistic high-relief scenes on all four sides. On one long and one short side are ▷battle scenes, on the other long and short side, hunt scenes. The specific battle represented on the long side is believed to be Issus, waged against the Persians by Alexander the Great and his Phoenician ally, Abdalonymos, in 333 BC. The long hunt scene is believed to represent Alexander and Abdalonymos hunting together. The narrative reliefs thus show the battle that gave Abdalonymos his throne as vassal-king to Alexander, and the special relationship he enjoyed with Alexander. This reading would strongly suggest that Abdalonymos himself had commissioned the sarcophagus. The elaborate detailing of the narrative ▷reliefs was once enhanced by metal attachments such as bows, arrows, lances, swords and horses' bridles and reins. Details would have been further clarified by the colour with which the entire sarcophagus was once richly painted (areas of red, yellow, blue and violet pigment survive). The sumptuous temple-roof shaped lid has carved ▷pediments at each short end, siren masks along the ridge, crouching lions at the corners and animal-head gutter spouts. The carving is everywhere extremely accomplished and of great precision. As an example of the finest ▷Hellenistic relief carving it is generally considered to be second only to the Great Altar of Pergamon.

Bib.: Robertson, M., *A History of Greek Art*, 2 vols., Cambridge, 1975; Smith, R.R.R., *Hellenistic Sculpture*, London, 1991

alfarje

(Arabic, 'ceiling'.) Architectural term referring to the frame that supports the roof in Moorish buildings of Spain and Portugal. The frames often contained elaborate carvings.

alfiz

An architectural term for the frame that surrounds a horseshoe ▷arch in ▷Islamic architecture.

Algardi, Alessandro (1598–1654)

Italian sculptor. He was from Bologna, where he trained in the ▷Carracci academy, and he had settled in Rome by c1625. Here he met and became friends with ▷Domenichino, ▷Poussin and ▷Sacchi, the principal representatives of the Classical faction in opposition to ▷Bernini's ▷Baroque faction. Despite this rivalry, even Algardi could not withstand Bernini's all-pervasive influence: not only is his statue of Innocent X (bronze, 1645–50, Rome, Palazzo Conservatori) clearly influenced by Bernini's *Urban VIII*, but his tomb for Leo XI (1634–44, Rome, St. Peter's) is just as clearly modelled on Bernini's tomb for Urban VIII, for all that Algardi has substituted austere white marble

for Bernini's opulent ▷polychromy. Notwithstanding this influence, in recognition of his leadership of the Classical faction, in 1640 Algardi was elected *Principe* of the Academy of St. Luke and during the papacy of Innocent X (1644–55), when Bernini was out of favour, Algardi's position as principal sculptor in Rome was unrivalled. His most important relief is the monumental 'Pope Leo driving Atilla from Rome' (1646–53), carved in white marble for an altarpiece in St. Peter's (full-sized ▷terracotta modello in Biblioteca Vallicelliana). The works for which Algardi is most admired today are his many portraits: early examples (e.g. the Frangipane portrait busts, Rome, S. Marcello al Corso, c1635–44) reflect his study of antique Roman portrait busts, whilst his best are characterized by their penetrating evocation of the sitter's character (e.g. Francesco Bracciolini, London, Victoria and Albert Museum).

Bib.: Heimburger, M., *Alessandro Algardi, scultore*, Rome, 1973; Montagu, J., *Alessandro Algardi*, 2 vols., New Haven and London, 1985

Algarotti, Count Francesco (1712–64)

Italian art collector and critic. Algarotti was based in Venice and involved in ▷Enlightenment intellectual circles. He knew Voltaire and Frederick the Great, and was friendly with such artists as ▷Canaletto and ▷Tiepolo. His knowledge of art, wide court acquaintance and urban character made him an appropriate middle man for European aristocrats who wished to collect Venetian art. His most famous action was the purchase of a large number of Italian pictures for the Dresden royal family.

Bib.: Aikema, B., 'A Group of Drawings by Francesco Algarotti', *Apollo*, 140 (Sept 1994), pp. 58–64

Alhambra

Moorish fortress palace in Granada, Spain. In 1238 King Alhamar (1232–72), the first monarch of the Nazarite dynasty, decided to move his court to a fortified hill outside Granada, to deter the increasingly frequent attacks on Muslims by Christian soldiers. Spain had been largely Muslim since the 8th century, but by the 11th century the Christian *reconquista* had begun. Work started on the palace at this time but the bulk of the building took place in the 14th century, during the reigns of Yusef I (1333–54) and Mohammed V (1354–91). Granada was important geographically because of its defensive situation, and thus the Muslims were keen to keep control of the area.

Alhambra is an abbreviation of *Qal'at al-Hambra*, meaning 'the red fort'. The palace is a city in miniature, with an open ground plan based around patios and courtyard. It is part of the city of Granada, but also independent of it with its own direct contacts with the outside world. It includes a Court of Law, the Mexuar, which is the heart of the Alhambra, and contains a

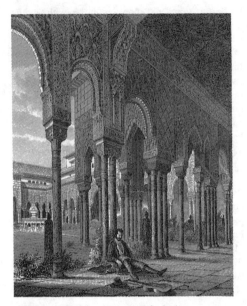

Alhambra, 13th–14th century, Granada, Spain

central courtyard with long halls around it and a small Mosque. The Cuarto Dorado or the Court of the Mosque is lavishly decorated with tiles and marble and may have originally been an entrance gate. The Court of the Myrtles has a rectangular pool in the centre, and is surrounded with porticos with remarkable marquetry ceilings. The Court of the Lions (begun 1377) was the royal family's winter residence and has a central fountain with sculptures of lions, and is surrounded with square rooms and chambers decorated with painted walls. The Generalife is a verdant garden area, served by the aqueducts constructed to the Sabikah Hill. There are also a harem and private apartments. The style of the buildings is almost haphazard. The marble pavements and tiled walls are unmistakably Moorish, but such decorative detail mixes with European medieval and Christian motifs. At least 22 towers of different styles and magnitude, most of which have now been demolished, enclosed the entire development. When Charles V of Spain visited in 1526, he decided to extend the Alhambra for his own uses and in so doing began the dissemination of the original Moorish architecture. This wholesale demolition continued until 1812, when evacuating French troops tried to blow up the remaining buildings. After this incident the Spanish started an extensive restoration programme which continues to this day.

alicatado

(Arabic, 'patios'.) An architectural term used to describe the coloured ▷mosaics used for walls and pavements in Spanish ▷Islamic architecture.

alienation

A term which has associations with both psychology and the economic theories of ▷Karl Marx. The discovery of Marx's 'Economic and Philosophical Manuscripts' in 1932 unearthed his idea that the worker was alienated from the processes of work through the dehumanizing systems of industrialization. By the 1920s, the terms also had a broader meaning, relating to the sense of isolation individuals felt in modern society. The latter idea was developed by German sociologists such as ▷Georg Simmel and ▷Max Weber, and the playwright, Bertold Brecht, used theatrical techniques designed to 'alienate' the audience from an empathetic response to his plays, thereby giving them greater 'objectivity'.

Alienation also became a prevalent concept in art theory, particularly in the Soviet Union and Germany in the 1920s and 1930s. Left-wing writers, such as the Russian Osip Brik, felt that artists should join with factory workers to create vital forms of art for a new society – an ideal which owes its origins to the socialist concerns of the 19th-century ▷Arts and Crafts movement. Such a merging of art with utilitarian production was intended to reunite the producer with the product, and this aspiration was adopted by the Soviet ▷Productivist movement.

Bib.: Bernstein, J.M., *The Fate of Art: Aesthetic Alienation from Kant to Derrida and Adorno*, Cambridge, 1992

Alison, Archibald (1757–1839)

Scottish philosopher. His *Essay on the Nature and Principles of Taste* (1790) was a highly influential contribution to debates about ▷aesthetics in the 18th century. Alison postulated an 'emotion of taste' which predates ▷Clive Bell's 'aesthetic emotion' by over 100 years. However, Alison's ideas about art were not concerned with the effects of pure form and colour but with the way in which the imagination stimulated aesthetic appreciation. In Alison's theory, an observer would respond to a work of art according to the associations that work had for him or her.

Bib.: Townsend, D., 'Archibald Alison: Aesthetic Experience and Emotion', *British Journal of Aesthetics*, 28 (Spring 1988), pp. 132–44

Alken, Samuel, senior (1750–1815); Samuel, junior (1784–1825) and Henry (1785–1851)

Family of British artists. The father and his two sons all specialized in sporting paintings and prints.

alla prima

(Italian, 'at first'.) Method used in (primarily oil) painting whereby the ▷pigment is applied directly to the ground without underpainting. It first came into widespread use in the second half of the 19th century, firstly with the ▷Romantics and then with the ▷Impressionists, in each case to achieve an appearance of spontaneity. Although ▷Hals, for example, had used

the technique in the 17th century it was only with the commercial production of softer, more malleable oil paints in tubes that the technique became really popular. In English it is sometimes called 'direct painting' and in French '*au premier coup*'.

Allan, David (1744–96)

Scottish painter. He was a genre painter and portraitist, often known as the Scottish ▷Hogarth, although there is little similarity. He was born in Alloa and through the patronage of the local Cathcart family, gained a place at Foulis Academy, Glasgow, in 1755. Sir William Hamilton, another member of the family, backed a trip to Italy in 1764, and Allan remained in Rome until 1777. He achieved some success: in 1773 he won the ▷history painting prize at the Academy of St. Luke where he was based, and in 1771 and 1773 he sent history paintings back to the ▷Royal Academy. His work of this period owes something to ▷Hamilton (e.g. *Origin of Painting*, 1775, Edinburgh, National Gallery of Scotland). In 1775, however, he visited Naples and started producing ▷watercolours and ▷etchings of Italian peasant life. Some were sent back to the Royal Academy in 1777, and on his return to Scotland, Allan began to concentrate on producing rustic scenes there. This work was later seen to anticipate ▷Wilkie, and was the basis of his fame. He was also a portraitist of some reputation (e.g. *Family of Sir James Hunter Blair*, 1785, private collection). He maintained a high profile in the administration of the Scottish art scene and in 1786 he succeeded ▷Runciman as the Master of the Academy of the Board of Manufactures in Edinburgh.
Bib.: Gordon, T. C., *David Allan of Alloa*, Alve, 1951; *The Indefatigable Mr Allan*, exh. cat., Edinburgh, 1973

Allan, Sir William (1782–1850)

Scottish painter. He was a ▷history painter taught at the Trustees Academy in Edinburgh, alongside ▷Wilkie, and later at the ▷Royal Academy schools in London (he exhibited at the RA from 1803). In 1805 he travelled to Russia, which later became the subject for his first successful paintings (*Bashkirs*, 1814, St. Petersburg, Hermitage). He returned to Edinburgh in 1814, where he began to work increasingly on subjects from Scottish history (*The Murder of David Rizzio*, 1835, Edinburgh, National Gallery of Scotland). His work was much admired by Walter Scott and he produced a series of works based on Scott's novels. He was one of the first artists to use exotic subject matter, which he treated with large, highly-finished and detailed canvases. He painted the popular *Battle of Waterloo* (1843, London, Apsley House). In 1844 he returned to Russia. He became an RA in 1835, President of the RSA in 1844 and was knighted in 1842.

allegory (adj. allegorical)

The expression of an idea or theme in the semblance of some other subject. The superficial narrative might be relatively simple: St. George, a hero, rescues a beautiful princess from a dragon, for example. However, the real meaning which underlies the simple narrative will be more important to the patron (in this case, the Church): a Christian saint (typified by St. George) overcomes paganism (the dragon) and converts a new country or township (the beautiful princess) to Christianity. Allegory was often conveyed through mythological or biblical subjects from which a topical interpretation may be derived or onto which a completely new meaning may be subsequently grafted. The understanding of the chosen personifications or symbols in an allegory may rely on a common ideological currency within a society or may be somewhat abstruse and need an explanatory text. Allegory has been used as a vehicle in both painting and sculpture to convey moral, intellectual, religious and political meanings. Its power resides in the mind's natural propensity to be more attracted to, and to find more memorable, visual images rather than abstract concepts.

Allegri, Antonio
▷Correggio

Allianz
▷Lohse, Richard

Allied Artists Association

A group of British artists who were part of the circle of ▷Sickert. The group, including ▷Gore, ▷Gilman and ▷Ginner, banded together in 1908 with the intention of creating a new exhibition society that would serve the same purpose as the French ▷Salon des Indépendants. This particular group was superseded by the formation of the ▷Camden Town Group.

Allingham, Helen (née Paterson) (1848–1926)

English painter. She was primarily a watercolourist. She was born near Burton on Trent, the daughter of a doctor. The family moved to Birmingham following the death of her father, and during her childhood she was much influenced by her aunt, who was also an artist. She attended Birmingham School of Design and the ▷Royal Academy schools in 1867, where she was influenced by ▷Breton Rivière and Fred Walker. She began her career as an engraver with the *Graphic* (1870–74), and produced book illustrations (e.g. *Far From the Madding Crowd*), before marrying the poet and editor of *Fraser's Magazine*. After her marriage she was part of a wide literary circle which included Carlyle (whom she painted), ▷Ruskin, Tennyson and Browning. She settled in Surrey and began painting landscapes, concentrating on sunny, pretty images of the villages and countryside which she knew. In her later career, she

increasingly painted cottages and their gardens, works for which she became highly popular. She was often compared to her contemporary ▷Birkett Foster. Ruskin likened her to ▷Kate Greenaway. She was elected RA in 1890 but exhibited mainly at the Old Watercolour Society.

Bib.: Huish, M.B., *The Happy England of Helen Allingham*, London, 1903; Taylor, I., *Helen Allingham's England*, Exeter, 1990

Allori, Alessandro (1535–1607) and Cristofano (1577–1621)

Italian painter. He was from Florence. He was a nephew and then adopted son, following his own father's death, of ▷Bronzino, whose pupil and principal follower he became. In 1554–6 he was in Rome where he was impressed by ▷Michelangelo's late painting manner, particularly that of his *Last Judgement*, the influence of which can be seen in Alessandro's frescos in SS Annunziata (early 1560s). In 1575 he was commissioned to paint one of a cycle of new altarpieces (*Christ and the Samaritan Woman*) for Santa Maria Novella, Florence; and in 1570–72, two panels, including *The Pearl Fishers*, for the Studiolo of Francesco de' Medici. Many of Allori's nude figures are derived from Michelangelo, for example in *The Pearl Fishers*, the climbing nude seen from behind comes straight from *The Battle of Cascina*. His elegant style, however, with its polished smoothness and artificiality, owes a closer debt to the courtly art of Bronzino. He was also a portraitist.

Cristofano, Alessandro's son, was a leading Florentine painter of the next generation who went to Rome and came under the influence of ▷Caravaggio, as can be seen in his remarkably sadistic *Judith with the Head of Holofernes* (c1615, Florence, Pitti Palace) in which his mistress is cast as ▷Judith, and Holofernes' severed head is based on his own features. Cristofano, like his father, also worked as a portraitist.

Bib.: Lecchini, G.S., *Alessandro Allori*, Turin, 1991

all-over painting

A term referring to painting that covers an entire canvas in an equal way. The term was adopted after ▷Jackson Pollock invented drip paintings which had no top or bottom, left or right.

▷colour field painting

Allston, Washington (1779–1843)

American painter. He attended Harvard University, and visited England from 1801 to 1808. There he studied under ▷Benjamin West, and then travelled to France with ▷John Vanderlyn who shared his ideals about landscape painting. He returned to England in 1811–18 after extensive travel in Switzerland and Italy and a visit to America. His English paintings of this period are primarily ▷history paintings in the tradition of West but with the emotional energy of ▷John

Martin's works. He went back to America in 1818, where he specialized in landscape paintings with biblical and literary themes which were both evocative and visionary. He knew Coleridge, Washington Irving and ▷Thorvaldsen and perpetuated the ideals of ▷Romanticism through both his art and his writing. He was elected an ▷ARA in 1818.

Alma-Tadema, Sir Lawrence (1836–1912)

English painter of Dutch birth. He was born at Dronryp in Friesland. He seemed destined for a legal career, but showed early artistic talent and enrolled at Antwerp Academy under the genre artist, ▷de Keyser, where he received a traditional academic training. In 1860 he became a pupil of the history painter, Leys. He travelled to London in 1862 to view the ▷Elgin Marbles, and in 1863 visited Italy on his honeymoon. His early work had depicted scenes of northern European history but he now turned to Egyptian and Classical subjects (e.g. *Pyrrhic Dance*, 1869, London, Guildhall). He came to London in 1870, heavily promoted by the dealer Gambart, and became an instant success. He decorated his homes in Regent's Park and St. John's Wood in a Classical style, held lavish parties and became an important member of the social scene. His small, detailed images of antique life were highly popular (e.g. *In the Tepidarium*, 1881, Port Sunlight). Increasingly he abandoned all pretence of subject and concentrated on scenes of domestic tranquillity, languid beauty and statuesque female figures, utilising the wet white ground of the ▷Pre-Raphaelites to achieve a vivid Mediterranean light (e.g. *Reading from Homer*, 1885, Philadelphia). His colours were increasingly intense blues and mauves, set off by gleaming marble, and exaggerated by perspective tricks to create a sense of scale. He did produce some modern life subjects (e.g. *94 Degrees in the Shade*, 1876, Cambridge, Fitzwilliam Museum). He became a British citizen in 1873, was knighted in 1899 and awarded the Order of Merit in 1905.

Bib.: *Sir Lawrence Alma-Tadema*, exh. cat., Sheffield, 1976; Ash, R., *Sir Lawrence Alma-Tadema*, London, 1989; Tomlinson, R.A., *The Athens of Alma-Tadema*, Stroud, 1990

Alpha and Omega

(Revelation of St John the Divine, 1: 11, 22: 13) The first and last letters of the Greek alphabet. In Revelation, God says to John, 'I am Alpha and Omega, the beginning and the end, the first and last' (22: 13), thus indicating his dominion over all things that have and ever will be created. In Early Christian art the two letters are frequently used with the ▷Chi-Rhó Monogram. In ▷Renaissance and later painting, God the Father is occasionally represented holding an open book, the pages of which are inscribed with the signs for Alpha and Omega, or alternatively the signs may

FIGURE 1 Francis Bacon, *Portrait of Isabel Rawsthorne*, 1966, Tate Gallery, London

FIGURE 2 Vanessa Bell, *View of the Pond at Charleston*, c1919, Sheffield City Art Galleries

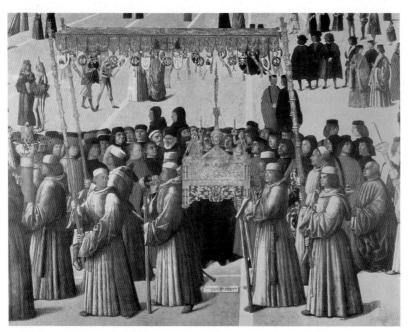

FIGURE 3 Gentile Bellini, *Procession in the Piazza di San Marco*, 1496,
Galleria dell'Accademia, Venice

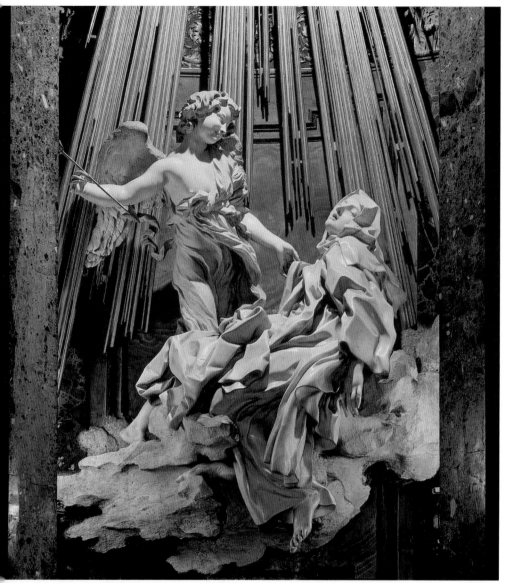

FIGURE 4 Gianlorenzo Bernini, *The Ecstasy of St. Theresa*, 1645–52, Cornaro Chapel,
Santa Maria della Vittoria, Rome

FIGURE 5 Gianlorenzo Bernini, *The Four Rivers
Fountain*, 1648–51, Piazza Navona, Rome

FIGURE 6 George Caleb Bingham, *Ferrymen
Playing Cards*, 1847, St. Louis Art Museum

FIGURE 7 William Blake, *The Marriage of Heaven and Hell*, 1790–93, private collection

FIGURE 8 Umberto Boccioni, *Unique Forms of Continuity in Space*, 1913, Museum of Modern Art, New York

FIGURE 9 Hieronymus Bosch, *The Garden of Earthly Delights*, c1500, Prado, Madrid

FIGURE 10 Sandro Botticelli, *The Birth of Venus*, c1483, Uffizi, Florence

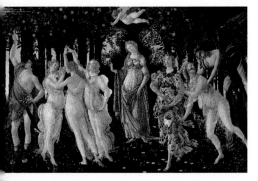

FIGURE 11 Sandro Botticelli, *Primavera*, c1478, Uffizi, Florence

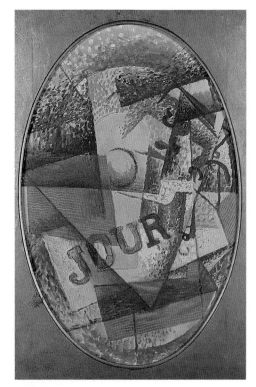

FIGURE 12 Georges Braque, *Still Life*

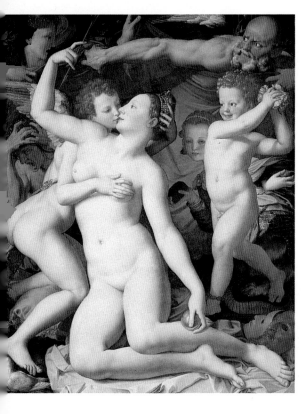

FIGURE 13 Agnolo Bronzino, *An Allegory with Venus and Cupid*, c1540–50, National Gallery, London

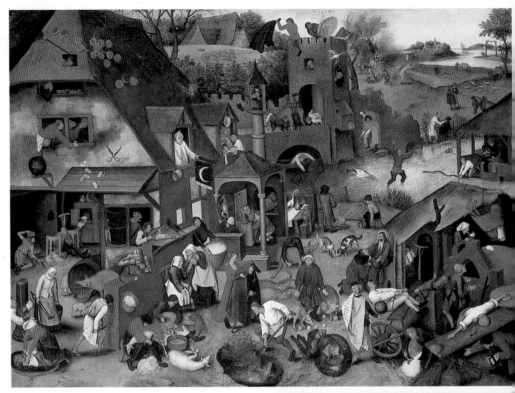

FIGURE 14 Pieter Bruegel the Elder, *The Flemish Proverbs*, 1559, Staatliche Museum, Berlin-Dahlem

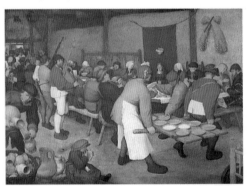

FIGURE 15 Pieter Bruegel the Elder, *Peasant Wedding*, 1568, Kunsthistorisches Museum, Vienna

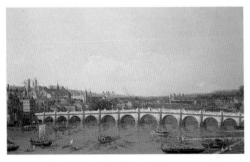

FIGURE 16 Antonio Canaletto, *Westminster Bridge from the North with Lambeth Palace in the Distance,* c1747, Yale Center for British Art, Newhaven

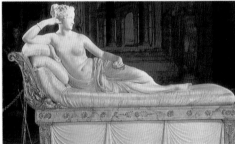

FIGURE 17 Antonio Canova, *Paulina Borghese*, 1805–7, Galleria Borghese, Rome

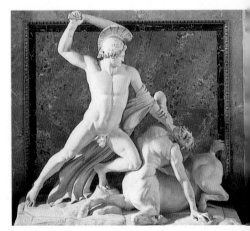

FIGURE 18 Antonio Canova, *Theseus Slaying the Centaur*, 1781–3, Victoria and Albert Museum, London

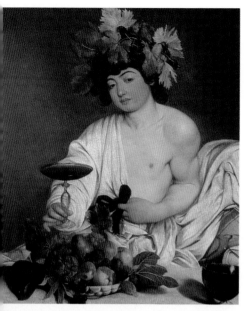

FIGURE 19 Michelangelo Merisi da Caravaggio, *The Young Bacchus*, c1595, Uffizi, Florence

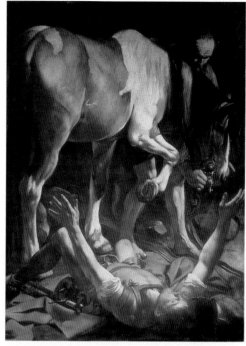

FIGURE 20 Michelangelo Merisi da Caravaggio, *Conversion of St. Paul*, 1601, Cerasi Chapel, Sta Maria del Popolo

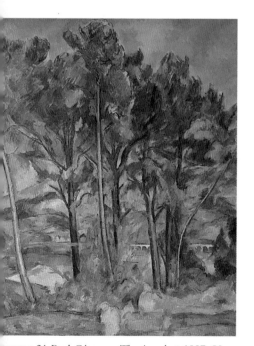

IGURE 21 Paul Cézanne, *The Aqueduct*, 1887–90, 'ushkin Museum, Moscow

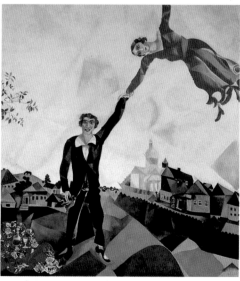

FIGURE 22 Marc Chagall, *The Walk*, State Russian Museum, St. Petersburg

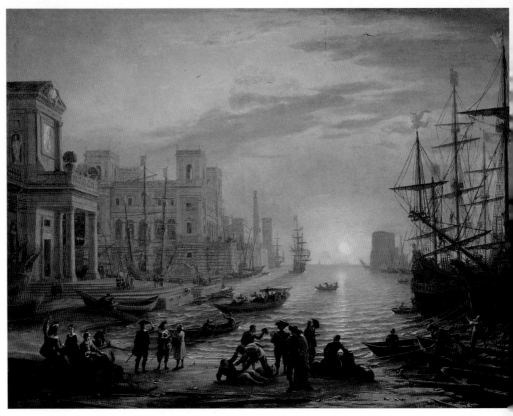

FIGURE 23 Claude Lorrain, *Seaport with Setting Sun*, 1639, Louvre, Paris

FIGURE 24 John Constable, *Golding Constable's Kitchen Garden*, 1815, Ipswich Museum and Art Gallery, Suffolk

FIGURE 25 Jean-Baptiste Camille Corot, *The Colosseum, Rome*, 1825, Louvre, Paris

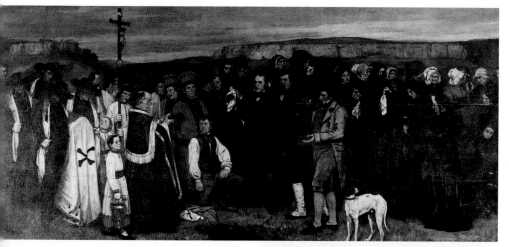

FIGURE 26 Gustave Courbet, *Burial at Ornans*, 1850, Louvre, Paris

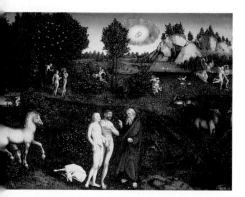

FIGURE 27 Lucas Cranach, *Adam and Eve in the Garden of Eden*, Kunsthistorisches Museum, Vienna

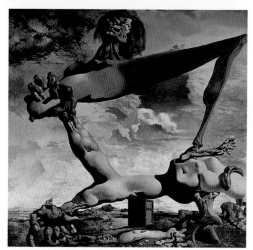

FIGURE 28 Salvador Dali, *Soft Construction with Boiled Beans: Premonition of Civil War*, 1936, Philadelphia Museum of Art, Pennsylvania

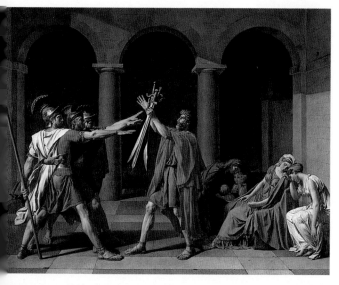

FIGURE 29 Jacques Louis David, *The Oath of the Horatii*, 1784, Louvre, Paris

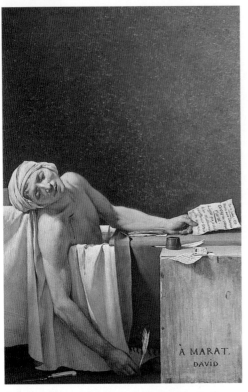

FIGURE 30 Jacques Louis David, *The Death of Marat*, 1793, Musées Royaux des Beaux-Arts de Belgique, Brussels

FIGURE 32 André Derain, *Martigues (Harbour in Provence)*, Hermitage, St. Petersburg

FIGURE 31 Sonia Delaunay-Terk, *Contrastes Simultanes*, 1912, Musée National d'Art Moderne, Paris

FIGURE 33 Otto Dix, *Three Prostitutes on the Str*, 1925, private collection

FIGURE 34
Duccio di
Buoninsegna,
*Maestà: Descent
into Limbo*,
1308–11, Museo
dell'Opera del
Duomo, Siena

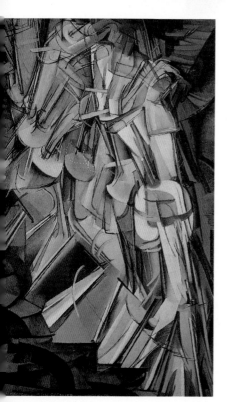

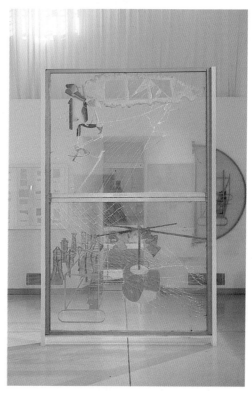

FIGURE 35 Marcel Duchamp, *Nude Descending
Staircase, No.2*, 1912, Philadelphia Museum
of Art, Pennsylvania

FIGURE 36 Marcel Duchamp, *The Bride Stripped
Bare by her Bachelors, Even* or *Large Glass*, 1915–23,
Philadelphia Museum of Art, Pennsylvania

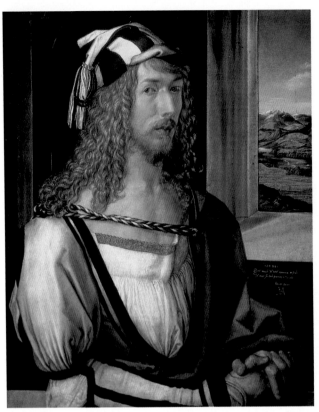

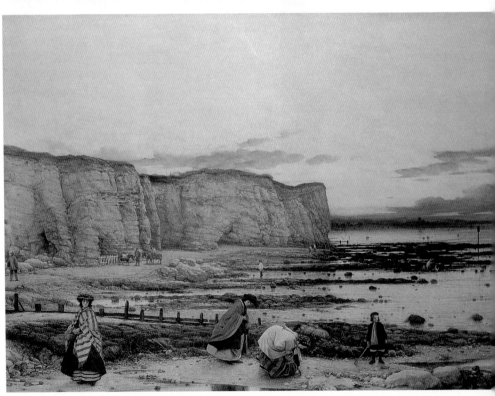

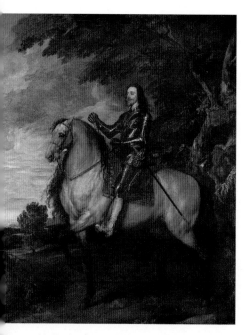

FIGURE 39 Sir Anthony Van Dyck, *Charles I on Horseback*, c1637–8, National Gallery, London

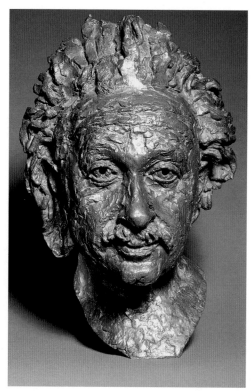

FIGURE 41 Sir Jacob Epstein, *Bust of Albert Einstein*, 1934, Fitzwilliam Museum, University of Cambridge

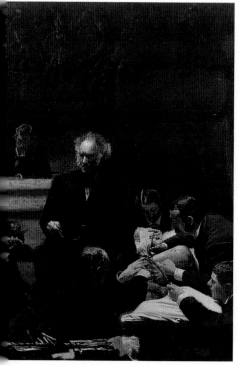

FIGURE 40 Thomas Eakins, *The Gross Clinic*, 1875, Jefferson Medical College, Philadelphia

FIGURE 42 Max Ernst, *The Entire City*, Kunsthaus, Zürich

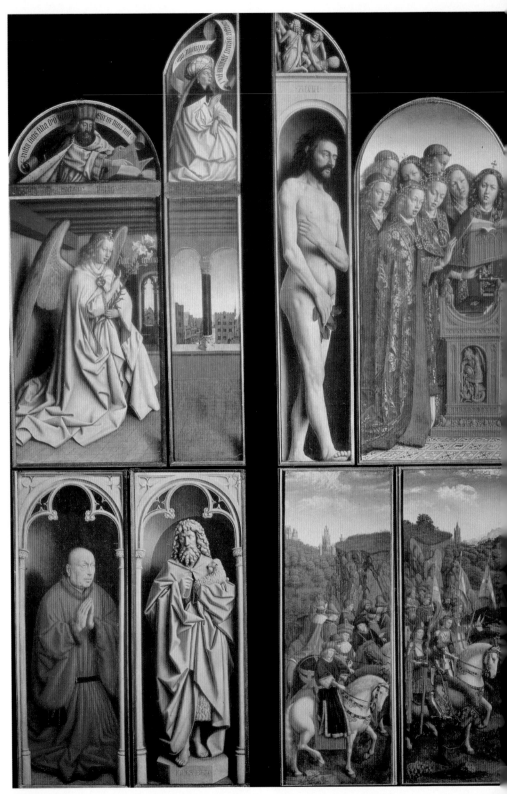

FIGURE 43 Jan van Eyck, Ghent Altarpiece, left panel, exterior and interior, c1432

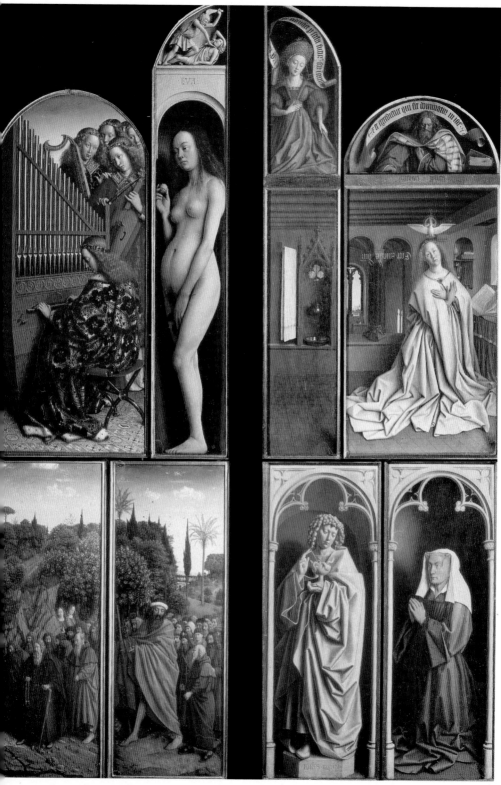

FIGURE 44 Jan van Eyck, Ghent Altarpiece, right panel, interior and exterior, c1432

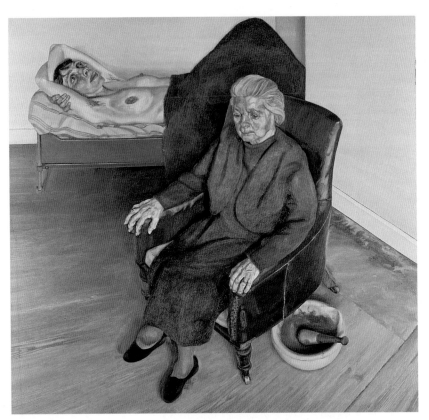

FIGURE 45 Lucian Freud, *Large Interior, W.9*, 1973, Collection of the Duke of Devonshire, Chatsworth

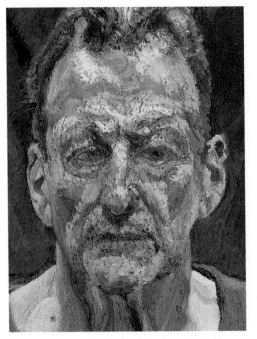

FIGURE 46 Lucian Freud, *Self-portrait*, 1990–91, private collection

FIGURE 47 Caspar David Friedrich, *The Cross in the Pine Forest*, 1808, Gemäldegalerie, Dresden

Sir Lawrence Alma-Tadema, Stapleton Collection

be placed within an equilateral triangle to symbolize the ▷Trinity (e.g. ▷Frederico Zuccaro, *Angels Worshipping the Trinity*, c1589, Rome, Gesù, Cappella degli Angeli).

Alsloot, Denis van (c1570–c1627)
Flemish painter. He worked in Brussels from 1599 and specialized in a style of landscape painting reminiscent of that of ▷Jan Bruegel. His most famous works show processions or festivals set in a landscape, and he painted a number of winter landscapes.

Altamira
Place in northern Spain near Santander where Palaeolithic rock paintings were discovered in 1869. These images of wild horses, boars and bisons were placed on the walls and ceilings of the cave and show facility and naturalism. They also adhere to bumps and depressions in the rock face and are located in a separate section of the cave – thus indicating a gallery or ceremonial spot.
▷Lascaux

altana
A loggia or covered terrace raised above the roof of an Italian house (e.g. Palazzo Davanzati, Florence, late 14th century).

altarpiece
A devotional work of art, either painted or sculpted or both, placed above, on or behind an altar in a Christian church.

▷ancona; pala; reredos; retable; diptych; triptych; polyptych

Altdorfer, Albrecht (c1480–1538)
German painter and printmaker. He studied in Austria, where he came into contact with engravings by both ▷Dürer and ▷Mantegna. However, he settled in Regensburg, where he spent the rest of his career, specializing in religious and historical subjects. Like some other artists of the ▷Reformation period, his emphasis was less on the religious aspects of his work than on the landscape, and Altdorfer became one of the most important representatives of the ▷Danube School of Painting, which was dominated by an interest in landscape. His most important work is the *Battle of Issus*, or *The Battle of Alexander and Darius* (1529, Munich, Alte Pinakothek). This work, which gives a sense of infinity through its use of panoramic landscape and thousands of minute figures, was a new development in ▷battle painting. The landscape here became more significant than the figures.
Bib.: Guillaud, J. and M. (eds), *Altdorfer and Fantastic Realism in German Art*, New York, 1985; Wood, C., *Albrecht Aldorfer and the Origins of Landscape*, London, 1993

alterity
Otherness (▷the other).

Althusser, Louis (1918–90)
French writer. He was the leading exponent of new ▷Marxist thinking in France during the 1960s, with works like *Reading Capital* (1968) and *Lenin and Philosophy* (1971). Working in the broad field of cultural studies, he redefined the relationship between the arts and ▷ideology; and between man and institutions. For him man was naturally ideological, and thus ideology (an apparatus of State control) influenced all aspects of life, including the arts.
Bib.: Elliot, G., *Althusser, A Critical Reader*, Oxford, 1994; Majumdar, M.A., *Althusser and the End of Leninism*, London, 1995; Smith, S.B., *Reading Althusser*, Ithaca, 1984

Altichiero (documented 1369–84)
Italian painter. He is believed to have been born in Zevio, near Verona. His most important surviving work, however, is found in Padua where his style was evidently formed under the influence of ▷Giotto's frescos in the ▷Arena Chapel. To Giotto's grave and monumental figure style, he added a closely-observed naturalism and an ability to handle vast and colourful crowd scenes. He and his workshop painted the ▷fresco cycle of scenes from the life of St. James in the Chapel of S. Felice, San Antonio, Padua in 1372–9 and, in c1377–84, scenes from the New Testament and from the lives of Sts. George, Lucy and Catherine in the nearby Oratorio di S. Giorgio. His

work in Verona is generally considered to have had a founding influence on the Veronese school, although only the late frescos in the Cavalli Chapel in the church of Sant' Anastasia (after 1384) survive.

Alvarez Cubero, José (1768–1827)

Spanish sculptor. He was in Rome between 1805 and 1825, where he came into contact with ▷Canova. Adopting a ▷Neoclassical sculptural style, he specialized in portraits and Classical subject-matter.

Bib.: *José Alvarez Cubero: exposicion*, Cordoba, 1986

Amarna art

The art produced in 14th century BC during the reign of the pharoah Akhenaten in Egypt. The new location of the Egyptian capital in Tel-el-amarna coincided with a change in religious practices and greater court prosperity. Amarna art is dominated by ▷mural painting which includes ▷genre scenes and glorifications of the royal family, as well as sculptural portraits. Although based on naturalistic representation, the works are stylized.

amateur

The name given to a non-professional practitioner of the arts. The status of the amateur has fluctuated through history. During the ▷Renaissance, cultivated gentlemen were expected to have some knowledge of and ability with the arts, and this idea prevailed well into the 18th century. Some amateur architects like Richard Boyle, the 3rd Earl of Burlington were responsible for designing their own homes. Amateur arts intensified in the late 18th century when theories of the ▷picturesque increased the popularity of amateur ▷watercolour painting. During this same period, the stigma of 'amateurism' persistently dogged women artists who sought to gain professional status. Women of genteel birth were expected to learn art practice as an 'accomplishment', but they were prohibited access to professional training bodies. Women artists, like ▷Berthe Morisot in the 19th century, broke free from the label of 'amateur' only after regular public exhibition and association with established male artists. In the 20th century, the term no longer carries so many associations, and it has come to signify a hobby.

Ambassadors, The

Painted by ▷Hans Holbein the Younger in 1533 (oil on canvas, 207 × 209 cm/6 ft 8 in × 6 ft 9 in). It is a double portrait of Jean de Dinteville, the French ambassador to England, and Georges de Selve, the Bishop of Lavaur, who is known to have visited London during the spring of 1533. The figures are shown in appropriate dress, standing on either side of a display of various still life objects. On the upper shelf of the whatnot are astronomical instruments and two sundials which record the day and time – 10.30 am on 11 April. The lower shelf includes a lute with broken strings, a prayer book and a globe. The objects can be seen as indicative of the sitters' status and accomplishments, but they can also be read as a ▷*vanitas*, recording mortality and the march of time. This is emphasized by the fact that Holbein records both figures' ages, shows a ▷crucifix in the top left-hand corner and includes a skull ornament on Dinteville's cap. Most notably, the foreground of the picture is dominated by an elongated skull, recognizable only if viewed from an acute angle (▷anamorphosis). The symmetry of the work with the figures balancing each other, and the carefully controlled picture space, defined by a dark curtain in the background, convey a formality and calmness which characterized much of Holbein's portraiture. Equally, the work exemplifies the artist's precise realism, with richly coloured detail and patterning. It is in the National Gallery in London.

amber

A hard fossil resin which is used for ▷varnish and in the ornamental arts.

Amberger, Christoph (c1500–62)

German artist. Amberger produced court portraits in Augsburg that revealed his knowledge of the Venetian portraiture of ▷Titian and others. His works included a portrait of the Emperor Charles V (c1532, Staatliche Museum, Berlin).

ambo (pl. ambones)

In early Christian churches, a raised stone pulpit or stand, sometimes with a flight of steps, for the reading of the epistle and the gospel during mass. Frequently there would be two, one on either side of the ▷choir enclosure, that on the north side reserved for the epistles, that on the south for the gospels (as in San Clemente, Rome).

Ambrogo da Fossano

▷Bergognone, Il

ambulatory

A processional aisle around the ▷apse in a Christian church; also, the covered walk of a ▷cloister.

American Gothic

Painted by ▷Grant Wood in 1930 (oil on canvas 72 × 63 cm/2 ft 4 in × 2 ft). It depicts the half-length view of a middle-aged Iowa farming couple, the man holding a pitchfork, against the background image of their farm. The couple dominate the foreground in an almost menacing and certainly proprietorial way, their features painted with an exaggerated realism. The whole work has a naive quality to it, achieved partly by the flatness of the picture space, and partly by the use of clear, bright colour and sharp definition. The artist seems caught between adopting a satirical approach and one of sympathetic honesty. The ▷folk

art style was characteristic of Wood's works as a whole and of the ▷Regionalist School to which he belonged. It can be seen as both a critique of European art trends and a search for a uniquely American art based on the traditional values of the settler farmers in the face of modernity and technological progress.

American scene painting

An umbrella term for the naturalistic style of painting of the 1920s and 1930s. Following the First World War, many American artists rejected the ▷modernist styles that had been perpetuated in the wake of the ▷Armory show. Instead, they adopted academic realism in scenes of urban and rural life. These contained a nationalist flavour, as they glorified or romanticized even mundane aspects of everyday American life. The most famous exponent of scene painting was ▷Edward Hopper. American scene painters could be either regionalists, who stressed local and small-town themes, or ▷social realists who focused on urban poverty.

Amiens Cathedral

High ▷Gothic cathedral in north-eastern France, begun in 1220. The ▷nave was designed by Robert de Luzarches, who was influenced by the architects of Chartres and ▷Reims. The cathedral marks the apex of High Gothic, with a huge interior space, three times as high (43 m/142 ft) as it is wide. The spatial movement is uninterrupted and the ▷transept crosses almost centrally, acting as a balance. The ▷vaulting and slender upward movement leaves no doubt as to the focus of the worshipper in the body of the cathedral. The window ▷tracery at Amiens is innovative, although it is unclear why this development happened here and at this time, and it has since been lost because of later extensions. The upper windows have four long lights, the first of the kind, and a single roundel. The vaulting springs high, meaning that the windows in all levels bring light into the nave. The cathedral clearly influenced other later Gothic architecture.

Amiens, School of

Sculptural school, developed in the 1230s during the rebuilding of ▷Amiens Cathedral in the High ▷Gothic Style. The school is characterized by the square, upright, restrained and somewhat austere figurative sculpture found at Amiens and in the locality, and was imitated at Chartres and elsewhere. ▷Byzantine overtones can be seen in the scale and the folds of the drapery.

Amigoni (Amiconi), Jacopo (?1682–1752)

Italian painter. Amigoni was trained in Venice, where he developed a style of decorative history painting in the ▷Baroque tradition. His skill led to major European commissions, such as a series of ▷history paintings for the Elector of Bavaria. In 1730 he moved to London and offered his services as a history painter to English patrons. He was commissioned to decorate the staircase at Bartholomew's Hospital, but ▷Hogarth overturned the commission by offering to do the work free of charge. Other historical commissions were not forthcoming, so Amigoni turned to portraiture, which was the most popular art form in England at this time. His success as a portrait painter led to patronage by the royal family and the jealousy of rival English artists. He returned to Venice in 1739, and by 1747 he was court painter in Madrid.

Bib.: Scarpa Sonino, A., *Jacopo Amigoni*, Soncino, 1994; Wilson, G., 'One God! One Farinelli! Amigoni's Portrait of a Famous Castrato', *Apollo*, 140 (Sept 1994), pp. 45–51

Amman, Jost (1539–91)

Swiss engraver. He worked in Nuremberg. He produced numerous drawings and especially book illustrations, many of contemporary subjects.

Bib.: O'Dell-Franke, I. and A. Szilagyi, 'Jost Amman und Hans Petzolt: Zeichnungvorlagen für Goldschmiedewerke', *Jahrbuch der Kunsthistorischen Sammlungen in Wien*, 79 (1983), pp. 95–105

Ammanati (Ammannati, Amannati), Bartolommeo (1511–92)

Italian sculptor and architect. He was from Florence, where he practised a ▷Mannerist style influenced by ▷Michelangelo and ▷Jacopo Sansovino. His best-known works are in Florence, namely the rusticated courtyard of the Palazzo Pitti (1558–70), the figures for the Neptune Fountain (1563–75, Piazza della Signoria) and the Ponte Sta Trinità (1567–69; destroyed in 1944, subsequently rebuilt). In 1550 he married Laura Battiferri, a celebrated Florentine poet (whose portrait ▷Bronzino painted). In his final years, Ammanati was deeply affected by the ideas of the ▷Counter-Reformation and destroyed some of his secular works on the grounds of their salaciousness. Certainly his surviving, but dismembered, Fountain of Juno (Florence, Museo Nazionale dell Bargello) demonstrates a deeply erotic vein in his work. His letter of 1582 to the Accademia del Disegno is an important post-Council of Trent document setting out, as it does, his opposition to the representation of the nude and the artist's moral responsibility for his work.

Bib.: Kinney, P., *The Early Sculpture of Bartolommeo Ammanati*, New York, 1976

amorino

(Italian, diminutive of *Amore*: 'Eros'.) A small ▷cupid or ▷*putto*.

amphiprostyle

Architectural term defining a Classical temple with columned ▷porticoes at the front and rear, but without columns along the sides. A prostyle is a temple with a coloured portico at the front only.

amphitheatre

A circular or elliptical structure consisting of an arena surrounded by seats in rising tiers, either built up or set into a natural slope. Used by the Romans principally for gladiatorial contests, the earliest known amphitheatres date from the 1st century BC becoming widespread at the height of the Roman empire, the most famous being the ▷Colosseum at Rome.

Amphitrite

▷Nereids

amphora

One of the common shapes of ancient Greek vases. They were tapering jugs with two handles. They were used to hold oil and wine.

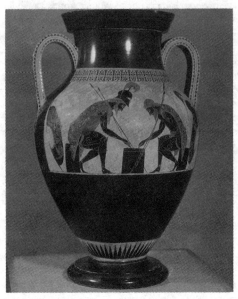

Exekias, amphora depicting Ajax and Achilles, c540 BC, Vatican Museums, Rome

Analysis of Beauty, The

An aesthetic treatise published by ▷William Hogarth in 1753. The *Analysis of Beauty* is unique in the history of ▷aesthetics for its advocacy of practical, empirical observation, rather than the ▷Neoplatonic ideals of ▷Classicism. The work was intended to overturn the prevailing concern with symmetry and regularity in art by an emphasis on the serpentine line, which Hogarth held to be the basis of all beauty. The *Analysis* draws most of its examples from daily life, and reveals concerns with ▷physiognomy which were also part of Hogarth's own art. Although the book gained a certain amount of attention and respect in Europe, it was savagely attacked by the engraver ▷Paul Sandby, and its premises were derided by Hogarth's political enemies shortly before his death.
Bib.: Burke, J. (ed.), *Hogarth's 'Analysis of Beauty'*, Oxford, 1955

Analytical Cubism

▷Cubism

anamorphosis

(Greek, 'distortion'.) A painting or drawing which is deliberately distorted so that the observer must look at it in a particular way in order to correct the distortion. Such a drawing was produced by squaring an original sketch and then copying it using a distorting grid. It was practised sporadically in the 16th century by artists as diverse as ▷Leonardo and ▷Holbein. Although primarily an optical trick, anamorphosis could also be used for symbolic or allegorical purposes.

▷*Ambassadors, The*

Anastasis

This term refers specifically to the resurrection of the Old Testament saints during ▷Christ's ▷Harrowing of Hell and is used in the Orthodox Church to represent redemption. In ▷Byzantine depictions, the redeemed generally move toward Christ, rather than Christ moving into hell to rescue them, which is more common in western European art. For example, the ▷mosaic cycles at Hosios Loukas and Nea Moni both contain Anastasis scenes.

anatomy

The study of anatomy formed a strong part of art education from the 17th century. Although it was rare for artists to be involved in dissection, ▷academies included lectures from surgeons as part of their curriculum. Normally, skeletons and ▷*écorché* figures were used. By the 19th century, textbooks supplied the relevant information, with detailed ▷engravings to accompany surgical descriptions. The study of anatomy was considered important because it allowed artists to understand the fundamental make-up of the human body, which itself was the basis of ▷history painting. Some artists were particularly drawn to this aspect of their study; ▷Leonardo, ▷Haydon and ▷Géricault were among the most notable. Others, such as ▷George Stubbs, avoided the human body in favour of a study of animal anatomy.

Anatomy Lesson of Dr. Tulp, The

Painted by ▷Rembrandt in 1632 (oil on canvas 170 × 216 cm/5 ft 6 in × 7 ft). It was commissioned

to commemorate a public lecture given by Tulp, an Amsterdam anatomist, in January 1632. The work shows Tulp, distinguished by a black hat, dissecting the left arm of a cadaver. Around the body are seven watchers, all portraits and all identifiable by Rembrandt's use of ciphers above the head of each man, which correspond to names written on a list held by the figure closest to Tulp. In the foreground of the work the back of a treatise on anatomy is visible. The dead body proves the central focus of the canvas, a strongly lit and pallid diagonal through the sombre dark costumes of the other figures. Rembrandt has carefully arranged the group to give each individual a specific pose and character, as well as using the men to enliven what could be a dull composition. The men stare eagerly at Tulp, at the body and at the book, whilst Tulp himself is set apart, the only figure displaying movement in his raised arm gesture. The tight positioning emphasizes the claustrophobia of the shadowy scene. The work can be seen as a variation on the group portraits which were popular during the period in Holland and is also a compelling study of death. Some of the figures may not be entirely the work of Rembrandt. The painting is now in the Mauritshuis, in The Hague.
Bib.: Schupbach, W., *The Paradox of Rembrandt's Anatomy*, London, 1982

Ancients, The

The name given to a group of English artists who were admirers and followers of ▷Blake and who chose the name because of their interest in Medieval mysticism. They included ▷Palmer, ▷Calvert and ▷George Richmond, and they congregated at Palmer's home in Shoreham, Kent, during the 1820s and 1830s. They were always individualists, and they did not remain together long after Blake's death.
Bib.: Lister, R., *Samuel Palmer and the Ancients*, Cambridge, 1984

ancon (pl. ancones)

(i) A bracket or console either side of a doorway or window, supporting an ▷entablature or ▷cornice. (ii) A projecting ▷boss left on a column drum or wall block for hoisting it into position.

ancona

An early type of Italian ▷altarpiece consisting of several panels in a single frame without folding wings.

Andrea da Firenze (Andrea Bonaiuti) (c1343–77)

Italian painter. He was a Florentine whose major work is the ▷fresco cycle (begun 1365) in the chapter house (now called the Spanish Chapel) of the Dominican Friary of Sta Maria Novella, Florence. Based on the treatise, the *Specchio della vera Penitenza* (*The Mirror of True Penitence*) by a former prior of the friary, Fra Jacopo Passavanti, the cycle illustrates the penitent's way to salvation through the ship of the Church, as guided by the teachings of the Dominican Order. Dominican dogma is expounded with maximum clarity through the artist's use of bright colours, rigid outlines and a meticulously detailed technique. Andrea's last documented work is the 1377 cycle of frescos of the *Life of St. Raynerius*, in the Campo Santo, Pisa.

Andrea del Castagno (Andrea di Bartolo di Bargilla) (c1421–57)

Italian painter. He was from Florence, where he was influenced firstly by ▷Masaccio and, in his later work, even more strongly by ▷Donatello, whose sculptural qualities and emotional intensity find an equivalence in ▷Castagno's paintings. His first important commission was a series of propaganda ▷frescos of the bodies of Florentine rebels hung by their heels (later destroyed). His explicit portrayal of their punishment earned him the nickname Andreino degli Impiccati ('of the hanged men') and was also perhaps the source of ▷Vasari's unfounded account of his violent and envious character (Vasari states that Andrea murdered ▷Domenico Veneziano out of professional jealousy, although Domenico is now known to have outlived Andrea). The known facts of Andrea's life are few: he was in Venice in 1442, where he helped to paint some frescos in the Church of S. Zaccaria. By 1444, he was back in Florence and designed a (surviving) stained-glass window for the Duomo and in c1447 he painted what is perhaps his masterpiece, the *Passion* and (especially) the *Last Supper* frescos for the refectory of S. Apollonia, Florence (now open to the public as the Castagno Museum). It is in the works following these that the emotionalism of ▷Donatello, accompanied by an increased linearity, begins to appear: these characteristics can be seen in his series of *Famous Men and Women* for a villa at Legnaia (now in the Uffizi, his ▷equestrian portrait of *Niccolò da Tolentino* (fresco, Florence, Duomo, commissioned as a pendant to ▷Uccello's *John Hawkwood*). His work, with its concentration on the nude rendered with sculptural clarity, greatly influenced the paintings of ▷Signorelli and, even more so, ▷Michelangelo.
Bib.: Even, Y., 'Andrea del Castagno's Eve: Female Heroes as Anomalies in Italian Renaissance Art', *Women's Art Journal*, 14 (Autumn/Winter 1993/4), pp. 34–42; Horster, M., *Andrea del Castagno 1423–57*, Oxford, 1980; Spencer, J.R., *Andrea del Castagno and his Patrons*, Durham, 1991

Andrea del Sarto (Andrea d'Agnolo di Francesco) (1486–1530)

Italian painter. He was a leading Florentine painter of the High ▷Renaissance, whose paintings are characterized by a Florentine feeling for simplified, monumental form wedded to an almost Venetian sense of colour and tone. He broke away from the traditional

Florentine style of painting in which form would be delineated and then coloured in: Andrea's forms are built up in areas of light and shade. He was trained by ▷Piero di Cosimo, but was influenced by ▷Fra Bartolommeo and ▷Raphael. His first major commission was the series of ▷grisaille frescos of the *Life of John the Baptist* for the cloister of the Scalzi Convent in Florence (1511–26). In 1514 and 1525, he painted two frescos for the ▷atrium of the Annunziata in Florence (a *Birth of the Virgin* and the *Madonna del Sacco*), generally regarded as perfect examples of the High Renaissance style. A major work is the serenely Classical *Madonna of the Harpies* (1517, Florence, Uffizi). In 1518 Andrea went to Paris at the invitation of Francis I, but he broke his contract and returned to Florence the following year to be with his wife who, according to ▷Vasari's probably unreliable account (as the accusation only appeared in the first 1550 edition, being edited out of the second in 1568), dominated her husband and exerted an increasingly vitiating effect on his work. Recognized today as one of the leading masters of the High Renaissance, Andrea's drawings (of which the most representative collection is in the ▷Uffizi) are as highly acclaimed as his paintings. His pupils included the ▷Mannerists ▷Pontormo and ▷Rosso.

Bib.: Beguin, S., 'A Propos des Andrea del Sarto's au Musée du Louvre', *Paragone*, 40 (Nov 1989), pp. 3–22; Natali, A., *Andrea del Sarto: catalogue complet des peintures*, Paris, 1991

Andrew

One of the first three of the Apostles of ▷Christ, a fisherman from Galilee, brother to ▷Peter. The gospels do not say much about him and so most of his ▷iconography derives from a 3rd-century apocryphal book, retold in *The Golden Legend*. His identifying attributes are the x-shaped cross upon which he was martyred – although in the early ▷Renaissance it is sometimes a ▷Latin cross (e.g. ▷Masaccio, panel from the Carmine altarpiece, 1426, Malibu, Getty Museum); a length of rope (alluding to the fact that he was tied to the cross, not nailed); and a net containing fish. He is sometimes shown with his inscription from the Apostles' Creed: '*Et in Jesum Christum, filium ejus unicum Dominum nostrum*'. In order to clearly identify him, especially in narrative paintings, up until the early Renaissance (and including the Masaccio, above) he is usually portrayed as an old man with white hair and a beard, even in scenes when he would have been young (e.g. ▷Duccio, *The Calling of the Apostles Peter and Andrew*, Washington, DC, National Gallery, c1308–11).

Andriessen, Jurriaen (1742–1819)

Dutch painter. He specialized in genre scenes. He worked in Amsterdam where he was an important teacher.

Andromeda
▷Perseus

angel

(Latin, *angelus*: 'messenger'.) In Christian art angels are heavenly messengers, personal guardians or the attendants around God's throne. In their role as messengers they are never described as winged figures, but they have been conventionally portrayed as such from the 4th century onwards, in imitation of the Roman *Winged Victory*. In the 5th century AD Dionysius the Areopagite codified God's heavenly hosts into three tiers of three ranks: (i) Seraphs, Cherubs and Thrones which surround God, perpetually worshipping him and sustaining his throne; (ii) Dominations, Virtues and Powers which govern the stars and elements; and (iii) Principalities, Archangels and Angels, of which the first rank dispenses the fate of nations, and the second forms a divine army as well as acting with the third as heavenly messengers. The nine ranks are represented in the 13th-century dome mosaic of the Baptistery in Florence. Following this codification the term 'angel' may only be used for the lowest two ranks; however, in its broadest sense it refers to all the heavenly hosts. In Italian medieval and early ▷Renaissance art the two highest ranks are sometimes differentiated: Seraphs are blue and Cherubs are red, both are multi-winged (see Isaiah 6: 1–4) and both frequently represented as disembodied heads: they are shown as such in many paintings of the ▷Ascension, the ▷Assumption, and the Coronation of the Virgin. The remaining five ranks are seldom differentiated. In both Italian and northern European art Archangels and Angels are usually portrayed as androgynously beautiful winged figures in human form. Some are known by name: Raphael as Tobias' guardian angel (Old Testament Apocrypha, Book of Tobit; ▷Elsheimer, c1610, London, National Gallery); Michael as the leader of God's angels in the war against Satan and holder of the scales in the ▷Last Judgement; and Gabriel as annunciating messenger to Zacharias and the ▷Virgin Mary. Winged cherubim heads continue beyond the 17th century as architectural decoration (e.g. ▷Borromini, 1646–9, interior of San Giovanni in Laterano, Rome), although even during the 15th century they were being replaced in Italian narrative paintings by Classical ▷putti.

Angelico, Fra (Giovanni da Fiesole, Guido di Pietro) (c1387–1455)

Italian painter. Born Guido di Pietro in Florence, he took Domenican orders as Fra Giovanni. His order took over San Marco in Florence in 1436, and he was responsible for producing a series of frescos of the life of Christ there between 1438 and 1450. These works were characterized by their deliberate simplicity and their rejection of some of the sophistication of contemporary Florentine work by artists such as

▷Masaccio. Some of them were contained in the monk's cells as an aid to piety, and their format corresponded with the religious convictions of the Domenicans. In 1436 he was commissioned by Cosimo de' Medici to produce three ▷altarpieces, and their format represented an early example of the ▷sacra conversazione. From 1449 he was prior of S. Domenico in Fiesole.

Despite his religious commitments, Fra Angelico became famous throughout Italy and travelled to accept commissions outside Florence. He journeyed to Rome, where he met Pope Nicholas II, and he began the Last Judgement ▷frescos at Orvieto Cathedral (1447; completed by ▷Signorelli). Because of his alleged piety, he earned the nickname 'Beata Angelico'. He died in Rome.

Bib.: Didi-Huberman, G., *Fra Angelico: Dissemblance and Figuration*, Chicago, 1995, Lloyd, C., *Fra Angelico*, London, 1992

Angelo di Cosimo
▷Bronzino, Angelo

angle buttress
▷buttress

Anglo-Saxon art
The art and architecture of the north European tribes whose arrival in Britain began in the 5th century AD, and flourished until 1066 and the Norman conquest. Much of the art from this time was made of perishable materials like wood and is no longer visible. Stone buildings, especially churches, were also demolished as ecclesiastical laws changed. However, a surprising amount from this period has survived. Churches, often attached to monasteries, were small and thick-walled, with narrow aisles and rounded windows. Manuscript decoration flourished as learning developed through the influence of the monasteries, notably those in the north of England, such as that at Lindisfarne. The decoration was intricate, with elaborate intertwining tendrils and bright colours, not unlike Celtic designs.

Angry Penguins
An Australian art movement and journal. The journal was published 1941–6 as a means of perpetuating a regionalist form of ▷Expressionism. It was based in Melbourne and included such artists as ▷Sidney Nolan and ▷Arthur Boyd.

Bib.: *Angry Penguins and Realist Painting in Melbourne in the 1940s*, exh. cat., London, 1988

Anguier, François (c1604–69) and Michel (c1613–86)
French family of sculptors. They were brothers. Like many sculptors of their generation, they travelled to Rome, arriving there in 1641. There they studied with ▷Algardi, from whom they learned the techniques of

classical ▷Baroque sculpture. In 1643 François came back to France, and his brother followed him 8 years later. They collaborated on some tomb sculpture, but they went their separate ways. Michel was the most interesting of the two, and he specialized in church sculpture.

Bib.: Black, B., *Michel Anguier's Pluto: The Marble of 1669: New Light on the Sculptor's Career*, London, 1990

Anguissola (Anguisciola), Sofonisba (c1530–1625)
Italian artist. She was one of the few women artists of the 16th century to gain an international reputation. She practised primarily in Cremona and produced mostly portraits. Her five sisters also worked as artists. She was summoned to Spain by Philip II in 1559. Her works represent a meeting of Italian and Spanish styles.

Bib.: Caroli, F., *Sofonisba Anguissola e le sue sorelle*, Milan, 1987; Perlingieri, I., *Sofonisba Anguissola: The First Great Woman Artist of the Renaissance*, New York, 1992

animal style
A term used to describe the art of Eurasian nomads during the medieval period. The animal style consisted largely of useful objects, such as mirrors and knife handles, which were decorated with stylized representations of animals. Examples of the work appear in Germany, Scandinavia and Russia, but it may have originated in Siberia or Mongolia. Objects in this style are often composed of carved bone or wood.

Bib.: Jettmar, K., *Art of the Steppes: The Eurasian Animal Style*, London, 1967

ankh
(Ancient Egyptian, 'life'.) A cross with a looped top. Also known as ansate cross or Egyptian cross.

Anne
The mother of the ▷Virgin Mary, she first appears in the 2nd-century Protevangelium of James though she is also chronicled much later in *The Golden Legend* by Jacobus de Voragine. She is represented in some 8th-century paintings at Sta Maria Antiqua in Rome but it is not until the 12th century with the development of Marianism, and the consequent interest in Mary's parents, that she starts to appear more frequently. In devotional paintings or sculptures Anne may be shown with the Virgin and Child (e.g. ▷Jacopo Sansovino, marble group, 1512, Rome, S. Agostino). ▷Giotto's narrative fresco cycle in the ▷Arena Chapel, Padua, c1305–6, includes all the principal scenes relating to Anne and her husband, Joachim, leading up to the birth of Mary. Important episodes include:

(i) The Annunciation to Anne. The scene is reminiscent of the ▷Annunciation to the Virgin, except that Anne is portrayed as an older woman. Giotto shows her indoors, although sometimes in accordance

with the legend, artists show her in her garden near a bay tree in which sparrows are nesting (reminding Anne of the fertility of nature).

(ii) The Meeting at the Golden Gate. Both Anne and her husband, Joachim (who has been in the hills tending his sheep), received their angelic annunciations of the impending birth of Mary simultaneously. They meet at the 'Golden Gate' of Jerusalem and the moment of their embrace is taken to symbolically represent the Immaculate Conception of Mary (i.e., she is born without sin). This theme, especially popular with the Franciscan order as an exposition of Mary's own virgin birth, was gradually superseded in the 17th century by the image of the adult Mary as the ▷Immaculate Conception.

(iii) The Birth of the Virgin. Anne gives birth in bed, surrounded by servants and midwives.

Annigoni, Pietro (1910–88)

Italian painter. He was born in Milan and moved to Florence where he studied at the Accademia di Belle Arti. Working against ▷modernist trends and influenced by the Italian ▷Renaissance painters, and ▷Rembrandt and ▷Dürer, his realist painting gained wide recognition in Italy in the 1930s. In 1937–41 he worked on a ▷fresco for St Mark's convent in Florence, depicting the lowering of ▷Christ from the cross. In 1949 he moved to London, where he won recognition at the ▷Royal Academy Summer Exhibition, and became known primarily as a society portrait painter. Among his most famous portraits were those of Queen Elizabeth II in 1955, and of President J.F. Kennedy and Pope John XXIII in 1961. Working in oil ▷tempera to create an almost photographic finish in which the brushstroke is hardly seen, his work has often been accused of being a pastiche rather than a reinterpretation of the Renaissance. He signed the manifesto of '*Pittoria della Realtà*' in 1967.
Bib.: Annigoni, P., *An Artist's Life*, London, 1977; idem, *Diario*, Florence, 1990; Pelizzari, L., *Pietro Annigoni, il periodo inglese 1949–71*, Rome, 1991

annulet

(i) In Classical architecture of the ▷Doric Order, one of the fillets encircling the lower part of the ▷capital between the ▷echinus above and the necking below. (ii) In medieval architecture of the 12th and 13th centuries, a ring round a circular ▷pier or ▷shaft, or binding together a number of circular piers or shafts. Also known as a shaft-ring or corbel-ring.

Annunciation

The New Testament account of how the ▷Virgin is told by ▷Gabriel that she will conceive a son. The story is of major importance in the Christian calendar, as it coincides with the Incarnation of ▷Christ and is celebrated on Lady Day (in Britain), 25 March. Artists have frequently resorted to symbolism to emphasize the significance of the scene, and have also made use of details in apocryphal gospel and Jacobus de Voragine's medieval chronicle, *The Golden Legend* to pad out the story. Thus in early illustrations Mary was often shown drawing water, wearing a purple thread given to her in the Temple, or spinning wool for the Temple priests' garb (all apocryphal). Later she was more commonly portrayed reading or at prayer, and startled by the arrival of Gabriel. The use of the ▷lily (purity), the dove (Holy Spirit), the fleur de lis (Gabriel's attribute) or various symbols to represent the virgin birth (water with a beam of light passing through it) are all common. The scene usually takes place indoors in northern depictions (▷Master of Flémalle, *Merode Altarpiece* 1425–8, New York, Metropolitan Museum), but in an open ▷loggia or walled garden (representing chastity) in Renaissance Italy (▷Fra Angelico, 1440–50, Florence, San Marco). The ▷Gothic architecture often chosen by artists can be seen to represent the new Church of Christ. By the ▷Counter-Reformation the scene had been broadened to include a landscape background, a dramatic sky – prefiguring the Virgin's Transfiguration (Mazzoni, 1650, Venice) and the celebratory presence of ▷*putti* around Gabriel (Swabian Gospel, c1150, Stuttgart; ▷Reims west portal, 1215–45; ▷Simone Martini, 1333, Florence, Uffizi; ▷Botticelli, 1490, Florence; ▷El Greco, 1605–12, Havana; ▷Rossetti, 1849, London, Tate; ▷Hughes, 1858, Birmingham City Museum and Art Gallery).

ansate cross
▷ankh

anse de panier
▷arch

Antaeus
▷Hercules

antechurch (forechurch)

An annex to the west end of a church, deeper than a ▷narthex or ▷porch, extending for several ▷bays and consisting of a ▷nave and side aisles.

antefix (pl. antefixae)

In Classical architecture, most frequently an upright slab fixed to the edge of a roof to conceal the open end of the lowest of the row of small half-round tiles covering the joints of the larger flat roof tiles. Usually made of ▷terracotta, antefixae were often decorated with stylized plant forms and were sometimes also used ornamentally on the ridge of the roof.

Antelami, Benedetto (fl 1178–96)

Italian sculptor. He worked in the ▷Romanesque style and was responsible for ▷reliefs on the doors of the Parma Baptistry.

Bib.: Quintavalle, A.C., *Benedetto Antelami*, Milan, 1990

Antenor

Greek sculptor of the late 6th century BC. He contributed ▷pediment sculpture to the temple of Apollo at Delphi.

antependium (altar frontal)

A cover over the front of an altar. It can be decorated and can contain expensive material such as gold or rich textiles.

Anteros

▷Sacred and Profane Love

anthemion

(Greek, 'flower'.) A form of ornamentation used in ancient Greek sculpture and vase-painting. Normally it took the shape of a leaf or flower and has been known for its honeysuckle configuration.

Anthemius of Tralles

Greek engineer. Justinian gave him responsibility for the design of Sta Sophia in Constantinople in 532.

Anthonisz, Cornelis (c1499–after 1533)

Dutch painter and engraver. He worked in Amsterdam as an engraver and cartographer. He was best known for his maps and group portraits. His paintings of civic guard groups prefigured the work of ▷Hals.
Bib.: Armstrong, C.M., *The Moralizing Prints of Cornelis Anthonisz*, Princeton, 1990; Hollstein, F.W.H., *Hollstein's Dutch and Flemish Etchings, Engravings and Woodcuts c. 1450–1700, 30: Cornelius Anthonisz T(h)eunissen to Johannes Den Llyl*, Amsterdam, 1986

anti-art

A term usually associated with the ▷Dada movement, anti-art came to signify a stance which rejected the significance of art as understood by a bourgeois public. It was first used by ▷Duchamp, whose ▷ready-mades revealed his contempt for easel painting and traditional sculptural form.

Antinous

A title given to statues of beautiful youths after Antinous, the favourite of the Emperor Hadrian who drowned whilst still a young man in AD 130. The most celebrated statue presumed to represent Antinous (though without conclusive evidence) is that in the Vatican Collections, the *Belvedere Antinous*. Typically, Antinous is of slender physique, stands in graceful ▷*contrapposto*, is curly-headed and gazes downwards with a somewhat wistful expression. The *Belvedere Antinous* was first recorded in 1543 when the Pope purchased it for the Belvedere Garden. Copies and casts were soon taken, many as diplomatic gifts, and

the statue soon assumed a canonical role as the supreme exemplar of physical perfection in a young man. ▷Bernini, in his address to the French Academy in Paris in 1666, confessed, 'In my early youth I drew a great deal from Classical figures, and when I was in difficulties with my first statue I turned to the 'Antinous' as to the oracle.' ▷Hogarth, in his ▷*Analysis of Beauty* (1753), stated that in the 'utmost beauty of proportion [it] is allowed to be the most perfect ... of any of the antique statues'. ▷Winckelmann wrote great praise of it before he had even seen the original and, despite his disappointment at the execution of certain details, still commended its sweetness and innocence of expression. The *Capitoline Antinous* (Rome, Capitoline Museums) is another, though less celebrated example, and there is a marble ▷bas-relief (the 'Antinous Bas-relief') in the Villa Albani, Rome (also greatly admired by Winckelmann who was for a while Albani's librarian). All three sculptures were ceded to the French in 1797 and restituted in 1815.
Bib.: Haskell, F. and N. Penny, *Taste and the Antique*, New Haven and London, 1981

antiphonal

A liturgical book used in church services, containing the text and music of the antiphons (responses) of mass and other offices. Frequently large for communal use and richly illuminated.

Antipodeans, The

An Australian group of artists, based in Melbourne. Like the ▷Angry Penguins, this group advocated figurative art that had a genuine relationship with Australian culture. They practised from 1959.

antique

A term referring generally to Greek and Roman art and architecture from the 5th century BC until the Middle Ages. The Antique became particularly important during the ▷Renaissance period in Italy, when artists and ▷connoisseurs realized the quality of ancient art and attributed a high intellectual purpose to the Greeks and Romans. With the formation of ▷academies, studying antique sculpture became an essential part of the training of an artist, and this intensified in the 18th century when the ▷Grand Tour drew both artists and collectors to Italy. In the late 18th century, ▷Winckelmann was one of the first historians to attempt to explain the purpose of meaning of antique art, and his theories were one of the inspirations for ▷Neoclassicism which was based on an archaeological reinterpretation of ancient Greek and Roman sources.
Bib.: Borinski, K., *Die Antike in Poetik und Kunsttheorie von Ausgang des klassischen Altertums bis auf Goethe und Wilhelm von Humboldt* 1914–24, Leipzig, 1924; Greenhalgh, M., *The Classical Tradition in Art*, London, 1978

antitypes
▷typology

Antonello da Messina (c1430–79)
Italian painter. He was born and trained in Sicily and later in Naples, probably under Colantonio, an Italian follower of ▷Jan van Eyck. He is likely also to have seen Flemish paintings in Naples (where they enjoyed great popularity with the Spanish court). However he saw them (and there is no evidence that he actually visited northern Europe) his manner represents a synthesis between a Flemish concern for meticulous detail (made possible by their pioneering exploitation of the technique of oil paint with glazes) and an Italian monumentalizing simplification of form. ▷Vasari's statement that Antonello actually introduced the technique of oil painting to Venice on his visit in 1474–6 has been disproved, but his mastery of the powerfully illusionistic medium in his *Altarpiece* (1475–6; two fragments remain, both in Vienna, Kunsthistorisches Museum) painted for the Venetian church of S. Cassiano was extremely influential. This also is one of the earliest (and perhaps the very first) ▷sacra conversazione to depict successfully the painted space as a continuation of the real space of the church and for both reasons strongly influenced ▷Giovanni Bellini and through his work, the course of Venetian art. Antonello's Flemish type, bust-length three-quarter face portraits were also deeply influential on the portraiture of ▷Gentile and Giovanni Bellini and ▷Mantegna (e.g. *The Condottiere*, signed and dated 1475, Paris, Louvre, but painted in Venice).
Bib.: Arbace, L., *Antonello da Messina: catalogo completo dei depinti*, Florence, 1991; Markgrai, E., *Antonello da Messina und die Niederlande*, Frankfurt, 1990

Antony of Padua (1995–1231)
A Franciscan saint, he was born in Lisbon and died in Padua of which city he is the patron saint. He is famous for his preaching and the many miracles which are associated with him. As he died at age 36, he is portrayed as a young man and is dressed in the brown habit of the Franciscan order. His ▷attributes are a flaming heart, or simply a flame, held in his hand; also in his hand may be a book, sometimes with the ▷Christ child seated upon it, a ▷lily (for purity) and a flowered cross. He may be accompanied by a kneeling ass in reference to the occasion when an ass knelt before the ▷Eucharist held by Antony, thereby convincing a heretic of the presence of Christ in the Eucharist. Other episodes from his life that may be represented are:

(i) The Finding of the Miser's Heart. Having quoted a particular passage from Luke whilst preaching at a miser's funeral ('For where your treasure is, there will your heart be also', 12: 34), Antony witnesses the finding of the miser's heart in his strong-box.

(ii) The Healing of the Wrathful Son. Antony miraculously restores the leg that a remorseful son had amputated after kicking his own mother (e.g. ▷Donatello, 1446–50, bronze altar relief, Padua, Sant'Antonio).

(iii) Preaching to the Fishes. Failing to find a human audience, Antony preaches to the fishes who keenly pay attention (derived from St. Francis preaching to the birds).

Antwerp School
The name given to a group of 16th-century ▷Mannerist painters who worked in Antwerp between c1510 and c1530.
Bib.: Filipczak, Z.Z., *Picturing Art in Antwerp 1550–1700*, Princeton, 1987; Friedländer, M., *Early Netherlandish Painting, vol. 11: The Antwerp Mannerists*, Leyden, 1974; Murray, J.J., *Antwerp in the Age of Plantin and Brueghel*, Norman, 1970

Apelles (fl mid-4th century BC)
Ancient Greek painter. He was born at Colothon on the island of Kos and was taught firstly by Ephorus of Ephesus and subsequently by Pamphilus of Sicyon. All of his works are lost, but he was accounted by contemporaries as the greatest painter of his time, renowned especially for his graceful style. He was court painter to Philip of Macedonia and his son Alexander the Great and is said to have also painted a self-portrait. The detailed descriptions of his works and the praise accorded to them by antique writers led the ▷Renaissance art theorist ▷Alberti in his *Della Pittura* to commend Apelles' *Calumny* as exemplary of the quality of invention which he felt was essential to a worthy painting. The challenge was taken up by ▷Botticelli in his painting, *The Calumny of Apelles* (Florence, Uffizi) and ▷Mantegna who produced a drawing of the same name (early 15th century, London, British Museum). Also, the account of Apelles' *Aphrodite Anadyomene* (Aphrodite rising from the sea), painted for the temple of Asclepius on Kos and later removed by Augustus to the temple of Caesar in Rome, inspired ▷Titian to attempt the same subject (Edinburgh, Scottish National Gallery).
Bib.: Robertson, M., *A History of Greek Art*, 2 vols., Cambridge, 1975

Aphrodite
▷Venus

Aphrodite of Cnidus (Knidos)
▷Praxiteles' most famous statue made, according to ▷Pliny, for the island of Kos, rejected in favour of a draped ▷Aphrodite, and purchased instead by the city of Cnidus in Ionia (Asia Minor) in c350–30 BC. The people of Kos had apparently found the nudity too shocking: it is likely to have been the first free-standing, life-size female nude in Greek art. Pliny regarded it as the 'finest statue not only by Praxiteles but in the

whole world', and described how it was placed in an open shrine, allowing the spectator to view the statue from all sides. The original is now lost, but several Roman marble statues have been suggested as copies. The foremost is in the Vatican Museums and is also variously referred to as the 'Standing Venus', the 'Venus emerging from the Bath', and the 'Pudic Venus'. The goddess is represented standing, turning slightly to pick up her robe with her right hand, masking her pudenda with her left. First described in the 16th century, the identity of this statue as a copy of the *Aphrodite of Cnidus* was first suggested in the early 18th century. Until then much admired, a closer re-evaluation as a copy of the most admired statue of the ancient world caused ▷Mengs at least to remark on the clumsiness of execution of the body. The diminished status of this copy remains to the present day.

Bib.: Haskell, F. and N. Penny, *Taste and the Antique*, New Haven and London, 1981; Robertson, M., *A History of Greek Art*, 2 vols., Cambridge, 1975; Smith, R.R.R., *Hellenistic Sculpture*, London, 1991

Apocalypse

The last book of the New Testament, more correctly known as The Revelation of St. John the Divine. It is believed to have been written at the end of the 1st century AD and had particular relevance to the early Christians in the time of their persecution, in that it largely consists of a series of apocalyptic visions in which the evil are overthrown and ▷Christ's kingdom is established on earth. The Revelation forms the basis for representations of the ▷Last Judgement which decorate the west ends of many churches. Among the other important images are the following :

(i) The apocalyptic beasts around Christ's throne (4: 7) – the lion, ox, man and eagle – considered to be symbolic of the Evangelists.

(ii) The Four Horsemen of the Apocalypse, released when the first four seals of the book containing the secrets of humanity's destiny are broken (6: 1–8).

(iii) The Adoration of the Lamb (7: 9–17), as in the central panel of ▷Jan van Eyck's ▷Ghent Altarpiece (1432, Ghent, St. Bavon).

(iv) The vision of the 'woman clothed with the sun' which appeared at the blowing of the seventh angel's trumpet (12: 1–6), developed by ▷Counter-Reformation artists as an image of the ▷Virgin of the ▷Immaculate Conception.

(v) A blasphemous beast with ten horns and seven heads which rises out of the sea (13: 1–10), thought to have signified Nero to the original writer, but adapted by Protestant reformers to signify the Pope, and by the Counter-Reformation to signify Luther.

(vi) The Whore of Babylon (17: 3–6) who rides a beast with seven heads, intended to signify Rome with its seven hills, but interpreted by Protestant Reformers as the Rome of the Popes.

Apollinaire, Guillaume (1880–1919)

French art critic of Polish heritage. His real name was Wilhelm Apollinaris de Kostrowitsky. In 1908 he met ▷Picasso and ▷Braque, and he was friendly with such artists as ▷Léger, ▷Delaunay and the ▷Futurists in Paris. He was one of the earliest critics to evince a genuine sympathy for ▷Cubism, which he voiced in his 1913 essay *Les peintures cubistes*. He also wrote ▷avant-garde poetry, which was influenced by the ▷collage techniques of Cubism. His *Calligrammes* (1918) consisted of a series of fragmented 'word pictures'. He is said to have coined the term ▷'Surrealism', and the French Surrealists of the 1920s looked to his poetry as a forerunner of their own experiments with ▷automatism.

Bib.: Breunig, L. (ed.), *Apollinaire on Art: Essays and Reviews 1902–1918*, London, 1972; Buckley, H., *Guillaume Apollinaire as an Art Critic*, Ann Arbor, 1981; Greet, A.H., *Apollinaire et le livre de peinture*, Paris, 1977; Mackworth, C., *Guillaume Apollinaire and the Cubist Life*, London, 1961; Steegmuller, F., *Apollinaire: Poet Among the Painters*, London, 1963

Apollo

Greek and Roman god, son of ▷Jupiter and Leto, twin brother of ▷Diana. As the god of the sun, he brought fruitfulness to the earth and, symbolically, the light of wisdom to humanity; in this role he is portrayed driving his quadriga across the heavens, bringing daylight with him and dispersing the darkness of night. Apollo was also the god of the visual arts, music and literature, and in this role he is portrayed dwelling on Mount Parnassus with the nine muses (e.g. ▷Raphael, *Parnassus*, c1509–11, Vatican, Stanza della Segnatura). Here he plays upon the viol, although other stringed instruments, such as the lyre may be substituted. He is also crowned with laurel, the laurel tree having become sacred to him after the nymph, Daphne, metamorphosed into one in order to escape his amorous attentions (e.g. ▷Bernini, *Apollo and Daphne*, 1622–5, Rome, Galleria Borghese). In all representations, he is a beautiful young man, the most famous and influential of which is probably the ▷*Apollo Belvedere* (Roman copy of Greek original, Vatican Museum). Here he has released the arrow with which he slew the Python of Mount Parnassus.

Other stories relating to Apollo, and extremely popular from the ▷Renaissance onwards, come from the *Metamorphoses* of Ovid. They include:

(i) Apollo and Marsyas. Marsyas, a flute-playing satyr, lost a musical competition to the lyre-playing god. The loser was to suffer any penalty exacted by the winner; Apollo chose to flay Marsyas alive. Representations either show the contest (e.g. ▷Perugino, c1495, Paris, Louvre) or the penalty (e.g. ▷Titian, c1570–76, Kroměříž, Státni Zámek). The contest was regarded as an ▷allegory of the victory of the intellect

(refined stringed music) over the passions (sensuous wind music).

(ii) Apollo and Hyacinthus. Apollo loved a Spartan youth, called Hyacinthus. The two were throwing the discus one day when Hyacinthus was killed by the rebound of Apollo's discus. Apollo ran to Hyacinthus, who died in his arms and whose drops of blood, at Apollo's command, transformed into flowers named after the youth (e.g. Jean Broc, *Death of Hyacinthus*, 1801, Poitiers, Musée des Beaux-Arts).

Apollo Belvedere

Marble statue of the god ▷Apollo as a semi-draped, idealized nude represented with arms outstretched, just having discharged an arrow from his bow. The statue, a Roman copy of a lost ▷Classical or ▷Hellenistic original in bronze, takes its name from its location in the Belvedere Courtyard of the Vatican Museum, in which collection it has been housed since shortly after its discovery towards the end of the 15th century. It was very soon regarded as the most celebrated representation of the god, one of the most famous works surviving from antiquity, and even one of the greatest works of art ever made. It became the supreme exemplar of ideal male beauty and was disseminated widely in case and print form. The Italian ▷Renaissance sculptor ▷Bandinelli based his marble statue of *Orpheus* (c1516, Palazzo Medici, Florence) on the *Apollo Belvedere* and the leading 18th-century British portrait painter, ▷Joshua Reynolds borrowed the pose for his portrait painting of *Commodore Keppel* (1754, London, National Maritime Museum). Such borrowings were very definitely intended to be noticed by the *cognoscenti* who would have regarded them as erudite and tasteful quotations, rather than plagiarism. ▷Winckelmann's ecstatic description of the *Apollo Belvedere* reinforced its canonical status for ▷Neoclassical sculptors such as ▷Canova and ▷Thorvaldsen. It was one of the art treasures ceded to the French in 1797 and displayed in the Louvre until 1815 when it was returned to Rome. Only with the removal of the Parthenon marbles from Greece to London and the consequent revelation of the vivacious naturalism of genuine classical Greek art did the *Apollo Belvedere*, which now appeared to some as coldly remote and lifelessly academic, slip from its exalted position.

Bib.: Haskell, F., and Penny, N. *Taste and the Antique*, New Haven and London, 1981; Robertson, M., *A History of Greek Art*, 2 vols., Cambridge, 1975

Apollodorus

An Athenian painter of the 5th century BC. He produced illusionistic works which gained their effects from a shading technique. He was discussed by ▷Pliny.

Apollodorus of Damascus (fl AD 97–130)

Greek architect and town planner. He was born, as his name indicates, in Syria. He was appointed official architect to Trajan in AD 97 and thus his principal works are to be found in Rome. His architectural style is a compromise between the Roman demand for axial symmetry and the seemingly casual harmonies suggestive of his ▷Hellenistic training. His earliest recorded work, an acclaimed bridge over the Danube, constructed of timber with masonry piers, indicates that he was also an accomplished structural engineer. He was responsible for the planning and design of the markets, Basilica, and Forum of Trajan with its famous Column, and also the Baths of Trajan, this latter building in particular showing his total mastery over the contemporary Roman medium of concrete. Following Trajan's death in 117, Apollodorus worked for his successor, Hadrian, for a while, and even dedicated a treatise on assault machines to him. According to Dio Cassius, however, their relationship ended in acrimony in c130 with Apollodorus' banishment and eventual execution for adversely criticizing Hadrian's Temple of Venus in Rome.

Bib.: Ward-Perkins, J., *Roman Imperial Architecture*, Harmondsworth, 1981

apophyge

On a ▷column, the concave curve of the ▷shaft as it rises from the ▷base or meets the ▷capital.

Apostles

'Apostle' derives from a Greek word meaning 'messenger' and in Christian teaching refers to the inner circle of ▷Christ's disciples who were sent out to preach the gospel after his ▷Ascension. According to Peter (Act 1: 21–3), to qualify as an Apostle one had to be a man who had been with Christ since his baptism by John and who had witnessed Christ after his ▷Resurrection. They are formed from the original disciples, plus Matthias, Judas' replacement. As in the Bible, in Christian art they never number more than twelve, although Paul and the ▷Evangelists ▷Mark and Luke are sometimes included in place of the more obscure figures of Jude, Simon and Matthias. The appearance of the leading members remains remarkably consistent from the ▷Early Christian period onwards: Peter is stocky with a white beard and short curly hair; Paul is bald with a dark beard; and John has long hair and is beardless. Each Apostle is also identifiable by his attributes, as follows:

Andrew: ▷saltire cross (instrument of martyrdom);

Bartholomew: flayer's knife (instrument of martyrdom);

James the Greater: pilgrim's staff and cockleshell;

James the Less: fuller's club (instrument of martyrdom);

John: chalice from which a serpent rises, eagle;

Jude (or Thaddeus): lance, or halberd (instrument of martyrdom);

Matthew: purse;

Paul: sword (instrument of martyrdom);

Peter: keys, fish;

Philip: cross (instrument of martyrdom, or cross staff;

Simon Zelotes: saw (instrument of martyrdom);

Thomas: builder's rule, or set-square.

Early representations of Christ with the complete group of twelve emphasize the authority the Apostles derived directly from Christ (e.g. *Christ Teaching the Apostles*, late 4th century, Milan, S. Lorenzo, Chapel of S. Aquilino). A variation on this theme with Christ flanked by the Apostles is the Christ in Majesty (e.g. apse mosaic, Rome, S. Pudenziana). The apostles are usually also ranked either side of Christ in the ▷Last Judgement. An image deriving from the ▷Apocalypse (7: 9–17) is Christ as a lamb (identifiable from the cruciform halo), standing on a mound from which four life-giving rivers (i.e. the gospels) run, with sheep (the Apostles) standing in attendance (e.g. marble sarcophagus of Constantius III, 400/425, Ravenna, S. Vitale). The apostles symbolized as twelve sheep or twelve doves is a frequent motif up to the early Middle Ages (e.g. the apse mosaic, 12th century, San Clemente, Rome shows them in both guises). Each of the Apostles was supposed to have contributed one article of faith to the composition of the Apostles' Creed and thus they are sometimes portrayed each holding his appropriate inscription on a scroll (e.g. ▷Orcagna, *Tabernacle*, 1359, Florence, Or San Michele).

apotheosis

(Greek, 'deification'.) The deification and reception of a human into heaven appears in Classical art (e.g. Archelaos of Priene, *Apotheosis of Homer*, marble relief, c150 BC, London, British Museum), and was revived for both religious and political purposes in the 17th century. The virtuoso development of ▷Baroque ceiling painting provided the ideal medium for such heavenly vistas, where the saint or the divinely chosen monarch could be received into heaven by appropriate religious and allegorical figures. Andrea Pozzo's *The Glory of Saint Ignatius* (1691–4, Rome, S. Ignazio) in an astonishing piece of ▷*trompe l'oeil*, shows Ignatius being received by ▷Christ and witnessed by angels, saints, and the entire known world; ▷Rubens (*Apotheosis of James I*, 1634, London, Banqueting House) shows King James I being received in the centre panel by Justice, Zeal, Religion, Honour and Victory, whilst in the south panel ▷Minerva drives Rebellion off to Hell.

Appel, Karel (b 1921)

Dutch artist. Born in Amsterdam, he studied at the Royal Academy of Fine Arts there, before moving to Paris in 1950. From 1948 involved with *Reflex*, a journal concerned with experimental ideas, and a founder-member of ▷Cobra. Reacting against geometric ▷abstraction and the purity of ▷De Stijl, and reflecting his interest in the art forms of primitive peoples and children, Appel began painting extremely simple forms and figures in bright colours, before evolving a highly abstract and ▷Expressionist style, for which he is often compared to his fellow countryman ▷de Kooning. In his work, crude images surge up out of the swirling mass of thick ▷impasto and violent ▷primary colours. Unlike de Kooning, however, Appel's stable of fantastic and often hallucinatory images suggestive of masks and contorted human, animal and demonic figures, reflect Appel's interest in Nordic folklore and mythology, and the raw visceral style is influenced by the direct expression of ▷Art Brut and ▷Dubuffet's emphasis on matter. As Appel explained, 'For me, the material is the paint itself. The paint expresses itself. In the mass of paint, I find my imagination and go on to paint it. I paint the imagination I find in the material I paint.'

After the demise of Cobra in 1951 Appel was closely associated with Michel Tapié's attempts to promote ▷Art Autre and ▷Art Informel, during which time Appel won many prestigious prizes for his painting, including the UNESCO Prize at the Venice ▷Biennale (1954), the International Prize at São Paolo Biennal (1959) and the International Guggenheim Prize (1960). In the late 1960s Appel turned to sculpture and wall reliefs closer to ▷Hard Edge than the Expressionism for which he is chiefly remembered.

Bib.: Ragon, M., *Karl Appel peintures 1937–57*, Paris, 1988

applied art

A name given to a type of art that is intended to be the opposite of ▷fine art because it is useful, rather than simply evidence of artistic creativity. The place of applied arts in the art world has been controversial since the ▷Industrial Revolution facilitated factory production of goods. During the 19th century, design schools were formed throughout Europe to respond to the new needs of industry, and artists who studied in these schools were expected to produce designs that would ultimately ornament such household goods as cutlery, furniture and wallpaper. The strong ideological separation between a fine artist, whose works were considered to be autonomous, and an applied artist, who was merely a servant of industry, was eroded with the formation of the ▷Arts and Crafts movement and its continental European counterparts. At this time applied art gained a new recognition, and artists subsequently worked together to bring about a unity of fine and applied arts. Organizations such as the Vienna Werkstätte (▷Wiener Werkstätte) had a close alliance with ▷avant-garde groups. The 20th century saw a greater alliance between functionalism and form.

▷decorative art

apse

A semi-circular or polygonal termination to the ▷nave of a ▷basilica or a Christian church or chapel, usually with a half-domed or domical vaulted ceiling. In Roman basilicas the ▷apse housed the praetor's chair, whilst in Christian churches the apse houses the altar and is traditionally situated at the east end.

A characteristic of ▷Romanesque church plans is the staggered arrangement of side chapels flanking the chancel apse in a ▷chevron or arrow-shaped formation known as apses in echelon (French, *chevet en échelon*). This technique was an attempt to provide extra space for the increasing number of holy relics on display and an improved circulation area for the larger crowds flocking to venerate them. The problem was more efficiently solved by the development of the ▷ambulatory.

aquarelle

A type of painting which is executed in transparent ▷watercolour.

aquatint

An ▷etching technique, which uses a resin-coated metal ▷plate and produces a grainy ▷print. When the plate, usually copper, is fully coated with resin, ▷varnish is applied as a resist to areas of the design which are to appear white. The plate is dipped into an acid bath, which eats away at the unvarnished resin and the metal below, thus creating a textured surface. The remaining resin can then be removed and the process repeated, in order to build up a complex pattern of darker and lighter areas. The plate is inked and printing proceeds in the usual manner.

ARA

An abbreviation for Associate Royal Academician.
▷Royal Academy

arabesque

A form of decoration based on interlaced lines. Arabesques were common in ▷Islamic ornament and medieval manuscript decoration. They also were popular during the ▷Rococo period and among ▷Art Nouveau artists. Flowing lines allowed a greater freedom of artistic expression, and patterns could be either purely geometrical or derived from flower or plant forms.

Ara Pacis Augustae

Roman monument decorated with important sculptural ▷reliefs, begun in 13 BC and dedicated on 30 January, 9 BC by the Senate to celebrate the safe return of Augustus from an extended period in Gaul and Spain. The Ara Pacis ('Altar of Peace') was originally erected on the Campus Martius, Rome, where the Palazzo Ottoboni now stands on the Corso (formerly Via Lata). The first relief slabs were discovered in c1568; the remainder in 1859 and 1903 and the site fully excavated in 1937–8. The monument was subsequently reconstructed slightly to the north, near the mausoleum of Augustus.

The Ara Pacis consisted of a monumental altar raised on steps and contained within an enclosure 11.6 × 10.6 metres (38 × 35 feet). The exterior of the enclosure was richly decorated by ▷relief carving in two superimposed zones. The upper zones of the two long sides were filled with friezes commemorating the procession on the consecration day in 13 BC. The figures in the procession, although idealized, are also in many cases vivid portraits of the emperor, his family, court officials and priests. Each of the short sides contained an entrance, flanked in the upper zone by mythological and allegorical subjects: on the front (towards the Via Lata), the two reliefs were carved with personifications of Tellus (Earth), prospering under Augustan rule, and Roma; on the back were the Lupercal and the story of Aeneas and Penates. The lower zone was a continuous frieze of naturalistic floral decoration including acanthus motifs and small animals and birds. The inside walls of the enclosure were decorated with garlands and *bucrania* (bulls' skulls), symbolizing sacrifice. The altar itself was carved with a ▷frieze of vestals, priests and sacrificial animals, commemorating the dedication in 9 BC. The designer of the Ara Pacis is not known, but the style is deliberately conservative: its form is probably based on an Athenian model, while the reliefs suggest that the sculptors were working in a neo-Attic, ▷Classical tradition, modified by a knowledge of naturalistic developments in Hellenistic relief sculpture. The carving is all of an extremely high quality, making the Ara Pacis one of the principal works of sculpture in Augustan Rome. The monument has been referred to by Strong as 'a masterpiece of political and social propaganda'.

Bib.: Strong, D., *Roman Art*, 2nd edn. Harmondsworth, 1988; Toynbee, J.M.C., 'The Ara Pacis Reconsidered and Historical Art in Roman Italy', *Proceedings of the British Academy*, 39 (1953), pp. 67–95

Arbeitsrat für Kunst

(German, 'Working Council for Art'). One of several organizations founded in the wake of the German Revolution of 1918. The Arbeitsrat für Kunst was modelled on a number of Provisional Councils of People's Commissioners that met in Berlin in the months following the Revolution. The Workers' and Soldiers' Councils were designed to reorganize German power structures to move towards a government of the people, inspired by Communist ideology. The Working Council for Art met first in December 1918 when it published a manifesto outlining a new organization of art for the new state. Its members aspired to an art for the masses and wanted new administrative structures in state institutions of art such as museums and academies. Its members tended to be

artists associated with the ▷avant-garde, particularly the ▷Expressionist movement, although there was great diversity of political and artistic approach in the organization. Its original membership included ▷Max Pechstein and ▷Käthe Kollwitz, and the first President was the idealist architect Bruno Taut. The group's leftist activism responded to the febrile enthusiasms of the post-Revolutionary period in Germany. With the changing political climate in Weimar Germany, the organization dissolved in 1921.

Bib.: Steneberg, R., *Arbeitsrat für Kunst: Berlin 1918–21*, Düsseldorf, 1987

ARBKD (ASSO)

ARBKD is an abbreviation of the Assoziation revolutionärer bildender Künstler Deutschlands (Association of revolutionary German artists), and it was the parent organization of ASSO (an abbreviation of the first word in the title). It was founded by the German Communist party (KPD) in 1928 as an explicitly propagandist organization designed to represent the artistic voice of the proletariat. Its members hoped to create an art that would be accessible to the masses and would mobilize them to revolutionary fervour. All artists who were members of the organization were thus also Communists, and many drew inspiration from the Soviet Union. It was related to the ▷Association of Artists of Revolutionary Russia. Among its members were ▷Grosz and ▷Heartfield. ASSO was a more radical fringe of the ARBKD.

arcade

A line of arches carried on ▷columns or ▷piers, either free-standing or blind (that is, applied to a wall as a decorative motif, especially in ▷Romanesque or ▷Norman buildings). An interesting arcade is a line of overlapping arches supported on every alternate ▷column or ▷pier. An interlacing arcade is a line of overlapping arches supported on every third column or pier.

Arcadian Stag

▷Hercules

arch

A curved structure for spanning an opening, usually constructed of wedge-shaped ▷blocks or ▷voussoirs. The arch provided the solution to the problem of bridging spaces between masonry walls wider than could be spanned by a single block or ▷lintel of wood or stone (the only means available before the introduction of ▷reinforced concrete). A single block of stone has a tendency to crack under its own weight beyond a certain length and suitable timber of sufficient length was not always freely available.

The most primitive form of arch is made by corbelling, that is, each layer of stone blocks either side of the opening advances slightly on the one beneath in uniform steps to close at the crown. Often the stepped sides are smoothed giving the appearance of a true arch, but the opening thus bridged is not load-bearing and is not a true arch.

The earliest true arches consist of small wedge-shaped blocks arranged in a semi-circle over an opening, each block held in place by its own downward weight and that of its neighbour. Furthermore, the downward thrust of the whole arch and the weight of the material above is deflected outwards and countered by the flanking walls. Round arches were used in Roman, ▷Romanesque and ▷Byzantine architecture and revived, for aesthetic reasons, in the Italian ▷Renaissance.

Although round arches represented a considerable technical advance, they require thick flanking walls to resist the outward pressure and have a tendency to be weak at the crown. Both of these structural problems were solved by the introduction of the pointed arch. Pointed arches transfer the load from the crown or apex vertically downwards, also thereby allowing thinner flanking walls. Whereas a round arch is formed from a semi-circle springing from one centre, such that the radius is half the span of the opening, the earliest pointed arches are formed by drawing arcs from two centres with radii greater than half the span of the opening.

There are several types of arch:

(i) *anse de panier* (basket arch; three-centred arch); a flattened arch formed from three radial points, the central one with a long radius forming the segment of a large circle extended at each end by quarter segments of smaller circles.

(ii) drop(ped) arch: a pointed arch with radii more than half but less than the whole span of the opening.

(iii) equilateral arch: a pointed arch with radii of the same span as the opening.

(iv) four-centred arch (depressed arch): one which springs from four points, two with short radii on the springing line forming the acute curves of the corners and two below the springing line with longer radii forming the shallower arcs meeting at the apex.

(v) horseshoe arch (Moorish arch): a round arch slightly greater then a semi-circle, such that its diameter is wider than the span of the opening below. Characteristic of ▷Islamic and ▷Byzantine architecture.

(vi) lancet arch: a pointed arch with radii greater than the span of the opening.

(vii) ogee arch (keel arch): a four-centred pointed arch with two centres within and two centres outside the arch. Each side of an ogee arch is thus formed of a pair of reversed curves – convex at the springing and concave towards the apex. Four-centred arches are characteristic of the ▷Perpendicular style of ▷Gothic architecture.

(viii) relieving arch (discharging arch): a segmental arch placed within a wall above the ▷lintel of an

opening to discharge the weight of the super-incumbent masonry to each side.

(ix) segmental arch: a round arch whose curve is drawn from a centre below the springing line.

(x) strainer arch: An arch inserted across an internal space, such as a nave, to prevent the walls from leaning inwards.

(xi) Tudor arch: a four-centred pointed arch which starts at its springing with a curve of almost a quarter of a small circle and then continues in a straight line to a shallow apex.

Archaic art

A term used to characterize Greek art before the ▷Classical period of the 5th century BC. Archaic art has been applied to works produced any time from the mid-7th century BC to 480 BC. The most famous archaic works are sculptures of nude men (▷Kouros) and draped women (▷Korai). The period was characterized by a formalism that was beginning to yield to the ideal beauty of Classical sculpture. During this period ▷black-figure vase painting also yielded to the more naturalistic ▷red-figure technique.

Archer, Thomas (1668–1743)

English architect. He was born into a gentry family in Warwickshire and educated at Oxford. He then spent four years (1695–9) travelling and studying ▷Baroque masters like ▷Bernini and ▷Borromini first hand. As a result his work is more consistent with European taste than that of most of his British contemporaries. Under Queen Anne he held a court sinecure, although he never held any official position, and in 1711 sat on the commission to build 50 new London churches. His own designs include St. Pauls, Deptford (1712–30), and St. John the Evangelist in Smith Square (1714–28), noted for their use of space and advanced Baroque forms. He also designed the north front at Chatsworth (1704) and St. Philips, Birmingham (1710–15). Chettle House Dorset (1711) is noted for its use of curved corner stones. Surprisingly, his own home, Hale House (Hants, 1715) was ▷Palladian in style.
Bib.: Whiffen, M., *Thomas Archer, Architect of English Baroque*, Los Angeles, 1973

Archipenko, Alexander (1887–1964)

American sculptor of Russian birth. Archipenko studied painting in 1902–5 at the Kiev Academy of Art, but his irritation with the academic system led him to abandon his studies and travel to Paris in 1908. Here he came into contact with ▷Modigliani and the ▷Cubists and began producing figure sculptures which utilized the potential of negative space. In works such as the 'Medrano' series, he attempted to marry the techniques of painting and sculpture by using a variety of materials, and he showed an early interest in

sculptural ▷polychromy. He exhibited in a number of major venues during the next few years, including the ▷Salon des Indépendants and the ▷Sturm Gallery in Berlin. He taught in Berlin from 1921 to 1923 and carried his pedagogic skills to the USA where he settled in 1923. His interest in negative space led to experiments with lights in sculpture of the late 1940s.
Bib.: Michaelsen, K., *Alexander Archipenko: A Centennial Tribute*, exh. cat., Washington, 1986

architect

A master builder. The term derives from the Greek word *architekton* meaning 'one who supervises the *tektones* (craftsmen)'. Thus the architect is not only the designer of a building, building complex or town plan, but also the supervisor of the craftsmen and artisans who actually engage in the construction. In ancient Greece architects enjoyed a relatively exalted position among artists and the names of the most successful are preserved: ▷Ictinus, ▷Callicrates, Mnesicles and Pytheos. The theoretical basis of ancient Roman architecture is known from the earliest surviving architectural treatise, that of Vitruvius. It is to Vitruvius that is owned the ▷Renaissance conception of the architect as a man of universal education. Vitruvius writes that the architect 'should be a man of letters, a skilful draftsman, instructed in geometry, familiar with history, a diligent student of philosophy, acquainted with music, not ignorant of medicine, learned in the responses of jurisconsults, familiar with astronomy and the theory of the heavens' (bk. I, ch. i, 3). Although there were professional architects throughout the Middle Ages (e.g. ▷Villard de Honnecourt), the terms architect and mason seem to have been often interchangeable and, certainly in Italy, an artist might be selected to design a specific building without necessarily having any architectural training (e.g. the sculptor ▷Arnolfo di Cambio was appointed master mason of Florence Cathedral in 1296 as was the painter ▷Giotto in 1334). Architectural theory and building techniques were considerably more sophisticated in northern Europe at this time as is evidenced by the sheer scale and complexity of the best ▷Gothic cathedrals. The architects of these buildings would have also had to have been engineers. In fact, engineering remained a requisite skill of the architect until the 19th century when new materials and rapid technological innovation necessitated a division of engineering from architecture.

architectonic

As an art historical term, it is used to describe something which, although not itself architecture, partakes of certain qualities associated with architecture. The term may be used to describe, for example, the landscape paintings of ▷Cézanne in which the painter's desire to analyse the underlying permanent structure

Linbov Popova, *Architectonic Composition*

of nature's forms (as opposed to the ▷Impressionists' concern with the fugitive effects of transitory light over their surfaces) resulted in compositions of a carefully constructed monumentality.

architrave

The lowest of the three principal horizontal members of an ▷entablature; the ▷lintel or beam that spans from one ▷column or ▷pier to another, resting upon the ▷abacuses on the capitals.

archivolt

A continuous ▷architrave moulding modified to follow the curved line of an arched opening, instead of a rectangular post and ▷lintel opening.

Arch of Constantine

The ▷triumphal arch erected in Rome in AD 315 to commemorate the Emperor Constantine's victory over Maxentius. It is a triple ▷arch, based on the Arch of Septimius Severus at the opposite end of the Forum, but with more sculptural decoration overall and a division of the ▷attic into three panels, the central one bearing the dedicatory inscription. The three arches are framed by four free-standing columns of the ▷Corinthian order, mounted on ▷pedestals and supporting projecting ▷entablatures. The arch incorporates amongst its sculptural decoration elements from earlier monuments, specifically parts of a great frieze from the reign of Trajan, roundels with hunting scenes from the reign of Hadrian and panels from another triumphal arch of the reign of Marcus Aurelius. A comparison of

the sculptural qualities of these earlier sculptures with those newly created for the arch has led some scholars to note a deterioration, whilst others have seen not so much declining craftsmanship as a changed set of aims and pictorial conventions which presage the coming of ▷Byzantine art. More telling, however, are those areas where Constantinian carvers have attempted to copy earlier sculptural reliefs, as in the ▷spandrels of the arches and on the pedestals of the columns: here a marked deterioration in technique is evident. This decline has been attributed (by Ward-Perkins) to the lack of opportunity to practise the art of sculptural carving in an age in which the fashion was for coloured marble, ▷mosaic and ▷stucco instead of carved decoration.
Bib.: Ward-Perkins, J.B., *Roman Imperial Architecture*, Harmondsworth, 1981

Arcimboldo, Giuseppe (1527–93)

Italian painter. He was a ▷Mannerist from Milan, remembered chiefly for his fantastic ▷allegorical heads composed of fruit, vegetables, animals and fish. These paintings enjoyed renewed favour this century with the ▷Surrealists who regarded their bizarre juxtapositions as antecedents to their own work. Arcimboldo received conventional training in Milan under his father, a stained-glass window designer, with whom he worked on the Cathedral windows (1549–58). From 1562–87 he was official painter to the imperial court in Prague, under Ferdinand I, Maximilian II and Rudolph II, the latter of whom created him Count Palatine. Here he painted his extremely popular bizarre heads as well as producing conventional portraits and being required to design masques and festivals.
Bib.: Barthes, R., *Arcimboldo*, Parma, 1978; Maiorino, G., *The Portrait of Eccentricity: Arcimboldo and the Mannerist Grotesque*, Pennsylvania State University, 1991; Pieyre de Mandiargues, A., *Arcimboldo the Marvellous*, New York, 1977

Arciniega, Claudio de (c1527–93)

Spanish architect. He worked in the Americas. In 1584 he was Master Mason at Mexico Cathedral.

Arena Chapel

Also known as the Scrovegni Chapel, in Padua. The site of a ▷fresco cycle painted by ▷Giotto in c1306. The chapel was built c1303–5 by Enrico Scrovegni, in part as atonement for the money-lending origins of his family's fortune. It is dedicated to the Virgin of Chastity. The rectangular, barrel-vaulted chapel has windows on one side only and Giotto's frescos completely cover the interior wall surfaces. The ceiling is decorated with a bright blue sky and stars, dotted with roundels containing ▷Christ, the ▷Virgin and the four ▷Evangelists. The entrance wall is given over to the ▷Last Judgement. The side walls are divided into three rows of narrative scenes, 38 in all, divided by

painted ornamental frames. On the right, the top row depicts the narrative of ▷Anne and Joachim, the middle row, the Infancy of Christ and the bottom, the ▷Passion. On the left can be seen the Life of the Virgin, Christ's Mission and the ▷Crucifixion and ▷Resurrection. Below these narratives is a painted ▷dado, containing ▷grisaille images of the Seven ▷Virtues (on the right) and Sins.

The unity of the building is maintained throughout this complex organization by Giotto's use of colour, particularly the rich blue of the ceiling which forms a background to all the scenes. Equally significant is the artist's use of limited landscape and architectural backgrounds in the narrative sections, which creates a shallow picture space, without distracting from the action. In many cases backgrounds and figures are bound together, for instance in the ▷Flight into Egypt the figures of Mary and Christ on the donkey are mirrored in shape by the craggy mountain which towers behind. The use of background is merely one element in Giotto's naturalism: his figures gesture like actors, their bodies made solid by his precise use of shadow and in scenes like the ▷Lamentation, the emotion is intensely conveyed. Throughout the work there is a deceptive simplicity which represents a major shift away from the complexity, symbolism and decoration of ▷Gothic work. This, together with the unity of the overall scheme, and Giotto's use of revolutionary modelling and spatial treatment, has led the chapel to be viewed as one of the most significant forerunners of the Italian ▷Renaissance.

Bib.: Stubblebine, J., *Giotto, the Arena Chapel Frescoes*, London, 1969

Ares
▷Mars

Argentina, art in
▷Latin America, art in

armature
A frame, often made of wire, used by a sculptor to provide a support for clay, plaster or other modelling materials.

Armitage, Kenneth (b 1916)
English sculptor. He trained at Leeds College of Art 1934–7, and at the ▷Slade 1937–9, before enlisting in the army for the duration of the Second World War. From 1946–56 he was Head of Sculpture at Bath Academy of Art, Corsham. He destroyed all his pre-war sculpture which consisted of ▷Egyptian and ▷Cycladic-influenced carvings, and from 1946 worked on simplified figure groups in plaster, and later bronze. This work is reminiscent of ▷Giacometti and some commentators have attributed it to a feeling of post-war angst, with his concentration on surface texture and figures perched precariously on pin-like

legs (e.g. 'People in the Wind', 1950, London, Tate; 'Figure Lying on its Side 5' 1958–9, London, British Council). By the 1950s Armitage's reputation was established: his first one-man show was held in 1952; he was one of three British representatives at the ▷Biennale in 1958 and he was given a Whitechapel retrospective in 1959. He also won the competition to design a German war memorial at Krefeld in 1956. In the 1960s his work developed on an increasingly abstract and more monumental scale and he exploited materials such as aluminium (e.g. *Sybil III*, 1965, London, Tate). His work has maintained a quality of restlessness, and an interest in movement. In 1969 he was awarded the CBE.

Bib.: *Kenneth Armitage*, exh. cat., London, 1972; *Kenneth Armitage*, exh. cat., Stoke, 1980

Armory Show
An exhibition held in the 69th Regiment armory, New York from 17 February to 15 March 1913. It consisted of over 1,500 modern artworks and was organized by the Association of American Painters and Sculptors (president ▷Arthur B. Davies). It was a result of growing dissatisfaction among ▷avant-garde artists who lacked exhibition opportunities and followed lesser shows like ▷The Eight (1908) and the Independent Artists' Exhibition (1910). The choice of exhibits was largely controlled by Davies who took ▷Fry's second ▷Post-Impressionist exhibition (1912) and the Cologne ▷Sonderbund (1912) as his guide. It was the first major exhibition of ▷Cubist and ▷Fauvist work in the United States – most controversially it exhibited ▷Duchamp's *Nude Descending a Staircase* – and had a seminal impact on American art and art criticism. The organizers also published pamphlets on ▷Cézanne, ▷Redon and others to help explain the art to a bemused public. But the show was highly selective: the American section was weighted in favour of young artists and the European works excluded German ▷Expressionism and Italian ▷Futurism in its concentration on the ▷School of Paris. Despite initial ridicule, over 300 works were sold and a quarter of a million visitors paid to view the exhibits. The show later toured Boston and Chicago.

Bib.: Brown, M.W., *The Story of the Armory Show*, London, 1963

Arnolfo di Cambio (fl c1264; d c1302)
Italian sculptor and architect. He trained under ▷Nicola Pisano and assisted him on both the shrine of S. Dominic at Bologna (1264–7) and the pulpit for Siena Cathedral (1265–8). In 1277 he went to Rome where he carved his *Charles of Anjou* (Rome, Capitoline Museum) one of the earliest surviving portrait statues of modern times by a known artist. His wall tomb of Cardinal de Braye who died in 1282 (S. Domenico, Orvieto), with the deceased represented recumbent upon a bier beneath an enthroned

▷Madonna and Child, the whole composition set within an architectural surround, served as the model for wall tombs for over a century. His also are the ▷ciboria in S. Paolo fuori le mura (1285) and Sta Cecilia in Trastevere (1293) in Rome, and the revered bronze statue, *St. Peter Enthroned* (Rome, St. Peter's), is attributed to him. In Florence he is documented as the first architect of the Cathedral (S. Maria del Fiore) and ▷Vasari attributes the design of S. Croce and the Palazzo Vecchio to him.

Bib.: Cuccini, G., *Arnolfo di Cambio e la Fontana di Perugia 'Pedis Plateo'*, Perugia, 1989; Mariani, V., *Arnolfo e il Gotico italiano*, Naples, 1969

Arp, Jean (Hans) (1887–1966)

German-French sculptor, painter and poet. He was born in Alsace and studied at the Strasbourg School of Arts and Crafts, at Weimar (1905–7) and the ▷Académie Julian, Paris (1908). In 1912 he went to Munich where he knew ▷Kandinsky and exhibited semi-figurative drawings at the second ▷Blaue Reiter exhibition in 1912, and 1913 he exhibited with the ▷Expressionists at the first Herbstsalon (Autumn Salon) in Berlin. Aware of the developments within the French ▷avant-garde through his contacts with such figures as ▷Apollinaire, ▷Max Jacob and ▷Robert Delaunay in 1914, Arp exhibited his first abstracts and paper cut-outs in Zurich in 1915, and began making shallow wooden ▷reliefs and compositions of string nailed to canvas. In 1916 he was a founder member of ▷Dada in Zurich, he participated in the Berlin Dada exhibition of 1920, and in 1923 he visited ▷Schwitters in Hanover. In Paris, Arp began to evolve his personal style of abstract compositions through an organic morphology, frequently sensuous in form, and began to experiment with automatic composition (▷automatism). In 1925 he participated in the first ▷Surrealist exhibition in Paris, before breaking with Surrealism to become a founder member of ▷Abstraction-Création in 1931, when his characteristic organic forms became more severe and geometrical. At a time when he began to turn towards full 3-D sculptures, Arp insisted that his sculpture was 'concrete' rather than 'abstract', since it occupied space, and that art was a natural generation of form: 'a fruit that grows in man', as he put it.

Arp visited the USA in 1949 and 1950, and completed a monumental wood and metal relief for Harvard University, and a mural relief for the UNESCO Building in Paris in 1958. He won the international prize for sculpture at the Venice ▷Biennale in 1954.

A dominant personality within Dada, Surrealism and abstract art, his reliefs and sculptures have had a decisive influence upon the sculpture of this century.

Bib.: Fauchereau, S., *Arp*, Paris, 1988; Read, H., *Arp*, London 1968; *Jean Hans Arp, the Hundredth Anniversary of his Birth*, exh. cat., New York, 1986; Schafer. J., *Dada Köln*, Wiesbaden, 1993

Arrangement in Grey and Black Number I: Portrait of the Artist's Mother

Painted by ▷James Whistler in 1871 (oil on canvas 144 × 163 cm/4 ft 8 in × 5 ft 4 in). The figure is shown seated on a chair in sharp profile, in a shallow picture space against a plain wall. The austerity is broken only by two framed pictures and a curtain in the background, but as a result of these the work is dominated by a series of strong verticals and horizontals. The compositional device had been used by Whistler before, and can be seen to derive from ▷Degas' early portraits. As the title suggests the painting is an experiment in near-monochrome, the colours reflecting the age and character of the tight-lipped old woman. Whistler repeated the 'arrangement' two years later with his portrait *Thomas Carlyle* (1872–3, Glasgow Art Gallery) and at the same time he was exploring tonality in landscape with his series of *Nocturnes*, begun in 1871. He referred to all these works as 'ideal constructions'. From the 1870s onwards Whistler increasingly turned to portraiture, using the device of a limited palette and simplified background to intensify the character of the sitter. It was these, especially his full-length images of society women, on which much of his later fame rested. The 1871 portrait of his mother was rejected by the ▷Royal Academy but exhibited at the Paris ▷Salon in 1883, to a mixed reception. It was later brought by the French and now hangs in the Louvre.

Arretine ware

A type of ancient Roman pottery of the 1st century BC produced most significantly in Arezzo.

arriccio, arricciato

(Italian, 'rendering'.) Term used in ▷fresco painting to denote the rough coat of lime and sand plaster applied to the wall surface, upon which the final painting surface (▷intonaco) is laid.

arris

▷fluting

Art Autre

A term coined by the French critic Michel Tapié in his book *Un Art Autre: ou il s'agit de nouveaux devidages du réel*, published in 1952. Arguing that both ▷Dada and the Second World War had created a *tabula rasa* by discrediting all notions of rationalism and humanism, and indeed of the 'impossibility of any new "ism" of any kind', Tapié argued that art could only be authentic if it were ▷'other', i.e. defined solely in terms of its oppositions to all conventional aesthetic norms. Drawing on the language of Existentialism for its vocabulary and philosophical justification, matter and

gesture emerge as the defining elements of a new aesthetic, although Tapié's refusal to be bound by traditional notions of style meant that 'art autre' was a necessarily vague concept. This fact is reflected in the heterogeneous selection of works with which he illustrated his thesis, by artists such as ▷Dubuffet, ▷Fautrier, ▷Hartung, ▷Mathieu, ▷Pollock and ▷Wols. Tapié attempted to promote 'art autre' with a series of exhibitions throughout Europe and Japan in 1957, as well as through his critical writing. However, the concept of 'art autre', by its very nature was never sufficiently defined as to cohere into a specific movement, and is virtually synonymous with ▷Art Informel.

Bib.: Tapié, M., *Un Art Autre*, Paris, 1952

Art Brut

Term coined by ▷Jean Dubuffet for art produced with no regard for traditional aesthetic norms, predominantly by people traditionally excluded from the established art world, such as psychiatric patients, children and graffitists (▷graffiti). These works were authenticated by their power of expression deriving from their directness of technique, uninhibited subject matter, chance choice of materials and complete disregard for conventional aesthetic practice (characteristics of Dubuffet's own work). Dubuffet was strongly influenced by Dr Hans Prinzhorn's book *Artistry of the Mentally Ill* (1924), with its insistence that the art of the mentally ill, like that of children and primitive societies, may be powerful and original creative expression uncontaminated by the social and cultural constraints of a 'moribund' fine art tradition.

Dubuffet began collecting 'works executed by people free from artistic culture' in 1945, and exhibited his collection at the Galerie Drouin, Paris, in 1947. In 1948 he founded the Compagnie d'Art Brut with ▷Breton, Tapié and Paulhan, which disbanded in 1951. At that time, the collection, numbering some 5,000 items, was rehoused with the painter Ossorio in New York, until it returned to Paris in 1962. An exhibition of Art Brut was held in 1967 at the Musée des Arts Décoratifs, Paris, and in 1972 the collection was presented to the city of Lausanne.

Bib.: *Art Brut*, exh. cat., Augsburg, 1993; *L'Art Brut*, 10 vols., Paris, 1946–76; Thevoz, M., *Art Brut*, Geneva, 1976

art criticism

The name given to any writing about art which involves a greater element of ▷aesthetic judgement than historical detachment. Art criticism did not really form a separate category of knowledge until the late 18th century. At that time, two factors contributed to its growth: the expansion of journalism, and a greater prevalence of public exhibitions. As works of art were exhibited more frequently to a wider public – not all of whom had the requisite education to understand what they were seeing – a body of art critics developed to explain and evaluate. Art criticism was a symptom of the greater accessibility of art, but art critics also helped shape public opinion by pandering to or shocking public taste. Eloquent art critics with a literary bent were rare, but critics like ▷Diderot and ▷Baudelaire are still read today for their insights. However, many critics before the end of the 19th century were hacks, and the professionalization of art criticism came only slowly. By the end of the 19th century, however, some critics had become spokespersons for ▷avant-garde artists, and critics such as Hermann Bahr in Austria and J.-K. Huysmans in France used a highly literary style to praise the works of rebel artists such as ▷Klimt and ▷Rops. In the 20th century, art criticism has become an increasingly specialized activity.

Bib.: Bell, Q., *The Art Critic and the Art Historian*, London, 1974; Darracott, J., *Art Criticism: A User's Guide*, London, 1991; Gee, M. (ed.), *Art Criticism Since 1900*, Manchester, 1993; Orwicz, M., *Art Criticism and its Institutions in Nineteenth-Century France*, Manchester, 1994; Stolnitz, J., *Aesthetics and the Philosophy of Art Criticism*, Boston, 1960; Venturi, L., *History of Art Criticism*, revised edn., New York, 1964; Wrigley, R., *The Origins of French Art Criticism: From the Ancien Régime to the Restoration*, Oxford, 1993

art dealing

A process of buying and selling art which came to prominence after the patronage systems of the medieval and ▷Renaissance periods began to break down. Art dealers acted as go-betweens in the relationship between the artist and the consumer. Although dealers existed in the competitive market of the 17th-century Netherlands, they began to gain prominence in the 18th century during the height of the ▷Grand Tour. Dealers helped collectors build up their supply of ▷old masters by travelling to Italy and buying in bulk works attributed to such Renaissance stars as ▷Michelangelo and ▷Raphael. The ignorance of many collectors was exploited by dealers, who were attacked by many artists for fuelling the sale of old masters to the detriment of contemporary work. As middle-class collecting grew in the 19th century, dealers turned their attention more to contemporary work. The English art dealer, Gambart, for example, made a fortune out of controlling the copyright of works by ▷Frith and ▷Holman Hunt, especially when the works were engraved for additional sale. By the end of the 19th century, dealers were more frequently associated with ▷avant-garde movements. ▷Durand-Ruel encouraged ▷Impressionism in this way, while Paul Cassirer and Herwarth Walden virtually created the ▷Expressionist 'movement' in Germany.

Bib.: Gee, M., *Dealers, Critics and Collectors of Modern Painting: Aspects of the Parisian Art Market Between 1910 and 1930*, Manchester, 1981; Jensen, R., *Marketing Modernism in Fin-de-Siècle Europe*, Princeton, 1994;

Maas, J., *Gambart, Prince of the Victorian Art World*, London, 1975

Art Deco

An art style in Europe and America during the 1920s and 1930s which took on characteristics of ▷Art Nouveau. The name derived from the 'Exposition Internationale des Arts Décoratifs et Industriels Modernes' held in Paris in 1925. The works shown here used expensive materials such as ivory and ebony, combined with a tame version of Art Nouveau extravagance. As with many Art Nouveau creations of the 1890s, Art Deco objects were intended to evince a return to real craftsmanship in the wake of mass industrial production. In 1926, the United States became

Art Deco: Lalique opalescent glass statuette, *Suzanna Bathing*

the main centre for Art Deco work when it also held an exhibition including a good deal of the works shown previously in Paris. Many other exhibitions followed, including some sponsored by Macy's department store, which realized the commercial potential of this new elegance. Art Deco styles also entered architectural design, but here the ▷machine aesthetic was more apparent in monumental, starkly rectilinear designs with the occasional kitsch or distinctive touch.

Bib.: Arwas, V., *Art Deco*, London, 1980; Duncan, A., *The Encyclopedia of Art Deco*, Sydney, 1988; Bouillon, J.-P., *Art Deco 1903–40*, Geneva and New York, 1989

art education

In the Middle Ages, art education was conducted mainly in workshops and was considered, like any other craft, to be an essential part of the craftsman's training. An artist was not expected to have knowledge outside his craft until the ▷Renaissance, when the status of the artist was enhanced. At this time, the formation of ▷academies allowed artists to be trained in a liberal tradition, in which they imbibed Classical and scientific knowledge in addition to the techniques of their craft. The artist was expected to be an educated gentleman who used his art for educative purposes. In the 17th and 18th centuries, artists often received official court recognition and maintained friendly personal relations with members of the educated aristocracy and upper middle classes.

Art education diversified in the 19th century when design schools in England and ▷*Kunstgewerbeschulen* in Germany provided more practical training for artists who wished to work for industry. The 19th century also witnessed a proliferation of drawing manuals which provided source books for amateur artists. Art education was revolutionized in the 1920s with the pedagogic methods of the ▷Bauhaus. Here, art and craft were meant to be learned together, and teachers such as ▷Itten encouraged the students to practise creative experimentation. These less prescriptive methods were carried to America by Bauhaus exiles, and many of them are still practised in art classes today. Although art education has never disappeared, some 20th-century artists have insisted on the primacy of an artist's personal expression and have minimized the importance of formal teaching.

▷academies

Artemis

▷Diana

Arte Povera

A term first used by the Italian critic Germano Celant in 1967 to characterize the work of certain artists exhibiting at the Galleria La Bertesca, Genoa, who rejected the traditional ▷iconography and materials of fine art. The installations created by artists such as Mario Merz, Mario Ceroli, Michelangelo Pistoletto, Anselmo and Boetti, making use of a whole range of normally neglected materials, including such things as earth, cement, rope, felt, newspaper, twigs and neon, implicitly rejected traditional artistic values of taste and beauty, whilst at the same time resisting the art market's desire for a finished and saleable product, (though many of its artists have become commercially successful). Celant attempted to extend the scope of the movement beyond Italy in 1969 in his book *Arte povera*, by pointing to the similarities between Arte Povera and artists such as Carl Andre, ▷Joseph Beuys and ▷Robert Morris. For Celant, 'Arte Povera expresses an approach to art which is basically anti-commercial, precarious, banal and anti-formal, concerned primarily with the physical qualities of the medium and the mutability of the materials. Its importance lies in the artists' engagement with actual materials and with total reality and their attempt to interpret that

reality in a way which, although hard to understand, is subtle, cerebral, elusive, private, intense.' Arte Povera is connected with ▷happenings and is a precursor of both ▷Conceptual and ▷Earthwork art.

Bib.: Bouisset, M., *Arte Povera*, Paris, 1994; Celant, G. (ed.), *Arte Povera*, Milan, Electa, c1985

artesonado

(from Spanish: *artesón*: 'wooden panel'.) Ornamental ceiling timber used on Moorish ceilings in Spain. They were often painted as well as carved.

art for art's sake

The philosophy that art exists for no ulterior purpose and should be judged by no non-aesthetic standards. ▷Kant was one of the first to put forward such a view, which was emphasized by German ▷Romantic writers like ▷Schiller, ▷Goethe and Schelling. In England, Carlyle and Coleridge, and, in America, Poe and Emerson expressed similar views. The ideas were most fully articulated in 19th-century France, at first by writers like de Staël, Jouffroy and Cousin, whose Sorbonne lectures *Le vrai, le beau et le bien* (*The True, the Beautiful and the Good*) were published in 1836. Later critics such as the ▷Goncourt brothers and Gautier kept the idea alive and it was epitomized by the paintings of ▷Ingres. In the 1880s the ▷Symbolists and the ▷Aesthetic Movement in England reinvigorated the concept yet again.

art history

▷history of art

Arthois, Jacques d' (1613–86)

Flemish painter. He worked primarily in Brussels, where he painted landscape scenes. He had an active studio and other members of his family were also landscapists.

Art Informel

A broad term applied to non-figurative art in post-war Paris defined in opposition to geometric ▷abstraction and ▷Social Realist art. The vocabulary of the Informel was non-figuration, gestural improvisation, the manipulation of physical matter as the expressive basis of art and antipathy towards defined form. The critic Waldemar George had ambiguously called ▷Fautrier's '*otages*' exhibition of 1954, 'a triumph of the formless', while the writer Ponge made a parallel between the *otages* and ▷Bataille's concept of the '*informe*'. ▷Dubuffet also invoked the notion of the *informe* in his book *Notes for the Well-Read* in 1945, linking ideas of chance and gesture: 'Beginning with the formless: the beginnings of the adventure are the surface which will come to life and the first spot of colour or ink thrown on to it.' It was Michel Tapié who promoted the term as a critical concept, first in relation to the formless art of ▷Wols, and then in relation to artists such as

Dubuffet, Fautrier, ▷Mathieu and Michaux, through a series of exhibitions entitled *Les Signifiants de l'Informel* in Paris in 1951 and in 1952. Art Informel is also variously known as ▷Lyrical Abstraction and ▷Tachisme.

Bib.: Paulhan, J., *L'Art Informel*, Paris, 1962

art mobilier

The name given to prehistoric artefacts which have been discovered at archaeological sites and which are portable.

Art Nouveau

An international style of decoration and architecture which developed in the 1880s and 1890s. The name derives from the *Maison de l'Art Nouveau*, an interior design gallery opened in Paris in 1896, but in fact the movement had different names throughout Europe. In Germany it was known as ▷'Jugendstil', from the magazine *Die Jugend (Youth)* published from 1896; in Italy 'Stile Liberty' (after the London store, Liberty Style) or 'Floreale'; in Spain 'Modernista', in Austria 'Sezessionstil' and, paradoxically, in France the English term 'Modern Style' was often used, emphasizing the English origins of the movement.

In design Art Nouveau was characterized by writhing plant forms and an opposition to the ▷historicism which had plagued the 19th century. There was a tension implicit throughout the movement between the decorative and the modern which can be seen in the work of individual designers as well as in the chronology of the whole. Its emphasis on decoration and artistic unity links the movement to contemporary ▷Symbolist ideas in art, as seen in the work of the Vienna ▷Secessionists, but the movement was also associated with ▷Arts and Crafts ideas and, as such, Art Nouveau forms a bridge between ▷Morris and ▷Gropius (recognized by ▷Pevsner in his book, *Pioneers of the Modern Movement*, 1936).

In Britain the style was exemplified by the architecture of ▷Rennie Mackintosh, and the design work of the ▷Macdonald sisters. The lingering impact of ▷Morris in England slowed down the progress of the new style in design although ▷Mackmurdo, ▷Godwin, Townsend and even ▷Voysey were influenced towards Art Nouveau. It was in illustration that the ideas were most keenly felt, through the new periodicals and presses – the ▷*Yellow Book*, the *Studio*, the *Savoy*, the *Hobby Horse* – and though the work of ▷Beardsley, ▷Ricketts and Selwyn Image.

In France, despite Guimard's famous glass and iron Métro designs, the movement was best expressed in the ▷applied arts, especially the glassware of Lalique (1860–1945) and Gallé (1846–1904). In Belgium, the style was promoted through the *Société des Vingts* (▷Les Vingt) established in 1884, and including ▷Ensor as well as the more characteristically Art Nouveau architects ▷Horta and ▷Van de Velde in its members. In

Spain the style was concentrated in the eccentric hands of ▷Gaudí in Barcelona. In Vienna, architects like ▷Wagner, Hoffmann and ▷Olbrich, and artists such as ▷Klimt gathered to promote the style through the Secessionist magazine ▷ *Ver Sacrum*. In Germany, the movement split between the decorative tendencies of Otto Eckman (1865–1902) and the *Pan* magazine, and the streamlined design of ▷Behrens. In America architects like ▷Sullivan and ▷Wright were influenced by European ideas but conceived Art Nouveau in different terms, whilst designers like ▷Tiffany enthusiastically embraced the movement.
Bib.: Barilli, R., *Art Nouveau*, London, 1969; Bouillon, J.-P., *Art Nouveau*, London, 1985; Masini, L.V., *Art Nouveau*, London, 1984; Schmutzler, R., *Art Nouveau*, London, 1962

art pour l'art
▷art for art's sake

Art Students' League
An American art school. It was founded in 1875 in New York City. Although there were other art schools in New York at the time, this one was unusual in that it was organized by students and deliberately broke away from traditional ▷academic teaching methods. Among its notable teachers was ▷Thomas Eakins.

Art Unions
A series of organizations set up in England and America during the 19th century for the purpose of educating and expanding the art-buying public through exhibitions and publications. The London Art Union was founded in 1836, while the first American ones opened in the 1840s. Members paid a set subscription fee for which they received an ▷engraving, and sometimes prizes were offered as an incentive to new members. The English Art Union founded a journal, *The Art Union* (1844–8), which became the *Art Journal* in 1849 and remained a bastion of conservative bourgeois taste throughout the 19th century.
▷Kunstverein
Bib.: King, L., *The Industrialization of Taste: Victorian England and the Art Union of London*, Ann Arbor, 1985; Mann, M., *The American Art-Union*, Washington, 1977

Arts and Crafts Movement
A movement which developed in the second half of the 19th century, in opposition to industrialization and associated social changes. The idea spread after the ▷Great Exhibition of 1851, which had supposedly shown off in London the best craftsmanship of the day, but it had earlier roots in the emphasis which Jean-Jacques Rousseau had placed on craftsmanship in the 18th century and on the medievalism of ▷Gothic revivalists like ▷Pugin in the early 19th century. It was articulated in the writings of ▷Ruskin, whose belief in the moral qualities of art led him to oppose machine production, and who believed in the ultimate inspiration of nature, rather than the rehashed historicism of the period. It was exemplified by the design work of ▷William Morris, through his firm ▷Morris, Marshall, Faulkner and Co., established in 1861. He employed artists such as ▷Burne Jones and produced many designs himself, notably for wallpaper, textiles and ▷stained glass, in which natural inspiration and truth to materials are the paramount considerations. The movement also inspired a generation of architects, led by Webb (who designed the Red House for Morris), Shaw, ▷Ashbee and ▷Voysey, who used vernacular architecture and traditional materials without resorting to the overt period style of the ▷Queen Anne Movement.
The Arts and Crafts Movement had a strong socialist streak, seen in Morris's own writings (e.g. *News from Nowhere*, 1891) and in the numerous attempts to educate the masses (e.g. Ashbee's Guild and School of Arts and Crafts established in 1888). But the politics was always tempered by a nostalgia for the Middle Ages with their craftsmanship, guilds and religious endeavour. The movement organized exhibitions from 1888, but by then was already being superseded by the development of ▷Art Nouveau which shared similar ideas but with a more contemporary outlook. However, its ideal lingered and is apparent in ▷Gropius' ▷Bauhaus manifesto.
Bib.: Anscombe, I., *Arts and Crafts in Britain and America*, London, 1978; Davey, P.J., *Arts and Crafts Architecture*, London, 1995; Naylor, G., *Arts and Crafts Movement*, London, 1971; Richardson, M., *Architecture of the Arts and Crafts Movement*, London, 1983

Arts Council of Great Britain
A government-sponsored central funding and administrative body responsible for the encouragement of all the arts. In 1940 the CEMA (Committee for the Encouragement of Music and the Arts) was set up, in order to ensure arts activities continued through the war years and to 'show publicly and unmistakably that the Government cares about the cultural life of the country'. Its initial budget of £20,000 ($35,000) expanded rapidly, with donations from charitable trusts. The operation was so successful that at the end of the Second World War the coalition government decided to incorporate the Committee by Royal Charter as the Arts Council. The first Chairman was John Maynard Keynes, who believed that the Council was to fund professional arts, rather than concentrating on amateurs. The Council's objectives have always been to raise the standard of achievement in the arts in Great Britain and to make those arts reach as many people as possible.
In 1951 the Arts Council was given responsibility by the government to plan the celebrations for the Festival of Britain, and through the 1960s the Council's

activities continued to flourish. In 1967 responsibility for the Council was transferred from the Treasury to the Department of Education and Science and the Scottish and Welsh Committees were made into partially-autonomous Arts Councils. After 1979 and the arrival of the Conservative government, the Council continued to move further and further from central government and was forced to embrace enterprise culture. In the 1990s further decentralization and the first actual cash cut in subsidies to the arts stretched the Council.

Forms encouraged by the Council in addition to the visual arts include dance, opera, ballet, theatre, film and video, architecture and disability arts. In the visual arts, the Council has two main bases of activity: exhibition services and the purchase of work by living artists. Recent purchases include work by Abigail Lane, Antony Gormley and Mark Wallinger. In addition, the Council gives research and development grants to artists and curators, and provides studio space and materials. The Hayward and the Serpentine in London have both been Council galleries, and as such have had large-budget, blockbuster displays. Despite the cutbacks the Arts Council remains the single most important source of patronage in British arts.

Arundel, Thomas Howard, Earl of (1584–1646)

English collector and patron of the arts. He was a member of a long-established family, but throughout his life suffered from the factionalism of contemporary politics (his father was imprisoned for most of his childhood). Although brought up a Catholic, he converted to Protestantism and stood back from the flamboyance of much of court life. He was educated at Westminster and Trinity College, Cambridge. Much of his later life was spent on the Continent – he lived in Padua from 1641 – and he had numerous contacts in Europe. He was a patron of ▷Rubens and ▷Van Dyck and brought ▷Hollar to England. Through ambassadors abroad he organized for the importation of antiquities (much of his collection, the Arundel Marbles, is now in the Ashmolean, Oxford, presented to the museum in 1667) and he also collected paintings, notably by ▷Dürer and ▷Holbein. He visited Italy with ▷Inigo Jones. He was instrumental in developing the artistic patronage which flourished at the court of Charles I.
Bib.: *Thomas Howard, Earl of Arundel*, exh. cat, Oxford, 1985; Springell, F.C., *Connoisseur and Diplomat, Earl of Arundel*, London, 1963

aryballos (aryballus)

A globe-shaped ancient Greek pot used to hold oils and ointments.

Asam, Kosmas Damian (1686–1739) and Egid Quirin (1692–1750)

German family of architects. These brothers visited Rome in 1711–14 and admired the works of ▷Bernini and ▷Pozzo. They returned to Bavaria with high ▷Baroque idealism and proceeded to design and decorate churches in a style that was much more elaborate than that of their Italian predecessors. The church of St. John Nepomuk in Munich (called the 'Asamkirche') of 1733–46 is the best example of the way they manipulated space, light and illusionistic methods to create a harmony of painting, sculpture and architecture. While both brothers had architectural ability, Kosmos also specialized in painting and Egid in ▷stucco.
Bib.: Rupprecht, B., *Die Brüder Asam: Sinn und Sinnlichkeit im bayerischen Barock*, Regensburg, 1987; Trottman, H., *Cosmas Damian Asam 1686–1739: Tradition und Invention in malerischen Werk*, Nuremberg, 1986

Ascension

(Mark 16: 19; Luke 24: 50–3; Acts 1: 1–11). The term refers to the Ascension of ▷Christ into Heaven at the end of his earthly ministry. ▷Mark and Luke give only very brief accounts, whereas Acts treats the episode in more detail. Forty days after his ▷Resurrection, Christ gathered his disciples together for the last time and told them to stay in Jerusalem until they had received the power of the Holy Ghost so that they could carry his message throughout the world. After saying this he was taken up into a cloud. As the disciples continued to look up they became aware of two men dressed in white, standing with them. The men told the disciples not to be amazed that Christ had been taken up into Heaven for he would one day return the way he had left.

The Ascension is a theme treated relatively seldom in art (the Resurrection of Christ, with its promise of life after death, being of far greater importance to Christian patrons). It usually appears as part of a narrative cycle, either on an ▷altarpiece (e.g. ▷Jacopo di Cione, *San Pier Maggiore Altarpiece*, 1370, London, National Gallery), or perhaps as part of the decoration of a room (e.g. ▷Jacopo Tintoretto, c1578/81, the Upper Hall, Scuola Grande di San Rocco, Venice). Jacopo di Cione follows earlier treatments of the subject, like the 7th-century illustration in the *Rabbula Gospels* (eastern Syrian, 586, Laurentian Library, Florence). In both the men in white are presumed to be angels (with wings) and the disciples are accompanied by Mary (who is not mentioned as present in any of the accounts). It is usual to depict angels escorting the ascending Christ into Heaven, although in the *Rabbula Gospels* Christ is framed by a ▷mandorla, whereas Jacopo's Christ is surrounded by emanating rays. The eleven remaining disciples are made up to twelve in the *Rabbula Gospels* by the unscriptural addition of St. Paul, who had not yet been

converted, but whose presence in his symbolic guise as the Gentile founder of the Christian Church balances Peter who was his Jewish counterpart. In Tintoretto's picture the unscriptural Mary and Paul are absent. Tintoretto shows Peter, in his guise as the author of the Acts, looking up from his writing as if the main scene is a vision conjured up by his memory. Furthermore, the two men in white have now become ▷Moses and Elijah in a clear reference to the ▷Transfiguration and a reinforcement of the doctrine that Christ's coming was the fulfilment of the biblical prophecy.

Ashanti
▷African art

Ashbee, Charles Robert (1863–1942)
English architect and designer, associated with the ▷Arts and Crafts Movement and with ▷Art Nouveau. He was born in London and studied history at King's College, Cambridge, before joining Bodley's architectural practice. His own architecture moved from a moderate ▷Queen Anne style to a simplified vernacular, using asymmetrical, elongated windows, brick and plasterwork (72–4 Cheyne Walk, London 1897–8). He later settled in Chipping Camden (1902) where he restored and reworked many of the local buildings (Norman Chapel 1906–7 was a ruined medieval church turned into a house). He is perhaps better known for his design work, however. Throughout his life he worked in metal and ▷ceramics. He established the Guild and School of Handicrafts in 1888, and shared many of ▷Morris's socialist ideas. In 1901 he visited ▷Wright in America and shared design ideas with him. He was also a writer and founded the Essex House Press in 1894. In the same year he also established the London Survey Commission (which later became the Royal Commission on Historic Monuments). After the First World War he spent time in Egypt and Palestine working as an architect.
Bib.: Crawford, A., *Charles Robert Ashbee*, New Haven and London, 1985; MacCarthy, F., *A Simple Life, Charles Robert Ashbee in the Cotswolds*, London, 1981

Ashcan School
The name given to a group of American painters who specialized in realist urban scenes between 1908 and 1914. The group came together at the exhibition of ▷The Eight in 1908, and included ▷Robert Henri and his pupils ▷William Glackens, ▷George Luks, ▷Everett Shinn and ▷John Sloan, all of whom had worked as artists for Philadelphia newspapers in the 1890s. These artists rebelled against the exclusivism and unnaturalism of academic art, and they adopted a realist style to scenes of city life. Some of these artists also worked for the Philadelphia Press, which gave them a sympathy for reportage. Although not a member of The Eight, ▷George Bellows was also associated with the group.
Bib.: Braider, D., *George Bellows and the Ashcan School of Painting*, Garden City, 1971; Perlman, B.B., *Painters of the Ashcan School*, New York, 1978

ashlar
Masonry of hewn stone, even-faced and rectangular, laid in regular courses. It is often thinly cut to serve as a facing to rubble or brick walls.

Ashmolean Museum
Collection of art and antiquities at Oxford. The first public museum in Britain, the body of works was donated to Oxford University in 1675 and opened to the public in the building designed by Thomas Wood in 1683. The original collection was made up of souvenirs and curiosities collected by the gardener John Tradescant. He left the unusual collection to Elias Ashmole in 1659, who in turn gave it to the University. As the holdings of the University expanded, it became clear that more space was needed and in 1845 Charles Robert Cockerell's building in Beaumont Street was completed. The holdings of the Ashmolean are noted for antiquities and paintings, particularly those of the Italian ▷Renaissance, including work by ▷Michelangelo and ▷Raphael.

Asplund, Erik Gunnar (1885–1940)
Swedish architect. He helped bring ▷modernist architectural practices to Stockholm After a visit to Italy and Greece in 1913–14, he returned to Stockholm to design buildings using glass and steel with modern functionalism. One of his most famous buildings was the Stockholm City Library (1924–7).
Bib.: Doumato, L., *Erik Gunnar Asplund: A Bibliography*, Monticello, Ill., 1990

Asselyn, Jan (c1615–52)
Dutch painter. After travelling to Italy in the 1630s and 1640s, he assimilated the influence of ▷Claude to a series of landscapes representing the Roman Campagna. He was a friend of ▷Rembrandt.

assemblage
A term which is used loosely to refer to a three-dimensional work that is neither a ▷collage nor a ▷sculpture, but takes on properties of both. The invention of assemblage technique is disputed, but ▷Picasso was one of the first artists to make consistent use of it. From 1914, he employed techniques of ▷Cubist collage to three-dimensional objects. Assemblage became an important preoccupation for Russian revolutionary artists such as ▷Tatlin who sought new ways to use materials and wished to escape the dominating influence of bourgeois easel painting (▷Constructivism, ▷Productivism). The term 'assemblage' was allegedly first coined by ▷Jean Dubuffet in the

1950s, and it had entered cultural discourse fully by 1961 when an exhibition called *The Art of Assemblage* was held at the ▷Museum of Modern Art in New York. Subsequently, artists specializing in assemblage include ▷Joseph Cornell, whose boxes consist of an infinite variety of odd or unusual combinations of objects. Assemblage has the advantage of being a flexible method that allows a variety of materials.

Bib.: Seitz, W.G., (ed.), *The Art of Assemblage*, exh. cat., New York, 1961

ASSO
▷ARBKD

Association of Artists of Revolutionary Russia
▷AKhRR

Association of Revolutionary German Artists
▷ARBKD

Assumption
(New Testament Apocrypha: *The Book of John Concerning the Falling Asleep of Mary* and *The Passing of Mary*; also chronicled by Jacobus de Voragine in *The Golden Legend.*) This is the Assumption into Heaven of the ▷Virgin Mary's body and soul at the command of God. The term 'Assumption' derives from the Latin '*adsumere*', 'to take up', and stresses the important difference the Church observed between Mary's Assumption (she was a human lifted up to Heaven by angels at God's command) and ▷Christ's ▷Ascension (as he was one with God he went up of his own volition). The story of the Assumption of the Virgin is entirely unscriptural but it reflects the need to explain the nature of Mary's perfection. She was human, so by nature's laws she had to have died; but she was God's perfect and incorruptible vessel, so that after death her body could not decay. The conundrum was rationalized in the story of her physical assumption into Heaven. The apocryphal gospels date from the 3rd and 4th centuries, but the theme achieved its greatest popularity in Italy with the growth of Marianism in the 13th century.

Depictions of the Assumption generally show the ▷Apostles clustered around Mary's tomb looking up in amazement as she is carried up by a host of angels (e.g. ▷Andrea del Sarto, 1526–9, Florence, Pitti Gallery), sometimes into the awaiting arms of God (e.g. ▷Titian, 1518, Venice, Chiesa dei Frari). The tomb, frequently depicted as a ▷sarcophagus, may be shown full of sprouting flowers, symbolic of Mary's purity (e.g. Paolo di Giovanni Fei, c1400, Washington, National Gallery). On occasion the Virgin is shown dropping her girdle into the uplifted hands of the apostle Thomas who needed proof that both her body as well as her soul had been taken up into Heaven (e.g. ▷Matteo di Giovanni, 1474, London, National Gallery). In earlier treatments Mary may be carried up

within a ▷mandorla (e.g. ▷Nanni di Banco, Porta della Mandorla, 1414–21, Florence, Duomo). The Assumption is sometimes conflated with the Virgin's heavenly ▷Coronation (e.g. ▷Raphael, *Coronation of the Virgin*, c1503, Rome, Vatican Museum).

Assyrian art
The art of Mesopotamia of the 15th–7th centuries BC. The majority of extant Assyrian art dates from the height of Assyrian power in the 9th century BC until 612 BC when the capital Nineveh was destroyed. Much of this art consists of luxury items composed of lavish materials, as it was court art rather than popular culture. Among the relics of Assyrian civilization are many sculpted ▷bas-reliefs which depict scenes from the life of kings. Ivory carving and bronze bowls are also characteristic of the society, and monumental art in the form of giant sculpted winged bulls is one of its most memorable features. Assyrian art was always somewhat stylized, and there was no attempt at perspective in naturalistic representation.
▷Babylonian art

Bib.: Barnett, R.D., *Assyrian Palace Reliefs and their Influence on the Sculptures of Babylonia and Persia*, London, 1960; Lloyds, S.H.F., *The Art of the Ancient Near East*, London, 1974; Reade, J., *Assyrian Sculpture*, London, 1983

astragal
▷moulding

astrology
An ancient system of prophecy, based on interpreting the position of the constellations. The 12 signs of the zodiac are: Aries, Taurus, Gemini, Cancer, Leo, Virgo, Libra, Scorpio, Sagittarius, Capricorn, Aquarius and Pisces. Each of these signs is represented by a distinctive symbol, and these symbols were used commonly in medieval manuscript illumination. They often accompanied representations of the ▷Labours of the Months, or other forms of calendrical display.

Asturian
A style of architecture concentrated in the northern Spanish kingdom of Asturias during the 8th and 9th centuries. Most remaining examples of Asturian architecture are in Oviedo. The characteristics of the style are small churches built in a tradition that bears a greater resemblance to ▷Romanesque architecture than Moorish architecture. Some churches in this style include ▷barrel vaulting.

ataurique
(from Arabic, *waraq*: 'leaf'.) A ▷stuccoed wall decoration consisting of a leaf or flower pattern. It is used in Moorish decoration in Spain.

atelier

A French term meaning 'studio'. It can be used either singly to describe the workplace of a particular artist or collectively as a 'school' of apprentices or students surrounding a single master. During the 19th century the term became associated with the growing number of art schools. The 'atelier system' represented the formalized academic training procedure under which painters were expected to copy ▷engravings and statues before being allowed to draw and finally paint from life. The '*atelier libre*' was a freer alternative to this: institutions like the Académie Suisse provided models without instruction from 1825. By 1860 the Atelier Julian (▷Académie Julian) allowed artists the same freedom but encouraged famous professionals to give advice without charge.

Atelier 17

▷Hayter, S(tanley) W(illiam)

Athena

▷Minerva

atlantes

Greek architectural term for carved male figures employed to support an ▷entablature in place of ▷columns. The term derives from the plural of Atlas, the Greek god who supported the sky. The Roman term is telamones. Supports in the form of carved female figures are called ▷caryatids.

atmospheric perspective

▷aerial perspective

atrium

In Roman domestic architecture, the main inner court, with an opening in the roof for rain-water and a centrally placed rectangular basin (*impluvium*) to receive it. In ▷Early Christian and ▷Romanesque architecture, an open-roofed, colonnaded, rectangular court in front of a ▷basilica, usually with a central fountain.

attic

In Classical architecture, an attic storey is one placed over an ▷entablature and in strictly proportional relation to it. Employed to add height and grandeur on a ▷triumphal arch (such as the Arch of Septimus Severus), it generally bears the inscription, and on the façade of a building it can hide the roof, as in St. Peter's in Rome.

attribute

A symbolic object associated with and serving to identify a saint, hero or deity in a visual representation, well-known examples being the wheel of St. Catherine, the club and lion skin of ▷Hercules and the thunderbolts of ▷Jupiter. The study of attributes and their symbolism is included within ▷iconography.

Bib.: Hall, J., *Dictionary of Subjects and Symbols in Art*, London, 1974, rev. edn. 1979

attribution

Term used in relation to a work of art, indicting that the authorship has not been completely proven. The most secure evidence of authorship is that which is derived from an unbroken ▷provenance going back to the time of production, preferably supported by contemporary documentation such as a contract, correspondence between artist and patron describing the progress of the work, etc. An attribution is generally attempted when no such provenance or documentation exists. The process involves certain analytical investigations which inevitably involve ▷connoisseurship. Stylistic and ▷iconographical analyses, using as reference authenticated works from the period and geographical area to which the work putatively belongs is the most common; physical analysis of the materials used, where circumstances allow, provides an invaluable corroboration. The end result may be as definite as an attribution to a specific artist, but often a 'workshop of', ▷'school of', 'circle of' or, most vague of all, 'follower of' designation will have to be settled for (until the next revaluation). Attributions achieve their greatest urgency in the art market and are susceptible to financial considerations, rendering in some cases the designations at best dubious. Sale rooms and dealers' catalogues observe a number of conventions indicating the strength of any attribution: the artist's surname alone indicates that the work in question is thought to be no closer than 'school of'; the artist's surname with initials indicates that the artist is thought to have perhaps only partly executed the work; and the artist's name in full indicates that the dealer believes it to be wholly by the artist named.

Audran, Claude III (1658–1734)

The most important member of a family of French decorators. Audran's father worked for the royal court during the 17th century, and Audran followed in his father's footsteps when he became curator of the Luxembourg Palace during the regency of Philippe Duc d'Orleans. He was best known for his use of ▷arabesques, which had an important influence on subsequent ▷Rococo decorative style. He was also one of ▷Watteau's first teachers.

Audubon, John James (1785–1851)

American painter and illustrator. He was born in Haiti and came to America in 1803, before studying in France, where he came into contact with ▷David. When he returned to America, he pursued an interest in wildlife by travelling across the United States, hunting and sketching birds. After efforts to raise subscriptions to produce a book of bird engravings, Audubon travelled back to England in 1826 to elicit

the help of the publisher Robert Havell and Son. The result of their collaboration was *The Birds of America* (1827–38), a four-volume set of ▷aquatints. Audubon's illustrations were distinguished by their sensitive observation of bird behaviour, as many birds were represented in their habitat or in the midst of catching food. Audubon also published *The Viviparous Quadrupeds of America* (1845–8). He was assisted by his sons Victor Gifford (1809–60) and John Woodhouse (1812–62).:

Bib.: Anderson, P., *John James Audubon: Wildlife Artist*, New York, 1995

John Woodhouse Audobon, *Portrait of John James Audobon*, c1841, National Portrait Gallery, Smithsonian Institute

Augean stables
▷Hercules

aureole
The light, sometimes gold, depicted around the head and body of a sacred figure.

Australian art
Australian ▷Aboriginal art has a prehistoric genesis, but the art of Australian colonizers developed only much later when Australia grew in importance as a site of immigration in the 19th century. The capital, Sydney, became a British penal colony in 1788, and during the next 40 years, new building there followed a conservative colonial style. However, artists from Europe were attracted to Australia because of its reputation as an unspoilt, beautiful wilderness, and it became a focus for landscape painting in particular. Among the earliest European artists to move to

Australia were John Glover (1767–1849) and Conrad Martens (1801–78), both of whom were landscape painters.

After the discovery of gold in 1851, the Australian population boomed, and its urban spaces began to develop along the lines of European ▷historicism. The number of landscape painters increased, as did the symbiotic relationship with Europe. Artists who were born in Australia, such as John Russell (1858–1931), and those such as ▷Tom Roberts, who spent their youth there, studied in Europe and were particularly attracted to the naturalist landscapes of ▷Bastien-Lepage and French ▷*plein air* painters. Although there was an intensification of emigration to Europe during the depression of 1893, when the Symbolist painter Rupert Bunney (1864–1947), for example, abandoned the country at the same time national schools of landscape painting were also beginning to develop artists' colonies like those of Europe.

Unlike in Europe, ▷academic art continued to have a strong presence in Australia during the first 20 years of the 20th century. Although ▷Post-Impressionism and ▷abstraction were both practised by Australian artists before the First World War, the naturalistic tonalism of ▷Max Meldrum (1875–1955) continued to be popular, especially in Melbourne. Melbourne became a centre for more conservative artistic tendencies, and the Australian Academy of Art was founded there. In contrast, Sydney artists embraced more progressive tendencies during the 1930s and they formed a ▷Contemporary Art Society in 1938 which was intended to rival the more traditional Melbourne Academy. Artists such as Grace Crowley and Ralph Fizelle (1891–1964) introduced ▷Cubist and ▷Constructivist tendencies into art during this time, while the flagrantly avant-garde *Exhibition I* was held in Sydney in 1939.

Throughout the history of Australian art, tensions had existed between those who sought to adopt the latest European styles and those who wished to develop a distinctive Australian style of art. The latter issue became more urgent during and immediately after the Second World War, when nationalist feeling intensified. During this time, the ▷Angry Penguins, the ▷Antipodeans in Melbourne and Australian ▷Surrealists, such as ▷William Dobell and ▷Sidney Nolan, attempted to develop figurative art which drew on Expressionist vitalism and Australian legend. After the war, the Sydney Group shifted the mythological emphasis to a series of religious works influenced by medieval styles, but this tendency gave way to the abstraction of John Passmore (1904–84) and others in the 1950s. Melbourne continued to be a centre of figurative art. By the 1960s, America became a more prominent influence than Europe, although regionalism and nationalism continue to be dominant in Australian attitudes to art.

▷Aboriginal art

Bib.: Bonyhady, T., *Images in Opposition: Australian Landscape Painting 1801–90*, Melbourne, 1985; Hughes, R., *The Art of Australia*, Harmondsworth, 1970; Stubbs, D., *Prehistoric Art of Australia*, 1974

Austria, art in

Prehistoric objects are extant from the part of central Europe that is now within Austria, including the famous *Venus of Willendorf*, a fertility goddess from c30,000 BC. Some archaeological finds indicate Roman occupation, and a small number of ▷Romanesque churches survive. Although some outstanding manuscript illumination was produced in Salzburg during the 12th and 13th centuries, the flowering of Austrian art did not occur until the Habsburgs consolidated their power in this part of Europe during the 14th century. The ▷Renaissance artist ▷Michel Pacher brought a sophisticated style of religious painting to Austria, and German artists such as ▷Altdorfer and ▷Cranach worked in Austria during their careers. ▷Gothic architecture is represented in St. Stephen's Cathedral in Vienna, while the best examples of ▷Renaissance architecture are in Innsbruck, where Archduke Ferdinand II of Tyrol erected his Schloss Ambras. Italian influence intensified during the ▷Counter-Reformation, when Austria remained a strong Catholic centre. At this time, the architecture of ▷Fischer von Erlach and ▷Hildebrandt was based partly on Italian ▷Baroque models but was adapted to the pietism of Austria. A number of churches were also altered to conform to the new Baroque style, and sculptors such as Raphael Donner (1693–1741) and Balthasar Moll (1717–85) contributed to public buildings in a complementary style. The Baroque dominated Austrian painting and architecture for much of the 18th century, when the elaborate ceiling decorations of ▷Maulbertsch and ▷Rottmayr were the dominant force in both court and religious buildings.

In the early 19th century, Austria followed Germany in the popularity of ▷Biedermeier art and furniture. Austria produced one of the most famous Biedermeier landscape painters, ▷Waldmüller, whose images of peasant life pandered to the illusions of a powerful bourgeoisie. Architectural reform came after the abortive 1848 revolution, when the Emperor Franz Josef decided to modernize Vienna. He had the ancient fortifications of the city destroyed and replaced them with a modern radial street, the Ringstraße, which was punctuated by many new buildings in different ▷historicist styles.

The conservatism of artistic taste and of public morality in late 19th-century Vienna inspired a series of rebellions which initiated some important tendencies in ▷modernist art. In 1897 ▷Klimt and other artists broke from the Künstlerhaus to form the Vienna ▷Secession – a pluralist organization which encouraged such new stylistic tendencies as ▷Art Nouveau. The

next generation of artists, including ▷Egon Schiele and ▷Richard Gerstl, was able to formulate its styles with the knowledge of the Secession's many innovative and successful exhibitions. Architecture also flourished from the 1890s, when ▷Otto Wagner and ▷Adolf Loos rejected the historicism of their predecessors in favour of modern materials and clinical, unornamented styles.

Austrian art of the 1920s lost some of its momentum, although the muddy realism of ▷Albin Egger-Lienz is a particularly distinctive example of the ▷Neue Sachlichkeit tendencies of this period. The development of Austrian art was further eroded during the Second World War. After the War, Austrian artists such as ▷Hundertwasser, Markus Prachensky and ▷Arnulf Rainer have maintained the representationalism of pre-war artists, but they have directed this feature towards ▷Fantastic Realism.

Bib.: Bertsch, C. and Neuwirth, M., *Die ungewisse Hoffnung: österreichische Malerei und Graphik zwischen 1918 und 1938*, Salzburg, 1993; Hempel, E., *Baroque Art and Architecture in Central Europe*, Harmondsworth, 1965; Schorske, C., *Fin-de-Siècle Vienna: Politics and Culture*, New York, 1980

auteur theory

A theory of art that originated with ▷Roland Barthes' essay *Death of the Author* of 1977. Referring particularly to literature, Barthes questioned the emphasis given to the author (*auteur*) to the work, and gave greater prominence to the reader, whose interpretation was seen to be more important that the artist's intention. The theory was countered and developed by ▷Foucault in his essay of 1978, *What is an Author?* in which he argued that the author should be understood in relation to all the social, political, cultural and aesthetic circumstances that impinged upon his creation. Foucault proposed an 'author-function' which was separate from the physical individual, the author, and he distinguished the 'text', or the variety of possible meanings of a work of art, from the 'work' itself, which was a mere physical object. Both Barthes and Foucault have been criticized for a reductivist theory that reduces the author to a passive receptor of social convention. ▷Freudians have also condemned these authors for their failure to acknowledge the importance of irrational subconscious forces in moulding an author's work. Although both Foucault and Barthes were referring to literature, art historians since 1970 have frequently used their theories to develop ideas about painting and sculpture.

Bib.: Barthes, R., *Image-Music-Text,* London, 1977; Foucault, M., *Language, Counter-Memory, Practice; Selected Essays and Interviews*, Oxford, 1977; Merquior, J.G., *Foucault*, London, 1985; Pease, D.E., 'Author', in *Critical Terms of Literary Study*, ed. F. Lentricchia and McLaughlin, T., Chicago, 1990

auto-destructive art

Literally, art that self-destructs, but actually a term used in reference to any intentionally ephemeral artistic creation. There is no coherent theory of auto-destructive art, but different practitioners have used it variously to shock the public or to make statements about the futility of life, or of art itself. It was particularly popular during the 1960s, when Gustav Metzger (b 1926) painted a cloth with acid in order to dissolve it, and ▷Jean Tinguely's *Homage to New York* exploded before an audience at the ▷Museum of Modern Art in New York.

autograph

An adjective applied to a two-dimensional work of art that can be safely attributed solely to one artist, either by stylistic methods or because of a secure signature on the work.

Automatistes, Les

Canadian group of artists. Based in Montreal during the period c1946–51, this group included ▷Paul-Émile Borduas and ▷Jean-Paul Riopelle. They developed an abstract art based on ▷Surrealist theories of ▷automatism.

Automne, Salon d'

▷Salon d'Automne

Autun Cathedral

▷Romanesque cathedral, dedicated to St. Lazare, situated in eastern France and completed in 1130. The architecture is unremarkable, but the cathedral is known for the extraordinary sculpture in the portals. The giant ▷tympanum above the north ▷transept ▷portal, although badly damaged, shows a distinctive image of Christ in a ▷mandorla next to angels weighing up the souls of the righteous and the damned. Images of ▷Adam and Eve, and ▷Lazarus are also included, along with a writhing mass of devils and roundels containing depictions of the seasons and the signs of the zodiac (▷astrology). Interestingly Eve is depicted as a reclining nude, with the devil's claw as big as her hand looming behind her. The sculpture is signed '*Gislebertus hoc faecit*' ('Gislebertus made this').

avant-garde

Art that deliberately overturns conventions, traditions or common practices in favour of something new. As the power of art ▷academies began to collapse in the late 19th century, young artists began to adopt rebellious stances as a matter of course. The idea that a style of art should be new intensified in the early years of the 20th century, when a succession of 'isms' resulted in a fragmentation of conventional monolithic views of art. The commercial success of such new styles as ▷Expressionism was fuelled by the intervention of dealers, who saw the possibilities of novelty in a free art market.

Bib.: Bazin, G., *Histoire de l'avant-garde en peinture du XIIIième au XXième siècle*, Paris, 1969, Eng. trans. as *The Avant-Garde in the History of Painting*, London, 1969; Benjamin, A., *Art, Mimesis and the Avant-Garde: Aspects of a Philosophy of Difference*, London, 1991; Bürger, P., *Theorie der avant-garde*, Eng. trans. as *Theory of the Avant-garde*, Manchester, 1984; Butler, C., *After the Wake: An Essay on the Contemporary Avant-Garde*, Oxford, 1980; Cork, R., *A Bitter Truth: Avant-Garde Art and the Great War*, New Haven, 1994; Poggioli, R., *Theory of the Avant-Garde*, Cambridge, MA, 1968; Silver, K., *Esprit de corps: The Art of the Parisian Avant-garde and the First World War 1914–25*, London, 1989; Weightman, J., *The Concept of the Avant-Garde: Explorations in Modernism*, London, 1973

Aved, Jacques-André-Joseph-Camelot (1702–66)

French painter. He studied in Amsterdam and returned to France to practise portraiture. He was patronized by a new breed of bourgeois art buyer, particularly the financiers and merchants whose influence intensified during the reign of Louis XV. His naturalistic style of portrait painting was in contrast to the ▷Baroque conventions of his predecessors such as ▷Largillière, but his skill with painting faces and costume nevertheless flattered his sitters.

Bib.: Wildenstein, G., *Le peintre Aved, sa vie et son oeuvre 1702–1766*, 2 vols., Paris, 1922

Avercamp, Hendrick (1585–1634)

Dutch painter. He was a landscape painter, born in Amsterdam and active in Kampen. A deaf mute, he was known as '*de stom van Campen*' ('the mute of Kampen'). He specialized in vivid and highly detailed paintings representing the leisure side of village life in winter, populated with little figures of ice skaters, tobogganers, golfers, etc., and filled with amusing anecdotal incidents. He also executed drawings of such scenes, often tinted with water colour, which he sold to collectors who bought them for their albums. His early work reveals the influence of ▷Pieter Bruegel the Elder and ▷Gillis van Coninxloo. The realistic Dutch landscape style of his maturity was carried on by his nephew, Berent Avercamp (1612–79). Many of his drawings are in the Royal Collection at Windsor.

Bib.: Welcker, C.J., *Hendrick Avercamp 1585–1634*, Doornspijk, 1979

Averlino, Antonio

▷Filarete

Avignon, School of

French school of painting originating during the period of the papal exile from Rome (1309–77). The greatest Italian to follow the popes was ▷Simone Martini, remains of whose frescos may be found in Avignon Cathedral. The school continued to flourish after the departure of the papal court, producing works characterized principally by a fusion of Italian with Flemish influences, but without necessarily sharing any close stylistic affinities. The leading known masters associated with Avignon in the 15th century were ▷Froment and ▷Quarton and the outstanding work of the school is the *Pietà* ▷ from Villeneuve-les-Avignon (now Paris, Louvre), generally attributed to Quarton.

axis

In architecture, an imaginary straight line dividing a ground-plan, ▷façade, or other compositional unit, into equal halves, such that the two halves appear to balance or reflect each other.

axonometric projection

A graphical projection showing an object or, more usually, a building in three-dimensional form. The planes are drawn at 45 degrees to the base line, in order to show an exploded view of a structure. Unlike ▷perspective drawings, projections make it possible to make scale measurements along the plane lines. When the planes are drawn at 30 degrees a drawing is referred to as an ▷isometric projection.

azulejo

(Arabic, 'the tile'.) A small coloured tile used on walls and floors in Spanish ▷Islamic architecture. Consisting of bright colours, these tiles contained both geometric designs and narrative figure subjects.

Baan, Jan van (1633–1702)

Dutch painter. He travelled to England and produced portraits for Charles II's court.

Baargeld, Johannes Theodor (Gruenwald, Alfred Ferdinand) (1892–1927) (op. 1920)

German artist who worked under the pseudonym of Baargeld. With ▷Max Ernst and ▷Hans Arp he founded the Cologne branch of ▷Dada. He was the editor of a Communist cultural magazine, *Ventilator*, and he produced ▷collages and ▷photomontages. He ceased to produce art in 1921.

Baburen, Dirck van (c1590–1624)

Dutch painter. He studied in Rome from 1617 to c1621, where he assimilated the influence of ▷Caravaggio. While in Rome he also painted a deposition for the church of S. Pietro in Montorio. He returned to Utrecht and became part of a circle of artists practising Caravaggio's style in Holland.

Babylonian art

The art of what is now Southern Iraq but what was the Babylonian empire from 2000 BC until the 6th century BC. This work was produced by the Sumerian peoples and was complementary to, but distinct from, ▷Assyrian art. The dearth of natural resources such as stone, metals and wood led them to produce clay pots, as well as objects of gold, silver and bronze or jewelled inlay. Extant religious artefacts consist of sculptures, ▷bas-reliefs and wall-paintings. A distinctive type of carved cylindrical seal was also characteristic of their work. The religious emphasis of much Babylonian art is notably in opposition to the secular glorifications of the monarch practised by their Assyrian rivals.

Bacchantes

▷Bacchus

Bacchiacca, Francesco Ubertini (1494–1557)

Italian artist. He practised in Florence and produced religious works in the style of ▷Andrea del Sarto.

Bacchus

The Roman god of wine known also to the Greeks as Dionysus. Originally a fertility god worshipped in the form of a goat or bull, he was by Classical times represented in the form of a naked youth, wearing a crown of vine leaves and grapes and wielding a

Bacchus (Dionysus), 1553; *Cosmographia*, Munster

pine-tipped wand (a thyrsus), sometimes wound with ivy. His followers were known as Bacchantes or Maenads, ecstatically dancing women, usually dressed in swirling drapery and playing tambourines. Many of the classic ingredients are found in ▷Titian's painting *Bacchus and Ariadne* (1522, London, National Gallery). Bacchus leaps from his chariot, here drawn by leopards (sometimes tigers or goats, less often centaurs or horses). A Bacchante marches near the chariot clashing cymbals, while before her a young ▷satyr drags the head of an animal whose hind leg may be that wielded at right by a mature satyr: ancient Bacchic rites involved wild orgies in which animals were literally torn apart and their flesh consumed raw. In front of these figures a dark-skinned bearded man runs, wound about with snakes, a reference to the snake-handling that also formed part of the ancient rites. In the woods in the background is Silenus, portrayed here, as is usual, as a fat drunken old man, lolling back on his ass and being supported by satyrs. The specific moment represented in Titian's painting is when Bacchus discovers Ariadne, the daughter of King Minos of Crete, who had helped Theseus escape from her father's labyrinth, only to be deserted by him on the island of Naxos. Titian shows Ariadne's reaction to Bacchus'

advent: she is startled but her eyes and that of the athletic young god meet in awakening love. Above her in the sky is the constellation Bacchus had created for her from her jewelled crown. On the distant horizon is Theseus' ship sailing away to Greece. ▷Michelangelo also famously represented Bacchus in an intoxicated state, walking tipsily, eyes barely able to focus on the cup he holds aloft, his body slightly bloated from the habit of excessive drinking (marble, c1497, Florence, Bargello).

Baccio (Bartolommeo) Bandinelli (1493–1560)

Italian sculptor, draftsman, painter and goldsmith. He was from Florence. He was the favourite sculptor of Duke Cosimo de' Medici, being perhaps more accommodating than ▷Michelangelo (to whom he considered himself the equal). To him went the ▷Medici commission for the sculpture group to act as a pendant to Michelangelo's *David* in the Piazza della Signoria, outside the Palazzo Vecchio. Bandinelli's group represents *Hercules and Cacus* (1534), the anatomy of which was scathingly described by ▷Cellini as a 'sack of melons'. The venomous rivalry between Bandinelli and Cellini is graphically portrayed in the latter's autobiography. Bandinelli's finest sculptures are perhaps the series of marble ▷reliefs in the choir of Florence Cathedral. His importance also lies in the fact that he founded two of the earliest academies of the art: in 1531 at the Vatican and in c1550 at Florence.
Bib.: *Baccio Bandinelli 1493–1560: Drawings from British Collections*, exh. cat., Cambridge, 1988

Baciccia, Bacicio (Il Baciccio) (Giovanni Battista Gaulli) 1639–1709)

Italian painter. He was born in Genoa and was an important painter of the late ▷Baroque, strongly influenced by ▷Rubens and ▷Van Dyck. He was in Rome by 1657 and became closely associated with ▷Bernini, who may have been involved in the design of his masterpiece, the *Adoration of the Name of Jesus*, the ▷*trompe l'oeil* ceiling painting of Il Gesù, the principal Jesuit church in Rome (1672–83). A trip to Parma in 1669 had allowed Baciccia to study the illusionistic ceiling paintings of ▷Correggio. The sophistication of the pictorial illusion in the Gesù ceiling shows that the lesson was well learnt. Painted figures (modelled in stucco by Bernini's pupil, ▷Antonio Raggi) seem to have burst out from the painted area and to have moved into the spectator's space, thus increasing the immediacy of the heavenly vision depicted in the centre of the ▷vault; such remarkable illusionism had not been achieved before and was only matched later by ▷Pozzo in the S. Ignazio ceiling (1691–4). Baciccia was also highly regarded as a portraitist (painting all seven successive popes from Alexander VII to Clement XI) and as a painter of ▷altarpieces.
Bib.: Gaulli, G.B., *Il Baciccio*, Rome, 1994

Backer, Harriet (1845–1932)

Norwegian painter. She was educated in Oslo (then called Christiana), and a comfortable family income allowed her to travel throughout Germany, France and Italy. In 1878 she studied with ▷Bastien-Lepage, and she adopted a naturalistic manner. Like many women artists of the time, she concentrated on interior scenes of domestic life, but applied a ▷*plein air* technique.
Bib.: Kielland, E., *Harriet Backer*, Oslo, 1958; Vishny, M., 'Harriet Backer: A Northern Light', *Arts Magazine*, 59 (May 1983), pp. 79–80

Backhuysen, Ludolf
▷Bakhuyzen, Ludolf

Backof(f)en, Hans (fl 1505–19)

German sculptor. He worked in Mainz in the early 16th century, and produced funerary sculpture for Mainz cathedral.

back-painting

A technique for transferring a print to a piece of glass. It was used primarily in the 17th and 18th centuries.

Backsteingotik

(German, 'brick Gothic'.) A distinctive mode of ▷Gothic architecture located in north Germany and Scandinavia/the Baltic during the 14th century. Because of the special characteristics of the brick produced in such centres as Lübeck and Stralsund, Gothic architecture in these areas took on a simple, monumental appearance that was in contrast to some of the more elaborate wall surfaces of Gothic buildings elsewhere in Europe.

Bacon, Francis (1909–92)

English painter of Irish birth. Bacon came to London in 1925 and although he received no formal art training, he created a sensation in 1945 when he exhibited his *Three Studies for Figures at the Base of a Crucifixion* (London, Tate Gallery) at the Lefevre Gallery in London. His work was ▷Expressionist in style, and his distorted human forms were unsettling. He developed his personal style and gloomy subject matter during the 1950s, when he achieved an international reputation. Aside form his unpleasant images of corrupt and disgusting humanity, Bacon deliberately subverted artistic conventions by using the ▷triptych format of ▷Renaissance ▷altarpieces to show the evils of man, rather than the virtues of Christ. In

Pope Innocent X he reworked a famous portrait by
▷Velázquez into a screaming mask of angst.

Lucian Freud, *Francis Bacon*, 1952, Tate Gallery, London

Bib.: Deleuze, G. *Francis Bacon: logique de la sensation*,
3rd edn, Paris, 1994; Vickers, B., *Francis Bacon*, New
York, 1996

Bacon, John, the Elder (1740–99)

English sculptor. He began as a modeller of figures for
a porcelain factory and later worked for the Wedgwood
and Crown Derby factories, before becoming chief
designer to Coade's of Lambeth. He held this post for
thirty years whilst also running a large and immensely
fashionable studio of his own, producing marble
chimney pieces characterized by fine ornamental relief
carving as well as church monuments of all sizes, most
importantly the Monument to Thomas Guy (1779) in
Guy's Hospital, the Monument to the Earl of Chatham
(1779–83) in Westminster Abbey and the Monument
to Dr. Johnson (1796) in St. Paul's cathedral. He was
elected ▷ARA in 1770 and ▷RA in 1778. His
son and pupil, John Bacon the Younger (1777–1859)
carried on the practice and is chiefly remembered for
his church monuments.
Bib.: Archer, M., 'Neoclassical Sculpture in India',
Apollo, 120 (July 1984) pp. 50–55; Clifford, T., 'John
Bacon and the Manufacturers', *Apollo*, 122 (Oct 1985),
pp. 288–304; Gunnis, R. *Dictionary of British Sculptors
1660–1851*, London, 1951; Penny, N., *Church Monu-
ments in Romantic England*, New Haven and London,
1977; Sanders, A., *John Bacon RA 1740–99*, London,
1961; M. Whinney, *Sculpture in Britain 1530–1830*,
2nd edn., Harmondsworth, 1988

Bad Art

One of the names given to the revival of ▷Ex-
pressionism in America, Italy and Germany during the
1980s. Its practitioners include ▷Baselitz, ▷Kiefer
and ▷Clemente.
 ▷Neo-Expressionism

Badger, Joseph (1708–65)

American painter. Born in Massachusetts, Badger prac-
tised portrait painting there from the 1740s. As with
much colonial portraiture, his style is rather stiff and
his figures are not wholly convincing. However, he
was successful early in his career. His naive manner of
painting was superseded by the popularity of ▷Copley.

Baertling, Otto Charles (1897–1973)

Swiss painter and sculptor. He was influenced by
▷Léger and ▷Mondrian and developed their abstrac-
tion into a clinical metallic style based on geometric
form. In 1952 he was one of the founders of Groupe
Espace.

Baglione, Giovanni (cl1573–1644)

Italian painter and writer. He was active chiefly in
Rome and was influenced first by the late ▷Man-
nerism of ▷Arpino, and then by the more modern
work of ▷Caravaggio. He seems to have been reason-
ably successful in his lifetime, receiving papal com-
missions, such as for the frescos in the Vatican Library.
He was also among the artists selected by Pope Paul V
to paint frescos in the church of S. Maria Maggiore.
Baglione's admiration for the work of Caravaggio was
met with abuse from the latter artist, whom he sued
for libel in a famous court case in 1603. Considered
today rather mediocre as a painter (although it is gen-
erally agreed that those pictures painted under the
influence of Caravaggio are of a higher quality), he is
now remembered mostly for his biographical history
of contemporary Roman painters (including
Caravaggio), *Le vite de' pittori, scultori ed architetti* (*The
Lives of Painters, Sculptors and Architects*, Rome, 1642).
Bib.: Meiser, B.W., 'Giovanni Baglione in S. Maria
Maggiore', *Master Drawings*, 31 (Winter 1993), pp.
414–21; Moller, R., *Der römische Maler Giovanni Bag-
lione*, Munich, 1991

bagpipe

European musical instrument of great antiquity, basi-
cally consisting of a reed pipe through which the player
blows into a large wind bag made of skin. The wind
bag is equipped with another reed pipe through which
the air escapes. The player alters the musical notes by
variously covering the finger holes of this second pipe.
Because of its associations with European folk music,
one or more of the shepherds in ▷Adoration scenes
may be depicted playing a bagpipe. In Italian ▷tre-
cento ▷altarpieces it features frequently as one of
the instruments in an angel concert. However, in

16th- and 17th-century Flemish and Dutch paintings, particularly rustic scenes (e.g. ▷Bruegel, *Peasant Wedding*, c1568, Vienna, Kunsthistorisches Museum), it takes on a phallic significance (derived from the shape of the instrument).

Bailly, Alice (1872–1938)

Swiss painter. She studied in Switzerland and Germany and travelled throughout Italy. In 1910 she was in Paris, where she came into contact with ▷Cubist art and exhibited at the ▷Salon d'Automne. She adapted the Cubist style and transferred her allegiance to ▷Futurism in 1912. She returned to Switzerland during the First World War and began to produce ▷collages using wool as the main material.
Bib.: Butler, J., 'Alice Bailly: Cubo-Futurist Pioneer', *Oxford Art Journal*, 3 (April 1980), pp. 52–5

Baily, Edward Hodges (1788–1867)

English sculptor. He was the son of a ship's carver and was trained by ▷John Flaxman. He produced mostly mythological and allegorical subjects and portrait busts. His reputation was made with his *Eve at the Fountain* (model 1818; marble, Bristol City Art Gallery, 1821). His most famous sculpture is the colossal statue of Lord Nelson (1839–43) for Railton's Nelson Column in Trafalgar Square, London. He was also employed on the carvings for the Marble Arch (1826) and Buckingham Palace (1828). His masterpiece is generally considered to be the Monument to Viscount Brome (1837; Linton church, Kent). He was elected ▷ARA in 1817 and ▷RA in 1821, his diploma work being a bust of Flaxman.
Bib.: Gunnis, R., *Dictionary of British Sculptors 1660–1851*, London, 1951

Baizerman, Saul (1889–1957)

American sculptor of Russian birth. In 1910 he studied at the ▷National Academy of Design in New York, and his academic training remained with him throughout his career. He frequently used copper, and he would thus hammer, rather than mould, his sculptural forms. He produced a number of monumental nudes, as well as city themes.

Bakhtin, Mikhail (1895–1975)

Russian philosopher and literary theorist. He studied classics at St. Petersburg University in the 1920s and began to develop criticisms of the Russian ▷Formalists and ▷Saussurean linguistics. In 1928 he published *The Formal Method in Literary Scholarship* (under the name P.N. Medvedev, an associate), a critique of Formalism based on an assertion of the essentially social nature of language. He explored this further in *Marxism and the Philosophy of Language* (1929) and *Problems of Dostoevsky's Art* (1929), arguing that Dostoevsky had initiated a 'polyphonic' fiction, in which different ▷discourses express different ideological positions, but are not placed or judged by an authorial discourse. Later he revised this argument, seeing this type of writing as inherent in all novels. He traced its roots to the Satyr plays and the culture of carnival, and wrote about it in *Rabelais and His World* (1963). Harassed by the Russian State in the 1930s, 40s and 50s, Bakhtin was rehabilitated and permitted to publish again in the 1960s. He moved away from an abstract system of '*langue*' focus upon concrete utterances, and asserted that language was 'dialogic, in that every speech springs from a previous utterance and is structured in expectation of a future response'. This theory has implications beyond literary studies.
▷semiotics
Bib.: Haynes, D., *Bakhtin and the Visual Arts*, Cambridge, 1995

Bakhuyzen, Ludolf (1631–1708)

Dutch painter. He primarily produced ▷marine scenes and followed in the wake of ▷Willem van de Velde II.
Bib.: Nannen, H., *Ludolf Backhuysen, Emden 1630–Amsterdam 1708: ein Versuch, Leben und Werk des Künstlers zu beschreiben*, Emden, 1985

Bakić, Vojin (b 1915)

Yugoslavian sculptor. His early style was in the tradition of ▷Rodin, but he began to move towards more abstract sculpture once he came into contact with the works of ▷Brancusi and ▷Arp. Some of his later work was in the mode of ▷Op art.

Bakst, Léon (Lev Rosenberg) (1886–1925)

Russian artist and stage designer. He was famous for his work with ▷Diaghilev. He was born in St. Petersburg and studied there (although he was expelled for not following the school style) and in Paris from 1893. Back in St. Petersburg, he worked with ▷Benois and Diaghilev on the magazine ▷*Mir Iskusstva* (World of Art). He designed his first stage sets in 1902, initially working under the influence of Greek design. In 1909 he returned to Paris with Diaghilev's Ballets Russes and produced a series of ground-breaking designs among them the 1909 *Cléopatre* and 1910 *Schéhérazade*. He also worked on Nijinsky's ballet *Le Spectre de la Rose* (1911), and on plays such as *Le Pisanella* by d'Annunzio. Bakst's early work was influenced by ▷Art Nouveau, particularly the work of German illustrators in *Die Jugend*, as can be seen in his illustrations to Gogol. His later ballets' designs continued to use swirling line, but incorporated the colour and pattern of Persian and Middle Eastern art. He was one of the first artists to appreciate the need for total integration of design, combining costume and stage sets.
Bib.: Alexandre, A., *Decorative Art of Léon Bakst*, New York, 1972; Schouvaloff, A., *Léon Bakst: Theatre Art*, New York, 1991; Spencer, C., *Léon Bakst*, London, 1973

Léon Bakst, Stapleton Collection

Bakuba
▷African art

baldachin (*baldacchino*)
An ornamental canopy over a high altar, throne or tomb. It may be raised on ▷columns or ▷piers, projected from a wall or suspended from the ceiling. Originally a baldachin was a portable canopy of rich material, raised on poles, sometimes used in processions, to cover a sacred object or revered person. As a permanent fixture, ▷Bernini's *Baldacchino* (1624–33; Rome, St. Peter's), reflects these origins in the bronze tasselled valence of its canopy. As a permanent fixture, it is also called a ▷ciborium.

Baldacchino of St. Peter's
The canopy (also described as a ▷tabernacle) over the central altar in ▷St. Peter's, Rome designed by ▷Bernini 1624–33, of partly gilded bronze. It stands over 28 metres high. It consists of four ornate corkscrew columns each entwined with vine leaves (real leaves were said to have been employed in the casting), supporting an elaborate canopy. Above each column, and supported by it, stands an angel, seemingly stepping out from the structure. Behind these figures a complex pattern of ▷scrolls curves up to support a central cross, resting on a globe, which can be seen as symbolizing the triumph of Christianity over the world. Bernini had originally intended a large figure of ▷Christ for the central feature but this had to be abandoned due to the technical difficulties of supporting such a weight. As it is the whole structure is a miracle of engineering. The canopy is a mass of decorative detail including ▷*putti* who display the papal arms, although features like the garlands held by the corner angels are actually brass in order to lessen their weight. The attention to detail is such that the tassels around the base of the canopy are actually free to move. The whole structure, standing as it does under the crossing of St. Peter's, represents the ostentation of the Catholic ▷Baroque, a total experience of colour, decoration and scale. Along with the throne (cathedra) of St. Peter, it establishes Bernini's place as a leading member of that movement.
Bib.: Chandler Kirwin, W., 'Bernini's Baldacchino Reconsidered', *Römisches Jahrbuch*, 19 (1981), pp. 141–64

Baldinucci, Filippo (1624–96)
Italian art historian. He was from Florence and his principal work, *Notizie de' professori del disegno* (published in successive volumes from 1681 to 1728), is a biographical history of artists from ▷Cimabue to his own time. It is notably different from ▷Vasari's *Lives* in so far as Baldinucci relies less on anecdote and more on documentary sources, and his work is a valuable source for the artists not only of his own century, but also of the 16th century. His other main literary work is his biography of ▷Bernini (1682), the primary source for information regarding the artist. In the course of his research, Baldinucci also assembled an enormous collection of drawings (now housed in the ▷Uffizi).

Baldovinetti, Alesso (c1426–99)
Italian painter, mosaicist and stained-glass window designer. He was from Florence. It is not known by whom he was trained, but his linear style, his elegantly attenuated ▷Madonnas and his interest in the effects of natural light (e.g. *Madonna and Child* c1460/65, Paris, Louvre) show the influence of ▷Domenico Veneziano, ▷Fra Angelico and ▷Andrea del Castagno. He seems to have joined the painters' guild (Compagnia di S. Luca) at Florence c1448 and worked there for the rest of his life. His surviving works in Florence include panel paintings of the *Annunciation* in the ▷Uffizi (formerly in the church of S. Giorgio alla Costa, c1459) and in the chapel of the Cardinal of Portugal in S. Miniato al Monte (1466/7), and a rather damaged, but delicately beautiful fresco of the *Nativity* in the atrium of SS Annunziata 1460/62). In the National Gallery, London, is an excellent profile portrait of an unknown young woman (c1465).

Balduccio, Giovanni da (fl 1315–49)
Italian sculptor. He worked in Pisa and Florence and in 1334 he brought the Pisan style of the ▷Pisano to Milan. There his most important works were shrines, such as that of St. Peter Martyr in S. Eustogorio.

Baldung Grien, Hans (1484/5–1545)

German painter and designer of woodcuts, stained glass and tapestries. He was from Strasbourg. It is not certain where he received his training, but his ▷woodcuts, in particular, show the influence of ▷Dürer, indicating that he may have worked for a time in Dürer's Nuremberg workshop. However, his paintings, with their bright colour contrasts, often brutal subject matter and tendency towards expressive distortion are closer to ▷ Grünewald. Although mainly active in Strasbourg, he lived in Freiburg-im-Breisgau from 1512 to 1517 during which period he worked in the cathedral on his most important commission, the main altarpiece for the choir, the front of the central panel showing the *Coronation of the Virgin* and the back the *Crucifixion*. Secular subjects were also an important part of his output, particularly after the ▷Reformation had reduced the opportunities for religious subjects. Many of his secular subjects are imbued with an intensely sado-erotic feeling, such as his witches' sabbaths and his many variations on the theme of *Death and the Maiden* (Basel (Offentliche Kuntstammlung), Berlin, Ottawa and Vienna).

Bib.: *Hans Baldung Grien: Prints and Drawings*, exh. cat., New Haven and London, 1981; Koerner, J.L., *Self Portraiture and the Crisis of Interpretation in German Renaissance Art*, Ann Arbor, 1988; Osten, G. van der, *Hans Baldung Grien: Gemälde und Dokumente*, Berlin, 1983; Wolf, S.R., *Desire Passes Away: The Theme of Death and the Woman in the Work of Hans Baldung Grien*, Columbus, Ohio, 1994

Balen, Hendrick van (1575–1632)

Flemish painter. He visited Italy in the 1590s, and returned to Antwerp to practise a ▷Mannerist style. He painted primarily small mythological landscapes which were similar to those of ▷Jan Bruegel. He was one of the teachers of ▷Van Dyck.

Balestra, Antonio (1666–1740)

Italian painter. He was a student of ▷Maratta, and worked in northern Italy.

Ball, Hugo (1886–1927)

German painter and poet. He was involved with the ▷Dada movement in Zurich and founded the journal ▷*Cabaret Voltaire*.

Balla, Giacomo (1871–1958)

Italian painter associated with ▷Futurism. He was born in Turin, and after training in Paris in 1900, he returned to Italy where he met ▷Marinetti and became interested in the ideas expressed in the 1910 Futurist Manifesto, which he signed. In Paris Balla had picked up an interest in ▷divisionism and ▷Impressionism, which he incorporated into his own work and passed on to other Futurists, like ▷Boccioni and ▷Severini. Partly as a result of his French experiences, he remained interested in light and movement (e.g. *Portrait in the Open Air*, 1902, Rome, Gallery of Modern Art) without taking on board some of the more violent and modernist Futurist ideas, and his work often has a playful quality (e.g. *Dog on a Leash*, 1912, Buffalo, Albright-Knox Foundation), which uses superimposed images to suggest movement. Balla's later work developed towards abstraction, whilst retaining his interest in motion (e.g. *Automobile and Noise*, 1912, Venice, Guggenheim Foundation; *Patriotic Demonstration*, 1915, private collection). Increasingly he worked in ▷tempera. After the First World War, however, he reverted to a more traditionalist style.

Bib.: *Giacomo Balla*, exh. cat., Oxford, 1987; Robinson, S.B., *Giacomo Balla*, Michigan, 1977

ball-flower ornament

In ▷Gothic architecture of the first quarter of the 14th century, a spherical ornament consisting of a conventionalized three-petalled flower enclosing a small ball, usually in a concave moulding. Employed widely in the English ▷Decorated Style.

Balthus (Count Balthasar Klossowski de Rola (b 1908)

French artist of Polish heritage. He was born in Paris and had no formal academic training. However, he was encouraged by ▷Bonnard and ▷Derain. He gradually developed a distinctive realist style which was used to represent themes of adolescence and suppressed sexuality. He primarily painted interior scenes which seem to have a narrative content, but evade a narrative explanation. The claustrophobic and often heady nature of his work was related to the sexual obsessions of the ▷Surrealists. In 1961 he became Director of the French Academy in Rome, but he has avoided publicity throughout his life.

Bib.: Leymarie, J., *Balthus*, London, 1982

Baluba

▷African art

baluster

(i) One of the short posts or railings, often bellied in profile and circular in section, supporting the upper rail or coping of a ▷balustrade, or the handrail of a staircase. (ii) In Classical architecture, a baluster is the roll (i.e. in depth, from the front to the back) of the ▷volute of an ▷Ionic capital, also called a bolster or a pulvinus.

balustrade

A line of ▷balusters supporting a coping or upper rails, as on a balcony or parapet, sometimes terminated with pedestals.

Bambara

▷African art

bambocciata (pl. bambocciate)

A type of low-life street scene or peasant subject prac-
tised mainly by Dutch and Flemish painters in Italy
principally in the second quarter of the 17th century.
Bambocciate were highly popular with buyers, although
viewed with contempt by classicist theorists such as
▷Bellori. The term derives from the Italian nickname
given to ▷Pieter van Laer who was the first of the
Netherlandish artists to achieve popularity in this
genre. He was nicknamed '*Il Bamboccio*' ('awkward
little fellow') because of his hunchback; his followers
were consequently termed '*Bamboccianti*' and their
paintings, '*bambocciate*'. Laer's subjects and exaggerated
▷chiaroscuro were derived from ▷Caravaggio's early
work, but he shows a far greater concern for conveying
the effects of natural light. Bambocciate are usually
small in size and often humorous in content, featuring
drinkers outside taverns, street musicians, beggars and
brawling ruffians. The most important among the
Bamboccianti were the Flemings Jan Miel (1599–1663)
and ▷Michiel Sweerts (1618–64) and the Italian,
▷Michelangelo Cerquozzi.

Bamboccio

▷Laer, Pieter van

banderole

(i) A long narrow flag or streamer with a split end. (ii)
A painted or carved architectural decoration in the
form of a ribbon-like ▷scroll, usually bearing a device
or inscription.

Bandinelli

▷Bacchio Bandinelli

Banks, Sir Thomas (1735–1805)

English sculptor. He was an important practitioner
of ▷Neoclassicism. Trained at the ▷RA, he won a
travelling scholarship to Italy in 1772, staying until
1179. In 1781 he went to St. Petersburg to work
for Catherine the Great, but preferring London soon
returned home. His heroic reliefs, revealing the influ-
ence of ▷Fuseli, are particularly admired (e.g. *Thetis
and her Nymphs Rising from the Sea to Console Achilles*,
c1778, London, Victoria and Albert Museum) as are
his strongly characterized portrait busts (e.g. *Warren
Hastings*, 1799, London, Commonwealth Relations
Office). Perhaps his most influential work is the Monu-
ment to Penelope Boothby (1793, Ashbourne Church,
Derbyshire); cf. Chantrey's *The Sleeping Children*
(1817, Lichfield Cathedral), in which the deceased
child is represented in sleep, not in death, as the para-
digm of innocent childhood (famously reducing
Queen Charlotte to tears when she saw it at the Royal
Academy Exhibition). His last major commissions
were the prestigious Monuments to Captains Burgess
(1802) and Westcott (1802–5) for St. Paul's Cathedral
which, despite the fine ▷relief carving on the

▷pedestals, were damned for the utter absurdity of
their main sculptural groups which attempted an
unsuccessful marriage of the Classical ideal and portrait
naturalism. He was elected RA in 1786.
Bib.: Archer, M., 'Neoclassical Sculpture in India',
Apollo 120 (July 1984), pp. 50–55; Bell, C.F., *The
Annals of Thomas Banks, Sculptor*, Cambridge, 1938;
Gunnis, R., *Dictionary of British Sculptors 1660–1851*,
London, 1951; Penny, N., *Church Monuments in
Romantic England*, New Haven and London, 1977;
Whinney, M., *Sculpture in Britain 1530–1830*, 2nd
edn., Harmondsworth, 1988

baptism

The ceremony which initiates people into the Chris-
tian Church, either by immersion into, pouring on, or
sprinkling with holy water. It is symbolic of puri-
fication and rebirth, the latter aspect being emphasized
by the Church use of the font, which is symbolic of
the womb of the ▷Virgin.

The most frequently depicted baptism is that of
▷Christ in the River Jordan by ▷John the Baptist
(Matthew 3: 13–17; Mark 1: 9–11; Luke 3: 21–22;
John 1: 29–34). The earliest depictions show Christ
standing naked and deeply immersed in the River
Jordan which may be personified as a river god, the
waters issuing from his urn (e.g. the centre of the
▷dome of the Arian Baptistry, Ravenna, early 6th
century). The gospel account mentions the descent of
the Holy Dove and the voice of God. The Dove is
always present, but God the Father, if indicated, may
be only head and shoulders, or perhaps a pair of hands
emerging from a cloud (e.g. ▷Verrocchio, c1470,
Florence, Uffizi). By the 15th century certain aspects
of the representation had become usual: Christ is
shown only ankle-deep in the water; John pours the
water over his head from a small bowl; two or three
angels witness from the left bank; and other neophytes
may prepare for baptism in the background (e.g.
▷Piero della Francesca, c1450, London, National
Gallery).

Other baptisms include *St. Peter baptising the Neo-
phytes* (▷Masaccio, 1423–7, Florence, Brancacci
Chapel); St. Peter baptising Cornelius, the centurion;
St. Ambrose baptising St. Augustine; St. James the
Greater baptising the magician Hermogenes and the
miraculous baptism by Christ of the 4th-century St.
John Chrysostom in the prison cell (▷Bordone,
London, National Gallery).

▷Seven Sacraments

baptist(e)ry

A building designed for baptisms. They contain fonts
and are often situated near churches, but are not always
connected to the church. They are frequently pol-
ygonal (primarily octagonal) in shape. The first one to
be built was the 7th-century baptistry of S. Giovanni
in Laterano, Rome, and many others followed. The

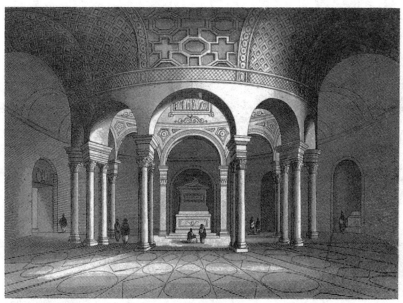

Baptistry

Pisa baptistry of the 12th century was one of the latest ones, as the ceremony of baptism was more frequently held within the church after this date.

Bar at the Folies Bergères, The

Painted by ▷Edouard Manet in 1881–2, his last major work before his death (oil on canvas, 96 × 130 cm/3 ft 2 in × 4 ft 2 in). It depicts a typical young barmaid at the fashionable café-concert in Paris, in the process of apparently serving a customer who is visible, like the rest of the room, by means of a mirror behind the woman's back. The work contrasts the blank, emotionless expression of the woman with the opulence and glitter of the world in which she works, from the lavish, sensual still life on the front of the bar, to the dazzling lights of the reflected scene. A trapeze artist is visible in the top left of the picture and the Folies Bergères is clearly packed with dark-suited men and their jewel-bedecked companions. As in his earlier works, ▷Olympia (1863, Paris, Musée d'Orsay) and ▷Déjeuner sur l'Herbe (1863, Paris, Musée d'Orsay) Manet uses the device of a staring female figure to engage the viewer, and here adds the extra subtlety of suggesting that the viewer is in fact the customer at the bar. He does this, however, as has been often pointed out, without considering spatial logic – either the mirror or the figure is at the wrong angle. The foreground and background of the work are distinguished by a difference in treatment, with Manet reserving his dashed ▷Impressionistic brushwork to create the noise and the bustle of the distant scene and painting the barmaid with a sense of strength and solidity in this transient world. Perhaps equally charac-

teristic is his reliance on tonal contrast and the dominance of the flat black of the women's dress anchoring the centre of the canvas. The work is now in the Courtauld Galleries in London.

Barbara

Virgin saint, allegedly martyred c303 AD in the persecution of Maximian. According to Jacobus de Voragine's medieval chronicle, *The Golden Legend*, Barbara's jealous father locked her in a tower in order to isolate her from any potential suitors. Notwithstanding this precaution, she did manage to arrange for a Christian disciple to gain access, disguised as a physician. He converted her to Christianity and as a token of her new-found faith she had a third window opened up in her tower, so that the three together should symbolise the ▷Trinity. When the father discovered her conversion he was outraged and turned her over to the authorities. She was sentenced to death for refusing to renounce the proscribed religion and her father, at his own request, was allowed to carry out the execution by decapitation with his sword. On his way home he was struck down by lightning. In devotional paintings, Barbara is identifiable by her tower, usually with three windows (e.g. ▷Jan van Eyck, c1433–7, Antwerp, Musée Royal des Beaux-Arts), and sometimes by a ▷Eucharistic cup and wafer, or a peacock. Owing to the nature of her father's death, she is the patron saint of gunners and in this context may appear with a cannon at her feet. Her first known appearance is in an 8th-century fresco at Sta Maria Antigua, Rome, but she was especially popular in the later Middle Ages.

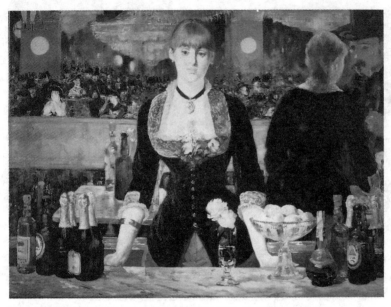

Edouard Manet, *The Bar at the Folies Bergères*, 1882, Courtald Institute Galleries, London

Barberini

Family of Italian patrons. The Barberini family came to power in Rome in the early 17th century when Matteo Barberini (1568–1644) became Pope Urban VIII. Through encouragement of artists and architects such as ▷Bernini, ▷Borromini and ▷Maderno, Urban VIII stimulated the popularity of the ▷Baroque style in Rome. This was perpetuated through both public and private commissions. The nephew of Urban VIII, Cardinal Francesco Barberini (1597–1697) hired Maderno, Bernini and Borromini to redesign the Palazzo Barberini, and he commissioned ▷Pietro da Cortona to produce an elaborate ceiling that glorified the Barberini name.

Bib.: John Scott, J., *Images of Nepotism: The Painted Ceilings of the Palazzo Barberini*, Princeton, 1991

Barberini Faun

▷Hellenistic marble statue of a faun sprawled in a drunken slumber, now in the Glyptothek, Munich. It is also known as the *Drunken* or *Sleeping Fawn* or *Satyr*. It is first recorded in 1628 in the collection of Cardinal Francesco ▷Barberini and, according to the same document, was discovered a few years earlier at the Castel S. Angelo, Rome. It was sold by the Barberini to Crown Prince Ludwig of Bavaria in 1814, but such was its fame that an export ban (enthusiastically supported by ▷Canova) delayed its removal to Munich until 1819 where a room in the newly-built Glyptothek had been specially designed to receive it. The museum opened to the public in 1830. Admired from the 17th century onwards (Cassiano del Pozzo

considered it 'not inferior to the *Belvedere Torso*, its fame grew in the second half of the 18th century with the greater accessibility of the Palazzo Barberini to the public. There was great competition for the piece when it was put up for sale and the attempts to keep it in the country further increased its fame. ▷Winckelmann admired it, but not as much as the ▷*Apollo Belvedere*, the ▷*Belvedere Torso*, and the ▷*Laocoön*, which seem to have formed his Classical trinity. Admiration for the *Barberini Faun* has not diminished over the years and it is variously considered to be either an original from c200 BC or a very high quality Roman copy of a Hellenistic original.

Bib.: Haskell, F. and N. Penny, *Taste and the Antique*, New Haven and London, 1981; Smith, R.R.R., *Hellenistic Sculpture*, London, 1991

barbican

An outer fortification defending a castle or town, often in the form of a double watch-tower over a gate or bridge.

Barbieri, Giovanni Francesco

▷Guercino, Il

Barbizon School

The name given to a group of French landscape artists working in the mid-19th century and based around the village of Barbizon on the edge of the Fontainebleau forest. The artists opposed academic traditions of landscape, still strong in France through the influence of ▷Valenciennes and ▷Corot. They sought to portray a *'paysage intime'*, a naturalistic landscape,

born of close study and an understanding of nature. They looked to 17th-century Dutch artists like ▷Ruisdael for inspiration, and were also influenced by the work of ▷Constable, well known in France since the 1824 exhibition of ▷ *The Haywain*. The group was led by ▷Théodore Rousseau and included others who painted, at least temporarily, in the area: ▷Diaz, Jules Dupré (1811–89), ▷Daubigny, ▷Troyon, Charles-Émile, Jacques (1813–94). Often ▷Millet is also included despite his interest in people rather than pure landscape. They were, however, only a loose grouping and the name has become a term of convenience for French landscape painting of the 1840s–1860s. The artists are often seen as forerunners of the ▷Impressionists because of their interest in ▷ *plein art* painting and naturalism, but they also looked back to the ▷Romantics in their love of nature and their rebellion against contemporary urbanization. They inspired a generation of lesser escapees, and Barbizon itself became something of a tourist attraction as a result of their work.

Bib.: Adams, S., *The Barbizon School and the Origins of Impressionism*, London, 1994; *Barbizon Revisited*, exh. cat., London, 1962; Bouret, J., *L'École de Barbizon*, Neuchâtel, 1972; Weisberg, P.G. (ed.), *Millet and his Barbizon Contemporaries* Tokyo, 1980

Bargello

The name by which the Museo Nazionale in Florence is more commonly known. Built c1255 as the fortified residence of the Capitano del Popolo, it became the Palazzo el Podestà in 1260. In 1574 it was converted into the city prison (*bargello*) and in 1857–65 it underwent its final transformation into the present museum. Devoted to sculpture and the ▷applied arts, it contains some of the seminal sculptures of the Florentine ▷Renaissance, for example: the bronze Baptistery competition panels by ▷Brunelleschi and ▷Ghiberti, *The Sacrifice of Isaac*; ▷Donatello's bronze *David* and marble *St. George*; ▷Verrocchio's bronze *David*; ▷Pollaiuolo's bronze *Hercules and Antaeus*; ▷Cellini's bronze bust of Cosimo I; ▷Giambologna's bronze *Medici Mercury* and marble *Florence Triumphant over Pisa*; and ▷Michelangelo's *Apollo, Bacchus, Brutus*, and *Pitti Tondo* (all marble).

Barker, Thomas (Barker of Bath) (1769–1847)

English landscape painter. He was born near Pontypool, the son of a second-rate horse painter, who showed some early talent copying Dutch landscapes and was taken up by a local patron, Charles Spackman. His funding enabled Barker to spend three years in Rome (1790–93), although he had no formal training there. On his return he settled in Bath, where he proceeded to make a good living producing peasant ▷genre paintings, ▷Gainsborough-style landscapes (e.g. *Landscape near Bath*, 1798, London, Tate) and ▷fancy pictures (e.g. *The Bandits*, 1793, Bristol Art

Gallery). Many of these were engraved or transferred onto Worcester pottery. Barker exhibited regularly at the ▷Royal Academy (1791, 1796–8, 1800, 1804, 1829), and held a one-man show in London, in 1797, but he always failed to make any real breakthrough in the capital. His brother, Benjamin Barker II (1768–1838), and his son, Thomas Jones (1818–82), were also minor artists.

Bib.: *Barkers of Bath*, exh. cat., Bath, 1986

bark painting

A method practised by ▷Oceanic and Australian ▷Aboriginal peoples, in which tree bark was painted.

Barlach, Ernst (Heinrich) (1870–1938)

German sculptor and graphic artist. He was associated with ▷Expressionism. Born near Hamburg, he studied at Dresden Academy 1891–5, before training in Paris 1895–6. His art was also influenced by travels in Russia (1906) where he gained an interest in ▷folk art, and Florence in 1909. His early work was in an ▷Art Nouveau style and he produced illustrations for *Die Jugend* (1898–1902), ceramic figures (c1903/4) and bronzes (c1906/7), before turning to the past for inspiration. From 1910 he lived in Güstrow in increasing isolation, experimented with woodcarving because of its peasant and medieval associations, and employed religious symbolism in his work (e.g. *Solitary One*, 1911, Hamburg, Barlach Museum; *Have Pity*, 1929, New York, Museum of Modern Art). His simplified, roughly-carved figures reflected the same social concerns as his graphic work (e.g. the *Dead Day* series, ▷lithographs, 1912). During the 1920s he was a member of the Berlin Academy and produced a number of public sculpture memorials. Under the Nazi regime he faced persecution, and his sculpture for St. Catherine's, Lübeck, was abandoned under political pressure. He also wrote poetry and plays (e.g. *Die Sundflut* 1924), and an autobiography in 1928. There is a museum dedicated to his work in Hamburg.

Bib.: Carls, C.D., *Ernst Barlach*, London, 1969; *Ernst Barlach*, exh. cat., Cologne, 1991; *Ernst Barlach*, exh. cat., London, 1967; Fuhmann, F., *Barlach in Gustrow*, Leipzig, 1993

Barlow, Francis (?1626–1704)

English painter. He concentrated on animals and sporting scenes. He practised in a variety of media, producing both book illustrations and large decorative cycles. His decorative scheme at Clandon Park, Surrey is his most famous.

Bib.: Sparrow, W., *British Sporting Artists from Barlow to Herring*, London, 1965

Barnaba da Modena (fl 1362–83)

Italian painter. He was best known for his depictions of the ▷Virgin and Child in a ▷Byzantine style. Little evidence about him remains, although it is thought

that he was training in 1361 with Angelo da Firenze in Genoa. He appears to have remained in that city for at least ten years, in order to gain citizenship and Genoa's cosmopolitan, mercantile atmosphere may account for the obvious Byzantine overtones in his work, in terms of the solemnity and frontality of the figures, although the stance of his images of the Virgin takes account of Italian design customs. He is thought to have been an early experimenter with gold leaf and punchwork. Paintings include versions of the *Virgin and Child* (1367 Frankfurt; c1370, Rivoli; c1370, Turin; c1370, London, Courtauld Institute of Art) and an ▷altarpiece now in the National Gallery, London (1374). Towards the end of his life Barnaba seems to have been painting ▷frescos in Pisa. He was dead by 1383.

Barna da Siena (fl c1350/6)

Italian painter. He was from Siena. In his *Commentarii*, ▷Ghiberti attributes the ▷fresco cycle of the *Life of Christ* in the Collegiata at S. Gimignano (c1350/6) to him. These frescos are conservative in style, revealing a greater stylistic kinship with the linear art of the masters of the early ▷trecento, ▷Duccio and ▷Simone Martini, than with any of the more recent mid-century developments towards descriptive naturalism. Above all, they exhibit a very personal sense of heightened drama and violent emotion. Apparently Barna died from injuries sustained in a fall from the scaffold whilst painting this cycle. A *Christ Carrying the Cross* (New York, Frick Collection) has also been attributed to him on stylistic grounds.

Barnes, Dr. Albert C. (1872–1951)

American collector. He accumulated his wealth from his involvement with the drug industry, and used it to amass a collection of ▷Impressionist and early ▷modernist paintings. From c1913 he began collecting the work of artists such as ▷Matisse, ▷Cézanne and ▷Picasso, as well as a number of ▷old masters. In 1922 he founded the Barnes Foundation in Merion, Pennsylvania, as a venue for the study of art history. He commissioned Matisse to paint a mural for the Foundation, and the second version of the work, *The Dance II* (1932–3) is now there.

Barney, Alice Pike (1857–1931)

American painter. She was born in Ohio, but in 1867 she moved to New York. She travelled to Europe and studied with ▷Carolus-Duran and ▷Whistler in Paris during 1886–9. She developed a ▷Symbolist aesthetic style of painting that she used in her many portraits, as well as scenes of myth and images of the ▷*femme fatale*.
Bib.: McClelland, D., *Where Shadows Live: Alice Pike Barney and her Friends*, Washington, 1978

Barns-Graham, Wilhelmina (b 1912)

Scottish painter. She was associated with the St. Ives painters in Cornwall during the 1940s, and her interest in landscape has prevailed throughout her career. Her works became increasingly abstract, and she gained particular inspiration from her travels in the Swiss Alps, where she studied the formations of glaciers. She has held various teaching posts, but spends most of her time in Cornwall or St. Andrews, carrying the traditions of rural landscape painting to the present day.
Bib.: *Wilhelmina Barns-Graham – Paintings and Drawings*, exh. cat., St. Andrews, 1982

Barocci, (Baroccio) Federico (c1535–1612)

Italian painter. He was from Urbino and worked mostly in his home town but with two major trips to Rome. His earlier work with its crowded canvases and ambiguous space has been called late ▷Mannerist, whilst undoubtedly some of his later paintings, such as the *Assunta* (Dresden, Gemäldegalerie) are, in their vigorous handling and overt emotionalism, moving towards the ▷Baroque. His unique style, influenced by ▷Raphael (himself from Urbino) and ▷Correggio, is characterized by soft, blurred edges, lively colour and an emotional content that occasionally tends towards sentimentality (e.g. the *Madonna del Gatto*, before 1577, London, National Gallery). Barocci's emotionalism found favour with the Roman Catholic ▷Counter-Reformers who were looking for a more affective art to reach the Catholic faithful. In particular, Barocci was a favourite of the Oratorian St. Philip Neri and one of his finest ▷altarpieces is to be found in the Oratorian church in Rome (*The Presentation of the Virgin*, 1593–4, Chiesa Nuova). He was highly acclaimed in his time, including among his patrons the emperor, Rudolph II. However, he appears to have been of an extremely nervous disposition and apart from his two trips to Rome early in his career, would not leave Urbino. Nonetheless, he was a prolific painter and also a fine draftsman, being one of the earliest artists to exploit coloured chalks as a medium. ▷Bellori, the leading Italian art historian of the Baroque age, considered Barocci to be the most important central Italian painter of his time.
Bib.: Emiliani, A., *Federico Barocci: Urbino 1535–1612*, Bologna, 1985; Pillsbury, E.P., *The Graphic Art of Federico Barocci*, exh. cat., New Haven, 1978; Walters, G.R., *Federico Barocci, Anima Naturaliter*, Princeton, 1981

Baronzio, Giovanni (fl 1345–62)

Italian artist. He produced ▷frescos in Ravenna in the style of ▷Giotto.

Baroque

An art-historical term used both as an adjective and a noun to denote, principally, the style that originated in Rome at the beginning of the 17th century, superseding ▷Mannerism. The Council of Trent (1545–63).

had strongly advocated pictorial clarity and narrative relevance in religious art and to a degree Italian artists such as Santi di Tito (1536–1603) had responded with a more simplified style which has been called 'Anti-Mannerism'. Yet it was not until the 17th century, with the groundswell of renewed confidence and spiritual militancy in the ▷Counter-Reformation Catholic Church that a radical new style, the Baroque, developed. Rome was the most important centre of patronage at this period and the return to compositional clarity was facilitated by a renewed interest in the ▷antique and the High ▷Renaissance in the work of ▷Annibale Carracci and his Bolognese followers, ▷Domenichino, ▷Guido Reni and ▷Guercino. Their work is characterized by a monumentality, balance and harmony deriving directly from ▷Raphael. Carracci's great rival, ▷Caravaggio, by contrast modified his ▷Classic style with an early naturalism, using for his strongly-felt religious subjects characters who appeared to have walked in straight from the streets, the spiritual meaning of the narrative heightened by dramatically theatrical ▷chiaroscuro.

The era known as High Baroque covered the period c1625–75 and is best represented by its leading artist, ▷Gianlorenzo Bernini. In High Baroque all the visual arts – painting, sculpture and architecture – are forged together to make ensembles intended to exert an overwhelming emotional impact (e.g. the crossing of St. Peter's and the Cornaro Chapel, Sta. Maria della Vittoria, Rome). Reposeful balance is forsaken for dynamic movement and the integrity of individual materials is subsumed into the all-important illusionism calculated to impress upon the faithful the actuality of the spiritual experiences of the Catholic saints represented before, above and all around them. After Bernini, the greatest architect of the period was ▷Borromini, and this was also an age when some of the greatest masterpieces of illusionistic ceiling painting were executed, the leading artists being ▷Pietro da Cortona, ▷Lanfranco, ▷Baciccio and, slightly later, ▷Andrea Pozzo. Contemporaneous with these exponents of the High Baroque, however, was a continuance of the Classical strand, characterized by the work of ▷Algardi, ▷Sacchi and ▷Maratta.

Although Baroque art had its origins in the Catholic church the possibilities for propaganda afforded by the involving and illusionistic techniques of the Baroque style were not lost on secular patrons. The ▷Barberini family employed ▷Cortona to proclaim their divine right to the papacy in his ceiling painting for their palace in Rome, while Colbert, chief minister to Louis XIV of France, was instrumental in the adoption of Baroque in France for the sole purpose of exalting the reign of Louis XIV. Consequently, ▷Versailles is one of the most grandiose of Baroque palaces. Indeed, French Baroque is, by virtue of its use chiefly as political propaganda, characterized by a certain pomposity. With its codification by ▷Lebrun, the director of the French Academy, it also moved more towards a rather ossified Classicism based on teachable rules and precepts derived largely from the paintings of ▷Poussin who had spent almost his entire active life in Rome.

Baroque art soon spread through the other Catholic countries of Europe. ▷Rubens in Flanders produced religious and secular works with equal success, while in Spain religious art reached new heights of religious fervour and in South Germany and Austria the beginning of the 18th century saw some of the most remarkably elaborate and overwhelming church architecture ever erected (e.g. ▷Neumann and ▷Hildebrandt). Because of its base in the Catholic Counter-Reformation, Baroque was resisted in Protestant countries such as Holland and Britain, although ▷Rembrandt in Holland and the painter ▷John Thornhill and architect ▷Vanbrugh in Britain are exceptions. During the 18th century, Baroque gradually gave way to the lighter, more decorative ▷Rococo style.

A secondary use of the term 'baroque', usually with a lower-case 'b', designates art of any era that demonstrates the salient characteristics of art of the Baroque period. Thus, ▷Hellenistic art is sometimes described as the baroque phase of Greek art because of its tendency to dynamic movement, exaggerated naturalism and overt displays of artistic virtuosity.

In Britain, until the beginning of the 20th century, baroque was also used as a term of abuse to describe anything that was considered overdone.

Bib.: Haskell, F., *Patrons and Painters: A Study in the Relations Between Italian Art and Society in the Age of the Baroque*, 1980; Martin, J.R., *Baroque*, London, 1977; Montagu, J., *Roman Baroque Sculpture: The Industry of Art*, New Haven and London, 1989; Wittkower, R., *Studies in the Italian Baroque*, London, 1975; Wittkower, R., *Art and Architecture in Italy 1600–1750*, New Haven and London, 1982

Barr, Alfred Hamilton (1902–81)

American museum director and art historian. He was the first director of the ▷Museum of Modern Art in New York, and he held this position 1929–43. During 1947–67 he had a slightly different role as director of the collection. In his monographs on ▷Matisse and ▷Picasso, and in the survey, *Cubism and Modern Art* (1936), Barr helped create the canon of ▷modernism that still dominates modern art museums throughout the world. In recent years, Barr's influence has been criticized as perpetuating an élitist form of art which is inaccessible to the vast majority of the population. This retrospective judgement has done little to minimize his influence.

barrel vault

▷vault

Barret the Elder, George (?1732–84)

Irish painter. He came to London in 1762 and was a founder member of the ▷Royal Academy in 1768. He painted landscapes with a topographical slant and gained aristocratic patronage in England. Several of his children were also painters.
Bib.: Bodkin, R., *Four Irish Landscape Painters*, Dublin, 1920

Barry, James (1741–1806)

Irish history painter. He was based in London. He came from a poor background in Cork but when training with the artist Robert West in Dublin was lucky enough to gain the attention of ▷Burke, who financed a trip to Italy (1761–71). There Barry studied ▷Michelangelo and ▷Raphael, and achieved his ambition to be a ▷history painter. On his return to London, he attracted the interest of ▷Reynolds, and quickly became an ▷RA (1773). In 1782 he was made Professor of Painting at the Academy, but his relations with the establishment were not happy: from 1776 he refused to exhibit at the Royal Academy because of criticism of his *Death of Wolfe* (1776, New Brunswick Museum), and in 1799 he was expelled from his post because of his attacks on the now-dead Reynolds. Despite occasional portraits (e.g. *Hugh, Duke of Northumberland*, 1784, private collection), Barry remained dedicated to history painting. In 1777–83 he produced six pictures representing the *Progress of Human Culture* for the Great Room at the Society of Artists, working without payment. He died destitute, and though buried in St. Paul's, had never been able to establish his genre in the hearts of the British. *The Death of Cordelia* (1774, London, Tate) is typical of his style.
Bib.: *James Barry: Artist as Hero*, exh. cat., London, 1983; Fryer, E., *Works of James Barry*, London, 1909; Pressly, W.L., *Life and Art of James Barry*, New Haven and London, 1981

Barthes, Roland (1915–86)

French ▷structuralist writer. Using the theories of ▷Marx and ▷Freud he has argued for the decentring of the created work, which is not a concrete reality produced by an individual for the consumption of others but a fluctuating 'text', part of a broader field of interactions. The author's role is thus reduced – Barthes calls him/her a 'guest' in the text – but it is reduced not by semantics (▷Derrida) so much as by socio-cultural forces. Barthes argues for an inter-disciplinary approach to art and literary studies. In *Mythologies* (1954–6) he examined the function of language and its relation to ▷ideology, but he carried his conclusions not only to written texts but to the whole range of ▷culture. For him culture was not merely a reflection of life but a series of powerful and shifting mythologies of life. In the *Pleasures of the Text* (1975), he compared 'pleasure' (a comforting, unchal-lenging sensation) with 'bliss' (a sense of unsettling crisis).
▷auteur theory
Bib.: Culler, J., *Roland Barthes*, London, 1983; Heath, S., *Roland Barthes: Image, Music and Text*, London, 1977; Rylance, R., *Roland Barthes*, New York, 1994; Sontag, S. (ed.), *Barthes Reader*, London 1982

Bartholomew

Apostle-saint, martyred by flaying and beheading, and in some versions crucifixion, mentioned in Jacobus de Voragine's *The Golden Legend*. His Feast Day is 24 August and his symbol is a butcher's knife. He was also the Florentine patron saint of salt, oil and cheese merchants, and was very popular elsewhere in Tuscany. Little is actually known about the life of the saint. Some assume that as an ▷Apostle he must have been from Galilee, although others argue that he was Syrian in origin, and his name derives from 'bar', meaning 'son' and Ptolomey. ▷Matthew says that he preached throughout Europe, Arabia, Armenia and Persia and was martyred in India. He performed miracles, exor-cisms and resurrections. In the ▷altarpiece by Simone da Cusighe (1397) in the Accademia, Venice, Bar-tholomew's life is illustrated in eight panels, which have clear Christological parallels: the saint exorcizes a demon from a pagan king's daughter and drives out the idols from the temple, thus converting the population. The king's brother is enraged, tries Bartholomew and condemns him to flagellation and crucifixion. Other images include altarpieces by Lorenzo di Nicolò Gerini (14th century) and Neri di Bicci (15th century *St Bartholomew and St James*, Lawrence, Kansas, Spencer Museum of Art; *Bar-tholomew and Four Saints*, S. Gimignano, Mus. Communale.). Bartholomew was often afforded a panel in medieval ▷polyptychs.

Bartlett, Jennifer (b 1941)

American painter. She is from California and studied art there and at Yale. She was at first influenced by ▷Abstract Expressionism, but from 1969 she developed her distinctive style of art. This consisted of series of painted grids, initially composed on canvas, and later made of steel plates. Her use of painted panels led to increasingly monumental work, and she was given a series of major decorative commissions, includ-ing the Federal Building at Atlanta, Georgia.
Bib.: Goldwater, M., R. Smith and C. Tomkins, *Jen-nifer Barlett*, New York, 1985

Bartoli, Taddeo

▷Taddeo di Bartolo

Bartolo di Fredi (c1330–1410)

Italian painter. He was from Siena but also active in San Gimignano and Montalcino. His individual style is founded on the work of ▷Simone Martini, ▷Lippo

Memmi and ▷Pietro Lorenzetti. In 1353 he is documented as sharing a workshop with Andrea Vanni and later as working in collaboration with Luca di Tommé. His earliest dated painting is the 1364 *Madonna of Mercy* (Pienza, Museo d'Arte Sacra) and his major surviving work is probably the Old Testament ▷fresco cycle in the Collegiata, San Gimignano (1356). Bartolo's panel paintings include a *Coronation of the Virgin* (1388, Montalcino, Museo Civico), *Assumption of the Virgin* (two paintings of this title in Saint-Jean-Cap-Ferrat, Musée de Île de France) and a *Presentation in the Temple* (after 1380, Paris, Louvre). His characteristic use of brilliant colours in decorative combinations, combined with a lively crowding of incidental details may be seen at its best in his *Adoration of the Kings* (1390s, Siena, Pinacoteca).
Bib.: Harpring, P., *The Sienese Trecento Painter, Bartolo di Fredi*, London, 1993; Os, H.W. van, 'Tradition and Innovation in Some Altarpieces by Bartolo di Fredi', *Art Bulletin*, 67 (March 1985), pp. 50–66

Bartolommeo, Fra (Baccio della Porta) (c1472–1517)

Italian painter. He was from Florence and considered to be one of the most influential artists of the early High ▷Renaissance. Baccio trained in the workshop of ▷Cosimo Rosselli and was influenced early on by ▷Perugino and later by ▷Leonardo da Vinci. For some years he worked as an independent master, his *Last Judgement* (1499, Florence, Museo di San Marco, finished by Albertinelli), greatly influencing the young ▷Raphael (cf. the *Disputa*, c1509–10, Vatican, Stanza della Segnatura). In 1500 Baccio, enthused by the religious ideas of Savanarola, became a Dominican friar (hence the title *Fra*, 'Brother') at Prato. He painted no more until 1504, when he returned to Florence and assumed control of the monastery workshop at the Convent of San Marco, a position formerly held by ▷Fra Angelico. In 1508 he visited Venice and was much impressed by ▷Giovanni Bellini's altarpieces, which influence can be seen in the *Mystic Marriage of St. Catherine* (1511, Paris, Louvre). The Venetian predilection for landscape can also be seen in Fra Bartolommeo's many surviving landscape drawings. On his return to Florence he set up shop with ▷Albertinelli. He was in Rome in 1514, where he painted a *St. Paul* and a *St. Peter*, the latter being left incomplete and later finished by Raphael (now in the Vatican). ▷Vasari records that on his return to Florence he was confronted with criticism that he could not paint nudes. He more than confounded his critics, however, by painting a *St. Sebastian* (lost) for the church of San Marco which was so convincing that it very soon had to removed from public display as it was found to be giving the female members of the congregation unholy thoughts. Fra Bartolommeo developed a balanced and simplified style of composition with an elimination of anecdotal details and an eloquent use of gesture and

pose in the service of a clear religious message. He was an excellent draughtsman, many of whose drawings survive: these include figure and drapery studies, as well as landscapes.
Bib.: Chastel, A., 'Fra Bartolomeo's Carondelet Altarpiece', in Humfrey, P. and Kemp, M. (eds.), *The Altarpiece in the Renaissance*, Cambridge, 1990; Fischer, C., *Fra Bartolomeo et son Atelier*, Paris, 1984; Humfrey, P., 'Fra Bartolomeo, Venice and St. Catherine of Siena', *Burlington Magazine*, 132 (July 1990), pp. 476–83

Bartolozzi, Francesco (1727–1815)

Italian engraver. He came from Florence and worked in Venice, where he met George III's librarian, Richard Dalton. Dalton encouraged Bartolozzi to come to England in 1764, and here he gained the attention and patronage of George III. Because of his privilege within the royal circle, Bartolozzi was chosen to be a founder member of the ▷Royal Academy, although engravers were technically excluded from this privilege. He was a prolific engraver, and he popularized the ▷stipple technique in England. His many engravings of works by ▷Cipriani and ▷Kauffman stimulated a soft form of ▷Neoclassicism in the decorative arts. In 1802 he was elected Director of the National Academy in Lisbon, and he left England.
Bib.: Brinton, S., *Bartolozzi and his Pupils in England*, London, 1903

bar tracery
▷tracery

Barye, Antoine-Louis (1796–1875)

French sculptor and painter. He was best remembered for his work as an *animalier*, or sculptor of animal subjects; he also painted landscapes in the ▷Barbizon manner. The son of a goldsmith from Lyons, Barye's study of sculpture began only after his demobilization from service in the Napoleonic armies in 1814. From 1818 to 1823 he attended the ▷École des Beaux-Arts, but it was his experience working for the goldsmith ▷Fauconnier, 1823–31, modelling animals (which he made from studies of living animals in the Jardin des Plantes), that presumably convinced him where his true talent lay. His position as the leading *animalier* in Paris was established with his critically-acclaimed Salon entry of 1831, *Tiger Devouring a Gavial of the Ganges*. Following this he received royal commissions from the House of Orléans and was created a chevalier of the Legion of Honour in 1833 (he received the Cross from Napoleon III in 1855). However, with the fall of the House of Orléans in 1848, patronage dried up and Barye went bankrupt. He thereafter had to take a job as keeper of casts at the Louvre (1848–50), and then as teacher of zoological drawing at the Paris Natural History Museum (from 1854 until his death). In 1854 he also re-established his own practice when he received his first major non-animal commission, the

tympanum group for the Pavillion de l'Horloge of the Louvre, *Napoleon Dominating History and the Arts* (1855–7), followed in 1860 by the Equestrian Statue of Napoleon for Ajaccio, Napoleon's birthplace in Corsica. Barye's most important work, his bronze animal sculptures, often deal with violent combat. The animals are accurately observed but the conflict (tiger and gavial, lion and snake) is first and foremost a ▷Romantic expression of the unrestrained ferocity of nature.

Bib.: Ballio, J., *The Wild Kingdom of Antoine-Louis Barye*, New York, 1994; Piver, S., *The Barye Bronzes: A Catalogue Raisonné*, Woodbridge, 1974; Sonnabend, M., *Antoine-Louis Barye 1795–1875, Studien zum plastischen Werk*, Munich, 1988

Basaiti, Marco (c1470–1530)

Italian painter. He worked in Venice and produced religious works in the style of ▷Giovanni Bellini. His *Madonna* (c.1500) is in the London National Gallery.

basalt(es)

A hard dark stone used for carving and building by the ancient Egyptians. Basalt ware was also the name given to black ▷ceramic works produced in the factory of Josiah Wedgwood in the late 18th century.

Baschenis, Evaristo (1617–77)

Italian painter. He was one of a family of painters from Bergamo. He was known for his still lifes which contained musical instruments. His skill in the use of light and shade enhanced the naturalistic effect of these paintings.

base

In its most general sense, the bottom or supporting part of any structure. The base of a building is the lowest visible part of a wall – as a thicker and distinctive course it is called a ▷plinth. The base of a ▷column is that part which rests directly on the ground, ▷stylobate or ▷pedestal and supports the shaft.

Baselitz, Georg (b 1938)

German painter. He trained at the East Berlin Academy of Fine and Applied Arts and at the Academy of Fine Arts in West Berlin. His early works were figurative, rejecting the influence of ▷Tachism. From the late 1960s, he reduced the figurative elements in his work and became known for representing images upside down. In the 1980s he began to practise sculpture as well, and he has taught in Karlsruhe and Berlin. He is an important figure in the ▷Neo-Expressionist movement.

Bib.: *George Baselitz*, exh. cat., Brunswick, 1981

basement

(i) The lowest storey of a building, usually partly or entirely sunk below ground level, or, if wholly above ground level, with a lower ceiling than the storeys above – it is distinct from a cellar in that it is intended not for storage, but as living accommodation. (ii) The lowest portion of any structure.

Bashkirtseff, Marie (1858–84)

French painter of Russian birth. She was from a privileged background and lived in France with her family from 1877. Determined to be a painter, she studied at the ▷Académie Julian from 1877 and exhibited at the ▷Salon in 1879. She adopted the style of ▷Bastien-Lepage but concentrated on portraits and ▷genre scenes. Her posthumous fame rested not on her art but on her diaries, which were published by her family in 1887 after her premature death of tuberculosis. Much expurgated at the time, these diaries nevertheless attest to the difficulties facing women artists in the late 19th century.

Bib.: Bashkirtseff, M., *Journal of Marie Bashkirtseff*, Eng. trans., London, 1985; Cosnier, C., *Marie Bashkirtseff: un portrait sans retouches*, Paris, 1985; Garb, T., ' "Unpicking the Seams of her Disguise'': Self Representation in the Case of Marie Bashkirtseff', *Block*, 13 (Winter 1987–8), pp. 79–86

basilica

A rectangular building common from the 2nd century BC in Rome. It contained a ▷colonnade on all four sides. Originally, the basilican plan was used for public buildings, but from the 4th century, the growth of Christianity led Christians to adopt the form for churches (▷Early Christian art).

basket arch

▷arch

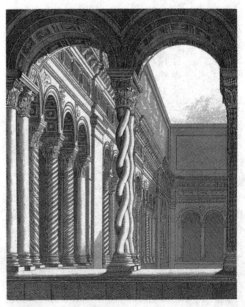

Basilica

basket capital

▷capital

Baskin, Leonard (b 1922)

American sculptor and printmaker. He studied at Yale University, and in New York, Paris and Florence. He developed an ▷Expressionistic mode of art in which he concentrated on themes of death and injury. He privileged the figure of the Existential anti-hero, and in works such as *Youth: Oak* (1956, University of Nebraska), he responded to the holocaust by representing the victims of concentration camps.

bas-relief (*basso rilievo*)

A sculptural ▷relief in which the objects represented project less than half their true depth from the surface of the panel or slab. Also called a low relief.

maintaining links with Venice. His paintings, revealing in their use of colour the influence of ▷Titian, are mostly biblical subjects, characterized by a realism that pervades the landscape settings and is manifest in the stocky peasant types and animals appearing in supporting roles. Often there will be at least one barefoot figure kneeling, the soiled soles of his feet exposed to the viewer (e.g. *Rest on the Flight into Egypt*, c1550, Milan, Ambrosiana). In some of his paintings the biblical subjects seem almost an excuse for a picture that is basically ▷genre and it has been said that Jacopo's concentration on these aspects helped create the market for unabashed genre as an independent category. Jacopo's four sons, Francesco the Younger (1549–92), Leandro (1557–1622), Giovanni Battista (1553–1613) and Gerolamo (1566–1621) were also painters, Francesco the Younger was initially the head

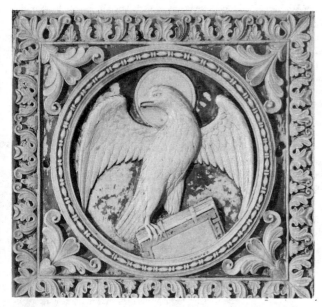

Bas-relief: North Italian Carolingian ivory symbol of St. John the Evangelist, 9th century, Victoria and Albert Museum, London

Bassá, Ferrer (c1285/90–138)

Spanish painter. He worked in Barcelona for the court of Aragon. His only known work is the series of ▷frescos in the chapel of S. Miguel at the convent of Pedralbes near Barcelona (1345–6). The style in which these works are produced indicates a knowledge of Sienese painting.

Bassano, Jacopo (Jacopo da Ponte) (c1510/15–92)

Italian painter. He was from Bassano near Venice, trained first by his father, Francesco da Ponte the Elder (c1475–1539), and afterwards in Venice by ▷Bonifazio de' Pitati. Jacopo returned to Bassano in c1530 and remained there for the rest of his life, presumably avoiding the pitfall of provinciality by

of their workshop in Venice, but Leandro took over following his elder brother's suicide. None are particularly individual as painters, generally working in a style so close to that of their father that their paintings are often mistaken for his.

Bib.: Aikema, B., *Jacopo Bassano and his Public*, Princeton, 1996; *Jacopo Bassano c1510–92*, exh. cat., Fort Worth, 1993; Pallucchini, R., *Bassano*, Bologna, 1982

Bastien-Lepage, Jules (1848–84)

French painter who specialized in rural subject matter. He was born to a peasant family in Damvillers and after beginning a career in the Post Office, he studied with ▷Cabanel at the ▷École des Beaux-Arts (1867). He exhibited at the ▷Salon from 1870, but once he had failed the ▷Prix de Rome in 1876 (with *Achilles*

and Priam; Lille), he returned to his village with the intention of painting peasant subjects. Lepage worked within the ▷Realist tradition of ▷Courbet and ▷Millet, but adopted a different palette (of pallid, clear grey-greens) and new technique, his so-called square brush style, in his studies of the French peasantry. Working at the same time as the ▷Impressionists he is often associated with their aims, but although Lepage worked ▷*plein air* and sought objectivity, his use of square brushes and cool, sharp colours produced monumental, not transient images, and he was less interested in nature than in people (e.g. *Pauvre Fauvette*, 1881, Glasgow). He also produced portraits (e.g. *Artist's Mother*, 1874, Nice, Musée Cherat) and ▷history paintings (e.g. *Joan of Arc*, 1879, New York, Metropolitan Museum). In all these his figures dominate the foreground of the canvas and stare disconcertingly out at the viewer. He had little influence on French art because of the current dominance of Impressionism, but inspired British artists like ▷Clausen, ▷Forbes and the ▷Glasgow School, and also Australians such as ▷Tom Roberts. He visited London in 1882 (cf. his *Shoeblack*, 1882, Paris), but died prematurely in 1884. ▷Marie Bashkirtseff was a pupil and admirer of his and produced a sweeter version of his style.

Bib.: Sickert, W.R., *Bastien-Lepage and Modern Realism in Painting*, London, 1892

Bataille, Georges (1892–1962)

French theorist. He was a member of the ▷Surrealist circle in France, but he was expelled from the group in 1930 when ▷Breton recast the Surrealist movement into a ▷Marxist mode. Bataille wrote a 'Critical Dictionary' published 1929–30 in the journal *Documents* in which he criticized the uncompromising Marxism of the new Surrealist movement.

Bib.: Daniel Hawley, *L'oeuvre insolite de Georges Bataille*, Geneva, 1978; Richman, M. H., *Reading Georges Bataille*, 1982; Sollers, P., et. al., *Bataille*, Paris, 1973

Bateau-Lavoir

(French, 'washerwoman's boat'.) The nickname for the studios in Montmartre where artists such as ▷Picasso, ▷Gris and others congregated in the early years of the 20th century. The studios were also frequented by literary men such as André Salmon and ▷Max Jacob, who invented the name.

bathers

A group of naked women bathing in a stream or river. This subject was especially popular in the late 19th and early 20th centuries, and it became a standard theme for ▷avant-garde painters. ▷Cézanne, ▷Renoir, ▷Matisse, ▷Kirchner and many other artists used experimental styles in their representations of this theme. Ironically, the theme of nude women in a landscape had many traditional echoes, although in a modern context, such works were inevitably seen as subversive. The bathers subject had a number of advantages for artists. Its outdoor setting allowed the practice of ▷*plein-air* painting. The emphasis on nudity reinforced either artistic bohemianism or a prevalent concern with naturism, particularly in northern Europe, before the First World War. The plethora of bathers in early 20th-century art has subsequently been condemned as an example of the exploitation of female models by early ▷modernist artists.

Bathsheba

▷David

batik

(Japanese, 'painted'.) Textile printing process, in which hot wax is applied in a desired pattern to a piece of cloth, which is then dyed. The wax acts as a resist, and the fabric retains its original colour in those areas which have been covered. The process can be repeated in order to build up complex designs, and when the final result is achieved the wax can be ironed out.

Battistello

▷Caracciolo, Giovanni Battista

Batlle-Planas, Juan (1911–66)

Argentine painter of Spanish birth. He was interested in the relationships between psychology and art. During the 1930s, he invented ▷Superrealism, a form of realist art similar to that practised by Italian ▷metaphysical painters. Like ▷Max Ernst, he employed imaginary figures and produced many ▷collages. He also produced murals.

Bat(t)oni, Pompeo Girolamo (1708–87)

Italian painter. He was born at Lucca, and probably trained there, but he was active in Rome from 1727. In Rome he studied under and was influenced by ▷Sebastiano Conca; his other influences being principally the ▷antique and the paintings of ▷Raphael and ▷Annibale Carracci. From c1740 he devoted himself to painting portraits of the foreign visitors to Rome, especially wealthy English travellers on the ▷Grand Tour and by the mid-century he was considered to be, alongside his chief rival ▷Anton Raphael Mengs, the leading portraitist working in the city. Never penetratingly characterized, though generally executed with ▷bravura, a portrait by Batoni was partly a souvenir of the stay, the sitter often set in front of some famous antiquity, such as the ▷*Laocoön* (e.g. *Portrait of Lord Dundas*, 1764, Yorkshire, Aske Hall). He also painted many ▷altarpieces for churches in Rome and elsewhere in Italy, as well as mythological subjects for private patrons, and many fine drawings from the antique. He was curator of the papal collections and numbered among his friends the key ▷Neoclassical theorist ▷Johann Winckelmann.

Bib.: Clark, A.M., *Pompeo Batoni: A Complete Catalogue of his Works*, New York, 1985; *Mostra d'Pompeo Batoni*, exh. cat., Lucca, 1985

battlement

▷crenellation

battle scenes

A type of imagery with an ancient heritage. Battle scenes first appeared in the ▷bas-reliefs of ▷Assyrian art, where they were used to glorify the successes of the king. A different purpose lay behind the battle art represented in Greek vase-painting and sculpture, where the battles depicted were those of the gods rather than men. The Romans revived the practice of representing real battles, and these portrayals appeared on both ▷sarcophagi and victory columns, such as that of Trajan (AD 113). The revival of antique modes in the ▷Renaissance may have inspired ▷Leonardo's cartoon, *The Battle of Anghiari* (1503–6), now known only in sketches.

The real growth of battle painting as a separate genre came in the 17th century when Dutch artists such as ▷Wouverman specialized in it. Wouverman's battle scenes rarely represent specific moments and individuals, but are generalized depictions of the various actions of battle. Attitudes to battle painting altered dramatically during the Napoleonic period, when battle scenes became either glorifications of the emperor or satirical attacks on the horrors of war. ▷Géricault and ▷Gros were responsible for laudatory ▷Romantic battle scenes, while ▷Goya's ▷*Disasters of War* attacked the whole enterprise.

During the 19th century, battle painting returned sporadically in times of war or colonial conquest. In England, ▷Lady Butler's wildly popular images of soldiers in the Crimea were, to an extent, superseded by the war photography of Roger Fenton. By the early 20th century, battle painting and photography became more of a means of documentation than a glorification or fictional recreation of heroism, although British ▷Neo-Romantic artists such as ▷Nash returned to war as a subject of interest.

Bib.: Hichberger, J., Images of the Army, Manchester, 1988; Thomas, D., *Battle Art: Images of War*, 1977

Bauchant, André (1873–1958)

French painter. He began a career as a gardener, but took up painting without any training. He met and was encouraged by ▷Le Corbusier, and came to the attention of ▷Diaghilev for whom he designed sets in 1928. His style was realist and he concentrated on historical themes. His background as a gardener provided him with ample subject-matter for his many flower paintings.

Baudelaire, Charles-Pierre (1821–67)

French poet and critic. He was well-known for a series of writings on art. Baudelaire was one of the foremost defenders of ▷Romanticism, particularly in his enthusiasm for ▷Delacroix, whom he praised for his passion, his use of colour (which for Baudelaire was the key to creating an emotional 'bridge' between artist and spectator) and his ability to encapsulate the spirit of the age. In his own poem cycle *Les Fleurs du Mal* (1857) Baudelaire compared the monotony of daily existence with the moments of ecstasy and inspiration experienced by the artist. He believed in the need for artistic suffering and artistic freedom (he was often criticized for immorality). Beauty was created by emotion, and a result of individual experience; it could therefore be found anywhere (although he had difficulty seeing it in the frock coats of his own time), and was not restricted to academic rules. Many of his ideas paved the way for ▷Symbolism: he promoted ▷synaesthesia which features in the writing of Mallarmé and Rimbaud, as well as in Romanticism. His enthusiasm for Edgar Allen Poe, whose works he translated, led to an exploration of beauty in evil and danger (and an association with ▷Manet). However, he was also interested in naturalism (▷Taine) and was friendly with ▷Courbet, who painted him (c1847, Montpellier). One of his constant cries was the need for an 'artist of modern life', epitomized for him by ▷Guys.

Bib.: Carrier, D., *High Art, Charles Baudelaire and the Origins of Modern Painting*, Pennsylvania, 1996; Hyslop, L., *Baudelaire: A Man of his Time*, New Haven and London, 1980; Mayne, J. (ed.), *Art in Paris*, London, 1965; Quennel, P., *Baudelaire and the Symbolists*, London, 1954; Troyat, H., *Baudelaire*, Paris, 1994

Baudrillard, Jean (born 1929)

French theorist. Baudrillard's writings about ▷postmodernism have emphasized the prevalence of ▷mass media in the modern world and the effect it has had on human perceptions and relationships. In a manner that ranges from the enthusiastic to the disgusted, he has exposed the fact that human understanding and communication has been clouded by what he called 'simulacra', or the plurality of visual images. His ideas on 'simulacra' challenge traditional notions of originality and authenticity. The modern environment of mass consumption, electronic imagery and the circularity of information means that we cannot maintain an objective 'reality' separate from our means of generating it; artists must, therefore, find reality in representation. This theory has been taken by some artists as an endorsement for a socially irresponsible form of self-reference in which images have meaning only within the ▷discourse of art.

Bib.: Kellner, D., *Baudrillard: A Critical Reader*, Oxford, 1994

Baudry, Paul (Jules Aimée) (1826–86)

French painter. He was born in Le Roche sur Yon and trained in Paris from 1844, working with Drolling at the ▷École des Beaux-Arts. He won the ▷Prix de Rome in 1850 and began exhibiting at the ▷Salon in 1852. As a result of time spent in Italy, his work was Classical in inspiration, based on his admiration for 16th-century Italian art. He produced portraits (e.g. *Charles Garnier*, 1868, Versailles), Classical subjects (e.g. *Toilet of Venus*, 1857, Bordeaux) and history subjects (e.g. *Charlotte Corday*, 1860, Nantes) in a highly finished academic style, but he is best known for his ▷fresco designs for the Paris Opera (*Dream of St. Cecelia*, 1866–74). Throughout the 1860s he travelled widely, spending 1870 in the safety of Venice and visiting Egypt. In his later career he loosened his ▷brushwork under the influence of ▷Impressionism and began producing ▷Renoiresque nudes, but these were badly received.
Bib.: *Baudry 1826–86*, exh. cat., La Roche sur Yon, 1986

Baugin, Lubin (1610–63)

French painter. He produced religious paintings and possibly still lifes. His religious work bears a resemblance to that of ▷Guido Reni, although there is no evidence of contact between the two artists.

Bauhaus

An institute established in 1919 by ▷Gropius from the old Weimar Academy of Fine Arts and the Weimar School of Arts and Crafts (which had been established by ▷van de Velde). Gropius's aim was to unify the teaching of all the arts under the umbrella of design and with an eye to producing for the machine age. The school took some of the ideas of the ▷Arts and Crafts Movement and updated them, producing designs suitable for mass productions and using modern materials like chrome and plastic (including the famous tubular-framed and moulded plastic chairs). In this it shared many of the ideas of ▷de Stijl and the Russian ▷Constructivists. During the 1920s the influence of the School spread, thanks to books published by Gropius and ▷Mies van der Rohe, and to the international staff employed: ▷Kandinsky, ▷Klee, ▷Feininger, ▷Bayer, ▷Breuer and ▷Schlemmer were all teachers there at some time. In 1925, after a dispute over funding and complaints about the lack of success, the Bauhaus moved to new purpose-built premises at Dessau, designed by Gropius and which themselves became models of the new ▷International style architecture. In 1928 Gropius left to pursue his own career and Mies van der Rohe succeeded him as director, but the school began to suffer under the Nazi rule and was closed in 1933. In 1937 ▷Moholy Nagy became the new director of a Chicago branch of Bauhaus.
Bib.: Forgacs, E., *The Bauhaus Idea and Bauhaus Politics*, Oxford, 1995; Franciscono, M., *Gropius and the Creation of Bauhaus*, Illinois, 1971; Naylor, G., *Bauhaus Reassassed*, London, 1985; Whitford, F., *Bauhaus*, London, 1984

Ba(o)ule

▷African art

Baumeister, Willi (1889–1955)

German artist. He studied in Stuttgart and travelled to Paris in 1912 and 1914, where he became interested in the developments of ▷Cubism. During the 1920s, he was friendly with ▷Schlemmer, and he transferred his interest to abstract wall paintings that incorporated varying textures such as sand. He taught at the Frankfurt School of Art in 1928–33, until he was declared a ▷degenerate artist by the Nazis. He remained in Germany during the Second World War and regained a teaching post after the war, this time in the Stuttgart Academy. He was particularly concerned with the subconscious motivations behind abstract art, and he published a book in 1947 *The Unknown in Art*, which articulated these theories.
Bib.: W. Grohmann, *Willi Baumeister – Leben und Werk*, Cologne, 1963

Bawden, Edward (1903–89)

English painter and designer. He studied at the ▷Royal College of Art in 1922–5 and taught there from 1930. He was a war artist during the Second World War and became known for his mural painting in the 1950s and 1960s. He is best known for his contribution to the decoration of the pavilions at the Festival of Britain and his book illustrations.

Marcel Breuer, Armchair designed for the Bauhaus, oak lath and linen, 1924

Bib.: Richards, J.M., *Edward Bawden*, Harmondsworth, 1946

Baxter, George (1807–67)

English printmaker. In 1835 he invented a new technique of colour printing which became popular until the 1860s. The 'Baxter Prints' were patented.
Bib.: Lewis, C.T.C., *George Baxter, His Life and Work*, Wakefield, 1972

bay

An architectural term referring to a regularly repeated vertical division of the exterior or interior of a building, defined by such elements as ▷columns, ▷pilasters, ▷piers, ▷fenestration or ▷vaulting compartments.

bay window

▷window

Bayer, Herbert (1900–85)

Austrian painter and graphic artist. He studied at the ▷Bauhaus and was one of the first student masters at the Dessau Bauhaus in 1925. He left the Bauhaus in 1928 and set up his own advertising company. He was particularly interested in typography, and he produced book and magazine covers. He left Germany when Nazi rule was consolidated, and moved to New York in 1938. There he practised as a commercial artist and exhibited in a number of major shows.
Bib.: G. F. Chanzit, *Herbert Bayer and Modernist Design in America*, Ann Arbor, 1987

Bayeux Tapestry

This is the misleading name given to the embroidery, probably executed in an Anglo-Saxon workshop, telling the story of William I's conquest of England in 1066. It is thought that the work was commissioned by Odo, Bishop of Bayeaux and William's half-brother, for his cathedral dedicated in 1077. The narrative begins in 1064, when Harold, sent by Edward the Confessor, sets out to tell William, Duke of Normandy, that he has been named as successor to the English throne. The story is related from a French point of view, and concludes with William's coronation. The main narrative is depicted in the centre band, with intriguing mythological birds and beasts in the two outer bands, comparable to ▷marginalia found in contemporary manuscripts. At the height of the battle the story spills out into the outer bands, with images of decapitated soldiers and horses. The embroidery is over 70 m long and 50 cm high (231 ft × 20 in) and was worked in worsted thread on linen. It was stitched with crewel-work and couching, which keeps all the thread on one side and is therefore more economical than sewing on both sides. Eight colours were used, and there appears to have been little attempt to relate colour to subject, as we find green horses and red trees. Lengths of linen were sewn together to make the embroidery, suggesting that many people, probably women, worked on the piece simultaneously although it is unclear who oversaw the design and execution.

Bayeu y Subías, Francisco (1734–95)

Spanish painter. In 1777 he became director of the royal tapestry works, and he produced many ▷cartoons for tapestries. He was court painter of Charles IV from 1788, and he worked under ▷Mengs to help decorate the Royal Palace in Madrid. He also painted portraits, and was the teacher of his brother-in-law, ▷Goya.

Bazaine, Jean (1904–75)

French artist. Born in Paris, he initially studied sculpture at the ▷École des Beaux-Arts, before abandoning it for painting in 1924 at the ▷Académie Julian. He exhibited at the ▷Salon d'Automne in 1931. In 1937 he joined the predominantly Catholic 'Témoignage' group of artists, who proposed to reinvest art with the spirituality they believed it had lost. In 1941 he helped organize the exhibition *Jeunes Peintures de la Tradition Française* which sought to re-establish an identity for French art at the time of the German occupation. For Bazaine, who believed in the immanence of God, the true task of the painter was to draw out the rhythms which informed man and nature, since 'art has always been man and the world together'. Starting from nature, Bazaine attempted to find an equivalence rather than an appearance of the real, by combining a ▷Cubist armature that establishes the rhythm of the composition, with a ▷Fauvist sense of colour. From his early semi-figurative paintings heavily indebted to Cubism, his work became progressively less figurative until by 1947 his natural objects are unrecognizable. Bazaine denied that his paintings were 'abstract', by which he meant unconnected to the real. He designed stained-glass windows for Assy (1944–6), a ▷ceramic ▷mural for the church at Ardincourt (1948–51), a ▷mosaic for the UNESCO building in Paris (1958), and stained-glass windows for Saint-Severin, Paris (1964–9). Exhibitions in Paris between 1947 and 1954 won him an international reputation which was enhanced by his inclusion in *The New Decade* exhibition at the Museum of Modern Art, New York in 1955, and a retrospective at the Kunsthalle, Berne, in 1958. In 1964 he won the Grand Prix National des Arts.
Bib.: *Bazaine, exposition retrospective*, exh. cat., Rouen, 1977; Maeght, A., *Bazaine*, Paris, 1953

Bazille, (Jean)-Frédéric (1841–70)

French painter associated with the ▷Impressionists. He was born into a wealthy family in Montpellier. After beginning a medical career in Paris (1862), he began to study painting part-time with ▷Gleyre where he met ▷Renoir, with whom he shared a studio. ▷Monet and ▷Sisley. Through th

▷Manet, and he worked with the ▷Impressionists at Honfleur in 1864. He also painted at ▷Barbizon in 1863. He gave up medicine in 1865 and shared a studio with Monet. His career was cut short by the Franco-Prussian war in which he fought and died. He was interested in ▷*plein air* painting, but of figures rather than pure landscape, and his work is of interest for its exploration of the effects of light on flesh tones (e.g. *Family on the Terrace*, 1867, Paris, Musée d'Orsay). Much of his work retained a high finish and dark palette (e.g. *Negro Woman and Peonies*, 1870, Montpellier Musée Fabre). He was also a portraitist and recorder of the Impressionist scene (e.g. *Studio in the Rue de la Condamini*, 1870, Paris, Musée d'Orsay).

Bib.: Bajou-Charpentreau, V., *Frédéric Bazille 1841–70*, Aix-en-Provence, 1993; *Bazille et ses amis impressionistes*, exh. cat., Montpellier, 1993

Baziotes, William (1912–63)

American painter. He was born in Pittsburgh and studied at the ▷National Academy of Design in New York. During the 1930s, he contributed realist murals to the ▷Federal Art Project, but by 1942 he was moving towards a more abstract ▷Surrealist style. Influenced by ▷Miró, his ▷biomorphic abstract works used ▷automatist methods, but they were also related to the experiments of the ▷Abstract Expressionists.

Bazzi, Giovanni Antonio

▷Sodoma, Il

bead-and-reel

In Classical architecture, the characteristic decoration of an astragal (a small moulding of semi-circular profile). The beads vary from barrel-shaped, to spherical or elongated-pointed, and the reels may be rounded or pointed in section – yet the arrangement is always identifiable as one of longer bead and shorter reel motifs alternated in a band.

Beale, Mary (1633–99) and Charles (b 1660)

English family of painters. Mary Beale was a friend of ▷Lely and painted works in a style similar to his. By 1654 she was practising as a professional artist and she gained great acclaim in court circles. When Lely died, she made a good income copying his works. Her son Charles was a ▷miniature painter.

Bib.: Walsh, E., and R. Jeffree, *The Excellent Mrs Mary Beale*, exh. cat. London, 1975

Beardsley, Aubrey Vincent (1872–98)

~~lish~~ draughtsman and illustrator. Along with Oscar ~~has~~ come to typify the ▷*fin-de-siècle* deca- ~~1~~890s. He was born in Brighton and ~~nce~~ clerk until ▷Burne-Jones ~~e~~ an artist in 1891. He

studied at Westminster Art School, but his big break came when he illustrated Dent's edition of the *Morte d'Arthur* (1893) with over 500 drawings in a style heavily influenced by Burne-Jones. He moved on to work for the newly-established *Studio* in 1893, increasingly influenced by the fashion for Japanese art. His association with Wilde produced the *Salome* illustrations in 1894, and he became art editor of the ▷ *Yellow Book* the following year, only to be forced to resign because of the Wilde scandal. In 1896 Arthur Symons employed him on the *Savoy*, another of the ▷Art Nouveau-inspired magazines which published Beardsley's *Rape of the Lock* illustrations and also excerpts of his own writings, *Under the Hill*. This later work was more flamboyant and intricate, showing an interest in 18th-century French design. He died of tuberculosis in Menton, having retired to the south of France because of his health.

Bib.: Benkovitz, M.J., *Aubrey Beardsley*, New York, 1981; Brophy, B., *Beardsley and his World*, London, 1976; Reid, A., *Beardsley*, New York, 1991; Snodgrass, C., *Aubrey Beardsley, Dandy of the Grotesque*, Oxford, 1995; Zatlin, G., *Beardsley and Victorian Sexual Politics*, Oxford, 1990

Beata Beatrix

Painted by ▷Dante Gabriel Rossetti c1864 (oil on canvas, 85 × 65 cm (33 × 25 in)). The work was begun as a portrait of his wife ▷Elizabeth Siddal, but abandoned and only completed after her death. In it she is shown as Dante's love ▷Beatrice, at the moment of death, caught in a trance-like state between heaven and earth. She stands on a balcony, holding out her hands, into which a heavenly bird drops a poppy. A sundial shows the time as 9 a.m. Behind her Florence is identifiable by the Ponte Vecchio and the figures of Dante himself and an angel represent the transition Beatrice is making. The whole work glows with a richness but softness of colour unusual on Rossetti's oils: Siddal's hair is a flame red, emphasized by the warm sunlight flooding the background. This was one of a number of works in which Rossetti associated himself with Dante and Dante's life (e.g. *Dante on the First Anniversary of Beatrice's Death*, watercolour, 1853, Oxford, Ashmolean Museum). It was one of the first oils he painted after having earlier abandoned the medium on the break-up of the ▷Pre-Raphaelite Brotherhood, and also marked the beginning of a large number of idealized images of women which became Rossetti's main preoccupation in the last years of his life. He painted several versions of this same scene. The painting is in the Tate Gallery, London.

Beatrice

The woman loved by Dante (1265–1321), whose death in 1290 at the age of 24 inspired the writing of the *Vita Nuova* (*New Life*), a series of love poems in which Dante explores his love for her and his grief at her

death. In the 19th century the ▷Pre-Raphaelite poet and artist, ▷Dante Gabriel Rossetti, identified himself and his love for his own short-lived wife, ▷Elizabeth Siddal, with the love between Dante and Beatrice. Rossetti not only translated the *Vita Nuova* into English, but also executed a whole series of ▷water-colours and drawings illustrating the main events of the love story (e.g. *Dante Drawing an Angel on the Anniversary of the Death of Beatrice*, watercolour, 1853, Oxford, Ashmolean Museum). In ▷*Beata Beatrix* (dated 1864, London, Tate Gallery) he depicts Siddal as Beatrice, in a state of blissful heavenly contemplation.

Beatrice also features in Dante's *Divine Comedy*. Towards the end of the second book, *Purgatorio*, Dante meets Beatrice who replaces Virgil as Dante's guide through Paradise in the final book, *Paradiso*. A number of artists have illustrated the *Divine Comedy*, including ▷John Flaxman (1802) and ▷Gustave Doré (1860s). The 15th-century Sienese painter, ▷Giovanni di Paolo produced a sumptuous illustrated edition of the *Paradiso* (see J. Pope-Hennessy (ed.), *Paradiso*, New York, 1993).

Beaumont, Sir George Howland (1753–1827)

British patron and amateur landscapist. He was born at Dunmow, Essex, succeeded to his baronetcy in 1762 and inherited the Coleorton estate (Lancashire). He studied landscape under ▷Alexander Cozens and was friends with most of the leading artists and writers of the day, including ▷Constable, ▷Haydon, ▷Wilkie, Byron, Scott and Wordsworth. From 1800, together with ▷Dance, he rebuilt Coleorton. He collected English 18th-century painting, particularly the work of ▷Wilson and ▷Girtin and was instrumental in promoting contemporary artists like ▷Landseer and ▷Gibson. He also helped to establish the ▷National Gallery in London, giving 16 of his own collection in 1826. He admired ▷Claude, carrying *Hagar and the Angel* about with him, but his own work was in a mediocre ▷picturesque vein (e.g. *Peel Castle in a Storm*, 1806, private collection). He exhibited ▷Wilsonesque oils at the ▷RA (1779, 1794–1825) and possibly received lessons from Wilson.

Bib.: Greaves, M., *Sir George Beaumont: Regency Patron*, London, 1966; *Noble and Patriotic, the Beaumont Gift*, exh. cat., London, 1988; Owen, F., *Collector of Genius, Life of Sir George Beaumont*, New Haven and London, 1988

Beauvais

One of the most important French ▷tapestry works. It was founded in 1664 by Louis XIV. In the 18th century it specialized in lavish tapestries with *commedia dell'arte* designs and elaborate ▷chinoiserie. It was independent until 1940, when it became part of ▷Go-belins tapestry manufacturers.

Bib.: Goubert, P., *Beauvais et le Beauvaisis de 1600 à 1730*, 2 vols, Paris, 1960

Beaux-Arts, École des

▷École des Beaux-Arts

Beccafumi, Domenico (c1486–1551)

Italian painter. He was the leading Sienese painter of the 16th century and a principal exponent of *maniera* (▷mannerism). He was in Rome 1510–12, where he saw and was influenced by the works of ▷Raphael, ▷Michelangelo and ▷Fra Bartolommeo, whose influence can be seen in the early *Stigmata of St. Catherine with SS Benedict and Jerome* (c1514, Siena, Pinacoteca). Soon after his return to Siena in c1513, his own very individual style asserted itself, characterized by Manneristic figural distortion, extreme ▷contrapposto, exaggerated perspectival effects and sometimes strident colour combinations, all harnessed to produce works of emotional and spiritual intensity. In paintings like *St. Michael Expelling the Rebel Angels* (c1526–30, Siena, S. Nicolò al Carmine) and *The Decent of Christ into Limbo* (c1530–35, Siena, Pinacoteca) he shows himself a master of ▷ch-iaroscuro, and in his decorative scheme for the Sala della Concistoro in the Palazzo Pubblico (1529–35) a virtuoso draughtsman, capable of maintaining pictorial clarity whilst rendering both figures and architectural settings in extreme foreshortening. Beccafumi also worked as a sculptor, modelling the eight bronze angels with candelabra (1548–50) in the ▷presbytery of Siena Cathedral.

Bib.: Briganti, G., *L'opera completa del Beccafumi*, Milan, 1977; *Domenico Beccafumi e il suo tempo*, exh. cat., Milan, 1990

Becker, Paula

▷Modersohn-Becker, Paula

Beckford, William (1760–1844)

English collector and writer. He was born in London, the only son of the Lord Mayor, and in 1770 inherited a fortune which enabled him to indulge his extravagant and often fantastic tastes for much of his life. He studied architecture with ▷Chambers and landscape with ▷Alexander Cozens, both leading members of their fields (as well as taking piano lessons from Mozart). With Cozens he made a ▷Grand Tour to Italy in 1782. A scandal over his friendship with a young man led to his self-enforced exile in 1785. On his return to England, Wyatt designed the ▷Gothic fantasy of Fonthill Abbey for him (1796–1807), employing a central octagonal tower (now destroyed). Beckford himself designed the smaller scale (necessitated by his reduced circumstances) Landsdowne Tower in Bath in 1826. He was also the author of *Vathek*, a Gothic novel.

Bib.: Fothergill, B., *Beckford of Fonthill*, London, 1979; Jack, M., *William Beckford, An English Fida* York, 1992

Beckmann, Max (1884–1950)

German painter and printmaker. He was associated with the ▷Neue Sachlichkeit. Beckmann trained in Berlin and Frankfurt. After serving in the medical corps during the First World War he suffered a nervous breakdown and returned to Frankfurt where he taught at the Art School (1915–33) until being dismissed by the Nazi regime. He moved to Amsterdam in 1937 and settled in the United States after the war (1947). His early work was influenced by ▷Gothic art (e.g. *Young Men by the Sea*, 1906, Weimar, Schlossmuseum), but he is perhaps best known for his hellish, distorted

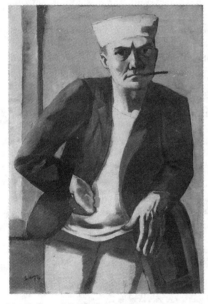

Max Beckmann, *Self portrait*, 1926

▷Expressionist work of 1917–18 (e.g. *Self Portrait with Red Scarf*, 1917, Stuttgart, Staatsgalerie; *Night*, 1918, Düsseldorf, Kunstmuseum). This led on to his Neue Sachlichkeit realism in the early 1920s and to an increasingly satirical style, using strong colours and simplified images (e.g. *Circus Caravan*, 1940, Frankfurt, Städelsches Kunstinstitut). He produced a variety of work, including landscape and still life and was familiar with ▷Cubist ideas, using a limited palette and strong tonal contrasts (e.g. *Still Life with Large Fish*, 1927, Hamburg, Kunsthalle). In his later career he used heavily outlined and bulbous figures, reminiscent of ▷Matisse (e.g. *Olympia*, 1946, St. Louis, M. D. May Collection). A strong religious element ran through ʰh of his work (*Temptation Triptych* 1936–7, ᴮayerisches Staatgemäldesammlungen).

ᴴ., *Beckmann: Tradition as Problem in* ᵏ, 1989; Fischer, F.W., *Beckmann*, ᵇmann, exh. cat., Munich, ᵇe 1907–50, exh. cat.

Stuttgart, 1994; Selz, P., *Max Beckmann Self-Portraits*, New York, 1991

Beechey, Sir William (1753–1839)

English painter. He attended the ▷Royal Academy schools in 1772 and became a Royal Academician in 1798, at which time he was also knighted. He was known primarily for his portraits and became portrait painter to Queen Charlotte in 1793. He was particularly adept at group portraits of children, and he worked extensively for the royal family. ▷Hoppner was his principal rival.

Beerbohm, Sir Max (1872–1956)

English satirist and caricaturist. He was known as the 'incomparable Max'. After studying at Charterhouse and Merton College, Oxford, he began producing ▷caricature drawings for magazines in the 1890s (e.g. the *Strand* from 1892, the ▷*Yellow Book* from 1894), and was part of the decadent scene which included Oscar Wilde and ▷Beardsley. This led to his first book, *Caricatures of 25 Gentlemen* in 1896. He was also an energetic member of the art world: in 1909 he became a member of the ▷New English Art Club, and in 1911 he helped to establish the National Portrait Society. From 1910 he made his home in Rapallo, Italy. He was knighted in 1929. Some of his most famous caricatures include *Poets Corner* (1904) and *Rossetti and his Circle* (1922). He was also an essayist, and wrote the comic novel *Zuleika Dobson* (1911). **Bib.**: Cecil, M., *Max*, London, 1964

Beerstraten, Anthonie (fl 1639–65) and Jan Abrahamsz. (1627–66)

Flemish family of painters. Both artists produced landscapes. Anthonie was known especially for his winter scenes, and Jan produced view pictures of Amsterdam and imaginary landscape scenes.

Beethoven Frieze

Produced by ▷Gustav Klimt in 1902, as part of the 14th ▷Secessionist Exhibition in Vienna (▷casein paint and semi-precious stones on plaster, 2.2 × 13.8 m/7 ft 3 in × 45 ft 6 in). The work was intended as an accompaniment to the centrepiece of the show, ▷Klinger's sculpture of Beethoven, and Klimt took his inspiration from the composer's Ninth Symphony, containing the *Ode to Joy*. The piece consists of three sections, each displayed on a different wall. *The Yearning for Happiness* shows three nude figures, representing the sufferings of humanity, pleading before a knight, resplendent in gold armour. Behind the knight stand two figures symbolizing compassion and ambition. The second section depicts the *Hostile Powers*: three gorgons with gold snakes in their hair, an ape-like monster and the figures of Sickness, Mania and Death. To the right are three entwined figures representing Unchastity, Debauchery and Excess, whilst still further

to the right stands the isolated, contoured figure of Grief. Much of the right hand side of the panel is given over to a swirling, snake-like background showing the abstracted desires of mankind. The last panel depicts *Solace in Poetry*, in which the symbolic figures of the arts point the way towards a heavenly choir and the central *Kiss for the Whole World*. It is in this section which Klimt explores his love of pattern and decorative line: the whole image is dominated by the use of gold, which is treated sparingly throughout the rest of the work, and the heavenly choir stand on a flattened carpet of flowers. The work was highly influential throughout the rest of the artist's career: he repeated the idea of the decorative frieze at the Stoclet House, reworked the Kiss several times and individual figures with their strong, flattened profiles and curvilinear silhouettes can also be traced in his later work. Equally, the Beethoven Frieze exemplifies the early phase of the ▷Art Nouveau style with its use of symbolism and mythology, its elevation of the arts, the use of organic decoration, and the integration of art and design. The work is now in the Österreichische Galerie in Vienna. **Bib.**: Bouillon, J.-P., *Klimt: Beethoven*, Geneva, 1987

Bega, Cornelis (1620–64)

Dutch painter. He was a pupil of ▷Ostade and produced ▷genre scenes.

Beggarstaff Brothers

A pseudonym used by two British artists, ▷William Nicholson and his brother-in-law ▷James Pryde. They produced posters 1893–c1898.

Beham, Hans Sebald (1500–50) and Bart(h)el (1502–40)

German family of engravers. They were brothers from Nuremberg, who were associated with the ideas of the Protestant ▷Reformation. They were expelled from Nuremberg for their beliefs in 1525. Under the influence of ▷Dürer they produced ▷engravings of scenes from the Bible. Hans, the more prolific of the two, practised in Frankfurt and Bartel in Bavaria.

beholder

Literally, the observer of a work of art. The 'beholder' has become an important subject of art theory since the 1970s, particularly in the wake of ▷reception aesthetics. The work of art and the artist have lost their prominence in interpretations of art works, and the perception of the beholder has become central to any consideration of meaning in a work of art. The biases of the beholder and the beholder's cultural and ▷gender make-up are seen to influence the way he or she looks at a work of art. This, in turn, helps shape contemporary and subsequent interpretations of that work. Art historians have also proposed that there is such a thing as a 'period eye' in which a particular way of looking at art prevails at different points in history.

Bib.: Frangenberg, T., *Der Betrachter: Studien zur florentinischen Kunstliteratur des 16. Janrhunderts*, Berlin, 1990; Fried, M., *Absorption and Theatricality: Painting and Beholder in the Age of Diderot*, Berkeley, 1980; Holub, R.C., *Reception Theory: A Critical Introduction*, London, 1984

Behrens, Peter (1846–1940)

German architect, designer and painter. He was associated with the ▷Deutscher Werkbund. He began his career as a painter, but became interested in design at Darmstadt in 1899, inspired by ▷van de Velde and ▷Olbrich. He was one of the first architects to realize the possibilities afforded by industrial design: in 1907, he co-founded the Deutscher Werkbund, and in 1907–12 he was the chief designer for the electrical firm

Peter Behrens, Deutscher Werkbund-Ausstellung, poster, 1914, Victoria and Albert Museum, London

AEG responsible for every aspect of design from buildings to packaging. Whilst working for them, he conceived the famous Berlin Turbine Factory which became a landmark in ▷modernist industrial architecture. Behrens also produced domestic architecture, originally in an ▷Arts and Crafts style, influenced by ▷Voysey, and later working on clean modernist lines (e.g. his 1926 house at Northampton). He was also a leading administrator: he was Director of the Düsseldorf Art School (1903–7); Director of the Vienna Academy (1922) and Director of the Prussian Academy of Art, Berlin (1936).

Bib.: Moeller, G., *Peter Behrens in Düsseldorf* Weinheim, 1991; Windsor, A., *Peter Beh~* *and Designer*, London, 19⁸¹

Beijeren, Abraham Hendricsz. van
▷Beyeren, Abraham Henricsz. van

belfry
Specifically, the upper room of a church tower in which the bells are hung, although in a more general sense the term is often taken to mean the bell tower itself, either attached to a church or standing as a discrete structure. The term derives from the Old French, *berfrei*, meaning tower, specifically the sort of movable wooden tower used as a siege machine.

Belgian and Flemish art
The country now known as Belgium was not independent until 1831, but during many centuries of boundary changes and foreign domination, the arts flourished in this region of Europe. Under the Burgundian Duke, Philip the Bold (1342–1404), art in this part of the Low Countries absorbed the ▷International Gothic style in the work of ▷Broederlam and ▷Sluter. In 1419 Philip the Good moved the Burgundian court from Dijon to Bruges, and there a new naturalistic form of religious art with a complex ▷iconography was developed. ▷van Eyck, ▷Weyden, ▷Memling and ▷Bouts all contributed to this, as well as to the development of free-standing portrait painting. Flemish art of this period developed quite differently from its Italian counterpart, where idealism and experiments with ▷perspective were adopted instead of detailed observationalism. However, because of trade connections between Flanders and Italy, many Flemish works were exported to Italy and influenced art there. Flemish architecture in the 15th century was dominated by the Brabant stone which can be seen especially at Antwerp Cathedral (1352–1411).

Sixteenth-century Flemish artists travelled more frequently to Italy, and they brought ▷Renaissance architectural and artistic styles back with them. Public buildings such as Antwerp Town Hall (1561–6) contained Classical motifs. Landscape painting was especially varied during this time, ranging from the lurid colours of ▷Patenier's panoramic views to the quiet night scenes of ▷Elsheimer. An even greater naturalism in portrait painting and religious painting was developed by ▷Massys, who carried on the experiments of his 15th-century predecessors.

In the 17th century, ▷Rubens' presence in Antwerp fostered a new style in religious painting, as Flanders remained Catholic in the wake of the greater Calvinist trends in the more northern part of the Low Countries. However, secular ▷genre painting also flourished with ⸱ of ▷David Teniers. The 18th century was not ⸱⸱d period for art in the region that was to ⸱ many of its best artists left the ⸱⸱r independence, Belgium ⸱ centre for modern ⸱⸱ flourished

in Brussels with the work of ▷Victor Horta, while ▷Meunier and the artists of ▷Les Vingt perpetuated the relationship between representation and socialist ideology. Distinctive individualists such as ▷Ensor also practised in Belgium at the time, and Belgium was the first home of the odd ▷Symbolist group, ▷Rose + Croix.

Belgian art in the 20th century has had sporadic international success. The ▷Surrealist work of ▷Magritte and ▷Delvaux, the ▷Expressionism of ▷Permeke and the ▷Laethem-Saint-Martin groups, as well as the ▷Abstract Expressionism of the ▷Jeune Peinture Belge group after the Second World War bear witness to Belgium's contribution to modern art movements.

▷Flemish art

Bib.: Borsi, F., *Bruxelles, capitale de l'art nouveau*, Brussels, 1971; Gerson, H., *Art and Architecture in Belgium, 1600 to 1800*, Harmondsworth, 1960; Herbert, E., *The Artist and Social Reform: France and Belgium 1885–1898*, New Haven, 1961

Bell, (Arthur Howard) Clive (1881–1964)
English writer on art. He was born in Berkshire and studied at Trinity College. In 1902 he visited Paris, where he discovered the work of the ▷Post-Impressionists and formulated many of his ideas. Along with ▷Fry he promoted the Post-Impressionist exhibition of 1910. He developed the idea of ▷significant form, which emphasized the aesthetic role and primacy of form and promoted the autonomy of art. For him this was exemplified by the work of ▷Cézanne. He married ▷Vanessa Bell in 1907, and was associated with the ▷Bloomsbury Group. His writings include *Art* (1914), *Civilisation* (1928), and *Landmarks in Nineteenth Century French Painting* (1927).

Bib.: Bell, Q., *Bloomsbury*, London, 1968; Rosenblaum, S.R., *Bloomsbury Group*, London, 1975

Bell, Graham (1900–43)
British painter of South African birth. He was associated with the ▷Euston Road School.

Bell, Larry (b 1939)
American sculptor. He specializes in ▷Minimalist sculpture made of glass and plastic. Using different types of glass and glass panels, he has produced sculptural tubes and cubes that are meant to be walked around.

Bell, Vanessa (1879–1961)
English painter and designer. She was educated at the ▷Royal Academy schools, 1901–4, under ▷Sargent, having first studied with Arthur Cope. Having visited France and married ▷Clive Bell in 1907, she became interested in ▷Post-Impressionism, contributing to the 1912 exhibition. She was a member of the ▷London Group (1919), and from 1913 she played a

major role in the ▷Omega workshops (as co-director until 1919). She was a member of the ▷Bloomsbury Group – one of the original organizers of the Friday Club (1905) from which it grew. Her work was influenced by ▷Matisse and she adopted flat colours and heavy outlines to create stylized pieces (e.g. *Studland Bay*, 1912–13, London, Tate). In 1914–15 she briefly

Duncan Grant, *Portrait of Vanessa Bell*, 1919

experimented with abstraction (e.g. *Abstract Painting*, 1914, London, Tate), but returned to representational work with portraits and interiors (e.g. *Interior*, 1939, Birkenhead). From the 1920s she concentrated increasingly on design, collaborating with ▷Duncan Grant, with whom she lived at Charleston, Sussex and working for Walton Textiles and Brain and Co. Tableware (1933/4). In 1940–3 she produced murals for Berwick Church, Sussex.
Bib.: Caws, M.A., *The Women of Bloomsbury*, New York, 1990; Shone, R., *Bloomsbury Portraits*, Oxford, 1976; Spalding, F., *Vanessa Bell*, London, 1983

Bellange, Jacques (fl 1600–17)

French painter and etcher. He worked in Lorraine and developed a ▷Mannerist style similar to that of ▷Parmigianino and the ▷Fontainebleau school. His paintings now exist only in engraved copies.

Bellechose, Henri (d 1440/4)

Flemish painter. He was from Brabant and acted as court painter in Dijon during 1415–25. He followed ▷ Malouel in this role and may have completed an ▷altarpiece begun by his predecessor.

Bellegambe, Jean (c1470/80–c1535)

Netherlandish painter. He was from Douai, which was then part of the Spanish Netherlands. He produced ▷altarpieces which revealed a combination of French and Flemish influences.

Bellini, Jacopo (c1400–c1470), Gentile (c1429–1507) and Giovanni (c1430–1516)

Italian family of painters. They were from Venice. Although the birthdates of Jacopo's two sons, Gentile and Giovanni, are not certainly known, it is generally assumed that Gentile was the elder as it was he who took over the workshop on the death of his father.

Jacopo was trained by ▷Gentile da Fabriano. Unfortunately, most of his major works have been lost, only four signed paintings remaining. In 1441 he successfully competed against ▷Pisanello for the commission to paint a portrait of Lionello d'Este, but this too is lost. Jacopo's style is rooted in the ▷International Gothic, as practised by his master, Gentile, but he also displays a new austerity and a feeling for volume which reflects his contact with the ▷Renaissance art of Tuscany (e.g. *Madonna and Child*, Lovere, Gallerie Tardini). The greater part of his surviving work is to be found in the two important sketchbooks in the British Museum and the Louvre, many of the ideas and designs in which were later used in the paintings of his two sons, Gentile and Giovanni, and of his son-in-law ▷Andrea Mantegna. The drawings in these books reveal a rich mixture of closely observed naturalistic detail, bizarre fantasy and rigorous experiments with perspectival construction (e.g. *A Warrior Presents Hannibal's Head to Prusias*, Paris, Louvre). Like his contemporary ▷Antonio Vivarini, Jacopo Bellini is generally regarded as a transitional artist, poised between the Venetian ▷Gothic of the earlier part of the century and the ▷Renaissance developments introduced by his son-in-law, Andrea Mantegna, and his younger son, Giovanni Bellini.

Following Jacopo's death, Gentile took over as head of the workshop. He soon achieved international recognition as an independent master, receiving a knighthood from Emperor Frederick III in 1469. In 1479–81, he was in Constantinople, painting erotic harem scenes (now lost) and portraits for the Sultan (e.g. *The Sultan Mehmet II*, 1480, London, National Gallery). Before and after his trip, beginning in 1474, he was in Venice engaged in painting a great cycle of ▷history paintings in the Doge's Palace, all of which were destroyed in a fire in 1577. The lost paintings were probably similar to the large-scale narrative painting, *Procession in Piazza San Marco* (1496, Venice, Accademia), resplendently colourful, packed with incidental details and recognizable portraits and set in topographically accurate Venetian locations. Gentile's narrative paintings, provided the standard type for a genre that was to become a speciality in Venice. On his father's death he had inherited his sketchbooks, the

importance of which can be gauged from the fact that on his own death Gentile bequeathed them to his younger brother only on condition that Giovanni complete Gentile's unfinished *St. Mark Preaching at Alexandria* (1504–7, Milan, Brera).

Giovanni is by far the most important member of the family, influenced initially by his father Jacopo, and his brother-in-law Mantegna, but himself influencing not only his own generation, but most of the next generation of Venetian painters. He is generally considered to have initiated the greatest period of Venetian painting in which Venice rivalled contemporary Rome as a centre of art production. Amongst the most important of Giovanni's pupils were ▷Giorgione, ▷Titian, ▷Palma Vecchio and ▷Sebastiano del Piombo – all of whom he influenced profoundly. Although Giovanni worked in the family workshop until his father's death, he seems also to have been working as an independent master from much earlier. Nonetheless even after Jacopo's death, Giovanni maintained his connections with the family workshop for, when Gentile went to Constantinople in 1479–81, Giovanni took over his brother's work on the history paintings in the Doge's Palace.

Giovanni's early work is linear, the forms hard-edged and sculptural in a manner similar to that of Mantegna, though certainly by c1460 Giovanni's own manner was establishing itself. This difference may be seen clearly in the paintings Mantegna (c1455) and Giovanni (c1460) derived from the same drawing from Jacopo's sketchbook in the British Museum, *The Agony in the Garden* (both paintings London, National Gallery): Giovanni's figures are still brittle-looking, but his landscape is by now more expansive, atmospheric and, above all, suffused with light. In the later 1470s the influence of ▷Antonello da Messina (in Venice 1475–6) becomes apparent. Like Antonello, Giovanni began to use oil paint, the freedom that a slow-drying ▷medium allowed him accelerating the development of a non-linear ▷painterly style in which forms are described in colour and light. He excelled most of all in paintings of the ▷Madonna and Child, on which theme he produced abundant subtle variations, catering for commissions ranging from small panels for private devotion to major ▷sacra conversazione, such as the *San Zaccaria Altarpiece* (1505, Venice, San Zaccaria). He was a fine portraitist, the *Doge Leonardo Loredan* (c1501, London, National Gallery), being remarkable for its characterization as well as the virtuoso rendering of the texture of the Doge's costume. Giovanni also painted mythologies, such as the *Feast of the Gods* for the Duke of Ferrara (1514, Washington, National Gallery) although in this work as it exists today, the landscape has been repainted by Titian to make it harmonize with his own canvases which completed the Duke's series. Even into old age and in competition against the richest field Venice had ever produced, Giovanni maintained supremacy in his

art, ▷Dürer writing the famous eulogy on him in 1506, 'He is very old, but still the best in painting.'
Bib.: Degenhart, B., *Jacopo Bellini: The Louvre Album of Drawings*, New York, 1984; Eisler, C.T., *The Genius of Jacopo Bellini*, New York, 1989; Goffen, R., *Giovanni Bellini*, New Haven and London, 1989; Meyer, J., *Zur Capellen Gentile Bellini*, Stuttgart, 1985; Olivari, M., *Giovanni Bellini*, Florence, 1990; Robertson, G., *Giovanni Bellini*, New York, 1981; Tempestini, A., *Giovanni Bellini: catalogue complet des peintures*, Paris, 1992

Bellmer, Hans (1902–75)

French artist of Polish birth. He was trained at the Berlin Technical School of Art from 1923. He became interested in ▷Surrealism after a move to Paris in 1938, and he developed the Surrealist interest in eroticism through his doll series. These jointed dolls were posed in various suggestive or violent postures and then photographed to create fetishistic and pornographic images. After the Second World War, Bellmer turned to ▷etching.

Bellori, Giovanni Pietro (1615–96)

Italian writer, collector and antiquarian. He is chiefly remembered for his *Vite de' pittori, scultori et architetti moderni*, published in 1672. In the preparation of his book, the basic source for the lives and works of the artists of the ▷Baroque period in Italy, Bellori was assisted by his friend ▷Poussin. In the preface, taken from a lecture given at the Academy of St. Luke in Rome in 1664, Bellori expounded the rational Platonist (▷Neoplatonism) concept of art upon which the Academy based its theories and practice. Artists must strive towards the ▷ideal, selecting the best of the moderns: ▷Raphael, ▷Annibale Carraccci and ▷Poussin. The influence exerted by Bellori's preface was enormous: it was used as the model for later academic theory, particularly that of the French and ▷English Royal Academies and was later adopted by ▷Winckelmann as the basis for his ▷Neoclassicism.

Bellotto, Bernardo (1721–80)

Italian painter. He was from Venice and the nephew and pupil of ▷Canaletto. He was known for his townscapes (▷vedute). He is listed in the *fraglia* (Venetian painters' guild) from 1738 to 1743, by which latter date he had established his reputation. In 1747 he left Venice for Dresden and there in 1748 was appointed court painter to Frederick Augustus II of Saxony; in c1758 he was at Vienna working for Empress Maria Theresa; in 1761 he was working in Munich, after which he returned for a while to Dresden, before moving in 1767 to Warsaw to work for King Stanislas Poniatowski, staying there for the remainder of his life. Outside of Italy he seems to have called himself, or allowed himself to be called, Canaletto (presumably to exploit his more famous uncle's reputation), a fact which has caused considerable confusion given the

close similarity between Bellotto's early style (up to his departure from Italy in 1747) and that of his uncle. His later style is characterized by a cooler palette, more intense shadows, and an interest in the naturalistic depiction of cloudy skies which relates more closely to the Dutch school of painting. Most of his best work is naturally in Dresden and Warsaw and his pictures were considered to be so topographically faithful that they were used as guides for the rebuilding of the latter city after its devastation in the Second World War.
Bib.: Bowron, E.P., 'A Venetian Abroad: Bellotto and the Most Beautiful Views of Rome', *Apollo* 140 (Sept 1984), pp. 26–32; Rizzi, A., *Bernardo Bellotto warschauer Verduten*, Munich, 1991

Bellows, George Wesley (1882–1925)
American painter. A pupil of ▷Henri, he never exhibited with ▷The Eight, but adopted their focus on contemporary urban scenes. Bellows was particularly interested in representing crowded urban streets and the daily life of the working classes. His various scenes of prize fights, such as the illegal boxing match in *Stag at Sharkey's* (1907; Cleveland, Museum of Art) were among his most famous works. Unlike most artists of the ▷Ashcan school, Bellows' style was a modified form of ▷Impressionism.
Bib.: *The Paintings of George Bellows*, exh. cat., Los Angeles, 1992

Belshazzar's Feast
(Daniel 5: 1–28) Belshazzar, the king of Babylon, held a great feast, using the gold and silver vessels his father Nebuchadnezzar had looted from the temple at Jerusalem. The king and his company of princes, wives, concubines and courtiers toasted the gods of gold, silver, brass, iron, wood and stone. As they drank a mysterious hand appeared and wrote upon the wall of the palace: '*Mene, Mene, Tekel, Upharsin.*' The King was terrified by the apparition, but neither he nor any of his wise men could interpret the writing. The queen advised the king to have the Hebrew slave, ▷Daniel, brought before them as he had the power to interpret dreams and visions. Daniel was brought forward, censured Belshazzar and his court for committing sacrilege and praising false gods with the religious vessels from the Jewish temple, and revealed that the writing meant that the days of his kingdom were numbered, that he had been weighed in the balance and found wanting, and that his lands would be conquered by the Medes and Persians. That same night Belshazzar was assassinated and Darius the Median took the kingdom. ▷Rembrandt (c1636–8) London, National Gallery) shows the moment that Belshazzar sees the apparition. The picture is an opportunity to create drama with bold ▷chiaroscuro, and to reveal the full virtuoso range of material effects – gold, silver, fur, skin, silk, velvet, etc. – possible with oil paint.

Beltraffio, Giovanni Antonio
▷Boltraffio, Giovanni Antonio

belvedere
▷gazebo

Belvedere Torso
Marble fragment, formerly in the Belvedere Courtyard in the Vatican from whence it takes its name, but housed in the main body of the museum since the 18th century. The heavy muscularity of the torso and the animal skin upon which it is seated suggest that the completed statue represented ▷Hercules. An inscription on the fragment states that the sculptor was the otherwise unknown 'Apollonius, son of Nestor, Athenian'. Whether it is an original late ▷Hellenistic sculpture or a later Roman copy has not been established. The date of its rediscovery is not known although it is recorded in the collection of Cardinal Colonna in Rome in the 1430s and was in the Belvedere statue court by the early 16th century. Like many of the most celebrated antiquities from the collection, it was ceded to France in 1797 and restituted in 1815. The esteem in which it was held from the 16th to the 19th centuries seems to derive largely from ▷Michelangelo's admiration for it and the belief that he had discovered in it 'a certain principle … which principle gave his works a grandeur of gusto equal to the best antiques'. Its fragmentary state has been linked to Michelangelo's *nonfiniti* (unfinished works), although recent scholarship suggests the more plausible theory that Michelangelo failed to finish so many of his works simply because he was overwhelmed with commissions. Certainly the fragmentary state of the *Torso* has meant that subsequent admiration for it has been largely academic. Consequently copies and casts are more likely to be found in art academies than in private collections. Although never restored (unlike the ▷*Apollo Belvedere* and the ▷*Laocoön*, a number of artists have tried to visualize its completed state (e.g. ▷Flaxman, *Hercules and Hebe*, plaster, 1792, London, Victoria and Albert Museum).
Bib.: Haskell, F., and N. Penny, *Taste and the Antique*, New Haven and London, 1981

Benedetta (Benedetta Cappa) (1897–1977)
Italian painter and writer. She was born in Rome and studied with ▷Balla. In 1917–18 she met ▷Marinetti, whom she married in 1923. Her association with ▷Futurist artists led to her participation in their ▷modernist enthusiasm. She not only produced stage designs for Marinetti's plays, but she also wrote many essays about Futurism and helped popularize the movement.
Bib.: Katz, B., 'The Women of Futurism', *Women's Art Journal*, 7/2 (Fall 1986–Winter 1987), pp 3–13

Benedetto da Maiano (1442–97)

Italian sculptor. He was from Florence, where he matriculated in the sculptors' ▷guild in 1473. He was perhaps taught by ▷Antonio Rossellino, as is suggested by the verism of his early portrait bust *Pietro Mellini* (1474, Florence, Bargello; cf. Rossellino, *Giovanni Chellini*, 1456, London, Victoria and Albert Museum). His masterpiece is generally considered to be his marble pulpit in Sta Croce, Florence (1472–5) with its five narrative ▷relief panels of St. Francis (three ▷terracotta ▷*bozzetti* of which are in London's Victoria and Albert Museum), executed in a style owing much to ▷Donatello and ▷Ghiberti. In this work and in others with architectural elements, Benedetto collaborated with his architect brother Giuliano (1432–90). The brothers also worked together on the important commission for the marble doorway in the Sala dei Gigli in the Palazzo Vecchio, Florence (c1480). The surmounting figure of *St. John the Baptist* has been seen, like other late figures such as the *St. Sebastian* (Florence, Misericordia), as an important influence on the early work of 16th-century Florentine sculptors such as ▷Andrea Sansovino and ▷Michelangelo.
Bib.: Lein, E., *Benedetto da Maiano*, Frankfurt, 1988; Radke, G.M., 'Sources and Composition of Benedetto da Maiano's San Savino Monument in Faenza', *Studies in History of Art*, 18 (1983), pp. 7–27

Benedict (c480–c550)

The founder of Western monasticism. The Benedictine Rule requires constant prayer and study, interspersed with manual work conducted in an atmosphere of chastity and obedience. The only source of information about Benedict's life, Book II of Gregory's *Dialogues* (6th century), attributes to him the gift of second sight, and numerous miracles and acts of exorcism. These episodes form the basis of narrative cycles of his life (the most comprehensive being that by Spinello Aretino, c1387, in the ▷sacristy, San Miniato al Monte, Florence).

Benedict is invariably portrayed as an old man, but may be either clean-shaven or bearded and in either a black or a white monastic habit. He may hold his finger over his lips in allusion to the rule of silence which was imposed in his order. In devotional paintings his most usual identifying attributes are a pastoral staff and mitre (as founding Abbot of Monte Cassino), a rod (for corporal punishment) and an aspergillum or brush (to sprinkle holy water, for example in the act of exorcism). His reforms occasioned jealousy such that there were several attempts to poison him. For example, one priest tried to murder Benedict with contaminated bread; Benedict realized that the bread was poisoned and requested a raven to take the loaf away, so that he may be depicted as accompanied by a raven with a loaf in its beak. Sometimes the loaf alone is represented, in which case it may have a snake emerging from it to represent the poison. A broken wine glass, or a glass containing a serpent, refers to another attempt to assassinate him with poisoned wine, which Benedict foiled by blessing the cup which then shattered, spilling the contents. The glass may sometimes be placed upon a book. A thorn bush refers to his successful attempt to subdue his repressed sexual urges by throwing himself naked into a thorn bush. A broken vessel refers to his miraculous repair of a pot broken by his nurse on a journey to Rome. He is sometimes shown with his sister Scholastica, who founded the first community of Benedictine nuns. She wears a black habit and holds a ▷lily and a ▷crucifix, and may be accompanied by a dove. Sometimes, in representations of Benedict, her presence may be symbolized by the dove alone.

Bengelsdorf, Rosalind (1916–79)

American painter. She trained at the ▷Art Student's League during 1930–34, after which she studied in ▷Hans Hofmann's studio. In 1936–9 she was involved in producing murals for the ▷Federal Art Project. Despite the realist emphasis of her work at this time, she was interested also in ▷abstraction and she was one of the founding members of the ▷American Abstract Artists group in 1936. She called her form of abstraction, 'new realism'. After 1940, she gave up painting for writing.

Benin

▷African art
Bib.: Dark, P., *An Introduction to Benin Art and Technology*, Oxford, 1973

Bening, Alexander (Sanders) (d c1519) and Simon (1483/4–1561)

Members of a Netherlandish family of illustrators. They were father and son. Alexander worked in Ghent and Bruges, and Simon was best known for his manuscript illuminations. Simon has sometimes been conflated with the so-called ▷Master of Mary of Burgundy.

Benjamin, Walter (1892–1940)

German writer. Although his works were appreciated by the ▷Frankfurt School during his lifetime, his importance for art history was only recognized after his death, when his writings became widely known and republished. His most famous text was *The Work of Art in the Age of Mechanical Reproduction*, which was written while he was in Paris. His text praised the possibilities of new technology to create a true mass culture. According to Benjamin, photography and cinema destroyed the importance of the unique work of art and thus 'changed the reaction of the masses towards art'. Collective experience therefore became possible, and art was no longer the privilege of an élite. His tract was an important contribution to the study of ▷modernism's impact on the life of the mass

population. His theories grew from his Communist sympathies, but those same sympathies (as well as his Jewishness) led to despair during the Nazi period. He committed suicide in 1940.
Bib.: Ridless, R., *Ideology and Art: Theories of Mass Culture from Walter Benjamin to Umberto Eco*, New York, 1984

Benois, Alexandre (1870–1960)
Russian painter, theatre designer and art critic. He was born in St. Petersburg and was largely self-taught. In 1899 in St. Petersburg he helped to established the ▷World of Art group, a cosmopolitan opposition to the ▷Wanderers which hoped to end Russian artistic isolation. His friendship with ▷Diaghilev lead to an interest in ballet and in 1909–11 he produced a series of designs (e.g. *Les Sylphides*, *Petrushka* and *Le Pavillion d'Armide*) in which he combined a Russian folk style with a love of French ▷Rococo design. He treated the stage set as a painting, combining all in a unified whole and often using a restricted number of colours. From 1938 he also produced designs for La Scala. He was also an art historian, publishing a *History of Russian Painting* in 1904, and becoming curator of the Hermitage after the Revolution of 1917. In 1928, however, he settled in Paris.
Bib.: *Alexandre Benois*, exh. cat., Florence, 1984

Benson, Ambrosius (d 1550)
Netherlandish painter. He was born in Lombardy but moved to Bruges in 1519. His Italian heritage continued to exert an influence on his style, and he has been called the 'Master of Segovia' because of southern tendencies in his work. While in Bruges, he painted pictures which were sold to Italy and Spain through the vast Flemish export market.
Bib.: G. Marlier, *Ambrosius Benson et la peinture à Bruges au temps de Charles Quint*, Damme, 1957

Bentivoglio, Mirella (b 1922)
Italian sculptor and performance artist. She was born in Austria and studied in Switzerland and England. In the 1940s she wrote poetry and art criticism which formed the basis of the 'concrete poetry' she produced from 1966. This sculptural work focuses on themes of eggs and words. From 1976 she has concentrated on ▷performance art.
Bib.: Pohl, F., 'Language/image/object: The Work of Mirella Bentivoglio', *Women's Art Journal*, 6/1 (Spring-Summer 1985), pp. 17–22

Bentname
▷Schildersbent

Benton, Thomas Hart (1889–1975)
American painter. He was born in Missouri, but studied in Paris in 1908–11. Although he began his training in conventional ▷ateliers, he soon came into contact with the work of ▷Cézanne and ▷Matisse. However, the most significant early influence on him in Paris was the work of his compatriot ▷Stanton Macdonald-Wright, who encouraged Benton to an initial emphasis on ▷abstract form. After serving in the American Navy during the First World War, Benton's work became more conventional, and he set out to perpetuate a form of ▷mural painting that focused on themes of American history. From c1929 he was associated with the ▷American scene painters, whose ▷Regionalist emphasis was deliberately opposed to ▷avant-garde tendencies and had a nationalist flavour. His glorification of American rural life formed a strong basis for the mural painting of the ▷Federal Arts Project during the 1930s. Benton's most famous pupil was ▷Pollock.
Bib.: *Thomas Hart Benton: An American Original*, exh. cat., Kansas City, 1989

Bentvueghels
▷Schildersbent

Bérard, Christian (1902–49)
French painter and designer. He studied with ▷Vuillard. He is best known for theatre and film designs, and he worked for Jean Cocteau.

Berchem (Berghem), Nicolaes (1620–83)
Dutch landscape painter, principally of Italianate pastoral scenes. Born in Haarlem, he worked mostly in Amsterdam. He trained first under his father, the still-life painter ▷Pieter Claesz., and later, according to ▷Houbraken, under the landscape painters ▷Jan van Goyen and ▷Jan Baptist Weenix. In 1642 he was admitted to the Haarlem Guild of Painters. The formative experience of his artistic career was his visit to Italy, possibly with Weenix, in 1642–5. Whilst in Italy he made numerous studies which he later used as the basis for the Italianate landscapes which form his mature manner. These are characteristically arcadian landscapes with antique ruins, running brooks, hills and distant mountains, with a few peasants contentedly herding livestock or travelling to their destination; often a peasant woman in white blouse, blue jerkin and bright red skirt will provide a chromatic focal point. He also painted imaginary Mediterranean seaport scenes. Successful in his lifetime, his picturesque style remained very popular throughout the 18th century, but fell out of favour towards the end of the 19th. In an artistic climate of specialization, he painted both his landscapes and the figures that populated them, whilst also painting in the figures (▷staffage) for other landscape painters such as ▷Hobbema and ▷Ruisdael.
Bib.: E. Schaar, *Studien zu Nicolaes Berchem*, Cologne, 1958

Berckheyde, Gerrit Adriaensz. (1638–98)

Dutch painter who specialized in townscapes. He was born in Haarlem and worked principally in Haarlem, Amsterdam and The Hague. He was a pupil of ▷Frans Hals and his own older brother, Job Adriaensz. (1630–93), but was chiefly influenced by the work of the Haarlem architectural painter ▷Pieter Saenredam. Berckheyde's meticulous paintings provide a useful source for the appearance of those towns in the second half of the 17th century (e.g. *Haarlem Market Square*, 1674, London, National Gallery). However, he often rearranged the component elements in order to achieve a satisfying composition. Even when topographically faithful, his subtle rendering of the play of light and shade on stone and brick prevents his work from being merely dry documentation. He also travelled with Job to Germany and painted views of Cologne, Heidelberg and Bonn. He entered the Haarlem painters' guild in 1660.

Bib.: Lawrence, C.M., *Gerrit Adriaensz. Berckheyde 1638–98; Haarlem Cityscape Painter*, Doornspijk, 1991

Berenson, Bernard (1865–1959)

Lithuanian art historian and philosopher. Born in Lithuania and educated in America, Berenson settled in Europe in 1887. He developed a theory of the 'tactile value' of a work of art, which stimulated increased awareness in the spectator. His particular area of study was the ▷Renaissance: *Italian Painters of the Renaissance* (essays 1894–1907) and *Italian Pictures of the Renaissance* (1932) include almost exhaustive catalogues of less well-known artists of the era. He also wrote about history, aesthetics and politics.

Bib.: Samuels, E., *Bernard Berenson: The Making of a Legend*, Cambridge, MA, 1987; M. Secrest, *Bernard Berenson*, Paris, 1991

Berghe, Frits van den (1883–1939)

Belgian painter. With ▷Gustave de Smet and ▷Constant Permeke, he formed the Second Laethem Group of painters at ▷Laethem-Saint-Martin in 1904. During the First World War, he was in exile in the United States, but returned to Belgium afterwards to perpetuate a form of Flemish ▷Expressionism based partly on ▷Cubism. By the late 1920s he was producing fantastical paintings in a ▷Surrealist manner.

Bergognone, (Borgognone) Il (Ambrogio da Fossano) (fl c1480–1523)

Italian painter. He was Milanese and worked in the older ▷quattrocento tradition of ▷Vincenzo Foppa, with some Flemish characteristics, but virtually nothing from ▷Leonardo whose ▷Renaissance ideas were otherwise pervasive in early 16th-century Milan. His most important works are generally considered to be his ▷altarpiece and ▷frescos for the Certosa (Carthusian monastery) at Pavia. He also painted frescos in the church of S. Satiro, Milan (fragments of

which are now in the Brera Gallery, Milan). His paintings aim to achieve a sense of devotional calm, are essentially non-dramatic, and are characterized by pale and delicate colour combinations (e.g. *Virgin and Child with SS Catherine of Alexandria and Siena*, c1490, London, National Gallery).

Bib.: Marrani, C.P., *Ambrogio Bergognone*, Florence, 1989

Bergson, Henri (1859–1941)

French writer. He was influential on much early 20th-century art. His most important work in this respect was *Creative Evolution*, which was first published in 1907. In this difficult tract, he explored ideas of subjectivity and instinct and their importance to what he called the *élan vital* (life force). He was particularly concerned with the interpenetration of mind and matter and the ways in which reality is ordered through subjective response. His interest in mental states had a strong impact on early 20th-century ▷avant-garde artists, particularly ▷Futurists and ▷Expressionists.

Bib.: Antliff, M., *Inventing Bergson: Cultural Politics and the Parisian Avant-Garde*, Princeton, 1993

Berlinghieri

Family of Italian painters of the 13th century. The father of the family was Berlinghiero who was responsible for a Byzantine Cross (Lucca, Pinacoteca). He had three sons, Marco, Barone and Bonaventura, the latter of whom produced an ▷altarpiece for the church of S. Francesco at Pescia (1235). This was the earliest altarpiece devoted to the life of St. Francis, who was not canonized until 1228. The monumental central figure of St. Francis is surrounded by panels with episodes from his life.

Bermejo, Bartolomé (fl 1474–95)

Spanish painter. His style was influenced by the naturalism of ▷Flemish art. He worked in Barcelona and produced a ▷pietà for Barcelona Cathedral in 1490.

Bernard, Émile (1868–1941)

French painter and critic who was the originator of ▷cloisonnism. He was born in Lille and displayed a precocious talent, studying under Corman at the ▷École des Beaux-Arts (1886–7), where he met ▷Toulouse-Lautrec. His work of this period was ▷pointillist in style (he worked with ▷van Gogh at Asnières), but he destroyed much of it after developing ▷synthetism (e.g. *Bridge at Asnières*, 1887, New York Museum of Modern Art). He was a leading ▷Symbolist, working at ▷Pont Aven in 1888, where he introduced ▷Gauguin to cloisonnism (e.g. *Breton Women with Umbrellas*, 1892, Paris, Musée d'Orsay). The two men later disputed who was the actual innovator of the technique. His work of the period tended to be even more abstracted than Gauguin's, using strong pure colour, surrounded by heavy black outlines

and repetitive shapes, based on agricultural landscapes and local costume. He went through a religious crisis in 1890 which led to a split with Gauguin (see Bernard's *Christ Taken Down from the Cross*, 1890, private collection). He visited Italy in 1893, where his style was modified by a new enthusiasm for the ▷Renaissance and moved towards a paler palette and more angular stylization of figures. He also travelled to the Middle East, where he remained until 1903. During the 1890s he wrote widely on art, and published his own magazine *La Rénovation esthétique*. He also corresponded with ▷van Gogh (with whom he had exhibited jointly in 1890 – letters published 1893) and ▷Cézanne (1904–5). Later he tried to promote a revival in religious art.
Bib.: *Emile Bernard Retrospective*, exh. cat., Amsterdam, 1990; Jaworska, W., *Gauguin and the Pont Aven School*, London, 1972

Bernardino de'Conti (fl 1490–1522)

Italian painter. He worked in Milan and was a follower of ▷Leonardo.

Bernardino di Betto

▷Pintoricchio

Bernhardt, Sarah (1844–1923)

French sculptor and actress. Her real name was Henriette Rosine Bernard. She learned painting from ▷Alfred Stevens, but from 1873 turned to sculpture. She produced portrait busts, some of which she exhibited at the Paris ▷Salon. She continued her demanding sculpting practice after her performances.
Bib.: Bernhardt, S., *My Double Life: Memoirs of Sarah Bernhardt*, London, 1907

Bernini, Gianlorenzo (1598–1680)

Italian sculptor, architect and painter. He was the son of a sculptor and studied with his father who also helped him gain early patronage. Extensive patronage from the powerful Borghese and Barberini families contributed to his notoriety, but, from the beginning, Bernini was a virtuosic sculptor. For Cardinal Scipione Borghese, he produced a series of sculptures of subjects from Ovid's *Metamorphoses* and from the Bible (1618–25). These works show Bernini's ability to use the observer's space to expand the possibilities of sculpture beyond the medium itself. *Apollo and Daphne*, for instance, shows Daphne trying to escape from the pursuing Apollo and turning into a laurel tree as she does so. The observer must walk around the sculpture to witness Daphne's transformation, thus denying a unitary viewpoint. This type of multiple viewpoint was common in ▷Mannerist sculpture, but in works such as *David* (also produced for Borghese), Bernini goes a step further and shows David in the process of slinging a stone at the imaginary Goliath, who

seemingly occupies a place behind the observer of the sculpture.

Virtuosity of design and conception was complemented by a willingness to use different sorts of marble, as well as both painting and architecture to enhance sculptural form. Bernini's facility drew him to the attention of Pope Urban VIII (▷Barberini), who made him the principal architect for St. Peter's in 1629. In this capacity, he contributed both the ▷*Baldacchino* (1624–33), with its mingling of architectural and sculptural features, the *Cathedra Petri* (Throne of St. Peter) (1657–65) and the oval ▷colonnade surrounding the forecourt. He also produced for St. Peter's the tomb of Urban VIII, with its rich mixture of materials. Bernini also contributed fountains and churches (e.g. S. Andrea al Quirinale) to Rome, and with ▷Borromini, ▷Cortona and others, he helped give Rome a ▷Baroque aspect.

Urban VIII's successor, Innocent X, was less impressed with Bernini's ability, but Bernini was not short of commissions and during this time, he produced the ▷*Ecstasy of St. Theresa* for the Cornaro chapel in Sta Maria della Vittoria (1645–52). He also produced a number of portrait busts, which revealed his facility for capturing character. In 1665–6 he went to Paris following the invitation of Louis XIV, who wished to make use of his skills as an architect. However, the trip was not very successful and resulted in little but an elaborate portrait bust of Louis XIV. Bernini was best known for his blending of media, which gave his sculpture the fluidity of painting and his architecture the plasticity of sculpture. His popularity declined after his death and he was an anathema to generations of ▷academic artists who favoured a more ▷classical style.
Bib.: Hibbard, H., *Bernini*, Harmondsworth, 1965; Perlove, S.K., *Bernini and the Idealization of Death: The Blessed Ludovico Albertoni and the Altieri Chapel*, University Park, 1990; Wittkower, R., *Gian Lorenzo Bernini: The Sculptor of the Roman Baroque*, London, 1955

Bernward of Hildesheim

Archbishop of Hildesheim c1000–25 and a major patron of ▷Ottonian arts. The three-aisled ▷basilica of St. Michael at Hildesheim was probably commissioned by Bernward, who was also responsible for the internal decoration of the church. He was a wily politician and tutor to the young Emperor Otto III. He is said to have been experienced in sculpture, cast bronze work and architecture, but was probably only influential in these areas through the cathedral's prolific workshop. Important examples of German ▷Romanesque art attributed to the Hildesheim workshop include: the Ringelheim Crucifix (c1000); the extraordinary bronze doors of Hildesheim Cathedral, with scenes from Genesis and the Life of Christ (c1015); Bernward's column, cast in ▷bronze and based on a

Roman monumental column, but containing Christian images (c1020); and numerous other smaller portable artefacts, such as ▷reliquaries and ▷crucifixes.

Berruguete, Pedro (d 1504) and Alonso (c1488–1561)

Castilian family of painters. Pedro was court painter to Ferdinand and Isabella. He came to Toledo after 1483. His Flemish stylistic influences may have come through work he did in Urbino. His son Alonso certainly worked in Italy between 1504 and 1517, where he came into contact with the ▷Mannerist style through his association with ▷Filippino Lippi. He may have finished Lippi's *Coronation of the Virgin*. In 1518 Alonso became court painter to Charles V, and he also produced ▷reredos for Toledo Cathedral.

Bertaux, Hélène (1825–1909)

French sculptor. She began a sculpture course for women in Paris in 1873. She mainly took commissions for statues and fountains, and she won a medal in the ▷Salon. In 1881 she became the first president of the *Union des Femmes Peintres et Sculpteurs*.
Bib.: Garb, T., 'L'art féminin: The Formation of a Critical Category in Late Nineteenth-century France', *Art History*, 12/1 (March 1989), pp. 35–65; Lepage, E., *Une conquête féministe: Mme Hélène Bertaux*, Paris, 1911

Bertoldo di Giovanni (c1420–91)

Italian sculptor. He was from Florence and was the pupil and assistant of ▷Donatello from c1460. At his master's death in 1466 he finished his ▷bronze panels, now on the two pulpits in the church of S. Lorenzo, Florence. His independent work was mostly small-scale bronzes, influenced both by Donatello and the ▷antique. From c1489 Bertoldo was head of ▷Lorenzo de' Medici's proto-academy established in connection with the collection of sculpture in the garden of the Palazzo Medici, his most celebrated pupil there being ▷Michelangelo. Bertoldo's bronze relief, *The Battle of the Horsemen* (c1480–90, Florence, Bargello), based on a Roman ▷sarcophagus in the Medici collection was the basis for Michelangelo's early marble relief, *Battle of Lapiths and Centaurs* (c1490–94, Florence, Casa Buonarroti). Bertoldo also produced statuettes and medals.
Bib.: Draper, J.D., *Bertoldo di Giovanni: Sculptor of the Medici Household*, Columbia, 1992; Pope-Hennessy, J., *Italian Renaissance Sculpture*, Oxford, 1986

Besnard (Paul) Albert (1849–1934)

French painter. Although trained in a Classical tradition, from 1883 he began to adopt the ▷Impressionist style. He also produced ▷pastels and ▷etchings.

bestiary

A medieval treatise on animals (i.e. beasts). It takes the form of a series of illustrations of real and fabulous beasts, each accompanied by a moral text and a natural history usually based on traditional, scientifically unfounded lore (e.g. the 'fact' that the flesh of the peacock does not decay). The illustrations provided a rich source for medieval manuscript illuminators and wood carvers decorating such features as ▷misericords and roof ▷bosses.

Betrayal of Christ

(Matthew 26: 47–56; Mark 14: 43–52; Luke 22: 47–53; John 18: 1–12.) The Betrayal follows the ▷Agony in the Garden. ▷Judas has brought a group of the High Priest's soldiers to Gethsemane to arrest Jesus. It is night-time and they carry lanterns. The first three gospels state that Judas identified ▷Christ with a kiss; whilst John instead states that Christ identified himself and the soldiers initially backed off and fell to the ground, before regathering their courage and arresting him; however, this latter version is seldom depicted. All accounts mention the lopping off of the High Priest's servant's ear, and although only John identifies the assailant as Peter, most depictions show him with Peter's standard features.

Earlier treatments combine the kiss and the lopping off of the ear, whilst some include also the subsequent flight of the disciples (e.g. ▷Duccio, ▷*Maestà*, 1308–11, Siena, Museo dell'Opera del Duomo). ▷Caravaggio, on the other hand, concentrates the action on the kiss and the violence of the arrest with Christ surrounded by a dense pack of faces picked out of the enveloping dark by the harsh light of their lanterns (1603, Dublin, National Gallery of Ireland).

Beuckelaer, Joachim (c1533–73)

Flemish painter. He was the nephew by marriage of ▷Pieter Aertsen. He painted kitchen ▷genre scenes, but he worked mostly as an assistant.

Beuys, Joseph (1921–86)

German sculptor. After serving in the Second World War, he trained at the State Academy of Art in Düsseldorf. He was professor at Düsseldorf Academy from 1961 until 1972, when he was dismissed for his unorthodox teaching methods, political radicalism and subversive anti-professionalism. During this time he was involved with ▷Fluxus events throughout Europe. He produced ▷assemblages and ▷junk sculpture which contained environmentalist themes, often with a strong political subtext. He also practised ▷performance art. In his *How to Explain Pictures to a Dead Hare* (1965), he carried a dead hare around the Shmela gallery in Düsseldorf and gave it a lecture about art. He became something of a cult figure, and his works are present in many German municipal museums today.
Bib.: Beuys, J., *In Memoriam Joseph Beuys: Obituaries,*

Essays, Speeches, Bonn, 1986; Ulmer, G., *Applied Grammatology, post(e)-pedagogy from Jacques Derrida to Joseph Beuys*, Baltimore, 1985

Bevan, Robert Polhill (1865–1925)

English painter. He was born in Hove and trained firstly with Alfred Pierce, then at Westminster School of Art under Fred Brown and later at the ▷Académie Julian in Paris. This education was backed up by travel, to Spain in 1891, to Morocco with Crawhall and Armour, and to Brittany where he met ▷Gauguin in 1894. In the 1890s he lived at Hawkbridge, Exmoor, but from 1900 was based in London. His early style, seen in a one-man show at the Baillie Gallery in 1905, was influenced by Gauguin in his use of flat decorative colour (e.g. *Cabyard at Night*, 1910, Brighton) and by ▷pointillism (e.g. *Ploughing the Hillside*, 1906–7, Aberdeen Art Gallery), but from 1908 he became involved in the English art scene, joining the ▷Fitzroy Street Group, exhibiting with the ▷NEAC (from 1910) and helping to establish the ▷Camden Town Group in 1911. Along with artists like ▷Gore and ▷Gilman he experimented with ▷divisionism. In 1913 he became a member of the ▷London Group and two years later of the Cumberland Market Group (e.g. *Artist's Window St. John's Wood*, 1915–16, Leicester, Museum and Art Gallery). His subject matter was essentially traditional – horses, markets and landscapes – and he worked in both oil and watercolour. He received the honour of a retrospective at the Goupil Gallery in 1926.

Bib.: Baron, W., *The Camden Town Group*, London 1979; Bevan, R.A., *Robert Bevan: A Memoir by his Son*, London 1965; *Robert Bevan*, exh. cat., London, 1956; Dry, G., *Robert Bevan: Catalogue Raisonné of Lithographs and Prints*, London, 1968

Bewick Thomas (1753–1828)

English ▷wood engraver and book illustrator. He was especially known for his pictures of birds and animals. He was born in Newcastle, where he later established a school of ▷engraving. As a young man he was apprenticed to Beilby (1744–1817) and later they went into partnership (1777), producing *A History of British Birds* (2 vols, 1794) and *A General History of Quadrupeds* (1790). Bewick also illustrated fiction: in 1775 he received a prize from the Society of Artists for his work on Gay's *Fables* and he illustrated Goldsmith's *The Traveller* and *The Deserted Village*. He was a naturalist who sketched from nature and worked from his own watercolours – as represented by his popular tailpiece vignettes of country life. He was a pioneer of wood engraving who cut his own blocks, and introduced techniques such as the use of a ▷burin instead of a knife, which increased the range of the medium. He wrote an autobiography, *Memoirs of Thomas Bewick by Himself*, published posthumously in 1862. His brother John and his son Robert were also artists.

Bib.: Bain, I., *Watercolours and Drawings of Thomas Bewick*, London, 1981; *Thomas Bewick*, exh. cat., Manchester, 1993; Hicklin, F., *Bewick's Wood Engraving*, London, 1978; Robinson, R., *Life and Work of Thomas Bewick*, Newcastle, 1972

Beyeren (Beijeren), Abraham Hendricsz. van (1620/1–90)

Dutch painter. He specialized in still-life painting, principally of fish and seafood, with luxurious cutlery and china.

Bibiena (Galli-Bibiena)

A family of Italian stage designers. Based in Bologna, Giovanni Maria Galli (1625–65) was the father of several artists who became famous throughout European courts for their contribution to stage design. During 1670–1787 the Bibiena dynasty designed permanent and temporary architecture for operas, court ceremonies and celebrations. Giuseppe (1696–1757) designed theatres in Italy and Germany, while Ferdinando (1657–1743) produced books on architecture. Many of their designs were engraved. They were especially known for their ability to use ▷Baroque formulas for impressive stage effect.

Biblia Pauperum

(Latin, 'Bible of the Poor'.) An illustrated book, in manuscript or printed, showing in pictorial form the Old Testament prefiguration of Christ. This type of Bible seems to have originated in Germany and to have flourished in the late 13th century, when block printing was developing (▷block book). There are usually 40 different scenes depicted, with three images displayed for each event. Thus, it is possible to make direct comparisons between the prefiguration and the New Testament version.

Bicci di Lorenzo (1373–1452)

Italian painter. Born in Florence, he was the son of Lorenzo di Bicci and the father of Neri di Bicci, also painters. He painted in a very conservative manner, running a flourishing workshop which supplied well-crafted pictures for less adventurous patrons in both Florence and the surrounding provincial towns. His early style was rooted in the late ▷trecento tradition of ▷Agnolo Gaddi (e.g. Bicci's *Annunciation with Saints*, 1414, S. Maria Assunta, Stia), later enriched by the influence of ▷Gentile da Fabriano, after the latter master's visit to Florence in 1422–5. In about 1441 Bicci seems to have been working as an associate (along with ▷Piero della Francesca) of ▷Domenico Veneziano, on Domenico's ▷frescos in Sant' Egidio, Florence. His last commission was for a ▷fresco cycle of the *Legend of the True Cross* in the main chapel in San Francesco in Arezzo; he had commenced work on the ▷vault, when he became too ill to work and the chapel decoration was taken over by Piero della Francesca.

Biedermeier

A name given to art and furniture of central Europe from the Congress of Vienna in 1815 until the revolutions of 1848. The name was derived from a fictional character Gottlieb Biedermaier (sic), who became a symbol of petty bourgeois values in the growing middle-class economy of Germany. Biedermeier artists produced works which contrasted with the elaborate ▷history paintings favoured by the aristocracy and courts of the 19th century. They preferred instead small, cabinet-size scenes of domestic life. Their history paintings were more theatrical costume pieces than dramatic recreations of past heroism. Scenes of rural life particularly interested such Biedermeier artists as ▷Waldmüller, and their works were invariably sentimental. Biedermeier furniture was similar to that of French ▷Empire Style. The term came to have pejorative connotations, and was later used by artists to attack both the way of life and the art of a period of bourgeois prosperity.

Bib.: *Biedermeier in Wien 1815–1848: Sein und Schein einer Bürgeridylle*, exh. cat., Mainz, 1991; Himmelheber, G. (ed.), *Kunst des Biedermeier 1815–1835: Architektur, Malerei, Plastik, Kunsthandwerk, Musik, Dichtung und Mode*, Munich, 1988; Norman, G., *Biedermeier Painting 1815–1848: Reality Observed in Genre, Portrait and Landscape*, London, 1987

Biennale

An international art exhibition held every two years, which is assessed and amassed by an international panel. The first Biennale was held in Venice in 1895, and displayed works by artists of 16 different nationalities, including ▷Burne-Jones and ▷Liebermann. The exhibition was so successful that it was expanded during the first two decades of the 20th century in order to include increasingly controversial work. Other cities modelled their own Biennales on the Venetian example: São Paulo (founded 1951) is seen as Venice's closest rival, and there are others in Menton, Paris, Tehran and Tokyo. Different cities place different stress upon the reasons behind the staging of such an elaborate exhibition. For instance, the Paris Biennale (founded in 1959) was initiated specifically to give young artists a platform. The Venetian Biennale was closed in 1974 having been accused of élitism and wasting public money. However, it was resurrected after the organizers emphasised social realism and environmental issues.

Bib.: Martino, E. D., *La Biennale di Venezia*, Milan, 1995; West, S., 'National Desires and Regional Realities in the Venice Biennale, 1895–1914', *Art History*, 18/3 (1995), pp. 404–34

Bierstadt, Albert (1830–1902)

American artist of German heritage. He came to the United States with his family in 1832, but he studied in Germany in 1853. There he came into contact with the Düsseldorf school, which was the most important centre for German landscape painting before the unification of Germany in 1871. When he returned to the United States in 1858, he joined an expedition to the West where he observed and sketched a number of scenes in the Rockies. He subsequently produced panoramic landscape paintings, such as *The Rocky Mountains* (1863, New York, Museum of Modern Art). These works glorified the beauties of the West and the nobility of the Native Americans through their ▷sublime effects. In several subsequent trips to the West, he produced more works in the same vein. Although very popular early in his career, by the 1870s, ▷*plein air* painting overtook Bierstadt's particular brand of western sublimity, and his works fell out of fashion.

Bib.: Anderson, N., *Albert Bierstadt*, exh. cat., New York, 1991

Bigot, Trophime (1579–1650)

French painter. He studied in Rome between 1600 and 1634, and then he moved to Aix-en-Provence. He became known for candlelight scenes that employed the ▷tenebrism of ▷Caravaggio. He was also adept at reproducing facial expression.

Bijlert, Jan van

▷Bylert, Jan van

Bilibin, Ivan (1876–1928)

Russian illustrator. He was a cartoonist who became associated with the ▷World of Art, but unlike being characterized by the urbanity of that group, his work exhibited the influence of Russian ▷folk art.

Bill, Max (b 1908)

Swiss painter, sculptor and architect. In 1927–9 he studied at the ▷Bauhaus in Dessau, and from 1932 to 1936 he was involved with the ▷Abstraction-Création group in Paris. From the beginning he was interested in the mathematical properties of art, and he practised ▷abstraction. Working on Doesberg's principles of ▷concrete art, he brought these ideas to Switzerland when he taught at the Zurich Technische Hochschule from 1944. During the 1950s he was rector at the Hochschule für Gestaltung at Ulm, and he began to write books of art theory. He posited his own form of ▷Minimalist abstraction called ▷Kalte Kunst (Cold Art). He also produced architectural designs.

binder

A ▷medium in which ▷pigments can be suspended in order to create a solution which can be applied more readily to a surface (e.g. egg, oil and gum arabic).

Bingham, George Caleb (1811–79)

American painter. He grew up in Missouri, but went to Pennsylvania to train for a short time at the Philadelphia Academy of Fine Arts. During the 1830s and

1840s he produced portraits to earn money, but from 1848 he began to produce his characteristic representations of everyday life in the Midwest. He spent some time in Düsseldorf in 1856–8, absorbing the influence of the landscapists there, but he settled in St. Louis. There he continued to paint scenes of Mississippi boatmen and traders, and he became known for his nationalistic American sentiment. His strong feelings about his country led him to become an elected member of the Missouri legislature, where he promulgated traditionalist values.

Bib.: Maurice Bloch, E., *George Caleb Bingham*, 2 vols., Berkeley, 1967

biomorphic

A term most commonly associated with ▷abstract art to describe a form that is irregular or organic, often derived from shapes found in nature. Biomorphic forms are frequently found in ▷Surrealist art, most notably in the paintings of ▷Yves Tanguy and the sculpture of ▷Arp and ▷Henry Moore.

Birch, Thomas (1779–1851)

American painter. He came to Philadelphia from England in 1794. From 1806 he painted portraits and ▷marine scenes, as well as views of Philadelphia. During the War of 1812, he gained recognition through his depiction of American naval campaigns, but he also produced popular shipwreck scenes. His works were considered to be within the Dutch tradition of landscape art, but his luminous style of painting was distinctly American.

Bird, Francis (1667–1731)

English sculptor. He studied in Brussels and Rome, where he absorbed ▷Baroque influences. He worked with ▷Caius Cibber in the 1680s, and later produced sculpture for the ▷pediments on St. Paul's Cathedral. He also produced funerary monuments.

Birolli, Renato (1905–59)

Italian painter. He studied at the Academy of Art in Verona. In 1927 he moved to Milan where in 1938 he played a prominent part in founding the anti-fascist movement ▷Corrente. In 1947, after several months spent in Paris, he joined the ▷Fronte Nuovo delle Arti and in 1952 was one of the founders of Gruppo degli Pittori Italiani.

His early work was influenced by ▷van Gogh, which Birolli characterized as 'poetic expressionism', and his fascination with ▷Picasso in the late 1930s and early 1940s led Birolli's search for a synthesis of form and colour, though still based on observable nature, to an increasingly ▷Cubist idiom. Believing that 'the picture is the architecture of the emotions', his work became progressively more abstract from 1945 until by 1952 he was painting in the style of ▷Art Informel.

Birolli had an important influence within Italy,

winning many prizes and participating in the Venice ▷Biennale. He was given a retrospective in Milan in 1960.

Bib.: *Renato Birolli*, exh. cat., Milan, 1989; Venturi, L., *Italian Painters of Today*, Venice, 1959

Birth of Venus, The

Painted by ▷Botticelli, c1482 (173 × 275 cm/5 ft 7 in × 9 ft). It shows a nude, her hands in the pose of the Classical *Venus Pudica*, standing on a cockleshell which floats on a calm blue sea. The figure has the flowing fair locks and elegant, 's'-curved body seen in Botticelli's work as a whole. On the right of the painting, on a zigzagging coastline, stands a clothed female Hour, holding a robe with which to cover Venus when she comes ashore. On the left, two personifications of wind blow her inland and scatter flowers around her. The painting was known to hang alongside ▷ *Primavera* (1482, Florence, Uffizi Gallery) in the 16th century and is often read, like the latter, in ▷allegorical terms. Thus it can be seen as the birth of divine beauty. This reading is perhaps emphasized by Botticelli's refusal to treat the subject naturalistically: his Venus, complete with gold pigment in her hair and marble-like skin, lives in a flat, stylized landscape. The waves are represented by 'v'-shapes; the outlines are crisp, and the whole work balances delicacy with extreme artistic definition. The work is unusual in being painted on canvas. It now hangs in the Uffizi Gallery in Florence.

biscuit

A type of unglazed ▷porcelain, which has a granular texture, hence the name.

Bisschop-Robertson, Suze (1857–1922)

Dutch painter. She trained in the Academy in The Hague, and taught in schools in Amsterdam and Rotterdam. She came into contact with ▷Israëls and married the painter Richard Bisschop. She produced primarily ▷genre paintings which focused on women in the domestic environment.

Bib.: Wagner, A., and H. Henkels, *Suze Robertson*, Amsterdam, 1985

Bissière, Roger (1888–1964)

French painter. He studied at the École des Beaux-Arts, Bordeaux, before moving to Paris in 1910. He lived in North Africa in 1911–18, returning to Paris in 1919, the year that he exhibited at the ▷Salon d'Automne. From 1925 to 1938 he taught at the Académie Ranson, where his students included Le Maol, ▷Manessier and da Silva. Creeping blindness caused by glaucoma forced him to give up painting in the 1940s, when he turned to large, tapestry-like compositions, whose crude figures and elementary patterns, woven from scraps of material, evoke

comparisons with primitive art. He returned to painting after an eye operation in 1945 restored his sight, producing both tapestry-like paintings and highly lyrical and abstract compositions blending ▷Fauvist colour and ▷Cubist structure in an attempt to capture the expressive features of natural forms.

In 1952 he was awarded the Grand Prix National des Arts and represented France at the Venice ▷Biennale. The Musée des Arts Décoratifs in Paris hosted a large memorial exhibition in 1966.

Bib.: Abadie, D., *Bissière, ides et calandes*, Neuchâtel, 1986; *Bissière*, exh. cat., Paris, 1966; Bissière, R., *Ecrits sur la peinture 1945–64*, Cognac, 1994

bistre

Brown ▷pigment prepared by boiling the soot of charred wood. It may be used as an ▷ink and can be applied in a transparent wash. Bistre was widely used for 17th-century pen-and-ink drawings, especially by ▷Rembrandt and ▷Claude.

biting in

One of the stages of the ▷etching process. After the ground has been removed from areas of the plate, the etching plate is dipped into acid. The acid bites in the areas in which the ground has been removed. The length of time the plate is placed in the bath effects the final appearance of the etching.

bitumen

As an art material, a ▷pigment prepared from asphalt. When first applied it is a rich transparent brown, but it darkens and becomes opaque with age. It never dries out properly and develops a marked ▷craquelure. Painters of the 18th and 19th centuries (especially ▷Reynolds) used bitumen as an underpainting in order to impart an added richness to their darker colours, which areas, because of the inherent instability of the ▷medium, are now impenetrably black and extremely cracked. It has been used with more success as a glaze (e.g. by ▷Rembrandt).

Blackadder, Elizabeth (b 1931)

Scottish painter. She was born at Falkirk and trained at the Edinburgh School of Art. She travelled extensively throughout Europe, and from 1959 she began exhibiting primarily abstract ▷landscapes and ▷genre scenes in an ▷Expressionist style.

Bib.: Bumpus, J., *Elizabeth Blackadder*, Oxford, 1988

Blackburn, Joseph (fl 1754–63)

American painter. He was a colonial portraitist who trained in England. During 1752–4 he was in Bermuda, before moving to Rhode Island. He was practising in Boston in c1755. In 1763 he returned to England. His ▷Rococo portraits were less stiff than many of those produced by contemporary itinerant painters. He may have influenced ▷Copley.

black-figure vase painting

A technique of Greek vase painting, invented in Corinth c700 BC, spreading to Athens by c630 BC and continuing throughout the 6th century BC, before finally being succeeded by the ▷red-figure technique in c530 BC.

Greek vases were made of a pale clay which, owing to its rich iron content, turned an orangey-red when fired. The areas of decoration which appear as black in the finished vessel were painted on before firing in a concentrated slip of the same clay as the body of the vase. The process was as follows. First the design would be sketched in outline. Then, using a brush, the design area would be filled in with the concentrated slip which at this point was of the same colour as the rest of the vessel. Linear details would be added to the design areas by scratching through the slip to the clay beneath. The vessel would then be stacked with others in the upper part of the kiln and the kiln heated to c800°C. In this initial stage of the firing the vents would be left open. The resultant oxidization turns the whole vessel an overall orangey-red. The temperature is then raised to c950 °C while the vents are all closed and green wood is introduced into the firing chamber in order to remove the oxygen from the kiln. In this reduced atmosphere the vessel turns an overall black. The final stage involves the opening of all the vents to readmit the oxygen while the kiln is allowed to cool down completely. Oxidization causes the bodies of the vessels to return to the orangey-red of the first stage of firing, while the areas that have been painted in concentrated slip remain the glossy black they became in the second stage. The concentration of the slip caused vitrification of the painted area in the reduced atmosphere and intense heat of the second stage, whilst preventing the re-entry of oxygen which would have returned those areas to the orangey-red colour of the unpainted bodies of the vessels.

Although the black silhouette is the principal design characteristic of black-figure vases, other colours were sometimes employed. The two most common were a yellowish-white derived from a slip of very purified clay from which all deposits of iron had been removed, and a purplish-red derived from a mixture of the same slip that produced the black areas mixed with red iron-oxide pigment (ochre) and water. In contrast to the glossy surface of the black areas, these have a matt surface. Only a few painters are known by name, but many of the vases have been grouped on the basis of painting style and labelled as, for example: the Amasis Painter, after the potter who has signed some of the vases in the group; the Painter of Berlin 1686, from a key vase in the group; the Oakeshott Painter, from the name of the owner of a key vase: and Elbows-Out, after a stylistic characteristic common to the group.

The most famous named painter is ▷Exekias.

Bib.: Boardman, J., *Athenian Black Figure Vases*, London, 1974; Williams, D., *Greek Vases*, London, 1985

Black Mountain College
One of the American educational institutions that promulgated ▷Bauhaus principles. It was founded in 1933 and located in North Carolina. ▷Albers taught there, and it was also visited by a number of important ▷modernist artists such as ▷Léger and ▷Feininger.
Bib.: Lane, M. (ed.), *Black Mountain College: Sprouted Seeds: An Anthology of Personal Accounts*, Knoxville, 1990

Blake, Peter (b 1932)
English artist. He was a leading member of the ▷Pop art movement. He was born in Dartford, and studied first at Gravesend Technical College and School of Art (1946–51), and then at the ▷Royal College of Art, having completed his national service. In 1956/7 he made use of a travelling scholarship and visited Holland, Belgium, France, Spain and Italy studying popular art. His early work was based on childhood images and memorabilia combined with the popular culture associations of the music hall, wrestling (e.g. *On the Balcony*, 1955–7, London, Tate, and *Self Portrait with Badges*, 1961, private collection) and, from the 1960s, pop music. (He designed the *Sergeant Pepper* album cover for the Beatles). He worked slowly and deliberately in a combination of highly-finished ▷*trompe l'oeil* and ▷collage (e.g. *Got a Girl*, 1960–61, University of Manchester), with the result that some works remained uncompleted. In 1963 he married the artist Jan Haworth and together they helped to establish the Brotherhood of ▷Ruralists in 1975, a group dedicated to exploring and representing the myths of rural life. Blake has taught periodically at both St. Martins and at the RCA. He was made an ▷RA in 1975 and was given a retrospective at the Tate Gallery in 1983. Although often associated with ▷Pop art his work does not always fit easily into that mould and he has often been left on the sidelines of the movement.
Bib.: Bailey, E., *Pop Art*, London, 1976; *The Sixties Scene in London*, exh. cat., London, 1993

Blake, William (1757–1827)
English writer, artist, draughtsman and printmaker. He was an archetypal ▷Romantic. He was an apprentice engraver under James Basire (1772–9), where he developed an enthusiasm for ▷Gothic art after working on ▷engravings of Westminster Abbey. He studied briefly at the ▷Royal Academy, but despite friendships with ▷Fuseli, ▷Barry and ▷Flaxman, left with a healthy disrespect for ▷Reynolds and all his ideas on art. Instead, he began illustrating and publishing his own writings (e.g., *Poetical Sketches*, 1783; *Songs of Innocence*, 1789; *Songs of Experience*, 1794) using

a technique of ▷relief etching, with coloured inks which he retouched by hand. This was just one of his many experiments, which also included colour prints using ▷distemper on millboard (e.g. *Nebuchadnezzar,*

William Blake

Hecate, both 1795, London, Tate). Throughout his career he lived in poverty supported by friends: in 1800–03, he left London for Felpham, when he joined William Hayley's circle and produced engravings for his patron's poetry. It was at Felpham that an argument with a soldier led to Blake being charged with sedition, and although he was acquitted, his political views were firmly at odds with those of the government (he was friends with the radicals Tom Paine and William Godwin). He tried to promote his work and organized a one man show in 1809, with the help of another patron, Thomas Butts, but this too was a failure. His later life was eased by his friendship with ▷Linnell, whom he met in 1818, and through Linnell with a group of younger artists (▷Palmer, ▷Calvert and ▷Richmond) who became his disciples. Linnell commissioned 21 watercolour illustrations for the *Book of Job* (1825) and watercolours for Dante's *Divine Comedy* (1826). During this period Blake also produced woodcut illustrations of Virgil's *Georgics*.

Although Blake produced some paintings (mainly worked in a form of ▷distemper) he was suspicious of the establishment medium of oils. His technique was conditioned by his training: he used sinuous line, symbolic decoration, non-naturalistic backgrounds and strong, simplified images. His figures, however, were influenced by ▷Michelangelo – idealized, muscular and mannered. As important as his style was his philosophy. He believed his art was a result of divine

inspiration, but his religious views were far from ortho-dox. For Blake, God was a vengeful figure, tempered by the humanity of Christ, but nevertheless to be feared.

Bib.: Bindman, D., *Complete Graphic Work of William Blake*, London, 1978; Lister, R., *Paintings of William Blake*, Cambridge, 1986

Blakelock, Ralph Albert (1847–1919)

American painter. He studied in New York. In 1869, he began to discover the visual possibilities of the West, and he was one of a number of artists who used the spectacular ▷landscapes of the West as the subject of his painting. Blakelock specialized in mood landscapes, many of which were set in the evening or night. He had a nervous breakdown in 1899.

Bib.: Geske, N.A., *Ralph Albert Blakelock*, exh. cat., Nebraska, 1974

Blanc, Charles (1813–82)

French writer on art and engraver. He began his career writing for *L'Artiste* in 1845 and went on to establish the *Gazette des Beaux-Arts* in 1859. In both 1848 and 1878 he was appointed director of fine arts and he later became professor of aesthetics at the Collège de France. He wrote widely on art, maintaining conservative views which were nevertheless influential, particularly with ▷Seurat. His works include *Les Artistes de mon temps* (*Artists of my time*) and *Grammaire des arts du dessin* (*Grammar of the Arts of Design*, 1867), in which he expressed the view that 'colour, which is controlled by fixed laws, can be taught like music' – an idea which became central to ▷Neo-Impressionist theory.

Bib.: Song, M., *Art Theories of Charles Blanc*, Ann Arbor, 1984

Blanchard, Jacques (1600–38)

French painter. He studied in Rome and Venice in 1624–8, and he absorbed the style of ▷Veronese. He returned to France to paint portraits and religious subjects on a small scale.

Blanchard, Maria (1881–1932)

French painter of Spanish birth. She left Madrid in 1908 to study in Paris, where she came into contact with ▷Cubist artists and studied with ▷Van Dongen. In 1914, she was working in Madrid with ▷Lipchitz and ▷Marie Laurencin, but she settled in Paris from 1916. She adopted Cubist ideas about the human figure, but she never entirely absorbed the Cubist influence. She painted many scenes of domestic life.

Blast

The short-lived magazine of ▷Vorticism, edited by ▷Wyndham Lewis. It only survived two volumes in 1914–15. Subtitled the *Review of the Great English Vortex*, the first issue in June 1914 included Ezra Pound's definition of a vortex, the movement's manifesto, reproductions of art by Lewis, ▷Wads-worth, ▷Epstein and ▷William Roberts, and a sat-irical list of people to be blasted or blessed. Other contributors included T.S. Eliot, Robert West and Richard Aldington.

Blauen Vier, Die

▷Blue Four

Blaue Reiter, Der (The Blue Rider)

A German ▷Expressionist group, established by ▷Kandinsky, ▷Marc, ▷Macke and others in Munich in 1911. The name was invented because of Kan-dinsky's enthusiasm for horses and Marc's love of blue. They got together as a result of the ▷Neue Kün-stlervereinigung's (NKV) rejection of Kandinsky's *Last Judgement*, and showed 43 works by 14 artists at their first exhibition which toured Germany in 1911. The following year they showed over 300 works by an international collection of artists, including members of ▷Die Brücke, ▷Henri Rousseau, ▷Delaunay, ▷Larianov, ▷Malevich, ▷Picasso, ▷Vlaminck and ▷Klee. They also published an almanac which illus-trated an eclectic range of contemporary, primitive and ▷folk art, and paintings by children. In 1913 they exhibited as part of the first German Herbstsalon, but disbanded in 1914.

Der Blaue Reiter was a loose group without a clear manifesto, and it was dependent largely on the charac-ters of Kandinsky and Marc. They believed not only in the promotion of modern art, but in the connection between art and music (they included articles by Sch-oenberg in the *Almanac*), the spiritual and symbolic association of colour and the need for spontaneous, intuitive painting (hence their support of children's art). Because of their international connections they picked up ▷Cubist and ▷Rayonist ideas and pushed their work towards abstraction. They were, thus, very different in both philosophy and organization from the other pre-war German expressionist group, ▷Die Brücke.

Bib.: *Blaue Reiter*, exh. cat., Hanover, 1989; Zweite, A., *Blaue Reiter in Munich*, Munich, 1989

Bloch, Ernst (1885–1977)

German writer. He contributed to an important debate with ▷Lukács about the best form of art for a modern Communist state. In a series of essays of the 1930s, Lukács attacked the dominance of ▷Expressionism, which he saw as a bourgeois art that only pretended to be revolutionary. Instead, he advocated ▷Socialist Realism as the most appropriate style of art for leftist tendentiousness. However, Bloch denied Lukács' assertion, claiming that Expressionism was a truly rev-olutionary style in its denial of realism and its use of ▷primitivist and folkloric elements. Bloch's theories attempted to show that pure ▷aesthetics was not incompatible with a revolutionary ideology.

Bib.: Hudson, W., *The Marxist Philosophy of Ernst Bloch*, London, 1982; Schmidt, B., *Ernst Bloch*, Stuttgart, 1985

block

A piece of dense wood which, carved in relief and inked, can be pressed on to or in to a surface, thus producing an image. During the 15th century metal blocks were developed, which lasted longer and produced cleaner images. Block printing underwent a revival in the late 19th century.

block book

Books printed using a single carved block for each page. Before the invention of moveable type, books could be printed more easily if a single block related to a single page. Northern European examples of books of this type survive from the 1440s and 1450s. With developments in printing technology in the 16th century, block books all but died out, although craft revivals have since rehabilitated them to some extent.

block capital

▷capital

Bloemaert, Abraham (1564–1651)

Dutch painter who worked in Utrecht. He employed a ▷Mannerist style influenced by ▷Caravaggio's ▷tenebrism, which he applied to biblical subjects. He taught ▷Honthorst and ▷Terbrugghen.

Bloemen, Jan Frans van (1662–1749) and Pieter van (1657–1720)

Flemish family of painters. Jan Frans was working in Rome in c1681, where he began to produce Classical landscapes in the manner of ▷Poussin and ▷Claude. His brother Pieter was also in Rome during c1674–93.

Blondeel, Lancelot (1496–1561)

Flemish artist. He worked in Bruges as an architect and designer. In 1550 he was responsible for restoring ▷Jan van Eyck's ▷Ghent Altarpiece, with the collaboration of ▷Scorel.

Blondel, Jacques-François (1705–74)

French architect. He was professor at the Paris Académie Royale de l'Architecture from 1759, and was known for his art treatise, *De la distribution des maisons de plaisance* (*The distribution of Summer Houses*, 1737–8). He designed buildings at Strasbourg and Metz. He was possibly related to ▷Nicolas Blondel, although this fact cannot be substantiated.

Blondel, Nicolas-François (1618–86)

French engineer and architect. He was professor of mathematics at the Collège de France and director of the Royal Academy of Architecture. He also designed military fortifications. He was possibly related to ▷Jacques Blondel, although this fact cannot be substantiated. He published *Cours d'architecture* (1675) in which he propounded his classical views of architecture.

Bloomsbury Group

A group of artists and writers who met in two houses in Bloomsbury Square during the 1920s and '30s. It developed out of both the Friday Club established in 1905 and from the friendships established at the semi-secret Apostles Club at Cambridge University. It was centred around the Stephens family, which included Virginia Woolf and ▷Vanessa Bell. Other members were ▷Clive Bell, ▷Fry, ▷Grant, the writers E.M. Forster and Lytton Strachey, the economist John Maynard Keynes, the philosopher George Moore. The group was a loose association only, based on Moore's ideas of the pleasures of friendship. They held left-wing political views and promoted ▷avant-garde European ideas, which in artistic terms led them to ▷Post-Impressionism, ▷Matisse and, to a lesser extent ▷Cubism. They had an élitist reputation which gradually led to a decline in their influence.

Bib.: Caws, M.A., *Women of Bloomsbury*, New York, 1990; Rosenblaum, S.P. (ed.), *Bloomsbury Group*, London, 1975; idem, *Edwardian Bloomsbury*, Basingstoke, 1994; Shone, R., *Bloomsbury Portraits*, Oxford, 1976

blot drawing

A technique used by the English landscape artist ▷Alexander Cozens as a basis for creating a ▷landscape design. Cozens advocated making a blot on a piece of paper and then using it as a means of developing a landscape with a pleasing distribution of light and shade. This method is seen as a forerunner to the techniques of the 20th-century ▷Surrealists, who advocated the use of chance in their work. However, Cozens's employment of this method was concerned with the aesthetics of landscape painting, rather than with manifestations of the subconscious.

Blue Four, The (Die Blaue(n) Vier)

A group of German artists composed of ▷Kandinsky, ▷Jawlensky, ▷Klee and ▷Feininger. They formed in 1924, when three of the group's members were teaching at the ▷Bauhaus. The group's name signalled its role as successor to the pre-War ▷Blaue Reiter, and they held exhibitions, just as the Blaue Reiter had done. However, during this period, the artists involved were more mature and commercially minded, and their work received international attention.

Blue period

▷Picasso, Pablo

Blue Rider
▷Blaue Reiter, Der

Blue Rose Group
A group of Russian artists who succeeded the ▷World of Art in 1906 as the leaders of the Russian ▷avant-garde. They were closely associated with the ▷Golden Fleece which held exhibitions and published a magazine at the same time. The group held an exhibition in 1907, at the home of one of its members, the painter ▷Kusnetsov, ▷Larianov and ▷Goncharova were among the members.

Blume, Peter (1906–92)
American painter of Russian birth who went to the US when he was five years old. He studied at the ▷Art Students' League and adopted a ▷Precisionist technique which he applied to subjects with a ▷Surrealist tone, such as *The Eternal City* (1934–7, New York, Museum of Modern Art) – an attack on Mussolini. He was awarded Guggenheim Fellowships in both 1932 and 1936 which allowed him to spend time in Italy.

Blunden, Anna (1829–1915)
English painter. She trained as a governess but left this profession to study art in private classes and make copies of paintings in the National Gallery. She exhibited her works publicly from 1854. Her pictures concentrated on the plight of contemporary women, and they contributed a distinctive vision to the genre of paintings on the themes of social problems. From 1867 she spent a great deal of time travelling around Europe.

Blunt, Anthony (1907–83)
English art historian. He was Director of the ▷Courtauld Institute of Art from 1947 to 1974 and Surveyor of the King's/Queen's Pictures from 1945 to 1972. He specialized in French and Italian ▷Baroque art. In 1979, he achieved notoriety when it was discovered that he had been acting as a spy for the USSR. He was stripped of his knighthood and retired in disgrace.
Bib.: Penrose, B., and Freeman, S. *Conspiracy of Silence: The Secret Life of Anthony Blunt*, London, 1986

Blythe, David Gilmour (1815–65)
American painter. He was from Ohio and worked for a time as an ▷itinerant portrait painter. In the 1830s he moved to Pittsburgh and produced ▷genre paintings of Pittsburg low-life with ▷caricatural figures. During the Civil War, he supported the Union and continued to produce satirical paintings with a political slant.

Boccaccio, Giovanni (Boccaccino) (1313–75)
Italian novelist, poet and ▷humanist. Born in Florence, Boccaccio was a friend of Dante and witnessed the Black Death of 1348. This experience influenced his most famous work, *Decameron* (1348–58), in which ten young people tell stories to each other while escaping from the plague. Boccaccio's work and his narrative fiction have influenced generations of writers, from Chaucer to Tennyson.

Umberto Boccioni, *Self-portrait*, 1908, Pinacoteca di Brera, Milan

Boccioni, Umberto (1882–1916)

Italian painter and sculptor associated with the ▷Futurists. He was born in Reggio-Calabria, and after starting a career as a journalist, he turned to painting in 1900. He studied under ▷Balla in Rome and visited Paris in 1906 and Russia in 1907 before moving to Milan where he painted a series of pictures illustrating the dramatic modernity of the city (e.g. *The City Rises*, 1910, New York, Museum of Modern Art). Inspired by ▷Marinetti's Futurist Manifesto of 1907, he himself wrote a *Manifesto of Futurist Painting* in 1910 and a *Manifesto of Futurist Sculpture* in 1912 (he summarized these in his 1914 *Pittura Scultura Futuriste*). In 1912 he contributed to the Paris Futurist Exhibition. He tried to synthesize the remembered and the seen by using multiple viewpoints and superimposed images (e.g. *The Street Enters the House*, 1911, Hanover, Kunstmuseum). In painting, this took him towards ▷abstraction (e.g. *Dynamism of a Cyclist*, 1913, Milan, Mattioli Collection). In sculpture, he produced multimedia constructions similar and contemporary to those of ▷Picasso, and a series of figures which showed 'pure plastic movement' (e.g. *Unique Forms of Continuity in Space*, 1913, New York, Museum of Modern Art).
Bib.: *Umberto Boccioni*, exh. cat., New York, 1989; Schneede, U.M., *Umberto Boccioni*, Stuttgart, 1994

Bochner, Mel (b 1940)

American painter. He began in a rationalist ▷Minimalist style, but his ▷serial art images began taking on some of the properties of ▷conceptual art.

Böcklin, Arnold (1827–1901)

Swiss painter born in Basle. He studied in Düsseldorf (1845–7) under Schirmer, Geneva (1847) and Paris (1848). His early works were sentimental Classical ▷landscapes of Switzerland and Italy, which he based on natural observation. He visited Rome in 1840 and 1850–2 where he studied with ▷Feuerbach and produced work influenced by ▷Corot. He established his reputation during the late 1850s and worked at Weimar Art School (1860–2). His work developed into fantastic scenes incorporating creatures of Classical and Germanic legend, painted in the precise style of ▷Friedrich but with an added theatricality (e.g. *Triton and Nereid*, 1873–4, Winterthur, Oskar Reinhart Foundations; *The Isle of the Dead*, version 1880, Basle, Kunstmuseum). He spent 1874–85 in Florence and 1885–92 in Zurich. In his later career he was associated with the German ▷Symbolists. He designed ▷frescos for Basle Museum (1868–77).
Bib.: *Arnold Böcklin*, exh. cat., London, 1971; Linnebach, A., *Arnold Böcklin und die Antike*, Munich, 1991; Schmidt, G., *Arnold Böcklin*, London, 1963

bodegón

(Spanish, 'tavern' or, by extension, 'still life'.) The name given to ▷genre scenes, usually set in a kitchen, which contained still-life elements. The early works of ▷Velázquez, such as *Old Woman Cooking Eggs* (1628, Edinburgh, National Gallery of Scotland) were in this mode.

Bodichon, Barbara (1827–91)

English painter. She began as an amateur artist, producing ▷watercolours in a diluted ▷Barbizon mode. She was able to work with ▷Corot from 1864 and she began to exhibit her work frequently. She co-founded Girton College, Cambridge, with Emily Davies, as a place for women's education, and she was one of the most influential figures in the early English ▷feminist movement. In 1857 she married a French doctor, Eugène Bodichon, and they spent much of their subsequent lives in Algeria.
Bib.: Mathews, J., 'Barbara Bodichon: Integrity in Diversity', in D. Spender, (ed.), *Feminist Theories*, London, 1983

body art

The artist's use of his or her own body, or the body of a model, as the subject or expression of their art. Body art came to prominence in the late 1960s and 1970s, and it was initially designed to shock the observer. It took many different forms. Artists such as ▷Yves Klein painted the naked bodies of female models and dragged them around on a canvas placed on the floor. Other artists such as Orlan used mutilation to make ▷feminist statements about the use and abuse of female bodies.

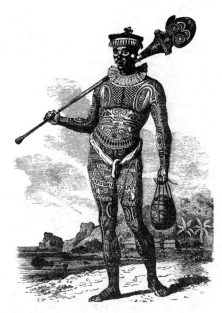

Body art: Marquesas' tattoos, c1860

Body art could be produced as a performance, or, more frequently, it was filmed. The diversity of body art has precluded it from classification as a movement, but it has regained momentum in recent years with a new interest in the body exhibited by both feminist and homosexual groups.

body colour

Water-based paint made opaque by mixing it with white (also called ▷gouache). True ▷watercolour ▷pigments are translucent and lighter areas are created by applying increasingly diluted washes, with white areas created by an absence of paint. However, where tinted paper is used, body colour may be applied to render highlights.

Boethius (c475–525)

Ancius Boethius was an eminent public figure and scholar under the Ostrogoth Emperor Theodoric, whose writing and translations made a profound impact on the intellectual life of the Middle Ages. He was made consul to Theodoric in c510, but fell from favour (possibly because of involvement in a conspiracy or because of theological disputes) and was imprisoned at Pavia, where he studied the Greek philosophers and wrote the *Consolation of Philosophy* whilst awaiting execution. A Menippean Satire (i.e. alternating verse and prose), it is a dialogue between an ailing prisoner and his 'nurse', Philosophy. She offers him advice on the nature of good and evil, fortune and happiness, fate and free will, thus helping him recover and achieve enlightenment. The fact that the book was translated into the vernacular throughout Europe proves its enduring popularity – it was translated into English by Alfred, Chaucer and Elizabeth I. Boethius' translations of Aristotle and commentaries on Cicero were also hugely influential, as were his treatises on arithmetic, geometry, astronomy and music. Boethius' firm belief that one must master the ▷Liberal Arts to master one's enemies underpinned many medieval doctrines, and in manuscript illustrations the Liberal Arts are often depicted as handmaidens of philosophy and theology. Boethius' sense of proportion and numerical systems can be seen in medieval treatises and the few surviving medieval secular manuscripts.

Bohemian Master

A painter who produced ▷Madonnas in an ▷International Gothic style in Prague from the mid-14th century. The Bohemian Master worked for the court of Charles IV.

Boilly, Louis-Léopold (1761–1845)

French painter and engraver. He produced portraits during the ▷French Revolution, but afterwards turned to ▷genre paintings as well. He also practised ▷lithography from 1823.

boiserie

▷panel

Bol, Ferdinand (1616–80)

Dutch painter and etcher. He worked in ▷Rembrandt's studio, and in recent controversies about Rembrandt attribution, many of Rembrandt's more famous works have been attributed to him. He was the teacher of ▷Kneller.

Boldini, Giovanni (1842–1931)

Italian painter. He was from Ferrara but he gained an international reputation from his work in Paris and London. In 1867, he saw ▷Manet's work in Paris, and he was later influenced by the society portraits of ▷Sargent. He specialized in society portraiture himself, and he became recognized for his ability to flatter the sitter, a somewhat mannered style and a ▷bravura ▷brushwork.

bole

▷bolus ground

Bolgi, Andrea (1605–56)

Italian sculptor. He worked in ▷Bernini's studio from 1626 and helped contribute to the sculptural programme at St. Peter's.

Bologna, Giovanni da (Giambologna) (Jean Boulogne) (1529–1608)

Italian sculptor. After ▷Michelangelo, the most successful sculptor in Florence in both bronze and marble, and on both a colossal and small scale. His bronze statuettes, maintaining a consistently high quality whilst being produced in some quantity, helped disseminate the ▷Mannerist style throughout Europe.

Born in Douai, he was trained in Flanders before moving to Italy c1550. After about two years in Rome he moved to Florence where he competed unsuccessfully against ▷Ammanati and ▷Cellini for the commission for the *Neptune Fountain* in the Piazza della Signoria. Ammanati won the competition, but Giambologna worked on the fountain as an assistant and in 1563–7 took the opportunity to use his own Florentine design when he was awarded the commission for the Bolognese Neptune Fountain. His most remarkable sculpture, the so-called *Rape of the Sabines* (marble, 1579–83, Florence, Loggia dei Lanzi; wax sketch models in London, Victoria and Albert Museum) has, in fact, no specific subject (the name was added afterwards) and was designed by Giambologna specifically as a work of art which would demonstrate his ability to create a sculpture with not one principal viewpoint (the Classical aesthetic) but multiple viewpoints which encourage the viewer to completely circumnavigate the sculpture in order to enjoy it from every angle (the Mannerist aesthetic). Multiple viewpoints, complex twisting poses and a daring willingness

to cut right through the block are also explored in his two colossal marble groups: *Samson Killing the Philistine* (c1561–2, London, Victoria and Albert Museum) and *Florence Triumphant over Pisa* (1575, Florence, Bargello; wax and ▷terracotta models in London, Victoria and Albert Museum).

Giambologna's success was founded principally on the continued patronage of the Medici, two of his best known bronzes being the ▷equestrian statues of the Grand Dukes Cosimo I (1594, Florence, Piazza della Signoria) and Ferdinand (Piazza dell' Annunziata) – the former being the first Florentine equestrian statue and one that influenced many later examples throughout Europe. For a pool in the garden of the Medici villa at Pratolino, Giambologna made the colossal (c10 m/33 ft high) crouching giant, *Appennino* (1577–81, brick, stone, lava, iron, etc.). His most famous small bronze is perhaps *Mercury* (1564, Florence, Bargello; other versions in, amongst other places, Washington, National Gallery, and Bologna, Museo Civico).
Bib.: Avery, C., *Giambologna,* Oxford, 1987; Gibbons, M.W., *Giambologna: Narrator of the Catholic Reformation,* Berkeley, 1994

Bologna, School of

The style of painting initiated and perhaps epitomized by 13th/14th-century Bolognese manuscript illumination. The university and law schools in Bologna made it a gathering ground for scholars and intellectuals during the late 13th century. Bolognese ▷Romanesque, like the Romanesque in other northern Italian cities, was dominated by ▷Byzantine types. This style shown in manuscripts such as the Paris Bible (Paris, Bibliothèque Nationale, Lat.18) and the bible in the cathedral at Gerona, where figures start to look more solid and appear more often in initial illustrations. Byzantine trends are also shown in secular books, like the Book of Canons (MS. Vat.Lat.1375). Bolognese style spread throughout Italy, as far as Naples, and beyond. Outside illumination, Vitale da Bologna (fl, 1334–61) is the only really important painter of this era, and he was greatly influenced by the Sienese School, as demonstrated in the Edinburgh panel (c1350). Vitale also painted in ▷fresco at Pomposa, where the fluidity, colours and crowded scenes seem typically Bolognese.

Bolognese, II

▷Grimaldi, Giovanni Francesco

Boltraffio (Beltraffio), Giovanni Antonio (1466/67–1516)

Italian painter. He was the principal pupil and follower of ▷Leonardo da Vinci in Milan. A *Madonna and Child* (London, National Gallery) and a *Narcissus* (Florence, Uffizi) have been attributed to him and a female portrait in the Louvre, *La Belle Ferronnière,* has been variously attributed both to Boltraffio and Leonardo.

Bib.: Henry, R.R., *Giovanni Antonio Boltraffio: A Stylistic Study of his Work*, London, 1959

Bolus, Michael (b 1934)

South African sculptor who lives in England. He worked with ▷Caro in 1959–62. His distinctive work consists of ▷Minimalist installations from steel grids.

bolus ground

A clay containing iron oxides, usually a reddish-brown colour, used as the under layer for gold-leaf in water-gilding. Also called bole.

Bombelli, Sebastiano (1635–before 1716)

Italian painter. He was from Venice and specialized in ▷history and portrait painting.

Bomberg, David (1890–1957)

British artist. He was a landscape painter associated with ▷Vorticism. He was born in Birmingham of Polish parents and grew up in the Jewish community in Whitechapel. Through the Jewish Educational Aid Society he was able to go to the ▷Slade. He was a founder-member of the ▷London Group and an associate of the Vorticists (he exhibited with them in 1915) although he refused to sign their manifesto. In 1913 he visited Paris with ▷Epstein and on his return produced *In the Hold* (1914, London, Tate Gallery), a large, strongly coloured geometric abstraction based on the loading of a ship. In the same year he held a one-man show at the Chenil Gallery. He served during the First World War and afterwards was employed by the Canadian War Records Office, for whom he produced *Sappers at Work* (1918/9, Ottawa, National Gallery of Canada). He lived in Hampshire for a time, before travelling to Palestine with a Zionist group (1923–7). This inaugurated a series of travels, especially to Spain. He began producing landscapes in hot tones and heavy ▷Expressionist paint (e.g. *Mt. St. Hilarion and Castle Ruins*, 1948, Liverpool, Walker Art Gallery). His work was not popular despite critical acclaim, and he lived in poverty, helped by a teaching position at the Borough Polytechnic (1945–53), where he established the Borough Group along with pupils, Auerbach and Kossoff.
Bib.: *David Bomberg*, exh. cat., London, 1986

Bombois, Camille (1883–1970)

French painter. He was of working-class origin and travelled around taking up casual jobs. He exhibited his works on the pavements of Paris, but he was discovered and encouraged by ▷Wilhelm Uhde. He was thus one of many ▷naive artists whose works were popular in the early decades of the 20th century.

Bonanno of Pisa

Late 12th-century Italian sculptor and architect who was responsible for the bronze doors of Pisa Cathedral. He also began work on the ▷Campanile (leaning tower).

Bone, Sir Muirhead (1876–1953)

Scottish draughtsman and etcher. He was especially known for architectural subjects. He was born in Partick and, after studying architecture, trained at Glasgow School of Art under Archibald Kay. In 1898 he made a series of ▷etchings of the city based on Meryon's views of Paris. He settled in London in 1901, became a member of the ▷NEAC and had a one man show at the Carfax Gallery in 1902. By 1909 (when Dodgson's ▷catalogue raisonné of his work was published) he was considered the major etcher since ▷Whistler. He was an official artist in both wars (see *Ruins of London from St. Bride's Wall, Recorded in the Blitz*). He was a trustee of the Tate and National Galleries and was knighted in 1937. His son, Stephen (1904–58) was also a painter and critic.
Bib.: *Muirhead Bone*, exh. cat., St. Andrews, 1986

Bonfigli, Benedetto (fl 1445, d 1496)

Italian painter. He worked in Perugia where he frescoed part of the town hall. He worked in the style of ▷Gozzoli.

Bonheur, Marie-Rosalie (Rosa) (1822–99)

French painter who produced chiefly animal subjects. She was born in Bordeaux, the daughter of a painter. After moving to Paris in 1829, she was trained by her father and exhibited regularly at the ▷Salon from 1841. She achieved fame in 1849 with *Ploughing in the Niverne* (Fontainebleau) which was bought by the government, the first of a series of large-scale animal works. From 1851 she was studying horses from life, dressed as a man, and she travelled widely throughout France, especially in the Pyrenees. This experience led to *Horse Fair* (1853, New York, Metropolitan Museum). Her work was highly popular in her day and she was something of a celebrity, and the first woman to be awarded the Légion d'Honneur. Much of her time, however, was spent reproducing her famous works. In 1867, she returned to the Salon after 12 years absence and began work on a series of paintings of wild animals (e.g. *Royalty at Home*, 1885, Minneapolis) which were criticized for their similarity to ▷Landseer's work. She also painted Bill Cody (1889, New York, Whitney Museum) and his Wild West show when it visited Paris. Her works were large, romanticized images of rural life, painted with finish but freedom, and providing an acceptable face of realism for the Second Empire. Her two brothers were also painters.
Bib.: Ashton, D., *Rose Bonheur: Life and Legend*, London, 1983; Stanton, T., *Reminiscences of Rosa Bonheur*, London, 1976

Bonifazio de' Pitati (Bonifazio Veronese) (1487–1553)

Italian painter. He was born in Verona and went to Venice in 1528. There he was exposed to the styles of ▷Palma Vecchio, with whom he studied, and ▷Titian, whose colourism influenced him. His only signed work is a *Madonna and Child with Saints* (1553, Venice, Accademia).

Bonington, Richard Parkes (1802–28)

English painter and lithographer. He was born near Nottingham, but spent most of his life in France, based in Calais, after his family moved there in 1817. There he first trained as an artist, before studying in Paris under ▷Gros at the ▷École des Beaux-Arts in 1820. He specialized in oils and ▷watercolours of marine subjects which combined an interest in English topographical watercolour with the freedom of French ▷Romanticism (e.g. *Scene on the Normandy Coast*, 1826, private collection; *Versailles*, 1925, Paris, Louvre). He was friendly with ▷Lawrence and ▷Delacroix and travelled to England with the latter in 1825. He also visited Italy in 1826, making a series of sketches of Venice. His work was widely appreciated in France, following a gold medal at the 1824 Salon (which also honoured ▷Constable). He was one of the earliest artists to practise ▷plein air oil sketching. He died of tuberculosis at an early age.
Bib.: Cormack, M., *Richard Parkes Bonington*, Oxford, 1989; Noon, P.J., *Richard Parkes Bonington on the Pleasures of Painting*, New Haven and London, 1991; Peacock, C., *Richard Parkes Bonington*, London, 1979; Pointon, M., *Bonington Circle*, Brighton, 1985

Bonnard, Pierre (1867–1947)

French painter, designer and lithographer. He was born in Paris and studied law before turning to painting. He trained at the ▷Académie Julian in 1888, with ▷Sérusier and ▷Denis, and at the ▷École des Beaux-Arts in 1889, where he met ▷Vuillard. These friendships led to establishment of the ▷Nabis, who met together at the Café Volpin from 1889 and first exhibited in 1892. He also shared a studio with Vuillard and Denis during the 1890s. Bonnard's early work was mainly graphic: he illustrated books for Vallotton (e.g. *Parallelement* in 1900; *Daphnis et Chloe* in 1902), designed the cover for the *Revue Blanche* in 1895 and produced posters (e.g. *France Champagne*, 1891). After meeting ▷Redon in 1894, he became interested in ▷lithography (e.g. *Quelques aspects de la vie à Paris* series, 1898). He also experimented with stage design (e.g. *Ubu Roi* in 1896) and throughout his life worked on decorative projects for friends. His work was influenced by

▷Art Nouveau in its use of line and flat colour, and by Japanese prints in its stylization.

From 1900 Bonnard increasingly turned to oils, developing with Vuillard the ▷Intimiste style of claustrophobic pattern and interior subjects, hiding his figures in a patchwork of iridescent colour (e.g. *Dining Room in the Country*, 1913, Minneapolis, Institute of Arts). After meeting ▷Signac at St. Tropez in 1904, he also became interested in landscape (e.g. *Riviera*, 1923, Washington, Phillips Collection). From 1911 he was based at Vernon, from 1939 Le Cannet, living in increased isolation and concentrating on painting repeated images of his wife (e.g. *Marthe in the Dining Room*, 1933, Lyons, Musée des Beaux-Arts). He travelled widely and exhibited internationally; he was, unusually, elected to the ▷RA in 1940.

Bib.: *Bonnard at le Bosquet*, exh. cat., London, 1994; Fermigier, A., *Pierre Bonnard*, London, 1987; Watkins, N., *Bonnard*, London, 1994

Bonnat, Léon (1833–1922)

Spanish artist of French birth (from Bayonne). He worked in France and was particularly influenced by the style of the 17th-century ▷Caravaggisti. From 1870 he concentrated on painting portraits. Both ▷Toulouse-Lautrec and ▷Braque studied in his private studio in Paris.

Bonnet, Anne (1908–60)

Belgian painter. She was a founder member of the groups La Route Libre and ▷Jeune Peinture Belge. From the 1950s she produced mainly abstract works.

Bonomi, Joseph (1739–1808)

Italian architect. He was born in Rome, settled in England and is best known for his ▷Classical style country houses. Already a respected architect in Italy, having produced designs for eminent patrons including the Pope, Bonomi moved to England in 1767 at the invitation of ▷Robert and James Adam. His work was in vogue and he is mentioned in Jane Austen's *Sense and Sensibility*. Important buildings include: Dale Park, Sussex; the Chapel in Spanish Place, Manchester Square, London; Laverstock House, Hampshire; Roseneath, Dumbartonshire; and Ashtead Park, Surrey. He moved in fashionable and artistic circles: his wife was ▷Angelica Kauffman's cousin, his nomination for the ▷Royal Academy's professorship of perspective was championed by ▷Sir Joshua Reynolds, and his son, also called Joseph, was a celebrated artist and Egyptologist.

Bonvicino, Alessandro

▷Moretto de Brescia

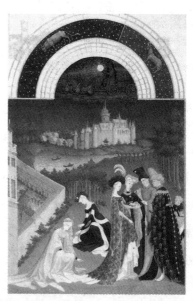

Book of Hours: Limbourg Brothers, *Très Riches Heures du duc de Berry*, c1413–16; *April: Courtly Figures in the Castle Grounds*, Musée Condé, Chantilly

Book of Hours

A prayer book, intended for the private devotions of a lay person. Achieving the height of their popularity in the 15th century, Books of Hours contained prayers suitable to the specific canonical hours of the day (e.g. matins, prime, terce, sext, none, vespers and compline) and specific days of the week, month and year. They often contain rich illumination, among the most beautiful being the ▷ *Très Riches Heures du Duc de Berry* (c1413–16, Chantilly, Musée Condé), illuminated by the ▷Limbourg Brothers for Jean de Berry.

Bor, Paulus (c1600–69)

Dutch painter. He was in Rome in the early 1620s, where he became involved with the art as well as the extracurricular activities of the ▷Schildersbent. In 1628 he went to Amersfoort, where he spread the influence of ▷Caravaggio.

Bordone (Bordon), Paris (1500–71)

Italian painter, born in Treviso. He was in Venice training with ▷Titian by 1518 and, despite (according to ▷Vasari) leaving the workshop abruptly following an allegation that Titian had stolen his first commission from him, continued to show the influence of his former master. He was also influenced by ▷Giorgione, painting pastoral landscapes and mythologies that obtained great popularity for him. He achieved a degree of international renown, travelling to France (possibly 1538 and 1559) and Augsburg (c1540) to execute commissions. The earlier date for the French trip seems to be evidenced in the ▷Mannerist style

(possibly derived from contact with the Second School of ▷Fontainebleau) which invests his later paintings. A comparison of two paintings on erotic themes (popular with his many private patrons) suggests the shift from Titian to Fontainebleau influence (cf. *Two Lovers*, c1525, Milan, Brera, with *Venus, Cupid and Mars*, c1545, St. Petersburg, Hermitage). Bordone was also in great demand as a portraitist. One of the most popular Venetian artists of his day, Bordone is today less highly rated, his paintings lacking much of the poetry of his influences, but his style is markedly individual with a hard and linear description of forms and a preference for rather acerbic combinations of purplish-red and indigo-blue (e.g. *Daphnis and Chloe*, c1540, London, National Gallery).
Bib.: Canova, G., *Paris Bordone*, Venice, 1964; Plebani, L., *Paris Bordone 1500–71*, Milan, 1984

Borduas, Paul-Émile (1905–60)

Canadian painter. He studied in Montreal until 1928 when he went to Paris. There he came into contact with the work of ▷Denis and ▷Desvallières and he changed his direction from church decoration to painting. During the 1940s, he was influenced by the ▷Surrealists and helped found ▷Les Automatistes in Quebec. Although many of his early commissions had been for the Catholic Church in Quebec, he became violently anti-clerical and anti-Catholic, and was expelled from his teaching position in Montreal. From 1953 he began a period of work outside Canada, staying in New York, Massachusetts and Paris. He helped promulgate ▷Tachism in America.

Borghese, Scipione (1576–1633)

Roman Cardinal, nephew of Pope Paul V (Camillo Borghese), art collector and enthusiastic patron of the arts. The Cardinal was famous for his worldly good humour and hedonistic attitude to life. His taste in art was relatively wide and included paintings by ▷Raphael, ▷Titian and ▷Veronese, as well as ▷antique sculpture. He also bought paintings by contemporary artists, such as ▷Cavaliere d'Arpino, ▷Domenichino and ▷Caravaggio. He ordered the building of the so-called Villa Borghese (1613–15) by G. Vasanzio of Utrecht to house his art collection (since 1902 a state museum housing the Borghese family collection of art). He was the earliest and principal patron of ▷Bernini whose sculptures for Scipione (all housed in the Villa) include most of his important early works: *Pluto and Persephone* (1621–2), *Apollo and Daphne* (1622–5), *David* (1623–4) and the bust of Cardinal Scipione Borghese (1632). He also patronized ▷Guido Reni whose painting, *Aurora*, decorates the ceiling of his garden casino in the Palazzo Rospigliosi, Rome. He was a totally unscrupulous collector, most famously ordering the theft by night of ▷Raphael's *Deposition* from the Baglione Chapel in Perugia, and its removal to his own collection.

Bib.: Antinori, A., *Scipione Borghese e l'architettura*, Rome, 1995; Reinhardt, V., *Kardinal Scipione Borghese 1605–33*, Tübingen, 1984

Borghese Gladiator

▷Antique marble statue of a man in a vigorous pose, striding forward and lunging upwards, apparently to strike at an opponent on horseback. It is generally accepted that the figure once held a sword and shield (both now missing). An inscription declares it to be by 'Agasius, son of Dositheos, Ephesian', a sculptor believed to have been active in the late 2nd and early 1st centuries BC and working under the influence of ▷Lysippus. Despite the almost universal acclaim for the work, it is considered more likely to be a Roman copy of the ▷Hellenistic original. It was found in 1611 at Nettuno, near Anzio, and was by 1613 recorded in the collection of the Villa Borghese, Rome. In 1807 Napoleon Bonaparte (brother-in-law of Camillo Borghese) purchased the piece and by 1811 it was in the ▷Louvre. From shortly after its discovery, copies, casts and reductions were being produced, one of the earliest casts, in bronze, being for Charles I of England by ▷Hubert Le Sueur (c1633, now at Windsor). Demand for casts reached such a pitch by the end of the 18th century that the then Prince Borghese prevented further moulds being taken. The *Borghese Gladiator* was in demand not just from collectors but also from art ▷academies: its particularly naturalistic rendering of the anatomy of a male figure in action made it an essential accessory for the best life-drawing classes. ▷Bernini considered it among the finest statues of all time and produced his *David* (1623) for the Villa Borghese in a spirit of admiring rivalry. It is also known as the *Borghese Warrior, Fighting Gladiator, Hector* and ▷*Discobolus*.
Bib.: Haskell, F. and Penny, N., *Taste and the Antique*, New Haven and London, 1981

Borglum, Gutzon (Gutsom) (1867–1941)

American sculptor. He was from Idaho and studied in Paris at the ▷Académie Julian. In 1896 he was in London, and he returned to the United States in 1901. He became known for a number of bronze sculptures of Indians, but his most famous work was his monumental carving on Mt. Rushmore in South Dakota (1927–41). This was a government commission that involved the carving of portraits of four U.S. Presidents – George Washington, Thomas Jefferson, Abraham Lincoln and Theodore Roosevelt – into the side of the mountain.

Borissov-Mussatov, Victor (1870–1905)

Russian painter. He was influenced by ▷Moreau and ▷Puvis de Chavannes while in Paris, and he returned to Russia in 1899 to practise a ▷Symbolist style there. He was one of the founder members of the ▷Blue Rose Group. His works were distinguished by their

emphasis on one particular lonely old mansion and women wandering mysteriously and aimlessly through fields.

Borrassá, Luís (fl 1388–1424, d c1425)

Spanish painter. He worked in Barcelona, producing altarpieces in the ▷International Gothic style.

Borromini, Franceso (1599–1667)

Italian architect. He was the chief rival of ▷Bernini in the ▷Baroque style. His architecture, based on geometric forms invested with sculptural dynamism and spatial movement, was perhaps too unclassical to be very influential in Italy, although ▷Guarini's work in Turin is heavily indebted to Borromini, and Borromini's influence was greater in non-classical transalpine Europe, especially Austria and southern Germany.

The son of a mason, Borromini was born at Bissone on Lake Lugano and worked in Milan before moving to Rome in 1619. Here he secured work with his distant relation ▷Carlo Maderna as a carver of decorative architectural details. Under him he executed work in St. Peter's – he is credited with the design for the wrought-iron gates for the Chapel of SS Sacramento (1627) – and the Palazzo Barberini. After Maderna's death in 1629 he continued working for his successor, Bernini, becoming ultimately his chief assistant. Borromini was by nature neurotic and obsessive (he is said to have ultimately committed suicide during an attack of melancholia) and his relationship with Bernini was apparently stormy. They parted for ever in 1634 when Borromini secured his first independent commission, S. Carlo alle Quattro Fontane (erected 1637–41).

Built on a cramped and irregular site, like all Borromini's architecture, the ingenious plan for this church is based on a subdivision of basic geometric forms: in this case, the oval ground plan is based on two contiguous equilateral triangles with a coffered dome to enhance the oval. Far from being a dry mathematical exercise the interior is enlivened by the succession of ▷niches and engaged ▷columns which impart a rhythmic undulation to the whole. The formal plasticity is further enhanced by the austere white of the plastered walls, relieved only by a few decorative motifs of palm or star. The façade is composed of orthodox Classical elements, but energized with a concave-convex-concave arrangement of bays. For the Oratory of S. Philip Neri (1638–50), Borromini designed a concave façade, imparting not only grandeur to a cramped site, but also linking the chape to the monastic buildings in a unified and harmonious composition. During this busy period he was also commissioned to build S. Ivo della Sapienza (1643–60), the ground plan of which is based on a star-hexagon, with a dome, stepped on the outside and surmounted by a spiral-topped, incurved lantern. In S. Agnese in Piazza Navona (1653–7) Borromini imparted drama to a conventional design already begun by ▷Rainaldi with a concave façade, high drum and dome and flanking ▷campanili, an arrangement which inspired ▷Wren's west towers for St. Paul's, London. Borromini was also engaged to remodel the interior of S. Giovanni in Laterano (1646–9), though his intended nave vaulting was never executed. He also worked on a number of secular buildings, the most important of which are the Palazzo Spada, Palazzo Falconieri and Palazzo Pamphili, all in Rome.
Bib.: Blunt A., *Borromini*, London, 1979; Connors, J., *Borromini and the Roman Oratory*, New York 1980; Pittoni, L., *Francesco Borromini, l'iniziato*, Rome, 1995

Bosboom, Johannes (1817–91)

Dutch painter and lithographer. He was influenced by Dutch 17th-century paintings of church interiors, which he transformed into costume pieces. He inspired the ▷Hague School of art.

Bosch, Hieronymus (c1450–1516)

Netherlandish painter. He was born and mainly active in the town of s'Hertogenbosch in northern Brabant. His real name was Jerome van Aken, the name Bosch deriving from that of his hometown. His 40 or so surviving paintings, mostly religious or ▷allegorical, include some of the most bizarre and inexplicable images in the history of western European art. None are dated, and a generally accepted chronology has

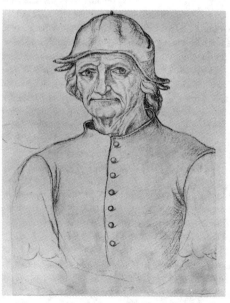

Hieronymus Bosch, 16th century, Flemish School, Bibliothèque Municipale, Arras

never been worked out, but it is thought that the more conventional paintings, such as the *Crucifixion* (Brussels, Musées Royaux des Beaux Arts) and the *Mocking of Christ* (London, National Gallery) are among the earliest. The paintings presumed to be from his mature period are usually populated with small-scale, rather frail-looking human beings, surrounded by nightmarish demons and monsters in half-human, half-animal form (e.g. *Garden of Earthly Delights*, Madrid, Prado and *Temptation of St. Anthony*, Lisbon, Museu Nacional de Arte Antiga). The style of the mature paintings seems to owe more to popular prints than to the prevailing high art tradition, although the influence of ▷Bouts and ▷Rogier van der Weyden has been discerned in his early works.

Because of the idiosyncratically bizarre nature of much of Bosch's imagery, there have been many attempts to interpret his works as reflections of the beliefs of an heretical cult. This, however, has been rejected by most historians on the grounds that Bosch was an orthodox Catholic, well-respected by his fellow citizens and that his paintings were not only sought after by his contemporaries, but also avidly collected by that most conventionally Catholic of kings, Philip II of Spain. And yet as early as the 17th century, suggestions that Bosch's paintings were heretical began to appear. It would seem that the understanding of the complex symbolism had been lost within a few generations. Modern psychological interpretations have also failed and, even though the ▷Surrealists claimed him as one of their own, there is no internal evidence to suggest that Bosch's paintings are the uncontrolled expressions of his subconscious mind – on the contrary, his contemporary reputation strongly suggests that his paintings contain a very definite pro-gramme, well understood at the time. There are indeed a number of his allegorical paintings, which, even though receiving a characteristically fantastical treat-ment, are nonetheless thematically conventional, such as *The Seven Deadly Sins* (Madrid, Prado), *The Hay Wain* (Madrid, Prado) – a visual evocation of 'All flesh is grass' – and the *Ship of Fools* (Paris, Louvre). However, the enduring attraction of Bosch lies not merely in is fantastical imagery, for he was also a technically brilliant draughtsman and a painter of great fluency with a superbly delicate colour sense.
Bib.: Hlawaty, G., *Bosch*, Riverside, 1995; Marisnissen, R.H., *Hieronymus Bosch: The Complete Works*, Antwerp, 1987; Merton, E., *Hieronymus Bosch*, London, 1991; Orienti, S., *Hieronymus Bosch*, New York, 1979; Rooth, A.B., *Exploring the Garden of Delights*, Helsinki, 1992

Boshier, Derek (b 1937)

British painter. He studied at the ▷Royal College of Art in London, with ▷Hockney, ▷Jones and ▷Kitaj. He was one of the artists who inspired the beginnings of ▷Pop art through his participation in the 'Young

Contemporaries' exhibition held at the RBA Galleries in 1961. He became a teacher in 1963. His Pop art made extensive use of advertisements.

boss

An ornamental projection or knob, usually richly carved, concealing the intersection of ▷ribs or ▷beams in a ▷vault or ceiling.

Bosschaert, Ambrosius (1573–1621)

Flemish painter. Born in Antwerp, he moved to Holland where he established himself as the first of a school of flower painters. His meticulous Flemish approach was softened under the influence of the Dutch interest in subtle effects of light. He frequently painted on copper, its smooth surface combining with Bosschaert's suppression of all signs of ▷brushwork to produce a heightened naturalism. However, this naturalism is merely apparent as his paintings are arrangements of flowers from different seasons com-posed to achieve a pictorial harmony. Furthermore, such flower paintings were undoubtedly intended to be symbolic: in *Vase with Flowers in a Niche*, The Hague, Mauritshius, the raggedness of some of the petals seems to refer to the transience of life and the fly on the sill was a well-known symbol of death. Bosschaert's style of flower painting was perpetuated by his three sons, Ambrosius the Younger (1609–45), Abraham (1613–c1645), and Johannes (c1610–c1650), and his brother-in-law, ▷Balthasar van der Ast.
Bib.: Bol, L.J., *The Bosschaert Dynasty: Painters of Flowers and Fruit*, Leigh-on-Sea, 1960

Bosse, Abraham (1602–76)

French engraver. He taught in the ▷Académie Royale from its foundation in 1648 until 1661, when he was expelled for his vocal opposition to the Academy's director, ▷Charles Lebrun. He became known through teaching and published treatises as an advocate of rigid rules in art. His own prolific production con-sisted largely of engravings after ▷genre paintings and scenes of contemporary life.

Botero, Fernando (b 1932)

Columbian painter. He specializes in figure painting representing pneumatic, *outré* figures and self-con-scious parodies of the work of famous artists of the past.

Both, Jan (c1618–52) and Andries (c1612–41)

Dutch family of painters. Jan specialized in Italianate landscapes. Born in Utrecht, he trained first under his father and then ▷Abraham Bloemaert. The formative experience of his artistic career was his visit to Italy c1637–41. His brother, Andries, had preceded him there in c1632, and had taken up painting ▷bam-bocciate somewhat in the style of ▷Brouwer (e.g. *Boors Carousing*, 1634, Utrecht, Central Museum).

Andries is also said to have painted the figures for some of Jan's landscapes, although none have been identified with certainty.

In 1641, the two brothers' Italian trip ended in tragedy. According to ▷Sandrart, they were visiting Venice and Andries drowned by falling into a canal while returning from a party. Following the death of his brother, Jan returned to Utrecht where he remained for the rest of his life. He himself had been influenced not at all by the *Bamboccianti*, but instead had discovered in Rome the paintings of ▷Claude Lorraine. Like Claude, he used sketches taken directly from nature in the Italian countryside as the basis for paintings which are romanticized idylls – and yet they are unmistakably his own. Carefully composed, they nonetheless appear to be less formally constructed and reveal a preference for mundane subjects (e.g. *Italian Landscape with Artists Sketching*, Amsterdam, Rijksmuseum) – although, like Claude, Jan did sometimes paint pictures of biblical and mythological subjects (e.g. *Judgement of Paris*, London, National Gallery, with figures by ▷Cornelis van Poelenburgh). Jan's landscapes are characteristically bathed in the warm golden haze of a Mediterranean evening. They created a vogue among northern European collectors who were attracted to this romanticized vision of the warm south; and they influenced a generation of Dutch landscape painters, some of whom like ▷Aelbert Cuyp, were never to visit Italy.
Bib.: Burke, J.D., *Jan Both: Paintings, Drawings and Prints*, New York, 1976

bottega

(Italian, 'shop, workshop'.) In the Middle Ages and ▷Renaissance, a workshop or studio run by a master, with assistants and apprentices. An *opera di bottega* is a piece of work, executed not by the master himself, but under his supervision.

Botticelli, Sandro (Alessandro di Mariano Filipepi) (c1445–1510)

Italian painter. He was Florentine and extremely successful at the peak of his career, with a highly individual and graceful style founded on the rhythmic capabilities of outline. With the emergence of the High ▷Renaissance style at the turn of the 16th century, he fell out of fashion, died in obscurity and was only returned to his position as one of the best-loved ▷quattrocento painters through the interest of ▷Ruskin and the ▷Pre-Raphaelites. His nickname 'Botticelli' means 'little barrel' and was originally bestowed on his older brother. For some reason the name was passed on to, and adopted by, the younger painter brother.

Botticelli's early years are obscure, but he seems to have been trained in the studio of ▷Filippo Lippi whose style informs his earliest dated work, the *Fortitude* panel (1470, Florence, Uffizi). This was commissioned to be one of a series of seven, the others having been executed by ▷Piero Pollaiuolo. A stylistic affinity here also with Pollaiuolo is perhaps due to the patrons' requirements for unity within the series (certainly it is never as evident again). Many of Botticelli's paintings are undated, but an *Adoration of the Magi* (Florence, Uffizi) has been dated by modern scholarship to c1475. This is important because it provides evidence of Botticelli having already secured the patronage of the Medici whose portraits (according to ▷Vasari) appear in the picture. So well did this work establish Botticelli's reputation that in 1481–82 he was commissioned to join ▷Perugino, ▷Ghirlandaio and ▷Rosselli (the most celebrated painters of the day) to paint frescos for the ▷Sistine Chapel. Botticelli's two most famous paintings were painted around about this time, possibly for Lorenzo di Pierfrancesco de' Medici. They are the ▷*Primavera* (c1478) and the ▷*Birth of Venus* (c1483), both in the Uffizi. These are mythologies, not of the capricious Ovidian sort but, it has been suggested, ones that embody the moral and metaphysical ▷Neoplatonic ideas that were then fashionable in Medici circles. Pure visual poetry, they are stylistically the quintessence of Botticelli: there is a deliberate denial of rational spatial construction and no attempt to model solid-looking figures; instead the figures float on the forward plane of the picture against a decorative landscape backdrop, and form, defined by outline, is wilfully modified to imbue that outline with expressive power.

That Botticelli could work in more than one manner at a time (perhaps, like the *Fortitude*, adapting it for the context) is shown in his fresco of *St. Augustine in his Study*, painted in 1480 for the Florentine church of the Ognissanti and in rivalry with ▷Ghirlandaio's nearby *St. Jerome* (both still *in situ*). Here Botticelli's style is more monumental, with a close attention to naturalistic detail. His workshop in these years was highly successful, one of its most lucrative lines being panels depicting the Madonna and Child, perhaps the most beautiful of which is the tondo of the *Madonna of the Magnificat* (c1485, Florence, Uffizi). Like his master Lippi, before him, Botticelli has created his own instantly recognizable type of feminine beauty, used for Madonnas and Venuses alike. His most remarkable painting is also the only one that is signed, the *Mystic Nativity* (1500, London, National Gallery). It is deliberately archaic with hieratic differences in scale (the Virgin and Child dwarfing the other figures) and carries a cryptic inscription (partly erased) forecasting the end of the present troubled world and the beginning of a new order. Many of his works datable to this period seem to be imbued with the same spiritual tension (which some scholars have attributed to Botticelli's association with the hellfire preacher Savanarola, although such an association has not been substantiated). During his last decade his style must have appeared absolutely out of date and he seems to have done very little work. Without doubt the High Renaissance style obscured his achievement and,

despite his earlier success, he had no followers of any merit. His most important pupil was the son of his own master, ▷Filippino Lippi.

Bib.: Lightbown, R., *Botticelli: Life and Work*, London, 1989

Botticini, Francesco di Giovanni (c1446–97)

Italian painter. He was from Florence where he was apprenticed, according to ▷Vasari, to Neri di Bicci. His only surviving documented work is an ▷altarpiece at Empoli, commissioned in 1484. Attributions to him are complicated by the fact that his style was derived at one time or another from most of the leading artists of his day. The most remarkable painting now ascribed to Botticini was cited by Vasari as being by ▷Botticelli: it is the large-scale *Assumption of the Virgin* (c1474/6, London, National Gallery), the programme for which was explicitly laid down by the ▷donor of the work, Matteo Palmieri. Its chief claim to fame is that it occupies the unique position in the ▷quattrocento of being an altarpiece accepted by a church and only subsequently discovered to have been executed to illustrate a tenet that is fundamentally heretical. Palmieri wrote a poem entitled *Città di Vita* (*City of Life*) which expressed the belief that humans are the angels who remained neutral when Satan and his followers rebelled. Botticini's painting depicts recognizable saints seated amongst the ranks of angels in Heaven, indicating that they had regained their former places through their earthly saintliness. The poem was not published until after Palmieri's death by which time the painting was already *in situ* in a side chapel in the church of S. Pier Maggiore and, although it was not immediately removed, it was covered with a veil.

Bouchardon, Edmé (1698–1762)

French sculptor. A spell in Rome during 1723–32 instilled an interest in ▷Baroque public fountains and monuments. When Bouchardon returned to France, he produced fountains and statues for Louis XV at Versailles and in Paris. He stood against the prevailing trend of ▷Rococo decorative art and helped pave the way for acceptance of Neoclassicism in France following his death.

Boucher, François (1703–70)

French painter and decorator. He was one of the most characteristic of the ▷Rococo artists. He studied under ▷Lemoyne and engraved ▷Watteau's work, but his major influences arose from a trip to Italy in 1727–31 (after wining the ▷Prix de Rome in 1723), where he discovered the work of ▷Tiepolo and ▷Francesco Albani. Back in France in the 1740s he benefited from the patronage of Mme de Pompadour (e.g. 1759, London, Wallace Collection), whom he painted several times, and rose to become chief painter to Louis XV. He also produced ▷tapestry designs for the royal makers at ▷Gobelins and ▷Beauvais. He

specialized in mythological scenes, using delicate pink tones and fleshy titillating nudes, reminiscent of, but more overtly attractive than, those of ▷Rubens and ▷Veronese (e.g. *Aurora and Cephalus*, 1739, Nancy, Musée des Beaux-Arts; *Birth of Venus*, 1740, Stockholm, Nationalmuseum). He was also a landscapist (e.g. *Landscape and Windmill*, 1743, Barnard Castle), ▷genre painter (e.g. *Déjeuner*, 1739, Paris, Louvre) and a major decorator of royal residences, working at Versailles, Marly, Fontainebleau and Bellevue. He was an Academician and became director of the French ▷Académie in 1765.

Bib.: Ananoff, A., *François Boucher*, 2 vols., London, 1976; Brunel, G., *François Boucher*, London, 1986; *François Boucher*, exh. cat., New York, 1969

Boucicault Master (early 15th century)

Franco-Flemish manuscript illuminator, whose style is ▷International Gothic, but anticipates the later Netherlandish school of painting. The Master's name is taken from a ▷Book of Hours, now in Paris, made for Jean le Meingre Boucicault. From this work several other attributions have been derived.

Boudin, Louis Eugène (1824–98)

French painter who specialized in seascapes. He was born, the son of a harbour pilot at Honfleur. From 1844 he ran a stationary and picture-framing business at Le Havre and there came into contact with many of the leading landscape artists, who inspired and encouraged him to paint. He specialized in coastal scenes of his local area around Trouville, which were sketched ▷plein air, with an emphasis on luminous skies and a light loose palette (e.g. version of *Beach at Trouville*, 1873, London, National Gallery). Although he painted larger studio works (e.g. *Breton Pardon*, 1858, Le Havre, Musée des Beaux-Arts), he was most successful with his sketches. ▷Corot referred to him as the 'master of the skies', and he influenced ▷Monet's early work, painting in the same area of France. Boudin is often described as a pre-▷Impressionist because of these characteristics and indeed he exhibited at the first Impressionist exhibition, though subsequently his style developed little and his works retained a traditional tonality and finish (e.g. *Beach at Etretat*, 1890, Philadelphia, Museum of Art).

Bib.: Aubry, G.J., *Eugène Boudin*, London, 1969; *Eugène Boudin*, exh. cat., Santa Barbara, 1976; Hamilton, V., *Boudin at Trouville*, London, 1992; Manoeuvre, L., *Boudin et la Normandie*, Paris, 1991

Bouguereau, Adolphe William (1825–1905)

French painter, born in La Rochelle. He studied at the ▷École des Beaux-Arts under a pupil of ▷David, F. E. Picot, and won the ▷Prix de Rome in 1850. He spent the next four years in Rome, was influenced by the works of ▷Raphael, and rapidly established a reputation as a painter of highly finished, idealized

compositions. He specialized in female nudes, which were extremely popular in his own day (e.g. *Birth of Venus*, 1879, Paris, Musée d'Orsay), but he also exploited a wide range of other subjects, including portraits (e.g. *Mother and Children*, 1879, Cleveland, Museum of Art). His religious paintings owed something to the ▷Pre-Raphaelites in their high finish and sentimentality (e.g. *Pietà*, 1876 Richmond, Virginia Museum). He also completed decorative work such as that in La Rochelle Cathedral (1883). Many of his works were engraved, which widened his popularity. He had a highly successful administrative career, as Professor at the École des Beaux-Arts from 1875, president of the Société des Artistes Françaises and a member of the ▷Salon and Universal Exhibitions juries, where he steadfastly opposed ▷Impressionism. Along with ▷Cabanel he was seen as a leader of ▷academic conservatism and as such his reputation suffered during the 20th century.
Bib.: *Bouguereau*, exh. cat., Montreal, 1984

Boulogne, Jean
▷Bologna, Giovanni da

Bourdelle, Émile-Antoine (1861–1929)
French painter, sculptor and designer. He was born in Montauban, the son of a cabinet maker. After studying at Toulouse, he moved to Paris in 1884 and studied there at the ▷École des Beaux-Arts, before becoming ▷Rodin's assistant in 1896. He exhibited at the ▷Salon des Artistes Français in 1884–90. His work was initially influenced by Rodin's vigorous delineation (e.g. 'Mask of Beethoven', 1901, private collection), but he later became interested in Egyptian and Greek art: *Hercules the Archer* (1909) was an exercise in Hellenic archaism and his reliefs for the Champs Elysées Theatre (e.g. 'Apollon et sa Méditation', 1911–12) were stylized in an Egyptian mode. He shared Rodin's enthusiasm for heroic subjects and his painstaking work from life. In the early years of the 20th century he became increasingly sought-after for monumental commissions (e.g. General Alvear Monument, Buenos Aires, 1917; Micklewicz War Memorial, 1917–29). He taught at the Grande Chaumière from 1909 until his death. His Paris studio has been preserved as a museum.
Bib.: Cannon-Brookes, P., *Bourdelle*, London, 1983; *La Catalogue du Musée Bourdelle*, Paris, 1990

Bourdichon, Je(h)an (c1457–1521)
French painter and manuscript illuminator. He was a student of ▷Fouquet and worked mostly in Tours. He completed the Hours of Anne of Brittany in c1508 (Paris, Bibliothèque Nationale). This was a very detailed manuscript which showed that Bourdichon may have been influenced by contemporary Italian art.

Bourdon, Sébastien (1616–71)
French painter. He was from Montpellier and he served in the French army until 1634, when he went to Rome. During his three years in Italy, he was impressed by the landscapes of ▷Claude and ▷genre scenes of the ▷*Bamboccianti*. His major works upon his return to Paris were subjects from Classical history and mythology painted in a ▷Baroque manner. However, he worked in many different styles, and his versatility led him to become court painter to Queen Christina of Sweden in 1652–4. When he returned to Paris in 1654 he concentrated on portrait production.

Bourgeois, Louise (b 1911)
American sculptress of French birth. Her early artistic training began after she obtained a degree at the Sorbonne in 1935, at which time she studied at the École du Louvre, the ▷École des Beaux-Arts and at the Académie de la Grande Chaumière. She also studied briefly with ▷Léger. When she moved to New York in 1938, she developed a mode of ▷Surrealist figure sculpture expressive of anxiety. Her early concentration on stone carving was extended by the 1960s to include metal casting and work with plastic and latex. At this time she extended her subject-matter, which became redolent of sexuality and included phallic and totemic imagery. At this time, she also began producing 'lairs' or sculpted concavities containing suggestive objects.
Bib.: Storr, R., 'Louise Bourgeois: Gender and Possession', *Art in America*, 71, no. 4 (1983), pp. 128–37

Bourgeois, Sir Peter Francis (1756–1811)
English painter. He was court painter to Stanislaus II, King of Poland, and later landscape painter to George III. His principal fame rests on his art collection, which he acquired from the dealer Noel Desenfans and left as a legacy to Dulwich College.

Bouts, Dieric (Dirk) (c1415–75)
Netherlandish painter, born in Haarlem. His early years are obscure but he arrived in Louvain in c1448 and may have trained with ▷Rogier van der Weyden. His manner combines elements from both van der Weyden and ▷Jan van Eyck. By 1468 he had been made town painter of Louvain. His earliest dated painting is the *Portrait of a Man*, (1462, London, National Gallery), and already mature work. Those paintings most heavily indebted to van der Weyden are generally believed to be earlier than this (e.g. *Deposition Altarpiece*, c1450–55, Capilla Real, Granada). His mature period, taken to begin in c1457, includes his major Louvain commissions: the *Last Supper Triptych* (1464–7) for the Church of St-Pierre (still *in situ*), and the two completed panels (of four projected) for the *Justice of Otto* (1470–75) painted for the Hôtel de Ville and now in Brussels, Musée Royaux. These are his only two

documented works and it is on the style of these that his *oeuvre* is built.

Bouts' figures are thin and rather doll-like, lacking the dramatic expressiveness of van der Weyden and therefore perhaps less suited to scenes of violence such as the *Martyrdom of St. Erasmus* (c1460, Church of St-Pierre, Louvain), where the saint's horrific evisceration is reduced to a mechanical chore, than to the hieratic solemnity of the St-Pierre *Last Supper* or the charming intimacy of the *Virgin and Child* (c1465, London, National Gallery). Nonetheless, the delicate beauty of the landscape setting and the rich colour harmonies of the *Erasmus* are qualities for which Bouts is greatly admired.

Bouts ran a large, successful workshop and his appealing, accessible style spawned a great many imitators and followers, amongst whom were his two sons, Dieric the Younger (c1448–90/1) and Aelbrecht (c1460–1549). Their stylistic similarity has produced problems of attribution, such as that of the *Pearl of Brabant Altarpiece* (Munich, Alte Pinakothek), attributed variously to both Dieric and to Dieric the Younger.

Bib.: *Dirk Bouts*, exh. cat., Brussels, 1957; Wolff, M., 'An Image of Compassion: Dirk Bouts' *Sorrowing Madonna', Museum Studies*, vol. 15, no. 2 (1989), pp. 112–25

Boyd, Arthur (b 1920)

Australian painter, etcher and ceramicist, born in Victoria. His earliest works consisted of landscape painting in a diluted ▷Impressionist style, but by the late 1930s he had become involved with the ▷Contemporary Art Society. At this time, he altered his style to an ▷Expressionistic interpretation of Australian mythology. He expressed the darker side of Antipodean legends in violent, distorted forms reminiscent of the late medieval paintings of ▷Bosch. During the 1950s, he concentrated more specifically on ▷Aboriginal themes, which he expressed in series of paintings, such as *Love, Marriage and Death of a Half-Caste*. He brought these ideas to England in 1959.

Boydell, John (1719–1804)

English engraver and printseller. From the 1740s he produced prints from his own drawings of views of England and Wales, taking advantage of the contemporary vogue for ▷picturesque tourism. This business made his fortune and enabled him to conceive the grand scheme for which he is most famous – the Shakespeare Gallery. From 1786, he commissioned the major artists of the day to produce oils of Shakespearian subjects, which were exhibited in Pall Mall and engraved for publication in 1802. One hundred and sixty-two pictures were produced by ▷Reynolds, ▷Fuseli, ▷Romney, ▷West, ▷Kauffman and others, but they rarely represented the artists' best work, and the project ended in bankruptcy when the paintings

were sold off by auction in 1804. Boydell was Lord Mayor of London in 1790. His nephew, Josiah (1752–1817), was his business partner and also the painter of seven Shakespearian works.

Bib.: Friedman, W.H., *Boydell's Shakespeare Gallery*, New York, 1976

Boydell's Shakespeare Gallery

▷Boydell, John

Boys, Thomas Shotter (1803–74)

English lithographer. During a trip to Paris in 1823, he came into contact with the topographical ▷watercolour painting of ▷Richard Bonington and his circle, and he also learned the technique of ▷lithography. When he returned to England in 1837, he began producing a series of lithographs designed as illustrations for travel literature. His *Picturesque Architecture in Paris, Ghent, Antwerp, Rouen etc.* of 1839 was one of the earliest major publications employing the technique of ▷chromolithography.

Bib.: Roundell, J., *Thomas Shotter Boys 1803–1874*, London, 1974

bozzetto

(Italian, 'sketch', 'scale model'.) The Italian word is a diminutive of *bozzo*, meaning literally a 'lump' of something and is therefore most accurately applied to a sculptor's small-scale rough model in clay or wax in which the composition is worked out preparatory to the full-scale model. However, it is also sometimes applied to a painter's small-scale sketch or study for a larger picture.

bracket

General architectural term for a constructional member projecting from a wall to support either an overhanging weight such as a ▷cornice or ▷balcony, or a superincumbent weight such as an ▷arch or ▷vaulting shaft, or set at either end of a horizontal member spanning a void. There are two widely used types of bracket: (i) corbels, which are blocks, usually of stone, sometimes carved, sometimes plain, employed to support either an arch at the springing, or else a horizontal member such as a beam; and (ii) consoles, which are carved as 'S'-shaped ▷scrolls, with one end broader than the other and set either vertically to support, for example, the shallow cornice over a door or window, or horizontally to support, for example, the main cornice of a building.

▷cantilever; ancones

Bracquemond, Marie (1841–1916)

French painter. She studied with ▷Ingres, but moved away from his more academic style towards ▷*plein air* painting by the 1870s. She exhibited at the conventional ▷Salon in 1874–5, but then abandoned conventionalism and joined the ▷Impressionist

exhibitions of 1879, 1880 and 1886. Like many women Impressionists, she concentrated on paintings of domestic life which adhered to the Impressionist desire to show modern life in all its aspects.
Bib.: Bouillon, J.-P. and E. Kane, 'Marie Bracquemond', *Women's Art Journal*, 512, pp. 21–7

Braij, Jan de
▷Bray, Jan de

Bramante, Donato di Angelo (1444–1514)
Italian architect. He was born near Urbino. From early in his career he was interested in theories of ▷perspective, and these experiments can be seen in his first commission. In c1479 he was hired by ▷Ludovico Sforza in Milan to design the church of Sta Maria presso S. Satiro, and he included in this church an illusionistic painted chancel and coffered ▷dome. While in Milan, he knew ▷Leonardo, with whom he worked, and he may have been influenced by Leonardo's sketches of ideal buildings. When the Sforzas were deposed by the French in 1499, Bramante went to Rome, where he designed the cloister of S. Maria della Pace (1500), using the ▷Doric and ▷Ionic orders in ways which deliberately echoed the ▷Colosseum. At this point, his tendency to look back to a pure Classical style was apparent, and this was realized in his most famous building, the ▷Tempietto at S. Pietro in Montorio (1502). For this circular building, he used a pure Tuscan Doric order for the ▷colonnades, avoiding all decoration and creating a stark building echoing the best work of ancient Rome. His architectural skill led Pope Julius II to commission him to design a plan for the new St. Peter's (from 1506), and Bramante settled on a ▷Greek cross plan that went against the tradition of building Christian churches in a ▷Latin cross formation. Although his centralized St. Peter's was never realized, the monumentality of his design was present in the final building. He also contributed other architectural work to the Vatican. Bramante was one of the most important architects of the Italian High ▷Renaissance.
Bib.: Bruschi, A., *Bramante*, London, 1977

Bramantino (Bartolomeo Suardi) (c1460–1530)
Italian painter. Bramantino is the nickname of the Milanese painter and architect Bartolomeo Suardi. The details of his artistic career are obscure, but the nickname (meaning 'Little Bramante') suggests that he was a follower of ▷Bramante. In 1508 he is recorded working in the Vatican, although nothing of his work there is known and by 1509 he was back in Milan. In 1525 he was appointed Court Painter and Architect to ▷Duke Francesco Sforza, a post he retained for his remaining years. Bramantino's early painting is characterized by sharp contours and angular forms in a style

reflecting the influence of ▷Mantegna and, through Bramante's Umbrian origins, ▷Piero della Francesca (e.g. *Adoration of the Magi*, 1500–5, London, National Gallery). The presence in Milan of ▷Leonardo's *Last Supper* (c1495–8) and a possible visit to Florence in 1509 on his way home from Rome seems to have exerted a certain influence, for from this time onwards, the new developments introduced by Leonardo and ▷Raphael begin to pervade Bramantino's work. An atmosphere blurs the edges of the forms and the forms themselves are more generalized (e.g. *The St. Michael Altar*, c1518, Milan, Ambrosiana).

Bramer, Leonaert (1596–1674)
Dutch painter. Like many artists of his time, he travelled to Italy, where he was impressed by the ▷chiaroscuro effects of ▷Caravaggio and the ▷Caravaggisti. When he returned to Holland, he specialized in ▷fresco painting.

Brancusi, Constantin (1876–1957)
Romanian sculptor. He was from a peasant family, but studied at the École des Beaux-Arts in Bucharest from 1898. In 1904 he went to Paris and studied at the ▷École des Beaux-Arts there. In Paris he also saw the work of ▷Rodin, which he initially admired. However, he rejected Rodin's naturalism and turned down the chance of working with him. Instead, in the early years of the 20th century, he moved towards ▷abstraction. He never moved away from nature entirely, but his works were inevitably radical simplifications of natural forms. Despite the abstract nature of his work, he claimed that all his forms had a spiritual depth and purpose and that he was striving for truth. He frequently repeated subjects, sometimes over a period of years (e.g. *Bird in Space*, 1923–40), and he also used modular units in works such as *Endless Column* (the first produced in 1920). Like many artists of his time, he was interested in ▷primitivist forms, and he used characteristics of African masks as well as tribal objects and Romanian folk art in his work. He advocated ▷direct carving.
Bib.: Hulten, P., *Brancusi*, Paris, 1986; Miller, S., *Constantin Brancusi: A Survey of his Work*, Oxford, 1995

Brandt, Marianne (1893–after 1980)
German designer. She studied at the Weimar Academy of Fine Art and remained there when it was incorporated into the ▷Bauhaus. During 1923–8 she was involved with the metal workshop at the Bauhaus, and she took control of this workshop when ▷Moholy-Nagy left in 1928. Her contribution there was mainly in the design of lamps, and when she left the Bauhaus, she began a lucrative career as an industrial designer.

Brangwyn, Sir Frank (1867–1956)

British painter, etcher and designer. He was born in Bruges, of Welsh parents. His father was an architect. He was largely self-taught, but spent two years (1882–4) apprenticed at ▷Morris and Company. He exhibited at the ▷Royal Academy from 1885 but became best known for his large-scale murals, amongst which are works for the Royal Exchange (1909), Skinner Hall (1909) and a project for the House of Lords which ended up in the Guildhall, Swansea. His works employed many figures and brilliant colours and he also experimented with ▷lithography. He was an official war artist in 1914–18 (e.g. *Departure*, 1914–18, Nottingham, Castle Museum). He was elected RA in 1919 and knighted in 1941.
Bib.: de Belroche, W., *Brangwyn, A Pilgrimage*, London, 1948; *Frank Brangwyn*, exh. cat., Walthamstow, 1974

Braque, Georges (1882–1963)

French painter. He was the son of a house painter in Argenteuil, and studied in Paris from 1900. From 1902 to 1905 he attended the ▷École des Beaux-Arts, but his traditional education was interrupted when he saw the works of ▷Fauve painters in 1905. In 1906, he attempted his own brand of Fauvism in landscape painting produced at L'Estaque and Le Ciotat, which he visited with ▷Othon Friesz. The real turning point in his work came in 1907 when he attended the ▷Cézanne retrospective exhibition at the ▷Salon d'Automne and met ▷Picasso. With Picasso, Braque was responsible for the advent of ▷Cubism. Although many of his works from 1909 are almost indistinguishable from Picasso's, his primary contribution to Cubism was the invention of ▷*papiers collés*, and his use of lettering on canvas. His work was interrupted during the First World War, and he was injured in battle. During the 1920s, he continued to produce works in a muted version of a Cubist style, but these later works were more lyrical and harmonious, reflecting contemporary Classical tendencies in French art.
Bib.: *Braque: oeuvres de Georges Braque (1882–1963)*, exh. cat., Paris, 1982; *Georges Braque, exh. cat., Munich, 1988; William Rubin, Picasso and Braque: Pioneering Cubism*, New York, 1989

Bratby, John Randall (1928–92)

English painter. He was educated at Kingston School of Art (1949–50) and at the ▷Royal College of Art (1951–4). His early, and most famous, works were ▷New Realist figurative oils which portrayed down-to-earth domesticity in bold, heavy colours and rhythmic ▷impasto patterns. He was identified as part of the ▷Kitchen Sink School, which included writers like John Osborne and Kingsley Amis, as well as artists who opposed the dominance of ▷abstraction. His work included still life, portraits (e.g. *Jean and Still Life in Front of a Window*, 1956, Southampton) and landscape (*Coach House Door*, 1959, Arts Council). He taught regularly throughout the 1950s at Carlisle Art School and at the RCA, but also achieved an international reputation, winning the Guggenheim award in 1958. In 1960 he suffered a breakdown, which led to a change towards a lighter palette, and an attempt at writing. He was elected ▷RA in 1971.
Bib.: *John Bratby*, exh. cat., London, 1911

Brauner, Victor (1903–66)

Romanian-French painter. He studied at the Academy of Fine Arts, Bucharest. In 1924 he designed sets for Wilde's *Salome* and collaborated with the poet Ilarie Voronca in founding the ▷Dada magazine *75 HP*. He also produced work for the ▷Surrealist magazines *Unu* (1928–31) and *Alge* (1930–3). In 1930 he settled in Paris, where he worked with ▷Brancusi and was introduced to the Surrealists by ▷Tanguy. In 1934 ▷Breton wrote an introduction for an exhibition of his Surrealist paintings, held at the Galerie Pierre, Paris. In 1934 he returned to Romania where he worked on a series of paintings representing the mutilation of the eye, which, surreally, prefigured the loss of Brauner's own left eye in a fight between the artists Oscar Dominguez (1906–58) and Esteban Francès (b 1914) on his return to Paris in 1938. He produced a 'magic' series of objects and paintings whose hallucinatory quality seemed to stretch even the limits of Surrealism. In 1948 he broke with the Surrealists and his later work shows influences by ▷Matta, ▷pre-Columbian art and ideas from ▷Art Brut, in which crude images are scratched into the

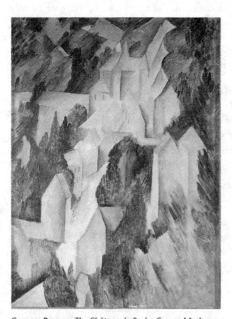

Georges Braque, *The Château, la Roche-Guyon*, Moderna Museet, Stockholm

surface of the paint. Michel Tapié promoted Brauner's work in the 1950s as ▷Art Autre.

Bib.: *Victor Brauner 1903–66*, exh. cat., Lyons, 1991; Jouffroy, A., *Victor Brauner*, Paris, 1959; Semin, D., *Brauner*, Filipachi, 1990

bravura
(Italian, 'bravery'.) The skill of an artist's technique. The term is most often applied to painting and generally refers to the ▷brushwork of an artist that is visible, rather than muted. If the brushstrokes are noticeable, violent or otherwise unusual, they are said to exhibit bravura.

Bray (Braij), Jan de (c1627–97)
Dutch painter. His father, Salomon de Bray (1597–1664) was an architect and painter who settled in Haarlem where Jan was born. There he came into contact with the work of ▷Hals and adopted the latter's specialism of portrait painting, although his style was less free than that of Hals.

Brera
One of the principal art galleries in Milan. The Palace of Brera had been in the hands of the Jesuits, but after the ▷Enlightenment expulsion of them and other religious orders, the Brera and many other rich repositories of the arts were passed to State control. Empress Maria Theresa arranged for the Brera to house many of the paintings dispersed after the closure of religious orders, and from 1809 it was open to the public as an art gallery.

Bresdin, Rodolphe (1825–1866)
French engraver. He was admired by ▷Baudelaire and nicknamed 'Chien-Caillou'.

Bib.: *Odilon Redon, Gustave Moreau and Rodolphe Bresdin*, exh. cat., New York, 1961

Breton, André (1896–1966)
French poet. He was the founder of ▷Surrealism. Breton's interest in ▷Freudian theories was shared by a number of ▷avant-garde artists and writers in Paris during the early 1920s, who were also infected by the ▷anti-art sentiments of ▷Dada. In 1921, Breton was involved in the move to break away from Dada's influence, and in 1924 he was responsible for the First Surrealist Manifesto. He wrote *Surrealism and Painting* in 1927, and edited the journal *The Surrealist Revolution*. He wrote further Surrealist manifestos in 1930 and 1942. He not only helped spread knowledge of Sigmund Freud's theories to the artistic and literary avant-garde, but he cultivated an uncompromisingly political art. His leftist tendencies were not shared by all Surrealists, including ▷Dali, whom Breton expelled from the movement. His involvement in Surrealism led him to obtain the ironic nickname 'the Pope of Surrealism'.

Bib.: Balakian, A., *André Breton: Magus of Surrealism*, New York, 1971; Breton, A., *What is Surrealism?: Selected Writings of André Breton*, ed. Franklin Rosemont, London, 1978

Brett, John (1831–1902)
English landscape painter. He attended the ▷RA Schools in 1854, but soon came under the influence of ▷Pre-Raphaelitism, becoming a friend of ▷Hunt and ▷Millais. His 1857 *Stonebreaker* (Liverpool, Walker) attempted a realist subject but it was the delicate spring-like landscape which clearly attracted the enthusiasm of the artist. His bright, minutely detailed landscapes (e.g. *Glacier at Rosenlaui*, 1856, London, Tate) attracted the notice of ▷Ruskin, who persuaded him to visit the more noble countryside of Italy in 1958, but this led to a stagnation in his work, as emotion was subordinated to scientific observation (e.g. *Val d'Aosta*, 1959, private collection). His style changed in the 1870s when he turned to Cornish coastal scenes (e.g. *Echoes of a Storm Far Off*, 1980, London, Guildhall). He was also a member of the Royal Astronomy Society.

Bib.: Staley A., *Pre-Raphaelite Landscape*, London, 1973

Breu, Jörg the Elder (1475/6–1537)
German painter. Following in the ▷*Wanderjahre* tradition, much of Breu's education and training was acquired travelling in Austria (1496–1502), but he returned to his native Augsburg in 1502. There he worked for the emperor Maximilian and produced frescos for the Town Hall (destroyed). He also produced some portraits and manuscript illumination. He travelled to Italy in c1514.

Breuer, Marcel (1902–81)
Hungarian architect and designer. He studied in Vienna and at the ▷Bauhaus, where he was put in charge of the furniture design department from 1924. He is best known for his tubular steel chairs, which continue to be used in office design today. With the advent of Nazi power, he left Germany in 1933 and worked as an architect in England from 1935 until 1937, when he emigrated to the United States. There he helped disseminate the Bauhaus pedagogic method through his teaching. He joined ▷Gropius at Harvard, where he taught while continuing his own work as an architect.

breviary
A book used by priests during the Middle Ages to say offices at canonical hours. The earliest appeared in c11th century. They were frequently illustrated and could be quite elaborate.

Bride Stripped Bare by her Bachelors, Even, The

Produced by ▷Marcel Duchamp between 1915–23 and also known as the *Large Glass*, it consists of materials (the main elements are defined by wire) sandwiched between pieces of plate glass enclosed in a metal frame 262 × 170 cm (8 ft 6 in × 5 ft 6 in). The work was cracked during transit in 1926, upon which Duchamp declared it 'finished'. He also produced the *Green Box* in 1934 which contained documents explaining the making and meaning of the *Large Glass*. The complex and mysterious image can be seen as the culmination of Duchamp's artistic interests up to the 1920s. The upper section represents a mechanistic, ▷Cubist influenced Bride, the last of a series of works which treated sexuality as a sinister technological game. The lower Bachelor section recalled Duchamp's interest in ▷readymades by including a 3-D design of a coffee-grinder also recognizable in his earlier work. Throughout the piece Duchamp employed chance and ▷automatism: he fired paint-dipped matches out of a toy cannon to create the shot marks in the top right-hand corner; he allowed dust to collect on the sieves over a period of months before fixing it permanently with glue; he photographed gauze blowing in the wind to achieve the three irregular elements of the inscription for the top. The use of glass adds a further element of chance: the work can be seen from two sides and also looked through, integrating the surroundings into the piece. The title of the work has been associated with alchemical practices, but even with Duchamp's explanations the work remains elusive, a challenge above all to the whole accepted concept of art. It also, to a certain extent, represented the culmination of Duchamp's whole career; he produced little afterwards and the piece effectively sums up his ▷Dada experiments of the period up to 1920. It is now in the Philadelphia Art Gallery.

Bib.: Golding, J., *Marcel Duchamp, The Bride Stripped Bare by her Bachelors, Even*, New York, 1972

Bridge, The

▷Brücke, die

Bridgwater, Emmy (b 1902)

English painter. She studied in Birmingham, Oxford and London. During the 1930s, she adopted a ▷Surrealist style and became an active member of the British Surrealist Group in 1940. She was particularly interested in ▷automatism.

Bril(l), Mattheus (1550–83) and Paul (1554–1626)

Flemish family of painters. They were brothers from Antwerp. Mattheus travelled to Rome in 1570, and he adopted a landscape style based partly on the model of ▷Claude. While in Rome, he produced ▷frescos for the Vatican, which his brother Paul completed when he came to Italy in c1574. Paul's primary specialty was small landscapes of Rome and its environs. He too was influenced by Claude, but he produced works largely for the tourist market.

British Museum, London

In 1753 an Act of Parliament was passed, declaring the intention of finding a repository for Sir Hans Sloane's personal collection, bequeathed to the nation on his death in that year, together with the manuscript collection of the 1st and 2nd Earls of Oxford, and the library of the Cotton family, previously acquired by the Crown. A body of Trustees, headed by the Archbishop of Canterbury, was appointed by Parliament to oversee the project and £10,000 ($17,000) was raised by public lottery to pay for the founding collections and a building. In 1754 Montagu House, Bloomsbury, a mansion on the site of the present museum, was purchased and in 1759 the new national collection went on display.

During the 18th and 19th centuries the collection increased rapidly and diversified. There were several controversial moves. For example, in 1802 the Trustees received Egyptian antiquities captured from the French, including the Rosetta stone. The Towneley and ▷Elgin Marbles were also acquired at this time. By the start of the 19th century Montagu House could no longer accommodate the exhibits, and in 1823, when George IV presented George III's library to the nation, Robert Smirke was commissioned to design a new premises. The new ▷Neoclassical Museum building opened in 1847, and by 1857 was extended, the new wing including the Great Dome of the Reading Room. However, as the collections continued to expand, more and more space was required. The Scientific and Natural History Museums moved to new sites in South Kensington in 1883, and proposals for further extensions have continued to the present day. The latest plans concern the redevelopment of the Reading Room when the British Library moves to St. Pancras.

Holdings at the Museum include coins, ▷Egyptian antiquities, ▷Greek and ▷Roman antiquities, ▷Byzantine ▷icons, relics and ornaments, medieval works, (including sculpture, manuscripts, panel painting and the ▷decorative arts), prehistoric objects and remains (including the Lindisfarne man), and Oriental objects and paintings.

Broederlam, Melchior (fl 1381–1409)

Netherlandish painter. He was court painter to the Dukes of Burgundy, born and mainly active in Ypres. He is first recorded in 1381 in the service of the count of Flanders and, from 1385, Philip the Bold of Burgundy. In 1392 he was commissioned to execute his only surviving work, the painted wings of a carved altarpiece in the charterhouse of Champmol (completed 1399, now in Dijon, Musée des Beaux-Arts). The panels, representing the *Life of the Virgin*

(*The Annunciation and The Visitation* and *the Presentation and Flight into Egypt*), reveal a new concern to construct a deeper space in which solid figures may move (see especially *The Presentation*). The panels fuse together influences from France (elegant figures), Italy (▷perspective constructions and stylized rocky landscapes) and the Netherlands (naturalistic details) and as such are considered to be among the earliest surviving manifestations of the ▷International Gothic style.

broken pediment

Term used to describe a ▷pediment in which either the sloping sides do not meet at the ▷apex or the ▷base has a gap in the middle. For exactness, the terms 'broken-apex pediment' should be used for the former and 'broken-bed pediment' for the latter. Widely used in ▷Roman and ▷Baroque architecture.

bronze

An alloy of 90 per cent copper to 10 per cent tin (though it can be up to 32 per cent tin), much used in ▷cast ▷sculpture. Statuary bronze is rarely just copper and tin and often also contains small amounts of lead and zinc, depending on the colour required. The advantages of bronze are that it combines tensile strength with relative lightness and high resistance to atmospheric corrosion. Very few large bronzes have survived from ▷antiquity simply because they were melted down. The antique bronze Equestrian Statue of Marcus Aurelius survived in Rome only because the early Christian Church thought it represented the first Christian emperor, Constantine. The two so-called 'Riace Warriors' (found in 1972 but dating from the mid-5th century BC) survived because the ship in which they were being transported sank. Yet despite the age of these three sculptures, and the submersion of the 'Warriors', they are all in remarkably good condition. In Classical antiquity and the ▷Renaissance, bronze was considered a more prestigious and noble medium than ▷marble. Antique Roman marbles were generally relatively cheap copies of the more expensive Greek bronzes. The tell-tale signs are the struts, unnecessary in the original bronze, that Roman copyists had to provide in order to give legs the extra strength needed to support the body. In the ▷Renaissance, ▷Cellini employed an open composition in his *Perseus* (1545–54, Florence, Loggia dei Lanzi), with the young hero holding the Gorgon's head at arm's length away from his body, a feat that would have been impossible in marble. And only with the redevelopment of founding techniques during the Renaissance (which had mostly been lost in Europe after the fall of the Roman empire) was there a proliferation of ▷equestrian statues (the earliest being ▷Donatello's *Gattamelata*, 1443–53, Padua, Piazza del Santo), bronze being the ideal medium for this genre which required four relatively slender verticals to support the mass of the horse's body and its rider.

The primacy of bronze over marble lasted until the vogue for ▷Neoclassicism in the 18th century, when white marble was considered to the purest of media: the discovery of the ▷Elgin Marbles only served to reinforce this idea. Yet where marble can appear cold and impersonal, bronze can exactly replicate the marks of the sculptor's hands on the original wax or clay model. Thus, with the development of ▷Romanticism and the taste for variegated surfaces and anything that smacked of the artist's individuality, bronze (helped in no small measure by the 19th-century improvement in mining and smelting techniques) came back into its own.

▷chasing; *cire-perdue*; patina

Bronzino, Angelo (Angelo di Cosimo) (1503–72)

Italian painter. He was a leading Florentine ▷Mannerist, the pupil, adopted son and lifelong friend of ▷Pontormo. According to ▷Vasari, Pontormo depicted Bronzino as the child sitting on the steps with a basket at the bottom of his painting *Joseph in Egypt* (London, National Gallery). Bronzino's early work, whilst still in Pontormo's studio, can be seen in the *St. Mark* roundel in the vault of Pontormo's Capponi Chapel at Sta Felicita, Florence. A comparison with the other *Evangelist* roundels by Pontormo shows how close their style was at this time. Notwithstanding Bronzino's brilliance as a draughtsman, the chief difference between him and his master is his avoidance of any deep emotional expression. He secured the patronage of the ▷Medici for most of his career and his most accomplished works are his portraits of the family, depicted in their exquisite remoteness, exuding a studied self-assurance and refined superiority; and yet it is easy to read a certain melancholy behind the mask in such a work as *Eleonora of Toledo and her Son* (c1546, Florence, Uffizi).

Bronzino's most remarkable painting is the so-called *Venus, Cupid, Time and Folly* (London, National Gallery) in which the eroticism of the open-mouthed kiss and sensual caress of ▷Venus by her son, ▷Cupid, is deliberately contradicted by the glacial pallor of their nude bodies, drawn with consummate precision and enclosed within steel-hard outlines. The picture is evidently a moral ▷allegory on the pains of sexual love, but first and foremost it is a beautifully-wrought work of art and was obviously intended as such. What connects the *Eleonora* portrait and the *Venus* mythology is Bronzino's concern with the creation of elegant surface patterns. Both successful and well-respected by the artistic community, he was a founder member of the Florentine Accademia del Disegno in 1563. His most important pupil was ▷Alessandro Allori who was also his adopted son, just as Bronzino himself had been adopted by Pontormo.

Bib.: Cox-Rearick, J., *Bronzino's Chapel of Eleonora in*

the Palazzo Vacchio, Berkeley, 1993; McCorquodale, C., *Bronzino*, London, 1981

Brooking, Charles (?1723–59)

English painter. He was known for his ▷marine paintings, which showed a strong Dutch influence. They were similar to the seascapes of ▷Willem van de Velde.

Brotherhood of St Luke

▷Nazarenes

Brook Watson and the Shark

Painted by ▷John Singleton Copley in 1778 (oil on canvas, 182 × 226 cm/5 ft 10 in × 7 ft 4 in). It was commissioned by Brook Watson himself, in memory of a real event which occurred when he was attacked by a shark whilst swimming in Havana harbour. That he would want a painting of such a near-tragedy is in itself slightly odd, but Copley turned the personal narrative into a universal image of horror and redemption. The nude figure has classical overtones, the shark becomes a nightmarish vision and Watson's 'saviours' fight off the fish from the prow of a boat. Watson is caught between life and death. The work marked the beginning of Copley's interest in contemporary subject matter and can be paralleled with ▷West's ▷*Death of General Wolfe* (1770, Ottawa, National Gallery of Canada) in its heroic treatment of a real-life incident. In his painting Copley combines contemporary dress and local colour (the boat includes an African–American figure) with the dramatic expectations and compositional control of history painting. It is now in the Boston Museum of Fine Arts.

Brouwer, Adriaen (1605/6–38)

Flemish painter working in Holland. In 1623 he was in Haarlem, but in 1631 he went to Antwerp, where he met ▷Rubens and became involved in the local painters' ▷guild. He specialized in tavern scenes which represented drunk peasants in a sketchy style. The Spanish presence in Holland led to his imprisonment for suspected political subversion, and he may have died of the plague.
Bib.: Renger, K., *Adriaen Brouwer und das niederländische Bauerngenre 1600–1660*, exh. cat., Munich, 1986

Brown, Ford Madox (1821–93)

English painter. He was born in Calais, and studied throughout Europe, including Antwerp (under Baron Waupers 1837–9), Paris (1841–4) and Rome (1845), where he came into contact with the ▷Nazarenes, before settling in London, in 1848. There he took on ▷Rossetti as a pupil, and through him remained a close associate of the ▷Pre-Raphaelite Brotherhood. His early works were romanticized historical subjects (e.g. *Execution of Mary, Queen of Scots*, 1841, Manchester, Whitworth Art Gallery), but in the 1850s he turned to contemporary issues (e.g. *The Last of England*, 1855, Birmingham, City Museum and Art Gallery) and landscape, which he produced largely for his own pleasure (e.g. *Carrying Corn*, 1854, London, Tate). He also painted literary and religious themes (e.g. *Christ Washing the Feet of St. Peter*, 1851–6, London, Tate). Stylistically he conformed to the ▷Pre-Raphaelite's desire for detail, observation, strong sunlit colour, symbolism and morality, but he retained a broader, more ▷painterly style than some of the group. He was notoriously slow and painstaking in his work, spending 13 years on *Work* (1852–65, Manchester, City Art Gallery). In the 1860s he became a partner in ▷Morris and Company. He also completed decoration for Manchester Town Hall. Much of his later work was watercolour, perhaps showing Rossetti's influence.
Bib.: *Ford Madox Brown*, exh. cat., Liverpool, 1964; Newman, T., *Ford Madox Brown and the Pre-Raphaelite Circle*, London, 1991; Rabin, L., *Ford Madox Brown and the Pre-Raphaelite History Picture*, New York, 1978

Brown, Lancelot ('Capability') (1716–83)

English landscape gardener. Unlike his predecessor in the field of garden design, ▷William Kent, Brown concentrated not on garden architecture, but on the landscape itself. He popularized a form of 'naturalistic' landscape garden which was nevertheless based on a very contrived reorganization of the natural landscape. He re-routed rivers, planted trees and formed new lakes. His method was known as 'improvement', and it was sought after by many country house owners from the 1760s onwards. Examples of his work can be seen at Hampton Court, Blenheim, Chatsworth,

Nathaniel Dance (or Holland) *Portrait of Lancelot 'Capability' Brown*, Burghley House Collection, Lincolnshire

Bowood and Longleat. His landscaping was directly oppositional to the formal landscape gardens of the ▷Baroque period, and the influence of ▷Claudean landscapes on his style helped prepare the ground for the ▷picturesque aesthetic.

Bib.: Stroud, D., *Capability Brown*, 2nd edn., London, 1975; Turner, R., *Capability Brown and the Eighteenth-Century English Landscape*, London, 1985

Brown, Mather (1761–1831)

American painter. He studied with ▷Gilbert Stuart and made his living initially as an ▷itinerant portrait painter. In c1780 he travelled to England, where he made contact with ▷Benjamin West and continued his experience as an itinerant artist by painting portraits of Americans visiting England. His skill with portraiture drew him to the attention of the Prince of Wales, and he became historical painter to the Prince.

Browne, Hablot Knight ('Phiz') (1815–82)

English illustrator. He was best known for his illustrations to Dickens' novels, which verge on ▷caricature but nicely represent the characterizations of the novelist.

Bib.: Steig, M., *Dickens and Phiz*, Bloomington, 1978

Bruce, Patrick Henry (1880–1937)

American painter. He was born in Virginia but moved to New York in 1901, where he studied with ▷Chase and ▷Henri. A visit to Europe from 1907 brought the work of ▷Cézanne and ▷Matisse to his attention, and he briefly studied with the latter. From 1912 to 1914 he worked with ▷Robert Delaunay and with ▷Macdonald-Wright. He adopted Macdonald-Wright's ▷Synchromism in his various *Compositions* produced between 1913 and 1920. His interest in the importance of colour continued although he was much more interested in geometric pattern than either Delaunay or Macdonald-Wright had been. In 1937 he committed suicide.

Brücke, die (The Bridge)

A German Expressionist group, established in 1905 in Dresden by ▷Kirchner, ▷Heckel and ▷Schmidt-Rottluff. It also included ▷Nolde, ▷Pechstein, ▷Mueller and ▷Bleyl. The title was chosen because the artists wished to foster relations with the general public and believed in a social role for the artist. Because of the their enthusiasm for German art of the past, particularly ▷Gothic and folk styles, they also viewed themselves as a bridge between the past and present. Few of the members of the group had any formal training (except in architecture). They were suspicious of intellectualism and promoted spontaneity, craftsmanship and ▷primitivism, inspired by their discovery of African and Pacific art. Despite their nationalist stance, they were initially inspired by French

▷Post-Impressionism, particularly the work of ▷van Gogh, ▷Gauguin and ▷the Fauves. Their early work concentrated on landscape, interiors and nudes, incorporating vigorous broken brushstrokes and later flattened planes of pure colour, but from the outset their work had a less lyrical and a harsher quality than that of their French counterparts. This was exaggerated in their graphic art, particularly in their exploration of the ▷woodcut, resurrected from its medieval origins. In 1910 the group moved to Berlin and established the ▷Neue Sezession after the Berlin ▷Secessionists refused to exhibit Nolde's *Pentecost*. The move influenced all the members in different ways and contributed, along with personality clashes between Kirchner and Schmidt, to the break-up in 1913.

Bib.: Herbert, B., *German Expressionism: Die Brücke and der Blaue Reiter*, London, 1983

Bruegel (Brueghel), Pieter the Elder (c1525–69), Pieter the Younger (c1564–1638), Jan the Elder (1568–1625) and Jan the Younger (1601–78)

Netherlandish/Flemish family of painters and draughtsmen. Pieter the Elder was the most important Netherlandish artist of his generation and founder of a dynasty of successful painters. He is also known as 'Peasant Bruegel' because of the rustic nature of many of his village and landscape paintings. However, the appellation is misleading for, although his early life is obscure, it is highly unlikely that he himself was a peasant: the indications are that he was a educated artist who numbered ▷humanists among his friends and whose paintings were calculated to appeal to a sophisticated audience.

He trained with ▷Pieter Coecke van Aelst and was accepted as a Master in the Antwerp Guild in 1551. Shortly after this he visited Italy (travelling as far as Sicily) and worked in Rome with ▷Giulio Clovio. More influential than the works he saw in Italy was his experience of travelling through the Alps, as is attested by the drawings he made on the spot (and later developed into a series of twelve prints, the *Large Mountain Series*, c1555–60) and the way his landscape style subsequently developed. His style and subject matter back in Antwerp were heavily influenced by ▷Bosch, so much so that the print publisher, Hieronymus Cock, passed off some of the ▷engravings of Bruegel's designs as by Bosch (e.g. *Big Fish Eat Little Fish*, published 1557, Albertina, Vienna).

In 1563 Bruegel moved to Brussels where he married Pieter Coecke's daughter. It is in these last few years that he produced his greatest paintings. They were sought by the most influential patrons, among whom was Cardinal Granvella who bought the *Flight into Egypt* (1563, London, Courtauld Institute Galleries) and the wealthy Antwerp banker, Niclaes Jonghelink who, in 1565, commissioned the series of *The Labours of the Months*, (five survive: three, including

the *Hunters in the Snow,* in Vienna, Kunsthistorisches Museum and the other two in New York, Metropolitan Museum).

An important contribution made by Bruegel to the development of landscape painting was his use of the high viewpoint to achieve a feeling of universality. Following his move to Brussels his paintings underwent a transformation, perhaps most importantly under the influence of ▷Raphael's ▷tapestry designs for *The Acts of the Apostles* (then in Brussels): the landscape is more coherently structured, the action less encyclopaedic and diffuse, and the figures have more amplitude (c.f. *Netherlandish Proverbs,* 1559, Berlin-Dahlem and *Parable of the Blind,* 1568, Naples, Museo Nazionale).

Bruegel's paintings and, more particularly, the prints made after them, exerted a tremendous influence on later painters throughout the Netherlands, an influence that was perpetuated by those of his many sons and grandsons who also became painters. His reputation as a landscape painter and a deeply perceptive observer of the tragic frailty of the human condition is perhaps even greater today than in his own time.

Pieter the Younger was the son of Pieter the Elder and elder brother of Jan the Elder. He is sometimes known as 'Hell Bruegel', owing to his predilection for scenes of conflagrations. He followed his father's style extremely closely and continued adapting and even copying his father's works long after his father's death. His own son, also called Pieter (1589–c1640), was a rather mediocre painter. Pieter the Younger was the master of ▷Frans Snyders.

Jan the Elder was the second son of Pieter the Elder (his older brother being Pieter the Younger), remembered chiefly for his still lifes, flower paintings, and landscapes. He was also known as 'Jan Velvet' for his virtuoso skill at rendering textures. Before settling down to a highly successful career in Antwerp, he visited Cologne and Italy. In 1597, he enrolled in the Antwerp Painters' Guild, eventually being elected Dean. As Court Painter to the Regents Albert and Isabella he executed about 50 pictures and frequently visited the court at Brussels. His landscape style is founded on that of his father, but perhaps suggests an even closer debt to the artificial, highly detailed and decorative landscapes of ▷Coninxloo and ▷Bril (the latter of whom he had met in Rome in 1591). In an age of specialization, he frequently collaborated with other artists such as his friend ▷Rubens (e.g. *Earthly Paradise with the Fall of Adam and Eve,* c1615, The Hague – figures by Rubens; landscape setting by Bruegel). His highly popular styles was carried on by his pupil ▷Daniel Seghers, his sons Jan the Younger and Ambrosius (1617–75) and his grandson Jan van Kessel (1629–79).

Jan the Younger was the son of Jan the Elder. He carried on his father's style with his younger brother Ambrosius.

Bib.: Dobbels, D., *Brueghel,* Paris, 1994; Ertz, K., *Jan Bruegel der Altere 1568–1625,* Cologne, 1981; Ertz, K., *Jan Bruegel the Younger 1601–78,* Frenen, 1984; Francastel, P., *Brueghel,* Paris, 1995; Gibson, W. S., *Brueghel,* London, 1977; Roberts, K., *Brueghel,* London, 1994; Sullivan, M., *Bruegel's Peasants: Art and Audience in the Northern Renaissance,* Cambridge, 1994; 'The Triumph of Death' by Pieter Bruegel the Younger, exh. cat., Antwerp, 1993

Brunelleschi, Filippo (1377–1446)

Italian architect and sculptor. He was from Florence and was the most famous Italian architect of his generation. He was not only one of the founders of the ▷Renaissance style, but also a brilliantly inventive structural engineer. He is moreover credited with the invention of the geometrical means for constructing single ▷vanishing point ▷linear perspective, a method for representing the appearance of solid objects in depth on a flat surface, pioneered by Brunelleschi's friends, ▷Donatello and ▷Masaccio, and formulated by the theorist ▷Alberti.

As far as his contemporaries were concerned the crowing glory of his career was the design and construction of the dome of Florence cathedral (1420–36). A ▷dome to cover the crossing had been required since the 14th century and one looking not unlike Brunelleschi's had been envisaged by at least the 1360s (see ▷Andrea da Firenze's fresco in the Spanish Chapel of Sta Maria Novella). The seemingly insurmountable problem was how to construct a dome over a crossing which at over 120m in diameter, was too wide for centring the temporary wooden framework traditionally needed to support a dome during its construction. Brunelleschi's achievement was to devise a self-supporting constructional system that dispensed with the need for centring.

He had trained as a goldsmith, joining the Arte della Seta (the guild of silkworkers and goldsmiths) in 1398 (admitted as a master in 1404). He was runner-up to ▷Ghiberti in the competition to design the bronze doors of Florence Baptistry (1401–2, Ghiberti and Brunelleschi competition panels, *The Sacrifice of Isaac,* Florence, Bargello). The tradition that Brunelleschi gave up sculpture in recognition of Ghiberti's preeminence in that field, and immediately departed for Rome to study architecture is today largely discounted. He executed at least one more major piece of sculpture, the painted wooden crucifix (1412, Florence, Sta Maria Novella), although it is true that architecture appears to have absorbed all his creative energies from c1418. The Rome trip of 1402, mentioned by Brunelleschi's first biographer, Manetti, and taken up by ▷Vasari, may have been introduced by Manetti to emphasize his claim that Brunelleschi had 'restored the ancient Roman manner of building'. However, recent scholarship has found plausible models for most of his

principal innovations in local Tuscan architecture of the 11th and 12th centuries.

Brunelleschi introduced a system of clearly expressed proportional relationships into his architecture, investing it with a new sense of Classical harmony, unity and balance. His two large Florentine churches, San Lorenzo (begun around 1418) and Santo Spirito (begun 1434), are constructed to a traditional ▷basilical plan of the kind as may be seen in such Florentine churches as S. Trinità (11th–14th centuries) and Sta. Maria Novella (13th–14th centuries), but Brunelleschi designed his interior spaces to a modular pattern. These modules are explicitly traced out on the floors of both churches, so that it can be seen, for example in San Lorenzo, that the basic unit of the ground plan is the square of the ▷crossing. This unit is repeated in each of the two square transepts and square ▷chancel and then four times to form the length of the ▷nave. The nave is eight ▷bays long and thus each rectangular nave bay is half the area of the crossing and each square aisle bay a quarter. Furthermore, the central axis of the nave is also indicated along its entire length by a bold line. The internal articulation is clearly defined by the characteristic Brunelleschian contrast of white plaster walls and grey *pietra serena* (sandstone) architectural members (first used by Brunelleschi in 1418–28 in the Old Sacristy of S. Lorenzo). Similar refinements of recent local models can be seen by comparing the designs of Brunelleschi's loggia of the Ospedale degli Innocenti (1419–24) with that of S. Matteo (14th century) and Brunelleschi's Old Sacristy with the Baptistry of Padua Cathedral. Brunelleschi's invariable use of ▷Corinthian capitals is just as easily related to local models (e.g. the nave of S. Apostoli). His achievement lies in his understanding of the controlling grammar of Classical Roman architecture, whereas his predecessors had merely used, in an increasingly arbitrary way, the vocabulary.

Although none of his putative trips to Rome is actually documented it is perhaps unreasonable to insist that Brunelleschi never visited the prime centre of Classical Roman architecture. If a trip was made, the changes that occur in Brunelleschi's architecture during the 1430s would in fact seem to suggest a date in that decade (instead of, or in addition to, the earlier visit mentioned by Manetti). There is a distinct shift towards a more sculptural plasticity in his structures as may be seen from a comparison of the planar forms of S. Lorenzo (spaces defined by flat walls with articulation by ▷pilasters) with the sculptural forms of S. Spirito (the 'forest' of columns carried in an uninterrupted row from the nave around the ▷transepts and ▷chancel, and the half columns instead of ▷pilasters framing the semi-circular side chapels which now belong to and extend the main space). There is also a more strongly defined Classicism in work commenced in this period: the lantern (begun 1446) of the ▷dome and the ▷exedrae (1439–70s) around the ▷drum of the Cathedral; and the rotunda of S. Maria degli Angeli, the first centrally-planned ▷Renaissance church (begun 1434, left unfinished 1437). Brunelleschi's work influenced ▷Michelozzo (who completed Brunelleschi's lantern after his death) and ▷Giuliano da Sangallo in Florence. His influence also spread as far afield as Urbino (cf. ▷Laurana's cortile in the Palazzo Ducale) and informed the early work of ▷Bramante in Milan. ▷Michelangelo's New Sacristy for S. Lorenzo sensitively echoes the basic plan of Brunelleschi's Old Sacristy.

Bib.: Battista, E., *Filippo Brunelleschi*, London 1981; Saalman, H., *Filippo Brunelleschi: The Buildings*, London 1993

brush

Tool made from hairs, usually either pig, horse or synthetic fibres, supported by a handle, usually wood or bone, with which it is possible to apply paint or other fluids to a surface. Brushes can be made in various sizes.

brushwork

The markings made by the strokes of a ▷brush, usually discernible on the surface of a work of art.

Brusselmans, Jean (1884–1953)

Belgian painter. He studied at the Brussels Academy and developed a muted ▷Expressionist style which he applied to landscapes and scenes of peasant life. The influence of the Flemish ▷primitives seemed to inform his work.

Brutus

Lucius Junius Brutus is recorded in the chronicles of Plutarch and Livy. He was the nephew of Tarquin the Proud and led the rebellion against the ruler after the rape of Lucretia, becoming one of the first two consuls of the Roman republic. His sons then tried to restore the Tarquinian monarchy, and were sentenced to death by their father, in a gesture of stoicism and loyalty to the State. The trial was a popular theme for artists decorating halls of justice in the 17th century (e.g. Rembrandt, Utrecht). A variation was employed by ▷David in *The Lictors Bringing Brutus the Bodies of his Sons* (1789, Paris, Louvre) and ▷Hamilton in *Brutus Swearing to Avenge Lucretia's Death* (1763, London, Tate Gallery).

Bruyn, Bartholomaeus (1493–1555)

German painter. He worked in Cologne and painted religious works. However, his primary specialism was portraiture, which he produced in a realistic style largely for bourgeois patrons.

Brygos Painter

A Greek vase painter of early 5th century BC. The name comes from the cups which were signed 'Brygos'. The painted designs appeared primarily on ▷red-figure vases, and they were characterized by economy of line and an emphasis on movement.
Bib.: Cambitoglou, A., *The Brygos Painter*, Sydney, 1968

Bubbles

Painted by ▷John Everett Millais in 1886 (oil on canvas 108 × 78 cm/3 ft 6 in × 2 ft 6 in). It was a portrait of the artist's grandson, Willie, aged five, whom Millais had seen playing with soap bubbles. The painting portrays the small boy dressed in an old-fashioned knickerbocker suit and ruffled shirt, looking up at a bubble he has just made (which Millais painted by using a specially-made glass sphere). The boy is shown as almost angelic with fair curls and rosy cheeks, although the characterization of his puzzled expression does something to raise the work above the level of mere pot-boiler. It was made into the Christmas Special plate for the *Illustrated London News* in 1887, but the copyright was granted to Pears Ltd, who subsequently used the image to advertise their translucent soap. Millais strongly objected to this commercial use of his painting and he was much criticized as a result, but the image became one of the best known of the 19th century. In fact it was merely one of a number of images of children (e.g. *My First Sermon*, 1863, London, Guildhall) which had helped to cement Millais' popularity after the break-up of the ▷Pre-Raphaelite Brotherhood, and even before the Pears adverts he could have been accused of pandering to the market. The work was painted in the richer, broader style which was characteristic of his later work, with the figure picked out against a vague, shadowy interior. The work is now owned by Pears Ltd.

Buddhist Art

The art celebrating the teachings of the Buddha (563–c481 BC). Buddhism originated in India and became the dominant religion in China, Tibet and South-East Asia. At first, it was deemed improper to represent the Buddha directly so early images tended to be symbolic (e.g. bodhi trees, wheels, empty thrones, pillars, the Buddha's footprints). Once personal images of the deity became acceptable, these were strictly regulated. Certain features – the cranial protrusion (*ushnisha*), webbed fingers, tuft of hair on the brow, and lotus marks on the feet – were prescribed in sacred texts. More individual meanings were conveyed by hand gestures or symbolic attributes. Narrative scenes from the life of the Buddha were also popular. Images of his historical existence were confined to India, but portrayals of his previous incarnations (*Jatakas*) were freed from geographical constraints. In addition, the Buddha was often shown with spiritual attendants, such as Bodhisattvas (devotees who delay entry into Nirvana in order to help others). Buddhist ideals were also encapsulated in mandalas. These are complex, pictorial diagrams of the universe, used as an aid to prayer and meditation. They combine abstract symbols with representative deities from the enormous Buddhist pantheon.
Bib.: Fisher, Robert E., *Buddhist Art and Architecture*, London, 1993; Seckel, D., *The Art of Buddhism*, New York, 1964

Buffalmacco (Buonamico di Cristofano) (fl first half of 14th century)

Italian painter. According to ▷Ghiberti and ▷Vasari, one of the leading Florentine painters of the generation after ▷Giotto. He is also the subject of some amusing stories in ▷Boccaccio's *The Decameron* (eight day: stories three, six and nine). Unfortunately no surviving works have been securely attributed to him and it has even been suggested that he may after all have been a purely legendary character. However, one suggestion has been that he might be the painter responsible for the frescos of the *Triumph of Death* in the Campo Santo, Pisa (as opposed to the more commonly accepted author ▷Francesco Traini). Another theory has been that he might be the painter presently known only as the ▷Master of St. Cecilia.
Bib.: Bellosi, L., *Buffalmacco e il Trionfo della Morte*, Turin, 1974

Buffet, Bernard (b 1928)

French painter. He studied at the ▷École des Beaux-Arts in 1944. In 1948 he was joint winner of the Prix de la Critique with Bernard Lorjou. Influenced by the realism of Gruber, Buffet joined the Homme-Temoin 'Man as Witness' group, which distinguished itself from the political realism of ▷Social Realist painting. Buffet found enormous success with his '*misérabiliste*' paintings in the late 1940s, with their images of existential anguish, poverty and despair that captured the mood of post-war Paris in an accessible form. His austere palette, consisting of dismal greys and dirty browns, depicted emaciated and desperate figures, that were flattened, elongated and heavily contoured in domestic settings composed of sharp and spiky lines. As his fame and wealth increased, Buffet's work became more stylized and decorative, and his limited repertoire revealed the shortcomings of illustrating rather than expressing the post-war despair. A Bernard Buffet museum was founded in Surugadaira, Japan in 1973.
Bib.: Avila, A.A., *Bernard Buffet*, Casterman, 1989; *Bernard Buffet, Retrospective*, exh. cat., Kassel, 1994; Descargues, P., *Bernard Buffet*, Paris, 1952; Pichon, Y. le, *Bernard Buffet*, Paris, 1986

Bulfinch, Charles (1763–1844)

American architect. He was a pioneer of the ▷Neoclassical style in America and was responsible for both domestic and public architecture in Boston, including the Franklin Crescent (modelled on the Royal Crescent at Bath). He was best known for his work on the Capitol building in Boston (1798), and was also involved with the Capitol in Washington, D.C. Bulfinch's distinctive Neoclassical style has been associated with a surge of American nationalism after the War of Independence, and his references to Classical Greek architecture have been seen to embody the democratic spirit of American culture.

buon fresco
▷fresco

Buonamico di Cristofano
▷Buffalmacco

Buonarroti, Michelangelo
▷Michelangelo

Buonconsiglio, Giovanni (Il Marescalco)

An Italian painter working in Venice 1495–d. 1535/37. He worked mainly in Vicenza and Venice, and his work shows the influence of ▷Antonello da Messina.

Buontalenti, Bernardo (1536–1608)

Italian architect. He was a leading Florentine ▷Mannerist. A man of great versatility, he was also an accomplished military engineer, sculptor, painter and official designer of masques, firework displays and similar entertainments for the Tuscan Grand Ducal court by whom he was employed for most of his working life. His chief importance, however, is as an architect. Most of his principal works are in Florence and include the Porta delle Suppliche (c1580) and the gallery and tribune (1584) of the ▷Uffizi, the grottoes in the Boboli Gardens (1583–8), the façade of S. Trinità (1592–4 – now S. Stefano), the Fortezza del Belvedere (1590–95) and the Palazzo Nonfinito (1593–1600). His Medici villa at Pratolino (1569–75) was destroyed in the 19th century. He also prepared an extremely Mannerist design for the façade of Florence Cathedral (c1587, unexecuted). His architecture contains many details of typically Mannerist sophistication, such as ▷*trompe l'oeil* altar steps in S. Stefano, Florence (1574–6, formerly in S. Trinità): and the segmental ▷pediment, broken, with the pieces set back-to-back, over the Porta delle Suppliche.

Bib.: Fara, A., *Bernardo Buontalenti, l'architettura, la guerra e l'elemento geometrico*, Genoa, 1988

Burchfield, Charles Ephraim (1893–1967)

American painter. He was from Ohio, and throughout his life his landscapes referred to familiar Ohio scenery. He attended the Cleveland School of Art from 1912 to 1916, where he began to produce landscape painting. After a stint in the army in 1918–19, he went to Buffalo, New York during the 1920s. At this time, he became a prominent practitioner of ▷American scene painting. Despite his urban habitat, he concentrated on the grimness and banality of rural life and expressed the more dejected aspects of contemporary America. His landscapes were always evocative, but they became even more so after 1943, when he paid a greater attention to their spiritual undercurrents.

Burckhardt, Jacob (1818–97)

Swiss historian. He studied with the historian Leopold von Ranke and was professor at the University of Zurich (1855–8) and at the University of Basle (1858–93). He was distinguished primarily for his cultural history, which appeared first in his guidebook *Cicerone* (1855) and, most notably, in his history of the Italian ▷Renaissance, *Die Kultur der Renaissance in Italien* (*Renaissance Culture in Italy*, 1860). From German philosophy, especially ▷Hegel, he adopted the idea of a ▷*Zeitgeist*, or spirit of the age, and he attempted to define Italian art in relation to its specific political and social development.

Bib.: Janssen, E.M., *Jacob Burckhardt und die Renaissance*, 1970; Maikuma, Y., *Der Begriff der Kultur bei Warburg, Nietzsche und Burckhardt*, Königstein, 1985

Burden, Chris (b 1946)

American performance artist. His emphasis on self-mutilation was intended to draw attention to the violence of contemporary American culture.

Burghers of Calais, The

Bronze sculpture by ▷Rodin 1884–6 (210 × 240 × 190 cm/6 ft 10 in × 7 ft 10 in × 6 ft 2 in). It was commissioned by the town council of Calais to commemorate a significant moment in the town's history. During Edward III's siege of Calais in the Hundred Years War, hostages were asked for and six leading figures from the town including Eustache de St. Pierre went out to meet the king, dressed as penitents with bare feet and ropes round their necks, to hand him the keys of the city. The men were saved on the intervention of the English queen. Rodin chose to represent the six men not as heroes volunteering to sacrifice themselves, but as weary, doubting figures at their moment of humiliation. The group was placed on a low ▷plinth, so that one views them almost as equals, with the figures almost casually placed, and there is no central focus, the middle of the group being open space. The figures themselves, each with an individual character (Eustache, for instance, was modelled on Cazin (Jean-Charles, 1840–1901, French painter), are reminiscent of ▷Donatello's aged prophets, with their combination of deeply etched features, heavily draped shifts and strong, sinewy muscle.

Perhaps unsurprisingly the work was a shock to its commissioners, who considered it 'insufficiently heroic', and the sculpture was not erected in Calais until 1895. It can be seen in the context of Rodin's other commemorative works (including the equally controversial portrayal of the novelist Balzac), all of which were an obvious attempt to reinvent that most conservative of genres, monumental sculpture. There are copies of the work in London and at the Musée Rodin in Paris.

Bib.: McNamara, M.J., *Rodin's Burghers of Calais*, Cantor, 1977

Burgkmair, Hans the Elder (1473–1531)

German painter and designer of woodcuts. He studied with ▷Schongauer and visited Venice as part of his training. In 1498 he settled in Augsburg where he received commissions from Emperor Maximilian I. Among other works, he contributed to the *Triumph of Maximilian* – a series of ▷woodcuts attached to the Emperor's writings.

Burgundy

In the 14th and 15th centuries, Burgundy was an independent state incorporating areas of what are now France and Belgium. In 1384, Philip the Bold, the brother of Charles V King of France, was made Duke of Burgundy and in subsequent generations, strategic marriages and imperial conquest turned what had been a French backwater into a separate and powerful empire. In 1420 Philip the Good moved the court from Dijon to Bruges, which became an important artistic centre. Artists such as ▷Jan van Eyck, ▷Rogier van der Weyden, ▷Claus Sluter and ▷Dirk Bouts flourished under the court patronage of the Dukes of Burgundy. Burgundy later came to be dominated by the Habsburgs.

Bib.: Edson Armi, C., *Masons and Sculptors of Romanesque Burgundy: The New Aesthetic of Cluny III*, University Park, 1983; Prevenier, W., *The Burgundian Netherlands*, Cambridge, 1986

Burial at Ornans, The

Painted by ▷Gustave Courbet in 1849 (oil on canvas, 315 × 668 cm/10 ft 3 in × 21 ft 8 in). The work shows a funeral in Courbet's home town of Ornans, where the picture was painted, and consists of over 60 life-size figures, many from portraits. The group stands in a barren landscape, characteristic of the area around the town and significant in setting the bleak mood of the portrayal. On the left the clergy are grouped, separated from the townspeople by their richly coloured robes. In the centre the open grave of the unknown corpse is watched only by the family mourners and a dog, whilst the townsfolk on the left seem relatively uninterested. The figures are treated in harsh black and white, their aged, ugly faces pallid against the trappings of mourning. Courbet's grandfather had died in 1848 and the artist himself suggested that the grave was his, but the work has also been read as an ▷allegory of the death of ▷Romanticism. On a more straightforward level it is an uncompromising attack on the expectations of the bourgeois Parisian ▷Salon audience, who were presented with an enormous, unattractive reminder of their despised provincial cousins. The painting is also a challenge to the artistic establishment itself; it conforms to the demands neither of academic subject nor style, with Courbet's emphasis on an austere, flattened and near monochrome landscape. It was exhibited at the free Salon of 1850–51 amid huge controversy, and, along with the *Stonebreakers* (1849, destroyed), established him as one of the leaders of the ▷Realist ▷avant-garde.

Bib.: Ferrier, J-L., *Courbet: Un Enterre à Ornans*, Paris, 1980

burin

The principal tool of the engraver. It is also known as a 'graver'. It is a short steel rod of square, lozenge or triangular section with a round wooden handle for cupping in the palm of the hand. The working end is cut obliquely to form a point which the engraver pushes across the metal to create a furrow. The rough, ploughed-up edges of the furrow are called ▷burrs. These are scraped off for ▷line engravings where a sharp outline is needed, but retained for ▷drypoint engraving where a richer, blurred effect is required.

Burke, Edmund (1729–97)

Irish-born statesman and philosopher. He was born in Dublin, but spent most of his life in England where he was a longstanding MP. He wrote the influential *A Philosophical Enquiry into the Origin of Our Ideas of the Sublime and the Beautiful* (1757), which ran into 17 editions in his own lifetime. It developed the ideas of ▷Addison, influenced ▷Diderot and became the basis of much German writing on aesthetics in the early 19th century (▷Kant, ▷Lessing). Not only did the work define the ▷sublime as the feeling of awe and fear derived from unknown powers, particularly those of nature, but it also established that there was no inner sense of beauty. Instead our emotions were triggered by the properties of objects.

Bib.: Furniss, T., *Burke's Aesthetic Ideology*, Cambridge, 1993

Burliuk, David (1882–1967) and Vladimir (1886–1916)

Russian family of artists. They were brothers who both went to Munich in 1902 and joined in the Russian exile community there, along with such artists as ▷Kandinsky and ▷Münter. They exhibited with the ▷Blaue Reiter in 1911. In 1910, they became associated with the ▷Jack of Diamonds exhibition in Russia, and in 1911, they joined in the Russian ▷Futurist movement. Their interest in Russian ▷icons and

▷*lubki* gave a ▷primitivist influence on their work, but, like ▷Larianov and ▷Goncharova, they attempted to use this ▷primitivism as a means of creating a distinct modern Russian art. Vladimir died during the First World War, but David emigrated to the United States in 1922 and took up American citizenship.

Burne-Jones, Sir Edward Coley (1833–98)

English painter and illustrator. He was from Birmingham, but he spent most of his career producing works which rejected the smoky modernism of that industrial city. While at Oxford, he met ▷William Morris and the two of them contributed to what has been called the second generation of ▷Pre-Raphaelitism. Burne-Jones studied under ▷Rossetti from 1856, but his skilful draughtsmanship quickly surpassed Rossetti's less accomplished designs. Burne-Jones also moved away from Rossetti's influence in looking more deliberately to the influences of ▷quattrocento Italian ▷Renaissance art, particularly the work of ▷Botticelli and ▷Mantegna, with which he came into contact while travelling through Italy in 1859. He exhibited his own work from 1877, and was elected an ▷ARA in 1885, although he resigned the post eight years later. By this time, his works were known throughout Europe and were a decisive influence on the development of European ▷Symbolism. He specialized in fairy tales and Arthurian legends peopled with anaemic men and women and a prevailing sense of languor (e.g. the *Pygmalion* series; *King Cophetua and the Beggar Maid*). His works were frequently adopted by Morris for stained glass and tapestry designs.
Bib.: Burne-Jones, G., *Memorials of Edward Burne-Jones*, 2 vols., London, 1904; *The Last Romantics: The Romantic Tradition in British Art, Burne-Jones to Stanley Spencer*, exh. cat., London, 1989

burr

When an engraver uses a ▷burin to cut into an ▷engraving or ▷drypoint ▷plate, the ridge of copper that is left is called a burr. A burr can be scraped away to allow a clean and unimpeded line (as in engraving), or it can be left to give a more textured image (as in a drypoint).

Burra, Edward (1905–76)

English painter and stage designer. During the 1920s, he trained in a number of English art schools including the ▷Royal College of Art in 1923. A series of travels inspired his interest in urban low-life scenes, which he exemplified in a series of paintings of Harlem in New York during the 1930s. His figures verged on the ▷caricatural and they partook of the distortions of ▷George Grosz's social satires, although Burra was always less trenchant than Grosz. Although his style remained distinctive, Burra's subject-matter changed from ▷surrealistic scenes of skeletons in the 1930s to religious themes and landscapes in the 1950s and 1960s.
Bib.: Causey, A., *Edward Burra*, Oxford, 1985; *Edward Burra*, exh. cat., London, 1985

Burrell, Sir William (1861–1958)

A prosperous Glasgow ship owner with shrewd business sense and a passion for art, Burrell collected works of art from childhood. He was especially interested in medieval tapestries, ivories, wood and ▷alabaster sculpture, and ▷stained glass, although he also collected Chinese ▷ceramics and ▷bronzes, furniture and Persian rugs. He amassed dozens of paintings, including works by ▷Géricault, ▷Manet and ▷Whistler, which he often sold when he judged the market to be right. He donated his collection to the City of Glasgow in 1944.
▷Burrell Collection

Burrell Collection

William Burrell donated his collection of over 6,000 items, ranging from paintings to furniture and glass to tapestry, to the City of Glasgow in 1944. Shortly after this he gave £450,000 ($800,000) for the construction of a building to house the collection with the condition that it should be within 4 miles of Killearn, Stirlingshire, and not less than 16 miles from the Royal Exchange, Glasgow. Although the collection was not housed at the time of Burrell's death (1958), in 1967 it was decided that the works should be displayed in Pollock House, which had recently been presented to the City by Anne Maxwell Mcdonald. For overall representation of the ▷decorative arts the collection is the finest in Great Britain outside the Victoria and Albert Museum.

Burri, Alberto (b 1915)

Italian painter. He first began painting in 1944 as a prisoner of war in Texas, having previously been a doctor. He returned to Rome in 1945 and held his first exhibition there in 1948. In 1949 he began his '*Catrami*' series, experimenting with splashed and dribbled paint to create thick ▷impastos. In 1950 he joined the 'Origine' group which was concerned with the expressive power of the materials themselves. In 1952 he began his series of '*Sacchi*', in which scraps of sackcloth, rags and other materials were stitched together with surgical skill, and spotted red, resembling blood-stained bandages. He continued exploring the expressive potential of different materials, such as metals, wood and plastics, combining abstract painting techniques and ▷collage to construct highly resonant and beautiful works, similar to that of ▷Art Informel with which he has been associated.

If there are elements of ▷Klee and ▷Schwitters in his work, then his combination of object and painting also looked forward to ▷Rauschenberg's 'combine' paintings, as well as influencing ▷Fontana and ▷Yves Klein, just as his use of poor and debased materials

anticipated ▷Junk Art and ▷Arte Povera. Burri stated that, 'The poorness of a material is not a symbol; it is a device for painting.'

Burri exhibited at the Venice ▷Biennale in 1952 and 1960 when he won the International Critics' Prize. He was also represented at the *New Decade* exhibition in 1955 at the Museum of Modern Art in New York. **Bib.**: *Alberto Burri*, exh. cat., Houston, 1963; *Alberto Burri*, exh. cat., Bologna, 1991; *Alberto Burri, Catalogue Raisoné*, Città di Castello, 1990

Burton, Decimus (1800–81)

English architect. The tenth child of a builder, Decimus Burton entered an architectural profession dominated by Sir John Nash, with whom his father worked, and ▷Sir John Soane, with whom he trained at the ▷Royal Academy schools. Burton's first building, a ▷villa for his family in the newly laid-out Regent's Park, was designed in 1815. Nash recognized his talent and accepted two further plans for Regent's Park: Cornwall and Clarence Terraces (1821 and 1823). However, friction with Nash led to Burton forming his own practice in 1823. He completed further buildings in Regent's Park alone, including Grove House (1824) and The Colosseum (1828) and Lodges at Cumberland Gate and Prince of Wales Gate. His Wellington Arch (1825–8), based on the Roman Arch of Titus, remains in place. In 1826 he started work on the first Zoological Gardens in Regent's Park, which he revised and expanded throughout his career. Burton had already clashed with Nash again in 1824, when he was commissioned to design the Athenaeum Club in Waterloo Place. Nash was to design the United Services Club opposite and the two buildings were to be uniform. Disputes led to the construction of two different structures. During the 1830s Burton's architecture became increasingly unfashionable as the ▷Gothic Revival began and he moved to Kent, where his practice survived by designing churches and villas around Tunbridge Wells whilst he also planned extensive schemes for St. Leonards and Fleetwood in the 1840s and 50s. He returned to London to work on a series of projects at Kew Gardens, including the Palm Stove (1848) and the Temperate House (1863).

Busch, Wilhelm (1832–1908)

German painter and graphic artist. He was a contributor to the important illustrated journal *Fliegende Blätter*, and invented the *Max und Moritz* picture stories that appeared in that journal from 1865 onwards.

Bush, Jack Hamilton (1909–77)

Canadian painter. At the beginning of his career he practised as a commercial artist, but he became involved with the ▷Group of Seven and then the ▷Automatistes. A series of trips to New York, including a crucial one in 1952, exposed him to ▷Abstract Expressionism. From this point he moved away from the regionalist emphasis of his earlier work and concentrated on pure form and colour. In 1949 he held his first solo exhibition.

Bushnell, John (c1630–1701)

English sculptor. As a young man he fled the country to avoid an enforced marriage and spent many years in Europe. He travelled through France and Italy, settling for a time in Venice where he executed the huge Monument to Alvise Mocenigo (1663–4) for the church of San Lazzaro dei Mendicanti. While in Italy he seems to have visited Rome where he fell under the influence of the ▷Berninesque ▷Baroque and, when he finally returned to England, he achieved considerable success with his rather superficially assimilated version of it, winning the prestigious commissions for four royal statues for the newly built Temple Bar (1670) and two more (plus Thomas Gresham) for the Royal Exchange (now in the Old Bailey) in the following year. His masterpiece is generally considered to be the Monument to John, 1st Viscount Mordaunt of Avalon (after 1675, Fulham Parish Church, London). His work is uneven in quality; the trappings of the ▷Baroque are repeated, but with little knowledge of underlying anatomical structure in his figures. Bushnell did, however, enjoy a considerable success with an English public unused to the real article. Unfortunately, his Italian experience seems to have instilled in him a pride way beyond his achievement and he became increasingly eccentric and then mentally unstable, finally dying completely insane.
Bib.: Gunnis, R., *Dictionary of British Sculptors 1660–1851*, London, 1951; Whinney, M., *Sculpture in Britain 1530–1830*, 2nd edn., Harmondsworth, 1988

bust

Strictly speaking, a sculptured representation of the head and upper part of a person's body. The term is sometimes erroneously applied to representations of the head alone.

Butinone, Bernardino (fl. 1484–1507)

Italian painter. He worked primarily in Milan, where he produced ▷frescos such as those in S. Pietro in Gessate. Although his style still retains ▷Gothic elements, it does reveal some knowledge of the works of ▷Mantegna.

Butler, Elizabeth Thomson, Lady (1846–1933)

English painter. She was a popular and sensational artist in her own day, known for her ▷battle paintings at a time when this type of subject was only rarely treated by women artists. Her training was primarily through specialist schools for women artists, and she studied life drawing privately. Her fame and skill led her to be proposed for election to the ▷Royal Academy, but she lost the vote. Her depictions of common soldiers

were particularly popular during the Crimean war, when they appealed to English sentiment.

Bib.: Usherwood, P. and Spencer-Smith, J., *Lady Butler, Battle Artist 1846–1933*, Gloucester, 1987

Butler, Reg(inald) (1913–81)

British sculptor and architect. From the beginning he was influenced by ▷Constructivism, and he began producing metalwork. During the Second World War, he was a conscientious objector and gave up professional art to work as a blacksmith. After the war, he became known for his fetishistic sculptures of female nudes which included real hair. In 1953 he won a competition for a Monument to the Unknown Political Prisoner, but this was never built.

Bib.: *Reg Butler*, exh. cat., London, 1983

Butterfield, William (1814–1900)

English architect. Born in London, the son of a chemist, he was one of the leaders of the Victorian ▷Gothic revival. He trained as an architect and travelled to Europe but little is known of his early life. His first major work was Highbury Chapel, Bristol (1840) built the year that he set up in independent practice. As with much of his early work this was a solid, severe ▷Gothic building influenced by ▷Pugin. It was also the first of many churches designed for the Anglo-Catholic Cambridge Camden Society. By the 1850s his work was characterized by a new use of brick, often in ▷polychromatic stripes and patterning and with elaborate painted interiors (e.g. All Saints, Margaret Street, London, 1850–63). This style reaches a peak in the black and grey brick and limestone stripes of Keble College, Oxford in 1866–86. Butterfield also had associations with the ▷Arts and Crafts movement, in that he increasingly became interested in the textures and properties of his materials and made design use of the functional aspects of his buildings, like chimneys. Unlike many Victorian designers, he wrote no books and had few pupils.

Bib.: Thompson, P., *William Butterfield*, London, 1971

buttress

A structure of masonry or brick built against, and projecting from, the exterior of a wall to strengthen or support it against the lateral thrust exerted by a superincumbent roof, ▷arch or ▷vault. Buttresses are of a number of different types:

(i) Angle buttresses are set at right angles to each other at the corner of a structure. A clasping buttress encases a corner.

(ii) A diagonal buttress is set diagonally against a corner, forming an equal angle with the face of each receding wall.

(iii) A pier buttress is an exterior pier bonded to a wall throughout its entire height, serving to counteract the thrust of a vault or arch.

(iv) Set back buttresses are set at right angles to each

Buttresses, Corner of a monument, Spilsby Church, Lincolnshire

other at the corner of a structure, but slightly set back from it.

▷flying buttress

Buytewech, Willem Pietersz. (1591/2–1624)

Dutch painter, draughtsman and etcher, also known as 'Geestige Willem' ('Witty', or 'Inventive William'). He was born in Rotterdam, was active there and in Haarlem and is closely associated with ▷Frans Hals. According to a contemporary source they may have collaborated on pictures. They definitely shared models (cf. Hals, *Shrovetide Revellers*, c1615, New York, New York Metropolitan Museum, with Buytewech's *Merry Company*, c1617–20, Rotterdam, Museum Boymans-van Beuningen: the bearded reveller with the garland of sausages appears in both) and Buytewech actually copied some of Hals' paintings. However, Buytewech's touch is less painterly and more minute. In 1612, he enrolled in the Haarlem Guild of St. Luke. Only about ten of his paintings survive and they are mostly of a specialized category of ▷genre developed by himself, known as ▷'Merry Company' (as above). Foppish young men and finely dressed ladies disport themselves in a better class of tavern, or smoke and drink around a table laid for a banquet in a palatial garden (e.g. *Merry Company in the Open Air*, c1616–17, Berlin, Gemäldegalerie). Buytewech's graphic work survives in greater numbers and covers a wider range of subjects, including landscapes, religious themes and fashion plates, as well as genre, and in fact this work shows a greater freedom of execution than his paintings. However, it is his paintings that had more impact

on other artists, influencing, among others, Dirck Hals (1591–1656), the younger brother of Frans.

Bib.: *Willem Pietersz. Buytewech 1591/2–1624*, exh. cat., Paris, 1974

Bylert (Bijlert), Jan van (1597/8–1671)

Dutch painter. He was a pupil of ▷Bloemaert and also visited France and Italy, where he absorbed the influence of ▷Caravaggio. When he returned to Utrecht in 1625, he first practised the ▷chiaroscuro of Caravaggio, but soon abandoned this dark-toned style for a lighter palette.

Byzantine art

Architecture and highly decorated art, usually ▷mosaics, ▷frescos, ornate metalwork, manuscripts or panel paintings produced in the area under the influence of the eastern Roman empire, from the 5th century AD to the Fall of Constantinople in 1453. Constantinople, founded in AD 330, was the artistic centre of the Byzantine world, although other cities as far flung as Antioch, Jerusalem, Venice, Ravenna, Alexandria and Rome also produced important work. Indeed, the influence of the Byzantine Empire fell beyond its geographical boundaries, and many areas of Russia and the Slav countries continued to produce perceptibly Byzantine works well after the fall of the Byzantine empire. However, in many cases the remains of Byzantine art are now hard to find *in situ*. Areas now under Muslim control have had their Christian churches whitewashed, and portable pieces have found their way into western museums.

Byzantine art displays an almost entirely formal and hierarchical ▷iconography and its subject usually pertains to the Christian or political doctrines of its age. No division is drawn between 'art' and 'craft' as all media combine to inform the Orthodox experience. The art contains a degree of abstraction, and the spiritual basis for the production of the work is more important than its resemblance to any known object or person. In the Byzantine empire the belief prevailed that images of holy figures were not just depictions of them but held within them some of the sacred spirit of the personality portrayed. It was thought that St. Luke had painted the first picture of the ▷Virgin and that this depiction contained a part of her spirit. Therefore, although aspects of the work, the bright colours and frontality of the figures for example, suggest a naiveté to the work, the resonances provided by the artworks are sophisticated and complex. Art and its production was tied closely with the Church.

Bib.: Beckwith, J. *Early Christian and Byzantine Art*, Harmondsworth, 1970; Cormack, R., *Writing in Gold: Byzantine Society and its Icons*, London, 1985; Kitzinger, E. (ed), *The Art of Byzantium and the Medieval West*, Bloomington, 1976

C

Cabanel, Alexandre (1823–89)

French academic painter. Born in Montpellier, he was a very popular academic painter in his day. He studied under Picot at the ▷École des Beaux-Arts from 1840 and won the ▷Prix de Rome in 1845, spending five years in Italy. His early works were conventional ▷history paintings, but from the 1850s he increasingly turned to portraiture, becoming one of the most popular portrayers of Second Empire society. After the huge success of his *Birth of Venus* (1863, Paris, Louvre), which was bought by Napoleon III, he turned to mythological subjects combining the idealism and finish of ▷Ingres with a contemporary naturalism (e.g. *Phèdre*, 1880, Montpellier). He enjoyed the patronage of royalty both in France and abroad (see his portrait *Napoleon III*, 1865, Baltimore). He was also employed on decorative commissions (e.g., Palais du Senat, Paris, 1856). Along with ▷Bouguereau, he remained a conservative stalwart in opposition to ▷Impressionism. He was a member of the Légion d'honneur (1863) and a professor at the École des Beaux-Arts.

Cabaret Voltaire

A cabaret founded in Zurich in 1916 by the poet Hugo Ball. It became a site for pacifist protest and an incubator for the first stirrings of the ▷Dada movement. The cabaret drew artists, writers and performers, such as ▷Jean Arp, Marcel Janco, ▷Emmy Hennings and ▷Tristan Tzara. There they engaged in a series of events such as simultaneous poetry readings and nonsense music. On one level designed to show the absurdity of art forms, the Cabaret Voltaire also became a place for political protest against the hegemony of bourgeois culture in Europe and the responsibility borne by that sector of society for the First World War.

cabinet of curiosities

A translation of the German word, '*Wunderkammer*', this was a collection of expensive or rare items, including art objects, fossils and scientific artefacts. The origins of such collections seem to lie in the ▷Renaissance, but they were most popular in the 17th and 18th centuries. They were a sign of noble education, but also functioned as forerunners to the modern museum. Cabinets of curiosities offer particularly revealing insights into the attitudes of European collectors towards those non-European cultures which they felt were strange or primitive.

Bib.: Impey, O. and MacGregor, A., *The Origins of Museums: The Cabinet of Curiosities in Sixteenth and Seventeenth-Century Europe*, Oxford, 1985

cabinet painting

Name given to a small oil painting which could fit inside a cabinet. They were particularly popular in the 17th-century Netherlands, when a growing middle class required pictures to decorate their modest homes. Smaller houses required smaller pictures. Cabinet paintings could represent any type of subject-matter, but they were most frequently ▷genre scenes.

cabriole

Leg of a table or a chair designed in the shape of a goat's foot.

Cacus

　▷Hercules

cadavre exquis

This was a game played by ▷Surrealist artists which was meant to express the ▷psychoanalytic notion of a 'collective unconscious'. It originated as a word game in which each player would write down a word or words and then all the words would be revealed to create nonsense sentences. In its artistic manifestation, each individual in a group would draw a design on a piece of paper which was folded over so that the next person was unaware of what the others had done. It was particularly popular among Parisian Surrealists.

caduceus

The identifying attribute of ▷Mercury, the messenger of the gods. In its most familiar form it is a wand entwined with two serpents and tipped with wings. The earliest known form of caduceus is that used by the ▷Assyrians, Hittites, and Phoenicians: a rod surmounted by a circle and crescent. The snakes were added in its Greek form and the wings are perhaps a development of the crescent. In ancient and Classical times it was carried by messengers and heralds to ensure their safe passage, and thus became a symbol of commerce, and Mercury the patron god of commerce (see ▷Giambologna, *The Medici Mercury*, bronze, 1580, Florence, Bargello). Because of its association with safe passage, the caduceus is originally among the attributes of Peace personified.

Caffà, Melchiorre (1535–67)

Maltese sculptor. He worked in Rome and produced marble ▷reliefs influenced by ▷Bernini.

Caillebotte, Gustave (1848–94)

French painter and collector of art. He was associated with the ▷Impressionists. He was born to a wealthy Parisian family and began his career as a naval architect. Having fought in the Commune, he joined ▷Bonnat's studio but his failure to achieve ▷Salon success turned him towards the Impressionists. He was a prolific producer of still life, urban and leisure scenes, similar to those of ▷Degas in subject matter and composition but with a finished technique (e.g. *Place de l'Europe on a Rainy Day*, 1877, Chicago). He exhibited with the Impressionists – *The Floor Scrapers* in 1875 (Paris, Musée d'Orsay) – and organized the 1877 exhibition. His work was criticized by ▷Zola for its finish, but increasingly after 1878 he turned to boating scenes which followed ▷Renoir in a use of looser brushwork. During the 1880s his interest in art decreased. He was an enthusiastic collector and after his early death he left his collection of 65 Impressionist works to the Musée du Luxembourg (now held in the Musée d'Orsay), despite the opposition of artistic conservatives like ▷Gérôme.

Bib.: Berhaut, M., *Caillebotte: sa vie et son oeuvre*, Paris, 1978; *Gustave Caillebotte*, exh. cat., Houston, 1976; Varnedoe, K., *Gustave Caillebotte*, New Haven and London, 1987

Calder, Alexander (1898–1976)

American sculptor and painter. He studied mechanical engineering between 1915 and 1919, before studying at the School of the ▷Art Students' League in New York in 1923. There he began producing his first wire sculptures in 1925. In 1926 he moved to Paris where his moving wire *Circus* attracted considerable attention. In 1931 he joined ▷Abstraction-Création, and produced his first non-figurative constructions. His moving constructions, powered either by hand or motor, were christened ▷'mobiles' by ▷Duchamp in 1932, and the non-moving ones were called 'stabiles' by ▷Arp. His unpowered mobiles, for which he is most famous, were first produced in 1934. They are constructed from metal discs of varying shapes and sizes painted in primary colours or black, and suspended on thin wires that respond to the air currents. Calder described these as '4-D drawings', fulfilling his desire to make 'moving ▷Mondrians', a reference to an artist he had met and admired in 1930. He continued making mobiles and stabiles, sometimes combining the two, into the 1970s, as well as exhibiting ▷gouaches from the 1950s. Calder received many public commissions, such as the mobile for Kennedy Airport in 1957, and produced some extremely large constructions, such as 'Man' for the Montreal World Exhibition in 1967, that stood 23 m (76 ft) high.

Calder's balanced constructions succeed in effecting a synthesis between engineering and sculpture, design and chance, constructivism and lyricism, and simplicity and mystery. In his introduction of movement into sculpture he is regarded as a precursor of ▷kinetic art.

Bib.: *Calder*, exh. cat., London, 1992; *Calder*, exh. cat., Antibes, 1993; *Calder's Universe*, exh. cat., New York, 1977; Martier, J.-M., *Alexander Calder*, Cambridge, 1991

Callcott, Sir Augustus Wall (1779–1844)

English painter. He specialized in landscape and ▷genre and was very fashionable in his own day. He was born in Kensington and studied with ▷Hoppner at the ▷Royal Academy Schools, originally exhibiting portraits after the success of his first RA exhibition in 1799. Around 1804, he turned to landscape. He travelled widely throughout Europe, particularly to Italy. His early work had a freshness influenced by ▷*plein air* sketching and Dutch 17th-century landscape (e.g. *Old Pier Littlehampton*, 1812, London, Tate). However, this facet of his painting later became lost in his attempts to emulate ▷Turner and in the development of an Italianate style – he became known as the 'English ▷Claude'. He also attempted a few ▷history paintings (e.g. *Milton Dictating to his Daughters*, 1840, London, Victoria and Albert Museum). In 1827 he married Maria Graham, herself an authoress of topographical books, and together they hosted one of London's most fashionable salons. He was elected as an RA in 1810, and knighted in 1837. He was Keeper of the Royal Collection from 1844.

Bib.: *Augustus Wall Callcott*, exh. cat., London, 1981

Callery, Mary (1903–77)

American sculptor. She studied in New York at the ▷Art Students' League during the 1920s. In the 1930s, she travelled to Paris, where she knew ▷Picasso and ▷Laurens. After 1940 she was in New York, where she worked with ▷Léger on architectural commissions. Her style was distinguished by its attenuated figure types.

Callicrates (Kallikrates)

One of the leading architects of Periclean Athens. He collaborated with ▷Ictinus on the ▷Doric Parthenon (447–38 BC), and himself designed the ▷Ionic Temple of Athena Nike (448–after 421 BC), also on the Athenian Acropolis. He built in addition the southern and central sections of the 9.5 km (6 miles)-long walls which connected Athens to Piraeus, the Athenian port.

calligraphy

An art of writing, in which the form of the letters is as important as the meaning of the words. Calligraphy is primarily associated with China, where it flourished from the 4th century AD. In Chinese calligraphy a

brush, rather than a quill or pen, was used to form the letters. It continues to be considered a fine art there, as it does in other non-European cultures which concentrated on developing writing and decorative styles as much if not more than the representational arts (e.g. ▷Islamic art). European calligraphy was associated with manuscript illumination from the 12th to the 15th centuries, but with the introduction of printing, it became a more specialized and rare art form.

Bib.: Safadi, Y.H., *Islamic Calligraphy*, London, 1978; Stevens, J., *Sacred Calligraphy of the East*, Boulder, 1981; *2000 Years of Calligraphy*, Baltimore, 1976; *The Universal Penman: a Survey of Western Calligraphy from the Roman Period to 1980*, exh. cat., London, 1980

he applied to low-life scenes and subjects from the *commedia dell'arte* which was then popular in France. His many ▷etchings and ▷engravings included the *Grandes Misères de la Guerre*, which was a collection of scenes of the Thirty Years War. His ▷grotesque figure types gave his style a distinctive character.

Bib.: Ternois, D., *L'art de Jacques Callot*, Paris, 1962; idem., *Jacques Callot: catalogue complet de son oeuvre dessiné*, Paris, 1962

Calumny of Apelles

Calumny is the title of an allegorical painting by the 4th-century BC Greek painter ▷Apelles. The work itself is no longer extant, but a detailed description is

An example of calligraphy

Callimachus

Greek sculptor of the 5th century BC who is credited with the invention of the ▷Corinthian capital.

Calliope

▷muse

Callisto

▷Diana

calotte

▷dome

Callot, Jacques (1592–1635)

French engraver. After spending ten years in Rome and Florence, he returned to his native Nancy in 1621. He brought back from Italy a ▷Mannerist style which

given by the Roman author Lucian (2nd century AD). Lucian's description was known to ▷Renaissance ▷humanist scholars and was cited in ▷Alberti's treatise for painters, *Della Pittura* (1436), as an exemplary subject. To Alberti the *Calumny*, as described by Lucian, was a prime example of invention, a quality he deemed to be of primary importance to painters who would lift their work from medieval craftsmanship (made by manual workers) to the elevated level of a ▷Liberal Art (created with the intellect). To this end he advised artists to aspire to be 'as learned as possible' and to 'associate with poets and orators' who were respected above all other qualities for their invention. So full of invention was Apelles' painting that even without the physical existence of the painting itself, its learned subject could still exert a powerful force on the imagination merely through a verbal description.

And yet as powerful as the word may be, the power of the visual image is even greater: after his recounting of Lucian's description Alberti declares to the reader: 'If this story pleased as it was being told, think how much pleasure and delight there must have been in seeing it painted by the hand of Apelles.' Painters were exhorted to study the writers of antiquity for the kind of narrative themes which Alberti knew would appeal to the enlightened humanist patron. The most famous response to this challenge, and one which follows closely the description given by Alberti, is by ▷Botticelli (1490s, Florence, Uffizi).

Calvaert, Denys (Dionisio Fiammingo) (c1540–1619)

Flemish painter. He was from Antwerp, but settled in Bologna, where he opened an Academy in 1572. He was primarily a landscape painter, but he is known mostly for his teaching. His Academy preceded the ▷Carracci Academy in Bologna, and among his pupils were ▷Albani, ▷Domenichino and ▷Reni.

Calvary

The hill outside Jerusalem where ▷Christ was taken for ▷Crucifixion. It is also known as Golgotha, the hill of skulls. The Franciscans established the devotions of the 14 Stations of the Cross, marking specific events on the way to the Crucifixion, and the first scenes are usually grouped under the name The Road to Calvary. According to western tradition Christ carried his own cross to the place of execution, still wearing the crown of thorns and jeered along the road by bystanders. The eastern Church believed that Simon the Cyrenian carried the cross, and he is often included in scenes, helping Christ when he stumbles. The journey emphasized the hardships undergone by Jesus, and to this end the size of the cross was often exaggerated.

Calvert, Edward (1799–1883)

English painter and engraver. He was born at Appledore in Devon, and after sailing with the Navy for five years, studied art first at Plymouth, then at the ▷Royal Academy Schools. He first exhibited at the RA in 1825, but met ▷Palmer there the following year and, under his inspiration and that of ▷Linnell and ▷Fuseli, he was wooed away from the establishment. Together with the rest of the ▷Ancients at Shoreham, he admired ▷Blake as both a man and an artist, and he began to produce small-scale, visionary and imaginative works (e.g. *The Primitive City*, ▷watercolour, 1822; London, British Museum). He also began to experiment with wood ▷engraving and ▷lithography, developing an individual and skilful technique (e.g. *Return Home*, 1830). By 1831, however, this influence was waning. In 1844 Calvert visited Greece

and from then on his work became infused with an idealized and often sentimental Classicism. His son, Samuel, wrote a memoir of his father's life in 1893.
Bib.: Lister, R., *Edward Calvert*, London, 1962

camaïeu

(French, 'like a cameo'.) A monochromatic painting meant to give the illusion of a sculptured relief. It was used primarily for interior decoration from the ▷Renaissance onwards. It is distinguished from ▷grisaille, in that it can be in colours other than grey.

Cambiaso, Luca (1527–85)

Italian painter. He was from Genoa, but travelled to Spain in 1583 at the request of Philip II, who wanted him to be involved in the decoration of the ▷Escorial. His style was a modified version of ▷Michelangelo's, with a greater emphasis on geometric form, particularly in his drawings.

Cambio, Arnolfo di
▷Arnolfo di Cambio

Camden Town Group

Established in 1911 out of the ▷Fitzroy Street Group associated with ▷Sickert. The group took its name from the then working-class area of London where he had his studio. It represented a secession from the ▷NEAC, by a younger generation of English artists influenced by ▷Post-Impressionism, who sought to express the reality of ordinary life through the artistic language of ▷divisionism and ▷cloisonnism. However, in their subject matters of interiors, portraits, landscapes and still lifes, they continued to owe something to ▷Impressionism, particularly to the art of ▷Degas. The group included ▷Ginner, ▷Gore, ▷Gilman, ▷Grant, ▷Bevan, ▷Augustus John, ▷Lucien Pissarro, Walter Bayes, Henry Lamb and the critic Frank Rutter. Membership was strictly controlled: it was limited to 16 and expressly excluded women. They held two exhibitions at the Carfax Gallery in 1911 (at which each member exhibited four works), and one the following year, but in 1913 they merged with the ▷London Group, although the Brighton exhibition of that year still bore their name.
Bib.: Baron, W., *The Camden Town Group*, London, 1979; idem., *Painters of the Camden Town Group*, exh. cat., London, 1955; *The Camden Town Group*, exh. cat., Leeds, 1984

cameo

A carved ▷gem in which colours are superimposed

in ▷relief. It often takes the form of jewellery and can include ▷silhouette portraits.

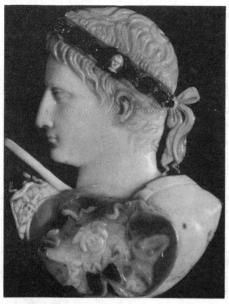

Cameo of Emperor Augustus

camera lucida

(Latin, 'light room'.) A prismatic device used to concentrate and project the light from an object on to a screen, so it can be traced.

camera obscura

(Latin, 'dark room'.) A black box with a hole in one side to concentrate light and cast the shadow of an object on to a screen, so it can be traced.

Cameron, Charles (1740–1812)

British architect. He was from Scotland and, under the influence of ▷Robert Adam, helped popularize the ▷Neoclassical style in Britain. In 1772 he published *The Baths of the Romans*. In 1779 Catherine the Great called him to Russia, where he designed buildings in a ▷Palladian style.

Cameron, Julia Margaret (1815–79)

English photographer. She was born in Calcutta and settled in England only after her marriage in 1838, first in London and then at Freshwater on the Isle of Wight, where Tennyson was her neighbour. She began to take photographs as an amateur at the age of 48 but soon established a reputation as one of the major portrait photographers of the 19th century, specializing in intense close-ups with directional lighting to emphasize features and character. As part of a wide intellectual circle (she also dabbled in poetry), she photographed her friends, including Browning and Tennyson. Many

of these treated the subject in a theatrical or ▷allegorical character (e.g. ▷Watts in the *Whisper of the Muse*, 1865). She also experimented with imaginative compositions (e.g. *May Day*, 1875), influenced by ▷Pre-Raphaelite painting, perhaps most famously in illustrations of Tennyson's *Idylls of the King*. She went to live in Sri Lanka in 1875, and died there.

Bib.: Gernsheim, H., *Julia Margaret Cameron: Her Life and Photographic Work*, 2nd edn., London, 1975; Hinton, B., *Immortal Faces: Julia Margaret Cameron on the Isle of Wight*, Newport, 1992; Hopkinson, A., *Julia Margaret Cameron*, London, 1986; Weaver, M., *Julia Margaret Cameron*, exh. cat., Southampton, 1984

Campagnola, Giulio (c1482–c1518) and Domenico (1500–after 1552)

Italian family of artists. Giulio was an ▷engraver who worked in 1499 at the ducal court of Ferrara, where he was exposed to the work of ▷Dürer. He trained under ▷Mantegna and worked in Venice in 1509. His engravings mainly represented landscapes. His son, Domenico, was a painter who produced ▷altarpieces in the style of ▷Titian and worked in Padua during the 1520s.

Campania, Pedro de (1503–80)

Flemish painter who worked in Spain. He studied and worked in Bologna and Venice in the late 1520s. In the mid-1530s he went to Seville where he produced ▷altarpieces such as *The Descent from the Cross* (1547). His works show the influence of ▷Mannerism. From 1562, he worked in Brussels, producing designs for a ▷tapestry factory. He was known in Flanders as Pieter de Kempeneer.

campanile

Italian architectural term, meaning 'bell-tower', usually detached from the main body of the church building (e.g. Giotto's Campanile, begun 1334, Florence, Duomo).

Campbell, Colen (1676–1729)

English architect. He was responsible for popularizing the ▷Palladian style in England through his publication *Vitruvius Britannicus*, the first volume of which appeared in 1715. This work reproduced engravings of principal buildings in England, and it emphasized the Palladian designs of ▷Inigo Jones. It became a popular pattern book for Whig nobles who were anxious to improve or redesign their country houses as proof of their wealth and power. Campbell's own architectural production included the very Palladian Mereworth Castle in Kent (c1722–5).

Bib.: Stutchbury, H., *The Architecture of Colen Campbell*, Manchester, 1967

Campen, Jacob van (1595–1657)

Dutch painter and architect. He worked in a ▷Renaissance style and designed theatres, palaces and churches in Amsterdam. He was interested in the architecture of ▷Palladio, and he helped promote a Classical architectural style in Holland during the 17th century.

Campendonk, Heinrich (1889–1957)

German painter and designer of woodcuts. He studied with ▷Thorn-Prikker at Krefeld and in 1911 joined the ▷Blaue Reiter. Like members of that group, he was interested in Bavarian glass painting, and in his own work he cultivated the ▷primitivism of German ▷folk art. He also flirted with ▷Orphism which can be detected in his brightly coloured works. When the Nazis came to power in 1933, he went into exile in Amsterdam.

Campin, Robert (fl 1406–44)

Flemish painter. He was known to have been active in Tournai in the early 15th century and to have numbered among his pupils ▷Jacques Daret and ▷Rogier van der Weyden. Unfortunately none of his documented works survive and no undocumented works have been securely linked to his name. The most widely accepted theory is that he is identical with the painter known as the ▷Master of Flémalle.
Bib.: Friedlander, M.J., *Rogier van der Weyden and the Master of Flémalle*, New York, 1969; Frinta, M.S., *The Genius of Robert Campin*, The Hague, 1966

camposanto

(Italian, 'holy field'.) A cemetery, the most celebrated being the *camposanto* at Pisa (begun 1277), built by Giovanni di Simone.

Canada, art in

Before the 19th century, Canadian art was dominated by foreign influences – at first through the infiltration of French religious art in Quebec during the 17th century, and then later in the 18th century from European artists who travelled to Canada to paint its untamed landscapes. The Royal Canadian Academy and National Gallery of Canada were founded in 1880, and the expansion of the railways brought more visitors in from America and with them their artistic influences. The earliest extra-academic organizations were also devoted to European and American styles. The Canadian Art Club (CAC), founded in Toronto in 1907, promoted ▷Impressionistic and ▷Hague School styles. However, it was a rebellious faction of the Art Club that first began to search for a genuine Canadian style of art. ▷J.E.H. Macdonald, ▷Lawren Harris and others of the CAC decided that the best way to obtain a Canadian art was by attention to the specific landscape features of their country. In 1914, these artists and others travelled in the Canadian provinces and painted the countryside and way of life of the outer reaches. In May 1920 these artists formed the ▷Group of Seven, based in Toronto, but devoted to the promotion of a national style and subject-matter.

While Toronto dominated much of Canadian art life in the early years of the 20th century, other important events were happening in Montreal. There William Brymner (1855–1925) trained a whole generation of students in styles borrowed from Paris. The foreign influence continued through to the 1930s, when the ▷Contemporary Art Society (CAS) was founded with members such as ▷Borduas and Alfred Pellan. The impact of Parisian art came first in the form of the bold colourism of ▷Matisse and then as ▷Surrealist ▷automatism. The formation of the group ▷Les Automatistes reflected this trend. In 1947–8 the publication of the 'Refus Global' by members of the CAS called for a rejection of the influence of the Church in the art of Quebec. This aroused a certain amount of controversy and resulted in the expulsion of Borduas from his teaching post.

While Toronto encouraged 'Canadianism' and Montreal veered towards the opposing European influences, a few individualists followed their own brand of Canadian art. ▷Emily Carr who began her career in Vancouver painted ▷Fauvist works, using totemic imagery of the native peoples of British Columbia as a way of expressing her Canadian style.

Canadian art since the Second World War has been distinguished by a greater eclecticism and the more noticeable influence of New York movements, such as ▷Abstract Expressionism. Toronto and Montreal continue to be important artistic centres, but other major Canadian cities have also become havens of contemporary art. The Canadian countryside has also continued to dominate the subject-matter of art with a national impetus. Additionally, new attention has been given to the work of 'First Nation Canadians' or Native Americans of Canada.
Bib.: Hutcheon, L. (ed.), *Double Talking: Essays on Verbal and Visual Ironies in Canadian Contemporary Art and Literature*, Toronto, 1992; *Three Hundred Years of Canadan Art*, exh. cat., Ottawa, 1967

Canadian Group of Painters

A group of Canadian artists based in Toronto from 1933 to 1969. It grew out of the ideals of the ▷Group of Seven and fostered a nationalist emphasis in contemporary Canadian art through exhibitions in both Canada and the United States.

Canaletto (Giovanni Antonio Canal) (1697–1768)

Italian painter. He was a painter of townscapes (▷*vedute*), principally of Venice, and was trained initially by his father as a scene painter. His earliest known signed and dated work, *Architectural Capriccio*, (1723, Milan, private collection) reflects this training.

However, in c1719–20 he was in Rome, where he saw and was influenced by ▷Panini's paintings of recognizable Roman views. Canaletto was back in Venice in 1720 for, from that date until 1767, he is listed in the *fraglia* (Venetian painters' guild). His earliest documented views of Venice were for Stefano Conti of Lucca (four paintings, 1725–6, Montreal, private collection). The paintings of this period, generally regarded as his best, display the qualities which ensured he would take up the mantle of his principal precursor ▷Luca Carlevaris. The finest work is perhaps *The Stonemason's Yard* (c1729, London, National Gallery): the paint is fluently handled, the colour is rich with bold contrasts of light and shade, and the figures, though small in scale, are lively to an extent lost in the shorthand figures of his later pictures. These early paintings are unusual for their time in that they were apparently painted directly from nature, rather than from the traditional practice of making studies on site for working up back in the studio; only later did Canaletto revert to the more usual practice, frequently using a ▷camera obscura as a drawing aid. (The lens of this device has the unfortunate effect of reducing distant figures to blurs and has been presumed as the source of Canaletto's later manner of creating figures from blobs of colour.) *The Stonemason's Yard* is unusual in that it represents a ramshackle working area of the city. Canaletto's real market was for views of the splendid architectural sights, preferably richly decked out for some festive occasion (e.g., *Venice: the Feast Day of St. Roch*, early 1730s, London, National Gallery) or better, a regatta on the Grand Canal (e.g., *The Bucintoro Returning to the Molo on Ascension Day*, c1730, Milan, Aldo Crespi Collection).

Canaletto soon attracted the notice of English visitors and by 1730 had come to a working arrangement with Joseph Smith (later British consul in Venice) who not only bought pictures from him, but acted as agent for sales to other British customers. Encouraged by the strength of his English market, Canaletto travelled to England in 1746, returning to Venice only for short periods, until his final return c1756. He attempted developing a market for English views, but experienced great difficulty. Also, his style had by now become somewhat hardened, mechanical even, to the extent that in 1749, the English art critic and historian, ▷George Vertue, publicly suggested that the present 'Canaletto' was an impostor. Canaletto responded by giving public demonstrations of his ability as a painter, but seems not to have largely improved his fortunes. He eventually returned to Venice and in 1763 was finally elected to the Venetian Academy. He continued to paint until his death in 1768, but never regained the commercial success of his early years. Owing to his popularity with English travellers, most of his paintings are in Britain. Canaletto's nephew and pupil, ▷Bernardo Bellotto, worked in a similar style.
Bib.: Baker, C., *Canaletto*, London, 1994; Bronberg,

R., *Canaletto's Etchings*, San Francisco, 1993; Constable, W.G., *Canaletto*, 2 vols, Oxford, 1989; Links, J.G., *Canaletto*, London, 1994

Cano, Alonso (1601–67)
Spanish painter, architect and sculptor. His versatility led to his nickname 'the ▷Michelangelo of Spain'. He was a contemporary of ▷Velázquez. He studied in Seville from 1614 to 1638, when he became court painter in Madrid to Count-Duke Olivares. There he was exposed to the works of ▷Titian in the royal collection, and his own works took on the style of 16th-century Venetian art. He produced portraits and religious works for the court, but he was notorious for his violent temper, which led to imprisonment for duelling and suspected murder.

canon
A name given to a list of works of art accepted as authentic or superior. Most recently it has come to refer to those works or artists which are considered 'great', although the very idea of a canon of 'great' artists has also been attacked by theorists who see it as a limited approach to the ▷history of art. The canon tends to exclude women and minorities and consists largely of male artists who were either accepted in court or academy circles before the late 19th century, or rejected by such circles from the end of the 19th century onwards.
Bib.: Winders, J., *Gender, Theory and the Canon*, Madison, 1991

canopy
A hood, usually ornamented, above a door, ▷niche, window, choir stall, ▷pulpit, or tomb, either projecting from a wall, supported on vertical members, or suspended from the ceiling.

Canova, Antonio (1757–1822)
Italian sculptor. He was the most successful ▷Neoclassical sculptor, and he enjoyed an international reputation in his lifetime surpassing his principal rivals, ▷Thorvaldsen and ▷Flaxman. His work, immensely influential until superseded by the taste for ▷Romanticism, has been reassessed in the 20th century and his importance acknowledged.

Born at Possagno, the son of a stonemason, his earliest major work in Venice – *Daedalus and Icarus* (1779, Venice, Museo Correr) – was executed in a lively, naturalistic, neo-▷Baroque style. In 1781 he transferred to Rome and here was awarded a commission by the Venetian ambassador with the choice of subject left to himself. The result, *Theseus and the Minotaur* (1781–3, London, Victoria and Albert Museum), was initially conceived as an action group, but he was encouraged by his new acquaintance, the arch-Neoclassicist ▷Gavin Hamilton, to reconceive it as a Classical group in a state of timeless repose (the

Dolfino, *Antonio Canova*, Biblioteca Nazionale, Turin

1816. Apparently an extremely generous man, he was renowned for his encouragement of young sculptors. His most famous pupil was ▷John Gibson. Canova eventually retired to Possagno where he built a studio that is now a museum devoted to him.

Bib.: *Antonio Canova*, exh. cat., Venice, 1992; Finn, D., *Canova*, New York, 1980; Honour, H., *Canova e l'incisione*, exh. cat., Bassano del Grappa, 1994; Marton, P., *Canova: scultore, pittore, architetto e possagno*, Padua, 1990; Pavanello, G., *L'opera completa del Canova*, Milan, 1976

cantilever

In architecture, a horizontal ▷bracket, projecting from a wall and employed to support a ▷balcony or ▷cornice. A modillion is one of a series of small cantilevered brackets which supports (or appears to support) the upper member (corona) of a Roman ▷Corinthian or ▷Composite cornice.

canvas

A strong, coarse cloth, probably named after *cannabis* (Latin for 'hemp'), which is used as the material for sails and tents, and in a lighter form, as a support for paintings or embroideries. Canvas is a versatile material, which can be prepared in a number of different ways to create different effects.

canvas board

A type of board upon which ▷canvas is attached, so that the texture upon which paint or other ▷pigment is to be applied is extremely taut and resilient. It was a popular and cheap substitute for canvas in the 19th century.

Capek, Josef (1887–1945)

Czech painter. He worked in Prague, and from 1911 he was one of a group of artists who promoted ▷Cubism and ▷Expressionism there. He died in a concentration camp during the Second World War.

moment after the action). The piece was an instant success and from then on he was to work wholly in the Neoclassical idiom.

The success of *Theseus and the Minotaur* helped secure for him the prestigious papal commission for the Tomb of Pope Clement XIV (1783–7, SS. Apostoli, Rome) – a static, balanced, classical reworking of the tradition established by ▷Bernini's papal tombs. He soon attracted many of the most important patrons in Europe and a visit to Canova's studio was a prerequisite for the cultivated tourist's trip to Rome. His clients included the papacy, Napoleon and his family, the British aristocracy and Catherine the Great of Russia. For Pauline Bonaparte he carved the celebrated reclining semi-nude portrait of her as Venus (1805–7, Rome, Villa Borghese). For Napoleon himself he carved a colossal nude statue of Napoleon as Mars (based on the *Apollo Belvedere*); this being later bought by the British government from the restored Bourbon dynasty (who obviously had no use for it) and given as a war trophy to the Duke of Wellington (1806, London, Apsley House). Although Canova admired the ▷antique he refused ever to copy it: when the antique *Venus de' Medici* was confiscated by the French from the Uffizi Gallery in Florence, the Florentine authorities commissioned Canova to carve a replacement; they wanted a copy, but got an original Canova, the *Venus Italica* (1804–12, Florence, Pitti Palace), which soon rivalled its antique predecessor in fame. Following the fall of Napoleon Canova was dispatched to Paris by the Pope to organize the return of all the antiques looted from Italy by the French; in gratitude for this service the Pope created him Marchese d'Ischia in

capital

In architecture, the upper member or head of a ▷column, ▷pilaster or pillar – the member which forms the transition to the superincumbent ▷entablature or ▷arch. The basic shape of the capital is determined by its transitional function, moving from the circular section of the column to the rectangular

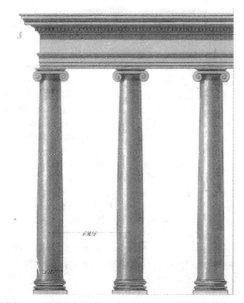

Columns with Ionic capitals

section of the masonry above. However, capitals came to be highly elaborated and are the principal distinguishing features of the classical ▷orders. A variety of other distinctive capitals have also been employed in non-Classical architecture. These non-Classical capitals include:

(i) Basket capital: a ▷Byzantine type, hemispherical or nearly hemispherical in shape with carving resembling the weave of a wicker basket.

(ii) Crocket capital: a ▷Gothic type (in use until the early 13th century), carved with stylized broad leaves with rolled-over tips (e.g. in the nave at Laon Cathedral, France, c1175–90).

(iii) Cushion, block, or cube capital: a ▷Romanesque and ▷Byzantine type (11th to 12th century). The clearest illustration of a capital as a transitional member, with an inverted lunette on each face where it meets the square ▷abacus, and the lower part of the capital rounded off to meet the circular necking of the column.

(iv) Lotus capital: an ancient Egyptian type shaped, as the name suggests, like a lotus bud.

(v) Palm capital: an ancient Egyptian type in the form of the spreading crown of a palm tree.

(vi) Scalloped capital: a 12th-century Romanesque type and development of the cushion capital. Each lunette shape is modified to a series of semi-circular surfaces topping the truncated cones below.

(vii) Stiff-leaf capital: an ▷Early English type (late 12th to early 13th centuries), and a development from the crocket capital, which is characterized by stylized many-lobed leaf shapes (e.g. in the nave at Lincoln Cathedral).

(viii) Water-leaf capital: a Romanesque type (late 12th century) with a broad, unribbed leaf curving up towards each angle of the ▷abacus and then curling under its corners.

▷Orders of Architecture

Capogrossi, Giuseppe (1900–72)

Italian painter. He studied law and began painting after a visit to Paris in 1927. He joined the Roman School of painters in 1933 which practised a tonal figurative painting. After the Second World War his painting underwent a radical change in which he experimented with various artistic languages until, in 1949, he developed his own characteristic signature, a morphology of signs based upon a pronged form. For the rest of his career Capogrossi explored the rhythmic, structural and spatial potential of the sign, investigations similar to those of ▷Tobey and Henri Michaux and other artists associated with ▷Art Informel. Capogrossi was a founder member of the Origine group in 1951, and from 1952 worked closely with the ▷Spatialists. He exhibited widely in Italy, as well as in France and was represented in 'The New Decade' exhibition of 1955 in New York. He was awarded the prize for painting at the Venice ▷Biennale in 1962.
Bib.: Seuphor, M., *Capogrossi*, Venice, 1954

Cappelle, Jan van de (c1624–79)

Dutch painter and engraver. He produced principally seascapes, river and estuary scenes, but also some 40 winter landscapes. A wealthy Amsterdam dyer by trade, he taught himself to paint in his spare time. His seascapes are, however, by no means amateurish, ranking as they do amongst the most accomplished maritime paintings of the century. Characteristically they are carefully balanced compositions with atmospheric harmonies of silvery-greys and browns. They generally portray ships in calm waters with virtually unruffled reflections of sails and hulls, and a wide expanse of sky filled with fleecy clouds (e.g. *A River Scene with Many Dutch Vessels Becalmed*, c1650 London, National Gallery). His wealth allowed him to assemble a fine collection of Dutch and Flemish works by ▷Simon de Vlieger (whose paintings exercised a great influence on his early work), ▷Rembrandt (about 500 drawings), ▷Jordaens, ▷Seghers, ▷Rubens, ▷Brouwer and ▷Van Dyck. He is also known to have had his portrait painted by Rembrandt, ▷Hals and ▷Eeckhout (although none of these portraits have been certainly identified).
Bib.: Russell, M., *Jan van der Cappelle*, Leigh-on-Sea, 1975

capriccio

(Italian, 'caprice'.) A term used for painting based on the imagination rather than reality. It is most commonly used for 18th-century works by artists such as

▷Canaletto and ▷Guardi, who often mingled real and fictional elements in their landscapes. Canaletto, for instance, painted *capricci* representing the Colleoni Monument (in Venice) juxtaposed with the ▷Colosseum (in Rome). In reference to landscape painting, a *capriccio* is the opposite of a ▷*veduta*, which is topographical, rather than fanciful. *Capriccio* is also used more loosely as a term to represent any sort of bizarre or unusual subject-matter, such as ▷Goya's ▷*Los Caprichos*.

Caprichos, Los

A series of 80 aquatints by ▷Francisco Goya published on 6 February 1799. Goya had been ill during the 1790s and had come to feel increasingly alienated and embittered. In the prints he expressed these sentiments with a series of satirical attacks of the follies and evils of contemporary Spanish society. The character of the work is revealed by what was initially intended as the title page (now no. 43) – *The Sleep of Reason Produces Monsters* – an image of rational man plagued by nightmarish beasts, and inspired by Rousseau's *Philosophie*. Many of the plates were anticlerical (e.g. no. 73, *Thou Specks of Dust*, attacked the Inquisition) and critical of the monarchy and court (e.g. no. 39, *And so was his Grandfather*, showed a donkey looking up his family tree). Increasingly the later plates became dominated by the imagery of weird beasts and witchcraft which was to reappear in Goya's Black Paintings (e.g. aquatint no. 75 *Can Anyone Untie Us?*, criticized arranged marriage by representing a couple roped together and tormented by a sinister bat-owl figure). It is interesting to remember that whilst Goya was venting these views, he was employed as a successful painter at court and the style of his engraving, particularly of the figures, is recognizably that of the official portraitist. *Los Caprichos*, along with the later series the ▷*Disasters of War*, place Goya among the foremost early 19th-century graphic artists.

Bib.: Johnson, R.S., *Francisco Goya: Los Caprichos*, Chicago, 1992; López-Rey, J., *Goya's Caprichos: Beauty, Reason and Caricature*, 2 vols., Westport, 1970

Caracciolo, Giovanni Battista (Battistello) (1578–1635)

Italian painter. He worked in Naples, where he came into contact with ▷Caravaggio in c1606. He adopted Caravaggio's emphasis on peasant figure types and ▷chiaroscuro, and was particularly important for spreading the significance of this style in Naples. By 1615 he was in Rome, and he worked in Florence in 1618.

Caravaggio, Michelangelo Merisi da (1571–1610)

Italian painter. He was the most influential Italian painter of the 17th century. Although he had no pupils,

his original style attracted followers in Rome (Orazio and Artemisia ▷Gentileschi, ▷Manfredi and ▷Saraceni) and was taken back to the Netherlands by the so-called Utrecht ▷Caravaggisti. The paintings of ▷Rembrandt, ▷Ribera, ▷Velázquez, ▷Murillo, ▷Georges de la Tour and the ▷Le Nain brothers all show the influence of Caravaggio's characteristic use of extreme ▷chiaroscuro and peasant types. The art of his mature period (1599 onwards) has been described as realistic, but it is a realism carefully manipulated for dramatic effect. The term has meaning, however, when used to contrast Caravaggio's work with the Classically idealized work of his chief rival, ▷Annibale Carracci.

Caravaggio was named after his home town near Milan. By 1584 he was in Milan, starting a four-year apprenticeship with Simone Peterzano, a mediocre painter who professed to have been a pupil of ▷Titian. Caravaggio's greatest influences from this time were not his master but ▷Savoldo, ▷Lotto, ▷Moretto and ▷Giulio and Antonio Campi. By 1592 he was in Rome and obtained work in the studio of the late ▷Mannerist painter ▷Cavaliere d'Arpino. Caravaggio's earliest independent works were still lifes and small half-length ▷allegories, sometimes using himself as a model – all showing his northern origins in the use of strong chiaroscuro and closely observed details. Many of these paintings are also of an intensely homoerotic nature (e.g. *Young Bacchus*, c1595, Florence, Uffizi). At this time he secured his first important patron, the Cardinal del Monte who commissioned a number of these small ▷cabinet pictures. In the summer house of the Cardinal's Roman palace, the Villa Ludovisi, is a ceiling painting, *Jupiter, Neptune and Pluto* (c1597, oil on plaster), also attributed to Caravaggio. Del Monte also seems to have secured Caravaggio his earliest Church commission, the three scenes from the life of St. Matthew for the Contarelli Chapel in S. Luigi dei Francesi (1599–1603). This, Caravaggio's first large-scale public work, gave him considerable difficulties, both compositionally (the *Martyrdom* underwent a radical repainting) and on the grounds of lack of ▷decorum, for which infraction a first version of *St. Matthew Writing the Gospel* was rejected, Caravaggio having depicted the Apostle as an ungainly labourer with dirty bare feet. A second, more decorous version was completed by 1603 (still *in situ*) and the first version (later in Berlin; destroyed in 1945) was eagerly bought by a private patron, Vincenzo Giustiniani. These are the first of Caravaggio's paintings to use the dramatically exaggerated chiaroscuro for which he was to become well-known.

Although he was from now on one of the most successful painters in Rome, some of Caravaggio's works still caused offence (but always found ready private buyers). The most celebrated case was that of the *Death of the Virgin* (1605–6, Paris, Louvre). Rejected by the monks of S. Maria della Scala because it was believed that Caravaggio had used the corpse of

a drowned whore as a model for the dead ▷Virgin, the painting was immediately bought by the Duke of Mantua for his private collection. It is important to understand, however, that there was no intention to shock and that in all cases Caravaggio was doing no more than following to the letter the recommendations of the Council of Trent (▷Counter-Reformation) that religious art should be clearly composed and the figures convincingly and appropriately portrayed so as to convey the essential religious meaning. While still working on the *Matthew* canvases, Caravaggio had secured another Church commission, *The Martyrdom of St. Peter* and *The Conversion of St. Paul*, for the Cerasi Chapel of S. Maria del Popolo (1600–01). Here the figures are fewer, larger in scale and closer to the viewer, even to the point of appearing to push through the picture plane. The chiaroscuro is again dramatic – in *The Conversion* appropriately so.

Caravaggio's brilliant career in Rome was brought to an abrupt halt in 1606, however. Belligerent by nature, he got involved in a héated quarrel over a game of racquets and stabbed his opponent to death. He fled to Naples and, over the next few years, moved to Malta, Sicily and back to Naples. In Malta, he was accused of the assault of a local dignitary and imprisoned. He escaped to Sicily, returned to Naples and was later badly wounded in a tavern brawl. He eventually died of malarial fever at Port' Ercole on the Tuscan coast, on his way back to Rome in the hope of a pardon. His style from 1606 onwards is radically simplified with only the most essential elements remaining. The paint is more thinly applied, the shadows darker, the colours less rich, but the mood often more intensely religious (e.g. *The Raising of Lazarus*, 1609, Messina, Museo Nazionale).

Bib.: Calvesi, M., *La realtà del Caravaggio*, Turin, 1990; Gilbert, C., *Caravaggio and his Two Cardinals*, Pennsylvania State University, 1995; Hibbard, H., *Caravaggio*, London, 1983; Longhi, R., *Caravaggio*, Rome, 1992; Moir, A., *Caravaggio*, London, 1989

Caravaggisti

Term applied to the followers and imitators of ▷Caravaggio in the 17th century. They do not form a school as much as a movement. Their paintings are characterized by exaggerated ▷chiaroscuro and realism. More frequently it is the scenes of low-life from Caravaggio's early period which are taken up, but also to a lesser extent his religious subjects.

The movement first took hold in Rome, where Caravaggio worked until 1606. It included both Italian and foreign painters, the latter visiting Rome as the artistic capital of Europe. These visitors often returned home and continued the manner there, the most notable being perhaps the Utrecht Caravaggisti, ▷Baburen, ▷Honthorst and ▷Terbrugghen. In fact, Caravaggio's fame had spread to the Netherlands as early as 1604, when the Dutch painter and art historian

▷Karel van Mander wrote of 'Michelangelo da Caravaggio, who is doing extraordinary things in Rome'. Among the Italian painters influenced by Caravaggio, the foremost were ▷Orazio Gentileschi, ▷Carlo Saraceni and ▷Bartolommeo Manfredi. In fact, it was Manfredi who more deeply influenced the Utrecht painters with his half-length figures in taverns and guard-rooms, subjects only loosely derived from Caravaggio's early work, but steeped in his manner.

Once he was resident in Naples, Caravaggio influenced a new group of painters, including ▷Giovanni Battista Caracciolo, ▷Artemisia Gentileschi and the Spaniard, ▷José Ribera, whose works were exported to Spain, where they in turn influenced, among others, the young ▷Murillo. Apart from the Netherlands and Spain, the other main centre of Caravaggio's influence outside Italy was Lorraine, where ▷Georges de la Tour was active – he himself is not known to have visited Italy and may have derived his personal predilection for candlelit effects from the Utrecht Caravaggisti.

Caravaggism was superseded in Rome in the 1620s, but lasted until the middle of the century elsewhere, and clearly informs the work of ▷Rubens, ▷Rembrandt and ▷Velázquez.

Bib.: *Die utrechter Malerschule Caravaggisti des Nordens*, exh. cat., Cologne, 1984

Carceri

First published by ▷Piranesi in 1740 as series of 14 plates – *Invenzioni caprici di carceri*. The *carceri* – prisons – were a series of imaginative subterranean structures which exemplified the artist's interest in monumental antique architecture. The publication caused little excitement: the structures were seen as being unfinished yet without the necessary rusticity and wear to qualify as ruins. Piranesi constructed his caverns from a mass of complex, sweeping lines, which suggest rather than create form. Similarly he used ambiguity and the monochrome medium to achieve shadow and confusion, combining this with ▷perspective tricks which exaggerated scale and spatial distortion. The *Carceri* did not really achieve popularity until the early 19th century, although ▷William Beckford was among one of their early supporters in England. By the ▷Romantic period they were reinterpreted as representing prisons of the mind as much as of the body, amid rumours that Piranesi himself had used opium whilst designing them. They came to be seen as the embodiment of the ▷sublime in architecture.

Cardi, Ludovico

▷Cigoli, Il

Card Players, The

Painted by ▷Cézanne in 1890–2 (oil on canvas 45 × 57 cm/18 × 22 in). The work, deceptive in its simplicity, shows two men, one on either side of a small table,

playing cards. The table is bare apart from a centrally placed dark bottle, which effectively divides the painting in two, by means of a strong, vertical highlight running down its neck. The men are seen in sharp profile, distinguished by their hats and the pipe smoked by the figure on the left, but otherwise almost a mirror image of each other in terms of pose, each creating the appearance of intent concentration as their bowed heads survey their hands of cards. The palette appears at first glance to be limited, but the range of earth tones is in fact made up of rich and varied colour patches, from the orange highlights on the front edge of the tablecloth, to the cool blues of the background. The composition, controlled by a series of verticals and horizontals, is equally deceptive: the bottle lies slightly off-centre, the figures and table are assertively solid, and the volume of the objects, created by the artist's handling of colour, creates an element of tension in the flattened picture space and placidity of the subject. Cézanne produced a series of paintings of Cardplayers during the early 1890s, which all explore the same themes in different ways. Along with his series of ▷Bathers, they represent his major figurative work from his Provence years and reiterate, in terms of the human form, the ideas about volume, colour and space, which he was exploring in his landscape work. *The Card Players* is now in the Musée d'Orsay, Paris.

Cardinal Virtues
▷Virtues and Vices

Carducci, Bartolomé and Vincenzo
▷Carducho, Bartolomé and Vincente

Carducho (Carducci), Bartolomé (1560–1608) and Vincenzo (c1576–1638)
Italian family of painters who worked in Spain. Bartolomé travelled first to Spain where his brother Vincenzo joined him. Vincenzo was responsible for publishing the *Diálogos della pintura* (*Dialogues on Painting*) in 1633, which advocated an Italianate style of painting in direct contrast to the currently popular realism of ▷Velázquez.

caricature
A drawing, painting or sculpture, but most usually a print which represents a named individual in an exaggerated or distorted way. The term 'caricature' has come to be used loosely to refer to any ▷'cartoon' which includes individuals with distorted features, but, strictly, it is a form of portraiture which can be used for satirical or political purposes. Its origins are 16th-century Italian theories of ▷physiognomy. Artists such as ▷Leonardo and the ▷Carracci believed that the artist's purpose was to reveal the hidden ideal of individuals through ennobled or beautified representations

of them. Caricature was seen to have a complementary opposite purpose: to reveal the individual's malevolent or negative qualities. In the 18th century, caricature became a popular practice of amateur artists, and the Italian ▷Pier Leone Ghezzi commercialized the practice by caricaturing ▷Grand Tourists for comic effect. English artists such as ▷Hogarth and ▷Gillray employed caricature as a mode of political satire: for example, Hogarth's engraving of the radical politician John Wilkes emphasizes his subject's squint and scrawny form. This practice was continued in 19th-century France in the works of artists such as ▷Daumier. Caricature continues to the present day as a political weapon, but its earlier comic purposes have also been revived.
Bib.: Goldstein, R.J., *Censorship of Political Caricature in Nineteenth-Century France*, Kent, 1989; *English Caricature 1620 to the Present*, exh. cat., London, 1984; Gombrich, E. and E. Kris, *Caricature*, Harmondsworth, 1940; Lambourne, L., *An Introduction to Caricature*, 1983; Langemeyer, G., *Bild als Waffe: Mittel und Motive der Karikatur in fünf Jahrhunderten*, Munich, 1985; Wechsler, J., *A Human Comedy: Physiognomy and Caricature in Nineteenth-Century Paris*, London, 1982

Caritas Romana
(Latin, 'Roman Charity'.) An illustration of filial piety, originating in antiquity and retold by the Roman historian, Valerius Maximus, in his *De Factis Dictisque Memorabilibus Libri IX*, a series of anecdotes exemplary of good and bad behaviour. In the story entitled *De pietate in parentes*, he relates how an aged man named Cimon was in prison awaiting execution and forbidden food. His jailers, however, did permit a visit from his pregnant daughter, Pero. Whilst there she surreptitiously breast-fed him. Apart from its moral value as an example of filial piety, the story has obvious erotic overtones and it was this aspect that was frequently emphasized in ▷Baroque illustrations of the theme (e.g., ▷Caravaggio, *Seven Works of Mercy*, 1606, Naples, Pio Monte della Madonna della Misericordia). In the more austere art of late 18th-century ▷Neoclassicism, the eroticism was subdued and the theme was given back its high moral tone.

Carlevaris, Luca (1665–1731)
Italian painter. He was born in Udine but practised in Venice. He was one of the earliest artists to produce ▷*vedute* in Venice, and he popularized this sub-genre of landscape through his book of ▷etchings (*Vedute*) published in 1703. He was particularly interested in exploiting ▷perspectival illusion for scenic effect. He was an important influence on ▷Canaletto and ▷Guardi.
Bib.: Rizzi, A., *Luca Carlevaris*, Venice, 1967

Caro, Sir Anthony (b 1924)

British sculptor. He studied with ▷Henry Moore (1951–3), but the decisive influence in his development was meeting the American ▷David Smith during a trip to the USA in 1959. At this time he became interested in the possibilities of prefabricated sculpture, and his works became exercises in welding, rather than carving. His sculpture is primarily abstract and consisted of many disparate elements, such as I–beams and screens, joined together. He has often painted his work, and frequently exhibited it without a pedestal. He was fond of evocative titles.

Bib.: *Anthony Caro: Sculpture 1969–84*, exh. cat., London, 1984; Blume, D., *Anthony Caro: Catalogue Raisonné*, Cologne, 1982

Carolingian art

The art and architecture of France, Italy and western Germany during the reign of ▷Charlemagne (800–14), the first Holy Roman Emperor, and under his immediate successors, until about 900. Charlemagne attempted to provoke a cultural revival during his reign, based on that of the Classical Roman empire. The Palatine Chapel at Aachen (792–805) is typical of Carolingian architecture. Innovations include the introduction of a porch and towers on the west end of a church. Little survives of Carolingian mural paintings or ▷mosaics, but surviving manuscripts suggest the naturalistic and expressive style such works may have had. Similarly, no large-scale surviving sculptures or statues have survived, but smaller ▷ivories and metal-work suggest the form such works may have taken. Carolingian art had clear influences on the ▷Ottonian and ▷Romanesque.

Bib.: Beckwith, J., *Early Medieval Art: Carolingian, Ottonian, Romanesque*, 2nd edn, New York, 1994; Conant, K., *Carolingian and Romanesque Architecture 800–1200*, New Haven and London, 1993

Carolus-Duran, Charles-Émile-Auguste (1838–1913)

French painter. He was a society portrait painter and director of the French School in Rome from 1905. He was also an important teacher, and ▷Sargent was among his pupils.

Caron, Antoine (c1520–c1600)

French painter. He was court painter to Queen Catherine de'Medici, for whom he produced designs for festivals and ballets, as well as paintings. He worked with ▷Primaticcio at ▷Fontainebleau and adopted that artist's ▷Mannerist style. He produced ▷history paintings as well as allegorical works and scenes representing ceremonies and massacres. Many of his paintings include fantastical architecture, and they generally focus on fantasy, rather than reality.

Carpaccio, Vittore (c1450/60–1525/6)

Venetian painter. His life is poorly documented and it is not known by whom he was trained although his work shows the influence of ▷Gentile Bellini. His best paintings are religious narrative, the contemporary Venetian settings and lively anecdotal details conveying to their original viewers a strong sense of immediacy and veracity. Carpaccio is chiefly remembered for two important cycles of oil paintings: *Scenes from the Life of St. Ursula* (1490s, Venice, Accademia) and *Scenes from the Lives of SS George and Jerome*, painted for the Scuola di S. Giorgio degli Schiavone, Venice (1502–7, still *in situ*). His rich decorative colours bound by emphatic outlines must have appeared old-fashioned by the 1510s (by this date ▷Giorgione, ▷Giovanni Bellini and ▷Titian had revolutionized Venetian painting) and Carpaccio's career seems to have declined and he was almost forgotten until interest in him was revived by ▷Ruskin in the 19th century.

Bib.: Brown, P.F., *Venetian Narrative Painting in the Age of Carpaccio*, New Haven and London, 1988; Garbi, V.S., *Carpaccio*, New York, 1994; Humfrey, P., *Carpaccio: catalogue complet des peintures*, Paris, 1992

Carpeaux, Jean-Baptiste (1827–75)

French sculptor. He was the most important French sculptor of the Second Empire. He trained with ▷Rude and also studied at the ▷École des Beaux-Arts where, in 1854, he won the ▷Prix de Rome. His period at the French Academy in Rome was crowned with the success of his dramatic group, *Ugolino* (1860–62). Executed in plaster, the state commissioned it in bronze (Paris, Musée d'Orsay) which, when shown at the 1863 ▷Salon, won a first-class medal. Carpeaux very soon began to win prestigious establishment commissions, including the sculptural decoration of the south facade of the Pavillon de Flore (1863–6) and portrait busts for Napoleon III and his court (e.g. *The Prince Imperial*, 1865–7, Paris, Louvre). His most famous commission, however, was for the group, *La Danse* (1865–9, original in the Musée d'Orsay, modern replica *in situ*), for the exterior of Garnier's new Paris Opera House. Following its unveiling, the work was greeted with extreme hostility; the exuberance of the nude figures and the fleshy realism of their bodies was shocking to a public accustomed to the bland generalized surfaces of establishment sculpture (cf. the other three groups on the façade, all of which work safely within the prevailing ▷Neoclassical taste). It was intended that the offending sculpture should be removed, but the Franco-Prussian War intervened, the Third Republic was established, the original scandal was largely forgotten and *La Danse* soon came to be hailed as Carpeaux's masterpiece. It typifies Carpeaux's work with the lively ▷chiaroscuro of its modelling and confirms him as ▷Rodin's principal precursor. He was also a painter, and a representative collection of his paintings may be seen at the Petit Palais, Paris.

Bib.: Wagner, A., *Jean-Baptist Carpeaux: Sculptor of the Second Empire*, New Haven and London, 1986

Carr, Emily (1871–1945)

Canadian painter. She studied at San Francisco in 1889–95, and in 1899 she travelled to England, where she was involved with the ▷St. Ives group and with ▷Hubert von Herkomer's private school. She was in France in 1910 where the work of the ▷Fauves influenced the colourism of her work and she came into contact with ▷Frances Hodgkins. Discouraged by her lack of artistic success, she returned to Victoria where she came close to giving up art altogether. However, her contact with the ▷Group of Seven in 1930 resurrected her interest in art, and throughout the 1930s she specialized in scenes from the lives and rituals of Native Americans. She also showed her awareness of Canadian native culture through a number of works representing the British Columbian rainforest. She lived among the native Americans to research her subjects. Many of her ▷Expressionistic paintings represent totem poles and other artefacts of Indian culture.

Bib.: Carr, E., *Growing Pains: The Autobiography of Emily Carr* (1946), 2nd edn, Toronto, 1986

Carrà, Carlo (1881–1966)

Italian painter. He had a conventional academic training at the ▷Brera in 1905–8, and became involved with the ▷Futurists, signing their painting manifesto in 1910. In 1911 he visited Paris and saw works of the ▷Cubists at the ▷Salon d'Automne. From that point, his Futurist style showed elements of Cubist influence. Like the Futurists, he was interested in both violence and interpenetration of space, as seen in his *Funeral of the Anarchist Galli* (1911, New York, Museum of Modern Art). In 1913, he himself contributed to the Futurists' string of manifestos with his *Manifesto on the Painting of Sounds, Noises and Smells* in which he argued for an art that reproduced the character of non-visual experience. He also adopted ▷Marinetti's use of 'words set free' ('*parole in libertà*') for a series of patriotic ▷collages produced in 1914 and 1915, shortly before Italy entered into the conflict of the First World War. At a medical hospital in Ferrara in 1916, he met ▷de Chirico and the two of them conceived of the idea of ▷metaphysical painting. This represented a decisive move away from Futurism for Carrà. After the war, he turned against modern life subjects and began producing classicizing art. He became a member of ▷Valori Plastici.

Bib.: *L'opera completa di Carrà: dal futurismo alla metafisica e al realismo mitico 1910–30*, Milan, 1970

Carracci, Lodovico (1555–1619), Agostino (1557–1602), Annibale (1560–1609) and Antonio (c1589–1618)

Italian family of painters. Carracci was the family name of three important Bolognese painters: Lodovico and his cousins, the brothers Agostino and Annibale. Their early careers are bound up with the family workshop of which Lodovico as the eldest was possibly head. Their collaborative efforts include cycles of ▷frescos for the Palazzo Fava (1584) and Palazzo Magnani (1588–91) in Bologna. In the early 1580s the brothers founded an art academy in Bologna, aiming to break away from the somewhat moribund formulaic academicism of late ▷Mannerism and to revitalize painting by putting the emphasis back on drawing from life. The finest members of the next generation who trained at this academy were ▷Domenichino, ▷Reni and ▷Guercino.

In 1595 Annibale, the most talented and original of the Carracci, was called to Rome by Cardinal Odoardo Farnese to execute some decorations in his family palace. He began with a little room (known as the *camerino*) for which he executed an ▷allegorical oil painting of *Hercules at the Crossroads* (1595–7, now in Naples, Capodimonte), surrounded by ▷frescos of related scenes from Classical mythology. His major task, however, was to decorate the ceiling of the so-called *Galleria Farnese*, a barrel-vaulted hall of about 20 × 7 metres, with love scenes from ▷Ovid's *Metamorphoses* (begun 1597). The organization of the decorative scheme, with its illusionistic combination of scenes painted like framed easel-paintings fixed to the ceiling (▷*quadri riportati*) and painted architecture that appears to extend the real architecture of the room (▷*quadratura*) had first been employed in ▷Raphael's Vatican *Loggie* (1518–19), although the greater emphasis given to the *quadri riportati* in Annibale's scheme also reflects the influence of ▷Michelangelo's ▷*Sistine Ceiling* (1508–12). Indeed these two masters of the High ▷Renaissance are, along with ▷antique ▷Classical art, Annibale's greatest influences. Until the 18th century Annibale's ceiling was ranked alongside those of Michelangelo and Raphael as not just a supreme exemplar of painting in the ▷Grand Manner, but as one of the greatest masterpieces of European art. With its brilliant draughtsmanship, exuberant composition, lightness of touch and general vitality, its reduced status today is perhaps chiefly due to its relative inaccessibility (the Palazzo Farnese is now the French Embassy). The many preparatory drawings that survive are eloquent testimony both to the thoroughness of Annibale's approach and to his professed method of idealization based on drawings from life (such systematic preparation finally fell out of fashion in the ▷Romantic period when it was held as being antipathetic to inspired creativity).

Another important commission in this period was the altarpiece of the *Assumption of the Virgin* (1601) for the Cerasi Chapel in S. Maria del Popolo, presumably intended by the patron to form a contrast with the flanking canvases of Annibale's principal rival, ▷Caravaggio. Annibale's contribution to the development

of the ideal landscape is also important and paintings such as the ▷lunette of c1604, *The Flight into Egypt*, in the Galleria Doria-Pamphili, Rome, with its idyllic landscape inspired by Venetian painting, but more classically composed, exerted a formative influence on the landscapes of ▷Domenichino, ▷Claude and ▷Poussin.

About 1605 Annibale began to suffer from some form of melancholia and he painted no more after 1606. Agostino had assisted Annibale on the ceiling 1597–1600 but, following a disagreement, moved to Parma where his work (e.g. for the Palazzo del Giardino; unfinished at his death in 1602) nonetheless reveals a rather academic version of his brother's style. His most important work is the Venetian-inspired ▷altarpiece of the early 1590s, *The Communion of St. Jerome* (Bologna, Pinacoteca). He was also an accomplished engraver.

Lodovico remained in Bologna running the academy. His work is less Classical, more emotional, and reflects the influence of ▷Correggio and even more, ▷Tintoretto (e.g. *The Holy Family with St. Francis*, 1591, Cento, Museo Civico). At his best (from the early 1600s the quality of his work began to deteriorate) he exerted a profound influence on many of the next generation of Bolognese masters, particularly ▷Lanfranco and ▷Guercino. Agostino's illegitimate son Antonio was also a painter and worked as an assistant to ▷Guido Reni in the decoration of the Cappella dell'Annunciata (1609–13) in the Quirinal Palace. His independent work was highly acclaimed in his day, was largely forgotten after his premature death, but has lately been reassessed.

Bib.: Dempsey, C., *Annibale Carracci*, New York, 1995; Emiliano, A., *Ludovico Carracci*, exh. cat., Milan, 1993; Reckerman, A., *Amor Mutuus: Annibale Carracci's Galleria Farnese Fresken*, Cologne, 1991

Carrara marble

A white marble obtained from the quarries around the towns of Carrara, Massa and Pietrasanta in the Apuan Alps of Tuscany. It is generally associated with the purest type of white statuary marble and was used by ▷Giovanni Pisano for his statues of prophets and sibyls on the ▷façade of Siena Cathedral. ▷Michelangelo particularly favoured it, visiting the Carrara quarries himself on a number of occasions to select his own blocks; ▷Bernini used it for many of his sculptures (e.g. *Apollo and Daphne*, Rome, Villa Borghese); and it was especially favoured by ▷Neoclassical sculptors, particularly ▷Canova who appreciated its ability to take a sensuously smooth surface finish (e.g. *Cupid and Psyche*; Paris, Louvre).

Carreño de Miranda, Juan (1614–85)

Spanish painter. He was painter to King Charles II

from 1669, and he produced portraits of the royal family.

Carriera, Rosalba Giovanna (1675–1758)

Italian painter. She lived in Venice, where she came into contact with a number of foreign visitors who commissioned portraits from her. She became famous throughout Europe for her ▷pastel paintings, which she used for both portraits and ▷allegories. Her success led to an invitation to Paris, where she went with her sister and brother-in-law ▷Pellegrini in 1720–1. Her diaries of her Paris visit reveal the class diversity of her sitters, who ranged from financiers to the royal family. She also travelled to Vienna in 1730, and her works were enthusiastically collected in the Dresden court. The popularity of her flattering pastel portraits led her works to be collected throughout Europe, and they became an important example of Venice's contribution to ▷Rococo art. She went blind towards the end of her life and ceased painting.

Bib.: Sani, B., *Rosalba Carriera*, Turin, 1988

Carrington, Dora Houghton (1893–1932)

English painter. She studied at the ▷Slade and became closely connected with the ▷Bloomsbury group of artists and writers. Few of her paintings are known, but she became involved with the ▷Omega Workshops and produced many interesting crafts. She committed suicide.

Carrington, Leonora (b 1917)

English painter. She studied in Florence, London and Paris, where she met ▷Max Ernst in 1937. She settled in Paris with Ernst and adopted a ▷Surrealist style of art and writing. During the Second World War, she suffered a nervous breakdown as well as a separation from Ernst. In 1941 she moved to New York. Her post-war work developed her Surrealist subject-matter and concentrated on mythological themes and insectile figures.

Bib.: Chadwick, W., 'Leonora Carrington: Evolution of a Feminist Consciousness', *Women's Art Journal*, 7, no. 1 (Spring/ Summer 1986), pp. 37–42

Carstens, Asmus Jacob (1754–98)

German painter and draughtsman. He was born in Denmark but moved to Germany and became director of the plaster class of the Berlin Academy in 1787. In 1790 he was appointed Professor at the Berlin Academy. The decisive influence in his development was a trip to Rome in 1792, where he came into contact with ▷Flaxman's circle. There he developed a severe ▷Neoclassical style which showed some influence of ▷Michelangelo in his figure types. He subsequently produced a number of large ▷cartoons for works that he never painted.

carte-de-visite

A photographic calling card. It was used from the 1860s after the invention of photography as a substitute for a written calling card.

cartellino

(Italian, 'little paper'.) An illusionistic ▷scroll painted onto a picture, used primarily in 15th- and 16th-century Netherlandish and Italian painting. The *cartellino* often contained a motto or the signature of the artist.

cartoon

Originally, the full-scale design on paper (hence the name 'cartoon', from the Italian word for paper, '*carta*') for a painting or ▷tapestry. Once drawn, the design may then be transferred to the final support. In the case of a panel or canvas, this is done by tracing (i.e. ▷charcoal is rubbed over the back of the cartoon which is then laid face up on the panel or canvas while the design on the cartoon is retraced with a metal stylus, thus transferring the image in charcoal to the

THE SIX-MARK TEA-POT.
Æsthetic Bridegroom. "IT IS QUITE CONSUMMATE, IS IT NOT ?"
Intense Bride. "IT IS, INDEED ! OH, ALGERNON, LET US LIVE UP TO IT !"

A cartoon by Du Maurier, 1880, from 'Punch'

underlying panel or canvas). In the case of a design for a ▷fresco tracing is achieved by holding the piece of paper against the still soft plaster and applying a stylus along the lines of the design to make an impression. An alternative method is to lay the cartoon over another piece of paper held against the plaster surface and 'prick through' both pieces of paper along the lines of the design. The cartoon sheet is then removed and the second pricked sheet of paper is ▷pounced by rubbing charcoal through the holes, thereby marking the plaster with the design. The signs of these techniques are clearly visible on many frescos.

The term 'cartoon' may also be applied to a humorous drawing or ▷caricature. This popular usage may derive from the parodies produced by the English satirical magazine, *Punch*, on the 1843 competition designs submitted for the frescos in the Houses of Parliament.

cartouche

(i) In Egyptian hieroglypics, the oval frame used to enclose the name or title of the pharaoh or divinity.
(ii) An ornamental panel in the form of a ▷scroll, usually inscribed and sometimes elaborately framed.
(iii) A scroll-like ▷bracket, such as a modillion (▷cantilever).

carving

▷direct carving; modelling

caryatid

In Classical architecture and its derivatives, a vertical support, in the form of a statue of a draped female figure, employed as a ▷pier or ▷column to support an ▷entablature (as in the south porch of the Erechtheum, Athens, c425–400 BC) or other superincumbent weight. Male figures serving this function are called ▷atlantes or telamones.

casein

An adhesive used since the Middle Ages but most popularly employed as a paint ▷binder in the 18th century. It was used primarily for ▷mural and ▷tempera painting. As it was made from milk curd it had strong adhesive qualities. In the Middle Ages, it was used to bind panels together.

Cassatt, Mary (1844–1926)

American painter who was associated with the ▷Impressionists. She was born in Pittsburgh, the daughter of a banker who did not approve of her artistic interest. After studying in Philadelphia, she travelled widely. From 1868 she studied in Paris at the ▷Académie and she settled permanently in the capital in 1874, the year of her first ▷Salon success. She met ▷Degas in 1877 and under his influence embraced ▷Impressionism, exhibiting with the group in 1879–81 and 1886 (e.g. *Girl Arranging her Hair*, 1886, Washington). She developed her own unique style, concentrating on domestic subjects (e.g. *Lady at Tea Table*, 1885, New York, Metropolitan Museum), most famously scenes of the mother and child, which she explored unsentimentally using soft tones. Her early work had a rather idealized golden light, but in the 1890s under the influence of Japanese art, she used bolder colour. She experimented with a range of media, working in ▷pastel, ▷aquatint and ▷drypoint. By 1912, however, she was almost blind and forced to abandon her work. She was also of major importance in

promoting Impressionism in America through her family contacts, especially her brother Alexander, and she herself was a major collector of the movement's work.

Bib.: *Mary Cassatt*, exh. cat., Washington, 1987; Pollock, G., *Mary Cassatt*, London, 1980

Cassirer, Ernst (1874–1945)

German philosopher and author of important books on *Individual and Cosmos in the Renaissance* (1927) and the *Philosophy of Symbolic Forms* (1923–9). See also a collection of his essays and lectures in *Symbol, Myth and Culture* (1979). Inspired by 18th-century rationalist ideas, Cassirer saw language, art, religion and science as symbolic forms used by man to build a new, ideal world. When first informed in 1920 of the unorthodox arrangement of books in the ▷Warburg Institute (philosophy next to astrology and magic, and art linked with literature and philosophy), he remarked, 'The library is dangerous. I shall either have to avoid it altogether or imprison myself here for years' – which he did.

Bib.: Itzkoff, S.W., *Ernst Cassirer: Philosopher of Culture*, Boston, 1977; Ferretti, S., *Cassirer, Panofsky and Warburg: Symbol, Art, History*, New Haven, 1989

cassone (pl. cassoni)

(Italian, 'chest'.) An Italian marriage chest, often richly carved and, in the ▷quattrocento, decorated with inset panel paintings usually of Classical or biblical stories which taught a lesson or were appropriate to the subject of a successful marriage in some way. *Cassoni* were often made in pairs, one bearing the coat of arms of the bride's family, the other of the groom's (e.g. the pair in the Courtauld Galleries, London, dated 1472). One of the more successful *cassoni* workshops appears to have been that of Marco del Buono and Apollonio di Giovanni, whose records and account books have survived. Most *cassoni* paintings are of a fairly mediocre standard, although artists of the calibre of ▷Botticelli and ▷Uccello did execute them on occasion. *Cassoni* have been in later years removed from their chests, framed and hung as easel paintings. Those from chest fronts are, however, recognizable by their distinctive dimensions – 130–200 cm long by 30–45 cm high. Painted *cassoni* fell out of fashion during the ▷cinquecento and were superseded by carved chests.

Bib.: Schubring, P., *Cassoni*, Leipzig, 1923

Castiglione, Giovanni Benedetto ('Il Grechetto') (c1610–65)

Italian painter and etcher. He was from Genoa and worked in a ▷Baroque style. For an Italian painter of this period, he was remarkably susceptible to northern European influences, which he may have picked up in the Genoese studio of Sinibaldo Scorza, who was himself a follower of the Flemish school. Castiglione's main influences at this time were ▷Rubens and ▷Van Dyck, both of whom had worked in Genoa. He is first recorded in the Academy of St. Luke in Rome in 1634, remaining there until 1648, during which time he added ▷Poussin and ▷Bernini to his list of influences. He left Rome to take up an appointment as court painter at Mantua, a position he retained for the rest of his working life. Here he encountered and admired the works of ▷Domenico Fetti, whose influence is mainly evident in the more spirited brushwork of Castiglione's later work. Castiglione painted monumental religious subjects (e.g. *St. Bernard Adoring Christ on the Cross*, 1645, S. Maria della Cella, Genoa), ▷history paintings and rustic ▷genre scenes, and he was also an accomplished animal painter. A brilliant draughtsman, he developed an original technique of oil sketching in thin washes on paper (examples of which exist in the Royal Collection at Windsor). His work as a graphic artist is also important as he is generally credited with the invention of ▷monotype. His ▷etchings are influenced principally by ▷Rembrandt, but sometimes incorporate a sense of the fantastic, close to ▷Salvatore Rosa (e.g. *The Genius of Castiglione*, 1648). Later artists who were, in turn, influenced by Castiglione included ▷Tiepolo and ▷Fragonard.

Bib.: Percy, A., *Giovanni Benedetto Castiglione: Master Draughtsman of the Italian Baroque*, Philadelphia, 1971; Reed, S.W., 'Giovanni Benedetto Castiglione's *God Creating Adam*', *Museum Studies*, 17, no. 1 (1991), pp. 66–73

Castillo, Antonio del (1616–68)

Spanish painter. He worked in Cordoba. He painted portraits and landscapes in the style of ▷Zurbarán. ▷Murillo was among his pupils.

casting

The process of producing sculpture not by ▷direct carving, but by creating a design out of clay or wax and then making a cast of that design using a mould. Casting is also used for coinage, when liquidized metal is poured into a pre-designed mould. Casting is a common form of making ▷bronze sculpture, and the technique can be used by skilled craftsmen working on the basis of an artistic design.

catacomb

A subterranean cemetery, consisting of a network of galleries, sometimes on several levels, leading to tomb chambers, but also with shelves and ▷niches in the gallery sides for other ▷sarcophagi and cinerary urns. The term 'catacomb' was first employed in the 5th century AD to describe the underground burial place beneath the church of San Sebastiano on the Via Appia, Rome (in use from the middle of the 3rd century AD) and it later came to be used for similar places in Rome and other ▷Early Christian centres in Italy and north Africa. Catacombs were placed underground not for

secrecy, but because of the expense of available land. There is no evidence to suggest that Christians met in these places to avoid persecution; rather they gathered here to commemorate their dead, perhaps for a funeral meal on the anniversary of the death. Specific terms are used to refer to the various types of burial, including arcosolium (arched tomb niche), cubiculum (tomb chamber) and loculus (shelf tomb).

catalogue raisonné

A complex detailed catalogue of an artist's works. It gives factual information about individual works of art, such as size, materials used and ▷provenance. The catalogue raisonné was a common form of art publication in the 1960s and 1970s, but given the greater expense of art book publishing, it became less common by the 1980s, and its functions have, to an extent, been taken over by exhibition catalogues.

Catena, Vincenzo di Biagio (c1478/89–1531)

Italian painter. He was Venetian, trained and initially influenced by ▷Giovanni Bellini. He may have had private means and certainly was on friendly terms with some of the leading Venetian humanists of his day. Following his training, he seems to have had some kind of working partnership with ▷Giorgione as is revealed by an inscription on the back of Giorgione's *Laura* portrait (1506, Vienna, Kunsthistorisches Museum) in which they are described as colleagues. After Giorgione's death in 1510, Catena's style evolved into one closely approximating that of his former partner: his *Warrior Adoring the Infant Christ and the Virgin* (1520s, London, National Gallery) first entered the National Gallery catalogue as attributed to Giorgione. The frieze-like composition of simplified forms, the even mellow light, warm colours and tranquil landscape are typical of Catena's style. In addition to religious pictures, he also, according to ▷Vasari, painted numerous portraits.

Cathedra Petri

▷Baldacchino, St. Peter's

Catherine of Alexandria

(Chronicled in Jacobus de Voragine's *The Golden Legend*.) Virgin saint, allegedly martyred in the 4th century in the persecution of Maxentius. Her cult does not appear before the 9th century and achieved its greatest popularity in the Middle Ages. Catherine, a noblewoman, rejected the hand of the emperor in marriage, as she was a bride of ▷Christ. She also converted the 50 philosophers whom the emperor ordered to refute her beliefs, and even the emperor's wife. She was sentenced to death on an instrument consisting of four spiked wheels, but the wheels were shattered by angelic intervention (e.g. ▷Lelio Orsi, *The Martyrdom of St. Catherine*, c1560, Modena,

Galleria Estense) and she was beheaded instead. Because of her successful debate with the philosophers she is patron saint of education and because of the (failed) mode of her execution, wheelwrights. She first came to the emperor's notice when she protested to him on his continuing persecution of Christians and she is thus the protectoress of the dying. Consequently, she appears frequently in devotional pictures. She is instantly recognizable by her attribute, the ('Catherine') wheel, spiked or unspiked, intact or broken. She may be crowned (indicating her noble lineage), may carry the sword of her execution or her martyr's palm, and may hold the ring signifying her mystic marriage to Christ. She may also have books and other paraphernalia of learning; sometimes she holds an open book inscribed: '*Ego me Christo sponsam tradidi*' ('I have offered myself as a bride to Christ'). In Italian devotional paintings she frequently appears with ▷Catherine of Siena. The most frequently depicted narrative relating to her is her mystic marriage to Christ, an episode which appears in an alternative version of her legend, dating from the Middle Ages. Catherine was given an image of the Madonna and Child; the Christ child turned to her and placed a ring on her finger, symbolizing their union (e.g., ▷Parmigianino, *The Mystic Marriage of St. Catherine*, 1821, London, National Gallery).

Catherine of Siena (c1347–80)

Dominican mystic. Born Caterina Benincasa, she witnessed the deaths from plague of most of her numerous brothers and sisters. She devoted herself to prayer from an early age, experienced religious visions, refused all offers of marriage and joined the Dominican order. After her initial period of voluntary solitude she re-entered society and gave herself to nursing and missionary work. Her fame spread through her published thoughts and ideas which, because she herself was illiterate, were committed to paper by an amanuensis. She was popularly believed to have been instrumental in persuading the papacy to return to Rome from its exile in Avignon. She was canonized in 1461 and became Siena's principal patron saint, whilst nonetheless achieving international fame. In devotional pictures, she wears the black cloak over a white veil and tunic of the Dominican habit, and sometimes bears the marks of the ▷stigmata (allegedly mystically received at Pisa). She frequently is depicted holding a cross surmounted either by a ▷lily (for purity) or a heart, and may wear a crown of thorns and carry a rosary. She may also hold a book (in allusion to her writings) and trample a demon underfoot. She often appears with other Dominican saints, or ▷Catherine of Alexandria or, in Sienese pictures, the other patron saints of that town. Like her namesake, she is sometimes depicted mystically marrying Christ, but is distinguishable by her Dominican habit.

Catlin, George (1796–1872)

American painter and writer. He travelled among the Native American groups, recording their lifestyles and customs. Before becoming a painter in the early 1820s, he practised law. He taught himself to paint and established himself as a portraitist in Washington, DC and Philadelphia. In 1830, however, he moved to St. Louis, then a frontier city, using it as a base for trips across the Mississippi in order that he might visit the various Native American groups. Over the next six years he made five trips, painting and drawing sometimes over 500 pictures. He afterwards assembled a touring exhibition entitled *Gallery of Indians*, taking it around the USA in 1837–40 and then on to London and Paris during 1840–5. His work proved far more popular in Europe (his show was reviewed well even by ▷Baudelaire) than in America, and he returned to Europe in 1858, remaining until 1870. In 1841 he published *Manners . . . of the North American Indians*, illustrated with his own ▷engravings. Most of his work is preserved in the Smithsonian Institution, Washington.
Bib.: Catlin, G., *The George Catlin Book of American Indians*, New York, 1988; Sufrin, M., *George Catlin: Painter of the Indian West*, New York, 1991; Troccoli, J.C., *The First Artist of the West: George Catlin Paintings and Watercolours*, Tulsa, 1993

Cavaliere d'Arpino

▷Cesari, Giuseppi

Cavallini, Pietro (fl 1273–1308)

Italian artist. He worked mainly in Rome at the time of great artistic change at the end of the 13th century. He moved away from traditional ▷Byzantine models towards a greater fluidity and naturalism, as shown in the ▷fresco cycles at S. Cecilia in Trastevere and S. Paolo in Fiori, and the ▷mosaic work at S. Maria in Trastevere. He is mentioned by ▷Vasari, who places him chronologically later, and who says he worked with ▷Giotto on mosaics in St. Peter's, Rome, being 'not an unworthy pupil of so great a master'. Vasari also maintains that Cavallini studied in Florence, and executed frescos in San Marco and in the lower church at San Francesco, Assisi. This seems unlikely. It is recorded that he worked for Robert II of Anjou in Naples, in the early 1300s, and the fresco of the Tree of Jesse in Naples Cathedral has been attributed to him.

Cavallino, Bernardo (1616–56)

Italian painter. He was a Neapolitan who specialized in religious work. A pupil of Andrea Vaccaro and Massimo Stranzioni, his work was influenced by that of ▷Ribera, ▷Velázquez and ▷van Dyck. His individual style is characterized by elongated figures, unusual colours and complex background landscapes.

cave art

Art of the upper Paleolithic era (before c30,000 BC). Cave art was not discovered until the late 19th century when archaeologists found caves in ▷Altamira (Spain) and ▷Lascaux (France) which contained paintings and engravings of animals. These often naturalistic representations were designed to adhere to the rock formations themselves, and they were frequently coloured. The purposes of the hunting themes shown have never been adequately explained, although a number of theories exist. Many people believe them to be part of a religious or secular ritual or that they reveal significant aspects of the society and culture of the prehistoric past.
Bib.: Delluc, B., *L'art pariétal archaïque en Aquitaine*, Paris, 1991; Fock, G., *Felsbilder in Südafrika, Teil 1: Die Gravierungen auf Klipfontein*, Cologne, 1979 and *Felsbilder in Südafrika, Teil II: Kinderdam und Kalahari*, Cologne, 1984; Leroi-Gourham, A., *The Dawn of European Art: An Introduction to Paleolithic Cave Paintings*, Cambridge, 1982; Ruspoli, M., *The Cave of Lascaux: The Final Photographic Record*, London, 1987; Sieveking, A., *The Cave Artists*, London, 1979; Vialou, D., *L'art des grottes en Ariège magdalénienne*, Paris, 1986; Ucko, P., *Paleolithic Cave Art*, London, 1967

cavo rilievo

▷intaglio

Caylus, comte Claude-Philippe de Tubières de (1692–1765)

French antiquarian and engraver. He produced ▷engravings after ▷old master drawings, and was made honorary counsellor to the French Académie Royale in 1731. He was opposed to the popularity of the ▷Rococo style, which he saw as frivolous, and contributed to the reaction against it. His advocacy of ▷Neoclassicism came through his publications, which included *Recueil d'antiquités égyptiennes, étrusques, grecques, romaines et gauloises* (*A Collection of Egyptian, Etruscan, Greek, Roman and Gaulish Antiques,*) (1752–67). For this work, he used his own large collection of antiquaries as a source. He helped establish archaeology as a science and was an important influence on ▷Winckelmann.

Cecilia

(Chronicled in Jacobus de Voragine's *The Golden Legend*.) Virgin saint, allegedly martyred in the early 3rd century. According to a 5th-century legend she was a Roman patrician who refused to consummate her marriage to her pagan husband, having vowed herself to Christian celibacy. At her wedding ceremony, on hearing the organs, she silently sang a hymn of virginity to God. Subsequently, she managed to convert her husband and brother-in-law whose adherence to this proscribed religion came to the attention

Cave painting of a bull, Lascaux, France

of the authorities. Refusing to recant, they were executed. Cecilia was then summoned and ordered on pain of death to sacrifice to the Roman gods; she refused and the Roman prefect ordered that she be boiled to death in her own bathhouse. This she miraculously survived and was there and then sentenced to execution by decapitation. Roman law allowed only three blows to the neck and these she survived, so she was left to die at her home (e.g. ▷Domenichino, *The Death of St. Cecilia*, 1615–17, Rome, Sta Maria del Popolo). After three days she finally died, having distributed all of her goods to the poor. Her private hymn to God during her wedding ceremony led to her association with music and thus her principal attribute in devotional paintings is a musical instrument, usually an organ (e.g. ▷Raphael, *St. Cecilia Altarpiece*, c1513–16, Bologna, Pinacoteca). She may also wear a crown of red and white roses. Her remains are housed in her titular church in Rome. At the time of the rebuilding of the church in 1599, Cecilia's body was allegedly found to be undecayed and, in commemoration of this miracle, a life-size marble statue was commissioned of her lying, as she was found, on her side, the deep sword marks in her neck clearly visible (▷Stefano Maderno, *S. Cecilia in Trastevere*, Rome).

celadon

Chinese porcelain with a green glaze. Its resemblance to jade gave it a particular value in China.
Bib.: St. George Montague Gompertz, G., *Chinese Celadon Wares*, London, 1980

cella

In Classical architecture, the Latin term for the ▷sanctuary, or enclosed chamber of a temple (as distinct from the open ▷portico), containing the cult image. Also known by the Greek term ▷naos.

Cellini, Benvenuto (1500–71)

Italian sculptor, medallist and goldsmith. He was a Florentine ▷Mannerist, most widely known for his autobiography (1558–62, first published in 1728). It is justly famed for the vivid account it gives of the disturbed political climate of Italy after the Sack of Rome in 1527 in which Cellini gives himself an heroic role. Although Cellini's account of his own exploits, both private and public, is generally boastful, biased and highly exaggerated, the book nonetheless gives an accurate (and unique) insight into aspects of artistic production in Italy in the second half of the 16th century. Of particular importance is Cellini's account of the ▷cire-perdue casting of his masterpiece, the bronze statue of Perseus (1545–54, Florence, Piazza della Signoria). The main influences on his artistic style were ▷Raphael and, above all, ▷Michelangelo, whom he adulated. He correspondingly loathed ▷Bandinelli, the sculptor who had set himself up as Michelangelo's rival (and was in fact rival to, and far more successful than, Cellini himself in securing Medici patronage). Cellini also professed to have turned down an offer from ▷Torrigiano of lucrative work in England as soon as he realized that he was the sculptor who had broken Michelangelo's nose. Of the art works of his own career very little survives. From his first period (up to 1540), working mainly in Rome,

but with trips to Venice and Florence, there are only a few coins and medals and a couple of seals (e.g. the Seal of Ercole Gonzaga, decorated with a Raphaelesque *Assumption*, 1528, Mantua, Curia Vescovile). In 1540, Cellini went to France and executed two of his most celebrated works: the golden salt-cellar (1540–3, Vienna, Kunsthistorisches Museum) and the large bronze lunette relief, *The Nymph of Fontainebleau* (1543–4, Paris, Louvre) with its characteristically exquisitely elegant attenuated nude. The rest of Cellini's work at Fontainebleau has been lost, but it exerted a profound influence, not only on the expatriate Italians of the School of ▷Fontainebleau, but on the best of the French sculptors, notably ▷Goujon. He returned to Florence in 1545 to execute the *Perseus* commission for Cosimo I de' Medici and remained there for the rest of his life. In this period he also executed a bronze bust of Cosimo I (Florence, Bargello), which unfortunately Cosimo did not like as much as the one by Bandinelli. Cellini also made his one work in marble, a crucifix (1556–62, Madrid, Escorial) and wrote the important *Treatises on Goldsmithing and Sculpture*.

Bib.: Ashbee, C.R. (ed.), *The Treatises of Benvenuto Cellini on Goldsmithing and Sculpture* (first published 1888), New York, 1967; Bull, G. (trans.), *Autobiography of Benvenuto Cellini*, Harmondsworth, 1956; Pope-Hennessy, J., *Benvenuto Cellini*, Paris, 1985

Celtic art

The art of the Celts, ancient peoples of central and western Europe. The Celts inhabited much of Europe, from Spain to the Slav countries, in pre-Roman times. Their surviving art consists mainly of metalwork and some stone carvings.

The earliest known Celtic objects are from the 5th century BC and were found at La Tène, Switzerland. Practical objects, like knives and cups, were highly decorated and the Celts had well-developed metalworking techniques. The ornamentation is usually abstract and often consists of tightly spiralling coils, with stylized animal and foliage forms within. Human depictions are rare, but these are also highly stylized.

After the Roman conquest of western Europe, Celtic art was suppressed and survived only on the outskirts of Europe, notably in Ireland. Metalwork declined, but as the Christian faith spread, Celtic art became expressed in ▷manuscript illumination. Intricate latticework borders surround lavishly decorated text, as seen famously in the Book of Kells (c800). After the Romans left Britain in the 5th century there was a great influx of Celtic art, which greatly affected subsequent artistic output even in non-Celtic areas of the British Isles, but especially in the north. It was at this time that the Lindisfarne Gospels were executed (c700). In sculpture, Celtic art is epitomized by the free-standing stone cross, a type seemingly unique to the British Isles. Carvings combined Christian subjects and pagan decoration.

Although it was later much modified by Scandinavian influences, Celtic art continued to flourish in Ireland until the Anglo-Norman invasion of 1170. The influence of Celtic art continued beyond this time however, and these influences can be seen in art produced not only in Britain but all over Europe. For example, Catalonian ▷Romanesque murals show distinct Celtic overtones, particularly in their colour and decoration, while churches such as Kilpeck, Herefordshire, with its intertwining columns and decorated corbels, can only be attributed to a continuing interest in Celtic art.

Bib.: Megan, M. R., *Celtic Art*, London, 1989

Cenni di Peppi

▷Cimabue

Cennini, Cennino d'Andrea (fl 1370–1395)

Writer in c1390 of the earliest surviving Italian handbook on painting, *Il Libro dell'Arte*, known in English as *The Craftsman's Handbook*. It is extremely thorough in its description of all aspects of workshop methods and practices and is our principal source for late medieval Italian ▷tempera and ▷fresco painting techniques. So detailed are the stage-by-stage descriptions of the processes of preparation and painting that it is possible to use the treatise as one would a recipe book. The techniques are traditional and completely orthodox, as Cennini was in his own words 'an unimportant practising member of the profession of painting' (none of whose paintings is known), trained, he says, by ▷Agnolo Gaddi, who himself trained with his father ▷Taddeo Gaddi who was in turn trained by ▷Giotto.

Bib.: Cennini, C., *The Craftsman's Handbook*, trans. by Daniel V. Thompson, New York, 1960

centaur

An ancient mythological creature that has a man's head and a horse's body. Centaurs were considered to represent the bestial side of human beings, and they were often depicted as either drunk or lascivious. They were part of the retinue of ▷Bacchus and often represented in art as such. They were featured in a narrative subject that was popular during the ▷Renaissance, *The Battle of the Lapiths and the Centaurs* (e.g. ▷Piero di Cosimo, London, National Gallery). In this episode from ancient mythology, the centaurs wreak havoc at the wedding of the peaceful lapiths, but the lapiths win the ensuing battle. In the Renaissance this was seen to represent the triumph of civilization over barbarism.

Centre de Recherche
▷Domela, César Nieuwenhuis

Ceramics
General term for articles shaped out of pliable, earthy materials and hardened through heating. Principally, it refers to pottery, ▷porcelain, and tiles. Pottery is one of the most ancient crafts, dating back to at least the 5th millennium BC. It was used for a wide variety of purposes, ranging from cooking utensils to ritual and funerary vessels. Porcelain is the purest form of ceramic, notable for its white, translucent appearance. The process for creating porcelain was invented by the Chinese during the Tang dynasty (AD 618–906), but reached a peak of refinement during the time of the Sung (960–1279) and Ming (1368–1644) emperors. European attempts to imitate the material began in Italy in the 16th century and blossomed at Delft in Holland, but the earliest experiments only produced a less durable, soft-paste porcelain. True or hard-paste porcelain did not make its appearance in Europe until the 18th century. The first factory was at Meissen (1710) in Germany, where the breakthrough had been made, and similar establishments were rapidly set up in other European countries. Notable examples include Sèvres (1756) in France, Capodimonte (1743) in Italy, and Bow (1744) in England.
Bib.: Cushion, John P., *Pottery and Porcelain*, London, 1972; Meister, P., *European Porcelain of the Eighteenth Century*, Oxford, 1983

Cerano, Il
▷Crespi, Giovanni Battista

Cercle et Carré (Circle and Square)
A group of ▷Constructivist artists, including ▷Michel Seuphor and ▷Joaquín Torres-García, who assembled in Paris in 1929. They were in favour of ▷abstraction, but following the ideas of artists such as ▷Malevich, they had a mystical, rather than a pragmatic, approach to abstraction. They also published a journal. Their endeavours were brought to an end by the growing strength of the much larger ▷Abstraction-Création group.

Cerquozzi, Michelangelo (1602–60)
Italian artist. While in Rome, he came into contact with expatriate Dutch artists, and he was a pupil of the Flemish artist Jacob de Hase (1575–1634). This influence helped inspire his own specialism of ▷battle painting, and he was known as the ▷'Michelangelo of the Battles'.

César (Baldaccini) (b 1921)
French sculptor. He was a member of the ▷Nouveau Realisme group established in Paris in 1960 by ▷Yves Klein and the critic Restany. From the 1950s he produced ▷Junk Art: insects and fantastic winged creatures created from rubbish (e.g. *Man of St. Denis*, 1958, London, Tate). These developed into figure ▷assemblages using scrap metal and machine parts. However, he is probably best known for his work of the 1960s, when he created monoliths out of crushed car bodies (e.g. *Compression*, 1960, Paris, Musée Nationale d'Art Moderne).

Cesari, Giuseppe (Cavaliere d'Arpino) (1568–1640)
Italian painter. He worked in a late ▷Mannerist style and was active mostly in Rome where he ran a flourishing practice, being patronized by the papacy (he designed the mosaics for the dome of St. Peter's, 1603–12), the major churches in Rome and the Roman aristocracy. An infant prodigy, at the age of fifteen he was invited by the painter Circignani to help paint Gregory XIII's Loggie (frescos now lost). Amongst his major commissions are the painting of the ▷vaults of the ▷choir and ▷sacristy of the Certosa di S. Martino, Naples (1589–91, resumed after 1595); the vault of the Contarelli Chapel, Rome (1591–3); and the Cappella Ogiati, S. Prassede, Rome (c1593–5) and artistic directorship of the redecoration of the transepts of S. Giovanni in Laterano (1597–1601). He remained virtually untouched by the aesthetic innovations of the early 17th century, embodied in the works of the ▷Carracci and his own erstwhile pupil ▷Caravaggio and his later style is characterized by a degeneration into academic formula. Seen at his best before the turn of the century, he marshals the hallmarks of ▷Mannerism, such as virtuoso draughtsmanship, abstracted forms and clear, bright, non-naturalistic colours, in the service of compositional and spatial clarity in pictures and decorative schemes of considerable vigour.
Bib.: Forcellino, M., *Il Cavaliere d'Arpino Napoli*, Milan, 1991

Cézanne, Paul (1839–1906)
French painter. He was a leading French ▷Post-Impressionist, considered by many to be a forerunner of 20th-century ▷abstraction and ▷Cubism. He was born to a wealthy family in Aix-en-Provence. After studying law, to please his father, in 1861 he was wooed to the Paris art world by his childhood friend ▷Zola. There he studied at the Académie Suisse along with ▷Pissarro, came into contact with ▷Manet and ▷Courbet and exhibited at the 1863 ▷Salon des Refusés, but also tried to succeed at the official ▷Salon and enter the ▷Académie des Beaux Arts. His early style reflected these contradictions: he copied and enthused about ▷Rubens and ▷Delacroix and produced dark, brutal and often erotically charged works alongside more ▷Realist images (e.g. *The Artist's Father Reading a Newspaper*, c1860, Washington, National Gallery).

During the war of 1870 Cézanne retired to l'Estaque and rediscovered the landscape of Mediterranean France, and in 1872 he began working with Pissarro at Pontoise, developing a more ▷Impressionist style

which he exhibited at the group's 1874 and 1877 exhibitions (e.g. *Le Mansion du Pendu*, exhibited 1874, Paris, Musée d'Orsay). His palette lightened and his brushwork developed into small detached strokes, but already Cézanne was approaching landscape in a controlled and structural manner which set him, with Pissarro, apart from the rest of the Impressionists.

During the 1880s Cézanne cut himself off from the Paris art scene and began to develop his own brand of Impressionism (e.g. *Marseilles from l'Estaque*, 1883–5, New York, Metropolitan Museum). He returned to Provence, inheriting the family estate on his father's death in 1886. His friendship with Zola ended acrimoniously following the publication of *L'Oeuvre* (Zola's art novel which seemed too close to reality for Cézanne). He began a slow and deliberate artistic programme working from still life, landscape and portraits of himself and his wife, Hortense, the aim of which was to give Impressionism durability, 'like the art of the museums'. He simplified subject matter to create a sense of monumentality, and restricted his

Marc Chagall, *Self-portrait*, private collection

tonal range and employed colour as a means of modelling. He also developed a patchwork of blocked brushstrokes to emphasize this style (e.g. ▷ *The Card Players*, 1885–90, Paris, Musée d'Orsay). In all these innovations he claimed ▷ Poussin as his model.

Towards the end of his life Cézanne's work became increasingly abstracted through his emphasis on colour and structure. He worked increasingly in watercolour using the translucence of the medium to emphasize the three-dimensionality of his work. He revisited subjects frequently, including images of ▷ Mte. St. Victoire, and returned to some themes of his youth,

such as ▷ *Bathers* (1895–1906, London, National Gallery). By 1900 he had become something of an artistic elder statesman: in 1895 he had exhibited 150 works at Ambrose Vollard's gallery; he was invited to exhibit with the Vienna ▷ Secessionists and ▷ Les Vingts in Brussels; and in 1904 he had a separate room for his work at the ▷ Salon d'Automne. By the 1906 retrospective his ideas were being taken over by the ▷ Cubists, who developed his concept of multiple viewpoints and limited tonality.

Bib.: *Cézanne: The Early Years*, exh. cat., London, 1988; Geist, S., *Interpreting Cézanne*, Cambridge, MA, 1988; Kendall, R. (ed.) *Cézanne by Himself*, London, 1988; Shiff, R., *Cézanne and the End of Impressionism*, Chicago, 1984; *Cézanne*, exh. cat., London, 1995

Chadwick, Lynn (b 1914)

British sculptor. Born in London, he trained as an architect before turning to sculpture after the Second World War (in which he fought in the RAF). His early works were metallic ▷ mobiles. During the 1950s these developed into ▷ surreal figures and finally into the famous 'balanced sculpture' – metal figures supported by precariously thin legs (e.g. *Inner Eye*, 1952, London, Tate; *Winged Figures*, bronze, 1955, London, Tate). He exhibited three works at the 1951 Festival of Britain, and won the international sculpture prize at the 1956 ▷ Biennale. By the 1960s his work had become more monumental, using block-like figure shapes and replacing an early lack of finish with polished surfaces.

Bib.: Bowness, A., *Lynn Chadwick*, London, 1962

Chagall, Marc (1889–1985)

French artist of Russian birth. He was best known for his murals, ▷ stained glass and brightly coloured paintings, which often contain complex personal imageries. Born into a Hasidic Jewish family, Chagall studied in Vitebsk and St. Petersburg, under ▷ Léon Bakst, before moving to Paris in 1910. He continued his studies, exhibiting at the ▷ Salon des Indépendants, supported by a Russian patron, Vinaver, and met ▷ Modigliani, ▷ Léger and other ▷ Cubist artists then living in Montmartre. In 1914 he went to Berlin, and held his first one-man exhibition at the ▷ Sturm Gallery. Visiting Vitebsk later in the same year, he found himself detained in Russia for the duration of the war. In 1915 he married Bella Rosenfeld, who features in many works, like *Birthday* (1915–23, New York, Guggenheim). During this time in Russia Chagall developed his ▷ avant-garde ideas and became a Commissar for Art in Vitebsk after the October Revolution. He became responsible for the decoration of the city, but his plans proved too radical and he quarrelled with town councillors, was ousted by ▷ Malevich and eventually left the city. From 1919 to 1922 he was based in Moscow experimenting with different ideas and designing stage sets for the Jewish State

Theatre. In 1923 he returned to Paris at the invitation of Ambrose Vollard, and started working on book illustrations, including Gogol's *Dead Souls*. He had his first retrospective exhibition at the Barbazange-Hodebert Gallery (1924). In the succeeding years he travelled widely in Europe and the Middle East, which provided him with a variety of themes which are discernible in the paintings and illustrations produced in these years, for example his illustrations of the Bible.

In 1941 Chagall was forced to flee Europe and settled in America, where he worked in the theatre, producing work including the stage design for Stravinsky's *Firebird* in New York in 1945. He also visited Mexico, which led to an explosion of colour and fantasy in works such as *The Juggler* 1943, Chicago Art Institute and *At Dusk*. In 1945 Chagall was devastated by his wife's death, which led to a period of paintings showing an artist confronting a woman's ghostly presence, including *The Clock on the Wall*. In 1947 he returned to Paris where he continued painting, designing and illustrating, started stone sculpture and undertook a selection of public art commissions, including stained glass for Metz Cathedral (1958–68), murals at the Paris Opera (1963–4) and the New York Metropolitan Opera (1965), and tapestries for the Parliament of Israel at Tel Aviv (1963). In 1950 he moved to Vence, where he was inspired to produce a series of 17 large paintings in the Chapelle du Calvaire. Russian and Jewish symbolism can be seen in these works, and the bright colours and dislocations favoured by Chagall can be traced to his formative experiences with the Cubists. His use of ▷allegory is often impenetrable – he himself said of his paintings, 'I don't understand them at all.' His work breathes the spontaneity of folk art, but without false naïveté and was admired by the ▷Surrealists.

▷Jewish art; School of Paris

Bib.: Alexander, S., *Marc Chagall*, London, 1978; Compton, S., *Chagall*, London, 1985; West, S., *Chagall*, London, 1990

chalk

A soft stone formed into a stick and used for drawing. Chalk can come in white, black and red and has been used for different kinds of drawing activity. Red chalk was particularly popular during the ▷Renaissance, when it was used to highlight drawings.

Chambers, Sir William (1723–96)

British architect. His parents were Scottish, but he was born in Sweden, educated in England and then during 1740–9 worked in the Far East for the Swedish East India Company. In c1749 he trained in Paris with ▷Blondel, one of the leading architectural teachers of the day, and he also spent five years in Italy. This eclectic education became the basis of his style. He was appointed architecture tutor to the Prince of Wales in 1755 and from 1760 was one of the chief architects

at the Office of Works (a position he shared with ▷Adam, to whom he was unsympathetic). It was in this capacity that he designed Somerset House (1776–86), the first large administrative block in England which he modelled heavily on existing French examples. He wrote several books, including *Designs of Chinese Buildings* in 1757 (he designed the Pagoda in Kew Gardens) and *Civic Architecture* (1759). He also played a major role in the institution of the ▷Royal Academy, being a founder member and treasurer, and establishing a code of conduct for architects. He opposed the ▷Greek revival of architects like ▷Stuart and ▷Revett.

Bib.: Harris, J., *Sir William Chambers*, London, 1970

Champaigne, Philipe de (1602–74)

French painter of Flemish birth. He was a painter of portraits and religious subjects, who trained first as a landscape painter in Brussels. In 1621 he moved to Paris with his master Jacques Fouquières and was entrusted, along with ▷Poussin, with the decoration of the gallery of the Luxembourg Palace, built to house ▷Rubens' cycle of paintings of the life of Marie de' Medici. In 1628 he was himself appointed painter to Marie de' Medici, whilst also enjoying the patronage of Louis XIII and Cardinal Richelieu. For Richelieu he painted ▷frescos in the dome of the Sorbonne church and a full-length portrait (c1630s London, National Gallery). He also executed a triple head-and-shoulders portrait of Richelieu (c1640s London, National Gallery) to serve as model for ▷Bernini's bust of the Cardinal. (▷Van Dyck had earlier made a similar painting of Charles I of England for the same purpose.) In the youthful part of Champaigne's career, his portraits were influenced by Van Dyck and his religious subjects by Rubens. Yet in both cases, Champaigne's works are less painterly, more sculptural and certainly lack the ▷bravura evident in the technique of these early influences.

Champaigne's mature period begins c1643. At about this time he began to work for the Jansenists, an austere Catholic sect based in Port Royal. Their doctrines seem to have encouraged Champaigne to move away totally from the ▷Baroque of Rubens and Van Dyck and to formulate a cooler, simpler, more austere, ▷Classical style, much more attuned to his own innate tendencies. In this switch of style he pursued a course parallel to that which his friend Poussin was following independently in Rome. The most remarkable painting of Champaigne's maturity is *Ex Voto de 1662* (Paris, Louvre), painted as a thanksgiving for his daughter's miraculous recovery from paralysis following the prayers of the Jansenist community at Port Royal where she was a nun.

Bib.: Arand, O., *Philipe de Champaigne: Studies in Style, Theory and the Jansenist Influence*, Ann Arbor, 1970; Dorival, B., *Philipe de Champaigne 1602–74*, 2 vols.,

Paris, 1976; Marin, C., *Philipe de Champaigne ou la presence cachée*, Paris, 1995

Champfleury (Jules Hussar of Fleury) (1828–89)

French writer and art historian. He was one of the first defenders of ▷Realism. He was one of ▷Courbet's few supporters, meeting with him at the Brasserie Andler and in 1857 he wrote *Le Realisme*, which was one of the first studies of the movement. He also wrote novels which he described as realist, including *Les Souffrances du Professeur Delteil* (1853). As an art historian he helped to rehabilitate the work of the ▷Le Nain brothers, and promoted the study of popular art and ▷caricature (*Histoire de la Caricature Antique*, 1865–90). He opposed all art which was not rooted in everyday life and as such was an influence on ▷Manet and ▷Degas. He was director of the Sèvres ▷porcelain factory and a major collector of art.
Bib.: Flanary, J.A., *Jules Champfleury*, Detroit, 1980

champ-levée enamel

▷enamel

chancel

In a Christian church, the area east of the crossing containing the ▷choir (where divine service is sung) and the ▷presbytery or ▷sanctuary (where the high altar is placed), and reserved for the clergy and choir (as distinct from the ▷nave, west of the crossing, and intended for the laity). Frequently, the two areas are separated by a choir screen, the Latin term for which, '*cancellus*', is the source of the English term 'chancel' which came to refer not to the screen itself but rather to the whole area beyond it.

Chantrey, Sir Francis Legatt (1781–1841)

English sculptor. He specialized in portrait busts, statues and church monuments. Born near Sheffield, he began his career as an apprentice wood carver before earning his living as a portrait painter for a short period. In 1802 he moved to London where he studied intermittently at the ▷Royal Academy. Whereas his most important contemporaries looked to the ▷antique and High ▷Renaissance Italy, Chantrey professed to take nature as his principal model, although the calm poses and generalized surfaces of his figures reveal more of an affinity with the ▷Neoclassical than he himself would have admitted. His works are nonetheless characterized by a greater informality and an ability to render convincingly the softness of flesh. His reputation was established at the RA exhibition of 1811 with his bust of the Revd J. Horne Took (Cambridge, Fitzwilliam). His studio flourished and he was able to select judiciously the commissions he wanted, his busy practice meaning that much of the carving was increasingly left to assistants. In the late 1820s, in response to the paucity of statuary foundries

in England and to ensure an advantage over his chief rivals, he established his own foundry, the first important commission from which was his Equestrian George IV for Marble Arch (1828–30, now London Trafalgar Square). Perhaps his most popular sculpture of all is the poignant Monument to the Robinson Children (1817, Lichfield Cathedral). He was elected ▷ARA in 1816 and RA in 1818 and was knighted in 1835. Most of his fortune was bequeathed to the RA in the form of the Chantrey Bequest (now part of the Tate Gallery collection), designated for the purchase of works of art executed in Great Britain.
Bib.: *Sir Francis Chantrey, Sculptor to an Age 1781–1841*, exh. cat., Sheffield, 1981; *Sir Francis Chantrey, Sculptor of the Great*, exh. cat., London, 1980; Yarrington, A., Lieberman, I.D., Potts, A., and Baker, M. (eds.), 'An Edition of the Ledger of Sir Francis Chantrey, R.A., at the Royal Academy, 1809–1841', *Walpole Society* (1994)

chantry chapel

A chapel, inside or attached to a Christian church, endowed for the celebration of masses by the clergy for the soul of the ▷donor or any other he or she may designate.

chapter house

A building attached to a cathedral, abbey or church where the chapter (either secular canons or a monastic order responsible for the running of the foundation) meets to discuss and administer its business. The chapter house is often situated at the east side of the ▷cloister (as, for instance, in Lincoln Cathedral, England, early 13th century; Pazzi Chapel, Santa Croce, Florence, mid-15th century). Chapter houses are generally rectangular in plan, but peculiar to England is the polygonal chapter, a fashion started at Lincoln.

charcoal

Black sticks or twigs which have been charred. They can be used for drawings and were used in the Middle Ages and ▷Renaissance to make outlines for ▷fresco painting. Unless a ▷fixative is applied, charcoal rubs off easily, but rubbing can be used to create textured or hazy effects in charcoal drawing.

Chardin, Jean-Baptiste-Siméon (1699–1779)

French painter. He was the leading French painter of still life and ▷genre. His still life, *The Rayfish* (1728, Paris, Louvre), was highly praised for its realism by ▷Diderot and earned Chardin his entry into the ▷Académie. He was later, for a period of 20 years, treasurer to the Académie and responsible for hanging its pictures. In an age dominated by the highly successful ▷Rococo frivolities of ▷Boucher, Chardin pursued his own independent course. His immediate influences were the ▷cabinet paintings of 17th-

century Holland, then enjoying a certain vogue in France. His paintings are, however, unmistakable. He characteristically used ▷impasto and ▷scumbled paint to evoke surface textures and to build up rich tonal contrasts which, with his deliberately restricted palette and the classical simplicity of his compositions, achieve a monumental grandeur (despite the small scale of his paintings) from the simplest of kitchen utensils and the homeliest of middle-class objects (e.g. *A Copper Cistern*, c1734, Paris, Louvre). His genre paintings, featuring just one or two figures unselfconsciously performing their chores, are neither sentimentalized nor idealized, but always dignified (e.g. *La Bénédicité*, 1740, Paris, Louvre). In his later years, his eyesight began to fail and he took up ▷pastel. He was a brilliant pastel portraitist – in the Louvre are two self-portraits and a portrait of his wife, all shown at the ▷Salon of 1775. ▷Fragonard was his pupil for a while, but the relationship was not a success and Fragonard, not surprisingly, moved on to Boucher.

Bib.: Conisbee, P., *Chardin*, Oxford, 1986; Demoris, C., *Chardin, la chair et l'objet*, Paris, 1991; Roland, Michel, M., *Chardin*, New York, 1996; Rosenberg, P., *Chardin*, New York, 1991

Charlemagne (742–814)

King of the Franks (768–814) and the Lombards (774–814), and Holy Roman Emperor (800–814), whose reforms and wide-ranging interests revolutionized European life. His military and political expansion was mirrored by the so-called ▷Carolingian Renaissance, which emanated from his court at Aix-la-Chapelle. Charlemagne was canonized in 1165.

Charonton (Quarton), Enguerrand

▷Quarton, Enguerrand

Chase, William Merritt (1849–1916)

American painter. He studied in New York and Munich, travelled extensively in Europe and was particularly influenced by the art of ▷Velázquez, ▷Manet and ▷Whistler. He was a teacher at the ▷Art Students' League in New York from 1878 to 1894, and he opened his own School of Art in New York in 1898. He was most influential as a teacher, and his pupils included ▷Demuth and ▷O'Keeffe. Although he never adopted a ▷modernist style himself, many of his students used his training as a springboard into modernism.

Bib.: Gallati, B.D., *William Merritt Chase*, New York, 1995

chasing

(i) On a sculpture of cast metal, a finishing process involving the elimination of small imperfections and the reworking of any details lost during the course of ▷casting. The main chasing tools are tracers (or ciselets), punches and matting tools. The process is also called tooling. (ii) On metalwork, ornaments which are engraved or ▷embossed.

Chassériau, Théodore (1819–56)

French painter, who specialized in ▷history paintings and portraits. He was born in Antilles, in the French West Indies, and studied in Paris and Rome under ▷Ingres. Throughout his career he tried to marry the ▷Classicism of Ingres (e.g. *Venus Anadyomene*, 1838, Paris, Louvre) with the colour and subject matter of ▷Romantics like ▷Delacroix, producing scenes of North Africa (e.g. *Arab Presenting a Mare*, 1853, Lille) – he visited Algiers in 1846 after becoming disenchanted with Rome – and gaining inspiration from religion, literature and mythology. He produced a number of large decorative works, including *Peace and War* for the Court des Comptes at the Palais d'Orsay (1844–8; destroyed by fire). He was also well known for his portraiture (e.g. *Two Sisters*, 1843, Paris, Louvre), including his detailed lead pencil drawings reminiscent of Ingres.

Bib.: Sandoz, M., *Portraits et visages dessinés par Théodore Chasseriau*, Paris, 1986

Chavannes, Puvis de

▷Puvis de Chavannes, Pierre

Cheere, Sir Henry (1703–81)

English sculptor, probably of Huguenot descent. He was responsible for executing statues, busts, monuments and mantlepieces in a variety of materials, notably ▷marble, ▷bronze, stone and lead. He was born in London. After an apprenticeship with mason-sculptor Robert Hartshorne he worked from 1729 in partnership with Henry Scheemakers (d 1748) until the latter's departure from England c1733. Cheere's early work is in a late Classicizing ▷Baroque manner (possibly showing the influence of Antwerp-trained Scheemakers); his later work, however, is characterized by a lighter ▷Rococo manner, his monuments ornamented with ▷scrolls and shell motifs (e.g. Monument of Capt Philip de Sausmarez, 1747, Westminster Abbey), many with coloured marble backgrounds. He also executed much work for Oxford University (e.g. statue of Christopher Codrington, 1732, All Souls College). Cheere helped establish ▷Roubiliac's career by obtaining for him his first important English commission (*Handel* for ▷Vauxhall Gardens in 1738) and he was one of the group who unsuccessfully attempted to promote an English academy of arts (prior to the establishment of the ▷Royal Academy). He was knighted by George III in 1760 and granted a baronetcy in 1766.

Bib.: Whinney, M., *Sculpture in Britain 1530–1830*, 2nd edn., Harmondsworth, 1988

Théodore Chassériau, *The Tepidarium*, Musée d'Orsay, Paris

Chevalier, Sulpice Guillaume
▷Gavarni, Paul

chevet
The French term for the east end of a Christian church when it comprises an ▷apse, an ▷ambulatory and chapels opening off the ambulatory.

chevet en echelon
▷apse

chevron
A zigzag moulding characteristic of ▷Romanesque (and in England, ▷Norman) architecture.

chiaroscuro
(Italian, 'light-dark'.) In oil painting, the modelling of form through the subtle gradation of colour from the brightest highlights to the darkest shadows. It is thought to have been first evolved by ▷Leonardo da Vinci, while ▷Caravaggio later pioneered its strongly contrasted use to create heightened drama in his paintings. Chiaroscuro effects also characterize the paintings of ▷Rembrandt and ▷Georges de la Tour.

chiaroscuro woodcut
(Italian, *chiaro*: 'light' and *oscuro*: 'darkness'.) Effects of light and shade are produced by building up tone from a number of different blocks, printed on top of each other. The key block is inked with the darkest tone and printed first, and subsequent blocks are progressively lighter in tone, and are carefully positioned on top of the image to produce gradated shades. Usually only one colour is used, but the differences in tone produce strong modelling. The technique was developed in 16th-century Italy, and spread all over Europe by the 17th century. It died out with the inception of mechanized printing processes, but underwent a revival in the 19th century.

Chicago, Judy (Judy Cohen) (b 1939)
American feminist artist. Born in Chicago, she studied in Los Angeles, where she took her Masters in Fine Arts in 1964. Her feminist activism and sexually suggestive sculptures were controversial, but her activity led to the first ▷feminist art course in America and the Feminist Art Program (set up with Miriam Shapiro at the California Institute of Art). Her most famous work is a collaborative project, *The Dinner Party* (1974–9) – a large triangular table set with 39 plates, all named after famous women of the past. The table includes seats with original needlework and unusual plates with abstract patterns reminiscent of female genitalia.
Bib.: Caldwell, S., 'Experiencing *The Dinner Party*', *Women's Art Journal*, 1, no. 2 (Fall 1980–Winter 1981), pp. 35–7; *Judy Chicago: The Second Decade*, exh. cat., 1973–1983, New York, 1984

Chicago School
The name given to a group of architects who practised in Chicago from the time of the ▷Great Fire in 1871 until the World Exhibition of 1893. These architects helped rebuild Chicago with a modern image after the Great Fire, and they were the first to make consistent use of the ▷curtain wall and the ▷skyscraper. ▷Louis Sullivan is the most famous of them. The term

'Chicago School' is also applied to the works of Sullivan and ▷Frank Lloyd Wright produced between 1893 and 1914.

Bib.: Condit, C., *The Chicago School of Architecture: A History of Commercial and Public Building in the Chicago Area 1875–1925*, Chicago, 1964

Chicago window

▷window

Chinese art

With origins reaching back more than 4,000 years and artefacts ranging from armour through painting and ▷ceramics to architecture, and exhibiting mastery of many materials from ▷bronze to silk and paper, Chinese art covers an enormous chronological, technical and cultural span, influencing regions as distant as Europe, India and the Middle East. The use of bronze, which was worked with unsurpassed skill, was common in the Shang (1766–1122 BC) and Chou (1028–256 BC) periods, when it was fashioned into ceremonial vessels and domestic utensils. Sculpture of stone, marble and bronze was also widely practised and was a feature of funerary ornamentation, as in the tombs of the Han period (206 BC–AD 220).

Stylistically, ▷Buddhism, which arrived in China in the period of wars between the Han and the Sui (581–618) periods, introduced Indian naturalism to the region's sculpture. In ceramics, the invention of ▷porcelain during the T'ang period (618–906) revolutionized pottery manufacture and design. Reaching its apogee in the Ming period (1368–1644), porcelain

exerted a tremendous influence on European ceramics without, however, the Europeans ever succeeding in imitating true porcelain. (Chinese ceramics were the focus of European ▷chinoiserie in the 18th century.) Painting, considered in China, as in the post-▷Renaissance West, as an intellectual rather than a manual art, was dominated by ink painting, which fuses the arts of representation and ▷calligraphy. This technique migrated to Japan, where the scrolls are known as ▷yamato-e.

Central to Chinese art is the representation of landscape, rendered in a non-scientific form of ▷perspective that attempts to reconcile distance and foreground through the judicious use of devices such as meandering rivers. This tradition continued for centuries until in the 19th century it fell into an academicism and sterility that was broken only when China was rudely confronted by the economic and cultural power of the West at the beginning of the 20th century. The influence of European movements such as ▷Cubism and ▷Surrealism was replaced after the Communist take-over in 1949 with the imposition of ▷Socialist Realism.

Bib.: Cahill, J., *The Distant Mountains: Chinese Painting of the Late Ming Dynasty 1570–1644*, New York, 1982; idem., *Painting at the Shore: Chinese Painting of the Early and Middle Ming Dynasty 1358–1580*, New York, 1978; idem., *The Compelling Image: Nature and Style in Seventeenth-Century Chinese Painting*, Cambridge, MA, 1978; Chang, K.C., *Art, Myth and Ritual: The Path to Political Authority in Ancient China*, Cambridge, MA, 1983; Lee, S.E., *A History of Far Eastern Art*, 5th edn., New York, 1993; Loehr, M., *The Great Painters of*

Chinese wood-block print

China, New York, 1980; Sickman, L., *The Art and Architecture of China*, Harmondsworth, 1956; Sullivan, M., *The Arts of China*, revised edn., London, 1973; Watson, W., *The Art of Dynastic China*, London, 1981

Ch'ing
▷Chinese art

Chinnery, George (1774–1852)
English painter. In 1797 he worked as a portrait painter in Dublin, but he left for Madras in 1802, where he stayed until 1807, when he moved to Calcutta. He remained abroad for the rest of his life and painted portraits and landscapes for English people in India.
Bib.: Hutcheon, R., *Chinnery*, 2nd edn., Hong Kong, 1989

chinoiserie
The European adaption of ▷Chinese artistic styles. Chinoiserie was popular from 1670, but it reached its height during the ▷Rococo period, when it was principally used for decoration and furniture. Its prominence in Europe was fuelled by the opening of trade routes to China. Chinoiserie took many forms. It was popular for wallpaper, imitation Chinese vases and garden architecture. Although it was associated with the Rococo, it continued to remain popular even after the advent of ▷Neoclassicism.
Bib.: Jacobsen, D., *Chinoiserie*, London, 1993

Chi-rho
The Sacred Monogram, denoting Jesus ▷Christ from the earliest Christian times, but coming into more general use after the Roman Emperor Constantine adopted it following its appearance in his vision and his subsequent conversion to Christianity (AD 312). It is based on the first two letters of the Greek word for Christ, chi and rho, laid one over the other (resembling an X over a P). An elaboration includes a cross-bar, such that a direct allusion to the Crucifixion is made. On ▷sarcophagi the chi-rho is frequently contained within a circular wreath of laurel, denoting victory over death through Christ's redemptive sacrifice (e.g. sarcophagus of Archbishop Theodore, 5th century; Ravenna, S. Apollinare in Classe). On the example at Ravenna, the chi-rho monograms are combined with the Greek letters, alpha and omega.

Chirico, Giorgio de (1888–1978)
Italian painter and sculptor. He was born in Greece of Sicilian parents. After studying painting in Athens, he moved to Munich (1906–9) where he was influenced by the work of ▷Böcklin and ▷Klinger, and developed an interest in ▷Nietzsche and Schopenhauer. In 1909 he moved to Italy where he painted his first ▷'metaphysical' paintings, which he exhibited in Paris in 1911, attracting the attention of ▷Picasso and ▷Apollinaire. These paintings convey a strange

dreamlike atmosphere of uneasiness and mystery, in which objects appear to be voided of their natural and emotive significance, trapped in the immobility of empty space. The hallucinatory effect of these paintings, full of bizarre and unaccountable juxtapositions, illogical shadows and distorted perspectives, in which mannequins replaced the human figure, was a style and technique later to be exploited by the ▷Surrealists, who recognized de Chirico as the great precursor of Surrealism on his return to Paris in 1925. De Chirico commented that 'to be truly immortal a work of art must stand completely outside human limitations; logic and common-sense are detrimental to it. Thus it approximates dream and infantile mentality.'

In 1917 de Chirico founded the Scuola Metafisica (▷metaphysical painting) with ▷Carrà whom he had met in hospital, while recovering from a nervous breakdown. However, the 'School' broke up in 1920 after de Chirico wrote a harsh review of Carrà's book *Pittura Metafisica*. His painting began to lose that sense of urgent anxiety and became increasingly academic after 1919, as his subject matter became increasingly Classical, depicting horses, Roman villas and landscapes.

His bronze sculptures of futuristic faceless figures and ▷Baroque horses studded with Classical motifs, emblematize de Chirico's increasingly reactionary attitude, both aesthetically and politically.
Bib.: Barucco, P., *Le Fracas et le Silence: de futurisme à la metaphysique de de Chirico*, Marseilles, 1993; *Giorgio de Chirico*, exh. cat., New York, 1955; Lista, G., *De Chirico*, Paris, 1991

Chloris
▷Flora

Chodowiecki, Daniel Nikolaus (1726–1801)
Polish painter and engraver. He worked in Germany and became director of the Berlin Academy in 1797. He was known for his ▷genre paintings, which represented scenes of middle-class life, and for his book illustrations, which often verged on the ▷caricatural.
Bib.: von Oettingen, W., *Daniel Chodowiecki. Ein Berliner Künstlerleben im achtzehnten Jahrhundert*, Berlin, 1895

Christ
Nowhere does the New Testament give any indications as to the physical appearance of Christ. In fact, before the 3rd century Christ is represented only by symbols, such as the lamb, the fish, or the sacred monogram, due, it is believed, to an aversion to pictorial representation of the divinity, inherited from the Judaic tradition. During this period, Christ was represented as the Good Shepherd, but again this was essentially a symbolic representation and in no way sought to portray Christ as he might have looked. The image is derived from Christ's statement, 'I am the good

shepherd' (John 10: 11) and also from his parable of the shepherd who, leaving his flock to look for one sheep that was lost, returns home rejoicing, carrying it on his shoulders (Luke 15: 3–7). In antique pagan art ▷Mercury was sometimes portrayed in this guise as guardian of his flocks and it is this image that early Christian artists used as a model for the Christian Good Shepherd. Like his pagan forebear, Christ is young, short-haired and beardless, with the sheep carried upon his shoulders (e.g. *The Good Shepherd with a Milk-pail*, early 3rd century; Catacomb of St. Callistus, Rome).

With the adoption of Christianity as the official religion of the Roman state in 313 AD, the idea of Christ as King of Heaven takes hold and images begin to appear which represent him as older, authoritative, bearded, and kingly, perhaps enthroned, and invariably haloed in the tradition of a deified Roman emperor (e.g., apse mosaic, 5th century, Sta Pudenziana, Rome). By the 12th century, Christ is also sometimes crowned (e.g. Moissac ▷Tympanum). Originating in the Byzantine Church, but adopted early by the western Church, is also the image of Christ as the ▷Pantocrator (Greek 'All-mighty' or 'Creator of all'). This figure is generally found in the highest part of the ▷apse or the centre of the ▷dome: Christ is depicted either as a bust within a roundel, with cruciform halo, holding a book or ▷scroll (the gospels) in his left hand and blessing with his right (e.g. dome mosaic, 11th century, Church of the Dormition, Daphni), or as the whole figure, enthroned (e.g., cupola mosaic, 12th century; Church of the Martorana, Palermo). The ▷Byzantine Church had always favoured the image of the bearded Christ and by the 12th century, this convention had become almost universal in both East and West – with celebrated exceptions such as ▷Michelangelo's clean-shaven Apollonian Christ in his ▷fresco of the *Last Judgement* (1536–41, Vatican, Sistine Chapel).

The 'All-mighty' image of Christ was increasingly superseded in the 13th and 14th centuries by the image of Christ dying or hanging dead on the cross – a shift influenced by Christian mystics such as Francis of Assisi and Bridget of Sweden, who meditated on the humanity of Christ and the nature of his sufferings (e.g. Cimabue, *Crucifix*, c1280–85, Florence, Uffizi). This type reached a peak of horrific, expressionistic distortion with ▷Mathias Grünewald (*Isenheim Altarpiece*, 1509–15, Colmar, Unterlinden Museum). Italian ▷Renaissance representations of Christ crucified are generally more dignified, reflecting perhaps a preoccupation with Classical decorum and harmony. In Protestant countries, following the ▷Reformation and the ban on images in church, there are obviously fewer representations of Christ, although ▷Rembrandt's images are among the most human and moving ever made. There are no real developments after that period until the 20th century when artists such as ▷Rouault and ▷Epstein attempted to

find a fresh way of representing Christ and Christian imagery.

Christ Walking on the Water
▷Navicella

Christie's
British Fine art auctioneers. Founded by James Christie (1730–1803) in 1760, it is the oldest specialist art auctioneers business in the world. James Christie was a friend of ▷Reynolds and ▷Gainsborough and used the original premises of the ▷Royal Academy for the first sales. The firm expanded and used several London addresses, and in 1859 Manson and Woods became partners. The company is now a world-wide concern.

Christo (Javacheff) (b 1935)
Bulgarian-born artist. He was born in Gabrovo and studied at the Sofia Academy of Fine Arts (1952–6), before moving to Prague, where he worked with the Burian Theatre, and Vienna in 1957. He then travelled to Paris before settling in New York in 1964. From 1958 his work has consisted of wrapping objects in plastic or semi-translucent materials, at first on a small scale (bottles), but then large, as with buildings (Berne, Kunsthalle, 1968; Pont Neuf, Paris, 1985). His aim was to emphasize the form of the object by partly concealing it. In the 1970s he developed other environment art projects, putting him on a par with the ▷Land Artists (e.g. *Running Fence*, 1976, 40 km of white fabric stretched across a Californian valley). His work is intended to be 'a temporary transformative act', recorded in photographs and in his own project sketches, and is dependent on sponsorship.
Bib.: Alloway, L., *Christo*, New York, 1970

Christopher
(Chronicled in Jacobus de Voragine's *The Golden Legend*.) Saint, allegedly martyred in the 3rd century. His name in Greek means 'Christ-bearer'. Some of the legends of his life are very early, but his cult reached the height of its popularity in the Middle Ages, finally losing official favour after the ▷Reformation. *The Golden Legend* tells how Christopher, a man of gigantic stature, was originally a devil worshipper, but converted to Christianity when he discovered that the devil was afraid of the sign of the cross. He took lessons from a Christian hermit who assigned him to help travellers cross a treacherous stretch of river. One day he carried a child who became increasingly heavy, ultimately revealing himself as ▷Christ and informing Christopher that he had borne not only the weight of the whole world, but he that made it, upon his shoulders. As a sign of the veracity of his words, Christopher was instructed to plant his staff by his hut and, as Christ

promised, in the morning it bore flowers and fruit. Christopher proceeded to Samos and converted thousands by making his staff flower again through prayer. Eventually he was arrested and, refusing to make a sacrifice to the pagan gods, was sentenced to be shot to death with arrows. Instead of hitting Christopher, however, the arrows miraculously hung in the air until one fell and blinded the king. As proof of the power of his God, Christopher informed him that if he were to smear some of his blood on his eye, he would regain his sight. After Christopher's decapitation the king did as Christopher had suggested, his sight was restored, and he himself was baptised. The most frequently represented episode in Christopher's story is his bearing of Christ across the swollen stream (e.g. Master of the Female Half-Lengths, London, National Gallery). In the Ovetari Chapel, Church of the Eremitani, Padua, are the remains of a much damaged fresco of *The Martyrdom of St. Christopher* by Mantegna (c1454–47).

Christus, Petrus (d c1472)

Netherlandish painter. He was first recorded as a master of the painters' guild at Bruges in 1444 and the leading painter in that town after ▷Jan van Eyck's death in 1441. Christus is thought to have been a pupil of van Eyck, most of his paintings having been attributed to the earlier master at some time. Further, it has been proposed that two paintings, a *St. Jerome* (c1442, Detroit, Institute of Arts) and a *Madonna* (c1443, New York, Frick Collection) were begun by van Eyck and completed by Christus after van Eyck's death. On the basis of a possible trip to Italy, Christus is sometimes credited with introducing the Flemish manner and technique of oil painting to ▷Antonello da Messina. Christus' style is a simplification of van Eyck's and his figures can be somewhat doll-like (e.g. *St. Eligius and the Lovers*, 1449, New York, Metropolitan Museum). His style is also indebted to ▷Rogier van der Weyden, however, as is evidenced by Christus' two versions of *The Lamentation* (painted at the beginning and end of his career, Brussels, Musées Royaux des Beaux Arts, and New York, Metropolitan Museum), which follow closely the composition (whilst lacking the drama) of van der Weyden's *Deposition* (143(?) Madrid, Prado). Although Christus' religious paintings may be, for all their charm, somewhat derivative, his portraits are very definitely his own. One of his most accomplished is the *Portrait of Edward Grimston* (1446, private collection), which reveals a concern for and understanding of effects of light, and the construction, through linear perspective, of a convincing corner of a room.
Bib.: Ainsworth, M.W., *Petrus Christus: Renaissance Master of Bruges*, New York, 1994; Gellman, L.B.M., *Petrus Christus*, Baltimore, 1970; Upton, J.M., *Petrus Christus: His Place in 15th Century Flemish Painting*, Pennsylvania State University, 1990

Christus Patiens

(Latin, 'suffering Christ'.) Representations of Christ on medieval and early ▷Renaissance crucifixes. These images show Christ dead and with his eyes closed. They are contrasted with Christus Triumphans, which shows Christ alive.

Christus Triumphans

▷Christus Patiens

chromolithography

An outdated form of ▷lithography which uses a separate plate for each colour. It was the earliest lithographic technique which employed colour. Colour lithography superseded it.

chryselephantine

(Greek, 'made of gold and ivory'.) The term usually refers to ancient Greek cult statues, housed within a temple, often of colossal proportions and made of a wooden armature covered with gold sheeting for the drapery and ivory for the exposed flesh parts. ▷Phidias' colossal 'Athena' (lost) in the Parthenon was a chryselephantine statue.

Church, Frederic Edwin (1826–1900)

American painter. He was born in Connecticut and studied with ▷Thomas Cole. However, he rejected Cole's fanciful landscapes in favour of contemporary American landscape scenes influenced by the writings of Henry David Thoreaux and Ralph Waldo Emerson. He travelled extensively around the United States and in South America. He also visited Europe and the Middle East in 1867–9. His landscapes concentrated on dramatic scenery; works such as *Niagra* (1857, Washington DC, Corcoran Art Gallery) show his response to famous North American sites. He did a number of paintings of the Andes as well as icebergs of the Arctic. He settled in a house on the Hudson River.
Bib.: Carr, G., *Frederic Edwin Church: Catalogue Raisonné*, 2 vols, Cambridge and New York, 1994

Churrigueresque

A Spanish style of architecture and sculpture, taken from Churriguera, the name of a family of Madrid architects who worked in Salamanca. This family included José Benito (1665–1725), who designed buildings in the town of Nuevo Baztán, Joaquín (1674–1724), who was responsible for the dome of Salamanca cathedral (destr. 1755) and Alberto (1676–1750) who designed the Plaza Mayor at Salamanca. However, the term referred not only to the work of this family, but also came to be used more widely for an elaborate form of ▷Baroque architecture, characterized by excessive ornament and twisted columns, which was prominent in Spain and Mexico during the early 18th century. The term Churrigueresque was a derogatory label

invented by late 18th-century ▷Neoclassical artists who disliked the excesses of the style.

CIAM (Congrès internationaux d'architecture moderne)

Group founded in Switzerland in 1928 to promote an international exchange of architectural ideas through annual conferences and publications. They were particularly concerned with the problems of town planning and helped promote ▷modernist architecture.

Cibber, Caius Gabriel (1630–1700)

Danish-born sculptor. He was trained in Italy and the Netherlands, the influences of which countries are revealed, respectively, in a ▷Baroque manner inflected, in later works, with a tendency to naturalism (e.g. tomb of Thomas Sackville, 1677, Withyham, Sussex). Cibber arrived in England shortly before the ▷Restoration and worked with John Stone until the latter's death in 1667. His first major commission was the allegorical relief for the Monument to the ▷Great Fire of London, *Charles II Succouring the City of London* (1674), which Margaret Whinney described as 'the most elaborate piece of sculpture ... produced in England since the Middle Ages ... a provincial variant of Italian Baroque.' Throughout the 1690s Cibber did much garden and architectural sculpture at, amongst others, Chatsworth (1688–91), Hampton Court (1691–6) and St. Paul's (1698–1700). Perhaps his most unique and dramatic works are the figures of *Raving* and *Melancholy Madness*, executed for the gate of Bedlam Hospital in c1676 (now Beckenham, Royal Bethlem Hospital). He was usually short of money, despite a successful career and the wealth of his second wife, Jane Colley (who became the mother of Colley Cibber, the dramatist): he was, in fact, arrested for debt during the execution of his Monument relief, much of which was executed in prison.
Bib.: Faber, H., *Caius Gabriel Cibber 1630–1700: His Life and Work*, Oxford, 1926; Whinney, M., *Sculpture in Britain 1530–1830*, 2nd edn., Harmondsworth, 1988

ciborium

In Christian churches, the permanent canopy, generally in the form of a ▷dome supported on columns, erected over the high altar. Also known as a ▷baldachin.

Cignani, Carlo (1628–1719)

Italian painter. He was from Bologna, where he was the last significant master of Late ▷Baroque Classicism. He was highly esteemed by contemporaries, ran a flourishing studio and had many pupils. He trained under ▷Albani and was influenced principally by ▷Guido Reni whose style he resembles, but also by ▷Correggio, the ▷Carracci and ▷Guercino. His most important work is the decoration of the dome of the Cathedral at Forlì (1681–1706). In 1711 he became the first president of the Accademia Clementina in Bologna.
Bib.: Buscaroli Fabbri, B., *Carlo Cignani: affreschi, dipinti, designi*, Bologna, 1991

Cignaroli, Giambettino (1706–70)

Italian painter. He worked in Verona, where he produced ▷history paintings and decorative subjects.

Cigoli, Il (Ludovico Cardi) (1559–1613)

Italian painter and architect. He worked in Florence, where he was the pupil of ▷Allori. His colourful works show some influence of Venice and the ▷sfumato of ▷Correggio. He worked in Rome in 1604. He also produced architecture in the style of ▷Palladio.
Bib.: Chappell, M. (ed.), *Disegni di Lodovico Cigoli (1559–1613)*, exh. cat., Florence, 1992

Cimabue (Cenni di Peppi) (c1240–?1302)

Italian painter and mosaicist. Only one work is securely documented as his, namely, a figure of St. John within a large ▷mosaic by another artist, in the ▷apse of Pisa Cathedral (1302). A Florentine contemporary of ▷Dante, he is mentioned in *Purgatorio* (canto 11: 94–96): 'In painting Cimabue thought to hold the field and now Giotto has the cry, so that the other's fame is dim.' Dante's illustration of the transitoriness of earthly glory seems to have been the basis for the tradition (taken up most famously by ▷Vasari) that Cimabue was the leading master of a generation still working in the waning ▷Byzantine tradition of conventionalized picture making and that he accomplished, within this tradition, some small movement towards a greater naturalism, but was then totally eclipsed by the revitalising genius of his pupil who completed the move. Certainly the works that have been attributed to Cimabue would suggest an artist of very high quality and furthermore one who imbued his pictures with a greater humanity than his predecessors. The principal attributed works are the *Sta Trinità Madonna* (Florence, Uffizi), some ruined ▷frescos in the Upper Church of S. Francesco, Assisi, and a painted *Crucifix* (Florence, S. Croce Museum, much damaged in the 1966 Florence flood). Whilst not denying the quality of these works, however, modern scholarship sees the increase of pictorial naturalism as a more general tendency whose leading artists were Cimabue's Roman contemporaries, ▷Cavallini and ▷Torriti. As Cimabue is documented in Rome in 1272 it is just as likely that he was influenced by, or was part of, a stylistic current that had its origins among the Roman, not the Florentine, school of painters.
▷Giotto
Bib.: Baldini, U., *The Crucifix by Cimabue*, New York, 1982; White, J., *Art and Architecture in Italy 1250–1400*, 2nd edn., Harmondsworth, 1987

Cima da Conegliano, Giovanni Battista (1459/60–1517/18)

Italian painter. He was from Conegliano, but was active in Venice by 1492, which was the centre of his activity for the remainder of his life. He was strongly influenced by ▷Antonello da Messina (his monumental simplification of form) and ▷Giovanni Bellini (his light, colour and landscape). His painting style is instantly recognizable and his paintings are most commonly devotional compositions of the ▷Madonna and Child before a peaceful, light-filled landscape.
Bib.: Humfrey, P., *Cima da Conegliano*, Cambridge, 1983; Menegazzi, L., *Cima de Congeliano*, Treviso, 1981

Cimmerian Sibyl
▷Sibyl

cinquecento

Literally, 'five hundred', the Italian art term for the 16th century. It is used only to refer to Italian art and may be used as either an adjective, as in 'cinquecento art', or a noun, as in 'art of the cinquecento'.

Cione, Andrea, Jacopo and Nardo di
▷Orcagna, Andrea

Cipriani, Giovanni Battista (1727–85)

Italian painter and engraver. He studied at the Accademia del Disegno in Florence and worked in Rome from 1750. In 1756 ▷William Chambers brought him to England, where he established an aristocratic clientele and became one of the founding members of the ▷Royal Academy. He mainly produced designs for decoration and book illustration, many of which were engraved by his compatriot, ▷Bartolozzi. Cipriani also gained royal patronage, and he produced some temporary work for royal displays and parades. His success inspired the resentment of his contemporaries, who were anxious to promote a native English school of art.

Circe
▷Ulysses

Circle and Square
▷Cercle et Carré

Circumcision

(Luke 2:21) Only Luke mentions the circumcision of Christ. Christ is circumcised, as required under Mosaic law as a token of the Covenant, at the age of eight days and, as was the custom, is thereupon given his name. Although Luke does not mention the location of the ceremony, which could be performed either at home or in the temple, most depictions that give a setting show it officiated by a priest in the temple. The importance of the subject lies in the fact that it shows the first shedding of Christ's blood and is therefore symbolic

of his ▷Passion. To the Jesuits, who had a particular reverence for Christ's name, it had also a special significance as being associated with his naming. Christ usually sits upon Mary's lap (▷Virgin Mary) whilst Joseph observes the operation (e.g. Luca Signorelli, c1491, London, National Gallery).

cire-perdue

(French, 'lost wax'.) A method of ▷bronze casting, dating back to ancient times. Its advantages over sand casting, the other principal method, are that it allows a much finer finish to the bronze surface and can exactly replicate models of much greater intricacy. The stages of the process are as follows:

(i) A heat-proof core is made to the same shape, but slightly smaller than, the intended bronze sculpture. This core can be made from either a mixture of ▷plaster of Paris and grog (ground ▷ceramic) or, alternatively, clay.

(ii) The plaster core is covered with a coating of wax a few millimetres thick, exactly replicating on its outer surface, the intended form of the bronze sculpture. This is the wax model.

(iii) Steel or iron pins are driven through the wax into the core, leaving the upper halves of the pins projecting from the surface of the wax. To the top of the wax model several obliquely-set thick rods of wax are attached. These are positioned so as to meet in a solid bunch to form a kind of inverted cone. Longer thin wax rods are attached to all protruding parts of the wax model and bent along their length so that their other ends point straight upwards.

(iv) The wax model with all its wax rods and metal pins is encased in an outer heat-proof mould of plaster of Paris and grog (but without covering the ends of the thin wax rods or the bunched thick wax rods). The wax model is now sandwiched between two heat-proof layers, namely the core and the mould.

(v) The whole structure is inverted and placed in a kiln. The cone of bunched thick wax rods is now at the bottom. The wax is next melted out (i.e. 'lost'). The metal pins now serve to hold the core and mould in their relative positions with a space between them. Where the bunch of thick wax rods once was is now an open funnel leading to runners (passageways through the mould) into which the molten metal can be poured. Where the thinner wax rods once were are now risers (air and gas vents).

(vi) The structure is next turned the right way up and packed firmly into a sandpit (to prevent the mould bursting with the expansion of the heated air in the cavities when the molten metal is poured in), with only the funnel and riser openings left clear. The molten metal is then poured into the funnel. It flows down through the runners and fills the thin sculpture-shaped cavity between the core and the mould. The air from the cavities escapes through the risers.

(vii) When the metal has cooled and solidified the

outer mould is broken away and also the inner core removed. The result is a hollow bronze sculpture with bronze protrusions in the shape of the runners and risers and protruding metal pins.

(viii) Finally, the bronze protrusions and metal pins are sawn off and the metal surface cleaned up.

An exciting account of the casting of the bronze statue of *Perseus* by the *cire-perdue* method is given by ▷ Benvenuto Cellini in his autobiography.

Čiurlionis, Mikalojus Konstantus (1875–1911)

Lithuanian painter. He studied music at Leipzig and Warsaw and only began painting in 1905. Given his musical background, he attempted to use art to express synaesthetic ideas (▷ synaesthesia). His paintings were meant to show the more essential spiritual effects of music and in that sense, they were distinct from the rather artificial musical analogies made by ▷ Kandinsky in his work. He exhibited with the ▷ World of Art group in Russia, but mental instability led to insanity by 1908.

Cixous, Hélène (b 1938)

French poststructuralist critic, novelist and playwright. Although concerned with '*écriture feminine*' she has occasionally rejected the term ▷ feminist on the grounds that it perpetuates the hierarchical opposition of masculine/feminine which she is trying to deconstruct. Her work is psychological not sociological, and purely theoretical. It includes *La Jeune Née* (*The Newly Born Woman*) (1975).

Bib.: *The Hélène Cixous Reader*, London, 1994; Shiach, M., *Hélène Cixous: A Politics of Writing*, London, 1991

Claesz, Peter (c1597–c1660)

Dutch painter. He was a ▷ still life painter, born in Westphalia. He moved to Haarlem, married there in 1617 and remained in the town for the rest of his life. His most characteristic genre is that of the breakfast piece ('*ontbijt*'), although he also painted banquet pieces and a few ▷ *vanitas* still lifes. With his contemporary, the Haarlem painter ▷ Willem Claesz. Heda, he was the most important exponent of the 'monochrome' breakfast piece. Not strictly monochromatic, these works are composed in subtle harmonies of grey, brown and green, often with a sharp yellow accent provided by a peeled lemon. Claesz's breakfast pieces are generally distinguishable from Heda's by the homelier types of objects he depicts. Claesz's monochrome period, in fact, spans only the period of the 1630s; after 1640 his style became grander and more decorative. Although he and Heda could be said to have invested still life with an increased dignity and refinement, Claesz.'s own son, ▷ Nicolaes Berchem, established himself instead as a landscape painter.

Clark, Kenneth McKenzie, Lord (1903–83)

English art historian and critic. He was educated at Winchester School and Oxford. Having worked with ▷ Berenson in Florence, Clark became Director of the ▷ National Gallery in London at the age of 30. His publications were judged audacious and inventive, and include *Landscapes into Art* (1949), *The Nude: A Study of Ideal Art* (1956), *Looking at Pictures* (1960) and *Civilisation* (1969). Through this latter book he pioneered the use of television as a medium for artistic debate.

Clark, Robert
▷ Indiana, Robert

Classicism

Multifarious word which is applied to art which places emphasis on older models, often specifically on ▷ Antique art. However, the term does not always refer to art derived from Greek or Roman examples, but rather from important works of other eras, which have become synonymous with the 'perfection' once accorded to Classical art. Classicism can be seen widely in architecture, with a variety of consequences.

Claude Gellée le Lorrain (Claude Lorraine) (1600–82)

French painter. He was one of the most important landscape painters of the 17th century. He was from Lorraine, but he went to Rome at an early age to work as a pastry cook for the artist ▷ Agostino Tassi. Tassi was impressed by his abilities and took him on as an assistant in his studio. Claude visited Naples and Lorraine, but came back to Rome in 1627, where he settled.

Like ▷ Poussin, Claude was influenced by the beauties of the Italian landscape, but his approach was radically different. Claude's work showed his interest in light and tonal effect which brought out the special light of the Roman campagna. In opposition to the artistic hierarchies (▷ hierarchy of genres) of the time, he painted pure landscapes as well as works which set Biblical and mythological subjects in obviously Italian countryside. By the 1630s he had a wide reputation, and he gained commissions from the French ambassador in Rome, as well as Pope Urban VIII. To protect himself from voracious plagiarists, he published the ▷ *Liber Veritatis*, a collection of ▷ etchings based on his landscapes (1635–6).

Bib.: *Claude Gellée dit Le Lorrain 1600–1682*, exh. cat., Paris, 1983; *Claudo de Lorena y el ideal clásico de paisaje en el siglo XVII*, exh. cat., Madrid, 1984; Askew, P. (ed.), *Claude Lorrain 1600–1682, a full symposium*, Washington, DC, 1982; Langdon, H., *Claude Lorrain*, Oxford, 1989

Claude glass

A convex black glass used to view landscapes. The Claude glass reflects landscapes but distorts their colour and form slightly to allow a greater simplification. It was particularly popular amongst amateurs and ▷picturesque painters of the late 18th and early 19th century, as they could use it to make their oils and ▷watercolours appear more like the works of ▷Claude.

Claudel, Camille (1864–1943)

French sculptor. She was born in Villeneuve-sur-Fere. After her family moved to Paris, she attended the Colarossi Studio (1881) and was given a place in ▷Rodin's studio, where she began work on the *Gates of Hell*. By 1883 she was Rodin's mistress, a position which led to her work being largely ignored for many years as merely derivative. She was indeed influenced by Rodin, but developed her own approach during the 1890s, specializing in small-scale, roughly worked figure pairs which suggested movement through pose and imbalance (e.g. *La Petite Chatelaine*, 1892–3, private collection; *Waltz* series, 1892–5). Works like *Sakountala* (1888) also received contemporary recognition when exhibited at the Salon des Artistes Françaises. She often made several versions of works, employing ▷marble and ▷bronze, but found it difficult to work to commissions. Around 1900, she became increasingly interested in the possibilities of onyx, which she used as a jade substitute, giving a Japanese feel to her work (e.g. *Wave*, 1900, private collection). Overall, her work took on a more decorative appearance, with smooth polished surfaces and an ▷Art Nouveau elegance (e.g. *Flute Player*, 1904, bronze). She became increasingly psychologically unstable, living in isolation and destroying much of her work, and was eventually placed in an asylum by her family, after the death of her adoring father (1913).
Bib.: Paris, R.-M., *Camille Claudel*, Paris, 1984; *Camille Claudel*, exh. cat., Martigny, 1990

Clausen, Sir George (1852–1944)

English artist of Danish extraction. He was famous for his images of agricultural life. From 1867 to 1873 he worked for a firm of Chelsea decorators (Messrs Trollope), and was encouraged towards art by Edwin Long, while employed on his house. Clausen was already attending evening classes at South Kensington Art School. In 1875 he travelled to Holland and Belgium, painting local rural subjects in a ▷Hague School style (e.g. *High Mass in a Fishing Village on the Zyder Zee*, 1876, Nottingham). He visited Paris but failed to gain admission to ▷Gérôme's studio and returned to London, where he became acquainted with ▷Whistler, ▷Tissot and other French-influenced artists. In 1882 he went to Brittany on a sketching tour with ▷Forbes and the following year enrolled at the ▷Académie Julian in Paris. His early work was dominated by his enthusiasm for ▷Bastien-Lepage: he produced scenes of the Essex and Berkshire countryside peopled by peasants using the characteristic cool palette and blocked brushwork of the Frenchman (e.g. *Stonepickers*, 1887, Newcastle). He was one of the founders of the ▷NEAC and defended Lepage's style in *Art Magazine* in 1888. By the 1890s however, his work was becoming more monumental, his brushwork and colour range had taken on an ▷Impressionistic air and his figures were more akin to those of ▷Millet (e.g. *Mowers*, 1891, Lincoln). He also experimented with ▷pastels (influenced again by Millet and by ▷Degas) and ▷watercolour. This style proved more conducive to academic tastes. He was elected ▷RA in 1908, having already held the post of Professor of Painting (1803), and he published his lectures, *Aims and Ideals in Art* (1906). He was an official war artist (e.g. *Gun Factory at Woolwich Arsenal*, 1918, London, Imperial War Museum) and was commissioned to paint *Return to the Reconquered Land* in 1919 (Ottawa, Canadian War Museum) and to produce a mural for St. Stephen's Hall in the Palace of Westminster in 1927.
Bib.: *Sir George Clausen, RA*, exh. cat., Bradford, 1980

clearstory

▷clerestory

Clerck, Hendrik de (1570–1629)

Flemish painter. He was court painter to Archduke Albert in Brussels from 1606. His work showed an Italian influence, and he was responsible for perpetuating a ▷Mannerist style in Brussels long after the style had been superseded in Italy.

clerestory (clearstory)

An architectural term used for the upper stage of the ▷nave, ▷choir and ▷transept walls of a church, above the aisle roofs, pierced with windows to admit light to the centre of the building.

Cleve, Joos van

▷Joos van Cleve

cliché-verre

(French, 'glass negative'.) An early method of printing which took on qualities of both ▷etching and photography. A plate was drawn upon and then printed on photographic paper to bring out special light effects. It was used as a preparatory device by ▷Corot and the ▷Barbizon painters to aid the naturalism of their landscapes.

Clio

▷muse

Clodion, (Claude Michel) (1738–1814)

French sculptor. He was the son-in-law of the sculptor Augustin Pajou and nephew of the sculptor L.-S. Adam. He received his first training as a sculptor with the latter, followed by a brief period with ▷Pigalle (1759). In the same year he won the ▷Prix de Rome and from 1762 to 1771 attended the French Academy in Rome where he not only studied the ▷antique but also attracted an increasingly wide circle of influential French patrons. His best works (e.g. *Satyr Carrying a Bacchante Playing a Tambour*, Philadelphia, Museum of Art) are small-scale decorative ▷terracotta figures and groups in which the immediacy of the medium gives full scope to the vivacity of his ▷modelling. His subjects are usually ▷Classical – and of immediate appeal to wealthy private patrons. Neither learned nor stoic, they are instead light-hearted and sensuous pastoral subjects, dealing with nymphs, satyrs and shepherds, typical of the ▷Rococo style of which he became the principal sculptural exponent. In this he is often considered as the sculptural counterpart to ▷Fragonard. Following the ▷French Revolution he managed to adapt his style to suit the seriousness of the prevailing Neoclassical taste and contributed to the decoration of the Vendôme Column (1806–10) and the Arc de Triomphe du Carrousel (1806–9), though his most accomplished work is undoubtedly to be found in his pre-Revolutionary Rococo subjects.
Bib.: Poulet, A.L., *Clodion 1738–1814*, Paris, 1992

cloisonné

(from the French, *cloison*: 'partition'.) A technique of ▷enamel work in which thin strips of metal are attached to the background surface, to form the framework of a design, made up of various compartments, which can then be filled with vitreous enamel paste. The technique was known in the ancient Mediterranean world and has been used in China, but is associated most with ▷Byzantine art (e.g. the Pala d'Oro at San Marco, Venice, 11th and 12th centuries).

cloisonnism

(from French *cloison*: 'partition'.) A term derived from *cloisonné* enamelware which was used to describe the work of the French ▷Symbolist painters who employed flattened, heavily-outlined areas of colour. The term was first used by the critic Dujardin in 1888, to describe an exhibition of ▷Anquetin's work in *La Revue Indépendante*. The invention of the technique was claimed by ▷Bernard, although it is associated with the work of the ▷Pont Aven Group in general, and particularly with ▷Gauguin's painting of that period. It was both a reaction against the fragmented techniques and naturalism of ▷Impressionism, and an attempt at simplification, in order to express key emotional and spiritual ideas. Because of the artists' interest in medieval and religious art, it may well have been inspired by ▷stained-glass designs.

Bib.: Rookmaaker, H., *Synthetist Art Theories*, London, 1959

cloister

In a monastery, a roofed or vaulted walk, generally set around a quadrangle or court, walled on the outer side and ▷colonnaded or ▷arcaded on the side facing the enclosed space, used for the purposes of exercise or study. The cloister generally connects the monastic living accommodation to a monastic church and is usually situated on the south side of the ▷nave, west of the ▷crossing.

Close, Chuck (b 1940)

American painter. He produced giant ▷Superrealist pictures. From 1967 he produced drawings made from photographs which had been put beneath a grid. The grid acted like a ▷drawing frame and allowed him to copy the photographs with strict accuracy. Most of his works represent faces, and they tend to be produced in black and white on a massive scale. As a means of making reference to the artificiality of his technique, he later left the grid marks on his drawings.

Clouet, Jean the Elder (b c1420), Jean (c1485–1541) and François (before 1510–1572)

French family of painters of Flemish origin. Jean the Elder went to France in c1460, but very little is known of his activities. His son Jean was a portrait painter who worked in a style reminiscent of Flemish naturalism. Jean the Younger's son François was also a portraitist, but with a style which reflected the ▷Mannerism of ▷Pontormo, rather than the naturalism of the Flemish School. François also produced ▷genre scenes and odd representations of nude women. Both Jean and François were called 'Janet', so their works are sometimes confused.

Clovio, Giulio (1498–1578)

Italian painter from Croatia. He came to Rome in 1516 and produced miniatures in the style of ▷Michelangelo and ▷Raphael. He later became a monk.

Cluny

Abbey church in central France, now all but destroyed. The Cluniac order sprung out of the monastic conflict between the idea of the monk as hermit and the monk as community worker. The Cluniac order based itself on the ideals of community life and a complex of monasteries with estates, houses and land attached helped bring in revenue and feed an estimated 17,000 poor per year. The monks themselves celebrated the liturgy all day, usually singing for about seven hours per day, and sometimes all night as well, while lay brothers tended the estates. Cluny itself was the papal flagship from 910 to 1000, exercising increasing power under three successive abbots – Odo, Odillo and Hugh. Indeed, Cluny proved to be a good training ground

for future Popes, including Gregory VII and Urban II. The first church, built by Odo in 955, was a comparatively primitive ▷Romanesque structure, with three ▷apses, two ▷transepts and semi-circular ▷vaulting. Abbot Odillo started the expansionist programme, adding a new ▷cloister, chapter house, refectory and infirmary in the 1030s and 40s. By 1063 the Abbey was a model of sophistication, recorded to have latrines and running water. But it was during the time of Abbot Hugh that Cluny started to gain the mythical status it still retains in part.

Under Hugh a vast new infirmary and guest wing for 2,000 people was added and the largest Romanesque church in Europe was built. It had a centralized ▷chevet, ▷radiating chapels, stepped aisles, a central aisle with a barrel vault of over 30 metres, fluted ▷pilasters and lantern towers. Politically this huge church had great impact, allowing Cluny, which had no important relics, to become an important site for pilgrimage and to exercise enormous power over neighbouring diocese. Treatises were published suggesting the dimensions were calculated from the harmonies of the Gregorian chant and comparing the church to an image of heaven. Indeed a myth circulated that one of the monks had been given the plans of the church by St. Peter himself. Architecturally, the church pointed towards the increasing extravagances and follies which were to mark the ▷Gothic age. The structure teetered on the limits of the possible and in 1125 the vaulting collapsed. By then Speyer had surpassed Cluny as the largest church in Europe and the Cistercian backlash had begun. The church was virtually demolished during the ▷French Revolution, and all that survives of it are eight capitals, in the Cluny Museum, Paris. A virtual reality programme has recreated the original church.

Bib.: C.E. Armi, *Masons and Sculptors in Romanesque Burgundy: The New Aesthetic of Cluny III*, University Park, 1983

Coade stone

An artificial cast stone, also known as 'Mrs Coade's stone' in reference to Mrs Eleanor Coade who was the proprietor of the firm in Lambeth (London) which invented the material and produced it from c1770 until c1820. It is a type of stoneware made from a mixture of clay, grog, flint, quartz sand and ground glass fired in a kiln at a high temperature. Its chief benefits are that it is relatively inexpensive (it was made into moulds for mass production) and extremely durable (as Mrs Coade herself proclaimed, it is resistant to frost) and thus was used principally for exterior work such as architectural ornamentation and garden sculptures. The firm was highly successful: ▷Robert Adam was among those architects who made use of the stone and the sculptors ▷John Bacon the Elder and John Charles Felix Rossi were among Mrs Coade's modellers.

Bib.: Kelly, A., *Mrs Coade's Stone*, Upton-upon-Severn, 1990

CoBrA (Cobra)

An international ▷Expressionist movement founded in Paris in 1948. The name is an acronym of Copenhagen, Brussels and Amsterdam, the native cities of the artists involved, which included the Dane ▷Asgar Jorn, the Dutchmen ▷Karel Appel, Corneille and George Constant, and the Belgian Pierre Alecinsky. Opposed to geometric ▷abstraction, *belle peinture* and ▷Social Realism, Cobra sought an authentic art 'that permits a man to express himself in accord with the exigencies of the instinct', free from social and political constraints and the academic distinction between abstract and figurative painting. Similar in its concerns to ▷Art Brut, Cobra shared ▷Dubuffet's interest in children's art, primitive art and ▷graffiti, as well as in Nordic art and folklore, from which much of the movement's subject-matter derives. Images, often disturbing, appear out of the violent whirl of powerful colours and thick ▷impasto. The group published eight issues of *Cobra Review* and 15 monographs, and held four group exhibitions in Copenhagen (1948), Amsterdam (1949), Paris (1950) and Liège (1951). Although the group only lasted three years, breaking up in 1951, it was extremely influential upon European post-war painting.

Bib.: Lambert, J.-C., *CoBrA*, London, 1983; Miller, R., *CoBrA*, Paris, 1994

Cock, Jan Wellens de (d c1526), Matthys (c1509–48) and Hieronymus (or Jerome) (c1510–70)

Netherlandish family of artists. Jan Wellens de Cock was one of ▷Bosch's earliest followers, thought to be identical with the Jan van Leyden who was listed as a master of the Antwerp Guild in 1520. His oeuvre consists chiefly of small-scale paintings of fantastic landscapes inhabited by saints and hermits, etc. Jan's two sons, both of whom were active chiefly in Antwerp, were Matthys, a landscape painter with enough of a contemporary reputation to be mentioned by both ▷van Mander and ▷Vasari and, perhaps the most important member of the family, Hieronymus (or Jerome), an engraver, printer and publisher of prints, whose business, known as 'Aux Quatre Vents' ('At the Sign of the Four Winds'), enjoyed an international reputation. Among Cock's most celebrated employees were ▷Marten Heemskerk and the young ▷Pieter Bruegel the Elder. Bruegel was at that time a close follower of Bosch, a quality of which Cock took unscrupulous advantage: Breugel's drawing, *Big Fish Eat Little Fish*, was engraved and published by Cock in 1557 with the inscription 'Hieronymus Bos Inventor'.

Codde, Pieter (1599–1678)

Dutch painter. He worked in Amsterdam and specialized in drinking scenes. His *Meagre Company* (1637, Amsterdam, Rijksmuseum) is typical of his comic style. He also completed a civic guard portrait that had been begun by ▷Hals.

Coello, Claudio (1642–93)

Spanish painter. He succeeded ▷Carreño as painter to the king in 1686. He studied the works of ▷Rubens and ▷Titian in the royal collection, and travelled to Italy to complete his education. He worked at the ▷Escorial and produced flattering allegories of the king's power and religious conviction, such as *Charles II Adoring the Host* (1685–90, Madrid, Prado).

Cold Art (Kalte Kunst)

A form of pure mathematical ▷Constructivism based on the ▷concrete art of ▷Max Bill. It was popular in Switzerland during the 1950s and 1960s, when artists adopted a coldly mathematical approach to sculpture and painting as a means of showing their control over the art process. Some of them later used computers to assist this purpose. The artist Karl Gerstner published a book, *Kalte Kunst*, in 1954.

Coldstream, Sir William Menzies (1908–87)

English painter and teacher of art. He was born in Belford, Northumberland, the son of a doctor. The family moved to London in 1910 and he received a private education, with the aim of following in his father's profession, until he decided on painting in 1925 and enrolled at the ▷Slade (1926–9). He was a member of the ▷NEAC from 1928, and of the ▷London Group from 1934. In 1937, he established the ▷Euston Road School along with ▷Pasmore. His early influence was ▷Cézanne from whom he developed a simplified technique, employed with cool objectivity (e.g. *Nude*, 1937, private collection). In the 1930s he worked with the GPO film unit and produced portraits of friends (e.g. the poets W. H. Auden and Stephen Spender). He enlisted in the Royal Artillery in 1940, but was also an official war artist. After the Second World War he became an important teacher, first at Camberwell (1945), then as Professor of Fine Art at the Slade (1949–75). During the 1950s he produced a series of realist nudes, and also increased the colour range of his work. He was knighted in 1956.
Bib.: Laughton, B., *Euston Road School*, London 1986; *The Paintings of William Coldstream*, exh. cat., London, 1990

Cole, Thomas (1801–48)

American painter. The founder of the ▷Hudson River School, he came originally from Liverpool, England, but emigrated to the United States in 1818. In 1819 he visited the West Indies. In 1825 he was in New York, where he became a founding member of the ▷National Academy of Design in the following year. He settled in a house on the Hudson River, where he began producing topographical and fanciful landscape views. He travelled to Europe several times and there came into contact with the ▷sublime landscape painting of ▷John Martin. Like Martin, he was more interested in the landscape itself than the human beings within it, and his panoramic scenes were meant to inspire awe and admiration in the observer.
Bib.: Noble, L.L., *The Life and Works of Thomas Cole*, Cambridge, MA, 1964

collage

(From the French, *collé*: 'to stick'.) Making a collage involves cutting up newspaper, cardboard, wallpaper or cloth and pasting them onto a piece of paper. It has long been popular with amateurs, but it was first used extensively by professional artists in the early part of the 20th century. Among their ▷Cubist experiments, ▷Picasso and ▷Braque began to add cut-out bits of newspaper and wallpaper to their paintings from c1912 onwards. ▷Futurist artists also adopted the technique for their pro-war propaganda pieces during the First World War. It was used for a different purpose by ▷Dada and ▷Surrealist artists, who were more interested in the unconscious forces that were involved in the process of making collages. ▷Kurt Schwitters in Germany produced collages which were intended to express the spiritual qualities of the abstract materials he used.
▷*papier collé*, photomontage, assemblage
Bib.: Poggi, C., *In Defiance of Painting: Cubism, Futurism and the Invention of Collage*, New Haven, 1992

collecting

The practice of amassing works of art, sometimes on a thematic basis. During the 17th and 18th centuries, as travel became easier and the ▷Grand Tour became a fashionable pursuit, young noblemen were keen to collect souvenirs from their journeys. These collections had prestige value, and are often the foundations for today's public collections (e.g. the ▷Wallace Collection). During the 20th century collecting more mundane items, as well as collecting important works of art, has become a popular hobby.

Colleoni Monument

Bronze sculpture by ▷Verrocchio 395 cm (13 ft) high. It was commissioned in 1483 and worked on by the artist until his death in 1488. For the initial competition Verrocchio produced a life-size wooden model of the piece. It was finally cast by Alessandro Leopardi and erected in 1496 in Campo SS Giovanni e Paolo in Venice. The work commemorates Bartolomeo Colleoni, a local *condottiere* and civic benefactor, who is represented in armour on horseback. The sculpture owes much to the tradition of ▷equestrian

monuments from Marcus Aurelius in Rome through to ▷Donatello's *Gattamelata* (1447–52, Padua, Piazza del Santo), but Verrocchio adds much that is new. His horse, reminiscent of those in St. Mark's in Venice, is full of character and movement, a powerful symbol of the might and personality of its rider who struggles to maintain his control. Colleoni himself is a portrait, with a deeply etched face and stiff limbs, identifiable less as a universal hero than as a hard-bitten and determined individual fighter. The whole sculpture implies forward movement, of a man leading his troops, though the twisting pose of horse and rider also gives a variety of viewpoints and hints at the sculptural developments to come during the 16th century. Standing as it does, on a high pedestal in the centre of the square, much of the detail is obscured but the character of the man remains unmistakable.

Collins, William (1788–1847) and Charles Allston (1828–73)

British family of artists. William Collins specialized in landscapes and rustic ▷genre. He was taught by ▷Morland, about whom his father wrote a biography. In 1807 he entered the ▷Royal Academy Schools and exhibited at the RA from 1820. He was a friend of ▷Wilkie and produced rural, sentimental scenes which were highly popular in their day (e.g. *Rustic Civility*, 1832, London, Victoria and Albert Museum; *Kitten Deceived*, 1817, London, Guildhall). His work tended towards repetition but he had a good sense of colour. He travelled widely on the continent, visiting Holland and Belgium in 1828, Italy in 1826–8 and Germany in 1840.

William Collins's son was Charles Allston, who attended the RA Schools but was influenced by the ▷PRB during the 1850s (e.g. *Convent Thoughts*, exhibited RA 1851, Oxford, Ashmolean). He was friendly with ▷Millais and went on painting expeditions with him. However, after 1858 he stopped painting in favour of writing and was the author of several novels and travel books. His brother was Wilkie Collins, also a novelist whose most celebrated work is *The Woman in White*, and who wrote a memoir of their father in 1848.

Collinson, James (1825–81)

English painter. He studied at the ▷Royal Academy schools, where he met ▷Rossetti and ▷Hunt. His RA exhibit of 1847, the *Charity Boys Debut*, influenced ▷Rossetti with its high finish and Collinson was an original member of the ▷Pre-Raphaelite Brotherhood (e.g. *St. Elizabeth of Hungary*, 1848–50, Johannesburg). He was engaged to Rossetti's sister Christina in 1849–50, but was also a strict Catholic and began to train for the priesthood at Stoneyhurst in 1851–4. He returned to painting in 1854 but changed his style to a more popular sentimentalism (e.g. *The Empty Purse*, 1857, London, Tate).

Bib.: *Artists of the Pre-Raphaelite Circle*, exh. cat., Liverpool, 1988

Colombe, Michel (c1430–after 1512)

French sculptor. His work showed the mixed influences of French ▷Gothic and Italian ▷Renaissance art. Among other works, he produced the tomb of Francis II of Brittany and Marguerite de Foix for the Cathedral of Nantes (with ▷Perréal, 1502–7), and a ▷relief of St. George and the Dragon for an ▷altarpiece (1508–9, Paris, Louvre).

colonnade

A row of columns topped by an ▷entablature.

colore

> ▷*disegno*

colossal order

An ▷order whose ▷columns or ▷pilasters rise from the ground through two or more storeys to the full height of the building. Colossal orders were particularly popular in 16th-century Roman architecture, following ▷Michelangelo's innovatory employment of a colossal ▷Corinthian order in the Palazzo dei Conservatori and its twin, the Palazzo Nuovo, in the Piazza del Campidoglio, Rome. The effect is to enhance the grandeur of the two buildings (whilst still acknowledging their two-storey structures through the use of a secondary ▷Ionic order) and to achieve a new unity between the buildings across the square. The colossal order is also sometimes called a giant order.

Colosseum

Also known as the Flavian amphitheatre, the Colosseum in Rome was the largest of the ancient amphitheatres. Elliptical in plan, it measures 188 × 156 m and is 48.5 m in height (620 × 515 × 160 ft). Begun by the Emperor Vespasian in AD 75 on the site of the artificial lake of Nero's Golden House, it was completed by Titus and Domitian towards the end of the century. It is first and foremost a remarkable feat of constructional engineering and organizational skill comprising seating for c45,000 spectators, each of whom entered by one of 76 numbered entrances, moving along designated passageways and staircases to the specific seat as indicated on their ticket. The main load-bearing constructional material is dressed stone: tufa for the internal parts and travertine for the external facings. Concrete was restricted to the vaults and upper internal walls, with the very uppermost seating in timber. Externally, the Colosseum consists of three superimposed arched storeys, topped by an ▷attic. Each storey is faced with a Classical order, used purely decoratively. From the bottom storey they are: ▷Tuscan, ▷Ionic and then ▷Corinthian half-columns, with Corinthian pilasters for the attic – the

The Colosseum, Rome, c1880

ascending arrangement of half-columns exerting a canonical influence on the designs of ▷Renaissance architects.

colour

Each surface absorbs certain portions of light and reflects others. The light that it reflects is perceived as its colour. The most important colours are usually shown on a circle. These include ▷primary colours (red, yellow, blue) and ▷secondary colours (orange, green and violet). Colour has obviously been very important for painters throughout the history of art, but it became a subject of psychological study in the 19th century. Subsequently, artists such as the ▷Impressionists and ▷Expressionists developed theories about the relationship between colours and certain emotional or spiritual properties. Colour has also been important to sculpture at various points in its history.

 ▷polychromy; Poussinistes versus Rubenistes

Bib.: Gage, J., *Colour and Culture: Practice and Meaning from Antiquity to Abstraction*, London, 1993

Colour Field Painting

A term first used in connection with ▷Abstract Expressionist art to distinguish the style of ▷Rothko, ▷Newman, ▷Still, etc., from ▷gestural painters like ▷Pollock. It also refers to the work of later abstractionists: the ▷hard-edge painting of ▷Reinhardt, ▷Stella and ▷Noland. It denotes the use of a large abstract canvas, without any point of focus or importance and without overlapping, where the key element of the work is colour rather than technique or subject.

Initially artists employed brushwork to explore movement, subtle depth and luminosity within the colour field, but increasingly even these variations were eliminated by the ▷Post-Painterly Abstractionists. As early as 1952 ▷Helen Frankenthaler was soaking canvases in tinned paint to avoid application by brush. The artists use strict colour combinations, either of limited tonal range, or of equal intensity to create a lack of spatial tension and recession.

Bib.: Auping, M., *Abstract Expressionism*, London, 1987; Anfam, D., *Abstract Expressionism*, London, 1990; Shapiro, D. and C., *Abstract Expressionism*, Cambridge, 1990

Colquhoun, Robert (1914–62)

British painter. He studied at the Glasgow School of Art 1932–7, where he became influenced by ▷Cubism. With his life-long companion ▷Robert MacBryde, he adopted a ▷Neo-Romantic style of art during the 1940s. They established a studio together in London and formed a circle of painters around them. When evicted from their studio in 1947, they lived in Sussex and Essex and took commissions for theatre designs.

column

In architecture, a vertical member of circular section. Generally, it consists of three parts: a ▷base, a ▷shaft and a ▷capital. The shaft may be monolithic or built up from circular ▷drums. Principally, columns are employed to support ▷lintels or ▷arches, but may also stand independently as monuments (e.g. Column of Trajan, AD 113, Rome). Columns were first used

in a major functional way by the ancient Egyptians, who by the Third Dynasty (2686–2613 BC) were employing tapered and fluted shafts with a variety of different capitals. But it was the architects of Classical Greece who made refinements and set standards which were to persist into modern times. By c700 BC Greek architects had already begun to employ the characteristic ▷entasis, the swelling of the column shaft. Greek architects developed three modes: ▷Doric, ▷Ionic and ▷Corinthian, in each of which strict proportional relations were imposed upon the component parts of the column, and upon the entire column and the other principal parts of the building. Roman architects adopted, but also developed, Greek architectural practice, the principal Roman technical innovation being to employ columns to support arches. To the three Greek modes, they added the ▷Tuscan and the ▷Composite. They also exploited – to great decorative effect – attached, or engaged, columns, that is, columns sunk partially into the wall. Attached columns had previously been employed by the Mesopotamians in the Temple of Erech (c.3000 BC, on the banks of the River Euphrathes, in present day Iraq), but it was the Romans who most fully exploited their sculptural (i.e. non-functional) potential (e.g. on the ▷Colosseum, AD 75, Rome). Thus the full range of uses had been established by the end of the Classical period, all future developments being stylistic adaptions.

Varieties of column include the blocked column in which circular drums alternate with rectangular blocks, and the Solomonic (also known in Spanish as a ▷*salomónica*) barley-sugar, or twisted column, in which the shaft is spirally fluted. This latter was widely used in Baroque architecture (e.g. ▷Bernini's ▷Baldacchino in St. Peter's, Rome). An attached column sunk to half or just under half its diameter into a wall may be more specifically referred to as a half- or quarter-column. Columns are also sometimes coupled, that is arranged in a row in linked pairs.

combine painting

Painting that includes real objects. It is similar to ▷collage, but the objects used are often larger and more complete (unlike collage, which uses cut-out and abstract patterns). The term is applied primarily to the art of ▷Robert Rauschenberg, particularly his work of the 1950s.

commercial art

Art associated with advertising and industry. It is intended to be a pragmatic art that responds to the particular needs of an organization, rather than a fine art that is a reflection of an artist's 'genius'. It is one of the few steady jobs for trained artists, and many students in art schools now train to be commercial artists.

Communion

▷Seven Sacraments

complementary colour

A colour that reflects the wavelengths of its opposite colour. If two ▷primary colours are mixed together, the resulting colour is complementary of the third primary colour. Thus red and green (the mix of yellow and blue) are complementary, as are yellow and violet (the mix of blue and red), and blue and orange (the mix of red and yellow).

▷secondary colour

composite photography

An early photographic method invented by the professional photographer Oscar Rejlander and practised by Henry Peach Robinson in the 19th century. It involved taking a series of pictures and then combining their negatives into a coherent image. It was primarily used for early photographic images which were intended to parrot contemporary ▷genre painting. It was easier for the photographer to stage individual elements of his scene separately, rather than attempt to capture the entire scene in one shot.

composition

The arrangement of elements in a painting. Originally, the term referred to language and was important in treatises on rhetoric in the ancient world and the ▷Renaissance. With the growth of art ▷academies, the need to form theories of art led artists to look to these ideas of language as a basis for their art. Composition was thus appropriated as an artistic term.

Conca, Sebastiano (1680–1764)

Italian painter. He specialized in decorative ceiling schemes, ▷altarpieces and portraits. Born near Naples, he trained under ▷Solimena in the High ▷Baroque tradition before moving in 1706 to Rome, where he rapidly gained a great reputation as both an artist and a teacher. With his elegant decorative style he became one of the leading practitioners of Roman ▷Rococo in the first half of the 18th century. Many of the churches of Rome contain altarpieces by Conca, but perhaps his most important Roman work is the ceiling fresco of *The Crowning of St. Cecilia* (1725, St. Cecilia in Trastevere). In 1751, he was recalled to Naples to decorate the church of Sta Chiara (totally destroyed in World War Two) and remained there for the rest of his life. His most important pupil was ▷Pompeo Batoni.
Bib.: *Sebastiano Conca 1680–1764*, exh. cat., Gaeta, 1981

Conceptual art

A type of art that burgeoned in the 1960s. The term covers a wide variety of art practices but it generally involves works of art which deliberately draw attention to the processes of artistic creation. In Conceptual art,

the final art object is usually irrelevant, and artists use it as a means of attacking the commercialization of easel-painting and other forms of gallery art. Conceptual art has also privileged the ideas of artists, as conception is more important to it than perception, and the creative processes of the artists have been seen to be all-important. Conceptual art takes many forms: the written word, the photograph or the video. Among its practitioners are ▷Sol LeWitt, ▷Joseph Kosuth and ▷Bruce Naumann.

Bib.: Meyer, U., *Conceptual Art*, New York, 1972

concrete art

A term used broadly to refer to non-descriptive abstract art and specifically to refer to the work of ▷Max Bill. In the former definition, concrete art encompasses ▷Constructivism, ▷Suprematism, ▷Neo-Plasticism and other forms of ▷non-objective art. The term was first used by ▷Theo van Doesberg in 1930 in his manifesto *Art Concret*. Here he claimed that the work of art was opposed to nature and was concerned only with 'pure plastic elements'. In 1936 Max Bill began organizing exhibitions of concrete art in Switzerland, and the movement soon became international.

▷Cold Art

Bib.: *Konkrete Kunst. 50 Jahre Entwicklung*, exh. cat., Zurich, 1960

Condivi, Ascanio (d 1574)

Italian painter. He is not known for his own works but for his *Life of Michelangelo* (1553), an apologia for ▷Michelangelo's career written in the wake of ▷Vasari's *Lives of the Artists*.

Confirmation

▷Seven Sacraments

Congrès internationaux d'architecture moderne

▷CIAM

Conixloo, Gillis van (1544–1607)

Flemish painter. He was one of a family of artists. He was born in Antwerp and worked in Frankenthal from 1587 where he painted landscapes. In 1595 he worked in Amsterdam producing panoramic landscapes with biblical subject-matter.

connoisseurship

Term coined by ▷Bernard Berenson to describe the ability to deduce simply from a work of art alone its period, aesthetic merit and possible relationship with other works. Berenson suggested that it was possible to make deductions about a work and its creator without consulting external supporting evidence.

conservation

The practice of attempting to keep a work of art in its original condition. Modern conservators tend to use non-interventionist methods, like X-ray, ultra-violet and infra-red photography to assess the condition of a work, and then attempt to preserve the work using delicate and painstaking techniques. In previous centuries there was a tendency to confuse conservation with restoration, and conservators used more drastic measures, like repainting, stripping and remounting fragile pieces on new backings.

console

▷bracket

Constable, John (1776–1837)

English painter. He was born at East Bergholt in Suffolk, the son of a well-to-do agricultural family. He studied in London from 1795 and at the ▷Royal Academy Schools in 1799, but he was most influenced not by other artists but by his own work, copying from ▷Girtin and 17th-century Dutch artists, and sketching from nature. He rejected conventionally ▷picturesque landscape, preferring to study that which he had grown up with (e.g. *Dedham Vale*, 1802, London, Victoria and Albert Museum), in a series of ▷plein air oils sketches which captured changing weather and times of day. After his marriage in 1816, and his subsequent move to London (e.g. *Hampstead Branch Hill Pond*, 1828, Cleveland), he developed many of these sketches into cloud studies, employing a systematic and almost scientific technique (perhaps influenced by works like Howard's *Climate of London*, 1818). He also began to

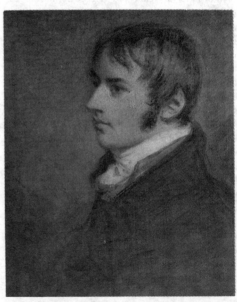

Daniel Gardner, *John Constable, RA, aged twenty*, 1796, Victoria and Albert Museum, London

work on six-foot landscapes, increasingly idealizing his memories of Suffolk for the RA (e.g. *The Haywain*, 1821, London, National Gallery). He never left England but travelled to Salisbury and Brighton, sketching there also (e.g. *Salisbury Cathedral from the Meadows*, 1831, London, National Gallery). He gained recognition only slowly, and was elected RA in 1829 by one vote. After his wife's death he retreated into the past even more, creating idyllic scenes of an agricultural golden age. His work became ever freer in his attempt to achieve natural life and movement, using ▷impasto and white highlights, together with tempestuous skies. In his later career he increasingly experimented with ▷watercolours (e.g. *Old Sarum*, 1834, London, Victoria and Albert Museum).
Bib.: *Constable*, exh. cat., London, 1973; *Constable and the Art of Nature*, exh. cat., 1971; Rosenthal, M., *Constable: Man and his Art*, New Haven and London, 1983

Constructivism

A term often used loosely and inaccurately. Specifically it refers to a type of abstract sculpture originating in Russia shortly after the revolution of 1917. Strictly speaking, Constructivism was invented by ▷Antoine Pevsner and Naum Pevsner (▷Gabo), whose *Realist Manifesto* of 1920 insisted on the separation of art from any political or social purpose. It was thus a form of ▷'art for art's sake' which concentrated on the importance of raw materials such as wood, glass and wire. Gabo and Pevsner carried their Constructivist ideas to other parts of Europe in 1922, when the style was condemned by the Soviet regime as a bourgeois form of art.

However, the term 'Constructivism' is often also used to refer to a type of art practised by Gabo and Pevsner's ideological rivals in Russia. The ▷assemblages produced by ▷Tatlin from c1913 used raw materials in an abstract way, and Tatlin carried this ▷'culture of materials' philosophy into his post-revolutionary constructions. However, unlike Gabo and Pevsner, Tatlin's constructions were always intended to have a social purpose. He was vehemently anti-bourgeois and saw easel-painting and pure sculpture as irrelevant to the Communist regime. His followers, such as ▷Rodchenko and ▷Popova, also produced theatre designs and useful objects in a style that has been deemed 'Constructivist', although ▷'Productivism' is strictly the more appropriate term for their practice.
Bib.: Bann, S. (ed.), *The Tradition of Constructivism*, London, 1974; Kopp, A., *Constructivist Architecture in the USSR*, London, 1985; Lodder, C., *Russian Constructivism*, New Haven, 1993

consular diptych

A small pair of ivory ▷reliefs produced throughout the Roman empire from the 4th to the 6th centuries AD. Consular diptychs are carved with portraits of Roman consuls and can be open and shut.
▷diptych

Conté crayon

A non-greasy crayon. The name comes from the French scientist who invented it, Nicolas-Jacques Conté (1755–1805).

Contemporary Art Society

An Australian exhibition society that was founded in Melbourne in 1939 but soon had branches throughout Australia. The Society was reacting against the foundation of the Australian Academy of Art which was seen to inculcate moribund ▷academic values to the detriment of ▷avant-garde experiment. Members of the Contemporary Art Society did not adhere to one style, and their diverse productions included everything from ▷Constructivism to ▷Social Realism. They held their first exhibition in 1939 at the National Gallery of Victoria.

continuous narrative

A pictorial narrative device involving the representation of successive episodes from the same story within a single picture and against a unified background. In continuous narrative characters will be repeated and must therefore be immediately recognizable. For example in ▷Masaccio's ▷fresco of *The Tribute Money* (Brancacci Chapel, Sta Maria del Carmine, Florence, c1425–8), St. Peter, stockily built with short white hair and beard and dressed in his traditional golden yellow mantle and blue tunic, is, in the centre of the picture, instructed by Christ to go to the lake and pull out a fish in whose mouth will be found the tribute money demanded by the tax collector; in the middle distance on the left Peter can be seen taking the coin from the fish's mouth and then again on the right paying the tax collector who is recognizably the duplicate of the figure importuning Christ in the central group. Continuous narrative was used in ancient art (e.g. on Roman ▷sarcophagi), and is particularly common in European art during the Middle Ages and early ▷Renaissance (e.g. in ▷Botticelli's frescos for the walls of the ▷Sistine Chapel, Rome, 1481–2). A late example is ▷Pontormo's *Life of Joseph* (c1515, London, National Gallery). Continuous narrative is also sometimes known as continuous representation.

contrapposto

(Italian, 'opposite', 'opposing'.) In a sculpture or painting, the arrangement of the parts of the body in balanced, but opposing, oblique axes to imbue the figure with a relaxed asymmetry: for example the weight may be borne chiefly on the vertical right leg with the relaxed left leg flexed at the knee, with the consequence of that the right hip juts out and is placed slightly higher than the left; the axis of the hips is in turn

balanced by the opposing axis of the shoulders, that is, the left shoulder will be slightly higher than the right. The vertical axis of the body is thus relaxed to a subtle 'S' curve. Additionally the upper part of the body will twist slightly forward at the shoulders on the relaxed (left) side and be balanced by the forward projection of the hips on the tensed lower (right) side of the body (e.g. the *Belvedere Antinous*, Rome, Musei Vaticani). This device was first used by the sculptors of ▷Classical Greece to solve the problem of stiffness inherent in the rigid symmetry of ▷Archaic statues. The ▷Mannerist artists of the 16th century took the use of contrapposto to an exaggerated extreme (e.g. ▷Giambologna, *Apollo*, bronze statuette, 1573, Florence, Palazzo Vecchio).

conversation piece

A portrait of two or more individuals who may be friends or members of the same family. Conversation pieces are usually small and are intended to represent informal events, such as tea-drinking or picnicking. They were popular in England from 1730, but they began to fall out of fashion by 1770, although there are examples dating to the end of the century. Their putative informality gives them a theatrical quality, and their use of a narrative event relates them to Dutch ▷genre painting, which may have been one of the formulative influences on their development. The principal producers of conversation pieces included ▷Hogarth, ▷Zoffany, ▷Devis and ▷Hayman. They were popular among both aristocracy and royalty, and the bourgeoisie. The genre continued, but infrequently, into the 19th century (e.g. ▷Orpen, *Homage to Manet*, 1909, Manchester).

Bib.: D'Oench, E., *The Conversation Piece: Arthur Devis and his Contemporaries*, New Haven, 1980; *Polite Society by Arthur Devis 1712–1787: Portraits of the English Country Gentleman and his Family*, exh. cat., Preston, 1983; Praz, M., *Conversation Pieces: A Survey of the Informal Group Portrait in Europe and America*, London, 1971; West, S., 'The Public Nature of Private Life: The Conversation Piece and the Fragmented Family', *British Journal for Eighteenth Century Studies*, 18 (1995), pp. 153–72; Williamson, G.C., *English Conversation Pictures of the Eighteenth and Nineteenth Centuries*, New York, 1975

cool art

A term applied to ▷Minimalist ▷serial art of 1965 and after. The term signifies an art which is impersonal, but it could be either abstract or figurative (in the case of some ▷Pop art). Its main practitioner was Irving Sandler.

cool colour

Blues, greens and violets. They are opposed to ▷warm colours and they tend to create recessive effects on the canvas.

Cooper, Samuel (before 1609–after 1660)

English miniaturist. He studied with his uncle, John Hoskins, and began practising miniature painting from c1642. His works could be called ▷Baroque in their emphasis on lighting. He worked for both Cromwell and Charles II.

Bib.: Foskett, D., *Samuel Cooper 1609–1672*, London, 1974; idem., *Samuel Cooper and his Contemporaries*, London, 1974

Coorte, Adriaen (fl 1683–1707)

Dutch painter. He produced mainly small still lifes.

Copley, John Singleton (1738–1815)

American painter. He was born in Boston, of Irish immigrant parents. He was largely self-taught, and gained a knowledge of European art through his stepfather (▷Pelham), a painter and engraver. He made his name with a series of powerful portraits of Boston society (e.g. *Mrs. Thomas Boylston*, 1766, Harvard), characterized by their informal settings, crisp line and subtle modelling, which were exhibited in London at the Society of Artists from 1766, where they were praised by ▷Reynolds and ▷West. He initially rejected a journey to Europe, satisfied by the financial rewards in Boston, but finally arrived in 1774, as a result of the War of Independence. He spent some time in Italy, absorbing Classical and ▷Renaissance art before settling in London in 1775. There he developed a new style of portraiture, with an increased elegance more suited to the London market (e.g. *The Three Princesses*, 1785, Windsor Castle) and, more importantly, developed a radical line in ▷history painting, first seen in ▷*Brook Watson and the Shark* (1778, Boston, Museum of Fine Arts), a privately commissioned bizarre piece which combined realistic emotion with evidence of ▷antique and ▷Renaissance inspiration. It established Copley as a purveyor of contemporary history, rivalling West, but with a keener eye for drama and figure composition (e.g. *The Death of Major Pierson*, 1783, London, Tate). He was especially successful at multi-figure compositions (e.g. *Charles I Demanding the Surrender of the Five Impeached MP's*, 1785, Cambridge, MA, Fogg Art Museum). Although he was elected ▷RA in 1779, he preferred to exhibit his work privately, charging a shilling to see the *Death of Chatham* (London, Tate) in 1781 and making considerable gains from his sales of ▷engravings. His later work became increasingly ▷Romantic in its concentration on horror (e.g. *Relief of Gibraltar*, 1791, London, Guildhall), and he eventually fell from favour, ending his life in debt-ridden obscurity, although his son did rise to the position of Lord Chancellor.

Bib.: Neff, E., *John Singleton Copley in England*, London, 1995; Prown, J.D., *John Singleton Copley*, Cambridge, MA, 1966

Coppo di Marcovaldo (fl 1250–75)

Italian painter. He was from Florence, where he was conscripted into the army and was captured by the Sienese at the Battle of Montaperti in 1260. He stayed in Siena for some time after and in 1261 painted the *Madonna and Child Enthroned* (*Madonna del Bordone*) for the church of Sta Maria dei Servi (although the faces of the figures were later repainted, c1300, in the new ▷Duccio-inspired idiom). His next recorded work is the painted Crucifix for Pistoia Cathedral in 1274 (executed in collaboration with his son, Salerno). These documented works form the basis for the attribution to him of two other works of high quality: a *Madonna and Child Enthroned* in Sta Maria dei Servi, Orvieto, and a painted Crucifix in the Pinacoteca, San Gimignano. In addition, the ▷mosaic of hell in the baptistery at Florence has been attributed to him. Although rooted in the conventional representational formulas of the ▷Byzantine tradition, there is a new sense of monumentality, a more convincing spatial treatment and an increased humanity in the treatment of the figures. Coppo's development in this direction seems to run parallel with that of his most important Sienese contemporary, ▷Guido da Siena, and it is now generally believed that the two exercised a mutual influence on each other.

Bib.: Corrie, R.W., 'The Political Meanings of Coppo di Marcovaldo's *Madonna and Child* in Siena', *Gesta*, 29, no.1 (1990), pp. 61–75

Coptic art

The art of the native Christians of Egypt, particularly in the 3rd to 8th centuries. The Copts are native Egyptian Christians and the term Copt has been applied mainly to the poorer classes, although it seems likely that Coptic art was accessible to all classes. Christianity came to Egypt with the Greeks in the 4th century and spread from Alexandria to many parts of the rural community. At the Council of Chalcedon (AD 451) the Egyptian Christians formed a distinctive and separate church, following a creed of Single Nature closely aligned with the Monophysite church. These alliances can be discerned in Coptic art, which retains a certain rustic quality – bright, flat colours and stumpy proportions, symbols derived from ancient Egyptian beliefs combined with Christian signs and crowded, sometimes clumsy designs – though Coptic art itself marries these simpler elements with more sophisticated borrowings from Syria and the near east, including ▷acanthus and vine scrolls.

Coptic art was executed in four main media – wall-painting, textiles, stone and ivory carvings and manuscript illumination. Little survives of Coptic wall-painting and many Coptic textiles have proved to be much later than was previously thought. (For example, one textile was demonstrated to have been made in 19th-century Paris rather than 6th-century Egypt.) However, Coptic carvings have survived and many are now preserved in the Coptic museum, Cairo. They show naive, geometric treatment of the soft stone or bone and bear parallels to wood-carving techniques. From the 8th to the 12th century Egypt was under Arab control and Coptic art all but vanished. In 1169, at the victory of Saladin, the Copts became segregated from the Muslims and in many cases benefited from this by increasing mercantile links with other Christian countries in Europe. Coptic art therefore enjoyed a resurgence, and ▷icons and panel paintings like the ▷iconostasis at El Moallaka were produced. Motifs from this time can be traced to ▷Byzantine, Venetian and Genovese influences. The influence of Coptic art has often been underestimated and it is possible that it had an effect on the production of work as far afield as Spain and Ireland.

Bib.: Badawy, A., *Coptic Art and Archaeology*, Cambridge, MA, 1978

copy

A duplicate of an image, hand made by a different person or people from the artist(s) who made the original work. Although copies may ape the original in every way, their artistic value has been questioned and they have little commercial worth.

Coques, Gonzales (1618–84)

Flemish painter. He was called 'little van Dyck' because of his skill with portrait painting and its superficial similarity to the work of ▷van Dyck. He worked in Antwerp and also produced ▷genre paintings.

corbel

▷bracket

corbel-ring

▷annulet

Corinth, Lovis (1858–1925)

German painter. He studied at the Königsberg Academy (1876–80) and at the ▷Académie Julian in Paris (1884–7) with ▷Bouguereau. Throughout his life he retained the subject-matter characteristic of his academic training, specifically nudes and mythological subjects. However, his style evolved towards a form of ▷Impressionism which he shared with his contemporary ▷Liebermann. The free brushwork and ▷*plein air* style contrasted with his academic nudes and conventional portraiture. He exhibited with the Munich and Berlin ▷Secessions. In 1911 a stroke impaired his ability to work, and his style changed to a more violent ▷Expressionism, which he used especially for landscape paintings.

Bib.: Felix, Z. (ed.), *Lovis Corinth 1858–1925*, exh. cat., Cologne, 1985; Uhr, H., *Lovis Corinth*, Berkeley, 1990

Corinthian order

In Classical architecture, the third of the Greek ▷orders of architecture. It was invented by Athenian architects in the 5th century BC and later developed by the Romans. The Greeks invented a unique ▷capital with a bell shape, ▷acanthus leaves and ▷volutes, but the column and ▷entablature were still essentially ▷Ionic. Significantly, the earliest surviving example is a single column, deliberately isolated, within the Temple of Apollo at Bassae (400 BC). It is centrally placed on one of the short sides in an otherwise Ionic colonnade. The story of the invention of the Corinthian capital is related by the Roman architect and theorist, Vitruvius. Whether true or not, the charming story gives a vivid description of the appearance of the

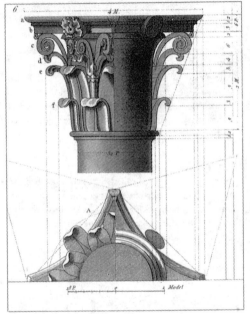

Dissection of a Corinthian capital

capital: a young girl 'just of marriageable age' had succumbed to a fatal illness. Her nurse gathered together some of her favourite trinkets and put them in a basket which she placed on the grave. She then covered the basket with a roof tile as some protection against the elements. But she had unknowingly placed the basket over an acanthus root which the following spring began to sprout, sending its shoots up the sides of the basket to furl back and outwards when they met with the tile. It was this that ▷Callimachus, the Athenian architect, saw by chance as he passed and which formed the basis of his design for the capital of his new order. Also, the Corinthian capital being taller than the Ionic, the overall height of the column is effectively increased, thus giving a more elegant appearance in keeping with its mythical associations with the young Athenian girl. It was the Romans who fully developed the Corinthian ▷entablature with its

distinctive and more elaborate ▷cornice and it was this Roman model that became the prototype for architects in the ▷Renaissance and after.

Cormon, Fernand (Fernand-Anne Piestre) (1845–1924)

French painter. He produced decorative art and portrait painting and was a teacher of ▷Matisse and ▷van Gogh.

Corneille de Lyons (fl 1533–74)

Dutch painter. He worked mainly in Lyon. In 1540 he became painter to the Dauphin (later Henry II), for whom he produced small delicate portraits. Because he was from The Hague, he was often referred to as 'Corneille de La Haye'.

Cornelis van Haarlem (Cornelisz Cornelis) (1562–1638)

Dutch painter. He produced portraits and ▷history paintings in a ▷Mannerist style. He spent some time in France but was working in Haarlem from 1583. With ▷Goltzius and ▷Van Mander, he was one of the founder members of the Haarlem Academy.

Cornelisz. van Oostsanen, Jakob (c1470–1533)

Dutch painter and designer of woodcuts. He worked in Amsterdam where he produced ▷woodcuts of religious subjects. He taught ▷Scorel.

Cornelius, Peter von (1783–1867)

German painter. He trained at the Düsseldorf Academy and travelled to Rome in 1811, where he became a founding member of the ▷Nazarenes. In 1819 he was called to Munich by Crown Prince Ludwig of Bavaria, and there he received a number of large-scale decorative commissions, such as his *Last Judgement* ▷fresco for the Ludwigskirche (1836–9). He made an important contribution to the revival of fresco technique in Germany. He also worked for Frederick William IV of Prussia.

Cornell, Joseph (1903–72)

American sculptor. His works are distinctive and coherent, consisting primarily of a series of ▷assemblages in boxes. He filled his boxes with objects which carried particular resonances and meanings. Although his methods related to the previous work of ▷Schwitters and ▷Surrealist artists, Cornell's images were more geared to nostalgia than to unconscious or hidden sexual forces.

Bib.: Cornell, J., *Joseph Cornell's Theatre of the Mind: Selected Diaries, Letters and Files*, New York, 1993

cornice
In Classical architecture, the highest of the three principal horizontal members of an ▷entablature. Also, any moulded projection which crowns or finishes a ▷pedestal, ▷arch, or exterior wall, or an ornamental moulding which masks the join of an interior wall and ceiling. The two sloping sides of a ▷pediment are called raking cornices.

corona
▷cantilever

Coronation of the Virgin
Although entirely unscriptural, this subject is one of the most popular in Christian art and was chronicled by Jacobus de Voragine in his *The Golden Legend*. It shows ▷the Virgin Mary not only as the human mother of God, but also as Queen of Heaven. The Coronation may appear as the consummating scene in a cycle of the life of the Virgin or, in a church dedicated to the Virgin, as either the subject of the high ▷altarpiece (e.g. Bernardino Fungai, 1500, Sta Maria dei Servi, Siena), or the semi-dome of the apse (e.g. ▷Jacopo Torriti, c1296, Santa Maria Maggiore, Rome). Most usually ▷Christ is depicted enthroned next to his mother, placing the crown upon her head, although sometimes the complete ▷Trinity is present, with the dove of the ▷Holy Ghost hovering over a kneeling Mary and the Father and Son on either side of her in the act of placing the crown upon her head (e.g. ▷Johann Rottenhammer, c1596; London, National Gallery). The heavenly surroundings are often filled with rank upon rank of angels and saints. Sometimes in the bottom part of the picture is depicted the earthly realm with the ▷Apostles around her empty tomb (e.g. ▷Raphael, *Coronation of the Virgin*, c1503, Rome, Vatican Museum). The subject became more prevalent from the 13th century with the rise of Marianism, but was eventually superseded in the 17th century by the portrayal of Mary as the ▷Immaculate Conception.

Corot, Jean-Baptiste-Camille (1796–1875)
French painter. He was the son of a businessman, trained in the Classical tradition of ▷Poussin by Achille-Etna Michallon, after initially embarking on a commercial career in preference to art. In 1825–7 he made the first of many trips to Italy, recording the landscape in free sketches which he later worked into sunlit, strongly delineated and richly toned architectural landscapes (e.g. *Roman Campagna with Claudean Aqueduct*, 1826, London, National Gallery). These works retained a ▷classicism, which generated contemporary Salon success, but wedded it to a spontaneity and feeling for nature which later appealed to ▷Cézanne. He also sketched throughout France (e.g. *Forest of Fontainebleau*, 1831, Washington, DC,

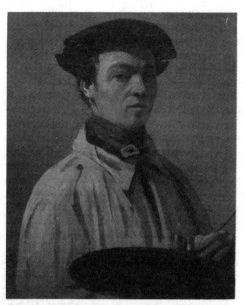

Jean-Baptiste-Camille Corot, *Self-portrait*, Uffizi Gallery, Florence

National Gallery) and produced historical subjects (e.g. *Hagar in the Desert*, 1835, New York, Metropolitan Museum). Around 1850, his style changed to a greater emphasis on brushwork and a paler silvery palette. For the rest of his career, he produced these feathery evocations of the French countryside, sometimes peopled by nymphs, sometimes by contemporary peasants. The visible brushwork and light airiness seemed to prefigure ▷Impressionism but Corot's naturalism was always tempered by imagination and poetry. He also increasingly produced portraits and studies of women, in seductive shadowy tones which emphasized surface and texture (e.g. *Woman with a Pearl*, 1868–70, Paris, Louvre). Corot lived in Paris throughout his career but spent much time travelling throughout France and Europe. He was a great supporter of artists, especially those of the younger generation.
Bib.: *Jean-Baptiste Corot*, exh. cat., Chicago, 1960; *Jean-Baptiste Corot*, exh. cat., Manchester, 1991

Correggio (Antonio Allegri) (c1489–1534)
Italian artist. Born in the small town in Emilia from which he gets his popular name, he worked for most of his life in and around nearby Parma. It is not known from whom he received his training, although the early influence of ▷Mantegna and ▷Costa suggests at least a visit to Mantua. The hard, linear manner derived from these two painters was softened by his next major influence, ▷Leonardo da Vinci, whose ▷sfumato oil painting technique Correggio adopted and employed with great subtlety. The pointing figure of St. John the Baptist in Correggio's earliest documented work, the *Madonna of St. Francis* (1514, Dresden, Gemäldegalerie)

is clearly adapted from a Leonardoesque prototype. In his earliest known dome ▷ fresco, that of the Camera di S. Paolo, Parma (c1518), Correggio employs a unifying trellis motif and dramatically bold ▷ foreshortening to give a ▷ *sotto in sù* effect, reflecting a knowledge of Mantegna's work in Mantua for the ▷ Gonzaga (cf. respectively Mantegna's *Madonna della Vittoria*, oil on canvas, now Paris, Louvre; and the ceiling frescos of the Camera degli Sposi). However by the time of Correggio's frescos of the *Vision of St. John* (1520, cupola, S. Giovanni Evangelista, Parma) and his larger *Assumption of the Virgin* (1526–30, dome, Parma Cathedral), his portrayal of emotionally interacting, floating or flying figures is painted with even more daring illusionism. This later style was extremely influential on later ▷ Baroque painters such as ▷ Lanfranco, who was also active in Parma. Although there is no evidence that Correggio ever visited Rome (and ▷ Vasari states that he did not), his more monumental post-1520 figure style and his increasingly subtle aerial effects nonetheless strongly suggest contact with ▷ Michelangelo's frescos for the ▷ Sistine Ceiling (1508–12) and ▷ Raphael's Stanza della Segnatura (1511–14) (although copies of these works were widely available in engravings and drawings). Correggio is also famous for his series of oil paintings on erotic mythological subjects, the sensual appeal of which is intensified by his consummate ability as a painter of flesh. Most of these were painted for the Gonzaga court (e.g. *Venus, Satyr and Cupid*, Paris, Louvre; and *Mercury Instructing Cupid Before Venus*, 1523–8, London, National Gallery). A number of these paintings, for Federigo Gonzaga, were commissioned as a series of the *Loves of Jupiter* (c1531) (e.g. *Danaë*, Rome, Galleria Borghese; *Leda*, Berlin, Staatliche Museen; *Io* and *Ganymede*, both Vienna, Kunsthistorisches Museum).

Bib.: *The Age of Correggio and the Carracci: Emilian Painting of the Sixteenth and Seventeenth Centuries*, Washington, DC, exh. cat., 1986; Bottari, S., *Il Correggio*, Novara, 1990; Brown, D.A., *The Young Correggio and his Leonardesque Sources*, New York, 1981; Giampaolo, M. di, *Correggio: catalogo completo dei dipinti*, Florence, 1993; Gould, C., *The Paintings of Correggio*, London, 1976

Corrente

A group of Italian artists opposed to Fascism. It was formed in 1938 by ▷ Guttuso, Mario Mafai (1902–65) and Afro (1912–72). They reacted to the traditionalist classicism of the ▷ Novecento group and favoured ▷ modernist styles. They launched regular exhibitions and had their own journal.

Cortona, Pietro da (Pietro Berrettini)

▷ Pietro da Cortona (Pietro Berrettini)

Cosmati work

A form of geometric decoration employed on marble pavements, pulpits, tombs and other church furnishings, comprising inlays of coloured stones, glass, gilding and ▷ mosaic, combined with strips of white marble. Cosmati work was a Roman specialism and is found mainly in church interiors in Rome and Naples between c1100 and c1300. Such decorators are generically known as Cosmati workers owing to the fact that among the families specializing in the technique the name Cosma recurs several times.

Bib.: Hutton, E., *The Cosmati*, London, 1951

Cossa, Francesco del (fl 1456–d c1477)

Italian painter. He worked mostly in Ferrara. He is first recorded in Ferrara in 1456, but may have been trained in Florence, his style showing similarities to that of ▷ Andrea del Castagno (e.g. *St. John the Baptist*, 1473, Milan, Brera). Overlaying this is the influence of ▷ Mantegna, also visible in the *St. John* panel. ▷ Cosimo Tura, Cossa's more famous Ferrarese contemporary, was another influence, but Cossa's work has none of Tura's extreme emotionalism. Cossa's more urbane style obviously appealed to the ▷ d'Este court and his most important work was for the ▷ fresco cycle *The Months* (painted in collaboration with ▷ Ercole de' Roberti, c1470) in the Palazzo Schifanoia of Duke Borso d'Este. He was apparently dissatisfied with his payment for this work and precipitately left for Bologna where he remained for the rest of his life.

▷ Ferrara, School of

Bib.: Bacchi, A., *Francesco del Cossa*, Soncino, 1991; Manca, J., 'A Ferrarese Painter of the Quattrocentro', *Gazette des Beaux-Arts*, 6, no. 116 (Nov 1990), pp. 157–72

Costa, Lorenzo (c1460–1535)

Italian painter. He trained in Ferrara, but is recorded in Bologna by 1483, working for the Bentivoglio Court in partnership with the painter ▷ Francesco Francia. From Ferrara he brought with him a style which had assimilated the influences of the leading Ferrarese masters ▷ Tura, ▷ Cossa and ▷ Roberti, along with a knowledge of Netherlandish painting. In 1504–5 he painted two allegories for Isabella ▷ d'Este (now Paris, Louvre) and in 1506 was appointed court painter to her and her husband, ▷ Francesco Gonzaga, at Mantua, succeeding ▷ Mantegna. A portrait *Young Woman with a Lap Dog* (c1500, Royal Collection), suggests both a familiarity with Flemish portraits and also the other important strand of influence in his work, that of ▷ Perugino. Costa's art has been proposed as an important non-Venetian influence on ▷ Giorgione's early artistic development, notably his Perugino-derived landscapes and somewhat languidly graceful figure types.

▷ Ferrara, School of

Bib.: Brown, C.M., *Lorenzo Costa*, 2 vols., Ann Arbor, 1992

Cosway, Maria (1759–1838)

English painter. She was born in Florence and retained a cosmopolitan image throughout her life. She married ▷Richard Cosway and the two of them formed an important base for high society in London during the latter part of the 18th century and the first part of the 19th century. She produced portraits and historical themes in the manner of ▷Angelica Kauffman. When Richard died in 1821, she returned to Italy.

Bib.: Lloyd, S., *Richard and Maria Cosway*, exh. cat., London, 1995

Cosway, Richard (1742–1821)

English miniaturist. He studied first under ▷Hudson, then he trained at the ▷Royal Academy schools and became a Royal Academician in 1771. He was painter to the Prince of Wales from the 1780s. He is remembered less for his rather timid miniature portraits than for his social posing. He was married to ▷Maria Cosway.

Bib.: Lloyd, S., *Richard and Maria Cosway*, exh. cat., London, 1995; Williamson, G., *Richard Cosway*, London, 1905

Cotes, Francis (1726–70)

English painter. He was trained by ▷Knapton and was a founder member of the ▷Royal Academy. His early portraits were in ▷pastel, but he gradually developed a grand portrait style which was similar to that of ▷Reynolds.

Bib.: Johnson, E.M., *Francis Cotes*, Oxford, 1976

Cotman, John Sell (1782–1842)

English painter and engraver. He was born into a Norwich merchant family. After working for Dr. Monro in London in 1798, he became the first Professor of Drawing at King's College, London. He was a friend of ▷Girtin and ▷Beckford and like many watercolourists of the day made regular ▷picturesque tours including Wales (1800), Yorkshire (1803–5) and France (1817–8), where he engraved plates for Dawson Turner's *Architectural Antiquities of Normandy*. In 1806 he settled in Norwich and he became a leading figure in the ▷Norwich School. His early watercolours were austere washes, which incorporated minimal colour and a simplified almost geometric structure (e.g. *Greta Bridge*, 1805, London, British Museum; *Mousehold Heath*, 1910, London, British Museum). He painted few oils (e.g. *Drop Gate*, 1810, London, Tate). By 1831 he was experimenting with a more elaborate textured style painted in watercolour on rice paper, but this was to prove less popular.

Bib.: Holcomb, A.M., *John Sell Cotman*, London, 1978; *John Sell Cotman*, exh. cat., London, 1982; Kitson, S.D., *John Sell Cotman*, London, 1937; idem., *Life of John Sell Cotman*, London, 1982; Oppé, A.P., *Water-colour Drawings of John Sell Cotman*, London, 1923

cottage orné

(French, 'decorated cottage'.) These were common in the late 18th and early 19th centuries. They generally formed part of large estates or landscape gardens in England, where they served as an ornament to the landscape. They were ▷picturesque flourishes, not designed to be lived in but designed to be seen from the outside. They were part of an upper class ▷Romanticism about the rural poor at the turn of the 18th century.

coulisse

(French, 'theatre wing'.) The term is strictly applied to side exits on a stage, but is also used as a means of explaining recession in landscape painting. ▷Perspective can be created on a stage by a series of flaps alternating from left to right, and the same sort of technique was used by landscape painters to lead the eye back to the distance.

▷repoussoir

Council of Trent

▷Baroque; ▷Counter-Reformation

counterproof

Reverse impression of a print made by transferring the ink of a drawing to damp paper. It is usually used as a way of checking the details of the drawing.

Counter-Reformation

The period soon after the Protestant Reformation in Europe when the Catholic Church attempted to regain its former authority. The Counter-Reformation strictly refers to a series of church reforms initiated by the Council of Trent held between 1560 and 1648. It had a significant impact on art. Art and architecture were commissioned to be striking and overwhelming and had the impact of propaganda. This was particularly the case in Rome, where the Baroque style became the stamp of Counter-Reformation ▷ideology.

Bib.: Davidson, N.S., *The Counter Reformation*, Oxford, 1987; De Maio, R., *Michelangelo e la controriforma*, Rome and Bari, 1978; Hilbrich, P., *The Aesthetic of the Counter Reformation and Religious Painting and Music in Bologna 1565–1615*, Ann Arbor, 1969; Johns, C., *Papal Art and Cultural Politics: Rome in the Age of Clement XI*, Cambridge, 1993

Courbet, Gustave (1819–77)

French painter. He was leader of the ▷Realist movement, born in Ornans, of a prosperous farming family. After studying at Besançon, he went to Paris in 1839 and for the next ten years studied with minor artists there and taught himself through copying in the

Louvre. His early works were mainly self-portraits in a variety of styles influenced by ▷Romanticism, by 17th-century Spanish art and by his own vanity. He came to prominence during the 1848 Revolution (in which he claimed to have fought) with his painting the ▷*Stonebreakers* (1849, destroyed), a harsh, ugly evocation of social injustice which suited the mood of the time. It was followed by a series of controversial, monumental images of contemporary life, notably the ▷*Burial at Ornans* (1850, Paris, Louvre) containing over 40 life-size figures of provincial petty bourgeois mourners. In 1855 he held his own one-man exhibition entitled *Le Réalisme* (a flop beside the *Universal Exposition*) which featured *The Artist's Studio* (Paris, Louvre), a large, self-indulgent and symbolically confusing work. He was friends with the socialist, Prudhon (whose portrait he painted, 1865–7, Paris, Musée d'Orsay) and died in exile for his part in the 1870 Commune. Towards the end of his life, he began to realize that his radical art was going nowhere and by the 1860s he had turned instead to landscapes, richly painted inspirations for ▷Whistler and the ▷Impressionists (e.g. *Woodland Scene at the Puits Noir*, 1865, Vienna, Kunsthistorisches Museum, Neue Galerie) and to exploitative nudes (e.g. *Sleep*, 1866, Paris, Petit Palais).

Bib.: Callen, A., *Gustave Courbet*, London, 1980; Fried, M., *Courbet's Realism*, Chicago, 1990

Courtauld Institute

Faculty of art history, part of the University of London, and gallery, founded in 1931. Bearing the name of its benefactor, the Institute was originally housed in Samuel Courtauld's house in Portman Square. As the collection expanded, the Institute was forced to divide the collection from the school due to lack of space, and the Courtauld Institute Galleries were transferred to Woburn Square in 1958, sharing a building with the ▷Warburg Institute. The school was reunited with its collection in 1989 when the Institute moved into the North Block of Somerset House in the Strand.

The Courtauld Gallery is most famous for its collection of ▷Impressionist and ▷Post-Impressionist paintings and drawings and the 'Prince's Gate' collection, though the collection ranges from 12th-century Limoges enamels to works by living artists. The academic institute has a prestigious reputation, having produced many of the art world's leading academics and curators.

Courtauld, Samuel (1876–1947)

Chairman of the textile manufacturers, Courtauld Ltd, and collector of ▷Impressionist and ▷Post-Impressionist paintings from 1922. He donated £100,000 ($180,000) to the foundation of a school to teach art history that now bears his name. After the death of his wife in 1931, he gave the lease of his house in Portman Square to the ▷Courtauld Institute, where it remained until 1989. He bequeathed his collection to the Courtauld at his death in 1947.

Bib.: House, J., *Impressionism for England, Samuel Courtauld as Patron and Collector*, London, 1994

Courtois (Cortese), Jacques (1621–75) and Guillaume (1628–79)

Italian family of painters. They are also known by their Italian name (Cortese) and as Il Borgognone. Jacques worked in Milan, and travelled to Bologna in 1638 where he saw works by ▷Reni. In Rome he was influenced by ▷Pietro da Cortona. In 1657 he joined the Jesuit order. Guillaume also worked in Rome and produced ▷engravings.

Cousin, Jean the Elder (c1490–1560/61)

French painter, engraver, and designer of stained-glass and tapestries. From 1526 he is recorded working in his native Sens and then from c1538 in Paris. Although highly successful in his lifetime, very little work can be confidently attributed to him. The design of two ▷stained-glass windows in Sens Cathedral of *Augustus and the Sibyl* (1530) and the *Life of St. Eutropius* (1536) are attributed to him, as is what is generally considered to be the first important female nude in French painting, the *Eva Prima Pandora* (Paris, Louvre). Presumed also to have been executed in Sens, it reveals the influence of ▷Rosso and ▷Leonardo. His only securely documented works are three tapestries of the life of St. Mammès (begun 1543) for Langres Cathedral (two are still in the Cathedral and a third is in a private collection). In 1560 he published a treatise on ▷perspective.

Coustou, Nicolas (1658–1733), Guillaume I (1677–1746) and Guillaume II (1716–77)

French family of sculptors. They adopted the style of ▷Coysevox, who trained his nephew Guillaume. Guillaume's brother Nicolas worked at Versailles, and Guillaume II also produced monumental work in France.

Couture, Thomas (1815–79)

French painter. He was born near Chantilly, the son of a shoemaker. In 1826 he went to Paris and entered the studio of ▷Gros (1830) and ▷Delaroche (1838). He won the ▷Prix de Rome at his second attempt (1839) and exhibited regularly at the ▷Salon from 1840. He set up a studio in 1847 and established himself as a leading teacher of art, with pupils including ▷Manet, ▷Puvis de Chavannes and ▷Fantin Latour. He was popular for his small-scale *commedia dell'arte* works, and pretty ▷genre scenes (e.g. *Duel after the Ball*, 1857, London, Wallace Collection; *Soap Bubbles*, 1859, New York, Metropolitan Museum), portrayed with bold tonal contrasts and loose brushwork. He

also attempted ▷history painting, most notably in the *Romans of the Decadence* (1847) and his unfinished government commission *Enrolment of the Volunteers in 1792* (1848–50, Springfield, MA). Increasingly, from 1867, he exhibited less and wrote on art.

Bib.: Boime, A., *Thomas Couture and the Eclectic Vision*, New Haven and London, 1980; *Thomas Couture*, exh. cat., Baltimore, 1970

Cox, David (1783–1859)

English painter. He was born in Birmingham. Initially employed as a scene painter in London, he studied under ▷Varley (1804) and first exhibited at the ▷Royal Academy in 1805. He worked mainly in ▷watercolour until he belatedly took lessons in oils in 1840 from Muller – much of his later work repeated old themes in this new medium (e.g. *Rhyl Sands*, 1854, Manchester). Throughout his career he made regular sketching trips, especially to Wales, to Holland and Belgium (1826) and to France (1829, 1832). He developed a free style, using cheap wrapping paper (which became known as Cox Paper) for its absorbency. His work is characterized by huge skies, with billowing clouds, set off by flat landscapes and some figure interest (e.g. *Flying a Kite, Windy Day*, 1851, Liverpool, Walker). He also produced more topographical ▷watercolours (e.g. *Laugharne Castle*, 1836, Birmingham, City Art Gallery). In 1814 he wrote *A Treatise on Landscape Painting and Effect in Watercolour*.

Bib.: Cox, T., *David Cox*, London, 1947; *David Cox*, exh. cat., Birmingham, 1983; Hall, W., *Biography of David Cox*, London, 1881

Coypel, Noël (1628–1707), Antoine (1661–1722), Charles-Antoine (1696–1751) and Noël-Nicolas (1690–1734)

French family of artists. Noël began his career as a designer of tapestries and was also employed on large decorative projects at Versailles. His work for Louis XIV helped him become director of the French Academy in Rome in 1672–6. His son Antoine was in Rome with him and learned his profession there. He was particularly influenced by the work of ▷Poussin and the ▷Carracci, and when he returned to France, he was commissioned to paint the ceiling of the chapel at Versailles. Here he brought a ▷Baroque decorative style to France.

Antoine's son, Charles-Antoine, was also a painter who in turn became director of the Royal Academy (in 1747). Noël-Nicolas, Antoine's half-brother, was less distinguished than his other relatives. He produced ▷pastels and is best known as the teacher of ▷Chardin.

Coysevox, Antoine (1640–1720)

French sculptor. The principal sculptor to Louis XIV of France, Coysevox worked in a lively ▷Baroque style owing much to ▷Bernini, in contrast to the ▷Classical style of his main rival ▷Girardon. Born at Lyons, he moved to Paris in 1657, studied under Lerambert and in 1676 was accepted into the Academy, where his diploma work was a bust of ▷Charles Lebrun (original ▷terracotta of 1676, London, Wallace Collection; marble of 1679, Louvre, Paris). As a portraitist he was much in demand, his best works animated by convincing characterization combined with a penetrating but sympathetic naturalism (e.g. bust of Antoine Coypel, marble, 1706–11, Paris, Louvre). From 1679 he worked extensively at Versailles. It is in the Baroque decorations of the Galerie des Glaces, the Salon de la Guerre (especially the stucco relief of Louis XIV riding over his fallen enemies) and the Escalier des Ambassadeurs that the full range of Coysevox's technical virtuosity and inventive flair is best seen, whereas the Classical manner he attempted for the statues and fountains in the gardens is generally considered to have been rather less than successful. He also made several monumental tombs, of which the most accomplished is the tomb of Cardinal Mazarin (1689–93, now Paris, Louvre). His most important pupils were his nephews, the ▷Coustou brothers.

Cozens, Alexander (c1717–86) and John Robert (1752–99)

English family of watercolourists. Alexander was born in Russia, the son of a shipbuilder. He came to England in 1746 and became a highly sought-after drawing master, working at Eton and teaching two of George III's sons. He toured Italy with ▷Beckford in 1762. He is perhaps most famous for his method of semi-automatic drawing explained in his book *A New Method of Assisting the Invention in Drawing Original Compositions of Landscape*, 1785, which used ink blots to suggest landscape forms (▷blot drawing). His own works were often in monochrome (e.g. *Lonely Tower*, 1746, Leeds).

Alexander's son, John Robert, was also a watercolourist, taught by his father. He travelled to Italy in 1776–9 with ▷Payne Knight, and in 1782 with Beckford. He developed away from the topographical traditions of watercolour to add a poetic quality to his work, especially that of the Alps, using muted, limited colours and a broader handling (e.g. *In the Canton of Unterwalden*, 1780, Leeds; *Lake Nemi*, 1783, London, Victoria and Albert Museum). His work was greatly admired by the next generation including ▷Girtin and ▷Turner, but Cozens suffered mental illness from 1793, which ended his career. There is one recorded oil by him, *Hannibal Crossing the Alps*, exhibited at the ▷Royal Academy in 1776 and probably now lost.

Bib.: *Alexander Cozens*, exh. cat., London, 1987; *John Robert Cozens*, exh. cat., London, 1971; *John Robert and Alexander Cozens*, exh. cat., Ontario, 1987; *John Robert and Alexander Cozens*, exh. cat., New Haven, 1980

Cranach, Lucas the Elder (1472–1553)

German painter, etcher and woodcut designer. He was named after Kronach in southern Germany, presumably his place of birth. His early years are obscure, but by c1500, he seems to have settled in Vienna. Here he associated with the humanists of the recently founded university, and two particularly fine portraits, of a university lecturer and his wife, date from this period (*Johannes Cuspinian* and *Anna*, both Winterthur, Reinhart Collection). In Vienna Cranach also painted his earliest known religious subjects, of a type which associates him with the ▷Danube School, the paintings usually being set in vast pine woods and mountainous landscapes (e.g. *Rest on the Flight into Egypt*, 1504, Berlin). By c1505 he had transferred to Wittenberg, securing appointment as court painter to the electors of Saxony. He was ennobled, served as burgomaster for some years, and ran a large and flourishing workshop, which included an apothecary, printing works and bookshop.

In Wittenberg Cranach became close friends with Martin Luther, painting several portraits of him and designing propaganda ▷woodcuts for him. These woodcuts, among the best of his later works, include the illustrations for the first German translation of the New Testament in 1522. His commitment to Protestantism did not, however, preclude him from working for Catholic patrons. A fine portraitist, he appears to have been one of the first to paint, or perhaps was the inventor of, the full-length independent portrait (e.g. *The Duke of Saxony* and *The Duchess*, 1514, Dresden, Gemäldegalerie), these works pre-dating the earliest Italian examples, such as those by ▷Moretto. Another genre developed by Cranach was that of the erotic nude, particularly popular with the private collectors who formed the bulk of his clientele. Usually in some mythological guise or another, the figures represent nymphs or goddesses, sometimes wearing only a very elaborate plumed hat and some jewellery, calculated to further enhance the nudity (e.g. *The Judgement of Paris*, c1530, New York, Metropolitan Museum). His paintings are signed with a distinctive winged snake and the monogram LC, although this does not guarantee that the work is not just a shop piece. His two sons, Hans (d 1537) and Lucas the Younger (1515–86), followed his style and continued the family workshop.

Bib.: *Lucas Cranach, ein Maler-unternehmer aus Franken*, exh. cat., Augsburg, 1994; Schade, W., *Cranach: A Family of Master Painters*, New York, 1980

Cranbrook colony

Group of ▷genre painters working in Cranbrook, Kent, in England from around 1850. This group included Thomas Webster, John Callcott Horsley and A.E. Mulready. They were influenced by the rural genre scenes of ▷Wilkie and ▷W. Mulready.

Crane, Walter (1845–1915)

English painter, illustrator and designer. He was born in Liverpool, the son of an artist. After an apprenticeship with the ▷wood engraver, W.J. Linton (1859), he took evening classes at Heatherley's and became an illustrator in 1862. He exhibited at the ▷Royal Academy from that year also. He was a leading member of the ▷Arts and Crafts Movement, associated with ▷Morris and Co. (e.g. *Story of the Glittering Plain* for Kelmscott, 1894), a co-founder of the Art Workers Guild (1884), and an organizer of the Arts and Crafts Exhibition Society (1888). He also shared Morris's interest in the Socialist League. His early work was influenced by ▷Burne Jones (e.g. *Renaissance of Venus*, 1877, London, Tate), but he became increasingly interested in Japanese art and collaborated with ▷Godwin (e.g. *One, Two, Buckle My Shoe*, 1868). He is chiefly remembered for his designs for children's books 1863–96 (e.g. *Baby's Opera*, 1877; *Floral Fantasy*, 1899) which employed delicate line and pastel shades, though he was also a major writer and administrator. His books included *The Bases of Design* (1898) and *Line and Form* (1900), and he was director of design at the Manchester School of Art in 1893–7 and principal of the ▷RCA, 1898–9. He produced a large range of design work from tiles and vases to wallpapers and textiles and designed the mosaics for ▷Leighton's Arab Hall (in Leighton's house in London, now a museum, 1877–9).

Bib.: Egen, R.K., *Walter Crane as Book Illustrator*, London, 1975

craquelure

(French, 'crackle', 'cracking'.) The network of fine cracks which, with ageing, appears on the surface of an oil painting. It is caused by the different rates of expansion and shrinkage of the increasingly brittle ▷varnish, paint and ▷ground of an oil painting. Examination of the craquelure is used to authenticate an oil painting's age, although fakers have developed increasingly sophisticated means to counterfeit the effect. Craquelure is also sometimes called crazing.

Crawford, Thomas (1813–57)

American sculptor. In 1835 he went to Rome, where he came into contact with ▷Thorvaldsen whose ▷Neoclassical style he adopted. He produced ideal sculpture and portraiture. Although he lived in Rome, he gained a number of commissions for public sculpture in America. These included his ▷equestrian statue of George Washington in Richmond, Virginia, and work on the United States Capitol building in Washington, DC.

crayon manner

A form of ▷etching that was popular in the 18th century. It was discovered in France in c1750 and was used to produce works which looked like red ▷chalk

drawings. It was particularly popular for ▷Rococo decorative art and was used to copy works by such artists as ▷Boucher and ▷Fragonard. By the early 19th century, changes in taste and the invention of ▷lithography rendered it obsolete.

crazing
▷craquelure

Credi, Lorenzo di (c1458–1537)
Italian painter. He was born in Florence, the son of a goldsmith, and was apprenticed to ▷Verrocchio's workshop in c1480, remaining there until the death of his master in 1488. His work reflects the influence not only of his master, but also the early paintings of his more famous fellow apprentice in Verrocchio's workshop, ▷Leonardo da Vinci. In fact, throughout his working life, in the face of the aesthetic innovations of the High ▷Renaissance, he held onto an essentially ▷quattrocento style. Most of his surviving work is religious and it is said that he was among those painters who burnt their profane works in Savonarola's famous 'Bonfire of Vanities' in 1497.
Bib.: Brewer, R., *A Study of Lorenzo di Credi*, Florence, 1970; Dalli Regoli, G., *Lorenzo di Credi*, Milan, 1966

crenellation
A fortified parapet with alternate indentations or embrasures and upward projections or merlons. Also called a battlement.

Crespi, Daniele (c1598–1630)
Italian painter. He worked in Milan and produced work approved by official ▷Counter-Reformation ideology. The simplicity of his prolific religious painting was fully in line with the demands of the Council of Trent.

Crespi, Giovanni Battista (Il Cerano) (c1575–1632)
Italian painter from Lombardy. He travelled to Rome in 1586–95, but was back in Milan from c1598 and became head of the Accademia Ambrosiana in Milan in 1620. In 1629 he was put in charge of the sculptural programme at Milan cathedral. There he also produced scenes from the life of Charles Borromeo, under the direction of Cardinal Federigo Borromeo. These works show a ▷Mannerist colourism. He taught ▷Guercino.

Crespi, Giuseppe Maria (Lo Spagnuolo) (1665–1747)
Italian painter. He was from Bologna, but he rejected the Bolognese heritage of ▷academic art in favour of ▷genre painting. He employed ▷chiaroscuro in his various scenes of everyday life to striking effect. Through his pupils ▷Piazzetta and ▷Longhi, he influenced a tendency towards genre painting in the next generation of Venetian artists.

Bib.: Spike, J., *Giuseppe Maria Crespi and the Emergence of Genre Painting in Italy*, exh. cat., Fort Worth, 1986

Cretan Bull
▷Hercules

criticism
▷art criticism

Crivelli, Carlo (fl 1457–93)
Italian painter. He possibly trained in the ▷Vivarini workshop and, perhaps also in Padua; his mixture of an essentially ▷Gothic style with hard, linear forms and a frequent use of Classicizing architecture, reflecting both Vivarini and the Paduan school of ▷Squarcione (particularly ▷Schiavone and ▷Mantegna). His life seems to have been eventful: in 1457 he was imprisoned in Venice for adultery; he left shortly afterwards, never to return, but always signing his paintings as 'Carlo Crivelli of Venice' (invariably in Latin and usually dated); by 1465 he is recorded as a citizen of Zara in Dalmatia; and from 1468 he is documented in the Marches, principally at Ascoli Piceno. In 1490, he was knighted (an unusual honour for a painter) by Ferdinand II of Naples. All of his surviving paintings are religious and in a very distinctive, somewhat archaic, style. Many of his ▷altarpieces still employ gold backgrounds and incorporate areas of raised gilded ▷gesso for haloes, costume ornaments, etc. all practices which had been out of fashion in the more advanced centres for many years (e.g. *The Demidoff Altarpiece*, 1476, London, National Gallery). Also characteristic of his altarpieces are the symbolic gourds and fruit which often hang in bunches from thrones, pilasters etc. (e.g. *The Demidoff Altarpiece*, above, and *The Madonna della Candeletta*, 1491, Milan, Brera).
Bib.: Bovero, A., *L'opera completa del Crivelli*, Milan, 1975; Zampetti, P., *Carlo Crivelli*, Florence, 1988

Croce, Benedetto (1866–1952)
Italian philosopher, historian and critic. His ideas on art, expounded in his book *Aesthetic*, published in 1902, were highly influential in Italy up until the 1950s. Idealist in nature, he conceived of art as a 'pure and spontaneous imaginative form', in which immediate knowledge or impressions, which he called 'intuition', are transformed through the imagination into images, which are the expression of that 'intuition'. 'Intuition' is thus barely distinguishable from expression, which serves to privilege the conception rather than the physical process of art, and suggests that art is only art by virtue of its possessing 'intuition'. In 1903 he founded and edited *La Critica*, a review of contemporary Italian literature, which was retitled *Quaderni della Critica* in 1944. He served as the Minister of Education before Mussolini came to power in 1922, and again after the Second World War.

Bib.: Giudice, G., *Benedetto Croce*, Rimini, 1994; Roggerone, G.A., *Nuovo prospettive Crociane*, Rome, 1994

Crome, John (1768–1821) and John Bernay (1794–1842)

English painter and etcher. He was often referred to as 'Old Crome'. He was born in Norwich, the son of a journeyman weaver. Although apprenticed to a sign painter (1783), he was largely self-taught, and influenced by the copies he made in his youth of 17th-century Dutch landscapists, like ▷Hobbema and ▷Ruisdael. His early career was one of struggle; he shared a studio with J.B. Ladbroke and depended on the patronage of locals like Thomas Harvey and William Beechey. He was a founder member of the ▷Norwich School (the local Society of Artists) in 1803 and in 1801 had already established an art school in his own house. He exhibited regularly at the ▷Royal Academy from 1806 onwards, and gained a reputation as a drawing master. In 1814 he travelled to Belgium and Paris, where he viewed Napoleon's collection, but most of his painting was done locally around Norfolk (e.g. *Slate Quarries*, 1803, London, Tate; *Porington Oak*, 1818, London, National Gallery). He painted mainly in oils, although ▷watercolours do exist, and he was an accomplished ▷etcher (e.g. *Norfolk Picturesque Scenery*, published 1834).

John's son, John Bernay (1794–1842) was also a landscape painter who exhibited at the RA, as well as with the Norwich School. He travelled widely and became especially known for his moonlight paintings. After 1835 he was based in Yarmouth.

Bib.: Clifford, D., *John Crome*, London, 1968

cromlech

▷megalith

cross-section

Drawing of a building or other object seen as if it were cut through. Cross-sections are used to reveal the interior structure of an object.

Crucifixion

The subject is most usually the crucifixion of ▷Christ (Matthew 27: 33–56; Mark 15: 22–41; Luke 23: 33–49; John 19: 17–37). It is the principal image in Christian art, representative of Christ's redemption of mankind's original sin through his own sacrifice. Although scriptural, the subject was seldom depicted in the early Church and was instead merely alluded to by a symbolic lamb and cross. The first depictions date to the 6th century, but not until the 9th century do they start to become common. Because of its central importance the image of the Crucifixion may take any one of a vast number of forms ranging from an isolated wooden sculpture standing in a chapel as an object of contemplation and devotion (e.g. ▷Donatello, c1410–25, Florence, Sta Croce) to a vast and crowded narrative

scene (e.g. ▷Tintoretto, 1565, Venice, Scuola di S. Rocco). The earliest depictions of Christ on the cross show him alive with his eyes open; at this time he is always dressed in a long tunic called a *colobium* (e.g. a wall painting in the chapel of Theodotus, 741/52, Sta Maria Antiqua). By the 11th century the image has changed; Christ is dying, his eyes closed and his head hanging to one side (e.g. nave mosaic, c1020, Hosios Loukas, near Delphi, Greece).

As it was ▷Adam and Eve's original sin that had made the Crucifixion necessary, medieval writers sought to firmly link the ▷Redemption to the ▷Fall, so that Golgotha was held to be also the place of Adam's burial. Although Golgotha means 'the place of the skull', the skull at the foot of the cross does not merely allude to this name – the skull is in fact Adam's skull. Christ's regenerating and purifying blood trickles down the cross and over the skull of the first man, washing away his sin and, by extension, that of all humanity. The blood from Christ's hands and side is caught by angels in ▷Eucharistic chalices, further reinforcing the point.

In the medieval period and up to the end of the 15th century, the sun and moon were frequently depicted on either side of the cross – specifically they allude to Augustine's statement that the moon and sun symbolize the Old and New Testament respectively, the former only to be understood by the light shed on it by the latter. A very late example of this symbolism is by ▷Raphael (c1503, London, National Gallery). Another symbol which frequently appears above the cross in medieval art is the pelican, owing to the fact that medieval ▷bestiaries told how the mother pelican pierces her breast to feed her young with her blood – a clear allusion to Christ's sacrifice.

A number of figures are usually shown standing at the foot of the cross. These may be part of the biblical narrative, or they may be an assembly of saints from different periods, contemplating Christ's sacrifice (so that the Crucifixion becomes essentially devotional, rather than narrative). The saints will be recognizable by their traditional attributes and their inclusion determined by their relevance to the ▷donors of the altarpiece, or the church in which it is set. The two most frequently depicted figures at the foot of the cross are the ▷Virgin and ▷John the Evangelist, the disciple into whose care Christ entrusted his mother (John 19: 26–27); both figures usually conform to traditional types and are therefore instantly recognizable. When the composition is strictly narrative, the good are generally placed on the left of the picture (at Christ's right hand, he being almost always in the centre) and the bad – the soldiers and pharisees – on the right (at Christ's left hand). This also determines the positions of the good (repentant) and bad (unrepentant) thieves on the crosses either side of Christ: the good thief on the left appears composed, his face is often lit and, if dead, his soul may be carried away by angels; the bad

thief will be anguished, his face in darkness, his soul carried off by demons. Northern European altarpieces frequently show the thieves with their legs broken to hasten their death (John 19: 31–32). Amongst the soldiers may be one with a long lance; this is ▷Longinus who pierced Christ's side with his lance and was later converted and martyred. The central group of the virtuous onlookers is the holy women, amongst whom the Virgin generally is shown swooning (an apocryphal, but very popular incident), whilst ▷Mary Magdalene (usually in red with blonde hair) may have broken away from the companions to throw herself at the foot of the cross.

In addition to the death of Christ, there are several saints whose crucifixions are depicted in western art: St. Andrew, recognizable by the 'X'-shaped cross (e.g. Borgognone, 1668, Rome, S. Andrea al Quirinale); St. Peter, recognizable by the fact that he elected to be crucified upside down (e.g., Masaccio, 1423–7, Florence, Brancacci Chapel); and St. Philip, who is depicted on a conventional ▷Latin cross, but is tied (not nailed) to it (e.g. ▷Filippino Lippi, c1497–1502, Strozzi Chapel, Florence).

Cruikshank, George (1792–1878)

English artist. He was born in Bloomsbury, the son of the caricaturist Isaac Cruikshank (?1756–?1811) and trained with his father. He became one of the major satirists of the period, influenced by ▷Gillray (he took over from him at Mrs. Humphrey's), who first gained a reputation for his treatment of the trial of Queen Caroline. He made strong social comments in his work, criticizing slavery, the criminal code and patronage, as well as contemporary fashion and taste and the French (e.g. *Life in Paris*, 1822). He established the *Wits Magazine* and worked for a number of other publications. In the 1830s he turned increasingly to book illustration, working on Dickens' *Oliver Twist* (1838), Scott's novels and the translation of the Grimms' *German Popular Stories* (1823). During the 1840s he became involved with the Temperance movement and put much of his energy into condemning the evils of drink (including a large unfinished oil, *Worship of Bacchus*, 1862, London, Tate). By his later career he was out of step with contemporary taste.

Bib.: Jones, M.W., *George Cruikshank*, London, 1978; *George Cruikshank*, exh. cat., London, 1974; Krumbhaar, E.B., *Isaac Cruikshank*, Oxford 1966; Patten, R.L., *Cruikshank: A Revaluation*, Princeton, 1992

cube capital

▷capital

Cubism

One of the most important art movements of the early 20th century. It was formed from a collaboration between ▷Picasso and ▷Braque, who were evolving separate but complementary ideas about art in

c1907–8. Picasso's ▷*Les Demoiselles d'Avignon* resisted traditional notions of ▷perspective and beauty in its use of flat pattern and Iberian and ▷African sculptural models. In the same year, Braque painted a large nude in which the body was broken up into a series of block-like shapes. Between them, and under the influence of ▷Cézanne's analysis of natural form, Picasso and Braque created a new style of art that was based on the idea that objects should be looked at from all points of view. The basis of Cubism was thus conceptual rather than perceptual, as it was not predicated on what could be seen by the naked eye but the stable components of an object, both seen and known about. The name Cubism was a pejorative term used in 1908 by the art critic Louis Vauxcelles, who referred to Braque's works as '*bizarreries cubiques*', but it was soon adopted by the artists themselves as an adequate expression of their style. Although many examples of Cubism appeared abstract, Cubists always based their work on the object itself, and they therefore promoted a form of realism which was intended to be distinct from the ephemeral optical illusions of ▷Impressionist art. Although Braque's Cubism evolved from his Cézannesque landscape painting, Cubist landscape paintings were very rare, and the artists concentrated on still lifes and (less frequently) portraiture and genre.

Traditional histories of Cubism see several phases of the movement, although these are not mutually exclusive or always totally accurate. The earliest phase of Cubism has been called analytical or hermetic (c1908–12). This period was characterized by works which represented an analysis of real objects into their component parts. At this stage, muted colours made it difficult to determine the actual subject of the painting, hence the term 'hermetic'. Picasso and Braque would sometimes play tricks with the observer by including ▷*trompe l'oeil* effects which could further confuse the reading of the painting. In c1912, Braque began moving away from easel painting by sticking bits of paper to his canvases. His invention of ▷*papier collé* signalled the beginning of the next stage of Cubism, which has been called synthetic cubism. During this period, Picasso and Braque retreated from straightforward easel-painting towards ▷collage and sculpture. Here they used real materials as a means of drawing attention to both the artificiality of the canvas and the reality of the objects they were trying to represent. Cubism of this period is often arcane and humorous.

By 1912, Cubism had become an international style, practised by a variety of artists. In France, ▷Gris, ▷Metzinger, ▷Léger and ▷Gleizes all developed their own individual modes of Cubism, while ▷Laurens and ▷Archipenko carried its abstract ideas into sculpture. The acceptance of the term led to several books on the subject, including *Du Cubisme* by Gleizes and Metzinger (1912). Both before and after the war, other artists and movements borrowed the superficial forms of Cubism for their own works. Cubism was

the progenitor of ▷Orphism, ▷Purism, ▷Cubo-Futurism and ▷Precisionism, and its style was used selectively by ▷Expressionist, ▷Futurist and ▷Constructivist artists. However, although it continued to retain a certain force in abstract art movements, Cubism as such suffered a demise during the First World War.

Bib.: Cooper, D., *The Essential Cubism: Braque, Picasso and their Friends 1907–1920*, exh. cat., London, 1983; Golding, J., *Cubism: A History and an Analysis 1907–14*, 2nd edn., London, 1968; Green, C., *Cubism and its Enemies: Modern Movements and Reaction in French Art 1916–28*, New Haven, 1987

Cubist Realism

Also known as ▷Precisionism, this was an American style of the 1920s and 1930s. It was practised by artists such as ▷Demuth and employed primarily for urban and industrial subjects. Its products bore a resemblance to those of European ▷Purism. It was intended to present modern subject matter in a cool and precise way.

Cubo-Futurism

A Russian variant of ▷Cubism, initiated by ▷Malevich in 1913. Works such as *The Knife Grinder* (1912, New Haven, Yale University), which Malevich exhibited at the ▷Donkey's Tail and ▷Target exhibitions of 1913 combine Cubist use of form with a Futurist interest in ▷dynamism. It was very short-lived, gained few followers, and Malevich soon abandoned it for a form of pure ▷non–objective art.

Cullen, Maurice (1866–1934)

Canadian painter. He went to Paris in 1889 where he stayed until 1895. He also travelled to North Africa. He returned to Canada with the ▷Impressionist style, which he popularized there.

culture

A term used loosely to refer to knowledge, institutions and belief systems which have a national or racial base. Art historians use it as synonymous with civilization, or high culture, whereas anthropologists adopt the broader definition of the term. Art is obviously part of cultural history, and different forms of cultural interaction which effect and influence visual culture are among the concerns of art historians. The term 'culture' often has ▷fine art associations, but art historians are also concerned with manifestations of popular culture, including ▷mass media.

Bib.: Gombrich, E.H., *In Search of Cultural History*, Oxford, 1969; Jordan, G. and C. Weedon, *Cultural Politics: Class, Gender, Race and the Postmodern World*, Oxford, 1994; Lewis, J., *Art, Culture and Enterprise: The Politics of Art and the Cultural Industries*, London, 1990; Ridless, R., *Ideology and Art: Theories of Mass*

Culture from Walter Benjamin to Umberto Eco, New York, 1984; Williams, R., *Culture*, 1981

culture of materials

A phrase frequently used in relation to the constructions of ▷Tatlin and his followers, and it became an important concept for ▷Productivism. It refers on a practical level to these artists' interest in the properties of individual materials, such as wood, glass and metal, though the term also suggests the importance of materialism in art, as opposed to spiritual aims.

Cumaean Sibyl

▷Sibyl

Cumberland Market Group

In 1913, this group was formed by the consolidation of the ▷Camden Town Group and the ▷London Group. Its name came from the studio of ▷Robert Bevan at 49 Cumberland Market in London. Its members included ▷Gilman, ▷Ginner, ▷Nash and ▷Nevinson.

Cupid

(Greek, '*Eros*'; Latin, '*Amor*'.) The god of love, represented frequently since ▷Hellenistic times, either in a mythological narrative or as a merely symbolic presence in a picture to indicate that the theme is love. In the ▷Renaissance, Cupid was portrayed as a young winged boy with a bow, an arrow and a quiver. Traditionally it was a wound from one of Cupid's darts (arrows) that caused mortals (and sometimes gods) to fall in love. In narrative paintings a number of episodes recur: he is often depicted with ▷Venus, the goddess of love and, according to one tradition, his mother. Thus, in the *Education of Cupid*, Venus stands over him, whilst ▷Mercury teaches him from a book (e.g. ▷Correggio, c1523, London, National Gallery). Cupid is essentially capricious insofar as he inflicts his wounds wilfully, causing all manner of unwanted complications in a life that would be rational, so that he is often portrayed as a naughty child who merits punishment (e.g. ▷Bartolommeo Manfredi, *The Chastisement of Cupid*, c1605–10, Chicago, Art Institute). A lesson in kind is illustrated in paintings of Cupid stung by a bee: in trying to take some honey from a honeycomb, Cupid is stung. He complains to Venus who replies that the pains his darts inflict on lovers are far worse (e.g. ▷Lucas Cranach, *Venus and Cupid*, London, National Gallery). One popular fable from late antiquity (retold by Apuleius in the *Golden Ass*) portrays Cupid as himself a young lover. In the story of Cupid and Psyche, Psyche is a young girl of such beauty that Venus herself is jealous. She sends Cupid to make Psyche fall in love with some worthless mortal, but instead Cupid falls in love with her. He visits her

every night but forbids her to look upon him. Overcome by curiosity one night she lights a lamp to watch him as he sleeps. However, some hot oil drips onto Cupid's shoulder. He wakes up in alarm, becomes angry and storms off. Psyche searches the length and breadth of the earth for Cupid, is set various harsh tasks by the still vengeful Venus, and eventually is pitied by ▷Jupiter who orders Mercury to bring Psyche to Olympus, where she is reconciled with Cupid. The attraction of this fable for ▷Renaissance ▷humanists was that it contained for them an ▷allegory of the yearning of the Soul (Psyche) for Love (Cupid).

cupola

(From Latin, 'small cup' or 'vessel'.) A ▷dome (more correctly a small dome) on a circular or polygonal base, it may be set on the ridge of a roof, or surmount a turret.

curator

One who investigates works of art, their appearance and relationship with each other and members of an audience, and makes decisions about the way in which they might be displayed, often within a gallery space. Curators are also responsible for signage and interpretation in labels and catalogues.

Currier and Ives

Nathaniel Currier (1813–88), who ran a publishing company, was joined in 1857 by James Ives (1824–95), and together they formed a print publishing empire which dominated the American market until the early years of the 20th century. They produced primarily hand-coloured ▷lithographs which represented various aspects of American life, from the mundane to the most exciting events (such as the Chicago fire (▷ *Great Fire of Chicago*) of 1871).

Curry, John Steuart (1897–1946)

American painter. He was from Kansas and was one of the many ▷Regionalist artists who produced ▷murals for the ▷Federal Art Project during the 1930s. He concentrated on scenes of the rural mid-west.

curtain wall

(i) in medieval fortifications, that section of wall or rampart which connects two bastions, towers, or gates. (ii) an outer wall of a building which does not support the roof and which stands forward of the framed structure solely to keep out the weather.

cushion capital

▷capital

Cuvilliés, Jean François de (1698–1767)

French architect and engraver. He was architect to the Elector of Bavaria, for whom he completed commissions which helped disseminate the ▷Rococo style in Germany. One of his most famous works is the Amalienburg hunting lodge at the Nymphenburg palace near Munich (1734–9).

Cuyp, Jacob Gerritsz (1594–1651/2), Benjamin Gerritsz (1612–52) and Aelbert (1620–91)

Dutch family of painters. They were from Dordrecht. The earliest is Jacob, a pupil of ▷Abraham Bloemaert at Utrecht. He appears from contemporary accounts to have been chiefly considered as a landscape painter specializing in views of the countryside around Dordrecht, although he is now most highly regarded as a portraitist, particularly of children. His half-brother Benjamin specialized in biblical and ▷genre scenes, influenced by the young ▷Rembrandt's use of ▷chiaroscuro examples in Glasgow).

The most famous member of the family is Aelbert, son and pupil of Jacob. His early works, however, show the influence of ▷Jan van Goyen (e.g. *A River Scene with Distant Windmills*, c1642, London, National Gallery) and ▷Saloman van Ruysdael. Unusually for a Dutch painter of this period, he painted in a wide range of genres, but is now chiefly valued for his Italianate landscapes, characterized by scenes of herdsmen tending their well-fed cattle in the golden glow of a late summer evening with rivers meandering into a mountainous distance.

Aelbert is not known to have visited Italy himself and only started painting in this style in the 1640s, after ▷Jan Both and ▷Nicolaes Berchem had returned from their trips. Although presumably influenced by them, his own Italianate style is unmistakable. It is, above all, more clearly rooted in an idealized vision of the Dutch countryside. Despite enjoying considerable success as a painter, Aelbert seems to have stopped painting altogether following his marriage to a wealthy widow in 1658. After his death, he slipped into relative obscurity until rediscovered in the second half of the 18th century by English collectors and, in fact, England now holds a larger and more representative collection of his work than even The Netherlands. His paintings in English collections exerted a strong influence on native landscape painters such as ▷Richard Wilson. Although prolific, Aelbert's *oeuvre* has probably been numerically overestimated as he had many imitators in Dordrecht, amongst whom was Abraham Calraet (1642–1722) who confusingly also signed himself 'AC'.

Bib.: Reiss, S., *Aelbert Cuyp*, London, 1975

cybernetic art

Art that is interactive, like ▷kinetic art, but more responsive to the direct stimulation by the spectator. Certain forms of computer art are cybernetic.

Cycladic art

Referring to the Cyclades islands in the Aegean, this is the name given to Bronze Age Greek art of c2000–c1400 BC, when ▷Mycenaean forms became dominant. This art is characterized by a large number of objects, many of them decorated with ornamental patterns. The most famous Cycladic objects are white marble cult figures, which may have served as fertility talismans. Cycladic art was primarily portable, and its artefacts have appeared in several parts of Europe.

Bib.: Ekschmidtt, W., *Die Kykladen: Bronzezeit, geometrische und archaische Zeit*, Mainz, 1993; Fitton, J., *Cycladic Art*, Cambridge, MA, 1990

cyma recta
▷moulding

cyma reversa
▷moulding

D

Dada

An intellectual movement that began in neutral Zurich in 1916, during the First World War. One of its founders, the poet ▷Tzara, called Dada a 'state of mind', and certainly the movement evaded stylistic characterizations. It was not solely an art movement and its premises were ▷anti-art, rather than positively creative. In Zurich, Tzara, with ▷Huelsenbeck, Hugo Ball, ▷Arp and Marcel Janco put on performances at the ▷Cabaret Voltaire to express their disgust with the war and with the bourgeois interests that had inspired it. The term Dada has several possible origins: it is certainly a nonsense word, but may also be the French word for 'hobbyhorse', discovered by Huelsenbeck in a German-French dictionary.

While exiled intellectuals launched their Dada protest in Switzerland, in New York ▷Picabia and ▷Duchamp arrived at similar anti-art sympathies by a different route and for different reasons. Criticizing the whole basis of museum art, Duchamp exhibited ▷'found objects' such as bicycle wheels, while both artists attacked the traditionalist basis of museum art. Picabia's visit to Switzerland in 1918 brought the two strands of Dada closer together.

Dada entered a different phase in Germany after the war, where it flourished in separate regional centres. Here it became much more strongly associated with art, and the anti-art sentiments of the Zurich movement gave way to positive expressions of political or social meaning. The first of these German centres was Berlin, where Huelsenbeck gave his first Dada speech in February 1918 and produced a Dada manifesto later that year. In Berlin, Dada artists such as ▷Grosz and ▷Höch used the movement to express Communist sympathies in the post-Revolutionary climate of Germany, and the invention of ▷photomontage was seen as part of this tendentious activity. These artists produced a series of short-lived political journals, and they launched an International Dada Fair in 1920. There was a great deal of in-fighting among them, and ▷Kurt Schwitters, among others, was excluded from their ranks. Schwitters moved to Hanover to launch his individualist version of Dada which he called ▷Merz. In Cologne, ▷Ernst and ▷Baargeld joined with Arp to launch a controversial Dada exhibition, which stressed the nonsense and anti-bourgeois sentiment of its Swiss forerunner. Ernst and Tzara both ended up in Paris, where Dada melted into ▷Surrealism by 1924.

Bib.: Ades, D., *Dada and Surrealism Reviewed*, London: Arts Council of Great Britain, 1978; Richter, H., *Dada Art and Anti-Art*, London, 1965; Huelsenbeck, R., *Memoirs of a Dada Drummer*, ed. H. Kleinschmidt, Berkeley, 1991; Rubin, W., *Dada and Surrealist Art*, London, 1969

Dadd, Richard (1817–1886)

English painter. He was a member of a sketching club called the Clique and specialized in fairy subjects. Insanity and commitment to institutions halted his artistic progress, although he did paint while in Bedlam and Broadmoor asylums.

Bib.: Allderidge, P., *The Late Richard Dadd 1817–1886*, exh. cat., London, 1974

Daddi, Bernardo (c1290–c1348)

Italian painter. A leading Florentine painter of the generation after ▷Giotto's death, he ran a flourishing workshop. Signed and dated works include a triptych of *The Madonna and Child with SS Matthew and Nicholas* (1328, Florence, Uffizi) and a ▷polyptych of *The Crucifixion with Eight Saints* (1348, London, Courtauld Institute). Also attributed to him and his workshop are the frescos of the *Martyrdoms of SS Lawrence and Stephen* (c1330, Pulci Chapel, Sta Croce, Florence). Founded in the tradition of Giotto, Daddi's style is more linear, his colours brighter, and his mood sweeter and more lyrical, reflecting the increasing influence of Sienese painting towards the middle of the century.

Bib.: Offner, R. (ed.), *The 14th Century Bernardo Daddi: His Shop and Following*, Florence, 1991

dado

(i) In Classical architecture, the middle division of a ▷pedestal above the ▷plinth and below the ▷cornice. Also called a die. (ii) Protective wooden panelling covering the lower part of a wall.

Daguerre, Louis-Jacques-Mandé

▷daguerrotype

daguerrotype

A pre-photographic process invented in 1839 by Louis-Jacques-Mandé Daguerre (1787–1851). The process was half-way between printmaking and photography. It involved sensitizing a silver-coated plate with iodine to form an image. Unlike photography, it did not include a ▷negative.

Dahl, Johan Christian (1788–1857)

Norwegian painter. From 1824 to 1857 he was Professor at the academy in Dresden, where he knew ▷Friedrich. He also painted landscapes, particularly scenes of Norway, and he helped create a sense of Norwegian nationalism during the ▷Romantic period.

Bib.: Bang, M.L., *Johan Christian Dahl, 1788–1857: Life and Works*, Oslo, 1987

Dahl, Michael (1659–1743)

Swedish painter. He produced portraits. In c1682–5 he worked in London, and travelled to Italy and other parts of Europe during 1685–9. His English portraits were particularly important, and he cornered the market after ▷Kneller's death. He produced portraits of Queen Anne.

Dahomey

 ▷African art

Daibutsu

Japanese term for 'great Buddha'. These are giant statues of the Buddha in Japan.
 ▷Buddhist art

Dali, Salvador (1904–89)

Spanish painter. He studied at the École des Beaux-Arts in Madrid where he began to produce ▷metaphysical painting in the manner of ▷de Chirico. In 1928 he visited Paris, where the works of ▷Miró and ▷Picasso led him to consider changing his direction. He became associated with the ▷Surrealist movement,

Salvador Dali

although his anti-Marxist stance and support of Franco in 1937 led ▷Breton to expel him from the group. He shared with the Surrealists an interest in unconscious forces and ▷automatism, but he invented his own form of automatism called 'paranoia-criticism'. Through this method, Dali claimed that the artist should cultivate paranoia and delusions as a way of enhancing the creation of his work. In *The Persistence of Memory* (1931, New York, Museum of Modern Art), the realistically represented melting clocks create the sense of unease he attempted to evoke in all his works. Dali's own style was academic and precise but his subject matter was the stuff of dreams or nightmares. He cultivated an extravagant public image that eventually became as popular as his art. A trip to Italy in 1937 led him to enhance the academic aspects of his style. In 1940 he moved to the United States, but he returned to Spain in 1955.

Aside from painting, Dali also produced sculpture, theatre design and wrote novels. Among his most famous works were films he produced with Luis Buñuel, including *Un Chien andalou* (1929) and *L'age d'or* (1930).

Bib.: Ades, D., *Dali*, London, 1982; Gibson, I., *Salvador Dali: The Early Years*, exh. cat., London, 1994

Dalmau, Lúis (fl 1428–60)

Spanish painter. He came from Valencia, is known to have been in Bruges in 1431, but had returned to Valencia by 1437, where he became court painter of Alfonso of Aragon. He adopted a Flemish style reminiscent of that of ▷van Eyck. His only securely attributed work is the *Virgin of the Councillors* (1443–5; Barcelona Museum).

Dalou, Aimé-Jules (1838–1902)

French sculptor. He trained at the Petite École and then the ▷École des Beaux-Arts, and his most familiar works are associated with the ▷Realist movement. A committed Socialist, he supported the Paris Commune and, following its suppression, fled to Britain where he worked from 1871 until the amnesty of 1879. In Britain he achieved his first professional success with domestic and peasant subjects executed in a rather idealized, sentimental manner (e.g. *Paysanne française allaitante*, 1873; London, Bethnal Green Museum). Following his return to France he came second in a competition for a monument to the republic in the Place de la Republique, Paris. So impressed was the panel, however, that Dalou was commissioned to execute his entry for the Place de la Nation *Triumph of the Republic*, 1879–99). This, with its ▷Baroque-style ▷allegories, represents the other tendency in his work (unusually for his time, he was a great admirer of ▷Bernini). Despite such belated success he refused official honours and took only those commissions which chimed with his political and social convictions. He even gave his services free of charge, notably in the

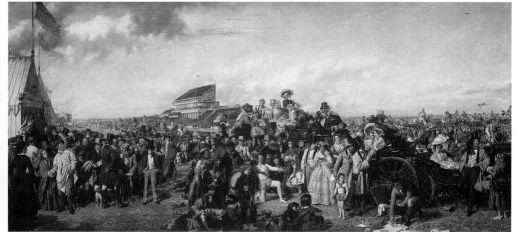

FIGURE 48 William Powell Frith, *Derby Day*, 1856–8, Tate Gallery, London

FIGURE 49 Agnolo Gaddi, *The Archangel Gabriel, Christ the Redeemer and the Virgin Annunciate,* late 14th century

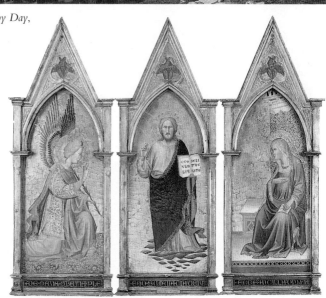

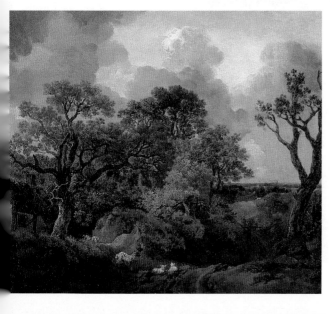

FIGURE 50 Thomas Gainsborough, *Wooded Landscape*

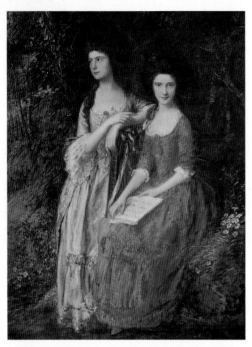

FIGURE 52 Paul Gauguin, *The Vision after the Sermon: Jacob Wrestling with the Angel*, 1888, National Gallery of Scotland, Edinburgh

FIGURE 51 Thomas Gainsborough, *The Linley Sisters (Mrs Sheridan and Mrs Tickell)*, c1772, Dulwich Picture Gallery, London

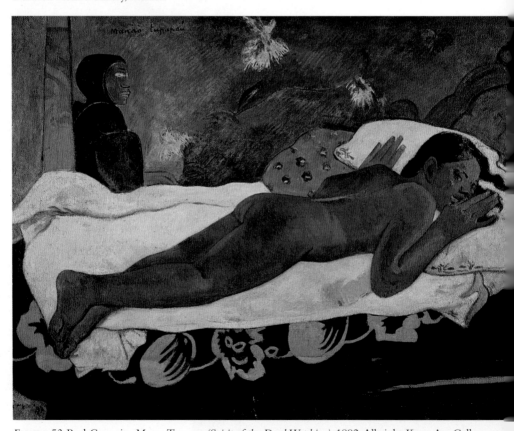

FIGURE 53 Paul Gauguin, *Manao Tupapau (Spirit of the Dead Watching)*, 1892, Albright Knox Art Gallery, Buffalo, New York

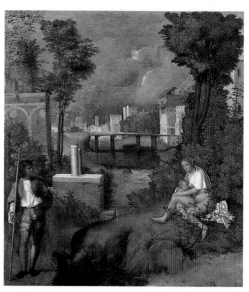

FIGURE 55 Giorgio da Castelfranco Giorgione, *The Tempest*, c1506, Galleria dell'Accademia, Venice

FIGURE 54 Grinling Gibbons, *Wood Carving*, late 17th century, National Trust, Petworth House, Sussex

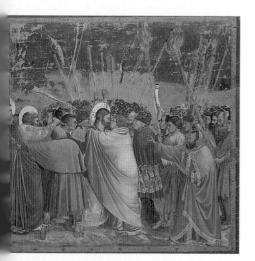

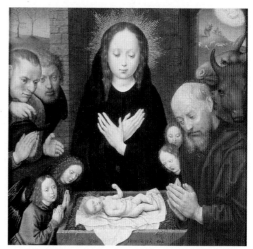

FIGURE 56 Ambrogio Bondone Giotto, *Betrayal of Christ*, c1305, Scrovegni (Arena) Chapel, Padua

FIGURE 57 Hugo van der Goes, *Adoration of the Shepherds*, 1485, Collection of the Earl of Pembroke, Wilton House

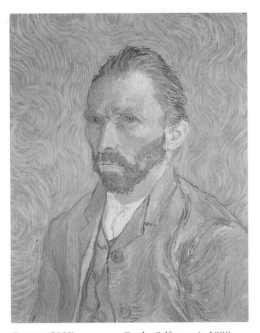

FIGURE 58 Vincent van Gogh, *Self-portrait*, 1889, Musée d'Orsay, Paris

FIGURE 59 Vincent van Gogh, *The Church at Anvers-sur-Oise*, 1890, Musée d'Orsay, Paris

FIGURE 60 Francisco José de Goya y Lucientes, *Execution of the Defenders of Madrid, 3rd May 1808*, 1814, Prado, Madrid

FIGURE 61 Richard Hamilton, *Towards a Definitive Statement*, 1962, Tate Gallery, London

IGURE 62 William Hogarth, *The Contract* from 'Marriage à la Mode', c1743, National Gallery, London

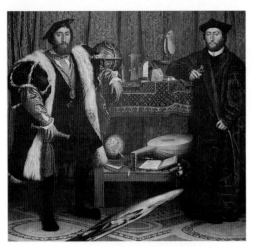

FIGURE 63 Hans Holbein the Younger, *The Ambassadors*, 1533, National Gallery, London

FIGURE 64 Hans Holbein the Younger, ▶ *Christina of Denmark, Duchess of Milan*, 1538, National Gallery, London

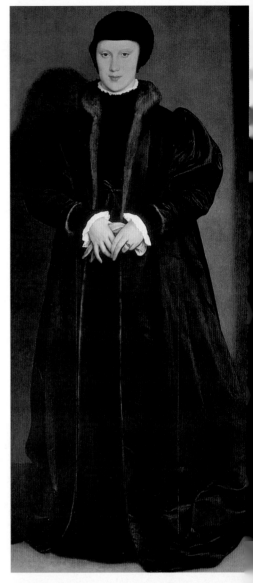

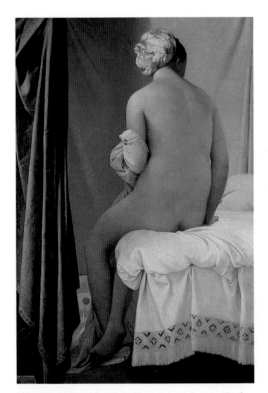

FIGURE 65 Jean-Auguste Dominique Ingres, *Bather* or *Valpincon*, 1808, Louvre, Paris

FIGURE 66 Wassily Kandinsky, *Murnau*, 1909, Kunstmuseum, Düsseldorf

FIGURE 67 Wassily Kandinsky, *Battle*, 1910,
Tate Gallery, London

FIGURE 69 Paul Klee, *Keramisch Mystisch* ▶

FIGURE 68 Ernst Ludwig Kirchner, *Street Scene in
Berlin*, 1913, Brücke Museum, Berlin

FIGURE 70 Gustav Klimt, *Fritza von Riedler*,
Österreichische Galerie, Vienna

FIGURE 72 Sir Edwin Landseer, *Monarch of the Glen*, 1851, Dewar House, London

◀ FIGURE 71 Yves Klein, *Cosmogeny*, Kaiser Wilhelm Museum, Krefeld

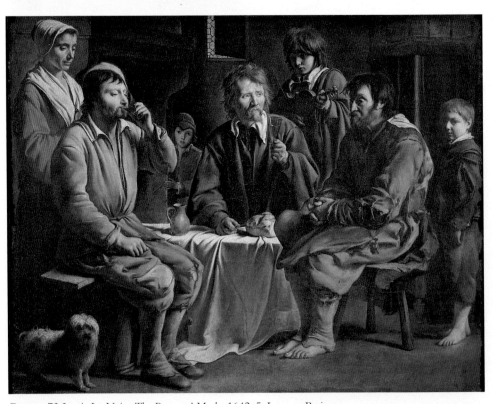

FIGURE 73 Louis Le Nain, *The Peasants' Meal*, c1642–5, Louvre, Paris

FIGURE 74 Fernand Léger, *Composition*, 1920, Galerie Louis Carré, Paris

FIGURE 75 Frederic, Lord Leighton, *Winding the Skein*, c1878, Art Gallery of New South Wales, Sydney

FIGURE 76 Philippe de Loutherbourg, *Coalbrookdale by Night*, 1801, Science Museum, London

FIGURE 77 August Macke, *Promenade*, 1913, Bayerische Staatsgemäldesammlungen, Munich

FIGURE 78 Kasimir Malevich, *Suprematist Composition*, Stedelijk Museum, Amsterdam

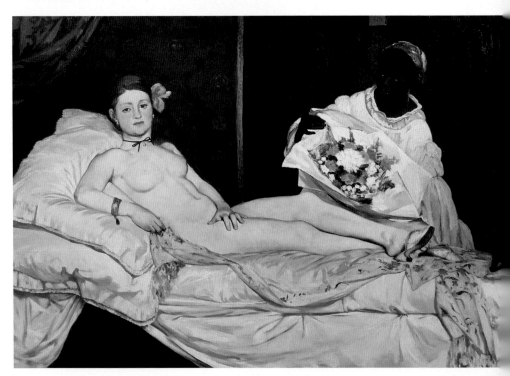

FIGURE 79 Edouard Manet, *Olympia*, 1863, Musée d'Orsay, Paris

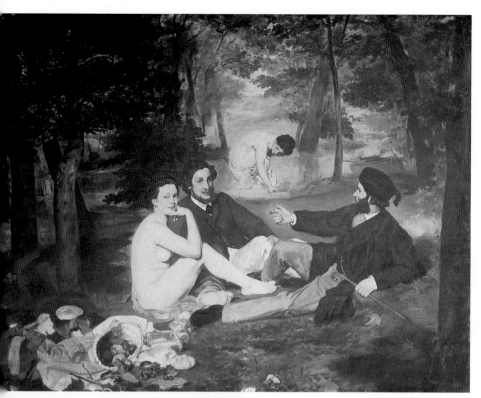

FIGURE 80 Edouard Manet, *Déjeuner sur l'Herbe*, 1863, Louvre, Paris

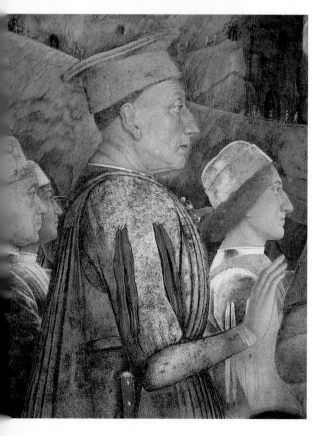

FIGURE 81 Andrea Mantegna,
Marchese Ludovico Gonzaga (detail),
1472–4, Palazzo Ducale, Mantua

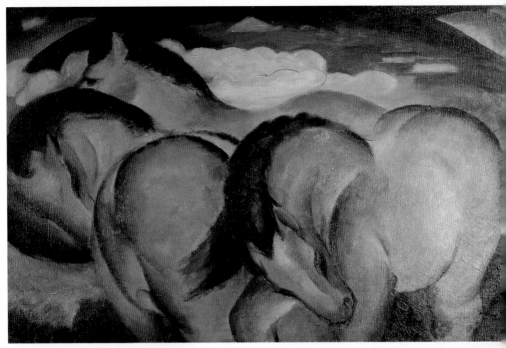

FIGURE 82 Franz Marc, *Little Yellow Horses*, 1912, Staatsgaleri Stuttgart

FIGURE 83 Master of Flémalle, Robert Campin, *St. Joseph portrayed as a Medieval Carpenter,* early 15th century, from the Mérode Altarpiece, Metropolitan Museum of Art, Cloisters, New York

FIGURE 84 Michelangelo Buonarroti, *The Dying Slave*, c1513, Louvre, Paris

GURE 85 Sir John Everett Millais, *Bubbles*, 1886,
lida Fabergé Collection, London

FIGURE 86 Joan Miró, *Harlequin's Carnival*, 1924–5,
Albright Knox Art Gallery, Buffalo, New York

JURE 87 Paula Modersohn-Becker, *Head of a*
l, Stadelsches Kunstinstitut, Frankfurt

FIGURE 88 Amadeo Modigliani, *Portrait of Kisling*,
1915, Pinacoteca di Brera, Milan

FIGURE 90 Piet Mondrian, *Composition with Red, Yellow and Blue*, c1937–42, Tate Gallery, London

FIGURE 89 Laszlo Moholy-Nagy, *Composition*, 1941–6, private collection

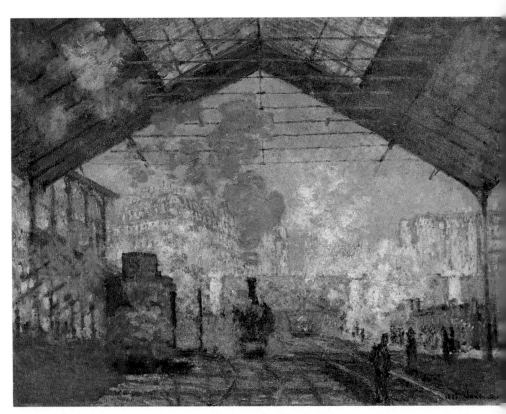

FIGURE 91 Claude Monet, *Gare St. Lazare*, 1877, Musée d'Orsay, Paris

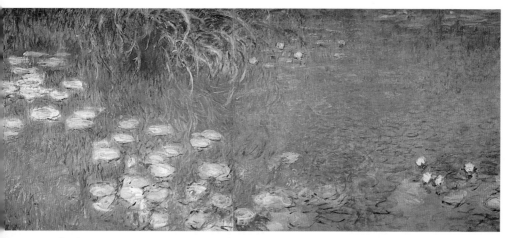

FIGURE 92 Claude Monet, *Waterlilies: Morning* (left section), 1916–26, Musée de l'Orangerie, Paris

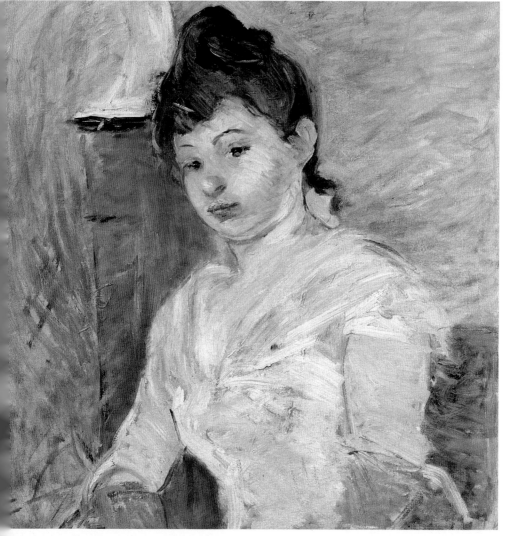

FIGURE 93 Berthe Morisot, *Jeune Fille en Blanc*

FIGURE 94 Alphonse Mucha, poster, *A Girl*, 1899, Victoria and Albert Museum, London

FIGURE 95 Edvard Munch, *The Scream*, 1893, Nasjonalgalleriet, Oslo

FIGURE 96 Bartolomé Esteban Murillo, *Rebecca and Eliezer at the Well*, Prado, Madrid

extraordinary Tomb of Victor Noir (1890; Paris, Père Lachaise Cemetery) in which the ▷bronze effigy shows the liberal journalist as he had died – shot dead in the street. Dalou's last work was also self-generated, the ambitious Monument to Labour, left uncompleted at his death. Today his ▷terracotta sketches, of which some rather Millet-like figures were produced for this last project, are admired for the boldness and freedom of their handling.

Bib.: Cadet, P., 'L'edition des oeuvres de Dalou par la Maison Suisse', *Gazette des Beaux Arts*, 6, no. 123 (Feb 1994), pp. 97–110; Hunisak, J.M., *The Sculpture of Jules Dalou: Studies in his Style and Imagery*, New York, 1992

Dalziel, George D. (1815–1902), Edward D. (1817–1905), Thomas (1823–1906), John and Edward Gurdon (1849–89)

English family of painters. George, Edward, Thomas and John were all brothers, born in Wooler, Northumberland. Edward studied painting and then took up ▷wood engraving (1839), following George to London where he studied at Clipstone academy with ▷Tenniel. He exhibited at the ▷Royal Academy, but most of his energies were directed towards the family firm. This was a company of English illustrators and wood engravers, established in London in 1859. They were the most prolific book illustrators of their day, producing over 50,000 plates, and employing a number of notable artists. Thomas was perhaps the most talented of the brothers, particularly in landscape illustrations (e.g. *Arabian Nights*, 1865). Edward's son, Edward Gurdon (1849–89) was a minor oil painter, with some RA success, who also worked for the family firm and illustrated *Fun*, a magazine of country life and manners (1878–80).

Bib.: Dalziel, George and Edward, *The Brothers Dalziel, A Record of Work*, London, 1901

Damer, Anne Seymour (1748–1828)

English sculptor. She was born in London, into a noble family. She studied with Ceracchi and ▷John Bacon but only turned to sculpture full-time after ten years of unhappy marriage which culminated in the suicide of her husband in 1776. Throughout her early career she enjoyed the patronage and friendship of ▷Horace Walpole, who probably overrated her talents. After his death in 1797, she lived at his home, Strawberry Hill until 1811. She exhibited regularly at the ▷Royal Academy (1784–1818) and produced a number of public works, including the statue of George III (1795), now outside the Register Office, Edinburgh. She also sculpted a number of portrait busts for the aristocracy, and her family connections undoubtedly aided her career. She was an enthusiast for Napoleon and sent a bust of him to France. Having for many years been considered as little more than an oddity – a lone woman in the very male profession of marble

sculpture – she is now undergoing something of a revival of interest.

Bib.: Noble, P., *Anne Seymour Damer*, London, 1908

Danby, Francis (1793–1861)

Irish painter. He specialized in landscape. He was born in Wexford and was educated in Dublin, before coming to Bristol in 1713, where he trained under O'Connor. He exhibited at the ▷Royal Academy from 1820 and moved to London in 1823. His early work was ▷picturesque: small-scale, detailed scenes of woodland and water (e.g., *Little Boys Sailing Boats*, 1821, Bristol), characteristic of a number of artists working at the time, commonly known as the Bristol School. He later developed a monumental style influenced by ▷Turner and ▷Martin, incorporating apocalyptic and religious subject matter on large-scale but highly finished canvases (e.g. *Delivery of Israel out of Egypt*, 1823, Preston, Harris Museum and Art Gallery). He settled in Geneva, Switzerland (1829–41) because of domestic problems, having in that year failed to become a full Academician (he had been made ▷ARA in 1826). He also lived in Paris for a time in 1845, and whilst abroad he painted a number of landscape sketches which confirmed his ▷Romantic enthusiasm for expressing the moods of nature. His last and highly popular works were heroic, highly coloured seascapes, often incorporating sunsets and exotic mythological scenes (e.g. *Wood Nymphs' Hymn to the Rising Sun*, 1845, London, Tate Gallery). He retired to Exmouth in 1847 and continued to paint from there. His sons, James Francis and Thomas were also landscapists.

Bib.: Adams, E., *Francis Danby, Varieties of Poetic Landscape*, London, 1973; *Francis Danby*, exh. cat., London, 1961; *Francis Danby*, exh. cat., London, 1988

Dance, Nathaniel (1736–1811)

English painter. He was the son of the architect George Dance (1695–1768). He studied with ▷Hayman and began practising as a portrait painter. A trip to Rome in 1755 brought him into contact with the fashionable ▷Grand Tour portraits of ▷Batoni, whose style he later imitated. He was a founder member of the ▷Royal Academy. In 1776 he inherited a fortune and later become a baronet, adopting the name Dance-Holland. His brother George (1741–1825) was, like their father, an architect.

Bib.: *Nathaniel Dance 1735–1811*, exh. cat., London, 1977

Dance of Death

A representation of a procession involving both the living and the dead and symbolizing the inevitability of death coming to all. The living participants are usually arranged hierarchically, starting with the Pope and moving downwards through the orders of society. The earliest known representation is the (now lost) wall painting from the cloisters of the Church of the

Holy Innocents in Paris, of 1424–5. An idea of its appearance is preserved in a series of poems and woodcuts called ▷ *Danse Macabre*, published in Paris in 1485 by the printer Guyot Marchant. The theme enjoyed a highly popular vogue in print form in the late Middle Ages, culminating in the most famous and influential representation of all, the series of 40 ▷ woodcuts designed by ▷ Hans Holbein the Younger in 1523–26 and first published in Lyons in 1538.

Bib.: Clark, J., *The Dance of Death in the Middle Ages and the Renaissance*, Glasgow, 1950

Daniel

One of the four great Old Testament prophets, along with ▷ Jeremiah, ▷ Isaiah and Ezekiel. His life is told in the Book of Daniel. Like Joseph, he gained influence because of his ability to read dreams (including one of a ram, often associated with him). He is most commonly portrayed with lions because of his miraculous survival in a lion's den for seven days, which prefigures the ▷ Resurrection of Christ. This has been a popular artistic theme since the time of the early Christians (e.g. ▷ fresco in S. Priscilla's catacomb in Rome, 230–40; ▷ Rubens, 1615, Washington, DC, National Gallery). During his seven days in the lion's den, Daniel was fed with bread and fish by Habakkuk, an event which constitutes a prefiguration of the ▷ Last Supper.

Another popular narrative in early Christian art was the miracle of the fiery furnace, in which three Hebrew friends of Daniel (Shadrach, Meshach and Abednego) who refused to worship Nebuchadnezzar's golden image were cast into the flames but survived. Daniel is also present at ▷ Belshazzar's feast, when he was called to interpret the words written on the wall by a disembodied hand, which warned of the destruction of Babylonian civilization. (e.g. ▷ Rembrandt, 1635, London, National Gallery and ▷ Martin, 1820, private collection). Daniel is in addition associated with justice, as it was he who cross-examined the elders who accused Susannah, and proved her innocence.

Daniele da Volterra (Daniele Ricciarelli) (c1509–66)

Italian painter and sculptor. He was from Volterra, but travelled to Rome in 1536 where he saw the works of ▷ Michelangelo. He studied with ▷ Sodoma, and while in Rome he painted a *Deposition* for the Cappella Orsini in SS Trinità dei Monti (after 1541). He sculpted the death mask of Michelangelo, and in the severe climate of the ▷ Counter-Reformation, he was the artist commissioned to paint draperies over the nudes of Michelangelo's *Last Judgement* in the ▷ Sistine Chapel.

Danse Macabre

▷ Dance of Death

Danti (Dante), Vincenzo (1530–76)

Italian sculptor. He was Perugian and trained originally as a goldsmith. He was strongly influenced by ▷ Michelangelo (cf. especially his marble group, *Honour Triumphant over Falsehood*, Florence, Bargello). He established his reputation with a statue of Pope Julius II (bronze, 1553–6) outside Perugia Cathedral, before moving to Florence to work for the ▷ Medici (1557–73). His most important work in Florence is his *Decollation of St. John the Baptist* (bronze, 1571) over the south door of the Baptistery (he also completed ▷ Andrea Sansovino's *Baptism of Christ* over the eastern door). His figures are characterized by an elegant elongation typical of ▷ Mannerist sculpture (such as that of ▷ Ammannati). In 1567 he published a treatise on proportion (dedicated to the Grand Duke Cosimo de' Medici). In 1573 he returned to Perugia as one of the founder professors of the new Accademia del Disegno.

Bib.: Santi, F., *Vincenzo Danti scultore*, Bologna, 1989; Summers, J.D., *The Sculpture of Vincenzo Danti*, New York, 1979; idem, *The Chronology of Vincenzo Danti's First Works in Florence*, Florence, 1972

Danube School

Not strictly a school or movement, but a name used to designate a number of painters working in the Danube region in the early 16th century who were the first to give landscape a prominent role in their subject paintings and who are therefore at the wellspring of modern landscape painting. ▷ Altdorfer, one of the leading painters of the 'school', was perhaps the earliest painter to paint a pure landscape, i.e. one without a subject (*Landscape with a Footbridge*, c1518/20; London, National Gallery). The other leading artists were ▷ Wolfgang Huber and, in his early years, ▷ Lucas Cranach the Elder. Apart from the poetical potential of pure landscape, the wild, mountainous scenery of the Danube region seems to have inspired in them an awareness of the power of landscape to reflect the emotions of the human protagonists of their pictures.

Bib.: *Prints and Drawings of the Danube School*, exh. cat., New Haven, 1989

Dau al Set

(Spanish, 'die with the seven'.) An artistic grouping formed in Barcelona in 1948–53. The group included both writers and artists, and its most notable member was ▷ Tàpies. They published a journal and promoted a ▷ Surrealist style, following the tendencies of ▷ Miró.

Bib.: Cirlot, L., *El grupo 'Dau al Set'*, Madrid, 1986

Daubigny, Charles-François (1817–78)

French painter. He was born in Paris, and first taught by his father, Edmé-François Daubigny (1789–1843). He also studied with François-Maurius Granet and ▷ Delaroche at the ▷ École des Beaux Arts in 1838, and he worked as a restorer at the Louvre and as an

engraver. Although he travelled regularly, including to Italy in 1834, England in 1866, Holland and Spain, he worked mainly around the Île de France, near Paris (e.g. *Banks of the Seine* 1850, Limoges). He exhibited his first landscape at the 1844 ▷Salon. He sketched ▷*plein air*, concentrating on quiet water scenes, with little incident and calm skies. Latterly he worked from a studio boat, to make the most of his river scenes. He is associated with the ▷Barbizon School, first visiting in 1844, although he never settled in the village. He also worked with ▷Corot in Dauphine (1852) and adopted something of his silvery palette and brushwork (e.g. *View in Normandy*, 1865, Paris, Louvre). In his interest in light and his unfinished palette he is often associated with ▷Impressionism (e.g. *Apple Blossom*, 1873, New York, Metropolitan Museum), and as a member of the Salon jury (1866–8) he tried to promote the young artists. During the Commune (1870) he visited London, where he painted the Thames. His son, Karl (1846–86) was also an artist.

Bib.: *Barbizon Revisited*, exh. cat., London, 1962; Bouret, J., *L'École de Barbizon*, Neuchâtel, 1972

Daumier, Honoré Victorin (1808–79)

French caricaturist, painter and sculptor. He began work as a graphic artist, having learnt ▷lithography techniques in 1830, and been employed on *Charivari* and *La Caricature* (1830–35) until the latter's suppression by the government. He was imprisoned in 1832 for his anti-monarchical satire of Louis Philippe as Gargantua and during the course of his life he produced over 4,000 lithographs of political and social comment, including large-scale works (e.g. *Rue Transnonian le 15 Avril 1834*, 1834). After 1848, he produced ▷watercolours which continued this vein, parodying the Courts of Justice, and depicting the existence of the poor. He created two memorable characters in Robert Macaire, the corrupt and money-obsessed bourgeois, and Ratapoil (skinned rat), the sinister government agent. He also experimented with oils including several on the theme of *Don Quixote*, although many of his pictures remained unfinished, producing loosely-handled, thickly impasto works of strong ▷chiaroscuro (e.g. *Third Class Carriage*, c1856, Cardiff, National Museum of Wales; *Heavy Burden*, 1850–55, Cardiff, National Museum of Wales). He also produced sculpture which showed the same roughness of handling and concern for social issues (e.g. *Ratapoil*, bronze, 1850–51, Buffalo, Albright-Knox Art Gallery; *Refugees*, bronze relief, 1850, Washington, DC). He became blind in old age, and was rescued from poverty by ▷Corot, who was one of his many artistic admirers. ▷Degas collected his work which was appreciated by ▷Delacroix and ▷Baudelaire as well as, perhaps not surprisingly, Balzac. He was also greatly admired by the 20th-century ▷Expressionists, who applauded both his radical stance and the freedom with which he used materials.

Bib.: Symons, S.S., *Daumier*, London, 1979; Vincent, H.P., *Daumier and his World*, Evanston, 1968

David

King of Israel, direct ancestor of Christ (Matthew 1: 1–17), and important in Christian art as an Old Testament prefiguration of Christ. Many of the events of his life, told in the Old Testament Books of Samuel, have been interpreted in this way and thus feature frequently in Christian art. He began life as a shepherd in Bethlehem and was selected by Samuel the prophet as the successor to King Saul. David was also a musician, famed for his harp-playing, and was summoned by Saul, who suffered from bouts of depression, to ease his spirits with his playing (e.g. ▷Rembrandt, *David Playing Before Saul*, The Hague, Mauritshuis).

At this time the Israelites were at war with the Philistines. David offered to fight the Philistines' champion, the giant Goliath, and to give evidence of his courage, he told Saul how, as a shepherd, he would fearlessly take on lions and bears with his bare hands. The image of David slaying a lion appears in medieval art as a symbol of Christ's victory over the Devil. He was allowed to challenge Goliath and defeated him by striking him in the forehead with a well-aimed stone from his sling. (Again, this episode is often taken as symbolizing Christ's victory over the Devil or, more loosely, the victory of right over wrong.) David then decapitated Goliath with his own sword (e.g. ▷Donatello, c.1433–40, bronze; Florence, Bargello). Notwithstanding the fact that the Bible specifies that David refused to wear armour because he had not yet earned the right to, he is frequently portrayed clad in Roman-style cuirass and greaves (e.g. ▷Verrocchio, bronze, c1473–75; Florence, Bargello). David returned to Jerusalem in triumph, carrying Goliath's head, sometimes on the point of a spear, an event which was seen as a prefiguration of Christ's ▷Entry into Jerusalem.

The other frequently depicted event of David's life occurs in the period of his kingship and concerns his love for Bathsheba, the wife of a Hittite man named Uriah who was serving in his army. One day David is taking the evening air on the roof of his palace when he sees Bathsheba in her bath (e.g. ▷Hans Memling, *David and Bathsheba*, Stuttgart, Staatsgalerie). He desires her and, Uriah being away on active service, he takes her. She later becomes pregnant and, in order to get rid of Uriah permanently, David sends him out to battle with instructions to the commander of his army that Uriah is to be put in the most dangerous part of the field. Uriah is duly killed and David marries Bathsheba, though the child dies a few days after birth and David does penance. Despite the reprehensible nature of David's actions, medieval theologians saw this episode as symbolic of the love of Christ (David) for the Church (Bathsheba). The moment most often depicted, no doubt for the opportunity it gave for the depiction of the female nude, is when Bathsheba steps

out of the bath and receives David's message summoning her. ▷Rembrandt is unusual in depicting Bathsheba's mental turmoil (*Bathsheba at her Toilet*, 1654, Paris, Louvre). As a devotional image, David is portrayed playing a harp, lyre, or viol and wearing a crown. As an ancestor of Christ, he appears amongst the figures in the ▷Tree of Jesse.

David, Gerard (d 1523)

Netherlandish painter. He was the leading painter in Bruges following the death of ▷Memling. Born in Oudewater, he was admitted to the painter's guild in Bruges in 1484. His works are mostly religious subjects, imbued with a gentle piety, showing the influence of the earlier Netherlandish masters, such as ▷Jan van Eyck and ▷Hugo van der Goes, but now inflected with an Italianate influence which is manifested in a new formal monumentality. Among his more important works is the pair commissioned by the town of Bruges, *The Judgement of Cambyses* and *The Flaying of Sisamnes* (1498, Bruges, Groeningemuseum). These are gruesome, admonitory paintings, warning of the retribution ensuing from corruption and injustice, subjects perhaps not best suited to David's placid style. More appropriate were the devotional ▷sacra conversazione themes, exemplified by *The Virgin and Child with Saints and Donor* (c1505/09, London, National Gallery). By the time of David, Bruges was beginning to lose both its economic and artistic primacy to Antwerp and David is generally regarded as coming at the end of a tradition, though he did number among his followers artists of the calibre of ▷Adriaen Ysenbrandt and ▷Ambrosius Benson.
Bib.: Miegroet, H.J. van, *Gerard David*, Antwerp, 1989

David, Jacques-Louis (1744–1825)

French painter. He was a supporter of the ▷French Revolution and one of the leading figures of ▷Neoclassicism. He was a distant relative of ▷Boucher, who perhaps helped his early artistic progress as a pupil under ▷Vien (1765). He won the ▷Prix de Rome in 1774 and travelled with his master to Rome where he spent six years. It was during this period (1775–81), that he abandoned the grand manner of his early work, with its ▷Baroque use of lighting and composition, for a stark, highly finished and morally didactic style. This was influenced by the ideas then current in Rome (▷Winckelmann) and by artists such as ▷Hamilton who were already experimenting with a Neoclassical idiom. In 1784 the change of style was confirmed by the *Oath of the Horatii* (Paris, Louvre), probably the most famous and certainly the most severe of a series of works which extolled the antique virtues of stoicism, masculinity and patriotism. During the French Revolution, David played an active role both artistically – he reorganized the Académie and produced numerous and spectacular propaganda exercises – and politically, as an avid supporter of Robespierre, who voted for

Jacques-Louis David, *Self-portrait*, Louvre, Paris

the execution of the king. He also attempted to catalogue the new heroes of the age, abortively in the *Oath of the Tennis Court*, and successfully in his ▷pietà-like portrayal of the ▷*Death of Marat* (1793, Brussels, Musée Royaux). He eventually lost out in the confused politics of the 1790s, was imprisoned under the moderate Directory and saved by the intervention of his estranged wife, symbolized in his *Intervention of the Sabine Women* (1799, Paris, Louvre), a work which strained his Classicism in the search for Greek purity. In 1799 Napoleon gained power, and David gained a new hero. He recorded the general and later the Emperor in numerous propaganda pieces (e.g. *Napoleon at Mont St Bernard*, 1800, Versailles; *The Crowning of Josephine*) in which his sobriety was loosened by Napoleon's demand for grandeur. In professional terms, he failed to survive the fall of his master, and in 1815 retired in exile to Brussels, where he continued to work in a highly finished Classical vein, but resorted to myth for his subject-matter (e.g. *The Disarming of Mars*). Throughout his career he produced portraiture which not only catalogued the changing political spectrum, but also his own artistic developments (e.g. *Antoine Lavoisier and his Wife*, 1788, New York, Metropolitan Museum). He was also a great teacher, numbering among his pupils ▷Gros, ▷Ingres, ▷Gérard and ▷Girodet, although few of them actually followed the severity of his style.
Bib.: Brookner, A., *David*, London, 1980

David d'Angers, Pierre Jean (1788–1856)

French sculptor. He practised in a ▷Neoclassical style and took his name from his home town, where he

grew up with his father (also an artist), and received his first education. He went to Paris in 1808 and worked on the sculptures for the Arc du Carrousel. He won the ▷Prix de Rome in 1811 and spent five years in Italy, where he met ▷Canova, ▷Ingres and ▷Thorvaldsen. He developed a highly finished Classical style, tempered with naturalism (e.g. *Boy with Grapes*, 1845, marble, Paris, Louvre), and especially effective in his portraiture where he achieved striking characterization (e.g. *Balzac*, bronze medallion, 1842). Among his contemporaries, he was considered a ▷Romantic. In 1837 he designed the Panthéon ▷pediment ▷relief, illustrating *France Distributing Wreaths to Great Frenchmen*. His political sympathies were apparent in works like *Jean Bart* (1839) and his refusal to design a monument to the battle of Waterloo. In 1828 he was made a member of the Légion d'honneur. He was also a professor at the ▷École des Beaux-Arts. He designed the Condé Monument at Versailles and the Gutenbourg Monument at Strasbourg, but was perhaps most famous for his portrait busts and medallions.
Bib.: Caso, J. de, *David d'Angers: Sculptural Communication in the Age of Romanticism*, Princeton, 1992

Davie, Alan (b 1920)

British painter. He studied at the Edinburgh College of Art from 1937 to 1940. He had a number of solo exhibitions and also performed as a jazz musician. His works are essentially ▷Abstract Expressionist, but are much more stylized than many American versions of this tendency. He often gave his paintings evocative titles.
Bib.: Tucker, M. (ed.), *Alan Davie: The Quest for the Miraculous*, exh. cat., Brighton, 1993

Davies, Arthur Bowen (1862–1928)

American painter. In 1893 he visited Europe and admired works by ▷Böcklin and ▷Puvis de Chavannes. He was an early member of ▷The Eight. Although his subsequent painting showed some ▷Cubist influence, he remained a conservative artist, producing nudes and pastoral landscapes in a moderated realist style. He also produced ▷lithographs and designed tapestries. His principal contribution to the development of American art was not through his own work but through his organizational ability. He became president of the Association of American Painters and Sculptors, and in this capacity he was involved in the organization of the ▷Armory Show. Although he did not practise modernist styles himself, he was deeply involved in encouraging ▷modernism in American through this activity.

Davis, Stuart (1894–1964)

American painter and graphic artist. He studied with ▷Robert Henri, but he was most strongly influenced by the ▷Armory Show and by his contact with the work of ▷Léger. From the ▷Cubists, he developed a ▷collage technique which used lettering as a means of stressing the modernity of his work. Throughout the 1920s, he concentrated on using modern advertising and other aspects of modernity as a subject for his paintings. Among these works, his *Eggbeater* series showed a ▷Precisionist attention to realism to enhance their modernity. He continued to concentrate on American themes and worked for the ▷Federal Arts Project during the 1930s, but his works became increasingly abstract By the 1940s, he was using jazz themes in his brightly coloured paintings.
Bib.: Myers, J. (ed.), *Stuart Davis: Graphic Work and Related Paintings with a Catalogue Raisonné of the Prints*, Fort Worth, 1986

De Andrea, John (b 1941)

American sculptor. He was a ▷Superrealist and produced life-like models such as those of ▷Duane Hanson.

death mask

A cast made of a person's face after they die. Wax or plaster was used to form the cast. Death masks have an ancient origin and were used by both the Egyptians and the Romans, for whom they played an important part in ancestor worship. They were also prominent during the Renaissance and the Romantic period.

Death of General Wolfe

Painted by ▷Benjamin West in 1770 (oil on canvas, 150×210 cm/5 ft \times 6 ft 10 in). The painting represents the death of General Wolfe during the battle of Quebec in 1759, and depicts the moment when, fatally wounded, Wolfe hears of victory. On the left of the work a figure carrying a captured French standard runs in. The right background shows the St. Lawrence river with troops mustering and behind the foreground group the action of the battle is seen to continue. In 1776 West published a key in which six of the foreground figures were identified, although none of them were present at the General's death. Equally, the group includes a Native American, despite the fact that none fought with the British Army. Both he and the green-jacketed American ranger can be seen as local colour – West's attempt to clarify the location of the battle. Wolfe is posed directly beneath the British flag, surrounded by mourners as if almost part of a Biblical lamentation. Prior to exhibition the work was questioned by those, including George III, who thought that ▷history painting and contemporary dress were irreconcilable, but after its ▷Royal Academy exhibition, the painting was hugely popular. Not only did West try to emulate it in later works, but other artists attempted the marriage of classicism and contemporary

Death mask: *Mask of Agamemnon*, Mycenae, Greece

subjects. The painting is in the National Gallery of Canada, Ottawa.

Death of Marat

Painted by ▷Jacques-Louis David in 1793. It was presented to the National Convention, of which David was a member, as a tribute to the murdered revolutionary, Marat, who had been stabbed in his bath by Charlotte Corday. Marat suffered from a severe skin complaint which meant he spent hours in a bath and often worked from there, using a packing chest to lean on whilst writing. David utilizes these details in his work, showing Marat on the point of death, quill still in his hand, the bloody knife on the floor at his side. He has been writing to offer a grant of money to a soldier's widow, showing himself to be a charitable man as well as an enthusiast of the regime. A further scrap of paper represents Corday's petition, which enabled her to gain access to her victim. The packing chest becomes almost a tomb, etched with the sombre inscription, *'A Marat David, l'an deux'* ('To Marat, from David, the year 2'). David ignores the reality of Marat's comfortable lifestyle in favour of a plain background and even a patch on the sheet which covers the bath. Marat himself is posed almost like a ▷pietà, showing no evidence of illness, and the whole painting avoids contemporary detail in favour of creating a timelessness. The work represented the most successful of David's revolutionary propaganda paintings and perhaps the only work in which he transposed the sense of honour, sobriety and intense emotion of his ▷Neoclassical works into the world of his own time. The painting is in the Musées Royaux in Brussels.

Bib.: Guilhaunou, J., *La Mort de Marat*, Brussels, 1989

Death of Sardanapalus, The

Painted by ▷Eugène Delacroix in 1827 (oil on canvas, 395 × 495 cm/12 ft 10 in × 16 ft). The subject is based on a poem by Byron about the legendary 7th-century Assyrian monarch, who ordered the death and destruction of all his possessions rather than have them fall into the hands of his enemies. Delacroix portrays the chaotic scene of the possessions, including women and horses as well as jewels and finery, being gathered together in front of the King. Sardanapalus sits impassively on an elaborately carved and oversized bed, almost hidden in the shadows of the background, and seems to meditate on the forthcoming destruction. The subject was one of a number based on Byron's poetry which Delacroix painted during his career, but in this case he seems to have been attracted to the exotic detail of the scene. The previous and successful *Massacre of Scio* (1824, Paris, Louvre) also exploited the possibilities of Middle Eastern costume and decoration. The painting is an orgy of colour and curving movement: the foreground is dominated by the dual image of a nude woman with a knife held to her throat, and a powerful white horse being dragged in by a coloured slave. The whole palette is dominated by gold and red, the colours of power, destruction and hell itself. In the midst of the movement, Sardanapalus seems an intensely ▷Romantic figure, not merely a study in the effects of corrupting power. The work was seen as debauched when first exhibited and helped to cement Delacroix' reputation as the radical opposition to ▷Ingres, but it remained unique in his *oeuvre*, both in terms of scale and complexity. It is now in the Louvre in Paris.

Bib.: Spector, J., *Delacroix: The Death of Sardanapalus*, London, 1974

Death of the Author
▷auteur theory

Death of the Virgin
Most commonly portrayed as an interior, death-bed scene with an aged ▷Virgin surrounded by the ▷Apostles (including ▷John the Evangelist holding a palm, ▷Peter conducting the last rites with a book and Andrew swinging a censor). Often ▷Christ, attended by angels, watches from a cloud above, sometimes holding an effigy of his mother (e.g. Strasbourg Cathedral south portal, 1230–39; ▷Van der Goes, 1470–5, Bruges; ▷Duccio, ▷*Maestà*, 1309–11, Siena, Pinacoteca). In ▷Counter-Reformation scenes, to emphasize the peacefulness of her demise, the Virgin sits on a throne: she is not dead, merely sleeping until her Assumption into Heaven.

The scene is sometimes part of a narrative sequence which shows the Annunciation of the Virgin's death (she is give the palm of paradise by an angel three days before), her last communion taken from ▷John the Evangelist, and the carrying of the body to the tomb. Most commonly however, artists portrayed the ▷Assumption of the Virgin, in which mourning is replaced by triumphalism and celebration (e.g. ▷El Greco, 1608–13, Toledo, Museo de Santa Cruz; ▷Titian, 1516–18, Sta Maria dei Frari, Venice; ▷Correggio, 1525, Parma, Duomo).

decadence
Decline, but with specific connotations of morbidity, corruption and decay. It was used as a means of characterizing anti-bourgeois tendencies in literature and art at the end of the 19th century in France and England. Artists such as ▷Beardsley, and authors such as Huysmans and Oscar Wilde were said to be promoting a form of decadence that was part of the ▷aestheticis of the turn of the century.
▷fin de siècle; aestheticism
Bib.: Birkett, J., *The Sins of the Fathers: Decadence in France 1870–1914*, London, 1986; Dowling, L., *Aestheticism and Decadence: A Selective Annotated Bibliography*, New York, 1977; Gilman, R., *Decadence: The Strange Life of an Epithet*, London, 1979

decalcomania
A technique which involves inking a piece of paper and then pressing it against a blank sheet of paper and rubbing the two together. It was used by the ▷Surrealists, and especially ▷Ernst, to create unusual and unexpected forms. Ernst then used these forms as the basis of some of his more fanciful paintings. It was invented by Oscar Domínguez (1906–58) in c1936. Its psychological properties later made it the basis of the Rorschach ink blot tests – a psychological method for testing personality on the basis of a patient's 'interpretation' of abstract ink blots. The term has also been used to refer to a specific transfer technique used in industrial design.

decastyle
▷portico

Deccani miniature painting
▷Islamic art

décollage
(French, 'unsticking'.) The opposite of ▷collage. Rather than adding bits and pieces to an existing composition, *décollage* involves peeling bits off.
Bib.: McEwen, S., *Décollage*, Cheltenham, 1989

deconstruction
According to ▷Derrida, deconstruction is 'a world of signs without fault, without truth and without origin, which is offered to our active interpretation'. In other words deconstruction aims to shows that any text inevitably undermines its own claim to have a determined meaning, and licenses the reader to produce his own meanings out of it by an activity of semantic free play. The critic or viewer, and not the artist, is host.
Bib.: Elam, D., *Feminism and Deconstruction*, London, 1994–, Silverman, H. (ed.), *Derrida and Deconstruction*, New York, 1989

Decorated Style
The style of English Gothic architecture which followed Early English and preceded ▷Perpendicular, lasting c1250–c1370. Surfaces in general are more richly decorated than in Early English architecture and windows are broader. The early phase of Decorated is termed Geometrical and is characterized by simple ▷bar-tracery patterns of circles, ▷trefoils, quatrefoils, etc. which rest upon or between the arches of the window lights. The later phase, from c1300, is termed Curvilinear and is characterized by a richer, more fluid, reticulated pattern of circles drawn out at top and bottom into ogee shapes, flowing continuously from the mullions of the window. Decorated capitals are often carved with extremely naturalistic plant forms, those at Southwell Cathedral chapter house being especially finely carved and clearly identifiable as hawthorn, buttercup, hop etc. Right-angled plans begin to be modified through the use of diagonal corners, as in polygonal chapter houses (an English speciality) and the octagon at Ely Cathedral.

Characteristic details of Decorated style are: (i) ▷ball flower ornament; (ii) ▷liernes, non-structural ribs which extend neither from main springers nor the central ▷boss but connect the main structural ribs to form tracery-link decoration; (iii) ▷ogee arches.
Bib.: Bony, J., *The English Decorated Style: Gothic Archi-*

tecture Transformed 1250–1350, Oxford, 1979; Coldstream, N., *The Decorated Style, Architecture and Ornament 1240–1360*, London, 1994

decorative art

An art concerned with the design and decoration of objects which themselves may have utilitarian functions and might not be in themselves aesthetically pleasing, for example, ▷ceramics, glassware, ▷textiles, furniture, clothing and architectural details. It is difficult to make a hard distinction between decorative art and craft, but it may be useful to note that the term 'decorative art' was first coined during the ▷Industrial Revolution in response to mechanically-made objects rather than hand-made ones. Non-western cultures tend not to make this distinction, and do not differentiate between the decorative arts and the ▷fine arts. Contemporary artists tend not to make this distinction either, and ▷installation art, which uses a wide variety of different media, underlines this fact.

▷applied art

decorum

Propriety and suitability for purpose. In the ancient world, the concept of decorum was used to refer to literature which was written in a style suited to its content. Certain poetic and prose forms were felt to be appropriate for particular modes of literature. In the Italian ▷Renaissance, the idea was adopted to refer to art, and it became codified in Italian and French ▷academies. In artistic theory, decorum dictated that an idealized and elevated style should be used for ▷history painting, whereas realism was only appropriate for lower forms of art. It was also used as a means of praising or criticizing artists for their visual interpretations of biblical and mythological subjects.
Bib.: Ames-Lews, F. and A. Bednarek (eds.), *Decorum in Renaissance Narrative Art*, London, 1992

découpage

Cut out forms pasted onto a surface and often lacquered.

Deësis

An image of Christ on a throne between the ▷Virgin and ▷John the Baptist. It was very common in Russian and ▷Byzantine churches, but less so after the 15th century.

Degas, (Hilaire Germain) Edgar (1834–1917)

French painter, draughtsman and sculptor. He was one of the leading ▷Impressionists. Born into a wealthy banking family, he originally studied law but from 1855 he was a pupil at the ▷École des Beaux-Arts under Lamothe, a former pupil of ▷Ingres who passed on his admiration of Ingres to Degas. Degas also travelled to Italy (1854–9), where he absorbed the

Classical and ▷Renaissance traditions which are visible in his early work. He met ▷Manet in 1861 and gradually became influenced towards contemporary subject matter, whilst his compositions of this period reflect the flattened space and geometric frameworks of ▷Whistler (e.g. *Belleli Family*, 1860–2, Paris, Musée d'Orsay). Through these connections he met the other Impressionists and in the 1870s became one of the key organizers of the group, despite obvious individualisms of style. Apart from a visit to New Orleans (his mother was a Creole), he remained in Paris, abandoning the

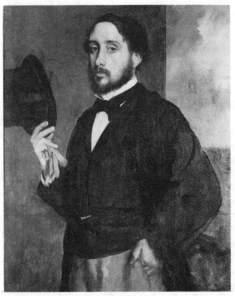

Edgar Degas, *Self-portrait*, c1863, Museu Calouste Gulbenkian, Lisbon

▷Salon in 1870 in favour of the Impressionist exhibitions (he showed at seven of them) and exploring a new range of subject matter which included the ballet, café concerts, brothels and the races (e.g. *At the Races*, 1869–72, Paris, Musée d'Orsay; *Ballet Rehearsal*, 1874, Glasgow, Burrell Collection; *Absinthe Drinker*, 1876, Paris, Musée d'Orsay). In these works Degas set himself the task of objective observation, employing tricks of composition and finish which implied rapid snapshot sketching and an almost photographic detachment. In reality, his works were carefully conceived in the studio, and he remained fascinated by technique. He experimented with all forms of print-making, with thinned down oils and with ▷pastel, which he used increasingly (e.g. *Woman Combing her Hair*, 1887–90, Paris, Musée d'Orsay). Due to this experimentation, as well as to his failing eyesight, his work from the 1880s was freer, employing stronger, almost expressionist colour, layered for depth. In these works, which concentrated on women and particularly a series of nude bathers, objectivity and poetry seem to vie for dominance (e.g. *Women Ironing*, 1884, Paris, Musée d'Orsay). From

1874 he also worked in three dimensions, producing a series of wax models (later cast in bronze) of captured poses and imbalance which are often compared to ▷Rodin. In his later life, Degas was increasingly reclusive.

Bib.: Armstrong, C., *Odd Man Out: Readings of the Work and Reputation of Edgar Degas*, London, 1991; Reff, T., *Notebooks of Edgar Degas*, 2 vols., Oxford, 1976; idem, *Degas, the Artist's Mind*, London, 1976; Degas beyond Impressionism, exh. cat., London, 1995

Degenerate Art

(From the German, '*Entartete Kunst*'.) This term was used by Hitler and the Nationalist Socialists to describe much modern, ▷avant-garde art that they regarded as 'cultural Bolshevism' and an attack on the purity of the German people. After coming to power in 1933 Hitler closed the ▷Bauhaus in Berlin, and organized the expropriation of modern art from private and public collections. A number of exhibitions of this confiscated art were held, and included works by ▷Erich Heckel, ▷Emil Nolde, ▷Ernst Ludwig Kirchner, ▷Georges Braque, ▷Marc Chagall, ▷Giorgio de Chirico, ▷Paul Gauguin, ▷Vincent van Gogh, ▷Wassily Kandinsky, ▷Piet Mondrian, ▷Edvard Munch, and ▷Pablo Picasso. The actual exhibition, *Entartete Kunst*, was held at the Hofgarten, Munich, in 1937, alongside an exhibition of new nationalist, official German art at the Haus der Deutschen Kunst. In his opening speech the president of the Reich Culture Chamber, Adolf Ziegler, stated, 'What you are seeing here are the crippled products of madness, impertinence, and lack of talent.' The exhibition included approximately 650 works by 112 artists, including ▷Barlach, ▷Beckmann, Kandinsky, ▷Klee, Kirchner, ▷Kokoschka, and Nolde. In 1939 many works were either sold abroad or burnt. Artists and teachers who failed to follow State-controlled directives were forbidden to exhibit or in extreme cases forbidden to work.

Bib.: Barron, S. (ed.), '*Degenerate Art*': *The Fate of the Avant-Garde in Nazi Germany*, Los Angeles, 1992; Schuster, P.-K. (ed.), *Die 'Kunststadt' München: Nationalsozialismus und 'Entartete Kunst'*, Munich, 1987

Deianeira

▷Hercules

Déjeuner sur l'Herbe

Painted by Manet in 1863. It shows two male figures in contemporary dress, lounging in conversation after a picnic near St. Ouen. They seem oblivious of the presence of a naked woman, who sits staring out at the viewer, her clothes clearly visible in a crumpled heap in the foreground. Another woman, dressed only in a shift, paddles in the water in the background of the painting. The inspiration for the work may well have come from ▷Giorgione's (or ▷Titian's) *Fête*

Champêtre (c1510) in the Louvre, which depicts a similar scene in the 16th-century Italian countryside. Although an allegorical work, it would not have been seen as such in Manet's time, and he has clearly transposed the subject up to the present day, perhaps with the intention of making a commentary on the use of the ▷nude in art. The subject matter was controversial in itself, but the problems were emphasized by Manet's treatment. The inclusion of the nude woman's clothes and the juxtaposition between her and the sensual foreground still life, as well as the defiant stare of the model, Victorine Meurand, similar to that employed by the artist in *Olympia* (1863, Paris, Musée d'Orsay), appeared as a direct challenge to bourgeois expectations. Equally the work was criticized for the 'objectivity' of Manet's style, his palette is dominated by muddy colour and harsh tonality, the background darkened by roughly painted trees, and he appeared no more interested in the figures than in the inanimate components of the scene. Along with the *Olympia* and *Music in the Tuileries* (1862, London, National Gallery), *Déjeuner sur l'herbe* established Manet as a leader of the ▷avant-garde. Although retrospectively the works are often associated with ▷Impressionism, for their use of contemporary Parisian subject matter and free technique, they fit equally well into the ▷Realist tradition of portraying unpleasant aspects of life with an apparent indifference and coldness. The work is now in the Musée d'Orsay in Paris.

De Kooning, Willem (b 1904)

American painter of Dutch birth. He was one of the leading ▷Abstract Expressionists. He settled in the United States in 1926, having been influenced by Dutch ▷Expressionism and ▷De Stijl. Initially, he worked as a decorator, before joining the WPA (▷Federal Art Project) in 1935. This brought him into contact with ▷Surrealist-influenced artists like ▷Gorky who were deconstructing and distorting reality as the basis of their art and exploring automatic techniques. His first major works (see in his 1948 one-man show) were in this vein, using commercial paint, employing initially only line and later added colour to create fluid, abstracted forms (e.g. *Excavation*, 1950, Chicago, Art Institute). In 1952, he began his *Woman* series (*I* to *VI* exhibited in 1953), a controversial return to figuration which abandoned line in favour of violent slashes of colour, creating images at once misogynistic and erotic. Similar technique, but greater abstraction, was employed in his landscapes of the 1950s and 1960s, characterized by their lyrical titles (e.g. *Door to the River*, 1960, New York, Whitney Museum). He later returned to the theme of women, now adding a more humorous slant, emphasized by a playfully brightened palette. He also experimented with sculpture. In recent years, suffering the effects of Alzheimer's disease, he has become reclusive but remains active, producing work more like that of his early ▷Surrealist influence

which, some argue, is his subconscious reaction to his illness. His wife Elaine, whom he married in 1943, was an Expressionist painter and writer.

Bib.: Waldman, D., *Willem de Kooning*, New York, 1988; *Willem de Kooning: Drawings, Paintings, Sculpture*, exh. cat., New York, 1983

Delacroix, (Ferdinand Victor) Eugène (1798–1863)

French painter. He was one of the leading ▷Romantic artists. He was supposedly the illegitimate son of the politician and diplomat, Tallyrand, and he studied under ▷Guérin at the ▷École des Beaux-Arts, where he met, admired and shared the same inspirations as ▷Géricault (▷Gros, ▷Rubens, ▷Michelangelo). His first ▷Salon success, *The Barque of Dante* (1822; Paris, Louvre), reflected these inspirations, as well as his love of literature (he painted themes from Shakespeare,

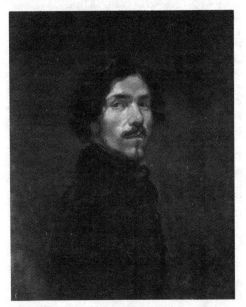

Eugène Delacroix, *Self-portrait*, Uffizi, Florence

Scott and Byron). His second major work *The Massacre of Chios* (1824, Paris, Louvre), showed an interest in contemporary events – the Greek War of Independence, which he also painted in the *Ruins of Missilonghi* (1826, Bordeaux) – and the French Revolution of 1830 featured in *Liberty Leading the People* (1830, Paris, Louvre). An enthusiasm for the exotic was encouraged by a visit to Morocco in 1832, which was to form the basis for many pictures including the sultry, languid *Women of Algiers* (1834, Paris, Louvre), and dramatic versions of the *Lion Hunt* (1858, Boston). He had also visited England in 1825, having been inspired by ▷Constable's *The Haywain* (exhibited at the 1824 Salon) and by his friendship with ▷Bonington.

Delacroix' choice of subject matter and his increasingly free and vibrant use of paint and colour (he was one of the great experimenters in the use of complementary colour) earned him the label of a ▷Romantic and caused some early controversies, notably over the ▷*Death of Sardanapalus*, his Byronic extravaganza of 1827 (Paris, Louvre). Moreover, throughout his career he was championed by ▷Baudelaire and others as the polarized opposition to ▷Ingres' Classicism. Delacroix did indeed have many friends in the Romantic movement (e.g. *Portrait of Chopin*, 1838, Paris, Louvre), yet he was not himself a revolutionary. He admired and wished to emulate his artistic heroes of the past, remained heavily influenced by his classical training in his painting method, and worked on numerous official decorative schemes (e.g. the Salon d'Apollon at the Louvre, 1849; the Chamber of Deputies and the Senate Libraries, 1838–47). He also produced religious scenes (e.g. *Christ on the Cross*, 1853; London, National Gallery), and politically he was a conservative. He also survived long enough to become an establishment institution (his works along with those of Ingres dominated the 1855 Universal Exposition). He was awarded a Légion d'honneur in 1831 and elected to the Institute in 1857.

Bib.: Serullaz, M., *Delacroix*, New York, 1971; Trapp, F., *Attainment of Delacroix*, Baltimore, 1971

Delaroche, Paul Hippolyte (1797–1856)

French painter. He produced primarily historical subjects. He was born in Paris and entered the ▷École des Beaux-Arts in 1816. He initially wanted to be a landscapist but after failing the ▷Prix de Rome for landscape in 1817, he became a pupil of ▷Gros. He exhibited at the ▷Salon for the first time in 1820 (*Deposition*; Chantilly, Musée Conde) and over that decade developed an academic style coupled with ▷Romantic sentiment which produced highly popular images. They provided detailed naturalistic treatment of historical narratives, aimed at stimulating the viewer's emotions. Many were on English history themes (e.g., *The Princes in the Tower*, 1831, Paris, Louvre; *The Execution of Lady Jane Grey*, 1834, London, National Gallery) and sometimes used a deliberately archaic ▷troubadour style. Despite continued critical opposition, he received the Légion d'honneur in 1828 and, after 1830, official commissions (e.g., the École des Beaux-Arts Hemicycle, 1841). In his later career he abandoned Salon exhibition in favour of portrait and religious commissions. He was perhaps best known as a teacher.

Bib.: Ziff, N.D., *A Study in 19th Century French History Painting*, New York, 1977

Delaunay, Robert (1885–1941)

French painter. From the very outset of his career, he was interested in the properties of colour, and his earliest works of c1906 show his knowledge of ▷Seurat's colour theories. Focusing on themes of Paris

and the Eiffel Tower, he evolved a ▷Cubist form of art that was more concerned with colour than the work of ▷Picasso and ▷Braque. ▷Apollinaire called his work ▷'Orphism'. Delaunay's work became increasingly abstract before the First World War, as

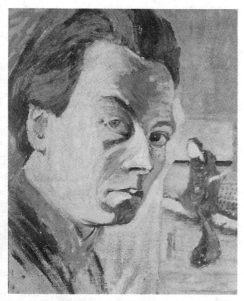

Robert Delaunay, *Self-portrait with a Japanese print*, Collection Sonia Delaunay-Terk, Paris

colour properties became the subject of works such as the *Disques* series. He exhibited at the ▷Salon des Indépendants in 1911, and his work was particularly influential on German artists such as ▷Klee, ▷Marc and ▷Macke, who invited him to exhibit with the ▷Blaue Reiter. During the First World War, he spent time in Spain and Portugal, but he was back in Paris during the 1920s. He was married to ▷Sonia Delaunay.

Bib.: Buckberrough, S., *Robert Delaunay: The Discovery of Simultaneity*, Ann Arbor, 1982; Schuster, P.-K.(ed.), *Delaunay und Deutschland*, exh. cat., Cologne, 1985

Delaunay-Terk, Sonia (1885–1979)

She was from the Ukraine, but in 1905 she came to Paris, where she met ▷Delaunay in 1910. Although she adopted aspects of Delaunay's ▷Orphism, her own work took a distinct direction. Rather than easel-painting, she concentrated on textile and costume design, as well as book illustration. While Delaunay's work lost direction after the First World War, Sonia's greatest success came at this time. In 1918 she designed the sets for ▷Diaghilev's production of *Cleopatra*, and she was hired by a number of important film stars to design their clothes. In the 1930s, she joined the ▷Abstraction-Création group, and she continued to make a name for herself designing clothes and textiles.

Bib.: Baron S. and J. Damase, *Sonia Delaunay: The Life*

of an Artist, London 1995; *Sonia Delaunay, a Retrospective*, exh. cat., New York, 1980

Delft(ware)

A mid-17th-century form of earthenware produced in Delft, in the Netherlands. It was glazed tin with a distinctive blue and white design. It was often used in combination with ▷chinoiserie.

Bib.: Fourest, H.-P., *Delftware: Faience Production at Delft*, New York, 1980; Montias, J.M., *Artists and Artisans in Delft: A Socio-economic Study of the Seventeenth Century*, Princeton, 1982

Delphic Sibyl

▷Sibyl

De Loutherbourg, Philippe Jacques (1740–1812)

English painter of French birth. He was born in Basel, and trained in France under ▷Carle van Loo, exhibiting landscapes which showed Dutch influence. He settled in England in 1771, having been brought over to design stage sets for David Garrick at the Drury Lane Theatre. He also painted theatrical portraits, such as *Garrick as Don John* (1776, London, Victoria and Albert Museum). Influenced by his work there, he invented the Eidophusikon in 1781, a device for presenting paintings with lighting and movement which fascinated many artists of the day. He exhibited at the ▷RA from 1772, and worked in a range of landscape styles, from topography, anecdote and ▷Morlandesque rusticity (e.g., *Midsummer Afternoon with Methodist Preacher*, 1777, Ottawa) to ▷Turner-like storms (e.g. *Storm and Avalanche*, 1804, Petworth). He visited Wales in 1786 and produced ▷Romantic views of Snowdon, and continued to produce slightly stage images of continental scenes. He also attempted historical themes (e.g. *Great Fire of London*, 1793, New Haven, Yale University Art Gallery) and Biblical epics and was appointed history painter to the Duke of Gloucester in 1804. He designed plates for Macklin's illustrated Bible in 1791–1800. In the 1790s he went through a mystical phase, following the fashion of the period.

Delvaux, Laurent (1696–1778)

Flemish sculptor. In 1717 he visited London with ▷Scheemakers. In 1728 he visited Italy, and he became a court painter in Brussels in 1733. He produced primarily religious and tomb sculpture, including the pulpit in Ghent Cathedral (1745). He became sculptor to Emperor Charles VI and to Charles, Duke of Lorraine.

Delvaux, Paul (b 1897)

Belgian painter. His early work was in the ▷Expressionist mode of the Second ▷Laethem Group, although he was never officially a member of the

movement. In 1935 he came into contact with ▷Surrealism, and his own work developed a distinctive style and subject matter that adapted and altered some of the ideas of both ▷Magritte and ▷de Chirico. His leitmotif was nude women performing meaningless rituals in bizarre landscape settings, often with Classical ruins.

Bib.: Butor, M., et al., *Delvaux*, Lausanne, 1975

De Maria, Walter (b 1935)

American sculptor. From the 1960s he was a practitioner of ▷Minimalist sculpture, which took the form of ▷earthworks. His most famous work was two parallel lines two miles long which he drew in the Mojave Desert (1968).

Demoiselles d'Avignon, Les

Painted by ▷Picasso in 1907 (oil on canvas 144 × 234 cm/4 ft 8 in × 7 ft 8 in). The work was a major undertaking for the artist, the product of a number of preliminary sketches and reworkings, which Picasso never considered to have been completed. The subject was originally to have been a brothel scene, containing two male figures, one of whom held a skull, but Picasso abandoned this in favour of five female nudes. What was originally an explicit commentary on human sin, death, and possibly even venereal disease, thus becomes a more generalized study on the theme of artistic beauty. The women stare challengingly out of the canvas, their bodies distorted and angular, in a violent attack on aesthetic traditions. The treatment of the women shows the range of influences affecting Picasso during 1907: the standing figure on the left has an almost ▷Gauguinesque profile; the central women owe their heavily marked eyes to traditional Iberian sculpture; whilst those on the right have their heads substituted for African masks. In addition, Picasso is clearly exploring space and spatial relationships, influenced in part by ▷Cézanne: the still life in the foreground of the work is tilted towards the viewer, the kneeling woman on the right has her head twisted over her back and the space between all the figures is defined by crumpled embryonic facets of blue and pink. It is this feature especially which has led the work to be seen as the first ▷Cubist painting, although there are many features, including the colouring, which hark back to Picasso's earlier Blue and Rose periods. However, the work was something of a talisman for the select group who first saw it and it has since become one of the most infamous images of 20th-century painting. It is now in the Museum of Modern Art in New York.

Bib.: Leah, B., *Picasso's Les Demoiselles d'Avignon: A Sketchbook*, London, 1988; Rubin, W.S., *Les Demoiselles d'Avignon*, New York, 1994

Demont-Breton, Virginie Elodie (1859–1935)

French painter. She was the daughter of Jules Breton, and began her art training early. She exhibited at the ▷Salon and won a number of awards for her work. However, her major contribution to art was her activism for the cause of women artists. She helped train women artists from the 1880s and campaigned to have women admitted to the ▷École des Beaux-Arts. She was also involved with the Union des Femmes Peintres et Sculpteurs. Her success led her to be elected Officer of the Légion d'honneur in 1894. Her own paintings concentrated on themes of women and children, and she was particularly known for her scenes of life in a fishing village, painted in Wissant in Normandy, where she lived for a time.

Demuth, Charles (1883–1935)

American painter. He was from Pennsylvania and initially studied in the Academy there. In 1912 he travelled to Paris where he attended the ▷Académie Julian. When he returned to America in 1914, he became associated with abstractionists and ▷modernists, such as ▷Marcel Duchamp. From 1919 he practised a form of ▷Precisionism or ▷Cubist-Realism, in which he used a clinical form of ▷Cubism for works which represented scenes from urban life. He deliberately stripped his works of any emotional associations. He also invented the 'poster portrait' which was a unique form of portraiture designed to move the practice away from merely copying the face. His portrait of William Carlos Williams, *I Saw the Figure 5 in Gold* (1921, New York, Metropolitan Museum) uses letters and patterns, rather than words to characterize Williams' personality.

Bib.: Frank, R.J., *Charles Demuth Poster Portraits, 1923–9*, exh. cat., New Haven, 1994

Denis, Maurice (1870–1943)

French painter and art theorist. He was a member of the ▷Nabi group and is best known for his famous quip of 1890: 'Remember that a picture – before being a war horse or a nude woman or an anecdote – is essentially a flat surface covered with colours assembled in a certain order.' Although this phrase was to be quoted frequently as an apology for ▷modernist ▷abstraction, Denis' own work went only a short way towards being fully abstract. Instead, he began to become more concerned with Catholic religious art, and he became involved in decorating churches. In 1919 he founded the Ateliers d'Art Sacre.

Bib.: *Maurice Denis et la Bretagne*, exh. cat., Morlaix, 1985

Denmark, art in

▷Scandinavian art

dentils

In classical architecture, the band of small, closely spaced, tooth-like blocks which decorate the ▷cornice in the ▷Ionic, ▷Corinthian and ▷Composite orders, and less frequently, the ▷Doric order.

Deposition

▷Descent from the Cross

Derain, André (1880–1954)

French painter, sculptor and graphic artist. He was born in Chatou and began painting in 1895. From 1989 he studied at the Académie Camillo. He worked with ▷Vlaminck at Chatou in 1900 and with ▷Matisse at Collioure in 1905 (e.g. *Landscape at Collioure*, 1905, Washington, DC, National Gallery), establishing a ▷Fauvist style which combined ▷pointillism with a use of flattened pure colour suggestive of Mediterranean heat. In this he was heavily influenced by an exhibition of ▷van Gogh's work he saw in 1901. In 1905/6 he visited London (see *Westminster Bridge*, 1906, private collection). From then on, he became interested in ▷Cubism (he met ▷Picasso in 1906), producing simplified, structured images reminiscent of ▷Léger (e.g. *Bagpiper*, 1910–11, Minneapolis, Institute of Arts). He was also one of the first artists to realize the potential of ▷primitive art (e.g. *Les Baigneuses*, 1908, Prague, National Gallery). After the First World War he reverted to a more traditionalist style, producing nudes, landscapes and still lifes in dull colours. He also produced some designs for ▷Diaghilev's *Ballets Russes* (from 1919). He produced stylized geometric sculpture from 1905, and graphic art, including ▷woodcuts for ▷Apollinaire.

Bib.: *André Derain*, exh. cat., London, 1967

Derrida, Jacques (b 1930)

French philosopher and deconstructionist. In works like *Phenomena* (Eng. trans., 1973) and *Writing and Difference* (Eng. trans., 1978), he argued that language was not fixed, but composed of 'differences' which combined to form meaning/signs. Signs can never have a full, permanent meaning because of this lack of authority and control. In this way he opposed the traditional idea that philosophy was a search for metaphysical truths and opposed the holding of any philosophical doctrine in favour of a study of the text. For him there was 'nothing outside the text', and language (including visual language) was the sole basis of analysis. He related these ideas to art in *Truth in Painting* (1978).

Bib.: Silverman, H. (ed.), *Derrida and Deconstructionalism*, New York, 1989; Wood, D., *Derrida: A Critical Reader*, Oxford, 1992

Descent from the Cross (Deposition)

The scenes narrated in all the ▷Gospels in which ▷Christ is taken down from the Cross, for burial. It is a general scene of mourning (e.g. ▷van der Weyden, 1435, Madrid, Prado; ▷Fra Angelico, 1434, Florence, S. Marco). Traditionally present are Joseph of Arimathea, the rich Sanhedrin member who gave up his tomb for Christ, ▷Nicodemus (with myrrh and pincers to pull out the nails), the ▷Virgin, usually overcome with emotion, ▷Mary Magdalene (recognizable with her long hair, sometimes kissing Christ's feet) and ▷St John. The scene was gradually extended by artists, to include extra figures to take the weight of the body, up to four ladders to help with the deposition (e.g. ▷Rosso Fiorentino, 1521, Volterra) and symbols like the foreground skull of Adam, or the ▷Instruments of the Passion. ▷Rembrandt depicted it at night (Munich). The same grouping of figures was also used in ▷Lamentation scenes (▷pietà), which show the body of Christ resting on the ground, surrounded by mourners (e.g. ▷Giotto, 1306, Padua, Arena Chapel; ▷Donatello, 1443–53, Padua, Santo; ▷Carracci, *Three Maries*, 1604, London, National Gallery). A rarer scene represents the body being carried to the tomb. In the ▷Renaissance artists employed this theme to show off their anatomical ability, and it was also commonly represented as a night scene (e.g. ▷Michelangelo, c1506, London, National Gallery; ▷Pontormo, 1525–8, S. Felicità, Florence).

Descent into Limbo

▷Harrowing of Hell

Desiderio da Settignano (c1430–64)

Italian sculptor. Florentine by birth, he matriculated in the Florentine sculptor's ▷guild in 1453. A stone and marble carver of great virtuosity, he may have been taught by ▷Donatello, his very own relief (*rilievo schiacciato*) style certainly showing the latter's influence. Desiderio's only important public commission was the tomb of Carlo Marsuppini (after 1453; Florence, Sta Croce), the overall architectural design strongly influenced by the tomb of Leonardo Bruni against the opposite wall of the church, executed by ▷Bernardo Rossellino, who has also been suggested as Desiderio's master. The other main work of Desiderio's short life is the Tabernacle of the Sacrament (installed 1461, Florence, S. Lorenzo). He was also highly skilled as a sensitive carver of marble portrait busts of young women (e.g. *Portrait of a Lady*, c1460–64; Bargello, Florence) and children (e.g. *Laughing Boy*; Vienna Kunsthistorisches Museum), both of which are typified, like the best of his works, by an extreme delicacy of handling.

design

Either the form of any building or work of art, whether in the mind or developed as a drawing or model, or the particular shape of an object and the way in which it functions. In the ▷applied arts, design is the pattern for making a product. In the ▷fine arts, design is the creative process of producing a work of art. In engineering, design is an exact calculation of the workings of particular parts to form a whole. In architecture, design encompasses all the processes from the choice of structure to the details of the interior. Therefore, design is a complex and many-faceted term. Increasingly it is also used to refer to the form and structure of artefacts that might provide information and comment about a civilization or society. In other words, it may be said that design provides a 'figurative utopia'.

Desportes, Alexandre-François (1661–1743)

French painter. In 1695–6 he worked at the court of Jan Sobieski in Poland, but his principal responsibility was as a designer for ▷Gobelins tapestries. He specialized in hunting and landscape subjects which drew upon the tradition of ▷Snyders' still-life realism. He also produced hunting pictures and still lifes for Louis XIV and XV.

Deutsch, Niklaus Manuel (1484–1530)

Swiss painter. He was influenced by ▷Dürer and produced pro-▷Reformation religious paintings. His subject-matter was often grotesque and dominated by scenes of death. He was also a politician and acted as a member of the Inner Council at Berne. He may have been called simply 'Niklaus Manuel', but his monogram 'N.M.D' has led to the more commonly used name.

Deutsche Werkbund

A German association of artists established in 1907, in Munich, to promote artistic design in architecture and industry. It was formed by the architect and superintendent of the Prussian School of Arts and Crafts, Hermann Muthesius (1861–1927), who had been the German cultural attaché in London, and had there come into contact with ▷Morris's ideas. The Deutscher Werkbund soon split between the ▷Art Nouveau-influenced group, led by ▷Van de Velde, and those who favoured a more ▷modernist approach, led by ▷Behrens. Behrens' ideas became dominant and triumphed at the 1914 Cologne exhibition, with ▷Gropius' factory design.

The Deutsche Werkbund inspired other similar groups throughout Europe: Austria (1912), Switzerland (1913), Sweden (1913) and the Design and Industries Association in England in 1915. It was revived after the First World War in Germany, organizing housing design projects in Stuttgart in 1927 (including work by ▷Mies van der Rohe, ▷Le Corbusier and ▷Gropius), and although disbanded in

the political climate of 1933, it was briefly reformed after World War Two.

Bib.: Campbell, J., *The German Werkbund*, Princeton, 1978; *Deutsche Werkbund*, exh. cat., London, 1980

Deverell, Walter Howell (1822–54)

British painter. He was born in Charlottesville, Virginia, the son of an English schoolmaster. The family returned to London in 1829 and he was educated at Sass' Drawing School and under ▷Rossetti, with whom he shared a studio in 1851. Deverell shared many of the ideas of the ▷PRB (cf. *Twelfth Night*, 1850, private collection; *Pet*, 1852–3, London, Tate Gallery) and was proposed as the replacement for ▷Collinson in 1850 (although never elected). He discovered ▷Elizabeth Siddal in 1849. He was appointed as assistant master at the government School of Design. He died prematurely of Bright's disease, having exhibited only four works at the ▷Royal Academy.

Bib.: *Artists of the Pre-Raphaelite Circle*, exh. cat., Liverpool, 1988

Devil

▷Satan

Devis, Arthur (1711–87)

English painter. He was born in Preston. After studying with Tillmans, he established himself in the North of England as a portraitist of the gentry, using interior ▷conversation piece groupings (e.g. *James Family*, 1751, London, Tate Gallery). By 1745 his reputation had spread to the capital and he flourished until challenged by ▷Zoffany in the 1760s. His work was almost forgotten until the 1930s when the naive charm of his paintings with their doll-like figures and stiff poses became popular (e.g. *Young Gentleman at a Drawing Board*, 1761, Manchester. He exhibited regularly at the Society of Artists and became its President in 1768.

Devis's half-brother, Anthony (1729–1816), was a topographical artist and his sons, Arthur William (1763–1822) and Thomas Anthony (1757–1810) were also painters.

Bib.: *Arthur Devis*, exh. cat., Preston, 1983; *Arthur Devis and his Contemporaries*, exh. cat., New Haven, 1980

de Wint, Peter

▷Wint, Peter de

Diaghilev, Sergei Pavlovich (1872–1929)

Russian ballet director. He was born in Perm and went to St. Petersburg in 1905, where he became an active member of the ▷World of Art group (he edited the magazine from 1898), along with ▷Benois. In this capacity he was instrumental in promoting ▷avant-garde art styles within Russia. He studied law and learned music from the composer Rimsky Korsakov. From 1895 he began collecting art and in 1897

organized an exhibition of English and German watercolours. After a brief spell as director of the Imperial Theatres, he established the Ballets Russes (based in Paris from 1909). He made use of his artistic contacts in the designs of his productions, employing Benois, ▷Bakst, ▷Rouault, ▷Picasso, ▷Braque, ▷Larianov, ▷Goncharova and others, and promoting a new style of both design and dance. In his later exhibitions he also employed Bakst's design skills, for example in an exhibition of 18th-century Russian portraiture held in 1903.
Bib.: Kochno, B., *Diaghilev and the Ballets Russes*, London, 1971

diagonal buttress

▷buttress

Diana

(Greek 'Artemis'). One of the 12 gods and goddesses of Olympus, the twin sister of ▷Apollo. As virgin huntress she is portrayed as an athletically-built woman, armed with bow and quiver full of arrows, her body covered chastely in a knee-length tunic girdled at the waist, and her feet shod practically in sandals. The celebrated ▷antique statue, *Diane Chasseresse* (marble, Roman copy of 4th-century Greek bronze original; Paris, Louvre) shows her thus. On her head she wears her principal identifying attribute, the crescent moon (originally the attribute of Selene, with whom Diana later became associated). She is here accompanied by a stag, although hunting dogs may also feature. In imitation of the Classical model, the mistress of King Henry II of France, Diana de Poitiers, was portrayed as the goddess, both in allusion to the shared name and in order to endow her flatteringly with the goddess's virtuous image (School of ▷Fontainebleau, c1550, Paris, Louvre).

The theme of Diana and her attendant virgin nymphs bathing naked in a woodland pool after their hunt became popular with artists in the ▷Renaissance period. Other episodes often portrayed are:

(i) Diana and Actaeon (from Ovid's *Metamorphoses*). Diana and her nymphs are bathing naked in a pool when Actaeon, a young male hunter, stumbles across them. Outraged at being seen naked, Diana changes Actaeon into a stag and he is then pursued and torn apart by his own hounds. (See Titian, *Diana and Actaeon*, 1959, Edinburgh, National Gallery; and the same artist's *Death of Actaeon*, 1959, London, National Gallery).

(ii) Diana and Callisto (also from Ovid's *Metamorphoses*). Diana's nymphs were required to observe the same rules of chastity as Diana herself. The nymph Callisto, however, is seduced by ▷Jupiter (who has metamorphosed himself into a semblance of Diana) and she becomes pregnant. Later, while Callisto is bathing with the rest of the company,

Diana notices her pregnancy and punishes her by changing her into a bear. The hunting dogs are then set upon her, but Jupiter whisks her up to heaven just in time. The two parts of the episode have both been depicted. In the seduction scene, the informed viewer knows that it is not Diana, but Jupiter transformed, by the inclusion of Jupiter's eagle, usually with thunderbolts in its claws, in the background. In the bathing scene Diana points accusingly at Callisto while a crowd of other nymphs reveal her swollen belly (e.g. Titian, *Diana and Callisto*, 1556–9, Edinburgh, National Gallery).

(iii) Lucian in his *Dialogues of the Gods* tells the story of the love of Diana (in her guise as the moon goddess) for a beautiful mortal youth, Endymion. In order to preserve his beauty for ever, Jupiter orders that he be put to sleep. Diana visits him nightly to embrace him (chastely, of course). The scene, bathed in moonlight, but minus Diana, received an acclaimed treatment in the 18th century with ▷Anne-Louis Girodet's painting *The Sleep of Endymion* (1791, Paris, Louvre).

Diana, Benedetto (c1460–1525)

Italian painter. He worked in Venice and produced pictures in the style of ▷Giorgione.

diaper-work

An all-over pattern with motifs placed in a repeated design, especially, on a rectangular or diagonal grid.

Diaz (de la Peña), Narcisse-Virgile (1807/8–76)

French painter. He was born in Bordeaux, of Spanish descent, was orphaned at 12 and had a wild childhood. After beginning his career as a painter of ▷porcelain, he turned to historical and mythological subjects (e.g. *Venus Disarming Cupid*, London, Wallace Collection) before discovering landscape through a meeting with ▷Dupré. He was taught by ▷Théodore Rousseau from 1837, and his work sometimes resembles that of his teacher. He was also a loose member of the ▷Barbizon School. He never fully escaped his origins, preferring to include figures, often nymphs and gypsies, in his woodland scenes (he exhibited his first view of Fontainebleau in 1837), and employing a heavy, restless brush, in imitation of ▷Delacroix, whom he admired (e.g. *Roches Fontainebleau*, 1840–5, Paris, Musée d'Orsay). In his later career he increasingly explored flat, open landscapes in which the emphasis was placed on the skies (e.g. *Storm*, 1871, London, National Gallery). His son, Emile (1835–60), was also a painter.
Bib.: *Barbizon Revisited*, exh. cat., London, 1962; Bouret, J., *L'École de Barbizon*, Neuchâtel, 1972

Dickinson, Edwin (1891–1978)

American painter. He studied in New York, and made several trips to Europe throughout his career, the first in 1919. He has been called a ▷Surrealist because of his imaginative subject-matter and the sense of unease that prevails in his landscapes, but he was really a traditionalist both in terms of themes and style. In 1959–60 he went to Greece, where he taught art.

Dickinson, Preston (1891–1930)

American painter. He lived in Paris from 1915 to 1919, and there he became influenced by ▷Cubism. When he returned to America, he began practising ▷Cubist-Realism, but his ▷Precisionist works contained obvious brushstrokes, unlike those of many of his contemporaries. Like many other Cubist-Realists, his subject-matter was primarily urban and industrial.

Diderot, Denis (1713–84)

French writer and critic. He was one of the leading members of the ▷Enlightenment in France, responsible for the first *Encyclopaedia* (1751–72). His novels and plays put forward ideas of anticlericalism and promoted bourgeois morality in opposition to the nobility. He believed that beauty resided in everyday life, that taste was a result of experience, not simply of breeding, and he opposed classical rules which restricted art. His plays were a series of tableaux, illustrating narrative and morality, and often compared to ▷Greuze's paintings, which he admired. He was one of the first great ▷Salon critics (1759–71, 1775, 1781) and influenced much 19th-century art criticism in France.
Bib.: Fried, M., *Absorption and Theatricality: Painting and Beholder in the Age of Diderot*, Berkeley, 1980; Furbank, P.N., *Diderot: A Critical Bibliography*, London, 1992

Diehn-Bitt, Kate (b 1900)

German painter. She was born in Berlin, and after her marriage to a dentist she moved to Dresden, where she studied in the Academy from 1929 to 1931. There she adopted a ▷Neue Sachlichkeit style. She later settled in Rostock. She concentrated on images of working-class poverty, particularly mothers and children, and her work contains obvious echoes of 16th-century German art, such as the work of ▷Cranach. After the Second World War, she remained active in the German Democratic Republic.

Dilettanti, Society of

A group established in 1732, of young gentry and aristocracy, which initially met socially in a tavern on the first Sunday of every month. They had in common their enthusiasm for the Classical world, cultivated from the ▷Grand Tour. After initially trying to promote Italian opera, it developed into a cultural society which backed archaeological research, promoted Classical architecture and helped to establish the ▷British Museum. It was rooted firmly in the spirit of the ▷Enlightenment, and was one of the major promoters of ▷Neoclassicism in England. Its members were instrumental in applying systematic research principles to the study of the ancient world, with a series of publications (e.g. *Investigation of Athenian Architecture*, 1752), although they failed to back the ▷Elgin marbles. Members included ▷Payne Knight and the antiquarian Charles Townley, but it remained an élite society, with its membership never numbering more than 70. By the 1850s it was in decline due to changing tastes. The Society also appointed portraitists, including ▷Reynolds, ▷Lawrence, ▷Eastlake, ▷Leighton, ▷Poynter and ▷Sargent.
Bib.: West, S. 'Libertinism and the Ideology of Male Friendship in the Portraits of the Society of Dilettanti', *Eighteenth-Century Life*, 16 (May 1992), pp. 76–104

Diller, Burgoyne (1906–65)

American painter and sculptor. He studied at the ▷Art Students' League in New York. During the 1930s, he adopted ▷Mondrian's ▷Neo-Plasticism and he joined the ▷American Abstract Artists group. From 1935–1940 he was head of the Mural Division of the ▷Federal Arts Project. He was always interested in geometrical abstraction.

Dine, Jim (b 1935)

American artist. He was from Ohio and was best known for his ▷Happenings and ▷Pop art objects which he produced alone and with ▷Claes Oldenburg in the 1950s and 1960s. He used mundane household objects as his subjects, but his backgrounds were ▷painterly. Sometimes he painted his central subjects, but at other times he actually attached the objects themselves to the canvas. He also participated in ▷performance art activities.

Diocletian, Palace of

The palace built on the coast of Dalmatia in AD 300–306, by the Emperor Diocletian for his retirement, on a site now occupied by the modern town of Split (Spalato). The palace covered around eight acres and was protected by a rectangle of walls 2 m (7 ft) thick and c18 m (60 ft) high with a square bastion at each corner, octagonal bastions flanking the gates at the centre of each landward wall, and a further square bastion midway between each corner and central gateway. Between the two corner bastions on the seeward side the wall took the form of a continuous façade surmounted by an arcaded gallery. The symmetrical ground plan is disposed around two colonnaded streets which intersect at right-angles, thus dividing the palace into four. The two northern blocks are presumed to have been barracks while the Emperor's apartments were the two southern blocks (with the arcaded gallery) overlooking the sea. Fol-

lowing the publication of Robert Adam's *Ruins of the Palace of the Emperor Diocletian at Spalato* in 1764, the palace exercised a great influence on ▷Neoclassical architecture.
Bib.: Ward-Perkins, J.B., *Roman Imperial Architecture*, Harmondsworth, 1981

Dionisio Fiammingo
▷Calvaert, Denys

Dionysus
▷Bacchus

diorama
A large-scale painting of a landscape or townscape, illuminated so as to give the viewer the impression of being actually present in the scene. The technique, which was extremely popular before the advent of photography, was invented by Louis Jacques Mandé Daguerre and Charles Bouton in 1822. By leaving translucent areas and then back-lighting the images, the scene gained depth. Dioramas were often housed in special buildings, like those in Regent's Park (Dauguerre, opened in 1823). They later became sensational backdrops in the Victorian and Edwardian theatre, as seen in Beerbohm Tree's productions of Shakespeare.

dipper
A bowl or cup which can be attached to a ▷palette. It is used to hold the medium or turpentine. Sometimes there are two of them (known as 'double dipper'). The dipper is also known as a palette cup.

diptych
A pair of wood or ivory panels hinged together to close like a book. The form developed from Roman writing tablets which had recessed waxed writing surfaces which could be closed together for protection. From the 4th century AD ivory diptychs were used by Roman consuls for presentation to the emperor and senate, for instance at the commencement of their term of office. These ▷consular diptychs would be carved on the inner surfaces with an image of the consul and some accompanying celebratory scenes. The form died out with the abolition of the office of consul in the 6th century. However, the diptych form was later adapted to religious use. By the Middle Ages and in the ▷Renaissance period, the panels were generally of wood with painted images on the inner surfaces and were used as portable altarpieces for private devotion. Frequently one panel would contain an image of ▷Christ, the ▷Virgin and Child or perhaps the owner's name saint, whereas the facing panel might be painted with a portrait of the owner in an attitude of devotion. The exterior surfaces would often be decorated with personal emblems and coats-of-arms (e.g. *The Wilton Diptych*, c1495, London, National Gallery).

direct carving
A name given to sculpture that is carved by the artist without being based on a previously produced design or model. Normally the materials used are stone or marble. Direct carving was popular in early 20th-century sculpture, where the rawness of the materials and a ▷primitivist sincerity to the object were felt to be important.

Disasters of War, The (Los Desastres de la Guerra)
A series of 80 ▷aquatints by ▷Francisco Goya, roughly 15 × 20 cm (6 × 8 in) which were designed largely c1810–15 but not engraved until after 1820 when Goya was living in Bordeaux. They represent scenes from the French occupation of Spain, some of which Goya himself witnessed (no. 44 is entitled *I Saw It*), some based on notorious events (e.g. no. 7, *What Courage!*, records the actions of a Saragossan woman manning the barricades). They portray the conflict and resulting famine with a bleakness which goes far beyond any of the artist's other work (including even his 'Black Paintings'), and do not flinch from representing rape, burning and mutilation of the dead. They were not Goya's only images of the war – he famously produced the *Second and Third of May 1808* on royal commission – but the engravings abandon any nationalist or propagandist intentions in favour of showing the horror of the conflict itself. The plates were not published until 1863 when they were accompanied by captions, taken from Goya's own notes by Ceran Bermudez. It is these which underline the artist's personal feelings (e.g. no. 69 is called simply *Nothing*). *The Disasters of War* was Goya's second major print series, following from ▷ *Los Caprichos*. His handling of aquatint, with his use of delicate line and a lack of extraneous detail, qualifies him as one of the leading graphic artists of the early 19th century.

Discobolus
Most famously, a bronze statue of an athlete about to throw a discus executed by ▷Myron, the sculptor from the mid-5th-century BC. The work has been lost since antiquity, but was made famous by the descriptions of Lucan and Quintilian and is today known through several Roman copies in marble. The best of these (now in the Museo delle Terme, Rome) was discovered in 1781 at the Massimo family's Villa Palombara on the Esquiline Hill, Rome. Almost complete, it is the only copy to have survived with the correct head. It remained in the possession of the Massimo family in a state of virtual inaccessibility until the 20th century. Meanwhile, in 1791, two other versions had been discovered: one was acquired for the Vatican Museum, the other by Charles Townley (now in the British Museum in London). This latter statue suffered the

embarrassment of an incorrect restoration when a head was found for it and fixed on looking down at the ground, not back at the discs. A further replica of the work was found in 1906 (now in the Museo delle Terme with the Villa Palombara replica). The Massimo family's *Discobolus* had always been acknowledged as superior to the other replicas, and in 1937 Hitler made offers to buy the statue, ultimately succeeding in 1938, in the face of protests from certain quarters in Italy. It was displayed in the Munich Glyptothek until 1948, when it was returned to Italy.

The name 'Discobolus' has also been applied to statues of standing figures merely holding the discus. One, at the Vatican Museums, is presumed to be a Roman copy of a statue by ▷Polyclitus; another, at the Capitoline Museo Nuovo, Rome, is believed to be a copy of a statue by Polyclitus' brother, Naukydes (described by ▷Pliny). The ▷*Borghese Gladiator* has also been referred to as a 'Discobolus'.
Bib.: Haskell, F. and N. Penny, *Taste and the Antique*, New Haven and London, 1981

discourse

A problematic term which is often used loosely and imprecisely, but is frequently evoked by both literature specialists and art historians. Generally, it refers to a conversation or a written treatise which has an argument. However, in literary and art theory it is now also used to define the distinctive qualities, ▷ideologies, vocabularies and other elements that constitute a particular historical moment. In speaking, for instance, of the 'discourse of race' in the 19th century, one refers to the ways in which race was understood and represented through literary texts and visual culture, as well as the means by which ideas of race were constructed. Discourse is assumed to be a shifting, rather than a fixed, entity.
Bib.: Schleifer, R., *Rhetoric and Death: The Language of Modernism and Postmodern Discourse Theory*, Urbana, 1990

disegno

(Italian, 'drawing', 'design'.) A term used in Italy to denote the design of a painting, conceived above all in terms of drawing. To the Tuscan art theorists *disegno* was considered to be the intellectual foundation of painting, with colour relegated to a subordinate role. It was this hierarchy that conditioned the negative attitude of ▷Vasari to Venetian painting which placed a greater emphasis on colour (*colore*) at the expense of line. By the 17th century, the two qualities, *disegno* and *colore*, were considered as opposite poles and in the French Academy two separate traditions developed with the so-called ▷Poussinistes and Rubenistes debating the superiority of the classical, rational and intellectual qualities of line as against the expressive, emotional qualities of colour.

distemper

Type of water-based paint which has a limited life and is often used for ephemeral scenery or decoration, rather than easel-painting.

distyle in antis
▷portico

divisionism

A term used to describe the technique of optically mixing pure colours, by applying them in small dots or dashes. It is most associated with the artists ▷Seurat and ▷Signac, the so-called ▷Neo-Impressionists of the 1880s and 1890s, but earlier ▷Watteau and ▷Delacroix had explored the same principle and many of the ▷Impressionists were interested in chromatic theory. The aim of the technique was to achieve brighter ▷secondary colours, by painting only with the ▷primary colours and white, but few artists applied it to their work without some modification. It was inspired by a spate of writings on colour theory at the end of the 19th century, including ▷Ogden Rood's *Modern Chromatics* (1879). The term is often treated as if it were absolutely synonymous with ▷pointillism, but whereas that term refers to the use of precise dots, divisionism can be used more generally, particularly when referring to early 20th-century painting (▷Fauvism; Futurism).

Dix, Otto (1891–1969)

German painter and graphic artist, associated with ▷Expressionism. He was born in Unternhausen, Thuringia, his father a potter. In 1905 he was apprenticed to the painter Gera, before enrolling at Dresden Academy in 1909. He fought during the First World War, and much of his later work recalled his experiences in the trenches. In 1919 he returned to Dresden and established a ▷Secessionist group there, but after meeting ▷Grosz, he became interested in the ideas of ▷Dada and the ▷Neue Sachlichkeit. During the 1920s he taught at Düsseldorf Academy, until ousted by the Nazis in 1933. He also travelled widely, visiting France and Italy. He settled in Switzerland in 1935, but continued to make visits to Germany, despite confiscation of his works in 1937 (as ▷Degenerate Art), and temporary arrest in 1939. He was conscripted into the Home Guard in 1945 and ended the Second World War as a POW.

His early work was highly traditional: inspired by ▷Gothic and early ▷Renaissance art, he produced highly detailed ▷tempera portraits (e.g. *Self-portrait with Carnation*, 1912/13, Detroit). His work changed dramatically during the First World War years as he absorbed new experiences and experimented with ▷Futurist and ▷Dada ideas: strong colour and semi-abstraction appear but his interest in observed detail remained. During the 1920s he turned his increasingly jaundiced eye on contemporary society, depicting

prostitutes, veterans and black-marketeers with jazzy colours and a merciless precision in a ▷Neue Sach-lichkeit manner (e.g. *Three Prostitutes*, 1925, private collection). He also recorded his experiences as a soldier, in a series of ▷etchings (*War*, 1924) and in painting (e.g. *Flanders*, 1934–36, Berlin, National-galerie). Increasingly, however, he returned to the medievalism of his youth, as religious imagery and symbolism became central to his art, and during the 1930s he worked on a series of monumental landscapes inspired by ▷Altdorfer (e.g. *The Triumph of Death*, 1934, Stuttgart Galerie der Stadt).

Bib.: *Otto Dix*, exh. cat., London, 1992

Dobell, William (1899–1970)

Australian painter. He studied with Julian Ashton, and then at the ▷Slade School in London from 1929. While in Europe he travelled extensively, before returning to Australia in 1938. In England, he con-centrated on painting individual London 'types', and he retained his interest in character and portraiture once back in Australia. His portraiture had an expressionist quality. In 1944 he won the Archibald Prize for Portraiture from the New South Wales Art Gallery, but his submission was so controversial that his competitors brought a court case against the gallery for its decision. The claim that Dobell's work was ▷'caricature', rather than portraiture, highlighted the interesting problem of the relationship between mod-ernist abstract styles and portraiture – conventionally a representational mode.

Bib.: Gleeson, J., *William Dobell*, London, 1969

Dobson, Frank (1886–1963)

British sculptor. He joined the ▷London Group in 1922. He was best known for his portrait sculptures and his female nudes which were reminiscent of ▷Maillol in their classical purity. Both ▷Roger Fry and ▷Clive Bell were enthusiastic about his feeling for form, and he was an early practitioner of ▷direct carving.

Bib.: *Frank Dobson 1886–1963*, exh. cat., London, 1981

Dobson, William (1611–46)

English painter. He was one of the most important English portrait painters of the 17th century. His known portraits date from the 1640s, when he was court painter during the English Civil War, based in Oxford where Charles I's court was exiled. His paint-ings reveal his skill in conveying the character of his aristocratic sitters, and his colourism was rich and Venetian in effect. His work was comparable to ▷Van Dyck's in its sophistication, but his ability to represent character was perhaps more subtle.

Bib.: Rogers, M., *William Dobson 1611–46*, exh. cat., London, 1983

Doctors of the Church

Early Christian theologians. They are represented in medieval manuscripts and church decoration as elderly men holding books to show their wisdom. The eastern Church doctors are Basil, Gregory of Nazianzus, John Chrysostom and Athanasius. The western ones are Ambrose, Augustine, Jerome and Gregory the Great.

dodecastyle

▷portico

Doesburg, Theo van (1883–1931)

Dutch architect and painter. He was born in Utrecht, the son of a photographer. Against his parents' wishes, he studied art, working initially in a style influenced by ▷Rembrandt. In 1908 he discovered ▷Futurism, using faceted planes of colour in his work. He wrote as an art critic on the weekly *Eenheid* from 1912. He joined the army in 1914 and after the war was instrumental in setting up ▷De Stijl, along with ▷Oud, ▷Mondrian and ▷van der Leck. Doesburg provided many of the group's ideas on the social purpose of art and edited their magazine. His painting of the time also shows the group's influence (e.g. *Cow*, 1917, New York, Museum of Modern Art), using abstract rectangles of colour, strict verticals and hori-zontals and incorporating rhythm and music.

During the 1920s Doesburg turned increasingly to design. He spent 1921–2 at the ▷Bauhaus and in 1923 collaborated with van Eesteren on architectural projects. His ideas were exemplified in the Aubette project of 1926–8, organized with ▷Arp, in which an 18th-century building was transformed for the modern world into a cinema, dancehall and café. The interior was conceived as a three-dimensional painting, using primary colours and geometric shapes. In it Doesburg used diagonals, which can also seen in his painting of the period (e.g. *Contracomposition of Dissonance*, 1925, The Hague, Gemeentemuseum). These design features were the reason for his split with Mondrian.

Bib.: Balfeu, J., *Theo van Doesburg*, New York, 1974

Dogon

▷African art

dogtooth

In medieval architecture of the ▷Early English period (c1190–c1250), ornamentation, used in a band, con-sisting of a series of pyramidal motifs, notched in the middle of each base side to produce a four-leafed diagonally-set plant shape. (Each individual petal or leaf resembles a canine tooth.)

Dolci, Carlo (1616–86)

Italian painter. He was from Florence and painted mainly devotional subjects, usually half-length Madon-nas and female saints in attitudes of prayer, brought to

a smooth and polished finish. Though popular with contemporaries, his intensely pious pictures, judged by today's taste, seem to have descended into cloying sentimentality. He was, however, a sensitive and objective portraitist, showing a prodigious talent at the age of 16 with his *Portrait of Fra Ainolfo de' Bardi* (1632; Florence, Palazzo Pitti).

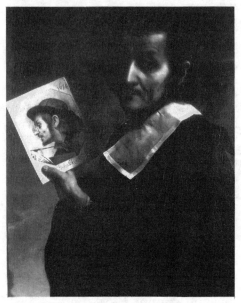

Carlo Dolci, *Self-portrait*, Uffizi, Florence

dolmen

▷megalith

dome

A ▷vault rising from a circular base, most often semi-circular in section, but sometimes segmental, pointed or bulbous. Domes often rise over a cuboid or polygonal space, such as the ▷crossing of a church, in which case transitional members such as ▷pendentives or ▷squinches will be needed. Frequently, a cylindrical ▷drum may be interposed between the transitional members and the dome, in order to give the dome greater elevation and, where the drum is ▷fenestrated, more light to the interior. Also, the dome may be crowned by a ▷lantern – a small cylindrical drum terminated by a ▷cupola, or perhaps a ▷spire. There are various types of dome:

(i) The calotte: without a drum and semi-circular in section.

(ii) The saucer dome: without a drum and segmental in section.

(iii) The sail vault: rising from a cuboid space, the curvature of the pendentives carrying on upwards to form the dome itself.

(iv) The umbrella, or melon dome: divided into

webs, or segments, with concave base lines, but still, like a true dome, rising from a circular base.

A domical vault is not a true vault – it too is divided into webs, but the base lines are straight and the base is not circular, but square or polygonal, corresponding to the number of webs.

Domela, César Nieuwenhuis (b 1900–92)

Dutch painter. He was born in Amsterdam, and went to Switzerland in 1919 where he became involved with ▷Constructivist art. He exhibited with the ▷Novembergruppe in Berlin in 1923 and in 1924 he joined ▷De Stijl. Constructivism remained his primary fascination, and it was enhanced when he met ▷Gabo in 1927. In 1933 he joined the ▷Abstraction-Création group and worked with ▷Arp and ▷Sophie Taeuber-Arp on the journal *Plastique*. His enthusiastic support for abstraction never waned, and as late as 1946, he was a co-founder of a new abstract group, the Centre de Recherche.

Domenichino (Domenico Zampieri) (1581–1641)

Italian painter. He was Bolognese, and was trained by ▷Calvaert and ▷Ludovico Carracci in Bologna, but had moved to Rome by 1602. Here he worked for, and became chief assistant to, ▷Annibale Carracci at the Palazzo Farnese. The ▷fresco of the *Maiden with the Unicorn* over the entrance to the gallery is by Domenichino. Following Annibale's death in 1609, Domenichino became the leading painter in Rome, perpetuating the tradition of Bolognese ▷Classicism established by his master. Among his most important early commissions is the cycle of frescos of *Scenes from the Life of St. Cecilia* in S. Luigi dei Francesi (1613–14). These are even more Classical than those by Annibale, with some figures directly derived from antique statues, details rendered with archaelogical correctness and evidence of a deeper study of ▷Raphael. Domenichino's next major commission, the frescos for the choir and ▷pendentives of S. Andrea della Valle (1622–28), show him moving towards a more ▷Baroque amplitude (especially in the *Four Evangelists* of the ▷pendentives). By now Domenichino's position was being usurped by his arch-Baroque rival ▷Lanfranco (who had been awarded, much to Domenichino's chagrin, the commission for the dome ▷fresco) and he may have been attempting to adapt to the changing circumstances. In 1631 he went to Naples to paint the even more Baroque ceiling frescos of the S. Gennaro Chapel in the cathedral. In 1634, before his work was completed, however, he was forced by the jealousy of local artists to flee in fear of his life back to Rome. He returned to Naples some years later and resumed work in the cathedral, but the decorations were unfinished at his death. He was also an accomplished oil painter, his idyllic landscapes exerting a powerful influence on ▷Claude. His altarpiece, *The Last Communion of St.*

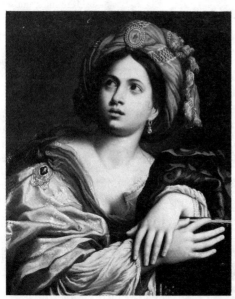

Domenichino, *The Persian Sibyl*, c1620, Wallace Collection, London

Jerome (1614, Rome, Vatican) was greatly admired in the 18th century and Domenichino was revered as one of the greatest painters of all time. His reputation, along with that of the other Bolognese Classicists, took a plunge in the 19th century with the taste for ▷Pre-Raphaelitism, but his art is today enjoying renewed appreciation.
Bib.: Borea, E., *Domenichino*, Florence, 1965; Spear, R., *Domenichino*, New Haven and London, 1982

Domenico Veneziano (Domenico di Bartolommeo) (d 1461)

Italian painter. He was possibly from Venice (as is suggested by his name), but was active chiefly in Florence. His Venetian origin is further suggested by the fact that he is more concerned with the modifying effects of light on colour than his Tuscan contemporaries, whose art was dominated by linear composition. He is first recorded in 1438 in Perugia, from whence he wrote to the ▷Medici seeking work and comparing himself favourably with ▷Fra Angelico and ▷Fra Filippo Lippi. His earliest documented work, a ▷fresco cycle of *Scenes from the Life of the Virgin* for S. Egidio, Florence, dates from shortly after this, in 1439–45. These frescos no longer survive, but are of interest for the fact that ▷Piero della Francesca is named as one of Domenico's assistants. There are only two authenticated works (both signed but not dated). One, from a street ▷tabernacle, survives in three fresco fragments in the London National Gallery: the so-called *Carnesecchi Madonna* and two *Saints*. This work is generally given the earlier date (1430s) as the second painting, the *St. Lucy Altarpiece* (1440s), one of the masterpieces of the Florentine ▷quattrocento, is characterized by a new monumentality in the figures, a more assured draughtsmanship and a significantly greater mastery of spatial relationships and specifically the new science of single point ▷linear perspective. The central panel, one of the earliest ▷sacre conversazioni, is in Florence (Uffizi) and the ▷predella panels are in Cambridge (Fitzwilliam Museum), Washington (National Gallery) and Berlin (Staatliche Museum).
Bib.: Wohl, H., *The Paintings of Domenico Veneziano*, Oxford, 1980

domical vault

▷vault

Dominic (1170–1221)

Founder of the Order of Preachers, better known as the Dominicans or Black Friars. He was born in Spain of noble parentage, studied theology as a young man, entered the Church and rose to the position of prior of the canons regular. He accompanied a papal mission to convert the Albigensian heretics of southern France and when this failed he decided to found his order of itinerant priests, specially trained to promote orthodoxy and root out heresy. The order was given papal approval in 1216. Dominic himself travelled throughout Europe, preaching and establishing friaries, dying ultimately in Bologna. His tomb, decorated with reliefs of scenes from his life by the workshop of ▷Nicola Pisano, is the Arca di S. Domenico in the church of S. Domenico Maggiore. In visual representations he wears his order's distinctive black cloak and hood over a white tunic and scapular. To distinguish him from other Dominican saints he holds a ▷lily (symbol of purity) and a book (the ▷gospels, the source of his teaching). He may have a star upon his forehead, or slightly above it, in allusion to a contemporary account alleging that his brow radiated a supernatural light. Sometimes he holds a rosary, a string of beads used as memory aids for praying, introduced, it is believed, by Dominic; he may be handed the rosary by the ▷Virgin, or the ▷Christ Child seated upon the Virgin's lap. A black and white dog alludes to the pun on the word Dominican: 'Domini Canis', or Hound of God (the name earned by the order for its hunting down of heretics). Later members of the order included the painters ▷Fra Angelico and ▷Fra Bartolommeo, the former of whom decorated the Dominican Content of San Marco in Florence with a series of ▷frescos. Dominic is often grouped with other saints of the order, such as Peter Martyr, Thomas Aquinas, and ▷Catherine of Siena, whilst in a ▷sacra conversazione, or ▷Coronation of the Virgin, he is usually balanced by ▷St. Francis.

Donatello (Donato di Niccolò di Betto Bardi) (1386–1466)

Italian sculptor. Generally regarded as the greatest sculptor of the 15th century, he was, with ▷Brunelleschi, ▷Ghiberti and ▷Masaccio, one of the creators of the Florentine ▷Renaissance. Although initially apprenticed to Ghiberti (he worked on Ghiberti's first Baptistry doors from 1404–6), Donatello's earliest independent sculpture shows him rejecting Ghiberti's linear elegance (derived from the prevailing ▷International Gothic tradition) in his concern to express in sculptural terms drama, emotion and, above all, the heroic spirit of the individual.

Following his short term with Ghiberti, Donatello secured a series of commissions for marble figures for the cathedral façade (along with ▷Nanni di Banco). His standing figure, *David* (1408–9, reworked and partially gilded 1416, now Florence, Bargello), is still in a ▷Gothic formal idiom, but his slightly later, seated *St. John the Evangelist* (1408–15, now Museo dell' Opera Florence) powerfully embodies the new heroic ideal and, in the lengthened torso, exaggerated to counteract the visual effect of ▷foreshortening resulting from the figure's elevated position on the cathedral façade, shows an innovatory awareness of the viewer's position. About the same time he began his series of statues for the ▷niches of the guild church of Or San Michele. His first was the marble *St. Mark* (1411–12, still *in situ*). ▷Vasari relates how the commissioning guild, on seeing the statue in Donatello's workshop, thought it distorted, but on seeing it later in the niche, wrongly assumed that the sculptor had followed their instructions to correct it. Donatello had, in fact, deliberately given the figure a lengthened torso, knowing that the niche's height would necessitate such an exaggeration to counteract the optical effect of ▷foreshortening. The *St. Mark* is also notable for its innovatory Classicism; in stark contrast to Ghiberti's recently installed and quintessentially ▷Gothic *St. John the Baptist*, the draperies hang rationally and reveal the underlying form of the body, posed in convincing ▷contrapposto. This new, fully absorbed Classicism has suggested to some scholars a possible trip to Rome, perhaps in 1409/11. Next was a marble statue and relief of St. George (c1416–17; relief still *in situ* on Or San Michele; statue now replaced by a copy, original in the Bargello, Florence). The ▷relief is important in that it employs two innovatory devices for creating pictorial space: it is the earliest surviving example of the use of ▷linear perspective, following by only a few years Brunelleschi's two lost experimental painted panels and preceding by several years Masaccio's paintings; and it is also the earliest known example of a technique of very shallow relief developed by Donatello, known as *rilievo schiacciato*, here providing an effective ▷aerial perspective. From 1415 to 1436 he was also engaged upon a series of statues of prophets for the ▷Campanile, the most dramatic of which is *Habakkuk* (now Museo dell' Opera, Florence).

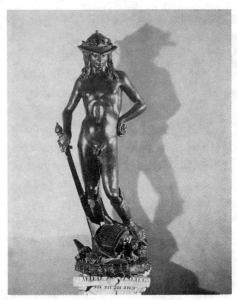

Donatello, *David*, c1430, Bargello, Florence

From 1425 Donatello worked in partnership with ▷Michelozzo, their collaborative efforts including the monuments of Pope John XXIII for the Baptistery, Florence, and Cardinal Brancacci for S. Angelo a Nilo, Naples, (both still *in situ*), and also the external pulpit for Prato Cathedral. The *John XIII* established the type of the Florentine wall tomb, followed by ▷Bernardo Rossellino and ▷Desiderio da Settignano in their tombs for S. Croce. For the 'Brancacci Tomb', Donatello had executed a marble relief of the *Assumption of the Virgin*, further exploiting the expressive and spatial possibilities of *rilievo schiacciato*. Another particularly fine example is the relief, *The Ascension with Christ Giving the Keys to Peter* (c1427, now in London, Victoria and Albert Museum) which is believed to have been part of the altar in the Brancacci Chapel in Florence. If so, it provides a unique example of Masaccio (who, with ▷Masolino, painted the frescos) and Donatello working on the same decorative scheme.

In 1427, Donatello was commissioned to execute his first ▷bronze relief, *The Feast of Herod*, for the Siena Baptistry font. Here, linear perspective is employed to construct a convincing space in which realistic characters are shown reacting with repulsion to the horrific display of John the Baptist's decapitated head. A trip to Rome with Brunelleschi in 1431–3 appears to have resulted in an increased Classicism in his subsequent works. His bronze *David* for the courtyard of the Palazzo Medici (now in the Bargello), dated to the period after this trip, is the earliest free-standing life-size male nude since ▷antiquity. Even more antiquising is the marble *cantoria* (1433–9) for Florence Cathedral (intended as a pendant to ▷Luca della Rob-

bia's; both now in the Museo dell' Opera), with its frieze of bacchanalian ▷*putti*. Donatello's is unarguably the more successful (despite the delicate beauty of Luca's individual figures) because again Donatello has made allowance for the height at which the *cantoria* was to be set. Also in the 1430s he worked on the sculptural decoration of Brunelleschi's Old Sacristy for S. Lorenzo – his are the painted stucco ▷tondi of the ▷Evangelists in the four corners of the vault (notable for their extreme ▷*sotto in sù* foreshortening) and the remarkable bronze doors decorated with highly animated saints engaged, two to a panel, in heated debate.

From 1443 to 1453 Donatello was in Padua working on the bronze figures and reliefs for the high altar of the Santo and the Equestrian Monument to Gattamelata, the first life-size bronze ▷equestrian statue of modern times and showing a knowledge of the only surviving antique example, the *Marcus Aurelius* in Rome. Donatello's Paduan works exerted a profound influence on the art of northern Italy, particularly that of ▷Mantegna. In these years he also made two ▷polychromed and gilded wooden figures: one a *St. John the Baptist* for the Frari in Venice and the other an emaciated *St. Mary Magdalene*, for the Florence Baptistry, revealing the full extent of Donatello's power to express the tragedy of the human condition. This ascetic type of figure was particularly influential on Florentine painters such as ▷Castagno and ▷Botticelli who saw the linear possibilities in the Donatello's wiry and expressive contours. His last sculptures are the bronze panels on the two pulpits in S. Lorenzo, Florence. Works of great pathos, employing spatial and figural distortion to express a highly emotional religiosity, they are unique in Florentine art and were not immediately appreciated by most Florentine contemporaries. They also do not fit the pulpits very well, which has led the art historian Francis Ames-Lewis plausibly to suggest that the panels may have been intended originally for the doors to the Sienese Baptistry.

Donatello's influence was enormous, affecting painters and sculptors alike, throughout Italy. In his earlier period he had created the type of an especially touching ▷Madonna and Child which leading sculptors such as ▷Desiderio took up and built their careers on and, although his last dramatically emotional works seem to have been beyond the comprehension of most of his contemporaries, they were profoundly admired by a later generation of artists and especially by ▷Michelangelo.

Bib.: Ames-Lewis, F. and A. Bednarek (eds.), *Decorum in Renaissance Narrative Art*, London, 1992; Bennett, B.A. and D.G. Wilkins, *Donatello*, Oxford, 1984; Janson, H.W., *The Sculpture of Donatello*, London, 1957; Pope-Hennessy, J., *Donatello*, London, 1993; Poeschke, J., *Donatello and his World*, New York, 1993; Rosenauer, A., *Donatello*, Milan, 1993

Donatian (d 390)

Christian saint and martyr. According to legend he was killed and thrown into the Tiber. A group of followers attempted to locate his body by floating along the river a wheel equipped with five lighted candles. The wheel miraculously stopped over Donatian's body and his followers retrieved it and restored him to life by prayer. He was Bishop of Rheims and patron saint of Bruges. In this latter capacity he appears in ▷Jan van Eyck's altarpiece, *The Madonna of Canon van der Paele* (1436, Bruges, Groeningemuseum). Donatian stands on the left in Bishop's robes and mitre, holding a crozier in his left hand and the wheel with five candles in his right.

Dongen, Kees (Cornelius) van (1877–1968)

French painter of Dutch birth. He went to Paris in 1897, and his early works show an interest in ▷Impressionism. He produced many nudes and society portraits, but he changed direction in 1906 when he saw ▷Fauvist paintings in Paris, going on to exhibit with ▷Die Brücke. After the First World War he lost momentum.

Bib.: Kyriazi, J.M., *Van Dongen et le Fauvisme*, Lausanne, 1989

Dong-son

A prehistoric Indo-Chinese site. Between c500 BC and the 2nd century AD, a series of ritual objects and furniture were produced here. At this time it formed a separate artistic direction, with its own unique features, but afterwards became incorporated into the mainstream of ▷Chinese art.

Donkey's Tail (*Oslinyi Khvost*)

Russian exhibition launched in March 1912 in Moscow by ▷Larianov and ▷Goncharova. They had both previously exhibited with the ▷Jack of Diamonds, but had become disgusted at the European bias of the artists in that group. To their eyes, Jack of Diamonds artists were too reliant on ▷Cézanne and the ▷Fauvists, and their favouritism of French styles was working against genuine Russian ▷modernism. The name 'Donkey's Tail' came from an anecdote about a French artist who produced works by tying a brush to a donkey's tail. Aside from Larianov and Goncharova, ▷Tatlin and ▷Malevich also exhibited there, and all of these artists sought to use ▷primitivist Russian sources for their work. Their religious paintings were in the manner of Russian ▷icons but the style of abstract modernism offended large numbers of the public. The ▷Target exhibition of 1913 superseded the Donkey's Tail.

Donner, Georg Raphael (1693–1741)

Austrian sculptor. He visited Italy before 1715, then worked in Salzburg in 1725–8 and Vienna from 1728 to 1738. Initially he was influenced by Italian ▷Baroque art, but gradually his style became more Classical. He produced primarily fountains and cathedral sculpture in lead, rather than wood. Among his most important works is the figure grouping on the fountain formerly located in Vienna's Mehlmarkt.

donor

The person or group responsible for commissioning a painting or object. The term usually refers to the practice in late medieval and ▷Renaissance Europe of nobles or religious groups commissioning ▷altarpieces for particular churches or monasteries, in which they themselves are depicted alongside the patron saint and other religious figures. For example, the altarpiece by Simone da Cusighe in the Accademia, Venice, shows the ▷Madonna della Misericordia with a group of flagellants who commissioned the work.

Doré, Gustave (1832–83)

French painter, sculptor and graphic artist. He was born in Strasbourg but travelled to Paris in 1847 where he established a reputation as a ▷lithographer and illustrator on the *Journal pour Rire* (1848–51). He also exhibited drawings at the ▷Salon. His first important book illustrations were for Balzac's *Contes Drolatiques* (1848). He also established a new large format of illustration, which became extremely popular (e.g. *Wandering Jew,* 1856). He visited London in 1869, making a series of drawings of the capital which were engraved and published with Douglas Jerrold as *London, A Pilgrimage* (1872), and influenced later artists like ▷van Gogh (e.g. Doré's *Newgate Exercise Yard,* 1872). He is best known for his illustrative ▷wood engravings particularly of fantastic and grotesque subjects with seething masses of people and a ▷Baroque sense of drama (e.g. Dante's *Inferno,* 1861; *Don Quixote,* 1862). He was prolific, employing over 40 woodcutters and often producing his work rapidly. During the 1870s he also turned to painting and sculpture (e.g. Dumas Monument, Paris, 1883) but much of it was over-ambitious and pretentious.
Bib.: Richardson, J., *Gustave Doré: A Biography,* London, 1980; *Gustave Doré,* exh. cat., Strasbourg, 1983

Doric order

The earliest of the Greek ▷orders of architecture, developed by the Dorian Greeks, and later modified by the Romans. The column of the Doric order is almost always ▷fluted (but never with intervening fillets) and, in the Greek original, is without a ▷base (although it generally has one in Roman Doric). The most distinctive features of the order are the ▷capital, which is always a simple cushion shape, and the ▷entablature frieze, which is always composed of alternated

▷triglyphs and ▷metopes. On the underside of the upper member of the cornice (the corona) is a feature peculiar to the Doric order (but not always used by the Romans), a series of small flat blocks called mutules. Although merely ornamental features, the mutules, with the triglyphs directly beneath them, are generally believed to derive from the constructional members of earlier timber buildings (and Doric, more than the succeeding ▷Ionic and ▷Corinthian orders, more clearly reflects these origins). The mutules correspond to the ends of rafters visible beneath the overhanging wooden eaves (i.e. the corona) and the triglyphs to the ends of the roof beams. Furthermore, both mutules and triglyphs appear to be fixed to the member beneath by little peg-like decorations called guttae. The columns of the earliest Greek Doric temples are stouter and more closely spaced than in later examples, which probably reflects the builders' growing confidence in the strength of stone. As the most robust and unadorned of the columns of the Classical orders it was believed, according to Vitruvius, that the proportions related to those of a man – in fact, he suggests that the Doric order should be reserved for temples dedicated to 'virile' gods. Indeed, the order has often seemed particularly suited to buildings of a defensive, aggressive, or utilitarian nature, such as barracks, city gateways, prisons etc., and also as a strong-looking support to the other orders, as in the ▷Colosseum where the Doric order forms the lowest level.

dormer window

▷window

Dormition

(Chronicled by the medieval hagiographer, Jacobus de Voragine in *The Golden Legend*.) Otherwise known as the ▷Death of the Virgin, this subject generally forms part of the narrative cycle of the life of the ▷Virgin, appearing immediately before her ▷Assumption. The word 'Dormition', which means asleep (as opposed to dead), refers to the belief that the Virgin, being perfect, did not suffer death but only went to sleep for the three days preceding her resurrection. The cycle appears frequently in churches dedicated to the Virgin (e.g. ▷Pietro Cavallini, mosaic, 1290s, Rome, Sta Maria in Trastevere). The legends upon which *The Golden Legend* account is based date back to about the 4th century. When the Virgin has been visited by an angel who tells her of her imminent death, she takes her last communion and, while the Apostles, who are scattered around the world preaching, are supernaturally brought back to her bedside. Sometimes a lighted candle will be shown either in her hands, or about to be passed to her, a traditional custom for the dying (e.g. ▷Hugo van der Goes, c1481, Bruges, Groeningemuseum). Van der Goes shows Christ appearing above the Virgin's bed as if in a vision; in

medieval depictions (such as Cavallini's), Christ will be standing behind her bed, framed by a ▷mandorla, flanked by angels, and holding her soul like a baby in his arms.

Doryphorus

A Greek sculpture produced by ▷Polyclitus. It is also known as the 'Spear Bearer' and it represents an upright male nude figure holding a spear. It was an important example of sculpture from the ▷Classical period of Greek art, and it was long considered a perfect example of ideal sculpture.

dosseret

Architectural term for a transitional member resting on the ▷abacus of a ▷column ▷capital and supporting the spandrel of the superincumbent ▷arch or ▷vault. Also called an impost block or super-abacus, it is characteristic of ▷Byzantine and ▷Romanesque architecture.

Dossi, Dosso (d 1542)

Italian painter. He was from Ferrara and his real name was Giovanni Luteri (the name by which he is most commonly known today dates only from the 18th century). Strongly influenced by ▷Giorgione, ▷Titian and ▷Raphael, he nonetheless managed to assimilate them all into a highly distinctive, rather more worldly, style (e.g. *Melissa*, c1523, Rome, Borghese Gallery). He is first recorded in 1512 in Mantua, although by 1514 he was employed, along with his brother and collaborator, Battista (d c1548), as court painter at Ferrara. He painted mythological and religious subjects, portraits, and decorative frescos, but his main importance lies in his development of the Venetian-style pastoral landscape.
Bib.: Ballarin, A., *Dosso Dossi*, 2 vols., Padua, 1994

dotted manner

An ▷engraving technique invented in the 15th century but used mainly in the 18th century. It involved punching an engraving plate with a series of dots which appeared on the final print as a rich textured background. It was called *manière criblée* in France.

Dou, Gerrit (1613–75)

Dutch painter. He was from Leiden and produced ▷genre scenes and portraits. He first trained with his father, a glass-engraver, and was a member of the glazier's guild in 1625–7. In 1628 he entered ▷Rembrandt's studio. His early paintings are heavily influenced by, and have sometimes been mistaken for, those of Rembrandt. Indeed, he frequently produced mere pastiches of his master's style, but always in a more visibly laboured manner, without Rembrandt's broad touch. When Rembrandt moved to Amsterdam in c1631, Dou remained in Leiden and gradually asserted his own meticulous style. Small-scale highly detailed

genre subjects (sometimes painted with a magnifying glass, the paint brought to an enamel-like finish) now predominated in his work and found a ready market amongst collectors, soon making him one of the most sought after and highly paid of Dutch painters. His influence on the painters of Leiden lasted into the 19th century, his imitators and followers being designated *fijnschilders* ('fine', or 'meticulous small-scale painters'). Amongst his pupils, the most famous are ▷Frans van Mieris the Elder and Younger, ▷Gabriel Metsu and ▷Gottfried Schalcken. In 1648, he was one of the founders of the Leiden Guild of St. Luke.

Paintings of domestic interiors are his most typical works, characteristically viewed through an arched stone window and frequently hung with sumptuous drapes. They may contain just one or a few figures, surrounded by books, household utensils and musical instruments. The lighting, often provided by a candle, finds its source in Rembrandt's early work, but is here used principally as a forum in which Dou can display the full virtuosity of his brilliant technique on candle-lit flesh, fabric, wood, stone and metal. His works continued to command high prices throughout the 18th and 19th centuries until the rise of the taste for ▷Impressionism rendered his tightly-painted precious works unfashionable.

Douanier, Le

▷Rousseau, Henri

Doughty, Thomas (1793–1856)

American painter and lithographer. He was from Philadelphia, but he trained and lived in New York during the 1820s and 1830s. He was one of the first artists to produce landscape scenes of the ▷Hudson River area, which were poetic, rather than sublime. He did not always use specific settings, but the geography was recognizably that of the Hudson River. He travelled to Europe in 1837 and 1845, and also produced ▷lithographs.
Bib.: Tahach, M.H., *Thomas Doughty, American Painter*, Binghampton, 1973

Dove, Arthur Garfield (1880–1946)

American painter and illustrator. He began his career as an illustrator in New York, but a trip to Europe in 1907 introduced him to the experiments of the ▷Fauvists. From c1910 he began producing works in New York which he called 'extractions'. They were among the first examples of abstract art anywhere and certainly the first in America. During 1911–20 he developed his abstract technique, but unlike many of his European contemporaries, he always used nature as a starting point. He was associated with ▷Stieglitz's ▷291 Gallery in New York and he exhibited at the ▷Armory Show. Even after 1920 he continued to produce abstract works, though his later paintings show a less obvious relationship with the natural world.

Some of his works of the 1930s also contain sexual imagery.

Bib.: Cohn, S., *Arthur Dove: Nature as Symbol*, Ann Arbor, 1985

Downman, John (c1750–1824)

English painter. He was a pupil of ▷Benjamin West and went to Italy in 1773–5 with ▷Joseph Wright. He became an ▷ARA in 1795 but never achieved the ranks of ▷Royal Academician. He specialized in portraiture, but in contrast to the elaborate easel-paintings of many of his contemporaries, he became known for modest chalk drawings. He also acted as an itinerant portraitist, travelling to houses in Cambridge, Exeter and Plymouth.

Bib.: Williamson, G.C., *John Downman, A.R.A.: His Life and Work*, London, 1907

drapery painter

An artist who specializes in the painting of clothes and costumes. Drapery painters were used primarily as assistants to portrait painters. Although this division of labour was practised from the ▷Renaissance, it was most commonly used in the 18th and early 19th centuries. The 'master' painter would concentrate on the head and sometimes the hands of the sitter, while the drapery painter laboured to produce the costume. The practice allowed the artist to create an assembly line technique of producing works, and it relieved the sitter of long sessions. As drapery painters were so skilled with the textures of costumes, the combination of their work and the portrait painter's ability to capture a likeness would flatter the sitters. One of the most famous drapery painters of the 18th century was Joseph Van Aken (c1699–1749), who worked for ▷Hudson, ▷Ramsay and many other artists in England at that time.

drawing books

Books used for teaching art which included illustrations intended to be copied by the student. Drawing books existed from the earliest days of printing in the 15th century, but they became more common after the formation of ▷academies. The rule-based methods of academic teaching were facilitated by the production of drawing books, among the most famous of which was ▷Charles Lebrun's *Méthode pour apprendre à dessiner les passions* (published 1698). The growth of amateur artists in the 18th and 19th centuries increased the production of drawing books, but their scope and methods became increasingly mechanical. Drawing books became 'how to' manuals, rather than attempts to educate the artist in the principles behind these practices.

drawing frame

A frame set before a sitter which allows the artist to focus on small parts of the subject separately. It originated in the 15th century when artists prided themselves on their ability to imitate reality.

▷mimesis

Dreier, Katherine Sophie (1877–1952)

American painter. She travelled throughout Europe from 1907, but in 1913 she was back in the United States where she met ▷Marcel Duchamp and saw the ▷Armory Show. She became committed to the dissemination of ▷modernist art and with Duchamp and ▷Man Ray founded the ▷Société Anonyme in 1920. This organization was geared to the promotion of modern art through travelling exhibitions and conferences. Her own painting was abstract with a spiritual emphasis, and she became a member of the ▷Abstraction-Création group. She had an extensive art collection of her own which she donated to Yale University in 1941.

drip painting

The name given to ▷Jackson Pollock's method of allowing paint to drip on the canvas. The canvas was placed on the floor and paint was dripped through meshing or netting to create an abstract work.

drop(ped) arch

▷arch

Drouais, François-Herbert (1727–75)

French painter. He was born in Paris and was taught by his father, Hubert (1699–1767), a minor portrait ▷pastellist, and by ▷Boucher and ▷Van Loo. He studied at the ▷Académie under ▷Bouchardon (1758) and rose to court prominence through the patronage of Mme de Pompadour (portrait 1763–4, London, National Gallery) and Mme du Barry. He rivalled ▷Nattier and also exhibited regularly at the ▷Salon. His speciality lay in the portrayal of women and children, in a graceful and flattering ▷Rococo style (e.g. *Artist's Wife*, 1758, Paris, Louvre; *Comte d'Artois and his Sister*, 1763, Paris, Louvre).

Drouais' son, Germain (1763–88), was a favourite pupil of ▷David, working in a ▷Neoclassical style (*Marius at Mintunae*, 1786; Paris), but he died prematurely of malaria.

drum

An architectural term for a wall which supports a dome.

dry-brush painting

A painting technique, using oils or ▷watercolour, where the brush is kept very dry, with little paint on it. It is applied to a textured surface, such as coarse, untreated canvas, and the paint clings only to the raised areas of the uneven surface.

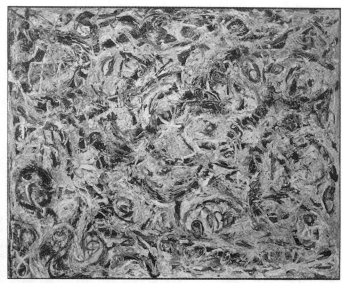

Drip painting: Jackson Pollock, *Grey Composition*

drying oils

Fatty oils, like linseed, poppy and walnut oils, in which
▷pigment can be suspended, and which dry into a
hard, transparent substance on exposure to the air.
They are essential materials in oil painting, as they bind
the pigment to the ▷ground.

drypoint

An ▷engraving method. The design to be printed is
scratched directly on to a metal ▷plate (usually copper)
using a sharply pointed instrument. The plate resists
the engraving point, and prints made from this tech-
nique are characterized by abruptly angular lines, and
a fuzziness where the rough ridges thrown up on
either side of the engraved line cause impressions.
The technique is sometimes used to strengthen details,
especially dark areas, in an ▷etching or it can be
used as a preliminary sketch for other methods of
line engraving. ▷Dürer and ▷Rembrandt were early
exponents of drypoint, which died out with the advent
of mechanized printing. ▷Whistler revived it in the
20th century.

Drysdale, Sir Russell (1912–81)

Australian painter of English birth. He grew up in
Australia, but came to England in 1938, when he
came across the work of ▷Nash and ▷Sutherland.
Influenced by their ▷Surrealist landscapes, he
returned to Australia to produce landscape paintings
representing the bush. These works conveyed an image
of the often bleak nature of the countryside. He exhi-
bited with the ▷Contemporary Art Society in Mel-
bourne in 1939, and moved to Sydney in 1940. Many
of his works represent ▷Aboriginal subjects.

Dubuffet, Jean (1901–85)

French painter. He studied at the ▷Académie Julian
in Paris in 1918 before giving up painting in 1924 to
manage his father's wine business. He resumed paint-
ing in 1942 and achieved an immediate *succès de scandale*
with his first exhibition in 1944 and his *Mirobolus,
Macadam et Cie* exhibition of 1946, in which crude
images were scratched onto '*hautes patés*', a mixtures
of thick paint and foreign matter such as sand, gravel,
glass and tar. Scornful of the traditional values associ-
ated with the ▷School of Paris, his art evidences a
search for a new ground for art, both literally and
metaphorically, as his own crude images excavated
from a physically resistant surface, so similar to
▷graffiti, are literally a starting from scratch. Dubuffet
claimed that his 'disparagement of traditional artistic
materials' was necessary in order 'to bring all dis-
paraged values into the limelight'.

Both his own art and that which he collected under
the term ▷Art Brut attempted to jolt the viewer out
of his or her conventional aesthetic complacency, and
rejected the traditional classifications and hierarchies
of art, including that of composition and ▷perspective.
Dubuffet's philosophy is best exemplified by his *Corps
des Dames* series of 1950–51, in which the crude flat-
tened female form, her sex graphically exposed, is
coterminous with the ground upon which she is
figured. The expressive potential of matter was further
explored in the *Assemblages* series of 1956, ▷collages
using various materials such as discarded canvas, but-
terfly wings, leaves etc., and in the maculated surfaces
of the *Texturologies* series of 1957–9 (Amsterdam, Ste-
delijk Museum; Chicago, Art Institute; London, Tate

Gallery). The *Hourloupe* series begun in 1962, with its tightly interlocking forms enabled Dubuffet, in his words, 'to erase all categories and regress towards an undifferentiated continuum', and provided him with forms for his sculpture in the late 1960s, constructed from fibre glass, plastic and concrete. He had retrospectives at the Musée des Arts Décoratifs, Paris, in 1960–61 and at ▷MOMA in New York in 1962. Initially synonymous with ▷Art Brut and ▷Art Autre, his anti-cultural position and articulate writing was of enormous influence in creating the aesthetic conditions for much art of the 1960s.

Bib.: Glimcher, M., *Dubuffet*, New York, 1987; Pacquet, M., *Dubuffet*, Paris, 1993; Picon, G., *Le Travail de Jean Dubuffet*, Geneva, 1973

Duccio di Buoninsegna (documented from 1278; d before 1319)

Italian painter. Effectively the founder of the Sienese school of painting, he revitalized the prevailing ▷Byzantine tradition, drawing his own inspiration in part from the sculpture of ▷Giovanni Pisano and exerting a formative influence on all the major Sienese painters of the 14th century. He stands in relation to the development of Sienese painting as ▷Giotto does to that of Florence. Indeed, even in the rival town of Florence Duccio's contemporary reputation was sufficiently high that it was he, and not the Florentine ▷Cimabue, who was awarded in 1285 the prestigious commission for the 4.5 m (15 ft) high *Rucellai Madonna* altarpiece for Sta Maria Novella in Florence. It is instructive to compare this with Cimabue's contemporary and more conservative *Madonna of Sta Trinità* (both now in Florence, Uffizi). That Duccio's posthumous reputation has not been higher is undoubtedly due in part to ▷Vasari's partisan, but extremely influential, account of the development of Tuscan art. Both Giotto and Duccio reflect the new humanity required in sacred art by the recently formed preaching orders, the Franciscans and Dominicans, but Duccio's vision is the more conservative, breathing new life into Byzantine pictorial conventions, rather than rejecting them. Moreover, the hallmarks of Duccio's art were to be characteristic of Sienese painting for the next hundred years: rich colours, rhythmic line and lavish gold used decoratively to achieve an intense and emotional spirituality.

Very little is known of Duccio's life and his only fully documented work is also his most important commission, the so-called ▷*Maestà* (1308–11), the magnificent altarpiece for the high altar of the Cathedral of Siena (dismembered, the major part now being in the Siena Cathedral Museum, with a few small panels from the ▷predellas in London, Washington and elsewhere, while others are missing). Double-sided, the front consisted of one huge main panel showing the enthroned ▷Madonna with the ▷Christ Child seated upon her lap, surrounded by adoring angels and saints (hence, *Maestà*, or 'majesty') with, in the predella beneath and the pinnacles above, narrative scenes of the life of the Virgin and the young Christ interspersed with small images of saints and prophets. The rear, by contrast, consisted of 26 scenes from Christ's ▷Passion with, below and above, scenes of Christ's mission and his appearances after the ▷Resurrection. The front, therefore, was a devotional ▷icon, on a scale large enough to be legible to the congregation, whereas the rear consisted of smaller narrative scenes, visible only to the canons seated within the ▷choir. That the *Maestà* was not widely imitated is testament only to the extreme expense of its production.

The style and pictorial conventions inaugurated by Duccio are present in the work of the ▷Lorenzetti brothers and, even more, in that of ▷Simone Martini who, with Duccio, was the most important Italian influence on the future ▷International Gothic style.

Bib.: Deuchler, F., *Duccio*, Milan, 1984; Ragionieri, G., *Duccio, catalogo completo dei dipinti*, Florence, 1989; Stubblebine, J.H., *Duccio di Buoninsegna and his School*, Princeton, 1979; Van Os, H., *Sienese Altarpieces 1215–1460*, Groningen, 1984; White, J., *Duccio*, London, 1979

Duchamp, Gaston
▷Villon, Jacques

Duchamp, Marcel (1887–1968)

American artist of French birth. He was born near Blainville-Crevon, Eure, into an artistic family that included his brothers, the painter ▷Jacques Villon and the sculptor ▷Raymond Duchamp-Villon. In 1903 he moved to Paris and briefly studied at the ▷Académie Julian; between 1905 and 1910 he drew cartoons for the *Courier Français* and *Le Rire*, and he had his first solo exhibition at the ▷Salon des Indépendants in 1909.

Duchamp's early portraits and landscapes (e.g. *Maison rouge dans les pommiers*, 1908, Philadelphia) were influenced by ▷Neo-Impressionism and the ▷Nabis, and then by ▷Cubism (e.g. *Joueurs d'échecs*, 1911). However his radical *Nude Descending a Staircase No. 2* (1912, Philadelphia) was withdrawn from the Indépendants when several older ▷Cubists objected; the same picture, which represented in a series of repeated straight and curved planes the dynamic movement of a semi-abstract figure, caused a sensation when displayed at the New York ▷Armory Show of 1913. The same year he largely abandoned conventional media and embarked on the first of his ▷ready-mades: *Bicycle Wheel* (1913, private collection) and *Bottle Rack* (1914, private collection). In 1915 he moved to New York and started work on the (unfinished) glass and metal 'sculpture' ▷ *The Bride Stripped Bare by her Bachelors, Even* (1915–23, Philadelphia Museum of Art). In 1917 he submitted his signed urinal *Fountain* to an

exhibition of Independent Artists; when it was rejected he resigned as the society's vice-president. In 1920 he included the picture ▷*LHOO* (1919) to a ▷Dada demonstration in Paris, and, along with ▷Picabia, he brought European Dada to America. In 1923 he virtually abandoned art, though he continued his interest in experimental film with ▷Man Ray, and organized exhibitions including the International ▷Surrealist Exhibition at Paris in 1938. A major figure of 20th-century art as much for his life as his artistic achievements, his achievement was his breaking down of conventions and illusions of taste, beauty and the role of the artist.

Bib.: de Duve, T., *Pictorial Nominalism: On Marcel Duchamp's Passage from Painting to the Ready-made*, Minneapolis, 1991

Duchamp-Villon, Pierre-Maurice-Raymond (1876–1918)

French sculptor. He was the brother of ▷Jacques Villon and ▷Marcel Duchamp, whose surname he adopted in homage. In 1898 he gave up his medical training to practise sculpture. His first influence was the work of ▷Rodin but his early naturalistic works were superseded when he discovered ▷Cubism in 1910. After this point, he began to produce sculpture which was increasingly abstract. The ▷Futurist sculpture of ▷Boccioni also had an impact on his work, which expressed ▷dynamism rather than the stasis of much Cubist painting. His series of sculptures of *The Horse* (1912–14) combine Futurist movement with Cubist analysis of form. He was a member of the ▷Section d'Or. During the First World War he was gassed, and he died of blood poisoning.

Ducros, Louis (1748–1810)

Swiss landscape painter. He travelled to Italy in c1770, returned to Switzerland in c1805 and produced primarily landscape ▷watercolours from that point onwards.

Bib.: *Images of the Grand Tour: Louis Ducros 1748–1810*, exh. cat., Geneva, 1985

duecento

▷dugento

Dufresne, Charles (1876–1938)

French painter. He travelled to Italy and later worked in the Department of Metal Engraving at the ▷École des Beaux-Arts. In 1910 he won the Prix de l'Afrique du Nord, and travelled to Algiers, where his work developed a colouristic expressiveness. After the First World War, he worked primarily as a teacher and a designer. He was one of a group of ▷Expressionistic realists which also included ▷Dunoyer.

Dufy, Raoul (1877–1953)

French painter. Born in Le Havre, he studied at evening classes at the École des Beaux-Arts there and then, thanks to a small bursary, at the Academy in Paris, where he developed a brightly coloured style, influenced by ▷van Gogh and the late ▷Impressionists, especially ▷Boudin and ▷Pissarro. In 1903 he exhibited his first work, *End of the Journey to Havre* at the ▷Salon des Indépendants, and he continued to show there annually. In 1905 he joined the ▷Fauves, after having seen ▷Matisse's *Luxe, Calme et Volupté* at the ▷Salon d'Automne. Matisse's work proved extremely important to Dufy, and his works produced in these years show clear parallels. The use of colour is flatter and less fluid than in the very early pieces. *Street Decked*

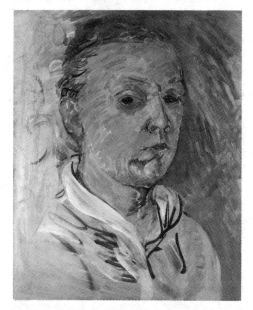

Raoul Dufy, *Self-portrait*, c1945, Musée des Beaux-Arts, Le Havre

with Flags (1906, Paris, Centre Pompidou) demonstrates this influence and clearly displays Dufy's Fauvism in the colours associated with that movement. By 1908 Dufy was becoming increasingly interested in the work of ▷Cézanne, though he was also friendly with ▷Braque, and together they visited L'Estaque, so that in Dufy's work of this period the softer colours of Cézanne are infused with ▷Cubist lines. This experiment did not appeal for long, however, and Dufy was soon back painting racecourses, society gatherings and regattas with a renewed fluid and gesturing lines.

Dufy worked with other media besides pure paint, including fabric, upon which he applied decorative washes and calligraphic notation, and ▷woodcuts, which occupied him during the war years. His interest in textiles was encouraged by the fashion designer Poiret, and from 1912 onwards, Dufy intermittently produced designs for silk. Poiret also commissioned

tapestries from Dufy, in 1925 the pair travelled to Morocco. This visit inspired 14 such works, which were shown at the *Exposition Internationale des Arts Décoratifs*. In 1937 Dufy was commissioned to design an enormous mural, 10×60 m (33×198 ft), on the theme of scientific progress, for the Palace of Electricity at the Paris World Fair. This large scale public art was seen again at the monkey house in the Jardin des Plantes. During the 1940s, Dufy expanded his interest in the ▷decorative arts, producing painted pottery and ▷lithographs. In 1952 he won International Grand Prix at the Venice ▷Biennale. In his latter years he settled at Forcalquier, and painted less and less because of partial paralysis by arthritis in his hands. His work is now considered to be highly original, and an important document of 20th-century styles. It is held in almost all major public collections worldwide.

dugento (duecento)

Literally, 'two hundred', the Italian art term for the 13th century. It is used only to refer to Italian art and may be used as either an adjective, as in 'dugento art', or a noun, as in 'art of the dugento'.

Dughet, Gaspard (Gaspard Poussin) (1615–75)

French painter. He was born in Rome and became the brother-in-law of ▷Poussin with whom he studied. He adopted Poussin's name as a homage to his master, and like Poussin, he produced Classical landscapes. However, his works also show his knowledge of the atmospheric perspective of ▷Claude.
Bib.: *Gaspard Dughet, called Gaspard Poussin 1615–75*, exh. cat., London, 1980

Dujardin, Karel (1622–78)

Dutch painter. He studied with ▷Berchem and then visited Italy, where he began painting landscapes and ▷genre. He produced a number of paintings and etchings of Italianate landscapes and rustic scenes.

Dunlap, William (1766–1839)

American painter and playwright. He was from New Jersey, but he studied art with ▷Benjamin West in London. He produced a series of large-scale religious paintings which he toured around America, although they failed to make the impression he wished. The bulk of his energy was devoted to the writing of plays and the production of *A History of the Rise and Progress of the Arts of Design in the United States* (1834), which was the first comprehensive survey of American art.

Dunoyer de Segonzac, André (1884–1974)

French painter. He studied briefly at the ▷École des Beaux-Arts in 1902. In 1910 he exhibited at the ▷Salon d'Automne and the ▷Salon des Indépendants. His work was naturalistic, but the naturalism was counteracted by his use of thick ▷impasto. He produced landscape paintings and watercolours, as well as book illustrations and designs for the theatre.
Bib.: *Dunoyer de Segonzac*, exh. cat., Paris, 1985.

Dupont, Gainsborough (1754–97)

English painter. He was the nephew of ▷Thomas Gainsborough, and much of his work was a pastiche of Gainsborough or a commissioned copy of his uncle's work. One of his most famous independent commissions was a series of theatrical portraits for Thomas Harris, the proprietor of Covent Garden theatre.

Duquesnoy, François (1597–1643) and Jerome II (1602–54)

Flemish family of sculptors. François was known in Italy as 'Il Fiammingo' ('the Fleming'). Born in Brussels, he was trained by his father Jerome I (d 1641) whose most famous work is the 'Mannekin-pis' fountain, 1619, in Brussels. François was in Rome by 1618 and remained there for the rest of his life. In about 1621, after a few years scratching a meagre living, restoring ancient marbles and selling small sculptures of wood or ivory, Duquesnoy finally established himself. He became the most successful non-Italian sculptor of his day and, with ▷Algardi, was the leading representative of the classical ▷Baroque tendency in sculpture, in opposition to the more theatrical Baroque of ▷Bernini and his followers. One of Duquesnoy's earliest jobs, however, was working on Bernini's ▷Baldacchino in St. Peter's (1627–28). He was a close friend of ▷Poussin and both artists enjoyed the patronage of the antiquarian, Cassiano dal Pozzo. In 1639 Poussin accepted the post of Peintre Ordinaire to Louis XIV in Paris and possibly helped secure the post of Sculpteur du Roi for Duquesnoy. Unfortunately, Duquesnoy seems by this time to have been suffering from some sort of neurotic condition and was given to chronic procrastination. He finally accepted the offer in 1643, though only because he needed to consult a doctor in Paris, but he died on the journey, in Livorno.

Duquesnoy's major works are still in Rome and include *Sta Susanna* (1627–33, S. Maria di Loreto) and *St. Andrew* (1628–40, St. Peter's). The diarist John Evelyn, visiting Rome in 1644, wrote that it was the poorly-lit positioning of this latter statue that brought on Duquesnoy's madness and hastened his death. He was particularly renowned for his charming ▷*putti*, excellent examples of which can be seen in his Monuments to Andrien Vryburch (1629) and Ferdinand van den Eynde (1633–40) in S. Maria dell' Anima, Rome, and in his celebrated ▷relief, *The Concert of Angels*, in SS. Apostoli, Naples (1642). Additionally, his fame was spread throughout Europe by the numerous high-quality reliefs and statuettes that poured out from his flourishing studio.

François' brother, Jerome II, was also a sculptor and the two worked together in Rome. Shortly before his departure from Rome, François was offered the

commission for the tomb of Bishop Anton Trest. Following his sudden death, this commission passed to Jerome and it is now regarded as the latter's most important work (c1640–54, Ghent Cathedral).

Durand, Asher Brown (1796–1886)

American painter. With ▷Thomas Cole, he was one of the founders of the ▷Hudson River School. He began his career as an ▷engraver, and he achieved fortune and notoriety from his engraving of ▷Trumbel's *Declaration of Independence* (1786–97). He travelled throughout Europe in 1840–41, and began producing landscapes initially in the style of ▷Claude, with a strong sense of ▷atmospheric perspective. His landscapes were diverse and reflected his fidelity to nature as well as the drama of American scenery. From 1845 to 1861 he was president of the ▷National Academy of Design.

Duranty, Edmond (1833–80)

French novelist and art critic. He was an advocate of ▷Realism and an early supporter of the ▷Impressionists. His novella *Le Peintre Louis Martin* perfectly captures the tensions between the ▷avant-garde and the establishment in mid-19th-century Paris.
Bib.: Duranty, E., 'Le Peintre Louis Martin', in *Le Pays des Arts*, 1881

Dürer, Albrecht (1471–1528)

German painter, draughtsman, graphic artist and art theorist. He was the leading ▷Renaissance artist in northern Europe. Born in Nuremberg, he was apprenticed first to his father, a goldsmith. Dürer was a child

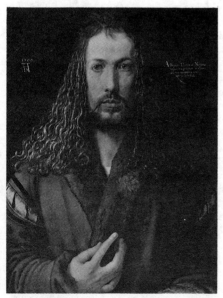

Albrecht Dürer, *Self-portrait in a fur coat*, Alte Pinakothek, Munich

prodigy, one of his earliest surviving drawings being the *Self-Portrait* of 1484 (Vienna, Albertina). He was next apprenticed to the painter Michael Wolgemut, whose large workshop also produced ▷woodcut illustrations published by Dürer's godfather, Anthony Koberger. At the termination of his apprenticeship in 1490, he set off on his ▷*Wanderjahre*: four years of travelling around Germany, working in other masters' shops. He visited Colmar (where he had hoped to obtain work with ▷Schongauer who had just died) and Basle and Strasbourg (where he worked as a book illustrator).

Dürer returned to Nuremberg in May 1494 and got married, though by the autumn of the same year it is believed (though without conclusive documentation) that he was in Venice, returning home once more to set up his own workshop in spring 1495. Certainly, however, he was in Venice in 1505, staying until early 1507. On this trip he met ▷Giovanni Bellini, whom he greatly admired. He also painted, for the German merchants in Venice, the ▷*Feast of the Rose Garlands* (1506, Prague, National Gallery), which was Dürer's successful attempt to imbue his own work with Venetian colour. His other main Italian work, *Christ among the Doctors* (Lugano, Thyssen Collection), shows the influence of ▷Leonardo da Vinci. He was deeply impressed by the higher status enjoyed by Italian painters (in Germany painters were still classed as artisans) and, on his return, applied himself to intellectual pursuits such as Latin and ▷humanist literature, mathematics and geometry in an effort to raise his own status. He also sought out the company of German scholars and correspondingly avoided other artists.

By 1512 Dürer was court painter to the Emperor Maximilian and, in 1520, he travelled to the Netherlands in order to secure the same post with his successor, Charles V. His journey to the Netherlands and his return trip are recorded in a surviving diary: he visited .towns throughout the Low Countries and Germany, and was received with honour at every stop as northern Europe's most famous artist. He finally returned home the following year, albeit suffering the after-effects of a debilitating fever, possibly contracted in the swamps of Zeeland, whence he had ventured in order to sketch a stranded whale. He continued working until his death and in his final years added to his output a number of treatises, including the *Treatise on Measurement* (1525) and the *Four Books on Human Proportion* (1528, published posthumously) – his investigations into ideal human proportions showing again the influence of Leonardo.

More than any other artist, Dürer was responsible for introducing, mainly via the dissemination of his graphic work, Italian forms and ideas to northern Europe. His own work is never subsumed beneath this Italian influence, however, and he at all times retains a distinctive identity as a German artist working within the indigenous ▷Gothic tradition. The closest he ever comes to Italian art is in his two late panels of the four

Apostles (1526, Munich, Alte Pinakothek) where the model is clearly ▷Bellini's altarpiece in the Frari, although Dürer's meaning is unequivocally Lutheran. Moreover, the flow was not all one way: despite the confidence felt by Italian artists in a period in which they believed themselves to be world-leaders, Dürer managed to exert a profound influence on at least one major Italian, ▷Pontormo (e.g. the frescos at the Certosa di Val d'Ema, 1523–4). In fact, his influence was immense throughout the whole of Europe and his prints were used by numerous artists as basic source material for their own work (e.g. ▷ Gossaert's painting, *Neptune and Amphitrite*, based on Dürer's engraving, *Adam and Eve*).

Dürer's graphic work, which outnumbers considerably his surviving paintings, is unrivalled in technical expertise, emotional and intellectual profundity, and originality of conception. The main ▷woodcuts are the series of the *Apocalypse* (1498), the *Great Passion* (1510) and the *Little Passion* (1511), the *Life of the Virgin* (1510), and a number of single prints, such as the *Men's Bathhouse* (1497). Among the ▷engravings are the *Engraved Passion* series (1512) and single prints such as the *Sea Monster* and the *Prodigal Son* (both 1497), *St. Eustace* (c1501), *Adam and Eve* (1504), *Knight, Death, and the Devil* (1513) and *St. Jerome in his Study* and *Melancolia I* (both 1514). On his travels around Europe he also made ▷watercolour and ▷gouache landscape sketches, perhaps the first to have been executed out of sheer interest and not principally as a preparatory sketch for a finished composition (e.g. *The Pool in the Woods*, watercolour, c1497, London, British Museum).
Bib.: Anzelewsky, F., *Albrecht Dürer: das malerische Werk*, 2 vols., Berlin, 1991; Bailey, M., *Dürer*, London, 1995; Bialostocki, J., *Dürer and His Critics, 1500–1971*, Baden Baden, 1986; Vaisse, P., *Albrecht Dürer*, Paris, 1995

Düsseldorf school

The name given to a group of artists who produced primarily landscapes and who studied in, or were influenced by, the Düsseldorf Academy. The Academy was founded in 1767, but its influence intensified in the 1830s and 1840s, in the wake of the popularity of ▷Nazarene art. Among the artists trained in the Academy, ▷Karl Friedrich Lessing and Christian Köhler showed both a Nazarene purity of composition and a concentration on ▷Romantic landscape. The Düsseldorf school was most strongly influential on American artists, some of whom studied there. ▷Bierstadt and ▷Bingham were among those Americans who found the emphasis on landscape sympathetic to a developing style of American art.

Dutch art

The 'Golden Age' of Dutch art in the 17th century has, to an extent, eclipsed discussion of Dutch work before and after that period. Before 1600, art in the Low Countries was dominated by the ▷Burgundian court, which provided a lure for both Dutch and Flemish artists. By contrast, few artists remained to practise in Holland itself, although a number of important individuals helped create a distinctive style in particular cities. ▷Albert van Ouwater, for example, remained in Haarlem during a point in the 15th century when other Dutch artists, such as ▷Gerard David and ▷Claus Sluter, were flocking to Bruges and Dijon. In the later 15th century, the distinctive moralistic ▷polyptychs of ▷Bosch attracted the attention of the Spanish and Portuguese courts after Bosch's death. The first distinctive movements in Dutch art came in the 16th century, when a number of artists travelled to Italy and brought a ▷Mannerist style back to Holland. ▷Lucas van Leyden in Antwerp and ▷Spranger and ▷Goltzius in Haarlem created a distinctive breed of Dutch Mannerism that was in many ways more extreme than its Italian source. The ▷Gothic style of architecture remained predominant in Holland until the 16th century, when Italianate influence crept in.

Dutch art came into its own in the 17th century, during a period in which the country was free from foreign dominance. This has been known as the 'Golden Age' of Dutch art. Political freedom and the relative prosperity of the region led the United Provinces (as they then were called) to cultivate the arts in a way that had not been possible before. Amsterdam became an important trading port, and civic pride stimulated a number of public artistic commissions. During this period, secular subject-matter prevailed, as the predominantly Calvinist country turned its back on the Catholicizing religious art of the past. Small ▷genre and landscape scenes were also more appropriate for private homes, which were modest in scale and did not allow the large-scale paintings of the past. Aside from landscape and genre painting, portraiture also prevailed, and public commissions for portraits of civic guards and charitable groups were very common. The catalogue of artists working in the United Provinces during the 17th century is massive, but among them, ▷Rembrandt and ▷Vermeer are perhaps the most famous. Civic pride and prosperity also led to more commissions for public sculpture, but the style of sculpture is not as distinctive as that of painting.

The 18th century in Holland is seen as a continuation and attenuation of the glories of the 17th century. The genre and landscape paintings of the 'Golden Age' prevailed until the early 19th century, when artists began self-consciously to imitate the art of their 17th-century predecessors. Dutch art gained a new importance in the 1870s with the work of the ▷Hague School, but many of the most distinguished or individual of Dutch artists, such as ▷Jongkind and ▷van Gogh, travelled abroad.

In the 20th century, Dutch art is dominated by the figure of ▷Mondrian, whose art theories were crucial

to the development of 20th-century ▷abstraction. But like many other Dutch artists, Mondrian's greatest impact came outside Holland – in Germany and the United States – and Dutch art lost the central place it had held in European consciousness.

Bib.: Alpers, S., *The Art of Describing: Dutch Art in the Seventeenth Century*, Princeton, 1982; *Bruegels tid: nederländsk konst 1540–1620*, exh. cat., Stockholm, 1984; Defoer, H., *The Golden Age of Dutch Manuscript Painting*, exh. cat., New York, 1990; Franits, W., *Paragons of Virtue: Women and Domesticity in Seventeenth-Century Dutch Art*, Cambridge, 1993; Haak, B., *The Golden Age: Dutch Painters of the Seventeenth Century*, London, 1984; Kettering, A., *The Dutch Arcadia: Pastoral Art and its Audience in the Golden Age*, Totowa, NJ, 1983; von der Osten, G., *Painting and Sculpture in Germany and the Netherlands 1500 to 1600*, Harmondsworth, 1969; Rosenberg, J., *Dutch Art and Architecture 1600 to 1800*, 3rd edn, Harmondsworth, 1972; Schama, S., *The Embarrassment of Riches: An Interpretation of Dutch Culture in the Golden Age*, London and New York, 1987; Stechow, W., *Dutch Landscape Painting of the Seventeenth Century*, 3rd edn, Oxford, 1981

Duveen, Sir Joseph (1869–1939)

An art dealer who elevated dealing from mere trade to an art in itself by convincing some of the great magnates of the USA to buy (largely) Italian ▷Renaissance art for prestige and pleasure – but not yet for investment, although very large sums did change hands. In the process Duveen was instrumental in denuding the British Isles and Continental Europe of many first-class paintings, which now, thanks to the USA's generous tax concessions, hang on the walls of that country's public galleries. He paid a little back by endowing the Duveen Galleries in the ▷British Museum. ▷Bernard Berenson facilitated the process of this continental rearrangement of art collections by signing certificates of authenticity that reassured the (largely unknowledgeable) Duveen buyers that they were getting what was said on the labels – labels often originated by Berenson's own ▷connoisseurship.

Bib.: Behrman, S.N., *Duveen*, Boston, 1972; Simpson, C., *The Partnership: The Secret Association of Bernard Berenson and Joseph Duveen*, London, 1987

Duvet, Jean (c1485–1561)

French engraver. He was also called Master of the Unicorn. He worked in a ▷Mannerist visionary style. His most famous works are 24 engravings of scenes from the Apocalypse (1561).

Bib.: Eisler, C., *The Master of the Unicorn: The Life and Work of Jean Duvet*, New York, 1979

Duyster, Willem Cornelisz (1599–1635)

Dutch painter. He was a pupil of ▷Codde and produced drinking scenes and groups of soldiers.

Dyce, William (1806–64)

Scottish painter. He was born in Aberdeen, the son of a lawyer who opposed his son's decision to become an artist. He studied in London and Rome (1827), where he came into contact with the ▷Nazarenes. Their simple, precise 15th-century style was an immediate inspiration, which he tried to recreate not only in oils but also in ▷fresco work for the House of Lords. He produced a number of religious subjects (e.g. *The Meeting of Jacob and Rachel*, 1855, Hamburg; *Virgin and Child*, 1838, Nottingham) and took scenes from literary and artistic history (e.g. *George Herbert at Bemerton*, 1861, London, Guildhall). Unsurprisingly, many of his paintings are reminiscent of the ▷Pre-Raphaelites in their use of high colour and precise detail (e.g. *Pegwell Bay, Kent*, 1858, London, Tate Gallery). He was a high-minded man, with an interest in education and science. In his later career his administrative role in the government schools restricted his artistic output.

Bib.: Pointon, M., *William Dyce 1806–64: A Critical Biography*, London, 1979

Dyck, Sir Anthony Van

▷Van Dyck, Sir Anthony

Dying Gaul

Antique Roman marble copy of a lost ▷Hellenistic statue, presumed to have been bronze, from the Pergamene school of the late 3rd century BC. Now in the collection of the Capitoline Museum, Rome, it was first recorded in 1623 in the Ludovisi collection in Rome, presumably having been discovered shortly before during the excavations for the foundations of the Villa Ludovisi. It soon afterwards became one of the most celebrated works from antiquity, copied, reduced and frequently engraved. It retains its high reputation today, principally because of its naturalism and its sense of pathos, this latter quality having been the inspiration for the fourth canto of Byron's poem, *Childe Harold* (1818). It was among the works ceded to the French in 1797 and returned to Rome in 1815, following the fall of Napoleon. Despite the fact that the statue undoubtedly represents a gallic warrior with typical hairstyle, moustache, and neck torque, it has nonetheless also been variously referred to as a 'Dying' or 'Wounded Gladiator', 'Roman Gladiator', and 'Myrmillo Dying'. The present base was added after its rediscovery.

Bib.: Haskell, F. and N. Penny, *Taste and the Antique*, New Haven and London, 1981; Smith, R.R.R., *Hellenistic Sculpture*, London, 1991

Dying Slave, The

A marble statue by ▷Michelangelo, now in the Louvre, carved c1514 for the tomb of Pope Julius II

Giacomo Balla, *Dynamism of a Dog on a Lead*, 1912, Albright Knox Art Gallery, Buffalo, New York

in the church of San Pietro in Vincoli, Rome. Julius had been the patron for Michelangelo's ▷Sistine Chapel ceiling, and whilst alive he had grand ambitions for an elaborate tomb. Following Julius' death in 1513, the artist was commissioned to produce some 40 statues, and *The Dying Slave*, together with its companion piece *The Rebellious Slave*, were probably the first figures he executed. Though both statues remain unfinished they reflect the artist's skill in portraying the sensuality and beauty of the male form that he had shown in both his *David* and the Sistine chapel fresco.

dynamism

A term popularly adopted to describe the obsessions of ▷Futurist artists from 1909. Because of their interest in modern life, the Futurists embraced the notion of the dynamic nature of modern existence, and they attempted to express this aspect of modernity in their work. Dynamism can also be used more broadly to express any aspect of a ▷modernist work that attempts to show something of the speed and frenetic nature of modern life.

Bib.: *Dynamism: The Art of Modern Life Before the Great War*, exh. cat., Liverpool, 1991

E

Eakins, Thomas (1844–1916)

American painter. In 1866 he studied in Paris, where he saw the works of ▷Manet and became a committed ▷Realist. He attended the ▷École des Beaux-Arts, where he studied with ▷Gérôme and ▷Bonnat, returning to Philadelphia in 1870 to begin painting ▷genre scenes and portraits, as well as teaching at the Pennsylvania Academy of Fine Art. His experience at the Academy between 1876 and 1886 was not a wholly happy one, as his extensive use of the life model led to suspicion amongst the more conservative Academicians. Equally, his genre scenes, such as the *Gross Clinic* (1875, Philadelphia, Jefferson Medical College), offended many observers with their brutal realism. His portraits were among his most accomplished works. For them he adopted ▷Rembrandt's dark tones and sympathetic rendering of human character. He was one of the earliest American artists to conduct experiments with photography. Although not fully acknowledged in his own time, Eakins became a figurehead for other early 20th-century Realist artists, including members of ▷The Eight.

Bib.: Goodrich, L., *Thomas Eakins*, Cambridge, MA, 1982; Wilmerding, J. (ed.), *Thomas Eakins*, Washington DC, 1993

Eardley, Joan (1921–63)

Scottish painter. She studied at the Glasgow School of Art in the 1940s, where she specialized in paintings of Glasgow tenements. She took many trips abroad, and she gradually developed a distinctive ▷Expressionist landscape style. From the 1950s, she spent a great deal of time in a small Scottish village called Catterline, near Aberdeen, where she concentrated on producing scenes of fishing village life.

Bib.: Buchanan, W., *Joan Eardley*, Edinburgh, 1976; Oliver, C., *Joan Eardley, A Retrospective*, Edinburgh, 1988

Earl, Ralph (1751–1801)

American painter. Known primarily for his scenes of Revolutionary War battles, Earl was one of the earliest New England ▷history painters, who helped move American art away from the provincialism of the colonial period. He worked throughout Connecticut, Massachusetts and Vermont as a portraitist. In 1774, he was working as a painter in Connecticut. When war broke out in 1776, he concentrated on painting ▷battle scenes, but his overt loyalty to the British led to problems. He travelled to England in 1778, and

worked with ▷West there, returning to New York in 1785. Upon his return, he was arrested for debt, but he later made a living as a portrait painter in New England.

Early Christian art

The name given to European art and especially architecture of the period c313–c750. The term is used primarily for art produced in Italy and the ▷Byzantine empire. As the name implies, the art represents a period in which Christianity was beginning to become widespread, and the growth of Christianity led to the need for new forms of art and architecture to accommodate the new religion. The beginning of this period was heralded by Constantine's recognition of Christianity in 313, which led to significant church building programmes throughout Europe. Christianity became the religion of the late Roman empire in 391, consolidating its predominance in Europe. The forms of Early Christian art were based partly on antique art; for example, images of the ▷Good Shepherd were converted to representations of Christ in the ▷catacombs of Italy. Existing motifs were therefore adopted to new ideals. Church architecture developed a plain ▷basilican plan. Early Christian art was superseded by more sophisticated ▷Romanesque forms.

Bib.: Krautheimer, R., *Early Christian and Byzantine Architecture*, rev. edn., Harmondsworth, 1975; Milburn, R.L.P., *Early Christian Art and Architecture*, Aldershot, 1988

Early English Style

English architectural style which superseded the ▷Romanesque, or as it is more commonly known in Britain, ▷Norman Style. Lasting from c1190 to c1250, it is the earliest of the three phases of English ▷Gothic architecture, and precedes the ▷Decorated and ▷Perpendicular Styles. The transition from Norman to Gothic is best seen in the choir at Canterbury Cathedral (1175–85), where the architect, William of Sens, imported French building methods, including the pointed ▷arch, but had to follow the pre-existing Norman plan. The fully developed Early English Style is first seen at the cathedrals of Wells (c1175–1239) and Lincoln (c1190–1280); whilst Salisbury Cathedral, built in the remarkably short period of 1220–c1266, is almost entirely Early English. The hallmarks of the style are a lightness and elegance of construction (in contrast to the massive solidity of the Norman architecture), the use throughout of the

pointed ▷arch (Wells being the first English building to show this trait), a new horizontal emphasis (especially in the nave at Wells) and east ends which are typically square, not apsidal. Characteristic details of the style are:

(i) bell capitals: capitals shaped like an inverted hand-bell (e.g. the nave of Salisbury Cathedral);

(ii) ▷dog tooth ornament;

(iii) lancet windows: narrow, pointed-arch windows without ▷tracery which are deployed separately at first, but later in series (e.g. the 'Five Sisters' window, north transept, York Cathedral, c1250);

(iv) plate tracery: the stone ▷spandrels between windows are sometimes pierced by decorative circular or quatrefoil ▷Foil openings (early 13th century);

(v) stiff-leaf mouldings: conventionalized lobed-leaf foliage decoration used on capitals, ▷bosses, etc. (e.g. the choir aisle capitals at Lincoln Cathedral).

earthworks

Also known as ▷land art, an artistic concept that emerged in the late 1960s, partly as a reaction to ▷Minimalist art, and partly in reaction against the art market's focus on collection and assessment: land art literally existed beyond or outside the gallery space. Artists such as ▷Carl Andre, ▷Robert Smithson, Michael Heizer, Walter de Maria and ▷Robert Morris all aimed to make land itself the physical subject of art. The concept was established by exhibitions at the Dwan Gallery and Cornell University in 1968, which included photographic records of ▷Sol LeWitt's *Box in a Hole* and Walter de Maria's *Mile Long Drawing* (two parallel white lines in the Nevada desert). As the form often only existed as projects or ideas, and due to the expense involved in putting ideas into practice and then displaying the results, this form of artwork has been related to ▷Conceptual Art.

easel

Portable support for artists' work, usually ▷canvas or ▷panel painting. Probably first used by Egyptian or Roman artists as a term to distinguish portable works from works on the wall.

Easter Sepulchre

In medieval Christian churches, a shallow ▷niche with a tomb-chest, usually in the north wall of a ▷chancel, intended to represent Christ's sepulchre at Jerusalem. On Good Friday the Host and/or a cross would be placed in the niche. For the Easter Sunday celebrations these would be replaced by a carved image of the ▷Resurrected Christ, which would then be carried in procession. The earliest examples of such niches date from the 13th century. A richly sculptured niche, in the ▷Decorated style, can be seen in Lincoln Cathedral.

Eastlake, Sir Charles Lock (1793–1865)

English painter, writer and administrator. He was a pupil of ▷Haydon. His 1815 painting *Napoleon on Board the Bellerophon* was well received and on the proceeds of the sale he journeyed to Italy (1816–30). There he developed a popular line in paintings of the Roman Campagna enlivened by *banditti* figures. On his return to England he devoted his time increasingly to administration: he was the ▷RA librarian (1842–44); the Secretary to the Fine Arts Commission (1842); a Great Exhibition commissioner (1851) and President of the RA (1850). Most important, however, he was first Keeper (1843–7) and then Director (1855–65) of the National Gallery. In these roles he built up the Italian collection of the Gallery. He also wrote *Materials for a History of Oil Painting* (1847). His wife, Elizabeth, translated Gustav Waagen's *Treasures of Art in Great Britain* and wrote a memoir of her husband in 1870. His son, Charles Locke (1836–1906) was also Keeper of the National Gallery (1878–98) and wrote art books, including *A History of the Gothic Revival* (1871).
Bib.: *Sir Charles Eastlake*, exh. cat., Plymouth, 1965; Robertson, D., *Sir Charles Eastlake and the Victorian Art World*, London, 1988

ébéniste

Craftsperson specializing in veneered cabinet-making. The word originated in the early 17th century because ebony became a popular material for highly decorated case furniture (desks, bookcases and cupboards) rather than carved pieces. However, an *ébéniste* may use other exotic woods besides ebony, such as mahogany, lemon-tree wood and rosewood.

Ecce Homo

(Latin, 'behold the man'.) The words of ▷Pontius Pilate when he presented Christ to the Jewish crowd after having him whipped. The crowd were asked to choose whether Christ or Barabbas should be crucified. The subject, which was uncommon in art until the ▷Renaissance, is presented either as a narrative of the crowd scene, or as a devotional image. The latter usually depicts Christ's head or half-length figure, wearing the crown of thorns and the robe given to him by the mocking Roman soldiers. His hands are tied and often a knotted rope encircles his neck. The marks of the scourging may be visible. Sometimes Christ is actually shown weeping, symbolic of his compassion. (▷Massys, *Christ Presented to the People*, Madrid, Prado; ▷Rembrandt, *Christ Presented to the people*, 1634, London, National Gallery; ▷Daumier, *We Want Barabbas*, 1850, Essen).

Ecclesia

(Latin, 'church'.) In Christian art, the personification of the Church as a crowned female figure, sometimes with a halo, holding a cross and chalice, or banner, frequently paired with Synagoga, the personification of

Judaism, a blindfolded woman whose crown is slipping from her head, to indicate the supersession of the ▷Old Dispensation (Judaism) by the New (Christianity). Sometimes Ecclesia rides a tetramorph (a composite beast combining the ▷apocalyptic symbols of the ▷Four Evangelists), while Synagoga rides a donkey or pig. The pairing of the figures may also represent the Old and New Testaments.

Echaurren, Roberto Sebastian Antonio Matta
▷Matta

echinus
In Classical architecture, a convex, eccentrically-curved, ▷moulding beneath the ▷abacus of a ▷Doric ▷capital. Its name derives from the resemblance of its curve to that of the shell of an echinus or sea urchin. By adaption, the term also refers to the moulding, often ornamented with ▷egg and dart, below the cushion of an ▷Ionic capital.

échoppe
A needle used for ▷etching and ▷engraving. Normally, a ▷burin would be used to make the lines on the plate, but the échoppe was designed to fatten lines to create particular effects. It was used extensively in 17th-century etching and engraving.

Echo
▷Narcissus

Eckersberg, Christoffer Wilhelm (1783–1853)
Danish painter. He studied in Copenhagen in 1803–10, and during 1811–13 he worked with ▷David in Paris. He completed his education in Rome from 1813 to 1816, and the combination of teachers and places led him to adopt wholeheartedly a ▷Neoclassical style. He was friendly with ▷Thorvaldsen and produced both portraits and landscapes. One of his most significant contributions was as a teacher at the Copenhagen Academy from 1818.

eclecticism
The blending of influences from various sources to form a new style or approach. Eclecticism was highlighted by ▷Vasari as a characteristic of ▷Raphael's art, although in truth the concept goes back to antiquity. To the extent that most artists develop their own style from an amalgam of influences, then most art is eclectic, but the term is properly used only of a conscious and indeed synthetic combination of influences: for example, ▷Tintoretto's intention to combine the ▷disegno of ▷Michelangelo with the colore of ▷Titian. If the term is sometimes misleadingly used of the ▷Carracci and their followers, and targeted as the very opposite of originality, it is correctly applied to the host of 19th-century artists concerned with various forms of revivalism.

Bib.: Boime, A., *Thomas Couture and the Eclectic Vision*, New Haven and London, 1980; Dohmer, K., *In welchem Stil sollen wir bauen?: Architekturtheorie zwischen Klassizismus und Jugendstil*, Munich, 1976, London, 1984; Girouard, M., *Sweetness and Light: The Queen Anne Movement 1860–1980*

École de Paris
▷School of Paris

École (Nationale Supérieure) des Beaux-Arts
The official French art school. Founded as part of the ▷Académie Royale in 1648, the École des Beaux-Arts was an exclusive institution designed to encourage the 'best' artists to learn the style and subject-matter advocated by the academy. In 1680, it published a number of rules to which all art should adhere. These rules were both prescriptive and restrictive and consequently led to a severe and ▷academic style which revered the classical mode. During the ▷French Revolution, the abolition of the Academy resulted in the reorganization of the École, which became a separate entity in 1795. It was reorganized and reestablished in 1816 after the defeat of Napoleon. The difficulty of gaining admittance to the school irritated artists throughout the 19th century and led to the growth of private ▷ateliers which were used as prep schools for the École itself. Although several ▷Impressionist and ▷modernist artists trained there, the ▷avant-garde ethos of the early 20th century came to see the school as oppressive and stifling to creativity.

Bib.: Brunchec, P., *The Grand Prix de Rome: Paintings from the École des Beaux-Arts 1797–1863*, Washington, 1984

ecological art
Art that offers some form of protest against the destruction of the environment. It originated in the late 1960s in Europe and America. Among its practitioners are Alan Sonfist and ▷Hans Haacke.

écorché
(French, 'flayed'.) An écorché figure is a statue or a drawing of a person or animal with the skin removed to reveal the underlying musculature, used by both artists and anatomists. Well-known écorché studies include those of human figures by ▷Leonardo da Vinci in his notebooks and those of horses by ▷George Stubbs in his *The Anatomy of the Horse* (1766). A bronze statue by ▷Alfred Gilbert shows the famed 18th-century surgeon, Dr. John Hunter, demonstrating a point of anatomy, using a miniature écorché figure (1893–1900, London, St. George's Hospital Medical School).

Ecstasy of St. Theresa
An ▷altarpiece designed by ▷Bernini for the Cornaro Chapel in S. Maria della Vittoria in Rome, 1645–52. St Theresa had been canonized in 1622 and was a

Ecological art: Andy Goldsworthy, *Derwent Water, Cumbria*, 1988

popular ▷Counter-Reformation saint. A member of the Carmelite order, which owned S. Maria, she had received visions of Christ in which she described being pierced through the heart by an arrow of divine love. Bernini shows the bare-footed figure of Theresa swooning at the feet of an angel who holds the symbolic arrow, her face turned outwards to reveal an open-mouthed expression of intense and joyous emotion, her voluminous draperies swirling around her in seeming empathy. The two life-size figures are contained in an elliptical niche, lit from above through a window of yellow glass to which Bernini added artificial rays of his own. The use of multi-media, coloured marble and a unified spatial can be seen as characteristic of the Italian ▷Baroque, and of Bernini's work as a whole. The artist again exploited the sexual power of the swooning female figure in other works (e.g. *The Blessed Ludovica Albertoni*, 1671–4, S. Francesco a Ripe, Rome).

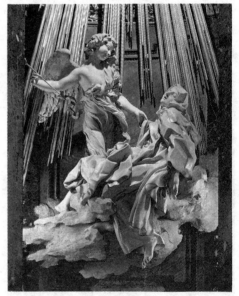

Gianlorenzo Bernini, *Ecstasy of St. Theresa*, 1645–52, Cornaro Chapel, Sta. Maria della Vittoria, Rome

Edelfelt, Albert (1854–1905)

Finnish painter. He studied in Antwerp and Paris and became one of many European artists who produced ▷*plein air* landscapes in the style of ▷Bastien-Lepage. When he returned to Finland, he adopted primarily Finnish subjects for his ▷genre scenes, some of which had religious subject-matter. His works therefore are seen to represent visually a brand of Finnish patriotism that was rife at the turn of the century.

Edo

The historical name for Tokyo. Edo art was particularly important from the 17th to the 19th centuries, when ▷ukiyo-e and ▷yamato-e dominated prints and painting.

Bib.: *Masterpieces from the Shin'ekan Collection: Japanese Painting of the Edo Period*, exh. cat., Los Angeles, 1986

Edridge, Henry (1769–1821)

English painter. He produced portraits and landscape ▷watercolours and became an ▷Associate Royal Academician in 1820.

Edwards, Edward (1738–1806)

English painter. He produced largely landscapes and ▷history paintings, and was one of many artists working for ▷Boydell's Shakespeare Gallery. After 1788, he became Professor of Perspective at the ▷Royal Academy. Although he is little known for his works of art, his publication of the *Anecdotes of Painters* in 1808 made him one of the earliest Royal Academicians to write about the history of British art. Edwards' work followed the researches of ▷George Vertue and ▷Horace Walpole and filled the gaps about important artists of the so-called 'English school'.

Eeckhout, Gerbrandt van den (1621–74)

Dutch painter. He was a friend of ▷Rembrandt and studied with him. He produced primarily religious works in the style of Rembrandt and ▷genre scenes reminiscent of those of ▷Terborch.

Egas, Hanequin (d c1475), Egas (d 1495), Anton (fl 1495), Enrique (d 1534)

Flemish family of sculptors and architects, working in Spain. Hanequin was Master of Works at Toledo Cathedral. His brother, Egas, was a sculptor who produced tomb monuments at Toledo and Guadalupe. The son of Egas was Anton, who followed his father at Toledo Cathedral, working as Assistant Master there. Enrique was Anton's brother, who took the surname Egas in honour of their father. From c1498 he worked as an architect at Toledo Cathedral, but from 1505 he was Master of Works at Granada. The family was one of the principal proponents of the ▷Plateresque style.

Egg, Augustus Leopold (1816–63)

English painter. He was born in London, the son of a goldsmith, and studied at Sass' Academy and the ▷Royal Academy Schools (1835), where he was a member of the drawing group known as the Clique, along with ▷Frith. Egg initially specialized in anecdotal subjects often based on scenes from literature (e.g. *Scene from A Winter's Tale*, 1845, London, Tate). He produced a small number of contemporary moral subjects, inspired by ▷Pre-Raphaelite work of the 1850s, most famously the trilogy *Past and Present* (1858, London, Tate; cf. also *Travelling Companions*, 1862, Birmingham City Art Gallery). He was one of the few academicians who supported the PRB. He was also a friend of Dickens and accompanied him to Italy. In fact, he spent much of his later life abroad because of ill health and eventually died in Algiers. He was elected RA in 1860.

egg and dart

In Classical architecture, a type of ornament consisting of alternated egg-and dart-shaped motifs. It is used to enrich ovolo and ▷echinus mouldings. Also known as egg and arrow, and egg and tongue.

Egger-Lienz, Albin (1868–1926)

Austrian painter. He studied at the Munich Academy in 1885, and there he developed an interest in ▷history painting and an ▷academic style. However, as the First World War approached, he was influenced by German ▷Expressionist art, and during the war he adopted a distinctive form of Expressionism for his paintings of

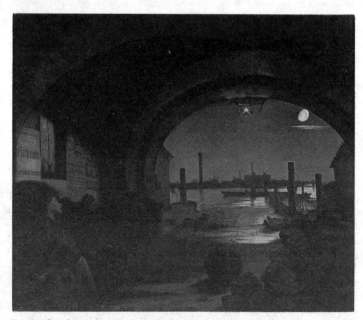

Augustus Egg, *Past and Present No. 3*, 1858, Tate Gallery, London

soldiers and war scenes. From 1912, he was a teacher at the Weimar Academy.

egg tempera

An emulsion consisting of egg yolk (and rarely the white also) and water into which a powdered ▷pigment is mixed. Egg tempera is quick drying (thus blending is not possible and modelling of form has to be carried out by the application of small, hatched ▷brushstrokes) and has a limited range of tones and colours (which dry lighter). Although used across Europe, it is most notably associated with Italian panel paintings from the 12th until the late 15th century when it was largely supplanted by oil paint with its wider range of colours, its slower drying time (allowing adjustments and blending) and its potential for more subtle, expressive and illusionistic effects, such as ▷impasto and ▷sfumato.

Egyptian Art

The people of the Nile Valley began producing art as early as the 7th millennium BC. Pre-dynastic pottery design initiated motifs that would be influential for many centuries, though early Egyptian art's greatest expression was in stone sculpture, especially stone palettes such as the Old Kingdom Na'rmer Palette. The Old Kingdom was important for its impressive monumental architecture, notably the pyramids, but the decorative arts of statuary, painting, furniture and jewellery also flourished at this time. These artefacts reflected an ideal world with attributes of character or meaning given symbolically. Labels and inscriptions were added to convey meaning and combined easily with other images. Egyptian art also developed a sophisticated, stylized manner of human portraiture which is instantly recognizable. The head is presented in profile, shoulders from the front, and the hips and legs in three-quarter view. This convention made innovation difficult and the essential features of the style changed little through three millennia. The building of the city of ▷Amarna in the reign of Akhenaten (1353–35 BC) did result in a brief period of artistic innovation that developed a much more naturalistic style, but figure art returned to the traditional canon under Rameses I. Painting was used extensively in tomb decoration – especially wall-painting – coffin ornamenting, furniture, and illuminated ▷papyri. Though artists made use of some shading and overlaying, there was little characterization of subjects, backgrounds were rendered schematically if at all, and three-dimensional perspective was unknown. Statuary retained a combination of profile and frontal views that was used in painting, and figures could be produced to massive scale. Concentration on the essentials of appearance produced a simplicity of form in figures that are noticeable for their solidity and strength. Again, identity was fixed by inscription rather than by physical portrayal. Jewellery of gold and semi-precious stones was widely made from early times, to high standards.

From 332 BC until AD 326 Egypt was under the influence of the Graeco-Roman world, with Alexandria becoming the capital and Greek the official language. However, Egyptian styles have influenced a number of subsequent western cultures, making a significant impact on Roman art, and influencing the art of the ▷Renaissance and the early 19th century (▷Egyptian revival).

Egyptian revival

What ▷Renaissance scholars and artists knew of Egypt, and their interest in ▷hieroglyphs, was mostly picked up from Roman sources, and a comprehensive knowledge of Egyptian art came to western Europe only after Napoleon's Egyptian expedition of 1798, when the French army was accompanied by scholars. D.V. Denon's resulting *Voyage dans la haute et dans la basse Égypte* (1802) offered contemporary artists many designs to imitate (far more than Piranesi's *Diverse maniere di adornare i cammini*, 1796, which was not based on first-hand knowledge) but it was the *Description de l'Égypte*, the fruit of researches made by a number of Napoleon's scholars in nine folio volumes, which really fascinated Europe and laid the foundations not only for later scholarly excavation in North Africa, but also for the style that has been dubbed the Egyptian revival.

The Egyptian revival was manifested largely in the ▷decorative arts, not least because of the grip the Greek and Roman revivals has on all architecture except for the funereal, as may be seen from Boullée's designs or from any 19th-century cemetery. In some cases, as with the collector ▷Thomas Hope, the Egyptian style was adopted to complement Egyptian antiquities, collected in increasing numbers as the century wore on.

Bib.: Baltrusaitis, J., *La Quête d'Isis: essai sur la légende d'un mythe*, Paris, 1985; Clayton, P.A., *The Rediscovery of Ancient Egypt: Artists and Travellers in the Nineteenth Century*, London, 1982; Humbert, J.M., *L'Egyptomanie dans l'Art Occidental*, Paris, 1989

eidophusikon

A device invented by ▷de Loutherbourg when he was in England. It was a miniature theatre in which gauze and light effects were used to create a sense of weather and atmosphere on painted landscape scenes. It was exhibited in London in 1782 and created a sensation in that year, as spectators responded to the sense of movement it created. Loutherbourg also used sound effects with the presentation, which were designed to give the impression of storms and wind.

Eiffel, Gustave (1832–1923)

French engineer. He is chiefly remembered as the designer of the Eiffel Tower, built for the Paris Exhibition of 1889. At 308 m (1,010 ft), it was the highest building in the world prior to the erection of the 319 m

Gustave Eiffel, photograph by Stanislas Walery, Stapleton Collection

(1,046 ft) Chrysler Building (1928–30) in New York. Eiffel's earliest work was as a structural engineer, exploiting the advantages of rolled steel over the heavier, more rigid and less stress-resistant cast iron for wide-span railway bridges at Douro, Portugal (1876–7), and Garabit, France (1880–84). As engineer to Boileau's Magasin au Bon Marché in Paris (1876), he revolutionized department-store construction with his tiers of lightly constructed iron galleries rising around a central, glass-roofed, light well. He also constructed the iron armature for Bartholdi's copper Statue of Liberty (1875–84) in New York Harbour. Although the Eiffel Tower was originally intended only as a temporary structure and although the majority of Eiffel's contemporaries at first considered it an eyesore, it soon became the definitive symbol not only of Paris, but also for the birth of the modern machine age, praised in verse by ▷Guillaume Apollinaire and in paint (about 30 times) by ▷Robert Delaunay.

Bib.: Buren, C. von, *La Tour de 300 metres*, Lausanne, 1988; Lemoine, B., *Gustave Eiffel*, Basel, 1988; Marrey, B., *Gustave Eiffel, une enterprise examplaire*, Paris, 1989

Eight, The

A group of American artists, many of whom concentrated on urban realist scenes. The members of The Eight were ▷Robert Henri, ▷Ernest Lawson, ▷George Luks, ▷John Sloan, ▷William Glackens, ▷Arthur B. Davies, ▷Maurice Prendergast and ▷Everett Shinn. They came together in 1907 when the ▷National Academy of Design rejected some works by Luks, Sloan, Glackens and Henri for their annual exhibition, and The Eight exhibited jointly at the Macbeth Gallery, New York, in 1908. The group shared a desire for a non-juried exhibition and a distaste for the dominance of ▷academic art, but their styles and choices of subject-matter was various. While Lawson was primarily an Impressionist, Prendergast preferred ▷Post-Impressionism. Among the group, Luks, Sloan, Glackens, Shinn and Henri painted modern urban life, and they later formed the ▷Ashcan School. Henri was the guiding spirit of the group, as he had taught a number of them and was of an older generation. Although they did not remain together as a group for an extended period, their anti-academicism and common endeavour was an important forerunner of the ▷Armory Show.

Eisenstein, Sergei Mikhailovich (1898–1948)

Russian film director. He started his career as a set and costume designer in the Moscow theatre before turning to film in 1923. His most famous films, *Strike* (1925), *The Battleship Potemkin* (1925) and *October* (1928) were ▷modernist, patriotic history films of the recent Russian Revolution which made him the leading Russian film maker of the time. He had a brief, unsuccessful period in Hollywood in 1930, moving on to Mexico to the massive, unfinished documentary film *Que Viva Mexico!* (1932). He returned to Russia to make *Alexander Nevsky* (1938) which included a score by Prokofiev, and *Ivan the Terrible I* and *II* (1944 and 1946). He has been widely praised for his innovative use of ▷montage and his command of strong, forceful visual images, for which *The Battleship Potemkin* in particular has been highly influential, but as narrative wholes his films were much less successful.

Sergei Eisenstein, The Kobal Collection

ekphrasis

(Greek, 'description'.) A verbal or written description of a painting, undertaken as an exercise in rhetoric. The picture so described may even be imaginary. Lucian's ekphrasis of a subsequently lost painting by ▷Apelles, *The Calumny*, attracted the attention of ▷Alberti, who recommended that the young painters of his own time should compete with the greatest artists and works of the antique world. The challenge was taken up memorably by ▷Botticelli who produced his own *The Calumny of Apelles* (1490s, Florence, Uffizi).

élan vital

▷Bergson, Henri

Eleanor Crosses

Monumental sculptures commissioned by Edward I to commemorate his dead queen, Eleanor. They were produced from 1290 and positioned in those places where the funeral bier had stopped to rest when her body was carried from Harby, Nottinghamshire to London. Twelve crosses were erected, although only two remain in their original locations. They were ornamented.

Elementarism

The name given to ▷Theo van Doesberg's conception of ▷Mondrian's ▷Neo-Plasticism. The name came from a manifesto published in the journal *De Stijl* in 1922, in which a group of artists, including ▷Hausmann, ▷Arp and ▷Moholy-Nagy, repudiated the intuitive aspects of Neo-Plasticism in favour of an art based solely on construction. In 1923 van Doesberg expanded this argument in another article published in *B*, an avant-garde journal, in which he called for the use of diagonals in geometric painting, in addition to the horizontals and verticals favoured by Mondrian. Mondrian, needless to say, was strongly opposed to van Doesberg's view of Neo-Plasticism, but it was adopted by other artists, including ▷César Domela.

Elements

▷Four Elements, The

Elgin Marbles

Popular name for the collection of antique Greek sculptural remains, procured from the Ottoman Turks who governed Athens by the British diplomat Thomas Bruce, the 7th Earl of Elgin. All of the material dates from the second half of the 5th century BC and was removed from the Athenian ▷Acropolis, consisting of sections of ▷frieze, various ▷metopes and pedimental statues from the ▷Parthenon, along with one ▷caryatid from the Erectheum. The Elgin Marbles were brought to London in 1801–3 and purchased for the nation in 1816 for £35,000 ($60,000), a sum which did not even cover Elgin's costs. They are now in the British Museum. The delayed purchase was caused by the debate which raged over the perceived quality and authenticity of the pieces which seemed to contradict all hitherto strongly held opinions concerning the nature of Classical sculpture. Classical taste had been formed, unknowingly, upon the generalized surfaces of late ▷Hellenistic and imperial Roman marble copies of Classical Greek statues, not the original works themselves. The Parthenon marbles were, by contrast, vividly naturalistic. It is surely significant that the advo-

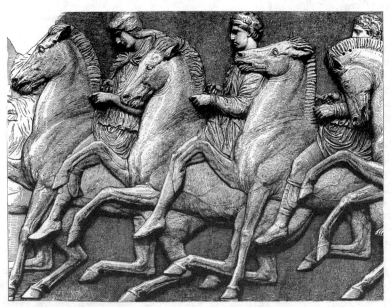

Engraving of the Parthenon frieze (Elgin Marbles), 5th century BC, British Museum, London

cates of the marbles included sculptors, such as ▷Westmacott and ▷Flaxman, who perhaps saw with 'sculptors' eyes', whereas one of the principal opponents to the purchase was ▷Richard Payne Knight, a respected connoisseur and collector, who perhaps had a vested interest in protecting both his own collection of antiquities and his reputation as a man of taste. While Flaxman declared that the *Theseus* from the Parthenon ▷pediment made the ▷*Apollo Belvedere* look like nothing more than a 'dancing master', Knight protested that Elgin had wasted his time and money, dismissing his marbles as 'not Greek [but] Roman of the time of Hadrian'. A Royal Commission, appointed to adjudicate on the matter, came down on the side of the supporters of the purchase, the controversy abated (as did the taste for ▷Neoclassical art anyway), and today the marbles are universally accepted as masterpieces from one of the great periods of European art. By contrast, most of the once celebrated statues which had formed the backbone of European Neoclassical taste are today viewed as cold, academic productions by no more than competent copyists.

Today a different kind of controversy surrounds the Elgin Marbles concerning the morality and even the legality of obtaining examples of a nation's artistic property from an occupying power. The debate has enormous ramifications for museums throughout the world and particularly in Europe and North America, for if the Elgin Marbles were to be restituted, then arguments could be raised in favour of the restitution of much more material that had left its originating country under analogous circumstances. The Elgin Marbles also raise the question of the length of time necessary before art objects, procured in whatever circumstances, become part of the heritage of the country of their new owners.

Bib.: Boardman, J., *The Parthenon and its Sculptures*, London, 1985; Cook, B.F., *The Elgin Marbles*, London, 1984; Hitchens, C. (ed.), *The Elgin Marbles: Should they be Returned to Greece?*, London, 1987; St Clair, W., *Lord Elgin and the Marbles*, Oxford, 1983

El Greco

▷Greco, El

Elijah (9th century BC)

Hebrew prophet, a fierce opponent of the cult of Baal amongst his people, the Israelites. According to legend, he lived as a hermit on Mount Carmel and is thus taken by the Carmelite friars, founded in the 12th century, as the spiritual founder of their order. In images in Carmelite churches, he is often paired with the ▷Virgin, the other principal protector of the order. Elijah's attributes are the ravens which brought him food in the desert and a wheel of the fiery chariot in which he ascended into heaven. The events of his life most often represented are:

(i) Elijah fed by Ravens (I Kings 17: 1–6). The ravens bring him bread and meat in the desert. He is depicted by a brook, the Cherith (e.g. ▷Guercino, *Elijah Fed by Ravens*, London, National Gallery).

(ii) Elijah and the Widow of Zarephath (I Kings 17: 8–24). During a drought the brook dries up and God tells Elijah to go to the city of Zarephath. Here he is given food, water and shelter by a widow whose son shortly falls sick and dies. Elijah commands the woman to give him her son. He takes the boy upstairs, lays him upon a bed, stretches himself out upon the boy's body three times and calls out to God who duly restores the boy to life.

(iii) The Rival Sacrifices of Elijah and the Priests of Baal (I Kings 18: 17–40). Elijah challenges Queen Jezebel's priests of Baal to a public contest to prove which is the true god. Elijah and the priests each select a bullock and set its dismembered carcass upon an unlit pyre. The priests call out to Baal to no effect, whilst Elijah successfully calls down the fire of God to light his pyre. The people are convinced and fall on their faces, worshipping the true God. This episode was seen by Christian theologians as an Old Testament prefiguration of the descent of the pentecostal fire upon the Apostles.

(iv) Elijah visited by the Angel (I Kings 19: 4–8). Jezebel drives Elijah out of the city into the desert. Here he is brought food and drink by an angel. In Christian art the angel offers Elijah bread and a chalice, in allusion to the ▷Eucharist.

(v) Elijah and the Chariot of Fire (II Kings 2: 9–15). Whilst Elijah is walking with his disciple, Elisha, they see a vision of fiery chariots and horses, accompanied by a whirlwind. Elisha becomes separated from Elijah who is taken up into the sky by the whirlwind. Elijah's mantle drops and Elisha picks it up, thus showing that Elisha was Elijah's chosen successor. In Christian art, Elijah is usually depicted taken up by the chariot, rather than the whirlwind (e.g. ▷G.B. Piazzetta, *Elijah Taken Up in a Chariot of Fire*, Washington, DC, National Gallery). The theme was regarded as an Old Testament prefiguration of the ▷Resurrection.

Elizabeth

(Luke 1.) The mother of ▷John the Baptist, cousin of the ▷Virgin Mary. Luke tells us that Elizabeth was married to Zacharias, a priest in the temple. They were devout but childless, as Elizabeth was barren (generally considered to be a punishment from God). The angel ▷Gabriel appeared to Zacharias in the temple and announced the forthcoming birth of John. When Zacharias returned home (temporarily dumb because he had doubted Gabriel), he found Elizabeth to be pregnant. In cycles of the life of John the Baptist, Elizabeth is shown in her bed, having given birth; and watching whilst the dumb Zacharias writes his assent to the child being called John (e.g. ▷Andrea Pisano,

south door, Baptistry, Florence). Elizabeth appears only one more time in Luke, when Mary visits her to share the mutual good news of their respective pregnancies (▷Visitation). The Franciscan Pseudo-Bonaventura (c1300) fills out these bare details with an account of the Holy Family's stay with the Baptist's family on their return from the ▷Flight into Egypt. This is the source for pictures of the infant St. John playing with, or kneeling to, the Christ child. Sometimes Elizabeth appears in the group (e.g. ▷Bronzino, *Madonna and Child with SS Elizabeth and John*, c1538–9, London, National Gallery).

Elmes, Harvey Lonsdale (1814–47)

English architect. He was trained by his father, the writer and architect, James Elmes (1782–1862). In 1836, while still virtually unknown, Elmes won the prestigious commission for St. George's Hall, Liverpool, which he designed in a ▷Neoclassical, ▷Greek Revival style. The large scale of the commission and the other commissions that were immediately encouraged by it overtaxed Elmes mentally and physically and he retired to Jamaica but died there of consumption with his masterpiece uncompleted. Although the exterior of the hall follows his austere Classical Greek style, the interior, completed by C.R. Cockerell, is in the style of the Baths of Caracalla at Rome. Elmes' other main surviving building, also in Liverpool, is the Collegiate Institute, Shaw Street (1840–43), this time in ▷Gothic Revival style.

Elsheimer, Adam (1578–1610)

German painter, etcher and draughtsman. He produced mostly landscapes, and his mature work was executed principally in Italy. Despite his small output, his work played a seminal role in the development of 17th-century landscape painting. He was born in Frankfurt and his early work reflects the northern ▷Mannerist landscape tradition carried on by ▷Gillis van Coninxloo. He was in Venice by c1598, where he worked with ▷Hans Rottenhammer who may have introduced him to painting on copper. By 1600 he was in Rome, where he married a Scottish exile in 1606 and remained for the rest of his short life. According to ▷Sandrart, Elsheimer suffered from a kind of melancholia which at times prevented him from working. He was certainly imprisoned for debt and died in poverty. Following his death, his pictures were sold off at auction to help his widow.

Elsheimer's landscapes show a number of important innovations. He developed a more coherent unity between figures and setting. He was also fascinated by the effects of light, a concern which perhaps shows the influence of ▷Tintoretto and his contemporary in Rome, ▷Caravaggio. Elsheimer would sometimes employ multiple light sources in his pictures: in *St. Paul Shipwrecked on Malta* (c.1600, London, National Gallery) the setting sun illuminates the clouds and waves at lower left, above, a lightning flash streaks across the sky, a beacon burns brightly on a promontory overlooking the sea, and a campfire lights the figures in the foreground. He also developed a more naturalistic low viewpoint (as opposed to the panoramic view) and diagonal recession (as opposed to the sharply differentiated successive planes used by the Mannerist landscapists). The unity thereby achieved gives his paintings a monumentality that belies their actual size (e.g. *Dawn*, 17 × 22 cm/6½ × 8½ in, c.1600, Brunswick, Herzog Anton Ulrich Museum). These small, precisely painted pictures were always executed on copper, a ground which allows a smoother, more detailed finish than even the finest canvas. Through the engravings made of his work by his pupil Hendrick Goudt (1573–1648), his new formulae for landscape made a great impact on the Dutch painter ▷Esaias van de Velde and through him the most advanced landscapists of the next generation. His work was also valued by and influenced his friend ▷Rubens and, later, ▷Rembrandt and ▷Claude.

Bib.: Andrews, K., *Adam Elsheimer: Paintings, Drawings, Prints*, Oxford, 1977; Lenz, C., *Adam Elsheimer: Die Gemälde im Stadel*, Frankfurt, 1989; Sello, G., *Adam Elsheimer*, Munich, 1988

Embarkation for Cythera

Cythera was an island off Laconia in the south of Greece, said to be the place where ▷Venus/Aphrodite first came ashore after her birth at sea. In a play of 1700, *Les Trois Cousines*, Dancourt described youthful pilgrims of all classes going to Cythera to pay homage to Venus at the temple of love. The scene suited the 18th-century fashion for ▷*fêtes galantes* and was most famously painted, several times, by ▷Watteau, who also produced scenes of groups leaving the island. (cf. ▷Giulio Romano, *Isle of Venus*, 1528, Mantua, Palazzo del Te).

emblem

A distinctive image or symbol which carries with it a set of connotations for the viewer. Emblems, in the form of crests or arms are often worked into works of art in order to identify the owner or commissioner, or later to identify the artist. Emblems were particularly popular devices in the 16th and 17th centuries, made available to artists with the publication of such books as Geoffrey Whitney's *A Choice of Emblemes* (1586).

embossing

Also known as repoussé. The art of producing raised patterns on the surface of metal, leather, fabric, paper and other substances. On a small scale, engraved dies may be set in a hand press, and the material to be embossed inserted between the dies. This is a common process in the embossing of paper with monograms and addresses, or the embossing of leather, for ornamental book covers, for example. On a larger scale, copper

cylinders are engraved with raised patterns, and can be rolled over wallpapers or textiles. The cylinders either press against a yielding surface or into corresponding depressions in another cylinder. Other processes of embossing include carving, casting, chasing, moulding or stamping.

embroidery

Ornamental stitchwork applied to any fabric using any kind of thread. Embroidery has been a ▷decorative art since ancient times and was used in Assyria, Babylon and Egypt as well as in the Far and Near East. Most embroidery surviving today dates from the Middle Ages. For instance, the ▷Bayeux Tapestry demonstrates the remarkable ambition and technical awareness of 11th century craftspeople. This example is unusual in that it records a secular theme; most embroideries from the period are ecclesiastical. It has been argued that embroidery is one of the arts which women practised from an early stage. However, it is unclear how much freedom of expression these artists had and who designed the large canvasses they executed.

Empire Style

The fashion in architecture and design which spread in the years after the ▷French Revolution. The term comes from Napoleon's first empire (1804–14), but the style lingered after his fall, until the popularity of the ▷Gothic Revival spread in the 1830s. In both period and appearance it is comparable with the ▷Regency Style in England. It developed out of the 18th-century enthusiasm for the ▷antique (▷Neoclassicism), but satisfied Napoleon's requirement for grandeur, and adopted Middle Eastern and particularly Egyptian features in celebration of French victories in North Africa. It was exemplified by Percier and Fontaine's architecture and interior design (e.g. Arc du Carrousel, Paris, 1806–7; examples also at the Château of Malmaison, Compiègne and Fontainebleau). Women's fashion was also heavily influenced: high waists, turbans and lavish embroidery were all features of the style.
Bib.: Apra, N., *Empire Style*, London, 1972

emulsion

Literally, the chemical term for a mixture of two or more liquids in which one is present in droplets of microscopic size, distributed throughout the other. For example, ▷tempera is an emulsion, as the ▷pigment is distributed throughout the medium. Emulsions can be used for dyeing, tanning and painting, although they are sometimes misnamed. For example, photographic emulsion is in fact a gelatin gel.

enamel

A highly coloured, glass-like ▷glaze usually applied to the surface of metalwork, and often used to decorate items of jewellery or small ornamental objects. Enamel is a soft glass, obtained from adding metal oxides to base enamel powder. Different oxides make different colours; for example, copper creates blues and greens. The powdered enamel is wet and put on a metal base, generally copper, brass, bronze, silver or gold. The area that is to be covered can be regulated by a variety of methods. In *champ-levé* enamel the enamel is put in a prepared groove in the metal; in ▷*cloisonné* enamel segments are made using dividing wires; in *ronde basse* enamel, several layers of enamel are applied on top of each other on a three-dimensional object. The enamel is then left to dry out, before being fired at a high temperature. This causes the powder to melt and fuse with the base, forming a hard vitreous surface. Enamelling may take place directly on the item to be decorated (*en plein* enamelling) but sometimes plaques are decorated and then applied to the object later.

The skill of enamelling is thought to have existed in the 13th century BC, in the ▷Mycenaean civilizations. It was used widely in jewellery and ornamental objects such as ceremonial swords by the Romans and the Celts. The technique may be said to have reached a zenith in the enamel crucifixes and icons of the Limoges School in the 13th century. During the 15th century a technique called 'painted enamel', was developed in which a metal plaque is painted with different coloured enamels which melt at different temperatures. Those with high melting points are applied first, but the colours mingle and create a blurred effect. This technique was refined over the centuries, and in the 17th century ▷miniature portraits using the method were popular. More recently, Fabergé used enamels and jewels on gold, at the beginning of the 20th century.

encarnado

(Spanish, 'flesh coloured'.) A term used for the realistic painting effect on wooden figure sculptures, primarily of the 16th and 17th centuries. It was used to produce the effects of flesh, and it was designed to make ▷Crucifixions and other holy works often brutally realistic for greater emotional effect.
▷*estofado*

encaustic

Painting method that uses ▷pigments mixed with hot wax as a ▷medium. The term derives from the Greek meaning 'burnt in' and was a principal technique of the ancient world. Common in the Early Christian period it fell out of use in the 8th or 9th century. Occasionally revived, its best known 20th-century use is in ▷Jasper Johns' *Flag* and *Target* paintings.

Endell, August (1871–1925)

German designer. He was one of the foremost proponents of ▷Art Nouveau in Bavaria during the 1890s. His most famous work was his own studio, the Atelier Elvira, erected in Munich in 1897–8. His use of elaborate organic patterning for gates, doors and wall ornaments was an unprecedented imaginative application of Art Nouveau for interior decoration. He was also a teacher and wrote *Uber die Schönheit* (*On Beauty*), an early apology for pure form in art.

engraving

Technique of making ▷prints from inking incisions made on a hard surface. Most usually, the term refers to prints made from a metal plate. A ▷burin, or cutting tool, is used to incise a design on a plate, usually made out of copper. Tone and shade can be described using fine ▷cross-hatching or different grades of tool. Having originated in the Rhine Valley and northern Italy in the early 1400s, engraving was developed, particularly in Germany, by goldsmiths like the ▷Master of the Playing Cards and ▷Maso Finiguerra. In the 16th century, the technique was epitomized by the work of ▷Dürer and ▷Lucas van Leyden, and further developed with the use of ▷stipple and other versatile new tools. Engraving died out during the 18th and 19th centuries, but was revived by such artists as ▷Eric Gill and ▷Stanley William Hayter in the 20th century.

Enlightenment

A term first used in the 1860s to describe the movement associated with 18th-century French philosophers such as ▷Diderot, Voltaire and Montesquieu. It has since been broadened to include the pan-European ideas of rationality and scepticism which dominated much of 18th-century thought. The movement could be said to originate with the ideas of Locke ('reason must be our last judge') and Newton, whose scientific discoveries did something to unlock the mysteries of the universe. It is perhaps epitomized by Diderot's *Encyclopédie*, a publication whose aim was the cataloguing all knowledge. The movement is also specifically associated with a number of aspects of 18th-century culture: religious scepticism (although this side of the Enlightenment should not be exaggerated); a desire for political reform manifested most clearly in the work of Jean-Jacques Rousseau and in the ideas behind the American Revolution; the rise of the gentry or bourgeoisie; the promotion of science and learning; and a belief that man could and should control the world around him (▷Industrial Revolution). In art, the Enlightenment is linked with ▷Neoclassicism: the ancient world was elevated to a rational, civilized ideal which the educated classes of the 18th century attempted to emulate in life as well as in art and architecture. Eventually, the optimism of the Enlightenment by the failure and bloodshed of the ▷French Revolution, and the ideas of ▷Romanticism took over.

Bib.: Gay, P., *The Enlightenment*, 2 vols., London, 1970

Ensor, James (1860–1949)

Belgian painter and engraver. He was born in Ostend, his father being an Englishman who ran a souvenir shop there. He studied in Brussels, and in 1884, after being rejected by the ▷Salon, he joined the ▷Art Nouveau group ▷Les Vingts which was based in the Belgian capital. In 1889, however, the group objected to Ensor's controversial image of *Christ's Entry into Brussels* (1888, Antwerp, Koninklijk Museum voor Schone Kunsten). He was expelled from Les Vingts and spent the rest of his life as a semi-recluse in Ostend. He gave up painting in 1939 (when he received the belated official recognition of being made baron) although most of his best work was produced before the turn of the century. His early style was almost ▷realist: sombre, heavily painted scenes of bourgeois life, portraits, interiors and still lifes influenced by ▷Courbet and ▷Manet (e.g. *Still Life*, 1882, Liège). By 1883 his palette had become brighter, his paintwork more textured, his subject matter a bizarre combination of carnival gaiety and death. His most famous works, which come from this period, make use of masks to convey an atmosphere of deceit and confusion (e.g. *Singular Masks*, 1891, Brussels, Musées Royaux des Beaux-Arts). Although his work is unique, he is often compared to ▷Munch as a forerunner of ▷Expressionism and he was rediscovered by the ▷Surrealists. His work may be seen as part of a long-running tradition of the macabre in the art of the Low Countries (▷Bruegel, ▷Bosch). He was also a successful engraver (e.g. the *Cathedral* series, 1886).

Bib.: Janssens, J., *James Ensor*, London, 1978; van Gindertael, R., *James Ensor*, London, 1975

en plein enamel

▷enamel

entablature

In Classical architecture, the superstructure supported by the ▷columns, the principal horizontal members of which are, from bottom to top, ▷architrave, ▷frieze and ▷cornice.

Entartete Kunst

▷Degenerate Art

entasis

In Classical architecture, the intentional swelling of the vertical profile of the ▷shaft of a ▷column, used to counteract the optical illusion of concavity which characterizes perfectly cylindrical shafts. Generally, the shaft is cylindrical in the lower third of its height, after which a curving diminution is calculated towards the capital.

James Ensor, *Masks and Death*, 1897, Musée des Beaux-Arts, Liège

Entombment

(Matthew 27: 57–61; Mark 15: 42–47; Luke 23: 50–55; John 19: 38–42) The entombment of ▷Christ is related in all four ▷ gospels. It forms part of the cycle of the ▷Passion of Christ and comes between the bearing of the body and the ▷Resurrection. A wealthy Jewish follower of Christ, named Joseph of Arimathea, obtained permission from ▷Pilate to take down Christ's body from the cross. ▷Nicodemus, another recent convert, brought myrrh and aloes and they wound Christ's body in a linen shroud with the spices. They then placed the body in the sepulchre that Joseph had had made for himself. The holy women, including ▷Mary Magdalene and Mary (▷Virgin Mary) the mother of Jesus, were also present.

Notwithstanding the Gospel account of the sepulchre being hewn out of the rock with a stone laid across the doorway, ▷Renaissance artists usually depicted Christ being lowered into a Classical ▷sarcophagus (e.g. ▷Titian, c1525, Paris, Louvre). Joseph is usually depicted as an old man, sometimes bald, generally well dressed and holding Christ under the arms as the body is lowered into the tomb; Nicodemus is generally portrayed as the man of somewhat lower status who holds Christ's body by the feet. The Virgin Mary and ▷John the Evangelist (into whose care Christ had entrusted his mother), although not mentioned in the gospel accounts, are generally recognizable amongst the holy women. Mary Magdalene may throw up her arms in an excess of grief or be shown anointing Christ's feet (e.g. ▷Rubens, Munich, Alte Pinakothek). Sometimes, angels holding the ▷Instruments of the

Passion will witness the entombment (e.g. ▷Robert Campin, c1415–20, London, Courtauld Institute Galleries).

Entry into Jerusalem

(Matthew 21: 1–11; Mark 11: 1–10; Luke 19: 29–38; John 12: 12–15) This is the first scene of Christ's ▷Passion, either represented as part of a cycle, or as a separate subject. It was popular in Christian art from the 4th century until the 16th century, after which time it appears less often. Taken together, the slightly differing gospel accounts furnish most of the incidents of the scene. Christ sent his disciples to find him an ass with a foal, mounted the ass, and rode into Jerusalem (in fulfilment of an Old Testament prophecy that the Messiah would arrive riding on an ass, with its foal following behind). The people of the city had heard of his arrival and rushed out to strew his path with their garments and palm branches, crying, 'Hosanna', and praising him as the King of Israel.

▷Duccio renders all these details in his panel from the ▷*Maestà* (1308–11, Siena, Museo dell'Opera del Duomo) and, in common with many other depictions, incorporates two figures climbing trees: one is pulling off branches to strew in Christ's path; the other, transferred from the earlier story of Christ's entry into Jericho (Luke 19: 1–4), is Zacchaeas, a tax collector who was too short to see Christ over the heads of the crowd. Earlier, in ▷Byzantine art, Christ might be shown riding side-saddle on the ass, as was the fashion in the east (e.g. *The Rossano Codex*, manuscript, 6th century; Rossano Cathedral).

entresol

▷mezzanine

environment art

A term used from the early 1960s for a type of ▷assemblage that allows the spectator to walk into it or through it. Many environmental art works are intended to give a variety of sensory experiences to the viewer and some are interactive. ▷Ed Kienholz, ▷James Dine and ▷Claes Oldenburg, among others, all produced environments.

Envy

(From the Latin, *invidia*.) One of the Seven Deadly Sins, most often portrayed as an old and ugly woman, whose chief attribute is a poison-fanged snake. ▷Giotto (c1305–6, Padua, ▷Arena Chapel) portrays her with a snake emerging from her mouth (like a poison tongue) and biting her own forehead. ▷Ripa in his *Iconologia* shows her with snakes growing Medusa-like from her head (her poisonous thoughts). Sometimes she is portrayed gnawing at her own heart or entrails. According to Ripa, her skin is a livid colour, owing to the absence of any human warmth or charity. He also shows her resting her hand upon a hydra (like Envy, its poisonous breath could kill). Envy is often accompanied by a starved-looking dog – a traditional symbol of envy, as in the fable of the dog in the manger. ▷Bosch, in the *Invidia* scene from his *Tabletop of the Seven Deadly Sins* (Madrid, Prado), shows a dog neglecting the bone he already has in order to covet another held by a man leaning from a window. Giotto's *Envy* also clutches a moneybag and her feet are consumed by flames.

Epiphanius of Evesham (1570–after 1633)

English sculptor. He was from Herefordshire, and worked in London in 1592. From 1601 to 1614 he was in Paris, where he worked as a master sculptor, but he returned to England to produce a number of tombs in the provinces. His patrons were primarily Catholics, and his tomb effigies are more individualized and accomplished than many of those of his predecessors.

episteme

A term now commonly used in literary and art theory but initially popularized by ▷Michel Foucault in his *The Order of Things: An Archaeology of the Human Sciences* (1970). He used the concept of the episteme as synonymous with modes of knowledge, or the ways in which different periods attempt to frame their knowledge through institutions, written ▷discourse and ▷culture.

épreuve d'artiste

(French, 'artist's proof'.) The first impression of a print which is deliberately not numbered and thus more valuable than later impressions. The creation of these 'proofs' is practised extensively by 20th-century artists.

Epstein, Sir Jacob (1880–1959)

American sculptor. He was born of Jewish parents in New York. He developed an early interest in sketching, learned ▷ bronze casting by working in a foundry and studied ▷modelling at evening classes. He moved to Paris in 1902 and studied at the École des Beaux-Arts, then the ▷Académie Julian, with the collections of primitive art at the ▷Louvre exerting a profound influence on his future work. In 1905 he moved to London and was naturalized in 1911. He studied at the British Museum, again deriving his chief inspiration from the ancient and ethnographic collections. His very unclassical nude figures for the exterior of the British Medical Association Building in the Strand

Jacob Epstein, *Portrait Head of Somerset Maugham*, Fine Art Society, London

(1908), commissioned by the building's architect, outraged conservative opinion (they were later virtually destroyed when the building was transferred to the Southern Rhodesian Government in 1937). Others of his public works, including his tomb for Oscar Wilde (1912, Paris, Père Lachaise Cemetery) also met with prurient attacks. In England he associated with the ▷Vorticists, his most important work in this style being his *Rock Drill* (1913–14, London, Tate Gallery). Despite the continued abuse aimed at his more uncompromisingly sexual and unclassical mythic or religious works (such as his *Lucifer*, which was rejected even as a gift by several major museums) he was highly

esteemed by many of his fellow artists. Only with his portrait ▷bronzes did he achieve early and widespread acclaim. He received little official recognition before the 1950s, though in the last decade of his life he was awarded numerous public commissions, including the *St. Michael and the Devil* for Coventry Cathedral (1958). He was knighted in 1954.

Bib.: Silber, E., *The Sculpture of Epstein*, Oxford, 1986

equestrian sculpture

A statue of a horse and rider. A natural image of authority, the equestrian statue has been employed frequently in the portrayal of emperors, monarchs and any petty ruler with sufficient wealth to fund such a project. The type presents a formidable structural problem to the sculptor, however, with the heavy mass of the horse's body and the superincumbent rider supported on four relatively spindly verticals representing the horse's legs. Not surprisingly, the proliferation of equestrian statues in modern times had to await the rediscovery of efficient bronze founding techniques. One of the most celebrated equestrian statues of all time is the antique bronze *Marcus Aurelius* (c AD 161–80, Rome, Capitoline Museum), which avoided being melted down during the Middle Ages only because it was believed to represent Constantine, the first Christian emperor of Rome. The *Marcus Aurelius* has exerted a tremendous influence from the ▷Renaissance onwards and the first two full-scale equestrian statues of modern times, ▷Donatello's *Gattamelata* (bronze, c1446, Padua, Piazza del Santo) and ▷Verrocchio's *Bartolommeo* ▷*Colleoni* (bronze, begun 1481, Venice, Campo SS. Giovanni e Paolo), both reflect its influence. Amongst the most important equestrian statues of later years are: ▷Giambologna's *Cosimo I de' Medici* (bronze, 1587–95, Florence, Piazza della Signoria); ▷Pietro Tacca's *Philip IV* (bronze, 1639–42, Madrid), the first full-scale equestrian statue in which the horse rears up with both forelegs off the ground; and ▷Falconet's *Peter the Great* (bronze, 1766–78, St. Petersburg).

equilateral arch

▷arch

Equipo 57

A group of artists from Cordoba who banded together in 1957. The group include José Duarte (b 1926), Juan Serrano (b 1929) and Ángel Duart (b 1929). They were originally members of the Grupo Espacio (founded in 1954), but they pulled away to concentrate more specifically on the dissemination of ▷Constructivism. In an attempt to devalue the role of the individual artist, they produced much collaborative work and exhibited in Europe and America in the 1950s and 1960s. They ended their activities in 1966.

Eragny Press

A publishing enterprise founded by ▷Lucien Pissarro in 1894, and based in London. The name came from a village in Normandy. The press was best known for its distinctive typeface and for the high quality of illustrations, especially ▷woodcuts, which it produced. It ceased production in 1914.

Erasmus, Desiderius (c1466–1536)

Dutch humanist whose studied moderation and whose extensive publications were influential throughout Europe. The illegitimate son of a priest, Erasmus was educated at Gouda by the brethren of Common Life and at the Augustinian monastery at Steyn. In 1492 he was ordained as a priest and first travelled to Paris. He started lecturing and writing to many eminent men throughout Europe about ▷humanism. He was afforded great respect and in 1506 he moved to England where he became friendly with theologians Thomas More, John Colet and Warham. His works include *Adagia* (1500), *Manual of a Christian Soldier* (1501), *In Praise of Folly* (1511) and a number of additions and translations of the Bible, early Christian authors and the classics. In some ways these texts revolutionized European literary culture and prepared the way for the ▷Reformation. However, Erasmus refused to align with any one doctrine during the Reformation and distanced himself from Luther's violence and extremism. In 1523 his *De Libero Arbitrio* affirmed his belief in free will against the doctrine of Divine determinism. His influence on Dutch humanist artists was immeasurable but the fact that his writings were placed on the Index of 1559 made him accessible to generations of Catholics.

Erato

▷muse

Erechtheum (Erechtheion)

An ▷Ionic Greek temple on the north side of the ▷Acropolis (opposite the Parthenon), constructed by an unknown architect 421–407 BC. Built to an irregular plan on two levels (in order to incorporate pre-existing sacred spots), it consists of a hexastyle ▷portico facing east, a tetrastyle portico facing north (with taller columns to accommodate the drop in the ground on this side whilst keeping the roof all at one level) and, facing south, a ▷porch supported by ▷caryatids (balancing, on a smaller scale, the north portico). A western portico was not possible as it would have involved removing Athena's sacred olive tree and building over the tomb of King Cecrops, so instead the outer wall of the western chamber was made to take a line of four columns (to balance the tetrastyle portico on the east side) engaged in their lower sections, set between ▷antae, and mounted on a high basement (the west ground being lower than the east). The main building contained four chambers: the

largest, the eastern chamber, entered by the eastern portico, is believed to have been dedicated to Athena Polias; the western chamber, entered by the north and south porch, served as an anteroom to the two central chambers, which were oriented longitudinally, with altars to Hephaestus and Butes forming the shrine of Erechtheus. The temple was built entirely of Pentelic ▷marble, with ▷friezes of black Eleusinian limestone to which white marble ▷relief sculpture was applied. The doorways and windows were elaborately carved, and the column capitals were of special elegance, enriched with painted colours, gilding, gilt bronze and inset glass beads in four colours.

Ermolayeva, Vera Mikhailovna (1893–1938)

Soviet painter. She studied in St. Petersburg, and became involved with the ▷Union of Youth. She adopted the ▷Suprematism of ▷Malevich, and after the Revolution of 1917, she became Director of the Art Institute in Vitebsk, where Malevich also taught. She opened her own workshop in Petrograd, where she perpetuated Suprematist ideas. In 1923 she became Director of the ▷Inkhuk Colour Laboratory in Leningrad. Her own production was most distinguished by her children's books. Like many other artists, she was interred in a concentration camp under Stalin's dictatorship.

Ernst, Max (1891–1976)

German–French painter. He began painting at Bonn University where he studied philosophy and psychiatry (1908–14). In 1911 he made contact with the ▷Blaue Reiter through ▷Macke and exhibited at the first German Herbstsalon (Autumn Salon) in 1913. After serving in the War, he became leader of the Cologne ▷Dada group in 1919. Encouraged by ▷Arp, he began to make ▷collages from various printed matter, which he called Fatagaga, creating powerful and often disturbing symbolic images. In 1922 he settled in Paris, and joined the ▷Surrealists at their formation in 1924, where his early paintings such as Oedipus Rex (1922, private collection) and Hommes n'en sauront rien (1922, London, Tate Gallery), were acclaimed as the first masterpieces of Surrealism. Influenced by ▷de Chirico and drawing on childhood memories and his early fascination with the art of psychotics, his paintings developed an almost private mythology, creating startling original and strange images of hallucinatory intensity. Always experimental in technique, he combined ▷collage and ▷photomontage in his collage book La Femme Cent Têtes (a pun meaning both The Woman with One Hundred Heads and The Woman Without Heads) in 1929, followed by Une Semaine de Bonté in 1934. In 1925 he also began to use the technique of ▷frottage, making rubbings with black lead on paper placed initially on floorboards and then extended to a variety of different objects. Ernst claimed that these frottage

drawings evoked an 'hallucinatory succession of contradictory images' and he published a collection of them, Histoire Naturelle, in 1926. This technique, with its element of chance, freed him from figuration, and was used to great effect in the Forest series in 1927–33 (example 1927, London, Tate Gallery). In 1937 he broke with Surrealism and in 1941 moved to New York where he married Peggy Guggenheim (whom he divorced soon after to marry ▷Dorothea Tanning in 1946), and collaborated with ▷Breton and ▷Duchamp on the magazine VVV. In 1946 he returned to Paris, by which time his painting had become more lyrically abstract. In 1954 he won the Prize for Painting at the Venice ▷Biennale. Major retrospectives were held at Berne (1956), the Musée National d'Art Moderne, Paris (1959) and ▷MOMA, New York (1961).

Bib.: Camfield, W.A., Max Ernst, Dada and the Dawn of Surrealism, New York, 1993; Diehl, G., Max Ernst, 1973, Paris; Schafer, J., Dada Köln, Wiesbaden, 1993

Eros

▷Sacred and Profane Love

Erwin von Steinbach (d 1318)

German architect. He was made famous as the hero of ▷Goethe's prose poem about Strasbourg Cathedral, Von deutscher Baukunst (On German Architecture) of 1772. He is documented as master of works at Strasbourg Cathedral from 1284 onwards and his tomb states that he was 'master-mason' ('Gubernator') of the cathedral. Also, the Chapel of the Virgin (1275–1319, destroyed 1682, fragment in Strasbourg, Musée de l'Oeuvre de Notre Dame) once bore an inscription which translated as 'Master Erwin built this work'. Goethe assumed the façade and steeple to be by Erwin, although the steeple was in fact built after his death. The façade, however, and a drawing for it of c1275, known as dessin B (Musée de l'Oeuvre de Notre Dame, Strasbourg) are generally believed to be by Erwin and suggest a knowledge of the façades of Notre-Dame in Paris and Reims Cathedral. Far from the status he enjoyed following the publication of Goethe's poem, modern research suggests that he was actually a rather minor architect.

Erymanthian Boar

▷Hercules

Erythraean Sibyl

▷Sibyl

Escher, M(aurits) C(ornelis) (1898–1972)

Dutch graphic artist. From 1919–22 he studied at the Technical School of Art in Haarlem, where he learned the mathematical principles for which he would later become famous. From c1944 he developed his own brand of ▷Surrealism based on optical illusion,

manipulation of ▷perspective and mathematical formula. The rationality which underlies the construction of his pictures belies their bizarre ▷oneiric effect. Escher was not central to the Surrealist movement, and his work is often derided as mere trickery, though it has achieved great popularity through its frequent reproduction on posters, calendars and other forms of consumer goods.

Escorial

A palace and monastic community 50 km (31 miles) from Madrid. It took its present form under the reign of Philip II who moved his palace there and arranged to have the whole complex redesigned. The work began in 1563 under the supervision of Juan Bautista de Toledo, and was completed in 1584 by Juan de Herrera. A number of Italian artists and architects were also involved with the commission. The complex covers 12 acres, and the distinct, unornamented building style was a departure from the ornateness of previous palace design. The Escorial included a number of significant altarpieces by Mannerist artists such as ▷Tibaldi and ▷Cambiaso and it became the nucleus of a school of Spanish ▷Mannerist painting.
Bib.: Rosemarie Mulcahy, R., *The Decoration of the Royal Basilica of El Escorial*, Cambridge, 1994

escutcheon

A shield-shaped ornament, usually bearing an armorial device.

esonarthex

▷narthex

Esprit Nouveau, L'

A French movement and journal which flourished from 1920 to 1925. It was founded by ▷Ozenfant and Jeanneret (▷Le Corbusier) in part to publicize their brand of ▷Cubism, called ▷Purism. However, its utopian emphasis and rather vague support for a new art for the post-war world drew in a diverse collection of artists, poets and critics, which included writers Louis Aragon, ▷Breton, and Paul Eluard as well as artists such as ▷Carrà. L'Esprit Nouveau never became a coherent movement as such, and its ideals were adopted by different artists for different purposes during the 1920s.

Este

Lords of Ferrara until 1598 (thereafter of Modena and Reggio), and patrons of artists including ▷Alberti, ▷Pisanello, ▷Jacopo Bellini and ▷Cosimo Tura. Isabella d'Este (daughter of Ercole I) married Francesco Gonzaga of Mantua, and bought paintings by ▷Mantegna, ▷Perugino and ▷Correggio for her ▷studiolo. Collecting clearly ran in the family, for her brother Alfonso patronized ▷Bellini and ▷Titian, and in the 17th century, Francesco I

commissioned portraits from ▷Bernini and ▷Velázquez. Many of their best pictures were sold to Augustus III of Poland at Dresden in 1744.
Bib.: Brown, C.M., *Isabella d'Este and Lorenzo da Pavia: Documents for the History of Art and Culture in Renaissance Mantua*, Geneva, 1982; Rosenberg, C.M., *Art in Ferrara During the Reign of Borso d'Este (1450–1471): A Study in Court Patronage*, Ann Arbor, 1974

estípite

Spanish term for a ▷column which has a ▷shaft in the shape of an ▷obelisk. This unusual column form was common during the ▷Churrigueresque period, but it should be differentiated from the *salomónica*, or twisted column, which was also common at that time.

estofado

(Spanish, 'quilted'.) The name given to the realistic painting effects used on wooden figure sculptures in the 16th and 17th centuries. *Estofado* was used for drapery.
▷encarnado

etching

An ▷engraving method where the design is bitten into the engraving plate by acid. Also the name for the ▷print thus produced. A plate usually of copper, or sometimes steel or zinc, is coated with an acid resistance substance, the 'etching ▷ground' (a compound of beeswax, ▷bitumen and resin melted onto the plate), and then drawn upon with a steel etching needle. The plate is then immersed in a bath of dilute acid (usually nitric) which bites into the metal of the plate exposed by the design. The plate can be placed in the acid a

Etcher's Tools and Techniques, Engraving

number of times, using a ▷stopping-out varnish on those areas wanting less depth. When this process is complete the plate is cleaned of the ground and is reading for printing. The process may be used in conjunction with other engraving methods such as ▷drypoint to allow additional working of the image without needing to relay the ground. Etching was introduced in the early 16th century as a labour-saving device; unlike engraving it gives smoother lines of a constant width. Early practitioners included ▷Albrecht Dürer, ▷Albrecht Altdorfer and ▷Anton Graff. The method allows the spontaneity of sketching without the formality of ▷line engraving, and this property was used to greatest effect by ▷Rembrandt, who drew freely on plates, often radically reworking them.

Et in Arcadia ego

Latin epigram formulated in the 17th-century Italian ▷humanist circles, meaning: 'Even in Arcadia, I (i.e. Death) am present'. Arcadia is the idealized pastoral region of simple rustic pleasures; the epigram thus was intended to mean that even in an escapist world there is no escape from death. The earliest known painting of the subject is by ▷Guercino (*The Arcadian Shepherds – 'Et in Arcadia Ego'*, c1618, Rome, Palazzo Corsini). Two Arcadian shepherds stumble across a skull lying on a piece of fallen masonry inscribed with the words, *Et in Arcadia Ego*. Later in the century ▷Poussin painted two versions of the subject (*The Arcadian Shepherds*, c1629–30, Chatsworth, Derbyshire; and c1650, Paris, Louvre). In these works the significance of the words is modified. In each case the shepherds and a nymph come across a sepulchre bearing the epigram. They look sadly at each other as they contemplate the meaning of the epitaph which now means 'I too (i.e. the person whose body is now in the tomb) once lived in Arcadia'.

Etruscan art

Art from the culture of central Italy (Etruria is modern-day Tuscany) from the 9th century BC until Roman absorption following its conquest in the 1st century BC. The Etruscans were especially notable as engineers, bronze-casters, metalworkers and builders of monumental tombs; their culture, of complex influences, especially prized ▷Classical Greek work, which is why some of the best Greek vases have been found on Italian soil. It is believed that the Romans developed their taste for art from their various conquests, especially from Greece and the Etruscans. Thereafter Etruscan art had no apparent influence until the ▷Renaissance, when ▷Leonardo and ▷Michelangelo may have known something of it. Its main revival was in the 18th century, when it was part of the general movement of ▷Neoclassicism towards pre-Roman sources.

Bib.: Brendel, O., *Etruscan Art*, 2nd edn., New Haven, 1995; Neppi Modona, A., *A Guide to Etruscan Antiquities*, rev. edn., Florence, 1968; Spivey, N.J., *Etruscan Italy*, London, 1990

Etty, William (1787–1849)

English painter. He was especially famous for his nudes. He was born in York and after attending art college there, joined the ▷Royal Academy Schools. He also studied with ▷Lawrence. He met ▷Delacroix on his

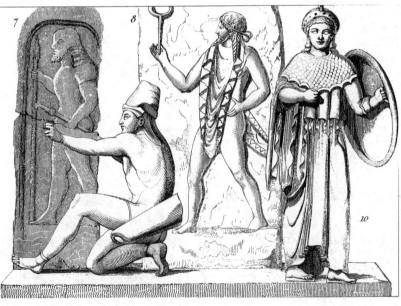

An Etruscan bas-relief

visit to England in 1825, and Etty himself made several trips to the Continent, including Italy. His artistic ideals were ▷Rubens and ▷Titan and he tried to emulate their rich colour and sensuality. Throughout his career he attended the life classes at the RA (e.g. *Nude*, 1825, London, Tate), but most of his oils made use of mythological subject-matter to give his figures a veneer of artistic respectability (e.g. *Aurora and Zephyr*, 1845, Port Sunlight). He was also an accomplished portraitist (e.g. *Mlle Rachel*, 1841, York). Even so, his work was often considered indecent and he spent much of his life in poverty.

Bib.: Farr, D., *William Etty*, London, 1958; Gilchrist, A., *Life of William Etty, RA*, 2 vols., London, 1855; *William Etty*, exh. cat., York, 1979

Eucharist

The consecrated elements of the Holy Communion, especially the bread. The Communion is a ritualized celebration of the ▷Last Supper in which Christ announced to his disciples that the bread and wine of which they were partaking was his body and blood (Matthew 26: 26–29, Mark 14: 22–25, Luke 22: 19–20). That the Eucharistic elements are actually, not just symbolically, transformed into the body and blood of ▷Christ at each celebration of Communion is still an article of faith for the Catholic Church. Thus the Communion is a ritualized re-enactment of the redemption of mankind through Christ's sacrifice and is therefore not only the central rite of the Catholic Church, but also a frequent theme in Christian art. In the Early Christian art of the ▷catacombs the Eucharist was sometimes represented by the *Miracle of the Loaves and Fishes* (e.g. c AD 350, Catacomb of Commodilla, Rome). By the 6th century, ▷Byzantine artists were depicting the Last Supper itself (e.g. ▷nave mosaic, early 6th century, Ravenna, S. Apollinare Nuovo). Eucharistic symbols appear frequently in ▷Renaissance paintings of the ▷Nativity in order to stress the significance of Christ's incarnation. For example, in ▷Hugo van der Goes' *Portinari Altarpiece* (c1475, Florence, Uffizi) a sheaf of wheat lies on the ground parallel to and therefore echoing the body of the Christ Child lying near it.

Euphronios

A Greek ▷red-figure vase painter of the 6th–5th centuries BC. He was best known for his careful observation of anatomy.

Euphrosyne
▷Three Graces

Europa
▷Rape of Europa

European Sibyl
▷Sibyl

Eurydice
▷Orpheus

Euston Road Group

A group of British artists, based around the art school established on the Euston Road in 1937 by ▷Coldstream, ▷Pasmore and Rogers. The title was first used by ▷Bell. The group opposed ▷abstraction and ▷Surrealism, as well as what they called the 'pseudo reality' of the ▷RA, and promoted austere naturalist townscapes, landscapes and interiors. Although the school closed as a result of the Second World War, its influence lingered on after 1945 due to the teaching of its members at the ▷Slade and Camberwell. Other members included Graham Bell, Lawrence Gowing, and Rodrigo Moynihan.

Bib.: Laughton, B., *Euston Road School*, Aldershot, 1986

Euterpe
▷muse

Evangelists

The writers of the four New Testament ▷gospels which narrate the events of ▷Christ's life. ▷Matthew, associated with an angel because his gospel starts with an account of the ▷Garden of Eden, is usually older and bearded (e.g. Savoldo, 1535, New York), as is ▷John, often shown with an eagle (his book begins with a discussion of the word of God, spread by the strongest of the birds). ▷Mark and Luke are generally younger figures. The former has a lion associate (he gives an account of ▷St John the Baptist in the wilderness), the latter a calf (representing sacrifice). All four figures are usually shown writing or holding a book, and often a dove is present, to represent divine inspiration. Depiction of them in this way has been common since the 5th century (e.g. S. Vitale, Ravenna). In ▷Coptic and ▷Romanesque depictions the figure and animals are sometimes combined in a single zoomorphic image (e.g. 1180, St. Trophime, Arles; St. Mark, 700, *Echternach Gospels*, Paris). The Evangelists were commonly depicted in manuscripts following the Greek custom of giving a portrait of the author at the start of his work (e.g. 6th century, *Gospels of Romano*; St. Matthew, *Gospel of Charlemagne*, c800–810, Vienna; St. Luke, *Gospel Book of Otto III*, 1000, Munich). In church decoration the Evangelists are often shown with other groups of four, for example the Old Testament prophets or the ▷Doctors of the Church (Ambrose, Jerome, Augustus and Gregory).

Everdingen, Allart van (1621–75) and Caesar (1617–87)

Dutch family of painters. Allart concentrated on landscapes and ▷marine scenes, which became more dramatic after a visit to Sweden in the 1640s. His theatrical waterfalls influenced ▷Ruisdael. His brother Caesar painted portraits and ▷history pictures and adopted Italian styles in his work.

Bib.: Davies, A., *Allart van Everdingen*, New York, 1978

Eworth, Hans (c1520–after 1573)

Flemish painter. He was influenced by the Antwerp ▷Mannerist style, but he worked primarily in England during c1545–73 producing portraits of Queen Elizabeth and her court.

exedra

In Classical architecture, a ▷niche, semi-circular or rectangular in plan, often lined with a bench; also any apsidal extension of a larger space, whether a room or an uncovered space.

Exekias

Greek ▷black-figure vase painter of the 6th century BC. He was most noted for his ▷battle scenes, and his most famous work is an ▷amphora with the story of ▷Achilles and Ajax (London, British Museum).

exhibitions

Public displays of artistic work, either inside a gallery space or in other contexts.

Experiment with a Bird in an Air Pump

Painting by ▷Joseph Wright of Derby, oil on canvas (183 × 244 cm/6 × 8 ft), dated 1768, now in the National Gallery, London. It shows a group of men, women and children watching a man demonstrating the effect of the removal of air from a closed space. The lecturer is poised with his hand on a valve that will allow air back into the glass vessel and thus save the bird from suffocation. This dramatic pose, and the closely studied reactions of the observers gives the painting an intensity that relates it to earlier religious subjects as well as the contemporary fascination with the ▷sublime. This combination is totally original, and the painting was quickly recognized as extraordinary and critically acclaimed. Like Wright's earlier painting, *A Philosopher Giving a Lecture on the Orrery*, it reflected the 18th-century interest in scientific discoveries though the skull and candle on the table give it a greater religious symbolism. Its dramatic use of light and darkness was used in Wright's later industrial scenes, *A Blacksmith's Shop* (1771) and *An Iron Forge* (1772/73).

expression

The art of showing the emotions, the mind and the soul by means of facial and bodily movements, expression was recognized as a linchpin of any art involving a naturalistic account of human beings from ▷Alberti's *Della Pittura* (1436) onwards. In a famous retort reported by ▷Vasari about the preparation of his *Last Supper*, ▷Leonardo made the same point: expression is the only means allowing artists to communicate that which is inside. In the theatre of the Greeks and Romans, expression was formalized by the use of masks, whilst in the 17th century, with its emphasis on the academic and cerebral, attempts were made to systematize expression for the artist, so that it might be taught in the ▷academies. ▷Charles Lebrun's treatise *Méthode pour apprendre à dessiner les passions . . .* (1698), and the subject of his lectures to students at the ▷Académie were but the formalization of the lessons he learned through studying the art of ▷Poussin. The same ideas prospered in the 18th century, bolstered by the study of ▷physiognomy (considered a science), which seeks to determine character from appearance; see, for example, ▷Lavater's *Physiognomical Bible* (1772).

Bib.: Sircello, G., *Mind and Art; An Essay on the Varieties of Expression*, Princeton, 1978

Expressionism

A term first used at the 1911 ▷Fauvist and ▷Cubist exhibition in Berlin. It describes art which distorts reality through exaggeration, vigorous and visible brushwork and strong colour, in order to express an artist's ideas or emotions. Although these tendencies are apparent in art before the 20th century, particularly that of Northern Europe (▷Grünewald), the term is primarily associated with the German groups, ▷Die Brücke and ▷Der Blaue Reiter, with post-First World War German art and to a lesser extent with the Fauves in France. There were also a number of individuals, working at the same period, who are commonly linked to the movement, including ▷Kokoschka, ▷Rouault, ▷Soutine and ▷Schiele. These artists opposed the naturalism of the ▷Impressionists but were inspired by ▷van Gogh, ▷Gauguin, ▷Toulouse-Lautrec, ▷Munch, ▷Ensor and others. They were among the first to appreciate non-European and primitive art forms and also looked to the ▷folk art of their own countries in the belief that spontaneity of feeling was greatest where intellect and training were least. This exploration led to a strong spiritual element in the work of many Expressionists such as ▷Kandinsky, Rouault and ▷Nolde. It also encouraged an interest in graphic art, particularly ▷woodcuts (▷Barlach). Despite their links with the past, Expressionists were at the forefront of ▷modernist developments in painting: artists like ▷Marc and ▷Feininger incorporated ▷Cubist elements into their work and Kandinsky produced early examples of abstraction. But their

sympathies, as reflected in their subject matter, were anti-modernist: the industrial city was a place of danger and immorality, the First World War was a personal and international disaster, politics, especially in post-war Germany were corrupt. For some, this state of affairs led to escapism into landscape or a discovery of the self, others experienced an alienation akin to that expressed by ▷Dada (▷Grosz) and later by the ▷Abstract Expressionists. Expressionism has continued to be influential in later 20th century art (▷Baselitz).

Expressionism was not purely associated with two-dimensional art. Sculptors such as Barlach, ▷Lehmbruck and ▷Kollwitz were motivated by aims similar to those of Expressionist painters. In architecture the language of internationalism was strained and distorted by ▷Mendelsohn, ▷Steiner and in some works by ▷Behrens and ▷Mies van der Rohe. Bertolt Brecht, Sean O'Casey and Franz Kafka also explored comparable ideas in literature. In all its forms the movement stood out against fascism and this, together with its so-called ▷'degenerate' qualities (it was anti-Aryan and anti-naturalism) led to the persecution of many Expressionist artists under the Nazi regime.

Bib.: *German Expressionist Sculpture*, exh. cat., Los Angeles, 1983; Herbert, B., *German Expressionism*, London, 1983; Lloyd, J., *German Expressionism: Primitivism and Modernity*, New Haven and London, 1991; *Masters of German Expressionism*, exh. cat., Detroit, 1982; Willett, J., *Expressionism*, London, 1970

Exter, Alexandra Alexandrovna (1882–1949)

Russian painter. She studied in the Kiev School of Art in 1906, and in 1907 joined the Moscow ▷Blue Rose group. The formative influence on her style was a trip to Paris in 1908, where she saw ▷Cubist and ▷Futurist work. By 1913 she was producing increasingly abstract works in Russia, and she also experimented with ▷collage. She was one of several artists who helped put Russia in touch with western developments in art. Both before and after the Revolution of 1917 she was best known for her ▷avant-garde theatre designs. She was responsible for designing the sets and costumes of a number of plays, and she perpetuated her interest through courses she taught at the Kiev School of Art in 1918 and in her own studio. She was involved in designing posters for ▷agitprop. In 1924 she moved to Paris.

Extreme Unction

▷Seven Sacraments

ex-voto

(From Latin: *ex voto suscepto*, 'from the vow made'.) The term is now synonymous with an object, token, painting or plaque bearing a message of devotion and humility. These objects are placed in a church or chapel at the appropriate altar where the worshipper seeks

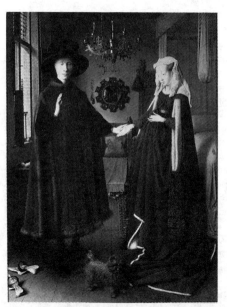

Jan van Eyck, *Giovanni Arnolfini and his Wife*, 1434, National Gallery, London

patronage to ask for special grace or to give thanks for a prayer which has been granted. Shrines decorated with these votive offerings are often sought out by those on pilgrimage.

Eyck, van, Jan (d 1441) and Hubert (d ?1426)

Jan van Eyck is regarded as the most important Flemish painter of the first half of the 15th century; his brother Hubert, as the greatest art historical mystery. The source of the mystery is the Latin inscription on the huge ▷polyptych of the *Adoration of the Lamb* (▷Ghent Altarpiece) in the Cathedral of S. Bavo, Ghent, generally translated as: 'The painter Hubert Eyck, than whom none was greater, began this work; Jan, second in art, having completed at the expense of Jodocus Vyd, invites you by this verse on the 6th May [1432] to contemplate what has been done.' Apart from this mention, there are only four other possible references to Hubert, all in 1425 and 1426 and each time with the name varied slightly (a not uncommon situation). In three of the documents he is referred to as head of a workshop in Ghent (in one of which he is specifically referred to as a painter), and in one document (in which no mention of his trade is given) his death is implied. His death at the end of 1426 is thus consistent with the reference on the S. Bavo altarpiece. Also, all of Jan's accredited paintings date from after this altarpiece, which might suggest him striking out on his own after his more established brother's decease. The major problem centres on how a painter who was considered to be greater than Jan van Eyck could remain so obscure, when Jan himself, in his mature years, is so amply documented. Fur-

thermore, whereas a substantial corpus of work is known to be by Jan, nothing, apart from the S. Bavo altarpiece, has been linked to Hubert. The verse remains a mystery; some art historians think it has been tampered with to include the reference to Hubert and, indeed, the very existence of Hubert has been doubted.

Where and by whom Jan van Eyck was trained is not known and he is first recorded working for Count John of Holland at The Hague, 1422–4. At Count John's death in 1425 Jan secured appointment as Court Painter and '*valet de chambre*' (equerry) to Philip the Good, Duke of Burgundy, in Lille. In c1430, still working for Philip, he moved to Bruges and bought a house in 1431/2, remaining there until his death. His diplomatic work for the Duke took him on secret missions to Spain in 1427 and to Portugal in 1428. Many of his works are signed and dated and some bear a more than usual assertion of the artist's self-confident presence. In the *Man in a Red Turban* (1433, London, National Gallery) the frame is inscribed with the remarkable '*Als ich kan*', 'As I can', or, as it is sometimes interpreted, 'As only I can'. In the double portrait of *Giovanni Arnolfini and his Wife* (1434, London, National Gallery), Jan depicts himself, the painter, in the mirror behind the couple and inscribes on the wall beneath it '*Johannes de Eyck fuit hic*', 'Jan van Eyck was here', which statement has led to an interpretation of the portrait as the record of a marriage ceremony with Jan as witness. His reflection also appears in the gleaming armour of St. George in the *Madonna of the Canon van der Paele* (1436, Bruges, Groeningemuseum). Jan's other important works are: the *Portrait of a Man* (inscribed 'Tymotheus Leal Souvenir 1432', London, National Gallery); the *Madonna of Chancellor Rolin* (c1435, Paris, Louvre); the *St. Barbara*, a drawing on a gesso ground for an unknown painting (1437, Antwerp); and the *Portrait of the Wife of Jan van Eyck* (1439, Bruges, Groeningemuseum).

Although the idea that Jan van Eyck invented oil painting is now discredited, he undoubtedly raised it to a peak of expertise never before realised. He excelled in the minute recording of detail, the faithful description of the subtlest effects of light, and the accurate construction of form and space, and all in rich and glowing colours, only possible in oil and which to this day have lost none of their brilliance. His portraits are not merely objective records of each sitter's appearance, but convincing in their psychological penetration. His religious subjects are usually iconographically complex – none more so than the S. Bavo altarpiece. The sophistication of his representation of the objective world makes him slightly later than the other principal founder of the early Netherlandish school, the ▷Master of Flémalle. He was highly acclaimed in his own day on both sides of the Alps, but his influence within the Netherlands, although considerable, was surpassed by that of ▷Rogier van Weyden, whose less austere, more emotional art has always been more accessible. Jan van Eyck's principal follower was ▷Petrus Christus.

Bib.: Belting, H., *Jan van Eyck als Erzähler*, Worms, 1983; Harbison, C., *Jan van Eyck: The Play of Realism*, London, 1991; Pacht, O., *Van Eyck and the Founders of Early Netherlandish Painting*, London, 1994; Seidal, L., *Jan van Eyck's Arnolfini Portrait*, Cambridge, 1993

F

f., fe., fec., fecit

(Latin, 'made'.) Sometimes appearing after a name on a painting, drawing or print. On a painting or drawing it follows the artist's name, but on a print the name refers to the printer (i.e. he who literally made it) who may not necessarily be the artist who designed the image. On an ▷engraved print (as opposed to an ▷etching), the engraver may be indicated by ▷s., sculp., sculpsit.

Fabritius, Carel (1622–54)

Dutch painter. Born in Midden-Beemster, Fabritius moved to Amsterdam in the early 1640s where he married and in about 1642, entered the studio of ▷Rembrandt. Following the death of his wife, Fabritius left Amsterdam and is recorded in Delft, the home of his second wife, from 1651. The exact date of his own death, 12 October 1654, is firmly established. On this day the Delft gunpowder mill exploded, demolishing most of the town, including Fabritius's studio where he was working at the time. Not only did the explosion kill the painter, it also destroyed a significant body of his work. Only about a dozen paintings are securely attributed to him, but they cover a remarkable diversity of genres in an age of artistic specialization. His earliest work, from his time with Rembrandt, is heavily influenced by his master's typical formula of highlighting figures against a dark background (e.g. *The Raising of Lazarus*, 1642, Warsaw National Museum). In his mature period, Fabritius retained the fluent painterly technique learnt from Rembrandt, but in his predilection for dark figures against light backgrounds reversed his master's usual formula (e.g. *Self-portrait*, c1645, Rotterdam, Museum Boymans-van Beuningen). Furthermore, Fabritius's colour harmonies are cooler, his palette lighter than Rembrandt's and he forms a link with ▷Vermeer, over whom he seems to have exerted some influence. Perhaps the most remarkable example of his work in this mature style is the *Goldfinch* (1654, The Hague) which, given its small scale and its almost ▷trompe-l'oeil effect, is remarkably painterly.

Carel Fabritius's younger brother, Barent (1624–73), a painter of biblical and mythological scenes and portraits, may also have trained under Rembrandt but, of a lesser talent than his older brother, he remained throughout his artistic career an imitator of Rembrandt.

Bib.: Brown, C., *Carel Fabritius: Catalogue Raisonné*, Ithaca, 1981

façade

The architectural front of a building, sometimes emphasized by richer ornamentation.

façadism

Shorthand for a type of style, or equally a reproach directed at architects whose interest in architecture seems limited to the construction of façades, and who neglect to provide any coherence between the façade and what lies behind. All stage scenery designers would gladly plead guilty to this crime, which has come to prominence recently with the expansion of ▷post-modernism, a style whose detractors claim is largely restricted to cardboard-like façades, many imitated from book illustrations, or misunderstood or abbreviated from the work of dead and better architects. The description is frequently accurate, since post-modernism often erects façades that stand well clear of what lies behind (like stage sets), and which bear an unclear structural relationship (if any at all) to the rest of the building. It is also poignantly appropriate in those instances where façades have been preserved for town-planning proprieties when the building layout behind no longer serves any useful purpose, as exemplified by the 20th-century Robert Adam Riverside scheme in Richmond, London.

In a more general sense, façadism is the propensity for designing architecture like state sets, a characteristic which Richard Brilliant identified in Roman architecture: 'The creation of the stunning façade as an architectural motif, the awesome, grandiose scale of buildings set an impressive stage for the presentation of great actors and weighty assertions.'

face painting

An archaic term referring to portraiture. It was a common term from the 16th century onwards but fell out of use by the 19th century. The term is slightly derogatory in that it evokes the mechanical character of portraiture, which was seen to be an imitative art, rather than one based on idealism.

Face painting can also refer to a type of ritual or aesthetic ▷body art used in Third World cultures (e.g. ▷African art).

facsimile

An exact copy, engraved or photographed, of an original book, print or drawing.

facture

(French, 'handling'.) The way in which a work of art is constructed, or the techniques and means employed in its execution. More specifically, the way brushmarks remain visible in the ▷impasto or ▷bravura application of oil paint.

faïence

A type of tin-glazed earthenware originally made at Faenza in northern Italy from the late medieval period. The word was used for a time to describe any similar lustrous pottery, now termed ▷majolica.

Faith

One of the three theological ▷Virtues along with ▷Hope and ▷Charity. It is usually personified by a woman, often carrying a cross, chalice or book (Bible) and with her hand on her heart. She is sometimes opposed by a symbol of idolatry, a man worshipping a monkey. The presence of a ▷font representing Baptism, or a stone block beneath the figure representing a solid foundation are common. Increasingly from the ▷Counter-Reformation, a candle and a helmet (protection against heretics) were shown. (▷Giotto, 1306, Padua, Arena Chapel; ▷Michelozzo, 1430, Montepulciano Cathedral.)

Faithorne, William (1616–91)

English engraver. He visited Paris in the 1640s. He was a Royalist, and he worked from 1650 in London engraving portraits by ▷van Dyck, ▷Dobson and ▷Lely. He was known for his ability to reproduce the sitter's face faithfully, although he usually stripped the portrait of extraneous features, such as background detail, and placed the sitter's head in an oval format.

Faiyum portraits

▷Fayum portraits

fake

▷forgery

Falcone, Aniello (1607–56)

Italian painter. He was Neapolitan. He trained with ▷Ribera and probably died in the plague of 1656. He is chiefly remembered today as an early specialist in ▷battle scenes, although he is documented as a painter of religious subjects, mostly for the churches of Naples. Among the few that have survived in this latter genre are *Rest on the Flight into Egypt* (signed and dated 1641) in the sacristy of Naples Cathedral and the decorations for the Chapel of Sant'Agata in S. Paolo Maggiore, Naples (1641–2), both revealing the influence of Romano-Bolognese ▷classicism. Falcone's high reputation as a painter of battle scenes is demonstrated by his inclusion among the group of famous artists commissioned by Philip IV of Spain to decorate the Buen Retiro with a series of Roman historical subjects (now in the Prado, Madrid). His most important pupil was ▷Salvator Rosa.

Bib.: Alabiso, A., 'Aniello Falcone's Frescos in the Villa of Gaspar Roomer at Barba', *Burlington Magazine*, 131 (Jan 1989), pp. 31–6

Falconet, Étienne-Maurice (1716–91)

French sculptor and writer. He was a pupil of ▷J.B. Lemoyne, but he was most deeply influenced by ▷Puet. His main sculptural output consisted of mildly erotic ▷Rococo statuettes of nymphs and ▷bathers (e.g. *Baigneuse*, marble, Salon of 1757, Paris, Louvre). He had by 1757 secured the patronage of Madame de Pompadour and, with her influence, was able to secure the position of chief modeller at the Sèvres Porcelain Manufactory (1757–66), producing models (of which the *Baigneuse* became one) for mass reproduction in biscuitware. ▷Diderot admired his work and, in 1766, recommended him to Catherine II of Russia, who commissioned from him the monumental Equestrian Statue of Peter the Great for St. Petersburg (bronze, completed 1778). The result is generally held to be not only Falconet's masterpiece, but the most daring and accomplished ▷equestrian statue of the 18th century – a heroic image of the serene ruler, effortlessly controlling his fiery horse. The horse is ascending a rocky escarpment, its forelegs raised and unsupported; their weight is balanced at the back by a luxuriant tail which brushes the serpent that the horse and rider have just crushed. Falconet had little interest in portraiture and the execution of the head of Peter the Great he gave to his pupil and daughter-in-law, Marie-Anne Collot. His sight had by now begun to fail and in 1783 he suffered a stroke and was forced to give up sculpture altogether, devoting himself henceforth to writing. However, his best-known literary work, the *Réflexions sur la sculpture* (*Reflections on Sculpture*) dates from earlier (1761). It achieved a certain notoriety with contemporaries for its shocking pronouncement that modern sculptors were superior to the ancients, especially in their portrayal of the warmth of the human body.

Bib.: Weinshenker, A.B., *Falconet: His Writings and his Friend Diderot*, Geneva, 1966

Falk, Robert Rafailovich (1888–1958)

Russian painter. He was from Moscow, and studied there. He began exhibiting from 1906. He travelled to Italy in 1909–10, and he returned to Moscow to become one of the founder members of the ▷Jack of Diamonds. His advocacy of a style based on ▷Cézanne was soon seen to be too reactionary by some members of the Jack of Diamonds, including ▷Larianov, who left the group. From 1918 to 1928 he taught at ▷Vkhutemas, and lived in France from 1928 to 1938. He later returned to Moscow.

Fall of Man

The story from the Book of Genesis which narrates how ▷Adam and Eve came to be cast out of the ▷Garden of Eden. Although forbidden by God to eat the fruit of the Tree of Knowledge, Eve was persuaded by a serpent to taste the apple which she then offered to Adam. Having done so they became aware of their nakedness. As punishment for their disobedience they were expelled from the Garden in order to prevent them gaining immortality from the fruit of the Tree of Life, which was guarded by an angel with a sword. Adam was forced to till the land for survival and Eve was made to suffer in childbirth. The snake was also punished by losing its legs and being forced to crawl on its belly. The narrative is important not simply as a morality tale; it also prefigured the ▷Annunciation when Mary (▷Virgin Mary) redeemed the sins of Eve (e.g. mosaic, 1200, Venice, San Marco; Michelangelo, 1508–12, Rome, ▷Sistine Chapel). It was always a common theme in art, most often depicted at the moment of the tasting of the apple. The Expulsion from Eden (e.g. Hildesheim Cathedral doors, 1015; ▷della Quercia, 1325–38, Bologna; ▷Masaccio, 1426, Florence, Brancacci Chapel) and the subsequent life of hardship also feature.

Fall of the Rebel Angels

(Isaiah 14: 12–15; Revelation 12: 7–9). Isaiah refers to Lucifer's attempt to set his throne 'above the stars of God' and of his subsequent expulsion from Heaven into the pit for his pride; the author of ▷Revelation refers to a war in Heaven in which ▷Michael marshals his angels and defeats and casts out ▷Satan (variously the dragon, the serpent and the Devil) and throws him down to earth. Both passages are taken to refer to the same event, which the early Church assumed had occurred before the creation of man, thus accounting for how Satan came to be waiting to tempt Adam and Eve in the earthly paradise of Eden. ▷Pieter Bruegel the Elder (1562, Brussels, Musées Royaux des Beaux-Arts) shows the demonic hosts already transformed into monstrous shapes, although often emphasis will be given to the loss of beauty and assumption of ugliness as Satan and his followers tumble to earth (e.g. ▷Luca Giordano, *The Archangel Michael Flinging the Rebel Angels into the Abyss*, c1655, Vienna, Kunsthistorisches Museum).

fancy picture

An 18th-century term applied most frequently to ▷Gainsborough's rural ▷genre scenes. The term is used loosely and infrequently from the mid-18th to the mid-19th centuries. It evokes a type of genre painting based on fantasy and imagination. The popularity of fancy pictures was linked with the cult of sensibility in late 18th-century England.

Henri Fantin-Latour, *Self-portrait*, Uffizi, Florence

Fang

▷African art

fanlight

A window over a doorway, commonly used in Georgian and Regency buildings. It is usually semi-circular with radiating glazing bars in the form of an open fan.

Fantastic Realism

A school of painting that developed in Vienna immediately after the Second World War; together with a contemporaneous trend towards ▷abstraction, it is regarded as a typical of post-war Austrian painting. Its chief proponents are Erich Brauer (b 1929), Ernst Fuchs (b 1930), Rudolf Hausner (b 1914), Wolfgang Hutter (b 1928), and ▷Friedrich Hundertwasser, many of whom were pupils of ▷A.P. Gutersloh, a leading painter and teacher of the inter-war period. Though the artists had different styles and qualities of painting, they shared an interest in the art of the past (e.g. ▷Bruegel the Elder), the literary character of painting, and the combination of minute realism with a world of fantasy and imagination.

Fantin-Latour, Henri (1836–1904)

French painter and lithographer. He was especially known for still life and figure groups. He was born in Grenoble, the son of an artist. He was taught first by his father and later by Boisbraudan (1851). He also had a brief spell at the ▷École des Beaux-Arts (1854). He began as a portraitist but turned to still life in 1856. Although a friend of ▷Courbet, ▷Manet, ▷Whistler and other ▷Impressionists, he was a regular ▷Salon

exhibitor from 1859. He also took part in the ▷Salon des Refusés and was an admirer of ▷Delacroix and ▷Pre-Raphaelitism. He visited England in 1861 and maintained strong links there, exhibiting at the ▷Royal Academy. His work ranged from Romantic fantasy (e.g. *Immortality*, 1889, Cardiff), to Dutch-inspired flower pictures (e.g. *Spring Flowers*, 1878, Glasgow, ▷Burrell Collection) and precise portraits. Most famously he produced group portraits of his artistic contemporaries, such as *L'Atelier aux Baignolles, Hommage à Manet* ('The Studio at Baignolles, Homage to Manet', 1870, Paris, Musée d'Orsay). He was also a lover of Wagner's music (*Tannhauser*, 1886–9, Cleveland, Museum of Art) and produced a series of ▷lithograph illustrations to his works, after taking up the medium in 1877

Bib.: *Fantin-Latour*, exh. cat., Ottawa, 1983; Smith, E.L., *Fantin-Latour*, Oxford, 1977

Farington, Joseph (1747–1821)

English topographical draughtsman and landscapist. He was born in Manchester. In 1763 he became first a pupil, then an assistant of ▷Wilson, whom he much admired. He entered the ▷Royal Academy Schools in 1769, began exhibiting there in 1778 and was elected an RA in 1785. He was a prolific but limited painter in oils, influenced by ▷Canaletto and by the contemporary fashion for topographical sketches (e.g. *Bridge at Bridgenorth*, 1791, private collection). He made regular tours of the Lake District, and published engravings of views there in 1789 and 1816 (e.g. *Britannia Depicta*). But he is most famous for his diaries, one of the major art historical sources of the period. The diaries contain inside information about the workings of the London art world during this period, and they reveal the tensions and corruption beneath the formal veneer of the Royal Academy. The manuscript is in the Royal Library at Windsor and a full edition was published in 1978

Bib.: *Joseph Farington*, exh. cat., Bolton, 1977; Farington, J., *The Diary of Joseph Farington*, ed. K. Garlick and A. Macintyre, New Haven, 1978

Farnese

Italian family of noted statesmen and soldiers who ruled the Parma Duchies from 1545 to 1731, and encouraged the arts and culture in the region. The first duke, Alessandro (1468–1549) became Pope Paul III, and his nepotism advanced the family greatly in Italian affairs. He commissioned *The Last Judgement* in the ▷Sistine Chapel, from ▷Michelangelo. His son, Pierluigi (1503–47), and grandson, Ottavio (1542–86), patronized scholars and artists, commissioning paintings and palaces at Rome and Caprarola. The Palazzo Farnese, Rome was designed by ▷Antonio da Sangallo (1517–89) in a fashionably ostentatious High ▷Renaissance manner. On Sangallo's death the palace was unfinished, and Michelangelo was appointed to complete it. Michelangelo was responsible for the balcony, the large coat of arms, the cornice and the upper storey in the main courtyard. ▷Annibale Carracci decorated the interior with ▷frescos.

Farnese Hercules

Colossal marble statue, signed by the AD 3rd-century Athenian sculptor Glycon and made for the Baths of Caracalla, Rome. It is believed to be an enlargement of a smaller Greek original by ▷Lysippus or his school. It is first recorded in 1556 in the Palazzo Farnese, Rome. The head, according to Guglielmo della Porta, was found in a well in Trastevere six years before the torso was found in the Baths in 1546. It was displayed in the courtyard of the Palazzo, with legs added by Guglielmo. These legs were retained even after the original legs were found shortly afterwards, apparently following ▷Michelangelo's advice that it would 'show that works of modern sculpture can stand comparison with those of the ancients' (Baglione, *Le Vite de' pittori scultori . . .*, 'Lives of Painters, Sculptors, and Architects', Rome, 1642). In 1787 the original legs were finally restored and the statue transferred to Naples. By 1792 it had been placed in the future Museo Nazionale, Naples, where it remains to this day; by 1802 the bronze fig leaf had been added. The heavily-muscled ▷Hercules is represented standing, leaning on his gigantic club, the golden apples from the Hesperides Garden behind his back in his right hand. On the whole, greatly admired from the time of its discovery until the end of the 19th century, the heavy musculature has, however, engendered adverse criticism from those who considered it unclassical and brutish. Oddly, the physique did not upset the arch ▷Neoclassicist ▷Winckelmann who accepted the exaggeration as poetically acceptable, whereas ▷Hogarth thought the muscles 'finely fitted for the purposes of the utmost strength the texture of the human form will bear' (▷*Analysis of Beauty*, 1753). Copies and, especially, reductions, enjoyed a tremendous vogue throughout the 17th and 18th centuries, while in 1717 in Wilhelmshöhe Park, near Cassel, a copper enlargement 9.20 metres high was erected on a pyramid-shaped pavilion 63 metres high.

Bib.: Haskell, F. and Penny, N., *Taste and the Antique*, New Haven and London, 1981

fasces

Originally a bundle of birch or elm rods bound around an axe, it was the ensign of a senior Roman magistrate's authority, carried before him in procession by his attendant. The rods and axe represented his right to impose corporal punishment by scourging or capital punishment by beheading. From the early Republic onwards, fasces carried within Rome omitted the axe, and so representations may be of either type. A fasces sometimes appears as an attribute of the personification of Justice.

fascia (pl. fasciae)

In Classical architecture of the ▷Ionic and ▷Corinthian orders, each of the two or three horizontal bands of the ▷architrave. The bands slightly overlap, perhaps suggesting their origin in timber buildings where courses of weatherboarding would have been employed to protect the wooden roof beams supported by the columns.

Fassbender, Joseph (1903–74)

German painter. He studied in Cologne. In 1929 he won the Villa Romana prize, which enabled him to travel to Florence. He developed an abstract style of art which had a naturalistic basis.

Fattori, Giovanni (1825–1908)

Italian painter. He studied in Florence, and was involved in fighting for the liberation of Italy during the Risorgimento. He painted military scenes and peasant landscapes, and became involved with the ▷Macchiaioli. His combination of patriotic activity and Italianate subject matter made him one of the figureheads of Italian art after the unification of Italy in 1871.

Fautrier, Jean (1898–1964)

French painter. He was brought up in London from 1909, and studied at the ▷Royal Academy of Arts and the ▷Slade, before returning to Paris in 1917. He illustrated Dante's *Inferno* in 1928 with ▷lithographs, in a style anticipating ▷Art Informel. He gave up painting in the 1930s, but resumed it during the Second World War, when he produced a series of heavily ▷impastoed and painted panels, *Otages*, whose subject matter and technique aroused great critical interest when first exhibited at the Galerie Drouin in 1945. Built up in layers of thick paint and rag paper, with a simple outline sketched on the final layer, the small panels depicted the half-obliterated remains of human faces, creating what Malraux called 'hieroglyphs of pain' and marking 'the first attempt to dissect contemporary pain, down to its tragic ideograms'. Fautrier's manipulation of physical matter as the expressive basis of art, and the dislocation of image from form, became the defining characteristics of ▷Art Informel and ▷Art Autre. The Galerie Rive Droite mounted a retrospective 'Fautrier: 30 années de figuration informelle' ('Fautrier: 30 Years of Informal Figuration') in 1957, and he won the Grand Prize at the Venice ▷Biennale in 1960.
Bib.: Cabanne, P., *Jean Fautrier*, Paris, 1988; Paulhan, J., *Fautrier l'enragé*, Paris, 1962; Peyre, Y., *Fautrier ou les outrages de l'impossibles*, Paris, 1990

Fauvism

A term developed from the critic Louis Vauxcelles' derogatory description of ▷Matisse, ▷Derain, ▷Vlaminck and others as 'fauves' (wild beasts) when they exhibited at the ▷Salon d'Automne of 1905. Fauvism was a short-lived and loose grouping of artists who shared an interest in strong, pure colour, and flat pattern and anti-naturalism. They were inspired by ▷Post-Impressionism, particularly the ▷Synthetism of ▷Gauguin and ▷Divisionism, and there are similarities with ▷Symbolist groups like the ▷Nabis. Like the Post-Impressionists, their subject matter was landscape- and figure-based, and appears almost as an escapist rejection of modernity. Matisse, who might be considered the leader of the group, was taught by ▷Moreau, alongside ▷Rouault, and from 1900 he collaborated with ▷Marquet. In 1904 he met ▷Signac at St. Tropez and began to experiment with divisionism, and the following year he went with Derain to Collioure. Previously Derain had worked with Vlaminck, who painted at many of the old ▷Impressionist haunts around Paris. Meanwhile ▷Dufy was producing similar, though more softly-toned works in Northern France. Fauvism was therefore a series of collaborations. It failed to survive the development of ▷Cubism, which lured artists with its more radical ideas (▷Braque and ▷Metzinger had exhibited with the Fauves).

Fauvism is often associated with ▷Expressionism, although it had none of the harshness of German art of the period. Certainly it influenced ▷Kandinsky, ▷Marc and others. It was also popular in Britain among artists of the ▷London Group and ▷Bloomsbury Group (▷Grant).
Bib.: Duthuit, G., *The Fauvist Painters*, New York, 1950; Elderfield, J., *The Wild Beasts*, New York, 1976; Oppler, E.C., *Fauvism Re-examined*, New York, 1976; Whitfield, S., *Fauvism*, London, 1989

Favrile glass

A type of glass made with many different colours. The name was coined by ▷Tiffany in the 1890s to describe his own ▷Art Nouveau productions.

Fayum (Faiyum) portraits

Fayum is a part of Egypt known for portraits which were painted on mummies. The portraits were possibly done in ▷encaustic or ▷tempera, and they were strikingly realistic.
▷Egyptian art

Feast in the House of Levi

Painted by ▷Veronese in 1573, this was a controversial work which led to the artist being put on trial by the Venetian Inquisition. The painting was commissioned for the refectory of SS. Giovanni e Paolo in Venice. Its original subject was ▷The Last Supper, and in the work Veronese attempted to enliven the biblical story by creating a crowded and complex scene of festivity. Not simply content with representing the Biblical narrative, in which Christ reveals that one of his disciples will betray him, Veronese loaded his painting with

people, animals and an atmosphere of opulence, characteristic of much of his earlier secular work. His complex organization of space and symbolic use of ▷perspective (placing Christ at the perspectival centre of the composition), and his knowledge of ▷Palladio's architecture in his theatrical use of space, were important features of the work.

However, certain breaches of ▷decorum led Veronese to be denounced to the Inquisition, and he appeared before the Inquisitors on 18 July 1573. The Inquisitors objected to the painting because they claimed it was filled with 'buffoons, drunkards, Germans, dwarfs and other such scurrilities'. The reference to Germans hinted at the contemporary ▷Counter-Reformation anxieties about the Protestant ideas of Martin Luther filtering into Italy. In defending his work, Veronese claimed that the number of figures was due entirely to the size of the work and his desire to decorate it 'as he saw fit'. This statement is conventionally seen to represent Veronese's views about the role of the artist, although this is a Post-▷Romantic interpretation.

The Inquisition demanded that Veronese make changes to the subject to render it a more appropriate depiction of The Last Supper, but Veronese chose merely to change the title to *Feast in the House of Levi*, another biblical feast scene. As this feast was attended by 'publicans and sinners' as well as Christ, the indecorous elements of the composition could be allowed.

Feast of the Rose Garlands

Painting by ▷Albrecht Dürer, produced in Venice in 1506 and now in the Prague Museum. The work was commissioned as an ▷altarpiece by the German merchant community in Venice and intended for the church of San Bartolomeo where some of their members were buried. It shows Pope Julius II, the Emperor Maximilian and Cardinal Grimani of Venice at the head of a large group of worshippers paying homage to the ▷Virgin Mary, the Christ child, and ▷St. Dominic, the founder of the cult of the rosary. From these three, mankind receives the blessing of the rosary in the symbolic form of rose garlands. Other characters in the group have been identified as portraits of donors, and include a self-portrait of Dürer holding an inscription with his name and the year of painting. The painting reflects the influence of the great Venetian painter ▷Giovanni Bellini and is one of Dürer's most important religious group scenes.

Federal Art Project

A United States government agency established in 1935 to alleviate unemployment amongst artists by employing them on public projects. It was part of the New Deal, Franklin Roosevelt's plan to combat the effects of the Depression. The project can be seen as an umbrella term for a number of initiatives and was inspired by local schemes in the early 1930s, like the Gibson Committee in New York. The Mexican ▷mural programme of the 1920s was also an inspiration. In the winter of 1933–4 artists were given a weekly salary for work under the Public Works of Art Project, organized by Edward Bruces and Forbes Watson, which in 6 months helped over 3,000 artists and produced over 15,000 works on the theme of the American scene. The following year a Section of Painting and Sculpture was established at the Treasury, which organized projects until 1943: the Treasury Relief Art Project, run by Bruce, gave over 5,000 artists the chance of a monthly wage producing posters, decorating buildings and participating in exhibitions. Similar schemes were operated for writers and musicians. The project also had a general educative purpose: Holger Cahill organized a collection of American ▷folk art, and an Index of American Design was published. The project assisted and brought together many artists who became famous after 1945. **Bib.**: O'Connor, F.V., *Art for the Millions*, Greenwich, 1973

Federal Style

A style of architecture and decorative arts common in New England from c1789 to c1830. It was most dependent upon the ▷Neoclassicism of ▷Robert Adam. Its name derives from its association with the early days of the American post-Revolutionary federal government.

Feininger, Lyonsel (1871–1956)

American painter who worked in Germany. He was born in the United States but studied at the Hamburg ▷Kunstgewerbeschule in 1887. Feininger originally worked as a cartoonist in both America and Germany, where he contributed to the humorous magazines *Ulk* and *Lustige Blätter*. He visited Paris, and became influenced by ▷Cubism there. This was embodied in his art from 1911, when he exhibited at the ▷Salon des Indépendants. He was associated with the ▷Blaue Reiter group, and after the War taught at the ▷Bauhaus from early in its development. His paintings became increasingly abstract under the influence of Bauhaus theories. Throughout the 1920s he became increasingly interested in architectural form, and the geometric quality of medieval architecture began to dominate his work. With ▷Kandinsky, ▷Klee and ▷Jawlensky, he formed the ▷Blue Four in 1924. He returned to the United States in 1937 to escape Hitler. **Bib.**: Luckhardt, U., *Lyonsel Feininger*, Munich, 1989

Feke, Robert (fl 1740s)

American painter. Little is known about his life and career. He was based in Rhode Island and may have travelled to England. From c1741–50 he practised as an ▷itinerant portraiter along the East Coast. His portraits retain the awkwardness of the colonial style with a new emphasis on dress.

Félibien des Avaux, André (1619–95)

French theorist and writer, friend and biographer of
▷Poussin. He was historiographer in the French
Academy (▷Académie Royale) and supported the
▷Poussinistes in their dispute with the Rubenistes.
He is best remembered for his *Entretiens sur les vies et sur
les ouvrages des plus excellents peintres anciens et modernes
(Conversations on the Lives and Work of Outstanding
Ancient and Modern Painters)* (1666–88).

feminism

Since the 1960s feminist artists, critics and historians
have increasingly questioned and challenged traditional
notions of art and the role of the female artist. They
criticised the art world for focusing on a grand manner
of academicism that has excluded women and using
'sexual difference as a basis for aesthetic valuations'
(Helen Chadwick). Whilst some female artists such as
▷Frida Kahlo and ▷Georgia O'Keeffe have been
accepted into the ▷canon of 'great artists', feminist
art historians have challenged this very notion of artistic
valuation and production. Turning to theories of struc-
turalism, ▷psychoanalysis, ▷semiology and ▷Post-
structuralism, they have attempted to break down cat-
egories of 'privileged' art forms, focusing on the very
idea of what it means/meant to be a woman in patri-
archal society. Critics such as ▷Hélène Cixous and
▷Julia Kristeva used the psychoanalysis of ▷Lacan to
examine ideas of sexuality, society and the body,
themes seen as important in female art. Feminist artists
have thus drawn on social and cultural experiences
such as violence and women's rights in their art, as
well as notions of power, ▷discourse and ▷ideology.
American artists such as ▷Mary Kelly and Barbara
Kruger have used language in art to challenge and
question images of women in society and the ▷mass
media, and campaigns such as the Guerrilla Girls in
New York in the late 1980s attacked the dominance
of male-produced art in museums and galleries. The
photography of ▷Cindy Sherman explores ideas of
female identity and representation in film and tele-
vision. Feminism in ▷art history has therefore a
number of directions, highlighting the place of women
in the whole corpus of art production, and exploring
the unique experience of female gender.
Bib.: Broude, N. and M. Garrard (eds.), *Feminism and
Art History*, New York, 1982; Chadwick, W., *Women,
Art and Society*; London, 1990; *Difference: On Rep-
resentation and Sexuality*, New York 1985; Nochlin, L.,
Women, Art and Power, 1988; Pollock, G., Vision and
Difference: *Femininity, Feminism and Histories of Art*,
London, 1988

femme fatale

(French, 'fatal woman'.) A phrase used to refer to
dangerous or evil women. It came into frequent cir-
culation during the last decades of the 19th century,
when this type of woman became very common in art

and literature. In art, historical and biblical figures
such as ▷Salome and ▷Judith, as well as the vaguely
vampiric women of ▷Rossetti and ▷Munch, were
examples of the type. ▷Symbolist art throughout
Europe is riddled with examples. The sudden popu-
larity of this type of woman coincided with the rise of
women's emancipation, and it is often seen to represent
the ambivalent response of male artists to the 'new
woman' who was both frightening and alluring.
Bib.: Dijkstra, B., *Idols of Perversity: Fantasies of Femi-
nine Evil in Fin-de-Siècle Culture*, New York, 1986

fenestration

The arrangement and design of windows in a building.

Ferguson, William Gouw (1632/3–c1690)

Scottish painter. He was in the Hague in 1660, where
he produced still lifes in a Dutch mode. He also worked
in Amsterdam and Utrecht. He was a rare example of
a British artist succeeding abroad at a time when British
art was dominated by foreign influence.

Fergusson, John Duncan (1874–1961)

Scottish painter. He received no formal training, but
came under the influence of ▷Whistler and, later, the
▷Fauves. From 1907 to 1912 he exhibited at the
▷Salon d'Automne and the ▷Allied Artists' Associ-
ation. From 1910 he began concentrating on painting

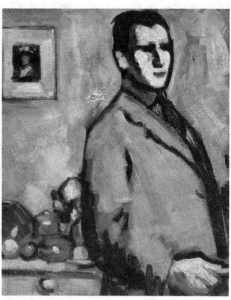

John Duncan Fergusson, *Self-portrait*, Fine Art Society, London

the nude, but his primary interest was formal rhythm
and colour. Between the Wars he travelled extensively,
and after 1940 he spent much of his time in Glasgow.
Bib.: *Colour, Rhythm and Dance: Paintings and Drawings
by J.D. Fergusson and his Circle in Paris*, Edinburgh, 1985

Fernández, Alejo (c1470–1543)

Spanish painter. He may have been of German origin, but he worked in Seville in a Flemish ▷Mannerist style.

Fernández (Hernandez), Gregório (1576–1636)

Spanish sculptor. He produced monumental sculpture for religious processions, but was best known for his wooden religious sculpture produced primarily in Valladolid. His works were characterized by their realistic portrayal of their subjects.

Ferrara, School of

The name given to a group of artists who practised in Ferrara during the second half of the 15th century. Their style was severe and took on elements of both ▷Gothic and ▷Renaissance art. ▷Tura, ▷Ercole de'Roberti and ▷Costa were among the most notable of this school, and many of them obtained patronage from the ▷Este family. The severity of the Ferrarese style was softened towards the end of the century, and by the 16th century, it was no longer so distinctive.
Bib.: Gardner, E., *The Painters of the School of Ferrara*, London, 1911; Southorn, J., *Power and Display in the Seventeenth Century: The Arts and their Patrons in Modena and Ferrara*, Cambridge, 1988

Ferrari, Gaudenzio (1471/81–1546)

Italian painter. He was from Lombardy. His works are eclectic, taking on the influence of ▷Leonardo, ▷Perugino, ▷Correggio and contemporary German art. He produced chapel ▷frescos in Vercelli and Varallo, as well as other fresco cycles in towns near the Swiss border. His works are characterized by their crowded compositions.

ferro concrete

A type of concrete containing iron bars which reinforce it. It was first used extensively in ▷modernist architecture.

festoon

A ▷carved or ▷moulded decoration representing a garland of flowers, fruit and leaves (or any combination), hanging in a curve from ribbons attached to each end. Also called a swag, it is frequently used in ▷frieze decorations.

fête champêtre

(french, 'outdoor feast'.) A type of painting representing a group of courtiers or townspeople enjoying a picnic, making music, dancing, and courting in an idyllic pastoral setting, the most notable example being that formerly ascribed to ▷Giorgione, now usually given to ▷Titian, the *Concert Champêtre* (Paris, Louvre).

fête galante

(French, 'courtship feast'.) A term invented by the French Academy (▷Académie) in 1717 to describe ▷Watteau's reception piece to the Academy that year, ▷*Embarkation to the Island of Cythera* (Paris, Louvre). From then on it was used to describe the characteristic paintings of Watteau and his followers, ▷Lancret and ▷Pater, which featured courtiers in masquerade costume or ball dress dancing and courting in a parkland setting.

Fet(t)i, Domenico (c1589–1624)

Italian painter. He worked in Rome and studied under ▷Cigoli. There he became interested in ▷Caravaggio's ▷chiaroscuro, but he also absorbed the rich colourism of ▷Elsheimer. He produced ▷genre scenes and religious works which emphasized genre elements. From 1613 to 1622 he was court painter to Vincenzo Gonzaga at Mantua. From 1621 he worked in Venice.

fetish

Originally fetish meant an inanimate object worshipped by 'primitive' people as having inherent spiritual or magical powers. It has since been used in psychology to refer to a non-sexual object which produces an abnormal sexual stimulus in an observer. More widely, it refers to any object that is objectified and venerated for its own sake, set apart to be looked upon; for example, ▷Duchamp 'fetishized' everyday objects in his ▷ready-mades.

Feuchtmayer, Joseph Anton (1696–1770)

German sculptor and stuccoist. He was responsible for much of the ▷Rococo decorative work in German pilgrimage churches.

Feuerbach, Anselm (1829–80)

German painter. He studied at the Düsseldorf Academy, as well as at Antwerp, and at Paris with ▷Thomas Couture. His academic training formed the basis of his style, which was ▷Neoclassical and idealistic. From 1855 to 1873 he lived in Italy, where he painted many large works with Classical and historical themes. He was particularly interested in Venetian ▷Renaissance art, and he adopted Venetian colourism in his own works. His distinctive monumental canvases never gained him the reputation he wished for, and he complained vociferously about this neglect in his published autobiography *Ein Vermächtnis* (*A Testament*, published 1882). In 1873 he took a post as Professor of History Painting in Vienna.

Fielding, Anthony Vandyke Copley (1787–1855)

English painter. He was from a family of painters. He studied with ▷Varley and, like his master, specialized in watercolour painting of the Lake District and Wales.

In 1831 he became President of the Old Watercolour Society.

field painting
▷colour field painting

figurative art
A representational painting in which figures or objects are portrayed as they might appear in nature, or as they appear to an artist who wishes to execute a painting with commonly understood external references. Although as a term, representational painting is generally to be preferred to figurative art, the latter retains currency as specifically identifying an artist's concern with the human figure. Thus ▷Francis Bacon and ▷Henry Moore are figurative artists.

Filanov, Pavel Nikolaevich (1883–1941)
Russian painter and graphic artist. He studied in St. Petersburg and joined the ▷Union of Youth in 1910. His interest in abstraction resulted in his theory of 'Analytical Painting', and he never became part of ▷Constructivist or ▷Productivist movements. In 1925 he founded a school in Petrograd, where he perpetuated his theories. His work increasingly resembled that of ▷Paul Klee.

Filarete (Antonio Averlino) (c1400–c1469)
Italian sculptor and architect. He was born in Florence. His main work as a sculptor is the set of bronze west doors for ▷St. Peter's in Rome (1433–45), comprising three panels in each leaf: stiffly frontal, wilfully archaic images of the ▷Salvator Mundi and ▷Virgin at the top, then standing images of Sts Peter and Paul, and at the bottom, their martyrdoms. On the stripes between the main panels is depicted Pope Eugenius IV's attempt to unite the Eastern and Western Churches. Although he may have been rained in ▷Ghiberti's workshop, nowhere in these panels can there be seen anything of the fluency or invention of his supposed master (that the panels should have been at all acceptable perhaps indicates Rome's artistic backwardness at this time). He subsequently fled from Rome, accused of stealing a relic from S. Giovanni in Laterano. From 1451 he was engaged by ▷Francesco Sforza as an architect, designing and commencing the building of the Ospedale Maggiore in Milan (not completed until the 18th century). The Ospedale is important in that it helped to introduce ▷Brunelleschi's ▷Renaissance style to northern Italy. Under Sforza's patronage he also published the work for which he is chiefly remembered: his treatise *Il trattato d'architettura* (1461–4). A truly eccentric work, it contains, however, a remarkably ambitious diagram of an ideal city, named Sforzinda after his patron, and representing the earliest known symmetrical town plan of modern times. ▷Vasari remained unimpressed, considering that it was 'probably the most ridiculous and silly book that was ever produced'.
Bib.: Filarete, A.A., *Treatise on Architecture*, New Haven, 1965; Quadflieg, R., *Filarete's Ospedale Maggiore in Mailand*, Cologne, 1881

filigree
Open-work decoration made from wires and small balls of metal soldered together to form jewellery or decorative objects. Gold and silver are the usual metals used in filigree, but ▷bronze and other metals have also been used since classical times.

fin de siècle
(French, 'end of the century'.) The term refers to a state of mind/culture that is perceived to be characteristic of the anxiety in cultures/civilizations facing the end of one period of history and the dawn of a new century. In the 19th century it referred to the 'decadent' art of Oscar Wilde, ▷Aubrey Beardsley, ▷Odilon Redon and the ▷Symbolists. It is characterized by an apparent obsession with sexuality and death (e.g. Bram Stoker's novel *Dracula*, 1897) and anxiety over traditional morality, identity and behaviour (e.g. Robert Louis Stevenson's *Dr. Jekyll and Mr. Hyde*, 1886).
Bib.: West, S., *Fin de Siècle: Art and Society in an Age of Uncertainty*, London, 1993

fine art
Painting, sculpture and architecture were not considered by the ancients to be amongst the ▷Liberal Arts, although they were distinguished from mere craftsmanship. A similar confusion existed in the Middle Ages, and the 'intellectualization' of the arts. Their promotion to 'fine' – rather than 'applied' (▷decorative arts) – was sanctified by theorists of the ▷Renaissance from ▷Alberti and ▷Leonardo to ▷Vasari, and stamped with the approval of the ▷academies.

finial
In architecture, an ornament, frequently in the form of a fleur-de-lis, erected at the apex of a ▷pediment or ▷gable, the tip of a ▷spire or pinnacle, or at each corner of a tower.

Finiguerra, Maso (1426–64)
Italian goldsmith. He was from Florence, and a pupil of ▷Ghiberti. He worked largely in ▷niello and used copper ▷engraving.

Finlay, Ian Hamilton (b 1925)
British artist. He was born in Nassau, Bahamas, in 1925 and brought up in Glasgow. He briefly attended the Glasgow School of Art, before being called up for active service in 1942. Working as a shepherd and agricultural labourer in Scotland after the Second World War, he started having his short stories, short

plays, and poems published in the 1950s. In 1961 he founded the Wild Hawthorne Press with Jessie McGuffie, publishing Finlay's work and other innovative and experimental poetry. From the mid-1960s he started creating poems to be set in the environment, and became interested in the concrete poetry movement. Much of his work is created in collaboration with a range of artists and craftspeople, using stone, metal, ▷ceramics, and neon to create ▷Neoclassical signs and images that often comment on revolutionary and idyllic themes. Mixing classical typography with modern imagery such as the battleship, submarine, and submachine gun, his allegorical and symbolist works allude to historical moments such as the ▷French Revolution, the Second World War, and Nazism. His concrete works are often supported by documentary or written material that are integral to their meaning. The abandoned croft in the Southern Uplands he settled in with his wife in 1966 has been landscaped and developed into a renowned sculpture garden known as the Little Sparta Temple Garden. In its consideration of the man-made landscape and the ▷sublime, it has been likened to the 18th-century landscaped gardens of Stowe and Stourhead. He was shortlisted for the Turner Prize in 1985.

Bib.: Abrioux, Y., *Ian Hamilton Finlay: A Visual Primer*, London, 1992

firing

A process of heating clay or enamel in a kiln. It is designed to harden the heated substance to make ▷ceramics.

First Laethem Group

▷Laethem-Saint-Martin

Fischer von Erlach, Johann Bernhard (1656–1723)

Austrian architect. With his chief rival ▷Lucas von Hildebrandt, they were the leading architects of the Imperial ▷Baroque style in Austria. Fischer and his generation finally superseded the Italians who had dominated 17th-century Austrian architecture. Born near Graz, he was trained first as a sculptor, before going to Italy (c1674), where he stayed for a number of years and was impressed with the work of ▷Bernini, but above all by ▷Borromini and ▷Guarini. He settled in Vienna in 1685 and was appointed Court Architect in 1704. His first important building was the Schloss Frain in Moravia (1690–94). Three of his churches in Salzburg show Italian influence (especially that of Borromini): the most heavily influenced being the Dreifaltigkeitskirche (1694–1702); then the Kollegienkirche (1694–1707), in which his own style begins to assert itself; and the Ursulinenkirche (1699–1705). His masterpiece, the Karlskirche in Vienna (begun 1716), has a Pantheon-type portico flanked by two replicas of Trajan's column, preceding the main

oval body of the building surmounted by an oval ▷drum and ▷dome. From 1689 he was architectural tutor to the future Joseph I. Fischer von Erlach's secular architecture includes the ▷façade and monumental staircase with ▷atlantes of the Stadtpalais of Prinz Eugen, Vienna (1695–8); the Palais Batthyány-Schönborn, Vienna (c1700); the Palais Clam Gallas, Prague (1707–12); the Palais Trautson, Vienna (1710–16); and the Hofbibliothek in the Hofburg, Vienna, begun 1723 and finished by his son Joseph Emanuel (1693–1742). He was knighted by the Emperor in 1697, at which point he assumed the title 'von Erlach'.

Bib.: Brilliant, L., *Johann Bernhard Fischer von Erlach and Political Rhetoric under Karl VI, 1712–22*, Ottawa, 1992; Lorenz, H., *Johann Bernhard Fischer von Erlach*, Zurich, 1992

Fitzwilliam Museum

Founded in 1816 to house the collection bequeathed to Cambridge University by Viscount Fitzwilliam. The imposing building was designed successively by Basevi, Cockerell and Barry, completed in 1875, and has since been added to considerably. The collection contains ▷Egyptian, ▷Greek and ▷Roman antiquities; medieval and ▷Renaissance objects, including ivories, enamels and scientific instruments; French, Italian, Dutch and Flemish paintings; a library of musical manuscripts; and the Henderson Collection of armour.

Five Senses

The five senses – sight, hearing, taste, smell and touch – have been frequently represented either combined in one painting, or as a series. Originally, the personifications were women engaged in activities related to each of the particular senses. Thus Sight would be a woman gazing into a mirror or, less frequently, holding a torch (light being necessary for sight). Hearing would be a woman playing a musical instrument; Taste, a woman holding a basket of fruit; Smell, a woman holding a bunch of flowers, or occasionally a jar of perfume; and Touch, a woman stroking two contrasting animals, a hedgehog (sharp spines) and an ermine (soft fur). Animals might also be used to symbolize the senses, such as an eagle or a lynx (Sight), a stag (Hearing), an ape eating fruit (Taste), and a dog (Smell). The Five Senses was a popular theme with 17th-century Flemish and Dutch painters who might populate a tavern scene with figures that could be read as personifications: drinkers tasting their ale, pipe smokers enjoying the smell of their tobacco, men and women touching amorously, and musicians entertaining the crowd with the sounds of their music. Numerous individual pictures have been interpreted as surviving parts of series representing the Five Senses, such as ▷Frans Hals' *Boy Drinking* and *Boy Holding a Flute*, c1626/8, Schwerin, Staatliches Museum.

5 × 5 = 25

An exhibition held in Moscow in September 1921. Each of the five organizers contributed five works each, hence the title. Those involved were ▷Rodchenko, ▷Stepanova, ▷Popova, ▷Exter and Alexander Vesnin (1883–1959). The exhibition was to be the declared end of easel painting, and all the artists concentrated on ▷'laboratory art' which would have a use in post-Revolutionary Russia.

fixative

A resinous ▷binder suspended in a volatile solvent, sprayed over ▷chalk, ▷charcoal or ▷pastel drawings to protect them from rubbing.

Flagellation

(Matthew 27: 26; Mark 15: 15; Luke 23: 16, 22; John 19: 1) A scene from Christ's ▷Passion, immediately before the ▷Mocking of Christ. ▷Pontius Pilate, the Roman governor of Judaea, could not find that Christ's crime was capital and wanted simply to have him scourged. However, the demands for Christ's death from the chief priests and elders, and the shouts from their supporters in the mob outside, were so insistent that Pilate washed his hands of all responsibility for Christ's death and sent him to be scourged prior to his crucifixion. Despite the very brief matter-of-fact accounts in the ▷gospels, it was a scene that greatly exercised the minds of Christian writers who needed to partake of Christ's suffering. Thus, a tradition of vivid representation which was almost always adhered to, developed. The gospels state that the scourging took place in Pilate's palace, so Christ was shown tied to a ▷Corinthian-style column in a Roman hall. The artistic problem was to show the incident without obscuring his face, so he is either tied with his hands around a slim column in front of him, being whipped across the back (e.g. *Parement de Narbonne*, c1375, Paris, Louvre), or with his hands bound to a column behind him being whipped across his front (e.g. ▷Lorenzo Ghiberti, north Baptistry doors, Florence). He is stripped, but for a loincloth, and his torturers are generally two or three in number.

Flamboyant style

(French, 'flaming'.) Architectural term coined by the early 19th-century French antiquarian, Arcisse de Caumont, to denote the final phase of French ▷Gothic architecture, lasting from c1370 until the 16th century, when it was supplanted by the ▷Renaissance style. De Caumont categorized the Flamboyant style purely on the basis of its ▷tracery, which is the major innovation from the preceding ▷Rayonnant period. The tracery, which decorates both windows and wall surfaces, consists entirely of reversed curves whose opposition forms elegantly sinuous flame-like patterns. Principal examples are: Rouen Cathedral's west front (c1370, its first known appearance) and Tour de Beurre; the rose windows of Beauvais, Évreux, and Sens cathedrals; the north tower of Chartres; and the west fronts of Troyes Cathedral (c1507) and La Trinité, Vendôme. Built entirely in the Flamboyant style are the Church of Notre-Dame-de-l'Épine, near Chalons, and the Churches of S. Maclou (1432–1500) and S. Ouen (1318–1515), both in Rouen. It was also used for secular buildings, the finest examples being the House of Jacques Coeur at Bourges (1442–53) and the Law Courts of Rouen (1499–1509).

Flanagan, Barry (b 1941)

British sculptor. He studied at the St. Martin's School of Art from 1964–6. There he began experimenting with environments and three-dimensional abstract works. He also used film and all types of sculptural media. During the 1970s he produced sculptures in metal and stone which contained witty references to works of the past. The variety of his work, and his tendency to blend traditional reference with abstraction and the use of environment, indicates his flexibility.

Bib.: *Barry Flanagan: Prints 1970–1983*, exh. cat., London, 1986

Flandrin, Hippolyte (1809–64)

French painter. He was born in Lyons and studied there before becoming a pupil of ▷Ingres in Paris (1829). He won the ▷Prix de Rome in 1832, and was influenced by the ▷Nazarenes in Rome as well as by ▷Renaissance painting. His work was influenced both by his teacher and by his stay in Italy, and he developed a clear, detailed but rather cold style (e.g. *Christ and the Little Children*, 1839, Lisieux). He was sought after for large-scale decoration and ▷frescos (St. Vincent de Paul, 1849–55; St. Germain des Pres 1842–6, 1856–61), but also produced ▷history paintings and portraits, especially of women and children. He became official portraitist to Napoleon III (e.g. 1860–61, Versailles). His brothers, Auguste (1804–43) and Paul (1811–1902), were also painters of portraits and landscapes respectively, and his son, Paul-Hippolyte (1856–1921) followed in his footsteps.

Bib.: *Hippolyte Flandrin*, exh. cat., Lyons, 1984

Flaxman, John (1755–1826)

English sculptor, draughtsman and designer. He was a ▷Neoclassical artist who enjoyed a European reputation such as no English artist had before. The son of a moulder of plaster casts, he enrolled at the ▷Royal Academy schools in 1770 and met his life-long friend ▷William Blake there. From 1775 to 1787 he was employed by Josiah Wedgwood as a modeller of friezes for his Neoclassical pottery. With Wedgwood's help Flaxman went to Italy in 1787, staying on until 1794, studying and making drawings of everything from the antique to ▷Bernini whose work he incidentally professed to detest (sketchbook in London, Victoria and

Albert Museum). During his period in Rome he illustrated the *Iliad* and the *Odyssey* (engraved and published 1793). These drawings, employing a simplified graceful line, suggest a close study of ancient Greek vases, whilst also owing a debt to his years working for Wedgwood. They effectively secured his European reputation, their influence later being particularly noticeable in the work of ▷Ingres and the ▷Nazarenes. There then followed illustrations to Aeschylus (1795) and Dante (1802) and, rather later, Hesiod (1817, engraved by Blake). Whilst still in Rome, Flaxman was awarded two extremely prestigious commissions, the monuments to the poet William Collins (1795, Chichester Cathedral) and to Lord Mansfield (1795–1801, Westminster Abbey). Following his return, he established a large and successful practice and secured the commission for the most important of the Napoleonic war monuments in ▷St. Paul's, that to Lord Nelson (1809). While these rather cumbersome memorials are little regarded today, his more intimate monuments enjoy an undiminished reputation. Among the best is his monument to Agnes Cromwell (1797–1800, Chichester Cathedral), in which the beautiful low relief carving of the soul of the deceased being borne up to heaven by angels, gives freest rein to his feeling for the rhythmic qualities of line. Flaxman was elected RA in 1800 and appointed the Royal Academy's first Professor of Sculpture in 1810 (his lectures were published posthumously in 1829). A large collection of his drawings and plaster models is held in University College, London.
Bib.: Bindman, D. (ed.), *John Flaxman*, London, 1979; Irwin, D., *John Flaxman*, London, 1979

Flemish art
▷Belgian and Flemish art

Flemish primitives
▷primitivism

Flight into Egypt
The episode in the ▷Gospels when Joseph, warned in a dream of Herod's ▷Massacre of the Innocents, takes Mary (▷Virgin Mary) and ▷Christ to Egypt for safety. Although only briefly narrated in the Gospels, the story was elaborated in apocryphal works and became a popular one in art from the 11th century, although it was first recorded as early as the 8th century (S. Maria Antigua, Rome). Traditionally, Joseph is shown leading Mary on a donkey, sometimes guarded by an angel (e.g. ▷Gentile da Fabriano, 1423, Strozzi Palace, Florence). The scene was elaborated in the early ▷Renaissance with the presence of a midwife, Salome, an ox or Joseph's three sons. Often it took place at night, as specified in the Gospels. A background cornfield illustrated the miracle of Mary making corn grow overnight to persuade people to keep silent. By the ▷Counter-Reformation, the

family usually travelled on foot, to emphasise their humility; and from the 17th century they were often shown being ferried across a river (e.g. ▷Poussin, c1629, Cleveland). Increasingly artists used the subject as an excuse to paint landscape, with the figures playing an ever more minor role (e.g. ▷Carracci, c1604 Rome; cf. ▷Goncharova, 1908, private collection).

The Rest on the Flight was also a common scene, being a chance simply to portray a devotional image of the Holy Family and to experiment with landscape (e.g. ▷Altdorfer, 1510, Berlin; ▷Cranach, 1504, Berlin). They might be seated under a palm (symbol of both the ▷Passion and of Mary), or surrounded by broken fragments (broken idols as mentioned in ▷Matthew). The Return from Egypt has also been illustrated, usually similar to the flight, but for the presence of an older Christ, and possibly ▷John the Baptist.

Flinck, Govert (1615–60)
Dutch painter. He specialized in large historical subjects and portraits. He first trained with L. Jacobsz at Leeuwarde, but later moved to Amsterdam and, in the early 1630s, trained under ▷Rembrandt, whose manner he adopted so closely that works formerly attributed to his master have now been reassigned to him (e.g. *Rembrandt wearing a Cap* and *The Good Samaritan*, both London, Wallace Collection). Always more inclined than his master to elegance of execution, his first successes date from the mid-1640s when he adopted the smoother, more fashionable manner of ▷Rembrandt's principal rival, ▷Bartholomeus van der Helst. A measure of his success is that it was he, and not his former master, who was awarded the most prestigious public commission of the day: the decoration with twelve pictures of Amsterdam Town Hall. Unfortunately, Flinck died within three months of signing the contract, and only then was the commission given to Rembrandt who had to share the work with ▷Levens and ▷Jordaens.
Bib.: Gorissen, F., *Govert Flinck: Der kleefsche Apelles 1616–60*, Amsterdam, 1965

Flint, Sir William Russell (1880–1969)
British graphic artist and painter. He was particularly known for his ▷watercolours. He was educated at the Royal Institute in Edinburgh 1895, at Heatherley's Art School in London from 1900 and learnt etching at Hammersmith School of Art. He first made his name as a book illustrator and won a silver medal at the 1913 Paris ▷Salon for his illustrations of *Morte d'Arthur*. He visited Italy in 1912–13 and developed a popular watercolour style specialising in gypsies and mildly erotic subject matter, but he also worked in a topographical style (e.g. *Beach by the Faroes*, 1920, London, Victoria and Albert Museum). He was elected ▷RA in 1924 and was President of the Royal Society of

Painters in Watercolour (1936–54). He wrote an auto-biography, *In Pursuit*.

Bib.: Lewis, R., *William Russell Flint*, Edinburgh, 1980

Flora

(Greek 'Chloris'.) The ancient Italian goddess of flowering or blossoming plants, associated with spring-time. Her prototype, the Greek Chloris, was married to Zephyr, the west wind which ushers in springtime. In the *Fasti*, Ovid tells how Chloris fled initially from Zephyr, but he caught up with her, embraced her and, as flowers spilled from her mouth, she was transformed into Flora. This was the source for the image in ▷Botticelli's ▷*Primavera* (c1478, Florence, Uffizi). Representations of Flora as an alluring young woman have been popular since the ▷Renaissance. Often the picture is intended as a tribute to the sitter, as in ▷Rembrandt's painting of his wife, Saskia, as Flora (London, National Gallery). The sitter may be holding a posy or basket of flowers, while more flowers are garlanded in her hair.

Floris, Cornelis (Floris de Vriendt) (1514–75), Frans (Frans de Vriendt) (1516–70)

Flemish family of artists and architects. Cornelis worked as an architect and sculptor. On a trip to Italy, he came into contact with ▷Renaissance architecture, and he returned to Antwerp to design the Town Hall (begun 1561) with deliberate Renaissance motifs. He also produced a collection of ▷engravings of Italian architecture which served as a pattern book for his Flemish contemporaries. His brother Frans also travelled to Italy in 1542–7, but he worked as a painter. He was particularly impressed with ▷Michelangelo's *Last Judgement* in the ▷Sistine Chapel, and on his return to Antwerp, he adopted a ▷Mannerist style following Michelangelo's influence.

Flötner, Peter (c1495–1546)

German sculptor and engraver. He worked primarily in Nuremberg, and he produced a number of fountains. A visit to Italy in 1530 led him to adopt an Italian ▷Renaissance manner.

fluting

Parallel grooves or channels, of rounded section, running vertically on the ▷shaft of a ▷column or a ▷pilaster. In classical architecture, flutes are never used in the ▷Tuscan order and are optional in the ▷Doric, ▷Ionic and ▷Corinthian orders. In the Doric and early Ionic orders, each adjacent flute meets at a single ridge called an arris; in the developed Ionic and Corinthian orders, the arris of each adjacent flute is separated by a flat band called a fillet. Fluting with the lower part filled with a moulding of cylindrical section is called cabled fluting.

Fluxus

A group of artists who joined together in Germany in 1962. This group, which included ▷Beuys, assumed an anarchist stance by objecting to the professionalization of the art market.

Bib.: Kellein, T., *Fluxus*, London, 1995

flying buttress

A typical feature of ▷Gothic construction, a flying buttress is an ▷arch or half-arch, abutted to a building and carried on a ▷pier or other outer support. It is employed to counteract the lateral thrust received by the upper walls from a pitched roof or ▷vault and to transmit the thrust along the sloping span of the arch and downwards through the vertical support to the foundations.

▷buttress

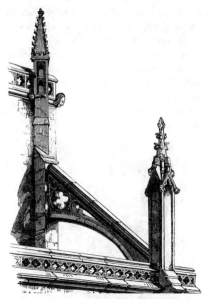

Flying buttress, Sherborne Church, Dorset, c1450

Focillon, Henri (1881–1943)

French art historian and Professor of Art History at the Sorbonne, Paris. Although his interests were wide-ranging, including the study of Buddhist, ▷Japanese and graphic art (his father was an ▷engraver), he focused on medieval art in *Art des sculptures romans (The Art of Romanesque Sculptors*, 1931) and *Art d'Occident (Art of the West*, 1938). With his *Vie des formes (The Life of Forms in Art*, 1934), these books expound his view that understanding the technical possibilities of an age is a prerequisite to understanding its art.

foil

An ornament formed by inscribing tangential part-circles within a larger circle or ▷arch, forming a

pattern of cusps and lobes. A three-lobed pattern of this type is called a trefoil; four-lobed, a quatrefoil; five-lobed, a cinquefoil, etc. A characteristic decoration of ▷Gothic architecture, especially ▷tracery.

foliation

Ornamental decoration, using the shape of leaves and other vegetation. It was particularly popular as a carved motif on masonry in the Middle Ages. For example, capitals at Canterbury and those from ▷Cluny demonstrate this. The term also refers to manuscript decoration, specifically to the decoration of initial letters without using figuration.

folk art

A term used to describe art and artefacts made within the parameters of rural craft industries by artisans with little or no interest in emulating ▷fine art production. Thus woodwork, fabrics and pottery decorated with the traditional designs of a region, reflecting the interests and tastes of that community, are typical folk art products. It is a characteristic of folk art that it remains largely uninfluenced by fine art movements (there is no ▷Baroque period of folk art, for example), but finds its continuity in the self-sufficient craft practices of rural communities.

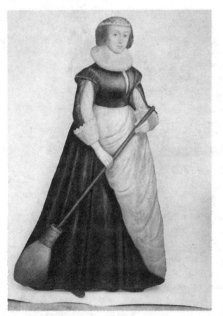

Folk art: Jacobean dummy-board figure of maidservant, mid-17th century, Victoria and Albert Museum, London

font

In a Christian church, a basin, usually of stone, for the water used in baptism.

Fontainebleau, School of

There were two Schools of Fontainebleau:

(i) The First School of Fontainebleau, active from c1530 to c1560, had its origins in the interior decorations for the Galerie François I (1533–40). This was carried out by a group of Italian artists, ▷Niccolò dell' Abbate, ▷Primaticcio and ▷Rosso Fiorentino, brought in by François I as there was no existing indigenous tradition of interior decoration to equal the kind found in the grander and more fashionable Italian *palazzi*. These artists combined painting, ▷stucco, sculpture, metalwork and woodwork in a rarefied elegance deriving from ▷Parmigianino and hitherto unseen outside Italy. The Italian artists not only adapted their style to French courtly taste, but French and Flemish artists assisted them on the decorations and thus a distinctively French style, based on Italian ▷Mannerism, was disseminated throughout France. The most important French painter to be influenced by the school was ▷Jean Cousin the Elder.

(ii) The Second School of Fontainebleau was formed in the second half of the 16th century during the reign of Henri IV, as an attempt to revive French interior decoration after the disruption of the Wars of Religion. The Salle Ovale at Fontainebleau is the most important example of the Second School. Unfortunately, the work of the leading artists of this school – ▷Ambrose Dubois, ▷Toussaint Dubreuil, and ▷Martin Freminet – is all now rather obscure, and never rose above the mediocre.

Bib.: Leveque, J.J., *L'École de Fontainebleau*, Neuchâtel, 1984

Fontana, Prospero (1512–97) and Lavinia (1552–1614)

Italian family of painters. Prospero was from Bologna, but worked in Florence, Genoa and Rome, as well as producing some commissions at Fontainebleau. His more distinguished daughter Lavinia studied with ▷Vasari, and produced fashionable portraits and religious works. She adopted a Florentine ▷Mannerist style in her portraits. She worked in Bologna, but she lived in Rome from 1603. In addition to her notable work as a painter, she had eleven children.

Fontana, Lucio (1898–1968)

Italian sculptor and painter. He was born in Argentina to Italian parents (his father was a sculptor), and he settled in Milan in 1905. He studied art at the Brera Academy, and had his first exhibition of sculpture in Milan in 1930, which marked the first appearance of non-figurative sculpture in Italy. In 1934 he joined ▷Abstraction-Création, and in 1935 was a signatory to the first manifesto of Italian abstract artists. In 1937 he exhibited abstract ceramics at the Galerie Bucher in Paris. From 1940–46 he returned to Argentina and taught at the Altamira Academy in Buenos Aires, from where, in 1946, he published *Manifesto Blanco*, which

anticipated the ideas he would pursue with ▷Spazialismo, the movement he founded on his return to Milan in 1947. In 1949 he created a 'Spatial Environment': a room painted black and 'lit' by black light, investing art with a social dimension, which makes the art a concept rather than a saleable product. Fontana is perhaps best known for his series of slashed and pierced monochrome canvases, *Concetti Spaziali*, where the Informel gesture creates and defines space. In 1960 he began to create massive oval-shaped sculptures, with their characteristic slash.

Fontana anticipated the ideas of art as ▷performance, concept and ▷environment, and although creating no school, his ideas were influential upon emerging ▷avant-garde groups, such as the German group ▷Zero.

Bib.: *Lucio Fontana 1899–1968: A Retrospective*, exh. cat, New York, 1977; de Sanna, J., *Lucio Fontana: materia, spazio, concetto*, Milan, 1993

Foppa, Vincenzo (c1427–1515/16)

Italian painter. He was born in Brescia, but most of his working life was spent in Milan and Pavia. Under the influence of ▷Mantegna and the ▷Bellini family he produced a number of religious works, including ▷frescos for churches. He was one of the most important Lombard artists of the 15th century, but his importance was eclipsed when ▷Leonardo came to Milan in 1481.

Forain, Jean-Louis (1852–1931)

French painter and illustrator. He was originally from Reims. He studied at the ▷École des Beaux-Arts with ▷Gérôme. Under the influence of ▷Daumier, he produced ▷caricatures for journals, for which he focused on scenes of contemporary Paris life.

Forbes, Stanhope Alexander (1857–1947)

English painter. He was born in Dublin and studied at Lambeth School of Art and at the ▷Royal Academy (1876–8), before travelling to Paris where he worked under ▷Bonnat. In 1881 he worked with ▷La Thangue in Brittany, sketching peasant subjects ▷*plein air* in a Realist style influenced by the French artist ▷Bastien-Lepage (e.g. *Street Scene in Brittany*, 1881, Liverpool, Walker). In 1884 he settled in Newlyn, Cornwall, and produced a series of carefully observed but monumental records of life for the fishermen there (e.g. *Fish Sale on a Cornish Beach*, 1885, Plymouth). He became the unofficial leader of the ▷Newlyn School, a group of artists with similar aims including Bramley, Gotch, Langley and his wife, Elizabeth Armstrong. In 1899 they together founded a formal School of Art at Newlyn. He continued to visit France during the 1890s but increasingly his style moved away from the light, grey tones and square brushwork of his youth to a more vigorous, strongly coloured and naturalistic one. He increasingly concentrated on interiors (e.g. *Health of the Bride*, 1889, London, Tate). He exhibited

regularly at the RA from 1878, although he was initially viewed as a radical (he was one of the original members of the ▷NEAC) and was not elected RA until 1910.

Bib.: Birch, L., *Stanhope Alexander Forbes, ARA, and Elizabeth Stanhope Forbes, ARWS*, London, 1906; Hind, L.C., *Stanhope Alexander Forbes*, London, 1911; *Painters in Newlyn 1880–1930*, exh. cat., London, 1985

Forces Nouvelles

A group of artists exhibiting together in Paris from the mid-1930s. The group included Robert Humblot (1907–62), Georges Rohner (b 1913) and Jacques Despierres (b 1912). They were in favour of naturalism at a time when Parisian art was dominated by abstract art and ▷Surrealism. Their exhibitions of 1935 and 1936 contrasted directly with the ▷Constructivist emphasis of the ▷Abstraction-Création group.

forechurch

▷antechurch

foreground

That part of a painting which seems closest to the ▷beholder. Most usually it is identical with the picture plane, but artists have presented objects that appear to project out into the beholder's space, as with the tombstone in ▷Caravaggio's *Entombment* (1604).

foreshortening

The artistic contrivance by which an object is portrayed with the apparent shortening due to visual ▷perspective.

forgery

An art work that purports to be by someone it is not, or has claimed for it a false age or ▷provenance. The practice of forgery is as old as collecting, and 'original' forgeries are known from the ancient Roman world. Modern techniques of microscopy, X-ray, infra-red, ultra-violet and carbon dating make detection easier. Forgery itself raises questions over the importance of the art market and ▷connoisseurship, and the place of the artist as the creator of original work.

formalism

An approach to the appreciation and evaluation of an art work based on the exclusive consideration of the qualities of line, colour, mass or volume that the work exhibits. The strengths of the approach reside in its ability to confront the art work without recourse to non-figural qualities. Thus, for example, we might say that ▷Leonardo's *Last Supper* is a planimetric composition articulated through a linear rather than a ▷painterly handling, offering a typically ▷Renaissance solution to the problem of the representation of a crowded interior. What this analysis does not give us is the religious significance of the subject matter, any

indication of the critical fortunes of the painting, its social context, aesthetic appeal or the nature of the symbolism.

Formalism however, was particularly useful when, at the beginning of the 20th century, art history was searching for a critical framework that offered the scope to analyse all visual artefacts, irrespective of their time and place of making. The art historian ▷Wölfflin was particularly instrumental in developing this approach in books such as *Principles of Art History* (1915). Other notable practitioners have included ▷Roger Fry and ▷Clive Bell, who promoted ▷Post-Impressionism on largely formalist grounds, and towards the middle of the 20th century, ▷Clement Greenberg, who used a formalist critique to argue for the superiority of ▷modernism over the narrative painters of the 19th century.

Bib.: Bell, A.C., *Art*, 1914 ed. J.B. Bullen, Oxford, 1987; Fry, R., *Cézanne*, London, 1927; Greenberg, C., *Art and Culture: Critical Essays*, Boston, 1965

Fortitude

One of the four ▷Cardinal Virtues, along with ▷Justice, ▷Prudence and ▷Temperance. Fortitude encapsulates strength, endurance and courage, and is sometimes represented as an armoured and helmeted female, carrying a sword or a shield or both. Her ▷attributes are derived from biblical and mythical exemplars: a broken column refers to Samson who prayed to God for strength before destroying the Philistines' palace by pulling down the supporting columns, knowing he would also die himself (Judges 16: 28–30). A club and lion's skin refer to Hercules. On many ▷Renaissance tombs (e.g. ▷Pietro Lombardo, The Monument to Pietro Mocenigo, Venice, SS Giovanni e Paolo) actual scenes from the Labours of ▷Hercules (in this case *The Nemean Lion* and *The Lernaean Hydra*) are represented in order to invest the memory of the deceased with the fortitude associated with Hercules. Sometimes Fortitude may be accompanied by a lion, traditional symbol of strength. ▷Giotto's figure of Fortitude (c1305–06) in the ▷Arena Chapel, Padua, is a female wearing a cuirass and lion-skin mantle, wielding an iron cudgel, and standing behind a full-length shield decorated with a rampant lion.

Foster, Myles Birkett (1825–99)

English painter and book illustrator. He was born in North Shields, to a Quaker family. He trained as a ▷wood engraver and produced illustrations to Longfellow's poetry. During the 1850s he was employed by the *Illustrated London News*. But from 1858 he increasingly worked in ▷watercolours and became very popular for his pictures of English rustic life which concentrated on cottage gardens and leafy lanes. Their style was recognizable and partly determined by his training, making use of stippling and precise detail. They often included children, and a standardized,

picturesque view of rolling wooded countryside around his Witley home from 1863 (e.g. *Children Running Down Hill*, 1886, London, Victoria and Albert Museum). The house was decorated in a ▷Pre-Raphaelite style and was treated as a artistic centre. He went to Venice with Fred Walker and ▷Orchardson in 1868 and produced some 50 views of the city (e.g. *Grand Canal Venice*, London, Victoria and Albert Museum). Although he produced some oils, these were less successful. He exhibited over 400 works with the Old Watercolour Society. He knew and influenced ▷Helen Allingham.

Bib.: Huish, M.B., *Myles Birkett Foster, His Life and Work*, London, 1890

Foucault, Michel (1926–1984)

French philosopher. He was an important advocate of ▷Structuralism. He studied under ▷Althusser. His work is important for his non-economic analysis of power, which he saw based on knowledge and the 'principle of exclusion' by which society uses knowledge to define itself and exclude sections from it. This he explored in works on the history of madness (*Madness and Civilization*, 1965) and of prisons (*Discipline and Punish*, 1977). In *The Archaeology of Knowledge* (1972) he stressed the importance of language for the development of self-consciousness. He also disputed the idea of a 'genius' author, who preceded the text and existed as a private individual. For him the individual was merely an ideological construct. He also wrote a *History of Sexuality* (3 vols, 1978–87).

▷auteur theory

Bib.: McNay, L., *Foucault: A Critical Introduction*, London, 1994; Rainbow, P., *A Foucault Reader*, New York, 1991

Foujita, Tsuguharu (Léonard) (1886–1968)

Japanese artist living in France. He studied at the Tokyo Imperial Academy of Fine Arts from 1906 to 1910. In 1913 he moved to Paris and remained there, except for a return to Tokyo during the Second World War. He painted ▷Expressionist works which could be broadly considered as part of the ▷School of Paris. He specialized in nudes and his works show some attention to his Japanese artistic heritage. He converted to Roman Catholicism in 1959 and he changed his name to Léonard in homage to ▷Leonardo da Vinci.

found object

▷*objet trouvé*

Fou(c)quet, Jean (c1420–81)

French painter. He was from Tours, but he travelled to Rome (1443–7) where he absorbed some Classical influence into his art. This Classical tendency manifested itself in the sculptural forms which dominated his painting. He produced some important illuminated manuscripts, including the *Book of Hours* for Étienne

Chevalier, and in 1475 he became Royal Painter to Louis XI. His monumental figures were probably seen to best effect in his ▷altarpieces, in which he also used ▷perspective – most likely derived from Italian theory. Although no altarpieces are securely attributed to him, works such as the *Melun Diptych* are most likely from his hand.

Bib.: Perls, K.G., *Jean Fouquet*, London, 1940; Schaefer, C., *Jean Fouquet an der Schwelle zur Renaissance*, Dresden, 1994

Four Elements

Fire, Water, Air and Earth usually represented as females or associated with particular gods/goddesses. They were often mentioned in classical literature and Aristotle associated them with the four humours which affect personality. They were commonly seen in Italian ▷Renaissance art, in Northern European genre painting and in ▷*fêtes galantes*.

Earth was associated with fertility, represented by a cornucopia, by a mother suckling several children, or by a general harvest scene or sheaf of corn. The Phrygian earth mother, Cybele, recognizable by her turreted crown and the Roman goddess, Ceres, accompanied by a snake, were popular personifications. Air was sacred to ▷Juno and associated with her or her symbol, the peacock. She was suspended with anvils tied to her feet as a punishment by her husband ▷Jupiter and may be shown thus. According to tradition the chameleon lived on air and both it and birds, together with windmills, bubbles and other objects, are often symbolic of the element. Fire was linked to Vulcan, recognized by an anvil or a thunderbolt, and commonly depicted making Aeneas' armour under the eyes of ▷Venus and ▷Cupid. A flame-headed woman or a phoenix, said to rise from the ashes, are also common symbols. Water was associated with ▷Neptune or any of his attendant Tritons, ▷nereids, dolphins or sea centaurs. Specific rivers were often shown by a male figure holding an overflowing urn. Anglers were a more earth-bound representation (e.g. ▷Albani, 1626–8, Turin, Gallery Sabanda).

Four Seasons

The cycle of the seasons has been a popular theme in visual art since late antiquity. Each season may be personified as a woman: Spring is a young woman, lightly clad, with garlands in her hair, flowers bunched in her hands, and sometimes also a spade or hoe; Summer has a sickle, sheaves of corn and sometimes fruit; Autumn has grapes and vines; Winter is an old woman, thickly wrapped against the cold. Thus, the Four Seasons are often linked to the passage of time from youth to old age in an individual life. Alternatively, the seasons may be represented in a more naturalistic way as landscapes populated by people performing the labours of those seasons.

Four Temperaments

In the Middle Ages, man was seen as a microcosm of the universe whose behaviour was determined by his physiology which was, in turn, subject to planetary and, to a lesser extent, terrestrial influences. Four different kinds of behaviour or temperament were recognized. Each was governed by the preponderance within the body of one of four particular fluids, or humours, secreted by organs. Individuals, because of astrological influences, would be naturally inclined throughout their life to one particular temperament. The four temperaments are: Phlegmatic, caused by a preponderance of phlegm in the body; Sanguine, by blood; Choleric, by bile (or choler); and Melancholic, by black bile. Each of the Four Temperaments was in turn related to the ▷Four Seasons, the ▷Four Elements and four animals whose nature was thought to exemplify the specific temperament: Phlegmatic to winter, water and the lamb; Sanguine to spring, air and the ape; Choleric to summer, fire and the lion; and Melancholic to autumn, earth and the pig. The Four Temperaments are occasionally personified in medieval ▷Books of Hours, but only Melancholy enjoyed a separate existence which lasted into ▷Renaissance times. Melancholy, the daughter of Saturn, was of gloomy and introspective temperament. This introspection was equated with contemplation and thus naturally became associated with philosophers, poets and artists. Melancholy is generally represented as a winged woman seated at a table surrounded by books and accompanied by a dog (replacing the pig). She leans her head on her hand in a pose which becomes standard for all representations of someone in contemplative pose. There may be a skull on the table, signifying, as in a ▷*vanitas*, the futility of her efforts to understand all. The most famous representation is perhaps the ▷engraving by ▷Dürer (1514): Dürer's *Melancolia I* holds a pair of compasses, whilst on the ground there are some solid geometrical objects, signifying that she is also a geometer (Geometry being the ▷Liberal Art over which Saturn presided). Also littered on the ground are carpenter's tools, carpenters also being the children of Saturn.

Fragonard, Jean-Honoré (1732–1806)

French painter. He was an important practitioner of the ▷Rococo style. He was born in Grasse, the son of a glovemaker, and moved to Paris in 1838. There he studied with ▷Boucher in 1747, under whom he won the ▷Prix de Rome (e.g. *Jeroboam Sacrificing the Golden Calf*, 1852, Paris, École des Beaux-Arts), ▷Van Loo (1753–6), and then spent 5 years in Italy. There he was influenced by ▷Tiepolo and ▷Murillo, but also spent time travelling, with ▷Robert, and absorbing the landscape (e.g. *Gardens of the Villa d'Este*, 1762, London, Wallace Collection). He originally worked in the ▷grand manner, producing the *High Priest Coresus Sacrificing Himself to Save Callirhöe* (Paris,

Louvre) in 1765, with considerable success, but increasingly he turned to small scale, landscape subjects, peopled with lovers (e.g. *Swing*, 1767, London, Wallace Collection). He ceased to exhibit at the ▷Salon in 1767 and relied on private patrons, including the royal favourite Mme du Barry (although his *Progress of Love* series for her home was rejected). After his marriage in 1769, he favoured family scenes and children (e.g. *Cradle*, 1790, Amiens). He returned to Italy in 1773. During the ▷French Revolution he lived in poverty in Grasse until offered a position in the museums service by ▷David. He died forgotten, having outlived the Rococo. His works were rarely dated and are consequently difficult to place in chronology.

Bib.: Wildenstein, G., *Paintings of Fragonard*, London, 1960; Wakefield, D., *Fragonard*, London, 1976; Rosenberg, P., *Fragonard*, New York, 1987

Frampton, Sir George (1860–1928)

English sculptor and craftsman. He worked firstly in an architect's office, then for a firm of architectural stone carvers, before training at the Lambeth School of Art and then, from 1881–7, at the ▷Royal Academy schools. In 1887 he won the RA gold medal and travelling scholarship. He visited Paris in 1888–90, studying sculpture under Antoine Mercié and gaining a gold medal in the 1889 ▷Salon. In the 1890s he became involved in the ▷Arts and Crafts Movement and wrote influential articles on enamelling, woodcarving and ▷polychromy, in addition to actually producing works in those categories. His bust, *Lamia* (ivory and bronze with opals, 1899–1900, exhibited RA), one of the major works of the ▷New Sculpture movement, shows not only an expressive use of polychromy, but also the influence of French ▷Symbolism. Frampton was a member of the Art Workers Guild from 1887 and a Master from 1902. He was elected ▷ARA in 1894 and RA in 1902. In 1908 he was knighted. From 1911 to 1912 he was President of the Royal Society of British Sculptors, having been a founder member. Such recognition brought increasing public commissions, mostly dated from after 1900.

Bib.: Beattie, S., *The New Sculpture*, New Haven and London, 1983

France, art in

Although there was much important ▷Carolingian and Merovingian architecture from the geographical area now known as France, the dominance of France in terms of European art dates from the 10th century when a number of important ▷Romanesque churches were built. The architecture of ▷Cluny, St. Pierre at Moissac and Vézeley is as distinctive as the sculpture of these three famous buildings. By the 12th century, the relative wealth of France and the theological importance of scholasticism resulted in a series of ▷Gothic cathedrals which combined architectural innovation

with arcane religious ▷iconography. The cathedrals of Notre-Dame in Paris, Chartres, ▷Reims and ▷Amiens contained naturalistic sculpture and richly coloured stained glass. The French Gothic cathedral became increasingly lighter and airier with new techniques of ▷buttressing and ▷vaulting allowing for taller buildings with larger windows. By the 13th century, Paris had become a centre of European art – a role it retained, with some gaps, up to the 20th century.

During the 14th and 15th centuries, France's relationship with ▷Burgundy, to a certain extent, eclipsed its own contribution to art, as Flemish influence crept into the art of, for instance, ▷Jean Fouquet at Tours. ▷Renaissance art flourished under the patronage of Charles VIII and Francis I, the latter of whom brought a number of important Italian artists to ▷Fontainebleau, where the ▷Mannerism of ▷Rosso and ▷Primaticcio became the sign of a new secularised art. Chateau building also flourished during this time, and some of the most distinctive French contributions to the Renaissance were in the form of chateau architecture.

The 17th century witnessed a period of increasingly centralized power as Henry IV altered the appearance of Paris through an implementation of a grand ▷Baroque style. The relationship with Italy was particularly strong during this period, and artists such as ▷Poussin and ▷Claude spent much of their careers there. Louis XIV added an extra layer to the art world when he oversaw the creation of the ▷Académie Royal, and, with Colbert as his administrator, he created a shrine to his own absolutist rule at Versailles. The painting, sculpture, architecture, decorative arts and garden design at Versailles were all geared to convey Louis' power, but this power was eclipsed by his own ineffectiveness and the greater influence of non-aristocratic citizens.

The grand Classical Baroque style of the late 17th century yielded to the lighter paintings of the ▷Régence period (1715–23), when works by ▷Watteau were popular, and bourgeois patronage expanded. At this time, the rigid ▷hierarchy of genres erected by the Académie Royale was undermined by the predominance of the ▷genre painting of Watteau and the still lifes of ▷Chardin and ▷Oudry. The fading importance of Versailles led to much private building in Paris, and houses were decorated in the new accessible ▷Rococo style. Under Louis XV (reigned 1715–74), the Rococo continued to flourish, not least because of the support of his mistress Madame de Pompadour, but under Louis XVI (reigned 1774–93), a new sobriety led to the colder ▷Neoclassicism of ▷David.

To an extent, art became deregulated in the 19th century, as private art dealers proliferated and bourgeois patrons gained the dominant position once held by the court. The best academic art was never stultified, as the ▷Romantic essays of ▷Géricault, ▷Delacroix

and ▷Ingres indicate, while landscape painting was reformed by the experiments of the ▷Barbizon school. By the end of the 19th century rebellion against the hegemony of the Academy and the ▷Salon had led to the ▷Realist exhibition of ▷Courbet and the ▷Impressionist exhibitions, while a series of individualist artists, such as ▷Cézanne and ▷Seurat, carried out experiments in colour and form that were crucial to the development of early 20th-century art. While ▷avant-garde artists were breaking new ground, academic art continued to have a crucial role in French art life of the late 19th century. Many important European artists were trained at some point in their careers by ▷Gérôme and ▷Bouguereau at the ▷École des Beaux-Arts, and the rural realism of ▷Bastien-Lepage was popular throughout Europe.

In the early 20th century, Paris became the centre of painting and sculpture in Europe, as artists flocked from all over the world to attend its exhibitions and meet other artists who lived there. ▷Fauvism, ▷Cubism and ▷Orphism all began in Paris, while foreign artists of the ▷School of Paris adopted individualistic ▷Expressionist styles. Although the First World War to an extent interrupted the artistic authority of Paris, this power was regained after the War, when ▷Surrealism was founded in the city. Artists continued to play out their debates about abstraction and realism in Paris, and during the 1930s, the ▷Forces Nouvelles and ▷Abstraction-Création groups revealed just how diverse the attitudes towards art could be.

The dominant style after the Second World War was ▷Tachism, but by this time France had lost its central place in world art to New York.

Bib.: Blunt, A., *Art and Architecture in France 1500 to 1700*, 4th edn, Harmondsworth, 1980; Collier, P. and R. Lethbridge (eds), *Artistic Relations: Literature and the Visual Arts in Nineteenth-Century France*, New Haven, 1994; Johnson, D., *The Age of Illusion: Art and Politics in France 1918–1940*, London, 1987

Francesco di Giorgio Martini (1439–1501/2)

Italian painter, sculptor, architect, military engineer and theorist. He was one of the leading figures of the Sienese ▷Renaissance. Trained in the workshop of ▷Vecchietta, his sculpture, like that of his master, was influenced by ▷Donatello (e.g. *The Flagellation of Christ* bronze relief, Perugia, Pinacoteca) and his paintings, mostly dating from the early part of his working life, by ▷Filippo Lippi. However, both influences were assimilated into a totally Sienese style, marked by a poetic mysticism characteristic of that city. In the Pinacoteca at Siena are two documented paintings, the *Coronation of the Virgin* (1471) and the *Nativity* (1475, signed). He was in Urbino by 1477, working for Federigo da Montefeltro as a military engineer, fortifications expert and medallist. In 1485 he returned to Siena, and it is from this period that his

two bronze angels (1489–97) on the high altar of the Duomo date. In his final years he wrote an architectural theses, *Trattato di architettura civile e militare (Treatise on Civil and Military Architecture*; not published until 1841), based on Vitruvius and ▷Alberti, but of a more practical nature, a copy of the manuscript of which was owned by his friend, ▷Leonardo da Vinci. He may have contributed to the design of the Palazzo Ducale at Urbino, but only one building can be confidently ascribed to him – the church of Sta Maria del Calcinaio, near Cortona (1485–1516).

Bib.: Betts, R.J., *The Architectural Theories of Francesco de Giorgio Martini*, Ann Arbor, 1977; *Francesco di Giorgio*, exh. cat., Milan, 1993; Toledano, R., *Francesco di Giorgio Martini, pittore e scultore*, Milan, 1987; Volpe, G., *Francesco di Giorgio architecture nel Ducato di Urbino*, Milan, 1991

Francia (Francesco Raibolini) (c1450–1517)

Italian goldsmith and painter. He was from Bologna. He met ▷Costa in 1483 when the latter artist visited Bologna, and he adopted the softer style of the School of ▷Ferrara. His style was further softened when he came into contact with the work of ▷Perugino and ▷Raphael, and Francia became one of the most important Bolognese artists of the early 16th century.

Franciabigio (Francesco di Cristofano) (c1482–1525)

Italian painter. He was from Florence, and was a pupil, until c1506, of ▷Albertinelli. ▷Franciabigio shared a workshop with ▷Andrea del Sarto, their styles at this time being rather similar, though with Andrea, the greater talent, ultimately leading the way. Franciabigio was also heavily influenced by ▷Raphael, his *Madonna del Pozzo* (Florence, Accademia) being so deliberately ▷Raphaelesque that it was once attributed to him. Andrea and Franciabigio each executed ▷frescos in the ▷atrium of the church of SS Annunziata, Florence; Franciabigio was responsible for the fresco of the *Marriage of the Virgin* (1513). In 1518–19, during Andrea's temporary absence on a trip to Paris, Franciabigio executed two scenes in Andrea's fresco cycle of the *Life of St. John the Baptist* in the Chiostro dello Scalzo, Florence. Franciabigio's most accomplished works are generally considered to be his portraits (e.g. *Knight of Rhodes*, London, National Gallery).

Bib.: McKillip, S.R., *Franciabigio*, Berkeley, 1974

Francis of Assisi (c1182–1226)

The founder of the Franciscan order of Friars Minor, recognizable by their brown or grey habit and girdle of three knots (representing the vows of poverty, chastity and obedience). He is often shown bearing the ▷stigmata (the wounds of the crucifixion), holding a skull (mortality) or a ▷lily, and within a landscape

(e.g. ▷Bellini, 1485, New York, Frick Collection). The colourful narrative of his life was popular during the ▷Renaissance. He came from a rich family, but sold his possessions to restore a church and, after a dream, sought permission from the Pope to preach. He tried to convert the Sultan during the crusades by offering to walk through fire; tamed a wolf; made birds fly in the shape of a cross; inspired a female follower in St. Clare; received the stigmata on Mount Alverna which doubters then touched and performed miracles, like getting water from a rock. The similarities with the life of ▷Christ made this narrative all the more powerful (e.g. ▷Giotto, 1290s, Assisi; ▷Sassetta, 1337–44, London, National Gallery). By the ▷Counter-Reformation, devotional images of St. Francis had become more popular (▷El Greco painted over 50; cf. ▷Zurbarán, 1739, London, National Gallery). Here he was shown kneeling in penitence and prayer (e.g. ▷Carracci, *Holy Family and St. Francis*, 1591, Cento).

Francis, Sam (b 1923)

American painter. He took up painting as therapy in hospital in San Francisco between 1943 and 1947, whilst recovering from injuries sustained as a fighter pilot. He studied art at the University of California at Berkeley from 1948 to 1950, and influenced by ▷Gorky, ▷Still and ▷Rothko, he developed a style of ▷lyrical abstraction which became more gestural as he began to pour and spill paint. In 1950 he went to Paris, where he exhibited with the ▷Art Informel artists. A long stay in Japan, in 1957, led many to see in his work a Zen-like quality in which the empty spaces of the canvas balanced and controlled the areas of splashed and dripped colour. Francis declared his aim in painting 'to make the late ▷Monet pure', to produce a landscape of pure colour. Between 1956 and 1958 he painted a series of murals for the Kunsthalle in Basle. In 1962 he returned to live in Los Angeles. He had a retrospective at the Houston Museum of Fine Arts in 1967.
Bib.: Michaud, Y., *Sam Francis*, Paris, 1994; Selz, P., *Sam Francis*, New York, 1975

Francken, Frans I (1562–1616), Frans II (1581–1642)

Flemish family of painters. Frans I worked in Antwerp, where he produced small religious paintings with crowded compositions. His son Frans II often copied his father's work, but he also produced ▷genre scenes which were brightly coloured. He was one of the first artists to represent the interior of a picture gallery.

Frankenthaler, Helen (b 1928)

American painter. She studied art in Vermont and art history at Columbia University. She met ▷Clement Greenberg and became interested in ▷Abstract Expressionism. In 1958 she married ▷Robert Motherwell. Her work was a foretaste of ▷colour field painting. It consisted of large canvases which were ▷unprimed, so that the canvas showed through the thin paint that was applied to them. She often used ▷gestural techniques to smear or drip paint on the canvas. One of her most famous works was *Mountains and Sea* (1952). The use of naked canvas and large spaces of colour was influential on ▷Morris Louis and ▷Kenneth Noland. In recent years, she has become involved with theatre decoration and won many accolades as an artist.
Bib.: Rose, B., *Helen Frankenthaler*, New York, 1970

Frankfurt School

Otherwise known as the Institute of Social Research of the University of Frankfurt, founded in 1923. In 1933 the Institute was forced into exile in the USA by the Nazis, but it returned to Germany in 1949. The importance of the school for art history is that its ▷Marxism has had a massive impact on the study of the social sciences and humanities. Broadly speaking, the school places great importance on the transformative powers of the Marxist 'superstructure' (the cultural domain), thereby giving art much greater power than either economic liberal or hard-line Communists allowed. Members of the school of interest to art history include ▷Theodor Adorno, Herbert Marcuse and ▷Walter Benjamin.

Fréminet, Martin (1567–1619)

French painter. He spent 15 years of his life in Italy, where he adopted a ▷Mannerist style. In 1603 he went to work for Henry IV in France and was one of the most important artists of the Second ▷Fontainebleau School. He was responsible for the decoration in Trinity Chapel, Fontainebleau.

French, Daniel Chester (1850–1931)

American sculptor. He was born in New Hampshire, but lived in Massachusetts. In 1876 he went to Italy, where he became interested in public monuments. He took on a number of commissions for public academic monuments of American heroes. His statue of Abraham Lincoln (completed 1922) was one of his most famous works, but he also produced large-scale ▷allegorical sculptures, such as the *Minute Man*, which inspired a poem by Emerson.

French Revolution

Events of 1789–99 which led to the breakdown of *ancien régime* France, the overthrow and execution of Louis XVI, and eventually to Napoleon's coup. The period can also be seen to mark the end of the ▷Enlightenment, which to a certain extent had championed the policies of liberty, equality and fraternity which went so disastrously wrong in France, and is often quoted as being the beginning of 'modern' Europe. It had pan-European consequences, both as a

result of the wars waged by the aggressive revolutionary regimes, and because of *émigré* aristocrats spreading word of the Terror outside France. In England, some initial support amongst Whigs and Radicals (▷Blake), as well as the revolutionary rhetoric of Tom Paine and others, and the freshness of events in America, led to government fear of an uprising and consequently a series of repressive measures. In artistic terms, the Revolution is inseparable from the career and work of ▷David, who painted the major propaganda images of the new regime and organized its increasingly elaborate festivals and parades. He was also responsible for the reorganization of artistic institutions during the 1790s, spurred partly by his democratic sympathies but equally by personal pique over his treatment by the Académie. Thus, in 1790, he established the Commune des Arts as a rival to the official institution which was already being condemned as élitist; the following year he demanded an open Salon, breaking the Académie exhibition monopoly and establishing a precedent for the large-scale Salons of the 19th century; and in 1792 he established the Jury des Arts, a body which effectively took control of student prizes out of the Académie's hands. In 1793 the Académie was finally abolished, in favour of the more democratic Institut, a body which survived until 1816 with the establishment of the Académie des Beaux-Arts.

Bib.: Crow, T.E., *Emulation: Making Artists for Revolutionary France*, New Haven and London, 1995

fresco

(Italian, 'fresh'.) A method for painting walls and ceilings in which powdered ▷pigment, mixed only with water, is applied directly to unset ('fresh') lime plaster, thereby fusing with the surface. The great advantage is its permanence, for the painting will obviously last as long as does the plastered surface which, in a relatively dry climate, is a considerable time. Therefore fresco has been widely used in Italy (with the exception of maritime Venice), but seldom in the damper climate of northern Europe. The wet method is more specifically termed buon fresco or fresco buono, in order to distinguish it from fresco secco, in which the pigment is applied to set or dry laster (secco meaning 'dry'). Fresco painting was certainly used by the Minoans, and examples from Pompeii have also survived. The greatest examples are from Italy in the late Middle Ages and the ▷Renaissance: ▷Giotto's ▷Arena Chapel, ▷Masaccio and ▷Masolino's Brancacci Chapel, ▷Piero della Francesca's *Legend of the True Cross* in San Francesco at Arezzo, ▷Raphael's *Stanze* in the Vatican, and ▷Michelangelo's ceiling and *Last Judgement* in the ▷Sistine Chapel. The technique is thoroughly described by ▷Cennini in the *Libro dell'Arte* (c1400). The wall is first coated with a rough layer of plaster, called the ▷arricio or arricciato. Upon this, the design is drawn in ▷charcoal and then made permanent with a red ochre ▷pigment called ▷sinopia (this term is also used to refer to the underdrawing itself). Starting from the top of the wall (to avoid splashing and dripping onto painted parts), an area of smooth plaster (▷intonaco) is laid, concealing that part of the underdrawing, which now has to be redrawn onto the fresh intonaco. This area has to be finished in one day, before the plaster dries. Each of these areas is called a *giornata* ('day's work'). Any mistakes can be rectified only by removing the affected area of plaster and relaying it. A confident approach and an assured draughtsmanship is essential, and explains the prestige this method carried and why it was called *buon* ('true'/'good') and why ▷Vasari esteemed it so much more than fresco secco. However, many frescos employ both methods, for the range of colours usable in buon fresco is limited and, for example, where deep blue or gold were needed, additions in secco were unavoidable (hence the areas of loss where the ▷Virgin Mary's blue drapery has peeled away in Giotto's Arena Chapel). In fact, even Vasari's hero, Michelangelo, used secco to add gold decorations and other embellishments to the frescos on the Sistine Ceiling. The last great Italian master of fresco was, ironically, a Venetian, ▷G.B. Tiepolo, and although attempts were made to revive fresco in the 19th century, it was not until the twentieth century with the work of the great Mexican mural painters, ▷Orozco, ▷Rivera and ▷Siqueiros, that the method again came into its own.

Bib.: Borsook, E., *The Mural Painters of Tuscany*, 2nd edn, Oxford, Clarendon, 1980; Cennini, C., *The Craftsman's Handbook*, trans. D.V. Thompson, New York, 1960

Freud, Lucian (b 1922)

British artist of German birth. He is the grandson of ▷Sigmund Freud, born in Berlin but a naturalized UK citizen from 1939. He initially worked in Wales, a friend of the poet Stephen Spender and ▷Bacon. After being invalided out of the merchant navy in 1942, he became a full-time artist. His early work consisted of bleached colour and hard linear realism, particularly of people and plants combined in an almost ▷Surrealist manner (e.g. *Cock's Head*, 1952, London, Arts Council). From the 1950s he increasingly explored portraiture, producing physically truthful and meticulous studies (e.g. *Mother* series, 1971–3; *Girl and White Dog*, 1951–52, London, Tate; *Ester*, 1980, private collection). He won a prize at the 1951 Festival of Britain and has long been recognized as one of the leading contemporary artists, with a 1988 international retrospective. Increasingly his work has concentrated on the nude (e.g. *Two Men*, 1987–8, Edinburgh, Scottish Gallery of Modern Art), treating the human body in a deliberately objective, formal way which combined realism with a sensuality of paint surface.

Bib.: Hughes, R., *Lucian Freud*, London, 1987

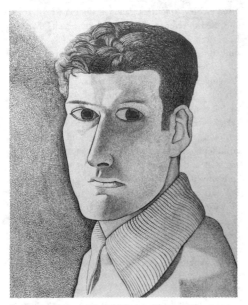

Lucian Freud, *Man at Night* (Self-portrait), 1947/48, private collection

He was politically committed, and after the German Revolution of 1917 he joined the ▷November-gruppe. A representation of one of his abstract figure sculptures was used for the cover of the ▷Degenerate Art exhibition catalogue, as it was seen to be representative of all the tendencies that Hitler most despised in modern art. He was a member of the ▷Abstraction-Création group. He died in a concentration camp.

Frick, Henry Clay (1849–1919)

American art collector. He was influenced by the tastes of ▷Roger Fry and ▷Joseph Duveen, and he collected both modern art and ▷Old Master works. On his death he left money and property which resulted in the Frick Collection, opened in New York in 1935.

Friedlaender, Walter (1873–1966)

Teacher of Panofsky at the University of Freiburg, but expelled by the Nazis in 1933, whereupon he emigrated to New York, and became professor at the university there. His works include *David to Delacroix* (1952) and *Mannerism and Anti-Mannerism in Italian Painting* (1957).

Freud, Sigmund (1856–1939)

An Austrian doctor and psychologist. He was born in Moravia, but trained and lived in Vienna. He developed a technique of free association to treat hysteria, and his case studies became the basis of most of his ideas. He believed that all mental events have meaning, even dreams and, therefore, the analysis of these is important (see *Interpretation of Dreams*, 1899). The unconscious was dynamic and represented the repression of desires, thus creating a tension and crisis in all civilized humans (*Civilization and its Discontents*, 1930). He stressed the importance of infantile experience (this recalled the early 19th-century emphasis on the importance of the child), particularly the sexual relationship between a child and its mother (Oedipus Complex); and of the importance of sexuality in general. Art, he believed, was created by the libido and was full of latent sexual symbolism. His work on civilization, mythology and anthropology was continued by his pupil, Jung. His ideas have had a profound affect on all 20th-century culture and thinking. He especially appealed to the ▷Surrealists, who attempted to reveal their subconscious in their art, and the ▷Abstract Expressionists. Later thinkers like ▷Lacan developed his ideas.
Bib.: Wollheim, R., *Freud*, London, 1974; Spector, J.J., *Aesthetics of Freud*, London, 1972

Freundlich, Otto (1878–1943)

German painter, sculptor and graphic artist. He studied in Paris from 1909 and became involved with the artists of the ▷Bateau-Lavoir. He was interested in ▷abstraction, and joined the ▷Cercle et Carré group.

Friedländer, Max J. (1867–1958)

German art historian and Wilhelm von Bode's successor as Director of the Berlin Gemäldegalerie. His scholarly monument is the fourteen volumes of *Die altniederländische Malerei (Early Netherlandish Painting*, 1924–37).

Friedrich, Caspar David (1774–1840)

German painter. He was a quintessential ▷Romantic landscapist. He was born at Greifswald, on the Baltic coast of Germany and studied at the Copenhagen Academy under ▷Abildgaard (1794–8), before settling in Dresden. He initially worked only in ▷sepia, producing topographical and minutely observed landscapes. From 1907 he produced oils and combined his naturalism with a personal and religiously motivated symbolism. Heightened colour, exaggerated distance, crisp detail and insignificant figures were his stock-in-trade, partly inspired by German artists such as ▷Altdorfer, partly by contemporary Romantic ideas of nature. In works like the controversial *Cross on the Mountains* (1908, Dresden), he promoted the natural, evergreen and sun-blest Protestantism; in comparison Catholicism was a ▷Gothic ruin, a man with a broken crutch. Later he expressed his liberal political ideas (e.g. *The Wreck of Hope*, 1824, Hamburg, Kunsthalle) and his personal life (he married in 1818) in a similar way (e.g. *Woman at the Window*, 1822, Berlin). His work inspired a group of contemporaries in Dresden and he knew ▷Goethe, but he was an introspective artist and his work was largely forgotten in the years after his death, until its rediscovery by the ▷Symbolists. He remained a dedicated observer of nature and

Caspar David Friedrich, *Self-portrait*, 1803, Kunsthalle, Leipzig

Sculpted frieze, Cathedral of St. Dimitri, Wladimir

made sketching trips to Pomerania (e.g. *Mountainous Landscape*, 1910, Munich). In 1835 a stroke reduced his ability and he returned to sepia, with works which increasingly concentrated on the inevitability of death.
Bib.: Borschsupen, H., *Friedrich*, London, 1974; *Friedrich's Winter Landscape*, exh. cat., London, 1990; Koerner, J.L., *Friedrich and the Subject of Landscape*, London, 1990

Friesz, Othon (1879–1949)

French painter. He studied at the École des Beaux-Arts in Le Havre and went to Paris in 1898. He exhibited at the ▷Salon des Indépendants in 1903, and adopted a ▷Fauvist style. He made contact with ▷Braque in 1906–7 and travelled with him to Le Ciotat and Cassis, where they both painted landscapes. His new formal interests led him away from Fauvist colourism. After the First World War, he lost some momentum.

frieze

In classical architecture, the middle horizontal member of an ▷entablature, below the ▷cornice and above the ▷architrave, usually decorated, occasionally plain. The ▷Doric frieze alternates ▷triglyphs and ▷metopes (such as the Temple of Zeus at Olympia), whilst an ▷Ionic or ▷Corinthian frieze has a continuous ▷relief (such as the Temple of Athena Nike, Athens). Also, a decorated band at the top of a wall immediately below the cornice.

Frink, Dame Elizabeth (1930–93)

British sculptor and graphic artist. She was born at Thurlow in Sussex and trained at Guildford and the Chelsea School of Art under Bernard Meadows. Her early work was influenced by ▷Moore and ▷Giacometti: angular and menacing bronze figures with touches of ▷Surrealism (e.g. *Horizontal Bird-Man*, bronze, 1964), like the use of goggles on her Algerian war figures. From the 1960s her work became smoother and more direct with a concentration on horses (e.g. *Rolling over Horse*, 1972) and male figures. She used exaggerated modelling and anatomy to try to express the inner spirit of the subject. She increasingly worked on public commissions (e.g. *Walking Man* for Salisbury Cathedral). She lived in Dorset, and became a Dame in 1982. In 1985 she was given a ▷Royal Academy retrospective.
Bib.: *Elizabeth Frink*, exh. cat., London, 1985

Frith, William Powell (1819–1909)

English painter. He was born in Aldfield, Yorkshire. He studied at Sass' Academy and at the ▷Royal Academy Schools (1837), where he worked with ▷Egg and ▷Dadd in the Clique, a drawing club. He exhibited at the RA from 1840, originally producing paintings inspired by literature (e.g. *Uncle Toby and the Widow Wadman*, 1865, London, Tate Gallery), but in 1851 turned to contemporary subjects for inspiration and produced a series of extremely popular panoramic scenes of life and human incident. *Life at the Seaside, Ramsgate Sands* (1852–4) was bought by Queen Victoria, and *Derby Day* (1858, London, Tate) had to be railed off at the Royal Academy such were the crowds.

These guaranteed his international reputation and, thanks to his exploitation of new steel engraving techniques, personal financial gain. His work always had a tendency towards anecdote and light ▷genre (e.g. *Sleepy Model*, 1853, London, Royal Academy), and increasingly he became moralising and repetitive. He wrote two autobiographies, *Reminiscences* (1887) and *Further Reminiscences* (1888), which showed his conservative artistic tendencies.

Bib.: Noakes, A., *Frith: An Extraordinary Victorian Painter*, London, 1978; West, S., 'Tom Taylor, 'William Powell Frith and the British School of Art', *Victorian Studies*, 33, no. 2 (Winter 1990), pp. 307–26

Froben, Johann (1460–1527)

German printer. He worked at Basel on the Amerbach Press producing high-quality books. He helped disseminate the ▷humanist ideas of such European writers as Erasmus.

Froment, Nicolas (fl 1450–90)

French painter. He was from Provence but worked in Italy for René of Anjou. Only two works of his are known: *Lazarus* (1461, Florence, Uffizi) and *Mary in the Burning Bush* (1475/6, Aix-en-Provence Cathedral). The latter was a particularly unusual subject of the time, combining New and Old Testament ▷iconography. His works show some sense of naturalism.

Bib.: Vaudoyer, J.-L., *Les peintres provençaux de Nicolas Froment à Paul Cézanne*, Paris, 1942

Fromentin, Eugène (1820–76)

French painter. He travelled to North Africa in 1846, 1848 and 1852, and he became one of a number of artists to adopt exotic subject-matter. His ▷orientalism inspired him to look to the paintings of ▷Delacroix. He was also a writer, and produced a novel, as well as books on Dutch and Flemish art.

Bib.: Mickel, E., *Eugène Fromentin*, Boston, 1981; Wright, B, and P. Moisy, *Gustave Moreau and Eugène Fromentin: Documents inédits*, La Rochelle, 1972

Fronte Nuovo della Arti (New Art Front)

A group of Italian painters and sculptors formed out of the Nuova Secessione Artistica Italiana (New Italian Art Secession) in 1946. They were dedicated to a post-war revival of French painting, and they had an idealistic desire to return art to more human values. They opposed the ▷modernist extremes of the ▷Art Informel group. They exhibited together at Milan in 1947 and the Venice ▷Biennale in 1948. They include ▷Birolli and ▷Guttuso.

Frost, Terry (b 1915)

English painter. He began painting in 1943 and became associated with the artists of ▷St. Ives from 1946. He studied under Pasmore at the Camberwell School of

Eugène Fromentin, *A Falcon Hunt in Algeria*, Musée d'Orsay, Paris

Art from 1947–50. He was also an art teacher.
Bib.: Brown, D., *Terry Frost*, exh. cat., London, 1976

frottage

(French, 'rubbing'.) The term describes the technique of making a design by placing paper or canvas over a rough surface such as grained wood, sackcloth, foliage etc. and rubbing with a pencil, ▷crayon or paint to transfer the effect to the other surface. The method was pioneered by ▷Max Ernst and used by the ▷Surrealists as a technique of ▷automatism, the chance patterns produced being a stimulus to the unconscious imagination.

Frueauf, Rueland I (c1440/5–1507) and Rueland II (c1470–1545)

Austrian family of painters. Frueauf I worked in a Flemish style at Passau and Salzburg from 1470. His son was a councillor in Passau and an artist there from 1545. He painted scenes from the life of St. Leopold for Klosterneuburg.

Fry, Roger Eliot (1866–1934)

English painter and writer on art. He was educated at Clifton College and Kings' College, Cambridge, before studying art at the ▷Académie Julian in Paris. He was a curator of painting at the ▷Metropolitan Museum in New York 1905–10. In 1903 he co-established the *Burlington Magazine*, of which he was editor 1910–19. In 1910 he organized the first, and highly influential, exhibition of ▷Post-Impressionist (in reality, contemporary) art in England, and a second in

1912. He was a member of the ▷Bloomsbury Group and the ▷London Group, and a founder of the ▷Omega workshops in 1913. His initial interest lay in Italian ▷Renaissance painting (see his book *Bellini*, 1899) and the work of ▷Claude, but by 1906 he had turned his attention to ▷Cézanne, ▷Fauvism and ▷Cubism (*Cézanne*, 1927). This change was reflected in his own painting which became strongly coloured and structured (e.g. *Farm Pond Charleston*, 1918, Wakefield). By the 1920s his style had softened towards naturalism. He also produced sculpture influenced by ▷Cubism. He wrote a number of influential books, including *Vision and Design* (1920), *Transformations* (1926) and *Reflections on English Painting* (1934).
Bib.: Bell, Q., *Roger Fry*, London, 1964; Spalding, F., *Roger Fry: Life and Art*, London, 1980

Fuller, Isaac (c1606–72)

English painter and decorative artist. He studied in France, but practised mainly in Oxford when the English court was exiled there. He produced large ▷history paintings representing Charles II in battle (1651, London, National Portrait Gallery). He also produced portraits and mural painting.

fumage

A ▷Surrealist technique invented by Wolfgang Paalen (1907–59) in the 1930s. It involves using a candle to blacken a piece of paper and then creating a work of art from the resultant image.

Functionalism

The notion that to create an artefact that serves the purpose for which it is made is to create a thing of beauty. The idea, which is present in the writings of Plato (▷Neoplatonism) and Aristotle, engaged 18th-century writers on ▷aesthetics, but by then a distinction tended to be drawn between fitness for the purpose being a component of beauty, and fitness being the sole criterion of beauty. In its modern sense it makes a connection between function and form, as in the oft-repeated aphorism coined by the American ▷modernist architect ▷Louis Sullivan in his *Kindergarten Chats* (1901): 'Form follows Function'. For modernists such as Sullivan, the beauty of a structure was revealed through the logical way in which it expressed the inherent qualities of the materials used and the purpose for which it had been designed. In this sense a skyscraper and an ▷Abstract Expressionist painting may both be said to be 'functional' or 'expressive'. Functionalism played a crucial guiding role in the ▷Bauhaus but has more recently been questioned, particularly in the modernist confusion of functionalism and ▷brutalism. There is, after all, no reason why a highly decorated ▷Art Nouveau teapot should not pour tea as well as one embodying a rigorously austere ▷machine aesthetic. ▷Postmodernism has reacted against functionalism by reintroducing

decoration, whimsy, colour and a sense of play, without losing the advances made by the application of functionalist principles.
Bib.: Blake, P., *Form Follows Fiasco: Why Modern Architecture Hasn't Worked*, Boston, 1977; Sharp, D., *The Rationalists: Theory and Design in the Modern Movement*, New York, 1979; Wolfe, T., *From Bauhaus to Our House*, London, 1981

funk art

The name given to a type of scatological, pornographic or otherwise shocking type of art that was popular in California from the 1960s. Funk art challenges social taboos, and deliberately sets out to shock or sicken the observer. It could take the form of ▷assemblages or performances. Its principle practitioners were ▷Edward Kienholz and Bruce Connor. Its name comes from 'funky', which suggests 'smelly'. Its motivations and effects were similar to those of the ▷Dada movement.

Furini, Francesco (1600–46)

Italian artist. He was from Florence, and he produced many nudes and mythological subjects. He changed his emphasis in the 1630s when he became a priest and began concentrating on religious works.

Furniss, Harry (1845–1925)

Irish artist. In London from 1873, he produced ▷caricatures and book illustration.

Fuseli, Henry (Johann Heinrich Füssli) (1741–1825)

Swiss painter, draughtsman and engraver. Born in Zurich, he was forced by his father, the painter Johann Caspar (1707–82), to train for the church in 1761. He later rebelled and studied art in Berlin (1763) and Rome (1770–78), where he copied ▷Michelangelo and influenced a number of British artists in Rome, including ▷Runciman. He settled in London, and anglicized his name, earning money as a translator (including Shakespeare's *Macbeth* and ▷Winckelmann's *Reflections on the Painting and Sculpture of the Greeks*) and illustrator, until he was recognized as a talent by ▷Reynolds. He was elected ▷RA in 1790 and became Professor of Painting in 1799, despite his own poor and largely self-taught technique. He had a succession of famous students, including ▷Etty, ▷Mulready, ▷Leslie, ▷Constable, ▷Landseer and ▷Haydon, and published his *Lectures on Painting* in 1801. His art was influenced by his youthful attachment to the Sturm und Drang movement, by his love of Italian ▷Mannerism, and his preference for violent and often erotic fantasy subjects (e.g. *Nightmare*, 1785–90, Frankfurt). He contributed to ▷Boydell's Shakespeare Gallery (e.g. *Bottom, Titania and the Fairies*, 1793–1811, Zurich) and tried to establish his own

Milton Gallery, with 47 works exhibited unsuccessfully in Pall Mall in 1799. He worked often in near-monochrome, concentrating on isolated, strongly lit and mannered figures against sketched backgrounds (e.g. *Brunhild Watching Gunther Suspended from the Ceiling*, 1807, Nottingham).

Bib.: *Henry Fuseli*, exh. cat., London, 1975; Powell, N., *Fuseli, The Nightmare*, London, 1973; Tomory, P., *Henry Fuseli: Catalogue Raisonné*, London, 1972

Futurism

Italian ▷avant-garde art movement launched in 1909 when ▷Filippo Tommaso Marinetti published his 'Futurist Manifesto' in the Parisian newspaper *Le Figaro*. Marinetti and the painters ▷Umberto Boccioni, ▷Giacomo Balla, ▷Gino Severino and ▷Carlo Carrà proclaimed the destruction of the old order, of the museums, libraries and traditions that shackled Italy to the past, and as such was originally a nationalistic, Italian phenomena. Marinetti declared in his manifesto that 'a new beauty has been added to the splendour of the world – the beauty of speed', and 'we will sing of the multicoloured, polyphonic tides of revolution in the old capitals' and the 'speed of war'. Marinetti was a wealthy writer and poet who financed the movement and led it in its ideas, which claimed not only to be pictorial but literary, cinematic, architectural, musical, theatrical, social and political. Between 1909 and 1916, over 50 manifestos were produced, using a provocative style that predates ▷Dada. Formally, Futurism was an Italian development of ▷Cubism, expressing artistically an interest in speed and movement best represented by Balla's *Speeding Car* series (1913), Boccioni's *The City Rises* (1910–11) and Carrà's *Funeral of the Anarchist Galli* (1911). Though Marinetti revived the movement after the First World War they had praised and anticipated, it suffered irreparably from the death of Boccioni in that very conflict. Futurism however was a significant influence on the development of ▷Vorticism in Britain, had a great impact as ▷Cubo-Futurism in the Soviet Union, and provided the model for Herwarth Walden's ▷Der Sturm movement in Berlin.

Bib.: Hultzen, P., (ed.), *Futurism and Futurisms*, London, 1986; Perloff, M., *The Futurist Moment: Avant-garde, Avant Guerre, and the Language of Rupture*, Chicago, 1986

Fyt, Jan (1611–61)

Flemish painter. He produced still life and hunting scenes and worked with ▷Snyders. He visited Paris and Italy, but was in Antwerp from 1641.

G

gable

The vertical triangular piece of wall at the end of a pitched roof, from the level of the eaves to the ridge. The raking sides are usually straight but there are some variants, including the crow, corbie, or step gable in which the sides are stepped; the Dutch gable in which

Wooden gable

the sides have a double curve and are surmounted by a ▷pediment; the hipped, clipped, or jerkin-head gable in which the sides incline further backwards about halfway to the ridge; and the shaped gable in which the sides are multi-curved.

Gabo, Naum (Naum Neemia Pevsner) (1890–1977)

American sculptor of Russian birth. He was the brother of ▷Antoine Pevsner, but he changed his name to Gabo to distinguish himself from his brother. Although of Russian origin, the formative influences on his early career came through Munich, where he heard lectures by ▷Wölfflin, and in Paris, where he travelled in 1913 and 1914. During the First World War, he spent time in Scandinavia, where he produced a number of constructions that showed the influence of the ▷Cubism he had encountered on his travels. His 'Constructed Heads' of this period were based in part on ▷Picasso's constructions. He returned to

Russia in 1920, when revolutionary ▷Productivism was in the ascendant. In contradiction to the prevailing anti-aesthetic tendencies of Russian art, he and his brother produced the *Realistic Manifesto*, claiming the aesthetic value of art and implicitly attacking the Productivism of ▷Tatlin and his followers. To Gabo, the term 'realism' indicated the 'real' significance of works of art, which he felt were things of beauty and importance in themselves, rather than for what they signified. The *Realistic Manifesto* became the foundation of ▷Constructivism. Although he shared Tatlin's interest in modern materials (▷culture of materials), Gabo was concerned with emotional and aesthetic aspects of the materials – qualities rejected by the Productivists. He was also an early pioneer of ▷kinetic sculpture, and he continued to practice kineticism throughout his career. His ideas were not taken up by his Russian contemporaries, and Gabo travelled to Berlin, where he remained from 1922 to 1932, producing Constructivist sculpture. He lived in England when the Nazis were in power (1935–46), and then he moved to the United States, becoming a citizen in 1946, and teaching at the Harvard Graduate School.

Bib.: Nash, S.A. and Merkert, J., (eds.), *Naum Gabo: Sixty Years of Constructivism*, Munich, 1985

Gabriel

One of the four named archangels, a messenger of God, venerated by Christians as the herald of birth and rebirth (the ▷Resurrection). He is first mentioned in the Old Testament as visiting ▷Daniel (Daniel 8: 16; and 9: 21). In the New Testament, he appears first to Zacharias to announce the birth of ▷John the Baptist (Luke 1: 5–22). His principal role in Christian art, however, is as the angel of the ▷Annunciation. He appears to the ▷Virgin who is usually shown at her devotions, and kneels before her. In medieval and early ▷Renaissance representations, his words to the Virgin, 'Ave Maria', or 'Ave gratia plena Dominus tecum' ('Hail, thou art highly favoured, the Lord is with thee' – Luke 1: 28) are sometimes inscribed on a scroll attached to the fleur-de-lis tipped sceptre he carries, or inscribed in the space between them (e.g. ▷Fra Angelico, c1434, Cortona, Museo Diocesano). During the Renaissance the sceptre is usually replaced by a ▷lily. These Biblical accounts presumably led to Gabriel being named as the angel in the apocryphal account of the annunciation of the birth of the Virgin to Joachim; and, although not named, Gabriel is traditionally identified with the angel who, in the Biblical accounts, announces the

birth of Christ to the shepherds and the ▷Resur-rection of Christ to the three Maries.

Gaddi, Taddeo (c1300–c1366) and Agnolo (fl 1369–96)

Italian family of painters. Taddeo was born in Florence, the son of the painter and mosaicist ▷Gaddo Gaddi (c1250–1327/?30) and whose son was the painter, Agnolo Gaddi. According to ▷Cennini, Taddeo was ▷Giotto's godson and pupil, working in his studio for 24 years. He also ran a flourishing workshop of his own, producing panels and ▷frescos in a style founded on Giotto's monumental art, but more descriptive and anecdotal. A measure of his fame is that in 1347 his name headed a list of the most celebrated artists, drawn up to aid the selection of painter to paint a ▷polyptych for the high altar of S. Giovanni Fuorcivitas, Pistoia – he was awarded the commission and the polyptych (dated 1353) remains *in situ* to this day. Taddeo's prin-cipal works were painted for Sta Croce, Florence: the panels of *The Life of Christ and St. Francis* (c1330) intended for a sacristy cupboard, now dispersed; and the frescos of *The Life of the Virgin* (1332–8, Baroncelli Chapel). A number of other works are signed and dated, including a triptych of the Madonna (1334), now in Berlin, which shows a considerable debt to ▷Bernardo Daddi. Agnolo continued the Giotto tra-dition to the end of the century, but in a more elegant and decorative manner. His principal work is the ▷fresco cycle of *The Story of the True Cross* (c1380) in the ▷choir of Sta Croce.

Bib.: Laddis, A., *Taddeo Gaddi: A Critical Reappraisal and Catalogue Raisonné*, Columbia, 1982

Gainsborough, Thomas (1727–88)

English painter. He was born in Sudbury, Suffolk. From 1740, he trained in London under ▷Gravelot at the ▷St. Martin's Lane Academy, where he met ▷Hayman. This early French influence was tempered by his copying of 17th-century Dutch landscapes. He returned to Sudbury in 1748 and began to establish himself as a portraitist (e.g. ▷*Mr. and Mrs. Robert Andrews*, 1748–9, London, National Gallery), although he continued to produce landscapes largely for his own satisfaction (e.g. *Cornard Wood*, 1748, London, National Gallery). With his increased reputation, he moved to Ipswich in 1750, and later to Bath in 1759, where he became the major painter of fashionable society there. In Bath, the French influence in his work increased, as he flattered his sitters with a delicate ▷Rococo use of colour and strongly feathered brush-work, emphasized by his use of thinned-down paint (e.g. *Mrs. Graham*, 1775–6, Edinburgh, National Gallery of Scotland). He changed from small-scale ▷conversation pieces, with their slightly awkward figures, to life-size, full-length portrayals, emulating ▷Van Dyck and establishing himself as the equal and opposite of ▷Reynolds, then working in London (e.g.

Thomas Gainsborough, *Self-portrait*, Royal Academy of Art, London

The Morning Walk, 1785, London, National Gallery). Finally, in 1774, Gainsborough moved to the capital. He had exhibited there since 1761 and had been a founder-member of the ▷Royal Academy but increas-ingly he differed with the RA, particularly over the hanging of his work, and from 1784, he showed paint-ings at his own house in Pall Mall. He continued to produce landscapes, increasingly idealized and Arca-dian, as first the Rococo influence and then that of ▷Rubens began to tell. By the end of his career he was also increasingly painting ▷fancy pictures, remi-niscent of ▷Murillo.

Bib.: Cormack, M., *Paintings of Thomas Gainsborough*, Cambridge, 1991; Hayes, J., *Landscape Paintings of Thomas Gainsborough*, 2 vols, London, 1982; Kalinsky, N., *Gainsborough*, London, 1995; *Thomas Gainsborough*, exh. cat., London, 1980

Galatea

(i) A sea nymph, or Nereid, whose story is told in Ovid's *Metamorphoses* (13: 750–897). Galatea loves the handsome young man, Acis, but is in turn loved by the giant cyclops, ▷Polyphemus. On a promontory overlooking the sea, Polyphemus plays a wistful tune of love on his syrinx (Pan pipes). Whilst wandering lovesick along the shore, he spies Acis and Galatea embracing. The couple see him and flee. Polyphemus flies into a jealous rage and hurls a boulder which kills Acis (e.g. ▷frescos by ▷Annibale Carracci, *Poly-phemus and Galatea* and *The Wrath of Polyphemus*, 1597–1600, Palazzo Farnese, Rome). In the Villa Farnesina, Rome, is ▷Raphael's celebrated fresco of *The Triumph of Galatea* (1511–12) showing Galatea standing in her

cockle-shell chariot, pulled by dolphins. Around her swim hippocampi, and Tritons blowing conch-horns and disporting with Nereids. In the sky above Galatea, amoretti aim their arrows of love at her.

(ii) Ovid (*Metamorphoses*, 10: 243–297) also tells the story of Pygmalion, the legendary sculptor-king of Cyprus who made a statue of a woman, fell in love with it, and prayed to ▷Venus, goddess of love, that he might have a wife as beautiful as the statue. Venus duly gave life to the statue itself. Although Ovid does not name the statue, it later came to be identified as Galatea. The statue is nude and usually shown stepping down from the pedestal as the sculptor kneels before it in adulation (e.g. ▷Falconet, *Pygmalion and Galatea*, marble, 1673, Baltimore, Walters Art Gallery).

galilee
A chapel or vestibule at the west end of a church, often enclosed in a porch. It is also called the ▷narthex. It is particularly common on elaborate ▷Gothic fronts of the 12th century (e.g. Durham, Ely and Lincoln).

Also Sea of Galilee, scene of Christ walking on the water (e.g. ▷Delacroix, 1854, Baltimore).

Gallego, Fernando (fl 1466–1507)
Spanish painter. He worked in Salamanca and produced ▷altarpieces that revealed his knowledge of Netherlandish art. His ▷triptych of the Virgin, St. Andrew and St. Christopher in the cathedral of Salamanca shows the influence of both ▷Rogier van der Weyden and ▷Dirk Bouts.

Gallén-Kallela, Aksel (1865–1931)
Finnish painter. He studied in Helsinki and in Paris with ▷Bouguereau and ▷Bastien-Lepage from 1884 to 1890. He developed a ▷Symbolist style for his landscapes and paintings of scenes from Finnish mythology. His illustrations of the Finnish epic, the *Kalevala*, contributed to the nationalist sentiment in Finland at the turn of the 19th century. He also exhibited with ▷Die Brücke.

gallery
(i) In ecclesiastical architecture: (a) an upper storey situated over a side aisle and open to the main body, but not to the exterior, of the church, sometimes called a tribune gallery (and often erroneously a ▷triforium); (b) on the exteriors of ▷Romanesque churches in Lombardy and Germany are sometimes found small-scale ▷arcaded wall passages, generally situated just below the roof, called dwarf galleries.

(ii) In secular architecture: (a) an elevated platform or balcony with ▷balustrade, supported on ▷brackets or ▷columns and overlooking a large hall or space, as in 'minstrel gallery', or 'music gallery'; (b) in a large house, a long upper room used for promenading or other recreation, sometimes hung with paintings (from which the modern term 'art gallery' derives). In

Elizabethan or Jacobean manor houses also referred to as 'long galleries'; (c) in a theatre, the highest balcony, where the cheapest seats are found, sometimes referred to as the 'gods'.

Galli da Bibiena
▷Bibiena

Ganymede
In Greek mythology, the cup-bearer of Zeus (▷Jupiter), originally the handsome shepherd son of Tros, King of Troy. The story is told by both Homer and Ovid. In the *Metamorphoses* (10: 152–161), Ovid tells how Ganymede was seen and desired by Zeus who transformed himself into an eagle and carried him off to Mount Olympus. The subject was popular in Classical Greek times as giving religious sanction to the theme of homosexual love and in ▷Renaissance times as giving the same a respectably antique veneer. Ganymede is more usually carried comfortably on the back of the eagle with Renaissance artists concentrating on the youth's ideal beauty (e.g. ▷Correggio, *The Rape of Ganymede*, c1530, Vienna, Kunsthistorisches Museum). ▷Rembrandt, however, gives an idiosyncratically realistic treatment with the terrified, screaming toddler urinating as he is snatched up in the eagle's talons (1635, Dresden, Gemäldegalerie). While the popular medieval *Moralized Ovid*, an edition of *Metamorphoses* which interpreted the myths in Christian terms, viewed the subject as a pagan equivalent of ▷St. John the Evangelist's assumption into heaven, Renaissance commentators saw it as an allegory of the soul's journey towards God.

garden
▷landscape garden

Garden City
Urban development based upon ▷Ruskin's and ▷Morris's ideals of model, harmonious communities. In *Sesame and Lilies* (1865) Ruskin called for new homes to be built 'strongly, beautifully and in groups of limited extent.' By the mid-19th century a number of enlightened industrialists had started to provide this sort of practical housing for their workforces. For example, Sir Titus Salt's village, Saltaire, near Bradford, was started by planners H.F. Lockwood and R. Mawson in 1850, and provided three-bedroom houses, parkland, playing fields and almshouses for his workers. Another early example was Port Sunlight, built by William Hesketh Lever (later Lord Leverhulme), on the south bank of the Mersey. Over 1,000 houses were built around a town centre, laid out with parks and avenues. In the Midlands, the Cadbury family built Bournville, and insisted that each house had its own garden. Ebenezer Howard (1850–1928) was a theorist who coined the term 'garden city'. His book *Tomorrow: A Peaceful Path to Real Reform* (1898, revised as *Garden Cities of*

Tomorrow in 1902) drew on the ideas of Whitman, Emerson and Ruskin, and argued that social, economic and environmental issues should all be taken into account when planning a town. In 1903 the Garden City Pioneer Company was founded. Their first scheme, by Unwin and Parker, was for Letchworth, Hertfordshire. Houses by Lethaby, Ricardo and Baillie Scott were built at Letchworth, and despite the ridiculing of the town in the London press, many professionals settled there. Letchworth's example was followed in 1905 by Hampstead Garden Suburb (the brainchild of Henrietta Barnett) and in 1919 by Welwyn Garden City. Whereas towns like Welwyn became economically self-sufficient, Garden Suburbs were rapidly populated by the middle classes, and Hampstead soon became a more up-to-date version of Bedford Park. As the 20th century progressed, municipal housing schemes attempted, with varying success, to imitate the idealism pioneered by the 19th-century philanthropists. Metro-land suburbs like Uxbridge and Watford were established but without the sensitive detailing or emphasis on individuality shown in the earlier schemes.

Garden of Earthly Delights, The

A large ▷altarpiece (220 × 195 cm/7 ft 3 in × 6 ft, oil on panel), though unsigned, universally attributed to ▷Hieronymus Bosch. Now in the Prado, Madrid, the painting takes its (modern) title from the centre panel which shows hundreds of naked men and women cavorting in a large garden filled with animals, oversized fruits and birds, water pools and fountains, and exotic plants and rocks. To the modern eye, this scene appears strangely beautiful and erotic, and has led some art historians to interpret it as a symbolic portrayal of Man before the Fall, unashamed of his sexuality or nakedness, enjoying the fruits and abundance of earthly life. However, since the left panel shows ▷Adam and Eve with ▷Christ in the ▷Garden of Eden, and the right panel presents an horrific representation of Hell, the central panel should be seen as a representation of lust and carnal sin. What Bosch shows is an artificial paradise of beauty that will lead the unwitting to damnation. Like his other moralizing subjects, the *Ship of Fools*, the *Haywain* or the *Death of the Miser*, the *Garden* subtly reveals the folly of Man. Considered to have been painted late in Bosch's career (after 1500), the painting is significant for the varied sources upon which it draws. The garden of the central panel may allude to the famous poem, the 'Romance of the Rose', its response to Hell and sin, and its didactic message is medieval, whilst its allegorical programme draws on ▷Renaissance influence.

Garden of Eden

Described in the story of the Creation in Genesis, it was the paradise on earth in which ▷Adam and Eve lived before the ▷Fall of Man. It can be compared with classical descriptions of the Golden Age in Arcadia (Ovid's *Metamorphoses*). Depictions in art were common and popular for enabling artists to show off their naturalistic and landscape abilities. Scenes of Adam naming the animals were typical, as were complete narrative cycles of the Creation (e.g. ▷della Quercia, *Creation of Adam*, 1430, Bologna). In Northern art, the Garden is usually a lush green area, packed with detail (e.g. ▷Bosch, *Paradise*, c1510, Madrid, Prado). In Italian painting, it is more often seen as an oasis in the desert sometimes surrounded by walls.

Gare St. Lazare

This is the name of a series of painting by ▷Monet produced in the 1870s. The Gare St. Lazare was the Paris terminus for the line from Argenteuil, where Monet lived at this time. His choice of the train station as subject matter was not without precedent: ▷Manet had painted *Le Chemin de Fer* and ▷Caillebotte had also painted scenes from the Gare St. Lazare. It was a symbol of modernity. ▷Zola wrote of these painting 'that's the art of today . . . our painters have been forced to discover the poetry of railway stations, as their fathers discovered that of forests and rivers.' Monet's paintings of the Gare St. Lazare have been seen as the first example of his more celebrated series paintings (e.g. Rouen Cathedral). Seven of the twelve views of the station were produced between January and April 1877, and were exhibited together at the third Impressionist Exhibition. Unlike the later series paintings, Monet does not maintain a consistent angle or viewpoint. In some of the canvases he paints from the level of the platforms, and the great billows of steam partially eclipse the human figures hurrying in their anonymity; in others he concentrates on the vast glass and steel constructions of the station itself. The canvases differ in size, composition and ▷perspective, and therefore do not offer sufficient comparisons with his future experiments in testing the effects of different atmospheric conditions on light. He does, however, capture the specific moments of seeing and this connects with his statement that the subject is not a view but the act of seeing.

gargoyle

On a building, a water spout projecting from a roof gutter, in the form of a ▷grotesque animal or human.

Garnier, Tony (1869–1948)

French architect. He began working in an academic style and won the ▷Prix de Rome in 1899. An interest in new materials, such as reinforced concrete, led to a series of more experimental designs, which he produced with Auguste Perret. He also designed an ideal city and put some of his theories into practice in the city of Lyons.

Henri Gaudier-Brzeska, *Red Stone Dancer*, c1913, Tate, London

Gates of Hell, The

▷Rodin was commissioned to produce a set of portals for the new Museum of Decorative Arts in Paris in 1880, to be based on Dante's *Divine Comedy*. Rodin's influences for the Gates were diverse, and included ▷Michelangelo's statues and paintings of male nudes, ▷Ghiberti's bronze *Gates of Paradise* of the Baptistry doors in Florence, and his interest in French ▷Gothic architecture. Later in the 1880s he was also influenced by ▷Baudelaire's ideals of human personality that mixed the sensual with the spiritual. The project occupied the rest of Rodin's life to a greater or lesser degree, inspiring a number of his most famous individual works, including *The Thinker*, *The Three Shades* and *The Prodigal Son*. Though the doors were never cast in ▷bronze in his lifetime, two copies were made from his original casts in 1917 for the Philadelphia Museum of Art and the Musée Rodin, Paris.

Bib.: Tancock, J.L., *The Sculpture of Auguste Rodin*, Philadelphia, 1976

Gaudier-Brzeska, Henri (Henri Gaudier) (1891–1915)

French sculptor. In 1911 he was in England, where he adopted the name of his Polish partner Sophia Brzeska. He knew ▷Roger Fry and exhibited with the ▷London Group, and he was friendly with ▷Epstein and ▷Lewis. With them, he signed the ▷Vorticist manifesto in ▷*Blast*, and he adopted a ▷Cubist style for his own sculpture. He concentrated primarily on carving. He joined the army in 1914, and his early death cut short a promising career.

Bib.: Cole, R., *Burning to Speak: The Life and Art of Henri Gaudier-Brzeska*, Oxford, 1978

Gaudí y Cornet, Antonio (1852–1926)

Catalan architect and designer. He was best known for the unfinished Sagrada Familia and his extraordinary use of shape and colour. Born in Reus, Catalonia, into a family of coppersmiths, he began studying architecture at the University of Barcelona, but attended more philosophy and aesthetics lectures than architecture. He became influenced by Pau Milá i Fontals, who had worked with the ▷Nazarenes in Rome. This attracted him to the revival in crafts taking place at this time, and he came to venerate the honesty of medieval art. Gaudí was also involved with the Spanish Modernisme movement, but remained loyal to his Catalan roots, taking an active part in the Renaixenca of Catalan language and poetry. His investigations into Catalan medieval history made him look at uses of nature as an inspiration not just for decoration, but for forms used in construction. It was at this early stage in his career that he started experimenting with the parabolic ▷arch, which was to become his hallmark. Gaudí's first project was the Casa Vicens, Barcelona (1878). The exterior looks almost Moorish, with stepped prismatic blocks, alternating brick and stone, and ▷polychrome tiles. Inside Gaudí used different light sources to create modulating effects.

Gaudí's patron was Count Güell, a textile manufacturer, who had been interested by the Arts and Crafts movement and wanted to develop Gaudí's interest in this direction. He was to play a decisive role in Gaudí's career, and provide him with several important commissions. The first of these was for the Palau Güell, Barcelona (1885–9), in which the parabolic arch makes its first appearance. In 1898 Gaudí started on the Colonia Güell Church at Santa Coloma de Cervello, near Barcelona. He planned it with a string model, which represented the structural ribs of the building. He hung weights from the strings, proportional to the loads which they were to bear, in order to ensure that the vaulting structure could be supported without the means of ▷buttresses. Güell also supported Gaudí in his experiments at Güell Park, Barcelona (1900–14), which was planned as an ideal community, in the ▷Arts and Crafts manner, with houses, gardens and a market. Mosaics made from ▷ceramics, broken plates and glass decorate the park walls and bizarre, brightly coloured beasts inhabit fountains. The covered market has many complex shapes and structures in its pillars, and its roof is a terrace from which there is a spectacular view of the whole city. Güell Park was never finished, but it is now a popular park.

Gaudí did not just work for Güell. In 1905 he started work on the Casa Battló, Barcelona, where his use of natural forms reach their zenith, to the extent that the roof of the house is shaped with the vertebrae of a dragon's back, and bone-shaped columns appear to support the windows. Inside, the use of graduated blue tiles in the stairwell gives the impression of rising up from the sea to the sky. Gaudí has moved in this

building from sculptural plasticity to structural plasticity. This is shown again on the same street at the Casa Milà (known as La Pedrera) (1905–10). The building, a block of flats, occupies the corner of a block, but appears almost surreal in the fact that it does not contain a single straight line. The organic form twists around the corner, and balconies undulate away from the surface of the structure. On the roof, all the chimneys twist in different sculptural forms.

As Gaudí grew older he became obsessed with one particular project. In 1883 he was commissioned by the City Council to continue the work already under way on the Sagrada Familia, Barcelona. Work continues on this church today. A Neo-Gothic design by Vilar existed, but Gaudí abandoned this, developing what he called 'nature in stone'. He designed an extraordinary building, totally without precedent. He foresaw four interpenetrating square-based towers at each end of the nave, tapering up to the height of 107 metres, and terminating in thin, curved features. Three open portals, with an elaborate ▷nativity scene all around them, lead into the body of the church, which has coloured ▷mosaic decoration. The ▷vaulting was to be supported by suitably inclined pillars, and not ▷buttresses. He asserted that the straight line belonged to man, but the curved one to God, and continued to refine his hyperboloids and paraboloids, based on muscles, wings, caves and stars. In his final years, Gaudí gave up all his other work to devote his attention to the Sagrada Familia. He lived in a hut on the site, and became increasingly difficult to work with. It is said that when he died, after having been knocked down by a tram, no one recognized the famous architect, and he was mistaken for a tramp.

Gaudí is one of the few true originals in 20th-century architecture and design. Although he was never the nucleus of a school or a movement, his work has been universally admired and continues to astound. **Bib.**: Sweeney, J.J., *Antoni Gaudí*, London, 1970

Gauguin, Paul (1848–1903)

French painter, sculptor and graphic artist. Born in Paris, of a journalist father and Peruvian mother, he led an unsettled early life, living briefly in South America and travelling as a seaman for six years (1865–71). He settled in Paris as a stockbroker's agent, and became a friend of the ▷Impressionists, collecting their work and indulging in part-time painting of his own. He exhibited with the group in 1881, before deciding to become a full-time artist in 1883. There followed difficult years, during which he left his family and struggled to make a living, briefly staying in Denmark and visiting Martinique and Panama in 1887, before settling in Brittany at ▷Pont Aven. It was here, among an artist's colony which included ▷Bernard, that he changed his style and developed ▷Synthetism.

Gauguin's early work had been influenced by ▷Pissarro, his unofficial teacher, towards landscape

Paul Gauguin in front of his canvases

subject-matter painted with a brown-orange palette and visible, controlled dashes of paint (e.g. *Cattle Drinking*, 1885, Milan). By 1887, having seen ▷Seurat's work at the 1886 ▷Impressionist exhibition and the tropical landscape of Latin America, he enriched his use of colour, abandoning naturalism in favour of symbolism and portraying the spirituality of the Breton peasantry (e.g. *The Vision after the Sermon*, 1888, Edinburgh, National Gallery of Scotland). In the autumn of 1888 he was persuaded by ▷van Gogh's brother, Theo, to visit the artist in Arles, for an unsuccessful two months (e.g. *Night Cafe, Arles*, 1888, Moscow).

He travelled to Tahiti in 1891, staying for two years until his money ran out, in a bid to escape the trappings of civilization and rediscover the spiritual simplicity which he had initially sought among the peasants of France. There his style softened, developing into rhythmic flowing patterns which reflected the new landscape, and incorporating imagery culled from Tahitian, and other primitive cultures (e.g. *Spirit of the Dead Keeps Watch*, 1892, Buffalo). He returned to Paris in 1893, as something of a celebrity, due in part to the publication of his diary, *Noa Noa*, but left for the South Seas again, having inherited money from his uncle in 1895. He spent the rest of his life living on increasingly remote islands, at odds with the local government and bitter at the encroachment of Westernization. In 1897 he attempted suicide, having completed the monumental *Where de we come from, what are we, where are we going?* (1897, Boston) which seemed to sum up his increasing sense of despair. Throughout his career he produced ▷woodcuts, a medium chosen for its primitive associations and heavy line technique. His work

influenced other ▷Symbolist groups in the 1890s (▷Nabis) and he was given a ▷Salon d'Automne retrospective in 1906.

▷Post-Impressionism

Bib.: Cachin, F., *Gauguin, Quest for Paradise*, London, 1992; *Gauguin*, exh. cat., Washington, 1988; Jaworska, W., *Gauguin the Pont-Aven School*, London, 1972; Mongan, E., *Paul Gauguin: Catalogue Raisonné of Prints*, Bern, 1988; Rewald, J., *Post-Impressionism: Van Gogh to Gauguin*, London, 1978; Sweetman, D., *Paul Gauguin, A Complete Life*, London, 1995; Thompson, B., *Gauguin*, London, 1987

Gavarni, Paul (Sulpice Guillaume Chevalier) (1804–66)

French wood engraver and lithographer. He began his career in Paris, where he designed theatre costumes and contributed to French periodicals such as *Le Charivari* in the 1820s and 1830s. He visited London in 1847 and 1848–52, and he was shocked by the poverty of the East End there. After these trips, his illustrations became increasingly harsh and satirical.

gazebo

More usually, a summerhouse commanding an extensive view; also called a belvedere. Gazebo may also refer to a small pavilion, turret or ▷lantern on the roof of a house, affording a similarly extensive view.

Geddes, Sir Patrick (1854–1932)

Scottish town planner. He studied with T.H. Huxley and began a career as a sociologist in Scotland. His primary concern was in improving society by improving the environment, and he opened an 'Outlook Tower' on Castlehill in Edinburgh as a centre of research into town planning. He published works on town planning, including *City Development* (1904). From 1920–23 he was Professor of Sociology at the University of Bombay, where he studied Indian architecture and disseminated his ideas there.

Bib.: Meller, H., *Patrick Geddes: Social Evolutionist and City Planner*, London, 1990

Geertgen Tot Sint Jans (c1460–c1490)

Netherlandish painter. His name means 'Little Gerard of the Brethren of St. John'. He was born at Leyden, but active in Haarlem where he was trained, according to ▷van Mander, by ▷Albert van Ouwater. Van Mander also states that Geertgen died at the age of 28. Only one of his works is documented, a large ▷triptych ▷altarpiece, of which the central *Crucifixion* is lost, but whose wings, the *Lamentation over the Dead Christ* and *Julian the Apostate Ordering the Bones of St. John the Baptist to be Burnt* are both in the Kunsthistorisches Museum, Vienna. These were painted for the Monastery of St. John at Haarlem (of which order Geertgen was a lay brother). Around these panels have

been grouped about 15 other works, mostly on a small scale, which exhibit the same stylistic qualities – most characteristically the egg-shaped heads of his slightly built figures. They include a *Holy Kinship* (Amsterdam, Rijksmuseum), a *St. John the Baptist in the Wilderness* (Berlin, Staatliche Museum), and a nocturnal *Nativity at Night* (London, National Gallery) in which the brilliant radiance, emanating from the Christ child and illuminating the other figures, endows the picture with an unforgettable mystical intensity.

Bib.: Friedlander, M.J., *Geertgen Tot Sint Jans and Jerome Bosch*, New York, 1969

gems

A stone or mineral used for jewellery or other decorative objects. Gems can be used for decorative art as ▷intaglios, which are cut, or ▷cameos, which are ▷reliefs. They were used in ancient Egypt and ancient Rome and Greece. In the ▷Renaissance, gem collecting became one of the many acceptable pastimes for cultured gentlemen.

gender

Not simply the biological properties of maleness and femaleness, but aspects of masculinity and femininity which are not stable but fluctuate constantly throughout history. In art, representations of men and women are important gauges of gender construction in particular historical epochs, but visual culture has also contributed to stereotypes and conceptions of gender.

Bib.: Hoorn, J., *Strange Women: Essays in Art and Gender*, Carlton, 1994

genius

(Latin, 'begetter'.) The earliest meaning of genius refers to an attendant spirit of person or place, or the spirit of a family or clan. Later, as the idea of *daimon*, a guardian spirit, developed, genius came to refer to a personification of an individual's natural desires and appetites. For example, Horace said that only the genius knows what makes one person different from another, because genius is a god who is born and dies in each individual. Since these beginnings, the term has evolved to refer to a person of extraordinary intellectual power. Sir Francis Galton, a 19th-century British scientist, formulated the idea that genius referred to an individual's great achievement, so long as they are not transitory or an accident of birth. Lewis Terman countered this by arguing that potential genius could be measured through an assortment of tests, and therefore children and others who had not achieved anything concrete, could also be geniuses. Both said that while talent was a natural aptitude, genius involved originality, creativity and an explorative nature. From these theories, the idea that genius was a separate psychobiological species developed, and a myth began to develop around artists – that they should be revered as 'different'. More recently, genius has become an

unfashionable and mockable concept. Arguments about why most so-called geniuses came from white, male, European backgrounds have discredited earlier theories and it is now thought to be a 19th-century, proto-Darwinian myth.

genre painting

A term used for paintings depicting scenes of daily life, animals or ▷still life. Although these themes have long been represented in art, they were generally incorporated into the major genres (in the broader sense of the term, meaning a particular branch or category of art or literature) of religions, history and portrait painting. Genre painting first became important in its own right in 17th-century Holland, where it met the desire of the middle class for a representational painting that reflected their secular, commercial, pragmatic lives. Prominent among Dutch genre painters are ▷de Hooch, ▷Metsu, ▷Vermeer and ▷Steen.

In the 18th century genre painting found a major representative in France in ▷Chardin, whose still lifes and interiors are among the finest of their kind, imbued as they are with a reverent attention to the quotidian that transcends mere representation. Nineteenth-century genre painting formed a significant minority at exhibitions such as the Paris ▷Salon, but without commensurate critical attention. With the advent of ▷Impressionism, however, the belief that an 'important' painting required an 'important' subject was challenged and defeated, with the result that artists such as ▷Cézanne were able to find the full range of aesthetic and intellectual possibilities within very simple still-life motifs, a concern with form rather than content being a hallmark of ▷modernism. The 20th century has witnessed the collapse of the ▷hierarchy of genres, which saw genre painting allocated a lowly position.

Bib.: Alpers, S., *The Art of Describing: Dutch Art in the Seventeenth Century*, London, 1983; Conisbee, P., *Chardin*, Oxford, 1986

genres, hierarchy of

▷hierarchy of genres

Gentile da Fabriano (c1370–1427)

Italian painter. He was born in Fabriano and was first recorded in 1408, working in Venice. In 1409 he was painting a series of historical frescos in the Doge's Palace, later finished by ▷Pisanello (now destroyed). From 1422 to 1425 he was in Florence, where he painted his *Adoration of the Magi* for the powerful Strozzi family (1423, originally Sta Trinità, now Uffizi), one of the most important examples of the ▷International Gothic style in Italy, characterized by a sense of courtly elegance, the lavish use of bright colours, and gold leaf married to a concern for closely-observed, naturalistic details (see especially the precise observation of different light sources in the predella scenes). To the Florentine period also belongs the *Quaratesi Altarpiece*

(1425), now dispersed between London (main panel of the Madonna and Child, Royal Collection, on extended loan to the National Gallery); Uffizi (wings); the Vatican; and Washington (cut ▷predella panel). Following his Florentine period, Gentile worked in Siena and Orvieto, before arriving in Rome, where he was commissioned to paint a series of frescos in the cathedral of Rome, S. Giovanni in Laterano (1427; now destroyed). It is important to remember that Gentile's surviving work is exactly contemporary with the austere and intellectual art of ▷Masaccio, and to contemporaries represented an equally mainstream and influential alternative, the success of which is attested by the prestigious commissions won by Gentile in the main centres of art production.

Bib.: Christiansen, K., *Gentile de Fabriano*, London, 1982; Zampetti, P., *Gentile e i pittore di Fabriano*, Florence, 1992

Gentileschi, Orazio (1563–1639) and Artemisia (1593–1651)

Italian family of painters. Orazio was born in Pisa. In Rome from c1576, he became a friend and follower of ▷Caravaggio. Gentileschi's original Tuscan ▷Mannerism was soon replaced by a Caravaggesque naturalism which remained the dominant influence on his work. Although Gentileschi's subjects tended more towards the lyrical, his temperament was of a gentler sort, and, almost as soon as he left Rome, he moved progressively away from Caravaggio's ▷chiaroscuro towards a lighter palette. Furthermore, his forms are, in typical Tuscan style, almost always rendered with distinct contours. A very peripatetic painter, he was largely responsible for the spread of Caravaggism throughout Europe. In 1621 he left Rome for Genoa. In Genoa he painted for Charles Emanuel I of Savoy one of his most accomplished paintings, *The Annunciation* (Turin, Pinacoteca). In c1623 he moved to Paris to work for Marie de Medici and by 1626 was Court Painter to Charles I of England, a position which he held until his death. In England his principal commission was a series of nine ceiling paintings (in oil on canvas) for ▷Inigo Jones's Queen's House at Greenwich (now in Marlborough House, London).

His daughter Artemisia was born in Rome. She worked in a style influenced by ▷Caravaggio, but which was nonetheless strongly individual, and today she is regarded as one of the most accomplished of the so-called ▷Caravaggisti. Though rather marginalized in earlier art historical accounts of her period, Artemisia has been reassessed in recent years, particularly by ▷feminist art historians, who have discerned a specifically female point of view in her work. Her treatment of *Susanna and the Elders* (1610, Pommersfelden, Schloss Weissenstein), for example, concentrates on the vulnerability of a naked woman whose private bath has been violated by the predatory elders; male painters generally appear to give emphasis to the

sensuality of Susanna's nudity, such that the (presumably male) viewer of the painting becomes in effect a third voyeur (e.g. ▷Tintoretto, 1557, Vienna, Kunsthistorisches Museum; ▷Guido Reni, London, National Gallery). Artemisia's *Judith Beheading Holofernes* (Florence, Uffizi; a subject to which she returned a number of times) is notable for its extreme violence and has been linked to the trauma of her alleged rape in 1612 at the age of 19 by her painting instructor, ▷Agostino Tassi. Her father sued Tassi for the crime, but in the ensuing legal proceedings Artemisia was tortured and Tassi was ultimately acquitted. The violence of these particular paintings is thus sometimes seen as a kind of therapeutic revenge substitute. During her lifetime she enjoyed a Europe-wide reputation as a painter, working mainly in Rome and Florence, before settling in Naples from 1630. The Royal Collection contains her remarkable *Self-portrait as Painting*.

Bib.: Bissel, R.W., *Orazio Gentileschi and the Poetic Tradition in Caravaggesque Painting*, Pennsylvania State University, 1981; Garrard, M.D., *Artemisia Gentileschi*, New Jersey, 1989

Geometric art

Greek art produced from c10th century BC until the 7th century BC. This period was dominated by vase painting, which included abstract geometric patterns and crude sculptures of animals. It was superseded by the ▷Classical phase of Greek art.

Gérard, Baron François Pascal Simon (1770–1837)

French painter. He was a ▷Neoclassical artist who specialized in portraits and ▷history paintings. He was born in Rome. In 1780, thanks to the patronage of the Duc de Breteuil, he entered the Pension de Roi, an exclusive art school in Paris. In 1786 he became ▷David's pupil, and due to his influence avoided military service during the ▷French Revolution, although only by sitting on one of the notorious tribunals. Although he never won the ▷Prix de Rome, he spent two years in Italy (1791–3). His *Cupid and Psyche* (1798, Paris) was highly popular and he gained a reputation as a portraitist which rivalled that of his master (e.g. *Jean Baptiste Isabey and his Daughter*, 1796, Paris, Louvre). He utilized the same precision and finish, but added a sweeter, more mannered grace to David's Neoclassicism. Under Napoleon he produced decorations for Malmaison based on the Saga of Ossian, as well as oil commissions (e.g. *Battle of Austerlitz*, 1810, Versailles). After the Restoration he remained in favour thanks to the patronage of Tallyrand, and continued to produce classical and history themes (e.g. *Entry of Henri IV to Paris*, 1817, Versailles), as well as decorative work (1836, Pantheon). He had a large studio and was professor at the ▷École des Beaux-Arts from 1811. He was made a baron in 1819.

Gérard, Jean-Ignace-Isidore
▷Grandeville

Géricault, Théodore (1791–1824)

French painter. He was born of a well-to-do Rouen family. In 1808 he became a pupil of ▷Vernet, and two years later joined ▷Guérin's studio, where he met ▷Delacroix. He was also influenced by ▷Gros' dramatic and heroic war paintings, and initially his political sympathies lay with Napoleon (e.g. *Charging Cuirassier*, 1812, Paris). In 1816 he visited Italy, where he discovered the work of ▷Michelangelo and wedded it to his already established enthusiasm for the ▷Baroque and ▷Rubens. He returned to France, discontented with Restoration conservatism, to paint the *Raft of the Medusa* (1819, Paris, Louvre), a monumental, highly finished and dramatically lit history painting recalling a contemporary and controversial political cause célèbre. In 1820 he visited England, producing ▷lithographs of the London poor and sleek ▷Stubbs-inspired oils of race horses. His last project was a series of ten honest and sympathetic portraits of inmates at Dr. Georget's asylum (e.g. *Madman*, 1821–4, Ghent). He produced some sculpture (e.g. *Satyr and Nymph*, bronze, 1818, private collection). He died following a riding accident. Despite only exhibiting three pictures during his life, Géricault was highly influential on the French ▷Romantic movement. He combined a ▷Neoclassical fastidiousness (reconstructing the raft in his studio and sketching in a mortuary) with an interest in the heroism of the common man, and a love of drama.

Bib.: Bazin, G., *Theodore Géricault, étude critique, documents et catalogue raisonné*, Paris, 1992; Eitner, L., *Géricault, His Life and Work*, London, 1983; *Géricault*, exh. cat., Paris, 1990; Michel, R., *Géricault, l'invention du reel*, Paris, 1992; Sagne, J., *Géricault*, Paris, 1991

Germ, The

The magazine published by the ▷Pre-Raphaelite Brotherhood between January and April 1851. Only four issues appeared, the first two being subtitled *Thoughts Towards Nature in Poetry, Literature and Art*, the last called *Art and Poetry, Being Thoughts Towards Nature*. They were edited by William Michael Rossetti (1839–1919) and contained contributions from his brother (▷Rossetti), including the *Blessed Damozel*.

Germanicus, (Death of)

A Roman general, nephew of Tiberius and son of Nero, whose life (15 BC–AD 19) is recorded in Tacitus' *Annals*. He was famed for his successful campaigns against the German tribes. He was poisoned by Piso, the governor of Syria, and his death led to scenes of great mourning in Rome. The deathbed scene, portraying his wife, Agrippina, and loyal officers pledging revenge, was chosen by artists as a fine example of the Roman virtues of stoicism and comradeship (e.g.

▷Poussin, *Death of Germanicus*, 1627, Minneapolis).

A related subject portrays the arrival of his wife with his ashes at Brundisium. She carries an urn, wears a widow's veil and is usually accompanied by her two children amid crowds of mourners.

Germany, art in

Germany was not a fully unified nation until after the Franco-Prussian war in 1871, but there is much evidence of distinctively German art in many regions of what is now known as Germany throughout the Middle Ages and the ▷Renaissance period. The ▷Carolingian court at Aachen was the centre of a flourishing of the arts under ▷Charlemagne's leadership, and ▷Ottonian art in the form of architecture and manuscript illumination was concentrated in Mainz, Worms, Speyer and Hildesheim. The ▷Gothic infiltrated Germany in the 13th century, where imposing cathedrals were built at Cologne, Ulm and Freiburg, while northern Germany developed its own ▷Backsteingotick, based on the appearance of local stone.

Throughout the 15th century, Flemish influences dominated German art at a number of centres, and influenced the realistic detail in religious art by ▷Hans Holbein the Elder. Germany became an even more significant centre of early printing, and ▷engraving reached an early sophistication with ▷Schongauer and ▷Dürer. It was Dürer as well who brought the Italian ▷Renaissance interest in ▷perspective and anatomy to Germany, although the importance of the Italian style was to an extent eclipsed by the advent of the ▷Reformation, which led to some suspicion of religious imagery. Despite some ▷iconoclasm on the part of advocates of the Reformation, Martin Luther and his princely followers encouraged a new form of Biblical and secular art, and ▷Cranach became the foremost artist of the Reformation. Secular subject matter in the form of mythological scenes, ▷genre and the landscape paintings of the ▷Danube School gained prominence over the previously dominant religious art.

Sixteenth-century religious conflicts in Germany led to a more decisive division between the Protestant north and the Catholic south, the latter of which embraced the ▷Baroque, and later the ▷Rococo, in its various pilgrimage churches. Bavarian Baroque architecture was more elaborate, illusionistic and complex than its Italian counterpart, and it was designed to overwhelm and attract its captive Catholic audience. In the 18th century, church design and decoration continued to dominate German artistic production, but at the end of the century ▷Winckelmann travelled to Italy and perpetuated classical ideals which would lead to the adoption of ▷Neoclassicism throughout Europe.

German art flourished again in the early 19th century, when the country became the intellectual centre of ▷Romanticism, with authors such as ▷Goethe and Schiller and artists such as ▷Friedrich and ▷Runge perpetuating the idealism of this new tendency. Many different styles and modes of art were practised: local art ▷academies in cities such as ▷Düsseldorf, and the ▷Nazarenes, first in Rome, and then in Berlin and Munich, fostered a revolution in mural decoration and easel painting. Throughout the middle part of the century, the ▷Biedermeier phase inspired trivial paintings of scenes from everyday life and simple vernacular furniture, which appealed to the bourgeoisie.

The fragmentations in the German art world remained after unification in 1871, when local academies maintained their power, while in Munich, Berlin and other cities rebel artists formed ▷Secessions to challenge the authority of the academies. In the 1890s, Secession artists favoured the ▷plein air painting of the French ▷Impressionists, or the new decorative styles of ▷Art Nouveau, and they contributed to major changes in the decorative arts, inspired in part by the English Arts and Crafts movement. At the same time, artists' colonies in Dachau and ▷Worpswede promoted German landscape and peasantry as important subjects for the modern artist.

The most memorable modern 'movement' in German art was ▷Expressionism, although this name was not used commonly before the First World War. Expressionist groups included ▷Die Brücke (formed 1905) and ▷Der Blaue Reiter (formed 1911), but many individuals also produced Expressionist works outside of these formations. The assistance of influential art dealers such as Paul Cassirer and Herwarth Walden (▷Sturm) helped disseminate the Expressionist style and influence throughout Europe.

The upheavals of the First World War and its revolutionary aftermath did little to halt the impetus of German art. After the War, the ▷Novembergruppe formed as a positive response to revolutionary principles, and the art school the ▷Bauhaus was founded initially in the utopian spirit of the early Weimar Republic. During times of civil unrest, from 1918 to 1921, ▷Dada appeared in different manifestations in Berlin, Hanover and Cologne, but by the mid-1920s, a return to realism in the form of the ▷'Neue Sachlichkeit' style gave art a more academic flavour.

The realism of the Neue Sachlichkeit was exploited by the Nazis in the 1930s. They favoured academic paintings of German landscapes, life and people, which perpetuated the Aryan myths extolled by Hitler and his agents. Meanwhile, a series of ▷'Degenerate Art' exhibitions from 1933 demonized all modernist forms of art and effectively buried modernism in German consciousness until after the Second World War.

Since the Second World War, Germany has contributed greatly to modern art movements. German artists have pioneered forms of ▷Conceptual art and ▷Abstract Expressionism. Despite the ruptures caused by the division of Germany into East and West, and its

subsequent reunification, German artists have made an important mark on post-war international art through their involvement with such organizations as ▷Fluxus, the ▷Zero group and ▷Neo-Expressionism.

Bib.: Christensen, C., *Art and the Reformation in Germany*, Athens, 1979; von Einem, H., *Deutsche Malerei des Klassizismus und der Romantik 1760 bis 1840*, Munich, 1978; *German Art in the Twentieth Century: Painting and Sculpture 1905–1985*, exh. cat., London, 1985; Hartley, K., et al. (eds), *The Romantic Spirit in German Art*, exh. cat., London, 1994; Mitchell, T., *Art and Science in German Landscape Painting 1770–1840*, Oxford, 1993; van der Osten, G., *Painting and Sculpture in Germany and the Netherlands 1500 to 1600*, Harmondsworth, 1969; Vaughan, W., *German Romantic Paintings*, New Haven, 1980

Gérôme, Jean-Léon (1824–1904)

French painter and sculptor. He was born in Vesoul, the son of a goldsmith. After studying drawing locally, he became a pupil of ▷Delaroche in Paris (1840). He travelled to Rome (1843), and returned to Gleyre's studio. His first salon exhibit – *Cock Fight* (1847, Paris) – set the tone for much of his work. In his day he was extremely popular for his portrayal of classical subjects, which he painted with detailed observation, gentle colouring and glossy finish (e.g. *Anacreon, the Child Bacchus and Love*, 1843, Toulouse; *Death of Caesar*, 1865, Baltimore). Increasingly his work abandoned any ▷Neoclassical pretensions in favour of anecdotal subject-matter and titillating nudes (e.g. *Phryne before the Aeropagus*, 1861, Hamburg Kunsthalle). He also led the vogue for exotic eastern subjects, travelling to Turkey (1853) and Egypt (1857), and he was also an ardent grecophile. He was highly prolific and worked in a range of subjects and media, experimenting with sculpture in the 1870s. He was also influential as a teacher and conservative administrator – he opposed the state purchase of ▷Impressionist work.

Bib.: Ackerman, G.M., *Life and Work of Jean-Léon Gérôme*, London, 1986; *Jean-Léon Gérôme*, exh. cat., Minneapolis, 1972

Gersaint's Shop Sign

Painted by ▷Watteau in 1721, it was the last important work produced before his death. Watteau painted it for his friend Edmé Gersaint, an art dealer with whom he lived when the painting was produced. Gersaint owned a shop and, as a favour, Watteau painted this work as an over-door decoration intended for the outside of the building. This accounts in part for its massive size (306 cm/10 ft long). It contained a number of elements of Watteau's earlier ▷fêtes galantes, especially its emphasis on fashionable society, but it moved away from these fantasy works in its focus on a real modern public. It represents a series of fashionable clients in an art dealer's shop, most of whom do not seem to be enormously interested in the works for sale. Most of the paintings for sale cannot be identified, but one woman is carrying away a portrait of Louis XIV based on a version by ▷Hyacinthe Rigaud. This focus on contemporary urban life, and the social mix that characterized it, showed a new direction in Watteau's work that was cut short by his untimely death.

Bib.: Vidal, M., *Watteau's Painted Conversations*, New Haven and London, 1992

Gerstl, Richard (1883–1908)

Austrian painter. He was influenced by the ▷Secession style, but he turned to ▷Expressionism early in the 20th century. He painted portraits in a disturbing, heavily ▷impasted style, and he looked to artists such as ▷Munch for distortions of facial expression. He was friendly for a time with Arnold Schoenberg, but committed suicide because of an unsatisfactory affair with Schoenberg's wife.

Gertler, Mark (1892–1939)

English painter. He was from a poor Jewish family, but was able to study at the ▷Slade 1908–12 with financial help from the Jewish Educational Aid Society. He became a member of the ▷New English Art Club 1912–14, and he met ▷Roger Fry. He was friendly with ▷Nevinson and ▷Wadsworth, and joined the ▷London Group in 1915. His work consisted largely of nudes and still lifes, as well as the disturbing *Merry-Go-Round* (1916, London, Ben Uri Gallery). His lack of confidence and continual problems with debt led to depression in the 1920s, and he committed suicide in 1939.

Bib.: Woodeson, J., *Mark Gertler: Biography of a Painter: 1891–1939*, London, 1972

Gesamtkunstwerk

(German, 'total work of art'.) A term coined by the composer Richard Wagner, which suggests the co-operation of the arts that he felt was characteristic of his own operas. Painting, sculpture, architecture, music, dancing and language all came together on the stage. Subsequently, the idea was taken up by ▷modernist artists in Germany and elsewhere to convey a sense of the blending of the arts. It was commonly used by decorative artists to suggest the unity between fine art and craft, and artists such as ▷Kandinsky went beyond the idea of mere unity to develop theories of ▷synaesthesia, in which one form of sensory experience becomes inexplicably linked with another.

gesso

(Italian, 'gypsum'.) A form of brilliant white plaster consisting of a mixture of ▷gypsum and ▷size used in the Middle Ages and ▷Renaissance, mainly as a ▷ground for ▷tempera paintings on panel or canvas. It was applied in several layers. According to ▷Cennini, the lower layers were relatively coarse (*gesso grosso*), with the final layers finer (*gesso sottile*) and polished off

to a perfectly flat smoothness. Gesso was also used to model low-relief embellishments on furniture or picture frames (*gesso rilievo*).

Gestalt

(German, 'form', 'configuration' or 'shape'.) The term generally refers to a school of psychology founded in Germany in the 1910s whose basic principle was that the ultimate elements of experience were structures and organizations that could not be broken down into components parts, i.e. the whole was not the sum of its parts. They thus directly challenged the structuralist position that phenomena could be broken down into parts that could then be examined.

gestural painting

The application of paint in such a way that the artist's expressive or 'gestural' brushwork is emphasized. Gestural or ▷painterly execution is a feature of the work of ▷Tintoretto and ▷Rubens (▷Poussinistes vs. Rubenistes) and ▷Expressionist artists such as ▷van Gogh. In the 20th century gestural painting was an important component of ▷Abstract Expressionism's reaction to the machine-like paintings of the geometric abstractionists. Gestural painting returned to prominence in the 1980s in the work of the ▷Neo-Expressionists, for example ▷Baselitz and ▷Immendorf.

G(h)eeraerts the Elder, Marcus (c1530–c1590) and Marcus the Younger (1561/2–1636)

Flemish family of painters. The Elder Geeraerts was a Huguenot who came to England from Bruges in 1568 and produced history and religious paintings. His son travelled with him. He was a decorative artist and a portrait painter, who may have been responsible for various portraits of Queen Elizabeth, including the Ditchley portrait (c1592).

Ghent Altarpiece

A ▷polyptych painted primarily by ▷Jan van Eyck, possibly with the assistance of his brother ▷Hubert van Eyck. It is also known as the Altarpiece of the Holy Lamb. It was produced in 1432 while Jan van Eyck was the court painter to Philip the Good, the Duke of Burgundy. However, it was undertaken as a private commission for one of Philip the Good's functionaries, Joos (Jodocus) Vijd, and his wife Elisabeth Borluut, and intended to be placed in the parish church of John the Baptist in Ghent (now St. Bavo's Cathedral). Its ▷iconography is complex and has been the focus of endless speculation by art historians. The work is made more problematic by the fact that the organization of its many panels has changed over the years, and at least one panel has been lost and replaced by a copy. The closed portion of the altarpiece consists of eight sections. At the bottom, van Eyck has represented the ▷donor and his wife with careful realism, and next to each of them he has painted a patron saint (▷John the Baptist and ▷John the Evangelist) in a ▷grisaille imitation of sculpture. Above is a scene of the Annunciation, which is topped by representations of Old Testament prophets and ▷sibyls.

The opened state of the altarpiece represents one of the most stunning and complex scenes in early Netherlandish religious art. Here van Eyck's skill with both symbolic ▷perspective and the nude form represents a break with previous traditions of medieval art. The top panels of the interior review represent the Trinity with the ▷Virgin Mary and John the Baptist, flanked by playing and singing angels. At the far left and right of the top portion of the altarpiece are representations of Adam and Eve, painted in the nude. The bottom panels represent an unusual scene of the Adoration of the Lamb, which may depict a passage in Revelation that was read in church during the Feast of All Saints Day. The Lamb is being worshipped by biblical patriarchs, ▷Apostles, virgin martyrs and other holy figures. Thus, the top and bottom registers represent visions of paradise or the Second Coming. Van Eyck's attempt to unify the spatial relationship between panels, and his sensitive representation of nudity in the figures of Adam and Eve, were new developments in religious art.

Bib.: Dhanens, E., *Van Eyck – The Ghent Altarpiece*, London, 1973; Philip, L., *The Ghent Altarpiece and the Art of Jan Van Eyck*, Princeton, 1971

Gheyn, Jacob (Jacques) de II (1565–1629)

Dutch engraver and painter. He was the son of a ▷miniature painter. He studied with ▷Goltzius 1585–90 and worked for the court at the Hague. He also designed garden ornaments.

Bib.: Van Regteren Altena, J.Q., *The Drawings of Jacques de Gheyn*, Amsterdam, 1936

Ghiberti, Lorenzo (c1378–1455)

Italian designer, sculptor, goldsmith, architect and writer. He was Florentine and first came to prominence as winner of the 1401 competition for a set of ▷bronze doors to the Florence Baptistry, intended to match those of ▷Andrea Pisano. The original brief seems to have been for a set of 28 Old Testament scenes, the trial subject being ▷The Sacrifice of Isaac. Both Ghiberti's winning relief and that of the runner-up, ▷Brunelleschi, survive (Florence, Bargello). The programme was subsequently changed to a series of New Testament scenes, plus saints, but the format of 28 quatrefoils (▷foils) was retained. Each scene employs just a few figures, dramatically set in high ▷relief against a neutral background, with the context conveyed by minimal stage-like settings (though with some minutely observed details in the landscapes), and all executed in the graceful linear rhythms of the ▷International Gothic style. Executed between 1403

and 1424, the commission necessitated the establishment of a large workshop in which many of the future masters of the Florentine school received their training, including ▷Donatello, ▷Masolino, ▷Uccello and ▷Antonio Pollaiuolo.

As soon as the first set was completed, the Merchants' Guild (which was responsible for the upkeep of the Baptistry) commissioned Ghiberti to produce a second set for the last remaining doorway. These, the celebrated *Gates of Paradise* (as ▷Michelangelo later admiringly dubbed them), took from 1425 to 1452 and, instead of 28 quatrefoils, there are just ten rectangular window-like frames containing scenes presented in a radically new style, conveying a sense of depth through ▷linear perspective, with the relief graded through to very low for distant objects and a rational diminution of figure scale. Since the commencement of the first doors, Donatello had used exactly these means to revolutionize narrative relief (e.g. *St. George and the Dragon*, c1417, Florence, Or San Michele), and Ghiberti quickly assimilated them.

The Merchants' Guild, taking advantage of Ghiberti's unrivalled bronze casting facilities, had also commissioned him in 1412 to execute a monumental gilded bronze statue of *St. John the Baptist*, their patron saint, for their niche on Or San Michele. Still in the graceful International Gothic style, it was the first monumental bronze figure since antiquity. In outright competition with the Merchants' Guild, the Bankers' Guild then commissioned Ghiberti to design and execute a gilded bronze figure of *St. Matthew* (1419) for their ▷niche on Or San Michele. The surviving contract reveals unequivocally their aspirations: *St. Matthew* had to be 'at least as large' as the Merchants' Guild figure, 'or larger if it seems better'. This figure was, like the second set of doors, in the new classical language of the ▷Renaissance; again, perhaps, Donatello had provided the challenge with his *St. Mark* (1411–13). Ghiberti's last bronze figure for Or San Michele, *St. Stephen* (1428), for the Wool Guild, is something of a return to a more graceful ▷Gothic style.

A keen collector of classical antiques, he was also a historian, his *Commentarii* (uncompleted at his death) providing a valuable source of information about ▷trecento artists, as well as containing the earliest surviving autobiography by an artist.

Bib.: Finn, D., *The Florence Baptistry Doors*, London, 1980; Ghiberti, L., *The Commentaries of Lorenzo Ghiberti*, London, 1948; Krautheimer, R. and T., *Lorenzo Ghiberti*, Princeton, 1956; Nagel, B., *Lorenzo Ghiberti und die Malerei der Renaissance*, Frankfurt, 1987

Ghirlandaio, Domenico Bigordi (1449–94)

Italian painter. The most successful Florentine fresco painter of the second half of the ▷quattrocento, he trained in the workshop of ▷Baldovinetti and possibly ▷Verrocchio. A brilliant businessman, he ran a large and flourishing studio which included other members of his family, notably his brothers Davide (1452–1525) and Benedetto (1458–97). His most celebrated pupil was ▷Michelangelo. Ghirlandaio's works were stylistically conservative for their time and are characteristically prosaic with lots of naturalistic and often contemporary detail, executed with assured draughtsmanship and to a high technical standard. His most important commissions were two ▷frescos for the ▷Sistine Chapel cycle (1481–2), one survives: *The Calling of the Apostles Peter and Andrew*); the frescos and ▷altarpiece of the Sassetti Chapel, Sta Trinità, Florence (completed 1485); and the cycle of *Scenes from the Lives of the Virgin and St. John the Baptist* (1486–90) for the choir of S. Maria Novella, Florence, commissioned by the wealthy banker Giovanni Tornabuoni. In each of these commissions he included life-like portraits of his patrons and their families, one of the most attractive features of his work to the merchants and bankers who were his typical patrons. The altarpiece of the *Adoration of the Shepherds* in the Sassetti Chapel, in particular, shows the influence of ▷Hugo van der Goes' *Portinari Altarpiece*, only recently unveiled in Florence. Ghirlandaio's son and pupil Ridolfo (1483–1561) was an accomplished portrait painter.

Bib.: Cadogan, J.K., 'Observations on Ghirlandaio's Method of Composition', *Master Drawings*, 22 (Summer 1984), pp. 159–172; Casazza, O., *Domenico Ghirlandaio, la pittura*, Florence, 1983; Micheletti, E., *Domenico Ghirlandaio*, New York, 1990

Giacometti, Alberto (1901–66)

Swiss painter and sculptor. His father was a ▷Post-Impressionist painter. In 1919 and 1920 he studied painting at the École des Beaux-Arts, Geneva, and sculpture at the École des Arts Industriels. In 1921 he went to Rome to study painting, before moving to Paris in 1922 where he studied at the Académie de la Grande Chaumière. He produced a series of *Plaques* 1927–8, before becoming involved with ▷Surrealism, which, as Giacometti said, was 'the only movement where something interesting was happening'. His first solo exhibition in 1932 at Galerie Pierre Colle confirmed his position as Surrealism's most important sculptor, with works such as *Suspended Ball* and *The Palace at 4am*. In 1935 he grew dissatisfied with the purely imaginary aspect of Surrealism, and until 1940 he returned to nature, using his brother Diego as model, in an effort to work out a practical phenemonology of perception. His ambition was to 'render only what the eye sees', through an act of pure perception unfettered by knowledge and habit, in order 'to give the nearest possible sensation to that felt at the sight of the subject'. In 1940 he returned to working from memory, but found his sculptures becoming smaller and smaller as he attempted to strip away all that intervened between perception and the real. Giacometti overcame this problem by introducing

the concept of distance to his sculptures, making his figures taller and slender, almost hieratic in appearance, their roughly textured surfaces animating the space around them. Many saw his single standing figures and group figures, such as *City Square* with its attenuated figures on a large base, as a metaphor of existential man, solitary stripped figures inhabiting a vast and meaningless silent void. Sartre wrote the introduction for his exhibition at the Pierre Matisse Gallery, New York, in 1948, his first show since 1932. His portraits also attempt to capture not merely a likeness, but a reality in space, in which the numerous brush strokes both define and bind form to the surrounding space, as well as suggesting the rapid movement of the eye. In 1961 he won the Carnegie Sculpture Prize, in 1962 the First Prize for Sculpture at the Venice ▷Biennale, and in 1964 the Guggenheim International Award for Painting.

Bib.: *Giacometti*, exh. cat., Paris, 1991; Hohl, R., *Giacometti*, London, 1972

Giambologna

▷Giovanni da Bologna

giant order

▷colossal order

Gibbons, Grinling (1648–1721)

Dutch woodcarver and sculptor. He was born in Rotterdam of English parents. He seems to have been trained in Holland, but was in England by c1667. He was discovered by the diarist John Evelyn (purely by chance, according to the account in Evelyn's diary for 18 January 1671), as he was walking past the cottage in which Gibbons was carving a ▷relief, after an ▷engraving of ▷Tintoretto's *Crucifixion*. So impressed was Evelyn with the young man's virtuoso skill that he introduced him to ▷Christopher Wren, who employed him at Windsor Castle (chimney-piece) and later at ▷St. Paul's Cathedral (choir-stalls and screen, 1696–7). In 1684 Gibbons was appointed Master Carver in Wood to Charles II (after an introduction to the Comptroller of the Royal Works, either by Evelyn, or by the painter ▷Sir Peter Lely). In this capacity he executed decorative work at Kensington Palace (1691–3) and Hampton Court Palace (1691–6; 1699–1710), as well as an ambitious monument to Admiral Sir Cloudesley Shovel at Westminster Abbey (1707). From 1714 Gibbons was Master Carver to George I. He was without rival as a wood carver, and his extremely influential work is characterized by decorative garlands which, although composed of intricately carved naturalistic elements such as fruit, flowers, shells, small animals, and cherub heads, still maintain an overall unity of design. So pervasive was his influence that much work has been attributed to him and his large and flourishing workshop, that is undoubtedly by others merely imitating his style. His skill as a marble or bronze sculptor did not match that of his wood carving and, according to ▷George Vertue, he employed other craftsmen to execute works in these media. The bronze statue of James II (1686), outside the National Gallery, London, is a case in point, for it was in all likelihood executed by his partner from c1684 onwards, ▷Arnold Quellin (although Gibbons was credited with it and paid for it). Quellin also collaborated with him on the altar of the Catholic Chapel in Whitehall Palace (1685–96; dismantled 1688). Gibbons's other documented commissions include decorative work at Luton Hoo (originally executed for Cassiobury House, 1676–7), Burghley House (1682), and Trinity College Chapel, Oxford (1693–4). He was an important practitioner of the ▷Baroque in English decoration.

Bib.: Beard, G., *The Work of Grinling Gibbons*, Chicago, 1990; Green, D.B., *Grinling Gibbons, His Work as a Carver and Statuary, 1648–1721*, London, 1964; Oughton, F., *Grinling Gibbons and the English Wood Carving Tradition*, London, 1979

Gibbs, James (1682–1754)

Scottish architect. He was the most original British architect of the first half of the 18th century. Born in Aberdeen of Catholic parents, he first intended training for the priesthood and to this end went to Rome in 1703. Here, however, he changed his mind and instead studied to be an architect under a leading Italian ▷Baroque architect, ▷Carlo Fontana. He returned to England in 1709 with an understanding of the Italian Baroque far superior to that of any of his contemporaries. In 1713 he obtained employment as one of the Surveyors for the 1711 Act for Building Fifty New Churches in London, and designed his first important building, St. Mary-le-Strand (1714–17), a mixture of ▷Wren and Italian ▷Mannerist influences. Gibbs was a Tory and perhaps also a Jacobite, and thus with the crushing of the Jacobite Rising of 1715 and the consequent ascendancy of the Whigs over the Tories, Gibbs lost his official position. Henceforth his only government commission was to be, ironically, the first of his two masterpieces, St. Martin-in-the-Fields, London (1722–6). Its original design employing a ▷Corinthian ▷pedimented ▷portico, from the roof of which rises a majestic steeple, became a pattern for churches throughout England and the American colonies, largely through it being illustrated in Gibbs's influential *Book of Architecture* (1728). Apart from this commission, Gibbs's patrons were now mainly the Tory aristocracy and the universities. For Cambridge he built the Senate House (1722–30) and King's College Fellows' Building (1724–9), and for Oxford he built the second of his two great buildings, the circular, domed library known as the Radcliffe Camera (1737–49). Undoubtedly his most original building, it is based on an earlier design by ▷Hawksmoor, but transformed into a completely personal interpretation

of, to a certain extent, Venetian ▷Baroque (e.g. the curved ▷buttresses of the dome recall Longhena's S. Maria della Salute), but above all ▷Roman ▷Mannerism (e.g. the defiance of 'structural logic' in so far as the buttresses of the ▷dome rest upon the ▷bays between the coupled columns and not on the columns themselves). His other major architectural works are the Octagon room at Orleans House, Twickenham (1720), with its lively ▷Rococo interior decoration executed by Gibbs's regular Italian stuccoists, Artari and Bagutti; Sudbrooke Park, Petersham, Surrey (c1720); and Ditchley House, Oxfordshire (1720–25). His other major publication is his *Rules for Drawing the Several Parts of Architecture* (1732). A characteristic feature of his architecture (though not invented by him) is the so-called 'Gibbs surround', a framing for doors or windows consisting of alternating large and small blocks.

Bib.: Friedman, T., *James Gibbs*, New Haven and London, 1984

Gibson, John (1790–1866)

British sculptor. Born in Wales, he was an important practitioner of ▷Neoclassicism. His family moved to Liverpool, and Gibson was first apprenticed to a woodcarver, then Messrs Franceys, the Liverpool statuaries. His work at Franceys attracted the attention of the connoisseur William Roscoe, who became his first patron and sponsor, equipping him with letters of introduction on his move to London in 1817. Later that year he left for Rome, where he trained under ▷Canova and then for a time, ▷Thorvaldsen. Apart from occasional visits to England on business, he remained in Rome for the rest of his life, winning lucrative commissions from the many wealthy English visitors. His most prestigious patron was Queen Victoria, to whose statue he introduced touches of colour, as Canova had done before him, in accordance with Greek practice. The culmination of his experiments with polychromy is *The Tinted Venus* (1851–6, Liverpool, Walker Art Gallery). Notwithstanding the Greek precedent, many contemporaries found the increased naturalism to be an unsettling clash with the formal idealization of the figure. Gibson was elected ▷ARA in 1833 and ▷RA in 1838, exhibiting at the Royal Academy from 1816 until 1864. At his death, his fortune and the contents of his studio were left to the Royal Academy.

Bib.: Lady Eastlake, (ed.), *Life of John Gibson, RA, Sculptor*, London, 1870; Stevens, T., 'John Gibson's *The Sleeping Shepherd Boy*' in P. Curtis, (ed.), *Patronage and Practice: Sculpture on Merseyside*, Liverpool, 1989

Gilbert, Sir Alfred (1854–1934)

English sculptor. He was born in London. His most famous work was the Shaftesbury Memorial Fountain at Piccadilly Circus (1886–93), the balletic pose of its crowning figure of Eros made possible by the use of cast aluminium instead of heavier bronze. Gilbert originally studied to be a surgeon, but found art more congenial and in 1873 gained entry into the ▷Royal Academy Schools. This was followed by a period of study in Paris and six years working in Italy where he executed his earliest ideal ▷bronzes, learning the ▷*cire-perdue* process, which he later reintroduced into England. The sensitive control of modelling facilitated by this method helped make Gilbert the most influential British sculptor of his generation. His *Icarus* (1884, Cardiff, National Museum of Wales) commissioned by ▷Lord Leighton (▷PRA), secured Gilbert's election as ▷ARA in 1887 (he was elected RA in 1892). He obtained important commissions from the Royal Family, including the prestigious Tomb of the Duke of Clarence (1892–1901, 1926–8) for Windsor – a remarkable tour-de-force of sculptural ▷polychromy. In 1897 he was appointed MVO, and in 1900 was nominated Professor of Sculpture at the Royal Academy Schools. In 1901, however, he became bankrupt and, amidst a scandal over his unauthorized sale of figures from the unfinished royal tomb, he fled to Bruges, returning only in 1926 following George V's personal request that he finish the tomb. On his return he was awarded the gold medal of the Royal Society of British Sculptors and in 1932 was knighted.

Bib.: Dorment, R., *Alfred Gilbert*, New Haven and London, 1985

Gilbert and George

Gilbert Proesch (b 1942) and George Passmore (b 1943) are two artists who studied together at St. Martin's School of Art in London and subsequently joined together to produce works of conceptual art which they called 'living sculpture'. They have worked in a wide variety of media. Most of their works are based on their own images. They won the ▷Turner Prize in 1986.

Bib.: *Gilbert and George: The Complete Pictures 1971–1985*, exh. cat., London, 1986; Jahn, W., *The Art of Gilbert and George, or an Aesthetic of Existence*, New York, 1989

gilding

The process by which a surface is covered with thin leaves of gold. In panel paintings (generally religious) of the Middle Ages, extensive areas of the surface were gilded, the background to the picture forming an area of continuous gilding with the frame. Additionally haloes, thrones and jewelled costumes would be gilded. ▷Cennini explains that in the process of gilding a panel painting, the white ▷gesso ground would be coated in bole (a red ochre clay) in those areas where the gold leaf was to be laid, in order to give the gold a warmer glow; this bole can be seen today in many medieval panels where the gold leaf has worn away. The leaves were then carefully laid side by side on the bole, which had first been coated with a mordant

adhesive, and then polished to a glowing finish with a burnishing tool (Cennini recommends the canine tooth of a dog). The gilding of areas within a picture became relatively unfashionable in the ▷Renaissance when a more 'scientific', veristic approach to representation was demanded by the more aesthetically sophisticated patrons. However, gilding was still used on picture frames and only in the 19th century did some painters begin to advocate simpler framing. It was also common practice to gild the surfaces of other metals to obtain a richer effect: all the ▷bronze doors of the Baptistry in Florence were originally gilded.

Gill, Arthur Eric Rowton (1882–1940)

English engraver, sculptor and typographer. He was born in Brighton, the son of a minister. He was apprenticed to Caroe (a member of the Ecclesiastical Architecture Commission), but took evening classes at the Central School of Art and studied letter design with Edward Johnston. He began his career as a letter-cutter, (he designed the new typographic styles Gill sanserif and Perpetua) before turning to sculpture in 1910. He was deeply religious, converting to Catholicism in 1913, and publishing *Christianity and Art* in 1927. He shared many of the ideals of the ▷Arts and Crafts movement, establishing an artistic community at Ditchling, and like ▷Morris, he viewed himself as an artist-craftsman with a strong social purpose. His sculpture, like his graphic work, was characterized by simple, clean lines and strong form; he preferred ▷direct carving and many of his works were done in relief to emphasize the form of the original block. He produced illustrations for the Golden Cockerel Press.
Bib.: *Eric Gill Sculpture*, exh. cat., London, 1992; MacCarthy, F., *Eric Gill*, London, 1989

Gillies, Margaret (1803–87)

Scottish painter. She studied art in London in 1820. She produced portraits and miniatures and exhibited at the ▷Royal Academy. She was particularly known for her images of famous literary figures such as Wordsworth and Dickens. She became a member of the Old Watercolour Society in 1852. She exhibited in the Paris exhibition of 1855 and spent much of her later life travelling around Europe.

Gillot, Claude (1673–1722)

French painter and draughtsman. He was one of the first artists to engrave scenes from the ▷*commedia dell'arte*. He oversaw a decorative programme at the Paris opera, and he was a teacher of ▷Watteau.

Gillray, James (1757–1815)

English caricaturist and engraver. He was the son of a Chelsea Pensioner. After an apprenticeship with a letter engraver, he became a strolling player for a time before enrolling at the ▷Royal Academy schools in 1778. There he studied ▷engraving, which he practised

with limited success, working in the stipple style of ▷Bartolozzi. In 1786 he became a professional ▷caricaturist, using his engraving skills and working in ▷aquatint and occasionally in ▷watercolour. He made a name for himself with a series of ▷Hogarthian satires, which showed his personal wit (e.g. *A New Way to Pay the National Debt*, 1786). His subjects were mainly political, and from 1797 he received a pension from the Tory party for his increasingly anti-Whig work. He was prepared to express the views of others, although some of his own opinions, particularly his anti-French stance, shine through (e.g. *Zenith of French Glory*, 1793). He was also critical of contemporary academic art (e.g. *Shakespeare Sacrificed*, 1789: an attack on the ▷Shakespeare Gallery; *Weird Sisters*, 1791: an affectionate parody of ▷Fuseli). He also developed new letterheads. His work declined after 1807 and he developed a mental illness in 1811. He remained the standard against which much 19th-century caricature was judged.
Bib.: Hart, R.M., *James Gillray, Prints by an 18th-Century Master of Caricature*, Hanover, NH, 1994; Hill, D., *The Satirical Etchings of James Gillray*, New York, 1976; *James Gillray, Drawings and Caricatures*, exh. cat., London, 1967

Gilly, Friedrich (1772–1800)

German architect. He specialized in monumental designs in a ▷Neoclassical style, not all of which were built. Among his most famous works is a monument to Frederick the Great. He was a teacher of ▷Schinkel.
Bib.: *Friedrich Gilly 1772–1800 und die Privatgesellschaft junger Architekten*, exh. cat., Berlin, 1984

Gilman, Harold John Wilde (1876–1919)

English painter. He was educated at Hastings School of Art (1896) and at the ▷Slade (1897–1901), where he met ▷Gore. He travelled to Spain in 1902, where he discovered the work of ▷Velázquez, and to the USA in 1905. He was initially part of ▷Sickert's circle and a member of the ▷Camden Town Group (e.g. *Sickert's House*, 1907, Leeds), but was increasingly influenced by the work of ▷van Gogh, after a visit to Paris in 1911. He developed a heavily painted style using small directional dashes which created texture and structure (e.g. *Canal Bridge, Flekkefjord*, 1913, London, Tate Gallery). His treatment of working-class subjects was enlivened by bright colour and simplified colour planes (e.g. *Mrs. Mounter at Breakfast*, 1916, London, Tate). He was president of the ▷London Group in 1913 and instrumental in the establishment of the ▷Cumberland Market Group (1914), after publishing *Neo-Realism* with ▷Ginner. He taught at Westminster School of Art (1915) and was a war artist (see *Halifax Harbour*, 1918; Ottawa). His career was cut short as a result of the post-war flu epidemic.
Bib.: *Harold Gilman*, exh. cat., London, 1981

Gilpin, Sawrey (1733–1807) and William (1724–1804)

English family of painters and writers on aesthetics. Sawrey studied under ▷Samuel Scott in 1749 and was most famous for his sporting art, especially scenes of horses. He became an ▷RA in 1797.

His brother, William, was one of the earliest advocates of the ▷picturesque ▷aesthetic. His ideas first germinated in his *Essay on Prints* of 1768, and especially his chapter 'Remarks upon Principles of Picturesque Beauty'. He travelled around England, Wales and Scotland in the 1760s and 1770s, making sketches and looking for picturesque scenes, and in the 1790s he wrote other essays on the picturesque which helped establish it as an aesthetic category alongside the ▷sublime and the beautiful.

Ginner, Charles Isaac (1878–1952)

British painter. He was born in Cannes, in the south of France, and studied at the ▷École des Beaux-Arts in Paris before settling in London in 1910, encouraged by ▷Sickert who saw his work at the ▷Allied Artists' Association (1908). He was a founder member of the ▷Camden Town Group (1910) and a member of the ▷London Group (1913), producing Edwardian-style interiors (e.g. *Cafe Royal*, 1911, London, Tate Gallery). He admired the ▷Post-Impressionists, especially ▷van Gogh, and experimented with ▷pointillism (e.g. *Dieppe, Evening*, 1911, London, Fine Art Society). This developed into an ordered textured use of paint for his scenes of contemporary urban life (e.g. *Leeds Canal*, 1916, Leeds), a style which he defined as ▷Neo-Realism in a pamphlet of 1914, co-written with ▷Gilman. He was employed as a War artist (e.g. *Shell Filling Factory*, 1918–19, Ottawa). He was a member of Group X.

Bib.: *Charles Isaac Ginner*, exh. cat., London, 1985

Gioconda, La

▷*Mona Lisa*

Giordano, Luca (1632–1705)

Italian painter. He was Neapolitan. He was known, on account of the natural facility his father was supposed to have inculcated in him, as '*Luca fa presto*' ('Luca, paint quickly'). In Naples he was probably a pupil of ▷Ribera, and his early style reflects the dark palette and ▷Caravaggesque ▷chiaroscuro of his master. He later moved to Rome, however, and was influenced by the more fluent technique, lighter palette, and richer colourism of ▷Pietro da Cortona. He next went to Florence, where in 1682 he was commissioned to paint the vast ceiling of the ballroom in the Palazzo Medici-Riccardi. A move to Venice, and the influence of ▷Veronese's great decorative paintings, had the effect of lightening his palette to the extent that all trace of Ribera had disappeared. By now his fame was sufficient to attract the notice of Charles II of Spain who, in 1692, commissioned him to execute a series of ceiling paintings in the Escorial, Madrid, considered by some to be his masterpieces. Having worked in Spain for ten years, he returned, in 1702, to Naples. Giordano combined a prodigious facility and lightness of touch with a tendency to eclecticism, the former qualities earning him as much praise as the latter occasioned adverse criticism. He was by far the most significant Neapolitan painter of the second half of the 17th century and was highly influential on most of the European decorative painters of the first half of the 18th century.

Bib.: Ferrari, O., *Luca Giordano, l'opera completa*, Naples, 1992

Giorgione (Giorgio Barbarelli) (Giorgio da Castelfranco) (c1477–1510)

Italian painter. He was a Venetian who, from very shortly after his premature death, probably from the plague, was hailed by ▷Vasari as the superior of ▷Giovanni Bellini (who may have been his master) and the rival, as one of the authors of the modern style, of ▷Leonardo da Vinci. Virtually nothing is known of Giorgione's life. Vasari states that his name was Giorgio, that he came from Castelfranco (in the Veneto) and that 'Giorgione' ('Great George') refers to 'his stature and the greatness of his mind'. His only two documented commissions are for a now lost oil painting in the Doge's Palace (1507–8) and the ▷frescos on the Fondaco dei Tedeschi (the German Warehouse) (1508). His collaborator on the latter, which survive only in a ruinous condition (although 18th-century engravings exist), was ▷Titian. One painting, a portrait known as *Laura* (Vienna, Kunsthistorisches Museum), has an inscription on the back, stating that it was painted by 'Master Zorzi [a Venetian variant of Giorgio] da Castelfranco' in 1506, and that Zorzi shared a studio with Vincenzo Catena, the only known connection between these two artists. There are four paintings ascribed to Giorgione by a reliable contemporary source (the collector Marcantonio Michiel): namely *The Tempest* (Venice, Accademia); *The Three Philosophers* (Vienna, Kunsthistoriches Museum); *Sleeping Venus* (Dresden, Gemäldegalerie); and *Christ Carrying the Cross* (Venice, S. Rocco). Of these four, *The Three Philosophers* was finished by ▷Sebastiano del Piombo and the *Sleeping Venus* by ▷Titian. Titian later borrowed the pose for his own *Venus of Urbino* and replicated the hill-top town at the upper right – which may have been his contribution anyway – in his *Noli Me Tangere* (London, National Gallery).

Part of the problem with establishing Giorgione's *oeuvre* is that the early works of Titian and Sebastiano are so profoundly influenced by Giorgione. For example, a *Concert Champêtre* (Paris, Louvre) and a *Judgement of Solomon* (Dorset, Kingston Lacy), once attributed to Giorgione, are now reattributed,

respectively, to Titian and Sebastiano. Such confusion prevailed even from the earliest days: Vasari attributed the S. Rocco *Christ Carrying the Cross* to Giorgione in his life of Giorgione, and to Titian in his life of Titian (it is nonetheless universally accepted as by Giorgione). Of the other paintings attributed to Giorgione, the most important (and secure) is the so-called *Castelfranco Altarpiece* (first mentioned in 1648 by Ridolfo), still in the chapel for which it was evidently painted, in the cathedral of Giorgione's home-town. It appears to be an early work (c1500) and shows the influence of not just Bellini, but also ▷Antonello da Messina and ▷Perugino. The transformation in Giorgione's work came, according to Vasari, after seeing Leonardo's oil paintings: 'rich toned and exceedingly dark ... Giorgione made them his model, and imitated them carefully in painting in oils'. Certainly the paintings Michiel ascribes to Giorgione exploit the evocative qualities of oil to the maximum.

Giorgione's historical importance is related to such men as Michiel, for Michiel was a collector and Giorgione was perhaps the first artist to paint specifically for private collectors (as opposed to public buildings and religious foundations). Here we see the origins of a new concept of the picture as an object of intrinsic beauty: its aesthetic qualities begin to take precedence over whatever it may purport to represent. The supreme exemplar of this type of ▷'cabinet picture' is the so-called ▷ *Tempest*, the subject of which, it is clear from Michiel's description, he was not sure. Furthermore, X-ray photography has revealed that Giorgione changed not just the position of the picture's figures (which is not unusual), but radically changed their identity (which suggests they are mere ▷staffage). Despite the advancement of a number of ingenious theories by scholars, it is generally accepted that the subject of the *Tempest* is the mood created by the picture itself. By the 19th century, the desire to own a Giorgione had contributed to the enormous number of Giorgionesque paintings in existence. That this agglomeration was even possible is testament to the extent of Giorgione's influence, not just on Titian and Sebastiano, but also on such artists as ▷Palma Vecchio, ▷Savoldo and ▷Dosso Dossi and many of their lesser known contemporaries.

Bib.: Holberton, P., 'Giorgione's *Tempest* or "little landscape with the storm with the gypsy"': More on the Gypsy, and a Reassessment', *Art History*, 18 (1995), pp. 383–404; Rigon, F., *La terra di Giorgione*, Citadella, 1994; Settis, S., *Giorgione's Tempest*, Chicago, 1990; Torrini, A.P., *Giorgione: catalogue complet des peintures*, Paris, 1993

Giottesques

The followers of ▷Giotto. These artists, some of whom may have known or worked with Giotto, and others who only knew his work, followed the brightly coloured, modelled figures of Giotto. They include ▷Taddeo Gaddi, ▷Maso di Banco, ▷Bernardo Daddi and ▷Orcagna, all of whom became reputable artists in their own right.

Giotto di Bondone (c1267–1337)

Italian painter. He was a Florentine painter generally credited with consummating the break away from ▷Byzantine conventionalism towards naturalism, a movement which had been gathering strength in the work of the painters ▷Cavallini and ▷Cimabue (Giotto's presumed master) and the sculptors ▷Nicola and ▷Giovanni Pisano and ▷Arnolfo di Cambio, and which would lead ultimately to the achievements of the Italian ▷Renaissance. Giotto's artistic originality was recognized by his contemporaries. During Giotto's lifetime, Dante wrote: 'In painting Ciambue thought to hold the field and now Giotto has the cry, so that the other's fame is dim' (*Purgatorio*, canto xi: 94–6; trans. J.D. Sinclair, New York, 1939). In c1390, ▷Cennini wrote in his treatise, *Il Libro dell'Arte*: 'Giotto changed the profession of painting from Greek [i.e. Byzantine] back into Latin, and brought it up to date' (trans. D.V. Thompson, New York, 1960). His new manner influenced all the leading painters in Florence as well as some of those in Siena (particularly the ▷Lorenzetti) for the first half of the 14th century. In the second half of the century his influence was superseded temporarily by that of the ▷International Gothic style, only to be revived with more comprehension of its true potential by ▷Masaccio. A century later ▷Michelangelo made studies of Giotto's Peruzzi Chapel frescos.

There are just three signed works: the *Stigmatisation of St. Francis* (Paris, Louvre), the *Baroncelli Altarpiece* (Florence, S. Croce), and a ▷polyptych of the *Madonna and Saints* (Bologna, Pinacoteca Nazionale). And yet these are generally considered to be products of the workshop, executed with Giotto's approval, but not necessarily by his hand. A document of 1342 attributes to him the *Stefaneschi Altarpiece* in the Vatican, but this is also thought to be largely workshop. The work most highly regarded by his contemporaries, the *Navicella* (c1300) at St. Peter's, survives, cut down and so thoroughly reworked that its original qualities are impossible to determine. None of the handful of surviving works universally accepted as having been designed and executed to a significant extent by Giotto (all large-scale commissions would in any event have required workshop assistance) is signed or documented. Yet it is on these that the current understanding of Giotto's stylistic evolution centres. The greatest is undoubtedly the ▷fresco cycle in the ▷Arena Chapel, or (as it is otherwise known after its patron, Enrico Scrovegni) the Scrovegni Chapel, Padua (c1304–13). There is the majestic altarpiece, the *Ognissanti Madonna* (c1305–10, Florence, Uffizi). And lastly there are two late fresco cycles (c1320s) in S. Croce: the *Life of St. Francis* in the Bardi Chapel and the *Lives*

of *Sts. John the Baptist and Evangelist* in the Peruzzi Chapel in the church of S. Croce in Florence. One further work of major artistic significance is the fresco cycle of the *Life of St. Francis* in the Upper Church of S. Francesco at Assisi, given to Giotto by ▷Vasari. The attribution here, however, has been largely refuted by many present-day art historians who, whilst not denying the quality of the work at Assisi, discern in it a stylistic character irreconcilable with that at Padua. Furthermore, significant stylistic differences have been detected within the cycle itself, necessitating the creation of the anonymous ▷Master of St. Cecilia for the first scene and last three scenes (the rest in this case being given to the ▷Master of the St. Francis Cycle). Giotto is also known to have worked in Naples (1329–33) as court painter to Robert of Anjou, but nothing of his work there remains.

The quality that sets Giotto's paintings above those of his contemporaries is first and foremost his ability to represent believable form and space on a flat surface, in order to convey a clear and convincing narrative. Rejecting medieval pattern-book formulae, he appears to have learnt much about how to represent solid figures, arranged in depth, and engaged in meaningful interaction from the most advanced sculptors of his time (i.e. the ▷Pisani), as well as from direct observation of the world around him. Forms are simplified and all superfluous anecdotal detail eliminated, giving a gravity to his figures and a universal significance to the events he depicts. Furthermore, he has a natural storyteller's eye for the significant moment of any action, and an unsurpassed ability to isolate and portray the most telling gestures of its actors.

From 1334 he was appointed capomaestro (overseer) of the Florence Cathedral works. In this capacity he designed the ▷campanile, although following his death its lower levels had to be fortified to prevent collapse, and the design was much altered by his successor, Andrea Pisano.

Bib.: Cole, B., *Giotto and Florentine Painting 1280–1375*, New York, 1976; d'Arcais, F., *Giotto*, New York, 1995; Edgerton, S., *The Heritage of Giotto's Geometry*, Ithaca, 1993; Guillard, J., *Giotto, Architect of Colour*, New York, 1987

Giovanni da Fiesole
▷Fra Angelico

Giovanni da Udine (Giovanni Nanni) (1487–1546)
Italian painter. He was one of the foremost Italian decorative artists of his time, notable particularly for his use of ▷grotesque ornamental motifs and antique ▷stucco techniques, inspired by the recent archaeological discoveries at Nero's Golden House on the Esquiline Hill. Born at Udine, he studied in nearby Venice under ▷Giorgione, before moving to Rome, where he entered ▷Raphael's workshop as his principal stuccoist. His style of grotesque ornamentation can best be seen in Raphael's Vatican Loggie (1517–19) and the Villa Madama, Rome (1520–21).

Giovanni di Paolo (fl 1420; d 1483)
Italian painter. Also known as Giovanni dal Poggio (from the district of Siena in which he lived), he was, with ▷Sassetta, the leading Sienese painter of the 15th century. In addition to the Sienese masters of the ▷trecento, the main influence on Giovanni was ▷Gentile da Fabriano (working in Siena 1424/6). Giovanni's own unique style is distinguished by an intensely emotional spiritualism.
Bib.: Pope-Hennessy, J., *Giovanni di Paolo*, 1937; Pope-Hennessy, J. (ed.), *Paradiso*, New York, 1993

Girardon, Francis (1628–1715)
French sculptor. He was responsible for some of the decoration of Versailles, including *Apollo and the Nymphs* (1666) and the grotto of Thetis. He also contributed to the decoration of the Galérie d'Apollon in the Louvre. His work was very much in the ▷academic style. One of his most famous works was an ▷equestrian statue of Louis XIV originally designed for the Palace Vendôme in Paris (1683–92), but destroyed during the ▷French Revolution as an example of *ancien régime* decadence.

Girlhood of Mary Virgin, The
One of the earliest paintings of the ▷Pre-Raphaelite Brotherhood that formed in 1848, ▷Rossetti's painting was first exhibited at the Free Exhibition in London in 1849. The subject referred to the Tractarian belief in the ritual accorded to the ▷Virgin Mary, who is presented as a young woman surrounded by symbolic objects, including a vine emblematic of the true Church, a ▷lily symbolic of virginity, and books signifying chastity and purity. The style of this and his *Ecce Ancilla Domini!* (a scene of the ▷Annunciation), derived through ▷Madox Brown from the ▷Nazarenes, a German school of painters of the early 19th century. In their subject matter, their use of bright colours and lack of ▷chiaroscuro, these two paintings are the principal example of the Brotherhood reinterpreting the vision of 15th-century artists like ▷Fra Angelico. It also contains characteristic elements of Rossetti's subsequent pictures, such as close figure composition, the separation of foreground from background, literary images, vegetation, and sonnets attached to the frame.

Girodet de Roucy, Anne-Louis (Girodet-Trison) (1767–1824)
French painter, illustrator and poet. He was born in Montargis and changed his name in honour of a benefactor, Dr. Trison. He was a pupil of ▷David from 1784, winning the ▷Prix de Rome at his third

attempt, in 1789 (*Joseph Recognized by his Brothers*, Paris, ▷École des Beaux-Arts). His first ▷Salon exhibit (*Endymion*, 1793, Paris) was highly popular. He was in Rome at the French Academy when David ordered the replacement of the royal arms, and in the ensuing riot fled to Naples and then to Genoa, where he was taken under the protection of ▷Gros. He combined a strict ▷Neoclassical style with an enthusiasm for literature and romance, which led not only to a softer palette and moody use of lighting but to some unusual subject matter (e.g. *Burial of Atala*, 1808, Paris). After returning to Paris in 1795, he produced portraits (e.g. *Mlle Lange as Danae*, 1799, Minneapolis) and illustrations for Racine and Virgil, before becoming part of Napoleon's propaganda machine (e.g. *Revolt of Cairo*, 1810; *Ossian Welcoming the Heroes of the Republic*, 1802, Malmaison). He also designed decorations for Compeigne (1809). In 1812 he abandoned painting altogether, having inherited money, to turn his attention to writing.
Bib.: *Anne-Louis Girodet*, exh. cat., Paris, 1967; Bernier, G., *Anne-Louis Girodet*, Paris, 1975

Girtin, Thomas (1775–1802)

English watercolourist. He was born in Southwark, the son of a rope-maker, and apprenticed to Edward Dayes, before joining ▷Dr. Monro's celebrated circle of artists, which included ▷Turner. Although his career was brief, he revolutionized ▷watercolour painting, abandoning the 'tinted drawing' and use of underpainting common in 18th-century topographical work, in favour of a freer application of paint onto semi-absorbent paper (e.g. *Tintern Abbey*, 1793, Blackburn). His early work, influenced by copying ▷Canaletto, retains a topographical appearance, and he painted a number of ▷picturesque ruined sites (e.g. *Great Hall, Conway Castle*, 1799, London, British Museum). But pieces like the *White House* (1802, London, Tate Gallery) show the change. He travelled widely throughout Britain (Scotland 1792, north England 1796) and visited Paris in 1801–2 (a collection of ▷etchings of the visit was published in 1803). In 1802 he also produced his *Eldometropolis*, a panoramic view of London (lost, but sketches in British Museum). He was supported by a number of patrons including Lord Hardwicke, for whom he produced a series of large-scale views of his estate, and ▷Beaumont. He exhibited at the ▷Royal Academy from 1794.
Bib.: Haycroft, F.W., *The Watercolours of Thomas Girtin*, London, 1975

gisant

(French, 'recumbent'.) French term for a recumbent effigy on a tomb, portraying the deceased as a corpse, sometimes in a state of decomposition.

Gislebertus (fl early 12th century)

French sculptor. He was a ▷Romanesque sculptor whose identity is known from his signature on the west doorway of ▷Autun Cathedral. It has been suggested that the position of the signature, below the sculpture of the *Last Judgement* (c1125), demonstrates that he was appreciated as an individual artist in his own times. Other sculptures have subsequently been attributed to him.

Giuliano da Maiano (1432–90)

Italian architect and sculptor. He was from Florence, and often worked in collaboration with his sculptor brother Benedetto. Giuliano began as a woodcarver, and among his earliest commissions (executed with his brother to designs attributed to ▷Maso Finiguerra and ▷Alesso Baldovinetti) were the ▷intarsia cupboards in the New Sacristy, Florence Cathedral (1463–5). In his architecture he was influenced by ▷Brunelleschi and ▷Michelozzo, and helped disseminate their early ▷Renaissance style throughout Tuscany and beyond. From 1477 until his death, he was master architect of Florence Cathedral. What is probably his masterpiece, however, is the cathedral of Faenza (1474–86). His other principal works are the Chapel of S. Fino in the Collegiata, San Gimignano (1466), the Palazzo Spannochi, Siena (begun 1473), the Palazzo Venier, Recanati (1477), and the Palazzo di Poggio Reale, Naples (c1488; destroyed).

Giulio Romano (Giulio Pippi) (1492–1546)

Italian painter and architect. He was one of the founders of ▷Mannerism. He was ▷Raphael's chief assistant from 1515, working chiefly on the ▷frescos on the Stanza dell' Incendio in the Vatican. Following Raphael's death in 1520, Giulio completed his master's Stanza di Constantino frescos, the *Transfiguration* (also Vatican), and the decorations for the Villa Madama. On his own account he painted an ▷altarpiece, the *Holy Family*, for S. Maria dell' Anima, Rome, and another, the *Stoning of St. Stephen* for Sto Stefano, Genoa. Giulio's works take further the Mannerist tendencies in late Raphael and add to them the influence of ▷Michelangelo. He appears to have left Rome in something of a hurry in 1524 shortly after designing some pornographic prints, illustrating poems by Pietro Aretino, and engraved by ▷Raimondi (who had been imprisoned for the offence). He went to Mantua and executed for ▷Federigo Gonzaga his first major architectural commission, the Palazzo del Tè (1524–34), one of the most Mannerist buildings ever erected, full of quirky architectural motifs whose witty contradiction of their implied function is only fully appreciated by an observer with a thorough knowledge of the ▷canon of Classical Roman and High ▷Renaissance architecture. In addition, there are the more obvious witticisms, such as slipping ▷keystones etc. Giulio also painted the fresco decorations, including

the astonishing *Fall of the Giants* which, completely covering all the walls and vault of a windowless room, shows the Titans being crushed by the thunderbolts of Jove (in the vault) – so violent is his retribution that the very walls of the room itself appear to be collapsing around the spectator, and with only one door and no windows onto the real world outside there is nothing to break the illusion. ▷Vasari, who greatly admired the scheme, wrote that the fireplace was intended to play its part too: 'Between these falling walls is the fireplace, and when a fire is lighted the giants seem to be burning.'
Bib.: Massari, S., *Giulio Romano, pinxit et delineavit*, Rome, 1993; Salvy, G.-J., *Giulio Romano, une manière extravagante et moderne*, Paris, 1994

Giverny

A small rural village in the Seine Valley to which ▷Claude Monet moved in 1883 and where he lived until his death there in 1926. His famous series of paintings of ▷haystacks and fields were painted in the locality, and his water-lily series were painted in the fabulous gardens he created there. During this later period of his life he simplified his compositions, choosing subjects awash with colours and textures of light.
Bib.: *Monet's Years at Giverny: Beyond Impressionism*, New York, 1978

Glackens, William James (1870–1938)

American painter and illustrator. He began his career as an illustrator. He travelled to Paris in 1895, and returned to New York, where he studied with ▷Robert Henri. The subject-matter of the French ▷Impressionists crept into his work, which was largely concerned with scenes of middle-class leisure life. He was a member of ▷The Eight and considered part of the ▷Ashcan School, although his work showed little evidence of ▷social realism. He moved towards an Impressionist style from 1905. He was involved with organizing the ▷Armory Show. After 1912, ▷Albert Barnes hired him as an agent to purchase paintings.

Glasgow School

The term is used for two distinct groups:
(i) In architecture, it refers to the group of designers around ▷Rennie Mackintosh, who promoted ▷Art Nouveau ideas in Scotland. They included the ▷Macdonald sisters.
(ii) In painting it is synonymous with the Glasgow Boys, a group of French-influenced artists working in Glasgow c1880–1900, who portrayed landscape and peasant subjects using techniques inspired by ▷Bastien-Lepage (and his 'square brush' style), the ▷Barbizon School, the ▷Hague School and ▷Impressionism. The group included W.Y. MacGregor, Guthrie, ▷Lavery, ▷Cameron and Crawhall. They opposed the dominance of the Royal Scottish Academy, which encouraged a landscape style based

on the romanticized views of Scotland of ▷Landseer and MacCulloch, and were encouraged by the popularity of naturalist landscape amongst Glasgow patrons. Some became members of the ▷NEAC, and they achieved international recognition with exhibitions at Munich. Many of the group went on to become influential in Glasgow School of Art. In their later careers, however, most abandoned the style and subject-matter of their youth (e.g. Lavery became one of the leading portraitists of the period and Guthrie became President of the Royal Scottish Academy).
Bib.: Bilcliffe, R., *The Glasgow Boys, Glasgow School of Painting*, London, 1985; Irwin, D., *Scottish Painters at Home and Abroad 1700–1900*, London, 1975

glass painting

A type of ▷folk art, especially common in central Europe, in which glass is painted with images, sometimes of a religious nature. Bavarian glass painting was inspirational to early 20th-century German artists, such as ▷Kandinsky and ▷Münter.

glass print

▷cliché-verre

glaze

A glass-like film applied to pottery to make it watertight and give it a smooth finish. Glazes are usually made from sand and a fluxing agent which gives its name to the glaze. For example, lead glaze uses sand and the fluxing agent lead. Painted or printed decoration can be executed before or after glazing. Underglaze decoration has a limited colour range but is more permanent than overglaze decoration. Glazes can also be applied to paintings and, as such, are thin transparent layers of paint. From the 16th century glazes became increasingly complex and have often deteriorated in subsequent years, thus obscuring the subject-matter.

Gleizes, Albert (1881–1953)

French painter. He was born in Paris. After training as an industrial designer, he turned to painting in 1900. He began his career as an ▷Impressionist but in 1910 became interested in ▷Cubism, and exhibited at the Cubist exhibitions in 1911 and 1912. He worked in a restrictive style, using flat pattern, monochrome palette and abstracted shapes (e.g. *Kitchen*, 1911, private collection; *Man on a Balcony*, 1912, Philadelphia). His work increasingly explored colour and decoration, following that of ▷Léger and ▷Delaunay (e.g. *Woman and Animals*, 1914, Venice). In 1912 he collaborated with ▷Metzinger on the first explanation of the movement, *Du Cubisme*, and in the same year he co-established the ▷Section d'Or. He spent the War years in America, having exhibited at the ▷Armory Show in 1913. After World War One, he tried to revive Cubist ideas, but with little success. He turned to ▷mural painting during the 1930s but then underwent a

religious conversion in 1941, which affected his later work. He published *Souvenirs de Cubisme* 1908–14 (1957).

Bib.: Alibert, P., *Gleizes, biographie*, Paris, 1990; *L'Art sacre de Albert Gleizes*, exh. cat., Caen, 1985

Gleyre, Marc Gabriel Charles (1808–74)

Swiss painter. He was born in Chevilly. He trained in Paris under Hersent (1825) and spent time in Italy 1828–33, where he discovered the work of the ▷Nazarenes and of ▷Raphael, both major influences. He travelled to the Middle East 1843–7, making a number of sketches (e.g. *Turkish Woman of Smyrna*, watercolour, 1844, Lausanne). His breakthrough came in the 1843 ▷Salon with *Evening or Lost Illusions* (Paris), a grand yet calm piece of historical genre. But in that year he took over ▷Delaroche's Paris studio, and gradually the burden of his teaching restricted his exhibitions. He became one of the major teachers of the period (his pupils included ▷Monet, ▷Renoir, ▷Bazille, ▷Sisley) and allowed his students considerable freedom, based on sketching from nature. His career ended because of eye problems in 1864. His work remained strictly classical, employing mythology (e.g. *Hercules at the Feet of Omphale*, 1861, Neuchâtel) and the female nude (*Charmeuse*, 1868, Basle).

Bib.: Hauptman, W., *Charles Gleyre, 1808–74: Life, Works and Catalogue*, Princeton, 1995

Gluttony

(From the Latin, 'Gula'.) One of the Seven Deadly Sins, classed with ▷Lust as a sin of the flesh (*vita carnalia*). It is represented in cycles of the ▷Virtues and Vices and features inevitably in the scenes of Hell that accompany ▷Last Judgement pictures (e.g. ▷Taddeo di Bartolo, 1396, *Last Judgement* fresco, San Gimigniano, Collegiata). Gluttony may be male or female but is invariably obese. Usually he or she will be consuming vast quantities of food and drink, and is frequently portrayed vomiting. Sometimes Gluttony may wear a crown of vine leaves. Animals that are often associated with Gluttony are pigs (synonymous with greedy and impartial eating), bears (for their proverbial love of honey), and hedgehogs (believed in the Middle Ages to have gathered their food by rolling on the ground and spearing it on their spines).

Glyptothek

A building in Munich erected in the 19th century in a ▷Neoclassical style. It was designed by ▷Klenze and meant to house Ludwig I's collection of antiques. ▷Peter Cornelius designed ▷frescos for it.

Gobelins

The Gobelins were a celebrated family of dyers, in whose property in Paris the Royal Manufactory of Tapestry was founded in 1667 by Colbert (Minister of Finance to Louis XIV). As the 'minor arts' grew in importance (France being pre-eminent) during the 17th and 18th centuries, the ▷tapestry became a status symbol at court, being easily transported and also serving a decorative purpose. The name Gobelins over time came to refer to the tapestries themselves, whether woven at the Gobelins or not. The typical technique employed was the *haut lisse* method, and an adjustable mirror was fitted behind the warp allowing the weaver to oversee the progress of work. This enabled a wide range of tapestries to be produced with elaborate borders, and inspired by the Classical ▷Baroque designs of ▷Lebrun.

God the Father

The first person of the ▷Trinity. In Early Christian and early medieval art he resembles Christ, on the scriptural authority that the Son (Christ) was one with God the Father and had existed from the beginning of time. This doctrine is expressed in the words of the 4th-century Nicene Creed: '... Jesus Christ ... by whom all things were made'. The mosaic *Creation Scenes* in the abbey church of Monreale, Sicily (before 1183) show him thus, while in the same church, in the contemporaneous mosaic of *King William II offering Monreale to the Virgin*, God the Father's presence is signified by a hand issuing from the clouds; both treatments were frequently used. From c1300, representations of God the Father as an aged, white-bearded, patriarchal figure appear. The biblical authority is found in ▷Daniel's vision of the 'Ancient of Days' (7:13–14). ▷Giotto represents him thus in the ▷Arena Chapel ▷fresco of the *Baptism of Christ* (c1305–6), as does ▷Michelangelo in the *Creation Scenes* on the ▷Sistine Chapel ceiling (1508–12). In representations of the ▷Trinity, it became desirable (though not inevitable) that the Father and Son should be differentiated. God the Father may wear a papal tiara or a royal crown. He appears also in scenes of the ▷Annunciation, ▷Agony in the Garden, ▷Immaculate Conception, ▷Assumption and ▷Coronation of the Virgin.

Godwin, Edward William (1833–86)

English architect and designer. He was born in Bristol, the son of a currier. After training with a local architect, he established a practice in Bristol (1854) and won the competition to design Northampton Town Hall in a reformed ▷Gothic style. This attracted the attention of ▷Ruskin. From the 1860s he worked in collaboration with Crisp (Dromore Castle, Limerick), and collected Japanese and Persian art which was to form the basis of much of his later inspiration. He produced his first ebonized and gilt furniture in 1867, and published a catalogue of his designs in 1877. Despite its delicacy, his furniture was simply made and ideal for factory production. During the 1870s he was a friend of ▷Whistler, and designed the White House, Tile Street, Chelsea, for him in 1877. They worked

together on the 'Butterfly Suite' for the 1878 Paris Exhibition.

Bib.: Aslin, E., *Edward William Godwin: Furniture and Interior Decoration*, London, 1986

Goes, Hugo van der (c1440–82)

Netherlandish painter. He was the leading painter of the generation, after ▷Jan van Eyck. He is first recorded in the painter's guild in Ghent in 1467, and was elected dean in 1474. In the same year he became a lay brother at the Augustinian monastery of the Roode Clooster, near Brussels, and continued to paint and travel until 1481, when he had a complete mental breakdown (he had apparently been suffering from bouts of severe depression for some time). None of his works is signed, but one, the *Portinari Altarpiece* (c1475, Florence, Uffizi), his most important work, is documented as his. A ▷triptych, it represents the ▷Adoration of the Shepherds, flanked by donors and patron saints, and is named after the patron who commissioned it, the Italian agent for the Medici bank at Bruges, Tommaso Portinari. Its arrival in Florence (it was commissioned for the Portinari family chapel in Sant' Egidio) proved to be a revelation to contemporary Florentine painters: the accomplishment of its oil painting technique facilitated a faithful description of the objective world, impossible in the ▷tempera technique then still widely used in Italy. Furthermore, the shepherds are shown as credibly awe-struck individuals whose kind had not been seen before in Italian painting. The influence of van der Goes' *Portinari Altarpiece* is especially noticeable in ▷Domenico Ghirlandaio's *Adoration of the Shepherds*, painted shortly after, in 1485 (Florence, Santa Trinità). Also attributed to van der Goes is a pair of painted organ shutters (Edinburgh, National Gallery of Scotland) and what is thought to be his last work, the supremely poignant and disquieting, *Death of the Virgin* (Bruges, Groeningemuseum).

Bib.: Sander, J., *Hugo van der Goes: Stilentwicklung und Chronologie*, Mainz, 1992; Thompson, C., *Hugo van der Goes and the Trinity Panels in Edinburgh*, Edinburgh, 1974

Goethe, Johann Wolfgang von (1749–1832)

German poet, polymath and amateur artist. He was born in Frankfurt and studied at Strasbourg University. In his early career, he was a friend of Herder and a member of the Sturm und Drang movement, who believed in German national art and individual creative genius and who admired writers like Shakespeare. In this vein, he made his name with one of the classic novels of the ▷Romantic period, the *Sorrows of Young Werther* (1774), and wrote a defence of ▷Gothic architecture. The following year he became chief of state of Weimar, and increasingly turned his attention to political economy and science – subjects which would be useful in his new role. He visited Italy in 1786 and 1790, and there developed an enthusiasm for Classicism, which changed his outlook and led to a second group of critical writings. He also wrote a book on colour theory (which influenced ▷Turner amongst others), *Zur Farbenlehre*.

Bib.: Gage, J., *Goethe on Art*, London, 1980

Gogh, Vincent van (1853–90)

Dutch painter. He was born near Brabant, the son of a minister. In 1869, he got a position at the art dealers, Goupil and Co. in The Hague, through his uncle, and worked with them until he was dismissed from the London office in 1873. He worked as a schoolmaster in England (1876), before training for the ministry at Amsterdam University (1877). After he failed to get a post in the Church, he went to live as an independent missionary among the Borinage miners. He was largely self-taught as an artist, although he received help from his cousin, Mauve. His first works were heavily painted, mud-coloured and clumsy attempts to represent the life of the poor (e.g. *Potato-Eaters*, 1885, Amsterdam), influenced by one of his artistic heroes, ▷Millet. He moved to Paris in 1886, living with his devoted brother, Theo, who as a dealer introduced him to artists like ▷Gauguin, ▷Pissarro, ▷Seurat and ▷Toulouse-Lautrec. In Paris, he discovered colour as well as the ▷divisionist ideas which helped to create the distinctive dashed brushstrokes of his later work (e.g. *Père Tanguy*, 1887, Paris). He moved to Arles, in the south of France, in 1888, hoping to establish an artists' colony there, and was immediately struck by the hot reds and yellows of the Mediterranean, which he increasingly used symbolically to represent his own moods (e.g. *Sunflowers*, 1888, London, National Gallery). He was joined briefly by Gauguin in October 1888, and managed in some works to combine his own ideas with the latter's ▷Synthetism (e.g. *The Sower*, 1888, Amsterdam), but the visit was not a success. A final argument led to the infamous episode, in which van Gogh mutilated his ear. In 1889, he became a voluntary patient at the St. Remy asylum, where he continued to paint, often making copies of artists he admired. His palette softened to mauves and pinks, but his brushwork was increasingly agitated, the dashes constructed into swirling, twisted shapes, often seen as symbolic of his mental state (e.g. *Ravine*, 1889, Otterlo). He moved to Auvers, to be closer to Theo in 1890 – his last 70 days spent in a hectic programme of painting. He died, having sold only one work, following a botched suicide attempt. His life is detailed in a series of letters to his brother (published 1959).

Bib.: *English Influences on Vincent Van Gogh*, exh. cat., London, 1974; Hulsker, J., *Van Gogh in Close Up*, Amsterdam, 1993; van Gogh, V., *Complete Letters*, 3 vols, New York, 1959; *Vincent Van Gogh, Paintings*, 2 vols, exh. cat., Amsterdam, 1990; *Van Gogh in Arles*, exh. cat., New York, 1984; *Van Gogh at St. Remy and Auvers*, exh. cat., New York, 1986; Zemel, C.M.,

Formation of a Legend: Van Gogh Criticism, Ann Arbor, Michigan, 1980

Golden Fleece

A magazine published in Moscow, monthly, from 1906 to 1909. It was edited by a wealthy collector and banker, Nikolai Riabushinsky, and promoted ▷Symbolist ideas in literature and art, inspired in part by the ▷World of Art group. It was the sponsor of the 1908–9 Franco-Russian exhibition, which introduced ▷Fauvism to Moscow, as well as the work of ▷Vuillard, ▷Bonnard, ▷Denis, ▷Gauguin, ▷Cézanne and ▷van Gogh. It also promoted the work of avant-garde Russian artists like ▷Goncharova and ▷Larianov.

The Golden Fleece was also sought by ▷Jason and the Argonauts.

Golden Section

An ideal proportion based on a mathematical formula of Euclid. It was the basis of much ▷perspective theory during the Italian ▷Renaissance. Its perfection is said to result in proportions which are more aesthetically satisfying than others.

Goltzius, Hendrick (1558–1617)

Dutch graphic artist and painter. In 1583 he established, with ▷Cornelisz. van Haarlem and ▷Karel van Mander, an art academy in Haarlem, and he began painting from 1600. His style was initially heavily influenced by late Italian ▷Mannerism via the work of the Flemish artist, ▷Bartholomaus Spranger. Goltzius travelled to Rome 1590–1 and, following a study of the Roman ▷antique and High ▷Renaissance, he rejected Mannerism for a more ▷Classical style. He had a remarkable capacity for imitating other artists' styles, and c1593 he produced a series of six ▷engravings of the life of the Virgin entitled *Meisterstiche* (*Masterpieces*) and consciously executed in the style of ▷Barocci, ▷Raphael, ▷Dürer, ▷Lucas van Leyden, ▷Bassano and ▷Parmigianino. His line engravings are technically superb, and he was the first to exploit to the full the tonal possibilities of the medium. From about 1600 he also became one of the first artists to make drawings of the Dutch countryside in the open air.

Bib.: Bialler, N.A., *Chiaroscuro Woodcuts: Hendrick Goltzius and his Time*, Amsterdam, 1992; Melion, W.S., 'Love and Artisanship in Hendrick Goltzius: *Venus Bacchus and Ceres of 1606*', *Art History*, 16 (March 1993), pp. 60–94 and 'Hendrick Goltzius' Project of Reproductive Engraving', *Art History*, 13 (Dec 1990), pp. 458–89

Gombrich, Sir Ernst (b 1909)

British art historian of Austrian birth. His books have had a profound influence upon the study of ▷history of art for nearly half a century. Born in Vienna, the son of a lawyer and a pianist, Gombrich studied at the University of Vienna, before emigrating to London to take up a position at the ▷Warburg Institute. In 1936 he became its director. Arguably his most famous work is *The Story of Art* (1950). Originally conceived as a children's book, it has been reprinted on numerous occasions and remains the standard textbook on the subject. Other works, in which Gombrich shows an interest in the psychology of art, include *Art and Illusion*, *In Search of Cultural History*, *Art and Scholarship* and *The Sense of Order*. The wide subject matter treated in these works belies Gombrich's meticulous attention to detail. He coined the term 'cultural relativism' and advocates a Classical, but open-minded approach to Western art.

Gonçalves, Nuño (fl 1450–71)

Portuguese painter. He was court painter to Alfonso V (c1450–72). He adopted a Flemish style, similar to the restrained realism of ▷Dirk Bouts. His only certain work is the virtuosic ▷polyptych designed for the convent of St. Vincent in Lisbon (c1465–7), which includes portraits of some contemporary court figures.

Goncharova, Natalia Sergeevna (1881–1962)

Russian painter and designer. She was born in Tula Province, the daughter of an architect from an old noble family. She studied science, and sculpture under Pavel Trubetskoi in the Moscow Academy, before turning to painting in 1904. She became a lifelong companion of ▷Larianov, after meeting him in 1900, and together they were instrumental in organizing a series of avant-garde groups and exhibitions: ▷World of Art (1909–11); ▷Jack of Diamonds (1910); and ▷Donkey's Tail (1911). She also exhibited abroad, with the ▷Blaue Reiter in 1912 and at the Second ▷Post-Impressionist exhibition in London. Her own work explored Russian ▷folk art (e.g. *Peasants Picking Apples*, 1911, Moscow), before developing towards ▷Rayonism – she signed the group's manifesto in 1913 – (e.g. *Cyclist*, 1912–13, St. Petersburg; *Cats*, 1911, New York). She had a strong interest in traditional religion, using the stylized simplification of ▷icons in much of her work (e.g. *Flight into Egypt*, 1908, private collection). In 1915 she moved to Paris, and designed a number of ballets for ▷Diaghilev (e.g. *Coq d'Or*, 1914, *Espagne*, 1916). She also produced book illustrations. In her later career she painted little.

Bib.: Bowlt, J.E., 'Natalia Goncharova and Futurist Theatre', *Art Journal*, 49 (Spring 1990), pp. 44–51; Gray, C., *The Russian Experiment in Art*, London, 1971; Tsvetaeva, M., *Natalia Goncharova, sa vie, son oeuvre*, Paris, 1990

Goncourt, Edmond Huet (1822–96) and Jules (1830–70)

French family of writers and art critics. They were brothers. After receiving an inheritance on their mother's death in 1848, they played the role of wealthy connoisseurs, promoting the art which they favoured in their work *L'Art du Dix-huitième Siècle* (*Art of the 18th Century*, 1875), and commenting on the contemporary scene. They published 22 volumes of *Journals*, continued by Edmond after Jules's death from syphilis, and wrote novels which followed the contemporary interest in obsessive naturalistic detail (e.g. *Germinie Lacerteux*, 1864). Edmond latterly became interested in Japanese art, writing on ▷Hokusai (1896). They left money for the founding of the Académie Goncourt and the Prix Goncourt.

Bib.: Bannour, W., *Edmond et Jules Goncourt ou le genie androgyne*, Paris, 1985; Galantière, L. (ed.), *The Goncourt Journals*, London, 1937

Gonzaga

Ruling family of Mantua and Montferrat (1328–1707), who patronized the arts from the outset. Lodovico (1445–78) employed ▷Mantegna in the court, and later ▷Alberti worked on churches in the region. One of the most important of the Gonzaga family was Giovan Francesco III, who married Isabella d'Este. He was captured by the Venetians during a confrontation, and after his release in 1509 he started a more peaceful life as a great patron of the arts. Under Vincenzo I (1587–1612), Rubens worked at the Court and later under Ferdinando (1612–26), ▷Van Dyck and ▷Albani were employed.

Gonzales, Eva (1849–1883)

A French painter, associated with the ▷Impressionists. She was the daughter of a fashionable novelist. After studying art with the academician, Chaplin, she met ▷Manet in 1867 and became his pupil (his portrait of her at work is in the National Gallery, London). Her early works were influenced by him in subject matter, but retained a more conservative style, which enabled her to exhibit at the Paris ▷Salon (in 1870 she showed a picture of a boy soldier, Manet's version of the subject having been rejected). During the 1870s, however, her work developed towards a looser ▷Impressionism, and her subject matter frequently reflected social realist concerns which led to her being praised by ▷Zola (e.g. *The Milliner*, 1877, Chicago). She experimented with ▷pastels, and produced much of her best work in that medium, exploiting a smooth surface and soft colours in her depiction of feminine subjects (e.g. *Pink Morning*, 1874, Paris, Louvre). In 1878 she married the engraver, Guerard. She died as a result of complications during childbirth.

Bib.: Delafond, M., *Les Femmes impressionistes*, Paris, 1993; Sainsaulieu, M.-C., *Eva Gonzales 1849–83: Étude critique et catalogue raisonné*, Paris, 1990

González, José Victoriano

▷Gris, Juan

González, Julio (1876–1942)

Spanish sculptor. He was born in Barcelona, but travelled to Paris in 1900. There he met ▷Picasso and turned his attention to ▷Cubism. As he was from a family who specialized in metal work, he began to use metal, particularly iron, as the basis of his sculpture. Although always connected with abstract groups, his sculpture was inevitably based on natural form. He joined the ▷Cercle et Carré in 1932 and ▷Abstraction-Création in 1934. In the early 1930s, he helped Picasso develop iron sculpting. One of his most notable works of the 1930s was *La Montserrat* (1936–7, Amsterdam, Stedelijk), which was a life-size image of a peasant woman, exhibited at the Spanish Pavilion at the Paris Universal Exhibition.

Bib.: *Julio Gonzáles: Sculptures and Drawings*, exh. cat., London, 1990

Good Shepherd

The symbolism of ▷Christ as the Good Shepherd derives from the words of Christ as recorded in the Gospel of John: 'I am the good shepherd: the good shepherd giveth his life for his sheep' (10: 11). In the context of the Good Shepherd, the sheep symbolize the faithful, and therefore the lost sheep that is found and borne back to the flock on the shoulders of the shepherd, the repentant sinner (Luke 15: 3–7). The image of Christ as the Good Shepherd was adapted from shepherd figures in Classical pagan art. The earliest Christian versions in the 2nd century are scarcely different from their bucolic pagan prototypes, though by the 5th century the figure of Christ, albeit beardless, is, with his cross staff and nimbus, unmistakable (e.g. lunette mosaic, 425/450, Ravenna, S. Vitale). Although popular in ▷Early Christian art, the image of Christ as the Good Shepherd fell from use during the Middle Ages.

Gore, Spencer Fredrick (1878–1914)

English painter. He was born in Epsom and went to school at Harrow. He trained at the ▷Slade (1896–9), before spending time in France (Dieppe in 1904 with ▷Sickert), where he picked up a good knowledge of ▷Post-Impressionist ideas; he was also a good friend of ▷Lucien Pissarro, whose heavy ▷pointillism he mimicked (e.g. *Mornington Crescent*, 1911, British Council), and of ▷Gilman. He was included in ▷Fry's 1912 Post-Impressionist exhibition. He was the first President of the ▷Camden Town Group in 1911, and joined the ▷London Group in 1913. His subject matter was influenced by Sickert's love of the music hall and of domestic interiors (e.g. *Nude Washing her Hands*, 1908, Leeds), but he also explored landscape, and his use of simplified planes of strong colour was inspired directly by his experiences in France

(*Letchworth Station*, 1912, York). He died young of pneumonia. His son, Fredrick (b 1913), was also an artist. He taught at Westminster, Chelsea and St. Martin's Art Schools.

Bib.: *Spencer Fredrick Gore*, exh. cat., London, 1985

Gospels

The four books of the New Testament, which relate the life of Christ. They consist of ▷Matthew, ▷Mark, Luke and John.

▷Evangelists

Gossaert, Jan (Mabuse) (1470/80–c1533)

Netherlandish painter. He was first documented as a Master of the Antwerp Guild in 1503, but born probably at Mauberge in Hainault (from which his nickname derives). His early style, influenced by ▷Gerard David, ▷Hugo van der Goes, and ▷Dürer, but with a tendency to over-elaborate detailing, is exemplified in the highly ornate *Adoration of the Kings* (c1507, London, National Gallery). His visit to Rome in 1508/9 exerted a considerable change in the appearance of his work: his *Neptune and Amphitrite* (dated 1516, Berlin, Staatliche Museen), in particular, reveals a new interest in the ▷Classical nude and ▷antique Roman sculpture and architecture, allied to a close study of Dürer's engraving of *Adam and Eve* (1504, London, British Museum). Indeed, the Italian ▷Renaissance elements are never fully assimilated and remain more or less as superficial graftings onto an essentially Flemish style. Vasari wrote that Gossaert was 'almost the first to take to Flanders from Italy the true method of making scenes full of nude figures and poetical fancies'. Gossaert was very influential and enjoyed a highly successful career, including among his patrons the Royal House of Denmark, for whom he painted the *Portrait of the Children of Christian II of Denmark*. His most important pupil was ▷Jan van Scorel.

Bib.: Friedlander, M.J., *Jan Gossaert and Bernart van Orley*, Leyden, 1972; Silver, L., 'The Gothic Gossaert', *Pantheon*, 45 (1987), pp. 58–69

Gothic

Style of art, and principally architecture, dominant in Europe from the 12th to the 16th century. Its forms are characterized by pointed ▷arches, variations of rib ▷vaulting and ▷flying buttresses. These elements combined to allow for more breaks in the walls and thus more ▷stained glass windows, leading to a lighter atmosphere in church interiors. The Gothic style was a solution to some of the deficiencies of ▷Romanesque architecture. For example, heavy vaulting put too much pressure on walls, sometimes causing them to buckle or collapse, so new forms of ribbed vaulting and buttressing were invented to carry a heavier weight. Once the load-bearing elements were more sophisticated, walls could be thinner, and window

Gothic architecture

▷tracery developed. As walls were more frequently punctured, stained glass took the place of mosaic decoration in many churches. In France, rose windows were a special feature of Gothic architecture.

Indeed, the Gothic style first developed in France in the church of St. Denis, where ▷Suger first commissioned the combination of features that would become characteristic of the high Gothic style. The cathedrals of Chartres, ▷Reims and ▷Amiens were among the most important Gothic buildings. In England, sophisticated forms of vaulting were developed at cathedrals such as Lincoln and Salisbury, while the Gothic developed national as well as regional variations in Germany (▷Backsteingotik) and Italy.

The term 'Gothic' is also used to refer to sculpture and manuscript illumination. Sculpture flourished in the Gothic period, as the ▷portals of cathedrals were decorated with symbolic, often naturalistic figures. Manuscript illumination also showed greater naturalism, and the new attention to nature resulted in an ▷International Gothic style, which presaged the ▷Renaissance.

Bib.: Bony, J., *French Gothic Architecture of the 12th and 13th Centuries*, Berkeley, 1983; Camille, M., *The Gothic Idol: Ideology and Image-Making in Medieval Art*, Cambridge, 1989; Erlande-Brandenburg, A., *Gothic Art*, New York, 1989; Wilson, C., *The Gothic Cathedral*, London, 1990

Gothick

The extremely elaborate and ostentatious early period of the ▷Gothic Revival movement.

Gothic Revival

A European and American art movement of the 18th and 19th centuries that grew out of a ▷Romantic interest in the architectural forms of the ▷Gothic period of medieval art. The ▷Renaissance had rendered the Gothic obsolete, but the Romantic inclinations of some 18th-century connoisseurs led them to revive some of its ornamental forms. The first notable example of this was ▷Horace Walpole's house at Strawberry Hill, which he redesigned with profuse Gothic ornament in the 1750s and 1760s. By the early 19th century, the Gothic was evoked for its associations with religious piety of the past. This idea, perpetuated by ▷Pugin, led to a rush of Gothic Revival buildings in England, including the new Houses of Parliament (1836–65). In France, the Gothic Revival was less emotive and more technical, as ▷Viollet-le-Duc explored the architectural accomplishments of the Gothic past. The style became an accepted part of European ▷historicism of the 19th century, and was used for public buildings throughout Europe and America for its evocative and associative properties.
Bib.: Clark, K., *The Gothic Revival*, 3rd edn, London, 1970; McCarthy, M., *The Origins of the Gothic Revival*, New Haven, 1987

gouache

Opaque paint consisting of ▷watercolour ▷pigment, with a gum ▷binder mixed with a white filler such as chalk or barite. Lighter tones are achieved by the addition of increased amounts of white, although allowance has to be made for the fact that gouache dries to a lighter tone. It is nonetheless much easier to use than true ▷watercolour, which is transparent, insofar as mistakes can be painted over; however, the opacity of gouache may be an aesthetic disadvantage insofar as it lacks the lucency watercolour obtains from the whiteness of the paper reflecting through the pigment. If used too thickly, it is also prone to cracking. Gouache is also known as body colour or poster paint.

Goujon, Jean (fl 1540–62)

French sculptor. The most important French sculptor of the mid-16th century, he worked in an original style, ultimately derived from a completely assimilated blend of Classical sculpture and Italian ▷Mannerist painting, via the First School of ▷Fontainebleau, plus, very importantly, the work of ▷Benvenuto Cellini. Goujon's sculpture is characterized by the remarkably crisp carving of rippling draperies with their linear patterns swirling rhythmically around elongated, graceful figures. His origins are unknown, and he is first recorded in 1540 as carver of the columns for the organ loft in the church of S. Maclou at Rouen – the Classical purity of the carving leading to the supposition that he had previously visited Rome to study ▷antique sculpture and architecture at first hand. By 1544 he is recorded in Paris, working in collaboration with the architect, Pierre Lescot, on the rood-screen in S. Germain-l'Auxerrois (now in the Louvre); the five ▷bas-relief panels (a *Pietà* and four ▷Evangelists) are by Goujon. His most acclaimed work is the series of bas-relief panels for the *Fontaine des Innocents*, Paris (1547–9, mostly now in the Louvre): the reclining nymphs of the horizontal panels, in particular, revealing the influence of ▷Cellini's *Nymph of Fontainebleau*. From 1549 to 1562 he was working at the Louvre, again with Lescot, both on the exterior sculpture of the Lescot wing and on the ▷caryatids in the Salle des Caryatids (all Goujon's work at the Louvre was, unfortunately, heavily restored in the 19th century). He is also referred to by contemporary documents as an architect, although no work has been securely attributed to him.

Gower, George (fl 1570–96)

English painter. He was Serjeant Painter to Elisabeth I from 1581, and he painted a number of portraits of her. The *Armada Portrait* is attributed to him.

Goya y Lucientes, Francisco José de (1746–1828)

Spanish painter and graphic artist. He was born in Fuendetodos, the son of a goldsmith. He trained at Saragossa (1760) under the Italian-influenced artist, Luzan, before working with ▷Bayeu. He visited Italy in 1771, where he was influenced by ▷Tiepolo. Finally, he reached Madrid in 1775, securing a position as a tapestry designer, and making his name with a

Francisco José de Goya y Lucientes, *Self-portrait in the Studio*, Academia San Fernando, Madrid

series of images of Spanish life which combined a free ▷Rococo touch with a sharp sense of observation (e.g. *Parasol*, 1777, Madrid, Prado). He moved on to portraiture, eventually becoming Principal Painter to the King in 1799, after a decade of representing the nobility. He celebrated with a double-edged group portrait which seemed to betray his own republican sympathies and showed a shift away from the decorative work of his youth (e.g. *Family of Charles IV*, 1800, Madrid, Prado). In 1792, he began to go deaf, and illness caused increasing bitterness, seen in his ▷engravings ▷*Los Caprichios* (1796–8) with their satirical attacks on society. His work was affected by the French invasion, belatedly attacked in the *Third of May 1808* (1814, Madrid); in this and other works, his pretty ▷pastels were abandoned in favour of roughly painted realist tones (e.g. *Majas on the Balcony*, 1801, New York). After the Restoration, however, he found himself out of favour and retired, plagued by illness, to paint a series of nightmarish *Black Paintings* on the walls of his house, Quinto del Sorbo (e.g. *Saturn Devouring his Son*, 1821–2, Madrid, Prado). In 1824, he left Spain altogether, settling in Bordeaux, and seemingly finding peace with works which returned to the colours and themes of his youth. Throughout his career he experimented with graphic art, exploring aquatint and the newly invented ▷lithography.

Bib.: Tomlinson, J.A., *Francisco Goya, Tapestry Cartoons and Early Career*, Cambridge, 1989

Goyen, Jan van (1596–1656)

Dutch painter. He was from Leiden, but from 1634 worked in The Hague. He was primarily a landscape painter, who produced many views of Dutch cities with a sense of atmosphere. His works were formulaic, but all stressed tonal qualities. He was the father-in-law of ▷Jan Steen.

Gozzoli, Benozzo di Lese (c1421–97)

Italian painter. He was from Florence, and worked with ▷Ghiberti on the Florence Baptistry doors. He also assisted ▷Fra Angelico in Rome. His early works such as the *Adoration of the Magi* (1423) show influences of Flemish tapestries, particularly in their lack of ▷linear perspective and studied realism of individual figures. Piero de' Medici hired him to decorate the Medici Palace in Florence, and he produced for this his *Journey of the Magi* (1459–61) – a crowded composition with carefully observed characters.

Graces

▷Three Graces

Graff, Anton (1736–1813)

German painter of Swiss birth. Although categorized as a ▷Biedermeier artist, Graff was primarily a portraitist, whose works were reminiscent of the Grand Style of ▷Joshua Reynolds. He painted many literary

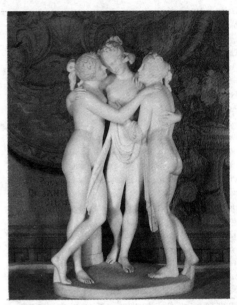

Antonio Canova, *Three Graces* Aglaia, Euphrosyne, Thalia

figures of German ▷Romanticism. He taught at the Dresden Academy from 1766.

graffito (pl. graffiti)

(Italian, 'scratched'.) The term describes the method of producing a design by scratching through a layer of paint or other material to reveal a ground of a different colour or texture. The technique was commonly used in medieval ▷panel painting and wall painting; in the painted façades of ▷Renaissance architecture using different coloured plaster; and also in pottery, scratching through ▷glazes. The interest in surface and texture of much 20th-century art has involved the use of deliberate scratching in painting, photographs, drawing etc.

Grande Jatte, La

▷*Sunday Afternoon on the Island of La Grande Jatte*

Grandeville (Jean-Ignace-Isidore Gérard) (1803–47)

French illustrator. He was from Nancy, but came to Paris at the age of 20, where he began to produce ▷lithographs. Although primarily a political ▷caricaturist, he also illustrated La Fontaine's *Fables* (1838). He was best known for his representations of animals, which had human qualities or were half human. His use of amphibious creatures contributed to the efficacy of his satire, but often created an odd effect. Among his published collections of ▷engravings were *Les Métamorphoses du jour* (1828) and *Un Autre monde* (1844).

Bib.: *Grandville: das gesamte Werk*, Munich, 1969; *Grandville: dessins originaux*, exh. cat., Nancy, 1986

Grand Manner

Another name for a style associated with ▷academic ▷history painting. ▷Reynolds made reference to the Grand Manner in his lectures to the English ▷Royal Academy, the Discourses. To him, it signified the best and most appropriate style for history painting – one which was based on generalities, rather than particularities, and the ideal, rather than the real. The painting and sculpture of High ▷Renaissance masters such as ▷Raphael were considered the epitome of this style.

Grand Tour

An extended trip, typically taken during the 18th century as the finishing touch to a good education. The aim was to see the great sights of Europe including the Netherlands, France, and especially Italy, where the highlights were the newly discovered Classical remains at Herculaneum and ▷Pompeii. Tourists were often accompanied by tutors, and many artists made a living as guides and sketchers (▷Canaletto, ▷Piranesi, ▷Pannini, ▷Richardson.) They also inevitably brought back souvenirs, which formed the basis of the vast collections of antiquities and objects of *virtù* which decorated the country houses of the period. The experience did much to enhance the cosmopolitanism of the century; it represents the increasing importance of a liberal education promoted by ▷Enlightenment thinkers, and was crucial for spreading the ideas of ▷Neoclassicism (see ▷Zoffany, *Cognoscenti in the Tribuna of the Uffizi*, 1770, Royal Collection). There were also a number of contemporary guide books (▷Richardson).
Bib.: Black, J., *The British and the Grand Tour*, London, 1985

Granet, François-Marius (1775–1849)

French painter. He was from Aix, and was one of ▷David's pupils. From 1802 to 1809 he was in Rome, where he painted Italianate landscapes and interiors in a dark Dutch style. In 1826, he was appointed curator of the Louvre, and in 1830 he became Keeper of Pictures at Versailles.

granite

A crystalline igneous rock, consisting of an amalgam of feldspar, mica and quartz. It is found throughout the world and occurs in a range of colours including grey, white, rose red, green and yellow. The small scales of mica give the rock its characteristic sparkle, and the surface can be polished to a brilliant shine. Being a rock of compact structure, it is immensely hard, resistant to frost and therefore durable. It has therefore always been used for building where permanence and impregnability is required: it is the stuff of which the Great Wall of China is made. Notwithstanding its resistance to carving, the ancient Egyptians used it extensively in monumental sculpture, not only for relatively uncomplicated forms such as obelisks (e.g. *Cleopatra's Needle*, 1500–1450 BC, now London, Thames Embankment), but also for more complex forms (e.g. the pair of sentinel lions formerly guarding the Temple of Amenhotep III in Nubia, c1391–1353 BC, now London, British Museum). The nature of the rock permits only the carving of closed forms: bold projections, deep undercutting and perforations are avoided. The modern exploitation of granite for ▷modelled or rounded forms needing a highly polished finish (e.g. ▷columns, fountain basins and even statues), only became viable with the introduction of steam mechanization in the early 1830s by stonemasons such as Alexander MacDonald of Aberdeen.

Grant, Duncan James (1885–1978)

English painter and designer. He trained at Westminster Art School (1902–5), the ▷Slade (1908), in France (with ▷Lewis 1906–7) and Italy. As a cousin of Lytton Strachey, he was a member of the ▷Bloomsbury Group, and also exhibited with the ▷NEAC and the ▷London Group. In 1912, he exhibited at ▷Fry's ▷Post-Impressionist exhibition, and designed the poster. His early influences, after a period of solid realism, were French and he continued to use ▷Fauvist colour and vibrant, curling line (e.g. *Flowers*, 1956, Arts Council), as well as a more structured style (e.g. *Lewes Landscape*, 1934, Leicester). He also painted portraits (e.g. *James Strachey*, 1910, London, Tate). From 1913 he collected African sculpture. He was also increasingly interested in more radical ideas – in 1914 he produced his *Abstract Kinetic Collage Painting* (London, Tate), a work designed to be unrolled to music. Increasingly, design became his major interest: from 1914 he worked with ▷Vanessa Bell (e.g. *Blue Sheep Screen*, 1912, London, Victoria and Albert Museum).
Bib.: Shone, R., *Duncan Grant, Designer*, London, 1980; Watney, S., *The Art of Duncan Grant*, London, 1990

Grant, Sir Francis (1803–78)

Scottish painter. He was primarily known for his portraits. He became President of the ▷Royal Academy after ▷Eastlake.

graphic art

Most commonly refers to the various kinds of ▷fine art printmaking, while 'graphics' refers to the layout of books and other publications. In the first category, where printmaking is a form of artistic expression, many artists, from ▷Dürer and ▷Rembrandt through to ▷Goya and ▷Manet, have made prints, but in most cases printing has been subservient to their careers as painters. In the second category, some artists in the

present century have made 'artists' books', that is, highly priced limited-edition publications, commissioned by dealers (▷art dealing) such as ▷Vollard and ▷Kahnweiler.

grattage

A process invented by ▷Max Ernst that transfers the method of ▷frottage from drawing to oil painting. Also a process invented by Esteban Frances in 1938, which uses a razor blade to work a layer of paint and reveal shapes and colours of underlayers of paint.

GRAV

▷Groupe de Recherche d'Art Visuel

Gravelot, Hubert-François Bourguignon (1699–1733)

French engraver. He came to England in 1732 and remained there until 1755, interrupted only by a short visit to Paris in 1746. While in England he was friendly with ▷Hogarth and became involved with the artists of the ▷St. Martin's Lane Academy. Among his many activities, he engraved ▷Francis Hayman's paintings for ▷Vauxhall Gardens. He produced many engravings of English literary works, including such contemporary novels as *Pamela* (1742). His graceful use of contour helped popularize the ▷Rococo style in England.

gravure

▷photogravure

Great Exhibition

An exhibition held at Crystal Palace in 1851, which aimed to display the achievements – artistic, scientific and technological – of all parts of the British Empire. The Crystal Palace was designed and built specially to house the exhibition, which attracted thousands of visitors and was hailed as one of the greatest achievements of the age. Other similar events staged across the world were based on the Great Exhibition, but with varying success.

Great Fire of Chicago

The largely wooden city of Chicago was decimated by fire during 8–10 October 1871: 4 square miles (10 km) were destroyed, leaving 90,000 homeless and $2 million of damage. Yet the fire had destroyed little of the city's infrastructure, and in the following years Chicago underwent a boom period. The new city was to be safer, healthier and modern, and its architects' vision of the future was the skyscraper. By 1894, 21 buildings of 12 storeys and more had been erected, using steel frames, regularized façades and open-plan interiors. In 1893 the city celebrated its new grandeur

Chicago: Fleeing via Randolph St. Bridge

with the World Exposition, promoting modernity, in the shape of electricity, alongside the traditional Classicism of the pavilions. The building boom spawned a whole generation of architects, the so-called ▷Chicago School, and became a model for America as a whole.
Bib.: Crome, R., *The Great Chicago Fire*, Nashville, 1994; Miller, R., *American Apocalypse: The Great Fire and the Myth of Chicago*, Chicago, 1990

Great Fire of London

It raged over four days during 1666, having supposedly started in a bakery in Pudding Lane, reaching the Tower in the east, the Temple Church in the West and Holborn Bridge in the north. It was recorded in Pepys' *Diary*. In total, 13,200 houses and 400 streets were destroyed leaving over 100,000 people homeless. Rebuilding took ten years. A number of major public buildings were also lost, including the Guildhall, the Customs House and St. Paul's Cathedral. There were 87 churches burnt in total. ▷Wren, Evelyn and Robert Hooke, the city surveyor, all quickly produced plans for rebuilding – Wren's characterized by a European regularization and widening of the streets – but none of these were carried through, and much of the rebuilding repeated existing layouts. In 1669, however, Wren was appointed Surveyor of the King's Works, and began a programme of church rebuilding (51 in total) which left a lasting impression on the skyline of the city. Equally significantly, he produced plans for the rebuilding of St. Paul's which was eventually begun in 1876.
Bib.: Weiss, D.A., *The Great Fire of London*, New York, 1992

J. Franklin, *Great Fire of London: The End of Old St. Paul's*

Greco, El (Domenikos Theotocopoulos) (1541–1614)

Spanish painter of Greek birth. He was the leading artist of the 16th-century Spanish school, born in Crete. His early years are obscure, the first record of him being a Cretan document of 1566 in which he is referred to as a master painter. Only a few of his Cretan paintings survive, and these are in the ▷Byzantine tradition of ▷icon painting. A fine signed example, *The Dormition of the Virgin* (Church of the Koimesis tis Theotokou, Island of Syros), was rediscovered in 1987. In this period, Crete was a Venetian dominion and thus it was natural that he should go, in c1560, to Venice to further his career. Although he was described by his friend, the ▷illuminator ▷Giulio Clovio, as a pupil of ▷Titian, the artist who had most impact on El Greco was ▷Tintoretto.

In 1570 El Greco moved to Rome where his discovery of the work of ▷Michelangelo and the ▷Mannerists exerted a further and abiding influence. Nevertheless, with what would today be considered shocking philistinism, he undertook, according to a 17th-century source, to paint a new altar wall for the ▷Sistine Chapel if Pope Pius V would allow him to demolish Michelangelo's *Last Judgement*, the nudity of which had been causing concern to the post-Tridentine papacy (who had merely required someone to paint drapery over the offending parts). If the story is true, it was partly the enmity that this unknown young foreigner had incurred with the presumptuousness of his offer that encouraged him to leave Rome soon afterwards. Paintings which survive from El Greco's Roman years include *The Purification of the Temple*

(Washington, National Gallery) and *Portrait of Giulio Clovio* (Naples, Museo di Capodimonte).

By 1577 he was in Spain, and it is here that his distinctive style evolved with its attenuated, flame-like figures, dramatic light and shade, unusual colour harmonies, and intensely spiritual mood. While in Rome, he had met Diego de Castilla, Dean of Canons at Toledo Cathedral, who commissioned him to paint the altarpiece, *The Assumption of the Virgin*, for the high altar of the Church of S. Domingo el Antiguo (1577, centre panel now in Chicago, Art Institute). Working principally in Toledo, he soon achieved recognition and a number of prestigious commissions for other ▷altarpieces began to come his way, notably *El Espolio* (*The Disrobing of Christ*) for Toledo Cathedral (1577–9, still *in situ*) and *The Burial of Count Orgaz* (1586–8, Church of S. Tomé, Toledo). In addition to these large-scale altarpieces he also showed himself as an accomplished portraitist, many of them of ecclesiastics (e.g. *Fray Hortensio Paravicino*, 1609, Boston Museum), while in Glasgow (Pollok House) there is a sensitive portrait of c1577–80, traditionally believed to be of his common-law wife, Jeronima de las Cuevas. There are also two visionary views of Toledo (New York, Metropolitan Museum; and Toledo, Museo del Greco), and a unique mythological subject, *The Laocoön* (Washington, National Gallery) with Toledo in the background (a local legend held that the Toledans were descendants of the Trojans). He never secured royal patronage as Philip II's taste was for the balanced, harmonious art of Titian; El Greco's Mannerist painting he found unpleasing. Nevertheless, although he seems to have been financially

El Greco, *Self-portrait*, Museo de Bellas Artes, Seville

hard-pressed in his final years, at his peak he was continuously successful with religious commissions and ran a flourishing workshop turning out replicas of his more famous works.

His style was too personal to attract any followers apart from his son, Jorge Manuel Theotocopouli, whose work seems to be a rather mediocre imitation of his father's. In the ensuing centuries his reputation fell into relative obscurity, although by the end of the 19th century it had risen again, and in the early 20th century interest in his work intensified with the advent of ▷Expressionism. There are absolutely no grounds for the traditional belief that his personal, attenuated-figure style was due to a sight defect such as astigmatism, rather it may be seen as reflecting a combination of the influence of Italian Mannerist aesthetics and the religious fervour of his host country, which seems to have been compatible with his own mystical tendencies.

Bib.: Brown, J. and Andrade, J.M.P., *El Greco: Italy and Spain*, exh. cat., Washington, 1984; Calvo Serralier, F., *El Greco: 'The Burial of the Count of Orgaz'*, London, 1995; Lafuente Ferrari, E., *El Greco: The Expression of his Final Years*, New York, 1973; Mann, R.G., *El Greco and his Patrons*, Cambridge, 1989

Greek art

Conventionally divided into four periods (▷Geometric, ▷Archaic, ▷Classical, ▷Hellenistic), Greek art stretches from the 11th century BC to the time of Augustus. Its importance in painting and sculpture lies in its representations of the ideal beauty of gods, heroes and humans. Architecture, reviving perhaps in the 8th century BC, used post and lintel construction, at first in wood, later in limestone, and then widely in marble, to erect buildings that impressed by the beauty of their form and exquisite materials, rather than (until the Hellenistic period) by their overbearing scale or structural adventurousness. ▷Bronze was the preferred material for sculpture (except architectural sculpture), but we know of the important works only through the marble copies of the Romans. The Greek contribution to town planning (both the regimented grid and the scenographic varieties) was also influential.

Relatively little Greek sculpture or architecture has come down to us, but we know about them because the Hellenistic Greeks, and later the Romans, bought the whole package, as it were, of Greek culture. Their reactions to Greek art and architecture formed the launching pad for the Classical tradition.

Bib.: Ashmole, B., *Architect and Sculptor in Classical Greece*, London, 1972; Boardman, J., *Greek Sculpture. The Archaic Period. A Handbook*, London, 1985; *Pre-Classical: From Crete to Archaic Greece*, London, 1967; Pollitt, J.J., *The Ancient View of Greek Art: Criticism, History and Terminology*, New Haven, 1974; Robertson, M., *A History of Greek Art*, 2 vols, Cambridge, 1975

Greek cross

A cross with four arms of equal length set at right angles.

Greek Revival

Architectural movement expressing a new interest in the simplicity and forms of ancient Greek buildings. As the knowledge of Greek buildings increased through the 18th century, there was a movement to use this knowledge to build in a new style. By the 1790s Neo-Greek architecture was fashionable but it reached its peak in the 1820s and 1830s with such architects as Ledoux, ▷Soane and ▷Schinckel.

Green, Valentine (1739–1813)

English engraver. He was from Worcester, but travelled to London in 1765. His skill in ▷mezzotint engraving brought him to the attention of ▷Reynolds, who employed him to engrave, and thus popularize, a number of his portraits. He was elected ▷ARA in 1775, but strictures on the election of engravers prevented his climbing to the status of ▷RA.
Bib.: Whitman, A., *Valentine Green*, London, 1902

Greenaway, Catherine (Kate) (1846–1901)

English artist and illustrator. She was the daughter of a wood engraver, and attended Islington Art School, Heatherleys and the ▷Slade. She first exhibited in 1868 and produced illustrations for the *Illustrated London News*. From 1877, she worked with the publisher Edmund Evans on a series of children's books, including her *Almanacs* (1883–97). Although she illustrated other authors (e.g. *Pied Piper of Hamlin*, 1889), she preferred to write her own children's books (e.g. *Marigold Garden*, 1885), developing a highly popular style, which used 18th-century dress, fine line drawings and delicate colour washes. She also produced some oils (e.g. *Garden Seat*, c1890s, Exeter). She was a friend of ▷Ruskin, who admired her work.
Bib.: Holme, B., *The Kate Greenaway Book*, New York, 1976; Thomson, S.R., *Kate Greenaway: A Catalogue*, Detroit, 1977

Greenberg, Clement (1909–94)

American writer on art. He studied at the ▷Art Students' League in New York, and at Syracuse University, and did exhibit some work in New York galleries, but his main contribution was as a writer. In magazines like *Commentary*, which he edited, he was responsible for publicizing and defending the work of the ▷Abstract Expressionists and later of the ▷Post Painterly Abstractionists (e.g. Los Angeles exh. cat., 1964). During 1959–60, he organized a series of one-man shows at the French and Company Gallery, which promoted the work of artists like ▷Newman, ▷Noland and ▷Smith. His criticism was based on his belief in the importance of formalism, something which led to criticism of his

work in the 1960s. His best known book is *Art and Culture* (1965).

Bib.: Kuspit, D.B., *Clement Greenberg: Art Critic*, Wisconsin, 1979

Greenhill, John (c1644–76)

English painter. He studied with ▷Lely, and like his master became a portrait painter. He produced portraits from c1665. Unlike many of his contemporaries, his primary specialism was not court portraiture but theatrical portraits.

Greenough, Horatio (1805–52)

American sculptor. He studied at Harvard, where he received a Classical education. He travelled to Rome, first in 1825, when he met ▷Thorvaldsen, and again in 1828. He spent much of his subsequent life in Italy, and threw himself wholeheartedly into producing ▷Neoclassical sculpture. Much of his monumental work was done for public commissions in America, including his famous statue of George Washington as Zeus (1833–43), produced for the Capitol building in Washington DC.

Greuze, Jean-Baptiste (1725–1805)

French painter. He was born near Macon, the son of an architect. After studying at Lyons under Grandon (1845–50), he moved to Paris, where he studied at the ▷École des Beaux-Arts under ▷Natoire. He exhibited the *Father of the Family Reading the Bible* at the 1755 ▷Salon, a work highly praised by ▷Diderot, and thereafter gained a reputation as a painter of moral ▷genre scenes. He specialized in tableaux, using dramatic gestures and frozen movement to suggest narrative, but fixing his work in the period with contemporary dress and choosing his subjects from among the poor (e.g. *Village Bride*, 1761, Paris; *Drunkard's Return*, 1780, Portland, Ohio). His work was popularized through engravings, and was known in England and Russia (he was a favourite of Catherine the Great). He travelled to Italy in 1855–7 and attempted ▷Neoclassical work, but this proved a failure (e.g. *Septimus Severus Reproaching Caracalla*, 1769, Paris). As a result he quarrelled with the ▷Académie, and increasingly he exhibited his pictures privately. During the 1780s his work became more sentimental and less popular, and he also suffered personal difficulties, leading to divorce from his wife (an ex-model). He also produced portraiture (e.g. *Benjamin Franklin*, 1777, Washington), especially of children, which is highly regarded today. He was ruined by the ▷French Revolution, although he joined the Commune des Arts and later received limited commissions under Napoleon.

Bib.: Brookner, A., *Greuze: The Rise and Fall of an 18th-Century Phenomenon*, London, 1972; *Jean-Baptiste Greuze*, exh. cat., Hartford, 1977

Grimaldi, Giovanni Francesco (Il Bolognese) (1606–80)

Italian painter. He produced landscapes in the manner of ▷Carracci while he was in Rome, and he also was responsible for ▷frescos, including those in the Villa Doria-Pamphili. From 1649 to 1651 he was in Paris.

Grimshaw, Atkinson (1836–93)

English painter. He was born in Leeds, the son of a policeman. After working as a clerk for the Great North Railway, he turned to painting, against his parents' wishes. He worked mainly in Leeds and in the North of England, where he gained a reputation for his romantic moonlight portrayals of towns and ports (e.g. *Liverpool Quay by Moonlight*, 1887, London, Tate Gallery). He was popular, despite rarely exhibiting at the ▷Royal Academy. His work was precise and highly finished, using strong, luminous colour. Although he is best known for night scenes, some of his best works were daytime landscapes which showed a ▷Pre-Raphaelite interest in detailed foliage (e.g. *Autumn Glory Old Mill*, 1869, Leeds). He also experimented with literary and historical subjects (e.g. *Elaine*, 1877, private collection). His sons, Arthur (1868–1913) and Louis (1870–1943) imitated his style.

Bib.: *Atkinson Grimshaw*, exh. cat., Liverpool, 1979; Wood, C., *Atkinson Grimshaw*, London, 1990; Robertson, A., *Atkinson Grimshaw*, Oxford, 1888

Gris, Juan (José Victoriano González) (1887–1927)

Spanish painter and sculptor. He was from Madrid. He went to Paris in 1906, where he made contact with ▷Picasso, became interested in Picasso's early experiments with ▷Cubism, and lived with him for a time. He exhibited with the ▷Section d'Or, and from 1912 was taken under the wing of the art dealer ▷Kahnweiler, who supported him fulsomely. Gris' version of Cubism was distinctive from that of Picasso and ▷Braque. He avoided those artists' monochromatic palette and concentrated on bright colours. He was particularly interested in the Synthetic strand of Cubism, and produced much ▷*papier collé*.

Bib.: Green, C., *Juan Gris*, exh. cat., New Haven, 1992

grisaille

(French, *gris*: 'grey'.) A method of painting in grey or greyish monochrome, sometimes used merely as an underpainting for a full colour oil, but also used as a finished work to imitate sculpture. A celebrated example is the series of personifications of ▷Virtues and Vices along the lowest register of ▷Giotto's ▷fresco decorations for the ▷Arena Chapel, Padua: each figure is painted to resemble a statue standing in a ▷niche. Grisaille paintings were also a common feature of early Netherlandish winged ▷altarpieces.

The central panel and flanking wings would be painted in full colour, but when the wings were closed, the backs, now facing the congregation, would reveal grisaille images of saints, in imitation of carved altarpieces (e.g. ▷Jan van Eyck, ▷ *The Ghent Altarpiece*, Cathedral of St. Bavo, Ghent).

groin vault

▷vault

Gropius, Walter (1883–1969)

German architect. He was born in Berlin, the son of an architect. After studying at the technical school in Berlin, he visited Spain, before returning to join ▷Behrens' practice in 1907. By 1909 he was working independently, in collaboration with ▷Meyer (e.g. Fagus factory, Alfeld, 1911–12), and was also a member of the ▷Deutscher Werkbund. For them he designed the Werkbund Pavilion for the Cologne Exhibition in 1913–14, a model factory, a development of the Fagus design with separate machine shop and office areas, the latter defined by glass-encased spiral staircases and a functionalist, symmetrical façade. After serving in the First World War, Gropius became one of the leading members of the ▷avant-garde art scene, by becoming president of the tendentious ▷Arbeitsrat für Kunst, a member of the ▷Novembergruppe and, in 1919, the originator of ▷Bauhaus, a new concept in integrated art teaching. He held the Bauhaus directorship until 1928. Gropius abandoned the old hierarchy between art and design, and set about producing students and buildings fit for the age. These included his own Sommerfeld House (1921 Berlin), which reused old teak timbers from a German battleship in a pared-down vernacular style. It also included housing projects (e.g. in Stuttgart, 1927) and skyscraper designs. Most importantly in 1925, he designed the new Bauhaus buildings at Dessau, a series of rectilinear, strip-windowed blocks which became a model of modernist architecture. He gradually handed over the reins to others at Bauhaus (including Meyer and ▷Mies van der Rohe), eventually leaving Germany entirely in the changing political climate of 1934. He stayed in England briefly (Impington Village College, 1936), before settling in America (1937), where he was appointed Harvard professor. His own house, built in Lincoln, Massachusetts (1938), was a less functional style, integrated into the landscape and incorporating features of local American architecture. After the Second World War, Gropius established The Architects' Collaborative (TAC) and continued to contribute to designs, albeit with less importance (e.g. Pan Am Building, 1957).

Bib.: Franciscono, M., *Walter Gropius and the Creation of Bauhaus*, Illinois, 1971; Fitch, J.M., *Walter Gropius*, New York, 1960

Gros, Baron Antoine Jean (1771–1835)

French painter. His parents were minor artists, and he was taught first by his father, a miniaturist, and then by ▷David, and travelled to Italy in 1793, where he first met Napoleon, and helped in the selection of looted works. He followed Napoleon's campaigns, painting a series of large, dramatic propaganda images (e.g. *Plague House at Jaffa*, 1804, Paris; *Battle of Eylau*, 1808, Paris). Increasingly, his academic education was tempered by sensual colour, inspired by his love of ▷Rubens, and exotic locations, which were later to inspire the French ▷Romantics. His portraiture also developed towards a romantic appreciation of mood (e.g. *Mme. Lucien Napoleon*, 1800, Paris). He took over David's role as teacher, and managed to survive the changing politics of the Restoration (e.g. *Louis XVIII Taking Leave of his Followers*, 1818, Paris); he was created baron by Charles X for his work on the Pantheon dome. He felt his later years were a failure and committed suicide.

Gross Clinic, The

Painted by ▷Thomas Eakins in 1875, after the artist had attended Jefferson Medical College 1873–4. It shows Dr. Gross, of the College, performing an operation for the removal of dead bone in a man's thigh. The man's mother is visible watching anxiously from behind the doctor, and the table is surrounded by assistants, whilst the patient, in a severely ▷foreshortened pose, is clearly visible in the centre of the canvas. Gross is distinguished by his dominant position, but he, like the rest of the medical staff, wears everyday dress, and it is partly this which gives the painting its dark, slightly threatening quality. The room is shadowy with strong light picking out the patient, and the largely monochrome palette is only broken by blood red. Yet Eakins' extreme ▷realism, even down to the blue socks the patient is still wearing, gives the work a suitably clinical objectivity, and its heavily painted surface also acts a barrier between viewer and subject. The work was first exhibited to a mixed reception, although it has since become one of the most familiar images of 19th-century American painting. It is now in the Medical College at Jefferson University.

Grosz, George (1893–1959)

German painter and graphic artist. He was born in Berlin. He was taught at Dresden Art School (1909–12) and the School of Applied Arts in Berlin (1912–16), before enlisting in the Army. His military service ended in a breakdown, and in 1917 he was discharged after a court martial for striking an officer. He met ▷Heartfield (they both anglicized their names as an anti-war gesture), and together they established the Berlin ▷Dada group, and in 1918 he joined the Communist Party. He experimented with ▷Futurist styles

to show the disintegration and confusion of the period (e.g. *Funeral Procession Dedicated to Oskar Panizza*, 1917, Stuttgart). Throughout the 1920s, as part of the ▷Neue Sachlichkeit, he used ▷caricature and simplified draughtsmanship to point out contemporary corruption (e.g. *Pillars of Society*, 1926, Berlin). His work was hard-hitting – he was charged with obscenity and blasphemy – and, like ▷Dix, used strong colour and exaggeration to make his political points. He also produced portraits (e.g. *The Poet Max Hermann Neisse*, 1925, Mannheim). Increasingly, however, the harshness of his work gave way to softer satire (e.g. *Demagogue*, 1928, Amsterdam). He left Germany in 1933, to avoid Nazi persecution, and became a lecturer at the ▷Art Students' League in New York. However, his romantic landscapes of the period were less successful. He returned to Berlin in 1959 but died soon after, as a result of a fall.
Bib.: Flavell, M., *George Grosz*, New York, 1988

grotesque
A kind of fanciful wall or ceiling decoration, first discovered in the late 15th century in antique Roman ruins such as Nero's Golden House. These ruins were by then underground and were referred to as *grotte*, the origin of the term for their characteristic ornamentation. Grotesque decoration may be either painted, carved, or modelled in ▷stucco, and consists of human, animal, and fabulous hybrid monster figures, some contained within tablets or medallions, and all loosely interwoven with tendrils, scrolls and delicate foliage into an overall symmetrical pattern. Motifs were originally used piecemeal by artists such as ▷Filippino Lippi and ▷Pinturicchio, but were first employed as the basis of a consistent decorative scheme by ▷Raphael's assistant, ▷Giovanni da Udine (e.g. Vatican Loggie, c1519).

ground
A mixture placed on the surface of a ▷canvas, wood, or paper in advance of painting. It prevents the surface from absorbing the paint, which would otherwise cause the colour to sink and the texture to dull. A ground consists of a filler mixed with ▷binder, usually ▷size or oil, or an ▷emulsion of the two.

Group of Seven
Organization of Canadian artists who exhibited together from 1920. They included Frank Carmichael (1890–1945), ▷Harris, ▷Jackson, Frank Johnston (1888–1949), Arthur Lismer, ▷MacDonald and ▷F.H. Varley. They were influenced by the ▷Fauvist colourism of ▷Tom Thomson, but they adopted this for a mode of landscape painting which was intended to evoke distinctly Canadian sensations. Their first exhibition in Toronto was followed by many others until 1933, when they changed their name to the ▷Canadian Group of Painters, to take account of their wider membership.

Groupe de Recherche d'Art Visuel (GRAV)
A group formed in Paris in 1960. Among its members were ▷Julio Le Parc, Horacio García-Rossi (b 1929), Joel Stein (b 1926) and Francisco Sobrino (b 1932). In the wake of international ▷Constructivism, they stood for an art which grew from modern industrial materials and scientific method. Gradually, they moved towards interactive art, and they pioneered early experiments in ▷kinetic art.

Grosvenor Gallery
Established in 1877 in Bond Street by Sir Coutts Lindsay, with his wife's money (she was a member of the Rothschild dynasty), and Charles Halle, it became one of the first exhibition rivals to the ▷Royal Academy and one of the showcases of ▷aesthetic and ▷avant-garde art in London. Whistler's infamous *Nocturnes* were exhibited at the first show, leading to the ▷Ruskin libel trial which effectively established the gallery's name, and ▷Burne-Jones was persuaded to exhibit eight pictures, thereby establishing his reputation as one of the leading artists of the day. Artists as diverse as ▷Legros, ▷Watts, ▷Poynter, ▷Steer and the ▷Glasgow Boys contributed to the subsequent shows, but it became most associated with ▷aestheticism, jokingly referred to as 'greenery yallery' by W.S. Gilbert in his 1880 opera *Patience*. The establishment of the ▷New English Art Club in 1886, the year in which the Grosvenor showed a retrospective of ▷Millais' work, encouraged the French-influenced ▷avant-garde away from Lindsay's gallery. It finally closed in 1890. Apart from its importance in providing a showcase for new artistic style and talents, the gallery was also influential in promoting a new exhibition style, with light, spacious rooms and well-spaced canvases.
Bib.: Newall, C., *The Grosvenor Gallery Exhibitions: Continuity and Change in the Victorian Art World*, Cambridge, 1995

Grundig, Lea (1906–77)
German printmaker. She was from a Jewish family. She studied from 1922 to 1924 at the Dresden School of Art and from 1924 to 1926 at Gussmann's School. In 1928 she married the artist Hans Grundig. Together they became committed to the Communist party and the problem of alleviating working-class suffering. Grundig's work reflected the oppressive and stifling conditions of the working classes. During the Nazi regime, she lived at a refugee camp in Palestine, but in 1949, she returned to Dresden to take up a post as Professor in the School of Figurative Art.
Bib.: Grundig, L., *Gesichte und Geschichte* (1958), Berlin, 1978

Grünewald, Mathis (c1470/80–1528)

German painter. He was the greatest of ▷Dürer's contemporaries, and at the artistic opposite pole from Dürer. Where Dürer strove to create an ideal art, deriving inspiration from the Italian ▷Renaissance, Grünewald, though aware of, and willing to utilize, Italian developments in ▷perspective and spatial construction, was more thoroughly grounded in the late ▷Gothic world of northern Europe. Where Dürer would faithfully record, in minute and naturalistic detail, the appearance of a tuft of grass or a hare, Grünewald was only concerned, as far as we know, with religious subjects, which he would imbue with the most concentrated spiritual emotionalism imaginable. Where Dürer sought to represent the human body in its perfect form, Grünewald deliberately distorted it to express extreme physical or psychological states.

The known details of his life are few, his early years unknown. His art was so individual, he appears not to have had any pupils, although both ▷Baldung Grien and ▷Ratgeb show his influence. Furthermore, no known prints by him have survived, and as the fame of most of his contemporaries was disseminated through the medium of the print, this may be another reason for his obscurity. Even the name by which he is today known is the result of an error by the 17th-century painter/historian, ▷Sandrart. His real name appears to have been Mathis Gothardt (or Neihardt). He was certainly successful in his lifetime for, from 1508 to 1526, he is recorded as court painter to two successive Archbishop-Electors of Mainz. A deeply religious man, in these years he became Lutheran and, in 1525, was involved in the Peasants' Revolt. He was fortunate to suffer no more than dismissal from his court post, and moved to Frankfurt. He is last recorded in 1527 in Halle where he died from plague.

His known paintings are few. His earliest work, suggesting the influence of Bosch, is thought to be *The Mocking of Christ*, (c1504, Munich, Alte Pinakothek). His most celebrated work, however, is unquestionably the harrowing ▷*Isenheim Altarpiece* for the hospital church of the Anthonite Abbey at Isenheim in Alsace (completed c1515; now in the Musée d'Unterlinden, Colmar). This elaborate altarpiece consists of a carved wooden ▷polyptych with ▷polychrome figures by Niklaus Hagenauer. The wings may be opened out to reveal Grünewald's paintings. The central panel shows the *Crucifixion* with Christ's body expressively distorted, racked with pain, and covered in festering wounds and sores. The inmates of the hospital were mainly terminal plague victims, this horrifically expressionistic depiction of Christ's suffering on the Cross perhaps being intended to produce a bond of sympathy with their suffering. Their freedom from pain and disease in the hereafter is suggested by the panel of the *Risen Christ*, displaying his ▷stigmata, but with a body otherwise radiantly clean. Thus, although the treatment of the subject is terrifying (and derived in great part from the *Revelations of St. Bridget*), the ultimate message is one of hope.

Bib.: Hayum, A., *The Isenheim Altarpiece: God's Medicine and the Painter's Vision*, Princeton, 1990; Lucking, W., *Mathis: Nachforschungen über Grünewald*, Berlin, 1983

Guardi, Francesco (1712–93)

Italian painter. A Venetian, the son of a minor painter called Domenico Guardi, Francesco is chiefly remembered for his ▷*vedute* (views) of Venice. However, his earliest pictures in this genre date only from c1760, before which time he worked in the family studio (which handled all kinds of commissions), headed by his older brother, Gianantonio (1698–1760). After his brother's death, Francesco's first views appear, and in 1761, now an independent painter, he joined the *fraglia* (Venetian painters' guild). He still painted religious pictures, as is evidenced by his altarpiece of *SS. Peter and Paul* (1778, parish church, Roncegno). In 1782 he was commissioned to paint four pictures of the ceremonies attending the visit of Pope Pius VI to Venice (e.g. *Pontifical Ceremony in the Church of SS. Giovanni e Paolo*, Cleveland Museum). In 1784 he was finally elected to the Venetian Academy. Many of Francesco's numerous *vedute* are undated and so a chronology is difficult to establish. Contemporaries did not value Francesco's freely-handled, atmospheric pictures as highly as ▷Canaletto's, which are by contrast, architecturally precise, meticulously handled and usually larger. Francesco's sold for about half the price of Canaletto's; he was often in debt and died in poverty. Only since ▷Impressionism has created a taste for pictures which attempt to capture fleeting effects of light have Francesco's pictures been as highly regarded. Francesco seems to have worked largely by himself, although his son, Giacomo (1764–1835), who copied many of his pictures, may have occasionally assisted him. Francesco's brother Nicolò (1713–86) was also a painter, but no pictures have been successfully attributed to him.

Bib.: *Francesco Guardi: vedute, capricci, feste*, exh. cat., Milan, 1993; Morassi, A., *Guardi*, 3 vols, Milan, 1993

Guarini, Guarino (1624–83)

Italian architect. He was born at Modena and active chiefly in Turin, where he spent his last 17 years and where are to be found all of his important surviving buildings. Before becoming an architect, he was a Theatine father and had established a considerable reputation as a philosopher and a mathematician, his interest in mathematics exerting a determining influence on his architecture, which is always characterized by a fundamental concern with extremely complex geometry and spatial composition. He was principally influenced by ▷Borromini, as is evidenced by his Palazzo Carignano, Turin (1679), with its oval saloon and undulating façade, reminiscent, on a larger scale,

of Borromini's S. Carlo alle Quattro Fontane in Rome. Guarini's Cappella della SS. Sindone, Turin (1667–90) and S. Lorenzo, Turin (1668–87) are notable for the intricate geometry of their cone-shaped domes, strongly suggesting a study of Hispano-Moresque and French ▷Gothic architecture. Guarini's profoundly original buildings exerted a profound influence on contemporary ▷Baroque architecture in southern Germany and Austria, and his influence was further increased by the posthumous publication, in 1737, of his *Architettura civile*.

Bib.: Meek, H.A., *Guarino Guarini and his Architecture*, New Haven and London, 1988

Guas, Juan (d 1496)

French architect and sculptor. He studied in Brussels, but moved to Toledo in c1450, where he became involved in the construction of the Cathedral. He was appointed Master of Works at Segovia Cathedral from 1473 to 1491, and Toledo Cathedral from c1483 to 1495. He was one of the primary exponents of the ▷Plateresque style.

Guercino, Il (Giovanni Francesco Barbieri) (1591–1666)

Italian painter. He was born at Cento near Ferrara. His nickname, referring to his eye defect, means 'the squint-eyed one'. His early work, influenced by ▷Ludovico Carracci, the Venetian school and ▷Caravaggio, but modified by his own sensibilities and moulded into a unique style, is characterized by a rich palette, flickering ▷chiaroscuro and an atmospheric softening of form. In 1621 he was summoned to Rome by the Bolognese pope Gregory XV. Artistically, Guercino's most important commission was for the casino of the Villa Ludovisi, owned by the Pope's nephew. The ceiling ▷fresco (1621–3) represents *Aurora* traversing the sky in her chariot, from the realm of Day towards that of Night. Represented in steep foreshortening from below (▷*sotto in sù*), and rendered with brilliant sketch-like ▷brushwork, Aurora and her chariot are framed by ▷Agostino Tassi's painted architecture (▷*quadratura*). This masterpiece of ▷Baroque illusionistic decoration contrasts boldly with ▷Guido Reni's Classical ▷*quadro riportato* rendering of the same subject only ten years earlier for the Casino Rospigliosi. When the Bolognese pope died in 1623, Guercino returned to Cento. Unfortunately, instead of building on his vigorous new style, he diluted it with the Classicism he had encountered in Rome. In 1642 ▷Guido Reni, his chief rival in Bologna, died, and Guercino transferred there and took over his studio practice, maintaining a position as Bologna's leading painter until his own death, producing ▷altarpieces in a rather predictable, but very successful, pietistic mould. His studio account books for the years 1629–66 have survived, providing a valuable record of his patrons and the prices he charged, with a summary of each year's earnings. One of the finest draughtsmen of his age, the richest collection of his drawings is in the Royal Library, Windsor Castle.

Bib.: Bagni, P., *Il Guercino e i suoi incisori*, Roem 1988; Mahon, D., *Il Guercino*, Bologna, 1991

Guernica

Large ▷mural painting by ▷Picasso, painted in 1937 and first exhibited in the Spanish Pavilion at the International Exposition in Paris, and now in the ▷Prado, Madrid. The small Basque town of Guernica was destroyed in April 1937 by German planes under General Franco, and the artist's horror and pity for one of the most famous atrocities of the Spanish Civil War is fully expressed in his painting. Like the photos of the massacre that appeared in the press, the picture uses only black, white and grey. Its late ▷Cubist style vividly portrays the feeling of destruction and the agony expressed by its human figures, as well as the horse and bull that share this suffering. As well as its importance as an image of the arbitrary violence of war in the 20th century, it is significant as the culmination of a number of styles and themes on which Picasso had been focusing through the 1930s.

Guggenheim Museum

The museum was inaugurated to house the collection of Solomon R. Guggenheim (1861–1949), an industrialist who collected works of art. At first he concentrated on ▷Old Masters and the French ▷Barbizon school, but by the 1920s he was collecting 19th-century and contemporary art. In 1937 he set up the Solomon R. Guggenheim Foundation, and by 1939 he was exhibiting his collection in temporary spaces in New York. In 1943 he commissioned ▷Frank Lloyd Wright to build a museum, and in 1951 an entire block on 5th Avenue was purchased as a site. The museum was opened in 1959, and the controversial spiral building marks the zenith of Wright's career. He intended the six-storey cylindrical structure to bring the viewer into more direct contact with works of art than was possible in more conventional spaces. The collection itself is remarkable, and houses the largest number of works by ▷Chagall, ▷Delaunay, ▷Gleizes, and ▷Léger in America. A ▷ceramic ▷mural was commissioned from ▷Miró in memory of Mrs. Harry F. Guggenheim. In addition there are over 180 ▷Kandinskys, over 170 ▷Klees, and good representations of the work of ▷Seurat, ▷Cézanne, ▷Rousseau, ▷Bonnard, ▷Picasso, ▷Braque, ▷Modigliani, ▷Mondrian, ▷Pissarro, ▷Renoir, ▷Rouault, ▷Pollock, ▷Kline, ▷Gottlieb, ▷Bacon, ▷Rauschenberg, ▷Brancusi and ▷Calder.

Guglielmo della Porta (d 1577)

Italian sculptor. He began his career in Genoa, but was active in Rome from 1537 onwards and, in 1547, succeeded ▷Sebastiano del Piombo as Keeper of the

Pablo Picasso, *Guernica*, 1937, Museo Nacional Centro de Arte Reina Sofia, Madrid

Royal Seal at the Papal Mint. The main influence on his work was ▷Michelangelo, particularly his Medici Chapel tombs, the influence of which can be seen most strongly in the reclining allegories (now in the Palazzo Farnese) formerly on Guglielmo's most important commission, the Tomb of Pope Paul III in St. Peter's, Rome (1549–75). His Lombard origins are, however, revealed in his predilection for coloured marbles (▷Michelangelo always using pure white marble). His other major works include the Cesi Monuments (S. Maria Maggiore), three marble portrait busts of Pope Paul III (two in the Museo Nazionale di Capodimonte, Naples, and one in the Museo di San Martino, Naples) and a series of 16 reliefs of scenes from Ovid. Apart from his original work, he was also employed as a restorer and copier of ▷antique sculptures.

Bib.: Gramberg, W., *Die düsseldorfer Skizzenbucher des Guglielmo dell Porta*, Berlin, 1964

Guido da Siena (fl 13th century)

Italian painter. He was Sienese, but no other biographical facts are known with certainty. He is held to be the founder, with ▷Coppo di Marcovaldo, of the Sienese School. Only one signed and dated painting of his survives (*Madonna and Child*, dated 1221, Siena, Palazzo Pubblico). The date has posed great problems, in that stylistically the picture belongs to the period of half a century later, where there are other pictures attributed to Guido (e.g. *Madonna and Child with Four Saints*, date partially missing 127-, Siena, Pinacoteca). One solution proffered is that the Palazzo Pubblico painting is a faithful copy, even down to the date, of

an older revered image, and that it too was painted c1270. Guido's work is still firmly rooted in the schematized ▷Byzantine tradition of representation but, like Coppo, he shows a movement towards a more realistic depiction of figures, set more convincingly in space.

Bib.: Stubblebine, J.H., *Guide da Siena*, Princeton, 1964

Guido di Pietro

▷Angelico, Fra

guild

Before the rise of ▷academies of art in the late 16th century, art making was controlled by guilds, such as the Communauté des Maîtres Peintres et Sculpteurs de Paris formed in 1391. The statutes of the guilds, many of which date back to the 13th century, took pains to define and quantify the work of members, especially in establishing the line of demarcation between the various trades of, for example, gilder, painter and woodcarver. Placed under the patronage of Saint Luke (many guilds were known as 'academies' of Saint Luke), they acted as professional associations, overseeing the execution of commissions, verifying the quality of the work and the materials used, imposing fines, arbitrating in disputes involving members, and exempting the artist from some forms of taxation and military service.

The guild artist (master) employed qualified assistants (▷journeymen) and employed and trained apprentices. The apprentice joined a workshop in his early teens, and after training for between five and ten

years (six to seven years was the norm) was received in the guild on presentation and acceptance of a masterpiece. After a period often spent travelling from workshop to workshop as a journeyman, the artist was free to set up his own workshop. The guilds were familial, providing a social infrastructure, as well as financial relief when necessary, for members and their dependants. Many guild artists intermarried: it was common for a good apprentice to marry the daughter of the studio head and eventually inherit the workshop.

The guild workshop was a place of routine and formulae. Once initiated into the community, the artist was sworn to secrecy and to protect the guild's interests against all comers. Each member of the workshop knew his role, from the apprentice who ground colours and ran errands, to the journeyman assistant who lacked none of the skill of the studio head, to the master who co-ordinated his team. By the 17th century, this structure was less able to respond to the newer aspirations of artists who sought to break free from what they saw as a craft practice in favour of voicing an artistic philosophy that academies seemed better to articulate.

Bib.: Antal, F., *Florentine Painting and its Social Background*, New York, 1948; Baxandall, M., *Painting and Experience in Fifteenth Century Italy*, Oxford, 1972; Guiifrey, J., 'Histoire de l'Académie de Saint-Luc', *Archives de l'art Francais*, 9 (1915)

guilloche

A pattern formed by two or more bands, interlaced in a continuous series, leaving circular openings.

Gully, John (1819–88)

English painter. He spent much of his life in New Zealand, where he lived from 1852. His propensity for painting emotional landscapes gave him the nickname 'The New Zealand ▷Turner'.

Gupta

North Indian art of the 4th–6th centuries AD. The name derives from the leader Chandra Gupta II. During this time, the sophisticated painting at ▷Ajanta was complemented by further refinement in Buddhist sculpture.

Bib.: Agrawala, P.K., *Gupta Art*, Varanas, 1977; idem., *Gupta Temple Architecture*, Varsanas, 1981

Guston, Philip (1913–80)

American painter of Canadian birth. He was born in Montreal, but studied in Los Angeles. In the 1930s he first saw the works of the Mexican muralists, which influenced his subsequent move towards ▷Magic Realism. His work for the ▷Federal Arts Project reveals this influence. In addition to painting many murals during the 1930s and 1940s, he worked as an art teacher in Iowa, Washington and New York.

During the 1950s, his style became more abstract, but his 'abstract impressionism' was more lyrical than the work of his ▷Constructivist contemporaries. He knew ▷Pollock, ▷de Kooning and other ▷Abstract Expressionists. During the 1970s, he returned to figurative work.

Gütersloh, Albert Paris (Albert Konrad Kiehtreiber) (1887–1973)

Austrian painter. He was from Vienna, and worked in the theatre and as a journalist while teaching himself to paint. He became known through exhibiting his work, and he was appointed a teacher at the Vienna School of Arts and Crafts in 1919. He remained in Austria through the Second World War and gained academic success in Vienna. His own work was conceived in a ▷Fantastic Realist vein and encouraged a whole generation of post-War Austrian artists.

Bib.: Laue, I., *Pictorialism in the Fictional Miniatures of Albert Paris Gütersloh*, New York, 1996

Guttuso, Renato (1912–87)

Italian painter. He was born near Palermo and retained a sympathy with the political and social problems of Sicily. He was one of the founder members of ▷Corrente, and he worked against the Fascists in his art and political activism before and during the Second World War. He painted in an ▷Expressionist style, but with representational elements, borrowing motifs self-consciously from other important ▷modernist artists. He was also a member of the ▷Fronte Nuovo delle Arte.

Bib.: Costantini, C., *Ritratto di Renato Guttuso*, Brescia, 1985

Guys, Constantin (1805–92)

French draughtsman, watercolourist and illustrator. He was born in Vlissingen. He was largely self-taught, and worked in drawing and watercolour. He lived a Bohemian existence, at various times a soldier in the dragoons (1827), and a vagabond, and in his youth he took part in the Greek War of Independence (1818). He worked for the *Illustrated London News* from 1848 and reported for them on the Crimea campaigns in 1854 (e.g. *Spanish Cavalry Officers*, 1856, London, British Museum). He is perhaps best known for his sketches of Second Empire Paris, which were lauded by ▷Baudelaire as the best images of 'modern life', and inspired artists like ▷Daumier and ▷Toulouse-Lautrec. He never signed his work and received little recognition during his lifetime, much of which he spent in poverty.

gypsum

Calcium sulphate dihydrate, a mineral which, when heated to about 100°C and then finely ground, forms the powder, calcium sulphate hemihydrate which, when remixed with water, makes ▷*gesso*, or ▷plaster of Paris.

H

Haacke, Hans (b 1936)

German sculptor. He was born in Cologne and studied in Cassel, Paris, and the USA. He developed sculptures which were concerned with the effects of wind and light, and used the ▷environment as his subject. He was also responsible for interactive ▷assemblages.

Haarlem

▷Dutch art

Bib.: Levesque, C., *Journey Through Landscape in Seventeenth-Century Holland: The Haarlem Print Series*, University Park, 1994

Hackaert, Jan (c1628–c1699)

Dutch painter. He was primarily a landscapist, and he was most influenced by travel in Switzerland and Italy in 1653–8. He was particularly interested in the effects of light.

Hackert, Jakob Philipp (1737–1807)

German painter. He travelled to Italy in 1768, and there he began producing ▷Claudean landscape paintings largely designed to appeal to ▷Grand Tourists. In 1786 he became court painter to Ferdinand IV of Naples.

Hagenbund (Künstlerbund Hagen)

Organization of Austrian artists formed in 1899. They took their name from Herr Haagen, the proprietor of an inn they frequented. The group included ▷Gütersloh, Wiegele, ▷Kokoschka and ▷Schiele. They began working within the conservative Vienna Künstlerhaus, but, like the Vienna ▷Secession, they rebelled against the older organization and became independent.

Hagia Sophia

The most important example of 6th-century ▷Byzantine architecture, the Hagia Sophia in Constantinople was built in only six years (AD 532–7) during the reign of the Emperor Justinian. Built on the site of two earlier churches of the same name, one under Constantine (335) and one under Theodosius (415), the latter being destroyed by fire. The architects Anthenius of Tralles and Isidorus of Miletus have been seen as great innovators, although more recently their achievements have been seen to be advancements of Roman/Byzantine techniques displayed in earlier religious buildings. The Church forms a near square in shape, with the ▷narthex at the west and the ▷apse at the east; a large central ▷dome supported by four stone ▷piers covers a large central space 32.5 m (107 ft) square. To the east and west this space is continued as hemi-cycles and semi-domes. The complex-looking exterior includes ▷buttresses to the north and south, added following an earthquake in 1305, and four Turkish ▷minarets added in the 16th century. Like most Byzantine architecture, the exterior is undecorated and unpretentious. All surfaces of the interior were faced with marble in white, green, blue, rose and black. The floors and ▷apses were decorated with coloured ▷mosaics, with gold background and figures of ▷Apostles, saints and angels. Much of the interior decoration was looted by participants of the Fourth Crusade in 1204, and when the city was conquered by the ▷Ottoman Turks in 1453 the church was converted into a mosque. It was equally influential on Ottoman mosque architecture in the 16th and 17th centuries, with contemporaries impressed particularly by the size of its dome. The Turks maintained and added to the support of the structure. Now used as a museum, fears of the threat of destruction by earthquake have led to detailed study of the building and its construction method.

Bib.: Mark, R. and A. Cakmak (eds), *Hagia Sophia: From the Age of Justinian to the Present*, Cambridge, 1992

Hague School, The

A group of ▷Realist artists working in Holland c1860–1900. They saw themselves as followers of the 17th-century Dutch landscape tradition, but were also influenced by the work of 19th-century French landscapists (▷Corot, ▷Daubigny, ▷Barbizon School). Although they are best known for scenes of peasant and fishing life, they also painted still life, church interiors and street scenes, mostly with an emphasis on traditional Dutch architecture. In all their work they concentrated on light and atmosphere, working tonally in cool subtle colours. Their work was popular and influential in late 19th-century Britain (▷Newlyn School, Glasgow School). They included ▷Israëls, ▷Mauve, the ▷Maris brothers, Mesdag, Weisenbach and Bosboon.

Bib.: *Hague School: Dutch Masters of the 19th Century*, exh. cat., London, 1983

ha-ha

A boundary to a garden which is disguised by a ditch and perpendicular wall, making it invisible from a distance, giving the illusion that the garden continues

further than it actually does. The advantages in using this method are that the view is uninterrupted from the house, and that it is possible to recreate a pastoral setting without the danger that animals will stray into the cultivated garden area. Ha-has were extremely popular in the 18th century, with the interest in landscape architecture.

Haida

A tribe of British Columbian Native Americans who produced interesting wood carving, particularly in the form of totem poles.

half-length

One of several sizes of portraits, in this case showing half of the human body, but normally not the hands. Half-length portraits measure roughly 127 × 102 cm (50 × 40 in).

hall church

A German church building type with ▷nave and ▷aisles, but with aisle roofs being of approximately equal height as that over the nave. Thus it follows that there is no ▷clerestory level, nor are there ▷transepts or a differentiated ▷chancel. The oldest example is St. Bartholomew's Chapel (1017, now north side of the Cathedral), Paderborn, Germany.

Hallenkirche

▷hall churches

hallmark

A British name given to a mark on silver or gold which indicates the initials of the maker. The name comes from the Goldsmiths' Hall of the Worshipful Company of Goldsmiths, which authenticated British silverware and goldware through this process.

halo

(From the Greek, *halos*: 'disc'.) Also known as a nimbus (Latin, cloud); it is the conventionalized form of the supernatural radiance surrounding the head of a divine, or divinely inspired, personage. Originally it was the radiance emanating from the head of Helios, the Greek sun god. Subsequently, the Romans adopted it for the emperor's portrait on their coins. Initially it was used to signify the emperor's deification, but the later, Christian, emperors retained it to symbolize their imperial authority. The halo in Christian art was probably derived from this latter image of the emperor, in order to express Christ's universal authority in an understandable way. It first appears about the 4th century. The design and shape of the Christian halo is often significant and distinguishes its bearer: God the Father, as the first person of the ▷Trinity, often has a triangular halo; ▷Christ's circular halo may contain a cross to indicate his redemptive sacrifice; whereas the circular haloes of angels, the ▷Virgin and saints are

usually plain, but sometimes with an appropriate inscription; a square halo indicates that the person was alive when the image was made; and a hexagonal halo indicates a virtue personified. During the early ▷Renaissance, artists tried to incorporate haloes into their newly formulated perspectively controlled image of the world, and transformed them into solid discs seen edge-on. By the 16th century many Italian artists had virtually abandoned the representation of conventionalized haloes, though after the Council of Trent, some Catholic artists regained the original significance of the halo by representing it as a blaze of light around the head (e.g. ▷Tintoretto, 1565–87; canvases in the upper hall, ▷Scuola Grande di San Rocco).

Hals, Frans (1580/5–1666)

Dutch painter. He was born in Antwerp, and may have studied with ▷Van Mander in Haarlem, where he moved in 1610. He returned to Antwerp in 1616 where he met ▷Rubens. This was also the year of one of his earliest and most important portraits, representing the Haarlem Civic Guard Banquet of the St. George Militia (Haarlem, Hals Museum). The work showed his ability to represent many different individuals in a composition, to give them equal prominence, and to capture their salient features. Following this portrait, he was commissioned to paint other large Civic Guard groups, at a time when the Civic Guard had an important local function. The importance of the militia declined after 1648 when the Spanish wars were over, but Hals' facility with portraiture led to other civic commissions, most notably the *Regents of the St. Elizabeth Hospital* (1641, Haarlem, Frans Hals Museum) and the *Regentesses* (1664, Haarlem, Frans Hals Museum). His representations of such philanthropic groups show an even greater ability to represent character, and in his later work, Hals loosened his brushwork, which enhanced the ▷physiognomic subtlety of his paintings. Aside from major group portraits, he also painted individuals and ▷genre scenes, such as *The Laughing Cavalier*. Among his pupils were ▷Brouwer, ▷Wouwerman and ▷Judith Leyster. Despite his success as a painter, the demands of a very large family led him to destitution at the end of his life.
Bib.: *Frans Hals*, exh. cat., Munich, 1989

Hambling, Maggi (b 1945)

English painter. She was from Suffolk, and studied at the Camberwell School of Art and the Slade in the 1960s. In 1972 she turned to figure painting.
Bib.: *Maggi Hambling*, exh. cat., London, 1987

Hamilton, Gavin (1723–98)

Scottish painter and collector. He was born in Lanark, a landowner's son, and educated at Glasgow University (1738–42), before travelling to Rome. There he

trained with the artist Masucci, and fell under the influence of the ▷Neoclassicists ▷Mengs and ▷Winckelmann. After a brief period in London (1752–4) when he tried to establish himself as a portraitist, he returned to Rome permanently and began to experiment with ▷Poussinesque ▷history painting (e.g. *Brutus Swearing to Avenge Lucretia's Death*, 1763, London, Drury Lane). In this he achieved success, particularly on the Continent, were he prefigured the work of ▷David. He most famously worked on Homeric subjects, producing six scenes from the *Illiad* (including *Achilles Mourning Patroclus*, 1760–63, Edinburgh), and on decorations for the Villa Borghese (1782–84, some now in the Museo di Roma). He was also a major excavator and dealer in Classical remains, helping to satisfy the demands of the ▷Grand Tour visitors for antique souvenirs, and making his own academic studies of his discoveries. In Britain, to which he periodically returned, his work was chiefly known through engravings, although he had an influence on such artists as ▷West. He died in Rome.
Bib.: Irwin, D., *Art Bulletin*, 44 (1962)

Hamilton, Richard (b 1922)

British painter. He was born in London, and is an important figure in British ▷Pop art. Before the Second World War he studied at St. Martin's School of Art and the ▷Royal Academy schools, and between 1941 and 1945 he was a tools draughtsman. He was briefly readmitted to the RA schools after the war, but then studied at the ▷Slade from 1948 to 1951. In the 1950s he taught at the ▷Central School of Arts and Crafts (1952–3) and the ▷Royal College of Art (1957–61), and was a founder member of the ▷Independent Group, which met intermittently at the ▷ICA between 1952 and 1955. In this period he was particularly involved in the organization of a number of important exhibitions, including Growth and Form (ICA, 1951), Man, Machine and Motion (Hatton Gallery, Newcastle, and ICA, 1955), and, with John McHale and John Voelcker, This is Tomorrow (Whitechapel Art Gallery, 1956). One of his most famous images, the ▷collage ▷*Just what is it that makes today's homes so different, so appealing?*, was made at this time, and heralded the start of Pop art in Britain. Hamilton was particularly interested in the advertising images of popular culture and ▷mass-media imagery. His *Homage à Chrysler Corp* (1957), for example, used pared-down details, including references to tail fins and hubcaps, a diagram of the Exquisita Form Bra, and a woman's lips, suggesting the relationship between car advertising and female sexuality. Hamilton had an idiosyncratic idea of what Pop art should be, defining it as 'Popular (designed for a mass audience), Transient (short-term solution), Expendable (easily forgotten), Low cost, Mass produced, Young (aimed at youth), Witty, Sexy, Gimmicky, Glamorous, Big Business'.

Hammershøi, Vilhelm (1864–1916)

Danish artist. He worked in Copenhagen, where he produced interiors, in the manner of ▷Vermeer, and architectural scenes.

Hamnett, Nina (1890–1956)

Welsh painter. She studied art in Dublin, London and Paris. She was part of the circle of artists around ▷Roger Fry, and she knew ▷Sickert and ▷Gaudier-Brzeska, among others. She became involved with the ▷Omega workshops, but her primary interest was in painting, rather than decorative art. She specialized in scenes of everyday life and portraits.
Bib.: Hooker, E., *Nina Hamnett: Queen of Bohemia*, London, 1986

Han

▷Chinese art

Hanson, Duane (b 1925)

American sculptor. He was from Minnesota. He studied in Germany (1953–61), where he began to use fibreglass and polyester. In 1966, he came into contact with the work of ▷George Segal, whose realistic sculptures appealed to his own ideas, but he went further than Segal by including real hair, clothes and accessories on his figures. His works were deliberately satirical, and often satirized the absurdities of middle America. His *Tourists* (1970, Edinburgh, Gallery of Modern Art) is a realistic sculpture of two American middle-aged tourists replete with wrinkles, silly expressions and outlandish summer clothes. His technique has been called ▷Superrealism.

Happening

Term coined by ▷Allen Kaprow in 1959, to refer to a spontaneous, plotless theatrical event. Such events were not confined to a particular environment and could take the form of music, visual art or theatre. Evolving in New York in the late 1950s, they became popular phenomena in the 1960s and 1970s, under the influence of ▷John Cage and his theories of the importance of chance in artistic creation. Other artists who contributed to the development of the Happening include ▷Claes Oldenburg, ▷Robert Rauschenberg, and ▷Roy Lichtenstein. In Japan the Gutai Group and in Europe the ▷Fluxus Group developed the original American ideas. To these groups the Happening represented chiefly an opportunity to transform a normal event into an extraordinary occurrence, through the use of everyday objects and materials taken out of context. Although, by definition, the Happening was an event unconstrained by the formality of the institution or the gallery, in many instances artists used such venues in order to stage Happenings which outraged or shocked the audience and demanded a degree of participation (e.g. the Happenings of ▷Joseph Beuys).

hard-edge painting

An aspect of geometric ▷abstraction that in the 1960s reacted to the ▷gestural and ▷painterly canvases of the ▷Abstract Expressionists. The style emphasized geometric, rectilinear compositions that respected the 'flatness' of the picture surface. Rendered with a sharp, 'hard' edge, the machine-like application of colour likewise emphasized the impersonality of the canvas and the artist's desire to avoid the autobiographical or subjective reference inherent in ▷Expressionism. Major practitioners of the movement included ▷Ellsworth Kelly, ▷Kenneth Noland and ▷Al Held.

Hardouin-Mansart, Jules (1646–1708)

French architect. He took the surname of his great-uncle François Mansart. He was an important architect for Louis XIV, and became Architect to the King in 1675. He was put in charge of the architecture at Versailles in 1678, and he was responsible for much of the design and the overseeing of the final building. Among his many court and public commissions was Les Invalides in Paris. In 1685 he was promoted to First Architect to the King, and in 1699 became Surveyor of the Royal Works.
Bib.: Bourget, P., *Jules Hardouin-Mansart*, Paris, 1956

Hardwick, Thomas (1752–1829)

English architect. He was a pupil of ▷William Chambers. He was primarily responsible for churches in Essex and London, including the Parish Church of St. Marylebone. In addition to designing new churches, he rebuilt a number of them. His son Philip (1792–1870) was architect of Euston station (1847).

Harlot's Progress, A

A 1732 series of six ▷etched and ▷engraved prints by ▷William Hogarth, based on paintings which were later destroyed. They chart the arrival in London of a young woman from the country and her rapid fall. She is taken in by a matron providing prostitutes for the aristocracy, becomes a 'kept woman' and a street prostitute, enters a house of correction, and ultimately dies. Primarily didactic, the prints reveal the folly of vice, but also the effects of urban life and the corrupting nature of society. By creating a series of prints relating a consecutive narrative that had to be read, Hogarth created a new kind of art work and literary device. With the *Rake's Progress*, it is one of his major Modern Moral Subjects.

Harnett, William Michael (1848–92)

American painter of Irish birth. He studied at the Pennsylvania Academy of Fine Art in the 1860s, and in 1871 moved to New York where he worked as a silver engraver. He began painting in 1875. His knowledge of the work of ▷Peto led to an interest in still life painting, and like the older artist, he began producing realistic still lifes. Most of these works consisted of tabletops filled with objects and racks of letters, and many resembled the work of ▷Raphaelle Peale. In 1880 he travelled to Europe, where he developed a greater illusionism in his series of works *After the Hunt*. He produced these in Paris, where he would have come into contact with a tradition of French sporting still life reaching back to ▷Oudry in the 18th century.
Bib.: Frankenstein, A.V., *After the Hunt: William Harnett and Other Still Life Painters, 1870–1900*, rev. edn, Berkeley, 1969

Harpignies, Henri-Joseph (1819–1916)

French landscape painter and engraver. He was born in Valenciennes. He began to paint only in 1846, when he enrolled as a pupil of the landscapist Achard, but was a prolific artist for the rest of his life and was popular on both sides of the English Channel in his day. Sometimes he is connected to the ▷Barbizon School, but his work is more similar to that of ▷Corot, with whom he visited Italy in 1860 (e.g. *Landscape with Pool*, 1883, Lille). He shared with the ▷Barbizon School a nostalgic love of nature for its own sake and also an interest in the portrayal of woodland scenes. He was never as interested in the effects of light and colour, preferring to concentrate on draughtsmanship, and incorporating detail into his work. Towards the end of his career, poor eyesight led to a loosening of brushwork which increased the similarities between the two. He painted in both oils and watercolour.
Bib.: *Barbizon Revisited*, exh. cat., London, 1962; Bouret, J., *L'École de Barbizon*, Neuchâtel, 1972

Harris, Lawren Stewart (1885–1970)

Canadian painter. He was in Berlin from 1904 to 1908, where he came into contact with early ▷Expressionist work. In 1911 he met ▷J.E.H. Macdonald and began painting landscapes. He was one of the earliest artists to look to the geography of northern Ontario for his subject matter, but he was drawn to other dramatic landscapes in the Arctic and in the Rocky Mountains. He was a founder member of the ▷Group of Seven, and he worked mainly in Toronto. From 1936 his works became increasingly abstract, and in 1938 a visit to New Mexico brought him into contact with the Transcendental Painting movement – a variation on ▷Kandinsky's ideas of colour and spirit. From 1940, he brought his new interest in abstraction to Canada and helped foster abstract art there.

Harrowing of Hell

(Chronicled by the medieval hagiographer Jacobus de Voragine in *The Golden Legend*). Also known as the 'Descent into Limbo', it follows Christ's ▷Crucifixion and is a prelude to his ▷Resurrection. The single source for the details of this event is the 5th-century apocryphal Gospel of Nicodemus, which Jacobus refers to in *The Golden Legend*. The Church Fathers

discriminated between Hell proper, where the irredeemably damned are punished for all eternity, and Limbo, in which the virtuous souls from the pre-Christian era awaited their release by Christ in his descent. The Harrowing of Hell achieved an especial importance in the Greek Church as an example of the defeat of Satan's plot against humanity and, though the Greek term 'Anastasis' refers to both the Harrowing of Hell and the Resurrection, it is more often the former that is depicted under this title (e.g. mosaic panel, c1100, Church of the Dormition, Daphni, Greece). The scene also enjoyed a certain popularity in the Western Church throughout the medieval and ▷Renaissance periods (e.g. ▷Beccafumi, c1530–35, Siena, Pinacoteca), but appears seldom after the 16th century. Christ dominates the scene, usually a network of dark and fiery caverns. He has just smashed down the doors of Hell and carries either a Cross of Lorraine (Greek Church) or the Resurrection banner (Latin Church). The Devil lies crushed beneath the doors. Christ is about to lead the virtuous who died before his Crucifixion to Heaven. Identifiable at the front are ▷Adam and Eve, then ▷Moses (rays of light on his forehead) and King ▷David (crowned and carrying his harp). Also present are Dismas, the penitent thief (with his cross, scarred legs and a length of rope to indicate that he was not nailed to his cross) and ▷John the Baptist (dressed in animal skins and carrying a cross standard).

Hartley, Marsden (1877–1943)

American painter. He was from Maine, and studied in Cleveland and New York. In 1908 he began painting landscapes in an ▷Impressionist mode, but they were more similar to the ▷Symbolism of ▷Segantini and ▷Ryder than to the colour theories of the French Impressionists. His contact with ▷Alfred Stieglitz in 1912 encouraged the dealer to send him to Europe. In Germany, between 1913 and 1915, he became interested in the colour theories of Kandinsky and exhibited with the ▷Blaue Reiter. His contact with German ▷Expressionism led him to experiment with abstraction when he returned from Europe during the First World War. He was involved with the ▷Armory Show. In 1918 he returned to figurative art after a visit to New Mexico, which was to influence his work for the rest of his life. From 1921 to 1931 he lived again in Europe. He was particularly interested in art theory, and he also wrote poetry.
Bib.: Robertson, B., *Marsden Hartley*, New York, 1995; Weinberg, J.E., *Speaking for Vice: Homosexuality in the Art of Charles Demuth, Marsden Hartley and the First American Avant-garde*, New Haven, 1993

Hartung, Hans (1904–89)

German–French painter. He studied art in Leipzig, where he learnt about ▷Klee and abstract art in a lecture by ▷Kandinsky. He then studied at Dresden,

where he saw the International Exhibition of 1926 which gave a panorama of French painting from ▷Impressionism. He also trained in Munich. He began painting abstracts in 1922 and had his first solo show in Dresden in 1931. He divided his time between Paris and travelling in various countries until the Second World War, when he served in the French Foreign Legion, was imprisoned in Spain and had a leg amputated. In 1945 he became a French citizen, settling in Paris, and was a leading exponent of ▷Art Informel. Hartung overlays a simple ground of translucent colour crossed and bordered with black, creating a sense of depth, with lines of varying thickness, length and direction, often resembling ▷calligraphic scribbling. He won the Grand Prize at the 1960 Venice ▷Biennale.
Bib.: Daix, P., *Hans Hartung*, Paris, 1991; *Hans Hartung*, exh. cat., Paris, 1990

Hassam, (Frederick) Childe (1859–1935)

American painter and printmaker. From 1886 to 1889 he was in Europe, where he studied at the ▷Académie Julian in Paris and saw the work of the ▷Nabis. He returned to the United States with an interest in ▷Impressionism, which he disseminated through the foundation of the ▷Ten American Painters group. This organization promoted an Impressionist style, representing contemporary scenes of American leisure life.
Bib.: Hiesinger, V.W., *Childe Hassam: American Impressionist*, Munich, 1994

hatching

Technique used by draughtsmen, engravers and other artists who use media which do not allow blending to show light and shade, or modelling (e.g. ▷pen and ink, ▷engraving and block printing). Appropriate areas are filled with a mass of parallel lines of varying length and intensity, to build up the effect of light and dark. When these lines are crossed by others, the effect is known as ▷cross-hatching.

Hausmann, Raoul (1886–1971)

Austrian artist. With ▷Grosz and ▷Heartfield, he was one of the principal members of the Berlin ▷Dada group and a founder of Club Dada in 1918. He helped invent ▷photomontage with ▷Hannah Höch, and he was the editor of *Der Dada*.
Bib.: Benson, T., *Raoul Hausmann and Berlin Dada*, Ann Arbor, 1987

Haussmann, Baron Georges Eugène (1809–91)

French administrator. He was born in Paris and became a career civil servant, astutely judging his political sympathies, until rising to the position of prefect of Paris. In this capacity he was placed in charge of the rebuilding of the city by Napoleon III in 1853, with

the aim of creating a fitting Imperial capital, a city able to cope with its growing population and, most importantly, a seat of government able to withstand revolution. Over the next 17 years, until his dismissal in 1870, he oversaw the construction of 144 km (90 miles) of new roads, over 4,000 acres of parks and 560 km (350 miles) of sewers. His personal architectural taste, towards Classicism, influenced the designers he employed, and created a series of vistas (like the eight radiating boulevards from the Place de l'Étoile) and uniform four-storey apartment blocks, as well as set pieces like the Palais de Justice (1857–68). He also encouraged the use of new materials like iron and glass for the city's covered markets. Although he is credited with the mass destruction of medieval Paris, regardless of human or architectural cost, he did attempt to blend the old with the new. Perhaps most importantly his ideas, known as Haussmannization, became the basis of much later town planning, including Rome, Brussels, Toulouse and Lyons.

Bib.: Chapman, B., *The Life and Times of Baron Haussmann*, London, 1957; Pinkey, D.H., *Napoleon III and the Rebuilding of Paris*, Princeton, 1958; Saalman, H., *Paris Transformed*, New York, 1971

Hawksmoor, Nicholas (1661–1736)

English architect. From about the age of 18 he was employed by ▷Wren, continued to work for him for the next 20 years, rose ultimately to clerk of works, and was closely involved in all of Wren's late buildings (e.g. Greenwich Hospital). From 1690 onwards he assisted or perhaps, more accurately, collaborated with ▷Vanbrugh on Castle Howard and Blenheim Palace – his professional expertise evidently allowed the untutored Vanbrugh to realize his grandiose conceptions. Hawksmoor's own highly original ▷Baroque style is an assimilation of Wren, along with a passion for Classical Roman and medieval ▷Gothic building, the latter two influences frequently combined in a personal and unpedantic way in the same building (e.g. the medieval brooch spire rising above the Roman ▷Doric ▷portico of Christchurch, Spitalfields). These influences are united with a personal sense of the abstract sculptural qualities and dramatic effects of mass – in this latter concern his affinities being closer to Vanbrugh than Wren. His first major independent building was Easton Neston (exterior completed 1702). He designed the west towers of Westminster Abbey (1734) and the north quadrangle and hall of All Souls, Oxford (completed 1734), both in a Neo-Gothic style (though typically, the interior of All Souls is ▷Classical). Also at Oxford, he designed the Clarendon Building (1712–15) and submitted an early design for the Radcliffe Camera which influenced the ultimately approved design by ▷Gibbs. His most original buildings result from his appointment as architect for six churches to implement the 1711 Act for Building Fifty New Churches in London, these being St. Alphege, Greenwich (1712–14), St. Anne's, Limehouse (1714–30), St. George-in-the-East (1714–34; gutted 1941), St. Mary Woolnoth (1716–27), St. George's, Bloomsbury (1716–27), and Christchurch, Spitalfields (1714–29). His final major work was the circular Doric mausoleum at Castle Howard (1729), strongly influenced by ▷Bramante's ▷Tempietto.

Bib.: Downes, K., *Hawksmoor*, London, 1987

Haydon, Benjamin Robert (1786–1846)

English painter. He was one of the last vociferous supporters of ▷history painting in early Victorian England, and his obsessiveness about his own importance led to disappointment and disaster in his life. Although he was an admirer of ▷Wilkie, he was opposed to the popularity of ▷genre painting and set out to counteract its influence by painting grand biblical and Classical scenes which he exhibited privately. His paranoia led him to reject the ▷Royal Academy, which he felt did not give him enough recognition, but he was unable to sustain a living as an artist and was arrested and imprisoned for debt. At this time, he painted some of his best work, including (ironically) a genre painting *May Day*. When he was released from prison, he was forced to earn a living through portraiture, including numerous copies of a portrait of the Duke of Wellington. In his published writings he campaigned enthusiastically for greater state art patronage, as well as for the retention of the ▷Elgin Marbles. His failures and disillusionment led him to commit suicide. His status as a quintessential ▷Romantic artist is partly based on the diaries and autobiographical notes which he left.

Bib.: Jolliffe, J. (ed.), *Neglected Genius: The Diaries of Benjamin Robert Haydon*, London, 1990; Pope, W.B. (ed.), *The Diary of Benjamin Robert Haydon*, Cambridge, MA, 1960–63

Hayez, Francesco (1791–1882)

Italian painter. He was born in Venice, and studied in Rome, where he was sent on a scholarship in 1809. There he met ▷Ingres, ▷Canova and the ▷Nazarene artists, and his own work evolved their ▷Neoclassical style. He was particularly influenced by Ingres' portraits. He worked in Milan, where he taught art at the ▷Brera from 1850 and became director there in 1860.

Bib.: *L'opera completa di Hayez*, Milan, 1971

Hayman, Francis (1707/8–76)

English painter and book illustrator. He was born in Devon and began his career as a scene painter working for Robert Brown at the Drury Lane theatre (1718). He developed into one of the most versatile artists of his day. In the years after the death of ▷Thornhill, he was considered the major ▷history painter in the country (e.g. *Finding of Moses*, 1746, London, Foundling Hospital), yet he produced portraits, ▷conversation pieces (e.g. *The Bedford Family*, 1747–8,

Exeter), and scenes from literature (e.g. *Wrestling Scene from As You Like It*, 1744, London, Tate) and folklore. Perhaps his best known works were the Vauxhall Gardens decorations, produced for Jonathan Tyers (one of Hayman's major patrons) (1741–61) showing scenes from literature and rustic life (two are now in London, Victoria and Albert Museum). In 1743–4 he worked with the French engraver ▷Gravelot (having trained under him) on engravings from Hanmer's edition of Shakespeare and he retained a ▷Rococo influence in his work, which was to help form ▷Gainsborough's style. He was also an enthusiastic administrator: he helped to establish the Society of Artists and was its President 1766–8, and later was a founder member of the ▷Royal Academy. He became the librarian of the RA in 1771, and exhibited there 1769–72.
Bib.: Allen, B., *Francis Hayman*, New Haven and London, 1987

Haystacks

An extensive series of ▷Impressionist paintings by ▷Monet, produced in the summer, autumn and winter of 1890–91, fifteen of which were exhibited in ▷Durand-Ruel's gallery in May 1891. The period of this series was a productive one for the artist, and the paintings established his reputation as one of the leading painters in France. The pictures record the changing light patterns and effects of the seasons on two large haystacks in a field behind his house at ▷Giverny. Monet said he set out to depict what he experienced as much as what he saw, and as such is closer to the ▷Symbolists than the ▷Realists in his execution of the subject. This theme was traditionally associated with agricultural labour, but by removing any human presence and in his use of colour and light Monet created a mystical aura. Whilst he made his studies in the open he completed the canvases in the studio, and is indebted to the 19th-century landscape painting of ▷Turner and ▷Corot.
Bib.: Tucker, P., *Monet in the '90s: The Series Paintings*, New Haven and London, 1989

Hayter, Sir George (1792–1871)

English painter. He attended the ▷Royal Academy Schools and studied in Rome. He worked for Queen Victoria from the 1830s, painting royal portraits. In 1841 he was appointed Principal Painter in Ordinary to the Queen.

Hayter, S(tanley) W(illiam) (1901–88)

British engraver and painter. He spent most of his life in Paris. Although he had a degree in chemistry and an early career working for an oil company, in 1926 he decided to become an artist, and settled in Paris. In 1927 he founded the Atelier 17, a workshop for experiments in print techniques. Through this workshop, he was an important figure in a revival of interest in print techniques amongst ▷modernist artists. Among those who came into contact with his workshop, ▷Picasso, ▷Miró, ▷Ernst, ▷Chagall and ▷Dali were influenced by him. From 1941 to 1951 he lived in New York, where he opened a new workshop during the War. He also wrote about his theories in *New Ways of Gravure* (1949).

Haywain, The

Also known as *Landscape: Noon*, *The Haywain* (now in the National Gallery, London) was painted in 1821 and formed part of the sequence of Stour Valley subjects that had commenced with *The White Horse* (1819). Constable's reputation was made by these large, six-foot studio paintings of Suffolk scenes, though his image of a cart crossing a river has been so over-reproduced that it loses a lot of its beauty, suggesting today some lost idyll of Old England. Constable was surprised when the painting failed to sell after its exhibition at the ▷Royal Academy, but it won a Gold Medal at the Paris ▷Salon and was much acclaimed by ▷Delacroix and Stendahl.

Hazlitt, William (1778–1830)

English essayist and writer on art. He was born in Maidstone, the son of a Unitarian minister, and spent part of his childhood in America, on one of his father's preaching missions. As a youth he considered becoming a painter and travelled to Paris to study in 1802, but although he did execute portraits of his friends, like Charles Lamb (1804, London, National Portrait Gallery), it is as a writer that he is best known. He was the major commentator on art between ▷Reynolds and ▷Ruskin but, unlike them, he wrote for the general public rather than for the artistic community. He also held different views. Hazlitt was a ▷Romantic, who promoted the idea of genius and self-expression above adherence to any ▷academic ▷canon. He wrote regularly for Hunt's *Examiner*, was friends with many of the leading literary figures of the day and held consistently radical views. His best-known work, *Spirit of the Age* (1825), examined the period in the light of its great minds, but he also published collections of essays and his conversations with the artist ▷Northcote.
Bib.: Barrell, J., *Political Theory of Painting from Reynolds to Hazlitt*, New Haven and London, 1986

Heartfield, John (Helmut Herzfelde) (1891–1968)

German engraver. He changed his name to Heartfield as a protest against Germany and his German origins. From the beginning, his work exhibited a tendentious and subversive stance. He founded the journal *Neue Jugend* in 1916, which was banned during the First World War for its anti-war sentiment. He founded the publishing company Malik Verlag with his brother

John Constable, *The Haywain*, 1821, National Gallery, London

Wieland, and they became the public face of the Berlin ▷Dada group through various short-lived journals. Heartfield was particularly distinguished for his effective ▷photomontage technique, in which a small number of evocative images were juxtaposed for political effect. In the later 1920s and early 1930s he worked for the communist journals *Arbeiter Illustrierte Zeitung* (*Workers' Illustrated Journal*) and *Rote Fahne* (*Red Flag*). During the Hitler regime, he moved to London, but he returned to East Berlin in 1950, where he remained until his death.
Bib.: *John Heartfield: Idee und Konzeption*, exh. cat., Cologne, 1991; Pachnicke, P. and K. Honnef (eds), *John Heartfield*, New York, 1992

Heckel, Erich (1883–1970)
German artist. He was an ▷Expressionist and one of the leaders of ▷Die Brücke (e.g. *Brickworks*, 1907, private collection; *Nude on a Sofa*, 1909, Munich). In 1911 he moved to Berlin where he came into contact with ▷Marc, ▷Macke and ▷Feininger, and through them developed an interest in form and structure (e.g. *Glassy Day*, 1913, Munich). At the same time, along with his fellow members of Die Brücke, his work seemed to grow more pessimistic and cynical, when faced with the realities of modern urbanization. During the First World War he served as a medical orderly in Flanders, where he met ▷Ensor and ▷Beckmann, and like the latter, was powerfully affected by what he saw. His work developed into desolate, mud-coloured landscapes with isolated figures (e.g. *Spring*, 1918, Berlin). But during the 1920s, both the Expressionism and the despair of his

work eased, and he produced more lyrical, almost decorative, landscapes. He was proscribed in 1937 as one of the ▷'degenerate artists', but remained in Germany until his Berlin studio was destroyed by fire in 1944. He then retired to Lake Constance, Switzerland. After the War (1949–55) he taught at the Karlsruhe Academy.
Bib.: Dube, W., *The Expressionists*, New York, 1972; Lloyd, J., *German Expressionism: Primitivism and Modernity*, New Haven and London, 1991

Heda, Willem Claesz. (1594–1680/2)
Dutch painter. He produced still lifes, particularly breakfast pieces, in Haarlem. He was particularly skilled at the depiction of different kinds of food.

Heem, Jan Davidsz. de (1606–83/4)
Dutch painter. He was born in Utrecht, but worked in Antwerp and Leiden as well. His work shows the influence of both Dutch and Flemish art. In 1636 he moved to Antwerp, possibly because of religious conflict, and he became a citizen in 1637. He primarily painted lavish still lifes showing elaborate tables full of fruit, cheese and meat. Living in Utrecht in 1669, he became a member of the ▷guild, but he moved back to Antwerp in 1672.

Heemskerck, Maerten Jacobsz. van (1498–1574)
Dutch painter. He was a pupil of ▷Scorel from c1527 to 1529. He adopted his master's speciality of religious

Maerten Jacobsz. van Heemskerck, *Self-portrait*, 1553

works, and he travelled to Rome in 1532–5, where he did drawings based on antique sculpture and was influenced by ▷Michelangelo. In 1537 he returned to Haarlem, where he adopted a ▷Mannerist style, using crowded compositions.
Bib.: Veldman, I., *Maarten van Heemskerck and Dutch Humanism in the Sixteenth Century*, Maarssen, 1977

Hegel, Georg Wilhelm Friedrich (1770–1831)

German writer and philosopher. He was born in Stuttgart and educated at Jena University (1788) with Schelling. He subsequently became Professor of Philosophy at Jena (1800) and later at Berlin (1818). In his great work *Phenomenology of Mind* (1807) he developed two key ideas. Firstly, the importance of the Germanic world, cradle of the ▷Reformation and centre of contemporary civilization – an idea which fitted in with the growth of national consciousness in Germany, and with ▷Romantic ideas of national culture. Secondly, he saw history as a progressive search for freedom and individual consciousness. Based on the progress of antagonism, which would eventually lead to synthesis in the ideal state (which he conceived as 19th-century Protestant Prussia), he viewed freedom in an ▷Enlightenment context, as a securer of moral and social awareness. In the *Science of Logic* (1816) he conceived of the universe as a system, but one which could be understood only if viewed as a whole. After his death, his views on Prussian supremacy gave way to New Hegelians who argued that the perfect synthesis was yet to be achieved (▷Marx).
Bib.: Bungay, S., *Beauty and Truth: A Study of Hegel's Aesthetics*, Oxford, 1984; Singer, P., *Hegel*, Oxford, 1983

Heian

▷Japanese art

Heidegger, Martin (1889–1976)

German writer and philosopher. After joining the Jesuits as a novice, he studied at Freiburg University and taught there (1928) and at Marburg (1922) before resigning in 1934. He was later banned from teaching by the Allies after World War Two, after his work was considered tainted by Nazism (he justified German domination). His thinking could be summed up in the phrase 'being is', the central idea of his complex *Being in Time* (1927). Man had to ask himself 'what is it to be?', and only by doing this, and standing back from absorption into objects and others, could he actually exist. The constant fear of death and the anxieties of life help man to ask the question. Many have argued that Heidegger's search for being is simply a search for God. For him, art, like language, was important evidence of existence, something which was real existence rather than a mere recreation of reality. He opposed technology, which he believed caused ▷alienation, and advocated a return to an agrarian economy in which the individual had a greater role. His ideas owe much to Nietzsche, and were taken up by the Existentialists.
Bib.: Spanos, W., *Heidegger and Criticism*, Minneapolis, 1993; Waterhouse, R., *A Heidegger Critique*, Brighton, 1981

Heidelberg School

Australian school of ▷*plein air* painters who worked in Heidelberg, Victoria, in the 1880s. An exhibition, the '9 × 5 Impressions', was held at Buxton's Galleries in Melbourne in 1889. The group, which may be considered the first white Australian school of painting, included ▷Tom Roberts, ▷Streeton, ▷McCubbin and Conder.

▷Australian art

Bib.: Smith, B., *Australian Painting 1788–1960*, rev. T. Smith, Melbourne, 1991; Clark, J. and B. Whitelaw (eds), *Golden Summers: Heidelberg and Beyond*, Sydney, 1986

Held, Al (b 1928)

American painter. He is best known for his ▷Abstract Expressionist works, which he produced throughout the 1950s. He gradually evolved a ▷colour field technique which comprised heavily ▷impasted canvases. He also experimented with ▷acrylic and has been associated with ▷Op art.

Hell

In Christian art, the domain of ▷Satan and the ultimate destination of the damned after the reunification of their bodies with their souls at the ▷Last Judgement. It is an underworld (as was the Greek Tartarus from which some of its imagery derives) where the punishment suits the crime: gluttons are force-fed for all eternity, toads and serpents attack the genitals of the lustful, and the proud are condemned to carry great weights. In medieval Last Judgements, the entry to Hell (into which sinners are hurled by hideous demons) is often represented as a monster's mouth, though this image was superseded in ▷Renaissance times by the mouth of a cavern. Satan himself presides over the torments, sinners sometimes dangling from his mouth (e.g. attributed to ▷Coppo di Marcovaldo, mosaic c1300, Florence, Baptistry). Dante's vision of Hell in his *Inferno* (c1314–21) has proved enormously influential, providing the source for numerous cycles of illustrations including those by ▷Botticelli, ▷William Blake, ▷Gustave Doré and, most recently, Tom Phillips (1983). The influence of the *Inferno* can also be discerned in ▷Nardo di Cione's *Last Judgement* fresco (after 1350, Florence, Sta Maria Novella, Strozzi Chapel) where Hell is visualized in nine Dantean circles, and in ▷Michelangelo's *Last Judgement* (1536–41, Vatican, ▷Sistine Chapel) in which Minos, the judge of the damned, his tail wrapped around his body, looks on whilst Charon, the infernal ferryman, drives the damned into Hell with his oar. The tragic implications of Dante's tortured sinners later appealed to the ▷Romantic imagination and provided ▷Delacroix with the subject of his first large-scale painting (*The Barque of Dante*, 1822, Paris, Louvre).

Hellenistic

Term denoting the culture of ancient Greece between the establishment of Alexander the Great's empire in c330 BC and the beginning of the reign of the Roman emperor Augustus in 27 BC. During this period Greece spread its dominion from the Aegean to North Africa, and across Asia Minor as far as India. Alexander's successors ruled over a series of city states, sometimes at war, sometimes co-operating with each other, but all inheriting a Greek culture enriched by contact with its subject peoples. Thus Hellenistic art is more diverse than that of the ▷Classical period (5th and 4th centuries BC) which it succeeded. Where Classical architecture aimed at achieving beauty of form, through the imposition of eternally valid proportional harmonies in buildings which were nonetheless human in scale, Hellenistic architecture aims to impress by a superhuman scale and lavish decoration (e.g. the Mausoleum at Halicarnassus, c350 BC). Hellenistic sculpture aims at similar effects and is characterized by ▷bravura displays of technical virtuosity, a concern with dramatized realism, and the portrayal of violent movement and heightened emotion (e.g. the Great Altar at Pergamon, c190–150 BC, Berlin, Staatliche Museen; and the ▷*Laocoön*, c50 BC, Vatican Museums).

Bib.: Robertson, M., *A History of Greek Art*, 2 vols, Cambridge, 1975; Smith, R.R.R., *Hellenistic Sculpture*, London, 1991

Helst, Bartholomeus van der (1613–70)

Dutch painter. He was born in Haarlem, but he worked primarily in Amsterdam, where he was responsible for a number of Civic Guard group portraits. His style showed the influence of both ▷Hals and ▷Rembrandt, and he became a member of the Amsterdam Guild in 1653.

Hemessen, Jan Sanders van (c1500–c1566)

Netherlandish painter. He was from Antwerp, but worked in Haarlem in c1550. He produced religious and ▷genre paintings, as well as portraits, and he illustrated proverbs.

Hennings, Emmy (1885–?)

German performer. She was the partner of ▷Hugo Ball, and was one of the people responsible for the ▷Dada emphasis of the Zurich ▷Cabaret Voltaire. She took part in the scurrilous presentations there, and she developed her own artistic contribution through satirical puppet shows (using dolls she had made), as well as her novels and poetry.

Bib.: Rugh, T., 'Emmy Hennings and the Emergence of Zurich Dada', *Women's Art Journal*, 2/1 (1981), pp. 1–6

Henri, Robert (1865–1929)

American painter. He studied at the Pennsylvania Academy of Fine Arts under ▷Anshutz, and from 1888 to 1891 in Paris at the ▷École des Beaux-Arts under ▷Bouguereau. Despite his ▷academic training, his influences were not academic. He was attracted to the work of ▷Hals and ▷Manet, which he saw while he was in Europe, and he appreciated the realism of his compatriot, ▷Thomas Eakins, long before Eakins had gained recognition. In 1891 he taught in Philadelphia, and at the New York School of Art from 1900 to 1908. Through his teaching, he developed an important following, and with his students (including ▷Glackens, ▷Sloan and ▷Luks), he formed ▷The Eight, which later became the basis of the ▷Ashcan School. In 1909 he opened his own school in New York, where he worked with both ▷Bellows and ▷Hopper. He was a particularly important catalyst for the evolution of realism in early 20th-century American art.

Bib.: Perlman, B.B., *Robert Henri: His Life and Art*, New York, 1991

Dame Barbara Hepworth (photo. Peter Kinnear)

Henry, Charles (1859–1926)

French writer and theorist. He studied science and music, using both in his later ▷aesthetic theories. From 1886 he was part of ▷Seurat's circle. As a writer on art, although he also published a biography of ▷Watteau, he was most influential for works such as *Theory of Directions* (1885) and *A Scientific Aesthetic*. He also collaborated with ▷Signac on *The Spirit of Forms* and *The Spirit of Colours* (1888). In these he discussed the emotional significance of colour and line (suggesting for instance that inclining lines had pleasant properties). His ideas influenced Seurat in his later work (*The Parade*, 1886–8, New York, Metropolitan Museum) and can be seen in the swirling background to Signac's portrait of Fenéon (1890; New York).

Bib.: Argüelles, J., *Charles Henry and the Formation of a Psychophysical Aesthetic*, Chicago, 1972

Hepworth, Dame Barbara (1903–75)

English sculptor. She trained at Leeds School of Art (where she met and became a friend of ▷Henry Moore) and the ▷Royal College of Art. In 1924 she won a scholarship for one year's study abroad and went to Italy, staying till 1926. In Italy she learned to carve stone, a skill not taught at the Royal College as it was at that time considered stonemason's work. In 1928 she had her first important exhibition: stone carvings of figures and animals, still naturalistic, but with a marked tendency towards formal simplification. From the early 1930s she was in the forefront of the development of abstract art in Britain, simplifying her forms to the point of complete abstraction, a process encouraged by her association with ▷Ben Nicholson, who became her second husband in 1932 following the dissolution of her first marriage. The couple visited

Paris and were in touch with the international ▷avant-garde, notably ▷Brancusi, ▷Braque, ▷Arp, ▷Gabo and ▷Mondrian, both becoming members of the Paris-based ▷Abstraction-Création. They were also members of the English ▷Seven and Five Society and ▷Unit One. In 1939 they moved to ▷St. Ives, where Hepworth stayed for the rest of her life, allowing the Cornish landscape to influence her abstract forms. She has had numerous retrospective exhibitions, including the São Paolo Biennal of 1959, when she was awarded the Grand Prix. Her most prestigious commission was the memorial to Dag Hammarskjöld, *Single Form* (1963), for the UN Building in New York. She was appointed CBE in 1958 and DBE in 1965. Her St. Ives studio is now a museum dedicated to her life and work.

Bib.: Bowness, A., *Barbara Hepworth: Complete Sculpture*, London, 1971; Festing, S., *Barbara Hepworth, A Life in Forms*, London, 1995; *Barbara Hepworth, A Retrospective*, exh. cat., London, 1994

Hera

▷Juno

Herakles

▷Hercules

Hercules

(Greek: Heracles, Herakles.) Semi-divine Greek hero famed for his courage and physical strength. He was the son of a mortal woman, Alcmene, and the chief Greek god, ▷Jupiter (Zeus). His cult was widespread and important to ancient Greeks and Romans alike as

a powerful superhuman protector. Images of Hercules abound in art from ▷antiquity onwards. He is recognizable by his heavily muscled physique, and his principal attributes, a lion-skin cloak and a club (as in the ▷Farnese Hercules). He may appear in this guise in a series of the ▷Virtues, in which case he represents ▷Fortitude. The lion-skin was taken from the Nemean lion, the extermination of which formed one of Hercules' Twelve Labours (see below), undertaken on the instructions of the Delphic Oracle as penance for the murder of his own children in a fit of madness. Hercules had to carry out any 12 tasks that Eurystheus, King of Tiryns, might impose upon him. The Twelve Labours of Hercules came to be viewed as symbolic of the triumph of good over evil. The earliest complete cycle is the set of relief carvings in the ▷metopes of the Temple of Zeus at Olympia (c560 BC)

The Twelve Labours of Hercules are:

(i) The Nemean Lion. The lion had been terrorizing the people of Nemea, and Hercules was dispatched to kill it. His weapons made no impression on the beast, so he used his bare hands, either by strangling it, or tearing its jaws apart. Both versions are represented in art. The metope at Olympia unusually shows Hercules standing over the lion after the kill, ▷Minerva (Athena) reassuring him and ▷Mercury (Hermes) standing behind him.

(ii) The Lernaean Hydra. The hydra was a multi-headed (seven or nine, accounts vary) monster terrorizing the people of Lerna. Hercules attacked it, but for every head he cut off another two grew in its place. He therefore instructed his servant to cauterize each stump immediately after cutting, and in this way he defeated the monster. The final head to be removed was immortal and Hercules had to bury it under a rock. He used the monster's blood to poison-tip his arrows.

(iii) The Arcadian Stag, or Ceryneian Hind. Hercules was ordered to capture this alive. He is shown pressing down on the stag, one knee in the small of its back, his hands grappling its antlers.

(iv) The Erymanthian Boar. Another wild animal on the rampage, this time attacking the people who lived around Mount Erymanthus. Hercules had to take this one alive. He drove it into a snowdrift and then successfully netted it. He carried it back to Eurystheus who was so frightened by the boar, he hid in a large urn. It is this end to the labour that is represented in the ▷metope at Olympia.

(v) The Augean Stables. Augeas, King of Elis, owned stables containing 3,000 oxen, which had not been cleaned for 30 years. Hercules, ordered to clean them, performed the feat in one day by diverting the course of a river through them. In the Olympia ▷metope, Athena shows Hercules where to breach the walls of the stables to let the river in most efficiently.

(vi) The Stymphalian Birds. Around Lake Stymphalus lived a colony of murderous birds with claws, beaks

and wings of brass, and feathers which flew out like poison darts. Hercules first frightened them from their trees with the noise of a rattle, then shot them with his arrows. At Olympia he is represented handing the dead birds to Athena.

(vii) The Cretan Bull. Hercules was sent to capture the mad, fire-belching bull belonging to King Minos. He struggled with and defeated the bull, lassoing it around the neck and beating it into submission with his club.

(viii) The Horses of Diomedes. Hercules took a band of his followers to subdue the horses of King Diomedes, which lived on human flesh. In the battle to take them, Diomedes was killed and his flesh fed to the horses which then became tame. At Olympia, Hercules is shown grabbing a horse's head and raising his club. The theme is also represented by the British sculptor ▷William Theed the Younger in the sculptured ▷pediment (1859) of the Riding House in the Royal Mews of Buckingham Palace, London.

(ix) The Girdle of Hippolyta. Eurystheus sent Hercules to take the girdle of Hippolyta, Queen of the Amazons, as a present for his daughter. Hercules succeeded by killing Hippolyta.

(x) The Oxen of Geryon. Geryon was a human monster with three bodies. Hercules was sent to take his herd of oxen which were guarded, not only by Geryon but by a giant and a two-headed dog. Hercules killed them all, Geryon last, and drove the herd back to Eurystheus.

(xi) The Golden Apples of the Hesperides. The tree upon which the golden apples grew was guarded by the serpent Ladon in the garden of the Hesperides, the daughters of Night and Erebus. The garden was close to where the Titan Atlas stood, supporting the world on his shoulders. Hercules persuaded Atlas to take the apples for him, while he, in turn, supported the world for Atlas.

(xii) Cerberus. Eurystheus dispatched Hercules to bring him Cerberus, the three-headed dog which guarded the underworld. Hercules descended into the underworld with Athena and Hermes. ▷Pluto (Hades), the god of the underworld, allowed Hercules to take Cerberus, provided he used no weapons. Hercules took Cerberus and, having shown Cerberus to Eurystheus, returned it to the underworld.

Other frequently represented events from Hercules' life are:

(i) Hercules as an infant killing snakes. ▷Juno (Hera), the wife of Jupiter, was angry at her husband's infidelity and sought to destroy the infant Hercules by sending two poisonous snakes to his cradle. Hercules is shown strangling the snakes, while Alcmena and her cuckolded husband, Amphitryon, look on.

(ii) The Judgement of Hercules; Hercules at the Crossroads. A moral fable, dating from antiquity, but achieving its greatest popularity in ▷Renaissance and ▷Baroque art. Hercules had to choose between a life of ease and luxury offered by a seductive nude or

semi-nude young woman (Vice) who points towards sunny pastures, and a life of heroic endeavour offered by a fully clothed woman (Virtue) who points up a narrow, rocky road towards Pegasus, the winged horse (in this context symbolizing fame). Hercules is generally depicted sitting between them, pondering the better course (see ▷Annibale Carracci, *Hercules at the Crossroads*, c1596, Naples, Capodimonte Museum).

(iii) Hercules and Antaeus. Returning from the garden of the Hesperides, Hercules encountered the giant Antaeus, son of ▷Neptune (Poseidon) and Earth. The two fight to the death. Antaeus is invincible as long as he maintains contact with his mother, Earth. Hercules lifts him from the ground and crushes the life out of him. ▷Antonio Pollaiuolo painted a panel (Florence, Uffizi) and modelled a bronze statuette (c1475–80, Florence, Bargello) on this subject.

(iv) Hercules and Cacus. Returning home with Geryon's oxen, Hercules rests one night by the River Tiber. Cacus, a fire-breathing giant, steals the oxen while Hercules sleeps and hides them in a cave. Hercules tracks them down and kills Cacus. ▷Bandinelli's colossal marble statue in the Piazza della Signoria, Florence (1534), shows Hercules standing, club in hand, over the crouched Cacus who raises his hand in a futile plea for mercy. The statue, commissioned to flank the entrance to the Palazzo Vecchio, symbolizes the fortitude of the ▷Medici rulers of Florence against outside aggressors.

(v) Hercules and Omphale. To expiate the sin of murdering his friend in (another) fit of madness, Hercules has to serve for three years as a slave to Omphale, Queen of Lydia. Omphale sets him chores usually performed by women. Away from his more masculine labours, he grows effeminate to the extent of wearing women's clothes. Hercules may be represented in Omphale's clothes, with Omphale wearing Hercules' lion-skin cloak and holding his club (e.g. ▷Bartholomeus Spranger, *Hercules and Omphale*, 1575–80, Vienna, Kunsthistorisches Museum).

(vi) Hercules, Deianeira, and the shirt of Nessus. Hercules is travelling with his lover, Deianeira, the daughter of a river god. In order to cross a river they have to use the ▷centaur Nessus' ferry. Hercules goes across first. Nessus returns to the other bank and, instead of transporting Deianeira across, attempts to abduct her. Hercules shoots the centaur with an arrow, poison-tipped with the blood of the hydra. Before Nessus dies he convinces Deianeira that his own blood has the power to serve as a love potion; he realizes, in fact, that it is now contaminated by the hydra's poison. Deianeira, not knowing about the hydra, believes Nessus and gathers up some of the blood. Some time later while Hercules is in foreign parts, Deianeira hears that he is being unfaithful and sends him a gift of a shirt smeared with Nessus' blood. As soon as Hercules dons the shirt, the poison starts to eat into his skin, driving him mad with pain. He picks up the messenger,

Lichas, whom he suspects of treachery, and hurls him into the sea (see ▷Canova, *Hercules and Lichas*, marble, 1815, Rome, Galleria d'Arte Moderna).

(vii) The Apotheosis of Hercules. After his death, Hercules is transported to Mount Olympus in Athena's chariot and becomes one of the gods. Here he marries Hebe, daughter of Jupiter and Juno, in the presence of the other Olympian gods. This scene was naturally a popular choice for Baroque ceiling paintings (e.g. ▷François Lemoyne, 1736, the ceiling of the Salon d'Hercule, Versailles).

heritage
A term which refers literally to that which has been or will be inherited. In recent years there has been a growth in popular interest in heritage and many countries have government ministries dedicated to the presentation of works, objects and sites of historical interest. Some methods of preserving the past are controversial, such as theme parks and expensive reconstructions, but much has been preserved and, in countries such as Britain, highly lucrative heritage industries created.

Herkomer, Sir Hubert von (1849–1914)
British painter, designer and composer of German birth. He was born in Bavaria, where his father was a woodcarver, but came to England with his family in 1857, where he remained for the rest of his life. A largely self-taught artist, his early ▷genre scenes were sentimental, but he later gained a reputation for social ▷Realist paintings (e.g. *Hard Times*, 1885, Manchester City Art Gallery; *On Strike*, 1891, London, Royal Academy). He was particularly praised for his studies of age (e.g. *Sunday at Chelsea Hospital*, 1875, Port Sunlight). His later career was dominated by portraiture, which brought both financial and critical success. He established an Art School at Bushey, Herts, in 1883, which he ran until 1904, and was appointed Slade Professor of Fine Art at Oxford 1885–94. In his later career he designed film and theatre sets and also wrote opera.
Bib.: Courtney, W.L., *Hubert von Herkomer, Life and Work*, London, 1892

herm
A rectangular pillar, tapering towards the base, surmounted by a sculptured head, usually that of Hermes (▷Mercury). Herms were used originally in ancient Greece as boundary-markers, milestones or signposts, but architects have used the form for ornamental purposes since the ▷Renaissance.

Hermes
▷Mercury

Hermetic Cubism
▷Cubism

Hermitage
State collection of art housed in the former Russian Winter Palace and other major buildings in St. Petersburg. There are six departments: prehistoric culture, culture of antiquity, culture of peoples of the East, Russian culture, West European art and numismatics. The collection of Western European art is impressive, and was built up by travelling Russian rulers and through the spoils of war. For example, Peter the Great is known to have purchased a number of works by ▷Rembrandt in Amsterdam in 1716, and Catherine II brought back 225 canvases from a trip to Germany in 1764. Indeed, Catherine was a voracious collector, first purchasing groups of works by single artists and then buying whole collections, including those of Nicholas Gaignal (1769), Count Bruhl of Saxony (1772) and Pierre Crozat (1772). Crozat's collection included ▷Giorgione's *Judith*, ▷Raphael's ▷*Holy Family* and ▷Titian's *Danae*. By 1770 ▷Quarenghi had been engaged to extend the Small Hermitage to house the expanding collection, which encompassed a large part of ▷Sir Robert Walpole's collection (1779) and new commissions from ▷Joshua Reynolds and ▷Chardin. Complaints about the poor display of the works resulted in a great upheaval, spurred on by a fire in 1837, and in 1852 the Hermitage was declared a public museum. However, it was still extremely difficult to fulfil the necessary criteria actually to gain admission to the collection, and the Hermitage remained almost private until the October Revolution. The great expansion continued through the 19th and 20th centuries, with purchases of works by ▷Delacroix, ▷Picasso, ▷Sisley, ▷Monet, ▷Pissarro, ▷Gauguin, ▷Bonnard and ▷Matisse. There is little doubt that the Hermitage is one of the world's greatest galleries, but the provenance of many of its works is controversial.

Hernandez, Gregório
▷Fernandez, Gregório

Heron, Patrick (b 1920)
English painter. He was with the ▷St. Ives group in 1958, and he evolved an abstract style that had affiliations with ▷Tachism and ▷colour field painting. He was also an art critic.
Bib.: Gooding, M., *Patrick Heron*, London, 1994

Herrara, Francisco the Elder (c1590–1656), Francisco the Younger (1627–85)
Spanish family of painters, engravers and architects. Francisco the Elder worked primarily in Madrid, where he produced ▷genre and religious paintings in a ▷Baroque realist style. He may have taught ▷Velázquez in 1611–12. His son studied in Rome,

where he produced mainly still lifes. In 1656 he was back in Spain, where he painted portraits and religious works. He was one of the founders of the Academy of Seville, where, from 1660, he assisted ▷Murillo. He earned the title Painter to King Charles II in 1672 and in 1677 became Master of the Royal Works.

Herring, John Frederick Senior (1795–1865)
English painter. He specialized in animals and rustic scenes. He rose from humble origins, originally as a stable lad, then a coach painter, to become one of the leading artists in his field. Throughout his career he benefited from good patrons. His farmyard scenes were popular, but he also painted racehorses, like the winners of the St. Leger and the Derby (e.g. *Four Racehorses with Jockeys Up*, 1841, private collection), and most of his work was widely publicized through ▷engravings. He also established an artistic dynasty: his brother Benjamin (1806–30), and his three sons, including John Frederick Junior (d 1907), were all imitators of his style.

Herzfelde, Helmut
▷Heartfield, John

Hesse, Eva (1936–70)
American painter and sculptor of German birth. She was born in Hamburg but emigrated to New York in 1939 during the height of Nazi persecution. In 1945 she became an American citizen. She studied at Yale University. In 1961 she married the sculptor Tom Doyle (b 1928), which affirmed her own fascination with sculpture. A visit to Germany in 1964 helped her develop her distinctive style of string sculpture. She concentrated on grid formations and erotic themes, and she often hung her ladder-like objects from ceilings. Her work classifies her with other early ▷minimalist sculptors.
Bib.: Lippard, L., *Eva Hesse*, New York, 1976

Heyden, Jan van der (1637–1712)
Dutch painter. He is principally valued for his townscapes of Amsterdam, painted in the 1660s, though in the earliest and latest parts of his career he also painted ▷still lifes. He is generally credited with introducing townscape painting into Amsterdam, though the genre had earlier been established in Haarlem by ▷Gerrit and ▷Job Berckheyde. The careful delineation of each architectural element gives an appearance of topographical fidelity. Yet, although stones, bricks and foliage are always meticulously rendered, his delicacy of touch and concern with colour and sunlight prevent his work from being merely academic. Very often, in fact, the component elements are slightly rearranged to create a harmonious and elegant composition (e.g. *View of the Westerkerk, Amsterdam*, London, Wallace Collection, in which the position of the steeple was altered and the foreground space exaggerated) and

sometimes his compositions are imaginary combinations of disparate buildings (e.g. *An Architectural Fantasy*, London, National Gallery, figures probably by ▷Adriaen van de Velde). Principally concerned with the townscape itself, the figures in van der Heyden's paintings were often painted by specialists like Adriaen van de Velde.

Apart from painting, van der Heyden was involved in civic administration, devoting much time to improvements in street lighting and firefighting. He published in 1690 his *Brandspuiten-boek* (*Fire Engine Book*), which he illustrated himself with, amongst other things, designs for improved fire engines and hoses.
Bib.: Vries, L. de, *Jan van der Heyden*, Amsterdam, 1984; Wagner, H., *Jan van der Heyden*, Amsterdam, 1971

Heysen, Sir Hans (1877–1968)

Australian painter of German birth. He specialized in landscape ▷watercolours and was a practitioner of ▷Heidelberg School landscapes.

Hicks, Edward (1780–1849)

American artist. He was an itinerant painter. He was born in Bucks County, Pennsylvania, a self-taught artist who began his career painting coaches and signs. Throughout his life he was a staunch Quaker and lay preacher, whose conscience was troubled by his artistic aspirations. His most famous work, which he reproduced over 100 times, was the *Peaceable Kingdom*, a scene based on Isaiah's prophecy incorporating the meeting of William Penn and some Native Americans in the background. He worked with flattened, stylized colours, combining decoration and naturalism. His cousin, Thomas (1823–90), was a painter of landscapes and portraits, taught by him.

hierarchy of genres

This term refers not to ▷genre painting but to the various genres (French, meaning 'type', 'category') of painting. The notion that some art works are automatically more important than others because of their subject matter is alien to our thinking, but until at least the middle of the 19th century this idea had real force. The ▷academies, which practised an elevated form of painting in the ▷Grand Manner, classified painting in this way, beginning at the bottom with still life (inanimate objects), moving through animals to genre (peopled, but only by peasants) and landscape, to portraits (for the most part of sitters of some social standing), and from there to religious and ▷history painting. These last two were 'naturally' the most important categories because they encompassed all other genres. While the genre painter could only paint one kind of scene, the history painter was also a landscape/genre/still-life painter, since all these skills were needed to represent the dramatic narrative of history.

This system militated against genre painters such as ▷Chardin, who found himself fulsomely praised by the critic ▷Diderot but denied access to comparison with history painters, while ▷Greuze, who failed to enter the French Academy as a history painter, was awarded the dubious privilege of being received as a genre painter.

hieroglyphics

Writing system that uses the picture or image of an object to stand for a word, syllable or sound. The ancient ▷Egyptian hieroglyphic script is one of the oldest known writing systems. An offshoot of pictorial art, it has its origins at the beginning of the dynastic period towards the end of the 4th millennium BC. Used for over 3,000 years, it fell out of use during the ▷Coptic Period; its meaning was rediscovered in 1822 by J.F. Champollion with the aid of the Rosetta stone.

Highmore, Joseph (1692–1780)

English painter. He produced primarily portraits, ▷conversation pieces and scenes from literature. Highmore originally studied law, before training at ▷Kneller's Academy. He began as a portraitist but, under the influence of French ▷Rococo, his art developed into small-scale, dainty scenes of contemporary life. He is sometimes compared to ▷Hogarth, but Highmore was never interested in satire or social comment. His most famous works were those inspired by Richardson's novel *Pamela* (12 works, 1745, four in London, Tate Gallery). He also dabbled in ▷history painting, producing *Hagar and Ishmael* for the Foundling Hospital in 1746. He retired from art in 1761, and spent the rest of his life in Canterbury writing.

High Renaissance

▷Renaissance

Hildebrand, Adolf von (1847–1921)

German sculptor. He travelled to Rome in 1867, where he met ▷Marées, who became a close friend. Like Marées, he was committed to the perpetuation of an ▷academic or Classical style, which he evinced in his own work. He was in Italy again from 1872 to 1877. His work in Germany consisted largely of fountains and portrait busts in a Classical style, among which the Wittelsbach Fountain in Munich (1891) is the most distinguished. He was also an art theorist, and his *Das Problem der Form in der Bildenden Kunst* (*The Problem of Form in Fine Art*, 1893) may have influenced ▷Wölfflin.

Hildebrandt, Johann Lukas von (1668–1745)

Austrian architect. He was born in Genoa, and he absorbed the styles of north Italian architecture. He practised primarily in Vienna, where he was responsible for designs of palaces and churches.

Hill, David Octavius (1802–70)

Scottish painter and photographer. He worked with Robert Adamson, with whom he developed some early calotype processes. In the 1850s he produced a number of photographed portraits and genre scenes. His works were directly reminiscent of ▷Old Master paintings, and he was thus one of the pioneers of early artistic photography.

Bib.: Ward, J., *Printed Light: The Scientific Art of William Henry Fox Talbot and David Octavius Hill with Robert Adamson*, Edinburgh, 1968

Hilliard, Nicholas (1547–1619)

English painter. A leading painter of ▷miniatures in the Elizabethan and Jacobean periods, Hilliard was the son and grandson of goldsmiths, and was first apprenticed to a jeweller in London. He was appointed Court Miniaturist and Goldsmith c1570, executing Queen Elizabeth's Second Great Seal. His *Art of Limning* declared his debt to ▷Holbein, and also remarked on the influence of Elizabeth in developing

Nicholas Hilliard, *Self-portrait, aged 30,* 1577, Victoria and Albert Museum, London

his personal technique, which avoided the use of shadow, producing flat but colourful images. He was a creative innovator, introducing the use of actual gold rather than pigment. His experience as a jeweller allowed him to emphasize the decorative possibilities of the miniature. His subjects included Sidney, Raleigh, Drake and Elizabeth I, as well as many minor figures at court. After 1600 he was increasingly superseded by his former pupil, ▷Isaac Oliver.

Bib.: Murdoch, J., J. Murrell, P. Noon and R. Strong, *The English Miniature*, New Haven and London, 1981; Edmond, M., *Hilliard and Oliver*, London, 1983

Hilton, Roger (1911–75)

English painter. He studied at the ▷Slade School of Art from 1929 to 1931, and in Paris during the 1930s. There he developed a distinctive style of ▷abstraction using primarily black and white. After suffering as a prisoner of war during the Second World War, he became involved with the ▷St. Ives group in the 1950s and, like them, produced landscape work. By this time, his abstract style was fully developed. During the 1960s, he concentrated on images of women, also abstracted, but by this stage, colour had strongly re-entered his art.

Bib.: Gooding, M., et al., *Roger Hilton*, London, 1993

Hindu art

The main features of Hindu culture originated in India. Its earliest sacred texts, the Vedas, date from c1500–900 BC, but the true flowering of Hindu art did not occur until the Gupta period (AD c320–c540), when Buddhism began to wane. Initially, the emphasis was on monumental sculpture in cave-shrines. Notable examples can be found at Udayagiri (AD 401–2) and Elephanta (7th century). These were later superseded by elaborate, free-standing temples. The most ambitious scheme was at Khajuraho, where more than 80 such temples (c950–c1050) were once grouped together. On their outer walls, these were decorated with multi-layered friezes, each of which contained hundreds of individual scenes. Carvings of this kind usually depicted figures from the sizeable Hindu pantheon, although nymphs and temple dancers might also be included. In extreme cases, these could be frankly erotic (e.g. the Surya temple, 13th century). Following the Arab invasions of the late 12th century, Hindu art showed increasing signs of ▷Islamic influence.

Bib.: Craven, Roy, *A Concise History of Indian Art*, London, 1976.

hipped gable

▷gable

historicism

The movement of looking back to historical styles, particularly in architecture and the decorative arts, in order to recreate parallels in modern life. In the 19th century historicism thrived, with the ▷Greek and ▷Gothic revivals. The 20th century has had similar sentimental forays.

history of art

This is not, as many people believe, art appreciation, but an exploration of the art of the past. The discipline of art history is not unitary in its methods. Its explorations can take a number of forms, such as an examination of the lives of artists, an assessment of the historical circumstances that gave rise to particular conditions in the art market, a ▷psychoanalytic analysis of particular factors in an artist's life, or the

relationship between art and constructions of ▷gender or sexuality in particular historical periods. The history of art is more correctly the history of visual ▷culture, as both 'high' and 'low' forms of art are encompassed within the discipline.

▷new art history

Bib.: Belting, H., *The End of the History of Art?*, Chicago, 1987; Pointon, M., *The History of Art: A Students' Handbook*, 3rd edn, London and New York, 1994; Preziosi, D., *Rethinking Art History*, New Haven and London, 1989

history painting

The term describes a ▷genre of painting in which scenes taken principally from the Bible, mythology and Classical literature are treated in an elevated and morally edifying way. The historical genre, which stylistically is associated with, but not identical to, the ▷Grand Manner, was the preferred genre of ▷academic artists, who regarded it as the highest expression of art. Notable practitioners of history painting include ▷Poussin, ▷Charles Lebrun, ▷Benjamin West and ▷David.

Hitchens, Ivon (1893–1979)

British painter. He trained at St. John's Wood School of Art and at the ▷Royal Academy Schools, before joining the ▷London Group, where he picked up an enthusiasm for ▷Matisse. He later became a member of the ▷Seven and Five Society. During the Blitz he was bombed out of London, and settled in Sussex where he began to concentrate on landscape subjects. He produced abstract images which were rooted in nature, working mainly on wide canvases in fluid, vibrant colours. His palette changed from natural tones in his early works to increasingly strong yellows and purples. In 1963 he was commissioned to produce murals for Sussex University.

Bib.: Khoroche, P., *Ivon Hitchens*, London, 1990

Hoare, William (1707–92)

English artist. He studied in Italy 1728–37, then settled in Bath as a portrait painter for the members of fashionable society who spent part of their year in that city. He produced mainly ▷pastel portraits, but his successful practice was checked when ▷Gainsborough came to Bath in 1759.

Hobbema, Meindert (1638–1709)

Dutch painter. He was a pupil of ▷Ruisdael, and he produced realistic landscapes from c1658. His calm and balanced views of flat Dutch countryside influenced 18th-century English landscape painting. Among his most famous works is *The Avenue at Middelharnes* (1689, London, National Gallery). From 1668 he was forced to make a living as an excise officer, and he painted only sporadically after that date.

Bib.: Broulhiet, B., *Meindert Hobbema*, Paris, 1938

Höch, Hannah (1889–1978)

German painter and graphic artist. She was born in Gotha and moved to Berlin in 1912, where she studied at the School of Applied Arts. There she saw an exhibition of ▷Futurist painting, which was to have a significant influence on her later ideas. In 1915 she met ▷Raoul Hausmann in Berlin and became his collaborator as well as lover. Together they became involved with the Berlin ▷Dada group after the German Revolution of 1918. She was particularly interested in ▷collage, and during her Dada years became a pioneer of ▷photomontage techniques. In works such as *Cut with the Kitchen Knife*, she launched a bitter attack on the society and politics of the new Weimar Republic by using hundreds of images cut out of popular magazines. Despite her wit and innovation, she was excluded from the largely male environment of the Berlin Dada group, and she broke with Hausmann in 1922. From 1926 she developed a relationship with the Dutch author Til Brugman, and lived for a time in Amsterdam. During the Second World War, she remained in Berlin.

Bib.: *Hannah Höch 1889–1978: ihr Werk, ihr Leben, ihre Freunde*, exh. cat., Berlin, 1989; Lavin, M., *Cut with the Kitchen Knife: The Weimar Photomontages of Hannah Höch*, New Haven, 1993

Hodges, William (1744–97)

English painter. He was a pupil of ▷Richard Wilson from 1758 to 1765. From 1772 to 1775, he sailed with Captain Cook in the Pacific and Antarctica, where he produced numerous landscape drawings. He extended his skills as a documentary travel landscapist in 1779, when he went to India, where he remained until 1784. Once he had returned to England, he continued to paint landscapes, including works for ▷Boydell's Shakespeare Gallery.

Hodgkin, Howard (b 1932)

English painter and printmaker. He studied at the Camberwell School of Art 1949–50 and the Bath Academy of Art 1950–54. He travelled to India, and developed an abstract style that was partly influenced by Indian miniature painting. His interest was in intense colourism. He has had many national and international exhibitions and worked as a teacher at a number of institutions, including the Chelsea School of Art (1966–72).

Bib.: Graham-Dixon, A., *Howard Hodgkin*, London, 1994; Knowles, E. (ed.), *Howard Hodgkin Prints 1977 to 1983*, exh. cat., London, 1985

Hodgkins, William Matthew (1833–98) and Frances Mary (1869–1947)

New Zealand family of painters. William was from Liverpool, but he travelled to Australia and New Zealand in 1859. He settled in Dunedin, New Zealand, where he painted landscapes in the style of

▷Turner. His daughter Frances studied at the Dunedin School of Art, and then, in 1900, travelled to Europe. She travelled back and forth to New Zealand over the next few years, and produced primarily ▷watercolour landscapes and still lifes. During her travels, she became associated with the ▷St. Ives group (1915), and she became a member of the ▷Seven and Five Society. At first, her works were traditional in style, but by the 1930s she had developed a striking abstract colourism.
Bib.: McCormock, E.H., *Portraits of Frances Hodgkins*, Auckland, 1981

Hodler, Ferdinand (1853–1918)

Swiss painter. He studied in Geneva at the École des Beaux-Arts in 1872. His early works were naturalistic landscapes, and the rhythms of nature continued to interest him throughout his career. While in Paris in 1881, he met the ▷Rosicrucian group, and became interested in the mystical possibilities of art. He developed his own theory of natural rhythm, which he called 'parallelism' – indicating that the visible forms of nature were disguising deeper spiritual meaning. His heavily loaded works included such obscurities as *Night* (1890), which shows a group of naked people being woken from their dreams by a hooded demon. His style remained in the academic tradition, although there was some flatness which had affinities with ▷Art Nouveau. He was particularly valued by early ▷Expressionist artists, and he was given a solo exhibition at the 1904 Vienna Secession.
Bib.: *Ferdinand Hodler 1853–1918*, exh. cat., Paris, 1983; Hirsch, S., *Ferdinand Hodler*, London, 1982

Hoffmann, Josef (1870–1956)

Austrian architect. He was a pupil of ▷Wagner, and one of the early members of the Vienna ▷Secession. He was also a founder member of the Wiener Werkstätte. Through his architectural practice, he helped spread the Sezessionstil throughout Europe. He was most noted for his design of the Stoclet House in Brussels (1905), which was conceived as a total environment, and on which he collaborated with other Secession artists, such as ▷Klimt. In 1920 he was named City Architect of Vienna.

Hofmann, Hans (1880–1966)

American painter of German birth. He studied in Munich, and from 1904 until 1914 he was in Paris, where he saw works of ▷Cubist and ▷Fauvist artists. From 1915 to 1932 he taught art in Munich, then emigrated to the United States, where he became an American citizen in 1941. He was one of the first artists in America to develop pure ▷abstraction before the Second World War. He used techniques of dripping and pouring paint as early as 1940, anticipating the development of ▷Abstract Expressionism. He was also known in America as a teacher, and he opened his own school, which he closed again in 1958 to concentrate on his painting.

Hogarth, William (1697–1764)

English painter and engraver. He was one of the leading British artists of the first half of the 18th century. He was trained as an engraver and by 1720 had established his own business printing billheads, book illustrations and funeral tickets. In his spare time he learnt to paint, firstly at ▷St. Martin's Lane Academy and then under ▷Sir James Thornhill, whose daughter he married in 1729. He made a name for himself with small family groups (e.g. *The Wollaston Family*, 1730, H.C. Wollaston's Trustees) and ▷conversation pieces (e.g. *The Beggar's Opera*, one of several versions, c1729, London, Tate Gallery). Around this time he also set himself up as a portrait painter. Shortly afterwards, in c1731, he

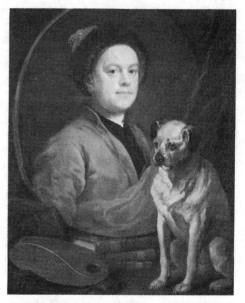

William Hogarth, *The Painter and his Pug*, 1745, Tate Gallery, London

executed his first series of modern morality paintings, a totally new concept intended for wider dissemination through engraving. ▷*A Harlot's Progress* (six scenes, destroyed by fire) was followed by ▷*A Rake's Progress* (c1735, eight scenes, London, Sir John Soane's Museum) and ▷*Marriage à la Mode* (c1743, six scenes, London, National Gallery). So popular were the engravings of the first series that they were soon pirated, and Hogarth's subsequent campaign against the pirates led to the Copyright Act of 1735. Unfortunately, as well as the engravings sold, he always had difficulty selling the original paintings. Hogarth compared his sequential paintings to theatrical performances, and thus in each series, minor vices and social affectations are incidentally satirized as the main theme – the punishment of a major vice – takes centre

stage. Also the butt of his satire was the prevailing taste for all things French and Italian (a special concern of Hogarth's, as foreign artists were, he felt, robbing him of his livelihood). A related series is *The Election* (1754, four scenes, London, Sir John Soane's Museum), while an independent painting in a similar vein is *O the Roast Beef of Old England* (1748, London, National Gallery). This latter painting was inspired by a trip to Calais during which he was arrested as a spy when caught drawing the fortifications, an incident represented at the left of the painting. Despite his by now exacerbated xenophobia, he did attempt to show his ability in the Italian ▷Grand Manner, although the results, e.g. *Sigismunda* (1759, London, Tate Gallery), are not among his most successful works and were very poorly received. If anything, the fascinating wealth of anecdotal invention and perceptive ▷caricature in his morality paintings tends to obscure his very considerable abilities as a painter. This ability, most evident in his fluent and vigorous ▷brushwork, is better revealed in his sensitive portraits – although his natural pugnacity and insistence on painting what he saw as the truth precluded him from a successful career in this field. Significantly, among his most accomplished portraits are the vivacious *Shrimp Girl* and the affectionate *Artist's Servants* (both London, Tate Gallery), both uncommissioned, while his most acclaimed official portrait was of a friend, *Captain Coram* (1740, London, Thomas Coram Foundation). From 1735 to 1755 he ran his own academy in St. Martin's Lane, this being generally credited as an important forerunner of the Royal Academy founded a few years after his death in 1768. Indeed, Hogarth did more than any other artist to establish a credible English school of painting. In the late 1730s he gathered a group of painters together to paint history paintings for presentation to Thomas Coram's Foundation, the exhibition of which was immensely successful. In 1753 he published ▷*The Analysis of Beauty*, written from the conviction that an artist has a better understanding of the arts than do connoisseurs. An important contribution to contemporary aesthetics, it is notable for Hogarth's espousal of the 'S' line, a line of beauty supposedly inherent in all successful works of visual art. His *Painter and his Pug* (1745, London, Tate Gallery), a kind of visual manifesto, portrays the artist as personifying solid English common sense, as well as displaying the famous 'S' line on his palette.

Bib.: Bindman, D., *Hogarth*, London, 1981; Lindsay, J., *Hogarth and his World*, London, 1977; *Manners and Morals: Hogarth and British Painting 1700–1760*, exh. cat., London, 1987; McWilliam, N., *Hogarth*, London, 1993; Paulson, R., *Hogarth*, Cambridge, 1993

Hokusai Katsushika (Nakajima Tet-Sujiro) (1760–1849)

Japanese printmaker. He was one of the foremost exponents of ▷ukiyo-e colour prints, which were distinguished by their fierce colours and schematic designs. However, Hokusai also had a sensitivity to nature, and an economical use of line. He was best known for his views of Mount Fuji, which were available in Europe during the second half of the 19th century and had an important influence on the Impressionists.

Bib.: Hillier, J.R., *Hokusai: Paintings, Drawings and Woodcuts*, Oxford, 1978

Hol(l)anda, Francisco de (1517–84)

Portuguese art theorist and miniaturist. He travelled to Rome in 1538, where he made drawings of antiquities and portraits of contemporary Italian artists. In 1545 he returned to Portugal and continued a portrait practice, gaining royal commissions. His most notable contribution to art was his manuscript produced in 1548 entitled *Da Pintura Antigua* (*Antique Painting*). Although not published until 1890–96, this work represented an important indication of mid-16th-century art theory outside Italy. He also wrote *De Tirar polo Natural* (*Of Drawing from Nature*) (1549) in dialogue form.

Holbein, Hans the Elder (c1465–1524) and Hans the Younger (1497/8–1543)

German family of painters and draughtsmen. Holbein the Elder was a late ▷Gothic painter who ran a large and flourishing workshop in Augsburg, in which his sons Ambrosius (1494–c1519) and Hans the Younger were trained and worked until the shop closed in 1514. Hans the Elder then moved on to Isenheim c1517. His signed works include a *Death of the Virgin* from the

Lucas Horenbout, *Hans Holbein the Younger*, 1543, Wallace Collection, London

1490s (now in Budapest), but his major work was the *Altarpiece of St Sebastian* (1515/17, Munich, Alte Pinakothek). A sketchbook, containing mostly portrait drawings and including a double portrait of his sons, also survives (now in Berlin).

Hans the Younger is generally ranked as one of the greatest portraitists of all time. He trained with his brother, Ambrosius, in his father's Augsburg workshop, although by 1515 the two brothers were working for a painter in Basle. Here, Hans also worked for the print publisher Froben, through whom he probably met Erasmus. His earliest portraits, *Burgomeister Meyer and his Wife* (1516, Basle, Öffentliche Kunstsammlung) date from this time. In 1517 he went to Lucerne to assist his father with a decorative commission. A probable visit at this time to Italy is suggested by the new formal monumentality and more subtly graduated modelling that appears in his work following his return to Basle in 1519. The *Dead Christ* (1521, Basle, Öffentliche Kunstsammlung), for example, has echoes of both ▷Mantegna and ▷Leonardo, the latter particularly in Holbein's assured use of ▷chiaroscuro; the *Entombment* (c1525, Basle, Öffentliche Kunstsammlung) derives its composition from ▷Raphael. In 1520 Holbein became a citizen and married, and in 1521, by now the leading painter in Basle, he was commissioned to decorate the Town Hall Council Chamber with ▷frescos of law-givers and scenes of justice. This cycle was not finished until 1530, owing to interruptions caused by the civic disturbances resulting from the Reformation, as well as his own absence from France 1523–4; the frescos themselves are lost, but copies reveal their Italianate influence. Meanwhile his graphic work continued with illustrations for the Luther Bible and designs for the celebrated *Dance of Death* ▷woodcut series (1523–6, published in Lyons in 1538), the latter traditional medieval theme being given added poignancy by the pessimism and turmoil of the Reformation and the Peasants' War. In 1523 he established his reputation as a portraitist with three ▷Massys-influenced portrait paintings of Erasmus (Paris, Louvre; Earl of Radnor Collection, Longford Castle, Wiltshire; Basle, Öffentliche Kunstsammlung). In 1526 he began his greatest altarpiece, for the leader of the Basle Catholic party, the *Madonna and Child and Burgomeister Meyer and his Family* (Darmstadt, Schlossmuseum), a work combining an Italianate idealized Madonna with naturalistically painted donor portraits. By 1526 religious disturbances had caused a shortage of work for painters and thus Holbein left for England, armed with letters of introduction from Erasmus to Thomas More and Archbishop Warham. He stayed 18 months, during which time his most ambitious work was the large group portrait, *The Family of Thomas More* (now lost; known from a diagrammatic drawing at Basle and a later full-size copy at Nostell Priory). The carefully executed studies for seven of the heads are among his most sensitive and penetrating portrait drawings (and contrast remarkably with his later, more schematic drawings, rapidly produced to meet an increased demand). In 1528 he returned to Basle, but the religious climate had deteriorated, religious pictures were banned and patronage in general was at a low ebb and so, although Holbein by now had accepted Protestantism, he returned in 1532 to England. In his absence More had incurred King Henry VIII's displeasure by refusing to approve the royal divorce and Holbein instead secured the patronage of the German Merchants of the Steelyard, producing a series of half-length portraits (e.g. *Georg Gisze*, 1532, Berlin-Dahlem, Staatliche Museen). In 1533 he painted ▷*The Ambassadors* (London, National Gallery), an astonishing display of Holbein's ability to reproduce naturalistic appearances. It seems to have impressed the court (and may have been intended to do so), for shortly afterwards began a stream of court commissions. Apart from the many individual portraits of officials, his most important work is the dynastic group portrait, painted on a wall of Whitehall Palace (destroyed by fire in 1698; part of the ▷cartoon survives in London, National Portrait Gallery), representing Henry VIII and his queen, Jane Seymour, with Henry VII and his queen, Elizabeth of York. The figure of Henry VIII in this work became the archetypal representation and served as a model for many future representations (e.g. portrait by a follower of Holbein, Liverpool, Walker Art Gallery). Aside from the usual jobs a court artist could expect to perform (such as designs for court entertainments), Holbein was sent abroad to paint prospective royal wives, e.g. the *Duchess of Milan* (1538, London, National Gallery) and *Anne of Cleves* (1539, Paris, Louvre). Hugely increased demands on his time meant that the portraits of these years were painted from drawings (as opposed to direct from life, as with his earlier works), thus they became more linear and somewhat less vivid. Although he had many followers in England, none could achieve his level of technical accomplishment, or his ability to evoke the characters of his sitters. Many of Holbein's drawings survive, the largest collections of which are at Basle and in the Royal Collection (with 85 portrait drawings at Windsor).

Bib.: Michael, E., *The Drawings of Hans Holbein the Younger for Erasmus' 'In Praise of Folly'*, New York, 1985; Rowlands, J., *Holbein: The Paintings of Hans Holbein the Younger*, Oxford, 1985

Hollar, Wenceslaus (Wenzel) (1607–77)

Bohemian engraver. He was from Prague, but worked in Frankfurt as an engraver. In 1636 he was in Cologne, where he met the ▷Earl of Arundel, who invited Hollar to accompany him on his travels. He produced topographical engravings for Arundel, and he eventually settled in London.

Bib.: Godfrey, F., *Wenceslaus Hollar: A Bohemian Artist in England*, New Haven, 1994

Holy Family

Also known as the Sacra Famiglia, the term most commonly given to the group of the ▷Virgin Mary, her husband ▷Joseph and the ▷Christ child. It may also include Mary's cousin ▷Elizabeth, her son ▷John the Baptist and (rarely) Elizabeth's husband Zacharias. However, in an attempt to explain the awkward references in the scriptures to Jesus' 'brothers' (e.g. Galatians 1:19) northern European painters sometimes represented an extended family deriving from the second and third marriages of his grandmother ▷Anne (e.g. ▷Metsys, *St. Anne Altarpiece*, 1507–9, Brussels, Musées Royaux de Beaux-Arts). Although Jesus and his parents had featured in depictions of the ▷Nativity, ▷Adoration of the Shepherds/Magi and Flight into Egypt, scenes merely representing the Holy Family in a homely setting only became popular in the 15th century. Notwithstanding the apparent domesticity, the scene usually contains elements of prefigurative symbolism referring to Christ's Passion (e.g. ▷Correggio, *The Madonna of the Basket*, 1520/25, London, National Gallery, where Jesus's outstretched arms allude to his ▷crucifixion). The Council of Trent (sat 1545–63) decried such apparently mundane treatments and urged that a great symbolism be invested, prescribing a formula that would emphasize more explicitly Christ's dual role as human and divine: the three persons of the Holy Family were to be viewed as the earthly counterpart of the Holy ▷Trinity, with the single figure of Jesus belonging to both groups (e.g. ▷Murillo, *The Two Trinities*, London, National Gallery).

Holy Ghost

Also known as the Holy Spirit, it is the third person of the ▷Trinity (Father, Son and Holy Ghost), represented as a dove from ▷John the Baptist's reference to 'the Spirit descending from heaven like a dove' above Christ during his baptism (John 1:32). Thus, the Holy Ghost in this form is also in the *Annunciation* (e.g. ▷Pietro Cavallini, mosaic, 1290s, Rome, Sta Maria in Trastevere) and the *Descent of the Holy Ghost* (e.g. *Rabbula Gospels*, early 5th century, Florence, Laurentian Library). The Holy Ghost as a dove is also the attribute of Pope Gregory the Great: it will be seen hovering at his ear endowing him with divine inspiration.

Homer, Winslow (1836–1910)

American painter. Having been apprenticed to a ▷lithographer in his native Boston, he studied painting at the ▷National Academy of Design (1859) and began to exhibit in 1860. During the Civil War, he covered the Virginia front as an illustrator for *Harper's Weekly*. In 1866 he spent ten months in France, and showed work at the Exposition Universelle before returning to his New York base. He later lived at Tynemouth (1881–2), where he became fascinated by the harsh existence of the Northumberland fishing community, finally settling at the similarly bleak Prout's Head on the Maine coast.

Homer was a painter of land and seascapes, whose rough-edged and sometimes harsh vision of nature reflects a contemporary American ambivalence towards the wilderness and frontier land. His images of the Civil War, concentrating on life in camp rather than the heat of battle, were praised for realism, and paintings such as *The Veteran in the New Field* (1865) and *Prisoners from the Front* (1866) address the complexities of the post-war settlement. In the late 1860s he turned to more genteel scenes of the outdoor life, portraying middle-class women and children at leisure. These show a heightened sensitivity to light and nature, and from 1873 Homer tended to work outdoors and use ▷watercolours. After returning to England, he produced seascapes showing nature as increasingly hostile, a vision ultimately pared down to the stark image of a wave beating against a rock in *The Northeaster* (1895).

Bib.: Hendricks, G., *The Life and Work of Winslow Homer*, New York, 1979; Robertson, B., *Reckoning with Winslow Homer: His Late Paintings and their Influence*, Cleveland, 1990

Hondecoeter, Melchior d' (1636–95)

Netherlandish painter. He was from a family of painters, and he studied with his father, Gysbert (1604–53). He worked in Utrecht, Amsterdam and The Hague. He was best known for his still lifes and paintings of live animals. He was particularly skilled at birds, and was known as 'The ▷Raphael of the Birds'. His works were particularly popular with English country house owners, and his paintings were often hung in dining rooms.

Hone, Nathaniel (1718–84)

Irish painter. He studied in Italy c1750–52, and he worked subsequently in England. He is best known for miniature painting on ▷enamel, but also did large-scale portraits. He was one of the founder members of the ▷Royal Academy, but his reputation suffered when he painted *The Conjuror* (1775) – a scurrilous attack on ▷Reynolds. This work implied that Reynolds' 'borrowings' from ▷Old Master paintings were really plagiarisms.

Honnecourt, Villard d' (13th century)

French master mason. His sketchbook, in the Bibliothèque Nationale, Paris, is thought to date from c1220–30 and contains sketches of elevations of cathedrals like ▷Reims and Chartres, his own designs, geometrical calculations for setting out pointed ▷arches and the like, and suggestions for the treatment of sculptures. It

is a rare document and was thought to be an active account of an early itinerant architect and his work. For example, he records techniques for cutting stone and placing ▷keystones which would have been stock practice for master masons. However, more recently, doubt has been cast over the purpose of the sketchbook. It has been suggested that the drawings are inaccurate, the calculations incorrect and the drawings are those of an outsider recording the construction of buildings without participating in the work. Therefore, the identity of Villard d'Honnecourt and his reasons for producing his sketchbook remain uncertain.

Honthorst, Gerrit van (1590–1656)

Dutch painter. He was from Utrecht, and specialized in historical, mythological and biblical subjects, genre scenes and portraits. He trained under ▷Abraham Bloemaert, but the formative artistic experience of his life was his long visit to Italy (c1610–20), where he experienced the works of ▷Caravaggio and his Roman followers. His preoccupation with candle-lit scenes (e.g. *Christ before the High Priest*, London, National Gallery; painted in Rome c1617 for the Marchese Vincenzo Giustiniani) earned him the nickname in Italy of 'Gherardo della Notte'. On his return to Utrecht, he entered the painter's guild and was, with ▷Baburen and ▷Terbrugghen, a principal member of those Dutch followers of Caravaggism, known as the ▷Caravaggisti. Whereas Honthorst was, like the other Caravaggisti, in reality more influenced by ▷Manfredi's interpretation of ▷Caravaggio's half-length genre groups (e.g. *Merry Company*, 1622, Munich, Alte Pinakothek), he could also exploit the drama and violence of Caravaggio's own manner (e.g. *St. Sebastian*, c1623, London, National Gallery) and seems to have exerted an influence on Rembrandt's early work. After the 1620s he gradually abandoned Caravaggio's methods and, in a lighter and more elegant style, influenced by ▷van Dyck (e.g. *Elizabeth Stuart, Queen of Bohemia*, 1642, London, National Gallery), he achieved international renown as a portrait painter. His first move towards this latter manner can be seen perhaps in the large ▷allegory he painted for Charles I of England, *Mercury Presenting the Liberal Arts to Apollo and Diana* (1628, Hampton Court Palace). Later, he was employed by the Elector of Brandenburg and King Christian IV of Denmark, and ultimately attained the position of court painter at The Hague (1637–52).
Bib.: Braun, H., *Gerrit und Willen van Honthorst*, Göttingen, 1966; Judson, J.R., *Gerrit van Honthorst: A Discussion of his Position in Dutch Art*, Gravenhage, 1956

Hooch (Hoogh), Pieter de (1629–84)

Dutch painter. He was born in Rotterdam and trained under ▷Berchem, but seems not to have been influenced by his master's Italian pastoral landscape style. His earliest identified paintings are guardhouse and tavern scenes, in which the play of light, whether natural or artificial, evidently engaged his interest as much as the activities of his figures. In these works the influence of the Utrecht ▷Caravaggisti can clearly be discerned (e.g. *By the Fireside*, Rome, Galerie Corsini). In 1654 he married a woman from Delft, subsequently moving there and entering that town's Guild of St. Luke in 1655. The paintings of middle-class domestic interiors or courtyards, inspired by his stay in Delft, are those for which he is chiefly remembered. Characteristically they feature two or three people, either engaged in domestic chores or enjoying simple pleasures in an atmosphere of peaceful comfort. De Hooch's interest in rendering effects of natural light is apparent in all of these works: a frequent pictorial device is to set a slightly darker foreground room against a brighter space glimpsed through an open door (e.g. *A Boy Bringing Pomegranates*, c1662, London, Wallace Collection). Such paintings of middle-class domesticity may have influenced the work of ▷Jan Vermeer.

In about 1662, de Hooch moved to Amsterdam, where he continued to paint in his Delft style. He achieved considerable success, but with greater demand in a more cosmopolitan city, his style underwent a considerable change. From the late 1660s the simple domesticity of his middle-class Delft interiors was substituted by scenes of the high life in sumptuous palatial interiors, painted in a rather coarser manner (e.g. *The Burgomaster's Room in the Amsterdam Town Hall*, c1668, Thyssen-Bornemisza Collection).
Bib.: Scala, A., *Pieter de Hooch*, Paris, 1991; Sutton, P.C., *Pieter de Hooch*, Ithaca, 1980

Hoogstraten, Samuel van (1627–78)

Dutch painter, etcher and art theorist. He painted interiors, genre, still lifes, portraits and religious scenes, working mostly in his native Dordrecht, but also in The Hague and Amsterdam, where in c1642 he had trained in ▷Rembrandt's studio. He travelled widely outside Holland, visiting London, Vienna and Rome. His early work shows Rembrandt's influence (e.g. *Doubting Thomas*, 1649, Mainz, Mittelrheinisches Landesmuseum), though influences from ▷Metsu, ▷Pieter de Hooch and ▷Jan Steen predominate in his later work. He also constructed 'perspective boxes', in which complex ▷trompe l'oeil interiors can be glimpsed through peepholes (examples at London, National Gallery; Detroit Institute of Arts). In 1678 he published his *Inleyding tot de Hooge Schoole der Schilderkonst (Introduction to the Art of Painting)*, which is notable for containing a rare insider's account of Rembrandt's workshop. In addition, Hoogstraten was a poet and director of the Dordrecht mint. ▷Houbraken, one of the foremost biographers of Dutch painters, trained in his studio.

Bib.: Brusati, C., *Artifice and Illusion: The Art and Writing of Samuel van Hoogstraten*, Chicago, 1995

Hope, Thomas (1769–1831)

English collector and writer. He was born in Amsterdam, but he was in England from 1795. He was very wealthy, and he purchased a vast quantity of art for his mansion in Duchess St., London, and his country house, Deepdene, in Surrey. He was particularly fond of the works of ▷Canova and ▷Flaxman, and he advocated a ▷Neoclassical style. He also collected antiquities. His interest in Neoclassicism and its application to interior decoration led him to write *Household Furniture and Interior Decoration* (1809), which was influential on élite taste during the ▷Regency period.
Bib.: Watkin, D., *Thomas Hope 1769–1831 and the Neo-classical Idea*, London, 1968

Hopper, Edward (1882–1967)

American painter. He was a pupil of ▷Robert Henri, and like his teacher, an exponent of 20th-century American Realism. He depicted scenes from city life in New York and the countryside of New England. He described his art as being 'intimate transcriptions from nature', and he used typically 'inartistic' subjects to describe the modern urban world of anonymity within a crowd, loneliness and transience. Probably his best-known painting, *Nighthawks* (1942, Art Institute of Chicago) shows four figures in an all-night diner. The viewer assumes the role of a passer-by (and is therefore included in this hostile night-world), and glances through the uncurtained windows which

Edward Hopper, *Self-portrait*, Whitney Museum of American Art, New York

expose the scene. The interior is lit by uncompromisingly harsh light contrasting with the drab greens and dark reds of the shadowy night. The four figures engaged in this banal tableau communicate only the currency of commercial exchange. Hopper's realism in paintings such as *Nighthawks* is governed by a disciplined formality of composition.

▷American scene painter; Ashcan School
Bib.: Lyons, D., *Edward Hopper and the American Imagination*, exh. cat., New York, 1995

Hoppner, John (1758–1810)

English painter. He trained at the ▷Royal Academy schools, and began practising as a portrait painter. He came to the attention of George III who gave him money to study at the RA schools, but by 1789 he was Portrait Painter to the Prince of Wales, thus severing his relationship with the Prince's father. He became an RA in 1795, and he was one of the principal rivals of ▷Thomas Lawrence.

Horatii, Oath of the

Canonical ▷Neoclassical painting that established ▷Jacques-Louis David's reputation, extolling the primacy of public duty over personal sentiment (exhibited ▷Salon of 1785; now Paris, Louvre). The specific theme of the oath-taking is apparently of David's own invention, derived from Livy, via a contemporary drama, *Horace*, by Pierre Corneille. Livy recounts how the three Roman Horatii brothers resolved to settle the war with Alba in a fight to the death with the three Alban Curatii brothers. In the ensuing battle, the Horatii were victorious, but at the cost of the lives of two of their number. The surviving brother, Horatius, returns home to find his sister mourning for one of the Curatii to whom she was betrothed. In a fit of anger, Horatius kills his sister and is himself then condemned to death only to be reprieved through the intervention of his father in the light of his heroic victory over the Curatii. David selects the more morally elevating part of the story, only implicit in Livy. The three brothers raise their hands in oath as their father passes their swords to them. To emphasize the stoic rectitude of the brothers, standing erect, prepared to sacrifice their lives in the service of the state, David includes, on the right of the picture, the slumped group of the women of the family, collapsed against each other's shoulders, lamenting the grief that will ensue from whichever outcome. Masculine duty and self-controlled resolve is thus contrasted with feminine weakness and emotionalism. The large scale of the picture (330 × 427 cm/11 × 14 ft), the sparseness of the interior with its austere ▷Doric ▷arcade, the hard-edged forms, the frieze-like arrangement of figures, and the limited palette of sombre colours are all calculated to underline the central themes of civic virtue and patriotism.

horseshoe arch
▷arch

Horta, Victor (1861–1947)
Belgian architect and designer. He was one of the leaders of the ▷Art Nouveau movement in Brussels. He was born in Ghent, the son of a shoemaker. After a visit to Paris in 1878, which inspired him to study architecture, he entered the Brussels Academy in 1881. After attracting the notice of the Royal Architect, Balat, he joined his practice in 1884, producing his first works in a Classical style. He opened his own business in 1890, and with his first major project, the Tassel House (1892), established his characteristic style using wrought-iron exterior decoration and an integrated interior scheme of flowing lines, marble and clever use of lighting. This reached its peak with the Solvay House (1894–1900), with its large windows, asymmetrical façade and iron balconies. His next major works were public buildings, the Maison du Peuple (1895–1900, Brussels, destroyed 1964), a large co-operative including shops and an auditorium in which Horta exploited the structural possibilities of glass and iron, and L'Innovation (1901, destroyed), a glass-fronted department store in Brussels. Increasingly, however, he was taken up with teaching (at the Free University) and administration, including a long-running plan to reform Belgian art galleries. He was also a leading figure in the Art Nouveau movement and a member of ▷Les Vingts. In his later work he experimented with more modernist designs including the Brussels Central Railway Station (1911–37), in which he used reinforced concrete and regimented windows, despite a curving pillared entrance, but these are considered second-rate. He was appointed president of the Brussels Academy (1927) and made a baron (1932).

hortus conclusus
(Latin, 'enclosed, or close-locked garden'.) The term refers to the virginity of Mary (▷Virgin Mary), the mother of ▷Christ. It comes from the Old Testament song to the Shulamite maiden, the Song of Solomon. The subject of the love song was considered to be a prefigurative type of Mary, and many of the phrases in praise of her were taken to refer symbolically to Mary's ▷Immaculate Conception and virginity. The phrase 'a garden enclosed is my sister' (4:12) was taken to refer to the fact that the birth of Mary's son, Jesus, was not the result of concupiscence, but was divinely inspired. The garden is therefore her womb; it is to be considered as not merely enclosed, but with a close-locked gate (Ezekiel 44:1–2), that is, that the hymen remains unbroken. The metaphor of the 'enclosed garden' in the Song of Solomon is expanded with references to fountains and images of fruitfulness, many of which feature in the walled gardens which enclose the Virgin's house in devotional paintings of the Madonna and Child, or of the ▷Annunciation.

Hoskins, John (c1595–1665)
English miniaturist. He painted portraits and produced miniatures in the style of ▷Nicholas Hilliard, but the presence of ▷van Dyck in England led him to embellish his style in the light of the latter's work. He was Limner to Charles I in 1640 and associated with the court. Among his pupils was his nephew ▷Samuel Cooper.

Houbraken, Arnold (1660–1719)
Dutch painter and writer. He was best known, not for his own works, but for his biographical work *De Groote Schouburgh der Nederlantsche Konstschilders en Schilderessen* (*The Great Theatre of Netherlandish Painters*, 3 vols, 1718–21), which is based on Van Mander's *Het Schilderboek* (*Book of Painters*), and contained important information about the lives of Dutch and Flemish artists.

Houdon, Jean-Antoine (1741–1828)
French sculptor. He was the most successful French sculptor of the second half of the 18th century. He studied under ▷J.-B. Lemoyne and ▷J.-B. Pigalle, before entering the French Academy (▷Académie Royale). In 1761 he won the ▷Prix de Rome and worked in the Rome branch of the Academy from 1764 to 1768. In Rome he came under the influence of ▷J.J. Winckelmann and his circle, and established his reputation with his serenely Classical statue of *S. Bruno* (1767, S. Maria degli Angeli) and his most extraordinary work, a life-size ▷écorché figure (executed in the French Hospital in Rome). Throughout his life, he secured a steady income from the production of hundreds of replicas of the latter for sale to art academies. In 1769 he was elected Associate of the French Academy and in 1777 full Academician, his Academy piece being *Morpheus* (Paris, Louvre). He fell out of favour during the Terror, following the ▷French Revolution, narrowly missed imprisonment, but was rehabilitated under the Empire, although he produced nothing to equal his pre-Revolutionary work. His portraits include statues and busts of the most celebrated men of his time, including ▷Diderot, Rousseau and Voltaire, some of which were reproduced in great numbers. Following the success of his bust of Benjamin Franklin (1778), his fame spread to the USA and he was invited there in 1785 by the State Parliament of Virginia to execute, from life, a statue of George Washington (marble, completed 1791, Virginia State Capital, Richmond; bronze copy, London, National Gallery). He ceased working as a sculptor in 1814 but continued to teach at the ▷École des Beaux-Arts until senility forced him to retire in 1823. Houdon's great accomplishment as a portraitist resides in his precise understanding of bone structure and musculature

married to a remarkable ability to capture characteristic expression and gesture.
Bib.: Arnason, H.H., *The Sculptures of Houdon*, London, 1975

Howard, Sir Ebenezer (1850–1928)

A founder of the Garden City movement. Born in London, he worked as a clerk from the age of 15. He emigrated to America in 1871, trying unsuccessfully to raise crops in Nebraska, and working as a court reporter in Chicago. Returning to London in 1876, he became a parliamentary reporter. His book *Tomorrow: A Peaceful Path to Real Reform* (1898, reissued as *Garden Cities of Tomorrow*, 1902) set out a blueprint for the ideal urban community in the form of the Garden City. This would be a socially and economically self-sufficient entity, surrounded by a 'green belt' of protected rural land which served as a limit to over-expansion. All industrial and commercial activity, while carried out by private companies, would be on publicly owned land. The first city to be built according to Howard's proposals was Letchworth in 1902, followed by Welwyn Garden City in 1920. Howard was knighted in 1927.
Bib.: Beevers, R., *The Garden City Utopia: A Critical Biography of Ebenezer Howard*, New York, 1988; MacFadyen, D., *Ebenezer Howard and the Town Planning Movement*, Cambridge, 1970; Philips, R.A., *The Garden City Movement: Its Origins and Influence on Modern Town Planning*, Ottawa, 1978

Huber, Wolfgang (c1490–1553)

Austrian painter, draughtsman and designer of woodcuts. After ▷Altdorfer, whose pupil he may have been, he was the most important member of the ▷Danube School. Only a few of his paintings survive, and it is in his ▷woodcuts and drawings that his poetic approach to Austrian landscape can be best seen (e.g. *View of Feldkirch*, pen and ink, 1523, London, British Museum). He was active firstly in Regensburg and then, from 1515, in Passau, where he was court painter to the Prince-Bishop.
Bib.: Rose, P., *Wolfgang Huber Studies*, New York, 1977

Hudson, Thomas (1701–79)

English painter. He was a pupil and son-in-law of ▷Jonathan Richardson, and like his predecessor, he specialized in the practice of portrait painting. He had a large studio in London, where he produced portraits of fashionable society, using the assistance of ▷drapery painters. His work had a superficial flair, but it lacked penetration of character. He taught some of the best portrait painters of the next generation, including ▷Joseph Wright of Derby and ▷Joshua Reynolds, but Reynolds' rise to popularity led to his own retirement from practice.

Bib.: *Thomas Hudson, 1701–79: Portrait Painter and Collector*, exh. cat., London, 1979

Hudson River School

Group of American painters who depicted the Catskills and the Hudson River area during the 19th century. This group included ▷Bierstadt, ▷Church, ▷Cole and ▷Doughty, many of whom represented the American landscape in a ▷sublime or ▷Romantic way. The zenith of their practice was from c1825 to 1875, when their work was superseded by a new interest in Realist landscape. They specialized in mountains and rivers, and were particularly attracted to uncultivated or wild sections of American scenery. Their work has been called both pantheistic and nationalistic.

Hughes, Arthur (1830–1915)

English painter. He was associated with the ▷Pre-Raphaelites. He achieved popularity in the 1850s with a series of sentimental subjects painted in a broad, highly coloured style (e.g. *April Love*, 1856, London, Tate; *Eve of Saint Agnes*, 1856). He also produced a highly evocative and unusual interpretation of *Ophelia* (1852, Manchester City Art Gallery). In his later career he increasingly resorted to rustic ▷genre (e.g. *Bedtime*, 1862, Preston, Harris Museum and Art Gallery). In 1872 he illustrated Christina Rossetti's poem 'Sing Song'. He died a recluse.
Bib.: *Arthur Hughes*, exh. cat., Cardiff, 1971

Huguet, Jaime (fl 1448–92)

Spanish painter. He was in Barcelona in 1448, where he practised a Catalan style of painting ▷altarpieces, with stylized figures and an excess of gold leaf. He took this Catalan style to Sardinia.

humanism

Although often used as shorthand to describe the period of the ▷quattrocento and ▷cinquecento in Italy, it refers more precisely to the intellectual mind-set of that period, with its rejection of scholastic theology and philosophy in favour of interests and horizons derived from the ▷antique. By studying rediscovered antique texts ('the Classics') and thence the mind of the ancients, humanists set the tone and provided the context for the reuse of ancient art forms by artists and architects. More generally, humanism refers to any philosophy that favours studying the deeds of mankind rather than those of the godhead.
Bib.: Chastel, A., *The Age of Humanism: Europe 1480–1530*, New York, 1963; Clark, K., *The Art of Humanism*, London, 1983; Grassi, E., *Renaissance Humanism: Studies in Philosophy and Poetics*, Binghampton N.Y., 1988; Rabil, A. (ed.), *Renaissance Humanism: Foundations, Forms and Legacy*, Philadelphia, 1991; Weiss, R., *The Renaissance Discovery of Classical Antiquity*, Oxford, 1969

Humphrey, Ozias (1742–1810)

English painter. He began his career in Bath, where he produced portraits and ▷miniatures for the captive market there. In 1763 he travelled to London, and in 1773–7 went to Italy with ▷George Romney. In Italy he abandoned miniature painting because of his poor eyesight and took up ▷pastel. This practice served him well on a trip to India in 1785–8. He went blind in 1797.

Bib.: Williamson, G., *Life and Works of Ozias Humphrey*, London, 1918

Hundertwasser, Fritz (Friedrich Stowasser) (b 1928)

Austrian painter. He was born in Vienna and studied at the Vienna Academy of Fine Arts in 1948. While in Vienna he saw the work of ▷Schiele. He had a mystical approach to art, which he developed self-consciously throughout the rest of his career. This is exemplified, for example, in his decision to change his name from Stowasser to Hundertwasser ('*sto*' is Czech for 'hundred'). In the late 1940s he came into contact with ▷Art Informel, and he began producing his own abstract works. His fascination with the spiral developed from 1953, and soon thereafter he developed his theory of 'transautomatism', which was based in part on ▷Surrealist ▷automatism, but concentrated on the role of the observer, rather than the artist. He has, since then, become an important international figure, whose works have been exhibited worldwide.

Hunt, William Holman (1827–1910)

English painter. He was one of the ▷Pre-Raphaelite Brotherhood. He trained at the ▷Royal Academy schools, in 1844, came into contact with ▷Millais there and in 1848, together with ▷Rossetti, they established the Pre-Raphaelite Brotherhood. After the break-up of the Brotherhood, Hunt travelled to Palestine in 1854, one of a series of visits (1869, 1873) in order to paint religious subjects in an authentic setting (e.g. *The Scapegoat*, 1854, Port Sunlight, Lady Lever Art Gallery). This was one of the key principles of the Brotherhood – fidelity to nature – which he adhered to throughout his career. Hunt's art was dominated by his ideas of morality, which he conveyed by means of often obscure symbolism (e.g. *Awakening Conscience*, 1853, London, Tate Gallery). He did however produce one great, and certainly the most popular, religious image of the 19th century, *The Light of the World* (1853, London, St. Pauls), which toured the Empire to packed audiences. In his later career, he seemed obsessed with

preserving, and even exaggerating, the principles of Pre-Raphaelitism, working on large-scale canvases, with precise detail and increasingly harsh colour. Many of his subjects were taken from literature (e.g. *Isabella and the Pot of Basil; The Lady of Shallot*). In 1905 he published *Pre-Raphaelitism and the Pre-Raphaelite Brotherhood*, the first account of the movement, and in the same year he was awarded the Order of Merit.

Bib.: Holman Hunt, exh. cat., Liverpool, 1967; Maas, J., *Holman Hunt and the Light of the World*, London, 1984

Hutcheson, Francis (1694–1747)

English aesthetician. His important work *An Inquiry into the Original of our Ideas of Beauty and Virtue* (1725) was a development of Shaftesbury's ideas of an innate sense of beauty. Hutcheson's theory was essential to 18th-century notions of a 'standard of taste', which argued that taste was not acquired but was innate.

Huysum, Jan van (1682–1749)

Dutch painter. He produced primarily paintings of flowers and still life. He was born in Amsterdam and was trained there by his father, a wide-ranging artist. He developed his own style of flower painting, which became popular throughout Europe and set the trend for the 18th century. He was the first artist to use light backgrounds for his still lifes and worked with a high finish, creating intricate decorative patterns of interwoven foliage and petals and employing jewel-like colours (e.g. *Flowers in a Terracotta Vase*, 1837, London, National Gallery). Among his patrons were the kings of Prussia and Poland, and Robert Walpole. A number of artists copied his style. He also painted Dutch-style landscapes, but these were repetitive and showed little flair. He had two artist brothers: Jacob became a successful imitator of Jan's work, based in England from 1721, and his younger brother was a successful painter of battle scenes.

Hyperrealism

▷Superrealism; Photorealism

hypostyle

Most usually, any hall or other large space over which a flat roof is supported by rows of ▷columns or ▷piers. Used more specifically in ▷Egyptian architecture to refer to a structure with flat roofing at more than one height, supported by appropriately scaled columns or piers. A prime example is the hypostyle hall of the Temple of Amon-re at Karnak, in which the loftier central section is lit by ▷clerestories.

I

Ibbetson, Julius Caesar (1759–1817)

English painter. He was born near Leeds, his name the result of his caesarean birth. He taught himself by copying landscape paintings, and gained a reputation for small-scale scenes of figures and cattle – the ▷'Bercham of England' according to ▷West. He worked in oils, ▷watercolour and ▷etching, and exhibited regularly at the ▷Royal Academy (1785–1815). Although based in London, he made regular tours of ▷picturesque areas such as the Lake District (where he lived 1799–1804), Wales and the Isle of Wight. He also travelled to Java in 1789 and witnessed the burial of Captain Cathcart, which he painted. His later work was increasingly emotional, as he combined ▷picturesque and stormy scenes (e.g. *Phaeton in a Storm*, 1798, Leeds). In 1803 he wrote a *Treatise on Painting in Oil*. He was a friend of ▷Morland and lived a similarly dissolute life, which luckily had little effect on his career. He died at Masham.

Bib.: Clay, R.M., *Julius Caesar Ibbetson*, London, 1948

ICA

▷Institute of Contemporary Arts

Icarus

In Ovid's *Metamorphoses* (8: 183–235), Icarus was the son of the Athenian inventor, Daedalus. Both were held captive by King Minos on the island of Crete. Daedalus conceived a bold plan of escape, fashioning wings for himself and his son. The father warned the son not to fly too close to the sun as the wings were attached with wax which would melt with the heat. Father and son took off and began their flight towards freedom. Icarus, elated by the sensation of flight, climbed too high, the sun melted the wax, the wings fell apart, and he plummeted into the Aegean Sea and drowned. The story was interpreted variously as an ▷allegory of pride, or of man's quest for knowledge. It was represented often on antique Greek vases, appears in wall paintings at ▷Pompeii, and from ▷Renaissance times onwards enjoyed renewed popularity. The two parts of the story generally depicted are:

(i) Daedalus fastening the wings to his son's arms. ▷Canova (1777–9, marble, Venice, Accademia) used this as an opportunity to display his skill at the differentiated representation of the lithe musculature of the adolescent son and the sagging flesh of the elderly father.

(ii) The Fall of Icarus. The boy falls into the sea as his unglued feathers scatter in the air around him.

Alois Kolb, *Icarus*, c1900

▷Bruegel the Elder (*Landscape with the Fall of Icarus*, c1555–8, Brussels, Musées Royaux des Beaux-Arts) shows the moment after the boy's upper body plunges into the sea, with only his legs still visible. A boat sails past without noticing, while a ploughman on the hillside in the foreground carries on his work just as oblivious to the tragedy. In the late 19th century, the English sculptor ▷Alfred Gilbert sought to reinterpret the theme (bronze statuette, exhibited at the 1884 Royal Academy) as an autobiographical representation of his own ambition at the commencement of his career: 'It flashed across me that I was very ambitious: why not "Icarus" with his desire for flight.'

icon

(Greek 'image' or 'likeness'.) A religious image painted on a panel, either of the ▷Byzantine school or for the Greek or Russian Orthodox Church. The earliest date from the 6th century. Typically, an icon is an image of ▷Christ or a saint set against a gold background. Because an ▷icon is an object of such intense veneration, the subject is presented in a way strictly prescribed by tradition. Consequently, most painters of icons are anonymous and there is very little stylistic difference over the centuries.

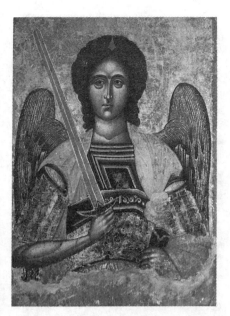

Icon of the Archangel Michael, Greek Icon, 18th century, private collection

iconoclasm

In general terms, an opposition to images of any sort which leads to destructiveness. Specifically, this refers to a European Christian sect of the 8th century who attacked the prevalence of imagery in ▷Early Christian art. To them, the production of images led to idolatry, and images should therefore be destroyed. They gained the political backing of the Emperor Leo III who, in 730, decreed that all sacred images should be destroyed. Because of this act, many sacred works of the period prior to 750 have been lost to posterity. The Iconoclasts were opposed by the Iconodules, who in 843 restored the production of icons with the backing of the Council of Nicaea. Iconoclasm had a resurgence in Europe after the Protestant Reformation when religious imagery became associated with the Catholic Church. This could be seen particularly in Germany and the Low Countries where Protestantism was strong.
Bib.: Davidson, C. and Nichols, A.E. (eds), *Iconoclasm versus Art and Drama*, Kalamazoo, 1989; Freedberg, D., *Iconoclasm and Painting in the Revolt of the Netherlands 1566–1609*, New York, 1988

iconography

Originally, the study and identification of portraits. Now, more commonly, the study and analysis of subject matter, as opposed to form and style.

iconostasis

In Greek or Russian Orthodox Churches, the screen separating the space reserved for the clergy (the ▷chancel, or bema) from the space open to the laity (the ▷nave). The term iconostasis derives from the practice, dating back to the 14th century, of covering the screen with ▷icons.

Ictinus (fl 2nd half of 5th century BC)

One of the leading architects of Periclean Athens, he collaborated with ▷Callicrates on the building of the Parthenon (447–432 BC). Pericles also commissioned him to design the new Telesterion (Hall of Mysteries) at Eleusis (a large square hall with five rows of four columns), although after the fall of Pericles, Ictinus' design was substantially altered by other architects (increasing the number of columns to seven rows of six). According to Pausanias (2nd century AD), Ictinus also designed the Temple of Apollo Epicurius ('Apollo the Succourer') at Bassae. It was built, he stated, as a votive offering to the god from the survivors of the plague of 430–429 BC. However, recent scholarship suggests that Pausanias may be in error and that Apollo's title here refers to his succour, or help, in time of war, not plague – thus the plague does not necessarily provide an earliest date for commencement. Externally a ▷Doric-style temple, its ▷cella has engaged ▷Ionic columns and one single ▷Corinthian column, the earliest surviving example.

ideal

In the history of art, 'ideal', 'idealism' and other variants are frequently used. The concept of the ideal can be traced back to antiquity, especially Aristotle's *Poetics*, which categorizes artists according to those who represent things as they are, worse than they are or better than they are. The latter artists achieve the ideal, and that was then seen to be the goal of all artists in ▷academic art theory from the 16th century onwards. This was crystallized in the late 17th century in the work of ▷Bellori, who opposed the 'ideal' to the 'mechanical' – the former representative of the educated, ▷liberal artist, while the latter relegated to artist with the status of a craftsperson or artisan. Both the French and English ▷academies adopted this rhetoric, but it began to be undermined by the ▷Realists of the mid-19th century. From the time of ▷Courbet, the ideal was no longer seen as the sole aim of an artist, nor was it valued to the extent it had been in previous centuries. Instead it became associated with a stilted and obsolete academic style that was rejected by the ▷avant-garde.

ideology

A term frequently associated with ▷Marxism but which also carries a more general meaning. Ideology represents the belief systems – religious, political, social – that dominate a society. Whether imposed from powerful leaders or developing as part of mass

culture, ideology can permeate all forms of representation, including the visual arts. However, its manifestations are not always obvious.

Bib.: Luke, T., *Shows of Force: Power, Politics and Ideology in Art Exhibitions*, Durham, NC, 1992; Parker, R., *Old Mistresses: Women, Art and Ideology*, London, 1981; Pointon, M. (ed.), *Art Apart: Art Institutions and Ideology Across England and North America*, Manchester, 1994; Ridless, R., *Ideology and Art: Theories of Mass Culture from Walter Benjamin to Umberto Eco*, New York, 1984

Ife

▷African art

Bib.: Willett, F., *Ife in the History of West African Sculpture*, London, 1967

ignudo (pl. ignudi)

(Italian, 'a male nude'.) A representation of a male nude, a term most closely associated with ▷Michelangelo's painted *ignudi* on the ▷Sistine Ceiling.

IHS(US), IHC(UC)

IHS is the abbreviation of the Greek form of ▷Christ's name, occasionally written IHC as the Greek S in this context sometimes appears in a form resembling a C. The IHS form was adopted by the Western Church, where it was transformed into a monogram denoting 'Iesus Hominum Salvator' ('Jesus the Saviour of Men') and in the 15th century became associated with St. Bernardino of Siena who promoted it as an object of veneration and whose attribute it became (e.g. ▷Vecchietta, *S. Bernardino*, Siena, Pinacoteca). In the 16th century, the Society of Jesus (the Jesuits) adopted it as their device and invested it with another meaning: 'Iesum Habemus Sociam' ('We have Jesus for our companion') (e.g. ▷Baciccio, *The Adoration of the Name of Jesus*, ceiling fresco, 1672–85, Rome, Chiesa del Gesù).

illuminated manuscript

Handwritten leaves of ▷parchment, bound or unbound, often containing religious texts, which are embellished with lavish gold, silver and coloured illustrations, particularly in the margins and around the first letter of a verse or chapter. Two traditions are outstanding in the history of illuminated manuscripts: the Eastern and ▷Byzantine tradition, and the Western European tradition. In both, the illuminations tend to have been produced by highly trained craftsmen, often monks, who produced the manuscripts from well-organized workshops. After the end of the 15th century, with the advances in printing processes, illuminated manuscripts became extremely rare.

illusionism

Art thrives on illusion when it attempts to convince us that what is factitious is real: a landscape on a wall is indeed a real landscape; the figures in the dome of a

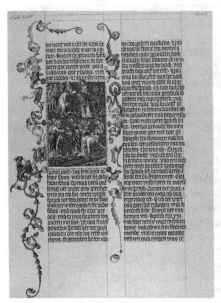

Illuminated manuscript from the 'Wenzelbibel', c1400

church are really part of a vision of Heaven itself vouchsafed to the viewer; a portrait actually breathes; or the fly that the apprentice painter paints on his master's work, and which the latter tries to brush away, is real; or the bunch of grapes so lifelike that a bird tries to eat them. Such ▷ *trompe-l'oeil* work began early, and continues today.

In a sense the artist is a magician, who when he or she 'imitates nature', conjures up a whole new world with many of the features of the 'real' one. Works of art have often been the subject of miraculous claims, such as wooden Black Madonnas or Thrones of Wisdom who cry, or walk round their church, or cure infertility, or statues that come to life which direct Don Giovanni to Hell. Then there is the ▷ *Mona Lisa*, said to be so lifelike that she could be seen to breathe, and figures of the crucified Christ that drip real blood. During much of the earlier Middle Ages, ▷antique statues were creations that were considered magical, almost superhuman. There are many medieval stories of such statues.

The belief that statues are sometimes more than the illusion of human beings has a long history, going back to the story of Pygmalion, who made a statue and fell in love with her. Conjuring three dimensions from painted plaster on a flat wall goes back at least to the 1st century BC (and probably to ▷Hellenistic art). In some cases there is only a hint of man's hand, as in the wicker fence that separates us from the garden, its trees and birds in the Garden Room of the Villa of Livia (wife of the Emperor Augustus) from Prima Porta (now in the Museo Nazionale delle Terme, Rome).

At certain periods, Roman *cognoscenti* demanded

complete architectural frameworks, with false doors (sometimes half-open to reveal painted servants), peacocks on balconies and yet more ranks of architecture beyond. A similar illusionism, which may derive (statues and all) from late Hellenistic fountain architecture, is also found in mosaic, as in the Great Mosque in Damascus, converted from the Church of St. John.

Painted illusionism was ignored by the Middle Ages, although they must have seen examples of it in the remains of Roman villas. The ▷Renaissance took it up with a vengeance, ▷Mantegna being the foremost early practitioner in Padua and Mantua, and the first since antiquity to practice ▷*sotto in sù*. Such works depend on a correct perspective delineation of architecture and figures (as well, sometimes, as the atmosphere itself) to make them convincing.

Illusionism was particularly popular during the ▷Baroque, a movement that sought (especially in its religious art) a complex emotional experience depending on the fusion of the arts. Occasionally used by the somewhat staid French (▷Coypel, ▷Lebrun, ▷Delacroix), it was used little in England (▷Thornhill is an exception) but was especially popular during the 18th century in the Catholic area of northern Europe, where Baroque intensity lightened to the more playful and whimsical ▷Rococo.

If full-blown illusionism is nowadays out of fashion even in religious contexts, it survives in private secular locations, amongst those who wish to enliven and appear to extend the small size of modern rooms.
Bib.: Mastai, M.L.d'O., *Illusion in Art: Trompe-l'oeil, a History of Pictorial Illusionism*, New York, 1975; Sandstrom, S., *Levels of Unreality: Studies in Structure and Construction in Italian Mural Painting During the Renaissance*, Uppsala, 1963

illustration

A picture in a book which is intended to accompany a text. Illustrated books were especially common in the 18th and 19th centuries, when a various and often subtle relationship between text and image developed.

Imari

The name given to a type of Japanese ▷porcelain which was exported to Europe from Imari in the 17th century. It had a distinctive red and gold appearance, and Europeans soon began to imitate it.

imbrication

A pattern of overlapping elements used in decoration.

imitation

The concept of imitation in art stretches back to ▷antiquity and few terms in art theory have been more misunderstood. The concept has been out of favour since ▷Romanticism wrongly equated imitation with copying, and made it the hallmark of a lack of originality. The Latin term '*imitatio*' is associated with the

Greek emulation of the best of an existing ▷canon of art works, and was so discussed in Quintilian's *De Institutione Oratoria*. It was never a question of slavishly copying older art, but of creating a dialogue with the best of the past. While imitation was a live issue throughout the Middle Ages, it was from the ▷Renaissance onwards that it became central to many theories of art, and was institutionalized by the ▷academies, who needed to reconcile a belief in rules and precedent with a sense of invention that they claimed was absent from the craft-dominated ▷guilds.

Thus the doctrine of the copying of great artists of the past began, at first with profit, but later it became ossified into a mindless veneration of the past that dominated training throughout the student's apprenticeship, making it difficult for all but the strongest wills to emancipate themselves from its influence. Those, like ▷Rubens, who did, gained great profit from studying older art, but those who remained under its yoke were drained of originality. Since the Romantics' veneration of originality was an essential rather than a learned quality, imitation in the 20th century has become associated with parody and pastiche, and, as such, forms an important aspect of ▷postmodernism.

▷eclecticism; *ut pictura poesis*
Bib.: Muller, J.M., 'Rubens' Theory and Practice of Imitation of Art', *Art Bulletin* (1982)

Immaculate Conception

The belief that the ▷Virgin Mary was herself immaculately conceived. The idea is central to the belief in her absolute perfection and purity as the vessel of ▷Christ's incarnation. Although not declared as dogma by the Roman Catholic Church until the 19th century, the Immaculate Conception was fiercely debated from medieval times (the Franciscans supporting, the Dominicans rejecting, the idea), reaching a climax during the ▷Counter-Reformation when the Jesuits propounded the idea in defiance of Protestantism. It was popularly believed that Mary was miraculously conceived at the moment of Joachim and ▷Anna's embrace at the Golden Gate of Jerusalem and this was how it had been alluded to until the 16th century. But in the fight against the Reformers, biblical, rather than legendary, sources were needed and the resultant images move from narrative to devotional. Thus, in the 16th century Mary is represented standing on a serpent (e.g. ▷Rubens, *Immaculate Conception*, c1628, Madrid, Prado): her coming as the second Eve who would redeem the sin of the first is prefigured in God's words to the serpent: 'I will put enmity between thee and the woman, and between thy seed and her seed; it shall bruise thy head' (Genesis 3: 15). Further ▷typological references were discerned in the Old Testament Song of Solomon – the Shulamite woman is seen as a prefiguration of Mary. But it is in the art of 17th-century Spain that the details become firmly established, using the imagery from Revelation

12: 1. Mary is the 'woman clothed with the sun, and the moon under her feet, and upon her head a crown of twelve stars . . .'. The Spanish painter and art censor to the Inquisition, ▷Francesco Pacheco, added that she should be shown as a young girl on the verge of womanhood, dressed in white (for purity) robe under a blue (for Heaven) cloak, a girdle with three knots (like the Franciscan habit, signifying poverty, chastity and obedience), her hands folded in prayer. This prescription informs the numerous images of the Immaculate Conception by ▷Murillo and ▷Velázquez.

impasto

Painting technique, especially associated with oil painting, in which the paint is applied thickly, so that it deliberately stands out from the ▷canvas or ▷panel. It is applied either from a loaded brush or knife, or, more recently, straight from the tube. Impasto was used in the 17th century by such artists as ▷Rubens, ▷Rembrandt, ▷Hals and ▷Velázquez, to bring out certain features. In the 19th century the practice was taken further by artists like ▷Manet and ▷van Gogh, who used impasto to give a sense of depth and texture.

impost

An architectural feature. It is a horizontal form attached to a wall, sometimes positioned at the top of a ▷pier or ▷pilaster and sometimes appearing to support an ▷arch.

impresa

An emblem or device, often accompanied by a motto – also, the sentence thus accompanying an emblem.

Impression: Sunrise

▷Monet painted this view from his window at Le Havre in 1872, recording the mist and murk of dawn in a thin wash of blue and green. The arrangement of elements on the canvas suggests the simplicity of a Japanese print: a scatter of hazily defined boats bob in the foreground, with the crane and chimneys of the harbour barely perceivable behind them, and the reflection of the orange sun is represented by a series of brushstrokes on the surface of the water. Eschewing a sophisticated composition, the painting achieves its effects solely through colour, capturing the transitory pattern of light at dawn.

Monet only gave the painting a title for its inclusion in the first exhibition of the Société Anonyme des Artistes, Peintres, Sculpteurs, Graveurs etc. in 1874. It was singled out for criticism by Louis Leroy, who compared it unfavourably to wallpaper in an embryonic state. Drawing on the title of Monet's painting, Leroy's review condemned the whole group under the banner 'Exhibition of Impressionists', thereby giving a name to the new movement. The painting was stolen from the Musée Marmottan in 1985, but recovered in 1990.

Impressionism

A general title given to painters working at the end of the 19th century in a spontaneous, naturalistic style with visible brushwork, a light palette and open composition. It also refers to a specific group of artists working in Paris in the 1870s and 1880s, who painted scenes of everyday life in this style. The name was first coined by Leroy in *Charivari* magazine after ▷Monet exhibited ▷*Impression: a Sunrise* in 1874, and became used for five of the eight exhibitions (1874, 1877, 1879, 1880, 1881, 1882, 1886) by a group who had initially called themselves the Société Anonyme des Artistes, Peintres, Sculpteurs, Graveurs, etc. In 1877, a short-lived review, *L'Impressioniste* was edited by the critics Duret and Rivière, and the group was consistently promoted by the dealer ▷Durand Ruel. Impressionist works had earlier been seen at the ▷Salon des Refusés, and the origins of the group lay earlier in French ▷Realism of the 1850 which had sought to portray concrete and down-to-earth reality, and in the growing interest in naturalist landscape, seen in the works of the ▷Barbizon School, and in artists like ▷Boudin, ▷Jongkind and ▷Corot. The Impressionists were also influenced by non-artistic factors: the colour theories of ▷Chevreul and others gave scientific backing to the ideas of light and complementary shadow put forward by ▷Delacroix. The development of the modern city of Paris, along with the bourgeois prosperity which it brought, created a new interest in the depiction of urban scenes; photography inspired new, seemingly casual, approaches to composition, which mirrored the Japanese print style.

Despite these common factors, the Impressionists were a vague, fluctuating group of artists, who had met by chance, or occasionally worked together. They never set out a programme and by the 1880s most were developing along independent lines. ▷Monet, ▷Renoir and ▷Sisley were, initially at least, perhaps the closest associates (originally based in ▷Gleyre's studio); ▷Degas and ▷Pissarro were enthusiastic group exhibitors but each had a quite individual approach; artists like ▷Morisot, ▷Caillebotte, ▷Cassatt and ▷Bazille, although often neglected besides the big names, played important roles. ▷Manet refused to exhibit with the group, but shared many of their interests and remained their close friend. ▷Post-Impressionists such as ▷Cézanne, ▷Signac, ▷Seurat and ▷Gauguin, as well as older artists like ▷Boudin, also exhibited with them. By the 1890s the group was no longer part of the ▷avant-garde: in 1891 an exhibition of Monet's work sold out in three days and ▷Caillebotte's collection of Impressionists' works was accepted by the French government.

Inevitably, Impressionism spread outside France. In Britain ▷Sickert and ▷Steer both worked with French artists. In these countries, however, the term is often, and confusingly, used more generally to include all artists who employed broken brushwork, or modern

subject matter. In Germany, ▷Liebermann was the leading exponent. It is also employed in sculpture, although there are few artists in this field who qualify as Impressionist. ▷Degas and ▷Renoir both worked in three dimensions. ▷Rodin shared many of their interests in light, movement and naturalism, and the Italian ▷Rosso used broken, textured surfaces in his work.

Bib.: Denvir, B., *The Impressionists First Hand*, London, 1987; Herbert, R., *Impressionism: Art Leisure and Parisian Society*, London, 1988; Rewald, J., *The History of Impressionism*, New York, 1973; Venturi, L., *Les Archives de l'Impressionisme*, 2 vols, Paris, 1939

imprimatura

(Italian, 'primary coat'.) Coloured ▷glaze painted thinly on a ▷ground. It functions partly to modify the tone in a painting, but also as a way of minimizing the ground's absorbency. It is also known as undertint or veil.

in. inv. invenit. inventor

Abbreviation of the Latin *invenit*, referring to the designer. Any of these abbreviations can appear on a print after the artist's name to indicate that s/he is responsible for the design, but not the execution, of the work.

inc. incid. incidit incior

Abbreviation of the Latin *incidit*, referring to the cutter or ▷engraver. The abbreviation 'sculp' is also used in this context. Any of these abbreviations can appear on a print after the artist's name to indicate that s/he is responsible for the execution, but not necessarily the design, of the work.

in situ

(Latin, 'in its original place', 'in position'.) Expression used to indicate a painting or sculpture that was executed in the very location for which it was intended, or to indicate that the work remains in the location for which it was originally executed.

incunabula (singular, incunabulum)

(Latin, 'swaddling clothes', 'cradle', 'infancy'.) Term denoting the earliest printed books, specifically, those printed before 1501 (i.e. in the 'infancy' of printing).

Independent Group

A small informal organization established at the ▷ICA in London in 1952 by Reyner Banham. The aim was to promote discussion of artistic techniques and especially of the use of science in art, and the group organized an exhibition in 1953, the *Parallel of Life and Art*. ▷Alloway re-established the group in 1954 with the emphasis this time on popular culture and the arts. The group became central to the development of

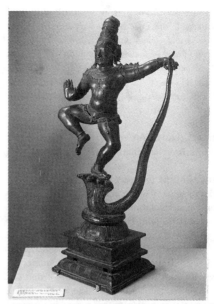

Indian art: Krishna as a boy subduing the snake Kalilya, bronze, from Madras, 16th/17th century, Victoria and Albert Museum, London

British ▷Pop art during the 1950s, with artists like ▷Hamilton, ▷Blake, ▷Paolozzi and Smithson all involved. In 1956 they organized the 'This is Tomorrow' exhibition.

Bib.: Massey, A., *The Independent Group: Modernism and Mass Culture in Britain 1945–1959*, Manchester, 1995

Indépendants, Salon des

▷Salon des Indépendants

India, art in

This refers to the subcontinent of India, the art of which needs to be considered in relation to religious, as well as geographical, demarcations. Indian art embraces ▷Buddhist, ▷Hindu, Jain and ▷Islamic tendencies, and it varies from Buddhist architecture to Hindu sculpture and manuscript illumination. The first significant art works remain from the 3rd century BC, when the large Mauryan empire produced monumental stone carvings. During the early years of Buddhism, the image of the Buddha began to infiltrate architectural relief carving as well as sculpture. This became increasingly elaborate, reaching a climax during the Gandhara period of the 2nd to 6th centuries AD, when Buddhist carving was especially ornate. The ▷Gupta period of 320–500 is seen to be a 'Classical' phase of Indian art, but very little survives from this time. From the 5th to the 9th centuries, Hinduism gained prominence, particularly in the form of temple carving, but Buddhism remained strong from the 6th to the 13th centuries.

Bib.: Butler, J., *Christian Art in India*, Madras, 1986; Chakrabarty, J. and D.C. Bhattacharyya (eds), *Aspects of Indian Art and Culture*, Calcutta, 1983; Craven, R., *A Concise History of Indian Art*, London, 1976; Gray, B. (ed.), *The Arts of India*, Oxford, 1981; Miller, B. (ed.), *The Powers of Art: Patronage in Indian Culture*, Delhi, 1992; Rowland, B., *The Art and Architecture of India*, 3rd edn., Harmondsworth, 1967

Indian art (North America)

▷ North American Indian Art

Indiana, Robert (Robert Clark) (b 1928)

American painter, sculptor and graphic artist. He was born in Indiana and took the name of his home state. He studied at the John Heron Art Institute, and from 1953 to 1954 at the Edinburgh College of Art. He settled in New York in 1956, where he developed ▷ hard-edge painting. During the 1960s, he became increasingly interested in the function of letters and signs in his art, and he became associated with the ▷ Pop art movement. His paintings contain many references to advertising imagery, and he used lettering archly in his works. He collaborated with ▷ Andy Warhol in producing the film *Eat* in 1964.

Individualists

A European term applied to ▷ Chinese artists of the 17th and 18th centuries who rebelled against the Classicism of Ming court art. The western bias of the term is apparent, as it privileges a group of artists who were non-traditional in a traditional society, but it applies, retrospectively, notions of the ▷ avant-garde in an inappropriate context.

Indonesia, art in

Indonesian art has prehistoric roots in surviving ▷ dolmens, but much of what we know about it can be traced to the influence of ▷ Buddhism and ▷ Hinduism much later. From the 8th century, Indian influence infiltrated the islands of Java and Bali – first in the form of Buddhist and Hindu art, and then, after 1450, Islamic art. The most distinctively Indonesian art form is a type of ▷ stupa architecture which has cosmological and mystical connotations. In the 19th and 20th centuries, the effect of western imperialism has been to obliterate native tradition.

Industrial Revolution

The phrase used to describe the period of social and economic change which occurred in Britain in the late 18th and early 19th centuries. During this period the country was transformed from a place of traditional rural agriculture to an urbanized, capitalized culture. The same phenomenon occurred throughout the western world during the 19th century, but its effects were felt first and most dramatically in Britain. The first stage was the development of trade and prosperity during the 18th century, coupled with an Agricultural Revolution which introduced new methods of land usage. At the same time a number of scientific inventions led to changes in, particularly, the textile industry with the first factories, mechanization, the use of steam power, etc. Increased production encouraged a transport revolution of turnpike roads, canals (▷ Telford) and finally in the 19th century the railways. It also led to a mass migration from the countryside to the towns, which in turn caused overcrowding and slum conditions which were only gradually improved over the course of the 19th century. The changes produced a new wealthy urban class and stirred up the political aspirations of the workers, in the Chartist movement in England and throughout Europe in revolutions in 1848. In literature novelists tackled the issues of industrialization, but in art the subject is referred to obliquely, often by a nostalgia for a better, rural past and an increase in landscape. Increasingly, however, from 1848 ▷ Realists sought to represent the ugly truth of modernity.

Bib.: Ashton, T.S., *The Industrial Revolution*, London, 1948; Klingender, F., *Art and the Industrial Revolution*, rev. edn., London, 1968; *Art and the Industrial Revolution*, exh. cat., Manchester, 1968

Ingres, Jean Auguste Dominique (1780–1867)

French painter. He was the leading academic artist of his day. He was born at Montauban, where his father, Jean-Marie-Joseph (1755–1814) was a second-rate artist. After training at Toulouse Academy, he joined ▷ David's studio at the Académie des Beaux-Arts in Paris in 1797. In 1801 he won the ▷ Prix de Rome

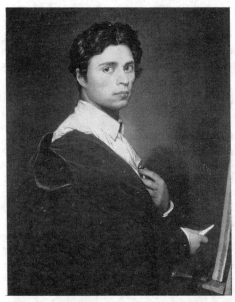

Jean Auguste Dominique Ingres, *Self-portrait, aged 24*, 1804, Musée Condé, Chantilly

with a severely ▷Neoclassical work partly inspired by ▷Flaxman's Homeric illustrations; throughout his life he returned to Classical subjects (e.g. *Oedipus and the Sphinx*, 1808, Paris, Louvre). He delayed his journey to Rome, leaving only after his portrait *Napoleon I on the Imperial Throne* (1806, Paris, Musée de l'Armée) was badly received. He remained in Italy until 1825, making a living as a portraitist (especially with detailed lead pencil works), and producing a range of oils, including the first of his Odalisque/Bathers (*Grande Odalisque*, 1814, Paris, Louvre). On his return to Paris he was hailed as the defender of David's tradition in the face of the ▷Romantic opposition of ▷Delacroix and others, partly as a result of his ▷Raphaelesque *Vow of Louis XIII,* the ▷altarpiece he painted in Florence for Montauban Cathedral. He was elected to the Academy and later became both a member of the Légion d'honneur (1855) and a senator (1862). In 1834–41 he returned to Rome as Director of the French Academy there. He was never wholly happy in this official role: he failed in his attempts to produce large-scale decorative work to rival that of Delacroix, and in both his colour and his often exotic subject matter he often seemed to have Romantic sympathies. He was a prolific and precise portraitist (e.g. *Louis Bertin*, 1832, Paris, Louvre), especially of women (e.g. *Mme Moitessier*, 1856, London, National Gallery). His own artistic philosophy, despite his emphasis on rigid draughtsmanship, was concerned with beauty: for him art needed no moral purpose or external justification (▷art for art's sake). Despite his involvement as a teacher he had few successors (▷Chassériau), but his work was revived by ▷Degas' interest in the 1860s.

Bib.: Condon, P., *Ingres: In Pursuit of Affection*, Indiana, 1983; Ockman, C., *Ingres's Eroticized Bodies: Retracing the Serpentine Line*, New Haven, 1995; Wildenstein, G., *Ingres*, London, 1956

ink

Invented in China and Egypt around the same time – 2500 BC. In India and China, complex combinations of ingredients are used to make ink for both ceremonial and practical purposes. It is prepared by dissolving sticks of ▷pigment in water or solvents. Ink has impermanent colour properties unless protected from daylight. Artists have used inks for detailed studies, and also washes akin to ▷watercolours.

INKHUK

The abbreviated title of the Institut Khudozhestvennoy Kultury, or the Institute of Artistic Culture. Established in post-Revolutionary Moscow as a section of ▷Narkompros, its role was to examine the theoretical imperatives of art and provide ideological guidance for artists and students. ▷Kandinsky was appointed director in May 1920, and devised an initial programme to analyse the relation between art and spirit or psyche. This was rejected by other members of the Institute,

who argued for a more objective approach, and Kandinsky was ousted in 1921. The committed proceeded to define and implement a broadly ▷Constructivist programme. Branches of INKHUK were opened in Petrograd under ▷Tatlin, and Vitebsk under ▷Malevich, but the Institute was abolished in 1923.

Innes, James Dickson (1887–1914)

Welsh painter. He studied at the ▷Slade School of Art and was a member of the ▷NEAC. He knew ▷Augustus John and painted landscapes.

INRI

The inscription nailed to ▷Christ's cross. It was the custom to attach an inscription to a criminal's cross to make known the nature of his crime. John (19: 19–20) relates that Pontius Pilate wrote out the title 'Jesus of Nazareth the King of the Jews' in Hebrew, Greek and Latin. INRI are the four initial letters of the Latin version: Iesus Nazarenus Rex Iudaeorum (e.g. ▷Mantegna, *Crucifixion*, 1456–9, Paris, Louvre). In post-Tridentine art all three languages are sometimes given.

inscriptions

Writing on stone, marble, or metal, inscription was an important form of decoration and information in many ancient civilizations. Greek craftsmen created the European tradition of monumental inscriptions, producing the artistic style of writing within a design or composition that was skilfully adopted by the Romans and maintained through the medieval and modern worlds.

installation

A three-dimensional work of art which uses a variety of materials, sometimes including humans or other living things. Installation art is unconventional and often challenging, and may be inside a gallery or elsewhere. Sometimes the challenge lies in seeing a familiar set of objects placed in a different context; an artist may respond to a particular issue through a collection of objects; the installation may have sculptural overtones and may relate to technology arts. This type of expression, which is related to performance art, music, sculpture and textiles, is a 20th-century phenomenon and increasingly popular. It is very hard to define as it is so diverse, and as it evolves, different types of installation practice will become apparent.

Institute of Artistic Culture

▷INKHUK

Institute of Contemporary Arts (ICA)

The ICA was founded in 1947 by ▷Roland Penrose, a collector and intellectual, in the basement of a cinema in Oxford Street, London. Penrose had met ▷Herbert Read in Paris, and decided to try to bring ▷Surrealist

art to England, and to imitate the ideas of the new ▷Museum of Modern Art, New York. The first exhibitions included 'Forty years of Modern Art' and 'Forty-thousand years of Modern Art'. By 1949 the ICA had moved to a small room in Dover Street, which acted as a meeting room. Early members and motivators included ▷Eduardo Paolozzi, ▷Alison and Peter Smithson, ▷James Stirling and ▷Richard Hamilton. In the 1960s the ICA was seen as the radical and ▷avant-garde centre for arts in Britain. Various ▷happenings and installations enforced this reputation. For example Guy de Bordes and the International Situationists took over the building, and led trips through London 'Deriving', in which participants had to obey every commandment they encountered, like road signs, arrows and notices. In 1968 the ICA moved to its current position on the Mall in London. Critics saw this as a shift away from the early radical years, and believed that the Institute had become mainstream. The premises on the Mall enabled the Institute to become a centre for arts, with a theatre, cinema, gallery, bookshop and restaurant, which led to the start of a more interdisciplinary approach to art. For example, themes like 'Cybernetic Serendipity' and 'Mirage' made use of all the ▷media available.

Instruments of the Passion

The objects linked to the events leading up to the ▷Crucifixion which are often included in religious works as symbols of the narrative. On devotional images they may be carried by angels surrounding an enthroned Christ. At a mass by the Pope, St. Gregory, they were said to have appeared above the altar as proof for unbelievers. The objects include the crown of thorns, nails, rope and a hammer, a spear (used to wound Christ's side), a sponge (used to give him vinegar on the cross), a pillar and whip (he received 40 lashes on ▷Pilate's instruction), dice (the Roman soldiers gambled for his clothes), a basin (representing the washing of Pilate's hands), a cock (which crowed at Peter's denial) and ▷Judas' head. They may also include disembodied hands showing the nail wounds.

intaglio

(From the Italian, *intagliare*: 'to carve', 'to cut into', 'to engrave'.) A term used for a design which is carved or ▷engraved into a surface, usually a hard stone, a ▷gem, or glass, its opposite being a ▷cameo, which is a design in ▷relief. The most common form of intaglio carving is that on a seal-ring, upon the surface of which a design is engraved, to form the matrix for a relief design created when the seal-ring is pressed into hot wax. Intaglio is also known as *cavo rilievo*.

intaglio printing

This denotes a form of printing in which a design is ▷engraved, cut or ▷etched into a metal plate. To make a print, the plate is inked with a roller and the surface then wiped clean. The engraved channels will retain the ▷ink, and when the ▷plate is put under pressure against a sheet of paper, a reverse image of the design will be transferred from plate to paper. The opposite of intaglio printing is ▷relief printing.

intarsia (tarsia)

(From the Italian, *intarsiare*: 'to inlay'.) A type of furniture decoration involving laying differently coloured woods, mother-of-pearl and ivory into a wooden, and generally upright, surface to form a design, usually pictorial. It was developed by Sienese craftsmen (*intarsiatori*) in the 14th and 15th centuries (see especially the choir stalls with intarsia designs by Domenico di Niccolo de' Cori in the chapel of the Palazzo Pubblico, Siena, 1415–28) and reached a peak of virtuoso picture-making with sometimes quite elaborate architectural ▷perspectives in the work of the Florentine and Venetian designers of the 15th and 16th centuries. ▷Still life was also popular, as were figure subjects. Leading artists such as ▷Botticelli, ▷Lotto, ▷Piero della Francesca, and ▷Uccello all made designs for execution on intarsia.

interlace

An ornament that appears in architecture and decorative art, especially during the medieval period. It consists of intertwined lines.

International Gothic

A style that flourished in painting, sculpture and decorative arts throughout Europe from c1375 to c1425. It was characterized by an emphasis on secular themes, a combination of naturalism and stylization, and a relationship with an aristocratic or court ethos. It was particularly strong in Italy, France and the Netherlands (e.g. the work of ▷Simone Martini, the ▷Limbourg brothers and ▷Broederlam), although examples of it also appeared in Germany, Spain and England (e.g. the ▷Wilton Diptych). It can be seen, for example, in the profusion of detail appearing in ▷Gentile da Fabriano's *Adoration of the Magi* (1423, Florence, Uffizi) as well as in the seasonal ▷genre elements contained in ▷*Les Très Riches Heures du Duc de Berry*.
Bib.: *The International Style: The Arts in Europe around 1400*, exh. cat., Baltimore, 1962

International Style

A term coined by the architectural historian Henry-Russell Hitchcock and architect Philip Johnson to describe the ▷avant-garde architecture which appeared in Europe between 1920 and 1930. The term was probably derived from ▷Gropius' *Internationale Architektur* (1925), which stated that as machines were international so the architecture that they made would become so. Hitchcock argued in *Modern Architecture, Romanticism and Reintegration* (1929) that the style of

work by ▷Le Corbusier, ▷Oud, Gropius, ▷Lurçat, ▷Rietveld and ▷Mies van der Rohe was utterly different from other modern architecture and that these differences broke with the tradition of architecture, to the extent that they deleted all references to past architecture. This definition was taken up by Johnson, whose book, written with Hitchcock, *The International Style Architecture since 1922* (1930) and the accompanying exhibition at the ▷Museum of Modern Art, New York, promoted and ultimately defined the style. They pinpointed four features of the International Style: emphasis on volume, not mass; emphasis on regularity not symmetry; the use of elegant materials; and the use of technical precision and proportion as decoration, and not applied ornament. In addition, architecture was worked from the inside out, so logical planning was important rather than the appearance of symmetry. These tenets found expression in such buildings as Mies van der Rohe's Farnsworth House, Fox River, Illinois (1945–50) and Gordon Bunshaft's Lever House, New York (1951–2), for SOM (▷Skidmore, Owings and Merrill). One of the problematic features of the International Style is its geo-political context. The term was first applied to the work of European architects in Europe, like Mies van der Rohe's Tugendhat House, Brno (1930). This building conforms to the defining features of the International Style, but has an added political agenda. European architects of the 1920s and 1930s were searching for a new social order and a new approach to housing and accommodation problems. Such powerful, functional and untraditional works as these show the overturning of old architectural styles, and the revivalist styles of the 19th century, in the quest for radical and uncompromising answers to difficult questions. However, by the end of the 1930s this aspect of International Style was all but lost, as the term became synonymous with American architecture. Gropius and other leading members of the ▷Bauhaus emigrated to America in the late 1930s, and it was there, in the years following World War II, that International Style reached its potential. Pure, ideal forms, with clean, rational agendas using new technology and utopian ideals were perfect for the optimism of post-war America. ▷Curtain-walled metal and glass ▷skyscrapers sprung up across the continent. Their simplicity, poise and precision were in tune with the original principles of the International Style, but without the social context of Europe, and the sense of overturning the old in the quest for the new, the architecture inevitably lost something of its original audacity and urgency. However, despite criticisms that the style was too dry and did not relate to site, climate or function, the International Style is arguably the most important architectural development in the 20th century, and its legacy can be seen in almost every city in the world.

Bib.: Hitchcock, H.-R., *The International Style*, New York, 1932

intimisme

The name given to indoor scenes, often without a narrative content, painted by ▷Vuillard and ▷Bonnard in the early years of the 20th century. The intimiste style was related to ▷Impressionism and the flat patterns of ▷Nabi artists.

intonaco

(Italian, 'plaster'.) The final layer of plaster upon which a ▷fresco is painted.

Ionic Order

The second of the Greek ▷orders of architecture (following ▷Doric), the earliest examples of which date from the middle of the 6th century BC in the Greek communities of Ionia (present-day western Turkey and adjacent islands); the proportions and details of the order becoming established by about the middle of the 5th century BC. According to Vitruvius, the Ionic order originated from the Ionians' desire to design a temple suitable for the goddess ▷Diana: the proportions of the columns (more slender than those in the Doric order) were intended to characterize

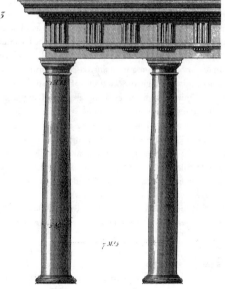

Ionic Order

female slenderness, and the ▷capital, with its distinguishing ▷volutes, was intended to symbolize the curly ringlets of a woman's hair. The flutes of the Ionic column shaft are separated by flat strips called fillets (unlike the Doric shaft, where the flutes meet at sharp crests called arrises). Vitruvius convincingly links this feature to an imitation of the folds of a matron's robe (thus, Ionic is considered more 'matronly' in its proportions than the even more slender ▷Corinthian column, likened by Vitruvius

to a maiden). The Ionic column was also the first of the Greek orders to be set upon a ▷base (which Vitruvius likened to a shoe). Although Vitruvius' account is perhaps no more than a retrospective rationalization (the capital having credible prototypes in the non-Greek cultures of Asia Minor and Egypt), it is memorably descriptive of the visual characteristics of the column and is rendered historically important through the fact that ▷Renaissance architects, following Vitruvius' prescript, often employed the Ionic order for buildings dedicated to Mary, the mother of Christ (for example, ▷Bramante, the cloister of Sta. Maria della Pace, Rome, completed 1504). The Ionic ▷entablature is also different from the Doric: the ▷architrave is divided horizontally by two or three strips, or ▷fasciae, overlapping downwards (probably imitating the weatherboarding of a timber building); the ▷frieze is now continuous (not alternated with ▷metopes and ▷triglyphs as in the Doric order); and, in the ▷cornice, the underside of the projecting corona is usually decorated with a row of small tooth-like blocks called ▷dentils. The Ionic order occupies a midway position – less robust than the Doric, yet less slender (and also less elaborate) than the Corinthian.

Irigaray, Luce (b 1941)

French author and linguist. She was trained as a Lacanian psychoanalyst (▷Lacan). Irigaray took the Lacanian symbolic order of the Real, the Symbolic and the Imaginary to be fundamentally masculine, and in order to formulate a rigorous critique of this, she exposes the feminine condition as being absence. Language is constructed around the masculine symbolic order, and therefore even an apparently ▷gender-free, neutral statement has been filtered through this organizing principle. The system is predicated on male (fullness) and female (lack), and therefore for women to be able to communicate they must adopt this masculine pattern.

Bib.: Whitford, M., *The Irigaray Reader*, Oxford, 1991; idem., *Luce Irigaray: Philosophy in the Feminine*, London, 1991

Isaac

The second Hebrew patriarch, son of ▷Abraham, father of Jacob and Esau, husband of Rebecca. As a child, his father was prepared to kill him on God's order. His wife was brought from Mesopotamia by Eliezer, sent by Abraham to find a suitable bride from their own people (e.g. ▷Claude, *Marriage of Isaac and Rebecca*, 1648, London, National Gallery). Her meeting with Eliezer as well, came to represent the ▷Annunciation (e.g. ▷Poussin, 1648, Paris; ▷Murillo, 1668, Madrid, Prado and St. Petersburg, Hermitage). In old age Isaac was tricked by his younger son, Jacob, into blessing him and naming him heir at the expense of his brother (Jacob spread goat skins

on his hands to imitate Esau's hair) (e.g. ▷Ghiberti, Florence Baptistry doors, 1435; ▷Gerbrandt van der Eeckhout, 1642, New York; ▷Murillo, c1620, Leningrad).

Isaiah

One of the four great Old Testament prophets. He is associated with a book or scroll. In the Middle Ages, he was often shown with a saw, the instrument of his death, and artists also portrayed him with tongs – an angel supposedly touched his lips with a glowing coal. He was responsible for two major prophesies: that Mary would bear a son and that 'a shoot will grow from the stock of Jesse' (often emphasized by a tree branch) (e.g. ▷Michelangelo, ▷Sistine Chapel, 1508–13; ▷Raphael, Sant-Agostino, c1512; ▷Sluter, ▷*Moses Fountain*, Dijon, 1393–1402).

Isenbrandt

▷Ysenbrandt

Isenheim Altarpiece

In about 1512, ▷Matthias Grünewald was commissioned by Guido Guersi, preceptor of the Monastery of St. Anthony in Isenheim, to paint a series of panels for a shrine carved by Niclas Hagenauer of Strasbourg. Completed c1515, the ▷altarpiece is a winged ▷retable, opening out in three stages and comprising a total of eight large panels.

When fully closed, it shows Grünewald's stunning *Crucifixion*, with Christ's body twisted and riven with wounds beneath a solar eclipse, flanked on the left by Mary, ▷St. John the Evangelist and ▷Mary Magdalene, with ▷John the Baptist and the Lamb on his right. Panels on either side show ▷St. Sebastian and St. Anthony. The altarpiece opens out to reveal jubilant and richly coloured panels of the *Annunciation*, the *Concert of Angels* and *Nativity* and the *Resurrection*. The final innermost panels are *The Temptation of St. Anthony* and *St. Anthony and St. Paul in the Wilderness*. The Order of St. Anthony specialized in treating the sick, and the Isenheim monastery housed a hospice for victims of the plague. Grünewald's ▷iconography is usually interpreted with this in mind, since St. Anthony and St. Sebastian were both protectors against the plague. However, interpretation remains controversial, and it is not certain on which day the panels were opened, or what purpose each stage served. The altarpiece was neglected until the 20th century, when taste in Germany was being reshaped by ▷Expressionism and the nationalist desire for native masterpieces. The powerful composition and command of colour are now regarded as the highest achievement of the northern European ▷Renaissance, and a reflection of the tortured spirituality of German art on the brink of the ▷Reformation. It is now at the Musée d'Unterlinden in Colmar.

Bib.: Hayum, A., *The Isenheim Altarpiece: God's Medicine and the Painter's Vision*, Princeton, 1990

Isou, Isidore (Samuel Goldstein) (b 1925)

French artist of Romanian birth. Isidore Isou was the pseudonym for Samuel Goldstein, a poet, film maker and theorist who arrived in Paris in 1945 and a year later founded ▷Letterism. A megalomaniac, he chose the name Isou because it was close to Jesu; Isidore refers to Lautréamont's *Isidore Ducasse*, and the alliteration recalls his ▷Dada predecessor, ▷Tristan Tzara. Isou simultaneously announced the death of Dada and the existence of Letterism in typically Dada style by interrupting the première of Tzara's new play, *The Flight*, in 1946, which had to be abandoned. He published his manifesto, *Introduction to a New Poetry and Music* and *The Making of a Name, the Making of a Messiah*, in 1947. Drawing on the early ▷Cabaret Voltaire 'simultanist' experiments and the '*poème-affiche*' of ▷Raoul Hausmann, Isou sought to found a radically new art based on the letter. Though primarily a writer and polemicist, declaring at one point 'I'm not a painter because I don't have enough time to be a painter', he produced *Amos* in 1952, a series of photographs covered in signs and pictographs, and a series of 36 paintings *Numbers* exhibited in 1953, composed of rebus-like sign-writing. In 1956 he wrote *An Introduction to Imaginary Art*, arguing that one doesn't need to manipulate elements in reality to create art, and in 1963 at ▷MOMA, New York, he created the 'first world-wide sculpture', a telex machine churning out news all over the planet.

Isou argued that the fragmentation of poetry should be pursued to the limit. Only by reducing language to its smallest component element – the letter – could purity be regained and the development of new forms begin. These would underline the creation of a revolutionary utopia. Although influenced by Dadist sound-poetry, the paratactic juxtapositions of Letterism could only be fully realized on the printed page. Equally, Isou differed from his predecessors through his understanding of the rise of mass-consumerism, which had eradicated the pre-war social models of proletarian versus bourgeoisie. Only youth culture, he argued, could provoke social change. A breakaway group, the Letterist International, became the foundation of the ▷Situationist International.

Bib.: Devaux, F., *Traité de bavé et d'éternité de Isidore Isou*, Crisnee, 1994; Isou, I., *Entretiens*, Charlieu, 1992; *Isou*, exh. cat., Paris, 1987

Islamic art

The art of the Muslim world, it is foremost a religious art and is a much more homogeneous style than Christian art. The Islamic artist is generally forbidden from portraying living creatures, as this is considered to be mimicking God's act of creation, and as such is ▷iconoclastic and dominated by ornamentation and decoration. A very advanced and skilful style of decoration has evolved that tends very much towards the abstract or stylized rather than the natural. This is typified by the swirling plant design termed ▷'arabesque' by Europeans, but also includes palmettes, rosettes and the lotus. The use of ▷strapworking and ▷interlacing where no detail is highlighted creates a decoration that is highly meditative. The inclusion of Arabic script and phrases from the Koran add to Islamic art's religious purpose. There is a strong resistance to blank spaces, so that ornamental design tends to dominate the whole of a surface. As Muhammad prohibited the use of precious metal for vessels, bronze or copper decorated and engraved vessels are common in domestic ware, together with colourful lustre pottery ware. Colour is a distinctive attribute of Islamic art, especially in pottery, ▷manuscript illumination and carpets. The same is true of architectural decoration, which makes use of carved stone, moulded ▷stucco and tiles in painted glazes. Islamic art has its origins in the Umayyad period (660–750), when the rapid success of the Arab Muslims in conquering Egypt, Syria, Persia and Mesopotamia led to an eclectic art based on Christian and Middle Eastern crafts and traditions. The Abbasid period from 750, however, saw the emergence of a more unified style inspired by the art of ancient Persia. By the 10th century, the Islamic world had divided into three principal regions – north-west India/Turkestan/Persia, Mesopotamia/Asia Minor/Syria/Egypt, and North Africa/Spain – producing more regional styles and influences. As Islam's political power declined in the face of West European advancement, Islamic art was undermined, losing a lot of its innovation and character.

Bib.: Papadopoulo, A., *Islam and Muslim Art*, London, 1980

Isnik

The name given to 16th- and 17th-century pots from Turkey (Isnik is part of Anatolia). The pots were brightly decorated with patterns of flowers in blues and greens.

Israëls, Jozef (1824–1911)

Dutch painter. He specialized in peasant and fishing subjects and was associated with the ▷Hague School. He was born in Groningen, of Jewish origin, and educated at Amsterdam Academy (1840) and at the ▷École des Beaux-Arts in Paris, under ▷Vernet and ▷Delaroche. On his return to Amsterdam in 1847, he worked as a history and religious painter and increasingly, from 1852, concentrated on Dutch history. It was a visit to Zandvoor which changed his style: he started to work on fishing subjects, but retained an interest in anecdote and a highly finished technique. The work for which he was best known dates from the 1860s and after, when his brushwork loosened and

he developed a soft tonal range of greys and browns (e.g. *Maternal Bliss*, 1890, Amsterdam, Rijksmuseum). By this time, he had settled in The Hague and had become the leader of The Hague School of like-minded artists. He was often known as the Dutch ▷Millet because of a similarity of subject matter and sympathy for the poor (e.g. *Growing Old*, 1878, The Hague). His work was especially popular in Britain after his *Fishermen Carrying a Drowned Man* (1861, London, National Gallery) was exhibited at the ▷Royal Academy. In his later life his work was influenced by his son, towards a lighter, more impressionistic palette.

His son, Isaac (1865–1934), was also an artist. He was largely self-taught, and worked with Breitner, painting in an ▷Impressionist style but similarly concentrating on social subjects.
Bib.: Holme, G., *Jozef Israëls*, London, 1924; *The Hague School*, exh. cat., London, 1983

Italy, art in

▷Etruscan art; Roman art; Renaissance; Baroque; Macchiaioli; Divisionism; Futurism; Novecento Italiano; metaphysical painting; Fronte Nuovo delle Arti; Transavanguardia
Bib.: Bomford, D. (ed.), *Italian Painting before 1400*, exh. cat., London, 1989; Hartt, F., *A History of Italian Renaissance Art: Painting, Sculpture, Architecture*, rev. ed., London, 1980; *Italian Art in the 20th Century*, Munich, 1989; White, J., *Studies in Late Medieval Italian Art*, London, 1984; Wittkower, R., *Art and Architecture in Italy 1600 to 1750*, 3rd edn, Harmondsworth, 1973

itinerant artists

Artists who travelled from place to place in order to obtain commissions. Not to be confused with the ▷ *Wanderjahre* of medieval journeymen. Itinerancy was particularly common in colonial America, before art became institutionally established. Itinerant artists most frequently painted portraits. The practice died out with the growing urbanization of the 19th century.

Itten, Johannes (1888–1967)

Swiss painter. He studied with ▷Adolf Hölzel in Stuttgart between 1913 and 1916. He then went to Vienna, where he taught in his own school. He worked at the ▷Bauhaus from 1919 and initiated the famous preliminary course there. He was known for his pedagogical innovation, and he encouraged free expression amongst his students. His unorthodox methods caused some scepticism amongst his colleagues, and he left the Bauhaus in 1923 to set up his own school in Berlin. He taught at the School of Arts and Crafts in Zurich

from 1938. He remained interested in methods of art education and published *The Art of Color* in 1961.

Ivanov, Alexander (1806–58)

Russian painter. He trained at St. Petersburg Academy, where his father Andrei was a teacher. Winning prizes for his early work, he travelled to Dresden in 1830 and met the ▷Nazarenes, whose spiritual commitment influenced him. He settled in Rome for most of his adult life as part of a thriving émigré community which also included Gogol. Shortly after returning to Russia in 1858, he died of cholera. Ivanov was obsessed with the idea of producing a masterpiece, and devoted 20 years of research and over 600 preliminary sketches to the monumental *The Appearance of Christ before the People*, St Petersburg, State Russian Museum. Depicting the moment when ▷John the Baptist glimpses the Messiah, it was completed in 1858 but regarded as a rigid, unaffecting failure. A lack of conviction in the painting may be due to Ivanov's loss of faith and changes in his theories of art during the long gestation, despite which he felt obliged to follow his original plans. His talent seems to have been misdirected, since his modest works, including scenes of the Italian countryside and vignettes of Roman street life, show far greater fluidity and a keen responsiveness to light and landscape.
Bib.: Alpetov, M.V., *Alexander Andreevich Ivanov*, Leningrad, 1983

ivory

Hard, smooth, white or creamy-white organic substance, derived principally from the tusks of the elephant and walrus and the teeth of the hippopotamus. In ancient Greece it was cut into thin sheets and used in combination with sheets of gold (over a wooden superstructure) in chryselephantine cult-statues. Much used in ▷Byzantine and medieval art, the natural curvature of the entire tusk was often exploited to give a graceful ▷Gothic sway to figures (especially of the ▷Virgin and Child); 13th-century Paris being a notable centre of production. In Italy, ▷Giovanni Pisano executed a poignant figure of *Christ Crucified* (c1300, London, Victoria and Albert Museum) from elephant ivory. The arms, formed of separate pieces of ivory, are now missing. After a period of decline (perhaps due to the disruption of trade routes), ivory was revived in the 17th and 18th centuries. A more important revival took place in the 19th century (particularly in those countries, e.g. France, Belgium and Britain, with African colonies), when it was used in combination with bronze, semi-precious stones etc. for ▷polychrome sculpture.

FIGURE 97 Emil Nolde, *Ruttebull Tief*

FIGURE 98 Georgia O'Keeffe, *Only One*, 1959, National Museum of American Art, Smithsonian Institute

FIGURE 99 Samuel Palmer, *Cornfield by Moonlight*, private collection

FIGURE 101 Max Pechstein, *Artist and Female Model on a Beach*

FIGURE 102 Francis Picabia, *Parade Amoureuse*, 19 private collection

FIGURE 103 Pablo Picasso, *Mother and Child*, 1902, Scottish National Gallery of Modern Art, Edinburgh

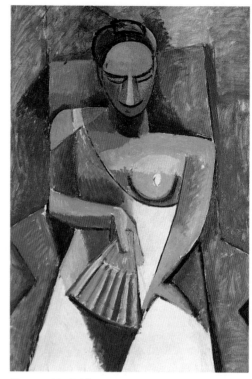

FIGURE 104 Pablo Picasso, *Woman with a Fan (After the Ball)*, 1908, Hermitage, St. Petersburg

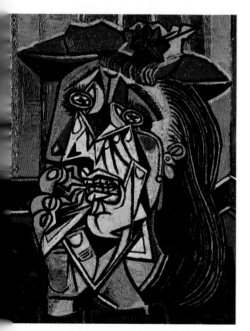

FIGURE 105 Pablo Picasso, *Woman Weeping*, 1937, Tate Gallery, London

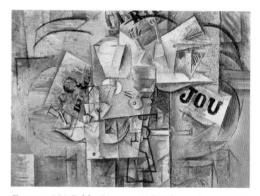

FIGURE 106 Pablo Picasso, *Still Life*, Prado, Madrid

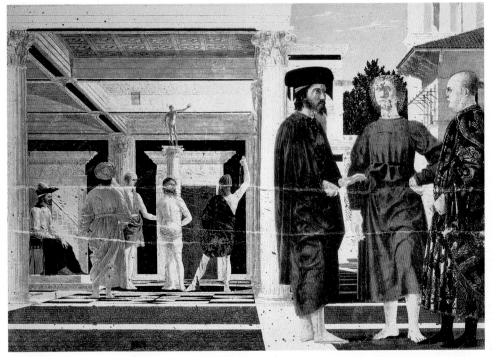

FIGURE 107 Piero della Francesca, *The Flagellation of Christ*, c1450–60, Galleria Nazionale Delle Marche, Urbino

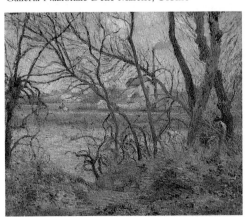

FIGURE 108 Camille Pissarro, *The Banks of the Oise, near Pontoise, Cloudy Weather*, Musée d'Orsay, Paris

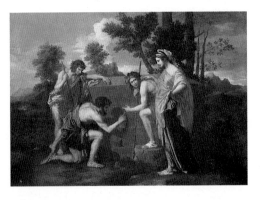

FIGURE 109 Jackson Pollock, *Grey Composition*, private collection

◀ FIGURE 110 Nicolas Poussin, *The Arcadian Shepherds*, 1638–9, Louvre, Paris

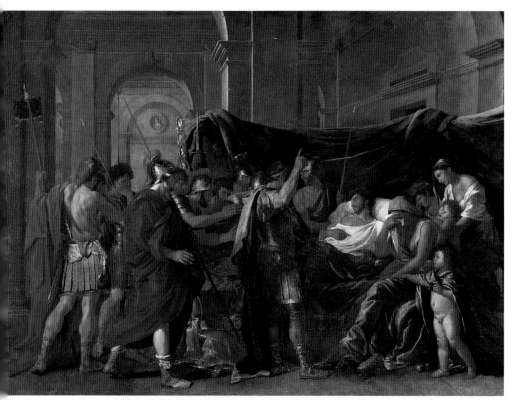

FIGURE 111 Nicolas Poussin, *The Death of Germanicus*, 1627, Minneapolis Institute of Arts, Minnesota

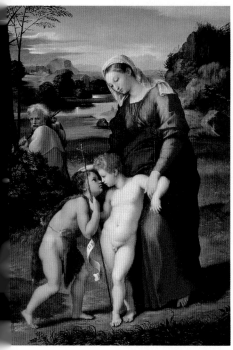

FIGURE 112 Raphael, *Madonna del Passeggio*, 1516, National Gallery of Scotland, Edinburgh

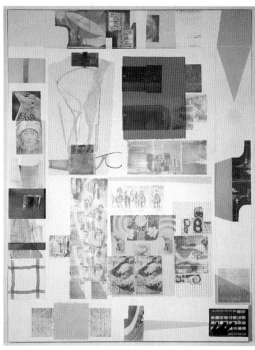

FIGURE 113 Robert Rauschenberg, '*Cloister*' *Rush No.5*, 1980, private collection

FIGURE 114 Odilon Redon, *L'Ange du Destin*, private collection

FIGURE 115 Paula Rego, *The Family*, 1988, Saatchi Collection, London

FIGURE 116 Rembrandt Hermensz. van Rijn, *Self-portrait in Old Age (Aged 63)*, 1669,
National Gallery, London

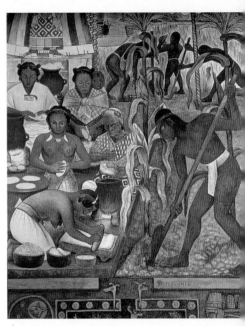

FIGURE 118 José Diego Maria Rivera, *Cultivation of Maize and Preparation of Pancakes* (detail), National Palace, Mexico City

FIGURE 117 Sir Joshua Reynolds, *Mrs Siddons as the Tragic Muse*, 1789, Dulwich Picture Gallery, London

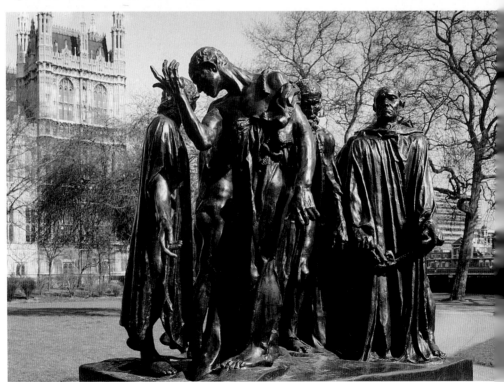

FIGURE 119 Auguste Rodin, *Burghers of Calais*, Victoria Tower Gardens, London

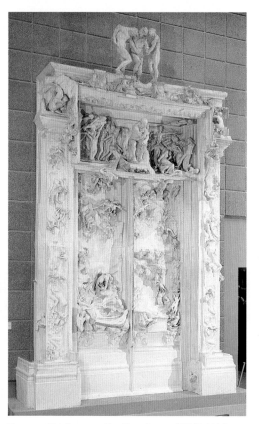

FIGURE 120 Auguste Rodin, *Gates of Hell*, 1880, Musée d'Orsay, Paris

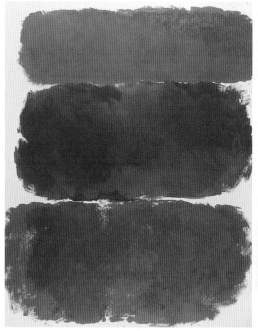

FIGURE 121 Mark Rothko, *Untitled*, private collection

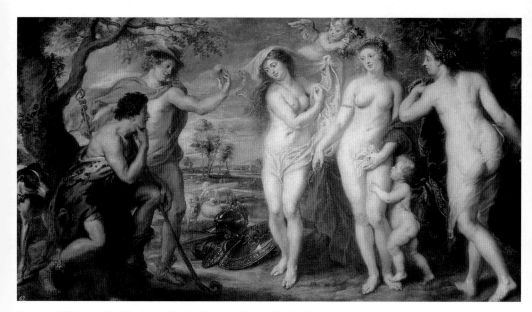

FIGURE 122 Peter Paul Rubens, *The Judgement of Paris*, Prado, Madrid

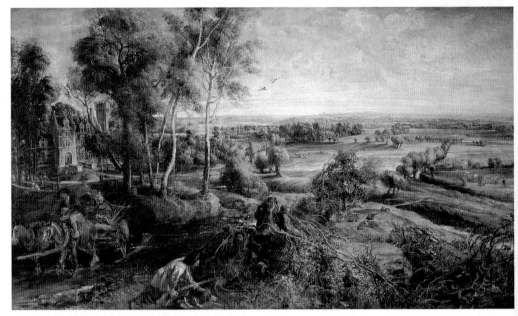

FIGURE 123 Peter Paul Rubens, *Landscape with Château de Steen*, c1636, National Gallery, London

FIGURE 124 John Singer Sargent, *Carnation, Lily, Lily, Rose* (detail), 1887, Tate Gallery, London

FIGURE 125 Kurt Schwitters, *Untitled*, c1923–5, Scottish National Gallery of Modern Art, Edinburgh

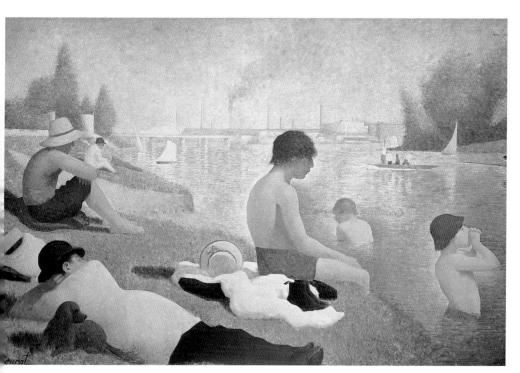

FIGURE 126 Georges Pierre Seurat, *Bathers at Asnières*, 1884, National Gallery, London

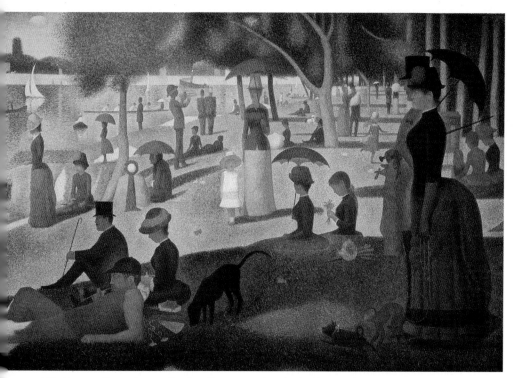

FIGURE 127 Georges Pierre Seurat, *Sunday Afternoon on the Island of la Grande Jatte*, 1886, Art Institute of Chicago

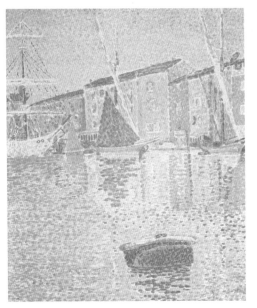

FIGURE 128 Paul Signac, *Buoy, Port of St. Tropez*, 1894, Hermitage, St. Petersburg

FIGURE 129 Chaim Soutine, *The Idiot,* Musée Calvet, Avignon

FIGURE 130 Jan Steen, *Beware of Luxury*, c1663, Kunsthistorisches Museum, Vienna

FIGURE 131 Jan Steen, *Grace before Meat*, Belvoir Castle, Leicestershire

FIGURE 132 George Stubbs, *The Grosvenor Hunt*, Grosvenor Estate, London

FIGURE 133
Vladimir Tatlin, *The Sailor (Self-portrait),* 1911–12, State Russian Museum, St. Petersburg

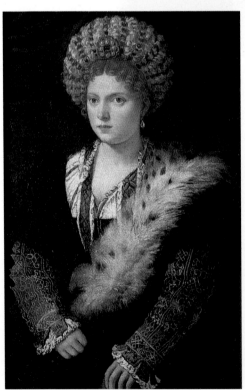

FIGURE 134 Tiziano Vecellio Titian, *Isabella d'Este,* Kunsthistorisches Museum, Vienna

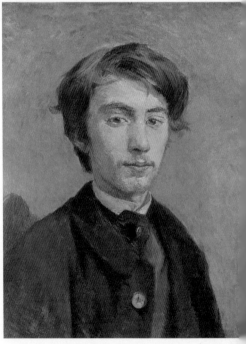

FIGURE 135 Henri de Toulouse-Lautrec, *Émile Bernard,* 1886, Tate Gallery, London

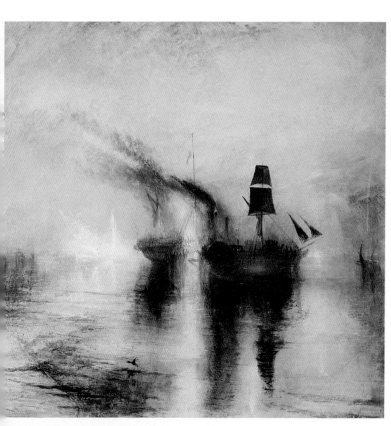

FIGURE 136 Joseph Mallord William Turner, *Peace: Burial at Sea*, 1841, Tate Gallery, London

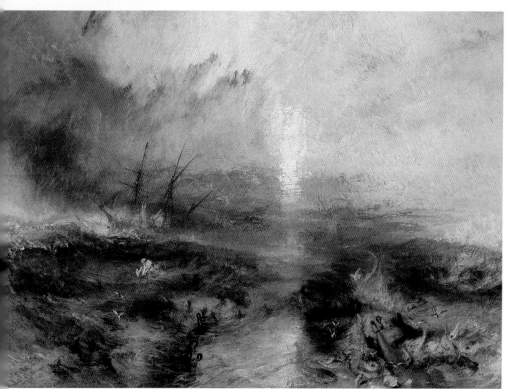

FIGURE 137 Joseph Mallord William Turner, *Slave Ship (Slaves Throwing Overboard the Dead and Dying)*, Museum of Fine Arts, Boston

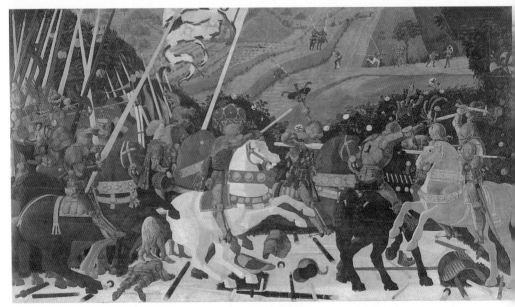

FIGURE 138 Paolo Uccello, *The Rout of San Romano*, c1451–7, National Gallery, London

FIGURE 139 Victor Vasarely, *Paz-Ket*, Museo de Bellas Artes, Bilbao

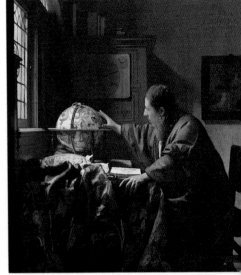

FIGURE 140 Jan Vermeer, *The Astronomer*, 1668, Louvre, Paris

Jack (Knave) of Diamonds

Name given to an ▷avant-garde artists' association in Moscow from 1910. They organized exhibitions with the aim of promoting modern, western art in Russia, particularly the work of ▷Cézanne and the ▷Cubists. The group initially comprised ▷Larianov, ▷Goncharova, ▷Malevich, ▷Burliuk and several young artists expelled from the Moscow Academy for their radical views. The first exhibition in December 1910 included the work of these, ▷Le Fauconnier, ▷Gleizes, ▷Kandinsky, ▷Jawlensky and other German ▷Expressionists. In subsequent years ▷Picasso, ▷Matisse and ▷Léger had work shown. By 1912, however, Larianov, Goncharova and Malevich had ceded from the group, because of the dominance of 'Munich decadence' and the ▷School of Paris, to form the ▷Donkey's Tail, a group aimed at promoting Russian art. The Russian ▷Futurists became dominant and the group developed a strong literary aspect, through the work of the poet Mayakovsky, and their theatrical productions. It continued in existence until 1918.

Bib.: Gray, C., *The Russian Experiment in Art*, London, 1971

Jackson, Alexander Young (1882–1974)

Canadian painter. He was born in Montreal, and studied in Chicago. He travelled in Europe from 1908 to 1909. From 1919 he was based in Toronto, but he took a number of trips to Algoma with other artists to paint untamed nature along the St. Lawrence River. He was one of the original members of the ▷Group of Seven. He specialized in landscape paintings of remote parts of Canada, particularly Quebec.

Jacob

The third of the Old Testament patriarchs, son of ▷Isaac and younger twin brother to Esau, he was considered by the early Church to be a prefigurative type of ▷Christ. The four main episodes of his life achieved their greatest popularity in the 17th century. These are:

(i) Isaac Blessing Jacob (Genesis 25: 19–34; 27). With his mother Rebecca's help, Jacob secured the leadership of their tribe (his elder brother's birthright) by deceiving his purblind father into thinking he was Esau. Rebecca had been told by God that her first-born would grow up to serve the second. Esau was hairy-skinned and became a hunter, whereas smooth-skinned Jacob became a herdsman. In Christian times, the Church saw the elder brother as symbolizing Judaism whose dominance would be superseded by the younger religion, Christianity, personified by Jacob. ▷Govert Flinck's version is typical (c1638, Amsterdam, Rijksmuseum). Jacob leans forward to obtain his father's blessing. Isaac feels his son's hair to ensure that it is the right son that he is blessing, the texture of Esau's hairy hands having been counterfeited by animal-skin gloves. The meat with which Isaac was to celebrate the blessing is on a table near the bed. Rebecca looks on. Although it is not mentioned in the Bible, Flinck, like most of his contemporaries, assumes that Isaac is bedridden.

(ii) Jacob's Ladder (Genesis 28: 10–22). While on a journey to Haran in search of a wife, Jacob lies on the ground to sleep, using a large stone as a pillow. He dreams of a ladder reaching to Heaven upon which angels ascend and descend. The voice of God tells Jacob that the land in which he sleeps will become his and that his descendants will dominate the earth. By the Middle Ages this story was seen as a prefiguration of Christ's ▷Ascension; again, it was especially popular in the 17th century (e.g. ▷José de Ribera, 1639, Madrid, Prado).

(iii) Jacob, Leah and Rachel (Genesis 29: 9–30). Jacob arrives at Haran, sees his cousin Rachel tending her father's flocks by a well and falls in love with her (e.g. ▷William Dyce, *Jacob and Rachel*, exhibited ▷RA, 1853, Hamburg, Kunsthalle). Jacob agrees to work for Rachel's father, Laban, for seven years in return for the hand of his daughter. At the end of the seven years Laban sends to Jacob his elder daughter, Leah, instead. Only in the morning does Jacob realize that he has been tricked into lying with the elder daughter and is compelled to work for Laban for a further seven years to secure Rachel also. Leah and Rachel were characterized by Dante in the *Purgatorio* as personifications of active and contemplative types; see also ▷Michelangelo, *The Tomb of Pope Julius II*, Rome, San Pietro in Vincoli.

(iv) Jacob's Struggle with the Angel (Genesis 32: 24–32). On the journey back from Haran, Jacob sends the caravan on across a river but is himself detained by a stranger who wrestles with him. Neither prevails and at daybreak the stranger asks Jacob to end the struggle; Jacob will not, however, until the stranger has blessed him. The stranger informs him that Jacob will from thenceforth be called not Jacob, but Israel, whereupon Jacob realizes that the stranger is God. Only in the earliest examples is the stranger depicted as God;

usually Jacob wrestles with an angel (e.g. ▷Rembrandt, c1660, Berlin). This passage is taken as another example of Jacob's favour with God.

Jacob, Max (1876–1944)

French poet, novelist and painter. He was an influential figure in the ▷Cubist movement. Arriving in Paris in 1894, he embraced a bohemian lifestyle and would become a close friend of ▷Picasso, ▷Gris and Cocteau. In 1909 he converted from Judaism to Catholicism and retreated in 1921 to a monastery at Saint Benoit-sur-Loire. During the occupation of France he was arrested by the Gestapo and died in a concentration camp at Drancy.

With ▷Apollinaire, Jacob was a leading theorist and promoter of Cubism. His own poetry follows the Cubist aesthetic, continually breaking into puns and sardonic parody to unmask and subvert a world of appearances. His most famous works were the volume of prose poems entitled *Le Cornet à dés* (*The Dice Cup*, 1917) and the lyric poems of *Le Laboratoire central* (*The Central Laboratory*, 1921).

Bib.: Kamber, G., *Max Jacob and the Poetics of Cubism*, Baltimore, 1971

Jacobean

Name given to the style of English decorative art and architecture that coincided with the reign of James I (1603–25). At that time there was an interest in the architectural forms of the Italian ▷Renaissance.

Bib.: Airs, M., *The Buildings of Britain: Tudor and Jacobean*, London, 1982

Jacopo da Ponte

▷Bassano, Jacopo

Jacquemart de Hesdin (d c1411)

French miniaturist. He was painter to the Duc de Berry from 1384, and he produced some important ▷Books of Hours for him, including the *Grandes Heures du Duc de Berry* (Paris, Bibliothèque Nationale). He preceded the ▷Limbourg brothers in the Duke's court.

jade

A hard stone, normally coloured green or white. It is used extensively in the Orient, and great skill is required to carve it.

jamb

The vertical posts at each side of a doorway, archway or window opening.

Jameson, George (c1590–1644)

Scottish painter. He was from Aberdeen, and studied in Edinburgh. He painted portraits in a Flemish manner. He produced a portrait of Charles I when the King visited Scotland.

Bib.: Thomson, E., *The Life and Art of George Jameson*, Oxford, 1974

Janco, Marcel (1895–1984)

Romanian artist and architect. He later became a citizen of Israel. He trained as an architect in Bucharest and Zurich, where early in 1916 he became a member of the ▷Dada group and designed sets, costumes and shockingly disfigured masks for the ▷Cabaret Voltaire. In 1919 he followed the Dadaists to Paris, but quarrelled with ▷Tzara and left the group two years later. He returned to Bucharest to practise architecture, and edited *Contimporamul*, a journal of ▷avant-garde art. He emigrated to Israel in 1940, and established an artists' colony called Ein Hod. Janco's significant work was all produced during his brief Dada period. In addition to his designs for the Cabaret Voltaire, he produced a series of abstract plaster ▷reliefs, some of which were painted or decorated with shards of broken mirror.

Bib.: Mendelson, M.L., *Marcel Janco*, Tel Aviv, 1962; Seiwerk, H., *Marcel Janco*, Frankfurt, 1993

Jannssens, Abraham (1575–1632)

Flemish painter. He began his career in Antwerp, and then he went to Rome from 1598 to 1601. In c1604 he made a second visit to Italy, where he absorbed ▷Mannerist influence. In 1606 he was appointed Dean of the Painters' Guild in Antwerp, and he gradually refined his style to a more Classical mode. In later life, his work showed the influence of ▷Rubens.

Japanese art

Throughout its history, Japanese art was frequently influenced by the stronger presence of ▷Chinese art, especially Chinese ▷Buddhism, although some distinctive developments occurred in Japan by the 17th century. Chinese Buddhism was strongest from the 7th to the 10th centuries when there was frequent interaction between the two countries. From the 12th century, ink paintings became more common, and from that point onwards, two-dimensional art became one of Japan's major contributions. The Tokugawa dictatorship, which dominated from 1615 to 1868, moved the capital of Japan to ▷Edo (Tokyo), where the Japanese ▷ukiyo-e colour prints were developed. Decorative art such as ▷Imari porcelain was particularly valued by westerners, whose infiltration from the 17th century led to a new attention to Japanese art and culture. By the 19th century, western practice began to influence Japanese art, and in the 20th century – especially after the Second World War – ▷modernist styles entered Japan.

Bib.: Ienaga, S., *Japanese Art: A Cultural Appreciation*, New York, 1979; Paine, R., *The Art and Architecture of Japan*, Harmondsworth, 1955; Smith, B., *Japan: A History in Art*, London, 1964

Japanese art: *Naruto Rapids in Awa Province*, Hiroshige, 19th century print

and took over the kingdom. Jason was to be allowed to regain the throne if he succeeded in capturing the Golden Fleece from Colchis, ruled by King Aeetes, on the Black Sea. He gathered 50 heroes (including ▷Hercules and ▷Orpheus) on board the Argo. Their journey was fraught with danger – clashing rocks through which the ship had to pass, sirens who wooed men from duty – and the fleece itself, hung on a tree protected by a dragon and two fire-breathing bulls. Aeetes' daughter, Medea, fell in love with Jason and helped him capture the fleece by magic, before fleeing with him on the Argo. Their meeting was often the subject of Italian marriage chest (▷cassone) decoration. When Jason abandoned Medea for another woman her jealousy drove her to murder her own children and to practise magic. See ▷Carracci, *Story of Jason*, 1583–4, Palazzo Fava, Bologna; ▷Troy, *Jason and Medea*, 1743–6, London, National Gallery; ▷Thorvaldsen, *Jason and the Golden Fleece*, 1802–28, marble; ▷Delacroix, *Medea*, 1838, Lille.

Japanese prints

Prints, usually colour ▷woodcuts, produced by artists of the ▷Edo School between the 17th and 19th centuries. These works are broadly considered ▷ukiyo-e ('pictures of the floating world'), and they represent genre scenes of Japanese life. Their unusual compositions, broad use of colour and perspectival shallowness was influential on ▷Impressionist and ▷Post-Impressionist artists in the late 19th century.

japonaiserie (japonisme)

Following the relaxation of trade barriers with Japan in the mid-19th century, a great number of Japanese art works, 'objets' and ▷woodcuts were imported, and gained great popularity, especially in Paris. The ▷Impressionists were particularly influenced by such artists such as ▷Hokusai and ▷Utamaro: the inception of ▷Monet's series paintings where he repeatedly paints the same motif and the copies of woodcuts appearing in ▷Manet's portrait of ▷Zola attest to this. More notably, ▷van Gogh's interest in the expressive nature of the linear quality, flat colour and experimentation with ▷perspective indicate the Japanese influence on the beginnings of modernity.

Jason

Greek hero, whose life was written by Apollonius of Rhodes and Philostratus the Younger. Although popular in literature, especially in the 19th century, surprisingly, he is little represented in art, despite the drama of the narrative. Jason was brought up by a ▷centaur, after his uncle, King Pelias, killed his father

jasperware

A type of English ceramic ware invented in 1774 by Josiah Wedgwood. It had a distinctive blue colour, and was often decorated with white relief or ▷cameo. It was a popular form of ▷Neoclassical decoration.

Jawlensky, Alexei von (1864–1941)

Russian painter. He was associated with German ▷Expressionism. After attending Moscow's military school, he studied at ▷Repin's classes at St. Petersburg Academy in 1889, but left for Munich in 1896 disillusioned with the historical realism then current in Russia. In Munich he trained with Anton Azbe and met ▷Kandinsky. In 1905 he visited France, travelling to ▷Pont-Aven and witnessing ▷Fauvism first-hand. He returned to Germany and became involved in the ▷avant-garde Expressionist scene: in 1909 he joined Kandinsky's New Artists Association (▷Neue Künstlervereinigung) in Munich and began producing works in strong, violently executed colour (e.g. *Girl with Peonies*, 1909, Wuppertal). He retired to St. Prex, Switzerland, for the duration of the First World War, producing a series of landscapes from his window – e.g. *Songs without Words* (the title suggests his interest in Kandinsky's musical and spiritual ideas). By the 1920s he had become interested in ▷Cubist ideas, and in 1924 contributed to the ▷Blue Four exhibition along with Kandinsky, ▷Klee and ▷Feininger; like the others he was developing his interest in abstraction (e.g. *Head*, 1935, private collection). For much of the rest of his life, he lived in semi-retirement at Wiesbaden, paralysed from 1938.

Bib.: *Der Blaue Vier*, exh. cat., Hanover, 1989; Rathke, E., *Alexei Jawlensky*, London, 1968

Jazz

A series of 20 plates, 42 × 65 cm (16 × 25 in), and text published by ▷Henri Matisse in Paris in 1947. The images employed paper cut-out designs which Matisse had been working on during the Second World War, in a process which he equated to carving in stone. The use of ▷collage can be seen as a culmination of Matisse's interest in two-dimensional design: as in earlier works, he here tried to describe form and space using a minimum of flat, coloured shapes. The colour was achieved by hand-painting in ▷gouache, and in the original images brushmarks are clearly visible. For reproduction, Matisse originally intended to use ▷lithography, but turned instead to stencilling. The shapes and colours he used were influenced by his Pacific journey (e.g. no. XVII, *Lagoon*), as well as earlier paper works like *La Danse* (1931–3, Barnes Foundation). Many of the images had playful and humorous overtones (the frontispiece was called *The Clown*). The handwritten-style text included quotes from Thomas a Kempis' *Life of Christ*, as well as some of the artist's ideas on art.

Bib.: *Henri Matisse's Jazz*, exh. cat., Nice, 1984

Jeanneret, Charles-Édouard

▷Le Corbusier

Jefferson, Thomas (1743–1826)

American president, architect and 'Renaissance man'. He was born in Virginia and educated at William and Mary College in Williamsburg. A self-taught interest in architecture led to the largest collection of architectural books in the United States. His first enthusiasm was for ▷Palladianism, which he saw as a rejection of English influence, and his home at Monticello, Virginia, was originally modelled on strict Palladian lines (1769–70) but later reworked as his architectural ideas changed (1796–1806). After being appointed Minister to France (1784–9), his discovery of Roman Classicism, particularly the temple at Nîmes, and his friendship with the French ▷Neoclassicist, Charles-Louis Clérisseau, led to a change of heart. In 1785 he influenced the design of the Richmond State Capitol (modelled on Nîmes). He was later instrumental in employing the French engineer L'Enfant, for the ▷Baroque-inspired radiating design of Washington DC, although both the White House (James Hoban modelled it on Prior Park, Bath) and the Capitol (by William Thornton) were English in inspiration.

His last great project was the design of the University of Virginia (1817–26), based on nine separate faculty pavilions, with different orders and a Rotunda. He was also interested in landscape gardening, again experimenting at Monticello. His architecture was also eminently practical: he used brick insulation, double sashes against storm damage and tin roofs.

Bib.: Lehman, K., *Thomas Jefferson: American Humanist*, Chicago, 1847; Weymouth, L., *Thomas Jefferson, the Man, his Works and Influence*, London, 1973

Jehan de Paris

▷Perréal, Jean

Jeremiah

One of the four major Old Testament prophets and the supposed author of the Book of Lamentations (telling of the destruction of Jerusalem by the Chaldeans in 586 BC). He was persecuted, and eventually stoned, for preaching that the spiritual salvation of the Hebrews depended on earthly suffering. He is commonly depicted as an old, bearded figure, thoughtful, and carrying a book or scroll to represent his prophecies. He is also associated with the cross, because of his foretelling of the ▷Passion. He is part of the ▷Tree of Jesse (e.g. *Calling of Jeremiah*, Winchester Cathedral miniature, c1140; ▷Donatello, 1427–35, Florence; ▷Michelangelo, ▷Sistine Chapel, c1508–13; ▷Rembrandt, *Jeremiah Weeping over Jerusalem*, 1630, Amsterdam, Rijksmuseum).

Jerome (Eusebius Hieronymous Sophranius) (342–420)

One of the four Fathers of the western Church. He was born in Stridon, Dalmatia and after leading the life of a pilgrim in his youth, retired to the Syrian desert for four years' isolation as a hermit, studying Hebrew. He then settled in Bethlehem, where he translated the Bible into Latin (the *Vulgate*, which became the official text at the Council of Trent). He held an unofficial position in the Church under Pope Damascus I. Jerome is represented in three ways.

(i) The Hermit. He is shown half-naked, dishevelled in the desert (e.g. ▷Patenier), often with a stone (with which he supposedly beat his breast to rid himself of unwanted sexual impulses), a skull or hourglass (mortality), and a cross. According to the medieval hagiographer Jacobus de Voragine writing in *The Golden Legend*, he befriended a lion, having removed a thorn from its paw, and the animal is often present. He also had visions, such as dreaming of trumpets of the ▷Last Judgement (e.g. ▷Parmigianino, *Vision of St. Jerome*, 1527, London, National Gallery; ▷Liss, 1628, S. Nicolo da Tolentino, Venice).

(ii) The Scholar. Shown in his study, translating the Bible. Jerome also dreamed of being whipped by angels as a punishment for his love of Classical literature. Whilst in Bethlehem, he converted a wealthy Roman noblewoman (St. Paula), who is sometimes shown present at his last sacrament.

(iii) The Cardinal. Although he was never appointed as such, Jerome is often shown in red cardinal's robes and hat, often holding a model of a church to represent his role in its institution (e.g. ▷Masaccio, Sta Maria Maggiore, 1423; ▷El Greco, 1600, London, National Gallery).

Jervas, Charles (c1675–1739)

Irish painter. He studied with ▷Kneller, and travelled to Rome 1703–9. When he returned from abroad, he settled in London. He produced mainly portraits. He was friendly with Pope and Swift, and gained important court patronage. He was Principal Painter to George II from 1723, after the death of Kneller.

Jesse, Tree of

▷Tree of Jesse

Jesus Christ

▷Christ

Jeune Peinture Belge

A group of mostly ▷Abstract Expressionist artists who joined together in Brussels in 1945. The group included Gaston Bertrand, ▷Anne Bonnet, Pol Bury and Jean Milo, and they favoured the influence of youth on the development of contemporary art. They lost momentum by 1952.

Jewish art

Because the Bible and, specifically, the Ten Commandments, forbids images, Jewish art from the Middle Ages onwards has consisted, with few exceptions, of aniconic, decorative motifs. In the ancient world, it swung pendulum-like between representation (▷frescos at Duras Europos, 3rd century AD) and ▷iconoclasm, influenced by and influencing the Muslims. By the same token, synagogues are rarely lavishly decorated. Nevertheless, there are plenty of Jewish artists who work iconically (▷Soutine, ▷Chagall, ▷Modigliani, ▷Epstein), as well as much Jewish ▷iconography in Christian art. However, the circumstance under which most Jews usually lived perhaps militated against the formation of schools of art, to the extent that it is arguable whether there is in fact such an entity as 'Jewish art' – as opposed to art done by and for Jewish people – since the majority of their work can easily be related to gentile practices of the same period and country.

Bib.: Roth, C., *Jewish Art: An Illustrated History*, rev. edn., Jerusalem, 1971

Joachim and Anna

The parents of the ▷Virgin Mary, referred to only in the ▷apocryphal literature of the New Testament, upon which Jacobus de Voragine based his account in the 13th-century *Golden Legend*. The most comprehensive visual representation of their story is to be found in ▷Giotto's ▷fresco cycle in the ▷Arena Chapel at Padua (c1305–6).

(i) Expulsion of Joachim from the Temple. Joachim and Anna are a wealthy and pious, but childless, couple living in Jerusalem. One day Joachim visits the temple to make a sacrificial offering of a lamb. He is turned away by the high priest, barrenness being considered a sign of God's displeasure.

(ii) Joachim's Return to the Sheepfold. Ashamed, Joachim flees to the desert and takes up residence with the shepherds.

(iii) Annunciation to Anna. Whilst Joachim is away, Anna is visited in her garden by the angelic messenger ▷Gabriel. Gabriel informs her of her pregnancy and

Jewish art: Moses ben Maimon (Maimonides), *The Guide for the Perplexed* (1190), 14th century copy

instructs her to go to the city's Golden Gate to meet Joachim. Anna may be seated under a tree in which sparrows nest, in reference to her lament that even the birds are more fruitful than she. A servant may be standing close by.

(iv) Annunciation to Joachim. Gabriel gives a similar message to Joachim.

(v) Meeting at the Golden Gate. The couple meet at the Golden Gate as instructed. Anna's servants and Joachim's shepherds accompany them, while Gabriel hovers overhead. Giotto's depiction of the couple embracing tenderly is particularly poignant. The importance of this particular scene lies in the fact that the medieval Church considered the actual embrace to be the moment of the conception of the Virgin Mary. The embrace of Joachim and Anna was gradually superseded in post-▷Reformation art by the more explicit image of Mary herself as the ▷Immaculate Conception.

Job

Old Testament personification of faith, patience and suffering. An upright man, living in Uz, he refused to forsake God, despite the pain heaped on him by ▷Satan. He lost his cattle, his servants were killed, his children and home swept away by a hurricane, and he himself was afflicted by boils. He was also subjected to ridicule by his wife (e.g. ▷Dürer, 1503–4, Frankfurt-am-Main, Städelisches Kunstinstitut) and friends (e.g. ▷Giordano, 1695, Madrid, Prado), and is often shown seated on a dunghill, surrounded by tormentors.

For early Christians (illustrated in the Roman ▷catacombs), he prefigured the sufferings of ▷Christ. For the Middle Ages he represented a protector against plague, which he had apparently survived. In Venice, he was sometimes given the halo of a saint. Usually, he is represented as an old man with a long white beard, partially clad (e.g. ▷Blake, *Book of Job*, 1825). Sometimes, especially in Northern painting, he is shown actually being whipped by Satan.

John, Augustus Edwin (1878–1961) and Gwen (1876–1939)

British family of painters. Augustus was born at Tenby in Wales, and studied at the ▷Slade where he was renowned for his brilliant drawing skills. His early preference was for the ▷Old Masters and 19th-century French ▷Romanticism (e.g. *Rustic Scene*, 1900, London, Tate). After teaching at Liverpool Academy 1901–2, he joined the ▷NEAC (1903) and became more interested in contemporary art trends. He began living the life of an artistic bohemian and experimented with large-scale ▷Symbolist works inspired by ▷Puvis de Chavannes (e.g. *Way Down to the Sea*, 1913, Exeter, New Hampshire), as well as with ▷Post-Impressionist techniques (as part of the ▷Camden Town Group).

Augustus John, *Self-portrait*, c1938, private collection

During the First World War he was an official artist. In the 1920s he increasingly turned to portraiture, producing works in the Grand Manner, with a spontaneous, yet almost flashy style (e.g. *Madame Suggia*, 1923, London, Tate), as well as more intimate portrayals of friends (e.g. *Dylan Thomas*, 1938, Cardiff). Elected to the ▷RA in 1928, he resigned and was re-elected in 1940. He wrote *Chiaroscuro, Fragments of an Autobiography* in 1952, and *Finishing Touches* was published posthumously in 1964.

Gwen was the sister of Augustus. She studied at the ▷Slade under ▷Ambrose McEvoy, but settled in Paris in 1898. There she developed friendships with ▷Whistler and Rilke, and was ▷Rodin's mistress for a time. She discovered Catholicism through her friendship with Jacques Maritain and, after converting, entered the Meudon Dominican convent. Little was known about her art during her lifetime (until the 1936 Chenil Gallery exhibition) and her work developed in isolation. She is especially known for her portraits of single female figures in subdued but subtle tones which convey character and mood (e.g. *Self-portrait*, 1900, London, Tate). Her early work was ▷Impressionist in style (e.g. *Corner of an Artist's Room*, 1907–9, private collection) but increasingly she developed a simplified, ▷primitivist approach (e.g. *Convalescent*, 1920–24, London, Arts Council).

Bib.: Chiffy, S., *Gwen John*, London, 1981; *Gwen John*, exh. cat., Stamford, 1982; Holroyd, M. and M. Easton, *Art of Augustus John*, London, 1974; Shone, R., *Augustus John*, Oxford, 1979; Langdale, C., *Gwen John: Catalogue Raisonné*, New Haven and London, 1987; idem., *Gwen John: An Interior Life*, Oxford, 1985

John the Baptist

The last of the prophets and a forerunner of ▷Christ, whose story is told in the ▷Gospels and is popular in art. He is commonly represented either as a small child (often in scenes of the Holy Family, e.g. ▷Leonardo da Vinci, *The Virgin of the Rocks*, c1483, London, National Gallery) or as a suffering bearded hermit. In both cases he commonly wears an animal skin, in which he was dressed in the desert, and carries a reed cross; often he is shown making the sign of blessing, carrying a lamb (he proclaimed Christ the Lamb of God), and with a locust and a honeycomb, his food in the desert. St. John was the patron saint of many Italian cities (including Florence), and his image was commonly represented in the ▷Renaissance (e.g. ▷Ghiberti, 1412–16, Florence, Or San Michele). Sometimes in ▷Byzantine art he is represented with wings (as prophesied in Malachi).

The narrative of his life was also popular:

(i) Birth. He was the son of Zacharias, a temple priest, and Elizabeth, related to the ▷Virgin Mary. When Zacharias was told the news of the birth by an angel, he was struck dumb, and only regained his speech after promising to call the child John. He is often shown with a finger to his mouth; Elizabeth is represented as aged. Mary was present at the birth, according to the medieval hagiographer Jacobus de Voragine's *Golden Legend*, as is often represented.

(ii) In the Wilderness. Sometimes shown as a youth led to the desert by an angel, or preaching to a crowd from a rock. Most commonly he is shown baptizing Christ in the River Jordan. Originally (3rd-century Roman ▷catacombs) Christ was shown naked and the Jordan was personified by a river-god. By the early Renaissance it had become acceptable to show Christ merely ankle-deep in water with an angel present (e.g. ▷Piero della Francesca, 1442, London, National Gallery; ▷Ghiberti, 1427, Siena). After the ▷Counter-Reformation, the humility of Christ was emphasized by his kneeling for the ceremony.

(iii) His martyrdom. He was imprisoned after rebuking Herod Antipas for marrying his brother's wife, Herodius. She got her daughter, ▷Salome, to dance for Herod and he, captivated, acceded to her request for the Baptist's head. Salome's dance (e.g. ▷Donatello, *Feast of Herod*, 1427, Siena; ▷Lippi, 1452–66, Madrid, Prado), the prison yard, and even the head itself (which was thought to have restorative properties and was a sought-after relic), were all common representations. John's bones were burned by Julian the Apostate. He is also represented in scenes of Christ's ▷Harrowing of Hell (until then he had remained in Limbo).

John the Evangelist

One of the four ▷Evangelists, the son of Zebedee, brother of James, and one of the 12 disciples. Traditionally he was considered the writer of the Book of ▷Revelation. As a disciple he is usually represented as a young, effeminate man, often shown at the ▷Last Supper leaning his head on Christ's breast, and present at the ▷Transfiguration. At the ▷Death of the Virgin he is usually seen holding a palm. As an Evangelist he is shown as an old man, often accompanied by an eagle (e.g. ▷Donatello, marble, 1408, Florence, Duomo; ▷Caravaggio, *Vision of St. John*, 1620–24, Parma). Narrative scenes from his life are also common:

(i) Martyrdom. According to the medieval hagiographer Jacobus de Voragine's *Golden Legend*, the Emperor Domitian tried to kill him by boiling him in a vat of oil (he is often shown with a cauldron). When this failed, John was exiled to Patmos, where he had a vision of the ▷Virgin crowned by stars. Eventually, dying of old age, he dug his own grave in the shape of a cross, and stepped into it.

(ii) Miracles. In Ephesus, according to the *Golden Legend*, he raised Drusiana from the dead and turned sticks and stones into gold and jewels. When the priest of the Temple of Diana tried to poison him (represented by a snake in a chalice), John survived (e.g. ▷El Greco, 1600, Madrid, Prado).

Johns, Jasper (b 1930)

American painter, printmaker and sculptor. He was born in Augusta, Georgia, and spent his childhood in South Carolina, before moving to New York in 1949, where he began his career as a commercial artist. Working with ▷Rauschenberg in the 1950s, he developed a style which combined the imagery of ▷Pop art with the techniques and interest in paint of ▷Abstract Expressionism (e.g. *Numbers in Colour*, 1959, Buffalo). In 1955 he produced the first of a series of familiar images (e.g. *US Flag*, 1958, Pasadena) interpreted in a way which was both objective and ironic. His use of flat surface and simplified images influenced ▷Minimalism, but through his use of encaustic paint he retained a richness of texture. He experimented with sculpture from 1958 (e.g. *Ale Cans*, 1964, private collection). During the 1960s his work became freer and less rigidly based on representation. He incorporated ▷found objects and ▷collage into his work in combination with bold colour patches (e.g. *Map*, 1961, New York), and experimented with body painting. From 1972 the abstraction of his work increased and he produced a series of works based entirely on ▷cross-hatching. He has also experimented with ▷lithography (from 1960) and ▷silk screening.

Bib.: Crichton, M., *Jasper Johns*, London, 1972; Francis, R.H., *Jasper Johns*, New York, 1984; *Jasper Johns*, exh. cat., London, 1978; Orton, F., *Figuring Jasper Johns*, London, 1994

Johnson, Adelaide (1859–1955)

American sculptor. She was from Illinois, and studied art at St. Louis and Chicago. In 1883–4 she travelled in Europe and set up a studio in Rome. She was both

a suffragette and a vegetarian, and she devoted herself to the women's movement through her art and politics. In 1921 she produced a monument to the women's movement for Washington DC.

Johnson, Cornelius (1593–1661)

English painter of Flemish origin. He produced primarily small portraits in an oval format for members of the English royal family. From 1643 he lived in Holland.

Johnson, (Jonathan) Eastman (1824–1906)

American painter. He was born in Maine and worked as an itinerant charcoal portraitist on the East Coast. He then went to Düsseldorf in 1849, studying there, then travelled to The Hague. When he returned to the United States, he specialized in scenes of frontier America, including life among black Americans. He also became a fashionable portrait painter.

Jonathan Richardson, *Portrait of Inigo Jones wearing a Black Tunic and Cap*

Jones, David (1895–1974)

English painter, engraver and writer of Welsh extraction. He was born at Brockley, Kent. Between 1909 and 1915 he studied at Camberwell School of Art, and served in the Welsh Fusiliers during the War before studying under Walter Bayes and Bernard Meninsky at the Westminster School between 1919 and 1922. After joining the Roman Catholic Church in 1921, he met the sculptor and writer ▷Eric Gill, and joined the Guild of St. Joseph and St. Dominic at Ditchling, Sussex – a guild of craftsmen founded by Gill with the purpose of reviving a religious attitude to arts and crafts. He learnt wood engraving from Gill, who directed him towards a more symbolic style. From 1925 he illustrated books for the Golden Cockerel Press, and from 1928 to 1933 was a member of the ▷Seven and Five society. Abandoning ▷engraving in 1932 due to eyesight problems, he worked mostly in ▷watercolours and pencil, using thin transparent washes to produce detailed ethereal images, often representing religious or legendary themes, such as the Arthurian legends. He also wrote two important literary works, 'In Parenthesis' (1937), a poem based on the Great War, and 'The Anathemata' (1952).

Jones, Inigo (1573–1652)

English architect and stage designer. His early life is obscure, but it is known that he was a Smithfield clothmaker's son. Some time before 1603 he travelled to Italy and purchased there a 1601 edition of ▷Palladio's *I Quattro Libri dell' architettura* (*Four Books of Architecture*) (now Worcester College, Oxford), presumably the beginning of his lifelong admiration for

Palladio's architecture. He first came to prominence in 1605, employed by James I's queen, Anne of Denmark, as a designer of Italian-influenced scenery and costumes for the court masques (many drawings of his fantastic and elaborate designs survive, e.g. at Chatsworth). In 1608 Lord Salisbury consulted him over the building of Hatfield House and the New Exchange in the Strand, although he built neither of the final buildings. From 1610 he was artistic adviser to Prince Henry and, following the latter's premature death in 1612, travelled to Italy (1613–14) with ▷Lord Arundel in the same capacity, but also to further his own architectural studies and to assemble a collection of Palladio's drawings (now at the Royal Institute of British Architects, London). In 1615 he was appointed Surveyor of the King's Works (a post held until the outbreak of the Civil War in 1642) and soon commenced work on his two most important buildings, the Queen's House at Greenwich (begun 1616–18; work resumed and completed 1629–35) and the Banqueting House, Whitehall (1619–22). Both buildings reveal a revolutionary Palladian influence, breaking away from the prevailing Jacobean taste. The former building is in the style of a villa, the latter a *palazzo*, but neither is derivative and both are clearly English. Where earlier English architects had applied ▷Renaissance motifs as surface decoration to traditional building types, Jones' architecture reveals his concern for the essential structure of a building and the harmonic relationships of its various parts one to another, in other words, a concern with the grammar rather than the vocabulary. He believed architecture should be 'solid, proportionable according to the rules,

masculine and unaffected'. From Jones' time onwards it became increasingly important for the aspirant English architect to make the trip to Italy to study the masterpieces of ▷antique and Renaissance buildings at first hand. In 1623–7 he built the Queen's Chapel, St. James's Palace, London, the first English church designed in a Classical style and, 1633–40, the ▷Corinthian portico to Old St. Paul's. With columns 50 ft (15 m) high, it was the grandest in northern Europe. He also planned the first London square, the Piazza at Covent Garden, revolutionary for its coherent design of housing with unified façades above a continuous arcaded ▷loggia (1631–7; destroyed), completed with St. Paul's Church (1631–3), built in the austere ▷Tuscan Order. Relatively untouched by current ▷Baroque developments, the influence of his Palladian style was virtually restricted to the court and its immediate circle during the 17th century, although it was to exert a much wider and more profound influence in the 18th century in ▷Burlington's and ▷Kent's Neo-Palladian reaction to what were seen as the excesses of the ▷Baroque style of ▷Vanbrugh.

Bib.: Harris, J., *Inigo Jones: Complete Architectural Drawings*, New York, 1989; Peacock, J., *The Stage Design of Inigo Jones*, Cambridge, 1995; Summerson, J.N., *Inigo Jones*, Harmondsworth, 1989

Jones, Thomas (1742–1803)

Welsh painter. He was a pupil of ▷Richard Wilson and also studied at the ▷Royal Academy schools, 1763–5. He travelled to Rome and Naples 1776–83 and made a number of landscape oil sketches. He also wrote his memoirs. Like Wilson, he produced Classicizing landscapes in a ▷Claudean mode.

Bib.: Lawrence Gowing, L., *The Originality of Thomas Jones*, London, 1985; Oliver, R., *The Family History of Thomas Jones the Artist*, Llandysul, 1970

Jongkind, Johan Barthold (1819–91)

Dutch painter. He was a landscapist, considered one of the forerunners of the ▷Impressionists. He worked mainly in France, after an early training in The Hague with the ▷Romantic artist ▷Schelfhout. From 1846 he was based in Paris (e.g. *Paris, Notre Dame*, 1864, Oxford, Ashmolean), and exhibited there along with members of the ▷Barbizon School. He later worked with ▷Boudin at Le Havre and shared the same interest in light and atmosphere which was to influence ▷Monet (e.g. *Rotterdam Harbour*, 1881, Amsterdam). He exhibited at the ▷Salon des Refusés of 1863. He produced ▷*plein air* watercolours, although most of his oils were finished in the studio and retained a certain amount of finish and detail. His later career was blighted by alcoholism, and he died in poverty in Grenoble.

Joos van Cleve (Joose van der Beke) (c1480–1540) and Cornelis van Cleve (1520–67)

Flemish family of painters. Joos was born presumably at Cleves, but first recorded in Antwerp as a Master of the Painters' Guild in 1511 (Dean in 1515 and 1525). He is usually identified with the ▷Master of the Death of the Virgin, but there are wide stylistic differences between, on the one hand, the objective naturalism of his portraits, which show the influence of ▷Quentin Massys, and on the other, his religious subjects. In about 1530, Joos is believed to have worked for Francis I of France, but although many portraits of Francis and his queen survive, none has been securely attributed to him. A portrait of Henry VIII of England in the Royal Collection is attributed to him. ▷Karel van Mander states that Joos collaborated on some works with ▷Joachim Patenir: the *Rest on the Flight into Egypt* (Brussels, Musées Royaux) has been suggested as a possible joint work (the figures by Joos; the landscape by Patenir). Joos' son, Cornelis, was also a painter. He was known as 'Sotte (i.e. Mad) Cleve', owing to the fact that he became insane in 1556 after failing to secure appointment as Court Painter to Philip II of Spain (the post went to ▷Antonio Mor). An *Adoration of the Kings* in the Antwerp Museum, by the so-called Master of the Antwerp Adoration, is sometimes attributed to Cornelis.

Bib.: Scaillierez, C., *Joos van Cleve au Louvre*, Paris, 1991

Joos van Wassenhove (Justus of Ghent) (fl 1460–80)

Flemish painter. He was Master in Antwerp in 1460, and he produced works in a manner similar to that of ▷Rogier van der Weyden. In 1464 he met ▷Hugo van der Goes in Ghent. He also travelled to Italy (where he was known as Giusto da Guanto), and took on a commission to paint portraits of 28 famous men (c1476, Paris, Louvre and Urbino, Galleria Nazionale) for the Ducal Palace of Urbino. This was one of the earliest commissions of a portrait series.

Bib.: Friedländer, M., *Early Netherlandish Painting*, vol. 3: *Dieric Bouts and Joos van Gent*, Leyden, 1968

Jopling, Louise (1843–1933)

English painter. She was from Manchester, and she travelled extensively with her diplomat husband throughout Europe. While in Paris, she met and studied with ▷Alfred Stevens. Deserted by her husband, she returned to England and exhibited her works, while obtaining portrait commissions. In 1874 she married Joseph Jopling.

Jordaens, Jacob (1593–1678)

Flemish painter. He was born in Antwerp and specialized in ▷genre and banquet scenes, and religious paintings. He trained under Adam van Noort for eight

Bib.: D'Hulst, R.A., *Jacob Jordaens*, London, 1982; *Jacob Jordaens 1593–1678*, exh. cat., Brussels, 1993

Jorn (Jorgenson), Asgar (1914–73)

Danish artist. He was from West Jutland. He began to paint while training as a teacher (1930–32) and moved to Paris, where he studied under ▷Léger (1936–7) and worked for the Spanish embassy. During the Second World War he edited an anti-Nazi magazine in occupied Denmark. In the late 1940s, he formed the Revolutionary ▷Surrealist movement, which attempted to redefine ▷Breton's cult of ▷primitivism and the unconscious in ▷Marxist terms. When this collapsed, he pursued similar aims through the artistic group ▷CoBrA (1948–51). Recovering from tuberculosis at a sanatorium in Silkeborg, he began to work in ▷ceramics. In 1954 he went to live in Italy, where he founded a new group MIBI (International Movement for an Imaginist Bauhaus), which was later absorbed into the ▷Situationist International. Jorn's continual involvement in agitatory groups was based on a distrust of individualism, which was also articulated in his work. Both his paintings and sculptures draw on motifs from Scandinavian culture, particularly archaeological research, in the belief that such imagery is embedded in society, and therefore in the subconscious. He was also dedicated to breaking the barriers between high and popular culture, between figurative and abstract art, and between art and ▷kitsch. For the 'Modifications' exhibition, for instance, he bought canvases by amateur painters on second-hand stalls and violently overpainted them.

Bib.: Atkins, G. and Andersen, T., *Jorn in Scandinavia 1930–53*, Copenhagen, 1968; idem., *Asgar Jorn: The Crucial Years*, Copenhagen, 1977; idem., *Asgar Jorn: the Final Years*, Copenhagen, 1980; *Asgar Jorn 1914–73*, exh. cat., Amsterdam, 1994

Joseph

(Old Testament, Genesis.) The elder son of ▷Jacob and Rachel. His various older half-brothers (often referred to simply as brothers) were the sons of Jacob and either Leah or one of Jacob's handmaidens. Joseph's importance in Christian art lies in the medieval belief that the events of his life prefigured those of Christ.

(i) Joseph Sold into Slavery (Genesis 37). Joseph's position as favourite son to Jacob caused the enmity of his half-brothers. One night Joseph, who was skilled in the interpretation of dreams, dreams that during the harvesting, the sheaves bound by his brothers make obeisance to his. On another night he dreams that the sun and moon and the eleven stars also bow down to him. He tells his half-brothers, who understand the import of his dreams and now detest him more than ever. Thus, they plan to get rid of him. When Joseph is sent into the fields by Jacob to find out how the family's sheep are faring, his brothers take him and cast

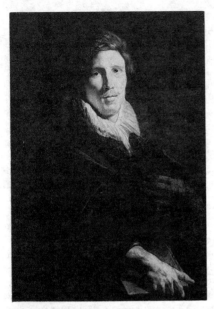

Jacob Jordaens, *Self-portrait*, Uffizi, Florence

years from 1607, marrying his daughter in 1616, the year he was admitted to the Antwerp Guild as a painter in ▷tempera and ▷watercolour. At this point, the greatest stylistic influence on his work was that of ▷Caravaggio, notably in his use of strong contrasts of light and shade, and figures of an earthy realism (e.g. *Satyr in the Peasant's House*, after 1620, Paris, Louvre). In 1621 he became head of the Antwerp Guild and from about this time ran his own large and successful workshop, whilst at the same time working for ▷Rubens, initially alongside ▷van Dyck. When van Dyck left for Italy in 1622, Jordaens became Rubens' principal associate until the latter's death in 1640. The completion of a number of Rubens' most prestigious commissions (e.g. *Hercules* and *Andromeda* for Philip IV of Spain) was entrusted to him, and from now on he began to win for himself important work previously monopolized by Rubens (e.g. *The Story of Psyche*, for Charles I of England, destroyed; *The Triumph of Frederick Hendrik*, 1651–2, for the Huis ten Bosch, The Hague).

Rubens was undoubtedly the greatest influence on the work of Jordaens' mature period. As with Rubens, his female figures are amply fleshed, his male figures robust and powerful-looking, and yet he retains the early influence of ▷Caravaggio in the somewhat coarser physical types he chooses and the stronger contrasts of light and shade which are so characteristic of much of his work (e.g. *Christ driving the Merchants from the Temple*, c1650, Paris, Louvre). Despite becoming a Calvinist in about 1655, he continued to work for Catholic clients, although his conversion seems to have imparted a certain restraint to his later work.

him into a well, but refrain from killing him. Instead they sell him as a slave to a passing Ishmaelite caravan and return home carrying Joseph's coat soaked in goat's blood. They tell Jacob that the blood is Joseph's and that he has been devoured by a wild beast. Meanwhile the Ishmaelite caravan reaches Egypt and sells Joseph to Potiphar, an officer in the Pharaoh's guard (e.g. ▷Pontormo, *Joseph Sold to Potiphar*, 1515, London, National Gallery). The casting of Joseph into the well and his subsequent raising to be sold to the Ishmaelites was considered to be a prefiguration of the ▷Entombment and ▷Resurrection of Christ.

(ii) Potiphar's Wife (Genesis 39: 7–20). Potiphar's wife desires Joseph, who has been appointed Potiphar's chief steward. She tries to lure Joseph into her bed. As Joseph runs from her clutches she pulls his cloak from him. Bitter at his rejection of her, she informs her husband that Joseph had come to her bed and tried to rape her. She had called for help and Joseph, in his desperation to escape, had dropped his cloak. Potiphar believes her story and has Joseph arrested and thrown into prison. Artists usually depict the half-undressed wife leaning alluringly from her bed and reaching out to Joseph who attempts to flee (e.g. ▷Orazio Gentileschi, *Joseph and Potiphar's Wife*, Royal Collection).

(iii) Joseph Interprets Dreams (Genesis 40, 41). While in prison, Joseph interprets the dreams of a disgraced butler and baker, both formerly of the Pharaoh's household. He informs the baker that his dream presages death, whilst the butler's signifies his impending release. Both interpretations are realized and the butler is returned to the Pharaoh's service. Two years later, when the Pharaoh experiences a particularly vivid dream of seven lean cows devouring seven fat cows, and seven thin ears of corn devouring seven ripe ears of corn, the butler remembers Joseph's talent and recommends him to the Pharaoh. Joseph explains to the Pharaoh that the dreams signify that seven years of plenty will be followed by seven years of famine. The Pharaoh is convinced, and as a reward for the warning Joseph is appointed governor of Egypt with special responsibility for storing the harvest for the lean years. Joseph's role here was seen as a prefiguration of Christ's Feeding of the Five Thousand with the loaves and fishes.

(iv) Joseph's Brothers Visit Egypt (Genesis 42–47). The seven years of famine follow, as Joseph had foretold they would, and people from the surrounding lands flocked to Egypt to buy corn. Jacob sends his sons, all but the youngest by Rachel, Benjamin. When they arrive in Egypt, Joseph recognizes them but they do not recognize him. He takes his revenge by accusing them of spying and imprisoning them. The only way to prove their trustworthiness is for one of them to go back to their father and return with Benjamin. This is done and Joseph releases them, but not before he has had his silver cup secreted in Benjamin's sack. The

brothers depart for home, are pursued by Joseph's soldiers, the cup is discovered, and the brothers arrested. On being brought back to Egypt they are taken before Joseph and fall at his feet begging for mercy (this is the fulfilment of his dream of their sheaves of corn bowing before his). His vengeance is satisfied, Joseph reveals himself and is reconciled to his brothers (see ▷Bacchiacca, *Joseph Pardons his Brothers*, c1515, London, National Gallery). Later Jacob journeys to Egypt to be reunited with Joseph (see Pontormo, *Joseph with Jacob in Egypt*, c1515, London, National Gallery).

(v) Jacob Blessing Ephraim and Manasseh, the Sons of Joseph (Genesis 48). The aged Jacob is about to die, and Joseph brings his sons to him for the customary blessing. Joseph deliberately positions his sons so that Manasseh, the elder, will receive a blessing from Jacob's right hand, while Ephraim, the younger, will be blessed with Jacob's left hand, thus establishing the primacy of the elder. Jacob, however, crosses his arms and blesses Ephraim with his right arm, explaining that the younger will be the greater (see ▷Rembrandt, *Jacob Blessing the Sons of Joseph*, 1656, Kassel, Staatliche Gemäldegalerie). The medieval Church saw this as a prefiguration of the pre-eminence of the younger religion, Christianity, over the older, Judaism. Rembrandt seems to allude to this reading by making Ephraim blonde-haired (European) and Manasseh dark (Semitic). Jacob's crossed arms were also read as an allusion to the ▷Crucifixion.

Joseph of Arimathea

This is the wealthy follower of Jesus, mentioned in all the gospel accounts of ▷Christ's ▷Deposition from the cross and subsequent ▷Entombment. According to Luke, he was a Jewish councillor who had not consented to Christ's execution, being a secret follower. All the accounts say that following the ▷Crucifixion he obtained permission from Pilate to have Christ's body removed from the cross and entombed in his own sepulchre. He is portrayed in the Deposition as a richly attired old man, either up a ladder, lowering Christ's body, or at the bottom receiving it. He also features in the ▷Lamentation and the Entombment. In devotional paintings, he is recognizable by his attributes: the shroud, the crown of thorns and the nails from the cross. Later legends grew up around his name, including one that he caught the blood from Christ's wounds in the cup of the ▷Last Supper (the Holy Grail) and took it to England whither he had been sent by St. Paul to preach the gospel and where he founded the first English church at Glastonbury. ▷William Blake, keen to establish a link between biblical 'history' and England, produced an engraving of Joseph of Arimathea walking, huddled against the cold, 'among the Rocks of Albion' (1773, London, British Museum).

journeyman

Term for a phase of art training during the Middle Ages and the ▷Renaissance, when art was still firmly fixed within a ▷guild system. After an apprenticeship, an artist would progress to the next phase in his training by moving from one master's workshop to another (▷ *Wanderjahre*). This phase preceded the status of Master, when the artist would have his own workshop.

Jouvenet, Jean (1644–1717)

French painter. In 1661 he was in Paris, working in ▷Lebrun's studio. He participated in decorative work at Versailles, where he collaborated with ▷La Fosse on the decoration of the Trianon. He was also involved with the decoration of Les Invalides in Paris. He was a master of the ▷Baroque.

Ju ware

A type of ▷Chinese stoneware dating from the 12th century and produced for the Sung court at Ju Chou. It has a light blue colour and is extremely rare.

Juan de Juni (c1507–77)

Spanish sculptor. He was possibly from Burgundy, but from c1533 he was at León and Salamanca. He worked at Valladolid from 1540, producing religious sculpture.

Judas (Iscariot)

The disciple who betrayed Christ. One of the original 12, he was the steward who kept the communal purse. He is usually portrayed as dark-skinned, sometimes with an emphatically Jewish face (in contrast to the Europeanized faces of the good disciples) and sometimes with red hair (to symbolize his angry character). Judas features in a number of different scenes:

(i) Anointment of Christ's Feet. He objects to Mary, the sister of Martha and Lazarus (but later identified with ▷Mary Magdalene), using expensive oil to anoint Christ's feet when it could have been sold to give money to the poor (John 12: 4–6).

(ii) At the ▷Last Supper. Until the early ▷Renaissance, it was customary to sit Judas alone on the viewer's side of the table, his purse in his hand. Christ may be looking at him, as he announces the imminent betrayal, and Judas may hold a sop of bread in his hand (Mark 14: 20). Sometimes Judas' face may be shaded and, where the artist has portrayed the others with haloes, generally he is without one (though not always, e.g. he is haloed in the *Last Supper* mosaic, 1175–1200, San Marco, Venice).

(iii) Judas and the Thirty Pieces of Silver. Judas conspires with the chief priests and takes their money to betray Christ (e.g. ▷Barna da Siena fresco, early 1350s, S. Gimignano, Collegiata).

(iv) The ▷Betrayal. Judas' brutal features are juxtaposed with the serene face of Christ, as he betrays him with a kiss (e.g. ▷Giotto, fresco, c1305–6, Padua, ▷Arena Chapel).

(v) The Remorse of Judas. After Christ's arrest, Judas returns to the chief priests and begs them to take back the money. Caiaphas, the High Priest, rejects it and Judas throws the money down (Matthew 27: 3–5).

(vi) The Suicide of Judas. The legend grew that Judas hanged himself. Acts 1: 18–19 says that he bought a field with the thirty pieces of silver and fell down dead in it as his entrails burst out. In the early Renaissance he may be portrayed both hanging and disembowelled.

Judd, Donald (1928–94)

American sculptor. He was born in Missouri and studied at the College of William and Mary in Virginia and Columbia University. He rejected ▷Expressionist tendencies in modern sculpture and was one of the earliest practitioners of ▷Minimalism. He was known for his use of boxes, in which serial components were arranged. He was not a ▷Constructivist, but he was concerned with the repetition of individual forms.

Judgement of Hercules

The episode, first related by Prodicus, when ▷Hercules (Heracles) chooses between vice and virtue. Hercules was the son of Jupiter (▷Zeus), the archetypal hero who combined strength with generosity and throughout his life completed 12 arduous labours. As a youth, on his way to tend cattle, he meets two women, representing Vice and Virtue, and he chooses Virtue. It became a popular subject during the ▷Renaissance, with Hercules shown as a clean-shaven and idealized youth. Virtue is represented either by a narrow and rocky path leading to Pegasus (the winged horse symbolizing fame), or by a woman, sometimes the goddess ▷Minerva (representing wisdom, with helmet, shield and owl, she was traditionally Hercules' mentor), clothed and holding a laurel and an open book. The trumpet of fame and the fatherly figure of Time may also feature. Vice (or lust) may be symbolized by a nude female figure (sometimes ▷Venus), or by an apparently idyllic scene with bathers, ▷satyrs, a mask (deceit), a tambourine, reed pipe or the rod and fetters of wrongdoing. In ▷Baroque works, Hercules may appear to waver towards vice before choosing the right path (e.g. ▷Veronese, 1578–81, New York; ▷West, 1764, London, Victoria and Albert Museum).

Judgement of Paris

The episode in which Paris chooses the most beautiful of the goddesses. Paris, son of Priam of Troy, was brought up as a shepherd after his mother had a vision that he would cause the destruction of the city. Eris (goddess of strife), who was not invited to the wedding of Peleus and Thetis, arranged for the beauty contest with the prize of a golden apple 'of destruction' in revenge; and Paris, the most handsome mortal, was chosen as judge. ▷Juno (or Hera, symbolized by a peacock), ▷Minerva (with an owl, or shield decorated

with ▷Medusa's head) and ▷Venus (or Aphrodite accompanied by ▷Cupid-Eros) take part, and ▷Mercury is usually present. Each offered Paris bribes: Juno, riches; Minerva victory; and Venus, the most beautiful woman on earth, offered him Helen, wife of King Menelaus of Sparta. Venus was the victor. Paris brought Helen to Troy and the ten-year-long Trojan war began. The scene was popular as an opportunity to portray three nudes in a landscape setting (e.g. ▷Cranach, 1530, Karlsruhe; ▷Rubens, 1632–5, London, National Gallery; ▷Renoir, 1916, Cleveland).

Judgement of Solomon

The Old Testament episode in which Solomon, renowned for his wisdom, is asked to judge between two prostitutes who each claim a child is theirs. The women had shared a house and given birth at the same time, but one child had died. Solomon discovered the real mother by ordering the child to be cut in half: she was prepared to give up her claim for the sake of the baby. The scene became a popular one for the decoration of courts of justice. It was also seen to prefigure the ▷Last Judgement. Usually, the moment immediately prior to the proposed killing is represented for dramatic effect (e.g. ▷Raphael, 1509–11, Vatican Museums; ▷Giorgione, c1508, private collection; ▷Rubens, 1615–17, Copenhagen).

Judith and Holofernes

An apocryphal story of the Jewish heroine who assassinated an Assyrian general and saved her people. The Jews were being besieged at Bethulia, when Judith, a rich widow, and her maid, pretended to desert to the enemy camp, and having got Holofernes, the general, drunk and off-guard, severed his head and returned with it in a sack. Having lost their leader, the Assyrians fled. The story came to represent any struggle against oppression (it was adopted by the Florentine Republic after the fall of the Medicis, when ▷Donatello's version was placed in the Piazza della Signoria). In the 15th century, Judith was considered one of nine 'Worthy Women'. It was also, perhaps surprisingly, seen as symbolic of virtue (humility) triumphing over vice, and during the ▷Counter-Reformation the subject was seen as prefiguring the ▷Visitation for the same reason (e.g. Chartres north door, c1230; ▷Botticelli, c1490, Amsterdam, Rijksmuseum; ▷Artemisia Gentileschi, 1621–6, Florence, Uffizi).

Juel, Jens (1745–1802)

Danish painter. He studied in Hamburg 1760–65. He travelled throughout Europe, visiting Rome, Paris, Dresden and Geneva during the 1770s. He gained his inspiration from 17th-century Dutch painting and from contemporary English portraiture. When he returned to Denmark, he was made court painter in Copenhagen (1780), and he practised portraiture there.

He was also appointed Professor of the Copenhagen Academy.

Jugendstil

The German variant of ▷Art Nouveau, taking its name ('style of youth') from the satirical magazine *Jugend*, in which its designs appeared. Heavily influenced by ▷William Morris and the English ▷Arts and Crafts Movement, Jugendstil attempted to restore a close relationship between art and everyday life through an emphasis on design and the ▷applied arts. There was also a nationalist motivation, aiming to create an organic culture for the newly united Germany.

The first isolated practitioner of Jugendstil was Hermann Obrist, whose embroidered wall-hangings introduced the sharp, flowing curves (compared by one critic to the crack of a whip) representative of the movement. In 1897 Obrist helped to found a United Workshop for Art in Craftwork, based in Munich, where a community of artists designed furniture, tableware and other household accessories for commercial production. The other major centre for Jugendstil was at Darmstadt, where Grand Duke Ernst Ludwig of Hesse established an artists' colony in 1898. Neither community broke away from a dependency on wealthy and aristocratic patrons, and the movement as a whole never achieved the broad base of popular support which would have enabled it to realize a wider programme of culture reform. Eventually, its stylish curvilinear forms became just another motif in the repertory of industrial designers.

Bib.: *Art Nouveau in Munich*, exh. cat., Philadelphia, 1988; Lorenzo, O., *Art Nouveau Graphic Art*, San Diego, 1981; Wickmann, S., *Jugendstil, Art Nouveau: Floral and Functional Forms*, Boston, 1984

junk art

A movement of the 1950s and 1960s that used industrial junk, urban debris and the detritus of consumer society as the raw material for art. In both its examination of the accepted limits of fine art practice and its use of junk it is related to ▷Braque and ▷Picasso's Synthetic ▷Cubist ▷collages and the ▷found objects of the ▷Dadaists and the ▷Arte Povera group. Thus, the sculptor ▷César assembled synthetic sculptures, turning car bodies crushed in a hydraulic press into grotesque building blocks.

▷assemblage

Bib.: *César*, exh. cat., Rotterdam, 1976

Juno

(Greek: Hera.) In ancient mythology, she is the sister, as well as the wife, of ▷Jupiter. She is the goddess of women and is represented in art as a statuesque, matronly woman whose attribute is a peacock. She appears in representations of the ▷Judgement of Paris as one of the three beauties, and Juno is sometimes

shown enthroned with Jupiter, especially in ▷Baroque ceiling painting. Because one of her principal qualities is her endurance of Jupiter's extra-marital affairs, she is not as commonly represented in art as her philandering husband.

Jupiter

(Greek, Zeus.) In ancient Greek mythology, the supreme ruler of the gods of Olympus and therefore of all mankind. His domain is the sky and his principal attributes are the eagle and thunderbolts, usually held in his hand. He is usually depicted bearded and long-haired. The chief centre of his cult was at the Temple of Zeus at Olympia, in which was housed the colossal chryselephantine statue by ▷Phidias, one of the seven wonders of the ancient world. Jupiter was the son of Saturn (Chronos), to whom it had been prophesied that one of his children would usurp him. In order to avert this, Saturn devoured his children (see ▷Goya, *Saturn Devouring One of his Children*, c1820–23, Madrid, Prado). Jupiter's mother, however, substituted the infant Jupiter for a stone wrapped in swaddling clothes, which Saturn unsuspectingly consumed instead. Jupiter was raised in secret on Crete, cared for by nymphs and fed on wild honey and milk from the goat, Amalthea (see ▷Bernini, *The Goat Amalthea Nursing the Infant Jupiter*, c1615, Rome, Galleria Borghese). From the ▷Renaissance onwards, his amorous exploits, as retold by Ovid in *The Metamorphoses*, constitute a popular source for painters. In his unrelenting quest to satisfy his libido, Jupiter seduces numerous mortals, adopting all manner of disguises in order to evade the watchful eye of his jealous wife, ▷Juno, and to dupe his mortal victims. To Antiope he appears as a ▷satyr, to Danae as a shower of gold, to Europa as a bull, to ▷Ganymede as an eagle, to Io as a cloud and to ▷Leda as a swan. A woman consumed in the awful radiance of his true, divine appearance is Semele, tricked by Juno into demanding of Jupiter that he prove his real identity (see ▷Gustave Moreau, *Jupiter and Semele*, 1896, Paris, Musée Gustave Moreau).

Jürgens, Grethe (1899–1981)

German painter. She studied at the School of Applied Arts in Hanover, where she met ▷Gerta Overbeck and Ernst Thoms. With them, she became committed to a ▷Neue Sachlichkeit style and politically tendentious art. She painted scenes of proletarian life and joined the Communist arts organization ▷ASSO. In the 1930s she organized exhibitions and subsequently worked mainly as a illustrator.

Bib.: *Grethe Jürgens, Gerta Overbeck: Bilder der zwanziger Jahre*, exh. cat., Bonn, 1982

Just what is it that makes today's homes so different, so appealing?

A ▷photomontage by the artist ▷Richard Hamilton, created in 1956 for use as a catalogue illustration and poster for the exhibition 'This is Tomorrow'. The exhibition was organized by the ▷Independent Group, and Hamilton's image humorously combines the Group's main interests of modern technology and ▷mass-media culture. It shows a modern room filled with modern household objects and advertising images of the 'perfect' man and woman under a poster titled 'Young Romance'. It illustrates the Group's interest in comic and magazine images, and represents the postwar luxury of Harold Macmillan's 'you've never had it so good' and American materialism. The image is an icon of British ▷Pop art and the title has almost become a slogan for the period.

Justice

One of the four Cardinal ▷Virtues. In *The Republic*, Plato states that Justice is the principal virtue, through the correct exercise of which the other three Cardinal Virtues, ▷Fortitude, ▷Prudence, and ▷Temperance may flourish. The figure of Justice, as a separate figure, inevitably crowns a court of law or similar building where justice is dispensed (e.g. Old Bailey, London, bronze gilt figure of Justice surmounting the dome, 1906–7, F.W. Pomeroy). The attributes of Justice are usually: scales, with which to weigh the evidence; a blindfold, to indicate that the brain, not the senses, guides true justice; and a sword, to signify strength and the punishment of offenders. From the late 16th century, the scales, which as a symbol date back to Roman times, are sometimes replaced by the Roman *fasces*, a bundle of rods bound round an axe, a symbol of the magistrate's authority. In ▷Ripa's *Iconologia*, both are employed. Sometimes she may stand upon a globe to show that her dominion is universal; or hold a pair of compasses (e.g. ▷Beccafumi, *La Giustizia*, fresco, c1535; Siena, Palazzo Pubblico).

Justus of Ghent

▷Joos van Wassenhove

Juvarra, Filippo (1678–1736)

Italian architect. He was a leading late ▷Baroque architect, born in Messina and active mainly in Turin. From 1703 to 1714, he lived in Rome, training under ▷Carlo Fontana, before establishing a reputation from 1708 onwards as a stage-designer for Cardinal Ottoboni's theatre in the Cancelleria. This early experience in the creation of scenic effects exerted a profound impact on his subsequent architectural work and, characteristically, in all his buildings he enlisted the services of the best available decorative painters, sculptors and craftsmen in Italy. His principal architectural influences were ▷Borromini and ▷Cortona. In 1714

he was called to Turin by King Vittorio Amadeo II of Savoy to serve as First Architect to the King. With the exception of a trip to Portugal, London and Paris in 1719 to 1720, Juvarra remained in Turin for the next 20 years of his life. His principal ecclesiastical buildings are the Basilica of the Superga (1717–31) and the chapel of the Venaria Reale (1716–21), both near Turin, while his major secular buildings include the Palazzo Birago della Valle (1716), the Palazzo Madama (1718–21), the Venaria Reale (1714–26), the Palazzo Richa di Covasolo (1730) and the Palazzo d'Ormea (1730). His masterpiece, executed for the King, is generally considered to be the royal hunting lodge at Stupinigi (1729–33). He died in Madrid, having been summoned there in 1735 by Philip V of Spain for whom he designed the garden façade of S. Ildefonso near Segovia, and the new Royal Palace at Madrid.

Bib.: Millon, H., *Filippo Juvarra*, Rome, 1984; Wittkower, R., *Art and Architecture in Italy 1600–1750*, Harmondsworth, 1982

K

Kahlo, Frida (1910–54)

Mexican painter. She was born in Mexico City of German/Amerindian/Spanish parents. An accident with a tram when she was 15 left her crippled and in pain for much of the rest of her life. She taught herself to paint whilst convalescing, and this accident had a profound influence on her art. She reveals a sensitive, and often painful, relationship between her body and the act of painting, for example in the self-portraits *The Two Fridas* (1939) and *The Broken Column* (1944). Married to the Mexican artist ▷ Diego Rivera in 1929, she suffered a number of miscarriages; her experience of childbirth, including her own birth, were represented in paintings such as *Henry Ford Hospital* (1933) and *My Birth* (1932). In 1939 ▷ André Breton claimed her as a ▷ Surrealist. He assisted in her first exhibition at the Julien Levy Gallery, New York, in 1940, and with ▷ Duchamp arranged an exhibition at the Pierre Collé Gallery, Paris. But whilst sharing the ▷ Surrealist's fascination with eroticism and death (e.g. in *The Dream*, 1940) she drew this from the Mexican belief in the indivisible unity of life and death, and considered herself a Mexican realist, not a Surrealist. In using painting to explore her own body, especially in experiences exclusive to women, she is of particular interest to ▷ feminist critics.

Bib.: Herrera, *Frida*, London, 1989

Kahnweiler, Daniel-Henri (1884–1976)

German art dealer, publisher and writer. Kahnweiler moved to Paris and opened a gallery in 1907 in which he promoted the work of the ▷ Fauves and ▷ Cubists. He was ▷ Picasso's dealer and was painted by the artist during his ▷ Cubist period.

kakemono

(Japanese, 'hanging picture'.) A painting or print on a scroll, which is intended to be hung.

kakiemon

Style of Japanese glazed porcelain, based on the work of the 17th-century craftsman Sakaida Kakiemon (1596–1666).

Kalf, Willem (1622–93)

Dutch painter. He specialized in still life. Born in Rotterdam, he studied under Henrik Pot. In the early 1640s he travelled to Paris, returning home in 1646. He finally settled in Amsterdam in 1654, where he flourished and continued a highly successful career until his death.

Kalf specialized in *pronkstilleven*, a Dutch form of still life based around man-made objects. His earliest works, largely produced in France, are rustic interiors scattered with pots and other cooking utensils. Returning to the Netherlands as an age of mercantile extravagance was reaching its peak, he began to paint more opulent arrangements with goblets, Venetian glass, tureens and decorated porcelain on marble surfaces covered in folds of dark red tapestry. Other frequent motifs include glasses of wine and half-peeled lemons and oranges, capturing the glistening flesh and elaborate curls of skin hanging from the fruit. This richness is further emphasized by a faint, diffuse light influenced by ▷ Rembrandt, setting his objects against heavy, almost all-enclosing shadow. Typical examples of his work include *Still Life with Nautilus Goblet* (1660) and *Still Life with Drinking Horn* (1665).

Bib.: Grisebach, L., *Willem Kalf, 1622–93*, Berlin, 1974; Mai, E., *Willem Kalf: Original und Wiederholung*, Cologne, 1990

Kalte Kunst

▷ Cold Art

Kamakura

A period of ▷ Japanese history from the 12th to 14th centuries, when the capital was at Kamakura, while the imperial court was in Kyoto. It was dominated by Zen Buddhism and the sumi-e paintings influenced by Zen.

Kandinsky, Wassily (1866–1944)

Russian painter. He was born in Moscow. After studying law, he turned his attention to art, inspired by ▷ Monet's works at an ▷ Impressionist exhibition in Moscow. He went to Munich in 1896, where he trained, but also travelled widely, visiting Paris in 1906, where he encountered the work of the ▷ Fauves and the ▷ Nabis, and Tunisia. In Germany, he played a leading role in many ▷ avant-garde groups, including the ▷ Jugendstil-oriented ▷ Phalanx, established in 1901, and the Berlin ▷ Secession. In 1911, he founded the ▷ Blaue Reiter with ▷ Marc, as a result of disagreements with the Secessionists. His early work was influenced by a wide range of factors, from the Russian folk tales of his youth through to the colour of the Fauves and the decorative brushwork of ▷ Vuillard (e.g. *Colourful Life*, 1907, Munich). Increasingly, he

turned to landscape, using a strong palette influenced by ▷van Gogh, as much as by ▷Matisse (e.g. *Grüngasse in Murnau*, 1908, Munich), and it was from these studies of nature that his first ▷abstracts developed in c1909. His *Improvisations* and *Compositions*, titles which derived from his love of music and his desire to avoid figurative terms, were landscape-based explorations of colour and line. His philosophy was set out in *Concerning the Spiritual in Art* (1912), as well as in the Blaue Reiter Almanac, and he shared with Marc a belief in the mystical and spiritual qualities of painting. In 1914 he returned to Russia, and remained there during the Revolution, his style modified by exposure to the ▷Suprematist and ▷Constructivist abstractionists. His swirling free-formed line became more controlled, his colours reduced to geometric shapes (e.g. *Several Circles*, 1926, New York). Although he developed a modern programme for teaching art in Russia, Kandinsky suffered the fate of many of the avant-garde, and found himself out of favour with the Bolshevik regime. He left for the ▷Bauhaus in 1922, becoming a teacher there, and writing *Point and Line to Plane* (1926). He renewed his association with ▷Klee, in the ▷Blue Four group, and became a German citizen. With the closure of Bauhaus in 1933, he moved to Paris, where his work underwent yet another change under the ▷Surrealist influence of ▷Miró. In the last years of his life he produced brightly coloured canvases of quixotic anthropomorphic shapes (e.g. *Sky Blue*, 1940, Paris). He also wrote plays (e.g. *Violet*) and published an autobiography, *Reminiscences*, in 1913.
Bib.: Beks-Malorny, V., *Wassily Kandinsky's Journey to Abstraction*, Cologne, 1984; *Kandinsky in Munich*, exh. cat., New York, 1982; *Kandinsky's Compositions*, exh. cat., New York, 1995; Overy, P., *Kandinsky, the Language of the Eye*, London, 1969; Roethel, H.K., *Kandinsky, Catalogue Raisonné*, London, 1984; Weiss, P., *Kandinsky, The Formative Jugendstil Years*, Princeton, 1979; idem, *Kandinsky and Old Russia*, New Haven and London, 1995

Kane, John (1860–1934)

American painter. He was born in Scotland, but moved to Pennsylvania in 1879. He worked for a time as an itinerant odd jobs man, acting as a miner and a railway guard, as well as a carpenter. At first, painting was only a spare time activity, but he began devoting more serious attention to it after 1910, when he began painting industrial scenes in his ▷naïve style. In 1927 he won the Carnegie prize.

Kangra school

Name given to the painting at the Indian Rajput court from 1775 to 1823. Kangra was in the western Himalayas. The painting consisted primarily of images of women.

Kanō

A dynasty of ▷Japanese painters who produced works in a ▷Chinese style from the 15th to the 17th centuries. They specialized in screen painting.

Kant, Immanuel (1724–1804)

German philosopher. As a lecturer at Königsberg University, Kant published such philosophical treatises as *Critique of Pure Reason* (1781), *Metaphysical Rudiments of Natural Philosophy* (1786), *Critique of Practical Reason* (1788), *Critique of Judgement* (1790) and *Religion within the Boundaries of Pure Reason* (1793). In these he

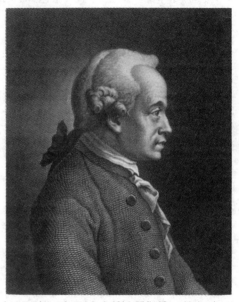

Immanuel Kant (engraving), 1816, Bibliothèque Nationale, Paris

developed a variety of arguments about reason and knowledge, which were eventually censured by the authorities. Knowledge springs from the senses and understanding. Space and time allow us to feel, and turn sensation into consciousness. Therefore, without space and time there can be no knowledge, even though they themselves are only constructs of our consciousness. By bringing together all the knowledge given to us by our senses we can reach understanding. Kant identifies 12 laws of thought, including Quality, Quantity and Causation, which can be applied to the external world. In other words, we can identify certain phenomena within the external world, but the causes of these phenomena lie outside the limits of knowledge. Hence, reason cannot lead us to truth. As man cannot attain Truth in a finite time, he must have some sort of immortality. Kant's arguments, and his atheism, were taken up by ▷Romantic authors like Coleridge and modified by such philosophers as ▷Hegel and Schelling.

Bib.: Crowther, P., *The Kantian Sublime: From Morality to Art*, Oxford, 1989

Kaprow, Allen (b 1927)

American artist. He studied at New York University and the Hofmann School during the late 1940s. In 1950 he was at Columbia University. He collaborated with ▷John Cage 1956–8, and he was one of the first artists to participate in ▷happenings. He was also interested in ▷environmental art and in works created by chance.

Kara-e

A ▷Japanese term for painting in a ▷Chinese mode.

Karnak

A complex of temples on the east bank of the Nile, at Thebes in Ancient Egypt, built over a period of 2,000 years. Known to the ancient Egyptians as Ipet-isut ('the most select of places'), it is now known by the neighbouring modern village of el-Karnak. Thebes became Egypt's capital in the 12th Dynasty (1991– 1786 BC), and Karnak was established as the cult-centre of Amun. Rulers of the 18th Dynasty (1567– 1320 BC) extended it as the seat of their great deity Amon-Re. Most subsequent kings added to the site, and it became the most important and powerful religious centre in Egypt. Its main areas are the pre-cincts of Montu and Mut and the largest temple, to Amun, in the central enclosure.

Kashmiri art

The art produced in Kashmir. The golden age of Kashmiri art was the 8th century, when Tantric ▷icon-ography dominated temple sculpture, and monumental bronze and stone works.

Kauffer, E. McKnight (1890–1954)

American-born painter and illustrator who worked in England. He was in England from 1914, and formed Group X with ▷Wyndham Lewis. He was also a member of the ▷Cumberland Market Group. He was best known for the posters he produced for the London Transport Authority.
Bib.: Haworth-Booth, M., *E. McKnight Kauffer: Painter, Poster Artist, Graphic Designer Extraordinary*, London, 1989

Kauffman(n), Angelica (1741–1807)

Swiss painter. Born Maria Anna Catharina Angelica Kauffman, she was active in England and Italy. She was a talented artist and musician as a child and, at 16, accompanied her artist father to seek commissions in Austria and Italy where she soon established her reputation. Having produced portraits for several English clients, Kauffman was invited to London by Lady Wentworth in 1766. She befriended ▷Reynolds and was a founder-member of the ▷Royal Academy.

In 1767 she was briefly married to a man posing as the Swedish 'Count Frederic de Horn', later exposed as a fraud and a bigamist. She married the Venetian painter Antonio Zucchi in 1781 and returned to Italy, where she continued to prosper, receiving commissions from the courts of Naples, Russia and Austria.

Kauffman developed a light, highly fluid style, based on ▷Neoclassicism, which she adapted to the diverse demands of the contemporary art market. Her repu-tation in England was based on portraits and dec-oration. However, her preferred area was the traditionally male enclave of ▷history painting. Their sources ranged from Classical mythology to British history and Shakespeare, but her paintings usually centre on strong or resourceful heroines. She was also interested in art theory, and produced allegorical studies of painting entitled *Invention, Composition, Design* and *Colour* for the ceiling of the Royal Academy. Her *Self-portrait in the Character of Painting Embraced by Poetry* (1782) illustrates her belief in the narrative function of art.
Bib.: Baumgartner, B., *Angelika Kauffmann 1741– 1807*, Weinheim, 1990; Mayer, D.M., *Angelica Kauff-man RA 1741–1807*, Gerrards Cross, 1972; Roworth, W.W., *Angelica Kauffman: A Continental Artist in Geor-gian England*, London, 1992

Kelly, Ellsworth (b 1923)

American painter and sculptor. He was born in New York and also studied there. From 1946 to 1954 he was in France, where he saw the works of ▷Arp and ▷Miró and began producing ▷automatic drawings. He developed his ▷Surrealist interests in a series of grid paintings, but he veered towards ▷Post-Painterly abstraction by the late 1950s. His large, often shaped, canvases were monochromatic, and many of them were in grid formations. He also produced sculpture from the late 1950s.

Kelly, Mary (b 1941)

American artist. She was born in Minnesota, and studied in Florence and London during the 1960s. She became actively involved in feminism during the 1970s, and her subsequent works were direct expressions of her ▷feminist self-consciousness. Her most famous work is *Post-Partum Document* (begun 1973), which uses objects to represent the relationship between mother and child. During the 1970s she also became involved in film-making.

Kennington, Eric Henri (1888–1960)

English painter, sculptor and draughtsman. He trained at Lambeth School of Art and the City and Guilds School, Kennington. His early success was as a painter of portraits, cockney types and London scenes. During the First World War, he was invalided out from active service and was appointed an official war artist, his most famous painting being *The Kensingtons at Laventie*

(1915, London, Imperial War Museum). He continued to paint after the war, taking up sculpture only when his old regiment (the 24th East Surrey Division) commissioned from him a war memorial (Battersea Park, 1924), with its rather futuristic stone carving of three infantrymen. Between the wars (he was an official war artist in the Second World War also) he worked mainly as a portraitist and book illustrator. He not only illustrated his friend T.E. Lawrence's *Seven Pillars of Wisdom* (1926), but also carved the recumbent effigy for his tomb at St. Martin's, Wareham (1940). He was elected ▷ARA in 1951 and ▷RA in 1959.

Kent, William (1685–1748)

English painter, architect and garden designer. He began painting coaches, but a gentleman financed a trip to Italy in 1709. There he became a guide for wealthy Englishmen on the ▷Grand Tour, and he developed an interest in the ▷antique. He also took on painting commissions, including a ceiling for S. Giuliano dei Fiamminghi (1717) in Rome. Among his many contacts was Lord Burlington, with whom he returned to London in 1719. The two then collaborated on Burlington's ▷Palladian villa at Chiswick, where Kent was responsible for the garden and some interior design. His aristocratic associations in Italy led to further commissions in England, and he designed Holkham Hall (1734 onwards) for the Earl of Leicester, and the gardens at Rousham, among other commissions. ▷Hogarth was deeply opposed to Kent's Classical interests and satirized his inability to paint.
Bib.: Dixon Hunt, J., *William Kent: Landscape Garden Designer*, London, 1987; Wilson, M., *William Kent: Architect, Designer, Painter, Gardener 1685–1748*, London, 1984

Kersting, Georg Friedrich (1785–1847)

German painter. He studied at the Copenhagen Academy. He moved to Dresden in 1808, where he was best known for his portraits. He was appointed supervisor of the Meissen ▷porcelain factory in 1818.

Kessel, Jan van (1626–79)

Flemish painter. He was from Antwerp, where he joined the Guild in 1645. He was the grandson of ▷Jan Bruegel. He produced mostly still lifes, concentrating on flowers, shells and insects, and reminiscent of scientific displays.

Ketel, Cornelis (1548–1616)

Dutch painter. He worked at Fontainebleau in 1566, and he also travelled and worked in London. He may have produced a portrait of Elizabeth I. He was best known for his portraits of groups and individuals, although he was also a ▷history painter.

Kettle, Tilly (1735–86)

English painter. He studied at the ▷St. Martin's Lane Academy, and he exhibited portraits at the Incorporated Society of Artists in 1765 and at the ▷RA in 1777. He was in India 1769–76, where he was a successful painter among the princes.

Key, Willem (c1515–68), Adrian Thomasz. (c1544–after 1589)

Flemish family of painters. Willem became master of the Antwerp Guild in 1542, and Adrian, his nephew, was master in 1568. They both painted portraits.

Keyser, Hendrick de (1565–1621)

Dutch sculptor and architect. He was appointed city sculptor and architect to Amsterdam in 1594. There his work includes the Zuiderkerk (South Church, 1606–14), the first large-scale Protestant church in the Netherlands, and the Westerkerk (West Church, 1620–38). These two churches, which succeeded in breaking away from the prevailing elaborate northern ▷Mannerism, introduced a simpler ▷Classicism to Dutch architecture and were highly influential throughout Protestant Netherlands and Germany. De Keyser's most important secular buildings were the Amsterdam Exchange (1608–11), based on Gresham's London Exchange which de Keyser had travelled to London especially to see, and Delft Town Hall (1618). His principal sculptural work in Amsterdam was the *Erasmus Monument* (bronze, 1618), although his most prestigious sculptural commission was the tomb of William the Silent (commissioned by the States-General in 1614) in the Niewe Kerk at Delft. His *Bust of an Unknown Man* (marble, 1608, Amsterdam, Rijksmuseum) reveals his abilities as a portraitist of penetrating psychological realism. Two of de Keyser's sons, Pieter (1595–1676) and Willem (1603–after 1674), became sculptors and were trained by their father; his most important pupil, however, was the English sculptor, Nicholas Stone. Another son, also trained by his father, was Thomas de Keyser (1596/97–1667), who became city architect to Amsterdam in 1662, although he is chiefly remembered as Amsterdam's leading portrait painter of the years before ▷Rembrandt acceded to that position in the 1630s. His portraiture is most effective on a small scale, amongst the best of which is the *Constantin Huygens and his Clerk* (1627, London, National Gallery).
Bib.: Lawrence, C., 'Hendrick de Keyser's Monument', *Simiolus*, 21 no. 4 (1992), pp. 265–95

keystone

The central stone or ▷voussoir at the crown of an ▷arch or a ▷rib vault, which serves to lock the whole structure together.

Kienholz, Edward (b 1927)

American sculptor. He was initially involved with ▷assemblages from the 1950s, and he was later associated with Californian ▷funk art. He used tableaux extensively, and concentrated on themes of sex and murder. His works were satires on American society. Since 1975, he has been based in Berlin.

kinetic art

Kinetics is the study of the relationship between moving bodies, and the term kinetic art is thus used to describe both three-dimensional ▷mobiles and constructions that operate in a predetermined or random way, driven by motor or by natural energy such as wind, and ▷Op art paintings, which use optical illusions to cause the picture surface to appear to move. Examples of the former are the mobiles of ▷Alexander Calder and the powered constructions of ▷Jean Tinguely, while ▷Victor Vasarely's geometric abstractions exemplify the latter. Other artists who have experimented with kinetic art include ▷Marcel Duchamp and Pol Bury.

Bib.: Bann, S. et al., *Four Essays on Kinetic Art*, St. Albans, 1966; *Kinetics*, exh. cat., London, 1970

Kip, Johannes (1653–1722)

Dutch topographical artist and engraver. With Knyff he produced the *Britannia Illustrata* (1707), a collection of 80 plates of English castles and stately homes which used a distinctive bird's eye view that Kip had first used in an engraving of Chelsea Hospital in 1690. The plates were reused together with many county maps in the *Nouveau Théâtre de la Grande Bretagne* (1715). Kip also engraved Gloucestershire houses for Sir Robert Atkyn's *Gloucestershire* (1712) and Dr. Harris's *Kent* (1719). He was the most fashionable architectural engraver of his day, and responded to a growing contemporary interest in prints of landscapes and antiquities.

Kiprensky, Orest (1783–1836)

Russian painter. He studied at St. Petersburg Academy 1816–23, and travelled to Italy 1828–36. He was best known for his grand style portraiture, and was known in his own time as the 'Russian ▷Van Dyck'.

Kirchner, Ernst Ludwig (1880–1938)

German painter, sculptor and graphic artist. He was an ▷Expressionist associated with ▷Die Brücke. He was born in Aschaffenberg. He studied architecture

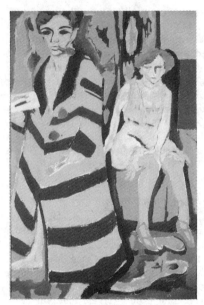

Ernst Ludwig Kirchner, *Self-portrait with a Model*, Kunsthalle, Hamburg

1901–5 at Dresden, along with ▷Schmidt-Rottluff and ▷Bleyl. His early work was influenced by ▷Art Nouveau, but he had no formal artistic training. Increasingly he became interested in ▷Post-Impressionism, especially the work of ▷van Gogh, and later of ▷Matisse. He developed a strongly coloured, violent technique, first channelled into landscapes created with ▷impasto dashes, then into studio subjects with flattened blocks of colour (e.g. *Reclining Nude and Mirror*, 1910, Berlin). By 1907 he was working in his 'hieroglyphics', treating the picture surface as flat and the subject as increasingly incidental to the painterly expression. He was a founder member of Die Brücke in 1905 and shared the other members of the group's interest in German ▷folk art and traditional techniques. This led to an exploration of ▷woodcut, where he achieved a heavy angularity which was increasingly apparent in his painting also. In 1910 the group moved to Berlin and Kirchner began a series of works based on modern city life. These showed street scenes, circuses, cafés and dance halls as places of deception and despair, using a vigorous hatching and hellish colour schemes (e.g. *Street Scene in Berlin*, 1913, Berlin). He served during the First World War until he suffered a nervous breakdown in 1916 and retired to Switzerland. For the rest of his career he painted increasingly lyrical, escapist works of the area around his adoptive home at Davos. His work during the 1920s showed some influence of ▷Cubism, and his serene monumentalism became increasingly abstract in his later years. He committed suicide, after hearing of the Nazi confiscation of his paintings as ▷degenerate.

Bib.: Dube-Heynig, A., *E.L. Kirchner: Das graphische*

Werk, Munich, 1991; Gordon, D.E., *Ernst Kirchner*, Cambridge, MA, 1968; *Kirchner*, exh. cat., Berlin, 1979; Roslie, T., *Ernst Ludwig Kirchner*, Frankfurt, 1993; Schulz-Hoffmann, C., *E.L. Kirchner: Gemälde 1908–20*, Munich, 1991; Whitford, F., *Kirchner: Drawings and Pastels*, New York, 1982

Kiss of Judas
▷Judas

kit-cat

A size of portrait, roughly 90 × 70 cm (3 ft × 2 ft 3 in) and including the sitter's head and shoulders, as well as one or both hands. The name came from an early 18th-century Whig dining club in London, whose proprietor, Christopher Cat, gave the name 'kit-cat' to his mutton pies. ▷Kneller was commissioned to paint a series of portraits of the club by the Secretary Jacob Tonson. The 42 portraits were executed c1702–17, and the inclusion of the hands allowed Kneller a greater variety of poses than the standard head-and-shoulders portrait format.

Kitaj, R.B. (b 1932)

American painter. He was from Cleveland, Ohio. He studied at the Cooper Union in New York before serving in the army. During the 1950s, he went to Vienna to study art, and he also studied in England at the Ruskin School and the ▷Royal College of Art. He was involved with the formation of ▷Pop art, and was associated with ▷David Hockney and Allen Jones while in London. He relied less on the imagery of mass culture than his contemporaries, and looked back to the ▷abstract experiments of ▷Picasso and ▷Matisse for inspiration. He went back to America in 1967 and began experimenting with pastel.
Bib.: Livingstone, M., *Kitaj*, London, 1992

Kitchen Sink

British ▷social realist painting produced following the Second World War. The post-war depression and disillusionment of a generation of 'angry young men' was mobilized by the playwright John Osborne, in his play *Look Back in Anger* (1956), and this method was adopted in art by ▷John Bratby, Jack Smith and Derrick Greaves.

kitsch

(from German verb: *verkitschen*, 'to cheapen'.) Originally the term referred simply to objects with no practical application. During the 1960s the appreciation of kitsch objects, decor, fashion and entertainment evolved as an ironic, aesthetic stance opposing the accepted notions of 'good taste'. These objects are usually the mass-produced, 'throw away' paraphernalia of industrial consumer culture. The self-consciousness of such taste has at times a dubious aspect, for it requires the ▷fetishizing of objects in one case which in another context would be highly prized (e.g. the work of Jeff Koons).

Klee, Paul (1879–1940)

Swiss painter and graphic artist. He was born near Berne. His father was an organist; he himself became an accomplished violinist and in 1906 he married the pianist Lily Strumpf. As an artist he was both inventive and prolific, executing throughout his career some 9,000 works, mostly on a small scale. He embraced both ▷abstraction and figuration, but his work, although extremely varied and imaginative, is always recognizable, always related in some way, however

Paul Klee, *Flowers in Stone*, 1939

indirect, to nature. His early work is principally in monochromatic graphic media and is characterized by an exquisitely precise and sensitive line and a strong vein of fantasy and humour which remained throughout his life. Highly manneristic, influenced by a range of artists including ▷Ensor, ▷Hodler, ▷Blake and ▷Beardsley, his titles are indicative of the satiric humour contained in the images (e.g. the ▷etching *Two Men Meet, Each Believing the Other to be of Higher Rank*). His attitude to his art, and the importance of improvisation controlled by an understanding of the elements of underlying pictorial structure, is perhaps best summed up in his definition of drawing as 'taking a line for a walk'. Yet despite his humour, his art is essentially intellectual, guided as it is by his lifelong quest for the laws of this pictorial structure and those elemental symbols which, he believed, lay beneath surface appearances.

After studying at the Munich Academy of Fine Art 1898–1901 under Knirr and ▷Stuck, he visited Italy

1901–2. In 1906 he settled in Munich and in 1911 made contact with the ▷Blaue Reiter group. His closest contacts were ▷Macke and ▷Kandinsky. Although profoundly influenced by Kandinsky's ideas, Klee's art continued to move in a different direction, always maintaining its relation to nature. In 1912, he took part in the second Blaue Reiter exhibition. In the same year he visited Paris and met ▷Delaunay whose coloristic ▷Orphism further encouraged Klee to work in colour. In 1914 a visit to Tunisia with his friends ▷Louis Moilliet and Macke endorsed his growing feeling for the pre-eminence of colour ('I and colour are one. I am a painter!', he wrote in his journal). His ▷watercolours of 1914 to 1916, with their subtly arranged areas of translucent colour, reflect this discovery. During the First World War he served in the German army (having been a German citizen for a number of years). In 1919 an exhibition of 362 of his works in Munich finally established his international reputation and in 1921, at the invitation of ▷Walter Gropius, he took up a post as a teacher at the ▷Bauhaus in Weimar, moving with the school to Dessau in 1926. In 1925 his *Pädagogisches Skizzenbuch* (translated into English in 1953 as *Pedagogical Sketchbook*) was published as the second Bauhausbuch. He left in 1931 to teach at the Düsseldorf Academy but was dismissed in 1933 following the Nazi denunciation of his work. He left Germany and moved back to Berne. Many of his works in German museums were confiscated by the Nazis and, in 1937, 17 of his works were included in the notorious ▷Degenerate Art exhibition in Munich. During his years in Switzerland he began to suffer from bouts of depression, and in 1935 the first symptoms of scleroderma, the debilitating illness which eventually killed him, appeared. It is perhaps significant that the paintings of these last years (he was active until the end) were painted in a darker range of tones and with a more bitter mood; the sense of humour remained, but it had now taken on deeply pessimistic and sardonic overtones. His other main published work is *On Modern Art* (1948), the English translation of a lecture given at Jena in 1924 and first published in 1945.
Bib.: Hall, D., *Klee*, London, 1994; Jardi, E., *Paul Klee*, Paris, 1990; Plant, M., *Paul Klee: Figures and Faces*, London, 1978; Spiller, J. (ed.), *Paul Klee Notebooks*, Woodstock, 1992

Klein, Yves (1928–62)

French artist. He was born in Nice, and both his parents were painters. In 1950 he produced his first monochromes but did not turn seriously to art until 1955. In 1952–3 he went to Japan where he practised Zen and gained a black-belt in Judo. Influenced by his belief in Rosicrucianism, that matter arose out of the void and to which an evolved humanity will eventually return, and at the same time mocking ▷Art Informel's emphasis on the unique gesture, Klein's work deals with notions of transcendence from which all traces of the artist's hand is absent. His monochromes, for which he is most famous, painted in an electric ultramarine, which Klein was to patent in 1960 as IKB (International Klein Blue) suggest a weightless, limitless space of infinite immateriality. As Klein explained 'Blue has no dimensions, it is beyond dimensions … all colours arouse specific associative ideas … while blue suggests at most the sea and sky, and they, after all, are in actual, visible nature, what is most abstract.' In a lecture at the Sorbonne in 1959, entitled 'The Evolution Towards the Immaterial', Klein argued that the worth of art lies beyond its physical constituents, as he had demonstrated in 1957 at the Galerie Apollinaire, Milan, when he sold identical monochromes at different prices, and again at 'Le Vide' exhibition, which featured a totally empty space, held at the Iris Clert Gallery in Paris in 1958, when he sold zones of empty space impregnated with his own sensibility. In 1959 he created murals for the Gelsenkirchen theatre. In 1960 he produced *Anthropometries*, in which he used models as his 'living brushes', coated in IKB, or sprayed around a figure, to give the illusion of a figure liberated from its own corporeality, afloat in a boundless depth, whilst an orchestra played his *Symphonie Monotone*, alternating one note played for 20 minutes with 20 minutes' silence. He produced a series called *Cosmologies* which depicted the effects of rain, sun and wind on canvas tied to a car roof, a series of fire pictures and in the 1960s worked on 'an architecture of the air'. In 1960 he was a founder member of ▷Nouveau Realisme. His work has been associated with ▷Happenings, ▷Performance Art and ▷Conceptual Art.
Bib.: *Yves Klein*, exh. cat, London, 1995

Kleitias

A Greek vase-painter who lived during the early 6th century BC.

Klenze, Leo von (1784–1864)

German architect. He was born near Brunswick. In 1800–3 he studied architecture in Berlin, part of ▷Gilly's circle. He then studied at Paris under Percier and Fontaine (▷Empire Style) and worked for Napoleon, before settling in Munich in 1816, employed by the Crown Prince of Bavaria. He made state-sponsored trips to Italy (1823) and Greece (1834) which had considerable impact on his style, and worked in Russia. His work was ▷Neoclassical, although he had an admiration for ▷Renaissance architects and often made use of the *palazzo* style for his urban buildings. He built one of the earliest public museums, the Glyptothek at Munich (1816–30, destroyed) and a number of government buildings (War Ministry, Munich 1826–30). His work could also be deeply ▷Romantic in inspiration: the Walhalla at Regensburg (1830–42) was a Greek temple design dedicated to German heroes. His later career was less successful, as he fell out of favour with the Bavarian authorities.

Bib.: Hederer, O., *Leo von Klenze*, Munich, 1981; Linnenkamp, I., *Leo von Klenze*, Munich, 1992; Norbert, L., *Leo von Klenze: Paintings and Drawings*, Chicago, 1982

Klimt, Gustav (1862–1918)

Austrian painter and graphic artist. Born in a suburb of Vienna, Klimt trained at the School of Decorative Arts, Vienna, and his art is still closely associated with

Gustav Klimt, *The Knight*, detail of the 'Beethoven Frieze', 1902, Osterreichische Galerie, Vienna

that city. On leaving the School, he worked with Ernst Makart and Franz Matsch in an artist-decorator's business, executing ▷murals and decorative ▷friezes. In 1894 his early large-scale works were publicly acclaimed and Klimt was commissioned to design a painted ceiling for the University Hall, Vienna. He presented inventive designs for *Philosophy, Jurisprudence* and *Medicine* in 1896, and later added *Theology*. In 1897 Klimt was one of the founder members of the Vienna ▷Secession, of which he became the first President. By 1898 Klimt had come under the influence of ▷Art Nouveau and the Munich painters, and his style began to change, as shown in *Pallas Athene* (1898). Here Klimt developed a frontal style, entwined with surface patterns, and using gold and other precious metals. To some critics Klimt's work was too daring, and his university murals were rejected. In 1903 a visit to Ravenna led Klimt to experiment with other decorative techniques, using metals, as seen in the *Stoclet Frieze* (1905–11), Brussels. At around this time Klimt's work became increasingly controversial, as he began to use nude figures and explore themes of sexuality, as

in *The Kiss* (1908, Vienna). Here what might be a loving embrace is instilled with a tension, as the woman's hands clench as fists, and the decorative tendrils seem to bind her. By 1905 Klimt was becoming isolated from the artistic community of Vienna, after a split in the Secession. Klimt's painting was continually changing and responding to different stimuli, and at the time of his death his work was starting to experiment with more sketch-like forms and lines, as shown in work by the next generation of artists, like ▷Kokoschka and ▷Schiele.
▷*Beethoven Frieze*

Bib.: Partsch, S., *Klimt: Life and Work*, London, 1989; Vergo, P., *Art in Vienna 1898–1918: Klimt, Kokoschka, Schiele and their Contemporaries*, 2nd edn., Oxford, 1981

Kline, Franz (1910–62)

American painter. He was born in Pennsylvania, and studied at Boston University and London (1937–8). He moved to New York in 1939. During the 1930s and 1940s he was involved in the ▷Regionalist movement and produced realistic views of urban scenes. However, during the 1950s he moved to ▷non-objective art, producing distinctive large black and white images which resembled ▷calligraphy. He was associated with ▷de Kooning and was on the margins of the ▷Abstract Expressionist group. He taught at Black Mountain College in 1952.

Klinger, Max (1857–1920)

German engraver, painter and sculptor. Born in Leipzig, he studied at the School of Fine Arts in Karlsruhe (1874) and the Academy of Fine Arts in Berlin (1987). He began to work as an engraver, later receiving commissions for sculpture and murals. He travelled widely, living for extended periods in Paris (1883–6) and Rome (1888–93), before settling in Grossjena. After 1900 he devoted himself wholly to sculpture. Klinger's early ▷engravings are fantastic and often dream-like, and were admired by ▷de Chirico. The series *The Glove* (1881), for example, follows the adventures of a trivial piece of clothing after it has been separated from its owner and acquires an independent existence. His monumental paintings and sculptures combine Classicism with elements of contemporary ▷Art Nouveau. The painting *Christ on Olympus* (1897), as the title suggests, attempts an uneasy hybrid of Classical and Christian themes. The statue of *Beethoven* exhibited at the Vienna Secession in 1902 with panels by ▷Klimt, revived the Greek method of using marble in different colours in a late ▷Romantic tribute to the epitome of a great artist. Klinger also published a volume of artistic theory, *Malerei und Zeichnung* (*Painting and Drawing*, 1871).

Bib.: Holloway, M.J., *Max Klinger: Love, Death and Beyond*, Melbourne, 1981; *Max Klinger: Graphic Work*, exh. cat., Stuttgart, 1981; Schneider, C., *Max Klinger*

1857–1920: graphische Zyklen, Aachen, 1990; Winkler, G., *Max Klinger*, Leipzig, 1984

Kliun (Kliunkov), Ivan Vasilievich (1873–1942)

Russian painter. He was born in Kiev and studied in Moscow. In 1910 he was involved with the ▷Union of Youth. He was also interested in ▷Malevich's ▷Suprematist experiments and other ▷avant-garde movements before and after the Russian Revolution. He exhibited with the ▷Jack of Diamonds and at the 'Tramway V' (1915) and '0.10' (1915) exhibitions. After the Revolution, he was Professor of Painting at ▷Vkhutemas (1918–21) and adopted a ▷Purist style during the 1920s.

Knapton, George (1698–1778)

English painter. He studied under ▷Jonathan Richardson the Elder and in Italy 1725–32. He returned to England to work as a portraitist, primarily in the ▷pastel medium. His major commission was for a series of portraits of the members of the ▷Society of Dilettanti, which he was commissioned to paint for them in 1736. Following in the tradition of ▷Kneller's ▷kit-cat club portraits, Knapton used the portraits as a means of representing the member's solidarity with the club ethos, but the humour of the portraits (which shows club members in fancy dress) departs from the serious intention of Kneller's works.
Bib.: West, S., 'Libertinism and the Ideology of Male Friendship in the Portraits of the Society of Dilettanti', *Eighteenth-Century Life*, 16, n.s., 2 (May 1992), pp. 76–104

Knave of Diamonds

▷Jack of Diamonds

Kneller, Sir Godfrey (1646/9–1723)

English painter of German birth. He was born in Lübeck, and studied in Amsterdam in the studio of ▷Bol. There he saw the works of ▷Rembrandt. In 1672 he travelled to Rome, then Venice and continued his travels to England in c1676, where he remained. He succeeded ▷Lely as the most significant court painter, and he was responsible for several generations of monarchs from Charles II to Queen Anne. In 1688 he was appointed joint Principal Painter to the King (with ▷Riley) – a post he retained alone from 1691. He was knighted in 1692 and made a baronet in 1715. In 1698 his portrait style changed under the influence of ▷Rubens, and he produced portraits in a much freer style. His studio was large and his success formidable, but his works often suffered from their formulaic quality. In 1711 he started his own academy in London and thus influenced the next generation of portrait painters.
Bib.: Stewart, D., *Sir Godfrey Kneller and the English Baroque Portrait*, Oxford, 1983

Knight, Dame Laura (1877–1970)

British painter. She was born in Long Eaton, but moved to Nottingham in 1877 after the death of her father. She entered Nottingham School of Art at the age of 13, and met her future husband, the portraitist Harold Knight (1874–1961) there. Together they settled in the fishing community of Staithes (1895), inspired by ▷Newlyn and by Dutch realists like ▷Israëls, and she began a series of dark cottage interiors (e.g. *Dressing the Children*, 1906, Hull). After visiting Holland, the couple moved to ▷Newlyn in 1907, where Laura increasingly turned to landscape, exploring a light, bright palette and a more ▷Impressionistic technique (e.g. *Spring*, 1916, London, Tate). She settled in London after the First World War and began a series of ballet pictures, some of her most popular, working backstage at ▷Diaghilev's Ballets Russes (e.g. *Ballet Shoe*, 1932, Brighton). These led on to circus and finally gypsy themes, coarser in their use of paint and colour and occasionally clumsy. She began ▷etching in 1922 and during the 1930s produced ▷ceramic and glass designs. During the Second World War she was an official artist and produced precise images of factory work and airmen (e.g. *Balloon Site, Coventry*, 1943, London, Imperial War Museum), as well as her portraits of the Nuremberg trials. After the Second World War she continued to paint, increasingly landscapes. She was the first woman since the 18th century to be elected a ▷Royal Academician (1935), and in 1929 was made a Dame. She wrote two autobiographies – *Oil Paint and Grease Paint* (1936) and *Magic of a Line* (1965).
Bib.: Dunbar, J., *Laura Knight*, London, 1975; Fox, C., *Dame Laura Knight*, Oxford, 1988

Knight, Richard Payne (1751–1824)

English collector and connoisseur. He was the son of a clergyman. In 1767 he made the first of a number of trips to Italy, travelling with the German artist, ▷Hackert. He wrote a diary of the visit, later published, and began his collection of ▷bronzes. He inherited an estate in Herefordshire, which he remodelled himself, and owned a house in Soho Square, which included a museum for his collections. He was also an MP. He was a member of the ▷Society of Dilettanti from 1781 and collaborated with Charles Townley on *Specimens of Antique Sculpture in Great Britain*. He left his important collection of bronzes and coins to the ▷British Museum, but he had little interest in marble and failed to appreciate the importance of the ▷Elgin marbles. He was also an important writer on taste. *The Landscape* (1794) was a didactic poem written (although badly) in the style of Alexander Pope, as an apology for the ▷picturesque movement and an attack on the landscape design of ▷'Capability' Brown. In 1805 he wrote *An Enquiry into the Principles of Taste* which re-emphasized and clarified those ideas. He also published *An Account of*

the Remains of the Worship of Priapus (1786), considered obscene.

Bib.: *Arrogant Connoisseur: Richard Payne Knight*, exh. cat., Manchester, 1982; Messmann, F.J., *Richard Payne Knight: Twilight of Virtuosity*, The Hague, 1974

Købke, Christen (1810–48)

Danish painter. His father managed the bakery of the citadel of Copenhagen, where Købke attended the Royal Academy of Fine Arts (1822–32) under Lorentzon and C.W. Eckersberg. In 1833 he moved with his family to the suburbs, where they remained until 1843 when the death of his father forced them back to a cramped apartment in the city. In 1838 Købke had travelled through Dresden to Italy, where he copied ▷frescos at ▷Pompeii and sketched the landscape around Capri.

Largely unknown during his lifetime, Købke is now the most highly regarded artist of the Danish Golden Age. Most of his paintings are views of the architecture and surrounding landscape of Copenhagen, remarkable for their clarity of detail and pale, placid light. Commentators have noted the haunting emptiness of the skies which surround his spires and turrets. His portraits, restricted to a close circle of family and friends, are relaxed and carefully observed. *The Landscape Painter F. Sodring* (1832) is a notable example. With *The North Gate of the Citadel* (1834) he embarked on a 'monumental' phase, painting larger canvases with grander compositions. Many of these were subjects from his Italian travels and are regarded as less interesting.

Bib.: Schwartz, S., *Christen Købke*, New York, 1993

Koch, Joseph Anton (1768–1839)

Austrian painter. He was born in Tyrol. An English patron made it possible for him to travel to Italy in 1794, where he saw works by ▷Carstens and ▷Thorvaldsen and soon adopted their ▷Neoclassical style. He produced landscapes in the style of ▷Poussin. He worked in Vienna (1812–15) and was associated with the ▷Nazarenes 1825–9. He took on a number of decorative commissions, including the Casino Massimo in Rome.

Koekkoek, Barend Cornelis (1803–62)

Dutch painter. He was one of a large family of painters. He travelled extensively through Belgium and Germany painting landscapes. He was especially influenced by ▷Hobbema, but specialized in forest and mountain scenes.

Kokoschka, Oskar (1886–1980)

Austrian painter. He was associated with ▷Expressionism. He was born at Pöchlarm, near Vienna, and studied art in the capital from 1905 at the Applied Art School and with the Vienna Workshops. In 1910 he went to Berlin, where he contributed to ▷*Der Sturm* magazine, and experimented with ▷lithography, producing several poster designs. He also produced the first of his 'psychological portraits', which used limited natural colours and an intense, nervous brushwork to get an insight into his sitters (e.g. *Adolf Loos*, 1909, Berlin), as well as a series of dramatically Expressionist landscapes (e.g. *Tempest*, 1914, Basle). He served in the First World War until injury in 1915. From 1917 he taught at the Dresden Academy and began to work on cityscapes, which used a high viewpoint to create strongly coloured panoramas (e.g. *Bridge over the Elbe*, 1923, Essen). He spent time in Prague from 1934, until the Nazi invasion, when he moved to England, eventually becoming a British citizen in 1947. Throughout his later years he travelled widely painting landscapes in a continuing Expressionist style. His later work was more linear and more joyful in colour (e.g. *View of Salzburg*, 1950, Munich). He also produced decorative schemes (e.g. Count Seilern's House, London, *Prometheus* ceiling, 1950, and the *Thermopylae* ▷triptych at Hamburg University). He wrote plays and an autobiography.

Bib.: Calvocoressi, R., *Kokoschka, Painter*, Paris, 1992; Gombrich, E.H., *Kokoschka and his Time*, London, 1986; *Kokoschka*, exh. cat., London, 1986; Kokoschka, O., *Letters*, London, 1992; Whitford, F., *Kokoschka: A Life*, London, 1986

Kollwitz, Käthe (née Schmidt) (1867–1945)

German sculptor and graphic artist. She was born in Königsberg, the daughter of a wealthy mason. She

Käthe Kollwitz, *Self-portrait*, 1899, private collection

attended Berlin School of Art (1884) and Munich (1887), before marrying a doctor in 1891. They lived among the poor of Berlin where she developed a strong social awareness and left-wing politics. This was first visible in a series of ▷etchings, the *Weavers' Revolt* 1893–8, based on a play but with a strong contemporary message, in which she concentrated on depicting the expression and suffering of the workers. She visited Paris in 1904 and Florence in 1907, and in 1910 turned to sculpture for the first time. After the First World War she developed pacifist tendencies, because of the death of her son (her grandson was killed in World War Two; see *Mourning Parents*, 1932, Roggevelde) and became more overtly political (e.g. *Memorial for Karl Liebknecht*, 1919–20; series of posters including *Bread!*, 1924). She met ▷Barlach in 1917, developed an interest in ▷lithography (e.g. *Mothers*, 1919), and began to work in a more angular ▷Expressionist style. She became the first woman elected to the Prussian Academy in 1919. She visited Russia in 1927 but was disillusioned by the regime there. She was expelled from the Academy by the Nazis in 1933, but unlike many artists remained in Germany and continued to work, producing mainly small-scale sculpture (e.g. *Towers of Mothers*, 1937–8, bronze).
Bib.: Humphries, S., *Käthe Kollwitz*, London, 1971; Klein, M.C., *Käthe Kollwitz: Life in Art*, New York, 1975; *Käthe Kollwitz: Meisterwerke der Zeichnungen*, Cologne, 1995; Prelinger, E., *Käthe Kollwitz*, Washington, 1992; Reimer, P.B., *Compassion and Protest in the Work of Käthe Kollwitz*, Toronto, 1989; Zigrosser, C., *Prints and Drawings of Käthe Kollwitz*, New York, 1969

Konenkov, Sergei (1874–1971)
Russian sculptor. He worked in the United States but returned to Moscow after the Second World War. He began as a ▷Symbolist, then later adopted a Classical style.

Koninck (de Koninck), Philips (1619–88) and Solomon (1609–56)
Dutch family of painters. Philips was a pupil of ▷Rembrandt and produced images of elderly people in the chiaroscuro manner of Rembrandt. He also painted ▷genre scenes and panoramic landscapes, and left many drawings. It is difficult to ascertain his exact relationship with Solomon, who may have been a cousin, and who also painted genre scenes and biblical subjects in the style of Rembrandt.

kore (pl. korai)
(Greek, 'maiden'.) A type of Greek sculpture of the ▷Archaic period representing a standing female with stylized draperies.
▷kouros

Korea, art in
Korea, like Japan, was dominated by the influence of ▷China, particularly during the Han period. From the 4th to the 7th centuries, ▷Buddhist sculpture was the principal form of artistic production, but the influence of Confucius from the 10th to the 14th centuries led also to a more intellectual art in which ▷calligraphy was common. In the 14th century, the Mongol invasion interrupted the steady progression of art, but court painting flourished afterwards, under the influence of the Ming and Ch'ing dynasties.
▷Chinese art; Japanese art
Bib.: Whitfield, F., et al. (eds), *Korean Art Treasures*, Seoul, 1985

Kōrin School
A school of Japanese decorative art named after Ogata Kōrin (1656–1716), who was not actually its founder. Prominent during the ▷Edo period, this style of art owed much to ▷Chinese influence, but it also evinced a greater naturalism than previous art. The works of its practitioners were popular in the West.

Kostrowitsky, Wilhelm Apollinaris de
▷Apollinaire, Guillaume

Kosuth, Joseph (b 1945)
American artist. Taking his cue from ▷Duchamp, he produced ▷Conceptual art in the 1960s in which he stressed the greater importance of the artistic activity itself.

kouros (pl. kouroi)
(Greek, 'youth'.) A statue of a standing nude youth, typical of Greek art of the ▷Archaic period. The usual type stands with one foot (generally the left) forward, arms hanging lightly flexed down at the sides. They were used as grave markers, or as dedicatory statues in sanctuaries of male gods.

Kraf(f)t, Adam (c1455/60–c1508/9)
German sculptor. He was one of the leading German late Gothic sculptors, active chiefly in Nuremberg and working invariably in stone. His work is notable for the strong characterization of the figures. His masterpiece is the multi-figured, richly decorated, 19 m (62 ft)-high *Tabernacle* (1493–6) in the choir of the Church of St. Lorenz, which includes as a supporting figure what is supposed to be a self-portrait. He also executed the Schreyer Monument in St. Sebald's Church. Many examples of his work can also be seen in the Germanisches Nationalmuseum in Nuremberg.

krater
(Greek, 'mixing bowl'.) Ancient Greek wide-mouthed bowl for mixing wine and water. There are four main types: bell-, calyx-, column-, and volute-shaped, the first three being defined by the shape of the body,

the last having a bell-shaped body but with ▷volute handles.

Kress, Samuel H. (1863–1955)

American businessman with very broad philanthropic aims who established the Samuel H. Kress Foundation in 1929. The Foundation was active in the restoration of buildings in war-ravaged Europe following the Second World War, and Kress' own interests in ▷Renaissance art led to his large donation to the National Gallery of Art in Washington.

Krieghoff, Cornelius (c1812–72)

Canadian painter of Dutch birth. He was born in Amsterdam and studied in Düsseldorf. He came to North America in 1837, and from c1840 painted landscapes and scenes of Native American life in Quebec.

Kristeva, Julia (b 1941)

French ▷feminist ▷psychoanalytic theorist. Born in Bulgaria, Kristeva settled in Paris in 1966 and identified a crisis in social structure which she sought to explain through emerging psychoanalytic and feminist thought. Discordant and disturbing social behaviour was connected to shattered social, linguistic and artistic practices. Her publications include *Revolution in Poetic Language* (1974) and *Powers of Horror – An Essay on Abjection* (1980).

Bib.: Moi, T. (ed.), *The Kristeva Reader*, Oxford, 1986

Krøhg, Christian (1852–1925) and Per (1889–1965)

Norwegian family of painters. Christian studied in Paris during the 1880s and came into contact with the work of the novelist ▷Zola there. He became fascinated by working-class life and wrote a novel *Albertine* (1886). His interest in realism also influenced his art. He taught in Paris 1902–9 and became director of the Art Academy in Oslo (1909).

Per, his son, also lived in Paris, where he adopted a ▷Cubist technique. He was responsible for a number of public mural commissions in Norway.

Krøyer, Peder Severin (1851–1909)

Danish painter of Norwegian birth. Like many European artists of the 1870s, he was fascinated by the work of ▷Velázquez, and he also adopted an ▷Impressionist technique. His combination of realist subject matter and light effects appeared in a series of paintings of working-class men (1878–80). In 1872 he went to live at the artist's colony in Skagen, where he concentrated on Impressionist landscapes painted in natural light.

Kruger, Barbara (b 1945)

American artist and theorist. She is best known for her ▷photomontages and critique of consumerism. Born in New Jersey, she studied at Syracuse University (1964–5) and the Parsons School of Design (1965–7). She joined Conde Nast as a junior designer in 1967, and within a year had been promoted to senior designer for *Mademoiselle* magazine. She began to sculpt in the early 1970s, and exhibited woven wall-hangings in a number of spaces including the Whitney Biennal (1973). While teaching at the University of California at Berkeley, she published *Picture/Readings* (1977) – photographs of residential buildings with an accompanying text imagining the lives of their inhabitants. In 1981 she curated the exhibition *Pictures and Promises*, consisting of magazine advertisements, signs and television commercials. In the same year she began to exhibit works in what has become a signature style. These consist of a large black and white image (usually culled from a magazine or other existing source, but cropped, reshaped or somehow altered) with a punchy slogan enclosed within a red border. Kruger has credited her early work as a graphic artist for this approach, which draws on the techniques of advertising. However, the frequently ironic juxtaposition of word and image in Kruger's work highlight and challenge the assumptions of consumer fulfilment, and ▷gender and sexual identity, which underline the operations of the ▷mass media.

Bib.: Linker, K., *Love for Sale: The Words and Pictures of Barbara Kruger*, New York, 1990; Squires, C., 'Diversionary (Syn) Tactics: Barbara Kruger Has her Way with Words', *Art News* (Feb 1987), pp. 76–85

Kubin, Alfred (1877–1959)

German graphic artist. He studied in Munich in 1898 and began his career as a book illustrator. He travelled to Italy and France 1905–6, and in 1910 met ▷Kandinsky. He was involved in the ▷Blaue Reiter exhibitions (1911). His work was on the borderline between late 19th-century ▷Symbolism and early 20th-century ▷Expressionism. He was fascinated by morbidity, imagination, death and horror, and his works show the influence of ▷Goya's satirical imagination. He wrote a futuristic novel, *The Other Side* (1909), and he was known to be neurotic. Nevertheless he became Professor of the Prussian Academy of Arts in Berlin (1937).

Kunstgewerbeschule

German term for 'Arts and Crafts School'.
▷Arts and Crafts; art education

Kunsthistorisches Museum, Vienna

(German 'art museum'.) Museum and art gallery, opened to the public in 1781. The museum, which houses paintings, sculptures, and works of decorative art, was formed from the private collections of the Habsburg family, who had been collecting since the 16th century. The museum is rich in Italian High ▷Renaissance paintings (particularly the Venetian school: ▷Giovanni Bellini, ▷Giorgione, ▷Titian,

▷Veronese, and ▷Tintoretto are all well represented). It also has an extensive ▷Baroque collection. Its star exhibits, however, are perhaps the unrivalled collection of paintings by ▷Pieter Bruegel the Elder.

Kunstkammer
▷cabinet of curiosities

Künstlerbund Hagen
▷Hagenbund

Kunstverein
The German version of the English ▷Art Union. The first one was formed in Berlin in 1814.
Bib.: Langenstein, Y., *Der münchner Kunstverein im 19.Jahrhundert*, Munich, 1983

Kupka, František (Frank, François) (1871–1957)
Czech painter and graphic artist. He was trained in Prague and Vienna, where he lived in 1892. In 1896 he was in Paris, where he produced book illustrations. From an early age he was interested in spiritualism, and he adopted all the latest spiritualist beliefs, including theosophy. In artistic terms, he looked to ▷folk art and what he saw as the simple and sincere art of the ▷Nazarenes. From 1909 he began to experiment with photography and motion, and from 1910 painted a series of brightly coloured ▷pastels on the themes of motion and music. He called his works 'colour symphonies' and, like ▷Kandinsky and the composer Alexander Scriabin, adopted ideas of ▷synaesthesia. His dynamic colourism was similar to the work of his contemporary ▷Orphist artists, such as ▷Delaunay. He was in the Czech Legion during the First World War and settled in Prague after the war to teach. He sustained his commitment to pure abstraction and was one of the founders of the ▷Abstraction-Création group in 1931.
Bib.: Vachtova, L., *Frank Kupka*, London, 1968

Kusnetsov, Pavel Varfolomevich (1878–1968)
Russian painter and graphic artist. He studied at Sartov (1891–6), the Moscow School of Painting, Sculpture and Architecture (1897–1904) and for a year in Paris (1905). His early paintings were exhibited by the ▷Mir Isskustva group, and he was closely associated with the Russian ▷Symbolists. He helped to organize the Crimson Rose exhibition (1904) and was a founder and leader of the ▷Blue Rose in 1907. He taught at the Stroganov Institute (1917–18; 1945–8) and at the Moscow Institute of Fine Arts (1918–37). He headed the painting section of ▷Narkompros until 1921, but fell out of official favour with the advent of Socialist Realism.

Kusnetsov's early paintings are typical of the Blue Rose group's poetic explorations of an interior, imaginative world through archetypal symbols. After 1910 he drew increasingly on folk culture, continuing to draw on the rich colours and harmonious rhythms of the Symbolists but simplifying his compositions to depict the everyday life of village communities of Kirghizstan in Central Asia.
Bib.: Strupples, P., *Pavel Kusnetsov: His Life and Art*, Cambridge, 1989

kylix
Ancient Greek drinking cup with a wide and shallow bowl, two horizontal handles on opposite sides close to the rim, a slender stem and a small base.

L

L.H.O.O.Q.

A now infamous photograph by ▷Marcel Duchamp of ▷Leonardo's *Mona Lisa* ▷graffitied with a pointed moustache and beard, which was first published by ▷Picabia in Paris in the 12th issue of the journal ▷*391* (March 1920). The letters of the title, written beneath the picture, are meaningless, but become 'Elle a chaud au cul' ('she has a hot ass') when pronounced aloud. The picture has come to represent ▷Dada's attack upon the Western artistic tradition, and with the durability and popularity of Leonardo's portrait, continues to shock in its simplicity. It is now in New York, in a private collection.

La Fosse, Charles de (1636–1716)

French painter. He studied with ▷Lebrun and assisted him at Versailles. From 1658 to the early 1760s he was in Italy, where he saw the works of ▷Correggio and ▷Veronese. His interest in colour was enhanced when he came into contact with ▷Rubens in the 1680s. He travelled to London, where he got a commission to decorate Montagu House (1689–92). He also decorated Les Invalides in Paris. Like ▷Roger de Piles, he was an advocate of Rubenism ▷(Poussinism versus Rubenism), and his works lack the severity of much French Classical ▷Baroque work.

La Fresnaye, Roger de (1885–1925)

French painter. In 1903 he studied at the ▷Académie Julian, and then at the Académie Ranson (1908), and at the ▷École des Beaux-Arts in 1909. Through his various studies he came into contact with ▷Denis and ▷Sérusier, but the most important influence on his work was the art of the ▷Cubists. He was involved with Cubism from 1912, when he exhibited at the ▷Section d'Or. He was in the army during the First World War, when he was debilitated by tuberculosis. After this he worked very little. Although his works were painted in a Cubist style, he veered more towards realism than many of his Cubist contemporaries.

La Hyre (Hire), Laurent de (1606–56)

French painter. He primarily painted landscapes with religious subjects, and his eclecticism led him to try out many different styles in his lifetime. He began in the ▷Fontainebleau style, and from c1638 painted Classical landscapes that showed the influence of ▷Poussin. He also imitated ▷Caravaggio and produced portraits and ▷engravings.

Bib.: Rosenberg, P., *Laurent de la Hyre 1606–1656: l'homme et l'oeuvre*, exh. cat., Geneva, 1988

La Tène Style

Artistic style of a new ▷Celtic culture that emerged in the 5th century BC in an area stretching from eastern France to Bohemia, identified by the archaeological site of La Tène on the edge of Lake Neuchâtel, Switzerland, discovered in 1857. Successor to the Hallstatt Culture of the early European Iron Age, La Tène culture is characterized by furnished graves, and curvilinear art, often applied to metalwork. The style associated with this culture was largely abstract, with its roots in the earlier Hallstatt geometric style but influenced by ▷Etruscan and Greek style on imported goods. Early La Tène artists adopted and adapted Classical vegetal elements such as the palmette, lotus bud and blossom, and ▷acanthus tendrils; whilst human faces were a popular motif, whole figures were not. The style survives largely in metalwork, reaching its greatest expression in the art of Bronze Age Britain. Its vestiges survived in Ireland, and can be seen in the scrollwork of early medieval Irish illuminated manuscripts.

La Tour, Georges de (1593–1652)

French painter. He was active all his life in Lorraine. Despite a successful career – he was patronized by both the Duke of Lorraine and King Louis XIII – he fell into complete obscurity after his death and was not rediscovered until 1915. The details of his life are sparse, but his earliest paintings are considered to be the daylit genre paintings (e.g. *The Cheat*, Paris, Louvre). The paintings of his maturity are religious and are painted in a style founded on the dramatic ▷chiaroscuro of ▷Caravaggio, but in all likelihood received via the Utrecht School of Dutch ▷Caravaggists. For example, they are generally nocturnal scenes, often with the figures brightly illuminated by a single unshielded candle (e.g. *Christ and St. Joseph*, c1645, Paris, Louvre). This device, and the narrow, but rich, range of creamy and coppery tones characteristically employed, relate more to ▷Honthorst (e.g. *Christ before the High Priest*, London, National Gallery) than Caravaggio. He also sometimes created remarkable effects by obscuring the source of light (e.g. *St. Joseph's Dream*, in which only the glow and the very tip of the candle flame are visible behind the angel's outstretched arm). Only about 40 paintings have been securely linked to his name and the construction of a chronology is made difficult by the fact that only three of his works – all mature – are dated. His most remarkable works are those that are generally considered to be his latest. In these, the more descriptive

style of his earlier work is dropped in favour of a simplified style in which forms are reduced to their underlying geometry (e.g. *The Nativity*, c1650, Rennes). In this, as in all the best of his work, the simplified forms, rich illumination, deep shadows and balanced composition, evoke a stillness and a serene religiosity that supports the theory that La Tour was involved in the Franciscan-inspired religious revival in Lorraine in the first half of the 17th century.

Bib.: Reinbold, A., *Georges de la Tour*, Paris, 1991; Rosenberg, P., *Georges de la Tour: catalogue complet des peintures*, Paris, 1992; Thuillier, J., *Georges de la Tour*, Paris, 1993

La Tour, Maurice-Quentin de (1704–88)

French painter. He was born in St. Quentin and travelled throughout Europe. He lived in Paris 1724–84, where he earned a reputation painting ▷pastel portraits for the court as well as the bourgeoisie. He worked for Louis XV in 1750. He was an especially skilled draftsman.

Bib.: Bury, A., *Maurice-Quentin de la Tour: The Greatest Pastel Portraitist*, London, 1971

Labille-Guiard, Adélaïde (1749–1803)

French artist. She was one of the few female members of the French ▷Academy in the 18th century. She studied with ▷Maurice de La Tour and, like him, became known as a ▷pastel painter. She was made an Academician in 1783, simultaneously with her rival ▷Elisabeth Vigée-Lebrun. Unlike Vigée-Lebrun, she became involved with the Revolutionary cause and was responsible for painting the Deputies of the National Assembly. Her chief contribution to French art was her skill as a teacher, as she imparted her wisdom to another generation of largely female artists.

laboratory art

The name given to art produced in Russia after the Revolution that repudiated easel painting in favour of art with a social purpose. Although revolutionaries advocated socially useful art from 1917, the prominence of laboratory art dated from 1921, when the ▷5 × 5 = 25 exhibition declared the death of easel painting. Applied art and a ▷culture of materials dominated this ethos, and laboratory art was taken up under the auspices of ▷INKHUK as the official revolutionary art. However, it was superseded by ▷Socialist Realism which became the state art form under Stalin and reintroduced easel painting.

▷Productivism; Constructivism

Labours of the Months

The earthly cycle of agricultural tasks, each associated with a month, often compared to the heavenly cycle of the ▷zodiac. The popular representation of the seasons as human figures only engaged in tasks associated with the time of year can be traced back to Roman art: it was a familiar motif in ▷mosaics, and the months themselves appear in Philocalus' calendar of 354. Ninth-century German calendars employed agricultural scenes; the months were commonly represented in Early Christian and medieval art as landscapes, in Psalters, miniatures and ▷Books of Hours. From the 12th century, the Labours of the Months became a common motif in cathedral architecture throughout Europe. In this context they acquired a moral significance, extolling the spiritual value of work (e.g. portal sculptures at ▷Amiens, Chartres and Vézelay in France, Ripoll in Catalonia, and the Doge's Palace in Venice). In tapestries of the 16th and 17th centuries, where they are also seen, they may be associated with specific pagan gods. Another common association is with the 12 ▷Ages of Man. The monthly tasks vary from Northern Europe to Italy because of climate but include:

(i) January: youth and age; ▷Jupiter; tree felling; feasting.

(ii) February: fish; ▷Venus and Cupid; grafting.

(iii) March: ram; ▷Mars; shepherds; digging; pruning vines.

(iv) April: bull; Jupiter and Europa; training vines.

(v) May: Castor and Pollux; Venus; scything; falconry.

(vi) June: crab; Phaethon; haymaking.

(vii) July: lion; ▷Hercules; threshing; corn cutting.

(viii) August: Ceres; harvesting; ploughing.

(ix) September: scales; Ceres; grape harvest.

(x) October: scorpion; ▷Bacchus; sowing.

(xi) November: archer; Nessus (centaur); wood cutting; olive pressing.

(xii) December: goat; Ariadne; ploughing; killing pigs.

Perhaps the finest examples are those of the ▷Limbourg Brothers in their ▷*Les Très Riches Heures du Duc de Berry* (1413–16, Chantilly).

▷Four Seasons

Lacan, Jacques (1901–81)

French ▷psychoanalyst and ▷structuralist. He established the Freud School of Paris. In his books *Writings* (1966) and the *Language of the Self* (1968), he re-read ▷Freud and advocated language as a tool with which to reach a highly structured subconscious. He distinguished between two stages of consciousness; the 'mirror-phase', pre-linguistic, pre-Oedipal and dependent on the recognition of visual images; and the 'symbolic phase', the adult world of language in which the father-figure became dominant. The first paralleled many of the ▷Surrealist ideas expressed in ▷Dali's writings. He opposed the concept of a unitary 'self' (the basis of Classical and ▷Expressionist views) in favour of a decentring, in which the individual was simply one element in an overall analysis.

Bib.: Arup, M.S., *Jacques Lacan*, New York, 1992; Forrester, J., *Seductions of Psychoanalysis*, Cambridge, 1990

Lachaise, Gaston (1882–1935)

French sculptor. He studied at the ▷École des Beaux-Arts 1898–1904. In 1906 he moved to the United States, where he worked in Boston and New York. He specialized in nude women, which he produced for public commissions. He was an early advocate of ▷direct carving, and he was also known for his portrait sculpture. In 1912 he worked with ▷Paul Manship in New York.

lacquer

Hard, highly polished, opaque ▷varnish which originated in the Far East. Lacquer takes its name from lac, which is the basis for some lacquers. True lacquer, as used in China and Japan, is the purified and dehydrated sap of the Rhus vernicifera tree. In its natural state it is thick and syrupy, and it turns brown or black when exposed to the air. In Europe, where this was not available, especially in the 18th and 19th centuries when the technique was first adopted, other substances were developed, which are not as hard as real lacquer. The lacquer is usually applied to wood, although ▷porcelain and metal can be used. It is purified by straining and stirred to liquefy. At this stage the lacquer can be coloured with the addition of different substances. For example, the addition of cinnabar creates a red lacquer. It is then heated and applied in thin layers. Each layer must be left to dry in a damp atmosphere to go really hard. It is then polished. Large blocks of lacquer can be made, which can be carved. The technique has been popular in the Far East for many centuries, and came to prominence in Europe with the ▷Rococo style.

Lady Chapel

In a church, a chapel dedicated to the ▷Virgin Mary, usually situated at the east end, beyond the ▷chancel.

Laer, Pieter van (c1592–1642)

Dutch painter. He was called 'Bamboccio' ('pretty baby, little clumsy one') – a nickname given to him as part of his association with the ▷Schildersent in Rome. He painted low-life scenes in Rome during the 1620s, and worked in Haarlem from 1639. His significant impact on Dutch art in Rome led to a number of followers, who were known as the Bambboccianti and their paintings as ▷bambocciate.

Laethem-Saint-Martin

A village in Belgium, not far from Ghent. In 1900 it became the site of an artist colony, attracting such ▷Symbolists as ▷Albert Servaes. These artists were known as the First Laethem Group, and they depicted scenes of peasants and landscapes in a late ▷Pre-Raphaelite style. ▷George Minne was also associated with the group. From c1910, a new wave of artists, including ▷Berghe and the ▷Smet brothers, established the Second Laethem Group, which continued after the First World War. ▷Permeke was among the associates of this group, and they developed a distinctive style of Flemish ▷Expressionism.

Laguerre, Louis (1663–1721)

French painter. He worked with ▷Lebrun in 1683, but he came to England in 1684. There he gained a number of commissions to produce decorative work for country houses, including Chatsworth (1689–94) and Blenheim (1719). He also decorated Christ's Hospital (1684). He worked for a time with ▷Verrio. He specialized in illusionistic devices used to extravagant effect on both walls and ceilings of country houses.

Lairesse, Gerard de (1641–1711)

Dutch painter, etcher and writer. He was born in Liège and worked in Amsterdam (from 1665) and The Hague (from 1684). He produced mainly decorated work in a Classical mode, which earned him the nickname 'the Dutch ▷Raphael'. In 1690 he went blind. His most significant contribution to art was his *Great Painting Book* (1707). He also wrote the *Foundation of Drawing* (1701).

lake

Any type of organic ▷pigment made to be insoluble through the use of a metal compound. For example, mordant and acid dyes are made from pigment bound together with metal ions, like calcium or aluminium. This extends the range of colours available in inks and paints.

Lam, Wifredo (1902–82)

French painter of Cuban birth. He was born in Cuba of mixed Chinese, African and Spanish ancestry. He left Havana in 1923 for Madrid, where he studied painting, but dissatisfied with the academic style, he arrived in Paris in 1937. He studied painting with ▷Picasso, before joining the ▷Surrealists in 1938. He had his first exhibition in 1939 at Galerie Pierre Loeb and, in 1940, he illustrated ▷Breton's book *Fata Morgana*. In 1941 he sailed to the United States with ▷Masson, Breton and ▷Lévi-Strauss. His return to Cuba stimulated his interest in African and Oceanian sculpture, as well as primitive mythology, which he translated into his own work creating irrational and fantastic hybrid images, as disturbing as they are surprising. He began to incorporate totemic elements and voodoo idols into his work after a visit to Haiti in 1946, the same year he returned to Paris. His totemic forms, after 1950, increasingly became pure signs, and his painting more ▷Expressionistic, and he was invited by ▷Cobra to exhibit them in Liège in 1951. From the late 1950s, Lam divided his time between Paris and Italy, where he established a studio. In 1946 he won the Guggenheim International Award.
Bib.: Jouffroy, A., *Lam*, Paris, 1972; Leiris, M., *Wifredo Lam*, Milan, 1970

Lamb

In Christian art the lamb carries the double significance of ▷ Christ who redeemed humanity through his sacrifice, and the faithful themselves for whom Christ is the ▷ Good Shepherd. Christ as the Lamb derives from the words of ▷ John the Baptist, 'Behold the Lamb of God, which taketh away the sins of the world' (John 1: 29). He is thus represented in Early Christian art and is distinguishable by his cruciform nimbus; in later art he may carry a ▷ Resurrection banner and/or have blood issuing into a chalice from a wound in his breast, this last image deriving from the vision of the Lamb in ▷ Revelation 7: 9–17 (e.g. ▷ Jan van Eyck, the central panel with the Adoration of the Lamb from ▷ *Ghent Altarpiece*, 1432, Ghent, St. Bavo). In the relief on the Marble Sarcophagus of Constantius III (400/425, Ravenna, S. Vitale), the Lamb of God stands between two other lambs representing Apostles. Sometimes there may be a procession of 12 lambs flanking the Lamb of God, symbolizing Christ and the 12 Apostles (e.g. apse mosaic, 12th century, Rome, San Clemente). Because of his reference to Christ as the Lamb of God, a lamb is one of the attributes of John the Baptist; it is also the main attribute of ▷ Agnes, deriving from a play on her name (Agnes: *Agnus*). ▷ Cesare Ripa (*Iconologia*) describes a lamb as one of the attributes of ▷ Patience personified.

Lamb, Henry (1883–1960)

English painter. He was part of the ▷ Bloomsbury Group, and like them, he was sympathetic to the introduction of ▷ Post-Impressionism in England. He painted mostly portraits and served as a war artist during the Second World War.
Bib.: Clements, K., *Henry Lamb: The Artist and his Friends*, Bristol, 1985

Lambert, George (1670–1765)

English painter. He was born in Kent and taught by Hassells and ▷ Wootton, but much of his work was influenced by that of ▷ Gaspard Dughet. He was employed as a scene painter at Lincoln's Inn Fields Theatre, and at Covent Garden where he worked with ▷ Amigoni. He was a friend of ▷ Hogarth and a founder of the Beefsteak Club. He also helped to press for a Copyright Bill. He produced topographical scenes (e.g. *Chiswick House from the North Façade*, 1742, Chatsworth) but had aspirations to Classical landscape, inspired by his enthusiasm for ▷ Claude and ▷ Rosa (e.g. *Landscape with Diogenes*, 1740, London, Victoria and Albert Museum). In many of his works, he included figures painted by others, notably his collaborations with ▷ Scott on marine subjects, and views of India for the East India Company (1732). He was a member of the ▷ Society for Artists from 1761.
Bib.: *George Lambert*, exh. cat., London, 1970

Lamentation

The subject of the followers grieving over the dead body of ▷ Christ after the ▷ Deposition and before the ▷ Entombment is not specifically mentioned in the gospel accounts of Christ's ▷ crucifixion, but the characters generally portrayed are those that the ▷ Evangelists mention as present at the crucifixion. The scene, a tableau of grief between two active scenes, was an obvious one which became established in the Christian imagination early on and which features in narrative art from the early Middle Ages onwards. Christ lies either flat on the ground, or with his head propped on his mother's lap. ▷ Mary Magdalene may be holding Christ's feet, whilst ▷ John the Evangelist, with a tear-stained face, stands close to the ▷ Virgin. Also present may be the other holy women: Mary, the wife of Cleophas, Mary, the mother of James the Less and Joses; and Mary Salome. And finally, ▷ Joseph of Arimathea and ▷ Nicodemus may be standing to one side. In medieval versions, angels may be seen swooping around in the sky overhead in contortions of extreme grief (e.g. ▷ Giotto, fresco, c1305–6, Padua, ▷ Arena Chapel). This narrative subject should be distinguished from the devotional variant, known as the ▷ Pietà.

lampblack

A very light carbon pigment made from soot.

lancet

A type of window, used extensively in ▷ Gothic cathedrals. It is narrow and capped by a pointed ▷ arch.

lancet arch

▷ arch

Lancret, Nicolas (1690–1743)

French painter. He studied with ▷ Gillot and became an imitator of ▷ Watteau. Like Watteau, he was patronized by Pierre Crozat. He specialized particularly in theatrical scenes, and his ▷ genre paintings were one of the formative influences on the English ▷ conversation piece.
Bib.: Wildenstein, G., *Lancret*, Paris, 1924

Land Art

Sometimes known as ▷ earthwork, after a 1969 exhibition at Cornell University. A development in the late 1960s based on the concept that geography and land should be the materials of art, not merely the location. Land Artists objected to use of technology and consumer products in art, as well as to contemporary movements such as ▷ Minimalism. They produced works which either transported natural objects into galleries as an ▷ installation, or used outdoor sites, creating often temporary pieces which were recorded by photographs. In many ways, therefore, they paralleled the ideas of ▷ Performance artists. During the

1970s this developed in line with ▷Conceptual Art to include the use of words and poetry to describe these artistic experiences. Increasingly also, they developed the idea of participant art in which the public would 'walk' an art object (e.g. ▷de Maria, *Mile Long Drawing*, Nevada Desert). Increasingly there is an ecological aspect to the movement. The major artists of the movement are ▷Smithson (e.g. *Spiral Jetty*, Salt Lake, 1970) and Oppenheimer in America, and ▷Richard Long (e.g. *Stones*, Connemara, Ireland, 1971) in Britain.

Bib.: Garraud, C., *L'Idée de nature dans l'art contemporain*, Paris, 1993; Tiberghien, G.A., *Land Art*, New York, 1995; Werker, P., *Land Art USA*, Munich, 1992

landscape

Originally a painter's term of Dutch derivation, 'landscape' was first used in the late 16th century to describe the representation of natural scenery in painting. Landscape was for a long time an important part of painting in the European artistic tradition, but ▷Altdorfer's *Landscape with a Footbridge* (c1520) is considered the earliest painting to treat landscape as a subject in its own right. In ▷Hellenistic and ▷Roman art the representation of nature was largely tied to illustration and decoration, often with a strong pastoral element associated with literature. The Roman's interest in the countryside is shown in their letters, poetry and enjoyment of country villas, and wall paintings from ▷Pompeii attest to the importance of natural scenes. This interest was revived during the ▷Renaissance, with artists such as ▷Leonardo and ▷Dürer making close examination of the natural world that was subsequently used in their paintings and ▷engravings, whilst the pastoral images of Classical literature influenced artists such as ▷Giorgione, ▷Peruzzi and ▷Veronese. But it was in northern Europe and the Netherlands especially that landscape really came into its own. Medieval and Renaissance Flemish paintings of religious scenes often contained detailed background of landscapes, and it was a short step for Altdorfer to focus sole attention on this aspect of painting. Towards the end of the 16th century, pastoral and idyllic landscape scenes were popularized in Rome by ▷Annibale Carracci and ▷Claude Lorrain, whilst ▷Nicholas Poussin developed a Classical, heroic landscape. By the 18th century European artists were able to draw from a number of landscape genres – the ideal, pastoral, heroic and a Netherlandish naturalism. The ▷Rococo fashion favoured the pastoral moods of ▷Watteau and ▷Gainsborough, whilst the development of ▷Romanticism and the ▷picturesque was expressed in landscape by painters such as ▷Turner, ▷Constable and ▷Friedrich. However, critical acceptance for landscape did not really arrive until the ▷Impressionist landscapes of ▷Monet and the ▷Post-Impressionism of ▷van Gogh, ▷Cézanne and ▷Seurat. In the 20th century ▷Surrealist artists such as ▷de Chirico and ▷Tanguy have explored the possibilities of the dream landscape, and the ▷Neo-Romantics have returned the mysticism and ▷sublime to nature.

landscape format

A painting or drawing, of any subject, having a greater width than height. So-called because landscapes are usually represented in this format
▷portrait format

landscape garden

A term coined in 1763 by William Shenstone (i.e. 'landskip or picturesque gardening') to denote the parkland of composed informality with which English landowners had begun surrounding their country houses in the early 18th century. It may be seen as a reaction against the extreme formal symmetry of 17th-century garden design. It derives its inspiration from the fashionable landscape paintings of ▷Claude Lorrain, ▷Gaspard Dughet and ▷Salvator Rosa, brought back to England by returning ▷Grand Tourists. The earliest examples were designed to resemble Classical landscapes with vistas framed by clumps of trees on gentle hills, a lawn sweeping right up to the house, a lake in the middle distance and the occasional Classical temple acting as a focal point. The supreme exponent of this type was ▷Lancelot 'Capability' Brown, so-called because he was able to see capabilities in any location. Among his most celebrated creations are the parks at Chatsworth, Moor Park and Longleat. The generation of designers after Brown catered for a taste which at times favoured a more ▷picturesque treatment, with Classical temples giving way to Gothic ruins, both genuine and custom-built.

Bib.: Cowell, F.R., *The Garden as Fine Art*, London, 1978; Hunt, J.D., *The Figure and the Landscape*, Baltimore, 1976; Jacques, D., *Georgian Gardens: The Reign of Nature*, London, 1983; Martin, P., *Pursuing Innocent Pleasures*, Hamden, 1984

Landseer, John (1769–1852), Sir Edwin Henry (1802–73), Thomas (1795–1880) and Charles (1799–1879)

English family of painters, sculptors and engravers. John, the father, was a landscape artist and engraver, who gave lectures to the Royal Institute on engraving (1806) and illustrated a number of books on landscapes and architecture.

Edwin was born in London, and received little education apart from artistic training. He became a child prodigy, educated by ▷Haydon, who produced ▷etchings at the age of eight and exhibited his first work at age 16. His first works were exotic animal paintings, but in 1824 he travelled to Scotland with ▷Leslie, met Walter Scott (he produced illustrations for the *Waverley Novels* 1831–41) and began to paint

Landseer at work on the Trafalgar Square Lions, c1860, The Illustrated London News, 1873

Highland subjects (e.g. *Illicit Whisky Still*, 1829, London, Victoria and Albert Museum). These included a number of powerful landscapes (e.g. *Lake Scene, Effect of Storm*, 1836, London, Tate) as well as hunting and ▷genre scenes. He was a social success, with a wide artistic and literary acquaintance – including Thackeray and Dickens – and a favourite of the royal family, whose portraits he painted (e.g. *Victoria, Albert and the Royal Princesses*, 1840–3, Royal Collection). He made a name as a painter of animals, producing a series of sentimental but highly popular images of dogs (e.g. *Dignity and Impudence*, 1839, London, Tate; *Old Shepherd's Chief Mourner*, 1837, London, Victoria and Albert Museum). He sculpted the lions at the foot of Nelson's Column (1867) and throughout his career produced work for sporting magazines. He was knighted in 1850, and turned down the offer of the Presidency of the ▷Royal Academy in 1865.

Edwin's brother, Thomas, who was also educated with Haydon and apprenticed to an engraver, engraved much of his work. His brother Charles trained with Haydon and at the Royal Academy (1816). After a trade mission to Portugal and Brazil, he exhibited his sketches at the British Institute (1828). He was a regular exhibitor of historical and literary genre at the RA (e.g. *Clarissa Howe at Spunging House*, 1833, London, National Gallery) and became Keeper of the RA (1851). He gave £10,000 ($17,000) to establish the Landseer Scholarships at the RA.

Bib.: Graves, A., *Sir Edwin Landseer*, London, 1876; *Edwin Landseer*, exh. cat., London, 1961; *Edwin Landseer*, exh. cat., London, 1981; *Landseer and his World*, exh. cat., Sheffield, 1972; Mansons, J.A., *Sir Edwin Landseer RA*, London, 1902

Lanfranco, Giovanni (1582–1647)

Italian painter. He was born near Palma. He was, with ▷Guercino and ▷Cortona, one of the founders of the High ▷Baroque style. A pupil of ▷Agostino Carracci, his mature work combines Carracci's heroic figure style with a virtuoso development of ▷Correggio's ▷*sotto in sù* illusionism, which Lanfranco would have seen in the latter's dome paintings in S. Giovanni Evangelista and the Cathedral in Palma. He went to Rome in 1602 to work as an assistant to ▷Annibale Carracci on the Farnese Gallery ceiling; his own ceiling painting for the Casino Borghese (c1616) revealing a great debt to the earlier work. His most celebrated commission, the fresco of the *Assumption* in the dome of S. Andrea del Valle, Rome (1625–7), was won at the expense of his principal rival, ▷Domenichino, the leading Bolognese Classicist. Apparently the latter was so angered, that he is said to have attempted to loosen part of Lanfranco's scaffolding in the hope that he would fall and sustain a fatal injury. The success of Lanfranco's dome fresco led directly to his employment, until 1631, at St. Peter's. In 1633 he moved to Naples. His virtuoso use of illusionistic ▷foreshortening appealed just as much to Neapolitan taste, and his work there influenced, among others, ▷Giordano, ▷Preti and ▷Solimena. His dome fresco for the Chapel of S. Gennaro in the Cathedral (again he appears to have supplanted the more Classical Domenichino, the beginnings of whose dome fresco he was in fact replacing), greatly influenced

▷Cortona's decorations for the Chiesa Nuova, Rome. Lanfranco returned to Rome in 1646, one of his latest works there being the apse painting for S. Carlo di Catinari.

Bib.: Bernini, G.P., *Giovanni Lanfranco 1582–1647*, Terenzo, 1985; Novelli, M.A., *Giovanni Lanfranco*, Milan, 1966; Posner, D., *Domenichino and Lanfranco: The Early Development of Baroque Painting in Rome*, New York, 1965

Langley, Batty (1696–1751)

English landscape gardener. He was the author of a number of books with ▷engravings of garden buildings in different styles. He helped popularize the use of ▷Gothic in English gardens and was in favour of variety in landscape design.

lantern

A cap or turret located on the top of a ▷dome. It often contains windows which allow light into the dome and can be thus used to illuminate and enhance the spectacular effect of a dome.

Lanzi, Luigi (1732–1810)

Italian art historian. He was the Keeper of the galleries in Florence from 1773, and he pursued interests in art history as well as archaeology. His principal contribution was the *Storia pittorica dell'Italia* (*History of Italian Painting*, 1792), a survey of Italian art to his own time.

Laocoön

Marble group, just under life-size, discovered on the site of the Baths of Titus in Rome in January 1506, bought soon afterwards by Pope Julius II, and thereafter housed in the Belvedere Courtyard of the Vatican Museum. It represents the Trojan priest, Laocoön, and his two sons, being crushed to death by two giant snakes as punishment for warning the Trojans against the wooden horse of the Greeks. On hearing of the discovery of the marble, Julius had sent his architect, ▷Giuliano da Sangallo, to inspect it. Giuliano (who, in turn, invited ▷Michelangelo along), apparently recognized it as the work described by ▷Pliny in his *Historia Naturalis* as being in the palace of the Emperor Titus. It was, he had written, 'of all paintings and sculptures, the most worthy of admiration', and had been executed by Hagesandrus, Polidorus, and Athenodorus of Rhodes. The dating is still problematic. It has traditionally been regarded as a product of the late ▷Hellenistic period (1st century BC). This, however, predates the sculpture's most likely source in Virgil's vivid description in the *Aeneid*. In 1957 other works, signed by the same Rhodian sculptors and subsequently dated to the 1st century AD, were found at Sperlonga, and so this dating is now gaining acceptance. From the time of its discovery, the *Laocoön* was ranked alongside the ▷*Apollo Belvedere* and the

▷*Belvedere Torso* as one of the greatest works of art of all time. Like these, the image of the *Laocoön* was disseminated widely in the form of copies, casts, and prints. It had exerted an immediate and profound impact on ▷Michelangelo, who saw in it new possibilities for the expression of a wider range of emotions (cf. Michelangelo's *St. Matthew*, Florence, Accademia, which has been dated to immediately after the discovery of the *Laocoön*, in the summer of 1506). The dramatic expression of these emotions was also important for ▷Baroque sculpture. Most curious of all was the impact it exerted upon the ▷Neoclassical theorist ▷Winckelmann, who saw in it not drama and turbulent emotion, but the dignified nobility of heroic silent suffering and a supreme example of the Greek ideal of 'noble simplicity and quiet majesty' (*Reflections on Painting and Sculpture of the Greeks*, 1755). This eccentric interpretation was not surprisingly contradicted by ▷Lessing in his *Laokoön*, published in 1766. The *Laocoön* was, along with the *Belvedere Torso* and the *Apollo Belvedere*, one of the art treasures ceded to the French in 1797 and displayed in the Louvre until its restitution in 1815. Unlike the *Apollo*, however, its reputation as a great work of antique sculpture has remained intact.

Bib.: Bieber, M., *Laocoön: The Influence of the Group since its Rediscovery*, rev. and enlarged edn, New York, 1967; Haskell, F. and N. Penny, *Taste and the Antique*, New Haven and London, 1981; Smith, R.R.R., *Hellenistic Sculpture*, London, 1991

Largillière, Nicolas de (1656–1746)

French painter. He trained in Antwerp (1674–80) and went to London where he worked with ▷Lely. From 1682 he was in Paris, where he became the rival to ▷Rigaud as a portraitist of the aristocracy and bourgeoisie. He contributed to decoration at Versailles with ▷Lebrun. He was a prolific and influential portrait painter, and towards the end of his life, in 1743, he was appointed Director of the ▷Académie Royale.

Bib.: Rosenfeld, M.N., *Largillière and the Eighteenth Century Portrait*, Montreal, 1982

Larianov, Mikhail (1881–1964)

Russian artist. He was associated with ▷Rayonism. He was born in Tiraspol and studied at the Moscow Art Institute (1898–1908), where he met his life-long companion ▷Goncharova. In 1906 he visited Paris with ▷Diaghilev and returned to promote modern international art in a series of groups and exhibitions: ▷World of Art (1906–13); ▷Golden Fleece (1907–10); ▷Jack of Diamonds (1910); and ▷Donkey's Tail (1912). He also exhibited internationally (1912 ▷Post-Impressionist exhibition in London; 1913 German Autumn Salon). His own work developed from an ▷Impressionist style (e.g. *Corner of a Garden*, 1905, St. Petersburg) to one influenced by traditional Russian art (e.g. *Relaxing Soldiers*, 1911, Moscow). In 1912 he

became interested in ▷Futurism and the following year published the Rayonist manifesto. His art developed towards ▷abstraction and abandoned ▷primitivism in favour of broken, faceted, ray-like images (e.g. *Portrait of Tatlin*, 1913–14, St. Petersburg; *Rayonist Landscape*, 1912, St. Petersburg). He travelled to Switzerland with Diaghilev in 1915 and produced designs for the Ballets Russes (e.g. *Le Renard*, 1922). He settled permanently in Paris in 1917.
Bib.: Gray, C., *The Russian Experiment in Art*, London, 1979; Larianov, I., *Larianov*, Winnipeg, 1990; Parton, A., *Mikhail Larianov and the Russian Avant-Garde*, Princeton, 1993

Larkin, William (d 1619)
English painter. He was known for his portraits painted in oval formats, and for his skill and virtuosity.

Laroon (Lauron), Marcellus (1653–1701/2) and Marcellus Laroon the Younger (1679–1772)
Dutch family of artists. The elder Laroon came to London from The Hague. There he worked as an assistant to ▷Kneller, and produced an ▷engraved series of the 'Cryes of London' showing London street performers and buskers in their characteristic activities. His son was an actor, soldier and musician, who specialized in ▷*fête galante* scenes in the manner of ▷Watteau. He was also one of the first artists to paint the type of group portrait known as a ▷conversation piece.
Bib.: Raines, R, *Marcellus Laroon*, London and New York, 1967

Larsson, Carl (1853–1919)
Swedish painter. He specialized in ▷watercolours of everyday life scenes, which he produced both in France in the 1880s and in Switzerland. He also produced large ▷murals.
Bib.: *Carl Larsson*, exh. cat., London, 1983

Lascaux
The site of probably the most famous prehistoric cave-paintings in the world, near Montignac, Dordogne, southern France. The cave was discovered by schoolboys in 1940, and studied in depth by H. Breuil and F. Windels. The paintings show stylized representations of prehistoric animals, often using a twisted perspective that shows the body in profile but horns or antlers seen from the front. Tentatively dated to the later Aurignacian period/15,000 BC, the cave was closed in 1963 due to deterioration to the paintings caused by thousands of visitors.

Laserstein, Lotte (1898–1993)
German painter. She grew up in Danzig, but moved to Berlin in 1912. There she attended the Berlin Academy and won a gold medal in 1925. After this she opened her own studio and took a number of students. She specialized in a ▷Neue Sachlichkeit style, and, like many women artists of the 1920s, painted striking self-portraits. She was forced to close her studio with the rise of the Nazis in 1935, and went to Sweden, where she gradually abandoned Neue Sachlichkeit precision for a looser style.
Bib.: Stroude, C. and A. Stroude, 'Lotte Laserstein and the German Naturalist Tradition', *Women's Art Journal*, 9/1 (1988), pp. 35–9

Last Judgement
The second coming of ▷Christ and a time of general resurrection, when sinners and saved will finally be separated for eternity. The event is described in the Book of ▷Revelation but is foretold elsewhere in the Bible (▷St. Matthew described the separation of the sheep from the goats). The early Church expected the second coming in 1000, and, when this failed to materialize, depictions of the Last Judgement became increasingly common. Typically, the scene portrays Christ as a central figure, surrounded by apostles and saints, with his mother, ▷Mary, at his right hand, interceding for the souls of the dead. He may be seated on a throne, a rainbow or simply among the clouds of heaven. Angels convey the saved upwards. St. Michael, clad in armour and winged, may be represented with scales to weigh the souls or a drawn sword to bar the sinners from heaven. Hell was often shown as gaping jaws, or a dark cavern. Increasingly Classical references were included (e.g. the presence of ▷Charon; Michael represented as ▷Mercury). The strict hierarchy of early representations became increasingly loose and chaotic (e.g. ▷Giotto, ▷Arena Chapel, Padua, 1305; ▷Signorelli, Orvieto Cathedral, 1399–1404; ▷Michelangelo, ▷Sistine Chapel, 1536–41; ▷El Greco, 1579–80, Madrid; ▷Spencer, 1923–6, London, Tate).

Last Supper
The story narrated in all ▷gospels of the Passover meal held by Christ and his disciples on the Thursday before Easter, at which Jesus announced that one (▷Judas) would betray him and one (▷Peter) would deny him; and when the first ▷Eucharist was celebrated. In early representations the emphasis was on the ▷Sacrament, with Christ as an almost priest-like figure. The table was often D-shaped, and the figures might be shown reclining as was the Roman custom at meals. By the early ▷Renaissance, the tradition of a long table, with Christ at the centre, had been established. By the 15th century, the emphasis was increasingly on the human drama, with Judas separated from the rest by his appearance (e.g. ▷Leonardo da Vinci, Sta Maria delle Grazie, Milan, 1596–8), and often by being placed on the opposite side of the table (e.g. ▷Castagno, 1445, Florence). ▷Baroque representations increased the drama and the number of figures (e.g. ▷Tintoretto, 1592–4, S. Giorgio, Venice). Another incident some-

times shown was the washing of the disciples' feet by Christ, emphasizing his humility.

Last Supper, The

A wall-painting by ▷Leonardo da Vinci in the convent of the Dominican Friars at Santa Maria della Grazie, Milan, begun c1495 and finished c1497. Described by ▷Kenneth Clark as 'the climax of Leonardo's career as a painter', the image has deteriorated badly and suffered from repeated efforts at restoration. Leonardo's slow working methods and his experimental techniques, using a mixture of oil and ▷varnish rather than traditional ▷fresco, were as much to blame as the damp wall he worked upon. As early as 1556 ▷Vasari described it as 'so badly handled that there is nothing visible except a muddle of blots'. Leonardo departed from traditional representations of this popular New Testament scene, concentrating on the moment when Jesus announces his forthcoming betrayal. Contemporaneous treatments of the subject, such as by ▷Ghirlandaio and ▷Perugino, focused on the conventional moment of the breaking of the bread and wine. Despite their damaged form, Leonardo's figures retain some of the characterization and gesture that make this an important work on the route to ▷Renaissance ▷Mannerism.

Lastman, Pieter (1583–1633)

Dutch painter. He travelled to Italy (1603–7), where he was influenced by the ▷chiaroscuro of ▷Caravaggio and the tonal properties of ▷Elsheimer's work. He returned to Amsterdam to produce religious works which contained distinctive crowd scenes and a skilful use of gesture and expression. In c1624, Rembrandt became his pupil, and he also taught ▷Lievens.

Bib.: Tümpel, A., *Pieter Lastman: leermeester van Rembrandt*, Zwolle, 1991

Latin America, art in

The geographical and, in some ways, emotional unity of the arts in Mexico, Central and South America has often led to them being classified as 'Latin American' – despite their variety and diversity. Although the history of different Latin American nations is complex, certain general patterns can be determined in speaking of their history of art. The beginnings of Latin American art were ancient, with aboriginal populations in Mexico and the Andes producing decorated pottery as early as 8000 BC. Among indigenous populations, the Aztecs and Incas were skilful engineers and erected monumental public and religious edifices. Andean art also included richly decorated objects such as textiles and ceramics. In Central America, the Maya produced complex pictographic statuary.

Throughout Latin America, a phase of imperialism and European influence entered art from the Spanish defeat of the Incas in 1532. For several hundred years, Spanish and Portuguese explorers and colonists brought contemporary ▷Renaissance, ▷Baroque and ▷Plateresque styles in painting and architecture. In the 19th century, Latin American nations began gaining independence, although they did not shake off European influence for many years. For example, the independent state of Argentina dates from 1816. Its lack of an artistic heritage was thus filled temporarily

Leonardo da Vinci, *The Last Supper*, c1495–7, Santa Maria della Grazie, Milan

by expatriate Europeans who translated scenes of local Argentine life into prevailing modes of ▷genre and landscape. Brazil gained independence from Portugal in 1822, and at that time, and for many years afterwards, its art and architecture relied heavily on European models. This European influence was enhanced in 1816, when a group of French artists, such as Nicolas Taunay (1755–1830) and August Grandjean de Montigny (1776–1850) founded an ▷academy there. The first academy (the Academy of San Carlos) had appeared in Mexico under Spanish dominion in 1781, but other academies were founded in Latin America after countries became independent.

The flowering of an independent Latin American art did not come until the 20th century, when political instability ironically bred artistic fecundity. Three distinctive tendencies can be isolated in 20th-century Latin American art. First of all, a self-conscious exploration of European and American ▷modernism was important to artists in most countries. Modernism appeared with the growth of an ▷avant-garde in Mexico, Cuba, Argentina, Chile and Brazil during the 1920s, ushered in by notable events such as the Modern Art Week, held in São Paolo in 1922. Latin American artists practised ▷Expressionism (▷Rivera), ▷Constructivism (▷Torres-García), as well as ▷Surrealism (▷Battle-Planas, ▷Lam and ▷Matta). Surrealism was particularly important for artists after ▷Breton visited Mexico in 1938. The most distinctive contribution of Brazil to modern art was in the form of architecture. In 1936, on a trip to Rio de Janeiro, ▷Le Corbusier advised local architects on a new public building scheme. The subsequent Ministry of Education and Health, and designs of Oscar Niemeyer and others, revealed the possibilities of adapting ▷International Style ▷modernism to a tropical climate. A second major tendency was politicized realism, which appeared with fascist dictatorial regimes in Argentina and Brazil during the 1920s and 1930s. Artists looked to ▷Novecento art for their inspiration. Finally, the 20th century is characterized by an exploration of indigenismo, or indigenous art. Artists from 1900 onwards looked to the Indian roots of Latin American art. This influenced the public style and orientation of the Mexican Muralists, as well as the work of artists exploring questions of national identity during the period 1960–90. Towards the end of the 20th century, Latin American art has been also characterized by an exploration of new materials, such as light and plastic, as well as new modes of representation, such as ▷kinetic art (▷Le Parc; ▷Groupe de recherche d'art visuel).

▷Mexico, art in; Pre-Columbian art

Bib.: Ades, D. (ed.), *Art in Latin America*, exh. cat., London, 1989; Gilbert Chase, *Contemporary Art in Latin America: Painting, Graphic Art, Sculpture, Architecture*, New York, 1970; Lucie-Smith, E., *Latin American Art of the 20th Century*, London, 1993

Latin Cross

A cross in which the upright is significantly longer than the cross-piece and the two arms of the cross-piece and that part of the upright above the crossing are all of equal length.

Latrobe, Benjamin Henry (1766–1820)

American architect of English birth. He is best known for his ▷Neoclassical buildings, in a stark, Greek style. In 1803 ▷Thomas Jefferson appointed him Architect to the Capitol (Washington DC), and many other subsequent state capitol buildings were based on his model.

Bib.: Cohen, J.A., *The Architectural Drawings of Benjamin Henry Latrobe*, New Haven, 1994

lattice

The diamond pattern formed by an arrangement of structures, usually metal or wooden bars, which sometimes occupy the space of a window. The term can also refer to diamond shapes woven in textiles.

Laurana, Francesco (c1430–1502)

Italian sculptor of Dalmatian birth. He worked in Naples in 1453 and in France from 1461 to 1466 and again from 1477 to 1484. He worked for the royal family while in Naples, and he specialized in tomb sculpture and busts of women. One of his most notable works was the Chapel of St. Lazarus in the Old Cathedral at Marseilles.

Laurencin, Marie (1885–1956)

French painter. She was born in Paris, but despite being surrounded by artists' studios had no formal training. In 1905 she met ▷Picasso and ▷Apollinaire, the latter of whom became her lover. She began painting, and from 1908 adopted a ▷Cubist style. She broke with Apollinaire and his circle as the First World War approached, but she remained in Paris, where she produced theatre and ballet designs, book illustration and ▷pastel paintings. Her subject matter was concentrated on themes of actors and circuses. Her later work showed the influence of Persian miniatures.

Bib.: Fagan-King, J., 'United on the Threshold of the Twentieth-century Mystical Ideal: Marie Laurencin's Integral Involvement with Apollinaire and the Inmates of the Bateau-Lavoir', *Art History*, 11 (1988), pp. 88–114; Groult, F., *Marie Laurencin*, Paris, 1987

Laurens, Henri (1885–1954)

French sculptor. He was born in Paris and trained with a decorator there. In 1902 he lived in Montmartre, where he met a number of other artists. Contact with ▷Braque in 1911 led him towards ▷Cubism, but he concentrated his energies on sculpture and was more interested in ▷polychromy than many other Cubists. During the 1920s, his sculpture became more ▷biomorphic, and in the 1930s he earned the patronage of Helena Rubenstein, who was particularly impressed

by his mythological subjects and ▷terracotta work.
Bib.: *The Sculpture of Henri Laurens*, New York, 1970

Lautrec
▷Toulouse-Lautrec, Henri de

Lavery, Sir John (1856–1941)
Irish painter. He was born in Belfast and trained there, in London (1879) at Heatherley's Academy, and in Paris (1881) at the ▷Académie Julian under ▷Bouguereau and at the Académie Colarossi. He was influenced there by the ▷Impressionists towards a free, ▷*plein air* naturalism, best seen in his work at Grez-sur-Loing, where he spent the summers with O'Meara. In 1885 he settled in Glasgow and became associated with the ▷Glasgow Boys. He travelled to Spain (where he admired the work of ▷Velázquez) and North Africa with Crawhall in 1890, and bought a house in Tangiers. His moderate ▷Impressionism, similar to that of ▷Sargent, was exploited in ▷*plein air* leisure subjects (e.g. *Tennis Party*, 1885, Aberdeen). By the 1890s, however, he had turned from landscape to portraiture, and became a successful interpreter of society, based in London from 1896 (e.g. *Royal Family*, 1913, National Portrait Gallery). He was an official War artist in 1917. He was elected ▷RA in 1921 and knighted in 1918.
Bib.: Lavery, J., *Life of a Painter*, London, 1904; *John Lavery*, exh. cat., Belfast, 1984

Lawrence, Sir Thomas (1769–1830)
English painter. He was primarily a portraitist. He was born in Bristol. Largely self-taught, he was a child prodigy, who made a living as a portrait draughtsman in Oxford from 1779 and Bath (1782–6), before coming to London in 1786. He entered the ▷Royal Academy Schools, gained the admiration of ▷Reynolds, and made rapid progress as a painter of society and royalty (e.g. *Miss Farren*, 1790, New York; *Queen Charlotte*, 1789–90, London, National Gallery). He became Painter-in-Ordinary to the King in 1792 and was commissioned by the Prince Regent in 1818 to tour Europe painting heads of state for the Waterloo Chamber at Windsor. After 1800 much of his work suffered in quality from over-production, necessary because of his continual debts. He was also a collector of art, especially of ▷Old Master drawings (now in the Ashmolean Museum, Oxford). He became ▷RA in 1794, was knighted in 1815 and appointed President of the RA (▷PRA) in 1820. He developed a flamboyant style, using textured, loosely applied brushwork and creating the appearance of spontaneous naturalism in his sitters which was to inspire French artists like ▷Delacroix. Although primarily a portraitist, he also produced historical subjects (e.g. *Satan Calling his Legions*, 1797, London, Royal Academy).
Bib.: Garlick, K., *Sir Thomas Lawrence*, London, 1989; *Sir Thomas Lawrence*, exh. cat., London, 1979; West, S., 'Thomas Lawrence's "Half-History" Portraits and

the Politics of Theatre', *Art History*, 14 (1991), pp. 225–49

Lawson, Ernest (1873–1939)
American painter. During the 1890s he studied at Kansas City, the ▷Art Students' League and in Paris at the ▷Académie Julian. He was influenced by ▷Impressionism in Paris, and adopted their focus on country and leisure scenes to his own views of American life. He was one of the original members of ▷The Eight, and he exhibited in the ▷Armory Show in 1913.

lay figure
An artist's wooden figure of any size, from a few inches high to life-size, articulated so that it may be made to adopt any pose desired. In particular, they have been used by ▷history painters to work out multi-figure compositions and, suitably attired, they have been used by portraitists, in order to paint the costume in the subject's absence, thus avoiding unnecessary sittings. The earliest known description of a lay figure is given by ▷Filarete in his *Treatise on Architecture* (1461–4), whilst ▷Vasari in his *Lives* (1550) records that ▷Fra Bartolommeo used a life-size lay figure.

laying in
In traditional oil painting, as opposed to the direct ▷*alla prima* method, the painter would carefully draw out the design on the support, and then lay in the tonal values in a monochrome 'dead colour' such as brown, grey or green. The colour would be added only after the tonal values of the whole composition were established.

Lazarus
(i) The brother of Martha and Mary who died at Bethany. According to the gospel of St. John, Christ came four days after the death, removed the stone at the mouth of the tomb, and Lazarus walked out. The scene is commonly depicted with kneeling women. In early representations the body is shown buried upright, as was the tradition, but by the ▷Renaissance artists showed a coffin (e.g. ▷Caravaggio, 1606–9, Messina). (ii) An episode in St. Luke's Gospel in which a leper, left to die at Dives' (a rich man's) gate, enters heaven, whilst the owner goes to hell. Lazarus became the medieval patron of beggars.

Lear, Edward (1818–88)
English artist, writer and traveller. He was born in Holloway, of Danish origins. By age 15 he was earning a living with his drawings of birds. From 1831 he was employed by the Zoological Society as a draughtsman. He worked for Lord Derby at his Knowsley menagerie (1832–6), and began to entertain the children there with what became his *Book of Nonsense* (1846). He travelled widely, after 1837, largely because of his

health, and increasingly took up landscape. He worked in Rome as a drawing master and travelled to India at the invitation of the Viceroy. He worked in both oils and ▷watercolours, showing exotic landscapes in a style reminiscent of ▷David Roberts (e.g. *Forest of Bavella*, 1878, private collection). Much of his work was also published: *Illustrated Excursions in Italy* (2 vols, London, 1846); *Journal of a Landscape Painter in Corsica* (London, 1870). He was Drawing Master to Queen Victoria in 1840. He died in San Remo.
Bib.: Davidson, A., *Edward Lear*, London, 1938; Dehejia, V., *Impossible Picturesqueness: Edward Lear's India Watercolours*, New York, 1989; *Edward Lear*, exh. cat., London, 1985; Lehmann, J., *Edward Lear and his World*, London, 1977; Levi, P., *Edward Lear: A Biography*, New York, 1995; Noakes, V., *Edward Lear: Painter*, Newton Abbot, 1991

Lebrun, Charles (1619–90)

French painter and art theorist. He studied in Italy from 1642 to 1646, and was instrumental in founding the ▷Académie Royale de Peinture et de Sculpture in 1648. He was First Painter to the King from 1664, Inspector-General of Louis XIV's collections (including the Gobelins and furniture factories) from 1663, and Rector of the Academy from 1668. Because of his Academy lectures (including a famous one on the expression of the emotions), as well as his other positions in the art world of Louis XIV, it is not surprising that Lebrun was no less than the arbiter of taste for the King's Grand Siècle. Far more than just a painter, he saw to palace decoration, furniture and taste in general, and stamped his own modified ▷Baroque style on French art at the same time as his Academy taught students to follow a similar path.
Bib.: Hargrove, J. (ed.), *The French Academy: Classicism and its Antagonists*, Newark, 1990; Montagu, J., *The Expression of the Passions: The Origin and Influence of Charles Le Brun's 'Conférence sur l'expression générale et particulière'*, New Haven and London, 1994

Leck, Barth (Bart) Anthony van der (1876–1959)

Dutch painter. He was born in Utrecht, and studied there and at Amsterdam. His early works were in the mode of the ▷Hague School, but he veered away from representational art as the First World War approached. In 1917, he joined the ▷De Stijl movement, and his work became more geometrical. Throughout the 1920s and 1930s, he specialized in decorative art and textiles.

Le Corbusier (Charles-Édouard Jeanneret) (1887–1965)

French architect. He was born in Neuchâtel, Switzerland, but became a French citizen in 1930. From 1900 he attended the local art school under L'Eplattenier. He travelled regularly to Italy, and in 1906 won

Le Corbusier, *Ligne de Main*, 1930

a Milan exhibition diploma. In 1907 he visited England and Paris, where he studied briefly with the architect Auguste Perret. In 1910 he was commissioned to write a book on German decorative art and spent part of his time working in ▷Behrens' practice. From 1916, he was based in Paris, where he became interested in ▷Cubism, through his friendship with ▷Ozenfant. He painted a number of ▷Purist, geometric works and published the tract *Après le Cubisme* (*After Cubism*, 1918). By the 1920s, he had turned his attention to architecture again, with his famous *Vers une Architecture* and a series of domestic houses (e.g. Villa Savoye, 1928–31) which applied his 'five points' (free plan, free façade, ribbon windows, roof garden and pilotis [stilts]). The elegant, clean lines in reinforced concrete mirrored his paintings. During the 1930s this purity was reduced, as texture, imbalance and solidity were used, and he began to apply himself to the challenge of mass housing (e.g. Swiss Pavilion, Paris, 1930–32). He also produced a series of plans for ideal modern cities (e.g. Ville Radieuse, 1930), partially realized after the Second World War in his Unité d'Habitation (1946–51, Marseilles) with its internal shops, rooftop leisure facilities and cell-like flats. The exterior, broken by a series of sunscreens, pointed the way forwards to his later work, which became increasingly ▷Expressionist and organic (e.g. Nôtre Dame du Haut, Ronchamp, 1955). When he finally designed a city, Chandigarh (1953–63), it was not along the clean lines of the 1920s but with a sense of drama and local character. His work was some of the most influential produced this century.
Bib.: Besset, M., *Le Corbusier*, Geneva, 1992; Blake,

P., *Le Corbusier: Architecture and Form*, Baltimore, 1964; Boesiger, W., *Le Corbusier*, Barcelona, 1994; Evenson, N., *Le Corbusier: The Machine and the Grand Design*, New York, 1969; Gans, D., *The Le Corbusier Guide*, London, 1987; Jenger, J., *Le Corbusier: architecture pour émouvoir*, Paris, 1993; Jencks, C., *Le Corbusier and the Tragic View of Architecture*, London, 1973; Walden, R., *Open Hand: Essays on Le Corbusier*, London, 1977

Leda and the Swan

In ancient Greek mythology, the wife of Tyndareus, King of Sparta. Leda was desired by Zeus (▷Jupiter), who transformed himself into a swan and copulated with her. She laid two eggs, from one of which were born the twins Castor and Pollux, and from the other, Helen of Troy and Clytemnestra. Leda may be depicted naked and standing with the swan leaning against her, caressing her leg with his wing (e.g. ▷Ammanati, marble statue, London, Victoria and Albert Museum). In paintings of the subject, the two hatched eggs may lie nearby with the newly emerged twins. Alternatively Leda may be depicted reclining, or lying on her back, and actually copulating with the swan (e.g. the lost painting of 1529–30 by ▷Michelangelo, of which a contemporary copy is at the National Gallery, London).

Ledoux, Claude-Nicolas (1736–1806)

French architect. He began his career designing houses for patrons in Louis XVI's court, and his most notable contribution to Paris architecture was a series of 46 city gates, which he designed in the 1780s. He is most famous today for his utopian architectural plans, in which cities are conceived of as consisting of monumental, starkly ▷Neoclassical buildings, whose functions are strictly defined. Few of these designs were realized, but later they were influential on the functionalism of early 20th-century architecture. Some of Ledoux's ideas were articulated in his theoretical treatise *L'Architecture considérée sous le rapport de l'art* (*Architecture Considered in Relation to Art*, 1804).
Bib.: Vidler, A., *Claude-Nicolas Ledoux: Architecture and Social Reform at the End of the Ancient Regime*, Cambridge, MA, 1990

Leduc, Ozias (1864–1955)

Canadian painter. He was from Quebec, and studied in Paris in 1897, where he absorbed ▷Symbolist ideas. In Canada, he painted still lifes and did liturgical decoration.

Leech, John (1817–64)

English illustrator. He was best known for his many contributions to the humorous magazine *Punch* from 1841. He produced thousands of pictures for that periodical, as well as illustrations for Dickens' Christmas books.

Bib.: Houfe, S., *John Leech and the Victorian Scene*, Woodbridge, 1984

Le Fauconnier, Henri (1881–1946)

French painter. He studied in Paris, where, in 1906, he met ▷Dunoyer de Segonzac and ▷La Fresnaye at the ▷Académie Julian. In that same year, he produced paintings in Brittany which showed his admiration for the work of ▷Cézanne, and in 1910 to 1911 he exhibited with the ▷Cubists. He was also involved with German ▷Expressionist artists and was a member of the ▷NKV and a contributor to the ▷Blaue Reiter Almanac. The Expressionist aspect of his work dominated both before and during the First World War, which he spent in the Netherlands. In the 1920s, he returned to Paris.

Léger, Fernand (1881–1955)

French painter. He was originally trained as an architect's draughtsman and photographic retoucher. Having failed the entrance exam to the ▷École des Beaux-Arts in 1903, he studied at the École des Arts Décoratifs and the ▷Académie Julian. In 1909 he ranked as one of the three major ▷Cubists and became a member of the Puteaux group in 1911. He was the first of the Cubists to experiment with non-figurative ▷abstraction, contrasting curvilinear forms against a rectilinear grid. He renounced abstraction during the First World War, when he claims to have discovered the beauty of common objects, which he described as 'everyday poetic images'. He began painting in a clean and precise style, in which objects are defined in their simplest terms in bold colours, taking cityscape and machine parts as his subject matter. In 1924 he made a 'film without scenario', *Ballet Mécanique*, in which he contrasted machines and inanimate objects with humans and their body parts. During the Second World War, Léger lived in the USA where he taught at Yale, returning to Paris in 1945, when he opened an academy. His large paintings celebrating the people, featuring acrobats, cyclists and builders, thickly contoured and painted in clear, flat colours, reflected his political interest in the working class, and his attempt to create accessible art. From 1946 to 1949 he worked on a ▷mosaic for the façade of the church at Assy, produced windows and tapestries for the church at Ardincourt in 1951, as well as windows for the University of Caracas in 1954. In 1950 he founded a ▷ceramics studio at Biot, which, in 1957, became the Léger Museum. In 1967 it became a national museum. Léger was one of the giants of French painting this century, whose influence has been almost as great as his reputation.
Bib.: Bauquier, G., *Fernand Léger: catalogue raisonné*, Paris, 1993; Fauchereau, S., *Fernand Léger: A Painter in the City*, London, 1994; *Fernand Léger*, exh. cat., Paris, 1971; Neret, G., *Fernand Léger*, London, 1993

Legros, Alphonse (1837–1911)

French painter, sculptor and graphic artist. He was born in Dijon. After a poor childhood, he was apprenticed to a builder and decorator in Dijon. He travelled to Paris as a scene painter and trained there as an engraver under Boisbaudran. He entered the ▷École des Beaux-Arts in 1855 and had his first ▷Salon success two years later. He became part of the ▷Realist circle, and friends with ▷Whistler, ▷Fantin-Latour, ▷Courbet and ▷Manet. After exhibiting at the ▷Salon des Refusés (1863), he was encouraged by Whistler to settle in London and eventually became a British citizen in 1881. He became known for his ▷Realist subject matter, portrayed with sentiment and a clear draughtsmanship reminiscent of ▷Ingres (e.g. *Ex voto*, 1861, Dijon; *Angelus*, 1859, private collection; *Calvaire*, 1874, Paris). In London he gained a reputation as a teacher, first at the Kensington School of Art and later at the ▷Slade (1876–92), where he was professor of ▷etching.
Bib.: *Alphonse Legros*, exh. cat., Dijon, 1988; Weisberg, G., *The Realist Tradition in France*, Chicago, 1980; Wilcox, T., *Alphonse Legros, 1837–1911*, London, 1989

Lehmbruck, Wilhelm (1881–1919)

German sculptor. He was the son of a miner. He studied in Düsseldorf at the Academy and at the School of Applied Art. He was in Paris 1910–14, where he became interested in the work of ▷Rodin, although the simplicity of his own forms was more akin to that of ▷Maillol. While in Paris, he was also impressed by the work of ▷Brancusi and ▷Archipenko and maintained their clarity of form. He worked in both modelling and casting. The simplicity and emotional appeal of forms such as *Kneeling Woman* (1911) gave his work an ▷Expressionist quality. He worked in a military hospital during the First World War, but his pacifist tendencies led to depression. He committed suicide when the War was over.
Bib.: Hoff, A., *Wilhelm Lehmbruck: Life and Work*, London, 1969

Leibl, Wilhelm (1844–1900)

German painter. He was from Cologne. In 1869 he met ▷Courbet and was influenced by his ▷Realist style. He was disgusted with the urban art scene in Munich and withdrew to Bavaria, where he painted many peasant scenes and portraits. His realist style is exemplified by such works as *Three Women in a Church* (1878–82, Hamburg, Kunsthalle), and his peasant subject matter appealed to a later generation of nationalistic Germans.
Bib.: Petzet, M., *Wilhelm Leibl und sein Kreis*, Munich, 1974

Leighton, Lord Frederic (1830–1896)

English painter and sculptor. He was the son of a Scarborough doctor. From 1839 he travelled widely throughout Europe, studying at Berlin (1843), Florence (1845) and Frankfurt (1846), where he was influenced by the ▷Nazarenes, Rome (1852), where he produced *Cimabue's Celebrated Madonna is carried in Procession Through the Streets of Florence* (1855, Royal Collection) and Paris (1855–8), before settling in London in 1859. By 1864 he had achieved popularity and academic success, and had purchased a house on Holland Park Road which became a centre of fashion, and famous for its Arab hall, designed by Leighton himself (1877–9). He continued to travel widely, and exotic influences played a major role in his increasingly ▷aesthetic paintings of mood and beauty (e.g. *Music Lesson*, 1877, London, Guildhall). He painted his first nude in 1867, and went on to produce many monumental recreations of mythology and antiquity (e.g. *Actea, Nymph of the Shore*, 1868, London, Tate; *Perseus and Andromeda*, 1891, Liverpool). He was an accomplished portraitist (e.g. *Sir Richard Burton*, 1876, London, National Portrait Gallery). He also experimented with sculpture (e.g. *Athlete Struggling with a Python*, 1874–7, London, Tate Gallery). He was elected ▷RA in 1868 and made President in 1878. He was ennobled in 1896.
Bib.: Barrington, R., *Life, Letters and Works of Frederic Leighton*, 2 vols, London, 1906; Newall, C., *The Art of Lord Leighton*, Oxford, 1993; Ormond, L. and R., *Lord Leighton*, London, 1975; *Frederic Leighton 1830–96*, exh. cat., London, 1996.

lekythos

Ancient Greek oil jug, with an almost cylindrical body tapering towards the foot, a vertical handle resting on the high shoulder and set against the short narrow neck, and a small mouth.

Lely, Sir Peter (1618–80)

English portrait painter of Dutch birth. He was born in Soest, in Westphalia, of Dutch parents. He studied in Haarlem and became a member of the Haarlem Guild in 1637. In c1643 he came to London, where he made a successful career, taking advantage of a lacuna following the deaths of ▷van Dyck and ▷Dobson. He was appointed Principal Painter to the King in 1661, and was knighted in 1679. During his career, he painted portraits of Charles I and Charles II as well as Oliver Cromwell. He was particularly skilled at producing sensuous portraits of women, as indicated by his series of court 'Beauties', now at Windsor Castle. His sumptuous and sensual style was balanced by repetitious postures resulting from the extensive use of pattern books and studio assistants.
Bib.: Beckett, R.B., *Lely*, London, 1951

Portrait Photograph of Frederic, Lord Leighton, J.P. Mayall, for the 'Artists at Home' series, 1884, private collection

Lemoyne (Lemoine), François (1688–1737)

French painter. He was official painter to Louis XV from 1736, at which time he painted ceilings at Versailles, including that in the Salon d'Hercule. He also did work for churches. He followed the patterns of ▷Lebrun and was the teacher of ▷Boucher. He committed suicide.

Lemoyne, Jean-Baptiste the Younger (1704–18)

French sculptor. He was one of a family of sculptors. His father was Jean Baptiste the Elder (1679–1731), who was a figure and portrait sculptor. The Younger Lemoyne was also a portrait sculptor, who worked for Louis XV at Versailles. He had a series of important and distinguished students, including ▷Falconet, ▷Pigalle and ▷Houdon.

Le Nain, Antoine (d 1648), Louis (d 1648) and Mathieu (1607–77)

French family of painters. Le Nain was the family name of three brothers, Antoine, Louis and Mathieu. Only about 15 paintings by the brothers are signed and dated. The question of ▷attribution to each of the brothers is made problematic as none are signed with a forename and all the dates are before 1648, the year that Antoine and Louis both died. The few known facts about the brothers are as follows. They were born in Laon and were all in Paris by 1630. In 1633, Mathieu was appointed painter to the City of Paris and in 1648 all three brothers were founder members of the French Academy (▷Académie Royale). Mathieu went on to become even more successful and wealthy and was,

by 1652, Painter to the King. Within the corpus of paintings signed by and attributed to the brothers, three groups have been assembled and allotted to the brothers. To Antoine is ascribed a group of small-scale pictures of family scenes, sometimes bourgeois, sometimes peasant, mostly painted on copper in strong colours and with the spatial relationships between the figures somewhat uncertain. A much larger group, mainly of peasant scenes, but with some religious and mythological subjects, is attributed to Louis. These pictures are on a larger scale; they are much more Classically composed and the colour is in a more subdued, cool range. The peasants in Louis' pictures are painted with a quiet dignity that make them among the finest of their type (e.g. *Peasants at Supper*, c1645–8, Paris, Louvre). Though without the savage satirizing of Bamboccio (▷Bambocciata), the stylistic influence of that painter may suggest that Louis had spent some time in Rome. The remainder of the works, attributed to Mathieu, reveal a style deriving in part from Louis, but above all to the Dutch school, particularly the Utrecht ▷Caravaggisti (e.g. *La Tabagie – Le Corps de Garde*, 1643, Paris, Louvre). Although Louis is thus considered to be the best of the brothers, the specific ascriptions are only traditional and depend mainly on a now discredited belief that Antoine was older and therefore would have had a more archaic style. Though he is now believed to have been born about the same time as Louis, the ascriptions have been retained for convenience.

Bib.: Rosenberg, P., *Toute l'oeuvre peinte des Le Nains*, Paris, 1993

Lenbach, Franz von (1836–1904)

German painter. He studied in Rome 1858–9, and was in Rome again in 1863 with ▷Arnold Böcklin. He specialized in portraits and became the darling of German society during the last decades of the 19th century. He was patronized strongly by Bismarck, for whom he produced over 80 portraits. His works are skilled but superficial, and exemplify the image projected by a prosperous liberal regime.

Bib.: Wichman, S., *Franz von Lenbach und seine Zeit*, Cologne, 1973

Le Nôtre, André (1613–1700)

French landscape gardener. He was responsible for laying out the grounds of numerous châteaux and town houses. His most important and influential commissions were for Vaux-le-Vicomte (1656–61) and Versailles (1662–90). Their gardens are characterized by geometrically conceived parterres (see especially the Grand Trianon, Versailles) and their parks by straight avenues radiating from *ronds-points*, accentuated by fountains.

Leochares

Greek sculptor working in the mid-4th century BC. He worked for Alexander the Great and is said to have produced the ▷*Apollo Belvedere*.

Leonardo da Vinci (1452–1519)

Italian artist and scientist. He was one of the most imaginative and important thinkers of the High ▷Renaissance. The small number of paintings he produced was complemented by voluminous notebooks filled with evidence of his scientific interests and inventions. He was born near Vinci in Tuscany, but his artistic training began in Florence where he was a member of the ▷guild of St. Luke. He studied with ▷Verrocchio, and it has been suggested that he may have painted an angel in Verrocchio's *Baptism of Christ* (c1472, Florence, Uffizi). The idealized kneeling angel certainly stands out in the work, and Leonardo worked with Verrocchio until 1476. By 1482 he was in Milan, where he produced both court portraits and altarpieces. He worked for the ▷Sforza family while there, and he produced designs for a Sforza Monument under the direction of Duke Ludovico. In his early works, he showed an interest in ▷physiognomy that would remain important to him throughout his career. Important paintings such as the *Adoration of the Magi*, produced at this time, were left unfinished, and Leonardo's inexhaustible artistic curiosity often led him to abandon projects to follow other paths of enquiry. There he also painted the famous *Last Supper* (c1495–8) for the refectory of Sta Maria delle Grazie. The painting technique he used for this outstanding work was faulty, and from his lifetime onwards, there has been a constant battle to restore and maintain his creation. Here again Leonardo showed his ability to observe human response and reaction in his careful depiction of the reactions of each of Christ's disciples. While in Milan, Leonardo also began to use ▷sfumato in his paintings to enhance the expressions of his figures as well as the mood of the work. This can be seen most notably in the two versions of the *Virgin of the Rocks* (one in London, National Gallery; the other in Paris, Louvre).

In Milan he began to make numerous sketches which explored artistic concerns such as human and animal anatomy, but which also represented his own inventions and experiments in engineering as well as architecture. These notebooks were produced throughout his career, and among their pages can be found representations of ideal buildings (later influential on High Renaissance and ▷Baroque architecture), as well as some of the earliest known ▷caricatures.

He left Milan in 1499, when the Sforzas were deposed, and travelled to other parts of Italy. During this period, he worked as an engineer for Cesare Borgia in Florence, and he also went to Rome. While in Florence, he painted the ▷*Mona Lisa* (1503–6), which is most famous for its mysterious smile but really represents a further stage in his experimentation with expression in portraiture. In 1504–5 he also produced a cartoon for a fresco representing the Battle of Anghiari. This was intended for the Palazzo Vecchio in Florence, and if it had been completed, it would have been an outstanding example of public ▷battle painting. The original cartoon is now lost and survives only in copies. In 1516 he was invited to France by Francis I, and he died there. His art was an important influence on early ▷Baroque painting, and his writings, published posthumously (1651) as *The Treatise on Painting*, were important to subsequent ▷academic art theory throughout Europe.

Bib.: Kemp, M., *Leonardo da Vinci: The Marvellous Works of Nature and Man*, London, 1981; Kemp, M. (ed.), *Leonardo on Painting*, New Haven, 1989

Leoni, Leone (1509–90)

Italian sculptor. He trained as a goldsmith, although none of his goldsmith work is known to have survived. He worked throughout Italy and also for the Emperor Charles V, in Augsburg and Brussels, practising a ▷Mannerist style. His *oeuvre* consists mainly of portraits (both busts and medals), with the bulk of the imperial commissions now in Spain. From 1538 to 1540 he was engraver at the papal mint in Rome, but his career was abruptly terminated when he was condemned to the galleys, having been found guilty of attempting to murder the papal jeweller. The intervention of a powerful patron, Andrea Doria, secured his release in 1541 and he moved to Milan where he obtained the post of Master of the Imperial Mint (1542–5 and 1550–89). Some time before 1565, the Senate of Milan granted him a house in Via Omenoni,

the façade of which he decorated with some remarkable sculpture, including a series of six three-quarter-length captives and, above the central window, a ▷relief of a ▷satyr devoured by two lions (his personal device), while in the courtyard was a cast (now lost) of the Equestrian Statue of Marcus Aurelius. His son, Pompeo Leoni (c1533–1608) was also a sculptor. Trained by his father, he moved to Spain in c1556 to complete some of his father's unfinished works, the best known being *Charles V Restraining Fury* (1549–64, Madrid, Prado). In 1579 he collaborated with his father on a series of 27 bronze statues for the high altar of the Escorial. As an independent artist, Pompeo also executed a number of tombs in Spain.

Bib.: Mezzatesta, M.P., 'The Façade of Leone Leoni's House in Milan: The Artist and the Public', *Journal of the Society of Architectural Historians*, 44 (Oct 1985), pp. 233–49; Pope-Hennessy, J., *Italian High Renaissance and Baroque Sculpture*, Oxford, 1986

Le Parc, Julio (b 1928)

Argentinian artist. He studied in Buenos Aires and went to Paris in 1958 where he was one of the founders of the ▷Groupe de Recherche d'Art Visuel. He became interested in optical (▷op art) and ▷kinetic effects, and in ideas of collectivity and objectivity in art. Much of his work from the 1960s was experimental: he used light and ▷mobiles, as well as other forms of kinetic experience.

Lepicié, Nicolas-Bernard (1735–84)

French painter. He produced portraits and ▷genre scenes and was a contemporary of ▷Chardin. However, he lacked Chardin's detachment, and his works often degenerated into sentimentality.

Le Sueur, Eustache (1616–55)

French painter of religious and mythological subjects. He was active principally in Paris, where he ran a flourishing studio. From c1632 he was a pupil of ▷Simon Vouet, his early work revealing the strong influence of his master (e.g. *Presentation of the Virgin*, c1640, St. Petersburg, Hermitage). From 1646 to 1649 he was employed at the Hôtel Lambert in Paris, firstly on a *History of Cupid* for the Cabinet d'Amour and then in the Cabinet des Muses, by which time his work had become immersed in a ▷Classicism derived from ▷Raphael and ▷Poussin (the latter of whom had revisited Paris in 1640–42). Poussin's influence is even more evident in the series of paintings of *The Life of St. Bruno*, painted for the Charterhouse, Paris, in c1648, and now in the Louvre. This series shows Le Sueur at his best, evoking a mood of deep religious contemplation that seems to derive purely from his innate sympathy with the subject. Although he never visited Rome, Le Sueur's late work follows Raphael to the point of lifeless imitation (e.g. *St. Paul at Ephesus*, 1649, Paris, Louvre, which extensively quotes from

▷Raphael's ▷tapestry designs). In 1648 he became a founder member of the French Academy and although he was considered in his time as second only to ▷Poussin, he is now regarded as a comparatively minor master.

Le Sueur, Hubert (c1580–after 1658)

French sculptor. He worked chiefly in Britain (1626–43). He executed 12 figures for the catafalque of James I (1626) and the ▷bronze sculpture for the tombs of the Duke of Lennox and Richmond, and the Duke of Buckingham, both in Henry VII's Chapel in Westminster Abbey. His best-known work in Britain is the Equestrian Statue of Charles I (1633) at Charing Cross which, while displaying his skill as a bronze caster (his principal attraction to English patrons), also reveals his limitations as an artist in the bland, lifeless surfaces and the poverty of the design. His importance lies in his introduction to England of the independent portrait bust set upon a pedestal.

Bib.: Whinney, M., *Sculpture in Britain 1530–1830*, 2nd edn, Harmondsworth, 1988

Leslie, Charles Robert (1794–1859)

English painter. He was born in London, to American parents. After a childhood spent in the United States, where he was taught art by ▷Sully in Philadelphia, he returned to Europe to study. He entered the ▷Royal Academy Schools in 1811, where he was promoted by ▷West, and visited Brussels and Paris in 1817, with ▷Collins. He developed a ▷genre style influenced by ▷Wilkie, his friendship with Walter Scott, and his enthusiasm for literature (e.g. *Uncle Toby and the Widow Wadman*, 1830, London, Tate; *Sancho Panza in the Apartment of the Duchess*, 1824, London, Tate). He had the patronage of Lord Egremont and was a close friend of ▷Constable, writing his biography in 1843. He produced illustrations for the Waverley Novels (1824), wrote a *Handbook for the Young Painter* (1855) and was Professor of Painting at the Royal Academy (1848). He was the father of George Dunlop (1835–1921), landscape and genre painter, and Robert Charles (d 1887), a marine artist.

Bib.: Taylor, T. (ed.), *Autobiographical Reminiscences of the Life of Charles Robert Leslie*, 2 vols, London, 1860

Lessing, Gotthold Ephraim (1729–81)

German dramatist and aesthetician. His distinguished literary criticism, especially in his celebrated essay *Laocoön* (1766), challenged the dominance of French ▷Classicism and ▷Winckelmann's idealism over German thought. It championed a more subjective and expressive aesthetic that was to influence the proto-▷Romantics of the late 18th century. His importance for the history of art lies primarily in his consideration in the ▷*Laocoön* of the limits of poetry and painting (▷*ut pictura poesis*) and of the nature of imitation in art. According to Lessing, each art should employ the

means proper to that art: painting will fail unless it addresses concerns proper to its form, rather than those suitable for other art forms, such as poetry. This way of thinking freed painting from too great a reliance on literature and allowed it to seek justification on its own terms, and not those of an art form alien to it.

Bib.: Lessing, G.E., *Laokoön*, (ed.) D. Reich, London, 1965; Wellbery, D.E., *Lessing's 'Laokoön': Semiotics and Aesthetics in the Age of Reason*, Cambridge and New York, 1984

Lessing, Karl Friedrich (1808–80)

German painter. He was born in Breslau and attended the Berlin Academy, before working under ▷Schadow at Düsseldorf (1826). He became one of the major artists in the Düsseldorf School of ▷history painting, which opposed the orthodoxy of the Prussian style. He also promoted the study of ▷Romantic landscape (▷Schinkel, ▷Friedrich) and worked from 1832 in the Eifel region, producing meticulous images of untamed nature. He was in constant conflict with the authorities, and was ousted from the Academy in 1848. He took up an appointment as director of the Karlsruhe Gallery and later refused an offer to become head of the Düsseldorf Academy in 1867. His work often reflected his liberal political views (e.g. *Hussite Prayer*, 1838, Berlin).

Lethaby, William Richard (1857–1931)

British architect. Lethaby studied at the ▷Royal Academy schools and worked with Norman Shaw early in his career. He was strongly influenced by ▷William Morris and Philip Webb, and looked to indigenous traditions and craftsmanship to produce the most memorable architecture of the ▷Arts and Crafts movement (e.g. Avon Tyrrell, Hampshire (1891), the Eagle Insurance Company offices, Birmingham (1899) and Brockhampton Church, Herefordshire (1900–1902), which was modelled after an English tithe barn and had a roof made from local thatch). Lethaby was a philanthropist and socialist, and in 1884 became a founder-member of the Art Workers' Guild, with E.S. Prior, Ernest Newton, Mervyn Macartney and Gerald Horsley. Later in his career he became involved with the move to build good quality housing for artisans and the ▷garden city movement. He was an influential theorist as well as an able practitioner, and in 1894 he became the first director of the Central School for Arts and Crafts, London. This was the first architectural school with workshops teaching building craft and techniques, and was a prototype for the ▷Bauhaus. Lethaby was unusual in that he advocated traditional building methods, but also explored newer technological innovations. For example, he justified his use of concrete by arguing that it would have been used by the Romans if it had been available to them.

Letterism

A neo-▷Dada movement begun by ▷Isidore Isou in Paris in 1946, which sought to create a terrestrial paradise by overthrowing all social, political and cultural paradigms, and refounding the arts on the letter. Explaining the evolution of art as a dialectic of creation and collapse, Isou held that Letterism was the third essential structure of art, after figurative and abstract painting: 'In art beauty doesn't exist, it is imposed by the necessity of aesthetic evolution, which imposed firstly figurative elements, then abstract elements, and now letters.' Previously artists as diverse as ▷Schwitters, ▷Hausmann and ▷Klee had either used the letter as a basis for art or acknowledged its expressive power, though none had explored its potential as systematically as the Letterists. Early Letterist paintings are stylistically close to ▷Lyrical Abstraction, with letters flying and swelling into a whirl of colours. By 1950 the Letterists named their works 'metagraphy' and 'hypergraphy', and extended the letter to include the whole field of phonetic, lexical, ideographic, existing and invented signs. Isou believed that since the system of signs was inexhaustible, Letterism, in its amplitude, was thus 'the most important discovery in the history of art' through which 'all the ancient styles, on all levels from ▷Giotto to ▷Picasso, will be revealed as simply failed alleyways'. Artists associated with Letterism include Lemaître, Pomerand, Sabatier, Satie and Vallot. Letterism was superseded after much in-fighting by Letterist International in 1952, which became the Situationists in 1957.

Bib.: Curtay, J.-P., *Les Créations du Lettrisme*, Paris, 1970; Home, S., *Assault on Culture: Utopian Currents from Letterism to Class War*, Stirling, 1994

Leutze, Emanuel Gottlieb (1816–68)

German–American painter. He studied in Düsseldorf where, in 1840, he met ▷Karl Lessing. Although he lived mostly in Düsseldorf, he took on historical commissions for American patrons, and acted as a liaison for American artists who wished to study in Düsseldorf. Among his large-scale ▷history paintings is the famous *Washington Crossing the Delaware* (1851, New York, Metropolitan Museum). He also gained a commission to produce a mural for the Capitol building in Washington DC; his subject for this was *Westward the Course of Empire Takes its Way*.

Le Vau, Louis (1612–70)

French architect. His Classical emphasis appeared both in his Paris houses and in his châteaux, such as Vaux-le-Vicomte. He was patronized by wealthy aristocracy, who hired him for both urban and rural domestic architecture. He also worked for Louis XIV, and under Colbert's direction, he was one of the architects of the Louvre during the 1650s and 1660s, as well as the designer of the garden façade at Versailles.

Lévi-Strauss, Claude (b 1908)

French anthropologist. He was educated at the Sorbonne, and from 1959 to 1982 was Professor of Social Anthropology at the Collège de France. He developed the method of structural analysis which applied the techniques of ▷structuralism to the anthropological study of primitive kinship systems, myths, folktales and ritual. This aimed to show how the unconscious structures of the human mind were expressed through its cultural materials. In his preface to *Structural Anthropology 2* (1977) he wrote that 'structuralism uncovers a unity and a coherence which could not be revealed by a simple description of the facts'. His other publications include *Tristes tropiques, Totemism, The Raw and the Cooked* and *La Pensée sauvage.*

Lewis, Percy Wyndham (1882–1957)

American painter, writer and graphic artist. He was educated in the United States and at Rugby, and came to London to study at the ▷Slade in 1898, where he was awarded the drawing prize. He later trained in Paris at the ▷Académie Julian. He became friendly with ▷Gore, travelling with him to Spain and Germany in 1902, and was, along with him, a member of the ▷Camden Town Group from 1911. He exhibited at the second ▷Post-Impressionist exhibition and joined the ▷Omega Workshops in 1913, but fell out with ▷Fry over the Ideal Home Exhibition and left to establish an opposition group – the Rebel Art Centre – in 1914. This, together with ▷ *Blast*, the magazine which he edited, became the focus for ▷Vorticism, Lewis' version of ▷Futurism. His ▷avant-garde style was seen in a number of drawings and a few paintings of the period, some of which pushed towards abstraction (e.g. *Crowd*, 1914–5, London, Tate Gallery). After serving in the Artillery, Lewis continued to produce work influenced by a mechanical, faceted ▷Cubism, which suited his war subjects (e.g. *Battery Position in a Wood*, 1918, private collection). He joined Group X in 1920 and although he continued to produced Vorticist works (e.g. *Surrender of Barcelona*, 1936, London, Tate), he turned increasingly to portraiture (e.g. *Edith Sitwell*, 1923–35, London, Tate; *Ezra Pound*, 1938–9, London, Tate). He travelled widely in the 1930s (Germany in 1930, North Africa in 1931, the US in 1939–45). Throughout his career, Lewis combined painting and writing: he published his first stories in 1909, having met Ezra Pound, and was famous for novels like *Tarr* (1918) and *Revenge for Love* (1937). His writing on art – he was critic for the *Listener* – became increasingly polemical.

Bib.: Foshay, T., *Wyndham Lewis and the Avant-Garde*, Montreal, 1992; Meyes, J., *Enemy: A Biography of Wyndham Lewis*, London, 1980; Michel, M., *Wyndham Lewis: Paintings and Drawings*, London, 1971; Normand, T., *Wyndham Lewis the Artist*, Cambridge, 1992; Paul, E., *Wyndham Lewis: Art and War*, London, 1992; *Wyndham Lewis*, exh. cat., Manchester, 1980

LeWitt, Sol (b 1928)

American sculptor and printmaker. He was from Connecticut and practised architecture working for ▷I.M. Pei (1955–6). From the 1960s, he became interested in sculpture, and concentrated on serial and modular works in a conceptual mode. He calls his works 'structures', and stresses the perfection of pure geometric forms as representative of higher ideas. Unlike many other ▷Minimalist sculptors, he does not stress the mathematical aspects of modular production, and he uses pure colours, such as white, to emphasize the ▷Neoplatonic aspects of his work.

Bib.: *Sol LeWitt Drawings 1958–1992*, The Hague, 1992; *Sol LeWitt: Prints 1970–86*, exh. cat., London, 1986

Leyster, Judith (1609–60)

Dutch painter. She produced ▷genre scenes, portraits and still lifes, and worked mostly in Haarlem and Amsterdam. At the outset of her career she was influenced by the Utrecht ▷Caravaggisti. She may also have been a pupil of ▷Frans Hals. In fact, her style is sometimes so close to his that it has been difficult to tell the difference (e.g. her copy of Hals' *Lute-playing Fool*, Amsterdam, Rijksmuseum, was once attributed to Hals). She is mentioned as a painter in a history of Haarlem, written in 1627 (thus by that time she must have been an established painter). By 1633 she was a member of the Haarlem Guild of St. Luke (the first woman known to have been admitted) and by 1635 she had three students. In 1636 she married the painter

Percy Wyndham Lewis, *A Reading of Ovid (Tyros)*, 1920–21, Scottish National Gallery of Modern Art, Edinburgh

▷Jan Miense Molenaer, and the couple moved to Amsterdam until 1648, when they transferred to Heemstede, near Haarlem. They shared a studio, the same models and props often appearing in both their work. Leyster's monogram contains a star motif, a play on her surname 'Ley-ster' (lode star).

Bib.: Hofrichter, F.F., *Judith Leyster: A Woman Painter in Holland's Golden Age*, Doornspijk, 1989; *Judith Leyster: A Dutch Master and her World*, exh. cat., Worcester, 1993

Lhote, André (1885–1962)

French painter and sculptor. He received no formal training, but came into contact with ▷Fauvists such as ▷Dufy and with ▷Cubists from 1911. He painted landscapes, interiors and still lifes in a Cubist style which showed a particular debt to ▷Cézanne. He exhibited with the ▷Section d'Or in 1912. From 1917 to 1940 his most influential work was as an author and art critic; he wrote books which advocated the cause of modern art. He also opened his own academy in Paris in 1922.

Liberal Arts

In the Middle Ages, the Liberal Arts formed the traditional curriculum of secular learning which dated back to late antiquity. There are seven in number, and they are divided into two groups – the *trivium*: Grammar, Logic (or Dialectics), and Rhetoric, and the *quadrivium*: Geometry, Arithmetic, Astronomy, and Music. The Liberal Arts were so called because they were originally the province of free ('liberal') men, as opposed to the mechanical arts which were performed by slaves. The Liberal Arts were intellectual and derived from philosophy, the fount of all knowledge, whereas the mechanical arts involved only routine craftsmanship. In the 15th century, ▷Alberti published his *Della Pittura* as part of a programme to secure the acceptance of painting as a Liberal Art, until then considered a craft whose terms were dictated by the patron and merely carried out by the craftsman-painter. The status of the painter did indeed rise and in Italy ▷Minerva, the patron of the arts, may be represented introducing the figure of a painter to the personifications of the seven existing Liberal Arts. The appearances of the personifications were established originally in the 5th century and are as follows:

(i) Grammar: In medieval representations, a woman with two young pupils at her feet, reading from books. She may hold a whip with which to provide incentive to her pupils. During the 17th century, her image became more elaborate. ▷Ripa, in his *Iconologia*, shows Grammar watering plants in a garden (the pupils are gone, but the whip lies upon the ground). Above Grammar is part of the motto, 'Vox litterata et articulata debito modo pronuntiata' ('A literate and articulate tongue, the words properly pronounced'). Behind Grammar are busts of Cicero and Terence, two great writers of Latin.

(ii) Logic: A woman holding one or two snakes, or a scorpion or lizard. Ripa shows her tying a knot in a rope: the knot represents the problem that she has raised in order that she might solve it. Her motto is 'Verum et falsum' ('True and false').

(iii) Rhetoric: A woman with a book and scroll, armed with a sword and shield.

(iv) Geometry: A woman with a pair of compasses, usually taking a measurement from a terrestrial globe. Her other attributes include a set square and ruler. Ripa shows her surrounded by surveying equipment and looking at a plan held up by a small boy.

(v) Arithmetic: A woman holding a tablet covered with figures which she may be in the act of inscribing. Alternatively, she may hold an abacus and sometimes a ruler.

(vi) Astronomy: A woman holding a globe, usually, but not invariably, a celestial globe from which she may take measurements with a pair of compasses. She may have also a sextant or an armillary sphere. Originally Astronomy was part of ▷astrology, and Ripa uses the latter term for his personification, which is clearly intended to represent the scientific study of the stars, not forecasting the future from their conjunctions.

(vii) Music: A woman playing an instrument, the type of which varies with the fashion of the age. The personification of Music may be accompanied by a swan. Ripa shows her writing sheet music, seated upon a star-spangled celestial globe, a reference to Pythagoras who wrote that all earthly harmony depends entirely on the harmony of the spheres of heaven.

Liber Studiorum

A book of 70 ▷engravings compiled by the landscape painter ▷J.M.W. Turner between 1807 and 1819. It consisted of a mixture of original landscapes and copies of his painted landscapes, the idea for which was inspired by the engraved volume of ▷Claude's ▷*Liber Veritatis*. Whereas Claude's drawings were produced as an authentication record, Turner's were intended to show the range of the types of his landscapes (e.g. historical, mountainous, pastoral, marine, etc.) and to publicize his work to a wider audience than would have seen his paintings.

Liber Veritatis

A collection of detailed sketches of his compositions, compiled as an authentic record by the landscape painter ▷Claude Lorrain to counter the increasing numbers of imitations and forgeries of his work. The whole collection of 195 drawings, begun c1635, is now in the British Museum, London. In 1777 they were engraved in ▷mezzotint by R. Earlom.

Liberty

British company, among the first to mass-produce high quality 'craft' textiles, furniture, metalwork and ceramics and sell it through the Liberty department store, London. In 1875 Arthur Lazenby Liberty opened the shop, which stocked both one-off, hand-made items, like Compton pottery, and factory-made items. The demand for such goods was strong, due to the fashionable ▷Arts and Crafts Movement. Liberty soon expanded, opening a textile workshop in 1904 and a furniture workshop in 1905. Customers wanted work which looked hand-made, but was more affordable, and Liberty shrewdly developed this market using known producers, but marking their work only with the Liberty name. For example, W.H. Hasler, Birmingham produced the silver 'Cymric' and pewter 'Tudric' ranges, from designs by Archibald Knox (1864–1933). The designs were based on ▷Celtic and medieval patterns, and were machine-made, but finished with real hammering to give a hand-wrought appearance. Although Liberty had a huge following among the middle classes, it was criticized by many craftsmen and the Society of Arts and Crafts Workers because it undercut their market.

Liberty style

Another term for ▷Art Nouveau, applied particularly to arts and crafts produced in Italy.

Lichtenstein, Roy (b 1912)

American artist associated with ▷Pop art. He was born in New York, and studied with the ▷Arts Students' League (1939–40) and at Ohio State University (1940–43). After serving with the US army in Europe (1943–6), he returned to Ohio and took a Masters in Fine Art in 1949. His first solo show was in New York in 1951. He supported himself as a commercial artist until 1957, after which he taught at New York State College of Education (1957–60) and Rutgers University (1960–63). Lichtenstein first established himself as an ▷Abstract Expressionist, but in the late 1950s turned to pop culture (such as advertising and bubble-gum wrappers) for his subject matter. In 1961 he began to paint large-scale copies of frames from comic strips, usually romantic or military stories, complete with speech bubbles. Lichtenstein even hand-painted the benday dots with which variations of shade are reproduced on the printed page. His rejection of Abstract Expressionist doctrine was made explicit by the mid-1960s *Brushstrokes* series, slickly reproducing a dripping stroke of paint against a benday background. Through the late 1960s and 1970s he applied what had now become a signature style to parodies of early modern artists including ▷van Gogh, ▷Matisse and ▷Picasso. His more recent paintings portray carefully furnished domestic spaces in an ironic commentary on upper-middle-class concerns with interior design.
Bib.: Waldman, D., *Roy Lichtenstein*, New York, 1993

Liebermann, Max (1847–1935)

German artist. He studied in Amsterdam, where he was influenced by ▷Hague School painting. However, he lightened his palette considerably after contact with French ▷Barbizon painting in 1874. At this time also he began concentrating on the rural peasant themes favoured by ▷Millet. From the 1890s, French influence on his work intensified, and he became one of the earliest German artists to practise a form of ▷*plein air* painting, similar to that of ▷Impressionism in France. He was the first President of the Berlin ▷Secession in 1899, and he was construed as a subversive artist by the anti-French establishment of his day. However, he was popular and had a number of patrons, leading eventually to his position as President of the Prussian Academy of Arts. By the 1920s, when he was still practising, his work was considered old-fashioned. His tame, pretty paintings were declared degenerate by the Nazis who objected to his Jewishness.

lierne

Type of ▷vault. A lierne is a short rib which joins ▷bosses together. It extends neither from the main ▷springers nor from the central boss, but it connects the main structural ▷ribs. This type of vaulting was particularly common in England and was a dominant feature of the ▷Decorated style.

Lievens, Jan (1607–74)

Dutch painter and engraver. He was born in Leiden and studied with ▷Lastman in Amsterdam. From 1625 to 1631 he worked closely with ▷Rembrandt in Leiden, and the two artists shared models and subjects. He went to England 1632–4, and was in Antwerp 1635–44, where he changed his style under the influence of ▷Rubens.

life drawing

The practice of using models (usually nude) for close study of the human form.

lily

A Christian symbol of purity, associated particularly with the ▷Virgin Mary. It features in representations of the ▷Annunciation where it is either carried by ▷Gabriel or stands in a vase placed between Gabriel and Mary: thus, by extension, it becomes an identifying attribute of Gabriel. It is also the attribute of a number of virgin saints of both sexes, including Antony of Padua, ▷Catherine of Siena, Clare, ▷Dominic, ▷Francis of Assisi, Joseph, and Scholastica. The Erythraean ▷Sibyl is likewise associated with the lily because she is supposed to have foretold the Annunciation. When Clovis, King of the Franks, was baptized, he adopted a particular sort of lily, the fleur-de-lis, as a symbol of his purification; this subsequently became the emblem of the kings of France and particularly Saint Louis (the ninth French king of that name), and St.

Louis of Toulouse. The fleur-de-lis is also the emblem of Florence and thus the attribute of its principal patron saint, Zenobius. In scenes of the ▷Last Judgement, a lily on the right of God's face and a sword on the left, symbolize the separation of the blessed from the damned (e.g. ▷Memlinc, *Last Judgement Triptych*, 1473, Danzig, Muzeum Pomorskie).

Limbourg (Limburg) brothers

Netherlandish family of manuscript illuminators. They are Paul (variously Pol, Polekin), Jean (Jehanequin, Hennekin) and Herman de, all three dying in 1416, presumably of the plague. Paul is thought to have been the eldest and therefore the head of the workshop, but the first mention of any of the brothers is in the late 1390s when Jean and Herman were apprenticed to a goldsmith in Paris. In 1402 Paul and Jean were contracted to illuminate a Bible for Philip the Bold, the Duke of Burgundy (probably the *Bible moralisée*, Paris, Bibliothèque Nationale). In 1404 Philip died and soon afterwards the brothers transferred to the Duke's brother, Jean, Duc de Berry. In the service of the Duc de Berry they enjoyed a privileged lifestyle, moving with the court as it progressed around the Duke's many castles. Their two important works for the Duc are the *Très Belles Heures* (New York, Metropolitan Museum), finished by 1408/09, and the sumptuous ▷ *Très Riches Heures* (Chantilly, Musée Condé), begun c1413, unfinished at the time of their deaths in 1416 and completed about 70 years later by the French illuminator, Jean Colombe (c1440–c1493). The *Très Riches Heures*, with its 12 beautiful full-page illuminations illustrating the months of the year, and full of closely observed naturalistic detail, is generally considered to be one of the cardinal works of the ▷International Gothic style. To the International Gothic tradition of ▷Broederlam and their predecessor at the court of the Duc de Berry, ▷Jacquemart de Hesdin, the Limbourg brothers brought a vitalizing Italian influence, apparent chiefly in their more sophisticated rendering of space. **Bib.**: Bath, M., 'Imperial Renovation Symbolism in the *Très Riches Heures*', *Simiolus*, 17, no. 1 (1987), pp. 5–22; Meiss, M., *French Painting at the Time of Jean de Berry*, New York, 1974; Pognon, E., *Les Très Riches Heures du Duc de Berry*, Fribourg, 1989

limner

Originally, in the Middle Ages, an illuminator of manuscripts (the verb, to limn, deriving from *lumine*). However, in Britain, from the 16th century onwards the term was used to refer to a painter of miniature portraits. ▷Nicholas Hilliard, the celebrated English miniature portrait painter, wrote a treatise on the subject, entitled *The Art of Limning* in c1600. In New England, in the 17th and 18th centuries, the term was used to denote portrait painters, regardless of the size of their portraits.

Lindner, Richard (1901–78)

American painter of German birth. He was born in Hamburg and studied at the Nuremberg School of Fine and Applied Arts in 1922 and the Munich Art Academy in 1924. In 1933 he went to Paris, and to America in 1941, where he became a US citizen in 1948. He practised book illustration as well as painting. His works were luridly coloured and represented a cross between ▷Expressionist vibrance and ▷Surrealist eroticism. He used many images from the ▷mass media.

Lindsay, Percy (1870–1953), Sir Lionel (1874–1961), Norman (1879–1969), Ruby (1887–1919), Sir Daryl (1889–1976)

Australian family of artists. All of the family produced graphic works, and some of them painted. Lionel was also an art critic; Norman a novelist; and Daryl was Director of the National Gallery of Victoria (1942–56).

line engraving

A type of intaglio print. The design is incised on a metal ▷plate (usually copper), with a sharp needle called a ▷burin. The burin is pushed into the plate and, in gouging out its groove, raises a ridge either side, called a ▷burr. This burr is removed, leaving a clean groove. The plate is then inked and wiped, leaving ink only in the grooves. A sheet of dampened paper is then pressed onto the incised plate so that the ink in the lines transfers an impression onto the paper. The resulting print is thus a reverse of the design on the plate. Line engraving has been used since the 15th century and, until the advent of photography in the 19th century, was the principal means of disseminating reproductions of paintings.

linear perspective

▷perspective

Linnell, John (1792–1882)

English painter. He was born in Bloomsbury, the son of a frame knitter. He was largely self-taught, earning a living from making copies of ▷Morland's works, but in 1805 briefly studied at the ▷Royal Academy Schools and was probably apprenticed to ▷Varley. His early works were mainly portraits but he went on sketching tours and in 1821 he exhibited his first landscape at the RA. He was influenced by ▷Mulready (e.g. *Gravel Pits at Kensington*, 1813, London, Tate) and produced a number of rustic ▷genre scenes (e.g. *Shepherd Boy Playing a Flute*, 1830, New Haven, Yale). The biggest influence, however, was that of ▷Blake, whom he met in 1818 and supported financially through the *Job* commission (1821). He introduced his friend and later his son-in-law, ▷Palmer, to Blake. In his later work, after the success of *Eve of the Deluge* (1848, Cleveland), he produced a series of ideal

panoramas of a lush, pastoral Surrey (e.g. *Last Gleam Before the Storm*, 1847–8, Liverpool). Throughout his career he was a ▷journeyman, prepared to take on any commission and work on any subject (he produced ▷watercolours and ivory ▷miniatures). He was hugely popular despite the repetitiveness of his late work, and won a gold medal in Paris (1855).

Bib.: Firestone, E.V., *John Linnell, English Artist*, Madison, 1971; Linnell, D., *Blake, Palmer, Linnell and Co.: The Life of John Linnell*, Sussex, 1994; *John Linnell*, exh. cat., Cambridge, 1982

linocut

Type of ▷print made from a sheet of linoleum, into which a design has been cut in ▷relief. The technique is similar to that of ▷woodcuts, but because lino is easier to work, a greater variety of effects is possible. For example, large prints can be made for fabric and textile printing. Although thought to be of little artistic value in the 19th century, lino prints were popularized by such artists as ▷Matisse and ▷Picasso in the 20th century.

linseed oil

An oil derived from the seeds of flax. Mixed with turpentine it is the most common medium in ▷oil painting. Like walnut oil and poppy oil (its chief rivals), it hardens into a solid transparent state on exposure to air and is thus important as a drying ▷medium. The principal advantage of linseed oil over the other drying oils is that it is less prone to cracking.

lintel

In a building, a horizontal structural member, traditionally of stone or wood, placed over an opening (and supported by the ▷jambs) to carry the weight of the masonry above it.

lion

Common symbolic animal with a wide diversity of meanings. Most generally it symbolizes the positive qualities of courage, strength, fortitude and majesty, although in specific contexts it may symbolize the sin of pride, or the Devil himself. Medieval ▷bestiaries related that new-born lion cubs lay dormant for three days until the father breathed life into them: thus the lion became a symbol of the ▷Resurrection. Because the Gospel of ▷Mark describes the Resurrection in most detail, it was Mark who was presumed to be symbolized by the winged lion of Ezekiel's vision (▷Evangelists); it is also the emblem of Venice whose patron saint is Mark. The lion is also associated with a number of mythological, biblical and historical characters: ▷Hercules defeated the Nemean lion and thenceforth wore his pelt; the pelt thus became an attribute of Hercules personified as ▷Fortitude, or Fortitude itself. Samson (Judges 14: 5–9) and ▷David (1 Samuel 17: 34–37) each killed marauding lions with their bare

hands. They are seen as Old Testament prefigurations of ▷Christ, and in this context the lion symbolizes the Devil. Jerome, whilst in the desert, extracted a thorn from a lion's paw who thenceforward became devoted to him – the lion is his most common attribute. A lion may also symbolize Africa as one of the Four Parts of the World.

Liotard, Jean-Étienne (1702–89)

Swiss miniature painter. He studied in Italy in 1738, and painted portraits for English visitors. With some Englishmen, he travelled to Constantinople 1738–42 and then to England 1753–5. He worked in Holland 1755–72 and was back in London 1772–4.

Lipchitz, Jacques (Chaim Jacob) (1891–1973)

French sculptor of Lithuanian birth. He studied at the ▷École des Beaux-Arts, ▷Académie Julian and Académie Colarossi in Paris. While in Paris in 1909 he became interested in ethnic artefacts, which became a lifelong influence on him. He became friendly with other foreigners in Paris, including ▷Modigliani, ▷Archipenko and ▷Picasso, and he travelled to Majorca in 1914 with ▷Diego Rivera. African influence on his sculpture first appeared in 1913, when he also used ▷Cubist forms. The geometrical, largely rectilinear, emphasis continued throughout the 1920s, when he began experimenting with negative space and his works became more rounded. In 1925 he became a French citizen, and in 1941 he moved to New York. During the 1940s, he began producing more monumental work for public commission.

Lippi, Filippino (c1457–1504)

Italian painter. He was from Florence and was the son of ▷Filippo Lippi. Following his father's death in 1469, Filippino, aged about 12, is supposed to have set off alone for Florence where he became ▷Botticelli's pupil. His earliest works are certainly close enough to Botticelli to support this. Filippino's earliest important commission (c1484) was the completion of the ▷fresco cycle in the Brancacci Chapel of the Carmine Church in Florence, left uncompleted earlier in the century by ▷Masaccio and ▷Masolino. Two years later (1486), he painted one of his most accomplished panel paintings and one most typical of his mature style, with its tender sentiment, graceful figures, expressive use of line, and bright colours: the altarpiece of *The Vision of St. Bernard* for the Badia, Florence (still *in situ*). Shortly after this (1487–1502) he was commissioned to paint the fresco cycles of Saints Philip and ▷John the Evangelist for the Strozzi Chapel of S. Maria Novella, Florence. A concurrent fresco cycle in Rome, *The Life of St. Thomas Aquinas*, in the Caraffa Chapel, S. Maria sopra Minerva (1488–93), displays the same archaeologizing ▷Classicism, full of antique details, that was to typify his work from this time onwards. The restless spirit with which these works

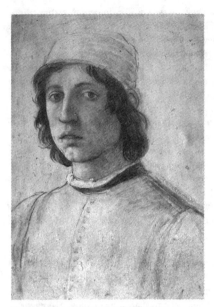
Filippino Lippi, *Self-portrait*, Uffizi, Florence

type of the Christ child) and Netherlandish painting (the new interest in textures, details and the domestic interior). Begun in the same year was the more complex *Barbadori Altarpiece* (completed 1438, Paris, Louvre), a ▷ sacra conversazione in a ▷ triptych form modified to read as one unified space. From the 1440s onwards there developed a movement towards a lighter, more linear, more graceful style (such as is seen in the contemporary sculptures of ▷ Desiderio, ▷ della Robbia and ▷ Rossellino). This can be seen in Lippi's *Annunciation* (mid-1440s), still on the altar for which it was commissioned in S. Lorenzo. Again there are the influences of Donatello (cf. the Virgin in Donatello's *Calvalcanti Annunciation*) and Netherlandish art (especially the ▷ *trompe l'oeil* of the glass vase against the bottom edge of the picture).

Notwithstanding these evident influences, Lippi's art is unmistakably his own, more decorative than his prototypes and with a delicacy of touch and a particular type of facial beauty that makes his angels, Virgins and Christ children instantly recognizable (see especially the *Pitti Tondo*, Palazzo Pitti, Florence). Among his most important and successful commissions is the fresco cycle of *Scenes from the Lives of SS Stephen and John the Baptist* in Prato Cathedral (1452–66). Vasari's life of Fra Filippo Lippi is one of his most colourful, even including an account of Lippi's (purely apocryphal) kidnap by pirates, enslavement and subsequent release following his Moorish master's discovery of how marvellous an artist he was.

Bib.: Christiansen, K., 'New Light on the Early Work of Filippo Lippi', *Apollo*, 122 (Nov 1985), pp. 338–43; Ruda, J., *Fra Filippo Lippi: Life and Work with a Complete Catalogue*, London, 1993

are imbued and their over-refined elegance have led to them being dubbed '▷ quattrocento ▷ Mannerism'. Although highly successful during his lifetime, just before his death his linear quattrocento style was quickly overtaken by the developments inaugurated and perfected by ▷ Leonardo da Vinci, ▷ Michelangelo and ▷ Raphael.

Bib.: Berti, L., *Filippino Lippi*, Florence, 1991; Peters-Schildgen, S., *Die Bedeutung Filippino Lippi für den Manierismus*, Essen, 1989; Sale, J.R., *Filippino Lippi's Strozzi Chapel*, New York, 1979

Lippi, Fra Filippo (c1406–69)

Italian painter. He was Florentine. An orphan, he was brought up in the Carmelite Convent of S. Maria del Carmine in Florence and took his vows there in 1421, although, as his later elopement with the nun Lucrezia Buti and the subsequent birth of their son ▷ Filippino Lippi and daughter Alessandra indicate, he was temperamentally unsuited to the monastic life. A definite advantage of his period in the monastery, however, was that it was contemporary with ▷ Masaccio's work in the Brancacci Chapel of the church. Although there is no evidence that Lippi was ever a formal pupil of Masaccio's, ▷ Vasari's statement that he assiduously copied from the Brancacci frescos is supported by the monumental simplification of the figures in Lippi's earliest surviving work, a fresco (also for the Carmine church) of the *Rules of the Carmelite Order* (c1432, remaining fragments in the Museum of S. Maria del Carmine). Lippi's earliest dated picture is the *Tarquinia Madonna* (1437, Rome, Palazzo Barberini) in which appear the influences of ▷ Donatello (especially in the

Liss (Lys), Johann (Jan) (c1597–1631)

German painter. He studied in the Netherlands and Paris, and moved to Venice in 1621. He was influenced by Venetian colourism, as well as the work of ▷ Caravaggio, which he saw in Rome in 1622.

Bib.: *Johann Liss*, exh. cat., Augsburg, 1975

Lissandrino, Il

▷ Magnasco Alessandro

Lissitsky, El (Lazar Markovich Lisitsky) (1890–1941)

Russian painter, illustrator and designer. He grew up in Smolensk, but restrictions on Jews in higher education forced him to Germany, where he studied engineering and architecture. In 1918 he joined IZO ▷ Narkompros and taught graphic art and architecture at the Art College in Vitebsk. Inspired by ▷ Malevich, he began to paint the *Proun* series of ▷ Constructivist paintings. In 1920 he moved to Moscow, where he joined ▷ INKHUK and preached Constructivist architecture at ▷ Vkhutemas. For most of the 1920s he travelled in Europe, forging links with ▷ De Stijl

and the ▷Bauhaus artists, and spreading Constructivist and ▷Suprematist ideas. Weakened by tuberculosis, he settled in Russia in 1929.

El Lissitzky worked in several fields. As an illustrator, he assisted ▷Chagall on books of Yiddish folk tales, reworking traditional woodcuts in a contemporary ▷Cubist style. His most important illustrations were for his short book *The Story of Two Squares* (1920), a series of ▷Suprematist ▷lithographs which form a narrative sequence with theoretical and political over-tones about the establishment of order in a world of jumbled formlessness. The *Proun* paintings also draw on Suprematism, but with an exploration of three-dimensional space reflecting El Lissitzky's architectural training and which culminated in the *Proun* rooms which he designed in 1923. These consisted of a series of objects, sculptures and paintings laid out in a space through which the viewer could wander freely, exam-ining the collection from a number of perspectives. They have exerted considerable influence on the layout of contemporary exhibition spaces.
Bib.: *El Lissitzky 1890–1941*, exh. cat., Eindhoven (publ. London), 1990; Lissitzky, S.K. (ed.), *El Lissitzky: Life, Letters and Texts*, London, 1980

lithography

A form of planographic or surface printing (▷intaglio; ▷relief), invented in 1798 by Aloys Senefelder. The process is based on the fact that grease repels water. First, a design is drawn with a waxy crayon or greasy ink onto a surface, originally of limestone, but these days, for economy and lightness, more usually a zinc or plastic plate. The design is then chemically fixed, the surface is wetted, and a greasy ink, which will only adhere to the greased design, rolled onto the stone. A sheet of dampened paper is then pressed to the surface and the design thus transferred. It soon became a popular medium among artists as it resembles drawing more closely than any other medium. Colour litho-graphy is also possible, as is the replication of water-colour washes, so it is also suitable for reproductive work. It was especially popular as a medium for posters as it is capable of producing many thousands of prints from the same stone. Among the most prominent artists to be attracted to the medium were ▷Fuseli, ▷Delacroix, ▷Goya, ▷Géricault, ▷Manet, and ▷Toulouse-Lautrec. The bulk of ▷Daumier's work was executed specifically for lithographic repro-duction.

local colour

In painting, the actual colour of an object in a neutral context and under diffused light, such that it is unmodified by light and shade, ▷aerial perspective and the ▷value of the colours of nearby objects.

Lochner, Stephan (d 1451)

German painter. He was the leading painter of the Cologne School, active in Cologne from at least 1442. He was one of the chief exponents of the so-called 'Soft Style', characterized by delicately beautiful Madonnas (*Schöne Madonnen*) and drapery painted in soft folds (cf. the angular folds of ▷Gothic). He was possibly trained in the Netherlands and shows the influence of the ▷Master of Flémalle and the ▷Limbourg brothers. His masterpiece is the *Dombild Triptych*, painted for Cologne Town Hall, but now in the Cathedral. This ▷altarpiece has long been considered one of the land-marks of German painting and in his journal ▷Dürer records that he paid two silver pennies to have the shutters unlocked and that he viewed it 'with wonder and astonishment'. When closed, the shutters display an ▷*Annunciation*; these open to reveal a sumptuous ▷*Adoration of the Magi* in the centre panel, with the patron saints of Cologne in the wings.
Bib.: Konig, E., *Stephan Lochner Gebetbuch 1451*, Stuttgart, 1989

loggia

An ▷arched or ▷colonnaded gallery or porch, open on one or more sides; a loggia may also stand as a discrete structure.

Lohse, Richard (b 1902)

Swiss painter and graphic artist. He was from Zurich, and in 1927 he became a founder member of the ▷avant-garde group of artists, the Allianz. This group advocated the ▷concrete art theories of ▷Max Bill, but they were more interested in colour than some of their ▷Constructivist contemporaries.

Lomazzo, Giovanni Paolo (1538–1600)

Italian painter. He was a ▷Mannerist from Milan, trained by Gaudenzio Ferrari, whose artistic career was prematurely ended at the age of 33 by blindness (see *Self-portrait*, 1568, Milan, Brera). He thereafter devoted his professional life to writing, most importantly, two influential art treatises, the *Trattato dell'arte de la pittura, scoltura, et architettura* (*Treatise on the Arts of Painting, Sculpture and Architecture*, 1584) and the *Idea del Tempio della Pittura* (1590). The first of these two works, which has been described as 'the Bible of Mannerism', was the most comprehensive art treatise published in the 16th century. An essentially academic work, its central premise is that artistic skills can be learnt by the absorp-tion of a set of precepts and formulas. It was translated into English as early as 1598 by Richard Haydocke, an Oxford physician and amateur engraver, who illus-trated it with 13 of his own engravings and added sections on the leading British artists of his day, ▷Nich-olas Hilliard and ▷Isaac Oliver.
Bib.: Blunt, A., *Artistic Theory in Italy, 1450–1600*, Oxford, 1956

Lombard, Lambert (1506–66)

Flemish painter and architect. He studied in Rome in 1537, and the influence of the antique led him to become one of the ▷Romanists. He worked primarily in Liège, where he produced portraits and taught ▷Frans Floris and ▷Goltzius among others. Many of his works have been lost.

Lombardo, Pietro (c1435–1515), Tullio (c1455–1532) and Antonio (c1458–1516)

Italian family of sculptors and architects. Pietro was the father of Tullio and Antonio. They were the leading marble sculptors of their time in Venice. Pietro, who was also an architect, was born in Lombardy. He is first documented working in Bologna 1462–3 where he executed carvings for the Rossi Chapel in S. Petronio. In 1464 he was in Padua; his principal work there is the Monument of Antonio Roselli in S. Antonio, revealing the influence of ▷Rossellino's and ▷Desiderio's tombs in S. Croce, Florence. About 1467 he settled in Venice, his adoption of the Tuscan ▷Renaissance style helping to establish the family workshop as the most advanced in the city. He executed the Tomb of Pasquale Malipiero (d 1462) and, with his sons, the Tomb of Doge Pietro Mocenigo (d 1476) both in SS Giovanni e Paolo. Pietro designed the Church of S. Maria dei Miracoli in Venice and his sons executed most of the interior sculptures (1481–9). Pietro also designed the lower part of the façade of the Scuola di San Marco (1488–90), upon which are the remarkable ▷perspective ▷reliefs executed by Tullio and Antonio. Tullio was the more accomplished sculptor, his best independent commission being the Monument to Andrea Vendramin in SS Giovanni e Paolo (c1493), the gracefully sensuous freestanding figure of *Adam* which is now in the Metropolitan Museum, New York. Antonio was later employed in Ferrara by Alfonso d'Este, for whom he carved a series of decorative mythological reliefs (1506–16). The sculptural work of all family members displays an assured mastery of marble carving and, in Tullio in particular, an understanding and assimilation of the Roman antique, new to Venice.

London Group

An exhibiting society formed in London 1913–14. It was largely composed of disaffected members of the ▷NEAC, as well as members of the ▷Camden Town and ▷Cumberland Market Groups. The president was ▷Harold Gilman, and other members included ▷Fry, ▷Grant, ▷Bell, ▷Bomberg, ▷Nash and ▷Sickert, each of whom joined at different times during and after the First World War. The first exhibition was held in March 1914 at the Goupil Gallery, and they devoted themselves to an anti-academic stance. The group still survives, but it lost much of its original impetus by the start of the Second World War.

Bib.: Wilcox, D., *The London Group 1913–1939: The Artists and their Works*, Aldershot, 1995

Long, Edwin (1829–91)

British painter. He produced archaeological ▷genre scenes in the late Victorian period. His most famous work was the *Babylonian Marriage Market* (exhibited ▷RA 1875, Egham, Royal Holloway).

Long, Richard (b 1945)

British artist. From 1965, he became one of the foremost practitioners of ▷environmental or ▷land art. He not only exhibited works made out of stones and sticks, but he also used real landscapes to create ▷'walks' based on patterns of the land. Much of this he photographed. His art is therefore in the conceptual mode, but he is also interested in geometric patterns.

Longhi, Pietro Falca called (c1702–85) and Alessandro (1733–1813)

Italian family of painters. Pietro was from Venice, and is chiefly remembered for his small-size oil paintings depicting, sometimes with a gentle satire, the leisure activities of the Venetian upper classes (e.g. *The Exhibition of the Rhinoceros*, 1751, Venice, Ca' Rezzonico; and *A Lady Receiving a Cavalier*, c1750, London, National Gallery). He achieved considerable success with this type of picture, although most of the foreign tourists who took in Venice on their ▷Grand Tour favoured views of the city itself, such as those produced by his contemporary ▷Canaletto. However, Longhi's detailed pictorial documentation of Venetian society has rendered his work especially useful to later social historians. He was trained firstly in the studio of the successful Venetian painter, ▷Antonio Balestra, and then (far more influentially) in that of the Bolognese genre painter, ▷G.M. Crespi. Longhi is listed in the *fraglia* (Venetian painters' guild) from 1737 and in 1756 was elected a member of the Academy of Venice. He also painted a number of altarpieces (e.g. *The Martyrdom of San Pellegrino* for the Church of S. Pellegrino, Bergamo, 1730–32) and some fresco commissions (e.g. *The Fall of the Giants*, 1734, Venice, Palazzo Sagredo). Alessandro was the son of Pietro Longhi and a portrait painter. Though successful in his lifetime (he was the official portrait painter to the Venetian Academy), he is chiefly remembered today for his biographical history of contemporary Venetian painters, the *Compendio delle vite de' pittori veneziani istorici* (*A Compendium of the Lives of Historic Venetian Painters*, 1762) illustrated with portrait ▷etchings by the author and the chief source of information about his more famous father.

Bib.: *Pietro Longhi*, exh. cat., Milan, 1993; Stammen, P., *Pietro Longhi und die Tradition der italienischen Genremalerei*, Frankfurt, 1993

Longinus

A Classical literary critic of the 3rd century, and supposed author of a work on the ▷sublime. This is unmentioned by other Classical writers but achieved considerable fame in the 18th century after it was translated by Boileau in 1674. The work became the basis of much 18th-century thought (▷Addison; Burke). It contains two key ideas: that the purpose of art and literature is not merely moral improvement but ▷aesthetic pleasure; and that the sublime is the 'ring of a great soul'.

Loo, van, Jean-Baptiste (1684–1745), Carle (1705–65) and Louis Michel (1707–71)

French family of artists. Jean-Baptiste was born in Aix, and travelled to Rome in 1714 and to Paris in 1719. While in Rome he painted works for churches, including his *Flagellation* for Sta Maria della Scala, and he also worked at restoration. His Paris commissions included further work for churches, and he was received as a member of the Academy (▷Académie Royale) in 1731. In 1737 he travelled to London, where he received commissions from the Prime Minister Robert Walpole, and his popular portraits ousted much of the native competition. He returned to Aix in 1742 to escape the foul London weather.

His brother, Carle, was also in Rome in 1714 and Paris in 1720, but he returned to Rome in 1727, establishing himself as a rival to ▷Boucher, both there and in Paris from 1734. He became a member of the Academy in 1735 and Principal Painter to the King in 1762. He was appointed Director of the Academy in 1763.

Louis Michel was the son of Jean-Baptiste, and he studied with his father in Italy. He returned to Italy 1727–32 with his uncle Carle, but his most important work was produced in Madrid, where he was appointed Court Painter in 1736. He was a founder member of the Madrid Academy in 1752, but returned to Paris in 1753, where he produced state portraits of Louis XV and became Director of the École Royale des Élèves Protégés (the school to train students intending to study in Rome) in 1765.

Loos, Adolf (1870–1933)

Austrian architect. Educated in Dresden, and first practising in Vienna, Loos was one of the first European architects to oppose ▷Art Nouveau and ▷Neoclassicism, and to expound rationalist design theories. In 1893 Loos travelled to America, where he worked as a stonemason and closely observed the work of the ▷Chicago School and ▷Louis Sullivan's austere, steel-framed structures. In 1896 he returned to Vienna, founded the Neue Freie Presse and announced his intention of avoiding the use of unnecessary ornament, attacking the aestheticizing tendencies preached by ▷Klimt and Hoffmann. Through the Press and his architecture, Loos set out to prove that Art Nouveau

and the ornamental style were suitable for European culture, and that work without ornament, in a pure, rational style, showed lucidity of thought and a high degree of civilization. In 1908 he published *Ornament und Verbrechen (Ornament and Crime)*. His work demonstrates his theories. For example, the Villa Karma, Clarens, Switzerland (1904–7), shows geometric simplicity, and the Steiner House, Vienna (1912), has been called the first completely modern dwelling, and is built from reinforced concrete. The Goldman and Salatsch Building, Michaelerplatz, Vienna (1910), is faced by huge areas of elegant, polished marble. From 1920 to 1922 Loos was in charge of municipal housing in Vienna, and advanced bold schemes like the Henberg Estate. In 1923 he moved to Paris, where he became involved with the ▷Dadaists, and built a memorable house for ▷Tristan Tzara (1926). Loos was one of the most important architects of the 20th century, and influenced a whole generation of architects.

Bib.: Munz, L., *Adolf Loos: Pioneer of Modern Architecture*, London, 1966

Lopes, Gregório (c1490–c1550)

Portuguese painter. He was Court Painter to Manuel I and John III. His works showed the influence of Italian ▷Renaissance art.

López y Portaña, Vicente (1772–1850)

Spanish painter. Born in Valencia, he came to Madrid in 1789 to study at the Fine Arts School of San Francisco. In 1801, he was appointed President of the Academy of San Carlos in Valencia, where he built up a reputation for his portraits and religious commissions. In 1815 he succeeded ▷Goya as First Painter to the Court of Ferdinand VII. He was appointed Director-General of the Academy in 1817, and Director of the ▷Prado in 1823.

López was a prolific artist, responsible for ▷frescos, religious paintings and decorations for several palaces, and numerous portraits of the court and other officials. A follower of ▷Mengs' academic style, he was an accomplished but uninspired technician. One critic has suggested that his portraits render costume, jewellery and tokens of rank superbly, but convey nothing of the person wearing them.

Lorenzetti, Ambrogio (fl 1319–48) and Pietro (fl 1320–48)

Italian family of painters. They were brothers, from Siena, who, with ▷Simone Martini, were the most important of the generation after ▷Duccio. Little is known of their lives, but Ambrogio is documented from 1319 (a dated *Madonna and Child* for Vico L'Abate, now Florence, Museo Diocesano) and Pietro from 1320 (a dated ▷polyptych attributed to him, *Madonna and Child with Saints*, Pieve di Sta Maria, Arezzo). Pietro, however, is generally believed to have been the elder and both are believed to have died from

the Black Death in 1348. They worked principally as independent artists, their only known collaboration being the lost ▷fresco cycle of the *Life of Mary* (1335) for the ▷façade of the public hospital in Siena. The style of both brothers takes as a starting point the work of Duccio, but is heavily inflected with the monumentality of ▷Giotto. Ambrogio is known to have worked in Florence as he is recorded in that town's painters' ▷guild in 1327. Yet despite similarities, significant individual characteristics identify each brother's *oeuvre*: Pietro's works are generally more dramatic and display more emotional intensity (e.g. *Descent from the Cross*, fresco, Lower Church of San Francesco, Assisi), whereas Ambrogio tends towards an intellectual approach, both in his penchant for more complicated perspective constructions (cf. Ambrogio's *Presentation in the Temple*, 1342, Florence, Uffizi, with Pietro's simpler *Birth of the Virgin*, also 1342, Siena, Museo dell'Opera del Duomo) and in the complex political ▷allegory (although the programme would have been prescribed for him) of his most important commission, *The Allegory of Good and Bad Government* (fresco, 1338–9, Siena, Sala della Pace, Palazzo Pubblico). This latter work is also notable for being the earliest painting of modern times to depict a credible townscape against a ▷panoramic landscape, populated with well-observed figures set in a convincing relationship with their surroundings.
Bib.: Starn, R., *Ambrogio Lorenzetti: The Palazzo Pubblico, Siena*, New York, 1994; Van Os, H., *Sienese Altarpieces 1215–1460*, Groningen, 1984

Lorenzo Monaco (Piero di Giovanni) (c1370–c1425)

Italian painter. He was born in Siena, but was active chiefly in Florence. He was in Florence by 1391 and took vows in the Camaldolensian monastery of S. Maria degli Angeli, from whence he earned the name by which he is best known, Don Lorenzo Monaco (i.e. Lorenzo the Monk). The monastery was famous for its school of ▷manuscript illuminators, and in the Laurentian Library, Florence, are several books produced by the monastery containing illuminations attributed to Lorenzo. His style is an essentially old–fashioned mixture of late ▷trecento Sienese school, with the love of exquisite patterning and detail one would expect from an artist trained as a miniaturist. Although he rose to the rank of deacon, he was, by 1402, living outside the monastery and a member of the painters' guild of St. Luke. His best ▷altarpieces are *The Coronation of the Virgin* (dated 1413, modern style 1414, Florence, Uffizi) commissioned by his own monastery (another version is in London, National Gallery) and *The Adoration of the Magi* (c1422, Florence, Uffizi). The two earlier *Coronations* are in a typical trecento manner: decorative, brightly coloured with gold backgrounds, populated by flat attenuated figures and with little attempt at any creation of depth. The

last shows a significant shift towards the ▷International Gothic style (and pre-dates ▷Gentile da Fabriano's International Gothic work in Florence): the figures are solid (but still elongated and elegant) and move in a spatial landscape of fantastic rocky shapes (but still with a gold sky). The costumes are sumptuous, but with purely decorative drapery folds that in no way indicate the anatomy of the underlying body. Details are now more naturalistic, but there is no rational spatial construction overall. Most importantly, naturalism has only been introduced piecemeal to give extra veracity to what were intended first and foremost to be beautiful devotional artefacts. Lorenzo was also a ▷fresco painter, his chief surviving work in this medium being the cycle of *Scenes from the Life of the Virgin* in the Bartolini Chapel of Sta Trinità (c1420–25).
Bib.: Eisenberg, M., *Lorenzo Monaco*, Princeton, 1989

Lorrain, Claude
▷Claude Lorrain

lost wax
▷cire-perdue

Lotto, Lorenzo (c1480–1556/7)
Italian painter. He was Venetian, but in addition to working in and around the Veneto, he is documented as working in the Vatican in 1509, though his work there is not known. He then worked in Bergamo until 1526, whereupon he returned to Venice, staying there until c1530. He thereafter worked in various towns in the Marches until 1554 when, his sight now partially gone, he became a lay brother at the monastery of the Santa Casa at Loreto. He was apparently a difficult character and the survival of his diary and account book (dating from 1538 onwards) suggests that he had little commercial success. His extremely individual, sometimes eccentric, style was early on influenced by ▷Giovanni Bellini (according to ▷Vasari, his master) and later by ▷Giorgione and ▷Titian (who, if Vasari is correct, would have been his fellow pupils), but his travels brought him into contact with the work of ▷Fra Bartolommeo, ▷Raphael, ▷Correggio, and even ▷Dürer, all of whose influence he reflects, while nonetheless preserving his own artistic identity. His paintings are mostly of religious subjects. His *Annunciation* (1520s, Recanati, Pinacoteca) is a good example of his unique vision: he has abandoned the traditional formulas – Mary is obviously startled, her cat is terrified and the angel's salutation looks energetically over-demonstrative. Lotto has shown the precipitate nature of this momentous supernatural event, an interpretation some perhaps found indecorous. He also painted some mythologies and many sensitive portraits, such as the *Portrait of Andrea Oldoni* (1527, Royal Collection) in which he not only convincingly suggests the sitter's presence, but also shows himself to be a fine colourist.
Bib.: Berenson, B., *Lorenzo Lotto*, London, 1956;

Caroli, F., *Lorenzo Lotto*, Florence, 1975; Klebanoff, R.P., *Lorenzo Lotto and the Surgeon's Painting*, Ottawa, 1988; Zampetti, P., *Lotto*, Bologna, 1983

Louis, Morris (Morris Louis Bernstein) (1912–62)

American painter of Russian descent. He studied at the Baltimore Institute of Fine and Applied Arts 1929–33. He moved to New York in 1936 and took on some commissions for the WPA (▷Federal Arts Project). In 1940 he returned to Baltimore, where he exhibited and taught. In 1952 he moved to Washington DC, where he met ▷Noland and came to the attention of ▷Clement Greenberg. The works of ▷Helen Frankenthaler influenced him to adopt a form of ▷Abstract Expressionism based on large patches of colour. These early experiments in ▷colour field painting were done with ▷acrylic paint, which was often poured, rather than painted, on the canvas. He used ▷unprimed canvas, and allowed areas of the work to remain unpainted. During the 1950s he produced several series of works, including ▷ *Veils* (1954, 1957–9) and *Florals* (1959–60). His colourism was less emotional than that of ▷Rothko.

Louvre: *Mona Lisa* is returned after the War, 1947

Louis Philippe style

The prevailing taste in the French decorative arts during the reign of Louis Philippe (1830–48). Essentially eclectic in nature, it is more a collection of styles, comprising a continuation of ▷Empire style in a heavier vein; also, in the early years of the period, the so-called Troubadour style, a mock-▷Gothic revival in which decoration derived from ▷Flamboyant Gothic architecture, was arbitrarily applied to furniture, clocks, tapestries and other luxury household objects. The Troubadour style was superseded in c1835 by more accurate (but nonetheless more ponderous) imitations of Gothic, ▷Renaissance and ▷Mannerist household objects. The period also saw a revival of ▷Rococo decoration.

Loutherbourg, Philippe Jacques de

▷de Loutherbourg, Philippe Jacques

Louvre

The French national collection based in Paris. The Louvre itself is an impressive palace, first constructed as a fortress in 1190 by King Philippe-Auguste to protect Paris against Viking raids. During the 1360s Charles V transformed the keep and added towers to make the Louvre into a palace rather than a bastion. Over the next four centuries, French Kings and Emperors altered, improved and enlarged the building, until it became the elegant complex of interlocking courtyards seen today. The collection, which contains European painting 1400–1900, European sculpture 1100–1900, Oriental, ▷Egyptian, ▷Greek, ▷Etruscan and ▷Roman antiquities and *objets d'art*, is founded principally on the state collection, gathered by the monarchy and through the spoils of war, and also includes a number of private collections left to the nation. Important holdings include work by ▷van Eyck, ▷Bosch, ▷van Dyck, ▷Hals, ▷Rembrandt, ▷Dürer, ▷Cranach, ▷Gainsborough, ▷Reynolds, ▷El Greco, ▷Zurbarán, ▷Ribera, ▷Goya, ▷Watteau, ▷Fragonard, ▷Poussin, ▷Ingres and ▷Delacroix. The collection is enormous and criticisms had been made of the hanging and the accessibility of some of the work. However, these problems have largely been solved by the latest architectural intervention, ▷I.M. Pei's Glass Pyramid (1989) which improves the entrance area and provides more visitor facilities.

Lowry, Lawrence Stephen (1887–1976)

English painter. He was born in Rusholme, a suburb of Manchester. He worked as a rent clerk and studied art intermittently from 1908 at Manchester and Salford Art Schools, establishing his own style of panoramic backgrounds, small stick-like figures and a limited palette (e.g. *A Manufacturing Town*, 1922, London, Science Museum). His early inspirations were ▷Expressionist (e.g. *Country Lane*, 1914, Salford), but his work was more closely associated with naive art than any other movement and he was not a member of the ▷London Group until 1948. In 1919 he received widespread recognition with a one-man show, but he remained an isolated figure, not honoured by the establishment until 1962 (when he was elected ▷RA). He was given an Arts Council retrospective in 1966. In his later life he travelled to Wales and Northumberland, and produced some eerily empty

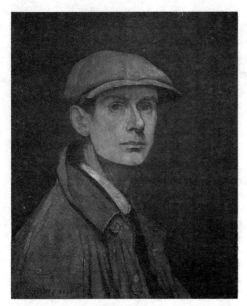

L.S. Lowry, *Self-portrait*, 1925, Salford Museum and Art Gallery, Lancashire

landscapes and beach scenes. He also painted a number of images of death, illness and isolation (e.g. *Cripples*, 1949, Salford). Today his work is popular, but noted for its subject matter – the recording of a now lost industrial life (e.g. *Britain at Play*, 1943, Lincoln) – rather than any great artistic merit.

Bib.: Andrews, A., *Life of Lawrence Stephen Lowry*, London, 1977; *Lawrence Stephen Lowry*, exh. cat., Salford, 1983

lubok (pl. lubki)

Russian folk ▷woodcut. They were a popular art form among the Russian peasantry in the 17th century, where they often took the form of song sheets. Their simple designs and relationship with Russian popular culture made them an important influence on early 20th-century ▷avant-garde art, especially the work of ▷Goncharova and ▷Larianov.

Lucas van Leyden (1494–1533)

Netherlandish engraver and painter. He was trained in Leiden by his father (by whom no works are known) and Cornelis Engelbrechtsz. A surprisingly mature print, *The Drunkenness of Mohammed*, signed 'L 1508' (i.e. when Lucas was 14 or 15) makes his traditional date of birth questionable. Furthermore, both of his known masters were principally painters and it is uncertain by whom Lucas was taught to engrave. He is known to have entered the Painters' Guild of Leiden in 1514, married there in 1515 and visited Antwerp in 1521 (where it is believed he met ▷Dürer, the strongest influence on his graphic work). In 1527 he went to Middelburg to see ▷Gossaert and travelled around Flanders with him. ▷Van Mander writes that

Lucas enjoyed travelling, often worked in bed, and loved wining and dining; his prodigious output of prints would, however, tend to suggest a rather greater application. It is in his prints that his chief importance lies, and he is generally regarded as one of the greatest of graphic artists, both technically and for his powers of invention. Many of his prints are dated, but there seems to be no particular pattern of stylistic development throughout his life. Although his paintings are rare, he produced a major work with his *Last Judgement* (1526, Leiden, Stedelijk Museum), commissioned for Leiden Town Hall. A ▷triptych, the panels are cut to an unusual bell shape at the top. The nudes, though revealing the influence of ▷Raphael (perhaps through ▷Raimondi's engravings) have an eloquence which also suggests study from life; they were in any case singled out for special praise by van Mander. The painting is particularly notable for the delicacy of its colour harmonies, the fluidity of its brushwork and, despite the subject depicted, the serenity of mood it conveys. Lucas seems to have had no pupils of any importance, nor any known followers.

Bib.: Jacobowitz, E.S., *The Prints of Lucas van Leyden and his Contemporaries*, exh. cat., Washington, 1983; Smith, E.L., *The Paintings of Lucas van Leyden*, Columbia, 1992

Lucchesino, Il
▷Testa, Pietro

Luchism
▷Rayonism

Luini, Bernardino (fl 1512; d 1532)

Italian painter. He was Milanese. His earliest work reflects the influence of ▷Bramantino, ▷Solari and ▷Bergognone, but his artistic personality later became totally swamped by that of ▷Leonardo da Vinci. A fresco at Chiaraville, Milan, dated 1512, gives the commonly accepted earliest recorded date of Luini's career; an altarpiece in the Musée André, Paris, dated 1507 and signed 'Bernardino of Milan' has not achieved similar acceptance. Luini's paintings popularize and to a great extent sentimentalize Leonardo's painting style and, like many popularizers, he achieved great success in his lifetime and was later highly esteemed by the Victorians who (▷Ruskin included) considered him a superior colourist to Leonardo. Luini's *Christ among the Doctors* (London, National Gallery) is typical of his Leonardesque work and was for many years considered to be by Leonardo.

Bib.: Jones, P.M., *Bernardino Luini's Magdalene*, Studies in History of Art, 24 (1990), pp. 67–72

Lukács, Georg (1885–1971)

Hungarian literary critic and Marxist philosopher. Born into a prosperous Jewish family in Budapest, he established himself as a major literary critic with the publication of *Soul and Form* (1911). In 1918 he joined

the Communist Party and served as Cultural Commissar in Bela Kun's Government, taking refuge in Vienna after its collapse in August 1919, and spending the 1920s writing in Austria, Russia and Germany. Following Hitler's rise to power in 1933, Lukács went to Moscow to join the Institute of Philosophy, returning to Hungary in 1945 to be appointed Professor of Aesthetics at the University of Budapest. He later defied Russia by supporting the Hungarian Uprising in 1956, but resigned the day before Soviet power was re-established. After a brief period of exile in Romania, he was permitted to continue publishing until his death.

Lukács' writings have been of prime importance to the development of Western ▷Marxism, particularly the study of ▷reification in *History and Class Consciousness* (1923), which was denounced by the Communist Party and subsequently disowned by Lukács himself. He was at the centre of artistic debates in the 1930s about the nature of realism, and championed ▷Social Realism for its continuity with high European culture. For Lukács, the 19th-century drift from narrative realism (whether in literature or the fine arts) to ▷Expressionism and an exaggeratedly subjective viewpoint reflected the ▷alienation of the artist under capitalism. Indeed, the ▷modernist insistence on the fragmentation of consciousness serves a counter-revolutionary purpose by hiding the social totality and the highly unified nature of global capitalism.

Bib.: Gluck, M., *Georg Lukács and his Generation 1900–18*, Harvard, 1991; Kadarkay, A., *George Lukács: Life, Thought and Politics*, Oxford, 1991; Sim, S., *George Lukács*, New York, 1994

Luks, George (1866–1933)

American painter. He was born in Pennsylvania and studied at the Academy of Fine Arts in Philadelphia as well as Paris and London. He worked as an illustrator, and later became one of the original members of ▷The Eight. His work focused on Realist scenes of New York city life.

Luminism

This term is used to refer to two separate art tendencies. The first of these is the work of a group of 19th-century American landscape painters who produced panoramic landscape scenes with virtuosic light effects. Artists such as F.H. Lane (1804–65), M.J. Heade (1819–1904) and some of the ▷Hudson River School group painted scenes in which sky and water were suffused with light. Luminist landscape painting was less popular after 1880.

The alternative usage of the term is in reference to a type of ▷synaesthetic art popular after the Second World War and practised internationally by artists such as ▷Le Parc, Richard Lippold (b 1915) and the ▷GRAV group. These artists used mirrors and light effects in their works from the 1960s. The term

'luminism' was coined in the exhibition catalogue of 'Light, Motion, Space', which took place in Minneapolis in 1967.

Lurçat, Jean (1892–1966)

French painter and tapestry designer. He studied at Nancy and became President of the Nancy Designer's group, following Émile Gallé. In 1912 he moved to Paris, where he studied at the Académie Colarossi and came under the influence of ▷Cubism. During the First World War he taught art, and afterwards travelled in the Middle East and Africa. The influence of the Orient filtered into his tapestry designs, which were primarily based on abstract and vegetative themes with an occasional ▷Surrealist tinge. In 1939 he worked for ▷Gobelins.

Lust

(from the Latin: '*Luxuria*)'. One of the Seven Deadly Sins; with ▷Avarice the most heavily condemned by the medieval Christian Church; with ▷Gluttony classed as a sin of the flesh (*vita carnalia*). The Church generally associated Lust with women, and in medieval ▷Last Judgement scenes, women who had been consigned to Hell for the sin of lust are often shown naked with snakes or toads devouring their breasts and genitals (e.g. ▷Taddeo di Bartolo, *Last Judgement*, 1393, fresco, San Gimignano, Collegiata) based on the belief that the torments of Hell would concentrate on the offending organs. ▷Bosch, in the *Luxuria* scene from his *Tabletop of the Seven Deadly Sins* (Madrid, Prado) shows two pairs of lovers in a marquee, surrounded by food, drink and musical instruments – Gluttony and music being regarded as preludes to Lust. The figure of Lust may also be associated with certain animals traditionally associated with sexual incontinence: the goat or bear, which she may ride; rabbits, or a dove (appropriated from ▷Venus, goddess of sexual love). Lust may, like ▷Pride, gaze at her reflection in a mirror. In the conflicts between the ▷Virtues and Vices, Lust is defeated by ▷Chastity. The medieval obsession with the sin of Lust lost much of its fervour in the humanistic society initiated by the Italian ▷Renaissance. By the time of the later editions of ▷Cesare Ripa's *Iconologia*, *Luxuria* had been replaced by the less damnable *Impudicitia* ('Lewdness').

Lutyens, Sir Edwin Landseer (1869–1944)

English architect. He was the foremost Edwardian architect, whose actual creative span ran from the late 1890s to the 1930s. He trained in the office of Ernest George and Harold Peto, but was chiefly influenced in his early career by Norman Shaw and Philip Webb. He began as a designer of country houses for wealthy clients. Masterpieces of ▷Arts and Crafts architecture, they employ local building materials in designs which derive from traditional vernacular building types, characteristically picturesque and asymmetrical.

Among the most successful are Orchards, near Munstead, Surrey (1897) and Deanery Gardens, Sonning, Berkshire (1899–1902); the latter was for Edward Hudson, the editor of *Country Life*, the magazine which did so much to promote Lutyens' work. In the building of Heathcote in Yorkshire (1906) can be seen a new development: a symmetrical composition in which are employed the Classical ▷orders. The finest of his Classical houses are generally held to be The Salutation, Sandwich, Kent (1911) and Gledstone Hall, Yorkshire (1922–6). He was also in demand to design public buildings. These are typically Edwardian: imposing, opulent and built on a grand scale. The most notable are the neo-▷Baroque office block, Britannic House, Finsbury Circus, London (1920–24; now named 'Lutyens House'); the Midland Bank, Poultry, London (1924–37), and, perhaps his masterpiece, the Viceroy's House at New Delhi, India (1912–31, now Rashtrapati Bhavan), a building that blended the European language of Classicism with oriental motifs, executed in local Dholpur sandstone. Lutyens also designed many war memorials, including the *Cenotaph* (1919–20) in Whitehall. He was knighted in 1918 and was President of the ▷Royal Academy from 1938 until his death (elected ▷ARA 1913, RA 1920).

Bib.: Butler, A.S.G., *The Architecture of Sir Edwin Lutyens*, London, 1950; Gradidge, R., *Edwin Lutyens, Architect Laureate*, London, 1981; Inskip, P., *Edwin Lutyens: An Architectural Monograph*, New York, 1986; Lutyens, M., *Edwin Lutyens*, London, 1980; O'Neill, D., *Sir Edwin Lutyens: Country Houses*, New York, 1980; Richardson, M., *Sketches by Edwin Lutyens*, London, 1994

Lyotard, Jean-François (b 1924)

French ▷postmodernist critic and philosopher. Lyotard sees the postmodern condition to be one of scepticism and does not believe in a consensus of criticism. He has published numerous articles and lectures, and his best-known book is *The Postmodern Condition: A Report on Knowledge* (1979).

Bib.: Williams, J., *Lyotard*, Oxford, 1995

Lyrical Abstraction

The term favoured and propagated by ▷Mathieu to describe the expressive ▷abstraction associated with the ▷School of Paris after the Second World War, and to distinguish it from geometric abstraction. Nonfigurative and based on gestural improvisation, the canvas records the marks of the artist's spontaneous and intuitive expression. The 'L'Imaginaire' exhibition of 1947, organized jointly by Bryen and Mathieu, was originally to be called 'Vers l'Abstraction Lyrique' (Towards Lyrical Abstraction). The term is virtually synonymous with ▷Art Informel and ▷Tachisme, associated with artists such as Bryen, Mathieu, ▷Hartung, Soulages and ▷Wols.

Bib.: Restany, P., *Lyrisme et Abstraction*, Milan, 1960

Lys, Johann

▷Liss, Johann

Lysippus (Lysippos) (fl second half of the 4th century)

Greek sculptor, the most famous and influential of his day. A native of Sicyon, he is said by ▷Pliny to have executed 1,500 bronze sculptures in a long and prolific career. He was Court Portraitist to Alexander the Great and his successors. None of his original bronzes survive, though a number exist in the form of Roman copies in marble. Lysippus was famed for the introduction of several important innovations:

(i) figures with smaller heads and a new system of more slender proportions to their bodies.

(ii) a shift away from statues with a single, frontal viewpoint, towards statues designed to encourage the spectator to view them from more than one position in order fully to understand the action.

(iii) a greater degree of naturalism in the human figure, achieved by combining (i) and (ii) with a less schematic, more subtle rendering of the musculature.

Each of these innovations can be best appreciated by a comparison of the Roman marble copy of Lysippus' *Apoxyomenos* (an athlete using a scraper to remove oil from his body, Vatican Museums) with the Roman marble copy of the ▷*Doryphorus* (or, 'Spear-bearer', Naples Museum) of ▷Polyclitus, the foremost sculptor of the previous generation. The ▷*Farnese Hercules* is believed to be a later enlargement of a bronze original by Lysippus.

Bib.: Robertson, M., *A History of Greek Art*, 2 vols, Cambridge, 1975; Smith, R.R.R., *Hellenistic Sculpture*, London, 1991

Lysistratus (Lysistratos) (fl 2nd half of the 4th century)

Greek sculptor, the brother of ▷Lysippus. According to ▷Pliny, he was a portraitist working, like his brother, towards an increased naturalism. He is said to have been the first sculptor to take a plaster cast of a face in order to make a portrait. Into the life-mask, thus created, molten wax would be poured which, when set, would form the basis upon which Lysistratus would work to create the portrait. As Martin Robertson has pointed out, this represents a significant difference of approach between, on the one hand, Classical portraiture, in which an ideal type is modified towards the subject's individual appearance, and, on the other, an idealized naturalism, in which an actual appearance is modified towards an ideal type. Pliny also states that Lysistratus began the practice of taking casts from statues.

Bib.: Robertson, M., *A History of Greek Art*, 2 vols, Cambridge, 1975

Mabuse
▷Gossaert, Jan

MacBryde, Robert (1913–66)
Scottish painter. He studied at the Glasgow School of Art, where he met ▷Robert Colquhoun who became his lifelong companion and collaborator. They worked together in London from 1941.

Macchiaioli
A group of Italian painters formed in Florence in c1855. Under the influence of ▷Corot and the ▷Barbizon school, they produced many landscapes, especially of the Tuscan countryside, as well as ▷genre paintings. A number of them were activists and involved with the military conflicts of the Risorgimento, and their goal was to break away from the strictures of the Italian art academy system to create a purely Italian modern art. Among the group were ▷Fattori and ▷Telemaco Signorini, and their use of patches (*macchia*) of pure colour gave them some affinities with the later developments of ▷Impressionism.
Bib.: Broude, N., *The Macchiaioli: Italian Painters of the Nineteenth Century*, New Haven, 1987

McCubbin, Frederick (1855–1917)
Australian painter. He was one of the founders of the ▷Heidelberg School. He produced ▷genre paintings representing bush subjects.

Macdonald, Frances (1874–1921) and Margaret (1865–1933)
English family of designers and watercolourists. Frances was born in Newcastle-under-Lyme. From 1890 she trained at the Glasgow School of Art with her sister, Margaret, where they met ▷Mackintosh and Herbert McNair. With the encouragement of the Principal, they formed the design group, The Four, and rapidly gained a local reputation. In 1896 they exhibited at the ▷Arts and Crafts Exhibition in London, where their work was criticized for its ▷Art Nouveau style. Margaret married ▷Mackintosh in 1900. She worked on designs for the ▷*Yellow Book* (e.g. *Ill Omen*, 1893) and later produced textiles for Foxton and Sefton (1916–23). Frances, like her sister, specialized in swirling plant forms and elongated, languid women. She married McNair in 1898 and moved with him to Liverpool, before returning as a teacher to Glasgow School of Art in 1907.

Bib.: *Glasgow Girls*, exh. cat., Glasgow, 1990; Helland, J., *The New Woman in Fin-de-siècle Art: Frances and Margaret Macdonald*, Ottawa, 1992

Macdonald, James Edward Hervey (1873–1932)
Canadian painter of English birth. He moved to Toronto in 1907 from England. He painted landscapes in Northern Ontario, and after meeting ▷Lawren Harris, devoted himself to creating a truly Canadian art. He was a member of the ▷Group of Seven. From 1918 he concentrated on scenes of the Algoma region of Ontario, and from 1921 he taught at the Ontario College of Art.

Macdonald, Jock (James Williamson Galloway) (1897–1960)
Canadian painter of Scottish birth. He began his career in Scotland, working as an architectural draughtsman, but in 1919 he went to the Edinburgh College of Art to pursue a strong interest in painting. In 1926 he moved to Vancouver, where he taught art and came into contact with the ▷Group of Seven. In 1934 he founded with ▷Fred Varley the British Columbia College of Arts, and he became friendly with ▷Emily Carr and ▷Lawren Harris. He worked on the fringes of ▷Surrealism, and his abstract compositions revealed his interest in ▷automatism. During the 1950s he met ▷Dubuffet and joined the Painters Eleven group.
Bib.: Zemans, J., *Jock Macdonald: The Inner Landscape*, Toronto, 1981

Macdonald-Wright, Stanton (1890–1973)
American painter. He was born in Virginia and studied in Los Angeles. He travelled to Paris in 1907 where he continued his training at the ▷Académie Julian, the Académie Colarossi and the ▷École des Beaux-Arts. He came into contact with ▷Delaunay and, like him, pursued colour experiments. With ▷Morgan Russell, he invented ▷Synchromism in 1913, and in that same year he exhibited at the ▷Armory Show. Like many European artists before the First World War, Macdonald-Wright claimed to have been the first artist to practise ▷abstraction, and his works are certainly among the earliest abstract compositions. He lived in London during 1914–16, before returning to the United States. He settled in California and became involved in early experiments in colour cinema.

McEvoy, Ambrose (1878–1927)

English painter. He studied at the ▷Slade in the 1890s and met ▷Orpen and ▷Augustus John there. He was fascinated by ▷Gainsborough and produced portraits in that artist's style. During the First World War, he painted officers and produced sketchy portraits of high society women. From 1915, he also painted landscapes and interiors.

Bib.: *Ambrose McEvoy*, exh. cat., Belfast, 1968

machicolation

A parapet or gallery supported on ▷brackets projecting from the top of a medieval fortification. Between the brackets are floor openings through which boiling oil, molten lead, missiles, etc. could be dropped on attackers.

machine aesthetic

A term describing the 20th-century love affair with the efficiency and gloss of machinery, which concentrated on the representation of speed, mechanical efficiency through streamlining, and reproducibility. This heady mixture was hymned by ▷Futurism, but is best seen in architecture and interior design, surviving into our day in the high-tech style of the ▷Pompidou Centre.

Bib.: Banham, R., *Theory and Design in the First Machine Age*, London, 1962; Cork, R., *Vorticism and Abstract Art in the First Machine Age*, 2 vols, London, 1976; Pevsner, N., *The Sources of Modern Architecture and Design*, London, 1968

Machuca, Pedro (c1490–1550)

Spanish painter, sculptor and architect. Born in Toledo, he studied in Italy under ▷Michelangelo until 1520. Returning to Spain, he decorated the carved panels behind the altar at Jaén Cathedral and settled in Granada. In 1527 Machuca was commissioned to design the Palace of Charles V. Work began in 1531 and continued well into the 17th century, but the building was never completed. Machuca provides a crucial link between Spain and the Italian ▷Renaissance. His *Madonna del Suffragio* (1517, Madrid, Prado) has been seen as an early, influential example of Florentine ▷Mannerism. More importantly, he carried the lessons of the ▷cinquecento back to Spain, both in his ▷altarpiece paintings and his design for the Palace of Charles V. Unsubtly planted within the grounds of the ▷Alhambra, the architectural masterpiece of the recently expelled Moors, the Palace is the first example of Classical architecture is Spain. The square plan, with a circular court large enough for bullfights, combines Italian Mannerism with ornamental Spanish ▷Plateresque style.

Macip (Masip), Vicente (1475–before 1550)

Spanish painter. He worked in Valencia in an Italianate style. He was responsible for the ▷altarpiece of Segorbe Cathedral (completed 1535). His son was Juan Vicente (▷Juan de Juanes).

Mack, Heinz

▷Zero Group

Macke, August (1887–1914)

German painter. He was born in Meschede, and during his childhood spent time in Basle, where he came into contact with the work of ▷Böcklin. He was taught by ▷Corinth (1907), and travelled widely throughout Europe (Italy in 1905, Holland in 1906, Paris in 1907). He met ▷Marc in 1910 in Munich, and with him joined the ▷Blaue Reiter, established the following year. In 1912 they both journeyed to Paris, where they discovered ▷Cubism and the work of ▷Delaunay. In 1914, he visited North Africa with ▷Klee. He was killed in battle the same year. His early ▷Impressionist style developed into a use of strong, sunlit colour, applied in painterly facets of light (e.g. *Woman in the Park*, 1914, New York, Museum of Modern Art). His preferred subject matter remained urban scenes of shopping and leisure. His North African work had a more structured appearance (e.g. *Turkish Café I*, 1914, Bonn, Städtisches Kunstmuseum), and in 1913 he experimented with pure abstraction. He produced many ▷watercolours.

Bib.: *Der Blaue Reiter*, exh. cat., Hanover, 1989; Jurgen, G., *August Macke*, Kirchdorf, 1989; Moeller, M.M., *August Macke: Voyage en Tunisie*, Paris, 1990

McKim, Mead and White

One of the leading and most prolific traditionalist architectural partnerships in the USA at the turn of the 20th century. It was led by C.F. McKim (1847–1909), who had studied architecture at the ▷École des Beaux-Arts in Paris. On his return to the USA he entered the office of ▷H.H. Richardson, where he met W.R. Mead (1846–1928), with whom he soon established a partnership, shortly to be joined by Stanford White (1853–1906). Their earliest successes were with country clubs and mansions (e.g. Isaac Bell Junior House, Newport, Rhode Island, 1881–2) in the ▷Shingle Style that Richardson had pioneered (under the initial influence of ▷Norman Shaw's English domestic revival style). The partnership then moved towards a more formal, classical approach, pioneering the Colonial Revival in such buildings as the H.A.C. Taylor House, Newport, Rhode Island, 1882–6. Their final and most grandiose phase was that of the ▷Beaux-Arts-influenced period revivalism of their most famous public buildings, amongst which were: the Boston Public Library (1888–95) modelled on the 19th-century Bibliothèque Ste-Geneviève in Paris; the

University Club, New York (1899–1900), based on the 15th-century Italian ▷Renaissance Palazzo Riccardi in Florence; and the Pennsylvania Railroad Station, New York (1906–10, now demolished), modelled on the antique Roman tepidarium of the Baths of Caracalla, Rome. Mead, the last surviving original member, retired in 1919, but the firm continued until 1961.

Bib.: Roth, L.M., *McKim, Mead & White, Architects*, New York, 1983 and London 1984; Wilson, R.G., *McKim, Mead & White*, New York, 1983

Mackintosh, Charles Rennie (1868–1928)

Scottish architect, designer and painter. He was born in Glasgow, and was apprenticed to two architect firms in the city – Hutchinson's (1884) and Honeyman and Keppie (1889) – whilst studying at the Art School evening classes. In 1891 he won a travelling scholarship to Italy. Meanwhile, he had become the leader of The Four, a design group including the ▷Macdonald sisters

Charles Rennie Mackintosh, Ebonized clock with inlaid decoration, c1917, The Fine Art Society, London

(he married Margaret in 1900) and Herbert McNair, which controversially exhibited at the London ▷Arts and Crafts Exhibition in 1896. Their work was later popularized by the *Studio* (an 1890s Scottish art magazine), as one of the few examples of a European ▷Art Nouveau style in Britain.

Mackintosh's first major architectural commission was the Glasgow Herald Building (1893), designed in Scottish baronial style, which he considered best suited the climate and location. He then won the competition for the redesign of the School of Art (1897–9) followed by the library wing (1906–10), which was not merely functional, with huge north-facing windows and plain,

stripped interiors, but also well suited to the heavily sloping site and given a grand, turreted entrance, emphasized by characteristic ironwork. The combination of streamlined modernity and traditional craftsmanship and motifs was used again in the Hill House (1902–6). Mackintosh's interior design, seen both there and in his tearoom designs for Mrs. Cranston, used stark white walls and careful lighting to set off black rectilinear furniture and more delicate, organic and floral-inspired murals. In 1900, he exhibited with the ▷Vienna Secessionists (e.g. *The Art Lover's House*) and his work was always more appreciated in Europe. By 1914, however, his practice was in decline and he moved to London to concentrate on fabric design, increasingly using stronger blues and reds, as reflected in his geometric interiors for Derngate, Northampton (1916). He retired to Port Vendres in 1923, producing stylized ▷watercolours of the waterfront.

Bib.: Billcliffe, R., *Mackintosh's Watercolours*, London, 1979; idem., *Charles Rennie Mackintosh: Furniture and Interiors*, London, 1979; Cooper, J. (ed.), *Mackintosh Architecture*, New York, 1980; Crawford, A., *Charles Rennie Mackintosh*, London, 1995; Howarth, T., *Charles Rennie Mackintosh and the Modern Movement*, London, 1990; MacLeod, R., *Charles Rennie Mackintosh*, London, 1968

Mackmurdo, Arthur Heygate (1851–1942)

English architect, designer, illustrator and writer. He was born in London. From 1869 he studied architecture, and from 1873 was employed by the ▷Gothic revivalist James Brooks, before opening his own practice in 1875. He also attended drawing classes with ▷Ruskin, whom he accompanied to Italy in 1874. He was an associate of ▷Morris in the Society for the Preservation of Ancient Buildings, and in 1883 he published the topographical *Wren's City Churches*, now remembered for its dramatic ▷Art Nouveau title page. In 1882, he established the Century Guild, for the promotion of beautiful yet functional design and he published the *Hobby Horse* magazine to promote its ideas. Throughout the 1890s he took part in various design exhibitions (Home Art and Industries, 1885, Manchester Jubilee, 1888). After the collapse of the Guild in 1888, he increasingly worked with ▷Crane and through him became interested in socialism, supporting the National Association for the Advancement of Art, and also writing (e.g. *Human Hive*, 1926). His own furniture design was based on solid, simple structures, often inlaid with lighter, more complex patterns, and influenced by ▷Voysey and later ▷Ashbee. He designed few buildings, but used a range of styles from the simple Queen Anne interpretation of 25 Cadogan Gardens (1893–4) to ▷the Baroque ornament at Great Ruffins, Essex (1904). In his later life he increasingly wrote on economics.

Bib.: Doubleday, J., *The Eccentric Arthur Heygate Mack-murdo 1851–1942*, Colchester, 1979

Maclise, Daniel (1806–70)

Irish painter and caricaturist. He was born in county Cork and attended art school there, before moving to Dublin (1826) where he made a living as a portrait draughtsman. He came to London in 1827 and entered the ▷Royal Academy schools the following year, again financing his studies with portraiture. He first exhibited at the RA in 1829 and travelled to Paris in 1830. He produced sketches in *Fraser's Magazine* under the pseudonym Alfred Croquis and book illustrations (e.g. Crofton Croker's *Fairy Legends*, 1826). Many of his subjects were taken from history and mythology (e.g. *Marriage of Eva and Strongbow*, 1854, Dublin; *Undine*, 1844, Windsor), using idealized figures and a grand scale. He was influenced by ▷Delaroche and by the ▷Nazarenes, although his work also had an earthy realism derived from ▷Wilkie. He was a friend of Dickens and influenced English artists such as ▷Frith. He painted the *Death of Nelson* for the Houses of Parliament in 1864, one of a number of works for the Palace of Westminster which took him 20 years to complete.

Bib.: Dafforne, J., *Pictures of Daniel Maclise RA*, London, 1873; *Daniel Maclise*, exh. cat., London, 1972

McTaggart, William (1835–1910)

Scottish painter. He was born in Macrahanish, Mull of Kintyre, but for most of his career was based in Edinburgh. He studied at the Trustees Academy there, under ▷Lauder, his fellow pupils including ▷Pettie and ▷Orchardson. His early work followed these artists in producing a series of ▷genre scenes inspired by ▷Wilkie, but in the 1860s he turned to landscape, producing lively, sketchy images of Scotland (e.g. *Spring*, 1864, Edinburgh, National Gallery of Scotland). Often these included children, which added to their breezy playfulness. Increasingly he concentrated on coastal scenes, developing a rough ▷impressionistic palette which concentrated on the movement and light of nature (e.g. *Storm*, 1890, Edinburgh, National Gallery of Scotland). He worked in relative isolation and his paintings were little known or appreciated outside Scotland until after his death. He has been compared to the Impressionists, but he had a ▷Romantic view of nature – seen in works like *Return of St. Columba* (1898, Edinburgh, National Gallery of Scotland) – which actually brings his work closer to that of ▷Constable.

Bib.: *William McTaggart*, exh. cat., Edinburgh, 1989

Maderna, Carlo (1556–1629)

Italian architect. He was the nephew of ▷Domenico Fontana. He worked in a ▷Baroque style, designing a number of important church façades in Rome, including Sta Susanna (1596–1603). He was also involved in the design of St. Peter's, which he devised as a ▷Latin cross plan (diverging from previous designs of a ▷Greek cross), and suggested the ▷giant order for the façade.

Bib.: Hibbard, H., *Carlo Maderna and Roman Architecture 1580–1630*, London, 1971

Maderno, Stefano (1576–1636)

Italian sculptor. He worked for Paul V, the ▷Borghese pope, who commissioned much religious, mythological and monumental sculpture from him between 1605 and 1621. He worked in a ▷Baroque style.

Madonna

The mother of ▷Christ, and one of the central figures of worship in the Catholic Church. She is depicted in devotional images, with or without her child, but narratives of her life are also common.

In the early Church the Madonna was portrayed enthroned, larger than surrounding saints, symbolic of the Church and of wisdom, and the Queen of Heaven (e.g. ▷Duccio, ▷*Maestà*, 1308–11, Siena). During the ▷Renaissance, artists increasingly represented her as an ordinary woman, humble, maternal and earthly (e.g. ▷Lippi, *Tarquinia Madonna*, 1437, Rome, Galleria Nazionale d'Arte Antica, Palazzo Barberini). This trend was however reversed again during the glorification of ▷Counter-Reformation, when images of her ▷Assumption became increasingly common. She was also sometimes portrayed as the Virgin of Pity or Solitude, emphasizing the sufferings of her life. Another popular image showed her with saints (▷sacra conversazione, e.g. ▷Veneziano, *St. Lucy Altarpiece*, 1445, Florence; ▷Giorgione, *Enthroned Madonna and Saints*, 1500–1505, Castelfranco St. Liberale) or donors (e.g. ▷Titian, *Madonna of the House of Pesaro*, 1519–26, Venice Sta Maria del Frari).

The main events of the life of the Madonna include: the ▷Immaculate Conception (she was preordained stainless, even from the womb of her mother, Anne); her birth; the ▷Annunciation; and the ▷death of the Virgin (▷Assumption). She also figures commonly in scenes from Christ's life (▷Crucifixion; ▷Deposition). She may be symbolized by a unicorn or ▷lily (virginity), an olive (peace), a rose garden (she was a 'rose without thorns'), and dressed in blue to represent heaven.

▷Virgin Mary

Madonna della Misericordia

The image of the ▷Madonna which shows her protecting figures beneath her cloak. For the Catholic Church her primary role was as intercessor, and this aspect of her becomes especially important at the ▷Last Judgement, where she sits at Christ's right hand. In pre-▷Renaissance art, she is often given a protective role over religious communities (symbolized by monks and donors under her cloak) and over the population at

large (e.g. ▷Piero della Francesca, 1445, Sansepolcro). Sometimes falling arrows are shown, and occasionally Christ is present.

Madonna of Humility

Images of the Virgin and Child seated on the ground, or on a low cushion, which symbolize the Virgin's humility (one of the Cardinal Virtues, ▷Virtues and Vices). She is often shown in a rose garden, symbolic of her virginity (an enclosed area), her purity (a rose without thorns) and of the ▷Passion (a red rose representing blood) (see ▷Lippi, *Profile Portrait of a Young Woman Madonna Adoring the Child*, 1450s, Berlin, Staatliche Museen).

Madonna with the Long Neck (Madonna del collo lungo)

▷Parmigianino's painting in oils embodies the excesses of ▷Mannerist artificiality. Although commissioned by Elena Baiardi in 1534 for the Church of Santa Maria de'Servi in Parma, it was left incomplete at Parmigianino's death in 1540, and ▷Vasari claims that the artist himself was unhappy with it. A representation of the ▷Virgin and Child is rendered extraordinary by the elongation of her limbs and the stalk-like neck. The five figures at her side are thought to be angels, but their role and spatial relationship to

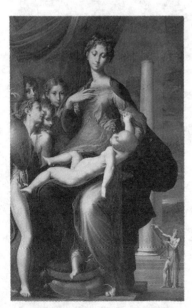

Francesco Parmigianino, *Madonna with the Long Neck*, 1534–40, Uffizi, Florence

Mary is uncertain. The infant Christ is outsized and perches precariously on her slanted knees, while in the background a row of columns echoes the tapering proportions of the central figure but serves no other functional purpose. In pursuit of visual beauty, Par-

migianino disregarded all ▷Renaissance standards of proportion and the integration of disparate elements into a meaningful whole. The strange elegance of the painting is set wholly against nature, and in the process acquires a new aesthetic autonomy. It is now in the ▷Uffizi Gallery, Florence.

Maes, Nicolaes (1634–93)

Dutch painter. He was born in Dordrecht, where he specialized in ▷genre scenes and portraits. In about 1648, he entered ▷Rembrandt's studio in Amsterdam (staying until 1654), adopting his master's use of rich dark shadows, simplified, strongly lit forms, and a warm, red-dominated palette. His paintings of sleeping servants (e.g. *The Idle Servant*, 1655, London, National Gallery) and below stairs assignations (e.g. *The Listening Maid*, 1656, London, Wallace Collection) of this period were very popular and reflect not only Rembrandt's, but also ▷de Hooch's influence. In about 1665 he visited Antwerp and presumably experienced French and Flemish portraiture and particularly that of ▷van Dyck, for following his return to Holland his style underwent a major shift towards that painter's style – he now principally painted elegant portraits, using a much cooler palette. Maes was, in fact, responding to a change of fashion in Holland which ▷van der Helst had led and which had already affected another of Rembrandt's followers, ▷Govert Flinck. In 1673, Maes moved permanently to Amsterdam, where his newly adopted style brought him considerable success. **Bib.**: Robinson, W.W., 'Nicolaes Maes as a Draughtsman', *Master Drawings*, 27 (Summer 1989), pp. 146–62

Maestà (Madonna and Child Enthroned with Saints)

▷Polyptych painted by ▷Duccio in 1308–11 (tempera on wood, 210 × 390 cm/7 ft × 12 ft 8 in) for the Duomo in Siena. The central panel of the ▷altarpiece depicts the ▷Virgin and Christ enthroned and surrounded by saints and angels; above were a series of arched panels containing busts of the prophets and below panels representing the infancy of Christ. The top ▷pinnacles contained scenes from the life of the Virgin surmounted by angels and the back depicted the ▷Passion. The altarpiece is now scattered (e.g. the ▷*Nativity* is in the National Gallery in Washington) although the central sections remain in the Duomo Museum in Siena. The depiction of the Virgin and Child represents a symbiosis of naturalism and the ▷Byzantine and late ▷Gothic traditions; figures are crammed into the gold background surrounding the elaborate inlaid marble throne but the Christ child is characterful and Duccio achieves a personal bonding between him and Mary, whilst the angels are given inquisitive personalities as they peep over the back of the throne in an attempt to see the mother and child. Similarly in the lesser panels, the artist exploits his interest in naturalism and character: the ▷*Crucifixion*

(Siena) depicts a violent crowd, their expressive heads silhouetted against the background, as well as the two thieves, whilst, in contrast, the figure of Christ is isolated in the empty centre of the panel. Duccio also displays an interest in humorous detail: the *Entry into Jerusalem* (Siena) sets the scene outside an Italian hill town, with figures climbing trees better to view Christ. All this however, takes place against a gold background, betraying Duccio's roots and pointing up the delicate line he treads between Gothic and naturalistic intention.
Bib.: *La Maestà di Duccio restaurata*, Florence, 1990

Maffei, Francesco (c1600–60)

Italian painter. He was born in Vicenza but was based largely in Venice. A disciple of ▷Mannerism, his paintings achieve spectacular and dissonant effects through their unorthodox compositions and vibrant colour. Portraits such as *The Glorification of Gaspare Zane* (1664, Vicenza Museum) and *The Glorification of the Inquisitor Alvise Foscarini* (1652, Vicenza Museum) place their subjects at the centre of a complex ▷allegorical scheme surrounded by the noncorporeal personification of their various ▷Virtues. In his later religious painting, Maffei's Impressionistic brushwork creates a haunting quality.
Bib.: Rossi, P., *Francesco Maffei*, Milan, 1991

magic(al) Realism

A term first used by the art critic Franz Roh in 1925 in a book on Post-Expressionism, to distinguish the ▷Verism of German post-war ▷Neue Sachlichkeit (New Objectivity) artists such as ▷Dix and ▷Grosz from the ▷Romantic naturalism of ▷Wilhelm Leibl and ▷Hans Thoma. The term suggested a link with ▷Surrealism, and indeed both movements shared ▷de Chirico's mystical sense of spatial ▷perspective. The term however has developed a wider use to describe any work sharing this conjunction of the real and the bizarre or fantastic, though in literature it is largely applied to Latin American novelists such as Jorge Luis Borges, Isabelle Allende and Gabriel García Márquez.

Magnasco, Alessandro (Il Lissandrino) (1667–1749)

Italian painter. He was born in Genoa, but worked first in Milan, where he had studied under Filippo Abbiati. He also spent a brief period in Florence (1709–11) and in 1735 retired to Genoa. Magnasco started out as a portrait painter, but became famous for his melodramatic landscapes influenced by ▷Salvator Rosa and peopled by romantic vagabonds and witches. A fascination with the grotesque deepened into images of torture, obscure ceremonies and mysterious tribunals, evoking a spooky atmosphere of flickering light through rapid brushstrokes.
Bib.: Mandel, O., *Art of Alessandro Magnasco: An Essay*

in the Recovery of Meaning, Florence, 1994; Muti, L., *Alessandro Magnasco*, Faenza, 1994

Magritte, René François Ghislain (1898–1967)

Belgian painter. He was an important ▷Surrealist, born in Lessines in Belgium. His mother drowned herself in 1912, a traumatic incident which some argue is echoed in Magritte's imagery. He studied at the Académie des Beaux-Arts, Brussels (1916–18) and associated with the city's circle of ▷avant-garde painters. He worked in a wallpaper factory, and as a freelance designer of posters and advertisements until 1926, when a contract with Galerie le Centaure in Brussels allowed him to paint full-time. In 1927 he moved to Paris and befriended ▷Breton, but was forced by the closure of the Galerie to return to Brussels and

René Magritte, *Son of Man*, 1964, private collection

advertising. With his brother he set up his own agency, and settled into a secure middle-class existence. He remained in Belgium during the German occupation, an experience which led him to break with Breton and renounce the violence and pessimism of his earlier work, although he later returned to these themes.

Magritte's use of an almost blandly neutral style to portray bizarre subjects dates from the late 1920s, and was heavily influenced by ▷de Chirico. The earliest examples, like other Surrealist paintings, follow the whims of the unconscious to produce a deliberately illogical image. After 1927 Magritte became more analytical, using painting to set out paradoxes and explore metaphysical and sexual themes. Many of these rely on transposing objects into unfamiliar surroundings, such as the giant egg in a cage in *Elective Affinities* (1933, private collection). Others use

contradictory written statements, or disjunctive images in windows, mirrors or paintings within the frame to question the nature of representation.

Bib.: Meuris, J., *René Magritte*, New York, 1991; Paquet, M., *René Magritte 1898–1967: Thoughts Rendered Visible*, Cologne, 1994; Sylvester, D., *Magritte, The Silence of the World*, London, 1992; Whitfield, S. (ed.), *René Magritte: Catalogue Raisonné*, London, 1992

mahlstick

A length of wood or bamboo with a cushion at one end that leans lightly on the canvas surface; used by an artist as a handrest to avoid touching the canvas, especially when painting details.

Maiano, Benedetto da

▷Benedetto da Maiano

Maillol, Aristide (1861–1944)

French sculptor and designer. He studied at the ▷École des Beaux-Arts, but he was most influenced in his early career by the work of ▷Gauguin and ▷Bernard. He began his artistic career at the turn of the 20th century, producing tapestry designs related to the ideas of the ▷Nabis. From his association with this group, he maintained an interest in ▷Symbolism throughout his career. He produced his first sculptures in 1895, and from 1900 onwards he began concentrating on sculpture. Although he looked to the legacy of ▷Rodin for the naturalism that would dominate his work, he rejected the detail and drama of Rodin's work in favour of more monumental and simplified designs. In 1905 he exhibited at the ▷Salon d'Automne, and his work became quickly known throughout Europe. Although most of his works had ▷abstract qualities, they were always based on nature, and Maillol looked back to the heritage of ▷Classical Greek sculpture much more than most of his contemporaries. He specialized in simplified sculptures of female nudes and fragments of nudes. He also produced ▷woodcuts, the most famous examples of which were his illustrations for an edition of Virgil's *Eclogues* (1926).

Bib.: *Aristide Maillol*, exh. cat., Tokyo, 1984

majolica (maiolica)

A type of tin-glazed Italian earthenware. The name, majolica, is a corruption of 'Majorca', the Mediterranean island whence such pottery, produced by Moorish craftsmen, was first introduced into Italy in about the 12th century. The greatest period of Italian majolica was the first half of the 16th century. Characteristically it is decorated with ▷polychrome historical, literary, Biblical, mythological or ▷genre scenes. This type of narrative-painted majolica is specifically termed *istoriato* ('decorated with stories') majolica. The most famous specialists in *istoriato* painting were Nicola da Urbino (fl 1520–37/8), Orazio Fontana (d 1571), and Francesco Xanto Avelli (fl 1530–45). The ▷Mannerist painter ▷Taddeo Zuccaro also occasionally supplied designs for *istoriato* majolica. Although the term majolica is sometimes used to refer to tin-glazed earthenware produced in northern Europe (e.g. ▷Delftware), it strictly refers only to Italian tin-glazed earthenware.

Makart, Hans (1840–84)

Austrian painter. He studied in Munich with ▷Piloty and was in Vienna from 1869. He produced mythological, historical and allegorical subject matter in a style deliberately reminiscent of ▷Rubens.

maki-e

(Japanese, 'sprinkled picture'.) A type of lacquer dotted with gold and silver powder while wet.

Malatesta, Sigismondo (1417–68)

Italian patron. He is best remembered as the despotic ruler who appropriated the church of San Francesco in Rimini and redesigned it as a mausoleum for himself, his mistress (and from 1456 his wife), Isotta degli Atti, and selected ancestors and courtiers. From 1432 onwards, he was Signore of Rimini, having succeeded his uncle. Sigismondo was a renowned *condottiere*, working initially for, among others, Pope Eugenius IV. However, in 1459, he incurred the enmity of Pope Pius II and was excommunicated; even worse, in 1462, the Pope publicly consigned him to Hell, the only person to suffer this condemnation during their lifetime. His private life had long been the subject of scandalous tales and when his second wife died in 1449, it was rumoured that she had been poisoned, although modern scholars believe the stories that surround him largely to have been concocted by his many enemies. At first (c1447) the commemoration at San Francesco was to have involved only a chapel to Sigismondo's name saint. However, the idea grew into a redevelopment of the entire church including a new marble façade designed by ▷Alberti with a Roman triumphal arch motif (specifically recalling the local Arch of Augustus), interior sculptural decoration by ▷Agostino di Duccio employing distinctly Classicizing, but above all pagan motifs, and ▷fresco decoration in the ▷sacristy by ▷Piero della Francesca. Ever since known as 'Il Tempio Malatestiano', work finished with the restoration still incomplete in 1461.

Bib.: Cavallari, O., *Sigismondo Malatesta*, Rimini, 1978

Mâle, Émile (1862–1954)

French art historian, who specialized in the medieval period. He was Professor of History of Art at the Sorbonne and his publications, such as *The Gothic Image*, remain read as much for their literary style as their art historical content.

Bib.: Mâle, E., *The Gothic Image: Religious Art in France of the Thirteenth Century*, 3rd edn., New York, 1961

malerisch

▷painterly

Malevich, Kasimir (1878–1935)

Russian painter. He was one of the forerunners of ▷abstraction. He was born in Kiev, and after little formal education settled in Moscow in 1902. His early influences were ▷Impressionist (e.g. *Flower Girl*, 1904, St. Petersburg, State Russian Museum), but by 1907 he was part of the ▷avant-garde art circle and exploring Russian ▷folk art which he combined with an enthusiasm for ▷Post-Impressionist ideas. He exhibited at the ▷Jack of Diamonds exhibition, and like ▷Larianov he experimented with ▷Cubist ideas, producing a series of chunky images of the peasantry (e.g. *Taking in the Harvest*, 1911, Amsterdam, Stedelijk Museum). He also experimented with confused, almost ▷Surrealist images (e.g. *An Englishman in Moscow*, 1914, Amsterdam, Stedelijk Museum), and with the depiction of ▷dynamism (e.g. *Knife Grinder*, 1912, New Haven, Yale University Art Gallery). In 1913 he designed the backcloth for the play *Victory over the Sun*, using a black and white square, and the following year he began to produce his abstract ▷Suprematist canvases, which used coloured geometric shapes to suggest dynamism and space. He first labelled these 'Trans-rational' but exhibited 36 of them in 1915 as Suprematism (e.g. *Suprematist Composition: Red Square, Black Square*, New York, Museum of Modern Art) and over the next years pushed the ideas further, incorporating curves, crosses and a wider range of colours. He also produced, in 1918, ▷*White on White*, a single colour canvas. He described his work as pure intuition, and believed that he had discovered a modern art form which could truly represent the Revolution. Like many of his contemporaries he was disappointed; although he was a teacher from 1922, the State mistrusted his abstraction. From 1918 he increasingly rejected painting in favour of three-dimensional art, producing a series of white geometric sculptures – architectonics. For much of the rest of his life, he tried to explain and justify his theories rather than produce new work (his edited writings were published by the ▷Bauhaus in 1927).
Bib.: Crone, R., *Kasimir Malevich: Climax of Disclosure*, London, 1991; Douglas, C., *Malevich*, London, 1994; Fauchereau, S., *Malevich*, New York, 1993; Milner, J., *Kasimir Malevich and the Art of Geometry*, New Haven and London, 1996; Zhadova, L.A., *Malevich, Suprematism and Revolution in Russian Art*, London, 1982

Malouel, Jean (d 1419)

Netherlandish painter. He was trained in Paris in 1396. From 1397 to 1415 he was court painter to the Dukes of ▷Burgundy, firstly Philip the Bold and then John the Fearless. He was an uncle of the ▷Limbourg brothers. Although it is difficult to attribute many works to him with confidence, he was responsible for ▷altarpieces for the Chartreuse of Champmol.

Malvasia, Count Carlo (1616–93)

Italian painter and art historian. Little is known of his own art, but he was responsible for an important study of Bolognese painting, *Felsine pittrice: vite dei pittori bolognese* (*Lives of the Bolognese Painters*, 1678), written in the biographical mode of ▷Vasari.

Mamontov, Savva Ivanovitch (1841–1918)

Russian industrialist and patron of the arts. After making his fortune by building the first railway from Archangel to Murmansk, he bought the ▷Abramtsevo estate near Moscow in 1870. In 1872 he invited the landscape painter Vassily Polenov and the sculptor Antokolsky (both associated with the ▷Wanderers group) to Abramtsevo as the basis of an artistic colony, and they were later joined by ▷Repin and the brothers Viktor and Apollinarius Vasnetsov. The estate became a focus for the revival in traditional Russian ▷arts and crafts, with the establishment of a pottery workshop and a museum of peasant art. Apollinarius Vasnetsov designed a church based on the architecture of medieval Novgorod, and the whole group's research into national traditions of architecture and ▷icon-painting (which had been largely submerged under western influences) was of primary importance to Russian ▷modernism. The Abramtsevo artists also contributed ornate set and costume designs to Mamontov's amateur dramatics; and when he founded his own stage and theatre companies, these greatly influenced theatre design in Russia. Mamontov assisted ▷Diaghilev with the funding of ▷*Mir Iskusstva*, but before the magazine had found its feet he was faced with bankruptcy by an economic slump in 1899 and placed under house arrest. This brought his career as patron to a halt, but he continued to paint and sculpt himself until his death.
Bib.: Grover, S., *Savva Mamontov and the Mamontov Circle*, Madison, 1978; Kopshitser, M.I., *Savva Mamontov*, Moscow, 1972

mandala

(Sanskrit, 'circle'.) A Tantric ▷Buddhist image, usually painted on a banner, intended to be a metaphorical representation of the structure of the universe. It generally consists of a circle enclosing a square, with a doorway in the middle of each side of the square. In the centre of the square may be an image of a Buddha, or other deity, or a bodhisattva. The mandala is used as a focus for contemplation.

Mander, Karel van (1548–1606)

Netherlandish painter and writer on art, he founded the Haarlem Academy with ▷Hendrick Goltzius and ▷Cornelius van Haarlem, and gave, in *Het Schilder Boeck* (*The Book of Painters*) both a theory of art and artistic biographies in the manner of ▷Vasari and ▷Pliny.
Bib.: Mander, K. van, *Dutch and Flemish Painters* (trans.

of *Het Schilder Boeck*), New York, 1993; Melion, W.S., *Shaping the Netherlandish Canon: Karel van Mander's 'Schilder Boeck'*, Chicago, 1991

mandorla

(Italian, 'almond'.) The almond-shaped framework which artists used as a conventionalized representation of the aureole or blaze of glory which surrounded Christ at his ▷Transfiguration (e.g. ▷mosaic, c1100, Church of Daphni, Greece) and ▷Ascension (e.g. Rabbula Gospels, 586, Florence, Laurentian Library), and the ▷Virgin Mary at her ▷Assumption (e.g. ▷Nanni di Banco, 1414–21, Florence, Porta della Mandorla, Duomo). It also frames Christ in scenes of the ▷Harrowing of Hell and the ▷Last Judgement (e.g. ▷Pietro Cavallini, c1290, Sta Cecilia in Trastevere). The mandorla first appears in ▷Early Christian art, but its use had been largely discontinued by the end of the 15th century. It is also called a *vesica piscis* (fish-bladder).

Manessier, Alfred (1911–93)

French painter. He studied architecture at the ▷École des Beaux-Arts, Amiens. In 1929 he went to Paris and studied painting by copying ▷Old Masters in the Louvre and attending art classes informally. In 1933 he exhibited at the ▷Salon des Indépendants, the ▷Salon d'Automne and the Salon des Tuileries. He was a pupil of ▷Roger Bissière in 1936, joined the Témoignage group a year later, and exhibited at the Jeunes Peintres de la Tradition Française exhibition in 1941. He underwent a conversion to Catholicism whilst staying at the Trappe de Soligny in 1943, and began to take his inspiration and titles from Catholic liturgy. His *Salve Regina* of 1945, painted to the strains of the Good Friday liturgy, suggesting the equivalence between music and colour, was one of the most widely exhibited works in the post-war exhibitions of Art Sacré. His abstract paintings attempted to reveal the interior force of things rather than their external appearance through symbol and suggestive colour. His fascination with the expressive qualities of light and colour found its perfect realization in the six ▷stained-glass windows he completed for the church of Saint Agathe in Breseux in 1947.

Bib.: Cayrol, J., *Manessier*, Paris, 1955; *Alfred Manessier, Peinture*, exh. cat., Abbeville, 1990

Manet, Edouard (1832–83)

French painter and illustrator. He was born in Paris, the son of a magistrate, and initially seemed destined to follow in his father's footsteps. However, in 1850 he entered ▷Couture's studio, where he spent six years developing a naturalistic ▷genre style, and he achieved some ▷Salon success (e.g. *Spanish Guitar Player*, 1859). In the 1860s with a series of

Edgar Degas, *Study for a Portrait of Manet*, Metropolitan Museum of Art, New York

revolutionary works, including two shown amidst derision at the 1863 ▷Salon des Refusés (▷*Déjeuner sur l'Herbe* and ▷*Olympia*), he showed that art should be about 'concrete reality' and modernity and gained the admiration of ▷Zola (whom he painted in 1867) and ▷Baudelaire. He visited Spain in 1865, where he admired the work of ▷Velázquez and ▷Goya (whom he directly quoted in works like the *Execution of Maximilian*, 1867, Mannheim). Stylistically, he remained tied to his roots, preferring a limited sombre palette, and intense tonal contrasts. Increasingly in the 1870s he was associated with the ▷Impressionists, and although he never exhibited with the group and rejected their title, he spent summers with ▷Monet at Argenteuil (e.g. *Boating*, 1874, New York, Metropolitan Museum) and taught ▷Morisot. Like Monet he painted scenes of Paris life (e.g. *The Railway*, 1873, Washington, National Art Gallery). His brushwork did become more unfinished (e.g. *Roadmenders*, 1877–8, private collection) and his colour more intense, emphasized by experiments with ▷pastels, but even his last great work, *The Bar at the Folies Bergères* (1882, London, Courtauld Institute Galleries) possessed the deliberate observation of his youth. He also worked in ▷lithography, producing illustrations for Edgar Allan Poe.

Bib.: Adler, K., *Manet*, Oxford, 1986; Clark, T.J., *The Painting of Modern Life: Paris in the Art of Manet and his Followers*, London, 1985; Hamilton, G.H., *Manet and his Critics*, New York, 1969; Hanson, A.C., *Manet and the Modern Tradition*, London, 1977; *Manet, 1832–1883*, exh. cat., New York, 1983

Manfredi, Bartolommeo (1580–1620/1)

Italian painter. He was from Mantua and studied in Rome. There he came under the influence of ▷Caravaggio, but he specialized in scenes of soldiers and card players with tavern settings. He received a great deal of private patronage, and his works were popular in both Italy and the Netherlands.

manière criblée

▷dotted manner

Mannerism

In its most specific sense the term refers to the period of Italian art of the post-High ▷Renaissance, particularly the art of Rome, c1530–90. The term, however, is problematic as it is a descriptive historical term rather than one which had contemporary currency in the 16th century, and it has been used in a pejorative way by some commentators since the 17th century. ▷Vasari used the term '*maniera*', meaning 'grace' or 'style', as a desirable quality in art that reached its greatest expression in the work of ▷Raphael and ▷Michelangelo. He praised the qualities in these two artists of idealized strength and beauty and elegance, especially as seen in Michelangelo's ▷Sistine Ceiling. This style of *maniera* was cultivated by artists such as ▷Rosso, ▷Primaticcio, ▷Bronzino, ▷Cambiaso and Vasari himself who saw themselves as successors to these artists. Their style is characterized by elongated, muscular figures, complex posture, heightened emotion, and intricate composition. The style became the popular court art of the period, its most bizarre extreme being represented at the court of Rudolf II of Prague where the intellectual atmosphere of magic, astrology and ▷Neoplatonism influenced ▷Savery and ▷Spranger. Some art historians have even extended the term to include ▷El Greco in his elements of religious ecstasy. Mannerism's demise came with the realism of ▷Caravaggio and the new classicism of the ▷Carracci in the 1590s.
Bib.: Shearman, J., *Mannerism*, Harmondsworth, 1967; Smart A., *The Renaissance and Mannerism in Italy*, London, 1971; idem, *The Renaissance and Mannerism Outside Italy*, London, 1972

Man of Sorrows

A devotional image of ▷Christ in which he displays the five wounds of his ▷Crucifixion (i.e. his pierced hands, feet, and right side). Christ wears a crown of thorns and may stand or be seated on the tomb. Either held by him or arranged around him are the instruments of the ▷Passion (the nails that fixed him to the cross, the cross itself, the lance that pierced his side, the vinegar-soaked sponge which was offered to him to drink, the pillar to which he was bound at the ▷Flagellation and the rope that bound him, etc.). The image also appears as a vision above the altar in

representations of the Mass of Gregory the Great. The vision had appeared in answer to Gregory's prayer for a sign to convince an unbeliever in his congregation.

Man Ray (1890–1976)

American painter, draughtsman, sculptor and photographer. He was born in Philadelphia. He studied painting at the Ferrer Centre, New York, and other schools while working in an advertising agency and as an engineering draughtsman. The ▷Armory Show in

Man Ray retouching a fashion print (photo. R. Schall), Stapleton Collection

1913 encouraged him to study ▷Cubism and abstract design. Through his friendship with the photographer and ▷avant-garde art dealer ▷Alfred Stieglitz he took up photography in c1915. He became friends with ▷Duchamp in 1915, and with him and ▷Picabia helped in founding the New York ▷Dada movement. In 1921 he moved to Paris and was a leading member of the Dada and ▷Surrealist movements there. As well as a number of Dada objects (especially *Gift*, 1921), his major contributions were his pioneering photographic techniques. These included the rayogram or photogram, a camera-less technique where an object was placed directly onto photographic paper, and solarization. He worked for a while with the photographer Lee Miller, whom he used as a model. He was also a leading experimenter in abstract and ▷Surrealist films; he produced *Anemic Cinema* with Duchamp in 1926, and his other films include *Le Retour de la Raison* (1923), *L'Etoile de Mer* (1928), and *Les Mystères du Château de Des* (1929).
Bib.: *Man Ray*, exh. cat., Ghent, 1995

mansard roof

A form of roof in which each of the four faces has a double slope, the lower longer and steeper than the higher. It is named after the French classicist architect ▷François Mansart (1598–1666).

Mansart, François (1598–1667)

French architect. He designed châteaux and churches in and around Paris. His cool classical style was particularly popular in the court at the time, and his Hôtel de la Vrillière in Paris was the model for classical townhouses for many years afterwards. His commissions were mostly private, rather than State, ones, and a number of his buildings were unfinished.

Mansart, Jules

▷Hardouin-Mansart, Jules

Manship, Paul (1885–1966)

American sculptor. He was born in Minnesota and studied at the St. Paul's School of Art (1892–1903), the ▷Art Students' League (1905) and the Pennsylvania Academy of Fine Arts (1906–8). He travelled to Rome (1909–12), where he was impressed with the art of the ancient world. He produced many works for public commission, most of which were in an ▷academic style. He was responsible for the Woodrow Wilson Memorial for the League of Nations in Geneva (1939).

Mantegna, Andrea (c1431–1506)

Italian painter and engraver. He was the pupil and adopted son of ▷Squarcione in Padua. Mantegna's life-long passion for Classical antiquity was given ample early nourishment through the archaeological interests of his master, the abundance of Roman remains in northern Italy and the ▷humanistic atmosphere generated by the local university of Padua. He terminated his apprenticeship with Squarcione at the age of 17 in a celebrated court case, apparently on the grounds of exploitation. Mantegna's earliest independent commission was for the ▷fresco decorations of the Ovetari Chapel of the Eremitani Church in Padua (1459, largely destroyed in the Second World War). These scenes, particularly the *St. James Led to Execution*, display a mastery of perspective and steep ▷foreshortening (the scene adapted to the low viewpoint of the spectator standing in the chapel) unrivalled in any contemporary paintings. Furthermore, Mantegna's understanding of anatomy and his archaeological exactitude are fully in evidence. The influence of ▷Donatello (note the quotation from Donatello's *St. George* in the figure of the Roman soldier) is even more apparent in Mantegna's next commission, the *San Zeno Altarpiece* (late 1450s, Verona, S. Zeno). The spatial construction of the painted *all'antiqua* hall in which the ▷Madonna and Child and attendant saints stand coincides with the actual frame, such that the painted architectural setting relates to the actual ▷entablature and four wooden columns of the altarpiece's frame; thus the frame itself simulates the front of a Classical temple. The figures do not have a sculptural solidity but, as it has been suggested, the composition probably derives from Donatello's dismembered altarpiece in the Santo at Padua.

In 1453, Mantegna married ▷Jacopo Bellini's daughter. Both he and his new brother-in-law, ▷Giovanni Bellini, used a drawing of Jacopo's as a basis for an *Agony in the Garden* (c1455, both London, National Gallery): a comparison of the two reveals the fundamental difference between Mantegna's sculptural conception and the new conception, that of forms modelled by colour and light, their edges softened by atmosphere, that Giovanni was to evolve for Venetian painting.

From 1460 Mantegna was court painter to the ▷Gonzaga rulers of Mantua, his most important work here being the decoration of the Camera degli Sposi (the Bridal Chamber, completed 1474) of the Palazzo Ducale. Again a mastery of ▷perspective is displayed, but also, in the representations of the Gonzaga family and court, Mantegna's skill as a portraitist. Perhaps the most significant part of the scheme is the painting of the ceiling, the middle of which is illusionistically opened up to the sky for the first time since antiquity. From over the fictive balustrade of a circular balcony, figures appear to look down into the room below. Such convincing illusionism was not accomplished again until ▷Raphael in the Vatican and ▷Correggio at Parma before reaching its consummation in the stunning illusionism of 17th-century ▷Baroque ceilings in Rome. Also for the Gonzaga family was the series of nine monumental canvases of the *Triumphs of Caesar* (c1486, London, Hampton Court) which, in addition to all his usual characteristics, reveal Mantegna's interest in antique ▷bas-reliefs. For Isabella d'Este, the wife of Francesco Gonzaga, Mantegna painted the *Madonna della Vittoria* (1495–6) and the *Parnassus* (both Paris, Louvre). Mantegna was also important as a graphic artist, his many ▷engravings exerting a powerful influence on ▷Dürer.

Bib.: Christiansen, K., *Andrea Mantegna: Padua and Mantua*, New York, 1994; Lightbown, R.W., *Mantegna, with a Complete Catalogue*, Berkeley, 1986; Martineau, J., *Andrea Mantegna*, New York, 1992

Manuel, Niklaus

▷Deutsch, Niklaus Manuel

Manueline

Portuguese architecture in late ▷Gothic style produced mostly during the reign of King Manuel I (1495–1521). It was similar to Spanish ▷Plateresque and preceded the introduction of Italian ▷Renaissance influences into Portuguese architecture. The distinctive decorative imagery of the Manueline style includes twisted ropes and other marine symbols.

Manzoni, Piero (1933–63)

Italian artist. He studied for a short time at the Brera Academy. His early paintings of 1956, influenced by nuclear art, show anthropomorphic figures and imprints of objects. In 1957 he was a signatory to the *Manifesto Against Style*, which called for a radically new art such as that of the monochromes of ▷Yves Klein. In 1957–8 he began his series of *Achromes*, identical white pictures signifying nothing beyond their immediate existence, which he then repeated using various materials, such as cotton, feather and bread. In 1959 he was a founder member of the Azimuth gallery in Milan and co-founded the magazine, *Azimuth*, which proposed a new conception of art freed from all traditional restraints: 'There is no need to say anything, being is all that matters.' To prove his point he placed an iron parallelepiped upside down upon the ground, suggesting that the earth itself was the work of art. Affirming that the essence of art is in its own existence, no matter what the object, he sold tins of his own excrement, and signed people's bodies.

Bib.: Battino, F., *Piero Manzoni: Catalogue Raisonné*, Milan, 1991; Celant, G., *Piero Manzoni*, Milan, 1991; *Piero Manzoni*, exh. cat., London, 1974

Manzù, Giacomo (b 1908)

Italian sculptor. He was born in Bergamo and became interested in sculpture in the 1920s when he saw the work of ▷Maillol reproduced in books. After military service, he went to Paris in 1928, although he was thrown out of the city as an 'undesirable alien'. From 1930 he lived in Milan and took on public sculptural commissions. There he saw the work of ▷Rosso and began exhibiting his interest in the work of ▷Donatello and ▷Rodin. He was also influenced by Greek and Egyptian sculpture, and his more traditional sources led him away from the abstract sculpture of contemporary ▷Cubists and ▷Constructivists. He was Professor of Sculpture at the Brera in Milan during the 1940s, but he came into conflict with Fascist authorities. He took on a number of religious commissions both inside and outside Italy, producing bronze doors for both St. Peter's in Rome (1950) and Salzburg cathedral (1958). He taught in Salzburg during 1954–60. He always had an individualistic style, and he remained outside the mainstream of ▷avant-garde movements.

Bib.: *Giacomo Manzù*, exh. cat., Salzburg, 1960

Maori art

▷Polynesian art; New Zealand, art in

Mappa Mundi

(Latin, 'map of the world'.) Term used to describe medieval maps of the earth. These were commonly of what is called a T-O pattern: a flat disc surrounded by water contains the three continents of Africa, Europe and Asia in the shape of a T. The maps mixed both Classical and biblical ideas of geography, with examples such as the Hereford Cathedral map of the late 13th century placing Jerusalem at the centre of the earth.

maquette

(French, 'model'.) A model made out of rough materials, used by architects and sculptors as a three-dimensional sketch from which they can develop their final work.

Maratta (Maratti), Carlo (1625–1713)

Italian decorative artist and painter. He was a pupil of ▷Sacchi in Rome, but he came under the influence of ▷Correggio and ▷Reni. He produced many portraits, images of the ▷Madonna and Child and ▷frescos, some of which indicated his admiration for ▷Raphael.

marble

A metamorphosed limestone, capable of taking a high polish, much used for sculpture and decorative architectural work. White or near-white marble has at various times been the most prized for sculpture. The most important quarry in the ancient world was in the area of Mount Pentelikos in Greece, which produced a fine-grained, golden-toned marble; the ▷Elgin Marbles are of this Pentelic marble. A rather coarser-

Marble: Nanni di Banco, *St. Luke*, Museo Del Opera Del Duomo, Florence

grained, purer white marble was quarried from the Aegean islands of Paros and Naxos, a celebrated example of Parian marble being the sculpture of the Mausoleum at Halicarnassus. From the 3rd century BC, marble of an especially pure whiteness, known

collectively as ▷Carrara marble, was quarried in Tuscany at Carrara, Massa and Pietra Santa. It was used for the ▷*Apollo Belvedere*, and ▷Michelangelo, who often visited the quarries to select his own block, held it in particularly high regard. Its smooth whiteness was also favoured by ▷Neoclassical sculptors.

Marc, Franz (1880–1916)

German painter. He studied philosophy at Munich University in 1897, before turning to art in 1900. He travelled to Paris and Italy in 1902 and was influenced by ▷Impressionism, but his real interest lay in mysticism and he used art to try and express spiritual ideas. He developed a specific theory of colour symbolism and preferred to show animals because they represented passion and intuition. Many of his ideas found sympathy with ▷Kandinsky, and together they established the ▷Blaue Reiter (the name was associated with a series of Marc's works such as *Large Blue Horses*, 1911, Minneapolis, Walker Art Centre). He visited Paris again in 1912, this time with Macke, and discovered ▷Cubism, returning to use coloured facets of light in his work. Initially, these created a sense of mystery as objects were hidden in the structure (e.g. *Deer in the Wood II*, 1913, Karlsruhe, Staatliche Kunsthalle), but increasingly he used dynamic diagonals, similar to those seen in Italian ▷Futurism (e.g. *Tyrol*, 1914, Munich, Staatsgalerie Moderner Kunst). He died on the field at Verdun during the First World War.
Bib.: Duchting, H., *Franz Marc*, Cologne, 1991; Levine, F.S., *Apocalyptic Visions in the Art of Franz Marc*, New York, 1979; Marc, F., *Letters from the War*, New York, 1992; Partsch, S., *Franz Marc, 1880–1916*, Cologne, 1993; Pese, C., *Franz Marc*, London, 1990

Marcuse, Herbert (1898–1979)

German philosopher who became an American citizen in 1940. He was born in Berlin, and attended the universities of Berlin and Freiburg where he conducted research under ▷Heidegger until 1932. He became a member of the Institute of Social Research (▷Frankfurt School) and was forced to flee to Geneva in 1933 following its closure by the Nazis. In 1934 he rejoined the Institute at its base in New York. During the Second World War and its aftermath he worked for Allied intelligence, returning to teaching at Columbia and Harvard in 1951. He was later based at Brandeis University (1954–65) and the University of California at San Diego (1965–76). He died at Starnberg, West Germany.

Marcuse attempted to analyse the repressive nature of western society and the apparent collusion of the masses in their own subjugation. In *Eros and Civilization* (1955) he combined ▷Marxism and ▷psychoanalysis to argue that the ▷Freudian death-instinct led people to desire domination. His most influential work,

however, was *One Dimensional Man* (1964), showing how consumerism, supported by the media and advertising, had enabled capitalism to lull the proletariat into acquiescence. Marcuse was a major influence on the development of the New Left and the counter-culture of the 1960s.
Bib.: Bleich, H., *The Philosophy of Herbert Marcuse*, Washington, 1977; Katz, B. *Herbert Marcuse*, London, 1982

Marées, Hans von (1837–87)

German painter. He studied in Berlin, Munich and Rome, and he travelled extensively through Europe, visiting Spain, France and Holland. He fought in the Franco-Prussian War, but subsequently returned to Italy to concentrate on his painting. He was one of several expatriate German artists in Italy at this time, and like ▷Feuerbach, he adopted a monumental classicism in his work which was nevertheless distinct from the classicism of academic art. Indeed, Marées' flat, frieze-like images and ▷Symbolist subject-matter made him an important forerunner of German ▷avant-garde painting in the early 20th century. While in Naples in 1873 he produced a series of frescos for the Zoological Institute, but he never completed this large commission, nor fulfilled his potential as an artist.

Marescalco, Il
▷Buonconsiglio, Giovanni

Margaret of Antioch

Legendary virgin saint and martyr, featured in Jacobus de Voragine's medieval hagiography, *The Golden Legend*. Her cult achieved great popularity, especially in the Middle Ages, on account of her being the protectoress of those in childbirth. She was a Christian convert in Antioch at the time of the persecution of Diocletian, and was disowned by her pagan father but desired by the local Roman governor. After the governor had failed to seduce her, he incarcerated her in a dungeon where the Devil appeared to her in the form of a dragon and consumed her. However, she made the sign of the cross and caused the dragon's belly to explode, releasing her unharmed. The following day, before she was beheaded, she promised that any child of a woman who invoked her name during pregnancy would be born safely, just as she had been safely released from the dragon's belly. It is this specific aspect of her story that made her so popular. A carving of her can be seen decorating the post of the marriage bed in ▷Jan van Eyck's *Arnolfini Marriage* (1434, London, National Gallery). Her attributes are: the dragon which she tramples and which she sometimes leads on a cord; the cross which ensured her release from its belly; and a palm to indicate that she was a martyr.

Margaret of Cortona (c1247–97)

A Franciscan penitent. The daughter of a Tuscan farmer, her mother died when Margaret was still a child. The cruelty of her step-mother caused her to leave home and thereafter she lived as a local nobleman's mistress for nine years, during which time she bore him a son. After her husband's murder she took refuge with the Franciscans and became a penitent, being admitted ultimately to the Order of Franciscan Tertiaries and devoting her life to nursing the sick poor. She practised extreme forms of self-mortification and appears to have induced visions, one of which involved the image of ▷Christ on a ▷crucifix nodding to her to signify his forgiveness of her former sinful life. In paintings she is represented in a Franciscan habit. Her attribute is a dog, usually a spaniel, in reference to the legend that her husband's pet dog led her to his body following his murder. Paintings of her ecstasy achieved considerable popularity during the 17th century: she collapses in front of a vision of Christ displaying his wounds to her and is supported by angels (e.g. ▷Giovanni Lanfranco, *The Vision of St. Margaret of Cortona*, c1618–19, Florence, Pitti Palace). The popularity of her cult is due to the miraculous cures associated with her name.

Margarito (Margaritone) of Arezzo (fl 13th century)

Italian painter. He was from Arezzo, and he worked in the Italian ▷Byzantine tradition. There seems to be only one documentary reference to him and this is dated 1262. He has signed, but not dated, several works, including the ▷antependium of an altar (*The Virgin and Child Enthroned, with Scenes of the Nativity and the Lives of the Saints*, London, National Gallery) and a *St. Francis* (Arezzo, Museum). ▷Vasari devotes a chapter to him and, given his prejudices against the 'Greek' (i.e. Byzantine) manner, is very positive about his work (particularly his craftsmanship), but perhaps this was because Vasari himself also came from Arezzo. He also states that Margarito was an architect. The National Gallery Margarito is interesting, if for no other reason than that the circumstances of its purchase reveal much about Victorian taste in art: the National Gallery Report for 1858 states that the reason for its purchase was 'to show the barbarous state into which art had sunk even in Italy previously to its revival'.

marginalia

Anything that appears in the margins of a book or ▷manuscript. The term is used frequently to refer to the sometimes whimsical, sometimes grotesque images that were deliberately added to medieval illuminated manuscripts.

Marin, John (1870–1953)

American painter, engraver and architect. He was born in New Jersey and began a career as an architect in the 1890s. He also produced ▷watercolours and studied at the Pennsylvania Academy of Fine Arts (1899–1901) and the ▷Art Students' League (1901–3). From 1905 to 1910 he was in Europe, where he saw the works of ▷Whistler and ▷Bonnard and began producing prints. From 1910, he concentrated his energies on scenes of New York, particularly the skyscrapers, which he produced in engraved and ▷watercolour formats. Colour experiments from 1912 led him away from these urban views, and from 1914, he specialized in seascapes of the Maine coast.

marine painting

One of the earliest of all frescos (from Akrotiri, Santorini, 2nd millennium BC) probably represents a naval battle, and sea scenes are naturally common all around the Mediterranean, given that the sea was a highway as well as a battleground. During the Middle Ages and the ▷Renaissance, most of the important battles (Lepanto was an exception) were fought on land, and marine painting came to the fore only with the rising hegemony of the Low Countries and Britain over the control of Atlantic and Eastern trade, when it could provide a visible exultation of a country's political power and commercial glory. Curiously, neither the Portuguese nor the Spanish, who between them had the world carved up in the 16th century, showed much interest in the genre. Marine painting also went hand in hand with the representation of landscape, being part of the non-academic representation of the outside world that flourished in northern, but not southern Europe.

Bib.: Brook-Hart, D., *British Nineteenth-Century Marine Painting*, 2nd edn., Woodbridge, 1978; Keyes, G.S., *Mirror of Empire: Dutch Marine Art of the Seventeenth Century*, Cambridge, 1990

Marini, Marino (1901–80)

Italian sculptor. He was one of the leading Italian sculptors of the 20th century. He initially studied painting and printmaking at the Florence Academy, working mainly as a graphic artist until, in 1928, he moved to Paris to devote himself to the study of sculpture. He travelled widely in the 1930s (including the USA), but remained apart from the ▷avant-garde movements he encountered. He lived in Switzerland during 1942–6 and thereafter he worked mainly in Milan. His early influences included ▷Medardo Rosso, ▷Rodin and ▷Maillol, but more remarkably ▷Etruscan and ▷Archaic Greek art, as is revealed in his first important sculpture, *Pomona* (bronze, 1941, Brussels, Musées Royaux des Beaux-Arts). From about 1935 he began to explore the theme of the horse and rider (also found in Archaic Greek art), working chiefly in ▷bronze and wood, often ▷polychromed,

(examples in Venice, Guggenheim Museum, and Zurich, Collection Krayenbühl). He also produced some powerful portrait busts (e.g. *Igor Stravinsky*, bronze, 1951, Hamburg, Kunsthalle). In 1970 he donated many of his works to the city of Milan, thereby founding the Marini Museum.

Bib.: Guastalla, G., *Marino Marini: Catalogue Raisonné of the Graphic Works*, Livorno, 1993; Hunter, S., *Marino Marini: The Sculpture*, New York, 1993

Marinus van Reymerswaele (c1509–after 1567)

Flemish painter. He produced ▷genre scenes and portraits of burghers based largely on the model of ▷Quentin Massys. His many paintings of bankers and tax collectors were enormously popular. He also painted a series of images of St. Jerome, based on ▷Dürer's *St. Jerome*.

Maris, Jacobus Hendricus (1837–99), Matthis Thijs (1839–1917) and Willem (1844–1910)

Dutch family of painters. Jacobus was born in The Hague and studied there and at Antwerp (1853), before travelling to Paris (1865–71), where he fell under the influence of ▷Corot and the ▷Barbizon School. His early work was influenced by ▷de Hooch but increasingly he turned from figures to landscape, working in soft, silvery tones (e.g. *Ferry*, 1870, The Hague, Gemeentemuseum; *Three Windmills*, 1880, London, National Gallery). His subjects were characteristically Dutch. He settled in The Hague from 1871 and became the leader of the ▷Hague School.

Jacobus' brother, Matthis Thijs, received the same training but became influenced by German ▷Romanticism after a visit to Germany in 1860. After visiting Paris with his brother (he fought for the Commune in 1870), he travelled to London and settled there in 1877. Although he painted some landscapes (e.g. *Souvenir de Amsterdam*, 1871, Amsterdam, Rijksmuseum), he concentrated on ▷Pre-Raphaelite subjects, especially women, using a similar silvery palette to that of Jacobus (e.g. *Christening*, 1873, Utrecht, Centraal Museum). Much of his work was in watercolour.

Another brother, Willem, was taught by his elder brothers and by ▷Mauve. He began working in a carefully drawn style (e.g. *Donkeys on the Beach*, 1865, The Hague, Gemeentemuseum), but developed a more ▷Impressionist approach, specializing in cattle scenes. His palette retained the cool, silvery tones of his brothers (e.g. *Summer*, 1897, Dordrecht). He taught Breitner.

Bib.: *The Hague School*, exh. cat., London, 1983

Mark

One of the four ▷Evangelists and an Apostle. His symbol is the winged ▷lion. He accompanied ▷Paul and Barnabas on their missions, including Paul's to Rome. According to tradition he was merely the scribe for Paul's gospel and they are sometimes shown together, Mark with a quill in his hand. He was the first bishop of Alexandria, and may be represented in bishop's robes. He carried out several miracles including the curing of a cobbler, the rescue of Venetian fishermen and the freeing of a Christian slave (e.g. ▷Tintoretto, *St. Mark Rescuing a Slave*, 1548, Venice, Accademia). He was martyred by being dragged through the streets with a rope around his neck. His remains were brought to Venice and he is the patron saint of the city (see ▷Donatello, *St. Mark*, 1411–13, Florence, Or San Michele).

Marlow, William (1740–1813)

English painter. He studied under ▷Samuel Scott. He travelled around England and Wales (1762–5) and in France and Italy (1765–8), where he produced landscape views. His works were ▷picturesque, and he specialized in ▷capricii. He also painted topographical landscapes.

Marmion, Simon (fl 1449; d 1489)

Franco-Flemish painter and illuminator. He worked in Amiens 1449–54 and in Valenciennes. He was a member of the Tournai Guild in 1468. Although some delicately painted religious art is attributed to him, there is no work confirmed to be his.

Bib.: Kren, T. (ed.), *Margaret of York, Simon Marmion and the Visions of Tondal*, Malibu, 1992

Marochetti, Baron Carlo (1805–67)

Italian sculptor. He was in England in 1848, and he came to the attention of Queen Victoria and Prince Albert who gave him patronage.

marouflage

(From French, 'maroufle', a glue made from a paint residue.) A process used in ▷mural painting which involves pasting a canvas to a wall or a panel using an oil-based glue.

Marquet, Albert (1875–1947)

French painter. He was born in Bordeaux and studied in Paris at the ▷École des Arts Décoratifs and with ▷Gustave Moreau. He met ▷Matisse at Moreau's studio and worked with him for a number of subsequent years. He exhibited at the ▷Salon des Indépendants and the ▷Salon d'Automne in 1901, and he became one of the first ▷Fauve painters in 1905. He travelled with Matisse to Morocco and began producing ▷watercolour painting. He was a particularly skilled draughtsman.

Marriage à la Mode

Aimed at an upper middle-class and aristocratic audience, the six engraved plates in ▷Hogarth's moral story of 1745 recount the tale of two young persons

forced into marriage by their greedy families. It charts their boredom and adultery, which ends in the husband being killed in a duel by his wife's lover, and the wife committing suicide. In a poetic tragedy that draws on John Dryden's play *Marriage à la Mode* (1663), Hogarth criticizes the selfishness and immoral behaviour of the aristocracy, and warns of the dangers of being more concerned with material rather than familial ends.

Bib.: Cowley, R., *Marriage à la Mode: A Re-View of Hogarth's Narrative Art*, Manchester, 1983

Marriage at Cana

The scene of Christ's first miracle, narrated in John's ▷ Gospel. Whilst attending a wedding feast, Christ, at the instigation of his mother, turns six stone jars of water into wine. Occasionally the groom is depicted with a halo, as according to legend he was ▷ John the Evangelist; separate accounts name the bride as ▷ Mary Magdalene. The event is one of the three festivals of Epiphany, and thus has Church significance. However, in art it became popular as an alternative to the ▷ Last Supper for refectory decoration (e.g. ▷ Veronese, 1563, Paris, Louvre; ▷ Murillo, Birmingham, Barber Institute).

Marriage of Heaven and Hell, The

An illuminated book by ▷ William Blake, begun c1790. It was his first book of the ▷ French Revolutionary era and its text and engraved illustrations reflect the concept of revolutionary energy destructive of the old order. The title refers to and satirizes Emanuel Swedenborg's tract *Heaven and Hell*. Swedenborg was a visionary writer on the Bible, whose fol-

lowers founded the Swedenborgian New Church with which Blake was briefly associated in the late 1780s. The work shows Bake's poetic enthusiasm for the revolutionary bursting of bonds of convention and reason, expressed in the Proverbs of Hell such as 'The road of excess leads to the palace of wisdom' and images of Man in a state of freedom. Its structure is built upon the metaphor of the enquiring soul passing through a moral universe where truth is slowly revealed. The book charts both Blake's and Man's spiritual journey, embodying Blake's belief that the French Revolution signified the first stage in the prophecy of Revelation that led to the ▷ Last Judgement.

Bib.: Bindman, D., *Blake as Artist*, Oxford, 1977

Marriage of the Virgin

A scene not recorded in the ▷ Gospels but popularized by *The Golden Legend* of the medieval author, Jacobus de Voragine. The Virgin chooses ▷ Joseph as her husband from a number of suitors, because of the miraculous flowering of a rod he carries. The scene is usually set in, or outside, the Temple, which was where Mary spent her childhood. It is witnessed by seven virgins who were her companions (e.g. ▷ Raphael, *Marriage of the Virgin*, 1504, Milan, Brera).

Mars (Greek, Ares)

The Roman god of war, the son of ▷ Jupiter and ▷ Juno. He is portrayed as an aggressive warrior, helmeted, sometimes wearing a breastplate, and equipped with shield, sword and spear. Venus, the wife of Vulcan (Greek, Hephaestus), the lame blacksmith god, fell in love with him. The theme of the adulterous union of Mars and Venus and their subsequent discovery and entrapment in Vulcan's net was a popular subject for 18th-century French painters, although in ▷ Renaissance times the same theme had been treated as an allegory of Love/Peace/Harmony (Venus) conquering Strife/War/Discord (Mars). Usually depicted in a rustic setting, Venus reclines elegantly, whilst Mars lies exhausted from their love-making. In ▷ Botticelli's panel painting, *Mars and Venus*, (c1480–1500, London, National Gallery), infant ▷ satyrs ridicule the sleeping warrior and steal away with his weapons and armour. Mars is not always conquered by love, however, and he sometimes retaliates and administers a sound thrashing to ▷ Cupid (e.g. ▷ Manfredi, *The Chastisement of Cupid*, c1605–10, Chicago, Art Institute).

Apart from his liaison with Venus, Mars' relations with the gods of Olympus were usually hostile. In the war between the Greeks and the Trojans, Mars took the side of the Trojans and ▷ Minerva (Athena) that of the Greeks. The two gods fought on the plain of Ilium and Minerva struck Mars down with an accurately thrown boulder. Whereas both Mars and Minerva often involved themselves in warfare, Minerva's involvement, deriving from her origin as Athena,

protectoress of the Greeks, was deemed to be in defence of civilization (i.e. the Greeks themselves), while Mars' involvement was always destructive (on the side of the enemies of Greece).

Marsh, Reginald (1898–1954)

American painter. He was born in Paris, and came to the United States in 1900. He studied at Yale University and the ▷Art Students' League, and then worked as an illustrator for magazines such as the *New Yorker*. He visited Paris in 1925–6 and began painting in the late 1920s. He was one of the 'second generation' of the ▷Ashcan school, and like them, he concentrated on the seamier side of New York city life. He produced murals during the 1930s.

Marshall, Benjamin (1767–1835)

English painter. Under the influence of ▷Stubbs, he produced portraits of horses and sporting pictures. He was deeply involved with sports, and became a writer on horse racing, moving to Newmarket in 1812.

Martha

The sister of Mary and ▷Lazarus. She is the epitome of a busy housekeeper, in comparison with her sister who sits quietly to listen to Christ's teaching (e.g. ▷Velázquez, *Christ in the House of Martha and Mary*, c1618, Edinburgh, National Gallery of Scotland; ▷Vermeer, c1652, Edinburgh, National Gallery). It is Martha who sends for Christ after the death of her brother. According to legend, she and her sister went on a mission to France, saving the people of Tarascon from a dragon.

Martin, John (1789–1854)

English painter and engraver. Although he exhibited at the ▷Royal Academy from 1811, he only came to public attention in 1816 when he showed his *Joshua Commanding the Sun to Stand Still* – a panoramic landscape with thousands of figures and a dramatic biblical subject. He subsequently specialized in such panoramic views, choosing his subjects primarily from the Bible (e.g. *Belshazzar's Feast*, 1826, London, Syon House), from history (e.g. *The Bard*, 1822, New Haven, Yale Centre for British Art) but ultimately painting scenes with a ▷Romantic literary emphasis (e.g. *Sadak Searching for the Waters of Oblivion*, 1812, St. Louis, Art Museum). His works were overtly theatrical, and he was much more skilled at effects of light and the sensation of magnitude than he was at representing the human figure. His works are virtual illustrations of ▷Edmund Burke's idea of the ▷sublime. He produced ▷mezzotints of his own paintings which were wildly popular in their own time, but his most accomplished work as an engraver was perhaps his series of mezzotints of *Paradise Lost* (1827), where the black and white of the medium lent itself to his broad, dramatic effects. His extensive popularity in his lifetime

was followed by relative obscurity after his death. He was later known as 'Mad' Martin because of the extremes of his work, although this nickname may also allude to the fact that his brother attempted to burn down York Minster.
Bib.: Feaver, W., *The Art of John Martin*, Oxford, 1975

Martin, Kenneth (1905–84)

English painter and sculptor. He studied at the Sheffield Art School (1921–9) and at the ▷Royal College of Art (1929–32). He married Mary Balmford (▷Mary Martin) and began collaborating with her. During the 1930s, he came into contact with the ▷Euston Road School, but his own distinct style of abstraction did not evolve until the late 1940s, when he and Mary Martin experimented with ▷Constructivism. They both looked to the mathematical experiments of ▷Max Bill and produced ▷mobiles and constructions, often using light as one of their media. They experimented with both ▷kinetic art and chance elements in their work.
Bib.: *Kenneth Martin*, exh. cat., London, 1975

Martin, Mary (Balmford) (1907–69)

English painter and sculptor. She was born in Kent and studied at Goldsmith's School of Art 1925–9, and at the ▷Royal College of Art, 1930–32, where she met ▷Kenneth Martin, whom she married in 1930. She produced landscape and still lifes, but from 1948 she concentrated on abstract work. Her emphasis on squares and cubes arranged in geometric formations owed much to the ▷concrete art experiments of ▷Max Bill, whose mathematical approach to sculpture she also adopted.
Bib.: *Mary Martin*, exh. cat., London, 1984

Martineau, Robert Braithwaite (1826–69)

English painter. He was born in London and studied law there, before being persuaded by his mother, an amateur artist, to study painting. He entered the ▷Royal Academy Schools and met ▷Hunt there and studied with him in 1851–2. For most of his career he shared a studio with Hunt and developed a similar, albeit coarser, style, and an interest in moralizing subjects (e.g. *Last Day in the Old Home*, 1862, London, Tate Gallery). His first RA exhibit, *Kit's Writing Lesson* (1852, London, Tate), set the theme of much of his work, based on literary and ▷genre subjects. He died young, leaving a large canvas, *Christians and Christians*, unfinished (1869, Liverpool, Walker Art Gallery).

Martorell, Bernardo (fl 1433–52)

Spanish painter and miniaturist. He worked in Barcelona. The altarpiece of St. Peter of Púbol (1437, Gerona Museum) has been attributed to him.

Maruyama School

A Japanese school of painting based in Kyoto during the 18th century. It was founded by Maruyama Ōkyo (1733–95) and displayed ▷Chinese motifs but employed European techniques. This school of painting had naturalistic tendencies.

Marx, Karl (1818–83)

German historian, writer and philosopher. He was born in Trier and studied at Berlin and Bonn, before meeting Friedrich Engels in Paris in 1844. In 1848

Karl Marx, Chinese portrait, private collection

they published the *Communist Manifesto* and Marx took part in the failed German uprising. As a result he went into exile in London for the rest of his life. His major work was *Capital* (1867) which set out his ▷Marxism, based partly on ▷Hegel's view of history (thesis, antithesis, synthesis) and on his own ideas of the class struggle and man's creativity. He was an idealist, who advocated a utopian society of co-operation, but he opposed those socialists who fought against the tide of history and industrialization (see ▷Morris, ▷Ruskin).

Marxism

The philosophy based on the writings of ▷Marx and 20th-century reinterpretations of them. It includes the belief that man is inherently creative (i.e. he labours with tools) and that his creativity is available for the benefit of the species as a whole. Art therefore is seen simply as a form of production, as part of this creativity. History is seen in purely economic terms, as the developing struggle to achieve an ideal balance of workers' co-operation, a struggle which has been

fought by successive classes through the ages. Under capitalism, the state which most concerned Marx, the bourgeoisie control the means of production and therefore treat the workers not as humans but as ▷alienated commodities. The only course open to the workers is to overturn the capitalist state. Increasingly since 1945, Marxism has become the domain of cultural theorists (▷Althusser). Marxist art historians view the discipline from the point of view of the market, with artists as producers and patrons in the role of the bourgeois. Artistic change therefore is determined by social and economic forces and the concept of artist as individual creative genius is thus negated.
Bib.: Kellner, D., *Critical Theory, Marxism and Modernity*, Cambridge, 1989; Mander, E., *An Introduction to Marxism*, London, 1979

Marxist art history

▷Marx's central belief in his theory of history, otherwise known as 'historical materialism', is most clearly expressed in his preface to *A Contribution to a Critique of Political Economy* (1859). This states: 'The mode of production in material life determines the general character of the social, political and spiritual processes of life.' Marx's methodology has been adopted by many historians of many political persuasions, and has been applied in many ways, not all of them compatible. However, most of these historians subscribe, at least to some degree, to the metaphor of an economic base onto which is built a superstructure (the realm of cultural production). The question of the degree to which the base influences the superstructure has created most of the disputes within Marxism. Prominent Marxist critics and historians include Frederick Antal, Arnold Hauser, Meyer Shapiro, John Berger and T.J. Clark, although there are many more who employ at least elements of Marxism in their work. To a large extent the 'social history of art' is synonymous with Marxist art history.
Bib.: Kramer, H., 'T.J. Clark and the Marxist Critique of Modern Painting', *The New Criterion* (March 1985), pp. 1–8; McLellan, D., *Karl Marx; His Life and Thought*, London, 1973; Pollock, G., 'Vision, Voice and Power: Feminist Art History and Marxism', *Block*, 6 (1982), pp. 2–20; Rifkin, A., 'Marx's Clarkism', *Art History* (Dec 1985), pp. 488–95; Wallach, A., 'Marxism and Art History', in *The Left Academy*, ed. B. Ollmann and E. Vernoff, vol. 2 (1984), pp. 25–53

Mary

▷Virgin Mary

Mary Magdalene

New Testament figure, follower of Christ. She is usually portrayed as a penitent (e.g. ▷Donatello, 1456, Florence, Baptistry; ▷Algardi, *Mary Magdalene in Ecstasy*, 1628, Rome, S Silvestro), but is also present in the narrative of the ▷Passion. According to tradition

she anointed Christ's feet, wiping them with her long hair, and she is also identified with the adulterous woman whom Christ protected. In Luke's gospel she was cured of evil spirits by Christ. She is also sometimes confused with the sister of ▷Martha. She is present in images of the ▷Descent from the Cross and she was the first to discover the empty tomb of the ▷Resurrection (e.g. ▷Rembrandt, 1651, *Christ Appearing to the Magdalene*, Brunswick, Herzog-Anton-Ulrich Museum).

Marzal de Sax, Andrés (fl 1393–1410)

Possibly a German painter. He worked in Valencia, and produced an ▷altarpiece of *Doubting Thomas* for Valencia Cathedral (c1400).

Masaccio (Tommaso di Ser Giovanni di Mone) (1401–c1428)

Italian painter. We know few biographical facts about him, but he was a Florentine, who in his short life revolutionized Italian painting and who, with the architect ▷Brunelleschi and the sculptor ▷Donatello, laid the foundations of the Italian art of the High ▷Renaissance. The earliest work attributed to Masaccio is the *San Giovenale Triptych* (1422, Florence, Uffizi). His earliest surviving documented work is the now dispersed and partly lost *Pisa Polyptych* (1426), the central panel, the *Madonna and Child*, being in London (National Gallery), with other panels in Pisa, Berlin, and Naples. His most celebrated works are his ▷frescos, still ▷*in situ* in Florence: *The Trinity* (c1428, Sta Maria Novella) and the cycle in the Brancacci Chapel of Sta Maria del Carmine (c1425–8), executed in collaboration with ▷Masolino (and later completed in 1484 by ▷Filippino Lippi). It was once thought that Masaccio had begun work on the cycle as Masolino's assistant, but Masaccio's enrolment in the Florentine painters' guild in 1422, a year before Masolino, contradicts this, as Masolino would not have been entitled to take on pupils before that time. The elements of the fresco cycle which are generally accepted as being by Masaccio are the *Expulsion from Paradise*, *The Tribute Money*, *St. Peter Enthroned* (part), *St. Peter healing the Sick with his Shadow*, *St. Peter Distributing Alms*, *The Baptism of the Neophytes*, *The Raising of the Praetor's Son* (most) and *St. Paul Visiting St. Peter in Prison* (part). Before completion of the commission, Masaccio was called away to Rome and no more is heard of him, it being generally presumed that he died there soon after his arrival.

Masaccio's achievement is that he broke away from the prevailing ▷International Gothic idiom and its concern with decorative line and colour, and sought to reinvest painting with the monumental gravity, solidity and moral seriousness first perfected in Tuscan painting by ▷Giotto a hundred years before. Like Giotto, Masaccio created a painted illusion of solid figures moving through believable space with noble deliberation. Yet whereas Giotto's figures have a block-like massiveness, Masaccio's are imbued with a sense of anatomically accurate construction under the draperies, their articulate solidity further enhanced by a consistency to the fictive fall of light and shade absent in the work of Giotto and his followers (note that the direction of fictive light in the Brancacci Chapel frescos is not only consistent throughout the cycle but is organized so that it appears to flow from the actual chapel window). Also, whereas Giotto's spatial continuum is intuitive, Masaccio's is rationally constructed, employing the latest discoveries in single-point ▷linear perspective, already used most convincingly by ▷Donatello in his marble relief of *St. George and the Dragon* (c1417, Florence, Bargello) and first formulated by ▷Brunelleschi (Brunelleschian architecture is recreated in paint in Masaccio's *Trinity* and it has been suggested that Brunelleschi may have advised Masaccio on its spatial construction). In the work of Donatello and Masaccio, this mathematically controlled pictorial organization not only creates depth but, just as importantly, directs the spectator to the core of the narrative by coinciding the narrative focus with the perspectival focus (e.g. the ▷vanishing point in the *Tribute Money* focuses attention on Christ's head).

The work of none of Masaccio's painter contemporaries is as rigorously austere as his, although he visibly influenced the rather different work of ▷Filippo Lippi and ▷Fra Angelico. It was amongst the more progressive painters of the next generation, ▷Andrea del Castagno and ▷Piero della Francesca, that his achievement was more fully understood. And by the time of ▷Michelangelo (who with his fellows from the Medici 'academy' made sketches of Masaccio's Brancacci Chapel frescos) Masaccio's work had become canonical.
Bib.: Baldini, U., *Masaccio*, Florence, 1990; Berti, L., *Masaccio*, Florence, 1988; Joannides, P., *Masaccio and Masolino: A Complete Catalogue*, London, 1993

mascaron

A mask used for architectural decoration, ceramics and furniture. Often the masks were tragic or comic faces.

Masereel, Frans (1889–1972)

Belgian painter and engraver. He studied in Ghent, London and Paris and adopted an ▷Expressionist style. He was most famous for his series of woodcuts which he called 'novels in pictures'. These were stories told through the medium of ▷woodcut, often with dramatic events, Expressionist distortions and socialist sub-texts.

Masip, Vicente

▷Macip, Vicente

Maso di Banco (fl c1325–c1350)

Italian painter. He was a Florentine and leading follower of ▷Giotto. His figures, convincingly set into a clearly constructed space are, if anything, more massively simplified than Giotto's, but his colour is more limpid and his forms more decorative. The only work securely attributed to him is the ▷fresco cycle of *St. Sylvester and the Emperor Constantine* (c1340, Florence, Bardi di Vernio Chapel, Sta Croce). Starting with ▷Vasari, his works were, until recently, confused with those of another follower of Giotto, Giottino.

Bib.: Wilkins, D.G., *Maso di Banco: A Florentine Artist of the Early Trecento*, New York, 1985

Masolino da Panicale (Maso di Cristofano Fini) (c1383–?1447)

Italian painter. He trained in Florence, perhaps in ▷Ghiberti's workshop, and his paintings are largely in the ▷International Gothic style. Few biographical details are known, though he enrolled in the Florentine painters' ▷guild in 1423 and in the same year painted a *Madonna* (now in Bremen, Kunsthalle), strongly influenced by ▷Lorenzo Monaco. The commission for which he is best remembered today is the cycle of ▷frescos in the Brancacci Chapel of Sta. Maria del Carmine (c1425–8), executed in collaboration with ▷Masaccio. Masaccio was formerly thought to have been Masolino's pupil, but as he enrolled in the painters' guild the year before Masolino this is now discounted. Far from being Masaccio's master, Masolino seems to have learnt much about the new advances in rational ▷perspective construction from the younger artist, and he clearly took a delight in perspective for its own sake, without necessarily attempting to use it to focus on the narrative core as did Masaccio. For the most part, their respective contributions to the cycle are relatively easily discerned, the sweet elegance of Masolino's *Temptation of Adam and Eve* forming a telling contrast with the tragic drama of Masaccio's *Expulsion* on the opposite wall. It should not be thought, however, that Masolino was eclipsed by Masaccio or that he was working in an outmoded style. There was a greater demand from wealthy patrons for works in the ▷International Gothic style than for the new and austere ▷Renaissance style. Indeed in 1427, before the commission was finished, Masolino was called away to execute a commission in Hungary. In c1430 he was then called to Rome to execute a fresco cycle in S. Clemente, his Roman patron, Cardinal Branda Castiglione, later also commissioning from him fresco cycles for the Collegiata and Baptistry at Castiglione d'Olona, near Como (one fresco dated 1435). These show a lessening of Masaccio's influence and a return to the elegance of Masolini's earlier International Gothic style.

Bib.: Joannides, P., *Masaccio and Masolino: A Complete Catalogue*, London, 1993; Roberts, P.L., *Masolino da Panicale*, Oxford, 1993

Massacre at Chios

A painting by ▷Delacroix of 1822 (oil on canvas), it portrays an atrocity from the Greek War of Independence. In 1822 the island of Chios was conquered by the Turks, who murdered thousands of its inhabitants and sold the survivors into slavery. Delacroix's painting, seizing a virtually contemporary subject, shows a huddle of semi-clothed Greeks seeking comfort from each other or lying in despondency while immediately behind them a contemptuous Turk rears his stallion. Another group of figures is fighting in the background, and at a far distance a town burns.

The painting was awarded a Gold Medal at the ▷Salon of 1824, but aroused great hostility for flouting accepted standards. Its lack of a strong compositional pattern is paralleled by a lack of moral structure, treating the passive Greeks with indifference and, if anything, deriving pleasure from the exotic setting and the pathos of their suffering. Delacroix seems to use the subject only as a pretext for a virtuoso display of flamboyant colour. Indeed, the disjointed composition and fragmentary morality of the canvas are given harmony only by painterly effects, notably the highlights inspired by ▷Constable's *The Haywain* and added by Delacroix after the painting had been hung.

Its excesses and association with the Greek War of Independence (in which Byron fought and died) made the *Massacre at Chios* something of a ▷Romantic manifesto, and it has been seen as the first wilful opening of the gap between the practice of the modern artist and the strictures of the ▷academy. It is now in Paris, in the Louvre.

Bib.: Michel, P.-H., *Massacre at Chios by Delacroix*, Paris, 1947

Massacre of the Innocents

The New Testament event (Matthew 2: 16–18) in which Herod ordered the execution of all children under two years old, in an attempt to kill ▷Christ (who escaped by the ▷Flight into Egypt). Herod had been warned by the Magi that the stars foretold the birth of the King of the Jews and the massacre was an attempt to safeguard his crown. The story was associated with the Catholic Cult of the Holy Innocents, and had Old Testament precedents. Artists usually represented a courtyard with fleeing women and children (e.g. ▷Matteo di Giovanni, 1482, Siena, S. Agostino; ▷Ghirlandaio, 1485–90, Florence, Sta Maria Novella).

mass media

Any popular means of disseminating culture, especially radio, television, advertising, etc. Technical advances in the 20th century made worldwide access to culture possible, and mass media have become an important form of culture for a broad public. The cultural importance of mass media was largely dismissed as insignificant before the Second World War and denigrated by the

denizens of ▷fine art, although a number of enlightened writers, such as ▷Benjamin and Siegfried Kracauer recognized its importance. However, since the Second World War, mass media have become the subject of serious academic study.

Masson, André (1896–1987)

French painter. He was an early member of the ▷Surrealist movement. He was born in France, but grew up in Belgium and attended both the Académie des Beaux-Arts in Brussels and the ▷École des Beaux-Arts in Paris. Badly wounded in the First World War, he spent time in psychiatric hospitals and emerged with a distrust of society. The dealer ▷Kahnweiler organized an exhibition for Masson in 1922, and enabled him to paint full-time. ▷André Breton converted him to Surrealism in 1924, but Masson left the movement with ▷Bataille in 1929. He then lived in Republican Catalonia (1934–7) and New York (1940–46), before returning to France, where he settled in Aix-en-Provence. In 1954 he was awarded the Grand Prix National des Arts.

Even before meeting Breton, Masson was fascinated by the imagery of the unconscious, and enthusiastically embraced the Surrealist idea of automatic drawing (▷automatism). The combinations of lines and blotches he produced under its influence in the mid-1920s are explorations of ambiguity, often suggesting two or more figural interpretations. In 1927 he began to produce works by smearing glue and throwing sand onto the canvas, using oil paint to create a picture out of these random shapes. Many of these automatic compositions suggested violent or sexual imagery, or the figures of savage animals. In the 1930s, the violence of Masson's work became more pronounced. He sketched slaughterhouses, and painted images of eroticism and cruelty in response to the Spanish Civil War. **Bib.**: Ades, D., *André Masson*, London, 1994; Noel, B., *André Masson, la chair du regard*, Paris, 1993; Saphire, L., *André Masson: The Illustrated Books, Catalogue Raisonné*, Geneva, 1994; idem., *André Masson: Complete Graphic Work*, New York, 1990

Massys (Matsys, Metsys), Quentin (1465/6–1530)

Flemish painter. He was born in Louvain but most of his career was spent in Antwerp, where he became Master of the ▷guild in 1491. He specialized in religious painting which showed the legacy of Netherlandish religious art, but his works were also tinged with the influence of Italian High ▷Renaissance art, especially that of ▷Leonardo. Works such as his *Lamentation* (1508–11, Antwerp, Museum Mayer van den Bergh) signal their debt to the heritage of ▷van der Weyden and ▷Gerard David, but their richer tones and greater attention to gesture also reveal the Italian influence. Apart from religious subject matter, Massys was known for his portraiture and ▷genre scenes

which often represented satirical jibes at the follies of the middle classes (e.g. *The Money-changer and his Wife*). He occasionally collaborated with ▷Patenier, who was responsible for some of the backgrounds in his works.
Bib.: Silver, L., *The Paintings of Quentin Massys, with a Catalogue Raisonné*, Oxford, 1984

Master E.S. (fl 1450–67)

German engraver and goldsmith. He was also known as Master of 1466, although he used the monogram E.S. He produced many prints of religious subjects. His ▷medium was ▷line engraving, and through it he was able to create tonal effects.

Master Francke (fl c1424)

German painter. He worked in Hamburg and produced an ▷altarpiece for the Englandfahrer trading guild in 1424 (Hamburg, Kunsthalle). This altarpiece showed scenes from the life of Thomas à Beckett, and he brought a strong sense of observation and a rich colourism to this work.

Master of ...

The name given to an unknown artist who is thought to have executed a number of works, grouped together for stylistic reasons (e.g. Master of the Palazzo Venezia, Master of the Female Half-Lengths, etc.). The term is extremely problematic, as it relies solely on ▷connoisseurship to define the groups of work.

Master of Alkmaar (fl early 16th century)

Named from an altarpiece of *The Seven Works of Mercy* painted in 1504 for the Church of St. Lawrence in Alkmaar (now in Amsterdam, Rijksmuseum). He has been linked with Cornelis Buys, but the figure style is closer to ▷Geertgen tot Sint Jans.

Master of Flémalle (c1375–1444)

Netherlandish painter. His name derives from three paintings in the Kunstinstitut, Frankfurt, wrongly supposed to have come from Flémalle, near Liège. These, and the other works that have been grouped around them on the grounds of strong stylistic affinity, reveal an artist who was one of the founders of the Netherlandish school and whose earliest paintings appear to precede those by ▷van Eyck in the naturalistic depiction of the objective world. The assembled group of paintings is of such a high quality that it seems inconceivable that their painter was not of the highest reputation. The most celebrated Netherlandish painter of this period of whose works we have no known surviving examples was ▷Robert Campin and it is now generally believed that he and the Master of Flémalle are identical. It was once supposed, on stylistic evidence, that the Master of Flémalle was none other than the young ▷Rogier van der Weyden. Van der Weyden is believed to have been the 'Rogelet de la Pasture' of Tournai, who is

recorded as Campin's pupil. Such a stylistic affinity between the works of a former pupil and his master was extremely common in the workshop tradition. A similar master/pupil affinity is, in fact, discernible in the documented works of Campin's other pupil, Jacques Daret (c1400–68). Thus, the case is strengthened for Campin being the painter of the works attributed to the Master of Flémalle. The third name that must be mentioned is the ▷Master of Mérode. To him was formerly attributed the *Mérode Altar*, a ▷triptych now in the Metropolitan Museum, New York. It bears all the hallmarks of the rest of the group with its homely naturalism, the strongly characterized ▷donor portraits in the left wing, and the contemporary townscape glimpsed through the window of ▷Joseph's workshop in the right wing. Consequently, it too has now been attributed to the Master of Flémalle.

An *Entombment* triptych (London, Courtauld Institute), believed to be the Master of Flémalle's earliest surviving painting is dated to 1410/20. Figures of a sculptural solidity and humanity, suggesting the influence of ▷Claus Sluter, are represented before a space-denying decorative gold background. It is thus a transitional painting, in the act of breaking away from the ▷International Gothic style towards a greater naturalism, and it precedes any surviving works by Jan van Eyck. By the time of the *Nativity* (c1420, Dijon, Musée des Beaux-Arts), with its blue sky and naturalistic landscape, the break has been made. In the National Gallery, London, is *The Virgin and Child Before a Firescreen*. Here, the artist reveals a radically innovatory intelligence as he uses a homely detail, the firescreen behind the Virgin's head, to double as her halo. *The Werl Altarpiece* (1438, Madrid, Prado) is the only dated picture of the group. It is a late work that shows a new assurance in the handling of perspective and suggests that the Master of Flémalle had learnt from his younger rival, van Eyck, who had by now gone beyond the Master's own attempts to represent objective reality. Thus, the Master of Flémalle both preceded and learnt from van Eyck, but even though van Eyck ultimately surpassed him, he is nonetheless of fundamental importance in the radical break with the International Gothic style and the foundation of the Netherlandish school.

Bib.: Friedlander, M.J., *Rogier van der Weyden and the Master of Flémalle*, New York, 1967

Master of Hohenfurth
▷Master Of Vyšší Brod

Master of Mary of Burgundy (fl last quarter of 15th century)
Netherlandish manuscript illuminator, named from two very high quality Books of Hours (Vienna, Österreichische Nationalbibliothek and Berlin, Kupferstichkabinett) made for Mary of Burgundy, who married Emperor Maximilian I in 1477 and died in 1482. Another ▷Book of Hours in the Bodleian Library, Oxford, with paintings containing similarly well-observed ▷genre scenes and still lifes, has also been attributed to him. The name of ▷Alexander Bening has been linked with the Master of Mary of Burgundy on the grounds that these books are of high quality and that Bening, a highly regarded illuminator working in Bruges and Ghent at the same time as the present Master, has no works securely attributed to him.

Master of Mérode
▷Master of Flémalle

Master of Moulins (fl c1480–c1500)
Painter, working in France, named from his *Triptych of the Virgin and Saints with Donors*, for the cathedral of Moulins (c1498). From the body of work ascribed to him on stylistic grounds (about 15 paintings, one stained-glass window, one miniature and one drawing), he appears to have been an excellent portraitist with a meticulous technique, his brightly coloured, naturalistic style influenced by Netherlandish painting of the last quarter of the 15th century, particularly that of ▷Hugo van der Goes. He may himself have been Flemish. He worked as portraitist to the Bourbons, some of whose portraits are identifiable and allow a chronology of sorts to be posited. Unfortunately, the Bourbon archives have been destroyed, so it is unlikely that documentary evidence relating to him has survived. Attempts have been made to identify him variously as ▷Jean Perréal, ▷Jean Prévost and Jean Hey, but no suggestion has met with general acceptance.

Master of Naumberg (fl c1230–70)
German sculptor named from a group of works in Naumberg Cathedral. The west choir of the Cathedral was built by Bishop Dietrich from 1249. Around the walls are 12 life-size statues of members of his family, the House of Weltin, each of which is portrayed as a credibly individual personality. Similar qualities, remarkable for this period, are noticeable in the ▷Passion reliefs and ▷Crucifixion group of the west ▷rood screen and have led scholars to assume the works to have been produced by the same workshop under a master of the highest quality. The work here is imbued with such an original style that it has been possible to associate with it sculptures in other locations, and to form an idea of a career that flourished for about 40 years. There are the fragments from the *Portal of the Virgin* at Metz Cathedral and the figurative sculpture from the west ▷rood screen at Mainz Cathedral (c1239, now dismembered and dispersed). Also attributed to the Master of Naumberg are a ▷relief, *St. Martin and the Beggar*, now in Bassenheim Parish Church, and the fragments of a *Last Judgement*, now in the Bischöflisches Dom und Diözesanmuseum, Mainz,

which is presumed to have come from Mainz Cathedral.

Master of St. Cecilia (fl c1304)

Italian painter. He was named from the *St. Cecilia Altarpiece* originally in the Florentine church of St. Cecilia (destroyed by fire in 1304), now in the ▷Uffizi. Other works attributed to him on the grounds of a stylistic similarity to this ▷altarpiece include the first and the final three ▷frescos of the *Life of St. Francis* cycle in the Upper Church of San Francesco, Assisi. The first fresco is opposite the last and John White has suggested that they were the last to be painted. On the grounds that the completion of this important fresco cycle in the principal church of the Franciscan order would only have been assigned to a master of the first rank, some scholars have suggested that the Master of St. Cecilia might be ▷Buffalmaco, one of the leading painters of his day to whom no works have as yet been incontestably linked. The Master of St. Cecilia's work in the Upper Church appears to be related to the ▷Master of the St. Francis cycle (the painter of the rest of the St. Francis cycle who is sometimes considered to be ▷Giotto), but his figures are noticeably taller, more slightly built, and with smaller heads. The influence of ▷Cavallini has also been detected. Although Vasari gave the entire cycle to Giotto, the painter(s) here appear to have a less monumental, less austere, and more decorative style.

Bib.: Boskovits, M., *The Fourteenth Century: the School of the Master of St. Cecilia*, Florence, 1986; White, J., *Art and Architecture in Italy 1250–1400*, Harmondsworth, 1987

Master of St. Giles (fl c1480–c1500)

Painter named from two panels of *The Life of St. Giles* in the National Gallery, London. Two more panels of a similar size in Washington, *S. Loup Curing the Children* and *S. Denis Baptising Lisbius*, have been attributed on stylistic grounds to the same painter. As the scenes in these panels are set in and around Paris, it has been suggested that the painter had his workshop there. His detailed and highly finished manner, however, reflects Netherlandish influences (particularly ▷Hugo van der Goes and ▷Gerard David), rather than French influences and thus he is generally believed to have had Netherlandish training.

Master of Segovia (fl 1519; d 1550)

Flemish painter, now identified with ▷Ambrosius Benson, a painter of religious works and portraits. The ascription to Benson of two paintings of the Holy Family (Brussels, Musées Royaux des Beaux-Arts and Nuremberg) which bear the monogram 'AB' has been generally accepted. From this followed the reattribution of a body of works in Segovia previously designated as by the anonymous Master of Segovia and another in Antwerp given to the Master of the Deipara Virgo of Antwerp. Born in Lombardy, Benson was working in Bruges from 1519, as in that year he was admitted to the Bruges painters' guild. He ran a flourishing business, exporting works to Italy and Spain and is recorded as exhibiting his works at the January and May fairs in Bruges between 1526 and 1530. He worked in the tradition of ▷Gerard David and ▷Adriaen Ysenbrandt, but also incorporated the northern Italian technique of ▷sfumato into his painting.

Master of the Aix Annunciation (fl 1440s)

French painter. He was named from a dispersed ▷triptych commissioned by Pierre Corpici, a cloth manufacturer, for the Church of St. Sauveur in Aix-en-Provence, executed in 1443–5. The central panel (*The Annunciation*), remains in Aix, Ste Madeleine the left wing, now cut in two, is divided between Rotterdam, Museum Boymans-van Beuningen (the *Prophet Isaiah*) and Amsterdam, Rijksmuseum (a *Still Life*); the right wing (the *Prophet Jeremiah*) is in Brussels, Musées Royaux des Beaux-Arts. The outer wings when closed depict *Christ Appearing to Mary Magdalene*. The triptych reveals a strong Netherlandish influence, the characterization of the figures and sculptural treatment of their forms in their heavy draperies with massive folds recalling most strongly the work of the ▷Master of Flémalle, but also ▷Jan van Eyck and ▷Claus Sluter. The Master of the Aix Annunciation has been variously identified as the Master of Flémalle, Jean Chapus, Bartholomew d'Eyck and Guillaume Dombet, but no attribution has been generally accepted.

Master of the Brunswick Monogram (fl c1520–40)

Painter named from a picture in the Herzog-Anton-Ulrich Museum in Brunswick, *The Parable of the Last Supper*. The picture bears a monogram which has been variously read and about which there is no consensus. Some read the monogram as that of Jan van Amstel of Amsterdam, while ▷Friedländer opts for Jan de Hemessen and Bergmans for Meyken Verhulst. About a dozen small pictures have been related to the Brunswick Monogrammist on stylistic grounds, consisting mostly of religious works in landscape settings and brothel scenes. His well-observed landscape scenes, with figures convincingly related to their setting, show him as a precursor to ▷Pieter Bruegel the Elder and it has been suggested that this painter may have actually trained Bruegel.

Master of the Death of the Virgin (fl 1507–37)

Painter named from two ▷altarpieces in Cologne and Munich, treating the subject of the death of the ▷Virgin. A body of works has been assembled around these on stylistic grounds. Several pictures attributed to him are dated (e.g. *Adam and Eve*, 1507, Paris,

Louvre). Motifs frequently recur from picture to picture and sometimes are borrowed from other painters. According to ▷Friedländer, the Master may have been trained by Jan Joest and appears to have exercised a considerable influence on the elder Bruyn of Cologne. Throughout his career, he seems to have been influenced by a succession of other painters: first ▷Memlinc and ▷David, then ▷Massys and ▷Patenier, and finally by ▷Leonardo da Vinci. He is generally identified with ▷Joos van Cleeve. The National Gallery in London has a *Holy Family* attributed to him.

Master of the Housebook (fl late 15th century)

German (or perhaps Netherlandish) engraver and painter. Formerly known as the Master of the Amsterdam Cabinet from the large number of his ▷engravings in the Print Room of the Amsterdam Rijksmuseum, he is now named from a 'housebook' illustrated with pen drawings in the collection of Prince von Waldburg at Wolfegg Castle. Paintings attributed to the Master of the Housebook include: the dispersed *Passion Altarpiece* of c1475 (panels in Freiburg-im-Breisgau Museum, Berlin-Dahlem and Frankfurt, Städelsches Kunstinstitut); a *Lamentation* of c1480 (Dresden, Gemäldegalerie); *The Lovers*, of c1480 (Gotha Museum); and *The Virgin and Child* (Munich). His most important works, however, are his line engravings, many of which are in ▷drypoint. ▷Gothic in style, often of secular subjects, sometimes humorously treated, they are lively in execution, an expert use of the drypoint imparting an almost spontaneous look. Considered the equal of ▷Martin Schongauer, the Master of the Housebook's influence has been detected in some of ▷Dürer's early drawings.

Master of the Legend of St. Barbara (fl c1470–c1500)

Netherlandish painter. He was named from the subject of the centre panel (now in Brussels, Musées Royaux des Beaux-Arts) of a dispersed ▷altarpiece dated to c1474; the left wing is in the Confrérie du S. Sang, Bruges and the right wing is lost. Attributed to the same hand are two wings of a ▷triptych, *Abner before David* and *The Queen of Sheba Bringing Gifts to Solomon* (New York, Metropolitan Museum). A minor master, his style was clearly influenced by both ▷Rogier van der Weyden and ▷Dieric Bouts.

Master of the Legend of the Magdalen (fl c1483–c1527)

This painter takes his name from a large dispersed ▷altarpiece, dated by ▷Friedländer to c1515/20. Several portraits attributed to him suggest that he may also have worked as a court painter at Brussels. He seems to have started painting under the influence of ▷Rogier van der Weyden, then ▷Barent van Orley, followed by the ▷Master of the Death of the Virgin,

amongst others. The National Gallery, London, has a *Magdalen* attributed to him.

Master of the Life of the Virgin (fl c1460–90)

Also known as the Master of the Life of Mary. His name is derived from eight panels of a dispersed ▷altarpiece, illustrating the *Life of the Virgin*, commissioned for the church of St. Ursula at Cologne. Seven panels are at Munich (Alte Pinakothek) and one at London (National Gallery). He was active in Cologne, but the influence of ▷Dieric Bouts and ▷Rogier van der Weyden which can be seen in the bright colours, attenuated figures, portrait-like faces and naturalistically described costumes, suggests that he may have been trained in a Netherlands workshop. Formerly he was known as the Master of the Lyversberg Passion, after a series of panels in Cologne, but though close in style these are now thought to be by a different painter. The earliest work attributed to the Master of the Life of the Virgin is a *Crucifixion with Nicholas of Cusa as Donor* (c1465) at the Hospital Church of Cues on the Moselle, whilst four panels of the 1480s, now in the National Gallery, London, but originally from the Abbey of Werden near Düsseldorf (e.g. *The Conversion of St. Hubert*) are attributed to him.

Master of the Playing Cards (fl mid-15th century)

German engraver. He was named after a set of playing cards depicting human figures, animals and plants, now divided between Dresden (Kupferstichkabinett) and Paris (Bibliothèque Nationale). The cards, dated to the mid-15th century, reveal a distinctive style, which has been detected in about 100 other prints which have been accordingly attributed to the same master. They all display a careful observation of nature allied to a strong graphic sense and a characteristic short hatched line which the artist has adapted to a multiplicity of uses, to convey shadow and texture.

Master of the Rohan Book of Hours (fl early 15th century)

Manuscript illuminator and painter working mainly in Paris, named from the *Grandes Heures du Duc de Rohan* (Paris, Bibliothèque Nationale). This Book of Hours was commissioned by the Court of Anjou (Rohan was a later owner) which also commissioned the same master and his workshop to illuminate other Books of Hours, including the *Heures de René d'Anjou* (Paris, Bibliothèque Nationale) and the *Heures dites 'd'Isabelle Stuart'* (Cambridge, Fitzwilliam). Only one panel painting has been attributed to the Master, a fragment of an *Annunciation* at the Laon Museum. His style is unique. Apparently deeply religious, his works have an intense supernatural quality at odds with the naturalistic preoccupations of his contemporaries: scale is used to convey meaning and figures are expressionistically distorted. He is thought to have been trained in either

Spain or the Netherlands. His powerful visionary style seems to have been far too personal to have attracted a school or followers.

Master of the St. Francis Cycle (fl c1290–c1330)

Name given to the putative master responsible for most of the St. Francis cycle of ▷frescos in the Upper Church of San Francesco at Assisi. The only point of agreement amongst historians is that the cycle is one of the most important works of European art. However, there is no consensus regarding the dates of execution, with suggestions ranging from the 1290s to the 1330s. Even more problematic is the question of authorship – ▷Vasari gave the entire cycle to ▷Giotto, but for a number of reasons, most modern art historians reject this attribution. In fact, the cycle is plainly by more than one master (and workshop). The opening scene and the last three have been attributed to the so-called ▷Master of St. Cecilia, while John White has proposed that scenes 20–25 form another stylistic group. The remaining scenes – 2–19 – are the body of work that is usually given to the so-called ▷Master of the St. Francis Cycle. His style is closest to that of ▷Giotto, particularly in the frescos of the west wall, *The Miracle of the Spring* and *St. Francis Preaching to the Birds*. His style is nonetheless felt by many to differ in a number of fundamental aspects from that of Giotto – his work is less monumental, more decorative and with a tendency towards the inclusion of anecdotal detail not found in accredited works by Giotto.

Master of the St. Lucy Legend (fl late 15th century)

Netherlandish painter named from a ▷triptych, *The Legend of St. Lucy*, dated 1480, in the Church of St-Jacques in Bruges. From this he is also known as the 'Master of Bruges of 1480'. Also attributed to him is: a panel of *St. Nicholas* (Bruges, Groeningemuseum); *The Virgin and Child with Angels* (Brussels, Musées Royaux des Beaux-Arts); *The Virgin and Child with Female Saints in a Rose Garden* (Detroit, Institute of Arts); *Lamentation Triptych* (Minneapolis, Institute of Arts); and *St. Catherine* (Philadelphia, Museum of Art). His style, influenced by ▷Rogier van der Weyden and ▷Memlinc, is characterized by a minute depiction of materials and foliage, coupled with a naive figure style that led ▷Friedländer to refer to his figures as 'marionettes'.

Master of the St. Ursula Legend (fl 1480–90)

Flemish painter named from the ▷diptych showing eight episodes from *The Legend of St. Ursula*, painted for the convent of the Black Sisters in Bruges (dated before 1482, Bruges, Groeningemuseum), and revealing the influence of ▷Memlinc and ▷Rogier van der Weyden. Other works attributed to him on the basis of their stylistic similarity to the these panels include

the *Nativity Triptych* (Detroit, Institute of Arts); *St. Anne with the Madonna and Child and Saints* (Vienna, Lederer Collection); and a dispersed diptych of which the *Madonna and Child* panel is in the Fogg Museum (Cambridge, MA) and the donor panel in the Johnson Collection (Philadelphia). The style of these works suggests that the painter may also have been a ▷miniaturist.

Master of the Třeboň Altarpiece (Master of Wittingau) (fl c1390)

Bohemian painter. He was named from three double-sided panels from an altarpiece in the Augustinian monastery at Třeboň (Wittingau) (c1390) in the Czech Republic (now in the National Gallery of Prague). Each panel has a ▷Passion scene (*The Agony in the Garden, The Entombment* and *The Resurrection*) on one side with saints on the other. Other paintings attributed to him and his workshop are *Our Lady of Sorrows*, (before 1380, Cirkvice Church); the *Roudnice Madonna*; *The Virgin of the Ara Coeli*; and a *Crucifixion* from the chapel of St. Barbara – of which the last three are all dated after 1380 and are now in the National Gallery, Prague. The Master of the Třeboň Altarpiece's style, which represents a development out of that of ▷Master Theodoric, reveals him as one of the creators of the Bohemian version of the ▷International Gothic Style: his figures, though elegantly attenuated in the ▷Gothic manner, retain the solidity of Master Theodoric's figures through a use of strong ▷chiaroscuro. Most distinctive, perhaps, is the deep mysticism which pervades his work, leaning more towards ▷Byzantine painting than the courtly elegance of much western European work in the International Gothic style.

Master of the Unicorn
▷Duvet, Jean

Master of the Virgo inter Virgines (fl c1470–c1500)

Netherlandish painter and maker of ▷woodcuts. He produced mainly religious works. He was named from an ▷altarpiece in the Rijksmuseum, Amsterdam, *The Virgin with Four Virgin Saints*. His style, typical of contemporary Delft workshops, and the fact that certain illustrations to books published in Delft have been attributed to him, strongly suggest that he was mainly active in that city. Other paintings attributed to him include: an *Adoration of the Magi* (Berlin-Dahlem); a *Deposition* (Liverpool, Walker Art Gallery); a *Lamentation* (Belgium, Enghien Hospital); an *Entombment* (St. Louis, City Art Gallery); and the *Triptych of the Crucifixion* (Barnard Castle, Bowes Museum). At his best in scenes of tragic content, his style is characterized by an accentuated emotional intensity conveyed by figures with a repertoire of expressively agitated gaunt faces and deliberately awkward gestures, set in airless barren landscapes.

Master of Vyšší Brod (Master of Hohenfurth) (fl c1350)

Bohemian painter. He was also known as the Master of Hohenfurth. He was named from a large dismembered ▷altarpiece with *Scenes from the Life and Passion of Christ* from the Cistercian monastery of Vyšší Brod (or Hohenfurth), painted c1350 and now in the National Gallery of Prague. The panels, with their rhythmic ▷Gothic linearity, recall contemporary French and Sienese painting and represent the earliest beginnings of the ▷International Gothic style in Bohemia. Other paintings attributed to the Vyšší Brod Master on the basis of a stylistic similarity to his central work are the *Veveri Madonna* and the *Vysehrad Madonna* (both Prague, National Gallery) and the *Kladsko Madonna* and the *Kaufmann Crucifixion* (both Berlin).

Master Theodoric (fl c1348–c1375)

Bohemian painter. He was the first head of the Prague Guild of Painters, founded in 1348. In a deed of 1359 he is designated *malerius imperatoris*, Painter to the Emperor, a position he held under the Emperor Charles IV until 1367. His surviving work consists of over 120 panels of saints, prophets and angels on the upper part of the walls of the Chapel of the Holy Cross in Karlstein Castle near Prague. Bust-length and half-length figures, solidly modelled in light and shade, stand out boldly against their gold backgrounds. Master Theodoric's new concern with form carried with it a softening of edges and an increasing naturalism which led away from the earlier linear style derived from contemporary French and Italian painting and in turn affected much later Bohemian painting.

Mater Dolorosa

(Latin, 'sorrowful mother'.) An image of the ▷Virgin shown with a sword piercing her or holding a heart scarred by seven wounds. It is a devotional image expressing grief at the ▷Passion of Christ.

material culture

A phrase used largely in ▷museology and anthropology to refer to the artefacts produced by a society, some of which subsequently gain the status of works of art, museum pieces or historical documents.
Bib.: Miller, D., *Material Culture and Mass Consumption*, Oxford, 1987; Pearce, S. (ed.), *Museum Studies in Material Culture*, Leicester, 1989; Schlereth, T., *Cultural History and Material Culture*, Charlottesville, 1992

Mathieu, Georges (b 1921)

French painter. He studied philosophy, mathematics and literature. He began painting in a figurative style in 1942 and by 1944 was painting non-figurative ▷abstractions. He was profoundly influenced by the ▷Wols exhibition of 1947, at which he declared, 'After Wols, everything has to be redone', and he was fiercely opposed to geometric abstraction. He consequently developed his own gestural ▷Expressionism, working at speed to preclude all conscious control, attacking huge canvases with paint applied directly from the tube or with rapier-like thrusts of the brush to produce his characteristic pyrotechnic ▷calligraphy, which ▷Herbert Read described as having 'the complexity of the serpent's nest'. In 1956 he gave a public performance of painting at the Sarah Bernhardt Theatre in Paris where he completed a 12 × 4 metre canvas in 30 minutes. 'Speed, intuition, excitement: ᵗhat is my method of creation', he declared. In 1957 he went to Japan where he repeated the performance dressed, appropriately enough, as a Samurai. Mathieu was one of the first in Europe to notice the similarities between American ▷Abstract Expressionism, which he had discovered whilst working at the American University in Biarritz in 1946, and ▷Art Informel, though Mathieu preferred the term ▷'Lyrical Abstraction'. He attempted to bring the two together in a joint French-American exhibition in 1948, which unfortunately did not come off. Regarded as one of the leaders of Art Informel, he wrote books on art history, organized exhibitions and exhibited widely in Paris in the 1950s, and he had a retrospective at the Musée d'Art Moderne de la Ville de Paris in 1963. In 1969 he designed the posters for Air France and the 10 franc coin. In 1975 he was elected a member of the Académie des Beaux-Arts.
Bib.: *Georges Mathieu*, exh. cat., Milan, 1991; Granville, P., *Mathieu*, Paris, 1993; *Mathieu*, exh. cat., Paris, 1963

Matisse, Henri (1869–1954)

French painter, sculptor and designer. He was born in Picardy, the son of a shopkeeper. He studied law in Paris (1887–8), before turning to art at the ▷Académie Julian and under ▷Bouguereau and ▷Moreau at the ▷École des Beaux-Arts. As a student he met ▷Rouault, ▷Marquet and ▷Derain, all of whom later exhibited together as ▷Fauves. He painted in Brittany in 1895, and after his military service continued to explore landscape at St. Tropez (1904 with ▷Signac) and at Collioure (1905 with Derain). He exhibited at the ▷Salon des Indépendants, and was increasingly attracted to ▷divisionism, having abandoned his earlier heavy ▷Impressionism (e.g. *Dinner Table*, 1897, private collection). In 1905, however, he began to use flattened areas of colour, and increasingly became interested in what was to be one of the central themes of his painting, the conflict between two and three dimensions (e.g. *French Window at Collioure*, 1914, Paris, Centre Pompidou). This theme was intensified by his interest in pattern, created by visits to North Africa and Spain, by an exhibition of Persian art in Paris in 1903, and by an increased interest in sculpture and primitive art (e.g. *Spanish Still Life: Seville II*, 1911, St. Petersburg, Hermitage). In 1907 he established a

Henri Matisse, *Self-portrait*, 1918, Musée Matisse et Herbin, Le Château-Cambresis

school and published his *Notes d'un peintre*, and whilst the rest of the Fauves turned towards ▷Cubism, he tried to follow his ideas to their logical conclusion in works like *Nasturtiums with 'The Dance'* (1911, Moscow, Pushkin Museum). An international reputation was ensured by exhibitions with the Berlin ▷Secessionists and at the ▷Armory Show in New York, as well as through the patronage of the Russian Shchukin.

Matisse's painting was dramatically influenced by the First World War, moving to near-abstraction and almost abandoning colour, before he found solace in Nice. It was there during the 1920s that he worked on a series of *Odalisques*, heavily patterned, intense images of idealism and beauty, inspired by ▷Ingres as much as by his own artistic interests. He travelled to America and Tahiti in 1930, recreating his *Dance* as a mural for the ▷Barnes Foundation. His work during the decade became more streamlined with increasingly exaggerated nudes portrayed against geometric backgrounds (e.g. *Pink Nude*, 1935, Baltimore, Museum of Art). He remained in France during the Second World War, increasingly bedridden, and forced to explore the possibilities of ▷collage as an alternative to paint (e.g. ▷*Jazz*, 1947, Paris, Centre Pompidou). Throughout his life he experimented with sculpture, producing a series of bronze nudes, which became stylized and idealized, following the progression of his aesthetic ideas.

Bib.: Elderfield, J., *Matisse: A Retrospective*, London, 1992; Flam, J. (ed.), *Matisse: A Retrospective*, New York, 1988; Schneider, P., *Matisse*, London, 1984; Watkins, N., *Matisse*, London, 1992

Matrimony
▷Seven Sacraments

Matta (Roberto Sebastian Antonio Matta Echaurren) (b 1912)

Chilean painter. He arrived in Paris in 1933, and initially trained as an architect with ▷Le Corbusier. In 1936 he travelled to Italy, Russia and Spain, where he met ▷Salvador Dali, through whom he was introduced to ▷Breton and the ▷Surrealists. He exhibited his first drawings in the Surrealist exhibition of 1937. He moved to New York in 1939, where his Surrealist paintings, which Matta called 'psychological Morphologies' or 'inscapes', depicting imagery of the unconscious mind through automatic composition, influenced many American painters including ▷Gorky, ▷Motherwell and ▷Rothko. In 1941 he went on a tour of Mexico with Motherwell exploring the Incan and Mayan cultures, at which time Matta became aware of 'the untameable nature' of the primitive world. His paintings became increasingly dynamic with totemic images and strange forms, often exploiting the accidental properties of the paint itself, floating and colliding in a vast fantastical space. Breaking with Surrealism in the later 1940s in order to create 'a cosmic plan that would unite art and science', some of his paintings began depicting comic man-machine hybrids, whilst others became more lyrical and Expressionistic in style. In the 1960s he treated many political issues, including producing a vast painting on Vietnam, as well as political murals for the UNESCO building in Paris. Matta had a retrospective at ▷MOMA in New York in 1958.

Bib.: *Matta*, exh. cat., Paris, 1985; Schied, W., *Matta*, Tübingen, 1991

Matteo di Giovanni (c1435–95)

Italian painter. He was possibly born at his family's home town of Borgo San Sepolcro, but he trained in the Sienese workshop of ▷Vecchietta and is generally considered to belong to the Sienese school. However, he evidently maintained his links with his home town for in 1465 he was commissioned to paint the wings and ▷predella of ▷Piero della Francesca's ▷polyptych, for which Piero's *Baptism of Christ* (London, National Gallery) is the central panel. In addition to the Sienese influences of Vecchietta and Sano di Pietro, that of the Florentine ▷Antonio Pollaiuolo may also be seen in Matteo's work. Matteo's style is linear, decoratively coloured and elegantly composed, but with a tendency towards the depiction of violent action, strikingly conveyed in his several versions of *The Massacre of the Innocents* (e.g. design for the pavement mosaic in the Siena Duomo, 1481; and altarpieces in Sant'Agostino, 1482 and Santa Maria dei Servi, c1487).

Matthew

One of the 12 ▷Apostles of ▷Christ, traditionally held to be the author of the first gospel. He was a tax collector, living at Capernaum, when Christ called him away from his table (Matthew 9:9). This episode is dramatically portrayed by ▷Caravaggio in the Contarelli Chapel in San Luigi dei Francesi, Rome (1599–1600). Along with the other ▷evangelists, Matthew is represented by a winged symbol, in his case a man, because his gospel opens with the genealogy of Christ. Occasionally, as in Caravaggio's painting, the winged man becomes an angel helping Matthew to write his gospel account. Matthew's identifying attributes are a book, pen and inkhorn (in his role as gospel writer) and a money bag (to allude to his erstwhile profession as tax collector). He is sometimes represented in art with an axe or halberd, in confusion with Matthias (▷Judas' replacement) who was martyred by beheading. The medieval hagiography, *The Golden Legend*, however, recounts the long-established legend that Matthew was murdered by a swordsman on the instructions of a local tyrant as he conducted mass at the altar (e.g. Caravaggio, Contarelli Chapel). His inscription from the Apostles' Creed is 'Sanctam ecclesiam catholicam; sanctorum communionem' ('I believe in the holy Catholic Church; the communion of saints'). Alternatively, he might be accompanied by an inscription from his gospel: either 'Primum querite regnum dei' ('But seek ye first the kingdom of God'; 6:33), or 'Liber generationis Jesu Christi' ('The book of the generation of Jesus Christ'; 1:1).

Maulbertsch (Maulpertsch), Franz Anton (1724–96)

Austrian painter and etcher. He was a member of the Vienna Academy in 1759 and a Professor there from 1770. Under the influence of Venetian colourism, he produced much decorative work for churches in central Europe. He was responsible for both ▷altarpieces and ▷frescos, and his lively style represented a transition from ▷Baroque to ▷Rococo in central Europe. He was particularly adept at oil sketches, many of which survive.

maulstick

▷mahlstick

Mauritshuis

The Dutch royal collections, opened to the public in 1820 in The Hague in a palace built for Prince John Maurice of Nassau – hence its name. Unsurprisingly, the Mauritshuis houses the best collection of 17th-century Dutch art, including works by ▷Vermeer and ▷Rembrandt.

mausoleum

Originally, the royal tomb at Halicarnassos (present day Bodrum, Turkey), built c350 BC for Mausolus, ruler of Caria. It is believed to have been started by Mausolus himself and carried on for him after his death by his widow, Artemisia. So magnificent was the Mausoleum that it was ranked among the Seven Wonders of the World. Today, the term mausoleum is used to refer to any commemorative edifice of requisite magnificence, built to house the dead.

Mauve, Antoine (1838–88)

Dutch painter. He was born in Zaandam and studied under an animal painter and with ▷Wouverman-influenced artists in The Hague. He worked with ▷W. Maris (1856–9), producing landscape and peasant scenes (e.g. *Scheveningen*, 1874, Glasgow, Burrell Collection). His work was heavily influenced by the French artists ▷Millet, ▷Corot and ▷Daubigny, producing soft-toned scenes in the style of the ▷Hague School (e.g. *Gathering Potatoes*, 1880s, Montreal). He travelled widely throughout Holland before settling in The Hague in 1871. He taught ▷van Gogh and co-founded the Dutch Drawing Society (1876). His later life was increasingly spent at Laren, where he settled in 1885 (e.g. *Heath at Laren*, c1886, Amsterdam, Rijksmuseum).
Bib.: Engel, E.P. *Antoine Mauve*, Utrecht, 1967; *The Hague School*, exh. cat., London, 1983

Mayakovsky, Vladimir Vladimirovich (1893–1930)

Russian poet, playwright, illustrator and designer. He began to write poetry at the age of 16 while imprisoned for political activities. At the Moscow School of Painting, Sculpture and Architecture (1911–14) he and ▷David Burliuk founded the Russian ▷Futurist group and published the manifesto *A Slap in the Face of Public Taste* (1912). Mayakovsky championed the ▷dynamism of the technological age, and saw the Revolution as its fulfilment. His play *Mystery Bouffe* (1918) and poems such as '150,000,000' (1919–20) and the elegy 'Vladimir Ilyich Lenin' (1924) were unabashed celebrations of the Bolshevik cause. He organized the Left Front of the Arts, a position which enabled him to promote and commission ▷Constructivist works of art. With ▷Rodchenko he designed ▷agitprop posters, cartoons and even sweet wrappers for the telegraph agency and state-controlled industries. Increasingly marginalized and depressed by the apparent victory of bourgeois culture under Stalin, he committed suicide.
Bib.: Shkolovsky, V., *Mayakovsky and his Circle*, London, 1972

Mayno (Maino), Juan Bautista (1578–1649)

Spanish painter. He was born in Pastrana, near Madrid. His father was Milanese and his mother came from Portugal. In his mid-20s he travelled to Italy, and is thought to have befriended ▷Guido Reni. Returning home in 1608, he began to undertake religious commissions. In 1612 he painted ▷frescos for the

Dominican monastery of San Pedro Matire (St. Peter the Martyr) at Toledo, and joined the order the following year. In 1620 he was appointed drawing teacher for the future Philip IV, and is thought to have assisted in the decorations for the Buen Retiro Palace.

Mayno's experience in Italy is imprinted on his work, typified in the six paintings for San Pedro Matire. He skilfully adopted the complex rhythms, strong light and dazzling painterly effects of ▷Caravaggio. However, the flamboyant colour (e.g. the rainbow sleeves and golden yellow cloak of the *Adoration of the Magi*, 1612) is distinctive to Mayno. His finely detailed landscapes are equally accomplished. Entering the monastery brought his career to a premature end, although there are works such as *The Head of a Monk* and *The Recovery of Bahia in 1625* dating from the mid-1630s.

Mazo, Juan Bautista Martínez del (c1612–67)
Spanish painter. He was the son-in-law of ▷Velázquez, with whom he studied. He went to Italy in 1657 and returned to Spain to become a court painter in 1661. He painted a number of important portraits, including that of Queen Mariana (1666, London, National Portrait Gallery).

Mazzola, Girolamo Francesco
▷Parmigianino

Mazzoni, Sebastian (c1611–78)
Italian painter and architect. He was born in Florence, and worked in Venice from 1648. He produced architectural designs in a ▷Baroque style.

Mécano
A journal founded in 1922 by ▷Theo van Doesburg. There were only four numbers, but they included the work of a number of important ▷Dada artists such as ▷Raoul Hausmann and ▷Jean Arp.

Meckenem the Younger, Israhel van (c1450–1503)
German engraver. He may have studied with the ▷Master E.S. He was a goldsmith and a prolific engraver, producing over 600 plates in his lifetime.
Bib.: Hollstein, F.W.H., *Hollstein's German Engravings, Etchings and Woodcuts 1400–1700, vol. 24: Israhel van Meckenem*, Amsterdam, 1986

medals
Conventionally, a coin of substantial size that has some commemorative function and is not intended as currency. We know that Augustus had medals produced and distributed amongst his friends, and many large pieces have survived from the Roman empire which appear to be medals, although we lack exact knowledge of how they were used. Here, as in so many other areas, the ▷Renaissance aped Roman antiquity and

took to striking medals on a large scale, usually for prestige, for commemorative purposes, or to distribute as keepsakes. The medals of ▷Pisanello are best known. Often, medals provide vital information which is otherwise unavailable: Matteo dei Pasti's foundation medal for the Tempio Malatestiano at Rimini shows the building with the (unbuilt) dome, while Caradossa's foundation medal for St. Peter's probably shows it as ▷Bramante intended it to be.

Highly centralized institutions have taken particularly enthusiastically to issuing medals. It would be foolish to study the papacy's attitudes to art without studying the large numbers of medals the popes have issued, and Louis XIV founded the Académie des Inscriptions et Belles-Lettres partly to look after the striking of suitable medals. They are still struck today to commemorate special events such as the Olympic Games, and may be awarded as part of scientific and literary prizes, or for artistic competitions.
Bib.: Addison, J., *Dialogues upon the Usefulness of Ancient Medals*, London, 1726; Hill, G.F., *Corpus of Italian Medals of the Renaissance before Cellini*, reprint, London, 1984; Kent, J., *Two Thousand Years of British Coins and Medals*, London, 1978

Medea
In Classical legend, a sorceress and wife of ▷Jason, the leader of the Argonauts. The sources for her story are to be found in Euripides' play *Medea*, Apollonius of Rhodes' *Voyage of Argo*, and Ovid's *Metamorphoses*. Two aspects of the story have appealed to artists: those that deal with her witchcraft and those that deal with her infanticide, the latter regaining its popularity in the 19th century (e.g. ▷Delacroix, *The Fury of Medea*, 1838, Lille, Palais des Beaux-Arts). Medea was the daughter of the King of Colchis who, for love of the Greek hero Jason, helped him steal the Golden Fleece from her father. She returned to Greece with Jason and bore him two sons. She also restored Jason's father to youth by draining the blood from his veins and replacing it with a magic potion. She then tricked the daughters of Pelias, the usurper of Jason's father's throne, into killing their own father by getting them to drain his blood with the false promise that he too would be restored to youth. By now Jason had deserted Medea for a Greek woman; Medea responded by sending Jason's new love a poisoned cloak and murdering the two sons she had had by Jason. She afterwards fled to Athens where she married and bore a son by King Aegeus, before moving back to Asia.

Medici
Florentine family of bankers and merchants. They rose to the position of supreme political power, firstly under Cosimo who, from 1434, was effective leader of the Florentine republic, through to Cosimo I who became in 1569 the first Grand Duke of Tuscany, with the family maintaining that title until 1737. Their chief

importance for the history of art is as ▷Renaissance patrons. The founder of their wealth, Giovanni di Bicci (1360–1429) commissioned ▷Brunelleschi to build the Old Sacristy in San Lorenzo; his son, Cosimo (1389–1464) commissioned ▷Michelozzo to build the Palazzo Medici and was a loyal patron of ▷Donatello; and Cosimo's son Piero (1416–69) commissioned from ▷Benozzo Gozzoli the ▷fresco cycle of the *Adoration of the Magi* for the family chapel in the palace and from Michelozzo the sumptuous ▷tabernacles in SS Annunziata and S. Miniato. Piero's son, Lorenzo the Magnificent (1449–92) was mainly a collector of antiquities, although he did establish the informal art academy in the Medici Gardens, where ▷Bertoldo di Giovanni was instructor and ▷Torrigiano and ▷Michelangelo the most celebrated pupils. Lorenzo's second cousin, Lorenzo di Pierfrancesco (1463–1503) was ▷Botticelli's principal patron and possibly commissioned the ▷*Primavera* and the ▷*Birth of Venus*. Lorenzo the Magnificent's son Giovanni (1475–1521) and nephew Giulio (1479–1534) became respectively Pope Leo X and Pope Clement VII, commissioning works from Michelangelo (e.g. the Biblioteca Laurenziana and the New Sacristy in San Lorenzo, Florence), ▷Raphael (cartoons for the ▷Sistine tapestries, now in London, Victoria and Albert Museum, and the *Transfiguration*, now in the Vatican Museums), ▷Giulio Romano and ▷Sebastiano del Piombo. Their cousin Cosimo I (1519–74) patronized ▷Bandinelli, ▷Cellini, ▷Pontormo, ▷Bronzino, ▷Ammanati, ▷Giambologna and ▷Vasari (although he failed to convince the committed republican Michelangelo to return to Florence) and founded the family art collection which became the ▷Uffizi. Of the later members, Marie de' Medici (1573–1642, Queen of France, by marriage to Henri IV, 1600–10) was the subject of an ▷allegorical cycle by ▷Rubens (▷*Medici Cycle*) and Leopoldo (1617–75) founded the Uffizi collection of artists' self-portraits.

Medici Cycle

Painted by ▷Peter Paul Rubens, 1622–5, for the Palais Luxembourg in Paris, then a new royal residence. It was commissioned by the Dowager Queen Marie de'Medici and represents in 24 works the narrative of her life, marriage and Regency in France. The canvases are crammed with ▷allegory and have been interpreted in a number of ways, either as a political challenge by an ostracised mother on her son, Louis XIII, or as an attempt at reconciliation between the two. Whatever their true intention they represented a huge challenge for Rubens, both because of the scale and number of the works, and because of the need to marry contemporary history with Classical allegory (e.g. the education of the future queen is carried out by ▷Minerva and the ▷Three Graces). The problems are apparent in some of the less successful canvases, but generally Rubens triumphs, and the scale of his success

can be judged by the plans, never implemented, for a second series. The complexity of his pictorial language and composition can be illustrated by the *Arrival of the Queen at Marseilles* which packs the vertical canvas with Classical architecture, a covered barge from which the queen and her attendants step forth, and, in the foreground, a number of Rubenesque ▷Nereids and Tritons celebrating her coming.

Bib.: Millen, R., *Heroic Deeds and Mystic Figures: A New Reading of Rubens' Life of Marie de' Medici*, Princeton, 1989

Medici Venus (Venus de' Medici)

Antique marble statue of nude ▷Venus, believed to be a 1st century BC copy, perhaps Athenian, of a lost bronze original of the mid-4th century BC. The Greek inscription, which states that it is by 'Cleomenes, son of Apollodorus', most likely records the signature on the bronze original. It is first recorded as being in the Villa Medici, Rome, in 1638. In 1677 it was sent to Florence and by 1688 was in the Tribuna of the ▷Uffizi, where it remains to this day. The arms, covering the breasts and pudenda, are not original, having been added by Ercole Ferrata following the statue's arrival in Florence. From its first publication in 1638 in Perrier's anthology of antique statues until its fall from fashion in the late 19th century, it was considered an unsurpassed model of ideal female beauty and was copied widely, perhaps more than any other antique statue. There exist numerous replicas in marble, bronze, and lead, the latter medium being most popular for garden settings, especially in England. Such was the admiration for the statue that the signature, by an otherwise unknown sculptor, was considered to be fake and attempts were made to reattribute it to ▷Phidias, ▷Scopas, or ▷Praxiteles, this last attribution being on the basis of its resemblance to that sculptor's ▷*Aphrodite of Cnidus*. ▷Luca Giordano drew the statue repeatedly and from all angles, and scores of writers, including Byron in *Childe Harold* (canto IV, stanzas xlix–liii), wrote rapturously about it. ▷Ruskin, writing in 1840, considered it 'one of the purest and most elevated incarnations of woman conceivable'. Nonetheless, there were some detractors, particularly of the arms which, until the 18th century, were not known to be later restorations. ▷Winckelmann accorded it qualified praise, thinking the navel too deep and the face insufficiently ideal. The general tone, however, was nothing short of adulatory. Other versions exist (e.g. the so-called *Jenkins Venus* at Newby Hall in Yorkshire), but none were considered the equal of the *Medici Venus*. So dismayed were the Florentines when it was removed in 1802 by the occupying French, that they commissioned ▷Canova to execute a free version, the *Venus Italica*, to replace it in the Tribuna, which it did until the *Medici Venus* was returned after the fall of Napoleon in 1815. Canova's *Venus Italica* is now in the Pitti Palace, Florence.

Bib.: Haskell, F. and N. Penny, *Taste and the Antique*, New Haven and London, 1981

medium

(i) A term to describe the liquid in which a ▷.pigment is suspended in order for it to be applied to a surface – for example, egg yolk or linseed oil.

(ii) A term to describe the physical composition of the means used by an artist to express his or her ideas – for example, clay can be used as a medium in sculpture.

Medusa

One of the three Gorgons, sisters whose appearance could turn men to stone. They were the children of Phorcys (a sea-god) and his sister Ceto, and had once been beautiful. They had snakes for hair, fang teeth and staring eyes. Medusa was the only mortal of the three (a punishment from ▷Minerva for her love of ▷Neptune). She was beheaded by ▷Perseus, who was given a mirrored shield by his protector, Minerva, so that he could avoid looking at the Gorgon. Even the decapitated head remained powerful, and was used on shields as a talisman (e.g. ▷Caravaggio, *Head of Medusa*, 1591–2, Florence, Uffizi). Medusa was pregnant when killed, and from her neck wound Pegasus sprang forth. Her blood was said to have restorative properties (see ▷Rubens, 1617–18, Vienna, Kunsthistorisches Museum; ▷Watts, 1843–5, Compton, Watts Gallery).

megalith

A stone of great size, unshaped or at most only roughly hewn, employed in prehistoric times for construction or erected as a discrete monument. Megalithic monuments are found mostly in northern Europe and date from c4000–1000 BC. They may take one of several forms: a ▷menhir or stone standing in isolation; a series of discrete standing stones aligned in rows (e.g. Carnac, Brittany); or a circle of standing stones, usually standing discretely, although sometimes, as at Stonehenge (c1800–1400 BC) capped by ▷lintels to form a continuous ring enclosing an inner ring of discrete trilithons (two standing stones capped by a lintel). Other megaliths may form chamber tombs, in which some standing stones form the walls whilst another is laid horizontally across to form a roof. These are known in Welsh as cromlechs, but in Brittany as dolmens, where confusingly the term cromlech is used to refer to a circle of standing stones.

megilp

A painting ▷medium consisting of ▷varnish and linseed oil. It was used extensively in the 18th and 19th centuries, but it was discredited in the 20th century because it ultimately damaged the oil paint.

Meidner, Ludwig (1884–1966)

German painter. He studied at the Breslau Academy (1903–5), and in Paris at the ▷Académie Julian (1906–7). He exhibited at the ▷Sturm gallery in 1912 and began producing ▷Expressionist scenes with apocalyptic themes. While living in Berlin before the First World War, he became involved with ▷Die Pathetiker – a group composed of both artists and writers, and his own writings show his ▷Futurist inclinations. His apocalyptic scenes were only thus named in retrospect, but they do show cities in a state of collapse or destruction. In 1935–9 Meidner was master at a Jewish High School in Cologne, but Nazi persecution drove him to England in 1939. He returned to Germany in 1953.
Bib.: Eliel, C., *The Apocalyptic Landscapes of Ludwig Meidner*, Munich, 1989

Meissonier, Ernest (1815–91)

French painter, sculptor and graphic artist. He was born in Lyons and studied in Paris under Cogniet. He developed his style as a result of copying works in the Louvre, and a trip to Italy. From 1834 he exhibited at the ▷Salon and became wildly popular for his small-scale ▷genre pieces (e.g. *Brawl*, 1855, Royal Collection; *Roadside Inn*, 1865, London, Wallace Collection). These showed a precise attention to historical detail and a highly finished style, and were collected for large sums, by the Marquis of Hertford amongst others. He recorded the events of the 1848 Revolution (e.g. *Barricade, Rue de la Mortellerie*, 1848, Paris, Musée d'Orsay) and in 1859 he followed Napoleon III to Italy and began to produce larger, highly finished military canvases of Napoleonic campaigns (e.g. *Napoleon III at the Battle of Solferino*, 1863, Paris, Musée d'Orsay). He also served during the Commune of 1870 as ▷Manet's commander. He was the first president of the Société Nationale des Beaux-Arts in 1890.
Bib.: Gottlieb, M., *The Plight of Emulation: Meissonier and French Salon Painting*, Princeton, 1996; *Ernest Meissonier Retrospective*, exh. cat., Lyons, 1993

Meit, Conrad (c1475–1550/1)

German sculptor. He was born in Worms and worked at the court of Frederick the Wise, Elector of Saxony 1506–10. He also worked in Wittenberg, where he knew ▷Cranach. He was appointed court sculptor for the Habsburgs in the Netherlands. His works were small in scale and evinced a ▷Renaissance elegance.

Melanesian art

The art of New Guinea and the smaller islands to the north and east of it. This art is tribal and remains so even today. In certain areas, it resembles ▷Indonesian art, but Melanesian art is distinguished by its many ephemeral works often in the form of festival masks and art made of palm leaves. These masks often contain

blunt or erotic symbolism and some are related to a cannibalistic culture of certain parts of the islands. Between the two world wars Melanesian art was influential on many European artists, particularly those with a ▷Surrealistic inclination, such as ▷Brancusi, ▷Ernst and ▷Henry Moore.

Meldrum, Max (1875–1955)

Australian painter of Scottish birth. He was born in Edinburgh and travelled to Melbourne in 1889. He studied in Victoria, then in France. He returned to Melbourne in 1911, and in 1917 he started his own school of art. He was opposed to the experimentation of modern art, and his work always had an affinity with the ▷Old Masters. His paintings were suffused with tonal qualities which became his distinctive stamp. He was strongly influential on the next generation of painters in Melbourne.

Meléndez, Luis Eugenio (1716–80)

Spanish painter. He was born in Naples, and in his early career he worked as an assistant of ▷Louis Michel van Loo in Spain (c1742–8). In 1775 he travelled back to Italy. He specialized in ▷*bodegón* pictures, and he has been called the 'Spanish ▷Chardin'.

Mellan, Claude (1598–1688)

French engraver. He trained in Rome, and produced portraits and prints after ▷Poussin and ▷Vouet.

Mellon, Andrew W. (1855–1937) and Paul (b 1907)

American family of patrons. Andrew Mellon was a businessman and art collector, whose money came from banking. He was Secretary to the United States Treasury (1921–32) and Ambassador to England (1932–3). He used his wealth to amass a large art collection, and he donated his Dutch and English art to the nation in 1937. He also gave money to build the National Gallery of Art in Washington DC.

Mellon's son Paul was also a businessman and collector, mainly of British art. He has been instrumental in the foundation of several galleries and research institutes, including the Paul Mellon Foundation for British Art (1962) and the Yale Center for British Art at New Haven (1966).

Bib.: O'Connor, H., *Mellon's Millions: The Biography of a Fortune: The Life and Times of Andrew W. Mellon*, New York, 1933

Melozzo da Forli (1438–94)

Italian painter. He is chiefly remembered for his use of extreme ▷foreshortening, seen in the fragmentary ▷fresco from the dome of SS Apostoli (c1478–80) showing an *Ascension with Christ in Glory* and Angel musicians and ▷Apostles (now split between the

Quirinale and the Vatican). He was at one time credited with the invention of this particular extreme form of foreshortening, known as ▷*sotto in sù*. His fresco, *The Inauguration of the Library of Pope Sixtus IV* (1474–7, detached, now in the Vatican, Pinacoteca) reveals an assured grasp of ▷perspective in the service of spatial illusionism, pictorial coherence and monumental grandeur. As his name suggests, he was from Forli in the Romagna, but no details of his training are known. He worked in Loreto, Rome and Urbino and reflects the influence of ▷Piero della Francesca, from whom he may have learned his perspective skills. Unfortunately very little of his work survives, which, combined with the fact of his base being outside the main centres of art production, has led until recently to his unjustified neglect.

Bib.: Clark, M., *Melozzo da Forli: pictor papalis*, Florence, 1989

Melpomene

▷muse

memento mori

(Latin, 'reminder of death'.) Any of a number of symbols, employed frequently in ▷*vanitas* still lifes, and intended to remind the viewer of the transience of life. Skulls, hour-glasses, clocks and candles are the most common.

Memlinc (Memling), Hans (c1430/40–94)

Netherlandish painter. He was born in Seligenstadt, near Frankfurt-am-Main. It is not known whether he was trained in Germany, and by 1465 he was active in Bruges. His style from this date suggests there may be truth in the tradition that he was trained rather by ▷Rogier van der Weyden. His work was certainly deeply influenced by Rogier (and to a lesser extent by ▷Bouts), but it is altogether sweeter, softer, more graceful and inflected with a quiet piety that gives it an unmistakable identity of its own. His *Last Judgement* (intended for an Italian patron, but captured at sea by Swedish pirates in 1473 and now in Gdansk, Pomeranian Museum) provides a telling contrast with Rogier's intensely emotional rendering of the same subject at Beaune. Memlinc's conservative style was obviously enormously successful as is suggested by the large amount of tax his returns show him paying. The most important collection of his paintings is now in the Memlinc Museum in the Hôpital de St. Jean at Bruges and it is here that the painting generally considered as his masterpiece, the *Mystical Marriage of St. Catherine* (1479), is still housed in the location for which it was intended. He was also a gifted portraitist, one of his most accomplished being the *Diptych of Martin van Nieuwenhove* (1487, Bruges, Memlinc Museum). His paintings were popular among Italian patrons (e.g. the *Last Judgement*, mentioned above, and *The Portrait of Tommaso Portinari and his Wife*, c1486, New York,

Metropolitan Museum) and his portrait style seems to have exerted a certain influence among the artists of northern Italy, as is evident in the work of ▷Giovanni Bellini.

Bib.: Friedländer, M.J., *Hans Memlinc and Gerard David*, 2 vols, Leiden, 1971; Vos, D. de, *Hans Memlinc: The Complete Works*, London, 1994

Memmi, Lippo (fl 1317–56)

Italian painter. He was Sienese, the son of Memmo di Filipuccio, with whom he collaborated in 1317 on the *Maestà* fresco in the Palazzo del Popolo in San Gimignano, and brother-in-law to ▷Simone Martini, whose principal follower he was (Lippo's *Maestà* closely following Simone's of two years earlier in the Siena Palazzo Pubblico). Although not a great innovator, Lippo was a painter of high quality, to the extent that in the Uffizi *Annunciation* (1333), which is signed by both Lippo and Simone, the individual contributions are not clear. Indeed, there are a number of paintings in which the attribution to Simone or Lippo is disputed. Lippo produced a great many panel paintings on the theme of the *Madonna and Child*, signed examples of which are in Siena (Pinacoteca), Orvieto (Duomo), Berlin (Staatliche Museen) and Altenburg (Lindenau Museum). He also worked as an architect, designing in 1341 the battlemented stone belfry of the Torre della Mangia of the Palazzo Pubblico, Siena.

Mendelsohn, Eric (1887–1953)

German architect. He was born in East Prussia, to a Jewish family. After graduating from architectural schools in Berlin and Munich, he served in the First World War. In 1919 he established an architectural practice in Berlin, where he became part of the ▷Novembergruppe. He travelled to Holland and the United States in 1924 (publishing a series of photographs, *Amerika*, in 1926), and visited Russia in 1925. From 1933 he was based in Britain where he designed the de la Warr Pavilion in Bexhill (1933–5) and in 1941 he moved to America, working in San Francisco. He also worked in Israel (e.g. Agricultural Institute, Rehovot, 1939). His work used ▷modernist materials such as reinforced concrete and glass but avoided the rectilinear qualities of the ▷International Style, in favour of curves and fluid lines. His most famous work, the Schocken Department Store, Stuttgart (1926), had a horizontal emphasis created by its façade of strip windows and alternation of concrete and glass. He is regarded as a primary exponent of ▷Expressionism in architecture.

Bib.: Beyer, O. (ed.), *Eric Mendelsohn: Letters of an Architect*, London, 1967; von Eckardt, W., *Eric Mendelsohn*, New York, 1960; Mendelsohn, E., *Complete Works of the Architect*, London, 1992; Zevi, B., *Eric Mendelsohn*, London, 1985

Mengs, Anton Raffael (1728–79)

German painter. He was born in Dresden, the son of a court painter. He went to Rome in 1741, a child prodigy, and first met ▷Winckelmann in 1755 (see *Portrait of Winckelmann*, New York, Metropolitan Museum). Although he returned to Dresden in 1746 to become a successful portraitist and court painter, he spent most of his life in Rome and converted to Catholicism in 1754. His early influences of ▷Correggio and ▷Raphael were soon modified towards the ▷antique and he became one of the leading exponents of early ▷Neoclassicism (e.g. *Cleopatra before Octavius*, 1760, National Trust, Stourhead, Wiltshire). In 1761 he painted *Parnassus* at the Villa Albani, which rejected the illusionism of ▷Baroque. He also painted religious subject matter (e.g. ▷*Noli me tangere*, 1771, All Souls College, Oxford). He became Charles III's court painter in Madrid. His style was superseded by the work of ▷Hamilton and ▷David, and is ponderous in comparison with them, but he was influential for a whole generation of visitors to Rome, especially British ones.

Bib.: Pelzel, T., *Mengs and Neoclassicism*, New York, 1979; Roettgen, S., *Mengs and his British Patrons*, London, 1993

menhir

▷megalith

Meninas, Las

Portrait of the Spanish Infanta Margarita Maria and her Maids of Honour (*meninas*) painted by ▷Velázquez in 1656, now in the Prado, Madrid. The painting has a complex visual structure and contains a number of figures, including a self-portrait of the artist who stares out of the picture from around a large canvas on which he is working. It is generally considered also to contain portraits of the king and queen, whose faces can be seen reflected in a mirror at the back of the chamber represented in the picture. ▷Ernst Gombrich wrote that it was perhaps 'the most daring case of drawing the beholder into a composition, and also artistically the most daring'. It is generally considered the highest achievement of Velázquez's art, combining his two principal characteristics of physical realism and complex form. The painting made a strong impression on the young ▷Picasso who first saw it aged 15, and made 44 variations upon its theme in 1957.

Bib.: Harris, E., *Velázquez*, Oxford, 1982

Menzel, Adolf von (1815–1905)

German painter. He worked in his father's ▷lithography firm from 1832, where he learned ▷engraving techniques. He produced illustrations from Franz Kugler's *History of Frederick the Great* (1840–42), which were both popular and controversial in the years leading up to the 1848 revolutions. His painting style became freer in the 1850s, and he began specializing

in modern life ▷genre scenes, including images of factories and industry. However, some of his most effective works represent interior scenes painted with a loose, feathery technique.

Bib.: *Adolf von Menzel 1815–1905: Zeichnungen, Aquarelle, Gouachen*, Vienna, 1985; *Prints and Drawings by Adolf Menzel: A Selection for the Collections of the Museums of West Berlin*, Berlin, 1984

Mercier, Philip (1689–1760)

French painter. He was a Huguenot. He trained in Berlin and travelled to England in c1716. He was supported by the Hanoverian monarchs who commissioned ▷conversation pieces from him. He was appointed Principal Painter to Frederick, Prince of Wales (1729–36), and thus encouraged a French ▷Rococo style in a court that stood in opposition to the anti-Gallic tendencies of King George II's circle. In 1739 he retired to York, where he began to paint ▷fancy pictures and scenes from the theatre.

Mercury (Greek: Hermes)

One of the 12 gods of Olympus, the son of ▷Jupiter and Maia and the messenger of the gods. He is usually represented as an athletic youth, with winged sandals and helmet and a wand (▷caduceus) which could induce sleep. He is often present at major mythological narratives (▷Judgement of Paris). He brought Pandora to earth, escorted Psyche to her marriage with ▷Cupid, took dead souls to Charon and led Proserpine back from the underworld. He was also the patron of a number of groups – travellers (hence the word 'herm' to describe roadside stones), shepherds (a ram symbol), traders (a purse), thieves (he stole cattle from ▷Apollo as a boy) – and he was also associated with reason and teaching (e.g. ▷Correggio, *Mercury Instructing Venus and Cupid*, 1520–25, London, National Gallery). He invented the lyre, was the father of Pan and the lover of ▷Venus (e.g. ▷Poussin, *Venus and Mercury*, 1620s, London, Dulwich Gallery). (See also ▷Praxiteles, *Hermes with Young Dionysius*, c350 BC, Olympia; ▷Giovanni de Bologna, *Flying Mercury*, bronze, 1567, Florence; ▷Tintoretto, *Three Graces and Mercury*, 1577–8, Venice, Palazzo Ducale).

Merian, Matthäus (1593–1650)

German engraver. He produced topographical prints of towns.

Bib.: Hollstein, F.W.H., *Hollstein's German Engravings, Etchings and Woodcuts 1400–1700*, vol. 25: *Johan Ulrich Mayr to Matthaeus Merian the Elder*; idem, vol. 26: *Matthaeus Merian the Elder (continued)*; idem, vol. 26A: *Matthaeus Merian the Elder to Matthaeus Merian the Younger*; Roosendaal, 1989–90

merlons

In an embattled ▷parapet, the solid upward projections that alternate with the indentations or embrasures.

Mérode Altarpiece

A ▷triptych attributed variously to the ▷Master of Flémalle and (with slightly less conviction) to ▷Robert Campin. Art historians have written volumes on this work, often concentrating on minute symbolic detail and owing much to the ▷iconographical approach of ▷Panofsky. The arguments surrounding the work mean that a unitary interpretation is impossible, but certain elements of the work have attracted the attention of scholars with competing theories. The ▷altarpiece was commissioned by the Ingelbrechts family for their private devotions. The central panel represents the ▷Annunciation, while the left wing depicts the ▷donors and the right wing shows ▷Joseph in his carpenter's workshop. The work is distinguished by its contemporary features as well as by its unusual use of symbolism; these elements combine to form what Panofsky called 'disguised symbolism'. For example, the brass pot hanging on the back wall, typical of contemporary Flemish metalware, could be a symbol of the ▷Virgin Mary's purity. The representation of Joseph in the right wing is a stunning example of early Netherlandish realism, and the tools of his workshop are represented in minute detail, as is the view of a contemporary Flemish town through the window behind him. Although its symbolism bore a relation to the heritage of medieval religious art, the Mérode altarpiece showed a new concern for contemporary life through the introduction of such secular elements.

Merritt, Anna (1844–1930)

American painter. She was born in Philadelphia to wealthy parents, who enabled her to travel to Europe. She was in London in 1871 where she met and married the artist Henry Merritt. She exhibited at the Royal Academy. Her ▷genre scenes were very popular, including the famous *Love Locked Out* (1890, London, Tate Gallery). Her memoirs survive, revealing the difficulties she had in forming a career and balancing her own practice with that of her husband.

Bib.: Gorokhoff, G., *Love Locked Out: The Memoirs of Anna Lea Merritt*, Boston, 1982

merry company

A name given to a type of 17th-century Dutch ▷genre painting which represents a group of people drinking or carousing in a tavern or a private home.

Merz

A ▷collage or ▷relief of randomly collected junk associated with the ▷Dada artist ▷Kurt Schwitters, who invented this meaningless word by chance when

making a collage (it was the result of cutting the letters 'merz' out of a newspaper clipping of the word 'Kommerzbank'). It was also the title of a Dada magazine Schwitters edited from 1923 to 1932.

Mesdag, Hendrik Willem (1831–1915)

Dutch painter. He studied with ▷Alma-Tadema in Brussels in 1866, but veered away from Alma-Tadema's archaeological style and towards the atmospheric effects of the ▷Hague School. He specialized in ▷marine subjects. He is most famous for his ▷panorama of Scheveningen (1881), which is 120 m (394 ft) in circumference.

Mesens, E.L.T. (1903–71)

Belgian poet, painter and composer. He began his working life as a composer, but he changed direction in 1921, when he met ▷Duchamp and ▷Picabia in Paris. There he also came into contact with the works of ▷de Chirico, and his enthusiasm for ▷Surrealism led him to contribute to organizing exhibitions of Surrealist art. He was in London from 1938. His own work was reminiscent of that of ▷Kurt Schwitters, consisting of ▷collages formed from bits of junk, such as discarded railway tickets, newspapers, etc. He was friendly with ▷Magritte, and like him enhanced Belgium's contribution to Surrealism.
Bib.: *E.L.T. Mesens: The Cubist Spirit in its Time*, exh. cat., London, 1947

Mesopotamian art

Art remains from this geographical region from the 4th millennium BC at a time before the Sumerians colonized the area. During this period it consisted largely of wall painting. By the 3rd millennium BC architecture in the form of ▷ziggurats was complemented by small-scale portable gold and silver work encrusted with precious jewels. Many of these art objects were used in tombs. Over the next 2,000 years, Mesopotamian art continued to diversify, and carved ▷reliefs remain from the 2nd millennium BC. The height of Mesopotamian civilization was the 6th century BC when Nebuchadnezzar ruled Babylon and organized a major building programme. The legacy of these architectural forms was left to ▷Islamic art in subsequent centuries.
Bib.: Braun-Holzinger, E.A., *Figürliche Bronzen aus Mesopotamien*, Munich, 1984; Moortgal A., *The Art of Ancient Mesopotamia: The Classical Art of the Near East*, London, 1969

Meštrović, Ivan (1883–1962)

American sculptor of Yugoslav birth. He studied in the Vienna Academy (1900–1904), and went to Paris, where he met ▷Rodin in 1907. He returned to Yugoslavia and produced sculpture in a Classical style. During the First World War he travelled in Italy, France and England, but he returned to Yugoslavia in 1919 where he took on a number of public commissions with a patriotic slant, including the Belgrade Mausoleum to the Unknown Soldier (1934). During the Second World War he lived in Switzerland, and he gained an international reputation soon after the war, when he moved to the United States. There he took up American citizenship in 1954 and became Professor of Sculpture at Syracuse and later Notre Dame Universities. His works were primarily on a monumental scale and for public commission.

metal cut

An ▷engraving on metal, usually lead or type metal, used to produce a ▷print.

metal point

A small, sharpened metal rod, usually silver, although lead, copper and gold can also be used, which is employed for drawing on paper or parchment. Shading and modelling must be developed by hatching. Fifteenth-century Flemish artists, such as ▷van Eyck and ▷Memlinc, used ▷silverpoint, although it lost favour in the 17th century, as pencil was used more. It has had periodic revivals since.

metaphysical painting

(From the Italian: *pittura metafisica*.) A style of painting centred on the Italian artist ▷Giorgio de Chirico in which both subject matter and representation are characterized by a sense of unreality, for example enigmatic figures fleeing across urban environments constructed in illogical ▷perspective, as in de Chirico's *The Mystery and Melancholy of a Street* (1914). Other practitioners of the genre include ▷Carlo Carrà.
Bib.: Carrà, M., *Metaphysical Art*, Eng. trans. 1971

methodology

The recognition that the study of art history is not a value-free 'transparent' activity unencumbered by ▷ideological expectations or intellectual implications has grown with an interest in the application to the discipline of approaches such as ▷formalism, ▷iconography, ▷Marxist art history and ▷semiotics. More recently, methodology has transcended this role to examine the aims of the discipline itself; whether, for example, art history is a humanistic discipline or a social science. It has recently become fashionable to demonstrate familiarity with a variety of art theories that purportedly clarify the methodological issues in play but in some cases seem only to obfuscate the object of study under a tide of rhetorical analysis.
Bib.: Fernie, E., *Art History and its Methods: A Critical Anthology*, London, 1995

métier

The sphere of art in which an artist is considered preeminent or the area on which s/he has chosen to

concentrate (e.g. painting, sculpture, photography), the type of subject matter favoured (e.g. portraiture, landscape, still life) or the style of work (e.g. ▷Cubist, ▷Expressionist, ▷Realist). The meaning in French describes a skill or occupation, whether mechanical or manual, which has utility for society. Use of the term thus serves to locate art within the framework of society in which the skills of the artist are recognized as a necessary function in the greater context.

metonymy
(Greek, 'change of name'.) A figure of speech in which the name of an object or concept is replaced with a word closely related to it (e.g. 'crown' for 'king'). In art this is most commonly seen when works are referred to by their artist. For example, 'The Tate has a collection of Turners' rather than 'The Tate has a collection of paintings by Turner'.

metope
In Classical architecture, one of the rectangular panels that alternate with the ▷triglyphs in a ▷Doric ▷frieze. Metopes are sometimes carved (e.g. the 92 metopes of the exterior frieze of the ▷Parthenon, each showing an incident in the Battle of the Lapiths and ▷Centaurs).

Metropolitan Museum of Art, New York
One of the largest museums in the world, with important collections of Egyptian, Greek and Roman art and antiquities, European and American paintings, arms and armour. In 1866, John Jay, an American statesman, started a movement for a 'National Institute and Gallery of Art' and this cause was promoted by the Union League of New York. In 1870 Congress granted a Charter for such a body, and funds were provided by private benefactors for the purchase of works of art. For the first ten years the Metropolitan Museum occupied large houses, but in 1880 it moved to its present location in Central Park. This building, by Calvert Vaux who laid down plans for the whole park, is the west wing of the modern museum, which has been extended and modified greatly over the years. The collection now contains work by artists including ▷Mantegna, ▷Ghirlandaio, ▷Cranach, ▷Raphael, ▷Tintoretto, ▷Caravaggio, ▷El Greco, ▷Chardin, ▷David, ▷Rembrandt, ▷Renoir, ▷Manet, ▷Degas, ▷Cézanne, ▷Gauguin, ▷Rodin, ▷Picasso, ▷O'Keeffe, ▷Hopper, ▷Eakins, ▷Benton and ▷Curry. Much has been made of the fact that the museum was democratically founded by individuals, for the education of the people, and did not grow out of royal treasure troves or the spoils of war. However, it does contain galleries of native American art, Egyptian, Roman and Greek artefacts.

Metsu, Gabriel (1629–67)
Dutch painter. He worked in Leiden, where he painted ▷genre scenes of middle-class life. In c1655 he was in Amsterdam, where he saw the work of ▷Rembrandt and introduced more ▷chiaroscuro into his own work. From 1660 he specialized in the middle-class interior genre scene, working in a mode established by ▷de Hooch and ▷Terborch which glorified the quiet domestic virtues of the Dutch burgher class.

Metzinger, Jean (1883–1956)
French painter. He was born in Nantes. Early in his career he was impressed by the paintings of ▷Ingres, and Ingres' classicism was always a fundamental component in his own work. He briefly flirted with ▷divisionism and ▷Fauvism, but in 1908 he became involved with the ▷Cubist circle. He exhibited at the ▷Salon des Indépendants and at the ▷Section d'Or, which he helped found. His brand of Cubism was more colouristic than that of ▷Picasso and ▷Braque. With ▷Gleizes, he produced the text *Du Cubisme* in 1912 and thus helped disseminate the Cubist style internationally.
Bib.: *Jean Metzinger in Retrospect*, exh. cat., Iowa City, 1985

Meulen, Adam Frans van der (1632–90)
Flemish painter and tapestry designer. He worked in Brussels, but moved to Paris in c1665, where he became court painter to Louis XIV and assistant to ▷Lebrun. He produced designs for ▷Gobelins tapestries, including battle imagery drawn from his experience of accompanying the king into battle. He also painted landscapes.

Meunier, Constantin (1831–1905)
Belgian painter and sculptor. He was born in Etterbeck and studied at the Brussels Academy. He exhibited his first sculpture in 1851 but turned to painting soon after. After a visit to a Trappist monastery he turned to religious subject matter in 1857 and only broadened his interests in the 1870s, when he began working on ▷genre and history scenes and portraiture. During the 1880s his palette became brighter, but he also developed an interest in industrial subject matter, working among the Borinage miners and producing the monumental ▷Realist images which made his name (e.g. *Return of the Miners*, 1905, Brussels). He also returned to sculpture in 1885 (e.g. *Pardon*, bronze, 1899).

mews
Originally, the royal stables at Charing Cross, London, so-called because the stables occupied the site where the royal hawks were formerly kept, or 'mewed'. By extension the term now refers, in a city or town, to a row of stables opening onto a court or alley, with living accommodation above.

Mexico, art in

Mexico has a distinguished artistic heritage from ▷Pre-Columbian times when the Aztecs built a particularly imaginative group of temples adorned with sculpture. From this time also, large stone sculptures, clay pottery and particularly ▷mural painting survives, glorifying the conquering abilities of the Aztecs, as well as their religious rituals. From the 16th to the 19th centuries, Spanish colonization replaced the native tradition with a European one. Spanish artists travelled to Mexico, and ▷Mannerist, ▷Baroque and ▷Plateresque styles can be seen in the painting, sculpture and architecture of this period. Mexico came into its own again in the 20th century when the Revolution of 1910 strongly politicized art. Mexican artists were actively involved in the Revolution, and the government patronized artists for many public commissions. In the 1920s and 1930s, a revival of early ▷mural painting traditions engendered a distinct form of modern Mexican art which was political, satirical and striking. Artists such as ▷Orozco, ▷Rivera and ▷Siqueiros gained an international reputation through their mural work. After the 1950s, this political commitment lessened.

▷Latin America, art in

Bib.: Lothrop, S.K., *Treasures of Ancient America: Pre-Columbian Art from Mexico to Peru*, London, 1979; Ryan, M. (ed.), *The Art of Ancient Mexico*, London, 1992; Smith, B., *Mexico: A History in Art*, London, 1975

mezzanine

A low-ceiling storey between two higher-ceilinged storeys, usually those of the ground and first floor; also called an entresol.

mezzo fresco

(Italian, 'semi-fresco'.) A corrective technique used in ▷fresco painting. ▷Pigment, once applied in *buon fresco*, is ineradicable because of the deep bond it makes with the plaster. Consequently, mistakes are usually rectified either by painting over the dry plaster (i.e. fresco secco), or by the complete removal of the plaster itself. The disadvantages are that the former technique is less durable than buon fresco and is liable to flaking, whereas the latter technique is laborious. With mezzo fresco, the affected area is scraped away only as deep as the buon fresco pigment has penetrated. A thin layer of watery plaster is then applied over the dry underlayer of plaster with a brush, after which the correction can be painted in and will form a durable bond. The term was first coined by the ▷Sistine Ceiling restorers who noted ▷Michelangelo's use of this technique.

mezzotint

(Italian, 'half tone'.) A form of ▷engraving, invented in the middle of the 17th century, which produces tonal prints, as opposed to the linear prints produced by ▷line engraving or ▷etching. The metal plate is worked over with a curved, toothed tool or ▷'rocker' which, as its name suggests, is rocked over the surface, producing a network of uniformly fine burred dots (▷burr). The plate is then inked and wiped, the burred dots holding a considerable amount of ink and, when printed, producing a rich, velvety black. By scraping away some of the burr, less ink is retained and a greyish tone results, whilst polishing the burr away entirely means that no ink is retained and a pure white can be printed. The great attraction of this type of printing was that, being tonal, it was able to give a closer approximation of an oil painting than a line engraving and was therefore, before photographic reproduction superseded it, widely used for the inexpensive commercial reproduction of popular paintings.

Bib.: Wax, C., *The Mezzotint: History and Technique*, London, 1990

Michael

Michael, the chief among God's army of Archangels (Revelation 13: 17), the weigher of the souls of the dead at the ▷Last Judgement and, in the legend of the life of the ▷Virgin, the angel who announces to the Virgin her imminent death. The Annunciation of the Death of the Virgin is distinguished from the ▷Annunciation of the Birth of Christ in that Michael offers a palm to the Virgin, whereas ▷Gabriel carries a ▷lily, or there is a vase of lilies close by (compare the two panels from ▷Duccio's ▷*Maestà*). Like all Archangels, Michael is both heavenly warrior and messenger. In the former role, he is the main character in the Fall of the Rebel Angels. His role as messenger of death presumably originates in the assumption that he is the weigher of souls and this link, in turn, probably originates in ▷Mercury's dual function as messenger of the gods and weigher of souls. In the Old Testament Michael is the guardian of the Hebrew nation (Daniel 12: 1), though he was later adopted as a symbol of the Christian Church militant and given the title saint. When he appears in devotional pictures or ▷sacre conversazioni, he is armoured, carries a shield and a spear or sword and his attributes are the scales and/or a serpent (the devil) crushed under his feet (e.g. ▷Piero della Francesca, panel from the polyptych of St. Augustine, c1455–69, London, National Gallery). He is invariably winged, which prevents any confusion with St. George, whose attributes are similar.

Michallon, Achille-Etna (1796–1822)

French painter. He was a pupil of ▷David and ▷Valenciennes and became a landscape painter. In 1817 he won the ▷Prix de Rome in the category of historical landscape. He taught ▷Corot.

Michel, Georges (1763–1843)

French painter. He was born in Paris and lived there throughout his life, becoming known as the ▷'Ruisdael of Montmartre'. Little is known about his life and he was a largely unrecognized artist until his work was rediscovered by the French ▷Realists, and ▷Thoré during the 1860s, when his work influenced the ▷Barbizon School. He had little ▷Salon success but did find a market for his copies of Dutch 17th-century art and his own Dutch-style landscapes of views around Paris. Throughout his career he enjoyed the patronage of the baron d'Ivry, and he also made a living as a teacher. He is now best known for his experimental sketches of stormy landscapes, painted during the 1820s and 30s in broad brushstrokes and a grey-brown palette (e.g. *Storm*, 1820s, Strasbourg, Musée des Beaux-Arts).

Michelangelo Buonarroti (1475–1564)

Italian sculptor, painter, architect and poet. He was one of the founders of the High ▷Renaissance and, in his later years, one of the principal exponents of ▷Mannerism. Born at Caprese, the son of the local magistrate, his family returned to Florence soon after his birth. Michelangelo's desire to become an artist was initially opposed by his father, as to be a practising artist was then considered beneath the station of a member of the gentry. He was, however, eventually apprenticed in 1488 for a three-year term to ▷Domenico Ghirlandaio. Later in life Michelangelo tried to suppress this apprenticeship, implying that he was largely self-taught, undoubtedly because he did not want to present himself as a product of the workshop system which carried with it the stigma of painting and sculpture being taught as crafts rather than ▷Liberal Arts. Nevertheless, it was in Ghirlandaio's workshop that Michelangelo would have learnt the rudiments of the technique of ▷fresco painting. Before the end of his apprenticeship, however, he transferred to the school set up by Lorenzo the Magnificent in the gardens of the Palazzo Medici. Here he would have had access to the ▷Medici collection of antiques, as well as a certain amount of tuition from the resident master, ▷Bertoldo di Giovanni. His work here included two marble reliefs, a *Madonna of the Steps* (Casa Buonarroti, Florence), carved in *rilievo schiacciato* and showing the influence of ▷Donatello (Bertoldo's master) and a *Battle of the Centaurs* (Casa Buonarroti, Florence), based on Bertoldo's bronze *Battle of the Horsemen*, which itself appears to be based on an antique prototype. Either at this time, or when he was in the Ghirlandaio workshop, Michelangelo also studied from and drew copies of the frescos of ▷Giotto and ▷Masaccio.

With the death of Lorenzo in 1492, the school broke up and Michelangelo was given permission to study anatomy at the hospital attached to Sto Spirito. In gratitude to the prior for allowing him this privilege he carved a wooden *Crucifix* (the one now in the Casa Buonarroti is considered by some scholars to be the work in question). In October 1494, Michelangelo transferred to Bologna and was awarded the commission for three marble figures to complete the tomb of St. Dominic in S. Domenico Maggiore, begun by the recently deceased Niccolò dell' Arca. By June 1496 he was in Rome and here established his reputation with two marble statues, the drunken *Bacchus* (c1496–7; Florence, Bargello) for a private patron and the *Pietà* for St. Peter's (1498–9). The latter is generally considered to be the masterpiece of his early years, deeply poignant, exquisitely beautiful and more highly finished than his later works were to be. In creating a harmonious pyramidal group from the problematic combination of the figure of a full-grown man lying dead across the lap of his mother, Michelangelo solved a formal problem that had hitherto baffled artists. He returned to Florence a famous sculptor and was awarded the commission for the colossal figure of *David* to stand in the Piazza della Signoria, flanking the entrance to the Palazzo Vecchio (1501–4, original now in the Accademia). Soon after this he was commissioned to paint a battle scene for the new Council Chamber of the Palazzo. On one wall he commenced the painting of the *Battle of Cascina*, while on the opposite wall his principal rival, ▷Leonardo, was commissioned to paint the *Battle of Anghiari*. Although neither painting was ever finished, copies of a fragment of Michelangelo's full-size ▷cartoon, showing a group of nude soldiers reacting variously to the battle alarm that has interrupted their bathing, soon began to circulate (e.g. Earl of Leicester Collection, Holkham Hall, Norfolk). These nudes, posed in a variety of turning and animated poses, established the Mannerist conception of the male nude as the principal vehicle for the expression of human emotions.

Michelangelo abandoned this Florentine commission when Pope Julius II summoned him to Rome to design his tomb. What should have been the most prestigious commission of his career, a free-standing tomb with some 40 figures, to be located in St. Peter's, became, in Michelangelo's own words, the 'tragedy of the tomb'. Julius died in 1513, the contract was redrawn several times over the following years with ever-diminishing funding, other demands were made on Michelangelo by successive popes, and the project was finally cobbled together in 1545, a shadow of its original conception, with much help from assistants, in S. Pietro in Vincoli (Julius' titular church). The tomb is now principally famous for the colossal figure of *Moses* (c1515), one of Michelangelo's greatest sculptures. Two slave figures, *The Dying Slave* and the *Rebellious Slave* (c1513), intended for the largest of the schemes for the tomb, are now in the Louvre in Paris, and four unfinished slaves, from an intermediate stage when the tomb had been only slightly reduced, are now in the Accademia in Florence. The four

unfinished slaves reveal eloquently Michelangelo's sculptural process: the figure would be outlined on the front of the marble block and then Michelangelo would work steadily inwards from this one side, in his own words 'liberating the figure imprisoned in the marble'. As the more projecting parts were reached so they were brought to a fairly finished state with those parts further back still only rough-hewn: thus the figures of these slaves literally appear to be struggling to be free. The (unintentional) pathos specifically evoked by the unfinished state of figures such as these and the *St. Matthew* (Accademia, Florence) exerted a tremendous impact on ▷Rodin who recognized in them expressive possibilities that would be lost in a 'finished' piece.

While in the early stages of work on the Tomb, Julius also commissioned Michelangelo to paint the ceiling of the ▷Sistine Chapel. Michelangelo was evidently reluctant to abandon his sculptural project for one of painting (always much less satisfying to him), but he nonetheless began work in 1508, completed the first half by 1510 and the whole ceiling by 1512. Dissatisfied with traditional methods of ▷fresco painting and mistrustful of assistants who could not meet his evolving demands, he dismissed his workshop at an early stage and completed the monumental task almost single-handedly. The main scenes – the histories – in the centre of the shallow barrel ▷vault, alternate larger and smaller panels and represent the opening passages of the Bible, from the *Creation* to the *Drunkenness of Noah* with, at each of the corners of the smaller panels, idealized nude youths, variously interpreted as angels or ▷Neoplatonic perfections of human beauty. The histories are treated like ▷*quadri riportati* with a horizon parallel to the picture plain. The ▷*ignudi*, however, inhabit a different reality – one created by the fictive architecture which also forms the shallow space occupied by the enthroned prophets and ▷sibyls (those who foretold Christ's coming) located towards the sides of the vault. Lower down still, in the ▷lunettes above the windows, are the ancestors of Christ and, at the four corners of the ceiling, Old Testament scenes that prefigure Christ's ▷Crucifixion and thus humanity's salvation. The programme of the ceiling, life before the establishment of the Mosaic Law, relates it to the frescos of the lives of Moses and Christ by ▷Perugino and other artists on the walls below. Michelangelo gives a poignant account of his gruelling task, painting bent over backwards, his neck permanently arched to look up, his arm stretching upwards to wield his brush, in one of his sonnets. The break in work in 1510 allowed him to see the effect of the fresco from the ground (hitherto hidden by scaffolding) and in the second half (that closest to the altar wall) there is a perceptible simplification of detail and a corresponding monumentalization of figure style. Always heralded as the supreme example of Florentine ▷*disegno*, the recent restoration has

also revealed Michelangelo to have been a brilliant colourist.

In 1516, the new pope, Leo X (Giovanni de' Medici) commissioned Michelangelo to design a façade for San Lorenzo, the Medici parish church in Florence. The commission came to nothing (the façade is unfinished to this day), but this unfulfilled scheme led to his two earliest architectural masterpieces, the Medici Chapel (or New Sacristy) attached to San Lorenzo and the Laurentian Library. Again neither was to be finished. Nevertheless, the 'molten' stairway and the architectural elements of the entrance hall to the library, whose positioning deliberately contradicts the structural function of their prototypes, are seminal in the foundation of architectural ▷Mannerism. The Medici funerary chapel (planned from 1520, abandoned when the Medici were temporarily expelled from Florence in 1527, recommenced in 1530 and left incomplete in 1534) was intended to be a fusion of architecture and sculpture accommodating the tombs of four members of the family. The idea was that looking from the altar, moving past the tombs, one's gaze would be directed by the gaze of the tomb figures who turn towards the far wall and the Madonna holding upon her lap the Christ child, whose sacrifice had made possible the ▷Resurrection of the soul of the faithful to everlasting life – the climax to the ▷iconographical programme of the ▷mausoleum. Only two tombs were completed and the *Madonna and Child* was half completed. Beneath the seated figure of Giuliano ('*vita activa*') are reclining figures of *Day* and *Night* and beneath that of Lorenzo ('*vita contemplativa*'), *Dawn* and *Evening*. These reclining figures symbolize mortality through the passage of time.

In 1534 Michelangelo departed for Rome, never to return to Florence. From now on he worked mainly for the papacy. Soon after his arrival Pope Clement VIII commissioned him to paint the fresco of the *Last Judgement* for the Sistine Chapel (work commenced under Pope Paul III in 1536, completed in 1541). The spirit of the work is totally different from that of the ceiling unveiled 29 years earlier. In the interim, the Church had been torn apart by the ▷Reformation, Rome had been sacked (1527), and Michelangelo's fresco breathes the new militancy of the Catholic ▷Counter-Reformation. The optimism and confidence of the ceiling is replaced by the pessimism and emotional turmoil of the altar wall: saints swarm around the Apollo-like figure of Christ, wielding their instruments of martyrdom, seemingly demanding righteous judgement on the sinners stirring to life from the bare earth at the bottom of the picture. The *Last Judgement* was intended as the climax of the chapel's account, represented in coherent stages, on the ceiling and walls, of the Christian history of the world. This was Michelangelo's most controversial work to date and was as much condemned (for its nudity) as it was praised (for its artistry). After the death of

Michelangelo, the fresco was nearly destroyed, but the Church authorities settled for ▷Daniele da Volterra painting draperies over the offending nudity.

Following the *Last Judgement*, Paul III commissioned from Michelangelo his two last major frescos for the Capella Paolina, the *Conversion of St. Paul* and the *Martyrdom of St. Peter* (1542–50). The same troubled spirit imbues Michelangelo's sculpture from this time, the *Pietà* (now Florence, Cathedral Museum), intended for his own tomb shows himself as ▷Nicodemus – again, a comparison with the St. Peter's *Pietà* is eloquent testimony to the spiritual uncertainty of these later years. In the year of his death, his 89th year, he was working on yet another ▷pietà, the *Rondanini Pietà*. In 1546 Michelangelo was appointed Chief Architect to St. Peter's and charged with the completion of the new church, the most prestigious architectural commission in Christendom. Rebuilding had almost ceased with the death of ▷Bramante in 1514, but Michelangelo, as reluctant to engage in architectural commissions as he had been with painting, had brought the work almost to completion (as high as the ▷drum of the dome) by the time of his death. The dome was erected after his death, to his designs but with some modifications (e.g. Michelangelo's hemispherical profile was made much steeper). Also the ▷nave was lengthened in the 17th century, changing Michelangelo's ▷Greek cross plan to a ▷Latin cross plan, and consequently the majesty of the dome is much obscured by the balustrade of the ▷Baroque façade.

Whether in painting, sculpture or architecture, Michelangelo's influence has been immense. Although he restricted himself to the nude in painting, his expressive use of the idealized human form had a tremendous impact on contemporaries and future generations – even ▷Raphael was not above directly referring to the Sistine Chapel sibyls, with his fresco of *Isaiah* in Sant' Agostino. Furthermore, there was not a major Italian sculptor of the 16th century whose style was not formed under the influence of Michelangelo, or in direct reaction against him (e.g. ▷Bandinelli). He was the first artist to be the subject of two biographies in his lifetime – those of ▷Condivi and ▷Vasari – with the latter doing much to promote the view of Michelangelo as the consummation of a progression towards artistic perfection that had begun with ▷Giotto.

Bib.: Ackerman, J.S., *The Architecture of Michelangelo*, Harmondsworth, 1971; Beck, J.H., *Michelangelo: The Medici Chapel*, London, 1994; Collinge, L.H., *Michelangelo*, London, 1991; Hibbard, H., *Michelangelo*, 2nd edn., Harmondsworth, 1985; Hirst, M., *The Young Michelangelo*, London, 1994; Richmond, R., *Michelangelo and the Sistine Chapel*, New York, 1995; Wallace, W.E., *Michelangelo at San Lorenzo*, Cambridge, 1994

Michelozzo di Bartolommeo (Michelozzo Michelozzi) (1396–1472)

Italian architect and sculptor. He was from Florence. He was an assistant to ▷Ghiberti on both the first and second sets of Baptistry doors and the *St. Matthew* on Or San Michele. From c1425 to c1433 he collaborated with ▷Donatello on a succession of important monuments – to Pope John XXIII (Florence, Baptistry), to Cardinal Brancacci (Naples, S. Angelo a Nilo) and to Bartolommeo Aragazzi (formerly Montepulciano Cathedral, sculpture now dispersed between Montepulciano and London, Victoria and Albert Museum). Michelozzo's earlier training with Ghiberti had given him bronze casting expertise, but the individual roles of the collaborators on the first two monuments are by no means clear. Certainly, Michelozzo seems to have been largely (if not totally) responsible for the Aragazzi Monument. He also designed the classical niche for ▷Donatello's *St. Louis of Toulouse* (later replaced by ▷Verrocchio's *Incredulity of Thomas*) on Or San Michele (1425) and the architectural elements on the outdoor pulpit of Prato Cathedral (1428). His independent work as a sculptor includes the silver *St. John the Baptist* (1452, Florence, Museo del Opera).

In the latter part of his career Michelozzo devoted himself almost exclusively to architecture. He was Cosimo de' Medici's favourite architect and in 1444 began the Palazzo Medici (later the Palazzo Medici-Riccardi), a ▷Renaissance-style town house of seminal importance – a harmoniously proportioned, nearly symmetrical design of three storeys with ▷rustication graded upwards from massive to smooth, each storey divided by a Classical string course, and the whole surmounted by a grand ▷cornice. The block surrounded a central arcaded court of ▷Brunelleschian design (cf the ▷loggia of Brunelleschi's Ospedale degli Innocenti). For Cosimo, Michelozzo also reconstructed parts of the Convent of San Marco (▷sacristy, ▷cloisters and library, c1436–43) and the villas at Caffagiuolo, Careggi and Trebbio. In 1444 he commenced the tribune of SS Annunziata (the first centrally planned building of the Renaissance which was completed by ▷Alberti) and in 1446 he succeeded Brunelleschi as *capomaestro* of Florence Cathedral, a post he held until 1451. His works outside Florence, such as the Portinari Chapel in S. Eustorgio, Milan, c1462 (reflecting the influence of Brunelleschi's S. Lorenzo Sacristy) and the Palazzo dei Rettori in Ragusa (now Dubrovnik, 1462–3) did much to disseminate the new Renaissance style of architecture.

Bib.: Ferrara, M., *Michelozzo di Bartolommeo*, Florence, 1984; Lightbown, R.W., *Donatello and Michelozzo*, London, 1980

Micronesian art

The art of the Northwest Pacific, including the Mariana, Caroline, Marshall and Gilbert Islands. It is linked to both ▷Indonesian and ▷Polynesian art, but

it has a distinctive style. Micronesian art shows great technical proficiency in its stark, highly finished and thinly decorated sculptural work.

Miereveld (Mierevelt), Michiel van (1567–1641)

Dutch painter. He produced portraits in Delft and The Hague, and his prolific output consisted of more than 1,000 examples. He was portrait painter to the House of Orange, and in 1625, Charles I tried unsuccessfully to lure him to England.

Mieris the Elder, Frans van (1635–81)

Dutch painter. He produced principally small interior ▷genre scenes and portraits, plus a few ▷history paintings, and was active mainly in Leiden. He was first apprenticed to the glass painter Abraham van Toorenvliet, and then, more importantly, to ▷Gerrit Dou, with a short interlude training with the history painter, Abraham van den Tempel. From Dou (who referred to Mieris as 'the prince of his students') he derived the *fijnschilder* style of minutely detailed, highly finished painting that was to be characteristic of his best work. In 1658 he entered the Leiden Guild of St. Luke. In his successful Leiden workshop he trained many young painters including his sons, Jan (1660–90) and Willem (1662–1747) and Willem's son, Frans van Mieris the Younger (1689–1763). His work was also in demand outside Leiden, for he received a commission from Duke Cosimo III de Medici in Florence and declined the position of court painter to the Archduke Leopold Wilhelm in Vienna.
Bib.: Naumann, O., *Frans van Mieris 1635–81, the Elder*, Doornspijk, 1981

Mies van der Rohe (1886–1969)

German architect. He was the son of a stonemason and had little formal education. He worked with ▷Behrens and ▷Gropius (1908–11) and with Hendrik Berlage in Holland (1912), but he developed his own style only after the First World War. As a member of the ▷Novembergruppe, he designed a number of futuristic glass and steel ▷skyscrapers (which were never built) and superintended the Stuttgart housing project (1927) which became a model of ▷International Style mass housing. He was, however, more interested in aesthetic and luxury projects – he designed the Barcelona Exhibition Pavilion (1927) using marble slabs and chrome-plated supports. From 1930 to 1933 he was director of the ▷Bauhaus. He emigrated to America in 1937 and began a successful career there, designing for the Illinois Institute of Technology (of which he was director from 1938). His Lake Shore Drive Apartments, Chicago (1957), and Seagram Building, New York (1958), set the style of much high-rise building with their simple rectilinear structure, raised ground levels and repetitive façades.

His architecture could be summed up in his own phrase 'less is more'.
Bib.: Blaser, W., *Mies van der Rohe*, Barcelona, 1994; idem., *Mies van der Rohe: The Art of Structure*, Basle, 1993; Carter, P., *Mies at Work*, London, 1974; Cohen, J.L., *Mies van der Rohe*, Paris, 1994; *Mies van der Rohe*, exh. cat., New York, 1953

Mignard, Pierre (1612–95)

French painter. He studied with ▷Boucher, and travelled to Rome in 1635–57, where he produced many ▷Madonnas. His specialism in this area led his contemporaries to nickname his Madonnas '*mignardes*'. He returned to France and produced court portraits. In 1690 he became Director of the ▷Académie on the death of ▷Lebrun, as well as First Painter to the King. His court portraits were ▷allegorical, and in the debate between the ▷Poussinistes and Rubenistes, he sided with those in favour of Rubensian colourism.

migration period art

Art of the Teutonic peoples (Visigoths, Ostrogoths, Lombards, Vandals and Franks) who swept through Europe from the 4th to the 9th centuries AD. As they were nomadic and conquering tribes, much of their art was portable and consisted largely of jewellery and ornamented goldwork. They were particularly interested in inlay.
Bib.: László, G., *The Art of the Migration Period*, London, 1974

Millais, Sir John Everett (1829–96)

English painter. He was born in Jersey, a child prodigy who entered the ▷Royal Academy schools at the age of 11. Having met ▷Hunt there, he helped to establish the ▷Pre-Raphaelite Brotherhood in 1848. He drew inspiration from religion (e.g. *Christ in the House of His Parents*, 1849, London, Tate Gallery) and literature (e.g. *Ophelia*, 1852, Tate), initially working in an extreme Pre-Raphaelite style with naive perspective, intense colour, and precisely detailed symbolism. Increasingly, however, he developed a broader approach, using colour to create mood and pictorial unity (e.g. *Autumn Leaves*, 1856, Manchester, City Art Gallery). He married ▷Ruskin's ex-wife Effie in 1854, causing a scandal and estrangement with one of the principal defenders of the PRB. He had already (1853) been elected ▷ARA, a move which was hardly consistent with PRB ideals, and these two events hastened the break-up of the group. Increasingly, Millais' art altered to suit popular taste: his brushwork broadened, his subjects became more anecdotal (e.g. *The Rescue*, 1855, Melbourne, National Gallery of Victoria; *North West Passage*, 1874, Tate), and he developed a reputation as a portraitist. He achieved great financial and social success, and became President of the RA in the year of his death.
Bib.: Cooper, R., 'Millais' "The Rescue" ', *Art*

Portrait Photograph of John Everett Millais, J.P. Mayall, for the 'Artists at Home' series, 1884, private collection

History, 9 (Dec 1986), pp. 471–86; Merio, C., 'John Everett Millais and the Shakespeare Scene', *Gazette des Beaux-Arts*, 6, 104 (Sept 1984), pp. 77–85; *John Everett Millais*, exh. cat., Liverpool, 1967; Millais, J.G., *The Life and Letters of John Everett Millais*, 2 vols, London, 1899

millboard

A type of cardboard used in the 19th century for oil painting and sketching. ▷William Etty used millboard extensively for his paintings of nudes.

mille-fleurs

(French, 'thousand flowers'.) Tapestries produced mostly in the 15th and 16th centuries which included flowery backgrounds.

Milles, Carl (1875–1955)

American sculptor of Swedish birth. He was in Paris during 1897–1905, where he saw the work of ▷Rodin. He took on public sculptural commissions both in Stockholm and in the United States, and he specialized in fountains. He often used Classical sources, but he was also influenced by the simplicity of ancient Greek sculpture and the elegance of ▷Mannerism. He was Professor of Sculpture at the Cranbrook Academy in Michigan, and he became a United States citizen in 1945.

Millet, Jean-François (1814–75)

French painter and draughtsman. He was born at Gruchy, Normandy, of peasant stock. After studying at Cherbourg with Langlois, he moved to Paris where he trained with ▷Delaroche. During the 1840s he worked in a ▷Rococo-influenced style producing pretty nudes and mythological subjects. He took no part in the 1848 Revolution and moved to the village of ▷Barbizon to protect his family, remaining there permanently. At the 1849 ▷Salon he exhibited the *Winnower* (London, National Gallery), which was immediately criticized for its ▷realism, putting Millet in the same category as ▷Courbet, despite differences in style and personality. The work was followed by a series of monumental images of the peasantry (e.g. *The Sower*, 1850, Boston, Museum of Fine Arts; *The Gleaners*, 1857, Paris, Musée d'Orsay), which combined an earthy palette and uncompromising naturalism with a nostalgic romanticism (at its height in his portrayal of peasant devotion in the *Angelus* (1855–7, Paris, Musée d'Orsay). Unlike the other Barbizon artists, he rarely painted Fontainebleau, but explored pure landscape in agricultural images of the Chailly plain near the village (e.g. *Spring*, 1873, Paris, Musée d'Orsay), and on sketching tours to Normandy and the Auvergne. He experimented with ▷pastel, using an increasingly free technique to portray the effects of weather. He frequently repeated many of his most common subjects in drawings and prints, catering for a small but enthusiastic market. By the end of his life, with a changed political climate and little fear of the peasantry, his works became highly popular.

Bib.: *Jean-François Millet*, exh. cat., London, 1976; Laughton, B., *The Drawings of Millet and Daumier*, New Haven and London, 1991; Lepoittevin, L., *Jean-François Millet: images et symboles*, Cherbourg, 1990; Pollock, G., *Millet*, London, 1977

Mills, Clark (1815–83)

American sculptor. He was born in New York and worked first in South Carolina. He made his reputation by his ▷equestrian statue of Andrew Jackson, which was the first of its kind in America. It was completed in 1853 and erected in Washington, DC, where he moved and opened a foundry. He continued to produce monumental bronzes and was particularly famous for equestrian statues of American heroes.

mimesis

(Greek, 'imitation'.) Imitation in this sense refers to representation, rather than copying. Plato and Aristotle both refer to art as a representation of nature, and Plato argued that all artistic creation is a form of imitation. In other words, all the objects man creates are representations of an ideal type, created by God. Therefore, an artist is an imitator twice removed from the things/he is mimicking, because s/he represents objects which are already a representation of an ideal form.

minaret

A tall tower or turret, either connected to a mosque, or standing close by, with one or more ▷balconies from which the muezzin gives the call to prayer.

Minerva (Greek: Athena)

The daughter of ▷Jupiter and Metis, a goddess of just war (as opposed to ▷Mars), clad in armour and goatskin aegis, and of learning and wisdom, associated with the owl and often seen with ▷Apollo and the ▷Muses. She was also associated with homely crafts (she defeated Arachne in a spinning contest) and invented the flute. She guarded many of the Classical heroes (▷Hercules, ▷Perseus against ▷Medusa). She competed with ▷Neptune to become patron of Athens, and won by producing an olive tree, considered more valuable than the horse he provided. She was a virgin goddess and is often shown as a representation of virtue triumphing over vice or might. (See works by ▷Giovanni da Bologna, 1578, Florence; ▷A. Gentileschi, *Minerva*, 1615, Florence, Uffizi; ▷Fragonard, *The Goddess Minerva*, 1773–6, Detroit, Institute of Arts; ▷Klimt, *Pallas Athene*, 1898, Vienna, Historisches Museum der Stadt Wien).

Ming

▷Chinese art

miniature

A small painting, particularly a portrait which can be held in the hand or worn as jewellery. Popular in the Elizabethan period, when ▷Nicholas Hilliard was working, miniatures have been fashionable ever since. The word miniature also refers to medieval ▷manuscript illumination.

Minimalism

A movement that rose to prominence in the 1960s, partly as a reaction against the ▷gestural painting of the ▷Abstract Expressionists. More common in sculpture than painting, Minimalism employed elemented geometric shapes that operated with what Richard Wollheim called in a 1965 article a 'minimal art content'. For Wollheim, ▷Duchamp's ▷ready-mades provide an example of this 'minimalism' in that they introduce into the domain of art an increasingly wide and eclectic category of objects that cannot be easily differentiated from objects in the non-art world.

Minimalism in the 1960s eschewed representation and narrative in favour of representing, in the first instance, itself. Thus the ▷'primary structures' of ▷Donald Judd or ▷Carl Andre, who often employed foundry-produced steel cubes or commercially made house bricks, offer the ▷beholder little information about their purpose beyond the fact of their industrial origin. Unlike the autograph techniques of the ▷Abstract Expressionists, Minimalist artists embraced the impersonality of industrial production as the vehicle of their expression. In painting, Minimalism is characterized by rejection of ▷gestural painting and an emphasis on either ▷hard-edge abstraction, as with ▷Frank Stella and ▷Ellsworth Kelly, or un-▷painterly qualities, as in ▷Morris Louis' understated stained canvases.

The apparent simplicity of Minimalist art hides the complexity of its intellectual structure. While the work may exhibit a 'minimal art content', it challenges the beholder to experience a layered and complex aesthetic response based on each individual's expectations and prejudices. In this way an artwork with minimal content demands of the beholder a maximal response, and perhaps for this reason Minimalism is often seen, at least in popular opinion, as a difficult and intractable movement best discussed within the narrow confines of the art world.

Bib.: Battcock, G. (ed.) *Minimal Art: a Critical Anthology*, Berkeley, 1995; *Carl Andre: Sculpture*, exh. cat., London, 1978; *Don Judd*, exh. cat., New York, 1968; *Morris Louis*, exh. cat., London, 1974; *Three American Painters: Kenneth Noland, Jules Olitski, Frank Stella*, exh. cat., Cambridge, MA, 1965

Minoan art

The Minoan civilization flourished on the island of Crete from c2500 to c1400 BC and was named after King Minos of Greek legend. The Cretans were great seafarers and their Bronze Age civilization was based around industrial and mercantile invention. Their highly developed skills were comparable with those of contemporary Egypt and ▷Mesopotamia, although the Cretans were less interested in the depiction and worship of the Gods, and took inspiration from their industrial innovations. The working of precious metals and gems was foremost and their bronzework and

weaponry were exported to Egypt, the Peloponnese and Asia Minor. Potters began to emulate the expertise achieved by the metalworkers and as a result Cretan ▷ceramics display an artistic rather than purely functional aspect. Typically the pots have slim contours with a dark glaze. The Kamares style (1800–1700 BC) shows vases and vessels painted with geometrical shapes, and later decorative forms taken from the natural world. The two great Minoan palaces at Knossos and Phaestos show the development of the Cretan style of painting in the ▷terracotta ▷frescos whose remains may still be seen. The bull, which forms the basis of the best-known Cretan myth of the Minotaur, is a predominant image. Scenes of bull-fighting and bull-leaping are seen in frescos and on pottery work. One of the best-known surviving Cretan bronzes, dated c1600 BC from the Minoan I period, shows a youth vaulting over a bull. It is in this 'naturalism' inspired by everyday themes of dance, ritual, play, animals and plants that the modernity of Minoan art is seen. Art, whether frescos, bronzes or the sculpted figurines which remain, was for decorative domestic use. Palaces other than Knossos and Phaestos were built at Hagia, Triada and Mallia along similar lines; complex systems of cellars, sewers and storerooms underlie the living quarters where chambers were constructed around inner courtyards. It has been suggested that these complicated structures of stone and wood gave rise to the Greek myth of the Minotaur at the heart of the labyrinth.

Bib.: Bettancourt, P., *The History of Minoan Pottery*, Princeton, 1985; Higgins, R., *Minoan and Mycenean Art*, rev. edn., London, 1981

Mino da Fiesole (1429–84)

Italian sculptor. His work was exclusively in marble. According to ▷Vasari, he was the pupil of his contemporary, ▷Desiderio da Settignano, although ▷Michelozzo has more recently been proposed. In 1453 he carved what may be his earliest surviving work, a marble bust of Piero de' Medici (Florence, Bargello), notable also for being the earliest known dated portrait bust of the ▷Renaissance. By 1454 he was in Rome and there carved the bust of the exiled Florentine banker Niccolò Strozzi (Berlin-Dahlem). He was to return to Rome in 1463 (collaborating on the Benediction Pulpit of Pius II) and again in 1474–80 (collaborating on, among other projects, the Tomb of Pope Paul II, St. Peter's). His last dated bust is that of Diotisalvi Neroni, (1464, Paris, Louvre). Whereas Mino's most important independent tomb monument, that to Count Hugo of Tuscany (1469–81, Florence, Badia) derives from ▷Rossellino's Bruni Monument and Desiderio's Marsuppini Monument, failing to achieve the clarity or integrity of either, his later portrait busts, evidently reflecting increased familiarity with antique portrait busts following his stays in Rome,

are generally more highly esteemed for their vigour and their strength of characterization.

Bib.: Sciolla, G.C., *La scultura di Mino da Fiesole*, Turin, 1970

minster

Originally denoting a monastic church, or the monastery as a whole, the term today may be applied to any major church. In England it is used principally in connection with Beverley, West(minster) Abbey, Wimbourne and York (the last being the only English cathedral to be invariably referred to as a minster, although Ripon and Southwell are also sometimes so-called).

Miraculous Draught of Fishes

(Luke 5: 1–11) The story is set in the early part of ▷Christ's mission. After preaching from a borrowed fishing boat to a great crowd of people on the shore of Lake Gennesaret, Jesus turned to the owner, Simon Peter, and told him to take the boat out into the middle of the lake to fish again. Having had no luck this far, Peter initially resisted the suggestion, but was ultimately persuaded and caught the greatest catch of his life. Realizing Christ's power, he fell at his feet, saying that he, Peter, was a sinful man and asking to be left alone. However, Christ told him not to be afraid, for from henceforth he would be a fisher of men, not fish. He and his partners in fishing, James and John, the sons of Zebedee, then laid down their nets and followed Jesus. The importance of the story lies in the fact that it recounts the calling of the first three disciples. Perhaps the most famous representation of this incident is ▷Raphael's ▷cartoon for the ▷Sistine Chapel tapestry (1515–16, London, Victoria and Albert Museum).

Mir Iskusstva (The World of Art)

An artistic group in Russia at the turn of the century, and the name of the fortnightly arts and crafts magazine they published from 1898 until 1905. The group originated as a circle of St. Petersburg aesthetes clustered around ▷Alexandre Benois, including Valentin, ▷Baksserov and ▷Diaghilev, who became their leading activist and the magazine's editor. Consciously provocative, they rejected the social commitment and Slavic isolationism of the ▷Wanderers and attempted to open Russian art to western European influences. While celebrating Russian painting, particularly that of the 18th century and the burgeoning ▷arts and crafts revival, the magazine was thoroughly cosmopolitan. Exponents of European ▷Art Nouveau, particularly ▷Beardsley, appeared in its large, expensively produced pages alongside translations of the French poets Mallarmé and Verlaine. In later issues the emphasis turned to ▷Post-Impressionism and the work of ▷Gauguin, ▷Cézanne, ▷van Gogh and ▷Matisse. The

magazine's own layout and designs proclaimed a theatricality and love of ornamentation combined with touches of Slav mysticism. The group also organized exhibitions, intended to bring western paintings to Moscow and present them alongside contemporary Russian artists. Following the demise of the magazine, the energies of the group and their distinctive amalgam of Russian tradition and European ▷Symbolism were channelled into Diaghilev's Ballets Russes.

Bib.: Carson, P.H., *Russian Art in the Silver Age: The Role of Mir Iskusstva*, Bloomington, 1993; Petrov, V.N., *The World of Art Movement in Early 20th Century Russia*, Leningrad, 1991

Miró, Joan (1893–1983)

Catalan painter, draughtsman and sculptor. He was one of the most important artists of the 20th century. Miró had early ambitions to be a painter, but was apprenticed to a grocer. He began painting during a long convalescence in Tarragona, and enrolled at the Gali School of Art, Barcelona, where he learned to draw from touch. His early painting is figurative and shows the influence of ▷Cézanne and the ▷Fauves – for example, *Mont-Roig Landscape* (1914). As Miró developed he began to take elements from the environment and treat them in an individual way, so that leaves and tiles started to become pieces of ▷calligraphy. In 1920 he visited Paris for the first time, where he became interested in conceptual art. His painting *The Farm* (1921–2) represents the culmination of his figurative work, and shows a number of elements which reappear again and again – the sun, farm animals, domestic articles and woman – each of which seems to have an individual life away from the rest of the painting.

Miró began to divide his time between Catalonia and Paris, where he was in contact with the ▷Surrealist movement. Paintings like *The Tilled Field* (1923, New York, Guggenheim Museum) and *The Hunter* (1924, New York, Museum of Modern Art) show a continuing exploration of the landscape, but also a rejection of realism and an interest in suggestive forces. In 1924 he started painting *The Carnival of Harlequin* (Buffalo, Albright-Knox Gallery), which tackles new problems of composition and demonstrates Miró's ▷Surrealist interests. At the end of the 1920s the Surrealist movement was shaken by ▷Breton's desire to link the group with Communist militancy. This led Miró to rethink his principles, and he stated that 'painting must be murdered'. His search for new means of expression led him to experiments with ▷collage and three-dimensional forms, made from ▷*objets trouvés* – the 18 *Paintings from a Collage* (1933, Barcelona, Fundació Joan Miró) are good examples of his work at this time.

In 1936 the Spanish Civil War broke out and Miró expressed his deep feelings about it by using materials such as sandpaper and tar, and through work like *Man and Woman in Front of a Pile of Excrement* (1935, Barcelona, Fundació Joan Miró) and *Still Life with Old Shoe* (1937, New York, Museum of Modern Art). This latter was a return to figurative painting, treating a traditional subject, the still life, with a passionate intensity. His series of black ▷lithographs, *Barcelona*, are violent and tragic. He also painted a series of self-portraits at this time, which reached a conclusion with the series of 23 *Constellations* (1941, Chicago, Art Institute), which were a reaction to the Second World War. Miró described these as an attempt to escape, and a network of symbols which were to recur for the rest of his life – earth, man, stars and particularly woman – were put in place.

During the next 20 years Miró's art became more fluid and uncluttered. He used bright colours and a variety of media – ▷pastels, ▷ceramics, ▷engravings, set design, ▷tapestry and painting. His ▷triptych, *Blue I, II and III* shows the sparse lines and expansive colours of the mature years. In 1970 Miró settled in Parma, Majorca, where he continued to paint dynamic, vibrant and unexpected canvases and design ceramics, murals and textiles until his 90th year. His experimentation and prolific output are a continuing influence on artists.

Bib.: Gimferrer, P., *The Roots of Miró*, Barcelona, 1993; Penrose, R., *Miró*, New York, 1992

misericord

In a church, the ▷bracket on the underside of a hinged ▷choir stall which, when the seat is raised, gives support to the worshipper or chorister in the longer periods of standing during the service. The undersides of such seats are often richly carved.

missal

Strictly, the book containing the Roman Catholic service of the mass for the whole year. It would usually contain only two full page miniatures: a ▷Crucifixion preceding the Canon of the Mass, and a Christ in Majesty. Additionally, the initial letters of the principal feasts might be historiated. More loosely, the term has been used to refer to any illuminated Roman Catholic prayer book.

mission furniture

A name given to American furniture produced in the early 20th century. The furniture is in the ▷Arts and Crafts tradition, and the name may relate to the vernacular style of early missions in California.

mixed media

An art work that uses more than one of the usual artistic media (e.g. oil paint, ▷acrylic, ▷watercolour, ▷collage, ▷sculpture, photographs, ▷found object, etc.) in its production.

mobile

A term coined by ▷ Marcel Duchamp to describe the ▷ kinetic sculptures of ▷ Calder. Although the earliest models were driven by motor, the most characteristic mobiles consist of a number of objects suspended on light wire and propelled into movement by currents of air.

Mocking of Christ

The event of the ▷ Passion in which Christ is persecuted by the Jews, forced to wear a Crown of Thorns, blindfolded and beaten. Usually Caiaphas is shown looking on (▷ Altdorfer, *Christ Before Caiaphas*, Linz; ▷ Honthorst, London, National Gallery) and sometimes the scene is shown in conjunction with the Denial of ▷ St. Peter. It is similar to the ▷ Flagellation of Christ ordered by ▷ Pilate and carried out by Roman soldiers. The items used in the scene form the ▷ Instruments of the Passion.

modelling

(i) In painting, the representation of three-dimensional objects on a two-dimensional surface by means of the depiction of areas of light and shade on the objects to give an impression of solidity.

(ii) In sculpture, working in a malleable medium like clay or wax, which can be shaped with the hands, or sculptor's tools, to produce the desired form. In this context its counterpart is carving, the former being an additive, the latter a subtractive sculptural process.

modello

(Italian, 'model', 'pattern', 'design'.) A small preliminary version of a painting, submitted to the patron for approval and hence, as it is supposed to promote the artist's idea to the intended patron, usually of a highly finished nature (unlike a ▷ sketch). Also sometimes used to refer to a preliminary small-scale sculptural model.

Moderne Kunstring

(German, 'circle of modern art'.) The name given to a group of modern artists who exhibited together in October 1910. Among those showing were ▷ Mondrian and the ▷ Cubists, and their work represented important innovations in early abstract art.

modernism

An artistic and literary 'movement' loosely of the period 1850 to 1970 that was characterized by an attempt to break with traditional and academic ties to the ▷ Classical and ▷ Renaissance worlds and produce work that reflected an industrialized, urban, politicized world that was characterized by change not tradition. ▷ Baudelaire in his essay 'The Painter of Modern Life' (1863) wrote that 'Modernity is the transient, the fleeting, the contingent; it is the one half of art, the other being the eternal and the immutable.' He called for an art that took account of the transformation of the 19th century and in its earliest form may be seen in the ▷ Realist school of ▷ Manet, ▷ Courbet, and the work of the novelist, Gustave Flaubert. These 'transformations' included in the 19th century the impact of science, photography, symbolism and ▷ primitivism, and, in the 20th century, ▷ psychoanalysis, revolution, total war and mechanization. Modernism has been characterized above all by change and progress, where successive ▷ avant-garde movements (▷ Impressionism, ▷ Post-Impressionism, ▷ Dada, ▷ Surrealism, ▷ Expressionism, etc.) overthrow their predecessors. ▷ Herbert Read wrote in *Art Now* (1933) that modernism was 'an abrupt break with all tradition ... The aim of five centuries of European effort is openly abandoned.' Such an emphasis on change and innovation often made modernist art unpopular with a generally conservative audience. Modernism has also been characterized by (and criticized most recently by ▷ postmodernism for) its totalizing theories such as ▷ Marxism, ▷ psychoanalysis and Nazism. In the post-Second World War period modernism has been seen as having been appropriated by America, its centre moving from Paris to New York and towards ▷ Abstract Expressionism, ▷ Pop art and ▷ Minimalism. The global political turbulence of 1968 – for example the student riots in Paris – have been taken as marking the end of modernism and the harbinger of post-modernism. As 'modernism' becomes increasingly an historic rather than ongoing phenomenon, greater understanding of its significance and meaning is gradually forthcoming.

Bib.: Guilbaut, S., *How New York Stole the Idea of Modern Art*, Chicago, 1983; Taylor, B., *Modernism, Postmodernism, Realism: A Critical Perspective for Art*, Winchester, 1987; Harvey, D., *The Condition of Postmodernity*, Oxford, 1989

Modersohn-Becker, Paula (1876–1907)

German painter. She was born in Dresden, into a middle-class family. In 1892 she visited England, before training as a teacher in Bremen. She later studied at the Society of Women Artists in Berlin (1896–8), and won a sponsorship to Paris in 1900, where she studied at the ▷ École des Beaux-Arts and met ▷ Nolde. She married Otto Modersohn in 1901 and settled in ▷ Worpswede, where her artist-husband lived in a painters' colony. She travelled to Paris again in 1903, meeting ▷ Rodin and studying at the ▷ Académie Julian. She developed an individual style, which opposed the naturalism of the other Worpswede artists, using the landscape and peasantry around her to create earthy, simple images (e.g. *Old Woman by the Poorhouse Duckpond*, 1906, Bremen, Roseliushaus; *Self-portrait*, 1907, Essen, Museum Folkwang). Her work was little recognized during her own life.

Bib.: Radycki, D., *The Letters and Journals of Paula*

Modersohn-Becker, Metuchen, 1980; Uhde-Stahl, B., *Paula Modersohn-Becker*, London, 1991

Modigliani, Amadeo (1884–1920)

Italian painter, sculptor and draughtsman. He worked mainly in Paris. He was encouraged to paint from an early age by his artistic mother, in order to convalesce from the pleurisy and tuberculosis that haunted him throughout his life. His visits to the south of Italy, in search of better weather, led him to study art in such centres as Naples, Capri and Rome, and in 1902 he enrolled in life classes in Florence. In 1906 he moved to Paris and immediately became part of the ▷avant-garde circle based around Montmartre, meeting such artists as ▷Picasso, ▷Soutine, Moïse Kisling, ▷Gris and ▷Derain (▷School of Paris). He rented a room from Dr. Paul Alexandre, a keen patron of the arts, whom Modigliani was to represent in numerous drawings and paintings. His ▷charcoal and pencil drawings from this time show an economy of line and an abstract sense of form. By 1910 Modigliani was exhibiting at the ▷Salon des Indépendants, where his painting *The Cellist*, a portrait of a neighbour, attracted some attention. However, he sold very little work and subsisted mainly from Alexandre's commissions. In 1910 he started experimenting with sculpture, recreating his drawings of ▷caryatids and elongated, stylized heads in marble and limestone. He exhibited seven of these works at the ▷Salon d'Automne in 1912, but again with little success. At this time he was studying African and Far Eastern art, the influence of which can clearly be seen in some of the sculptures. He also began experimenting with a number of basic shapes, from which he produced endlessly different carved faces and heads. In 1914 he met Paul Guillaume, who started commissioning work from him, and in 1916 Leopold Zborowski became a patron. Modigliani was working on a series of nudes, which epitomize his sinuous, flowing style. He worked with models who held poses for a very short time, in order to create an image swiftly and precisely, and eliminate extraneous details. This was unusual as Modigliani rarely drew from life, preferring to commit an image to memory and produce it later. This was the technique he used for his more heavily worked painted portraits, such as *L'Amazone* and *Small Boy*. By 1918 his health was rapidly degenerating, and he died in 1920. His mistress, Jeanne Hébuterne, then eight months pregnant, killed herself a day later. Modigliani's tragic and almost macabre life has coloured impressions of him ever since, but he was one of the great original talents of the early 20th century.
Bib.: Mann, C., *Modigliani*, London, 1980

modular design

An architectural term for design based on fixed units or dimensions. In the 20th century, modular design was essential for ▷prefabrication, as it allowed parts to be interchangeable and buildings to be quickly and cheaply assembled. In aesthetic terms, modularity has led to the repetition, and often monotony, of early 20th-century architecture.

Moholy-Nagy, László (1895–1946)

Hungarian painter, sculptor and writer on art. He was an exceptionally versatile artist and theoretician. He fought in the First World War and arrived in Berlin in 1920 with a thorough grounding in the tenets of ▷Constructivism. With ▷Lissitzky he attempted to organize a ▷Constructivist movement, and they set up their own group, 'G', which had great involvement with architects such as ▷Mies van der Rohe and ▷De Stijl in Holland. In 1923 he replaced ▷Johannes Itten at the Bauhaus where he advocated the ▷Suprematist theories of ▷Malevich.
Bib.: Hight, E., *Picturing Modernism: Moholy-Nagy and Photography in Weimar Germany*, Cambridge MA, 1995; Passuth, K., *Moholy-Nagy*, London, 1985

Moilliet, Louis (1880–1962)

Swiss painter. He studied with Fritz Mackensen at the ▷Worpswede colony during 1900–1903. In 1910 he befriended ▷Macke, and he exhibited with the ▷Blaue Reiter in 1911. With ▷Klee and Macke he travelled to Tunisia in 1914, and he lived in Switzerland during the First World War. He worked largely in ▷watercolour, painting brightly coloured landscapes. He also produced designs for stained glass. After 1919, he became more isolated, and travelled extensively on his own.

Moissac

A large Cluniac monastery (▷Cluny) in south-west France, on the pilgrimage route to Santiago de Compostela, Spain. It is famous for the ▷Romanesque sculpture of its ▷cloisters (completed 1100) and ▷portal with carved ▷tympanum of the Apocalyptic Vision (completed c1125). The style of decoration of animals, figures and foliage reflects the influence of both the northern art of the early Middle Ages, and the ▷relief sculpture of Classical Roman funerary art.
Bib.: Schapiro, M., *The Sculpture of Moissac*, London, 1985

Molenaer, Jan Miense (c1610–68)

Dutch painter and etcher. He worked in Haarlem and Amsterdam, painting peasants and bourgeois interiors. He was friendly with ▷Hals and married and collaborated with ▷Judith Leyster in 1636.

Moll, Marg (1884–1977)

German painter and sculptor. She was born in Alsace and studied at Wiesbaden and Frankfurt. She became a student of ▷Oskar Moll and eventually married him. She studied with ▷Matisse in Paris (1907–8) and became part of a circle of artists that included ▷Picasso

and the ▷Delaunays. She was a pivotal patron for many modern artists, but she veered towards sculpture in her own work after marrying Oskar. She was in Berlin in 1933, but after Oskar's death in 1947, she travelled to other parts of Europe. On a visit to England in 1950–51 she met ▷Henry Moore.

Bib.: *Marg Moll Bilder-Skupturen-Skizzen*, exh. cat., Düsseldorf and Berlin, 1974

Moll, Oskar (1875–1947)

German painter. He studied in Berlin with ▷Corinth, and travelled to Paris in 1908. With his wife, Marg, he was the centre of a circle of ▷avant-garde artists in Paris and Berlin. He was a member of the ▷Novembergruppe in 1918, and this activity led him later to be declared ▷degenerate by the Nazis. In 1925 he became Professor at the Breslau Academy, and he was appointed its Director in 1934. He painted in a ▷Fauvist style.

Molyn, Pieter de (1595–1661)

Dutch painter and etcher. He produced mainly landscapes in a realistic mode, similar to that of ▷Goyen and ▷Ruisdael. His works were monochromatic.

Momper, Joos(t) (Jodocus) II de (1564–1635)

Flemish painter. He was one member of a family of artists. He worked in Antwerp, and became a member of the Antwerp Guild in 1581. His paintings showed the influence of ▷Pieter Bruegel the Elder and ▷Adam Elsheimer, and he specialized in landscapes of mountains. Although not strictly in a realist mode, his works anticipated the realism of 17th-century landscapists.

Mona Lisa

Portrait by ▷Leonardo da Vinci (oil on canvas), completed in 1503 on his return to Florence, and now in the Louvre, Paris. A carefully constructed and composed picture, of which ▷Vasari wrote that, 'The nose, with its beautiful nostrils, rosy and tender, seemed to be alive. The opening of the mouth, united by the red of the lips to the flesh tones of the face, seemed not to be coloured but to be living flesh.' This image of an otherwise obscure Florentine lady is famous for its enigmatic smile, and is very much an icon of ▷Renaissance and European painting.

Monamy, Peter (1689–1749)

English painter. He was born in Jersey, but settled in London, where he painted marine scenes in the style of ▷Van de Velde. He was also involved in decorating Vauxhall Gardens.

Mondrian, Piet Cornelius (1872–1944)

Dutch artist. He was the developer of ▷Neo-Plasticism. He was born in Amersfoort and studied at Amsterdam Academy, where he developed a sombre naturalism, typical of Dutch art of the period. He was a member of the ▷Art Nouveau group 'Love of Art Society'. From 1907, he began to use bright, pure colour, influenced by ▷Symbolism and an exhibition of ▷Fauvist work. He joined the Theosophical Society in 1909 and from then on his work had a strong spiritual element. In 1910, he saw an exhibition of ▷Cubist art which encouraged him to visit Paris, and over the next years he experimented with a near-monochrome palette and grid-like divisions of space (e.g. *Still Life with Ginger Pot I*, 1912, The Hague, Gemeentemuseum). This was finally honed down to abstraction in the *Pier and Ocean* series (The Hague, Gemeentemuseum), where rhythmic verticals and horizontals suggest the lapping of waves. In 1917, he met ▷van Doesburg and joined ▷De Stijl, who shared many of his ideas on ▷abstraction. He moved to Paris in 1919 and began a systematic programme of Neo-Plasticism (described in a book of 1920), producing square white canvases with the primary colours controlled by a black grid (e.g. *Composition in Red, Yellow and Blue*, 1921, The Hague, Gemeentemuseum). The aim was to achieve 'universal harmony' through apparent imbalance, and the subordination of the individual. In 1925, he broke with van Doesburg over the latter's use of diagonals (Mondrian preferred to twist his canvas instead). He left Europe in 1938, travelling first to London before settling in America, where his last works were playful abstract evocations of the sights and sounds of New York (e.g. *Broadway Boogie Woogie*, 1942–3, New York, Museum of Modern Art).

Bib.: Blotkamp, K., *Mondrian: The Art of Destruction*, London, 1994; Bois, Y.A., *Piet Mondrian 1872–1944*, Berne, 1995; Fauchereau, S., *Mondrian and Neoplastic Utopia*, London, 1994; Jaffe, H.L., *Piet Mondrian*, London, 1971; Milner, J., *Mondrian*, London, 1994; *Piet Mondrian*, exh. cat., New York, 1971; Seuphor, M., *Piet Mondrian*, New York, 1957

Monet, Claude (1840–1926)

French painter. He was one of the originators of ▷Impressionism. He was born in Paris, but spent most of his childhood in Le Havre, where he met ▷Boudin and painted his first seascapes. In 1859 he entered the Académie Suisse, where he met ▷Cézanne and ▷Pissarro. After military service in Algeria, he studied under ▷Gleyre (1862), alongside ▷Renoir, ▷Sisley and ▷Bazille. Throughout the 1860s he continued to explore landscape, working with ▷Courbet at Trouville (1865), and frequently with Renoir (e.g. *La Grenouillère*, 1869, New York, Metropolitan Museum). In 1870, he came to London with Pissarro, a refugee from the Commune, and there discovered the work of ▷Turner which gave him new insight into the possibilities of colour. On his return he settled at Argenteuil on the Seine, and began a concentrated programme of nature study (e.g. *Autumn at Argenteuil*, 1873, London, Courtauld Institute) in which he employed ▷complementary colours, an increasingly

Pierre-Auguste Renoir, *Portrait of Monet*, Musée d'Orsay, Paris

Wildenstein, D. (ed.), *Claude Monet: biographie et catalogue raisonné*, 4 vols, Lausanne, 1974–84

monolith
A single stone, shaped into a pillar or other form of monument.

monotype
A print made by making a design in ▷oil paint or printer's ink on a metal or glass ▷plate, the design being then transferred directly to a sheet of paper. Metal plates may be printed in a press, although glass plates have to be printed by rubbing the back of the paper with the heel of the hand. In this method, one print only is generally taken. In practice, however, one or two subsequent prints can be taken, although the paint or ink has to be retouched after each print and each print is therefore unique (hence the name, 'monotype'). The specific attraction of the method lies in the textural qualities obtainable only by the process of printing. Monotype is believed to have been invented in the 17th century by G.B. Castiglione, but the most celebrated uses of it were perhaps made by ▷William Blake and ▷Edgar Degas.

free technique and casual compositions based on Japanese prints. He exhibited at five of the eight Impressionist exhibitions, and inadvertently gave the group its name with his picture title ▷*Impression: Sunrise* (1874, Paris, Musée Marmottan).

During the 1870s Monet also produced a series of ground-breaking works which showed modernity in Paris (e.g. *Gare St. Lazare*, 1877, Paris, Musée d'Orsay). Increasingly, however, he tired of the capital: in 1878 he moved to Vretheuil, in 1881 to Poissy and finally in 1883 he settled in ▷Giverny on the Seine between Paris and Rouen, buying property in 1890 and designing his own gardens. At the same time he began travelling throughout France, painting new scenes of nature which were unpeopled and wild. In the 1890s he produced a number of series paintings, which showed a single simple motif in a variety of weather and time settings (e.g. *Poplars on the Epte*, 1891, Edinburgh, National Gallery of Scotland). In these, subject was secondary to the interest in colour, and his brushwork became increasingly complex and intense and he achieved greater luminosity and depth. These paintings culminated in his huge semi-abstract images of waterlilies, a created world recreated like a vision (e.g. *Waterlily Pond*, 1899, London, National Gallery). He also revisited London (e.g. *Waterloo Bridge*, 1900–1903, Pittsburgh, Carnegie Museum of Art). His later breadth of technique was partly a result of increasingly poor eyesight, but it equally represented a development from the simple naturalism of the 1870s.
Bib.: House, J., *Monet: Nature into Art*, London, 1986; *Monet in the '90s*, exh. cat., London, 1989; Spate, V., *The Colour of Time: Claude Monet*, London, 1992;

Monro, Thomas (1759–1833)
English patron and amateur artist. He was educated at Oxford and took up a medical career, becoming physician to George III. He collected drawings and engravings and turned his home in Adelphi Terrace, London into an 'academy' for young artists. They were paid to attend, colour in his own drawings and sketches, and were also allowed use of his country home at Bushey, Hertfordshire. In particular he encouraged ▷Turner, ▷Girtin, ▷Varley, ▷Cotman and ▷de Wint to develop their watercolourist talents. His own work was second-rate and repetitive, based on his admiration for ▷Gainsborough. He supported ▷Cozens during his time in Bethlem Hospital.
Bib.: *Dr. Monro and the Monro Academy*, exh. cat., London, 1976

montage
A composite picture, musical piece or film produced from several different elements. In cinema or television this may be a selection of shots or scenes spliced into one sequence, or a blending/superimposition of shots to produce a single picture.
▷photomontage

Montagna, Bartolommeo (c1450–1523)
Italian painter. He produced mainly religious subjects, and his workshop was the most successful in Vicenza in the late 15th century. In 1469 he is recorded in Venice and may have been trained there, a probability suggested by the principal influences of his work: ▷Giovanni Bellini, the ▷Vivarini, and ▷Antonello da Messina (e.g. *Sacra Conversazione*, 1499, Milan,

Brera). After his death, his son Benedetto continued the workshop and perpetuated his father's style until at least 1541, but with work of a lower quality.

Montalba, Clara (1842–1929), Ellen (c1846– after 1902), Henrietta Skerret (1856–1893) and Hilda (1844/54–1919)

English family of painters and sculptors. They were all the daughters of the painter A.R. Montalba. Clara studied in France, spent time in Normandy and earned an international reputation through exhibitions in Europe and America during the 1890s. She settled in Venice, where she was elected to the Academy and became known for her Venetian scenes.

Her sister Ellen trained at the Royal College of Art and at South Kensington, and also travelled and painted Venetian subjects. Henrietta, a second sister, was a sculptor who produced portrait busts. The youngest sister, Hilda, was an early student at the ▷Slade. She painted landscapes and ▷genre scenes, and like her siblings settled in Venice.

Montañes, Juan Martínez (1568–1649)

Spanish sculptor. He was one of the foremost sculptors of the Spanish ▷Renaissance, particularly distinguished for his ▷polychromatic wooden religious sculpture. He became a member of the Seville Guild in 1588, and he produced works for Seville Cathedral, including the *Christ of Clemency* (1603–6). He was in Madrid during 1635–6, where he accepted a commission to do a portrait bust of Philip IV as a model for an ▷equestrian statue by ▷Pietro Tacca in Florence. His work was in an early ▷Baroque style which was both emotional and virtuosic. ▷Velázquez painted a portrait of him. His beautiful sculptures earned him the nickname 'el dios de la madera' ('the god of wood').

Montefeltro, Federico di (1422–82) and Guidobaldo (1472–1508)

Italian family of patrons. They were rulers of Urbino, where the family controlled the government from 1234 to 1508. During his reign (1444–82), Federico was an important ▷Renaissance patron of architecture, as well as literature.
Bib.: de La Sizeranne, R., *Federico di Montefeltro: capitano, principe, mecenate (1422–1482)*, Urbino, 1972

Monticelli, Adolphe (1824–86)

French painter. He was born in Marseilles, the illegitimate son of a civil servant. His first artistic training was undertaken at the drawing school in Marseilles and later with a local landscapist, Loubon, but in 1846 he moved to Paris and entered ▷Delaroche's studio. He returned to Provence in 1849 before settling in Paris in 1855 where he became known for his ▷*fêtes galantes* landscapes (e.g. *Strolling Players*, 1861, Glasgow, Burrell Collection). His early ▷Ingres-influenced style gave way to one influenced by ▷Delacroix and ▷Diaz with textured paint and increasingly small, tight brushstrokes. He was familiar with the innovations of ▷Impressionism and after 1875 his work shows the increased application of brighter colour and dashed ▷brushwork. He was also a significant figure in the so-called Lyons Renaissance, an explosion of artistic talent in Provence during the mid-19th century.
Bib.: Garibaldi, C., *Monticelli*, Geneva, 1991; *Monticelli*, exh. cat., Marseilles, 1987; Sheon, A., *Monticelli: His Contemporaries, his Influence*, Pittsburgh, 1978

Monticello

The home in Virginia of the American statesman and president ▷Thomas Jefferson. He inherited the site, whose name means 'little mountain', from his father and began clearing it of forest and levelled the top between 1767 and 1769. He designed the house himself, and was strongly influenced in his design by ▷Palladio and his time in Paris as American ambassador there. The building process was one of development and redevelopment and the house did not reach its final appearance until the 1790s. Jefferson's design of Monticello, and his plans for the University of Virginia which he founded, inaugurated the use of the Classical style in American public architecture which saw its greatest expression in the new national capitol at Washington. He also landscaped the gardens in an English style that reflected the fashion for the ▷picturesque and ▷sublime, planting the gardens with seeds he received from around the world. Through his wife, Jefferson had inherited an estate of some 10,000 acres and 180 slaves, but his public office led to massive debt and the house was sold on his death in 1826. The Thomas Jefferson Memorial Foundation, established in 1923, restored the house and gardens making it into a patriotic shrine to Jefferson, who is buried within its grounds.

Mont Sainte-Victoire

The mountain overlooking the Valley of the Arc, south of Gardanne in Provence, which was painted repeatedly by ▷Cézanne throughout the latter part of his career. The mountain stood close to his family home, at Jas de Bouffan, where he lived from 1883 until 1899, when it was sold. Although he occasionally painted the subject during the 1870s it was not until he permanently returned to Provence during the following decade that the mountain became such a central motif in his work. A series of canvases during the 1880s and 1890s explored the panoramic landscape of the valley, identifiable by the prominent railway viaduct and the rising, block-like mountain behind. In many cases the works exploit the same high viewing point, probably that of the hill at Bellevue on the estate of the artist's brother-in-law. Equally characteristic is the use of framing trees in the foreground, and the colour contrast of green landscape and grey mountain behind. By the last years of his career, Cézanne had purchased a studio

at Les Lauves, which provided a closer view of the mountain, exploited in a series of ▷watercolours which concentrated solely on the form the rock. By repeatedly painting the same image, Cézanne was effectively able to explore his idea of permanence in nature, whilst at the same time portraying the infinite variety of the landscape.

Bib.: Boehm, G., *Paul Cézanne: Montagne Sainte-Victoire*, Frankfurt, 1988

monument

An object intended to commemorate a person, event or idea. Although a monument may be a natural object associated with the subject of commemoration, in art historical usage it is, in broad terms, a built structure or edifice, sometimes incorporating sculpture. More specifically, a monument may be a structure, with or without sculpture, erected in a Christian church, graveyard or cemetery to commemorate the dead.

monumental

In its most obvious sense, relating to monuments, but generally used to connote massiveness and permanence.

Monument to the Third International

Designed by ▷Vladimir Tatlin and exhibited as a model in Petrograd in 1920, it was intended as a revolutionary riposte to the Eiffel Tower, but was never built. 'Tatlin's Tower', as it was known, was to have consisted of a steel, angled corkscrew spiral frame which contained a series of glass halls. The effect in silhouette was thrusting, dynamic and wholly modern compared with the static solidity of the 'capitalist' monuments it was designed to both emulate and out-scale. It was not, however, a piece of mere bravado: Tatlin intended the interior space to be functional as well as symbolic. A glass cube within the steel frame was to contain the new Soviet legislature, with a pyramid for the executive and a cylinder for the propaganda department. These were designed to rotate yearly, monthly and daily, respectively. Tatlin himself conceived of the tower as representing a body with external ribs and internal vital organs. It was a logical progression of his ▷Constructivist aesthetic, incorporating both the language of geometric abstraction and the required element of functionalism. Ultimately, however, the failure of the scheme represented a broader failure on the part of Tatlin and his fellow artists to find a satisfactory niche within the new Soviet regime.

Moore, Albert (1841–93)

English painter. He was born in York, the son of a painter of landscape and portraiture (William Moore, 1790–1857). Having been taught by his father, he entered the York School of Design, before moving to London to study at Kensington Art School and at the ▷Royal Academy (1858). His early work was ▷Pre-Raphaelite in influence (e.g. *Elijah's Sacrifice*, 1865,

Bury), and he also made several landscape tours to the Lake District (1857–9). He travelled to Paris (1859) and Rome (1862–3). During the 1860s he became increasingly interested in design, working on ▷stained glass for ▷Morris & Co. and producing a mural of the ▷*Last Supper* (1865, St. Albans, Rochdale). From 1864 he studied Classical art, including the ▷Elgin marbles. In the same year he met ▷Whistler and with him experimented with the possibilities of ▷aestheticism, using nudes and Classically draped women to explore mood, colour and beauty (e.g. *Beads*, 1875, London, National Gallery; *Midsummer*, 1887, Bournemouth). He was a regular exhibitor at the ▷Grosvenor Gallery. Initially, these works were essentially without subject, but by the 1880s they increasingly exploited the vogue for the ▷antique (cf ▷Leighton, ▷Alma-Tadema). He was a meticulous worker, producing large numbers of preparatory sketches, but unlike the Classicists of the period he had no interest in creating authentic period detail.

Bib.: Baudry, A.L., *Albert Moore: His Life and Works*, London, 1894

Moore, Henry (1898–1986)

English sculptor and graphic artist. He was from Yorkshire and studied first at the Leeds School of Art and then at the ▷Royal College of Art (1919–23) in London, where he later taught. While studying, he became involved with a circle of artists and writers which included ▷Ben Nicholson and ▷Barbara Hepworth. He obtained his first major public commission in 1928 – a representation of the *North Wind* in ▷relief for the London Transport Office in St. James's. From an early stage, he was interested in ▷direct carving, and like many of his contemporaries, he was concerned with the appropriate use of materials. Moore was also interested in the emotional impact of form. He was voracious in his appreciation of non-European sculpture, especially the sculpture of Mexico, as well as ▷African, ▷Assyrian and ▷Etruscan art, elements of which he incorporated into his abstract works. He was also deeply influenced by ▷Surrealism and adopted a Surrealist emphasis on ▷biomorphic form as a way of emphasizing the organic qualities of his work. In 1936 he participated in the British Surrealist exhibition.

During the Second World War he was hired as a war artist and he drew evocative visions of people sheltering in the London underground from bomb raids. He produced these works in ▷ink, ▷chalk and ▷watercolour. The suggestive forms of these representations became the foundation of much of his later sculpture. In 1940 he moved to Hertfordshire where he remained for most of his subsequent career. He was a well-known artist who accepted many public commissions and was prolific in his output. He frequently represented mothers and children or reclining figures, and his works always suggested a natural form even when they were most abstract. His interest in

natural form led him to consider carefully the landscape setting of his outdoor commissions, and to produce his works with the setting in mind. His forms were inevitably monumental, and he made a creative use of positive and negative space. From 1950 onwards, he moved away from carving and began casting works in bronze.
Bib.: Berthoud, R., *The Life of Henry Moore*, London, 1987; Bowness, A. (ed.), *Henry Moore: Sculpture and Drawings*, London, 1986; *Henry Moore*, exh. cat., London, 1988

Mor, Anthonis (Antonio Moro) (c1519–c1576)

Netherlandish painter. He specialized in portraits. He was trained by ▷Jan van Scorel in his native Utrecht. Mor visited Italy in c1550 and seems to have been influenced by the grand portrait manner of ▷Titian, although to this he added a typically Dutch sharp eye for detail, wedded to a skill in the diplomatic portrayal of the characters of his powerful sitters. By 1560 he was court painter to Philip II of Spain (the Netherlands was then under Spanish dominion). His polished technique exerted a strong influence on court portraiture in Spain and the Netherlands but, although he visited Britain with Philip in 1554 on the occasion of his marriage to Mary I of England, ▷Holbein's continuing influence in England ensured that Mor's style did not take root there. Whilst in Britain, however, Mor painted a very fine portrait, *Queen Mary I* (Madrid, Prado) for which he was knighted as Sir Anthony More. His most important pupil was the Spanish portrait painter ▷Alonso Sánchez Coello.
Bib.: Friedländer, M.J., *Anthonis Mor and his Contemporaries*, New York, 1975; Woodall, J., An Exemplary Consort: Anthonis Mor's Portrait of Mary Tudor, *Art History*, 14 (June 1991), pp. 192–224

Morales, Luis de (c1509–86)

Spanish painter. He specialized in painting on wood, and he produced small devotional images in a High ▷Renaissance style based partly on the work of ▷Michelangelo. He was one of the principal advocates of a ▷Mannerist style. He lived in Badajoz, near the Portuguese border. He was nicknamed 'El Divino'.

Morandi, Giorgio (1890–1964)

Italian painter. He was from Bologna, where he studied at the Academy of Fine Arts. After a short involvement with the ▷Futurists in 1914, he went his own way, showing a brief interest in the work of the Scuola Metafisica (▷metaphysical painting) in 1918. However, he tended to avoid artistic groupings, and by the early 1920s he had evolved his own economical style of still-life painting which concentrated on complexities of form. Following the legacy of both ▷Chardin and ▷Cézanne, he allowed objects to speak for themselves, and the simplicity of his forms gave his

works a superficial affinity with ▷Purism. He never moved away from representational art. He became Professor of Graphic Art at the Bologna Academy of Fine Arts in 1930 and a member of the Accademia di San Luca in 1948.
Bib.: *Giorgio Morandi: Etchings*, exh. cat., London, 1991

morbidezza

(Italian, 'softness'.) A term used in painting to denote an exaggeratedly soft or delicate rendering of flesh (i.e. with blurred edges and melting tones). In 18th-century art criticism it was used notably to refer to the paintings of ▷Correggio.

Moreau, Gustave (1826–98)

French painter. He was a ▷Symbolist artist who lived and worked in Paris. A pupil of Théodore Chassériau, he gained a reputation for oddness at the ▷Salon and though his *Oedipus* (1864, New York, Metropolitan Museum) made some impact, the harsh criticism he received meant he did not exhibit there after 1880, and not at all after 1886. However, his work was brought to a wider public attention through the literature of J.K. Huysmans, who wrote in his novel, *À Rebours* (1884), that 'never before had the art of watercolour succeeded in reaching such a brilliancy of tint', describing Moreau as 'a unique, an extraordinary artist'. Influenced by Italian art and the ▷Mannerists he had seen during his time in Italy between 1856 and 1860, the reclusive Moreau produced amazingly detailed visionary images of Classical subjects such as *Hercules and the Hydra of Lerna* (1876, Chicago, Art Institute) and *Jupiter and Semele* (Paris, Musée Gustave Moreau). He resisted the idea that he was a literary painter however, and declared that he was looking for an art that 'under a material envelope, mirror of physical beauty, reflects also the movement of the soul, of the spirit, of the heart and the imagination, and responds to those divine necessities felt by humanity throughout the ages'. In 1892 he was appointed professor at the ▷École des Beaux-Arts and he proved an influential teacher to ▷Matisse, ▷Rouault and Georges Desvallières. His studio was turned into a museum after his death and was a source of fascination to ▷Breton and the ▷Surrealists.
Bib.: Kaplan, J., *The Art of Gustave Moreau*, Ann Arbor, 1982

Moreelse, Paulus (1571–1638)

Dutch painter and architect. He was from Utrecht and became a co-founder of the St. Lucas guild there in 1611. He painted mostly portraits.

Morelli, Giovanni (1816–91)

Italian critic who concentrated on the problems of ▷attributing works and believed that the ways in which artists treated details such as eyes, ears and fingers

were as good as a signature, so that by grouping similar treatments an artist's *oeuvre*, if not name, could be assembled. There is no way of demonstrating Morelli's scheme to be either true or false, but it does form part of the attempted 'scientification' of art history away from the 'eye' of the ▷connoisseur towards objectively verifiable criteria.

Bib.: Gibson-Wood, C., *Studies in the Theory of Connoisseurship from Vasari to Morelli*, New York, 1988; Ginsburg, G., 'Morelli, Freud and Sherlock Holmes: Clues and Scientific Methods', *History Workshop*, 9 (1980), pp. 5–36

Moretto da Brescia (Alessandro Bonvicino) (c1498–1554)

Italian painter. This is the popular name of Alessandro Bonvicino, who was active chiefly in his native Brescia and the surrounding region. He painted mainly religious subjects, influenced by ▷Titian (whose pupil he may have been) and ▷Raphael, but with a typically Lombard concern for naturalistic detail. It is, however, for his less numerous portraits that he is best remembered. He may have introduced the full-length portrait into Italy. Although full-length portraits of ▷donors had sometimes appeared in Italian ▷altarpieces, the independent full-length portrait had been hitherto a German type (e.g. ▷Lucas Cranach the Elder). Moretto's earliest known example is the *Portrait of a Nobleman* (dated 1526, London, National Gallery). His most important pupil was ▷Moroni.

Bib.: Guazzoni, V., *Moretto, il tema sacro*, Brescia, 1981; Virgilio, P., *Alessandro Bonvicino, il Moretto da Brescia*, Brescia, 1988

Morgan, Evelyn Mary de (1855–1919)

English painter. She was from a wealthy family. She studied at the ▷Slade in 1873 with ▷Edward Poynter, and she moved to Rome in 1875, where she lived alone for two years earning money as an artist. She married William de Morgan in 1887. From 1893 to 1908 she lived in Florence, where she supported herself and her husband through her ▷allegorical images. Her work was in the manner of the late ▷Pre-Raphaelite ▷Symbolism of ▷Burne-Jones.

Bib.: Stirling, A.M.W., *William de Morgan and his Wife*, London, 1922

Morgan, John Pierpont (1837–1913)

American industrialist and book and manuscript collector. He collected illuminated and textual manuscripts from the 6th to 16th centuries, including the Constance Missal, the Gutenberg Bible, and original writings by Keats, Byron and Dickens. In addition, he amassed 270 etchings by ▷Rembrandt, book bindings from the 8th to 20th centuries, ▷Assyrian and ▷Babylonian seals, cylinders and cuneiform tablets. In 1905 Morgan commissioned ▷McKim, Mead and White to build him a 'palazzo-style' library next to his house

on 36th Street, New York. It is now a museum and library. Morgan's study remains as he left it, and contains a number of important works of art, including the Stavelot ▷triptych, and works by ▷Memlinc, ▷Cranach, ▷Tintoretto and ▷Perugino.

Morisot, Berthe (1841–95)

French painter and printmaker. She was associated with ▷Impressionism. She was born in Bourges, the daughter of a government official who was an enthusiastic amateur painter and supporter of the arts. She was also the granddaughter of ▷Fragonard. She was taught in Paris by ▷Corot (1862–8) under whom she produced delicate landscapes. She was also a friend of ▷Fantin-Latour and met ▷Daubigny sketching in

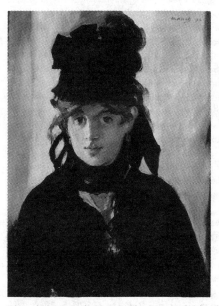

Edouard Manet, *Berthe Morisot with a Bouquet of Violets*, 1872, private collection

Fontainebleau. In 1868 she met ▷Manet, modelled for him and also became his pupil. Under him she began working ▷*plein air* (e.g. *Artist's Sister and Mother*, 1870, Washington DC, National Gallery) and was introduced to the ▷Impressionist circle in Paris. She married Manet's brother in 1874. She was an enthusiastic member of the Impressionist group, exhibiting at seven of their shows and collecting their works. She also achieved some ▷Salon success (exhibiting there during 1864–73). She experimented with seascapes but her personal style developed most markedly during the 1880s: sketchy, pale colours and subjects from her own experience including women, children and domestic life (e.g. *The Cradle*, 1873, Paris, Musée d'Orsay). She experimented with ▷pastel and ▷watercolour and continued to paint landscapes (e.g. *Villa by the Seaside*, 1874, Pasadena, Norton Simon Museum). In her later career her work moved closer

to that of ▷Renoir (e.g. *The Dining Room*, 1886, Washington DC, National Gallery). Morisot has been reclaimed as one of the forgotten women artists of the 19th century (cf ▷Cassatt) by ▷feminist historians, and as such has achieved greater fame in recent years than she did in her lifetime.

Bib.: Adler, K. and T. Garb, *Berthe Morisot*, Oxford, 1987; *Berthe Morisot: Impressionist*, exh. cat., New York, 1988; Higonnet, A., *Berthe Morisot: A Biography*, London, 1990; idem., *Berthe Morisot: Images of Women*, London, 1991; Stuckey, C.F. (ed.), *Berthe Morisot, Impressionist*, London, 1987

Morland, George (1763–1804)

English painter. He was taught (1771–84) by his father, Henry (1730–97), who was a painter of domestic scenes, and the young George suffered an isolated childhood from being forced to copy and forge Dutch landscapes for cash. His first works were small, sentimental ▷genre scenes, which he exhibited at the ▷Royal Academy from the 1770s, but his mature style did not develop until the 1790s. Then he produced larger pictures of rural life, centred around the cottage and the tavern (e.g. *Outside the Alehouse Door*, 1792, London, Tate Gallery; *Farmer's Forge*, 1793, Manchester, City Art Gallery) which became popular through ▷mezzotints. He represented a contented peasant population, which was reassuring to the establishment during troubled political times. He also produced landscape and coastal scenes influenced by ▷de Loutherbourg (e.g. *Coming Storm*, 1789, Wolverhampton). His personal life was plagued by alcoholism and debt and he produced much repetitive work.

Bib.: *George Morland*, exh. cat., Reading, 1975; *George Morland*, ex. cat., London, 1954

Moroni, Giovanni Battista (1520/5–78)

Italian painter. He was a pupil of ▷Moretto, whose style he adopted. He worked in Brescia, Bergamo and Albino painting religious works. However, he was best known for his portraits, many representing everyday individuals. Under the direct influence of the ▷Counter-Reformation, he simplified his forms and approach for greater clarity.

Bib.: Cugini, D., *Moroni pittore*, Bergamo, 1939

Morosov, Ivan Abramovich (1871–1921)

Russian patron. He earned his fortune from textiles and used some of it to purchase ▷Post-Impressionist paintings from 1905 to 1914. His collection of works by ▷Cézanne, ▷Gauguin, ▷Bonnard and ▷Monet was well ahead of its time in Russia, and it later became incorporated into the Hermitage and the Pushkin Museum. He also collected contemporary Russian art, and his patronage led to a higher profile for artists of the ▷Blue Rose group.

Bib.: Kean, B., *French Painters, Russian Collectors;*

Shchukin, Morosov and Modern French Art 1890–1914, London, 1994

Morrice, James Wilson (1865–1924)

Canadian painter. He was born in Montreal, where he studied law. He became interested in art and pursued his new occupation through travelling to Paris and studying at the ▷Académie Julian in 1890. While in Europe, he saw the work of ▷Whistler and became friendly with ▷Matisse, whose ▷Fauvist paintings he admired. He travelled to North Africa and the West Indies. He was also acquainted with ▷Glackens and ▷Henri in America and with ▷Clive Bell in England. From 1905 he lived mostly in Paris and associated with Fauvist artists.

Morris, Robert (b 1931)

American sculptor. He first worked in San Francisco, but he moved to New York in 1961, where he produced sculptures using geometric forms and sound accompaniment. He wrote extensively about art, and his writings on ▷Minimalism in *Artforum* magazine (1966) created a theoretical basis for the new art techniques. He experimented in using the ▷environment in his art and with modes of performance. From 1966, he was an advocate of earth art, and he produced a number of works ▷*in situ*.

Morris, William (1834–96)

English painter, designer, writer and graphic artist. He was born at Walthamstow, was educated at Marlborough College and at Exeter College, Oxford (1853–5), where he met ▷Burne-Jones and became interested in poetry and medieval architecture (after a tour of French cathedrals in 1854, he published the *Shadow of Amiens* in 1857). He studied as an architect under G.E. Street, before turning to painting in 1857 (e.g. *La Belle Iseult*, 1858, London, Tate Gallery), when he became a pupil of ▷Rossetti and worked with him on the Oxford Union ceiling. In 1859 he married Jane Burden and commissioned, from his architect friend Philip Webb, the Red House, a model of ▷Arts and Crafts design. In 1861 he established the design firm ▷Morris and Co., which employed many of his friends and leading artists of the day (e.g. Burne-Jones, ▷Brown, ▷Moore) although Morris himself also manufactured many of his own designs for wallpaper (e.g. *Daisy*, 1866), textiles and tapestries (e.g. *Woodpecker*, 1888). In 1890 he established the Kelmscott Press which promoted the same qualities in printing, and for which he invented two new typefaces. His work was heavily influenced by ▷Ruskin's ideas on truth to nature, honourable craftsmanship and the superiority of the ▷Gothic. Morris established the Society for the Preservation of Ancient Buildings in 1877 and was against industrial modernization. He was a ▷Romantic, writing *Earthly Paradise* and translating Icelandic sagas, yet he was also a socialist, who established the Socialist

League in 1884, and wrote of equality and comradeship in his idealized vision of the future, the utopian novel *News from Nowhere* (1890).

Bib.: Faulkener, P., *Against the Age*, London, 1980; Henderson, P., *William Morris: His Life, Work and Friends*, London, 1967; McCarthy, F., *William Morris: A Life for Our Time*, New York, 1995; MacKail, J.W., *Life of William Morris*, 2 vols, London 1899; Morris, M., *William Morris: Artist, Writer and Socialist*, Oxford, 1936; Thompson, P., *Work of William Morris*, London, 1967

Morris & Company (Morris, Marshall, Faulkner & Co.)

The firm established in 1861 by ▷Morris, originally called Morris, Marsall, Faulkner and Company, and described as 'Fine Art Workmen in Painting, Carving, Furniture and the Metals'. The firm was in theory a co-operative, in which each member invested an initial pound, but in practice it was dominated by the enthusiasm of Morris. In 1881 it expanded to works at Merton Abbey where Morris installed looms for ▷tapestries and woven ▷textiles; in 1883, the firm also began producing printed textiles there. Wallpaper was printed for the firm by Jefferson and Co. from 1862, and hand-knotted carpets were produced at Hammersmith. Morris did many of the designs for these products, and for the firm's ▷stained glass, himself. The furniture was in the hands of Philip Webb and the pottery was designed by William de Morgan (husband of Evelyn Mary de Morgan). The firm also employed a number of other ▷Pre-Raphaelite artists including ▷Brown, ▷Burne-Jones and ▷Rossetti. It was highly successful and remained in existence until 1940.

Bib.: Parry, C., *William Morris' Textiles*, London, 1982; Sewter, A., *Stained Glass of William Morris*, London, 1974; Willhide, E., *William Morris: Decoration and Design*, London, 1994

morse

A large, heavy clasp used for church vestments and often ornamented.

Morse, Samuel F(inley) B(reese) (1791–1872)

American painter. He was born in Massachusetts. He studied with ▷West and ▷Allston in London (1811–15) and exhibited Classical subjects at the ▷Royal Academy. In 1815 he returned to the United States where he helped found the ▷National Academy of Design and became its first President (1826–45). Although he also painted portraits, his real desire was to be a history painter, but like ▷Haydon in England, his ambitions were out of line with current art practice which favoured domestic ▷genre painting and landscape. He did win a commission for a historical portrait of Lafayette to be part of the decoration of the New York City Hall (1824–5), but his lack of success at obtaining other similar commissions depressed him.

He was back in Europe 1829–33, but he gave up art shortly after that and turned to invention. He is best known for inventing the telegraph and the Morse Code in the 1830s.

Mortimer, John Hamilton (1740–79)

British painter. He specialized in portraits, ▷conversation pieces, religious and historical subjects. He was a pupil of the portrait painter ▷Thomas Hudson at the same time (c1757) as his friend ▷Joseph Wright of Derby, before moving on in 1759 to study under the history painter ▷Robert Edge Pine. In 1764 Mortimer won the Society of Arts history painting prize for his *St. Paul Preaching to the Britons* (now in the Town Hall, High Wycombe). His portrait style is similar to that of his friend, Wright, and his conversation piece style akin to that of ▷Zoffany. His most individual works, begun c1770, are undoubtedly his drawings, prints and paintings of scenes of soldiers and *banditti*, violent in content and painted in a ▷Romantic style influenced by ▷Salvator Rosa and Stefano della Bella. Mortimer evidently led a wild and reckless life himself before settling down to marriage in 1775. He was elected ▷ARA in 1778, the year before his premature death at the age of 39.

Bib.: *John Hamilton Mortimer ARA, 1740–79, Paintings, Drawings and Prints*, exh. cat., London, 1986

mosaic

A design or picture made by arranging fragments of coloured marble, glass, semi-precious stones or other suitable materials (known generically as ▷tesserae) on a bed of plaster or cement. It was first developed by the ancient Romans for the decoration of pavements, but was used extensively for ▷vaults, interior walls and sometimes the façades of ▷Early Christian and ▷Byzantine churches during the Middle Ages, some of the best examples of which are to be found in Rome, Ravenna, Venice, Sicily, Istanbul and Greece. There was an important revival in the technique in 13th-century Rome, led by such masters as ▷Cavallini, ▷Torriti and ▷Giotto, but mosaic as an interior wall decoration was eventually superseded by ▷fresco painting which not only allowed a more naturalistic rendering of the narrative cycles required in the churches of the newly formed preaching orders, but was also much cheaper. Nonetheless, the art of mosaic continued to be practised in Venice (which had retained strong links with the Byzantine Empire) until the 15th century (for example, ▷Uccello is known to have worked on the mosaics in St. Mark's).

Mosaic design is also found in Aztec art and has been used in the 20th century by the Mexican architect and painter ▷Juan O'Gorman for the façade of his National University Library, Mexico City (1952–3).

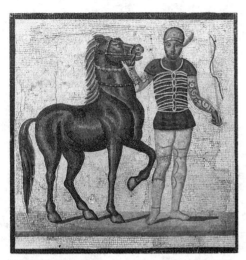

Mosaic: Charioteer, Roman, from Baccano, Italy, 2nd century

Mosan School

A school of ▷manuscript illumination and metalwork based in the Meuse Valley from the 11th to the 13th centuries. The centre of production was Liège. Known artists during this period include Godefroid de Claire, ▷Nicolas of Verdun and ▷Renier of Huy.
Bib.: *La civilisation mérovingienne dans le bassin mosan: actes du colloque international d'Amay-Liège du 22 au 24 août 1985*, Liège, 1986

Moser, Lukas (fl 15th century)

German painter. His only known work is the *Mary Magdalen and Martha* ▷altarpiece, produced for the Tiefenbronn church (1432). The style, reminiscent of ▷van Eyck, is startlingly naturalistic.

Moser, Mary (1744–1819)

English painter. She was the daughter of a goldsmith George Michael Moser (1704–83), and, like him, she was one of the founder members of the ▷Royal Academy. She exhibited there and at the ▷Society of Artists. She specialized in flower paintings, which were very popular at the time. She was also distinguished by being put forward as a candidate for President of the Royal Academy by ▷Henry Fuseli, who was making a revolutionary statement in suggesting a woman could form part of the inner sanctum of such a male-dominated institution.

Moses

Leading Old Testament figure, who led the Jews from captivity in Egypt and gave them the Ten Commandments. His life foreshadows that of ▷Christ and ▷St. Peter. He is usually shown as an aged bearded man, sometimes with horns on his head (a result of a mis-translation in the Vulgate) (e.g. ▷Michelangelo, 1515, Rome, St. Peter's). The narrative of his life includes numerous famous events: he was left in the bulrushes as a baby, to be discovered by the pharaoh's daughter; he married Zipporah after meeting the seven daughters of Jethro at a well; he witnessed the Burning Bush; he parted the Red Sea after following a pillar of cloud and fire as a guide out of Egypt (e.g. ▷Tintoretto, *Moses and the Pillar of Fire*, Venice, Seuola di S. Rocco); during 40 years of wandering in the wilderness, he found water in a rock and manna dropping from the heavens (e.g. ▷Poussin, 1638–9, Paris, Louvre); and after receiving the Ten Commandments from God, he destroyed the Golden Calf as a symbol of false worship. He finally died in sight of the Promised Land.

Moses, Grandma (Anna Mary Robertson) (1860–1961)

American painter. She was born in New York and grew up on a farm in New York state. She was self-taught and began her artistic experiments with embroidery. She did not start painting until the 1930s, when she was 'discovered' by the collector Louis J. Calder, who saw her works in a drugstore window. She subsequently produced over 1,500 pictures, many of farm scenes and nostalgic views of American rural life based on her personal experience. She became a cult figure.
Bib.: Humez, J., 'The Life and Art of Anna Mary Robertson Moses', *Women's Art Journal*, 1/2 (1980–81), pp. 7–12; Kallir, O., *Art and Life of Grandma Moses*, New York, 1969

Mostaert, Jan (c1475–c1555)

Dutch painter. He was from Haarlem. He is recorded as having painted a *West Indian Landscape*, which, it has been suggested, is the picture (c1530) now in the Hals Museum at Haarlem, and he was also employed as court painter by Margaret of Austria, Regent of the Netherlands, for about 18 years. Few details of his career have been definitely established and many of his works seem to have been destroyed in the Great Fire of Haarlem in 1576. No paintings are actually signed by him, but a group consisting principally of court portraits and religious subjects, showing the influence of a leading Dutch painter of the previous generation, ▷Geertgen tot Sint Jans, has been attributed to him. He may also be identical with the Master of Oultremont.

Motherwell, Robert (1915–91)

American painter. He was associated with ▷Abstract Expressionism. He was born in Aberdeen, Washington. He attended the Otis Art Institute, Los Angeles (1926), and the California School of Fine Art (1932)

before studying at Stanford University (1936), where he took a degree in philosophy. The following year he wrote a Harvard thesis on ▷Delacroix' ▷aesthetics and later studied art history at Columbia University. He travelled to Europe in the 1930s and spent time during the following decade studying ▷etching at the Atelier 17. His early work was ▷Surrealist, exploring ▷collage, ▷automatism and primitive art styles, especially Mexican art (e.g. *Pancho Villa Dead and Alive*, 1943, New York, Museum of Modern Art). By the late 1940s, however, he was moving towards ▷abstraction, using strong colour and lettering (e.g. *Je t'aime IIA*, 1955, private collection). Many of his works retained descriptive titles (e.g. his painting based on a Rosenberg poem, *Elegy to the Spanish Republic LV*, 1955–60, Cleveland, Museum of Art). His work increased in scale during the 1960s, incorporating collage and colour (e.g. *Open* series, based on central 'windows'). He worked on murals for the Kennedy Building in Boston (1966). He established an art school with ▷Rothko and ▷Newman in 1948 and edited the *Documents of Modern Art* series from 1944 (most famously *Dada Painting and Poetry: an Anthology*, 1951).

Bib.: Aranson, H.H., *Robert Motherwell*, New York, 1977; Flam, J.D., *Motherwell*, London, 1995; *Robert Motherwell*, exh. cat., London, 1978; Terenzio, C.S., *Prints of Robert Motherwell*, New York, 1995

motte-and-bailey

The characteristic defensive features of a ▷Norman castle, consisting of a steep mound (the motte) surmounted by a timber fortress and tower and surrounded by an open space (the bailey), protected by a ditch and palisade.

moulding

An architectural member, ▷carved or ▷modelled to give variety of profile to a larger vertical or horizontal surface. Of the mouldings developed in Classical architecture, the simplest are: the fillet (a raised narrow band, square in section); the astragal (a raised narrow band, circular in section); the torus (a large raised band, convex in section, generally found at the base of a column); and the ▷dentil. Of the more complex Classical mouldings still in use today are the *cyma recta*, a double curve, convex below, concave above, and the *cyma reversa*, concave below, convex above. Common non-Classical mouldings include: the ▷Norman beakhead moulding (in which laterally set fantastic heads bite with their beaks into a longitudinal roll moulding); the ▷Romanesque billet moulding (in which several bands of short studs, cylindrical or square in section, are placed at intervals, the bands staggered to create an alternating pattern); the Romanesque chevron moulding (in which 'v' or chevron-shapes are repeated in zigzag sequence); the ▷Early English ▷dogtooth moulding; the Early English nailhead moulding (in which pyramidal projections like nailheads are repeated as a band); and the ▷Decorated Style wave moulding (in which stylized wave motifs are repeated in a band).

Mozarabic

Term applied to the Spanish Christians under Moorish rule, and the distinctive art and architecture they produced. Permitted to continue practising their faith, they drew on western Christian traditions as well as the sophisticated ▷Islamic styles surrounding them. The Mozarabic formed the basis of a quite unique Spanish national art, but its influence weakened after the arrival of ▷Romanesque from northern Europe in the 11th century.

Mr. and Mrs. Andrews

The most famous of ▷Gainsborough's ▷conversation pieces, painted in c1748–50 (oil on canvas, 70 × 120 cm/2 ft 3 in × 3 ft 10 in) and now in the National Gallery, London. Following the examples of ▷Hogarth, ▷Devis, ▷Hayman and ▷Philips, Gainsborough developed his own style of portraiture which focused on his Suffolk patrons around Ipswich and Sudbury. Though the posture of the figures is slightly naive in execution, the painting equally balances its portrait and landscape elements. Painted early in his career it shows the influence of Dutch landscape painting and French ▷engraving. The freshly harvested fields possibly signify the couple's recent marriage and the image reveals a quiet confidence and serenity in its sitters.

Bib.: Cormack, M., *The Paintings of Thomas Gainsborough*, Cambridge, 1991

Mucha, Alphonse (1860–1939)

Czech artist. He was born at Ivancise and studied at the ▷Académie Julian and the Académie Colarossi in Paris. His decorative posters and paintings were an important expression of the late 19th-century fashion for ▷Art Nouveau. He achieved success through his theatre designs for ▷Sarah Bernhardt, including her *Gismonda* in 1894 at the Théâtre de la Renaissance in Paris, and *La Samaritaine* in 1897. He also designed jewellery for Bernhardt and became a popular designer and illustrator. His colourful, floral designs reflected the elegant lines of Japanese woodcuts and geometric decoration, curves and ▷arabesques were influenced by ▷Islamic and ▷Byzantine art. He also designed carpets, wallpapers and book illustrations, and painted a large cycle of the history of the Slav people.

mudéjar

(From the Arabic, '*mudajján*', 'allowed to remain'.) A style of Spanish decorative arts produced by Christians but in deliberate imitation of ▷Islamic styles. These examples of textiles, ivory and ▷ceramics were popular from the 12th to the 15th centuries when Spain and Portugal were being recovered by Christian

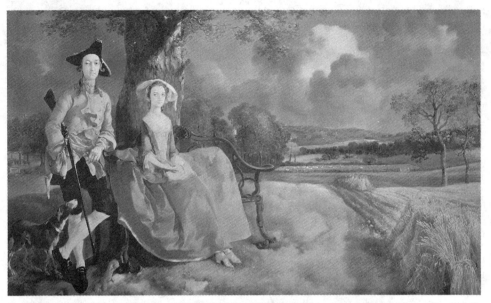

Thomas Gainsborough, *Mr. and Mrs. Andrews*, c1748–50, National Gallery, London

monarchs from the Moors. It is likely that many of these works were produced by Muslim artists working for Christian patrons.

Mueller, Otto (1874–1930)

German painter and graphic artist. He was born in Liebau, in Silesia. After studying ▷lithography (1890–94), he attended Dresden Academy (1894–6) and Munich (1898–9), before settling in Berlin in 1908,

Alphonse Mucha in his Studio, c1901

where he became a friend of ▷Lehmbruck. He was a member of ▷Die Brücke in 1910, and helped to found the New ▷Secession. In 1912 he visited Bohemia with ▷Kirchner. His work had little of the colour interest of Die Brücke and employed a harsh angularity (e.g. *Three Nudes in a Forest*, 1911, Hanover). After military service, he became Professor of Art at Breslau. He was fond of gypsy scenes, often repeating his subject matter in calm, harmonious images (e.g. *Gypsies with Sunflowers*, 1927, Saarbrucken). His use of ▷tempera created a denseness, increased by the sombre palette he adopted during the 1920s. He also had a enthusiasm for Egyptian art.
Bib.: von Luttichau, M.A., *Otto Mueller, ein Romantiker unter den Expressionisten*, Cologne, 1993

Mughal art

The art of the Muslim courts in India from the 16th century to the time of the Indian Mutiny and the deposition of the last Mughal emperor in 1858.

mullion

One of the vertical members dividing the lights of a window, or other opening.

Mulready, William (1786–1866)

Irish painter. He was born in Ennis, the son of a leather worker. After studying in Dublin he moved to London where he became a pupil of ▷Varley, whose sister he married, and a friend of ▷Linnell. He produced a number of landscapes, characterized by a harsh realism and brown palette, removed from the ▷picturesque expectations of the day. By 1809 he had begun to

produce the ▷genre scenes for which he became famous, working in a ▷Wilkiesque style (e.g. *Fight Interrupted*, 1816, London, Victoria and Albert Museum), which also revealed an interest in 17th-century Dutch painting. During the 1820s his palette became brighter and he began to work with a white ground (later made famous by the ▷Pre-Raphaelites) (e.g. *Crossing the Ford*, 1842, London, Tate Gallery). He was a good technician and draughtsman. His later work was highly popular, setting the trend for much Victorian ▷genre, with it emphasis on children, rustic courting and picturesque detail (e.g. *Sonnet*, 1839, London, Victoria and Albert Museum).

Bib.: Heleniak, K.M., *William Mulready*, London, 1980; *William Mulready*, exh. cat., London, 1986

multiples

While ▷prints and casts of sculpture are multiples in one sense, the term is generally taken as describing an artefact produced in unlimited numbers without necessary recourse to an artist's prototype. ▷Pop art's interest in consumerism made the idea of repetition a key concept in the work of ▷Andy Warhol, who often did little other than oversee the production of his ▷silk-screen prints. Thus a multiple is the opposite of the limited-edition fine art print, where the limited number of examples helps to boost their value. The true multiple is analogous to a consumer article – an industrially produced fashion accessory, disposable, freely available and antagonistic to the notion of 'fine' art.

Multscher, Hans (c1400–before 1467)

German sculptor. He worked in the Netherlandish style of ▷Sluter, and like Sluter, produced realist religious sculpture. He was based in Ulm. He was responsible for both the painting and sculpture on the high altar for the church at Sterzing in the Tyrol (1456–8).

Munch, Edvard (1863–1944)

Norwegian painter and graphic artist. His whole life was dominated by his tragic childhood, which saw the death of his sister and mother, and his own poor health. From 1881 he studied at Oslo School of Design and in 1889 travelled to Paris on a scholarship. There he studied under ▷Bonnat and discovered the palette and technique of ▷Impressionism (e.g. *Rue Lafayette*, 1891, Oslo). During the 1890s he was involved with the ▷avant-garde movement in Berlin, where he exhibited in 1892. He led an increasingly bohemian lifestyle, which included a tragic affair with Tula Larsen, and friendships with the playwrights Ibsen and Strindberg (see Munch's portrait of Strindberg, 1895, Stockholm). He also worked on his first ▷etchings and ▷lithographs and his *Frieze of Life* series, which was first exhibited complete in Berlin (1902) and included some of his most famous works (e.g. ▷*The*

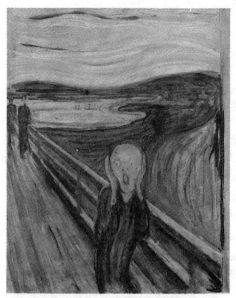

Edvard Munch, *The Scream*, 1893, Nasjonalgalleriet, Oslo

Scream, 1893, Nasjonalgalleriet Oslo; *Jealousy*, 1897, Bergen). In these he adopted his characteristic style of flattened colour patches, swirling line and repetitive symbolic images. He also regularly sketched from nature, spending his summers at Asgardstrand. In 1908 he suffered a mental breakdown and went to Denmark for treatment with Dr. Jacobsen. His work after this was increasingly ▷Expressionist, using angular lines and exaggeration (e.g. *Galloping Horse*, 1912, Oslo). He also worked on murals for Oslo University (e.g. *Sun*, 1909–11). He continued to paint until the end of his life, but without the obsessive qualities of his early work.

Bib.: *Edvard Munch: Frieze of Life*, exh. cat., London, 1992; Eggum, A., *Edvard Munch: Paintings, Sketches and Studies*, London, 1984; Heller, R., *Edvard Munch: Life and Works*, London, 1984

Munkácsy, Mihály von (1844–1900)

Hungarian painter. He lived in Paris from 1872, after winning a gold medal from the Paris ▷Salon for his *The Last Day of a Condemned Man* (1870, Budapest, National Gallery). He painted both ▷genre and landscape work and followed the style of ▷Courbet, rejecting the light experiments of the ▷Impressionists.

Munnings, Sir Alfred (1878–1959)

English painter. He brought the traditions of sporting art and horse portraiture into the 20th century and earned himself the accolade of President of the ▷Royal Academy (1944–9). He was vehemently opposed to ▷modernism and maintained the traditional profile of the Royal Academy immediately after the Second World War.

Münter, Gabriele (1877–1962)

German artist. She was born in Berlin and attended the Women's Academy in Düsseldorf (1897). She also studied at the ▷Phalanx school, where she met ▷Kandinsky and travelled with him throughout Europe during 1903–8. Together they purchased a house in Murnau in 1908, where they formed a small circle of Munich-based artists, many with Russian roots, such as ▷Jawlensky and ▷Werefkin. She helped found the ▷Neue Künstlervereinigung and was a member of the ▷Blaue Reiter. She painted a number of portraits in a Fauvist style, as well as distinctive still lifes based on a collection of ▷folk art objects she had amassed for her Murnau home. From 1914–20 she settled in Scandinavia, and she broke with Kandinsky in 1916.
Bib.: Hoberg, A. and Friedel, H., *Gabriele Münter 1877–1962: Retrospektive*, Munich, 1992

mural

Any wall-painting, either applied directly to the surface of the wall, as in a ▷fresco, or painted onto a permanently fixed panel.

Murillo, Bartolomé Esteban (1617/18–82)

Spanish painter. He was active chiefly in Seville. After Velázquez's departure for Madrid in 1632, he was, with ▷Zurbarán, the leading painter in Seville and continued to be regarded by many critics as one of the greatest painters of all time until the early 20th century when the sentimental nature of much of his work (which had hitherto been his greatest attraction) was the cause of his fall from favour. In recent years, however, his paintings have been reassessed and his position as a supreme draughtsman and painter of great technical accomplishment has, to some extent, been regained.

Although the first part of Murillo's career is poorly documented, his early work reveals a debt to the realism of the older Zurbarán whose contemporary fame he ultimately eclipsed following the success of his series of 11 paintings of the lives of Franciscan saints for a monastery in Seville (1645–6, now dispersed throughout numerous collections in Spain and elsewhere). The main body of Murillo's paintings is religious subjects adhering closely to the prescripts of ▷Counter-Reformation doctrine. A favourite theme was the ▷Immaculate Conception (examples in Madrid, Prado). His mature style, dating from the 1660s and termed *estilo vaporoso* ('vaporous style'), is characterized by a more ▷painterly approach with softened forms and rich colouring. This change was possibly the result of seeing the works of such masters as ▷Rubens, ▷Van Dyck, ▷Titian and ▷Barocci, all of whom were represented in the royal collections in Madrid, a city which he visited certainly in 1658 (and possibly on earlier occasions). Among the greatest works of this period are six that form part of a now dispersed series for the Hospital of the Brotherhood of

Charity (the *Caridad*) known as the *Acts of Mercy* (1667–70; e.g. *Return of the Prodigal Son*, Washington, DC, National Gallery; *Christ Healing the Paralytic at the Pool of Bethesda*, London, National Gallery). Also contemporary are the ▷genre paintings of pretty beggar boys and girls in tattered clothes which, although once among his most popular works, are today, with their cloying sentimentalization of an appalling social condition, among the most problematic. They are nonetheless brilliantly executed (e.g. *Young Boys Playing Dice*, c1665–75, Munich, Alte Pinakothek) and apparently painted from a genuine and innocent affection for children. Murillo was also an accomplished portraitist and his love for his own children is suggested in the prominent dedication to them in his *Self-portrait* (c1670–72, London, National Gallery). In 1660, he was, with ▷Valdés Leal and ▷Francisco Herrera the younger, a founder and the first president of the Seville Academy of Painting. He eventually died from injuries sustained in a fall from his scaffolding. His influence on Sevillian painting endured until the 19th century.
Bib.: *Bartolomé Esteban Murillo*, exh. cat., London, 1982; Brown, J., *The Golden Age of Painting in Spain*, New Haven and London, 1991; Gaya Nuno, J.A., *L'Oeuvre point de Murillo*, Paris, 1980; Taggard, M.N., *Murillo's Allegories of Salvation and Triumph*, Columbia, 1992

muse

A goddess of creative inspiration, one of the nine attendants of ▷Apollo in his guise as patron of arts and sciences, residing on Mount Parnassus. They were the daughters of Zeus (▷Jupiter) and Mnemosene, the goddess of memory. Each of the nine muses is named and has a specific sphere of influence, although many of the attributes are associated with more than one muse and the remainder have been subject to change over time:

(i) Calliope: the muse of epic or heroic poetry, her attributes being a laurel crown, a trumpet, a writing stylus and wax tablet.

(ii) Clio: the muse of history, she usually wears a laurel crown, and carries a trumpet, a writing stylus with book, scroll, or wax tablet; she is sometimes accompanied by a swan.

(iii) Erato: the muse of erotic poetry, she holds a musical instrument, most commonly a lyre, sometimes a tambourine, more rarely a triangle or viol; she is sometimes accompanied by a swan.

(iv) Euterpe: the muse of Dionysiac music and lyric poetry, her musical instrument is usually a flute (she was believed to have invented the double flute), sometimes pipes, less often a trumpet, and she may be crowned with flowers.

(v) Melpomene: the muse of tragedy, her musical instrument is the horn (for its doleful sound) and nearby may be tragic masks and other stage properties such as a crown, a sceptre, a sword or a dagger.

(vi) Polyhymnia: the muse of heroic hymns, whose musical instrument is usually a portative organ, but sometimes a lute or other instrument.

(vii) Terpsichore: the muse of dancing and song, her attribute may be a stringed instrument such as a viol, harp, or lyre etc.; she may also be crowned with flowers.

(viii) Thalia: the muse of comedy and pastoral poetry, her musical instrument may be a viol and she may carry a scroll or shepherd's crook; comic masks may lie nearby.

(ix) Urania: the muse of astronomy, who holds a pair of compasses and a celestial globe and may be crowned with a circle of stars.

Musée Imaginaire

(French, 'imaginary museum'.) Term coined by André Malraux to describe the illustrations and reproductions of works of art which make art available to almost everyone (e.g. postcards and the use of famous works of art in advertising).

museology

The study of museums and art galleries, and the development of theories about them, their contents, their visitors and the means by which they present works of art.
Bib.: Vergo, P. (ed.), *The New Museology*, London, 1989

Museum of Modern Art, New York

Founded in 1929 by five collectors, Miss Lillie Bliss, Mrs. J.D. Rockefeller, Mrs. Cornelius Sullivan, A. Conger Goodyear and Frank Crowninshield, the museum's purpose was 'to help people enjoy, understand and use the visual arts of our time'. The museum now houses over 20,000 works of art, in five departments – photography, industrial design, prints and drawings, painting and sculpture. It is based on West 53rd Street, New York, in a building by Philip Goodwin and Edward Durrell Stone, which opened in 1939. Artists featured in the collection include: ▷Rousseau, ▷Monet, ▷Cézanne, ▷van Gogh, ▷Matisse, ▷Rouault, ▷Modigliani, ▷Chagall, ▷Klee, ▷Hopper, ▷Dali, ▷Diego Rivera, ▷Mondrian, ▷de Kooning and ▷Pollock. ▷Picasso's ▷*Demoiselles d'Avignon* is also found here. Sculptors represented in the collection include ▷Brancusi, ▷Giacometti and ▷Calder. Photographers include ▷Stieglitz, ▷Man Ray and Dorothea Lange.

Muybridge, Eadweard (1830–1904)

American photographer of British birth. He emigrated to the United States as a young man. While surveying the Pacific Coast as Director of Photographic Surveys for the US Government in 1872 he was asked by Leland Stanford to photograph a race horse in motion. Using a sequence of cameras and trip wires he was able to produce a revolutionary series of images of a horse galloping. These were published in *The Horse in Motion* (1878), and were followed by hundreds of further studies of human and animal locomotion, published in 11 volumes entitled *Animal Locomotion* (1887). His invention of the zoopraxiscope, which allowed his images to be projected in rapid succession, was a significant innovation on the road to cinematography. His images have been used by or influenced numerous artists, including ▷Thomas Eakins, the ▷Futurists and ▷Francis Bacon.

Mycenaean art

Term referring to the late Bronze Age culture of the Greek mainland in the 2nd millennium BC (c1580 BC to c1100 BC). It takes its name from Mycenae, the principal city of Mycenaean civilization, excavated by Heinrich Schliemann in the 1870s. Mycenaean culture was heavily influenced by that of the ▷Minoan civilization of Crete which it had in turn superseded in c1400 BC, extending its own cultural influence throughout the Aegean. Characteristic architectural forms include: the megaron, a square or rectangular hall with a hearth in the centre and lateral walls which project beyond the entrance wall to form a porch of columns in antis, believed to be the ancestor of the ▷Doric temple; the tholos or beehive tomb, the finest example of which is the 'Treasury of Atreus' (c1360 BC); the cyclopean walls which surrounded Mycenaean fortified palaces (e.g. Mycenae and Tiryns, c1250 BC, the former of which had the celebrated 'Lion Gate', surmounted by high ▷relief carvings of confronted lions); and the fortified ▷acropolis, a raised citadel containing the civil and religious centre, also characteristic of later Greek cities.
Bib.: Higgins, R.A., *Minoan and Mycenaean Art*, rev. edn., London, 1981

Myron (fl c480–445 BC)

One of the leading Greek sculptors of mid-5th century BC Athens. ▷Pliny writes that he was, like his famous contemporaries ▷Phidias and ▷Polyclitus, a pupil of Ageladas of Argos. None of his original sculptures survives, but Roman copies of two of them have been identified from detailed contemporary descriptions. Several marble copies of ▷Myron's bronze ▷*Discobolus* (the best of which is in the Museo delle Terme, Rome) have been identified from Lucian's detailed description in his *Eikones*, 4. Copies of the two figures from his group, *Athena* and *Marsyas*, once located on the Athenian Acropolis, can be identified from Pliny's description and a later ▷red-figure vase painting (Berlin, Staatliche Museen, cat. 2418) which borrowed the composition. (The marble *Athena* is now in the Frankfurt Städtgalerie and the marble *Marsyas* in the Lateran Museum, Rome.) There are, however, no copies of Myron's most celebrated sculpture, a bronze cow, which once stood on the Acropolis and was so realistic that it was apparently often mistaken for real.

This pioneering realism is the quality for which ancient writers praised him. Both the *Discobolus* and the *Marsyas* show him experimenting with sculpture which is capable of expressing arrested movement whilst still retaining a harmonious balance: the discus thrower bends and twists forward, his right foot taking his weight, the toes of his left foot flexed against the ground as he prepares to launch the discus; *Marsyas* starts back in amazement, his right heel raised, his weight on his left foot, as he prepares to move forward again to pick up the pipes discarded by *Athena*. Myron is also reputed to have executed a statue of a runner, *Ladas*, whom he portrayed on tip-toe with his leg muscles taut.

Bib.: Boardman, J., *Greek Sculpture: The Classical Period*, London, 1985; Robertson, M., *A History of Greek Art*, 2 vols, Cambridge, 1975

Mystery and Melancholy of a Street, The

Painting by ▷ Giorgio de Chirico from 1914, his most imaginative period that followed his arrival in Paris from Florence and Munich, where he had trained. A young girl chases a hoop across a deserted piazza and into the dark shadow of an enormous building which conceals a carriage. The shadow of a figure looms from behind this building. The picture combines de Chirico's fascination with Italian Classical architecture and deep perspective with a ▷ modernist theme of brooding melancholy and anxiety. A contemporary reviewer in the magazine *Lacerba* wrote of these Parisian paintings that 'through almost infinite rows of arcades and façades, large straight lines, overgrown masses of simple colours, almost funeral-like light and dark spaces, he expresses the feeling of vastness, solitude, immobility, stagnation, awakened by the remembrance of certain scenes in our almost-dormant soul'. De Chirico himself has written that 'there is much more mystery in a "fossilized" village square in the afternoon sunlight than in a darkened room, in the dead of night'. This painting is exemplary of the phase of his painting that expressed the philosophical ideas of Nietzsche and Schopenhauer and the fantastic imagery of ▷ Klinger and ▷ Böcklin. It was also this period that was so attractive to ▷ Breton and the ▷ Surrealists who claimed de Chirico as a precursor and honorary member of their movement.

Mytens, Daniel (c1590–1647)

Dutch painter. He studied with ▷ Miereveld and went to London in 1618, where he worked for the ▷ Earl of Arundel. While in England, he came to the attention of James I and then Charles I. He became painter to the King until ▷ Van Dyck's arrival in 1632. He returned to The Hague in 1634.

Nabis, Les

A group of artists established in Paris in 1891 and including ▷Denis, ▷Bonnard, ▷Vuillard, Ker-Xavier Roussel and ▷Vallotton. They had met as students, shared studios together and frequented Père Tanguy's. The name, derived from the Hebrew for 'prophet', was invented by the poet, Cazalis. They held their first group exhibition in 1892 at Le Barc de Bouteville Studio and later in 1899 exhibited with the ▷Symbolists, but they had split up by 1900. *La Revue Blanche*, a magazine established in 1891, was the literary mouthpiece of the group. It was edited by Alexandre and Thadée Nathalson and included ▷Fénéon as art critic, with artists like Bonnard contributing illustrations. They also produced designs for the Théâtre de l'Opéra and were strongly influenced by graphic art. The group was influenced by ▷Gauguin's ▷Synthetism in their exploration of two-dimensional pattern and colour, expressed by Denis as the theory of 'two distortions'. Les Nabis also had strong links with ▷Toulouse-Lautrec and ▷Maillol.

Bib.: Boyer, P.E., *The Nabis and the Parisian Avant-Garde*, London, 1988; Chasse, C., *Nabis and their Period*, London, 1969; Fossler, F., *La nébuleuse Nabis*, Paris, 1993; Frèches-Thory, C., *Les Nabis*, Paris, 1990; Mauner, G., *The Nabis: Their History and their Art 1888–1896*, New York, 1978

Nadelman, Elie (1882–1946)

American sculptor of Polish birth. He was born in Warsaw, and studied in Munich and Paris. His pre-war sculpture was abstract, and he later claimed that he had originated abstract sculpture in Europe. In 1914, he travelled to London and then New York, where he gained the patronage of Helena Rubenstein, becoming an American citizen in 1927. In America he was best known for his smooth classicizing portrait busts and figures of dancers and circus performers, which were simplified to the point of abstraction. He worked in many media including ▷bronze, marble and ▷ceramic. His portrait busts of high society personalities were particularly popular. In the 1930s, many of his sculptures were accidentally destroyed.

naive art

Art, particularly painting, produced in technologically advanced societies which uses less sophisticated processes. Naive art from all periods shares common features – colours are usually bright and non-naturalistic and fill all available space, and perspective is rarely employed (e.g. ▷Henri Rousseau's work).

naked

In an art historical context, the term used to denote a representation of an unclothed human figure which had not been idealized.
 ▷nude

Nanni di Banco (Giovanni di Antonio Banco) (fl 1406–21)

Italian sculptor. He was from Florence and worked in marble as one of the pioneers of the transition from late ▷Gothic to ▷Renaissance style. His surviving works are all concentrated on the two principal centres of sculptural activity in Florence at the turn of the 15th century, the Duomo (Cathedral) and Or San Michele (guild hall). He is first recorded in 1406/7 working on the Porta della Mandorla (north door) of the Duomo with his father, Antonio Banco. In 1408 Nanni was awarded the commission for a standing figure of Isaiah for one of the ▷buttresses of the tribune, near the north door, its companion, David, going a month later, to ▷Donatello. From this time onwards Nanni and Donatello shared the most important commissions, being the two foremost sculptors of their generation working in stone or marble. At the end of 1408, Nanni was commissioned to produce a seated St. Luke (now Florence, Museo del Opera) for the façade. (Donatello produced a seated St. John.) At about the same time Nanni received his commissions for the niches of Or San Michele: St. Eligius, St. Philip, and the *Quattro Santi Coronati (Four Crowned Saints)*. From 1414 onwards he was working on the tympanum relief of the *Assumption of the Virgin* for the Porta della Mandorla. The dates of the Or San Michele sculptures are not known, but what seems clear is that far from evincing a 'progression' from Gothic to Renaissance (i.e. showing an ever-increasing degree of inspiration drawn from the works of ▷antique Rome), Nanni's sculpture was to a degree adapted to suit the context: the solid, Classicizing *Quattro Santi Coronati* are clearly derived from Roman senatorial types, whereas the Virgin in the *Assumption of the Virgin* of a later date is conceived in terms of ▷calligraphic line, suiting the pre-existing Gothic ▷portal. What perhaps can be said, however, is that Nanni's understanding of the antique matured from piecemeal use (only the head of the St. Luke is classicizing) towards the more thorough absorption of the *Quattro Santi Coronati*.

Nanteuil, Robert (1623–78)

French engraver. He specialized in engraved portraits both of his own origination and reproductive of the work of other artists such as ▷Champaigne. He engraved portraits of Mazarin, Louis XIV, Colbert and other court dignitaries. In 1658 he was appointed royal draughtsman by Louis XIV.

naos

(Greek, 'house'.) The section of ancient Greek temples that contained the sculpture of the god; thus the most holy place. Adapted from this classical usage, the term also refers to the sanctuary in ▷Byzantine churches.

Naples, School of

Naples was the major Mediterranean port of the early 17th century, and its population swelled from 300,000 in 1600 to 450,000 in 1647, making it the largest city in Southern Europe. It was also the capital of the Kingdom of the Two Sicilies, ruled by the King of Spain. Its importance as a centre for painting dates from two visits by ▷Caravaggio (1606–7 and 1609–10) and the paintings *The Flagellation* and *The Seven Acts of Mercy* which he executed there. Their dramatic realism, ▷chiaroscuro and deep spirituality struck a powerful chord with the artists of a city notorious for its lawlessness but paradoxically also a centre of the ▷Counter-Reformation. A local school developed, encouraged by the patronage of a series of Spanish viceroys and wealthy merchants. The dominant artist of the first half of the century was ▷Ribera. Arriving in 1616, he was born in Valencia and closely associated with the ruling powers. With fellow artists Belisario Corenzio and Battistello Carciolo he developed a ▷tenebrist style influenced by Caravaggio. These three drove away or terrorized any serious rivals, including ▷Reni and ▷Domenichino who had both been commissioned to paint frescos in the cathedral. ▷Artemisia Gentileschi settled in Naples in 1630, and ▷Salvator Rosa and François Nome produced proto-▷Romantic images of the grotesque and haunting, fantastical landscapes.

The apotheosis of Naples was brought to an end in 1647 as the plague spread through the overcrowded streets, claiming an estimated 250,000 lives. At the same time Neapolitan taste was changing. ▷Massimo Stanzioni's paintings of the early 1640s had already suggested a move towards a more reserved ▷Classicism, and in the wake of the plague's devastation, violent realism gave way to the softer and more reassuring ▷Baroque. In the latter part of the century, major artists such as ▷Mattia Preti, ▷Luca Giordano and ▷Francesco Solimena painted in an airy, fluid style with glowing Venetian-influenced colours.
Bib.: Whitfield, C. and Martineau, J. (ed.), *Painting in Naples 1606–1705: From Caravaggio to Giordano*, New York, 1982

Narcissus

A beautiful youth in Greek legend whose story is retold in Ovid's *Metamorphoses*. Ovid relates that Narcissus was so beautiful that not only young women but also other youths fell in love with him. One day he was spotted by the nymph Echo, who also instantly fell under the spell of his beauty. Echo had been given a speech impediment by ▷Juno: she could not initiate a conversation but only repeat the last word that another spoke to her. (This was as punishment for Echo's ruse of endlessly chatting with Juno in order to detain her whilst ▷Jupiter conducted his extra-marital affairs.) Echo who, like all suitors before her, was rejected by Narcissus, withered away so that finally only her voice remained. Another rejected suitor called down revenge on Narcissus' head. Thus, Nemesis, the goddess of retribution, condemned Narcissus to fall in love with his own reflection as it appeared to him in a pool until he too died of unrequited love. When his relatives came to take away his dead body, they found only a small yellow and white flower, ever since known as the narcissus. Narcissus may be shown alone and gazing lovingly into the pool (e.g. Follower of ▷Leonardo, *Narcissus*; London, National Gallery), or perhaps lying dead or dying as Echo fades away behind him, and narcissi blossom around his head (e.g. ▷Poussin, *Echo and Narcissus*, c1628/30, Paris, Louvre).

Narkompros

The familiar title of *Narodnyi Kommisariat po Prosveshcheniyu* ('People's Commissariat of Enlightenment'). Headed by Anatoly Lunacharsky it provided a centralized authority for the management of every aesthetic and intellectual activity in the Soviet Union. The Department of Visual Arts (*Otdel Izobrazitel'nykh Iskusstv*, or IZO) was founded in January 1918 with jurisdiction over painting, sculpture and architecture.
Bib.: Fitzpatrick, S., *The Commissariat of Enlightenment*, Cambridge, 1970

narrative painting

The genre of painting which tells a story. Narrative painting has always been popular, as one of the prime functions of painting is to set a scene and tell a story. For example, cave paintings are thought to depict special hunts and Egyptian tomb painting tells the story of the deceased. There are three main sources of narrative for western narrative paintings: religious stories, Classical mythology and folk tales. Good examples of Christian narrative painting include ▷Giotto's ▷Arena Chapel frescos, Padua, and later canvases like those of ▷Géricault and ▷Ingres. The ▷Pre-Raphaelites specialized in narrative painting and placed emphasis on each detail in the image to create a sense of the whole story.

narthex

A transverse ▷vestibule across the western end of some ▷Early Christian and ▷Byzantine churches. It may be either one of two types: an inner, or esonarthex, between the façade and the nave and aisles and divided from them by a wall, columns, or railing; or an outer, or exonarthex, preceding the ▷façade as an attached portico. More than just a vestibule, the narthex was used as a place of worship for catechumens and penitents, i.e. those not yet admitted to, or temporarily not in, full communion.

Nash, Paul (1889–1946)

British painter. He was born in London and educated at Chelsea Polytechnic (1906) and at the ▷Slade (1910). His early graphic work was inspired by ▷Rossetti (he also produced poetry) but in 1913 he became a member of the ▷NEAC and of the ▷London Group and in the same year met ▷Fry. He assisted Fry in the ▷Mantegna restoration at Hampton Court and joined the ▷Omega Workshops in 1914. After serving briefly in France, he recorded his experiences in a number of works (e.g. *Menin Road*, 1918–19, London, Imperial War Museum). He learned ▷lithography from ▷Nevinson and continued his graphic interests in the 1920s (e.g. *Genesis*, wood engravings, 1924). He also visited Paris in 1924 and 1930 and came into contact with contemporary French art: an initial interest in geometric ▷Cubism became increasingly abstracted (e.g. *Northern Adventure*, 1929–41, Aberdeen). During the 1930s he developed a ▷Surrealist style, joined ▷Unit One, and organized the Surrealist Exhibition in 1936 (e.g. *Monster Field*, 1939, Dublin). He worked in landscape, developing a romantic, lyrical style. He was an official artist during the Second World War, working for the Air Ministry (e.g. *Totes Meer*, 1940–41, London, Tate). He had a retrospective at the ▷Biennale in 1940.
Bib.: Eates, M., *Paul Nash: Master of Image*, London, 1973; King, J., *Interior Landscape: The Life of Paul Nash*, London, 1987; *Paul Nash*, exh. cat., Newcastle, 1971; *Paul Nash*, exh. cat., London, 1975

Nasmyth, Alexander (1758–1840) and Patrick (1787–1831)

Scottish family of painters. Alexander studied with ▷Allan Ramsay. He worked in Edinburgh as a portrait painter from 1778, but his primary specialism was landscapes, including topographical scenes. He visited Italy in 1782–5, where he was impressed by ancient art there. He was also known for his theatrical set designs.

Alexander's son Patrick was also a landscape painter, but he based his works on Dutch realist landscapes. This style earned him the nickname 'the English ▷Hobbema'. In 1810 he settled in London.
Bib.: Johnson, P., *The Nasmyth Family of Painters*, Leigh-on-Sea, 1977

National Academy of Design

An art training school founded in New York City in 1825. It was formed in opposition to the American Academy of Fine Arts, which many artists found unduly restrictive to artistic training and too dominated by business interests, rather than the ideals of ▷fine art. It was first called the Society for the Improvement of Drawing, but its name was changed to the National Academy of the Arts of Design in 1826 and again to the National Academy of Design in 1828. It contained an antique school and, from 1837, a life class. Women were allowed as students from 1831 – a progressive move for the time. However, by the 1870s, it was considered to be a conservative institution.
Bib.: Clark, E., *History of the National Academy of Design 1825–1953*, New York, 1954

National Gallery, London

British national collection of art, based in Trafalgar Square, London. The move to provide a permanent collection of art to the general public came as early as the 1780s, but it was not until 1824, when John Julius Angerstein offered his collection to the nation that the National Gallery was officially founded. Angerstein's collection had been open to the public at his house at 100 Pall Mall, but this was too small to house a whole national gallery and in 1837 William IV opened the building designed by William Wilkins in Trafalgar Square. However, even this space proved inadequate almost immediately and Charles Barry designed extensions, completed in 1876. At first the gallery was open to the public on three days a week and students for two days a week, but it was soon too popular for this arrangement and was opened to the public every day. The second director of the gallery was ▷Sir Charles Eastlake whose ebullient, if controversial, leadership led to the purchase of many unfashionable early and middle ▷Renaissance pictures, which now form the basis of the Sainsbury wing collection, designed by Venturi Scott Brown and opened in 1991. Bequests added to the collection and as the government became persuaded that the National Gallery was a viable and useful institution it gained standing on the European stage. Artists represented in the collection include ▷Giotto, ▷Duccio, ▷Rubens, ▷Canaletto, ▷Hogarth, ▷Botticelli, ▷Bellini, ▷Mantegna, ▷Leonardo, ▷van Eyck, ▷Velázquez, ▷Rembrandt, ▷Stubbs, ▷Gainsborough, ▷Turner, ▷Constable, ▷Renoir and ▷van Gogh.

National Gallery, Washington, DC

One of the youngest state museums in the world. The Washington Museum opened in 1836, and was chiefly an anthropological collection. It merged with The National Institute in 1840, and was subsequently taken over by the ▷Smithsonian Institution in 1862, meaning that the collection moved towards painting and the fine arts. The collection grew dramatically and

was in need of larger premises in 1936 when ▷Andrew Mellon offered his collection to the nation. He decided to build a new gallery, designed as a ▷Neoclassical edifice by John Russell Pope, which opened as the National Gallery in 1937. Today's holdings are based around four collections: the Mellon, Kress, Widener and Dale Collections. They include works by ▷Duccio (including panels from the ▷Maestà, ▷Botticelli, ▷Bellini, ▷Raphael, ▷Titian, ▷van Eyck, ▷van der Weyden, ▷Memlinc, ▷Hals, ▷Rembrandt, ▷Holbein, ▷Gaddi, ▷Perugino, ▷Carpaccio, ▷El Greco, ▷Velázquez, ▷Goya, ▷Caneletto, ▷Veronese, ▷Tiepolo, ▷Poussin, ▷Claude, ▷Fragonard, ▷Watteau, ▷Delacroix, ▷Ingres, ▷Monet, ▷Manet, ▷Renoir, ▷Degas, ▷Gauguin, ▷Braque, ▷Dufy, ▷Whistler and ▷Eakins. An extension, funded by Paul Mellon and Ailsa Mellon Bruce, was designed by ▷I.M. Pei.

National Portrait Gallery, London

The British national collection of portraiture. Philip Stanhope, 5th Earl Stanhope, founded the gallery, one of the first of its kind, in 1856. The pictures, which were taken from the ▷National Gallery collections and other sources, were chosen for the merit of the sitter rather than the merit of the artist, and therefore accomplished paintings by court painters such as ▷Holbein hang next to more personal and less artistically meritorious works. Recent extensions have created spaces for temporary exhibitions and displays of portraits of living subjects. There are affiliated galleries at Montacute House, Somerset; Beningbrough Hall, Yorkshire; Gawthorpe Hall, Lancashire, and Bodelwyddan Castle, Wales, as well as the National Portrait Gallery of Scotland, Edinburgh.

Native American art

▷North American Indian art

Nativity

(Matthew 2: 1–12; Luke 2: 1–20) This refers to the birth of ▷Christ. Only ▷Matthew and Luke describe the circumstances of Christ's birth. Both accounts are extremely brief and differ greatly. Luke says that ▷Joseph and the heavily pregnant Mary (▷Virgin) had to travel to Bethlehem to be taxed, but that they arrived so late at night that the inn was full and they had to take shelter in a stable. It was there that Christ was born in a manger and where he was visited by the shepherds. Matthew picks up the story at the point where the Magi arrive in Bethlehem and find the ▷Holy Family in a house. The bald details of this fundamentally important Christian subject became increasingly elaborated until, by the Middle Ages, the scene of the Nativity had become endowed with a rich and symbolic iconography, reflecting both typological and prefigurative requirements.

The ox and ass first appear in the 8th-century apocryphal Gospel of Pseudo-Matthew. Their inclusion (sometimes kneeling before the crib) refers to the prophecy in ▷Isaiah (1:3): 'The ox knoweth his owner, and the ass his master's crib: but Israel doth not know, my people doth not consider.' This verse was taken to mean that even the humblest animals would recognize that Christ was the Saviour, but that the Jews would reject him (e.g. ▷Gerard David, centre panel of Nativity with Donors and Patron Saints, New York, Metropolitan Museum). A sheaf of wheat lying on the ground near the manger symbolizes the Eucharistic bread and refers to Christ's future sacrifice (e.g. ▷Hugo van der Goes, c1480, Berlin, Staatliche Museen Preußischer Kulturbesitz, Gemäldegalerie).

From the late 14th century, following the publication of St. Bridget of Sweden's Revelations, the ▷Virgin is frequently represented, especially in northern European art, kneeling at prayer before Christ in allusion to Bridget's vision of Mary giving painless birth to Christ in just such an attitude (e.g. van der Goes and Gerard David, above). A theme which originated in the apocryphal Book of James and which appeared frequently in ▷Byzantine and sometimes in western European art is that of the two midwives. One doubted the virgin birth and demanded proof. On touching Mary her hand shrivelled, but on picking up the Christ child it healed again (e.g. ▷Master of Flémalle, c1420, Dijon, Musée des Beaux-Arts). This theme disappeared entirely following its condemnation at the Council of Trent.

▷Adoration of the Magi; Adoration of the Shepherds

Nattier, Jean-Marc (1685–1766)

French painter. He was best known for his mythological and ▷allegorical portraits of court women. He was appointed artist to the daughters of Louis XV, and his delicate portraits were perceived to be particularly appropriate for the representation of genteel women at the time. In 1717 he went to Amsterdam to paint Catherine I of Russia (St. Petersburg, Hermitage).

naturalism

In art, the term describes the attempt to imitate the appearance of the everyday world without the intervention of preconceived ideas or conventions. While much recent thinking has shown this 'innocent-eye' approach to be itself conventionalized and open to the play of the imagination or the intellect, naturalism has formed part of the occidental way of seeing since the ▷Renaissance, witness ▷Alberti's opening remarks in his treatise of painting, Della Pittura (1436), where he asserts that it is the artist's business to copy nature.

Alberti's ideal became central to naturalism, and by the 17th century was commonplace if not universally accepted. Naturalism is not, however, incompatible with notions of ▷idealism: academic theorists argued that the most naturalistic art has been produced by the

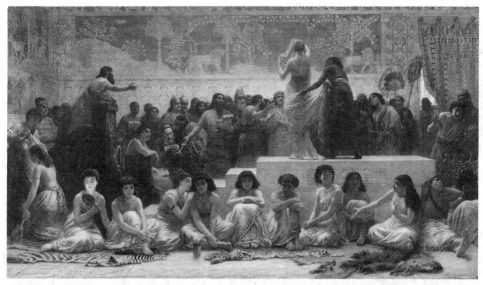

Naturalism: *The Marriage Market, Babylon,* a detailed Pre-Raphaelite work by Edwin Long, mid-19th century, Royal Holloway and Bedford New College

artists of ancient Greece (▷Greek art; ▷Classicism) who had been close to 'true' nature by being anatomically correct and showing the limitless potential of the human spirit. By the 19th century, however, naturalism had taken on its current meaning of referring to art that is both representational, and associated, by analogy, with the empirical procedures of science. Thus naturalism refers to the rendering of appearances through minute observation of the natural world, as in the work of the ▷Impressionists.

Bib.: Dvořák, M., *Idealism and Naturalism in Gothic Art*, Eng. trans., Notre Dame, 1967; Gombrich, E.H., *Art and Illusion*, 5th edn., London, 1977; Huizinga, J., *The Waning of the Middle Ages: A Study of the Forms of Life, Thought and Art in France and the Netherlands in the Fourteenth and Fifteenth Centuries*, Eng. trans., London, 1976

nature

Along with 'realistic', this is one of the most difficult terms for an art historian, since its art-inclined meaning differs radically from, and is much more specific than, its everyday use. By 'nature' we tend today to mean birds and flowers, mountains and streams, and we sometimes consider that presenting this (beautiful) external world is 'representing nature', and therefore a true aim of the artist. Theoreticians and artists since ancient Greece have had other ideas.

As an 18th-century ▷Royal Academy lecture had it, nature means, 'the general and permanent principles of visible objects, not disfigured by accident or distempered by disease, not modified by fashion or local habits. Nature is a collective idea, and, though its

essence exists in each individual of the species, can never in its perfection inhabit a single object.' In other words, the 'nature' we see around us, in our friends or the birds or mountains, is for the theorists essentially flawed (although Alexander Pope believed that, 'All nature is but art, unknown to thee,') and the task of the artist is to use knowledge and skill to distil true nature from what he or she observes. This requires both selection and combination – as shown in the well-known story of the Greek painter ▷Zeuxis (active in the latter 5th century BC), who needed a host of beautiful girls from Croton to help construct his picture of Helen of Troy. Clearly, choosing just one girl (with all her faults, as it were) would not serve to construct nature, which is an idea, not an observable reality.

From this special meaning of 'nature' the interest of artists and teachers in the ▷antique becomes clear: ancient art had followed this refining process and produced works difficult to surpass (although the modern side in the ▷Quarrel of the Ancients and Moderns thought differently) so that latter-day artists should learn to do the same by imitating them. What may now appear bald copying was simply considered the easiest way to train an artist to imitate nature itself. In the 18th and 19th centuries, as interest in the ▷antique and in this specific concept of nature declined, so did interest in a more general application rise to prominence, especially in those countries weak in the antique tradition but with strong naturalistic (▷naturalism) and landscape traditions to continue, such as England and the Low Countries.

As in so many aspects of 18th-century art, the ▷Industrial Revolution was crucial in altering attitudes

both to the landscape itself and to ways of representing it in art. Thus the cult of nature as a desire to recreate a wilderness in the tamed environment of a garden or park became a feature of a society that knew less of physical nature (in the sense of the countryside) the more it lived in cities. This kind of 'nature' is the opposite of 'civilization' and it was an important element in the ▷Romantic notion of the pathetic fallacy.

Bib.: Clayre A. (ed.), *Nature and Industrialization*, Oxford, 1977; House, J., *Monet: Nature into Art*, New Haven, 1986; Woodring, C., *Nature into Art: Cultural Transformations in Nineteenth-Century Britain*, Cambridge MA, 1989

nature morte
▷still life

Nauman, Bruce (b 1941)
American artist. He was born in Indiana and studied in Wisconsin and California. Working on the West Coast, he became involved with the ▷funk art movement and developed his own form of ▷body art using photography, hologram and video.

nave
In a general sense, that part of a Christian church west of the ▷crossing; the body of the church intended for the laity. Specifically, it is the middle aisle of a church, flanked by side aisles and divided from them by ▷piers or ▷columns.

Navez, François-Joseph (1787–1869)
Belgian painter. He was in Paris in 1813, where he studied in ▷David's studio. He travelled with David to Berlin and Brussels in the years immediately after the fall of Napoleon. While in Rome in 1817, he saw the works of ▷Ingres and was attracted to the style of ▷Raphael. He painted historical pictures and portraits in a ▷Neoclassical style. In 1821 he was appointed a teacher in the Brussels Academy.

Navicella
(Matthew 14:22–33.) Otherwise known as Christ Walking on the Water. Following the feeding of the 5000, ▷Christ goes up into the hills to pray and sends his disciples on ahead across the Sea of Galilee. At night, whilst the ship is still crossing the by now wind-tossed sea, Christ walks towards it across the water. The disciples at first think they are seeing a ghost, but Christ calls to them. ▷Peter tries to walk across the water towards Christ, loses his nerve, begins to sink, and is caught by Christ who gently rebukes him for his lack of faith. As they both re-enter the ship, the wind ceases. The ship was seen as a symbol of the Church, which protects humanity and leads it to salvation. This connection is made explicit by the name given to the main body of a church, the ▷'nave',

which is Latin for ship. At St. Peter's, Rome, a mosaic of the Navicella by ▷Giotto (replacing an earlier mosaic of the same subject) points to this symbolism, being sited in the ▷narthex preceding the nave over the main entrance.

Nay, Ernst Wilhelm (1902–68)
German painter. He was born in Berlin, and he studied there with Carl Hofer. In 1928 he was in Paris, where he came into contact with the work of ▷Picasso. He travelled to Rome in 1930 and was in Norway in 1936–7, where he was impressed by the work of ▷Munch. While in Norway, he painted landscapes of the fjords in an ▷Expressionist style, but his works became increasingly abstract. By the 1950s, he was painting in a style similar to that of ▷Tachism.

Nazarenes
A group of German artists, established in 1809 in Vienna and properly called the Brotherhood of St. Luke. They included ▷Pforr, ▷Overbeck, Vogel and Hottinger. These artists came to oppose their academic training and turned instead to late 15th-century art, including the work of ▷Dürer (they were later known as Düreristen), ▷Perugino and early ▷Raphael, finding there a simplicity and purity which they felt had been lost. They were influenced by ▷Romantic German writers of the period like ▷Schlegel and Ludwig Tieck, who were also looking to the past. In 1810 the group moved to Rome, converted to Catholicism and took over a disused monastery, Saint' Isodoro. There the lead was taken by ▷Cornelius and they became increasingly interested in Italian styles and tried to revive ▷fresco painting with communal work at the Casa Bartholdy (1816–17, now in Berlin) and the Casino Massino (1827–9). They influenced other artists in Rome, including ▷Ford Madox Brown, who carried their ideas to England. In 1819 Cornelius returned to Munich to teach and continued to spread the group philosophy.

Bib.: Andrews, K., *The Nazarenes: A Brotherhood of German Painters in Rome*, New York, 1964; *Die Nazarener*, exh. cat., Frankfurt, 1977

NEAC
▷New English Art Club

necropolis
Literally, in Greek, a city of the dead, that is, a cemetery, generally either in or near a city.

Neef(f)s, Peeter I (c 1578–1656/61)
Flemish painter. He painted architectural scenes in Antwerp, including many churches which resembled Antwerp Cathedral. His son, Peeter II (1620–after 1675) did exactly the same thing.

Neer, Aert van der (1603/4–77)

Dutch painter. He was a landscapist who worked in the style of ▷Avercamp, producing moonlit views of Amsterdam canals. He also specialized in winter landscapes. In 1658 he opened a wine shop in Amsterdam, but he went bankrupt in 1661.

negative

A photographic plate that contains the reverse of a positive image in terms of both colour and turn. When a negative is transferred to specially prepared paper, it creates a positive photographic image.

Neoclassicism

A term used to describe the 18th-century interest in Greek and Roman civilisation and the culture of rationality and morality associated with that interest. It is linked to the broader term ▷Enlightenment, and both movements were influenced by new archaeological discoveries made at the Classical sites of Herculaneum, ▷Pompeii and Paestum, by the writings of ▷Winckelmann and by the ▷Grand Tour enthusiasm for collecting and ▷connoisseurship. In America (manifested in the person of ▷Thomas Jefferson) and, to a lesser extent, in France the movement had a political side, and in general Neoclassicism was an idealist philosophy which sought to recreate what were perceived as the best cultures in history in the architecture of ▷Adam, ▷Soane and ▷Soufflot, in the sculpture of ▷Flaxman, ▷Canova and ▷Thorvaldsen and in the paintings of ▷Gavin Hamilton, ▷Mengs, and ▷David. The movement was also a reaction against the excesses of ▷Baroque and the prettiness of ▷Rococo, against the religious domination of the ▷Counter-Reformation, and, to a lesser extent, the political monopoly of the *ancien régime* aristocracy. It viewed Classical art as natural (hence the increased importance of landscape, and the integration of architecture with environment) and as perfect both in anatomical proportion and in virtue. Neoclassicists also believed in the importance of rational thought and behaviour, and placed an emphasis on precision, draughtsmanship and symmetry. However, many Neoclassical artists softened this rigid approach to suit contemporary taste, and increasingly scholars began to realize that insufficient evidence of Greek art meant that the whole movement was working under a false premise (▷Elgin Marbles).

The term 'neoclassicism' can also be used very broadly to indicate a revival of ancient styles.

Bib.: Honour, H., *Neoclassicism*, London, 1968; Hope, H.M., *The Theory and Practice of Neoclassicism in English Painting*, New York, 1988, Irwin, D., *English Neoclassical Art, Studies in Inspiration and Taste*, London, 1966

Neo-Dada

A term coined in the late 1950s to describe the work of the proto ▷Pop artists ▷Jasper Johns and ▷Robert Rauschenberg. The term refers to these artists' ▷Dada-like use of non-art motifs and materials, including ▷found objects such as the paint-splattered bedcovers and quilt of Rauschenberg's *Bed* (1955). Neo-Dada anticipated Pop art's interest in popular icons, as in Johns's *Three Flags* (1958), which depicts three superimposed Stars and Stripes.

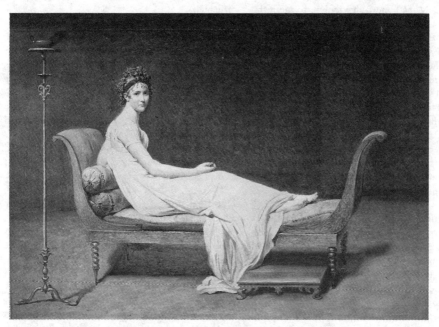

Neoclassicism: Jacques Louis David, *Madame Recamier*, Louvre, Paris

Neo-Expressionism

A label first used in the early 1980s to describe the work of narrative-based ▷Expressionist painters working principally in Germany who reacted against the banalities of ▷Conceptualism and impersonality of ▷Minimalism. Neo-Expressionism saw a return to the traditional concerns of ▷history painting, that is, the representation of narratives through the format of easel-painting. Anselm Kiefer, for example, treated his country's recent past in *To the Unknown Painter* (1983), a commentary on the tragedy of the Nazi period, while ▷Georg Baselitz seems to comment on the human condition in figurative paintings in which people are represented upside down. Rejecting the purist concerns of high ▷modernism, Neo-Expressionism contributed to the development of a new agenda which is in part (but only in part) represented by ▷postmodernism. Leading Neo-Expressionists include ▷Francesco Clemente, ▷Jorg Immendorf, A.R. Peck and Julian Schnabel.

Neo-Impressionism

A term first used by the critic ▷Fénéon in 1886, to distinguish the Classical and scientific interests of ▷Seurat from the naturalism of the ▷Impressionists. It became associated with the Société des Artistes Indépendants (▷Salon des Indépendants), established in 1884 by Seurat and ▷Signac, which influenced ▷Pissarro, ▷Toulouse-Lautrec, ▷van Gogh, Henri Cross, ▷Rysselberghe and Maximilien Luce. In 1899 Signac defined the ideas of the Société in his book *De Delacroix au Néo-Impressionisme* (*From Delacroix to Neo-Impressionism*). The term can be used as an alternative for ▷pointillism (which Seurat disliked because of its use by ▷Monet) and ▷divisionism, to mean the technique of applying pure colour to a canvas with small dots or dashes. However, Neo-Impressionism is a broader term, including the whole of Seurat's artistic ideas on the importance of contrasting line, colour and tone, inspired by ▷Charles Henry's *A Scientific Aesthetic* (1885). The movement came to influence ▷Fauvism in France.

Bib.: Herbert, R., *Neo-Impressionism*, New York, 1968; Lee, E.W., *Aura of Neo-Impressionism*, London, 1983; Sutter, J., *Neo-Impressionists*, London, 1970

Neopathetisches Cabarett

▷Pathetiker, Die

Neo-Plasticism

A term invented by ▷Mondrian to describe a form of rigid geometric ▷abstraction, which incorporated only the ▷primary colours, grey, black and white, and only vertical and horizontal lines. The aim of his work was to abandon all individualism, in the search for pure rational and universal truth and equilibrium. His work was intensely spiritual, inspired by his adherence to theosophy and he was heavily influenced by the popular philosopher, M.J.H. Schoenmaekers, in particular his *New World Picture*. The original term for Neo-Plasticism in Dutch is '*de nieuwe beelding*', which Mondrian used in the title of his book (1920), *De nieuwe beelding in de Schilderkunst*, translated into French as *Néo-plasticisme*. The term is also associated more generally with ▷De Stijl art and design which used Mondrian's geometry and colour. Neo-plasticism was a ▷non-objective art movement and was influential on both ▷Constructivist movements in the 1920s and on design.

Bib.: Blotkamp, L., *Mondrian and the Art of De Stijl*, London, 1994; Fauchereau, S., *Mondrian and Neoplastic Utopia*, London, 1994; Troy, N., *De Stijl*, Cambridge, MA, 1983

Neoplatonism

Philosophical and religious system that has had a long process of development, but had its origins in the ideas of Plato combined with oriental mysticism in Alexandria in the 3rd century A D. Through Augustine it had a profound influence on Christianity, and was revived in 15th-century Florence through Marsilio Ficino's translations for the ▷Medici of Plato into Latin, and his and Pico della Mirandola's attempt to reconcile Platonism with Christianity. The Neoplatonists believed that man might reach perfection through the apprehension and contemplation of beauty and love, raising him to a better, more spiritual plane. Contemplation is taken to lead beyond the physical world into the realm of the intellect and the ideal. The influence of such a highly intellectual programme of ideas is seen in ▷Botticelli's ▷*Primavera* and was developed by ▷Michelangelo in his representation of male nudes.

Neo-Realism

A term used by the English artists ▷Gilman, ▷Ginner and ▷Gore in 1913, when they exhibited together as Neo-Realists. Their theory was articulated in *The New Age* magazine in 1914. In some ways, it was conventional anti-academicism, as the artists rejected the idea of copying from ▷Old Masters or traditional formulas. To them, realism was the individual artist's interpretation of nature, and was something that could not be fixed but should be responsive to the needs of its own era.

Néo-Réalisme

The naturalistic tendencies of a group of French painters working in the 1930s, when ▷abstraction was endemic in Parisian art. This group included ▷André Dunoyer de Segonzac and ▷Charles Dufresne.

Neo-Romanticism

A British artistic movement of the 1940s and 1950s that revived the ▷Romantic interest in nature and landscape, modified and developed by the English

experience of ▷Surrealism and the Second World War. Artists such as ▷Graham Sutherland, ▷John Piper and ▷Paul Nash placed an emphasis on the place of imagination in the apprehension of the natural world, and shared other Romantic concerns such as mysticism, the individual experience and the sublime. Piper's *British Romantic Painters* (1942) interpreted Romanticism as, 'the result of a vision that can see in things something significant beyond ordinary significance,' and he traced Romanticism through British art right up to Nash and ▷Frances Hodgkins. The impact of the Second World War was significant on the movement, integrating a sense of history, patriotism and place that is expressed in Piper's views of bomb-damaged churches or Nash's *Totes Meer* (1941, London, Tate Gallery). At the time Neo-Romanticism was a term used to label a broad spectrum of British artists that included not only ▷Henry Moore, ▷Keith Vaughan and John Craxton, but also placed ▷Francis Bacon, John Tunnard, ▷Edward Burra and ▷Robert Colquhoun under its influence. However, the term now refers more specifically to the revival of interest in landscape and the particular influence of Sutherland, especially in his Welsh period. A revival of the movement, called Neo-Romanticism, occurred in the 1980s in a more abstract form, with painters such as Therese Oulton, Hughie O'Donoghue and Christopher Le Brun.
Bib.: Yorke, M., *The Spirit of Place*, New York, 1989; Rosenblum, R., *Modern Painting and the Northern Romantic Tradition*, London, 1975

Neptune

(Greek, Poseidon.) God of the sea. He is represented in art as an old man with a long beard. He is sometimes accompanied by his ▷attributes, which include a trident, or three-pronged fork, and dolphins. His entourage can include ▷Nereids (sea nymphs) and Tritons. Neptune is a popular figure in ▷Baroque art, and he is especially (and appropriately) a frequent subject of fountains. He also appears in Baroque ▷allegorical painting as a personification of the sea (e.g. ▷Rubens, ▷Marie de' Medici cycle, 1621–5, Paris, Louvre).

Nereids

The 50 daughters of Nereus, the old man of the sea in Greek mythology, who made up the retinue of ▷Neptune and ▷Venus along with the male Tritons, and hippocampi (sea ▷centaurs) (e.g. ▷Giordano, *Nereids Carrying the Corpse of Man*, 1705, Fontainebleau; ▷Böcklin, *Triton and a Nereid*, 1873–4, Munich, Schack-galerie). Major Nereids are ▷Galatea, Amphitrite and Thetis. Amphitrite became the consort of Neptune after he saw her dancing on Naxos, and she was the mother of Triton. She is often used as the personification of water (▷Four Elements) (e.g. ▷Mabuse, *Neptune and Amphitrite*, 1516–17, Berlin,

Bode Museum; ▷Poussin, 1630s, Philadelphia, Museum of Art). Thetis married Peleus and was the mother of Achilles, whom she tried to make immortal by dipping him in the river Styx. (e.g. ▷Watts, 1866, Compton, Watts Gallery; ▷Natoire, *Neptune and Thetis*, 1743, Stockholm, Nationalmuseum; ▷Giulio Romano, *Wedding of Peleus and Thetis*, 1531, Mantua, Palazzo de Tè).

Netscher, Caspar (1639–84)

Dutch painter. He may have been born in Heidelberg, but the bulk of his career was spent in the Low Countries. He studied with ▷Terborch, and like him, painted ▷genre scenes, as well as portraits and religious subjects. He was in France in 1659 and worked in The Hague from 1661. He was especially skilled at painting the textures of fabric.

Neue Künstlervereinigung (NKV)

An association of artists founded in 1909 by ▷Kandinsky, ▷Jawlensky and ▷Münter in opposition to the ▷Jugendstil-dominated art world of Munich. The group held its first exhibition in 1909 and a second, larger show in 1910, to which many of the French ▷avant-garde were invited.

Neue Sachlichkeit (New Objectivity)

A term first used by Gustav Hartlaub, the director of the Kunsthalle in Mannheim, in 1923, to describe an artistic and literary movement in Berlin in the early 1920s, which sought to portray the miseries and corruption of everyday life through clear, honest means. The movement was a product of the political turmoil in post-war Germany, and the desire of artists to produce relevant, socially-aware work. It was established in opposition to ▷Expressionism (▷Novembergruppe) and ▷abstraction which were considered to be introspective and élitist. The movement, characterized by simple images using strongly delineated colour and exaggerated caricature, was exemplified by the work of ▷Grosz, ▷Dix, ▷Beckmann and Carl Hofer. The artists concentrated on scenes of urban life which stressed ▷alienation, the ills of capitalism and the position of the worker. Many works were harsh and violent in their portrayal of murder and sexuality. The movement declined in the late 1920s as the political and economic situation in Germany stabilized but many of the artists found themselves persecuted as ▷degenerate during the 1930s. The playwright Berthold Brecht was also associated with the movement. In some manifestations, it could also be known as ▷Magic Realism.
Bib.: *German Expressionism 1915–25*, exh. cat., Los Angeles, 1989; Schmied, W., *Neue Sachlichkeit and German Realism of the 1920s*, London, 1979; Schrader, B., *Golden Twenties: Art and Literature in the Weimar Republic*, New Haven and London, 1988

Neue Sezession

A group formed in 1910 when the Berlin ▷Secession split. Tensions within the Berlin Secession about the rejection of certain ▷modernist paintings led artists such as ▷Nolde and ▷Pechstein to desert the older organization and set up on their own. ▷Kandinsky and ▷Jawlensky were also briefly members.

Neumann, Johann Balthasar (1687–1753)

German architect. He studied architecture at Nancy and Paris. He was Court Architect to the Prince Bishop of Würzburg in 1723. He was responsible for introducing a complex and elaborate ▷Baroque style into Germany that verged on the ▷Rococo. This is particularly apparent in his staircase at the Residenz in Würzburg and at Vierzehnheiligen, the Pilgrimage Church of the Assumption of Mary (1742–53).
Bib.: von Freeden, M., H., *Balthasar Neumann: Leben und Werk*, Munich, 1963; Menges, A. (ed.), *Balthasar Neumann: Abteikirche Neresheim*, Tübingen, 1993

Nevelson, Louise (1899–1988)

American sculptor, painter and graphic artist of Russian birth. She came to the United States in 1905 and from 1920 settled in New York. She studied there at the ▷Art Students' League in 1929–30, and she also worked with ▷Hans Hofmann in Munich. After contact and collaboration with ▷Diego Rivera in the early 1930s, she turned to sculpture. From 1942 she began producing ▷assemblages, and in the 1950s she created her first 'sculptured walls' which were relief works containing fragments of ▷found objects. Her tendency towards ▷Surrealistic imagery was complemented by her interest in ▷colour field painting, which led her to paint her reliefs in one dominant colour – white, gold or black.
Bib.: Glimcher, A., *Louise Nevelson*, London, 1972

New Art Front

▷Fronte Nuovo delle Arti

new art history

Term coined in the 1980s to refer to the increasing number of ▷methodologies being applied to the history of art, such as ▷feminist critiques, ▷gender based approaches, social theories of art (▷Marxism), and studies of race.
Bib.: Rees, A.F. and F. Borzello (eds.), *The New Art History*, London, 1986

New Brutalism

A term coined in 1954 to describe architecture influenced by ▷Le Corbusier's Unité d'Habitation at Marseilles. It is particularly associated with post-war British architects, although the style had adherents in America (Paul Rudolf) and Japan (Kenzo Tange). The style was characterized by the use of rough, heavy reinforced concrete, by chunky angular solids and by the creation of spatial tension, and was used to reflect the harshness and the confusions of modern life. In England, the style was exemplified by the work of Alison and Peter Smithson, who began their career working in a a ▷Mies van der Rohe-influenced form (e.g. Hunstanton School, 1954) but moved to the creation of urban housing and office blocks (e.g. Economist Building, London, 1962–4). ▷Stirling was associated with the movement in his early career (e.g. Ham Housing Project) and Denys Lasdun continued the style into the 1970s with the South Bank Complex in London. New Brutalism has become discredited in recent years, along with much post-war ▷modernist work.
Bib.: Banham, R., *New Brutalism*, London, 1966

New English Art Club (NEAC)

A group established in 1886 by landscape artists who opposed the ▷Royal Academy, and wanted to promote a naturalistic study of nature. They were heavily influenced by developments in French art (▷Barbizon School, ▷Bastien-Lepage, ▷Impressionism). Many of the members had studied in Paris and they initially wanted to take the name Society of Anglo-French Artists. They included ▷Clausen, ▷Forbes and members of the ▷Newlyn School, the ▷Glasgow School 'Boys', ▷Sargent, ▷Sickert, ▷Steer and ▷Tonks, who went on to become Slade Professor in 1893. The Club had difficulties in the early years: some members were in favour of broadening its membership to provide a national and democratic opposition to the RA and there was a split between the 'realist' and 'Impressionist' camps. In 1889 the 'Impressionists' won, Sickert became dominant, and many of the French Impressionists were invited to exhibit as guests. Until c1910 the Club represented ▷avant-garde art in England: in 1894 all contributors to the ▷*Yellow Book* were members, as were artists like ▷Fry, ▷Gore, ▷Johns and ▷Lucien Pissarro. The group held yearly exhibitions which increasingly rivalled those of the RA and had a number of supporters in the press (e.g. McColl at the *Spectator* from 1890). In this century, however, it was increasingly overtaken by new groups (▷London Group, ▷Allied Artists Association, 1908). The Club was ignored by Fry when he organized the ▷Post-Impressionist exhibitions and it eventually came to represent a conservative landscape style.
Bib.: *Early Years of the New English Art Club*, exh. cat., London, 1968; *Centenary of the New English Art Club*, exh. cat., London, 1986

Newlyn School

The term was first used by critics in 1888 to refer to a group of artists living and working in the Cornish fishing village of Newlyn, and taking their subject matter from the local community. It had been an artistic base since the early 1880s – Langley and Harris first went in 1882 and ▷Forbes, effectively the leader of

the group, arrived in 1884. Cornwall was chosen for its similarity to Brittany which was also a popular sketching haunt at the time; the county offered picturesque fishing subjects and cool, clear light. Most of the Newlyn artists had trained in France and were influenced by contemporary French art (▷Impressionism, ▷Bastien-Lepage) towards ▷plein air realism, though increasingly the work of the group tended towards soft-toned mood pictures, often concentrating on women's activities (Frank Bramley, Thomas Cooper Gotch). Although the group was associated with the ▷NEAC, most of the artists continued to exhibit at the ▷Royal Academy and they produced increasingly monumental images of a dying way of life. Newlyn remained an artistic colony into the 20th century (▷Knight), before being overtaken in popularity by ▷St. Ives. Forbes actually established an art school in the village.
Bib.: Fox, C., *Stanhope Forbes and the Newlyn School*, Newton Abbot, 1993; *Artists of the Newlyn School*, exh. cat., Newlyn, 1983

Newman, Barnett (1905–70)

American artist. He was born in New York, from a Polish Jewish background. During the 1920s he studied at the ▷Art Students' League (1922–6) and the City College, but he joined his father's clothing firm and struggled with the business during the Depression. Throughout the 1930s he was also interested in radical politics. Although he painted during this period in a ▷biomorphic ▷Surrealist style, he later destroyed most of his early works (e.g. *Pagan Void*, 1948, private collection). After the Second World War he turned to abstraction and in 1948 produced the first of his large mystical works *Onement I* (private collection) which utilized a single colour and a vertical 'zip' line. Many of his abstract works took themes from Classical mythology (e.g. *Achilles*, 1952, private collection) or Jewish theology, and were intended to express power, which Newman considered to be a more important criterion for art than beauty. In the same year he met with ▷Rothko, ▷Motherwell and ▷Baziotes and established with them the Subject of the Artist School. He also co-edited the ▷avant-garde magazine *Tiger's Eye*. Despite these associations his work did not conform to an ▷Abstract Expressionist mould and he was ignored for much of the 1950s, until an article by ▷Clement Greenberg praised him. His major paintings were produced in the 1960s, including the *Who's Afraid of Red, Yellow and Blue* series (1966–7, Amsterdam). In the early 1960s he produced a series of one and a half-inch wide canvases and also experimented with sculpture and ▷lithography (e.g. *Cantos* series, 1961–3). His works expressed spiritual ideas of power and creation. He used a limited ▷colour field but unlike ▷Rothko and others applied the paint with precision, drawing the viewer into the canvas by forcing them to study it carefully. The austerity of his

work points towards ▷Post-Painterly Abstraction and ▷Minimalism.
Bib.: *Barnett Newman*, exh. cat., London, 1972; Hess, T.B., *Barnett Newman*, New York, 1971; Newman, B., *Selected Writings and Interviews*, Berkeley, 1992

New Objectivity
▷Neue Sachlichkeit

New Realism

A vague term applied to, among other things, ▷Pop art at its inception. The principal use of the term describes those figurative artists working in opposition to ▷Abstract Expressionism such as ▷Lucian Freud, ▷Philip Pearlstein and Alice Neel.

New Sculpture

The term used to describe the sculptural renaissance in late Victorian Britain (c1875) which followed the death of ▷Stevens and represented a continuation of his style. The major practitioners included ▷Gilbert, ▷Thornycroft, ▷Onslow Ford and ▷George Frampton. Not only did these artists manage to raise the profile of sculpture in Britain but they also revolutionized its style by readopting the lost wax technique (▷cire perdue) for greater precision, employing multimedia on their small scale statuettes and adding a new naturalism and freedom of modelling to their works. To a certain extent, they were acting under the influence of contemporary French sculpture (Gilbert trained in Paris and the works of ▷Carpeaux were widely known in England following the exhibition of four of them at the ▷Royal Academy in 1871). The British sculptors were also part of the ▷Aesthetic Movement within Britain, however, with subject matter reduced to a minimum (e.g. Ford's *Folly*, 1885–6, London, Tate Gallery) and an interest in small-scale decorative works. Equally, they experimented with elegant figure shapes and new postures, which created both controversy for the freedom of modelling and awe at the audacity and lightness of the poses. They were nonetheless also involved in large-scale works, producing large numbers of architectural and commemorative sculpture: Gilbert's Clarence Tomb (Royal Collection, 1892–9), for example, was an extravaganza of bronze, marble, ivory and brass.
Bib.: Beattie, S., *The New Sculpture*, New Haven and London, 1983

New York School

To a certain extent, this is simply a synonym for ▷Abstract Expressionism, but it refers more generally to a group of artists working in New York in the 1940s and 1950s who created the first really innovative form of American art. These artists include ▷Pollock, ▷Rothko, ▷De Kooning, ▷Gorky and ▷Still. The term 'New York School' is meant to be a rejoinder to the ▷School of Paris, which it technically replaced, as

New York supplanted Paris as the international centre of modern art after the Second World War.

Bib.: Sandler, I., *The New York School: The Painters and Sculptors of the Fifties*, New York, 1978; Tuchman M., *The New York School: Abstract Expressionism in the 40s and 50s*, London, 1971; Guilbaut, S., *How New York Stole the Idea of Modern Art: Abstract Expressionism, Freedom and the Cold War*, Chicago, 1983

New Zealand, art in

Art produced in what is now called New Zealand was originally Maori art (▷Polynesian art), but the modern State of New Zealand and its art dates from the 1840s, when colonizers came from Britain and settled there. New Zealand art was dominated by ▷Romantic landscape painters throughout the 19th century. Artists such as Gully, Richmond and ▷Hodgkins brought techniques of European landscape painting there. European painters continued to colonize the country in the 20th century, but New Zealand did not gain its own artistic impetus until the 1940s.

Bib.: Thomson, K., *Art Galleries and Museums of New Zealand*, Wellington, 1981

niche

A wall recess. It can either be empty or contain a statue or vase.

Nicholson, Sir William (1872–1949) and Ben (1894–1982)

English family of artists. William was a painter and engraver. He studied at the ▷Académie Julian in Paris, and under the influence of Japanese prints, he began producing posters in the 1890s. He and his brother-in-law ▷James Pryde were known professionally as the ▷'Beggarstaff Brothers', and they produced a number of posters, particularly for theatrical performances.

William's son, Ben, was born in Denham, Buckinghamshire. He was educated at the ▷Slade but took little interest in art, and began to paint seriously only after his marriage to ▷Winifred Nicholson in 1920. He visited Paris in 1921, meeting ▷Picasso and ▷Braque and began to work in a ▷Cubist idiom, producing still-lifes and landscapes of Cumbria, which gradually developed towards abstraction (e.g. *Vertical Seconds*, 1953; London, Tate Gallery). He became friends with ▷Wood and ▷Wallis and was an active member of the ▷Seven and Five Society (he was its chairman in 1926). His work changed during the 1930s, when he met his second wife, ▷Hepworth, and began to work in low ▷relief abstracts, using limited colours and cardboard: in 1934 he exhibited the first of his all-white reliefs (e.g. *White Relief*, 1935, London, Tate). He was influenced in these by a meeting with ▷Calder at Dieppe in 1932, and by contact with ▷Brancusi and ▷Arp. In 1933 he established ▷Unit One with Hepworth and ▷Nash, and

in 1937 he co-edited the *Circle* with ▷Gabo. From 1939, he was based in ▷St. Ives. By the 1950s he had achieved an international reputation, and produced a ▷mural for the 1951 Festival of Britain. He was awarded the Order of Merit in 1968. He remarried again in 1957 and retired to Switzerland, were he continued to work on reliefs, producing large numbers of monumental works.

Bib.: Lewison, J., *Ben Nicholson*, Oxford, 1991; Lynton, N., *Ben Nicholson*, London, 1993; Neve, C., *Ben Nicholson*, London, 1993; *William Nicholson: Paintings, Drawings and Prints*, exh. cat., Cambridge, 1980

Nicholson, Winifred (1893–1981)

English painter. She married Ben Nicholson in 1920 and moved to Cumbria in 1923. She was a member of the ▷Seven and Five Society. She painted landscapes and flower pictures which were highly coloured and mildly abstract.

Bib.: Collins, J., *Winifred Nicholson*, exh. cat., London, 1987

Nicodemus

A New Testament character, mentioned in St. John's ▷Gospel. He was a Pharisee and member of the Sanhedrin, who was secretly instructed by ▷Christ at night, although he failed to understand much of the teaching. The two figures are often depicted seated at a table, by candlelight. Nicodemus opposed the condemnation of Christ and brought spices for the anointing of his body. He is often shown present at the ▷Descent from the Cross and the ▷Entombment of Christ, distinguishable by his rich dress. He gave his name to an apocryphal gospel.

Nicolas of Verdun (late 12th, early 13th centuries)

Flemish goldsmith and enameller. He was one of the foremost metalworkers of the ▷Mosan School. He worked in an early ▷Gothic style and enamelled the pulpit front for Klosterneuburg Abbey Church near Vienna (1181).

niello

(Italian, from the Latin: *nigellus*, 'black'.) A black alloy composed of powdered copper, lead, silver, sulphur and flux (borax). It is used in the decoration of silver or gold. A design is engraved into the metal and the channels filled with the powdered mixture. The whole is then heated to the melting point of the alloy, which is lower than that of the silver or gold, so that the alloy becomes fixed into the channels. The surface is finally polished smooth. The object thus decorated is said to be decorated in niello. The earliest use of this technique is found in ancient Egypt, but it was especially popular and reached a high level of technical expertise in the early Italian ▷Renaissance. The Florentine goldsmith

▷Maso Finiguerra was renowned for his works in niello (e.g. silver pax, 1452–5, Florence, Bargello).

Night Café, The

Painting by ▷Vincent van Gogh, produced September 1888. In a letter to his sister, Wilhelmina, in September 1888, van Gogh describes two recent canvases he had completed on the theme of cafés at night. One depicted a billiard parlour in Arles where he was currently living and showed in harsh reds and acidic greens the working-class environment which he described as a place where 'poor night wanderers sleep'. He said he wanted to show the café as the physical location and expression of the 'terrible passions of humanity', 'where one can ruin oneself'. The extreme and bleak condition of humanity in this proletarian café must be viewed in conjunction with his second vision of *The Night Café*. This second canvas shows a modish café in the town centre, Place du Forum. It is rendered in bright, optimistic yellows and blues and shows the brightly lit café windows facing onto the cobbled square under a romantic starry sky. It conjures up the night-life of the Parisian boulevards. In van Gogh's letter to his sister he also makes reference to the novel *Bel Ami* by Guy de Maupassant, where just such a night scene is described. The naturalist school of literature with its industrial, city-based subject matter interested van Gogh, as it did other contemporary painters, and the loci of sentiments as an external reference point would become more important in his future work. *The Night Café* is now in Amsterdam in the Rijksmuseum.

Nightmare, The

The most famous painting by the Swiss painter ▷Henri Fuseli, first exhibited at the ▷Royal Academy in London in 1782. It exists in several versions, one of which is now in the Goethe Museum, Frankfurt. Its image of a sleeping woman laid out across a bed, a strange devil on her stomach and the white head of a horse emerging from the shadows above her body was an immediate success, being reproduced in prints and forming a popular motif for cartoonists of the 18th and 19th centuries. The painting made Fuseli's name, and its fascination with the unconscious and its ▷Gothic imagery has marked it out as the foremost image of the ▷Romantic movement. Dr. Johnson had defined nightmare in his dictionary as 'a morbid oppression in the night, resembling the pressure of weight upon the breast', and it is the incubus rather than the horse that is the source of horror. Fuseli had visited Rome in 1770 on the advice of ▷Sir Joshua Reynolds, and all three figures have references in Classical art, and are executed in a ▷Mannerist style. Fuseli had recently returned to London from Zurich when he painted *The Nightmare*, and it has been interpreted as an expression of his unrequited love for Anna Landolt, whom he left behind there. Her portrait is painted on the back of the canvas.

Bib.: Powell, N., *Fuseli: The Nightmare*, London 1973

Night Watch, The

▷Rembrandt's painting was completed in 1642 under the title *The Company of Francis Banning Cocq Readying to March*, and became known as *The Night Watch* only in the 19th century when the glutted ageing varnish created the impression of darkness. Successive cleanings have now established that the scene takes place in daylight.

The musketeers assembled for the group portrait formed part of a company of the Amsterdam civic guards, the city's defensive militia. The painting was one of seven commissioned to hang in the Kloveniersdoelen, where the various companies of musketeers would assemble and practise on a firing range. A contemporary inscription states that Cocq is ordering his lieutenant Willem van Ruytenburch (dressed in white) to lead the company out, and most discussions of the painting centre on whether this relates to a particular historical or ceremonial event. However, its importance lies more in Rembrandt's transformation of a potentially staid group portrait into a dynamic composition, showing the company as a unified entity.

The artist received 1,600 guilders for the painting, including contributions from each of the sitters according to the prominence of their position. It was long held that the painting was greeted with hostility, but contemporary evidence suggests that it was actually very well regarded. A large section (around 60 cm/2 ft square) was cut from the left-hand side of the canvas when it was moved to the Town Hall in 1715. Since 1808 it has been in the Rijksmuseum in Amsterdam.

Bib.: Boka, G., *Rembrandt's Night Watch: The Mystery Revealed*, Quebec, 1994; Hymans, W., *Rembrandt's Night Watch: The History of a Painting*, Leiden, 1978

Nike of Samothrace

▷Victory of Samothrace

nimbus

(Latin, 'cloud', 'aureole'.) A bright disc or ▷halo, usually represented as golden, surrounding the head of a sacred personage. It may originally have derived from images of sun gods who were represented with sun-rays emanating from their heads and have been later simplified into a simple disc. A feature of the art of ancient Persia, India and Rome (the deified Emperor was sometimes thus depicted), it was adopted by Christianity to distinguish the three persons of the ▷Trinity, ▷angels and, later, saints. A triangular nimbus identifies God the Father and one with a cruciform design, ▷Christ.

Bib.: Hall, J., *Illustrated Dictionary of Symbols in Eastern and Western Art*, London, 1994

Nittis, Giuseppe de (1846–84)

Italian painter. He studied in Naples, and painted landscapes and urban scenes with the ▷Macchiaioli in Florence. He moved to Paris in 1867, where he settled. There he came into contact with ▷Degas and ▷Manet, and he showed with them in the First ▷Impressionist exhibition of 1874. He was a well-regarded artist.

NKP

▷Narkompros

NKV

▷Neue Künstlervereinigung

Noah

An Old Testament character, the descendent of ▷Adam and Eve through Seth, and the father of Shem, Hem and Japeth. He is usually depicted as an old, white-bearded figure, one of the patriarchs who lived to be over 500. The central episode connected to him is the story of the Flood, significant not only because it illustrates punishment for disobedience to the will of God but also because it prefigures the New Testament narrative of the ▷Baptism and ▷Resurrection. Noah's ark also came to be symbolic of the Church. The ark was traditionally portrayed as a box, then in the Middle Ages as a floating house, and in the ▷Renaissance as a boat. Scenes of the building of the ark and of the gathering of two of each kind of animal were common. The Flood lasted 40 days, and the water subsided after 150. The waters are often shown rising to drown the wicked (e.g. ▷Uccello, *Deluge*, 1445, Florence, Sta. Maria Novella). The sending out of first a raven and then a dove, which returned with an olive branch and proved that the waters had subsided (e.g. ▷Millais, 1857, Oxford, Ashmolean), are also shown because they represent hope and peace for the future. The Sacrifice of Noah took place to thank God for saving him and his family (e.g. ▷Maclise, 1847–53, Leeds). It was followed by God's granting of a covenant – a rainbow – as a guarantee that he would not send another deluge.

The drunkenness of Noah, a later scene in the narrative, tells of how his youngest son mocked him for lying naked in a drunken stupor, a result of wine from his own vineyards, planted after the Flood (e.g. ▷Michelangelo, ▷Sistine Ceiling, c1508–13). The story prefigures the ▷Mocking of Christ.

nocturne

A musical term ('night piece') used by ▷Romantic composers such as Chopin and adopted by ▷Whistler for titles of his paintings. Whistler used the phrase for a number of his own 'night pieces' to stress their analogies with music and undermine any hint of narrative content.

Nok

▷African art

Nolan, Sir Sidney (1917–92)

Australian painter. He was from Melbourne, and was involved with both the ▷Angry Penguins and the Australian ▷Contemporary Art Society, of which he was a founder member in 1938. He served as a soldier in Victoria in 1941–5, and he became interested in the landscapes of Australia as well as folk legends of the bush. After this period, he began painting scenes from Australian folklore, focusing specifically on the legends of the ranger Ned Kelly.

Noland, Kenneth (b 1924)

American artist. He was born in Ashville, North Carolina. He attended ▷Black Mountain College in 1946 (under ▷Albers) and the Zadkine School of Sculpture in Paris (1948–9). During the 1950s he developed the first of his famous abstracts, moving from a ▷gestural approach to a more structured one, producing a series of target pictures, concentric circles of colour, initially with softened edges (e.g. *Cantabile*, 1962, Minneapolis). Increasingly he used ▷acrylics to avoid any overtly ▷painterly qualities and along with Louis and ▷Helen Frankenthaler opposed ▷Abstract Expressionism. During the 1960s he developed the chevron or lozenge design (e.g. *Grave Light*, 1965, private collection) and gradually shifted to working on long 9 m (30 ft)-canvases with horizontal stripes (e.g. *Via Blues*, 1967, private collection), latterly in subdued pastel shades. He used staining rather than painting techniques to avoid all evidence of brushwork, and reduced his range of colour to avoid optical illusion. During the 1970s he incorporated overlapping colour and irregularly shaped canvases into his work. Like other ▷Post-Painterly Abstractionists, he wished to represent the physical reality of the paint and nothing more.

Bib.: *Kenneth Noland: A Retrospective*, exh. cat., New York, 1977

Nolde, Emil (Hansen) (1867–1956)

German painter. He was born in Nolde, Schleswig (he changed his name to that of his birthplace in 1904) into a farming family. He was apprenticed to a furniture maker in 1884, and later taught at the School of Applied Art at Karlsruhe in 1889. He trained under Adolf Hölzel at Munich in 1898–9, before spending time at the ▷Académie Julian in Paris. In 1903 he settled on the Isle of Alsen and began to concentrate on landscape, working in a vigorous, free ▷Impressionist style and depicting agricultural scenes (e.g. *Flower*

Emil Nolde, *Mother and Child*, c1940, private collection

Garden, Girl and Washing, 1905, Düsseldorf). He was a member of ▷Die Brücke in 1906–7 but found the group restrictive and never wholly agreed with their aims, although he had a nationalist sense of his artistic vocation. His own style developed into a highly personal, religiously-motivated portrayal of mask-like figures, deep rich colours and heavy tapestry-like ▷impasto (e.g. *Pentecost*, 1909, Berlin, Nationalgalerie). He was influenced more by ▷Ensor and ▷Munch than by the ▷Post-Impressionists. He joined the ▷Neue Sezession in 1910, after disagreements with ▷Liebermann. In 1913, he joined an official expedition to Russia, Korea, China and the Pacific Islands, which led to a book, *Art Experiences of Primitive Peoples*, and a series of intense, abstracted landscapes of the tropics (e.g. *Autumn Sea II*, 1910, Zurich). He continued to produce similar work throughout the 1920s and 30s, living at Seebüll from 1926. Despite his Nazi sympathies, his work was opposed by the Nazis and he was banned from painting in 1941. After the War, he became professor at the Berlin Academy.
Bib.: Poig, R., *Emil Nolde*, Washington, 1982; Urban, M., *Nolde: Catalogue Raisonné*, London, 1987

Noli me tangere

(Latin, 'Touch me not'.) The words spoken by Christ to ▷Mary Magdalene after his ▷Resurrection. The phrase comes from John 20:17.

Nollekens, Joseph (1737–1823)

English sculptor. He was the son of an Antwerp-born painter of the same name who had emigrated to England in 1733. He trained with ▷Peter Scheemakers in London before moving to Rome where he stayed from 1760 to 1770, earning a good living restoring, copying and faking antiques, mainly for English visitors on the ▷Grand Tour. On his return to England he established an extremely successful practice as a sculptor of marble portrait busts. The best are marked by a vivacity unequalled by any of his contemporaries (e.g. *Sir George Saville*, 1784, London, Victoria and Albert Museum). Ideal works being more highly regarded by the English art world, he turned his hand to the production of ▷Neoclassical ▷antique subjects, many of goddesses and in a mildly erotic vein (e.g. *Diana Hunting*, 1770s, London, Victoria and Albert Museum), although he never achieved quite the same level of success and recognition that he had with his portraiture. He also designed and executed a number of large tomb monuments and died an extremely wealthy man. The fullest account of his life is in the remarkably scurrilous and spiteful biography by his former pupil (and disappointed executor) J.T. Smith, *Nollekens and his Times* (1828). Still a highly readable account of the times, it provides, however, a very biased picture of Nollekens, generally at odds with the warmer estimation provided by other of his contemporaries (e.g. ▷Joseph Farington, in his *Diaries*). Nollekens was elected ▷ARA in 1771 and ▷RA in 1772.
Bib.: Whinney, M., *Sculpture in Britain 1530–1830*, 2nd edn., Harmondsworth, 1988

non-objective

Another term for ▷abstract art, but a more precise formulation which indicates that the work of art has no representational aspects at all. Abstraction could, strictly, relate to the observable world. The phrase 'non-objective' was used by ▷Kandinsky in his treatise, *On the Spiritual in Art*.

Norman style

As its name suggests, a style of art associated with Normandy, but actually dominant in England especially during the 11th and 12th centuries. It is, to a certain extent, the English version of ▷Romanesque. The term was brought into popular use by T. Rickman in 1817, who classified English medieval buildings according to his own periodization. It is therefore a somewhat loose and artificial term, although it does have some validity when dealing with a particular group of buildings. William the Conqueror purportedly carried the style over from Normandy, but its features were already established in England. Its first manifestations appear in Westminster Abbey. Its characteristics include a geometrical use of ornament and a three-storey elevation which was later also used in the English ▷Gothic style. Among the most important Norman buildings in England is Durham Cathedral, but many other churches also contain elements of the Norman Style.

Norman style: Ludlow Castle, Shropshire

Bib.: Little, B., *Architecture in Norman Britain*, London, 1985

North American Indian art

Even the briefest survey must emphasize the enormous cultural diversity of the art of the American native peoples, which stretches from the Eskimos of the Arctic to the Navajos of the South-West. The continent is usually divided into six broad, although culturally relatively discrete, regions: the Arctic; the North-West Coast; the West Coast; the South-West; the Great Plains; and the East. The form a culture takes is of course highly dependent on the materials available and the social structure and philosophy of each tribe or group. Thus the Eskimos principally carved ivory, the tribes of the North-West such as the Chinook made totemic art, the South-Western Pueblo Indians ▷ceramics, the Californian Gabrieleonño and Pono Indians pottery and basket-weaving and the tribes of the East wooden, copper and fabric artefacts. The nomadic tribes of the Great Plains, whose lifestyle demanded ease of transportation, decorated the hide of their tepees and pouches with highly stylized designs.

As with the art of ▷Aboriginal Australia, these once-ignored cultures, formerly of interest only to anthropologists, are now seen as eminently worthy of study, and their cultural production has been claimed as part of the heritage of all Americans.

Bib.: Berlo, J.C, *The Early Years of Native American Art History: The Politics of Scholarship and Collecting*, Seattle, 1992; Douglas, F. and R. d'Harnoncourt, *Indian Art of the United States*, New York, 1941; Feast, C., *Native Arts of North America*, London, 1980; Valliant, G.C.,

Indian Arts in North America, New York and London, 1939; Wade, E., *Magic Images: Contemporary Native American Art*, exh. cat., Norman, OK, 1981

Northcote, James (1746–1831)

English painter. He was born in Plymouth and taught himself before entering the ▷Royal Academy Schools in 1771. He was a pupil of ▷Reynolds, and later became his assistant and biographer (*Life of Sir Joshua Reynolds*, 1813). He worked as a portraitist in 1773–6 in order to finance a trip to Rome, 1777–80. There he developed a love of the ▷Grand Manner, illustrated by works such as *Alexander I of Russia Rescuing a Peasant Boy from Drowning* (London, Royal Society of Medicine). On his return to London he worked as a portraitist and from 1783 a painter of ▷fancy pictures which achieved a certain popularity through ▷engravings. He produced works for ▷Boydell's Shakespeare Gallery (e.g. *The Murder of the Princes in the Tower*, 1791; destroyed). He was elected RA in 1787.
Bib.: Hazlitt, W., *Conversations of James Northcote RA*, London, 1959; Surry, N., 'James Northcote as a Portraitist', *Burlington Magazine*, 136 (April 1994), pp. 234–7

Norway, art in
 ▷Scandinavian art

Norwich School

A group of artists working in Norwich from 1803, producing unpretentious, naturalistic local landscapes in oils and ▷watercolour. The group originated with the Norwich Society of Artists established in 1803 by ▷Crome to 'point out the best methods of study to attain greater perfection in these arts', and included John Thirtle, Robert Dixon, Vincent George, Crome the Younger and Stark. They held yearly exhibitions from 1805 to 1825 at Sir Benjamin Wrench's Court, which became the group's meeting place. After Crome's death ▷Cotman became the leader of the group during 1821–34. The Society was re-established as the Norfolk and Suffolk Institute for the Promotion of Fine Arts in 1827. However, it died out in the 1830s and no major artist is recorded as working in Norwich after 1833. The Society depended on local patrons who commissioned and bought works and paid artists as drawing masters, and many of the artists were connected by marriage and family links. Their landscapes were influenced by Dutch 17th-century art and by the English ▷watercolour tradition but the subjects were based entirely on Norwich and its environs.
Bib.: Clifford, D., *Watercolours of the Norwich School*, London, 1965; Dicks, W.F., *The Norwich School of Painters*, London, 1905; Hemingway, A., *Norwich School of Painters*, London, 1979; Mallilieu, H., *Norwich School*, London, 1974; Moore, A.W., *Norwich School of Artists*, Norwich, 1985

Notke, Bernt (1440–1509)

German painter and sculptor. He worked as a wood-carver in Lübeck from 1467. In 1483 he travelled to Sweden to undertake a commission for a victory monument, representing St. George and the Dragon, which was erected in Stockholm in 1489 to signal the Swedish victory over the Danes. He also worked in Denmark, where he created the high altar for Århus Cathedral (completed 1482).

Nôtre Dame du Haut

A Chapel designed by ▷Le Corbusier on a hill top at Ronchamp, Haute Saône in France (1950–55). The scheme was the brainchild of Father Alain Couturier, who also supported Le Corbusier's designs for the monastery at La Tourette (1960) and was a keen advocate of ▷modernist church architecture. A ▷Gothic chapel had been destroyed during the Second World War and Le Corbusier used rubble from this incorporated into his reinforced concrete replacement. The design responded to the unique site and represented a departure from the clean, geometric line of Le Corbusier's earlier work, towards a fluid, organic style. A projecting, curving roof, compared to the prow of a ship, overshadowed and seemed to weigh down the structure's thick walls and hidden doorway. The interior becomes almost cave-like, the floor and walls designed on a gentle, disorientating slope, light piercing a number of tiny openings to create a pattern of stars. The symbolic use of light is further emphasized by a cube-like altar, lit directly from above. In many ways the chapel harks back to ▷Expressionist architectural designs and remains unique in Le Corbusier's work, a highly individual attempt to reconcile location and traditional church design with a striking spirituality.

Nouveau Réalisme

Founded by the critic Pierre Restany in October 1960, it signified, in his words, 'a return to a concrete vision of the real world'. Making use of mass-produced objects and reproduced images, it sought to replace an art of representation with an art of presentation, taking as its subject, in the words of Restany, 'sociological reality in its entirety'. Taking its name from ▷Léger's aesthetic that the 'beautiful is everywhere', Restany declared that the movement represented 'the passionate adventure of the real perceived in itself and not through a prism of conceptual or imaginative transcription', to reveal the marvellous in the ordinary. Artists associated with the movement included 'Arman' (Arman Fernandez), ▷César, ▷Christo, ▷Klein, ▷Niki de St. Phalle, Martial Raysse, Mimmo Rotella and ▷Tinguely.

There were three manifestos issued in 1960, 1961 and 1963, as well as two festivals dedicated to Nouveau Réalisme, in Nice in 1961 and in Munich in 1963. There were also various exhibitions, in 1961, *Forty Degrees Above Dada* at Galerie J, Paris, and *Le Nouveau Réalisme à Paris et à New York* at the Galerie Rive Droite, Paris, which included works by ▷Johns and ▷Rauschenberg, and an exhibition in 1962 in New York at the Sydney Janis Gallery. The movement broke up in 1963.

Bib.: Abadie, D., *Nouveau Réalisme*, Soul, 1991; *1960: Le Nouveau Réalisme*, exh. cat., Paris, 1986; Restany, P., *60/90, trente ans de Nouveau Réalisme*, Paris, 1990

Nouvelle Tendance

A loose term for international ▷Constructivist tendencies of the 1960s. A series of international exhibitions during this decade highlighted a new approach to Constructivism in which the use of light and sound was stressed, and ▷Expressionist qualities were minimized. It relates specifically to the work of ▷Klein and ▷Manzoni.

novecento

Literally, 'nine hundred', the Italian art term for the 20th century. It is used only to refer to Italian art and may be used as either an adjective, as in 'novecento art', or a noun, as in 'art of the novecento'.

Novecento Italiano

An Italian art movement, it was founded in Milan in 1922, but did not hold its first exhibition until 1926 and disbanded in 1943. The founding members rejected contemporary ▷avant-garde art and attempted to revive ▷Classicism, which it associated with the greatness of Italy's artistic past. The inherent nationalism in such a stance led, during the 1930s, to an association with Fascism. The most significant artists associated with the movement were ▷Marino Marini, ▷Carlo Carrà, Massimo Campigli (1895–1971), and Mario Sironi (1885–1961)

Bib.: Bossaglia, R., *Il Novecento Italiano: storia, documenti, iconografia*, Milan, 1979

November Group

A group of Finnish artists founded in Helsinki in 1917. They perpetuated an ▷Expressionist style and a nationalistic attitude.

Novembergruppe

A group of artists and writers established in Berlin in 1918 to promote the cultural and political regeneration of the Weimar Republic. It grew out of the ▷Arbeitsrat für Kunst (The Workers' Council for Art) which in 1919 issued a questionnaire on the relationship between artists and the State. The Novembergruppe included ▷Pechstein, and later ▷Müller, ▷Campendonk and Rudolf Belling. There was an architectural section which included ▷Mies van der Rohe, ▷Mendelsohn, ▷Behrens and ▷Gropius. They issued a manifesto which aimed at the 'moral regeneration of a young, free Germany' and

demanded the reform of art schools and museums, as well as a political role for artists. The group had no coherent style, although its members were ▷Expressionists and the manifesto promoted complete freedom of creative expression. There was soon a split between the ▷Expressionists and the ▷Neue Sachlichkeit artists who sought objectivity and clarity. The latter became dominant and in the field of architecture the group was eventually swept up by ▷Bauhaus.

Bib.: Kliemann, H., *Die Novembergruppe*, Berlin, 1989; Schrader, B., *Golden Twenties: Art and Literature in the Weimar Republic*, New Haven and London, 1988; Weinstein, J., *Art and Revolution in Germany, 1918–19*, Los Angeles, 1986

nude

In an art historical context, a representation of an idealized ▷naked human figure. The male nude has been a central subject for European painting and sculpture since ▷Archaic Greece (c650–c480 BC). In ancient Greece male athletes performed naked and soldiers fought near-naked; idealized male nude statues of celebrated athletes, heroes, and gods were commonplace at gymnasia. Female nakedness was not acceptable in public and statues of female nudes were not, as a rule, acceptable before the 4th century BC. According to ▷Pliny, ▷Praxiteles made a statue of a nude Aphrodite (▷Venus) for the people of Kos, but they found its nudity too shocking and opted for a draped version; the people of Cnidus in Ionia (Asia Minor), however, did not have such reservations and purchased it (▷*Aphrodite of Cnidus*). From this period onwards, idealized nudes of both sexes became a principal subject in Greek art. The Romans followed suit.

In the Middle Ages, the nude virtually disappeared owing to the Christian Church's detestation of the physical body and its association with the sins of the flesh (and also paganism, of course). However, during the course of the ▷Renaissance, a reawakened interest in ▷antiquity ushered in the return of the nude both, where appropriate, in religious subjects, but more importantly, in mythological and ▷allegorical subjects. Florentine ▷humanists now regarded the nude in art as signifying more of virtue than the clothed figure: the nude Venus came to represent divine love (unclothed as a symbol of its rejection of worldly things), the clothed Venus, earthly love (see ▷Titian's *Sacred and Profane Love*, Rome, Galleria Borghese). The values of Classical antiquity and the Italian Renaissance were further endorsed by the art academies of the 17th century onwards. The aesthetic superiority of the idealized nude over the naked figure for the academic critic lies in the intelligence that necessarily goes into the process of idealization as opposed to the craft that is required

to simply imitate a natural (and by definition imperfect) appearance.

In the 20th century the nude has become an issue of contention for ▷feminist art historians, particularly the representation of the female nude by the (usually male) artist for the (presumed male) viewer and the objectification of woman that that necessarily implies. **Bib.**: Clark, K., *The Nude: A Study of Ideal Art*, Harmondsworth, 1960; Hobhouse, J., *The Bride Stripped Bare: The Artist and the Nude in the Twentieth Century*, London, 1988; Nead, L., *The Female Nude: Art, Obscenity and Sexuality*, London and New York, 1992

nymph

In ▷Classical art and its derivatives, a young and beautiful nude woman. In Greek mythology nymphs were female spirits associated with various natural habitats. ▷Nereids were sea nymphs, the daughters of Nereus, the old sea god, and Doris, the Oceanid. Of these numerous daughters, the most famous are Galatea, the nymph loved by ▷Polyphemus, and Thetis, the mother of Achilles by the mortal Peleus. It was she who dipped the infant Achilles in the waters of the River Styx in order to give him invincibility (e.g. ▷Thomas Banks, *Thetis Dipping Achilles in the River Styx*, 1790, marble group, London Victoria and Albert Museum). Unfortunately she has to hold onto his heel as she dipped him and this proved to be his one mortal spot.

Naiads were nymphs of rivers and fountains, the most famous of whom was Arethusa, who was desired by the river god, Alpheus. Having spied her bathing in his waters, he chased her all over the countryside before she was rescued by the goddess ▷Diana who transformed her into a stream which then disappeared underground. Naiads were not always victims, however. A beautiful boy called Hylas was retained as a page by Heracles (▷Hercules) when he was one of the Argonauts seeking the Golden Fleece. At landfall one evening Hylas was sent to fetch fresh water. When the Naiads saw him at their spring, they desired him and pulled him down into their waters (e.g. ▷J.W. Waterhouse, *Hylas and the Nymphs*, 1896, Manchester, City Art Gallery). Heracles here parted with the other Argonauts who continued the quest while he searched in vain for Hylas.

▷Jupiter was raised in secret by Oreads, nymphs of the mountains and grottoes (e.g. ▷Poussin, *The Nurture of Jupiter*, 1636–7, London, Dulwich Picture Gallery). Diana's virginal companions are also referred to as nymphs, their chastity being frequently assailed by lecherous ▷satyrs and even by Jupiter himself (e.g. Callisto and Antiope).

Oath of the Horatii, The

Painted by ▷Jacques-Louis David in Rome in 1784. The foremost example of French ▷Neoclassicism, it depicts a tragic incident from Roman history. To settle a border dispute, the Horatii brothers agreed to fight the Curatii from neighbouring Alba. The two families were already linked by intermarriage, so that in the ensuing bloodshed one of the Horatii was set against his wife's brothers, and the sole survivor would murder their sister for mourning her Curatii fiancé. The story is told by Livy and Plutarch, and was the basis of Corneille's play *Horace* (1640) but the oath of allegiance portrayed by David appears in none of his sources. Against a stark background of ▷Doric arches he shows the brothers swearing themselves to combat, stretching their arms towards their father, who raises three swords in a clenched hand in return. Behind him the women of the family weep and comfort each other. The painting was commissioned by the Comte d'Angivillers, the minister for arts, and exhibited in the Paris ▷Salon of 1785. The dramatic lighting, aggressive disregard for conventions of composition and the intensity of its subject matter caused a sensation. Its celebration of patriotism over the organic ties of love and family, underscored by a glorification of violence and republican austerity, have been seen as articulating the tensions which would explode into the ▷French Revolution. The painting is now in the Louvre.

Bib.: Crow, T.E., *Jacques-Louis David's 'Oath of the Horatii'*, Los Angeles, 1978

obelisk

A monumental stone shaft, usually monolithic, four-sided and tapering with a pyramidal top. Abundant in ancient Egypt where they were erected as solar symbols, many were removed under the Roman empire and re-erected in Rome (e.g. those now at the Piazza del Popolo and Piazza San Pietro). In the 19th century other Egyptian obelisks (now popularly known as 'Cleopatra's Needles') were re-erected in London, Paris and New York.

objet trouvé

(French, 'found object'.) It is an object literally 'found' but in actuality selected by the artist and through exhibition raised to the status of work of art. The idea was originated by ▷Duchamp as an ironic ▷anti-art statement. It was developed by the ▷Surrealists who used objects in strange juxtapositions and bizarre conjunctions. ▷Paul Nash used pebbles, broken branches of trees or strange natural objects, and set them on plinths or photographed them. The idea was later used

Obelisk at Alexandria, commonly called Cleopatra's Needle, from 'Egypt and Nubia', Vol. 1, David Roberts, Stapleton Collection

in ▷junk sculpture, ▷Pop art, and ▷Arte Povera, often for ▷kitsch, nostalgic or evocative purposes.

obverse

That side of a coin, medal or seal on which the head or principal design is struck; or that face of a print, picture, etc. which is presented to view. It is the opposite of reverse. In reference to a figure, the term is used to describe its being narrower at the base or point than at the apex or top.

Oceanic art

Art of the Pacific Islands, encompassing ▷Melanesian, ▷Micronesian and ▷Polynesian art. There are a wide variety of manifestations, including carving, canoe and mask decorations and the monumental ancestor figures of Easter Island.

Ochtervelt, Jacob (1634–82)

Dutch painter. He studied with ▷Berchem and worked in Amsterdam. He painted ▷genre scenes and portraits in the style of ▷Terborch and ▷Metsu.

octavo

A book or manuscript made up of pages which have been made from leaves which have been folded eight times.

oculus

A circular window in a wall or ▷vault or an opening at the crown of a ▷dome (e.g. The Pantheon, Rome).

odalisque

(French, from Turkish, *odaliq*.) A female slave in an eastern harem. As a subject in western European art, it became popular in the 19th and 20th centuries with artists like ▷Ingres (e.g. *Odalisque with Slave*, 1839–40, Harvard University, Fogg Art Museum), ▷Delacroix, and ▷Matisse. It presented an opportunity for representing a voluptuous female figure, either completely or semi-nude, in attractively 'Oriental' surroundings.

Odysseus

▷Ulysses

Oedipus and the Sphinx

An episode in the life of Oedipus, the son of the King of Thebes, who was left to die as a child and grew up, not knowing his origins, to fulfil the prophecy of his birth that he would kill his father and marry his mother. Having unwittingly murdered his father whilst travelling to Thebes, he met the ▷Sphinx, a monster with woman's head, lion's paws, snake's tail and eagle's wings, who guarded the road and challenged all travellers with a riddle – What goes on four legs in the morning, two in the afternoon and three in the evening? Oedipus correctly guessed the answer – a

Odalisque: *The Woman of the Harem and the Sultan*, hand-painted engraving, Laura Lushington, 1840

man – and so saved himself and the city of Thebes. He was rewarded with the hand of the queen, his mother. Later he discovered the truth and became so deranged that he killed her and blinded himself. In images of the Sphinx, he is usually shown as a heroic, youthful figure, exercising reason, but frequently portents of the future tragedy are present (e.g. ▷Ingres, 1908, Paris; ▷Moreau, 1864, New York).

oeuvre

(French, 'work'.) In art-historical parlance, the *oeuvre* of an artist refers to her or his output considered as a whole. To include a work in the *oeuvre* of an artist is to accept it as an authentic (▷attribution) example of that artist's output.

offset

A printing process used commonly with ▷lithography. It is a medial process which allows an impression of an image to be transferred to something else from which the final proof is taken. In printing, it absolves the artist of the need to draw on the plate in reverse.

ogee

▷arch

O'Gorman, Juan (1905–82)

Mexican painter and architect. He was a politically committed artist who painted incendiary ▷frescos during the 1930s. He was an enthusiast of the ideas of ▷Le Corbusier and was responsible for introducing Le Corbusier's architectural style to Mexico City,

where he acted as architect of the National University Library in the 1950s. He committed suicide.

oil paint

Paint made from ▷pigment bonded with oil, usually linseed or walnut oil.

O'Keeffe, Georgia (1887–1986)

American painter. She was born at Sun Prairie, Wisconsin, and studied in various places, including the Art Institute, Chicago (1904–5), and the ▷Art Students' League, New York (1907–8), giving up art teaching in 1918 to become a full-time painter. In 1916, 1917 and 1926 she exhibited at ▷Alfred Stieglitz's ▷291 Gallery, and she married Stieglitz in 1924. Stieglitz's interest in photography exerted an influence on O'Keeffe, as did the contemporary photographers Paul Strand and Edward Weston. She was an important

Georgia O'Keeffe, *Cow's Skull: Red, White and Blue*, Metropolitan Museum of Art, New York

pioneer of American ▷modernism, and her work was exhibited widely. She is best known for her highly colourful abstractions based on enlargements of flower and plant forms, bones and other natural forms – ▷biomorphic pictures which emphasized the formal qualities of organic things. She also produced works in the ▷Cubo-Realist manner of the ▷Precisionist school, and painted series of cityscapes of New York and landscapes of the American Southwest, where she lived for many years. Her floral studies have often been interpreted as sexual metaphors, but O'Keeffe always dismissed this interpretation.

Bib.: *Georgia O'Keeffe: American and Modern*, exh. cat., New Haven, 1993

Olbrich, Joseph Maria (1867–1908)

Austrian architect. He was born in Troppau, Silesia. After studying at the School of Applied Art in Vienna (1881), he entered the Fine Art Academy (1890) and travelled to Italy after winning a scholarship (1893). He was unimpressed by what he saw and travelled on to North Africa, admiring the simplicity of the flat-roofed houses there. He returned to ▷Wagner's office (1894–8), became closely involved with the Vienna ▷Secession and designed the exhibition pavilion for the group (1897–8), creating a solid classically-proportioned building topped by an intricate iron-work sphere of entwined laurel leaves. At the invitation of Philip of Hesse he moved to Darmstadt in 1899 and established an artists' colony there. He designed many of the buildings himself including the Ernst Ludwig House (1900–1901), a long low structure with skylight and two huge statues flanking the entrance. His own house, built the same year, reflected the local vernacular style but with a fussiness (it featured exterior blue and white tiles) which was increasingly prominent in his work. During the last years of his life his style became increasingly functional (e.g. Tietz department store, Düsseldorf, 1906–9) but there remained hints of mannerism nonetheless (e.g. Wedding Tower, Darmstadt, 1905–8).

Bib.: Latham. I., *Joseph Maria Olbrich*, London, 1980

Oldenburg, Claes (b 1929)

American sculptor, associated with ▷Pop art. He was born in Stockholm, but his parents emigrated to the United States in 1934 and settled in Chicago. After graduating from Yale University, he worked as an illustrator and reporter while taking evening classes at the Chicago Art Institute. He moved to New York in 1956 and became instrumental in organizing and designing props for ▷happenings around the Judson Gallery, where he had a one-man show in 1959. Already he was producing sculpture based on ▷junk objects and examples of popular and commodity culture. In 1961 he set up The Store, in which he exhibited and sold brightly painted plaster replicas of consumer goods, notably items of food and clothing. These were followed by a series of soft sculptures of giant hamburgers, ice-cream cones and slices of pie exhibited at the Green Gallery in 1962. From the mid-1960s he became interested in large scale public works and at the Sidney Janis Gallery in 1965 showed plans for public monuments similarly based on mass-produced consumer goods. These included replacing the Statue of Liberty with an electric fan and building a skyscraper in the shape of a fireplug. The first such project to be constructed was a giant *Lipstick Ascending on Caterpillar Tracks* for Yale University (1969). Since 1976 he and his wife Coosje van Bruggen have collaborated on public works including a giant baseball bat erected in Chicago (1977) and a match book in Barcelona (1992). Oldenburg was one of a group of 1950s artists in revolt against

▷ Abstract Expressionism. His fascination with commerce and consumerism made him one of the leading Pop artists, and his choice of materials such as foam rubber influenced the ▷'soft art' of the seventies.

Bib.: *Claes Oldenburg*, exh. cat., New York, 1995; Rose, B., *Oldenburg*, New York, 1970

Old Masters

The term does not relate to specific artists, but it has come to signify a group of (mostly male) artists of the ▷ Renaissance and ▷ Baroque period, whose work was admired by subsequent generations. The artists evoked by this term were generally those who formed (and still form) part of the ▷ canon of 'great' artists, such as ▷ Michelangelo and ▷ Leonardo da Vinci.

Olitski, Jules (b 1922)

American painter and sculptor of Russian birth. He came to America from Russia in 1924. He studied at the ▷ Art Students' League and the National Academy of Design 1939–42 and at the Zadkine School of Sculpture in Paris 1940–47. He became interested in the staining technique of ▷ Morris Louis and ▷ Helen Frankenthaler, and produced his own ▷ colour field work in the 1960s, often using spray painting. In 1968 he turned to sculpture and produced a series of works based around the idea of rings and circles.

Oliver, Isaac (1568–1617)

English miniature painter of French birth. His father was a Huguenot goldsmith, and the family came to London as refugees in 1568. Oliver quickly became a rival to ▷ Hilliard, with whom he studied, and he was appointed ▷ limner to Anne of Denmark. He produced miniature portraits of both Elizabeth I and Mary Queen of Scots. He visited Venice in 1596 and may have picked up some ▷ Mannerist stylistic quirks there. His brother-in-law was ▷ Gheeraerts, and his son Peter (c1598–1647) was also a ▷ miniaturist.

Bib.: Reynolds, G., *Nicholas Hilliard and Isaac Oliver*, 2nd edn., London, 1971

Olympia

Painting by ▷ Manet, first exhibited at the Paris ▷ Salon in 1865 and now in the ▷ Musée d'Orsay, Paris. Manet intended to represent a nude in the tradition of the masters in the Louvre, and his image is clearly based on ▷ Titian's *Venus of Urbino* (1538), though it also has references to the *Nude Maja* of ▷ Velázquez and ▷ Goya. Manet replaces the small dog of Velázquez's painting with a black cat – an erotic reference – and the two servants with a black maid holding a bouquet of flowers. Venus is presented as a courtesan or prostitute, coolly, confidently staring out at the viewer. Manet rejects the classical tradition of the nude for a modern image that, like his earlier ▷ *Déjeuner sur l'Herbe*, caused a storm, outraging the moral sentiments of the day; one critic responded by claiming that 'the body has the livid tones of a corpse at the morgue.'

Bib.: Cachin, F., *Manet*, London, 1991

Omega Workshops

A design group established by ▷ Fry, ▷ Vanessa Bell and ▷ Grant in 1913 at Fitzroy Street in ▷ Bloomsbury. Fry dealt with the organization and Grant produced most of the designs but a number of artists were employed for up to three and a half days a week, including ▷ Lewis, ▷ Bomberg and ▷ Nash. A wide range of goods from textiles to jewellery and furniture were sold anonymously under the Omega label. Fry was interested in creating modern design which was sympathetic to the needs and taste of the public, but which also expressed the artist's joy at creativity. Unlike ▷ Morris, however, he was not in favour of promoting craftsmanship, but rather surface ornament and decoration. Lewis left the group in 1913 after disagreeing with Fry over plans for an Ideal Home Exhibition commission and the group was further weakened by the withdrawal of Bell and Grant in 1916 to Charleston. The workshops eventually closed in 1919.

Bib.: Anscombe, I., *Omega and After*, London, 1989; Collins, J., *Omega Workshops*, London, 1983; *Omega Workshops*, exh. cat., London, 1983

Isaac Oliver, *Self-portrait* (miniature), private collection

oneiric

An adjective indicating 'dream-like'. The term is used frequently in the discussions of the work of ▷ de Chirico and the ▷ Surrealists.

one-point perspective

▷linear perspective

Oostsanen, Cornelisz. van

▷Cornelisz. van Oostsanen

Op art (Optical art)

As its name suggests, Op art exploits, in an ▷abstract context, visual ambiguities to trick the eye into mis-reading the image. Thus the wavy pinstripes of ▷Bridget Riley's paintings, such as *Drift 2* (1966), seem to shimmer before the eye, while ▷Victor Vasarely, the most successful exponent of Op art, has used various devices, such as positive-negative shapes, to make his paintings flicker like a movie image. Op art works by focusing interest exclusively on the question of visual perception while reducing to insignificance any potential interest in subject-matter and avoiding a gestural handling of paint liable to draw attention back to the physicality of the painting.
Bib.: Barret, C., *An Introduction to Optical Art*, London, 1971; Gombrich, E.H., *Art and Illusion*, London, 1977

Opie, John (1761–1807)

English painter. He specialized in portraits and historical subjects. Born at St. Agnes in Cornwall, he was an infant prodigy and at 15 was painting portraits for local landowners and their families. In 1781 he arrived in London as the protégé of John Wolcot, who promoted him as the naturally-gifted 'Cornish Wonder' in exchange for his earnings. Opie became a sudden celebrity, fêted by the court, but his fashionability was short-lived. However, he continued to receive a steady stream of commissions and exhibited regularly at the ▷Royal Academy, being appointed an Academician in 1787 and professor of painting in 1805.

Opie's early work displays a rough-edged freshness which complements his ▷Romantic image as a self-taught child of nature. His portraits of fashionable London, including ▷Burke, Dr. Johnson and Mary Wollstonecraft, are stiffer and more conventional. His historical paintings include *The Assassination of James I of Scotland* (1786) and *The Murder of Rizzio* (1787), which was destroyed in the Second World War.
Bib.: *John Opie RA 1761–1807*, exh. cat., Plymouth, 1957

Oppenheim, Meret (b 1913)

Swiss painter. Born in Berlin, she moved to Paris in 1932 and briefly studied at the Académie de la Grande Chaumière. She was introduced to the ▷Surrealists by ▷Giacometti and ▷Hans Arp, and exhibited with them from 1933 to 1937. She is best known for her Surrealist object *Fur Tea Cup* (1936), as the celebrated 'muse' of the male Parisian Surrealists, and as a model for ▷Man Ray.

optical mixture

A term used by ▷Impressionist and ▷Neo-Impressionist artists to suggest the process by which the eye perceives two juxtaposed ▷primary colours as a ▷secondary colour, despite the fact that they are not blended on the canvas. This optical illusion occurs when the viewer stands at a distance from the painting. The idea of optical mixture became an important part of the art theory of ▷Seurat and his followers.

opus sectile

(Latin 'cut work'.) A form of decorative inlay used for floors and walls in Roman, ▷Byzantine and ▷Islamic buildings, in which relatively large pieces of coloured marble or similar stone are cut to the shape of the intended design (unlike mosaic in which the small ▷tesserae are massed together to create the design).

orangery

A conservatory or greenhouse used for cultivating orange-trees in cooler climates. In the northern hemisphere the south-facing side is equipped with large, tall windows to trap the sun.

Orcagna, Andrea (Andrea di Cione) (d 1368/9), Jacopo (fl 1365–98) and Nardo (fl 1343/6, d 1365/6) di Cione

Italian family of painters. Orcagna was the nickname, possibly derived from *Arcangelo* ('Archangel'), of Andrea di Cione, the leading Florentine artist of the third quarter of the 14th century. He was famous as a painter, sculptor, architect and, according to ▷Vasari, poet. He enrolled in the painters' ▷guild in 1343/4 and the stonemasons' guild in 1352.

Only one painting by Orcagna is signed and dated, the ▷altarpiece of *Christ in Majesty with the Madonna and Saints* of 1354–7 in the Strozzi Chapel in Sta Maria Novella, Florence. This remarkable and richly-coloured work rejects the naturalistic tradition of ▷Giotto and his heirs, and instead presents a supernatural realm, symbolized by the gold, space-denying background against which the figures are set, with Christ, an awesome and remote judge enthroned within a ▷mandorla of seraphim, in the exact middle. In Sta Croce, Florence, are the fragments of a ▷fresco cycle attributed to Orcagna, the *Triumph of Death*, the *Last Judgement*, and *Hell* (?1360s). His only known sculptural work is the highly elaborate ▷tabernacle (completed 1359) built to house ▷Bernardo Daddi's *Virgin and Child* in Or San Michele, Florence. The most accomplished part is the great relief of the *Death and Assumption of the Virgin* on the rear face of the tabernacle (positioned so that it is the first thing that the incoming worshipper sees). From 1358 to 1362 Orcagna was Capomaestro of Orvieto Cathedral and also adviser on the construction of Florence Cathedral. In 1368 he fell ill and died while working on an altarpiece of *St. Matthew* (now Florence, Uffizi).

Orcagna's *St. Matthew* commission was completed by his brother Jacopo di Cione who carried on Andrea's style albeit in a rather less intense, more decorative mode, throughout his career. Works attributed to Jacopo are thus those bearing a stylistic similarity to Andrea, but dating from after 1368 (e.g. *Coronation of the Virgin*, London, National Gallery). Another brother, Nardo, was also a painter. Ghiberti ascribes the fresco of the *Inferno* in the Strozzi Chapel, Sta Maria Novella to Nardo (it is stylistically dissimilar to Andrea's ▷altarpiece) and his *oeuvre* has been built up on this basis. Between them, Jacopo and Nardo seem to have dominated Florentine painting until the end of the century.
Bib.: Kreytenberg, G., 'Image and Frame, Remarks on Orcagna's Raia Strozzi', *Burlington Magazine*, 134 (Oct 1992), pp. 634–8; id., 'L'Enfer d'Orcagna', *Gazette des Beaux-Arts*, 6 no. 114 (Dec 1989), pp. 243–62

Orchardson, William Quiller (1832–1910)

Scottish painter and illustrator. He was born in Edinburgh and educated at the Trustees Academy there, under Lauder. He travelled down to London in 1862 along with fellow pupils ▷Graham and ▷Pettie, and from 1863 exhibited regularly at the ▷Royal Academy. He first specialized in themes from literature, especially Shakespeare and Walter Scott, and historical ▷genre, before turning to the contemporary subjects which made him famous (e.g. *The First Cloud*, 1887, London, Tate; *A Marriage of Convenience*, 1883, Glasgow). In these works, middle-class figures were placed in alienating spaces using muted colours and a strong sense of theatre. ▷Sickert described him as belonging to the tradition of ▷Wilkie, but Orchardson achieved far greater psychological insight in his work. He was also a portraitist (e.g. *Mrs. John Pettie*, 1865, Manchester) and illustrator, working primarily with the magazine *Good Works*. His late works employed complex decoration, creating an abstracted quality despite his traditional technique (e.g. *The Borgia*, 1902, Aberdeen)
Bib.: Errington, L., *William Quiller Orchardson 1832–1910*, Edinburgh, 1980; Little J.S., *Life and Works of William Quiller Orchardson*, London, 1937; Orchardson, H.G., *Life of Sir William Quiller Orchardson RA*, London, 1930; *Orchardson*, exh. cat., Edinburgh, 1972

orders of architecture

In Classical architecture, the five accepted modes or types – ▷Doric, ▷Ionic, ▷Corinthian, ▷Tuscan, and Composite – as determined by the distinct and traditionally prescribed proportions and design of their columns (which consist of a ▷capital, ▷shaft, and, usually, a ▷base) and ▷entablatures (consisting of ▷cornice, ▷frieze and ▷architrave). The most visually distinctive member of each order is perhaps the capital, although most of the other architectural members could be allocated, in isolation, to a specific

order. The three Greek orders – the Doric, Ionic, and Corinthian – are the principal modes, with Tuscan and Composite being Roman derivatives of the Doric and Corinthian orders respectively. The present five orders were first described by ▷Serlio in 1537, the Composite order probably not yet having been invented when Vitruvius described the first four in the 1st century BC (the earliest surviving example of the Composite order being the Arch of Titus, Rome, of AD 82); and it was Vitruvius who had first listed the Tuscan order in addition to the existing three Greek orders. The Tuscan order is plainer and more massive than the Doric: it always has a base, a plain ▷frieze (no ▷triglyphs and ▷metopes), and no ▷mutules in the cornice. The Composite order combines the ▷volutes of the Ionic capital with the ▷acanthus decoration of the Corinthian.

It is important to remember that surviving examples of ancient Classical buildings reveal a great diversity of interpretation within each order; each proportion and detail is susceptible to variation within a set of limits which seem to have been empirically determined. It is only following the writings of later Classical theorists, such as Serlio and ▷Palladio, that ideal proportions and correct detailing have been more firmly established, giving a false impression of rigid prescription where an established set of guidelines is in fact a more accurate description of the orders.

Ordóñez, Bartolomé (fl 1514–20)

Spanish sculptor. We know that he was in Naples in 1514–15, and that he did some sculptural work while in Italy, including ▷reliefs and tomb sculpture. In 1517 he decorated the choir of Barcelona cathedral, and he was responsible for the tombs of Philip I and Juana of Castille.

Orientalism

The Orient has fascinated Western artists, scholars and littérateurs from ancient Greece onwards because of its strangeness and mystery, but until the 18th century the Orient was generally understood as the Middle, not the Far East. Middle Eastern contacts with the West were made through trade, embassies and sometimes as a result of Westerners collecting luxury objects usually unavailable further west, such as carpets, lapis lazuli, lustre pottery, ivories and certain types of glass, along with porcelain from the Far East.

The great Spanish and Portuguese voyages of the ▷Renaissance were important in opening up sea trade with cultures beyond Arabia, but they simply made goods cheaper than those brought overland, without changing their variety. The ethnographic art brought back from such voyages was placed in ▷cabinets of curiosities, rather than considered as art likely to interest Western artists. Dutch trade in the 17th century introduced several crazes to the West, not least those for tulips and blue and white ▷Delftware. Ambassadorial

missions from the East, travelling to Western countries, were remarkably exotic, and the East was represented thus in contemporary art and literature, its products also reflected in Western imitations, especially in the decorative arts.

In the 18th century, travel began to change the picture, as did military conquest (▷Egyptian art), but the mystique was both preserved and enhanced through the ▷Romantic vogue for Orientalism in literature. The ▷Industrial Revolution opened up the world still further as raw materials were imported from the East and manufactured products sold or exchanged there, while the extended travel of the later 19th century assured Orientalism a continuing place in literature and art. (▷Symbolism).

Bib.: Jairazbhoy, R.A., *Oriental Influences in Western Art*, New York, 1965; MacKenzie, J., *Orientalism: History, Theory and the Arts*, Manchester, 1995; Martin, R. and Koda, H., *Orientalism: Visions of the East in Western Dress*, New York, 1994, Rosenthal, D.A., *Orientalism the Near East in French Painting, 1800–1880*, exh. cat., University of Rochester, 1982; Said, E.W., *Orientalism*, reissued Harmondsworth, 1995

Orley, Bernard (Bernaert or Barend or Barent) van (c1490–1541)

Netherlandish painter. He was from Brussels. He was appointed court painter to Margaret of Austria, who was then Regent of the Netherlands (1518) and later held the same post under Mary of Hungary (1532). His work showed the influence of Italian art, particularly that of ▷Raphael, whose ▷cartoons for tapestries were in Brussels c1516–19. He also designed tapestries himself, as well as stained glass.

Bib.: Friedländer, M., *Early Netherlandish Painting*, vol. 8: *Jan Gossaert and Bernard van Orley*, Leyden, 1972

ormolu

(French, 'ground gold'.) ▷Gilded ▷bronze, as used in the decoration of furniture and on ornamental objects.

Orozco, José Clemente (1883–1949)

Mexican artist. He grew up in Mexico City, and his school was in the same street as ▷Posada's studio. Watching the illustrator at work inspired his own first sketches. He studied agriculture and cartography before enrolling at the Academia Nacional de Artes Plasticas (1908–14). As the revolution broke out, he drew ▷caricatures for radical newspapers. During 1917–20 he lived in the United States, working in a toy factory and painting signs. His first ▷murals were begun in 1923 at the National Preparatory School in Mexico City, but their aggressive, caricatured style offended the students and they were destroyed. Orozco returned to the United States from 1927 to 1934, with a trip to Europe in 1932, but after this remained in Mexico until his death. He continued to paint frescos

for museums, schools and government buildings in Guadalajara and Mexico City.

Alongside ▷Rivera, Orozco was the most significant of the muralists. His imagery is more direct and energetic, rooted in the rough style of his newspaper caricatures. At first his murals were highly didactic and addressed political themes. In the 1930s, however, he drew on mythical and historical subjects, painting *Prometheus* at Pomona College (1930) and *Quezalcoatl* for Dartmouth (1932). His dramatic murals for the Hospicio Cabañas in Guadalajara (1938–9) form a pessimistic vision of Latin American history, mixing images of the conquest with the rise of capitalism and fascism. His later work became more ▷Expressionist, attempting to find a universal resonance in his portrayals of suffering mankind.

Bib.: Elliot, D. (ed.), *Orozco*, New York, 1980; McKinley, H., *Man of Fire, José Clemente Orozco*, Boston, 1953

Orpen, Sir William Newenham Montague (1878–1931)

Irish painter. He studied at the ▷Slade, and became an ▷ARA in 1910 and an ▷RA in 1919, a year after he received a knighthood. He was one of the founder members of the ▷NEAC, but despite his association with a progressive art society, his work bore more affinities with the art of the 19th century than with the new tendencies of the 20th. He was primarily a portrait painter of high society figures, and he also produced interior scenes and ▷conversation pieces.

Bib.: Arnold, B., *Orpen: Mirror to an Age*, London, 1981

Orpheus

A legendary Thracian poet, skilled with the lyre, who married the wood nymph Eurydice. Orpheus is depicted either in a general scene where he charms the animals with his music (he was compared to ▷Christ by the early Christians), playing either a lyre or a viol, and represented as a youthful, idealized hero with laurel wreath. Alternatively, he is depicted as part of the tragedy of Eurydice, who died from a snake bite after fleeing the attentions of Aristaeus. Orpheus followed her to the underworld, where he bargained for her to be released, providing that he did not look round at her during the journey back to life. At the last moment he turned, and Eurydice was lost. As a result Orpheus became a misogynist and was finally killed by the Maenads. The subject has remained popular: earlier artists concentrated on the narrative, whilst in the 19th century Orpheus himself was commonly depicted, especially by ▷Symbolist artists (e.g. ▷Delacroix, *Orpheus Bringing Civilization*, 1838–47, Paris, Chambre des Deputés; ▷Tiepolo, *Orpheus and Eurydice*, 1625, Venice; ▷Redon, 1913–16, Cleveland). Orpheus also gave his name to ▷Delaunay's version of ▷Cubism – ▷Orphism.

Sir Edward Burne-Jones, *Orpheus leading Eurydice from Hades*, design for the Graham Piano, 1879–80, Fitzwilliam Museum, Cambridge

Orphism (Orphic Cubism)

A romantic or expressive offshoot of ▷Cubism. ▷Apollinaire applied the name to the works exhibited by ▷Delaunay, ▷Duchamp, ▷Picabia and ▷Léger in the 1912 ▷Section d'Or exhibition held in the Galerie la Boétie. The aim of the group was to sever Cubist links with the objective world in favour of the development of abstract painting. Apollinaire described Orphism in *Les Peintres Cubistes* (1913) as, 'the art of painting new structures out of elements which have not been borrowed from the visual sphere, but have been created entirely by the artist.' Delaunay in particular was interested in the expressive quality of colour used independently of nature, and studied the theory of the simultaneous contrast of colours adopted by the ▷Neo-Impressionists. The ▷Futurist idea of ▷dynamism had much in common with Orphism, which sought a ▷'simultaneity' of experience articulated in a non-figurative pictorial language. The expressive qualities of Orphism were influential on ▷Kandinsky, ▷Klee, ▷Macke and the artists of the ▷Blaue Reiter. **Bib.**: Delaunay, R., *De cubisme à l'art abstrait*, Paris, 1957; Spate, V., *Orphism*, Oxford, 1980

orthogonal

Term used to denote lines in a picture which in reality would run parallel at right-angles to the picture plane but which, in conformity to the rules of ▷linear perspective, converge at a vanishing point intended to be exactly opposite the eye of the spectator.

Os, Jan van (1744–1808) and Georgius Jacobus van (1782–1861)

Members of a Dutch family of painters. They specialized in the painting of flowers.

Osborn, Emily Mary (1834–after 1913)

English painter. She took private lessons in a London school, and on the basis of this experience, had work accepted for the ▷Royal Academy exhibitions, beginning in 1851. She studied in Munich in the early 1860s, where she absorbed contemporary European influences. Her fame brought her to the attention of Queen Victoria, who purchased some of her works. Some of her images were extremely popular in their own time, such as *Nameless and Friendless* (1857). Many of her works were engraved.

Osona, Rodrigo de (fl 1476–84)

Spanish painter. His work showed the influence of both Netherlandish and Italian styles. He worked primarily in Valencia.

Ostade, Adriaen van (1610–85)

Dutch painter (both in oils and ▷watercolours) and etcher. He specialized in rustic tavern scenes, portraits and still life, and was active principally in Haarlem. According to ▷Houbraken, he entered the workshop of ▷Frans Hals in c1627, where he trained with ▷Adriaen Brouwer. Hals's choice of subjects and style seems to have made little impact on him, whereas the influence of Brouwer's scenes of rustic boors drinking, smoking and brawling in taverns is very evident in his early work (e.g. *Carousing Peasants in an Interior*, c1638, Munich). By 1634 Ostade had been admitted to the Haarlem painters' guild, becoming its dean in 1662. From about 1640 the use of ▷chiaroscuro effects learnt from ▷Rembrandt's early style (evident even in Ostade's earlier work) becomes more assured, and he is able to use it to create a greater pictorial unity. His final works, after about 1660, depict a more affluent society and are more refined in technique with a greater delicacy of colour (a general trend in Dutch painting of this time). Ostade had numerous pupils and imitators, most notable amongst the former being his brother Isaak (1621–49) and ▷Jan Steen. Ostade's popularity (in the 18th century he was sometimes considered to be the equal of ▷Rembrandt) continued into the 19th century until the vogue for ▷Impressionism rendered his work unfashionable. A prolific artist, his work can be seen in many public collections.
Bib.: Godefroy, L., *The Complete Etchings of Adriaen van Ostade*, San Francisco, 1990; Pelletier, S.W., *Andriaen van Ostade: Etchings of Peasant Life in Holland's Golden Age*, Athens, GA, 1994

Other, the

Philosophical and critical idea originating from the German philosopher ▷Hegel, who showed how western thought and civilization identified and defined itself through its relationship with what it was not. In Hegel's example of the master and the slave or servant, the master can exist only in opposition to the slave, his 'Other'. The slave is thus an integral definer of the master's status, and vice-versa. The idea has become popular within ▷poststructuralist theory, where the Other is identified in Western society as such groups as blacks, gays or women. These groups are shown to be inherent in structuring the traditional, hierarchical 'norms' of white, heterosexual, male-dominated society, which, although marginalizing them, cannot exist without them. The term 'alterity' is sometimes used as a synonym for 'the Other'.

ottocento

Literally, 'eight hundred', the Italian art term for the 19th century. It is used only to refer to Italian art and may be used as either an adjective, as in 'ottocento art', or a noun, as in 'art of the ottocento'.

Ottoman

The Ottoman Turks were a clan from central Asia, named after one of their first leaders, Osman (d 1324). They dominated Eastern Europe in the 14th, 15th and 16th centuries, taking Sofia in 1382, Constantinople in 1453 and by 1520 ruling an empire which covered Greece, Serbia, Albania, Turkey, Syria and Egypt. Indeed, Ottoman sultans controlled the Near East until 1922, making them the longest-ruling Islamic dynasty. The Ottomans manipulated the architecture and arts of the countries they overran, and incorporated many different elements – ▷Byzantine and Seljuk, for example – into their own work. By the late 15th century, however, Sinan (1489–1588), Suleiman the Magnificent's chief architect, came to develop a more explicitly Ottoman style, which embodied vast spaces, vaulted but shallow domes and slender ▷minarets. Sinan is credited with over 300 buildings, and it is this architecture, epitomized by such work as the Selimiye Mosque, at Edirne in Turkey, by which Ottoman architecture is remembered.

Ottonian art

A style of art and architecture which flourished under the Ottonian emperors of Germany. After the death of ▷Charlemagne (814), the unity of the Holy Roman Empire crumbled and Western Europe became divided into three distinct regions roughly corresponding to modern Germany, western and central France, and a strip of land running from the Netherlands to Switzerland. In Germany stability was re-established by King Henry (919–36), his son Otto I (936–73) and their descendants. At this time Ottonian art (named after Otto) began to flourish.

In some senses Ottonian style is characterized by a conscious harking back to ▷Carolingian times, as seen on the west front of St. Pantaleon, Cologne (c1000); here, a chapel similar to Charlemagne's Palatine Chapel looks down into the main ▷nave of the church. Elements of Carolingian architecture can also be seen at St. Michael's, Hildesheim, financed and possibly designed by Bernward of Hildesheim. Here, however, is evidenced the spatial quality which defines Carolingian from Ottonian. The geometric scheme of the church – two ▷chancels, two ▷apses and two ▷transepts, with ▷piers clearly defining different areas – moves away from ideas of the ▷basilica, and anticipates ▷Romanesque architecture. Ottonian art was also distinguished in the field of ▷manuscript illumination. Modelling is more defined and Classical references in gestures and buildings can be seen. The colours owe much to ▷Byzantine influences and links between the two courts were cemented through marriage in 972. Manuscripts from the Abbey of Reichenau show these interests. In the field of the decorative arts the Ottonian style was extremely innovative. For example, the bronze doors at Hildesheim Cathedral are illustrated with scenes from the Old and New Testament with sharpness, clarity and self-confidence.

Oud, Jacobus Johannes Pieter (1890–1963)

Dutch architect. He was born in Amsterdam and studied there and at the Technical University in Delft. He spent a brief period in Munich, before settling in Leiden in 1914. His early work was influenced by Hendrik Berlage, and combined modern materials with an ▷Art Nouveau style. He was a member of ▷De Stijl in 1917–21 and worked with ▷van Doesburg on the De Vonk Workers' Retreat (1917). As Rotterdam City Architect from 1918, he put many of the group's ideas of modern functionalism into practice (e.g. Tusschendijken Flats, 1920; Garden Villa, 1922–3, using primary colours). His work had a streamlined simplicity which avoided the harsher aspects of ▷modernism (e.g. Hook of Holland housing, 1924–7, which utilized rounded corners). He exhibited at the Stuttgart housing show in 1927 (▷Deutscher Werkbund). Later his work became more ornate and he experimented with classical symmetry and brick (e.g. Shell Building, The Hague, 1938–42).
Bib.: Stamm, G., *The Architecture of J.J. Oud*, Tallahassee, 1978

Oudry, Jean-Baptiste (1686–1755)

French painter, illustrator and tapestry designer. He was a pupil of ▷Largillière. Throughout his career, he was best known for his still lifes and for scenes of the hunt and its aftermath. His skill with hunting imagery led him to employment in the ▷Beauvais tapestry works in 1726, as the hunt was a particularly prominent theme of tapestry design. He became the manager of Beauvais in 1734 and produced numerous tapestry

designs. He worked for ▷Gobelins from 1736, and he became court painter to Louis XV for whom he painted a series of hunting scenes which were woven into tapestries. In 1755–9 he illustrated Fontaine's *Fables*.

Bib.: *J.-B. Oudry 1686–1755*, exh. cat., Paris, 1982; Opperman, H., *Jean-Baptiste Oudry*, 2 vols., New York, 1977

Ouwater, Albert van (fl mid-15th century)

Dutch painter. He worked at Haarlem, but little is known about his career, other than what is mentioned by ▷Van Mander. He painted *The Raising of Lazarus* (Berlin, Staatliche Museen), and he taught ▷Geertgen tot Sint Jans.

Ovenden, Graham

▷Blake, Peter

Overbeck, Gerta (1898–1979)

German painter. She studied in Düsseldorf in 1915–18, and at the School of Decorative Art, Hanover (1919–22). While in Hanover, she met ▷Grethe Jürgens and Ernst Thoms, and the three of them advocated a ▷Neue Sachlichkeit style which they applied to scenes of working-class life. She taught for a time in Dortmund but returned to Hanover in 1931. Her work was dominated by ▷genre scenes and industrial landscapes.

Bib.: *Grethe Jürgens, Gerta Overbeck: Bilder der zwanziger Jahre*, exh. cat., Bonn, 1982

Overbeck, Johann Friedrich (1789–1869)

German painter. He studied in Vienna and helped found the ▷Nazarenes in Rome with ▷Pforr and ▷Cornelius. He converted to Catholicism in 1813 and concentrated on grand historical and religious themes. His style was deliberately modelled on that of ▷Raphael.

Bib.: Blühm, A. and G. Gerkens (eds.), *Johann Friedrich Overbeck 1789–1869*, Lübeck, 1989

OX

The ox as both draught animal and sacrificial animal appears frequently in art. In Christian art an ox is frequently represented with an ass in ▷Nativity scenes. The two beasts stand behind the manger looking towards the ▷Christ child. Their presence at the birth of Christ derives from Isaiah (1:3) 'The ox knoweth his owner, and the ass his master's crib: but Israel doth not know ...' This was interpreted as ▷Isaiah's prophecy that Israel would reject the true Messiah, Jesus Christ. Because of its pre-Christian role as a sacrificial animal, the ox was also employed as a symbol of Christ's sacrifice by the early Church. A winged ox also symbolizes St. Luke as one of the four ▷Evangelists and the ox is, in addition, sometimes used as an identifying attribute of the Dominican saint Thomas Aquinas who was, as a youth, nicknamed the 'dumb ox' (but one whose lowing, according to his teacher Albertus Magnus, 'would soon be heard all over the world'). In Greek mythology Heracles (▷Hercules) drives a herd of oxen after killing their owner, the three-bodied monster, Geryon. In Roman history (Livy 3:26) Cincinnatus is called from his plough to defend Rome, an example of ancient Roman virtue. In ▷allegorical painting, the ox is sometimes employed instead of a lamb as an attribute of Patience personified.

Ozenfant, Amédée (1886–1966)

French painter. He studied in Spain and France, where he came into contact with Jeanneret (▷Le Corbusier) in 1917. He also met ▷Dunoyer and ▷La Fresnaye. Although he was interested in ▷Cubism, he felt that it had veered dangerously close to pure decoration, and he wrote the polemical treatise *Après le Cubisme* (*After Cubism*) (1918) to suggest alternatives. With Jeanneret, he advocated ▷Purism, or a more simplified and clinical/industrial form of Cubism, and the two men also founded ▷L'Esprit Nouveau in 1920. He lived in London in 1935–8 and moved to New York in 1938 where he founded the Ozenfant School of Fine Arts.

P

p., pinx., pinxit, pictor

(Latin, *pinxit*, 's/he painted it'.) Any of these variants might, in a painting, follow the name of the artist who painted it. When it follows a name on a print it indicates that the print reproduces a picture painted by the artist named.

Pacheco, Francisco (1564–1644)

Spanish painter, teacher and art theorist. He was active mainly in Seville. In general, he was a rather mediocre painter, although his portraits are more accomplished than the religious paintings which were his chief concern. As a teacher, however, he appears to have been excellent, openly recognizing and diligently nurturing the superior qualities in his greater pupil and, from 1618 son-in-law, ▷Velázquez. This recognition was particularly generous considering the potential conflict between his pupil's nascent naturalism and Pacheco's own style, based on the idealization of nature. Pacheco achieved considerable public success, enjoying the post of Painter to the King from 1619, and he exercised much influence on the course of Spanish painting, particularly through his position as censor of paintings to the Inquisition (from 1618). The treatise for which he is chiefly famous, *El Arte de la Pintura* (*The Art of Painting*), completed in 1638 and published posthumously in 1649, comprises a technical manual, a history of the art of painting, biographies of Spanish painters, and a very important prescriptive section on the iconography of the chief themes of ▷Counter-Reformation art in Spain. His own paintings, such as *The Immaculate Conception* (Seville Cathedral) and *Christ on the Cross* (Granada, Fundación Gómez-Moreno), exemplify to the letter the orthodoxy expounded in the treatise. Pacheco also frequently collaborated with the sculptor, ▷Montañes, painting his carved wooden figures. Apart from Velázquez, Pacheco's most important pupil was ▷Alonso Cano.

Bib.: Brown, J., *The Golden Age of Painting in Spain*, New Haven and London, 1991

Pacher, Michael (fl 1445, d 1498)

Austrian woodcarver and painter. He was active chiefly in the Tyrol. His origins are obscure, but he seems to have been trained in the Netherlandish late ▷Gothic tradition disseminated through the presence in Austria of Nicolaus Gerhaerts (fl 1462–c1478). Pacher's earliest recorded work, a signed and dated altarpiece of 1465, is now lost. A possible trip to Padua in c1470 has been suggested; certainly the proximity of northern Italy and the evident influence of ▷Mantegna in his painting would support this. Pacher's masterpiece, the carved and painted polyptych for the pilgrimage church of St. Wolfgang, near Salzburg (commissioned in 1471, completed in 1481), is the earliest of his works to display this combination of carved, polychrome Gothic elements (in the intricate canopied central panel of the *Coronation of the Virgin*) and the Italianate concern for rational spatial construction and monumentally-conceived figures (in the painted wings). Even more Italianate is his *Altarpiece of the Doctors of the Church* (early 1480s, Munich, Alte Pinakothek). His work was considerably influential throughout Austria and Germany and he was one of the earliest artists north of the Alps to fully assimilate the new intellectually-based art of the Italian ▷Renaissance.

pagoda

The word is of Portuguese origin and is used to refer to a multi-storied ▷Chinese or ▷Japanese ▷Buddhist temple, or other sacred building. The stories, which diminish in size towards the top, are generally open, pent-roofed, wooden pavilions with ▷balconies. The Chinese term is *ta* and the Japanese, *to* (further classified as *taho-to* – two stories; *sanju-no-to* – three stories; *goju-no-to* – five stories; *nana-ju-no-to* – seven stories), or *shoro* (when it has a bell-tower). All stories are square in ground plan, except for the two-storied *taho-to* which has a lower square storey surmounted by a hemisphere on which the next cylindrical storey, crowned by a spire, or *sorin*, is set. This design may indicate the origin of the Chinese and Japanese pagoda in the Indian Buddhist ▷stupa, a memorial mound erected over a relic, or on a sacred site. The original hemispherical mounds developed over time into increasingly complex structures: they were raised on ▷plinths, sometimes with the mounds taking on a bell shape and generally being crowned with a spire and tiers of ornamental sunshades. It is this last feature, a spire with thirteen gilded sunshades (rising to over 700 ft), on the magnificent Gandharan stupa at Shah-ji-ki-Dheri, near Peshawar, Pakistan (c AD 14), that so impressed Chinese pilgrims and which is generally credited with influencing the Chinese invention of the pagoda.

Paine, James (1716–89)

English architect. He studied at the ▷St. Martin's Lane Academy and was involved in the designing and

redesigning of country houses. He worked at both Kedleston and Chatsworth in a muted ▷Palladian style.

Bib.: Leach, P., *James Paine*, London, 1988

painterly

(From the German, *malerisch*.) In *Principles of Art History* (1915), the formalist art historian ▷Heinrich Wölfflin analysed the development of art as a series of paired concepts, one such pair being the 'linearity' of the ▷Renaissance and the 'painterly' ▷Baroque. By painterly he meant to indicate the broad approach of artists such as ▷Tintoretto, ▷Velázquez and ▷Rubens who privileged colour, irregularity and a free handling of paint over the academic emphasis on line. In the 17th century partisans of the two positions were known as the ▷Poussinistes (line) and the Rubenistes (colour).

A renewed impetus to painterly qualities was given by the ▷Romantics, who believed they expressed the spontaneity and emotion of the artist better than the classicizing (▷Classicism) qualities of premeditated line. In modern art 'painterly' has been an important thread running through ▷art criticism. Interest in painterly qualities was received by ▷Clement Greenberg's formulation of modern painting as a ▷medium that draws attention to itself, as exemplified by the ▷Abstract Expressionists' interest in the ▷bravura, the gestural and the mark-making. Indeed, Greenberg referred to Abstract Expressionism as 'painterly abstraction' in order to distinguish it from geometric ▷abstraction. The 1980s saw yet another revival of the painterly in the work of the ▷Neo-Expressionists.

pala

Italian term for a large ▷altarpiece (short for *pala d'altare*).

Palazzo Farnese

This monumental palace stands south of the Campo dei Fiori in Rome, and is one of the most imposing and richly-decorated buildings of the Italian ▷Renaissance. It was commissioned by Cardinal Alessandro Farnese (later Pope Paul III) in 1517 and designed as a solid rectangle by ▷Antonio de Sangallo the Younger. Construction was halted after the Sack of Rome in 1527. When it was resumed in 1539, ▷Michelangelo was commissioned to design a new cornice bearing the Farnese arms, massive enough to give unity to a façade stretching 150 feet. Antonio died in 1546 (allegedly in shock at the changes to his plans) and the building was completed in 1550 with further alterations to the interior by Michelangelo. These alterations are full of idiosyncratic touches, breaking away from the regularized conventions of Renaissance architecture. Decoration for the palace was assigned to ▷Annibale Carracci in 1595, who painted *The Life of Hercules* for the Camerino, and the *Loves of the Gods* for the ceiling of the main gallery. ▷Giovanni

Lanfranco and Domenichino Zampieri also contributed frescos under Annibale's supervision. The building now houses the French Embassy.

palette

(French diminutive, from Latin *pala*, 'spade'.) A flat tray of wood or ▷porcelain, designed to be held in the hand, upon which an artist sets out and mixes his or her oil colours. By extension, palette is used to describe an artist's characteristic chromatic range, as in the expressions, 'wide palette' and 'limited palette'.

palette cup

▷dipper

palette knife

A flexible, blunt-edged, metal blade set into a handle, used by painters since the 18th century (before which ordinary knives were used) to mix paint on the ▷palette and also, where desired, to apply thicker layers of ▷pigment to the support. Conversely, a palette knife may also be used to scrape paint from either palette or support.

palimpsest

(i) A parchment on which an earlier inscription has been erased to allow the surface to be used again. (ii) A monumental slab or brass plate which has been reversed to conceal an earlier inscription or marking and so allow a new inscription to be engraved.

Palladianism

A phrase of English domestic architecture, lasting from about 1715 to almost the close of the 18th century. Palladianism was a reaction against the perceived excessive elaboration of the English ▷Baroque under ▷Wren, ▷Vanbrugh and ▷Hawksmoor. It sought to regain a Vitruvian ▷Classical purity enshrined in the buildings and ideas of the Italian architect and theorist, ▷Andrea Palladio, and his English follower, ▷Inigo Jones. It established the so-called Rule of Taste in which ▷connoisseurship could only be acquired by correct reading, travel and archaeological study. It aimed to replace 'sensuous' ▷Baroque artificiality with 'intellectual' Classical naturalness. Despite its origin in the writings of Vitruvius as interpreted by Palladio, Palladianism was essentially a nationalistic movement in that it looked back to ▷Inigo Jones, the founder of the English architectural ▷Renaissance, whilst rejecting contemporary foreign influences, specifically those of the French, Dutch and Italian Baroque. The two seminal publications of Palladianism were the new edition of Palladio's *I quattro libri dell' architettura* (*Four Books of Architecture*), illustrated by Giacomo Leoni and translated by Nicholas Dubois (published 1715), and ▷Colen Campbell's *Vitruvius Britannicus* (published in three volumes in 1715, 1717, and 1725). Campbell and the amateur architect ▷Lord Burlington were the

effective pioneers of Palladianism. Campbell designed the seminal Wanstead House, near London (c1714–20, demolished 1824) and Burlington was the architect of Chiswick House (c1723–9), based closely on Palladio's Villa Rotonda. The movement also included ▷William Kent (Holkham Hall, Norfolk, begun 1734), Henry Flitcroft (Wentworth Woodhouse, South Yorkshire, begun c1733) and Isaac Ware (Wrotham Park, Hertfordshire, 1754). There was also a revival of Palladian ideas at this time in the Veneto, affecting churches as well as domestic architecture, while later in the century English Palladianism spread to North America.

Bib.: Wittkower, R., *Palladio and Palladianism*, London, 1974

Palladian window

A large window with three lights, the middle light wider and arched, the flanking lights surmounted by horizontal ▷lintels. The lights are divided by ▷columns, or ▷piers resembling ▷pilasters. The motif derives from the arched opening actually invented by ▷Bramante, but later used to such great effect by ▷Palladio for both ▷arches and windows that it has become more widely known as a Palladian window. ▷Inigo Jones was deeply impressed with Palladio's work on his second trip to Italy (1613) and the Palladian window is one of the motifs he adopted under the overall influence of Palladio's style (cf. the east window of the Queen's Chapel, St. James's Palace, London 1623–7). It thereafter became a characteristic feature of ▷Palladianism, especially in 18th-century England. Notwithstanding Palladio's wide use of the motif, it was first illustrated in ▷Serlio's *Architettura* (1537) and hence is also known as Serliana or Serlian motif (which term is in addition used to refer to an arch of the same design). Yet another name for this motif is the Venetian window.

Palladio, Andrea (1508–80)

Italian architect. He was the most influential Italian architect and theorist of the second half of the 16th century. His work, based on a profound knowledge of Vitruvius and antique Roman architecture, is characterized by a belief in the necessity of creating harmonic, mathematically derived, proportional relationships between the various parts of plan and elevation. Born in Padua, the son of Piero della Gondola, he began as a mason. By 1524 he was in Vicenza having, in that year, enrolled in the Vicenza guild of bricklayers and stonemasons. In 1536 he secured employment with the wealthy ▷humanist poet, philosopher and mathematician Giangiorgio Tressino who, recognizing his potential, recommended he study Vitruvius and develop a liberal education. It was Tressino that nicknamed his young protégé 'Palladio' (from Pallas Athena, goddess of wisdom). In 1541 Tressino took Palladio to Rome for two years where he studied High

▷Renaissance architecture and ancient architectural remains. His reputation was established in 1545 when he won a competition for recasing the by now old-fashioned looking Palazzo della Ragione (or Basilica) in Vicenza (work begun 1549). With this design, owing much to ▷Sansovino's Library at Venice, Palladio encased an irregularly designed building with a harmoniously planned Classical shell. It was also here that he used for the first time a motif derived from ▷Serlio (whose treatises exerted a great influence on him). As it came to be a hallmark of Palladio's own work, however, the 'Serlian motif' has henceforth been known more commonly as the ▷'Palladian motif'.

Palladio was hereafter in great demand from the Vicenzan aristocracy, building numerous town houses for them, such as the Palazzo Thiene (begun 1542), the Palazzo Porto (begun c1548–52), the Palazzo Chiericati and the Palazzo Valmarana (begun 1565). With his last building in Vicenza, the Teatro Olimpico (begun 1580, completed by his pupil ▷Scamozzi), he sought to reconstruct the form of a Roman theatre as described by Vitruvius.

Because the Vicentine economy was land-based, many of Palladio's other commissions at this time were for ▷villas, designed both for comfort and as working farms. His villa format was established in the 1550s and persisted throughout the following years in many variations but with no significant development. They are all symmetrically planned, raised up on a basement level, and are usually preceded by a ▷portico (Palladio assumed, wrongly, that the grander domestic buildings of Classical times were designed with porticoes). The central residential block is linked to the farm buildings by long service ▷loggias, either at right angles or arching forward in quadrants. Symmetry was taken to its limit in the Villa Rotonda (1567) where the central domed hall has four equal living units around it with each of its four façades preceded by an identical portico.

Palladio's three churches are all in Venice: S. Francesca della Vigna (1562, façade only); S. Giorgio Maggiore (begun 1566); and Il Redentore (begun 1576) – each attempting, with increasing success, to solve the old problem of applying a Classical temple front to a Christian church with its high central nave flanked by low side aisles and lower side chapels. In 1570 he published his *I quattro libri dell' architettura* (*Four Books of Architecture*), in which he expounded his theories and illustrated them with examples of his own buildings, a work which was to have such a profound influence on the English architecture of ▷Inigo Jones in the 17th century and then the Palladians (▷Palladianism) of the 18th century, the latter of whom turned Palladio's ideas, so flexible in his own hands, into rigid doctrine.

Bib.: Ackerman, J., *Palladio*, Harmondsworth, 1966; Boucher, B., *Andrea Palladio: Architect of his Time*, New York, 1994; Trager, P., *The Villas of Palladio*, Boston 1992; Wundram, M., *Andrea Palladio, 1508–80*, Cologne, 1993

Palma Giovane (Jacopo Palma) il Giovane, (c 1548–1628)

Italian painter. He was from Venice and was a great-nephew of ▷Palma Vecchio. The circumstances of his training are unknown. In 1546 his work was admired by Guidobaldo, Duke of Urbino, who introduced him to a circle of influential patrons and seems to have supported a period in Rome (from 1567 to c1575) where presumably Palma studied the ▷antique and absorbed the influence of ▷Michelangelo and the late Roman ▷Mannerists, all of which is suggested in his one surviving Roman work, *Portrait of Matteo da Lecce* (New York, Pierpoint Morgan Library). His earlier work had been influenced by ▷Titian, but following his return to Venice his work was increasingly influenced by ▷Veronese and, above all, by ▷Tintoretto. By 1578 he had secured the prestigious commission for three large-scale history paintings in the Sala del Maggior Consiglio in the Doge's Palace. From then on he was one of the leading painters in Venice, admired for his clear uncomplicated narrative style. After the death of Tintoretto in 1594 he was without serious competition. At his best he was capable of works of sensitivity but, perhaps owing to the overwhelming demand of his later years, he was liable to rely on repetitive formulas.

Palma Vecchio (Jacopo Palma il Vecchio; Jacopo Negretti) (c 1480–1528)

Italian painter. He was born near Bergamo and trained in Venice, possibly under ▷Giovanni Bellini, and was considerably influenced by ▷Giorgione and ▷Titian. He is first documented in 1510 in Venice. Any chronology of his works is made difficult by the fact that none are dated. He painted ▷sacre conversazioni (e.g. Venice, Accademia) but also specialized in mildly erotic pictures of voluptuous blonde women, either nude in a somewhat gratuitous mythological guise (e.g. *Diana Discovering Callisto*, Vienna, Kunsthistorisches Museum) or provocatively *décolletée* in a half-length portrait format (e.g. *A Blonde Woman*, c1520, London, National Gallery). He also painted portraits (e.g. *Portrait of a Poet*, mid-1510s, London, National Gallery) and at least one history painting, which was very highly praised by ▷Vasari (*Sea Storm*, c1527–8, Venice, Scuola Grande di San Marco). His paintings are characterized by a sensual finish, opulent colour, a monumental figure style and a constant type of female beauty, whether in a religious or a secular context. He is known as Palma Vecchio (Palma the Elder) to distinguish him from his great-nephew, known as ▷Palma Giovane (Palma the Younger).
Bib.: Rylands, P., *Palma Vecchio*, Cambridge, 1992

Palmedesz, Anthonie (1601–73)

Dutch painter. He studied with ▷Mierevelt. He painted both portraits and ▷genre scenes of ▷merry companies.

Palmer, Erastus Dow (1817–1904)

American sculptor. He began his career producing ▷cameo pictures, but gradually shifted his attention to ▷Neoclassical sculpture with historical themes. He was mostly self-taught and worked in New York State. His *The White Captive* (1858, New York, Metropolitan Museum) was compared to ▷Hiram Powers' *Greek Slave* of 15 years earlier. He produced both free-standing and ▷relief sculpture.

Palmer, Samuel (1805–81)

English artist. He was a bookseller's son, born into a religious family. He exhibited at the ▷Royal Academy when only 14 and showed a precocious talent, influenced by ▷Turner. In 1821, however, he met ▷Linnell, who was to be a major figure throughout his whole life. At the time, Linnell was inspired by the work and philosophy of ▷Blake, whom he introduced to Palmer in 1824, and who encouraged them to abandon ▷academic art in favour of a purer, more archaic style influenced by ▷Gothic masters, ▷Dürer and ▷Bruegel. In 1826, Palmer moved to Shoreham with his father and there, together with a like-minded group who called themselves the ▷Ancients (▷Calvert, ▷Richmond), he began to put Blake's ideas into practice with a series of landscapes. For him, Shoreham was a step back in time, away from modernity and towards a more religious, peaceful and bountiful world. Working mainly in pen and ink and ▷sepia washes, he created dense, detailed, stylized images of shepherds and harvesters, watched over by the symbolic presence of God as sun or moon (e.g. *Young Men Yoking an Ox*, 1825, Oxford, Ashmolean; *Magic Apple Tree*, 1830, Cambridge, Fitzwilliam).

By the 1830s these visions were fading: Palmer visited Devon in 1832 and Wales in 1835 in an attempt to rediscover his inspiration and he also began to study ▷engraving. In 1838, he married Linnell's daughter. Having spent two years on honeymoon in Italy, and pressurized by his father-in-law into producing commercially viable art, Palmer began working on poetic, Italianate oils. He achieved little Academy success, and suffered personal frustration. In 1861, following the death of his son he finally broke with Linnell, moving to Redhill and beginning to recreate the work of his youth. This was particularly apparent in his late ▷etchings (e.g. *Open in the Fold*, 1880).
Bib.: Grigson, G., *Samuel Palmer: The Visionary Years*, London, 1947; Lister, R., *Catalogue Raisonné of the Works of Samuel Palmer*, London, 1988; idem., *Letters of Samuel Palmer*, London, 1974; Palmer, A.H., *Samuel Palmer, Memoirs*, London, 1882; *Samuel Palmer 1805–81*, exh. cat., Oxford, 1982

Palomino y Velasco, Acisclo Antonio (1655–1726)

Spanish painter and writer. He worked in Madrid, where he was appointed Painter to the King in 1688.

He produced a number of ▷frescos, but he is best known for his book *Museo Pitórico y Escala Optica* translation (1715, 1724), which included a vast amount of biographical information about Spanish artists.

Pan

The Greek god of woods, fields, flocks and herds, his name meaning 'all' in Greek. He was the son of ▷Hermes and Callisto (sometimes Penelope), lived in Arcadia, an area of the Peloponnese, and was part of ▷Bacchus' retinue, associated with the ▷nymphs, ▷satyrs, ▷centaurs and maenads, and often present in scenes of the triumph of Bacchus. He was given his goat's legs and horns by Bacchus. In Roman mythology he was associated with Faunus and the woodland god Silvanus. Increasingly in art, he came to represent lust, and his image changed from that of a handsome youth to, in ▷Baroque works, coarse debauchery. His symbol, the syrinx (or pan-pipes) was associated with lust. Traditionally, they were created when Syrinx, fleeing from Pan's advances, was changed into a bundle of reeds by Ladon the river god. Pan was also linked to Echo and ▷Diana, both of whom he loved (e.g. ▷Carracci, *Pan and Diana*, 1597–1600, Farnese Palace, Rome; ▷Poussin, *Triumph of Pan*, 1630s, London, National Gallery; ▷Calvert, *Pan and the Sacred Seat*, c1880, Cambridge, Fitzwilliam; ▷Burne-Jones, *Pan and Psyche*, 1872–4, Cambridge, MA).

panel

(i) In painting, a rigid support upon which to paint, as opposed to canvas. Most commonly the panel will be some form of wood, but it may also be metal. Before canvas was widely adopted in the 15th century, wood was the most commonly used painting support in Europe, although by the 17th century canvas, owing to its lower expense, greater portability and simpler preparation, had superseded it. The type of wood used depended on local availability: in northern Europe it was most likely to be oak (such as in ▷Jan van Eyck, *The Arnolfini Marriage*, 1434, London, National Gallery; ▷Rembrandt, *A Woman Bathing in a Stream*, 1654, London, National Gallery); while in Italy it was poplar (such as in ▷Duccio, ▷*Maestà*, 1308–11, Siena, Museo dell'Opera del Duomo). The preparation of a wooden panel is lengthy: it must be well-seasoned to prevent warping and splitting, the knots must be removed and holes filled, the surface must then be sized and several layers of ▷gesso, or ground, applied; in the case of a large work such as an ▷altarpiece, several planks must be accurately jointed together to make up the larger panel. The advantage of a wooden panel over canvas is, of course, durability. Copper was favoured by artists for small panel pictures because its smooth surface allowed a highly finished, meticulously detailed technique. It was the support employed for many paintings by the Dutch *fijnschilders*.

(ii) In the decorative arts, a recessed or raised portion of a flat surface, set within a framework. When the panel is raised, it is sometimes called a fielded panel. Wooden panelling was widely used in northern Europe from the 15th century onwards to cover plaster or stone walls in order to achieve more efficient draught-proofing. In the 17th and 18th centuries such panels were likely to be carved, inlaid or painted in wealthier houses. Linenfold panelling – each panel being decorated with a stylized representation of a piece of folded linen – originated in Flanders in the 15th century and achieved great popularity in Tudor England for both wall panelling and panel designs on furniture. *Boiserie* is a form of elaborately decorated wood panelling developed in France in the 17th century and which spread to southern Germany in the 18th. It is a typically ▷Rococo form of decoration, characterized by low ▷relief carvings of delicate foliage and ▷antique motifs, and is often painted – usually a white background with ornamentation picked out in gold or some other rich colour.

Pan(n)ini, Giovanni Paolo (1691/92–1765)

Italian painter. He specialized in ▷picturesque representations of Rome, in some cases topographically faithful ▷*vedute*, in others ▷*capricci* assembled from the better known sights, particularly antique ruins. These paintings were extremely popular amongst ▷Grand Tourists. He had been born in Piacenza and trained in the school of stage designers at Bologna. He is recorded in Rome, in the studio of the renowned teacher Benedetto Luti, by 1711, although his earliest known picture is dated 1727 (London, Apsley House). Panini also painted pictures of public festivities and

Samuel Palmer, *Sleeping Shepherd, Morning*, c. 1857, Fitzwilliam Museum, Cambridge

taught perspective at the French Academy in Rome. His links with France were strong – his wife was French – and as early as 1729 he had been commissioned to paint pictures of the fête given in Rome by Cardinal Polignac in celebration of the birth of the dauphin. His work was very influential not only on French – artists such as ▷Hubert Robert, but also and more importantly, on ▷Canaletto and ▷Piranesi.
Bib.: Kiene, M., *Giovanni Paolo Panini*, Brunswick, 1993

Pankhurst, Sylvia (1882–1960)

English artist. The daughter of the suffragette Emmeline Pankhurst, Sylvia was educated at the Manchester Municipal School of Art and the Royal College of Art, London. Her work was largely related to her political affiliations. She was a founder member of the WSPU (Women's Social & Political Union) and produced banners, posters, murals, 'The Holloway Brooch' and the 'Suffragette Tea Service'. She scandalized polite society by refusing to name the father of her child and became deeply involved with anti-Fascist activity. In her later life she turned to writing and published a life of her mother (1935) and a History of Ethiopia and Eritrea (1953). She died in Ethiopia.
Bib.: Romero, P., *Sylvia Pankhurst: Portrait of a Radical*, New Haven, 1987

Panofsky, Erwin (1892–1968)

American critic, academic and theorist. Educated at the universities of Berlin, Munich and Freiburg, Panofsky became professor at Princeton in 1933. He specialized in medieval and ▷Renaissance studies, and his arguments, although somewhat outdated now, are enthusiastic and compelling. His principal publications include *Albrecht Dürer* (1943), *Abbot Suger on the Abbey of St. Denis* (1946), *Gothic Architecture and Scholasticism* (1951), *Early Netherlandish Painting* (1953), *Meaning and the Visual Arts* (1955), *Pandora's Box* (1960), and *Tomb Sculpture: Its Changing Aspects, from Ancient Egypt to Bernini* (1964).

panorama

'Wide-screen' paintings of cityscapes and landscapes have been part and parcel of wall-painting from antiquity onwards, but true panoramas, foreshadowed by the deliberately broad landscape view of artists such as ▷Hollar, came into fashion in the later 18th century either as an all-round 360 degree view for which the spectator stands in the centre, or as a section of a scroll that passes before a static spectator. The craze was transferred to photography, and panoramas have been found in the travelling exhibitions that took art to the paying masses.
Bib.: *Panoramania*, exh. cat., London, 1988

Pantheon

Originally built under Agrippa in 27 BC, the present building is of AD 118–25 and is entirely the work of the Emperor Hadrian, an amateur architect. It is a cylindrical ▷drum, 21.5 m (71 ft) in height, carrying a hemispherical ▷dome of the same radius (thus the height of the crown of the dome from the pavement equals the diameter of the ground plan). The entrance is in the form of a ▷pedimented octastyle ▷Corinthian ▷porch, originally approached by a flight of five steps from a porticoed forecourt below the present street level (which would have concealed the awkward transition from rectangular porch to circular temple). The conventionality of the porch does not prepare the visitor for the ▷cella which is conceived as an interior space of majestic dimensions. The interior of the dome is decorated with five concentric rings of deeply-sunk coffers, 28 in each ring. At the crown of the dome an ▷oculus (8.2 metres in diameter) provides the sole source of the natural light which floods the interior, illuminating the ▷polychrome marble surfaces of the wall and casting deep shadows in the coffers of the dome, the blind windows of the upper zone and the ▷aedicules and recesses of the lower zone of the drum. The recesses reduce the dead weight of the building, as do a series of cavities introduced into the piers. The drum is strengthened over each of these openings by relieving ▷arches (visible today on the exterior). The building is entirely of concrete, the aggregate carefully graded from the heavy travertine and tufa of the lower walls, through tufa and brick, brick alone, and brick and pumice, to pumice only around the oculus. Furthermore, as it nears the highest level the shell of the dome reduces in thickness. Originally dedicated to all the gods (hence the name), it was in AD 609 rededicated as the Christian church of Sta Maria ad Martyres (now Sta Maria Rotunda).
Bib.: MacDonald, W.L., *The Architecture of the Roman Empire, Vol. 1: An Introductory Study*, New Haven and London, 1982

pantiles

Roofing tiles shaped with an ▷ogee curve, the (shorter) convex curve of one lying over the (longer) concave curve of its neighbour to form a watertight join.

Pantocrator

(Greek, 'all-mighty' or 'creator of all'.) ▷Byzantine image of ▷Christ as creator and ruler of the universe.

pantograph

A mechanical device used to reproduce the outline of an image on a larger or smaller scale. It is essentially an articulated arm with a ▷stylus at one end and a ▷pencil or ▷crayon attached to the other. The copy is executed by tracing the stylus over the original

image, which is then reproduced by the pencil or crayon set over a sheet of paper.

Paolo and Francesca

(Dante, *Inferno*, canto 5.) Tragic lovers whom Dante meets in the second circle of Hell. The actual Francesca lived in Rimini in the 13th century. She was the wife of Giovanni Malatesta, the crippled son of the Lord of Rimini. Francesca would often sit reading the romance of Lancelot and Guinevere with Giovanni's younger brother, Paolo. The love story evokes their own dormant feelings for each other, their eyes meet and they kiss. They become lovers, but Giovanni discovers them and kills them both. As adulterers they have been sent by Minos, the judge of the dead, to the second circle of Hell where they are constantly swept along and buffeted by swirling winds. Dante's canto has been memorably illustrated by, among others, ▷William Blake and ▷Gustave Doré. The Pre-Raphaelite sculptor, ▷Alexander Munro, produced one of his most popular sculptures with a marble group of the lovers about to kiss as they read from their romance (1851, copies in Birmingham City Art Gallery and Wallington Hall, Northumberland, the former originally purchased by W. E. Gladstone). ▷Dante Gabriel Rossetti painted a ▷watercolour ▷triptych of Dante led by Virgil, his guide through the underworld, flanked by images of the lovers, on the left passionately kissing, and on the right carried on the wind (1855, London, Tate Gallery).

Paolozzi, Sir Eduardo (b 1924)

Scottish sculptor and printmaker. Born in Edinburgh of Italian parents, he studied at Edinburgh School of Art and at the ▷Slade. After a brief spell in Paris he returned to teach at the Central School of Art and St. Martin's. He has also held a variety of academic positions abroad. Throughout his career his sculpture has been informed by his interest in technology and its relationship to art and society. His early work, which was influenced by his contact with the Parisian ▷Surrealists, has parallels with that of ▷Giacometti. His first commission was for a fountain at the Festival of Britain (1951). During the 1950s he worked mainly with bronze, in large box-like formats. Later he was involved with ▷Pop art, and produced fantastic heads and figures made from rubbish and discarded machine parts (e.g. *Jason*, 1956, and *Large Frog*, 1958). Colour became important to Paolozzi at this time and he also experimented with ▷silk-screens and ▷lithography. In the 1970s he worked with wood, as shown in the *Four Doors* at the Hunterian Art Gallery (1979).

paper

Palm leaves and ▷papyrus were used for writing and painting well before the invention of paper, which we know was being made in China in AD 105, although the technology reached Europe only in the 14th century. In the East, paper was made from vegetable fibres; in the West, rags were used as being more capable of withstanding the (acidic) oak-gall ink. Although all paper was handmade until the 19th century, this did not prevent its use occasioning a revolution in the 15th century in the accessibility of the printed word, replacing vellum manuscripts and bringing reading and writing to a wider audience. Henceforth students could use it for notes, and artists for drawings and prints. Paper was quickly perceived by artists such as ▷Dürer as a vehicle for the diffusion of ▷multiples, and so it remains today.

Paper can be useful to art historians for dating, since papermakers often incorporated some publicizing device or motto (called the watermark) in the mesh formed by the pulp when it was made into sheets. Chronologies of papers are thus possible through artists' birth and death dates, as well as through the publication dates of paper-printed books and advertisements.

Bib.: Hunter, D., *Papermaking: The History and Technique of an Ancient Craft*, New York, 1947

papier collé

(French, 'pasted paper'.) A type of ▷collage which involves glueing paper onto a picture. Its first recorded use was by ▷Braque in 1913, when he used bits of wallpaper in one of his paintings.
 ▷Cubism

papier mâché

(French, 'chewed paper'.) A substance created when paper is soaked in a floury ▷binder, then baked and painted.

papyrus

Early form of paper material made from the marsh plant papyrus. It was used in ancient Egypt for writing and painting from the 1st millennium BC onwards and was the standard writing material in ancient Greece and throughout the Roman Empire. It was largely superseded by ▷parchment in the 4th century AD.

paranoia-criticism

 ▷Dali, Salvador

parapet

(From the Italian, *parapetto*, 'wall breast-high'.) A low protective wall or barrier, sometimes battlemented, bordering a sudden drop such as on the sides of a bridge or the edge of a quay, terrace, ▷balcony, or roof.

parchment

The prepared skin of an animal, usually a goat or sheep, which is used to write or draw upon. The skin goes through a lengthy process of soaking in urine, several

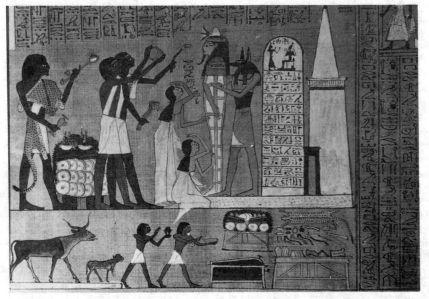

Papyrus: The Ceremony of the 'opening of the mouth', a funeral rite illustrated in Hunefer's Book of the Dead, 19th Dynasty, 1300 BC, Egypt

scrapings with a metal tool, stretching and drying before it can be used.

parecclesion
(Greek, 'beside the church'.) A side chapel in a Greek Orthodox church.

parergon
An additional or accessory part of a painting. For example, a still-life detail in a portrait can be referred to as a parergon.

Parian marble
White marble from the Greek island of Paros, the best of which, from the mines in Mount Margessa, was very fine-grained and highly prized in Classical times for sculpture. The *Venus de' Medici* (Florence, Uffizi) is carved from Parian marble.

Paris
(Lucian, *Dialogue of the Gods*, 20.) Paris was a son of Priam, King of Troy. At his birth it was prophesied that he would bring ruin to the city and thus he was given to a shepherd with orders that he be left out on the hillside to die. The shepherd instead raised Paris as his own. The fate of both Paris and Troy was finally sealed by the events at the wedding of Peleus and the nymph Thetis. All the gods were invited to the wedding except for Eris, the goddess of strife. True to her nature, she gatecrashed the festivities and threw down a golden apple, assigning it to the fairest. ▷Juno, ▷Minerva, and ▷Venus each claimed the apple as

theirs and looked to ▷Jupiter to arbitrate. He, however, decided that Paris should make the judgement and sent ▷Mercury to explain the nature of the contest to him. The three contestants tried to bribe Paris: Juno with lands and wealth, Minerva with prowess in battle, and Venus with the love of Helen, the wife of Menelaus of Sparta, and reputed to be the most beautiful woman in the world. Paris awarded the apple to Venus, abducted Helen and precipitated the war between the Greeks and Trojans which resulted, as predicted, in the complete destruction of Troy. The scene of the judgement has been often painted (several times by ▷Rubens). The three goddesses stand naked before Paris who is seated in judgement. He is identifiable by his shepherd's crook, and they by their usual attributes: Juno has her peacock, Minerva has, on the ground beside her, her gorgon-headed shield (aegis) and helmet, and Venus is accompanied by ▷Cupid. Mercury stands behind Paris dressed in a winged helmet and holding his ▷caduceus.
 ▷Judgement of Paris

Paris, Matthew (d 1259)
English monk at the Benedictine Abbey of St. Albans. Having joined the abbey in 1217/18, he was appointed its chronicler in 1236. He was exceptional as the illustrator of his own writings (most illuminators then being laymen). His principal work is the abbey's *Chronica Maiora*, now split between Corpus Christi College, Cambridge (Mss. 26, 16) and the British Library, London (Ms. Royal 14. c. vii). The chronicle is notable for the liveliness of Paris's marginal tinted outline

drawings. Also his is a *Life of St. Alban* (c1240, Trinity College, Dublin, Ms. E.I.40) with illustrations now assuming greater prominence, occupying the upper half of the page, and the *Historia Minor* or *Historia Anglorum* (c1250, British Library, Ms. Royal 14. c. vii), the frontispiece of which, showing Paris on his knees dedicating the book to the Virgin, is his only signed illustration. Paris's fame (and the evident high quality of his work) has led to the assumption that he created the style by which he is known; however, surviving fragments of contemporary wall paintings at Windsor show that the King's painters were working in a similar style and consequently it is equally possible that Paris was following fashion rather than setting it.

Bib.: Lewis, S., *The Art of Matthew Paris in the Chronica Maiora*, London, 1987; Vaughan, R., *Matthew Paris*, Cambridge, 1958, reprint 1979; Vaughan, R., *The Illustrated Chronicles of Matthew Paris*, Cambridge, 1993

Paris, School of
▷School of Paris

Parler, Peter (1330–99)

Czech stonemason and architect. He came from a large family of stonemasons (*Parlier* is German for foreman-mason) who worked across southern Germany and Bohemia in the 14th and 15th centuries. At this time a mason was responsible for elements of structural engineering and architectural design, rather than being just a skilled craftsman. It is recorded that Peter Parler went to Prague to work on the cathedral of St. Vitus in 1356 to continue the work begun by Mathias of Arras. He completed the choir from the triforium in a style reminiscent of French ▷Rayonnant and the English late ▷Gothic style, with diagonal ▷arches on the lower part of the ▷clerestorey and a net ▷vault. The pattern of the choir vault was copied in many churches across Bohemia, such as St. Barbara at Kutenberg (1388), but it is unclear how many churches Peter Parler himself worked on. Other works attributed to him include the royal tombs in Prague and other religious sculpture in the region.

Parmigianino (Girolamo Francesco Mazzola) (1503–40)

Italian painter and etcher. He was one of the most important early ▷Mannerist painters in Italy. He was born, as is indicated by his popular name, in Parma. A painter of extremely precocious talent, his earliest independent works, the ▷frescos in the transept of Parma Cathedral, date from 1522. In 1522/23 he was working in the church of S. Giovanni Evangelista, where he would have seen recent frescos by ▷Correggio, the most important influence on his work (his later influences included ▷Pordenone, ▷Raphael and ▷Michelangelo). He is recorded in Rome by 1523 and was taken prisoner by German mercenaries during

Parmigianino, *Self-portrait in the Mirror*, Kunsthistoriches Museum, Vienna

the Sack of 1527. ▷Vasari, in his *Lives*, relates the (undoubtedly romanticized) story of how Parmigianino was at work in his studio on *The Madonna and Child with SS John the Baptist and Jerome* (1527, London, National Gallery) when German mercenary troops, who had been murdering, raping and pillaging their way through the city, burst into his studio. Parmigianino was so engrossed in his work that he carried on painting, oblivious of their presence. The soldiers, in turn, were so awestruck by the quality of his work that they let him carry on and demanded of him nothing more than that he paint a few ▷watercolours as ransom. Whether there is any truth in this is uncertain, but anyway Parmigianino thought it expedient to flee to Bologna, then on to Verona and Venice, before returning to Parma in 1530.

Parmigianino's main work in Parma, the frescos in S. Maria della Steccata, were fraught with problems. By 1539, his patrons considered that he had done so little they sacked him and brought an action against him for breach of contract. Vasari states that his negligence was due to his obsession with alchemy which now absorbed his whole time. Within a year he was dead. Vasari describes him at the end: 'As Francesco still doted on his alchemy, overpowered by its infatuation, he allowed his beard to grow long and disordered, which made him look like a savage ... [he] grew melancholy and eccentric. Being attacked by a malignant fever, he died after a few day's illness ... [he] was buried at his own request naked, with a cypress cross on his breast.'

Always highly distinctive, Parmigianino's religious subjects are characterized by an intense mysticism (e.g.

Madonna with St. Margaret, 1528–9, Bologna, Pinacoteca). His figures are gracefully attenuated with long necks, slender hands and tapering fingers, and in many of his pictures he juxtaposes extremes of space and scale (e.g. ▷*Madonna with the Long Neck*, c1535, Florence, Uffizi). He was also an extremely sensitive portraitist, among his most interesting works in this genre being his early *Self-portrait* (1524, Vienna, Kunsthistorisches Museum) in which he shows himself reflected in a convex mirror. His work was very influential on the First School of ▷Fontainebleau and, through it, on French art.
Bib.: Giampaolo, M. di, *Parmigianino: catalogo completo dei dipinti*, Florence, 1991; Gould, C.H.M., *Parmigianino*, Rome, 1994

parquet
A type of flooring consisting of hardwood blocks laid in geometric (most commonly plated) patterns.

Parrhasius
Greek painter of the late 5th century BC. He was famous for his naturalism and the psychological insight of his works.

Pascin, Jules (Julius Pincas) (1885–1930)
American painter of Bulgarian birth. He studied in Vienna and Munich where he worked for the magazine *Simplicissimus*. He was in Paris in 1905, and inhabited a studio in Montmartre, where he knew ▷Soutine and ▷Modigliani. He specialized in painting female nudes. During the First World War he went to the United States and obtained American citizenship, but he returned to Paris in 1920 and rejoined the ▷School of Paris there. He later committed suicide.
Bib.: Brodzky, H., *Pascin*, London, 1946

Pasmore, Victor (1908–92)
English painter. He was educated at Harrow, where he showed an early talent for art. His first works were influenced by ▷Fauvism and ▷Cubism but he was a part-time clerk throughout the 1920s. In 1937, he established the ▷Euston Road School with ▷Coldstream and began a series of austere landscapes and views of London (e.g. *Chiswick Reach*, 1944, Ottawa). His work became increasingly abstract in the 1940s (e.g. *Inland Sea*, 1950, London, Tate) and the following decade he began to work on ▷reliefs, eliminating illusionistic space in his work. The reliefs were initially hand-made, but increasingly he used machine-produced materials like perspex. Throughout his career, he was interested in artistic theory (his reliefs were partly inspired by Biederman's *Art as the Evolution of Visual Knowledge*). He was also an architect of Peterlee New Town from 1966 and an influential teacher.
Bib.: Lynton, N., *Paintings and Graphics of Victor Pasmore 1908–1992*, London, 1992; Storey, D., *Victor*

Pasmore, London, 1972; *Victor Pasmore*, exh. cat., London, 1980

Passarotti, Bartolommeo (1529–92)
Italian painter. He worked in Bologna and in Rome in a ▷Mannerist style but was influenced by the early work of ▷Agostino Carracci. He had a large studio in Bologna which produced a number of ▷genre scenes, especially images of butcher's shops.

Passeri, Giovanni Battista (1610–79)
Italian painter and writer. He was best known for his biographical study of 17th-century Roman artists, *Vite dei pittori, scultori ed architetti che anno lavorato in Roma morti dal 1641 al 1673* (1772).

Passion
The events involving the suffering, death, ▷Resurrection and ▷Ascension of Christ, taken from the ▷Entry of Christ into Jerusalem to the Descent of the Holy Ghost. It is a popular theme for ▷fresco cycles from the 13th century onwards, especially in Franciscan and Dominican churches, although individual cycles differ as to the commencement and conclusion, as well as the scenes included. The pivotal scenes always included are the ▷Crucifixion and Resurrection.

▷Last Supper; Agony in the Garden; Betrayal of Christ; Mocking of Christ; Flagellation; Ecce Homo; Descent from the Cross; pietà; Lamentation; Entombment; *Noli me tangere*; Supper at Emmaus; Miraculous Draught of Fishes

pastel
Compound of dry pure ▷pigment with a minimum of gum/water. The colour permanence is unstable and today a ▷fixative solution is often used to ensure durability. Use of pastel first became popular in 18th-century English portraiture. The immediacy of the medium (which allows the use of techniques such as the finger-rubbed mark) appealed to the 'keyhole' styles of such artists as ▷Degas and ▷Toulouse-Lautrec. A variety of finishes can be achieved by different methods, for example flooding the surface with water or milk to mingle tones.

pastel manner
An 18th-century ▷engraving technique which made engravings resemble ▷pastel drawings.

pastiche (*pasticcio*)
A work executed in the style of another artist. The most successful pastiches are not direct copies but combined elements of several of an artist's works into a new composition (this was the method used by Tom Keating with his copies of ▷Samuel Palmer). When these works are fraudulently passed off as the work of an artist copied they are difficult to detect, since the pastiche recalls not a particular work (easy to trace) but

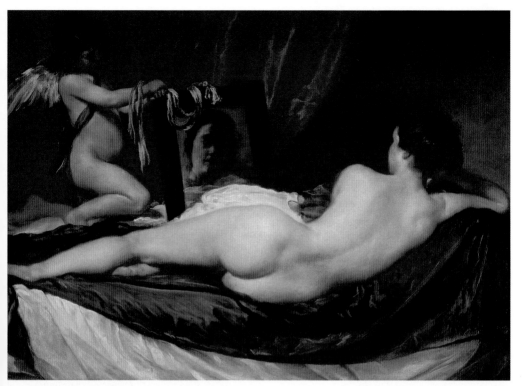

FIGURE 141 Diego Rodriguez de Silva y Velázquez, *The Toilet of Venus (The Rokeby Venus)*, 1644–8, National Gallery, London

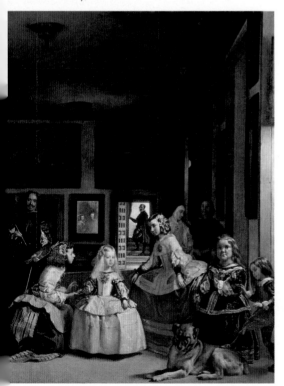

FIGURE 142 Diego Rodriguez de Silva y Velázquez, *Las Meninas* or *The Family of Philip IV*, 1656, Prado, Madrid

FIGURE 143 Paolo Caliari Veronese, *Venice Enthroned between Justice and Peace* (detail), 1583, Palazzo Ducale, Venice

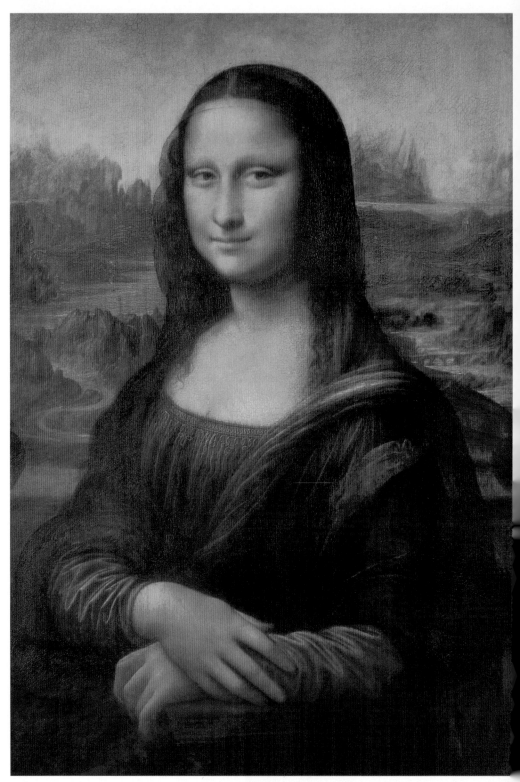

FIGURE 144 Leonardo da Vinci, *Mona Lisa*, c1503, Louvre, Paris

FIGURE 145 Edward
Wadsworth, *Marine Life*

FIGURE 146 Otto Wagner, *St.
Leopold's, Church of the Steinhof
Asylum (Kirche Am Steinhof),*
1902–7, Historisches Museum
der Stadt, Vienna

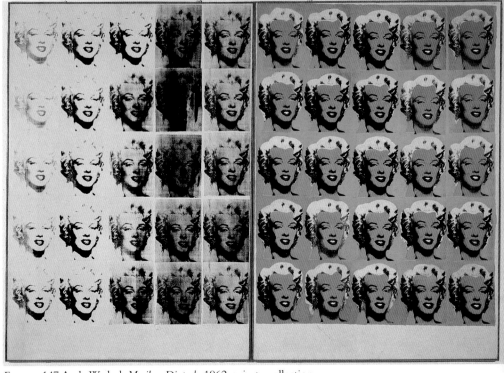

FIGURE 147 Andy Warhol, *Marilyn Diptych*, 1962, private collection

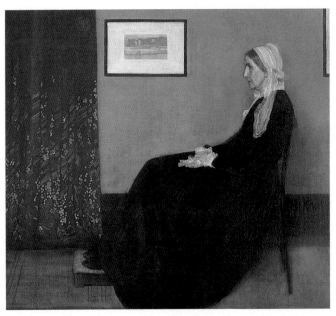

FIGURE 148 James Abbot McNeill Whistler, *Arrangement in Grey and Black (Portrait of the Artist's Mother)*, 1871, Musée d'Orsay, Paris

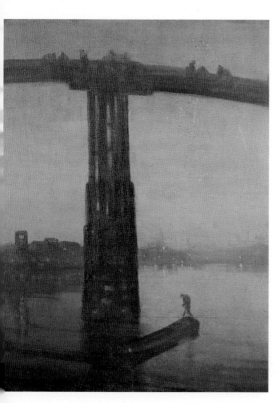

FIGURE 149 James Abbot McNeill Whistler, *Nocturne in Blue and Gold: Old Battersea Bridge*, c1872–5, Tate Gallery, London

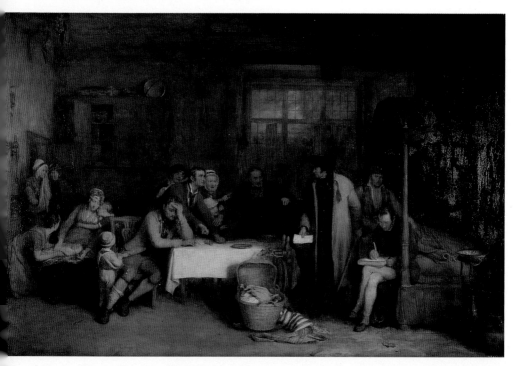

FIGURE 150 Sir David Wilkie, *Distraining for Rent*, 1815, National Gallery of Scotland, Edinburgh

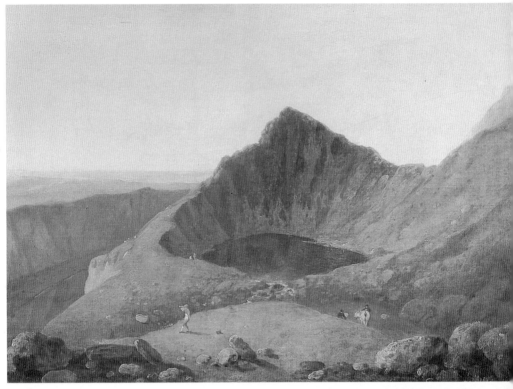

FIGURE 151 Richard Wilson, *The Valley of Mawddach and Cader Idris*, c1774, Tate Gallery, London

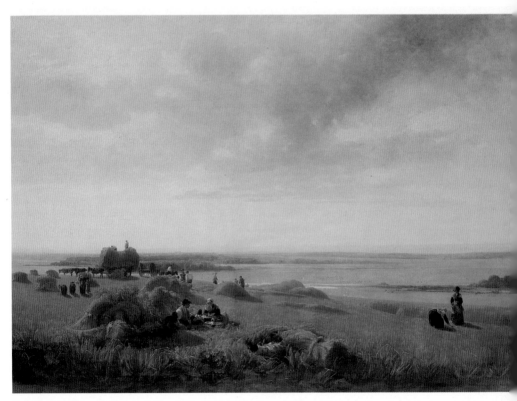

FIGURE 152 Peter de Wint, *A Cornfield*, c1815, Victoria and Albert Museum, London

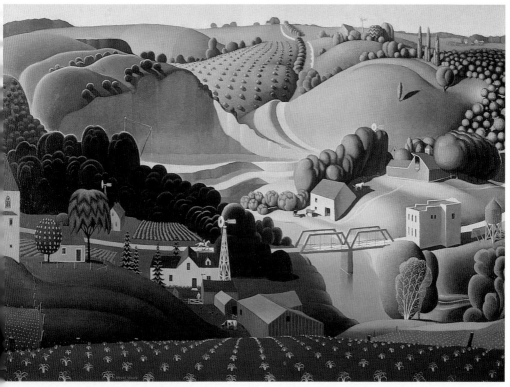

FIGURE 153 Grant Wood, *Stone City*, 1930, Joslyn Museum, Omaha

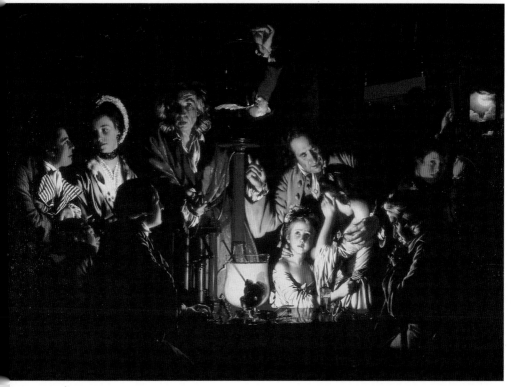

FIGURE 154 Joseph Wright of Derby, *An Experiment with a Bird in an Air Pump*, 1768, National Gallery, London

FIGURE 155 Joseph Wright of Derby, *Arkwright's Cotton Mills by Night*, c1782–3, private collection

FIGURE 156 Jack Butler Yeats, *The Two Travellers*, 1942, Tate Gallery, London

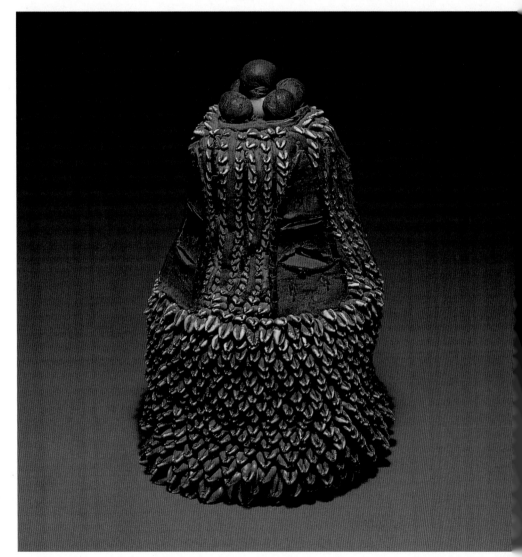

FIGURE 157 Yoruba, *House of the Head*, University of California, Museum of Cultural History

FIGURE 158 Limbourg brothers, *December: Hunting Wild Boar*, from the 'Très Riches Heures du duc de Berry', c1413, Musée Condé, Chantilly

FIGURE 159 Arabic tile decoration from the Alhambra Palace, Granada

FIGURE 161 Art Nouveau pendent, enamel and soapstone, c1900, private collection

FIGURE 160 Art Nouveau pendent entitled *Sylvia*, enamel and diamonds, c1900, Musée des Arts Decoratifs, Paris

FIGURE 162 Art Nouveau Lalique car mascot of a dragonfly

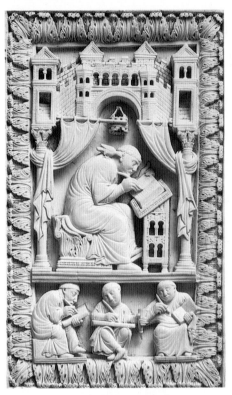

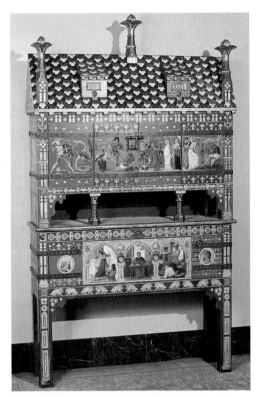

FIGURE 163 Carolingian, Franco–German School, *St Gregory Writing with Scribes Below*, c850–75, Kunsthistorisches Museum, Vienna

FIGURE 164 Arts and Crafts cupboard and secretaire designed by William Burges, late 19th century, Victoria and Albert Museum, London

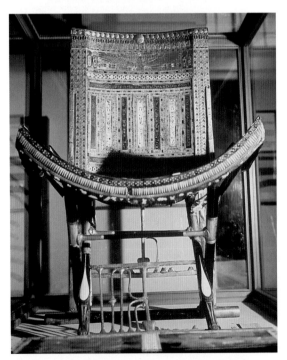

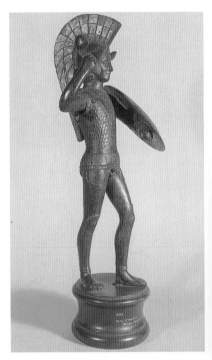

FIGURE 165 Egyptian Art: folding chair of inlaid ebony, tomb of Tutankhamun, c1361–52 BC (New Kingdom, 18th Dynasty), Egyptian National Museum, Cairo

FIGURE 166 Etruscan statue of Mars, bronze, c5th century BC, British Museum, London

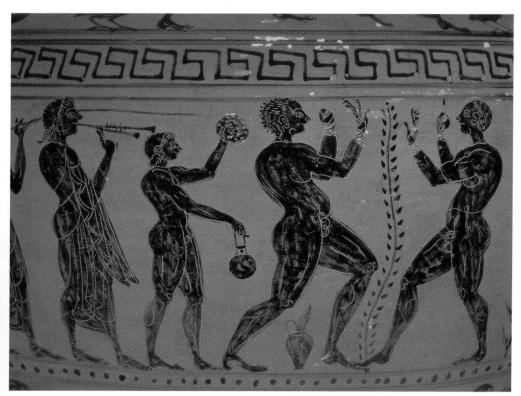

FIGURE 167 Etruscan vase showing boxers fighting and musicians, c500 BC, British Museum, London

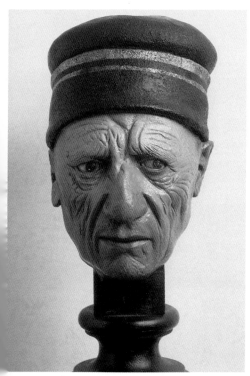

FIGURE 168 Terracotta, *Head of a Man in a Hat (Joseph of Arimathaea or Nicodemus)*, Guido Mazzoni, late 15th/early 16th century, Galleria e Museo Estense, Modena

FIGURE 169 *Icon of the Blessed Virgin with Three Hands*, Novgorod School, 16th century, private collection

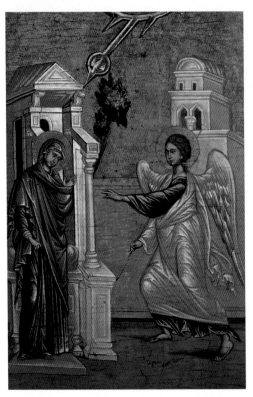

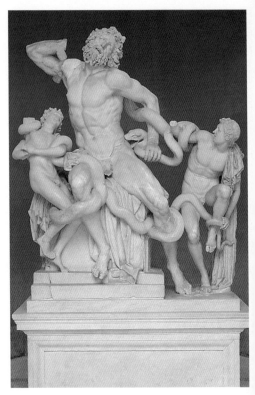

FIGURE 170 *Icon of the Annunciation*, Greek School, late 17th century, University of Liverpool Art Gallery and Collections

FIGURE 171 *Laocoön*, Roman copy, 1st century AD, Vatican Museums and Galleries, Rome

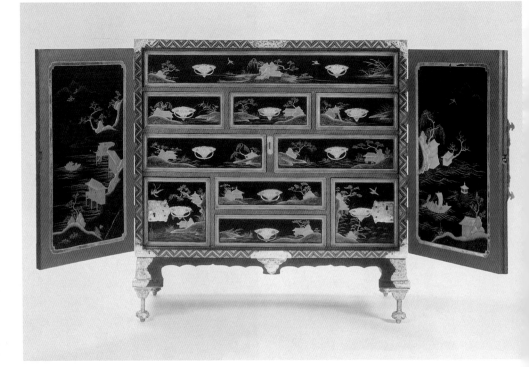

FIGURE 172 Japanese lacquer cabinet on gilt-bronze ball-and-shaft feet, 18th century, Wallace Collection, London

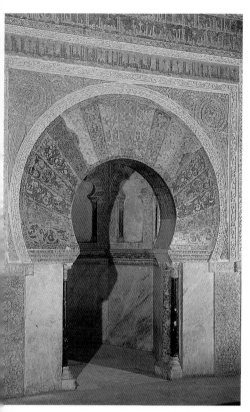

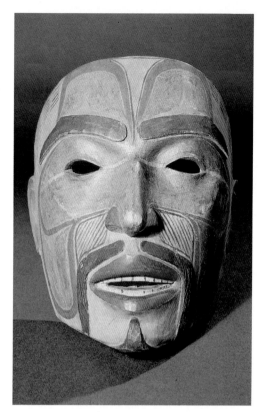

FIGURE 173 Islamic art: Entrance to the Mihrab (prayer niche) of the Mezquita Mosque, c786 AD

FIGURE 174 Northern Kwakiutl mask of a man, c1825–75, British Museum, London

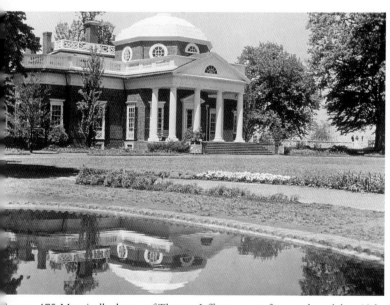

FIGURE 175 Monticello, home of Thomas Jefferson, west front and pool, late 18th century, Charlottesville, Virginia

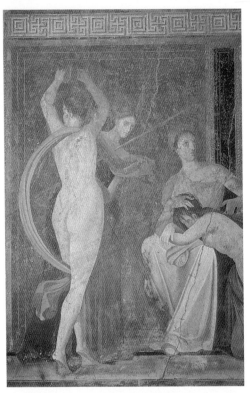

FIGURE 176 Pompeii, Villa dei Misteri, fresco of a nude maenad (bacchante) dancing with cymbals, south wall, Oecus 5, 60–50 BC

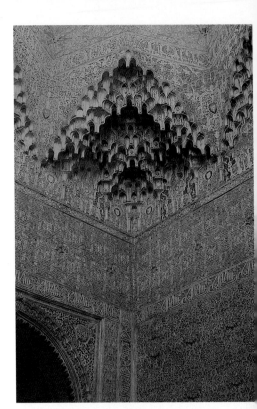

FIGURE 177 Alhambra Palace, Granada, 14th century, Hall of the Abencerrages with 'stalactite' decoration

FIGURE 178 Queen Anne walnut bachelor's chest, early 18th century, English

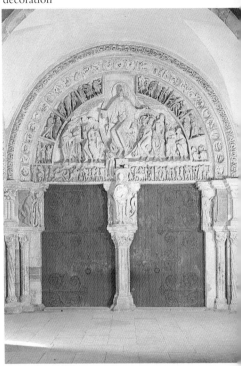

FIGURE 179 Gothic architecture: entrance at the West end of the Basilica of St. Madeleine, Vézeley, with a relief showing the Pentecost, c1150

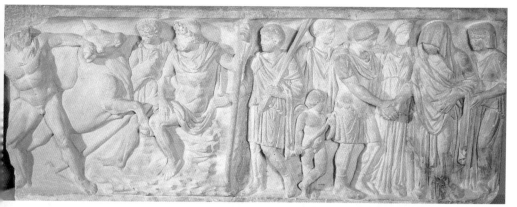

FIGURE 180 Sarcophagus depicting Jason and the fire-breathing bull at Colchis, Louvre, Paris

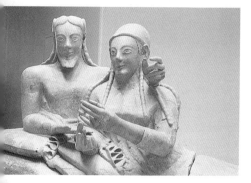

FIGURE 181 Etruscan Sposi sarcophagus, 5th century BC, Villa Guila, Rome

FIGURE 182 Sarcophagus of the Egyptian singer Amon Tentamon, 1069–945 BC (21st Dynasty), Musée de la Vieille Charité, Marseilles ▶

FIGURE 183 Roman art: the Pashley Sarcophagus: marble frieze showing the triumphal return of Dionysus from the East, from Arvi, Crete, c125–150 AD, Fitzwilliam Museum, University of Cambridge

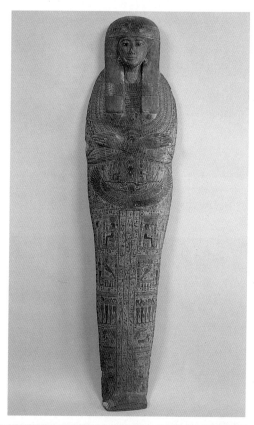

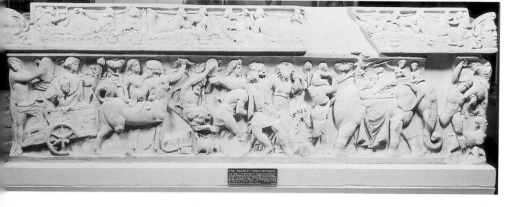

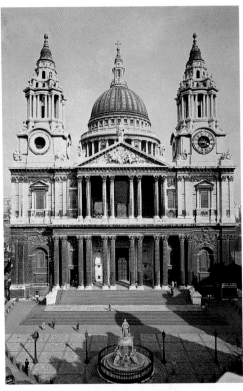

FIGURE 184 St Paul's Cathedral, London, designed by Sir Christopher Wren, built 1675-1710

FIGURE 185 Antoni Gaudí, Palacio Güell, Barcelona, 1885–9: view of the chimneys on the roof

FIGURE 186 Antoni Gaudí, Palacio Güell, Barcelona, 1885–9: view through to the main dining room, with the original furniture

FIGURE 187 Arts and Crafts: earthenware dish painted with a peacock pattern, William De Morgan, late 19th century, Victoria and Albert Museum, London

the entire ▷*oeuvre* of that artist. Another form of pastiche is when one artist is unduly influenced by another (as ▷Ingres was influenced by ▷Raphael) or when a student remains under the spell of a charismatic teacher (as Amaury-Duval did with his teacher, ▷Ingres). The term may also be used derogatively to describe a work lacking individuality.

Bib.: Amaury-Duval, *L'atelier d'Ingres*, Paris, 1993; *Fakes and Forgeries*, exh. cat., Minneapolis, 1973

pastoral

In literature and art, pertaining to shepherds and rustic life. Pastoral wall-paintings were popular from ▷Pompeii onwards, and were usually elegantly unrealistic to match the literary vision and fiction of the unspoiled beauty of the countryside. During the Middle Ages there was not much interest in the genre, but as a literary and artistic form it was revived with the ▷Renaissance, and is exemplified in the work of artists such as ▷Giorgione, ▷Titian and ▷Claude, with 18th-century English artists and even ▷Turner continuing much the same tradition. The popularity of parks and gardens provides a tangible extension of the fascination with pastoral.

Bib.: Freedman, L., *The Classical Pastoral in the Visual Arts*, New York, 1989; Pugh, S. (ed.), *Reading Landscape: Country, City, Capital*, Manchester 1990

pastose

A synonym for ▷impasted or thickly painted.

Patch, Thomas (1725–82)

English painter and engraver. He travelled to Italy in 1747 and remained there, studying with ▷Vernet. He sold his paintings to English tourists. In 1755 he left Rome, and moved to Florence where he began producing mild ▷caricatures of the English community there.

Patel the Elder, Pierre (c1620–c1676)

French painter. He studied with ▷Vouet and produced works in the manner of ▷Claude. He was also commissioned to produce a number of decorative programmes in Paris *hôtels*.

Patenier (Patinier, Patinir), Joachim (c1485–c1524)

Flemish painter. He was a landscapist, recorded in the Antwerp Guild in 1515. He was possibly a pupil of ▷Gerard David, but was certainly a friend of both ▷Quentin Massys and ▷Albrecht Dürer. Massys sometimes executed figures for Patenier's landscapes and became guardian of his children at his death, while Dürer owned one of his pictures, attended his second wedding in 1521, and executed a portrait drawing of him. Patenier's small landscapes generally conform to a panoramic format typical of Antwerp ▷Mannerism with tall, fantastically jagged mountains in the blue distance and naturalistic detail in the foreground. Although all of his accredited paintings are ostensibly religious or mythological subjects, the role of the figures is nonetheless primarily compositional and these works may be considered as among the earliest Flemish landscape paintings. They are characterized by cool colours, technically perfect execution and smooth finish, and they exerted a great influence on later Flemish landscape painting. Aside from the numerous paintings attributed to him on stylistic grounds, there are just three signed paintings, a *Flight into Egypt* (Antwerp), a *Baptism of Christ* (Vienna) and a *St. Jerome* (Karlsruhe).

Bib.: Falkenburg, R.L., *Joachim Patenier: Landscape as an Image of the Pilgrimage of Life*, Amsterdam, 1988; Friedlander, M.J., *Joos van Cleeve, Jan Provost and Joachim Patenier*, New York, 1972; Pons, M., *Patinir ou l'harmonie du monde*, Paris, 1980

patent furniture

A term used from the 19th century onwards for furniture which could be converted for different functions (e.g. chairs which could become tables).

Pater, Jean-Baptiste-Joseph (1695–1736)

French painter. He was a pupil of ▷Watteau and imitated the ▷*fête galante* themes of his master. Like other pupils of Watteau, his works were also collected outside France.

Pater, Walter (1839–94)

British critic and essayist. Born in east London, the son of a doctor, Pater was orphaned young and educated at King's School, Canterbury, and Queen's College, Oxford. He became a Fellow of Brasenose, Oxford, in 1864. From 1869 he lived with his spinster sisters in London, in a style greatly influenced by his ▷Pre-Raphaelite friends, ▷Rossetti and Swinburne. Pater's first publication, *Studies in the History of the Renaissance* (1873) included essays on ▷Winckelmann, ▷Botticelli and an evocative account of the ▷*Mona Lisa*. In other essays Pater argued that artistic sensation was a refinement that needed to be developed and his ▷aesthetic theories influenced a generation of young writers. His later works, like *Imaginary Portraits* (1887) tend to dwell on the theme of death and wasted youth. He is best remembered for *Marius the Epicurean* (1885), a fictional biography and intellectual history set in the time of Marcus Aurelius.

pâte tendre

(French, 'soft paste'.) A technique used throughout Europe from the 16th century. It was in imitation of ▷porcelain.

Pathetiker, Die

A group of German artists and writers who formed in Berlin in 1912. Their work had ▷Expressionist tendencies, but many of their ideas were ▷Futurist in tone. The group included such artists as ▷Meidner and the poets Jakob Steinhardt and Richard Janthur.

patina

An encrustation which forms on the surface of ▷bronze, usually as a result of extended exposure to the atmosphere (oxidation). Most commonly greenish in colour, blue and red patinas are also found, the latter two colourations occurring particularly as a result of prolonged burial in soil or immersion in water. The consequent mellowing of the appearance is generally considered to be attractive in bronze sculpture and various methods have been developed to accelerate natural patination, the most common since the ▷Renaissance being treatment with acid. By extension, the term patina is used to describe the discolouration caused on other surfaces, especially silver and furniture, by exposure, handling, polishing, etc.

Paton, Sir Joseph Noel (1821–1901)

Scottish painter. He was born in Dunfermline and studied at the ▷Royal Academy Schools in 1842–3 where he met ▷Millais, but his early influence was that of David Scott. In works like *The Reconciliation of Oberon and Titania* (1847, Edinburgh, National Gallery of Scotland) Paton produced grand scale, highly finished exercises which combined a classical idealism with an often romantic subject matter. By the 1850s he had become influenced by ▷Pre-Raphaelitism, increasingly exploring religious subjects (e.g. *Gethsemane*, 1859, private collection). In his later career these religious paintings became increasingly melancholic (e.g. *Luther at Erfurt*, 1861, Edinburgh, National Gallery of Scotland). He was, however, highly successful, and one of the few Scottish artists to embrace Pre-Raphaelitism.

Bib.: Storey, A.T., *The Life and Work of Sir Joseph Noel Paton*, London, 1895; Savanson, V.G., *Sir Joseph Noel Paton*, London, 1977

patriarchy

A term used in ▷gender theory to refer to the control exerted by male authority throughout history. The patriarch, or father figure, thus becomes the microcosm of heads of church and state. In the history of art, patriarchy could be said to direct the production and content of art in many periods of history when women have been oppressed.

patronage

The encouragement and support, often financial, of artists and craftspeople. In the Middle Ages there were two main sources of patronage – the church and the State. Particular orders or dioceses might encourage local artists or workshops to produce works solely for their establishments, in a mutually beneficial arrangement. This pattern was also seen in secular life with court painters and artists. More recently patronage has been on a less expansive scale, but has been proved to be extremely important. For example, ▷Vollard, Paul Alexandre and other art dealers and collectors can be said to have had a profound influence upon the history of 20th-century art.

Patroon Painters

American artists of Dutch origin, who practised in the early 18th century. They worked primarily in the Hudson River valley producing portraits based on the formula of English ▷mezzotints. Their name comes from the Dutch '*patroon*', meaning 'patron'.

pattern painting

A movement of decorative painting which often included work in other media, and which flourished in New York in the 1970s. Male and female artists used paint and fabric to take patterns, often those associated with particular historic traditions or cultures, and explore their motifs in radical ways. For example, Joyce Kozloff (b 1942) took decorative imagery as an inspiration for ▷feminist paintings such as *Hidden Chambers* (1975), which draws on ▷Islamic traditions.

Paul

An ▷Apostle, although not one of the original twelve, who had a special mission to preach the Word to Gentiles. He was author of the Epistles and hence is often associated with a book or scroll. In early art he was represented as short and bald, but ▷Renaissance painters preferred to represent him as dark, and some 17th-century artists showed him in old age with a white beard. (He was a controversial figure during the ▷Counter-Reformation because of his popularity with Martin Luther). He was often depicted alongside ▷Peter, as co-founder of the Church. He was executed by the sword, often shown as his ▷attribute.

Paul was born Saul in Tarsus c AD 10, Jewish but with Roman citizenship through his father. His conversion to Christianity took place on the road to Damascus, where he had been sent to arrest Christians. He fell from his horse, blinded by a light from heaven. His sight was later restored by Ananias who baptized him. The conversion is commonly represented in art: the horse symbolized pride and Paul is often dressed in Roman armour (e.g. ▷Caravaggio, 1600–1601, S. Maria del Popolo, Rome).

Other scenes from Paul's life have also been recorded in art. He escaped from Damascus following his conversion by being let down the city walls in a basket (this subject was rare after the ▷Gothic period). At Antioch, he disputed with Peter. He then travelled with Barnabas to Cyprus, where he preached to the Roman governor, and Elmyas, who tried to prevent

the sermon, was miraculously blinded. Paul also preached and performed a miracle at Lystra. At Philippi, he was imprisoned along with Silas; the prison walls were toppled by an earthquake but the Apostles remained to baptize the inmates. At Athens, Paul baptized the future bishop, Debnis the Areopagite (e.g. ▷Raphael, *St. Paul Preaching at Athens*, 1515–16, London, Victoria and Albert Museum). At Ephesus Paul burnt pagan books, and en route to his trial in Rome, he was shipwrecked in Malta, where he was bitten by a snake but survived. According to medieval hagiography, the *Golden Legend*, he also raised the son of King Theophilus of Syria from the dead. He had an ecstatic vision of three angels, a popular Counter-Reformation theme.

Paul's life ended when he was executed in Rome on the same day as ▷Peter. According to legend, he was given a veil to blindfold himself by Plautilla and three spurts of blood representing ▷faith, ▷hope and ▷charity spouted from his neck. His head is sometimes represented on a plate, blindfolded (▷John the Baptist).

Pausanius (fl c AD150)

Greek traveller, geographer and historian, whose ten-volume *Descriptions of Greece* is the single most important literary source for information relating to Greek architecture, painting and sculpture. These volumes, arranged by geographical region, were written as guide books for the traveller and cover topography, local histories, social customs, religious practices, and myths, as well as art. Where verifiable, his information has been found to be accurate. An English translation by Sir James Frazer was published in six volumes in 1898. Frazer declared 'Without him the ruins of Greece would for the most part be a labyrinth without a clue, a riddle without an answer.'

pavilion

(i). An ornamented temporary structure or tent, set up in a garden or field. (ii). A projecting section of a building, either in the exact centre of the facade or forming an angle of the building, generally of a greater height than the main mass of the building and often ▷domed or with a hipped or pavilion roof.

Peale, Charles Willson (1741–1827), Raphael(l)e (1774–1825), Rembrandt (1778–1860), Rubens (1784–1864); James (1749–1831), Anna Claypoole (1791–1878), Margaretta Angelica (1795–1882), Sarah Miriam (1800–85)

American family of painters. Charles Willson headed the dynasty. He studied with ▷West in London and settled in Philadelphia in 1775. There he worked as a portrait painter until 1769 when he returned to Maryland, his home state. He was also a natural scientist, and his collection of artefacts eventually became

the Peale Museum in Philadelphia. He helped found the Pennsylvania Academy of Fine Arts in 1805. He had three wives and 17 children, a number of whom also became artists.

Among his artist progeny was Raphaelle, who was a ▷miniaturist and still-life painter. He was best known for his ▷*trompe l'oeil* still lifes. Rembrandt, by contrast, painted mostly portraits and history paintings. He studied in London and Paris in 1802–3, and developed a style of ▷Neoclassical ▷history painting. He founded the Peale Museum in Baltimore in 1814. Another son, Rubens, worked in his father's museum and painted still lifes, concentrating on bird imagery.

Charles' brother James was also an artist. He was born in Maryland, and worked there as a miniaturist and landscape painter. He had seven children, a number of whom were also artists: Anna, who painted still lifes and portraits and was an early member of the Pennsylvania Academy; Margaretta, who specialized in still lifes; and Sarah, who became a successful portraitist in Baltimore.

Pearlstein, Philip (b 1924)

American painter. He was from Pittsburgh but moved to New York in the 1950s, where he developed a ▷realist style in opposition to the ▷Abstract Expressionism then in vogue. He maintained his interest in figuration and specialized in clinically realistic paintings of non-sexual nudes.

Peasants' Wedding

Painting by ▷Pieter Bruegel the Elder. Although not signed or dated, it is considered to be from c1567 and is now in the Kunsthistorisches Museum, Vienna. Bruegel was interest in moral themes and painting that depicted a theme or idea such as *The Fight Between Carnival and Lent* or *The Netherlandish Proverbs*. As such, though the *Peasants' Wedding* has been considered a simple ▷genre painting, it may also be seen as representing the sin of ▷Gluttony in the way that the comparable *Wedding Dance in the Open Air* shows the sin of ▷Lust. As the scene is characterized by realism, humour and drama and possesses interest for its detail of everyday Netherlandish life, its deeper significance can easily be overlooked.

Pechstein, Max (1881–1955)

German painter. He was an important ▷Expressionist artist, born in Zwickau and apprenticed to an interior decorator before enrolling at the School of Fine Arts in Dresden (1900–1902) and the Dresden Academy (1902–6). The vibrant tulips he painted for the ceiling of a pavilion at the International Arts and Crafts Exhibition impressed ▷Heckel, and in 1906 Pechstein was invited to join ▷Die Brücke. A scholarship enabled him to travel to Italy in 1907, and he returned via Paris where he encountered the work of ▷Matisse and the ▷Fauves. In 1909 he began a series of annual visits to

the village of Nidden in East Prussia, attracted by what he saw as the primitive lives of the remote fishing community. He was a founder of the ▷Neue Sezession and became its chairman. In 1914 he went to Palau, a German colony in the South Seas, but was captured by the Japanese when war broke out. After the War he founded the ▷Novembergruppe to support modern art and became a member of the Prussian Academy of Fine Arts, but was dismissed as a degenerate by the Nazis (▷Degenerate Art), who banned his work.

Pechstein's technical skills and brilliant colours made him the most popular of Die Brücke, but his paintings drew heavily on the innovations of others and he slipped from the forefront after 1918. His fascination with the exotic shows the influence of ▷Gauguin and led to a similar exploration of the primitive as a location of sensuality and colour in his paintings at Nidden and Palau, particularly in his studies of bathers which match the curves of the body to a sinuous landscape.
Bib.: Kruger, G., *Das druckgraphische Werk: Max Pechstein*, Tokendorf, 1988; Schilling, J., *Max Pechstein*, Bonen, 1989

pedestal
In Classical architecture, a support for a ▷column, the three main divisions of which are a ▷plinth or base, a ▷dado or die, and a ▷cornice or cap. More generally, the term also describes a support for any superstructure, such as a statue, an ▷obelisk or an urn. As part of a commemorative monument, a pedestal may present a useful surface or surfaces for explanatory and laudatory inscriptions and as a base for a statue it has a further, psychological, significance in that it sets the subject apart and ennobles it by making the viewer literally look up to it.

pediment
In Classical Greek architecture, the triangular area at the front and back ends of a gabled temple, created between the pitch of the roof and the horizontal ▷cornice of the ▷entablature. From Roman times onward, pediments were also used to crown windows, doors, ▷niches or other openings, and these are sometimes called frontons. Later developments include the segmental pediment. Both triangular and segmental pediments have been modified in a number of ways, the most common being the self-descriptive open-topped or broken-apex pediment and the open-or broken-bed pediment. An extreme modification was invented by the Italian architect ▷Bernardo Buontalenti who, in 1574, on the Porta delle Suppliche of the Uffizi, Florence, cut a segmental pediment in half and turned the pieces to face away from each other, so as to accommodate a bust of his patron, Cosimo de' ▷Medici.

peep-show box
A box whose interior has been decorated according to the laws of ▷perspective to create the impression of a three-dimensional space when viewed through a small eyehole. The first such devices are attributed to ▷Alberti in 1437. More elaborate models were produced in the 17th century, reproducing the designs of court masques with painted figures in the foreground, or lining the walls with mirrors to deepen the illusion of space.

Peeters, Bonaventura the Elder (1614–52)
Flemish painter. He worked in Antwerp, producing landscapes and marine scenes. He was also a satirist.

Peeters, Clara (1594–after 1657)
Flemish painter. She was from Antwerp but worked in Amsterdam (1612) and Haarlem (c1612–17). She specialized in the type of still lifes called 'breakfast pieces'.

Pei, Ieoh Ming (b 1917)
Chinese architect. He is famous for hi-tech glass and steel constructions. Born in Canton he studied at MIT and Harvard and opened his own practice in New York in 1955. His Mile High Centre in Denver (1956) has a ▷façade composed of two intersecting systems with supporting aluminium beams and air conditioning units placed behind bright enamelled bands. This work has been identified with the ▷International Style. Other buildings include the National Center for Atmospheric Research, Boulder, Colorado (1967), Everson Museum of Art, Syracuse (1968) and the east wing of the ▷National Gallery of Art in Washington, DC (1971–8). Most recently Pei's monumental but simple forms have been expressed in the Pyramid and Tuileries development at the Louvre, Paris (1989).

Peintres de la Réalité, Les
A name given to 17th-century French painters who produced scenes of daily life. They include ▷Georges de La Tour, ▷Le Nain and other artists working within a realist mode established by ▷Caravaggio. The term comes from a Paris exhibition of 1934 which attempted to classify their work as a coherent entity.

Pelham, Peter (c1694–1751)
English engraver. Born in Chichester, he studied ▷mezzotint engraving in London and from 1720 produced prints of public and historical figures. In 1726 he emigrated to America with his wife and two sons, setting up an engraving workshop in Boston. His portrait mezzotints represented leading figures of Massachusetts public life, including the Reverend Cotton Mather and the colonial governor William Shirley, and were the first to be produced in North America. Pelham's second wife was Mary Singleton

Copley, widowed mother of the painter ▷ John Singleton Copley.

pelican

The pelican piercing its own breast to feed its young with its blood is used in Christian art as a symbol of ▷ Christ's redemptive spilling of his own blood on the cross. The image derives from the red tip of the pelican's bill which it often rests against its breast whilst feeding its young, leading to the belief, propounded in medieval bestiaries, that it so loves its offspring that it actually spills its own blood for them. Thus, a nesting pelican feeding its young is often located at the top of the cross itself in medieval and early ▷ Renaissance crucifixion scenes (e.g. ▷ Francesco Pesellino, *The Crucifixion with SS Jerome and Francis*; Washington, National Gallery).

Pellegrini, Giovanni Antonio (1675–1741)

Italian painter. He was a Venetian. He studied under ▷ Sebastiano Ricci, but was influenced more perhaps by the work of ▷ Luca Giordano. In 1704 he married the sister of ▷ Rosalba Carriera and is thus mentioned occasionally in her diary. Pellegrini was much travelled and is generally credited with the introduction into northern Europe of the ▷ Rococo elegance and lightness of 18th-century Venetian decorative ceiling painting. He visited England (the first Venetian artist to do so, with ▷ Marco Ricci) in 1708–13; Düsseldorf (to serve the Elector Johann Wilhelm) in 1713–16; the Low Countries in 1716–18; and England again in 1719. He returned briefly to Venice in 1720, before travelling to Paris to execute the decoration of the

Giovanni Antonio Pellegrini, *Self-portrait*, Uffizi, Florence

ceiling of the Banque Royale (now destroyed). He returned once more to Venice in 1721, but nonetheless continued to travel widely throughout Europe.

Pellegrini's first visit to England had been in the train of the 4th Earl of Manchester (retiring British Ambassador to Venice). He produced a decorative scheme for the Earl's country seat, Kimbolton Castle, as well as at his London house (now destroyed). ▷ Vanbrugh (the architect engaged in the restoration of Kimbolton) then employed Pellegrini to decorate Castle Howard, and afterwards he did extensive work at Narford Hall, Norfolk. Pellegrini's light palette, fluid ▷ brushwork, sketchlike virtuosity and elimination of hard outlines gave his decorative schemes a lightness and grace ideally suited to their purpose. In his last years in Venice Pellegrini's work shows a decline – his outlines become harder and his palette duller – until he was eventually superseded by the younger generation of painters led by ▷ Piazzetta and ▷ Tiepolo.

Bib.: Knox, G., *Antonio Pellegrini 1675–1741*, Oxford, 1995

pen

(From the Latin, '*penna*', 'feather'.) An instrument used by artists for drawing, whether rapid sketches or finished presentation pieces. A popular technique since the ▷ Renaissance has been pen and wash, wherein outlines and textures are drawn with a pen in combination with tones which are applied in washes with a brush dipped in diluted ▷ ink or some similar coloured fluid. Although pens come in a variety of forms, the word 'pen' alludes to the type made from the quill of a bird, usually goose, swan, turkey or, for the finest point, crow. Quill pens were widely used in Europe from Early Christian times to the 19th century, gradually being superseded by steel pens which were manufactured from the 18th century. Reed pens have been used since Classical ▷ antiquity. ▷ Rembrandt made virtuoso use of the reed pen, his drawings evincing the broad and bold effects so characteristic of the medium.

pencil

(i) Originally a term for the tube or quill encasing sable, fitch or camel's hair, but in modern usage, a drawing instrument consisting of a slender rod of graphite encased in either wood (in which case the drawing tip is exposed by shaving away the casing) or metal (in which case the drawing tip is exposed through mechanical propulsion, i.e. a 'propelling pencil'). Graphite pencils encased in wooden holders were first developed in England in the 1680s. The range of expressive possibilities increased radically following Nicolas-Jacques Conté's (▷ Conté crayon) discovery in 1790 of a tempering process in which the graphite was mixed with clay before being fired in a kiln: the greater the proportion of clay the harder the graphite rod. Thus, for the first time, the manufacture of pencils of varying degrees of hardness and softness became

possible. Usually today's pencil, dating back to the early 19th century, is a cedar wood cylinder around graphite mixed with varying amounts of clay. The softness (blackness or density) of the pencil is measured on a scale EE>B>9H, i.e. very hard – suitable for technical drawing. Versatility is shown in the broad range of marks which may be obtained. Pencils are often used for preliminary studies preceding painting composition.

(ii) In 18th-century English usage, a pencil is an artist's paintbrush. This is how ▷Reynolds uses the word in his *Discourses on Art* (see, for example, Discourse II). In this context, 'pencilling' means ▷brush-work.

Pencz, Georg (Jörg Bencz) (1500–50)

German painter and engraver. He was a member of the Nuremberg Guild in 1523, but he was expelled from the town for his Protestant inclinations. He was later allowed to return. He probably spent some time in Italy, and his works certainly show a Venetian influence, as well as that of ▷Holbein. He also produced ▷engravings.

Bib.: Hollstein, F.W.H., *Hollstein's German Engravings, Etchings and Woodcuts 1400–1700, Vol. 31: Michael Ostendorfer (continued) to Georg Pencz*, Roosendaal, 1991

pendant

(i) An ornamental feature hanging from a stone vault or timber roof of a ▷Decorated or ▷Perpendicular ▷Gothic building and later, French and English vaults of the 16th and early 17th centuries. (ii) A form used to describe one of a pair of companion sculptures, paintings, etc.

pendentive

One of a set of curved wall surfaces, like concave ▷spandrels, which start in the angles of a square or polygonal compartment, rising upwards and arcing towards each other to support the rim of a circular dome: they are thus transitional members connecting an angular to a circular space.

Penelope

(Homer, *Odyssey*.) The wife of the Greek hero Odysseus (Roman, ▷Ulysses), she is the embodiment of the faithful wife. Odysseus' return from the siege of Troy is considerably delayed by his series of adventures on his homeward journey. Many people believe him to be dead and thus Penelope is beset by a group of increasingly importunate suitors. She sends her son Telemachus to try to find his father and meanwhile seeks to stall the suitors by declaring that she cannot consider marriage until she has finished weaving a shroud for her father-in-law, Laertes. Each night she undoes what she has woven the previous day until one day the suitors discover her ruse and become unruly.

She prays to the goddess ▷Athena for help and is advised to challenge the suitors to an archery contest, using the great bow that Odysseus left behind when he went to Troy. By this time Telemachus has found his father who has now returned disguised as a beggar. In the archery contest Odysseus defeats and kills all his rivals.

In London's National Gallery a detached ▷fresco by ▷Pinturicchio shows Penelope seated at her loom. A young man who may be Telemachus approaches Penelope, perhaps informing her of Odysseus' return. On the right of the room is a crowd of suitors and entering the door a figure who may be Odysseus in disguise. In the harbour seen through the window is a large ship, either that of Odysseus or allies of the suitors.

Penni, Francesco (c1488–c1528)

Italian painter. He was born in Florence and worked in Rome as an assistant to ▷Raphael and later ▷Giulio Romano. He was called 'il Fattore' ('the maker').

Penrose, Sir Roland (1900–84)

English painter. He was friendly with a number of ▷Surrealists such as ▷Ernst and ▷Miró, as well as ▷Picasso. He was responsible for the first Surrealist exhibition in England in 1936, and after the Second World War he helped found the ▷Institute of Contemporary Arts in London. He wrote monographs on Picasso and ▷Man Ray.

Bib.: *Roland Penrose*, exh. cat., London, 1980

pentimento (pl. pentimenti)

(Italian, 'repentance', 'regret'.) Visible evidence of an artist's change of mind. In painting, *pentimenti* often become visible when a superimposed layer of paint becomes transparent through chemical change wrought by time, or when a painting is overcleaned revealing an underlayer, or when a painting is viewed under raking light. An example of the last type of revelation occurs in ▷Gainsborough's *Portrait of Mrs. Siddons* (London, National Gallery) in which the artist, as he admitted afterwards, had experienced considerable difficulty getting the nose right – around the outline of the finished nose can be seen under raking light a series of ridges showing Gainsborough's painted-over earlier attempts. *Pentimenti* are often taken as evidence of a painting being original in so far as 'second thoughts' are more likely to be part of a process of original creation than of copying.

Pereda, Antonio de (c1608–78)

Spanish painter. He was an important ▷Baroque artist, born in Valladolid. In 1622 he moved to Madrid where he studied under Pedro de las Cuevas. Befriending the influential Giovanni Battista Crescenzi brought him court commissions, but after the latter's death in 1635

Pereda was dependent on painting ▷altarpieces and other work for religious orders.

Pereda produced ▷history paintings and religious subjects, but his most notable works were still lifes. Collections of natural objects such as *Still Life with Walnuts* (1634) and *Still Life with Vegetables* (1650) show Pereda's great technical skill, vividly conveying the texture of knotty walnut shells or rough cauliflower leaves. His arrangements of man-made objects are studies of ▷vanitas, often with an underlying political theme. The *Allegory of Transience* (c1640) alludes to Emperor Charles V, and its skulls, clocks and globe provide a meditation on imperial power. The chaotic abundance of treasures assembled in *The King's Dream* (c1655), including a gilded clock, strings of pearls, a violin and bishop's mitre, bear witness to an age of mercantile expansion but are rendered valueless (the painting suggests) by an awareness of mortality.
Bib.: *Antonio de Pereda*, exh. cat. Madrid, 1978

Performance art

A term describing the presentation of an event that may include music, poetry and dance as well as the visual arts of painting, sculpture, film and video. The context is usually theatrical in the sense that the performance takes place in front of an audience, but most Performance artists will insist that it is not theatre but an event in which the 'action' takes place in 'real' time and with 'real' content. There was a strong element of Performance art in the manifestations of the ▷Futurists and ▷Dadaists, and this social dimension was continued in such early expressions of Performance art as the ▷Action painting of ▷Yves Klein, who created paintings in front of an audience by dragging naked women covered in paint over a canvas laid on the floor. In the 1960s ▷happenings developed Performance art towards audience participation and the spontaneous unfolding of the event. Outside the USA the Gutai group in Japan and ▷Fluxus in Europe drew Performance art into the political arena with Dada-like attacks on social and aesthetic norms. Essentially, Performance art is an aspect of ▷Conceptual art in so far as it embraces the view that what matters is not the physical art object but the idea that lies behind it.
Bib.: Kaprow, A., *Assemblage, Environments and Happenings*, New York, 1966; Popper, F., *Art, Action and Participation*, Paris, 1975

Pergameme School

The name given to the sculpture produced in Pergamum during the ▷Hellenistic period, especially 3rd and 2nd centuries BC. The work was more violent and emotional than that of the High Classical period that preceded it. Examples of this work include the Altar of the Temple of Zeus at Pergamum (241–133 BC) and a group of ▷Dying Gauls.

peristyle

(From the Greek '*peri*', 'round' and '*stylos*', 'column'.) A ▷colonnade either around the outside of a building or around a courtyard within a building. It is a common architectural form in Greek temples.

Permeke, Constant (1886–1952)

Belgian painter and sculptor. He was from Antwerp and studied at the Bruges and Ghent Academies. He became associated with ▷de Smet and ▷Berghe and was involved with the Second ▷Laethem Group. During this time (1909–12) he painted scenes of peasants. He came to England in 1916 after being wounded in the First World War, and he returned to Belgium in 1918, where he painted subjects relating to fishing. In the 1930s he turned his hand to sculpture.
Bib.: Smeets, A., *Flemish Art from Ensor to Permeke*, Tielt, 1971

Permoser, Balthasar (1651–1732)

German sculptor. He studied at Salzburg in c1663. He took on commissions from the Grand Duke Cosimo III in Italy during c1675–89, and then returned to Germany to take up the post of court sculptor in Dresden. He returned from Italy with a style derived partly from ▷Bernini but with a more classical restraint. While in Dresden, he did decorative work for the Zwinger.

Perpendicular Style

The final phase of English ▷Gothic architecture, lasting from c1335 to c1530, following the ▷Decorated style and preceding the Elizabethan ▷Renaissance style. The term was first coined by Thomas Rickman in the early 19th century and was derived from a classification of the window ▷tracery which he saw as characterized by the prominent use of vertical mullions. The earliest surviving use of Perpendicular decoration is in the south ▷transept (1331–7) and ▷choir (c1337–c1350) of Gloucester Cathedral, though an early phase seems to have been evolved (perhaps deriving from French Court style) in the now lost St. Stephen's Chapel, Westminster (begun 1292) and the chapter house of Old St. Paul's (1320s). Perpendicular style windows are larger and divided horizontally into rows of panels, each panel decorated with a simple cusped ▷arch (see particularly the east window of Gloucester Cathedral). Perpendicular tracery is characterized by the rectilinear pattern formed by the intersection of these straight horizontals and verticals, repeated without variation and employed as a universal form of decoration even onto the surrounding masonry, such that the walls of a Perpendicular style building appear to be encaged. ▷Vaults were originally of the ▷lierne type, with the fan vault first introduced c1350–60, either in the cloisters at Gloucester or in the chapter house (demolished 1769) at Hereford. The finest example of

fan vaulting in the country can be seen at King's College Chapel, Cambridge. Many fine examples of the Perpendicular Style are found in parish churches, particularly in the rich wool counties of Norfolk and Suffolk, Somerset and the Cotswolds.

Perréal, Jean (Jehan de Paris) (c 1455–1530)

French painter, architect and sculptor. He worked in Lyons in 1483, and he made several trips to Italy between 1499 and 1505. He produced portraits and tomb designs, and his fame led him to gain commissions from Charles VIII, Louis XII and François I of France. He visited England in 1514.

Perrier, François (?1590–1650)

French painter and engraver. He was a ▷pastel portraitist and the principal rival to ▷La Tour. He travelled around Europe from 1755, visiting and accepting commissions in England, Italy, Poland, the Netherlands and Russia.

Perronneau, Jean-Baptiste (c 1715–83)

French painter. He was an important ▷pastel portraitist, and he travelled to fulfil commissions.

Perseus

Hero of Greek mythology whose story is retold in Ovid's *Metamorphoses*. The son of Danaë and Zeus (▷Jupiter), his most famous exploits were the killing of ▷Medusa, one of the three snake-haired Gorgons, and the rescue of the beautiful Andromeda from the sea-monster. Following Perseus's birth his grandfather, fearing a prophecy that his grandson will kill him, sets Danaë and the baby Perseus adrift on the sea in a chest. The chest is washed up at Seriphus and the king of that land takes the mother and child in. The king grows to desire Danaë and contrives to rid himself of the now adult Perseus by sending him on an impossible quest to fetch the head of the Gorgon whose mere gaze turns mortals to stone. Perseus, however, obtains divine help from ▷Athena, who equips him with a polished shield, and Hermes (▷Mercury), who gives him winged sandals and a sword. By the aid of his winged sandals he flies to the land of the Gorgons and severs Medusa's head.

Sometimes Perseus is depicted using Athena's polished shield to look at Medusa's reflection rather than her actual face, or else he is seen averting his gaze altogether as he kills her, as on a Greek ▷black-figure vase by the Amasis Painter (c550 BC, London, British Museum). Ancient Greek representations such as the latter show Medusa as hideously ugly with a wide, tusked mouth. From the ▷Renaissance onwards, however, artists preferred to humanize her and even to give her a rather haunting beauty (e.g. ▷Cellini, bronze statue, 1545–54, Florence, Piazza della Signoria). Cellini's is perhaps the most famous image of Perseus: an athletic young man, armed with a sword and naked but for a winged helmet and sandals.

Out of the ground soaked with the blood of the Gorgon sprang the winged horse, Pegasus, and in a departure from the ancient sources, some Renaissance painters have Perseus continue his flight, not using the winged sandals, but riding Pegasus. On the way home he sees a beautiful naked woman tied to a rock by the sea. She is Andromeda, a royal princess, offered as a sacrifice to Poseidon (▷Neptune) who has sent a sea-monster to ravage the land. Perseus offers to save Andromeda in return for her hand in marriage. The royal parents agree and Perseus kills the monster with his sword (or, in an alternative version, by showing it the head of Medusa). The wedding ceremony goes ahead, but is violently interrupted by Phineus, who had previously been betrothed to Andromeda. A fearful fight ensues, Perseus bravely fending off numerous of Phineus' followers until, at last, almost overwhelmed by sheer force of numbers, he draws Medusa's head out of the bag in which he had been carrying it, and turns all of his assailants to stone (e.g. ▷Luca Giordano, *Perseus Turning Phineas and his Followers to Stone*, early 1680s, London, National Gallery).

Persian art

The Persian civilization was based in what is now Iran, and art is evidenced as early as the 7th millennium BC from which a number of bronze artefacts remain. The cultural height of the pre-Islamic Persian empire came in the 6th–5th centuries BC when it was enlarged and Darius commissioned a large building programme at Persepolis. When Alexander the Great conquered the empire in 333 BC, Greek influence infiltrated the arts, but a more Oriental emphasis returned in the 1st century AD. The best art of the Persian empire was that of the Sassanian dynasty, which ruled from AD 224 to 642. At that time many palaces were built, and monumental rock sculpture remains extant from the period.

Conquest by the Arabs in the 7th century AD minimized the representational aspects of Persian art and more ornamental styles of design now appeared on textiles and manuscripts. Persian art during the ▷Islamic period is particularly distinguished for its manuscript illumination and ▷calligraphy. Its importance declined after the 18th century.

Bib.: Gans-Ruedin, E., *Iranian Carpets: Art, Craft and History*, London, 1978

Persistence of Memory, The

Painting by Salvador Dali, oil on canvas, first exhibited at the Pierre Collé Gallery, Paris, in 1931, now in the ▷Museum of Modern Art, New York. Dali writes in his biography that after completing a particularly ripe Camembert cheese he looked anew at a work in progress of a landscape near Port Lligat and, 'I knew that the atmosphere which I had succeeded in creating with this landscape was to serve as a setting for some idea,

for some surprising image, but I did not in the least know what it was going to be. I was about to turn out the light, when instantaneously I saw the solution. I saw two soft watches, one of them hanging lamentably on the branches of the olive tree.' This image of three melting fob watches, one being devoured by ants, together with a 'soft' self-portrait of the artist sleeping is Dali's most famous. The ▷Surrealists' other reality beyond the rational is placed by Dali somewhere outside time, but he also evokes the very malleability of time, dripping 'lamentably' like a wax candle. His use of 'soft' objects that cannot support themselves has also been associated with the artist's alleged impotence. Dali returned to the image of the melting watches again in 1954 with *The Disintegration of the Persistence of Memory.*

perspective

The method in art of creating an impression of spatial depth, either of a flat surface or in ▷relief. The use of perspective is rare or rudimentary in primitive civilizations, but western painting developed a profound interest in the optical or geometric representation of perspective through the ancient Greeks. The skill was 'lost' or not considered important during the Middle Ages, but rediscovered during the ▷Renaissance to become a dominant property of the art of that and successive periods.

The Florentine architect ▷Filippo Brunelleschi originated the first construction of scientific perspective, and his theory was developed and popularized by his contemporary ▷Alberti, who described a perspective construction for painters in his *On Painting* (1436). Artists such as ▷Uccello in ▷ *The Rout of San Romano* and *Hunt in the Forest,* and ▷Piero della Francesca put these ideas into practice. ▷Renaissance perspective focused on a ▷linear perspective that required a single viewing position, exemplified in ▷Leonardo's ▷ *Last Supper.* As it had been for the ancient Romans, the depiction of false architecture in internal spaces became a popular device using perspective. In later generations the importance of perspective in Western art as the dominant way of seeing has been questioned. ▷Romanticism considered perspective a restraint, and ▷Cubism proved the strongest attack on perspective, developing a multiple viewpoint; ▷de Chirico was able to use extreme perspectives to create a sense of mystery and unease. With later ▷modernism's appreciation of 'primitive' art, perspective could again be considered as only one among a number of representative modes.

Bib.: Gombrich, E., *Art and Illusion,* London, 1960

Perugino, Pietro (Pietro Vannucci) (c1445/50–1523)

Italian painter. He was possibly trained by ▷Piero della Francesca or, according to ▷Vasari, by ▷Verrocchio.

In 1481 he was contracted as one of a team (possibly its leader) of painters (including ▷Botticelli, ▷Ghirlandaio and ▷Cosimo Rosselli) to whom the decoration of the walls of the ▷Sistine Chapel were entrusted. Perugino painted the (now lost) altar wall and *Christ Giving the Keys to St. Peter,* the latter, his first major success, being characteristically balanced, harmonious and clearly composed. He was for a while regarded by many as the leading painter of his generation. His work is very distinctive but shows virtually no development over the years, and in 1506 he retired from Florence to Perugia, apparently unable to adapt to the new aesthetic demands of the High ▷Renaissance.

Perugino's paintings are at their best elegant and harmonious, though in later years they became formulaic. The standing figures in his religious paintings are virtually always posed in a gentle, dropping ▷contrapposto with somewhat pietistic expressions. His landscape backgrounds are broad and serene, with generally a few elegantly tall, thin-trunked trees, reflecting a ▷Netherlandish influence, close to ▷Memlinc. That Perugino was familiar with Memlinc's work is suggested also by the close similarity between his *Portrait of Francesco delle Opere* (1494, Florence, Uffizi) and Memlinc's *Portrait of a Man* (1470s, New York, Frick Collection). Perugino's most celebrated pupil was ▷Raphael, whose early works are virtually indistinguishable from his master's. Although eclipsed by the aesthetic revolution of the High Renaissance, the gentle piety of Perugino's art was again greatly acclaimed some three centuries later by the ▷Pre-Raphaelites.

Bib.: Palumbo, U., *Perugino e Perugia,* Perugia, 1985; Scarpellini, P., *Perugino,* Milan, 1991

Peruzzi, Baldassare (1481–1536)

Italian architect and painter. He was from Siena but worked in Rome in 1503, where he designed the Farnesina (c1509–11) and took on commissions for ▷fresco decoration. In 1520 he was put in charge of the architecture of St. Peter's, and he made the decision to retain ▷Bramante's plan for the cathedral. Towards the end of his career, his work began to show ▷Mannerist quirks, especially the Palazzo Massimi (1532–5), with its curving façade. He also produced designs for the stage.

Bib.: Frommel, C.L., *Baldassare Peruzzi als Maler und Zeichner,* Vienna, 1968

Peter

The leader of the ▷Apostles, one of the original three, with James and ▷John a member of Christ's inner circle and ultimately the founder of the Church and papacy. When Jesus asked the disciples who men thought he was, it was Peter who said that he was Christ; to which Jesus replied that Peter was the rock upon which he would build his Church and to whom

he would give the keys of the kingdom of Heaven (Matthew 17: 13–20). Peter is thus of unrivalled importance to the Catholic Church and appears frequently in both devotional and narrative paintings. His identifying ▷attributes are: a key, or pair of keys (one gold for Heaven, one iron for Hell); an upturned cross (to allude to the fact that at his execution he chose to be crucified upside down as he considered himself not worthy to emulate Christ's ▷Crucifixion); a papal crozier; a book (to allude to his writings, including the Epistles); and a cock (to allude to Christ's prophecy that he would deny Christ three times before the cock crowed on the night of Christ's arrest). He is almost always portrayed as a stocky man with short, curly, sometimes tonsured, white hair and beard and he is generally dressed in a gold mantle over a blue or green tunic. His inscription from the Apostles' Creed is: '*Credo in Deum Patrem omnipotentem, creatorem coeli et terrae* ('I believe in God, the Father Almighty, maker of Heaven and Earth').'

In devotional paintings St. Peter may be balanced with ▷St. Paul, so that they represent together the joint founders of the Church, specifically the Jewish and Gentile elements. Narrative paintings show a number of episodes from his life: his calling whilst still a fisherman; his denial of Christ (e.g. ▷Rembrandt, 1660, Amsterdam, Rijksmuseum); his vision of Christ walking towards Rome as Peter himself tried to escape arrest by fleeing from the city (e.g. ▷Annibale Carracci, '*Domini Quo Vadis?*', c1600, London, National Gallery). Peter asks Christ where he is going and Christ answers that he is going to Rome to be crucified again – thus Carracci shows Christ striding forward, carrying his cross and pointing ahead, whilst the startled Peter recoils. However, Peter understands that Christ means that he, Peter, must return to Rome to prepare for his own martyrdom. Peter returns and is crucified upside-down (e.g. ▷Filippino Lippi, 1484, Florence, Brancacci Chapel). A number of other important episodes from St. Peter's life are also represented in the Brancacci Chapel, including *The Death of Ananias*, *St. Peter Healing the Sick with his Shadow*, *The Raising of Tabitha*, *St. Peter in Prison* and *The Fall of Simon Magus*.

Peters, Reverend Matthew William (1741/2–1814)

Irish painter. He came from Dublin to London in c1765 and studied with ▷Hudson and with ▷Batoni in Rome, where he travelled in 1762. During the 1770s, he specialized in ▷genre scenes and portraits which already showed evidence of the lubricious emphasis his work would later retain. He travelled to France and Italy in 1772–6 and may have come into contact with the works of ▷Greuze. He became a ▷Royal Academician in 1777, but he was frequently accused of indecency in his art, and he resigned from that institution in 1788. In the meantime, he was

ordained in 1782. He continued to paint and produced some ▷genre scenes for ▷Boydell's Shakespeare Gallery.

Peto, John Frederick (1854–1907)

American painter. He specialized in ▷still life. Peto was born in Philadelphia, son of a dealer in picture frames. In 1877 he enrolled at the Pennsylvania Academy of Fine Arts, and exhibited at the Academy and the St. Louis Exposition (1881). After his marriage in 1887, he built a new home at the coastal resort of Island Heights, New Jersey, and became a professional cornet player. He sold paintings to local shopkeepers and summer visitors to the town, but never exhibited anywhere beyond the local drugstore. His work was virtually unknown until rediscovered by the critic Alfred Frankenstein in 1947.

Peto was a friend of ▷William Harnett, and his still lifes are superficially similar to Harnett's representations of a patron's noticeboard or desktop. However, the ▷brushwork is softer and more fluid, the light more diffuse, and the selected objects tend to be worn or broken. Depicting old letters, fading photographs and torn business cards pinned to a splintering shelf with the paint curling off the wall behind them, Peto's paintings treat the discarded junk of modern life with a hauntingly elegiac quality.
Bib.: Wilmerding, J., *Important Information Inside: The Art of John F. Peto and the Idea of Still Life Painting in the 19th Century*, New York, 1983

Pevsner, Sir Nikolaus (1902–83)

Architectural historian and author of the *Buildings of England* series. After training in Germany, Pevsner came to England and was Slade Professor of Fine Art at Cambridge University (1949–55). He initiated the *Buildings of England* series, published by Penguin, which traces the most important architecture, ecclesiastical and secular, ancient and modern, monumental and domestic, county by county. The series was phenomenally detailed and has been hailed as one of the greatest reference works in the English language. Pevsner published a number of other books including *An Enquiry into Industrial Art in England* (1937) and the *Englishness of English Art* (1956).

Pforr, Franz (1788–1812)

German painter. He was associated with the ▷Nazarenes. He was born in Frankfurt and studied there with his father, a landscape and animal painter, and his uncle, Kassel (1801–5). He then trained at the Vienna Academy (1805–9), where he met ▷Cornelius and established the Lukasbund (as the Nazarenes were known) in 1809, in opposition to the Academy's teaching. The following year he settled in Rome. He was influenced by ▷Bruegel and ▷Dürer as well as by German ▷Romantic literature (including the writing of Tieck). His work was characterized by an interest

in strong line and intense colour. He produced illustrations for ▷Goethe's *Gütz von Berlichingen*. Probably his most famous work, before his early death, is the *Entry of Emperor Rudolf of Habsburg into Basle 1273* (1808–10, Frankfurt).
Bib.: Andrews, K., *The Nazarenes: A Brotherhood of German Painters in Rome*, Oxford, 1964

Phalanx
An art school and exhibition society in Munich during the early years of the 20th century. For a time, it was under ▷Kandinsky's presidency. It was resolutely anti-academic, and organized important exhibitions on ▷Monet (1903) and ▷Neo-Impressionism (1904).

phallocentrism
A theoretical term which suggests the dominance of male or masculine viewpoints within history. More specifically, it refers to male sexuality, which some theorists believe has controlled and directed art production for most of history.

Phidias (d 432 BC)
Greek sculptor. He was from Athens, where he was known for the grace and classical purity of his figures. Although his work only survives in copies, the amount of writing about him in the ancient world attests to his importance. He was responsible for the statue of Athena in the ▷Parthenon and for the statue of Zeus in the Temple at Olympia. He is also said to have contributed to the ▷relief sculpture on the Parthenon.

Phillip, John (1817–67)
Scottish painter. He was a member of a group called The Clique, and spent time in Spain from 1851, where he was impressed with the work of ▷Velázquez. Velázquez' manner crept into his own ▷genre scenes, and he became known as 'Spanish' Phillip.

Philosopher Giving a Lecture on the Orrery, A
A painting (oil on canvas) by ▷Joseph Wright of Derby, first exhibited in 1766 and now in the Derby Art Gallery. It shows an early type of planetarium, an orrery, watched by a lecturer and seven men, women and children. The orrery was invented early in the 18th century to physically illustrate a planet's movement around the sun, and was operated by clockwork. In Wright's painting a lamp is used in the place of the sun, casting strongly contrasting areas of light and shadow. The observers show deep concentration and awe: the solar system reveals and retains its religious significance in the period of ▷Enlightenment. Wright was closely linked with the philosophical and scientific group that became the Lunar Society. Its members included Josiah Wedgwood, James Watt and Erasmus Darwin (grandfather of Charles Darwin), and Wright's painting illustrates their fascination with this kind of subject.

photogram
A photograph created without a camera but by using the photographic process of exposing sensitized paper to light. It was used by early photographers in the 19th century. Although superseded by advances in technology, it was rediscovered by ▷Surrealist and ▷Constructivist photographers in the 1920s.

photogravure
A synonym for gravure. A commercial reproduction process involving both photography and ▷engraving. An original drawing or painting is photographed onto a sensitized plate which is then coated and ▷etched. It was very common in the late 19th century.

photomontage
A technique of making pictures out of photographs, magazines, newspapers, drawings, etc., developed from ▷Cubist ▷collages by the Zurich ▷Dadaists, especially ▷Richard Huelsenbeck. Photomontage is more concerned with creating strange pictures of contrasting scales, images and perspectives compared with collage's interest in surface, texture and colour. The technique was popular amongst the ▷Surrealists, ▷Ernst and the Russians ▷Lissitzky and ▷Rodchenko who produced some of the best images. The propaganda potential of photomontage was brilliantly exploited by ▷John Heartfield, particularly in his attacks on Nazism.
Bib.: Ades, D., *Photomontage*, London, 1986

Photorealism
Also known as ▷Hyperrealism and ▷Superrealism, the movement flourished in the 1970s, especially in the USA. Photorealist artists, working large-format in ▷acrylics, made paintings that resembled photographs, especially of the snapshot kind, employing techniques that imitated the effects of amateur photography, such as information compositions and banal subject-matter – family picnics, suburban life or portraits. Leading exponents of the style include Malcolm Morley, Richard Estes and ▷Chuck Close.
Bib.: Meisel, L.K., *Photo-Realism*, New York, 1980

physiognomy
The stable, permanent features of the face that can be constructed as revealing aspects of a person's character. Theories of physiognomy were common from the ancient world, but their importance intensified in the light of ▷academic art theory in the 17th and 18th centuries.

piano nobile
(Italian, 'noble or great floor'.) An architectural term, referring to the principal floor of a large house, containing formal reception rooms. Originally used with reference to Italian ▷Renaissance *palazzi*, or town houses, the *piano nobile* was generally on the first floor,

above the noise and dust of the streets and below the stifling heat of the upper rooms. The *piano nobile* is often higher-ceilinged than the other floors and frequently differentiated from them on the outside of the building with larger windows and more elaborate decoration.

piazza

An Italian term referring to an open space, usually a public square, which is enclosed by buildings (e.g. the Piazza della Signoria, Florence).

Piazzetta, Giovanni Battista (1683–1754)

Italian painter. He was from Venice, the son of a sculptor and wood carver, from whose workshop he very soon moved to that of the painter, Antonio Molinari. He then moved to Bologna to study under ▷Giuseppe Maria Crespi, returning permanently to Venice by 1711 in which year he is first listed in the *fraglia* (Venetian painters' guild). In 1727 he was elected a member of the Accademia Clementina, Bologna and in 1750 became first Director of the Venetian Academy. He painted mostly religious subjects or ▷history paintings, though he also produced portraits and some ▷genre scenes (reflecting his training with Crespi). His usual ▷medium was oil, but he also painted at least one ceiling ▷fresco, *The Glory of St. Dominic* (c1727) for the Venetian church of SS Giovanni e Paolo. In addition, he produced many drawings for collectors and book illustrations, the latter to augment, apparently, the poor fees awarded for his mainly official commissions.

Always an original and fluent painter, Piazzetta's work occupies a transitional position: in the earlier years it is characterized by dramatic contrasts of ▷chiaroscuro reflecting his interest in the ▷Baroque painters of the first half of the 17th century, especially ▷Bernardo Strozzi; in the later years his work is characterized by a move towards a lighter palette with a more fluid technique – a shift towards ▷Rococo elegance completed by ▷Tiepolo whose early work Piazzetta greatly influenced.

Bib.: Knox, G., *Giambattista Piazzetta 1683–1754*, Oxford, 1992; Mariuz, A., *L'opera completa del Piazzetta*, Milan, 1982

Picabia, Francis (1879–1953)

An ▷avant-garde artist born in Poland and chiefly associated with ▷Dada and ▷Surrealism. He studied at the ▷École des Beaux-Arts and met ▷Pissarro, who became an important early influence. In 1909 he married Gabrielle Buffet, having by now renounced ▷Impressionism for ▷Cubism. He was a founder member of the ▷Section d'Or in 1911, and exhibited ▷Orphic works at the ▷Armory Show in 1913. Picabia spent much of the First World War in New York, having arrived with ▷Marcel Duchamp ostensibly to buy molasses for the French army. In 1917 he

was in Barcelona, where he began to publish the journal ▷*391*, a jokey response to ▷Stieglitz's ▷*291* in which his own diaries and poetry poured scorn on the art world. Having met ▷Tristan Tzara in 1918, he was instrumental in bringing Dada to Paris and thereby initiating ▷Surrealism. He retired in 1924 to a castle built to his own design near Cannes. Although isolated from the ferment of Paris, he continued to produce work and exhibit.

Picabia was a versatile artist, whose painting moved through virtually all the major movements of the contemporary art world. The only continuous element was his mocking wit. His most distinctive works are probably from the Dada 'mechanist' period (1915–21), in which he pasted together illustrations from technical manuals to produce images of absurd machines, often with a sexually threatening undercurrent.

Bib.: Camfield, W., *Francis Picabia: His Life, Art and Times*, Paris, 1979

Picasso, Pablo (1881–1973)

Spanish artist. He was born in Malaga, where his father was an art teacher, but the family later moved to Barcelona, where the young Picasso became involved with bohemian circles interested in ▷Art Nouveau. This influence appeared in his work of 1895–1904, which is called his 'Blue Period'. During this time, he painted scenes of beggars and impoverished people in a manner redolent of European ▷Symbolism. His moody evocations of lower-class life also revealed his anarchist inclinations at that time. He travelled to Paris in 1900, 1901 and 1902–3, where he lived in poverty himself, and became interested in the drawings of

Pablo Picasso, *Self-portrait*, 1906, private collection

▷Steinlen. A turning point in his career came in 1904, when he settled in Paris at the ▷'Bateau Lavoir' studio and became part of an extensive circle of artists and writers (▷School of Paris), attracting the patronage of Gertrude Stein and the art dealer ▷Kahnweiler, who helped foster his career. During 1905–7, his 'Rose Period' works were less melancholy, more fanciful and lighter in tone than those of his Blue Period.

Contact with the works of ▷Cézanne and ▷Iberian and ▷African sculpture led to a real change in Picasso's style in 1906–7. At this time he began incorporating figurative elements from non-Western sculpture into his painting and thus broke down traditional Western notions of both space and beauty. The starting point for this experimentation was ▷Les Demoiselles d'Avignon of 1907. Collaboration with ▷Braque led these developments towards the beginnings of ▷Cubism. The 'analytical' Cubist works of 1908–10 were superseded by experiments with ▷collage and later three-dimensional design. Picasso worked closely with both Braque and ▷Gris, and their work of the immediate pre-war period is often difficult to distinguish.

During the First World War, Picasso continued to practise his art, and he did costume and set designs for Jean Cocteau's ballet *Parade*, drawing his inspiration from Rome. During the 1920s, he pursued this Classical interest further and returned to representation in a series of Classical images of mothers and children in vague settings. By the end of the 1920s, his Classical interests had begun to wane, and his work was more akin to contemporary ▷Surrealist experiments. He became particularly interested in animals, producing works in which horses and bulls played an uncertain, if often erotic role. The climax of this Surrealist phase was his ▷*Guernica* of 1937, in which he used minotaurs and horses as part of a complex ▷allegory of the Spanish civil war. His works of the pre-war period returned to the abstraction of his Cubist phase, but by this time, his Surrealism had coloured the abstraction with erotic elements.

After the Second World War, Picasso lived first at Antibes, then at Vallauris, and from 1955 in Cannes, and he became even more prolific and experimental. At this time, he began to work in many different media. Adding to his previous work in painting, sculpture, ▷lithography and ▷etching, he also produced ▷ceramics and other forms of three-dimensional design. He accepted a number of important commissions such as the mural for the UNESCO building in Paris. His output was prolific, and his creative energy seemingly inexhaustible. However, his treatment and representation of his female models have subsequently caused much controversy and re-evaluation of his contribution to the art of the 20th century. He died of heart failure following a bout of influenza.

Bib.: Glaesemer, J. (ed.), *Der junge Picasso: Frühwerk und Blaue Periode*, Bern, 1984; *Late Picasso: Paintings, Sculpture, Drawings, Prints 1953–1972*, exh. cat.,

London, 1988; Leighton, P., *Re-ordering the Universe: Picasso and Anarchism*, Princeton, 1989; *Pablo Picasso: A Retrospective*, exh. cat., New York, 1980; Penrose, R., *Picasso: His Life and Work*, London, 1981; Richardson, J., *A Life of Picasso*, vol. I: *1881–1906*, London, 1991

pictograph

A schematic symbol, such as an Egyptian ▷hieroglyphic.

picture plane

An imaginary plane formed by the actual surface of a painting or drawing. In much non-Western art and in European art of the Middle Ages the picture plane and the physical surface of the picture can be considered identical in so far as there is no attempt to create an imaginary space beyond the picture plane. However, from the ▷Renaissance through to the second half of the 19th century, most representational painting in Europe sought to create an illusion of space beyond the picture surface by the use of ▷linear and ▷aerial perspective. In paintings of this sort, the picture surface and picture plane are to be considered different in so far as the former is the physical surface and the latter a purely conceptual surface. ▷Alberti (in his *On Painting* of 1436) makes this explicit when he refers to the picture plane as being like a 'window onto the world' and that artists should 'seek to present the forms of things seen on this plane as if it were of transparent glass'. During the second half of the 19th century ▷Manet in particular drew attention back to the picture surface with a ▷painterly technique married to a tendency to create a limited and often ambiguous recession. Many ▷modernist painters of the 20th century have been even more deliberate in drawing attention to the picture surface and concomitantly eschewing any attempt at pictorial illusionism, in their advocacy of the 'objectness' and purity of painting, thus rendering picture surface and picture plane synonymous once more.

picturesque

A term used particularly in the late 18th century, to describe a type of landscape and images of it. It was first used by writers like Alexander Pope, to describe vivid or graphic scenery and that suited to painting, but over the course of the century its definition was refined. ▷Claude's work could be described as classical picturesque and ▷Rosa's as Romantic picturesque because each had a certain irregularity and roughness. Landscape gardeners of the day (especially ▷Humphry Repton) sought to achieve the same effect, and the increasing numbers of tourists in areas such as Wales and the Lake District were interested in finding similar scenery. For writers such as ▷Gilpin and Uvedale Price (*Essay on the Picturesque*, 1794–8) the Picturesque was a standard of taste, lying between beauty (which

was merely pretty) and the ▷sublime (containing qualities of awe and danger). It was characteristically English, mixed, rolling countryside dotted with cottages or distant workers, containing interest through water, woodland, hills and variation in lighting. Although the Picturesque was sought in Nature, it was believed necessary for artists to improve on reality, composing what they saw into a truly picturesque scene, and this need encouraged ▷watercolour landscapists and engravers to reproduce Nature en masse. The theory was further developed by the ▷Reverend Archibald Alison and ▷Richard Payne Knight (*Analytical Inquiry into the Principle of Taste*, 1805) by introducing the theory of association, whereby objects were rendered more poignant by the thoughts which they inspired. This idea emphasized a nostalgic element: picturesque was by definition old or traditional at a time of increasing modernization and change in the countryside. As sublime became an ever more important watchword for the ▷Romantics, and more exotic landscape became the goal of most artists, the picturesque movement declined. By the end of the 19th century, the term had become redefined to mean simply quaint and generally pleasing.

Bib.: Clarke, M., *A Tempting Prospect*, London, 1981; Dyke, D., *Development of the Picturesque and the Knight, Price, Repton Controversy*, Ottawa, 1992; *Landscape in Britain 1750–1850*, exh. cat., London, 1973; Price, U., *Essays on the Picturesque*, London, 1971; Robinson, S.K., *Inquiry into the Picturesque*, Chicago, 1991

Piene, Otto

▷Zero Group

pier

A solid masonry support between ▷arches, doors and windows. Those employed in ▷Romanesque (or ▷Norman) and ▷Gothic buildings vary in section from simple round or square piers to the more elaborate compound or composite piers with slender colonettes attached to the massive central shafts.

Pierce (Pearce), Edward (c1635–95)

English sculptor, wood carver, mason and architect. He was the son of a decorative painter of the same name. It is not known by whom he was trained, but he may have worked for ▷Bushnell on one of his figures, that of Sir Thomas Gresham (1671). He also worked for the Royal Exchange and was certainly employed by ▷Wren as a mason and stone carver on the rebuilding of the City churches. He was much in demand as a wood carver, but his most accomplished surviving works are his portrait busts, the most impressive of which is that of Christopher Wren (marble, 1673, Oxford, Ashmolean Museum); not only is it full of animation and convincing as a portrait, it also evinces a more thorough understanding of the principles of ▷Baroque portraiture than any other known English

sculpture of this time. His chief surviving work as an architect is the Bishop's Palace, Lichfield (1686–7).

Bib.: Whinney, M., *Sculpture in Britain 1530–1830*, 2nd edn., Harmondsworth, 1988

Pierino (Perino), del Vaga (Piero Buonaccorsi) (c1500/1–47)

Italian painter. He was from Florence, where he was trained by ▷Ridolfo Ghirlandaio and later by a painter named Vaga, from whom Perino's nickname derives. In about 1518 he went to Rome and worked as one of ▷Raphael's assistants on the ▷fresco decoration of the Vatican ▷loggie. Following the Sack of Rome in 1527 he moved to Genoa, where his decorative ▷Mannerist style, deriving from Raphael and ▷Giulio Romano, exerted a strong influence. His principal work there was a series of mythological subjects for Andrea Doria's Palazzo del Principe. He returned to Rome in c1539, rapidly becoming Pope Paul III's favourite decorative painter – for him he executed the frescos of the life of Alexander the Great in the Sala del Consiglio of the Castel S. Angelo (1545–7).

Bib.: Parma Armani, E., *Perino del Vaga*, Genoa, 1986; Wolk, L., 'The Pala de Ciadonne by Perino del Vaga', *Studies in History of Art*, 18 (1985), pp. 29–57

Piero della Francesca (Piero dei Franceschi) (fl 1439–78; d 1492)

Italian painter and art theorist. Piero was born in Borgo San Sepolcro (now Sansepolcro) in Umbria, and he retained a lifelong affinity with his home, despite frequent travels elsewhere to accept commissions. The first record of his work as an artist is in Florence, where he assisted ▷Domenico Veneziano with ▷frescos at the church of Sant'Egidio (now lost). He not only absorbed Veneziano's crisp idealized style, but he obviously knew and appreciated the work of ▷Masaccio, ▷Lippi, ▷Donatello and other masters. His own work showed a strong attention to monumental form, often complex ▷linear perspective and a powerful sense of idealization. His first major commission was for a cycle of frescos in the choir of S. Francesco at Arezzo. The frescos represent a narrative of the Legend of the True Cross which came primarily from Jacobus de Voragine's apocryphal *Golden Legend*, but which Piero adapted freely and imaginatively. These frescos not only reveal his ability to manipulate space, but they may also carry contemporary political meaning, although the latter point is disputed. Other major religious works include the monumental *Madonna della Misericordia*, an ▷altarpiece commissioned by a Borgo charity in 1445.

However, Piero's most mysterious painting is the *Flagellation* (Urbino, Palazzo Ducale), which has been subjected to endless interpretations. The *Flagellation* represents a complex perspective view of Christ being flagellated in the left background (one of the episodes

from the ▷Passion), while in the right foreground, three unidentified figures appear to hold a conversation. The identification of the figures has caused much speculation and disagreement among art historians who claim variously that they are ▷allegorical, biblical or contemporaries of the artist.

Piero's principal patron was ▷Federico da Montefeltro, for whom he worked in Urbino. Piero's portraits of Federico and his wife (c1465, Florence, Uffizi) are a testimony to the idealizing theories of ▷Renaissance ▷Classicism and reveal a sculptural solidity of form.

Piero stopped painting in the 1470s and turned his attention to writing treatises on mathematics and perspective. These include *De prospetiva pingendi* and *De quinque corporibus regularibus* (*On the Five Regular Bodies*). In each work, he stresses the importance of simplification and pure form to the artist. He may have taught ▷Perugino and ▷Signorelli, but Piero did not leave an immediate legacy, in contrast to many other early ▷Renaissance artists. However, his work was rediscovered by artists such as ▷Seurat in the late 19th century, and the power of his simplified yet monumental forms has been recognized throughout the 20th century.

Bib.: Lavin, M.A., *Piero della Francesca: The Flagellation*, New York, 1972; Lightbown, R., *Piero della Francesca*, New York, 1992

Piero di Cosimo (Piero di Lorenzo) (c1462–1521)

Italian painter. He was Florentine and trained in the studio of ▷Cosimo Rosselli, working as his assistant in painting the ▷frescos in the ▷Sistine Chapel (begun 1481). The main source of information about him is ▷Vasari who, in the *Lives*, portrays him as a thoroughgoing eccentric whose diet consisted principally of eggs, hard-boiled 50 at once at the same time as his glue ▷size, to save time and fuel. None of his surviving paintings is signed, dated or documented and the current attributions mostly depend on Vasari's account. Piero was a painter of fantastical imagination: Vasari relates how he would wander around by himself conjuring 'castles in the air' and deriving 'extraordinary landscapes' and battle scenes from 'a wall where sick persons had used to spit'. His imagination was grounded nonetheless in observation, Vasari pointing out that he drew excellently from life. Of his mythologies, the most poignant perhaps is the erroneously-titled *Death of Procris* (London, National Gallery) in which a faun laments the death of a ▷nymph, whilst a hunting dog looks dolefully on. Piero was fascinated by animals, which feature in this and many of his other paintings. He also painted an elegiac portrait of the tragic *Simonetta Vespucci* (Chantilly), a celebrated Florentine beauty who died aged 23 – Piero's posthumous portrait is full of symbols relating to her early death. Religious paintings also featured in his output, the

most important being his *Immaculate Conception* (Florence, Uffizi). An extremely original artist, his influences include ▷Signorelli and later on ▷Leonardo and his most celebrated pupil was ▷Andrea del Sarto.

Bib.: Bacci, M., *L'opera completa di Piero di Cosimo*, Milan, 1976; Fermor, S., *Piero di Cosimo: Fiction, Invention and Fantasia*, London, 1993

Piero di Giovanni
▷Lorenzo Monaco

pietà

A purely devotional subject dealing with the grief of the ▷Virgin for her dead son. Its narrative equivalent is the ▷Lamentation episode from the cycle of the ▷Passion of Christ. A pietà group consists simply of the Virgin with the dead figure of Christ laid across her lap. It first appears in the north of Europe during the Middle Ages. By the end of the 15th century it had begun to appear in northern Italian art but received its most famous treatment in ▷Michelangelo's sculpture in St. Peter's, Rome (1497–1500), significantly a commission from a northern European (French) cardinal. The theme was known in Italy, however, for meditations on Mary cradling the dead body of her son on her lap and recalling how she sat him there as a baby had formed part of a famous sermon by St. Bernardino of Siena (1380–1444). It is this second layer of meaning which gives the subject its special poignancy.

pietre dure

(Italian, 'hard stones'.) Italian term for a type of ▷mosaic made from combinations of semi-precious stones such as agate, chalcedony, jasper, and lapis lazuli, used from the late 16th century onwards for furniture (especially altar frontals and table tops), for vases and bowls, and even for portrait busts and statuettes. Especially popular in Florence, it is sometimes known as Florentine mosaic, and the ▷Medici Grand Ducal workshops (founded in 1588) specialized in such work. Indeed, *pietre dure* was most sumptuously employed in the Medici Cappella dei Principi in the church of San Lorenzo where all the interior surfaces are completely covered in it. The technique is also known as *commesso di pietre dure*. The singular form of the term, *pietra dura*, is used for designs in which only one type of stone is used.

Pietro da Cortona (Pietro Berrettini) (1596–1669)

Italian painter and architect. With ▷Bernini, he was one of the founders of the Roman High ▷Baroque. Born in Cortona in Tuscany, he was probably first trained by his stonemason father, before moving to

Florence to train as a painter. He journeyed to Rome with his master in c1612 and stayed on after the latter's return to Florence. His earliest patrons were the Sacchetti family (e.g. *Rape of the Sabine Women*, oil on canvas, c.1629, Rome, Capitoline Gallery). His most important Roman patrons, however, were the ▷Barberini family (including Maffeo Barberini, Pope Urban VIII). For them he first executed ▷frescos in the church of Sta Bibiana (1624–6), and then, his most famous work, the ceiling fresco for the Palazzo Barberini, *Allegory of Divine Providence and Barberini Power* (1633–7, 1639). The fresco, illustrating Urban VIII Barberini's divine right to the papacy, is a *tour-de-force* of ▷*trompe-l'oeil* illusionism: the centre of the ceiling has apparently dematerialized and the open sky thus revealed is populated with scores of floating figures, some descending into the room, all depicted ▷*sotto in sù*. With its teeming figures, it may also be taken as an illustration of Pietro's belief that a ▷history painting should be allowed to use as many figures as was necessary to give it an appropriately epic quality; this was in direct opposition to the belief of his classicist rival, ▷Andrea Sacchi, that Classical decorum required that as few figures as possible be included in any composition. Work on this ceiling had been interrupted in 1637 by the Medici commission to decorate the Palazzo Pitti, Florence. With the ceiling now completed, Pietro returned to Florence and worked for the Medici from 1640 to 1647. His work at the Pitti, employing ▷relief ▷stucco to unite the ceiling paintings with the decorative framework of the rooms, was enormously influential throughout Europe and especially in France. Although he himself refused an offer by Cardinal Mazarin to work in Paris, his pupil ▷Romanelli accepted, and thus was Pietro's style disseminated.

By now regarded as the unrivalled master of Baroque ceiling decoration, Pietro was at this time also commissioned to decorate the Chiesa Nuova, Rome (1647–65, ▷cupola ▷modello now in the Wadsworth Atheneum, Hartford, Connecticut). Pietro is said to have regarded architecture more as a hobby than a serious profession like his painting and yet his church of SS Martini and Luca, Rome (1635–50) is the first homogeneously designed Baroque church in Rome. It is remarkable both for the unity of its structural organization and for the purity of its internal decoration, whitewashed throughout, and deliberately avoiding frescos and sculptures. Also of importance is the façade and piazza of Sta Maria della Pace (1656–7), conceived in theatrical terms as, respectively, the proscenium and auditorium. Of his numerous pupils, the most important, apart from Romanelli, was Ciro Ferri (1628/34–89).

Bib.: Benedetti, S., *Architettura come metafora: Pietro da Cortona Stuccatore*, Bari, 1990; Kugler, L., *Studien zur Malerei und Architektur von Pietro da Cortona*, Essen, 1985; Merz, J.M., *Pietro da Cortona*, Tübingen, 1991;

Scott, J.B., *Images of Nepotism: The Painted Ceilings of Palazzo Barberini*, Princeton, 1993

Pigalle, Jean-Baptiste (1714–85)

French sculptor. He was trained by ▷J.-B. Lemoyne. Having failed to win a scholarship to Rome, he paid his own way in 1736, ran out of money and was saved from virtual starvation by ▷G. Coustou II. He returned to France in 1739 and eventually gained admission to the ▷Académie Royale in 1744 with his celebrated *Mercury* (1742 ▷terracotta model in New York, Metropolitan Museum; 1744 marble in Paris, Louvre). From this point onwards he established himself as the most successful sculptor of his generation. He obtained commissions for prestigious church monuments (his most important being the Monument to the Maréchal de Saxe, 1753–76, S. Thomas, Strasbourg) and secured patronage from Mme de Pompadour (for whom he executed *Love and Friendship Embracing*, 1758; plaster at Baltimore; marble in Paris, Louvre). He was also a brilliant portraitist (see especially his *Self-portrait*, 1780, Paris, Louvre). His most extraordinary work is perhaps his *Nude Voltaire* (1776, Paris, Institut).

Bib.: Gaborit, J.-R., *Jean-Baptiste Pigalle, sculptures du Louvre*, Paris, 1985; Levey, M., *Painting and Sculpture in France*, New Haven and London, 1993

pigment

The colouring agent in paint or dye. Paint is pigment suspended in a ▷medium. Most modern pigments are manufactured synthetically, whereas originally they were made from mineral, animal or vegetable sources. For example, the much-prized ultramarine was obtained from the powdered semi-precious stone, lapis lazuli, sepia from the ink of the cuttle fish, carmine from the dessicated bodies of insects (cochineal), and gamboge from the gum-resin of trees of the genus *Garcinia*. A knowledge of the origins of natural pigments and when they first became available is an important aid in the field of picture authentication.

pilaster

A flattened ▷column or ▷pier, rectangular in section, projecting less than half its breadth from the wall to which it is engaged. When a feature of Classical architecture, pilasters conform to one of the orders. A pilaster without a base and capital is called a pilaster-strip or lesene.

Pilate

▷Pontius Pilate

Piles, Roger de (1635–1709)

French art theorist. He worked as a diplomat for Louis XIV, and his travels around Europe brought him into contact with a number of important court artists, such as ▷Rubens. He published a number of treatises on

art in which he wrote against the domination of rule in French ▷academic painting. Among these were his *Abrégé de la vie des peintres* (1699), *Cours de peinture par principes avec une balance des peintres* (1708) and his translation of Du Fresnoy's *De arte graphica*. His admiration for Rubens led him to favour the Rubensian tendencies in contemporary French art.

▷Poussinism versus Rubenism

Bib.: Puttfarken, T., *Roger de Piles' Theory of Art*, New Haven, 1985

pillar

A detached upright member, of any shape in section, used either as a support or independently as a monument.

Pillement, Jean-Baptiste (1727–1808)

French painter. He painted landscapes similar to those of ▷Boucher. His ▷Rococo drawings were made into prints and had an important influence on decorative arts during the mid-18th century in France.

Pilon, Germain (c1530–90)

French sculptor. With ▷Goujon, he was the most important French sculptor of the 16th century. Born in Paris, the son of the sculptor, André Pilon, his early work is much influenced by ▷Primaticcio's ▷Mannerist ▷stucco-work decorations at ▷Fontainebleau. Indeed, his earliest extant works were executed under Primaticcio's direction: first the figures of the ▷Three Graces for the Monument for the heart of Henry II (1560, Paris, Louvre); and second, the Tomb of Henry II and Catherine de' Medici (1563–70) at St. Denis. The tomb is particularly interesting in that it embodies in one work Pilon's stylistic evolution: whereas the ▷Virtues at the corners of the tomb retain the graceful Mannerist elongation of his earlier work, the kneeling figures of Henry and Catherine on the top of the tomb and the ▷*gisant* figures under the canopy reveal the first signs of a greater realism and a more intense emotion which characterizes his later work. This mixture of realism and emotional intensity is shown at its most poignant in two late works: the marble bas-relief *gisant* figure on the ▷sarcophagus of the Tomb of Valentine Balbiani (before 1583, Paris, Louvre) and the bronze *Deposition* bas-relief of c1580–85 (Paris, Louvre). Pilon was also an accomplished portraitist (Bust of Charles IX, marble, London, Wallace Collection) and medallist, and he was controller general of the Paris Mint from 1572.

Bib.: *Germain Pilon et les sculpteurs français de la Renaissance*, Paris, 1993

pilotis

A French architectural term for the piles, posts or stilts which support the base of a building, raising it to first floor level and leaving the ground level open.

Piloty, Karl von (1826–86)

German painter. He studied in Antwerp and Paris, and settled in Munich. There he became Professor of the Academy in 1856 and director in 1874. He produced massive ▷history paintings which showed his interest in archaeological accuracy.

pinacoteca

Italian term for an art gallery, the similar German term being *Pinakothek*, both terms deriving from the Greek, meaning 'picture repository'. Also sometimes spelt *pinacotheca* and *pinacothek*.

pinnacle

A small ornamental ▷turret, usually crowned with a cone or pyramid, surmounting a ▷buttress or the corner of a ▷parapet or tower, or rising above the main body of a building.

Pintoricchio (Pinturicchio), (Bernardino di Betto) (c1454–1513)

Italian painter. He was Perugian and trained in the studio of ▷Perugino whom he assisted in his ▷fresco decorations for the ▷Sistine Chapel (1481–2). An accomplished and prolific painter, his style was firmly wedded to the ▷quattrocento, even in the face of the new developments of the High ▷Renaissance; his compositions are often based on those of his master, as are his elegant figures, but his approach is more decorative, his pictures characterized by bright colours with ornamental details picked out in gold. A favourite with the Papal Court, he decorated the Borgia Apartments of the Vatican (1492–5) for Pope Alexander VI, executed the fresco cycle, *Scenes from the Life of Aeneas Sylvius Piccolomini*, in the Piccolomini Library of Siena Cathedral (1502–8) for the Sienese Pope, Pius II, and decorated the choir of Sta Maria del Popolo in Rome (1507) for Pope Julius II.

Bib.: Carli, E., *Il Pinturicchio*, Milan, 1960

Piper, John (1903–92)

English painter and designer. He was born in Epsom, the son of a lawyer, and embarked on a law career before turning to art in 1926, when he enrolled at Richmond Art School, and later at the Royal College of Art. He was an art critic for the *Athenaeum*, *The Listener* (1928–33) and *Nation*, and in 1935 he became art editor of *Axis*, an ▷avant-garde magazine, edited by Myfanwy Evans, whom he married in 1937. His early work was non-representational (e.g. *Abstract I*, 1935, London, Tate Gallery), but he experimented with ▷Surrealism before turning to a romantic naturalism in the 1930s, under the friendship of ▷Nash (e.g. *Beach and Shells*, 1932, London, Victoria and Albert Museum). He visited Wales and the South West, producing landscape ▷collages and paintings. A longstanding interest in architecture led to a series of works of decaying houses. He was an official artist

during the Second World War (e.g. *Coventry Cathedral, November 15 1940*, 1940, Manchester). He designed sets for the ballet *Job* and the opera *The Rape of Lucretia* (1946), ▷stained glass for the new Coventry Cathedral and gardens with Osbert Lancaster. He also wrote poetry and worked on the *Shell Guides to the British Isles* with John Betjeman.

Bib.: *John Piper*, exh. cat., London, 1984; *John Piper*, exh. cat., Oxford, 1979; West, A., *John Piper*, London, 1979

Piranesi, Giovanni Battista (1720–78)

Italian etcher, archaeologist and architect. He was born in Venice and was active in Rome from 1740. He was famous for his poetic views of Rome and also his fantastic imaginary interiors. Trained in Venice as an engineer and architect, his studies had included ▷perspective and stage design. These skills, allied to his deep knowledge of archaeology, provided the substance for his ▷*Vedute* (*Views*), a series of 135 ▷etchings of ancient and contemporary Rome, published from 1745 onwards, which established the popular mental image of the city. Piranesi's image was a thoroughly romanticized one, with effects of scale exploited to make the buildings appear larger and grander and exaggerating the contrasts of light and shade to invest them with drama. His most remarkable ▷etchings are perhaps those of imaginary interiors, the ▷*Carceri d'Invenzione* (*Imaginary Prisons*), a series of plates issued in 1749–50 and reworked in 1761.

Piranesi was also an outspoken architectural polemicist who believed absolutely in the supremacy of Roman over Greek architecture, an argument he expounded most forcefully in his *Della magnificenza ed architettura dei Romani* (*On the Magnificence of Roman Architecture*, 1761). In his other major treatise, the *Parere sull'architettura* (*Observations on Architecture*, 1765), he advocated an imaginative use of antique Roman models to produce a new style of architecture. Only one building was ever erected to his designs, the rather unexceptional church of S. Maria del Priorato, Rome (1764–6).

Piranesi's influence as an architect may have been negligible, but his romanticized views and imaginary interiors had a profound effect on stage designers, painters of ▷*capricci* such as ▷Hubert Robert, and even writers: William Beckford, the author of the Gothic novel, *Vathek* (1786) wrote, 'I drew chasms, and subterranean hollows, the domain of fear and torture, with chains, racks, wheels and dreadful engines in the style of Piranesi.' In the 20th century his imaginary interiors have been admired by the ▷Surrealists and provided source material for horror film set designers.

Bib.: Robinson, A., *Piranesi: Early Architectural Fantasies*, Washington, 1994; Wilton Ely, J., *The Mind and Art of Piranesi*, London, 1978 and *Piranesi as Architect and Designer*, New York, 1993

Pisanello (Antonio Pisano) (c1395–c1455)

Italian painter, medallist and draughtsman. After ▷Gentile da Fabriano's death, he was the principal Italian ▷International Gothic artist. His biographical details are obscure, but he was probably born, as his name suggests, in Pisa, and was trained in Verona, possibly by Stefano da Verona. His two most prestigious commissions were carried out in association with Gentile and thus it has been assumed that Pisanello was also trained by Gentile. The works in question are a series of ▷frescos in the Doge's Palace, Venice (1415–22; destroyed by fire) and another in S. Giovanni in Laterano, Rome, the latter completed by Pisanello after Gentile's death (1431–2; now destroyed). Pisanello's documented extant works, such as the *Annunciation* fresco surmounting ▷Nanni di Bartolo's sculptured Brenzoni Monument (1423–4, Verona, S. Fermo), and the *St. George and the Princess of Trebizond* fresco (1437–8, Verona, S. Anastasia) reveal a typically International Gothic style: a concern for an overall decorative effect, rich colours, elegant figures dressed in sumptuous costumes, and closely observed naturalistic details. One of the strongest influences on these, and all of his other generally accepted paintings, appears to be the work of the ▷Limbourg Brothers. In the Palazzo Ducale, Mantua, some mural fragments of jousting knights, uncovered in 1968, have been attributed to him; as have a number of panel paintings (e.g. *Apparition of the Madonna to SS Anthony Abbot and George*, c1445, London, National Gallery).

One of the most accomplished of medallists, Pisanello's earliest datable portrait medal, of John VIII Palaeologus, is from 1438, cast presumably to commemorate the ▷Byzantine emperor's diplomatic mission to Ferrara. A comprehensive collection of Pisanello's medals is now in the Victoria and Albert Museum, London. Also, an important collection of his drawings, the Vallardi Codex (Paris, Louvre), has survived, consisting of meticulous studies of animals, birds, antiques and costumes, along with sketches for paintings.

Bib.: Degenhart, B., *Pisanello und Bono da Ferrara*, Munich, 1995; Woods-Marsden, J., *The Gonzaga of Mantua and Pisanello's Arthurian Frescoes*, Princeton, 1988

Pisano, Andrea (Andrea da Pontedara) (c1290–1348/9)

Italian sculptor. He is first recorded in 1330 as the sculptor of the first set of ▷bronze doors for the Baptistry at Florence (completed 1336). Given the importance of the commission, he was presumably already well known. His name implies that he came from the region of Pisa, a centre of bronze ▷casting expertise; however, his style more closely resembles that of ▷Giotto than anyone else. His Giottesque door reliefs set into 28 elegant Gothic quatrefoils determined the composition of ▷Ghiberti's first set of

bronze doors seventy years later. Each episode is clearly composed with a minimum of characters and the simplest of 'stage-prop' scenery. His next commission was for a set of hexagonal ▷reliefs and some statues for the Cathedral ▷campanile, even more closely reflecting Giotto's influence. Following the death of Giotto (1337), Andrea succeeded him as *capomaestro* of the Cathedral works, moving to Orvieto in 1347 to become *capomaestro* there. At his death, he was succeeded by his son, Nino Pisano (c1315–?1368) whose smiling *Madonna and Child* (Florence, Sta Maria Novella) shows the influence of French ▷Gothic sculpture. Andrea and Nino are, however, unrelated to ▷Nicola and Giovanni Pisano.

Bib.: Moskowitz, A.F., *The Sculpture of Andrea and Nino Pisano*, Cambridge, 1986

Pisano, Nicola (fl 1258–78) and Giovanni (d after 1314)

Italian family of sculptors and architects. They were father and son, and forged a new style in sculpture in advance of the similar 'rebirth' in painting established by ▷Giotto. At the core of their work are the four great pulpits in Pisa, Pistoia and Siena, executed between 1259 and 1311. Nicola was probably born in the south, in Apulia, where the Emperor Frederick II had encouraged a Classical revival deliberately recalling the authority of Rome. The first of the pulpits, by Nicola alone, was for the Baptistry at Pisa (dated 1260, 1259 modern style): into the prevailing Tuscan ▷Romanesque style Nicola has injected a late ▷antique figural monumentality that reveals an understanding of the underlying forms of the antique absent in his contemporaries who did no more than lift antique motifs piecemeal. Where Nicola has borrowed motifs from, for example, the antique ▷sarcophagi in the nearby Campo Santo, he has assimilated them thoroughly into his own personal idiom and adapted them to the expressive and didactic purposes of his Christian art. The next pulpit was for Siena Cathedral (1265–8). Here his assistants included his son, Giovanni and also ▷Arnolfo di Cambio. By now there is a greater complexity in the design, the narrative panels are more crowded, more filled with movement and the carving more deeply cut (perhaps to facilitate legibility in the larger and gloomier interior of the Cathedral). Above all, there is a new French ▷Gothic stylistic influence. There is no evidence to suggest, however, that this shift from antique towards Gothic was not a move initiated by Nicola even though Giovanni was later to take it further. Shortly after the Siena pulpit, father and son together signed a fountain, the Fontana Maggiore, in the piazza at Perugia (dated 1278, rebuilt 1948–9), with dozens of figurative ▷reliefs (of the months, etc.) executed with a lively naturalism providing a striking contrast with the solemn grandeur of the pulpit figures. This was Nicola's last major work and the remaining two pulpits are by Giovanni alone.

The pulpit in S. Andrea, Pistoia, reveals a more dramatic emotionalism and an even greater French Gothic influence, whereas that in the Cathedral at Pisa (dated 1311, 1310 modern style) shows a shift back towards ▷Classicism (perhaps influenced by the requirements of a more Classically-rooted Pisan taste), with a moderation of Gothic movement and drama by Classical composure. Giovanni also designed the façade of Siena Cathedral and carved many of the animated figures of prophets and ▷sibyls with which it is decorated (originals mostly in the Cathedral Museum; a fragment of a prophet is also in London, Victoria and Albert Museum).

Bib.: Christiani Testi, M.L., *Nicola Pisano: architetto, scultore*, Pisa, 1987; Sanbo, E., 'Nicola Pisano, Ferrara e Bologna', *Paragone*, 39 (Jan. 1988), pp. 3–20

piscina

(Latin 'fishpond'.) In a church, a stone basin in which the priest washes the Communion vessels after the service. Usually located on the south side of the ▷altar, the piscina is generally fixed to a wall, set within a ▷niche and equipped with a drainage pipe.

Pissarro, Camille (1830–1903) and Lucien (1863–1944)

French family of painters and graphic artists. Camille was associated with the ▷Impressionists. He was born in the West Indies, his father Jewish and his mother Creole, and throughout his life suffered from a belief that he did not belong. He studied at the ▷École des Beaux-Arts from 1855, where he was influenced by ▷Corot, and at the Académie Suisse, where he met ▷Monet. He exhibited at the ▷Salon regularly (1859–67), although also at the ▷Salon des Refusés in 1863. His early style, explored in scenes of the Marne and Louveciennes, used cool, dark colours and heavy brushwork (e.g. *Banks of the Marne*, 1864, Glasgow). In 1870 he visited England with Monet, and saw ▷Turner's work there. He returned to Paris to find his studio ransacked and many of his early paintings destroyed. Over the next few years, working at Pontoise, he developed his own form of Impressionism, based almost entirely on landscape, and combining strong ▷complementary colours with deliberate, directional brushwork and a strong sense of design (e.g. *Côtes des Boeufs*, 1877, London, National Gallery). He taught ▷Cézanne, ▷Gauguin and ▷Cassatt, and although not living in Paris, was an active member of the Impressionist group, exhibiting at all eight exhibitions.

During the 1880s, Pissarro's style and interests changed. He moved to Eragny in 1884, met ▷Seurat in 1885 and became an enthusiastic support of the Anarchic Syndicalists, a romantic socialist party trying to retain traditional peasant life. He began utilizing ▷wood engraving techniques and his work explored

monumentalized images of peasant life, influenced by ▷Millet, but employing a ▷divisionist palette picked from Seurat (e.g. *Gleaners*, 1887–9, Basle). Increasingly, Pissarro's colour became lighter and brighter, generating a sparkling optimistic backdrop. By the 1890s he had achieved belated success with a one-man show of 100 works at ▷Durand Ruel's in 1892. His eyesight, however was deteriorating. His late works were cityscapes, painted from a window and fragmented by an increasingly loose technique, to encapsulate the bustle of modern life (e.g. *Avenue de l'Opéra*, 1898, Reims).

Lucien was the son of Camille, taught by his father and by ▷Manet and Cézanne. He exhibited at the 1886 Impressionist exhibition and at the second ▷Salon des Indépendants. In 1890 he came to England and settled there, becoming a member of the ▷Camden Town Group and the ▷London Group (e.g. *Crocker's Lane, Coldharbour*, 1916, Manchester). He worked in a ▷pointillist style, which influenced artists like ▷Sickert. He established the Eragny Press and experimented with ▷engraving.

Bib.: Brettel, R., *Pissarro and Pontoise*, New Haven and London, 1990; Lloyd, C., *Pissarro*, Geneva, 1991; *Lucien Pissarro*, exh. cat., London, 1963; Perkins, S.G., *Lucien Pissarro*, Zurich, 1974; *Pissarro*, exh. cat., Glasgow, 1990; Thorold A., *Catalogue of Lucien Pissarro's Oil Paintings*, London, 1983

Pitlessie Fair

Painted by ▷David Wilkie at Cults in 1804 and re-touched 1806 (oil on canvas, 59 × 107 cm/23 × 42 in). The subject shows the annual agricultural fair at Cults, the Scottish parish which included the village of Pitlessie, where Wilkie's father was a minister. The work was painted for Charles Kinnear of Kinloch and was exhibited at Wilkie's one-man show in Pall Mall in 1804. The subject and design can be seen to be based on Alexander Carse's *Oldhamstocks Fair* (watercolour, 1796) and Wilkie was also clearly influenced by 17th-century Dutch ▷genre painting in his interest in the characters and incidents of village life. The work derived from a series of detailed drawings and several figures in the painting are recognizable portraits. The artist has equally gone to considerable lengths to capture the variety of rural life, including the presence of a recruiting officer seeking volunteers for the French Wars. Many of the buildings in the background of the work can be seen as modern rather than conventionally picturesque. The painting represented a triumph for Wilkie personally, and was to influence much of his later work but it was equally significant for 19th-century British painting in general. Victorian artists like ▷Frith, with their detailed depictions of contemporary life, were his clear successors, and the public remained enthusiastic about genre subject matter.

Pitti Palace

Florentine palace, begun in 1440 for the wealthy rival of the ▷Medici, Luca Pitti, and presumably intended to dwarf the Palazzo Medici across the Arno. It remained unfinished owing to lack of sufficient funds until it was acquired in 1549 by Duke Cosimo I, who transformed it into a Medici residence. Luca's architect is unknown, though both ▷Brunelleschi and ▷Alberti have been mooted without gaining universal acceptance. It is certain, however, that Cosimo's architect was ▷Ammanati. To Ammanati are due the boldly rusticated courtyard and the great wings overlooking the Boboli Gardens at the back (1558–70). The Pitti Palace is today open to the public and houses the Galleria Palatina, situated on the first floor and containing the Medici collection of about 500 paintings, including extremely important portraits by ▷Raphael and ▷Titian, ▷Filippo Lippi's ▷tondo, *The Madonna and Child*, and ▷Canova's *Venus Italica*, commissioned to replace the antique ▷*Venus de Medici* removed to Paris by the French in 1799 (and restituted 1815). Furthermore, the ceilings of many of the rooms are decorated with ▷frescos by ▷Pietro da Cortona. On the ground floor is the Museo degli Argenti containing a rich collection of plate, goldsmith's work, ivories, enamels and vestments.

Pittoni, Giovanni Battista (1687–1767)

Italian painter. He was a Venetian, after ▷Tiepolo and along with ▷Pellegrini a principal exponent of Venetian ▷Rococo, and painted religious, mythological and ▷history pictures. He was trained by his uncle, Francesco Pittoni, but was influenced by a number of other painters active in Venice, principally Tiepolo, but also ▷Giordano, ▷Piazzetta and ▷Ricci. He is listed in the *fraglia* (Venetian painters' guild) from 1726–1755, though he continued to paint into the 1760s. From 1758 to 1761 he was president of the Accademia (succeeding Tiepolo). Though he remained in Italy all his life, his work was extremely popular both in Venice and the rest of Europe and he received numerous foreign commissions.

Bib.: Posner, D., 'Pietro da Cortona: Pittoni and the Plight of Polyxena', *Art Bulletin*, 73 (Sept. 1991), pp. 399–414

Pittura metafisica

▷Metaphysical painting

Place, Francis (1647–1728)

English artist. He was from York and was not trained but practised as an amateur. He did topographical drawings and portraits on many sketching tours throughout Britain. He was one of the earlier practitioners of ▷mezzotint engraving and was friendly with ▷Hollar.

Bib.: Wallace, G., *The Life of Francis Place 1771–1854*, London, 1951

Plamondon, Antoine (1804–95)

Canadian painter. He studied in Paris during 1826–30 before producing portraits and religious works in Quebec.

plan

The horizontal organization of the parts of a building. Also a drawing or diagram showing the horizontal organization of the parts at any of the levels. It is the counterpart, in architectural design, to the ▷elevation.

planimetric

A term describing a composition in which the figures are disposed across the picture plane, usually occupying the foreground of the picture space with little recession into depth. ▷Neoclassical painters frequently resorted to this device, as in ▷J.-L. David's *Brutus and His Sons* (1789).

plaquette

▷Relief made of either bronze or lead and used as decoration for swords or boxes, especially from the 14th to the 16th centuries. Plaquettes were particularly common in northern Italy, and some were made from ▷gems.

plaster

A mixture of lime, sand and water, plus hair as a strengthener. When first mixed it is malleable and may be applied to walls as a flat ground for ▷fresco or it may be moulded. When used for sculpture, plaster (usually ▷plaster of Paris) may be moulded either as a permanent, durable copy of a less durable clay original or it may be used to make cheap plaster casts of a famous marble or bronze original. When a sculptor makes a plaster cast of a clay original, the clay original is destroyed in the process. The plaster then represents the earliest surviving stage which will be sent to a public exhibition, such as the ▷Royal Academy in London or the ▷Salon in Paris, where it is hoped that it will attract the attention of a buyer who will commission the piece in a more expensive ▷medium such as ▷bronze or ▷marble. The plaster sent to a public exhibition is known as the original plaster. Plaster may also be moulded and carved as interior architectural decoration or on ornamental furniture and picture frames, in both of which cases it may be painted and/or gilded.

plaster of Paris

A type of fine white or pinkish plaster made from dehydrated ▷gypsum mixed with water. Mixing with water causes the gypsum to swell and then rapidly set in a uniformly dense and solid mass. It gets its name from the fact that it was first produced commercially in Paris. In sculpture it is the principal medium for making plaster casts and moulds.

plastic arts

A term for three-dimensional art, especially that which has been modelled, such as some forms of sculpture and ceramics.

plasticity

When used of sculpture, a term describing malleability of the material (e.g. clay or wax); of painting, a critical term indicating three-dimensional, sculpture-like characteristics.

plate

A thin metal such as steel, copper or zinc, which can be used for ▷engraving. The term also refers to gold and silver tableware.

Plateresque

Spanish architectural style of the 15th to 16th centuries. It is seen as a transitional point from ▷Gothic to ▷Renaissance work. The Plateresque style was highly ornamented and showed the influence of ▷Islamic decoration. It appeared mostly in Castile and in Spanish colonies.

plein air

(French, 'open air'.) A term used to denote paintings executed, in part or wholly, in the open air ('*en plein air*'). In the course of the 19th century factors as varied as the invention of the collapsible metal tube for oil paints (thus facilitating the transport of equipment) and the dislike of the formula landscapes of the ▷academic schools persuaded progressive artists to attempt to paint the spontaneity and freshness of directly perceived nature. The artists of the ▷Barbizon School were early exponents, and their methods influenced the younger ▷Impressionists.

Pleydenwurff, Hans (c 1420–c 1471)

German painter. He worked in Nuremberg (1450–72). His works showed the naturalism that was common to the ▷International Gothic style, and in this regard he was a forerunner to ▷Dürer.

plinth

The term derives from the Greek word for brick, and thus originally came to refer, in classical architecture, to architectural members which were 'brick-shaped' (or rectangular), that is, the lowest member of the ▷base of a ▷column, and the lowest of the three members of a ▷pedestal. The term plinth may also refer to the projecting lower course of an external wall.

Pliny the Elder (Gaius Plinius Secundus) (AD 23/4–79)

Roman encyclopaedist whose only extant work, the *Naturalis Historia* (dedicated to the Emperor Titus in AD 77) includes, in its wide-ranging 37 volumes, a

history of painting and sculpture which, although sometimes condemned as unreliable and inaccurate, is the earliest source of information on antique Classical art. Books 33–7 are devoted to metals and stones, including their application in art and architecture.

pochade

(From the French, '*pocher*', 'to make a rough sketch'.) As its French meaning suggests, a pochade is a rough, rapidly executed sketch done as an *aide-mémoire* or to train the eye in rapid observation of the transitory effects of nature.

podium

An architectural term deriving from a Latin word meaning 'elevated place', and thus used to describe a number of architectural members, which constitute a sort of raised platform. Thus, in Classical architecture:

(i) The high platform carrying a temple, widely used in Roman architecture.

(ii) The high platform enclosing the arena in an ▷amphitheatre or the racecourse in a circus.

(iii) A continuous pedestal used to support a ▷colonnade.

(iv) A low platform running round the walls of a room on which to place household objects.

Poelenburgh, Cornelis van (c1586–1667)

Dutch painter. He was born in Utrecht and studied with ▷Bloemaert. He travelled to Rome in c1617–25, where he saw the work of ▷Elsheimer. There he began producing small landscapes with biblical or mythological subjects, and he worked for the Grand Duke of Tuscany and Charles I of England. When he returned to Utrecht, he met and was influenced by ▷Rubens.

Poelzig, Hans (1869–1936)

German architect. He was born in Berlin and after a training in architecture, entered the Office of Public Works there before a period in the military (1894–5). He was appointed Director of Breslau Arts and Crafts Academy in 1903 and remained there until becoming Dresden City Architect in 1916. Despite his age, he was an active member of the post-war ▷Novembergruppe (1918) and the progressive architectural group, The Ring (1924). He also held the chair of the ▷Deutscher Werkbund in 1919. He held a post at the Berlin Academy from 1920, but was forced to resign under the Nazi regime, and spent time in Turkey in the 1930s completing design projects there. He is most associated with ▷Expressionist architecture, using modern techniques and materials to create dynamic, challenging structures (e.g. Posen watertower, 1911; Luban factory, 1912). He is most famous for the Grosses Schauspielhaus (Great Theatre) in Berlin (1919) which used ▷reinforced concrete to create interior stalactites.

Bib.: Biraghe, M., *Hans Poelzig Architektur 1869–1936*, Berlin, 1993; Heuss, T., *Hans Poelzig 1869–1936*, Milan, 1991; Posener, J., *Hans Poelzig: Reflections on his Life and Work*, New York, 1992

pointillism

A term first used by ▷Fénéon in relation to ▷Seurat's ▷*Sunday Afternoon at the Island of la Grande Jatte* (1886, New York), to describe the technique of using regular dots or dashes of ▷pigment. It is associated with ▷Neo-Impressionism and ▷divisionism, but whilst those terms refer to the scientific principle of mixing pure colour optically, pointillism refers specifically to brushwork. It was also used in connection with ▷Monet's later work and with that of the ▷Fauves.

Bib.: Herbert, R., *Neo-Impressionism*, New York, 1968; Lee, E.W., *Aura of Neo-Impressionism*, Indianapolis, 1983; Sutter, J., *Neo-Impresssionists*, London, 1970

pointing machine

In sculpture, an aid to the accurate translation of the proportions of a model on to a block of stone. While pointing may be carried out using plumb-lines suspended from a frame – a method known to ▷Alberti – the pointing machine is a refinement. This device is similar to a ▷pantograph (used for copying drawings) in that it is essentially an articulated arm with a ▷stylus attached at each extremity. By placing the stylus at a given point on the model, the measurement will be transferred to the stylus at the other end of the arm, thereby indicating to the sculptor the degree of excavation needed. By repeating this process as many times as is necessary a quasi-mechanical copy may be made.

Bib.: Alberti, L.B., *On Painting and On Sculpture*, ed. and trans. C. Grayson, 1972, pp. 120–33, 141

Poliakoff, Serge (1906–69)

Russian painter. He was associated with the ▷School of Paris. He moved to Paris in 1923, earning money by playing guitar, and began to study painting in 1930. Between 1935 and 1937 he was a student at the Chelsea School of Art and the ▷Slade, London. He abandoned his early figurative work, for an ▷abstraction based on tightly interlocking forms of colour with no depth or perspective, having been influenced by ▷Kandinsky and the ▷Delaunays whom he met in 1937. His approach to painting was essentially religious: he stated that, 'You've got to have the feeling of God in the picture if you want to get the big music in.' He had his first solo exhibition in Paris in 1945, and was widely exhibited with the School of Paris in the 1950s. He won the Kandinsky Prize in 1947.

Bib.: Brutsch, F., *Serge Poliakoff 1906–69*, Neuchâtel, 1993; Marchiori, G., *Serge Poliakoff*, Paris, 1976; *Serge Poliakoff, Retrospective*, exh. cat., Paris, 1991; Ragon, M., *Poliakoff*, Paris, 1956

Polidoro da Caravaggio (Polidoro Caldara) (c1500–43)

Italian painter. He was from Caravaggio in Lombardy and was an early exponent of ▷Mannerism. He trained in the studio of ▷Raphael in Rome, assisting in his master's decoration of the Vatican Loggie. As an independent painter, he achieved considerable success painting monochromatic ▷frescos, intended to imitate, but exceeding in vitality, ▷antique sculptural friezes and ▷niche figures for the ▷façades of Roman houses (a rare but heavily restored survivor being on the Palazzo Ricci, c1524–5, the design of some of his lost frescos being preserved in the numerous contemporary prints and drawings after them). In the chapel of Fra Marino Fetti in the church of S. Silvestro al Quirinale, Rome, are lateral murals of scenes from the lives of, respectively, ▷St. Mary Magdalene and ▷St. Catherine of Siena (oil, 1525). These scenes, set in poetic, antique-inspired landscapes which dominate the figures, prefigure the work of the later classical landscape painters, ▷Poussin and ▷Claude. Following the sack of Rome, Polidoro worked in Naples and then Messina where, away from the classical constraints of Rome, his work became decidedly strange, as is evidenced in his violent *Road to Calvary* (Naples, Capodimonte Museum). He was murdered in Messina in 1543.

Bib.: Ravelli, L., *Polidoro Caldara da Caravaggio*, Bergamo, 1978

Pollaiuolo (Pollaiolo, Pollajuolo), Antonio (c1432–98) and Piero (c1441–96)

Italian family of artists. They were brothers from Florence. Antonio may have been trained as a goldsmith and sculptor in metal by Vittorio Ghiberti and employed on the frieze of ▷Lorenzo Ghiberti's *Gates of Paradise*, while, according to ▷Vasari, Piero was trained as a painter by ▷Andrea del Castagno. The brothers jointly ran a flourishing workshop producing sculptures, paintings, gold and silver work, embroidery designs and ▷engravings. Although much of their work was produced in collaboration, Antonio is considered to be the stronger artist as the few paintings documented by Piero alone are rather mediocre (e.g. the set of *Virtues* in the Uffizi and an altarpiece, 1483, for the church of S. Agostino, S. Gimignano).

The most ambitious painting attributed to the brothers, the *Altarpiece of S. Sebastian* (c1475, London, National Gallery), one of the earliest Italian oil paintings, was probably executed chiefly by Antonio and to his design, as it contains three elements characteristic of other work attributed to him alone:

(i) A pioneering interest in scientifically observed anatomy, notably in the six archers, the front four of whom represent just two figures seen from contrasting angles (Vasari credits Antonio as one of the earliest artists to have dissected corpses in an effort to understand the structure of the body and the mechanics of strenuous muscular action).

(ii) A landscape background (based on a specific location – the valley of the Arno) in which is seen an early attempt to create plausible recession through the use of ▷aerial perspective (although the foreground is not yet related securely to the middle distance and background).

(iii) An interest in ▷antiquity – the ▷triumphal arch on the left of the picture being used to locate the scene of the action in ancient Rome.

A groundbreaking engraving, *The Battle of the Nude Men*, c1460, signed by Antonio, reveals not only his interest in the depiction of vigorous action, but also displays his superb draughtsmanship in the wiry bounding lines of the figures. To Antonio also is attributed the bronze statuette *Hercules and Antaeus* (c1475–80, Florence, Bargello), the first appearance in sculpture of a subject which was to absorb 16th-century Italian sculptors, including ▷Michelangelo. The two most important commissions (for which Antonio was workshop head) are both documented and dated, the Tomb of Sixtus IV (signed by Antonio and dated 1493) in the Vatican Museums and the Tomb of Innocent VIII (1492–8) in St. Peter's.

Bib.: Ettlinger, L.D., *Antonio and Piero Pollaiuolo*, Oxford, 1978

Pollock, Jackson (1912–56)

American painter. He was an important practitioner of ▷Abstract Expressionism. He was born in Cody, Wyoming, into a poor sheep-farming family and was originally interested in sculpture, but joined the ▷Art Students' League of New York in 1929 and was taught painting by ▷Benton. He developed a romantic ▷Regionalist style influenced by ▷Ryder during the 1930s. As a member of the ▷Federal Art project 1938–42, he met a number of ▷avant-garde artists (he exhibited with ▷de Kooning in 1940) and discovered ▷Picasso's work and ▷Surrealism (he was part of the New York Surrealist exhibition in 1942 and wrote automatic poetry). In 1939, he underwent psychiatric counselling and came into contact with the ideas of Jung. He began a series of semi-figurative pieces, using symbolism from ▷Native American culture (Navejo sand painting) and primitive art, influenced by the Mexican ▷Rivera and incorporating a heavily-applied technique which suggested violent spontaneity (e.g. *She-Wolf*, 1943, New York).

Pollock was already experimenting with Surrealist ▷automatism, but after the War he settled in Long Island and began to develop the ▷Action techniques for which he is best known, dripping and throwing paint onto large canvases which were laid on the studio floor and only cut once the work was completed. He produced his first such abstraction in 1945. The intention was to avoid a focus for the work, to be part of it during creation (actually walking over it), to

treat it as an object and to work semi-automatically ('painting has a life of its own'). His attitude was later influential to ▷Performance artists and ▷happenings. Despite his abstraction, Pollock used evocative, descriptive titles for many of these works (e.g. *Cathedral*, 1947, Dallas). The mesh of drips and dashes, often textured by the addition of sand and other materials, created a floating spatial rhythm. In 1951, suffering from alcoholic depression, he reduced his colours and began to work with black enamels of ▷unprimed canvas. Dreamlike figures began to creep back into his work (e.g. *Portrait and Dream*, 1953, private collection). He died in a car crash.

Pollock's brothers, Charles and Sanford, were also artists.

Bib.: Cernieshi, C., *Jackson Pollock: Meaning and Significance*, New York, 1993; Frank, E., *Jackson Pollock*, New York, 1983; Friedman, B.H., *Jackson Pollock: Energy Made Visible*, New York, 1973; *Jackson Pollock*, exh. cat., Paris, 1982; O'Connor, F. and E. Thaw, *Jackson Pollock*, New York, 1979; Ratcliff, C., *The Fate of a Gesture: Jackson Pollock and Post-War American Painting*, New York, 1995; Rose, B., *Jackson Pollock*, New York, 1980

polychromatic sculpture

The great majority of all sculpture, worldwide, is and always has been polychromatic, that is, painted in many colours, usually to embrace lifelikeness. (Real hair is not unusual, nor ivory teeth, pearl eyes, and so forth.) Sculpture in wood (by far the most popular material) has usually been painted on top of a coating of plaster, which helps fill in the grain. Greek sculpture, even in marble (for example the ▷Elgin Marbles), was routinely painted, and this tradition continued into the Middle Ages, so that the great portals of the ▷Gothic cathedrals might, to our chaste, ▷Renaissance-influenced taste, have seemed garish, if not vulgar, with their multicoloured stone figures. Plenty of traces remain from all periods: for example, the ▷tympanum of the Puerta de la Gloria at Santiago de Compostela, or ▷Sluter's *Well of Moses* in Dijon. Polychromatic multifigure wooden ▷altarpieces, often gilded, adorned Spanish and northern altars until well into the 17th century, when canvases usually took their place.

It seems to have been a misunderstanding of ▷Roman sculpture that encouraged Renaissance sculptors to promote plain marble for their works. The Roman material they studied had long since lost its colour, or perhaps they chose to ignore it. The liking for polychromy continued to challenge Renaissance ingenuity with other materials, and the development by the ▷della Robbias of a vitrified lead ▷glaze for ▷terracotta meant that material could be brightly coloured and made virtually weatherproof as well.

The Renaissance taste for 'pure' marble sculpture was broken by ▷Bernini, who observed and wished to imitate the Roman use of different-coloured stones

and marbles to produce composite busts or even complete groups, as can be seen from his funerary monuments in St. Peter's.

The Renaissance 'interlude' was, however, reconfirmed in the 18th century when the ▷Neoclassical quest for purity came up against incontrovertible proof of polychromy amongst the much-admired ancients and still won. There are a few academic examples of the technique in the 19th century, especially during the various revivals, but a renewed interest in the natural beauty of materials has meant that 20th-century sculptors have not been well disposed to hiding it under layers of polychromy.

Bib.: Reutersward, P., *Studien zur Polychromie der Plastik: Griechenland und Rom. Untersuchungen über die Farbwirkung der Marmor-und Bronzeskulpturen*, Stockholm, 1960

Polyclitus (Polycletus, Polykleitos) of Argos (fl 2nd half of 5th century BC)

With ▷Phidias, the leading Greek sculptor of the ▷Classical period. Both men were pupils of Ageladas. Polyclitus worked chiefly in ▷bronze, but also in ▷marble, gold, ▷ivory, and embossed metal. None of his original sculptures are known to have survived but contemporary descriptions have made it possible to recognize them in later Roman copies. Polyclitus was also a theoretician and made a special study of the ideal proportions of the human body, specifically the naked male athlete. The results of his studies he wrote down in a treatise called the *Canon*, now lost; it is the earliest known instance of a sculptor writing about his art.

▷Pliny describes a bronze statue made by Polyclitus to demonstrate his system of mathematical proportions. This is believed to be the so-called ▷*Doryphorus* or 'Spear-bearer', a marble copy of which was found at ▷Pompeii (Naples, Archaeological Museum). The head is relatively large, the forms massive, and the figure activated by a forward movement expressed in a perfectly balanced ▷contrapposto, though with a composition which nonetheless retains its single frontal viewpoint. Similar qualities are found in another later marble copy, the *Diadoumenos*, or 'Youth binding his hair' (Delos Museum). The treatment of the hair is less conventionalized, and suggests that the *Diadoumenos* is later than the *Doryphorus*. A third athlete figure associated with Polyclitus is the *Westmacott Athlete*, a youth crowning himself (London, British Museum), believed to be a Roman copy of Polyclitus' *Cyniscus*, described by Pausanius as being a dedication to a famous athlete and erected at Olympia. An inscribed base uncovered in excavations at Olympia verifies that Polyclitus made such a figure. A quality impossible to discern in any of these copies is the fine detailing, praised by contemporaries. Another statue, described by Pausanius and replicated on Argive coins, is the colossal chryselephantine *Hera* made for the new

Heraeum at Argos, following the destruction of the previous building in 422 BC. As this date would give Polyclitus a rather long career, however, some modern authorities think it might have been by another, slightly later, sculptor of the same name.

Bib.: Boardman, J., *Greek Sculpture: The Classical Period*, London, 1985; Robertson, M., *A History of Greek Art*, 2 vols., Cambridge, 1975

Polynesian art

The art of Hawaii, New Zealand and Easter Island. There are some particularly distinctive features of Polynesian art, including Maori carving and the large stone figures on Easter Island. Polynesians were also known for their carved furniture and canoes, as well as ephemeral work composed of feathers and ceremonial art.

Bib.: Alpers, A., *The World of the Polynesians: Seen through their Myths and Legends, Poetry and Art*, Auckland, 1987

Polyphemus

In Greek mythology, one of the race of giant cyclops.

(i) In Homer's *Odyssey* Polyphemus imprisons Odysseus (▷Ulysses) and 12 of his followers in the cave by the sea where he also keeps his sheep. Polyphemus eats several of Odysseus' followers before the captives succeed in getting him drunk and then blinding him by driving a large stake into his eye. Enraged with pain Polyphemus attempts to block the captives' escape, but they tie themselves under some rams and sneak past the blinded cyclops as he lets his flock out to pasture. Odysseus and the survivors of his company flee to their ship and once out of range of the shore,

Odysseus hurls insults at Polyphemus (see ▷J.M.W. Turner, *Ulysses Deriding Polyphemus*, London, National Gallery).

(ii) Polyphemus is also the name of the cyclops who loved the sea nymph, ▷Galatea.

polyptych

A work of art, either painted or sculpted or a combination of painting and sculpture, usually an ▷altarpiece, composed of four or more, sometimes hinged, panels.

Pomarancio, Il

▷Roncalli, Cristofero

Pompeii

Roman town near Naples that along with neighbouring Herculaneum and Stabiae was buried and preserved under volcanic ash after the eruption of Vesuvius in AD 79. The towns were discovered in the 18th century and had some influence on the prevailing taste for ▷Neoclassicism. However, few objects of great art have been recovered, and Pompeii's chief impact has been on the understanding of Roman wall-painting. ▷Murals survive spanning the period from the 2nd century BC to the 1st century AD, with subsequent discoveries further afield, including Britain, suggesting that their style is typical for most of the Roman empire. Four styles are generally agreed on, with the third which uses painted architectural forms and panels of monochrome colour with small painted scenes being the most influential on 18th-and 19th-century interior decoration. The murals formed part

Polynesian art: Tattooed Hand of Chief Marquesas, c1860

Pompeii: recreation of a mural

of a broader complex decorative scheme that used mosaic, painted ceilings, patios, pools and gardens to develop a refined style that has only recently begun to be understood. Previous artistic attention has tended to focus on individual scenes rather than the entire programme. As Pompeii was a small middle-class town, it gives a good indication of the taste and style of the ordinary provincial citizen as opposed to the grand imperial art of Rome.

Pompidou, Le Centre National d'Art

Centre for contemporary arts and architecture in Paris. In 1969 President ▷Georges Pompidou declared that Paris should have a cultural centre that would act as a centre of creativity and an exhibition space for all the arts. In 1975 the centre was created by law as a public body answerable to the Secretary of State for Culture. In 1977 the Centre was officially opened, in a controversial building designed for the purpose by architects Richard Rogers and Renzo Piano. Ducts, air-vents and the construction's steel framework were colour coded and placed on the outside of the building. The Centre has two departments: the Centre of Industrial Creation and the National Museum of Modern Art. This latter is an unrivalled collection, brought from the Louvre, and includes works by ▷Matisse, ▷Braque, ▷Picasso, ▷Léger, ▷Modigliani and ▷Rouault. At 17,000 square feet it is the largest centre for modern art in the world.

Pompidou, Georges (1911–74)

French Gaullist politician and patron of the arts. After a career in banking and as an assistant to de Gaulle,

Pompidou became premier of France in 1962, and was President of the Fifth Republic from 1969 until his death. He was involved with the settlement of the student uprising of 1968. His policies were enlightened, particularly in the direction of the arts, and he set in place ideas for galleries and museums, including the centre that bears his name, which were executed after his death.

Pompier, l'art

(From the French, 'pompier', 'fire-fighter'.) A pejorative term used in the 19th century to describe a kind of overblown ▷history painting in which bronze-helmeted warriors usually played a key role. The similarity of their attire to the uniforms worn by fire fighters is the origin of the name.
Bib.: Bouguereau, W.A., L'art Pompier, exh. cat., New York 1991

Pont-Aven, School of

A village in Brittany which became an artists' colony in the 1880s because of its isolation from modernity and the picturesque qualities of its traditional life. Brittany in general was a popular summer sketching area because of the clear light, varied landscape and, especially, the local costume and religious festivals, which seemed to hark back to the past. In 1888 ▷Gauguin and ▷Bernard invented ▷Synthetism whilst working there and a number of ▷Symbolists (▷Denis; ▷Sérusier) were encouraged to visit the area.
Bib.: Boyle Turner, C., Prints of the Pont-Aven School, New York, 1986; Gauguin and the Pont-Aven Group, exh. cat., London, 1966; Jaworska, W., Gauguin and the Pont-Aven School, London, 1972

Pontius Pilate

The Roman governor of Judea at the time of the arrest and ▷Crucifixion of Jesus ▷Christ. Christ is arrested by the soldiers of the Jewish High Priest in the Garden of Gethsemane. He is first taken to Annas, the High Priest Caiaphas' father-in-law, and then to Caiaphas himself. They both find Jesus guilty of the capital offence of blasphemy and send him to Pontius Pilate for sentence. Pilate, however, professes to find no fault with Jesus and sends him to the Jewish tetrarch, Herod Antipas (Luke 23: 1–7). Herod wants only to see a miracle and, when he is disappointed, returns Jesus to Pilate. Pilate is still reluctant to have Jesus condemned to death and offers to have him scourged and sent on his way, but the priests and elders stir up the mob who demand Christ's death. According to Jewish custom one condemned man can be released at the Passover and Pilate suggests that it be Jesus, but the priests and elders again incite the mob to call for the release of Barabbas, a convicted murderer. In the end Pilate, fearing a riot, yields to the pressure of the mob and sends Jesus away for Crucifixion, but not before he has

symbolically washed his hands in public of all blame for the shedding of the blood of a man he believes innocent. He does, however, order that Christ be scourged anyway before he is handed over to the Jews (Matthew 27: 11–26). Each of the separate events associated with Pilate is depicted in the ▷Passion scenes on the back of ▷Duccio's altarpiece, the ▷*Maestà* (1308–11, Siena, Cathedral Museum).

Pontormo (Jacopo Carucci) (1494–1556)

Italian painter. He was named after his birthplace, a village near Empoli, and, according to ▷Vasari, trained in Florence under ▷Leonardo da Vinci, ▷Albertinelli, ▷Piero di Cosimo and finally, from 1512, ▷Andrea del Sarto. In 1518 he painted an ▷altarpiece, *Madonna and Child with Saints*, for the Florentine church of S. Michele Visdomini, one of the earliest paintings that can be termed ▷Mannerist: although still showing the influence of ▷del Sarto, the classical calm of the High ▷Renaissance is now disturbed by a sense of unease, conveyed in the asymmetrical disposition of figures whose agitated poses and anguished expressions all combine to create a remarkable image of intense and emotional religiosity. His work attracted patronage from the ▷Medici family, who commissioned him (1520–21) to paint a fresco of *Vertumnus and Pomona* for their villa at Poggio a Caiano. During the plague of 1523 he took refuge at the Certosa at Galluzzo, just outside Florence. Here, in the ▷cloister, he painted (assisted by his pupil, ▷Bronzino) frescos of *Christ's Passion* (now detached and in the museum). ▷Vasari was highly critical of the pervasive influence of ▷Dürer's engravings in this cycle, to the non-classical distortions in which Pontormo had presumably turned for their expressive potential. In the scene of *Christ Carrying the Cross*, Pontormo portrays himself assisting Christ with his load. In fact, it is characteristic of Pontormo to include himself in his religious paintings, although in other cases as a spectator (e.g. *Joseph Sold to Potiphar*, 1516–17, London, National Gallery).

Pontormo also appears in his altarpiece of the *Deposition* (c1526–8, Florence, Capponi Chapel, Sta Trinità), a key work of Italian Mannerist painting. The strongly contrasting, pale colours of the *Deposition* are partly a response to the darkness of the Capponi Chapel (a lesson learnt from the Visdomini altarpiece which is too dark for its location). Here the influence of Dürer has subsided and is replaced, particularly in the drawing, by that of ▷Michelangelo; the emotional intensity, however, is pure Pontormo.

Pontormo was also a successful portraitist (e.g. *Lady with a Lapdog*, c1532–3, Frankfurt, Kunstinstitut) and a prolific draughtsman (the major collection of his drawings is in the Uffizi). His remarkable diary survives, revealing a neurotic character, obsessed with the state of his bowels. His principal rival was ▷Rosso.
Bib.: Berti, L., *Pontormo e il suo tempo*, Florence, 1993;

Costamagna, P., *Pontormo, catalogue raisonné de l'oeuvre peint*, Paris, 1994; Forlani Tempesta, A., *Pontormo*, Florence, 1994

Pop art

The term first appeared in Britain during the 1950s and referred to the interest of a number of artists in the images of ▷mass media, advertising, comics and consumer products. The 1950s were a period of optimism in Britain following the end of war-time rationing, and a consumer boom took place. Influenced by the art seen in ▷Eduardo Paolozzi's 1953 exhibition *Parallel between Art and Life* at the ▷Institute for Contemporary Arts, and by American artists such as ▷Jaspar Johns and ▷Robert Rauschenberg, British artists such as ▷Richard Hamilton and the ▷Independent Group aimed at broadening taste into more popular, less academic art. Hamilton helped organize the 'Man, Machine, and Motion' exhibition in 1955, and 'This is Tomorrow' with its landmark image ▷*Just what is it that makes today's home so different, so appealing?* (1956). Pop Art therefore coincided with the youth and pop music phenomenon of the 1950s and '60s, and became very much a part of the image of fashionable, 'swinging' London. ▷Peter Blake, for example, designed album covers for Elvis Presley and the Beatles and placed film stars such as Brigitte Bardot in his pictures in the same way that ▷Warhol was immortalizing Marilyn Monroe in the USA. Pop art came in a number of waves, but all its adherents – Joe Trilson, Richard Smith, Peter Phillips, ▷David Hockney and ▷R.B. Kitaj – shared some interest in the urban, consumer, modern experience.

Popova, Liubov Sergeevna (1889–1924)

Russian painter and designer. The daughter of a prosperous businessman, Popova travelled and studied throughout Russia and in Italy (1911) and France (1912–13). She worked in ▷Tatlin's studio (1911, 1913–15) where she met her husband Aleksandr Vesnin, and exhibited at '0.10' (1915) and 'The Shop' (1916). In 1918 she began to teach at ▷Vkhutemas, and in 1920 joined ▷INKHUK. By now Popova was a strong supporter of ▷Productivism and, after the ▷'5×5 = 25' exhibition, renounced easel painting to concentrate on writing, teaching, designing textiles and work for the theatre. Producing designs for a celebratory pageant *The Struggle and Victory of the Soviets* (1921) initiated a long-term collaboration with the playwright Meyerhold, and Popova taught at his theatre workshops. She died of scarlet fever.

Popova's first paintings (1908–12) were still lifes and landscapes influenced by ▷Cézanne. She studied ▷Cubist painting in Paris and absorbed the lessons of Tatlin and ▷Malevich to produce her own distinctive style. The ▷'architectonic' paintings she produced

after 1916 fill the canvas with intersecting planes of intoxicating strong colours, and reflect her theoretical interest in the exploration of a painterly space at odds with traditionally illusionistic notions of perspective. Her later ▷Constructivist reliefs anticipate the break with painting by subduing composition to the demands of materials and geometric considerations. Popova's designs for the stage were ground-breaking. *The Magnanimous Cuckold* (1922) was the first Constructivist production, designed by Popova's students under her close direction; and her designs for *The Earth in Turmoil* (1923) were based on using real objects (including rifles, machine guns and a truck) with images projected onto a screen to provide an ironic commentary on the hectic action.

Bib.: Sarabianov, D.V. and Adaskina, N.L. (trans. Schwartz, M.), *Popova*, Moscow, 1992

poppy oil

Oil extracted from poppy seeds, one of the most popular of drying oils used as a ▷medium in ▷oil painting.

popular culture

While there have long been forms of popular culture such as folk tales, ▷folk art and popular theatre that to some extent have opposed the 'high' art forms of ▷fine art, opera and classical literature, 'popular culture' is the relatively recent offspring of the ▷mass media – newspapers, pop music, television and advertising. The modern definition of popular culture initially emerged in the 19th century, although its impact on fine art was limited. Although ▷Courbet in his painting *Bonjour, Monsieur Courbet* (1854) borrowed his composition from a popular ▷woodcut of the Wandering Jew, and ▷Manet and the ▷Impressionists depicted the popular night-spots of ▷Haussmann's Paris, there was little interaction between 'high' and 'popular' art.

This attitude was not to change significantly until the 1950s, when the ▷Pop artists incorporated into their compositions the icons of popular culture such as Coca-Cola and similar products of the consumer society. Since the 1960s the interaction between the two cultures has increased, with artists actively embracing the new forms of communication such as television and video, spawning such movements as ▷conceptualism and ▷Performance art. Most recently, ▷feminist artists such as the photographer ▷Cindy Sherman have focused on the media's representation of women in advertising and the cinema, while the ▷postmodern artist Jeff Koons has made whisky decanters in the form of replicas of cartoon characters and media personalities.

Bib.: Varnedoe, K., *High and Low: Modern Art, Popular Culture*, New York, 1990

porcelain

A type of ▷ceramic invented by the ▷Chinese during the T'ang Dynasty. It was popular in Europe during the 18th century, particularly in England, when the Derby and Chelsea factories were celebrated manufacturers, and Germany, where the Meissen porcelain factory opened in 1709.

Bib.: Bradshaw, P., *Derby Porcelain Figures*, London, 1990; Cameron, E., *Encyclopedia of Pottery and Porcelain: The Nineteenth and Twentieth Centuries*, London, 1986; Godden, G., *British Porcelain: An Illustrated Guide*, London, 1974; Jenyns, S., *Japanese Porcelain*, London, 1965; idem., *Later Chinese Porcelain*, 4th edn, London, 1971; Meister, P., *European Porcelain of the Eighteenth Century*, Oxford, 1983; Savage, G., *Eighteenth-Century English Porcelain*, London, 1964

Porcellis (Percellis), Jan (c1584–1632)

Flemish artist. He lived in Holland, where he painted ▷marine scenes replete with atmospheric effects.

porch

A covered entrance located in the front of a building.

Il Pordenone (Giovanni Antonio de Sacchis) (c1484–1539)

Italian painter. As his nickname implies, he was from Pordenone in the Friuli district, near Venice. It is not known by whom he was trained although ▷Vasari says that he was self-taught. He seems initially to have been influenced by the Venetian colourism of ▷Giorgione (e.g. *Madonna della Misericordia*, 1516, Pordenone, Cathedral), to which was added, after a trip to Rome c1515–16, the monumental figure style of ▷Michelangelo. German prints also seem to have entered the mix to produce a very personal kind of *maniera* (▷Mannerism), for example the extremely violent and dramatic *Crucifixion* (1520–21, Cremona, Duomo). In 1519/20 he won the commission to paint the dome (destroyed in the Second World War) of Treviso Cathedral, which he decorated with a very accomplished illusionistic composition revealing, perhaps, familiarity with ▷Mantegna's achievement in the Camera degli Sposi. During the 1530s he worked very successfully in Venice, representing a Mannerist alternative to the High ▷Renaissance style of Titian. However, ▷Titian's style finally prevailed and Pordenone left Venice for Emilia, though not before influencing the future development of the art of ▷Jacopo Bassano and ▷Tintòretto.

Bib.: Cohen, C, *The Art of Giovanni Antonio da Pordenone: Dialect and Language*, Cambridge, 1995; Douglas-Scott, M., 'Pordenone's Altarpiece of the Beato Lorenzo Giustiniani', *Burlington Magazine*, 130 (Sept. 1988), pp. 692–9; Furlan, C., *Il Pordenone a Treviso*, Treviso, 1984 and *Il Pordenone*, Pordenone, 1985

porphyry

A very hard igneous rock composed of crystals of white or flesh-red feldspar embedded in a fine ground-mass of a deep red or purple colour. The ancient Romans confined the use of the term porphyry to those rocks quarried in Egypt, the finest quarry being Mons Igneus, Gebel Dokhan. Other types were subsequently included, however, the most widely used being the green porphyry of Greece, which was referred to by the masons of the Italian ▷Renaissance as 'antique serpentine'. True porphyry has been used mainly for architectural purposes: ▷column ▷shafts, wall cladding, paving, etc., and came to be associated with the emperor who largely controlled its use. The tombs of the Roman emperors were made of porphyry and so, for obvious reasons, is that of Napoleon, in the Church of the Dome, Paris. It has been less often used for sculpture because of its extreme hardness, although *The Tetrarchs*, the group of four embracing soldiers carved by Roman sculptors in the early 4th century AD and now embedded in the corner of the wall of the Basilica of St. Mark in Venice, is a celebrated example.

Bib.: Penny, N., *The Materials of Sculpture*, New Haven and London, 1993

portico

In Classical architecture, an entrance ▷porch consisting of a roof supported by ▷columns, and usually crowned with a ▷pediment. The portico may range forward from the ▷façade of the building, in which case it is called prostyle, or it may recede into the building such that the front row of columns are in line with the front corners of the building, in which case it is called *in antis* (i.e. between '*antae*', or corner posts). Porticoes may be further classified by the number of columns in the front row, viz. tetrastyle (4), hexastyle (6), octastyle (8), decastyle (10) or dodecastyle (12). Where only two columns are ranged between corner posts or pilasters, the portico is called *distyle in antis*.

portrait format

A painting or drawing, of any subject, having a greater height than width. So-called because portraits are usually represented in this format.

▷landscape format

portraiture

The evocation of a physical (and sometimes spiritual) likeness in painting and sculpture goes back to the ▷Egyptians, who for royalty and gods chose an idealized impression, but a naturalistic one for most mortals. The Greeks adopted from them the heroic and idealized portrait, but eschewed ▷ naturalism (and attendant ▷physiognomical description) until ▷Hellenistic times, when we find for the first time an almost ▷caricature-like exaggeration of physical features. The Roman republic sometimes went for the same 'warts and all' approach, but the empire, tapping the art of the Greek world it now largely owned and whose artists were in its employ, usually chose the heroic, idealized image. In the ▷Renaissance both idealized and naturalistic approaches were used, inspired by surviving examples from ▷ antiquity. These examples of attitudes to portraiture are also clearly seen in coins and medals.

Portraiture occurs when living individuals are highly

Portico

valued, but there are also traditions of likenesses (as with the ▷Apostles and ▷Christ) that are generic and highly stylized rather than specifically ▷physiognomical. Hence the Middle Ages passed on the stylized pseudo-portraiture of the holy figures to the Renaissance, and at the same time people of position (bishops, kings and abbots) were frequently represented as characterized through their attributes, but we find few indisputable portraits before the 12th century since individual likeness – nowadays perhaps the crux of a portrait – was of little interest. Following the Renaissance emphasis on the individual (partly based, as already noted, on antique examples), portrait painting and sculpture became (and still remain, despite the incursions of photography) one of the staples of European art, providing more bread to more artists than history or religious painting ever did.

Bib.: Breckenridge, J.D., *Likeness: A Conceptual History of Ancient Portraiture*, Evanston, 1969; Brilliant, R., *Portraiture*, London, 1991; Friedman, J.B., *An Iconological Examination of the Half-Length Devotional Portrait Diptych in the Netherlands 1460–1530*, Ann Arbor, 1977; Pointon, M., *Hanging the Head: Portraiture and Social Formation in Eighteenth-Century England*, New Haven and London, 1993; Shawe Taylor, D., *Genial Company: The Theme of Genius in Eighteenth-Century British Portraiture*, exh. cat., Nottingham, 1987; idem., *The Georgians: Eighteenth-Century Portraiture and Society*, London, 1990

Posada, José Guadalupe (1852–1913)

Mexican engraver and illustrator. Born into a peasant family in Aguascalientes, he was an apprentice lithographer at the print shop of Trinidad Pedrozo. His first illustrations were for Pedrozo's radical weekly *El Jicote* (*The Wasp*, 1871), but after 11 issues the magazine was closed down by the authorities and Posada was forced to flee with his employer to Leon in Guanajato. Here he taught and published ▷lithographs, and in 1888 was able to set up his own print shop in Mexico City. He began to illustrate Antonio Vanegas Arroyo's broadsheets of sensational news stories (accidents, executions and natural disasters) and urban myths (women giving birth to animals or turning into fireballs). In 1895 he began to etch on zinc, which became his preferred ▷medium. Despite a vast popularity, he died in poverty in Mexico City.

Posada was a model for the Mexican ▷ muralists as a popular artist producing vivid and simple images in a distinctively non-European mode with strong elements of political satire. He is best known for his *calaveras*, witty images of skeletons performing the rituals and pleasures of everyday life. Often dressed in bourgeois finery, they mock the pretensions and vanity of the living.

Bib.: Tyler, R. (ed.), *Posada's Mexico*, Washington, 1979

Poseidon

▷Neptune

Post, Frans (1612–80)

Dutch painter and engraver. He was born in Leiden and worked in Haarlem. He joined the Dutch West India Company on a trip to Brazil in 1637–44, and there he painted landscape scenes of the Brazilian tropical rainforests. When he returned to Haarlem, he became a member of the guild in 1646.

Post-Impressionism

A term first used by ▷Fry and adopted by ▷Bell to describe modern art since ▷Impressionism. The 1910 and 1912 exhibitions of French art organized by them were confusingly entitled 'Manet and the Post-Impressionists', although they included the work of ▷Matisse, ▷Picasso and ▷Braque. The term is now taken to mean those artists who followed the Impressionists and to some extent rejected their ideas. They include ▷van Gogh, ▷Gauguin, ▷Cézanne, ▷Seurat, ▷Signac and ▷Toulouse-Lautrec. Many were involved with the Société des Artistes Indépendants (▷Salon des Indépendants) established in Paris in 1884. Generally, they considered Impressionism too casual or too naturalistic, and sought a means of exploring emotion in paint.

Bib.: *Post Impressionism*, exh. cat., London, 1979; Rewald, J., *Post Impressionism van Gogh to Gauguin*, London, 1978; idem., *Studies in Post Impressionism*, New York, 1986; Thomson, B., *Post Impressionism*, London, 1983

postmodernism

A social, cultural and intellectual movement that has been developing away from and beyond ▷modernism since the early 1970s. Influenced by the critical ideas of ▷poststructuralism and reacting to the totalizing confidence of modernism, postmodernism questions and deconstructs the authoritative voice and the single path. Whilst emphasizing those chaotic elements of modernism such as fragmentation, ephemerality and discontinuity, it favours a 'schizophrenic' interpretation of the world as against modernism's idea of the outsider: the postmodern artefact is characterized by pastiche, irony, and inter-textuality. The French ▷poststructuralist historian ▷Michel Foucault wrote that we should 'prefer what is positive and multiple, difference over uniformity, flows over unities, mobile arrangements over systems'. The idea of boundaries is resisted, and the importance of the experience of 'otherness' (▷Other) highlighted. The French critic ▷Derrida considers ▷collage/▷montage as the primary postmodern ▷discourse, be it in painting, literature, architecture or cinema. In architecture postmodernism has been expressed by the reintroduction of ornament and individualism and the perception of the urban form as chaotic and eclectic rather than the

planned ▷New Brutalism of ▷Le Corbusier. Postmodernism has been described as nothing more than the 'cultural logic' of late capitalism, where image, culture and history are packaged and commercialized, and advertising becomes the ultimate postmodern art form.

Bib.: Harvey, D., *The Condition of Postmodernity*, Oxford, 1990; Jencks, C., *The Postmodern Reader*, London, 1992; Lyotard, J., *The Postmodern Condition*, Manchester, 1984; Taylor, B., *Modernism, Postmodernism, Realism: A Critical Perspective for Art*, Winchester, 1987

Post-Painterly Abstraction

A term invented by ▷Greenberg for his 1964 exhibition, to describe artists who abandoned the painterly and emotional qualities of ▷Abstract Expressionism but remained opposed to figurative art. The term ▷hard-edge Abstraction (as distinct from the blurred edges of ▷Rothko's work) is also used. ▷Stella, ▷Noland, Kelly, Poons, ▷Louis and others used precisely planned, defined and geometric areas of colour to emphasize the physical material reality of the paint. They tried to avoid optical and spatial illusion, dynamism and any external associations. In their desire to eliminate all inessentials, they point the way forward to ▷Minimalism. Artists such as Stella also broke down the boundaries between art and sculpture through their use of shaped canvases.

poster art

With the growing commercialism of the 19th century, publicly posted paper advertisements of goods and services became popular, just as ▷graffiti for the same purpose always had been. Artists were commissioned to produce posters, often as ▷ lithographs, ▷Toulouse-Lautrec creating some of the best-known examples. In the 20th century, the term has increasingly taken on political overtones (for example during the Russian Revolution, in post-Mao China, or in Paris in 1968), as the poster has been used as a vehicle for propaganda to sway the emotions as well as the mind.

Bib.: Hutchison, H.F., *The Poster: An Illustrated History from 1960*, New York, 1968; Weill, A., *The Poster: A Worldwide Survey and History*, London 1985

poststructuralism

Critical technique that goes beyond ▷structuralism's closed system of signs, poststructuralism argues that 'meaning' in words and language can never be fully achieved. Since each word or sign is related to another word or sign, and these in turn to others in an endless circle, meaning must be dependent on context or moment: language is perceived therefore in poststructuralism as a web or 'text' of circulating, interchanging elements. It undermines traditional theories of meaning, bringing into question the role of the

producer/author of signs and emphasizing the role of the observer/interpreter. A text is no longer considered as a closed entity with definite meaning, but seen to have many meanings which it is impossible to interpret in one definitive way. ▷Derrida's theory of ▷deconstruction forms an important part of poststructural practice. Important poststructuralists include ▷Michel Foucault, ▷Julia Kristeva, ▷Jacques Lacan, and Paul de Man.

Potter, Paulus (1625–54)

Dutch painter and etcher. He is most famous for his *Young Bull* (1647, The Hague, Mauritshuis) – a realistic image of a large bull in a landscape. In subsequent generations it has become a symbol of Dutch nationalism.

pouncing

A technique used to copy a design on to a wall or other surface, either in order to execute a fuller version from the initial work or to duplicate an image. Holes are pricked around the design, which is on a piece of paper or parchment. The paper or parchment is then held against the surface which is to receive the copy and a bag of chalk or coloured powder is banged against it, so that a faint impression is left. Pouncing can also be used in metalwork, where the form refers to tiny stippled dots on a metal surface, which give an object a matt finish.

Pourbus, Pieter (1510–84), Frans the Elder (1545–81), Frans the Younger (1569–1622)

Netherlandish family of painters. Pieter worked in Bruges in the 1540s. There he produced portraits and arcane ▷allegorical images in a ▷Mannerist mode. He worked with ▷Lancelot Blondel and married his daughter. His son, Frans the Elder, studied with ▷Floris and worked mainly in Antwerp. Frans the Elder's son, Frans the Younger, was court portraitist in Brussels 1600–1609, until Vincenzo ▷Gonzaga lured him to Mantua. He accepted a number of commissions from the aristocracy outside of Holland, including some from Marie de' Medici.

Poussin, Gaspard

▷Dughet, Gaspard

Poussin, Nicolas (1594–1665)

French painter. He was active almost wholly in Rome and was regarded as the founding figure of French ▷Classicism. He was born in Les Andelys in Normandy and was encouraged in 1611 to attempt a career in painting by the visit to his town of Quentin Varin (c1570–1634), a minor late ▷Mannerist painter. The following year Poussin journeyed to Paris. He studied with the Flemish portrait painter, Ferdinand Elle, and

Nicholas Poussin, *Portrait of the Artist*, 1650, Louvre, Paris

perhaps Georges Lallemant, evidently assimilating a style derived from the Second School of ▷Fontainebleau.

Very little is known of Poussin in the years before c1621 when he was engaged to execute, with ▷Philippe de Champagne, decorations for the Luxembourg Palace. In c1623 he was commissioned by the Italian poet Marino to produce some illustrations for Ovid's *Metamorphoses* (now Windsor, Royal Library). In the same year he set out for Rome (having previously made two unsuccessful attempts) and, through his friendship with Marino, was introduced to Cardinal Francesco ▷Barberini and his secretary, the antiquarian Cassiano dal Pozzo, the latter of whom was to be his most important early patron, exercising a major influence on the direction of his art. Along with Pozzo, two other factors combined to move Poussin away from late Mannerism towards classicism – a period working in the studio of ▷Domenichino and first-hand study of ▷ antique Roman sculpture. He was, from the first, antipathetic to the prevailing ▷Baroque tendency. His first public commission, from Cardinal ▷Barberini, for an altarpiece for St. Peter's, *The Martyrdom of St. Erasmus* (1628, Vatican, Pinacoteca) was coolly received, the dispassionate nature of his art ill-suiting the emotional impact required for such a gruesome martyrdom scene (disembowelment). His contemporary *Inspiration of the Poet* (c1628–9, Paris, Louvre), with its static, non-dramatic composition eloquently reveals his innate feeling for classical restraint as well as, in its cool colour, his debt to Venetian painting and to ▷Veronese in particular.

In 1629–30 Poussin was seriously ill and was cared for by the family of Jacques Dughet, a French chef working in Rome, whose daughter he married. Following his illness he gave up the pursuit of public commissions (preponderantly religious subjects and generally required to be in a Baroque mode) and devoted himself to the painting of mythologies frequently derived from Ovid and Torquato Tasso, which he treated in a poetic, ▷pastoral mode for a small circle of scholarly private collectors. Above all, the influence of ▷Titian can now be discerned (e.g. in *The Arcadian Shepherds*, c1629–30, Chatsworth, Derbyshire). In the latter half of the 1630s he began painting Old Testament (e.g. *The Adoration of the Golden Calf*, 1635–7, London, National Gallery) and historical subjects, favouring in both cases those involving pageants and processions. His work began to move away from the influence of Titian towards a more austere sculptural mode, influenced by a renewed study of Roman antiquities, along with late ▷Raphael and ▷Giulio Romano. His principal aim was the communication of emotion and motivation by the gestures, poses and facial expressions of his figures. In a letter of 1639 to his friend in Paris, the civil servant Paul Fréart de Chantelou, which accompanied the painting, *The Israelites Gathering the Manna* (Paris, Louvre), commissioned by the latter, Poussin expounds this essentially psychological and literary conception of art.

In 1640 Sublet de Noyers, Chantelou's employer, on the instructions of the French King and Cardinal Richelieu, directed Chantelou to persuade Poussin to return to Paris in order that he might superintend the decoration of the Grande Galerie of the ▷Louvre and to paint two ▷altarpieces and two large allegories for Richelieu. Given Poussin's preference for working without assistants and on a small scale, the projects were doomed to relative failure, although his Louvre decorations were well received and proved to be influential. By 1642 he was back in Rome and here he remained for the rest of his life. The trip, however, did bring to him the favourable attention of the intellectual circles of Paris who continued to patronize him even after his return to Rome.

Poussin's Roman paintings of the 1640s were, and remain, the most acclaimed of his career. In this decade he painted his most purely classical works and formulated his theory of 'modes' in which the subject and emotional content of a picture dictated their most appropriate treatment, a rational approach, expressible in language, which was later taken up by the ▷Académie. Each picture was painted methodically, involving numerous detailed studies and the use of wax models deployed on a stage-like set in order to gauge the most appropriate composition and lighting. The new austerity of his art in this period is most revealingly demonstrated in a comparison of the two sets of *Seven Sacraments*, the earlier set for Pozzo (1636–40; of which five are now in the collection of the Duke of Rutland,

Belvoir Castle, Leicestershire, one is in Washington's National Gallery and one destroyed), and the later, much more solemn set for Chantelou (1644–8, Earl of Ellesmere collection, on loan to Edinburgh, Scottish National Gallery). In his mythological subjects he turns from the lightheartedness of Ovid to the seriousness of the Stoical historians.

During the second half of the 1640s Poussin turned increasingly to landscapes, his rational system of composition resulting in pictures, monumental, clearly-ordered, geometrically simplified, spatially conceived and grave (e.g. *The Ashes of Phocion*, 1648, Earl of Plymouth collection, on loan to National Museum of Wales). These, along with the paintings of his friend Claude and brother-in-law, ▷Gaspard Dughet, formed the basis of ideal landscape painting for the next 200 years. No longer concerned with gesture, pose and facial expression to represent a historical event, these paintings attempt to embody a solemn, motionless, eternal truth. His last major works, *The Four Seasons* (1660–64), seem to presage a further new development with their wild, poetic, even mystical mood.

Poussin was enormously influential on the development of French academic art, his theories forming the basis of ▷Lebrun's teaching. In the late 17th century his name was invoked by those who favoured drawing (the ▷Poussinistes) over colour (the supremacy of which was promoted by the Rubenistes), a dispute which in the Italian Renaissance had exercised the passions of the Florentines (favouring ▷*disegno*) and the Venetians (favouring *colore*). Poussin's influence remained strong as long as classicism was the dominant mode, waning slightly in the ▷Romantic period, and reviving in the art of ▷Cézanne whose stated ambition was 'to do Poussin again, from nature'.

Bib.: Cropper, E., *Poussin: Friendship and Love*, Princeton, 1996; McTighe, S., *Poussin's Landscape Allegories*, Cambridge, 1996; Marin, L., *Sublime Poussin*, Paris, 1995; Thuillier, J., *Nicholas Poussin*, Paris, 1994; *Nicolas Poussin*, exh. cat., 1995

Poussinistes vs. Rubenistes

A shorthand designation for a dispute – sometimes known as the debate between line and colour – within the 17th-century French ▷Académie in which the Poussinistes, who advocated the ▷classical values of line (▷*disegno*), reason and restraint, were opposed to those championing ▷painterly Rubens as the leading exponent of the expressive use of colour (*colore*). (This is not to say that either ▷Poussin or ▷Rubens would have wanted to be associated with this kind of reductionist thinking.) Although in the 1670s the Poussinistes, led by the director of the Académie, ▷Lebrun, and its historiographer, ▷Félibien, held sway, at the end of the century the critic ▷Roger de Piles's championship of Rubens put the colourists on top.

Poynter, Sir Edward John (1836–1919)

English painter. He was the son of a London architect and studied there and in Rome where he met ▷Leighton and became an enthusiast of ▷Michelangelo. He also studied under ▷Gleyre in Paris (1856–9) where he met ▷Whistler. On his return to London he was employed as an illustrator by the ▷Dalziel brothers but made his name as a painter of monumental history paintings (e.g. *Israel in Egypt*, 1867, London, Guildhall; *Visit of the Queen of Sheba*, 1871–5, Sydney). He was a renowned draughtsman, and excelled in classical detail and architecture. He was a leading figure in the world of art administration, becoming Slade Professor (1871–5), Principal of the National Art Training School (1875–81), President of the ▷Royal Academy in 1896 and Director of the National Gallery in 1894, where he was instrumental in establishing the Tate Gallery. He was elected RA in 1876 and was a regular exhibitor there and at the ▷Grosvenor Gallery. He also produced design work and stained glass decoration. He was married to ▷Burne-Jones's sister-in-law.

Pozzo, Andrea (1642–1709)

Italian painter, art theorist, and architect. He was possibly the most accomplished of the ▷Baroque ▷*quadratura* painters. Trained in Milan, he became a Jesuit lay brother in 1665 (the title by which he is sometimes known, 'Padre Pozzo', was merely a courtesy title). At this point he wanted to give up architecture and painting to devote himself to God, but was persuaded by his superiors to continue working, principally for them. His masterpiece, a ▷fresco covering the entire vault of the ▷nave of S. Ignazio in Rome, is the *Allegory of the Missionary Work of the Jesuit Order* (1691–4). Best viewed from a specific point in the nave, the painted architecture appears to continue the real architecture of the church. The ceiling of the church is thus opened up to reveal a vision of Heaven, populated by hovering figures, some apparently on a level with the upper reaches of the actual vault of the church, others high above it, with S. Ignazio just below Christ in the highest reach of Heaven. Pozzo explained the programme of the fresco in 1694 in a letter to Prince Liechtenstein. Other ceiling paintings are in the Chiesa della Missione, Mondovi (1676–7) and the Palais Lichtenstein, Vienna (1704–8). He worked in Vienna from 1702 until his death. His architectural work, which is relatively unremarkable, includes S. Ignazio, Dubrovnik (1699–1725), and the University Church, Vienna (1705). He wrote a very influential treatise, *Perspectiva pictorum et architectorum* (*Perspective in Painting and Architecture*, vol. 1 1693; vol. 2 1700), which disseminated his ideas throughout Europe (translated into several European languages).

Bib.: Feo, V. de, *Andrea Pozzo: architettura e illusione*, Rome, 1988; Kerber, B., *Andrea Pozzo*, New York, 1971

Prado

Spanish national collection of art, Madrid. From as early as 1785 there were plans to build a national museum to house the Royal paintings, among other things, when Charles III commissioned Juan de Villanueva to design a museum building. It was officially opened by Ferdinand VII in 1819. In the following decades more and more of the Royal Collection, which had been built up over the centuries by the Habsburg and Bourbon monarchs, was transferred to the Prado. Bequests and donations swelled the collection. When Isabel II was dethroned in 1868 the collection was nationalized. The early collections were dominated by Italian High ▷Renaissance art, including works by ▷Raphael and ▷Titian, as well as Flemish art by ▷van der Weyden, ▷Bosch, ▷Rubens and ▷van Dyck. There was also a large number of Spanish primitives and today the Prado is known for its stunning collections of Spanish art from ▷El Greco, ▷Goya, ▷Ribera, ▷Velázquez and ▷Zurbarán to ▷Miró, ▷Gris, ▷Sorolla and ▷Picasso.

Prairie School

Name given to a group of US architects and referring specifically to the domestic architecture they produced between c1900 and c1920, mostly in Chicago and its suburbs. The seminal house in this style is generally taken to be ▷Frank Lloyd Wright's Winslow House of 1893–4 and most of the architects in this 'school' worked either with Wright himself or for the employer of Wright's early years, ▷Louis Sullivan. In addition, other architects throughout the country were influenced through the dissemination of architectural pattern books. Prairie Houses are characterized by low-pitched, usually hipped, roofs with widely overhanging eaves. They are generally open-planned, of two stories with single storey wings and/or porches. The ornamental detailing of eaves, ▷cornices and façades are generally calculated to emphasize horizontality. Among the leading architects included in the school are George W. Maher, Walter Burley Griffin, William G. Purcell and George G. Elmslie.
Bib.: Viser, K., *Frank Lloyd Wright and the Prairie School in Wisconsin*, Madison, 1992

Praxiteles (fl mid-4th century BC)

Greek sculptor, possibly the son of the Athenian sculptor, Cephisodotus. He worked in various materials, but was considered by ancient writers to be at his best in ▷marble. He appears to have created a new fashion for the medium which had been eclipsed by bronze throughout the ▷Classical period. His figures are characterized by a relaxed grace and an intimacy of feeling. Contemporaries, however, praised him above all for his skill at the representation of emotion. Slightly earlier than ▷Lysippus, who was soon to be experimenting with multi-viewpoints, Praxiteles still designed his figures to be seen from a single viewpoint.

To him is due what may be the only surviving statue by a major Greek sculptor of antiquity, the marble *Hermes with the Infant Dionysus* of c343 BC. Now at the Olympia Museum, it was found in 1877 at the Heraeum at Olympia, where Pausanius had described it. The subtlety of the carving, which is greatly superior to the bland workmanship usually found in Roman copies, has led some authorities to accept it as Praxiteles' original, although M. Robertson, for example, deems it to be a late ▷Hellenistic work by a top-rate copyist, made to replace the original when that was removed to Rome.

A Roman marble statue now in the Louvre, representing a sinuous, rather effeminate ▷Apollo leaning against a tree and looking at a lizard, conforms to the detailed description by ▷Pliny of Praxiteles' bronze *Apollo Sauroctonus* (or 'Lizard-slayer'). Another Roman statue in a similar pose, considered by some to be a copy of a work by Praxiteles, is the piece known variously as the *Leaning Satyr, Marble Faun* or *Faun of Praxiteles* (Rome, Capitoline Museum). His most famous work in antiquity was the ▷*Aphrodite of Cnidus*.
Bib.: Haskell, F. and Penny, N., *Taste and the Antique*, New Haven and London, 1981; Robertson, M., *A History of Greek Art*, 2 vols., Cambridge, 1975; Smith, R.R.R., *Hellenistic Sculpture*, London, 1991

PRB

▷Pre-Raphaelite Brotherhood

Pre-Columbian art

A catch-all term that refers to the native arts of the Americas – North, South, and Meso, as well as the West Indies – before the arrival of Columbus in 1492 and subsequent European invasion. Whilst the North American tribes, the Eskimo and the West Indian produced 'primitive' art and cult objects of wood, shell and bone, the most advanced civilizations were in the Andes region of the western side of South America, and in central Meso-America.

Though the Inca Empire dominated the Andes region for the last 200 years of the Pre-Columbian period, it was the culmination of a long cultural and artistic development, and pottery and textile designs have been found dating back as far as 3000 to 2500 BC. The major stage of progress, however, was c1000 BC to 800 AD, and the civilization of this period is represented in stone work, ▷ceramics and metalwork in bronze and gold, as iron was unknown until the arrival of the Spanish. An important archaeological site is Chavin de Huantar in the northern Andean highlands, whose art is characterized by stone carving and a stylized feline motif. Andean decorated pottery is one of the most abundant artworks in museums, along with highly decorative cotton and woollen textiles. The Incas' greatest surviving achievement is their architecture which used massive blocks of basalt and sandstone finely carved to interlock without mortar.

The Incas were remarkable and unprecedented town planners, and their settlements may still be seen at Sacsahuaman, Machu Picchu, and Cuzco.

The central American civilizations of the Aztec in Mexico, and the Maya in Yucatan, southern Mexico and Guatemala produced some of the most famous images of Pre-Columbian art. Their art was closely associated with religious rituals and beliefs, some of which focused on human sacrifice. This preoccupation is found in both graphic and plastic arts – designs and carvings on limestone, ▷jade, bone, wood, clay and gold, and stone sculpture from religious sites representing human and mythical figures in high and low ▷relief. This art reached its greatest expression at Mayan religious sites such as Copan, Tikal and Yaxchilan. Mayan craftspeople also worked obsidian, flint, rock crystal and ▷alabaster, and used turquoise, jade, shell and coral in ▷mosaics that decorated wood, bone and stone to create masks, shields and sacrificial and cultic objects. The study of Mayan, Aztec and Inca history is much hampered by these civilizations' lack of writing systems, though the Aztecs made painted codices which were a systematized method of history and myth using pictures.

The arts and crafts of the indigenous Americans always had an interest as 'curiosities' in Europe. ▷Dürer wrote of a display of Pre-Columbian items in 1520 that 'I have seen therein wonders of art and have marvelled at the subtle ingenia of people of far off lands.' But it was not until the 20th century that their aesthetic importance was really recognized in its own right; their masks made a particular influence on the ▷Surrealists and ▷Henry Moore adapted Aztec designs in his statuary.

Precisionism

An American art movement which began in c1915 and continued throughout the 1920s. It was similar to European ▷Purism in its concentration on the ▷machine aesthetic and a simplified ▷Cubist form, but Precisionism also drew its subject matter from urban industrial scenes. Paintings produced by artists such as ▷Demuth, ▷O'Keeffe and ▷Sheeler were geometric, clinical and non-narrative. The human and emotional elements were minimized. In the 1930s, Precisionism became more abstract and eventually lost its importance.

Preda (Predis), Ambrogio da (c1455–c1517) and Evangelista da (d after 1490)

Italian family of painters. They were from Milan and worked as court painters for the ▷Sforzas in 1482. They collaborated with ▷Leonardo da Vinci on the ▷altarpiece *The Virgin of the Rocks* (1483, London, National Gallery), for which they may have painted the wings. They also painted portraits.

predella

(Italian, 'altar step'.) Running along the base of an ▷altarpiece beneath the main panels, a long narrow panel often painted with narrative episodes relating to the devotional images above.

prefabrication

The manufacture of the component part of a building in a factory, for cheaper and speedier subsequent assembly on site.

Prendergast, Maurice (1859–1924)

American painter. He was from Newfoundland but came to Boston when he was two years old. He began as a card painter, but travel in England, France and Italy made him aware of European ▷modernist movements. In the 1890s he was in Paris, where he came into contact with works by ▷Whistler, ▷Manet and the ▷Nabis. He adopted a ▷Post-Impressionist style which he used on pleasant scenes of leisure life, similar to those of the ▷Impressionists. He was a member of ▷The Eight, but avoided the urban realism of other artists in the group. He exhibited in the ▷Armory Show. In 1909–10, he turned his attention to painting nudes.

Pre-Raphaelite Brotherhood (PRB)

Group of like-minded young artists who officially formed the Pre-Raphaelite Brotherhood in 1848. There were seven founder members, a number chosen for its symbolic significance: ▷William Holman Hunt, ▷Dante Gabriel Rossetti, ▷John Everett Millais, ▷Thomas Woolner, ▷James Collinson, ▷Frederick Stephens and William Michael Rossetti. They chose their name because of the inspiration they found in 15th-century Italian art (specifically ▷Gozzoli's Campo Santo ▷fresco at Pisa, which they knew from ▷engravings). The Brotherhood grew out of the Cyclographic Society, a sketching club based on the principle of mutual criticism, but the PRB, as its members cryptically referred to themselves, was more structured and had certain declared aims including to have 'genuine ideas to express, to study nature attentively, so as to know how to express them, to sympathize with what is direct and serious and heartfelt in art and to produce thoroughly good pictures'. The Brotherhood opposed the Royal Academy, though the members had a shared interest in Italian ▷quattrocento art, which, though unfashionable, was becoming increasingly accessible through ▷Eastlake's purchases at the National Gallery, Prince Albert's patronage and the burgeoning ▷Gothic Revival. Furthermore, the PRB was deeply influenced by the work of ▷Ruskin and his 'identification of realism'. These philosophies led artists of the PRB to the belief that every detail in a work of art was full of meaning, and total realism was inseparable from total symbolism. Hunt was already experimenting with this idea in such works as *The*

Flight of Madeleine and Porphyro (1848, London, Guildhall) when Rossetti introduced himself. Rossetti had come to admire this style through the work of ▷Ford Madox Brown, who was always to be closely associated with the PRB but never a member.

Favourite early subjects depicted by the PRB include Shakespearean plays (e.g. *Claudio and Isabella*, by Hunt, 1850, London, Tate; *Ophelia*, by Millais, 1852, Tate), Romantic poetry (e.g. *Isabella*, by Millais, 1849, Liverpool, Walker Art Gallery), Christian struggles (e.g. *A Converted British Family Sheltering a Missionary from the Druids*, by Hunt, 1850, Oxford, Ashmolean) and general Biblical scenes (e.g. *Christ in the Carpenter's Shop*, also called *Christ in the House of His Parents* by Millais, 1849, London, Tate; *Ecce Ancilla Domini*, by Rossetti, 1849, Tate). The paintings were heavily criticized in many circles, famously by Dickens, but there was also a feeling that this type of subject matter and meticulous attention was more 'suitable' for art than some recent movements had been.

During the 1850s the PRB became a less cohesive unit and the members began to follow different paths. Hunt became almost obsessed with spiritual realism, travelling to the Holy Land to paint works like *The Scapegoat* (1854, Manchester) and *The Shadow of Death* (1870, Manchester). Millais moved away from religious imagery and concentrated on sentimental images like *Autumn Leaves* (1856, Manchester). Rossetti, who had been the instigator of the movement, suffered a number of personal tragedies and began to paint the images of ▷Elizabeth Siddal and Jane Morris, including ▷*Beata Beatrix* (1863, London, Tate) and *Proserpine* (1873–7, Birmingham) which now seem to epitomize the PRB. The Brotherhood collapsed, but a second wave of Pre-Raphaelitism sprang up in the late 1850s; inspired to similar work were ▷Burne-Jones and ▷Morris, along with a whole generation of other artists including ▷Brown, an obvious candidate for the PRB but never elected, ▷Waterhouse, ▷Hughes and ▷Brett.

Bib.: Hilton, T., *The Pre-Raphaelites*, London, 1970; Pointon, M., *The Pre-Raphaelites Re-viewed*, London, 1989; *The Pre-Raphaelites*, exh. cat., London, 1984; Staley, A., *Pre-Raphaelite Landscape*, London, 1973

presbytery

A section of a church which is intended only for the clergy.

Presentation in the Temple

(Luke 2: 22–39). This is the presentation of ▷Christ in the temple 40 days after his birth. According to Mosaic law, women had to remain in confinement for 40 days after giving birth, until they were considered cleansed. The rite of purification required the sacrifice in the temple of a lamb and a young pigeon or turtle dove (Leviticus 12). From the early days of its adoption by the Christian church this ceremony included a procession with candles (Candlemas). Mosaic law also required that the firstborn males of all living things be sacrificed to God in thanksgiving for sparing the Jews when God slayed all the firstborn males of the Egyptians (Exodus 13: 11–15), firstborn human males being redeemed by the payment to the temple of five shekels. In Luke's account the presentation of the firstborn male (Jesus) and the purification of the mother (▷Virgin Mary) took place simultaneously. A painting by the ▷Master of the Life of the Virgin (c1460–65, London, National Gallery) shows a female at the left holding the two pigeons, several people carrying candles, and Joseph searching in his purse for the five shekels. Luke also mentions a devout old man called Simeon who had been told by God that he would not die until he had seen the Saviour and, feeling compelled to enter the temple, saw Jesus and immediately recognized him as the Saviour. Taking their lead from the apocryphal Protevangelium of James, artists generally combined this figure with that of the high priest. Simeon not only recognizes Jesus' divinity, but also prophesies that 'a sword shall pierce' Mary's soul – taken to be an allusion to the Seven Sorrows of the Virgin (corroborated in the Master of the Life of the Virgin's painting by the scenes prefigurative of Christ's ▷Passion on the temple altarpiece in the background). A second figure who recognizes Jesus' divinity, the aged prophetess, Anna, is mentioned by Luke, but she appears more often in Italian paintings of the subject (e.g. ▷Ambrogio Lorenzetti, 1342, Florence, Uffizi).

Presentation of the Virgin

(Chronicled by Jacobus de Voragine, *The Golden Legend.*) The Bible gives very little information about the ▷Virgin Mary, but early Christians felt a need to know more about the human mother of God; apocryphal texts and legends supplied that need and proved very popular as sources for the numerous depictions of her life. In his account of *The Nativity of the Virgin Mary*, Jacobus de Voragine recounts how, at the age of three, the Virgin was brought to the temple by her aged parents, Joachim and ▷Anne. The temple had 15 steps and Mary, unassisted by her parents, climbed to the top as if she were an adult. After making their offerings in the temple, Mary's parents left her there in accordance with their vow to God that, were they to be blessed with offspring, the child would be dedicated to his service. This scene is common in cycles of the life of the Virgin, especially in churches dedicated to her name (▷Tintoretto, 1551, Madonna dell'Orto, Venice). Its importance lies in the fact that it illustrates how from the very beginning, Mary was God's chosen vessel.

Preti, Mattia ('Il Cavaliere Calabrese') (1613–99)

Italian painter. He was born in Calabria and worked in both oil and ▷fresco. Preti was in Rome by 1630 and there saw and absorbed the influence of the

▷Caravaggisti, most evident in his early oil paintings of card players and musicians. ▷Sacchi was also an important early influence, as can be seen in Preti's earliest datable work, *The Charity of S. Carlo Borromeo* (fresco, 1642–4, Rome, San Carlo ai Catinari). In 1642 he became a Knight of the Order of Jerusalem. Throughout the 1640s he absorbed the influence of ▷Lanfranco, ▷Domenichino and ▷Guercino. These new influences are manifested in Preti's frescos of the *Stories of S. Andrea* (1650–51, Rome, S. Andrea della Vale). A trip to Venice has also been mooted in the light of Preti's subtle sense of colour, reminiscent of ▷Titian and ▷Veronese. By 1656 Preti was in Naples (many of whose principal painters had been wiped out in the plague). Here he enjoyed immense (and virtually unrivalled) success in a dramatic style further modified by experience of ▷Caravaggio's and ▷Ribera's Neapolitan paintings, the important areas of the picture now being powerfully and tellingly illuminated (e.g. *The Crucifixion of St. Peter*, 1650s, Birmingham, Barber Institute). In the early 1660s he was called to Malta to decorate St. John's in Valletta, becoming in 1661 a Knight of Malta and remaining on the island for the rest of his life. Many of his paintings are still to be seen in Malta.
Bib.: Cannata, F., *Il Cavaliere Calabrese, Mattia Preti*, Catanzaro, 1978; Strinati, C.M., *Mattia Preti, disegno e colore*, Catanzaro, 1991

Previati, Gaetano (1852–1920)

Italian painter. He was one of the early practitioners of ▷divisionism in Italy, and he wrote treatises on scientific theories of colours. These were *La tecnica della pittura* (*The Technique of Painting*, 1905), *I principii scientifici del divisionismo* (*The Scientific Principles of Divisionism*, 1960) and *Della Pittura* (*On Painting*, 1913). His interest in colour theories paved the way for ▷Futurist experiments with form.

Pride

(From the Latin, '*Superbia*'.) One of the Seven Deadly Sins, depicted as either a male or a female. In medieval cycles, Pride is usually shown as a rider thrown from his horse ('pride coming before a fall'), this image being the source for representations of ▷Paul being thrown down from his (non-scriptural) horse on the road to Damascus in order that he might be converted (Acts 9: 3–4) – the biblical equivalent of the defeat of Pride by Humility in the battle of the ▷Virtues and Vices. Female personifications may be accompanied by a lion (king of animals), an eagle (king of birds), a peacock and a mirror (symbols of vanity). ▷Bosch, in the *Superbia* scene from his *Tabletop of the Seven Deadly Sins* (Madrid, Prado) shows a woman admiring her new hat and trying out her jewellery in front of a mirror which is held (invisible to her) by a similarly bonneted demon. ▷Cesare Ripa, in the *Iconologia*,

shows a bejewelled woman looking into a mirror with a peacock standing nearby. In the sky is the quintessential symbol of Pride, the expulsion of the rebel angels from Heaven by St. ▷Michael.

primary colours

The three primary colours are red, blue and yellow, and, in theory, these can be mixed together to make all other colours (although to do so black and white are in fact also necessary).
▷secondary colours; tertiary colours

primary structures

A term coined in 1966 to signify sculpture composed of prefabricated geometric forms. It refers specifically to ▷Minimal art experiments. The artists who created primary structures included ▷Carl Andre, ▷Robert Morris and ▷Sol LeWitt.

Primaticcio, Francesco (1504/5–70)

Italian painter, sculptor, architect and decorator. Born in Bologna, his talent for large-scale, multi-media decoration was developed whilst working as assistant to ▷Giulio Romano on the decoration of the Palazzo del Tè, Mantua (1525/6–1532). In 1532 he was called to ▷Fontainebleau in France to work for Francis I with ▷Rosso (who had been there since 1530). The sophisticated decorations in paint and high-▷relief ▷stucco, with characteristically elongated figures, deriving stylistically from ▷Parmigianino and perfected by Primaticcio and Rosso at Fontainebleau, laid the foundation of the French style of ▷Mannerism known as the First School of Fontainebleau. In 1540 Francis I sent Primaticcio to Rome to buy antiques and have casts made of those more celebrated items not for sale (i.e. the ▷*Laocoön*). By the time of his return in 1542, Rosso had died and Primaticcio took over (he made one more trip, in 1546, on which occasion he had a cast made for Francis I of ▷Michelangelo's *Pietà* in St. Peter's, Rome).

Much of Primaticcio's work at Fontainebleau has been lost, including the highly acclaimed decorations of the Galerie d'Ulysse upon which he worked with ▷Niccolò dell' Abbate (who arrived in 1552). Some significant work remains, however, in the Chambre de la Reine (mantelpiece, c1533–7) and the Chambre de la Duchesse d'Étampes (c1541–5). It is not certain whether it was Primaticcio or Rosso who perfected the Fontainebleau style, although ▷Vasari, writing just a few years after, gives primacy to Primaticcio: 'The year before, Rosso had been sent to serve the King, and had done many things ... However, it is said that Francesco did the first stucco and frescos of any account in France.' Towards the end of his career Primaticcio turned increasingly to architecture, e.g. the Tomb of Henry II, St Denis (begun 1561; sculpture by ▷Pilon)

and the Aile de la Belle Cheminée, Fontainebleau (1568).

Primavera

Painting by ▷Sandro Botticelli, oil on panel, now in the Uffizi Gallery, Florence. Dated between 1472 and 1486, it probably originally formed part of a series or cycle with Botticelli's *Pallas and the Centaur* and the ▷*Birth of Venus* painted for Lorenzo de' Medici. The painting has various interpretations and has been the subject of enquiry of a number of leading art historians, including ▷Gombrich, ▷Warburg and Edgar Wind. However, it is most probably an ▷allegorical painting that embodies the central elements of 15th-century Florentine ▷Neoplatonist philosophy. Lorenzo had been educated by Marsilio Ficino who urged him to act only from spiritual motives, guided by his horoscope figures of ▷Venus and ▷Mercury. The figures of Venus, the ▷Three Graces and Mercury are thus directing the observer from an active to an elevated, contemplative life. The figures of Zephyr the wind transforming the ▷nymph Chloris into the goddess Flora who brings flowers and spring are taken from Ovid and represent the transformation of Love into Beauty. This conjunction of love and beauty is further represented by the presence of a blind ▷Cupid, who hovers above the scene.

Bib.: Baldini, U., *Primavera: The Restoration of Botticelli's Masterpiece*, New York, 1986

priming

In oil painting, the first coat of paint applied to a canvas after it has been ▷sized. It is usually of white lead or is slightly tinted so as to provide a neutral ground for the final painting.

primitivism

The awareness of human societies other than one's own has, throughout history, tended to be characterized in opposition to domestic familiarities out of which notions of self-esteem are nurtured. Most often this 'otherness' in Western culture has been construed in detrimental relation to the known social formation, that is, as 'primitive'. The underlying belief for this arguably erroneous view is that Western civilization has progressed beyond the 'primitive' stage exhibited by some non-European societies. However, this supremacist philosophy has not prevented European art being challenged and sometimes invigorated by the concept of either the distant past or the geographically distant.

The art of 'primitive' cultures has had important consequences for many Western art movements, for example ▷Oceanic art on the ▷Post-Impressionist ▷Gauguin, ▷African tribal sculpture on ▷Picasso's ▷*Les Demoiselles d'Avignon* (1906–7), and the illustrations of primitive art in the ▷Blaue Reiter Almanac. More recently, critics have become wary of employing

'primitive' as a critical concept implying 'inferior' or 'underdeveloped', as we now recognize the artistic production of these cultures to be a highly developed expression of societies that are different but not necessarily inferior to our own.

The term primitive may also be applied to artists who work in an unsophisticated ▷naive manner outside the prevailing orthodoxy or traditional norms of, for instance, ▷perspective, narrative structure or similar pictorial conventions. Artists celebrated for their 'primitivism' include ▷Henri Rousseau, the German ▷Expressionists and folk artists such as ▷Grandma Moses.

A final and now discredited use of the term is its application to some forms of European art, for example the Italian painters of the period before the ▷Renaissance and Early Netherlandish painters such as the ▷van Eycks and ▷Rogier van der Weyden. This sense of primitive as 'precursor' possibly derives from the French '*primitif*', meaning 'early'.

Bib.: Hiller, S., *The Myth of Primitivism: Perspectives on Art*, London, 1991; Rhodes, C., *Primitivism and Modern Art*, London, 1994; Rykwert, J., *On Adam's House in Paradise: The Idea of the Primitive Hut in Architectural History*, New York, 1972

print

The transfer of a master design from wood or metal on to paper (usually), the number of impressions to be pulled depending on the resilience of the plate or block. There are three main types of process: (i) ▷relief, such as ▷wood engraving and ▷woodcut, where the design prints from the proud surfaces, the unwanted (i.e. those that will print white) areas having been cut away; (ii) ▷intaglio, such as ▷etching and ▷engraving, where ink is forced into the cut channels, which will print, whilst the surface of the plate is wiped clean in order to print white; and (iii) surface, such as ▷lithography, which is based on the antipathy of water to the grease in the ▷crayon used. Each method leaves tell-tale signs by which it may easily be identified (although photographic methods can sometimes be deceptive), and catalogues of the main printmakers' work exist detailing changes to the plates (whether by the artist or after his death), each of which constitutes a new 'state' distinguishable from others, and sometimes also copies and imitations.

Prints are an essential tool for the art historian not simply because they are themselves art, but because they reflect the diffusion of styles, forms and ideas from country to country and century to century. As evidence, they are much more abundant than paintings or drawings: for example, the Bibliothèque Nationale in Paris can produce well over 30,000 prints dealing exclusively with the ▷French Revolution.

Bib.: Ivins, W.M., *Prints and Visual Communication*, London, 1953; Lambert, S., *The Image Multiplied*, London, 1987

Prix de Rome

(French, 'Rome Prize'.) Scholarship awarded annually by the ▷Académie in Paris to the winning competitors among the young painting, sculpture and architecture students, comprising several years' grant to attend its branch in Rome. The Prix de Rome was founded simultaneously with the Rome Academy in 1666. From the 17th to the 19th centuries the academic tradition accorded a central importance to the Roman antique and the Roman High ▷Renaissance. Thus, a period at the Académie's finishing school in Rome, and the opportunity it afforded to study the canonical works of European art, was considered the indispensable stepping-stone to the establishment of a successful artistic career and the obtaining of governmental commissions. Housed originally in the Palazzo Mancini, the Rome branch of the Paris Académie moved in 1803 to the Villa Medici, where it remains to this day. From France, the Prix de Rome spread to other countries, including Britain and Spain, and although Rome itself no longer enjoys its earlier prestige, the Prix de Rome continue to operate.

problem picture

A type of narrative painting very popular in late Victorian Britain in which the event depicted is left deliberately open-ended in order to encourage an imaginative interaction with the viewer. Two of the most celebrated exponents were William Frederick Yeames (1835–1918) and John Collier (1850–1934). Yeames's *And When Did You Last See Your Father?* (1878, Liverpool, Walker Art Gallery) is a prime example. The narrative is set in the English Civil War, though the incident represented is necessarily invented. Parliamentarian officers are questioning a young boy. From the title we know that his father, evidently a Royalist, has evaded capture; the setting, with anxious family and retainers looking on, is perhaps the family house. The spectator is encouraged to create his or her own sequence of events leading up to and following the interrogation, chief among which are presumably: where is the father and will the boy give him away?

Procaccini, Giulio Cesare (1574–1625)

Italian painter and sculptor. He was born in Bologna, but he trained and was mainly active in Milan, where he moved with his family in c1590. Until 1600 he worked mostly as a sculptor, his chief remaining sculptural work being the series of ▷reliefs for the façade of SS Nazaro e Celso (1597–1601). After the turn of the century he devoted himself almost entirely to painting, becoming one of the leading painters in Milan. In 1613–16, however, he was in Modena, where he saw and was influenced by the work of ▷Correggio and ▷Parmigianino (e.g. *Mary Magdalene*, c1616, Milan, Brera). In 1618 he was in Genoa, where he was influenced by ▷Rubens (e.g. *Deposition*, Milan, Fassati Collection). He also contributed to the

cycle of 40 paintings of the life of St. Charles Borromeo in Milan Cathedral. With the other two painters commissioned for this series, ▷Cerano and Morazzone (1573–1626), Procaccini also painted a remarkable, single, 'three-master' canvas, *The Martyrdom of SS Rufina and Seconda* (c1620, Milan, Brera). Procaccini's father, Ercole (1515–95), was a painter working in an extremely academic, late ▷Mannerist manner. Procaccini's brothers, Camillo (c1560–1629) and Carlo Antonio (1555–1605), were also painters.

Bib.: Berra, G., *L'attività scultorea dei Giulio Cesare Procaccini*, Milan, 1991; Brigstocke, H., 'Giulio Cesare Procaccini', *Revue de l'Art*, 85 (1989), pp. 45–60; Rosci, M., *Giulio Cesare Procaccini*, Sincino, 1993

process art

A term referring to art of the 1960s and 1970s in which the process of creation is more important than the work itself, and the work can thus be utterly ephemeral. Artists such as ▷Robert Morris and Richard Serra (b 1939) would use dying or fading items like grass and coal as part of their art as a means of drawing attention to the significance of the process of art making.

Prodigal Son

(Luke 15: 11–32.) One of ▷Christ's parables, frequently portrayed in art since the 13th century. It is popular for its vivid illustration of the virtues of repentance and forgiveness. The younger son of a wealthy man takes his share of the inheritance and squanders it in a far-off city. He is reduced to working on another man's land, feeding his pigs, but the pay is so poor he cannot feed himself and decides to return home to work as a servant for his father, who he knows pays his servants fairly. His father welcomes him with open arms and restores him to his position. The older, industrious brother thinks his younger brother does not deserve to receive such a welcome, but the father points out that he, the elder son, is always with him and will always have all that is his, whilst the son which was lost has repented and returned. This parable was particularly popular in the Netherlands in the 17th century: the scenes of riotous living in the brothels and taverns gave great scope for entertaining pictures that also paid lip service to a moral message, and the scene of the return was poignantly treated by ▷Rembrandt (e.g. St. Petersburg, Hermitage), whilst the scene where the prodigal son is working with the pigs allowed ▷Rubens to exercise his consummate skill at painting naturalistic detail (e.g. Antwerp, Musée Royal des Beaux-Arts).

Productivism

A movement founded by a group of ▷Constructivist artists in post-Revolutionary Russia who argued that artistic skills should have a practical, socially useful role as an element of industrial production. The term arose

in hostile response to ▷Naum Gabo's belief that Constructivism should be devoted to the highly abstract exploration of space and rhythm. The Productivists, headed by Alexei Gan, ▷Alexander Rodchenko and ▷Varvara Stepanova plunged instead into the ▷applied arts. Productivism became the prevailing aesthetic, and artists including ▷Malevich, ▷El Lissitzky and ▷Popova designed furniture, textiles and clothing, ceramics, typography, propaganda and advertising, along with sets and costumes for the theatre.

profil perdu

(French, 'lost profile'.) Term used to describe a head which is turned away from the viewer such that the profile is obscured by the outline of the cheek. When used, by extension, of an object, it is when the most distinctive profile is turned away from the viewer.

Proletcult (Proletarian Culture)

A popular cultural movement conceived by the Bolshevik Alexander Bogdanov in 1909 and brought into existence after the Russian Revolution. Pledged to eradicating bourgeois ▷culture and developing new proletarian art forms, it opened studios, theatres, libraries and exhibitions across the Soviet Union. At its height Proletcult drew over 800,000 members and enjoyed a unique autonomy within the centralized government; but this very independence was considered a liability and the organization was allowed to disintegrate after the early 1920s.

pronaos

In Classical architecture, the vestibule or porch leading to the ▷naos or ▷cella (the principal chamber of a temple) enclosed, more usually, by walls at the sides, but always with a row of columns in front.

proof

A trial impression of an ▷etching or ▷engraving, pulled from the ▷plate or block so that the artist can examine the work to see whether the composition needs to be revised in any way before committing himself to the full print run. Alterations may then be made by hand to the trial impression (which becomes a 'touched proof'), before any changes are made to the plate itself. Where the words 'artist's proof' are found on a printed sheet, alongside the artist's signature, this indicates a proof taken by the artist for his own reference and outside the numbering sequence of the commercial run.

proportion

In, for example, any picture, sculpture or building, the ratio between the constituent parts one to another, or any of the parts to the whole. That particular ratios might have a certain importance goes back at least to the discovery by Pythagorean philosophers (6th century BC) that the principal musical intervals, an octave, a fifth and a fourth, are produced on a single resonant string by stopping the string at the principal mathematical divisions, respectively half-way, two-thirds and three-quarters of the way along. Thus a concordance was assumed between numbers and beauty with harmony being producable by the observance of correct proportion. Throughout the history of art there have been attempts to establish a canon of proportions based on such mathematical relationships. Vitruvius codified the correct proportions for the ▷orders of architecture in his *De architettura* (early 1st century BC) and ▷Palladio expounded his own in his *Quattro libri dell'architettura* (*Four Books of Architecture*, 1570). ▷Leonardo da Vinci and ▷Dürer also attempted to create a canon of proportions for the ideal representation of a man, based on Vitruvius.

▷Golden Section

propylaeum (pl. propylaea)

Greek term for a monumental gateway to a sacred enclosure, or temenos, i.e. temple precinct. The most famous example is the gateway guarding the single, western, access route to the mount of the ▷Acropolis at Athens. Two ▷Doric ▷porticoes flank a central wall section pierced with five doorways. As the gateway is more than merely a simple, single entrance it is always given the plural designation, propylaea. It was constructed in 437–32 BC by Mnesicles.

prothesis

(Greek, 'before the place'.) A section of a ▷Byzantine church located to the north of the ▷sanctuary. The Sacraments were kept here.

Proud'hon, Pierre-Paul (1758–1823)

French painter and designer. He was born at Cluny. In 1774 he enrolled at the Dijon Academy and arrived in Paris in 1780 where he worked for a firm of ▷engravers for a time. In 1784 he went to Italy on a Rome Prize awarded by the States of Burgundy, became a friend and admirer of ▷Canova and, as his later work reveals, was influenced by the paintings of ▷Correggio, ▷Leonardo and ▷Raphael, although he appears to have done hardly any work in Italy. He returned to Paris in 1787 and at first earned only a small living executing drawings for engravers and occasionally painting portraits for provincial patrons. Remarkably, he eventually achieved success by pursuing a style which provided a ▷Romantic alternative to the prevailing ▷classicism practised by ▷David and his many followers, based on the kind of softly-modelled ▷sfumato technique he admired so much in ▷Correggio. David, unsurprisingly, disapproved of him and referred to him as the '▷Boucher of his time'. The Empresses Marie-Louise and Josephine, however, liked his style and employed him as drawing master and Court Painter. One of his most charming paintings is a portrait of Josephine (1805, Paris, Louvre). He also

executed several large official commissions, including *Crime Pursued by Justice and Divine Vengeance* (1808) for the principal chamber of the Napoleonic criminal court (now in the Louvre) and for which he was awarded the Légion d'honneur. For the bridal suite of the Empress Marie-Louise he designed all the furniture and interior decorations in a ▷Greek Revival idiom which proved to be extremely influential. Unhappily married for most of his adult life, he appears to have died from grief following the suicide in 1821 of his pupil and, since 1803, lover, Constance Mayer. Many of his paintings have deteriorated badly over the years owing to his use of ▷bitumen.

Bib.: Magnien, E., *La Vie de Pierre-Paul Prud'hon*, Paris, 1985

Prout, Samuel (1783–1852)

English watercolour artist. He was born in Plymouth and worked for local patrons until 1802 when he moved to London. There he met ▷Barry, ▷Northcote and ▷West. He made regular sketching tours (e.g. *Tenby Castle*, 1814, London, Victoria and Albert Museum) and established himself as a teacher and illustrator for ▷Ackermann's. He travelled abroad and produced ▷watercolours of Normandy streets and buildings (exhibited at the Old Watercolour Society in 1820) which helped to popularize a ▷Romantic image of Europe (e.g. *Regensburg Castle*, 1825, Victoria and Albert Museum). He visited Antwerp with ▷David Roberts in 1845 and illustrated several volumes of ▷picturesque landscape including Jennings's *Landscape Annuals* (from 1830) and Britton's *Beauties of England and Wales* (1801–15). He was much praised by ▷Ruskin.

Bib.: Lockett, R., *Samuel Prout*, London, 1985; *Samuel Prout and David Cox*, exh. cat., Cambridge, 1983

provenance

The history of the ownership of a work of art from the time of its making up to its present. A provenance able to keep track of an art work in this way is the surest guarantee of a work's authenticity (▷attribution). Such a pedigree is used by both art historians and ▷connoisseurs as a secure basis on which to build.

Bib.: Friedländer, M.J., *On Art and Connoisseurship*, London, 1944

Provost, Jan (c 1465–1529)

Flemish painter. He was Master of the Antwerp Guild in 1493 and worked in Bruges from 1494. While in Antwerp, he was influenced by the styles of ▷Massys and ▷David, and he carried this influence with him to Bruges where it appeared in his religious works commissioned there.

Bib.: Friedländer, M., *Early Netherlandish Painting*, vol. 9: *Joos van Cleeve, Jan Provost, Joachim Patenier*, Leyden, 1972–3

Prudence (Wisdom)

One of the four Cardinal ▷Virtues, along with ▷Fortitude, ▷Justice, and ▷Temperance. Most commonly represented as a woman with a mirror and a snake (e.g. ▷Piero del Pollaiuolo, 1469–70, Florence, Uffizi). The mirror motif originated in the late Middle Ages and signifies the wisdom of being able to see oneself as one really is. The snake derives from the Gospel of Matthew (10: 16): 'Be ye wise as serpents' – alternatively, the 'serpent' may be interpreted as a dragon. The other attributes of Prudence may be: a pair of compasses to show her measured judgement; a stag for its shrewd ability to evade the hunter; and a book. According to ▷Cesare Ripa's *Iconologia*, Prudence should be shown with two faces – the one facing forward a woman's, the one facing back, a bearded man – to see in both directions (past and future) at once in order that precedent and possible outcome may be considered before action is taken. Alternatively, Prudence may be portrayed as a triple-headed man. This image appears in the late Middle Ages and received its most famous treatment in ▷Titian's *Allegory of Prudence* (London, National Gallery). The three heads are those of an old, a mature, and a young man, below which are the heads of a ravenous wolf, a lion, and a fawning dog. An inscription reads: '*Ex praeterito/praesens prudenter agit/ni futura actione deturpet.*') ('From the experience of the past, the present acts prudently, lest it spoil future action.') The significance of the animal heads is to be found in the *Saturnalia* (5th century AD) by Macrobius. He describes an Egyptian statue of the god Serapis as being accompanied by just such a creature: the lion's head denotes the courage that present action necessitates; the wolf's head the past, the memory of which is devoured and carried away by time; and the fawning dog's head the future, because hope makes us look optimistically forward. Thus, the experience gained from past acts will give a mature understanding of the present situation to enable prudent actions that will build a positive future.

Pryde, James Ferrier (1866–1941)

English painter and designer. He was born in Edinburgh, the son of a headmaster, and studied at the Royal Scottish Academy and in Paris under ▷Bouguereau. He settled in London in 1890 and began working with his brother-in-law, ▷William Nicholson. Together they produced posters for the actor Henry Irving under the pseudonym '▷The Beggarstaffs' (e.g. *Girl on a Sofa*, 1895). During the 1890s he worked mainly in ▷ pastels. He also continued his interest in the theatre with a series of acting tours in Scotland. From 1909 he worked on his *Human Comedy* cycle, a series of semi-comic but revealing figures (e.g. *Doctor*, 1909, London, Tate Gallery). Increasingly he became interested in the depiction of architecture (e.g. *The Arch*, 1926, Manchester), concentrating on slums

and derelict buildings and creating an eerie, shadowy atmosphere. He also produced stage designs (e.g. *Othello*, 1930).

Bib.: *James Pryde*, exh. cat., Edinburgh 1992

psalter

A copy of the Psalms, either in manuscript or printed book form. The most common type was one arranged for liturgical or private devotional use (as opposed to merely transcribing the basic Biblical text). The psalter enjoyed its greatest popularity from the 11th to the 14th centuries until superseded in the 15th century by the ▷Book of Hours. The best medieval examples were often lavishly illustrated and are among the masterpieces of European art, e.g. the *Luttrel Psalter*, *Queen Mary's Psalter*.

psychoanalysis

Psychoanalysis was developed by ▷Sigmund Freud in Vienna in the late 19th century in response to patients displaying obsessional, hysterical or phobic behaviour. Freud believed that humans are forced to 'sublimate' their natural 'pleasure principle' in order to labour and produce, and that the repression of this desire results in neurosis. Unaware of such sublimation, he argued, we relegate these desires to the subconscious. The aim of psychoanalysis was to uncover the hidden causes of neurosis. Freud was particularly important in developing theories of the development of child sexuality and through the Oedipus Complex he defined the child's sexual competition with its parents. His belief that the unconscious could be accessed through the symbolism of dreams influenced the ▷Surrealists and the paintings of ▷Dali. After the Second World War, these theories were used or refuted by ▷Lacan, ▷Kristeva, ▷Cixous and others as a way of explaining the creative processes in art and writing.

Public Works of Art Project

▷Federal Art Project

Pucelle, Je(h)an (c 1300–c 1355)

French miniaturist. He was in Paris in the 1320s, where he was involved with the production of a number of important manuscripts. He helped decorate the Belleville Breviary (Paris, Bibliothèque Nationale) and the Hours of Jeanne d'Évreux (New York, Metropolitan Museum). These revealed an Italian influence, but they were also naturalistic in their use of space and humorous scenes of daily life as part of the ▷marginalia.

Bib.: Morand, K., *Jean Pucelle*, Oxford, 1962

Puget, Pierre (1620–94)

French sculptor and architect. He was from Marseilles, but spent time in Italy in 1640–3, where he worked with ▷Cortona on the ▷Pitti Palace, as well as working in Genoa. His style was a mixture of Roman

▷Baroque and French ▷classicism, but he never worked in the rigid classical style of ▷Lebrun. His work was consequently somewhat outside the mainstream of contemporary court art, although he did accept an important commission to sculpt the *Milo of Crotona* for Versailles (1671–82, Paris, Louvre). He worked in Toulon from 1656.

Bib.: Bresc, G., *Pierre Puget (1620–1694), peintre, sculpteur, architecte*, Lyons, 1994

Pugin, Augustus Welby Northmore (1812–52)

English architect, designer and writer, of French birth. He was the son of French artist Auguste Charles (1762–1832) and travelled to Paris regularly as a youth. He began his career as a scene painter at Drury Lane theatre and moved on to furniture design, publishing books of his work in 1833–6. In 1835 he converted to Catholicism and the following year he published his influential *Contrasts*, which set out a vision of an ideal medieval society, with ▷Gothic architecture and traditional craftsmanship and religious endeavour set against the mechanization and modernity of the 19th century. The work became a major propagandist piece for the ▷Gothic Revivalists and formed the basis of Pugin's own designs; it also made him an overnight success and led to ten church commissions in 1837–8. Initially, he promoted a tall slender Gothic style (e.g. St. Mary's, Derby, 1839) but he increasingly believed that this was 'un-English' and turned to a more squat style (e.g. Killarney Cathedral, 1842). His church interiors, like all of his design, were elaborate in their use of colour, glass and carving. His own domestic buildings were few: Scarisbrick Hall, Ormskirk (1837) and St. Augustine's, Ramsgate (1846), a flint and stone church with an adjoining house. Most importantly he designed the interior of the Houses of Parliament on which he collaborated with ▷Charles Barry. He also wrote *True Principles of Pointed or Christian Architecture* (1841) and *Apology for the Revival of Christian Architecture in England* (1843), and it is his books for which he is best remembered. He shared many of ▷Ruskin's and ▷Morris's concerns about his own industrial age. By 1845, his popularity had decreased with a rise in the numbers of Gothicists.

Bib.: Belcher, M., *A.W.N. Pugin: A Critical Bibliography*, London, 1987; Gwynn, D.R., *Lord Shrewsbury, Pugin and the Gothic Revival*, London, 1946; Stanton, P.B., *Pugin*, New York, 1972; Trappes-Lomax, M., *Pugin, A Medieval Victorian*, London, 1932; Wedgwood, A., *Pugin and the Pugin Family*, London, 1985

pulpit

In a church, an elevated and enclosed platform of stone or wood, for the use of the priest, preacher, or reader, when addressing the congregation. Sometimes a pulpit is surmounted by an acoustic canopy, called a tester or sounding board. Although usually inside the church,

on occasion a pulpit may be erected against the outside wall (e.g. the celebrated exterior pulpit by ▷Michelozzo and ▷Donatello of marble, ▷mosaic and bronze, 1428–38, attached to the exterior of the Duomo at Prato). Pulpits first came into widespread use in the later Middle Ages, replacing the earlier ▷ambos.

Purbeck marble

Not in fact a ▷marble, but a hard, brown or green, fossiliferous limestone obtained from the quarries of the Isle of Purbeck on the Dorset coast. It is capable of taking a high polish and is notably darker when polished. It has been used from the middle of the 12th century, mainly for architectural details, especially ▷columns and compound ▷piers (e.g. the nave of Lincoln Cathedral), although in the 13th century it was especially popular for tombs and tomb effigies.

Purism

A 20th-century movement, led by the painter ▷Amédée Ozenfant and the architect ▷Le Corbusier, against the decorative tendencies of ▷Cubism and in favour of an impersonal, ordered ▷machine aesthetic. The movement's two protagonists jointly published *Après le Cubisme* (*After Cubism*; 1918) and *La Peinture Moderne* (*Modern Painting*, 1925). The philosophy of the movement has had greater influence on design than on the fine arts.
Bib.: Green, C., 'Purism', in *Concepts of Modern Art*, ed. T. Richardson and N. Stangos, revised edn. London, 1981

putto (pl. putti)

(Italian, 'little boy'.) A little boy usually, but not invariably, winged, appearing both in Classical pagan and Christian art. First developed from Classical figures of ▷Cupid or Eros, the *putto* form was appropriated in 16th-century Italian art for use as cherubim.

Puvis de Chavannes, Pierre (1824–98)

French painter. He was born into a family of Lyons lawyers. He studied under ▷Delaroche, ▷Couture (1849) and Henri Scheffer in Italy (1846–8) but was most influenced by ▷Chassériau. After initial ▷Salon success in 1850, he had difficulty getting his work accepted, and was perhaps best known as a muralist, working on decorations for the Hôtel de Ville, Paris (1891–4) and the Panthéon (e.g. *St. Genevieve Watching over the Sleeping Town*, 1898). He painted a number of patriotic works during the Franco–Prussian War (e.g. *Le Ballon*, 1870, New York). In 1890 he co-established the Société Nationale des Beaux-Arts with ▷Rodin and became its president the following year. He specialized in pale, fresco-like colour, and simple idealized forms, with much of his work having symbolic and religious overtones (e.g. *Poor Fisherman*, 1881, Paris; *Shepherd's Song*, 1891, New York). His work was much admired by ▷Symbolists like ▷Sérusier.
Bib.: *Puvis de Chavannes*, exh. cat., Amsterdam, 1994; Wattenmaker, R.J., *Puvis de Chavannes and the Modern Tradition*, London, 1975

pylon

In ancient Egyptian architecture, a monumental gateway to a temple, consisting of a pair of truncated

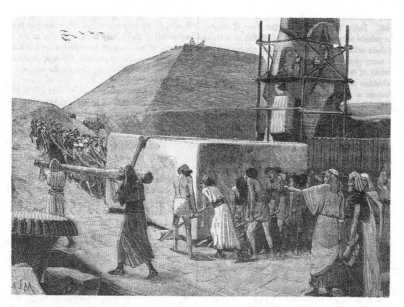

Construction of a Pyramid

pyramidal towers, rectangular in plan, flanking a lower central structure containing the entrance portal.

Pynacker (Pijnacker), Adam (1622–73)

Dutch landscape painter. He was from Delft. He travelled to Italy, staying for three years, and was back in Delft by 1649. In about 1658 he moved from Delft to Amsterdam, where he remained for the rest of his life. His landscapes are much influenced by ▷Jan Both and ▷Jan Asselyn, but have a characteristically silvery tonality. In London's Dulwich Picture Gallery can be seen one of his finest landscapes, *Landscape with Sportsmen and Game*, remarkable for the bright blue foliage in the foreground, the result of mixing green from blue and a fugitive yellow. He also enjoyed great popularity producing decorative hangings for the patrician houses of Amsterdam, based on his impressions of similar schemes in Italy.

Bib.: Harwood, L.B., *A Golden Harvest: Paintings by Adam Pynacker*, Williamstown, 1994 and *Reflections on Italy: Adam Pynacker*, London, 1991

Pynas, Jan (1583/4–1631) and Jacob (c1585–?1650)

Dutch family of painters and etchers. They were brothers, and spent some time in Rome, where they saw the works of ▷Elsheimer and ▷Lastman. They painted and ▷etched small historical works. Jacob may have been a teacher of ▷Rembrandt.

pyramid

Most precisely, a massive ancient Egyptian funerary structure in stone or brick, square in plan with four triangular sides sloping towards a single apex. The earliest examples had stepped sides, the later completely smooth. The term, pyramid, has also been more loosely used to refer to the ▷ziggurats erected by the Sumerians: rectangular temples set upon the top of stepped bases, shaped like truncated pyramids. Similar structures are found in ▷Pre-Columbian Central America.

quadrangle

An architectural term for a rectangular space or court-yard completely enclosed by a building or buildings, most frequently used in connection with academic buildings.

quadratura

(Italian, 'squaring'.) Ceiling, ▷vault, or wall decorations consisting of painted illusionistic architectural schemes that appear to continue the real architectural elements of the room itself into the imaginary space, characteristically with extreme ▷foreshortening and virtuoso ▷perspective effects. Popular in late antique Roman art (e.g. at ▷Pompeii), ▷Mantegna is generally credited with its modern revival (e.g. Camera degli Sposi, 1474, Mantua, Palazzo Ducale), whereas its most virtuoso exponent was probably ▷Andrea Pozzo (e.g. *Allegory of the Missionary Work of the Jesuits*, 1691–4, S. Ignazio, Rome). Frequently, however, the decoration would be a collaborative effort, the principal artist employing a specialist *quadraturista* to draw the architecture, transferring it from squared-up paper (hence the name quadratura) to the final surface (e.g. ▷Guercino, *Aurora*, with architectural framework painted by ▷Agostino Tassi, 1621; Casino Ludovisi, Rome).

Bib.: Sjostrom, I., *Quadratura: Studies in Italian Ceiling Painting*, Stockholm, 1978

quadro riportato (pl. quadri riportati)

(Italian, 'transferred picture'.) A picture painted on a ceiling as if it were on a wall (i.e. 'transferred'). In *quadri riportati* there is no attempt to create the illusion that the viewer in the room below is looking up at a continuation of real space (c.f. ▷*quadratura*, ▷*sotto in sù*). Thus, the picture's horizon will be parallel to the picture plane. Prime examples of *quadri riportati* are ▷Michelangelo's ceiling for the ▷Sistine Chapel (1508–12) and ▷Raphael's ceiling for the Stanza della Segnatura (1508–11), both in the Vatican, and ▷Annibale Carracci's ceiling for the Galleria Farnese at the Palazzo Farnese in Rome (1597). *Quadro riportato* thereby became associated with classicism, as *quadratura* later became associated with ▷Baroque illusionism. Thus, ▷Anton Raffael Mengs' celebrated (in its time) *quadro riportato*, *Parnassus*, for Cardinal Albani's villa in Rome was seen by contemporaries as an outright rejection of Baroque illusionism and a foremost espousal of ▷Neoclassical doctrine.

Quarenghi, Giacomo (1744–1817)

Italian architect. He settled in Russia in 1779 and became Catherine the Great's favourite architect. Never celebrated for his originality, Quarenghi's achievements are memorable for his experiments in ▷Neoclassical architecture in Russia (e.g. The Academy of Sciences, St. Petersburg, 1783–7, and the Hermitage Theatre, St. Petersburg, 1782–5).

Quarrel of the Ancients and Moderns

A running dispute, active for most of the 17th and 18th centuries, on the relevance and relative worth of ▷antique and modern art. The difference revolved around the excessive reverence accorded to the ancients by those who held it as an article of faith that modern art might and should seek to match that of ▷antiquity, but could never surpass it, and the confidence of others in contemporary achievements that, as they reminded their adversaries, were unknown in antiquity. The quarrel (as between ▷Diderot and ▷Falconet, for example) may seem silly today, but it affected attitudes not merely to ▷Renaissance art and the ▷Classical tradition, but also to the teaching of art in the ▷academies. Some sought to strike a balance: 'Speak of the moderns without contempt', wrote Lord Chesterfield to his son in 1748, 'and of the ancients without idolatry: judge them all by their merits, but not by their age.'

Bib.: Buck, A., *Die 'Querelle des anciens et des modernes' im italienischen Selbstverstandnis der Renaissance und des Barocks*, Wiesbaden, 1973; Rosen, S., *The Ancients and the Moderns: Rethinking Modernity*, New Haven, 1989

quarto

A book or manuscript which has been made up of pages from leaves which have been folded four times.

Quarton (Charonton), Enguerrand (c1410–c1466)

French painter. He was born in the northern town of Laon but, from 1447 to 1461, worked in the south at Avignon. Two paintings are documented, the *Virgin of Mercy* (1452, Chantilly, Musée Condé) and, perhaps the most important French painting surviving from the 15th century, the large-scale ▷altarpiece, the *Coronation of the Virgin* (completed 1454; Villeneuve-les-Avignon, Musée de l'Hospice). The contract for the latter (dated 24 April 1453) survives and is of great interest in that it reveals not only the theological demands of the patron, the priest Jean de Montagnac,

but also a remarkable concession to the painter's ideas on the subject. The contract stipulates that there should not be any difference between the Father and Son of the ▷Trinity who are placing the crown upon the ▷Virgin's head, but that 'Our Lady' is to be painted 'as it will seem best to master Enguerrand'. The contract also specifies that the earthly realms at the bottom of the picture should consist of Rome with St. Peter's clearly showing and, on the other side of the sea, part of Jerusalem. At his own instigation, it seems, Quarton introduced the landscape of Provence, with the outline of Mont Sainte-Victoire and the cliffs of L'Estaque clearly visible. A certain stylistic affinity between these two documented works and the greatest anonymous French painting of the century, the *Villeneuve Pietà* (c1460, Paris, Louvre) has also been discerned by some scholars.

Bib.: Pichon, J. le, *Le Mystère du Couronement de la Vierge*, Paris, 1982; Sterling, C., *Enguerrand Quarton: Le Peintre de la Pietà d'Avignon*, Paris, 1983

quatrefoil
▷foil

quattrocento
Literally, 'four hundred', the Italian art term for the 15th century. It is used only to refer to Italian art and may be used as either an adjective, as in 'quattrocento art', or a noun, as in 'art of the quattrocento'.

Queen Anne Style
(i) Most correctly applied to the prevailing style of British domestic architecture from the reign of Queen Anne (1702–14), characterized by a plain simplicity and extensive use of red brick. It is, in fact, often used to describe any similar architecture from the accession of William and Mary in 1688 to about 1720.

(ii) Sometimes applied to the eclectic architectural style of the last quarter of the 19th century in Britain and the USA, pioneered by William Eden Nesfield and Richard Norman Shaw (and popularized internationally by the latter), in which features from the architecture of the reigns of William and Mary and Queen Anne are borrowed and freely mixed with 17th-century Dutch architectural features, such as shaped gables (e.g. Basil Champneys' Newnham College, Cambridge, begun 1875). The characteristics of the Queen Anne Revival style are asymmetry and irregularity for picturesque effect, and the use of red brick, tiled roofs generally with gable dormers, bay windows and sash windows.

Quellin (Quellinus), Artus I (Arnoldus) (1609–68) and Artus III (Arnold, Arnout) 1653–86)
Netherlandish family of sculptors. Artus I studied in Rome, where he absorbed a classical ▷Baroque style working with ▷Duquesnoy there. In c1640 he came to Antwerp, and he also worked in Amsterdam where

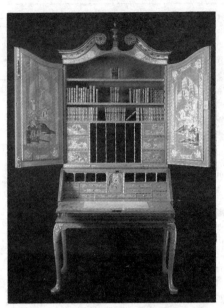

Queen Anne lacquer bureau cabinet, early 18th century

he did decorations for the town hall in 1650. His son Artus III was born in Antwerp. He went to London in c1678 where he worked with ▷Gibbons on Whitehall Palace and produced tomb sculpture.

Quercia, Jacopo della (c 1374–1438)
Italian sculptor. He was the leading Sienese sculpture of the early ▷quattrocento. He is first heard of as an unsuccessful competitor for the Florence Baptistry doors commission (won by ▷Ghiberti) in 1401. His earliest extant work is the (now incomplete) Tomb of Ilaria del Carreto (c1406, Lucca Cathedral). The beautiful marble effigy reclining on the ▷sarcophagus lid suggests a knowledge of the work of ▷Claus Sluter at the Burgundian court, although the garland-carrying winged ▷*putti* around the sarcophagus derive from antique Roman prototypes. His next major commission, in 1409, was for the public fountain for the main piazza at Siena, the Fonte Gaia; he eventually executed this work in 1414–19. (The marble ▷relief carvings are now housed in the loggia of the Palazzo Publico, the fountain itself bearing copies.) Between 1417 and 1431 Quercia was commissioned, with Ghiberti and two other Sienese sculptors, to execute bronze reliefs for the hexagonal font in the Baptistery of Siena. He was allocated a *Zacharias in the Temple* and a *Feast of Herod*, but owing to an innate tendency to dilatoriness (cf. the fountain, above), he never fulfilled the commission for the second and it was given to ▷Donatello. From 1425 Jacopo was also carrying out work for the portal of S. Petrona in Bologna. This included a series of ten Istrian stone reliefs of scenes

from Genesis in which the human figure predominates. The expressive force conveyed by these muscular, naked figures was to prove a major source of inspiration for ▷Michelangelo almost a hundred years later when evolving his ideas for his Creation scenes on the ▷Sistine Chapel ceiling.

Bib.: Beck, J., *Jacopo della Quercia* 2 vols., New York, 1991

RA

Abbreviation for Royal Academician. An elected member of the English ▷Royal Academy. The abbreviation is also used for the Royal Academy itself.

Rackham, Arthur (1867–1939)

English illustrator. He was born in Lambeth and after a brief trip to Australia in 1884, returned there. He studied at art evening school whilst working as a clerk 1885–93 and then took up a full-time post as an illustrator for the *Westminster Budget*. After several years of hack newspaper work, he developed skilful line drawings and a knowledge of print techniques. He is best known for his work on children's books which combined his use of heavy swirling line with delicate colour washes. His use of exotic costume, decorative foliage and flowers and intricate pattern is characteristic of ▷Art Nouveau design. His work was hugely popular in his own lifetime and from 1906 was regularly produced in both trade and deluxe editions. He illustrated a range of stories from *Aesop's Fables* (1912), to *A Midsummer Night's Dream* (1908) and *Peter Pan* (1906). He was a member of the Royal Watercolour Society (1908) and of the Art Workers' Guild (1909)
Bib.: Gettings, F., *Arthur Rackham*, London, 1975; Hamilton, J., *Arthur Rackham: A Life with Illustration*, London, 1990; Hudson, D., *Arthur Rackham: His Life and Work*, London, 1960

radiating chapel

One of a set of chapels arranged radially around an ▷apse or ▷ambulatory in a ▷Romanesque or ▷Gothic church or cathedral.

Raeburn, Sir Henry (1756–1823)

Scottish painter. He was born in Edinburgh. After being apprenticed to a goldsmith and working as a miniaturist, he entered the studio of David Martin (1737–98). By 1785 when he travelled to Italy, he had already established his own vigorous style (e.g. *Nathaniel Spens*, 1790, Edinburgh). From 1787, when he opened a studio in George Street, he was recognized as one of the major portraitists of the period (e.g. *The Elphinstone Children*, 1800, Cincinnati). He had little contact with the London art scene and rarely exhibited at the ▷Royal Academy, although he was elected to the Academy in 1815. He also received royal recognition: he was knighted in 1822 and made the King's Limner in Scotland in 1823. He painted directly onto the canvas, rarely producing preliminary drawings and

Sir Henry Raeburn, *Self-portrait*, c1815, National Gallery of Scotland, Edinburgh

creating characterful and dramatic portraits. He was one of the few Scottish artists who could rival those of London, particularly in the field of full-length portraiture (e.g. *Macdonell of Glengarry*, c1812, Edinburgh).
Bib.: Thomson, D., *Sir Henry Raeburn 1756–1823*, Edinburgh, 1994

rafter

In a roof, one of the inclined beams running from the top of the wall to the peak or ridge of the roof and supporting the roof covering.

Raft of the Medusa, The

First displayed at the Paris ▷Salon in 1819 as *Scene of Shipwreck*, ▷Géricault's massive 5 × 7 m (16 × 23 ft) painting represented the infamous loss of the government ship 'La Medeu' in 1816. When the ship's incompetent captain, a political appointee of the new Bourbon regime, ran his boat aground off the coast of Africa he left 150 of his passengers and crew to fend for themselves on a large raft. Only 15 were rescued, one of whom, the ship's surgeon Henri Savigny, published his experience, which included cannibalism, in the newspapers and a book. Géricault portrays the

moment of rescue, and illustrates a contemporary event in the grand manner of the ▷history paintings of ▷David and ▷Gros. The muscular figure studies owe a great deal to ▷Michelangelo and Géricault's visit to Rome in 1817, and their arrangement to his interest in historical battle scenes. But the emotional expression of the scene, its conjunction of grand scale with individual pathos, is Géricault's own. ▷Delacroix remarked on seeing the painting that, 'It felt like having one foot already in the water.'

Bib.: Eitner, L., *Géricault's Raft of the Medusa*, London, 1972

Raggi, Antonio (1624–86)

Italian sculptor. He worked for ▷Algardi and with ▷Bernini in Rome from 1647. He was responsible for the Danube fountain in the Piazza Navona in Rome (1650–51).

Raimondi, Marcantonio (c1480–c1534)

Italian engraver. He was born near Bologna. He was in Venice in c1506 where he saw the work of ▷Dürer. Influenced by Dürer's skill with ▷engraving, he produced reproductive engravings of ▷Raphael's and ▷Giulio Romano's work, as well as producing designs for ▷majolica. Among the works he reproduced were some of Giulio Romano's more salacious drawings. He worked in Rome c1520–27.

Bib.: Shoemaker, I.H., *Engravings of Marcantonio Raimondi*, Lawrence, Kansas, 1981

Rainaldi Carlo (1611–91)

Italian architect. He worked on a number of churches in Rome, including Sta Agnese in the Piazza Navona (completed by ▷Borromini), and the twin churches on the Piazza del Popolo (Sta Maria di Monte Santo and Sta Maria de' Miracoli).

Rain, Steam, Speed

Painted by ▷Turner in 1844 at the height of the early Victorian railway mania, and exhibited at the ▷Royal Academy in the same year. It portrays the landscape around the rail bridge at Maidenhead, with the Exeter Express hurtling through a swirling haze towards the viewer. The visual impression recorded by Turner has been created, as his title suggests, by a combination of nature (the weather) and technology (steam produced by the engine and its momentum along the track). Elements of a pre-industrial world such as a rowing boat and a hare dashing across the track ahead of the train have been interpreted by some commentators as nostalgic or satirizing the supposed wonders of progress. However, the painting is notable for the energy and enthusiasm with which it depicts a physical phenomenon, and the mode of perception which could not have existed before the age of rail. The painting has been seen as a direct influence on ▷Impressionism, particularly ▷Monet's paintings of the ▷Gare St. Lazare. The work is now in the National Gallery, London.

Bib.: McCombry, J., 'Time's Railway: Turner and the Great Western', *Turner Studies*, 6 (Summer 1986), pp. 33–6

Raising of Lazarus

(John 11: 1–44.) John relates how Jesus was called to Bethany by the sisters Mary and Martha to heal their brother Lazarus. By the time Jesus arrived Lazarus had died and been entombed for four days, but Jesus ordered the stone of the cave in which he was entombed to be rolled back and called out, 'Lazarus, come forth.' Lazarus duly stepped out of the cave, enwrapped in his shroud. In representations of the episode, either Mary alone (▷Sebastiano del Piombo, 1517–19, London, National Gallery), or both sisters (▷Giotto, fresco, c1305–6, Padua, ▷Arena Chapel), are portrayed kneeling at Christ's feet, crying that had he arrived earlier he could have saved their brother. Lazarus is sometimes portrayed entombed upright, especially in ▷Byzantine art, as was the Jewish custom (e.g. *The Homilies of St. Gregory Nazianzus*, manuscript, 867–86, Paris, Bibliothèque Nationale; also Giotto, above) though in later representations he rises from a coffin (e.g. ▷Salvator Rosa, Chantilly, Musée Condé). When Jesus had ordered the stone to be removed Martha had objected that by now the corpse would stink, and both Giotto and Sebastiano illustrate this aspect of the story graphically. When Martha had regretted Jesus' late arrival he had said, 'I am the resurrection, and the life.' It is this statement, as well as Lazarus' resurrection itself, prefiguring Christ's own, that gave the subject such importance for the Christian Church.

Rake's Progress, A

The success of his series of ▷engravings ▷*A Harlot's Progress* and its unlawful copying led ▷William Hogarth to delay publication of *A Rake's Progress* until 1735, when the Engraver's Act ensured his copyright. The Rake, like the Harlot in his earlier moral sequence, rejects a life of work and squanders the wealth inherited from a miserly father on the trappings of sycophantic society and aristocracy. The eight plates have a more complex narrative programme than the earlier Progress, with subplots developing and the main character's relationship explored more deeply. The Rake is ultimately arrested for debt, passing from debtor's prison to end his life in a madhouse.

Ramsay, Allan (1713–84)

Scottish painter. He was born in Edinburgh, the son of the poet Allan Ramsay. In 1734, he moved to London where he studied under the Swede, Hans Hysing, and two years later he travelled to Italy where he continued his training with Fernando Imperiali. He returned in 1739 and settled in London, establishing

himself as a cosmopolitan intellectual – he was a member of Dr. Mead's Dining Club (see portrait of Mead, 1747, London, Foundling Hospital). His early style conformed to the traditions of English portraiture, with dark tones and a sense of drama (e.g. *Norman, 22nd Chief of MacLeod*, 1748, private collection). But in 1854–7 he again visited Europe and was influenced by his travels, showing a ▷Rococo element both in his use of delicate pastel shades and fine feathered brushwork (e.g. *The Artist's Wife*, 1754/5, Edinburgh, National Gallery of Scotland). He was also a writer (e.g. *Dialogues on Taste*, 1754, in opposition to ▷Hogarth). He was popular with the royal family, and was made Painter-in-Ordinary to the King in 1760. He retired in 1773, following an accident. In his later career he had found it difficult to compete with ▷Reynolds.

Bib.: Brown, I.G., *Poet and Painter: Allan Ramsay Father and Son*, Edinburgh, 1984: *Sir Allan Ramsay*, exh. cat., Edinburgh, 1992

Rape of Europa

An ancient Greek myth, retold by Ovid in the *Metamorphoses*. Europa was the beautiful daughter of Agenor, King of Tyre. Zeus (▷Jupiter) saw her and desired her. In order to lull Europa into a false sense of security and to evade the watchful eye of his jealous wife Hera (▷Juno), he transformed himself into a white bull and ambled down to the shore to where Europa and her attendants were relaxing. So docile did the bull appear that Europa hung garlands from its horns and allowed her attendants to place her upon its back. No sooner had she mounted the bull than it made off for the sea and bore her away to the island of Crete, where Zeus resumed his normal form and raped her. ▷Veronese (Venice, Palazzo Ducale) depicts Europa being lifted onto the bull's back by her attendants, while the bull licks her foot and Cupid stands at the bull's head, whereas ▷Titian (1559–62, Boston, Isabella Stewart Gardner Museum) depicts the more dramatic part of the story where the bull bears Europa over the waves as she falls backwards, clutching on to his horn with one hand (as vividly described by Ovid). The sexual consummation of Europa's ride is indicated by the three winged amoretti which follow the bull. The medieval *Moralized Ovid* gave this rather unedifying tale a Christian significance by interpreting the white bull as an allegory of Christ carrying the Christian soul to Heaven.

Rape of Proserpine

(Greek, Persephone; Roman Proserpina.) Greek myth, retold by Ovid in *The Metamorphoses*. Proserpine, the daughter of Ceres, the corn goddess, is in the fields gathering flowers with her companions when she is seen by Hades (Pluto), god of the Underworld. A dart from ▷Cupid's bow inflames the god with love and he drives up in his chariot and abducts Proserpine and takes her with him through a chasm in the earth into his kingdom. Hades is usually black-bearded and crowned. Amoretti swirl around his chariot, symbolic of his love. Proserpine struggles in vain. ▷Bernini (1621–2, Rome, Villa Borghese) represents in his celebrated marble group the moment when the struggling goddess is swept up in his arms. Ceres wanders the earth, searching for her daughter. In her grief she renders the earth barren of crops. She eventually finds her daughter, but as Proserpine has already eaten food (a pomegranate) in Hades' kingdom, she cannot return to the upper world permanently. Ceres, however, refuses to let the crops grow until she does, so a deal is struck. Proserpine will spend three months of each year (the winter) in the Underworld, during which time the land will remain bare, and return to her mother each spring, at which point the land will be regenerated. The myth seems to have been originally intended to explain the cycle of the seasons. The pomegranate sometimes appears as an attribute of Proserpine (e.g. ▷D.G. Rossetti, *Proserpine*, 1874, London, Tate Gallery).

Rape of the Sabine Women

An episode from the legendary origins of Rome, retold in Livy's *History of Rome* and Plutarch's *Lives*. Romulus and his followers, having established a settlement on the Tiber, were faced with the problem of finding women to bear the children they needed to ensure the continuance of their community. At Romulus' suggestion, the Romans held a festival and invited the neighbouring tribes, including the Sabines. During the festivities, at a pre-arranged signal, the Roman men broke into the crowd and forcibly abducted as many of the unmarried women as they could carry (e.g. ▷Poussin, *Rape of the Sabines*, c1637, New York, Metropolitan Museum of Art). The sequel to this story is the Intervention of the Sabine Women. Three years have passed and the Sabine women have accepted their lot and taken Roman husbands. Their fathers and brothers, however, have finally managed to assemble an army and have besieged Rome. They breach the outer defences and are in danger of overrunning the city when the Sabine women interpose themselves, some with babies in their arms, between their fathers and brothers on the one side and their new husbands on the other. In this way the Sabine women establish peace between the two communities. ▷J.-L. David's painting of this subject (1799, Paris, Louvre) was read by contemporaries as an appeal for an end to the civil strife that had beset France in the years following the ▷French Revolution.

Raphael (Raffaelo Sanzio) (1483–1520)

Italian painter and architect. He was born in Urbino, the son of the painter and writer Giovanni Santi. His father died before he could become a substantive influence on Raphael, so the most important early

Raphael, *Self-portrait*, Uffizi, Florence

Raphael continued to produce portraits, and his representations of *Julius II* and *Castiglione* brought a new grace and subtlety to portraiture. In 1514 he became architect of St. Peter's on the death of ▷Bramante. He died at a young age, but nonetheless as a wealthy man whose work remained an important focus of ▷academic art for centuries after his death.

Bib.: Ettlinger, L.D., *Raphael*, Oxford, 1987; Jones, R. and Penny, N., *Raphael*, New Haven, 1983; Shearman, J., *The Vatican Stanze: Functions and Decorations*, London, 1970

Rastrelli, Bartolomeo Francesco (1700–71)

Italian architect. He trained with his father Bartolomeo Carlo (1670–1744). They both went to Russia in 1715, where they remained. He was appointed chief architect to the Imperial Court in 1736 and supervised a number of important building works in St. Petersburg. Both the father's and the son's designs reveal a knowledge of the Italian ▷Baroque as well as a willingness to adopt elements of an indigenous Russian architectural tradition.

Ratgeb, Jörg (c1480–1526)

Swabian painter in ▷fresco and oil, recorded as active in Heilbronn, Frankfurt, and Herrenberg. Few of his works survive, the earliest being an ▷altarpiece dated 1510, *The Martyrdom of St. Barbara* at Schwaigern. His main surviving work is his large Herrenberg altarpiece (Stuttgart, Staatsgalerie) of 1519. The scene of the *Flagellation* reveals a brutality close to ▷Grünewald. Ratgeb himself met a violent end – quartered by horses at Pforzheim for having taken part in the Peasants' Revolt.

Rauschenberg, Robert (b 1925)

American artist. He was born in Port Arthur, Texas. He studied art at a variety of institutions including the Kansas City Academy (1947–8), the ▷Académie Julian in Paris (1948), ▷Black Mountain College, North Carolina (where he was taught by ▷Albers) and the ▷Art Students' League in New York (1952). He was a close friend of ▷Johns. His early influences were ▷Dada and ▷Surrealism, and these inspired his first works, large-scale combines (e.g. *Monogram*, 1959, Stockholm) and boxes of ▷found objects with confusing and provocative titles. He claimed to have no political or personal points to make but many of his early works display nostalgia, which developed into a commentary on urbanism. He also experimented with ▷collage, usually in combination with paint (e.g. *Bed*, 1955, private collection) and with unusual materials such as blue print paper. By 1955, these works were increasingly abstracted, with a series of Black (1951–2) and of Red Paintings (1953). In the 1960s he began to work with ▷lithography and ▷silk-screen (e.g. *Retroactive*, 1964, New York) and throughout his career he used electronic devices in his works (including a

influence was from ▷Perugino. Perugino may have been his teacher, but he most likely was a collaborator. Elements of the Classical purity of his style can be seen in some early works of Raphael such as the *Sposalizio* (*Marriage of the Virgin*) (1504, Milan, Brera). Raphael travelled throughout Tuscany (1504–8), and during this time he worked extensively in Florence where he came into contact with the work of ▷Michelangelo. Although he became, like Michaelangelo, one of the major figures of the High ▷Renaissance, his style was more serene and certainly less dramatic than that of his contemporary. Raphael specialized in representations of the ▷Holy Family, and he painted many Madonna and Child scenes.

Raphael's fame drew him to the attention of Julius II, who invited him to Rome in 1508 to decorate the Stanza della Segnatura in the Vatican. The theme of the Stanza was the relationship between Christianity and Classicism, and Raphael employed his most Classical methods in producing the famous *School of Athens* and the *Disputà* for the Stanza. He was commissioned to decorate other rooms in the Vatican, as well as do decorative work, which resulted in the series of ▷arabesques he designed for the Vatican ▷loggie. His assistant ▷Guilio Romano took over much of the work for the Stanza d'Eliodoro, and the more crowded scenes and greater drama suggest a move away from the clarity and balance of Raphael's work. For the Vatican, Raphael also produced ▷cartoons for tapestries on New Testament subjects (now in London, Victoria and Albert Museum), such as the Miraculous Drought of the Fishes.

Apart from these time-consuming commissions,

light bulb in a 1953 collage). Indeed, he co-established Experts in Art and Technology (EAT), a group who promoted modern techniques for use in art. During the 1970s, Rauschenberg turned to using fragile materials such as cardboard in increasingly lyrical combines which seemed to reflect a rejection of modernity. He was also interested in ▷performance art, and worked with Merce Cunningham and ▷John Cage (fellow students at Black Mountain College) both designing and choreographing dance projects, his work *White Painting* (1951, New York) being a backdrop for one such venture.

Bib.: Alloway, L., *Robert Rauschenberg*, New York, 1976; Rosenthal, N., *Robert Rauschenberg*, New York, 1984; *Robert Rauschenberg*, exh. cat., London, 1980

Ravilious, Eric (1903–42)

British painter and graphic artist. He produced illustrations and designs for Wedgwood pots and furniture, as well as ▷wood engravings. He was a war artist in 1940–42.

Bib.: Binyon, H., *Eric Ravilious: Memoir of an Artist*, Guildford, 1983

Ray, Man

▷Man Ray

Rayonism

The term used by a Russian abstract group established in 1911 by ▷Larianov and ▷Goncharova. They were inspired by ▷Futurism, after ▷Marinetti delivered a series of lectures in Moscow, but went further than the Italians in their desire for an art which floated beyond abstraction, outside time and space. The name derived from the use of dynamic rays of contrasting colour, representing lines of force. The group sought a modern artistic expression, but they also aimed to destroy the traditional barriers between artists and the public. Many of the artists had revolutionary sympathies, although the group had scattered before 1917. They published a manifesto in 1913 and exhibited at a number of ▷avant-garde exhibitions in Moscow. As part of their desire to free art from its traditional hierarchy, they designed theatre sets and produced book illustrations, as well as working in oils.

Bib.: Bowlt, J.E. (ed.), *Russian Art of the Avant Garde: Theory and Criticism 1902–1934*, New York, 1976

Rayonnant

A style which represents one of the phases of French ▷Gothic art. The Rayonnant style was dominant in France from c1230 to c1350. Its characteristics are a greater use of ▷stained glass and ▷tracery to give a radiant effect to the inside of churches. It preceded the more elaborate ▷Flamboyant style. Like many taxonomies of medieval art, this term was a 19th-century invention.

Read, Sir Herbert (1893–1968)

English poet, writer and art critic. He was born in Yorkshire and educated at Leeds University. Between 1933 and 1939 he was editor of the *Burlington Magazine*, a close friend of the artists around ▷Henry Moore, ▷Barbara Hepworth and ▷Ben Nicholson, and closely associated with ▷Nash's ▷Unit One and the ▷Surrealist movement. With ▷Roland Penrose he was joint founder of the ▷Institute of Contemporary Arts in 1947. He was a leading art critic from the 1930s and a supporter of British modernism, especially through his books. These included *The Meaning of Art* (1931), *Art Now* (1933), *Art and Industry* (1934), *Art and Society* (1936), *Surrealism* (1936), and *Education through Art* (1943).

ready-made

Name given by ▷Duchamp to a mechanically produced object that he presented as an artistic work. The artist made little or no alteration to the object, ▷fetishizing it by isolating it from its function and meaning. Duchamp's first ready-mades, a bicycle wheel and a bottle opener, were first exhibited in 1913 and 1914. He distinguished it from the ▷*objet trouvé* on the grounds that a ready-made is one among thousands of mass produced objects. The idea has been expanded to include objects or parts of objects used in assemblages by ▷Pop artists and ▷Nouveaux Réalistes.

realism/Realism

Art historical/critical term meaning the portrayal of things as they are seen/appear, without embellishment or interpretation. It may also refer to the portrayal of the everyday rather than the idealized or the beautiful, with a further extension of sense to include the opposite of ▷abstract or distorted, or of stylization/idealization, especially in the school of ▷Verism. The most extreme form of realism is ▷*trompe l'oeil* which attempts to deceive the eye and make an image on a two-dimensional surface appear real.

Historically, 'Realism' (written with a capital 'R') was the dominant artistic movement of France, England and America in the period c1840 to 1880, generally placed somewhere between ▷Romanticism and ▷Symbolism. The art historian Linda Nochlin defines Realism's aim as 'to give a truthful, objective and impartial representation of the real world, based on meticulous observation of contemporary life'. Artists such as ▷Degas, ▷Courbet and ▷Manet, and writers such as ▷Zola and Flaubert were interested in the direct observation of everyday experience. Degas noted how 'no one has ever done monuments or houses from below, from beneath, up close, as one sees them going by in the streets'. The contemporary demands for social and political reform and democracy are mirrored by similar demands by artists. As a

reviewer of the ▷ Salon des Refusés wrote in 1863, 'The portrait of the worker in his smock is certainly worth as much as the portrait of a prince in his golden robes.' Most of all Realism demanded contemporaneity and presented society as it was; whilst social comment was not explicit in ▷ Millet's *The Gleaners* (1857, Paris, Louvre) or Courbet's ▷ *Stonebreakers* (1850) it was definitely seen as implicit by critics. Manet's *The Execution of the Emperor Maximilian* (1867) was reconstructed from photographs and eyewitness reports, and tries to present an event as it was. British realism tended to present a more 'heroic' picture, such as ▷ Bell Scott's *Iron and Coal* (1861) or ▷ Madox Brown's *Work* (1852–65), perhaps reflecting a greater ease with industrialization and reform amongst the artistically literate English middle class.
Bib.: Nochlin, L., *Realism*, Harmondsworth, 1971

Recco, Giacomo (1630–before 1753), Giuseppe (1634–95) and Giovanni Battista (?1615–?1660)

Italian family of painters, all of whom produced still lifes. Giacomo was less important than his son Giuseppe, who specialized in ▷ *bodegón* scenes. Giuseppe lived in Spain, where he also became particularly skilled at flower pieces. Giovanni Battista was either Giuseppe's brother or uncle.

reception aesthetics

Under this heading may be grouped those approaches to art that focus not on the artist but on the ▷ beholder. This represents for some a justified revision of those approaches where the attention paid to the artist (▷ Romanticism) or to the artwork (▷ formalism or ▷ iconograpy) is too exclusive to include the beholder in the process of signification. A leading exponent of reception theory was the French literary theorist ▷ Roland Barthes, and in the domain of art history proper, Michael Fried's *Absorption and Theatricality: Painting and the Beholder in the Age of Diderot* (1980) and T. Crow's *Painters and Public Life in Eighteenth-Century Paris* (1985) are good examples of studies that privilege the beholder as the generator of meaning.
Bib.: Eagleton, T., *Literary Theory: An Introduction*, Oxford 1985

recession

An illusion of depth. A term used in painting to refer to the effect of ▷ perspective.

red-figure vase-painting

A technique of Greek vase-painting, beginning c530 BC in Athens and spreading to southern Italy and Sicily by c440 BC. The technique eventually died out in the 3rd century BC. Red-figure painting is technically the reverse of ▷ black-figure painting which it succeeded. In red-figure painting the background is painted in concentrated slip which turns black during firing, while the design areas are left to read as the orangey-red of the fired clay. The linear detailing of the orangey-red design areas is painted on in the same concentrated slip as the background. The earliest known red-figure vase painter was the so-called Andokides Painter (fl c530–515 BC). In some of his vases he employed black-figure on one side and red-figure on the other – this kind of vase is termed 'bilingual'. Other important painters include ▷ Euphronios and Euthymides (both active at the end of the 6th century BC, the so-called Berlin Painter (fl c500–480 BC) and the Penthesilia Painter (fl c460–450 BC).
Bib.: Boardman, J., *Athenian Red Figure Vases: The Archaic Period*, London, 1975; Boardman, J., *Athenian Red Figure Vases: The Classical Period*, London, 1989; Trendall, A.D., *Red Figure Vases of South Italy and Sicily*, London, 1989

Redgrave, Richard (1804–88)

English painter. He specialized in contemporary ▷ genre scenes. He was born in London and worked in his father's business whilst attending art evening classes, but he eventually entered the ▷ Royal Academy Schools and paid for his training there by taking drawing lessons. He first exhibited at the RA in 1831 and throughout the 1830s painted a series of literature-based works (e.g. *Ophelia*, 1842, London, Victoria and Albert Museum). He is now famous for a series of social subject painting in the 1840s, which used images of attractive but down-trodden women to make their point (e.g. *Poor Teacher*, 1844, Victoria and Albert Museum; *Outcast*, 1851, London, Royal Academy). During the 1850s he increasingly turned to landscape, painting lush, rolling scenes of England (e.g. *Old English Homestead*, 1854, London, Victoria and Albert Museum). Throughout his career he worked in a design partnership with Henry Cole and produced architectural designs. He also collaborated with his brother on *A Century of Painters of the English School* (2 vols., London, 1886)
Bib.: Casteras, S. and Parkinson, R. (eds.), *Richard Redgrave 1804–1888, exh. cat.*, New Haven, 1988; Redgrave, F.M., *Richard Redgrave: A Memoir*, London, 1891

Redon, Odilon (1840–1916)

French painter, draughtsman, engraver and lithographer. He was born in Bordeaux, his father a French peasant, his mother Creole. After studying drawing with the teacher Gorin in 1855–8, he entered the ▷ École des Beaux-Arts but opposed ▷ Gérôme's teaching there, and studied instead under the engraver ▷ Bresdin. His other early influence came from a friendship with the botanist Clavaud, and throughout his career he produced flower paintings. He was later introduced to ▷ lithography by ▷ Fantin-Latour and produced over 200 pieces, published in series (e.g.

Dans le rêve, 1879; *À Edgar Poe*, 1882; *Hommage à Goya*, 1885).

Around 1890, Redon returned to oils. His early work had been landscape-based, influenced by ▷Corot, but he also produced figurative and religious paintings (e.g. *Portrait of Gauguin*, 1904, Paris). He was a close friend of the ▷Symbolist writers, Mallarmé and Huysmans, and his work shared the same disinterest in reality: objects floated in space, dreamlike and detached, as Redon explored their decorative qualities (e.g. ▷*Orpheus*, 1913–16, Cleveland). In 1899, he came into contact with the ▷Nabis, who were exploring similar themes. He described his work as hermeticism – sealed off from the real world, but his interest in the subconscious, later inspired the ▷Surrealists. He was also an illustrator (e.g. ▷Baudelaire's *Fleurs du Mal*, 1890). He became President of the Société des Artistes Indépendants in 1884 and exhibited at the ▷Salon d'Automne in 1904, as well as with ▷Les Vingt in Brussels and at the ▷Armory Show in New York.

Bib.: *Odilon Redon: Prince of Dreams*, exh. cat., Chicago, 1994; Werner, A., *Graphic Works of Odilon Redon*, New York, 1969; Wilson, M., *Nature and Imagination: The Works of Odilon Redon*, Oxford, 1978

Reformation

Term given to the changes in Western Christendom between the 14th and 17th centuries, largely resulting from what was perceived as worldliness and corruption within the Papacy and clergy. In so far as they affected art, the most important changes occurred in the 16th century, beginning with Martin Luther's protest and subsequent break away from the Catholic Church in 1517. In addition to his concern over the sale of indulgences, he held certain views inimical to the established Church. He believed that faith alone (not good works) assured a person of salvation, that the scriptures, not the priesthood, brought man closer to God and that there were not seven, but two ▷Sacraments (i.e. Baptism and the Eucharist). Lutheranism became the official religion in most of Germany and the whole of Scandinavia.

The Swiss reformer, Ulrich Zwingli, went further than Luther, denouncing, among other things, the belief in transubstantiation and the invocation of saints. Most disastrously for the arts, he adopted a literal reading of the second commandment and inveighed against the use of religious images (▷iconoclasm). This position was also taken up by the German reformer Andreas Bodenstein of Karlstadt. Thus, in the more radical territories, all religious images were removed, returned to their owners or destroyed. Furthermore, with faith alone justifying entry into Heaven, the main reason for the wealthy to commission art for churches disappeared. Whereas Catholic churches were filled with images on a multiplicity of altars in family chapels, Lutheran churches retained only the high altar (private masses having been abolished). Although high ▷altarpieces were still commissioned – notably of the ▷Last Supper – it is obvious that with the eradication of all other altars, demand for religious images overall was severely reduced. However, unlike his more radical contemporaries, Luther recognized the usefulness of pictorial images for the instruction of the illiterate and his German language New Testament (1522) contained about 20 woodcut illustrations. Many artists in Protestant territories either went out of business, adapted to the changed circumstances or moved.

The most successful adaption to the new order was in the Protestant United Provinces of the Netherlands which had won their independence from Catholic Spain in 1609. Religious art continued to be produced (notably by ▷Rembrandt), but 17th-century Dutch painting is chiefly characterized by its secularization and the rise to prominence of first-rate artists successfully specializing in types of painting – portraiture, landscape, ▷genre and still life – hitherto consigned to the lower levels of the ▷hierarchy of genres. The Protestant Reformation stimulated the Catholic ▷Counter-Reformation which, following its own internal reforms, expressed its renewed confidence in the militant proselitism of 17th-century Roman ▷Baroque art.

Bib.: Christensen, C.C., *Art and the Reformation in Germany*, Athens, Ohio, 1979; Coulton, G.G., *Art and the Reformation*, London, 1953; Michalski, S., *The Reformation and the Visual Arts*, London, 1993

Régence

A reference to the Regency of Philippe, Duc d'Orléans, who ruled in France 1715–23 after the death of Louis XIV and before the ascension of Louis XV. The Régence style was a reaction against the ▷classical pomposity of the ▷Baroque at Versailles. It was a forerunner of the ▷Rococo and directed towards decorative arts as much as grand schemes of architecture.

Regency

The period in England from 1811 to 1820 just before George IV ascended to the throne. It relates primarily to decorative arts in a ▷Neoclassical Greek style with some traces of ▷Rococo influence.

Bib.: Morley, J., *Regency Design 1790–1840: Gardens, Buildings, Interiors, Furniture*, London, 1993; Watkin, D., *Regency: A Guide and Gazetteer*, London, 1982

Regionalism

A mode of naturalistic representation combined with rural subject matter practised by a variety of American painters during the 1920s and 1930s. Among the painters in this category were ▷Benton, ▷Wood, ▷Wyeth and ▷Hopper. It was anti-urban, and concentrated on small town and rural America, especially of the south and mid-west.

▷American Scene Painting

register

A term used in printing to refer to the use of different blocks of colour for different sections of the print. The phrases 'in register' or 'out of register' refer to the way in which the separately coloured sections are positioned in relation to each other. A print that is 'in register' is successful, with each colour positioned correctly.

Rego, Paula (b1935)

British artist of Portuguese birth. She was originally from Lisbon and became subsequently based in Britain. She was an only child in a prosperous, liberal Portuguese family. While studying at the ▷Slade in London (1952–6) she met her husband Victor Willing. They lived in London and Portugal, and Rego represented her country at the São Paulo Biennal in 1969. However, she settled permanently in London after her family's business assets were seized in the upheavals following the 1974 military coup. Her husband's illness at the same period prevented her from working and she produced little until the early 1980s. She was a visiting lecturer at the ▷Slade in 1983, and represented Britain at São Paulo in 1985. A retrospective at the Gulbenkian Foundation, Lisbon, and the Serpentine Gallery, London was critically acclaimed. In 1990 she was given a residency as the first Associate Artist at the ▷National Gallery in London and produced a monumental painting for the Gallery restaurant. She continues to paint and exhibit.

In the late 1950s and early 1960s, Rego produced paintings and ▷collages whose figurative elements were aggressively jumbled and distorted, sometimes with explicit reference to the political violence in contemporary Portugal. The fable-like images of animals beginning with the *Red Monkey* series of 1981 show her moving closer to figurative painting, while retaining the cruelty of her earlier work. In the mid-1980s she initiated a remarkable series of ambivalent and allusive narratives of sexual power in a domestic setting. More recently, Rego's frequently disturbing paintings and illustrations have drawn openly on popular imagery, nursery rhymes and children's literature.

Bib.: McEwen, J., *Paula Rego*, London, 1992

reification

The error of confusing an abstract concept with a material object. The term was used by ▷Marx (and subsequently followers such as ▷Lukács and the ▷Frankfurt School) to describe a symptom of the ▷alienated labour force for whom the commodity acquires an objective existence, hiding its social origin. This idea has been presented as one of the fundamental principles underlying consumer society, in which once-unified social relationships and experiences are reconstructed in the fragmentary and artificial form of commodities. Lukács linked it to the process by which

any repressive society or ▷ideology, insisting on its absolute and objective character, reduces human beings to mere function.

Reims Cathedral

One of the greatest of the French ▷Gothic cathedrals. Building began under the first master architect, Jean d'Orbais, in 1211, as a replacement for an earlier church destroyed by fire. The interior design follows that of Chartres, but with a stronger vertical emphasis obtained from its higher and narrower proportions. The chief architectural importance of Reims is due to its origination of bar ▷tracery (as opposed to plate tracery) for the design of the windows, admitting more light and facilitating the development of a greater variety of tracery decoration. It is also richer in sculptural decoration than any other Gothic cathedral. The amount of sculptural work necessary attracted sculptors from all over Europe, and Reims became a melting pot of ideas, styles superseding each other in quick succession. The earliest sculpture of c1220, includes the *Visitation* group on the west front, which appears to derive from Classical ▷antique models (especially noticeable in the draperies). About 1230, possibly owing to a change of master mason, a more restrained figure style emerged, apparently related to ▷Byzantine ivories, employing flat, conventionalized draperies, similar to those at ▷Amiens. This style was in turn replaced c1250 by a style which is now associated specifically with Reims, characterized by lively, graceful figures imbued with a freer sense of movement, expressive, sometimes smiling faces, and with drapery bunched up and swinging across the body in broader, more sculptural folds. These successive styles can be seen in telling juxtaposition in the three figures of the *Presentation in the Temple* from the west ▷portal: the figure on the left (▷Joseph) being in the newer animated style and the two figures on the right (the ▷Virgin holding the Christ child, and Simeon) in the older more restrained style. Also in the carving of the foliage decorating the ▷capitals of the main ▷piers there appears a new naturalism. Reims became in effect the most influential sculpture workshop of its time and directly inspired later developments, in Germany with the ▷Master of Naumberg and in Italy with ▷Giovanni Pisano, when sculpture at last began to develop independently from architecture.

Reinhardt, Ad (1913–67)

American artist. He was born in Buffalo, New York. He studied under Meyer Schapiro at Columbia University (1931–5), at the ▷National Academy of Design (1936–7) and after the Second World War at the Institute of Fine Arts in New York (1945–51). During the War he served as a navy photographer. He was employed as an art critic in New York (1944–7) and later worked as a teacher at Brooklyn College (1947–67) and Hunter University (1959–67). He also worked

as a cartoonist for the *PM* newspaper. From the start, Reinhardt was interested in the possibilities of ▷abstraction: he was a member of the ▷American Abstract Artists group from 1937. During the 1930s he worked in a crisp geometric style, influenced by ▷Mondrian and ▷Cubism and combining paint and ▷collage, though this style developed into an ▷all-over approach similar to that of ▷Tobey, and partially inspired by Persian ▷calligraphy – Reinhardt collected Middle Eastern and Oriental art – (e.g. *Painting*, 1950, New York). His association with ▷Abstract Expressionism was emphasized by his connection with ▷Motherwell, with whom he co-edited *Modern Art in America* in 1950. During the 1950s, however, Reinhardt himself moved towards a more ▷Minimalist style, reducing his colour and returning to the geometric compositions of his youth. The first stage in this process was the use of tightly packed boxes of colour, which gradually increased to a few rectangles against a background. From the early 1950s, he was working in monochrome (e.g. *Red Painting*, 1951, New York). His intention was to separate art and life, to create a purity of form and to deny the problems of space and illusion by careful tonal control. This goal was exemplified in his *Black Paintings* of the 1960s, which used subtly different shades of non-reflective black in blocked and grid designs.
Bib.: Lippard, L.R., *Ad Reinhardt: Paintings*, New York, 1967

relief

A sculptural design which extends out from a flat surface but is not free-standing. There are several different levels of relief: alto-rilievo, or high relief; mezzo-rilievo, medium relief; and bas-relief or low relief. Rilievo schiacciato is the most shallow form of all and approximates most closely to two-dimensional media.

relief etching

A method of ▷etching that produces ▷plates for ▷relief printing (i.e. like ▷woodcuts) rather than the usual ▷intaglio plates of ordinary etching. The design is drawn on the plate with an acid-resistant ▷varnish, which is then placed in acid. The method dates from the 18th century, though it was little used then other than by ▷William Blake. More recently ▷S.W. Hayter and ▷Joan Miró have used relief etching in conjunction with intaglio printing to produce two-colour prints.

relieving arch

▷arch

relining

Transferring an old painting to a new canvas.

reliquary

An object made of ivory or metal used to hold sacred objects and relics. They were especially common during the 13th and 14th centuries when saints' relics were particularly prized. They were made in many different shapes.

Rembrandt, Harmensz. van Rijn (1606–69)

Dutch painter, etcher and draughtsman. He is widely regarded as the greatest Dutch artist. He was born at Leiden, studied at the Latin school, and enrolled for a short period at the university before leaving c1620 to train as a painter under Jacob van Swanenburgh (c1571–1638), a mediocre artist with whom Rembrandt stayed for about three years. A more significant influence was provided by the short period (about six months) he spent working for ▷Pieter Lastman in c1624. From Lastman Rembrandt learnt a way of investing mythological and religious subjects with drama through the use of animated gestures, exaggerated facial expressions and heightened lighting effects, rendered in a smooth and glossy finish, derived from ▷Caravaggio and ▷Elsheimer. This experience is reflected in Rembrandt's earliest dated painting, *The Stoning of St. Stephen* (1625, Lyons, Musée des Beaux-Arts). From this year Rembrandt is recorded in Leiden as an independent master, working closely with ▷Jan Lievens with whom he shared both studio and models. Rembrandt began to advance his reputation, painting mainly religious subjects and portraits, and in 1629 Constantin Huygens, connoisseur and secretary to the Stadtholder Prince Frederick of Orange, visited him and Lievens, proclaiming them both to be of great promise. In 1631 Rembrandt received his first official commission for a formal portrait, from the Amsterdam merchant Nicolaes Ruts (now New York, Frick Collection).

About this time, perhaps as a result of the Ruts commission, Rembrandt realized that Amsterdam, the commercial heart of the Netherlands, would provide the best market for his talents. He moved there in c1631/2 and soon established himself as the leading portrait painter of the city. His output in these early years was prodigious. He excelled at highly-finished single portraits (e.g. *Marten Soolmans*, 1634, Paris, private collection), but the ground-breaking work which established his reputation was ▷ *The Anatomy Lesson of Dr. Tulp* (1632, The Hague, Mauritshuis). Group portraits such as this were the bread-and-butter commissions for the more ambitious painters of Amsterdam and generally followed a rather conventional formula. In his painting Rembrandt invigorated the tradition by investing the lesson with human drama, with each member of Tulp's class reacting in a psychologically convincing way to his demonstration, the whole composition unified by the deep, rich shadows which surround the strategically-illuminated figures. This Caravaggesque ▷chiaroscuro is even

more pronounced in Rembrandt's religious works of the period, the most poignant being the cycle of five ▷Passion paintings he executed for Prince Frederick (c1633, Munich, Alte Pinakothek) and, most dramatic of all, *The Blinding of Samson* (1636, Frankfurt, Städtisches Kunstinstitut). This latter painting was presented by Rembrandt to Huygens who had possibly obtained the *Passion* commission for him.

In addition to his professional success, Rembrandt also at this time enjoyed personal happiness, marrying in 1634 Saskia van Uylenburch, the daughter of his wealthy picture-dealer. Rembrandt was evidently devoted to her, painting her on many occasions, notably in *Saskia as Flora* (1635, London, National Gallery). In 1639 the couple bought a splendid house in Amsterdam (now the Rembrandt Museum) and Rembrandt began to stock it with pictures, prints and all kinds of objects, from armour to old costumes, as prospective props for future paintings. The couple's happiness, however, was beset by the tragedy of a succession of infant deaths, culminating in Saskia's death in childbirth in 1642. Only one child, Titus (1641–68) lived beyond infancy. He, too, was painted often by Rembrandt (e.g. *Titus*, 1655, Rotterdam, Boymans-van Beuningen Museum).

The year of Saskia's death coincided with the commission that was to become Rembrandt's most famous painting, *The Militia Company of Captain Frans Banning Coqc and Lieutenant Willem van Ruytenburch* (Amsterdam, Rijksmuseum) popularly known from the late 18th century under the misleading title, ▷ *The Night Watch*. It is not a night-time scene, although a hundred years after its inception the varnish had darkened sufficiently for it to be mistaken for one. Also, the original composition would have been more balanced, as the picture was at some time drastically cropped, especially on the left side. Just as Rembrandt had invigorated the professional group portrait, so he did the militia group, the greatest examples of which genre were hitherto the banqueting table groups of ▷Frans Hals. These volunteer militia companies were a kind of civic guard; originally formed in the days of the rebellion against Spanish domination of the Netherlands, by 1642 they were more like social clubs. Rembrandt takes the members out of the banqueting hall and invests them with heroic dignity, showing them marching out into the street. A token of the superiority of Rembrandt's animated conception is the comment of his one-time pupil, ▷Samuel van Hoogstraten, who declared in 1678 that, 'It is so painter-like in thought, so dashing in movement, and so powerful that, according to some, all other pieces [in the hall in which it was originally hung] stand beside it like playing cards.' The work was evidently well-received by the sitters: the tradition that they were dissatisfied with the subordination of their portraiture to Rembrandt's narrative scene appears to date only from the 19th century. Nonetheless, Rembrandt's

financial situation did deteriorate during the 1640s and by 1656 he had declared himself insolvent.

From the 1640s onwards formal portraiture forms a smaller percentage of Rembrandt's total output, a change that has been attributed to his grief over the death of Saskia and his weariness of the expressive limitations of the genre. However, these years saw the rise of a whole group of technically first-rate portrait painters, many of whom had been taught by Rembrandt and who were content to continue to the fashionable, highly-finished style he had first introduced. In about 1645 Hendrickje Stoffels entered his house as a servant, the couple soon formed a relationship and produced two children although owing to the terms of Saskia's will they could not marry. The relationship seems to have been as loving as that Rembrandt had enjoyed with Saskia and again resulted in some of Rembrandt's most tender paintings (e.g. *A Woman Bathing in a Stream*, 1654, London, National Gallery). Meanwhile, Rembrandt was exploring the possibilities of religious subjects and landscape. In these years he produced some of his most deeply-felt biblical paintings, for example *Jacob Blessing the Sons of Joseph* (1656, Kassel, Staatliche Gemäldegalerie) and *The Denial of St. Peter* (1660, Amsterdam, Rijksmuseum). His female nudes are some of the most sympathetic ever painted by a male painter, notably the *Bathsheba* (1654, Paris, Louvre), a subject notoriously open to prurient treatment. His technique became broader, more experimental; often he would use the butt-end of his brush to create a desired effect. It is misleading to think that he was no longer in demand for official commissions, however, as is evidenced by two of his greatest works, *The Syndics of the Cloth Drapers' Guild* (1661/2, Amsterdam, Rijksmuseum) and *The Conspiracy of Claudius Civilis* (1661/2, Stockholm, National Museum). Sadly, more tragedy attended Rembrandt in his final years, with Hendrikje predeceasing him in 1663 and Titus in 1668. Nonetheless, he painted till the end; one of his most moving works, *The Return of the Prodigal Son* (St. Petersburg, Hermitage) dates from the year of his death.

A constant throughout Rembrandt's life was the remarkable series of self-portraits which are often seen, but were hardly intended as, a sort of pictorial autobiography. There is the confident self-advertisement of the *Self-portrait Leaning on a Stone Sill* (1640) in which he displays his superlative powers as a portraitist while at the same time deliberately echoing the composition of ▷Titian's *Ariosto* portrait (now in London, National Gallery; then in Amsterdam), thereby declaring his equality with one of the greatest portraitists of the past. By contrast, from his final years comes the unflinching self-investigation of the *Self-portrait* of 1661 (Amsterdam, Rijksmuseum). Rembrandt was also one of the most accomplished and innovative printmakers of all time, specializing in ▷drypoint and ▷etching, *Christ Healing the Sick* (the so-called 'hundred-guilder

print' of c1648–50) being his most celebrated graphic work. As a draughtsman, working most often in pen and wash or chalk, he has never been surpassed, creating in a few deft, astonishingly economical strokes images of total conviction (e.g. *Two Women Teaching a Child to Walk*, chalk, c1640, London, British Museum). A representative collection of his prints and drawings is at the Rembrandt Museum, Amsterdam. His influence was immense, both through his powers as a teacher and through the dissemination of his work, mostly through prints. His pupils included ▷Bol, ▷Dou, ▷Eeckhout, ▷Fabritius, ▷Flinck, ▷Aert de Gelder, ▷Philips de Koninck and ▷Maes. Many of the works of his pupils, followers and imitators were formerly ascribed to Rembrandt, partly through honest error, partly wishful thinking and undoubtedly often through opportunism. His *oeuvre* has recently been much reduced and a clearer picture of his own achievement obtained through the work of the Rembrandt Research Project (founded 1968); equally, some of his pupils, to whom a number of the contested works have been reattributed, now appear as more substantial individuals.

Bib.: Alpers, S., *Rembrandt's Enterprise*, Chicago, 1990; Baker, C., *Rembrandt*, Greenwich, CN, 1993; Bal, M., *Reading Rembrandt*, Cambridge, 1993; Bevers, H., *Rembrandt and his Workshop*, New Haven, 1991; Rosenberg, J., *Rembrandt, his Life and Work*, London, 1964

Remington, Frederic (1861–1909)

American painter and illustrator. Born in Canton, New York, he studied briefly at Yale University School of Fine Art (1878). Although based in New York City, he began to make regular trips into the West which provided subject matter for his paintings. Reproductions of his work in *Collier's* and *Harper's* magazine brought him popularity and financial success, although he never achieved critical respect. After 1895 he also produced sculptures on western themes. In 1899 he bought an island in the St. Lawrence River, where he painted wilderness scenes.

Remington hoped to capture something of the rapidly-disappearing landscape and way of life of the Old West. However, his lonely cowboys tending the herd, trappers on their canoe as dusk falls, or grandiose paintings of the US Cavalry attacked by marauding Indians, unquestioningly accept the prevailing, romanticized mythology of frontier life.

Bib.: Craze, S., *Frederic Remington*, New York, 1989; Hassrick, P.H., *Frederic Remington*, Avenel, NJ, 1973 and idem, *Frederic Remington's Studio*, Cody, 1994; Nemerov, A., *Frederic Remington and Turn-of-the-Century America*, New Haven, 1995

Renaissance

The word 'Renaissance' is a French term first coined in the 19th century to describe the intellectual and artistic revival, inspired by a renewed study of

▷Classical literature and art, which began in Italy in the early 14th century and reached its culmination in the early 16th century, having spread in the meantime to other parts of Europe. The equivalent Italian term is *Rinascimento*. The concept enshrined in the word 'Renaissance' is actually one of rebirth rather than revival and carries with it the loaded, and absolutely discredited, argument that the Middle Ages was a dead period intellectually and artistically. Such a view effectively renders ▷Byzantine, ▷Romanesque and ▷Gothic art as being without aesthetic value. Though this position is untenable, the term 'Renaissance' is useful in so far as it denotes a view that was held by contemporary, especially Italian, thinkers and because the period covered by the term, in the leading artistic centres of Italy, exhibits a growing preoccupation with a coherent set of values based on antique Classical models.

It was Petrarch (1304–74) who first evoked the complementary images of the prevailing darkness of the Middle Ages, when the intellectual achievements of the Classical world had been forgotten, and the subsequent illumination of his own period following their rediscovery by scholars such as himself. Thus, the renewal of interest in the ▷antique was first and foremost an intellectual and literary revival. The importance of Classical texts to the development of the visual arts was their inherent view of a world with man at the centre. Also, references to the arts in the antique world revealed that artists were valued for their ability to represent nature with great fidelity and that, furthermore, they enjoyed a higher status than their medieval counterparts. Thus, the beginnings of Renaissance art in Italy should be recognizable by seeking out not only those artists who adopted motifs or borrowed models from antiquity, but also those who sought to represent the human figure and the material world more naturalistically than had their predecessors.

Until the 20th century the generally accepted model for the development of the artistic Renaissance was that constructed by ▷Vasari, writing in 1550. He gave to ▷Giotto the credit for the rebirth of art after centuries of barbarism and structured his chronological model like the ages of man, with Giotto and his immediate heirs as representing the infancy of art; ▷Masaccio, ▷Brunelleschi, ▷Donatello and ▷Ghiberti as the experimental youth; and ▷Leonardo, ▷Raphael and ▷Michelangelo as the perfected maturity. Although notions of rebirth (and the previous death the term implies) and artistic progress are now rejected, and although it is recognized that Vasari was above all a Florentine writer structuring history in Florentine terms in order to set the scene for his friend and idol, the Florentine all-round artist, Michelangelo, Vasari's account is useful in that it does reflect what is a perceptible movement away from an art based on conventionalized representations of a supernatural reality towards an increasing technical expertise (in

which Florence mostly led the way) in the representation of a visually convincing and rationally ordered natural world. The subject matter was still preponderantly sacred, but Christ and the saints were now conceived with more corporeality, and increasingly not in an ethereal Heaven, but at the centre of the physical world.

If we accept Vasari's implication that Giotto was a Renaissance artist we should also be aware that he was in fact preceded by a non-Florentine, the sculptor, ▷Nicola Pisano. Both artists imbue the human figure with a new power, dignity and gravity, and, furthermore, Pisano quotes directly from antique Roman ▷sarcophagi, thus fulfilling the second requirement for a true Renaissance artist. Unfortunately, the following century does not present an ordered development from the achievements of these two figures and it is more usual today to agree with ▷Alberti (writing in 1435) that the artistic Renaissance of Italy actually began in Florence in the early 15th century. The strength of this model is that what follows in Florence and in all those centres affected by Florentine art, presents a largely coherent artistic development throughout the century.

Brunelleschi, placed by Alberti in the vanguard of the new art, was the first architect to go beyond the arbitrary usage of the vocabulary (i.e. the recognizable motifs) of Classical buildings towards a perception of the underlying grammar (the order and harmony created by the rational proportional relationships of part to part and part to whole). Brunelleschi also seems to have made the earliest experiments in single-point ▷linear perspective and may have advised Masaccio in its possibilities for constructing a rationally ordered picture space. Certainly the fictive architecture in Masaccio's *Trinity* (c1428, Florence, Sta Maria Novella) is Brunelleschian. The earliest surviving use of linear perspective, however, is in Donatello's *St. George and the Dragon* ▷relief (c1417, Florence, Or San Michele). Of the sculptors that looked towards Classical models, Donatello, like Brunelleschi with his architecture, was the one that most clearly understood the underlying spirit of Classicism. Throughout the 15th century (today usually designated the 'Early Renaissance'), Florentine artists were at the forefront of investigations into the representation of the natural world. To some, one particular area of investigation or another might take precedence: to ▷Uccello it was the underlying geometry of form and the organizational possibilities of ▷perspective and to ▷Antonio Pollaiuolo, ▷anatomy. Another hallmark of the Renaissance is that although the overwhelming majority of commissions were still sacred there was also, as the century progressed, a growth in lay patronage requiring portraits and other secular images, particularly those dealing with themes from Classical mythology.

The first quarter of the 16th century is generally termed the 'High Renaissance'. It is the period when the leading artists had sufficient technical expertise to achieve virtually any naturalistic effect they wished, coupled with a controlling, Classically-based intelligence which imposed visual harmony and compositional balance while eliminating gratuitous detail. Although most of the leading protagonists were Florentine – Leonardo, Michelangelo and Raphael – the centre of production had shifted to Rome (where these three men worked) and to Venice, where ▷Bellini, ▷Giorgione and ▷Titian were creating their own High Renaissance style. The most important architect of the High Renaissance, whose buildings were the first to be considered as having fully recaptured the grandeur of ancient Rome, was ▷Bramante.

It was not until this period that Italian Renaissance ideals began to spread in a significant way north of the Alps, ▷Dürer being the first northern artist to fully assimilate the ideals of the Renaissance into his work. Increasingly, from the 16th century onwards, northern artists would finish their artistic education by visiting Italy. Foreign rulers and states also sought to buy in Italian artists, but from the 1520s ▷Mannerism had supplanted the High Renaissance style and thus in France, for example, direct Italian influence in the 16th century is essentially Mannerist (e.g. Francis I's School of ▷Fontainebleau). Nevertheless, Mannerist art is inconceivable without the Classical ideals of the Renaissance (whether to flout deliberately or to exaggerate) and those ideals continued to exert a powerful influence on artists, alongside the art of Classical antiquity, as the supreme exemplar up until the second half of the 19th century and the advent of ▷Realism and ▷Impressionism.

Bib.: Ames-Lewis, F. and Bednarek, A., *Decorum in Renaissance Narrative Art*, London, 1992; Baxandall, M., *Painting and Experience in Fifteenth-century Italy*, Oxford, 1972; Bober, P.P. and R. Rubinstein, *Renaissance Artists and Antique Sculpture: A Handbook of Sources*, Oxford, 1986; Levey, M., *High Renaissance*, Harmondsworth, 1975; idem. *Early Renaissance*, Harmondsworth, 1977; Panofsky, E., *Renaissance and Renascences in Western Art*, London, 1960; Wackernagel, M., *The World of the Florentine Renaissance Artist*, Eng. trans., Princeton, 1982

Reni, Guido (1575–1642)

Italian artist. He was an important practitioner of the ▷Baroque, born in Bologna. Although greatly admired in the 19th century, notably by Byron and Browning, Reni's popularity plummeted in the 20th century. The main source of information about Reni is the *Life* by ▷Malvasia, a close friend of the artist. Reni was taught by ▷Denys Calvaert, a Flemish ▷Mannerist from Antwerp who had set up a school in Bologna. He was also influenced by the Bolognese artists, the ▷Carraccis (Agostino, Annibale and especially Ludovico). His first major work was the *Coronation of the Virgin with Four Saints* (c1595) which

shows insubstantial elongated figures with small heads, hands and feet. His style developed from this early work under the influence of ▷Caravaggio, which can best be seen in works like the *Massacre of the Innocents* and *Sampson Victorious* (c1612). Despite Caravaggio's domination of the artistic world during this era, Reni did, however, retain an independence. After visiting Rome in 1600 and becoming involved in an argument with the Spanish Ambassador over payment for a painting of the ▷Immaculate Conception, Reni lived in Bologna for the rest of his life. Malvasia informs us that later in his career Reni became a habitual gambler and started to use more and more students in his studio, passing their work off as his own. It is fair to say that he was one of the earliest financially astute artists who demanded high prices and equated them with high art. We can also discern a less vigorous style predominating in Reni's later career. He uses softer colours, the movement is more fluid and he takes a less naturalistic approach (e.g. *Girl with a Wreath*, c1640).

Renier of Huy

A ▷Mosan metal worker active in the early part of the 12th century. He worked in Liège, 1107–18, where he produced a bronze font for Notre Dame des Fonts. It contains a naturalistic depiction of oxen, and is his only known work.

Renoir, Pierre Auguste (1841–1919)

French painter and sculptor, associated with ▷Impressionism. He was born at Limoges and his first work was as a painter of ▷porcelain, a factor often associated with his later decorative style. In 1862 he entered ▷Gleyre's studio, where he met ▷Monet, ▷Sisley and ▷Bazille. He worked with these artists at Barbizon, Chailly (1866) and La Grenouillère (1869) with a mutual exchange of ideas but, unlike Monet and Sisley, Renoir was little interested in landscape for its own sake and preferred throughout his career to paint people and activity. During the 1870s he was an enthusiastic member of the Impressionist circle, exhibiting at four of their exhibitions and contributing his own colour ideas – his rainbow palette. His paintings showed Paris at leisure, concentrating on women and fashion, in a gay blur of bright feminine shades and soft, powder-puff brushwork, often compared with that of 18th-century ▷Rococo artists (e.g. *Dance at the Moulin de la Galette*, 1876, Paris). Even sunlight was treated in a decorative way, as a yellow patchwork across the surface of the canvas. At the same time, however, Renoir was increasingly seeking recognition and financial gain, and to this end he also produced more conventional portraits which he exhibited at the ▷Salon (e.g. *Mme Charpentier and her Children*, 1879, New York).

During the 1880s, Renoir's divergence from Impressionism was emphasized. In 1879, he travelled to North Africa, where the hot Mediterranean colours

Pierre Auguste Renoir, *Self-portrait*, 1910

were to prove a lasting influence, and in 1882 he visited Italy, which confirmed a longstanding enthusiasm for the art of ▷Raphael. This decade also saw Renoir experimenting with traditional glazed techniques (e.g. *Les Parapluies*, 1883–4, London, National Gallery) and with nudes (e.g. *Les Grandes Baigneuses*, 1885–7, Philadelphia). By the end of the century, partly because of increasing arthritis and his retirement at Cagnes in the South of France, Renoir's technique had loosened and his work displays ever more escapist images of women and nature, portrayed in voluptuous, sensual colours. He knew ▷Matisse and shared many of his decorative and emotional concerns. He also experimented with sculpture, working with Guino, a pupil of ▷Maillol, to produce solid nudes.

Bib.: Callen, A., *Renoir*, London, 1978; *Renoir*, exh. cat., London, 1985; White, B.L., *Renoir: His Life and Letters*, New York, 1984

Repin, Ilya Efimovich (1844–1930)

Ukrainian painter. He was associated with the ▷Wanderers. Born into a peasant family, he trained with a local artist before being taken on by the St. Petersburg Academy in 1863. In 1873 the exhibition of *Barge Haulers on the Volga* (1870–73) made him an instant celebrity, particularly amongst the liberal intelligentsia. Emphasizing political themes, his work attracted much controversy. In 1885 *Ivan the Terrible with the Body of his Son* (a symbol of the shattered chain of succession, undermining the legitimacy of the Romanov dynasty) was banned by Alexander III. Repin became uncomfortable with the reform movement as it slid into violence, and turned to portraiture. From 1893

to 1917, he taught at the Academy and retired to a house exuberantly designed by himself in Kuokkala.

After Repin's death, and with the adoption of ▷Socialist Realism in 1932, Repin was cited as the foremost model for Soviet painting. His uncompromising subject matter had placed him at the forefront of the revolt against the Academy and *Barge Haulers on the Volga* was praised for its painstaking depiction of every stray scrap of clothing and every wrinkle on the suffering peasants' faces – although a less partisan critic today might be tempted to suggest that its uncritical photographic ▷realism sometimes seems to highlight the artist's skill rather than the social inequalities it portrays. When it was initially displayed, however, the painting's popularity was largely due to Repin's fondness for rendering characters as Slavic archetypes, which touched a growing nationalist chord. Indeed Repin's later attempts to absorb the representational innovations of the ▷Impressionists were attacked as un-Russian and abandoned.

Repin's most haunting and ambiguous portrait is *They Did Not Expect Him* (1884), showing a radical returning from exile. As a young, gaunt man is shown into the drawing room, reactions of family and servants range from delight to consternation while the shadowy figure of the revolutionary registers the artist's own ambivalence about reform.

Bib.: Parker, F. and Parker, S.J., *Russia on Canvas: Ilya Repin*, Philadelphia, 1980; Valkenier, E.K., *Ilya Repin and the World of Russian Art*, New York, 1990

replica

A copy of a work made by the artist or executed under his or her direct supervision. The reasons for making replicas are many, but the most common are: the success of a composition (▷Champaigne); to satisfy two or more collectors (▷Chardin); to provide patrons with a cheaper 'by the studio of' version (▷Rubens); and, not infrequently, lack of imagination.

▷reproduction

Bib.: Friedländer, M.J., 'Artistic Quality: Original and Copy', *Burlington Magazine*, 78 (1941), pp. 192–7

repoussé

(French, 'pushed back'.) Metal panel (especially of brass, copper, or silver) hammered from the back to produce a design in relief on the obverse side. It is the opposite of ▷chasing.

repoussoir

(From the French, '*repousser*', 'to push back'.) A pictorial device much used by ▷academic landscape painters in which elements in the foreground are used to 'frame' the composition. Thus ▷Claude in *Landscape with the Father of Psyche Sacrificing to Apollo* (1660–70) has placed a copse of trees, typically rendered as near-silhouettes, to the right foreground and a Classical

temple to the left, thereby prompting the eye to wander towards a distant seaport and mountains painted with a very pale palette. As a means of 'setting back' part of the composition, it is most often used in conjunction with the recessional devices of ▷linear and ▷aerial perspective.

Bib.: Gombrich, E.H., *Art and Illusion*, 5th edn., London, 1977

Repton, Humphry (1752–1818)

Landscape architect. Repton came to landscape gardening after failing at several other careers. He started practice in 1788 and was soon admired for his 'pleasing illusions' and detailed presentation of schemes. He acknowledged his debt to ▷Capability Brown and drew on many of Brown's practices. For example, his driveways rarely approach a house by the most direct route and he often placed many trees over man-made hills. He saw the three guiding ideas of landscape gardening as utility, proportion and unity, and promoted himself as an artist painting with natural forms. This is clearly seen in his 'Red Books' which were albums in which he presented his proposals to the owners of properties using ▷watercolours, 'before and after' layers and paper flaps illustrating different features. These books displayed a keen sense of marketing as well as adventurous modern landscape design. He also published many accounts of his work and guides for gardeners. His association with the architect John Nash resulted in several designs, and his sons trained as architects with Nash. Repton achieved considerable notoriety in his own day, appearing as Mr. Milestone in Thomas Love Peacock's *Headlong Hall* and in Jane Austen's *Mansfield Park*, and he is remembered by such works as Donnington Hall, Leicestershire (c1790), Uppark, Sussex (c1805) and Sheringham Hall, Norfolk (c1812).

reredos

In a church, a screen of stone or wood, usually richly decorated, rising from floor level behind an altar and serving as an ▷altarpiece. A reredos is distinct from a ▷retable in so far as the latter is usually set up on the altar table itself or upon a ▷pedestal behind it.

resin

Sticky substance secreted by most trees and plants. Owing to its insolubility in water, it is used for making ▷varnish. In ancient times, it was also used to pigment wooden sculptures (e.g. tomb effigy of Tutankhamun, c1340 BC, Cairo Museum). In the 20th century it has been used by sculptors as the main component of a range of castable synthetic materials, most commonly polyester resin and epoxy resin.

Bib.: Mills, J., *The Encyclopaedia of Sculpture Techniques*,

London, 1990; Penny, N., *The Materials of Sculpture*, New Haven and London, 1993

Restauration Style

The style related to the period (1815–30) in which the Bourbons were restored to the French throne until the fall of Charles X. It is characterized by its ▷ Neoclassical purity, but it is much lighter than other Neoclassical forms.

restoration of art works

The restoration of art works has become increasingly specialized in response to the escalating value of art and the ethics of art appreciation which demand that the integrity of an art work should not be materially altered by later generations.

Whereas the conservation of art works is essentially preventative and aims to keep the art work in the best conditions possible to ensure its future well-being, a more radical intervention would consist of the partial or total restoration of damage. Here the aim is to replace or stabilize areas of damage or loss. Common examples of restoration in oil painting include the strengthening of a canvas by relining and the replacement of paint loss on the surface, while works on paper are often bleached to remove 'foxing' (mould grown from impurities in the paper).

The effects of restoration are often spectacular. Anyone who has seen a yellowed coat of varnish removed to reveal often brilliant tones will appreciate the effects of cleaning. However, such actions are not without risk. Overcleaning, where not only varnish but also the final ▷ glazes are removed, risks a loss of subtlety, resulting in a harsh and insensitive surface, a criticism that has been levelled at many restorations of the works of ▷ Titian, for example, and more recently at the major restorations of ▷ Michelangelo's ▷ frescos in the ▷ Sistine Chapel. A responsible restoration will allow both the specialist and the public to distinguish between original elements in the art work and restoration.

Unlike the restorers in the past (often artists in their own right and quite often commissioned by the owner to bring an art work 'up to date'), modern restorers shun overpainting and only apply paint where necessary, such as to a repair. If the repair is large, a restorer will usually apply a uniform tone to indicate that this work is not part of the original composition. This action implies that the restorer should go no further than ensuring the continued well-being of the art work, and certainly stop short of undermining the integrity of the original artist's conception or execution. However the line between thoughtful restoration and unwarranted interference is a fine one and open to debate.

Bib.: Kuhn, H., *Conservation and Restoration of Works of Art and Antiquities*, London, 1986; Ruhemann, H. and Plesters, J., *The Cleaning of Paintings*, London, 1968

Restoration Style

The style related to the period when Charles II was 'restored' to the English throne in 1660 after Cromwell's interregnum. It was dominated by the influence of Dutch and French styles, as well as a new emphasis on ▷ japonism.

Resurrection

(Matthew 28: 1–8; Mark 16: 1–8; Luke 24: 1–9; John 20: 1–18.) The most important episode in the story of ▷ Christ is his Resurrection on the third day after his ▷ Crucifixion. All four ▷ gospels take up the story early on Sunday morning when the Holy Women, whose numbers vary, go to the tomb to anoint Christ's body, having been precluded from doing so by the religious restrictions of the Sabbath the preceding day. They arrive to find that the stone that covered the cave in which Christ was entombed, has been rolled away. ▷ Matthew tells how the appearance of the angel of the Lord made the guards fall away in a faint. The other ▷ Evangelists do not mention the guards, but describe one or two angels either sitting on the fallen stone or within the sepulchre when the women arrive. The Holy Women are told by the angel(s) not to be afraid and to tell the disciples that Christ has risen. As there were no human witnesses to the actual Resurrection, the subsequent manifestations of Christ (which were proof that he had indeed risen) were considered more important to the Church right up until the 13th century; thus the Holy Women at the Sepulchre and the ▷ *Noli me tangere* were portrayed instead. However, the actual moment of Resurrection became increasingly popular in the ▷ Renaissance, especially for funerary chapels. Usually Christ is shown emerging from the tomb with the guards collapsed in a faint around him (e.g. ▷ Piero della Francesca, late 1450s, Sansepolcro, Pinacoteca). Most representations at this period show a corporeal Christ stepping solidly out of the tomb, holding the banner of the Resurrection. However, ▷ Grünewald (▷ Isenheim Altarpiece, 1515, Colmar) stresses the supernatural element of the episode: Christ has returned to earth (not merely awoken) and floats in a blaze of glory (in earlier representations Christ is shown in a ▷ mandorla). Both Piero and Grünewald show Christ's wounds although in both paintings the tomb is a ▷ sarcophagus, not a cave. This latter convention was common practice until the Council of Trent (▷ Counter-Reformation) demanded a return to scriptural accuracy, and from the mid-16th century onwards Christ is generally shown emerging from a cave (e.g. ▷ Santo di Tito, 1570–74, Florence, S. Croce).

retable

A type of ▷ altarpiece, in use since the 12th century, either standing upon the altar itself at the back, or upon a ▷ pedestal behind the altar. A characteristic form consists of a central panel flanked by wings, with

sacred images either painted, or carved in the round, or in relief, and then painted and gilded. A retable is distinct from a ▷reredos in so far as the latter rises directly from the ground behind the altar.

Rethel, Alfred (1816–59)

German painter and graphic artist. He studied in Italy in 1844–5 and again in 1852–3. He accepted commissions for large-scale historical works, including ▷frescos of the life of Charlemagne for the Aachen Town Hall (1847, unfinished). His interest in historical painting was fuelled by his admiration for the work of the ▷Nazarenes. His most famous work was a series of ▷woodcuts based on ▷Holbein's *Dance of Death* series. Rethel's *Another Dance of Death* (1849) was created in response to the events of the 1848 revolutions, which he felt were bloody and unnecessary. He went mad at the end of his life.

reticulated

Decorated with a net-like pattern.
 ▷tracery

retrospective

An exhibition dedicated to the entire career of an artist; looking back in retrospect.

Revett, Nicholas (1720–1804)

English architect. He met ▷James Stuart while studying in Rome and travelled with him to Athens in 1849. There they made a close study of ancient architecture and published the *Antiquities of Athens* in 1762. They travelled again to Asia Minor in 1764–6, and Revett continued his study of ancient artefacts there. He also designed some of his own buildings, but is best known for helping introduce a taste for Greek art into the ▷Neoclassical climate of England in the last quarter of the 18th century.

Reynolds, Sir Joshua (1723–92)

English painter. He was born in Plympton, Devon, the son of a schoolmaster. After a good education, he was apprenticed to the painter ▷Hudson in London 1740, and returned to Devon in 1743 to establish his own portrait practice. In 1749 he travelled to Rome and in 1752 to Venice, and there established many of his artistic ideas. He admired the work of the Venetian colourists (e.g. ▷Titian), studied the ▷antique and returned to England believing in the superiority of ▷history painting. On his return he established himself in London, where he quickly made a reputation particularly as a portrayer of children (e.g. *Miss Bowles and her Dog*, 1775, London, Wallace Collection). He was part of a wide literary circle which included Goldsmith, Johnson and Garrick. At the institution of the ▷Royal Academy in 1768 he was an obvious choice for President, and the following year he was knighted. His *Fifteen Discourses to the Royal Academy* (published

Sir Joshua Reynolds

1769–90) set out his theories of art: painters should emulate the great masters of the past; they should study nature but not merely copy it; art should generalize to create the universal rather than the specific and local. He put forward characteristically ▷Enlightenment ideas on taste (i.e. an educated power to distinguish between right and wrong, the product of the use of reason), but in other ways his views foreshadowed those of the ▷Romantics: for example, he promoted the idea of the ▷sublime in art, and its power to move and inspire.

For Reynolds and for the RA under him, history painting was superior to all other genres, and in his own art, although he produced few successful history paintings (e.g. *Death of Dido*, 1781, Royal Collection), he tried to elevate his portraits by giving them a historical or mythological veneer (e.g. *Mrs. Siddons as the Tragic Muse*, 1789, London, Dulwich Picture Gallery; *General Sir Banastre Tarleton* 1784, London, National Gallery). Because of his success, he employed a large studio and many of his works were of poor quality, primarily worked by assistants. He also suffered from poor sight in later life. In 1781, he visited Holland, where his ideas were modified slightly by his enthusiasm for ▷Rubens, which justified a warmer palette and freer style.

Bib.: Penny, N. (ed.), *Reynolds*, exh. cat., London, 1986; Postle, M., *Sir Joshua Reynolds: The Subject Pictures*, Cambridge, 1995

Ribalta, Francisco (1565–1628)

Spanish painter. He studied in Madrid, but worked in Valencia from 1599. He may have travelled to Italy,

and he certainly assimilated the ▷tenebrism of ▷Caravaggio, which appears in a number of his religious works.

Ribera, José (Jusepe de) (1591–1652)

Spanish painter, draughtsman and etcher. He was born in Valencia but was active throughout his whole known career in Italy, where he was known as Lo Spagnoletto ('the little Spaniard'). In Rome he became a member of the Accademia di S. Luca. His stay in Rome was relatively short and only one set of paintings, of the Five Senses, has survived (e.g. *Sense of Taste*, c1616, Hartford, Wadsworth Atheneum). By 1616 he had settled in Naples, then a Spanish territory, exploiting his dual nationality with preponderantly Spanish clients from the ruling élite and rapidly becoming the city's leading and most influential painter. The majority of Ribera's ▷etchings, dating from 1620–30 and showing a complete mastery of the medium, helped spread his fame beyond Naples and throughout Europe.

Ribera's early work combines a Spanish realist tendency with the dramatic ▷tenebrism of the ▷Caravaggisti, the followers of ▷Caravaggio. (Naples, whence Caravaggio had fled Rome in dramatic circumstances in 1606, was one of the main centres of the Caravaggesque manner.) Ribera's extreme ▷chiaroscuro, allied to his richly textured ▷brushwork and an unerring sense of dramatic composition, resulted in paintings that were admired above all for their impact – his brilliantly highlighted figures appearing to project powerfully from the surrounding darkness of the canvas (e.g. *St. Jerome and the Angel*, 1626, Naples, Museo di Capodimonte). Ribera was also one of the first Spanish artists to paint mythological subjects – though even here the normal Classical idealism is replaced by a visceral Spanish realism (e.g. *Drunken Silenus*, 1626, Naples, Museo di Capodimonte). A quite extraordinary series of pictures, painted for the Spanish viceroy, are the so-called 'beggar philosophers' – portrayals of famous Greek philosophers as ordinary men in ragged dress (e.g. *Archimedes*, Madrid, Prado).

From the 1630s onwards Ribera's style changed under the impact of visiting painters of the Roman-Bolognese school – ▷Guido Reni, ▷Domenichino and ▷Lanfranco – as can be seen in his *Virgin of the Immaculate Conception* (1635, Salamanca, Convent of Agustinas Descalzas). Ribera's palette becomes lighter and richer, his brushwork is more subdued and his dramatic chiaroscuro is abandoned. In his later years he suffered ill health and his output diminished, although his reputation remained high to the extent that he and ▷Murillo were the only Spanish painters with international reputations prior to the European rediscovery of Spanish painting following the Napoleonic wars.

Bib.: Brown, J., *The Golden Age of Painting in Spain*, New Haven and London, 1991; *José de Ribera*, exh. cat., Madrid, 1992; Spinosa, N., *L'opera completa del Ribera*, Milan, 1978

rib(bed) vault

A ▷vault with projecting stone bands or ribs diagonally arching from the corners of the base compartment, such that the cells between are supported, or appear to be supported, by them. Rib vaults grew increasingly complex throughout the ▷Gothic period, requiring an expanded nomenclature to identify the different types of rib. The simplest ribbed vault is carried on diagonal ribs which rise from the ▷springers and ▷arch diagonally across the vault to meet at the ▷boss in the centre of the ▷bay, and transverse ribs which separate one bay from the next. The early 13th century saw the introduction of ridge ribs, which run horizontally along the longitudinal and transverse ridges of each bay; and tierceron, or secondary ribs, each of which rises from a main springer to a point on the ridge rib where it meets obliquely with its pair rising from the opposite springer. In the 14th century ▷lierne ribs, or tertiary ribs, were introduced, issuing neither from the main springers or the central boss, but decoratively connecting the main ribs.

Ricci, Sebastiano (1659–1734) and Marco (1676–1730)

Italian family of artists. Sebastiano was a Venetian decorative painter, born in Belluno, trained in Bologna, but influenced chiefly by ▷Veronese. Until 1717, he worked mostly outside Venice, firstly throughout Italy and then in Vienna (Schönbrunn Palace), London (*The Resurrection*, Chelsea Hospital Chapel; two large canvases flanking the main staircase in Burlington House; and numerous paintings in the Royal Collection) and Paris. His lighter, less monumental adaptation of Veronese with his rather elongated figures and more open form of composition was extremely influential on the development of ▷Tiepolo's style.

Sebastiano's nephew and pupil, Marco was a stage designer and painter. In 1708, he and ▷Pellegrini were brought to London by Charles Montagu, Earl of Manchester and Ambassador to Venice, and they executed a number of commissions for Montagu and his friends. They decorated several houses, including painting large mythological scenes for Burlington House, and collaborated on designs for the opera. Ricci also painted scenes of London and theatrical life. He was in Venice in 1711, but returned to London the following year with his uncle and they worked as a team there until 1715. Thereafter he remained in Venice as a draughtsman, painter of landscapes and ▷capricci, and a stage designer.

Under the patronage of Montagu, Ricci helped to carry graceful, secularized Italianate painting into English country houses. His most notable works, however, were studies of landscape. The earliest of

these were naturalistic, but during his sojourn in England they became more lush, and ultimately Romantic, dominated by ruins. Although he usually painted with oils on canvas, he also pioneered the unusual method of using ▷tempera on goatskin.

Bib.: Daniels, J., *L'opera completa di Sebastiano Ricci*, Milan, 1976; Rizzi, A., *Sebastiano Ricci*, Milan, 1989; Scarpa, S.A., *Marco Ricci*, Milan, 1991; Succio, D. (ed.), *Marco Ricci e il paesaggio veneto del settecento*, Milan, 1993

Riccio, Il (1470–1532)

Italian sculptor. This was the popular name of the sculptor Andrea Briosco ('Il Riccio' means 'curly-haired one'). He was a virtuoso craftsman, working mostly in ▷bronze, in an antiquizing style influenced by ▷Donatello's, to which he may have been introduced by his putative teacher, Bartolommeo Bellano (c1440–96/7), a former assistant of Donatello. Riccio was trained as a goldsmith and was working in Padua by 1496/7. By c1504 he had established himself as a favourite sculptor among the ▷humanist patrons associated with the University of Padua. His most celebrated commission was for the elaborately ornamented Paschal Candlestick (1507–16) in the Santo, Padua, which has a remarkable amount of pagan Classical motifs for its ecclesiastical context. The programme, however, with its ▷sphinxes and bound ▷satyrs, was devised by a humanist philosopher and scholar, Giovanni Battista de Leone, and was intended to show the ascendancy of Christianity over Paganism. Riccio was to derive a lucrative source of income from reproducing and varying these satyrs and sphinxes as independent bronze ornaments for collectors. His most famous works are his statuettes, including the *Shouting Warrior on Horseback* (London, Victoria and Albert Museum), which strongly suggests a familiarity with ▷Leonardo's cartoon for the *Battle of Anghiari*, now lost (but known today through copies and in Riccio's lifetime still extant in Florence).

Richards, Ceri (1903–71)

Welsh painter and sculptor. He studied at the Swansea School of Art (1921–4) and at the ▷Royal College of Art (1924–7). During the 1930s he became interested in ▷Surrealism and began producing ▷assemblages. After the Second World War he was influenced by the later work of ▷Matisse and ▷Picasso. He accepted a number of ecclesiastical commissions at that time, including the Chapel of the Blessed Sacrament in Liverpool Cathedral. He was a particularly skilled draughtsman.

Bib.: *Ceri Richards*, exh. cat., London, 1981

Richardson, Jonathan the Elder (1665–1745) and Jonathan the Younger (1694–1771)

English family of painters and writers on art. Jonathan the Elder was born in London and taught there by ▷Riley. He worked in a style similar to ▷Kneller, the most successful portraitist of the day, and rivalled him especially in portraits of men (e.g. *Sir John Vanbrugh*, 1725, College of Arms). He helped to establish the ▷St. Martin's Lane Academy in 1711. He was also important as a writer on art: his *Theory of Painting* (1715) influenced ▷Reynolds and he wrote one of the major ▷Grand Tour guides *An Account of Some of the Statues, Bas-reliefs, Drawings and Pictures in Italy* (1722). He was one of the first in England to appreciate painting as a ▷Liberal Art rather than an 'innocent amusement' and thereby helped to raise the status of artists.

Jonathan the Younger collaborated with his father on the guide, and wrote himself on ▷connoisseurship and the education of a gentleman. He was also an amateur painter of portraits.

Richier, Germaine (1904–59)

French sculptor. She studied sculpture at the École des Beaux-Arts, Montpellier (1922–5) before going to Paris in 1925, where she worked with ▷Bourdelle. She spent the First World War in Switzerland, where she met and married the sculptor Otto Bäninger in 1929. From 1945 she lived in Paris. Her stick-like sculptures were similar to those of ▷Giacometti, and, like his, conveyed uneasy associations with insects. She worked mostly in a large scale.

Richmond, George (1809–96) and Sir William Blake (1842–1921)

English family of painters. George was one of the members of ▷Samuel Palmer's group at Shoreham (▷'the Ancients'), and like them his early work was influenced by ▷Blake. However, he later abandoned his visionary experiments to become a fashionable portrait painter, and his work from 1830 onwards is primarily in this genre. His son William was also a portrait painter, as well as producing some sculpture in a Classical style.

Ricketts, Charles (1866–1931)

English painter, sculptor, designer and writer. He was born in Geneva, his father a naval officer. Much of his childhood was spent abroad, in France and Italy, but from 1882 he trained as an illustrator and wood engraver at Lambeth School of Art in London. He was a close friend of fellow student ▷Shannon and together they established the *Dial* in 1889, a magazine promoting good design and influenced by the *Hobby Horse* (▷Mackmurdo). He produced a series of bindings, influenced by ▷Rossetti (e.g. *Dorian Gray*, 1890; *Tess of the d'Urbervilles*, 1891), as well as a number of successful illustrations (e.g. Oscar Wilde's *Sphinx*, 1894; *Daphnis and Chloe*, 1893). In 1896 he established the Vale Press with Shannon, in the traditional of ▷Morris's Kelmscott Press, and designed three new types, as well as publishing *Marriage of Cupid and Psyche* (1897). A fire damaged the Press in 1899 and it was

closed in 1903. He was a friend of ▷Lucien Pissarro during the 1890s and an enthusiast for French ▷Symbolist poetry. He concentrated on painting from 1904, and experimented with sculpture in a style influenced by ▷Rodin. He produced jewellery designs for friends and after the First World War developed an ▷Art Deco style. He was a major collector and wrote *Pages on Art* (1913).

Bib.: *All for Art*, exh. cat., Cambridge, 1979; Calloway, S., *Charles Ricketts: Sublime and Fantastic Decoration*, London, 1979; Darracott, J., *The World Of Charles Ricketts*, London, 1980; Moore, S.T., *Charles Ricketts RA*, London, 1973

Ridolfi, Carlo (1594–1658)

Italian painter, etcher and art historian. He was best known for his writings about Venetian art, including *Le miraviglie dell'arte* (*Marvels of Art*, 1648) and a life of ▷Tintoretto (1642).

Riemenschneider, Tilman (c1460–1531)

German sculptor. He was active in Würzburg from 1483. He and ▷Veit Stoss were the leading late ▷Gothic sculptors. Riemenschneider ran a large and flourishing workshop, producing mostly wood and some stone carvings. In 1483 he registered as a journeyman in the Würzburg Guild of St. Luke and in 1485 became a Master. Apart from being a sculptor, he held various civic positions, including, in 1520–21, Bürgermeister of Würzburg. His political career was violently terminated when, in 1525, he had his hands broken and was imprisoned for two months for taking the part of the rebels in the Peasants' Revolt (although he did eventually resume work as a sculptor). In a period when wooden sculpture had traditionally been painted, he was the first German sculptor to let the natural wood stand as the final form – the consequent distancing from reality being mainly a response to the ▷Reformation ban on idolatrous images. His sculpture is characterized by ascetic figures with exaggeratedly long fingers, dressed in heavy drapery with sharp-edged folds. At its best the craftsmanship is of the highest order, but with such a large workshop there is at times a tendency to formulaic repetition. Many of Riemenschneider's sculptures are still in the churches for which they were made.

Bib.: Baxandall, M., *The Limewood Sculptors of Renaissance Germany*, New Haven and London, 1980; Kalden, I., *Tilman Riemenschneider: Werkstattleiter in Würzburg*, Ammersbek, 1990; Sello, G., *Tilman Riemenschneider*, Munich, 1983

Rietveld, Gerrit Thomas (1888–1964)

Dutch architect and designer. He was associated with ▷De Stijl. He was born in Utrecht, where his father was a cabinet-maker. After an apprenticeship with the family firm, he trained with jewellers (1906–11) before establishing his own furniture business in 1911. He only became an architect in 1919 after studying at night classes. From 1918 he was a member of De Stijl, after meeting ▷van der Leck, and in that year he designed the chair constructed in primary-colour painted wood which came to epitomize the movement's style. In 1920 he designed the GZC jewellery store in Amsterdam, the first of a series of open-plan, airy buildings which made use of strong colour and modern materials. These culminated in 1924 in the Schroeder House, Utrecht, the exterior of which resembled a ▷Mondrian painting, the interior being functional and Japanese in its use of screens and minimal furniture. He returned to furniture design in the late 1920s with single piece chairs made of plywood and plastic and crate furniture, flat-packed from boxwood (including the Zigzag chair, 1934). He also explored the possibilities of ▷prefabrication with 'core' houses, which were built up of repeated units. He designed the Dutch Pavilion at the 1954 ▷Biennale, but much of his later career was spent teaching.

Bib.: Brown, T.M., *Work of Gerrit Rietveld, Architect*, Utrecht, 1958; Overy, P., *Rietveld's Furniture and the Schroeder House*, London, 1990; *Rietveld's Architecture*, exh. cat., Amsterdam, 1972

Rigaud, Hyacinthe (1659–1743)

French painter. He was in Paris studying in 1681, and won the ▷Prix de Rome the following year, although he did not take the opportunity to travel to Rome. He painted state portraits for Louis XIV, for whom he was principal painter, and for Louis XV. He was adept at adopting the influence of other artists, such as ▷Van Dyck and ▷Rembrandt, without crudely imitating their style. His portraits conveyed a sense of rank and status that was particularly attractive to the court. He was a principal rival of ▷Largillière.

Rijksmuseum

The Dutch national collection of art, based in Amsterdam. The collection is based upon the Royal Collections and was initially conceived to bring together the best of Netherlandish art as an act of national pride and as a spur to future production of great art. The Royal Museum was built by Louis Bonaparte in 1808, but it was transferred to the Trippenhuis where it became the Rijksmuseum in 1817. The current building was opened in 1885, and is a ▷Gothic Revivalist structure designed by Petrus Cuypers. The collection contains a comprehensive history of Dutch art from the earliest times, including a huge collection of ▷Rembrandts, and a less full collection of other European art.

Riley, Bridget Louise (b 1931)

English artist. She was associated with ▷Op art. She was trained at Goldsmith's College (1949–53), specializing in drawing, and then at the ▷RCA (1952–5) where she studied painting. She was a close friend of

the painter and teacher Maurice de Sausmarez and travelled with him through Europe in the 1950s, including to Italy where she was influenced by ▷Futurism. They also established the Basic Art Course at Loughborough University. In the 1960s she began to work on black and white abstracts which used geometry and stripes to create optical and illusionistic effects. She came to prominence with these in the 1965 *Responsive Eye* exhibition in New York. They were designed to dazzle and confuse, suggesting movement (e.g. *The Fall*, 1963, London, Tate Gallery), ambiguity and chaos. Gradually, the glaring noise of black and white was softened by the introduction of first grey (e.g. *Arrest I*, 1965, private collection) and then, from around 1965, pastel shades. During the 1970s her work became more restrictive: a series of pieces using vertical stripes of five or six colours (e.g. *Sea Cloud*, 1981, private collection), and more recently she has been working on diamond motifs. Most of these later works have descriptive and natural titles, and the use of increasingly bright colours has given them a poetic quality. Riley has always worked precisely with a slow technique which involves much studio preparation and assistants.
Bib.: *Bridget Riley: Paintings and Drawings 1961–73*, exh. cat., London, 1973; *Bridget Riley*, exh. cat., London, 1991

Riley, John (1646–91)
English painter. He studied with ▷Gerard Soest. He became Principal Painter to William and Mary – a post he held jointly with ▷Kneller. Aside from his formal court portraits, he was adept at painting portraits of lower-class individuals. These include *Bridget Holmes* (1686, Royal Collection), a royal housekeeper.

Rimmer, William (1816–79)
American sculptor and painter of English birth. He was born in Liverpool, but grew up in Boston, where he practised as a physician, although he had received no formal medical training. He went to Rome in 1855 and became impressed by Classical and ▷Renaissance sculpture there. He produced his own sculptures of dying gladiators which were ▷Baroque in emphasis but deliberately reminiscent of High Renaissance work. He was called the 'American ▷Michelangelo'. He also painted and produced the art treatises *The Elements of Design* (1864) and *Art Anatomy* (1877).

Riopelle, Jean-Paul (b 1923)
Canadian artist. He studied with ▷Borduas at the École du Meuble, Montreal, where he became interested in ▷Surrealist ▷automatism. He went to Paris in 1947 and spent many of his subsequent years there. He worked in many media. His early automatist experiments gradually gave way to a form of ▷action painting in which he used thick paint squeezed directly out of the tube and onto the canvas.

Ripa, Cesare (c1560–c1623)
The author of the *Iconologia*, the standard directory of the ▷iconography of ▷allegorical and emblematic figures, first published in Rome in 1593. Ripa's achievement was to codify the pre-existing attributes and appearance of each personified concept. The (non-illustrated) first edition was so well received that a second was published in Milan in 1602. This was followed in 1603 by an enlarged and illustrated Roman edition, the ▷woodcut illustrations for which were allegedly designed by ▷Giuseppe Cesari, the Cavaliere d'Arpino. All of the many subsequent editions were illustrated. During Ripa's lifetime four more editions were published and after his death the work was published in French, German, Dutch, Spanish and English. For two centuries the *Iconologia* was the standard handbook to which artists and scholars referred for the traditional attributes with which to equip their allegories in order to make them universally identifiable.
Bib.: Okayama, Y., *The Ripa Index*, Doornspijk, 1992; Tung, M., *Two Concordances in Ripa's 'Iconologia'*, New York, 1993

Rippl-Ronai, József (1861–1927)
Hungarian painter. He studied with ▷Munkácsy in Paris in 1887, and he later came into contact with the ▷Nabis. He developed his own form of ▷Art Nouveau and was deeply influenced by ▷Symbolist painting. From 1900 he produced interior scenes in the manner of ▷Vuillard.

Rivera, José Diego Maria (1886–1957)
Mexican artist. He was the most celebrated of the Mexican ▷muralists. He was born in Guanajato, where his parents were both teachers, and studied under José María Velasco at the Academia de San Carlos in Mexico City (1898–1905). After exhibiting with the modernist group Salvia Moderna (1906), he won a scholarship to study in Europe and went to Spain. In 1911 he settled in Paris, where he met ▷Modigliani, ▷Juan Gris and ▷Picasso and became a ▷Cubist. He returned to Mexico in 1921 and was commissioned to paint his first mural at Escuela Nacional Prepatoria in Mexico City. He married Guadalupe Marin (divorced 1928) and joined the Mexican Communist Party. With ▷Siqueiros, he founded the Union of Technical Workers, Painters and Sculptors. Rivera visited the Soviet Union in 1927, but was expelled from the Communist Party as a renegade in 1929. In the same year he became Director of the Academia Nacional de Artes Plastica, Mexico City, and married ▷Frida Kahlo. In 1930 he travelled to the USA, painting murals at the San Francisco Stock Exchange (1930–31), the California School of Fine Arts (1931) and the Detroit Institute of Arts (1932–3). The mural at the Rockefeller Centre, New York (1933), was destroyed apparently for depicting Lenin, but recreated at the Palacio de Bellas Artes when Rivera

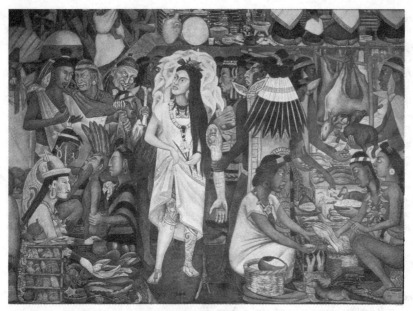

Diego Rivera, *The Market at Tenochtitian*, National Palace, Mexico City

returned to Mexico City in 1934. He befriended Trotsky in 1937, interceding with the government to allow him to stay in Mexico. Despite much pleading Rivera was not readmitted to the Communist Party until 1954. Diagnosed with cancer in 1955 he travelled to Moscow for treatment, and died in Mexico two years later after a heart attack.

Rivera's early paintings drew on ▷Post-Impressionism and Cubism, but he had already questioned the Parisian ▷avant-garde before his return to Mexico. Renouncing artistic élitism, his boldly coloured murals adopt a clearly-defined figurative style to create a politically-committed art accessible to the masses. Although influenced by ▷Renaissance ▷frescos, their compositions (organizing thousands of details along an intricate, snaking narrative) are modelled on indigenous ▷Pre-Columbian art. The subject matter is didactic, frequently in praise of technology, modern agriculture or medicine, or the Mexican people themselves. Rivera's ▷Marxism is clearly signalled, and the figure of ▷Karl Marx appears as a benevolent father figure in several murals. However, Rivera's political loyalties were not wholly unambiguous. He was willing to take commissions from American industrialists, including Rockefeller, and he celebrated Henry Ford's production line in his murals in Detroit.

Bib.: Rivera, D. with March, G., *My Art, My Life*, New York, 1960; Rochfort, D., *The Murals of Diego Rivera*, London, 1987

Rivers, Larry (b 1923)

American painter and sculptor. He was born in New York. He changed his name from Yitzroch Loiza

Grossberg to pursue a career as a jazz saxophonist in the early 1940s. Having attended the Julliard School of Music (1944–5) he studied painting at the Hans Hofmann School (1947–8) and art education at New York University (1948–51). His first solo exhibition was at the Jane Street Gallery, New York (1949). In the 1950s he took up sculpture and travelled to France and Italy. There was a major retrospective of his work at the Jewish Museum in New York in 1965.

Rivers' early paintings were influenced by ▷Bonnard and in the 1950s he was associated with ▷Abstract ▷Expressionism. However, he continued to explore figurative aspects, using the ▷painterly techniques of his contemporaries to rework and reinterpret paintings by ▷Old Masters such as ▷Courbet, ▷David and ▷Rembrandt. The most notable of these is *Washington Crossing the Delaware* (1953) based on elements from ▷Emmanuel Leutze's patriotic painting of 1851. Contemporary ▷objets trouvés such as cigarette packets, playing cards and menus (e.g. *Cedar Bar Menu I*, 1960) entered Rivers' work in the late 1950s and he is frequently cited as a precursor of ▷Pop art.

Bib.: Harrison, H.A., *Larry Rivers*, New York, 1984; Hunter, S., *Larry Rivers*, Barcelona, 1989

Robbia, Luca della (1400–82), Andrea della (1435–1525) and Giovanni della (1469–after 1529)

Italian family of sculptors. Luca was Florentine and regarded by contemporaries as the equal of ▷Donatello, ▷Ghiberti and ▷Masaccio, with whom he is ranked as one of the leaders of the new ▷Renaissance style by ▷Alberti in his *Della Pittura*. Luca's early

years are obscure, but he was obviously an established sculptor by 1431 when he was commissioned by the Opera del Duomo to carve a marble *Cantoria* (now Museo dell' Opera del Duomo). This work is typical of his style: the figures are based on Classical types but the mood is essentially non-dramatic, the charming reliefs of singing and music-making angels and children being prime examples of what Charles Avery has termed the 'sweet style' of Florentine sculpture.

Luca is chiefly known not for his ▷marble sculpture, however, but for his work in tin-glazed ▷terracotta. He invented (and appears to have kept secret) a technique for applying coloured vitreous glazes to terracotta figures and reliefs in order to render them impervious to damp, thereby making them eminently suitable for exterior decoration. Examples of Luca's work in this medium abound in Florence, principally half-length *Madonna and Child* reliefs and coats of arms (e.g. those for the guilds above the statue niches on Or San Michele). The *Madonna and Child* reliefs are often simply white figures on a blue ground, though the coats of arms and other decorative reliefs employ a wider range of colours. Luca's other important works in this medium are the *Resurrection* and *Ascension* ▷lunettes (1442–5 and 1446–51 respectively) over the bronze ▷sacristy doors (also by Luca) in Florence Cathedral, and the decorative ▷reliefs of ▷Apostles and ▷Evangelists in ▷Brunelleschi's Pazzi Chapel (1440s).

The tremendous demand for such relatively cheap, durable and high quality works was met by the establishment of a factory, perpetuated by Luca's nephew. Andrea della Robbia and Andrea's five sons, of whom Giovanni della Robbia is the most important. Andrea's most famous work is perhaps the series of foundling roundels decorating the spandrels of Brunelleschi's loggia of the Ospedale degli Innocenti, Florence (1463–6).

Bib.: Gentilini, G., *I della Robbia*, Florence, 1990; Pope-Hennessy, J., *Luca della Robbia*, Oxford, 1980

Robert, Hubert (1733–1808)

French artist. He was born in Paris and intended for the church but instead travelled to Italy in 1757, where he entered the ▷Académie as a result of family connections. He spent 12 years in Italy, including a period travelling in the south with ▷Fragonard (1761), and his style was influenced by that of ▷Piranesi and ▷Panini (e.g. *Villa Conti at Frascati*, 1760, Besançon). Robert returned to Paris in 1766 and established a reputation as a painter of ▷picturesque ruins and townscapes with *Port de Rome* (Paris). Under the patronage of ▷Boucher he achieved success and a softer, more attractive style. He was appointed Keeper of the King's Pictures by Louis XVI and was the first curator of the ▷Louvre. He also supervised the construction of an English park at Versailles. During the ▷French Revolution he was imprisoned and sen-

tenced to death (he escaped only because someone was mistakenly guillotined in his place) and in jail he continued to work with smuggled materials (e.g. *Couloir à St. Lazare*, 1794, Paris).

Roberti, Ercole d'Antonio de' (c1450–96)

Italian painter. He was active chiefly in Ferrara. The details of his biography are sparse. It is known that he replaced ▷Tura as court painter to the ▷Este family in Ferrara in 1486. It has been suggested that he may have been trained by ▷Cossa in Ferrara and probably went with him to Bologna as assistant before his return to work for the Este. The only major works securely attributed to him are a large ▷altarpiece, *The Madonna Enthroned with Saints* (1480, Milan, Brera), which is signed 'Ercole', and a small, intensely moving, *Pietà* (Liverpool, Walker Art Gallery). Stylistically he is closely related to Cossa and Tura, although Roberti's work is subtler in handling: the sharply defined bounding lines and somewhat metallic colours of these two masters are softened by what appears to be contact with the work of the Venetian ▷Giovanni Bellini.

Bib.: Manca, J., *The Art of Ercole d'Roberti*, Cambridge, 1992

Roberts, David (1796–1864)

Scottish painter. He was born in Edinburgh, where he was apprenticed to a house painter (1808). He worked as a scene painter in Glasgow and Edinburgh, before becoming an architectural painter working in oil and ▷watercolour (e.g. *Ruins of Elgin Cathedral*, 1853, London, Victoria and Albert Museum). He moved to London in 1822, where he met ▷Stanfield. He was a member of the Society of British Artists from 1834 and elected ▷RA in 1841. His most famous works were produced as a result of a series of travels: to Holland and Belgium (e.g. *St. Paul's, Antwerp*, 1848, London, Tate Gallery); to Spain and Morocco, 1832–3; and to Egypt and Palestine, 1838–9 (see *The Gateway of the Great Temple at Baalbek*, 1842, London, Royal Academy). His sketches of exotic scenes, similar to those of ▷Lear, were widely reproduced as ▷lithographs.

Bib.: Ballantine, J., *Life of David Roberts*, RA, Edinburgh, 1886; *David Roberts*, exh. cat., London, 1986; *David Roberts: Artist Adventurer*, ex. cat., Edinburgh, 1981; Gutterman H., *David Roberts, RA*, London, 1978

Roberts, Tom (1856–1931)

Australian painter of English birth. He went to Australia in 1869 and he later studied photography there. In 1875 he enrolled at the National Gallery School in Melbourne, and he travelled to England in 1881, where he was impressed by the work of ▷Bastien-Lepage. He returned to Melbourne in 1885 where he became one of the founders of the ▷Heidelberg School. His work showed some ▷Impressionist influ-

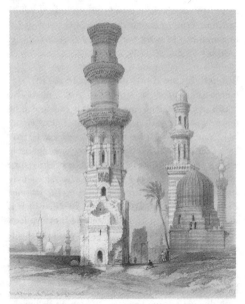

David Roberts, from *Egypt and Nubia*, Vol. 3, Stapleton Collection

ence, but he applied this to ▷genre scenes of Australian bush life. From 1903 to 1923 he lived in England.

Roberts, William (1895–1980)

English painter. He was born in London. He began an apprenticeship with the advertising firm Sir Joseph Causton Ltd., but attended evening classes at St. Martin's School of Art and won a scholarship to the ▷Slade in 1910. Once there, he also gained a travel bursary and spent 1912 in France and Italy. His early work was influenced by ▷Post-Impressionism, employing flattened, heavily applied colour and simplified shapes in his urban themes (e.g. *Leadenhall Market*, 1913, London, Tate Gallery). In 1913 he joined the ▷Omega Workshops, exhibited with the ▷NEAC and signed the ▷Vorticist Manifesto although he did not join the Rebel Art Centre. He was an official war artist and served with the Royal Field Artillery in 1917. After the First World War he spent time in France, producing paintings for the Eiffel Tower Restaurant (e.g. *Vorticists at the Restaurant de la Tour Eiffel*, 1961–2, Tate). He exhibited with Group X in 1920 and began to work on the stylized figure compositions which were to continue until his death. He illustrated an edition of T. E. Lawrence's *The Seven Pillars of Wisdom* in 1922. He was elected ▷RA in 1966.

Robertson, Anna Mary

▷Moses, Grandma

rocaille

(French, 'rock-work'.) Ornamental rock-work and shell-work first employed on fountains and in grottoes in the mid-16th century and revived in the 18th as a decorative motif for furniture and architecture. The term *rocaille* is used to describe objects that existed before the advent of ▷Rococo style. However, because *rocaille* is such a characteristic feature of particularly French 18th-century decoration, the two terms Rococo and *rocaille* are today sometimes used interchangeably by French art historians.

rocker

A tool used in ▷mezzotint engraving. It consists of a round blade with serrated edges which can be rocked across a ▷plate to roughen it and alter the texture of the final print.

Rococo

An 18th-century style, principally associated with the ▷decorative arts, deriving its name from the French, ▷*rocaille*, meaning 'rock-work'. The name was first used in the early 19th century as a pejorative term, denoting the frivolous over-elaboration which contemporary critics considered the salient feature of the style. Rococo evolved in France from, and as a reaction against, the formal and somewhat ponderous style centred on the court of Louis XIV at Versailles. Following Louis XIV's death in 1715 the court moved to Paris and Rococo reflected the new taste for lighter, more delicate decoration suitable for the smaller, more comfortable and intimate interiors of town houses. Interiors and furnishings alike were decorated with abstract 's'-curves and 'c'-scrolls combined with naturalistic motifs derived from shells and plants, often in a playfully asymmetrical arrangement. The paintings of ▷Watteau, ▷Boucher and ▷Fragonard, with their playful eroticism, soft colours and elegant forms, provided a perfectly attuned accompaniment to the interiors for which they were intended.

The most celebrated sculptor associated with Rococo style was ▷Falconet, particularly in his role as director of the Sèvres ▷porcelain factory. Another important Rococo porcelain factory was at Meissen, near Dresden. In fact, after France, the other main centres of the Rococo were Catholic parts of Southern Germany and Austria, where the churches of ▷Neumann and Dominikus Zimmerman took Rococo decoration to breathtakingly elaborate extremes. The leading German Rococo sculptor was Ignaz Günther. In Italy only Venice adopted the Rococo style, but it did produce in ▷Tiepolo the finest decorative painter of the period. He worked throughout Europe, notably at Würzburg and Madrid. Tiepolo's work in Spain influenced in turn the early paintings of ▷Goya. The style never took a firm hold in England, although ▷Hogarth's love of the 's'-curve clearly derives from the Rococo (▷*Analysis of Beauty*) and the elegance of ▷Gainsborough's paintings partakes of its flavour. The Rococo style was eventually supplanted in the 1760s by the radical seriousness of the ▷Neoclassical style.

Bib.: Conisbee, P., *Painting in 18th Century France*, Oxford, 1981; Kimball, F., *The Creation of the Rococo Decorative Style*, New York, 1980; Zafran, F.M., *The Rococo Age*, exh. cat., Atlanta, 1983

Rodchenko, Aleksander Mikhailovich (1891–1956)

Russian painter, sculptor, photographer and designer. He was born in St. Petersburg, the son of a craftsman and a laundress. He studied at the Kazan Art School (1910–14), where he met his future wife ▷Vavara Stepanova, and the Stroganov Art Institute (1914–16). Rodchenko began to exhibit in 1913, contributed to ▷Tatlin's 'The Shop' exhibition (1916) and assisted with the decoration of the Café Pittoresque. One of the most politically committed of the young Russian artists, Rodchenko joined ▷Narkompros in 1918, taught at the Moscow ▷Proletcult school and was instrumental in the rejection of ▷Kandinsky's programme for ▷INKHUK, arguing for a more rigidly ▷Constructivist stance. He moved towards a ▷Productivist ethic, and in 1921 renounced fine art and was one of the organizers of the exhibition ▷5 × 5 = 25. During the 1920s he was furiously active as a designer of furniture, textiles and costumes. With ▷Mayakovsky he produced a steady stream of propaganda posters, as well as advertisements for various state-owned industries, from bottled beer to the films of ▷Eisenstein and Dziga Vertov. In 1935 he returned to easel-painting.

Rodchenko was one of the most vociferous champions of Constructivism within the post-Revolutionary official bodies and educational institutions, and a key figure in its development into Productivism. His paintings and reliefs were heavily influenced by ▷Malevich and Tatlin, who befriended him in 1916. However, he was less concerned with rigid and precise geometries than some of his contemporaries, and more able to adapt his talents to popular and accessible aesthetically-pleasing industrial designs. It was here that he achieved innovations, particularly with his curved abstract furniture. His photography is equally distinctive, exploiting slanted or unusual angles which underline the 'framed', artificial nature of the medium while constructing a documentary record of industrial and agricultural activities, or revealing character in his portraits of Stepanova.

Bib.: Karginov, G., *Rodchenko*, London, 1979; Khan-Magomedov, S.O., *Rodchenko, The Complete Works*, London, 1986; *Rodchenko: graphico, designer, fotografo*, exh. cat., Milan, 1992

Rodin, Auguste (1840–1917)

French sculptor. He had an impoverished childhood and a number of early failures in his career, including being rejected three times by the ▷École des Beaux-Arts. During his early years, he studied at the so-called 'petite école' – the school for decorative arts, while he worked as a mason. A major point of inspiration came in 1875 when he went to Italy and saw the works of ▷Michelangelo. He chose to aim for Michelangelo's monumentality and expressive form in his *Age of Bronze* – a bronze sculpture of a naked man which avoided the idealization common in contemporary sculpture.

Rodin's interest in the expressive possibilities of sculpture led to both admirers and detractors, but he did gain several important commissions. The first of these was a commission from the French state in 1880 to produce a bronze door for the new Musée des Arts Décoratifs. Looking deliberately back to the heritage of ▷Ghiberti's *Gates of Paradise* (the bronze doors for the Florentine baptistry), Rodin produced what he called ▷ *The Gates of Hell*. Unlike Ghiberti's idealization, Rodin's figures were twisted and tortured, and his evocation of Dante's *Inferno* through the theme of his doors was an attempt to explore the human condition. Over a period of years, Rodin produced over 180 figures for the doors, many of which became the basis for free-standing works, such as *The Thinker*.

Rodin was also commissioned for other large group sculptures, such as ▷ *The Burghers of Calais* (1884–6) – intended for the town hall in Calais. The historical subject of six chained hostages aroused the hostility of the commissioning body, as they were shown ragged and downtrodden, rather than heroic. Greater objections were raised when Rodin produced his statue of the novelist Balzac (1892–8), commissioned by the Société des Gens de Lettres in 1891. The work was misunderstood as it was not a conventional heroic portrait of the writer, but an imaginative exploration of the idea of genius.

Rodin's many sculptural ideas were often carried through by his studio assistants, and other sculptors often carved parts of his work and cast from his designs. This tendency to distance himself from the sculptural object was derided in the early 20th century when ▷direct carving became valorized. Rodin was most interested in the expressive aspects of sculpture, including the power of sculptural fragments, which he exploited for their ▷antique associations as well as their imaginative forms. He was also interested in surfaces of sculpture and how they could be used. He had gained an international reputation by the beginning of the 20th century but his ▷Symbolist works were soon superseded by new experiments with ▷abstraction.

Bib.: Elsen, A., *The Gates of Hell by Auguste Rodin*, Stamford, 1985; Elsen, A., *Rodin's Thinker and the Dilemmas of Public Sculpture*, New Haven, 1985; Goldscheider, C., *Auguste Rodin: Catalogue raisonné de l'oeuvre sculptée*, Paris, 1989; Lampert, C., *Rodin: Sculpture and Drawings*, London, 1986

Roelas, Juan de (c1560–1625)

Spanish painter. He was based in Seville. Nothing is known about his early years, although he may have visited Italy. However, documentation places him in

Valladolid in 1598, when he helped to decorate a monument to Philip II. In 1603 he became a priest at Olivares, but resigned his chaplaincy three years later to paint full-time. He moved to Madrid in 1617, applying for the post of Court Painter but was turned down. In 1621 he returned to his position at Olivares.

Roelas was probably Seville's greatest painter, and virtually all of his surviving paintings, including *The Circumcision* (c1606), *Vision of St. Bernard* (1611) and *Pentecost* (1615), are still in Andalusia. The subjects are predominantly religious, with sophisticated and detailed compositions and a finely textured surface. Moreover, there is a vein of earthy realism to Roelas's work, and the combination of this feature with intense mysticism influenced many future Spanish artists, notably ▷Zurbarán.

Bib.: Valdiviesco, E., *Juan de Roelas*, Seville, 1978

Rogers, Claude (1907–79)

British painter. He studied at the ▷Slade School, exhibited with the ▷London Group and became a member of the group in 1938. During the 1930s he specialized in realist landscapes. He helped found the ▷Euston Road School with ▷Coldstream and ▷Pasmore, and taught at the Camberwell School of Arts and Crafts in the 1940s and subsequently at the Slade School of Art.

Rohlfs, Christian (1849–1938)

German painter. He was born in Niendorf. He studied at the Weimar Academy (1870–81) and later taught there, becoming Professor in 1902. He also worked as a teacher at the Folkwang School in Hagen. In 1906 he met ▷Nolde and worked with him at Soest, developing an ▷Expressionist style similar to that of ▷Die Brücke (e.g. *Winter Landscape*, 1900, Hagen). He employed vigorous ▷impasto dashes and increasingly strong colours in a series of landscapes. He worked in Munich 1910–12, before returning to Hagen where he settled until moving to Ascona in 1927. His work of the First World War years was more sombre and angular (e.g. *The War*, 1915, Essen), but in later years he developed a lyrical, visionary style, often choosing flowers as subjects.

Roldán, Pedro (1624–1699) and Luisa (c1656–c1704)

Spanish family of sculptors. Pedro studied in Granada and worked in Seville from 1656. There he became Director of Sculpture at Seville Academy (1664–72). He worked in a ▷Baroque style and is best remembered for the ▷reredos he designed for the high altar of the Church of the Hospital de la Caridada (1670–75). His daughter Luisa also worked as a sculptor in Cadiz and Madrid. She became Royal Sculptor to Charles II.

Roman art

Roman art is generally defined as much more than the art of the city of Rome; rather, it is the art of Roman civilization from Romulus to the Emperor Constantine, and covers a period of more than 1,000 years. Many characteristics of Roman art have their origins in the art of the ▷Etruscans, the Romans' predecessors as the dominant culture of Italy. As Roman domination spread through Italy, Europe and the Mediterranean, however, Roman art absorbed this Etruscan style and the Etruscan influence included temple architecture, sculpture, portraiture and wall-painting. Rome was also deeply influenced by the art of the ▷Hellenistic world, which had spread to southern Italy and Sicily through the Greek colonies there. Plutarch, writing in the 2nd century AD, wrote that before Rome's conquest of Greek Syracuse in Sicily, 'Rome neither had nor even knew of these refined things, nor was there in the city any love of what was charming and elegant; rather, it was full of barbaric weapons and bloody spoils.' As Greek treasures continued to arrive in Rome, for example after the sack of Corinth in 146 BC, Hellenistic art continued to exert a fascination on the more austere Romans. Yet Greek culture was not fully accepted until the reign of the Emperor Hadrian and his court (AD 117–38). In the later republic and early imperial period Greek artists were brought to Rome where they designed buildings, repaired sculptures and made new ones, and the Hellenization of Roman culture was continually forwarded. Original Greek statues were copied by Roman artists, though usually in ▷marble rather than ▷bronze, and removed from their original contexts. The portrait bust became

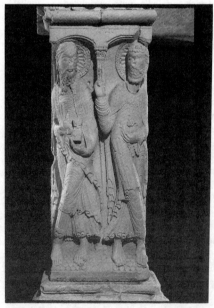

Romanesque: St. Peter and St. Paul, 12th-century French relief, Musée des Augustins, Toulouse

a popular form, tending to be more realist than Greek portraiture.

However, Roman art also had its own original contributions. Compared with Greek architecture, Roman was more secular and utilitarian and showed an interest in grandeur and scale, for example in the ▷Colosseum and public baths in Rome. The Romans also developed the use of the ▷arch, the ▷vault and the ▷dome, and discovered concrete, which all allowed for a much grander architecture, its culmination being found in religious buildings such as the Pantheon in Rome and the Hagia Sophia in Constantinople. Both these buildings (which still stand today) had important influence far beyond the Roman period. The ▷triumphal arch was another Roman invention that was revived in the ▷Renaissance and stands as an important example of Roman civic and monumental architecture. The trumphal arch used ▷relief sculpture and inscription to carry its historic and commemorative messages, and this narrative technique decorated the entire surface of the commemorative Trajan's Column. Relief sculpture was also used for funerary art. The Romans developed the use of ▷mosaic decoration from the Greek example and with wall-painting it became an important aspect of patrician domestic decoration, the best surviving examples being from ▷Pompeii and Herculaneum. Wall-painting showed an interest in landscape and the illustration of scenes from myth and literature. The ▷decorative arts included fine silver and glassware, such as the Portland Vase, and jewellery of amber, precious gems and gold.

Wherever the Roman empire extended, it took its arts and architecture, and its mosaic, theatres, temples and statuary may be found from Hadrian's Wall in the north of England to Leptis Magna in North Africa, and from Constantinople in the east to Emerita Augusta in Spain in the west. Though the barbarian tribes who finally overran the empire brought their own arts and traditions they held the Roman culture in awe, adopting and adapting their art as well as their laws and religion, by then Christianity, as they saw fit. However it was the 15th-century Italian ▷Renaissance that saw the greatest revival of Roman art, and its influence and heritage survives in all branches of the arts today.
Bib.: Walker, S., *Roman Art*, London, 1991; Ramage, N.H. and Ramage, A., *The Cambridge Illustrated History of Roman Art*, Cambridge, 1991

Romanelli, Giovanni Francesco (c1610–62)

Italian painter and tapestry designer. He was trained firstly by ▷Domenichino and then, more significantly for his mature style, by ▷Pietro da Cortona. His own style was a mixture of the two, preponderantly influenced by Pietro's energetic ▷Baroque, but with a certain ▷Classical restraint instilled through his early years with Domenichino. Romanelli was, through his connection with Pietro, patronized by the ▷Barberini family in Rome (e.g. the ▷fresco decorations of the Sala della Contessa Matilda in the Vatican, 1637–42, commissioned by Pope Urban VIII ▷Barberini). In 1645–7, however, Romanelli was invited to France by Cardinal Mazarin and executed decorations for the Galerie Mazarin (now in the Bibliothèque Nationale, Paris). On a second visit, in 1655–7, he decorated the Salle des Saisons in the Louvre (now in an extremely altered state), for Anne of Austria, mother of Louis XIV. Romanelli's Classically restrained style of Baroque decoration, combining sumptuously gilded ▷stucco work and painting, exactly suited French taste and was very influential on ▷Lebrun, particularly his decorative schemes at Versailles.

Romanesque

Art historical term for the art and architecture of Western Europe between the end of the ▷Carolingian ▷Renaissance in the 10th century and the rise of ▷Gothic in the 12th. In England it is known as ▷Norman. Architecture was the dominant art form in this period and the origins of the Romanesque style are principally associated with (i) a new requirement that each priest say mass each day, thus necessitating more altars and therefore more chapels in that part (i.e. the east end) of the church occupied by the clergy, and (ii) the growing cult of saints which necessitated the construction of clearer passageways to accommodate the free movement of the increased numbers of pilgrims who came to the churches to visit the relics, usually housed at the east end. Thus, Romanesque churches typically have either (i) in addition to the main ▷chancel ▷apse, a chapel at the east end of each aisle in a configuration known as staggered apses (*en échelon*), or (ii) an ▷ambulatory around the apse in order to facilitate the freer circulation of worshippers, plus ▷radiating chapels. Also, extra chapels may be opened up in the east wall of each transept.

Romanesque architectural forms are derived from antique Roman architecture (hence the name), thus the round ▷arch is characteristic. The problem of stone ▷vaulting a wide nave was solved (flat wooden ceilings having been the norm since the Roman technique of stone vaulting wide expanses had been lost), although the inexperience of architects necessitated what came to be other Romanesque characteristics such as thick walls, small windows and massive piers. Regional variations include tunnel vaults in France (e.g. ▷Cluny III), groin vaults in Germany (e.g. Speyer Cathedral) and rib vaults in England (e.g. Durham Cathedral) and Italy (e.g. S. Ambrogio, Milan). Exteriors may have either two towers on the west front with a third over the crossing (in England and Normandy) or a towerless screen façade (south of France). Multiple towers are characteristic of Germany, for example St. Michael's, Hildesheim, with its two crossings, each with a tower, plus towers at the ends of

both sets of transepts. Italian Romanesque retained the closest links with ▷Classical models, one of the finest examples being S. Miniato al Monte at Florence (12th century). Massive and unembellished castles and keeps were the most important secular buildings, a well-preserved example being the White Tower of London (1077–97).

Sculpture became an important feature of church decoration after centuries of neglect. Romanesque sculpture, characteristically non-naturalistic, highly stylized, with elongated figures and generally in relief rather than free-standing, combines elements derived from both the antique Roman figurative tradition and the geometric vegetal designs of barbarian art. It was usually ▷polychrome and was used to decorate ▷tympana, ▷capitals and other architectural features. Among the most important examples of Romanesque sculpture are in France in the Cathedral of St.-Lazare at Autun, the church of Ste.-Marie at Souillac and the abbey churches of St.-Pierre at Moissac and Ste.-Madeleine at Vézelay. The *Last Judgement* ▷tympanum at ▷Autun (before 1135) is signed by ▷Gislebertus, the greatest of the French Romanesque sculptors. German sculptors had kept alive the art of casting bronze, the finest surviving example being the bronze doors to the church of St. Michael at Hildesheim (1015).

Most of the interior walls of Romanesque churches were once decorated with paintings either in ▷fresco or ▷distemper, good examples surviving at S. Savin-sur-Gartempe (c1100) and Berzé-la-Ville (c1100), France. One of the leading schools of manuscript illumination was in England, the finest surviving example of its work being the *Winchester Bible* (c1160–70). The ▷*Bayeux Tapestry* (1066–77) is the most famous surviving example of Romanesque embroidered fabric.

Bib.: Beckwith, J., *Early Medieval Art*, rev. edn, London, 1969; Hearn, M.F., *Romanesque Sculpture*, Oxford, 1981; Shapiro, M., *Romanesque Art*, New York, 1977; Swarzenski, H., *Monuments of Romanesque Art*, London, 1954

Romanists

Flemish and Dutch artists who either worked in Italy during the first half of the 16th century or who deliberately cultivated the styles of the High ▷Renaissance. They also travelled back to the Low Countries and carried Renaissance modes of representation with them. These artists include ▷Mabuse and ▷van Orley.

Romanticism

An early 19th-century, pan-European movement in the arts and philosophy. The term derives from the Romances of the Middle Ages, and refers to an idealization of reality. In the late 18th century, it came to mean anti-Classical (▷Classical) and represented a trend towards the ▷picturesque and the ▷Gothic, and

a love of nostalgia, mystery and drama (e.g. ▷Walpole, ▷Beckford and ▷Fuseli). By the early 19th century it had been broadened to include: an enthusiasm for, and awe of, nature; a political support for liberty; an emphasis on the individual as a unique creative being; opposition to, and fear of, industrialization; an interest in the exotic and primitive; nationalism; and a dissatisfaction with life and a desire for new means of artistic expression. This breadth of meaning has led to the definition of Romanticism as a 'feeling' and very little else.

The Romantic movement took on different characteristics throughout Europe. In England, the poets Shelley and Keats sought beauty, Byron sought exotic glory and adventure, Wordsworth tried to express a love of nature in a new simple language and ▷Blake railed against the Establishment. Landscape painting was seriously explored by ▷Constable, ▷Palmer and others. The Middle Ages were revived as a source of artistic and architectural interest. Most significantly ▷Turner found a radical and expressive technique with which to depict his view of the natural world. In France the movement was politically motivated by the revolutions of 1789 and 1830, and with the patronage of Napoleon (see ▷Gros and ▷Géricault), artists looked increasingly to literature, history and exotic subjects. The ▷*art pour l'art* movement promoted beauty for its own sake (e.g. ▷Ingres), there was a search for painting of modern life (by ▷Baudelaire) and ▷Delacroix experimented with new colour theories and free brushwork. In Germany, an enthusiasm for nationalism and liberalism generated by the Napoleonic invasion inspired writers, artists and architects (e.g. ▷Friedrich, ▷Schinkel and ▷Klenze).

Bib.: Honour, H., *Romanticism*, London, 1979; Lister, R., *British Romantic Painting*, London, 1989; Vaughan, W., *Romantic Art*, London, 1978

Romayne work

A name given to 16th-century English provincial carving which showed some evidence of Italian ▷Renaissance influence.

Rombouts, Theodoor (1597–1637)

Flemish painter. He studied in Antwerp under ▷Janssens and became Master of the Antwerp Guild in 1601. He went to Italy in c1616–c1625, where he adopted the ▷tenebrism of ▷Caravaggio in his ▷genre scenes. When he returned to Antwerp, he changed his style in the light of the work that ▷Rubens was producing there.

Rome

City on the Tiber, on the eastern side of the Apennines in central Italy. According to legend, it was founded by the twins Romulus and Remus on the seven hills in 753 BC. The city and its people have their origins in the Iron Age, forming a culture distinct from the

neighbouring ▷ Etruscans in the region around Rome known as Latium. With the conquest of Italy and the victories of the Punic Wars against Carthage, Rome became the centre of a civilization that largely dominated Europe and North Africa from the 3rd century BC to the beginning of the 5th century AD. The greatest period of building was under the emperors and tetrarchs in the 1st to 4th centuries AD, and included the ▷ Pantheon, Diocletian's Baths, Nero's 'Domus Aurea' and the great Christian ▷ Basilica of Maxentius and Constantine. But with Constantine's foundation of a second imperial capital at Byzantium in AD 330, Rome's importance declined in the face of threatened barbarian invasion, and many of Rome's treasures were removed to new centres such as Ravenna, Constantinople and Milan. In 410 Rome was sacked by the Visigoths, and in 455 by the Vandals. Though barbarian rulers such as Theodoric I encouraged the restoration of baths, circuses, sewers and aqueducts in the late 5th century, large parts of the city were abandoned and ancient sites such as the Forum, Palatine Hill and Colosseum became overgrown. Though the city remained an important pilgrimage centre and seat of the Papal See for most of the medieval period, many of its Classical monuments were stripped of their marble, which was reused in new structures or burnt to make lime.

From the 15th century, however, the growth of ▷ humanism and the revival of Classical study led to renewed interest in Rome. Beginning with Martin V, projects of public work were organized by the popes, and men like Poggio Bracciolini studied the city's history. The papacy of Nicholas V (1447–55) saw a real attempt at the rebuilding of the city, and as the ▷ Renaissance flourished Rome became a centre of artistic production not seen since the emperors. Pope Sixtus IV built the ▷ Sistine chapel which was decorated by leading artists, including ▷ Botticelli, ▷ Ghirlandaio and ▷ Perugino, whilst Julius II commissioned ▷ Michelangelo to paint its ceiling, ▷ Raphael to decorate the Vatican stanze, and ▷ Bramante to start work on rebuilding St. Peter's. Discoveries of the city's ancient past, such as the excavation of the ▷ Laocoön statue in 1506, continued to fire the inspiration of the 'eternal city'. Leo X made Rome the artistic capital of the world before imperial troops of the ▷ Reformation sacked the city in 1527. The building of the Gesù, the first ▷ Baroque church between 1568 and 1575, had an enormous influence on European architecture.

Again in the 18th century Rome became the focus of European artistic attention, particularly as a port of call for English gentlemen on the ▷ Grand Tour. The Venetian artist ▷ Giovanni Piranesi made views of the city between 1748 and 1778 which highlighted both the ▷ picturesque and the archaeological, and ▷ Giovanni Pannini depicts the vogue for collecting and displaying antiquities and paintings of monuments in his

Gallery of Ancient Rome. The Prussian scholar ▷ Johann Winckelmann lived in Rome from 1755 where he wrote his *History of Ancient Art* (1764) and laid the foundations of ▷ Neoclassicism. The city was occupied by the French from the 1790s, who undertook extensive excavations. Following the Risorgimento, Rome was declared the capital of a united Italy in 1870. In the 1920s the fascists revived the idea of Rome as a symbol of Italian unity and civilization and the centre of a mythical empire. Mussolini in his claim of 1925 that, 'Rome must appear in all its splendour: immense, ordered, and as powerful as it was at the time of the first empire', was expressing an idea that had preoccupied the city's inhabitants since ▷ Charlemagne had been crowned emperor there on Christmas Day 800. Until the emergence of Paris as the centre of European ▷ modernism later in the 19th century, Rome had dominated the artistic imagination and education of post-medieval Europe for some 500 years.

Romney, George (1734–1802)

English painter. He was the son of a cabinet maker, born in Dalton-in-Furness. After an apprenticeship with his father, he was taught painting in Kendal and York by provincial portraitists, and established his own practice in 1755, before moving to London in 1762. In 1773–5 he travelled to Italy, where he was influenced by ▷ Raphael. He never exhibited at the ▷ Royal Academy but was a prolific and successful artist, and part of a wide literary circle which included Cowper and Hayley. He also shared radical political sympathies with ▷ Blake and Tom Paine. He was most famous for his portraits of women and children (e.g. *Lady Robard*, 1786, Port Sunlight), although his powerful images of men and his ▷ Neoclassically influenced group portraits (e.g. *The Beaumont Family*, 1777–9, London, Tate Gallery) are impressive. He also produced works for ▷ Boydell's Shakespeare Gallery and wanted to succeed as a ▷ history painter, although with few results.

Ronald, William (William Ronald Smith) (b 1926)

American painter of Canadian birth. He went to New York in 1955 and became one of several important artists of the 'second generation' of ▷ Abstract Expressionists. He became an American citizen in 1963, but his associations with Canada made him an important influence for artists in Toronto. From the 1970s, he expanded his repertoire to include ▷ performance art.

Roncalli, Cristoforo (Il Pomarancio) (1552–1626)

Italian painter. He was born in Pomerancio, near Volterra. He became an important ▷ fresco painter, and produced works for the Vatican in c1590–1610 in a ▷ Mannerist style. His patron, Vincenzo Giustiniani,

gave him the opportunity to travel throughout Europe, and he became Giustiniani's artistic advisor.

rood

In medieval Christian churches, the image of Christ on the cross (rood being the Saxon word for cross) erected upon the ▷rood-screen, and facing towards the ▷nave of the church. Roods were generally made of wood and flanked by figures of the ▷Virgin and ▷John the Evangelist.

Rood, Ogden (1831–1902)

American scientist and amateur painter. He published *Modern Chromatics* in 1879 (translated into French in 1891), in which he explored the scientific theory of colour. Like ▷Chevreul he devised a colour wheel which located all the colours of the spectrum and allowed artists to locate ▷complementary colour. He divided colours into three primaries (▷primary colour) and three binaries, which, if mixed together, would produce white, in contrast to ▷complementary colours which would produce grey if mixed. He also stressed the idea of optical luminosity, whereby colours mixed by the eye were more intense than those mixed on the palette. He was one of several colour theorists (▷Henry) who were influential amongst the ▷Neo-Impressionists.

rood-screen

In medieval Christian churches, the screen which carries the ▷rood. It divides the ▷chancel, reserved for the clergy, from the ▷nave, intended for the laity. The rood-screen is surmounted by the rood-beam which stretches between the responds of the chancel arch and actually supports the rood itself. The beam would have originally been supported along its length by columns, but the reforms of the 10th and 11th centuries, when a greater differentiation between the clergy and laity was imposed, led to the introduction of solid wooden or stone screens beneath the beams. The 15th century saw the introduction of rood-lofts, galleries erected above the screen and reached by wooden staircases at the sides of the rood-screen, or by stairways built into the walls of the church. Rood-lofts not only carried the rood and other sacred images, but were also used for preaching and reading the scriptures to the laity in the nave. A rood-altar was frequently sited in front of the rood-screen to serve the laity. Because of their association with monastic churches (where the separation of clergy and laity was essential) and the sacred images carried by the screens, most rood-screens were destroyed in the Reformation (although a stone rood-screen survives at St. Albans Cathedral, Herts, England).

roof

There are a number of different types of roof. These include:

(i) Gambrel roof. (a) In the United Kingdom, a hipped roof in which the gables slope back to within a short distance of the ridge at which point they form vertical gablets. (b) In the USA, a mansard roof with vertical gable ends.

(ii) Hammer-beam roof. A timber roof with horizontal brackets (hammer-beams) attached to the feet of the principal rafters and projecting part way across the width of a room (like an interrupted tie-beam), acting as cantilevers and supported beneath by hammer braces. The inner ends of the hammer-beams carry vertical posts (hammer-posts) which support the longitudinal horizontal timber (purlin). Higher up in the roof is a shorter transverse collar beam which is joined to the hammer-beams by an arched brace. The most celebrated example is by the king's master carpenter Hugh Herland in Westminster Hall, London (1394–1406).

(iii) Helm roof. A kind of squat steeple with a gable at the foot of each face, found in ▷Romanesque architecture.

(iv) Hipped roof. A pitched roof with back-sloping gables at each end.

(v) Pavilion roof. A roof with equal slopes on each face.

(vi) Pitched roof. A roof with a central longitudinal ridge, sloping sides and vertical gables at each end.

▷mansard roof

Rooker, Michael Angelo (1743–1801)

English painter and scene designer. He studied with ▷Paul Sandby and adopted his teacher's interest in topographical painting and drawing. He travelled throughout Britain from 1788 onwards, sketching and painting ▷picturesque scenes. His landscape skills also made him an important scene designer, and he worked for the Haymarket Theatre in London.

Bib.: Conner, P., *Michael Angelo Rooker 1746–1801*, London, 1984

Rops, Félicien (1833–98)

Belgian artist. He was a ▷Symbolist and a member of the Brussels-based ▷Les Vingt, but active in Paris from the mid-1870s. Primarily a printmaker with a brilliant and inventive ▷etching technique, his work is characterized by a somewhat perverse eroticism borne of a deep misogyny (e.g. *Pornokrates*, etching, 1896), blended at times with a keen interest in Satanism (e.g. in the series of etchings, *Les Sataniques*, Brussels, Bibliothèque Royale). His prints were executed as illustrations both for books and for his own satirical journal.

Bib.: *Félicien Rops 1833–98*, exh. cat., Paris, 1985; Rouir, E., *Félicien Rops: catalogue raisonné de l'oeuvre gravée et lithographie*, Brussels, 1982

Rosa, Salvator (1615–73)

Italian painter. He was born near Naples and educated by ▷Falcone, a painter of battle scenes which Rosa imitated in his youth, and possibly by ▷Ribera. In 1653, he went to Rome, encouraged by ▷Lanfranco, and made a name there as a poet and painter of ▷genre scenes. He later moved to Florence in 1640, having attacked ▷Bernini in a satire, and there became an artist to the ▷Medici (e.g. *Self-portrait*, 1641, London, National Gallery). He developed an intellectual circle at court and began to produce pastoral landscapes influenced by ▷Claude. He returned to Rome in 1749 and remained there until his death, increasingly interested in moralizing ▷history subjects, based on ▷Poussin (e.g. *Humana Fragilitas*, 1757, Cambridge, Fitzwilliam). He also produced his most characteristic works – bold, romantic landscapes, which were to become especially popular in 18th-century England.

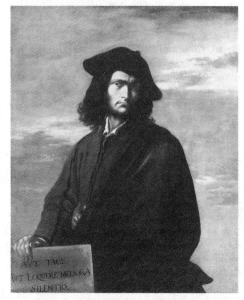

Salvator Rosa, *Self-portrait*, c1645, National Gallery, London

Rosalba Carriera

▷Carriera, Rosalba

Rose + Croix, Salon de la

A Salon established at the Durand-Ruel Galleries in opposition to the official ▷Salon by the occultist 'Sâr' Joséphin Péladan. Péladan believed ▷Rosicrucianism held secret truths of Catholicism and established his Salon as a source for art that would favour 'the Catholic ideal and Mysticism'. He drew up an extensive set of rules stating the aims of the Salon, exhibition at which was by invitation. These declared the rejection of ▷history painting, patriotic and military painting, rustic scenes and still lifes, and called instead for 'Legend,

Myth, Allegory, the Dream', 'Catholic dogma' and 'The nude male sublime'. Contributors to the Salon, which held six exhibitions, included ▷Emile Bernard, Charles Filliger, Alphonse Osbert, Armand Point and Alexandre Séon. As well as being an important exhibitor of French ▷Symbolist painters, the Salon drew to attention a number of other European Symbolists, including the Swiss ▷Ferdinand Hodler, the Dutch ▷Jan Toorop and the foremost Belgian Symbolists, ▷Jean Delville and ▷Fernand Khnopff.
Bib.: da Silva, J., *Le Salon de la Rose + Croix (1892–1897)*, Paris, 1991

Rose Period

▷Picasso, Pablo

Rosicrucians

A mystical secret society that announced itself in three manifestos published in Germany early in the 17th century. Telling of the life of Christian Rosenkreutz, they united magic, hermeticism and alchemy to announce a new age of knowledge and power over nature, and the founding of a secret 'invisible college'. Written by Johann Valentin Andrea the 'movement' probably never included any other members, but its ideas of religious mysticism influenced thinkers and scientists as diverse as Descartes, Kepler, Francis Bacon, John Dee and Isaac Newton, as well as artists such as the members of the Salon de la ▷Rose + Croix.

Roslin, Alexander (1718–93)

Swedish painter. He studied in Italy and France in the 1740s and worked at the courts of Bayreuth and Parma. He was in Paris in 1752, where he became a member of the French ▷Académie. He specialized in portraits and was known for his skill at representing costume, as well as for the insight of his portraits of the bourgeoisie. He travelled back to Stockholm in 1774, and he also worked in St. Petersburg and Vienna.

Rosselli, Cosimo (1439–1507)

Italian painter. He was from Florence, where he ran a flourishing workshop and was an extremely competent craftsman, although not a particularly original artist. He was highly enough regarded by his contemporaries, however, to be chosen with ▷Perugino, ▷Botticelli and ▷Ghirlandaio to decorate the walls of the ▷Sistine Chapel with ▷frescos in 1481. He executed four scenes: *The Crossing of the Red Sea, Moses and the Tablets of Law, The Last Supper* and *The Sermon on the Mount*, assisted by his pupil ▷Piero di Cosimo. Another celebrated pupil was ▷Fra Bartolommeo.

Rossellino, Bernardo (1409–64) and Antonio (1427–79)

Italian family of sculptors and architects. They were brothers, active chiefly as marble sculptors in Florence,

although Bernardo also worked as an architect. Bernardo's most important work is his Monument to Leonardo Bruni (1444–50, Florence, S. Croce) which set the standard compositional formula for the ▷Renaissance ▷niche tomb, including his brother, Antonio's, principal commission, the Monument to the cardinal of Portugal (1461–6, Florence, S. Miniato). The basic pattern is of a Classical ▷sarcophagus surmounted by an effigy lying upon a bier, contained within a niche framed by ▷Corinthian ▷pilasters and crowned by a semi-circular ▷lunette with a ▷relief of the Virgin and Child. Bernardo's monument is itself derived from ▷Donatello and ▷Michelozzo's Monument to Pope John XXIII (c1424–7; Florence, Baptistry), but rationalized with more graceful lines and harmonious proportions. Bernardo's chief project as an architect was the planning of the piazza and its buildings for Pope Pius II's new town of Pienza (1460–62). He was also appointed architect of Florence Cathedral and was responsible for completing the lantern on Brunelleschi's dome.

Antonio was Bernardo's pupil, although Donatello was also a major influence. However, like his contemporary ▷Desiderio da Settignano, Antonio embraced only what Charles Avery has called the 'sweet style', those graceful aspects of Donatello's early oeuvre, found in certain of his Madonna ▷reliefs and the *Cavalcanti Annunciation* (1430s, Florence, S. Croce) Antonio's *Virgin with the Laughing Child* (London, Victoria and Albert Museum) is typical of this 'sweet style'. Antonio was also a portraitist, one of his finest and most strongly characterized being the Bust of Giovanni Chellini (1456, London, Victoria and Albert Museum), his earliest surviving signed work.

Bib.: Finelli, L., *L'umanesimo giovane: Bernardo Rossellino a Roma e a Pienza*, Rome, 1984; Mack, C.R., *Studies in the Architectural Career of Bernardo di Matteo Ghamberelli, called Rossellino*, Ann Arbor, 1976; Schulz, A.M., *The Sculptures of Bernardo Rossellino and his Workshop*, Princeton, 1977

Rossetti, Dante Gabriel (1828–82)

English painter of Italian descent. He was the son of an Italian refugee living in England. He was taught drawing by ▷Cotman and later studied with ▷Brown and ▷Hunt. Together with Hunt and ▷Millais he formed the ▷PRB in 1848 and was also responsible for their first exhibited work, *The Girlhood of Mary Virgin* (1849). The secrecy and romanticism of the Brotherhood appealed to Rossetti, but he shared little of Millais' interest in technique or of Hunt's religious morality. In 1850, he met ▷Siddal, whom he later married in 1860, and he increasingly isolated himself from the group, creating an ideal existence with her. During the 1850s he abandoned oils, with which he was technically poor, for ▷watercolour, and embarked on a series of works with recurring themes: the poet ▷Dante, with whom he identified (e.g. *Dante Drawing*

an Angel on the First Anniversary of Beatrice's Death, 1849, Birmingham, City Art Gallery) and the Arthurian legends (e.g. *Wedding of St. George and the Princess Sabra*, 1851, London, Tate Gallery). In these works the Pre-Raphaelite concern with meticulous detail was adapted to incorporate complex two-dimensional design, and Rossetti increased the Brotherhood's ▷primitivism until his work resembled ▷Gothic and medieval tapestries. In 1862, after Siddal's death, his work began to centre around images of women, painted in oils (e.g. ▷*Beata Beatrix*, 1863, London, Tate) and was increasingly obsessed with his second great muse, ▷Morris's wife Jane (e.g. *Astarte Syriaca*, 1877, Manchester). These were claustrophobic, idealized, otherworldy paeans to beauty, which spawned a host of imitators attracted to Rossetti's reclusive lifestyle as much as to his art.

Bib.: *Dante Gabriel Rossetti: Poet and Painter*, exh. cat., London, 1973; Surtees, V., *Dante Gabriel Rossetti: Catalogue Raisonné*, 2 vols., London, 1971

Rosso, Giovanni Battista (Rosso Fiorentino) (1495–1540)

Italian painter. He was from Florence and was one of the pioneers of ▷Mannerism. Like his friend ▷Pontormo, Rosso was trained by ▷Andrea del Sarto. He was active in Florence from 1513 to c1523, executing at this time what is often considered to be his masterpiece, the intensely moving *Deposition* (1521, Volterra Museum). From c1522 until the Sack of 1527, he was in Rome. He then spent a number of unsettled years until 1530 when he was invited by Francis I to work for the French court, where he became one of the founders, with ▷Primaticcio, of the School of ▷Fontainebleau, exerting a considerable influence on the course of French painting. His most important work at Fontainebleau are the decorations for the Gallery of Francis I. By all accounts a turbulent personality, there is nonetheless no evidence to support ▷Vasari's statement that he committed suicide. His paintings are often characterized by intense and sometimes violent drama, displaying the strained poses, extremes of ▷foreshortening, crowded compositions and bold colour contrasts typical of early Mannerism (e.g. *Moses Defending the Daughters of Jethro*, c1523, Florence, Uffizi). His chief influences were ▷Michelangelo and the engravings of ▷Dürer.

Bib.: Carroll, E.A., *Rosso Fiorentino: Drawings, Prints and Decorative Arts*, Washington, 1987; Ciardi, R.P., *Rosso Fiorentino: catalogo completo dei dipinti*, Florence, 1991; Franklin, D., *Rosso in Italy: The Italian Career of Rosso Fiorentino*, New Haven and London, 1994

Rosso, Medardo (1858–1928)

Italian sculptor. He was born in Turin. In 1882 he studied at Milan Academy (although he was thrown

Max Beerbohm, *Dante Gabriel Rossetti in his back garden*, from 'The Poet's Corner', 1904, Central St. Martin's College of Art and Design, London

out for disruptive behaviour), and was part of the ▷avant-garde Scapigliature group. He then travelled to Paris where he worked under ▷Dalou (1884) and was later a friend of ▷Rodin. His first works were in clay and ▷bronze but by the 1890s he had achieved recognition for his technique of pouring wax over plaster (e.g. *Golden Age*, 1886, Rome). His work was associated with ▷Impressionism because of the freeness of modelling and his interest in light and movement (e.g. *Mme. X*, 1896, Venice, Gallery of Modern Art) and his attempts to inject a sense of spontaneity into his work (e.g. *Infant Laughing*, 1890, Rome). He was also interested in the effects of surroundings on objects, and in creating a unity between the figure and the surroundings. This led to his incorporating real objects into his work, something which prefigured many 20th-century sculptors. He was rediscovered by the ▷Futurists and praised in ▷Boccioni's sculpture manifesto.
Bib.: *Medardo Rosso*, exh. cat., London, 1994

Rothenstein, Sir William (1872–1945)
British painter and writer. He studied at the ▷Slade (1888–9) where he was influenced by his teacher, ▷Legros. He then moved on to the ▷Académie Julien in Paris, where he met ▷Whistler. He was also friendly with ▷Degas and ▷Pissarro. He adopted Whistler's style for a time, but his works remained representational, even after abstraction became the vogue for European art. He became a teacher and from 1920 to 1935 was Principal of the ▷Royal College of Art.
Bib.: Rothenstein, W., *Men and Memories: Recollections of William Rothenstein*, 2 vols., London, 1931–2

Rothko, Mark (1903–70)
American artist of Russian birth. He was born to a Jewish family in Dvinsk who emigrated to America in 1913. He studied with the ▷Art Students' League of New York (1925) and at Yale University, and was a member of the ▷Federal Arts Project (1936). After the Second World War he taught at the California School of Fine Art (1947–9). He was a co-founder of the ▷Expressionist group, ▷The Ten, in 1935 and spent the decade producing smoky figures in alienated urban backgrounds. During the 1940s he developed a ▷Surrealist style, influenced by ▷Miró's ▷biomorphism – spiky, semi-automatic line drawings and ▷watercolours (e.g. *Baptismal Scenes*, 1945, New York). These gradually became more amorphous, until in 1947 he was experimenting with abstraction and ▷colour fields. He was a founder of the Subject of the Artist School with ▷Motherwell and ▷Newman. From the 1950s he became famous for large-scale canvases of limited colour containing roughly-edged, floating squares of colour. The scale and the lack of focus, combined with careful use of paint created a meditative space which drew in the spectator. Rothko intended these paintings to express spirituality and a 'state of intimacy'. His colours became increasingly sombre as his career progressed, a fact often ascribed to the artist's state of mind. During the 1960s he varied his design to include a horizontal emphasis (e.g. *Two Openings in Black over Wine*, 1958, London, Tate Gallery). He produced several mural series (e.g. *Seasons Restaurant*, 1958, London, Tate) and canvases for the Rothko Chapel 1965–7. He committed suicide in 1970.

Bib.: Walden, D., *Mark Rothko*, London, 1978; *Mark Rothko*, exh. cat., London, 1987

Rottenhammer, Johann (Hans) (1564–1625)

German painter. He studied in Rome with ▷Paul Bril, and remained there from 1589 to 1596. He then moved to Venice, where he absorbed the influence of ▷Tintoretto. He specialized in small paintings, many of which were on copper, representing mythological scenes. After 1606, he worked in Augsburg.

Rottmayr, Johann Michael (1654–1730)

Austrian painter. He worked in Venice (1675–88), and while there, his work showed the influence of ▷Correggio. He was in Salzburg in c1688 and Vienna in 1696. He produced a number of decorated ceilings in a Baroque style, including the ceiling of the Karls-kirche in Vienna (1726–30).

rotunda

A building, or a room within a large building, circular in plan and usually surmounted by a ▷dome.

Rouault, Georges (1871–1958)

French painter. He was born in Paris, the son of a Breton cabinet-maker. In 1888 he was apprenticed to a glass painter, and worked on the restoration of medieval stained glass whilst taking evening classes at the École des Arts Décoratifs. In 1891 he entered the ▷École des Beaux-Arts, where he was taught by ▷Moreau and became friends with ▷Matisse and ▷Marquet. He exhibited at the ▷Salon and entered the ▷Prix de Rome in 1893 and 1895. After Moreau's death he became curator of the museum established in his studio. A psychological crisis led to a change of attitude and style, and at the turn of the century he began to work on dark, brooding landscapes. He exhibited at the ▷Salon d'Automne (1903–8) and at the ▷Salon des Indépendants (1905–12), and remained associated with the ▷Fauves despite differences in style. His work retained a realism, whilst employing a vigorous ▷Expressionist technique, and he chose as his subjects circus scenes and prostitutes (e.g. *Aunt Sallies*, 1907, London, Tate Gallery). From 1906 he worked with ▷ceramics, produced illustrations for ▷Vollard, and worked on designs for ▷Diaghilev's ballet *Le Fils Prodigue* (*The Prodigal Son*). By the 1930s his reputation had spread, but in 1939 the death of Vollard led to a dispute over the ownership of his canvases and he ended up burning over 300. In his later years he returned to religious subjects (e.g. *Judgement of Christ*, 1935, Tokyo).
Bib.: *Georges Rouault*, exh. cat., London, 1960

Roubiliac, Louis-François (c1705–62)

French sculptor. He was the most accomplished sculptor active in England in the 18th century. He worked in a ▷Rococo style, providing a lively contrast to the more sober, Classically-based sculpture of his chief rival ▷Rysbrack. Despite his contemporary fame, Roubiliac's years before his arrival in England are obscure. He was born in Lyons, studied at the ▷Académie in Paris and may have been trained by ▷Nicolas Coustou. There is also some evidence that he worked for ▷Permoser in Dresden. He was in England by the early 1730s and is said to have worked for ▷Cheere. He established his reputation in 1738 with his first independent commission, the statue of Handel for the ▷Vauxhall Gardens (▷terracotta in Cambridge, Fitzwilliam; marble in London, Victoria and Albert Museum). Shown seated in a cross-legged, informal pose, at once both stylishly executed and realistically conceived, the statue was an instant hit with the crowds who frequented the fashionable pleasure gardens. Its success secured several commissions for portrait busts, most of which are notable for the vivacity of their conception (e.g. ▷*Hogarth*, c1740, terracotta, London, National Portrait Gallery), though no immediate major commissions were forthcoming.

From 1745 Roubiliac taught sculpture at the ▷St. Martin's Lane Academy. For a short period in c1750 he worked as a modeller at the Chelsea china factory and in 1752 he visited Rome where he greatly admired ▷Bernini's sculptures. Roubiliac's most ambitious commissions were the series of tombs, from the 1747 Monument to Bishop Hough in Worcester Cathedral onwards, which introduced into England the full-scale dramatic ▷Baroque ensemble. His most remarkable tomb is the Monument to Joseph and Lady Elizabeth Nightingale (1761, London, Westminster Abbey). Lady Elizabeth had been struck dead by lightning and Roubiliac shows her at the moment of death, with Death personified as a hideous shrouded skeleton (derived from ▷Bernini's Tomb of Alexander VII in St. Peter's) aiming a dart at her as her husband tries vainly to protect her. Perhaps his most accomplished (and admired) tomb is the Monument to John, Duke of Argyll and Greenwich (1745–9, London, Westminster Abbey).
Bib.: Bindman, D. and Baker, M., *Roubiliac and the Eighteenth-Century Monument: Sculpture as Theatre*, New Haven and London, 1995

roughcast

A rough, textured mixture of lime and gravel applied to walls. This may be in preparation for further coatings as with ▷fresco or it may be the final appearance, as with pebble-dash.

roulette

A tool with a handle and a revolving wheel, used in ▷engraving to help create tonal effects. Eighteenth-century artists made extensive use of it, as it assisted the effects of the ▷crayon manner.

Rousseau, *My Self-portrait*, 1890, Narodni Museum, Prague

Rousseau, Henri (Le Douanier) (1844–1910)

French painter. He was born in Laval, to a poor family of tinsmiths, and received little formal education. He joined the army in 1862 as a saxophonist, and served in 1870, before retiring to become a customs official at the gates of Paris. He began copying in the Louvre and developing connections with artists. After retiring in 1885, he began to paint as an amateur, earning a living as a violin teacher. He claimed to have painted nothing before 1863, and was self-taught. In 1886, he exhibited at the ▷Salon des Indépendants after meeting ▷Signac, and during the 1890s he was known to ▷Seurat, ▷Pissarro and ▷Redon and became something of a celebrity in the Paris art world. He himself wanted to gain recognition as a serious academic artist (he repeatedly entered mural competitions without success) but he was instead praised and ridiculed in equal quantities for his *naiveté*. In 1906 he was rediscovered by the poets ▷Apollinaire and Alfred Jarry, who saw his work at the 1905 ▷Salon d'Automne, and admired his childlike intuitive style, qualities which later endeared him to the ▷Surrealists. He painted a wide range of subject matter from portraits (e.g. *Jo Brummer*, 1909, Basle) and scenes from his own life, to flowers and exotic dream-like scenes (e.g. *Tropical Storm with Tiger*, 1891, London, National Gallery).
Bib.: *Henri Rousseau*, exh. cat., New York, 1985

Rousseau, Théodore (1812–67)

French painter. He was the son of a Paris tailor. Classically trained, he turned to landscape in 1830, having failed to win the ▷Prix de Rome. In that year he visited the Auvergne and began to produce naturalist landscapes. These had only limited success, and although he exhibited at the ▷Salon in 1831, his works were rarely picked after his *Descente des Vaches* was refused in 1836, and he became known as the 'Grand Refusé'. He continued to have influential friends, however, including ▷Delacroix. He developed a broad, sketchy use of oils, often choosing to represent bleak landscapes with stormy skies (e.g. *Valley of St. Vincent*, c1830, London, National Gallery; *Plain of Montmartre*, 1835, Paris). From 1833 he was painting at Fontainebleau and in 1846 he settled in Barbizon where he became the leading figure of the ▷Barbizon School (alongside Dupré, ▷Diaz and ▷Millet), producing studies of the forest (e.g. *Avenue*, 1849, Paris; *Edge of the Woods*, 1854, London, National Gallery). Initially these works were influenced by 17th-century Dutch art and promoted a rather melancholic ▷Romanticism, but increasingly he became interested both in the depiction of nature's mood and seasons and in Japanese ▷woodcuts of landscape, and in both these he could be said to prefigure ▷Impressionism. He rarely produced finished work ▷*plein air*, and during the 1860s developed a highly finished, intensely coloured style which was much criticized. Throughout his life he campaigned to preserve Fontainebleau from tourism. Despite greater success (13 pictures at the 1855 Universal Exposition) he continued to have financial difficulties until his death.
Bib.: *Théodore Rousseau*, exh. cat., Norwich, 1982

Rout of San Romano, The

A large three-panel painting by ▷Paolo Uccello which is first mentioned in 1492 in an inventory of the property of Lorenzo de' Medici, and was probably originally placed in his bedchamber. It represents the events of a small battle that took place between Florentine and Sienese forces in 1432. The three sections are now in the ▷National Gallery, London, the ▷Uffizi, Florence, and the ▷Louvre, Paris; each section shows, respectively, the Florentine general Niccolo de Tolentino leading the attack, the unhorsing of the Sienese general Bernardino della Carda, and Micheletto da Cotignola leading the counter-attack of the Florentine squadrons. Though there is no firm date, the work is generally placed between 1451 and 1457. Uccello was an important user of the new theory of ▷linear perspective, but as the foreground and background of the painting have no spatial relationship, the action in the background has the impression of a theatrical curtain or backdrop. Furthermore his mixing of naturalism in his depiction of mounted figures, the geographical configurations of the horses, and his use of bright heraldic colours produces a curious two-dimensionality in the scenes.
Bib.: Pope-Hennessy, J., *The Complete Works of Paolo*

Uccello, London, 1950; Borsi, F. and Borsi, S., *Paolo Uccello*, Paris 1992

Rowlandson, Thomas (1756–1827)

English caricaturist and draughtsman. He studied at the ▷Royal Academy Schools in 1772 and possibly in Paris in 1773. From 1780 he was producing highly popular *tableaux de modes* which combined ▷Hogarthian observation and humour with flowing ▷Rococo line. These began as parodies of fellow artists (e.g. *Imitations of Modern Drawings*, 1888), but developed into a wide range of subject matter (e.g. *Smithfield Market*, 1816–20, London, British Museum; *Box Lobby Loungers*, 1786, London, Royal Academy). He produced a number of popular series including the *Comforts of Bath* (1798), the *Miseries of Life* (1808) and *Tours of Dr. Syntax* (which parodied the contemporary enthusiasm for the ▷picturesque) published by ▷Ackermann (1812–20). His work was not entirely light-hearted: he produced a number of erotic drawings and a version of the *Dance of Death* (1815–16). He was a friend of ▷Morland and travelled with him to France, Germany and Holland, making rapid sketches en route.
Bib.: Paulson, R., *Thomas Rowlandson: A New Interpretation*, London, 1972; Schiff, G., *Amorous Illustrations of Thomas Rowlandson*, New York, 1969; *Thomas Rowlandson*, exh. cat., London, 1960

Royal Academy of Arts

Established in 1768 in Pall Mall and then at Somerset House, London, it was founded by George III as a learned body to discuss and pontificate about the arts in their widest form. There was a philanthropic force to the Academy, in that the 40 Academicians were to arrange an annual free exhibition, which was to be of a high standard for the encouragement of the general appreciation of the arts (although they later introduced a charge). The Academy also sponsored a school which trained many generations of artists in the ▷Grand Manner by instructing them in copying plaster casts of ancient sculpture and life drawing. The first president was ▷Sir Joshua Reynolds, whose paintings, together with those by ▷Angelica Kauffman and others decorated the ceilings of the original Somerset House meeting rooms. The Royal Academy moved to its present site, Burlington House, Piccadilly, in 1869. It continues to present an annual exhibition, as well as a temporary exhibition programme and lecture series.
▷ARA; RA
Bib.: Hutchison, S., *The History of the Royal Academy*, London, 1986

Royal College of Art

Founded as the School of Design in London in 1837, it specialized in practical and industrial aspects of design, as opposed to the ▷Royal Academy which fostered the fine arts. After it had moved to various London sites, Queen Victoria took an interest in the college and gave it premises in Exhibition Road. It is now in Kensington Gore. As its academic potential grew in terms of the certificates it was able to award, so did the status of the artists who trained there: ▷David Hockney, ▷Barbara Hepworth and ▷Henry Moore are, amongst others numbered as alumni. The college now has numerous courses, academic as well as practical.

Rubenistes

▷Poussinistes vs. Rubenistes

Rubens, Peter Paul (1577–1640)

Flemish painter. One of the most important artists of the early ▷Baroque, he trained himself largely in the popular Italian manner, which he adapted for northern tastes. The very type of the educated (indeed scholarly) artist, he was at ease with kings, princes and cardinals because he 'spoke their language'; indeed, he was at home in Latin, French, Italian, Spanish, English,

Peter Paul Rubens, *Self-portrait*

German and Dutch. Well travelled, well read and urbane, he was frequently entrusted with diplomatic missions. As well as writing a short treatise (*On the Imitation of Antique Statues*), he redefined the political dimensions of painting – see, for instance, the cycle of paintings he did for Marie de' Medici, now in the Louvre (▷Medici Cycle), or the Whitehall Banqueting House ceiling in London. His many letters to scholars, patrons, dealers (▷art dealing), diplomats and other artists give a vigorous picture of his manifold activities and his manner was spread through the many prints made after his work. His general example – the

nature and range of his art – influenced the Flemish School for almost a century, and his published book illustrating the ▷triumphal arches, stage sets, paintings and other decorations he designed for the *Triumphal Entry of Ferdinand of Austria in Antwerp* in 1635 not only broadened the range of his achievements, but also provided models for later generations.

Bib.: Jaffe, A.M., *Rubens and Italy*, Oxford, 1977; Millen, R. *Heroic Deeds and Mystic Figures: A New Reading of Rubens's Life of Maria de' Medici*, Princeton, 1989; Muller, J.M., *Rubens: The Artist as Collector*, Princeton, 1989

Rublev, Andrei (c1370–c1430)

Russian ▷icon painter. The details of his life are uncertain. At an early age he became a monk at St. Sergius' Monastery of the Trinity in Zagorsk, which was a centre of resistance to the Tartars and a ferment of Russian nationalism. He moved later to the Andronnikov Monastery near Moscow. By 1405 he was assisting ▷Theophanes the Greek, and in 1408 worked alongside Daniel Chorny on murals for the Cathedral of the Assumption in Vladimir. His most famous icon, the *Old Testament Trinity*, was painted at his former monastery in Zagorsk in tribute to its founder, who died in 1411.

Rublev's delicate draughtsmanship and luminous colour are regarded as the first truly indigenous Russian painting. The visit of three angels to Sarah and ▷Abraham, depicted in the *Old Testament Trinity* was a familiar subject in ▷Byzantine ▷iconography. However, the lyricism and intimacy of Rublev's treatment, catching the casual drape of the angels' robes and imbuing their downturned faces with a humane intelligence, owes nothing to Greek models.

Bib.: Greschney, N., *L'Icone de la Trinité d'Andrei Rublev*, Burtin, 1986; Sergeev, V.N., *Andrei Rublev*, Milan, 1994; Tarkovskii, A.A., *Andrei Rublev*, London, 1991

rubrication

A term used in reference to medieval ▷manuscript illumination for initial capital letters or headings which were painted in a different colour – usually red – to give them emphasis.

Rude, François (1784–1855)

French sculptor. He was the principal French sculptor of the ▷Romantic period whose most important work is the heroic relief of the *Departure of the Volunteers of 1792 ('The Marseillaise')* on the Arc de Triomphe in Paris (1833–6). Trained in the art school of his home town, Dijon, in the Neoclassical style, he moved to Paris in 1807. He entered the ▷École des Beaux-Arts in 1809 and won the ▷Prix de Rome in 1812, but was unable to make the trip to Rome because of lack of public funds. A supporter of Napoleon, he left for Brussels when Bonaparte abdicated in 1814, remaining

there till 1827. His first major success on his return to France was at the 1831 Salon with his plaster *Neapolitan Fisherboy*, which the State bought in marble (1831–3, Paris, Louvre) and which earned him the cross of the Legion d'Honneur. Although his work was firmly grounded in his ▷Neoclassical training, and despite the popular success of *The Marseillaise*, Rude's sculpture was considered too fervently Romantic for the conservative ▷Académie and he was never elected an Academician. An enthusiastic follower of Napoleon till the end of his days, his final great work was the extraordinary *Napoleon Reawakening to Immortality* (1845–7), a private commission, the plaster (now in Paris, Musée d'Orsay) executed free of charge for another Bonapartist, Captain Claude Noisot, for erection as a ▷bronze monument on his own estate (Parc Noisot, Fixin, France). Rude's most important pupil was ▷Carpeaux.

Bib.: Drouot, H., *Une carrière: François Rude*, Dijon, 1958

Ruisdael, Jacob van (1628/9–82)

Dutch painter and engraver. Born in Haarlem, he may have trained first under his father, Isaac, but then, more importantly and with greater certainty, under his uncle, the landscape painter, ▷Salomon van Ruysdael. In 1648 he entered the Haarlem Guild, but in about 1656 moved to Amsterdam where, according to ▷Houbraken (although most modern scholars now doubt this), he also earned a living as a physician. He stayed there for about 30 years, returning to Haarlem in his old age, where he was buried in St. Bavo's Cathedral. (The story that he died sick and impoverished is without foundation, and is probably a case of mistaken identity as this was the fate of Jacob's cousin, Jacob Salomonsz. van Ruysdael.)

Ruisdael's early landscapes in Haarlem, principally of dunes and estuaries, were influenced by the work of his uncle and, more especially, ▷Cornelis Vroom. Shortly before he moved to Amsterdam he had travelled with his friend, ▷Nicolaes Berchem, to the hilly and wooded countryside of eastern Holland and western Germany. The wilder, more rugged nature of this area struck a deep chord with him and the studies he made on this visit were incorporated into the work of his maturity by which he is best known. Characteristically, these landscapes include waterfalls, pine forests and hills under dramatically stormy skies, the forces of nature often being used to symbolize the fragility of man's existence (e.g. *The Jewish Cemetery*, c1660, Dresden). A strong influence on the paintings of this period was ▷Allart van Everdingen, whose paintings of Swedish landscapes were even more evocatively remote. Ruisdael's figures were usually painted for him by specialists such as Berchem, ▷Adriaen van Ostade and ▷Wouwermans. His only known pupil was ▷Meindert Hobbema, but his influence both on his

contemporaries and on future landscape artists such as ▷Gainsborough, ▷Constable and the ▷Barbizon School painters was great. An extremely prolific painter, Ruisdael's work can be seen in most public collections.

Bib.: Slive, S., *Jacob van Ruisdael*, Amsterdam, 1981; Walford, E.J., *Jacob van Ruisdael and the Perception of Landscape*, New Haven and London, 1991

Runciman, Alexander (1736–85) and John (1744–68)

Scottish family of painters. Alexander was born in Edinburgh and apprenticed to the decorative artist Robert Norie there. His early oils were landscapes but in 1766 he travelled to Rome, met ▷Fuseli and ▷Barry and turned his attention to ▷history painting (e.g. *Origin of Painting*, 1771, Penicuik, Midlothian). He is most famous for his decorations at Penicuik house, showing the *Sagas of Ossian* (1770s, destroyed but known from ▷etchings). He was also a portraitist (e.g. *David, Earl of Buchan*, 1784, Perth). He taught at the Trustees Academy in Edinburgh (1871–85) and was instrumental in raising its status.

Alexander's brother, John, died young but was the more gifted of the two. His style prefigured ▷Romanticism (e.g. *King Lear in the Storm*, 1767, Edinburgh, National Gallery of Scotland).

Runge, Philippe Otto (1771–1810)

German painter. He was born into a Hamburg shipping family and studied in Copenhagen (1799–1801) and Dresden (1801). He had a strong religious vocation, nearly becoming a pastor, and apparently receiving a vision from God to paint. His drawing was influenced by the ▷Neoclassicism of ▷Flaxman but in Dresden he met ▷Friedrich and became increasingly inspired by the ▷Romantic writings of Tieck. After failing to win the Weimar Art Competition in 1801, he turned to a symbolic, mystical style with a series of designs, *Times of Day* (1802–3). He then set about studying colour, which led to a treatise, *Spheres of Colour* (1810). He was painting in Hamburg from 1803 and he developed a highly finished style to represent his spiritual views. Using limited shade and clear colours he portrayed children with the wisdom of adults and optimistic images of nature (e.g. *Morning*, 1808–9, Hamburg).

Bib.: Bisanz, R.M., *German Romanticism and Philippe Otto Runge*, Illinois, 1970; Rosenblum, R., *Romantic Child: Runge to Sendak*, London, 1988

Ruoppolo, Giovanni Battista (1629–93)

Italian painter. He worked in Naples, and, under the influence of ▷Caravaggio and Spanish painting, produced still lifes which emphasized flowers and seafood.

Rupert, Prince (1619–82)

Bohemian engraver. He was the nephew of Charles I and worked as an amateur etcher and engraver. He is said to have been responsible for bringing the technique of ▷mezzotint engraving to England.

Ruralists, Brotherhood of

A group of seven artists formed in 1975 who reacted against prevailing ▷modernism and sought to return to a British style of art that focused on the countryside and reflected the romantic, mystical and literary principles characterized by ▷William Blake, ▷Samuel Palmer, the Brotherhood of ▷Ancients, the ▷Pre-Raphaelites, ▷Stanley Spencer and ▷Paul Nash. The original seven members were Ann Arnold, Graham Arnold, ▷Peter Blake, Jan Howarth, David Inshaw, Graham Ovenden and Annie Ovenden, and they have exhibited widely.

Rusconi, Camillo (1658–1728)

Italian sculptor. He worked in a style similar to that of ▷Bernini, but was less emotional and more Classical. He sculpted a number of tombs, including that of Pope Gregory XIII in St. Peter's (1719–25).

Rush, William (1756–1833)

American sculptor. He was born in Philadelphia, where his father worked as a carpenter. Following in his father's footsteps, he began his career carving figureheads for ships in a naturalistic style which nevertheless contained echoes of the ▷folk art tradition. He became one of the first professional sculptors working in America, and accepted a number of commissions for monumental public sculpture. He worked in wood, plaster and ▷terracotta, rather than marble. He was also one of the founders of the Pennsylvania Academy of Fine Arts.

Ruskin, John (1819–1900)

English critic, art theorist and watercolourist. He was educated at Christ Church, Oxford (1836–42), and was one of the leading ▷Romantic thinkers of the Victorian period. The development of his taste was influenced by his continental trips, especially his 1845 tour to the Swiss Alps and northern Italy, and by his Biblical upbringing. The five volumes of Ruskin's *Modern Painters* (1843–60) explored his artistic interests, particularly in ▷Turner. In *Seven Lamps of Architecture* (1849) and *Stones of Venice* (1851–3), he wrote of his interest in medieval architecture. He supported and defended the ▷Pre-Raphaelite Brotherhood, and was aligned with ▷William Morris in supporting pre-industrial craftsmanship over the advancement of mass-production. He was a champion of several causes: of moral, useful art (and hence of the ▷Pre-Raphaelites in the 1850s); of ▷Gothic architecture and craftsmanship; of the study of nature; and of Turner, whom he met in 1840. Ruskin's St. George's Guild was an

unsuccessful attempt to revive the hand-made linen industry.

From the 1850s Ruskin taught at the Working Men's College, developing a strong interest in social and educational reform. In 1870 he was appointed Slade Professor at Oxford and founded the drawing school there. His lecture courses were immensely popular and seven volumes of them were published. He lectured around the country, was involved in planning the Oxford Museum of Natural History, and was an avid collector. He was also a ▷ watercolourist in his own right, having studied under Copley Fielding and employing his own precepts of truth to nature and fascination with geology (e.g. *Mer de Glace, Chamonix*, 1860, Manchester; *Study of Gneiss Rock, Glenfinlas*, 1853, Oxford, Ashmolean).

Ruskin produced an immense amount of writing and was influential in directing the taste of the period, though his views and opinions became increasingly 'peculiar', as demonstrated by the ▷ Whistler trial of 1878, and his resignation from the Slade Professorship in 1878 and again in 1883. His later life was troubled by mental illness and he published nothing after 1889. **Bib.**: Cook, E.T., (ed.) *John Ruskin: Works*, 39 vols., London, 1902–12; Hewison, R., *John Ruskin: Argument of the Eye*, London, 1976; Hilton, T., *John Ruskin: The Early Years*, New Haven and London, 1985; *John Ruskin*, exh. cat., London, 1983; Landow, G.P., *Aesthetic Theories of John Ruskin*, Princeton, 1971; Morley, C.W., *John Ruskin: Late Work*, New York, 1984

Russell, Morgan (1886–1953)

American painter. He began his training with ▷ Henri in New York, but, like many artists of his generation, he spent time in Paris and eventually settled there. In Paris he also worked with ▷ Matisse and met ▷ Macdonald-Wright in 1911. With Macdonald-Wright, he developed the theories of ▷ Synchromism, which led to a series of important abstract canvases in 1913 and 1914.

Russia and the USSR, art in

Russian art developed its distinctive identity from the first encroachments of Christianity upon the region after AD 1000. ▷ Byzantine influence appeared in architecture throughout Russia and soon took on its own distinct Russian flavour, although the Byzantine influence, with its domes and ▷ mosaics, remained strong in Russia even after the rest of Europe developed ▷ Romanesque and ▷ Gothic architectural forms. ▷ Icon painting was also important in medieval Russia (▷ Theophanus the Greek; ▷ Rublev), and many Russian artists of the 19th and 20th centuries looked back to icons as one of the most important examples of indigenous Russian art. However, from the 15th century onwards, the infiltration of Italian influences overwhelmed the Byzantine style and eventually a distinct form of Russian ▷ Baroque developed. In the 18th century, Peter the Great tried to compete with other European nations in cultural as well as political terms, and he invited Italian and French architects and sculptors to his new capital of St. Petersburg. He also professionalized art practice through the establishment of an Academy of Arts. Thus Russian art of the late 18th and early 19th century included types of ▷ genre painting and portraiture compatible with similar developments in the rest of Europe.

The next important developments of Russian art came in the late 19th century, when the ▷ Wanderers rebelled against the formalities of academic art in favour of a ▷ realist style and social content. From the closing years of the 19th century until the time of the Russian Revolution in 1917, Russian art was pulled in two directions: towards a creation of a distinctly Russian ▷ modernism based on folk art, and towards Western European styles and influences. The latter influence can be seen in the ▷ Symbolist work of the ▷ World of Art artists, as well as the ▷ Blue Rose Group. The self-conscious adoption of Russian modes of vision was first perpetuated by artists' colonies at ▷ Abramtsevo and elsewhere, where a distinctive form of Russian ▷ Arts and Crafts developed. However, many modernist art movements and tendencies actually took on qualities of both indigenous Russian art and Western European art and in the early years of the 20th century, Western European influence blended with ▷ primitivism in movements such as ▷ Rayonism and exhibitions such as the ▷ Golden Fleece, the ▷ Jack of Diamonds and the ▷ Donkey's Tail. ▷ Futurism also had important manifestations in Russia through the ▷ Cubo-Futurism of ▷ Malevich and the ▷ Union of Youth organization.

After the Revolution in 1917 the Russian art world was completely reorganized with new Communist State institutions of education and practice. Three distinct tendencies in Russian art developed in the years immediately following the Revolution. The first of these was an aesthetic and spiritual form of art, exemplified by the ▷ Suprematism of Malevich and the so-called 'realism' (▷ Constructivism) of ▷ Antoine Pevsner and ▷ Gabo. The second major tendency was towards a Communist art which avoided aesthetic concerns and easel-painting (▷ Tatlin; ▷ Productivism). A third tendency, towards ▷ Socialist Realism was perpetuated by the ▷ AKhRR organization. However, the enthusiasms and plurality of the early Communist regime were superseded by the oppressive State Communism of Stalin, who in 1932 dissolved artistic organizations and declared Socialist Realism the only valid style for a Communist country. For the next few decades, the arts were held back by the strictures of the State, although some artists continued to practise abstraction and other 'subversive' forms of art. The collapse of State Communism in the late 1980s reintroduced 'Western' styles of art.

Bib.: Bown, M.C. and Taylor, B., *Art of the Soviets: Painting, Sculpture and Architecture*, Manchester, 1993; Gray, C., *The Russian Experiment in Art 1863–1922*, London, 1971; Groys, B., *The Total Art of Stalinism: Avant-Garde, Aesthetic Dictatorship and Beyond*, Princeton, 1988; *100 Years of Russian Art*, exh. cat., London, 1989

Russolo, Luigi (1885–1947)

Italian painter. He was from a musical family, and throughout his career he maintained his interest in music. He signed the ▷Futurist manifesto in 1910 and became involved with Futurist artistic experiments. He was particularly interested in the possibilities of music, and he wrote his own manifesto *The Art of Noises* in 1913. He also invented noise instruments (*intonarumori*) which were intended to be the musical instruments of modernity, and his work foreshadowed later experiments with electronic music.

rustication

An architectural term referring to the practice of employing massive masonry blocks (or facing in imitation of massive blocks), either left deliberately rough or, if smoothly-cut, each individual block being strongly emphasized by deeply recessed joints. The intended effect is one of impregnability and thus has been used widely for bank buildings and courthouses. For similar reasons, rustication was used for Italian ▷Renaissance *palazzi* – frequently, the rustication would diminish in emphasis towards the top of the building, cyclopean rustication giving an impression of strength at street level and flat, smoothly-cut blocks, differentiated only by deeply chamfered edges, hinting at the graceful living at the level of the piano nobile (e.g. Florence, Palazzo Medici, begun 1444).

Ruysch, Rachel (1664–1750)

Dutch painter. She was born in Amsterdam, where her father was Professor of Botany. She carried on his interest in flowers in her own still life paintings. She studied with ▷Willem van Aelst and worked in Amsterdam, as well as The Hague (1701–8) and Düsseldorf (1708–16), where she was court painter to the Elector Palatine.

Ruysdael, Salomon van (1600/2–70)

Dutch painter. He concentrated on landscapes, river scenes and, in his last years, still lifes. Born in Haarlem, he was admitted to the Haarlem painter's guild in 1623. It is not known by whom he was trained, although his early style reflects the influence of the pioneering naturalistic landscapists, ▷Isaias van de Velde and ▷Pieter de Molyn. By the 1630s he was painting landscapes in which atmospheric unity is achieved by the suppression of local colour in favour of an almost monochromatic palette dominated by greens, yellows and greys. This development runs parallel to that of ▷Jan van Goyen, who may have led the way in this so-called tonal phase of landscape painting. In the 1630s, the landscapes of Ruysdael and van Goyen are extremely close, although by the middle 1640s Ruysdael developed a much wider chromatic range, the elements of the landscape more individualized, an overall decorative effect aided by a predilection for tall delicate trees silhouetted against the sky (e.g. *Halt at an Inn*, 1649, Budapest). He may have trained his nephew, Jacob van Ruisdael. His son Jacob Salomonsz. van Ruysdael (1629/30–81) was also a landscape painter, working in a style similar to that of his cousin, Jacob van Ruisdael.

Bib.: Stechow, W., *Salomon van Ruysdael, eine Einführung in seine Kunst*, Berlin, 1975

Ryder, Albert Pinkham (1847–1917)

American painter. He was born in the whaling port of New Bedford, Massachusetts, and moved to New York City around 1868–70. He was admitted to the ▷National Academy of Design at the second attempt in 1871, but studied only intermittently during his four years there. He took part in the ▷avant-garde Collier exhibition of 1875, but later retreated from artistic circles to develop along his own eccentric path. He was one of the original 22 signatories to the Society of American Artists, and was honoured in 1913 as the only American to be included in the ▷Armory Show. Ryder has been seen as an American equivalent of the ▷Symbolists, favouring seascapes and romantic themes drawn from Richard Wagner, Edgar Allan Poe, Shakespeare and Byron. However, Ryder's subject matter is merely a pretext for a dense swirling exploration of colour and form which anticipated the ▷Expressionists. For Ryder, the painted landscape was a reflection of an inner psychic state rather than an attempt to reproduce nature. He reworked each painting over a number of years, overpainting and re-varnishing them so that many are now in a degraded condition and difficult to date.

Bib.: Brown, E., *Albert Pinkham Ryder*, exh. cat., Washington, 1989; Hamer, W.I., *Albert Pinkham Ryder: Painter of Dreams*, New York, 1989

Rysbrack, John Michael (1694–1770)

Flemish sculptor. He was born in Antwerp, the son of a landscape painter who had worked for a time in England. He was probably trained by Michael Van der Voort, a sculptor who had spent a number of years working in Rome and whose style was based on the work of ▷Duquesnoy and ▷Quellin, all of which influences – ▷Classical and ▷Baroque – may be

detected in Rysbrack's sculpture. When he arrived in England in c1720 he came with a letter of introduction to the architect ▷James Gibbs for whom he initially worked. His style soon found favour with his new English patrons and throughout the 1730s he was the most successful sculptor in England. One of his most accomplished works is the reclining figure of Sir Isaac Newton (1731) for ▷William Kent's Monument in Westminster Abbey, but the height of his career was the commission for the Equestrian Statue of William III (bronze, 1735, Queen Square, Bristol), won in competition against ▷Peter Scheemakers. By 1740, however, Scheemakers had established his supremacy with his Westminster Abbey Monument to William Shakespeare, and, furthermore, the less formal style of the younger ▷Roubiliac was coming into fashion. Rysbrack's work in the 1740s is sometimes concertedly informal and invested with a markedly ▷Rococo flavour (e.g. *Sir Peter Paul Rubens*, terracotta statuette, 1743, private collection). However, in later years he seems to have regained his confidence and returned to a more dramatic style with which he perhaps felt more affinity (e.g. *John Locke*, marble, 1755, Christ Church, Oxford). Although always in demand and well regarded, the 1730s was undoubtedly his most successful period.

Bib.: Eustace, K. *Michael Rysbrack*, exh. cat., Bristol, 1982; Webb, M., *Michael Rysbrack, Sculptor*, London, 1954

Rysselberghe, Théo van (1862–1926)

Belgian painter and designer. He was co-founder of the artists' organisation ▷Les Vingt in 1883. He knew ▷Seurat and adapted his ▷Neo-Impressionist technique. In 1898 he was in Paris, where he came into contact with ▷Symbolist tendencies.

S

-s, -sculp, -sculpsit, -sculpebat

(Latin, *sculpsit*, 'he engraved it'.) As part of a signature, any of these variations may follow the name of the engraver who produced the particular engraving. In 17th-century England, the term 'sculptures' also referred to ▷engravings.

Saarinen, Eliel (1873–1950) and Eero (1910–61)

Finnish family of architects. Eliel was the leading Finnish architect of his generation. He studied painting and architecture at Helsinki and, from 1896 to 1923, ran his own successful architectural practice in Finland. His most acclaimed building is the Vienna ▷Secession-inspired, albeit highly original, Helsinki Railway Station of 1905–14 (won in competition in 1904). In 1923 he emigrated to the USA after receiving extremely encouraging notices for his second-placed design for the Chicago Tribune competition of 1922. He set up his first American office in Evanston, Illinois, in 1923, moving to Ann Arbor, Michigan, in 1924. Here, from 1937, he worked in collaboration with his son Eero, the practice being further augmented by J. Robert Swanson during 1941–7. From 1924 Eliel also taught at the Architecture School of the University of Michigan, Ann Arbor, becoming its Director in 1925 and President (until his death) in 1932. From 1948 he was also the Director of the influential Graduate Department of Architecture and Urban Planning at the Cranbrook Academy of Art in Bloomfield Hills, Michigan, having designed and erected the buildings for it in 1926–43. He also designed Christ Church, Minneapolis (1949). His publications include *The Cranbrook Academy* (1931), *Search for Form* (1939) and *The City: Its Growth, Its Decay, Its Future* (1943).

Eliel's son, Eero was active mostly in the USA, having moved there with his parents in 1923. He revisited Europe in 1929–30 to study sculpture in Paris, before returning to the USA to study architecture at Yale University (1930–34). After a brief visit to Finland (1935–6), he settled in America, teaching, from 1936, at his father's Cranbrook Academy of Art. In 1937 he joined his father's practice at Ann Arbor, Michigan, and from 1950 directed his own office in Birmingham, Michigan. His earliest major architectural work, General Motors Technical Center, Warren, Michigan (1948–56), is strongly influenced by ▷Mies van der Rohe and appears in stark contrast to his father's more traditional romanticism (although his father

collaborated with him on the project). He apparently adopted the strict geometry of Mies's style as being the best solution to the specific organizational problem with which he was then confronted. Although he was never to work again in such a severely purist style, this kind of pragmatic eclecticism characterizes all of his major buildings, as does his powerfully-expressed passion for strongly sculptural forms. His other important works include: the Kresge Auditorium of the Massachusetts Institute of Technology, Cambridge (1953–5); the chapel of Concordia Senior College (1953–8); the David S. Ingalls Ice Hockey Rink at Yale University (1953–9); the Trans-World Airline's Kennedy Terminal, New York (1956–62) – his best known building, emphatically structural, the dynamism of its swooping arches expressive of flight; the T.J. Watson Research Centre at Yorktown, New York (1957–61); the Ezra Stiles and Morse Colleges at Yale (1958–62); the US Embassies in London (1955–61) and Oslo (1959 onwards); and Dulles International Airport, Chantilly, Virginia (1958–63) – the curved roof here as suggestive of flight as were the arches of his TWA building in New York.

Bib.: Kader, J., *Eero Saarinen a Brandeisi 1949–52*, Waltham, 1984; Temko, A., *Eero Saarinen*, New York and London, 1962; Spade, R., *Eero Saarinen*, London and New York, 1971; Kuhner, R.A., *Eero Saarinen: His Life and Work*, Monticello, Illinois, 1975

Sacchi, Andrea (1599-1661)

Italian painter. He was a leading representative, with the sculptor ▷Algardi, of the Classical faction in Roman ▷Baroque painting. Born in Rome, he was trained first in Rome (under ▷Albani) and then, in Bologna, where he was influenced by ▷Lodovico Carracci. Back in Rome he secured patronage from the ▷Barberini family. His principal work for them was the *Divine Wisdom* fresco in the Palazzo Barberini (c1629–33). Immediately after his completion of this work, the Barberini family commissioned his archrival, ▷Pietro da Cortona, to paint a ceiling ▷fresco in a nearby room. The two frescos thus represent, respectively, the Classical and the High Baroque traditions of painting: characteristically Sacchi's painting has as few figures as will decorously tell the story, while Pietro's ceiling teems with scores of them, the number of figures required for a ▷history painting being one of the principal matters of contention between the Classicist and Baroque factions. Sacchi's work is generally more successful on a smaller scale and his solemn

and introspective altarpiece, *The Vision of St. Romuald* (c1631, Rome, Vatican Pinacoteca) is acclaimed as one of his most accomplished works. ▷Maratta, his most eminent pupil, carried on his Classical tradition.

Bib.: d'Avossa, A., *Andrea Sacchi*, Rome, 1985; Scott, J.B., *Images of Nepotism: The Painted Ceilings of Palazzo Barberini*, Princeton, 1993

sacra conversazione (pl. sacre conversazioni)

A term given to a type of devotional painting or sculpture which represents the ▷Virgin and Child with saints (and sometimes donors) ranged on either side of them in a formal grouping. The format grew out of the ▷polyptych type of ▷altarpiece wherein a central panel of the Virgin and Child is flanked by panels bearing images of saints, each panel separated from its neighbour by the framing mouldings of the altarpiece (e.g. ▷Pietro Lorenzetti, *Polyptych*, 1320, Arezzo, Pieve di Santa Maria). During the 14th century the compartmentalizing was sometimes dropped, until by the 15th century, the normal type became the formally grouped assembly within a single unified space. Being a strictly devotional type, the represented saints may be from different periods, usually chosen for specific reasons, perhaps to include the founder of the monastic order in whose church the altarpiece is situated, or the patron of the donor, or the titular saint of the church. In the *St. Lucy Altarpiece* which ▷Domenico Veneziano (c1445, Florence, Uffizi) painted for the Florentine church, Sta Lucia dei Magnoli, the Virgin and Child are enthroned between four saints: ▷St. Francis; ▷St. John the Baptist and St. Zenobius, the patron saints of Florence; and St. Lucy, the titular saint of the church.

Sacred and Profane Love

Florentine ▷humanists of the 15th century developed Plato's idea of there being two forms of love: that which is aroused by contemplation of the divine (spiritual or sacred love) and that which is aroused by an appreciation of things in the material world and which is allied to the sexually-expressed love between men and women (material or profane love). This concept is presumed to be the theme of ▷Titian's so-called *Sacred and Profane Love* (c1515, Rome, Borghese Gallery). Here the idea is perhaps expressed by two ▷Venuses, one richly clothed and symbolizing profane love (Plato's 'Common Venus'), the other nude and symbolizing sacred love (nudity equalling purity and truth, Plato's 'Celestial Venus'). Profane love was not decried, but merely considered as a step towards the more exalted, sacred love. The idea of sacred and profane love was also expressed in the difference between Eros and Anteros, the two sons of Venus, Eros symbolizing passionate, erotic love which appeals to the senses and Anteros symbolizing selfless, ennobling love. It is this latter figure which is represented on

▷Alfred Gilbert's Memorial to the Earl of Shaftesbury (1886–93, London, Piccadilly Circus).

▷Neoplatonism

sacristy

In a Christian church, the room, usually near the ▷chancel, in which the sacred vessels and vestments are stored, and in which the clergy vest and divest themselves before and after services.

Saenredam, Pieter Jansz. (1597–1665)

Dutch painter. He specialized in architectural subjects, particularly churches. Born in Assendelft, he entered the workshop of Frans Pietersz. de Grebber in Haarlem in 1612. In 1622 or 1623 he was admitted to the Haarlem Guild of St. Luke. Although he never visited Italy himself, some of his paintings are based on studies made in Rome in 1532/5 by ▷Martin van Heemskerck, at the time owned by Saenredam himself (e.g. *View of the Pantheon*, 1643, New York, private collection). He did, however, travel around the Netherlands drawing buildings in 'sHertogenbosch, Amsterdam and Utrecht. His own drawings were often painstakingly executed on site over a period of several days, and were followed by perspective projections and diagrams worked out in the studio. These would sometimes be laid aside and used a number of years later. For example, *The Old Town Hall in Amsterdam*, (Amsterdam, Rijksmuseum) was painted in 1657 from a highly detailed drawing (Amsterdam, Municipal Archives) executed across six days in July 1641. The finished paintings are thus notable for their scrupulous fidelity to the subject. However, Saenredam avoids documentary dryness by a strong, even austere, compositional sense, a sensitive use of a restricted, almost monochromatic palette dominated by whites, creams and ochres, and an interest in the play of light (e.g. *Interior of the Odulphuskerk in Assendelft*, 1649, Amsterdam).

Bib.: *Catalogue Raisonné of the Works of Pieter Jansz. Saenredam*, Utrecht, 1961; *Perspectives: Saenredam and the Architectural Painters of the 17th Century*, exh. cat., Rotterdam, 1991; Schwarz, G., *Pieter Saenredam: The Painter and his Time*, London, 1990

Saftleven, Cornelis (1607–81) and Herman III (1609–85)

Dutch family of painters. Cornelis specialized in ▷genre scenes painted in the manner of ▷Brouwer. He was also known for his paintings of animals which were dressed as people and anthropomorphized. Herman was his brother. He was a landscape painter who studied with ▷van Goyen. He spent a great deal of time in Germany, where he painted landscapes of the Rhine.

Bib.: Schulz, W., *Cornelis Saftleven, 1607–1681: Leben und Werk*, Berlin, 1978

Sage, Kay (1898–1963)

American painter. She was an important member of the ▷Surrealist circle. She was born in Albany, New York, but her wealthy parents separated in 1900 and she grew up with her mother in Italy. After a period in New York (1914–19) she began to paint while living in Rome in 1920. In 1925 she married Prince Ranieri di San Faustino, but felt stifled by her relationship and divorced him to go to Paris in 1937. ▷Breton and ▷Tanguy sought her out on the basis of a single painting exhibited at the Salon des Surindépendants (1938). In 1939 she returned to New York, where she married Tanguy in 1940 and settled in Connecticut. She exhibited throughout the 1940s and 50s, and she and Tanguy held a joint exhibition at Hartford in 1954. She became depressed after Tanguy's death and ultimately took her own life.

Sage's earliest works were studies of the Rapallo landscape and abstracts. In Paris she began to produce smoothly painted images of a bleak, Surrealist landscape marked by strange angular forms. In many ways, her work is reminiscent of Tanguy's, but her colours are cooler and her compositions are more hard-edged and forbidding. When Breton first saw her paintings, he refused to believe that a woman could produce anything so unfeminine. An early concern with architectural motifs developed into images of scaffolding in later paintings such as *All Soundings are Referred to High Water* (1947). She also published four volumes of poetry.

Bib.: Krieger, R.T., *Kay Sage 1898–1963*, exh. cat., Ithaca, 1977; Miller, S., 'The Surrealist Imagery of Kay Sage', *Art International*, (Sept–Oct 1983), pp. 32–56

Saint Andrew's cross

A cross shaped like an 'X'. This is the type of cross on which ▷Andrew was crucified. In heraldry it is known as a saltire.

St-Denis

Benedictine Abbey with close associations with the French monarchy on the northern outskirts of Paris. The choir of the church (1140–44) which was added to the existing building is often said to be the first ▷Gothic building, on account of its lightness of structure, the ribbed ▷vaults in the ▷ambulatory and chapels and the triple ▷portal. The sculpture which decorated the church was massive and imposing (it is now lost). Although it still had ▷Romanesque resonances the attention to the ▷iconographic detail was Gothic in principle.

Because St-Denis was favoured by the French monarchy it served as a pattern for other church architectures. The church was important as a symbol of French power because St. Denis was fast replacing St. Martin of Tours as protector of the kingdom and St-Denis itself was a royal burial place and the depository for the crown and coronation regalia. ▷Abbot Suger

was one of the King's closest advisors and through his treatises the new church took on symbolic force. The costly stained glass and the rich art works were not, argued Suger, ostentatious displays of wealth but an attempt to raise the worshipper from mundane thoughts to approach the glory of majesty. After Suger's death (1151) the building process slowed down. It is probable that Suger had planned to go on with his ambitious building programme, but this was postponed in the late 1140s because of the lack of available funds caused by the Abbey's huge donations to Louis VII's expenses on the Second Crusade. The choir was remodelled in c1231 and the ▷nave and ▷transepts were built c1240. These buildings were extremely important to the development of the High Gothic style, and owed much to ▷Amiens Cathedral. St-Denis was, however, considerably lower in height than most High Gothic churches, because it would have been necessary to demolish most of Suger's work if a high building were to have been constructed. The ▷clerestory windows have very fine ▷tracery, bringing great amounts of light into the building, as does the glazed ▷triforium. St-Denis remains an imposing monument despite the damage it suffered during the ▷French Revolution and through the 19th-century 'restorations'.

Bib.: Bruzelius, C.A., *The 13th-century Church at St-Denis*, New Haven, 1985; Rudolph, C., *Artistic Change at St-Denis*, Princeton, 1990

Saint-Gaudens, Augustus (1848–1907)

American sculptor of Irish birth. He was an important proponent of the ▷Renaissance style of sculpture in 19th-century America. While still a child, his family moved to New York, where he studied at the Cooper Union and the ▷National Academy of Design. From 1867 to 1870 he studied at the ▷École des Beaux-Arts in Paris, and he went to Italy in 1870–73, where he was impressed by the sculpture of the Renaissance. He returned to New York where he accepted commissions for portrait sculpture, as well as monumental work. He produced a Monument to Admiral David Farragut (1881, New York, Central Park) which was based on the model of ▷Donatello's St. George.

St. Ives School

A group of artists with little in common stylistically, but who lived and worked in the same Cornish village of St. Ives. The village had a long history as an artists' colony, visited by ▷Sickert and ▷Whistler in 1893–4, and by ▷Knight in 1908, but it was not until the radical potter Ben Leach settled there in 1920 that it achieved importance. In 1939 ▷Hepworth and ▷Nicholson moved there, attracted by its isolation from London, the light and the native talent of artists like ▷Wallis. Other settlers included ▷Heron, ▷Frost, ▷Gabo, ▷Hilton and ▷Pasmore, as well as locals like Peter Lanyon. Although most worked with

abstraction, they gleaned inspiration from the landscape. During the 1950s the St. Ives artists had close ties with American abstraction; they held 14 group exhibitions in New York (1956–66) and many of the artists visited the United States. Gradually the village became a tourist centre, and today the Tate Gallery there emphasizes the connection between the group and the community.

Bib.: Cross, T., *Painting in the Warmth of the Sun*, Penzance, 1984; *St. Ives 1939–64*, exh. cat., London, 1985

St. Martin's Lane Academy

Two separate 18th-century English schools for drawing and painting which were formed before the ▷Royal Academy dominated fine art training. The first was founded by ▷Chéron and ▷Vanderbank in 1720. This school was taken over from ▷James Thornhill's Academy (founded 1716), which itself superseded ▷Kneller's Academy (founded 1711). The first St. Martin's Lane Academy offered life drawing classes to artists at a time when such activities were severely limited in London. Although the first Academy did not last long, ▷Hogarth started it up again in 1734 using the furniture he had inherited from Thornhill, who was his father-in-law. His academy attracted such artists as ▷Hayman, ▷Moser and ▷Roubiliac.

St. Paul's Cathedral

Even before its virtual destruction in the ▷Great Fire of London of 1666, plans were in preparation involving ▷Christopher Wren to rebuild Old St. Paul's Church in London. Foundations were dug for a new church in the early 1670s, and Wren presented a number of models (some of which are still extant) showing his ideas. He wished to produce a ▷Baroque style cathedral based on a ▷Greek cross but he was forced to compromise by the church authorities, and blended the traditional ▷Gothic layout of a ▷choir and ▷nave with those of a ▷Renaissance form with a distinctive ▷dome. The cathedral was officially completed in 1710, and was the largest in Christendom after St. Peter's in Rome, and the greatest expression of Renaissance architectural style in Britain.

Bib.: Downes, K., *Sir Christopher Wren: The Design of St. Paul's Cathedral*, London, 1988

Saint Phalle, Niki de (b 1930)

American sculptor of French birth. She was raised in New York, although she returned to her native France in 1950. During the 1960s, she became interested in ▷assemblages, and she collaborated with the sculptor ▷Tinguely, whom she married. She began producing assemblages with a feminist message, including her ▷environment *She* which was erected in Stockholm in the Moderna Museet in 1966. This was intended to be representative of a giant woman which could be entered by the spectator. She also produced a series of

female figures which she called *Nanas*, after ▷Zola's heroine of that name. She moved to Tuscany, where she continues to create environments, now based on the Tarot pack.

Bib.: *Niki de St. Phalle: exposition rétrospective*, exh. cat., Paris, 1980

Sallinen, Tyko Konstantin (1879–1955)

Finnish painter. He worked as an itinerant tailor in Sweden before he trained as an artist in Stockholm. In 1909 and 1914 he spent time in Paris, where he came into contact with the work of ▷Fauvist, ▷Cubist and ▷Post-Impressionist artists. He was a member of the ▷November Group and painted landscapes and peasants with a strong Finnish theme.

Salome

(Matthew 14: 3–12; Mark 6: 21–28.) Daughter of Herodias and step-daughter of Herod. ▷John the Baptist had condemned Herodias for marrying Herod, her brother-in-law, after the death of her first husband (a transgression against Mosaic law). Herodias wanted the Baptist executed for this affront, but Herod, wary of the Baptist's popularity, resisted and merely had him imprisoned. At Herod's birthday banquet Salome's dance so entranced him that he rashly swore to give her in return anything she wanted; Herodias convinced her to ask for the head of the Baptist on a platter. Herod was appalled but had to adhere to his publicly sworn oath. The dance itself was frequently portrayed; sometimes in continuous narrative with the presentation of the head (e.g. ▷Filippo Lippi, fresco, Prato Cathedral). ▷Caravaggio shows the execution in the dungeon, the serving girl standing by with a dish (1608, Malta Cathedral). More often, this episode is represented simply as Salome with the Baptist's head on a platter. There seems to have been something of a tradition in the ▷Renaissance for the artist to portray himself as the Baptist and his mistress as Salome, reflecting the legend that Salome secretly desired the Baptist (e.g. according to Panofsky, ▷Titian, *Salome*, c1511, Rome, Galleria Doria-Pamphili). The awful drama of the presentation of the head to Herod at his banquet table is eloquently portrayed by ▷Donatello (1423–7, Siena Baptistry Font). The gruesome possibilities of the Salome theme were exploited by ▷Symbolist artists in the late 19th century, when it became a central image of the ▷*femme fatale*, used by artists such as ▷Gustave Moreau.

salomónica

▷*estípite*

Salon

The official exhibition of contemporary art in Paris, held biennially in the 18th century and annually from the 19th century. Originally staged infrequently, the first Salon exhibition was organized in 1667 by the

▷Académie Royale de Peinture et de Sculpture as a showcase for the work of its own members. From 1737 the exhibitions were biennial, the name 'Salon' deriving from the location of the exhibition in the Salon d'Apollon in the Louvre. Although the work of members continued to take precedence, from the ▷French Revolution (1789–99) onwards, the work of non-members was admitted, subject to selection by jury. The size of the exhibition had grown sufficiently to fill several rooms by the early 19th century before moving briefly to the Palais Royal and then, in 1857, to the Palais de l'Industrie on the Champs-Elysées. Generally only about half of the submissions were selected and there was profound dissatisfaction, among the rejected artists in particular, that the process of selection was rigged. In order to silence the protests (and to demonstrate to the public that the refused works were in fact poor), Napoleon III ordered, in 1863, an alternative, ▷Salon des Refusés, the most significant of the misunderstood ▷avant-garde works amongst the mass of unarguably mediocre exhibits being ▷Manet's *Déjeuner sur l'herbe* (now Paris, Musée d'Orsay). Also present were works by ▷Boudin, ▷Cézanne, ▷Fantin-Latour, ▷Jongkind, ▷Pissarro and ▷Whistler. Thus was effected the polarization of avant-garde art and establishment-favoured ▷academic art.

The Salon itself was still the major exhibition venue, however, and the only way to secure all-important official patronage. The mid-century figure of 4,000 works submitted to the Salon (against c2,000 accepted) had almost doubled by the early 1880s. However, the power of the Salon first began to be eroded when, in 1874, the ▷Impressionists, whose works were frequently rejected as unfinished, held the first of their own group exhibitions in the Paris studio of the photographer Nadar. Then, in 1881, the government withdrew its official mandate from the Salon which was henceforth managed by the newly-formed Société des Artistes Français, a committee of 90 elected Salon artists. In 1884 the Société des Artistes Indépendants (led by the ▷Neo-Impressionists) formed the juryless ▷Salon des Indépendants and further breakaways were effected in 1890 by the Société Nationale des Beaux-Arts, led by ▷Rodin and ▷Puvis de Chavannes, with its Salon de la Nationale (otherwise known as the Salon du Champs de Mars) and in 1903 by ▷Matisse and ▷Bonnard and their circle with the ▷Salon d'Automne. Towards the end of the century, the proliferation of independent dealers such as Paul Durand-Ruel, Goupil and ▷Ambrose Vollard, further weakened the stranglehold of the Salon.

Bib.: Boime, A., *The Academy and French Painting in the Nineteenth Century*, New Haven and London, 1971; Crow, T., *Painters and Public Life in Eighteenth-Century Paris*, New Haven, 1985; McWilliam, N., *A Bibliography of Salon Criticism in Paris from the Ancien Régime to the Restoration*, Cambridge, 1991

Salon d'Automne

A yearly salon established by the artists of the Salon de la Nationale in 1903, which became one of the showcases of ▷avant-garde art in Paris. The Salon de la Nationale had been established in 1890 by ▷Puvis de Chavannes, ▷Rodin, Eugène Carrière and others who sought an alternative to the official ▷Salon. In 1903 they were joined by ▷Matisse, ▷Rouault and ▷Bonnard. The Salon d'Automne is most famous for having been the first exhibition to show ▷Fauvist works in 1905, but it also held a major ▷Gauguin retrospective in 1903 and a major exhibition of 42 of ▷Cézanne's works in 1905. The idea was exported to Germany in 1913, where the autumn salon (Herbstsalon) became a showcase for ▷Expressionism.

Salon de la Rose + Croix

▷Rose + Croix, Salon de la

Salon des Indépendants

The exhibition organized in 1884 by the newly-established Société des Artistes Indépendants, which included ▷Seurat, ▷Signac, ▷Redon and Charles Angrand (1854–1926). The aim of the show was to allow any artist to exhibit if he paid, eliminating the controversies of a selection committee. The first exhibition of over 130 works was a financial failure but by the following year under new administration over 500 works were shown and medals awarded. Internal arguments led to a splinter 'Groupe des Artistes Indépendants' but the original organization survived. It remained a major exhibition in Paris until 1914, and was one of the principal showcases of ▷Post-Impressionism. The organization was dominated by ▷Neo-Impressionists, with Signac as President until 1934 when he was succeeded by Maximilien Luce until 1940.

Salon des Refusés

An exhibition held in 1863, comprising work which had failed the selection committee of the official ▷Salon. After a particularly harsh Salon jury discounted three-fifths of the proposed exhibits, including many by established artists, Napoleon III stepped in with the suggestion of a second Salon. From the start it was criticized as a show of rejected and therefore second-rate work, and many ▷academic artists refused to allow their works to take part. The exhibition also became notorious for showing works like ▷Manet's ▷*Déjeuner sur l'Herbe*, and attracted huge, ridiculing crowds – 10,000 people on the first day alone. The artists included ▷Whistler, ▷Fantin-Latour, ▷Jongkind, ▷Pissarro and ▷Harpignes.

The Salon des Refusés is often used as a convenient starting point for dating the birth of ▷modernism in France, and certainly it came to represent the first opposition to the monopoly of the ▷Académie in Paris. It did not lead, as many artists hoped, to a

wholesale revision of the Salon system, but the jury was extended and the age limit for ▷École des Beaux-Arts members reduced. ▷Couture and ▷Gleyre also closed their studios as a protest.

Salvator Mundi

In English, the 'Saviour of the World'. The term refers to the devotional image of ▷Christ making the sign of benediction with his right hand, whilst holding an orb (symbolizing the world), sometimes surmounted by a cross, in his left (e.g. ▷Hans Memlinc, *Salvator Mundi with Singing Angels*, c1490, Antwerp, Koninklijk Museum). He may also be crowned with thorns. The *Salvator Mundi* is an image found principally in northern European art.

Salvi, Giovanni Battista

▷Sassoferrato

Salviati, Francesco (Francesco de Rossi) (1510–63)

Italian painter. He was originally from Florence where he studied under artists including ▷Andrea del Sarto, and where he befriended his fellow student ▷Vasari. He travelled to Rome around 1531 and received commissions for ▷frescos, particularly from Florentine patrons in Rome. Salviati then worked in Venice (1539–41), Rome (1541–3) and Florence (1543–8) before settling in Rome. He also designed several tapestries in the 1540s.

Salviati's earliest surviving Roman frescos show him pushing his Florentine training towards ▷Mannerism, notably in the ornamental flourishes of his *Visitation* (1538) at the San Giovanni Decollato. That tendency is fully realized in *The Triumph of Camillus* (1534–5) for the Palazzo Vecchio in Florence, which uses the exploits of an authoritarian statesman from the 4th century BC to glorify the ▷Medici. Salviati modelled the series on frescos on ancient Roman ▷reliefs, recreating their profiled figures and lack of depth, and suggesting a sculptor's hand in its carefully-wrought surfaces. The extremes of Mannerism are reached with the *David* cycle of frescos at the Palazzo Ricci-Sacchetti, Rome (c1533) for which Salviati creates the illusion of a series of framed paintings hanging from the wall, with angels and other naked figures clambering between them or relaxing on plinths and supports.
Bib.: Mortari, L., *Francesco Salviati*, Rome, 1992

Samian sibyl

▷sibyls

Sánchez Coello, Alonso (1531/2–88)

Spanish painter. He studied with ▷Anthonis Mor in Flanders during the 1550s. He became court painter to Philip II of Spain in 1555 and painted portraits which showed the influence of ▷Titian. From 1557 he produced portraiture for the court at Valladolid.

Sánchez Cotán, Juan (1561–1627)

Spanish painter. Born in Orgaz, he studied under Blas de Prado in Toledo, where he produced the still lifes for which he is best known. In 1603 he joined a Carthusian order of monks at El Paular in Segovia, and turned to religious subjects. He moved to a monastery in Granada in 1612, where he painted a series based on the life of St. Bruno (1615–17).

Sánchez Cotán's still-life paintings broke with tradition in their simplicity and geometrical arrangements, typically depicting a few strikingly lit objects placed in a ▷niche or suspended on a string against a rich black background. Influenced by the Catholic mysticism prevalent in Toledo, they are infused with a spirituality arguably deeper than that of his more conventionally religious paintings. Sánchez Cotán's stark contrast of light and shadow provides an early example of Spanish ▷Baroque realism.
Bib.: Orozco Diaz, E., *El pintor Fray Juan Sánchez Cotán*, Granada, 1993; *La imitación de la naturaleza, los bodegónes de Sánchez Cotán*, exh. cat., Madrid, 1992; Taggard, M.N., 'Juan Sánchez Cotán and the Depiction of Food in Spanish Still Life Painting', *Pantheon*, 48 (1990), pp. 76–80

sanctuary

The most sacred part of a church that surrounds the principal altar at the east end.

Sandby, Paul (1725/6–1809)

English watercolour artist. He was born in Nottingham, the son of a frame-knitter. He followed his brother, Thomas (1721–98), to London in 1742 and possibly visited Paris with him, before they were both employed in 1745 as military draughtsmen by the Tower of London Drawing Office, to survey the Highlands following the '45 Rebellion. He returned to London in 1752 and later became well known for his views of Windsor Great Park, of which his brother was Deputy Warden (e.g. *Terrace of Windsor Castle Looking West*, 1800, London, Victoria and Albert Museum). He developed the art of ▷watercolour, experimenting with body colour in his work, using figures to add interest and life and refusing to be bound by topographical tradition. He also experimented with ▷aquatint and ▷etching and stood in opposition to ▷Hogarth's definition of beauty. He was a founder-member of the ▷Society of Artists and of the ▷Royal Academy. In 1768 he became chief drawing master at the Royal Military College, but his later career floundered as a new generation of watercolourists developed the medium.
Bib.: *Art of Paul Sandby*, exh. cat., New Haven, 1981; Ball, J., *Paul and Thomas Sandby RA*, London, 1985; Fagan, J., *Paul Sandby Drawings*, Sydney, 1981; Herrmann, L., *Paul and Thomas Sandby*, London, 1986; *Paul Sandby*, exh. cat., London, 1962; *Paul and Thomas Sandby*, exh. cat., Reading, 1972

Sandrart, Joachim von (1606–88)

German painter and writer on art. He studied with ▷Honthorst in Utrecht and travelled with him to London in 1627. He went to Italy c1628–35, where he met both ▷Claude and ▷Poussin. He wrote and published an important artistic treatise *Deutsche Akademie der Elden Bau-Bild-und Malerei-Künste* (*German Academy of the Noble Arts of Architecture, Sculpture and Painting*, 1675–9). In his later career, he was a founder of the Nuremberg Academy (1684/5), the first official art academy in Germany.

Bib.: Hollstein, F.W.H., *Hollstein's German Engravings, Etchings and Woodcuts*, vols. 38 and 39; *Jacob von Sandrart*, Roosendaal, 1994

Sangallo, Giuliano da (Giuliano Giamberti) (1445–1516)

Italian architect, military engineer and sculptor. He was the brother of Antonio da Sangallo the Elder (the name Sangallo coming from the area of Florence in which the family lived). Giuliano was one of the ablest followers of ▷Brunelleschi, controlling the latter's formal language with an understanding of ▷Alberti's architectural principals. The style thus formed he maintained throughout his career, even in the face of the High ▷Renaissance architecture of ▷Bramante and ▷Raphael. He was the favourite architect of Lorenzo de' ▷Medici ('Il Magnifico') and his principal works are mainly in Florence and its neighbourhood.

Sangallo designed the Villa Medici at Poggio a Caiano (1480–97). Influenced by Alberti and Vitruvius, it was the first Renaissance ▷villa to be symmetrically planned around a central hall and possibly the first to be fronted by a ▷portico modelled on a Classical temple, thus preceding by a considerable number of years the principal characteristics of ▷Palladio's villas. Sangallo also designed: the church of S. Maria delle Carceri, Prato (1484–91), the first Renaissance church to be built to a ▷Greek cross plan; the ▷atrium of S. Maria Maddalena de' Pazzi, Florence (c1490–95); the ▷sacristy, in collaboration with 'Il Cronaca' (Somone del Pollainolo, 1457–1508), of Brunelleschi's S. Spirito, Florence (1492–4); and the Palazzo Gondi, Florence (1490–94). Following the death of Lorenzo de Medici in 1492, Sangallo left Florence, one of the principal works of these later years being S. Maria dell' Anima in Rome (1514).

Bib.: Borsi, S., *Giuliano da Sangallo*, Rome, 1985

Sanmicheli, Michele (1484–1559)

Italian architect. He was a stonemason in Verona, but he went to Rome to work for ▷Antonio da Sangallo the Younger. There he absorbed a High ▷Renaissance architectural style which he took back to the Veneto. In and around Verona he designed palaces in a style akin to that of ▷Bramante, and he also took on commissions in Venice. He was responsible there for S.

Andrea, the fortress on the Lido, as well as the Palazzo Grimani.

San Rocco, Scuola Grande di

A religious order founded in Venice in 1478. Named after St. Roch of Montpellier, it was dedicated to helping the victims of epidemics. In 1517 Bartolomeo Bon was commissioned to design and supervise construction of a major new building for the order, which was finally completed in 1560 under the subsequent direction of Sante Lombardo, Scarpagnino and Giangiacomo dei Grigi. The decoration was assigned to ▷Tintoretto, who from 1564–88 produced a remarkable cycle of 60 paintings for the walls and ceilings of the building. The first room to be completed was the Sala dell'Albergo (1564–7) where a series depicting the ▷Passion culminates in the remarkable *Crucifixion*, spanning an entire wall of 12.25 metres and crowded with more than 50 figures. Almost ten years later, Tintoretto painted the Upper Hall (1576–81). The ceiling shows the scenes from the Old Testament (notably several from the story of ▷Moses), many of which have a specific relevance to the healing work of the Scuola Grande, as do the New Testament scenes along the walls including the ▷*Raising of Lazarus*, the ▷*Resurrection*, and the ▷*Ascension*. The Ground Floor Hall (1582–7) features six large canvases portraying the life of Mary from the *Annunciation* to the *Assumption of the Virgin*, accompanied by paintings of *St. Mary Magdalen* and *St. Mary of Egypt*. Tintoretto's paintings are still intact in their original settings, and show a sustained virtuosity in their complex compositions, dynamism and experimental imagination.

Bib.: Romanelli, G., *Tintoretto, La Scuola Grande di San Rocco*, Milan, 1994; Valcanover, F., *Jacopo Tintoretto e la Scuola Grande di San Rocco*, Venice, 1983

Sansovino, Jacopo (Jacopo Tatti) (1486–1570)

Italian architect and sculptor. He was from Florence, where he was trained by the architect Andrea Sansovino, from whom, as a token of admiration, he took his name. In 1505/06 he went with Andrea to Rome where he met ▷Raphael and ▷Bramante and was able to study at first hand the works of Classical ▷antiquity (including the recently excavated ▷*Laocoön*, of which he made a copy) and supplement his income with antique restoration work. He was again in Florence in 1511–17, sharing a studio with ▷Andrea del Sarto. From this period comes his *Bacchus* (1511–12, Florence, Bargello), which was so highly praised by ▷Vasari, and which has been seen by the modern art historian, John Pope-Hennessy, as a decorously Classical critique of ▷Michelangelo's realistically intoxicated *Bacchus* of c1498 (Florence, Bargello). Yet Sansovino's *Bacchus* is by no means dryly academic; it has a Classicism imbued with the warmth of life by long and painstaking observation from a live model.

Sansovino returned to Rome until the Sack of 1527,

when he moved to Venice where he became close friends with ▷Titian and Pietro Aretino. In 1529 he was appointed Protomagister of S. Marco (state architect). He was thereby instrumental in introducing the High ▷Renaissance style to Venetian architecture and sculpture, his most important Venetian buildings being the Mint (begun 1536); its neighbour, the splendid Library of San Marco (begun 1537) and the nearby Loggetta (begun 1537) at the foot of the ▷Campanile. His most familiar Venetian sculptures are the colossal statues of *Mars* and *Neptune* (1554–67) at the top of the Scala dei Giganti in the Doge's Palace. His most important pupil was the Venetian sculptor, Alessandro Vittoria (1523–1608).

Bib.: Boucher, B., *The Sculpture of Jacopo Sansovino*, New Haven, 1991; Howard, D., *Jacopo Sansovino*, London 1975

Sant'Elia, Antonio (1888–1916)

Italian architect. Although very few of his works were built, he produced designs for a number of buildings and towns which were prefigurative of later ▷modernist experiments. He worked very much within a ▷Futurist mode, and he was interested in the possibilities of ▷skyscrapers. He was killed during the First World War.

Bib.: Meyer, E. da C., *The Work of Antonio Sant'Elia: Retreat into the Future*, New Haven, 1995

Santi, Giovanni (d 1494)

Italian painter. He was ▷Raphael's father and lived in Umbria. His paintings are less known than a piece of poetry he wrote about the Dukes of Urbino which contained important information about contemporary artists.

Bib.: Martelli, F., *Giovanni Santi e la sua scuola*, Rimini, 1984

Saraceni, Carlo (Carlo Veneziano) (1579–1620)

Italian painter. He was from Venice, but he was in Rome by 1598 where he was influenced by ▷Caravaggio and ▷Elsheimer. His small-scale, meticulously painted pictures, often executed on copper, reveal a concern with light and landscape derived from Elsheimer (e.g. *Jacob reproaching Laban*, c1610, London, National Gallery). It is in his larger paintings that he shows a closer affinity to ▷Caravaggio (adopting the ▷chiaroscuro, whilst replacing Caravaggio's dramatic realism with his own more elegiac vision and a Venetian concern for harmonious colour); indeed his *Death of the Virgin* (Rome, S. Maria della Scala) was painted to replace the ▷altarpiece by Caravaggio rejected for its indecorous realism (1606, Paris, Louvre). In 1619 Saraceni returned to Venice where his last finished painting, the altarpiece of *St. Francis in Glory*, may still be seen in ▷Palladio's Church of the Redentore.

Bib.: Ottani Cavina, A., *Carlo Saraceni*, Milan, 1968

sarcophagus

In Classical antiquity, a coffin or tomb-chest of stone, ▷terracotta, wood, metal or other material, sometimes elaborately carved or painted and bearing inscriptions. The term is from the Greek, meaning 'flesh-eating', deriving from the Greek custom of lining the coffin with slate which, it was believed, consumed the flesh of the corpse.

Sargent, John Singer (1856–1925)

American painter. He was born in Florence to American parents. He studied in both Florence and Paris, where he trained with the portraitist, ▷Carolus-Duran

John Singer Sargent, *Self-portrait*, Uffizi, Florence

and at the ▷École des Beaux-Arts. He exhibited at the ▷Salon (first in 1877) and became friends with ▷Monet, before settling in England in 1885. He also travelled to North Africa in 1879. He was a member of the ▷NEAC, but also exhibited at the ▷Royal Academy from 1882 and was elected to the Academy in 1897. In his early career he painted ▷Velázquez-influenced naturalism (e.g. *Venetian Bead Stringers*, 1880–82, Buffalo) and landscapes in an ▷Impressionist style (e.g. *Carnation, Lily, Lily, Rose*, 1887, London, Tate Gallery), but he was best known for his portraits of society (e.g. *The Misses Vickers*, 1884, Sheffield, Graves Art Gallery; *Graham Robertson*, 1895, Tate). His flamboyant, virtuoso style was compared to that of ▷Lawrence, and he followed in the ▷Grand Manner with life-size canvases and glamorous costume, although he was criticized for a lack of psychological insight. After 1900, he turned again to landscape, working in ▷watercolour and in a freer style. He was an official artist during the First World War (e.g. *Gassed*,

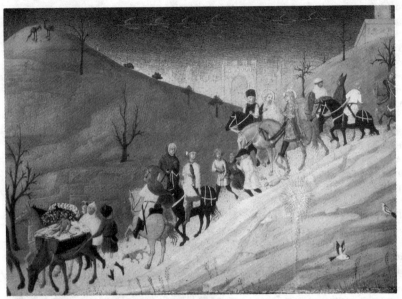

Sassetta, *The Journey of the Magi*, Metropolitan Museum of Art, New York

1818–19, London, Imperial War Museum) and produced ▷murals for Boston Library.

Bib.: *John Singer Sargent*, exh. cat., Chicago, 1954; *John Singer Sargent*, exh. cat., Birmingham, 1964; Ormond, R., *John Singer Sargent*, London, 1970; Ratcliff, C., *John Singer Sargent*, Oxford, 1983

Sarrazin, Jacques (1588–1660)

French sculptor. He studied in Rome 1610–c1627 with ▷Domenichino. There he developed a ▷Classical style of sculpture which he took back to Paris with him. In Paris he had a large workshop, and he was responsible for a number of sculptural commissions involving the decoration of buildings.

Sassetta (Stefano di Giovanni) (c1390–1450)

Italian painter. With ▷Giovanni di Paolo, he was the leading painter in 15th-century Siena. His main influences are from the Sienese ▷trecento, but he also absorbed more recent ▷International Gothic influences from ▷Gentile da Fabriano (working in Siena 1424/5) and ▷Masolino. He retains throughout his career a typical Sienese tendency towards mysticism expressed in compositions of graceful linearity, and yet in his *Altarpiece of the Madonna of the Snows* (1430–33; executed for Siena Cathedral, now in Florence, Palazzo Pitti) he showed that he could perfectly marry this established style to an assured grasp of the new developments emanating from Florence, with substantially modelled figures confidently located in a convincing, perspectively-constructed setting. However, by 1437–44, when Sassetta produced his major surviving work, the now

dispersed double-sided ▷polyptych for the Church of San Francesco in Borgo San Sepolcro (now in Paris, Louvre; Settignano, Berenson Collection; London, National Gallery; Chantilly; Berlin-Dahlem, Staatliche Museen), he had largely returned to the Sienese traditions of representation with his elegant line, rich colour and attenuated figures in a mystical and visionary work in which rational spatial relationships and naturalistic scale are no longer important. Although his influence was widespread in Siena, the painters most affected by him are ▷Sano di Pietro, ▷Pietro di Giovanni d'Ambrogio and the Osservanza Master, the last of whose paintings were until recently still attributed to Sassetta.

Sassoferrato (Giovanni Battista Salvi) (1609–85)

Italian painter. He was born in Sassoferrato, hence his nickname. He worked in Rome, where he saw the works of ▷Raphael and imitated that artist's madonnas. He produced portraits and religious works in the 'sweet style' of Raphael.

Satan

In Christian religion, the enemy of God and all his creation and the active promoter of evil within it. In fact, Satan in Hebrew means 'enemy'. He is known by a variety of names and in a variety of forms. He is first encountered in the Bible in the ▷Garden of Eden as the serpent which tempts Eve (Genesis 3: 1). ▷Isaiah calls him Lucifer, the morning star, and refers to the pride which led to him attempting to usurp God's throne and being cast into the pit for his temerity

(Isaiah 14: 12–15). In the 16th century, the Western Church merged this theme with John the Divine's visionary account of the war in Heaven (Revelation 12: 7–9). John refers to him as 'that old serpent, the Devil, and Satan', and also 'the dragon'. In medieval visions of the ▷Last Judgement, Satan presides over Hell in monstrous form with horns on his head, clawed hands and feet, a serpent-like tail and sometimes a supplementary face with a gaping mouth on his belly or buttocks. Satan was also represented symbolically in medieval art as a basilisk, a winged serpent with a cock's head whose look could kill. By the 15th century he was more often cast in the mould of ▷Pan with horns and cloven hooves, thereby indicating the 'enemy' specifically as paganism. Sometimes Satan may also be represented as a lion: ▷Peter refers to him as a roaring lion seeking to devour the unwary (1 Peter 5: 8). Thus, Samson, in his bare-handed fight with the lion (Judges 14: 5–9) is seen as a prefiguration of Christ triumphing over Satan.

satyrs

In Classical mythology, male spirits of the woods and hills, attendants of ▷Bacchus (in Greek, Dionysus). In appearance they are men with goat-like features: specifically hooves, hairy legs, horns and (in antique representations) a tail. In temperament they are notoriously lecherous and given to excessive drinking. As followers of Bacchus they indulge in orgiastic rites (Bacchanalia) and their female equivalents are maenads. Both types of creature are portrayed in this guise on Greek wine vessels from about the 7th-century BC and, most famously, in Titian's *Bacchus and Ariadne* (1522–3, London, National Gallery). In their positive role as fertility spirits they may carry cornucopias.

The mythological opposite number of the satyr is the woodland ▷nymph, the confrontation with whom provides perhaps an allegory of ▷Lust versus ▷Chastity, but certainly an overtly erotic theme, whether it be voyeurism – a satyr carefully removing the covering drapery of a sleeping nymph – attempted rape or even mutual attraction. However, a nymph asleep in a wood with a satyr uncovering her may represent ▷Jupiter, disguised as a satyr, about to ravish Antiope, this subject usually being distinguished by the proximity of a sleeping cupid (e.g. ▷Correggio, *Jupiter and Antiope*, c1524–5, Paris, Louvre).

Saura, Antonio (b 1930)

Spanish painter. He was self-taught from 1947. He went to Paris in 1953, where he made contact with ▷Breton, but returned to Spain in 1955 disillusioned with ▷Surrealism. In 1957 he started his *Crucifixion* series, as well as satirical sketches directed against the Franco regime, and was a founding member of 'El Paso', a group of ▷Informel artists. Between 1958 and 1959 he produced *Portraits Imaginaires*, celebrating and dedicated to Brigitte Bardot. In 1960 he won

the Guggenheim Prize and in 1964 the Carnegie Prize, and he is represented in many national collections.

Bib.: de Cortanze, G., *Antonio Saura*, Paris, 1994

Saussure, Ferdinand de (1857–1913)

Swiss linguist. His studies provide the basis of ▷Structuralism. In 1879, having studied philology and Sanskrit in Leipzig and Berlin, he published a book on vowel systems in Indo-European languages. At the age of 24 he was appointed Lecturer in Gothic and High German at the École Pratique des Hautes Études in Paris. From 1901 he taught at the University of Geneva. After his death, two of Saussure's students collated and edited notes taken from his lectures and published them as the *Course in General Linguistics* (1916).

Saussure opposed the traditional assumption that there was an underlying link between a word and the object to which it referred, arguing instead that its meaning was derived from its differential relationship to the overall structure of language. Thus the word 'grape' owes it existence to its ability to be distinguished from 'gape' or 'crêpe' rather than any inherent connection with a small, rounded fruit. This shift away from the isolated individual speech act ('*parole*') as a focus of investigation, in favour of its place in the wider linguistic structure ('*langue*') has provided a model for wider Structuralist study in sociology, ▷psychoanalysis, anthropology and culture. Moreover, Saussure's notion of the 'sign', produced by the arbitrary combination of 'signifier' (the word or emblem in a language system) and 'signified' (the object of concept it denotes) has inspired the field of ▷semiology.

Bib.: Culler, J., *Saussure*, London, 1986; Saussure, F. de, *Course in General Linguistics*, London, 1983

Savery, Roelan(d)t (?1576–1639)

Flemish painter. He studied in Amsterdam. His specialities were landscapes and flower pictures. He was well known internationally and worked for both Rudolf II in Prague and Mathias in Vienna.

Bib.: *Roelant Savery in seiner Zeit (1576–1639)*, exh. cat., Cologne, 1985

Salvoldo, Gian Girolamo (fl 1508–after 1548)

Italian painter. He was of Brescian origin, but he worked mainly in Venice, and also in Florence (where he matriculated in the painters' guild in 1508) and Milan. Valued today as an original talent, combining his native Lombard with Venetian influences (chiefly ▷Giorgione and ▷Titian), he was apparently neither prolific nor successful. His few paintings are mainly religious subjects and portraits and are characterized by a Lombard naturalism combined with a tendency to formal generalization and an interest in the different effects of light, particularly moonlight (e.g. *St. Mary*

Magdalene, London, National Gallery). In his interest in night-time scenes, Savoldo is often seen as an important precursor to ▷Caravaggio. He is presumed to have died not long after 1548 as in that year he was described by Pietro Aretino as 'decrepit'.

Bib.: Gilbert, C., *The Works of Girolamo Savoldo*, New York, 1986; Paldo, M., 'The Subject of the Magdelene', *Art Bulletin* 71 (March 1989), pp. 67–91

Scamozzi, Vincenzo (1552–1616)

Italian architect. He was born in Vicenza and worked in Venice, where he completed the building of the Marciana and designed the Procuratie Nuove (begun 1583). He absorbed the style of ▷Palladio and did a number of theatre designs. He also wrote a treatise *L'idea dell'architettura universale* (*The Idea of Universal Architecture*, 1619). He met and influenced ▷Inigo Jones in 1614.

Scandinavian art

The arts of the Scandinavian countries of Norway, Sweden, Finland and Denmark originated during the Bronze age, when representational rock engravings and decorated weaponry were common. However, the high point of the early history of Scandinavian art was the Viking period (c800–c1050), when the practices of trade and piracy meant that foreign influences infiltrated Scandinavia. Especially important here were ▷Celtic sources, which appeared in stone sculpture throughout Scandinavia. From then until the end of the 16th century, the dominant influence on Scandinavian art was German, and this relationship remained strong into the 19th century. The 17th century witnessed a period of political strength for Scandinavia, when Queen Christina of Sweden invited French and Italian artists to improve the state of Swedish culture. Scandinavian countries generally followed the patterns of ▷Renaissance, ▷Baroque and ▷Rococo art and architectural design until the end of the 18th century when ▷Thorvaldsen brought a severe ▷Neoclassicism to Denmark.

In the 19th century, each of the Scandinavian countries developed a more self-conscious sense of identity and, later, nationalism. Norwegian artists cultivated a self-reflexive sense of angst, stimulated by the work of ▷Munch. In Finland, a strong sense of nationalism inspired by the oppressive Russian regime led artists to look to the folk legends of the *Kalevala* (▷Gallen-Kallela). Sweden became known internationally for its ▷*plein-air* painting through the work of ▷Zorn and others. Danish artists, such as ▷Hammershøi, cultivated their relationship with the ▷Symbolist movement. All the Scandinavian countries became important centres for ▷applied arts in the wake of the ▷Arts and Crafts Movement and European ▷Art Nouveau, and Finland and Sweden especially became important centres for ▷modernist architecture (▷Aalto; ▷Saarinen). Scandinavian art reached its

peak during this ▷*fin-de-siècle* period, but it has since then been somewhat outside the mainstream of 20th-century art movements.

Bib.: Kent, N., *The Triumph of Light and Nature: Nordic Art 1740–1940*, London, 1987; *Scandinavian Modernism*, exh. cat., New York, 1989; Varnedoe, K., *Northern Light: Scandinavian Art at the Turn of the Century*, New Haven, 1988

Scarsellino, Lo (Ippolito Scarsella) (1551–1620)

Italian painter. He was from Ferrara, and there he painted scenes from religion and mythology, many of which contain dominant landscapes. His work was important for the development of ▷Guercino's style.

Schadow, Johann Gottfried (1764–1850)

German sculptor and writer on art. He studied in Rome (1785–7), where he knew ▷Canova and adopted a ▷Neoclassical style. He was appointed Court Sculptor in Berlin in 1788, and he took on a number of important public commissions as well as producing portrait busts. His most notable work was the *Quadriga*, or four-horse chariot, on the top of the Brandenburg gate.

Bib.: Mackowsky, H., *Die Bildwerke Gottfried Schadows*, Berlin, 1951

Schalken, Gottfried (Godfried) (1643–1703)

Dutch painter. He produced principally ▷genre scenes and portraits, but also biblical and mythological subjects. He was born in Made, near Dordrecht, and was trained, according to ▷Houbraken, by two former pupils of ▷Rembrandt, firstly ▷Hoogstraten and then, more importantly ▷Gerrit Dou. By 1665, he had returned to Dordrecht, where he married in 1679. He established a successful practice and was soon in demand from collectors and connoisseurs outside his native city. In early 1691 he must have been working at The Hague as in February of that year he paid a membership fee to the city's painters' guild. He was back in Dordrecht by the end of the year, but in 1692–7 was working in London, where he painted several portraits of William III. By 1698 he was back working at The Hague where, with the exception of a trip to Düsseldorf in 1703 to work for the Elector Palatine, Johann Wilhelm, he remained for the rest of his life.

Schalken's style throughout his life is characterized by the *fijnschilder* technique he had learnt from Dou, with its smooth, enamel-like surface and meticulous attention to details. However, his taste is marked in his earlier work by a greater predilection for nocturnal, candle-lit genre scenes, usually featuring pretty young women (e.g. *A Girl Threading a Needle by Candlelight*, London, Wallace Collection) and in his later work by the kind of élitist, Classical theme, preciously treated, favoured by the new patrician classes (e.g. *Lesbia Weighing her Sparrow against her Jewels*, c1675, London,

National Gallery). Schalken's specific, candle-light type of picture was perpetuated by his pupil, Arnold Boonen (1669–1729).

Bib.: Beherman, T., *Gottfried Schalken*, Paris, 1988

Scheemakers, Peter (1691–1781)

Flemish sculptor. He trained in Rome and worked in England c1716–71, where he contributed to tomb sculpture and collaborated with ▷Bird and ▷Laurent Delvaux. He was best known for his Shakespeare monument which he produced for Westminster Abbey. He visited Rome in c1728 and became ▷Rysbrack's principal competitor during the 1730s. During his last years he lived in Antwerp.

Scheffer, Ary (1795–1858)

French-based painter, engraver and illustrator. He was born in Dordrecht, to a German father and Dutch mother. After his father's death the family moved to Paris in 1809, where he trained with ▷Prud'hon (1810) and at the ▷École des Beaux-Arts under ▷Guérin (1811). He exhibited at the ▷Salon from 1812. His early work was ▷Neoclassical in style (e.g. *Hannibal Swearing to Avenge his Son's Death*, 1810, Dordrecht) but by 1814 he had introduced colour and drama into his work (e.g. *Orpheus and Eurydice*, 1814, Blois). He was highly popular in Paris during the 1830s for his sentimental merging of a highly finished technique and ▷Romantic subject-matter. He worked in a range of genres from portraiture to exotic and literary themes (e.g. *Leonora*, 1828, Lille). He was a supporter of Greek independence, an enthusiast for English and German literature and a friend of Gautier, and therefore could be seen as representing the acceptable face of Romanticism.

Schelfhout, Andreas (1787–1870)

Dutch painter. He painted winter landscapes scenes and seascapes in an evocative style that prefigured that of the ▷Hague School. He produced both oil paintings and ▷watercolours and was a teacher of ▷Jongkind.

Schiavone, Andrea (1522–82)

Italian artist. This was popular name of Andrea Meldolla ('*schiavone*' means 'the Slavonian'), a painter and engraver, born in Zara, Dalmatia, which was then under Venetian control. He worked principally in Venice in a lively and personal style derived from the ▷Mannerist forms of ▷Parmigianino and the Venetian colourism of ▷Titian (e.g. *Adoration of the Kings*, Milan, Ambrosiana). His paintings were mostly small-scale religious and mythological subjects, executed for private patrons.

Bib.: Richardson, F.L., *Andrea Schiavone*, Oxford, 1980

Schiele, Egon (1890–1918)

Austrian painter and draughtsman. He was an ▷Expressionist. He was born at Tulln on the Danube, the son of a railway official, with a family history of mental instability. He had a strict church education, against which he rebelled. In 1906 he entered the Vienna Art Academy under Christian Griepenker (1839–1916) and became involved with the ▷Secessionists in Vienna, exhibiting with the Kunstschau in 1909 and co-founding the Neukunstgruppe (New Art Group). As part of this ▷avant-garde circle he met ▷Klimt, who was to be a major influence on his work (e.g. *Death and the Maiden*, 1915–16, Vienna, Österreichisches Museum), and he gained the patronage of a number of influential individuals, many of whom he painted (e.g. *Eduard Kosmack*, 1910, Vienna, Österreichische Galerie im Belvedere). In 1911 he spent time at Krumau where he concentrated on landscape (e.g. *View of Krumau*, 1916, Linz). He was arrested in 1912 on charges of pornography, having already been forced to leave Krumau because of his relationship with a model. He was engaged in non-active duty throughout the First World War, but did little painting. He married in 1915, and seemed to gain a new contentment (e.g. *Family*, 1918, Vienna, Österreichisches Museum). After the war he designed the exhibition poster for the Secessionists in 1918, but died of influenza shortly after. His work was characterized by a restless use of line and sombre natural colour. His landscapes were design pieces, in which nature was flattened and distorted for the sake of art. He painted an obsessive number of self-portraits, many with a strong sexual element, and many of his drawings and watercolours of women employed provocative and voyeuristic poses.

Bib.: Mitsch, E., *Art of Egon Schiele*, Oxford, 1988; *Egon Schiele and his Contemporaries*, exh. cat., London, 1989; Whitford, F., *Egon Schiele*, London, 1981

Schildersbent

(Dutch, 'band of painters'.) A group of Dutch and Flemish artists working in Rome in the 17th and early 18th centuries. They formed together as a sort of club in c1623 and included such artists as ▷Pieter van Laer. They indulged in youthful activities such as excessive drinking and carousing, and they adopted nicknames (*bentnames*) and called themselves 'birds of a flock' (▷*bentvueghels*). Their shenanigans led them to be dissolved by papal decree in 1720.

▷Bambocciata; Romanists

Schiller, Johann Christoph Friedrich von (1759–1805)

German poet, dramatist and philosopher. As a child of the ▷Enlightenment, concerned with the themes of personal and political freedom and inspired by the ▷Romantic concept of ▷Classical Greece, Schiller also wrote on ▷aesthetics, defining beauty as 'freedom

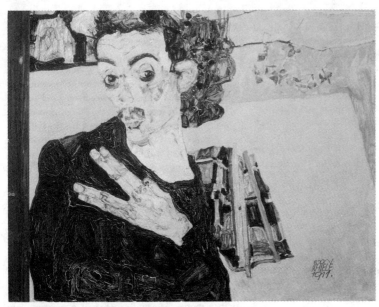

Egon Schiele, *Self-portrait*, 1911, Historisches Museum Der Stadt, Vienna

in appearance'. His use of themes from north and south in his drama and poems (along with his fervent Christianity) demonstrate the multiple interests of Romantic Classicism.

Bib.: Savile, A., *Aesthetic Reconstruction: The Seminal Writing of Lessing, Kant and Schiller*, Oxford, 1987

Schinkel, Karl Friedrich (1781–1841)

German architect. He was born in Neuruppin in Brandenberg and went to school in Berlin. After being inspired by an exhibition of ▷Gilly's work in 1797, he apprenticed himself to Gilly's father, before entering the new Berlin Academy in 1799. He made a trip to Italy in 1803. Inspired by Johann Gottlieb Fichte's *Vocation of Man* (1800), he viewed architecture as a public duty and entered the Prussian State Works office (1810), which he headed from 1830. Throughout his early career he painted popular ▷dioramas and ▷murals to support his family, as well as a number of highly finished oil paintings. He was responsible for many major projects within Berlin, and although he never achieved his aim of redesigning the city centre, he built the Schauspielhaus (Theatre, 1819–21) and the Altes Museum (1823–30), both in a ▷Greek Revival style, the latter with a severe ▷Ionic ▷colonnade. He also pioneered a ▷Gothic Revival in works like the Werderkirche, Berlin (1829) which reflected his own liberal nationalism. In 1826 he visited England and many of his later projects, particularly the Bauakademie (1831–6), were inspired in their use of brick by his visit there. He also worked in an Italian style (e.g. The Court Gardener's House, 1829–33), and designed furniture, theatre sets (e.g. *The Magic Flute*, 1815) and the Iron Cross (1813).

Bib.: Pundt, H.G., *Schinkel's Berlin: A Study in Environmental Planning*, Cambridge, MA, 1972; *Karl Friedrich Schinkel*, exh. cat., Berlin, 1980

Schjerfbeck, Hélène Sofia (1862–1946)

Finnish painter. She was born and studied in Helsinki. At the age of 18 she travelled to Paris and studied further at the Académie Trélat and the Académie Colarossi. She visited ▷Pont-Aven and ▷St. Ives in 1887. Her early work was reminiscent of ▷Bastien-Lepage's rural scenes, but she concentrated also on interiors peopled by women and children. After her move to a remote Finnish town in 1901, her works became increasingly simplified and she continued to paint ▷genre themes in an abstracted style for the rest of her career.

Bib.: Holger, L., 'The Convalescent Motif and the Free Replicas: Hélène Schjerfbeck's Painting of a Young Girl', Ateneumin Taidemuseo, *Museo-julkonisu*, vol. 23 (1980), pp. 40–45

Schlemmer, Oskar (1883–1943)

German painter, sculptor and stage designer. He trained at the Stuttgart Academy under ▷Adolf Hölzel (1909–14), and he exhibited his murals at the ▷Deutsche Werkbund exhibition of 1914. He was in service during the First World War, but in the 1920s he came back to art, producing both sculpture and theatre designs. He was put in charge of the theatre and the stone carving workshops at the ▷Bauhaus in 1920, and there he evolved and produced his Triadic Ballet in 1922. His painting and sculpture concentrated on schematic and simplified human shapes, while his

theatrical work stressed stylized and symbolic movement. His work was in many ways similar to the emphasis of the ▷Constructivists, but it was never completely abstract. In 1929 he was made Professor of the Breslau Academy, but his work was declared ▷degenerate in 1837.

Bib.: Eberle, M., *World War I and the Weimar Artists: Dix, Grosz, Beckmann, Schlemmer*, New Haven, 1985; Schlemmer, T. (ed.), *Oskar Schlemmer, Briefe und Tagebücher*, Stuttgart, 1977

Schlüter, Andreas (c1660–1714)

German sculptor and architect. He came to Berlin from Poland in 1694, and took up work in the court there. He travelled to France in 1695 and Italy in 1696, where he assimilated a ▷Baroque style. When he returned to Germany, he took on some major commissions, including an ▷equestrian statue of Frederick the Great (1696–1700, Berlin, Charlottenburg Castle). In 1714, he took up the post of Chief Architect at the Russian court, but he died soon after.

Schmidt-Rottluff, Karl (1884–1976)

German painter and graphic artist. He was associated with the ▷Expressionists. He was born in Rottluff, from which he later took his name. He was a friend of ▷Heckel from 1901 and painted regularly with him, especially at Dangast during the summers until 1912. He studied architecture at Dresden from 1905, meeting ▷Kirchner with whom he established ▷Die Brücke in that year. From 1906 he also worked regularly with ▷Nolde on the Island of Alsen, producing increasingly abstracted landscapes (e.g. *Dyke Beach*, 1910, Berlin). He moved to Berlin in 1911, where he developed an interest in African sculpture and met ▷Feininger who introduced him to ▷Cubism (e.g. *Four Bathers on the Beach*, 1913, Hanover, Niedersächsische Landegalerie). He fought during the First World War, and afterwards returned to his Berlin studio, where he remained until its destruction in an air raid in 1943. He made regular visits to Paris and Italy during the 1920s, and was a member of the Prussian Academy (1931–3) until he was excluded by the Nazi regime. He was forbidden to paint in 1941. After the Second World War he continued to live in Berlin and teach at the School of Art.

Schmidt-Rottluff's early work was influenced by ▷Impressionism, but he quickly developed a harsh Expressionist style using flattened areas of strong contrasting colour (e.g. *Self-portrait with Monocle*, 1910, Berlin, Nationalgalerie). In his landscapes and figure compositions he used rough geometric shapes to distort depth and surface, and increasingly in the years up to 1914, he moved towards ▷abstraction. His work softened during the 1920s.

Bib.: Brix, K., *Karl Schmidt-Rottluff*, Vienna, 1972; *Karl Schmidt-Rottluff*, exh. cat., Nice, 1995

Schnorr von Carolsfeld, Julius (1794–1872)

German painter. He was one of the original members of the ▷Nazarenes, with whom he worked in Italy in 1817–25. In 1825 he returned to Munich, where he took on large-scale decorative commissions for Ludwig I. Through his historical and religious ▷frescos, he helped spread the influence of the Nazarene style. In 1846 he became Professor of the Dresden Academy, and he was appointed Director of the Dresden Gallery.

Schönfeldt, Johann Heinrich (1609–82)

German painter and etcher. He travelled and studied in Italy during his early career, and absorbed Italian influences there. In 1652 he was in Augsburg, where he produced many ▷history paintings, ▷genre works and ▷altarpieces. His often delicate style anticipated the flourishing of ▷Rococo art in Germany.

Schongauer, Martin (fl 1465–91)

German painter and engraver. He worked at Colmar, where he produced his only known painting, *Madonna of the Rose Bower* (1473, Colmar, St. Martin's Church). However, he was best known for his many ▷engravings, which showed his great skill and imagination while working in a very new medium. ▷Dürer knew and was influenced by his engravings. He was the teacher of ▷Burgkmair.

Bib.: Minott, C., *Martin Schongauer*, New York, 1971

School of ...

Term used to describe paintings which have been grouped together because of the supposed place of their execution or their relationship with the work of another artist (e.g. School of ▷Rembrandt; Venetian School). Although this is justifiable in some cases because of documentary evidence about the work, the term is often difficult because of the arbitrary way in which it can be applied.

School of Paris (École de Paris)

A term applied to two very distinct groups of artists both centred in Paris.

(i) In connection with manuscript illumination, it refers to the medieval school of manuscript illuminators that flourished under the patronage of St. Louis and which continued in the work of ▷Master Honoré, ▷Jehan Pucelle and the ▷Limburg Brothers.

(ii) The term is often also used loosely to describe a group of primarily non-French artists working in Paris before the First World War, although it can, in addition, be applied to a similar group of artists living in the city between the two world wars. The 'School of Paris' consisted primarily of ▷modernist artists, who adopted the tendencies of ▷Post-Impressionism, ▷Cubism and ▷Fauvism. It included ▷Picasso, ▷Chagall, ▷Modigliani, ▷Mondrian, ▷Bonnard and ▷Matisse. Several of these artists (▷Chagall, ▷Soutine) were Jewish, a fact which is often cited as

a tie that bound them together. Many of the group lived in studios in Montmartre, and many of them practised what has been called French ▷Expressionism. In reality, their styles, origins and affiliations were very diverse, and the term is more appropriately indicative of the importance of Paris as an artistic centre in the early decades of the 20th century.

Bib.: Dorival, B., *The School of Paris in the Musée d'Art Moderne*, London, 1962

Schrimpf, Georg (1889–1938)

German painter. He was from Munich, but he did not take advantage of any of the art training available there. He began painting ▷Expressionist works, but in 1920, he travelled to both Switzerland and Italy, where he was influenced by the realist style of ▷ *Valori Plastici*. He began painting figure studies in a ▷Neue Sachlichkeit style and earned himself a reputation for this work. He taught at the School of Applied Art in Munich (1926–33) and later in Berlin.

Schwind, Moritz von (1804–71)

Austrian painter and graphic artist. He studied in Munich with ▷Cornelius, but he avoided the large scale of ▷Nazarene work. Instead, he specialized in small ▷genre paintings, many of which represented German myths, history and legends.

Schwitters, Kurt (1887–1948)

German painter, sculptor and writer. He studied at the Dresden Academy and, like many of his contemporaries, was an early admirer of ▷Expressionism. However, he changed his orientation after the war, when he settled in Hanover and evolved his own form of ▷Dada which he called ▷Merz. The name came from a newspaper advertisement for a '*Kommerz-und Privatbank*', and Schwitters merely isolated the phrase 'Merz' as a nonsense word to reflect the statement he was trying to make with his art. Although he was briefly involved with the Berlin Dada group, they soon abjured his merz compositions which they felt were too traditional and apolitical. Over the next decade, however, Schwitters developed his Merz compositions in both two-dimensional and three-dimensional form. He created ▷collages from junk which he collected on forages through the streets of Hanover. Newspaper cuttings, old tickets, hair, cigarette butts and other ephemera made its way into these Merz compositions. He also produced a *Merz* magazine from 1923 to 1932.

After his brief flirtation with Dada, Schwitters became attracted to the experiments of the ▷Constructivists. After a tour through the Netherlands with ▷van Doesburg in 1922, he became interested in the purity of the compositions of ▷De Stijl artists. His interest in abstraction led him to become a member of the ▷Abstraction-Création group in 1932. In his most significant three-dimensional work, the Merzbau, he

veered away from Dada and towards a Constructivist environment. The Merzbau evolved over a period of many years, and it gradually took over a large part of his Hanover home. He later erected another Merzbau in Norway, where he fled in 1937 after the Nazis had come to power, and a final one was produced in England, when he moved there in 1940. He also wrote a large collection of poetry.

Bib.: Elderfield, J., *Kurt Schwitters*, London, 1985; Schmalenbach, W., *Kurt Schwitters*, London, 1970

Scopas (Skopas) of Paros

With ▷Praxiteles and ▷Lysippus, the most celebrated Greek sculptor of the mid-to late 4th century BC, though unfortunately no architectural sculpture has been securely attributed to him and no later copies have been securely identified with his independent statues. In the 18th century ▷Winckelmann and others attempted to associate the *Niobe Group* (Florence, Uffizi) with him, but this judgement is now discounted. Pausanius states that he was architect as well as principal sculptor on the Temple of Athena Alea at Tegea; to him are due the lost marble cult-statues of Asclepius and Hygieia, once housed within the temple, and the design and supervision of the execution of the ▷pediments showing the Calydonian Boar-hunt and Achilles and Telephus. Scopas was also employed on the Mausoleum of Halicarnassus (after 351 BC), and was once thought to have executed the ▷friezes for the east side, representing *Greeks and Amazons Fighting* (three slabs now in London, British Museum). This attribution too has been contested, however, as the quality of the carving is unexceptional for such an acclaimed sculptor and, it is in any case more likely that Scopas would have been employed on the more important free-standing statues associated with the monument. A sculptured column from the Temple of Artemis at Ephesus was attributed to him by Pausanius, but this is also now rejected. His contemporary reputation was as an artist who excelled in the depiction of dramatic action and intense expression. He would thus appear to presage the principal characteristics of ▷Hellenistic sculpture.

Bib.: Burn, L., *The British Museum Book of Greek and Roman Art*, London, 1991; Robertson, M., *A History of Greek Art*, 2 vols., Cambridge, 1975

Scorel, Jan van (1495–1562)

Dutch painter. The first major Dutch painter to study in Italy, he was responsible for introducing the style of the Italian High ▷Renaissance to the Netherlands. The chief virtue of his work is the total assimilation of his Italian influences into a distinct, unified and essentially northern European style.

Scorel was born in Schoorel near Alkmaar (as is indicated by his name), trained in Amsterdam, but is recorded in Utrecht by 1517. In 1519 he set off on his travels, firstly to Nuremberg in the hope of training

with ▷Dürer. Unfortunately his Catholicism conflicted with Dürer's Lutheranism and he moved on to Carinthia where in 1520 he executed a ▷triptych for the Obervellach Parish Church (still *in situ*). He then visited Venice and was greatly impressed by the work of ▷Giorgione and ▷Palma Vecchio. From Venice he went on a pilgrimage to Jerusalem (a drawing of Bethlehem by him exists in London, British Museum). He returned to Venice and in 1522 was called to Rome by Pope Hadrian VI, also from Utrecht, who appointed him superintendent of the Vatican collection of ▷antiquities (in succession to ▷Raphael), commissioned a portrait from him and made him Canon of Utrecht. In Rome he was influenced not only by the antique sculptures which were in his charge, but also by ▷Michelangelo and ▷Raphael, particularly the latter (cf. Scorel's *Adam and Eve*, New York, Metropolitan Museum and ▷Raimondi's engraving after Raphael's *Fall of Man*, London, British Museum).

Following Hadrian's death in 1524, Scorel returned to the Netherlands, first to Utrecht and then to Haarlem, where ▷Maerten van Heemskerk was his pupil. In 1550 he was called to Ghent to restore the ▷Ghent Altarpiece. Many of his large altarpieces were destroyed by the ▷Iconoclasts in the 16th century. His principal works include *Pilgrims to Jerusalem* (versions in the Utrecht and Haarlem Museums), *St. Mary Magdalene*, and *The Presentation in the Temple* (Vienna, Kunsthistorisches Museum). He was also an accomplished portrait painter (e.g. *Portrait of Agatha Schoonhoven*, 1529, Rome, Doria Pamphili Gallery) and among his pupils was the portraitist ▷Anthonis Mor.
Bib.: Friedländer, M.J., *Jan van Scorel and Pieter Coeck van Aelst*, Leiden, 1975

Scott, Samuel (?1702–1772)

English painter and etcher. He was born in London, worked there during the 1720s, and established himself as a rival to the ▷van de Veldes in his ▷marine paintings (e.g. *Engagement Between the Lion and the Elizabeth*, 1745, private collection; *Entrance to the Fleet River*, 1750, London, Guildhall). He also collaborated with ▷Lambert, producing views of the settlements of the East India Company. From 1746, he was influenced by ▷Canaletto, and worked on a series of views of the Thames with small figures (e.g. *View of London, St. Paul's and Blackfriar's Bridge*, 1750, London, British Museum) which were significant for their observation of human incident and architectural detail. He settled in Bath in 1766, remaining there until his death.

Scott, William (1913–89)

Scottish painter. He was born in Greenock, of Irish extraction. He studied at Belfast School of Art (1928–31), and the ▷Royal Academy schools (1931–4), where he trained initially as a sculptor but won prizes for his painting. His early figurative work was influenced by ▷Cézanne and ▷Bonnard, and by his connections with the ▷Euston Road Group. He was a member of the ▷London Group from 1949. During the 1940s he taught at Bath Art Academy and developed links with the ▷St. Ives artists. He travelled to America in 1953, where he became interested in ▷Abstract Expressionism, and from 1956 abandoned teaching to concentrate wholly on painting. His prewar work, often nudes, had an austerity (e.g. *Seated Nude*, 1939, London, Tate Gallery) which he later dropped in favour of colourful, chunky still life, reminiscent of ▷Chardin and ▷Braque (e.g. *Mackerel on a Plate*, 1951–2, London, Tate). Increasingly, his work moved towards abstraction, using geometric shapes with softened painterly edges (e.g. *Blue Painting*, 1960, Buffalo). His work of the 1960s had a more sombre, naturalistic palette. In 1951 he was commissioned to provide work for the Festival of Britain and in 1958 he was the British representative at the Venice ▷Biennale.
Bib.: Alley, R., *William Scott*, London, 1963; Bowness, A., *William Scott: Paintings*, London, 1964; *William Scott*, exh. cat., London, 1972

Scott, William Bell (1811–90)

Scottish painter and poet. His father, Robert (1777–1841), was an Edinburgh ▷engraver. He studied at the Trustees Academy in Edinburgh from 1831 and helped out in his father's business before travelling to London in 1837. However, he failed as an illustrator and turned to painting, becoming a friend of ▷Rossetti, ▷Frith and ▷Egg. He worked in a ▷Pre-Raphaelite style, specializing in detailed paintings of historical and ▷Romantic subjects (e.g. *Keats' Grave in the Old Protestant Cemetery at Rome*, 1873, Oxford, Ashmolean). In 1842 he failed in the ▷mural competition for the Houses of Parliament. He was Head of Newcastle School of Design 1843–64. Perhaps his most famous works were a series of murals for Wallington Hall in Northumberland, depicting the history of the area (e.g. *Coal and Iron*, 1855). He also wrote poetry – he was a friend of Swinburne, whom he painted (1860, private collection) – and art books (*William Blake*, 1878, *Our British Landscape Painters*, 1872). His brother, David (1806–1849) was a ▷history painter.

scraper

A tool used in ▷engraving and ▷etching to smooth the plate and eliminate the ▷burrs.

Scream, The

Painting by the Norwegian artist ▷Edvard Munch which formed part of his *Frieze of Life* series of paintings and prints which developed through the 1890s and were described by Munch as 'a poem of life, love and death'. Painted in 1893, *The Scream* shows a figure on a pier beneath a vivid red sunset, clutching his hands to his ears, his eyes and mouth wide open. Munch had

developed the desire described by his fellow artist Christian Skredsvig in 1891, 'to paint the memories of a sunset. Red as blood. No, it was coagulated blood ... He longs for the impossible and has despair as to his religion, I thought, but advised him to paint it.' The image developed from the painting *Despair* (1892), and was used again, with more figures, in *Anxiety* (1894). ▷Lithographs of the picture were reproduced in a number of artistic magazines, often accompanied by a text that varyingly described the genesis of the painting: 'I walked along the road with two friends; then the sun went down, the sky suddenly became blood and I felt the great scream in nature.' Influenced by both ▷Gauguin and ▷van Gogh, Munch here fuses symbolism and naturalism to create an image expressive of the artist's anxiety with the world. The painting, housed in the National Gallery, Oslo, was stolen in February 1994 but was found three months later.
Bib.: Wood, M.-H. (ed.), *Edvard Munch: The Frieze of Life*, London, 1992

scroll
The ancestor of the book, common in ▷Egyptian, ▷Jewish and Graeco-Roman antiquity. Strips of ▷parchment, ▷papyrus or ▷paper were joined together to form a continuous scroll, attached at each end to the stick around which it was rolled. The scroll would usually be unrolled horizontally from the left hand, the already read portions going to the right hand, although some, such as Exultet rolls, could be read top to bottom, the illustrations inverted in relation to the text so that the priest could read the text and the congregation in front of him see the pictures. Representations of ancient philosophers often show them with scrolls kept in a kind of hatbox – a motif commonly used to add 'class' to the representation of the deceased on a ▷sarcophagus. In late antiquity, the codex or book gained popularity, which meant that the individual sheets were piled up and sewn together at one edge, with the advantage that both sides of the material could be used, and several volumes could be much more conveniently manipulated at the same time.
Bib.: Weitzmann, K., *Ancient Book Illumination*, Cambridge, 1959; idem., *Late Antique and Early Christian Book Illumination*, London, 1977; idem., *Illustrations in Roll and Codex: A Study of the Origin and Method of Text Illustration*, rev. edn., Princeton, 1970

Scrot(e)s, Guillim (William Stretes) (fl 1537–53)
Netherlandish painter. He was an important court portraitist who worked in the ▷Mannerist style for several monarchs. He was Painter to Mary of Hungary, who was regent of the Netherlands (1546–53), and Henry VIII and Edward VI of England also commissioned portraits for him.

Scrovegni Chapel
▷Arena Chapel

sculpture
Art works in three dimensions. Before the Second World War, the term 'sculpture' was unambiguous. It referred to one of several techniques: carving, in which stone or wood was cut to form a work of art; ▷modelling, in which clay was built up into a work of art and sometimes cast in metal or ▷plaster; and assembly (▷assemblage), in which a work of art was constructed out of two or more different elements. However, since the Second World War, and since the 1960s in particular, any non-two-dimensional art form is sometimes referred to as sculpture, including ▷environment art and some ▷conceptual art.

scumbling
A painting technique in which an opaque colour is painted over another colour so that the first colour can still be seen. It gives a mottled effect. It is the opposite of ▷glazing.

Scuola metafisica
▷metaphysical painting

Seasons
▷Four Seasons

Sebastian
Roman saint, martyred in the reign of Diocletian (3rd century AD), venerated from the 4th century, and whose story is told by the medieval hagiographer, Jacobus de Voragine in *The Golden Legend*. Sebastian was a Roman officer in the Praetorian Guard who, unknown to his superiors, was a Christian. On discovering he was a member of this proscribed religion Diocletian sentenced him to be shot to death by his own archers. He was left for dead, but some days after reappeared before the Emperor and berated him for his persecution of the Christians. This time Diocletian ordered him to be beaten to death with rods. His body was thrown into a sewer, but Sebastian appeared in a dream to one of his followers and she and her fellow Christians buried him near the Appian Way, close to which now stands the ▷basilica which bears his name. The earliest portrayals of him are from the 7th century (e.g. ▷mosaic, Rome, S. Pietro in Vincoli). His (attempted) martyrdom with arrows became a popular subject in the ▷Renaissance, partly due to the opportunity it gave artists to paint a young male ▷nude in a religious context, but more importantly because his cult enjoyed renewed popularity – his ability to survive the arrows (which were symbolically linked with ▷Apollo's arrows which dispensed fatal diseases) led to him being evoked as protector against the plague. In devotional paintings his attribute is the arrow and he is frequently paired with the other main

protector against the plague, St. Roch (e.g. ▷Titian, *St. Mark and the Plague Saints*, c1511, Venice, Sta Maria della Salute). In narrative paintings he is usually showed tied to a stake (e.g. ▷Antonio and Piero Pollaiuolo, 1475, London, National Gallery) or Classical column (e.g. ▷Mantegna, 1480s, Paris, Louvre), surrounded by archers and pierced by arrows. A rarely depicted theme is his followers tending his arrow wounds (e.g. ▷Georges de la Tour, *St. Sebastian tended by Irene*, c1649, Paris, Louvre).

Sebastiano del Piombo (c1485–1547)

Italian painter. This was the nickname of the painter Sebastiano Luciani, referring to his appointment in 1531 as keeper of the papal seal ('*piombo*' means 'lead', the metal from which the seals were made). He began his career in Venice, where ▷Vasari says he was first trained by ▷Giovanni Bellini, although his style is closer to his supposed second master, ▷Giorgione. Sebastiano's *Salome* (1510, London, National Gallery) exemplifies this well, although the fact that his unfinished *Judgement of Solomon* (National Trust, Kingston Lacy, Dorset) was once attributed to ▷Giorgione, more so. Following Giorgione's death in 1510, Sebastiano went to Rome at the invitation of Agostino Chigi to work with ▷Raphael at his villa, the Farnesina (e.g. *Polyphemus*). However, Sebastiano apparently quarrelled with Raphael and threw himself in with the ▷Michelangelo faction. The result of his alliance with the latter was a style founded on Venetian colourism controlled by Roman form: a not entirely successful combination (losing much of Sebastiano's sensual painterliness) of the traditional opposites of Italian art theory, ▷*disegno* and *colore*. ▷Michelangelo supplied Sebastiano with designs for several of his works, including the *Pietà* in Viterbo and the *Flagellation* at S. Pietro in Montorio, Rome. Sebastiano's *Raising of Lazarus* (1519, London, National Gallery), if not actually to a design by Michelangelo, is certainly imbued with his spirit, and was executed in direct competition with Raphael's *Transfiguration*, the two paintings being commissioned as companion pieces for Narbonne Cathedral. Following Raphael's death in 1520, Sebastiano became the leading painter in Rome, being particularly prized for his portraits. In 1526 he painted *Clement VII de' Medici* (Naples, Museo di Capodimonte), the Pope who, in 1531, awarded him his official appointment. Now a wealthy man, from this time he virtually gave up painting altogether.

Bib.: Hirst, M., *Sebastiano del Piombo*, Oxford, 1981; Lucco, M., *L'opera completa di Sebastiano del Piombo*, Milan, 1980

secco

(Italian, 'dry'.) In wall painting, fresco secco is the term used to denote colour that has been applied to an already set plaster surface and distinguishes the technique from *buon fresco*, or true ▷fresco, in which the colour is applied to an unset plaster surface. Either ▷tempera or ▷pigment mixed with lime-water can be used, although if the latter is used, the wall surface has to be moistened first; however, it is still secco (i.e. dry) in so far as the paint is applied to a plaster which has previously been allowed to dry and set. The disadvantage of fresco secco is that the colour merely lies upon the surface of the plaster (whereas buon fresco binds with it) and is therefore not as durable; the advantages are that the artist can work more slowly (not having to finish before the plaster sets) and that a greater range of pigments can be applied in secco. It is often used by painters for the application of finishing touches and minor modifications to a painting that is otherwise *buon fresco* (e.g. the ultramarine – lapis lazuli – of the Virgin's robe in ▷Giotto's ▷Arena Chapel, Padua, fresco cycle was applied secco and has peeled away revealing the underpainting).

Secession

▷Sezession

secondary colours

Colours made from mixing together two ▷primary colours. The secondary colours are green (blue and yellow), orange (red and yellow) and violet (red and blue).

▷tertiary colours

Second Futurists

A name given to the second generation of ▷Futurist artists who worked in Italy after the First World War and under the dictatorship of Mussolini. These artists included some members of the pre-war Futurist group, such as ▷Balla, and new devotees of the Fascist government, like Fortunato Depero (1892–1960) and Enrico Prampolini (1894–1956). Although they all shared an enthusiasm for the ▷machine aesthetic, their works are very different in style and theme.

▷Aeropittura

Second Laethem Group

▷Laethem-Saint-Martin

Section d'Or

(French, 'Golden Section'.) A group formed by a number of artists influenced by ▷Cubism. They held their first exhibition in the Galerie la Boétie in Paris in 1912. The core group included ▷Gleizes, ▷Metzinger, ▷Kupka, ▷La Fresnaye, ▷Léger, ▷Picabia, ▷Duchamp and ▷Duchamp-Villon, while on the fringes were ▷Marie Laurencin, ▷André Lhote, ▷Archipenko and ▷Juan Gris. ▷Robert Delaunay also exhibited with the group, thereby providing a connection with ▷Orphism. Their aim was to place Cubism on a more theoretically sound footing than the subjective approach of ▷Picasso and ▷Braque. Believing that Cubism needed to go beyond

timeless, still-life themes they adopted ▷Futurist subject matter that glorified the ▷dynamism of the modern world. The group splintered at the outbreak of the First World War.

Bib.: Spate, V., *Orphism*, Oxford, 1978; Green, C., *Cubism and its Enemies*, New Haven, 1987

Segal, George (b 1924)

American sculptor. He studied at the Pratt Institute of Design and the Cooper Union as well as New York University. He took his Masters degree in Fine Art at Rutgers University. He began his art career as a painter, but during the late 1950s he took up sculpture. He is best known for his life-size plaster casts of human figures. These figures are allowed to remain white or are bandaged. They are placed in everyday situations and give an eerie alienating effect.

Segantini, Giovanni (1858–99)

Italian painter. After an impoverished and traumatic childhood, Segantini discovered an interest in art and studied at the Brera in Milan. The art dealer, Vittore Grubicy, discovered him and encouraged his penchant for landscape painting. He settled in Brianza (1880–86) and later Grigioni (1886–94) where he concentrated on luminous landscapes with a ▷Symbolist flavour, such as the *Punishment of the Lustful* (1891, Liverpool, Walker Art Gallery). He painted landscapes in a ▷divisionist style, and as a reclusive artist he retired to the Swiss Alps just as his fame was becoming secured.

Bib.: *Giovanni Segantini*, exh. cat., Zurich, 1990

Seghers, Daniel (1590–1661)

Flemish painter. He studied with ▷Jan Bruegel the Elder, and became Master of the Antwerp Guild in 1611. He specialized in flower painting, but he did not do independent still lifes. Instead he was responsible for accessory flowers in religious paintings. He was very well known for his festoons and gained extensive patronage. He joined the Jesuits in 1614.

Seghers, Gerard (1591–1651)

Flemish painter. He studied in Antwerp and painted religious works there. He went to Italy at some time after 1611 and saw the works of ▷Caravaggio. His own paintings evince the ▷tenebrism of Caravaggio's work. He received some patronage from Spain and worked for Philip III in Madrid.

Seghers (Segers), Hercules Pietersz. (1589/90–1633/38)

Dutch painter and etcher. He worked mainly in Haarlem, but also in Utrecht, The Hague and Amsterdam, and he specialized in landscapes. He was born in Haarlem, but trained with ▷Gillis van Coninxloo in Amsterdam and returned to Haarlem to enrol in the Guild of St. Luke as an independent master in 1612. He is better remembered today as an etcher, his ▷etchings

having survived in greater numbers (54) than his paintings (about 12 firmly attributed). His work was admired by ▷Rembrandt, who owned eight of his paintings and a number of his etchings, and was strongly influenced by them (e.g. *Mountain Landscape*, c1630–35, Florence, Uffizi, was until 1871 attributed to Rembrandt).

Seghers' style shows a development from the fantastic panoramic mountain landscapes popularized by ▷Joos de Momper and ▷Roelandt Savery towards a concern for light and atmosphere which renders the treatment more naturalistic, but which is nonetheless overlaid with a feeling of romantic sublimity. Very few of his paintings are dated, so a chronology is difficult, but it is generally felt that the more naturalistic landscapes (apparently even views of specific places in some cases) are amongst his later work. His etching technique was experimental in so far as he used tinted washes and different coloured papers to achieve remarkably different moods and light effects from the same plate. Seghers seems to have achieved a certain fame in his lifetime, but apparently little financial success if contemporary reports which tell of his slide into alcoholism and poverty are to be believed. The last mention of him is in 1633 and by 1638 his wife was described as a widow.

Bib.: Boun, K.G. (ed.), *Hercules Seghers: The Complete Etchings*, Amsterdam, 1973; Collins, L.C., *Hercules Seghers*, New York, 1978

Segonzac

▷Dunoyer de Segonzac

seicento

Literally, 'six hundred', the Italian art term for the 17th century. It is used only to refer to Italian art and may be used as either an adjective, as in 'seicento art', or a noun, as in 'art of the seicento'.

Seisenegger, Jacob (1505–67)

Austrian painter. He produced court portraits for several monarchs. In 1530 he worked for Emperor Charles V and painted a famous portrait of him which ▷Titian later used as a model (1532, Vienna, Kunsthistorisches Museum). In 1531 he was appointed court painter to Emperor Ferdinand I at Augsburg.

self-portrait

A depiction of the artist, by the artist. The tradition of self-portraiture has been strong for thousands of years, and artists have often included themselves within larger crowd scenes, perhaps as a means of signature or for publicity. For example, it is thought that some of the ancient Egyptian painters included images of themselves in tomb paintings. More recently the genre has been explored by a large number of artists, including those as diverse as ▷Rembrandt, ▷Picasso and ▷Warhol.

Seligmann, Kurt (1900–62)

American painter and graphic artist of Swiss birth. He was born in Basle and studied at the École des Beaux-Arts in Geneva. In 1927 he went to Florence, and he lived in Paris during 1929–38. While in Paris, he became involved with the ▷Surrealist circle, and he created his own Surrealist objects. He moved to the United States and became a US citizen in 1939. There he carried his Surrealist ideas into his spiritual life and became interested in magic.

Semele

(Ovid, *Metamorphoses*, 3: 259–309.) The daughter of Cadmus, founder of Thebes, and the mother of Dionysus (▷Bacchus) by ▷Jupiter. Ovid tells how ▷Juno, the wife of Jupiter, discovers that Semele is pregnant by her husband and, in order to exact her revenge, disguises herself as Semele's nurse and sows the seeds of doubt in Semele's mind, insisting that young men are always pretending they are gods in order to seduce gullible females and that the only way to assure herself that her lover is indeed Jupiter is to get him to reveal himself in his true Olympian guise. Semele goes to Jupiter, tricks him into swearing an unbreakable oath that he will grant her a wish and then demands he reveal himself. Unable to recant his oath, Jupiter reveals himself and Semele is burnt to ashes (although the unborn Dionysus is saved). See ▷Gustave Moreau, *Jupiter and Semele*; Paris, Gustave Moreau Museum).

semiology

▷semiotics

semiotics

The study of signs, including words, tone of voice, body language and symbolism. John Locke first used the phrase at the end of the 17th century, but it was American philosophers Charles Pierce and Charles Morris who defined the modern meaning in the 1930s. Morris identified three distinct areas in semiotics: pragmatics and the way in which signs are used; semantics, which effect the way signs relate to their meanings; and syntax, which is concerned with signs without any associated meanings. Although many of their ideas have now been discredited, semiotics still informs the way in which we look at works of art in terms of a system of signs and visual signals.

Senefelder, Aloys (1771–1834)

German artist. He is credited with the discovery of ▷lithography, which he began to use in 1798. In 1818 he wrote *The Complete Course of Lithography*, which became a standard work on the subject.

sepia

A rich brown-coloured ▷pigment used in mono-chrome ▷watercolour painting, or as a fixing device in black and white photography. Now largely associated with Victorian photography, it is often used in modern film or photography to convey a sense of age or period.

Sequeira, Domingos António de (1768–1837)

Portuguese painter. He was in Rome in 1788–95, where he developed a ▷Neoclassical style. In 1802 he was court painter in Lisbon, and he produced both portraits and religious works. After 1823 he spent much time in Paris and Rome.

Séraphine (Séraphine de Senlis) (Séraphine Louis) (1864–1934)

French painter. She was a domestic servant from Senlis who painted in her spare time. Like many other untrained ▷'naive' painters, she was discovered by ▷Wilhelm Uhde in 1912. During the 1920s, her works were exhibited. She specialized in fantasy still lifes replete with fruit and flowers. She later went insane.

Sergel, Johan Tobias (1740–1814)

Swedish sculptor of German birth. He worked in Rome in 1767–78, where he came into contact with ▷Neoclassicism. In 1779 he returned to Sweden, where he took on a number of public commissions. He based many of his public sculptures on famous works of ancient art, such as his *Drunken Faun* (1770–74, Stockholm, National Museum). He also produced portrait sculpture. He was an accomplished draughtsman, and his drawings possessed some of the verve and imagination of ▷Fuseli's work.

serial art

The use of uniform, and sometimes prefabricated, elements to assemble sculpture. Serial art is modular, and it involves extensive repetition. It has been popular since the 1960s for abstract sculpture.

▷André, Carl

serigraphy

▷silk-screen printing

Serliana

▷Palladian window

Serlio, Sebastiano (1475–1554)

Italian architect. His chief importance is as author of *L'architettura*. Published posthumously as a single treatise, it was formed of six books originally published as separate volumes in Serlio's lifetime: 1, *Geometry* (1545); 2, *Perspective* (1545); 3, *Antiquities* (1540); 4, *The Orders* (1537); 5, *Churches* (1547); and 6, *Libro Estraordinario* (a compendium of designs for arches and gateways, 1551). The treatise contained the first codification of the five ▷orders of Classical architecture. Additionally, Serlio treated the orders as a vocabulary, with the inherent meaning of each order and its most

appropriate use explained to the reader. The treatise was, above all, intended to be practical as well as theoretical, and was richly illustrated with an extensive repertory of architectural motifs which formed the standard source-book for generations of architects throughout Europe.

Serlio was born and trained in Bologna, but went to Rome in c1514. Here he became a pupil of ▷Peruzzi, absorbing a ▷Renaissance style formed on the architecture of ▷Bramante and ▷Raphael. With the Sack of Rome in 1527, Serlio left for Venice and there commenced his treatise. As Peruzzi's favourite pupil, he inherited his master's vast collection of plans and drawings, many of which found their way into the treatise. The first (and only) English translation appeared in 1611 as *The Five Books of Architecture*. Serlio's treatise, with its combination of short text and accompanying woodcut illustrations was the inspiration for ▷Palladio's *Quattro libri*.

Serlio's principal work as a practising architect is to be found in France, where he had been invited by Francis I. Here he designed the Grand Ferrare at Fontainebleau (1544–6, destroyed) and the Château of Ançy Le Franc (begun 1546).

Bib.: Thoenes, C. (ed.), *Sebastiano Serlio: sesto seminorio internazionale*, Milan, 1989

Serpotta, Giacomo (1656–1732)
Italian sculptor. He was from Sicily, where he produced most of his work. He was an accomplished ▷stuccoist, and he specialized in decorative commissions. He lived in Palermo.

Bib.: Garstang, D., *Giacomo Serpotta and the Stuccatori of Palermo 1560–1790*, London, 1984

Sérusier, Paul (1865–1927)
French painter. He was born in Paris and studied philosophy before entering the ▷Académie Julian in 1885. He was a regular visitor to ▷Pont-Aven from 1888 and finally retired to Brittany in 1914. In 1888 he painted *Landscape at the Bois d'Amour* (Paris), on the back of a cigar box, a work which became a 'talisman' for the ▷Nabis in its use of flattened decorative colour. He was associated with the group and, like them, worked on theatre designs and illustrations during the 1890s (e.g. *Breton Cornfield*, 1895, Munich). In the late 1890s he increasingly turned to religion: he visited an artist friend, Verkade, who had become a priest at Beuron, became interested in theosophy and travelled to Italy several times with ▷Denis. His work became increasingly ▷Symbolist, as he used pale, flattened colour shapes to explore ideas of spirituality. He taught art at the Académie Ranson from 1908. In 1921 he published his *ABC de Peinture*, setting out his theory of art.

Bib.: Boyle-Turner, C., 'Sérusier's "Talisman"', *Gazette des Beaux-Arts*, 6/105 (May 1985), pp. 191–6;

Masson, H., *Paul Sérusier de Pont-Aven à Châteauneuf*, St. Brieuc, 1991

settecento
Literally, 'seven hundred', the Italian term for the 18th century. It is used only to refer to Italian art and may be used as either an adjective, as in 'settecento art', or as a noun, as in 'art of the settecento'.

Seuphor, Michel (b 1901)
Belgian painter, graphic artist and writer. He was committed to ▷abstraction and was one of the founder members of both the ▷Cercle et Carré and ▷Abstraction-Création. He wrote books on abstract painting and sculpture, including *L'art abstrait* (*Abstract Art*, 1949) and *Dictionnaire de la peinture abstraite* (*Dictionary of Abstract Painting*, 1957).

Seurat, Georges (1859–91)
French painter and draughtsman. He was born into a wealthy, Parisian family and studied at the ▷École des Beaux-Arts (1878–9) where he received a highly traditional training under Lehmann, a former pupil of ▷Ingres. After military service in 1879, he set himself a concentrated programme of drawing, which he was determined to master before embarking on oil painting in c1883. His drawings employed a deliberate stippled technique which became the basis of his later ▷Pointillism. He admired a wide range of artists including ▷Puvis de Chavannes and ▷Millet, whom he emulated in early works like *The Stonebreaker* (1882, private collection). He also explored the stylized formality of Egyptian art. In 1884 *Bathers at Asnières* (London, National Gallery) was refused by the ▷Salon jury and in the same year he met ▷Signac and established the Société des Artistes Indépendants (▷Salon des Indépendants) at which the painting was shown. At the same time he was experimenting with his own optical and stylistic theories, realized in the monumental ▷*Sunday Afternoon at the Island of la Grande Jatte* (1886, Art Institute of Chicago), in which simplified figures, often in sharp profile, were juxtaposed against a contemporary landscape, using pure colours optically mixed by means of small dots and dashes of paint. Despite the subject matter, the formality of the work was far removed from ▷Impressionism. From 1885, Seurat turned to pure landscape with a series of paintings of Grandcamp and the Normandy coast. He exhibited at the last Impressionist exhibition and with ▷Les Vingt in Brussels (1887). He also became more interested in the new aesthetic theories of ▷Charles Henry (*A Scientific Aesthetic*, 1885), which described the emotional qualities of line and form. In pursuit of these ideas his last works (e.g. *Le Chahut*, 1889–90, Otterlo) used a limited palette and increased ▷Symbolism.

Bib.: *Georges Seurat*, exh. cat., New York, 1991; Thomson, R., *Seurat*, Oxford, 1985

Seven, Group of

▷Group of Seven

Seven and Five Society (7 and 5)

A group of British artists, consisting of seven painters and five sculptors, who came together in 1919 in reaction against academic art. They advocated ▷abstraction and were more extreme in their views than the ▷Bloomsbury group. The society included such artists as ▷Moore, ▷Hepworth and ▷Ben Nicholson. By 1935, their commitment to abstract art intensified, and they changed their name to the Seven and Five Abstract Group.

Seven Liberal Arts

▷Liberal Arts

Seven Sacraments

In the Christian faith, the rites necessary to obtain grace (salvation). Catholics recognize seven: Baptism, Confirmation, Communion, Penance (or Confession), Matrimony, Holy Orders, and Extreme Unction. The full cycle was more popular in Flemish than in Italian churches (e.g. ▷Rogier van der Weyden, *Altarpiece of the Seven Sacraments*, Antwerp, Koninklijk Museum), although after the ▷Reformation and the Protestant recognition of only two Sacraments (Baptism and Communion) representations of the five rejected Sacraments proliferated in other Catholic countries. Moreover, although Protestantism accepted Communion as a sacrament, it denied transubstantiation (the actual presence of Christ's body and blood in the bread and wine), declaring it to be merely symbolic. Thus, the ▷Last Supper becomes more emphatically the first Communion, the bread being more frequently supplanted by a Eucharistic wafer. Theological authority for the efficacy of Penance was evoked by the Catholic Church in images of penitential saints such as ▷Mary Magdalene, ▷Peter and ▷Jerome, for the Extreme Unction in representations of the ▷Virgin on her deathbed.

Severe style

A style of Greek sculpture that represented a transitional phase between the ▷Archaic and ▷Classical periods. It was practised c480 BC–450 BC, and its primary exponent was ▷Myron. The term was invented in the 18th century by ▷Winckelmann who was particularly impressed by the stark simplicity of the style.

Bib.: Ridgway, B., *The Severe Style in Greek Sculpture*, Princeton, 1970

Severini, Gino (1883–1966)

Italian painter. He was born in Cortona and went to Rome in 1901, where he met ▷Boccioni and ▷Balla. He moved to Paris in 1906, and remained there for much of his career, becoming involved with ▷Cubist circles. He also experimented with colour, and looked to the work of ▷Seurat for inspiration. He was one of the signatories of the ▷Futurist manifesto in 1910, and he applied Futurist techniques to scenes of leisure life, such as *Dynamic Hieroglyph to the Bal Tabarin* (1912, New York, Museum of Modern Art). He helped introduce Cubist artists to the possibilities of colour. Before and during the First World War he became increasingly interested in proportion and mathematics. His classical fascination was articulated in his 1921 book *Du Cubisme au Classicisme (From Cubism to Classicism)*.

Bib.: *Gino Severini*, exh. cat., Florence, 1983

sexpartite vault

▷vault

Sezession (Secession)

The name taken by a cascade of German and Austrian movements of the 1890s which broke away from academic restrictions under the influence of new styles such as ▷Impressionism, ▷Symbolism and ▷Art Nouveau. The most famous breakaway was the Vienna Sezession (1897) under ▷Klimt. However, Munich (1892) and Berlin (1899) also had important Secession movements.

Sezessionstil

(German, 'Secession style'.) A name given to the ▷Art Nouveau tendencies of some art produced by members of the Vienna ▷Secession.

Sforza, Francesco (1401–66) and Lodovico (1452–1508)

Italian family who ruled Milan for the second half of the 15th century. The *condottiere* Francesco seized power and became Duke in 1450, stabilizing his position with an alliance with the ▷Medici in Florence. Francesco was succeeded by his eldest son Galeazzo who was assassinated in 1476 and succeeded by his younger brother, Lodovico (known as 'Il Moro' because of his dark complexion) who was ultimately deposed and imprisoned by the invading French in 1500, thus ending the Sforza domination of Milan. In his bid to develop Milan as a formidable power, Francesco had promoted building and the arts; most notably, he founded the Ospedale Maggiore (begun in 1451 by ▷Filarete). Lodovico was patron to ▷Leonardo da Vinci, although few major commissions ensued, Leonardo's most notable Sforza-related project being the abandoned ▷equestrian monument to Lodovico's father Francesco (commissioned in 1485). Two drawings by ▷Antonio Pollaiuolo also exist for the monument and may represent a failed bid to secure the commission (as such they are usually dated to the early 1480s). ▷Bramante was also patronised by Lodovico, designing under his patronage the east end of S. Maria Delle Grazie (begun 1493) and the cloisters of S. Ambrogio (1492 and 1497–8).

sfumato

(Italian, 'softened', 'blurred', 'delicately shaded'.) Term used to describe a painting or drawing technique in which contours, colours and tonal gradations are softened or blurred one into another without abrupt transitions. ▷Leonardo da Vinci was perhaps the earliest and finest exponent of the technique and ▷Vasari saw the atmospheric subtleties it allowed as one of the defining differences between the art of the Early ▷Renaissance and that of the High Renaissance.

Shahn, Ben (1898–1969)

American painter and photographer. Born in Lithuania, his family emigrated to the USA in 1906. He worked as an apprentice ▷lithographer in Brooklyn while completing his basic education in night school, studying biology at City College in New York (1919–20) and painting at the ▷National Academy of Design (1922–5). After travelling and studying in Paris, Italy and Africa he mounted a successful one-man show in New York (1930) and worked as a WPA (▷Federal Art Project) photographer. He assisted ▷Rivera on the ▷murals at the Rockefeller Centre (1933) and subsequently painted his own murals for public buildings in New York and Washington. He was appointed Charles Eliot Norton Professor at Harvard (1967–8).

Shahn was perhaps the foremost American ▷Social Realist painter. A series of 25 paintings of the trial and execution of the anarchists, *Sacco and Vanzetti* (1931–2) established his reputation. He continued to explore political and social issues through scenes of city life focusing on the exploited and the unemployed, and satirical portraits of those in power over them. Shahn's paintings are realist in style, with clear lines, simple colours and a rejection of strongly patterned compositions. His use of empty space and stray quotidian detail suggests to some critics the influence of ▷abstract painting.

Bib.: Morse, J.D., *Ben Shahn*, London, 1972; Pohl, F.K., *Ben Shahn*, San Francisco, 1993; idem., *Ben Shahn: New Deal Artist in a Cold War Climate 1947–54*, Austin, 1989

Shannon, Charles Hazelwood (1863–1937)

English painter and lithographer. He was an ▷ARA in 1911 and an ▷RA in 1920, although he was also a member of the ▷NEAC. He painted in the style of ▷Old Masters, but his best work was his ▷lithographs which he produced with ▷Charles Ricketts.

Shee, Sir Martin Archer (1769–1850)

Irish painter. He came to London in 1788 and worked as a portraitist, producing society portraits in the manner of ▷Lawrence. He was actively involved in campaigning for better State patronage of the arts, and he articulated his views in his *Rhymes on Art* (1805).

He became President of the ▷Royal Academy in 1830, but despite his elevated status, he never achieved the fame or reputation of his predecessors in that role.

Sheeler, Charles R. (1883–1965)

American painter and photographer. He was born in Philadelphia and studied at the Pennsylvania Academy of Fine Art with ▷Chase. He travelled around Europe (1904–9) to complete his education. He practised as a commercial photographer, and his paintings carried some influence from his photographs from a very early stage. He exhibited at the ▷Armory Show, and he had a particular penchant for the works of ▷Cézanne. During the 1920s, his paintings and photographs of urban scenes became more and more detached, and he was seen to be one of the major practitioners of ▷Precisionism. His clinical view of American life continued into the 1930s, when he included rural scenes in his repertoire. However, he was never a ▷Regionalist, as his works were always devoid of nostalgia and emotion.

Bib.: *The Rouge: The Image of Industry in the Art of Charles Sheeler and Diego Rivera*, Detroit, 1978

Sherman, Cindy (b 1954)

American photographer. She studied at the University College of Buffalo in New York, where she became interested in photography and began exhibiting in 1976. From the beginning, she used photography to challenge the images and myths of popular culture and ▷mass media. Initially, in her series of 'Film Stills', she made herself up in the role of characters from 'B' movies, and she followed up this theme in later series of photographs such as 'Back Screen' (1980) and 'Freaks' (1986). Increasingly, she turned to ▷Old Master paintings for inspiration and created a series of photographs in which she dressed herself up as figures in famous works by ▷Caravaggio, ▷Raphael and others. These photographs crossed the boundaries between ▷postmodern playfulness and the exploration of self through portraiture. Sherman has received mixed reactions from ▷feminist viewers who question whether she subverts the codes of female subjugation or perpetuates those same codes by constantly using female stereotypes.

Bib.: Meneguzzo, M. (ed.), *Cindy Sherman*, exh. cat., Milan, 1990

Shingle Style

A North American style of decorative arts and architecture common in the late 19th century. Its name derives from the fact that houses built in this style often had shingles on the exterior.

Bib.: Scully, V., *The Shingle Style and the Stick Style*, New Haven, 1971

Shinn, Everett (1876–1953)

American painter and graphic artist. He was from New Jersey, but moved to Pennsylvania to study at the Pennsylvania Academy of Fine Arts in 1893–7. He worked as an illustrator for the *Philadelphia Press*, where he met ▷Robert Henri, and he became one of the original members of ▷The Eight and a prominent example of the ▷Ashcan School. He concentrated on theatre and music-hall scenes in a realist mode, but his work lacked the pessimistic social comment of ▷Sloan. He later produced ▷mural decorations, and he also worked for film companies.

Ship of Fools

An ▷allegorical poem, published in 1494 by Sebastian Brant, known in its original Swabian dialect as *Narrenschiff*. It achieved widespread popularity, was translated into many languages and in addition received an English adaption by Alexander Barclay in 1509. A satirical inversion of the familiar metaphor of the Church as a ship leading humanity to salvation, it concerns the voyage of a group of typical characters embodying the follies of the time and was intended to be a mirror in which each reader might recognize his or her own failings. Brant's original edition is illustrated with ▷woodcuts uncertainly attributed to ▷Dürer. The most celebrated visualization of the subject, however, is undoubtedly that by ▷Hieronymus Bosch (c1500, Paris, Louvre). At the centre of the ship Bosch places a lute-playing nun singing a duet with a monk, either side of a table with a bowl of cherries (symbols of concupiscence and ▷Lust), while other passengers eat and drink or vomit over the side (symbols of ▷Gluttony).

Siberechts, Jan (1627–1703)

Flemish painter. He was born in Antwerp and became a member of the guild there in 1648. He painted landscapes which showed both Dutch and Italian influence. In 1672 he came to England with the Second Duke of Buckingham and took on commissions to paint 'portraits' of country houses such as Longleat and Wiltshire. These were topographical views, with the ▷perspective often distorted to offer the largest possible view of the scene.
Bib.: Fokker, T., *Jan Siberechts: peintre de la paysanne flamande*, Brussels, 1931

sibyls

Apollonian prophetesses, 12 of whom were adopted by the medieval Church as part of a programme of assimilation and consequent control of Classical pagan religion. The Sybilline books of prophecies (themselves replacements for earlier books destroyed by fire) were lost in the 5th century AD. By medieval times the sibyls were seen as Classical pagan counterparts to the biblical Jewish prophets, and their prophecies had been selectively reinterpreted as foretelling the coming of Christ. ▷Giovanni Pisano portrays six of them on his pulpits in Pistoia (1301) and Pisa (1302–10), and ▷Michelangelo portrays five of them on the ceiling of the ▷Sistine Chapel (1508–12). In both cases the sibyls are interspersed with Old Testament prophets and each holds a ▷scroll or book, the usual attributes of a sibyl, but the specific identity is made clear only by the inscription above or below each figure. Individual sibyls may occasionally be distinguished by their particular attributes, although some of these are subject to debate: Agrippine (whip); Cimmerian (cross, cornucopia); Cumaean (bowl, cradle); Delphic (crown of thorns); Erythraean (lily); European (sword); Hellespontic (cross, nails); Libyan (lighted candle, torch); Persian (lamp or lantern, snake or dragon beneath her feet); Phrygian (cross, ▷Resurrection banner); Samian (rose, cradle); Tiburtine (dove, severed hand).

siccative

An agent added to paint to make it dry quickly.

Sickert, Walter Richard (1860–1942)

British-based painter and graphic artist. He was born in Munich, from an Irish background. After briefly embarking on an acting career, he settled for art and studied at the ▷Slade under ▷Legros, before becoming a pupil of ▷Whistler. During the 1880s he spent much time in France, especially at Dieppe where he met ▷Degas. He visited Venice in 1895. He was a founder member of the ▷NEAC in 1888 and later became a focus for both the ▷Fitzroy Street Group and the ▷Camden Town Group. His early work employed a muted tonal range inspired by Whistler, but he increasingly became interested in ▷Impressionist and ▷divisionist techniques and increased the brightness of his palette. His early landscapes gave way to studies of the music hall and circus, influenced by Degas (e.g. *Old Bedford*, 1897, Liverpool, Walker Art Gallery), and later to intimate accounts of poverty and the sordidness of urban life (e.g. *Mantelpiece*, 1907, Southampton). He also produced ▷etchings in a ▷Hogarthian style. From the 1920s he became increasingly interested in the use of photography in art, and also overpainted prints. He taught at Westminster Art School until 1919, and was elected RA in 1934. He wrote a number of books on art including ▷*Bastien-Lepage; Modern Realism in Painting* (1892) and *A Free House!* (1947).
Bib.: Baron, W., *Sickert*, London, 1973; Browse, L., *Sickert*, London, 1960; Shone, R., *Sickert*, Oxford, 1989; *Sickert*, exh. cat., London, 1992

Siddal(l), Elizabeth Eleanor (1834–62)

English artist. She was a shop girl, who was discovered as a 'stunner' (the Pre-Raphaelite slang for an attractive woman) by ▷Deverell in 1850, and became a model for a number of ▷Pre-Raphaelite works, including

▷Hunt's *Converted British Family* (1850, Oxford, Ashmolean Museum) and ▷Millais' *Ophelia* (1853, London, Tate Gallery). She had a long affair with ▷Rossetti, who encouraged her talent for drawing and poetry. They finally married in 1860, when she was already seriously ill, but she took an overdose of laudanum two years later. Rossetti was heart-broken – he painted *Beata Beatrix* as a tribute to her and buried his poems with her (although he exhumed them seven years later). Her own drawings and ▷watercolours were heavily influenced by Rossetti's style and subject matter (e.g. *Lady Fixing a Penon to her Knight's Spear*, 1858, London, Tate).

Bib.: Marsh, J., *Legend of Elizabeth Siddall*, London, 1989

Siegen, Ludwig von (1609–c1680)
German inventor. He is credited with the invention of ▷mezzotint engraving.

Siena, School of
The artists, particularly painters, who flourished in Siena in the 14th century. From the 12th century to 1555 Siena was a rich independent republic, which produced artists such as ▷Guido da Siena, ▷Duccio, ▷Simone Martini and the ▷Lorenzetti. All these artists produced remarkable public works in the city. Their reputation and Sienese patronage for the arts attracted other artists to the city, including ▷Pisano, who worked on the Duomo.

Signac, Paul (1863–1935)
French painter. He was born in Paris, the son of a wealthy saddler. He was part of the ▷Impressionist circle of the early 1880s, exhibiting with them in 1886, frequenting Yves Tanguy's shop and painting with ▷Monet and ▷Sisley at Port-en-Bessin (1882). He met ▷Seurat in 1884 and with him founded the Société des Artistes Indépendants, of which he became President in 1908. His original ▷Impressionism was modified by Seurat's ideas to a luminous ▷divisionism, which retained a freedom and sensitivity to landscape (e.g. *Port of Marseilles*, 1905, New York, Metropolitan Museum). He was friendly with ▷Pissarro, with whom he shared radical political sympathies, and he associated with ▷van Gogh, with whom he shared a special fascination for Japanese art and techniques. During the 1890s he became interested in the decorative possibilities of painting, following the aesthetic ideas of ▷Charles Henry, the ▷Symbolists' interest in the connection between music and painting (e.g. *Portrait of Fénéon*, 1890, private collection). Increasingly his works were simplified towards ▷abstraction, and he also associated with the ▷Fauves (he spent the summer of 1904 at St. Tropez with ▷Matisse) in their use of exaggerated colours and motifs. He travelled widely, visiting Venice in 1904 and Holland in 1905–6. His later work was often in watercolour. In 1899 he wrote an account of divisionism, *De Delacroix au Néo-Impressionisme* (*From Delacroix to Neo-Impressionism*) and published a book on ▷Jongkind in 1927.

Bib.: Bullock, M., *Paul Signac*, Greenwich, 1971; *Paul Signac*, exh. cat., London, 1986; Ratcliff, F., *Paul Signac and the Colour of Neo-Impressionism*, New York, 1992; *Signac at St. Tropez*, exh. cat., St. Tropez, 1992

significant form
A term first used by ▷Clive Bell in 1913 which made the basis of his art theory in his book *Art* (1914). It refers to the abstract elements of a work of art – the form and colour. If a form were 'significant', Bell argued, its worth would be assured, as it would arouse a special 'aesthetic emotion' in the observer. Bell thus advocated the importance of form and colour in a work of art over the content, which he saw as insignificant or secondary. These theories reflected Bell's own enthusiasm for ▷Post-Impressionism, and they were important to the development of ▷abstract art in pre-war Europe.

Signorelli, Luca (c1441/50–1523)
Italian painter. He was born in Cortona and, according to ▷Vasari, was a pupil of ▷Piero della Francesca. More than Piero, his earliest works show the influence of ▷Antonio Pollaiuolo (e.g. *Flagellation*, c1480, Milan, Brera). Characteristically, Signorelli uses figures with accentuated musculature, their contours bounded by an emphatic wiry line, and usually engaged in some form of expressive or dramatic action. By c1483, his reputation had spread to Rome for he was called on to paint the last two remaining ▷frescos of the cycle begun by ▷Perugino and his collaborators on the walls of the ▷Sistine Chapel: *The Last Acts and Death of Moses* and *The Archangel Michael Defending the Body of Moses from the Devil*.

Signorelli's masterpiece is the cycle of frescos in the San Brizio Chapel of Orvieto Cathedral (1499–1504). These illustrate the *Anti-Christ*, the *End of the World*, the *Resurrection of the Dead* and the *Last Judgement*. Here Signorelli was given the opportunity to display his full range of sculpturally conceived nudes, many of which are shown in difficult ▷foreshortening. Vasari wrote: 'So he paved the way for his successors, who have found the difficulties of the manner smoothed away. Accordingly I do not wonder that Luca's works were always highly praised by Michelangelo, who in his divine *Last Judgement* ... partly borrowed from Luca such things as angels, demons, the arrangement of the heavens, and other things in which Michelangelo imitated Luca's treatment.' The Orvieto frescos also seem to have been seen and admired by ▷Raphael on his way from Florence to Rome to paint the Stanza della Segnatura frescos in the Vatican.

Signorelli returned to Rome, but was last recorded there in 1513. Unable to compete with the new developments of the High Renaissance style of

Raphael and ▷ Michelangelo, he ultimately retired to his native Cortona, where he ran a flourishing workshop producing conventional, somewhat old-fashioned ▷ altarpieces.

Bib.: Reiss, J.B., *The Renaissance Antichrist: Luca Signorelli's Orvieto Frescos*, Princeton, 1995; *Signorelli et Dante*, exh. cat., Milan, 1990

Signorelli, Telemaco (1835–1901)

Italian painter and etcher. He was a member of the ▷ Macchiaioli and initially painted in a realist mode. In 1861 he saw the works of ▷ Corot in Paris, and he admired both ▷ Degas and ▷ Toulouse-Lautrec. He also travelled to Britain. In 1893 he published his memoirs.

silhouette

A paper cut-out, named after its inventor Étienne de Silhouette (1709–67). This cheap form, usually of portraiture, coincided with a ▷ Neoclassical delight in the simplicity of outline (derived in part from ▷ Etruscan vases), but its popularity declined as photography began to offer more for a similar cost.

Bib.: McKenzie, S., *British Silhouette Artists and their Work, 1760–1860*, London, 1978

silk-screen printing

A colour stencil printing process in which non-printing areas are blocked out and the colour squeezed through a screen on to paper or cloth. Similar techniques are applied in the Orient, but its use in the West is known from the time of the First World War, since when it has been very popular.

Bib.: Elliot, B., *Silk-screen Printing*, London and New York, 1971

Siloe, Gil de (fl c1483–1500) and Diego de (c1495–1563)

Spanish family of architects and sculptors. Gil was best known for the ▷ reredos which he produced for churches at Vallodolid and Burgos. He also was a tomb sculptor, and designed the tombs of John II and Isabella of Castille for Burgos cathedral. These show a combination of Flemish ▷ Gothic style, with the ▷ *mudéjar* emphasis that was common at this time.

Gil's son Diego was an architect and sculptor who travelled to Naples in c1515 and learned his stylistic mannerisms there. In 1528 he was architect of Granada Cathedral where he completed the work that was already in process.

silverpoint

A drawing technique in which a slender rod of silver with a pointed end is used to make marks on a support (usually ▷ paper, ▷ parchment or ▷ panel) which has been prepared with a coating of opaque white, often with the addition of a ▷ pigment to give a slightly tinted ground. The fine lines thus made are of even strength, indelible and initially grey in colour, though later oxidizing to a light brown. It is essentially a linear medium, with shading producable only by ▷ hatching. First used in Italy during the Middle Ages, silverpoint achieved considerable popularity throughout Europe during the 15th and 16th centuries, numbering ▷ Dürer and ▷ Leonardo da Vinci among its greatest exponents. It was replaced in the 17th century by graphite pencil drawing, which is both erasable and capable of producing a line with a variable strength of tone, although silverpoint enjoyed a brief revival amongst French miniaturist artists in the 18th century.

Silvestre, Israël (1621–91)

French etcher. He was one of a family of ▷ etchers who did work for Louis XIII and Louis XIV, to whom he taught drawing.

Simmel, Georg (1858–1918)

German sociologist. He was Professor at the University of Berlin, and apart from very important investigations of the effects of capitalism on modern society, he also wrote works which were significant for the understanding of the psychological impact of modernization and urbanization. One of his most important essays, 'The Metropolis and Mental Life' was first published in 1902–3. In it he explored the ideas of specialization and fragmentation that he felt were characteristic of modern urban culture. What Simmel called 'the intensification of nervous stimulation' was the effect of living in the impersonal modern city where people were unable to relate to each other and individualism (even solipsism) was the norm. His ideas were particularly important for artists involved with the ▷ Futurist and German ▷ Expressionist movements, as many were concerned with the psychological effects of modern life and how to convey them.

Bib.: Frisby, D., *Fragments of Modernity: Theories of Modernity in the Work of Simmel, Kracauer and Benjamin*, Cambridge, 1988; Wolff, K. (ed.), *Georg Simmel 1858–1918: A Collection of Essays*, Columbus, 1959

Simone Martini (Simone di Martino) (c1285–1344)

Italian painter. He was from Siena and was the most important Sienese painter of his generation after ▷ Duccio. He was trained by a painter certainly in Duccio's circle, though not necessarily by Duccio himself. His earliest surviving work is the large ▷ fresco of the *Maestà* (1315, reworked 1321) in the Palazzo Pubblico, Siena. The basic composition is derived from Duccio's ▷ *Maestà* of 1308–11, then in the Cathedral, but Simone used outline even more decoratively, with an elegant ▷ Gothic sway to many of the figures and a greater pictorial depth. He was in Naples in 1317, where he was commissioned by the King of Naples, Robert of Anjou, to produce a painting of the King's elder brother, the recently canonized St. Louis of

Toulouse, resigning the crown to Robert. The ▷predella scenes contain some particularly important experiments in spatial construction (Naples, Capodimonte); an interest which is further developed in Simone's ▷fresco cycle of the life of St. Martin in the lower church of San Francesco in Assisi (?c1317/c1325) and which reflects a growing awareness of ▷Giotto's spatial innovations. In the Palazzo Pubblico, Siena, is a major work of Simone's *oeuvre*, the commemorative ▷equestrian portrait of the *condottiere* Guidoriccio da Fogliano, bearing the date 1328, which makes it the earliest known equestrian painting of modern times. However, the painting has recently been the subject of a heated debate, centring on the suggestion that the date is false and that the painting is of a later date and not by Simone. Dated 1333 is the *Annunciation* (Florence, Uffizi), jointly signed by Simone and his brother-in-law ▷Lippo Memmi. It is generally considered to be one of the finest examples of Simone's preciously crafted, linear style.

In 1340/41 Simone went to the papal court at Avignon, where he remained for the rest of his life. Here he painted the unusual subject of *Christ Reproved by his Parents* (1342, Liverpool, Walker Art Gallery), perhaps the surviving half of a ▷diptych. Simone met Petrarch at the papal court and painted for him the frontispiece to a Virgil manuscript (Milan, Biblioteca Ambrosiana) and a portrait (now lost, but mentioned in one of Petrarch's sonnets) of the poet's mistress Laura. Simone influenced the course of both French and Italian (particularly Sienese ▷quattrocento) painting and his work is one of the principal sources of the ▷International Gothic style.

Bib.: Christiansen, K., 'Simone Martini's Altarpiece for the Commune of Siena', *Burlington Magazine*, 136 (March 1994), pp. 148–60; Leone de Castris, P., *Simone Martini: catalogue complet des peintures*, Paris, 1991; Martindale, A., *Simone Martini*, New York, 1988

simulacra
▷Baudrillard, Jean

simultaneity
A term common in Europe shortly before the First World War. It related to both the colour theories of ▷Delaunay and the experiments of the ▷Futurists. Delaunay drew from Michel-Eugène Chevreul's *De la loi du contraste simultané des couleurs et de l'assortiment des objets colorés* (*Law of the Simultaneous Contrast of Colours*, 1839) the idea that juxtaposed colours could create a shimmering effect of movement. The ▷Futurists adopted the idea specifically for the way in which the fast pace of modern life makes everything seem to happen at once. Beyond these narrower conceptions of simultaneity, the term took on wider philosophical implications – relating to the pace and complexity of modern life.

Bib.: Buckberrough, S., *Robert Delaunay: The Discovery of Simultaneity*, Ann Arbor, 1982

singerie
(From French, '*singe*', 'monkey'.) This was a fashionable and amusing type of ▷decorative art whereby human forms were replaced by monkeys performing the actions of everyday polite society. It became a popular feature of ▷Rococo art under Louis XIV, and was allegedly invented by ▷Claude Audran. Examples of this extravagance may also be seen in works by ▷Gillot, ▷Watteau and ▷Christophe Huet. As a satirical tool in the post-Darwinian age a similar idea has been used to different ends and indeed the 'joke' persists today in certain forms of British advertising.

sinopia
A red ochre ▷pigment used to make a brush drawing of the basic composition of a ▷fresco on the first layer of plaster (the ▷arriccio). By extension, the term is used for the drawing thus produced. Modern techniques of conservation have allowed the top layer of painted plaster (the ▷intonaco) to be removed intact and the sinopia to be revealed (examples in the Museo delle Sinopie, Pisa).

Siqueiros, David Alfaro (1896–1974)
Mexican painter. He was one of the leading Mexican ▷muralists. He studied at the Escuela des Artes Plasticas in Mexico City (1911–13). Having fought in the Mexican Revolution, he was sent as a military attaché to Europe and met ▷Rivera in Paris, where they discussed the future of Mexican art. Siqueiros' ideas were finally formulated in the influential *Manifesto to the Artists of America* (1921), which rejected easel-painting for a politically-committed public art, embracing 20th-century technology within an indigenous national culture.

He returned to Mexico in 1922 and began to paint murals. With Rivera he co-founded the Union of Technical Workers, Painters and Sculptors and edited the magazine *El Machete* (The Machete). His political activities became so extensive that from 1925–30 he produced almost no artistic work, and started to paint again only while imprisoned after joining an illegal demonstration.

During the 1930s Siqueiros travelled through North and South America, executing murals and continuing to be involved in revolutionary politics, which would usually lead to his expulsion from whichever country he happened to be visiting. He gave up a teaching post in New York to serve as a Republican officer in the Spanish Civil War (1937–9). After 1944, however, these political activities lessened and he produced more paintings, working mostly in Mexico City. He was imprisoned for political activity again in 1960, but pardoned in 1964.

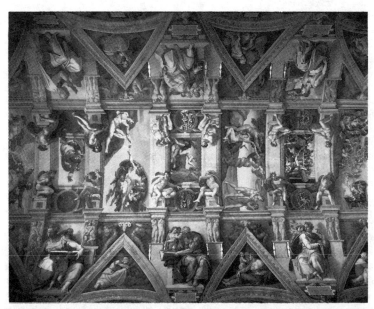

Michelangelo, Sistine Chapel, ceiling and lunettes, 1508–12, Vatican Museums and Galleries, Rome

Siqueiros' energetic, boldly-coloured murals with their abruptly distorted perspectives are aggressively political in character and experimental in technique. His early fascination with technology was pursued through methods such as the pioneering use of ▷air brush on cement (at the Plaza Art Centre in Los Angeles) and the use of heavy tools and photo-projection at the Laboratory of Modern Techniques in Art which he founded in New York in 1936. His most significant mural was the sprawling *March of Humanity* (1964), an apocalyptic vision of western culture.

Bib.: Folgarait, L., *So Far From Heaven, David Alfaro Siqueiros'* The March of Humanity *and Mexican Revolutionary Politics*, Cambridge, 1987; Stein, P., *Siqueiros: Life and Works*, New York, 1994; White, D.A., *Siqueiros: A Biography*, Encino, 1991

Sirani, Elisabetta (1638–65)

Italian artist. She was from Bologna, where she was encouraged to paint by ▷Malvasia. She began producing paintings from 1655, and for the rest of her career she was a painter of portraits, religious works and ▷allegory. Her works were in the style of ▷Guido Reni.

Sirens

▷Ulysses

Sisley, Alfred (1839–99)

French painter. He was associated with ▷Impressionism. He was born in Paris of English parents. In 1862 he entered the Académie ▷Gleyre, where he met ▷Monet, ▷Renoir and ▷Bazille. He exhibited at the ▷Salon des Refusés in 1863, but also managed to show his work at the official ▷Salon in 1866. He returned to England briefly in 1870 but was mainly based in Paris. He exhibited at four of the Impressionist exhibitions and was faithful to the ideas of the group throughout his career, despite suffering financial hardship following the breakdown of the family business in 1871, and limited artistic recognition. He concentrated on landscape, particularly on views around Paris, showing flood, snow and weather changes (e.g. *Flood at Port Marly*, 1876, Paris, Musée d'Orsay; *Snow at Veneux*, 1880, Paris, Musée d'Orsay). He followed Monet in his interest in nature, and used Renoir's rainbow palette, albeit in a limited fashion, but his brushwork was more heavy and deliberate than theirs. In his later work he increasingly experimented with colour and a more broken style. His subject matter often mimicked that of Monet, for instance in his choice of haystacks and poplars, and in his paintings of churches and his early work at Argenteuil (e.g. *Wooden Bridge at Argenteuil*, 1872, Paris, Musée d'Orsay).

Bib.: Shone, R., *Sisley*, Oxford, 1979; *Sisley*, exh. cat., London, 1992

Sistine Chapel

A chapel in the Vatican, originally constructed by Pope Sixtus IV and containing some of the most important decorations of the Italian ▷Renaissance. The large chapel was intended to be large enough to contain meetings of cardinals, as well as to hold masses, and it thus had a political and ceremonial function. A number of major artists contributed ▷frescos to the Chapel, and these frescos contained an underlying assertion of

the spiritual leadership of the Papacy. The first artists who were commissioned to work on the Sistine Chapel were ▷Botticelli, ▷Rosselli, ▷Ghirlandaio and ▷Perugino who contributed scenes from the Old and New Testaments to the chapel in 1480–81. The cycle of frescos was later completed by ▷Pintoricchio and ▷Signorelli.

However, the most notable contribution was that of ▷Michelangelo, who, under the direction of Pope Julius II, continued the work done by his predecessors. In 1508, possibly with the help of a theological advisor, Michelangelo embarked on the decoration of the ceiling and ▷spandrels of the Chapel. The ceiling represents scenes from Genesis, and the spandrels contain representations of prophets and ▷sibyls. The theological programme of Michelangelo's decorations is exceedingly complex, and many explanations have been forthcoming about them. He worked on the ceiling frenetically between 1508 and 1511. He returned to paint the *Last Judgement* in 1536–41 for Pope Paul III. This work replaced the *Assumption of the Virgin* by Perugino that originally covered the far wall of the Chapel. The *Last Judgement* was a complex and torturous representation, revealing Michelangelo's contribution to the beginnings of ▷Mannerism.

▷Raphael was also involved in decorating the Sistine Chapel, when he was commissioned to produce ▷cartoons for ▷tapestries portraying scenes from the Acts of the ▷Apostles.

Bib.: Richmond, R., *Michelangelo and the Creation of the Sistine Chapel*, London, 1992

Situation Group

A group of English artists who exhibited together in the Royal Society of British Artists Galleries in 1960. They precluded anything from their exhibition other than large abstract canvases, without obvious subject or ▷perspective. The ▷colour-field nature of their work was enhanced by the conception that the observer's experience of the picture was of fundamental importance. This group included such artists as Gillian Ayres (b 1930), William Turnbull (b 1922) and John Hoyland (b 1934).

Situationists International

▷Letterism

size

A dilute glue or ▷resin added to a surface to reduce absorbency and thus prepare it for paint or some other coating.

sketch

There are several kinds of sketch, but the terminologies distinguishing them are often used interchangeably, although all senses imply a loose finish or preparatory intention. A 'thumbnail' sketch is a small drawing or note recording an idea or composition. A compositional sketch sets out the broad outlines of a whole composition without regard either to detail or, necessarily, nature. A study, however, implies a careful rendering of observed nature and is often used to finalize a figure or other component of a composition before transferring it to a canvas through ▷squaring up. By the 19th century the sketch was valued for its spontaneous qualities revelatory of the genius of the artist. Although this line of reasoning was opposed by ▷academic artists, who kept the preparatory sketch phase and the finished canvas separate, the ▷Impressionists fused the two stages into one process, leaving in their works 'unfinished', sketch-like passages. Contemporary appreciation of sketches makes no distinction between sketches and finished works, seeing admirable qualities in both, but it is important to understand that until the 20th century the sketch occupied a distinct category from that of the finished work.

sketchbook

A small, portable drawing book used to record impressions while travelling or to work out compositions prior to consigning them to a canvas, or, in the case of architects, building them. Notable users of sketchbooks include ▷Turner, who recorded many views on his ▷picturesque tours of England and the Continent, and ▷Degas, whose studies after older art reveal his interest in the Classical tradition. In the age before photography or the wide diffusion of prints, sketchbooks were a vital channel for the dissemination of artistic ideas, and also a means by which we may judge the horizons of artists and art-making. ▷Villard de Honnecourt's sketchbook reveals how widely he travelled, whilst many sketchbooks made by ▷Renaissance artists feature antiquities, and it can be proved that several books were copied and passed from hand to hand throughout the Italian peninsula.

Bib.: Herrmann, L., *Turner: Paintings, Watercolours, Prints and Drawings*, 2nd edn., Oxford, 1986; Reff, T., 'New Light on Degas' Copies', *Burlington Magazine*, 106 (1964)

Skidmore, Owings & Merrill (SOM)

American architectural practice founded in Chicago in 1936 by Louis Skidmore (1897–1962) and Nathaniel Owings (1903–84), who were joined in 1939 by John Merrill (1896–1975). The practice became a training ground for many of the century's leading architects including Gordon Bunshaft, Roy Allen, Bruce Graham and Myron Goldsmith. From the start the office was organized on the principles of teamwork, individual responsibility and motivation. Individuals did not sign drawings and strictly economic working methods were enforced, equal weight being given to the work of engineers as to that of architects. As the practice expanded, offices sprung up all over America making it hard to identify one single SOM style. The

early style is epitomized by Lever House, New York (1952), a 121-storey office building which, with its distinct tower slab and transparent outer skin, unified a whole series of innovative compositional devices. Elements of the ▷International Style, ▷Mies van der Rohe and early ▷Le Corbusier can be detected. The San Francisco office had a different approach and might be said to be influenced by West Coast regionalism. For example, the Alcoa Corporation offices, Golden Gate Centre, San Francisco (1968) have a diamond pattern of external structure over the central tower. The Chicago office, on the other hand, continued to favour a construction form developed in that city, and in the Inland Steel Corporation, Chicago (1956–8) the structure is given full expression.

SOM has developed a worldwide network of practices and has more recently been responsible for a series of large building complexes outside the USA. The Haj Terminal at King Abdul Aziz International Airport, Jeddah, was built in 1985 to handle the influx of pilgrims to Mecca each year. It is a linear terminal building with aircraft parking aprons and a sheltered support complex. The tent-like canopy structure on the roof is reminiscent of certain local architectural types and necessary because of the intense heat.

Bib.: Danz, E., *Architecture of Skidmore, Owings & Merrill 1950–1962*, London, 1963

skyscraper

A tall, multi-storied building, usually used for offices. The term was coined in America in the 1880s, when increasing demand for business space in cities led architects to construct very tall buildings. This development was possible because of technological advances with iron and steel, and also because passenger lifts had been used safely since 1857. James Bogardus' Cast Iron Building (1848), New York, was the first to use a cast-iron frame. Later, steel was more widely used because it was stronger and lighter, as at William le Baron Jenney's Home Insurance Company, Chicago (1885) and in the buildings of Jenny's pupil, ▷Louis Sullivan. ▷Curtain walling was used, so that large amounts of weight could be supported from the framework without the need for load-bearing structures in the foundations.

Although new building techniques also called for a new stylistic treatment of architecture, many architects initially tended to try to use established styles in conjunction with many storied buildings. For example, Napoleon le Brun's Metro Life Insurance Building, New York (1909), is based on the Venice ▷Campanile in St. Mark's Square and the Woolworth Building by Cass Gilbert (1913) is neo-▷Gothic. The Chrysler Building (1929) and the Empire State Building (1931) are executed in an ▷Art Deco style. However, the ▷International Style brought a stark purity to the skyscraper, with such buildings as the Seagram Building, New York (1954–8), and the Lake Shore Drive Apartments, Chicago (1949–51). In the 1970s and 1980s the skyscraper became unfashionable and was criticized as unfriendly, both environmentally and socially. There have been subsequent attempts to landscape and soften the environment in which skyscrapers are built.

Slade, Felix (1790–1868)

Collector and patron of the arts. He specialized in the collection of books, bindings, ▷engravings and glass, which he bequeathed to the ▷British Museum. He endowed the universities of Oxford, Cambridge and London with funds to support a professorship for the study of Fine Arts. He also gave London University funds for scholarships for students, under the age of 19, to study fine art at the university. The Slade professorships have attracted distinguished artists, including ▷Ruskin, who was the first Slade Professor at Oxford.

Slade School

School of Art founded by ▷Felix Slade in London in 1871. The School has always emphasized the fundamental skills of drawing and painting, and trained artists like ▷Stanley Spencer, ▷Augustus John and ▷Ben Nicholson. The School was seen at one time as a livelier and more forward-thinking institute than the ▷RCA, although this is no longer true.

Slave Ship, The

The full title is *Slavers Throwing Overboard the Dead and the Dying – Typhoon Coming On*. This painting was executed by ▷Turner in 1840 and exhibited at the ▷Royal Academy. It depicts a lurid seascape of orange and red with the eponymous vessel heading away into the massy darkness of an oncoming moon, while the chained limbs of abandoned bodies flail surrounded by sharks and seabirds. The painting was accompanied by a seven line poem:

'Aloft all hands, strike the top-mast and belay
Yon angry setting sun and fierce-edged clouds
Declare the Typhoon's coming.
Before it sweeps your decks, throw overboard
The dead and dying – ne'er heed their chains.
Hope, Hope, fallacious Hope!
Where is thy market now?'

These lines were taken from Turner's epic poem 'The Fallacies of Hope'.

The principal sources of the picture seem to have been the denunciation of slavery in James Thomson's poem 'Summer' and T. Clarkson's *History of the Abolition of the Slave Trade*, first published in 1808 but reprinted in 1839. Clarkson recounts an episode from 1783 in which the ship, the *Zong* was wracked by plague. The captain, knowing he could claim insurance for slaves lost at sea, but not those dying from neglect or disease, proceeded to hurl them overboard.

The painting was ridiculed as sensationalist and

morbid during its exhibition at the Royal Academy, but was eulogized by ▷Ruskin in *Modern Painters* (1843) as the artist's supreme achievement. Ruskin owned the painting until 1872, when he declared it to be too painful to live with. It is now in the Boston Museum.

Slevogt, Max (1868–1932)

German painter and graphic artist. He studied at the Munich Academy (1885–9) and at the ▷Académie Julian in 1889. He began painting in a naturalist style similar to that of ▷Leibl, but he soon transformed his work under the influence of the ▷*plein air* painting of ▷Liebermann and ▷Corinth. He moved to Berlin in 1901 and exhibited with the Berlin ▷Secession. In 1915 he became a member of the Dresden Academy of Fine Art. He was best known for his scenes from the theatre painted in a loose ▷Impressionist style, and he also produced graphic work for ▷Art Nouveau journals such as *Simplicissimus* and *Jugend*.

Sloan, John (1871–1951)

American painter. He studied at the Pennsylvania Academy of the Fine Arts (1892–4) and worked on the *Philadelphia Press* as a graphic journalist. He became a friend of ▷Robert Henri and was an original member of ▷The Eight. He produced posters in an ▷Art Nouveau style, but he transferred his attention to painting from 1896. He was particularly interested in scenes of New York City life, and he attacked his subjects from a politically committed perspective. He was an active socialist from 1909, although his scenes of urban low life do not contain any overt messages. He was President of the Society of Independent Artists in 1918–44, and he was Director of the ▷Art Students' League in 1931. During the 1920s, his subject-matter changed, as he concentrated his attention on painting nudes.
Bib.: Brooks, V.W., *John Sloan: A Painter's Life*, London, 1955

Slodtz, René-Michel (1705–64), Sébastien (1655–1726), Sébastien-Antoine (c1695–1754), Paul-Ambroise (1702–58) and Dominique (1711–64)

French family of sculptors, designers, painters and decorators. The most important of them was the sculptor, René-Michel. In 1726 he won first prize for sculpture at the French ▷Académie and two years later went to Rome. A student at the Rome branch of the Académie until 1736, his admiration for ▷Michelangelo earned him the nickname, 'Michel-Ange' (which he adopted and used when signing his works). He remained in Rome until 1747, during which time he was awarded several important commissions, including the ▷polychrome-marbled ▷Baroque Monument to Archbishop Montmorin (1740–44, Vienne Cathedral) and the full-length, above life-size statue, *St. Bruno* (1744,

St. Peter's, Rome), which fully reveals the dramatic emotionalism of his best work. Returning to France after nearly 20 years he found it difficult to re-establish himself, although he did succeed in winning the prestigious commission for the Tomb of Languet de Gergy (completed 1753, St. Sulpice, Paris), a tour-de-force of the ▷Baroque, rhetorically-conceived, allegory: Death as a scythe-wielding skeleton (in ▷bronze) is vanquished by an Angel (in white ▷marble) who throws back the rippling curtain of morality (in lead) to reveal Paradise to the Deceased (portrayed in white marble). René-Michel's most important pupil was ▷Houdon.

René-Michel's father, Sébastien, was a Flemish sculptor who moved to Paris and became a pupil of ▷Girardon. Sébastien and his other sons, Sébastien-Antoine and Paul-Ambroise, both sculptors, and Dominique, a painter, were principally employed in creating temporary decorations and costumes for court festivals at the Menus-Plaisirs-du-Roi. Paul-Ambroise was the most significant artist after René-Michel, his most accomplished work being perhaps the marble *Dead Icarus* (1743, Paris, Louvre).
Bib.: Souchal, F., *Les Slodtz: sculpteurs et décorateurs du Roi*, Paris, 1967

Sluter, Claus (fl c1380; d 1405/6)

The leading northern European sculptor of his time who effected the break from the ▷International Gothic style to one based on realism and exerted a profound influence on the next generation of both sculptors and painters throughout the Low Countries, France and Germany. The details of his life are sparse. He is first recorded in Brussels in a document of c1379 which states that he came from Haarlem. By 1385 he was in Dijon working firstly as assistant to Jean de Marville, Court Sculptor to Philip the Bold, Duke of Burgundy, before becoming Court Sculptor himself.

All of Sluter's surviving work was for Philip, mostly at the Chartreuse de Champmol, a monastery founded by the Duke. First he carved figures for the ▷portal to the chapel (completed 1397, Dijon, Musée des Beaux-Arts); a comparison of ▷Jan van Eyck's kneeling donor in his *Madonna of the Canon van der Paele* of 1436 with the portrait-like realism of the kneeling figure of Philip the Bold suggests the extent of the painter's debt to Sluter. Next came the celebrated *Well of Moses* (1395–1403). Originally this work comprised a ▷Calvary group placed over the well head with, around the well head itself, six full-length figures of prophets, alternating with angels; a further example of Sluter's influence on painters can be seen in the way the ▷Master of Flémalle – in his *Seilern Entombment* – freely adapted the motif of the angel situated between Jeremiah and Zachariah wiping away a tear. Like all of Sluter's sculpture, the figures were once painted (in this case by the painter ▷Jean Malouel). The well (symbolizing the Fountain of Life)

was badly damaged during the ▷French Revolution and today only a head and part of the torso of the suffering Christ survive from the Calvary group (Dijon, Musée Archéologique), along with the six prophets (*in situ*). Each of the prophets bears a scroll inscribed with their specific words which the Christ interpreted as alluding to the ▷Crucifixion. The figures are unprecedented in their monumental gravity, their tragic facial expressions, their naturalistic gestures and the individuality of their portrayal. They stand in the same relationship to later northern European art as do the prophets and saints on the Florentine Duomo and Or San Michele by ▷Donatello and ▷Nanni di Banco – except that Sluter precedes the Florentines by a good few years.

From 1395, Sluter worked on the Tomb of Philip the Bold (begun by his predecessor in 1384, and completed after Sluter's death by his nephew, Claus de Werve, in 1411). Although much of the work on the tomb is not by Sluter, the mourning figures (*pleurants*) which surrounded the ▷sarcophagus are purely his (one is now in the Cleveland Museum; the others are with the tomb in Dijon, Musée des Beaux-Arts). They are noteworthy for the dramatic emotion conveyed by their stances and the abstract qualities of their drapery, even in those figures with faces totally obscured by their cowls.

Bib.: Morand, K., *Claus Sluter: An Artist at the Court of Burgundy*, London, 1991

Sluyters, Jan (Johannes Carolus Bernardus) (1881–1957)

Dutch painter. He studied in Amsterdam. He won the ▷Prix de Rome in 1904 and used it as an opportunity to travel. In 1906, he came into contact with ▷Fauvist works, and he later met, and was influenced by, ▷Le Fauconnier. He painted in an ▷Expressionist style which he called 'colourism', and his subject-matter was drawn from Amsterdam's lower classes. He was friendly with ▷de Smet and ▷Berghe.

Smart, John (1742/3–1811)

English miniaturist. He took up ▷miniature painting in 1760, and he knew ▷Richard Cosway. He travelled to Madras in 1785–95 and worked for the English community there.

Smet, Gustave de (1877–1943)

Belgian painter. He studied at the Ghent Academy, and in 1901 lived in ▷Laethem-St-Martin, where he became one of the founders of the Second Laethem Group. He created his own brand of Flemish ▷Expressionism, which was modified during the First World War, when he saw German Expressionist work, as well as ▷Le Fauconnier's ▷Cubist compositions. During the 1930s his Expressionism became more violent and extreme.

John Smart, *Self-portrait*, (Miniature), 1797, Victoria and Albert Museum, London

Smibert, John (1688–1751)

American painter of Scottish birth. He came to London from Edinburgh in 1709, and he studied at ▷Thornhill's Academy (▷St. Martin's Lane Academy). He travelled to Italy in c1719 and returned to London to practise portrait painting in 1722. In 1728 he joined Bishop Berkeley's expedition to what was then thought to be Bermuda, but he ended up in the United States. Smibert settled in Boston, where he obtained patronage for his portraiture. He was particularly adept at group portraiture, which he produced in a flattering ▷Baroque style.

Bib.: Saunders, R.H., *John Smibert: Colonial America's First Portrait Painter*, New Haven and London, 1995

Smirke, Sir Robert (1781–1867)

English architect. He was the son of a ▷Royal Academician and throughout his life enjoyed the patronage of establishment Tories. After training with ▷Soane, George Dance the Younger and at the Royal Academy schools, he travelled widely throughout Europe (1798–1805). He set up his own London practice in 1805 and achieved rapid fame with his Covent Garden Theatre (1808–10). In 1815 he joined Soane and John Nash in the Board of Works. He was also architect to the Royal Mint (1807) and Surveyor of the Duchy of Lancaster (1820). In 1811 he was elected RA and he was knighted in 1832. Although most famous for his solid Classicism (described by ▷Pugin as the 'new square style'), he actually built in a range of styles. His British Museum design (1823) was one of the major ▷Greek Revival buildings of the period; Eastnor Castle (1812–15) was one of a number of ▷Gothic Revival projects

and Smirke was also famous for his designs for London clubs, which utilized the ▷Renaissance *palazzo* style (e.g. Carlton Club, 1833–6). He was an innovator in his use of concrete (e.g. London Customs House, 1825–7) and cast iron (e.g. Cirencester Park, 1810–11) and was instrumental in developing the professionalism of architects – he was one of the first to use quantity surveyors. His pupils included Charles Robert Cockerell.

Smith, David (1906–65)

American sculptor. He was born in Decatur, Indiana, and followed his father into the factories as a young man, taking a correspondence course at Cleveland Art School. He then studied at the ▷Art Students' League in New York (1926–31) and was employed by the WPA (Federal Arts Project) during the 1930s as a painter. Later he turned to sculpture, influenced by ▷Picasso's use of modern materials to construct with welded steel. He also travelled to Europe and Russia in 1935 – the impact of this journey is seen in his cynical series *Medal of Dishonour* (1937–40). During the Second World War Smith worked in a factory and it was only after 1946 that his work became well known. During the 1950s he developed a style of 'drawing in space' using wire (*Hudson River Landscape*, 1951, private collection). This was soon replaced by monumental constructions using machine parts and metal to create standing figure-like totems and horizontal, often brightly painted abstractions (e.g. *Agricola* series). During the 1960s he worked in polished and textured geometric blocks of stainless steel, positioned in precarious vertical heaps (e.g. *Cubi* series). Throughout his career he tried to imply tension and movement in his work, moving the organic concept of a sculpture growing outwards, as well as redefining the use of industrial materials and objects. He died in a car crash. **Bib.**: *David Smith*, exh. cat., New York, 1969; Krauss, R.E., *Terminal Iron: The Sculpture of David Smith*, New York, 1971; MacCoy, G., *David Smith*, London, 1973

Smith, Sir Matthew Arnold Bracy (1879–1959)

English painter. He was born in Halifax and attended Manchester School of Art before going to the ▷Slade in 1905, against the wishes of his father. He visited ▷Pont-Aven in 1908 and briefly studied under ▷Matisse in Paris; in 1912 he returned to Grez, another 19th-century artists' colony. He enlisted in 1916 but was wounded the following year. He exhibited with the ▷London Group from 1918 but produced little work before 1926, when he held his first one-man show. His early ▷Fauvist style (e.g. *Nude Fitzroy Street No I*, 1916, London, Tate Gallery), developed into a fluent, rich use of colour and line (e.g. *Model Waking*, 1942, Leeds, City Art Gallery) which remained characteristic in his later still-life subjects (e.g. *Brie and Fruit*, 1955, London Museum). He remained a Francophile

and spent many years in France, especially in Cagnes before the Second World War. He was awarded the CBE in 1949.
Bib.: *Matthew Smith*, exh. cat., London, 1983; *Matthew Smith*, exh. cat., London, 1953; Rothstein, J., *Matthew Smith*, London, 1962

Smith, Tony (1912–80)

American sculptor and architect. He was from New Jersey and studied at the ▷Art Students' League (1933–6). He was at the New Bauhaus in Chicago during 1937–8. After a short period working with ▷Frank Lloyd Wright, he began practising architecture independently. From 1940 also produced geometrical sculpture which was a forerunner of ▷Minimalism and modularity.

Smithsonian Institution

In 1829 James Smithson, an English scientist, left $550,000 in gold to the government of the USA to 'increase and diffuse knowledge among men'. Smithson was the illegitimate son of the Duke of Northumberland, and he died in Genoa, bitter about the way he had been treated by English society because of the stigma of his birth. He had never visited America, but saw it as a classless land of opportunity. After initial confusion as to whether the government was constitutionally able to take the money, a fund was set up dedicated to scientific displays, and later used to fund museums of art too. The Institution is governed by a board of regents, including the Vice-President of America and the Chief Justice. The Institution is in charge of the Archives of American Art, the Cooper-Hewitt Museum of Decorative Arts and Design, the John F. Kennedy Centre for the Performing Arts, the National Air and Space Museum, the ▷National Gallery of Art, the National Museum of American Art, the National Museum of History and Technology, the National Museum of Natural History, the National Portrait Gallery, the National Zoological Park and a host of other smaller museums and enterprises.

Smythson, Robert (c1535–1614)

English architect. He worked during the reign of Elizabeth I and was renowned for his designs for English country houses. He was chief mason at Longleat, Wiltshire (1567–80), before becoming a designer in his own right. His masterpieces include Wollaton Hall, Nottinghamshire (1580–90) and Hardwick Hall, Derbyshire (1591–7). His son, John, was also an architect.

Snyders, Frans (1579–1657)

Flemish painter. He studied with ▷Pieter Bruegel the Younger and ▷van Balen. He travelled to Italy in 1608–9 and was back in Antwerp in 1609, where he specialized in still-life painting. Aside from painting accessory still-life elements for ▷Rubens and others,

he also produced his own still lifes which centred on themes of the hunt, including game and hunting dogs.

Soane, Sir John (1753–1837)

English architect. He was the son of a stonemason from Reading. He trained as an architect with George Dance and Henry Holland from 1768 and won a ▷Royal Academy gold medal in 1776. He received a travelling scholarship, sponsored by George III, to Italy and Greece in 1777–80. In 1788 he was appointed Surveyor of the Bank of England, and he worked on projects connected with the Bank until 1826 (e.g. The Rotunda, 1794–6, which incorporated one of Soane's characteristic ▷pendentive domes). In 1791 he was appointed to the Office of Works, a position shared with ▷Smirke and John Nash. He as elected RA in 1802 and later became Professor of Architecture (1806). He designed Dulwich Picture Gallery and his own house at Lincoln's Inn Fields (now a museum) which he filled with his vast collection of antiquities. He retired in 1833, already out of fashion, but at his peak he had been England's leading ▷Neoclassical architect. He admired the Neoclassical theories of Marc-Antoine Laugier, promoting simplicity of line and form, and his own style of restrained surface ornament.
Bib.: du Prey, P., *John Soane: The Making of an Architect*, Chicago, 1982; Stroud, D., *The Architecture of John Soane*, London, 1984

Social Realism

Any school of art that presents scenes or events of social importance or interest in a naturalistic manner. The term has been applied to such schools as the American ▷Ashcan painters of the early 20th century, who were interested in urban life and industry, and the ▷American Scene Painters of the 1920s to 1940s. It has also been applied more specifically to artists such as ▷Ben Shahn, Jack Levine, Jacob Lawrence and Philip Evergood who used art for social protest/ propaganda and social reform.

Socialist Realism

The officially sponsored ▷Marxist artistic and literary aesthetic of the Communist countries from 1932, Socialist Realism was the dominant artistic style of the USSR till the 1980s. The Statute of the Union of Soviet Writers in 1934 stated that Socialist Realism 'demands of the artist the truthful, historically concrete portrayal of reality in its revolutionary development. The truthfulness and historical concreteness of the artistic portrayal must be in harmony with the objective of the ideological alteration and education of the workers in the spirit of socialism'. This definition is applicable equally to painting, and whilst early prac- titioners such as Aleksandr Deineka (1899–1969) was able to produce interesting, expressionist and patriotic

scenes of the Second World War, collective farms, and sports, the regimented style (deliberately) stifled the ▷avant-garde art of the early revolutionary period.

Société Anonyme Inc.

An organization founded by ▷Katherine Dreier, ▷Marcel Duchamp and ▷Man Ray in 1920, designed to promote contemporary art through exhibitions, lec- tures and other activities. The group organized over 80 exhibitions between 1920 and 1940, and much of the work it promoted was abstract. It was also known as 'A Museum of Modern Art', and a permanent collection was formed from the exhibited work, which Dreier donated to the Yale University Art Gallery in 1941. The group dissolved in 1950.

Société des Artistes Indépendants
▷Salon des Indépendants

Society of Artists

The forerunner of the ▷Royal Academy, which cam- paigned and lobbied for a professional institute for artists in the 1750s and 60s. It held annual exhibitions from 1761. The Society of Artists was awarded a Royal Charter in 1791, but by then was already being super- seded by the Royal Academy.

Society of Independent Artists

American association which aimed to show annual exhibitions by progressive artists. Founded in 1916, the society based itself on the French ▷Salon des Indépendants, with exhibitions open to anyone who wished to display work, and without juries or prizes. The first exhibition, in 1916, had 2,000 exhibits, from all over the world. One of the first directors was ▷Marcel Duchamp. However, he resigned in 1917 when the Society refused to show his ▷ready-made, a urinal entitled *Fountain* 'by R. Mutt'. This was prob- ably a gesture by Duchamp at the contradictory nature of an artistic society which professed to allow anyone to display anything. The Society continued into the 1940s, but subsequent exhibitions were smaller and increasingly inferior in quality.

Sodoma, Il (Giovanni Antonio Bazzi) (1477–1549)

Italian painter. He was born in Vercelli (Piedmont), trained under the Lombard painter Martino Spanzotti from 1490 to 1497, and was resident in Milan from c1497, before arriving in 1501 in ▷Siena, to whose School his work belongs. In 1505–8 Sodoma painted a series of 31 ▷frescos in the Benedictine monastery of Monte Oliveto. In 1508 he journeyed to Rome and painted part of the ceiling of the Stanza della Segnatura (completed by ▷Raphael) in the Vatican and, in 1516, obtained the commission from the banker Agostino Chigi for perhaps his greatest work, the frescos in the

Villa Farnesina, Rome. In spite of this success the competition in Rome was apparently too keen for Sodoma and he returned to Siena where he became that city's most celebrated artist. However, in recent years his artistic reputation has been considerably eclipsed by that of his Sienese contemporary, ▷Domenico Beccafumi. The main influences on his style were the works of ▷Leonardo da Vinci, ▷Pintoricchio, ▷Signorelli and ▷Raphael.

The origin of Sodoma's strange nickname (apparently even used by the artist himself) has been debated, but ▷Vasari (who greatly disapproved of his dissolute lifestyle) explained that it was because of his love for 'boys and beardless youths'. Sodoma was married with numerous children, and although this proves nothing, an open indulgence in promiscuous homosexuality and the adoption of a name flaunting the fact would seem to have been foolhardy in the extreme at a time when it was considered a capital offence. In consequence, the question of Sodoma's name remains something of a mystery.

Bib.: Carli, E., *Il Sodoma*, Vercelli, 1979

soft art

Sculpture created from materials which are soft, rather than hard. The term was invented in the late 1970s, but the work it represents was produced from the 1960s onwards. The main materials used for soft sculpture are rubber, leather and paper. Its most famous practitioner was ▷Oldenburg. Soft sculpture was not an organized movement, but a tendency.

soft-ground etching

A variety of ▷etching in which the drawing is done not on the ▷resinous surface of the ▷plate, but through an interposed sheet of paper. The fineness or otherwise of the etched result depends on the characteristics of the paper. The technique has been used since its invention in the late 18th century to mimic ▷chalk, ▷crayon, and ▷pencil. It is important because it offers texture as well as lines, hence its frequent combination with ▷aquatint to offer a simulacrum of a wash drawing.

Solimena, Francesco (1657–1747)

Italian painter. The leading late ▷Baroque painter in Naples, he was regarded by many in the first half of the 18th century as the greatest artist of his time. His career was enormously successful; he became exceedingly wealthy, was created a baron, lived in a palace and was courted by the royal families of Europe. Solimena's decorative style was chiefly formed on the full Baroque of ▷Giordano, ▷Pietro da Cortona, ▷Lanfranco, and ▷Preti, but with elements borrowed also from the Classical masters: ▷Raphael, ▷Annibale Carracci, and ▷Domenichino. Representative paintings are in the churches of S. Paolo Maggiore (1689–90) and Gesù Nuovo (1725), both in Naples. An accomplished

teacher, he ran his own Academy, including among his many pupils his chief follower Francesco de Mura (1696–1784), Corrado Giaquinto (1703–65), ▷Sebastiano Conca, and even the Scottish portrait painter, ▷Allan Ramsay.

Solomon (c970–931 BC)

The son of ▷David and Bathsheba, he succeeded his father as king of Israel and is chiefly remembered for his proverbial wisdom. Two principal themes occur in Christian art:

(i) ▷The Judgement of Solomon (1 Kings 3: 16–28). Two prostitutes living in the same house had each given birth to a son. One of the children had died in the night and both claimed the living one for their own. Solomon revealed the genuine mother by ordering that the remaining child be divided in two: the genuine mother said that she would rather the other woman have it than it be killed. Solomon is usually shown enthroned and flanked by courtiers, a dead child lies on the ground, while another is held up by the executioner whose sword is raised in readiness as one of the women rushes forward.

(ii) Solomon and the Queen of Sheba (1 Kings 10: 1–13). The queen, hearing reports of Solomon's wisdom, visits his court and realizes that the reports, if anything, understated the case. The importance of this theme goes beyond it being an opportunity for a magnificent display, for it was taken to be an Old Testament prefiguration of the ▷Adoration of the Kings.

Solomon, Abraham (1824–62), Rebecca (1832–86) and Simeon (1840–1905)

English family of painters. Abraham painted modern life scenes and scenes from literature. He was a popular artist amongst the mid-Victorian middle class. However, his paired series *First Class, the Meeting* and *Second Class, the Parting* (1864, Southampton) had to be repainted due to the perceived impropriety of a sleeping chaperone in the first version of *First Class*. Abraham's sister, Rebecca, was a prolific painter who was taught by Abraham. She copied ▷Old Masters and did magazine illustration to earn money, but she also painted anecdotal ▷genre scenes. She later became an alcoholic. Simeon, the youngest brother, worked in the orbit of ▷Burne-Jones, producing idealist subjects in a late ▷Pre-Raphaelite manner. He too became an alcoholic, but his homosexual propensities led to arrest, disgrace and an eventual ignominious death in a poorhouse. His imaginative paintings and watercolours were an inspiration to the ▷Symbolist generation.

Bib.: Reynolds, S., *The Vision of Simeon Solomon*, Stroud, 1985; *Solomon: A Family of Painters*, exh. cat., London, 1985

Somer, Paul van (c1577–1622)

Flemish painter and engraver. He worked mainly in England, which he first visited in 1616. He painted and engraved primarily portraits, and he worked for the court of James I.

Sonderbund

The name of an exhibition in Cologne in 1913 which brought together various ▷Expressionist tendencies. It included the work of the ▷Die Brücke and ▷Der Blaue Reiter groups as well as ▷Munch, ▷Gauguin, ▷van Gogh and, as a precursor, ▷El Greco.
Bib.: Moeller, M., *Der Sonderbund*, Cologne, 1984

Sorolla y Bastida, Joaquin (1863–1923)

Spanish painter and graphic artist. He was from Valencia, but he had an international reputation and showed his works in major exhibitions throughout Europe and America. He produced portraits, landscapes and ▷genre scenes, as well as book illustrations. He was particularly skilled at creating light effects in a manner distinct from that of the ▷Impressionists.

Sotheby's

Founded in 1733 by Samuel Baker, a bookseller, Sotheby's is now one of the world's largest auction houses. Baker's business came originally from the sales of large private libraries, usually because of the deaths of their owners, and he gradually expanded to sell pictures and artefacts as well. On Baker's death (1778) the business was taken over by George Leigh and Baker's nephew, John Sotheby, who broadened the scope of the business, and cultivated an elegant image, attractive to the aristocracy involved with the fashionable activity of collecting. The business continued to thrive in a number of different addresses in London, and it was in family ownership until 1909, when it was bought by Montague, Barlow, Felix Warre and Geoffrey Hobson. The business now has premises in New York, but remains true to its origins with its many specialized house sales.

sotto in sù

(Italian, 'from below [looking] upwards'.) The term is used to describe the extreme ▷foreshortening employed in a painting to convince the viewer that he or she is looking up at something from below. ▷Mantegna used it in his ceiling painting for the Camera degli Sposi (1474, Palazzo Ducale, Mantua) and it was a basic device of the ▷*quadratura* painters of the ▷Baroque period.

Soufflot, Jacques Germain (1713–80)

French architect. The youngest son of a small town lawyer, he was sent to Paris to study law, but instead became interested in architecture. He visited Rome in 1731, and gained a place at the French ▷Académie there in 1733. He returned to France in 1738, becoming municipal architect in Lyons, where he built the Hôtel de Dieu (1740) and the Exchange (1747). He returned to Italy, especially Paestum, in 1750, with Marigny, Mme de Pompadour's brother, who later ensured Soufflot official patronage. He was made Director of the King's Buildings and in 1764 was put in charge of the Ste Geneviève (Panthéon) project, designing a Classical church for the centre of Paris. He was elected to the Institute in 1755. His work was steadfastly anti-▷Baroque, and he followed the principles of Marc-Antoine Laugier, in his promotion of natural ▷Classicism.
Bib.: Braham, A., *Architecture of the French Enlightenment*, London, 1980

Soutine, Chaim (1894–1943)

French painter of Lituanian birth. He was born in Lithuania and studied at the Vilna Academy of Art, before getting a job in a photographer's there. He moved to Paris in 1913, enrolled at the ▷École des Beaux-Arts under ▷Cormon and rapidly gained the friendship of the leading members of the ▷School of Paris. Along with ▷Chagall and ▷Modigliani he was known as a *peintre maudit* (anguished painter). He fought briefly during the First World War and painted a series of still-life and flower pictures. He lived in Provence after the War (1919–22) and produced a series of visionary landscapes influenced by ▷van Gogh, although many of these he later destroyed. During the 1920s he gained an international reputation through the patronage of ▷Albert Barnes. His work went through a number of phases – a series of praying men still life influenced by ▷Chardin and then, after a brief period in Holland where he discovered the work of ▷Rembrandt, he returned to Paris in 1926 and began work on his series of flayed carcasses (e.g. *Flayed Ox*, 1926, Grenoble, Musée de Peinture et de Sculpture) and grotesques. His work was characterized by intense colour, often red, and heavy brushwork (e.g. *Page Boy at Maxime's*, 1927, Buffalo, Albright-Knox Art Gallery). He remained in France during the Second World War, living in the country and painting landscapes. Throughout his career, a lack of confidence led to the destruction of many of his canvases.
Bib.: *Chaim Soutine*, exh. cat., Los Angeles, 1968; *Chaim Soutine*, exh. cat., Paris, 1973; Tuchman, M., *Chaim Soutine: Catalogue Raisonné*, Cologne, 1993; Werner, A., *Chaim Soutine*, New York, 1977

Soyer, Moses (1899–1974) and Raphael (1899–1987)

American family of painters of Russian birth. Moses came to the United States in 1913, and he became a citizen in 1925. He studied at the ▷National Academy of Design with ▷Henri and ▷Bellows and at Cooper Union. His twin brother Raphael also came to the United States and studied at the same places, although he did additional training at the ▷Art Students'

League. During the 1930s he produced ▷Social Realist murals for the WPA (Federal Arts Project). The brothers collaborated on these murals and on other Social Realist works depicting American themes. They were especially noted for their scenes of life in America during the Depression.

Spagnuolo, Lo
▷Crespi, Giuseppe Maria

spandrel
In architecture, the triangular wall surface formed between the extrados of an ▷arch, a vertical ▷moulding or line taken from the point of its springing and a horizontal moulding or line drawn from its crown; or, the surface of double this width between the extradoses of two contiguous arches. Also, the triangular ceiling surface between two adjacent ribs of a ▷vault.

Spazialismo (Spatialism)
A movement founded by, and virtually inseparable from, the works and figures of ▷Luciano Fontana in Milan in 1947. Its main ideas had been anticipated in the *Manifesto Blanco* (*White Manifesto*) published by Fontana in Argentina the year before. Believing that traditional art forms had lost their validity in the face of scientific and technological developments, Fontana called for a new 'spatial' art, using new materials and techniques, to produce an art 'consistent with the demands of the new spirit'. His emphasis on developing an ▷aesthetic of motion was similar to that of the ▷Futurists, whilst the defining linguistic elements of Spazialismo, those of space, sign and gesture, were preoccupations shared by ▷Art Informel. These elements were reflected in the participation of artists such as Alberto Burri, ▷Capogrossi, Roberto Crippa, Gianni Dova, and ▷Matta in exhibitions of Spatialist art. There were eight Spatialist manifestos published between 1947 and 1958, which were more philosophical credos than plastic programmes. The movement owed its rapid diffusion to Carlo Cardazzo, owner of the Galleria Naviglio in Milan, where the Spatialists held their first exhibition in 1951.
Bib.: Giani, G., *Spazialismo*, Milan, 1956; Marangon, D., *Spazialismo, protagonisti, idee, iniziative*, Quinto di Treviso, 1993

Speer, Albert (1905–81)
German architect. He was born in Mannheim, the son of an architect. He trained at Karlsruhe and developed a taste for national German architecture and ▷Classicism, which later stood him in good stead with the Nazi hierarchy. He took over from Troost in 1934 as Hitler's favourite designer and became the mind behind most of the major party rallies and building projects (e.g. Zepplinfield, Nuremberg, 1936). He planned the reorganization of the centre of Berlin in 1937 and designed the Chancellery, complete with a marble corridor to rival Versailles' Hall of Mirrors. During the Second World War he became Armaments Minister, with wide ranging powers and constant access to Hitler, a role which resulted in imprisonment (1945–66). His architecture placed an emphasis on size, using a bold monumental Classicism, heavy symbolism and rich materials.
Bib.: Hamsher, W., *Albert Speer*, London, 1970; Kriel, L. (ed.), *Albert Speer*, Brussels, 1985; Sereny, G., *Albert Speer: His Battle with Truth*, London, 1995

Spencer, Lilly Martin (1822–1902)
American painter and engraver of English birth. She moved from Exeter to Ohio when she was eight years old, and she settled in Cincinnati. She moved to New York City in 1848, and she painted domestic ▷genre scenes, portraits and massive ▷allegorical paintings. She also produced engravings based on her paintings. Her meagre training did not prevent her from making a successful career as an artist and supporting both her husband and her 13 children.
Bib.: Bolton-Smith, R. and W. Treuttner, *Lilly Martin Spencer: The Joys of Sentiment*, Washington DC, 1973; Freivogel, E., 'Lilly Martin Spencer: Feminist without Politics', *Archives of American Art Journal*, 12 (1972), pp. 9–14

Spencer, Sir Stanley (1891–1959)
English painter. He was born at Cookham, Berkshire. He studied at the ▷Slade (1908–12), where he won the Composition Prize in his final year. He exhibited

Sir Stanley Spencer, *Self-portrait*, 1939, Fitzwilliam Museum, University of Cambridge

Sphinx and Pyramid at Giza

at the second ▷Post-Impressionist exhibition in 1912 and was influenced by the ▷primitivism and colour of ▷Gauguin (e.g. *Apple Gatherers*, 1912–13, London, Tate Gallery). During the First World War he served with the Royal Medical Corps and the Royal Berkshire Infantry, and after the war he produced pictures of his experiences (e.g. Burghclere Church ▷murals, 1927–32). He was a member of the ▷NEAC from 1919. During the 1920s he produced a series of visionary works, using religious themes in a contemporary setting, often that of Cookham itself (e.g. *Resurrection, Cookham*, 1924–6, Tate). He was employed as a war artist in 1939, and spent time in Glasgow recording the shipbuilding there. Throughout his career he worked on naturalistic landscapes (e.g. *Cookham*, 1914, Carlisle). He also painted a number of self-portraits, which showed an obsession with his own sexuality (e.g. *Leg of Mutton*, 1937, Tate), manifested in an increasingly bizarre private life. His figures were clumsy, ordinary folk, precisely drawn using pale colours and even lighting; he abandoned traditional perspective and drawing techniques in order to achieve a naiveté but had a ▷Surrealist's fascination with the oddness of everyday life.

Bib.: Robinson, D., *Stanley Spencer: Visions from a Berkshire Village*, Oxford, 1979; *Stanley Spencer*, exh. cat., London, 1955; *Stanley Spencer*, exh. cat., London, 1980; *Stanley Spencer*, exh. cat., New Haven, 1981; Wilenski, R.W., *Stanley Spencer*, London, 1924

sphinx

Two distinct mythological beasts, one Egyptian, the other Greek. The Egyptian sphinx has the body of a lion with the head of a pharaoh and was symbolic of royal power (e.g. the Sphinx at Giza, c2620 BC). The Greek sphinx had the body and paws of a lion, the wings of an eagle, a serpent's tail and the head and breasts of a woman. The most famous story concerns the sphinx sent by Hera (▷Juno) to plague Thebes. It obstructed an essential pathway and confronted all who sought passage with a riddle on the Three ▷Ages of Man. All who failed to solve it were summarily devoured by the sphinx. ▷Oedipus eventually solved the riddle and the sphinx either killed itself or was killed by Oedipus. ▷Ingres (*Oedipus and the Sphinx*, 1808, Paris, Louvre) shows Oedipus in the process of solving the riddle, with the bones and a foot belonging to a less successful puzzler lying among the rocks.

Spinario

(Latin, '*spina*', 'thorn'.) Antique bronze statue (approx. 0.73m high) of a seated nude boy removing a thorn from his left foot. It was first recorded outside the Lateran Palace, Rome, in the 1160s, and by 1499–1500 it was in the Palazzo dei Conservatori of the Musei Capitolini, Rome. Along with other celebrated antiquities in Rome it was ceded to the French in 1797 and displayed in the ▷Louvre until restituted in 1815 following the fall of Napoleon. Over the centuries a number of suggestions have been proffered to explain the origin and meaning of the sculpture, the most popular from the 17th to the 19th centuries being that the Roman Senate had commissioned it to commemorate a conscientious messenger boy who removed a thorn from his foot only after he had done his duty and delivered his message (inspiring its popular

Italian name, *Il Fedele*, 'the faithful one'). Whatever its meaning, from the time of its first mention in the 12th century, the *Spinario* has excited keen admiration and been widely copied, often for use as a diplomatic gift. It has most often been copied in bronze, less often in marble and even, in 18th-century England, in Staffordshire salt-glazed earthenware. It was also used as the model for the draped servant boy (and was deliberately intended as a recognizable classical quotation) in ▷Brunelleschi's Baptistry competition ▷relief, *The Sacrifice of Isaac* (1401–2, Florence, Bargello).

The date of the *Spinario* is still uncertain, although the most recent theory is that it is a 1st-century BC Roman pastiche, uniting a ▷Hellenistic body with an earlier, somewhat ▷Archaic, head. It has been noted that the head is not only less naturalistic than the body, but that the hair hangs straight down as it would on an upright head, not one, as in the present case, bowed forward. The correct appearance of the head is suggested by another, closely related *Spinario* (London, British Museum), a Roman copy in marble of a lost Hellenistic original with a head as naturalistic as the body.

Bib.: Haskell, F. and Penny, N., *Taste and the Antique*, New Haven and London, 1981; Smith, R.R.R., *Hellenistic Sculpture*, London, 1991

Spinello Aretino (fl 1373; d 1410/11)

Italian painter. He was born, as his name implies, in Arezzo. He was trained in Florence, perhaps in the workshop of ▷Agnolo Gaddi, in a tradition still based on ▷Giotto. His most important works are the ▷fresco cycle of the life of St. Benedict in the sacristy of San Miniato al Monte in Florence (c1387) and that of the Sienese Pope Alexander III in the Sala di Balia of the Palazzo Pubblico, Siena. In the former cycle he reinvests into the Giottesque tradition some of the monumentality and clarity of the original (and in this he may be regarded as a precursor of ▷Masaccio); whereas in the latter, which is more dramatic, colourful and crowded, he is perhaps making some concession to Sienese taste. In the Siena cycle he was assisted by, among others, his son Parri Spinelli (d 1452).

Bib.: Calderoni Masatti, A.R., *Spinello Aretino giovane*, Florence, 1973

spire

A tall and slender conical, polygonal or pyramidal structure, tapering to a point and surmounting a building, or terminating a tower or ▷turret. Church spires are often octagonal and generally surmount a square tower. Where the tower is not surmounted by a ▷parapet and a smooth transition from tower to spire is required, four transitional architectural members known as broaches (shaped like half-pyramids) are set against the faces of the octagon over the corners of the tower: a spire on which these are employed is called a

broach spire. An extremely slender spire rising from the centre of the roof of a tower with a parapet and set well back from the parapet is called a needle spire.

Spitzweg, Karl (1808–85)

German painter. He began his career illustrating periodicals, and he travelled extensively in England, France and Italy. He painted landscapes and humorous ▷genre scenes in a ▷Biedermeier mode.

Spranger, Bartholomeus (1546–1611)

Flemish painter. He was trained by Jan Mandyn in Antwerp (1557–9), but his early work was clearly more influenced by the ▷Mannerist-inspired paintings of ▷Frans Floris. He left the Netherlands in c1565 to visit Paris, Lyons, Milan and Parma, before settling in Rome (c1567–75), where he worked as an assistant to ▷Taddeo Zuccaro. In 1575 he was working independently in Vienna for the Emperor Maximilian II and in 1581, he became principal court painter to Rudolph II at Prague, where he remained for the rest of his life. His paintings are characteristically of sinuous erotic nudes in ▷allegorical, mythological or biblical settings, arranged in virtuoso ▷Mannerist poses, influenced by ▷Correggio and ▷Parmigianino, but with less of their controlling Classicism (e.g. *Hermaphroditus and Salmacis*, Vienna, Kunsthistorisches Museum). His work was disseminated throughout Europe by the engravings of ▷Hendrick Goltzius and Egidius Sadeler and his influence was perpetuated in the Netherlands in the so-called Haarlem 'Academy', founded by Goltzius, ▷Cornelis van Haarlem and ▷Karel van Mander.

Bib.: Fabianski, M., 'Spranger and Italian Paintings', *Apollo*, 141 (March 1995), pp. 20–24; Henning, M., *Die Tafelbilder Bartholomeus Spranger 1546–1611*, Essen, 1987

sprezzatura

(Italian, 'nonchalance'.) Term used in Italian art criticism to describe the deliberately spontaneous, sketch-like quality in a drawing or painting.

Squarcione, Francesco (1397–1468)

Italian painter. He was active in Padua. He was originally a tailor but is referred to as a painter in a document of 1426. Early sources furthermore describe him as an antiquarian who travelled throughout Italy and even to Greece collecting antiquities. His principal importance, however, is as a teacher: among his pupils were ▷Mantegna, ▷Zoppo, ▷Crivelli and ▷Schiavone. He was once thought to have been a rather benevolent figure who even adopted some of his pupils, although it was long known that Mantegna ended his apprenticeship in an acrimonious lawsuit. Recent research suggests that Mantegna was not alone and that a number of his pupils broke their apprenticeships in a similar way on the grounds of

exploitation. Only two paintings have been securely linked to him, a signed *Madonna and Child* (c1448, Berlin, Staatliche Museen), showing the influence of ▷Donatello, and the documented *De Lazara Polyptych* (1449–52, Padua, Museo Civico). Unfortunately, the two works show very little stylistic affinity and it is not certain how much of either of them is purely workshop. Nevertheless, both are characterized by a dryness of style and a certain amount of archaeologizing detail, traits that are associated with the Paduan school which Squarcione was once believed to have founded and which were certainly present in the young Mantegna.

squaring up

A method of transferring a drawing on to another, usually larger, surface, for example from a ▷sketchbook to a canvas. This is achieved by drawing a grid of squares over the picture, then drawing a similar number of squares on to the larger surface. Where the grid intersects the drawing, points are taken and transferred to the corresponding square on the canvas, thereby assuring an accurate transposition of the proportions.

Stael, Nicholas de (1914–55)

Russian painter. He was associated with the ▷School of Paris. Born into a noble family in St. Petersburg, he was taken to Poland in 1919. In 1922 he was sent to school in Brussels, and in 1932 studied at the Académie des Beaux-Arts there. In 1933 he travelled widely in Europe and North Africa. He was influenced by the Dutch School (e.g. ▷Vermeer, ▷Rembrandt) in the Netherlands, and by ▷Cézanne and ▷Matisse. In 1938 he moved to Paris, only to join the French Foreign Legion in Tunisia at the outbreak of the Second World War. In 1940 he joined ▷Le Corbusier, ▷Arp and the ▷Delaunays in Nice, but financial hardship drove him back to Paris, where ▷Braque took an interest in his work. By 1945 he had broken with his earlier figurative painting to develop 'a freer form of expression'. Thickly ▷impastoed blocks of colour create a highly organized composition, whose rhythm is dictated by real objects. His use of the ▷palette knife, with which he crushed the thick paint, together with his heightened use of colour, gives his works an expressive tension. He committed suicide at a time when he had achieved critical and commercial success. The Musée National d'Art Moderne in Paris held a large retrospective of his work in 1956.
Bib.: Cooper, D., *Nicholas de Stael*, London, 1961; Dobbers, D., *De Stael*, Paris, 1994; Jouffrey, J.P., *La Mesure de Nicholas de Stael*, Neuchâtel, 1981; Messer, T.M., *Nicholas de Stael, Retrospective*, Frankfurt, 1994

staffage

Term originating in French ▷art criticism, but now used in English also, denoting the small figures and animals in a painted landscape serving no thematic purpose, but simply to impart liveliness and to give a sense of scale. Dutch landscape painters of the 17th century in particular often employed staffage specialists to paint the figures in after the landscape had been painted by themselves.

stained glass

Coloured glass used for making decorative windows and other objects, through which light passes. It is composed from ordinary glass which is coloured with the addition of metal oxides. The art was used extremely effectively in the 12th and 13th centuries, in combination with the massive and ornate structures of the ▷Gothic era. For example, Chartres, ▷St-Denis and Sainte-Chapelle in Paris all contain extraordinary examples of stained glass. It was formed by cutting shapes from thin sheets of coloured glass, and the design was assembled with lead strips. Features, like eyes or hair, were painted on to the glass using vitreous ▷enamel. The practice was neglected in the 17th and 18th centuries, but went through a revival in the 19th century with the work of ▷William Morris and ▷Louis Comfort Tiffany. Twentieth-century artists such as ▷Léger, ▷Matisse and ▷Chagall have also worked in this medium.

Stanfield, Clarkson (1793–1867)

English painter. He was born in Sunderland, the son of an actor. He was apprenticed to a heraldic painter in Edinburgh in 1806 but was press-ganged and spent a number of years at sea, both in the merchant navy (1808–12) and in the Royal Navy. He was invalided out in 1818 and became an artist through the encouragement of his captain, the novelist Marryat. He first worked as a scene painter at Drury Lane, producing ▷dioramas, but from the 1830s he concentrated on easel-painting (he had first exhibited at the ▷Royal Academy in 1820). He was elected to the Sketching Society in 1829 and was a founder-member of the Society of British Artists in 1823 (later becoming President in 1829). He was supported by ▷Ruskin and in 1855 won a gold medal at the Universal Exhibition. His work was highly popular in his own day, but repetitive and stagy. He specialized in highly finished, panoramic and often dramatic seascapes (e.g. *On the Scheldt, A Squally Day*, 1837, London, RA; *Off Dogger Bank*, 1846, London, Victoria and Albert Museum). In his later career he tried to shake off the marine-painter image with a series of sketching tours (Italy in 1838–9, Wales in 1848) (e.g. *View of Pic du Midi d'Ossau*, 1884, Egham, Royal Holloway College) and he also produced historical and ▷battle scenes.
Bib.: *Clarkson Stanfield*, exh. cat., London, 1967; *The Spectacular Career of Clarkson Stanfield*, exh. cat., Sunderland, 1979

stanza (pl. stanze)

Italian for 'room'. The term is often used to refer to important Italian ▷Renaissance and ▷Baroque decorative schemes, such as ▷Raphael's ▷frescos for the Stanza della Segnatura in the Vatican.

Stanzione, Massimo (1586–1656)

Italian painter. He was from Naples, where he supervised a large workshop and produced a number of important commissions for churches in the ▷Baroque style. Although he absorbed some of ▷Caravaggio's realism, the slightly more idealistic strain in his work earned him the nickname 'the Neapolitan ▷Reni'.

Starry Night

Painted by ▷van Gogh in June 1889 at the St. Remy hospital near Arles, transforming the view from his window into a tumultuous landscape dominated by 11 huge stars. In a letter to his brother, he suggested that the painting (oil on canvas, 74 × 92 cm/29 × 47 in) reflected an aim shared with ▷Gauguin and ▷Bernard to convey their own stylized personal vision rather than reproduce a precise external reality. Such an artistic project could supply the 'consolation' once provided by religious subjects.

Starry Night itself has been seen as an apocalyptic vision which is also a disavowal of institutional Christianity. Nature becomes a single vibrant swirl of energy in which the contours of the surrounding hills and olive groves mirror those of the night sky, and the rigid spire of a local church is dwarfed by the cypress in the foreground, leaping like a flame into the stars.

The painting represents the extreme point of van Gogh's stylization and, apparently dissatisfied with it, he returned to a more restrained form. For the ▷Expressionists, however, the painting embodied their own use of exaggerated and distorted images to portray subjective experience. It now hangs in the Museum of Modern Art, New York.

Bib.: Boime, A., 'Van Gogh's Starry Night – A History of Matter and a Matter of History', *Arts Magazine* 59, no. 4 (Dec 1984), pp. 86–103

state

A term used in ▷engraving and ▷etching for a particular stage (state) of the design. Each time a ▷plate is changed, a new state has been reached. The 'state' refers to both the plate and the ▷print. A reference to 'first state' and 'second state' indicates a plate that is being tested as final corrections are made.

Steen, Jan (1625/26–79)

Dutch painter. He painted ▷genre scenes, portraits and some history and biblical subjects. He enrolled at the University of Leiden in 1646, before training with the landscapist ▷Jan van Goyen, (whose daughter he married) and, more importantly, for his artistic development ▷Adriaen van Ostade. He was mainly active in Leiden, in 1648 becoming one of the founder-members of the Leiden Guild of St. Luke. However, he also worked in Delft, The Hague and Haarlem, entering the Haarlem guild in 1661. Apart from Ostade, he was greatly influenced by ▷Gerrit Dou and the Leiden *fijnschilders*, although his technique is always less precise than theirs. His scenes of drunken dissolution in disorderly houses are those by which

Vincent van Gogh, *Starry Night*, 1889, Musée D'Orsay, Paris

he is best known. Humorously treated and ostensibly partaking of the spirit of the debauch, the scenes are replete with moralizing symbolism, and thus must have carried a double-edged pleasure for the respectable collector. Although Steen was prolific, his paintings do not seem to have commanded very high sums. On occasion he bartered his paintings to pay off debts, receiving the relatively small sum of ten guilders per picture. This may be why he had to supplement his income by opening a tavern in Leiden in 1672 (although many successful Dutch painters at this time had professions in addition to painting). His paintings (he is supposed to have executed about 700) are represented in many public collections.

Bib.: Kirschenbaum, B.D., *The Religious and Historical Paintings of Jan Steen*, Oxford, 1977; Muller, D., 'Jan Steen, Burgher of Delft, and his Daughter', *Art History*, 12 (Sept 1989), pp. 268–97

Steenwyck, Hendrick van the Elder (d ?1603) and Hendrick van the Younger (d 1649)

Dutch family of painters. Both father and son were painters of architectural views, principally church interiors, and were active chiefly in Flanders. Steenwyck the Elder was trained by ▷Hans Vredeman de Vries and he later trained his own son, Steenwyck the Younger. The father is generally credited with the development of the church interior as a specific branch of architectural painting. Although Steenwyck the Elder remained in Flanders, the son transferred to Germany and finally to England.

The styles of father and son are similar. Interiors are usually imaginary, but are on occasion of real places (e.g. *The Cathedral at Aachen* by Steenwyck the Elder, 1573). Characteristically the architectural elements are firmly outlined, the colours hard and bright and the scale small. Interiors are viewed from above and usually along the ▷nave, in order to show as much of the interior as possible and to achieve the maximum in grandeur by an exaggerated sweep of ▷perspective. The figures were generally painted by specialists, such as ▷Jan Bruegel the Elder, to whom the figures in two of Steenwyck the Younger's paintings in London's National Gallery are attributed. The enamel-like finish and fine detailing is usually facilitated by the use of copper as a support.

Steer, Philip Wilson (1860–1942)

British painter. He was born in Birkenhead, the son of a portrait painter. He studied in Gloucester, and also in Paris at the ▷Académie Julian under ▷Cabanel and at the ▷École des Beaux-Arts with ▷Bouguereau (1882–4). He visited France regularly (1887–91) and his friends included ▷Whistler. He was a founder member of the ▷NEAC in 1886 and became Frederick Brown's assistant at the ▷Slade in 1893, teaching there for 40 years. His early work was influenced by the latest developments in French painting, including ▷Impressionism and ▷divisionism (e.g. *The Bridge*, 1888, London, Tate Gallery) and in 1898 he exhibited at the Goupil ▷Impressionist exhibition in London. He painted a number of landscapes, especially beach scenes, which used an intense colour scheme and light dappled brushwork (e.g. *Children Paddling, Walberswick*, 1894, Cambridge, Fitzwilliam Museum). By c1895 however, he had returned to a more conventional style, producing landscapes in an English tradition influenced by ▷Gainsborough and ▷Constable (e.g. *Richmond Castle*, 1903, London, Tate). He also began to produce more figurative work (e.g. *Seated Nude, Black Hat*, 1900, London, Tate). Increasingly in the 20th century he concentrated on ▷watercolour. His eyesight deteriorated steadily from the 1930s and he painted little in his last years.

Bib.: Ironside, R., *Wilson Steer*, London, 1943; *Wilson Steer*, exh. cat., London, 1960

Steinlen, Théophile-Alexandre (1859–1923)

French painter and graphic artist of Swiss birth. In 1882 he was in Paris, where he produced satires and ▷lithographs of low life in the city. During the 1890s he specialized in poster production, and his work was similar to that of ▷Toulouse-Lautrec, emphasizing contemporary café and cabaret life.

stele, stela (pl. stelae)

(Greek, 'standing block'.) An upright stone, usually a slab, marking a grave, especially in Ancient Greece. It is generally inscribed and may be carved in ▷relief, usually with an idealized image of the deceased. The term is also applied, loosely, to any prepared wall surface bearing a memorial inscription.

Stella, Frank (b 1936)

American artist. He was born in Maiden, Massachusetts and studied at Philips Academy there, under ▷John Pierpont Morgan, before going on to Princeton University (1954–8). From 1958 he lived in New York and began to work in his mature style, producing canvases divided by black parallel lines (e.g. *The Marriage of Reason and Squalor II*, 1959, New York, Museum of Modern Art). During the 1960s he became one of the leading exponents of ▷Post-Painterly Abstraction, producing a series of characteristic works in dayglo colours, using house paints to reduce the painterliness, but always divided by controlling parallels (e.g. *New Madrid*, 1961, private collection). In many of these he came close to ▷Op art, but his aim was not to create illusion. He also experimented with shaped canvases (e.g. *Union I*, 1966, Detroit, Institute of Arts), treading a fine line between painting and sculpture. He saw paintings as objects with an independent existence and sought to eliminate not only emotion but any connection with the artist.

Bib.: Guberman, S., *Frank Stella*, New York, 1995; Rubin, W.S., *Frank Stella*, New York, 1970

stencil

A piece of metal or paper with a design cut out from it. The holes are then filled in with paint to create a design. It is also a transfer process.

Stepanova, Varvara Federovna (1894–1958)

Russian painter. She studied in Kazan, where she met ▷Rodchenko, whom she later married. In 1912–14 she was in Moscow, where she studied ▷applied art, which became particularly important to her later career. She was very active after the Russian Revolution, being involved first with IZO ▷Narkompros in 1918, and then with ▷INKHUK in 1920. In 1921, she was one of the artists who launched the ▷5 × 5 = 25 exhibition. Like many ▷Laboratory artists, she did not produce easel-painting, but concentrated on theatre and textile designs, as well as typography. In 1924 she became Professor at the Textile Factory of ▷Vkhutemas.

▷Constructivism; Productivism

Bib.: Lavrentiev, A., *Varvara Stepanova: A Constructivist Life*, London, 1988

Stevens, Alfred (1817–75)

British painter, designer and sculptor. He was born in Blandford Forum, Dorset, the son of a decorator. His early ability as a portrait painter encouraged a local clergyman to collect funds to send him to Italy to study. Equipped with just £60, he set off to Italy at the age of 15 and stayed for 10 years, earning a precarious living drawing portraits, copying ▷Old Masters for dealers, and all the while studying the ▷Renaissance masters. During his last two years he worked for ▷Thorvaldsen in Rome, returning to England in 1842. He moved to London and secured a post teaching at the Board of Trade's School of Design before moving on to Sheffield to work as chief artist to a firm of bronze-and metal-workers, some of his designs being exhibited at the 1851 ▷Great Exhibition. By 1852 he was back in London and, in 1856, he won the competition for the Wellington Monument in St. Paul's. The project was beset with delays – the ▷equestrian statue surmounting the monument was not finally completed until 1912, 37 years after Stevens' death – both as a result of bureaucratic indecision and Stevens' own tendency to procrastination, but the monument is nonetheless considered to be both his masterpiece and the finest sculptural monument produced in England in the 19th century. Susan Beattie has proposed that the posthumous exhibition of the bronze, *Valour and Cowardice*, one of the supporting groups from this monument, at the 1876 ▷Royal Academy show, had a seminal effect on the foundation of the ▷New Sculpture movement. Stevens' other major works are the fireplace and other decorative elements for Dorchester House (c1856; the house is demolished but the fittings are now in the Victoria and Albert Museum, London, and the Walker Art Gallery, Liverpool), some ▷mosaic designs for the dome of St. Paul's (completed 1864) and a painted portrait, *Mrs. Mary Ann Collmann* (1857, London, Tate Gallery). He was also a first-rate draughtsman and representative collections of his drawings are held in Cambridge, Liverpool, London (Tate Gallery), Oxford and Sheffield.

Bib.: *Alfred Stevens*, exh. cat., London, 1975; Towndrow, K.R., *Alfred Stevens*, London, 1939

Stieglitz, Alfred (1864–1946)

American photographer and art dealer. His father, a wealthy wool merchant, moved his family from New York to Europe in 1881. Stieglitz studied mechanical engineering in Berlin and began to take photographs. He returned to New York in 1890, where he set up a photo-engraving business and married Emmeline Obermayer in 1893. After inheriting money from his father, he devoted himself to photography and promoting the ▷avant-garde. As manager of the Photo-Secession Gallery (later known as ▷291) he supervised the first American exhibitions of major contemporary European artists, including ▷Matisse in 1908, ▷Rousseau in 1910 and ▷Brancusi in 1914. The gallery also featured modern American artists, including ▷Georgia O'Keeffe, with whom Stieglitz lived after 1918, and married in 1924. He edited the journals *Camera Work* (1903–17), a forum for review and discussion of the visual arts, and *291* (1916–17) which promoted New York ▷Dada. After the closure of *291*, Stieglitz opened the Intimate Gallery (1925–9) and An American Palace (1929–46).

In his work as artist and critic Stieglitz was instrumental in establishing photography as an accepted mode of individual expression. Influenced by the ▷Cubist paintings he was exhibiting, his photography after 1911 became increasingly abstract, emphasizing line, space, depth and contrast rather than subject matter. His portraits isolate the sitter from a surrounding or explanatory context, and he used the same approach to portray natural phenomena in his photographs of clouds entitled *Songs of the Sky* (1923).

Bib.: Haines, R.E., *The Inner Eye of Alfred Stieglitz*, Washington, 1982; Homes, W.I., *Alfred Stieglitz and the Photo-Secession*, Boston, 1983

stigmata

Marks corresponding to the wounds of the crucified ▷Christ, allegedly formed supernaturally on the bodies of certain ecstatic mystics, such as ▷Francis of Assisi and ▷Catherine of Siena. The marks are on the hands and feet in imitation of the nails of the cross and in the side in imitation of the wound made by ▷Longinus' lance. In Christian narrative art these saints may be seen receiving their stigmata, or are portrayed displaying them, in devotional ▷sacre conversazioni, for example.

▷Crucifixion

Stil Liberty

▷ Liberty Style

Still, Clyfford (1904–80)

American artist. He was born in North Dakota. He claimed to be self-taught as a youth, but from 1933 he studied at Spokane University and Washington State College and he had a series of teaching appointments in Washington, California and New York before retiring to Maryland in 1963. His early work was figurative and ▷ Expressionist in influence, combining gaunt figures against desolate backgrounds in a rapid ▷ impasto. Increasingly, these images moved towards ▷ abstraction, showing the influence of primitive art styles, and by the 1940s he had departed from representation entirely, combining wiry lines and bright colour spots. These motifs were inspired by a new interest in ▷ lithography. By 1946 he had developed his own style of ▷ colour field painting (e.g. *Yellow*, 1951, private collection; *1957 D no. I*, 1957, Buffalo, Albright-Knox Art Gallery). His works resembled relief maps of eroded colour blocks, with jagged edges of colour oozing down vertical canvasses, initially bright but increasingly utilizing purples and blacks. He denied any psychological input into his works although he believed, like the existentialist philosophers, that art was a way of life.

Bib.: *Clyfford Still*, exh. cat., San Francisco, 1976; *Clyfford Still*, exh. cat., New York, 1979

still life

A painting or drawing of fruit, flowers, game or household objects. The genre of still life is mainly associated with the northern European schools, for example the German, Dutch and English. While still lifes were painted in ▷ Renaissance art, they usually appeared only as background or in a supporting role to human action, as in the brilliantly executed still life of the basket of fruit in the foreground of ▷ Caravaggio's *Supper at Emmaus* (1595–6, London, National Gallery). In some art, for example by ▷ van Eyck, what appears to be a still life might more probably be considered as an emblematic or symbolic representation.

True still life is concerned with the representation of intimate objects of the day-to-day world for its own sake, free of any symbolic or hierarchical function. Its popularity in 17th-century Holland is no doubt partly due to the twin factors of the lack of ecclesiastical patronage and the rise of a merchant class who appreciated paintings both as aesthetic objects and as commodities. Some of these still-life paintings were also ▷ *vanitas*, warning the beholder of the folly of taking comfort in the tangibility of the everyday, while others were disguised biblical themes. In the 18th century the still life found a great exponent in the French academician ▷ Chardin, but he remained something of an exception. The weakening of the ▷ hierarchy of the genres in the 19th century saw this formerly inferior form become a vehicle for the ▷ avant-garde in the work of the ▷ Impressionists and ▷ van Gogh, but most especially in ▷ Cézanne, who invested the still life with all the structural and perceptual complexities once reserved for ▷ history painting. The 20th century has seen still life continue as a legitimate form of expression for artists, but without the revolutionary potential of either the 17th or late 19th centuries.

Bib.: Alpers, S., *The Art of Describing: Dutch Art in the Seventeenth Century*, London, 1983; Bryson, N., *Looking at the Overlooked: Four Essays on Still-Life Painting*, London, 1990; Nash, J.M., *The Age of Rembrandt and Vermeer: Dutch Painting in the Seventeenth Century*, rev. edn., London, 1979; Sterling, C., *Still-Life Painting from Antiquity to the Present Time*, 2nd rev. edn., New York, 1981

Stillman, Maria (Spartali) (1844–1927)

English painter of Greek heritage. She was born in London, and took private lessons with ▷ Ford Madox Brown in 1864. She began exhibiting paintings from 1867, concentrating on themes from Classical history in a style similar to that of ▷ Burne-Jones. In 1871 she married the journalist W.J. Stillman, and the two of them helped disseminate the later ▷ Pre-Raphaelite style. From 1875 they lived in Italy, where Maria altered the themes of her paintings to subjects from medieval Italian history.

Bib.: Christian, J., 'Maria Spartali', *Antique Collector*, (1984), pp. 42–7

Stimmer, Tobias (1539–84)

Swiss painter, decorator and graphic artist. He painted portraits and produced book illustrations. He was best known for the astronomical clock he designed at Strasbourg Cathedral.

Bib.: von Bartsch, A., *The Illustrated Bartsch, 19, Part 2: German Masters of the Sixteenth Century: Hans Rudolf Manuel (Deutsch), Tobias Stimmer*, New York, 1988

stipple engraving

A method of ▷ intaglio printing whereby minute dots, produced by manipulating a ▷ roulette, show as a soft tone on the ▷ print.

Stirling, James (1926–94)

English architect. He was born in Liverpool and studied at the University there (1945–50), where he was influenced by the interest in 1920s utopianism of the historian, Rowe. Stirling's first independent designs (e.g. Ham Common Houses, 1956) owed much to ▷ Le Corbusier in their use of textured concrete and brick but he soon abandoned this primitivism in favour of mechanistic functionalism. This was first expressed in his Leicester University Engineering building (1959–63), a glass, brick, concrete and steel tower which employed sharp angles, overhangs, slender legs and an almost nautical vocabulary. This set the

tone for much of his work of the 1960s – a romantic ▷modernism which shied away from ▷New Brutalism and made constant references to the past. During the 1970s, the scale became grander and the geometry more streamlined in a series of industrial projects, but by the 1980s, Stirling was using the language of ▷postmodernism (e.g. Stuttgart Museum, 1977 and after) with low, sprawling forms, colour, free-standing structures and spatial ambiguities.

Bib.: McKean, J., *Leicester University Engineering Building*, London, 1994; Stirling, J., *James Stirling, Michael Wilford and Associates: Buildings and Projects 1975–1992*, London, 1994

stoa

An ancient Greek ▷portico.

Stokes, Adrian (1902–72)

English painter and writer on art. He was born in the fashionable London district of Bayswater, the son of a stockbroker. After attending Rugby, he read history at Magdelene College, Oxford (1920–22), and then embarked on a 'grand tour', which he later described in the memoir *Thread of Ariadne* (1925). He became a friend of the poet Ezra Pound in 1929, developed an interest in the ideas of ▷Freud and spent time in Paris and Italy during the 1930s. These influences led to his first writing on art (*Quattrocento*, 1932). He began painting in 1936 and joined the ▷Euston Road School in 1937, where he met ▷Hitchens (with whom he exhibited in 1938) and ▷Wallis. During the War he lived at ▷St. Ives. His own works employed pallid colours and dominant brushwork in a series of still-life, landscape and nude subjects. He had psychoanalysis after the death of his wife in 1947 and this increasingly influenced his writing: he believed that the task of art was to represent the soul (e.g. *Painting and the Inner World*, 1964). He experimented with poetry in the late 1960s. His collected works were published in 1978, edited by Lawrence Gowing.

Bib.: *Adrian Stokes*, exh. cat., Huddersfield, 1982; Wollheim, R., *Art and the Mind*, London, 1973

Stone, Nicholas (1586–1647)

English mason-sculptor and architect. After training in the London workshop of Isaac James, he went to Amsterdam to study under Hendrick de Keyser (1606–13). On his return to England he established a flourishing practice, gaining a reputation both for carving expertise and artistic innovation, far in excess of any of his British contemporaries. It is in his tombs that his best work is to be found. The marble slab of the Tomb of Sir William Curle (d 1617, Hatfield, Hertfordshire) is carved with a remarkably moving effigy of the deceased, partly covered by his shroud, his body twisted in death. The Monument to Francis Holles (d 1622, London, Westminster Abbey) includes the first Roman armour-clad figure (based on ▷Michelangelo's *Giuliano de' Medici*) in British sculpture, while Stone's Monument to John Donne (1631, St. Paul's Cathedral) shows the poet standing on a funerary urn, wrapped in a brilliantly carved shroud. In 1619, Stone had been appointed Master Mason for ▷Inigo Jones' Banqueting House, Whitehall, a position he held until 1622. In 1632 he was appointed Master Mason to the Crown, a position which allowed him access to Charles I's ▷antique sculpture collections. It has been suggested that this contact effected the radical shift in his style during the 1630s towards a purer Classicism, eschewing the coloured marbles employed in his early work, and attempting a closer approximation of antique figure forms and drapery. The prime example of this new style is the Monument to John and Thomas Lyttleton (1634, Oxford, Magdalene College). His flourishing workshop is unusually well-documented owing to the survival of an office notebook (1614–41) and account book (1631–42), now preserved in the Soane Museum, London. What little of his architecture survives has been described by Howard Colvin as charming 'vernacular classical' (e.g. the carved gateways to the Botanical Garden, Oxford, 1632–3). The family practice was continued after Stone's death by his youngest son, John (1620–67).

Bib.: Colvin, H.M., *A Bibliographical Dictionary of British Architects 1600–1840*, London, 1978; 'Stone's Notebook and Account Book', *Walpole Society*, 7 (1919); Whinney, M., *Sculpture in Britain 1530–1830*, 2nd ed., Harmondsworth, 1988

Stonebreakers, The

Painted by ▷Courbet at Ornans in November 1849. Its rejection of traditionally sentimentalized and ennobling images of rural life was a major influence on the development of ▷Realism in France. The two subjects are engaged in the process of breaking large stones into small pieces, an image of the absurd and futile nature of the work ethic. Their faces are turned away from the viewer, depersonalizing the two figures and suggesting them to have been reduced to the dehumanized state of machines. The surrounding countryside is a grim muddy green and brown, and their clothes are tattered versions of those which might have been worn in the city – there is nothing picturesque about this image of poverty.

Courbet claimed that he came across the two labourers near his studio. In contemporary letters, he suggests that the two figures, one aged 15, lifting a large stone, the other old and on his knees with a hammer, represent the bleak beginning and end of a worker's life. Critics have related the picture to the politicization of the countryside in the mid-19th century. It has also been seen as the first ▷avant-garde painting, in which the artist makes a personalized and oppositional political statement. *The Stonebreakers* was at the Gem-

Gustave Courbet, *The Stonebreakers*, 1849, Staatliche Kunstsammlungen, Dresden

äldegalerie in Dresden, but was destroyed by bombing in 1945.

Bib.: Raskin, R., *Gustave Courbet's 'Les Casseurs de Pierres': Aspects of a Major Work of Art*, Aarhus, 1988

stopping-out varnish

A type of varnish used in ▷etching and ▷aquatint. It resists acid and can be applied to certain areas of a ▷plate to prevent them from being bitten. These areas appear on the final print as lighter tones.

Stoskopff, Sébastien (1596–1657)

French painter. He was in Paris in 1621–41. He subsequently worked primarily in Strasbourg, where he painted still lifes showing the influence of Netherlandish art.

Stoss, Veit (c1450–1533)

German sculptor. With ▷Riemenschneider, he was the leading German sculptor of the late ▷Gothic period, working in both wood and stone. He was also a painter (most of his sculptures were painted) and an engraver. Trained in Nuremberg, in 1477 he went to Cracow in Poland, where he executed what is generally considered to be his masterpiece, the huge 13 m-high altarpiece of the *Life of the Virgin*, in carved and painted wood, for the high altar of the Church of St. Mary (1477–89). His other important work from this period is the Tomb of King Casimir IV (1492, Cracow Cathedral). He returned to Nuremberg in 1496 and established a successful practice. In 1503, however, he forged a document in an attempt to retrieve some money he considered to have been unwisely invested, was con-

victed of forgery and was branded on both cheeks and forbidden to leave the city. Although he continued to work he never quite regained his previous high status. He worked in a very distinctive style, characterized by a dramatically intense realism allied to a positively calligraphic treatment of drapery (e.g. *Christ on the Cross*, wood, c1500, church of St. Lorenz, Nuremberg). Although he is not known to have visited Italy, an undocumented wooden statue of St. Roch in Florence (c1500, SS Annunziata) is generally accepted as by Stoss purely on the evidence of his distinctive style.

Bib.: Chrzanowski, T., *The Marian Altar of Veit Stoss*, Warsaw, 1985; Funk, V., *Le Retable de Cracovie: l'oeuvre de Veit Stoss*, Paris, 1986; Kahsnitz, R., *Veit Stoss: Die Vorträge des Nürnberger Symposions*, Munich, 1985

Stothard, Thomas (1755–1834)

English painter, illustrator and designer. He was born in London, the son of an innkeeper and was apprenticed to a Spitalfields weaver before entering the ▷Royal Academy schools in 1777. There he met ▷Flaxman and ▷Blake with whom he shared an interest in radical politics. He developed a style of linear drawing influenced by Flaxman and produced a number of book illustrations (e.g. John Bell's *Poets of Great Britain*, 1779; Oliver Goldsmith's *Vicar of Wakefield*, 1792). He was employed to produce designs for Wedgwood and worked on decorations for Burghley House staircase (1794). He was librarian of the RA from 1812, having been elected ▷ARA in 1791. Most of his oils were small-scale history subjects (e.g. *Pilgrimage to Canterbury*, 1806, London, Tate Gallery) and increasingly in his later career he turned to

landscape (e.g. *Grasmere Water*, ▷watercolour, 1809, London, British Museum).

Bib.: Bennett, S.M., *Thomas Stothard: Mechanism of Art Patronage in England*, Columbia, 1988; Coxhead, A.C., *Thomas Stothard RA: An Illustrated Monograph*, London, 1906

Stowasser, Friedrich
▷Hundertwasser, Fritz

strainer arch
▷arch

strapwork
Interlaced ornament used in architectural decoration. It originated in ▷Fontainebleau in the 1530s, and it was transported to Flanders. It was also common during the Elizabethan and Jacobean periods in England.

Streeter (Streater), Robert (1621–79)
English painter. Like many artists in his time, he travelled to Italy as part of his training. He became Serjeant Painter to Charles II in 1660 and painted many ▷murals with landscapes and ▷allegorical subjects. He was responsible for the *Allegory of Truth and the Arts* on the ceiling of the Sheldonian Theatre at Oxford (1668–9), which showed evidence of the ▷Baroque style he had assimilated in Italy.

Streeton, Arthur (1867–1943)
Australian painter. He painted landscapes as part of the ▷Heidelberg School. From 1916 to 1918 he worked as a war artist.

stretcher
The wooden framework across which a ▷canvas is stretched in order that it can be worked evenly. Stretcher also refers to the positioning of bricks in a wall.

Stretes, William
▷Scrot(e)s, Guillim

Strickland, William (1787–1854)
American architect, painter and engraver. He studied with ▷Latrobe, and in 1836 he helped found the American Institute of Architects. He designed buildings in a ▷Neoclassical style, including the state capitol in Nashville.

Strozzi, Bernardo (1581–1644)
Italian painter. He was from Genoa, where he became a Capuchin priest and earned the nicknames 'Il prete genovese' ('The Genoese Priest') and 'll cappuccino' ('The Capuchin'). He left the order for family reasons in 1610, and travelled to Venice in 1631, where he produced rich ▷allegories and ▷genre scenes, in a colouristic and lavish style similar to that of ▷Rubens.

Structuralism
A school of criticism that developed from the ideas of the founder of structural linguistics, ▷Ferdinand de Saussure in his *Course in General Linguistics* (1915). He viewed language as a constructed system of signs, with the meaning of words (signs) arising through their difference to other words. The individual's interpretation and description of the world was seen as a function of language. Structuralism explores the laws by which signs are combined into meanings, and could be applied to myths and images as easily as to language. It flourished in the 1960s, particularly in the field of anthropology by ▷Claude Lévi-Strauss, and in language by the French critic ▷Roland Barthes. It has been criticized for privileging language at the expense of the human subject, but was important in the development of ▷deconstruction and ▷post-structuralism.
▷semiotics

Bib.: Hawkes, T., *Structuralism and Semiotics*, London, 1977

Stuart, Gilbert (1755–1828)
American painter. He was born in Rhode Island. He visited Edinburgh (c1771–2), and returned to Britain during the War of Independence to study in London with ▷Benjamin West. He practised portrait painting in Ireland in 1787–92, and then he returned to America, settling in Philadelphia. His most famous series of portraits represented the first American president, George Washington. They were iconic images of the president based on Classical models and included three major 'types': (i) *The Vaughan Portrait* (1795, Washington, DC, National Gallery); (ii) *The Athenian Portrait* (1796, Boston, Museum of Fine Arts); and (iii) *The Lansdowne Portrait* (1796, Philadelphia, Pennsylvania Institute of Fine Arts). They were frequently copied. Stuart moved to Boston in 1805 and painted many other famous Americans.

Stuart, James 'Athenian' (1713–88)
English architect. He studied in Rome, but became interested in Greek architecture when he travelled there 1751–3 with ▷Nicholas Revett. Their *Antiquities of Athens* provided a foundation for the ▷Greek Revival. Stuart designed some of his own work, including the chapel of Greenwich Hospital (1779–88).

Bib.: Watkin, D., *Athenian Stuart: Pioneer of the Greek Revival*, London, 1982

Stubbs, George (1724–1806)
English painter, draughtsman and graphic artist. He was born in Liverpool, the son of a currier and leatherseller, and was educated there. He was largely self-taught, and became a portraitist working in York (1745–52). He also produced book illustrations including those for Dr. Burton's *Treatise on Midwifery* (1751),

the result of his own studies of anatomy. He visited Rome in 1754. In his work he concentrated on the depiction of horses, employing techniques of scientific observation – he published *The Anatomy of the Horse* in 1766 based on his own researches. He settled in London in 1758 and made a name as a painter of animals, setting them in naturalistic and increasingly ▷Romantic landscapes (e.g. *Mares and Foals*, 1760, London, Tate Gallery). He also decorated pottery, and experimented in painting in enamel on earthenware for Josiah Wedgwood. He exhibited at the Society of Artists and the ▷Royal Academy regularly until 1774. He produced paintings of other animals, including lions (e.g. *Lion Attacking a Horse*, 1770, New Haven, Yale Center for British Art), well-to-do country gentry (e.g. *Milbanke and Melbourne Families*, 1770, London, National Gallery) and agricultural workers (e.g. *Reapers*, 1783, National Trust, Upton House, Warwickshire). By the 1780s however, his popularity had declined and he was in financial difficulties. A series of ▷engravings of his work by the *Turf Review* in the 1790s failed to complete its run through lack of interest.

Bib.: *George Stubbs: Anatomical and Animal Painter*, exh. cat., London, 1976; *George Stubbs*, exh. cat., London, 1984; Taylor, B., *George Stubbs*, London, 1971

stucco

A fine white modelling and moulding material made from a mixture of slaked lime mixed with various other ingredients, including a ▷binder and strengthener such as pulverized marble or animal hair, and a retarding agent such as wine or milk to allow time for the creation of elaborate decorative effects. It is extremely durable and has been employed both for external and internal architectural decoration since Classical antiquity. Although stucco continued to be used in ▷Islamic decoration, it was not until the early 16th century that it was revived in the west, reputedly by ▷Giovanni da Udine. He used it for the ▷grotesque ornamentation of ▷Raphael's Loggie in the Vatican and ▷Giulio Romano's Loggie at the Villa Madama, Rome. Stucco was later used for larger-scale ▷relief work and was exported to France by the Italian artists of the First School of ▷Fontainebleau. Much of the elaborate sculptural decoration of the ▷Baroque and ▷Rococo churches of southern Germany and Switzerland was executed in stucco (e.g. at Ottobeuren, Die Wies and Vierzehnheiligen). In the 18th century ▷Robert Adam employed specialist *stuccatori* to execute the crisp and delicate Classical ornament of his ▷Neoclassical interiors. During the 19th century stucco fell from fashion, but enjoyed a revival when its potential for the characteristic ▷Art Nouveau whiplash line was briefly exploited (e.g. on the façade of ▷Endell's Atelier Elvira, Munich, of 1897–8, now destroyed).

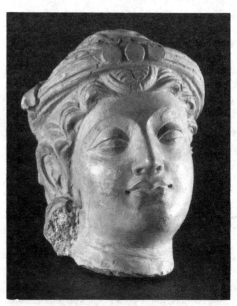

Stucco head, Gandhara, 4th century AD, National Museum of India, New Delhi

Stuck, Franz von (1863–1928)

German painter and sculptor. He was one of the founder members of the Munich ▷Secession in 1893, but his seemingly ▷avant-garde sympathies were belied by his acceptance of the post of Professor at the Munich Academy in 1895. He worked very much in the ▷Symbolist mode, producing salacious images of ▷*femmes fatales* such as ▷Salome. However, he was also a designer and was wealthy enough to build and design his own house in Munich, basing his ideas on ▷Jugendstil principles. He was also important as a teacher, and among his pupils were ▷Kandinsky and ▷Klee.

Bib.: Becker, E., *Franz von Stuck: Eros and Pathos*, exh. cat., Zwolle, 1994; Voss, H. (ed.), *Franz von Stuck*, Munich, 1983

studio

The artist's workshop, often a large room, and ideally with good light and north-facing. Usually in a private house, the room would serve for selling art as well as making it. Its size depended on the artist's success, so that 'studio' often refers to the crowd of people contributing to the making of an art work rather than the place itself. Few artists before the 19th century made an art work completely on their own and patrons would pay according to the amount of input the master artist had in the work's production; 'studio work' therefore means work in the master's manner, and probably from his shop, but certainly not by his hand. ▷Rubens, for example, established a scale of fees for his paintings according to the various gradations of the studio involvement, and it is a fine exercise of

▷connoisseurship to determine which members of ▷Raphael's large and even overstretched studio had a hand in which works.

▷attribution; *bottega*

Bib.: Camesasca, D., *Artisti in bottega*, Milan, 1966; Cole, B., *The Renaissance Artist at Work: from Pisano to Titian*, London, 1983

studiolo

A small study to which a ▷Renaissance potentate of intellectual disposition would affect to retire. The room's decoration would proclaim and enhance the potentate's thoughtfulness through being put together by excellent artists or because it contained priceless works. The best surviving examples are in Palazzo Vecchio, Florence (▷Vasari's studiolo of Francesco I) and in the Ducal Palace in Urbino (the studiolo of Duke Federico, by various artists). The studiolo at Ferrara belonging to that formidable woman ▷Isabelle d'Este is also very important in the history of Renaissance art because of the great artists whom she pestered to paint examples of their work for her.

Bib.: Cheles, L., *The Studiolo of Urbino: An Iconographic Investigation*, Wiesbaden, 1986; Tenzer, V.G., *The Iconography of the Studiolo of Federico di Montefeltro in Urbino*, Providence, 1985; Verheyen, E., *The Paintings in the Studiolo of Isabella d'Este at Mantua*, New York, 1971

stupa

Form of ▷Buddhist and Jain architecture. It is shaped like a hemisphere and is intended to hold religious relics.

Sturm, Der

(German, 'The Storm'.) A magazine established by Herwarth Walden in Berlin in 1910, and a gallery of the same name established in 1912, which were fundamental in spreading ▷avant-garde ideas to Germany. The magazine reproduced works by ▷Die Brücke and ▷Der Blaue Reiter, translated the ▷Futurist manifesto, and published an explanation of ▷Orphism by ▷Delaunay and ▷Loos' essays on modern architecture. In 1913 Walden organized the first German Herbstsalon (Autumn Salon), the equivalent of the French ▷Salon d'Automne. The magazine continued until 1932, but the gallery closed in 1924.

Bib.: Jones, M.S., *Der Sturm: A Focus of Expressionism*, New York, 1984; Winskell, K., 'The Art of Propaganda: Herwarth Walden and *Der Sturm*, 1914–1919', *Art History*, 18/3 (Sept 1995), pp. 315–44

style

'Style,' wrote Lord Chesterfield to his son in 1749, 'is the very clothing of thought'. Thus style itself can be a system of signs used to embrace meaning, whatever the art or its ▷medium. Every work of art and architecture has a meaning – an ▷iconography – and a set of characteristics special to it. In a statue these might include the way the marble is cut and polished; in a drawing, the way the ▷pencil or ▷chalk is handled to produce line and form; in a building, the particular combination of elements and masses. It is an article of art-historical faith that art works may be grouped together through stylistic features, so that unsigned ones may nevertheless be attributed (▷attribution) to one specific artistic personality because of the characteristics they all share. Periods and even countries might also share characteristics that will allow unattributed art works to be assigned to a country, a period or a ▷school.

If it were not possible to handle stylistic characteristics in this fashion, there would be little art history, since the discipline would be restricted to signed works of unimpeachable authenticity or ▷provenance, and neither of these factors takes into account the propensity of us all to increase our understanding by classifying our material. Some scholars are noted for possessing an 'eye' that enables them to group works together – Beazley for Greek vases, or ▷Berenson (with 'B.B.'s Lists') for early Italian paintings and drawings – the proof of the attribution being only that it stands the test of time. Other art historians, such as ▷Morelli, have found this approach too hit-and-miss and have sought to erect stylistic analysis into a science.

Bib.: Gombrich, E.H., 'Style', in *Encyclopaedia of the Social Sciences*, 15, New York, 1958, pp. 352–61; Schapiro, M., 'Style', in *Anthropology Today*, ed. A.L. Kroeber, Chicago 1953, pp. 287–312; Semper, G., *Der Stil in den technischen und tektonischen Künsten*, original edition, 3 vols., 1860–3, republished Frankfurt, 1974; Wölfflin, H., *Principles of Art History*, New York, 1932

stylize

The process of stylization involves not the 'direct representation' (if such a thing exists) of objects from the natural world (in particular), but the application of a 'filter' of some kind, for example simplification, insistent swinging linearity, geometricization, reworking of some other transformation. Perhaps all two-dimensional art is in some way stylized, not least because it seeks to make a flat pattern out of a three-dimensional object.

Subleyras, Pierre (1699–1749)

French painter. He produced mainly religious works, but also some mythological subjects and portraits. He was active mainly in Rome. Born in the south of France, he trained first at Toulouse in the studio of Antoine Rivalz (1667–1735). In 1724 he entered the Paris ▷Académie and in 1727 won the ▷Prix de Rome which gained him entry to the Académie de France in Rome. In 1728 he left for Rome never to return. His work was acclaimed by his masters and he very soon began to win commissions. He executed

several important works for various religious orders for churches in Rome and elsewhere in Italy. In 1739, he married Maria Felice Tibaldi, a miniature painter who made miniatures of her husband's paintings and also collaborated with him on a number of works. Subleyras ultimately enjoyed the patronage of Pope Benedict XIV, who commissioned from him an official portrait (1741, several versions extant). His most prestigious papal commission, however, was an ▷altarpiece, *The Mass of St. Basil*, for St. Peter's (1748, now in S. Maria degli Angeli). Unfortunately his triumph was short-lived for he was already suffering from the tuberculosis which killed him a year later. His paintings are rooted in an austere Classicism achieved through compositional equipoise, a purifying simplification of form and a limited and finely balanced scale of tonal values (e.g. *Charon Ferrying the Dead*, 1749, Paris, Louvre). For many years underrated, a major retrospective exhibition of his work, mounted in Paris and Rome in 1987, sought to re-establish him as one of the pre-eminent French painters of the 18th century.

Bib.: *Pierre Subleyras 1699–1749*, exh. cat., Paris, 1987

sublime

A term with Classical origins which came into popular use during the 18th century and is most associated with ▷Romanticism. It was commonly associated with the writings of ▷Longinus on rhetoric and had literary and religious uses, meaning immensity and boundlessness. By the time of ▷Addison's *Pleasures of the Imagination*, it had the added definition of divinely inspired genius. However, it was ▷Burke who endowed the word with its full Romantic significance, and who first emphasized its links with landscape: terrifying nature, when seen through art, could create the feeling of the sublime, in comparison with the safe, quiet feeling inspired by beauty. Initially artists such as ▷Rosa fulfilled sublime criteria but increasingly his controlled and ▷picturesque spectacles palled. By the 1790s sublime nature was identified as the Alps and both artists (e.g. ▷Turner and ▷Cozens) and poets like Shelley travelled there to be inspired and overawed. The insignificance of man was emphasized by artists such as ▷Martin and ▷Danby, whilst ▷Fuseli and others put the sublime into a historical and literary context.

Bib.: Monk, S.H., *Sublime: A Study of Critical Theories in 18th Century*, London, 1960; Paley, M.D., *Apocalyptic Sublime*, New Haven, 1986; Wilton, A., *Turner and the Sublime*, London, 1980

sudarium

(Latin, 'napkin'.) St. Veronica's handkerchief, which was used to wipe ▷Christ's face when he was carrying the cross to ▷Calvary and which remains an image of the suffering Christ.

Suger, Abbot (1081–1151)

Abbot of ▷St-Denis (1122–51), whose patronage has traditionally been believed to mark the start of the ▷Gothic period. He was an ambitious and controversial figure, whose twin ambitions – strengthening the power of the Royal House of France and 'aggrandizing' the abbey of St-Denis – involved a variety of dubious political moves. His treatises, including *De Administratione*, which often attacked St. Bernard and asceticism, demonstrate a love of brilliance, splendour and light, through which Suger believed men could be led away from material concerns to a closer understanding of the greatness of God. The treatises may well have had a political content in that they rebuffed critics of the Abbey's spending policies, changing materialism into a devotion to God. Although he was responsible for the rebuilding of St-Denis it is unclear how much Suger had to do with the formation of the Gothic style and how much depended upon the interpretation of his doctrines and philosophy by a particular group of craftspeople.

Sullivan, Louis (1856–1924)

American architect. He was born in Boston and studied at MIT, before a brief spell at the ▷École des Beaux-Arts in Paris (1874). He returned to work for Frank Furness from 1875 and for the steel pioneer, Jenner, in Chicago. Together with Dankmar Adler (1844–1900), he established the ▷Chicago School in 1881. He specialized in commercial buildings, designed with the emphasis on function and structure, and with only limited reference to historical styles. He utilized a light metal frame, creating open-plan floors and large windows, and building some of the first high-rise blocks (e.g. Auditorium Building, 1886, Transportation Building, Chicago World Exhibition, 1893). From 1895 he worked with Emslie (e.g. Carson Pirie Scott Department Store, Chicago, 1899–1904). The domestic side of his business was increasingly handled by Sullivan's protégé ▷Wright. His architectural philosophy, expounded in the publication *Kindergarten Chats* (1901–2), was summed up by the phrase 'form follows function', though his buildings did in fact utilize external decoration, much of which was influenced by ▷Art Nouveau.

Bib.: Frazier, N., *Louis Sullivan and the Chicago School*, London, 1991; Frei, H., *Louis H Sullivan*, Zurich, 1992; Morrison, H., *Louis Sullivan: Prophet of Modern Architecture*, Westport, 1971

Sully, Thomas (1783–1872)

American painter of English birth. He was born in Lincolnshire, but moved to South Carolina while still a boy. He moved again to New York City, Boston and Philadelphia, and in 1809 he returned to England to study art. There he was influenced by the work of ▷Lawrence. He was a prolific painter, producing over 2,000 portraits, as well as historical subjects. Among

his most famous historical works was *Washington Crossing the Delaware* (1819, Boston, Museum of Fine Arts), which glorified the deeds of the first President. He returned to England in 1837–8 when he was commissioned to paint portraits for Queen Victoria.

Sunday Afternoon on the Island of La Grande Jatte, A

Painted by ▷Seurat and exhibited at the eighth and final ▷Impressionist Exhibition in 1886. There it was acclaimed by critics but caused a public scandal. It is regarded as initiating the ▷Post-Impressionist movement. A large canvas, measuring 2 × 3 m (6 ft 8 in × 10 ft), it shows around 50 figures enjoying a day of leisure in a green, wooded area bordered by a river. La Grande Jatte, a small island in the Seine, north-west of the centre of Paris was a popular site for weekend excursions. Positioned between the bourgeois suburb of Asnières and industrial Clichy, it was a zone where the classes intermingled on Sunday – their only shared day off.

Seurat's characters are static and placed in profile, with no pretence of a naturalistic rendering. Their faces are mostly indistinguishable, so they are defined by their costumes and props: hats, umbrellas, bustles, canes. But while in the past such symbols would help to identify characters and fix their social status, in Seurat's painting bourgeois and worker (with one or two exceptions) use the same tokens of fashion to hide their social status. A few details, such as the girl fishing and the tame monkey, have also been seen as visual puns linking some of the apparently respectable female characters to contemporary Paris slang for prostitutes.

The geometric composition and ▷pointillist technique (drawing on contemporary ▷divisionist theories of colour) are a departure from the freedom and spontaneity associated with Impressionism. Moreover, through the formal composition within which these 'moderns' are located in an ironic vision of the classical mode, Seurat is also searching for an alternative to the Impressionists' idea that the moment is paramount. Seurat's friend ▷Félix Fénéon stated that the painter's divisionist art relied on 'structure and science, not intuition and chance'. However, Seurat's techniques do provide a suitable means of representing a world in which the rigid distinctions of fashion have entered nature and leisure time – the behaviour on the Grande Jatte is as highly formalized and controlled as during the working week.

The importance of this painting to the future of modernity and the ▷Neo-Impressionists is evident, and Seurat himself showed his own conviction and dedication to these goals to the extent that he even copied *La Grande Jatte* in one of his other paintings *Les Poseuses* (1886–8) as a canvas leaning against the wall of the artist's studio with the models of the title in the foreground. *A Sunday Afternoon on the Island of the Grande Jatte* is now in the Art Institute of Chicago.

Sung
▷Chinese art

Superrealism
▷Photorealism

Supper at Emmaus
(Luke 24: 28–32.) A manifestation of ▷Christ after the ▷Resurrection, mentioned only in Luke. Immediately after the tomb is found empty, two of Christ's followers are walking to Emmaus when they are joined by a third whom they do not recognize and who seems to know nothing of the recent events in Jerusalem. By now the followers know that Christ's tomb has been found empty and that the women who visited it that morning had a vision of an angel who told them that Christ had risen: all this they tell the stranger. On arriving at Emmaus they ask the stranger to stay with them; he does, and whilst dining with them he breaks the bread, blesses it and gives it to them. At this point they recognize him as Christ and he disappears.

Although the walk is sometimes portrayed (e.g. Altobello Melone, *The Road to Emmaus*, London, National Gallery), it is the supper with the breaking of bread that is doctrinally important, being a type of the ▷Last Supper, and an early proof that Christ had risen from the dead (and therefore that all who believed in him would too). The subject does not seem to appear before the 12th century. By the 16th century it had become a popular theme in Venetian art, but was often swamped with extraneous figures and secular details (e.g. ▷Veronese, c1559/60, Paris, Louvre); in the 17th century, however, it regained its spiritual content (e.g. ▷Caravaggio, c1600–1601, London, National Gallery). As in many versions, Caravaggio identifies the disciples as pilgrims (note the cockleshell pilgrim badge), and although Luke makes no mention of the location for the meal most painters assume it to take place in an inn (note the innkeeper watching the breaking of the bread). Caravaggio's version is unique for its time in showing a beardless Christ – perhaps, it has been suggested, to allude to his appearance being disguised from the two disciples.

support
The generic term given to the ▷canvas, ▷panel, ▷paper, ▷ivory or other material on which a painting is executed.

Suprematism
An early 20th-century form of geometric ▷abstraction. Suprematism avoided representing the visible world in favour of a ▷non-objective abstraction in which the art work stood only for itself – in other words, as 'pure' art. ▷Malevich, the movement's founder, published a manifesto explaining his aims in 1915. Stylistically, Suprematism used simple

geometrical shapes, such as the circle, square or cross, disposed across the picture plane with little or no recession into depth, as, for example in Malevich's *Suprematist Composition:* ▷*White on White* (1918, New York, Museum of Modern Art). The movement, which reached its apogee in revolutionary Russia, had a significant influence in the development of ▷Constructivism.

Bib.: Bann, S. (ed.), *The Tradition of Constructivism*, London, 1974; *Kasimir Malevich: 1878–1935*, exh. cat., London, 1976

Surrealism

An artistic movement that arose out of the ashes of the self-destructive ▷Dada, its arrival announced in Paris by the publication of ▷André Breton's *Surrealist Manifesto* in 1924. This defined Surrealism as 'pure psychic automatism by which it is intended to express, either verbally or in writing, the true function of thought. Thought dictated in the absence of all control exerted by reason, and outside all aesthetic or mental pre-occupations.' Breton and the earliest members of the movement – including Louis Aragon, Paul Eluard and Benjamin Péret – saw their literary antecendents in such writers as the Comte de Lautréamont, Mallarmé, de Sade, and ▷Apollinaire, and artists such as ▷Moreau and, especially, ▷de Chirico. The Surrealists' interest was in unlocking the ▷Freudian unconscious through ▷automatism, dreams and chance, and overthrowing the rational. Theirs was also a social and political movement that aligned itself to the Left, a position dictated in reviews such as *La Révolution Surréaliste* (*The Surrealist Revolution*, 1924)

and *Le Surréalisme au service de la Révolution* (*Surrealism in the Service of Revolution*, 1930). The Spanish film director Luis Buñuel made the most successful use of Surrealist techniques in the cause of socialism.

The Surrealist movement included a number of the foremost European artists of the 1920s and 1930s, including ▷Max Ernst, ▷Hans Arp, de Chirico, ▷Tanguy, ▷Miró, ▷Masson, ▷Man Ray, and the Belgians ▷Magritte and ▷Paul Delvaux. Their interest in the female nude drew numerous women within the circle of the movement, and Surrealism's concern for the body and the unconscious proved a fertile ground for artists such as ▷Meret Oppenheim, ▷Kay Sage, ▷Dorothea Tanning and and Léonor Fini. The First International Surrealist Exhibition took place in London in 1936, and the movement was taken up ▷Herbert Read, who wrote in his introduction to the exhibition catalogue that Surrealism was 'the desperate acts of men too profoundly convinced of the rottenness of our civilization to save a shred of its respectability'. It influenced leading British artists such as ▷Paul Nash, ▷Roland Penrose, ▷Henry Moore, ▷Eileen Agar, ▷Francis Bacon, Humphrey Jennings and ▷Ithell Colquhoun, though in Britain it merged with the less political tradition of English ▷Romanticism. Successive exhibitions occurred in Paris in 1938, 1947 and 1959 but by the 1950s Surrealism's force was largely spent.

Bib.: Ades, D., *Dada and Surrealism Revisited*, London, 1978; Breton, A., *Manifestos of Surrealism*, English trans., 1969; Chadwick, W., *Women Artists and the Surrealist Movement*, London, 1985; Nadeau, M., *The History of Surrealism*, Cambridge, MA, 1989

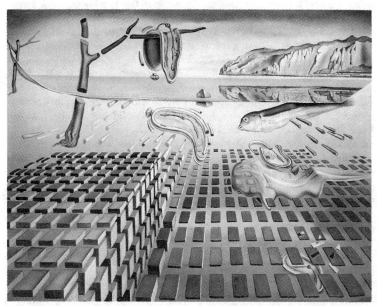

Surrealism: Salvador Dali, *The Disintegration of the Persistence of Memory*, 1952–4, Salvador Dali Museum, St. Petersburg, Florida

Susanna and the Elders

(Old Testament Apocrypha.) The story is set during the Hebrew captivity in Babylon. A beautiful young married woman of impeccable virtue was desired by two elders. Knowing that she was in the habit of bathing in her garden, they stole in, secreted themselves, waited for her maids to disperse and revealed themselves to her, threatening that unless she gave herself to them, they would accuse her of the capital crime of adultery. She resisted their advances and the two elders duly reported her as an adulteress. She was condemned to die but ▷Daniel intervened, cross-questioned the elders, broke their false story, and proved Susanna innocent. To the Early Church Susanna symbolized purity triumphant over evil and the Christian soul triumphant against non-believers. Susanna was also a prefigurative type of the ▷Virgin. In the Middle Ages the edifying episode of the unveiling by Daniel of the elders' lies was the episode most often portrayed, but during the 16th and 17th centuries the bathing scene became more attractive to both artist and patron, most often perhaps for the opportunity it offered for the portrayal of nubile female nudity, made respectable by its biblical context (e.g. ▷Tintoretto, 1555, Vienna, Kunsthistorisches Museum), although the vulnerability of a naked woman beset by the predatory elders is poignantly conveyed by ▷Artemisia Gentileschi (1610, Pommersfelden, Schloss Weissenstein).

Sutherland, Graham Vivian (1903–80)

British painter and etcher. He was born in London, the son of a lawyer, and in 1919 was apprenticed into the engineering department of the Midland Railway Works at Derby. He attended Goldsmiths College (1921–6), originally training as a goldsmith, before studying etching at the ▷Royal College of Art. He taught at the Chelsea Art School from 1927. He only began painting during the 1930s, when he became interested in landscape, portraying Pembrokeshire (from 1934) and Cornwall with a moody ▷Surrealism. His belief in the strangeness of nature was similar to that of ▷Nash and increasingly his work moved towards abstraction (e.g. *Entrance to the Lane*, 1939, London, Tate Gallery). He also produced landscape ▷etchings, influenced by ▷Palmer. He exhibited at the Surrealist exhibition in London in 1936. After the Second World War, during which he was an official artist (e.g. *Devastation, 1941, East End Street*, 1941, Tate), he increasingly concentrated on portraiture (e.g. *Somerset Maugham*, 1949, Tate), and expanded upon the design work he had undertaken during the War – the *Wanderer* ballet sets (1940), and the *Glory* tapestry for Coventry Cathedral (1954–7). He also produced ▷poster designs and book illustrations and from 1952 experimented with sculpture. His post-war work was increasingly influenced by ▷Picasso (e.g. *Deposition*, 1946, Cam-

bridge, Fitzwilliam Museum). He settled in France in 1956. He was awarded the Order of Merit in 1960.
Bib.: Alley, R., *Graham Sutherland*, London, 1988; Berthold, R., *Graham Sutherland: A Biography*, London, 1982; Hayes, J., *Graham Sutherland*, Oxford, 1980

Swart van Groningen, Jan (c1500–after 1553)

Netherlandish painter and illustrator. He worked in Antwerp. He was influenced by the works of ▷Dürer and ▷Holbein, and he produced ▷woodcuts for the Dutch Bible (1528). He also did designs for stained glass.

Sweden, art in

▷Scandinavian art

Sweerts, Michiel (1618–64)

Flemish painter. He specialized in portraits and ▷genre scenes. He was born in Brussels. He travelled to Italy in or before 1646 for, in that year, he is recorded as an associate member of the Accademia di San Luca in Rome. Until 1651 he is listed as a resident of the Via Margutta in the parochial registers of S. Maria del Popolo. He stayed until at least 1656, painting in a style influenced by the ▷*Banboccianti* (*banbocciata*), the Dutch and Flemish artists who painted low-life and genre scenes for the Italian market (e.g. *Soldiers Playing Dice*, c1649, Paris, Louvre). In addition, Sweerts painted a number of pictures of artists working in the studio (e.g. *The Academy*, c1656, Haarlem, Frans Hals Museum). He had definitely returned home by 1656 because in that year he applied to the magistracy of Brussels to open a drawing academy of his own. In 1659 he enrolled in the Brussels Guild of Painters. Once returned from Italy his work took on the influence of ▷Vermeer, and his best paintings (e.g. *Portrait of a Girl*, Leicester, Museum and Art Gallery) fully reveal the cool palette and classical simplification of forms hinted at in his earlier work. Sweerts was a Catholic, and in 1661 he became a lay brother and travelled to Syria and Persia, where he worked initially as a missionary. However, he seems to have been temperamentally unsuited to the work. He had a number of disagreements with his brothers and was dismissed. He nonetheless remained in the east, continued to paint, and later died in Goa, India.
Bib.: Bloch, V., *Michiel Sweerts: suivi les Sweerts et les missions étrangères*, La Haye, 1968; Waddington, M., 'Two Enigmatic Portraits by Michiel Sweerts', *Apollo*, 24 (Aug 1986), pp. 95–7

Symbolism

Symbolism began as a literary movement that developed from ▷Romanticism in France in the second half of the 19th century, taking its themes of decadence, dandyism and mysticism from the novels of J.K. Huysmans. The poet Jean Moréas gave the term general currency in his manifesto in *Le Figaro* in 1886,

though the poet Stéphane Mallarmé developed its ideas of suggestion, ambiguity and symbolism rather than direct conveyance of meaning: 'Suggestion, that is the dream', he declared. Like Romanticism, Symbolism favoured feelings over reason, but was more intellectual in its conception. Huysmans in his novels *À Rebours* and *Là-bas* was significant in promoting the painters ▷Gustave Moreau and ▷Odilon Redon and drawing the visual arts into the movement.

The use of symbols has had a long tradition in European art, and we may see origins of 19th-century Symbolism in the mystical and visionary works of ▷Piranesi, ▷Fuseli, ▷Goya and ▷Friedrich. The ▷Pre-Raphaelite Brotherhood's return to an Early ▷Renaissance style and mood was a more contemporary influence. The art of Symbolist painters such as ▷Puvis de Chavannes and Eugène Carrière was thus characterized by a desire to use evocative subjects and images rather than explicit analogy or direct description. However, the movement was more interested in the content and concept of expression of the inner life rather than artistic style or form. Many Symbolists were also interested in the macabre, the mysterious and the morbid, which has been seen as a phenomenon of the ▷*fin de siècle*. Symbolism had far reaching influences as a movement in reaction to ▷Realism and ▷Impressionism, and the ▷Nabis and ▷Gauguin were closely related to the Symbolists, as well as the Swiss painter ▷Ferdinand Hodler and the Norwegian ▷Edvard Munch.

Bib.: *Lost Paradise: Symbolist Art in Europe*, exh. cat., Montreal, 1995

synaesthesia

A condition in which one of the five senses seems to respond to stimuli directed at a different sense (e.g. smells which seem to have colour, or images which can be characterized as noisy). Synaesthesia was an important concept to some early 20th-century artists, especially ▷Kandinsky. In his book *Concerning the Spiritual in Art*, Kandinsky attempted to characterize properties of colour with reference to their synaesthetic aspects.

Synchromism

A theory devised by the American artists ▷Stanton Macdonald-Wright and ▷Morgan Russell while they were in Paris in c1912–13. Influenced by the colour experiments of ▷Delaunay and ▷Kupka,

and the colour theories of Michel-Eugène Chevreul, ▷Charles Blanc and ▷Ogden Rood, they developed a scientific theory of colour which helped pave the way for ▷abstraction. They had exhibitions at the Neue Kunstsalon, Munich, and at the Bernheim Jeune Gallery in 1913. They were especially influential in America during the years of the First World War.

Synthetic Cubism
▷Cubism

Synthetism

A term first used in 1876 to distinguish between the scientific and naturalistic strands of ▷Impressionism. It is most commonly associated with ▷Gauguin and ▷Bernard, who used it to define their ▷cloisonnist technique (heavy outline and flat areas of strong, pure colour) and their exploration of spiritual ideas in their art in Brittany c1888 (▷Pont-Aven): in Bernard's words, 'We must simplify in order to disclose meaning.' A Synthetist exhibition was held at the Café Colpinin in 1889 and Le Groupe Synthétiste was established in 1891, including also Charles Laval and ▷Anquétin. The group was part of a broader ▷Symbolist movement and had connections with the ▷Nabis through ▷Sérusier. Like the Symbolists they sought expressive and decorative qualities at the expense of naturalism.

Bib.: Rookmaaker, R.H., *Synthetist Art Theories*, Amsterdam, 1959

Systematic art

A term first used in 1966 by art historian Lawrence Alloway, in an exhibition of work at the Guggenheim Museum in New York, to describe an aspect of ▷Minimalism. He included in the description all artists who experimented with ▷serial works or with single abstract images in their art, thus achieving 'variety in unity'. The term came to be used to describe some ▷colour field artists and ▷Post-Painterly Abstractionists who used grids and repetition (e.g. ▷Stella, ▷Reinhardt and ▷Noland). Systematic art differed from ▷Abstract Expressionism in that the final appearance of the work was predetermined, planned and controlled by the artist. There is a link between the abstract repetitions of systematic artists and the use of serial images by ▷Pop artists.

Bib.: Battcock, G., *Minimal Art: A Critical Anthology*, London, 1968

tabernacle

(i) A free-standing canopied structure, or a canopied ▷niche or recess set into a wall or pillar, to house a statue or painted image. In Classical architecture, known as an ▷aedicule. (ii) In a Catholic church, an ornamental receptacle, often shaped like a small building, placed upon the altar to house the pyx containing the consecrated host. The term derives from the Latin *tabernaculum*, 'tent'.

Tacca, Pietro (1557–1640)

Italian sculptor. He was from Florence. He worked in bronze and was a pupil and then principal assistant of ▷Giambologna. Following his master's death, he became Giambologna's successor as Sculptor to the Grand Dukes of Tuscany. As heir to his master's studio, Tacca also completed a number of Giambologna's commissions, such as the ▷equestrian statues in Florence (Ferdinand I, 1608), Madrid (Philip III, 1616) and Paris (Henry IV, destroyed 1792). His most celebrated work is the group of *Four Slaves* (1615–24) around the base of Giovanni Bandini's Monument to the Grand Duke Ferdinand I in Livorno. His major Florentine commissions were the statues of Ferdinand I and Cosimo II (1627–34, San Lorenzo, Cappella dei Principi). His last work was the bronze Equestrian Statue of Philip IV (1634–40, Plaza de Oriente, Madrid). Tacca was required to base this work on the painting by ▷Rubens, showing Philip on a rearing horse. Although Tacca himself had already made a statuette in a similar pose, the difficulties inherent in achieving the correct balance meant that it had never been carried off at full-scale. Tacca tried and succeeded, and his brilliant technical achievement was the inspiration for ▷Falconet's Equestrian Statue of Peter the Great at St. Petersburg.

Bib.: Torriti, P., *Pietro Tacca da Carrara*, Geneva, 1984; Watson, K., *Pietro Tacca, Successor to Giovanni Bologna*, New York, 1983

Tachism(e)

A term introduced by the French critic Charles Estienne in 1954 to describe European ▷Abstract Expressionist and ▷Action painting (it is also sometimes used in the context of American painting). The term ▷Art Informel is also used to describe artists like ▷Wols, ▷Hartung, ▷Michaux and ▷Dubuffet who used blots, patches, heavy ▷impasto and calligraphic colour as 'gestures' of emotion. Such artists emphasize the spontaneous act of painting and the physicality of the paint above the final product or conventional subject matter. The term can also be used more generally to mean the application of colour spots for its own sake – '*tache*' translates literally as 'blob'. In the 19th century, Fénéon used the word to describe ▷Impressionism; it was also coined as a pejorative description of ▷divisionism, and in 1909 ▷Denis described the ▷Fauves as 'tachists'.

Bib.: Mathieu, G., *Au-delà du Tachisme*, Paris, 1963

tactile values

A term coined by ▷Bernard Berenson in his *Italian Painters of the Renaissance* (1896). He intended it to signify an image that appears to be so real that you could touch it. The term conveyed the sense of weight and texture that very skilled artists were able to convey through the two-dimensional medium of paint.

Taddeo di Bartolo (c1360/65–1422)

Italian painter. He was from Siena, where he ran a large and successful workshop and worked in a conservative style owing much to ▷Simone Martini (cf Taddeo's *Annunciation*, 1409, Siena, Pinacoteca with that by Simone, 1333, Florence, Uffizi). Outside Siena, Taddeo was active in San Gimignano (*Last Judgement* fresco in the Collegiata, 1393), Pisa (1395 and 1397), Perugia (1403) and Volterra (1411). In 1406–7 he painted the frescos for the Chapel of the Virgin in the Palazzo Pubblico, Siena, and in 1413–14, for the antechamber of the same chapel, a series of ▷frescos illustrating Roman Republican Virtues. Taddeo's last dated painting is a *Madonna* of 1418 (Harvard University, Fogg Museum).

Bib.: Solberg, G.E., 'A Reconstruction of Taddeo di Bartolo's Altarpiece for S. Francesco a Prato', *Burlington Magazine*, 134 (Oct 1992), pp. 646–56; Symeonides, S., *Taddeo di Bartolo*, Siena, 1965

taenia

An architectural term for the strip located between a ▷Doric ▷frieze and an ▷architrave.

Taine, Hippolyte (1828–93)

French historian and critic. He was born in Vouziers and educated in Paris. He taught throughout his life, including a period at the ▷École des Beaux-Arts from 1864, but was in constant difficulties with both the Church and civilian authorities of the Second Empire because of his views. He wrote a number of histories, and particularly admired England for its parliamentary

and Protestant traditions. In 1865 he published his *Philosophie de l'Art*, based on his academy lectures. He shared with Renan a Positivist view, influenced by the philosophers ▷Hegel and Spinoza, that art and artists were a product of their social environment, race and period. He opposed ▷Romantic ideas of individual creativity and inspiration.

Bib.: Goatz, T.H., *Taine and the Fine Arts*, Madrid, 1973

Takis (Panayotis Vassilakis) (b 1925)

Greek sculptor. He was born in Athens. He was untrained as an artist, but lived in London and Paris, where he began to produce wire ▷kinetic sculptures from the 1950s. During the 1960s, he carried his kinetic experiments further by using magnets to enable movement through natural forces.

Talashkino

A Russian school of art and art colony located on the estate of Princess Tenishevo during the 1890s. The estate was near Smolensk, and like the ▷Abramtsevo Colony, the artists who worked there were interested in developing native Russian craft traditions for the modern world. Among the artists who spent time there was ▷Vrubel.

Tamayo, Rufino (1899–1991)

Mexican painter of Zapotec descent. He was born in Oaxaca but following the death of his parents in 1911, went to live with his aunt in Mexico City. He studied at the Escuela des Artes Plasticas, and in 1921 was appointed head of the Department of Ethnographic Drawing at the Archaeological Museum, which introduced him to ▷folk art. In 1936–48, he was based in New York, and after the exhibition which marked his return to Mexico (at the Pallacio des Bellas Artes, 1948) was bitterly attacked by the ▷muralists for its disavowal of popular and accessible forms, he moved to Paris. He finally returned to Mexico City in 1964, donating his collection of ▷Pre-Columbian art to Oaxaca to form the Museo de Arte Prehispanico de Mexico Rufino Tamayo. In 1981 his collection of modern art opened to the public at the Museo de Arte Contemporaneo Internacional Rufino Tamayo in Mexico City.

Tamayo was an outsider in post-Revolutionary Mexico, politically neutral and opposing the muralists' commitment to a public, popular art. His own paintings draw on Mexican ▷folk art and ceramics for their themes and in their rich use of colour and texture, but their sophisticated compositions are more closely indebted to ▷Cubism. In the 1930s he painted tropical fruits, perhaps influenced by his experiences as a child working for his aunt's wholesale fruit business. Later his imagery became more grotesque, dominated by animals. From the mid-1940s onwards, he moved towards abstraction and placed greater emphasis on his use of strong colours.

Bib.: Paz, O. and Lassaigne, J., *Rufino Tamayo*, New York, 1982; *Rufino Tamayo, Myth and Magic*, exh. cat., New York, 1979

tanagra

A ▷terracotta figurine, named after the town of Tanagra in east Boetia, Greece, where the first were excavated by the French in 1874 in a cemetery dating from the late 4th and 3rd century BC. Generally brightly coloured, they were intended as votive figures and represent a wide range of ▷genre subjects, the most common being of elegantly draped women talking, laughing, singing and making music. They appear to have been produced in large numbers throughout ▷Hellenistic Greece and Greek Asia Minor. The figures aroused considerable interest in Paris in the 1870s and inspired the French painter and sculptor, ▷Jean-Léon Gérôme, to produce his own *Tanagra*: a monumental female nude in tinted marble, seated upon an excavation mound, pick-axe at her feet, holding in her left hand an imitation polychrome Tanagra figurine. It was the sensation of the Salon of 1890.

T'ang

▷Chinese art

Tanguy, Yves (1900–55)

French–American painter. He was born in Paris and started a career as a sailor. When he met Jacques Prévert he moved to Montparnasse in 1922, and, with no formal training as an artist, was inspired to become a painter on seeing a work by ▷de Chirico in a Paris gallery in 1923. In 1925 he met ▷André Breton and became a fully-fledged member of the ▷Surrealist movement. In paintings such as *He Did What he Wanted* (1927) and *Mama, Papa is Wounded!* (1927), he developed the geometric space and strange perspectives of de Chirico in paintings of exuberant space and colour. He shared the interest of ▷Max Ernst, ▷Miró, ▷Arp and ▷Dali in free-flowing lines and organic shapes, as seen in *Indefinite Divisibility* (1942). In 1939 he met the American Surrealist painter ▷Kay Sage and moved with her to the USA, settling in Woodbury, Connecticut, and becoming an American citizen in 1948.

Tanning, Dorothea (b c1910)

American painter and sculptor. She was from Illinois. She spent only two weeks at the Art Institute of Chicago, and otherwise was largely self-taught. While in New York in 1937 she saw a ▷Surrealist exhibition, and at that time began painting fantasy pictures in a realist style. She went to Paris in 1939 and returned there to live in the 1950s. She met and married ▷Max Ernst. While in France during the 1950s, her interest in fantasy intensified, and she became fascinated by the

works of Edgar Allen Poe and ▷Aubrey Beardsley. Many of her works take on themes from childhood and deal with issues of women's sexuality.

Bib.: Lumbard, P., 'Dorothea Tanning: On the Threshold of a Darker Place', *Women's Art Journal*, 21 (1981), pp. 49–52

tapestry

A fabric, usually of silk or wool or a mixture of the two, hand-woven on a loom; the design of the tapestry being woven in during manufacture to form an integral part of the textile. The most important places of manufacture from the 14th century onwards include: Arras, Brussels and Tournai in the Low Countries; Aubusson, ▷Beauvais and the ▷Gobelins factory, Paris, in France; and Fulham and Mortlake in England. The earliest surviving European tapestry is the Cloth of St. Gereon, woven in Cologne in the early 11th century, fragments of which are dispersed between the Germanische Nationalmuseum, Nuremberg, the Musée Historique des Tissus, Lyons, and the Victoria and Albert Museum, London. The so-called ▷Bayeux Tapestry is not, in fact, a tapestry but an ▷embroidery.

Tàpies, Antoni (b 1923)

Spanish painter. He studied in Barcelona, where he was a founder member of ▷Dau al Set in 1948. He was interested in Far Eastern sources for his art, as well as the work of ▷Picasso, whom he knew and visited in Paris. He exhibited in a number of international shows. His ▷collage and ▷graffiti work evinced elements of ▷Arte Povera. He used ▷junk objects which he decorated with dribbles and splashes of colour and to which he attached strings, dust and other objects.

Target Exhibition

Held in Moscow in March 1913. Organized by ▷Larianov as a showcase for the ▷Rayonist works of ▷Goncharova and himself, and an assertion of independence from the ▷Jack of Diamonds group. An accompanying manifesto decried the influence of the West and sought an art based on the exploration of colour and spatial forms. ▷Malevich also took part, exhibiting his ▷Cubo-Futurist works including *The Knife-Grinder* and *The Woodcutter*.

tarsia

▷intarsia

Tassi, Agostino (Agostino Buonamici) (c1580–1644)

Italian painter. He was from Rome. He painted the ▷quadratura details in ▷Guercino's *Aurora* (1621–3) in the Casino Ludovisi, Rome. He also produced small works in the manner of ▷Elsheimer and was a teacher of ▷Claude. He was accused of raping ▷Artemisia

Gentileschi, but was released from prison, despite a judgement against him.

taste

There are two aspects to taste, one fugitive, the other innate. In the words of the critic John Steegman, taste 'possesses both an immutable quality of discernment, criticism and perception, independent of special knowledge or training … and also an always active sensitiveness to temporary fashions; it can … imply both standards and enthusiasms and can include both those who not only know what they like but know why they like it, and those who only know what the majority of other people like.' Fugitive taste is subject to the appetites of fashion and the marketplace, and is just as swift-changing. In this form it is most clearly discerned in the ▷decorative arts, traditionally quicker to change than painting, sculpture and architecture, although the latter is certainly subject to taste/fashion in the less substantial constructions of parks and gardens. It frequently lives amongst high society, serving as a tool by which its members may be distinguished from the common herd, for whom fashions, whilst certainly existing even in the pre-industrial age, are slower-moving and, even then, usually the result of percolation after a time lapse from their betters.

However, taste can also be innate. For ▷Kant in *The Critique of Judgement*, taste is the completely disinterested faculty for judging an object or a manner of representation as either pleasing or displeasing. The object judged pleasing is beautiful.

Of inestimable benefit to the artists who survive by catering for it, taste changes the faster the more sections of society have access to funds to satisfy their desires, hence the importance of the ▷Industrial Revolution and its social changes in influencing art. Conversely, taste changed more slowly when controlled only by a ruling class, the more so when sumptuary laws regulating which degrees of society might wear what were in force.

Changing taste also affects the ways in which the art of the past is viewed, thereby subjecting it to continuing re-evaluation. This mutability of taste can be seen clearly in the fluctuating fortunes of ▷Classical sculpture, for example, and its appreciation during periods of revivalism such as the ▷Renaissance shows how the re-evaluation of the past can also affect the production of new art. The same holds true not only for art works themselves, but also for the parameters of the discipline of art history.

Bib.: Chambers, F.R., *The History of Taste: An Account of the Revolutions of Art Criticism and Theory in Europe*, 2nd edn., Westport, 1971; Curl, J.S., *Egyptomania, the Egyptian revival, a recurring theme in the history of taste*, rev. edn., Manchester, 1994; Haskell, F. and Penny, N., *Taste and the Antique: The Lure of Classical Sculpture 1500–1900*, New Haven, 1981; Reitlinger, G., *The*

Economics of Taste: The Rise and Fall of Picture Prices 1760–1960, 3 vols., London, 1961–70; Steegman, J., *The Rule of Taste from George I to George IV*, New York, 1968

Tate Gallery

Opened in London in 1897, as part of the National Gallery of British Art. The building designed by Sidney Smith built on the site of the old Millbank Prison was designed to contain the painting and sculpture collection given to the nation by Sir Henry Tate, together with a selection of British paintings transferred from the ▷National Gallery. Its particular concerns were for British art, by artists born after 1790. The premises soon proved to be too small and were extended by Smith in 1899 and subsequently, thanks to the support of the ▷Duveen family. In 1917, after the bequest of Sir Hugh Lane's paintings, the gallery's brief was extended to include modern foreign art, and it broke away from the National Gallery and set up its own Board of Trustees. However, the galleries still remained closely linked and were only legally separated in 1954. The Tate's holdings include works by ▷Hogarth, ▷Gainsborough, ▷Stubbs, ▷Reynolds, ▷Constable, ▷Turner, ▷Blake, ▷Millais, ▷Braque, ▷Modigliani, ▷Spencer, ▷Picasso, ▷Dali, ▷Bacon, ▷Matisse and many others. There are also sculptures by ▷Brancusi, ▷Giacometti and ▷Henry Moore housed in the central sculpture gallery (1937). The Tate has been an astounding success and now has other galleries throughout the UK, including the Tate in Liverpool (opened 1988) and the Tate in St. Ives (opened 1993). There are also plans for an enormous new gallery at Bankside, London.

Tatlin, Vladimir Yevgrafovich (1885–1953)

Russian painter and designer. He is regarded as the founder of ▷Constructivism. Tatlin attended the Moscow School of Architecture, Sculpture and Painting (1902–4) and Penza Art College (1904–10), interspersing his studies with working as a sailor and travelling as far as North Africa. Many of his earliest paintings, contributed to the ▷Jack of Diamonds exhibition (1910) and the Second ▷Union of Youth (1911), draw on imagery of sailors and the sea. In 1913 he visited Picasso, whose ▷Cubist experiments exerted an immediate and profound influence on him. He began to build his own 'constructions' modelled on ▷Picasso's ▷reliefs, and exhibited a series of 'painterly reliefs' in his studio in 1914. Already these showed a distinctive ▷dynamism, and with the 'corner constructions' he exhibited at the ▷Tramway V and ▷0.10 exhibitions in 1915 he formulated and brought to fruition his own Constructivist aesthetic of 'real materials in real space'.

Established as the leader of the ▷avant-garde, Tatlin organized a group exhibition, 'The Shop' (1916) and, with Georgy Yakulov and ▷Rodchenko, decorated the Café Pittoresque, a hang-out for Moscow bohemians.

Tatlin flourished in the early years of the Revolution as his Constructivist ideas were widely adopted as the artistic expression of revolutionary ideology, and he played an active role in the Bolshevik reorganization of art institutions. In 1920 he unveiled a wooden model of his projected ▷Monument to the Third International. While greeted with enthusiasm by other artists, this implausible construction was regarded with scepticism by Trotsky and Lenin, and Tatlin's political influence began to wane. Possibly in response, he issued a *Programme of the Productivist Group* the same year, arguing for art with a practical purpose. Through the early 1920s he designed furniture, cheap winter clothing and a stove, all intended for mass-production. He was appointed director of the Department of Theatre and Cinema at the Kiev Art School (1925–7), and held classes in wood, metal and ceramics at the Higher Technical Institute in Moscow (1927–30). From a tower at the Novadevichy Monastery in Moscow, he studied the flight of insects to develop his own wooden flying machine. The result was *Letatlin*, a model of which was exhibited in 1932 to a predictably hostile response, since for all its glories as an exercise in design it was incapable of flight. Marginalized in the last 20 years of his life, he taught intermittently (with a stint at the Moscow Centre for Glider Research, 1950–53), worked on theatre designs and painted relatively traditional portraits, still lifes and landscapes which he did not exhibit.

Tatlin's importance to 20th-century Russian art is inestimable. His 'corner constructions' were a genuinely revolutionary advance on their Cubist forerunners. No longer describing an external reality, their subject is the materials themselves (broken pieces of glass and wood, tin cans and bottles), breaking away from the use of a frame or background to explore a shifting rhythm of intersecting planes within a three-dimensional space. A similar dynamism and command of space operates through his later designs, but despite his avowed productivism, Tatlin was really a visionary rather than a practical designer. His major, all-consuming projects, *Monument to the Third International* and *Letatlin*, were a tower that could never be built and a flying machine which would never leave the ground, pointing to a strong vein of utopianism and fantasy in his work.

Bib.: Milner, J., *Vladimir Tatlin and the Russian Avant-Garde*, New Haven and London, 1985; *Vladimir Tatlin Retrospective*, exh. cat., Cologne, 1993; Zhadova, L., *Tatlin*, London, 1988

Täuber-Arp, Sophie (1889–1942)

Swiss artist. She studied applied art in Munich and Hamburg. She met ▷Jean Arp in 1915, and later married him. The two of them were involved together with the Zurich ▷Dada movement, and she designed

puppets and sets for the performances at the ▷Cabaret Voltaire. She also taught at the Zurich School of Arts and Crafts from 1916 to 1929. From the late 1920s she lived near Paris, where she continued her experiments with design. In the 1930s, she expressed her ▷Constructivist sympathies by joining the ▷Cercle et Carré and ▷Abstraction-Création groups. With ▷Sonia Delaunay and others, she formed an artists' colony which existed at Grasse in Switzerland from 1941 to 1943.

Bib.: Lanchner, C., *Sophie Täuber-Arp*, exh. cat., New York, 1981

Taylor, Sir Robert (1714–88)

English architect and sculptor. He studied with ▷Henry Cheere in England and went to Italy to complete his training. He worked at first as a sculptor, and later as an architect. He designed the pediment of Mansion House in London (1744) in a ▷Rococo style. He was appointed Surveyor of the Bank of England and advocated a ▷Palladian style.

Bib.: Binney, M., *Sir Robert Taylor: From Rococo to Neoclassicism*, London, 1984

Taylorism

The term for the method of 'scientific management' devised by the engineer Frederick Winslow Taylor. Taylor aimed to maximize the output of industrial workers by reorganizing the division of labour according to scientific principles based on time and motion studies. For artists and theorists in the early 20th century, Taylorism epitomized the highly rationalized and mechanistic nature of modern production.

Bib.: Taylor, F.W., *The Principles of Scientific Management*, New York, 1911

Tchelitchew, Pavel (1898–1957)

Russian painter and stage designer. He settled in the United States. Born into a privileged family, he studied stage design in Kiev with ▷Alexandra Exter (1918–29). After the Revolution, he lived in the White Russian communities of Germany and France, designing flamboyant sets for the *émigré* theatre companies of Berlin and exhibiting neo-romantic paintings in Paris and London. He emigrated to the USA in 1934.

Tchelitchew's paintings of the 1920s are highly mannered, and often whimsical with their fondness for circus imagery. His early work as a designer was more innovative. For ▷Diaghilev's ballet *Ode* (1928) he reduced the usually ornate costumes to starkly simple tights, while surrounding the performers with a combination of intricate lighting patterns and back-projected film sequences. This fascination with multiple images was developed in later, ▷Surrealist-influenced paintings such as *Leaf Children* (1939) and *Hide and Seek* (1940–2) showing the transformation of children into trees.

Bib.: Kirstein, L., *Tchelitchew*, Santa Fe, 1994; Tyler, P., *The Divine Comedy of Pavel Tchelitchew*, New York, 1967

Teerlinc, Levina (1510/20–76)

Flemish illuminator. She was born in Ghent. She worked for Henry VIII as well as in the court of Mary I and Elizabeth I.

Telford, Thomas (1757–1834)

British engineer and architect. He was born in Dumfries, the son of a shepherd. He was apprenticed to a stonemason in Edinburgh in 1780 and moved to London in 1782. He was self-taught but got on rapidly through a combination of hard work and good fortune. By 1793, through the patronage of William Pulteney at Shrewsbury Castle, he was surveyor of public works in Shropshire. In that capacity he built the Ellesmere Canal, the first of a series of such projects (he stood out against railways), including the Caledonian Canal. He also oversaw a major road-building programme in Scotland. He is perhaps best known for his use of iron (e.g. Congdon on Tern aqueduct, 1793–4; Bonar Bridge, 1811–12, with a 45 m/148 ft span), but he also designed a number of major stone bridges (e.g. Menai Straits, 1819–26). He was also an architect working in a restrained ▷Classicism (e.g. St. Mary Magdalen, Bridgnorth, 1792–3). He saw himself as a social reformer, promoting the general good through his projects.

Bib.: Beckett, L.D., *Telford's Britain*, Newton Abbott, 1987; Penfold, A. (ed.), *Thomas Telford*, London, 1980; Rolt, L.T.C., *Thomas Telford*, London, 1958

tempera

A method of painting, favoured especially in ▷Renaissance Italy, where an ▷emulsion is used as a ▷medium for the ▷pigment. Egg-yolk or whole eggs were the most common medium, hence egg-tempera, but other substances such as glue, milk, sap or vegetable juice were also used. The technique was used in both ▷panel panting and wall painting.

Temperance

One of the four Cardinal ▷Virtues, along with ▷Fortitude, ▷Justice, and ▷Prudence. Temperance is frequently thought of specifically in terms of alcoholic temperance, thus the most often depicted personification of this moral quality is a woman pouring liquid from one vessel into another, diluting wine with water (e.g. ▷Piero del Pollaiuolo, 1469–70, Florence, Uffizi). Alternatively, as the personification of sexual temperance, she may bear a pitcher and a torch, representing water to extinguish the flames of passion. As a representation of Temperance in general she may carry a sword bound into its sheath with a cord, and may either carry or wear in her mouth a bridle (e.g. ▷Giotto, c1305–6, ▷Arena Chapel fresco, Padua). Sometimes she may also carry a clock or an

egg-timer to indicate the well-regulated life (e.g. ▷Andrea Sansovino, from the Basso Monument, c1507–9, Rome, Sta Maria del Popolo).

Temperaments
▷Four Temperaments

Tempest, The
▷Giorgione's painting, probably executed around 1505, shows a young man with a staff and a woman draped in white cloth and suckling a baby in a lush landscape outside a seemingly empty city. A bolt of lightning overhead, signifying an oncoming storm, is responsible for the title by which the painting is now known. However the circumstances surrounding its composition, its purpose or meaning, and even the original title remain obscure.

The earliest reference was by Marcantonio Michiel in 1530, who noted 'a canvas of a little landscape, with a gypsy and a soldier' at the home of the Venetian nobleman and collector Gabriele Vendramin. By the 19th century the painting had acquired the title *The Family* and the male figure was thought to be Giorgione himself. In the 20th century the critic Edgar Wind described it as an ▷allegory in which ▷Fortitude (the soldier, who stands by a broken pillar) and Charity (the woman with child) are subjected to turbulent Fortune (the storm). Other interpretations have identified the scene as the birth of ▷Bacchus, the rest on the ▷Flight into Egypt, or ▷Adam and Eve exiled from Eden. Recent X-rays have also shown a figure of a woman bathing where the male figure now stands. However, the strength of the painting lies in its intricate and balanced visual structure, reflecting the autonomy of painterly composition from literal or allegorical meanings. The figures may indeed be secondary to the poetic depiction of landscape, and Giorgione has been seen as initiating the rich tradition of landscape painting developed in western Europe through the succeeding two hundred years. *The Tempest* is now in the Accademia in Venice.

Bib.: Holberton, P., 'Giorgione's *Tempest* or "little landscape with the storm with the gypsy": More on the Gypsy and a Reassessment', *Art History*, 18 (1995), pp. 383–403; Settis, S., *Giorgione's Tempest, Interpreting the Hidden Subject*, Chicago, 1990

Tempietto
Designed by ▷Donato Bramante at S. Pietro in Montorio, Rome, in c1502–11. The building was authorized by Ferdinand and Isabella of Spain and constructed on the spot where St. Peter was supposedly crucified. The circular 'little temple' was originally designed as the centrepiece of a circular courtyard, although this was never constructed. The Tempietto consists of a ▷colonnade of 16 ▷Doric columns, raised on three shallow steps, concealing an inner wall indented with niches and supporting a ▷balustrade

and hemispherical ▷dome. As it stands today the dome is more ornate than the ▷Pantheon-inspired structure Bramante envisaged, having been remodelled in the later 16th century. However, the structure retains the architect's immaculate sense of proportion, the width of the peristyle being half the height of the inner cylinder. This harmony in simplicity marked a shift away from 15th-century architectural practice and has led to the Tempietto being seen as one of the first buildings of the High ▷Renaissance.

Bib.: Murray, P. *Bramante's Tempietto*, Newcastle, 1972

Temptation in the Wilderness
(Matthew 4: 1–11; Mark 1: 12–13; Luke 4: 1–13.) Immediately after his baptism by ▷John the Baptist, ▷Christ retired to fast in the wilderness for 40 days. At the end of this period he was tempted by ▷Satan three times: first to turn the stones into bread that he might eat; then to jump from the pinnacle of the temple in Jerusalem in order that he might be caught by angels in proof that he was the Son of God; and lastly by being offered all the kingdoms of the world if he would only bow down and worship ▷Satan. Each temptation was countered by an Old Testament quotation and finally Satan left him and he was ministered to by angels. Having three equally important incidents, the subject lent itself to continuous narrative (e.g. ▷Jakob Cornelisz., *The Temptation of Christ*, c1470–1533, Aachen, Suermondt Museum). Medieval pictures generally showed Satan with horns, wings and claws (e.g. ▷Duccio, New York, Frick Collection), whereas at a later date he was portrayed as the fallen angel who might deceitfully charm, but whose cloven hooves or claws might still poke out from his robes to indicate his concealed nature.

Ten, The
Refers to two separate organizations. First, it was the name given to group of American artists at the ▷Académie Julian in the mid-1890s. This group included ▷Hassam, ▷F.W. Benson and other artists whose work showed an ▷Impressionist influence. They were also known as 'Ten American Painters', and they were active in 1898–1919. The second use of the term is also applied to a group of American artists, including ▷Rothko and ▷Gottlieb who practised an ▷Expressionist style in c1935–40.

Ten American Painters
▷Ten, The

tenebrism
A type of painting greatly concerned with shadows and a low-key tone, especially used by those Neapolitan and Spanish followers of ▷Caravaggio known as ▷Caravaggisti. Such an exaggerated interest in ▷chiaroscuro, with a preference for dark rather than light, suited the intentionally startling design formats

and majestic subject-matters of the early ▷Baroque and was especially useful for 'tying together' often very large ▷altarpieces, which was particularly important when they were to be viewed in the uncertain lighting of a church or chapel.

Bib.: *The Age of Caravaggio*, exh. cat., New York, 1985; Spear, R.E., *Caravaggio and His Followers*, rev. edn., New York, 1975

Teniers, David the Elder (1582–1649) and David the Younger (1610–90)

Flemish family of painters. The Elder Teniers was from Antwerp, where he studied with ▷Rubens. He later travelled to Rome and studied with ▷Elsheimer there. He produced mostly religious and ▷genre scenes in a ▷Mannerist style. He became Master in Antwerp in 1606. His son practised a rather different kind of art, becoming known for his peasant genre scenes in the style of ▷Brouwer. He became Court Painter to Archduke Leopold Wilhelm of Austria, who was Regent of the Netherlands, and he was hired to copy pictures in the court collection. His role as keeper of the royal collection led to the production of a catalogue of the works. He was Master in Antwerp in 1632/3, and he helped found the Antwerp Academy in 1662.

Tenniel, Sir John (1820–1914)

English illustrator. He trained briefly at the ▷Royal Academy Schools and intended to be an oil painter, producing his first major work at age 16, but increasingly he turned to drawing, largely teaching himself, and he became famous for his images of animals (e.g. *Aesop's Fables*, 1848). He became one of the major producers of *Punch* cartoons, employed by the magazine from 1851, and their chief illustrator from 1864, working on over 2,000 sketches. He developed a highly popular style of mild ▷caricature, working in fine pencil to produce detailed drawings with a slightly awkward angularity. He is perhaps most famous today for his illustrations to Lewis Carroll's *Alice's Adventures in Wonderland* (1865) and *Through the Looking Glass* (1872), but he illustrated many more books, including those of Dickens. He also worked for the *Illustrated London News*. He was a member of the New Watercolour Society from 1874 and was knighted in 1893.

Bib.: Engen, R.K., *Sir John Tenniel: Alice's White Knight*, Aldershot, 1991; Sarzano, F., *Sir John Tenniel*, London, 1948; Simpson, R., *Sir John Tenniel, Aspects of his Work*, London, 1994

Terborch (ter Borch), Gerard the Younger (1617–81)

Dutch painter. Born in Zwolle, he received his first training as a painter from his father, after which he worked in the workshop of ▷Pieter de Molyn in Haarlem. In 1635 he visited England, in 1640 Italy and in 1648 Münster, in which latter town he painted a group portrait of the participants of the famous Congress of the Peace of Münster (*The Swearing of the Oath of Ratification of the Treaty of Münster*, 1648, London, National Gallery). Following the establishment of peace with Spain, he visited Madrid and, according to ▷Houbraken, painted King Philip IV's portrait. The whole of the latter part of his career was spent working in Deventer.

Despite extensive travels during which he must surely have seen works by his great Italian and Spanish contemporaries, Terborch's mature work reveals no discernible influence. He was instrumental in developing the small-scale, upright-format ▷genre scene with two or three figures, painted with exquisite attention to details and brilliantly rendered textures such as silk, satin and velvet (e.g. *Brothel Scene* c1654, Berlin-Dahlem, Gemäldegalerie). The pictures are always tasteful, the themes subtly understated, the psychological relationships deliberately ambiguous – a hint of mystery magnifying their interest. In fact, the *Brothel Scene* is so discreetly treated that it was relatively simple for a prudish later age to effect a radical rereading by erasing the coin held by the customer and simply retitling the picture, '*Parental Admonition*', the name by which it was known for many years. The procuress became a respectable mother, the customer a mildly concerned father and the prostitute a suitably chastened daughter.

Bib.: Kettering, A.M., 'Terborch's Ladies in Satin', *Art History*, 16 (March 1993), pp. 95–124; *Gerard Terborch 1617–81*, exh. cat., Münster, 1974; Webster, S.L., *A Technical Study of Two Portraits by Gerard Terborch*, Winterthur, 1980

Terbrugghen (ter Brugghen), Hendrick (1588–1629)

Dutch painter. A Catholic, he was born in Deventer, his family moving to Utrecht about 1591. Here he trained with ▷Abraham Bloemaert, before travelling to Italy in c1604, staying for about ten years. In Italy, he absorbed the art of ▷Caravaggio and his Roman followers, particularly ▷Orazio Gentileschi and ▷Bartolommeo Manfredi. From Caravaggio Terbrugghen also adopted the practice of painting straight onto the canvas and using artificial light effects and heightened ▷chiaroscuro to create drama. On his return to the Netherlands, he entered the Utrecht Painters' Guild (1616). Only from the period of the 1620s is his work dated and, in fact, no authenticated paintings are known from his Roman years. In Utrecht he became, with ▷Baburen and ▷Honthorst, one of the foremost of the Dutch followers of Caravaggio, the ▷Caravaggisti, painting both ▷genre scenes and religious works. Whereas his religious works owe a clear debt to Caravaggio (e.g. *The Calling of Matthew*, c1617, Le Havre, Musée), his paintings of half-length figures making music are closer to ▷Manfredi and Orazio Gentileschi (e.g. *The Concert*, c1626, London, National Gallery). However, despite the obvious influences,

Terbrugghen's Caravaggism is an unmistakably Netherlandish interpretation: his figure types are less idealized, deriving more from Flemish and German antecedents than from Caravaggio and his palette with its emphasis on violets, creamy whites, lemon-yellows and red-browns, recalls Bloemaert and anticipates ▷Vermeer. In his compositions he shows a personal predilection for the curves made by puffed-out sleeves and wide-brimmed hats framing heads, and figures silhouetted against light backgrounds (e.g. *Flute Player*, 1621, Kassel, Staatliche Gemäldegalerie).
Bib.: Nicholson, B., *Hendrick Terbrugghen*, London, 1958.

Terpsichore
▷muse

terracotta
(Italian, 'baked earth'.) Clay which has been made hard and durable by firing at a high temperature, ranging in colour from buff to the more characteristic deep reddish-brown. Before firing, clay may be individually modelled, but it can also be pressed into a mould, thereby making relatively cheap mass production possible: thus, since prehistoric times it has been employed for repeat-pattern architectural decoration and for the cheap production of figurines for votive offerings, etc. Since the ▷Renaissance it has also been used by sculptors for ▷bozzetti. ▷Luca della Robbia exploited its relative cheapness and increased its durability (and attractiveness) by applying tin glazed colours, to produce, among other things, coats-of-arms and *Madonna* reliefs, which could be placed outdoors. The French 18th-century sculptor, ▷Clodion, is chiefly remembered for his vivacious terracotta figures in which, exploiting the malleability of the clay, he has imparted a sketch-like liveliness. Victorian architects also appreciated the malleability and imperishability of terracotta and none more so than Alfred Waterhouse who employed it both for ornamentation and brickwork in most of his buildings (e.g. his Natural History Museum in London, 1866, 1870–80).

By extension, the word 'terracotta' is also used to describe the more common reddish-brown colour of terracotta objects.

terribilità
(Italian, 'terribleness'.) A term normally applied to the later work of ▷Michelangelo and meant to convey the awesome quality of his art.

tertiary colour
The colours created when two ▷secondary colours are mixed together. The secondary colours are orange, violet and green, and the tertiary colours are generally shades of brown, black and grey.

tessera
A small square or cube of coloured glass, ▷marble, ▷ceramic or tile used to form part of a ▷mosaic. The term is taken from tiny square tablets of wood, bone or ivory which were used as tokens or tickets in ancient times.

Testa, Pietro (Il Lucchesino) (1611–50)
Italian engraver and painter. He was born, as his nickname suggests, in Lucca. He moved to Rome in c1630 and trained there under ▷Domenichino, later working with ▷Pietro da Cortona, and also studying the ▷antique, all of which experiences fundamentally influenced his style. He engraved and painted mostly Classical, mythological, but sometimes religious subjects, often of great originality and sometimes imbued with a rich and personal vein of bizarre fantasy. His most important painting is generally considered to be *The Massacre of the Innocents* (Rome, Galleria Spada). He executed a series of antiquarian drawings for Cassiano dal Pozzo, ▷Nicolas Poussin's patron. His ▷etchings, which are more plentiful than his paintings, are regarded as among the finest of the 17th century; unfortunately etching was considered a lesser art and was accordingly less well paid and Testa never achieved any financial success. He also seems to have been of a shy and melancholic disposition and his death by drowning was regarded by some contemporaries as suicide.
Bib.: Cropper, E., *Pietro Testa 1611–50*, Philadelphia, 1988; idem, *The Ideal of Painting, Pietro Testa's Düsseldorf Notebook*, Princeton, 1984

tetrastyle
▷portico

Thalia
▷muse; Three Graces

Theed, William the Younger (1804–91)
English sculptor. He received some initial training in the studio of his sculptor father, William Theed the Elder (1764–1817), afterwards entering the studio of ▷E.H. Baily and attending the ▷Royal Academy schools. In 1826 he went to Rome and studied under ▷Thorvaldsen, ▷Gibson, R.J. Wyatt and Tenerani. Gibson brought Theed's work to the attention of the Prince Consort who commissioned from him, while still in Rome, two ideal works, a *Psyche* and a *Narcissus*, (1847, London, Osborne House). Theed returned to England in 1848 and soon established a successful practice, maintaining his royal connections and winning large numbers of commissions, mainly of public statues and portrait busts. At the death of the Prince Consort in 1861 Victoria selected him to make the death mask. Royal patronage continued after Albert's death, the most remarkable commission from

Victoria perhaps being the life-size marble group, *Queen Victoria and Prince Albert in Anglo-Saxon Dress* (1868, Royal Collection). Theed's best known work is probably the colossal group, *Africa* (1869), for the London Albert Memorial.

Bib.: Read, B., *Victorian Sculpture*, New Haven and London, 1982

Theological Virtues
▷Virtues and Vices

Theophanes the Greek (c1335–1405)

A painter of ▷frescos and ▷icons active in Russia. He reputedly decorated several churches in Constantinople and the Crimea before his arrival in Novgorod around 1370. Contemporary accounts portray a gregarious lover of philosophy and long conversation, rejecting icon manuals and established formulae in favour of personal inspiration. He was also noted for secular murals, including a panoramic view of Moscow. However, his only surviving frescos are the cycle painted in 1378 at the Church of Transfiguration. By 1395 he had left Novgorod for Moscow and, assisted by ▷Andrei Rublev, contributed to the icon screen of the Cathedral of the Assumption in the Kremlin.

Theophanes the Greek adapted a ▷Byzantine sensibility and training to the more humanistic culture of Novgorod, resulting in a highly original and influential style. His work is marked by energetic and sweeping brushstrokes, striking colours and vivid highlighting.

Theophilus (fl 12th century)

Author of *De Divers Artibus*, an exhaustive account in Latin of the techniques of almost all known crafts in the first half of the 12th century. The book contains the first known references in Europe to ▷paper and ▷oil painting, and has numerous tips for the artist and craftsman. References in the book, including the continual entreaty to make work solely for the Glory of God, suggest that Theophilus was a monk, and it is probable that he belonged to the Benedictine order. It has been suggested that he was Roger of Helmarschausen, a German monk who was also a skilled metal-worker. There are certainly references to metalwork in the text, but there is no other real evidence to support this authorship theory.

Thetis
▷Nereids

Third of May, 1808, The

In 1814 ▷Goya was commissioned by Cardinal Don Luis Maria de Borbon, President of the Regency Council for the throne of Spain, to commemorate the insurrections which had sparked off the War of Independence, also known as the Peninsular War. The French armies had been permitted to enter Spain in 1807, ostensibly to invade Portugal. When the Spanish

Crown Prince Ferdinand seized power from his unpopular father Charles IV, the ensuing disorder allowed Napoleon to claim the already-occupied country for himself. Riots broke out in Madrid (which Goya portrayed in *The Second of May, 1808*) and were followed by the mass executions shown in *The Third of May, 1808*. Napoleon had only recently been defeated and Ferdinand restored, after years of horrific fighting, when Goya produced his two paintings.

Goya's composition is unremittingly bleak. The patriots' eyes are wide with terror as they stare, apparently on their knees, into the rifles of the rigid, faceless French soldiers. In the foreground are corpses streaming with blood. It has been said that the painting applies a religious intensity to its political subject. One of the victims stretches out his arms as if to be crucified, a tonsured monk crouches by his side and a monastery glows in the darkness behind them, but there is no sign of a God who could redeem or give meaning to the scene. Indeed, the only source of light is the executioners' own lantern, reflecting the crisis of the Spanish ▷Enlightenment (to which Goya had been allied) as the forces of secular reason become the perpetrators of senseless slaughter.

The painting hangs alongside *The Second of May, 1808* in the Prado, Madrid.

Bib.: Thomas, H., *Goya, The Third of May, 1808*, London, 1972

tholos

A term used in Greek and Roman architecture for a round structure usually possessing a ▷dome.

Thoma, Hans (1839–1924)

German painter. He studied in Paris in 1868 and went to Italy in 1874. He was friendly with ▷Leibl and ▷Böcklin but he developed his own distinctive style of ▷Romantic realist landscape painting that was partly influenced by French ▷Barbizon art and partly by his own relationship with his home region of the Black Forest. Thoma later became an idol of German nationalists who saw in his work the embodiment of German national character.

Thomas

An ▷Apostle of ▷Christ, he is famous for initially doubting Christ's ▷Resurrection (hence his nickname, 'Doubting Thomas'). He is generally portrayed as young and beardless. His identifying attributes are: a builder's set square or ruler (the 4th-century *Acts of Thomas* refers to him as an architect); a girdle (a legend tells that at the ▷Assumption, the Virgin dropped her girdle to him to give him proof that her body, as well as her soul, had risen); and a spear or lance (alluding to the method of his martyrdom). His inscription from the Apostles' Creed is (appropriately for one who doubted Christ's Resurrection): 'Descendit ad infernos tertia die resurrexit a mortuis' ('He descended

into Hell; on the third day he rose again from the dead'). Owing to the legend that he was an architect, he is the patron saint of architects and frequently was represented with his set square on medieval church fronts. It is his incredulity at Christ's Resurrection that is most often portrayed in narrative art. On the day of his Resurrection, whilst Thomas was absent, Christ appeared to the disciples. On his return, Thomas was told but did not believe, requiring proof. Eight days later Christ reappeared while Thomas was present and commanded him to touch the wounds on his hands and thrust his hand into the wound in his side, if he needed proof. Having seen and heard Christ, Thomas believed (John 20: 19–20). Notwithstanding the fact that Thomas believed by seeing alone (Christ said, '. . . because thou hast seen me, thou hast believed), artists have usually represented Thomas moving forward to touch Christ's wounds (e.g. ▷Verrocchio, 1467–83, Florence, Or San Michele) or, in ▷Caravaggio's case, thrusting his finger deep into Christ's side (c1602–3, Potsdam, Staatliche Schlößer und Garten).

Thomson, Tom (Thomas John) (1877–1917)

Canadian painter. He was from Ontario. He began working as a commercial artist but changed his direction in 1904 when he went to Toronto and met ▷J.E.H. Macdonald. The two of them took sketching trips into the wilds of Canada and painted landscapes. He was fascinated by the landscapes of northern Ontario, and in 1912–13 he did some important views of Algonquin Park. He spent much time travelling by canoe into the wilds and sketching there. He was an inspiration for the ▷Group of Seven. He died tragically by drowning on one of his many sketching trips.

Thoré (W Burger), Théophile (1807–69)

French critic and art historian. His real name was Burger. As a political journalist he was exiled from France during 1849–60 because of his role during the 1830 Revolution. It was in exile that he developed an interest in art history, and he became a pioneer of factual accounts of artists including ▷Chardin, the ▷Le Nain brothers and ▷Vermeer, whom he rediscovered. He was also a major critic of the ▷Salons, writing in 1832–49 and in 1860–68, and defending ▷Courbet, ▷Millet, ▷Daumier, ▷Manet and ▷Renoir in opposition to ▷academic artists like ▷Delaroche and ▷Meissonier. He was a believer in the social role of art and therefore of ▷Realism. He later supported the ▷Impressionists, recognizing the importance of their treatment of light and colour. However, for Thoré art could not simply be the depiction of reality and he criticized ▷Manet for treating all objects in a picture with the same cold observation. **Bib.**: Jowell, F.S., *Thoré Burger and the Art of the Past*, New York, 1977

Thorn-Prikker, Johan (1868–1932)

Dutch painter. He was a ▷Symbolist artist who produced ▷murals and ▷stained glass, as well as easel-paintings. His works were two-dimensional and showed the influence of contemporary ▷Art Nouveau work. After 1904 he lived in Germany.

Thornhill, Sir James (1675–1734)

English artist. He was born in Weymouth. After a seven-year apprenticeship with Thomas Highmore (1689–96), he worked with ▷Verrio, one of his major influences, on the Hampton Court decorations (1702). After spending time as a scene painter at Drury Lane Theatre, he embarked on a career as a decorator, becoming one of the few English artists working convincingly in the ▷Baroque style, and able to compete with foreign painters. He was influenced by ▷Laguerre and worked with him on decorations for Chatsworth House in 1706–7. He also worked on the dome of St. Paul's (e.g. *St. Paul Preaching*, 1716), on All Souls College, Oxford (1719), and at Greenwich Hospital Hall (e.g. *Triumph of Peace and Liberty*, 1708–27). He worked both on canvas and with oil on dry plaster. In 1711 he became the director of ▷Kneller's Academy, where ▷Hogarth among others studied. He visited the Low Countries in 1711 and Paris in 1717. He was History Painter to George I from 1718, and an MP and a Fellow of the Royal Society from 1723. He was also the first British artist to be knighted (1720). **Bib.**: *James Thornhill*, exh. cat., Dorchester, 1975

Thornycroft, Mary (1814–95), Thomas (1815–85) and William Hamo (1850–1925)

English family of sculptors. Mary was the daughter of the sculptor, John Francis, from whom she received her first training. Her 1839 exhibit at the Royal Academy. *The Orphan Flowergirl*, was praised for its delicacy and sweet conception. In 1840 she married Thomas Thornycroft, a hitherto unknown sculptor who was training in her father's studio. The two travelled to Rome where they remained and worked for some years. While they were in Rome, Gibson recommended Mary as a potential sculptor of the royal children to Queen Victoria. The resulting life-size statues of them in the guise of *The Seasons* were so well appreciated that Mary was commissioned to execute portrait busts of most of the rest of the Royal Family (all still in the Royal Collection).

Thomas took rather longer to establish his practice, although his plaster Equestrian Statue of Queen Victoria, executed for the 1851 ▷Great Exhibition was well received and led to a series of equestrian commissions of the Prince Consort, following the latter's death (Halifax, 1864, Liverpool and Wolverhampton, 1866). In 1865, Thomas was also commissioned to execute the group, *Commerce*, for the London Albert Memorial, but his most famous sculpture is probably his *Boadicea* for Westminster Bridge (begun in the

1850s; cast posthumously and unveiled in 1902). Mary's career seems in later years to have been subsumed into that of her husband and her collaboration has been noted in many of his commissions.

The Thornycrofts' son, William Hamo, trained first under his father and subsequently at the ▷Royal Academy schools, followed by a visit to Italy. On his return he assisted Thomas with the *Poets Fountain* (1875; formerly Park Lane). His first independent success was *Artemis* (shown as a plaster at the RA in 1880 and commissioned in marble by the Duke of Westminster). In 1881 he was elected ▷ARA, and he became RA in 1888. His *Mower* (bronze, 1884, Liverpool, Walker Art Gallery), one of the seminal works of the ▷New Sculpture movement, introduced a note of contemporaneity to a figure that was nonetheless ideal. Success brought with it increased demand for public monuments and statues. He was also responsible for one of the most acclaimed examples of the newly revived efforts to make sculpture an integral part of architectural design: the figurative friezes on John Belcher's Institute of Chartered Accountants at Moorgate in the City of London (1890–91). He was knighted in 1917.
Bib.: Manning, E., *Marble and Bronze: the Art and Life of Hamo Thornycroft*, London, 1982

Thorvaldsen (Thorwaldsen), Bertel (1768 or 1770–1844)

Danish sculptor. He was a ▷Neoclassical sculptor whose contemporary international reputation was second only to ▷Canova. Unlike Canova, however, he was more devoted to Greek sculpture than to Roman. Also, whereas Canova's ▷marble surfaces (the usual Neoclassical medium) are notable for their sensuality, Thorvaldsen aimed for a cool, uniform effect.

In 1797, after training at the Academy in his native Copenhagen, Thorvaldsen moved to Rome which was to be his centre of activity for the rest of his life. After a lean start, he eventually established his reputation with a plaster statue of Jason, based on the 5th-century BC ▷*Doryphoros* (or 'Spear Bearer') of ▷Polyclitus. ▷Thomas Hope, an English ▷connoisseur and collector commissioned it in marble (1802–28, Copenhagen, Thorvaldsen's Museum), becoming his first important patron. Such was the demand for his work henceforth that by 1820 he was running a large studio with 40 assistants. Thorvaldsen never visited Greece, but his close acquaintance with original ▷Archaic Greek art (as opposed to the later ▷Hellenistic sculptures or Roman copies of Classical Greek sculptures which were then in most common currency) began in 1816 with his restoration of the recently excavated ▷tympanum sculptures from the Temple of Aphaia at Aegina, then *en route* to the Munich Glyptothek, where they remain to this day (his extensive and, by today's standards excessive, restorations are now removed). A view of his studio by H.D.C. Martens (1830, Copenhagen, Thorvaldsen's Museum) entitled *Pope Leo XII Visiting Thorvaldsen's Studio on St. Luke's Day, 1826*, indicates both the level of his celebrity and incidentally shows, in the plaster models that fill his studio, the enormous number of his prestigious commissions, including the Tomb of Pope Pius VII (1823–31, Rome, St. Peter's), the Equestrian Statue of Prince Joseph Poniatowski (completed in 1832 for Warsaw and based on the only surviving antique equestrian statue, the Marcus Aurelius in Rome), and the colossal *Blessing Christ* and the *Twelve Apostles*, which had been commissioned by the Protestant Church of Our Lady in Copenhagen in 1920 during Thorvaldsen's triumphant visit to his homeland. Today most of Thorvaldsen's models, plasters and finished works (with casts of those that were not obtainable) are in a specially-built museum at Copenhagen, erected in his lifetime (1839–48) and ultimately housing (as was intended) his tomb.
Bib.: Hemmeter, K., *Studien zu Reliefs von Thorvaldsen*, Munich, 1984; Plon, E., *Thorvaldsen: His Life and Works*, Boston, 1980; *Bertel Thorvaldsen 1770–1844, scultore danese a Roma*, exh. cat., Rome, 1989

three-centred arch
▷arch

Three Graces
Three beautiful women from ancient myth. They were first named by Hesiod as Aglaia, Euphrosyne and Thalia. They have been frequently represented in art as personifications of Beauty, and they are usually represented with the outer two women facing front and the central woman facing to the rear.

391
A magazine founded by ▷Picabia. It began in Barcelona in 1917, and then was moved to New York. It deliberately echoed ▷Stieglitz's ▷291 gallery. It had a ▷Dada emphasis and contained drawings and literature.

Thulden, Theodor van (1606–69)
Flemish painter and engraver. He was a student of ▷Rubens. He designed tapestries and accepted commissions in The Hague, Paris and Antwerp.

Tibaldi, Pelegrino (1527–96)
Italian painter, sculptor and architect. His painting style was influenced principally by ▷Michelangelo, ▷Perino del Vaga, ▷Parmigianino, and ▷Niccolò dell' Abbate. Born in Bologna, he was in Rome in the late 1540s and early 1550s, working initially for Perino on the Sala del Consiglio of the Castel S. Angelo (which he completed at the latter's death). His earliest surviving independent painting is the *Adoration of the Shepherds* (1549, Rome, Borghese). In 1553 he returned to Bologna and there painted his most

acclaimed work, a cycle of ceiling ▷frescos illustrating the story of ▷Ulysses (c1553; originally Palazzo Poggi, now the university). These frescos, featuring energetically-posed ▷*sotto in sù* nudes, inspired by Michelangelo's ▷*ignudi* and seated in convincing painted architectural settings, fully display Tibaldi's prodigious powers as a ▷*quadratura* painter. For the same patron, Tibaldi decorated the Cappella Poggi in S. Giacomo Maggiore with two frescos of the life of St. John the Baptist (c1555). By the 1560s he was in Milan and, from 1567, was employed by the archbishop, Charles Borromeo, as chief architect of the cathedral. In 1587 he was summoned to Madrid by Philip II to superintend the building of, and to decorate with sculpture and frescos, the ▷Escorial. Tibaldi's work here was of signal importance for the spread of ▷Mannerism to Spain. He returned to Milan in the year of his death, wealthy and ennobled by Philip.

Bib.: della Torre, S., *Pelegrino Tibaldi Architetto e il S. Fedele di Milano*, Milan, 1994

Tiburtine Sibyl

▷sibyls

tie beam

In roof framing, the main horizontal transverse beam employed to link the lower ends of the principal rafters and prevent them from spreading.

Tiepolo, Giovanni Battista (Giambattista) (1696–1770) and Giandomenico (1727–1804)

Italian artist. He was the last of the great Venetian decorative painters, working mainly in ▷fresco. His mature painting is characterized by virtuoso draughtsmanship, vigorous brushwork and the use of light and sunny tonalities. A leading exponent of the ▷Rococo style, he worked within the Venetian tradition, his main influence being ▷Veronese, but his painting also revealing a debt to Roman and Neapolitan ▷Baroque. He learnt to paint under the conservative history painter, Gregorio Lazzarini (1655–1730) and was received into the Venetian painter's guild in 1717. Of greater influence than his master, however, was ▷Piazzetta whose dark-toned manner informs the earliest works with which Tiepolo established his reputation (e.g. *Sacrifice of Abraham*, 1715/16, Venice, Ospedaletto). In 1719 he married Cecilia Guardi, the sister of the ▷Guardi brothers.

By 1725 Tiepolo had received his first important commission, a fresco cycle in the Archbishop's Palace at Udine (completed 1728). Fresco, with its inherently lighter tonality and paler colours encouraged him to break away from Piazzetta's darker palette. In this work and throughout his career he was assisted by the ▷quadratura specialist, Gerolamo Mengozzi Colonna (c1688–1766). Tiepolo worked mainly outside Venice in the 1730s in both palaces and churches, in fresco and oil. By 1736 his fame and demand for his services

had spread sufficiently for him to turn down, on account of the low fee, an invitation to Stockholm to decorate the Royal Palace. In the next decade he worked chiefly in Venice, his principal commission being the decoration of the central saloon of the Palazzo Labia with a cycle of frescos on the theme of *Antony and Cleopatra* (1745).

The 1750s mark the qualitative peak of Tiepolo's activity. From 1750 to 1753 he was in Würzburg executing his most successful work, the decoration of the Kaisersaal (main state room) and the ceiling over the Grand Staircase of the prince-bishop's Residenz (built by ▷Neumann). Shortly after his return to Venice he was elected first President of the Venetian Academy (1755). In 1757 he decorated a series of five rooms in the Villa Valmarana, near Vicenza, with scenes from Homer, Virgil, Ariosto and Tasso. His last large-scale work in Italy was the ballroom ceiling in the Villa Pisani at Stra (1761–2). While working on this commission he was invited by Charles III to work in Madrid, and he remained there for the last eight years of his life.

Tiepolo's principal work in Madrid was the ceiling painting, *The Apotheosis of Spain*, for the Royal Palace throne room. However, these last years were embittered by the intrigues of his principal rival, the ▷Neoclassical painter, ▷Anton Raphael Mengs. The latter's final victory came after Tiepolo's death when the seven altarpieces he had painted for the church of S. Pascal Baylon at Aranjuez were removed and replaced by seven by Mengs. Tiepolo's altarpieces are now divided between the Prado and the Royal Palace in Madrid, with most of the surviving oil sketches in the Courtauld Galleries, London. Among the finest of Tiepolo's easel-paintings is the *Young Woman with a Macaw* (c1760, Oxford, Ashmolean Museum). A brilliant draughtsman, the Victoria and Albert Museum, London, has one of the finest collections of his drawings. Tiepolo was also an accomplished etcher, his work in this medium exercising a considerable influence on ▷Goya.

In order to carry out his many large-scale commissions Tiepolo ran a large, efficient workshop which included his two sons as principal assistants. Giandomenico worked for his father from c1745. Although his own contributions to his father's commissions are not certainly identifiable (in true workshop tradition the style of the master was faithfully adhered to), Giandomenico's independent work at the Villa Valmarana, for example, does reveal a distinctive style with a marked interest in ▷genre and caricature. Like his father, Giandomenico was also an accomplished etcher, his most celebrated work being a series of 22 plates on the theme of the *Flight into Egypt* (1753). Tiepolo's younger son, Lorenzo (1736–76) does not seem to have developed a distinctive style and is not known to have executed independent work of any particular merit.

Bib.: Alpers, S. and M. Baxandall, *Tiepolo and the Pictorial Intelligence*, New Haven and London, 1994; Barcham, W.L., *Giambattista Tiepolo*, London, 1992; Brunel, G., *Tiepolo*, Paris, 1991; Gemin, M., *Giambattista Tiepolo, dipinti: opera completa*, Venice, 1993; *Giambattista Tiepolo: Master of the Oil Sketch*, exh. cat., Milan, 1993

tierceron
▷rib vault

Tiffany, Louis Comfort (1848–1933)
American painter, decorator and architect. He was one of the central figures of ▷Art Nouveau in the United States. He studied landscape painting as a young man and travelled to Europe during the 1860s before settling in New York, where his father owned the design firm Tiffany and Company. He became an active figure in the New York arts scene, a member of the New York Society for the Decorative Arts and, in 1877, a co-founder of the Society of American Artists. In 1879 he established Louis Comfort Tiffany and Associated Artists, a firm based on ▷Morris and Co., and he used the company to promote fully integrated design, including wallpaper and textiles. By the 1890s however, he had developed a dominant interest in glassware, which led to the patenting of his Favrile technique, employing an iridescent surface. He was influenced by non-European art styles and also explored accidents in the production process to create a freedom of design. His work was widely promoted in Europe by Samuel Bing and became synonymous with the Art Nouveau movement. From 1902 he also ran the family firm in New York although the furnaces finally closed in 1928 as a result of financial difficulties.
Bib.: McKean, H.F., *Louis Comfort Tiffany*, Weingarten, 1981; Paul, T., *The Art of Louis Comfort Tiffany*, New York, 1987; Price, J.E., *Louis Comfort Tiffany: The Painting Career of a Colourist*, New York, 1995

Tinguely, Jean (1925–91)
Swiss-born sculptor. He studied at the Basel Art School under Julia Ris, who shared ▷Schwitters' interest in the expressive potential of non-art materials, junk and the found object (▷*objet trouvé*). He was obsessed by the idea of movement, and claimed: 'Life is movement. Everything transforms itself, everything modifies itself ceaselessly ... I want only to involve myself in the moving object that forever transforms itself.' Tinguely turned to ▷kinetic art and, in Paris from 1953, he began making mechanical reliefs with ▷biomorphic forms and hand-powered sculptures. Influenced by the 'useless machines' of Bruno Munari, whom he met in Milan in 1954, he called his works 'meta-machines'. For 'Le Mouvement' exhibition at the Galerie Denise René in 1955 he constructed his drawing machines, whose 'automatic' drawing parodied the gestural painting of ▷Art Informel and ▷Abstract Expressionism, and proved, Tinguely commented, 'that anyone can make an abstract picture, and even a machine'. His random robots, which he named 'Metamatics', were constructed from old car parts and were non-repetitive and unpredictable, parodying the notion of originality, as did his instructions on how to make a 'Meta-mechanical relief', contained in a catalogue to an exhibition at the Museum Haus Lange, Krefeld: 'I invite you to use this plan to construct this picture ... and I acknowledge the result, if accurately executed, as an original work of my own.' His most infamous Metamatic was *Hommage à New York* done for New York's ▷MOMA in 1960, an enormous and complex machine, combining movement, sound and painting, which self-destructed (▷auto-destructive art). In the 1960s he made numerous ▷junk constructions, including the series of machines called *Paradise*. His auto-destructive machines and functionless art, which he called 'l'art fonctionnel', served as a satire on the irrationality of a civilization in thrall to technology. He was a founder member of ▷Nouveau Réalisme in 1960.
Bib.: *Jean Tinguely*, exh. cat., Paris, 1989; Violand-Hobi, H.E., *Jean Tinguely: Life and Work*, New York, 1995

Tino da (di) Camaino (c1285–1337)
Italian sculptor. He was Sienese and specialized mainly in tomb monuments. He was possibly trained in the workshop of ▷Giovanni Pisano. He was working at Pisa by 1311, becoming head of the Cathedral works by 1315 (his Tomb for Emperor Henry VII in the Cathedral, parts of which survive, dates from this time). In 1319–20 he was head of works at Siena Cathedral (his Petroni Monument is still *in situ*), after which, from 1321 to c1324, he worked at Florence, where his most important work is the Tomb of Bishop Orso in the Cathedral, considered to be the earliest tomb to incorporate an effigy of the deceased seated as opposed to reclining. Summoned to Naples in c1324 to work for the Angevin court, Tino remained there for the rest of his life. For the Angevins he executed a series of tombs (e.g. for Catherine of Austria in S. Lorenzo Maggiore, and for Queen Mary of Hungary in Sta Maria Donnaregina), these works exerting a strong influence on Neapolitan tomb design for the next century. In Naples he was in close contact with ▷Giotto (who was at that time court painter) and ▷Pietro Lorenzetti (who became guardian to his children after his death). Tino's figures are grave with characteristically massive faces and block-like bodies. His types have often been likened to those of the Lorenzetti brothers.
Bib.: Carli, E., *Tino da Camaino*, Florence, 1984; Pope-Hennessy, J., *Italian Gothic Sculpture*, Oxford, 1986

Tintoretto (Jacopo Robusti)
(1518–94)

Italian painter. With ▷Veronese, he was the leading Venetian painter of the last quarter of the 16th century. His nickname derives from his father's profession as dyer ('*tintore*'). Despite his contemporary celebrity, the details of Tintoretto's life are obscure. One of the earliest biographies (1642), by ▷Ridolfi, states that Tintoretto had a brief and acrimonious apprenticeship with ▷Titian, although Tintoretto's early work would suggest a closer stylistic kinship with ▷Paris Bordone and ▷Schiavone. It was Ridolfi too who recorded that Tintoretto kept a motto pinned to the wall of his studio: 'The drawing of Michelangelo and the colouring of Titian.' Again, Tintoretto's characteristically rapid,

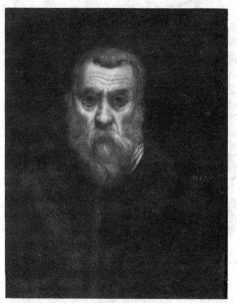

Tintoretto, *Self-portrait*, 1588, Louvre, Paris

sketch-like drawing bears little resemblance to ▷Michelangelo's intensely analytical drawing and his colour is more sombre than Titian's. Nevertheless, the combination perhaps contains a truth in so far as Tintoretto leant more towards ▷Mannerism (a Tuscan development) than any other Venetian painter. By 1539 he is recorded as a master, although his earliest surviving paintings can be dated no earlier than about 1545.

The painting which established Tintoretto's reputation was the *Miracle of the Slave* (1548, Venice, Accademia), commissioned by the Confraternity of San Marco and showing, for the first time, most of the qualities which characterize his mature work, such as fluent ▷brushwork, dramatic composition and a love of virtuoso ▷foreshortening. The swooping, steely foreshortened figure of St. Mark is evidence of Tintoretto's use of wax models as study aids, positioned (or in this case suspended) in boxes, where they can

be viewed from any number of angles and lit with spotlights. Tintoretto's most important work is the cycle of canvases for the Scuola di ▷San Rocco. He won the commission in 1564 in a way which earned him the enmity of his fellow artists. Each competitor was supposed to supply the judging panel with a design for one of the ceiling canvases. Tintoretto completed an actual canvas in oil at lightning speed and surreptitiously had it installed. Over the protests of his competitors, Tintoretto told the panel that if they were not satisfied with his canvas they could keep it anyway. With such calculated audacity he won the commission (and became a member of the confraternity in the following year). The cycle consists of a large upper hall with scenes from the life of Christ on the walls ▷typologically linked with Old Testament scenes on the ceiling, plus a large room (the Albergo) leading off the hall with Passion scenes dominated by the overwhelming presence of the celebrated 12-metre wide *Crucifixion* (dated 1565). The lower hall, executed last and with more workshop intervention, is decorated with scenes from the life of the Virgin. The whole scheme was completed in 1588. The cycle is the most important concentration of Tintoretto's work in existence, revealing his seemingly inexhaustible inventiveness in composition, his rapid and spontaneous-looking brushwork, his rich and personal colour sense and the profundity of his poetic and visionary imagination. His last great commission was for the Venetian state, the enormous canvas of *Paradise* for the entire end wall of the Sala del Maggior Gonsiglio in the Doge's Palace.

Although most of Tintoretto's work was of religious subjects, he did execute some important mythological subjects, such as *Susannah and the Elders* (1555–6, Vienna, Kunsthistorisches Museum) and *The Origin of the Milky Way* (c1578, London, National Gallery). He was also an accomplished portraitist, as his penetrating *Self-portrait* (1588, Paris, Louvre) reveals. In his large and flourishing studio his son, Domenico (c1560–1635) was his foreman and another son, Marco (1561–1637), and a daughter, Marietta (c1556–90) worked as assistants. Although extremely successful and influential, Venetian painting went into a relative decline between Tintoretto's death and the advent of ▷Piazzetta and ▷Tiepolo in the 18th century, and Tintoretto's greatest influence was on a non-Venetian, the Cretan-born ▷El Greco.

Bib.: Pallucchini, R., *Tintoretto*, 2 vols., Milan, 1990; Romanelli, G., *Tintoretto, La Scuola Grande di San Rocco*, Milan, 1994; Rosand, D., *Painting in Cinquecento Venice*, New Haven, 1986

Tischbein, Johann Heinrich the Elder (1722–89), Johann Heinrich Wilhelm (1751–1829) and Johann Friedrich (1750–1812)

German family of artists. The most famous is Johann Heinrich Wilhelm. Although he also painted historical

subjects, he is chiefly known for one specific portrait, *Goethe in the Roman Campagna* (1786–8, Frankfurt-am-Main, Städelsches Kunstinstitut), which shows the poet reclining among the ruins in a somewhat self-conscious pose, meditating on the lost glories of antiquity. So successful was this image that this particular Tischbein was distinguished from the rest of his family by being referred to as 'Goethe' Tischbein. In 1789 he was appointed Director of the Academy at Naples and from 1791 supervised the engravings of the antiquarian Sir William Hamilton's collection of Greek vases, the publication of which assisted the dissemination of ▷Neoclassicism throughout Europe. In 1799 he returned to Germany.

Johann Heinrich Wilhelm had been trained in Hamburg by his uncle, Johann Heinrich the Elder, who painted portraits and historical and mytho-logical subjects in a decorative ▷Rococo style. Johann Heinrich Wilhelm's cousin, also a nephew of Johann Heinrich the Elder, was Johann Friedrich, a painter of portraits in a style influenced chiefly by ▷Gainsborough.

Bib.: Bisanz, R.M., 'Goethe and Tischbein in Italy', *Gazette des Beaux-Arts*, 6 no. 113 (Feb 1989), pp. 105–14; Negro Spina, A., *Johann Heinrich Wilhelm Tischbein*, Naples, 1994; *Johann Heinrich Tischbein 1722–89*, exh. cat., Kassel, 1989

Tissot, James (1836–1902)

French painter and etcher. He was born in Nantes, the son of a wealthy businessman. In 1856 he attended the ▷École des Beaux-Arts, and in the same year met ▷Whistler. He exhibited at the ▷Salon from 1859, his early works being historical costume pieces. During the 1860s he travelled widely and exhibited at the English ▷Royal Academy, and in the same decade began to paint his characteristic images of fashionable society women, similar to those of ▷Stevens. He played a part in the Commune of 1870 and came to London the following year as a refugee, living in St. John's Wood in style until 1882, when his model/mistress died. Tissot achieved popularity for his portrayal of society at leisure, and for his glossy, detailed treatment of fashion (e.g. *London Visitors*, 1874, Toledo, Ohio, Museum of Art). He also favoured boating scenes (e.g. *The Last Evening*, 1893, London, Guildhall) and painted views of the Thames which influenced ▷Whistler. Throughout his career he produced illustrative works (e.g. for *Vanity Fair*, 1869–77) and in 1886 visited the Middle East in order to produce a series of Biblical illustrations (1888) which also proved popular. He exhibited at the ▷Grosvenor Gallery in 1877–9.

Bib.: *James Tissot*, exh. cat., London, 1984; Wentworth, M., *James Tissot*, Oxford, 1984; Wood, C., *James Tissot*, London, 1986

Titian (Tiziano Vecellio) (c1485–1576)

Italian painter. He was the greatest painter of the Venetian school. His date of birth is uncertain. It is thought that the statements he made about his extreme old age towards the end of his life were exaggerated to elicit sympathy and to create an image of a tireless genius. If Titian was to be believed, his date of birth would be 1477, making him older than ▷Giorgione, for whom he appears to have worked in 1508 as assistant on the Fondaco dei Tedeschi ▷frescos (Giorgione alone is mentioned in the documents,

Titian, *Self-portrait holding a palm frond*, 1561, Gemäldegalerie, Dresden

although Titian's name has always been associated with the commission) and by whom his early work is greatly influenced.

Titian was born at Pieve di Cadore in the Veneto and trained by Gentile and then ▷Giovanni Bellini. A *Gypsy Madonna* (Vienna, Kunsthistorisches Museum), believed to be an early work, shows his indebtedness to Giovanni in the type of the Madonna and the Bellinesque composition. Bellini's influence was soon superseded by that of Giorgione, however. Titian is supposed to have completed Giorgione's *Sleeping Venus* (Dresden, Gemäldegalerie) following the latter's premature death from plague in 1510 and their styles are so close at this point that the *Concert Champêtre* (Paris, Louvre), once ascribed to Giorgione, is now thought to be an early Titian. Also, the hilltop town in Giorgione's *Sleeping Venus* reappears in Titian's *Noli Me Tangere* (London, National Gallery). Titian's earliest documented commission is the fresco cycle for the Scuola del Santo at Padua (completed in 1511). Here, to a Venetian feeling for light and colour is added an almost Tuscan

mastery of monumental form, which suggests not only contact with the works of ▷Raphael and ▷Michelangelo, but also evidence of an artist adapting his style to the taste of a city long under the aesthetic influence of Florence.

In the year of Giovanni Bellini's death (1516), Titian was created official painter to the Republic and from then on he completely dominated painting throughout the Veneto. His earliest public commission in Venice was the huge *Assumption* for the high altar of the Frari (1516–18). With this majestic work, generally recognized as the first Venetian painting of the High ▷Renaissance, he established his reputation. This was immediately followed by a commission for another altarpiece in the same church, the *Pesaro Madonna* (1519–26). In this, Titian takes the traditional hieratic composition of a central Madonna and Child with saints and ▷donors evenly deployed above and below them and moves the Madonna and Child to the right of the picture, while swivelling them round to face left, thereby creating a composition based on a grand dynamic diagonal rather than a static pyramid. In both this and the *Assumption* can be seen Titian's sumptuous colour sense and his love of rich tonal contrasts obtained through the silhouetting of dark forms against light backgrounds. The third great ▷altarpiece of this period, the *Death of St. Peter Martyr* (1525–30, formerly Venice, SS Giovanni e Paolo) was lost in a fire in 1867 (although its appearance is known through ▷engravings). Its loss is rendered all the more tragic by ▷Vasari's acclamation of it as 'the most complete, celebrated, the best-conceived and executed of all Titian's paintings'.

In these years Titian was also in demand as a painter of mythological subjects, from the *Sacred and Profane Love* (c1516, Rome, Villa Borghese) to the trio of canvases painted for Alfonso d'Este's Camerino d'Alabastro in the castle at Ferrara (1518–23): the *Worship of Venus* and *The Andrians* (now both Madrid, Prado, and *Bacchus and Ariadne* (London, National Gallery). The first of this series of mythological canvases, a *Feast of the Gods*, had been painted by Bellini shortly before his death; once Titian had completed his trio, he was then commissioned to repaint the landscape background of Bellini's to make it harmonize with his own.

Apart from his expertise in religious and mythological subjects, Titian had early shown his mastery of portraiture, notably with the *Man with a Glove* (c1520, Paris, Louvre). During the 1530s his pictures took on a more restrained, more tranquil mood. In some cases, such as the *Presentation of the Virgin* (1434–8, Venice, Accademia) the solemnity was enhanced by what appears to have been a deliberately archaising frieze-like composition. In this decade his fame took on an international dimension. In 1530 he had met the Emperor Charles V and in 1533 painted a portrait of him (now Madrid, Prado) based on another by Charles's Austrian court painter, ▷Seisenegger. So impressed was Charles that he appointed Titian to the

post of court painter in 1533 and ennobled him with the title of Count Palatine and Knight of the Golden Spur. At the same time Titian was in greater demand from Italian patrons: to these years belong the *Venus of Urbino* (c1538, Florence, Uffizi), painted for Francesco della Rovere, Duke of Urbino, and *La Bella* (c1536, Florence, Pitti Palace), a clothed portrait of the woman who posed for the *Venus*.

Titian's work during the 1540s began to show evidence of the influence of ▷Michelangelo and ▷Mannerist painting (e.g. the *Crowning with Thorns*, c1542, Paris, Louvre). Then, in 1545–6 Titian visited Rome and, in addition to meeting Michelangelo and being profoundly impressed by his recently-painted *Last Judgement* (1536–41), also developed a deeper interest in the remains of ▷antiquity. During his visit to Rome, Titian painted a *Danaë* (1545–6, Naples, Museo di Capodimonte). Vasari relates that he and Michelangelo went along to Titian's studio in the Belvedere and saw the work in progress. After they had left Michelangelo modified his general praise for Titian's style and colour by deploring what he saw as Titian's typically Venetian disregard for firm drawing – thereby voicing the classic antagonism between Venetian *colore* and Florentine ▷*disegno*. Also while in Rome, Titian painted the revealing family portrait, *Pope Paul III and his Nephews* (Naples, Museo di Capodimonte).

Towards the end of the decade Titian was summoned to the Imperial Court at Augsburg to paint the Emperor, the results being an equestrian *Charles V at the Battle of Mühlberg* (1548, Madrid, Prado) and a rather more informal seated portrait (Munich, Alte Pinakothek). In 1550–51 Titian was again in Augsburg and met ▷Cranach (whose portrait of Titian is sadly lost). His portraits of these years established a type that was to have a great influence on court portraiture for years to come, not least in the work of ▷Rubens and ▷Van Dyck. Titian also painted a portrait of Charles's son, the future Philip II of Spain. Philip was to become one of his greatest patrons and in the late 1550s and early 1560s commissioned the series of seven *poesie* based on the erotic encounters between gods and mortals in Ovid's *Metamorphoses*, namely: *Danaë* and *Venus and Adonis* (Madrid, Prado); *Perseus and Andromeda* (London, Wallace Collection); *The Rape of Europa* (Boston, Gardner Museum); *Diana and Actaeon* and *Diana and Callisto* (both Edinburgh, National Gallery of Scotland); and the *Death of Actaeon* (London, National Gallery). For the chapel in the Escorial, Titian painted a *Martyrdom of St. Lawrence* (1564–7). In the later of these works, such as the *Death of Actaeon* and the *Martyrdom of St. Lawrence*, a new phase can be seen in Titian's work: the colours are more autumnal and the forms dissolved by almost ▷Impressionistic dabs of colour.

Titian's paintings from the 1560s onwards were criticized by some contemporaries as manifesting a deterioration of his powers, whereas today they are

ranked among his most admired works, the directness of the means contributing poignantly to their sublime pathos. Among the great tragic works of this last period are the *Crowning with Thorns* (c1570, Munich, Alte Pinakothek) and the *Entombment* (Venice, Accademia), the latter unfinished at Titian's death and completed by his pupil, ▷Palma Giovane. Palma provides a graphic description of his master's late working methods: 'The final touches he softened, occasionally modulating the highest lights into the half-tones and local colours with his fingers; sometimes he used his finger to dab a dark patch in a corner as an accent, or to heighten the surface with a bit of red like a drop of blood. He finished his figures like this and in the last stages he used his fingers more than his brush'.

Bib.: Freedman, L., *Titian's Independent Self-Portraits*, Florence, 1990; Nash, J., *Titian's 'Poesie' for Philip II*, Baltimore, 1983; Rosand, D., *Titien, l'art plus fort que la nature*, Paris, 1993; *Titian, Prince of Painters*, exh. cat., Venice, Munich, 1990; Valcanover, F., *All the Paintings of Titian*, New York, 1964

Tobey, Mark (1890–1976)

American painter. He initially worked as a fashion illustrator and interior decorator. He converted to Baha'i, a religion emphasizing the unity of life, in 1918. Between 1925 and 1927 he travelled in Europe and the Near East, and from 1930 to 1938 he was artist in residence at Dartington Hall, Devonshire, England. In 1934 and 1936 he travelled to the Far East where he studied ▷calligraphy and Zen, and began his 'white writing' paintings which he explored for the rest of his life. With his aim to free pictorial space and 'to smash form, to melt it in a moving and dynamic way', he created a calligraphic ▷all-over design, a tight field of abstract signs that create a profound and vital sense of space. He considered his painting, *New York* (Washington; DC, National Gallery) of 1944, to have brought his white writing 'to its highest peak'. His search for new signs that would articulate a different conception of space, with his belief that 'painting should come through the avenues of meditation rather than the canals of action', were ideas central to ▷Art Informel, with which he was closely associated in Paris in the 1950s. In 1958 he won a prize at the International Guggenheim Exhibition, and the Grand Prize at the Venice ▷Biennale. In 1961 he won First Prize at the Carnegie International Exhibition. From 1960 until his death he lived in ▷Klee's old house in Basel.

Bib.: Feininger, L., *Feininger and Tobey: Years of Friendship*, New York, 1991; *Mark Tobey*, exh. cat., New York, 1962

Tolstoy, Lev Nicolayevich (1828–1910)

Russian writer and philosopher. He studied jurisprudence and Oriental languages at Kazan University in 1844, before serving in the Crimean War and travelling widely during the 1850s. He then embarked on a career as a novelist (e.g. *War and Peace*, *Anna Karenina*), but in 1879 had a breakdown and after attempting suicide, abandoned his previous lifestyle and underwent a religious conversion. He wrote a series of philosophical works including *What is Art?* (1896) which set out his views on the need for morality

Ilya Efimovitch Repin, *Portrait of Leo Tolstoy*, 1887, Tretyakov Gallery, Moscow (detail)

and sincerity in all art. Although he believed that past works should be judged by the standards of their own period, he criticized many famous works (including ▷Michelangelo's *Last Judgement*) because of their lack of morals. He opposed the creation of an ideal of beauty because of its subjectivity and selfishness, but promoted the need for beauty of expression, which he believed was only achieved by genius – the intense and serious study of one's subject. He also believed that moral art would automatically appeal to the common people, who should be an artist's ultimate judge. Although many of his views were eccentric, they were used in argument against the ▷art for art's sake philosophy.

Bib.: Diffey, T.J., *Tolstoy's 'What is Art?'*, London, 1985; Orwin, D.T., *Tolstoy's Art and Thought 1847–1880*, Princeton, 1993

Tommaso da Modena (c1325–79)

Italian painter. He was a leading Italian painter of the second half of the ▷trecento in northern Italy. His most important work is the ▷fresco cycle of famous Dominicans in their cells, sitting at their desks, studying, contemplating, debating with their neighbours, or simply sharpening their quills, in the chapter house of S. Niccolò in Treviso (signed and dated 1352). So

well-observed are these figures that they have almost the character of portraiture, so individualized is each figure in both natural gesture and facial expression. Tommaso's reputation spread to Bohemia and work was commissioned from him by the emperor Charles IV (two panels survive in Karlstein Castle, Prague).

tondo

(Italian, 'round'.) Term used to denote a circular painting or ▷relief carving. ▷Michelangelo produced celebrated examples in both ▷media: the painted *Doni Tondo* (1504, Florence, Uffizi) and the carved *Pitti Tondo* (c1506, Florence, Museo Nazionale).

Tonks, Henry (1862–1937)

English painter, draughtsman and teacher. He was born in Solihull. After embarking on a medical career he turned to art in 1893, initially studying under Frederick Brown part-time whilst Senior Medical Officer at the Royal Free Hospital, London. He joined the ▷NEAC in 1891 and was appointed Slade Professor in 1892, where he worked alongside Brown to spread the pro-French ideas of the NEAC which could be seen in his own mildly impressionistic works (e.g. *Hat Shop*, 1897, Manchester). He travelled to France in 1898 and in 1903 visited Yorkshire with ▷Steer although he remained opposed to ▷Post-Impressionism. Increasingly his conservative approach stifled his students, and he failed to promote many of the leading young artists including ▷Johns, ▷Gilman and ▷Smith. He gave his name – Tonking – to the technique of drying each day's oils. His own work included satirical pictures and ▷conversation pieces (e.g. *Saturday Night in the Vale*, 1928–9, London, Tate Gallery). Increasingly in his later career he turned to ▷watercolours. He was an official artist during the First World War (e.g. *Advance Dressing Station*, 1918, London, Imperial War Museum).
Bib.: *Henry Tonks and the Art of Pure Drawing*, exh. cat., Arts Council, London, 1986; Horne, J., *Life of Henry Tonks*, London, 1939

Tooker, George (b 1920)

American painter. He was from New York, and studied at Harvard and at the ▷Art Students' League. He adopted Italian ▷Renaissance techniques, but his subject matter was a dehumanized and paranoid view of modern life. His works were akin to the existentialist literary movement and have been compared to the writings of Kafka.

Toorop, Jan Theodoor (1858–1928)

Dutch painter. He was born in Java but worked largely in Belgium. He was part of a circle of Belgian ▷Symbolists who were influenced by ▷Art Nouveau. His *Three Brides* (1893, Otterlo, Rijkmuseum Kröller-Müller) reveals the combination of ▷arabesque form and disturbing *femme fatale* subject-matter that

characterized his art. He was a member of ▷Les Vingt and produced decorative work, posters and book illustrations as well as easel-painting.

topographical painting

A type of landscape or cityscape painting that focuses on the 'mapping' of a prospect rather than on the representation of nature. Before the invention of photography, every scientific expedition included a topographical artist to record the regions visited. While such records are not without a degree of invention – the artist often included 'typical' examples of indigenous animals, human populations, and fauna – their purpose was not aesthetic but scientific, although the origins of landscape art in infant colonies such as Australia was confounded with the work of artists employed by the administration to assist in the survey of the region. A sub-genre of topographical painting is ▷panorama painting, which is effectively a prospect seen through 360 degrees.
Bib.: Smith, B., *European Vision and the South Pacific*, rev. edn., Oxford, 1985

Topolski, Feliks (1907–89)

British painter of Polish birth. He studied in the Warsaw Academy and came to England in 1935. He obtained British citizenship in 1947. He acted as a war artist and travelled to China and Burma with British troops. He returned to England to accept commissions as a portrait painter. From 1953 he produced many sketches which he referred to as 'Topolski's Chronicle' and which formed the basis for later paintings.

Torres-García, Joaquin (1874–1949)

Uruguayan painter and sculptor. His family moved to Spain in 1891 and he enrolled at the Escuela de Bellas Artes, Barcelona. He worked as a draughtsman, assisted ▷Gaudí with the construction of stained glass windows (1903–7), and designed murals for the Church of St. Augustin (1908). From 1914 to 1919 he manufactured wooden toys, and travelled to New York in 1920 to expand this business. In 1926 he moved to Paris where, after meeting ▷Doesburg and ▷Mondrian, he formed the group ▷Cercle et Carré (with a journal of the same name), devoted to ▷abstract and ▷Constructivist art. After a period in Spain (1932–4) he returned to Montevideo and formed the Association de Arte Constructivo (1935) to promote his ideas of Constructive Universalism. To the same end, he founded an art school, the Taller Torres-García, and published *Universalismo Constructivo* (1943).

Torres-García's early Neoclassical works reflect his belief that art should embody eternal truths. However, around 1916 he encountered ▷Futurism and began to produce fragmented images of urban life and industry. With the discovery of ▷Cubism and Constructivism he moved towards a synthesis, arguing that the geometrical exploration of abstract form enabled the artist

to trace a universal order embodied in the ▷Golden Section, which structured his compositions after 1929. The use of symbols from ▷Pre-Columbian art, exemplified in the inscribed stone wall *Cosmic Monument* (1933), reflected his belief in archetypal imagery, and his claim that Constructive Universalism would provide the basis for an indigenous Latin American art. Many of his works were destroyed by fire in 1978.
Bib.: Jardi, E., *Torres-García*, Boston, 1973; *Torres-García: Grid-Pattern-Sign. Paris-Montevideo 1929–1944*, exh. cat., London, 1985

Torrigiano, Pietro (1472–1528)

Italian sculptor. He was Florentine, but his most important works were produced in England. He was trained in the school of the Medici gardens under ▷Bertoldo di Giovanni and is best known to Florentines as the fellow student who broke ▷Michelangelo's nose, for which infraction both ▷Cellini and ▷Vasari loathed him. Following this incident (before 1492) he is said to have been exiled from Florence and spent some years working at different centres around Italy. He is known to have worked in Rome where he executed a new lost ▷terracotta bust of Pope Alexander VI, Borgia and also served as a mercenary under Cesare Borgia. In c1509–10 he is recorded working as a sculptor in the Netherlands before transferring to England in c1511. Here he executed the tombs of Lady Margaret Beaufort (1511) and of King Henry VII and Elizabeth of York (1512–18) in Westminster Abbey. The royal tomb was splendidly executed in black and white marble with gilt bronze figures and decorations. Although the royal effigies are still in the ▷Gothic style, the decoration of the tomb, with its Classicizing pilasters, nude ▷putti supporting the coat-of-arms and clothed child angels seated on the corners of the sepulchre, is in a pure Italian ▷Renaissance style never before seen in England. Torrigiano left England in c1522 and moved to Spain. Here, however, he was accused of heresy by the Inquisition and was thrown into prison where he died. In the Victoria and Albert Museum, London, is a terracotta bust of Henry VII and in the Seville Museum, Spain, a terracotta *St. Jerome* and *Madonna and Child*.
Bib.: Galvin, C. and Lindley, P., 'Pietro Torrigiano's Portrait Bust of King Henry VII', *Burlington Magazine*, 130 (Dec 1988), pp. 892–902

Torriti, Jacopo (fl late 13th century)

Italian painter and mosaicist. No details are known about his life. Nevertheless, he signed two ▷mosaics commissioned by Pope Nicholas IV for the apses of S. Giovanni in Laterano (1291) and S. Maria Maggiore (c1296), Rome. The importance of these commissions indicates that he must have been, with ▷Cavallini, one of the leading Roman artists of his time. The former appears to have been a reworking of an earlier mosaic and was in itself completely re-worked in the

19th century. The latter, less restored, provides a clearer idea of his style, principally ▷Byzantine revitalized by a naturalism derived from the late ▷antique, allied to an assured feeling for colour and decorative composition. The main scene in the shell of the ▷apse represents the *Coronation of the Virgin* with, in the zone below, five scenes from her life. In the upper church of S. Francesco at Assisi are some frescos also attributed to Torriti.
Bib.: White, J., *Art and Architecture in Italy, 1250–1400*, 2nd edn., Harmondsworth, 1987

torso

As in a human figure, the term for the trunk of a statue, but applied in sculpture to a figure where the limbs and sometimes also the head are lacking. The earliest examples were produced by the accident of time, the neck and limbs being fragile points especially susceptible to breakage: the most celebrated example being the late ▷Hellenistic ▷Belvedere Torso (Rome, Vatican Museums), so greatly admired by ▷Michelangelo. In the late 19th century, ▷Rodin radically departed from tradition by treating the independent torso as a finished work of art (e.g. *The Inner Voice*, 1890, London, Victoria and Albert Museum).

Toulouse-Lautrec, Henri de (1864–1901)

French painter, lithographer and draughtsman. He was born in a titled family in Albi. After breaking both his legs as a child (1878–9), he suffered from ill health and stunted growth. He was taught by a number of artists including the animal painter René Princteau and developed a colourful ▷Romantic style. In 1882 he moved to Paris to study under ▷Bonnat and Fernand Cormon, and by 1885, when he moved to Montmartre, he was part of the ▷avant-garde scene and friends with ▷van Gogh (see *Portrait of van Gogh*, 1887, Amsterdam), ▷Degas and ▷Bernard.

Having experimented with ▷Impressionist styles and discovered Japanese prints, Toulouse-Lautrec developed a method of sketching in thinned oils on cardboard, creating rapid, fluid images of cafés and dance halls, most famously of the Moulin Rouge (e.g. *At the Moulin Rouge*, 1892, Chicago, Art Institute). From 1890 he was also experimenting with ▷lithography and produced a series of ground-breaking ▷posters using ▷cloisonnist ideas and ▷Art Nouveau, stylized line (e.g. *Les Ambassadeurs, Aristide Bruant*, 1892). He exhibited with ▷Les Vingt in Brussels in 1889 and at the ▷Salon des Indépendants, and he was also associated with the ▷Nabis and met ▷Beardsley in London in 1892. During the 1890s he increasingly worked on images of women, especially of prostitutes, showing their lives harshly yet sympathetically (e.g. *In Bed*, 1893, Paris). His later work was increasingly colourful and freely painted, creating an almost ▷Expressionist impact. His own lifestyle

was debauched and dogged by alcoholism and he was hospitalized in 1899.

Bib.: Dortu, M.G., *Complete Paintings of Toulouse-Lautrec*, 2 vols., London, 1981; *Toulouse-Lautrec: Images of the 1890s*, exh. cat., New York, 1985; *Toulouse-Lautrec*, exh. cat., London, 1992

Tournier, Nicolas (1590–1638/9)

French painter. He worked in Rome in c1619–26, where he painted ▷genre scenes similar to the tavern subjects of ▷Caravaggio. He later worked in Toulouse, where he was best known for his religious paintings.

Towne, Francis (1739/40–1816)

English painter. He was probably born in Exeter, and lived there until 1807, when he moved to London after his marriage. He remained an amateur artist all his life and was little known or appreciated by his contemporaries. He was employed by both ▷Beckford and ▷Payne Knight, and he made a series of sketching tours: to Wales in 1777 (with ▷Abbott); to the Lakes in 1786 (e.g. *Grasmere from the Rydal Road*, 1787, Birmingham); to Italy in 1780–1 with his patron John Merivale and Warwick Smith (e.g. *Source of the Arveiron*, 1781, London, Victoria and Albert Museum). He specialized in ▷topographical ▷watercolours using a typical 18th-century tinted drawing style which combined pen and ink with coloured washes. His work was detailed and geometric but with a sense of poetry. He also produced some ▷picturesque oils (e.g. *Exeter from Exwick*, 1773, Exeter).

Bib.: *Francis Towne and John White Abbott*, exh. cat., Exeter, 1973

town planning

A term used to refer to the act of purposefully designing an area, usually urban, in terms of its housing, retail, transport and infrastructure. Town planning has been used from the earliest civilizations in order to run settlements practically and efficiently.

townscape

Term used to describe a ▷print or painting containing an overview of an urban environment, usually a city or town, occasionally contextualised through the inclusion of landscape elements (e.g. the work of ▷Canaletto).

▷*vedute*

trabeated

System of construction based on an arrangement of upright posts supporting horizontal beams or ▷lintels.

tracery

An architectural term applied to decorative stonework, most usually that occupying the upper part of the window opening of a ▷Gothic building, though in later medieval architecture tracery also covers wall surfaces as blind (or blank) tracery. The earliest type of Gothic tracery, first developed in the 13th century, was employed for windows of more than one light. Between the pointed-arch window lights of a pointed-arch window opening a blank stone spandrel is formed. This stone surface might be perforated by a simple ornamental opening, such as a circle or quatrefoil: this early form is called plate tracery. At ▷Reims in the early 13th century (c1211) a new type of tracery was developed. Instead of filling the space between the tops of the arched lights with a stone spandrel, the moulded ▷mullions separating the main parts of the lights would be continued into the head of the window opening as moulded bars intersecting and defining ornamental circles and quatrefoil patterns. All the space between the bars remains open: this form is called bar tracery and its decorative types become the principal distinguishing characteristic of a succession of Gothic styles. In England, two types of bar tracery, respectively, geometrical tracery and curvilinear (or flowing) tracery, distinguish early from late ▷Decorated Gothic. The ▷ogee patterns of curvilinear tracery reached their most fluid expression as the flame-like patterns of the French ▷Flamboyant style.

Other types of tracery include:

(i) Intersecting tracery: found in the 13th and 14th centuries, in this form the mullions continue up into the head of the pointed arch and follow a curve parallel with the outer arch of the window opening, intersecting with the curving upper continuations of the other mullions.

(ii) Panel tracery: characteristic of the ▷Perpendicular period of English Gothic and consisting of simple, narrow, arched panels repeated without variation on window openings, wall surfaces and screens.

(iii) Reticulated tracery: a frequent feature of buildings of the early to mid-14th century and consisting of a pattern of circles extended at top and bottom into ogee shapes and forming a net-like decoration which completely fills the head of the window opening.

Traini, Francesco (fl 1321–63)

Italian painter. He was from Pisa. He was influenced by the work of the Sienese ▷Simone Martini and the ▷Lorenzetti brothers, and by ▷Giovanni Pisano's pulpit erected in Siena Cathedral in 1302–10. Only one work is signed by Traini, a ▷polyptych of 1345, *St. Dominic and Scenes from his Life* (Pisa, Museo Nazionale), while in the church of Sta Caterina in Pisa is an altarpiece of the *Glory of St. Thomas Aquinas* which appears to be referred to in a document of 1363. There is a series of frescos attributed to him in the Campo Santo, Pisa: *The Triumph of Death, The Last Judgement* and *Legends of the Anchorites* (c1350). These were severely damaged in an air raid in World War Two and the ruined top painted layers were later separated from the underdrawing layers (▷sinopie), thereby exposing draughtsmanship of superlative

graphic strength and incisive characterization (now in the Museo delle Sinopie). Some attempt has been made to reattribute these frescos to the all but legendary ▷Buffalmacco, but the suggestion has not found widespread acceptance and the majority of authorities retain the original attribution to Traini.

Bib.: Bellosi, L., 'Sur Francesco Traini', *Revue de l'Art*, 92 (1991), pp. 9–19

Transavanguardia

(Italian, 'beyond the avant-garde'.) A name given to the international form of ▷Neo-Expressionism that was practised in Italy from the late 1970s to the 1980s. The artists who fall under this label include ▷Baselitz, ▷Clemente and Julian Schnabel.

transept

The tranverse part of a cruciform-plan church, running from north to south at right angles across the main body, usually with the nave to the west and the ▷chancel to the east. Occasionally the transept may be doubled with the smaller arms east of the junction of the ▷nave and chancel (e.g. Salisbury Cathedral), or there may be a second transept at the west end (e.g. Peterborough Cathedral). The term can also refer to either one of the two arms as an entity (i.e. the north transept or the south transept).

transfer printing

A term used in ▷lithography for the process of transferring a drawing which has first been made on a piece of paper directly onto the stone before it is printed. This prevents the image from being reversed when it is finally printed. Transfer printing is also used in ▷ceramics as a means by which to transfer an engraved design to a pot.

Transfiguration

(Matthew 17: 1–8; Mark 9: 2–8; Luke 9: 28–36.) An episode in the story of ▷Christ, recounted by the first three ▷Evangelists only. Christ takes ▷Peter, James and ▷John up onto a high mountain and there before their eyes is transfigured: his face shines like the sun and his clothes glow white. ▷Moses and ▷Elijah appear and converse with Christ; Luke says that they foretell Christ's death in Jerusalem. The Old Testament patriarchs disappear and then a cloud descends from which God's voice proclaims Jesus to be his son. The subject is important because it is the first manifestation of Christ's divinity to the disciples: he is shown to be the fulfilment of the Old Testament prophecies, the inheritor of Mosaic authority and the Son of God. The Feast of the Transfiguration was celebrated in the eastern Church from the 6th century and thus the subject appears in ▷Byzantine art from that time (e.g. ▷mosaic in the ▷apse, c548–65, Mount Sinai, monastery church of St. Catherine); in the West it became a feast in the 15th century. The first part of the episode

is usually illustrated, being particularly favoured by the Carmelites who regarded Elijah as the founder of their order. Moses is usually identified by rays of light like horns emanating from his head. The three disciples usually crouch in fear on the ground and are identifiable in standard ways: Peter with short grey hair and beard; James with long dark hair and beard; and John, younger and beardless. Until the 16th century Christ and the patriarchs stood solidly on a slight rise in the ground (e.g. ▷Giovanni Bellini, late 1480s, Naples, Museo di Capodimonte); from ▷Raphael onwards, however, they are often shown rising up supernaturally and dramatically into the air (e.g. painting of 1517, Vatican, Pinacoteca).

Transitional Style

The architectural style predominant in Europe which flourished between the waning of ▷Romanesque and the flourishing of ▷Gothic. For example, the nave of Ripon Minster (c1180) shows aspects of ▷Norman style in the rounded arches, but anticipates Gothic in other respects.

trecento

Literally, 'three hundred', the Italian art term for the 14th century. It is used only to refer to Italian art and may be used as either an adjective, as in 'trecento art', or a noun, as in 'art of the trecento'.

Tree of Jesse

The genealogical tree of Jesus, the idea for which originates in the prophecy of ▷Isaiah, which was supposed to refer to the coming of ▷Christ: 'And there shall come forth a rod out of the stem of Jesse, and a branch shall grow out of his roots: and the spirit of the Lord shall rest upon him.' (Isaiah 11: 1–3.) This basic image is fleshed out at the opening of the Gospel of ▷Matthew, which enumerates Christ's ancestors, starting with ▷Abraham, passing through Jesse and his son ▷David, and leading to ▷Joseph, the father of Jesus (Matthew 1: 2–16). Jesse is generally shown reclining on the ground, the trunk of the tree rising from his loins, the branches carrying the ancestors of Christ, the ▷Virgin and Christ at the top. The subject was widely represented in so-called 'Jesse Windows' in medieval churches and was popular in early Netherlandish painting. On either side of the tree may also be included various of the prophets and ▷sibyls who predicted Christ's birth.

trefoil

▷foil

Très Riches Heures du Duc de Berry, Les

The most celebrated ▷illuminated manuscript of the French ▷International Gothic style, largely the work of the brothers ▷Pol, Jean and Herman Limbourg. Left incomplete at their deaths in 1416, it was

assembled about 70 years later with elements by other hands, primarily Jean Colombe. The book had originally been designed for John of France, duc de Berry (1340–1416), a brother of the King who relentlessly taxed and plundered his territories of Berry, Poitiers and Languedoc to finance his expensive tastes for works of art and good living.

The *Très Riches Heures* was an example of the medieval ▷Book of Hours, containing a series of prayers richly illustrated with scenes from the Bible. Several illustrations represent the ▷Nativity and the ▷Passion, but the book features latter-day miracles such as the procession of St. Gregory around the walls of Rome which rid the city of plague, and the funeral of Raymond Diocres who emerged from his coffin to bewail the judgement of God. However, the most remarkable section is the opening calendar. Each month is represented by an elaborate miniature showing the changing landscape and the various activities of feudal society: huddling by the fire in February, harvesting in July, hawking and binding sheaves in August, sowing in October. It is distinguished from other contemporary calendars by the sophisticated integration of the life of humanity with that of nature, a wealth of closely-observed characterization and incidental detail (including some of the earliest representations of shadows in medieval art), and a witty eye for social differences.

Bib.: Cazelles, R., *Les Très Riches Heures du Duc de Berry*, Lausanne, 1988; Pognon, E., *Les Très Riches Heures du Duc de Berry*, Freibourg, 1989

Tretyakov, Pavel (1832–98)

A Moscow merchant who built up the first important collection specializing in Russian art. For 30 years he supported the ▷Wanderers group, but his collection also included works from earlier periods and medieval ▷icons, and was housed in a building flamboyantly designed by Victor Vasnetsov to resemble a boyar castle. In 1892 the collection, alongside that of Tretyakov's brother Sergei, was donated to the city of Moscow, where it now forms the basis of the Tretyakov Museum.

Trevisani, Francesco (1656–1746)

Italian painter. He was from Naples and studied in Venice. In 1678 he went to Rome. He produced ▷altarpieces in an anti-Classical mode that helped pave the way for the ▷Rococo style. He also painted ▷cabinet pictures.

Bib.: di Federico, F. *Francesco Trevisani: Eighteenth-Century Painter in Rome*, Washington DC, 1977

tribune

(i) The ▷apse of a Roman ▷basilica, semi-circular or square in plan, with a raised platform and seats for the tribunal; hence the apse of a basilican-planned Christian church in which, originally, the bishop's throne would be placed. (ii) A raised platform or

rostrum for a speaker. (iii) As a characteristic feature of ▷Romanesque or ▷Norman churches, the gallery over the aisles, extending across the whole of the aisle roof, bounded by the outer wall of the church on one side and an ▷arcade overlooking the ▷nave on the other; sometimes erroneously referred to as a ▷triforium gallery.

Tribute Money

There are two separate episodes to which this title refers, both the subject of Christian art. The more famous story is that in which the Pharisees attempt to trick ▷Christ by asking him whether taxes should be paid to Rome (also sometimes called 'The Tribute to Caesar'). Had Christ said no, he would have been guilty of sedition; had he said yes, the Jews would have considered him to have betrayed their struggle against Roman oppression. In fact, Christ asks to see a coin, points to the effigy of Caesar and replies, 'Render … unto Caesar the things which are Caesar's; and unto God the things which are God's.' (Matthew 22: 15–22; Mark 12: 13–17; Luke 20: 20–26.) Illustrations on this text may show Christ pointing to the coin (e.g. ▷Titian, Dresden, Gemäldegalerie), or to the sky (e.g. Titian, 1568, London, National Gallery), or to both. According to ▷Vasari the Dresden picture was originally produced, very appropriately, for the door of Alfonso d'Este's safe. Christ's noble face is generally surrounded and set off by the aggressive faces of his inquisitors. The setting, where specific, is usually presumed to be the temple, although no location is specified in the ▷Gospels.

The second story takes place at Capernaum. The tax collectors ask ▷Peter for tribute money for the upkeep of the temple. Christ asks Peter whether the kings of the earth take money from their own people or subject nations; Peter replies that it is the latter and Christ states that therefore the people should not have to pay. It is the same with God – his children should not need to pay tribute for the temple. However, so that the authorities are not antagonized, Christ asks Peter to go to the lake and catch a fish; inside the fish's mouth Peter will find a coin for the payment (Matthew 24–27). This is the episode represented in ▷Masaccio's fresco (1423–7, Florence, Brancacci Chapel). Masaccio uses ▷continuous narrative to illustrate the three important stages of the incident: in the centre the tax collector asks for the payment and Christ points Peter towards the lake; on the left Peter is taking the coin out of the fish's mouth, on the right he is paying the tax collector.

triforium

In medieval Christian churches, a wall passage above the main ▷arcade and below the ▷clerestory. Bounded on one side by a wall which conceals the space over the aisle roofs and on the other by an arcade

The Trinity, 15th century, St Neophytos Monastery, Cyprus

overlooking the ▷nave. It is essentially a passage, rather than a gallery. ·

> ▷tribune

triglyph

In Classical architecture, the slightly raised blocks which alternate with the ▷metopes in a ▷Doric ▷frieze. The word triglyph literally means 'thrice grooved' and refers to the three vertical grooves, or glyphs, of v-shaped section, on each triglyph (more accurately, the two whole glyphs that cut into the surface of the block and the two half-glyphs that cut into the edges). The three flat surfaces between the glyphs and half-glyphs are called shanks. Triglyphs reflect the timber origins of Doric temple construction: they are conventionalized beam ends, the row of guttae below each triglyph representing the pegs that held each beam onto the ▷architrave.

trilithon

> ▷megalith

Trinity

The Christian doctrine that God is three persons – Father, Son and ▷Holy Ghost – in one nature, originated in the Gospel of ▷Matthew (28: 19) and was later developed by Augustine in the *De Trinitate*. Visualizing this concept raised significant problems for artists: God the Father is inherently invisible and unknowable, and therefore to attempt to portray him could be deemed heretical. Thus, up until the early medieval period the Trinity was always represented by a symbolic ideogram such as a triangle, trefoil, three interlaced circles, etc. Where it was necessary to specifically indicate God the Father he might be represented as an eye within a triangle, or perhaps a hand or hands emerging from a cloud. Nevertheless, by the 12th century, naturalistic representations had appeared, and by the 14th century a standard formula had developed: typically God is an old and bearded patriarch, sometimes with a triangular ▷halo, sometimes with a papal tiara (a reminder of papal authority) or crown. His feet may rest on a globe and he may hold an open book showing the Greek letters alpha and omega (the beginning and end of all things). When he is represented with the Son, he is positioned behind and above him and may be supporting the horizontal beam of the Son's cross (e.g. ▷Masaccio, *Trinity*, c1427, Florence, Sta Maria Novella), or support the Son ▷pietà-fashion, on his lap (e.g. ▷Dürer, *The Trinitarian Pietà*, woodcut, 1511); alternatively Father and Son may be enthroned side by side. In almost all cases, the Holy Ghost, again taking authority from Matthew (4: 16), is represented as a Dove hovering above. The Trinity is most frequently seen in pictures of the ▷Baptism of Christ and the ▷Coronation of the Virgin.

triptych

A picture, often a portable ▷altarpiece intended for private devotion, consisting of a central panel with two hinged wings which can be closed over the central image for protection (e.g. ▷Duccio, *Madonna and Child with SS Dominic and Aurea*, c1300, London, National Gallery).

Triumphal Arch

Tristán, Luis (c1585–1624)

Spanish painter. He was born near Toledo. He studied with and assisted ▷El Greco from around 1603. After a period in Italy (c1606–11) he returned to work in Toledo, where he specialized in ▷altarpieces and other religious commissions. Tristán was the most significant follower of El Greco, and the composition and elongated figures of works such as *The Beheading of John the Baptist* (1613) and *Adoration of the Shepherds* (1620, Cambridge, Fitzwilliam Museum) are particularly indebted to the earlier artist. However, Tristán also absorbed the contemporary Italian influence of ▷Caravaggio, and is seen as a bridge between ▷Mannerism and the bolder, more dynamic Spanish ▷realism.

Triumph

Originally, the public honour accorded a victorious Roman general by the Senate. It took the form of a ceremonial procession through the streets of Rome in which the subject would be conveyed in a splendid chariot drawn by white horses. Dante, in canto 29 of his *Purgatorio* (before 1321) used the idea of a Triumph as an ▷allegory: the chariot is the Church, drawn by four-winged creatures – the apocalyptic symbols of the Four ▷Evangelists – and bearing ▷Beatrice. Later, Petrarch composed a set of six poems called the *Trionfi* (before 1374), in which a succession of allegorical or mythological figures process, each one triumphing over the previous. Thus Chastity triumphs over Love, only to be in turn defeated by Death, which is defeated by Fame, Fame by Time, and Time by Eternity. Largely through the influence of Petrarch's *Trionfi*, actual triumphs were revived in ▷Renaissance Italy, but as a

festive pageant rather than a military exercise. The poems became popular sources for paintings, particularly on wedding chests (▷*cassone*) and similar commemorative paintings, such as ▷Piero della Francesca's secular ▷diptych for ▷Federico da Montefeltro (Florence, Uffizi), with portraits of Federigo and his wife on one side and allegorical triumphs on the other. The whole series inspired a series of remarkable ▷frescos in the Sala dei Mesi of the Palazzo Schifanoia, Ferrara (1471; executed by ▷Cossa, possibly with ▷Roberti and ▷Tura).

Other triumphs include *The Triumph of Bacchus and Ariadne* (e.g. ▷Annibale Carracci, begun 1597, Rome, Farnese Gallery); *The Triumph of Caesar*, a series of nine paintings by ▷Mantegna (c1480–95; now at Hampton Court, Surrey); *The Triumph of Scipio* (Mantegna, London, National Gallery); and *The Triumph of Titus* (▷Giulio Romano, 1536–7, Paris, Louvre). There are also marine triumphs, most significantly, *The Triumph of Neptune, The Triumph of Galatea* (e.g. ▷Raphael, c1513, Rome, Villa Farnesina), and *The Triumph of Venus* (e.g. ▷Boucher, 1740, Stockholm, Nationalmuseum).

triumphal arch

A free-standing monumental arch, originated by the Romans to commemorate the triumphal return of a victorious army and in imperial times always dedicated to the emperor in whose reign the victory was won. The first triumphal arches were erected in 2nd-century BC Rome as richly decorated, temporary structures, although by the late 1st century BC the first permanent arches in stone appear. Temporary arches were erected

on the route of the triumphal procession, although later, permanent arches might be erected either as city gates, or as entrances to fora, or even as a non-functional urban monument. Examples are found throughout the Roman Empire. A triumphal arch may have one archway (such as the Arch of Titus, Rome, c82 AD) or one large archway flanked by two smaller (such as the Arch of Septimius Severus, Rome, 203 AD). The arch will usually be decorated with an ▷order (usually ▷Corinthian) and have an ▷attic storey with a dedicatory inscription; it may also originally have been richly decorated with ▷bronze statuary, including, on the top, the emperor standing in a quadriga, as well as being adorned with the ▷relief carvings on the arch itself, depicting the relevant victories.

Triumphal arches, both temporary and permanent, have also been erected since the ▷Renaissance in imitation of the power and grandeur of ancient Rome (for example, the temporary arch erected in Rome at the expense of Agostino Chigi to celebrate the election of Leo X to the papacy in 1513, and the Arc de Triomphe, 1806–35, Paris, erected originally to celebrate Napoleon's victories).

trivium
▷Liberal Arts

trompe-l'oeil
(French, 'deceives the eye'.) Term applied to a painting, or part of a painting, that is intended to deceive the spectator into thinking that it is a real object rather than a two-dimensional representation of it.

Troost, Cornelis (1697–1750)
Dutch painter and engraver. He was born in Amsterdam. He specialized in group portraits, especially of actors playing roles, and humorous scenes. His works were very popular and many of them were engraved.

Troy, Jean-François de (1679–1752)
French painter. He was born in Paris into a family of painters and tapestry designers and was taught by his father François (1645–73), who was Director of the French ▷Académie. He travelled to Rome in 1699 without having won the ▷Prix de Rome and spent time travelling throughout Italy. Returning to France in 1708 he was received into the Académie with the *Children of Niobe* (Montpellier, Musée Fabre) and launched a successful career. He collaborated with ▷Boucher on decorations for Versailles in 1734, produced designs for the ▷Gobelins tapestry works and made a good marriage. In 1738 he himself became director of the French Academy in Rome. Although he worked in a range of genres, his best works were large allegorical pieces painted with a ▷Rococo palette (e.g. *Time Unveiling Truth*, 1733, London, National Gallery; *Alarm*, 1723, London, Victoria and Albert Museum).

He also painted numerous portraits (e.g. *Marquis de Vandières*, 1751, Versailles) and contemporary landscapes (e.g. *Hunt Breakfast*, 1737, London, Wallace Collection). All his works combine high finish with sensual colour, although they have a tendency towards superficiality.

Bib.: *Age of Louis XV*, exh. cat., Chicago, 1975; Conisbee, P., *Painting in 18th Century France*, Oxford, 1981; Wakefield, D., *French 18th Century Painting*, London, 1984

Troyon, Constant (1810–1905)
French painter. He was born in Sèvres and entered the family trade there as a decorator of ▷porcelain, where he met ▷Diaz in 1824. From 1830 he started painting landscapes, which he exhibited at the ▷Salon from 1833. Prior to 1840 these were dominated by 17th-century Dutch art, but in 1841 he visited ▷Barbizon and came under the influence of ▷Rousseau and ▷Dupré, with whom he visited the Landes in 1843, and he began to paint with visible brushwork in an attempt to capture the effects of movement and light (e.g. *Forest of Fontainebleau*, 1848, Lille, Palais des Beaux-Arts). In 1847 he travelled to Holland and was increasingly influenced by the work of painters like ▷Cuyp and ▷Potter, to produce repetitive but popular pictures of grazing cows, frequently with a Normandy setting (e.g. *Cows in a Storm*, 1857, London, Wallace Collection). He followed Rousseau in his use of strong colours and returned to a sophisticated, finished technique. In his later career, he also produced seascapes, creating a fresh light style reminiscent of ▷Boudin (e.g. *Tréport*, 1860–2, private collection). He was a very prolific artist.

Bib.: *Barbizon Revisited*, exh. cat., London, 1962; Bouret, J., *L'École de Barbizon*, Neuchâtel, 1972

Trubetskoi, Pavel (1866–1938)
Russian sculptor. He was raised in Italy and studied in Milan. He lived in Russia in 1897–1906, where he produced portrait sculptures of famous Russians such as Tolstoy and Tsar Alexander III. His sculptural style was similar to ▷Impressionism in its blurred qualities. He was a teacher of ▷Goncharova. His skill earned him the nickname 'The Russian ▷Rodin'.

True Cross, History of the
Medieval legend which traces the history of the wood used for ▷Christ's cross back to the ▷Garden of Eden, thus linking Christ's redemption of mankind with the original ▷Fall of Man, and then forward to the 7th century.

When ▷Adam and Eve were expelled from Eden, Adam took with him a branch from the Tree of Knowledge. Following Adam's death, it was planted over his grave by his son Seth, whereupon it grew into a tree. The staff upon which ▷Moses mounted the Brazen Serpent, the raising of which was seen by the medieval

Church as a prefiguration of the ▷Crucifixion, was supposed to have been derived from the tree. By the time of ▷Solomon, the trunk was serving as a bridge across a stream at Jerusalem. The Queen of Sheba, recognizing it for what it was, knelt down and prayed before it and waded through the stream, rather than walk over the bridge. In the time of Christ the trunk was found floating in the Pool of Bethesda, from whence it was taken to make Christ's cross. After the Crucifixion, Christ's cross became buried with those of the two thieves who had been crucified with him on ▷Golgotha.

Following the adoption of Christianity by Constantine as the official Roman religion, his mother, Helena, involved herself in good works, amongst which was the founding of churches in the Holy Land. One day she heard of a man named Judas who had professed knowledge of the whereabouts of the lost True Cross. He refused to reveal the location and was put into a dry well until he relented, which he finally did. He was hoisted from the well, and then took Helena and her followers to the site of Golgotha. Here they unearthed three crosses. They ascertained which was Christ's by laying a corpse upon each one in turn. As the corpse made contact with the True Cross, it was restored to life. At this point Helena also retrieved the three nails which had fixed Christ to the cross.

The True Cross remained in Jerusalem until the 7th century when the Holy Land was overrun by the Persians under Chosroes II. The ▷Byzantine Emperor Heraclius waged war against Chosroes, defeated him and retrieved the Cross. Chosroes was subsequently executed for refusing baptism. On his return to Jerusalem, Heraclius was instructed by an angel to humble himself, so he removed his royal robes and carried the Cross into the city, either on foot or mounted on an ass or a horse. The Cross was then erected upon an altar at Golgotha. The narrative cycle of the True Cross was particularly popular in Franciscan churches. Santa Croce in Florence is, of course, dedicated to the True Cross and the legend is illustrated in a ▷fresco cycle by ▷Agnolo Gaddi and workshop in the choir. The most celebrated cycle of the History of the True Cross is perhaps that by ▷Piero della Francesco for the choir of the church of San Francesco at Arezzo (c1452–c1465).

Trumbell, John (1756–1843)

American painter. He was born in Connecticut and studied at Harvard. After fighting in the War of Independence, he travelled to London, where he studied art with ▷Benjamin West. Like West, he became interested in representing modern history subjects, and West's *Death of General Wolfe* formed the basis of his own *Death of General Warren* (1786, New Haven, Yale University Art Gallery). His skill at producing large-scale subjects of modern history made him an appropriate choice to decorate the Rotunda of the US

Capitol in Washington DC with scenes of American heroism. He was elected President of the American Academy of Fine Arts in New York. He also painted portraits.

trumeau

(French, 'pier glass'.) A mirror intended to hang over a chimney piece.

Tucker, William (b 1935)

English sculptor. He was born in Cairo, but studied at the Central School of Art and Design and at St. Martin's School of Art, London, with ▷Caro. He was an advocate of formal abstract sculpture, and he wrote a famous book on the subject *The Language of Sculpture* (1974).

Tudor arch

▷arch

tunnel vault

▷vault

Tura, Cosmè (Cosimo) (c1430–95)

Italian painter. He was the first of the great Ferrarese painters (▷Ferrara, School of). Employed by the court of ▷Este from 1451, much of his work is unfortunately lost. He was, in 1486, succeeded as court painter by ▷Ercole de' Roberti and is said to have died in poverty. Tura's influences, seen in his characteristically sculptural, even brittle, figure style, with angular forms circumscribed by a wiry contour line, and drapery resembling hammered metal, are principally ▷Mantegna and, through him, ▷Donatello. There is, however, also a monumentality deriving from ▷Piero della Francesco, who painted a (lost) series of frescos in Ferrara in the late 1440s. All of these influences are, however, assimilated into an intensely personal, deeply emotional and spiritual art that is totally original and instantly recognizable. Tura exerted a profound influence on both Roberti and the other leading painter of the period, ▷Francesco Cossa. Tura's principal surviving work in Ferrara is his pair of painted organ shutters (1469; representing *The Annunciation* and *St. George and the Princess*) for Ferrara Cathedral, now in the Cathedral Museum. In the National Gallery, London, is the central panel of his *Roverella Altarpiece*, the ▷lunette for which, painted with a moving ▷Pietà, is in the Louvre.

Turner, Joseph Mallord William (1775–1851)

English artist. He was born in Covent Garden, the son of a barber, and received little formal education. He entered the ▷Royal Academy schools in 1789 and achieved rapid success, exhibiting his first work in 1791 and becoming RA in 1802. During the 1790s he concentrated on ▷watercolour, making a series of sketching tours and working with ▷Girtin as part of

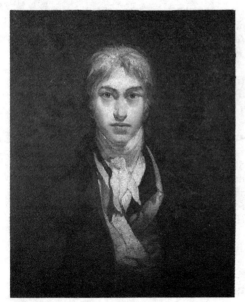

J.M.W. Turner, *Self-portrait*, c1798

▷Dr. Monro's circle (e.g. *Pass of St. Gothard*, 1804, private collection). His first oils were painted in a Dutch style (e.g. *Fisherman at Sea*, 1796, London, Tate Gallery). He made the first of many visits abroad in 1802–3, travelling to Switzerland where he made over 200 sketches, and to Paris to view Napoleon's collection of looted art. Later he became obsessed with Italy, visiting there first in 1819 and changing his style as a result of the Mediterranean light and colour he encountered (e.g. *Coast Scene near Naples*, 1828, London, Tate Gallery). He painted in a range of styles as if both to prove his abilities (e.g. *Tenth Plague of Egypt*, 1902, Tate; *Country Blacksmith*, 1807, Tate; *Frosty Morning*, 1813, Tate) and emulate his artistic heroes ▷Poussin, ▷Rembrandt, and most notably ▷Claude (e.g. *Crossing the Brook*, 1816, Tate). In 1810, he painted the first of many works which used the radically new vortex composition of swirling, imprecise brushwork (e.g. *Cottage Destroyed by an Avalanche in the Grisons*, 1810, Tate).

Turner achieved academic success, becoming Professor of Perspective at the Royal Academy in 1807 and Deputy President in 1845, and he enjoyed the patronage of ▷Beckford and Lord Egremont (see *Interior at Petworth*, 1837, Tate), as well as of ▷Ruskin who eulogized his work in *Modern Painters*. His paintings frequently contained patriotic sentiment (e.g. *The Fighting Temeraire*, 1838, London, National Gallery), and he was one of the first artists to portray the modernity of the steamer and railway (e.g. *Rain, Steam, Speed*, 1844, London, National Gallery). However, in his personal life he was increasingly reclusive and his work remained highly controversial, as he pushed back

the boundaries of acceptability (e.g. *Angel Standing in the Sun*, 1846, Tate). He continued to work in watercolour throughout his career and also produced a series of ▷engravings, *Liber Studiorum* (1806–19).
Bib.: Brown, D.B., *The Art of J.M.W. Turner*, London, 1990; Butler, M. and Joll, E., *The Paintings of J.M.W. Turner*, 2 vols., London, 1972; Gage, J., *J.M.W. Turner: A Wonderful Range of Mind*, London, 1987

Turner Prize

Awarded annually at the Tate Gallery by a selected jury to a British artist under 50 years of age for an outstanding exhibition or other presentation of their work in the preceding 12 months. The Turner Prize was established in 1984 by the Patrons of New Art, and is intended to promote public discussion of new developments in contemporary British art. Recent winners have included ▷Gilbert & George, ▷Richard Long, Anish Kapoor, Grenville Davey, Rachel Whiteread, Anthony Gormley and Damien Hirst.

turpentine

A distilled spirit of ▷resin from pine trees, used as a dilutent or thinner in oil painting.

turret

A small tower; when ▷corbelled out from the face of a wall or at a corner it is called a tourelle.

Tutankhamun

Eighteenth Dynasty king of Egypt who came to the throne aged nine and reigned from 1334 BC to 1325 BC. The outstandingly preserved treasures of his tomb were discovered in 1922 in the Valley of the Kings by the English archaeologist Howard Carter and his patron, Lord Carnarvon. Little had been known of Tutankhamun before this date, and the details of his parentage and his short reign remain obscure. However, the rich objects of his tomb, including ▷sarcophagus, gilt coffins, chariots, gold funeral mask and throne have made him the most famous Egyptian pharaoh. Carter's meticulous excavation and recording of the grave objects have allowed detailed study by specialists, but many of the organic objects are sadly deteriorating in the unsatisfactory conditions of Cairo Museum.
Bib.: Desroches-Noblecourt, C., *Tutankhamun: Life and Death of a Pharaoh*, London, 1963; Welsh, F., *Tutankhamun's Egypt*, Princes Risborough, 1993

291 Gallery

An art gallery located at 291 Fifth Avenue. It was founded by ▷Alfred Stieglitz in 1905 as the Photo-Secession Gallery, and it originally featured photography, which was Stieglitz's own speciality. Stieglitz soon devoted his gallery to the twin aims of bringing European ▷modernism to the attention of American artists, and promoting the work of young and

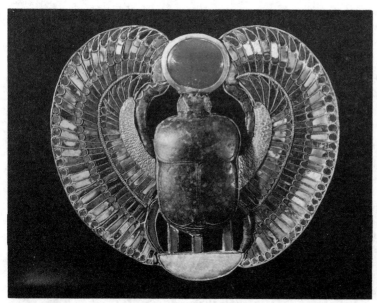

Scarab chest ornament from the tomb of Tutankhamun, c1361–52 BC, Egyptian National Museum, Cairo

innovative American artists like ▷O'Keeffe, ▷Hartley and ▷Dove. The gallery's innovative approach pre-dated the ▷Armory Show as a harbinger of American modernism. Stieglitz also published a journal *291* (1915–16), which was an important contribution to the ▷Dada movement in America. The gallery closed in 1917.

Bib.: Leavens, I., *From '291' to Zurich: The Birth of Dada*, Epping, 1983

Twombly, Cy (b 1928)

American painter and draughtsman. He was born in Lexington, Virginia, and trained at Boston Museum School, the ▷Art Students' League, New York, and ▷Black Mountain College, where he was influenced by ▷Franz Kline. He developed from ▷Abstract Expressionism an original manner of painting 'written images', a sort of ▷graffiti of marks on large blank canvases. His loose style of action painting is akin to ▷Pollock, and he belongs to the mid-1950s period of ▷Post-Painterly Abstraction characterized by the work of ▷Jasper Johns and ▷Robert Rauschenberg.

tympanum (pl. tympana)

(i) In Classical architecture, the triangular or segmental surface enclosed by the ▷cornices of a ▷pediment. Because of the important position of the pediment over the entrance to a Classical temple (occupying the entire length of the entrance ▷façade), the Greek tympanum, in particular, was often richly decorated with figure sculpture proclaiming the dedication of the

temple (e.g. the Temple of Zeus, Olympia and the Parthenon, Athens).

(ii) In a more general usage, covering both western and eastern architecture, a tympanum may be the wall surface enclosed by the ▷lintel of a doorway, window, or other opening and its surmounting ▷arch. The shape of the surface enclosed may vary according to the prevailing architectural style: in European architecture, the surface was semi-circular from the Classical until ▷Romanesque periods, being superseded in the ▷Gothic period by triangular tympana, followed by a revival of semi-circular tympana in the ▷Renaissance; in ▷Islamic architecture tympana may be horseshoe or ogee-shaped (▷arch), whilst in Indian architecture, a more complex, curvilinear form is common. As with Classical pedimental tympana, where the siting is over an important entrance, such as the west front portal of a Christian church, the themes treated are of cor-responding importance, such as the titular saint of the church, Christ in Majesty, the ▷Last Judgement, etc.

typography

A term once applied to printing from a raised typeface, but which now applies to the design of the appearance of printed material, from the choice of typeface, the type of ink and paper used and the placing of words and images on the page.

typology

The belief that the Bible, being divinely inspired, forms an integrated and consistent whole in which

personages and events in the Old Testament ('types') are prefigurations of corresponding personages and events in the New Testament ('antitypes'). The Church Fathers taught that God, in inspiring the writers of the scriptures, was preparing the way for the understanding and acceptance of Christ as the true saviour of the world by giving symbolic foreshadowings throughout the Old Testament. St. Augustine wrote, 'The Old Testament is nothing but the New covered with a veil, and the New is nothing but the Old unveiled.' (*City of God*, Bk. 16, ch. 26.) The various themes were grouped together to illustrate their typological correspondences in the *Biblia Pauperum* (c1300) and the *Speculum Humanae Salvationis* (c1324) and in various decorative schemes in churches, chapels, etc. An example is ▷Tintoretto's cycle of paintings for the upper hall of the Scuola di ▷San Rocco (1565–87, Venice) where the Old Testament scenes are selected precisely for this correspondence: the Miracle of Manna corresponds to the ▷Last Supper, Jonah leaves the Whale's Belly to the ▷Resurrection, Jacob's Ladder to the ▷Ascension, etc.

Tzara, Tristan (1886–1963)

Romanian poet. Tzara was the pseudonym of Sammy Rosenstock. Fleeing Romania to avoid military service, he arrived in Zurich, originally to study mathematics, but he became a co-founder of ▷Dada in February 1916. A prolific writer of Dada texts, such as the *First Adventure of Mr. Antipyrine*, he was also an energetic propagandist, seeking to establish Dada on an international level through his manifestos of 1917 and 1918, and the magazine *Dada* (1917–20). Calling for works 'for ever beyond understanding', Tzara's insistence on creating a cultural *tabula rasa* led to accusations of nihilism, and his self-advertising and suspicions that he was a plagiarist lost him many friends including ▷Picabia and ▷Breton. Moving to Paris, he eventually joined the ▷Surrealists in 1929, but left in 1935 when the Surrealists split with the Communists. As a Communist Party member he was active in the Resistance during the War, after which he became a wealthy collector of Stalinist memorabilia.

Bib.: Dachy, M., *Tristan Tzara, dompteur des acrobates*, Paris, 1992

U

Uccello, Paolo (1397–1475)

Italian painter. He was a Florentine, most famous for his obsession with ▷perspective. He is first documented in 1407 as a *garzone* (young apprentice) in ▷Ghiberti's workshop and then in 1415 as an independent master entering the Florentine painter's ▷guild. In 1425 he went to Venice to work on the ▷mosaics of St. Marks, although nothing there can be confidently ascribed to him. He was back in Florence by 1432, by which time the naturalistic revolution initiated by ▷Brunelleschi, ▷Donatello and ▷Masaccio was already in full swing. Uccello embraced the scientifically-constructed perspective system exemplified in Masaccio's painting, but instead of using it to endow his pictures with a 'window on the world' naturalism, he amalgamated it with a unique decorative style derived from the ▷International Gothic tradition he would have learned in Ghiberti's workshop. More than the creation of believable pictorial space, Uccello was interested in the problems of how to ▷foreshorten complex geometric forms. And yet although details in his paintings are sometimes clearly engineered to demonstrate this mastery, the resulting paintings are nonetheless some of the most poetic and enchanting of the period.

His earliest surviving public commission is his ▷fresco of the English *condottiere*, *Sir John Hawkwood* (or, as he was known in Italy, Giovanni Acuto), dating from 1436 in Florence Cathedral. The fresco, intended to imitate an actual ▷equestrian monument, is constructed on two perspective systems: the ▷pedestal is shown in steep ▷foreshortening from the actual viewpoint of a person standing in the ▷nave, whereas the horse and rider are portrayed at eye-level, a modification introduced most likely to maintain visual clarity. Also in the Cathedral are his frescos of *Four Prophets* (1443) around the face of the Cathedral clock and some stained-glass windows executed to his designs. In the 1430s or 1440s he painted his celebrated frescos in the Chiostro Verde of S. Maria Novella, Florence: the *Deluge* (recently restored) was his most complex exercise in perspective to date and shows an almost text-book exposition of Albertian ideas, even adhering to ▷Alberti's extraordinary advice that the wind should be represented by 'the face of Zephyrus who blows from the clouds making the draperies move in the wind.' Probably in the early 1450s Uccello was commissioned by the ▷Medici to paint three panels representing episodes from the ▷*Rout of San Romano* (one panel each in Florence, Uffizi, London, National

Gallery, and Paris, Louvre). These are less battle scenes than pageant, with dead soldiers and scattered weapons lying on the ground in neat and orderly ▷orthogonals, absolutely appropriate as colourful decorations for the Medici Palace. Two small paintings generally considered as late are the exquisite *St. George and the Dragon* (London, National Gallery) and a lively *Hunt in the Forest* (Oxford, Ashmolean).

Bib.: Padoa Rizzi, A., *Paolo Uccello: catalogo completo dei dipinti*, Florence, 1991; Pope-Hennessy, J., *Paolo Uccello*, London, 1969; Scheffer, J.L., *The Deluge, the Plague, Paolo Uccello*, Ann Arbor, 1995

Uden, Lucas (1595–1672)

Flemish painter. He worked in Antwerp as a landscape painter. He may have done some landscape backgrounds for ▷Rubens.

Udine, Giovanni da

▷Giovanni da Udine

Uffizi

The most important collection of art and artefacts in Italy, housed in the Palazzo degli Uffizi, Florence. The building itself, a huge edifice which stretches from the Piazza della Signoria to the Arno, is a technical feat, using iron to reinforce the building, which rests on sandy ground. It was commissioned by Cosimo I (1519–74) and designed by ▷Vasari in 1560 to serve as government offices ('*uffici*' means 'offices'). The Corridoio Vasariano was built in 1565 and connects the Palazzo Vecchio with the Palazzo Pitti, via the Uffizi and the Ponte Vecchio. The building was completed after Vasari's death by Alfonso Parigi the Elder and ▷Bernardo Buontalenti.

The origins of the collection also go back to Cosimo I, who patronized Florentine painters. Francesco I (1541–87) augmented the collection, which was then greatly enhanced by the ▷Medici. Ferdinando I (1541–87) transferred his collection of sculpture to the Uffizi and Ferdinando II (1549–1609) added works by ▷Raphael, ▷Titian and ▷Piero della Francesco. The last of the Medici, Anna Maria Lodovica (1667–1743) left the collection to the people of Florence. The collection is vast and was partly broken up in the 19th century, when many of the sculptures were taken to the ▷Bargello, and the prehistorical collection was moved to the Archaeological Museum. However, the collection has continued to grow as paintings are brought to the gallery from churches and religious

houses in Tuscany. Today the collection contains works by ▷Cimabue, ▷Duccio (including the attributed *Rucellai Madonna*), ▷Giotto, ▷Ambrogio Lorenzetti, ▷Simone Martini, ▷Lippo Memmi, ▷Bernardo Daddi, ▷Orcagna, ▷Lorenzo Monaco, ▷Fra Angelico, ▷Domenico Veneziano, ▷Masaccio, ▷Masolino, Piera della Francesca, ▷Paolo Uccello, ▷Lippi, ▷Botticelli, ▷Ghirlandaio, ▷Leonardo da Vinci, ▷Verrocchio, ▷Piero di Cosimo, ▷Bronzino, ▷Andrea del Sarto, Raphael, ▷Perugino, ▷Carpaccio, ▷Bellini, ▷Cosimo Tura, ▷Giorgione, ▷Mantegna, ▷Sodoma, ▷Michelangelo, ▷Tintoretto, ▷Veronese, ▷Gentileschi, ▷Carracci, ▷Guido Reni, ▷Tiepolo, ▷Memlinc, ▷Dürer, ▷Cranach, ▷Holbein and many others.

Ugo da Carpi (d 1532)

Italian painter and wood engraver. He invented a new technique by which a ▷woodcut could be made to appear as if it were painted. This ▷'chiaroscuro woodcut' was already known in Germany, but he obtained the patent for it in Venice in 1516.

Ugolino di Nerio (fl 1317–27)

Italian painter. He was from Siena, and he signed himself Ugolino da Siena ('Ugolino from Siena'; inscription now lost) on the high ▷altarpiece of the Florentine church of Sta Croce (c1324–5; now dispersed between Berlin, Gemäldegalerie; London, National Gallery; New York, Metropolitan Museum; and Philadelphia, Museum of Art). The style of this altarpiece shows him to be a close follower of ▷Duccio, whose art, albeit for the high altar of an important Florentine church, makes no concessions to the innovations of ▷Giotto. However, Ugolino's work is distinguishable from that of Duccio by its harsher colour, more jagged linearity and exaggerated emotionalism.

Bib.: *Art in the Making: Italian Painting Before 1400*, London, National Gallery, 1990; Stubblebine, J., 'Ugolino di Nerio: Old and New in an Early Madonna', *Apollo*, 121 (June 1985), pp. 366–72

Uhde, Wilhelm (1874–1947)

German collector. He was resident in Paris from 1904. He was a major patron of the ▷Cubists and an early supporter of the ▷naive painter ▷Henri Rousseau, about whom he published a monograph in 1910.

ukiyo-e

(Japanese, 'picture of the floating (fleeting) world'.) A school of Japanese ▷genre painting of the ▷Edo period (1615–1868) that depicted, as its name suggests, scenes of everyday life and fashion. Designed for popular taste, the usual form of these pictures was the woodblock (▷woodcut) print, at first in outline and coloured by hand, but from the middle of the 18th century in several colours. It was these prints,

exhibiting a strong sense of design through the use of flat areas of colour, that so influenced the ▷Impressionists ▷Manet, ▷Degas, ▷van Gogh and ▷Mary Cassatt, as well as the ▷Symbolists ▷Gauguin and ▷Emile Bernard. Among the most celebrated practitioners of the genre are Sharaku, ▷Utamaro, ▷Hokusai, Kunisada and Hiroshige.

Bib.: Swann, P., *Art of China, Korea and Japan*, 1963

Ulysses (Greek, Odysseus)

(Principal sources: Homer, *Odyssey* and Ovid, *Metamorphoses*.) King of Ithaca, whose long and dramatic journey home by sea from the siege of Troy forms the principal source for themes about him in art. His story was extremely popular in the Italian ▷Renaissance and enjoyed a revival amongst Academy and ▷Salon painters of the 19th century. The principal episodes are:

(i) Ulysses and ▷Polyphemus. Polyphemus, a giant man-eating cyclops, imprisoned Ulysses and his 12 companions in his cave. Ulysses got Polyphemus drunk, blinded him with a stake, and then he and his surviving companions made their escape. ▷J.M.W. Turner shows Ulysses' ship sailing out to sea. From the crow's nest, Ulysses derides the blinded cyclops, whose giant form can be seen crouched in agony on the cliff top (*Ulysses Deriding Polyphemus*, 1829, London National Gallery).

(ii) Ulysses and Circe. Circe was a sorceress who transformed men who visited her island into pigs. Ulysses' men were transformed, but he had been forewarned by ▷Mercury and took an antidote. He then forced Circe to restore his crew and sailed away despite her amorous advances.

(iii) Ulysses and the Sirens. The sirens drew sailors to their death on the rocks by their beguiling song. Ulysses wanted to hear the song, so he had himself tied to the mast, while his oarsmen rowed onwards, their ears plugged with wax. The sirens are described by Homer as having girls' faces, but birds' bodies, though they are more often portrayed in paintings as seductive mermaids (e.g. Herbert Draper, *Ulysses and the Sirens*, 1909, Hull, Ferens Art Gallery).

(iv) The Return of Ulysses. After many years Ulysses returns to Ithaca to find his wife Penelope beset by suitors who believe him to be dead. She has been putting them off for years by insisting that she must first finish her father-in-law's shroud (which she unravels again each night). Penelope is shown at her loom, surrounded by suitors, whilst Ulysses enters in a disguise donned to outwit the predatory suitors (e.g. ▷Pinturicchio, *Penelope with the Suitors*, London, National Gallery).

Umbria, School of

Umbria is a land-locked mountainous area of central Italy, through which the river Tiber and the principal road from Rome to Ancona pass. The area has been

artistically important since the Middle Ages and ▷Romanesque cathedrals survive in Spoleto, Todi, Narni and Assisi. The most remarkable artistic achievements are associated with the rise of the Franciscan movement, which started in Assisi. The construction of the extraordinary double ▷basilica (1228–53) split the Franciscan order, some of whom objected to such a grandiose building being dedicated to the saint who resolutely rejected all materialistic trappings; however, the basilica produced a series of unique artistic creations. In the lower church works by the Maestro di San Francesco cover the main ▷nave, while subsidiary chapels contain other masterpieces, notably the St. Martin cycle by ▷Simone Martine and the ▷Passion cycle by ▷Pietro Lorenzetti. The Upper Church contains a series of controversial ▷frescos recording the Life of St. Francis, which may be by ▷Giotto and ▷Cimabue. None of these artists was from Umbria, but their work at Assisi produced a reference point for Umbrian artists and craftsmen who imitated both the style of the basilica (as at Gualdo, Terni, Narni and Perugia) and its decoration. Indeed, Tuscan artists were to profoundly effect the course of Umbrian art. By the beginning of the 15th century Perugia was dominant artistically. ▷Domenico Veneziano and ▷Fra Angelico settled there briefly, but it is ▷Perugino (1445/50–1523) and ▷Pinturicchio (1445–1513) who dominate the Umbrian School. Both executed ▷fresco cycles in Umbria, notably ▷Perugino's cycle at the Colelgio di Cambio, Perugia (1500), and ▷Pinturicchio's cycle at Sta Maria Maggiore, Spello. Perugino and Pinturicchio both travelled widely in Italy, and collaborated on the east wall of the ▷Sistine Chapel, Rome. Their work was imitated by such painters as Sinibaldo Ibi, Giannicola di Paolo and Eusebio di San Giorgio, and their influence survived in one of Perugino's pupils, ▷Raphael. By 1540 political mayhem in Umbria had led to the decline of the Umbrian School.

Unanimism

A term relating to the ▷Futurist paintings of ▷Boccioni and others. It refers to the emotional and physical impact of crowd behaviour, which occurs simultaneously.

▷simultaneity

Underwood, Leon (1870–1975)

British sculptor, painter and graphic artist. He studied at the ▷Royal College of Art. He later taught there and opened his own school. ▷Henry Moore was one of his students. His sculpture was not abstract but it had a modern feeling of monumentality. He was in Mexico in 1928–9 where he was influenced by the art he saw there, and similarly the ▷African art which he saw in the 1940s had an impact on his work.

Bib.: Neve, C., *Leon Underwood*, London, 1974

Union of Youth

A Russian ▷Futurist organization formed in St. Petersburg in 1909 and formally launched in 1910. The group sponsored exhibitions, lectures and discussions in both St. Petersburg and Moscow. Its members and affiliates included artists such as ▷Malevich and ▷Talin, and poets, such as ▷Mayakovsky. The group became involved in opera and theatre production as well. They disbanded in 1914.

Bib.: Howard, J., *The Union of Youth: A Society of Artists of the Early 20th-century Russian Avant-Garde*, Manchester, 1992

Unique Forms of Continuity in Space

A ▷bronze sculpture by ▷Umberto Boccioni (120 × 87 × 82 cm/4 ft × 2 ft 10 in × 2 ft 8 in). It was designed in 1913, one of a series of ▷Futurist sculptures by the artist (cf. *Fusion of Head and Window,* 1912; destroyed). The work shows a figure in motion, one leg forward of the other, with a series of curving, aerodynamic 'facets' projecting behind the figure in a suggestion of movement through space and time. Despite Boccioni's ▷modernist intention, the work has a traditional quality, partly as a result of the ▷medium, partly because the figure remains recognizably human. It has in fact been compared to the ▷Victory of Samothrace. However, the sculptor has reduced the static parts of the body, notably the head, to mere tokens of form, and his interest clearly lies in the abstract power of movement, what he described as 'physical transcendentalism'. In this respect the work clearly follows the concerns of Boccioni's paintings. The original work is now in a private collection, although there are a number of versions, including one in the Tate Gallery, London.

Bib.: Golding, J., *Boccioni's Unique Forms of Continuity in Space*, Newcastle, 1972

Unit One

A British artistic group formed by the painter ▷Paul Nash in 1933. Its formation was announced in *The Times* on 2 June where Nash stated that his aim was to bring together artist who shared 'the expression of a truly contemporary spirit'. Its original eleven members were Nash, ▷Henry Moore, ▷Edward Wadsworth, Wells Coates, ▷Barbara Hepworth, ▷Ben Nicholson, ▷Edward Burra, John Bigge, John Armstrong, Colin Lucas (an architect) and ▷Tristram Hillier, and it had its base at the Mayor Gallery in Cork Street, London. An exhibition (accompanied by a book *Unit One*, with an introduction by ▷Herbert Read) followed in 1934 and toured the country. By 1935 the interests of many of the members had divided, though some were to play an important role in embracing the ▷Surrealist movement in Britain.

unprimed canvas

A canvas that has not been primed.
▷priming

Upjohn, Richard (1803–78)

American architect of English birth. He went to America in 1829 and opened a practice in Boston five years later. He designed historicist buildings primarily in a ▷Gothic Revival style, although he also worked in other revivalist styles, such as the ▷Romanesque. Among his most important buildings is Trinity Church in New York (1840s).

Urania

▷muse

Ursula

A fictitious saint whose chastity and gory martyrdom were favourite subjects among medieval and ▷Renaissance artists. According to Jacobus de Voraigne's *The Golden Legend*, Ursula was a Breton princess forced to marry a pagan king. She was permitted three years grace, in which to travel accompanied by an entourage of 11,000 virgins, but the group was massacred by marauding Huns. The most notable example of the Ursula legend is the cycle painted by ▷Carpaccio (1490s, Venice, Accademia).

Uruguay, art in

▷Latin America, art in

USSR, art in

▷Russia and USSR, art in

Utamaro, Kitagawa (1753–1806)

Japanese print maker. He was responsible for ▷ukiyo-e colour prints, especially concentrating on ▷genre scenes featuring women.

Bib.: Hillier, J., *Utamaro, Colour Prints and Paintings*, 2nd edn., Oxford, 1975

ut pictura poesis

(Latin, 'as is painting, so is poetry'.) An expression first coined by Horace in *Ars Poetica* (361) to draw attention to the similarity between poetry and painting, both of which were to be considered as, first and foremost, arts of imitation. Poetry describes actions and events in words and painting in pictures and, importantly, both demand that the artist exercise his intellect and sensibility to improve upon nature. The expression became important for painters during the Italian ▷Renaissance as the strongest substantiation for painting's right to claim equal status with poetry. Whereas poetry had always been revered as one of the ▷Liberal Arts, painting had hitherto been regarded as a mere craft requiring no more than the manual skill to follow the patron's requirements. Thus, ▷history painting, with its ennobling subjects represented in a suitably ▷Grand Manner, became the highest in the ▷hierarchy of genres, with ▷still life as a mere imitation of nature as the lowest.

Bib.: Lee, R.W., *Ut Pictura Poesis: The Humanistic Theory of Painting*, New York, 1967

Utrillo, Maurice (1883–1955)

French painter. He was the son of ▷Suzanne Valadon, who encouraged him to become an artist. Under pressure of his work, he became an alcoholic, but this did not prevent him from producing evocative and sometimes ▷oneiric street scenes of Paris between 1902 and c1908. Between 1909 and 1914, he entered his so-called 'white period' in which his works were suffused with white pigment. He continued in the same vein for the rest of his career. His works possess an emotional power and a sense of isolation.

V

Valadon, Suzanne (1865–1938)

French painter. She was the illegitimate daughter of a seamstress and cleaning woman, and she became an artist's model in the Bohemian circles of late 19th-century Paris. She was encouraged by both ▷Toulouse-Lautrec and ▷Degas to exhibit her paintings at the Salon de la Nationale in 1894. This switch from being an object which is viewed (the 'passive') – and, as a female model often mythologized as a muse – to assuming the traditionally masculine role of painter/creator (the 'active'), placed Valadon in a unique position. Both in her work and in her personal life she played the part of the 'Bohemian' male artist, living a hedonistic lifestyle, taking different lovers and disregarding money. She painted the ▷nude from the beginning of her career. In the context of the contemporary myth of the male artists and his female muse/model, and the implicit sexual overtones of this voyeuristic relationship, this practice was found shocking. Her investigation of the western ▷iconography of the nude in her attempts to capture the moment of viewing rather than a timeless portrayal of feminine beauty serves to demythologize female sexuality. Naked women are seen in intimate, daily activities as individuals rather than as fetishized objects for male consumption.

Valadon's son was the artist ▷Maurice Utrillo.
Bib.: Bayliss, S., *Utrillo's Mother*, New York, 1990; Rosinsky, T.D., *Suzanne Valadon*, New York, 1994

Valdés Leal, Juan de (1622–90)

Spanish painter and engraver of Portuguese descent. He was active in Seville from 1656 and, with ▷Murillo, was a founder member in 1660 of the Seville Academy (President, 1663–6). His paintings are typically dramatically lit, richly coloured, full of movement and intensely emotional, often with elements of a distinctly morbid nature, such as in his two large *Allegories of Death*, commissioned in 1672 for the Hospital de la Caridad, Seville. His paintings consist mainly of ▷vanitas themes and religious subjects executed for the churches and religious foundations of Seville and its neighbourhood. He was also an accomplished portraitist as is evidenced by the sensitive portrayal of the two donors in his *Immaculate Conception* (1661, London, National Gallery).
Bib.: Valdivieso, E., *Valdés Leal*, Donostia, 1991

Valenciennes, Pierre-Henri de (1750–1819)

French painter and writer. He was born in Toulouse and trained there before studying in Paris under Gabriel François Doyen. He travelled to Italy in 1769, where he was influenced by the work of ▷Claude and ▷Poussin and began to concentrate on landscape. Back in Paris in 1773 he came under the patronage of the Duc de Choiseul, through whom he met ▷Robert. He travelled widely in France (sketches from Brittany were rediscovered in 1973), returned to Italy in 1777 and visited the Middle East. After his return to Paris in 1787, he became successful as both an exhibitor – his work appeared in the ▷Salon regularly from 1789 – and a teacher (of Jean-Victor Bertin and ▷Michallon). He also produced a decorative cycle for the Comte d'Artois (1789). He created landscapes which were based on a study of nature, but retained a strict Classical composition and calm (e.g. *Biblis Changed into a Fountain*, 1792, Quimper; *Ancient town of Agrigentum*, 1787, Paris, Louvre). His 1800 treatise (*Elements of Practical Perspective*) defended landscape tradition, but Valenciennes himself, in his cloud studies and interest in lighting paved the way for 19th-century innovations (▷Corot). He was also instrumental in the establishment of a ▷Prix de Rome for landscape in 1817.
Bib.: Dora, H., 'Valenciennes' Theories', *Gazette des Beaux-Arts*, 6/124 (Nov 1994), pp. 185–194; *Pierre-Henri de Valenciennes*, exh. cat., Toulouse, 1957

Valentin, Moïse (c1591–1632)

French painter. He went to Rome in 1612 and worked there subsequently. He adopted some of the subject-matter and the style of ▷Caravaggio, specializing in scenes of card players and gypsies. He also painted religious works such as *The Martyrdom of SS Processus and Martinian* (1629–30, Rome, Vatican), which was a pendant to ▷Poussin's *St. Erasmus*. He knew Poussin and ▷Vouet.

Valkenborch (Valkenborgh), Lucas (c1530–97) and Marten (1535–1612)

Flemish family of painters. Lucas was in Antwerp in 1565, but he fled to Aix-la-Chapelle because of persecution of Protestants. He worked for Archduke Mathias and was with him in Frankfurt in 1593. His brother Marten travelled to Frankfurt and Italy. Both brothers worked in a manner similar to that of ▷Bruegel.

Vallotton, Félix (1865–1925)

French painter and engraver of Swiss birth. He became a French citizen in 1900. The son of a chocolate manufacturer in Lausanne, he travelled to Paris in 1882, and enrolled at the ▷École des Beaux-Arts. He befriended ▷Bonnard and became one of the early members of the ▷Nabis. Sporadically exhibiting his early paintings, he began to produce ▷woodcuts in the 1890s, and could concentrate on painting only after 1899 when marriage to Gabrielle Rodrigues-Henriques (a wealthy widow and sister of the prestigious dealer Alexandre Bernheim) brought him financial security. He settled into a comfortable bourgeois existence, acquiring a country house at Honfleur, and refusing the Legion of Honour in 1912.

Vallotton's reputation is based largely on his black and white ▷woodcuts, depicting crowds on the streets of Paris and bleak scenes of domestic life. They helped to stimulate a revival of interest in the form and influenced ▷Munch. His portraits are cold and analytical, often showing the discomfort of their well-dressed subjects under the misanthropic painter's gaze. His later studies include many still lifes and landscapes, which the same cold gaze reduced to mere material and flesh. The nudes of the same period seem stripped and exposed with misogynistic hostility. By contrast, a self-portrait of 1924 shows the artist as one of the successful bourgeoisie he had once so despised, peering securely from behind rounded spectacles, a moustache and a tuft of beard protected by the swathes of a grey coat and a palette which he holds like a shield.
Bib.: Newton, S.V., *Félix Vallotton*, New Haven and London, 1992

Vallyer-Coster, Anne (1744–1818)

French painter. She was one of the few women members of the French ▷Académie. She painted portraits and ▷genre scenes but was especially skilled at still lifes.

Valori Plastici

(Italian, 'plastic values'.) A movement and a journal founded by Mario Brogli in Rome in 1918. Its members included former ▷Futurist artists such as ▷Carrà and ▷Severini, as well as others with more classical inclinations, such as ▷de Chirico. The group advocated a return to ▷Renaissance ideals, and its works were classical in feel. It dissolved in 1921.
Bib.: Maurizio Fagiolo dell'Arco, M., *Classicismo pittorico: metafisica, valori plastici, realismo magico e '900*, Genova, 1991

values

Tones and hues in a painting and how they relate. Values are shades of black and white.

Vanbrugh, Sir John (1664–1726)

English architect and playwright. Vanbrugh was a true Renaissance man, also excelling as a soldier and an artist. After having spent time in prison in France, suspected of spying, Vanbrugh returned to England to write comedies, including *The Relapse* (1696) and *The Provok'd Wife* (1697). As an architect, he became one of the leading exponents of the ▷Baroque style, and was employed as ▷Wren's deputy on Royal buildings. He designed Castle Howard, Yorkshire (begun 1699), and Blenheim Palace, Oxfordshire (begun 1705). In building this latter, Vanbrugh became embroiled in a feud with Sarah, Duchess of Marlborough, and was eventually dismissed. Another notable work was Seaton Delaval, Northumberland (1720–28). Vanbrugh designed his own house, Vanbrugh Castle, Greenwich (1718), in a striking medieval style, and thus became the forerunner of the ▷Gothic Revival of the 19th century.
Bib.: Beard, G., *The Work of John Vanbrugh*, London, 1986

Vanderbank, John (c1694–1739)

English painter. He worked in England, painting portraits, and he gained a strong clientele after ▷Kneller's death. With ▷Chéron, he founded a private academy in 1720 where artists could be trained and copy the life model. This was one of the most important early art schools in England, and it preceded the ▷Royal Academy by nearly 50 years.

van der Helst, Bartolomeus

▷Helst, Bartolomeus van der

Vanderlyn, John (1775–1852)

American painter. He was born in New York, where he also studied. He travelled to Paris in 1796 and continued his education there, returning to America only in 1815. While in Paris, he adopted ▷David's style of ▷Neoclassicism, which he consolidated when on a trip to Rome with ▷Washington Allston. He painted monumental ▷history paintings based on ▷Renaissance models. He was better known in Europe than in America.

van Doesburg, Theo

▷Doesburg, Theo van

Van Dyck, Sir Anthony (1599–1641)

Flemish painter. He was born in Antwerp and had an apprenticeship with ▷Hendrick van Balen. From 1618 to 1620 he worked as a master but also assisted in ▷Rubens' workshop. The overwhelming presence of Rubens in Flanders led Van Dyck to seek work in London from 1620. There he fulfilled some commissions for James I, but did not remain in the city. From 1621–7 he lived in Italy, where he moved increasingly away from Rubensian ▷history painting and

towards portraiture. His portraits of the Genoese nobility were informed by his knowledge of Roman ▷Baroque art, and they showed a subdued colourism while exhibiting a strong sense of the sitter's importance. He returned to Antwerp in 1628, where he remained until 1632 when he travelled again to England. There he became court painter to Charles I and produced a number of portraits of the king, his family and the court. Van Dyck's iconic images of the monarch helped consolidate the king's absolutist power, while his lavish portraits of the court give an image of wealth and luxury. Although he also produced religious subjects, he was best known for his portraits and received a knighthood for his efforts. His influence dominated English portraiture throughout the 17th century, and it continued to be felt until the early 19th century.

Bib.: Brown, C., *Van Dyck*, Oxford, 1982; Miller, O., *Van Dyck in England*, London 1982.

van Eyck

▷Eyck, van

van Gogh

▷Gogh, van

vanishing point

The point at or on which obliquely observed parallel lines would appear to converge and meet. One-point ▷perspective painting or drawing observes a horizon plane at right angles, with one vanishing point; an oblique view produces two-point perspective with two vanishing points, whilst three-point perspective is used predominantly in specialist/technical areas.

vanitas

(Latin 'emptiness', 'worthlessness'.) A type of ▷still life which contains symbols of the transience of human life (▷*memento mori*) and the futility of all human achievements. The most common elements in such still lifes are skulls, hour-glasses, candles, clocks and wilting flowers. A pile of books alludes to the futility of learning, heaps of coins to the futility of wealth, and jewels and sumptuous clothes to the futility of accumulating earthly possessions. Weapons and armour signify that death cannot be defeated. Overturned and empty vessels refer directly to the theme *vanitas*, emptiness. *Vanitas* still lifes were particularly popular in Dutch painting of the 17th century.

Vanity

A minor vice of the Seven Vices (▷Virtues and Vices), often represented in secular art as a woman combing her hair in a mirror. Typically the woman will be overdressed and bejewelled and there will perhaps also be a figure of Death personified standing by unobserved. Alternatively her reflection may show her as an old woman. ▷Bernardo Strozzi (*An Allegory of Vanity*, c1630, Bologna, private collection) shows an aged woman in a low cut, diaphanous top, a rose in her right hand, admiring herself in a mirror while a servant arranges a plume in her hair. Upon the shelf in front of her mirror are a pearl necklace and a jar of perfume. In her efforts to appear young she appears merely ridiculous.

Van Loo

▷Loo, van

Vantongerloo, Georges (1886–1965)

Belgian painter and sculptor. He studied in Antwerp and Brussels, but was interned in the Netherlands during the First World War after sustaining an injury. At that time he met ▷Mondrian and other artists of ▷De Stijl, and he began producing sculpture following De Stijl principles of 'pure plastic values'. During the 1920s and 1930s, he spent time in Paris, where he helped found the ▷Abstraction-Création group and was a member of the ▷Cercle et Carré. He maintained an interest in the mathematical qualities of art.

Varley, John (1778–1842)

English watercolourist. He was born in London. After an apprenticeship with the portraitist, Barrow (1793–4), he joined the London Sketching Club in 1796. He exhibited at the ▷Royal Academy from 1798 and became a protégé of ▷Dr. Monro. Throughout his career he made a series of sketching tours, including Wales (1798–9), Yorkshire (1803) and Northumberland (1808). In his later career he was a member of ▷Blake's circle. He developed a style of bold, bleak topographical ▷watercolours (e.g. *Cheyne Walk, Chelsea*, 1811, London, Victoria and Albert Museum; *Snowdon from Capel-Curig*, 1805–10, Victoria and Albert Museum; *View from Polesden, near Bookham, Surrey*, 1800, Newcastle), but increasingly in his later work this gave way to a lighter, almost ▷Rococo touch with foreground details, wispy foliage and greater use of ▷body colour (e.g. *Tal-y-Llyn and Cader Idris*, 1839, London, Bethnal Green). He was an enthusiastic administrator, a member of the Sketching Society (1802) and a founder of the Old Watercolour Society (1804), and he wrote handbooks on technique. He was also important as a teacher, of among others ▷Linnell, ▷Palmer and ▷Cox. His brothers Cornelius (1781–1873) and William (1785–1856) were also watercolour artists.

Bib.: Bury, A., *John Varley and the Old Society*, London, 1946; *John Varley*, exh. cat., Leigh on Sea, 1978; Kauffmann, C., *John Varley*, London, 1984; Lyles, A., *John Varley: A Catalogue of his Watercolours and Drawings in the British Museum*, London, 1980

Varley, F(rederick) H(orsman) (1881–1969)

Canadian artist of English birth. He was a member of the ▷Group of Seven and produced important work during the First World War.

varnish

A solution, usually ▷resin in oil or a synthetic equivalent (although there are also albumen, spirit and wax varnishes), which has been used at least since the Middle Ages as a protective coat over paint. Though ideally a varnish should not affect the qualities of the painting, varnishes often deteriorate and darken with age and may modify the colours beneath them. This effect is not always reversible through ▷restoration or removal.

Vasarely, Victor (b 1908)

French painter of Hungarian birth. He was trained by ▷Moholy-Nagy in Budapest, but he went to Paris in 1930 where he worked as a commercial artist. He began painting seriously in 1943 and gradually

Victor Vasarely, *Supernovae*, 1959–61, Tate Gallery, London

developed an abstract form of art based on optical theories. He was involved with ▷GRAV, and from the mid-1950s he wrote manifestos about his optical ideas. After 1961 he lived in the south of France. He was one of the founders of ▷Op art.

Vasari, Giorgio (1511–74)

Italian painter, architect and art historian. He was born in the Florentine subject city of Arezzo. Today, he is chiefly remembered for his collection of artists' biographies, first published in 1550, and revised and enlarged in 1568, *Le vite de' più eccelenti architetti, pittori, et scultori italiani* (*The Lives of the Most Excellent Italian Architects, Painters and Sculptors*), commonly known as Vasari's *Lives* or the *Vite*. In his lifetime, however, Vasari was better known as a painter and architect, and one who enjoyed continuous Medici patronage.

Vasari's most important painting commissions include the decorative fresco cycles in the Salone dei Cinquecento (Council Chamber of the Five Hundred) in the Palazzo Vecchio, Florence, the Sala dei Cento Giorni (i.e. 'the Room of the Hundred Days', referring to the length of time it took Vasari to paint it) in the Palazzo della Cancelleria, Rome, and the Sala Regia in the Vatican. In addition, he was an important impresario, masterminding for Cosimo I de' Medici the post-Council of Trent redecoration of the churches of Sta Maria Novella and S. Croce in Florence. His most important work of architecture is the ▷Uffizi, Florence. Although this building is still regarded as an important piece of architecture, Vasari's status as a painter has not survived and he is today regarded as exemplifying the more arid and affected extreme of ▷Mannerism.

Unlike his painting, Vasari's *Lives* has an unassailable position as an art-historical work which for centuries shaped the way the development of European art was viewed, with the Florentine ▷Renaissance at the centre-stage; Vasari's influence, for example, was critical in the formation of London's ▷National Gallery, which from the first aspired to be a historically balanced collection and clearly reflects Vasari's Italian Renaissance-centred notion of art history. It is also significant that Vasari altered the title of his biographies between the first and second editions so that painters took precedence, for the work is essentially a history of art told in terms of the progress of painting towards what Vasari saw as its ultimate goal, an idealized representation of nature.

Vasari embraced the Italian ▷humanist concept that the imitative arts (painting and sculpture) had reached a state of perfection in ancient Rome, but had declined into barbarism in the ensuing years under the influence of the flat, lifeless 'Greek' style (i.e. that of Byzantium). At last, towards the end of the 13th century, a revolution was forged by ▷Cimabue and, more especially, ▷Giotto who for the first time since antiquity looked to nature and gave his characters an affectingly human expressiveness and imbued their bodies with a monumental dignity and solidity. At the beginning of the 15th century ▷Masaccio pushed the evolution one stage further and he and his contemporaries opened the way for a century of experimentation, particularly in ▷linear perspective and anatomy, both of which disciplines enhanced the naturalistic veracity of the century's paintings, although the intensity of concentration required in conquering the means of pictorial representation resulted, in Vasari's judgement, in a certain dryness or harshness of execution. Only with

the advent of the High Renaissance triumvirate, ▷Leonardo, ▷Raphael and ▷Michelangelo, were the means truly conquered and the execution so confident that the greatest pictorial problems were solved with consummate ease. Above all, in Michelangelo (Vasari's friend and hero) modern art had reached perfection and surpassed the ancients.

Vasari's image of artistic progress is essentially an anthropomorphic one, seen in terms of the three ▷Ages of Man, with Giotto as the childhood, Masaccio as the youth, and Michelangelo as the maturity. Today, however, not only is the idea of progress in the visual arts rejected, it must also be appreciated that Vasari's argument is chauvinistically loaded, with all the main protagonists Tuscan and all non-Tuscans (such as the Venetians) marginalized or ignored. Yet for all its faults, Vasari's *Lives* is still the single most important account of Italian Renaissance art in existence. Furthermore, the anecdotal content of many of the biographies makes for thoroughly entertaining reading. The *Lives* has been shown to be inaccurate in a number of cases, yet the biographies of those artists fairly close to Vasari's own time are usually factually accurate, and where he is on familiar ground Vasari's judgements are often illuminating.

Bib.: Conforti, C., *Vasari Architetto*, Milan, 1993 and *Vasari: catalogue complet des peintures*, Paris, 1991; Rubin, P.L., *Giorgio Vasari: Art and History*, New Haven and London, 1995; Satkowski, L., *Studies on Vasari's Architecture*, New York, 1979 and *Giorgio Vasari Architect and Courtier*, Princeton, 1993

Vatican

The palace and city (within Rome) of the papacy, deriving its name from Mons Vaticanus, the hill upon which it stands. The importance of the area originates from the fact that it is the site of the pagan cemetery in which ▷St. Peter was buried. Because of the sanctity of this site, other early Christians were buried in the vicinity of his grave and eventually Old and then New St. Peter's were erected there, the High Altar marking the grave's exact location.

Although the popes (St. Peter's successors) had a palace on the Vatican hill, their main residence, until the return of the papacy from Avignon (1420) under Martin V, was the Lateran Palace (next to the Cathedral of Rome, St. John Lateran). Papal prestige was at this point at a low ebb and Rome was relatively undeveloped and lawless. In order to improve their image and re-establish their position, the popes embarked on a grandiose building campaign erecting, throughout the course of the 15th and 16th centuries, a palace appropriate to their position as spiritual leaders of western Christendom.

Many of the popes were avid collectors and some of the Vatican buildings were designed specifically to hold their growing collections of art and artefacts. Not only did the popes sponsor archaeological digs, they also received gifts from the various rulers of Europe. From the 15th century onwards, the greatest Italian artists of the time were drawn to Rome to work in the Vatican. Leading painters decorated the various chapels and apartments: Pope Nicholas V commissioned ▷Fra Angelico to paint a cycle of ▷frescos for his private chapel (1447–50); Sixtus IV commissioned ▷Perugino, ▷Botticelli, ▷Ghirlandaio, ▷Pinturicchio and ▷Rosselli to decorate the walls of his newly-built ▷Sistine Chapel (1481–3); Julius II commissioned ▷Michelangelo to paint the Sistine Chapel ceiling (1508–12) and ▷Raphael to paint the ▷stanze (from 1509); Julius' successor, Pope Leo X, then commissioned Raphael to design tapestries for the lower zones of the Sistine walls (1515–16), while Clement VII recalled Michelangelo to the Sistine Chapel to paint the altar wall (1536–41) and Clement's successor, Paul III, commissioned him to paint two frescos in his private chapel, the Cappella Paolina (1542–50).

The leading architects of the time were also employed on the Vatican and, at the instigation of Julius II, on the rebuilding of St. Peter's. They include ▷Bramante (commencement of work on St. Peter's and the Cortile del Belvedere), Raphael (unexecuted plans for St. Peter's), ▷Antonio da Sangallo the Younger (interior of the Cappella Paolina, 1540–46), Michelangelo (extensive work on St. Peter's), Pietro Ligorio (Casino di Pio IV for the Vatican gardens, 1559–62), ▷Giacomo della Porta (dome of St. Peter's, 1588–90), ▷Carlo Maderno (façade of St. Peter's, 1607–12) and ▷Bernini (remodelling of the crossing of St. Peter's, 1628 onwards; the ▷Baldacchino, 1624–33; the cathedra petri, the ▷piazza and ▷colonnade, all 1656 onwards; and various other monuments).

The papal collections also continued to expand throughout the 17th and 18th centuries. In 1753 Benedict XIV added to the vast collections of Classical (i.e. pagan) art the Museum of Christian Sculpture. In 1836 the Museo Gregoriano-Etrusco was founded and in 1909 the Pinacoteca. Perhaps the most celebrated objects in the Vatican Museums are the various Classical sculptures which attained (certainly for the 18th and 19th centuries) canonical status – the ▷*Apollo Belvedere*, the ▷*Belvedere Torso* and the ▷*Laocoön*.

Bib.: Fagiolo dell'Arco, M. (ed.), *The Vatican and its Treasures: A Pictorial History and Guide*, London, 1983; Volpini, V., *Vatican City: Art, Architecture and History*, New York, 1986

Vaughan, Keith (1912–77)

English painter. He was born in Sussex. He worked for an advertising firm in the 1930s and in the 1940s took up painting professionally. He was a ▷Neo-Romantic artist who specialized in the male nude.

vault

A curved ceiling or roof in which the constructional principles of the ▷arch have been employed; the most common building materials are stone, brick and concrete. There are numerous types, including:

(i) Barrel, tunnel or wagon vault. The simplest form of vault, it is, in effect, a continuous masonry vault of semi-cylindrical or pointed section, supported by parallel walls or ▷piers.

(ii) Domical, cloister or coved vault. A domed vault rising from a square or polygonal base compartment. Segments or cells rise from the base, curving inwards to the apex. The sharp intersection of each cell is called a groin.

(iii) Fan vault. A vault of concave-sided semi-cones, whose diagonal ribs radiate, fan-like, from their ▷springers, the ribs of each semi-cone being of the same length and curvature, each equally distanced from its neighbour. This was a development of late medieval architecture.

(iv) Groin or cross vault. This is created where two barrel vaults of equal size cross at right angles, the sharp intersections being termed groins.

(v) Quadripartite vault. A vault, over a rectangular compartment or bay, consisting of four cells or segments.

(vi) Sexpartite vault. A ribbed vault in which a basic quadripartite arrangement is further subdivided by having the lateral cells bisected by a transverse rib, thus producing six cells in total.

▷rib(bed) vault

Vauxcelles, Louis (b1870)

French art critic and writer. He is perhaps best known for his remarks on ▷Fauvism and ▷Cubism. He worked as a reviewer for *Gil Blas* and produced highly popular pieces, often running to several pages, which expressed the generally conservative views of his readers. At the 1905 ▷Salon d'Automne he described the canvases of ▷Matisse, ▷Derain, and their fellow artists as 'fauves' (wild beasts). Four years later at the ▷Salon des Indépendants he criticized ▷Braque's 'bizarreries cubiques' and thereby effectively christened another movement. He was cautiously in favour of Fauvism but remained opposed to Cubism until after the First World War.

Vecchietta (Lorenzo di Pietro) (c1412–80)

Italian painter, sculptor and architect. He was from Siena. He trained as a painter, possibly under ▷Sassetta, and was certainly himself the teacher of ▷Matteo di Giovanni and ▷Francesco di Giorgio. Vecchietta's art reveals the influence of Florentine ▷Renaissance painting, even to the ▷Brunelleschian architectural framework so familiar from ▷Masaccio's *Trinity* (e.g. *Vision of the Virgin*, fresco, 1441, Siena, Hospital of S. Maria della Scala) – and yet the result is thoroughly un-Florentine. In all of Vecchietta's paintings there is a typically Sienese sense of religious fervour which unbalances any tendency to Florentine repose. The painting that is generally considered his masterpiece and which is unmistakably Sienese is his *Assumption* (c1462, Pienza, Cathedral); here there is no attempt to create rational space in a vision of an insubstantial Virgin ascending into a dazzling golden Heaven. Vecchietta's sculpture was influenced above all by ▷Donatello. This influence can be seen in Vecchietta's marble statues of SS Peter and Paul (Siena, Loggia di San Paolo) which reflect a knowledge of Donatello's statues on the Florentine ▷campanile, and in Vecchietta's bronze *Risen Christ* (1476, Siena, S. Maria della Scala) which reflects Donatello's bronze *St. John the Baptist* (late 1450s, Siena, Duomo).

Bib.: Os, H.W. van, *Vecchietta and the Sacristy of the Siena Hospital Church*, New York, 1974

Vedder, Elihu (1836–1923)

American painter. He was born in New York City, and he studied there, as well as in Paris and Italy. From the 1860s he began painting ▷allegorical works which prefigured European ▷Symbolism by two decades. Paintings such as *The Lair of the Sea Serpent* (1864, Boston, Museum of Fine Arts) were like ▷history paintings, but their vague subject matter was not specifically tied to literary, mythological or biblical incidents. In 1866 Vedder settled in Rome and became interested in ▷Old Master paintings. His most famous work is his series of illustrations for Fitzgerald's *Rubáiyát of Omar Khayyám* (1884).

Bib.: *Perceptions and Evocations: The Art of Elihu Vedder*, exh. cat., Washington DC, 1979

vedutà (pl. vedute)

(Italian, 'view'.) A drawing or painting of a landscape or, more usually, a town or city. Such works, which were popular from the 17th century but particularly so in the 18th when works by ▷Piranesi, ▷Panini, ▷Canaletto and ▷Guardi fetched high prices, catered to the aristocratic and gentle classes who travelled and wanted views of the places they had visited on the ▷Grand Tour, and of Italy in particular. Such views might be accurate (in which case their ancestry stretches back to 16th-century ▷topographical artists such as ▷Wenceslaus Hollar), but a favourite type was the ▷*capriccio*, many examples of which remain in British and Irish country houses.

▷*vedutisti*

Bib.: Boffito, G., *Piante e vedute di Firenze: studio storico topografico cartografico*, Florence, 1983

vedutisti

(Italian, 'view painters'.) A name given to artists such as ▷Carlevaris and ▷Canaletto, who painted scenes of Venice.

Veen, Otto van (1556–1629)

Flemish painter. He was born in Leiden and worked in Italy (c1575–80), studying with ▷Zuccaro there. In 1592 he moved to Antwerp where he painted pictures showing a ▷Mannerist influence, especially that of ▷Parmigianino.

vehicle

The substance in which the ▷pigment is suspended. The vehicle may be, for example, water, oil, turpentine or egg yolk (▷tempera). Together the pigment and the vehicle constitute paint.

Velázquez (Velasquez), Diego (1599–1660)

Spanish painter. Diego Rodriguez da Silva, who always signed his paintings 'Velázquez', is generally regarded as the greatest painter of the Spanish school. He may have been apprenticed initially to ▷Herrera the Elder, but was certainly, and more importantly, apprenticed in 1610 to ▷Pacheco. He became an independent master in 1617 and in the following year married Pacheco's daughter. Surviving paintings from these years, (e.g. *An Old Woman Frying Eggs*, 1618, Edinburgh, Scottish National Gallery and *The Adoration of*

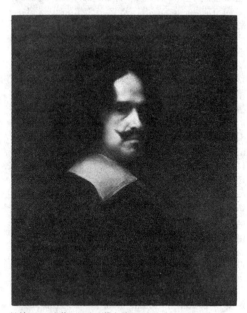

Velázquez, *Self-portrait*, Uffizi, Florence

the Magi, 1619, Madrid, Prado), reveal the exceptional precociousness of his talent. Given the classicizing tenor of his master's theory of art, Velázquez's early works are remarkable for their unidealized naturalism. Perhaps even more remarkable, however, is Pacheco's liberality in recognizing the superiority of his pupil's genius. Whereas Pacheco advised the direct study of nature, but merely as the necessary prelude to idealization, Velázquez used direct observations as a means to making a more truthful image. Such naturalism was to invest all of his work, from the ▷*bodegón* scenes – all of which date from this period and the finest of which is the *Waterseller of Seville* (c1620, London, Apsley House) in which the young painter proudly displays his consummate skill with the ▷*trompe-l'oeil* dribble of water down the belly of the water vessel – to his religious subjects, such as the *Immaculate Conception* (c1618, London, National Gallery) which, while closely following Pacheco's ▷iconographical prescriptions, portrays the holy personages with a portrait-like immediacy. The real quality of these works, however, lies not in their manifest technical dexterity, but in the dignity and, at times, pathos that Velázquez brought to his human subjects, no matter what their station in life.

In 1622 Velázquez visited Madrid, hoping to secure an official position. Initially unsuccessful, he returned to Seville but was recalled by Philip IV who had been impressed by his portrait of his friend and sponsor, the courtier, Juan de Fonseca. Velázquez duly painted the King's portrait (now lost) which was so successful that Philip appointed him a court painter and from thenceforth would allow no other painter to portray him. Thus, barely into his 20s, Velázquez had come to occupy the most prestigious artistic position in Spain, and one which he held for the rest of his life. From now on, although he continued to paint religious subjects and the occasional mythology, court portraits were to form the main body of his work. His experience of seeing the ▷Titians in the royal collection was also seminal, and his ▷brushwork became broader and more fluid. In 1627 he was appointed 'Usher of the Chamber', the first of his official positions which, while increasing his status, sadly limited the amount of time available to his art. In 1628 ▷Rubens visited the court, he and Velázquez became friends, and Rubens persuaded Philip to allow Velázquez to visit Italy. Velázquez left in August 1629, stayed mainly in Rome, but also visited Genoa, Venice and Naples (where he met ▷Ribera), returning to Madrid in 1631. His experience of a wider body of Italian painting further broadened his palette, gave him a clearer understanding of multi-figure composition and, in pictures such as *The Forge of Vulcan* (1630, Madrid, Prado), led him to explore the possibilities of the male nude (nudes, male or female, being rare in Spanish art).

In 1634 Velázquez, ▷Maino and ▷Zurbarán were among a group of painters selected to paint pictures for the main ceremonial room of the new Buen Retiro Palace with themes glorifying the royal family and the victories of Philip's reign. Velázquez painted all five ▷equestrian portraits and *The Surrender of Breda* (Madrid, Prado), this last generally recognized as the most successful of the series. Velázquez breaks away from the stiff, formulaic compositions used by the others and conveys a documentary sense of actuality,

the poignancy of the Dutch surrender sensitively conveyed by the magnanimous action of the victorious Spanish general who comfortingly touches the shoulder of his defeated opponent. Throughout the 1630s and 1640s Velázquez painted the majority of his most acclaimed portraits of the royal family, their courtiers, court dwarfs and fools, imbuing each with a sense of humanity, unprecedented in Spanish painting.

In 1648 Velázquez was dispatched to Italy to purchase pictures and antiquities for the royal collection, a journey from which he returned 1651. Whilst in Rome he painted *Pope Innocent X* (1650, Rome, Galleria Doria-Pamphili), one of his most accomplished portraits, remarkable for the ▷bravura assurance of its brushwork, the richness of its colour and the profound sense of the political shrewdness of the sitter. Also from this trip comes the portrait of Velázquez's mulatto slave (granted his freedom in Rome), *Juan de Pareja* (1650, New York, Metropolitan Museum) and Velázquez's only known female nude, the so-called *Rokeby Venus* (London, National Gallery).

Velázquez's greatest painting (and one of the most acclaimed European paintings of all time) is ▷*Las Meninas* ('*The Maids of Honour*', c1656, Madrid, Prado). Velázquez stands before his canvas and looks out at the spectator, whilst by his side is the Infanta Margerita and her maids of honour. Reflected in a mirror on the back wall of the room are the King and Queen who may indeed be the subject of Velázquez's canvas. It is a subtly-wrought visual conundrum, the mystery of the meaning and actual subject of which has exercised the minds of countless art historians. In 1659 Velázquez was accorded the ultimate honour, ennoblement as a Knight of the Order of Santiago. Despite his contemporary fame, he was almost forgotten outside Spain until after the Napoleonic Wars when his works were brought to the attention of the rest of Europe. He was very soon acclaimed as one of the greatest of all European painters, exercising a profound influence on ▷Manet in the 19th century and eliciting the deepest admiration from ▷Picasso in the 20th century.
Bib.: Brown, J., *The Golden Age of Painting in Spain*, New Haven and London, 1991 and *Velázquez, Painter and Courtier*, New Haven, 1988; Delenda, O., *Velázquez, peintre religieux*, Geneva, 1993; Harris, E., *Velázquez*, Oxford, 1982; McKim-Smith, G., *Examining Velázquez*, New Haven, 1988

Velde, Esaias van de (1587–1630)

Dutch painter and etcher. He specialized in ▷genre, battle scenes and landscapes. He may have trained in Amsterdam with the Flemish expatriate ▷Gillis van Coninxloo. He himself certainly trained ▷Jan van Goyen and thus would represent a link between the Flemish landscape tradition deriving from ▷Pieter Bruegel the Elder, characterized by stylized, bird's-eye view panoramas, and the naturalistic Dutch landscape painters of the next generation. *A Winter Landscape* (1623, London, National Gallery), reveals an already fluid ▷brushwork and deliberately restricted, almost tonal palette, techniques which were to be further developed to create the atmospheric unity sought by van Goyen and ▷van Ruysdael. A strong influence was ▷Elsheimer, who had introduced the naturalistic low viewpoint and diagonal recession first used by van de Velde in his ▷etchings (always more experimental) executed in c1614. Van de Velde was active in Haarlem in 1610–18, enrolling in the local painters' guild in 1612. In 1618 he transferred to The Hague, entering the local painters' guild in October of that year and becoming Court Painter to the Princes Maurits and Frederick Hendrik, a post he held until his death.
Bib.: Maddox, C.E., *Esaias van der Velde: His Landscapes and Merry Companies*, Richmond, VA, 1978; Renger, K., *Graphik in Holland*, Munich, 1982

Velde, Henry van de (1863–1957)

Belgian architect, painter and designer. He was born in Antwerp. He began as a painter exhibiting, from 1889, with the ▷avant-garde Brussels group ▷Les Vingt. His principal early influences were the ▷Post-Impressionists, first the ▷pointillism of ▷Seurat and then the ▷synthetism of ▷Gauguin, whose linear style influenced van de Velde's ▷embroidery and appliqué panel, *The Angels Guard* (1893, Zurich, Kunstgewerbemuseum). In about 1890 he discovered ▷Ruskin, ▷Morris and ▷Voysey and moved completely from painting to design, working in a style recognizably his own but within the nascent ▷Art Nouveau idiom. In 1895 he built a house for his own family at Uccle, near Brussels, and here he designed not only the overall structure of the building, but all the interiors, furniture, and every constituent aspect, even down to the dinner service, all in a co-ordinated, rational style inspired by the English ▷Arts and Crafts Movement. His work attracted the attention of art dealer Samuel Bing who, in 1896, commissioned him to design four rooms for L'Art Nouveau, his newly-established Paris shop, followed, in 1897, by his showing of a large collection of furniture designs at the Dresden Exhibition of Applied Arts.

The mixed reactions to van de Velde's work were most emphatically enthusiastic in Germany and, consequently, in 1899 he moved to Berlin where he established a flourishing practice, designing interiors for wealthy patrons, including, in 1901, the shop of the Imperial barber, Haby. In the same year he was called to Weimar by the Grand Duke of Saxe-Weimar to officiate as artistic consultant, charged with the mission of co-ordinating arts and crafts in industry and raising overall standards. In Weimar he furnished the Nietzsche Archive (1903) and designed the School of Applied Arts (1907); he was appointed Director of the latter in 1908. His theatre for the Werkbund Exhibition at Cologne (1914, since destroyed) reflects his Art Nouveau sensibilities, the curved corners and roofs

being emphasized by, and dominating, the straight angles. The outbreak of war disrupted his work, he left Berlin and, after a number of unsettled years, returned to Brussels in 1925. Although he continued to work, occasionally on very prestigious and successful commissions, such as the Kröller-Müller Museum at Otterloo, Holland (commissioned 1921, erected 1937–54), he was never to achieve the same degree of influence as in the pre-war years. His published writings include: *Déblaiement d'art* (*Preparing the Ground for Art*, Brussels, 1894); *Aperçus en vue d'une synthèse d'art* (*Surveys in Sight of a Synthesis of Art*, Brussels, 1895); *Vom neuen Stil* (*On New Style*, Leipzig, 1907); and an autobiography, *Geschichte meines Lebens* (*History of my Life*, published posthumously, Munich, 1962).

Bib.: Becker, I., *Henry van de Velde in Berlin*, Berlin, 1993; Schule, B., *Henry van de Velde in Hagen*, Hagen, 1992; Sembach, K.-J., *Henry van de Velde*, Stuttgart, 1989

Velde, Willem I van de (1611–93) and Willem II van de (1633–1707)

Dutch family of painters. Willem I was the son of a navy captain and briefly worked as a sailor himself. From 1652 he was employed as a painter of naval battles by the Dutch, but in 1673 he mysteriously changed sides and began to work for the British. He established a studio at Greenwich and received £100 (around $175) a year from the King. His work is characterized by detailed depictions of ships against poorly conceived backgrounds, and he frequently used ▷grisaille.

Willem I's son, Willem II was also an artist. He was taught by his father and by ▷Simon de Vlieger and also received a royal pension from the British Crown. He produced seascapes, but took more interest over the depiction of the background and in his later career started to work on landscapes. These were detailed but atmospheric.

Bib.: *Art of the Van de Veldes*, exh. cat., London, 1982

vellum

A fine kind of ▷parchment, prepared from calfskin, and intended for writing or painting.

Venetian School

Because of Venice's eastern and ▷Byzantine links, Venetian art is conspicuously different from say, Florentine art, over several centuries. Thus ▷Giotto's naturalism left Venice's luminous formalism untouched; the ▷Gothic flourished there (Doge's Palace) when it scarcely touched Florence; the ▷Renaissance came late in architecture (albeit with ▷Palladio); and in painting, ▷Renaissance forms and ideas arrived with an admixture of Flemish painting styles and their oil techniques from which the ▷Bellini, ▷Giorgione and ▷Titian developed a manner of painting that prized *colore* above ▷*disegno*. ▷Tintoretto and ▷Veronese developed sumptuous decorative

styles, and the line from them to ▷Guardi and the ▷Tiepoli (and in architecture from ▷Palladio to Baldassare Longhena) is clear. ▷Baroque painting would have been seriously 'overdesigned' had not the ▷Carracci and other members of the Bolognese School added the sensuous lightness and brilliance of the Venetian manner to the rigorously linear ▷Mannerism found in the Rome of the later 16th century.

Bib.: Steer, J., *Venetian Painting: A Concise History*, 2nd edn., London, 1989; Wilde, J., *Venetian Art from Bellini to Titian*, Oxford, 1974

Venturi, Robert (b 1925)

American architect. He was born in Philadelphia and taught by Louis Kahn at the Pennsylvania School of Architecture, before gaining a scholarship to the American Academy in Rome. He went into private practice in the late 1950s but received few commissions and spent much time teaching and writing. His book, *Complexity and Contradiction in Architecture* (1966), opposed the orthodoxy of ▷modernism in favour of an eclectic use of ornament, quotation and vernacular detail to create 'tension'. He promoted regionalism in favour of internationalism, advocated a return to the traditions of 'main street' and advised architects to take popular culture on board (e.g. in his book, *Learning from Las Vegas*, 1973), a view which paralleled the ideas of ▷Pop artists. His own work struck a balance between the streamlining of ▷Le Corbusier and American traditions such as gables, back porch and bricks (e.g. Chestnut Hill House, Philadelphia, 1963). He came to prominence in Britain with his design for the Sainsbury Wing of the ▷National Gallery (1981), which combined Classical pastiche with a free glass and steel structure.

▷postmodernism

Bib.: Mead, C., (ed.), *Architecture of Robert Venturi*, Albuquerque, 1989

Venus (Greek, Aphrodite)

Early Italian goddess, identified by the Romans with the Greek Aphrodite, goddess of love, beauty and fertility. Her son was ▷Cupid and her attendants the ▷Three Graces. According to Hesiod, Saturn castrated his father Uranus and, when he threw the testicles into the sea, Venus was born from the foam. She arrived naked and fully grown, riding on a scallop shell at the island of Cyprus (e.g. ▷Botticelli, ▷ *The Birth of Venus*, c1485, Florence, Uffizi). The scallop shell is thus one of her attributes. Her other attributes include a pair of doves or swans, which may draw her chariot in paintings of *The Triumph of Venus*, a theme developed in 15th-century Italy (e.g. ▷Francesco del Cossa, *Month of April*, fresco, 1470/75, Ferrara, Palazzo Schifanoia). Her sacred plant is the myrtle, a bush of which is behind the figure of Venus in Botticelli's *Venus and Mars* (c1483, London, National Gallery). Fifteenth-century Florentine humanists developed

Plato's idea of ▷Sacred and Profane Love, represented by a clothed and a nude Venus. In late 15th-century Venice, a taste grew for pictures of Venus reclining, an early and influential example of which is ▷Giorgione's painting of Venus asleep in a meadow (1509–10, Dresden, Gemäldegalerie). Among the more frequently portrayed stories concerning Venus is that retold by Ovid, concerning her love for the mortal hunter Adonis who died, as she had feared, after being gored by a boar. The two parts of this story most frequently represented are Venus restraining Adonis and Venus discovering his dead body. Venus has been a popular subject in sculpture since the 5th century BC, although a figure will frequently be identified as a 'Venus' simply because it represents a nude female of ideal beauty. A favourite theme is Venus preparing for, or rising from the bath (e.g. ▷Medici Venus, c200 BC, Florence, Uffizi; ▷Canova, Venere Italica, 1811, Florence, Palazzo Pitti).

Venus de' Medici

▷Medici Venus

Vénus de Milo

Antique Greek marble statue of ▷Venus (or more correctly Aphrodite), armless and draped only from the hips downwards. Despite the ▷Classical style of the head, which is suggestive of the late 5th century BC, the spiral pose, intended to be viewed from all sides, indicates a date not earlier than the 2nd century BC. Thus it is now thought to be a ▷Hellenistic piece making deliberate reference to an earlier period. It was discovered by a peasant on the Greek island of Melos (or Milo) in 1820, was immediately purchased by the French ambassador and presented to Louis XVIII who in 1821 presented it to the Louvre. It remains there to this day, as one of the museum's most favourite attractions. The Vénus de Milo was discovered just a few years after the French had been compelled to restitute to Florence the Venus de' Medici, along with all the other antiquities they had removed during the French occupation of Italy. Unsurprisingly, from its arrival in Paris the Vénus de Milo was promoted as the superior of the Italian-owned Medici Venus.

There has never been any attempt at restoration of the Vénus de Milo, not from policy, but because agreement has never been reached as to how the arms should be positioned or what attributes, if any, they might have held. A ▷plinth block, discovered with the statue but later lost, was inscribed with the signature 'Andros of Antioch on the Meander'. That such an excellent sculpture should have been carved by an otherwise unknown sculptor was unacceptable to many (particularly French) authorities and attempts were made to establish that the block was unconnected with the sculpture and, furthermore that the sculpture was by ▷Praxiteles. The inconvenient evidence afforded

by the inscribed block and its subsequent (and convenient) loss have led to the suspicion that the block was deliberately destroyed. Notwithstanding this major problem of attribution, numerous copies and casts of the Vénus de Milo soon circulated and a cast formed the centre-piece of a display of what were held to be the greatest antique sculptures in the Greek Court of the Crystal Palace (1860); the catalogue hailed it as the 'most perfect combination of grandeur and beauty in the female form'.

Bib.: Haskell, F. and Penny, N., Taste and the Antique, New Haven and London, 1981; Smith, R.R.R., Hellenistic Sculpture, London, 1991

veranda

An open gallery extending from the side of a building.

Verhaecht, Tobias (1561–1631)

Flemish painter. He travelled in Italy, but settled in Antwerp where he painted landscapes. He was the first teacher of ▷Rubens.

Verhulst, Rombout (1624–98)

Flemish sculptor. He worked in Holland, where he accepted a number of important public commissions, including sculpture for the Amsterdam Town Hall. He also produced a number of portrait busts in The Hague, where he worked from 1663.

verism

A term signifying brutal realism. It can be used to refer to any period of art history, but it is normally employed for some aspects of ▷Neue Sachlichkeit art in Germany in the 1920s. The distortions of ▷Otto Dix and the ▷caricatures of ▷George Grosz have been called veristic because of their stress on ugliness and deformity.

Vermeer, Jan (Johannes) (1632–75)

Dutch painter. He specialized in domestic interiors, portraits and city views. His entire life was spent in Delft, where, it has been suggested, he may have been trained by ▷Leonaert Bramer or ▷Carel Fabritius. His work does indeed show an affinity with that of Fabritius, but their relationship remains uncertain. Vermeer was a Master in the Delft painters' guild from 1653, was elected Dean (hoofdman) in 1662–3 and 1670–71, and was highly regarded in his lifetime, although he seems to have never been particularly wealthy, leaving his wife and 11 children in debt at his death. His name and reputation were almost forgotten until 1866 when the art critic ▷Thoré Burger published an essay attributing 66 pictures to him (only 34 paintings are firmly attributed to him today). The few contemporary references to his paintings all relate to surviving works, so it is unlikely that there were ever many more – he may have been a slow worker and probably (like many Dutch painters of this period) had

another source of income – a trip to The Hague in 1672 to authenticate some paintings suggests that he may have been a picture dealer.

A chronology of Vermeer's work is complicated by the fact that only three paintings are dated: *The Procuress* (1656, Dresden, Gemäldegalerie), *The Astronomer* (1668, private collection), and *The Geographer* (1669, Frankfurt, Städelsches). Two pictures are generally accepted as earlier than *The Procuress*; both are ▷history paintings, painted in a warm palette and in a relatively large format for Vermeer – *Christ in the House of Mary and Martha* (Edinburgh, National Gallery) and *Diana and her Companions* (The Hague, Mauritshuis). After *The Procuress* almost all of Vermeer's paintings are of contemporary subjects in a smaller format, with a cooler palette dominated by blues, yellows and greys. It is to this period that practically all of his surviving works belong. They are usually domestic interiors with one or two figures lit by a window on the left. They are characterized by a serene sense of compositional balance and spatial order, unified by an almost pearly light. Mundane domestic or recreational activities become thereby imbued with a poetic timelessness (e.g. *Woman Reading a Letter at an Open Window*, Dresden, Gemäldegalerie). To this period also have been allocated Vermeer's two townscapes, *View of Delft* (The Hague, Mauritshuis) and *A Street in Delft* (Amsterdam, Rijksmuseum). A few of his paintings show a certain hardening of manner and these are generally thought to represent his late works. From this period come *The Allegory of Faith* (c1670, New York, Metropolitan Museum) and *The Letter* (c1670, Amsterdam, Rijksmuseum).

The often discussed sparkling pearly highlights in Vermeer's paintings have been linked to his probable use of a ▷camera obscura, the primitive lens of which would produce halation and, even more noticeably, exaggerated perspective. Such effects can be seen in *Lady at the Virginals with a Gentleman* (London, Royal Collection). Vermeer's interest in optics is also attested in this work by the accurately observed mirror reflection above the lady at the virginals.

Bib.: Montias, J.M., *Vermeer and his Milieu*, Princeton, 1989; Pops, M., *Vermeer: Consciousness and the Chamber of Being*, Ann Arbor, 1984; Snow, E.A., *A Study of Vermeer*, Berkeley, 1994; Wheelock, A.K., *Vermeer and the Art of Painting*, New Haven and London, 1995

vernacular architecture

Originally, a building constructed according to regional forms and with local materials and not designed by a professional architect. In the second half of the 19th century, however, some professional architects turned to vernacular buildings as a way out of the impasse created by an eclectic historicist approach. At the forefront of this movement were

architects associated with the ▷Arts and Crafts Movement, notably George Devey, Philip Webb, Norman Shaw and ▷C.F.A. Voysey. In the 20th century there has been a return to the use of vernacular materials, such as brick, knapped flint, rubble masonry and wood, as a reaction to what is seen as the impersonal qualities of concrete, steel and glass as employed ubiquitously by International ▷modernist architects.

Vernet, Claude-Joseph (1714–89), Antoine-Charles-Horace (Carle) (1758–1835) and Émile-Jean-Horace (1788–1863)

French family of painters. Claude-Joseph was born in Avignon, the son of a successful artist. After training in Aix-en-Provence, under the patronage of the Marquis de Caumont, he spent the years 1733–53 in Rome, made a name as a landscapist and gained considerable popularity among British visitors, including Alexander ▷Cozens and ▷Wilson. He combined a ▷Claudean lighting with an added sense of drama which owed much to ▷Rosa (e.g. *Rocky Landscape, Italy*, 1738, London, Dulwich Picture Gallery). He made a series of 16 paintings of seaports for Louis XV (e.g. *Port de La Rochelle*, 1753, Paris, Musée de la Marine) which were highly popular, but on his return to Paris in 1762 his style became repetitive.

Claude-Joseph's son, Antoine-Charles-Horace, known as Carle, was a painter of ▷battle scenes for Napoleon and an official artist to Louis XVIII, producing hunting scenes. His other son, Émile-Jean-Horace was also a military artist under Napoleon. After an early career as a ▷lithographer, he became known as a painter of animals (e.g. *Mazeppa*, 1826, Avignon) and oriental subjects (e.g. *Hagar and Abraham*, 1837, Nantes). He became Director of the French Académie in Rome (1828–35) and worked on the decorations of the Chambre des Députés (1839).

Bib.: *Claude-Joseph Vernet*, exh. cat., Paris, 1977; *Claude-Joseph Vernet*, exh. cat., London, 1976; *Horace Vernet*, exh. cat., Paris, 1980

Veronese, Paolo (Paolo Caliari) (c1528–88)

Italian painter. He was born, as his popular name indicates, in Verona, and trained there under Antonio Badile. Nevertheless, he was active in Venice from 1553 onwards and his principal influence was ▷Titian. Along with ▷Tintoretto, he became the leading painter in Venice after Titian's death. Veronese specialized in a wide range of genres, specifically Biblical, mythological, allegorical and historical subjects as well as portraits, but always with the emphasis on each subject's decorative potentialities. He delighted in depicting pageants populated with crowds of extras whose sumptuous costumes would allow the fullest scope to his opulent colour sense, dominated by pale blue and green, lemon yellow, silvery white and orange. His earliest work in Venice was a State commission to execute ceiling paintings for the Sala del

Consiglio dei Dieci and the Sala dei Tre Capi del Consiglio in the Doge's Palace (1553). His next important commission, for the Church, was for ceiling paintings for the Venetian church of S. Sebastiano (1556). Both commissions gave full rein to Veronese's mastery of ▷ *sotto in sù* ▷ foreshortening. A trip to Rome has been posited for c1560 as his subsequent illusionistic decorations for ▷ Palladio's Villa Barbaro at Maser suggest contact with the Roman decorative painting of ▷ Raphael and ▷ Giulio Romano.

A huge feast scene, *The Marriage at Cana*, painted in 1562–3 for the refectory of S. Giorgio Maggiore (now in Paris, Louvre), includes among the crowds of splendidly dressed guests a chamber orchestra composed of portraits of Veronese and his fellow painters. In 1573 another feast scene, in which he exercised his predilection for pageant no matter what the subject, provided the occasion for his famous confrontation with the Inquisition. He had been commissioned to paint a vast *Last Supper* and had filled it with accessory figures solely for the visual delight of the beholder: whereas such treatment was just about acceptable in the Feast of Cana, the ▷ Counter-Reformation Church found similarly frivolous accessories for the Last Supper scripturally inaccurate and highly irreverent. Despite Veronese's spirited defence of the artist's right to poetic licence, the case was resolved only by altering the name of the picture to ▷ *A Feast in the House of Levi* (1573, Venice, Accademia).

Veronese's style developed little throughout his career and his works are seldom dated so that establishing a more thorough chronology is problematic. Also, the output of his flourishing studio was enormous and it is sometimes difficult to identify autograph from workshop pieces, although the quality of the work is generally of the highest order. Following his death, his studio was carried on by his brother Benedetto and his sons Gabriele and Carletto. One of his latest works, mostly studio, is the magnificent *Apotheosis of Venice* for the Sala del Maggior of the Doge's Palace. Although he had no major pupils, his style of painting exerted a strong influence on the decorative work of ▷ Tiepolo and his contemporaries in the 18th century.

Bib.: Cocke, R., *Veronese's Drawings: A Catalogue Raisonné*, London, 1984; idem., *Veronese*, London, 1980; Fondazione, G., *Paolo Veronese, disegni e dipinti*, Vincenza, 1988; Posselle, L., *Les Noces de Cana de Veronese*, Paris, 1992; Rearick, W.R., *The Art of Paolo Veronese*, Washington, 1988

Veronica

Legendary pious woman who, according to Jacobus de Voragine's *The Golden Legend*, was a devoted follower of ▷ Christ who wanted a painting of him as a keepsake. Veronica, by chance, met Jesus on his way to ▷ Calvary. She pressed the cloth against his face and miraculously imprinted his image upon it. In the 13th century a new version of this story appeared,

supplanting the earlier one: during the climb up to Calvary Jesus stumbled under the weight of his cross, Veronica stepped forward from the crowd and mopped his brow and later found the imprint of his face on the cloth. A cloth, known as the ▷ sudarium, vernicle or *volto santo*, bearing the image of Christ's face, has been one of the most precious relics preserved in St. Peter's in Rome since the 8th century. Considered a true likeness of Christ's face, it has been suggested that perhaps the legends of Veronica developed to explain the relic. Its location in a pier of the crossing of St. Peter's is marked by a marble statue of Veronica by Francesco Mochi of 1634–40. The most intense veneration of the sudarium, perhaps initiated by its public display during the Holy Week of 1292, was during the 14th and 15th centuries. In devotional paintings, the sudarium may be held up by Veronica (e.g. Master of St. Veronica, *St. Veronica with the Sudarium*, 1400/25, London, National Gallery), or by angels. In narrative paintings, Christ stumbles and Veronica leans forward to wipe his brow (e.g. ▷ Jacopo Bassano, *Christ on the Way to Calvary*, c1545/50, London, National Gallery).

Verrio, Antonio (c1639–1707)

Italian painter. He was active in England. Born near Otranto, he studied in Naples and worked as a ▷ history painter in France. Charles II initially invited him to England in 1672 to manage the ▷ tapestry works at Mortlake, but this appointment never actually came to fruition. Verrio was, however, commissioned to decorate the ceilings at Windsor Castle, and although few of these now survive, he was appointed court painter in 1684. Under William III, he undertook the decoration of Hampton Court, where he worked in association with ▷ Grinling Gibbons.

Verrio specialized in exuberant decoration, particularly ▷ *trompe l'oeil* ceilings with clouds and assorted goddesses spilling over the supposed borders of the painting. His work can be seen at Cassiobury, Chatsworth and Burghley, and influenced the decoration of numerous other houses of the period.

Verrocchio, Andrea del (Andrea di Cioni) (c1435–88)

Italian sculptor, goldsmith and painter. He was possibly trained by ▷ Donatello and, after that master's death, he became the most successful and accomplished sculptor in Florence. His large and flourishing workshop produced all manner of artefacts and counted the Medici amongst its clients. For them he executed: the Tomb of Giovanni and Piero de' Medici (completed 1472, Florence, San Lorenzo); a bronze statue, *David* (c1475, Florence, Bargello) clad in antiquizing armour, which has been seen as a critique of Donatello's dreamy nude *David*, Verrocchio's figure by contrast naturalistically tense from its muscular exertions, but lacking the haunting originality of Donatello's sculpture; a bronze *Putto with a Fish* (c1465, Florence,

Palazzo Vecchio), originally for a fountain at the Medicean villa at Careggi; and ▷terracotta portrait busts of Lorenzo and Giuliano de' Medici (1475, Washington, National Gallery). Verrocchio's most celebrated commission in Florence, however, was the *Christ and St. Thomas* for a ▷niche at Or San Michele (c1465–83). For Venice he executed an Equestrian Statue of Bartolommeo Colleoni (begun 1479, completed in 1495 after ▷Verrocchio's death by the sculptor-founder Leopardi), again produced in rivalry with ▷Donatello (his *Gattamelata*); Verrocchio has here attempted to convey the *condottiere*'s bravado with a group full of dynamism, forward momentum and muscular energy, but perhaps loses in the process the assured effortless control expressed by the *Gattamelata*.

None of Verrocchio's surviving paintings is signed or dated, but his *Baptism of Christ* (Florence, Uffizi) has achieved celebrity for the delicately beautiful kneeling angel at the extreme left, painted, according to ▷Vasari, by the young ▷Leonardo whilst an apprentice in his workshop. Another important apprentice was ▷Lorenzo di Credi.

Bib.: Adorno, P., *Verrocchio*, Florence, 1991; Seymour, C., *The Sculpture of Verrocchio*, London, 1971

Ver Sacrum

An important Viennese ▷Art Nouveau journal that was published between 1898 and 1903. Its production quality was high, and many artists of the Vienna ▷Secession contributed to it.

verso

The term used to differentiate the pages in manuscript form. Verso refers to the left hand page.

Vertue, George (1684–1756)

English engraver and antiquarian. He was born in London, the son of a tailor. After an apprenticeship with a French ▷engraver working in England, he established his own practice in 1709. He made a name for himself engraving ▷Kneller's portraits and in 1711 joined Kneller's Academy. He was a member of, and official engraver to, the Society of Antiquaries (1717–56) and worked on plates for the *Vetusta Monumenta* during that time. He also worked on Paul Rapin de Thoryas' *History of England* (1736) and the *Oxford Almanacs* (1723–51). A member of art circles, with patrons like the Earl of Oxford, his *Notes on the History of Art in England* are an important source for art historians. They became the basis of ▷Horace Walpole's *Anecdotes of Painting* after they were bought from Vertue's widow. There is a portrait of him by ▷Richardson (1734, London, National Portrait Gallery).

Bib.: Vertue, G., *Notebooks*, Walpole Society, 1947

vestibule

An anteroom or entrance hall preceding the interior of a building.

Vices

▷Virtues and Vices

Victoria and Albert Museum (V&A)

Museum of decorative and applied arts in London. The museum houses the national collection of post-▷Classical sculpture and also the National Art Library. The collection was developed out of the ▷Great Exhibition of 1851 by Prince Albert, who helped purchase a large site in Kensington. He envisaged this area as a cultural neighbourhood, with different museums and galleries educating and enlightening the population of London. The Museum of Ornamental Art was opened in 1857, and it was hoped that by providing examples of 'great' design and ornament from the past, inspiration would be gleaned by contemporary designers and architects. In 1899 Aston Webb began a new building for the collection, on the same site which was opened in 1909 as the Victoria and Albert Museum. The collection includes ▷tapestries and textile work from around the world, costume – historical and contemporary – furniture, ▷ceramics, ▷porcelain, earthenware, musical instruments, silverware, Oriental art and decorative art from different periods and continents. The collection is enormous, and thought to be the best in the world. There are outposts of the V&A at the Bethnal Green Museum of Childhood, Osterley Park House, Wellington Museum, the Theatre Museum and Ham House.

Victory

In ancient Greek and Roman art, Victory was personified as a winged female figure, the most famous example being the *Winged ▷Victory of Samothrace*. She was a messenger of the gods who descended from heaven to bestow a laurel crown on the victorious warrior, athlete, or poet. It was from the Roman image of the winged Victory that Early Christian artists derived the image of the angel, the messenger of God. Instead of the laurel crown, however, the Christian angel hands the Christian martyr a palm branch as a symbol of the Christian soul's victory over death.

Victory (Nike) of Samothrace

Colossal ▷Hellenistic marble figure, from the prow of a ship, dating from c200 BC, discovered on the Aegean Island of Samothrace in 1863 by a team of excavators led by Charles Champoiseau, the then French Consul. The headless and armless winged figure was taken to Paris and in 1867 set up in the Salle des Caryatides at the Louvre. In 1879 Champoiseau returned to the island and managed to reconstruct the ship's prow pedestal from the fragments on site which were in turn shipped back to Paris. The figure was then mounted

on its reconstructed pedestal in a commanding position at the top of the Escalier Daru, where it remains to this day as one of the Louvre's principal attractions. Over the succeeding years various small parts of the goddess's hands have been found, but not the arms. A work of virtuoso carving, its swirling drapery describing both the form and the forward motion of the lithe body, it has always had more admirers than detractors and it is perhaps significant that as early as 1908 ▷Marinetti in his Futurist Manifesto chose the *Victory* as the most instantly recognizable symbol of what he saw as the defunct Classical tradition of beauty: 'A screaming automobile that seems to run on grapeshot is more beautiful than the *Winged Victory of Samothrace*.' **Bib.**: Haskell, F. and Penny, N., *Taste and the Antique*, New Haven and London, 1981; Smith, R.R.R., *Hellenistic Sculpture*, London, 1991

video art

Video is a ▷medium like oil painting or photography, and like them has been employed by artists in a wide variety of ways. With the advent of the portable video camera, a means of recording visual imagery has become available that, at an elementary level, needs little technical skill or equipment to operate. Video has had an impact on ▷Performance and Installation art, media studies and 'Music Television' (MTV). Increasingly, video is seen as interactive with computer art and graphics, and, like photography in the early 20th century, is now transcending its initial function as a transparent 'recorder' to generate its own visual language.
Bib.: *Artistic Creation and Video Art*, UNESCO, 1982

Vien, Joseph-Marie (1716–1809)

French painter. He was born in Montpellier and, after making a living locally by drawing maps and architectural plans, went to Paris in 1740. There he studied under Charles Natoire and won the ▷Prix de Rome in 1743 with *David Giving Himself up to God* (Paris, École des Beaux-Arts). He studied in Rome under ▷de Troy until 1750, immersing himself in ▷Baroque art as well as the Classical; he was a member of ▷Winckelmann's circle and a friend of the antiquarian ▷Caylus. He became an academician with *Daedalus and Icarus* (1751, École des Beaux-Arts), a piece of ▷Baroque realism. During the 1760s however, he began to treat Classical subjects in a sentimental style which was initially very popular (e.g. *The Cupid Seller*, 1763, Fontainebleau); Mme du Barry used him to replace ▷Fragonard decorations at Louveciennes, for instance. He also achieved official success, as Director of the French ▷Académie in Rome in 1776 and First Painter to the King in 1789. In spite of this royal connection, he survived the ▷French Revolution to become a senator under Napoleon and a count in 1808. His son J.-M. the Younger (1762–1848) was a portrait painter.

Bib.: Gaehtgens, T.W., *Joseph-Marie Vien: Peintre du Roi*, Paris, 1988

Vienna Workshops
▷Wiener Werkstätte

Vigée-Lebrun, Marie Louise Élisabeth (1755–1842)

French painter. She was born in Paris, the daughter and pupil of Louis Vigée (1715–67), an artist famous for his ▷pastels. She was also educated by ▷Greuze and ▷Vernet, before her marriage to the picture dealer Lebrun in 1776. A precocious talent – she produced her first portrait at 15 – she was also highly popular. As a friend of Marie-Antoinette, whom she painted over 20 times, (the first in 1779, Vienna Kunsthistorisches Museum), she received official patronage and became a favourite court portraitist (e.g. *Princesse de Polignac*, 1783, National Trust, Buckinghamshire). She was also the hostess of one of the leading salons of the day. Despite opposition (based on objections to her being a married woman) she was allowed into the ▷Académie in 1783 with her work *Peace and Abundance* (1780, Paris, Louvre). She left France because of the Revolution (▷French Revolution) in 1789, settling first in Italy until 1793 (e.g. *Self-portrait*, 1790, Florence, Uffizi), then Vienna, St. Petersburg in 1795, England in 1802, Switzerland in 1805 and finally returning to a more sympathetic regime in France by 1809 by which time she had achieved an international reputation. She returned to continue her career, eventually retiring during the 1830s. Her portraits were delicate, particularly in her elegant handling of drapery, and sentimental but insightful. She also wrote memoirs of her travels – *Souvenirs* – in 1835–7.
Bib.: Baillio, J., *Elisabeth Vigée-Lebrun*, Fort Worth, 1982

Vigeland, Gustav (1869–1943)

Norwegian sculptor. He studied in Oslo, Copenhagen, Paris and Italy. He was particularly impressed by ▷Rodin, whose works he saw in Paris in 1892, and he adopted his own form of realism subsequently. After 1900 he looked to medieval sculpture for inspiration. He returned to Norway to accept major public commissions, including over 100 allegorical sculptures commissioned for Frognoer Park in Oslo.

Vignola, Giacomo Barozzi da (1507–73)

Italian architect. He worked in Bologna and France, but his greatest success came in Rome, when he was made architect to Pope Julius III. With ▷Vasari and ▷Ammanati he designed the Villa Giulia (1551–5) and a number of Roman churches with unusual oval domes. He began work on Il Gesù in 1568, creating a wider nave to allow larger congregations. He wrote *Regola delle cinque ordini* (*Rules of the Five Orders*, 1562),

which explained the detailed distinctions between each of the ▷Orders of architecture.

Vignon, Claude (1593–1670)

French painter and engraver. He was born in Tours. He worked in Rome (c1616–24) where he saw the works of ▷Elsheimer. He was involved with the founding of the French ▷Académie and he also acted as a picture dealer, handling Rembrandt's work among others. His own works were very brightly coloured and distinctive.

villa

(i) In the ancient Roman period, the residence or farmstead of a landowner on his country estate. The two basic types were known as the *villa urbana*, a country house situated near the city, intended as a place of occasional retreat for the city dweller, away from the cares of office, and the *villa rustica*, which functioned as a farm.

(ii) In the Italian ▷Renaissance, a villa was a country house close to the city, intended not for extended use (it was not equipped with bedrooms), but for the occasional day out (▷Giulio Romani's Palazzo del Tè, 1524–34, on the outskirts of Mantua, is a particularly opulent example). In the 16th century, many wealthy Venetians had villas (some of which actually incorporated working farms) in the Veneto, the finest of which were designed by ▷Palladio.

Villa of the Mysteries

This large, wealthy house was built in the 2nd century BC outside the walls of ▷Pompeii. Excavations in 1929–30 discovered a cycle of ▷frescos in one of its rooms, thought to have been executed around 50 BC. They relate to the rites of Dionysus (▷Bacchus), an eastern cult brought to Italy via Greece, and the virtually life-size figures are thought to have been drawn from earlier Greek paintings. However, the overall design is an unusual example of the illusionistic 'second style' of Roman painting, creating the impression that the physical space of the room opens out into an unreal, mythical world in which humans (virtually all women) are shown alongside the gods Dionysus and Ariadne, with various ▷satyrs and sileni.

Strips of black divide the painting into scenes, which have been interpreted as a sequence in which an initiate undergoes a ritual purification, after which she is subjected to a terrifying flagellation performed by a winged female figure. Finally, the initiate is dressed and veiled. The exact purpose or meaning of the images is unknown. They may relate to initiation into a cult or a marriage ceremony. However, a large window in the room suggests that the highly secretive Dionysiac mysteries were probably not actually performed there.

Villard d'Honnecourt (fl 13th century)

French master mason. His sketchbook, in the Bibliothèque Nationale, Paris, is thought to date from c1220–30 and contains sketches of elevations of cathedrals such as ▷Reims and Chartres, accompanied by his own designs, geometrical calculations for setting out pointed ▷arches and the like and suggestions for the treatment of sculptures. It is a rare document and was thought to be an active account of an early itinerant architect and his work. For example, he records techniques for cutting stone and placing keystones which would have been stock practice for master masons. However, more recently doubt has been cast over the purpose of the sketchbook. It has been suggested that the drawings are inaccurate, the calculations incorrect and the drawings are those of an outsider recording the construction of buildings without participating in the work. Therefore, the identity of Villard d'Honnecourt and his reasons for producing his sketchbook remain uncertain.

Villon, Jacques (Gaston Duchamp) (1875–1963)

French painter and graphic artist. He was the brother of ▷Duchamp-Villon and ▷Duchamp, but he changed his name in homage to a 15th-century French poet. He was in Paris in 1894, where he became friendly with ▷Toulouse-Lautrec. He exhibited there at the ▷Salon d'Automne from 1904. He became a member of the ▷Section d'Or and an enthusiastic exponent of ▷Cubist ▷abstraction. After the First World War, he continued to be interested in abstraction, which he applied to graphic works. He travelled to the United States in 1935 and settled in southern France in 1940, painting mostly landscapes.

Vinci, Leonardo da

▷Leonardo da Vinci

Vinckboons, David (1576–c1632)

Flemish painter. He went to Holland while still a child and settled in Amsterdam. Under the influence of ▷Bruegel he painted landscapes and ▷genre scenes in a late ▷Mannerist mode.

Vingt, Les (Les XX)

(French, 'The Twenty'.) A Belgian artists' group which organized a series of exhibitions from 1884 to 1893. The group was associated with the development of ▷Art Nouveau and facilitated the spread of ▷Neo-Impressionism and ▷Symbolism into Belgium through exhibiting the works of ▷Seurat, ▷van Gogh and ▷Cézanne.

Viollet-le-Duc, Eugène-Emanuel (1814–79)

French architect, engineer, archaeologist, critic and writer. He can be credited as the driving force behind the ▷Gothic Revival in France. As a friend of the Inspector of Ancient Monuments, Viollet-le-Duc became interested in the numerous ruins in France and set about restoring as many as possible to what he believed would have been their original state. For example, he practically rebuilt the walled town of Carcassone, and he has been criticized for hiding the original remains and making too many sweeping interpretations of what might have been. However, his interventions definitely saved many buildings from ruin. His numerous books on architecture, such as his exhaustive *Dictionnaire raisonné de l'architecture française* (*Practical Dictionary of French Architecture*, 1858–75), argue that Gothic architecture forms a rational base for modern architecture, but his own buildings are unmemorable.

Virgin Mary

▷Christ's mother. She was one of the most important figures in Christian art, despite the fact that much of her history was based on apocryphal gospels, rather than the Bible. Images of the Virgin Mary were related to cults and legends of the Virgin which caused great controversy throughout the Middle Ages. Marian cults, or groups devoted to the worship of the Virgin Mary, were common especially in the 12th and 13th centuries, despite some Church attempts to quell the Marian influence. Images of Mary tend to be either narrative or devotional, but the latter type of image strongly dominates western European art. Narrative scenes of the Virgin's life are often based on Jacobus de Voragine's *The Golden Legend*, and they represent her birth, childhood and betrothal and marriage to ▷Joseph. An excellent example of one such cycle can be seen in ▷Giotto's ▷Arena Chapel frescos. The Virgin also appears in narratives of Christ's life, most notably the ▷Nativity, the ▷Crucifixion and the ▷Lamentation, although Victorian ▷genre artists also included the Virgin in scenes of Christ's childhood (e.g. ▷Millais, *Christ in the Carpenter's Shop*).

Devotional images tend to fall into the following categories:

(i) The Virgin enthroned – a common view of the Virgin in ▷Byzantine art. Sometimes she is enthroned with the child, and from the 15th century onwards, they could be surrounded by saints (▷sacra conversazione).

(ii) Madonna and child: the Virgin with the Christ child, sometimes breastfeeding him (the Madonna lactans) or merely holding him. This scene can be accompanied by a number of attributes, including fruit which symbolizes aspects of Christ's ▷Passion.

(iii) The ▷Holy Family, in this case the Madonna and child, sometimes accompanied by Joseph, sometimes with ▷John the Baptist, and on other occasions with her cousin Elizabeth or her mother ▷Anne.

(iv) ▷Mater Dolorosa, showing the Virgin next to the cross, or the Seven Sorrows, showing her with attributes of the passion.

(v) Misericordia, showing the Virgin with a large cloak protecting the faithful.

(vi) ▷Immaculate Conception, alluding to the Virgin's own purity. This was a controversial subject until 1854 when it was declared an article of faith by Pope Pius IX. At certain points in European art history, this subject matter came to the fore, for example in the 17th-century Spain (e.g. Zurbarán).

(vii) ▷hortus conclusus, showing the Virgin in an enclosed garden, representing her own purity.

▷Assumption; Coronation of the Virgin; Visitation

virtù

(From Latin, '*virtus*', 'excellence'.) A collective term referring to the entire range of fine art objects and curios; by extension, it is also used for the discerning ▷connoisseur's taste for those things. In his book, *Il Cortegiano* (1528, translated into English in 1561 as *The Courtier*), ▷Castiglione specified *virtù* as one of the essential requirements of the ideal courtier. *Virtuosi* was the term originally used to designate collectors and connoisseurs of taste: their virtuosity was their skill (or excellence) in discerning copies from originals and fakes from authentic works. Only in modern usage has virtuoso come to mean a skilled practitioner in the arts (especially in music).

Virtues and Vices

In *The Republic* Plato lists the four virtues essential in the citizens of the ideal republic as ▷Prudence, ▷Fortitude, ▷Temperance and ▷Justice (4: 427). These moral qualities, the ▷'Cardinal Virtues', were adopted by the early Christian Church and added to the three 'theological virtues' – faith, hope and charity (1 Corinthians 13: 13) – to make the seven principle Christian virtues. Each virtue was paired with a corresponding vice (e.g. faith with idolatry, justice with injustice) in order that a moral lesson might be drawn from their comparison. In the 4th-century *Psychomachia* (*Fight for Man's Soul*), an allegorical work by the Spanish poet Prudentius, a whole range of personified Virtues were described triumphing over their opposed Vices (e.g. Chastity over ▷Lust, Patience over ▷Wrath). In the ▷Arena Chapel, Padua (1305–6), ▷Giotto has painted a line of ▷grisaille personifications of the *Seven Virtues* and *Seven Vices* along each long wall, so that the Virtues, significantly located on the right-hand (south) side are ranged against their corresponding Vices on the left wall. Personified *Virtues* and *Vices* are frequently enlisted in the glorification of political leaders, whether to boost the power of the living ruler shown conquering a

personified *Vice* (e.g. ▷Leone Leoni, *The Emperor Charles V Overcoming Fury*, begun 1551, Madrid, Prado) or, in the continuing interests of the dynasty, to commemorate the virtuous qualities of the dead. From the ▷Renaissance onwards, Classical gods and goddesses have been frequently employed to personify some of these moral qualities, so that ▷Hercules represents Fortitude, ▷Minerva Wisdom/Prudence, ▷Diana Chastity, etc. The constant demands on artists to represent such abstract moral qualities in works of visual art led to the publication of a number of illustrated guides, the most famous and influential of which was ▷Cesare Ripa's *Iconologia*, first published in 1593 and running into many subsequent editions.

Vision after the Sermon: Jacob Wrestling with the Angel, The

Painted by ▷Gauguin at Pont-Aven in September 1888 (oil on canvas, 73 × 92 cm/2 ft 4 in × 3 ft). A group of contemporary Breton women dressed in traditional costume are shown in the foreground witnessing the struggle between ▷Jacob and the angel (Genesis 32: 24–32) against a crimson landscape. The painting signalled Gauguin's fully-realized break from ▷Impressionism. There is no pretence that it represents an objective view of nature. The stylized delineation of the figures and the vivid colours convey the emotive and imaginative sensibility of the Breton women rather than simply recording what Gauguin 'saw'.

Several influences have been suggested. The absence of depth, collapsing the distance between the witnessing women and the vision itself, may have been drawn from Japanese prints. The most naively-painted figures suggest Breton ▷folk art, following ideas which Gauguin had developed alongside ▷Émile Bernard, and which Bernard expressed in *Breton Women at a Pardon* (1888). *Vision after the Sermon* is seen as a major statement of the ▷Synthetist (▷Symbolist) aesthetic, and as initiating the ▷primitivist art of the 20th century. It is in the National Gallery of Scotland, Edinburgh.

Bib.: Fraser, D., *Donald Hamilton Fraser on Gauguin's Vision after the Sermon*, London, 1969

Visitation

(Luke 1: 36–56.) This is the visit of the ▷Virgin Mary to her cousin Elizabeth immediately following the ▷Annunciation. After informing Mary that she would give birth to Jesus, the angel ▷Gabriel informed her that her aged cousin was by now six months pregnant (i.e. with ▷John the Baptist). Mary hastened to Elizabeth's house in a city in the hill country. As Mary greeted Elizabeth, the baby in Elizabeth's womb jumped, she became filled with the Holy Spirit, and she realized that the baby in Mary's womb was the Saviour. This scene is found both separately and as part of a cycle of the life of the Virgin. ▷Fra Angelico

portrays the episode in a ▷predella panel of his *Annunciation Altarpiece* (c1432, Cortona, Museo Diocesano). Mary is accompanied by a female servant who labours up the hill carrying a bag. In the distance can be seen the city of Nazareth in the lowlands. The women (both haloed, Mary the younger and in her identifying blue mantle and red robe) embrace as equals. ▷Pontormo (1515–16, fresco in the atrium of SS Annunziata, Florence) shows an alternative treatment with Elizabeth attempting to kneel before Mary who, in turn, tries to raise her to her feet.

Vitruvius Britannicus

An illustrated survey of British country houses, published by the architect ▷Colen Campbell in three folio volumes in 1715, 1717 and 1726. Campbell was a British follower of 16th-century Italian architect, ▷Andrea Palladio, who in turn based his architectural ideas on those of the Roman architect Vitruvius who was active in the 1st century BC. Just as the treatises of both of these earlier architects (Vitruvius's *De Architettura* of c27 BC and Palladio's, *I Quattro Libri* of 1570) had provided models of architectural correctness for their later followers, so Campbell intended that his volumes, illustrating the finest British buildings from ▷Inigo Jones up to, and culminating in, his own Wanstead House (c1714–20; demolished 1824), would in turn provide models of good architectural taste for his and later generations.

Vittoria, Alessandro (1525–1608)

Italian sculptor. He was Venetian, and was born and trained in Trento. In 1543 he moved to Venice and entered the workshop of ▷Jacopo Sansovino. His early work was thus based initially on Sansovino's Tuscan style. However, Vittoria soon discovered the sculpture of ▷Michelangelo and his figures became attenuated and began to display a new interest in such ▷Mannerist devices as the *figura serpentinata* (serpentine figure). Such features were totally opposed to Sansovino's ideals and in 1547 Vittoria and his master separated on bad terms, Vittoria moving to Vicenza. In 1553 ▷Titian and Pietro Aretino, mutual friends of the estranged sculptors, effected a reconciliation and Vittoria returned to Venice and worked for Sansovino, executing for him the ▷caryatids flanking the entrance to the Library of St. Mark's and the stucco decorations on the ceiling of the Scala d'Oro (Golden Staircase) of the Doge's Palace (1555–9). Vittoria established his own workshop in Venice and following Sansovino's death in 1570 became the city's leading sculptor. A number of Venetian churches contain examples of his sculpture, among the best of which is the marble *St. Sebastian* (based on ▷Michelangelo's ▷*Dying Slave*) from the Altar of the Scuola dei Luganegheri in S. Salvatore (c1600). In a notably more realistic style, he was also an accomplished portraitist (e.g. *Bust of Tommaso Rangone*, bronze, c1571, Venice, Ateneo

Veneto) and was highly esteemed as a producer of elegant bronze statuettes (e.g. *Neptune with a Sea-Horse*, c1580–85, London, Victoria and Albert Museum).
Bib.: Cessi, F., *Alessandro Vittoria*, 2 vols., Trento, 1961; Pope-Hennessy, J., *Italian High Renaissance and Baroque Sculpture*, 3rd edn., Oxford, 1985

Vivarini, Antonio (fl c1440; died 1476/84), Bartolomeo (c1432–c1499) and Alvise (c1445–1503/5)

Italian family of painters. They were from Venice. Antonio and Bartolomeo were brothers, and Alvise was Antonio's son. Most of Antonio's work was produced in collaboration, first with his brother-in-law Giovanni d'Alemagna (fl 1441–49/50) and then following Giovanni's death, with his brother Bartolomeo. Antonio and his successive collaborators ran a flourishing workshop, producing elaborate ▷gilded and painted ▷polyptychs, founded in the Venetian ▷Gothic tradition, but also reflecting the new developments in pictorial construction emanating from Tuscany (e.g. Antonio and Giovanni, *Madonna with Four Saints*, 1446, Venice, Scuola Grande della Carità). In 1448, concurrently with ▷Mantegna, Antonio and Giovanni worked in Padua in the Church of the Eremitani. Mantegna clearly influenced Antonio and his later works produced in collaboration with Bartolomeo (who may even have had some training in Padua) reveal attempts to use line more structurally and to define space more rationally. Bartolomeo was more heavily influenced by Mantegna than was Antonio, as his *St. John the Baptist* (1464, Venice, Accademia) attests. The most important influences on Antonio's son, Alvise, were ▷Antonello da Messina and ▷Giovanni Bellini. None of the family could be called innovators, but their best paintings were expertly crafted and in high demand not only in Venice but in all parts of her empire and beyond.
Bib.: Steer, J., *Alvise Vivarini: His Art and Influence*, Cambridge, 1982

Vivin, Louis (1861–1936)

French painter. He worked in a post office from 1881 and he never had any formal training. However, his ▷naive works were discovered by ▷Wilhelm Uhde in 1925, and he exhibited frequently after that. He painted scenes of Paris, as well as hunting and ▷genre subjects.

Vkhutemas

An acronym for *Vysshie Gosudarstvenny Khudozhestvenno-Tekhnicheskie Masterkie*, (the Higher State Artistic and Technical Workshops) established in 1918, combining the pre-Revolutionary Moscow College of Printing, Sculpture and Architecture and the Stroganov School of Fine Art. Its purpose was to develop a clear, coherent teaching programme taking on the experimentation of the ▷avant-garde, with figures

such as ▷Kandinsky, ▷Kuznetsov, ▷Popova and ▷Rodchenko as teachers.

Under the rectorship of Efim Ravdel (1920–23) and Vladimir Favorsky (1923–6), students of all disciplines undertook the same two-year 'Basic Course' in which they learned underlying principles. They then spent another two years within one of the departments of Architecture, Ceramics, Graphics and Typography, Metalwork, Painting, Textiles or Woodwork. In 1926 the workshops were reorganized as Vkhutein (the Higher Artistic-Technical Institute) with Pavel Novitsky as rector. Emphasis shifted to technical skills rather than artistic disciplines, and the Basic Course was reduced in favour of increased specialization.

Vkhutemas was one of the most dynamic crucibles of ▷Constructivism, where different disciplines could be combined and spark each other off into something new. Moreover, its teaching programmes allowed the ideas of the ▷avant-garde to feed into a wider artistic culture, enabling its students (including the architect Berthold Lubetkin) to carry their legacy into the post-war period.

Vlaminck, Maurice de (1876–1958)

French painter, draughtsman and graphic artist. He was born in Paris, although his parents were Flemish musicians. He received no formal education and made a precarious living as a mechanic, a professional cyclist, a writer of pornographic novels, an anarchist journalist and a violinist from 1893, before deciding to concentrate on art. In 1900 he met ▷Derain, and shared a studio with him at Chatou. His first works were violent, dark toned figures and landscapes (e.g. *Man with a Pipe*, 1900, Paris). Through Derain he met ▷Matisse and exhibited with the ▷Fauves in 1905, by which time he was experimenting with the characteristic pure, bright colour of the group (e.g. *Houseboats*, 1906, Paris). Increasingly however, he was interested in new ideas, discovering African art in 1905, the work of ▷Cézanne in 1907 and later that of the ▷Cubists. He was part of the ▷Bateau-Lavoir group based around ▷Picasso and ▷Braque but opposed the intellectualism of the movement, although evidence of geometricization is visible in his work (e.g. *Tower Bridge*, 1911, New York). In 1919 he settled in the country and established his mature style of landscape, less frenetic and vibrant than his pre-war work (e.g. *Fourth of July*, 1923–5, private collection). He experimented with ▷lithography and ▷woodcut and illustrated over 20 books. He also continued to write both novels and, in 1929, his memoirs.
Bib.: Ferrier, J.E., *Fauves: The Reign of Colour*, Paris, 1992

Vlieger, Simon de (c1600–53)

Dutch painter and etcher. He studied with ▷Willem van de Velde the Younger. He worked in Amsterdam,

Delft and Rotterdam and painted both ▷marine and landscape subjects.

Vollard, Ambroise (1865–1939)

French art dealer, publisher and collector. His patronage and encouragement of Parisian artists in the late 19th early 20th centuries may be said to have had profound effects on the history of art. His gallery in rue Lafitte (founded 1893) was host to the first important exhibition of the work of ▷Cézanne (1895), ▷Picasso (1901) and ▷Matisse (1904). He also brought such artists as ▷Pissarro, ▷Renoir, ▷Degas and ▷Rodin to the forefront of the French art scene. He was a shrewd businessman and commissioned artists who worked primarily in different media to illustrate classic books which he published. His entrepreneurial work was extremely important and · he is remembered through a series of portraits painted of him by Picasso, ▷Rouault, Renoir, Cézanne and ▷Bonnard.

Volterra, Daniele da

▷Daniele da Volterra

volute

A spiral ▷scroll, originally used on ▷Ionic column ▷capitals, later incorporated into ▷Corinthian and Composite column capitals; also used on ▷console brackets.

Vorticism

A term invented by the poet Ezra Pound in 1913, suggesting maximum energy and used by a group of English artists and writers inspired by ▷Futurism. The group included ▷Lewis, the self-styled leader, ▷Wadsworth, ▷William Roberts, ▷Nevinson, ▷Epstein and ▷Gaudier-Brzeska. It originated with a disagreement between Lewis and ▷Fry at the ▷Omega Workshops, after which Lewis walked out with Wadsworth and established the Rebel Art Centre. In the same year Nevinson invited ▷Marinetti to London, and his ideas became influential to the group. They retained links with the ▷London Group and exhibited with them at Brighton in 1913–14, but they also held their own exhibition in 1915. The magazine ▷*Blast*, edited by Lewis and containing the group's manifesto and examples of their work was published briefly in 1914. The group collapsed during the First World War when the ▷modernism, violence and mechanization of their art seemed unsympathetic and inappropriate. There was an attempt to revive it in the 1920s, with Group X.

Bib.: Cork, R., *Vorticism and Abstract Art in the First Machine Age*, 2 vols., London, 1976; Wees, C.W., *Vorticism and the English Avant-Garde*, Manchester, 1972

Edward Alexander Wadsworth, *Vorticist Composition*, c1918, Victoria and Albert Museum, London

Vos, Cornelis de (?1584–1651) and Paul de (c1596–1678)

Flemish family of painters. Cornelis specialized in portraiture, and produced a number of portraits of both children and Amsterdam burghers. His style was similar to that of ▷Van Dyck, and he worked with ▷Rubens for a time. His brother Paul was also the brother-in-law of ▷Snyders and, like Snyders, specialized in still lifes with hunting themes.

Vos, Martin de (c1531–1603)

Flemish painter. He studied with ▷Frans Floris and travelled to Rome, Florence and Venice in 1552. In Venice, he worked with ▷Tintoretto. After settling in Antwerp in 1558 he became one of the most important proponents of Venetian ▷Mannerism in Flanders.

Vouet, Simon (1590–1649)

French painter. He studied in Italy (1613–27), during which time he was appointed President of the Academy of St. Luke. He was influenced by ▷Caravaggio, but he tempered the extremes of that artist's work and produced religious and ▷allegorical works in a more muted classical style. In 1627 Louis XIII called him to Paris to accept commissions there.

Bib.: Crelly, W., *The Paintings of Simon Vouet*, New Haven, 1962

voussoirs

In architecture, wedge-shaped masonry blocks or bricks employed in the construction of ▷arches and ▷vaults. The downward converging sides of the

wedge-shaped blocks or bricks are radially aligned to the centre of the springing of the arch or vault.

Voysey, Charles Francis Annesley (1857–1941)

English architect and designer. He was born near Hull. From 1874 he worked in the office of the architect John Pollard Seddon, before establishing his own practice in 1883 (e.g. Royal Hospital, Teignmouth, 1882–4). After showing a cottage design in the magazine *Architect*, he received a number of commissions which established his characteristic simple style of domestic architecture challenging the fussiness of Victorian taste and the historicism of the Queen Anne movement. He specialized in rural, small-scale properties, using local materials, low, heavily ▷buttressed walls, small paned windows and deeply eaved roofs to create a solid, integrated vernacular (e.g. Broadleys, 1899). Internally, he created open-plan, plain rooms, and designed his own wallpapers and fabrics which followed ▷Morris in their use of natural techniques but had an added lightness and simplicity (e.g. *Tulip and Bird* wallpaper, 1896). He also produced a few urban and industrial designs which had modernist lines and used inspiration from Japanese art (e.g. The Studio House, Bedford Park, 1891; Sanderson Wallpaper Factory, 1902–9). He was an ▷Arts and Crafts enthusiast, interested in spreading good design and Master of the Art Workers' Guild from 1924, but also something of a loner. He stood apart from many of the Arts and Crafts organizations and forms a bridge between that movement and ▷Art Nouveau.

Bib.: *C.F.A. Voysey: Decorative Design*, exh. cat., Glasgow, 1993; Durant, S., *C.F.A. Voysey*, London, 1992; Gebhard, D., *C.F.A. Voysey, Architect*, Los Angeles, 1975

Vries, Adriaen de (c1560–1626)

Dutch sculptor. He was a late ▷Mannerist sculptor, born in The Hague, but active almost entirely outside the Netherlands. He trained in Italy under ▷Giambologna and the bronze figures for which he is chiefly known reflect his master's style. He worked principally in central Europe and was instrumental in the dissemination throughout Europe of the Mannerist style. His most notable patron was Emperor Rudolf II, for whom he worked in Prague from 1593. Following the removal of the court to Vienna after Rudolf's death, however, de Vries stayed on in Prague, running a flourishing bronze foundry and workshop, and executing commissions for patrons both abroad and in Prague, notably Albrecht of Wallenstein. Among de Vries' most important commissions were two fountains for Augsburg (the Mercury Fountain of 1598 and the Hercules Fountain of 1602), a Neptune Fountain for Copenhagen (1617–23) and another fountain (along with free-standing bronze statues throughout the garden) for the Wallenstein Palace, Prague (1624–6). During the siege of Prague by the Swedes in 1648 the bronze figures from the Wallenstein fountain were carried off as booty and are now in the Palace of Drottningholm, near Stockholm (casts have replaced the originals at Wallenstein). The same fate befell the figures from the Copenhagen fountain in 1660.

Bib.: Larsson, L.O., *Adriaen de Vries*, Munich, 1967

Vries, Hans Vredeman de (c1527–1606)

Netherlandish painter and architect. He was born in Friesland and travelled and worked in Germany, Belgium, Amsterdam and Prague. He was best known for his decorative architectural illusionism and he also produced pattern books containing imaginary ▷perspective scenes.

Vrubel, Mikhail Aleksandrovich (1856–1910)

Russian painter and designer. He was his country's leading exponent of ▷Symbolism. At the end of his studies at the St. Petersburg Academy (1880–84), he visited Venice and developed a lifelong passion for ▷Byzantine art. His first major commission was the restoration of the Byzantine ▷frescos and ▷icons in the church of St. Cyril and the Cathedral of St. Vladimir in Kiev. In 1889 he moved to Moscow where he managed to secure the patronage of the wealthy industrialist and connoisseur, ▷Savva Mamontov. Mamontov had established an artists' colony at ▷Abramtsevo, his summer estate, and here Vrubel met some of the leading neo-nationalist Russian artists. In the following year he began a series of paintings based on Mikhail Lermontov's poem, *The Demon* (examples at Moscow, Tretyakov Gallery). The earlier works are fairly naturalistic, but in the later paintings, thick ▷impasto begins to break up the image into mosaic-like slabs of rich colour. He was apparently obsessed with the poem's androgynously beautiful central character, doomed never to experience mortal happiness. It has been suggested that the fragmentation of these images reflects not just his absorption with pictorial technique (he himself described it as a 'mania'), but also his own gradual mental breakdown. He was diagnosed as insane in 1902, went blind in 1906, and ended his days in a mental asylum. As well as Abramtsevo, Vrubel was associated with the slightly later ▷Talashkino artists' colony near Smolensk and also with the ▷*Mir Iskusstva* ('World of Art') group.

Bib.: Kaplanova, S.G., *Vrubel*, Leningrad, 1975; Isdebsky-Pritchard, A., *The Art of Mikhail Vrubel*, Ann Arbor, 1982

Vuillard, Édouard (1868–1940)

French painter and lithographer. He was born at Cuiseaux and moved to Paris in 1877, where he attended the ▷Académie Julian under ▷Bouguereau in 1886 and the ▷École des Beaux-Arts under ▷Gérôme. At

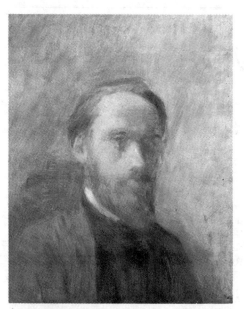

Édouard Vuillard, *Self-portrait*, c1890, private collection

established the ▷Nabis in 1891, producing work in a ▷cloisonnist style with curving ▷Art Nouveau lines and contemporary urban subject matter. Gradually, he evolved his ▷intimist style, of claustrophobic interiors and Parisian scenes (e.g. *Mme Vuillard in Front of the Mirror*, 1900, Birmingham), created by a dense ▷pointillist technique of soft, emotive colours. His interest in two-dimensional pattern obscured the subject of the works (e.g. *Under the Trees*, 1894, Cleveland, Museum of Art). Throughout his career he produced decorative commissions for friends (e.g. *Haystack*, 1907–8, panel for Prince Bibesco, Dijon). In 1899 he published a series of ▷lithographs, *Paysages et Intérieurs*. He travelled widely, first visiting Britain in 1892 and Italy in 1898. He returned to London with Bonnard in 1899 and regularly spent holidays on the Isle of Wight. In 1937 he became a member of the Institute and the following year he decorated the Palais des Nations at Geneva with an *Allegory of Peace*. His later work retained the rich, dark colours and interest in pattern but became less intensely two-dimensional (e.g. *Théodore Duret in his Study*, 1912, Washington).

Julian's he met ▷Denis and ▷Bonnard, with whom he shared a studio in 1891, and he also came under the influence of ▷Sérusier. Together the three friends

Bib.: Easton, E.W., *Intimate Interiors of Édouard Vuillard*, London, 1989; *Édouard Vuillard*, exh. cat., Glasgow 1991; Groom, G., *Édouard Vuillard: Painter and Decorator*, New Haven, 1993; Warnod, J., *Édouard Vuillard*, New York, 1989

Wadsworth, Edward (1889–1949)

English painter. He was born in Cleckheaton, York-shire, the son of a mill owner. After studying in Munich in 1906–7, he attended Bradford School of Art and then, in 1909–12, the ▷Slade, where he met ▷Nevinson. He was briefly a member of the ▷Omega Workshops, but left with ▷Lewis to join the Rebel Art Centre. He travelled widely before 1914. During the First World War he was employed to paint camouflage (e.g. *Dazzle Ships in Dry Dock at Liverpool*, 1919, Ottawa, National Gallery) after having been invalided out of the RNVR. In 1921 he became a member of the ▷NEAC and the ▷London Group. He published a series of drawings – *Black Country* (1920) – and experimented with a flat, stylized use of colour (e.g. *Rue de Caylus, Marseilles*, 1924, Leicester). This developed into his characteristic ▷Surrealist style: images of the sea in combination with isolated mechanical debris (e.g. *Coquillages*, 1926, Manchester, Whitworth Art Gallery). He had an almost ▷Romantic feeling for the sea, emphasized by his preference for ▷tempera over oils. He exhibited with ▷Unit One in 1933 and for a time became interested in ▷abstraction, employing amoebic coloured forms reminiscent of ▷Arp (e.g. *Dux et Comes I*, 1932, London, Tate Gallery). He was employed on the decoration of the Smoking Room of the *Queen Mary* and also produced numerous posters.

Bib.: *Edward Wadsworth: A Genius of Industrial England*, exh. cat., Bradford, 1990; Glazebrook, M., *Edward Wadsworth: Paintings from the 1920s*, London, 1982; Sitwell, O., *Tempera Paintings by Edward Wadsworth*, London, 1926; Wadsworth, B., *Edward Wadsworth: A Painter's Life*, London, 1989

Wagner, Otto (1841–1919)

Austrian architect. He was a pupil of Gottfried Semper at the Vienna Academy and was apprenticed to the architects building the Ringstrasse (the new ring road surrounding the centre of Vienna); this long apprenticeship led to a lingering interest in traditional architectural forms. In 1894, he became Professor of Architecture at Vienna Academy, where his lectures on modern architecture (*Moderne Architektur*), spelt out his belief in new materials, in buildings which represented contemporary society, and in a lack of extraneous ornament. Through his teaching he came into contact with the ▷Art Nouveau ideas of ▷Mackintosh and ▷Henri van de Velde which were inspiring his pupils. These criteria were apparent in his own designs as advisor to the Vienna Transport Commission from 1893 (e.g. Karlsplatz Metro Station in Vienna (1894) with its iron frame and lightweight marble facing slabs), though Wagner still often exploited the decorative potential of buildings: his Majolika House (1898–9) used colour ceramic tiles to give the façade a floral design. His later works like the Steinhof Church (1906, Vienna) had an almost ▷Byzantine richness.

Bib.: Geretsigger, H., *Otto Wagner*, London, 1970; Rossini, R., *Vienna: l'opera di Otto Wagner*, Milan, 1994

Walden, Herwarth

▷Sturm, Der

Waldmüller, Ferdinand Georg (1793–1865)

Austrian painter. He became Professor of Painting at the Vienna Academy in 1829 and was dismissed in 1857 for criticizing his colleagues there. During this period he travelled to Italy and France and painted landscapes in a ▷Biedermeier mode. In 1856 he went to London, where Queen Victoria and Prince Albert purchased some of his work. His paintings are sentimental and appealed to the German bourgeois consumer.

Walker, Dame Ethel (1861–1951)

Scottish painter. She was born in Edinburgh but studied in England at the Putney School of Art and the ▷Slade School (1892–4) where she worked with ▷Sickert and Fred Brown. She painted in an ▷Impressionist style that was similar to that of ▷Steer and the artists of the ▷NEAC. She produced portraits, flowers and seascapes, and later in her career, she settled in Robin Hood's Bay near Whitby and became known for her scenes of the hamlet. She was a member of the ▷London Group and the ▷Seven and Five Society. She was made an ▷ARA in 1940 and became a Dame in 1943.

wall painting

There are two main techniques for wall painting: fresco secco, in which paint is simply applied to a dry plaster wall, and buon fresco, in which the ▷pigment is applied to wet plaster in order to bind it more permanently. Both these techniques have been used for centuries and are eptomized by paintings such as the frescos in the Palazzo Pubblico, Siena. More recently

mural painting has been exercised with ▷acrylics and synthetic paints, often with community or political motives.

wall tomb

Until the early Middle Ages there were two principal types of tombs in churches: the flat tomb slat set into the floor and, less commonly, the ▷sarcophagus. As long as tomb slabs continued to be designed flat they provided no obstruction to pedestrian traffic and could be (and were) walked over. With the development of an interest in the production of the sculptural effigy in more naturalistic, higher relief it became necessary to remove the tomb slab from the floor and set it into a wall or pier of the church.

The earliest wall tombs were probably developed in France in the early 13th century and were taken up in Germany and, even more so, in Italy. A characteristic early French type resembled an altar beneath a ▷retable set within an arched recess. These are known in English as 'altar tombs' and in French as *enfues*. Frequently represented in a ▷lunette above the effigy of the deceased would be the ▷Virgin (as intercessor for the soul of the dead) with the ▷Christ child upon her lap and, to the sides, praying mourners and/or ▷angels. A particularly elaborate example of the German wall tomb is that by ▷Tilman Riemenschneider, the Tomb of Bishop Rudolf von Scherenberg (d 1495; Würzburg Cathedral), with the deceased commemorated as he appeared in life in his episcopal robes, standing within a ▷Gothic canopy. A characteristic Italian example is that by ▷Arnolfo di Cambio, the Monument of Cardinal de Braye (d 1282; Orvieto, S. Domenico). Conforming to the traditional French format, the dead is portrayed lying on a draped bier (inclined forwards for better visibility from below) on top of a two-tiered sarcophagus decorated with ▷Cosmati work, while above him is the enthroned Madonna and Child. Arnolfo's own innovation, and one which endured in Italy into the 15th century, is the pair of attendants drawing a curtain either side of the deceased.

Although other types of monument were erected throughout Italy, the main developments in 15th-century Florence were in wall tombs, with ▷Donatello, ▷Michelozzo, ▷Bernardo and Antonio Rossellino, and ▷Desiderio da Settignano each producing fine examples. Bernardo Rossellino's Tomb of Leonardo Bruni (1444–50, Florence, S. Croce) is generally credited as being seminal in the Italian ▷Renaissance development of the wall tomb in so far as it was the first in which the structure of the traditional format was clarified with a harmoniously-proportioned *all'antica* architectural framework. Its abiding influence may be seen in a 19th-century wall tomb in the same church, that of Countess Zamoyska (1837–44), by Lorenzo Bartolini.

Bib.: Panofsky, E., *Tomb Sculpture*, London, 1964

Wallace Collection

This is a major collection of historical works of art housed at Hertford House, Manchester Square, London. The collection comprises works purchased by four generations of the Hertford family, but the majority of the paintings were acquired by the 4th Marquess of Hertford between 1841 and 1870. Sir Richard Wallace, illegitimate son of the 4th Marquess added to the collection and in 1871 decided to move from his home in Paris to Hertford House, which had been bought by the 2nd Marquess in 1797. He installed the collection, fitting out the interior of the house in an array of red silk and gilding, and it became an extremely fashionable haunt for the late Victorian aristocracy. The collection is most noted for its 18th-century French paintings; including works by ▷Fragonard and ▷Boucher, and 17th-century European ▷Old Masters, like the *Laughing Cavalier* by ▷Hals. Wallace died in 1890. His widow maintained the collection, and bequeathed the major part of it to the nation, as the Wallace Collection, on her death in 1897. She specified that the collection must remain together, and in Hertford House, and that no work could be loaned or sold. This has restricted the number of visitors to the Collection, which has been said to have something of the atmosphere of a shrine. There are, however, new plans to extend the capabilities of the museum, with a new space to be developed in the basement for a resource centre and study area.

Wallis, Alfred (1855–1942)

English artist. He was born in Devonport, the son of a master paver. After sailing as a ship's boy, he settled in Penzance in 1875 and married a woman 21 years his senior. Together they opened a general stores in St. Ives in 1890. He only began to paint after his wife's death in 1922, producing ships and harbour scenes based on his early memories and filtered through a child-like imagination (▷naive art). He ignored the formalities of ▷perspective and worked with a limited palette, dependent on what paints he could find, but paid great attention to details like rigging. He worked on roughly-shaped pieces of cardboard, collected from local shops, as well as on surfaces throughout his house. Another popular subject was St. Ives itself, with local landmarks emphasized and ships given the greatest prominence (e.g. *Houses in St. Ives*, c1930, London, Tate Gallery). He was 'discovered' in 1928 by the ▷St. Ives Group, who were attracted to his naiveté, and he subsequently exhibited at the ▷Seven and Five Society exhibitions. By 1941 his health had declined and he was admitted to the local workhouse where he painted a series of black and white works which seemed to foreshadow his death.

Bib.: *Alfred Wallis*, exh. cat., London, 1968; Berlin, S., *Alfred Wallis, Primitive*, London, 1949

walnut oil

Used in ▷oil painting as a drying ▷medium. It was extremely common in the early days of oil painting, but is seldom used today. The faster drying ▷linseed oil largely superseded it, despite linseed oil having a greater tendency than walnut oil to yellow with age.

Walpole, Horace (1717–97)

English collector and connoisseur. He was the fourth son of the Prime Minister, Sir Robert Walpole, and inherited the title, Earl of Orford, in 1791. He made the ▷Grand Tour in 1739–41, accompanied by the poet, Thomas Gray. He is perhaps best known for his self-designed home at Twickenham, Strawberry Hill (1750–75), which became a repository for his large collection, and was itself a prime example of the popular enthusiasm for the ▷'Gothick'. Despite his interest in archaeological accuracy, Walpole used his imagination to design a building suited to current ▷Rococo and ▷picturesque tastes in its delicacy and which was later heavily criticized by 19th-century ▷Gothic Revivalists. He was also a writer, producing the Gothic fantasy novel, *The Castle of Otranto* in 1764, and printing his own editions of his *Anecdotes of Painting in England* (based on ▷Vertue's *Notebooks*) and a *Catalogue of Engravers in England* (1763), both of which are a valuable source for art historians.
Bib.: Hazen, A.T., *A Bibliography of Horace Walpole*, New Haven, 1948; Honour, H., *Horace Walpole*, London, 1987; Sabor, P. (ed.), *Horace Walpole: A Critical Heritage*, London, 1987; *A Guide to the Life of Horace Walpole*, exh. cat., New Haven, 1973

Wanderers (Itinerants)

The name coined to describe the group of ▷Realist Russian artists, including ▷Ilya Repin and Vasile Vereshchagin, who broke away from the traditional institutions of the Russian art scene in 1870 in order to popularize their naturalistic paintings with a wider audience. They believed their provocative social pictures could reach a larger audience and bring them more commissions if they promoted their work through travelling exhibitions, rather than through official shows in static venues. The group continued into the 20th century, but by this stage had become mainstream.

Wanderjahre

(German, 'years of travelling'.) A northern European artist of the Middle Ages or ▷Renaissance would usually complete his apprenticeship and then travel to work as a journeyman (i.e. paid by the day) in the shops of masters he admired, before returning to submit the work required for him to become a master craftsman in his home ▷guild – that is, his masterpiece. It was by such travels that artistic ideas and styles were disseminated, as can be seen from the experiences of ▷Dürer, who travelled from Nuremberg to Venice in

1494/5, and again in 1505/7. His style changed as a result of both visits, his meeting with ▷Giovanni Bellini during the second being especially fruitful. In architecture, of course, travelling (often abroad) was necessary to find work; see, for example, the work of ▷Villard de Honnecourt.

Wappers, Gustav (1803–74)

Belgian painter. He was in Paris in 1853. He produced ▷history paintings with lavish costumes. His works concentrated on scenes of Belgian history, and they helped fuel a sense of nationalism which in turn enhanced their enormous popularity.

Warburg, Aby (1866–1929)

German art historian. Warburg started an important library in Hamburg which was transferred to England in 1933 and which is now incorporated as an Institute of London University. Warburg studied 15th-century Florentine art but rejected traditional applications of formal categories to this period and took a more psychological approach to each individual work. He believed that religious loyalties, astrological superstitions and indigenous customs penetrated as profound subtexts in painting.
▷Warburg Institute

Warburg Institute

Now located in London, it was founded by ▷Aby Warburg in Hamburg with the help of Fritz Saxl. It originated with Warburg's large library, which he, as a scholar of independent means had built up around his studies on the survival of the ▷Classical tradition. In 1933, four years after Warburg's death, Saxl moved the Institute to London to avoid Nazi persecution. In 1944 it was incorporated into the University of London. It remains a centre for the study of history of the ▷Classical tradition.
Bib.: Gombrich, E.H., *Aby Warburg: An Intellectual Biography*, London, 1986; Gombrich, E.H. (intro.), F. Saxl, A. *Heritage of Images: A Selection of Lectures*, ed. H. Honour and J. Fleming, Harmondsworth, 1970, pp. 9–12

Ward, James (1769–1859)

English painter and engraver. He began his career engraving the works of his brother-in-law ▷George Morland, and he specialized in ▷mezzotint engraving. In 1794 he was appointed Painter and Mezzotint Engraver to the Prince of Wales. He began producing his own work, which was very much in a ▷Romantic vein and included animals battling in landscapes, as well as sublime landscapes scenes such as *Gordale Scar* (1815, London, Tate Gallery). He became an

James Ward, *Joseph Wright of Derby*, 1807, private collection

Andy Warhol, *Self-portrait*, 1967, Saatchi Collection, London

▷RA in 1811. Both ▷Delacroix and ▷Géricault admired his work.

Ward, John Quincy Adams (1830–1910)

American sculptor. He was born in Ohio. He studied with the sculptor Henry Kirke Brown in New York, and he assisted Brown in producing an ▷equestrian statue of George Washington. He produced a number of other equestrian monuments and war memorials, accepting many important public commissions.

Ward, Henrietta Mary Ada (1832–1924)

English artist. She was from an artistic family, and she trained in her own home and in Sass' Academy. She married Edward Ward (no relation) and had eight children whom she used as models in her ▷genre paintings. She received commissions from the royal family, and she began her own art school in 1879. She played an important role in strengthening the profile of women artists in Victorian London.

Bib.: Gerrish Nunn, P., 'The Case-history of a Woman Artist: Henrietta Ward', *Art History*, 1 (1978), pp. 293–308

Warhol, Andy (1930–1987)

American artist and film-maker. He was born in Pittsburgh of Czech immigrant parents. He studied at the Carnegie Institute of Technology from 1954 to 1959, and then worked as an advertising draughtsman in New York. In the early 1960s he started painting canvases inspired by everyday images and popular commercial art – magazine pictures of film stars and advertisements, labels, comic books, etc. – as well as screen-printed images, most famously *Campbell's Soup Can* (1962) and portraits of Marilyn Monroe and Elvis Presley. He was interested in repetition of images and mass-production, calling his studio 'The Factory'. From 1968 to 1972 he devoted himself to ▷avant-garde film-making, with films such as *Kiss*, *Empire* and *Chelsea Girl*. The 1960s pop group 'The Velvet Underground' were a product of The Factory, Warhol designing their first album cover. Interested in pop icons and cult figures, Warhol became a cult figure himself, often dubbed the 'Pope of Pop'.

Bib.: *Andy Warhol: A Retrospective*, exh. cat., New York, 1989

warm colour

A property of colour in which reds, oranges or purples predominate. It gives the colour an effect of advancing forward. It is the opposite of a ▷cool colour.

Washington Colour Painters

A group of artists who rejected the ▷Abstract Expressionism of the 1940s generation in favour of more optical qualities of colour. This group included ▷Morris Louis and ▷Kenneth Noland, and their name came from an exhibition of this title held in the Gallery of Modern Art in Washington DC in 1965. The artists used ▷acrylic paint on ▷unprimed canvases.

watercolour

Painting ▷medium made from very finely ground ▷pigment bound in gum, which is water soluble.

Traditionally applied to a paper support in thin transparent washes from lightest to darkest tones, watercolour is an exacting medium requiring a great degree of skill.

water-glass painting

A form of mural painting in which ▷pigments are mixed with water and then painted onto plaster which is then painted with a water-glass solution made of potassium silicate. This dries quickly and is intended to protect the ▷mural, although it has in fact been proven to contribute to deterioration. It was used commonly in the 19th century.

Waterhouse, John William (1849–1917)

English painter. He was born in Rome, where his father was working as an artist. From 1870 he attended the ▷Royal Academy Schools and exhibited regularly at the RA from 1874. His early style was based on ▷Classical inspiration, heavily influenced by contemporaries like ▷Alma-Tadema (e.g. *St. Eulalia*, 1888, London, Tate Gallery) and he also had a preference for warm exotic scenes which made use of his Mediterranean experiences (e.g. *Unwelcome Companion*, 1873, Burnley), but during the 1880s he developed the dreamy ▷Romanticism for which he is best known. He specialized in images from literature (e.g. *The Lady of Shallot*, 1888, London, Tate Gallery) and mythology (e.g. *Hylas and the Nymphs*, 1896, Manchester, City Art Gallery), portraying them with a ▷Pre-Raphaelite attention to detail, and a rich sensuality in the paint. In his later career he increasingly

John William Waterhouse, *Circe Offering the Cup to Ulysses*, Oldham Art Gallery, Lancashire

portrayed landscape-based subjects and nudes (e.g. *Mermaid*, 1910, London, RA) but avoided any move away from his basic formula.

Bib.: Hobson, A., *John William Waterhouse*, London, 1989; *John William Waterhouse*, exh. cat., Sheffield, 1978

Watteau, Jean Antoine (1684–1721)

French artist. He was one of the leaders of the ▷Rococo movement. He was born in Valenciennes. He trained with ▷Gillot, a theatrical painter in Paris during 1702–8 and earned a living making hack copies, before he apprenticed himself to ▷Audran (1708–9), the Keeper of the Luxembourg Palace, which housed ▷Rubens' *Marie de'Medici* cycle (▷Medici Cycle), one of Watteau's inspirations. Under Audran's influence, he also produced Chinese ▷arabesques for the Château de la Muette (now lost). He gained the patronage of Pierre Crozat, a collector of Flemish and Italian art, and produced the *Four Seasons* decorative cycle for him. Much of his early work was influenced by ▷Wouverman and his ▷genre pieces seem inspired by ▷Teniers. By 1709 he was producing military subjects, having in that year failed to win the ▷Prix de Rome.

Watteau's interest in landscape did not come until later and is usually dated from 1717, when he exhibited the ▷*Embarkation for Cythera* at the Academy, a work which challenged ▷academic assumptions, but was recognized as important and created the ▷*fête galante* style. It was the first of many such works: porcelain-like figures feature in stock poses, against rolling, woodland landscapes, with delicate colour and careless, feathery brushstrokes (e.g. *Fête in the Park*, c1718, London, Wallace Collection). He was a supreme colourist, experimenting with ▷divisionist techniques, yet, throughout his work there was a wistfulness, seemingly at odds with the gaiety of the subject matter, which was most apparent in his theatrical pieces (e.g. *Le Mezzetin*, 1718–20, New York, Metropolitan Museum). His last work, however, was a brisk observation of contemporary town life, ▷*Gersaint's Shop Sign* (*L'Enseigne de Gersaint*), (1720, Berlin, Schloss Charlotenberg) which was, literally, a shop sign. He was a consumptive and, after travelling to England in 1719 in search of a cure, died of the disease.

Bib.: Michel, M., *Watteau: An Artist of the 18th Century*, London, 1984; Parker, K.T., *Antoine Watteau*, 2 vols., London, 1957; Posener, D., *Antoine Watteau*, London, 1984; Vidal, M., *Watteau's Painted Conversations*, New Haven and London, 1992

wattle-and-daub

A method of wall construction, consisting of interlaced slender branches or twigs (wattle), roughly plastered with mud or clay (daub), usually used as a filling between the upright members of timber-framed buildings.

Watts, George Fredrick (1817–1904)

British painter and sculptor. He was born in London. Under the patronage of Lord Holland he attended the ▷Royal Academy schools from 1837, and exhibited his first works the following year. His early works, influenced by ▷Etty, took themes from literature and history. He travelled to Italy in 1843–7, after winning a prize for the decoration of Westminster Hall. There he developed an enthusiasm for the ▷Grand Manner, and a love of Venetian colour which was to remain characteristic (he revisited Venice in 1853). He was a great traditionalist, who tried to revive ▷fresco painting (e.g. Lincoln's Inn, London, 1853–9), and continued to produce ▷allegorical works up to the end of his career. From 1851 he was a permanent house guest with the artist ▷Val Prinsep and his family, an arrangement which brought him into contact with leading artists of the day, including those of the ▷Aesthetic Movement with whom he shared some sympathies. He expressed a belief in 'the exclusive worship of things formally beautiful', and pushed his painting towards the boundaries of abstraction (e.g. Sower of the Systems, 1902–3, Toronto, Art Gallery of Ontario). At the same time he supported the use of art as a moral guardian and during the late 1840s he produced a series of ▷social realist works (e.g. Under a Dry Arch, 1850, Guildford). Although his Classical and allegorical works were most famous in his day (e.g. Hope, 1886, London, Tate Gallery), he was a prolific portraitist, and these works are now most admired (e.g. ▷ William Morris, 1880, London, National Portrait Gallery). He made an unsuccessful marriage to the actress Ellen Terry in 1864 (portrait in London, National Portrait Gallery) and after the divorce in 1877 travelled widely including to Egypt (1886). He was also a successful sculptor from 1866 (e.g. Tennyson, 1898, Lincoln Cathedral) and produced ▷mosaic designs for St. Paul's (St. Matthew and ▷ St. John, 1861). His house at Compton, Guildford is a museum.

Bib.: Blunt, W., George Fredrick Watts, London, 1966; Chesterton, G.K., George Fredrick Watts, London, 1904; George Fredrick Watts, exh. cat., London, 1954; Jenkins, I., 'George Fredrick Watts' Teachers: Watts and the Elgin Marbles', Apollo, 120 (Sept 1984), pp. 176–181; Watts, M.F., George Fredrick Watts, 2 vols., London, 1912

Weber, Max (1881–1961)

American painter. He was born in Bialystok, now part of Poland, and his family emigrated to America in 1891. Weber studied at the Pratt Institute in New York (1898–1900) and in Paris at the ▷Académie Julian (1905–7) and under ▷Matisse. In New York he became part of the ▷Stieglitz circle and exhibited at the ▷291 Gallery in 1910. He also had a one-man show at the Gallery Bernheim-Jeune (1924) and a retrospective at ▷MOMA, New York in 1930.

Weber was one of the first American painters to take on the influence of ▷Fauvism and ▷Cubism, and his early works, such as The Geranium (1911, New York, Whitney Museum of American Art) combine the glowing colours of the one with the fragmented planes of the other. With Chinese Restaurant (1915) he successfully applied the forms of European abstraction to an American subject. After 1917 he returned to a more representational, ▷Expressionist idiom which he later used to illustrate the culture and religious imagery of his Hasidic background in paintings such as Adoration of the Moon (1944).

Bib.: North, P., Max Weber, The Cubist Decade 1910–20, Atlanta, 1991; idem, Max Weber, American Modern, New York, 1982; Rubenstein, D.R., Max Weber: Catalogue Raisonné of the Graphic Work, Chicago, 1980

Weenix, Jan Baptist (1621–before November 1663)

Dutch painter. He was born in Amsterdam and trained with ▷Abraham Bloemaert in Utrecht before visiting Italy in 1642–6. This proved to be a formative influence. For the next few years he painted mostly Italianate landscapes and seaports with picturesque ruins peopled by figures in contemporary dress (e.g. Coast Scene with Classical Ruins, 1649, London, Wallace Collection), in a style similar to ▷Nicolaes Berchem (who may have been his cousin). On his return from Italy he even styled himself 'Giovanni Battista'. His later work consists mostly of portraits and hunting trophy pictures. The latter was a subject hitherto more favoured by aristocratic Flemish patrons and Weenix appears to have been influenced by the work of the Flemish specialist ▷Frans Snyders (e.g. Dead Roebuck, Amsterdam, Rijksmuseum). Weenix's paintings can be seen in Amsterdam, Antwerp, Berlin, Brighton, Dresden, Edinburgh, Glasgow, Hartford Connecticut, London (National Gallery, Kenwood House, Wallace Collection), New York, Paris, Rotterdam, Utrecht and Vienna. His son Jan Weenix (?1642–1719), trained under his father and specialized in paintings of hunting trophies in a style so close to that of his father that it is difficult to tell them apart. He worked initially in Amsterdam and later at Bensberg and Düsseldorf for the Elector Palatine.

Weissenbruch, Hendrik Johannes (1824–1903)

Dutch painter. He studied with ▷Schelfhout. He was a member of the ▷Hague School and painted landscape and ▷marine paintings.

Werefkin, Marianne Vladimirovna von (1860–1938)

Russian painter. She studied with ▷Repin in St. Petersburg, where she met ▷Jawlensky. They moved to Munich together in 1896, and there she became part of the expatriate Russian art community which included ▷Kandinsky. She was a member of the ▷NKV and

exhibited with the ▷Blaue Reiter. Her early style was ▷Symbolist, but she began painting in bright patches of colour after contact with ▷Fauvist work. She painted a number of insightful portraits of her artistic friends. In 1914 she moved to Switzerland.
Bib.: Hahl-Koch, J., *Marianne Werefkin und der russiche Symbolismus*, Munich, 1967

Werenskiold, Erik (1855–1938)
Norwegian painter and graphic artist. He was in Paris in 1881–3 where he saw the work of ▷Bastien-Lepage. He painted portraits and produced a number of book illustrations, particularly focusing on Norwegian fairy tales.

Werff, Adriaen van der (1659–1722)
Dutch painter. He studied with ▷van der Neer, but he was most influenced by the Classical style of the French ▷Académie. He painted mythological and religious subjects, as well as portraits, and he worked both in Rotterdam and in Düsseldorf for the Elector Palatine.

Wesselmann, Tom (b 1931)
American painter. He was from Cincinnati. After a stint in the army, he studied at the Cincinnati Art Academy and at Cooper Union in New York. During the 1970s, he produced a series of ▷assemblages using modern objects such as televisions, and he was a prominent contributor to the ▷Pop art movement. He was also interested in erotic art and produced a series *The Great American Nude*.

West, Benjamin (1738–1820)
American painter. He was born in Springfield, Pennsylvania, to a Quaker family. An early talent for drawing led to classes with William Williams, an English amateur living in the United States, and Gustav Heselius, a Swedish artist. In 1760, West travelled to Europe, and spent three years in Italy before settling in London in 1763. In Rome he met ▷Hamilton and came into contact with ▷Neoclassicism, which he experimented with in works such as *Agrippina with the Ashes of Germanicus* (1767, New Haven, Yale), a picture which brought him to the attention of George III (he became ▷history painter to the king), and the *Departure of Regulus from Rome* (1769, Royal Collection). In 1771 he produced the ground-breaking ▷*Death of Wolfe* (1770, Ottawa, National Gallery of Canada), in which his Neoclassicism was tempered by modern subject matter and modern dress, to create contemporary ▷history painting. This and other similar works brought tremendous popularity and, through the sale of ▷engravings, financial reward. From the 1780s West also began to experiment with an almost ▷Romantic style, incorporating dramatic lighting and fantasy and literary subjects (e.g. *King Lear*, 1788–1906, Boston, Museum of Fine Art). He produced portraits

in a similar style. In 1792, he succeeded ▷Reynolds as President of the ▷RA. He was also employed on the decoration of the state rooms at Windsor.
Bib.: Alberts, R.C., *Benjamin West*, London, 1978; *Benjamin West*, exh. cat., Philadelphia, 1986; von Erffa, H., *Paintings of Benjamin West*, London, 1986; Staley, A., *Benjamin West: American Painter at the English Court*, London, 1989; Uhry Abrams, A., *The Valiant Hero: Benjamin West and Grand-Style History Painting*, London, 1985

Westall, Richard (1765–1836)
English painter and graphic artist. He studied at the ▷Royal Academy schools, and practised ▷genre painting thereafter. He was an important ▷Romantic artist in England, contributing to ▷Boydell's Shakespeare Gallery as well as book illustrations.

Westhoff, Clara (1878–1954)
German sculptor and painter. She was born in Bremen and studied in Munich and in Leipzig with ▷Max Klinger. In 1901 she married the poet Rainer Maria Rilke, and in 1903 they both became associated with the ▷Worpswede artists colony. There Westhoff studied with Fritz Mackenson, and she continued her studies at the ▷Académie Julian in Paris in 1908. In 1911 she lived in Munich and subsequently settled in Fischerhude.
Bib.: Sauer, M., *Die Bildhauerin Clara Rilke-Westhoff: Leben und Werk*, Bremen, 1987

Westmacott, Sir Richard (1775–1856)
English sculptor. He was a leading ▷Neoclassical sculptor, specializing in public monuments in both marble and bronze. He first trained with his father (Richard Westmacott the Elder), before studying in Italy (1793–7) where for a time he was a pupil in ▷Canova's studio. In 1795, he won the Academy of St. Luke's gold medal. Following his return to England, he soon established a flourishing practice, which in time achieved a position second only to that of ▷Francis Chantrey. His first major commission, the Monument to Sir Ralph Abercromby (1803–9) for St. Paul's, was awarded by the Committee of Taste and led to many other commissions in both St. Paul's and Westminster Abbey. Like Chantrey, Westmacott later had his own foundry, a singular advantage which led to many commissions for outdoor public monuments, notably the Equestrian Monument to George III (1822, Liverpool), the *Achilles* to the Duke of Wellington (1822, London, Hyde Park Corner) – significantly both replicas of Classical Roman monuments – and three monuments to Nelson (Barbados, Birmingham and Liverpool). He was elected ▷ARA in 1805, ▷RA in 1811 and was Professor of Sculpture at the Royal Academy from 1827, in succession to ▷Flaxman. He was granted arms in 1829 and knighted in 1837.

Bib.: Busco, M., *Sir Richard Westmacott, Sculptor*, Cambridge, 1994; Penny, N., 'The Sculpture of Sir Richard Westmacott', *Apollo*, 102, no. 162, (August 1975)

westwork

(From the German 'Westwerk'.) It is an architectural term used for ▷Carolingian, ▷Ottonian and ▷Romanesque churches. A westwork is located west of the ▷nave and contains many storeys and often towers.

wet collodion process

A photographic method invented by Frederick Scott Archer in 1851. It involved coating a glass plate with a silver iodide solution which was then developed under a light. In later decades of the 19th century, it was overtaken by more sophisticated technologies.

Weyden, Rogier van der (1399/1400–1464)

Netherlandish painter. He is believed to be identical with the 'Rogelet de la Pasture' who was a pupil of ▷Robert Campin with Jacques Daret in Tournai during 1427–32 ('Rogier van der Weyden' and 'Rogelet de la Pasture' being, respectively, Flemish and French for 'Roger of the Meadow'). None of Campin's work is known. Rogier van der Weyden's work and the only documented altarpiece by Daret, however, bear a stylistic kinship with works ascribed to the so-called ▷Master of Flémalle and this has led scholars to propose that the Master of Flémalle is actually Campin and that this similarity is of the sort that one would expect from pupils and their master in the kind of workshop tradition that prevailed in the 15th-century Netherlands.

Following the completion of his apprenticeship, Rogier moved to Brussels and, at some time before 1436, was appointed Painter to the City. He was by now a wealthy man with an established reputation. None of his works are signed or documented, but ▷van Mander's statement that the *Deposition* (c1435, for the church of Notre-Dame-du-Dehors, Louvain, now in the Prado, Madrid) is his, has been generally accepted and around this work has been assembled the rest of the closely unified *oeuvre*. The *Deposition* exemplifies the elements that made Rogier's style more popular and influential than even ▷Jan van Eyck's in the second half of the century; where van Eyck's art aims for a realism achieved through the dispassionate recording of the objective world, Rogier attempts to evoke a deep emotion expressed through the use of rhythmic line and rich colour.

Some of the most influential men of the time commissioned work from Rogier. In c1446 he was commissioned by Chancellor Rolin to paint a vast *Last Judgement* altarpiece for the chapel of the Hôtel-Dieu, a hospice he had founded at Beaune (still *in situ*). In 1450 he went to Rome and possibly Florence. His *Madonna with Four Saints* (Frankfurt Städelsches Kunstinstitut) may have been painted in Florence for the ▷Medici, as the picture bears the arms of Florence and includes Cosmas and Damian, the Medici patron saints, and SS John the Baptist and Peter, the name saints of Cosimo de' Medici's two sons. Its composition follows the Florentine ▷sacra conversazione type. Also in Florence he painted an *Entombment* (originally in the Medici Collection, now in the Uffizi), which indicates a close study of the work of ▷Fra Angelico.

Some time after Rogier's return to the Netherlands, Peter Bladelin, Duke Philip's controller of finances, commissioned the *Nativity Triptych* (c1452, Berlin-Dahlen, Staatliche Museen) and in c1453, Jean Chevrot, the Bishop of Tournai, commissioned the *Seven Sacraments Altarpiece* (Antwerp). Other important works include the *Braque Triptych* (c1452, Paris, Louvre) and the *St. Colomba Altarpiece* (c1462, Munich, Alte Pinakothek). He was also a fine portraitist (e.g. *Charles the Bold*, Antwerp, Koninklijk Museum voor Schone Kunsten). His most important pupil was ▷Memlinc.

Bib.: Apseren de Boer, J.R.J. van, *Underdrawing in the Paintings of Rogier van der Weyden and the Master of Flémalle*, Zwolle, 1992; Campbell, L., *Van der Weyden*, London, 1979; Davies, M., *Rogier van der Weyden: An Essay with a Critical Catalogue of Paintings Assigned to him and to Robert Campin*, London, 1972; Delenda, O., *Rogier van der Weyden, das Gesamtwerk des Malers*, Stuttgart, 1988

Wheatley, Francis (1747–1801)

English artist. He was born in London, the son of a master tailor. He had little formal training, although he is associated with a number of teachers including ▷Zoffany. He worked in a range of subjects, producing ▷conversation pieces (e.g. *Family Group with Negro Servant*, 1774–5, London, Tate Gallery), landscapes (e.g. *Harvest Waggon*, 1774, Nottingham, Castle Museum), ▷fancy paintings (e.g. *Return from the Market*, 1786, Leeds, Temple Newsham), and even morality pieces, which combined a ▷Hogarthian sense of observation with an added elegance, possibly inspired by his connection with French art through ▷Gravelot. He also produced some ▷history paintings and series of ▷engravings such as *Cries of London* (1795). He enjoyed a close friendship with ▷Boydell, who acted as his publisher from 1783, and produced a number of works for the Shakespeare Gallery. He spent 1779–84 in Dublin to escape his creditors (e.g. *Irish House of Commons*, 1780, Leeds, Lotherton Hall). He was an active member of both the Society of Artists and of the ▷Royal Academy.

Bib.: *Francis Wheatley*, exh. cat., Leeds, 1965; Roberts, W., *Francis Wheatley RA*, London, 1910; Webster, M., *Francis Wheatley*, London, 1970

wheel window

▷window

Whistler, James Abbott McNeill (1834–1903)

American painter. After failing to complete his military training at West Point, he studied as an etcher with a navy cartographer. In 1855, he travelled to Europe, briefly stopping in London, before journeying to Paris where he spent four years. There he studied at ▷Gleyre's Academy, and became friends with a number of influential artists including ▷Fantin-Latour and ▷Courbet. He developed a ▷Realist style, producing ▷etchings based on tours of France and Holland. In 1859 he settled in London, initially employing the same style in pictures of the docks of Wapping and Rotherhide (e.g. *Wapping on Thames*, 1861–4, Washington, DC, National Gallery), but in 1862, under the influence of ▷Rossetti, ▷Aestheticism and the increasing fashion for Japanese art, he painted the *White Girl, Symphony in White Number I* (Washington, National Gallery of Art).

During the 1860s, Whistler experimented further with a series of figure compositions, which showed an awareness of both ▷Degas' and ▷Manet's work, as well as that of his friend ▷Moore. In the following decade he turned to landscapes, and began producing his *Nocturnes*, dreamy evocations of night in the city, which emphasized their poetic aestheticism by the use of musical titles. It was one of these, *Falling Rocket* (1874, Detroit), which led to ▷Ruskin's comments and the infamous libel case of 1877 which divided the art world and bankrupted Whistler. He fled to Venice where he spent a year producing pastels and rediscovering etching and ▷lithography, now abandoning the heavy lines of his realist work for delicate, shimmering sketches.

By the mid-1880s, Whistler had been rediscovered by a new generation of French-influenced artists, such as ▷Sickert, who appreciated Whistler's anti-establishment stance (emphasized by the publication of the *Gentle Art of Making Enemies* in 1890, which set out his often polemically-expressed views). Increasingly, he concentrated on portraiture which brought renewed financial success (e.g. *Harmony in Red Lamplight*, 1884–6, Glasgow, Hunterian Art Gallery). He was also a designer, most notably of the Peacock Room for his patron, Leyland (1876–9, now in Washington).
Bib.: Prideaux, T., *The World of Whistler, 1834–1903*, New York, 1970; Sutton, D., *James McNeil Whistler: Paintings, Etchings, Pastels and Watercolours*, London, 1966; Taylor, H., *James McNeil Whistler*, London, 1978; Young, A.M., McDonald, M.F., and Spencer, R., *The Paintings of James McNeil Whistler*, 2 vols., London, 1980

Whistler, Rex (1905–44)

English painter, graphic artist and stage designer. He studied at the ▷Slade School and in Rome. He produced both murals and book illustrations, many of which suggest the ▷Rococo fantasy of the 18th century. He died in action in the Second World War.

Whistler's Mother

▷*Arrangement in Grey and Black no. I: Portrait of the Artist's Mother*

Whiteford, Kate (b 1952)

Scottish artist. She studied at the Glasgow School of Art and at Glasgow University in the 1970s. In 1977 she was the British Council Rome scholar, and while in Rome, she became interested in ▷Pompeii and Herculaneum. Archaeology and the ancient world always formed an inspiration on her often abstract works. She has been interested in ideas of the archetype and capturing essences.
Bib.: *Kate Whiteford: Rites of Passage*, exh. cat., Glasgow, 1984

White on White

A ▷Suprematist composition by ▷Kasimir Malevich, painted in c1918 (oil on canvas, 80 × 80 cm/2 ft 9 in × 2 ft 9 in). It depicts a white square against a white background and was one of a series of 'white on white' works painted by the artist during 1917–18. These represented the culmination of Malevich's exploration of Surprematist ideas which began with the exhibition of 39 of his abstract works in December 1915. Initially he employed black and red geometric forms, and his work went through a peirod of using complex multi-coloured shapes, before he started to paint solely with white. In all these paintings, however, the common theme of exploring a ▷non-objective world of pure 'sensation' was the guiding theme. For Malevich ▷abstraction represented freedom from the restraints of natural representation, as well as a physical embodiment of his spirituality. The white background signified infinity, through which his shapes could float freely, whilst the square represented both the purest and the least natural form. The works also seemed to exemplify the demands of a new, revolutionary world, freed from tradition, dynamic and the pure. Having produced the white on white series, however, Malevich felt that his abstract art had reached its ultimate state, and his later work followed new directions, including eventually a return to figuration. *White on White* is now in the Museum of Modern Art in New York.

Whitney, Anne (1821–1915)

American sculptor. She was born in Massachusetts, and was mostly self-taught as an artist. In 1867 she went to Rome, where she was impressed by ▷Neoclassical sculpture. She returned to the United States in 1871, setting up a studio in Boston, where she produced both portraiture and ideal sculpture. In 1875 she won a commission to produce a statue of George Washington for the Capitol building in Washington, DC, but the committee withdrew its offer when they discovered

she was a woman. She was an active campaigner for women's rights throughout her life.

Wiener Werkstätte

(German, 'Vienna Workshops'.) A private organization founded by ▷Hoffmann in Vienna in 1903. Its aim was to bring artists together with craftspeople and entrepreneurs to perpetuate new ideas of art in a design context. It was an important disseminator of ▷Art Nouveau and innovative, as well as highly crafted, furniture.

Wiertz, Antoine (1806–65)

Belgian painter. He produced absurdly large ▷history paintings in an attempt to make himself into a modern ▷Michelangelo. He was supported in his endeavours by the Belgian State, which supplied him with a studio.

Wijants, Jan (fl 1643)

Dutch painter. He worked in Haarlem and Amsterdam, where he painted landscapes. He was known for his naturalism, but his landscapes were often unpeopled, or the human figures were painted by other artists.

Wildens, Jan (c1585–1653)

Flemish painter. He was born in Antwerp, where he became Master in 1604. He painted landscapes of his own, but he also contributed to the landscape backgrounds in ▷Rubens' work.

Wiligelmo (fl c1100)

Italian sculptor. We know his name as it was inscribed on the façade of Modena Cathedral. His work was ▷Romanesque, and he made creative use of ▷antique sources.

Wilkie, Sir David (1785–1841)

Scottish painter. He was the son of a Fife minister, educated at the Trustees Academy in Edinburgh and at the ▷Royal Academy schools. After moving to London, his first RA exhibition in 1806 was highly successful and established him as one of the leading painters of ▷genre. Prior to 1825, he specialized in small-scale depictions of village life, reminiscent of Dutch artists like ▷Teniers and ▷Ostade, but without the associated buffoonery (e.g. ▷Pitlessie Fair, 1804, Edinburgh, National Gallery of Scotland). However, Wilkie also aspired to more serious ▷history painting, and works like the *Chelsea Pensioners Reading the Waterloo Despatch* (1822, London, Apsley House) set the tune for much narrative painting of the 19th century. He spent 1825–8 travelling in Spain, and afterwards began to produce more history and portrait painting (e.g. *Empress Josephine and her Fortune Teller*, 1837, Edinburgh, National Gallery of Scotland; *His Highness Muhemed Ali, Pacha of Egypt*, 1841, London, Tate Gallery). He was elected RA in 1811, made

Painter-in-Ordinary to the King in 1830 and was knighted in 1836.

Bib.: Baynes, W., *Sir David Wilkie*, London, 1903; *David Wilkie*, exh. cat., London, 1958; *Tribute to Wilkie*, exh. cat., Edinburgh, 1986; *Sir David Wilkie*, exh. cat., Raleigh, 1985

Wilkins, William (1778–1839)

English architect. He produced ▷Regency designs and wrote books on Greek architecture. His most famous ▷Greek Revival building was the London ▷National Gallery (1832–8).

Bib.: Liscombe, R.W., *William Wilkins 1778–1839*, Cambridge, 1980

Williams, Frederick (1927–82)

Australian painter and graphic artist. He was a pupil at the Melbourne Nnational Gallery School during 1944–9. After that he moved to London, where he worked at the Central School of Arts and Crafts from 1951–6. He returned to Australia in 1957, where he painted landscapes.

Willumsen, Jens Ferdinand (1863–1958)

Danish painter, sculptor, engraver and architect. He was in Paris in 1888 and again in 1890–94. There he saw the work of ▷Gauguin and the ▷Symbolist ▷engravings of ▷Klinger. He was also interest in ▷El Greco. His paintings were often heavily impasted, and he used vibrant colours, reflecting a vitalist interest in nature and natural forces.

Wilson, Richard (1714–82)

British painter. He was born in North Wales and was trained by ▷Wright in London (from 1729) as a portraitist (e.g. *Admiral Thomas Smith*, c1744, Greenwich Maritime Museum). He developed an interest in landscape around 1737. He travelled to Italy in 1752–6, where he became influenced not only by Italian scenery but by Classical landscapists such as ▷Claude (e.g. *Vale of Narni*, 1770–71, private collection). On his return to England he made a reputation producing Claudean-inspired works of the English countryside and depicting the country estates of the gentry and nobility (e.g. *View of Croome Court*, 1758–9, Birmingham). With less success he tried to follow ▷Reynolds' precept for ▷history painting (e.g. *Niobe*, 1760–61, destroyed). He was one of the artists who popularized the Welsh countryside with a series of ▷picturesque, but increasingly bleak views (e.g. *Summit of Cader Idris*, 1770, private collection). He also played an active role in the first years of the ▷Royal Academy. His popularity was not sustained, however, and his later career suffered as a result of alcoholism.

Bib.: Constable, W.G., *Richard Wilson*, London, 1953; *Richard Wilson and the Landscape of Reaction*, exh. cat., London, 1982

Wilson, Scottie (1889–1972)

Scottish painter. He was born in Glasgow. He undertook no training as an artist, but he practised from the 1930s, specializing in non-realistic decorative work. He later travelled and lived in Canada.

Wilton, Joseph (1722–1803)

English sculptor. He studied with ▷Pigalle in Paris and ▷Delvaux in Flanders. From 1747 to 1755 he lived in Italy, and he returned to England with ▷William Chambers. His connections helped him to be appointed Sculptor to King George III in 1764, and he was a founder member of the ▷Royal Academy in 1768. During the 1770s, he was responsible for much of the sculpture for the new venue of the Royal Academy in Somerset House. He became Keeper of the RA in 1790.

Wilton Diptych

Medieval panel painting in the form of a portable altarpiece since 1929 in the National Gallery, London, and formerly at Wilton House, whence it gets its name. The front faces of the two panels represent, on the left, the kneeling King Richard II of England being presented by Saints ▷John the Baptist, Edward the Confessor and Edmund. The objects of Richard's obeisance are in the right-hand panel: the ▷Virgin and Christ child surrounded by angels. On the backs of these panels (i.e. the outside when the ▷diptych is closed for transport) are the emblem of the white hart and Richard II's coat-of-arms.

A painting of the highest quality, the *Wilton Diptych's* exquisite elegance renders it one of the masterpieces of the ▷International Gothic style. Beyond these basic observations, nothing is certain. It is not known by whom it was painted, not from which country the artist came, although the favourite suggestions are France, England, or the Netherlands – and yet there are some stylistic links with Italian art. Nor is it known whether the work was painted for Richard (his coat-of-arms makes this likely, but not certain) or for one of his close circle of followers. It is generally believed to have been painted in the King's lifetime (before 1399) and after his 1396 marriage to Isabelle, daughter of Charles VI of France, as her father's emblem, the broom plant, forms the decoration of Richard's broomcod collar. Alternatively, the broom – *planta genista* – may already have been adopted as a symbol by Richard as a pun on his own surname, Plantagenet. Nevertheless, most scholars favour a date between 1396 and 1399. The problem is that the style of the painting closely matches no surviving work anywhere at that time. Even its meaning is uncertain, although recent conservation work at the National Gallery (1992) has revealed an image of an island with a castle set in a silver-coloured sea, possibly representing England, on the orb at the top of the red-cross banner either being presented to the Virgin by Richard, or vice-versa. It has most plausibly been suggested that the banner is the banner of St. George and that the central meaning of the *Wilton Diptych* relates to Richard II's divine right to rule England.

Bib.: D. Gordon, D., *Making and Meaning: The Wilton Diptych*, London, 1993

Winckelmann, Johann Joachim (1717–68)

German writer. He was a leading theorist of the ▷Neoclassical movement. He came from a poor background (his father was a cobbler), but rose to become a schoolmaster, before travelling to Rome with Cardinal Albani in 1755. He was employed as a librarian but established himself as a scholar with the publication of *Reflections on the Painting and Sculpture of the Greeks* (translated into English in 1765 by ▷Fuseli), a work which inspired artists like ▷Mengs, ▷Hamilton and ▷David and became one of the classics of the period. In it, Winckelmann expressed his belief in the superiority of Greek art, culture and even lifestyle. Despite a knowledge which was largely dependent on Roman copies of Greek work (▷Elgin marbles), he praised the Greeks for their naturalism, their 'noble simplicity and calm grandeur' and their use of the nude. He considered that imitation of such art was the only way forward. His writings also expressed an enthusiasm for Greek learning and rationality, which was seized on by ▷Enlightenment writers, and his espousal of republicanism was to prove influential in both the American (▷Jefferson) and ▷French Revolutions. Winckelmann was murdered in Trieste.

Bib.: Leppmann, W., *Winckelmann*, London, 1971; Potts, A., *Flesh and the Ideal: Winckelmann and the Origins of Art*, New Haven and London, 1994

window

An opening in the external wall of a building for the purpose of admitting light and allowing ventilation. The earliest glazed windows are from Roman times. Windows in Classical architecture are usually rectangular and may be framed by a simple ▷architrave, sometimes crowned with a ▷pediment or even more sumptuously framed within an ▷aedicule. Larger windows are divided into lights by vertical ▷mullions and horizontal transoms. In ▷Gothic buildings the upper part of the window opening may be divided by patterns of ornamental stone-work called ▷tracery. Gothic windows have pointed arches and are usually protected from rain by a projecting moulding called a hood-mould. Types of window include:

(i) Bay window. A window, three-sided to polygonal in plan, projecting from an external wall at ground level and sometimes extending through several storeys.

(ii) Bow window. A bay window which is curved in plan.

(iii) Chicago window. A window which extends the entire width of a bay, with a wide fixed central pane flanked by two narrower panes with sashes that open.

Typical of turn-of-the 20th-century architecture in Chicago, especially that by ▷Louis Sullivan (e.g. the Carson, Pirie & Scott Department Store, 1899–1904).

(iv) *Dormer window.* A window set vertically into a pitched roof and equipped with its own roof. Also called a lucarne.

(v) *Jesse window.* A medieval window decorated with the ▷Tree of Jesse.

(vi) *Lancet window.* A tall narrow pointed-arch window with a single light, found especially in early 13th-century ▷Gothic architecture.

(vii) *Oeil-de-boeuf* or bull's eye window. A small oval window, as in the Salon de l'Oeil de Boeuf at Versailles. Sometimes also circular.

(viii) *Oriel window.* A bay window corbelled out from the external wall of an upper storey.

(ix) *Rose window.* A circular window with tracery radiating from the centre to the cusps at the circumference, creating a pattern like the petals of a rose.

(x) *Wheel window.* An early form of rose window with mullions, shaped like columns with bases and ▷capitals, radiating from the centre like the spokes of a wheel.

Wint, Peter de (1784–1849)

English painter. He was born at Stone, Staffordshire, of Dutch descent. He trained in London, firstly with J.R. Smith, then at the ▷RA Schools, and he knew ▷Dr. Monro's circle. He painted in both oils and ▷watercolours, his work often compared to that of ▷Cox, but in general it is calmer in its handling (e.g. *View of Whitehaven Harbour*, 1830, Newcastle). His colouring owed something to ▷Girtin but retained a greater fluidity. He travelled to Wales (cf. *Caernarvon Castle*, 1829, Cambridge, Fitzwilliam) and France (1828) but concentrated on views of England, especially the flat fields of Lincolnshire. He also painted architectural and still-life subjects. His exhibited oils were precise and smoothly finished. He was highly popular in his day, and much admired as a teacher. **Bib.**: Armstrong, W., *Memoir of Peter de Wint*, London, 1888; *The Drawings of Peter de Wint*, exh. cat., Cambridge, 1979; *Peter de Wint*, exh. cat., Lincoln, 1973

Winterhalter, Franz Xavier (1806–73)

German painter. He was born in Menzenschwand and trained as an ▷engraver in Freiburg, before moving to Munich in 1823. There he worked as a ▷lithographer before enrolling in the Academy. By 1829 he was drawing master to the Grand Duchess of Baden and in receipt of a pension from the duke. He travelled to Italy in 1832 and Paris in 1834, where was employed by Louis Philippe. In 1842 he made the first of a number of visits to Britain, where he regularly stayed at Buckingham Palace and Windsor, painting members of the royal family (e.g. *Victoria and Albert*, 1842, Royal Collection). He made his reputation as a peripatetic painter of society and royalty throughout Europe,

working for Napoleon III, Franz Josef and the Russian nobility. His style developed from a early ▷Romanticism (e.g. *Grand Duchess of Baden*, 1831, Cleveland) into a glossy, richly coloured and flattering technique which hinted at 18th-century ▷Rococo (e.g. *Empress Eugénie and her Ladies in Waiting*, 1853, Compiègne). He developed a speciality in oval-shaped portraits of women. He also painted a number of Classical and ▷fancy pieces. **Bib.**: *Franz Xavier Winterhalter*, exh. cat., London, 1987

Wisdom

▷Prudence

Wit, Jacob de (1695–1754)

Dutch painter. He studied in Antwerp but worked in Amsterdam, especially for Catholic patrons and churches. He was responsible for much church decoration. His style was characterized by a lightness of touch suggestive of the ▷Rococo, and a skill in painting imitations of white marble.

Witte, Emanuel de (c1617–91)

Dutch painter. He produced scenes principally of church and domestic interiors, but also market scenes, mythological subjects and portraits. Born probably in Alkmaar, he enrolled in the Alkmaar Guild of St. Luke in 1636, following an apprenticeship in Delft with ▷Evert van Aelst, a still-life painter. He had returned to Delft by 1641, where in 1642 he enrolled in the Delft guild and married his first wife. By 1652 he had moved to Amsterdam, where in 1655, by now a widower, he married his second wife. Apparently unhappy in his final years owing to domestic problems and his lack of financial success, ▷Houbraken states that de Witte ended his own life.

Today, de Witte is generally considered to be, along with ▷Saenredam, the most important painter of church interiors, his earliest paintings in this specialized branch dating from c1650. The approaches of the two artists are significantly different, however: de Witte's interiors are less austere and monochromatic than Saenredam's, and whereas Saenredam's interiors are generally faithful reproductions of the model, de Witte's, despite their convincing appearance, are frequently composed from various sources (e.g. *Interior of a Church*, 1668, Rotterdam, Museum Boymans-van Benningen). In de Witte's interiors the figures take on a greater importance, are viewed more closely and help break the severity of the architectural lines. Their corporeal presence reinforces the plausibility of the scene. This realistic approach was pioneered in Delft by Gerrit Houckgeest. Yet whereas Houckgeest's pictures are often harsh and linear, de Witte's are softened by a greater sensitivity to colour, a more acute observation of the effects of light and an assured control of spatial relationships.

Bib.: Liedtke, W.A., *Architectural Painting in Delft*, Doornspijk, 1982; Manke, I., *Emanuel de Witte, 1617–92*, Amsterdam, 1963

Wittkower, Rudolf (1901–71)

German art historian. Wittkower's brilliant academic career began in Berlin (he took his doctorate in 1923). He was research fellow at the Biblioteca Hertziana in Rome from 1923 and 1933, on the staff of the ▷Warburg Institute from 1934 to 1956. He was reader and then Durning-Lawrence Professor at the University of London, 1945 to 1956, becoming Chairman of Fine Arts and Archaeology at Columbia University, New York, in 1956, the post from which he retired in 1969. He was Kress Professor at the National Gallery of Art in Washington, DC from 1969 to 1970, Slade Professor at Cambridge 1970–71, and a member of the Institute of Advanced Studies at Princeton. His books include *Gian Lorenzo Bernini* (1955), *Art and Architecture in Italy 1600–1750* (1958), and, with his wife Margot Wittkower, *Born Under Saturn; The Character and Conduct of Artists* (1963).

Witz, Konrad (c1400–44/6)

German painter working in Switzerland. He was a member of the Basle Guild in 1434. His works evinces the naturalism most characteristic of his Flemish contemporary, ▷van Eyck. His most famous work was the Altarpiece of St. Peter for the Cathedral of Geneva, which included an important example of early landscape painting in it *Miraculous Draught of the Fishes* panel (1444).

Wölfflin, Heinrich (1864–1945)

Swiss art historian. He was born in Winterthur, Switzerland. His ▷formalist theories have proved both enduring and popular. He succeeded ▷Burckhardt in the Chair of Art History at Basle in 1893, moving to the Chairs of Art History at Berlin in 1901, Munich 1912 and Zurich in 1924. Wölfflin wrote his first book *Renaissance und Barock* (*Renaissance and Baroque*) when he was 24 and *Die klassische Kunst* (*Classic Art*) in 1899 (translated into English as early as 1903). With these two books he established an art history as the history of ▷styles. This 'art history without names' was most cogently formulated in *Kunstgeschichtliche Grundbegriffe* (1915), translated into English as *Principles of Art History* in 1932. Wölfflin posited the idea of an autonomous art history that is not dependent on any one, or any set, of particular works of art; rather the particular works may stand as examples of the style. As he wrote in *Renaissance and Baroque*: 'It is not the business of the historian of style to give a detailed account of the whole treasury of artistic activity or to treat in detail of the work of individuals.' In practice this meant that he could ascribe to a given period any characteristics he believed significant without being troubled by the facts.

As L.D. Ettlinger has noted in connection with Wölfflin's approach: 'The individual work of art and all its qualities became submerged in something larger. Instead of being apprehended as a result of a concrete task and a personal creative act, it became the expressions of an inescapable super-individual force.' Wölfflin sought the big picture, to account in general terms for artistic development from the ▷Renaissance to the ▷Baroque without descending into detail. To accomplish this he posited in *Principles* a series of visual oppositions between linear and ▷painterly, plane and recession, closed and open form, multiplicity and unity, and clearness and unclearness. An example of this would be the linearity of a nude by ▷Dürer against the painterly approach of ▷Rembrandt; the stylistic opposition would be present even when drawings by the two artists were compared.

Wölfflin's approach is a formalism to the exclusion of other factors that could have direct bearing on the meaning of an art work. ▷Iconography is nowhere discussed in his works, often to the detriment of his argument. While formalists such as ▷Fry and ▷Bell privileged form as the central fact of painting, Wölfflin's formalism was so much a structuring element in his method as to preclude discussion of subject matter, thereby weakening his entire approach. However, Wölfflin's place in art history is secure as he established a new methodological rigour in a discipline that suffered, and continues to suffer, from the indiscreet mixing of history and ▷aesthetics.

Bib.: Hart, J., 'Reinterpreting Wölfflin: Neo-Kantianism and Hermeneutics', *Art Journal*, 42, (1982), pp. 292–300; Ettlinger, L.D., 'Art History Today', inaugural lecture delivered at University College, London, 1961; Wölfflin, H., *Renaissance and Baroque*, Ithaca, 1966; idem., *Principles of Art History: The Problem of the Development of Style in Later Art*, trans. M.D. Hottinger, New York, 1950

Wolgemut, Michael (1434–1519)

German painter and woodcut designer. He worked in Nuremberg and may have spent some time in Flanders in c1450. He inherited ▷Pleydenwurff's woodshop in Nuremberg, and his own workshop was massive and prolific. He produced ▷altarpieces, as well as numerous ▷woodcuts which gradually refined the new technique of ▷wood engraving. He was a teacher of ▷Dürer.

Wols (Alfred Otto Wolfgang Schulze) (1913–51)

German–French painter. He was born in Berlin, raised in Dresden, and studied ethnology and anthropology at the Institute of African Studies in Frankfurt. He went to Paris in 1932 at the suggestion of ▷Moholy-Nagy, under whom he studied at the Berlin ▷Bauhaus. He worked as a photographer, winning recognition at the Exposition Universelle of 1937, with his

photographs influenced by ▷Surrealism and the Bauhaus. Interned in 1939 and freed in 1940, he lived in poverty in the South of France, where, fascinated by the natural world at close hand, he began drawing and painting abstract pictures, enmeshing ▷biomorphic forms in a chaotic tangle of knotted lines. He returned to Paris in 1944, where he became friends with the writer Jean-Paul Sartre and did illustrations for Simone de Beauvoir. His exhibitions at the Galerie René Drouin in 1945 and 1947 attracted the attention of French intellectuals, including Sartre, Paulhan, Ponge and André Malraux, and his work became, in the words of Bernard Tapie, 'the catalyst of a lyrical, explosive, anti-geometrical and unformal non-figuration', from which came ▷Art Autre and ▷Art Informel. Paint is flicked, flung, scratched, scraped and stencilled over the stained canvas, suggesting distant galaxies or microscopic organisms, to produce, in the words of Sartre, 'an art full of nameless things'. He had a retrospective at the Venice ▷Biennale in 1958.
Bib.: Inch, P., *The Life and Work of W. Schulze*, Todmorden, 1978; Petersen, J.H., *Wols, Leben und Werk*, Frankfurt, 1994

Wood, Christopher (1901–30)
English painter. He studied architecture at Liverpool University, and came to London in 1920. In 1921 he travelled to Paris where he trained at the ▷Académie Julian and was friendly with ▷Picasso and Jean Cocteau. His work was in a modified ▷primitivist style. He died prematurely in a train accident.

Wood, Grant (1892–1942)
American painter. He was associated with the ▷Regionalists. Born in Iowa, he learned woodwork and metalwork in Minneapolis and opened his own handicraft store in Cedar Rapids. In 1912 he studied painting at the Art Institute of Chicago and, after the First World War, at the ▷Académie Julian in Paris before returning to Cedar Rapids. Commissioned to produce a series of ▷stained-glass windows, he travelled to Munich in 1928 and was influenced by the Flemish primitive paintings he saw there. In the 1930s he settled in Connecticut, working extensively for the ▷Federal Arts Project and producing murals in Washington DC and at Iowa State College. Wood's paintings use simple, stylized images drawing on folk art to depict the people and landscape of the American heartland. ▷*American Gothic* (1930) has become an archetypal image of the rural American couple, clutching a pitchfork and chewing on a straw with a wooden church in the background. Wood also portrayed scenes from American history, such as George Washington cutting down the cherry tree and Paul Revere's midnight ride. However, the apparent naiveté of these paintings is combined with elements of satire and sophisticated composition to set a 'knowing' distance between the work and its subject, and the deliberately ugly

representation of *Daughters of the Revolution* (1932) turned that satirical edge to open hostility. Some critics have rooted Wood's ambivalence towards national mythologies in his homosexuality, and a sense of himself as an outsider.
Bib.: Corn, W.M., *Grant Wood: The Regionalist Vision*, New Haven, 1983; Dennis, J.M., *Grant Wood, A Study in American Art and Culture*, Columbia, 1987; Jennings, K., *Grant Wood*, New York, 1994

wood carving
The use of wood as a sculptural medium dates back at least 5,000 years and is found in most cultures, saving only those where it is rare or absent as a natural resource. In essence wood is a relatively light, fibrous, organic materials with a characteristic grain. In favourable conditions it is reasonably durable, but it is easily destroyed by fire, damp and infestation. The many species of woods suitable for carving are divided broadly into hard and soft types, hard woods generally having a closer grain and taking a higher polish. Wood is suitable for a wide variety of sculptural uses including free-standing figures, ▷reliefs, and architectural and furniture decoration. Although sculptors in wood have probably always taken a craftsman's delight in bringing out the natural characteristics of the medium – its beautiful grain and ability to take a sharp cut, for example – it has often been coated with ▷stucco and painted and gilded or otherwise covered so that the inherent qualities of the medium are concealed. Such was the practice in ancient Egypt from at least the 3rd millennium BC. In China wooden figures have been lacquered since at least the Chou dynasty (c1027–256 BC) and in the ▷Pre-Columbian Andean area of South America figures were not only coloured, but were fitted with human hair and clothed in feathered cloaks. In ▷Archaic Greece, votive figures were often of wood, but the more important pieces were made of marble or stone.

Wood has always been important in Christian art for statue groups and ▷crucifixes, a principal function attraction of wood being its lightness and therefore its portability, a major consideration for objects intended for processional purposes. Invariably such sculpture was ▷polychrome. Some of the finest wooden sculpture, much of it limewood, was produced in ▷Renaissance Germany (a heavily-forested country), with major figures such as ▷Tilman Riemenschneider (the first German sculptor to leave the wood unpainted) and ▷Veit Stoss specialising in the medium. England also had a strong tradition of wood-carving, the most important exponent of the art being ▷Grinling Gibbons whose most delicate architectural decoration was also in limewood. In the 20th century there has been a considerable revival of interest in wood for high art sculpture, starting with ▷Gauguin (who sought to regain the 'primitive' power and directness he recognised in ▷Polynesian carvings) and the German

▷Expressionists, especially ▷Ernst Barlach and ▷Erich Heckel. Both ▷Archipenko and ▷Henry Moore have also done much to re-establish woods as a major sculptural medium.

Bib.: Baxandall, M., *The Limewood Sculptors of Renaissance Germany*, New Haven and London, 1980; Penny, N., *The Materials of Sculpture*, New Haven and London, 1993

woodcut

A ▷relief print made from a block of medium-soft wood, such as pear or alder, sawn along the grain. The design is first drawn out on the smooth block and the surface around the design areas cut away. Thus the design stands proud of the rest of the block. The block is then inked. Once transferred, by pressing onto a sheet of paper, the reliefs register as solid colour and the cut away areas as white. By a combination of two or more blocks, multi-coloured prints can be achieved – the most sophisticated examples of coloured woodcuts being produced in Japan. The technique is thought to have been invented in the Middle East in about the 5th century AD but was not used in the West until the late 14th or early 15th century, initially for playing cards and block-books. By the mid-15th century, it was being used by fine artists, its most brilliant exponent being ▷Albrecht Dürer. Having been gradually superseded in the 16th century by ▷line engraving, it was revived in the 19th century and later, in the early 20th century, was employed for its expressive potential, and because it was considered a German medium, by the German ▷Expressionists.

wood engraving

A technique of printmaking, using boxwood sawn into a slab across the grain, so that the surface will be smooth and grainless. Very fine lines can then be made into this surface with an engraving tool called a graver or ▷burin. The slab is then inked but, unlike metal ▷engraving in which the ink is forced into the grooves while the surface is wiped clean, in wood engraving the surface retains the ink while the grooves remain clear of ink to read as white lines: thus, despite an apparent similarity, metal engraving is an intaglio process, whereas wood engraving is a relief process. The first and greatest master of wood engraving was ▷Thomas Bewick.

Bib.: Chamberlain, W., *The Thames and Hudson Manual of Wood Engraving*, London, 1978

Woolner, Thomas (1825–92)

English sculptor. He studied at the ▷RA schools in 1842 and met ▷Rossetti in 1847. He became a member of the ▷Pre-Raphaelite circle, but he abandoned his association with them to travel to Australia in 1852. There he took on commissions for portraits busts and ideal works. In 1854 he returned to England and continued to practise as a portrait sculptor,

producing such works as a bust of Tennyson (1857, Library of Trinity College, Cambridge).

Wootton, John (c1682–1764)

English painter. He was born in Warwickshire and received training from a number of artists including ▷Lambert and ▷Siberechts. Little is known about his early career, but he possibly visited Rome and certainly developed an enthusiasm for Italianate landscape. He was a friend of ▷William Kent, and with him illustrated an edition of Gay's *Fables*. He had a number of influential patrons including the Prince of Wales (e.g. *George I at Newmarket*, 1717, New Haven, Yale) and was a founder member of the ▷Royal Academy. He became famous for his horse pictures but was increasingly interested in panoramic landscapes, often incorporating Classical backgrounds into his work (e.g. *Members of the Beaufort Hunt*, 1744, London, Tate Gallery). His early works have vibrancy and variety but in his later career he became repetitive and heavy-handed.

Bib.: Meyer, A., *John Wootton: Landscape and Sporting Art in Early Georgian England*, London, 1984

workshop

Term used for an artist's place of work, especially prior to the High ▷Renaissance, after which time it is more usually referred to as a studio ('workshop' having artisan connotations, which image the Renaissance did much to dispel). In ▷connoisseurship, the term is used to indicate an art work that has been made in the workshop of a master and under his supervision, sometimes with his signature, but with the master taking no personal part in the execution.

Works Progress Administration

▷Federal Arts Project

World of Art

▷*Mir Iskusstva*

Worpswede

A small village near Bremen which became an artists' colony in the 1890s. The artists who congregated there included Fritz Mackensen (1866–1956), ▷Otto Modersohn, Heinrich Vogeler (1872–1942) and, most famously, ▷Paula Modersohn-Becker. Unlike many similar German colonies, these artists rented cottages in Worpswede and remained there for most of the year, rather than merely visiting occasionally. They painted primarily scenes of peasants and landscapes of the surrounding moors, but Modersohn-Becker's adoption of French ▷modernist tendencies in her art brought a new dimension to their otherwise conventional work. They exhibited together for the first time in 1895 at the Munich Glaspalast.

Worringer, Wilhelm (1881–1965)

German writer. His book *Abstraction and Empathy* (1908) was crucially important to the development of German ▷modernist aesthetics and especially ▷abstraction. He saw pure form as an important indicator of cultural conditions and abstraction as resulting from the emotional tension that existed in 'primitive' societies. To Worringer, the return to abstraction in modern Germany was an indicator of a regressive culture. He also wrote *Form in Gothic* which helped stimulate an interest in Gothic form among German modern artists.

Wotruba, Fritz (1907–75)

Austrian sculptor. He was born and studied in Vienna. In 1938 he was in Switzerland, but in 1945 he returned to Vienna where he became Professor of the Academy there. He specialized in stone carving, and his figure sculptures were plain, often rough and verging on abstract.

Wouters, Rik (1882–1916)

Belgian painter and sculptor. His early painting shows the influence of the ▷Fauves, but he later saw the work of ▷Cézanne, which was an additional influence on his art. He studied at the Académie des Beaux-Arts in Brussels. From 1907 to 1914 he produced mostly ▷bronze sculpture. He fought in the First World War and died after an operation for cancer.

Wouwerman (Wouwermans), Philips (1619–68)

Dutch painter. He specialized in landscapes, generally set in hilly country, with horses, riders, hunts, battles and military encampments. Born in Haarlem, he is said to have trained under ▷Hals, (though apart from his fluid brushwork there is no resemblance) and Pieter Verbeeck, an ▷equestrian painter. However, his work owes a closer debt to the rustic landscapes of Bamboccio (▷Pieter van Laer, *bambocciata*). He enrolled in the Haarlem Guild of St. Luke in 1640. Some of Wouwerman's pictures are filled with literally hundreds of small figures and, in fact, he also worked as a figure specialist, painting the ▷staffage for other painters such as ▷Ruisdael and ▷Wynants. A prolific and very successful painter, his popularity was sustained through the 18th century where his subject matter made him popular with royal and aristocratic collectors. Despite his formulaic compositions (dunes standing picturesquely against the sky, a white horse forming a bright accent), his pictures are, at their best, characterized by elegantly handled, fluid brushwork, and a cool palette combined in subtle harmonies. The biggest collections of his works are in Dresden, London (Royal Collection, National Gallery and Dulwich), Paris, St. Petersburg and Vienna. His brothers Jan (1629–66) and Pieter (1623–82) were also landscape painters, Pieter imitating Philips and confusingly signing his work with the monogram 'PW'.

Bib.: Duparc, F.J., 'Philips Wouwerman 1619–68', *Oud Holland*, 107 no. 3 (1993), pp. 257–86

WPA (Works Progress Administration)

▷Federal Arts Project

Wrath (Anger)

(From the Latin, '*Ira*'.) One of the Seven Deadly Sins, usually seen only in cycles of ▷Virtues and Vices or in depictions of Hell's torments, seldom as a separate image. In the conflicts between the Virtues and Vices, Wrath is defeated by ▷Temperance. Wrath may be male or female. As a male he is usually a soldier or a brigand armed with a dagger or sword, murderously attacking an innocent victim (in medieval art often a monk). ▷Bosch, in the *Ira* scene from his *Tabletop of the Seven Deadly Sins* (Madrid, Prado) shows two men brawling outside a tavern, one armed with a sword, the other with a dagger and stool – excessive drinking leading to wrathful behaviour. In his cycle of *Virtues and Vices* in the ▷Arena Chapel, Padua (c1305–6), ▷Giotti portrayed Wrath as an enraged woman tearing at her clothes (and sited opposite her virtuous counterpart, ▷Temperance); in a clear parallel, in the same chapel, ▷Giotti shows Caiaphas, in the scene of ▷Christ before Caiaphas, tearing at his own clothes in his uncontrollable rage at Christ's words.

Wren, Sir Christopher (1632–1723)

English architect. The greatest of English architects, he was first an eminent scientist. He did not turn to architecture until the 1660s, and then only at first as a brilliant amateur. Before he was 30 he had held the Chairs of Astronomy, first at Gresham College, London, then at Oxford. He was a founder member of the Royal Society in 1660 and its president in 1680. His first known involvement with architecture came with his appointment in 1663 to the commission for the restoration of ▷St. Paul's. His earliest buildings are Pembroke College Chapel, Cambridge (1663, commissioned by his uncle, Bishop Matthew Wren), the first completely ▷Classical Chapel in either Cambridge or Oxford, and the Sheldonian Theatre, Oxford (1663–9) which incorporates, in the interior, an ingenious solution to the problem of spanning large interior space without visible supports. The exterior, however, reveals Wren's lack of architectural experience in the uncertainty of formal relationships. His complete conversion to architecture as a profession followed his trip to Paris in 1664–5, where he studied the local architecture and met ▷Bernini and, more importantly, the French architects ▷Mansart and ▷Le Vau. He perhaps also visited Holland at this time, as it is French and Dutch, not Italian, influences that are paramount in his work.

Wren's great opportunity came in the wake of the

Portrait of Sir Christopher Wren, c1680, private collection

1666 ▷Fire of London. By 1669 he had been created Surveyor-General of the King's Works and in 1673 he resigned his professorship at Oxford and received a knighthood. He was now responsible for building 51 new City churches (mostly built between 1670–86), plus ▷St. Paul's Cathedral (1675–1710). His opinion regarding the church interior was pragmatic: 'All should hear the service, and both see and hear the preacher'. Most of the church sites were cramped and, furthermore, time and financial resources precluded lavish exteriors, so it is in the steeples, the most visible part of each church, that originality and distinctiveness is concentrated (e.g. St. Bride, Fleet Street, with its steeple of four superimposed diminishing octagonal *tempietti*; St. Vedast, Foster Lane, seemingly inspired by ▷Borromini's St. Philip Neri in Rome; and St. Dunstan-in-the-East, which is pure neo-▷Gothic). Wren's masterpiece, however, is St. Paul's. The result is a compromise between Wren's desire for a ▷Greek cross plan and the clergy's demand for a more traditional ▷Latin cross type. His most ▷Baroque building, the most admired feature, both constructionally and formally, is the majestic ▷dome. His other important surviving buildings are Greenwich Hospital (1696–1716); Trinity College Library, Cambridge (1676–84); and Tom Tower, Christ Church, Oxford (1681–2). His most important pupil was ▷Hawksmoor.

Bib.: Amery, C., *Wren's London*, Luton, 1988; Beard, G., *The Work of Christopher Wren*, Edinburgh, 1982; Downes, K., *The Architecture of Wren*, London, 1982 and *Sir Christopher Wren: The Design of St. Paul's Cathedral*, London, 1988

Wright, Frank Lloyd (1869–1959)

American architect. Generally considered to be the greatest North American architect of the 20th century. He first worked for a short while with John Lyman Silsbee, who introduced him to the ▷Shingle Style; more importantly during 1888–93, he worked with ▷Louis Sullivan, for whose domestic architecture he was mainly responsible. His influences also included ▷Ruskin and in 1894 he was one of the founders of the Chicago ▷Arts and Crafts Society. His first independent architecture was a revolutionary and highly influential domestic type, the ▷Prairie House, characterized by low-pitched roofs with wide overhanging eaves, open-plan rooms and exterior detailing of emphatic horizontality. Mostly built for the outer suburbs of Chicago and essentially deriving from the American farmhouse tradition, they are designed to merge with the surrounding 'landscape'. The earliest is the Winslow House (1893–4) and the culminating example, the Robie House (1908).

During this period Wright also designed one office building, the greatly admired Larkin Building, Buffalo, New York (1904–5; demolished 1950), and a church, the Unity Temple, Oak Park, Illinois (1905–6), this latter with its ▷Cubist forms influencing the Dutch ▷De Stijl group. Larger commissions from this time include the Chicago open-air restaurant and pleasure grounds, Midway Gardens (1913, demolished 1929 during the prohibition). Wright's interest in Japanese architecture, originally inspired by seeing the Japanese Pavilion at the 1893 World's Columbian Exposition in Chicago was first revealed in his Imperial Hotel, Tokyo (1916–20, with Antonin Raymond, demolished 1967–8), which was specially designed to resist earthquakes. The houses he built during the 1920s are characterized by his use of pre-cast, textured concrete blocks and, in contrast to his earlier Prairie Houses are massive, dominating and differentiated from their setting, and grouped around an inner courtyard (e.g. the Millard House, Pasadena, California, 1921–3).

Wright's work was highly individual and only once, with his International Style Kaufmann House, Pennsylvania (1937–9), did he produce a building in line with contemporary developments in Europe. Called Falling Water, the house is dramatically cantilevered out over a stream at the point where it drops in a small waterfall. Always interested in teaching, he established a training centre at Taliesin, Wisconsin, in 1911 (rebuilt after fires in 1914 and 1925) and later a winter camp at Taliesin West, Arizona (1937). From the 1930s onwards larger commissions were offered to him fairly regularly, the first being the Johnson Wax Factory, Racine, Winconsin (1936–9, laboratory tower added 1944–50). Other important works include the chapel of Florida Southern College (1940), the Unitarian Church, Madison (1947), the design for the Guggenheim Museum, New York (1942–6, 1956–60) and the Price Tower, Barlesville, Oklahoma (1953–6).

Bib.: Gutheim, F. (ed.), *Frank Lloyd Wright on Architecture: Selected Writings 1894–1940*, New York, 1941; Gutheim, F. (ed.), *In the Cause of Architecture: Essays by Frank Lloyd Wright for the Architectural Review 1908–1952*, New York, 1975; Twombly, R.C., *Frank Lloyd Wright. His Life and Architecture*, New York, 1979; Secrest, G., *Frank Lloyd Wright*, Los Angeles, 1992; Storrer, W.A., *The Architecture of Frank Lloyd Wright. A Complete Catalogue*, Cambridge, MA, and London, 1974

Wright, John Michael (1617–94)

English painter. He studied with ▷George Jameson in Edinburgh, and he travelled to Rome. There he became a member of the Academy of St. Luke. From 1656 he worked mostly for English Catholic patrons, and he became Painter to Charles II. He painted a number of portraits, but he also did ▷allegorical works, including the ceiling of Charles II's Whitehall Palace Bedroom. In 1686–7 he was back in Rome.

Wright, Joseph (of Derby) (1734–97)

English painter. He was born in Derby and remained there for much of his career. During the 1750s (1751–3 and 1756–7) he studied with ▷Hudson in London, before returning to the Midlands to establish himself as a portraitist. He represented local society, including the self-made men of the first wave of the ▷Industrial Revolution, with a down-to-earth observation (e.g. *Sir Richard Arkwright*, 1789–90, private collection).

During the 1760s Wright began to produce works exploring the possibilities of candlelight and moonlight, possibly influenced by 17th-century painting (e.g. *Academy by Moonlight*, 1769, Royal College of Surgeons). This interest was combined with an enthusiasm for scientific and industrial subject matter, fostered by Wright's membership of the Lunar Society, an ▷Enlightenment group in Derby. Works like ▷*An Experiment with a Bird in an Air Pump* (1768, London, National Gallery) illustrate the power and the wonder of science, whilst giving the experiment a theatrical and dramatic quality. A similar approach characterized his landscapes of the period (e.g. *Cottage on Fire*, 1787–8, Brighton), which combine an interest in observed detail (often of industrial scenes) with a ▷sublime awe for the natural world. This was emphasized by Wright's trip to Italy in 1774–5 (e.g. *Fireworks at the Castel Sant'Angelo*, 1775–8, Liverpool, Walker Art Gallery) where he witnessed the eruption of Vesuvius. He lived briefly in Liverpool (1768–71) and in Bath (1775), where his style was too forthright for fashionable tastes. As his interest in landscape increased he made tours to the Lakes (1793–4) (e.g. *Rydal Waterfall*, 1795, Derby). **Bib.**: Hope, A., *Joseph Wright of Derby: A Bibliography*, Derby, 1967; *Joseph Wright of Derby*, exh. cat. Matlock, 1964; *Joseph Wright of Derby*, exh. cat., London, 1950; Nicholson, B., *Joseph Wright of Derby: Painter of Light*, London, 1968; *Wright of Derby*, exh. cat., London, 1990

Wtewael (Wttewael, Uytewael), Joachim Antonisz. (1566–1638)

Dutch painter. He was a ▷Mannerist painter of mythological and biblical subjects, portraits and kitchen scenes. Born in Utrecht, he trained under his father, a glass painter, and then Joos de Beer, before spending four years (c1588–92) in Italy (Padua) and France (St. Malo). He returned to Utrecht and remained there for the rest of his life, painting in a late Mannerist style derived from ▷Spranger, the ▷Bassani and the ▷School of Fontainebleau. His work is characterized by metallic colours and elegantly attenuated figures in deliberately exaggerated poses. Even after the fashion for Mannerism had been overtaken by the trend towards naturalism in about 1610, he continued to paint Mannerist pictures until the end of his working life, oblivious to the developments around him. The most representative collection of his work is to be found in the Centraal Museum, Utrecht (includes a self-portrait of 1601). **Bib.**: Lowenthal, A.W., *Joachim Wtewael and Dutch Mannerism*, Doorsnpijk, 1986

Wunderkammer

 ▷cabinet of curiosities

Wyatt, James (1746–1813)

British architect. He was the most successful British architect of his day, rivalling ▷Robert Adam. An eclectic artist, he is best known for his neo-▷Gothic buildings, although the building that established his reputation was the Pantheon in Oxford Street (completed in 1772, now demolished) which derived from the Pantheon in Rome and Hagia Sophia in Constantinople. The son of a Staffordshire builder, he had studied in Italy from 1762 to c1768, gaining the Pantheon commission soon after his return. His rise to fame, despite his reputation for unreliability and bad manners, was remarkable: he was elected ▷ARA in the year of the Pantheon's completion, ▷RA in 1785 and President of the Royal Academy (temporarily) in 1805. In 1796 he was appointed Surveyor-General and Comptroller of the Office of Works in succession to ▷William Chambers.

Wyatt's more important work in the Classical style includes Heaton House, Greater Manchester (c1772), and the library of Oriel College, Oxford (1788). His best known neo-Gothic works were the fantastical Fonthill Abbey, Wiltshire (1796–1812, now destroyed) and Ashridge, Hertfordshire (1808–13). The ▷picturesque asymmetry of his Gothic houses set the pattern for Gothic country houses for the rest of the 19th century. His knowledge of medieval Gothic architecture was gleaned from his extensive restoration

work on some of the main cathedrals in England: Lichfield, Salisbury, Durham and Hereford, and also at Westminster Abbey. So ruthless was the restoration he carried out on these buildings that he earned for himself the nickname, 'Wyatt the Destroyer'. His brother Samuel Wyatt (1737–1807) was also an architect (e.g. the Classical-style Doddington Hall, Cheshire, 1777–98) and his son, Matthew Cotes Wyatt (1777–1862), was a sculptor (e.g. Equestrian Statue of George III, Cockspur Street, London, 1836).

Bib.: Robinson, J.M., *The Wyatts: An Architectural Dynasty*, London, 1979

Wyeth, Andrew (b 1917)

American painter. He was from Pennsylvania. He painted mostly ▷watercolours and ▷tempera works that were distinctly non-modernist. His works are slightly lonely and haunting scenes of remote mid-Western locations. He was thus connected with American ▷Regionalism.

xylography
A synonym for ▷wood engraving.

Y

yamato-e

A school of ▷Japanese scroll painting (*e-makimono*). It originated in ▷Chinese T'ang dynasty painting and included landscape, ▷genre and narrative subjects (*monogatari-e*). It flourished from the 11th to the 14th century. The scrolls, about 30 cm high and often in excess of 10 m in length, are unrolled in sections from right to left, thereby unfolding a narrative often painted in a lively and engaging manner, as in *The History of Mount Shini* (Fugiwara period, AD 897–1185).

Bib.: Swann, P., *Art of China, Korea and Japan*, rev. edn., London, 1967

Yáñez (Yáñez de la Almedina), Fernando (fl 1506–26)

Spanish painter. He was in Valencia in 1506, where he painted 12 panels of the *Life of the Virgin* for the Cathedral ▷altarpiece (1507–10). He worked in collaboration with Fernando de los Llanos in a style drawn from the innovations of the Italian High ▷Renaissance.

Yeats, Jack Butler (1871–1957)

Irish painter. He was born in Sligo, the son of John Butler Yeats (1839–1922), a barrister and portrait painter, who took the family to London in 1887. He attended South Kensington and Chiswick Art Schools before spending two years at Westminster under Fred Brown. He travelled widely in Europe (1888–9) and exhibited works in the 1912 ▷Salon des Indépendants and 1913 ▷Armory Show in New York. His early works were watercolours using a linear style which he also employed in illustrations (e.g. for John Millington Synge's *Arran Hills*, 1907), but from 1919 he began to concentrate on oils, experimenting with a heavy ▷palette knife application. An original enthusiasm for ▷Impressionism developed into an ▷Expressionist use of vivid colour and loose, vibrant brushwork. He had settled in Ireland in 1910 and his subject-matter, like that of his poet brother, William Butler Yeats, was concerned with Irish and Celtic myth, and with everyday life in Ireland, expressing a sense of nationalism which was popular at the time (e.g. *Back from the Races*, 1925, London, Tate Gallery; *Last Handful of Water*, 1945, London, Tate). He also wrote books on art (e.g. *Aspects of Modern Irish Art*, 1922), novels and plays.

Bib.: *Jack Butler Yeats*, exh. cat., London, 1991; Rose, M.G., *Jack Butler Yeats: Painter and Poet*, Berne, 1972; Rosenthal, T.G., *Jack Butler Yeats*, London, 1966

James Sinton Sleator, *Portrait of Jack B. Yeats*, 1943, Crawford Municipal Art Gallery, Cork

Yellow Book, The

One of the numerous magazines which sprung up in the 1890s encapsulating the ▷Art Nouveau design and ▷*fin-de-siècle* decadence of the period. It was established in 1894 with ▷Beardsley as art editor and appeared in quarterly editions until 1897, published by Mathews and Lane. The appearance and the title suggested something more than a magazine: it was in a yellow hard cover, a style taken from contemporary French novels. The first edition contained a ▷Beerbohm piece on cosmetics, a ▷Sickert portrait of Beardsley, a Henry James story and drawings by ▷Leighton. Beardsley's connection with the publication ended in 1895 when his friendship with Oscar Wilde during the Wilde scandal threatened the *Yellow Book*, but it became notorious nonetheless and gave rise to the phrase 'Yellow Nineties'.

Bib.: Houfe, S., *Fin de Siècle: Illustrators of the Nineties*, London, 1992

Yoruba

▷African art

Ysenbrandt (Isenbrandt), Adriaen (d 1551)

Flemish painter. He was active in Bruges from 1510, when he became a Master in the local painter's ▷ guild. No works are signed by him, nor do any known documents link his name to specific works, but an early source described him as a pupil of ▷ Gerard David. In 1902 Georges Hulin de Loo, a Belgian art historian, proposed Ysenbrandt as the author of two bodies of works: the first formed around a divided diptych, *The Virgin of the Seven Sorrows* (Bruges, Notre Dame, and Brussels), formerly designated as by the anonymous follower of David, the 'Master of the Seven Sorrows of the Virgin'; and the second, a body of David-influenced works formerly assigned by the German art historian, ▷ Gustave Waagen, to ▷ Jan Mostaert. De Loo's reascription is accepted only with circumspection, to the extent that the name Ysenbrandt is sometimes used in connection with these works in inverted commas (e.g. for *The Magdalen in a Landscape*, London, National Gallery).

Z

Zadkine, Ossip (1890–1967)
Russian sculptor. He was born in Smolensk, Russia. He moved to England in 1905 to learn English but changed his mind and studied art, moving to London in 1906, where he attended the Regent Street Polytechnic and Central School of Art. In 1909 he moved to Paris and studied briefly (six months) at the ▷École des Beaux-Arts. He remained in Paris, met ▷Apollinaire, ▷Brancusi, ▷Archipenko, ▷Lipchitz and ▷Picasso and was influenced by a mixture of ▷Romanesque art, ▷African sculpture and the work of the ▷Cubists. He served in the First World War but was invalided out in 1915 after being gassed. He had his first one-man exhibition in Brussels in 1919. For the duration of the Second World War, he lived in New York, returning to Paris in 1945. In the postwar years he taught sculpture and obtained several important public commissions. In 1950 he was awarded the main sculpture prize at the Venice ▷Biennale. His earlier sculptures are usually in wood and stone, although from 1925 he began to model in clay for casting in bronze. His work is essentially representational and his chief interest is in dramatic expression achieved through figural distortion – the most significant criticism of his work is that the expression is occasionally exaggerated to the point of melodrama. Nevertheless, his most successful commission, a memorial commemorating the wartime destruction of Rotterdam, merited an extremely dramatic interpretation and he rose to the occasion with his monumental bronze figure *The Destroyed City* (1951–3).
Bib.: Lecombre, S., *Ossip Zadkine: L'oeuvre sculpté*, Paris, 1994; Marchal, G.-L., *Ossip Zadkine: la sculpture, toute une vie*, Rodez, 1992

Zais, Giuseppe (1709–84)
Italian painter. He worked in Venice producing decorative painting in a ▷Rococo style. His work was similar to that of ▷Marco Ricci and ▷Zuccarelli.

Zambaco, Maria Terpithea (1843–1914)
Greek painter and sculptor. She was born in London and in 1861 married a fellow Greek in Paris, although she deserted him soon after. She had a torrid affair with ▷Burne-Jones, with whom she collaborated in the 1860s. Her own work has a similar ▷allegorical and stylistic quality to his. After breaking with Burne-Jones, she returned to England in the 1880s, and by the 1890s she had transferred her attention to sculpture and ▷medals. At this time, she worked with ▷Legros.
Bib.: Attwood, P., 'Maria Zambaco: Femme Fatale of the Pre-Raphaelites', *Apollo*, 293 (1986), pp. 31–7

Zeitgeist
The 'spirit of the age', which according to ▷Hegel, ensures a similar complexion in all the activities of a period, from art and science to literature and music.
Bib.: Fertig, L., *Zeitgeist und Erziehungskunst: Eine Einführung in die Kulturgeschichte der Erziehung in Deutschland von 1800 bis 1900*, Darmstadt, 1984

Zero Group
A group of German artists who gathered in Düsseldorf in 1957. They included Heinz Mack (b 1931) and Otto Piene (b 1928). They published a magazine called *Zero* in 1958 and 1961, and they advocated the use of colour and light in their kinetic sculpture. The group dissolved in 1966.

Zeus
▷Jupiter

Zeuxis
One of the most famous ancient Greek painters, who worked in the late 5th century BC. He is best remembered in Classical literature for his famous statue of Helen of Troy, which was devised using the model of perfect body parts from a variety of beautiful women.

Zick, Januarius (1730–97)
German painter. He studied in Munich and Paris and went to Rome in 1757, where he came into contact with ▷Mengs. Like him, he was an advocate of ▷Neoclassicism, and he returned to Germany in 1758 to produce ▷altarpieces and decorative art.

ziggurat
A Mesopotamian temple-tower, rising in as many as seven stages, each ascending stage diminishing in area and usually in height, all stages connected by outside staircases or an encircling ramp, the whole surmounted by a temple. Ziggurats were built of mud-brick, sometimes faced with burnt mud-brick; the crowning temple was faced with blue-enamelled brick (the temple containing the image of the god and therefore being a representation of heaven). The earliest ziggurats date from the end of the 3rd millennium BC and were erected by the Sumerians to a square plan, their

successors, the ▷Assyrians, building to a rectangular plan. The best preserved example is at Ur, but the most famous (although only the foundations survive) is the 'Tower of Babel' at Babylon.

Zille, Heinrich (1858–1929)

German etcher and lithographer. He ▷etched and ▷engraved scenes of working-class life in Berlin, and was a committed Socialist. He inspired a series of realist 'street' films during the 1920s and 1930s which were known as 'Zille films'. They presented working-class characters in dingy or brutally realistic settings and were an important contribution to mass culture during the Weimar Republic.

Zoffany, Johann (1734/5–1810)

German painter who worked in England. He was born in Frankfurt am Main, the son of a cabinet-maker. After studying under Martin Speer at Ratisbon, he travelled widely in Europe, visiting Rome in 1750, where he met ▷Mengs and ▷Piranesi. He settled in England in about 1758. Here he first made a living decorating clock faces, before being employed as a scene painter at Drury Lane by David Garrick, who also commissioned the artist's first ▷conversation pieces. His theatrical portraits gained him popularity and royal patronage (e.g. *Queen Charlotte and her Two Elder Sons*, 1766, Royal Collection). His group portraits displayed the observation of ▷Hogarth but employed a more exuberant sense of colour and ▷Rococo delicacy (e.g. *Life School at the Royal Academy*, 1771, Royal Collection). He also produced grand-scale portraits (e.g. *Grand Duke of Tuscany and Family*, 1776, Vienna, Kunsthistorisches Museum), and attempted to compete with the modern history painting of ▷West and others (e.g. *Death of Captain Cook*, 1789–97, Greenwich, National Maritime Museum). In 1770 he travelled to Italy, commissioned by Queen Charlotte to paint the *Cognoscenti in the Tribuna of the Uffizi* (Royal Collection). A slump in his fortunes led him to visit India in 1783–9 (e.g. *▷Last Supper*, 1788, St. Johns, Calcutta). He ceased to paint in 1800. He was elected RA in 1769 and was a baron of the Holy Roman Empire.
Bib.: *Johann Zoffany*, exh. cat., London, 1977

Zola, Émile (1840–1902)

French Realistic novelist in the tradition of Honoré Balzac, and pioneering social reformer, famous for his intervention in the Dreyfus case in 1898. He was just as robust a champion of contemporary ▷avant-garde art; see, for example, *Mes Haines (My Hates)* (which contains his famous dictum that a work of art is 'a corner of creation seen through a temperament'), *Mon Salon* (1866) and *Edouard Manet* (1967).
Bib.: Brookner, A., *The Genius of the Future. Studies in French Art Criticism: Diderot, Stendhal, Baudelaire, Zola, the Brothers Goncourt, Huysmans*, London, 1971

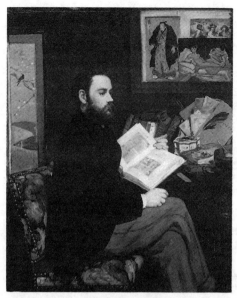

Edouard Manet, *Émile Zola*, Musée D'Orsay, Paris

Zoppo, Marco (1433–78)

Italian painter. He was from Bologna, but worked in Padua, where he was apprenticed to ▷Francesco Squarcione, and in Venice. His later work shows the influence of ▷Cosimo Tura and the School of ▷Ferrara.

Zorach, Marguerite Thompson (1887–1968)

American painter and embroiderer. She was born in California. She studied in Paris (1908–11), where she was part of the circle that included ▷Picasso and Gertrude Stein. She exhibited works in a ▷Fauve style. She travelled back to the United States in 1912 and married ▷William Zorach. She travelled extensively in India and Palestine, and painted landscapes which showed the influence of these other cultures. From 1912, she began adopting ▷modernist styles, including ▷Cubism, in her ▷embroidery and ▷batik work, and she produced a number of Cubist 'tapestry paintings'.
Bib.: Tarbell, R., *Marguerite Zorach, the Early years 1908–20*, Washington DC, 1973

Zorach, William (1887–1966)

American sculptor and painter of Lithuanian birth. He came to the United States in 1891 and settled in Ohio. He studied at the Cleveland Institute of Art (1902–5), and went to New York to continue his training at the ▷National Academy of Design (1908–10). He also travelled to Paris in c1910, where he was impressed by the work of the ▷Fauves, and began painting scenes of mothers and children in a Fauvist style. He also met and married ▷Marguerite Zorach there. From c1922

onwards, he transferred his attention to sculpture. He was a proponent of ▷direct carving, and he was particularly interested in non-European sculptural forms, particularly those of ▷African and ancient ▷Persian cultures.

Zorn, Anders (1860–1920)

Swedish painter and etcher. He studied at the Stockholm Academy but left it in 1881 and travelled to London, Paris and Spain. His early work was painted primarily in ▷watercolours, and it showed an ▷Impressionist influence. In 1888 he began producing oil paintings. He was best known for his paintings of female nudes, but he also produced portraits and peasant ▷genre scenes. In 1896 he settled in Mora in Sweden.
Bib.: Brown, E., *The Prints of Anders Zorn*, exh. cat., Lawrence, Kansas, 1979

Zuccarelli, Francesco (1702–88)

Italian painter. He was from Florence. He specialized in decorative pastoral landscapes populated with picturesque peasant figures, sometimes with a mythological theme, in a style influenced by ▷Marco Ricci. Although he studied in Rome, he was principally in Venice and London. In Venice in 1751 he met and exchanged pictures with ▷Richard Wilson. He was in London in 1752–62 and again in 1765–71. His landscapes appealed greatly to English collectors (more than the more serious work of Wilson). He was patronized by George III (many examples of his work are at Windsor Castle), and he became a founder member of the ▷Royal Academy in 1768. On his return to Venice he was elected President of the Venetian Academy, though this appears to have been an honorary title, as he did not become involved with the Academy in any way.

Zuccaro (Zuccari, Zuccheri), Taddeo (1529–66) and Federico (c1540–1609)

Italian family of painters. Taddeo and Federico were brothers, born near Urbino and active mainly in Rome. Taddeo was one of the leading exponents of late ▷Mannerism, initially influenced by the more elaborate work of ▷Salviati and ▷Tibaldi, although his religious work, under the influence of the ▷Counter-Reformation's demand for clearer narrative, moved towards a somewhat dry, Classicising style deriving from ▷Michelangelo and ▷Raphael (e.g. the altarpiece of the *Conversion of St. Paul* in the Frangipane Chapel of S. Marcello al Corso, Rome). His most prestigious commissions were the Sala Regia frescos in the Vatican and the Farnese histories in the family's villa at Caprarola (1561–6), both completed following his early death by his brother Federico. Working in a similar reforming style, Federico went on to become one of the most influential and celebrated painters of his time, working in France, the Netherlands and

England where he is supposed to have painted portraits of Queen Elizabeth and her court (many dubious attributions are to be found, but only two drawings, one of Elizabeth, the other of Robert Dudley, Earl of Leicester, in London, British Museum, are generally accepted). Back in Italy he worked in Florence and Venice in addition to Rome and in 1593 was a founder member of the Accademia di S. Luca, which used his house as headquarters. A keen believe in the efficacy of art theory for the production of good painting, he wrote a systematic and comprehensive treatise, *L'idea de' pittori, scultori, et architetti*, (*The Idea of Painting, Sculpture and Architecture*) published in 1607.
Bib.: Gere, J.A., *Taddeo Zuccaro: His Development Studied in his Drawings*, Chicago, 1969; Mulcahy, R., 'Frederico Zuccaro and Philip II', *Burlington Magazine*, 129 (Aug 1987), pp.502–9

Zuloaga y Zabaleta, Ignacio (1870–1945)

Spanish painter. He studied in Paris, where he knew ▷Rodin and ▷Gauguin. He was also influenced by ▷Goya and ▷Velázquez, whose works he saw in Toledo. He painted resolutely Spanish subjects, such as bullfights, set in bright sunshine. He had an important reputation outside Spain through a number of international exhibitions.

Zurbarán, Francisco (1598–1664) and Juan de (1620–49)

Spanish family of painters. Francisco was born at Fuente de Cantos in southern Spain and was apprenticed in 1614 to an obscure Sevillian painter of devotional images. In 1617 he moved to Llerena, near his birthplace, returning to Seville in 1629 when the City Council appointed him town painter. His work at Llerena is unknown, but he had calculatedly made himself known by obtaining a commission in 1626 for a series of paintings at rock-bottom prices for the Dominican monastery of San Pablo in the city. His *Christ on the Cross* (1627, now Madrid, Prado), intended for the ▷sacristy, established his reputation and was cited by the councillor who recommended his appointment to the city.

In 1634, at the request of Philip IV Zubarán visited Madrid to paint a large historical painting, *The Defence of Cadiz*, to hang with ▷Velázquez's *Surrender of Breda* and ▷Maino's *Recovery of the Bay of S. Salvador*. Also for Philip he painted a series of ten canvases of *The Labours of Hercules*. By 1635 he had returned to Seville where he remained until 1658. His first decade there was his most productive, painting the pictures by which he is chiefly known – austere images of single saints in deep meditation, ideally pitched for the more severe religious orders for which they were painted. The *St. Francis* now in London (National Gallery) is a typical example, with the saint kneeling, clutching a skull to himself, eyes closed and ardently praying; the mood of intense mystical contemplation is evoked by the

monumental simplicity of the figure brilliantly illuminated against a dark background from which all distracting irrelevant details have been excised. In such paintings he perfectly fulfilled the requirement of the ▷Counter-Reformation Church that religious art should be clear, direct and emotionally involving. So successful was he during this period that his large workshop also supplied images for the churches and monasteries in the Spanish territories of the New World, although much of this work appears to be principally by the workshop. In the middle 1640s his leading position was usurped by the younger ▷Murillo. Zurbarán reacted by attempting to alter his style to suit the taste Murillo had created for lighter, sweeter devotional images, but in so doing he lost much of his force. Ultimately, in 1658, he moved to Madrid where he remained for the rest of his life.

Francisco's son, Juan de Zurbarán, was a ▷still-life painter of considerable accomplishment (a rare example, dated 1640, is in Kiev) whose promising career was abruptly terminated by his premature death from plague.

Bib.: Baticle, J., *Zurbarán*, New York, 1987; Brown, J., *Francisco de Zurbarán*, New York, 1991; Caturla, M., *Francisco de Zurbarán*, Paris, 1994; Gállego, J. and Gudiol, J., *Zurbarán, 1598–1664*, London, 1977; Soria, M.S., *The Paintings of Zurbarán: Complete Edition*, London, 1953

PICTURE CREDITS & ACKNOWLEDGEMENTS